Grove Encyclopedias of the
Arts of the Americas

*Encyclopedia of American Art
before 1914*

Grove Encyclopedias of the
Arts of the Americas

Encyclopedia of
AMERICAN ART
before 1914

Edited by
JANE TURNER

Grove Encyclopedias of the Arts of the Americas
Encyclopedia of American Art before 1914
Edited by Jane Turner

Published in the United Kingdom by
 MACMILLAN REFERENCE LIMITED, 2000
25 Eccleston Place, London, SW1W 9NF, UK
Basingstoke and Oxford
ISBN: 0–333–76095–6
Associated companies throughout the world
http://www.macmillan-reference.co.uk

British Library Cataloguing in Publication Data
Encyclopedia of American art before 1914
 1. Art, Modern—United States—Encyclopedias
 2. Art, American—Encyclopedias
 I. Turner, Jane, 1956—
709.7'3'03
ISBN 0-333-76095-6

Published in the United States and Canada by
 GROVE'S DICTIONARIES, INC
345 Park Avenue South, New York, NY 10010-1707, USA
ISBN: 1–884446–03–5
http://www.grovereference.com

Library of Congress Cataloging-in-Publication Data

Encyclopedia of American art before 1914 / editor, Jane Turner
 p. cm – (Grove library of world art)
Includes bibliographical references and index.
ISBN 1–884446–03–5 (alk. paper)
 1. Art, American Encyclopedias.
 2. Art, Modern–18th century–United States Encyclopedias.
 3. Art, Modern–19th century–United States Encyclopedias.
 I. Turner, Jane Shoaf. II. Series
N6507 .E53 1999
709'.73'03–dc21
 99–41596
 CIP

Typeset in the UK by William Clowes, Beccles, Suffolk
Printed and bound in the UK by Bath Press Ltd, Bath

Jacket illustration: Alvan Fisher: *Niagara Falls*, oil on canvas, 872x1220 mm, 1820 (Washington, DC,
National Museum of American Art/Phto: art Resource, New York)

Contents

Preface

With the publication of this volume, we inaugurate the Grove Library of World Art, an exciting new publishing programme devoted to specialist topics, offering the award-winning scholarship of the 34-volume *Dictionary of Art* (London and New York, 1996) in more accessible and affordable one- to three-volume encyclopedias.

The Grove Library of World Art will initially be organized in six separate series:

> *Grove Encyclopedias of Ancient Art*
> *Grove Encyclopedias of Asian Art*
> *Grove Encyclopedias of African Art*
> *Grove Encyclopedias of Australasian Art*
> *Grove Encyclopedias of European Art*
> *Grove Encyclopedias of the Arts of the Americas*

The *Encyclopedia of American Art before 1914* is the first title in the last series, the *Encyclopedias of the Arts of the Americas*. The second volume in this series, the *Encyclopedia of Latin American and Caribbean Art*, is also scheduled to appear this year. There are plans to follow these two volumes in due course with the *Encyclopedia of American Art since 1914*, the *Encyclopedia of American Indian Art*, the *Encyclopedia of Pre-Columbian Art* and the *Encyclopedia of Canadian Art*.

For each of these spin-off volumes, we have gone back to the original specialist authors and invited them to update their entries. In some cases, the entries have been substantially rewritten by their contributors to reflect recent research and new interpretations. In addition, our own in-house editorial staff has checked each heading for new bibliographical items, using the following bibliographical databases: the *Bibliography of the History of Art*, published by the J. Paul Getty Trust, and *Art Abstracts*, published online by the H.W. Wilson Co.

Readers will also find completely new entries, for instance 30 biographies of 19th- and early 20th-century Californian artists, since it was felt that artists from the West Coast had been unfairly neglected in the original coverage of American art in *The Dictionary of Art*. The number of illustrations has also been greatly increased, with the addition of some 200 new black-and-white illustrations and nearly 100 colour illustrations.

The present alphabetically arranged volume covers all the major artistic developments in the United States of America from the Colonial period until 1914, with the start of World War I. The entries chart the evolution of the artistic traditions of the emerging American nation, from pioneering artists, such as John White, who recorded the native flora, fauna and peoples of the early Virginia and North Carolina settlements, to the pivotal 1913 Armory Show. Among the 500 biographies of artists are such well-known figures as John Singleton Copley, Benjamin West, Thomas Cole and Paul Revere.

However, like *The Dictionary of Art*, the coverage is not limited to artists' biographies. In order to accommodate the wide range of topics of interest to modern students and historians of American art, the *Encyclopedia of American Art before 1914* also offers entries on American patrons, collectors and writers (e.g. Henry David Thoreau), as well as articles on styles,

building types (e.g. skyscraper), cities with substantial artistic traditions, and a comprehensive survey of all the fine and decorative art forms in America from the late 17th century to the early 20th. A map at the beginning of the USA survey shows which sites and cities have individual entries in the encyclopedia.

Jane Turner
London, 1999

Introduction

I. Alphabetization and identical headings. II. Article headings and structures. III. Standard usages. IV. Cross-references. V. Locations of works of art. VI. Illustrations. VII. Bibliographies and other sources. VIII. Authors. IX. Appendices. X. Index.

I. Alphabetization and identical headings.

All main headings in this encyclopedia are distinguished by bold typeface. Headings of more than one word are alphabetized letter by letter as if continuous, up to the first true mark of punctuation, and again thereafter: the comma in **Greene, John Holden** therefore breaks the alphabetization, and his biography precedes the article on **Greene & Greene**. Parenthesized letters or words and square-bracketed matter are also ignored in alphabetization: for example, the article **Gilbert, Cass** precedes that on **Gilbert, C(harles) P(ierrepont) H(enry)**, which would come after **Gilbert, Christopher**. The abbreviation of 'Saint' (e.g. **St Louis**) is alphabetized as if spelt out in full. The prefixes Mc and Mac where occurring as the first two or three letters of a name are alphabetized under Mac:

> **McArthur, John**
> **McComb, John**
> **McEntree, Jarvis**
> **McIlworth, Thomas**
> **McKim, Mead & White**
> **MacMonnies, Frederick William**
> **Maginnis, Charles D(onagh)**

Numerals, except roman numeral epithets of generation, are alphabetized as if spelt out (**291** comes between **Twachtman, John H.** and **Union Porcelain Works**). Anonymous masters are alphabetized under the common name that precedes such generic titles as 'Limner', 'Master' or 'Painter' (e.g. **Pierpont Limner**).

II. Article headings and structures.

1. BIOGRAPHICAL. All biographies in this encyclopedia start with the subject's name and, where known, the places and dates of birth and death and a statement of nationality and occupation. In the citation of a name in a heading, the use of parentheses indicates parts of the name that are not commonly used, while square brackets enclose variant names or spellings:

> **Jones, Charles (Thomas)**: full name Charles Thomas Jones, referred to as Charles Jones
> **Jones, C(harles) T(homas)**: full name Charles Thomas Jones, referred to as C. T. Jones

> **Smith** [Smythe]**, Betty** [Elizabeth]: usually referred to as Betty Smith but sometimes in the form of Betty Smythe, Elizabeth Smith or Elizabeth Smythe
>
> **Smith, Betty** [Smythe, Elizabeth]: Betty Smith's name has the alternative version of Elizabeth Smythe only
>
> **Smith** [née Johnson]**, Betty**: Smith is Betty Johnson's married name, by which she is generally known
>
> **Jones, Charles** [Brown, William]: William Brown is known chiefly by his pseudonym of Charles Jones
>
> **Brown, William** [pseud. Jones, Charles]: William Brown is referred to as such and is also known by the pseudonym of Charles Jones

Statements of places and dates of birth and death are given with as much precision as the evidence allows and may be replaced or supplemented by dates of baptism (*bapt*) or burial (*bur*). Where information is conjectural, a question mark is placed directly before the statement that it qualifies. Where dates of birth and death are unrecorded but there is documentary evidence for the subject's activity between certain fixed dates, *floruit* (*fl*) dates are given; when such evidence is circumstantial, as for instance in the case of an anonymous master, this is cited as '*fl c.*'.

If the subject changed nationality or country of activity, this is stated where significant, as may also be the subject's ancestry; otherwise this information is evident from the parenthesized matter after the heading or is conveyed in the text. The subject's nationality is followed by a definition of occupation, that is to say the activity (or activities) of art-historical significance that justified inclusion in the encyclopedia; for non-artists, the subject's profession is also stated (e.g. 'American banker and collector').

Biographies are generally structured to present information in chronological order. Longer biographies usually begin with a brief statement of the subject's significance and are then divided into sections, under such headings as 1. Life and work. 2. Working methods and techniques. 3. Character and personality. 4. Critical reception and posthumous reputation; within sections there may be further divisions to aid the reader in finding specific information. The biographies of two or more related artists or patrons and collectors are gathered in 'family' entries, alphabetized under the main form of the surname. Within a family article, individual members of significance have their own entries, beginning with an indented, numbered bold heading; for the second and subsequent members of the family, a statement of relationship to a previous member of the family is included wherever possible. Members of the same family with identical names are usually distinguished by the use of parenthesized small roman numerals after their names:

> **Gallier.** American family of architects of Irish origin.
>
> (1) **James Gallier (i)** (b. . .; d . . .).
>
> (2) **James Gallier (ii)** (b . . .; d . . .). Son of (1) James Gallier (i).

The numbers allocated to family members are used in cross-references from other articles: 'He commissioned the architect James Gallier (ii) (see GALLIER, (2)) . . .;'

2. NON-BIOGRAPHICAL. As with biographies, the headings of all non-biographical articles provide variant spellings, transliterations etc in square brackets, where relevant, followed by a definition. Longer articles are divided as appropriate for the topic and are provided with contents lists after the heading, introductory paragraph or each new major subheading. In all articles the hierarchy of subdivisions, from largest to smallest, is indicated by large roman numerals (I), arabic numerals (1), small roman numerals (i) and letters (a). A cross-reference within a long survey to another of its sections takes the form '*see* §I, 2(iii)(b) above'. The extensive survey of the arts of the **United States of America** includes a detailed table of contents of all sections and subsections.

III. *Standard usages.*

For the sake of consistent presentation in this encyclopedia, certain standard usages, particularly in spelling and terminology, have been imposed throughout. In general, the rules of British orthography and punctuation have been applied, except that wherever possible original sources are followed for quoted matter and for specific names and titles. Many of the conventions adopted in this encyclopedia will become evident through use, for example the general abbreviations (which are listed at the back of this volume); some of the other editorial practices are explained below.

1. WORKS OF ART. Titles of works of art are generally cited in italics and by their English names, unless universally known by a foreign title. Some subjects, religious and mythological in particular, have been given standard titles throughout. The use of 'left' and 'right' in describing a work of art corresponds to the spectator's left and right. For locations of works of art *see* §V below.

2. FOREIGN TERMS AND TRANSLITERATION SYSTEMS. For citations of foreign-language material, a basic reading knowledge of art-historical terms in French, German, Italian and Spanish has been assumed (although wherever there is an exact English equivalent of a foreign term this has been used). Foreign words that have gained currency in English are cited in roman type, whereas those that have not are italicized and are qualified with a brief definition, unless this is clear from the context. The conventions of capitalization in foreign languages are generally adhered to within italicized matter (e.g. book titles) but not in running, roman text for job titles (e.g. Peintre du Roi), for names of institutions, professional bodies and associations and for recurring exhibitions. Abbreviations for foreign periodical titles cited in bibliographies (see §VII below) are capitalized, despite the relevant foreign-language conventions.

3. DATES. We have attempted, wherever possible, to provide biographical dates in parentheses in running text at the first mention of all art-historically significant individuals who do not have their own entries in the encyclopedia. (For the citation of conjectural dates of birth and death *see* §II, 1 above.) Where no dates are provided, the reader may assume that there is a biography of that individual in the encyclopedia (or that the person is so obscure that dates are not readily available). The use of a question mark, for example in the date of a work of art, queries an indistinct digit(s), as in 188(?7), or an illegible one, as in 188(?).

4. MEASUREMENTS AND DIMENSIONS. All measurements are cited in metric, unless within quoted matter or if the archaic form is of particular historical interest. Where two dimensions are cited, height precedes width; for three dimensions, the order is height by width by depth. If only one dimension is given, it is qualified by the appropriate abbreviation for height, width, length, diameter etc.

IV. *Cross-references.*

This encyclopedia has been compiled in the spirit of creating an integrated and interactive whole, so that readers may gain the widest perspective on the issues in which they are interested. The cross-referencing system has been designed and implemented to guide the reader easily to the information required, as well as to complementary discussions of related material, and in some cases even to alternative views. External cross-references (i.e. those to a different heading) take several forms, all of which are distinguished by the use of small capital letters, with a large capital to indicate the initial letter of the entry to which the reader is directed. External cross-references appear exactly as the bold headings (excluding parenthesized matter) of the entries to which they refer, though in running text they are not inverted (e.g.

'He collaborated on the project with BERTRAM GOODHUE. . .'). The phrases 'see', 'see under' and 'see also' are always italicized when referring to another entry or another section of a multipartite article in the encyclopedia; where the word 'see' appears in roman type, the reference is to an illustration within the article or to another publication.

Cross-references are used sparingly between articles to guide readers to further discussions or to articles they may not have considered consulting; thus within a phrase such as 'He was influenced by Thomas Cole' there is not a cross-reference to THOMAS COLE (though the reader can assume that there is a biography of Cole, since there are no dates after his name), whereas 'By the early 1840s, several HUDSON RIVER SCHOOL artists, including FREDERIC EDWIN CHURCH, had been inspired by Cole's example to take up landscape painting (*see* UNITED STATES OF AMERICA, fig. 13)' alerts the reader to useful descriptions in the style and bibliographical entries. Cross-references have also been used to direct the reader to additional illustrations and bibliography.

Another type of cross-reference appears as a main bold heading, to direct the reader to the place in the encyclopedia where the subject is treated:

> **Latter-day Saints.** *See* MORMONS.
> **Jones, Beatrix.** *See* FARRAND, BEATRIX JONES.
> **White, Stanford.** *See under* McKIM, MEAD & WHITE.

V. Locations of works of art.

For each work of art mentioned specifically, every attempt has been made to cite its correct present location. In general this information appears in an abbreviated form, in parentheses, directly after the first mention of the work. The standard abbreviations used for locations are readily understandable in their short forms and appear in full in Appendix A. Pieces that are on loan or on deposit are duly noted as such, as are works that are *in situ*. Works in private collections are usually followed by the citation of a published illustration or a catalogue raisonné number to assist in identification. Similarly, objects produced in multiples, such as prints and medals, are identified with a standard catalogue number. Works for which the locations are unknown are cited as untraced or are supplied with the last known location or, in the case of pieces that appeared on the art market, are given the city, auction house or gallery name and, when known, the date of sale and lot number or a reference to a published illustration; works that are known to have been destroyed are so noted.

VI. Illustrations.

As often as possible, pictures have been integrated into the text of the article that they illustrate, and the wording of captions has been designed to emphasize the subject to which the picture is related. For an article with a single illustration, the textual reference appears as '(see fig.)'; multiple illustrations are numbered. References to colour plates are in the form '(see colour pl. XII, 2)'. There are frequent cross-references to relevant illustrations appearing in other articles, and all captions have been indexed.

VII. Bibliographies and other sources.

All but the shortest of entries in the encyclopedia are followed by bibliographies and may also have sections on unpublished sources, writings, photographic publications or prints and video recordings or films. These function both as guides to selected further reading and viewing and as acknowledgments of the sources consulted by authors. In some family entries and in longer surveys, bibliographies may be located directly after the introduction and/or at the end of each section. All bibliographies are chronologically arranged by the date of first edition (thus

providing an abstract of the topic's historiography); longer bibliographies are divided into categories, in which the items are also in chronological order. Items published in the same year are listed alphabetically by authors' names and, where by the same author, alphabetically by title; items with named authors or editors take precedence over exhibition catalogues, which are cited by title first. Abbreviated references to certain alphabetically arranged dictionaries and encyclopedias (listed in full in Appendix C, List A) appear at the head of the bibliography (or section) in alphabetical order. The title of the article in such reference books is cited only if the spelling or form of the name differs from that used in this encyclopedia or if the reader is being referred to a different subject. Some other frequently cited works (*see* Appendix C, List B) are given in an abbreviated form, but in their correct chronological position within the bibliography and usually with their volume and page numbers. Appendix C, List C, lists the abbreviations used for works from publishers' series.

For books that have appeared in several editions, generally the earliest and the most recent have been cited (unless there was a particular reason to include an intermediate edition), and where page numbers are provided these refer to the most recent edition. Revisions are indicated by the abbreviation 'rev.', reprints with '*R*' and translations with 'trans.' prefaced by an abbreviation to indicate the language of the translation. Where the place or date of publication does not appear in a book, this is rendered as 'n.p.' or 'n.d.' as appropriate; where this information can be surmised, it appears in square brackets. Volume numbers usually appear in small roman numerals, both for citations from multi-volume publications and for periodicals; issue numbers of periodicals are in arabic numerals. The titles of periodicals are cited in abbreviated forms, a full list of which appears in Appendix B. Exhibition catalogues are provided with the name of the host location (not the place of publication) according to the list of location abbreviations (*see* Appendix A). Collected papers from conferences and congresses are arranged chronologically by date of their oral presentation rather than by the date of their publication in hard copy. Dissertations are included in the bibliography sections (rather than as unpublished sources), with an abbreviated form of the degree (diss., MA, MPhil) and awarding institution; if available on microfilm, this is noted.

Lists of unpublished sources, apart from dissertations, include such material as manuscripts, inventories and diaries. They are organized alphabetically by the location of the holdings, with an indication of the contents given in square brackets. Lists of selected writings are included in biographies of subjects who wrote on art; these are ordered according to the same principles as the bibliographies. Sections of photographic publications and prints list published books or collections of work by the subject of the article. If there is a significant collection of material on video or film, this is listed in its own section, in chronological order.

Throughout the production time of this encyclopedia authors were asked to submit important new bibliography for addition to their articles. Some contributors did so, while others left updating to be done by the editors. For the additions that were made by the editorial staff, this may have resulted in the text of an article apparently failing to take into consideration the discoveries or opinions of the new publications; it was nevertheless felt useful to draw readers' attention to significant recent literature that has appeared since *The Dictionary of Art* was published in 1996.

VIII. Authors.

Signatures of authors, in the form of their choice, appear at the end of the article that they contributed. Where two authors have jointly written an article, their names appear in alphabetical order:

CHARLES JONES, BETTY SMITH

If, however, Smith was the main author and was assisted or had her text amended by Jones, their signatures appear as:

BETTY SMITH, with CHARLES JONES

In the event that Jones assisted with only the bibliography to Smith's text, this would be acknowledged as:

BETTY SMITH (bibliography with CHARLES JONES)

Where an article or introduction was compiled by the editors or in the few cases where an author has wished to remain anonymous, this is indicated by a square box (□) instead of a signature.

IX. Appendices.

Readers' attention is directed to the Appendices at the back of this volume. These comprise full lists of: abbreviated locations of works of art (A); abbreviated periodical titles (B); standard reference books and series (C); authors' names (D).

X. Index.

All articles and illustration captions in this encyclopedia have been indexed not only to provide page numbers of the main headings but also to pinpoint variant names and spellings and specific information within articles and captions.

Acknowledgements

The preparation of the 34 volumes of *The Dictionary of Art* (London and New York, 1996) represented an enormous collective effort, one that took over 14 years and involved literally a cast of thousands. By contrast, the *Encyclopedia of American Art before 1914* has taken less than 14 months to prepare. To a large extent, however, we continue to be indebted to the same cast of thousands. We are particularly grateful to the countless former *TDA* contributors who updated their entries and approved their proofs within the very tight deadline for this single volume.

There is one new group of authors that deserves special recognition. Following informal discussions with Dr Paul J. Karlstrom, Regional Director of the Archives of American Art, San Marino, CA, at the College Art Association conference in Los Angeles in February 1999, it was decided that we should try to rectify an editorial imbalance in the original dictionary, which had resulted in West Coast artists being unfairly neglected. Dr Karlstrom immediately prepared a list of 30 important Californian painters who should be included in the forthcoming *Encyclopedia of American Art before 1914* and organized a team of writers to contribute the additional biographies. Because the production schedule was so tight, it was necessary for each of these contributors to produce his or her entries in less than ten days. Thanks to the miracles of modern technology and the unstinting hard work of these truly remarkable scholars, I am able to report a publishing first (unprecedented at least in my experience). Every single entry, written exactly to house-style and within the word allocation, arrived by e-mail by or *before* the deadline! In the same two-week period I received 34 new black-and-white photographs and a number of colour transparencies from California museums. My special thanks go out to each of the following people for their heroic efforts in enabling us to appreciate more fully the art produced in California during the 19th and early 20th century:

> Paul J. Karlstrom, Regional Director, Archives of American Art, San Marino
> Ann Harlow
> Harvey Jones, Senior Curator, Oakland Museum
> Patricia Junker, M.H. de Young Memorial Art Museum, San Francisco
> Ann Karlstrom, M.H. de Young Memorial Art Museum, San Francisco
> Marian Koshiki-Kovinick, Archives of American Art, San Marino
> Phil Kovinick
> Sally Mills
> Jean Stearn, Director, Irvine Museum

Further formal acknowledgements are divided into three sections: outside advisers, in-house staff and other outside sources. Although, for reasons of space, we are unable to mention everyone who participated in the creation of the *Encyclopedia of American Art before*

1914 (whether before 1996 or during the past twelve months), we should like to express our thanks to all for their role in making this prize-winning scholarship available to an even wider public.

1. OUTSIDE ADVISERS AND CONSULTANTS.

(i) Editorial Advisory Board. Our first debt of gratitude must again go to the members of the distinguished Editorial Advisory Board to *The Dictionary of Art* for the guidance they provided on matters of general concept and approach. The editorial policy that they helped to shape will continue to inform all of the subsequent reference works that are derived from *The Dictionary*:

> Prof. Emeritus Terukazu Akiyama (formerly of the University of Tokyo)
> Prof. Carlo Bertelli (Université de Lausanne)
> Prof. Whitney Chadwick (San Francisco State University)
> Prof. André Chastel (formerly of the Collège de France) †
> Prof. Oleg Grabar (Institute for Advanced Study, Princeton)
> Prof. Francis Haskell (University of Oxford)
> Prof. Alfonso E. Pérez Sánchez (formerly of the Museo del Prado, Madrid)
> Prof. Robert Rosenblum (Institute of Fine Arts, New York University)
> Dr Jessica Rawson (University of Oxford and formerly of the British Museum, London)
> Prof. Willibald Sauerländer (formerly of the Zentralinstitut für Kunstgeschichte, Munich)
> Mr Peter Thornton (formerly of the Sir John Soane's Museum, London)
> Prof. Irene Winter (Harvard University, Cambridge, Massachusetts)

(ii) Area advisers. For *The Dictionary of Art,* a number of outside experts were formally invited to develop plans for the coverage of the arts in their areas of specialization. Governed only by a general word allocation and suggestions for certain basic patterns of coverage, each was asked to prepare an outline (or report) with proposed headings, relative word lengths and names of potential authors. The following advisers offered guidance on our coverage of American art before 1914:

> *American architecture,* c. *1600*–c. *1914*
> William Jordy (*d* 1997)
> Professor Emeritus of Art History at Brown University, Providence, RI
>
> *American decorative arts*
> Gerald Ward
> Peter and Carolyn Lynch Associate Curator of American Decorative Arts and Sculpture
> Museum of Fine Arts, Boston, MA
>
> *American painting and sculpture,* c. *1600*–c. *1914*
> Jules Prown
> Paul Mellon Professor Emeritus of the History of Art
> Yale University, New Haven, CT

2. EDITORIAL AND ADMINISTRATIVE STAFF. Among my editorial colleagues, I should like first to express my gratitude to my Deputy Editor, Diane Fortenberry, who has shared with me the responsibility of devising The Grove Library of World Art publishing programme. In the preparation of this particular volume, I am indebted to Michael Dagon, who helped select the colour plates and who also searched for bibliographical updates for each article. The

† deceased

task of implementing the editorial changes and updates was shared by Anya Serota and Gillian Northcott. Gillian, who supervised the creation of the original index of some three quarters of a million references for *The Dictionary of Art*, also expanded and updated the index for the present volume.

Although one volume is certainly easier to prepare than thirty-four, the administration of a project of even this size—with 835 entries, 420 illustrations and 300 authors—is a formidable task. The entire *Dictionary of Art* text database is now stored electronically under the watchful eye of Richard Padley, who directed its conversion into an online product (*The Grove Dictionary of Art*, www.groveart.com), and we are grateful for his help in extracting the relevant articles for this volume. The illustrations database for the first three spin-off encyclopedias was maintained by Veronica Gustavsson; for this volume, she was ably assisted on matters of sizing and electronic digitization by Fiona Moffat, who oversaw the early production stages before her return to her native New Zealand earlier this year. Following Fiona's departure, we greatly benefited from the return of Sophie Durlacher as Editorial Manager, who once again applied her excellent project management skills. On the production side, we were fortunate to have the expert guidance and support of Publishing Services Manager Jeremy Macdonald, who was assisted in final stages by Senior Production Controller Claire Pearson. For the page makeup, it was a pleasure to work again with John Catchpole and his colleagues at William Clowes.

3. OTHER OUTSIDE SOURCES. Many people and organizations outside of the Macmillan editorial offices have provided generous help to us and to our contributors. We are particularly grateful to the staff of the Getty Research Institute, who provided excellent resources and cordial hospitality to Michael Dagon throughout his work on the project and to me during the initial planning stages in the summer of 1998. I should again like to thank Dr Paul Karlstrom and his colleagues at the West Coast regional office of the Archives of American Art for their official support of the project. Through their efforts, a number of California museums provided photographs at extremely short notice, including the Crocker Museum, Sacramento; the Irvine Museum; the Oakland Museum, and the San Francisco Museums of Fine Arts. Special thanks are owed to several other photographic sources and copyright-holders, who processed especially large orders from us, especially Art Resource, New York; the Metropolitan Museum of Art, New York; and the Library of Congress. The colour plates were designed by Alison Nick and the book jacket cover by Lawrence Kneath. The specific sources for all images in the *encyclopedia*, both black-and-white and colour, are acknowledged in the list of picture credits.

General Abbreviations

The abbreviations employed throughout this encyclopedia, most of which are listed below, do not vary, except for capitalization, regardless of the context in which they are used, including bibliographical citations and for locations of works of art. The principle used to arrive at these abbreviations is that their full form should be easily deducible, and for this reason acronyms have generally been avoided (e.g. Los Angeles Co. Mus. A. instead of LACMA). The same abbreviation is adopted for cognate forms in foreign languages and in most cases for plural and adjectival forms (e.g. A.=Art, Arts. Arte, Arti etc). Not all related forms are listed below. For the reader's convenience, separate full lists of abbreviations for locations, periodical titles and standard reference books and series are included as Appendices A–C at the back of this volume.

A.	Art, Arts	ARA	Associate of the Royal Academy	BC	Before Christ
A.C.	Arts Council			BC	British Columbia (Canada)
Acad.	Academy	Arab.	Arabic	BE	Buddhist era
AD	Anno Domini	Archaeol.	Archaeology	Beds	Bedfordshire (GB)
Add.	Additional, Addendum	Archit.	Architecture, Architectural	Behav.	Behavioural
addn	addition	Archv, Archvs	Archive(s)	Belarus.	Belarusian
Admin.	Administration			Belg.	Belgian
Adv.	Advances, Advanced	Arg.	Argentine	Berks	Berkshire (GB)
Aesth.	Aesthetic(s)	ARHA	Associate of the Royal Hibernian Academy	Berwicks	Berwickshire (GB; old)
Afr.	African	ARIBA	Associate of the Royal Institute of British Architects	BFA	Bachelor of Fine Arts
Afrik.	Afrikaans, Afrikaner			Bibl.	Bible, Biblical
A.G.	Art Gallery	Armen.	Armenian	Bibliog.	Bibliography, Bibliographical
Agrar.	Agrarian	ARSA	Associate of the Royal Scottish Academy	Biblioph.	Bibliophile
Agric.	Agriculture			Biog.	Biography, Biographical
Agron.	Agronomy	Asiat.	Asiatic	Biol.	Biology, Biological
Agy	Agency	Assist.	Assistance	bk, bks	book(s)
AH	Anno Hegirae	Assoc.	Association	Bkbinder	Bookbinder
A. Inst.	Art Institute	Astron.	Astronomy	Bklore	Booklore
AK	Alaska (USA)	AT&T	American Telephone & Telegraph Company	Bkshop	Bookshop
AL	Alabama (USA)			BL	British Library
Alb.	Albanian	attrib.	attribution, attributed to	Bld	Build
Alg.	Algerian	Aug	August	Bldg	Building
Alta	Alberta (Canada)	Aust.	Austrian	Bldr	Builder
Altern.	Alternative	Austral.	Australian	BLitt	Bachelor of Letters/Literature
a.m.	ante meridiem [before noon]	Auth	Author(s)	BM	British Museum
Amat.	Amateur	Auton.	Autonomous	Boh.	Bohemian
Amer.	American	Aux.	Auxiliary	Boliv.	Bolivian
An.	Annals	Ave.	Avenue	Botan.	Botany, Botanical
Anatol.	Anatolian	AZ	Arizona (USA)	BP	Before present (1950)
Anc.	Ancient	Azerbaij.	Azerbaijani	Braz.	Brazilian
Annu.	Annual	B.	Bartsch [catalogue of Old Master prints]	BRD	Bundesrepublik Deutschland [Federal Republic of Germany (West Germany)]
Anon.	Anonymous(ly)				
Ant.	Antique	b	born		
Anthol.	Anthology	BA	Bachelor of Arts	Brecons	Breconshire (GB; old)
Anthropol.	Anthropology	Balt.	Baltic	Brez.	Brezonek [lang. of Brittany]
		bapt	baptized	Brit.	British
Antiqua.	Antiquarian, Antiquaries	BArch	Bachelor of Architecture	Bros	Brothers
app.	appendix	Bart	Baronet	BSc	Bachelor of Science
approx.	approximately	Bask.	Basketry	Bucks	Buckinghamshire (GB)
AR	Arkansas (USA)	BBC	British Broadcasting Corporation	Bulg.	Bulgarian

Bull.	Bulletin	Colloq.	Colloquies	DE	Delaware (USA)
bur	buried	Colomb.	Colombian	Dec	December
Burm.	Burmese	Colon.	Colonies, Colonial	Dec.	Decorative
Byz.	Byzantine	Colr	Collector	ded.	dedication, dedicated to
C	Celsius	Comm.	Commission; Community	Democ.	Democracy, Democratic
C.	Century	Commerc.	Commercial	Demog.	Demography, Demographic
c.	*circa* [about]	Communic.	Communications	Denbs	Denbighshire (GB; old)
CA	California	Comp.	Comparative; compiled by, compiler	dep.	deposited at
Cab.	Cabinet			Dept	Department
Caerns	Caernarvonshire (GB; old)	Concent.	Concentration	Dept.	Departmental, Departments
C.A.G.	City Art Gallery	Concr.	Concrete	Derbys	Derbyshire (GB)
Cal.	Calendar	Confed.	Confederation	Des.	Design
Callig.	Calligraphy	Confer.	Conference	destr.	destroyed
Cam.	Camera	Congol.	Congolese	Dev.	Development
Cambs	Cambridgeshire (GB)	Congr.	Congress	Devon	Devonshire (GB)
can	canonized	Conserv.	Conservation; Conservatory	Dial.	Dialogue
Can.	Canadian	Constr.	Construction(al)	diam.	diameter
Cant.	Canton(s), Cantonal	cont.	continued	Diff.	Diffusion
Capt.	Captain	Contemp.	Contemporary	Dig.	Digest
Cards	Cardiganshire (GB; old)	Contrib.	Contributions, Contributor(s)	Dip. Eng.	Diploma in Engineering
Carib.	Caribbean	Convalesc.	Convalescence	Dir.	Direction, Directed
Carms	Carmarthenshire (GB; old)	Convent.	Convention	Directrt	Directorate
Cartog.	Cartography	Coop.	Cooperation	Disc.	Discussion
Cat.	Catalan	Coord.	Coordination	diss.	dissertation
cat.	catalogue	Copt.	Coptic	Distr.	District
Cath.	Catholic	Corp.	Corporation, Corpus	Div.	Division
CBE	Commander of the Order of the British Empire	Corr.	Correspondence	DLitt	Doctor of Letters/Literature
		Cors.	Corsican	DM	Deutsche Mark
Celeb.	Celebration	Cost.	Costume	Doc.	Document(s)
Celt.	Celtic	Cret.	Cretan	Doss.	Dossier
Cent.	Centre, Central	Crim.	Criminal	DPhil	Doctor of Philosophy
Centen.	Centennial	Crit.	Critical, Criticism	Dr	Doctor
Cer.	Ceramic	Croat.	Croatian	Drg, Drgs	Drawing(s)
cf.	confer [compare]	CT	Connecticut (USA)	DSc	Doctor of Science/Historical Sciences
Chap., Chaps	Chapter(s)	Cttee	Committee		
		Cub.	Cuban	Dut.	Dutch
Chem.	Chemistry	Cult.	Cultural, Culture	Dwell.	Dwelling
Ches	Cheshire (GB)	Cumb.	Cumberland (GB; old)	E.	East(ern)
Chil.	Chilean	Cur.	Curator, Curatorial, Curatorship	EC	European (Economic) Community
Chin.	Chinese				
Christ.	Christian, Christianity	Curr.	Current(s)	Eccles.	Ecclesiastical
Chron.	Chronicle	CVO	Commander of the [Royal] Victorian Order	Econ.	Economic, Economies
Cie	Compagnie [French]			Ecuad.	Ecuadorean
Cinema.	Cinematography	Cyclad.	Cycladic	ed.	editor, edited (by)
Circ.	Circle	Cyp.	Cypriot	edn	edition
Civ.	Civil, Civic	Czech.	Czechoslovak	eds	editors
Civiliz.	Civilization(s)	$	dollars	Educ.	Education
Class.	Classic, Classical	*d*	died	e.g.	*exempli gratia* [for example]
Clin.	Clinical	d.	denarius, denarii [penny, pence]	Egyp.	Egyptian
CO	Colorado (USA)			Elem.	Element(s), Elementary
Co.	Company; County	Dalmat.	Dalmatian	Emp.	Empirical
Cod.	Codex, Codices	Dan.	Danish	Emul.	Emulation
Col., Cols	Collection(s); Column(s)	DBE	Dame Commander of the Order of the British Empire	Enc.	Encyclopedia
Coll.	College			Encour.	Encouragement
collab.	in collaboration with, collaborated, collaborative	DC	District of Columbia (USA)	Eng.	English
		DDR	Deutsche Demokratische Republik [German Democratic Republic (East Germany)]	Engin.	Engineer, Engineering
Collct.	Collecting				

| | | | | | | |
|---|---|---|---|---|---|
| Engr., Engrs | Engraving(s) | ft | foot, feet | HRH | His/Her Royal Highness |
| Envmt | Environment | Furn. | Furniture | Human. | Humanities, Humanism |
| Epig. | Epigraphy | Futur. | Futurist, Futurism | Hung. | Hungarian |
| Episc. | Episcopal | g | gram(s) | Hunts | Huntingdonshire (GB; old) |
| Esp. | Especially | GA | Georgia (USA) | IA | Iowa |
| Ess. | Essays | Gael. | Gaelic | ibid. | *ibidem* [in the same place] |
| est. | established | Gal., Gals | Gallery, Galleries | ICA | Institute of Contemporary Arts |
| etc | *etcetera* [and so on] | Gaz. | Gazette | | |
| Ethnog. | Ethnography | GB | Great Britain | Ice. | Icelandic |
| Ethnol. | Ethnology | Gdn, Gdns | Garden(s) | Iconog. | Iconography |
| Etrus. | Etruscan | | | Iconol. | Iconology |
| Eur. | European | Gdnr(s) | Gardener(s) | ID | Idaho (USA) |
| Evangel. | Evangelical | Gen. | General | i.e. | *id est* [that is] |
| Exam. | Examination | Geneal. | Genealogy, Genealogist | IL | Illinois (USA) |
| Excav. | Excavation, Excavated | Gent. | Gentleman, Gentlemen | Illum. | Illumination |
| Exch. | Exchange | Geog. | Geography | illus. | illustrated, illustration |
| Excurs. | Excursion | Geol. | Geology | Imp. | Imperial |
| exh. | exhibition | Geom. | Geometry | IN | Indiana (USA) |
| Exp. | Exposition | Georg. | Georgian | in., ins | inch(es) |
| Expermntl | Experimental | Geosci. | Geoscience | Inc. | Incorporated |
| Explor. | Exploration | Ger. | German, Germanic | inc. | incomplete |
| Expn | Expansion | G.I. | Government/General Issue (USA) | incl. | includes, including, inclusive |
| Ext. | External | Glams | Glamorganshire (GB; old) | Incorp. | Incorporation |
| Extn | Extension | Glos | Gloucestershire (GB) | Ind. | Indian |
| f, ff | following page, following pages | Govt | Government | Indep. | Independent |
| | | Gr. | Greek | Indig. | Indigenous |
| F.A | Fine Art(s) | Grad. | Graduate | Indol. | Indology |
| Fac. | Faculty | Graph. | Graphic | Indon. | Indonesian |
| facs | facsimile | Green. | Greenlandic | Indust. | Industrial |
| Fam. | Family | Gr.-Roman | Greco-Roman | Inf. | Information |
| fasc. | fascicle | | | Inq. | Inquiry |
| *fd* | feastday (of a saint) | Gt | Great | Inscr. | Inscribed, Inscription |
| Feb | February | Gtr | Greater | Inst. | Institute(s) |
| Fed. | Federation, Federal | Guat. | Guatemalan | Inst. A. | Institute of Art |
| Fem. | Feminist | Gym. | Gymnasium | Instr. | Instrument, Instrumental |
| Fest. | Festival | h. | height | Int. | International |
| fig. | figure (illustration) | ha | hectare | Intell. | Intelligence |
| Fig. | Figurative | Hait | Haitian | Inter. | Interior(s), Internal |
| figs | figures | Hants | Hampshire (GB) | Interdiscip | Interdisciplinary |
| Filip. | Filipina(s), Filipino(s) | Hb | Handbook | | |
| Fin. | Finnish | Heb. | Hebrew | intro. | introduced by, introduction |
| FL | Florida (USA) | Hell. | Hellenic | inv. | inventory |
| *fl* | *floruit* [he/she flourished] | Her. | Heritage | Inven. | Invention |
| Flem. | Flemish | Herald. | Heraldry, Heraldic | Invest. | Investigation(s) |
| Flints | Flintshire (GB; old) | Hereford & Worcs | Hereford & Worcester (GB) | Iran. | Iranian |
| Flk | Folk | | | irreg. | irregular(ly) |
| Flklore | Folklore | Herts | Hertfordshire (GB) | Islam. | Islamic |
| fol., fols | folio(s) | HI | Hawaii (USA) | Isr. | Israeli |
| Found. | Foundation | Hib. | Hibernia | It. | Italian |
| Fr. | French | Hisp. | Hispanic | J. | Journal |
| frag. | fragment | Hist. | History, Historical | Jam. | Jamaican |
| Fri. | Friday | HMS | His/Her Majesty's Ship | Jan | January |
| FRIBA | Fellow of the Royal Institute of British Architects | Hon. | Honorary, Honourable | Jap. | Japanese |
| | | Horiz. | Horizon | Jav. | Javanese |
| FRS | Fellow of the Royal Society, London | Hort. | Horticulture | Jew. | Jewish |
| | | Hosp. | Hospital(s) | Jewel. | Jewellery |

Jord.	Jordanian	MBE	Member of the Order of the British Empire	MS., MSS	manuscript(s)
jr	junior			MSc	Master of Science
Juris.	Jurisdiction	MD	Doctor of Medicine; Maryland (USA)	MT	Montana (USA)
KBE	Knight Commander of the Order of the British Empire			Mt	Mount
		ME	Maine (USA)	Mthly	Monthly
KCVO	Knight Commander of the Royal Victorian Order	Mech.	Mechanical	Mun.	Municipal
		Med.	Medieval; Medium, Media	Mus.	Museum(s)
kg	kilogram(s)	Medic.	Medical, Medicine	Mus. A.	Museum of Art
kHz	kilohertz	Medit.	Mediterranean	Mus. F.A.	Museum of Fine Art(s)
km	kilometre(s)	Mem.	Memorial(s); Memoir(s)	Music.	Musicology
Knowl.	Knowledge	Merions	Merionethshire (GB; old)	N.	North(ern); National
Kor.	Korean	Meso-Amer.	Meso-American	*n*	refractive index of a medium
KS	Kansas (USA)			n.	note
KY	Kentucky (USA)	Mesop.	Mesopotamian	N.A.G.	National Art Gallery
Kyrgyz.	Kyrgyzstani	Met.	Metropolitan	Nat.	Natural, Nature
£	libra, librae [pound, pounds sterling]	Metal.	Metallurgy	Naut.	Nautical
		Mex.	Mexican	NB	New Brunswick (Canada)
l.	length	MFA	Master of Fine Arts	NC	North Carolina (USA)
LA	Louisiana (USA)	mg	milligram(s)	ND	North Dakota (USA)
Lab.	Laboratory	Mgmt	Management	n.d.	no date
Lancs	Lancashire (GB)	Mgr	Monsignor	NE	Nebraska; Northeast(ern)
Lang.	Language(s)	MI	Michigan	Neth.	Netherlandish
Lat.	Latin	Micrones.	Micronesian	Newslett.	Newsletter
Latv.	Latvian	Mid. Amer.	Middle American	Nfld	Newfoundland (Canada)
lb, lbs	pound(s) weight			N.G.	National Gallery
Leb.	Lebanese	Middx	Middlesex (GB; old)	N.G.A.	National Gallery of Art
Lect.	Lecture	Mid. E.	Middle Eastern	NH	New Hampshire (USA)
Legis.	Legislative	Mid. Eng.	Middle English	Niger.	Nigerian
Leics	Leicestershire (GB)	Mid Glam.	Mid Glamorgan (GB)	NJ	New Jersey (USA)
Lex.	Lexicon	Mil.	Military	NM	New Mexico (USA)
Lg.	Large	Mill.	Millennium	nm	nanometre (10^{-9} metre)
Lib., Libs	Library, Libraries	Min.	Ministry; Minutes	nn.	notes
Liber.	Liberian	Misc.	Miscellaneous	no., nos	number(s)
Libsp	Librarianship	Miss.	Mission(s)	Nord.	Nordic
Lincs	Lincolnshire (GB)	Mlle	Mademoiselle	Norm.	Normal
Lit.	Literature	mm	millimetre(s)	Northants	Northamptonshire (GB)
Lith.	Lithuanian	Mme	Madame	Northumb.	Northumberland (GB)
Liturg.	Liturgical	MN	Minnesota		
LLB	Bachelor of Laws	Mnmt, Mnmts	Monument(s)	Norw.	Norwegian
LLD	Doctor of Laws			Notts	Nottinghamshire (GB)
Lt	Lieutenant	Mnmtl	Monumental	Nov	November
Lt-Col.	Lieutenant-Colonel	MO	Missouri (USA)	n.p.	no place (of publication)
Ltd	Limited	Mod.	Modern, Modernist	N.P.G.	National Portrait Gallery
m	metre(s)	Moldav.	Moldavian	nr	near
m.	married	Moldov.	Moldovan	Nr E.	Near Eastern
M.	Monsieur	MOMA	Museum of Modern Art	NS	New Style; Nova Scotia (Canada)
MA	Master of Arts; Massachusetts (USA)	Mon.	Monday		
		Mongol.	Mongolian	n. s.	new series
Mag.	Magazine	Mons	Monmouthshire (GB; old)	NSW	New South Wales (Australia)
Maint.	Maintenance	Montgoms	Montgomeryshire (GB; old)	NT	National Trust
Malay.	Malaysian	Mor.	Moral	Ntbk	Notebook
Man.	Manitoba (Canada); Manual	Morav.	Moravian	Numi.	Numismatic(s)
Manuf.	Manufactures	Moroc.	Moroccan	NV	Nevada (USA)
Mar.	Marine, Maritime	Movt	Movement	NW	Northwest(ern)
Mason.	Masonic	MP	Member of Parliament	NWT	Northwest Territories (Canada)
Mat.	Material(s)	MPhil	Master of Philosophy		
Math.	Mathematic	MS	Mississippi (USA)	NY	New York (USA)

NZ	New Zealand	Phys.	Physician(s), Physics, Physique, Physical	Radnors	Radnorshire (GB; old)
OBE	Officer of the Order of the British Empire	Physiog.	Physiognomy	RAF	Royal Air Force
		Physiol.	Physiology	Rec.	Record(s)
Obj.	Object(s), Objective	Pict.	Picture(s), Pictorial	red.	reduction, reduced for
Occas.	Occasional	pl.	plate; plural	Ref.	Reference
Occident.	Occidental	Plan.	Planning	Refurb.	Refurbishment
Ocean.	Oceania	Planet.	Planetarium	*reg*	*regit* [ruled]
Oct	October	Plast.	Plastic	Reg.	Regional
8vo	octavo	pls	plates	Relig.	Religion, Religious
OFM	Order of Friars Minor	p.m.	post meridiem [after noon]	remod.	remodelled
OH	Ohio (USA)	Polit.	Political	Ren.	Renaissance
OK	Oklahoma (USA)	Poly.	Polytechnic	Rep.	Report(s)
Olymp.	Olympic	Polynes.	Polynesian	repr.	reprint(ed); reproduced, reproduction
OM	Order of Merit	Pop.	Popular		
Ont.	Ontario (Canada)	Port.	Portuguese	Represent.	Representation, Representative
op.	opus	Port.	Portfolio	Res.	Research
opp.	opposite; opera [pl. of opus]	Posth.	Posthumous(ly)	rest.	restored, restoration
OR	Oregon (USA)	Pott.	Pottery	Retro.	Retrospective
Org.	Organization	POW	prisoner of war	rev.	revision, revised (by/for)
Orient.	Oriental	PRA	President of the Royal Academy	Rev.	Reverend; Review
Orthdx	Orthodox			RHA	Royal Hibernian Academician
OSB	Order of St Benedict	Pract.	Practical	RI	Rhode Island (USA)
Ott.	Ottoman	Prefect.	Prefecture, Prefectural	RIBA	Royal Institute of British Architects
Oxon	Oxfordshire (GB)	Preserv.	Preservation		
oz.	ounce(s)	prev.	previous(ly)	RJ	Rio de Janeiro State
p	pence	priv.	private	Rlwy	Railway
p., pp.	page(s)	PRO	Public Record Office	RSA	Royal Scottish Academy
PA	Pennsylvania (USA)	Prob.	Problem(s)	RSFSR	Russian Soviet Federated Socialist Republic
p.a.	per annum	Proc.	Proceedings		
Pak.	Pakistani	Prod.	Production	Rt Hon.	Right Honourable
Palaeontol.	Palaeontology, Palaeontological	Prog.	Progress	Rur	Rural
		Proj.	Project(s)	Rus.	Russian
Palest	Palestinian	Promot.	Promotion	S	San, Santa, Santo, Sant', São [Saint]
Pap.	Paper(s)	Prop.	Property, Properties		
para.	paragraph	Prov.	Province(s), Provincial	S.	South(ern)
Parag.	Paraguayan	Proven.	Provenance	s.	solidus, solidi [shilling(s)]
Parl.	Parliament	Prt, Prts	Print(s)	Sask.	Saskatchewan (Canada)
Paroch.	Parochial	Prtg	Printing	Sat.	Saturday
Patriarch.	Patriarchate	pseud.	pseudonym	SC	South Carolina (USA)
Patriot.	Patriotic	Psych.	Psychiatry, Psychiatric	Scand.	Scandinavian
Patrm.	Patrimony	Psychol.	Psychology, Psychological	Sch.	School
Pav.	Pavilion	pt	part	Sci.	Science(s), Scientific
PEI	Prince Edward Island (Canada)	Ptg(s)	Painting(s)	Scot.	Scottish
Pembs	Pembrokeshire (GB; old)	Pub.	Public	Sculp.	Sculpture
Per.	Period	pubd	published	SD	South Dakota (USA)
Percep.	Perceptions	Publ.	Publicity	SE	Southeast(ern)
Perf.	Performance, Performing, Performed	pubn(s)	publication(s)	Sect.	Section
		PVA	polyvinyl acetate	Sel.	Selected
Period.	Periodical(s)	PVC	polyvinyl chloride	Semin.	Seminar(s), Seminary
Pers.	Persian	Q.	quarterly	Semiot.	Semiotic
Persp.	Perspectives	4to	quarto	Semit.	Semitic
Peru.	Peruvian	Qué.	Québec (Canada)	Sept	September
PhD	Doctor of Philosophy	*R*	reprint	Ser.	Series
Philol.	Philology	*r*	*recto*	Serb.	Serbian
Philos.	Philosophy	RA	Royal Academician	Serv.	Service(s)
Phoen.	Phoenician			Sess.	Session, Sessional
Phot.	Photograph, Photography, Photographic			Settmt(s)	Settlement(s)

S. Glam.	South Glamorgan (GB)	Tap.	Tapestry	US	United States
Siber.	Siberian	Tas.	Tasmanian	USA	United States of America
Sig.	Signature	Tech.	Technical, Technique	USSR	Union of Soviet Socialist Republics
Sil.	Silesian	Technol.	Technology		
Sin.	Singhala	Territ.	Territory	UT	Utah
sing.	singular	Theat.	Theatre	*v*	*verso*
SJ	Societas Jesu [Society of Jesus]	Theol.	Theology, Theological	VA	Virginia (USA)
Skt	Sanskrit	Theor.	Theory, Theoretical	V&A	Victoria and Albert Museum
Slav.	Slavic, Slavonic	Thurs.	Thursday	Var.	Various
Slov.	Slovene, Slovenian	Tib.	Tibetan	Venez.	Venezuelan
Soc.	Society	TN	Tennessee (USA)	Vern.	Vernacular
Social.	Socialism, Socialist	Top.	Topography	Vict.	Victorian
Sociol.	Sociology	Trad.	Tradition(s), Traditional	Vid.	Video
Sov.	Soviet	trans.	translation, translated by; transactions	Viet.	Vietnamese
SP	São Paulo State			viz.	*videlicet* [namely]
Sp.	Spanish	Transafr.	Transafrican	vol., vols	volume(s)
sq.	square	Transatlant.	Transatlantic	vs.	versus
sr	senior	Transcarpath.	Transcarpathian	VT	Vermont (USA)
Sri L.	Sri Lankan			Vulg.	Vulgarisation
SS	Saints, Santi, Santissima, Santissimo, Santissimi; Steam ship	transcr.	transcribed by/for	W.	West(ern)
		Triq.	Triquarterly	w.	width
		Tropic.	Tropical	WA	Washington (USA)
SSR	Soviet Socialist Republic	Tues.	Tuesday	Warwicks	Warwickshire (GB)
St	Saint, Sankt, Sint, Szent	Turk.	Turkish	Wed.	Wednesday
Staffs	Staffordshire (GB)	Turkmen.	Turkmenistani	W. Glam.	West Glamorgan (GB)
Ste	Sainte	TV	Television	WI	Wisconsin (USA)
Stud.	Study, Studies	TX	Texas (USA)	Wilts	Wiltshire (GB)
Subalp.	Subalpine	U.	University	Wkly	Weekly
Sum.	Sumerian	UK	United Kingdom of Great Britain and Northern Ireland	W. Midlands	West Midlands (GB)
Sun.	Sunday			Worcs	Worcestershire (GB; old)
Sup.	Superior	Ukrain.	Ukrainian	Wtrcol.	Watercolour
suppl., suppls	supplement(s), supplementary	Un.	Union	WV	West Virginia (USA)
		Underwtr	Underwater	WY	Wyoming (USA)
Surv.	Survey	UNESCO	United Nations Educational, Scientific and Cultural Organization	Yb., Y.-b.	Yearbook, Year-book
SW	Southwest(ern)			Yem.	Yemeni
Swed.	Swedish	Univl	Universal	Yorks	Yorkshire (GB; old)
Swi.	Swiss	unpubd	unpublished	Yug.	Yugoslavian
Symp.	Symposium	Urb.	Urban	Zamb.	Zambian
Syr.	Syrian	Urug.	Uruguayan	Zimb.	Zimbabwean

A Note on the Use of the Encyclopedia

This note is intended as a short guide to the basic editorial conventions adopted in this encyclopedia. For a fuller explanation, please refer to the Introduction.

Abbreviations in general use in the encyclopedia are listed on pp. xvii-xxii; those used in bibliographies and for locations of works of art or exhibition venues are listed in the Appendices.

Alphabetization of headings, which are distinguished in bold typeface, is letter by letter up to the first comma (ignoring spaces, hyphens, accents, and any parenthetized or bracketed matter): the same principle applies thereafter. The abbreviation of 'Saint' is alphabetized as if spelt out, and headings with the prefix 'Mc' appear under 'Mac'.

Authors' signatures appear at the end of the article that the authors have contributed. Where the article was compiled by the editors or in the few cases where an author has wished to remain anonymous, this is indicated by a square box (□) instead of a signature.

Bibliographies are arranged chronologically (within section, where divided) by order of the year first publication and, within years, alphabetically by authors' names. Abbreviations have been used for some standard reference books; these are cited in full in Appendix C as are abbreviations of periodical titles (Appendix B). Abbreviated references to alphabetically arranged dictionaries and encyclopedias appear at the beginning of the bibliography (or section).

Biographical dates when cited in parentheses in running text at the first mention of a personal name indicate that the individual does not have an entry in the encyclopedia. Where no dates are provided for an artist or patron, the reader may assume that there is a biography of that individual in the encyclopedia (or, more rarely, that the person is so obscure that dates are not readily available).

Cross-references are distinguished by the use of small capital letters, with a large capital to indicate the initial letter of the entry to which the reader is directed; for example . 'He commissioned ISABELLA STEWART GARDNER...' means that the entry is alphabetized under 'G'.

A

Abbey, Edwin Austin (*b* Philadelphia, PA, 1 April 1852; *d* London, 1 Aug 1911). American painter and illustrator, active in England. He began his artistic training in 1866, studying drawing with the Philadelphia portrait and landscape painter Isaac L. Williams (1817–95). In 1868 he attended evening classes in drawing at the Pennsylvania Academy of the Fine Arts under Christian Schussele (?1824–79). In the same year Abbey began to work as an illustrator for the Philadelphia publishers Van Ingen & Snyder. In 1870 *Harper's Weekly* published the *Puritans' First Thanksgiving*, and in 1871 Abbey moved to New York to join the staff of Harper & Brothers, thus inaugurating his most important professional relationship. Throughout the 1870s Abbey's reputation grew, both for his detailed exhibition watercolours and for his elegant line drawings, which, translated to wood-engravings in numerous periodicals, illustrated both factual and fictional events of the past and present. The influences on him were mainly English, in particular the works of the Pre-Raphaelite Brotherhood and illustrations in the English press, which he studied avidly. The success of his illustrations to some of Robert Herrick's poems, such as *Corinna's Going A-Maying* in *Harper's New Monthly Magazine* (May 1874), prompted Harper & Brothers in 1878 to send Abbey to England to do a complete series of drawings for an illustrated gift book, *Selections from the Poetry of Robert Herrick* (New York, 1882). On his arrival in England, Abbey found his spiritual home, and except for a few trips, he never left.

Abbey, a small, handsome, athletic man, had a genius for forging long-lasting and often profitable friendships. In 1877 he helped to found the Tile Club, which included among its members the architect Stanford White, Augustus Saint-Gaudens and Winslow Homer, whose activities resulted in gift-books and lengthy magazine articles. Abbey's most intense friendship was with the English landscape painter and illustrator Alfred Parsons (1847–1920). The two artists shared studios and gallery exhibitions, travelled together widely and collaborated on several projects, most notably the gift-books *Old Songs* (New York, 1889) and *The Quiet Life* (New York, 1890). Abbey derived much of the inspiration for these from his long sojourns in the English countryside, especially from 1885 to 1889, as one of the central figures in the artists' colony at Broadway (Hereford & Worcs), along with Parsons, Frank Millet (1846–1912) and John Singer Sargent.

Abbey undertook illustrative commissions throughout his life (his illustrations to Shakespeare's plays being especially noteworthy), but from 1889 on he devoted more time to mural projects and oil paintings. In 1890 he sent his first major oil, *May Day Morning* (New Haven, CT, Yale U. A.G.), based on one of the Herrick illustrations,

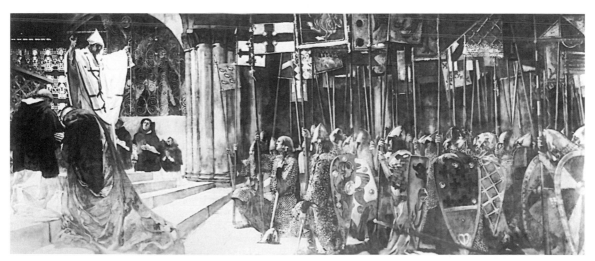

Edwin Austin Abbey: mural from the cycle of the *Quest for the Holy Grail* (1890–1901), h. 2.44 m, delivery room of the Boston Public Library, Boston, Massachusetts

to the Royal Academy Summer Exhibition, where it was favourably received. Until 1910 Abbey exhibited there frequently, and he was elected ARA in 1896 and RA in 1898. His exhibited works were usually based on Shakespearean, troubadour or Renaissance themes. Large and richly coloured, the paintings reflect Abbey's fascination with the stage, particularly in the arrangement of the figures, their poses and sumptuously coloured costumes (Abbey designed the costumes for John Hare's *Tosca* (1889) and Sir Henry Irving's *Richard II* (1898), among other productions). Although he received many honours and awards, the signal event of Abbey's career was the commission in 1902 to paint Edward VII's coronation (London, Buckingham Pal., Royal Col.).

The major projects of Abbey's later life were commissions for murals. He decorated the delivery room of McKim, Mead & White's Boston Public Library with a 15-panel series (1890–1901) based on the *Quest for the Holy Grail* (see fig.). Works for the Royal Exchange, London, and other commissions followed. In 1902 Abbey began the decorations for the Pennsylvania State Capitol at Harrisburg. An allegory of the state's history and its resources, Abbey's work here departed from the schematic narrative of his other murals and adopted a full-blown rhetorical style related to the work of Kenyon Cox and Edwin Howland Blashfield.

BIBLIOGRAPHY

E. V. Lucas: *Edwin Austin Abbey, Royal Academician: The Record of his Life and Work*, 2 vols (London, 1921)

Edwin Austin Abbey (1852–1911) (exh. cat., ed. K. A. Foster and M. Quick; New Haven, CT, Yale U. A.G., 1973)

M. Simpson: 'Windows on the Past: Edward Austin Abbey and Francis Davis Millet in England', *Amer. A. J.*, xxii/3 (1990), pp. 64–89

——: *Reconstructing the Golden Age: American Artists in Broadway, Worcestershire, 1885 to 1889* (diss., New Haven, CT, Yale U., 1993)

Unfaded Pageant: Edwin Austin Abbey's Shakespearean Subjects (exh. cat. by L. Oakley, New York, Columbia U., Miriam & Ira D. Wallach Gal., 1994)

MARC SIMPSON

Adler, Dankmar (*b* Stadtlengsfeld, nr Eisenach, 3 July 1844; *d* Chicago, 16 April 1900). American architect and engineer of German birth. His family moved to the USA in 1854, and he trained in Detroit, in the architectural offices of John Schaefer, E. Willard Smith and others. After his family moved from Detroit to Chicago, Adler worked under a German émigré architect, Augustus Bauer (1827–94), and gained valuable training in an engineering company during his military service in the American Civil War. After the war, he worked with O. S. Kinney (*d* 1868), and later Ashley Kinney, building educational and civic structures in the Midwest. Adler's ability soon brought him to the attention of an established practitioner, Edward Burling (1818–92), who needed assistance in the aftermath of the Chicago fire of 1871. Burling & Adler's many buildings include the First National Bank (1871) and Mercantile (1873) buildings and the Methodist Church Block (1872), all designed in Chicago by Adler and all demolished. In 1879 he and Burling parted.

Adler's first independent commission was the Central Music Hall (1879; destr. 1900), Chicago, which integrated an office-block, a multipurpose auditorium and shops, a successful formula that Adler later repeated. Other early commissions in Chicago were houses for John Borden (1880; destr. 1955) and Henry Leopold (1882; destr. before 1932), and a number of commercial buildings: the Borden Block (1881; destr. 1916), Jewelers' Building (1882), the Brunswick and Balke Factory (1882–91; destr. 1989) and the Crilly & Blair Complex (1881; destr. *c.* 1970). By 1881 Adler's employees included Louis Sullivan, as is evident from the style and placement of the ornament on the Borden Block. Adler made Sullivan a full partner in 1883, by which time the office was designing factories, stores, houses, office-blocks and especially theatres. The early success of Adler & Sullivan was due to Adler's planning and engineering innovations and his reputation as a careful builder and businessman of integrity. He could recognize and guide talent in others, and the firm also benefited from his many social connections. A founder of the Western Association of Architects, he led its merger into the American Institute of Architects, of which he was secretary in 1892.

Between 1879 and 1889 Adler executed many commissions for theatres and concert halls, ranging from remodellings to enormous multipurpose complexes. He was recognized as a leading expert in acoustics and served as acoustics consultant during the construction (1890–91) of Carnegie Hall, New York. Adler & Sullivan's records do not survive, and the contribution of the partners and their employees can only be inferred; for the Auditorium Building, Chicago (1886–9; see fig.), Sullivan, Paul Mueller and Frank Lloyd Wright, who was employed as a draughtsman, all contributed to the building complex, but the commission and the overall design were Adler's. Among the innovations Adler adapted for the Auditorium Building were caisson foundations (*see* SKYSCRAPER), huge trusses to support the rooms above the theatre space and hydraulic machinery to raise and lower sections of the stage. The plan of the concert hall, with its excellent provision for sight and sound, evolved from early Adler designs; Sullivan was engaged on the ornamental decoration, and Mueller contributed to the engineering. The result was a true synthesis of acoustics, aesthetics and technical innovation, with colour and ornament, science and technology harnessed in the service of art. Wright called it 'the greatest room for music and opera in the world'. Other theatre commissions carried out by Adler & Sullivan include the Schiller Theatre (1891–3; destr. 1961), Chicago, which —like the Auditorium Theatre—was part of a tall office building. Several influential early skyscrapers were also produced by the firm, notably the Wainwright Building, St Louis (1890–91; *see* UNITED STATES OF AMERICA, fig. 9), the Chicago Stock Exchange (1893; destr. 1971) and the Guaranty Building, Buffalo (1894–6; *see* SULLIVAN, LOUIS, fig. 1).

The financial crash of 1893–4, a shift in architectural taste and irreconcilable aesthetic and economic arguments between Adler and Sullivan led to the partnership being acrimoniously dissolved in 1895. That year Adler became a consultant for a company manufacturing lifts for new skyscrapers, mostly in New York. He left after six months, returning to architecture and to Chicago, taking his son Abraham (1876–1914) into partnership. Adler and Sullivan now became competitors—but not implacable enemies —in a shrinking market. Between 1896 and 1900 Adler's offices in Chicago and New York had fewer than a dozen

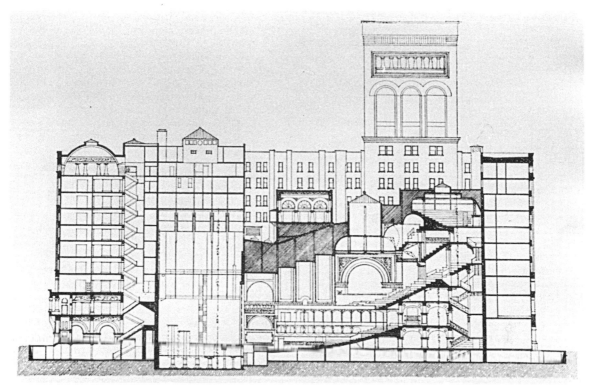

Adler & Sullivan: longitudinal section of the Auditorium Building, Chicago, 1886–9

commissions, whereas in 1886 Adler & Sullivan had had 18 jobs in addition to the Auditorium. Of the edifices built after the split with Sullivan, Adler's Morgan Park Academy dormitories (1896; destr. c. 1970) for a college preparatory school and Isaiah Temple (1898), both in Chicago, were architecturally the most interesting. The temple contains many elements he had used in the Central Music Hall, but the overall style is more historically derived than any Adler & Sullivan designs.

Adler spent much of his later life writing and working successfully for state licensing of architects. He was particularly interested in two causes: recognition for architecture as a learned profession and the education of both the public and the practitioners on how to design for modern society. There were some unbuilt projects, but after his death the firm he left behind did not flourish. The work of this brilliant and conscientious architect and engineer was dominated by the idea of the building as a synthesis, in which 'form and function are one' and in which 'there must be throughout, from foundation to roof, in the arrangement of all the parts, in the design of every line, the imprint and all-pervading influence of one master mind'. He solved practical problems creatively and literally put a firm foundation under the skyscraper and a solid skeleton under its skin. Adler opposed height limitations and slavish obedience to historical precedents, and he was unusual in his willingness to experiment with new materials and relatively untried structural and foundation techniques, as well as in the breadth of building type undertaken. With Sullivan he provided a model for the modern, multi-specialist architectural office, providing also a creative and productive milieu, in which some of the 20th century's leading architects began their careers.

UNPUBLISHED SOURCES
Chicago, IL, Newberry Lib., Dankmar Adler Archv [journals, letters, autobiography]
Chicago, IL, Richard Nickel Cttee [architectural photographs and archv, 1972]

WRITINGS
'Foundations of the Auditorium Building', *Inland Architect & News Rec.*, xi (1888), pp. 31–2
'The Auditorium Tower', *Amer. Architect & Bldg News*, xxxi (1891), pp. 15–16
'Tall Office Buildings—Past and Future', *Engin. Mag.*, iii (1892), pp. 765–73
'Theater Building for American Cities', *Engin. Mag.*, vii (1894), pp. 717–30; viii, pp. 814–29
'The Influence of Steel Construction and of Plate Glass upon the Development of Modern Style', *Inland Architect & News Rec.*, xxviii (1896), pp. 34–7

BIBLIOGRAPHY
M. Schuyler: 'Architecture in Chicago: Adler & Sullivan', *Archit. Rec. Suppl.*, 3 (1895), pp. 3–48
L. Sullivan: *Autobiography of an Idea* (New York, 1924)
F. Lloyd Wright: *Genius and the Mobocracy* (New York, 1949)
C. Condit: *American Building Art: Nineteenth and Twentieth Century* (New York, 1961)
R. Elstein: *The Architectural Style of Dankmar Adler* (MA thesis, U. Chicago, 1963)
R. Baron: 'Forgotten Facets of Dankmar Adler', *Inland Architect & News Rec.*, vii (1964), pp. 14–16
C. Condit: *The Chicago School of Architecture* (Chicago, 1964)
R. Elstein: 'The Architecture of Dankmar Adler', *J. Soc. Archit. Historians*, xxvi (1967), pp. 242–9
J. Saltzstein: 'Dankmar Adler: The Man, the Architect, the Author', *Wisconsin Architect*, xxxviii (1967): (July), pp. 15–19; (Sept), pp. 10–14; (Nov), pp. 16–19
N. Menocal: *Architecture as Nature: The Transcendentalist Idea of Louis Sullivan* (Madison, 1981) [with complete list of Adler's pubd writings, pp. 206–07]

C. Grimsley: *A Study of the Contributions of Dankmar Adler to the Theater Building Practices of the Late Nineteenth Century* (diss., Evanston, IL, Northwestern U., 1984)

L. Doumato: *Dankmar Adler, 1844–1900* (Monticello, IL, 1985)

R. Twombly: *Louis Sullivan: His Life and Work* (New York, 1986) [with full list of Adler & Sullivan commissions]

C. Gregersen: *Dankmar Adler: His Theatres and Auditoriums* (Athens, OH, 1990)

J. Siry: 'Chicago's Auditorium Building: Opera or Anarchism', *J. Soc. Archit. Hist.*, lvii (1998), pp. 128–59

ROCHELLE BERGER ELSTEIN

Affleck, Thomas (*b* Aberdeen, 1740; *d* Philadelphia, PA, 5 March 1795). American cabinetmaker of Scottish birth. He trained as a cabinetmaker in London. In 1763 John Penn, Governor of Pennsylvania, invited Affleck to Philadelphia, where the latter opened a shop on Second Street in the Society Hill area. He made stylish mahogany furniture (sold 1788; e.g. Philadelphia, PA, Cliveden Mus.; armchair, Winterthur, DE, Mus. & Gdns) for the governor's mansion at Lansdowne, PA, and for many of the most prominent families in the city, including the Mifflins, the Whartons and the Chew family at Cliveden.

A Quaker and Loyalist, Affleck refused to participate in the Revolution (1775–83), and he was banished for several months to Virginia in 1777. By the end of the war, however, he was the most prosperous cabinetmaker in the city. His Loyalist sympathies seem to have been forgiven because he was given a number of important commissions, including furniture, for the Pennsylvania Hospital, Congress Hall and the first Supreme Court Chamber in the City Hall, all in Philadelphia.

The large body of surviving furniture attributed to Affleck, which includes wall-brackets, chairs (New York, Met.; see fig.), grand chest-on-chests and elaborately carved tallboys or high chests-of-drawers, confirms his reputation as the leading cabinetmaker in Philadelphia in the 18th century. Much of his furniture was derived from designs in his personal copy of *Gentleman and Cabinetmaker's Director* by Thomas Chippendale I (1718–89). He also made furniture in the Neo-classical style. After his death, his son Lewis G. Affleck carried on the business for a short time until he went bankrupt.

BIBLIOGRAPHY

W. Hornor: *Blue Book, Philadelphia Furniture: William Penn to George Washington* (Philadelphia, 1935/*R* Washington, DC, 1977)

L. Beckerdite: 'Philadelphia Carving Shops', *Antiques*, cxxviii (1985), pp. 498–513

OSCAR P. FITZGERALD

African American [Afro-American; Black American] **art.** Term used to describe art made by Americans of African descent. While the crafts of African Americans in the 18th and 19th centuries continued largely to reflect African artistic traditions, the earliest fine art made by professional African American artists was in an academic western style.

The first African American artist to be documented was Joshua Johnson, a portrait painter who practised in and around Baltimore, MD. Possibly a former slave in the West Indies, he executed plain, linear portraits for middle-class families (e.g. *Sarah Ogden Gustin*, *c.* 1798–1802; Washington, DC, N.G.A.; for illustration *see* JOHNSON, JOSHUA). Only one of the *c.* 83 portraits attributed to Johnson is signed, and none is dated. There are only two African American sitters among Johnson's attributions.

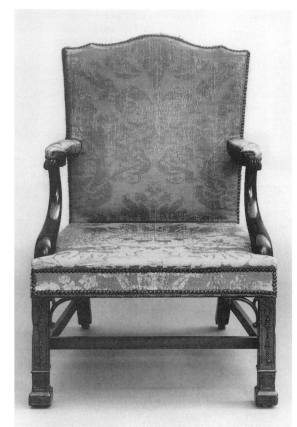

Thomas Affleck: mahogany chair, h. 1.09 m, last quarter of the 18th century (New York, Metropolitan Museum of Art)

Among the second generation of prominent 19th-century African American artists were the portrait-painter William E. Simpson (1818–72) of Buffalo, NY, Robert Douglass jr (1809–87) and Douglass's cousin and pupil David Bowser (1820–1900) of Philadelphia. Douglass, none of whose works survives, started as a sign-painter and then painted portraits as a disciple of Thomas Sully. Engravings and lithographs were produced by Patrick Reason (*b* 1817) of New York, whose parents were from Haiti. His engravings included illustrations for publications supporting the abolition of slavery and also portraits (e.g. *Granville Sharp*, 1835; Washington, DC, Gal. A., Howard U.).

Julian Hudson (*fl c.* 1831–44) was the earliest documented African American painter in the South. Having studied in Paris, he returned to his home town, New Orleans, where he taught art and painted portraits. Although his quarter-length figures were rigidly conventional, Hudson was a skilful painter of faces. His *Self-portrait* (1839; New Orleans, LA State Mus.) is the earliest surviving self-portrait by an African American artist. Jules Lion (1810–66) also studied and practised in Paris prior to returning to New Orleans, where he produced paintings and lithographs. He was also credited with introducing the daguerreotype to the city, where he was one of the earliest professional photographers.

Throughout the 19th century African American artists in Louisiana apparently did not experience as much

professional discrimination as their peers in other areas of the USA. However, even in Louisiana there are few examples of work commissioned by African Americans at this time. The Melrose Plantation House, built *c.* 1833 for the mulatto Metoyer family in Melrose, near Natchitoches, LA, is the only surviving plantation manor house built by an African American family in the southern states. It contained portraits of members of the family, probably executed by an unknown mulatto painter before 1830. The brick and timber African House, an out-house used in part as a prison for the control of slaves in the plantation at Melrose, was remarkable for the width and height of its roof: it was probably constructed during the early 19th century by African-born slaves owned by the Metoyer family.

Another artist from New Orleans, Eugene Warbourg (1826–59), was among the leading black sculptors of the 19th century. He worked in Rome, developing a Neoclassical style, as did Mary Edmonia Lewis, who trained in Boston before becoming the first professional African American sculptor, producing such works as *Hagar* (see fig.).

The most important African American landscape painters of the 19th century were Robert S. Duncanson, Edward Mitchell Bannister and Grafton Tyler Brown (1841–1918). Duncanson, who worked in Cincinnati and Detroit, was the earliest professional African American landscape painter. He studied in Glasgow and travelled extensively in Italy, France and England, as well as in Minnesota, Vermont and Canada. He was the first African American artist to receive international recognition. Although Duncanson painted portraits and still-lifes, he is best known as a Romantic realist landscape painter in the Hudson River school tradition (for illustration *see* DUNCANSON, ROBERT S.). His largest commission came in 1848, when he painted eight large landscape panels and four over-door compositions in the main entrance hall of Nicholas Longworth's mansion, Belmont (now the Taft Museum), in Cincinnati.

Bannister was the leading painter in Providence, RI, during the 1870s and 1880s. Born in Nova Scotia, he started by making solar prints and attended an evening drawing class in Boston. He is reported to have taken up painting in reaction to a newspaper statement in 1867 that blacks could appreciate art but not produce it. He was a moderately talented painter of poetic landscapes (e.g. *Landscape, c.* 1870–75; Providence, RI Sch. Des., Mus. A.), influenced by Alexander Helwig Wyant and the Hudson River school, and also made some genre scenes (e.g. *Newspaper Boy*, 1869; Washington, DC, N. Mus. Amer. A.; for illustration *see* BANNISTER, EDWARD MITCHELL). He was the earliest African American artist to receive a national award when he received a gold medal for *Under the Oaks* (untraced) at the Philadelphia Centennial Exposition in 1876. He was also one of the seven founder-members in 1873 of the Providence Art Club, which became the nucleus of the Rhode Island School of Design. He was the only prominent African American artist of the 19th century not to travel or study in Europe.

Brown was the earliest documented professional African American artist in California. He was first employed in San Francisco as a draughtsman and lithographer, also

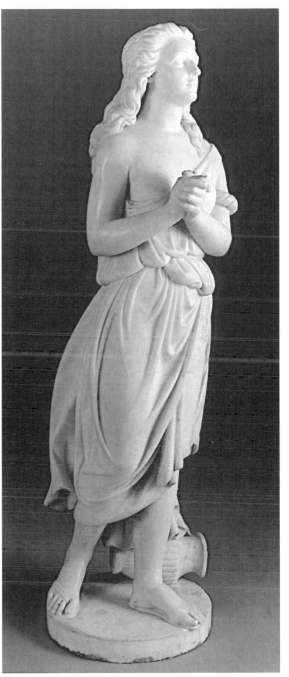

Mary Edmonia Lewis: *Hagar*, marble, h. 1337 mm, 1875 (Washington, DC, National Museum of American Art)

printing street maps and stock certificates, before turning to landscape painting. His most productive years were during the 1880s, when he painted many Canadian landscapes and scenes of the American north-west. He also lived in Portland, OR, and Washington. After 1891 Brown apparently ceased painting and in 1892 moved to St Paul, MN, where he worked as a draughtsman.

The most distinguished African American artist who worked in the 19th century was HENRY OSSAWA TANNER.

His early paintings of the 1890s included African American genre subjects and reflect the realist tradition of Thomas Eakins under whom Tanner studied at the Pennsylvania Academy of Fine Arts in Philadelphia. From 1903 he painted religious subjects, portraits and landscapes, primarily in subdued blues and greens. Like the majority of prominent 19th-century African American artists, Tanner went to Europe for further training and to escape racial and professional discrimination: he lived in Paris during most of his career and developed a painterly style influenced by Symbolism. He held his first one-man exhibition of religious paintings, however, at the American Art Galleries in New York in 1908, and in 1909 he became the first African American to be elected to the National Academy of Design.

In 1907 the Tercentennial Exposition in Jamestown, VA, included among the pavilions a 'Negro Building': its exhibits focused primarily on African American crafts, carpentry and inventions. Although there were 484 paintings and drawings, no works by prominent African American painters were included. The most important African American artist to be included in the Jamestown exhibition was the sculptor Meta Vaux Fuller (1877–1968), who had studied in Paris, where she had gained the approval of Rodin (1840–1917): she exhibited a series of dioramas depicting various aspects of black life in America. Other contemporary exhibitions, however, such as that of THE EIGHT in 1908 and the Armory Show in 1913, both held in New York, had little initial stylistic impact on African American art.

BIBLIOGRAPHY

J. A. Porter: *Modern Negro Art* (New York, 1943)
The Negro in American Art: One Hundred and Fifty Years of Afro-American Art (exh. cat. by J. A. Porter, Los Angeles, CA, Davis U. CA; San Diego, CA, State U., A. Gal.; Oakland, CA, Mus.; 1966–7)
The Evolution of Afro-American Artists, 1800–1950 (exh. cat., intro. C. Greene jr; New York, City Coll. City U., 1967)
M. J. Butcher: *The Negro in American Culture* (New York, 1969)
C. Dover: *American Negro Art* (London, 1969)
S. Lewis and R. Waddy, eds: *Black Artists on Art*, 2 vols (Los Angeles, 1969–71)
Afro-American Artists, 1800–1969 (exh. cat. by R. J. Craig, F. Bacon and B. Harmon, Philadelphia, PA, Mus. Civ. Cent., 1970)
Dimensions of Black (exh. cat., ed. J. Teihet; La Jolla, CA, A. Cent., 1970)
J. W. Chase: *Afro-American Art and Craft* (New York, 1971)
E. Fax: *Seventeen Black Artists* (New York, 1971)
R. Bearden and H. Henderson: *Six Black Masters of American Art* (New York, 1972)
A New Vitality in Art: The Black Woman (exh. cat. by G. Garrison and P. Long, South Hadley, MA, Mount Holyoke Coll. A. Mus., 1972)
E. H. Fine: *The Afro-American Artist: A Search for Identity* (New York, 1973)
S. Lewis: *Art: African American* (New York, 1978)
L. M. Igoe: *Two Hundred and Fifty Years of Afro-American Art: An Annotated Bibliography* (New York, 1981)
W. Ferris, ed.: *Afro-American Folk Arts and Crafts* (Jackson, MS, 1983)
R. F. Thompson: *Flash of the Spirit: African and Afro-American Art and Philosophy* (New York, 1984)
African-American Artists, 1880–1987: Selections from the Evans-Tibbs Collection (exh. cat. by G. C. McElroy, R. J. Powell, S. F. Patton and D. C. Driskell, Washington, DC, Smithsonian Inst. Travelling Exh. Serv., 1989)
Black Art—Ancestral Legacy: The African Impulse in African–American Art (exh. cat., ed. R. V. Rozelle, A. J. Wardlaw and M. A. McKenna; Dallas, TX, Mus. A.; Atlanta, GA, High Mus. A.; Milwaukee, WI, A. Mus.; Richmond, VA Mus. F.A.; 1989–91)
R. Bearden and H. Henderson: *A History of African-American Artists, 1792–1988* (New York, 1992)
Facing the Rising Sun: 150 Years of the African-American Experience, 1842–1992 (exh. cat. by B. A. Hudson, Hartford, CT, Wadsworth Atheneum, 1992–3)
Free within Ourselves: African-American Artists in the Collection of the National Museum of American Art (exh. cat. by R. A. Perry, Hartford, CT, Wadsworth Atheneum and elsewhere, 1992–3)
J. Smalls: 'A Ghost of a Chance: Invisibility and Elision in African American Art Historical Practice', *A. Doc.*, xiii/1 (Spring 1994), pp. 3–8
S. Stuckey: *Going through the Storm: The Influence of African American Art in History* (New York, 1994)
S. L. Jones: 'A Keen Sense of the Artistic: African American Material Culture in Nineteenth-century Philadelphia', *Int. Rev. Afr.-Amer. A.*, xii/2 (1995), pp. 4–29
Int. Rev. Afr.-Amer. A., xii/3 (1995) [issue dedicated to Nineteenth-century African American fine and craft arts of the South]
G. C. Tomlinson and R. Corpus: 'A Selection of Works by African American Artists in the Philadelphia Museum of Art', *Bull., Philadelphia Mus. A.*, xc/382–3 (1995)
S. F. Patton: *African-American Art* (Oxford and New York, 1998)

REGENIA A. PERRY

Alexander, Francis (*b* Killingly, CT, 3 Feb 1800; *d* Florence, 27 March 1880). American painter and lithographer. He studied briefly with Alexander Robertson (1768–1841) in New York and copied portraits by John Trumbull and Samuel Waldo. From 1821 to 1825 he painted portraits in Killingly, CT, and Providence, RI. He received encouraging advice from Gilbert Stuart in Boston, probably in 1825, and by 1828 was a prominent portrait painter and lithographer there. Portraits such as *Mrs Jared Sparks* (1830; Cambridge, MA, Harvard U.) demonstrate a well-developed sense of pattern and design but display some deficiency in draughtsmanship, with conventional shapes used to determine the sitter's features.

From 1831 to 1833 Alexander travelled and painted in Italy. After returning to Boston, he exhibited 39 paintings in 1834 at Harding's Gallery, many of which were derived from the Italian trip. His unusually theatrical portrait of

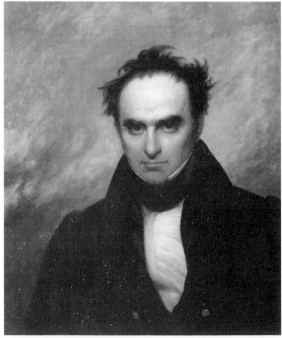

Francis Alexander: *Senator Daniel Webster*, oil on canvas, 762×635 mm, 1835 (Hanover, NH, Dartmouth College, Hood Museum of Art)

Senator Daniel Webster (1835; Hanover, NH, Dartmouth Coll., Hood Mus. A.; see fig.) shows the effect of his exposure to Romanticism; Webster is presented with fiery eyes and wild hair, silhouetted against a dramatic sky. When Dickens visited America in 1842, Alexander aggressively sought him out and depicted him as a slight youth (Dickens was 30) seated casually behind a large table (Boston, MA, Mus. F.A.).

Alexander was made an honorary member of the National Academy of Design in New York in 1840. He returned to Italy in 1853, settling in Florence, where he collected early Renaissance art, gave up painting and became a friend of Hiram Powers, the leader of the city's American art colony. He revisited America only once, in 1868–9. Most of the paintings in his collection, which included works attributed to Perugino (*c.* 1450–1523), Orcagna (1315/20–68) and Domenico Ghirlandaio (1448/9–94), were destroyed while in storage in Boston during the great fire of 1873; the remainder were sold at auction at Leonard & Co., Boston, in 1874. His daughter Esther Frances (1837–1917), known as Francesca, became a painter, illustrator and poet.

UNPUBLISHED SOURCES

Cole papers, New York, Hist. Soc. [copies of Alexander's corr. etc, comp. E. Parker Lesley (1938–48)]

BIBLIOGRAPHY

C. G. Alexander: *Francesca Alexander* (Cambridge, MA, 1927)

W. Dunlap: *History of the Rise and Progress of the Arts of Design in the United States*, iii (New York, 1934, rev. 3/1965), pp. 232–40

C. W. Pierce: 'Francis Alexander', *Old-Time New England*, xliv (1953), pp. 29–46

LEAH LIPTON

Alexander, Henry (*b* San Francisco, CA, *c.* 1860; *d* New York, NY, 16 May 1894). American painter. San Francisco's first native-born artist, he was among the most intriguing of late 19th-century American painters. Little is known about his short life and career, for which there are only four or five reliable dates. He was the second child of an eastern European Jewish immigrant family that settled in San Francisco sometime before 1860. He received his early art training at the California School of Design, where he studied with Toby Rosenthal (1848–1917), probably in 1872–3. A year or two later he left for Europe for prolonged study in Munich. The first definite date of his career is his arrival in New York in 1883 and subsequent return to San Francisco, where he maintained studios in the financial district for about four years. On 15 April 1887, he sailed by way of Panama for New York City, where, seven years later—ill, poverty-stricken and deeply despondent—he took his life by drinking a carbolic acid 'cocktail'. Most of what is known about Alexander, other than the evidence of some 30 surviving paintings, appears in the newspaper obituaries reporting his suicide at the age of about 35.

Once described in the *New York Herald* as one of the creators of the 'modern school of art', Alexander was, in fact, a traditional genre painter in the dark Munich manner, a style made unfashionable by the rise of the brighter, more cosmopolitan Impressionist movement. Along with his friend and fellow student Charles Frederick Ulrich (1858–1908), Alexander was a representative of the later academic Munich style that emulated the precise rendering

and subdued tones of the 17th-century Dutch 'little masters'. Among his other friends in Germany was fellow San Franciscan Henry Raschen (1854–1937), who later became a noted specialist in the depiction of native American Indians.

Most of Alexander's surviving works are San Francisco subjects depicting identifiable interiors and specific activities of the 1880s (see fig.). Typical of a series of scientific and trade genre pictures is *The First Lesson* (San Francisco, CA, F.A. Museums), in which taxidermist William Nolte is seen demonstrating his craft to apprentice William J. Hackimer in the former's Golden Gate Avenue studio (identification according to Williams). *The Lost Genius* (Berkeley, CA, Univ. A. Mus.), showing an aged cobbler in his meticulously detailed storefront shop playing his violin with a black boy listening at the door, brings to mind the work of William Sidney Mount, J. D. Chalfant (1856–1931) or even Eastman Johnson. Alexander is also known for his views of Chinese interiors, including 'opium dens'. Despite their descriptive realism, these paintings convey an evocative mood both contemplative and mysterious.

Alexander's slightly off-centre, enigmatic work never found a comfortable art-historical niche, in spite of his Munich training and clear ambitions to succeed as a genre and portrait painter, first in San Francisco and then in New York. The problem of his posthumous reputation is compounded by several factors, including his short career

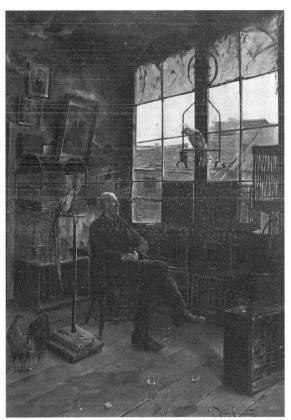

Henry Alexander: *The Old Man's Pleasure*, oil on canvas, 664×470 mm, c. 1885 (Oakland, CA, Oakland Museum)

and the destruction of the majority of his output by fire following the 1906 San Francisco earthquake. The unsold paintings were stored by the family in a warehouse on Sansome Street in anticipation of a major retrospective. It was not until three decades later, however, that the first retrospective of Alexander's work took place, at Gump's Art Gallery, San Francisco (1937). Only two further exhibitions of his paintings have been held, both also in San Francisco: one at the San Francisco Museum of Art (1940) and another at the M. H. de Young Memorial Museum (1973), which displayed the 20 paintings at the time believed to be the total of his extant oeuvre.

BIBLIOGRAPHY

A. Frankenstein: *After the Hunt: William Harnett and other American Still-life Painters, 1870–1900* (Berkeley, CA, 1953, 2/1969)

H. W. Williams jr: *Mirror to the American Past: A Survey of American Genre Painting, 1750–1900* (New York, 1973)

R. L. Wilson: 'Henry Alexander: Chronicler of Commerce', *Archvs Amer. A. J.*, xx/2 (1980), pp. 10–13

W. H. Gerdts: *Painters of the Humble Truth* (Columbia, MO, 1981)

P. J. Karlstrom: 'The Short, Hard and Tragic Life of Henry Alexander', *Smithsonian*, xii (March 1982), pp.108–17

W. H. Gerdts: *Art across America: Two Centuries of Regional Painting, 1720–1920*, iii (New York, 1990)

PAUL J. KARLSTROM

Alexander, John White (*b* Allegheny, PA, 7 Oct 1856; *d* New York, 31 May 1915). American painter and illustrator. He began his career in New York in 1875 as a political cartoonist and illustrator for *Harper's Weekly*. In 1877 he went to Paris for his first formal art training, and then to Munich, where he enrolled at the Kunstakademie under Gyuala Benczúr (1844–1920). In 1878 he joined a colony of American painters established by Frank Duveneck in Polling, Bavaria. In 1879 they travelled to Italy, where Alexander formed friendships with James McNeill Whistler and Henry James. In 1881 he returned to New York, working as an illustrator for *Harper's*, as a drawing instructor at Princeton and as a highly successful society portrait painter. He also exhibited at the National Academy of Design. By 1893 his reputation in both Europe and America had soared, and in 1895 he was awarded a prestigious commission for a series of murals entitled *Evolution of the Book* in the newly established Library of Congress in Washington, DC. After 1901 Alexander became deeply involved with the promotion of the arts in America. He won numerous mural commissions (e.g. Pittsburgh, PA, Carnegie Inst.; from 1905, unfinished) and continued to paint portraits.

Alexander's stylistic development falls into several distinct stages. His early landscapes and genre scenes of the 1870s bear the stamp of the Munich realism of Wilhelm Leibl (1844–1900), as espoused by Duveneck and William Merritt Chase. His fluid brushwork resembled that of Frans Hals (1581/5–1666) and Diego Velázquez (1599–1660), painters he deeply admired. After his return to the USA in 1881 and under the influence of Whistler, he favoured a more limited palette and experimented with the evocation of mood through shadow and gesture. His portrait of *Walt Whitman* (1886–9; New York, Met.) is one of his finest works of the 1880s. Many of his later portraits, notably of women, were psychological studies rather than specific likenesses, as in *The Ring* (1911; New York, Met.). His brushwork became less painterly and

more concerned with suggesting abstracted shapes. He also adopted a very coarse-weave canvas, the texture of which became an important element in his mature work. By applying thinned-down paint to the absorbent surface, his pictures appear to have been dyed in muted tones, in marked contrast to the glossy, impasted surfaces of his earlier work. Throughout his career Alexander favoured compositions with a single figure placed against a sharply contrasting background. The sinuous curvilinear outline of the heroine standing full-length in *Isabella, or the Pot of Basil* (1897; Boston, MA, Mus. F.A.) evokes contemporary Art Nouveau forms. Like the Symbolists, he sought by gesture and strong lighting to intensify the viewer's response to his sensuous treatment of the subject.

UNPUBLISHED SOURCES

Washington DC, Smithsonian Inst., Archv Amer. A. [John White Alexander papers]

BIBLIOGRAPHY

G. Monrey: 'An American Painter in Paris: John W. Alexander', *Int. Studio*, xi (1900), pp. 71–7

Amer. Mag. A., vii (1916) [whole issue]

Catalogue of Paintings: John White Alexander Memorial Exhibition (Pittsburgh, PA, Carnegie Mus. A., 1916)

John White Alexander (1856–1915) (exh. cat. by M. Goley, Washington, DC, N. Col. F. A., 1976)

John White Alexander (1856–1915): Fin-de-siècle American (exh. cat. by S. Leff, New York, Graham Gal., 1980)

M. A. Goley: 'John White Alexander's *Panel for Music Room*', *Bull. Detroit Inst. A.*, lxiv/4 (1989), pp. 5–15

——: 'John White Alexander: The Art of Still Life', *Amer. A. Rev.*, vii/4 (1995), pp. 148–53

ELEANOR JONES HARVEY

Allston, Washington (*b* Waccamaw, SC, 5 Nov 1779; *d* Cambridgeport, MA, 9 July 1843). American painter. The son of a prominent South Carolina plantation owner of English descent, he began to draw around the age of six, and he moved to his uncle's home in Newport, RI, at the age of eight. While there he came into contact with the portrait painter Samuel King, but it was the exhibited portraits of Robert Edge Pine that offered him inspiring models of glazing and colouring. Dubbed 'the Count' by his Harvard College classmates for his way with fashion, Allston explored alternatives to the portrait tradition with landscapes, as well as with depictions of irrational figures, for example *Man in Chains* (1800; Andover, MA, Phillips Acad., Addison Gal.). After graduating in 1800, he sold his patrimony to fund study abroad.

In 1801 Allston went with Edward Greene Malbone to London, where he frequented the circle of Benjamin West and studied drawing at the Royal Academy. In late 1803 he departed with John Vanderlyn for Paris, where an enthusiasm for heroic landscape temporarily usurped the ideals that he had attached to history painting. Allston exhibited at the Royal Academy in 1802 and 1803, and at the Paris Salon of 1804, but he achieved his first critical success with *Diana and her Nymphs in the Chase* (1805; Cambridge, MA, Fogg; see fig.), which he painted in Rome soon after his arrival there in 1805. The monumental canvas presents Classical figures, a chasm rupturing the shore of a crystalline lake and a jagged, gleaming mountain beyond. Allston achieved his brilliant sunlight and strikingly transparent colour with a Venetian method of glazing readily learnt in London but little known in Paris or Rome; it cast him into the role of an international conduit for

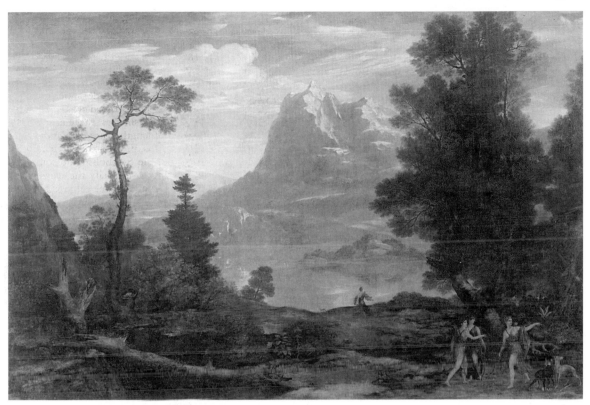

Washington Allston: *Diana and her Nymphs in the Chase*, oil on canvas, 1.66×2.48 m, 1805 (Cambridge, MA, Fogg Art Museum)

ideas about painting technique and consolidated his reputation. While in Rome he painted several portraits, including his *Self-portrait* (1805; Boston, MA, Mus. F.A.) and one of his friend *Samuel Taylor Coleridge* (1806; Cambridge, MA, Fogg).

Allston returned to Boston in 1808 and married the next year; during this stay he composed much of the verse that he published as a collection in 1813 and painted a few comic pieces, such as *The Poor Author and the Rich Bookseller* (1811; Boston, MA, Mus. F.A.). In 1811 he departed for London with his wife and his pupil, Samuel F. B. Morse. At this time he began to depict biblical themes, emphasizing in particular figural and facial expression. Participating in the current English vogue for resurrection imagery, Allston chose a rarely treated Old Testament subject, the *Dead Man Restored to Life by Touching the Bones of the Prophet Elisha* (1811–14; Philadelphia, PA Acad. F.A.). The prostrate protagonist, inspired by the monument to *Gen. William Hargrave* (London, Westminster Abbey) by Louis-François Roubiliac (1702–62), unfurls his shroud and thereby illustrates the divine process of reanimation. The other figures' dramatic responses to this miracle exemplify Allston's Romantic historical style (*see also* UNITED STATES OF AMERICA, fig. 12). The prize awarded by the British Institution to the *Dead Man* in 1814 and purchases made by English aristocrats and Americans in London provided Allston with a decided degree of success. Yet around the time of the sudden death of his wife in 1815, he first met the financial pressures that would plague him for the

balance of his career. Despite a first prize at the British Institution in 1818 for *Uriel in the Sun* (1817; U. Boston, MA, Mugar Mem. Lib.), Allston sailed for Boston that year.

Allston thought he had but several months' work remaining on a 3.6×4.8 m canvas that he had begun in London of *Belshazzar's Feast* (1817–18, 1820–28, 1839–43; Detroit, MI, Inst. A.), which, like West's treatment of the subject, emphasizes Daniel's act of interpretation. Allston intended from the outset to exhibit the canvas in America; the subject, a type of both the advent of the millennium and the Last Judgement, was especially potent for American audiences, given the formative role of Jeremiads in American thought. Before his recommencement of the project in 1820, Allston elaborated on the imagery of prophecy and divine vengeance in canvases featuring the Old Testament figures Miriam, Saul and Jeremiah (e.g. *Jeremiah Dictating his Prophecy of the Destruction of Jerusalem to Baruch the Scribe*, 1820; New Haven, CT, Yale U. A.G.), yet it was *Belshazzar's Feast* that he planned as his homecoming masterpiece, hoping it to be worthy of comparison with the great works of the past.

The ceaseless revisions that characterized Allston's work on the composition began with an overhaul of its spatial organization. Among the fruits of the protracted labours of 'Belshazzar's slave', as he referred to himself in 1825, were expressive chalk drawings (Cambridge, MA, Fogg) of the King's fear-stricken hands. In the winter of 1825–6 illness interrupted Allston's progress, just as it had in 1813 when work on the *Dead Man* undermined his

health. Given Allston's European successes, technical sophistication and intellectualism, such exertions only enhanced for many Americans his identification with the Romantic ideal of the fine arts. By 1827 twelve patrons had created a fund of $10,000 to free Allston from financial pressures; this increased his sense of obligation to complete the canvas, although the original idea must have been long lost to him. Moving to a smaller studio in 1828, Allston stored the canvas until 1839, when he began a final and unsuccessful period of work on it. Insecurity about his fitness for the task had progressively overwhelmed his aspirations, and he never completed the canvas.

In 1830 Allston married his late wife's cousin and moved to Cambridgeport, MA. While he had painted solitary, idealized women from the time of his first marriage, in his later years he was persistently concerned with depicting the single figure. The shimmering, mist-filled setting of his richly coloured and heavily glazed *Spanish Girl in Reverie* (1831; New York, Met.) creates a mood conducive to peaceful reflection, although the figure's poised right hand and the towering peaks beyond contribute dramatic counterpoints. Such cabinet pictures and his late landscapes (e.g. *Italian Landscape, c.* 1828–30; Detroit, MI, Inst. A.), exhibited in the major retrospective of his works in Boston in 1839, set the tone for his posthumous reputation as a refined and poetic Romantic genius. Allston inspired numerous American artists, including William Page and the sculptor Horatio Greenough.

WRITINGS
R. H. Dana jr, ed.: *Lectures on Art and Poems* (New York, 1850) [essays composed in the 1830s; the first art treatise by an American
N. Wright, ed.: *The Correspondence of Washington Allston* (Lexington, KY, 1993) [all letters to and from the painter, 1795–1843]

BIBLIOGRAPHY
J. B. Flagg: *The Life and Letters of Washington Allston* (New York, 1892)
E. P. Richardson: *Washington Allston: A Study of the Romantic Artist in America* (Chicago, 1948, rev. New York, 1967)
E. Johns: 'Washington Allston's *Dead Man Revived*', *A. Bull.*, lxi (1979), pp. 79–99
'*A Man of Genius': The Art of Washington Allston (1779–1843)* (exh. cat. by W. H. Gerdts and T. E. Stebbins jr, Boston, Mus. F.A., 1979)
B. J. Wolf: 'Romanticism and Self-consciousness: Washington Allston', *Romantic Re-vision: Culture and Consciousness in Nineteenth-century American Painting and Literature* (Chicago and London, 1982), pp. 3–77
D. Bjelajac: *Millennial Desire and the Apocalyptic Vision of Washington Allston* (Washington, DC, 1988)
M. B. Wallace: 'Washington Allston's *Moonlit Landscape*', *The Italian Presence in American Art, 1760–1860*, ed. I. B. Jaffe (New York, 1989), pp. 82–94
G. Eager: 'Washington Allston's *The Sisters*: Poetry, Painting and Friendship', *Word & Image*, vi/4 (1990), pp. 298–307
J. Hill Stoner: 'Washington Allston: Poems, Veils and "Titian's Dirt"', *J. Amer. Inst. Conserv.*, xxix/1 (1990), pp. 1–12
D. Bjelajac: 'Washington Allston's Prophetic Voice in Worshipful Song with Antebellum America', *Amer. A.*, v/3 (1991), pp. 68–87
D. B. Dearinger: 'British Travelers' Views of American Art before the Civil War, with an Appendix Listing Travel Books', *Amer. A. J.*, xxiii/1 (1991), pp. 38–69
K. A. P. Lawson: 'Washington Allston's *Hermia and Helena*', *Amer. A.*, v/3 (1991), pp. 108–9
D. Bjelajac: 'The Boston Elite's Resistance to Washington Allston's *Elijah in the Desert*', *American Iconology: New Approaches to Nineteenth-century Art and Literature* (New Haven and London, 1993), pp. 39–57
D. Strazdes: 'Washington Allston's *Beatrice*', *J. Mus. F.A., Boston*, vi (1994), pp. 63–75
D. Bjelajac: *Washington Allston, Secret Societies and the Alchemy of Anglo-American Painting* (Cambridge and New York, 1997)

DAVID STEINBERG

Amateur Photographic Exchange Club. *See* EX-CHANGE CLUB.

Amelung, John Frederick [Johann Friedrich] (*b* Hettlingen, nr Hannover, Germany, 26 June 1741; *d* Baltimore, MD, 1 Nov 1798). American glass manufacturer of German birth. He was associated with his brother's mirror-glass factory in the town of Grünenplan before his venture to make table wares and utility glass in America began in 1784. With backing from investors in Bremen, Germany, Amelung brought 68 glass craftsmen and furnace equipment to the USA. He purchased an existing glasshouse near Frederick, MD, along with 2100 acres. The factory, which he named the New Bremen Glassmanufactory, had been founded by glassmakers from Henry William Stiegel's defunct operation in Manheim, PA. It was well situated in western Maryland, not far from Baltimore, which offered a fast-growing market. Many settlers in the area were Germans, who were expected to be supportive of the enterprise. During the following decade Amelung built housing for his 400–500 workers. It is believed that he built four glasshouses.

Although Amelung's craftsmen made window glass, bottles and table glass, the most important group of objects associated with the factory are the high-quality, wheel-engraved presentation pieces (e.g. goblet, 1791;

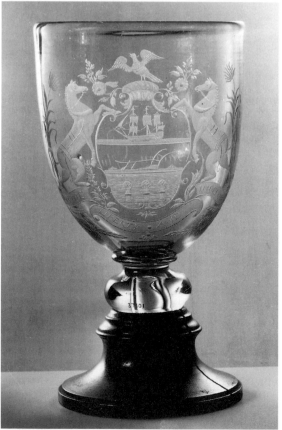

John Frederick Amelung: glass goblet, h. 254 mm, made for Pennsylvania governor Thomas Mifflin, 1791 (New York, Metropolitan Museum of Art)

New York, Met,; see fig..) made as gifts for friends and for such politicians as US president George Washington or Pennsylvania governor Thomas Mifflin, whom Amelung hoped to impress. These wares shared some of the *Waldglas* lily-pad decoration associated with Caspar Wistar's earlier glassworks, but Amelung's products are more spectacular in conception and execution. They are significant for often being signed and dated; Amelung's was the only American factory doing this at the time.

In 1787 Amelung published a pamphlet entitled *Remarks on Manufactures, Principally on the New Established Glass-house, near Frederick-Town in the State of Maryland*, in which he related the founding of his enterprise and speculated on its future. Its progress, he argued, would be greatly facilitated and the public interest best served by official support of American manufacturers through tax exemptions and interest-free government loans. Although the State of Maryland loaned him £1000 in 1788, additional state or federal government support was not forthcoming. Furthermore, a flood in the autumn of 1786 that damaged one glasshouse, a strong wind in the spring of 1790 that caused the collapse of several houses and mills, and shortly thereafter a fire that destroyed one of his factories and a warehouse, all combined to undermine an operation that was already overextended. Amelung's petition to the US Congress for help after the fire was denied for lack of security on a loan. In a second petition he further proposed to build glasshouses in Virginia and the Carolinas to serve the southern USA. Although the second request was rejected, his suggestion that duties be raised on imported glass was executed in several instalments between 1790 and 1794. Amelung's operations virtually ceased following his stroke in 1794, and he went bankrupt in 1795. His son, John Frederick Magnus Amelung, continued to make glass in the glasshouse given to him in 1795 by his father (the site was not included in his father's bankruptcy), but in 1799 he transferred the property to his partners Adam Kohlenberg and George Christian Gabler.

WRITINGS
Remarks on Manufactures, Principally on the New Established Glass-house, near Frederick-Town in the State of Maryland (Frederick-Town, 1787)

BIBLIOGRAPHY
D. P. Lanmon, A. Palmer Schwind and others: *John Frederick Amelung: Early American Glassmaker* (London, 1990)
ELLEN PAUL DENKER

American China Manufactory. *See* TUCKER CHINA FACTORY.

American Flint Glass Manufactory. *See under* STIEGEL, HENRY WILLIAM.

American Impressionism. *See under* IMPRESSIONISM.

American Pottery Manufacturing Co. American pottery manufacturer. Beginning in 1828 D. & J. Henderson made award-winning Rockingham in a factory previously occupied by the Jersey Porcelain and Earthenware Co. in Jersey City, NJ, but in 1833 David Henderson (*c.* 1793–1845) took control of the company and changed the name to the American Pottery Manufacturing Co. In addition to

the fine Rockingham modelled by the Englishman Daniel Greatbach (*fl* after 1839; *d* after 1866), the company was the first to make transfer-printed pearlware in the USA and *c.* 1833 reproduced Ridgway's 'Canova' pattern. Many English potters who settled in the USA during the second quarter of the 19th century started their American careers in Henderson's pottery. After Henderson's death in 1845, the firm continued until 1852, when John Owen Rouse (*d* 1896) and Nathaniel Turner (*d* 1884) took over the works for the production of whiteware, which was made there until 1892.

BIBLIOGRAPHY
E. A. Barber: *The Pottery and Porcelain of the United States* (New York, 1893, rev. 3/1909/*R* 1976), pp. 118–25
D. Stradling and E. P. Denker: *Jersey City: Shaping America's Pottery Industry, 1825–1892* (Jersey City, NJ, 1997)
ELLEN PAUL DENKER

Ames, Ezra (*b* Framingham, MA, 5 May 1768; *d* Albany, NY, 23 Feb 1836). American painter and craftsman. After working briefly in Worcester, MA (1790–93), painting miniatures, chimney-pieces, signs and sleighs, he settled permanently in Albany, NY. There he practised various crafts, including framemaking and painting ornamental clockfaces. Active in the Masonic Temple, he held a high position in the New York chapter from 1802 to 1826. For the Masons he made signs, aprons, urns and carpet designs. Entries in his account books indicate that by 1813 he was primarily painting portraits, improving his technique by copying works by John Singleton Copley and Gilbert Stuart. His first major success was the sale of a portrait of

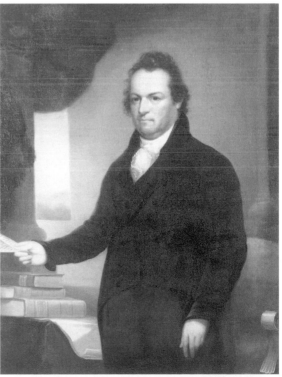

Ezra Ames: *DeWitt Clinton as Governor of New York*, oil on canvas, 762×610 mm, 1817–18 (Albany, NY, on deposit Albany Institute of History and Art)

George Clinton, Governor of New York and vice-president of the USA, to the Pennsylvania Academy of Fine Arts (1812; destr. 1845). Laudatory reviews generated requests for replicas, including an ambitious but somewhat awkward full-length version (*c.* 1813; Albany, NY, State Capitol). Ames also painted the official portrait of George Clinton's nephew, *DeWitt Clinton as Governor of New York* for the city of Albany (1817–18; on dep. Albany, NY, Inst. Hist. & A.; see fig.). It is a half-length portrait and demonstrates his straightforward, factual style. Ames was elected to the American Academy of Fine Arts in 1824 but never exhibited in New York. Nearly 500 of his works, mainly portraits of people in New York state, have been recorded.

BIBLIOGRAPHY

T. Bolton and I. F. Cortelyou: *Ezra Ames of Albany* (New York, 1955)
I. F. Cortelyou: *A Supplement to the Catalogue of Pictures by Ezra Ames of Albany* (New York, 1957)

LEAH LIPTON

Anderson, Alexander (*b* New York, 21 April 1775; *d* Jersey City, NJ, 17 Jan 1870). American wood-engraver. He was the first important American wood-engraver. He was self-taught and made woodcuts for newspapers at the age of 12. Between *c.* 1792 and 1798, when he studied and practised medicine, he engraved wood as a secondary occupation, but, following the death of his family in the yellow fever epidemic of 1798, he abandoned medicine and worked as a graphic artist. He was an early follower of the white-line style of Thomas Bewick (1753–1828). He usually engraved the designs of others, such as Benjamin West, but he was a skilful and original draughtsman, as can be seen in his illustrations for Durell's edition of Homer's *Iliad* (New York, 1808). He exhibited frequently at the American Academy and was a founder-member of the National Academy of Design (1825). Anderson spent his long and prolific career in New York, engraving mainly for book publishers and magazines but also producing pictorial matter for printed ephemera. He worked steadily until the late 1850s, cut his last blocks in 1868 and was described by Linton as 'the father of American wood engraving'. His reputation rests on his solid craftsmanship rather than his artistic abilities. A large collection of his proofs is in the New York Public Library, and his tools and some of his blocks are kept by the New-York Historical Society.

BIBLIOGRAPHY

W. J. Linton: *History of Wood Engraving in America* (Boston, 1882), pp. 1–9
F. M. Burr: *Life and Works of Alexander Anderson, M.D., the First American Wood Engraver* (New York, 1893)
H. Knubel: 'Alexander Anderson and Early American Book Illustration', *Princeton U. Lib. Chron.*, i (April, 1940), pp. 8–18
A. Gardner: 'Doctor Alexander Anderson', *Bull. Met.*, ix/x (1950–52), pp. 218–24
J. R. Pomeroy: 'Alexander Anderson's Life and Engravings before 1800', *Amer. Antiqua. Soc. Proc.*, c (1990), pp. 137–230

DAVID TATHAM

Annapolis. North American city and capital of the state of Maryland. It is situated on a peninsula in the Severn River (see fig.) and was founded as state capital in 1694. Originally called Providence, it was then named after Princess, later Queen, Anne, although it was also known at that time as Anne Arundeltown. Following the English Glorious Revolution of 1688, which brought William III and Mary II to the English throne, the formerly largely Catholic state of Maryland was divided into Anglican parishes by its new governor, Francis Nicholson. Although land had been set aside before 1694 on Annapolis's site, little development had occurred. The city plan (1695) is attributable to Nicholson: while several towns in the English colonies, including New Haven (founded 1638)

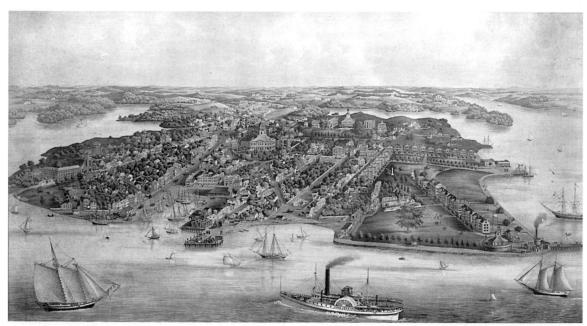

Annapolis, Maryland, view from the south-east, *c.* 1860; from a lithograph by E. Sachse and Company (Baltimore, MD, Maryland Historical Society Museum)

and Philadelphia (founded 1682), had adhered earlier to formal design principles, none was as obviously Baroque as his plan. Although the original was lost, another exists from 1743, which retraced a survey made in 1718; the original layout is believed to have been faithfully drawn but with additional streets to the north. Its Baroque character, with streets radiating out from two circles, affirms Nicholson's awareness of the plans by Christopher Wren (1632–1723) and John Evelyn (1620–1706) for rebuilding London after the Great Fire of 1666.

The firm connection between Church and State that the Glorious Revolution meant to effect is strongly expressed through the dominating Church Circle and Public Circle in the city plan. Nicholson intended each circle to house the Anglican church of St Anne and the statehouse respectively. Linking the two circles is the short School Street, on which was built King William's School (chartered 1696). Other features of the plan included Bloomsbury Square to the west of the circles and a market square to the east, neither of which survives. The main street, Church Street, led from Church Circle to the dock and harbour. Because of its constricted peninsular site and because Baltimore had surpassed Annapolis as Maryland's major town shortly after the Revolution, Annapolis never became a metropolis, and much of the character of the original town survives; government buildings lie to the west of the colonial city without destroying its intimacy. Although its first statehouse and churches are gone, the existing Statehouse or Capitol, begun in 1770 possibly by Joseph H. Sharpe, remains the oldest in continuous use in the USA. An unusual church was built to replace the first church in 1775–92, but it was destroyed by fire in 1858; a print of c. 1800 shows it as a two-storey brick rectangular structure with a pedimented roof and single bell-tower, the first storey ornamented with a series of blind arcades. A third significant colonial building in Annapolis was the house begun c. 1742 by Governor Thomas Bladen, intended to equal the Williamsburg Governor's Palace (see UNITED STATES OF AMERICA, fig. 6); due to its inordinate cost, however, funding was stopped, and it became known as Bladen's Folly. It was later remodelled on the campus of St John's College.

Annapolis has many high-quality houses dating to the mid-to-late-18th-century, at least five of which were worked on by WILLIAM BUCKLAND, who settled in Annapolis after 1771. These include the Chase-Lloyd House (1771), the James Brice House (c. 1772) and, the finest of all, the Hammond-Harwood House (1773–4). The last comprises five sections, with two end pavilions with octagonal bays. The United States Congress met in Annapolis in 1783–4, following the Peace of Paris (1783), and the city, with its central location, bid unsuccessfully to become the United States capital. Indeed, with nearby Baltimore's emergence as the USA's fifth largest city in 1790, Annapolis, with only 2000 inhabitants, had to fight to remain state capital. In 1808 the circular Fort Severn was built by the government at the tip of the peninsula to the north-east of the town; the site was later selected for the United States Naval Academy (1845). While the rate of restoration of the city's buildings may not have been as fast as in the colonial city of WILLIAMSBURG, a number of Victorian buildings that overshadowed important 18th-century sites have been removed, enabling the reconstruction of sites of interest.

BIBLIOGRAPHY

E. S. Riley: 'The Ancient City': A History of Annapolis, in Maryland, 1649–1887 (Annapolis, 1887)
W. B. Norris: Annapolis: Its Colonial and Naval Story (New York, 1925)
D. Davis: Annapolis Houses, 1700–1775 (New York, 1947)
M. L. Radoff: Buildings of the State of Maryland at Annapolis (Annapolis, 1954)
H. C. Forman: Maryland Architecture—A Short History (Cambridge, MD, 1968)
J. W. Reps: Tidewater Towns: City Planning in Colonial Virginia and Maryland (Williamsburg and Charlottesville, 1972)
B. Paca–Steele: 'The Mathematics of an Eighteenth Century Wilderness Garden: William Paca Garden, Annapolis', J. Gdn. Hist., vi (1986), pp. 299–320
M. P. Leone and others: 'Power Gardens of Annapolis: Landscape Archaeology of the American Revolution', Archaeology, xlii (1989), pp. 34–9
M. P. Leone and B. J. Little: 'Seeds of Sedition: Jonas Green's Printshop, Annapolis', Archaeology, xliii (1990), pp. 36–40
K. McCormick: 'Buried Treasures: William Paca House, Annapolis', Hist. Preserv., xlv (1993), p. 68
J. A. Headley: 'The Monument without a Public: The Case of the Tripoli Monument', Winterthur Port., xxix (1994), pp. 247–64
E. Kryder–Reid: 'The Archaeology of Vision in Eighteenth Century Chesapeake Gardens', J. Gdn. Hist., xiv (1994), pp. 42–54

JAMES D. KORNWOLF

Anshutz, Thomas (Pollock) (b Newport, KY, 5 Oct 1851; d Fort Washington, PA, 16 June 1912). American painter and teacher. In 1872 he moved to New York, where he enrolled at the National Academy of Design. By 1875 he had advanced to the life class but found the Academy 'a rotten old institution'. Moving to Philadelphia, Anshutz entered a life class taught by Thomas Eakins at the Philadelphia Sketch Club and transferred to the Pennsylvania Academy of the Fine Arts when it opened its new building in 1876. Continuing to study under Eakins and Christian Schussele (1824/6–79), Anshutz soon became Eakins's assistant demonstrator for anatomy courses taught by the surgeon William Williams Keen.

Anshutz's style quickly progressed from a tight linearity toward an emphasis on solid form, expressed through simplified modelling and a thorough knowledge of anatomy. For his first mature works he sought subjects in the active lives around him, whether in the lush pastoral setting of The Father and his Son Harvesting (1879; New York, Berry-Hill Gals) or the cruder homestead of The Way They Live (Cabbages) (1879; New York, Met.). The factual, yet measured depiction of both outdoor setting and human activity in these works also characterizes Anshutz's finest painting, The Ironworkers' Noontime (1880; San Francisco, CA, F.A. Museums; see fig.), a scene of factory workers at their midday break. Masterful in the arrangement and description of human form and industrial setting, the painting was groundbreaking for the choice of subject and the objectivity of the artist's approach. Curiously, Anshutz never attempted another work so bold or important, perhaps because his duties at the Academy were increasingly demanding of his energies.

By 1881 Anshutz had become Chief Demonstrator for life-class dissections at the Academy; two years later he became Assistant Professor in Painting and Drawing to Eakins. In 1884 he assisted Eakins and Eadweard Muy-

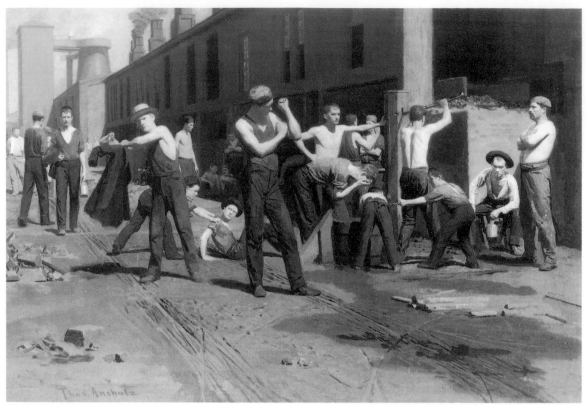

Thomas Anshutz: *The Ironworkers' Noontime*, oil on canvas, 435×610 mm, 1880 (San Francisco, CA, Fine Arts Museums of San Francisco)

bridge with their experiments in motion photography at the University of Pennsylvania. Yet by 1886 Anshutz had joined the students and faculty who charged Eakins with misconduct of the life class; after Eakins resigned, Anshutz succeeded him as Professor of Painting and Drawing. Thereafter teaching dominated his activities.

In 1892 Anshutz married and combined his honeymoon with a year's study at the Académie Julian, Paris. On his return, he began working more in pastels and watercolour, showing a greater interest in light and colour, even while basing his compositions on photographic sources. He resumed teaching at the Academy in 1893; five years later he joined Hugh Breckenridge (1870–1937) in establishing a summer school for landscape painting. In 1909 Anshutz succeeded William Merritt Chase as Director of the Academy; the next year he was elected President of the Philadelphia Sketch Club. Anshutz's portraits and figural paintings from these later years demonstrate his characteristic concern for modelling and form, yet works such as *The Tanagra* (1911; Philadelphia, PA Acad. F.A.) also display more fluid brushwork and a hint of decorative flatness, suggesting the influence of Chase as well as study in Paris.

One of the most influential American teachers of the 19th century, Anshutz transmitted Eakins's emphasis on careful observation, solid form and comprehension of anatomy. While insisting on fundamentals, he encouraged individual expression. His instruction formed a bridge between the analytical realism of Eakins and the more expressive, experimental styles of the early 20th century.

Anshutz's most successful students included the Pennsylvania landscape painter Edward Redfield (1869–1965), such members of the Ashcan school as Robert Henri and John Sloan, and artists who drew inspiration from European modernism, such as Charles Sheeler (1883–1965) and John Marin.

BIBLIOGRAPHY

F. Zeigler: 'An Unassuming Painter: Thomas P. Anshutz', *Brush & Pencil*, iv (1899), pp. 277–84
R. Bowman: 'Nature, the Photograph and Thomas Anshutz', *A. J.* [New York], xxxiii/1 (1973), pp. 32–40
Thomas P. Anshutz, 1851–1912 (exh. cat. by S. D. Heard, Philadelphia, PA Acad. F.A., 1973)
L. Goodrich: *Thomas Eakins*, i (Cambridge, MA, 1982)
Thomas Anshutz: Artist and Teacher (exh. cat. by R. C. Griffin, Huntington, NY, Heckscher Mus., 1994)
G. McCoy: '*The Ironworkers' Noontime*: Documents of Ownership of the Painting', *Archvs Amer. A. J.*, xxxv/1–4 (1995), pp. 83–6

SALLY MILLS

Armory Show [International Exhibition of Modern Art]. Exhibition of art held between 17 February and 15 March 1913 in New York at the 69th Regiment Armory, Lexington Avenue, Manhattan (*see* NEW YORK, fig. 7), from which it derived its nickname. The exhibition then travelled to the Art Institute of Chicago (24 March–16 April) and Copley Hall, Boston (28 April–19 May). Its importance was primarily as the first large-scale show of European modern art held in the USA (*see* UNITED STATES OF AMERICA, §III, 3), although two thirds of the 1300 works were by American artists. It resulted from the independent campaign of the Association of American Painters and

Sculptors, a group of progressive artists formed in 1912 to oppose the National Academy of Design. Arthur B. Davies, the President of the group, and Walt Kuhn (1877–1949) were determined to present an international survey for the first in what was to have been a series of exhibitions. The Armory Show was modelled on the *Sonderbund* exhibition in Cologne (1912) and on the two Post-Impressionist exhibitions organized by Roger Fry (1866–1934) in London. In 1912 Kuhn travelled to Cologne, The Hague, Amsterdam, Berlin and Munich to make selections and was joined by Davies in Paris and London. Assisted in Paris by Walter Pach (1883–1958), they succeeded in borrowing significant examples of Impressionism, Post-Impressionism, Fauvism and Cubism from leading European artists and dealers.

The organizers attempted in the Armory Show to trace the development of modern art movements from the 19th century to contemporary work. Selections ranged from Jean-Auguste-Dominique Ingres (1780–1867) to Post-Impressionists such as Paul Cézanne (1839–1906), Paul Gauguin (1848–1903) and Vincent van Gogh (1853–90), as well as Picasso (1881–1973), Georges Braque (1882–1963), Henri Matisse (1869–1954), Vasily Kandinsky (1866–1944) and Marcel Duchamp (1887–1968). The European section of the exhibition reflected Davies's preference for French art. German Expressionism was not adequately represented, and the Italian Futurists refused to participate. American entries ranged from the late Impressionism of Childe Hassam to the Ashcan realism of John Sloan and the Post-Impressionist modernism of Arthur B. Carles (1882–1952), Alfred H. Maurer (1868–1932) and Joseph Stella (1877–1946).

The publicity campaign for the exhibition ensured that modern art reached a broad public. Aided by the journalist Frederick James Gregg, the organizers produced posters, badges, postcards and educational brochures. They adopted the pine-tree flag from the American Revolution as their emblem and 'The New Spirit' as their motto. Around 300,000 people attended the exhibition during its three-city tour. Revenues from the sale of works amounted to $44,148.75. The Metropolitan Museum of Art acquired Cézanne's *The Poorhouse on the Hill* for $6700. Despite its success, the Association of American Painters and Sculptors did not survive to sponsor other exhibitions.

Although the Armory Show was not the first exhibition of modern art in the USA, it was unmatched in its scope and significance. With galleries and collectors of modern art flourishing in its wake, it transformed the art market in New York and thereby marked the advent of modernism in the USA.

BIBLIOGRAPHY

Association of American Painters and Sculptors: *For and Against: Anthology of Commentary on the Armory Show* (New York, 1913)
A. & Déc., iii (March 1913) [special issue]
Armory Show: 50th Anniversary Exhibition, 1913–1963 (exh. cat., Utica, NY, Munson–Williams–Proctor Inst., 1963)
M. Brown: *The Story of the Armory Show* (New York, 1963, rev. 1988)
The Armory Show: International Exhibition of Modern Art, 3 vols (New York, 1972) [anthol. of primary doc.]
J. Zilczer: '"The World's New Art Center": Modern Art Exhibitions in New York City, 1913–1918', *Archv Amer. A. J.*, xvi/3 (1974), pp. 2–7
R. Tarbell: 'The Impact of the Armory Show on American Sculpture', *Archv Amer. A. J.*, xviii/2 (1978), pp. 2–11
J. Zilczer: 'The Armory Show and the American Avant-garde: A Re-evaluation', *A. Mag.*, liii/1 (1978), pp. 126–30
G. McCoy, ed.: 'The Seventy-fifth Anniversary of the Armory Show', *Archv Amer. A. J.*, xxvii/2 (1987), pp. 2–33
M. Green: *New York, 1913: The Armory Show and the Paterson Strike Pageant* (New York, 1988)
C. I. Oaklander: 'Clara Davidge's Madison Art Gallery: Sowing the Seed for the Armory Show', *Archvs Amer. A. J.*, xxxvi/3–4 (1996), pp. 20–37

JUDITH ZILCZER

Arts and Crafts Movement. Informal movement in architecture and the decorative arts that championed the unity of the arts, the experience of the individual craftsman and the qualities of materials and construction in the work itself.

1. Introduction. 2. USA. 3. Conclusion.

1. INTRODUCTION. The Arts and Crafts Movement developed in the second half of the 19th century and lasted well into the 20th, drawing its support from progressive artists, architects and designers, philanthropists, amateurs and middle-class women seeking work in the home. They set up small workshops apart from the world of industry, revived old techniques and revered the humble household objects of pre-industrial times. The movement was strongest in the industrializing countries of northern Europe and in the USA, and it can best be understood as an unfocused reaction against industrialization. Although quixotic in its anti-industrialism, it was not unique; indeed it was only one among several late 19th-century reform movements, such as the Garden City movement, vegetarianism and folksong revivals, that set the Romantic values of nature and folk culture against the artificiality of modern life.

The movement was not held together by a statement of ideas or by collective goals and had no manifesto; its members simply shared, more or less, certain attitudes. The scalding critique of industrial work by John Ruskin (1819–1900) in *The Stones of Venice* (1851–3) taught them to see factory work as soulless and degrading; the pleasure in working in the traditional crafts was the secret of the object's beauty. They condemned the decorative arts of their own day as revivalist in style, machine-made and heavy with meaningless ornament, and looked instead for fresh, unpretentious design, honest construction and appropriate ornament. They wanted to break down the hierarchy of the arts, challenging the supremacy of painting and sculpture and rejoicing in the freedom to work in wood, metal, enamel and glass. The philanthropists among them saw the crafts as therapy for the poor, educationalists saw them as a way of learning about materials. It was in some ways a serious movement, in others merely playful and self-indulgent, and its professed ideals did not always accord with its practices.

2. USA. In the USA, as in the British Isles and elsewhere in Europe, the movement stemmed from a mixture of social concern and dilettantism and the rejection of historical styles in favour of a traditional simplicity. Many of the same groups of people, too, were involved in America: social reformers, teachers and women's organizations, as well as architects and designers. Ruskin and William Morris (1834–96) were the prophets of craftsmanship for Americans as for Britons, though Thoreau, Ralph

Waldo Emerson and Walt Whitman provided a sympathetic intellectual climate. Morris was also influential in book design and C. F. A. Voysey (1857–1941) and M. H. Baillie Scott (1865–1945) in architecture and furniture, and French artist–potters influenced their American counterparts. The Americans, however, were bolder than the British in making and selling large quantities. 'The World of Commerce', wrote Elbert Hubbard, 'is just as honorable as the World of Art and a trifle more necessary' (see 1987 exh. cat., p. 315). Compared with Europe, the American Arts and Crafts movement was much less influenced by Art Nouveau. There was a sturdy, four-square quality about much American Arts and Crafts that appealed, as Theodore Roosevelt appealed, to an American ideal of strong, simple manliness.

The movement in craftsmanship started in the 1870s and 1880s, in response to a demand from such architects as H. H. Richardson. The art pottery movement began in Cincinnati, OH, in the 1880s; in quantity and quality the work of, among others, the Rookwood Pottery (*see* UNITED STATES OF AMERICA, fig. 37 and colour pl. XXXIV, 4), the Van Briggle Pottery and the Grueby Faience Co. claims pride of place alongside furniture in American Arts and Crafts. The East Coast was always more aware of British and European developments, and the first Arts and Crafts exhibition in America was held at Copley Hall in Boston in 1897. This was followed by the foundation of the Society of Arts and Crafts, Boston, which sponsored local exhibitions, sale-rooms and workshops with great success. The Society's Handicraft Shop produced fine silverware, but it was in printing that Boston excelled: the city's tradition of fine printing fostered outstanding Arts and Crafts presses, notably the Merrymount Press run by Daniel Berkeley Updike. In Philadelphia the architects of the T-Square Club looked particularly to England and exhibited Arts and Crafts work in the 1890s, and in 1901 the architect William L. Price founded an idealistic and short-lived craft colony at Rose Valley, outside Philadelphia, devoted to furniture, pottery and amateur theatricals.

Upper New York State was another important centre of the Arts and Crafts, partly perhaps because of the attractions of the Catskill Mountains. At the Byrdcliffe Colony in Woodstock, for example, pottery, textiles, metalwork and furniture were produced in a romantic backwoods setting; the Arts and Crafts shared some of the pioneering mystique of the log cabin for Americans. The most important figure in the area, and arguably in American Arts and Crafts as a whole, was GUSTAV STICKLEY, a furniture manufacturer in Eastwood, Syracuse, NY, who began producing simple so-called Mission furniture about 1900 (see colour pl. XXXIII, 3). The design of Stickley's furniture was not as important as the scale of his operations and his power of communication. From 1901 he published *The Craftsman* magazine, which became the mouthpiece of the movement in America, and in 1904 he started the Craftsman Home-Builders Club, which issued plans for self-build bungalows. (By 1915 it was estimated that ten million dollars' worth of Craftsman homes had been built.) The furniture, house-plans and magazine together presented the Arts and Crafts as a way of life instead of a specialist movement. Simple, middle-brow, traditional, slightly masculine and slightly rural, it appealed to a large American market. The most flamboyant figure in New York State was ELBERT HUBBARD. At his Roycroft works in East Aurora, he produced metalwork, printed books and furniture very like Stickley's and published *The Philistine* magazine. Hubbard, too, created a powerful image for his craft enterprise, a slightly ersatz blend of bonhomie and culture, which made him seem almost a parody of Stickley or, more subtly, of himself.

In Chicago the focus of the movement was at first at Hull House, the settlement house run by the social reformer Jane Addams (1860–1935), where the Chicago Society of Arts and Crafts was founded in 1897. Here immigrants were encouraged to practise their native crafts, such as spinning and weaving, less to perfect the craft than to soften the shock of the new city. There were more Arts and Crafts societies and workshops in Chicago than in any other American city, a witness to its aspiring culture. Perhaps the most distinguished of the workshops were those of the metalworkers and silversmiths, such as the Kalo Shop, which was started in 1900 and continued production until 1970. It was in Chicago, also, that the Arts and Crafts made one of its most important contributions to American architecture, for Arts and Crafts influence can be seen in the work of the Prairie school architects Walter Burley Griffin, George Washington Maher (1864–1926), Purcell & Elmslie and most notably Frank Lloyd Wright. In their sense of materials, their creation of a regional style echoing the horizontals of the prairies and their interest in designing furniture, metalwork and decorative details in their interiors, they continued the Arts and Crafts tradition.

Arts and Crafts workshops and activities in California began only in the early 1900s and were often stimulated by architects and designers from the East settling in California. Although Californian Arts and Crafts showed a debt to the beauty of the landscape and to the building traditions of the Spanish Mission, it had no single stylistic character. It ranged from the richly carved and painted furniture made by Arthur F. Mathews and his wife Lucia in San Francisco (for illustration *see* MATHEWS, ARTHUR F.), through the simple, almost monumental, copper table-lamps of Dirk Van Erp (1859–1933), to the outstanding work of the architects Charles Sumner Greene and Henry Mather Greene. Between *c.* 1905 and 1911 GREENE & GREENE designed a number of large, expensive, wooden bungalows in and around Pasadena and equipped them with fine handmade furniture (see fig. and colour pl.). These houses lie along the contours of their sites, inside and outside merging in the kindness of the climate. Their timber construction, panelling and fitted and movable furniture all show the gentle and authoritative ways in which the Greene brothers could make one piece of wood meet another, with Japanese and Chinese jointing techniques transformed into a decorative Californian *tour de force*. Although most products of the American Arts and Crafts are strong and simple in character, the Greenes' finest houses, the masterpieces of American Arts and Crafts architecture, are delicate and exquisite.

3. CONCLUSION. In 1936 Nikolaus Pevsner published *Pioneers of the Modern Movement*, in which he traced the

origins of Modernism among various European movements of the late 19th century and the early 20th, including the Arts and Crafts. Pevsner's book has influenced the study of the Arts and Crafts Movement more than any other, and much writing on the subject has concentrated on the movement's progressive elements, the tentative acceptance of machine production by some Arts and Crafts writers and the simpler designs that seem to reject ornament and historical styles in favour of functionalism. The Modernist view has subsequently come to seem incomplete; it ignored the fact that Arts and Crafts designs, without being any less modern in spirit, are almost always informed by a sense of the past, that ornament is central to much Arts and Crafts designing and that, whatever some theorists may have said, the practical bias of the movement, with its little workshops set apart from the world of industry, was anti-industrial. If the Arts and Crafts Movement is seen in its own time and context, and not just as part of the story of Modernism, it appears as a deeply Romantic movement with its roots in the 19th century, a movement that belongs as much to the history of anti-Modernism as of Modernism.

The most distinctive feature of the Arts and Crafts Movement was its intellectual ambition. Ruskin's attack on factory work uncovered a fundamental malaise in modern industrial society, which Karl Marx identified as alienation. When Morris tried to make art more accessible, giving as much attention to a table and a chair as to an easel painting, he challenged the whole esoteric tendency of modern art. Arts and Crafts objects carry special, idealistic meanings; they tell the viewer about the value of art versus money, about how they are made, about nature or modernity or the satisfactions of hand work. Such idealism is incompatible with the world of manufacture, and if the Arts and Crafts Movement flourished it did so at the price of compromise and contradiction. In Britain the element of contradiction, or at least of inconsistency, was strongest. Arts and Crafts workers drew strength from Ruskin's words, which applied to all kinds of mechanized and factory work, but their own efforts were confined to the small (and relatively unmechanized) world of the decorative arts. In the USA compromise was sometimes the price that was paid. Stickley operated on so large a scale, Hubbard with such crude salesmanship, that it is sometimes hard to distinguish them from the enemy, from the industrial and commercial world that Ruskin denounced. The Arts and Crafts Movement was not always as radical as it aspired to be; and it is perhaps best understood, at the end of the day, as simply another movement of taste in the history of decorative arts.

Arts and Crafts table and chairs designed by Charles Sumner Greene, mahogany and leather, table h. 760 mm, l. 1663 mm, chairs h. 921 mm, 1906 (Pasadena, CA, David B. Gamble House)

P. Davey: *Arts and Crafts Architecture: The Search for Earthly Paradise* (London, 1980)
The Arts and Crafts Movement in New York State, 1890s–1920s (exh. cat., ed. C. L. Ludwig; Oswego, SUNY, Tyler A.G., 1983)
E. Boris: *Art and Labor: Ruskin, Morris and the Craftsman Ideal in America* (Philadelphia, 1986)
'The Art that is Life'. The Arts and Crafts Movement in America, 1875–1920 (exh. cat., ed. W. Kaplan; Boston, Mus. F.A., 1987)
E. Cumming and W. Kaplin: *The Arts and Crafts Movement* (London, 1991)
K. Trapp, ed.: *The Arts and Crafts Movement in California: Living the Good Life* (Oakland and New York, 1993)
Michael Conforti, ed.: *Art and Life on the Upper Mississippi, 1890–1915* (Newark, 1994)
Bert Denker, ed.: *The Substance of Style: Perspectives on the American Arts and Crafts Movement* (Winterthur, 1996)
Marilee Boyd Meyer, ed.: *Inspiring Reform: Boston's Arts and Crafts Movement* (Wellesley, 1997)

ALAN CRAWFORD

Ashcan school. Term first used by Holger Cahill and Alfred Barr in *Art in America* (New York, 1934) and loosely applied to American urban realist painters. In particular it referred to those members of THE EIGHT who shortly after 1900 began to portray ordinary aspects of city life in their paintings, for example George Luks's painting *Closing the Café* (1904; Utica, NY, Munson-Williams-Proctor Inst.; see colour pl. XXV, 1). Robert Henri, John Sloan, William J. Glackens, Everett Shinn and George Luks were the core of an informal association of painters who, in reaction against the prevailing restrictive academic exhibition procedures, mounted a controversial independent exhibition at the Macbeth Galleries, New York (1908).

Sloan, Glackens, Shinn and Luks had all worked for the *Philadelphia Press*. It was in Philadelphia, where Henri had trained at the Academy of Fine Arts, that he convinced them to leave their careers as newspaper illustrators to take up painting as a serious profession. In an explicit challenge to the 'art for art's sake' aesthetic of the late 19th century, Henri proposed an 'art for life', one that would abandon the polished techniques and polite subject-matter of the academicians; it would celebrate instead the vitality that the painter saw around him in everyday situations.

BIBLIOGRAPHY
N. Pevsner: *Pioneers of the Modern Movement: From William Morris to Walter Gropius* (London, 1936); rev. as *Pioneers of Modern Design: From William Morris to Walter Gropius* (Harmondsworth, 1974)
G. Naylor: *The Arts and Crafts Movement: A Study of its Sources, Ideals and Influence on Design Theory* (London, 1971)
The Arts and Crafts Movement in America, 1876–1916 (exh. cat., ed. R. J. Clark; Princeton U., NJ, A. Mus., 1972)
California Design, 1910 (exh. cat., ed. T. J. Andersen, E. M. Moore and R. W. Winter; Pasadena, A. Mus., 1974)
S. O. Thompson: *American Book Design and William Morris* (New York, 1977)
A. Callen: *Angel in the Studio: Women in the Arts and Crafts Movement, 1870–1914* (London, 1979)

In 1904 Henri set up his own school in New York in a Latin quarter on Upper Broadway. He was joined there by Sloan, Glackens, Luks and Shinn; George Bellows, Glenn O. Coleman (1887–1932) and Jerome Myers (1867–1940) also associated themselves with Henri's new urban realism. Henri and his followers were initially referred to as the 'revolutionary black gang', a term that alluded to the dark subdued palette that characterized much of the group's early paintings. They drew subject-matter from life in the Bowery, Lower Sixth Avenue and West 14th Street. Among the typical works of the Ashcan school were images of street urchins, prostitutes, athletes, immigrants and boxers, as in Bellows's *Stag at Sharkey's* (1909; Cleveland, OH, Mus. A.). Such figure studies, together with street scenes such as *Hairdresser's Window* (see fig.) by Sloan, convey a vivid impression of life in New York in the early years of the century.

Their choice of such picturesque contemporary motifs was generally considered bold, but as William B. McCormick, writing in the *New York Press* in 1908, observed, there were clear precedents in European art:

> 'Surely it is not "revolutionary" to follow in the footsteps of the men who were the rage in artistic Paris twenty years ago. Nor is it "a new departure in American art" to paint after the manner of Manet, Degas, and Monet.'

BIBLIOGRAPHY
I. Forrester: 'New York Art Anarchists', *N Y World Mag.* (10 June 1906), p. 6
B. B. Perlman: *The Immortal Eight, American Painting from Eakins to the Armory Show, 1870–1913* (New York, 1962)
W. I. Homer: 'The Exhibition of "The Eight": Its History and Significance', *Amer. A. J.*, i/1 (1969), pp. 53–64
——: *Robert Henri and his Circle* (Ithaca, 1969)
M. S. Young: *The Eight* (New York, 1973)
B. B. Perlman: 'Rebels with a Cause – The Eight', *ARTnews*, lxxxi/18 (1982), pp. 62–7
J. Zilczer: 'The Eight on Tour, 1908–1909', *Amer. A. J.*, xvi/64 (1984), pp. 20–48
B. B. Perlman: *Painters of the Ashcan School: The Immortal Eight* (New York, 1988)
E. H. Turner: *Men of the Rebellion: The Eight and their Associates at the Phillips Collection* (Washington, DC, c.1990)
Painters of a New Century: The Eight and American Art (exh. cat. by E. Milroy, Milwaukee, WI, A. Mus.; Denver, CO, A. Mus.; New York, Brooklyn Mus. and elsewhere; 1991–2)
V. M. Mecklenburg: 'New York City and the Ashcan School', *Antiques*, cxlviii (Nov 1995), pp. 684–93
Metropolitan Lives: The Ashcan Artists and their New York (exh. cat. by R. Zurier, R. W. Snyder and V. M. Mecklenburg, Washington, DC, N. Mus. Amer. A., 1995–6)
B. Fahlman: 'Realism: Tradition and Innovation', *American Images: The SBC Collection of Twentieth-century American Art*, ed. E. Whitacre, L. C. Martin and W. Hopps (New York, 1996)
V. A. Leeds: *The Independents: The Ashcan School and their Circle from Florida Collections* (Winter Park, FL, 1996)

<div align="right">M. SUE KENDALL</div>

Atlanta. North American city and capital of the state of Georgia. Situated in the north-western part of the state in the foothills of the Blue Ridge Mountains, the city has been an important transportation centre from its foundation in 1837. Originally named Terminus, it was established as part of the construction of the Western and Atlantic Railroad, planned to link the Midwest, from the Tennessee state line to the north, with the Atlantic coast at Savannah, c. 570 km to the south-east. As a rail centre, Atlanta was critical to the Southern Confederacy during the American Civil War (1860–65). The city was burnt by General William T. Sherman in 1864 but was rapidly rebuilt, marking the start of a period of extraordinary development and growth that made Atlanta more the leading city of the new south than a representative city of the rural old south. Its historic architecture is Victorian and eclectic, with academic classical and Tudor Revival styles predominating.

The late 19th-century city was characterized by the government district near the Italian Renaissance-style State Capitol (1885–9; by W. J. Edbrooke and Franklin P. Burnham; see fig.) and by the business district developed south of Central City Park. 'Streetcar suburbs' grew in West End and on the east side, Inman Park (after 1889), where some of the city's best Victorian Queen Anne houses are found. Another tramline from downtown into Midtown extended north of the Edward C. Peters's house (1883; now Mansion Restaurant), designed by Gottfried L. Norrman. In Midtown, substantial residential development is reflected by the few surviving mansions lining Piedmont Avenue in the Midtown Historic District, as well as by later middle-class houses and bungalows on parallel streets. Along the railway line connecting Atlanta to the nearby town of Decatur two small communities developed: Edgewood (now Candler Park) and Kirkwood, both annexed by Atlanta in 1908. They maintain the architectural character of their early years, with large, late Victorian residences and, in Kirkwood, some timber-framed houses from c. 1900; the character of Edgewood, however, is best defined by the popular, simple 'Craftsman' bungalows, of which there are hundreds; indeed, this style typifies pre-World War I housing throughout the city.

In Druid Hills, an area designed in the 1890s by Frederick Law Olmsted, larger houses were built from

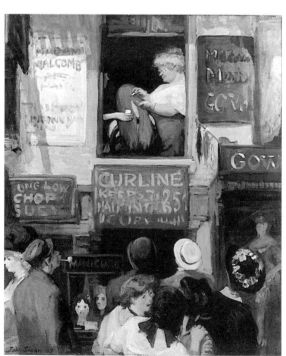

Ashcan school: *Hairdresser's Window* by John Sloan, oil on canvas, 810 × 660 mm, 1907 (Hartford, CT, Wadsworth Atheneum)

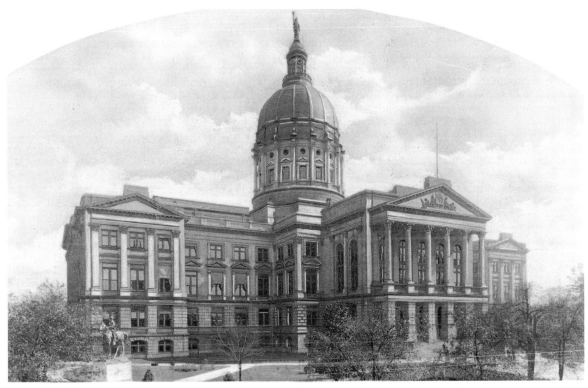

Atlanta, State Capitol by W. J. Edbrooke and Franklin P. Burnham, 1885–9

1908 in the eclectic historicist styles of the American academic tradition: Tudor Revival manor houses, Mediterranean-style villas, Georgian Revival houses based on 18th-century colonial mansions and various Federal, Colonial Revival and Neo-classical buildings, all with ample plots of land. With its system of parks and landscaping, Druid Hills represents one of Olmsted's finest and most complete designs. In the early 20th century many wealthy families also established manorial country houses in the Buckhead area, encouraging the continuing northward growth of the city.

BIBLIOGRAPHY

Atlanta: A City of the Modern South (New York, 1942)

Atlanta Architecture: The Victorian Heritage (exh. cat. by E. A. M. Lyon, Atlanta, GA, Hist. Soc. Mus., 1976)

E. Stanfield and others: *From Plantation to Peachtree: A Century and a Half of Classic Atlanta Houses* (Atlanta, 1987)

E. Dowling: *American Classicist: The Architecture of Philip Trammell Shutze* (New York, 1989)

P. Riani, P. Goldberger and J. Portman: *John Portman* (Milan, 1990)

W. Mitchell jr: *Classic Atlanta: Landmarks of the Atlanta Spirit* (New Orleans, 1991)

ROBERT M. CRAIG

Atterbury, Grosvenor (*b* Detroit, MI, 7 July 1869; *d* Southampton, NY, 18 Oct 1956). American architect, urban planner and writer. He studied at Yale University, New Haven, CT, and travelled in Europe. He studied architecture at Columbia University, New York and worked in the office of McKim, Mead & White before completing his architecture studies at the Ecole des Beaux-Arts in Paris. Atterbury's early work consisted of suburban and weekend houses for wealthy industrialists, such as the Henry W. de Forest House (1898) in Cold Springs Harbor

on Long Island, NY. De Forest was a leader in the philanthropic movement to improve workers' housing, an interest that Atterbury shared; through him Atterbury was given the commission for the model housing community of Forest Hills Gardens, NY, begun in 1909 under the sponsorship of the Russell Sage Foundation; the co-planners and landscape designers were the brothers John Charles Olmsted (1852–1920) and Frederick Law Olmsted jr (1870–1957), the sons of Frederick Law Olmsted. Atterbury developed a system of precast concrete panels to build a varied group of multiple units and town houses suggesting an English country hamlet. He continued his research into prefabrication largely at his own expense throughout his life.

WRITINGS

The Economic Production of Workingmen's Homes (New York, 1930)

BIBLIOGRAPHY

DAB Suppl.

'The Work of Grosvenor Atterbury', *Amer. Architect*, xliv (Aug/Sept 1908), pp. 68–72, 76–80

LELAND M. ROTH

Atwood, Charles B(owler) (*b* Charlestown, MA, 18 May 1849; *d* Chicago, IL, 19 Dec 1895). American architect. He received his architectural training in the offices of Eldridge Boyden (1819–96) in Worcester, MA, and Ware & Van Brunt in Boston, with a year's study (1869–70) in the Lawrence Scientific School at Harvard University, Cambridge, MA. In 1872 he set up on his own, designing the State Mutual Assurance Building (1872) in Worcester, MA, and the Holyoke City Hall (1874–5), MA. In 1875 he settled in New York, working for Christian Herter's firm

of decorators, Herter Brothers, and perhaps also for McKim, Mead & White. Between 1879 and 1881 he assembled a small team of draughtsmen to execute the design of the William Henry Vanderbilt house on Fifth Avenue (destr.), in collaboration with Herter Brothers and the architect John Butler Snook. After the death of John Wellborn Root in January 1891, Root's partner Daniel H. Burnham engaged Atwood as chief architect of the World's Columbian Exposition in Chicago, which opened on 1 May 1893, then made him a 27% partner in his firm, D. H. Burnham & Co. In these capacities he produced his most admired designs: the Fine Arts Building at the Exposition (rebuilt as the Museum of Science and Industry), the annexe of the Marshall Field Store (1892–3; interior altered) in Chicago, the Reliance Building (1891–5), Chicago (for illustration *see* SKYSCRAPER) and the Ellicott Square Building (1894–5), Buffalo, NY. His designs were not particularly original but, rather, in whatever style was practical or popular at the time; a crude Neo-Grec for the Vanderbilt houses, Beaux-Arts classical for the Fine Arts Building, Gothic Revival for the Reliance Building, Renaissance Revival for the Field annexe and Ellicott Square Building. His use of drugs caused him to be dismissed from Burnham's on 10 December 1895 and to commit suicide nine days later.

BIBLIOGRAPHY

D. H. Burnham: 'Charles Bowler Atwood', *Inland Architect & News Rec.*, xxvi (1906), pp. 56–7

A. L. Van Zanten: 'The Marshall Field Annex and the New Urban Order of Daniel Burnham's Chicago', *Chicago Hist.*, xi/3 (1982), pp. 130–41

DAVID VAN ZANTEN

Audubon, John James (Laforest) [Fougère, Jean-Jacques] (*b* Les Cayes, Santo Domingo [now Haiti], 26 April 1785; *d* New York state, 27 Jan 1851). American naturalist, painter and draughtsman of French–Creole descent. Brought up in a French village near Nantes, he developed an interest in art and natural science, encouraged by his father and the naturalist Alcide Dessaline d'Orbigny. He is thought to have moved to Paris by 1802 to pursue formal art training; although the evidence is inconclusive, Audubon claimed to have studied in the studio of Jacques-Louis David (1748–1825).

In 1803 Audubon travelled to the USA to oversee Mill Grove, an estate owned by his father on the outskirts of Philadelphia, PA. Uninterested in practical affairs, he spent his time hunting and drawing birds. His drawings (many in Cambridge, MA, Harvard U., Houghton Lib.) from this period are executed primarily in pencil and pastel. They are conventional specimen drawings that define individual birds in stiff profile with little or no background. A number of these works, however, bear notations from Mark Catesby's *Natural History of Carolina, Florida and the Bahama Islands* (1731–47). Catesby's etchings, which were some of the first natural history illustrations to stress the interaction between organisms and their habitats, clearly impressed Audubon, and soon his work began to address the complex relations that exist between birds and their environments. He also began to use watercolour, the medium he employed most regularly as a mature artist.

In 1807 Audubon moved to Louisville, KY, where his passion for the study and depiction of birds accounted, at least in part, for the failure of a series of business ventures. In 1810 he was visited by the Philadelphia naturalist–artist Alexander Wilson, who was looking for subscribers for his illustrated *American Ornithology* (1808–14). Audubon, who believed himself the better artist, did not subscribe, but Wilson's work undoubtedly inspired him to begin his own large-scale publication on American birds.

Having been declared bankrupt in 1819, Audubon moved to Shippingsport, KY, where he began to draw portraits in chalk. The following year he briefly ran a drawing school in Cincinnati, OH, and also worked for the Western Museum at Cincinnati College (now the Museum of Natural History), where he stuffed animal specimens and drew landscape backgrounds for museum displays. It was during this time that he dedicated himself to the publication of his own watercolours of American birds. In October 1820, accompanied by his student, Joseph Mason (1807–83), Audubon left for a three-month collecting and drawing expedition down the Ohio and Mississippi rivers. At the end of this trip, in 1821 he explored the Louisiana bayous in search of birds; he painted each new species, and Mason supplied detailed backgrounds for over 50 of the watercolours. In 1824 Audubon attempted to publish his pictures in Philadelphia, but he met with a disappointing reception from the scientific community there, due partly to his own arrogance and partly to the community's loyalty to Wilson. For the next two years he continued to observe and paint the birds of the southern states.

In May 1826 Audubon left for England, where he exhibited his watercolours at the Liverpool Royal Institution to great acclaim. In order to increase his income, he sold a number of copies of his works in oil. He also exhibited at the Royal Society of British Artists, London, the Royal Scottish Academy and the Royal Institution of Edinburgh. In November 1826 Audubon entered into an agreement with the engraver William Home Lizars to publish his watercolours as handcoloured engravings. After several months, however, with only ten plates completed, the contract was terminated, and Audubon was compelled to find a new publisher. The engraver Robert Havell jr undertook the project, and by the autumn *The Birds of America* was under way.

While overseeing the production of the plates for *The Birds of America*, Audubon worked on his accompanying text, the *Ornithological Biography* (1831–8). He also commissioned Joseph Bartholomew Kidd (1808–89) to copy his watercolours in oil. From 1831 to 1833 Audubon received from Kidd at least 94 copies of watercolours for the first and second volumes of *The Birds of America*. These, however, were unsigned, and have consequently been difficult to distinguish from copies painted by Audubon himself, and by his sons Victor Gifford Audubon (1809–62) and John Woodhouse Audubon (1812–60), both accomplished artists.

Audubon returned to America to seek new subjects, in 1829–30 in New Jersey and Pennsylvania, and in 1831 in the Florida Keys, accompanied by the artist George Lehman (*d* 1870). In Charleston, SC, he befriended the Rev. John Bachman (1790–1874), a naturalist whose sister, Maria Martin (*d* 1863), provided watercolours of plants and insects for the backgrounds of approximately 35

plates. Audubon continued his explorations in Labrador, Newfoundland, with his son John, returning to England in 1834.

The Birds of America was completed in early 1839 as a double elephant folio. Issued by subscription in 87 parts, the set contains 435 handcoloured prints of 1065 life-sized birds representing 489 species. Havell produced these prints by a complex process of engraving, etching and aquatint. The original watercolours for the set belong to the New-York Historical Society, New York (see colour pl. VIII, 2). The watercolours and the prints reflect the growing interest of naturalists to define species not only according to anatomical traits but also according to characteristic behavioural patterns. Audubon's works generally present several birds from the same species engaged in such typical group activities as hunting, feeding, courting or caring for their young (see fig.). Foreshadowing Darwinism, many of Audubon's most dramatic images openly challenge the traditional conception of a benevolent Creation by pitting predators against prey, and even showing members of the same species confronting one another in a violent struggle for survival.

Between 1840 and 1844 a seven-volume octavo version of *The Birds of America* was produced by the Philadelphia firm of J. T. Bowen. This publication, overseen by John Woodhouse Audubon, contains 500 lithographs of the original prints, as well as prints of several new birds. In 1842 Audubon settled on the Hudson River, at an estate

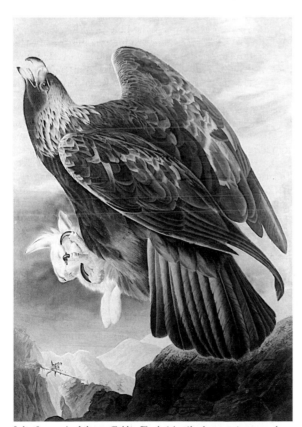

John James Audubon: *Golden Eagle (Aquila chrysaetos)*, watercolour, 887×587 mm, 1833 (New York, New-York Historical Society)

called Minnie's Land, and began work on *The Viviparous Quadrupeds of North America* (150 plates, 1845–8). His sons assisted, with John Woodhouse Audubon producing more than half the studies for the 150 handcoloured lithographs. Seeking new specimens for this publication, Audubon made his last extended expedition along the upper Missouri and Yellowstone rivers in 1843, accompanied by John Bachman and the young naturalist Isaac Sprague (1811–95). Bachman wrote all of the text which accompanied the plates for *The Viviparous Quadrupeds* in the volumes that appeared between 1846 and 1854.

WRITINGS AND PRINTS

The Birds of America, from Original Drawings Made during a Residence of 25 Years in the United States, 4 vols (London, 1827–39); rev. in 7 vols (Philadelphia and New York, 1840–44/*R* 1967)

My Style of Drawing Birds (MS.; 1831); intro. M. Zinman (New York, 1979)

Ornithological Biography, 5 vols (Edinburgh, 1831–8) [text to accompany *The Birds of America*]

with J. Bachman: *The Viviparous Quadrupeds of North America* (New York, 1845–8 [pls]; 1846–54 [text], rev. 3/1856)

L. Audubon, ed.: *The Life of John James Audubon, the Naturalist* (New York, 1869)

H. Corning, ed.: *Letters of John James Audubon, 1826–1840* (Boston, 1930)

A. Ford, ed.: *The 1826 Journal of John James Audubon* (New York, 1987)

BIBLIOGRAPHY

M. Audubon: *Audubon and his Journals*, 2 vols (New York, 1897/*R* 1972)

W. Fries: 'Joseph Bartholomew Kidd and the Oil Paintings of Audubon's *Birds of America*', *A. Q.* [Detroit], xxvi (1963), pp. 339–49

A. Ford: *John James Audubon* (Norman, OK, 1964)

A. Coffin: 'Audubon's Friend: Maria Martin', *NY Hist. Soc. Q.*, xlix (1965), pp. 29–51

A. Adams: *John James Audubon: A Biography* (New York, 1966)

W. Fries: *The Double Elephant Folio: The Story of Audubon's 'Birds of America'* (Chicago, 1973)

J. Chancellor: *Audubon: A Biography* (New York, 1978)

John James Audubon and his Sons (exh. cat., ed. G. Reynolds; New York U., Grey A.G., 1982)

C. E. Jackson: *Bird Etchings: The Illustrators and their Books, 1655–1855* (Ithaca and London, 1985), pp. 230–46

A. A. Lindsey: *The Bicentennial of John James Audubon* (Bloomington, IN, 1985)

J. Burroughs: *John James Audubon* (New York, 1987)

A. Ford: *John James Audubon: A Biography* (New York, 1988)

R. Tyler: *Nature's Classics: John James Audubon's Birds and Animals* (Orange, TX, 1992)

A. Blaugrund and R. F. Snyder: 'Audubon: Artist and Entrepreneur', *Mag. Ant.*, cxliv (1993), pp. 672–81

A. S. Blum: *Picturing Nature: American Nineteenth-century Zoological Illustration* (Princeton, 1993), pp. 88–118

T. E. Stebbins: 'The Birds of America: John James Audubon', *F.A. & Ant. Int.*, vi/6 (1993), pp. 30–5

John James Audubon: The Watercolors for the Birds of America (exh. cat., ed. H. Hotchner and others; Washington, DC, N.G.A., 1993); review by E. Gibson in *New Criterion*, xii (1993), p. 59

B. Galimard Flavigny: 'Les Livres d'oiseaux', *Obj. A.*, cclxxix (1994), pp. 34–43

S. May: 'John James Audubon: Sojourn in Texas', *Southwest A.*, xxiv (1994), pp. 80–84

M. Welch: *The Book of Nature: Natural History in the United States, 1825–1875* (Boston, 1998)

AMY MEYERS

Augur, Hezekiah (*b* New Haven, CT, 21 Feb 1791; *d* New Haven, CT, 10 Jan 1858). American sculptor. Although as a youth he showed talent for handling tools, his father, a joiner and carpenter, discouraged him from becoming a wood-carver. After opening a fruit shop in New Haven, he began carving musical instruments and furniture legs for a local cabinetmaker. With his invention

of a lace-making machine, he was able to settle his business debts and devote himself entirely to sculpture.

About 1825 Samuel F. B. Morse encouraged Augur to try working in marble. Among his earliest attempts in this medium was a bust of *Professor Alexander Metcalf Fisher* (*c.* 1825–7; New Haven, CT, Yale U. A.G.), which was exhibited in 1827 at the National Academy of Design in New York. The impact of the Neo-classical style is clearly evident in his most ambitious work, *Jephthah and his Daughter* (*c.* 1828–30; New Haven, CT, Yale U. A.G.), a pair of free-standing half life-size marble figures. The treatment of the heads shows Roman influence, which Augur must have absorbed from engravings; this is borne out by the detailed work on Jephthah's armour. The bold handling of the hair and drapery reveals his experience as a wood-carver. In 1834 Augur received a commission to execute a marble bust of *Chief Justice Oliver Ellsworth* (completed 1837) for the Supreme Court Room in the US Capitol, Washington, DC. Four years later he was commissioned to design bronze medals for the bicentennial of New Haven's settlement; this is his last-known work.

BIBLIOGRAPHY

H. W. French: *Art and Artists in Connecticut* (New York, 1879), pp. 47–9
G. Heard Hamilton: *Hezekiah Augur: An American Sculptor, 1791–1854* (MA thesis, New Haven, CT, Yale U., 1934)
O. Larkin: 'Early American Sculpture: A Craft Becomes an Art', *Antiques*, lvi (1949), pp. 178–9
W. Craven: *Sculpture in America* (Newark, 1968, rev. New York, 1984), pp. 92–4

DONNA J. HASSLER

Aust, Gottfried (*b* Heidersdorf, 5 April 1722; *d* Lititz, PA, 28 Oct 1788). American potter of German birth. Although originally trained as a weaver, he was apprenticed to a potter in Herrnhut, Germany, where the Moravian Brethren were centred. In 1754 he arrived in Bethlehem, PA, the Brethren's first colonial outpost. After ten months' work at the pottery there under master Michael Odenwald, Aust went to the new settlement in Bethabara, NC, where he established its first pottery. In 1768 the pottery was moved to another new settlement at Salem, NC. All the wares necessary for daily life were made in Aust's potteries, including large stoves. Aust's most distinctive work is found on decorative plates embellished with floral or geometric ornament delineated in green, red, brown, white and dark brown slips (e.g. earthenware dish used by Aust as a trade sign, diam. 555 mm, 1773; Winston-Salem, NC, Old Salem; see Bivins, p. 224). He trained a number of apprentices who worked in the Piedmont region, thereby creating a 'school' of his style that is associated with the area.

BIBLIOGRAPHY

J. F. Bivins: 'Slip-decorated Earthenware in Wachovia: The Influence of Europe on American Pottery', *Amer. Cer. Circ. Bull.*, i (1970–71), pp. 93–106
——: *The Moravian Potters in North Carolina* (Chapel Hill, NC, 1972)

ELLEN PAUL DENKER

Austen, (Elizabeth) Alice (*b* Rose Bank, Staten Island, NY, 17 March 1866; *d* New York, 9 June 1952). American photographer. She was introduced to photography by a friend, Oswall Muller, sometime around 1876, and quickly learnt the complexities of working with a variety of cumbersome cameras, dry-plate negatives and contact printing. As an avid amateur photographer, she documented a social history of a bygone era. Her work, dating between the 1880s and 1930s, recorded a charming portrait of the genteel activities of upper middle-class society on Staten Island. Although her photographs primarily documented the everyday life of the wealthy inhabitants and friends of her home, Cold Comfort, which overlooked New York's Upper Bay, she also produced a challenging series of images of New York's Lower East Side. These 'street types' were published as a portfolio by the Albertype Company in 1896. Unlike those of Jacob A. Riis and Lewis W. Hine, Austen's images of immigrants revealed no concern for social reform, but evidenced a hesitancy and curiosity experienced by both photographer and subject. Her life of stability was to end abruptly by the Stock Market Crash of 1929, after which she was eventually forced to sell all her possessions and ended up living in the City Farm Colony, a local poorhouse. With the aid of the Staten Island Historical Society, which had preserved her negatives and prints, and researcher Oliver Jensen, her earlier photographs were rediscovered and sold to several publications, particularly *Life* and *Holiday*, bringing her fame at the age of 85.

BIBLIOGRAPHY

'The Newly Discovered Picture World of Alice Austen: Great Woman Photographer Steps Out of the Past', *Life* (24 Sept 1951), pp. 137–44
H. Humphries and R. Benedict: 'The Friends of Alice Austen: With a Portfolio of Historical Photographs', *Infinity* (July 1967), pp. 4–31
A. Novotny: *Alice's World: The Life and Photography of an American Original: Alice Austen, 1866–1952* (Old Greenwich, CT, 1976)

FIONA DEJARDIN

Austin, Henry (*b* Hamden, CT, 12 April 1804; *d* New Haven, 12 Nov 1891). American architect. He was based in New Haven, from where his work and influence spread over much of Connecticut, with two major forays out-of-state: a speculative development (*c.* 1840) in Trenton, NJ, and the lavish Morse–Libby house (1859) in Portland, ME. After neglect in the Colonial Revival period, he was later recognized as Connecticut's foremost 19th-century architect. His work is mainly associated with the Villa style of the 1840s and 1850s in its many variations, Grecian, Italian, Tuscan, Renaissance, Oriental, but continuing, with less intensity, through the Victorian Gothic and French Empire styles of the 1860s and 1870s (*see* UNITED STATES OF AMERICA, §II, 2–5). To these popular fashions of his day, Austin brought a personal interpretation and a sometimes startling imagination, distorting and exaggerating familiar proportions with long, dripping brackets and excessively broad, flat eaves, modelling surfaces with deep shadows of strangely jutting pediments and short, square columns, and breaking the skyline with roof structures topped by exotic little finials from the Orient.

Austin trained as a carpenter in the environs of New Haven and in the 1820s moved to the city where he acted as agent for the New York firm of Ithiel Town and Alexander Jackson Davis while trying to start a practice of his own. Davis had a strong influence on his first attributed building, a Grecian villa of *c.* 1840 (destr.), and on his first major commission, a Gothic library (1842; now Dwight Chapel, Yale University, New Haven; see fig.) for Yale College. The library was followed in 1845 by another major commission, the monumental Egyptian Revival

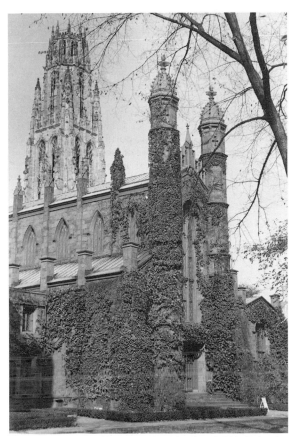

Henry Austin: Gothic library (now Dwight Chapel), Yale University, New Haven, Connecticut, 1842

style gate for the Grove Street Cemetery, New Haven. With these two projects, both highly visible and both in the vanguard of fashion, Austin's reputation was established. Over the next 20 years his output was enormous. Outstanding works include villas for the old New Haven gentry on Hillhouse Avenue and for the new manufacturing class around Wooster Square; three brownstone banks in the 1850s (all destr.); the Moses Beach House (1850; destr.) in Wallingford, CT, and New Haven City Hall (1861), a precocious High Victorian Gothic design praised by critics then and since (destr. 1977 except for façade and tower; stairwell and cast-iron stair restored 1994). The Willis Bristol House (1845) is a rare example of an oriental villa, while the Dana House (1848), New Haven, uses such exotic decorations as Indian plant columns and fringed cornices to embellish the basic cube of the Italian villa style, a formula that became an Austin trademark. The climactic building of this period is the New Haven Railroad Station (1848–9, destr. 1894), considered one of the most fanciful buildings ever erected in New England—a long, slim structure suggesting the proportions of a train, set directly over the tracks and topped with bizarre stupa-like forms.

After the American Civil War, patronage declined and Austin's work became tamer. However he retained his old verve in two late projects: Trinity Home (1868; mostly destr.), New Haven, an urban compound consisting of town houses framing the entrance to a tree-planted court containing chapel, school and home; and his swansong, the J. W. Clark seaside cottage at Stony Creek, Branford, CT (1879), with a high red-roofed tower that is one of the landmarks on the Connecticut shore.

Austin was among the first architects in Connecticut to establish a home-grown professional practice employing numerous draughtsmen, which affected the next generation of architects, including David R. Brown, Rufus G. Russell (1823–96) and Leoni Robinson (1852–1923). His office exemplifies the transition from the builder-architects at the start of the 19th century to the local professional firms at the end.

BIBLIOGRAPHY

Macmillian Enc. Archit.

E. M. Brown: *New Haven: A Guide to Architecture and Urban Design* (New Haven, 1976)

ELIZABETH MILLS BROWN

Avery, Samuel P(utnam) (*b* New York, 17 March 1822; *d* New York, 11 Aug 1904). American wood-engraver, art dealer, collector and philanthropist. His career as a wood-engraver and his involvement with the New York publishing trade began in the early 1840s. He worked for, among others, *Appleton's*, the *New York Herald* and *Harper's* and produced illustrations for trade cards, religious tracts, adventure stories and children's books. By the early 1850s Avery had begun compiling humorous books and commissioning drawings from such artist-illustrators as Felix Octavius Carr Darley, John Whetten Ehninger, Augustus Hoppin (1827–96), Tompkins Harrison Matteson and John McLenan (1827–66). His business contacts led to close relationships with such artists as Frederick Church, John F. Kensett and William Trost Richards.

By the late 1850s Avery had begun to collect drawings and small cabinet pictures by local artists. Other art collectors, notably William T. Walters, asked Avery's advice when commissioning works of art. In 1864 he turned his engraving practice over to Isaac Pesoa, his former apprentice, and became one of the first art dealers in the USA (*see* UNITED STATES OF AMERICA, §XIV). In 1867 Avery was appointed commissioner for the American section at the Exposition Universelle in Paris. Before leaving New York, he liquidated his collection in order to buy works of art abroad. With the assistance of GEORGE A. LUCAS, Avery commissioned paintings from such artists as William-Adolphe Bouguereau (1825–1905), Jules Breton (1827–1906), Jean-Léon Gérôme (1824–1904) and Ernest Meissonier (1815–91). He made annual buying trips to Europe during the 1870s; his diaries provide insight into the European art market and record information about contemporary Dutch, English, French and German artists. Avery auctioned his acquisitions in New York, although some works were selected for specific collectors, such as William Henry Vanderbilt. Avery's opinions were central in forming the Metropolitan Museum of Art in New York, of which he was a founder in 1872 and a lifelong trustee and to which he donated some of his American pictures.

Avery bought books with exceptional bindings, and he encouraged contemporary designers by commissioning examples of their craftsmanship. He was instrumental in

establishing a separate print room at the New York Public Library in December 1899, presenting it in 1900 with a gift of over 19,000 prints.

Avery remained active in numerous art societies. His son, Samuel P. Avery jr (1847–1920), assisted in his gallery, resumed the business in 1888 and left his collections mainly to the Brooklyn Museum, New York, and the Wadsworth Atheneum, Hartford, CT, where the Avery Wing was opened in 1934. Another son, Henry Ogden Avery (1852–90), studied at the Ecole des Beaux-Arts in Paris (1872–9) and worked as an architect. In 1887 he designed some exhibition rooms and a gallery in New York for his brother. Avery sr endowed the Avery Architectural Library at Columbia University, New York, in memory of Henry, bequeathing it part of his book collection.

WRITINGS

The Diaries 1871–1882 of Samuel P. Avery, Art Dealer, ed. M. Fidell-Beaufort, H. L. Kleinfield and J. K. Welcher (New York, 1979)

BIBLIOGRAPHY

R. Sieben-Morgan: *Samuel Putnam Avery (1822–1904), Engraver on Wood: A Bio-bibliographical Study* (MLS diss., New York, Columbia U., 1940, additions 1942)

D. Sutton: *Paris–New York, a Continuing Romance* (London, 1977); preface *R Apollo*, cxxv (1987), pp. 122–31

M. Fidell-Beaufort: 'Whistling at one's Ruskins', *Confrontation* (Spring-Summer, 1979), pp. 58–63

——: 'Jules Breton in America: Collecting in the 19th Century', *Jules Breton and the French Rural Tradition* (exh. cat., Omaha, Joslyn A. Mus., 1982), pp. 51–61

M. Fidell-Beaufort and J. K. Welcher: 'Some Views of Art Buying in New York in the 1870s and 1880s', *Oxford A. J.*, v/1 (1982), pp. 48–55

K. M. McClinton: 'Letters of American Artists to Samuel P. Avery', *Apollo*, cxx (1984), pp. 182–7

MADELEINE FIDELL-BEAUFORT

B

Babb, Cook & Willard. American architectural partnership formed in 1884 by George Fletcher Babb (*b* New York, 1836; *d* Holden, MA, 1915), Walter Cook (*b* Buffalo, NY, 22 July 1846; *d* New York, 25 March 1916) and Daniel Wheelock Willard (*b* Brookline, MA, 1849; *d* California, after 1902). Babb trained in the office of T. R. Jackson in the late 1850s before going into partnership (1859–65) with Nathaniel G. Foster. He then joined the office of Russell Sturgis, becoming senior draughtsman in 1868. Cook graduated from Harvard in 1869, then studied architecture at the Polytechnikum (1871–3) in Munich and the Ecole de Beaux-Arts (1873–6), Paris, where he joined the atelier of Emile Vaudremer (1829–1914). He returned to America in 1877, when he went into partnership with Babb, their first major commission being a warehouse (or loft; 1877–80) on Duane Street, New York. This had a brick façade of deeply cut arcades, an arcuated parapet and cast terracotta details, suggesting 15th-century Italian influences. Willard, who had trained as an engineer, joined the firm in 1884 to help with the design of the De Vinne Press Building (1885–6), 309 Lafayette Street, New York. This building developed the design of the Duane Street warehouse and was articulated with six large arches, framed by rows of smaller arched windows, with further ornamentation of Renaissance inspiration. Later commercial commissions included two important office buildings for the New York Life Insurance Company in St Paul (1888–9; destr.) and Minneapolis (1890–91, destr.), MN. Their domestic work included the Atwater-Ciampoline House (1890–91), New Haven, CT, in the Shingle style, and the Andrew Carnegie Residence (1899–1901; now the Cooper-Hewitt Mus.) on Fifth Avenue, New York. This is a stately four storey classical mansion. Other buildings designed wholly or primarily by Cook are the Mott Haven branch (1905) of the New York Public Library and the Choir School (1915) of the Cathedral of St John the Divine, New York.

BIBLIOGRAPHY
DAB; *Macmillan Enc. Archit.*
R. A. Cram: Obituary [Cook], *J. Amer. Inst. Architects*, iv/6 (1916), pp. 231–3
T. Hastings: Obituary [Cook], *Amer. Architect*, cix/2104 (1916), p. 257
V. J. Scully jr: *The Shingle Style: Architectural Theory and Design from Richardson to the Origins of Wright* (New Haven, 1955); rev. as *The Shingle Style and the Stick Style* (New Haven, 1971)
S. B. Landau: 'The Tall Office Building Artistically Reconsidered: Arcaded Buildings of the New York School, c. 1870–90', *In Search of Modern Architecture: A Tribute to Henry-Russell Hitchcock*, ed. H. Searing (Cambridge, MA, and London, 1982), pp. 136–64
'Carnegie Residence, Fifth Avenue, New York City', *Archit. Rec.* [New York], ix/1 (1988), pp. 77–81
M. G. Broderick: *Long Island Country Houses and their Architects, 1860–1940*, Society for the Preservation of Long Island Antiquities (New York, 1989)
MOSETTE GLASER BRODERICK, WALTER SMITH

Bacon, Henry (*b* Watseka, IL, 28 Nov 1866; *d* New York, 16 Feb 1924). American architect. The son of a distinguished civil engineer, he studied architecture at the Illinois Industrial University, Urbana, in 1884–5. In 1885 he moved to Boston to become a draughtsman for the architectural firm of Chamberlin & Whidden, known for its buildings in the Colonial Revival style, but in 1888 he moved to McKim, Mead & White, working as a draughtsman and perspectivist. In 1889 Bacon won the Rotch Traveling Scholarship, which enabled him to go to France, Italy, Greece and Turkey for two years. Influenced by his brother Francis Henry Bacon (1856–1940), an architect and furniture designer who assisted in the excavations at the Greek site of Assos in 1881–3, he became attracted to ancient, especially Greek, architecture. He returned to the McKim, Mead & White office in 1891 and became McKim's chief design assistant. The following year he represented the firm on the construction site of the World's Columbian Exposition in Chicago. Among other projects, he worked on the design of McKim's Rhode Island State House (1891–1903) in Providence.

In 1897 Bacon formed a partnership with James Brite (1865–1942), a colleague from the McKim office with whom he had travelled in Europe. Brite & Bacon specialized in the design of public buildings; they entered many competitions, including those for the Philadelphia Art Museum in 1895 and the New York Public Library in 1897, and executed designs for public libraries in Jersey City, NJ (1898–1900), and Madison, CT (1899–1900). Their domestic architecture is in a variety of styles. An outstanding example in the Federal Revival style is Chesterwood (*c.* 1900), near Stockbridge, MA, the summer home and studio of the sculptor Daniel Chester French, which is now a museum. The partnership ended in 1903, after which Bacon practised alone, running a small office and maintaining close personal control over all designs. Among his principal projects were the Danforth Memorial Library (1903–6), Paterson, NJ, the mausoleum to *Marcus Alonzo Hanna* (1904–6), Cleveland, OH, the Union Square Bank (1905–7), New York, the Halle Brothers Department Store (1910, addition 1914), Cleveland, OH, and the general plan for Wesleyan University (1912–13), Middletown, CT, where he also later designed the Van

Vleck Observatory (1914–16), the Clark Hall dormitory (1915–16) and a memorial library (1923; unexecuted). Bacon was also responsible for the design of many kinds of urban amenity, such as lampposts for Central Park, New York (1907), and Washington, DC (1923), and the Whittemore Memorial Bridge (c. 1910–14), Naugatuck, CT.

Bacon is principally remembered for his collaboration with sculptors in the design of monuments and memorials. He collaborated with Augustus Saint-Gaudens on several schemes, including the memorial to *James McNeill Whistler* (1903–7), US Military Academy, West Point, NY, the monuments to *Charles Stewart Parnell* (1900–11), Dublin, and *Marcus Alonzo Hanna* (1905–8), Cleveland, OH, and the *Christopher Lyman Magee* fountain-stele (1905–8), Pittsburgh, PA. He worked most often and harmoniously with French, producing many memorials, including those to the Melvin brothers (*Mourning Victory*, 1897–1907), Concord, MA; Spencer Trask (*The Spirit of Life*, 1913–15), Saratoga Springs, NY; *Abraham Lincoln* (1909–12), Lincoln, NB; and *Henry Wadsworth Longfellow* (c. 1913), Cambridge, MA. Bacon also collaborated, though less frequently, with the sculptors Karl Bitter (1867–1915), James Earle Fraser (1876–1953), Henry Hering (1874–1949), Evelyn Beatrice Longman (1874–1954), Charles Niehaus (1855–1935) and John Massey Rhind (1858–1936).

Bacon's major work resulted from the invitation in August 1911 to prepare a design for a national memorial to Abraham Lincoln at the west end of the Mall by the Potomac River in Washington, DC. This was the site recommended a decade earlier by the McMillan Commission. Bacon designed a classical structure in white marble on a podium, with a Doric peristyle and high attic, open to the east and containing a statue of heroic size and two tablets engraved with the texts of Lincoln's Gettysburg Address and Second Inaugural. His design, with modifications, was finally accepted by Congress in early 1913, but construction was delayed because of a change of administration as well as the outbreak of World War I, and the memorial was not completed until 1922. With French's marble statue of the seated *Abraham Lincoln* (1914–20) as its centrepiece (see colour pl. XXVIII, 2), this was the largest federal project of the kind since the erection of Robert Mills's Washington Monument (1884; see MILLS, ROBERT, fig. 2) and was hailed as a triumph by the press, the public and traditional architects. In May 1923 the American Institute of Architects awarded Bacon its gold medal in a night-time ceremony on the steps of the memorial.

UNPUBLISHED SOURCES

Washington, DC, 62nd Congress, 3rd session, Senate Doc. no. 965 (serial set no. 6347) [Lincoln Memorial Commission Report]

BIBLIOGRAPHY

Macmillan Enc. Archit.
G. Brown: *The Development of Washington, with Special Reference to the Lincoln Memorial* (Washington, 1911)
The Architecture and Landscape Gardening of the Exposition (San Francisco, 1915), pp. 124–37
R. A. Cram: 'The Lincoln Memorial', *Archit. Rec.*, liii (1923), pp. 478–508
Obituary, *Amer. Architect*, cxxv (1924), pp. 195–6; *Amer. A. Annu.*, xxi (1924–5), p. 282; *Amer. Mag. A.*, xv (1924), pp. 190–93; *Archit. Rec.*, lv (1924), pp. 273–6; *New York Times* (17 Feb 1924), p. 23; *Wesleyan U. Alumnus* (March 1924)
F. S. Swales: 'Henry Bacon as a Draftsman'; 'Master Draftsmen, v: Francis H. Bacon'; *Pencil Points*, v (1924), May, pp. 42–62; Sept, pp. 38–54
C. A. Platt: 'Henry Bacon', *Commemorative Tributes*, American Academy of Arts & Letters, 50 (New York, 1925), pp. 21–4
E. F. Concklin: *The Lincoln Memorial, Washington*, US Office of Public Buildings and Public Parks of the National Capital (Washington, DC, 1927)
H. F. Withey and E. R. Withey: *Biographical Dictionary of American Architects (Deceased)* (Los Angeles, 1956/R 1970) [separate entries on Bacon and Brite]
R. R. Selden: *Henry Bacon and his Work at Wesleyan University* (MA thesis, Charlottesville, U. VA, Sch. Archit., 1974)
B. Lowry: *The Architecture of Washington, D.C.*, i (Washington, DC, 1976), pp. 83—6, pls 96–106
Daniel Chester French: An American Sculptor (exh. cat. by M. Richman, New York, Met., 1976)
M. Richman: 'Daniel Chester French and Henry Bacon: Public Sculpture in Collaboration', *Amer. A. J.*, xii (1980), pp. 46–64
R. G. Wilson: *The AIA Gold Medal* (New York, 1984), pp. 150–51
L. Doumato: *Henry Bacon's Lincoln Memorial* (Monticello, IL, 1985) [Vance bibliographies]
C. A. Thomas: *The Lincoln Memorial and its Architect, Henry Bacon (1866–1924)* (diss., New Haven, Yale U., 1990)

CHRISTOPHER A. THOMAS

Badger, Daniel D. (*b* Badger's Island, Portsmouth, NH, 15 Oct 1806; *d* Brooklyn, New York, 17 Nov 1884). American iron manufacturer and builder in cast iron. He began as a blacksmith's apprentice; by 1830 he was in Boston making decorative wrought ironwork at his own smithy, and in 1842 he built Boston's first iron-fronted shop, a one-storey combination of iron columns and lintels that made large display windows possible. The following year, to protect such windows, he began producing rolling security shutters that fitted into grooves in the columns, having bought the patent from Arthur L. Johnson (1800–60). The 'Badger front' design was sold and copied across the USA, winning a gold medal at the American Institute Fair (1847).

In 1846 Badger moved to New York City, where he continued to manufacture his 'fronts'. Soon afterwards he began producing a new form of iron architecture introduced by JAMES BOGARDUS in 1848: the self-supporting, multi-storey exterior iron wall, constructed of cast-iron panels and columns bolted together. In 1852 Badger employed the English architect George H. Johnson (1830–79) and began making ornate multi-storey iron façades that became popular. Four years later he incorporated his firm as the Architectural Iron Works. It was to develop into one of the largest and most versatile of the time, producing high style prefabricated iron for commercial structures, small bridges and warehouses. The cast-iron architecture developed during the 1840s was to be supplanted by steel only towards the end of the 19th century.

Some of Badger's finest works were commercial buildings constructed in the 1850s, such as the Haughwout Building (see UNITED STATES OF AMERICA, fig. 8) and the Cary Building (both 1856) in New York, and the Lloyd and Jones Building (1857; destr. 1871) in Chicago. On the eve of the Civil War (1861–5) the American Government commissioned the all-iron Watervliet Arsenal (1859), Albany, NY, intended for storing gun-carriages. Badger also built two ornamented iron ferry terminals in Manhattan, New York: the Fulton (1863) and South Ferry (1864; both destr.). In 1865 Badger issued his catalogue. Through it he became the best-known iron-founder in the USA, and his

increasing number of commissions for large structures included the eight-storey Gilsey Hotel, New York, and the large Powers office building in Rochester, NY (both 1869). The same year he began construction of an iron-and-glass train shed (destr.) in New York for railway magnate Cornelius Vanderbilt's Grand Central Depot. This, the largest interior space then seen in the USA, was replaced in 1913 by Grand Central Station. The last of Badger's large structures, the huge and ill-fated Manhattan Market (1872), with a vaulted roof almost as high as that at Grand Central, was destroyed by fire in 1880. Throughout his career Badger also built many small-scale iron-fronted buildings and warehouses, such as the Boston Post Building in Boston, and 90 Maiden Lane, Manhattan (both 1872), for the Roosevelt family. He retired in 1873 due to ill-health, and without his dynamic leadership his company rapidly faded: the Architectural Iron Works closed in 1876.

WRITINGS
Illustrations of Iron Architecture Made by the Architectural Iron Works of the City of New York (New York, 1865); repr. in *The Origins of Cast Iron Architecture in America, Including Illustrations of Iron Architecture Made by the Architectural Iron Works of the City of New York*, intro. W. K. Sturges (New York, 1970); and *Badger's Illustrated Cast-iron Architecture*, intro. M. Gayle (New York, 1981)

BIBLIOGRAPHY
Obituary, *New York Times* (19 Nov 1884), p. 2
W. K. Sturges: 'Cast Iron in New York', *Archit. Rev.* [London], cxiv (1953), pp. 232–7
A. L. Huxtable: 'Store for E. V. Haughwout & Co., 1857', *Prog. Archit.*, xxxix/2 (1957), pp. 133–6
M. Gayle: *Cast-iron Architecture in New York. A Photographic Survey* (New York, 1974)

MARGOT GAYLE

Badger, Joseph (*b* Charlestown, MA, 14 March 1708; *d* Boston, MA, 11 May 1755). American painter. He was part of a small, active group of portrait painters who worked in Boston in the mid-18th century. Although he was well known in his own time, his work was rediscovered only in the early 20th century. Badger appears to have been a competent artisan with some artistic talent. The few documents that deal with his early life refer to him as a 'painter' and 'glazier', indicating that his primary profession was house and ship painting. He is described as a 'limner' and 'faice painter' only towards the end of his life. Badger moved to Boston around 1733 and began painting portraits about ten years later. He became Boston's principal portrait painter after the death of John Smibert in 1751, but his career was eclipsed shortly thereafter by the more accomplished and stylish portraits of John Singleton Copley. Unlike other Colonial artists, Badger was not an itinerant painter: most of his subjects lived in Boston, and many were related or attended the same church. He painted likenesses of three of his children and one grandchild (*James Badger*, 1760; New York, Met.).

Badger's oeuvre appears to be substantial: more than 150 unsigned portraits have been attributed to him. The documented portraits of *Timothy Orne*, his wife, *Rebecca Orne* (both priv. col., see Dresser, pp. 2–3), two of their children, *Rebecca and Lois Orne* (all 1756; Worcester, MA, A. Mus.), and the portrait of *Rev. Ellis Gray* (*c.* 1750; Boston, MA Hist. Soc.) express the basic characteristics of Badger's style and his approach to portrait painting. The poses rely heavily on published English mezzotints.

The portrait of Ellis Gray, for example, follows the convention of depicting a minister dressed in his robes, in a bust-length format. Badger painted Timothy Orne standing, three-quarter length, with one hand resting on his hip and the other holding letters indicating his occupation as a merchant. The pendant portrait of Rebecca Orne shows her seated, holding a rose in one hand. She wears a white cap and a simple, solid colour dress. Unlike Copley and Robert Feke, Badger paid little attention to the rich patterns and textures of cloth. The Orne children are charmingly painted as miniature adults, holding objects associated with childhood; the smaller child grasps a rattle, while her older sister pets a squirrel. These portraits illustrate a characteristic aspect of Badger's work: nearly one third of the attributed works are portraits of children.

In contrast to the sparse backgrounds and plain clothing, Badger gave character to his sitters' faces, defining their features with strong lines. Almond-shaped eyes invariably focus on the viewer, and a heavy shadow is cast by the nose. A thin red line separates the tightly closed lips of most subjects. In many pictures the minimal facial modelling has been removed by cleaning: most of Badger's work has suffered from over-cleaning. This has resulted in a poor impression of his artistic ability and the attribution to him of portraits by less competent painters.

BIBLIOGRAPHY
L. Park: 'An Account of Joseph Badger, and a Descriptive List of his Work', *Proc. MA Hist. Soc.*, ii (1917), pp. 158–201
—— : 'Joseph Badger of Boston, and his Portraits of Children', *Old-time New England*, xiii (1923), pp. 99–109
L. Dresser: 'The Orne Portraits by Joseph Badger', *Worcester A. Mus. Bull.*, n. s., i/2 (1972), pp. 2–3
R. C. Nylander: *Joseph Badger, American Portrait Painter* (diss., Oneonta, NY State U. Coll., 1972)
A. Millspaugh Haff and R. Urquhart: 'Paintings in the Massachusetts Historical Society', *Antiques*, cxxviii (1985), pp. 960–71

RICHARD C. NYLANDER

Badlam, Stephen (*b* Milton, MA, 1751; *d* Dorchester Lower Mills, MA, 25 Aug 1815). American cabinetmaker. His father, also Stephen Badlam (1721–58), was a part-time cabinetmaker and tavern keeper. Orphaned at a young age, Badlam was trained both as a surveyor and as a cabinetmaker. Soon after the outbreak of the American Revolution he was commissioned as a major in the artillery. He resigned within a year because of illness but after the war was made a general in the Massachusetts militia. On his return to Dorchester Lower Mills, he opened a cabinetmaking shop in his house and became active in civic affairs. He built up a substantial business, which included participation in the thriving coast trade, and even sold furniture through the warehouse of Thomas Seymour in Boston. He also provided turning for other cabinetmakers in the neighbourhood and sold picture-frame materials and window glass. Several chairs in the Federal style with characteristic carved and stopped fluted legs are stamped with his mark, but his fame rests on the monumental mahogany chest-on-chest (1791; New Haven, CT, Yale U. A.G.) that he made for Elias Hasket Derby (1739–99), a Salem merchant and one of the wealthiest men in the country, who ordered it as a wedding present for his daughter Anstis Derby. Ionic columns flank the upper case, and carved chamfered corners resting on ogee bracket

feet border the lower, serpentine section. John Skillin and Simeon Skillin executed the extraordinary figures of *Virtue* flanked by the reclining goddesses of *Peace* and *Plenty* that surmount the pitched pediment. At his death Badlam's estate was valued at over $24,000, a considerable sum for the time and an indication of the position he enjoyed.

BIBLIOGRAPHY

Appleton's Cyclopedia (New York, 1888)
M. Swan: 'General Stephen Badlam: Cabinet and Looking-glass Maker', *Antiques*, lxv (1954), pp. 380–83
G. Ward: *American Case Furniture in the Mabel Brady Garvan and Other Collections at Yale University* (Boston, 1988), pp. 171–7
D. Levison and H. Sack: 'Identifying Regionalism in Sideboards: A Study of Documented Tapered-leg Examples', *Antiques*, cxli (1992), pp. 820–33

OSCAR P. FITZGERALD

Bakewell & Co. American glass factory founded in Pittsburgh, PA, by Edward Ensell and purchased by Benjamin Bakewell (1767–1844) and Benjamin Page in 1808. Its prominent role in the development of the American tableware industry in the 19th century made it the most famous glasshouse in Pittsburgh. Bakewell's glasshouse produced the first successful lead crystal in America; it made the first American table glass ordered for the White House, Washington, DC, by James Monroe (1758–1831) in 1817 (untraced) and Andrew Jackson (1767–1845) in 1829 (Washington, DC, White House Col.); and it held the first recorded American patent for pressing glass (1825). The firm established Pittsburgh's reputation for high-quality engraved glass; for example, in 1825, of the 61 workers in Bakewell's factory, 12 were engravers and decorators. In addition to fancy table glass, the factory produced tubes for table lamps, globes, lanterns and apothecary's equipment. Its glassware was free-blown, mould-blown, pressed lacy, pattern-moulded or cut and engraved. The factory closed in 1882.

BIBLIOGRAPHY

L. Innes: *Pittsburgh Glass, 1797–1891* (Boston, 1976)
J. S. Spillman: *White House Glassware: Two Centuries of Presidential Entertaining* (Washington, DC, 1989)
A. Madarasz: *Glass, Shattering Notions* (Pittsburgh, 1998)

ELLEN PAUL DENKER

Ball, Thomas (*b* Charlestown, MA, 3 June 1819; *d* Montclair, NJ, 11 Dec 1911). American sculptor and painter. He began his career as a painter of miniatures, opening a studio in Boston in 1837. He did not have a formal training in sculpture and turned to modelling in 1851, fashioning a popular cabinet-sized bust of *Jenny Lind* (New York, NY Hist. Soc.). In 1853 Ball made his first life-size bust, of the statesman *Daniel Webster* (plaster, 1853; Boston, MA, Athenaeum), followed by a statuette of *Webster* (plaster, 1853; New York, Met.), which became one of the first sculptures to be mass-produced and patented in the USA. The statuette of *Webster*, and its companion piece of *Henry Clay* (bronze, 1858; Raleigh, NC Mus. A.), are two of Ball's finest works. In 1854 he left for a three-year stay in Florence, where he settled permanently in 1865. Although Ball joined the circle of the American Neo-classical sculptor Hiram Powers, his work remained rooted in an objective naturalism and a devotion to American subjects. The monuments, small bronzes and portraits he produced in the following years

are characterized by their smooth surfaces and minimal detail.

Shortly after his return to Boston in 1857, Ball executed his most acclaimed work, the equestrian statue of *George Washington* (bronze, 1858–61; Boston, MA, Pub. Gdn), a considerable technical feat for him. His next major commission was entitled the *Emancipation Group* (bronze, 1874), which stands in Lincoln Park, Washington, DC, in celebration of the liberation of the American slaves, and depicts Abraham Lincoln protecting a slave. During the 1870s Ball received numerous commissions for portrait statues, notably the over life-size portrait of *Charles Sumner* (bronze, 1878; Boston, MA, Pub. Gdn) and the colossal portrait of *Daniel Webster* (1876; New York, Central Park), the design of which was based on the 1853 statuette.

WRITINGS

My Three Score Years and Ten, an Autobiography (Boston, 1891/R New York, 1976)

BIBLIOGRAPHY

W. Partridge: 'Thomas Ball', *New England Mag.*, n.s., xii (1895), pp. 291–304
W. Craven: 'The Early Sculptures of Thomas Ball', *NC Mus. A. Bull.*, v (1964–5), pp. 2–12
——: *Sculpture in America* (New York, 1968, rev. Newark, 2/1984), pp. 219–28
M. Hatt: 'Making a Man of Him: Masculinity and the Black Body in Mid-nineteenth-century American Sculpture', *Oxford A. J.*, xv/1 (1992), pp. 21–35

MICHELE COHEN

Baltimore. North American city, the largest in the state of Maryland. It is situated on the Patapsco River in the northern reaches of Chesapeake Bay, 65 km north-east of Washington, DC. The city is named after the baronial title of the Calvert family, who founded it in 1729.

1. HISTORY, URBAN DEVELOPMENT AND ART LIFE. Baltimore was originally chartered as a tobacco port; it expanded as it began exporting grain and became a favoured route to the interior. A desire for freer trade led merchants to adopt the struggle for independence, and in 1797 Baltimore was established as a city. Fort McHenry (for illustration see MILITARY ARCHITECTURE AND FORTIFICATIONS), which was built in 1798 by Jean Foncin, was notably defended in the War of 1812 against the English; this defence inspired the American national anthem. Other extant buildings from the early period include plantation houses, such as Mount Clare (1753–87), built in the Colonial style. Of the many churches built in the early 19th century, the Roman Catholic Cathedral (1805–20) by Benjamin Henry Latrobe was a particularly important example of Neo-classicism (see FEDERAL STYLE, fig. 1, and LATROBE, BENJAMIN HENRY, fig. 2).

The first railway in North America, the Baltimore and Ohio, was created in 1827, enabling competition with other ports. The city prospered and became a major commercial centre for the South. Among the distinctive features of subsequent 19th-century architecture in Baltimore were red-brick terraced houses in a Georgian or Federalist style, featuring white marble steps, while notable individual houses included Ross Winans House (1882; see fig.), designed by McKim, Mead & White in the Italian Romanesque Revival style. A disastrous fire in 1904 destroyed much of the central business district, but the

city recovered quickly; indeed, while some steel-framed buildings had already been erected, the general rebuilding programme accelerated their construction. As heavy industry came to the city during World War I and steelworks and refineries were built, so the character of the city changed. However, Baltimore still has many ethnically diverse neighbourhoods that have retained their early architecture consisting of red-brick row houses in the Federalist style, although some buildings have been covered with formstone (a coloured cement placed over brick) or painted to protect their soft brick; the preservation of buildings of historical interest has become increasingly important.

Baltimore is also noted for its monuments, for example, the Battle Monument (1814), designed by Maximilian Godefroy, and the Washington Monument (1815–29)—the first monument to George Washington which was designed by Robert Mills. Educational institutions include Johns Hopkins University (1867); the Peabody Institute (1868), the first music conservatory in the USA, which was designed by Edmund G. Lind; and the Maryland Institute, a school of arts and architecture that includes the Rinehart School of Sculpture.

Among the many cultural organizations and museums in Baltimore, two are of outstanding importance: the Baltimore Museum of Art, which houses collections of North American and European painting and sculpture, and the Walters Art Gallery, the oldest in the USA, with collections ranging from Byzantine and medieval manuscripts to Near Eastern, Egyptian and European art. Also noteworthy are the Peale Museum, with its collection of paintings by the PEALE family, and the Maryland Historical Society, which has a collection of North American fine and decorative art.

BIBLIOGRAPHY
H. A. Williams: *Baltimore Afire* (Baltimore, 1979)
S. H. Olson: *Baltimore, the Building of an American City* (Baltimore, 1980)
J. Dorsey and J. D. Dilts: *A Guide to Baltimore Architecture* (Centreville, 1981)
L. H. Nast, L. N. Krause and R. C. Monk: *Baltimore, a Living Renaissance* (Baltimore, 1982)

JULIAN A. ECCLESHALL

2. CENTRE OF FURNITURE PRODUCTION. During the late 18th century tobacco production still dominated the economy of Baltimore, and such landowners as Edward Lloyd of Wye Plantation on the eastern shore of Chesapeake Bay traded tobacco for furniture, silver and silks from London. Coastal trade between the larger centres of Annapolis, MD, Philadelphia and Boston supplied such small towns as Baltimore with basic furniture like Windsor chairs, which could be shipped in bundles and reassembled.

During the American Revolution, Baltimore was not an important enough port to be blockaded. As the economy grew, the furniture industry developed and gained the momentum that established Baltimore as a centre of the craft at the beginning of the 19th century. From 1800 until 1812, when the war with England again cut off coastal prosperity, Baltimore cabinetmakers satisfied new patronage with elegant Federal style interpretations of Hepplewhite and Sheraton designs (*see* FEDERAL STYLE, §2). They specialized in marquetry and inlay using colourful contrasts

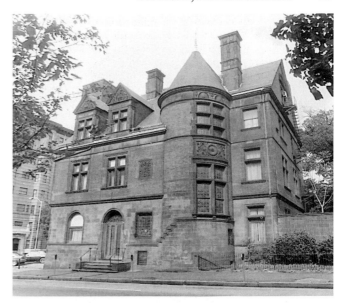

Baltimore, Ross Winans House, by McKim, Mead & White, 1882

of flame grains with lustrous satin-wood in swags, bellflowers, cross-banding, urns and eagles. Painters applied fancy designs in black-and-gold on red and yellow grounds. The most elaborate examples also used *verre eglomisé* panels set into the frame of a table or the prospect door of a secretary desk (*see* UNITED STATES OF AMERICA, fig. 30). The foremost practitioners of these techniques included John Finlay (1777–1851) and Hugh Finlay (1781–1831), who advertised 'Elegant Fancy Japanned Furniture' (see colour pl. XXXII, 3). Another was William Camp (1773–1822), who was trained in Philadelphia, moved to Baltimore in 1801 and by 1809 ran the largest shop in the city. Furniture attributed to Camp and his workshop represents the range of design and technical competence achieved by Baltimore furnituremakers during the period 1790 to 1812.

BIBLIOGRAPHY
C. Montgomery: *American Furniture: The Federal Period*, Winterthur, DE, Du Pont Winterthur Mus. cat. (London, 1966)
W. V. Elder: *Baltimore Painted Furniture, 1800–1840* (Baltimore, 1972)
J. B. Boles, ed.: *Maryland Heritage: Five Institutions Celebrate the American Bicentennial*, Maryland Historical Society (Baltimore, 1976)
G. R. Weidman: *Furniture in Maryland, 1740–1940: The Collection of the Maryland Historical Society* (Baltimore, 1984)

BEATRICE B. GARVAN

Bannister, Edward Mitchell (*b* St Andrews, NB, 1833; *d* Providence, RI, 9 Jan 1901). American painter. He grew up in St Andrews, a small seaport in New Brunswick, Canada. His interest in art was encouraged by his mother, and he made his earliest studies, in drawing and watercolour, at the age of ten. After working as a cook on vessels on the Eastern seaboard, he moved in 1848 with his brother to Boston, where he set up as a barber serving the black community. During the 1850s and 1860s he learnt the technique of solar photography, a process of enlarging photographic images that were developed outdoors in daylight, which he continued to practise while working in Boston and New York. Documented paintings from this time include religious scenes, seascapes and genre subjects,

Edward Mitchell Bannister: *Newspaper Boy*, oil on canvas, 765×635 mm, 1869 (Washington, DC, National Museum of American Art)

for example the noted *Newspaper Boy* (1869; Washington, DC, N. Mus. Amer. A.; see fig.), a rare study of urban black experience.

In 1870 Bannister and his wife moved to Providence, RI, where his work flourished and his paintings were collected by such patrons as George T. Downing (1819–1903), a wealthy local entrepreneur, and the black soprano Matilda Sissieretta Jones (1868–1933). In 1876 he became the first African American artist to win a national award, when he received first prize in the Philadelphia Centennial Exposition for *Under the Oaks* (untraced); in 1876 a contemporary described this as a 'simple composition, quiet in tone but with strong oppositions' ('Reminiscences of George Whitaker', *Providence Magazine*, Feb 1914). He drew inspiration from Millet and the Barbizon School. While he was conscious of his rights as an American citizen, Bannister did not bring politics into his art but aimed to win recognition for his achievement in landscape painting. The last part of his life was marked by ill health and declining patronage, which did not deter him from maintaining a productive output, with 27 paintings dating from the 1890s.

See also AFRICAN-AMERICAN ART.

BIBLIOGRAPHY
Edward Mitchell Bannister (exh. cat. by L. R. Hartigan, Washington, DC, N. Mus. Amer. A., 1985)
G. B. Opitz: *Dictionary of American Painters, Sculptors and Engravers* (New York, 1986)
Edward Mitchell Bannister, 1833–1901 (exh. cat. by C. Jennings, New York, Whitney, 1992–3)
J. M. Holland: 'To Be Free, Gifted and Black: African American Artist Edward Mitchell Bannister', *Int. Rev. Afr. Amer. A.*, xii/1 (1995), pp. 4–25

□

Baptists and Congregationalists. Christian Nonconformist denominations, basically Calvinist in theology. The Baptist tradition has roots in 16th-century Swiss Anabaptism and among the English Baptists of the 17th century. Their distinctive beliefs include baptism by immersion of self-professed believers, the separation of Church and State, the priesthood of all believers and a stress on biblical authority. Congregationalists, related to the European Reformed tradition and English separatists, are distinguished by the congregational form of church government and freedom for all believers using the Church and commonwealth as instruments of a theocratic society. Churches were established in North America in the early 17th century: the Congregationalists (Pilgrims and Puritans) in 1611 and 1623, and the Baptists in 1638–9. Both traditions made missionary inroads in Africa and the East, while Baptists also found converts in Europe, notably in 19th-century Russia. By the second half of the 20th century there were more than 50 groups of Baptists in the USA. American Congregationalists became part of the United Church of Christ in 1961.

Both Baptists and Congregationalists began as countercultural movements, separating themselves from the artistic tradition of Western Christianity. The arts of glass painting and Fraktur lettering survived through the German and Dutch Mennonites and the American Puritan heritage, illustrating biblical and moralistic themes in a naive style. Examples of early American Baptist and Puritan folk art and crafts (e.g. New York, Mus. Amer. Flk A.) parallel those of the Mennonite, Amish, Lutheran and Shaker traditions. Churches in a simplified Williamsburg style, adapted from the English churches of Christopher Wren, dot the New England landscape (*see* UNITED STATES OF AMERICA, §II, 1). Since the 18th century both denominations have established painting traditions. Congregationalists concentrated on portraits of divines and primitive paintings of biblical scenes, while Baptist artists commonly depicted scenes of baptism by immersion. Both denominations support institutions of higher education concentrating on the visual arts.

The principal art form in adult baptism congregations in America consisted of baptistery paintings often done by congregation members. These paintings or murals, executed on the back wall of the baptistery, are called Jordans because the scenes depict the Jordan River, or the artist's imaginative reconstruction of it. At the end of the 20th century such scenes were being replaced by other items of decoration and were becoming a passing folk art form of the Free Churches. Some artisans painted these scenes as an avocation: commercial artist Phil Preddy (1899–) of New Orleans, LA, painted more than 150 baptistery scenes.

BIBLIOGRAPHY
H. C. Vedder: *A Short History of the Baptists* (Philadelphia, 1907)
R. G. Torbet: *A History of the Baptists* (London, 1965)
J. Lipman and T. Armstrong, eds: *American Folk Painters of Three Centuries* (New York, 1980)
R. Kennedy: *American Churches* (New York, 1982)
C. K. Dewhurst, B. MacDowell and M. MacDowell: *Religious Folk Art in America: Reflections of Faith* (New York, 1983)
J. Dillenberger: *The Visual Arts and Christianity in America: From the Colonial Period to the Present* (New York, 1989)
W. L. Hendricks: 'Southern Baptists and the Arts', *Rev. & Expositor*, lxxxvii (1990), pp. 553–62
J. W. T. Youngs: *The Congregationalists* (Westport, CT, 1990)

WILLIAM L. HENDRICKS

Barnard, George Grey (*b* Bellefonte, PA, 24 May 1863; *d* New York, 24 April 1938). American sculptor and collector. At the age of 19 he entered the Art Institute of Chicago School, where he was inspired to become a sculptor after drawing from plaster casts of Michelangelo's works. In 1883 he went to Paris to continue his studies under Pierre-Jules Cavelier (1814–94) at the Ecole des Beaux-Arts. After three years there, Barnard met Alfred Clark, a wealthy American collector, who became his most important patron. Though Barnard often denied any comparison with Auguste Rodin (1840–1917), his sculptural style was strongly influenced by the work of the French master. In 1894 he exhibited six works in Paris, including his most famous marble group, *Struggle of the Two Natures in Man* (New York, Met.), which depicts two male nudes.

After teaching sculpture at the Art Students League in New York for three years, Barnard returned to Paris in 1904 to complete his sculptural programme of two marble allegorical groups, the *Broken Law* and the *Unbroken Law*, for the Pennsylvania State Capitol at Harrisburg. In 1911 he was working on his controversially unidealized bronze statue of *Abraham Lincoln* for Lytle Park in Cincinnati, OH. Barnard's last and most monumental project, known as the *Rainbow Arch*, which consisted of over 50 heroic figures, each approximately 2.7 m high, was not realized beyond the full scale plaster model.

While living in France, Barnard began collecting medieval architectural fragments and sculpture and created ambitious reconstructions incorporating them. He later displayed his collection at his home and studio in Washington Heights, NY. (In 1925 it was purchased by the Metropolitan Museum of Art, New York, and formed the basis of the Cloisters Museum erected in 1938 on the sculptor's former property.)

UNPUBLISHED SOURCES

Washington, DC, Smithsonian Inst., Archv Amer. A. [George Grey Barnard Papers]

BIBLIOGRAPHY

W. A. Coffin: 'A New American Sculptor: George Grey Barnard', *C. Mag.*, liii (1897), pp. 877–82

J. N. Laurvik: 'George Grey Barnard', *Int. Studio*, xxxvi (1908), pp. 39–42

George Grey Barnard. Centenary Exhibition, 1863–1963 (exh. cat., intro. H. E. Dickson; University Park, PA State U., 1964)

J. L. Schrader: 'George Grey Barnard: The Cloisters and the Abbaye', *Bull. Met.*, xxxvii (1979), pp. 3–52

W. H. Forsyth: 'Five Crucial People in the Building of the Cloisters', *Cloisters: Studies in Honor of the Fiftieth Anniversary: New York* (1992), pp. 50–63

E. B. Smith: 'George Grey Barnard: Artist, Collector, Dealer, Curator', *Medieval Art in America: Patterns of Collecting, 1800–1940* (exh. cat. University Park, PA State U., Palmer Mus. A., 1996), pp. 133–42

DONNA J. HASSLER

Barnard, George N. (*b* CT, 23 Dec 1819; *d* Cedarville, NY, 4 Feb 1902). American photographer. He began to take photographs *c.* 1842 and opened a daguerreotype studio in Oswego, NY, in 1843. His two views of a fire at Ames Mills, *Burning Mills at Oswego, NY, [5 July] 1853* (Rochester, NY, Int. Mus. Phot.; see fig.), are remarkable examples of early daguerreotype reportage. In the same year he was secretary of the New York State Daguerrean Association. After purchasing Clark's Gallery, Syracuse, in 1854, he began to produce ambrotypes; in the latter half of the decade he learnt the collodion process.

Barnard took photographs in Cuba in 1860, but these works are untraced. Shortly before the American Civil War (1861–5), he was employed by Mathew Brady in New York and, possibly, Washington, DC. Barnard made some of his earliest known collodions with J. B. Gibson at Bull Run, VA, the site of the first major land battle of the Civil War (e.g. *Ruins of Stone Bridge, Bull Run*, 1862; see Gardner, i, pl. 7); many were wrongly credited to Brady. He was briefly employed as a photographer at Gray's Gallery, Oswego, in 1862. From 1863 to 1865 he was official Army photographer, Chief Engineer's Office, Division of Mississippi. Afterwards he published *Photographic Views of Sherman's Campaign* (New York, 1866/*R* 1977, with preface by B. Newhall), a landmark portfolio of albumen prints made from collodion negatives, showing the aftermath of war, with a separate prospectus explaining its human aspect. He returned to Syracuse, NY, *c.* 1866 and is known to have run a studio at Charleston, NC (before 1869 and after 1871), where he produced and published notable series of stereographs of black street vendors (*c.* 1875; see *Photographic Views of Sherman's Campaign*, 1977, p. vii). Between 1869 and 1871 he ran a studio in Chicago and photographed the aftermath of the Great Fire (1871). In 1883 he promoted gelatin dry plates for George Eastman of Rochester, and he had his last studio in Plainsville, OH (1884–6).

WRITINGS

'Taste', *Phot. F./1. J.*, viii/4 (May 1855), pp. 158–9

BIBLIOGRAPHY

A. Gardner: *Gardner's Photographic Sketchbook of the War*, 2 vols (Washington, DC, 1866/*R* 1959 as *Gardner's Photographic Sketchbook of the Civil War*, intro. E. F. Bleiler)

Obituary, *Anthony's Phot. Bull.*, xxxiii/4 (1902), pp. 127 8

R. Taft: *Photography and the American Scene: A Social History, 1839–1889* (New York, 1938/*R* 1964), pp. 128, 230–32, 486

A. M. Slosek: 'George N. Barnard: Army Photographer, with Photographs by Barnard', *Oswego County, New York, in the Civil War* (Oswego, 1964), pp. 39–59

K. F. Davis: 'Death and Valor', *Register Spencer Mus. A.*, vi/5 (1988), pp. 12–25

R. L. HARLEY JR

Barnes, Hobbs. *See under* HOBBS, BROCKUNIER.

Bartlett, William Henry (*b* London, 26 March 1809; *d* at sea, off Malta, 13 Sept 1854). English draughtsman, active also in the Near East, Continental Europe and North America. He was a prolific artist and an intrepid traveller. His work became widely known through numerous engravings after his drawings published in his own and other writers' topographical books. His primary concern was to extract the picturesque aspects of a place and by means of established pictorial conventions to render 'lively impressions of actual sights', as he wrote in the preface to *The Nile Boat* (London, 1849).

During his apprenticeship to John Britton (1771–1857) between 1822 and 1829, Bartlett travelled widely in Great Britain and contributed illustrations to several of his master's antiquarian works. The popularity of travel books in the 1830s and early 1840s provided Bartlett with several commissions. He illustrated John Carne's *Syria, the Holy Land, Asia Minor &c* (London, 1836–8), William Beattie's *Switzerland Illustrated* (London, 1836) and *The Waldenses* (London, 1838), Julia Pardoe's *The Beauties of the Bosphorus*

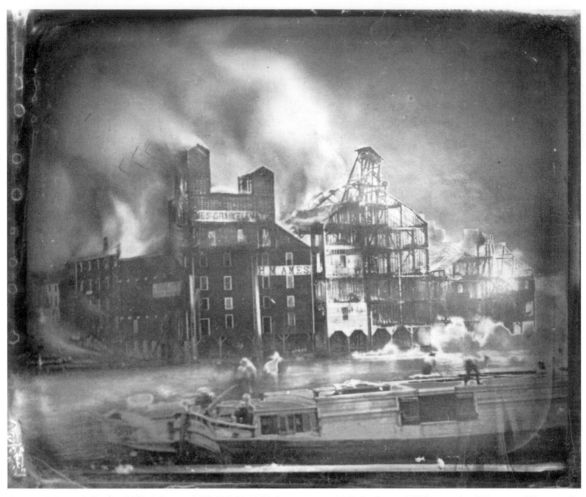

George N. Barnard: *Burning Mills at Oswego, NY, [5 July] 1853*, daguerreotype, 1853 (Rochester, NY, International Museum of Photography and Film at George Eastman House)

(London, 1838–40), Nathaniel Parker Willis's *American Scenery* (London, 1840) and *Canadian Scenery* (London, 1842), and many more. As suggested by these titles, Bartlett visited places as far afield as Constantinople and the Niagara Falls, as well as countries in Europe. He went six times to the Near East and four times to North America; among his artistic contemporaries he was perhaps rivalled only by Edward Lear (1812–88) in the range and frequency of his travels. From 1844 he wrote as well as illustrated his own travel books, such as *Walks about the City and Environs of Jerusalem* (London, 1844) and *The Pilgrim Fathers* (London, 1853).

In general, Bartlett's practice when travelling was to make numerous lively pencil sketches of the people, architecture and landscape he saw (examples sold London, Christie's, 17 Nov 1987, lots 19–29). These he would later incorporate into the small, but detailed brown ink and wash views that he supplied to the engraver (examples, London, V&A). Occasionally he would work up a more elaborate, watercolour view, such as *The Shâria 'El-Gôhargîyeh, Cairo* (London, V&A), showing himself as capable a colourist as he was a draughtsman. The contents

of Bartlett's studio were auctioned by Southgate & Barrett on 29 January 1855.

BIBLIOGRAPHY

A. M. Ross: *William Henry Bartlett: Artist, Author and Traveller* (Toronto, 1973) [reprints W. Beattie's *Brief Memoir of the Late William Henry Bartlett* (London, 1855)]

G. Poulter: 'Representation as Colonial Rhetoric: The Image of "the Native" and "the Habitant" in the Formation of Colonial Identities in Early Nineteenth-century Lower Canada', *J. Can. A. Hist.*, xvi/1 (1994), pp. 10–29

E. C. Worman: 'A Geographical Catalog of Bartlett Prints in American Scenery', *Imprint*, xix/2 (Autumn, 1994), pp. 2–16

E. Major-Marothy: 'The Wild and the Tamed: Bartlett's Canada versus Views by his Canadian Contemporaries', *Imprint*, xx/1 (Spring 1995), pp. 22–8

BRIONY LLEWELLYN

Bartram, William (*b* Kingsessing, PA, 9 Feb 1739; *d* Kingsessing, 22 July 1823). American naturalist and draughtsman. The son of the Pennsylvania naturalist John Bartram (1699–1777), he executed his first drawings in the 1750s as illustrations to his father's observations on the flora and fauna of North America. Bartram accompanied his father on numerous collecting trips in the northeastern colonies and on an expedition to Florida in 1765.

His drawings were disseminated to European naturalists by his father's friend and colleague Peter Collinson (1694–1768), an English merchant who was an important promoter of natural science in the 18th century. Compositionally, Bartram's early works were structured after etchings by the English naturalists Mark Catesby and George Edwards (1694–1773). These artists were among the first to present organisms as part of their larger physical habitats—a practice that Bartram carried forward in his own work, challenging the traditional notion that organisms can be defined solely according to their own physical attributes. Through his drawings Bartram explored the complex interchange that occurs between animals and plants and their environmental contexts, defying the notion that individual organisms fall naturally into an abstract, hierarchical chain of being. He characteristically employed an undulating line that imparts energy to all the elements of a scene, suggesting that the whole of organic creation is united by a single, animated spirit.

Bartram's works were greatly admired by European naturalists, and he won the patronage of Margaret Cavendish-Bentinck (1715–85), 2nd Duchess of Portland, and the botanist Dr John Fothergill (1712–80). In March 1773, with Fothergill's support, Bartram set out alone on an expedition to Florida that ultimately took him 3900 km across the American South, collecting seeds and making drawings. The detailed journals that Bartram kept of his explorations served as the basis for his *Travels through North and South Carolina, Georgia, East and West Florida, the Cherokee Country, the Extensive Territories of the Muscogulges, or Creek Confederacy, and the Country of the Chactaws* (1791). Like his drawings, this highly poetic work creates a picture of a spiritually unified cosmos that came to influence English and American Romantic thinkers, from William Wordsworth and Samuel Coleridge to Ralph Waldo Emerson and Henry David Thoreau.

After his return from the South, Bartram was approached by the recently established University of Pennsylvania, Philadelphia, to serve as the first Professor of Botany; he was also approached several times by the federal government to accompany expeditions into unexplored regions of the country. Bartram preferred, however, to work quietly in his father's experimental garden, tutoring the next generation of Philadelphia naturalists who visited him there and for whom he served as an essential model; his students included Benjamin Smith Barton (1766–1815), who took the professorial post he had rejected and who commissioned him to draw illustrations for the first textbook on American plants, *Elements of Botany* (Philadelphia, 1803). Bartram also served as a mentor to Charles Willson Peale and his children. Bartram encouraged Alexander Wilson to begin to draw birds and joined with Peale in helping Wilson to produce his *American Ornithology* (Philadelphia, 1808–14), the first study devoted entirely to American birds.

WRITINGS

Proposals for Printing by Subscription, on Fine Paper, with a New and Elegant American Letter, Cast by John Baine & Co. Travels through North and South Carolina, Georgia, East and West Florida, the Cherokee Country, the Extensive Territories of the Muscogulges, or Creek Confederacy, and the Country of the Chactaws: Containing an Account of the Soil and Natural Productions of Those Regions, Together with Observations on the Manners of the Indians (Philadelphia, 1790/R 1996)

BIBLIOGRAPHY

W. Darlington, ed.: *Memorials of John Bartram and Humphrey Marshall* (Philadelphia, 1849) [correspondence by and about W. Bartram]

N. Fagin: *William Bartram: Interpreter of the American Landscape* (Baltimore, 1933)

E. Earnest: *John and William Bartram: Botanists and Explorers, 1699–1777, 1739–1823* (Philadelphia, 1940)

J. Herbst: *New Green World* (New York, 1954)

W. Sullivan: *Towards Romanticism: A Study of William Bartram* (Salt Lake City, 1969)

J. Ewan, ed.: *William Bartram, Botanical and Zoological Drawings, 1756–1788: Reproduced from the Fothergill Album in the British Museum (Natural History)* (Philadelphia, 1978)

Bartram Heritage: A Study of the Life of William Bartram, Including a Report to the Heritage Conservation and Recreation Service, United States Department of the Interior: Bartram Trail Conference: Montgomery, AL, 1979

E. Berkeley and D. Berkeley: *The Life and Travels of John Bartram from Lake Ontario to the River St. John* (Tallahassee, 1982) [material on W. Bartram's early professional life]

T. Vance: *William Bartram and the Age of Sensibility* (n.p., 1982)

E. Berkeley and D. Berkeley, eds.: *The Correspondence of John Bartram, 1734–1777* (Gainesville, FL, 1992)

William Bartram on the Southeastern Indians (Lincoln, NE, 1995)

J. T. Fry: 'An International Catalogue of North American Trees and Shrubs: The Bartram Broadside, 1783', *J. Gdn Hist.*, xvi (1996), pp. 3–21

T. P. Slaughter: *The Natures of John and William Bartram* (New York, 1996)

AMY MEYERS

Baudouine, Charles A. (*b* New York, 1808; *d* New York, 1895). American cabinetmaker. He opened his first cabinetmaking shop in Pearl Street, New York, about 1830. Ten years later he moved to Broadway, near his competitor John Henry Belter, whose work, in particular the laminated rosewood chairs, Baudouine is claimed, perhaps unjustly,

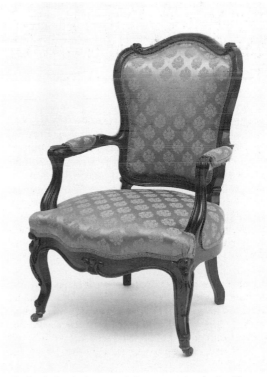

Charles A. Baudouine: arm chair, rosewood and ash with rosewood veneer, h. 952 mm, 1852 (Utica, NY, Munson–Williams–Proctor Institute)

to have imitated. Baudouine's production was huge; he employed up to 200 workers, including 70 cabinetmakers. He favoured the Rococo Revival style based on simplified versions of Louis XV designs and frequently travelled to France to purchase upholstery material, hardware and trim. He also brought back furniture made in France, which he sold in his shop along with his own stock. Anthony Kimbel (*d* 1895) was Baudouine's designer in the years before the shop closed about 1856.

The documented pair of card-tables (Utica, NY, Munson–Williams–Proctor Inst.), two parlour settees and six chairs (Utica, NY, Munson–Williams–Proctor Inst.; see fig.) that James Watson Williams purchased from Baudouine in 1852 for his home at Fountain Elms in Utica, NY, are in rosewood. Baudouine used little mahogany, no cheap walnut and only a limited amount of oak, mainly for dining-room furniture. His business success is reflected in the fortune of between $4 million and $5 million he left at his death.

BIBLIOGRAPHY

E. Ingerman: 'Personal Experiences of an Old New York Cabinetmaker', *Antiques*, lxxxiv (1963), pp. 576–80
B. Franco: 'New York City Furniture Bought for Fountain Elms by James Watson Williams', *Antiques*, civ (1973), pp. 462–7

OSCAR P. FITZGERALD

Beaux, Cecilia (*b* Philadelphia, PA, 1 May 1855; *d* Gloucester, MA, 17 Sept 1942). American painter. She began her career painting on porcelain and producing lithographs and portrait drawings. She studied with Catharine Ann Drinker (1871), Francis Adolf van der Wielen (1872–3) and Camille Piton (1879), at the Pennsylvania Academy of the Fine Arts in Philadelphia (1877–8), and privately with William Sartain (1881–3). Under Sartain's guidance, she learnt to paint, producing her first major portrait, the *Last Days of Infancy* (1883–5; priv. col., see 1974 exh. cat., p. 25). She completed her art training in Paris at the Académie Julian and the Académie Colorossi (1888–9).

On her return to Philadelphia, Beaux established her reputation with portraits of her family, such as *Ernesta with Nurse* (1894; New York, Met.). Commissions for double portraits, such as the *Dancing Lesson* (1899–1900; Chicago, IL, A. Inst.), brought her critical acclaim and won her numerous awards and prizes. Her last significant commission came in 1919 from the US War Portraits Commission, painting likenesses of *Cardinal Mercier, Georges Clemenceau* and *Admiral Sir David Beatty* (all Washington, DC, N. Mus. Amer. A.). Beaux's mature style was marked by unconventional compositions and flowing brushwork in the manner of John Singer Sargent. She was considered by her contemporaries the most distinguished woman portrait painter in America.

WRITINGS

'Why the Girl Art Student Fails', *Harper's Bazaar* (1913), pp. 221, 249
'Professional Art Schools', *A. & Prog.*, viii (1915), pp. 3–8
Background with Figures (New York, 1930)

UNPUBLISHED SOURCES

Washington, DC, Smithsonian Inst., Archvs Amer. A., Cecilia Beaux Papers
Philadelphia, PA Acad. F.A., Cecilia Beaux Papers

BIBLIOGRAPHY

A Catalogue of an Exhibition of Paintings by Cecilia Beaux (exh. cat. by R. Cortissoz, New York, Amer. Acad. A. & Lett., 1935)
T. Oakley: *Cecilia Beaux* (Philadelphia, 1943)
H. S. Drinker: *The Paintings and Drawings of Cecilia Beaux* (Philadelphia, 1955)
C. D. Bowen: *Family Portrait* (Boston, 1970)
E. Bailey: 'The Cecilia Beaux Papers', *Archvs Amer. A. J.*, xiii (1973), pp. 14–19
Cecilia Beaux: Portrait of an Artist, Pennsylvania Academy of the Fine Arts (exh. cat., Philadelphia, PA, Mus. Civ. Cent.; Indianapolis, IN, Mus. A.; 1974) [excellent pls]
J. E. Stein: 'Profile of Cecilia Beaux', *Fem. A. J.*, iv (1975–6), pp. 25–31, 33
E. Bailey: 'Cecilia Beaux: Background with a Figure', *A. & Ant.*, iii (1980), pp. 54–61
T. Tappert: 'Cecilia Beaux: A Career as a Portraitist', *Women's Stud.: Interdiscip. J.*, xiv/4 (1988)
C. Akullian and T. L. Tappert: 'Cecilia Beaux and the Art of Portraiture', *Amer. A. Rev.*, vii/5 (1995), pp. 134–41

TARA L. TAPPERT

Beaux-Arts style. Term applied to a style of classical architecture found particularly in France and the USA that derived from the academic teaching of the Ecole des Beaux-Arts, Paris, during the 19th and early 20th centuries. The style is characterized by its formal planning and rich decoration. The term is also found in writings by detractors of the Ecole's teaching methods and results: Frank Lloyd Wright, for example, called its products 'Frenchite pastry' ('In the Course of Architecture', *Archit. Rec.*, xxiii (1908), p. 163).

Beaux-Arts style is at its most spectacular in large public commissions. On the main façades, monumentality is conveyed by colossal orders and coupled columns, dynamism by marked wall projections and decorative details in high relief, such as swags, garlands and medallions. Well detached from the elaborate rooflines, figure sculptures often terminate the main and secondary vertical axes. In the 42nd Street façade of Grand Central Station (1903–13), New York, by WARREN & WETMORE (with Reed and Stem), motifs, which are maximized against large areas of unadorned smooth stone, successfully address the scale and communal spirit of this area of Manhattan. While the best-known and most ridiculed examples of the Beaux-Arts style in America were the major pavilions at the World's Columbian Exposition in Chicago (1893), its characteristic features may also be found in Manhattan townhouses and skyscrapers, as well as Long Island and Newport country estates.

When the Ecole des Beaux-Arts opened in 1819, amalgamating the special schools of architecture, painting and sculpture, it was unrivalled as a national training centre for artists of these disciplines. The architecture section was the descendant of the pre-revolutionary school of the Académie Royale d'Architecture, suppressed in 1793, and the curriculum remained virtually unchanged until 1968. Credits were attributed through a highly competitive system of the Concours d'Emulation; a major tenet of the design-orientated pedagogy was the practice of the *esquisse*, a preliminary sketch defining a *parti* (design orientation), to which competitors had to remain faithful. The teaching also emphasized the logical arrangement of programmatic requirements and the implementation of a suitable 'character' over stylistic and structural expression, social relevance and contextualism; projects for a specific site were exceptional. A basic rule for a successful composition was that visitors could find their way around any building without verbal orientation. Designs therefore represented

carefully orchestrated sequences of circulation and transitional spaces; hierarchical arrangements of rooms according to their ceremonial and/or functional significance; and the expression of the axis and cross-axis in elevation section and plan by advancing and receding planes, flights of steps, floor markings etc. According to Egbert, students were required to give their design a general character, which was conveyed by principles of form regarded as universally valid, such as a 'monumental', a 'public' or a 'French' character, as well as a 'type character', which was suggested by the particular programme of the building. Thus, far from being decorative, ornamentation was supposed to be symbolic in its suggestion of the appropriate character or characters.

The use of a classical heritage as a source for Beaux-Arts architecture was due to the stress given at the school on a thorough knowledge of the architecture of antiquity, the Renaissance and 17th- and 18th-century France. Students' interpretation of this evolved dramatically in the first half of the 19th century, from uncompromising Neoclassicism to unconventional syntheses of historical references. During the Second Empire the Beaux-Arts style developed, as the school experienced an increase in the number of projects focusing on interior design and the decorative arts, which gave freer rein to personal expression and imagination. Beaux-Arts eclecticism peaked in the 1880s, and it was quickly disseminated worldwide, as the student body at the school became increasingly cosmopolitan. Over 400 Americans studied architecture in Paris between 1846 and 1918, and many more followed a French-inspired curriculum in the USA, where the Beaux-Arts style had its greatest impact outside France. It was associated with the CITY BEAUTIFUL MOVEMENT. Around 1900, critics of Beaux-Arts style adopted anti-doctrinaire positions, which were best expressed in Guadet's *Éléments et théorie de l'architecture* (1907), but they were in marked contrast with the emerging theories of the Modern Movement.

BIBLIOGRAPHY

J. A. Guadet: *Éléments et théorie de l'architecture* (Paris, 1907)
L. Hautecoeur: *Histoire de l'architecture classique en France*, vii (Paris, 1957)
The Architecture of the École des Beaux-Arts (exh. cat., ed. A. Drexler; New York, MOMA, 1975–6)
R. B. Harmon: *Beaux Arts Classicism in American Architecture: A Brief Style Guide* (Monticello, IL, [1983])

ISABELLE GOURNAY

Beecher, Catherine (Esther) (*b* East Hampton, NY, 6 Sept 1800; *d* Elmira, NY, 12 May 1878). American writer. Daughter of the influential Presbyterian minister, Lyman Beecher (1775–1863), she was one of eight children. Her aim was to educate women and to raise their status as efficient managers and homemakers. Her books included works on improving domestic design. In *The Elements of Mental and Moral Philosophy* (1831) she advanced her view of the superiority of women, and the following book, *A Treatise on Domestic Economy* (1841), was enormously popular. The house designs she began to publish in 1841 were conventional spatially and technically. She rapidly improved her architectural knowledge and in 1869 published with her sister, Harriet Beecher Stowe (1811–96), her most influential book, *The American Woman's Home*. Included were plans for a model house arranged to maximize functional use and to minimize housekeeping drudgery. The latest inventions were incorporated, including water-closets, indoor plumbing, ventilation systems, central heating and gas illumination. Beecher also reproduced plans for a tenement house and settlement houses for the urban poor, as well as schemes for a suburban church, schoolhouse and a residence for two female missionary teachers. There is also discussion of a Model Christian Neighbourhood, in which ten to twelve families share a common bakehouse and laundry with mechanized washing equipment.

WRITINGS

The Elements of Mental and Moral Philosophy (n.p., 1831)
A Treatise on Domestic Economy, for the Use of Young Ladies at Home and at School (Boston, 1841)
'A Model Village', *The Revolution*, i (April 1868), p. 1
with H. Beecher Stowe: *The American Woman's Home: Or, Principles of Domestic Science, Being a Guide to the Formation and Maintenance of Economical, Healthful, Beautiful, and Christian Homes* (New York, 1869)

BIBLIOGRAPHY

DAB

D. Cole: *From Tipi to Skyscraper: A History of Women in Architecture* (Boston, 1973)
K. K. Sklar: *Catherine Beecher: A Study in American Domesticity* (New Haven, 1973)
D. Hayden: 'Catherine Beecher and the Politics of Housework', *Woman in American Architecture: A Historic and Contemporary Perspective*, ed. S. Torre (New York, 1977)
——: *The Grand Domestic Revolution: A History of Feminist Designs for American Homes, Neighborhoods, and Cities* (Cambridge, MA, 1981)
L. M. Roth: *America Builds: Source Documents in American Architecture and Planning* (New York, 1983), pp. 57–68

LELAND M. ROTH

Bellows, George (Wesley) (*b* Columbus, OH, 12 Aug 1882; *d* New York, 8 Jan 1925). American painter and lithographer. He was the son of George Bellows, an architect and building contractor. He displayed a talent for drawing and for athletics at an early age. In 1901 he entered Ohio State University, where he contributed drawings to the school yearbook and played on both the basketball and baseball teams. In spring of his third year he withdrew from university to play semi-professional baseball until the end of summer 1904; this, and the sale of several of his drawings, earned him sufficient money to leave Columbus in September to pursue his career as an artist.

Bellows studied in New York under Robert Henri at the New York School of Art, directed by William Merrit Chase. He initially resided at the YMCA on 57th Street. In 1906 Bellows moved to Studio 616 in the Lincoln Arcade Building on Broadway; over the following years the other tenants at this location included the urban realist painter Glenn O. Coleman (1887–1932), Rockwell Kent (1882–1971) and the playwright Eugene O'Neill. Across from Bellows's studio was the Sharkey Athletic Club, the setting for one of Bellows's most famous paintings, *Stag at Sharkey's* (1909; Cleveland, OH, Mus. A.), two fighters painted from the memory of a bout Bellows had witnessed there.

Although prizefighting where admission was charged was illegal in New York at this time, certain 'prizefighting clubs' such as Sharkey's circumvented the law by charging a club membership fee to view the fights. The promoter's way around the illicit nature of prizefighting is satirized in the title of another of Bellows's early paintings on this

theme, *Both Members of this Club* (1909; Washington, DC, N.G.A.). His early paintings are executed in a tonal palette of primarily creams and browns scumbled by streaks of white, with the vigorous broadly stroked brushwork characteristic of the work of Henri and his students. They evoke the smoky, dark, illicit crowded space of the ring, and capture the tawdry underworld flavour associated with these 'prizefighting clubs' at the turn of the century.

Bellows was associated with the ASHCAN SCHOOL of painting. An example of his early Ashcan work is the painting *Steaming Streets* (1908; Santa Barbara, CA, Mus. A.). Although he was not a member of THE EIGHT, he did show work at the Exhibition of Independent Artists in 1910. He was awarded a prize by the National Academy of Design in 1908 and in 1909 was elected an associate member, the youngest member ever elected. He also exhibited at and helped to organize the Armory Show (1913). Bellows was considered a quintessential American artist, one of the few who did not study abroad.

BIBLIOGRAPHY

P. Boswell, jr: *George Bellows* (New York, 1942)
F. Sieberling, jr: *George Bellows, 1882–1925: His Life and Development as an Artist* (diss., U. Chicago, 1948)
C. H. Morgan: *George Bellows: Painter of America* (New York, 1965)
K. M. Davis: *Bellows: Stylistic and Thematic Development* (diss., OH State U., 1968)
M. S. Young: 'George Bellows: Master of the Prizefight', *Apollo*, 89 (1969), pp. 132–41
D. Braider: *George Bellows and the Ashcan School of Painting* (New York, 1971)
C. H. Morgan: *The Drawings of George Bellows* (Alhambra, 1973)
M. S. Young: *The Paintings of George Bellows* (New York, 1973)
E. A. Carmean and others: *Bellows: The Boxing Pictures* (Washington, DC, 1982)
Portraits of George Bellows (exh. cat., Washington, DC, N.P.G., 1982)
E. Tufts: 'Realism Revisited: Goya's Impact on George Bellows and Other Responses to the Spanish Presence in Art', *A. Mag.*, lvii/6 (1983), pp. 105–13
R. Haywood: 'George Bellows's *Stag at Sharkey's*: Boxing, Violence, and Male Identity', *Smithsonian Stud. Amer. A.*, ii/2 (1988), pp. 3–15
M. Doezema: *George Bellows and Urban America* (New Haven, CT, 1992)
M. Quick and others: *The Paintings of George Bellows* (New York, 1992)

M. SUE KENDALL

Belter, John Henry (*b* Hilter, nr Osnabrück, 1804; *d* New York, 15 Oct 1863). American cabinetmaker of German birth. He arrived in New York in 1833 and became a naturalized American citizen in 1839. He was established as a cabinetmaker by 1844 and showed an ebony and ivory table at the New York Exhibition of the Industry of All Nations in 1853. In the following year he opened a five-storey factory on 76th Street near Third Avenue. In 1856 Belter's brother-in-law John H. Springmeyer joined the firm. William Springmeyer and Frederic Springmeyer joined in 1861, and in 1865 the firm's name was changed to Springmeyer Bros; it went bankrupt in 1867. Belter's fame is for technical innovation, reflected in four patents: the first, in 1847, for a device to saw openwork patterns into curved chair backs; the second, in 1856, for a two-piece bedstead of laminated construction; the third, in 1858, for a refinement to his process for achieving laminated construction with three-dimensional curves; and the fourth, in 1860, concerned with laminated construction and central locking. Belter's furniture—curvaceous rosewood chairs, sofas (*see* UNITED STATES OF AMERICA, fig. 32), tables, étagères, beds etc—is in a coarse and exuberant

Rococo Revival manner, characterized by elaborate open crestings and aprons, decorated with C and S scrolls, leaves, flowers and grapes, partly in high relief, where extra sections were glued to the laminated base. His imitators included Charles A. Baudouine, J. and J. Meeks & Co. (1797–1868) and Charles Klein of New York, and George J. Henkels of Philadelphia. Although his innovations in curved and laminated construction were, like those of Michael Thonet, firmly rooted in the Rococo Revival, Belter has been seen as a precursor of Charles Eames and other 20th-century users of laminate technology.

BIBLIOGRAPHY

C. Vincent: 'John Henry Belter: Manufacturer of All Kinds of Furniture', *Technical Innovation in the Decorative Arts: Winterthur, 1973*, pp. 207–34
D. A. Hanks: *Innovative Furniture in America from 1800 to the Present* (New York, 1981)
E. Dubrow and R. Dubrow: *American Furniture of the 19th Century, 1840–1880* (Exton, 1983)
S. G. Norman and M. S. Podmaniczky: 'Belter Furniture, 1840–1860: A Man who Lent his Name to a Style', *Fine Woodworking*, lxxi (1988), pp. 65–7
C. Greenberg: 'High Style in Old Gotham: New York City's Nineteenth-century Cabinetmakers', *A. & Ant.*, xix (1996), pp. 68–74

SIMON JERVIS

Beman, Solon S(pencer) (*b* Brooklyn, NY, 1 Oct 1853; *d* Chicago, IL, 23 April 1914). American architect. Although famous for his model industrial towns of Pullman (1880–95), IL, and Ivorydale (1883–8), OH, he contributed substantially to the first-generation achievement of the CHICAGO SCHOOL of architecture in the USA. Apprenticed to the firm of Upjohn & Upjohn, New York, he practised primarily in the Midwest, executing a large and important range of commercial, ecclesiastic and domestic projects, in a variety of styles. Beman designed the Mines and Mining and Merchant Tailors pavilions for the World's Columbian Exposition (Chicago, 1893; *see* BURNHAM, DANIEL H.), a crucial turning-point in his career. Thereafter, he abandoned his former playful eclecticism and took on the sobriety and unity of the Renaissance and classical styles.

Five important projects in Chicago summarize and distinguish Beman's long and prolific career. He planned the industrial suburb of Pullman with a factory complex, civic centre, landscaped grounds and housing for 10,000 residents. His house for W. W. Kimball (1890), patterned after the flamboyant, early 16th-century courtyard façade of the château de Josselin in Brittany, is regarded as his masterpiece. The iron and glass Grand Central Railway Station, New York, with its huge single-span balloon train shed, came closest of all 19th-century American stations to synthesizing engineering and architecture. His Studebaker (now Brunswick) Building of 1895, often compared with Louis Sullivan's Gage Building (1898–9), Chicago, was a brilliant exercise in the idiom of the delicately articulated curtain wall, albeit with Gothic detailing. Finally, Beman's First Church of Christ Scientist (1897), Chicago, a design derived from the Erechtheion in Athens, provided a model for many early churches of that denomination.

BIBLIOGRAPHY

C. Jenkins: 'Solon S. Beman', *Archit. Rev.*, xxi/7 (1898), pp. 47–99
T. J. Schlereth: 'Solon Spencer Beman: The Social History of a Midwest Architect', *Chicago Archit. J.*, v (1986), pp. 9–31

C. K. Laine: 'Renewing a Remarkable Planned Community: Pullman, South Chicago', *Archit.*, lxxvi (1987), pp. 60–65

T. J. Schlereth: 'A High Victorian Gothicist as Beaux-Arts Classicist: The Architectural Odyssey of Solon Spencer Beman', *Stud. Medievalism*, iii/2 (1990), pp. 128–52

J. S. Garner: 'S. S. Beman and the Building of Pullman', *Midwest in American Architecture*, ed. J. S. Garner (Urbana, IL, 1991), pp. 231–50

THOMAS J. SCHLERETH

Benbridge, Henry (*b* Philadelphia, PA, *bapt* 27 May 1744; *d* Philadelphia, *bur* 25 Jan 1812). American painter. He was educated at the Academy of Philadelphia (1751–8), from which he withdrew to study briefly with John Wollaston. Benbridge's first portraits, of his mother, stepbrother, half-sister and a large family group (all priv. cols, see 1971 exh. cat., pp. 35–7), show Wollaston's influence in composition and colour. Benbridge's paintings of *Achilles among the Daughters of Lycomedes* and the *Three Graces* (DE, priv. cols, see 1971 exh. cat., pp. 15–16) are based on European prints after Rubens.

In 1765 Benbridge travelled to Rome, where he shared rooms with the sculptor Christopher Hewetson. While in Rome in 1768, he accepted a commission from James Boswell to go to Corsica to paint the portrait of *General Pascal Paoli* (San Francisco, CA, F.A. Museums), which was well received when shown in London at the Free Society of Artists exhibition in May 1769. Benbridge was in London by December 1769, lodging in Panton Square and taking his meals with Benjamin West, to whose wife he was related. Benbridge's portraits of *Benjamin Franklin* (untraced) and the *Rev. Thomas Coombe* (ex-James Abernathy, Christ Church, PA, 1816) were shown at the Royal Academy in 1770. Benbridge was back in Philadelphia by 14 October 1770 and married Esther (Hetty) Sage, a painter of miniatures. In 1772 they settled in Charleston, SC, of which he wrote 'the only thing attended to is dress and disapation [*sic*]'.

Most of Benbridge's surviving paintings are portraits and miniatures of South Carolinians; perhaps the finest is of *Charles Cotesworth Pinckney* (Washington, DC, N.P.G.; see fig.). Although he overpainted the uniform when Pinckney threw in his lot with the Revolutionaries, the picture displays Benbridge's virtuosity with glazes and colour. When Charleston fell to the British (12 May 1780), Benbridge, also a Revolutionary, was taken prisoner and sent to St Augustine, FL, where he painted the prison governor *Benjamin Loring* (MI, Mr and Mrs S. P. Sax priv. col., see 1971 exh. cat., p. 42).

Benbridge was released in Philadelphia in 1782 and remained there until his return to Charleston in 1784. The most charming of his portraits 'in-the-small' (full-lengths painted on a small scale), the *Enoch Edwards Family* (*c.* 1783; Philadelphia, PA, Mus. A.), includes his self-portrait. His portrait of the mother of Washington Allston, *Rachel Moore Allston Flagg* (*c.* 1784; Winston-Salem, NC, Mus. Early S. Dec. A.), suggests that Benbridge may have had an indirect influence on Allston.

On 1 May 1788 Benbridge represented the limners of Charleston in a parade celebrating the adoption of the Federal Constitution of the United States, and he was listed in the city directory for 1790. In 1801 the portrait painter Thomas Sully received some instruction from Benbridge in Norfolk, VA. Here Benbridge painted his

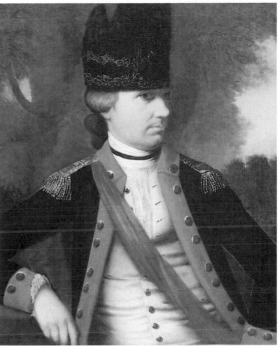

Henry Benbridge. *Charles Cotesworth Pinckney*, oil on canvas, 762×914 mm, 1775 (Washington, DC, National Portrait Gallery)

'in-the-small' family group *Mr and Mrs Francis Stubbs Taylor and Children* (Winston-Salem, NC, Mus. Early S. Dec. A.). He probably made his home with his son Henry who was in Norfolk until 1806. The record of Benbridge's burial gives his age as 70.

BIBLIOGRAPHY

A. W. Rutledge: 'Henry Benbridge (1743–1812?): American Portrait Painter', *Amer. Colr*, xvi/9 (1948), pp. 8–10, 23; xvi/10 (1948), pp. 9–11, 23

Henry Benbridge (1743–1812): American Portrait Painter (exh. cat. by R. G. Stewart, Washington, DC, N.P.G., 1971)

C. J. Weekly: 'Henry Benbridge: Portraits from Norfolk', *J. Early S. Dec. A.*, iv/2 (1978), pp. 50–64

R. G. Stewart: 'An Attractive Situation: Henry Benbridge and James Earl in the South', *Southern Q.*, xxvi (1987), pp. 39–56

S. E. Patrick: 'I Have at Length Determined to Have my Picture Taken: An Eighteenth-century Young Man's Thoughts about his Portrait by Henry Benbridge', *Amer. A. J.*, xxii/4 (1990), pp. 68–81

ROBERT G. STEWART

Benjamin, Asher (*b* Hartland, CT, 15 June 1773; *d* Springfield, MA, 26 July 1845). American architect and writer. He was one of the most influential architect–writers of the first half of the 19th century in the USA and was trained as a housewright in rural Connecticut between 1787 and 1794. Two of his earliest commissions, the carving of Ionic capitals (1794) for the Oliver Phelps House in Suffield, CT, and the construction of an elliptical staircase (1795) in Charles Bulfinch's Connecticut State Capitol at Hartford, reveal an exceptional ability with architectural geometry that was to help to determine the direction of his career. Benjamin worked as a housewright in a succession of towns along the Connecticut River during the 1790s. In 1797, dissatisfied with the publications of William Pain, an English popularizer of the Neoclassical style of Robert Adam (1728–92), Benjamin wrote

The Country Builder's Assistant, a modest handbook for carpenters that was the first such work by an American writer. In 1802 he attempted to establish an architectural school, in Windsor, VT, but may not have succeeded as he moved away that August and settled in Boston in the same year, probably drawn by the possibility of greater opportunities for work and a more settled existence. He continued to identify himself as a housewright and worked in relative obscurity until the publication of his second book, *The American Builder's Companion*, in 1806. This book, written in collaboration with Daniel Raynerd, a stuccoist, is larger, better organized and richer in information and decorative plates than *The Country Builder's Assistant*. These attributes and its clear debt to the work of Charles Bulfinch ensured its popularity through six subsequent editions during the following two decades.

Benjamin's architectural practice in Boston flourished between 1806 and 1810 when he designed the West Church, the Charles Street Meetinghouse, the Chauncey Street Church, the Exchange Coffee House and several fine town houses on Beacon Hill. Bulfinch's influence is apparent in the massing and detailing of these buildings, but Benjamin's work, though strong, lacks Bulfinch's characteristic restraint and refined sense of proportion.

Despite his successes, Benjamin curtailed his practice in 1810 in order to run a paint store. He published five further editions of *The American Builder's Companion*, as well as *The Rudiments of Architecture*, a book for students. The paint store did not succeed, and in 1824 Benjamin was forced to declare bankruptcy. He then took a position as a mill agent in Dunstable, NH, about 30 miles from Boston. Three years of hard work enabled him to regain solvency and return to Boston, but significant changes had taken place in architecture during his absence.

Led by Alexander Parris and Solomon Willard who were inspired by the example of Benjamin Henry Latrobe and his followers, the Neo-classical style was rapidly giving way to the Greek Revival in New England. Asher Benjamin's resilience and skill as a popularizer of style enabled him to absorb the changes and to embark on a substantial second career. The sixth edition of his *American Builder's Companion* (1827) included a new section entitled 'Grecian architecture' that was urged on Benjamin by his editor and other eminent architects and builders. By 1830, however, he had created his own simplified version of a Grecian decorative idiom, based on the rectilinear fret, for *The Practical House Carpenter*, his most popular and influential book. Two more books followed, *The Practice of Architecture* and *The Builder's Guide*, both of which show the influence of Minard Lafever whose elegant *Modern Builder's Guide* of 1833 introduced a new level of sophistication to architectural book engraving. Benjamin's final book, *The Elements of Architecture* (1843), placed a new emphasis on technology, theory and architectural history, a reflection of developments within the profession itself.

Benjamin's Greek Revival books and his post-1830 buildings reveal a reluctance on his part to embrace the Greek Revival fully. He included almost no buildings in these four publications, but preferred to present the Greek Revival as a new kind of decoration, a position that won favour with his vast country-builder readership. In practice, his town houses and detached houses tended to adhere to conservative plan forms, while in his churches and public buildings (including the Fifth Universalist Church, Boston, the Third Religious Society, Unitarian, in Dorchester, MA, and the Town Hall, Cambridgeport, MA) the temple form was *in antis* or prostylar.

WRITINGS

The Country Builder's Assistant (Greenfield, MA, 1797/*R*1972)
with B. Raynerd: *The American Builder's Companion* (Boston, 1806/ *R*1972)
The Rudiments of Architecture (Boston, 1814/*R*1972)
The Practical House Carpenter (Boston, 1830/*R*1972)
The Practice of Architecture (Boston, 1833/*R*1972)
The Builder's Guide (Boston, 1838/*R*1972)
The Elements of Architecture (Boston, 1843/*R*1972)

BIBLIOGRAPHY

F. T. Howe: 'Asher Benjamin: Country Builder's Assistant', *Antiques*, xl (1941), pp. 364–6
H. W. Congdon: 'Our First Architectural School?', *J. Amer. Inst. Architects*, xiii (1950), pp. 139–40
F. T. Howe: 'More about Asher Benjamin', *J. Soc. Archit. Hist.*, xiii (1954), pp. 16–19
J. Tomlinson: 'Asher Benjamin: Connecticut Architect', *CT Antiqua.*, vi (1954), pp. 26–9
H. Kirker: 'The Boston Exchange Coffee House', *Old-Time New England*, lii (1961), pp. 11–13
J. Quinan: 'Asher Benjamin as an Architect in Windsor, Vermont', *VT Hist.*, lxii (1974), pp. 181–94
——: 'Asher Benjamin and American Architecture', *J. Soc. Archit. Hist.*, xxxviii (1979), pp. 244–56
——: 'The Boston Exchange Coffee House', *J. Soc. Archit. Hist.*, xxxviii (1979), pp. 256–62
——: 'Asher Benjamin and Charles Bulfinch: An Examination of Baroque Forms in Federal Style Architecture', *New England Meeting House and Church: 1630–1850* (exh. cat., ed. P. Benes and P. Zimmerman; Manchester, NH, Currier Gal. A., 1979), pp. 18–29
W. N. Hosley, jr: 'Living with Antiques: Windsor House in Southern Connecticut', *Antiques*, cxxx (1986), pp. 106–15

JACK QUINAN

Benjamin, Samuel G(reen) W(heeler) (*b* Argos, Greece, 13 Feb 1837; *d* Burlington, VT, 19 July 1914). American writer. As an undergraduate at Williams College, Williamstown, MA, he wrote on art and travel. He wrote his first book on art, *What is Art or Art Theories and Methods Concisely Stated*, in 1877, followed by three articles published in *Harper's Monthly Magazine* concerning art in Europe. These articles, addressing English, French and German contemporary art, formed the basis of *Contemporary Art in Europe*, also published in 1877. Thereafter he wrote *Our American Artists* (1879) and *Art in America: A Critical and Historical Sketch* (1880), as well as several articles for *Harper's New Monthly Magazine*. Benjamin's writings tend to champion recent art. The second series of *Our American Artists*, written for young people, provided a helpful critical approach to, as well as much information on, contemporary artists.

WRITINGS

Contemporary Art in Europe (Boston, MA, 1877)
What is Art or Art Theories and Methods Concisely Stated (Boston, MA, 1877)
Our American Artists, 2 vols (Boston, MA, 1879)
Art in America: A Critical and Historical Sketch (New York, 1880)
Our American Artists: Painters, Sculptors, Illustrators, Engravers and Architects for Young People (Boston, 1881)

BIBLIOGRAPHY

National Cyclopedia of American Biography
E. Johns: 'Histories of American Art: The Changing Quest', *A. J.* [New York], xliv (1984), p. 339

DARRYL PATRICK

Benson, Frank W(eston) (*b* Salem, MA, 24 March 1862; *d* Salem, 15 Nov 1951). American painter, etcher and teacher. He attended the School of the Museum of Fine Arts, Boston, from 1880 to 1883 as a student of Otto Grundmann (1844–90) and Frederick Crowninshield (1845–1918). In 1883 he travelled with his fellow student and lifelong friend Edmund C. Tarbell to Paris, where they both studied at the Académie Julian for three years with Gustave Boulanger (1824–88) and Jules Lefebvre (1836–1911). Benson travelled with Tarbell to Italy in 1884 and to Italy, Belgium, Germany and Brittany the following year. When he returned home, Benson became an instructor at the Portland (ME) School of Art, and after his marriage to Ellen Perry Peirson in 1888 he settled in Salem, MA. Benson taught with Tarbell at the Museum School in Boston from 1889 until their resignation over policy differences in 1913. Benson rejoined the staff the next year (teaching intermittently as a visiting instructor until 1930).

In style and subject Benson's paintings closely resemble those of Tarbell, with whom he is often paired as a leader of the 'Boston School'. His early paintings were primarily portraits and figure studies in interiors. About 1898 he began the series by which he is best known, paintings in an Impressionist style of young women and children in bright sunny landscapes. Benson and his family summered on Penobscot Bay, ME, and their holidays provided inspiration for many of those works. In such paintings as *My Daughters* (1907; Worcester, MA, A. Mus.) and *Eleanor* (1907; Boston, MA, Mus. F.A.), women clothed in white or pastel colours relax outside in a seemingly endless summer of sunlit leisure. His interior scenes such as *Rainy Day* (1906; Chicago, IL, A. Inst.) and *Open Window* (1917; Washington, DC, Corcoran Gal. A.) are more directly influenced by Tarbell, since they depict young women in the still interiors favoured by that artist. In other paintings such as *Black Hat* (1904; Providence, RI Sch. Des., Mus. A.), Benson's figures are more monumental and the compositions more decorative than those of Tarbell.

Benson was involved in the decoration of the Library of Congress in Washington, DC, one of the major American mural projects of the late 19th century. His octagonal panels of the *Three Graces* and circular lunettes of the *Four Seasons* were completed in 1896. Executed in a bright Impressionist palette, these murals of half-length young girls were often cited as symbolic of the hope and optimism of the American spirit in the 1890s.

Benson was elected to the Society of American Artists in 1888 but resigned in 1898 to become a founder-member of the TEN AMERICAN PAINTERS, who grouped together to exhibit in a stylistically harmonious atmosphere. He was made an academician at the National Academy of Design in 1905. Benson was versatile in his use of many media, including watercolour, pastel, engraving and aquatint. In 1912 he turned to etching as a hobby and quickly gained critical acclaim after an exhibition of his etchings in 1915 at the Guild of Boston Artists. Always an avid sportsman and hunter, he specialized in wildlife scenes, especially in etching but also in watercolour and oil.

UNPUBLISHED SOURCES
Salem, MA, Essex Inst. [Benson Papers]

BIBLIOGRAPHY
Two American Impressionists: Frank W. Benson and Edmund C. Tarbell (exh. cat., ed. S. F. Olney; Durham, U. NH, A. Gals, 1979)
J. T. Ordeman: *Frank W. Benson: Master of the Sporting Print* (Brooklandville, MD, 1983)
The Bostonians: Painters of an Elegant Age, 1870–1930 (exh. cat., ed. T. J. Fairbrother; Boston, MA, Mus. F.A., 1986)
Frank W. Benson: The Impressionist Years (exh. cat., New York, Spanierman Gal., 1988)
F. A. Bedford: *Frank W. Benson, American Impressionist* (New York, 1994)
——: 'Frank W. Benson: The Divided Paintings', *Amer. A. Rev.*, vii/4 (1995), pp. 106–13

BAILEY VAN HOOK

Bierstadt, Albert (*b* Solingen, Germany, 7 Jan 1830; *d* New York, 18 Feb 1902). American painter of German birth. In a career spanning the entire second half of the 19th century, he emerged as the first technically sophisticated artist to travel to the Far West of America, adapt European and Hudson River School prototypes to a new landscape and produce paintings powerful in their nationalistic and religious symbolism.

Bierstadt spent his early years in New Bedford, MA, where his family settled two years after his birth. Lacking funds for formal art instruction, he spent several years as an itinerant drawing instructor before departing in 1853 for Düsseldorf, Germany, where he hoped to study with Johann Peter Hasenclever (1810–53), a distant relative and a celebrated member of the Düsseldorf art circle. Hasenclever's death shortly before Bierstadt's arrival altered the course of his study, for rather than finding German mentors, he responded to the generous assistance offered by fellow American artists Emanuel Gottlieb Leutze and Worthington Whittredge. After four years of study and travel in Germany, Switzerland and Italy, he had achieved a remarkable level of technical expertise. In 1857, his apprenticeship complete, he returned to New Bedford. The following year he made his New York début contributing a large painting, *Lake Lucerne* (1858; Washington, DC, N.G.A.), to the annual exhibition at the National Academy of Design.

The turning-point in his career came in 1859 when he obtained permission to travel west with Frederick W. Lander's Honey Road Survey Party. Bierstadt accompanied the expedition as far as South Pass, high in the Rocky Mountains, not only making sketches, but also taking stereoscopic photographs of Indians, emigrants and members of the survey party. On his return east, Albert gave his negatives to his brothers Charles Bierstadt (1819–1903) and Edward Bierstadt (1824–1906), who shortly thereafter opened their own photography business. Albert himself, after taking space in the Tenth Street Studio Building in New York, set to work on the first of the large western landscapes on which he built his reputation. In 1860 he exhibited *Base of the Rocky Mountains, Laramie Peak* (untraced) at the National Academy of Design and thereby laid artistic claim to the landscape of the American West. Of all the paintings he produced following his first trip west, none drew more attention than *The Rocky Mountains, Lander's Peak* (1863; New York, Met.; see fig.). A huge landscape combining distant mountain grandeur with a close-up view of Indian camp life, *The Rocky Mountains* was seen by some as the North American

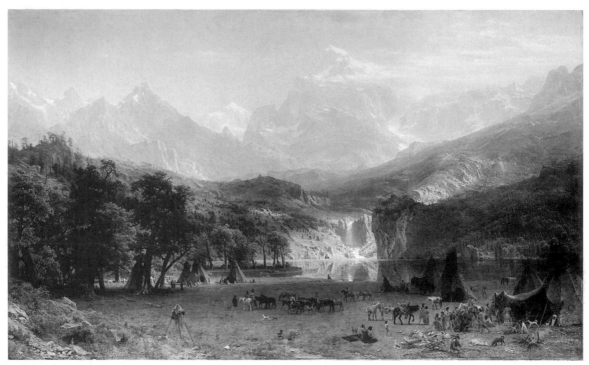

Albert Bierstadt: *The Rocky Mountains, Lander's Peak*, oil on canvas, 1.86×3.06 m, 1863 (New York, Metropolitan Museum of Art)

equivalent of Frederic Edwin Church's *Heart of the Andes* (1859; New York, Met.; for illustration *see* CHURCH, FREDERIC EDWIN).

In 1863 Bierstadt made his second trip west, accompanied by the writer Fitz Hugh Ludlow. Travelling by stagecoach and on horseback, the pair reached San Francisco in July, spent seven weeks in Yosemite Valley and then rode north as far as the Columbia River in Oregon before returning east. Following this trip, Bierstadt produced a series of paintings that took as their subject the awesome geography and spiritual power of Yosemite Valley. Such images of undisturbed nature served as welcome antidotes to the chaos and carnage of the Civil War then ravaging the eastern landscape. In 1865 Bierstadt sold *The Rocky Mountains* to James McHenry, an English railroad financier, for $25,000. The sale marked not only the artist's economic ascendancy but also his entry into European and American society. At the peak of his fame and wealth, Bierstadt built a magnificent home, Malkasten, on the banks of the Hudson River. He continued to produce large paintings of western mountain scenery, including *Storm in the Rocky Mountains, Mt Rosalie* (1866; New York, Brooklyn Mus. A.) and *Domes of the Yosemite* (1867; St Johnsbury, VT, Athenaeum).

In June 1867 Bierstadt and his wife departed for Europe, where they spent two years travelling and mixing with potential patrons among the wealthy and titled. In Rome during the winter of 1868 he completed *Among the Sierra Nevada Mountains, California* (Washington, DC, N. Mus. Amer. A.; see colour pl. XVII, 1), a key example of the mythic rather than topographical paintings that would occupy much of his time during the 1870s. In 1871 he returned to California and Yosemite, but the transconti-

nental railroad had flooded the valley with tourists, and he turned his attention to less accessible and still pristine areas such as Hetch Hetchy Valley, Kings River Canyon and the Farallon Islands. Returning east in 1873, he began work on a new series of paintings of California, as well as a commissioned work for the US Capitol, the *Discovery of the Hudson* (1875; *in situ*). In 1877, when his wife's health required a warmer climate, he began regular trips to Nassau. The island's lush landscape and tropical light offered new subject-matter and encouraged him to adopt a brighter palette. In the following decade he travelled constantly, returning to Europe, California, Canada and the Pacific Northwest. In 1881 he visited Yellowstone Park and eight years later Alaska and the Canadian Rockies.

The growing American taste for paintings exhibiting French mood rather than German drama, on an intimate rather than a panoramic scale, had begun to affect Bierstadt's reputation as early as the mid-1870s, but the most painful blow came in 1889 when his ambitious western canvas, the *Last of the Buffalo* (1888; Washington, DC, Corcoran Gal. A.), was rejected by an American selection committee for the Paris Exposition Universelle. Declaring the canvas too large and not representative of contemporary American art, the committee reinforced the view that Bierstadt was an outmoded master. The revival of interest in Bierstadt's work in the 1960s was sparked not by the large studio paintings celebrated during the 1860s and 1870s, but rather by the fresh, quickly executed sketches done as preparatory works for the larger compositions.

BIBLIOGRAPHY

R. Trump: *Life and Works of Albert Bierstadt* (diss., Columbus, OH State U., 1963)
E. Lindquist-Cock: 'Stereoscopic Photography and the Western Subjects of Albert Bierstadt', *A.Q.*, xxxiii (1970), pp. 360–78

G. Hendricks: *Albert Bierstadt: Painter of the American West* (New York, 1973)

M. Baigell: *Albert Bierstadt* (New York, 1981)

G. Carr: 'Albert Bierstadt, Big Trees, and the British: A Log of Many Anglo-American Ties', *Arts*, lx (1986), pp. 60–71

N. K. Anderson: 'The European Roots of Albert Bierstadt's Views of the American West', *Antiques*, cxxxix (1991), pp. 220–33

W. H. Truettner: 'Reinterpreting Images of Westward Expansion, 1820–1920', *Antiques*, cxxxix (1991), pp. 542–55

L. Buckley: '*The Sierras near Lake Tahoe* by Albert Bierstadt', *Porticus*, xiv–xvi (1991–3), pp. 42–51

Albert Bierstadt: Art & Enterprise (exh. cat. by N. Anderson and L. Ferber, New York, Brooklyn Mus.; San Francisco, CA, F.A. Museums; Washington, DC, N.G.A.; 1991–2; review by B. Nixon in *Artweek*, xxii (1991), p. 1; A. Wilton in *Apollo*, cxxxv (1992), p. 56

The West as America: Rethinking Western Art (exh. cat. by W. Truettner and others, Washington, DC, N. Mus. Amer. A., 1991); review by S. May in *Southwest A.*, xxi (1991), pp. 100–9

A. Blaugrund: 'The Old Boy Network in Rome: Tenth Street Studio Artists Abroad', *Italian Presence in American Art, 1860–1920*, ed. I. B. Jaffe (Rome, 1992), pp. 229–39

F.-B. Oraezie Vallino: 'Alle radici dell'etica ambientale: Pensiero sulla natura, wilderness e creatività artistica negli Stati Uniti del XIX secolo, pt. 2', *Storia A.*, lxxix (1993), pp. 355–410

J. Hines: 'Land of Extremes: Mythological Romanticism Associated with the West', *Southwest A.*, xxvi (1996), p. 40

NANCY ANDERSON

Bingham, George Caleb (*b* Augusta County, VA, 20 March 1811; *d* Kansas City, MO, 7 July 1879). American painter. Raised in rural Franklin County, MO, Bingham experienced from an early age the scenes on the major western rivers, the Missouri and the Mississippi, that inspired his development as a major genre painter. During his apprenticeship to a cabinetmaker, he met the itinerant portrait painter Chester Harding, who turned Bingham's attention to art. Teaching himself to draw and compose from art instruction books and engravings, the only resources available in the frontier territories, Bingham began painting portraits as early as 1834. The style of these works is provincial but notable for its sharpness, clear light and competent handling of paint.

Bingham travelled in 1838 to Philadelphia, where he saw his first genre paintings. He spent the years 1841 to 1844 in Washington, DC, painting the portraits of such political luminaries as *Daniel Webster* (Tulsa, OK, Gilcrease Inst. Amer. Hist. & A.). His roster of impressive sitters later enabled him to attract many portrait commissions. He settled back in Missouri at the end of 1844, and, although portraits would always form the greater portion of his work, it was over the next seven years that he made the outstanding contribution of his era to American genre painting. On the East Coast, Bingham's slightly older contemporary William Sidney Mount had been exhibiting genre scenes of farmers since 1830. In the 1840s, however, the major focus of national concern shifted to westward expansion and its meaning for American society. Bingham's work stunningly interpreted these concerns with three major motifs.

The first was that of the fur trader, which he developed in his painting *Fur Traders Descending the Missouri* (1845; New York, Met.; see colour pl. XII, 2). Against an imposing background of golden light and towering clouds, he placed a fur trader and his half-breed son (so identified in the original title of the painting), along with their chained bear cub, in a canoe floating downstream. Looking out at the viewer, the men seem thoughtful and cleanly dressed—not

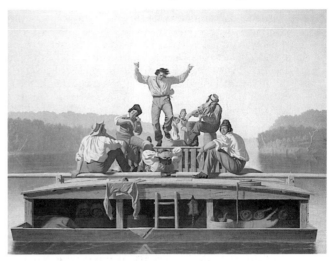

George Caleb Bingham: *Jolly Flatboatmen*, oil on canvas, 969×1232 mm, 1846 (Detroit, MI, Alex and Marie Manoogian private collection)

at all the uncivilized creatures described in contemporary literature. The surface of the water is mirror-like; reflections of the canoe, the oar and other details lock the scene into place. It is a romantic vision, transforming into a peaceful idyll the very terms of commercial gain in which the continent had been explored. The painting pays tribute to a vanishing phenomenon, for soon after the Panic of 1837 the market for pelts dropped disastrously and never recovered. As such, it epitomizes Bingham's role in preserving, and reinterpreting, the vanishing West. *Fur Traders* is moreover characteristic of his style. His clearly delineated figures derive from character studies of frontier people that he had sketched on paper. He created a formal design, which conveyed an ordered, inviolate world (there exist no studies for his works other than drawings of individual figures); he painted smoothly, with an absence of brushstroke; and his tonalities were light, dominated by areas of bright colour and often, as in this painting, luminous.

Bingham's second motif explored the life of the Mississippi raftsman. His *Jolly Flatboatmen* (1846; Detroit, MI, Manoogian priv. col.; see fig.), again dominated by a clear light, is even more tightly organized than *Fur Traders*, with a number of figures balancing one another. This predilection for order, fundamental to Bingham's very energies as an artist, contributed crucial meanings to his renderings of the West. These are often ironical meanings. No group of men on the western rivers seemed less responsible to society than the violent, fun-loving, gambling flatboatmen. He painted the flatboatmen in several versions, including scenes of dancing and cardplaying, for example *Raftsmen Playing Cards* (1847; St Louis, MO, A. Mus.), attracting audiences in St Louis and other western cities as well as in the East. His paintings transformed the terms in which frontier life had been understood, negating the threat of the rough frontiersman to civilized life. The American Art-Union, acting on a demand for this vision in the East during a period in which the nation was aggressively expanding westward, became Bingham's major patron. In 1847 it engraved *Jolly Flatboatmen* for an audience of about 10,000 subscribers.

The final motif that Bingham explored was that of the election. No longer near the river (and the river's associations with commerce and movement), these scenes take place in a village. Clearly influenced by Hogarth, but inspired by his own experience in politics, they show politicians arguing their point in *Stump Speaking* (1854), citizens casting their vote in *County Election* (1851 and 1852; one version in St Louis, MO, A. Mus.) and the electorate gathered to hear election results in *Verdict of the People* (1855; all three in St Louis, MO, Boatmen's N. Bank). In each painting Bingham showed the wide range of social class, economic standing and apparent intellectual capability in the electorate; he chronicled political abuses as well—such as drinking at the polls and electioneering at the ballot box. Bingham exhibited *County Election* widely and painted a second version that was engraved by the Philadelphia engraver John Sartain (1808–97).

Although the genre scenes are Bingham's major achievement, he also painted landscapes. His *Emigration of Daniel Boone* (1851; St Louis, MO, George Washington U.), while inspired by the popularity of the theme rather than his own experience, pictured the early Western scout leading a caravan of settlers over the Cumberland Gap. In 1857 Bingham went to Düsseldorf, where he painted several large historical portraits on commission, notably one of *Thomas Jefferson* (destr. 1911). His angry historical painting protesting against the imposition of martial law in Missouri during the Civil War, *Order No. 11* (1865–8; Cincinnati, OH, A. Mus.), is full of quotations from earlier works of art. Although Bingham was increasingly involved in state and local politics, he continued his work as a portrait painter. The major repositories for his paintings and drawings are the St Louis Art Museum and the Boatmen's National Bank of St Louis.

BIBLIOGRAPHY

C. Rollins, ed.: 'Letters of George Caleb Bingham to James S. Rollins', *MO Hist. Rev.*, xxxii (1937–8), pp. 3–34, 164–202, 340–77, 484–522; xxxiii (1938–9), pp. 45–78, 203–29, 349–84, 499–526

J. F. McDermott: *George Caleb Bingham: River Portraitist* (Norman, OK, 1959)

J. Demos: 'George Caleb Bingham: The Artist as Social Historian', *Amer. Q.*, xvii/2 (1965), pp. 218–28

E. M. Bloch: *George Caleb Bingham: The Evolution of an Artist*, 2 vols (Berkeley, 1967) [with cat. rais.]

R. Westervelt: 'Whig Painter of Missouri', *Amer. A. J.* [New York], ii/1 (1970), pp. 46–53

E. M. Bloch: *The Drawings of George Caleb Bingham* (Columbia, MO, 1975)

B. Groseclose: 'Painting, Politics, and George Caleb Bingham', *Amer. A. J.*, x/2 (1978), pp. 5–19

George Caleb Bingham (exh. cat. by M. Shapiro and others; St Louis, MO, A. Mus.; and Washington, DC, N.G.A.; 1990)

N. Rash: *The Painting and Politics of George Caleb Bingham* (New Haven and London, 1991)

The West as America: Reinterpreting Images of the Frontier (exh. cat. by W. Truettner and others, Washington, DC, N. Mus. Amer. A.; Denver, CO, A. Mus.; St Louis, MO, A. Mus.; 1991–2); review by A. Trachtenberg in *A. Amer.*, lxxix (1991), pp. 118–23

D. M. Lubin: *Picturing a Nation: Art and Social Change in Nineteenth-century America* (New Haven and London, 1994)

N. Rash: 'New Light on George Caleb Bingham and John Sartain', *Prt Colr Newslett.*, xxv (1994), pp. 135–7

ELIZABETH JOHNS

Binns, Charles Fergus (*b* Worcester, UK, 4 Oct 1857; *d* Alfred, NY, 4 Dec 1934). American potter and teacher of English birth. As the son of Richard William Binns (1819–1900), director of the Worcester Royal Porcelain Co. Ltd, he was exposed at an early age to the pottery industry. After holding various positions in the Worcester firm, he resigned. In 1897 he settled in the USA, where he was appointed director of the Technical School of Arts and Sciences in Trenton, NJ, and superintendent of the Ceramic Art Co., also in Trenton. In 1900 he became the first director of the New York College of Clayworking and Ceramics at Alfred University, NY. In this capacity and as a founder-member and officer in the American Ceramic Society, he greatly influenced the development of American ceramics. He frequently contributed articles to *Craftsman*, *Keramic Studio* and the *Transactions* and *Journal* of the American Ceramic Society, and he was the author of several books. His own technically exquisite stoneware, produced at Alfred, was inspired by early Chinese ceramics and emphasized the interrelationship of classical shape and finely textured glazes. His students included Maija Grotell (1899–1973), Arthur Eugene Baggs (1886–1947) and R. Guy Cowan (1884-1957), who became important potters and teachers.

WRITINGS

Ceramic Technology (London, 1897)
The Story of the Potter (London, 1898)
The Potter's Craft (New York, 1910, rev. 4/1967)

BIBLIOGRAPHY

S. R. Strong: 'Charles Fergus Binns: The Searching Flame', *Amer. Cer.*, i (1982), pp. 44–9

M. Carney: *Charles Fergus Binns: The Father of American Studio Ceramics* (New York, 1998)

ELLEN PAUL DENKER

Birch, Thomas (*b* Warwicks, 26 July 1779; *d* Philadelphia, PA, 14 Jan 1851). American painter of English birth. He was one of the most important American landscape and marine painters of the early 19th century. He moved to America in 1794 with his father William Birch (1755–1834), a painter and engraver from whom he received his artistic training. The family settled in Philadelphia, where William, armed with letters of introduction from Benjamin West to leading citizens of that city, became a drawing-master. Early in their American careers both Birches executed cityscapes, several of which were engraved. Thomas contributed a number of compositions to *The City of Philadelphia in the State of Pennsylvania, North America, as it Appeared in the Year 1800* (1800), a series of views conceived by the elder Birch in obvious imitation of comparable British productions. An English sensibility is also apparent in the many paintings of country estates executed by father and son in the early 19th century (e.g. *Eaglesfield*, 1808; priv. col., see 1986 exh. cat., p. 26). These compositions, along with such portrayals of important public edifices in and near Philadelphia as *Fairmount Waterworks* (1821; Philadelphia, PA Acad. F.A.; see fig.), emphasize the cultural progress and commercial prosperity of the young United States as well as its almost Edenic natural beauty. Birch is also known for his representations of winter landscapes (examples in Shelburne, VT, Mus.).

Among Birch's most accomplished landscapes from the 1810s are his two views of Point Breeze, the country seat of Joseph Bonaparte outside Bordentown, NJ. The sweeping view of the Delaware River as seen from the elegant terrace of this villa, decorated with Classical sculpture and

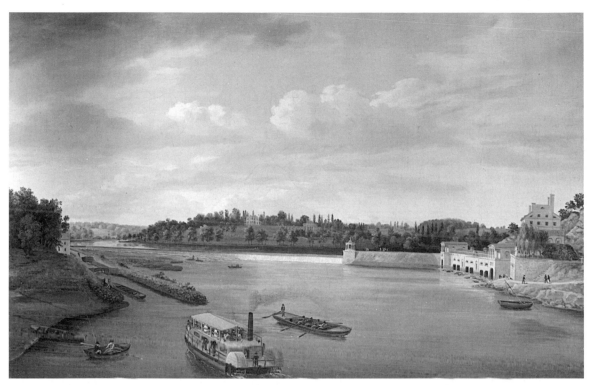

Thomas Birch: *Fairmount Waterworks*, oil on canvas, 511×764 mm, 1821 (Philadelphia, PA, Pennsylvania Academy of the Fine Arts)

populated with fashionably dressed men and women (1818; priv. col., see 1986 exh. cat., p. 146), is perhaps unique in American art of this period. Its pronounced French flavour seems particularly appropriate for a composition probably commissioned by Napoleon's brother or by one of the Prince's admirers. The collection of Old Masters and contemporary European works at Point Breeze was a major artistic attraction and a source of inspiration to many American painters, including Birch.

At the time of the War of 1812 with Britain, Birch took up marine painting. Although he continued to paint landscapes, particularly with river views (e.g. *View on the Delaware*, 1831; Washington, DC, Corcoran Gal. A.) and country estates, many of his works from the second half of his career are naval scenes that reflect his familiarity with the Anglo-Dutch tradition of marine painting. While these compositions frequently depict shipping on the Delaware and in New York harbour (several in Boston, MA, Mus. F.A.), he also executed a series of important canvases chronicling major naval engagements of the war (Philadelphia, PA, Hist. Soc.; New York, NY Hist. Soc.; see colour pl. VII, 1). His seascapes with shipping along rocky coasts buffeted by storms, such as *Shipwreck* (1829; New York, Brooklyn Mus. A.), recall the compositions of Joseph Vernet (1714–89), whose work Birch knew first hand and through prints, and those of Vernet's followers in England, such as Philippe de Loutherbourg. Birch was a frequent exhibitor at the Pennsylvania Academy, where he served as keeper from 1812 to 1817, as well as at other artistic institutions in Philadelphia and New York.

BIBLIOGRAPHY

D. J. Creer: *Thomas Birch: A Study of the Condition of Painting and the Artist's Position in Federal America* (MA thesis, Newark, U. DE, 1958)

Thomas Birch (exh. cat. by W. H. Gerdts, Philadelphia, Mar. Mus., 1966)

J. Wilmerding: *A History of American Marine Painting* (Boston, 1968), pp. 102–18

M. Hutson: 'The American Winter Landscape, 1830–1870', *Amer. A. Rev.*, ii (Jan–Feb 1975), pp. 60–78

Views and Visions: American Landscape before 1830 (exh. cat. by E. J. Nygren and others, Washington, DC, Corcoran Gal. A., 1986)

J. G. Sweeney: 'The Nude of Landscape Painting: Emblematic Personification in the Art of the Hudson River School', *Smithsonian Stud. Amer. A.*, iii/4 (1989), pp. 42–65

EDWARD J. NYGREN

Bischoff, Franz A. (*b* Bomen, Austria, 14 Jan 1864; *d* Pasadena, 5 Feb 1929). American painter and porcelain painter of Austrian birth. He began his artistic training at a craft school in his native Bomen. In 1882 he went to Vienna for further training in painting, design and ceramic decoration. He came to the USA in 1885 and obtained employment as a painter in a ceramic factory in New York City. He moved to Pittsburgh, PA, then to Fostoria, OH, and finally to Dearborn, MI, continuing to work as a porcelain painter. In 1906 he moved his family to the Los Angeles area. Two years later he built a studio—home along the Arroyo Seco in South Pasadena, which included a gallery, ceramic workshop and painting studio. Once in California, Bischoff turned to landscape painting, in addition to continuing his flower paintings and his porcelain work (see fig.).

One of the leaders of the California *plein-air* style, Bischoff was also one of the foremost porcelain painters of his day. He founded the Bischoff School of Ceramic Art in Detroit and New York City and formulated and manufactured many of his own colours. His porcelain works were exhibited at the 1893 World's Columbian

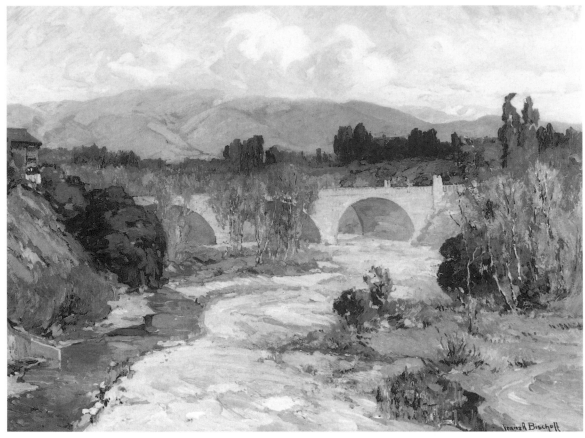

Franz A. Bischoff: *Arroyo Seco Bridge*, oil on canvas, 762×1016 mm, *c.* 1915 (Irvine, CA, Irvine Museum)

Exposition in Chicago and at the 1904 Louisiana Purchase Exposition in St Louis.

BIBLIOGRAPHY

J. Stern: *The Paintings of Franz A. Bischoff* (Los Angeles, 1980)
California Light, 1900-1930 (exh. cat. by P. Trenton and W. H. Gerdts, Laguna Beach, CA, A. Mus., 1990)

JEAN STERN

Blackburn, Joseph (*b c.* 1730; *d* after 1778). English painter, active in the American colonies. He first appeared in Bermuda in August 1752, and in a matter of months he painted many of the island's leading families. Approximately 25 of these portraits (e.g. *Mrs John Harvey*, Paget, Bermuda, priv. col.) survive; these demonstrate considerable skill in the painting of lace and other details of dress. Because of these abilities, it is thought he probably began his career in one of the larger studios in London as a drapery specialist.

By the end of 1753 Blackburn set out for Newport, RI. His portrait of *Mrs David Chesebrough* (New York, Met.), signed and dated 1754, is the earliest mainland portrait to survive. In the following year he proceeded to Boston where, with John Smibert dead and Robert Feke and John Greenwood departed, only two younger painters, Nathaniel Smibert (1735–56) and John Singleton Copley, were in competition. Blackburn's grandest picture, *Isaac Winslow and his Family* (1755; Boston, MA, Mus. F.A.; see fig.), a stylish and sizeable group portrait, indicates the level of success Blackburn achieved in Boston; however, not accustomed to painting group compositions, he employed three single portrait formats, tentatively linked by outstretched hands.

Over the next four years Blackburn painted more than 30 portraits for the upper levels of Boston society. He used a light, pastel palette that recalled that of Joseph Highmore (1692–1780), although Blackburn's handling of paint is not as fresh. He was not concerned with expressing the character of his sitters, but rather their chalky flesh-tones with fashionably rouged cheeks, artful gestures and exquisite trappings. Part of Blackburn's overt success may be attributable to his willingness to enhance his sitters' appearance. His attention to meticulously rendered lace, diaphanous neckerchiefs and delicate bows, in addition to attractive likenesses, enchanted his female sitters. Unfortunately for Blackburn, John Singleton Copley was a fast learner and within a year was skilfully emulating the visitor's success with such portraits of his own as *Ann Tyng* (Boston, MA, Mus. F.A. By 1758 Copley was threatening Blackburn's pre-eminence, which may have influenced the latter's decision to move to Portsmouth, NH, that year. After five years there, Blackburn returned to England. His signed and dated English portraits range from 1764 to 1778. A Mr Blackburn, possibly the same artist, exhibited three history pictures at the Free Society of Artists in 1769.

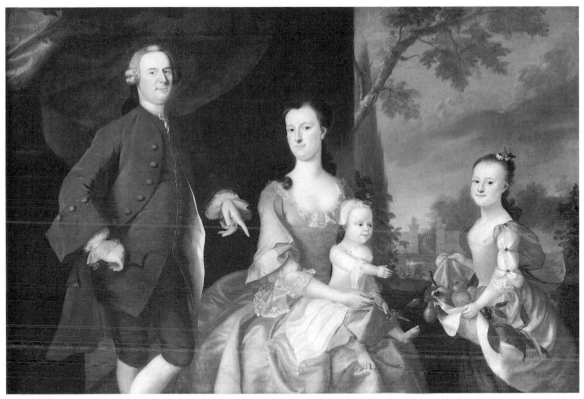

Jopseh Blackburn: *Isaac Winslow and his Family*, oil on canvas, 1.38×2.02 m, 1755 (Boston, MA, Museum of Fine Arts)

BIBLIOGRAPHY
L. Park: *Joseph Blackburn: A Colonial Portrait Painter with a Descriptive List of his Works* (Worcester, MA, 1923)
J. H. Morgan and H. W. Foote: 'An Extension of Lawrence Park's Descriptive List of the Work of Joseph Blackburn', *Proc. Amer. Antiqua. Soc.*, xlvi (1936), pp. 15–81
C. H. Collins Baker: 'Notes on Joseph Blackburn and Nathaniel Dance', *Huntington Lib. Q.*, ix (1945), pp. 33–47
W. B. Stevens jr. 'Joseph Blackburn and his Newport Sitters, 1754–1756', *Newport Hist.*, xl (1967), pp. 95–107
A. Oliver. 'The Elusive Mr Blackburn', *Colon. Soc. MA*, lix (1982), pp. 379–92
W. Craven: *Colonial American Portraiture* (Cambridge, 1986), pp. 296–304

RICHARD H. SAUNDERS

Blakelock, Ralph Albert (*b* New York, 15 Oct 1847; *d* Elizabethtown, NY, 9 Aug 1919). American painter. One of the most important visionary artists in late 19th-century America, he was self-taught as a painter. From 1867 he was exhibiting landscapes in the style of the Hudson River school at the National Academy of Design in New York. Rather than going abroad for advanced training, like most of his contemporaries, he spent the years 1869–72 in the western United States. Back in New York, Blakelock evolved his personal style during the 1870s and 1880s. Eschewing literal transcriptions of nature, he preferred to paint evocative moonlit landscapes such as *Moonlight* (Washington, DC, Corcoran Gal. A.; see fig.). These paintings, almost never dated, often included camp-fires or solitary figures; but such elements were absorbed into the setting rather than being the painting's focus, as in *Moonlight Indian Encampment* (Washington, DC, N. Mus.

Amer. A.). Blakelock's images, imbued with a melancholy that had been evident even in his early work, drew on his deeply felt response to nature.

Blakelock's technique was as individual as his subject; the surfaces, sensuously textured, were built up of layers of thick pigment, although his use of bitumen has disfigured some of his work. Blakelock's unconventional paintings were not well received, and he sold them for meagre sums to a few private patrons and through minor New York auction houses and art dealers to support his nine children. Financial distress led to mental breakdown, and in 1899 Blakelock was confined to a mental institution, where he spent most of the rest of his life. Ironically, Blakelock's unique artistry soon gained appreciation and brought substantial prices, from which neither he nor his family benefited. The popularity of his work has also encouraged numerous forgeries.

BIBLIOGRAPHY
E. Daingerfield: 'Ralph Albert Blakelock', *A. America*, ii (Dec 1913), pp. 55–68; rev. as *Ralph Albert Blakelock* (New York, 1914); rev. *A. America*, li (Aug 1963), pp. 83–5
Ralph Albert Blakelock Exhibition (exh. cat. by L. Goodrich, New York, Whitney, 1947)
Ralph Albert Blakelock, 1847–1919 (exh. cat. by N. A. Geske, Lincoln, U. NE, Sheldon Mem. A.G.; Trenton, NJ State Mus.; 1975)
D. Evans: 'Art and Deception: Ralph Blakelock and his Guardian', *Amer. A. J.*, xix/1 (1987), pp. 39–50
A. Theroux: 'Artists who Kill and Other Acts of Creative Mayhem', *A. & Ant.* (Summer 1988), pp. 95–8
A. A. Davidson: 'Art and Insanity, One Case: Blakelock at Middletown', *Smithsonian Stud. Amer. A.*, iii/3 (1989), pp. 54–71
E. Tebow: 'Ralph Blakelock's *The Vision of Life/The Ghost Dance: A Hidden Chronicle*', *Mus. Stud.*, xvi/2 (1990), pp. 166–72

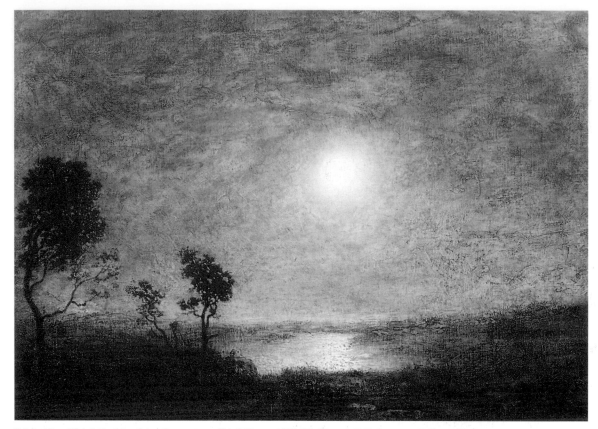

Ralph Albert Blakelock: *Moonlight*, oil on canvas, 686×940 mm, 1890 (Washington, DC, Corcoran Gallery of Art)

A. A. Davidson: *Ralph Albert Blakelock* (University Park, PA, 1996)
Ralph Albert Blakelock, 1847–1919: Paintings (exh. cat. by P. Auster, F. Bancroft and F. Skloot, New York, Salander-O'Reilly Gals, 1998)
LAURETTA DIMMICK

Blashfield, Edwin Howland (*b* Brooklyn, NY, 15 Dec 1848; *d* New York, 12 Oct 1936). American painter. He began to study art seriously in 1867 in Paris under Léon Bonnat (1833–1922), with whom he remained (except between 1870 and 1874) until 1880. Blashfield's mural style was significantly influenced by Pierre Puvis de Chavannes (1824–98), Jean-Paul Laurens (1838–1921) and Paul Baudry (1828–86), whose decorations he had studied in the Panthéon while in Paris. He made a trip in 1887 to England, where he became briefly associated with the Anglo-American artists' colony in Broadway, Glos, which included Edwin Austin Abbey, John Singer Sargent, Lawrence Alma-Tadema (1836–1912) and Frederic Leighton (1830–96).

Coming to prominence as a muralist at the World's Columbian Exposition (Chicago, 1893), Blashfield soon won the reputation of 'dean' of American muralists. Among his best works is the mural representing the *Evolution of Civilization* (1895–6), which decorates the dome of the main reading room in the Library of Congress, Washington, DC. Here a group of 12 allegorical figures representing historical culture and human achievement—from 'Egypt and written records' to 'America and science'—encircles the lantern, where 'Human Under-standing' sits with lifted veil, gazing upwards. Blashfield's subsequent decorations reflect the same humanist conception of art. His designs and subject-matter reflect the monumental character of the architecture they adorn. He decorated state capitols (Minnesota, Iowa, Wisconsin, South Dakota), courthouses (e.g. New York City Appellate Court and Baltimore Courthouse), churches (e.g. St Matthew the Apostle, Washington, DC) and private residences (e.g. the W. H. Vanderbilt mansion, New York; *see* VANDERBILT, WILLIAM HENRY). Blashfield was president of the National Academy of Design and of many other societies.

UNPUBLISHED SOURCES
New York, Brooklyn, Hist. Soc. [Blashfield's papers]
WRITINGS
with E. W. Blashfield: *Italian Cities* (London, 1901)
Mural Painting in America (New York and London, 1914)
BIBLIOGRAPHY
R. Cortissoz: *The Works of Edwin Howland Blashfield* (New York, 1937)
The Mural Decorations of Edwin Howland Blashfield (exh. cat., ed. L. N. Amico; Williamstown, MA, Clark A. Inst., 1978)
S. J. Moore: 'In Search of an American Iconography: Critical Reaction to the Murals at the Library of Congress', *Winterthur Port.*, xxv (Winter 1990), pp. 231–9
B. van Hook: 'From the Lyrical to the Epic: Images of Women in American Murals at the Turn of the Century', *Winterthur Port.*, xxvi (Spring 1991), pp. 63–80
F. V. O'Connor: 'Painting Women, Fainting with Eros', *A. Crit.*, vii/2 (1992), pp. 76–8
IRMA B. JAFFE

Blum, Robert Frederick (*b* Cincinnati, OH, 9 July 1857; *d* New York, 8 June 1903). American painter and illustra-

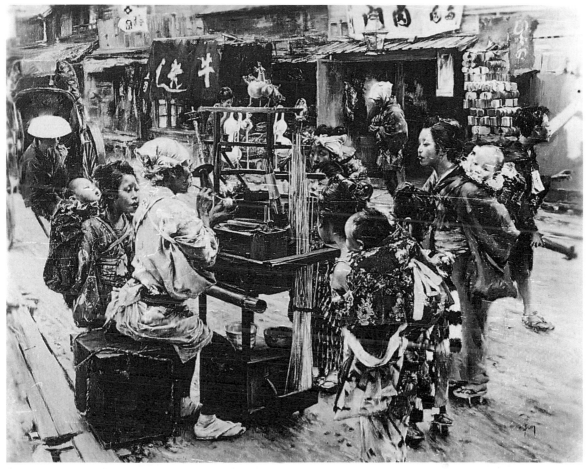

Robert Frederick Blum: *The Ameya*, oil on canvas, 637×789 mm, 1892 (New York, Metropolitan Museum of Art)

tor. The son of German–American parents, he probably became interested in magazine illustration while an apprentice at Gibson & Co., lithographers in Cincinnati, during 1873 and 1874. He began drawing lessons at the McMicken School of Design (now the Art Academy of Cincinnati) *c.* 1873, transferring to the Ohio Mechanics Institute in 1874. Blum visited the Centennial Exposition (1876) in Philadelphia and was impressed with paintings by Giovanni Boldini (1842–1931) and Mariano Fortuny y Mansal (1838–74) and by Japanese art. He remained there for about nine months, studying at the Pennsylvania Academy of the Fine Arts.

In 1878 Blum moved to New York, where he contributed illustrations to such magazines as *St Nicholas* and *Scribner's Magazine*. Two years later he took the first of numerous trips to Europe. In Venice he met James McNeill Whistler and Frank Duveneck and under their influence took up etching. He travelled frequently with William Merritt Chase, with whom he founded the Society of Painters in Pastel, New York, which held four exhibitions, the first in 1884. Sketchy pastels made in the Netherlands (1884) and relatively large, detailed and compositionally intricate paintings such as *Venetian Lacemakers* (1887; Cincinnati, OH, A. Mus.) demonstrate his stylistic range.

In May 1890 Blum was sent to Japan by *Scribner's Magazine* to make illustrations for articles by Sir Edwin Arnold. He remained there for about two years, making both small sketches and ambitious works such as *The Ameya* (1892; New York, Met.; see fig.), which depicts a crowded Japanese street scene.

In New York in 1893 Blum began the large murals for Mendelssohn Hall, *Mood to Music* and the *Vintage Festival* (both New York, Brooklyn Mus. A.). He was working on murals for the New Amsterdam Theater when he died of pneumonia.

WRITINGS
'Technical Methods of American Artists, vi: Pen and Ink Drawing', *The Studio*, iii (3 May 1884), pp. 173–5
'An Artist in Japan', *Scribner's Mag.*, xiii (April–June 1893), pp. 399–414, 624–36, 729–49

BIBLIOGRAPHY
Robert F. Blum, 1857–1903: A Retrospective Exhibition (exh. cat., ed. R. J. Boyle; Cincinnati, A. Mus., 1966)
B. Weber: *Robert Frederick Blum (1857–1903) and his Milieu* (diss., New York, City U., 1985)

CAROLYN KINDER CARR

Blyth, Benjamin (*bapt* Salem, MA, 18 May 1746; *d* ?1787). American painter. He began his professional career in the 1760s and may have been encouraged by his older brother, Samuel, who was an heraldic and commercial painter. He

worked primarily in pastels, or 'crayons', as he advertised in the *Salem Gazette* (May 1769), and he capitalized on their increasing popularity around Boston during this decade.

Approximately 30 pastels are now attributed to Blyth, and of those the best known is *John Adams*, the earliest portrait of the diplomat and second President of the United States, together with a pendant of his wife, *Abigail Smith Adams* (both 1766; Boston, MA Hist. Soc.). The Adams pastels are typical of Blyth's works: smoothly drawn, restrained in colour and highly finished. They are slightly lighter than their counterparts by John Singleton Copley but possess neither the dramatic lighting nor the masterful foreshortening of that artist's work. Blyth's sitters are frequently stiff and have a fixed, impenetrable gaze.

The Salem diarist Rev. William Bentley dismissed Blyth as a 'wretched dauber' but noted he had 'much employment from the money of the privateer men'. Despite this criticism, Blyth was able to remain in Salem completing pastels and oil portraits until 1786, at which point he moved to Richmond, VA.

BIBLIOGRAPHY

R. Townsend Cole: 'Limned by Blyth', *Antiques*, lxix (1956), pp. 331–3
H. W. Foote: 'Benjamin Blyth, of Salem: Eighteenth-century Artist', *Proc. MA Hist. Soc.*, lxxi (1959), pp. 82–102

RICHARD H. SAUNDERS

Blythe, David Gilmour (*b* Wellsville, nr East Liverpool, OH, 9 May 1815; *d* Pittsburgh, PA, 15 May 1865). American painter and sculptor. He began his career as an itinerant portrait painter in the early 1840s and became one of the leading satirical artists in America by the beginning of the Civil War. Self-taught, from 1840 to 1850 he worked in East Liverpool, OH, and Uniontown, PA, and nearby towns and villages, painting rather stiff likenesses of the local gentry. He also carved a monumental polychrome wooden statue of *Marie-Joseph, Marquis de Lafayette* for the Uniontown courthouse (*in situ*) and painted a landscape panorama of the Allegheny mountains (destr.), which he took on tour through Maryland, Pennsylvania and Ohio. The death of his wife in 1850 and the commercial failure of his panorama in 1852 led to a period of wandering; the bitterness he felt at his misfortune came to be reflected in his poetry and in his growing involvement with social and political issues.

Following his move to Pittsburgh, PA, in 1856, Blythe began to specialize in humorous genre scenes, attacking a broad range of human follies in paintings in which the treacly palette, wealth of narrative detail and grotesque distortions of anatomy and facial expression form a distinctive contrast to the sentimental realism of most American genre painting of the period. Blythe drew from a variety of sources: the paintings of Adriaen Brouwer (1605/6–38), David Teniers II (1610–90) and Bartolomé Esteban Murillo (1618–82), the caricatures of William Hogarth (1697–1764), Thomas Rowlandson (1756/7–1827) and George Cruikshank (1792–1878), the lithographs of Honoré Daumier (1808–79) and contemporary

David Gilmour Blythe: *Trial Scene*, oil on canvas, 559×686 mm, 1860–63 (Rochester, NY, University of Rochester, Memorial Art Gallery)

periodical illustration. *Trial Scene* (1860–63; U. Rochester, NY, Mem. A.G.; see fig.) is typical of Blythe's mature genre painting in both choice of subject and style. It depicts a kangaroo court being held inside a tavern by the 'Molly Maguires', a secret society of Irish–American miners known for their violence. The dramatic lighting and lurid colour of the scene, the exaggerated gestures of the figures and the surfeit of weapons scattered about the room graphically convey the participants' travesty of justice. During the Civil War the content of Blythe's paintings became even more topical. In political cartoons and allegories, often large-scale, he advanced Abraham Lincoln's efforts to preserve the Union while attacking obstructionists and extremists on both sides of the conflict. *Lincoln Crushing the Dragon of Rebellion* (1863; Boston, MA, Mus. F.A.) shows the President raising his log-splitting maul to crush a cloven-hoofed dragon, the artist's symbol for the evils of secession. Lincoln, however, is impeded in his assault by the gnarled figure of Tammany, the Democratic Party organization of New York, which had fought Union efforts to raise an army.

Unlike his contemporaries Thomas Nast, David Claypoole Johnston and Adalbert J. Volck (1828–1912) of Baltimore, whose primary medium was the print, Blythe worked almost exclusively in oil; only one of his paintings was reproduced for general circulation. Instead, he chose to display his barbs in the window of his Pittsburgh dealer, J. J. Gillespie. His audience was therefore entirely local, while his patrons were drawn from the city's new industrial class, which was predominantly Scots-Presbyterian, Republican and reformist. Blythe also painted some memorable images of the Civil War, including *Libby Prison* (1863) and the *Battle of Gettysburg* (both Boston, MA, Mus. F.A.), as well as a few landscapes and still-lifes. He died of 'delirium from drink', apparently the result of a depressive binge caused by the assassination of Lincoln a month earlier.

BIBLIOGRAPHY
D. Miller: *The Life and Work of David G. Blythe* (Pittsburgh, 1950)
Works by David Blythe, 1815–1865 (exh. cat., Columbus, OH, Mus. A., 1968)
B. W. Chambers: *The World of David Gilmour Blythe* (Washington, DC, 1980)
B. Wolf: 'All the World's a Code: Art and Ideology in Nineteenth-century American Painting', *A. J.* [New York], xliv (Winter 1984), pp. 328–37
BRUCE W. CHAMBERS

Boch, William, & Bros. *See under* UNION PORCELAIN WORKS.

Bodmer, Karl [Carl] (*b* Riesbach, Switzerland, Feb 1809; *d* Barbizon, Seine-et-Marne, 30 Oct 1893). Swiss painter and graphic artist, active in the USA and France. His earliest exposure to art probably came from his uncle, the landscape painter and engraver Johann Jakob Meyer (1787–1858). When he was 22, Bodmer moved to Paris, where he studied art under Sébastien Cornu (1804–70). In Paris he met his future patron, Prince Maximilian of Wied-Neuwied, who was planning an ambitious scientific expedition to North America. Bodmer was engaged to accompany the expedition and to provide sketches of the

Karl Bodmer: *Péhriska-Rúhpa, Hidatsa Man ('Two Ravens')*, oil on canvas, 406×267 mm, *c.* 1833 (Omaha, NE, Joslyn Art Museum)

American wilderness. After touring the East Coast, the party made their way westward via the Ohio and Mississippi rivers to St Louis, MO, and in 1833 travelled up the Missouri River into country scarcely inhabited by white men. On the journey north to Ft MacKenzie, WY, Bodmer recorded the landscape and the groups of Indians they encountered. Having wintered in Ft Clark, ND, they returned to New York and then Europe in 1834.

Bodmer's paintings of Indians are full of carefully observed anthropological detail. His delicate, linear style and subdued palette give a savage splendour to such works as *Péhriska-Rúhpa, Hidatsa Man,* also known as *Two Ravens* (Omaha, NE, Joslyn A. Mus.; see fig.). In his masterpiece, *Bison Dance of the Mandan Indians* (known only in engraving), Bodmer shows a skill in dramatic composition unmatched by his contemporary George Catlin. His watercolour sketches were exhibited in Europe to admiring audiences. The journals of the expedition were published in 1839 with aquatint illustrations based on Bodmer's watercolours. In 1849 he established himself in the Barbizon colony in France, where he painted such works as *Forest Scene* (1850; Paris, Pal. Luxembourg), exhibited regularly at the Paris Salons and was associated with Jean-François Millet (1814–75). The Joslyn Art Museum, Omaha, NE, has an important collection of Bodmer's paintings.

BIBLIOGRAPHY
F. Weitenkampf: 'A Swiss Artist among the Indians', *Bull. NY Pub. Lib.,* lii (1948), pp. 554–6
America through the Eyes of German Immigrant Painters (exh. cat., ed. A. Harding; Boston, MA, Goethe Inst., 1975)

H. Läng: *Indianer waren meine Freunde: Leben und Werk Karl Bodmers (1809–1893)* (Berne, 1976)

Pictures from an Expedition: Early Views of the American West (exh. cat. by M. A. Sandweiss, New Haven, Yale Cent. Amer. A., 1978–9)

Views of a Vanishing Frontier (exh. cat. by J. C. Ewers and others, Omaha, Joslyn A. Mus., 1984); review by M. V. Gallagher in *Amer. Ind. A.*, ix (Spring 1984), pp. 54–61

J. Hines: 'History Painting, Meeting of Minds', *Southwest A.*, xxi (1991), p. 36

W. Rawls: 'Audubon, Bodmer and Catlin: Facsimile Editions from the Editorial Side', *Imprint*, xvi/1 (1991), pp. 2–10

The North American Indian Portfolios from the Library of Congress, intro. by J. Gilreath (New York, 1993)

Karl Bodmer's Eastern Views: A Journey in North America (exh. cat. by M. V. Gallagher and J. F. Sears, Omaha, NE, Joslyn A. Mus., 1996)

LESLIE HEINER

Bogardus, James (*b* Catskill, NY, 14 March 1800; *d* New York, 13 April 1874). American inventor, engineer, designer and manufacturer. He trained as a watchmaker's apprentice in Catskill, NY, worked as an engraver in Savannah, GA and again in Catskill. About 1830 he moved to New York City to promote his inventions. He secured many patents for various devices, including clocks, an eversharp pencil, a dry gas meter and a meter for measuring fluids. His most remunerative invention was a widely useful grinding mill (first patented 1832), which provided steady income throughout his life. During years spent in England (1836–40) he was granted an English patent for a postage device and won £100 in a competition with his proposal for a pre-paid postal system. He also observed the extensive use of iron in the construction of British factories, bridges and large buildings. After a trip to Italy, he conceived the idea of erecting prefabricated multi-storey structures with cast-iron exterior walls that reproduced Classical and Renaissance architectural styles. Returning to New York in 1840, Bogardus became an apostle for cast-iron architecture.

In 1847 Bogardus displayed a small model of an all iron factory, attracting a financial backer, Hamilton Hoppin, whose support allowed him to begin construction of an actual factory at Duane and Center streets in Manhattan. He suspended work on it to erect what became the first iron front, an ornamental five-storey iron façade (1848; destr.) modernizing the pharmacy of the distinguished Dr John Milhau (1785–1874) on lower Broadway in Manhattan. By May 1849 Bogardus had completed the five unified iron-fronted Laing Stores (destr.) in Manhattan. Later in the same year he finished his own factory (destr.), constructed of iron throughout—frame, roof, walls and floors. A US patent was granted to him in 1850 for his construction system. In 1850–51 he erected a large five-storey publishing plant for the *Sun* newspaper in Baltimore, MD, (destr.). During the next decade he erected prefabricated structures in New York City, Albany, NY, Baltimore, Charleston, SC, Chicago, Philadelphia, Washington, DC, and even in Cuba. After a fire in late 1853 destroyed the Manhattan offices and printing plant of America's largest publisher, Harper & Brothers, Bogardus and others built on its site a large iron-framed structure. It had exposed ornamental interior cast-iron columns and trusses and also a non-flammable floor system incorporating America's first successful roll of lengthy wrought-iron beams, employed to support brick jack arches. The stately Harper Building, with its elaborate 130-ft (nearly 40 m) cast-iron

façade, was regarded as the first example of a new fire-proof building type. In 1856 Bogardus published a pamphlet extolling the merits of cast-iron architecture (*R* 1858). His two largest structures were both completed in 1860; in Manhattan, the three-storey Tompkins Market and 7th Regiment Armory (destr.), virtually all iron; and near Havana, Cuba, a huge iron-framed sugar warehouse (destr.). Only four iron-fronted buildings unquestionably by Bogardus survive. Three in lower Manhattan are official landmarks: the handsome 254 Canal Street (1856–7), erected for the inventor–printer George Bruce, 75 Murray Street (1857; see fig.) and 85 Leonard Street (1861). The fourth is the last structure Bogardus erected, a large iron front in Cooperstown, NY, affectionately called the Iron-clad Building (1863).

Bogardus also utilized the strength of cast iron to build unprecedented tall, skeletal iron-framed towers. Two fire watch-towers (1851 and 1853; both destr.) built for the City of New York rose to heights of 100 and 125 ft (30.5 and 38.1 m). A lighthouse (1853; destr.) in the Dominican Republic was 75 ft (22.85 m). He erected two even taller

James Bogardus: iron-fronted building at 75 Murray Street, New York, 1857

towers in lower Manhattan for manufacturing lead shot (1855 and 1856; both destr.), which soared to heights of 170 and 217 ft (51.8 and 67 m). Brick infill walls were added to the shot towers to keep out the wind; these formed curtain walls that were carried by the iron frame, an early demonstration of the principle that would later be used for skyscraper construction. With DANIEL D. BADGER, Bogardus was a pioneer in iron construction; his innovative structural use of metal led to its employment in ever-larger buildings and introduced what was to become a widespread building type for American commerical architecture in the 19th century.

WRITINGS

'Construction of the Frame, Roof, and Floor of Iron Buildings: Specification of Letters Patent No. 7,337, dated May 7, 1850'; repr. in *The Literature of Architecture: The Evolution of Architectural Theory and Practice in Nineteenth-century America*, ed. D. Gifford (New York, 1966)
with J. W. Thomson: *Cast Iron Buildings: Their Construction and Advantages* (New York, 1856, 2/1858); repr. in *The Origins of Cast Iron Architecture in America, Including . . . Cast Iron Buildings: Their Construction and Advantages*, intro. W. K. Sturges (New York, 1970)

BIBLIOGRAPHY

DAB

T. C. Bannister: 'Bogardus Revisited', *J. Soc. Archit. Hist.*, xv/4 (1956), pp. 12–33; xvi/1 (1957), pp. 11–19
J. G. Waite: 'The Edgar Laing Stores (1849)', *Iron Architecture in New York City*, ed. J. G. Waite ([Albany], 1972)
W. R. Weismann: 'Mid 19th-century Commercial Building by James Bogardus', *Monumentum*, ix (1973), pp. 63–75
M. Gayle: *Cast-Iron Architecture in New York: A Photographic Survey* (New York, 1974)
D. M. Kahn: 'Bogardus, Fire, and the Iron Tower', *J. Soc. Archit. Hist.*, xxxv/3 (1976), pp. 190–201
M. Gayle and C. Gayle: *Cast-Iron Architecture in America: The Significance of James Bogardus* (New York, 1998)
MARGOT GAYLE, CAROL GAYLE

Bond, Richard (*fl* 1820–50). American architect. There is evidence that Bond was trained by Solomon Willard. Certain of Bond's designs suggest the Greek Revival approach that Willard brought from Washington, DC. Bond's style moved between Gothic Revival and a Neoclassical heaviness. An example of Gothic Revival is St John's Episcopal Church and Rectory (1841), Devens Street, Boston, which has a rather heavy granite façade dominated by a square tower with a battlemented roofline; there are large quatrefoil windows in the walls below. In the same year Bond was called to Oberlin College in Ohio to design First Church, which had to be a Greek Revival design. He worked on Lewis Wharf (1836–40; later remodelled), Boston, where certain walls reflect his attraction to boldly massed granite surfaces. Bond's best-known buildings during his life were at Harvard University, Cambridge, MA. These included Gore Hall (1838; destr. 1913), alterations to Harvard Hall (1842; later remodelled) and Lawrence Hall (1847; much modified). As a representative architect from Boston, Bond was present at a meeting in New York in 1838, which resulted in the formation of the National Society of Architects, the first professional architectural organization in the USA.

BIBLIOGRAPHY

Withey

DARRYL PATRICK

Bonnin & Morris. American porcelain manufacturer. Gousse Bonnin (*b* ?Antigua, *c.* 1741; *d c.* 1779) moved in 1768 from England to Philadelphia, where he established the first porcelain factory in America with money from an inheritance and with investments from George Morris (1742/5–1773). The land was purchased late in 1769, and in January 1770 the first notice regarding the enterprise was published. The first blue-decorated bone china wares were not produced until late in 1770. Newspaper advertisements noted 'three kilns, two furnaces, two mills, two clay vaults, cisterns, engines and treading rooms' and listed such wares as pickle stands, fruit baskets, sauce boats, pint bowls, plates, plain and handled cups, quilted cups, sugar dishes in two sizes, cream jugs, teapots in two sizes and breakfast sets (*see* UNITED STATES OF AMERICA, fig. 34). Well-established foreign competition, however, was too formidable for the new business, which had to charge high prices to meet large expenses; production ceased by November 1772.

BIBLIOGRAPHY

G. Hood: *Bonnin and Morris of Philadelphia: The First American Porcelain Factory, 1770–1772* (Chapel Hill, NC, 1972)
ELLEN PAUL DENKER

Borglum, (John) Gutzon (*b* Ovid, ID, 25 March 1867; *d* Chicago, IL, 6 March 1941). American sculptor and painter. He was born into a Mormon family practising plural marriage and early suffered the loss of his mother when his father separated from the religion. Reared mostly in Fremont and Omaha, NE, he studied briefly at St Mary's Academy in Kansas City, KS (1882). Some time later (*c.* 1884), he worked as an engraver for an Omaha newspaper. Interested in a career in art, he next went to Los Angeles. There he apprenticed himself to a lithographer, then turned to fresco painting and etching; *c.* 1885 he met Elizabeth Janes Putnam (1848–1922), a divorcee and accomplished painter many years his senior, who became his wife (1889). Before that, however, encouraged by her, he travelled to San Francisco and studied at the California School of Design (*c.* 1885–6) under Virgil Williams (1830–86) and received criticism from William Keith. On his return to Los Angeles, while sharing a studio with Putnam, Borglum was working on *Staging over the Sierra Madre Mountains* (1889; Omaha, NE, Joslyn A. Mus.), which caught the eye of Jessie Benton Fremont, who became a benefactor. Other works followed, including a portrait of *General John C. Fremont* (1888; Los Angeles, CA, Southwest Mus.).

With his new bride, Borglum made two trips to Europe (1890–93 and 1896–1901). During the interlude, he acquired land in Sierra Madre, CA, on which the couple built a home, and he became deeply involved in the art life of Los Angeles. On their first stay abroad, Borglum studied in Paris at the Académie Julian and the Ecole des Beaux-Arts. In 1891 he was made an associate of the Societé Nationale des Beaux-Arts for his first public display of a sculpture, *Death of a Chief* (Glendale, CA, Forest Lawn Mem. Park), at the Salon of that year. On their second visit, spent mostly in London, he received some important commissions, but failed to gain the recognition he desired.

Amazed by the acclaim received by his younger brother, Solon Borglum (1868–1922) for a display of sculptures of Western subjects at the Exposition Universelle in Paris (1900), Borglum decided to specialize in sculpture as well.

Returning to the USA in 1901, he obtained a studio in New York City and, in 1910, following a second marriage in 1909, a home and studio in Stamford, CT ('Borgland'). During the next 40 years, while remaining a controversial figure not only involved in differences with the art establishment of New York City but also in political and social issues, he produced an astounding number of sculptures, many of heroic and monumental sizes (including his famous later carving of the heads of American presidents at Mount Rushmore, SD, 1941). Noteworthy among his earlier work is the *Mares of Diomedes* (New York, Met.), which was a gold medal winner at the Louisiana Purchase International Exposition in St Louis (1904).

UNPUBLISHED SOURCES

Washington, DC, Smithsonian Inst., Archvs Amer. A., reel 3056 [Gutzon Borglum papers]
Washington, DC, Smithsonian Inst., Archvs Amer. A., reels N69–98, 1054 [Solon Borglum papers]

BIBLIOGRAPHY

Obituary: *Chicago Daily Tribune*, 7 March 1941, 16:1
R. J. Casey and M. Borglum: *Give the Man Room: The Story of Gutzon Borglum* (Indianapolis, 1952)
W. Price: *Gutzon Borglum: Artist and Patriot* (Chicago, 1961)
A. M. Davies: *Solon H. Borglum: 'A Man Who Stands Alone'* (Chester, CT, 1973)
H. Shaff and A. K. Shaff: *Six Wars at a Time: The Life and Times of Gutzon Borglum, Sculptor of Mount Rushmore* (Sioux Falls, 1985)

PHIL KOVINICK

Boston. American city, capital and financial and commercial centre of Massachusetts on the north-east coast of the USA. With an excellent natural harbour, it is the main port and largest city in New England. Originally built on the hilly Shawmut Peninsula, where the Mystic and Charles rivers enter Massachusetts Bay, Boston was initially connected to the mainland only by Roxbury Neck, a low, narrow isthmus, now Washington Street, with the tidal flats, called the Back Bay, and Charles River to the north-west and a wide bay to the south. Rocks and earth from Copp's and Beacon hills have been used for extensive landfill to add to the city almost four times the area of the peninsula.

I. History and urban development. II. Art life and organization. III. Centre of production.

I. History and urban development.

In 1630 Puritans fleeing the control of the Church of England established a self-governing community in Boston, which was named after their home town and port in Lincolnshire, England. In the same year New Towne, a few kilometres to the west on the north bank of the Charles River, was chosen as the capital of the Bay Colony. In 1636 a theological college was established there; two years later New Towne's name was changed to Cambridge, after the English university town, and in 1638 the college was named after its first benefactor, John Harvard (1606–38). (Cambridge and Boston are now part of the same conurbation.) Boston was the site of crucial events—the Boston Massacre (1770) and the Boston Tea Party (1773)—leading up to the American Revolution (1775–83) against British rule.

The city has always been a major intellectual centre, where many architectural ideas have been successfully developed: there is a rich pre-Revolutionary architectural legacy, and in the development of 19th-century American building and planning the city nurtured the talents of such innovators as Alexander Parris, H. H. Richardson and Frederick Law Olmsted.

1. Before 1790. 2. 1790–*c.* 1875. 3. *c.* 1875–1914.

1. BEFORE 1790. During their first year of settlement the colonists lived in tents and wigwams. They soon built frame houses covered with weatherboard, much like those in parts of England, but they eliminated the hazardous thatched roofing and wooden chimneys. An early major municipal building was the Town House (destr.), erected in 1657 through a bequest from merchant Robert Keayne; a heavy timber structure with multiple gabled roofs, its open ground floor provided shelter for merchants, and an upper floor contained a library and court. Of the numerous frame houses of this period, only the Paul Revere House (*c.* 1680; rest. 1907–8) in the North End survives. Like other 17th-century residences, it has small diamond-paned windows, an upper storey overhanging the street and a massive brick end chimney (see fig. 1).

By the end of the 17th century brick was more generally used. One unusually large commercial building, called the Triangular Warehouse (destr. 1824), had a strikingly tall pyramidal roof. Even grander was the large brick residence built by Peter Sargeant (1679; destr. 1864), later known as the Province House when it served as the residence of the governors of the colony. After 1686, when the original charter was declared null and void, Massachusetts became a royal colony. Accordingly, a house of worship for the Church of England, King's Chapel, Tremont Street, was built in 1688. With the arrival of merchant families, the Puritan ethos of Boston began to change, and the character of domestic and public buildings followed that of England, with the late English Baroque and then the Georgian style.

Several buildings in the heart of Boston were rebuilt after a catastrophic fire in 1711. Nearly all were of brick. Although a new Town House was destroyed by fire in 1747, the surviving outer walls were incorporated into what is known today as the Old State House, State Street. Also built at this time were two surviving residences: the Pierce-Hichborn House (1711), next to the Revere House in the North End, and the Thomas Crease House (the Old Corner Book Store; 1711). The houses and churches of this period tended to be relatively simple in form and detail, for example the Episcopal Christ Church or Old North Church (1723; steeple 1740, by William Price), Causeway Street, built in the North End. Similar in external detail but planned for Congregational worship is Old South Meeting-house (1729), Washington and Milk streets. Their spires recall those devised by Christopher Wren (1632–1723) for his City of London churches built during the last quarter of the 17th century.

Near the middle of the 18th century, the Georgian style in Boston became more elaborate and richly detailed, as in Faneuil Hall (1740–42), a gift to the city from the merchant Peter Faneuil (1700–43). Built of brick, with engaged Tuscan and Doric pilasters and a tall central

1. Boston, Paul Revere House, c. 1680 (Rest. 1907–8)

cupola, it was designed by the painter John Smibert, but it was badly damaged by fire in 1761 and enlarged (1805–6) by Charles Bulfinch. Like the earlier Town House, it combined a large space below for merchants with room for public meetings on the upper floor, and it is still used today. Among the finest examples of fully developed Georgian architecture are the interiors of two Anglican churches by Peter Harrison of Newport: his new granite building for King's Chapel (1749–58), Tremont Street, Boston, and his Christ Church (1761–73), Zero Garden Street, Cambridge, built in wood. As in Harrison's other buildings, there is a clear debt to contemporary sources in London.

2. 1790–c. 1875. The greatest change in the character of architecture in Boston is often credited to CHARLES BULFINCH. His most important early work was the new Massachusetts State House (1795–7; extended; see fig. 2), inspired by Somerset House (from 1776), London, by William Chambers (1723–96). Even more important, as an urban plan, was Bulfinch's forward-looking project for a housing and public building complex called Franklin Place (or the Tontine Crescent; 1793–5), entirely demolished within 60 years (only the curve of Franklin Street survives). Among Bulfinch's other designs were two more

ranges of townhouses (destr.), Park Row (1803–5) and the Colonnade (1810–12), both of which faced towards the Common, an area in the south-west of the peninsula acquired by the town for pasturage in 1634 and now a public park.

Bulfinch left a lasting impression on the Mt Vernon area of Beacon Hill, which he laid out in 1795 with large lots and a central park square. The houses tended to be free-standing brick cubes set in gardens, for example the three that he designed for Harrison Gray Otis, Mayor of Boston. Bulfinch's second house for Otis, built 1800–02 on Mt Vernon and still free-standing in its own garden, is the best illustration of his hopes for the residential development of Beacon Hill. The lots were later filled by continuous row houses, but Louisburg Square, begun 1826 and largely built up by 1844, with bow-fronted townhouses ranged around an oval open space, demonstrates Bulfinch's impact. His influence was also felt through the work of his assistant Asher Benjamin, architect of the Charles Street Meeting-house (1807); in the same tradition is the imposing Park Street Church (1809) by Peter Banner (*fl* 1796–1848), which rises over the Common.

As Boston shipping grew in volume early in the 19th century, the commercial space along the waterfront was expanded by filling in the tidal flats with rock and soil

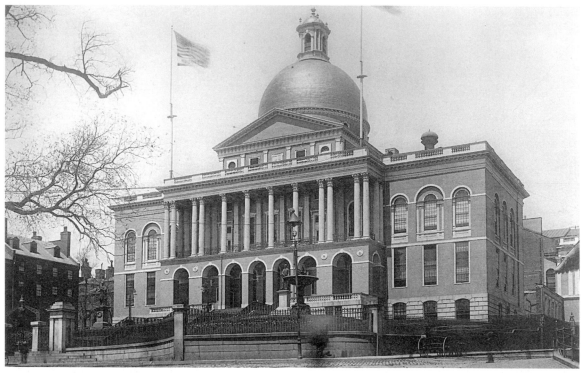

2. Boston, Massachusetts State House by Charles Bulfinch, 1795–7

from the hills. In the Mill Pond (formerly North Cove between Beacon and Copp's hills) Bulfinch laid out a grid of streets focused on a broad central avenue. On the former Town Cove to the south were built wharves and warehouses, particularly Bulfinch's huge brick-and-stone India Wharf (1803–7; destr.).

Granite was also used by a number of architects in early 19th-century Boston, for example Solomon Willard and ALEXANDER PARRIS, who designed the austere bow-fronted David Sears House (1816) on Beacon Hill. Bulfinch used it for such public buildings as Massachusetts General Hospital (1818–23; extended), the austere Doric portico of which reflected the growing interest in pure Greek forms, introduced by Parris. His most important enterprise was the Quincy Market (1825–6), east of Faneuil Hall, which consisted of three long granite buildings commissioned by Mayor Josiah Quincy (1722–1864); the long central block ended in duplicate tetrastyle Ionic temple porticos, with a central block capped by a low hemispherical dome. Parris also used the Greek temple form in St Paul's Church (1819; now Cathedral), Tremont Street, but the most dramatic adaptation of Grecian forms was in Ammi B. Young's Boston Custom House (1837), State and India streets, a Greek Doric temple with additional hexastyle porticos providing side entrances. Originally the Custom House had a central rotunda capped by a dome, but in 1911–14 Peabody & Stearns placed an office tower on top of Young's base.

In the early 19th century the fascination with historical styles of architecture was manifest in Boston in some of the earliest examples of Egyptian, Gothic and Renaissance revivals. The Gothic Revival Bowdoin Street Congrega-

tional Church (1831–3), attributed to Solomon Willard, is an early example of the style, even if the details are not particularly archaeologically correct. The Egyptian Revival appeared in several cemetery gateways, including the gate (1832; rebuilt 1842) by Jacob Bigelow (1787–1879) for the Mt Auburn Cemetery, Cambridge, and Willard's gate (1840) for the Old Granary Burying Ground next to the Park Street Church, Boston. More imposing was Willard's 68-m granite obelisk (1825–43) in Charlestown (north of the Charles River) commemorating the Battle of Bunker Hill (1755; for illustration *see* WILLARD, SOLOMON). The more easily modulated Italian Renaissance style is well represented in the brownstone Boston Athenaeum (1849), Beacon Street, designed by Edward Clarke Cabot (1818–1901) and based on the Palazzo Iseppo da Porta (now Festa), Vicenza, Italy, by Palladio (1508–80).

In the years before the Civil War (1861–5) there were significant additions to the urban plan. Mt Auburn Cemetery had been laid out in 1831 with drives winding through an idyllic pastoral landscape around copses and small lakes. The Public Garden on the south-west side of the Common was created in 1839 and improved after a landscaping plan by George F. Meacham in 1860. Perhaps the most important development of these years was the filling in of the Back Bay from 1857, gradually extending the new land south-west from Arlington Street and the Public Garden. Five broad streets led from the latter; the wide, central Commonwealth Avenue was divided by a landscaped parkway. At the approximate centre of the infill was set aside Copley Square, around which rose new public buildings and churches, making the Back Bay the cultural centre of the city. Prominent families moved from

Beacon Hill to large new houses in this area, the predominance of mansard roofs giving it the character of the new Paris being built by Napoleon III.

The Hotel Pelham (1857, by ARTHUR DELEVAN GILMAN), a 'French flat' apartment building, was an early example in the Back Bay of this Second Empire style, which appealed to the French tastes of the Bostonians. More ornate is the Old City Hall (1865, by GRIDLEY J. F. BRYANT; now offices) in the old city centre. The Second Empire style was one of several architectural idioms that arose with the return of prosperity after the Civil War and avoided historical replication in favour of consciously modern, although historically inspired forms. The principal alternative for public and government buildings was High Victorian Gothic Revival, an irregular, picturesque style that employed many varied building materials. A colourful version was employed for two buildings on Copley Square: Sturgis & Brigham's Museum of Fine Arts (1870–79; destr.; *see* STURGIS, JOHN HUBBARD) and the Old South Church (1876; for illustration *see* CUMMINGS & SEARS). Perhaps the most vivid example is Ware & Van Brunt's Memorial Hall (1865–78; now missing its crocketed tower; for illustration *see* WARE, (1)) for Harvard University. The most significant event, however, was the decision by H. H. Richardson to set up his office in Brookline, MA, in 1874.

3. *c.* 1875–1914. With Richardson's arrival, the last quarter of the 19th century marked the emergence of Boston as a national centre of architectural innovation. He had been commissioned to build the Brattle Square Church (1870–72) in the Back Bay and Trinity Church (1872; *see* RICHARDSON, H. H., fig. 1), Copley Square. His massive round arched style, adapted from Romanesque sources but increasingly abstracted into something highly personal, was used for a variety of works including such

educational buildings in Cambridge, MA, as Sever Hall (1878–80) and Austin Hall (1881–4; see fig. 3) for Harvard University, and the large Ames Estate Store (1886–7; destr.) on Harrison Avenue, Boston. The Mrs M. F. Stoughton House (1882–3), Brattle Street, Cambridge, represents the Shingle style, Richardson's major contribution to residential design (for illustration *see* SHINGLE STYLE).

The massive character of Richardson's work was continued by his assistants SHEPLEY, RUTAN & COOLIDGE in the Grain and Flour Exchange (1891–3) and the 14-storey Ames Building (1889), an office block at 1 Court Street, Boston. This, like other Boston office blocks, was relatively low, owing to the reluctance of architects and clients to adopt the light metal frame then being exploited in Chicago. Within four years, however, tall office buildings were being hung on metal frames, beginning with the Winthrop Building of 1893–4 by Clarence H. Blackall (1857–1942).

The other style of national importance to emerge from Boston in the 1880s was a resurgent neo-classicism led by McKim, Mead & White. Their most influential building, the imposing Boston Public Library (1887–95; *see* MCKIM, MEAD & WHITE, fig. 2), drew on Italian Renaissance, Roman and contemporary French sources. Throughout the building sculpture and mural painting were incorporated in rooms panelled with rare marbles, creating what the Library Trustees called a 'Place for the People' (*see* §II below). In 1883–6 the same firm built the John F. Andrew House in the Back Bay, an early evocation of Bulfinch's work, introducing a theme they perfected in their double bow-fronted Amory-Olney House (1890–92) further west on Commonwealth Avenue. Their bow-fronted granite George A. Nickerson House (1895–7) in the Back Bay referred to the work of Alexander Parris. Such houses were not so much a Georgian revival as a survival of

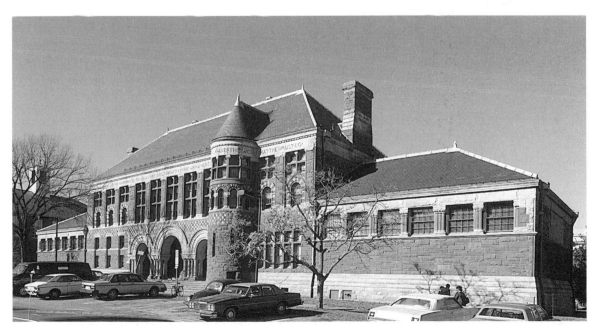

3. H. H. Richardson: Austin Hall, Harvard University, Cambridge, Massachusetts, 1881–4

Georgian forms that had never died out in Boston (Bunting, 1967). By the early 1890s countless variations on Georgian and Federal themes appeared in houses in the Back Bay as well as in the surrounding suburbs.

McKim, Mead & White made another significant contribution in Boston in their Neo-Georgian Boston Symphony Hall, Huntington Avenue, designed in 1892 but not built until 1900–01. During the hiatus they worked with Harvard physicist Wallace Clement Sabine (1868–1919) on the acoustics of the hall, which quickly set a new world standard for concert halls. Its exterior established a model followed in the Boston Opera House (1909), Washington Street, by Wheelright & Haven (see WHEELRIGHT, EDMUND M.). The neo-classical resurgence was manifest in the Copley Plaza Hotel (1912) on Copley Square by Henry Janeway Hardenbergh with Clarence H. Blackall (1857–1942), which replaced the brick-and-terracotta Museum of Fine Arts. A new and larger Neo-classical Revival Museum of Fine Arts was built (1907–15) on Huntington Avenue in the Back Bay from designs by Guy Lowell. Particularly grand was the large new domed church of Christ Scientist (1904–6), Huntington Avenue, by Charles Brigham (1841–1925) with Solon S. Beman.

Contemporary with McKim, Mead & White's introduction of a new vitality into neo-classical work in domestic and public buildings in Boston, Henry Vaughan (1846–1917) and RALPH ADAMS CRAM reinterpreted Gothic forms for church architecture. Vaughan's early chapel of St Margaret's Convent near Louisburg Square, Beacon Hill, was built in 1882.

Another innovation in Boston that spread nationwide was by landscape architect Frederick Law Olmsted, who, from 1878 until his retirement in 1895, devised an 'emerald necklace' (see OLMSTED, FREDERICK LAW, fig. 4) of connected parks and carriage parkways running from the Charles River around the Back Bay to the south of Boston all the way to the eastern shore on the estuary of the Neponset River. This linkage involved the reclamation of the Back Bay Fens and the making of Jamaica Pond and Franklin Park, connected to the Arnold Arboretum in Brookline. The system was further developed by Olmsted's former assistant CHARLES ELIOT, who by 1893 had got the Boston Metropolitan Park Commission set up. An important legacy of the work of Olmsted and Eliot was the first professional programme in landscape architecture set up at Harvard University in 1900.

BIBLIOGRAPHY

J. Winsor, ed.: *Memorial History of Boston*, 4 vols (Boston, 1881–3)
R. A. Cram: 'Architecture', *Fifty Years of Boston* (Boston, 1930)
W. Kilham: *Boston after Bulfinch* (Cambridge, MA, 1946)
H.-R. Hitchcock: *A Guide to Boston Architecture, 1637–1954* (New York, 1954)
S. B. Warner jr: *Streetcar Suburbs: The Process of Growth in Boston, 1870–1900* (Cambridge, MA, 1962)
B. Bunting: *Houses of Boston's Back Bay: An Architectural History, 1814–1917* (Cambridge, MA, 1967)
Back Bay Boston: The City as a Work of Art (Boston, 1969)
D. Freeman, ed.: *Boston Architecture* (Cambridge, MA, 1970)
W. M. Whitehill: 'The Making of an Architectural Masterpiece: the Boston Public Library', *Amer. A. J.*, xi (1970), pp. 13–35
R. B. Rettig, ed.: *The Architecture of H. H. Richardson and his Contemporaries in Boston and Vicinity* (Boston, 1972)
W. Holden: 'The Peabody Touch: Peabody & Stearns of Boston', *J. Soc. Archit. Historians*, xxxii (1973), pp. 114–31
W. M. Whitehill: *Boston: A Topological History* (Cambridge, MA, rev. 2/1975)
D. Shand-Tucci: *Built in Boston, City and Suburb, 1800–1950* (Boston, 1978/*R* Amherst, MA, 1988) [extensive cross-referenced bibliog.]
A. L. Cummings: *The Frame Houses of Massachusetts Bay, 1625–1725* (Cambridge, MA, 1979)
J. K. Holtz: *Lost Boston* (Boston, 1980)
D. Lyndon: *The City Observed, Boston: A Guide to the Architecture of the Hub* (New York, 1982)
C. Zaitzevsky: *Frederick Law Olmsted and the Boston Park System* (Cambridge, MA, 1982)
W. Morgan: *The Almighty Wall: The Architecture of Henry Vaughan* (Cambridge, MA, 1983)
B. Bunting and M. H. Floyd: *Harvard: An Architectural History* (Cambridge, MA, 1985)
M. Southworth and S. Southworth: *The Boston Society of Architects A.I.A. Guide to Boston* (Chester, CT, 1987)
D. H. Rau: 'The Development of American Apartment Houses from the Civil War to the Depression: John Pickering Putnam, Visionary in Boston: A Systematic Approach to Apartment House Design', *Architectura*, xxii/2 (1992), 109–34
J. M. Lindgren: *Preserving Historic New England: Preservation, Progressivism and the Remaking of Memory* (New York and Oxford, 1995)
K. Gyongy and A. Moravanszky: 'Richardson and Boston', *Domus*, dccxcviii (1997), 125–32

LELAND M. ROTH

II. Art life and organization.

The original Puritan English settlers in Boston created a strict theocracy that was essentially discouraging to artistic development. There was a proscription on religious painting; artisan-painters and itinerant limners concentrated on painting houses, heraldic devices and pictorial trade signs and producing engravings. Commissions from prominent local families made portraiture, or 'face-painting', dominant. Soon after 1660 there is evidence of a limner in Boston, who probably painted the portrait (c. 1665; priv. col.) of *John Endicott, Governor of Massachusetts* (c. 1588–1665). The earliest surviving works that can be positively dated were executed in 1670; the ministerial effigies of *John Davenport* (1670; New Haven, CT, Yale U. A.G.) and *John Wheelwright* (1677; Worcester, MA, A. Mus.) are attributed to the Boston-born John Foster, who also produced the first known Colonial woodcut print, *Richard Mather* (c. 1670; see fig. 4). Thomas Child (*fl* 1678–1706) moved to Boston from London, and his activities decorating cannons, hatchments for funerals and in portraiture date from 1688. Early Colonial portraits, modest in aesthetic character and technically crude, have their artistic origins in the Anglo-Dutch style, English provincial painting and Flemish Baroque taste.

By the early 18th century, as Boston showed increasing secularism, there was some early success in extending painting beyond portraiture. The flamboyant decorative landscape with figures appeared in America perhaps for the first time when William Clark (*fl* 1710–40) built a fine Palladian house (c. 1714), whose main parlour wall panels were decorated with landscapes. Anecdotal and landscape compositions also increased the range of painting. The settlers began to buy prints of Colonial scenes, so that views of the city's harbour and prominent buildings were engraved with greater frequency. William Burgis (*fl* 1715–31) produced the first rudimentary cityscapes of Boston between 1722 and 1730. The acquisition of portraits on a more liberal scale by the emerging privileged class, whose tastes were derived directly from Georgian England,

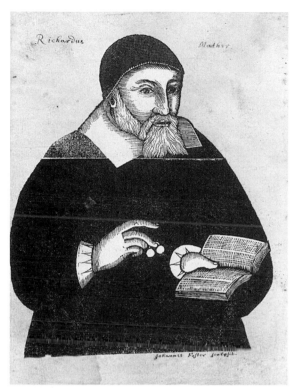

4. John Foster: *Richard Mather*, woodcut, *c.* 1670 (Cambridge, MA, Harvard University, Houghton Library)

attracted professional British artists soon after 1725. These portrait painters began greatly to influence the Boston-born artisans and helped to make Boston the centre of Colonial painting until the mid-18th century. The painter and engraver Peter Pelham, arriving from London in 1726, produced the first known Colonial mezzotint engraving from his portrait of the clergyman Cotton Mather (1663–1728) in 1727. JOHN SMIBERT, who reached Boston in 1729, soon became one of the city's favourite portrait painters, introducing the latest fashionable formulae, sophisticated techniques and a style essentially derived from the Baroque. His extensive collection of engravings, paintings and prints of Old Masters was the only means through which many colonists could learn about European art.

Nathaniel Emmons (1703–40), Joseph Badger, Thomas Johnston (1708–67) and John Greenwood were Bostonian portrait painters practising under the combined influence of European examples and 'native' artisans, but their portraits tended towards generalization. The more gifted Robert Feke spent some time in the 1740s in Boston, painting his only known group there, *Isaac Royall and his Family* (1741; Cambridge, MA, Harvard U. Law Sch.). The English-born Joseph Blackburn also stayed temporarily, introducing the animation and frivolity of the Rococo style. JOHN SINGLETON COPLEY, born in Boston, was the first American to transform craftsmanship into artistry and to achieve international recognition. He attempted a range of subject-matter, although local conditions confined him mainly to portraiture: 'Was it not for preserving the resemblance of particular persons, painting would not

be known [in Boston and the colonies],' he commented (Baigell).

The Revolutionary transition interrupted all the arts and crafts, but the pressures of political dissent encouraged print cartoons and caricatures. Paul Revere produced his famous, although technically awkward, print of the *Boston Massacre* (1770), and the blockade of Boston led to the series of watercolours (versions, 1768; Boston, MA, Hist. Soc.; Boston, MA, New England Hist. Geneal. Soc.; Salem, MA, Essex Inst.) depicting the event by Christian Remick (1726–?1784).

At the beginning of the 19th century Boston's artistic life was fragmentary, and tastes continued to remain close to those of London. The Boston Athenaeum was established as a library in 1807 and began to give annual exhibitions of painting, the first in New England, in 1826. Portraiture remained the dominant genre, and in 1805 Gilbert Stuart settled in Boston for the final, mature phase of his career, having already received recognition by face-painting the famous in Philadelphia and Washington. Samuel F. B. Morse, however, given no commissions for his historical pictures, turned after 1815 to portraiture with considerably more reluctance. Washington Allston spent over 20 years in the area, his dark subjective Romanticism imbuing American art for the first time with a sense of mystery and solitude. By the mid 19th century the city had become an early centre for art collecting; as early as 1835 John Lowell (1799–1836) sent back to Boston from Luxor some pieces from the temple at Karnak, the first Egyptian monuments to come to America. In the 1840s an Art Union was established, patterned after the American Art Union of New York, an organization that bought, exhibited and sold original paintings and distributed prints each year to its members; but this was ended by a court decision citing it as a lottery.

During the last third of the 19th century encouragement of the arts became an important component of Boston civic identity. Copley Square was designated as the site of a cluster of institutions that set the tone for public art patronage: the first Museum of Fine Arts building (replaced on Huntington Avenue from 1907; *see* §I, 2 and 3 above); H. H. Richardson's Trinity Church with mural decorations and stained-glass windows by John La Farge; and the Boston Public Library with murals of 1895–6 by Pierre Puvis de Chavannes and 1894 by Edwin Austin Abbey (for illustration *see* ABBEY, EDWIN AUSTIN) and John Singer Sargent and with bronze bas-relief doors by Daniel Chester French. The architects McKim, Mead & White collaborated in 1897 with Augustus Saint-Gaudens on the monument to Robert Gould Shaw (1837–63), the commander of the first African–American regiment to serve in the Civil War (*see* UNITED STATES OF AMERICA, fig. 17); facing the State House on Boston Common, this ensemble sought to knit together high-relief sculpture in an architectural framework with features of the natural landscape. Despite the lavishness of these commissions, the Puritan tradition occasionally reasserted itself: in 1893 the nude *Bacchante and Infant Faun* (New York, Met.; see colour pl. XXVII,1) by the American sculptor Frederick William MacMonnies was offered as a gift for the courtyard of the library; it was refused after protest by the Watch

and Ward Society, founded in 1884 as the New England Society for the Suppression of Vice.

Art education and the training and support of local artists were not neglected during this period. The School of the Museum of Fine Arts opened in 1877, in the same building as the museum. The Boston Art Club, organized informally by 20 artists in 1855, had over 800 members by 1881, and the Boston Art Students' Association (founded 1879), the Paint and Clay Club, the St Botolph Club and the Association of Boston Artists (all established in 1880) held regular exhibitions of the work of local and foreign artists. The appointment in 1873 by Harvard University of Charles Eliot Norton as the first Professor of Fine Arts in America laid the foundation for the academic study of art history; Norton's pupil Bernard Berenson assisted ISABELLA STEWART GARDNER in acquiring the Old Master paintings and decorative arts that enriched her Renaissance Revival palazzo, now Fenway Court, built by Willard T. Sears (see CUMMINGS & SEARS, fig. 2), which opened as a public museum in 1903.

As Bostonians became more cosmopolitan, tastes became less English in character. In 1883 the first exhibition in America of French Impressionist painting was held in Boston; it included *Luncheon of the Boating Party* (1880–81; Washington, DC, Phillips Col.) by Renoir (1841–1919), as well as works by Monet (1840–1926), Camille Pissarro (1830–1903), Eugène Boudin (1824–98) and Alfred Sisley (1839–99). Earlier in the century the painter and teacher William Morris Hunt had promoted the work of the Barbizon school, and many Boston artists supplemented their local training with experience in the workshops of Paris. As a result a large and important group of modern French painting began to accumulate in Boston in both private and public collections, at a time when the realistic Hudson River school tradition still prevailed in New York. French taste was also reflected in the work of artists connected with the Museum School: Edmund C. Tarbell, Thomas Wilmer Dewing, Willard Leroy Metcalf and especially Childe Hassam painted cityscapes and rural scenes, often with colonial associations, in a lively *plein-air* style that combined an Impressionist treatment of light and colour with a more conservative structural solidity (e.g. Childe Hassam: *Rainy Day in Boston*, 1885; Toledo, OH, Mus. A.; for illustration see HASSAM, CHILDE). This style reached its highest development in the first 30 years of the 20th century with the work of the Boston School; such painters as Frank W. Benson and William Paxton (1869–1941) fused Impressionist colour with academic technique to produce dignified portraits and genteel interiors (e.g. William Paxton: *New Necklace*, 1910; Boston, MA, Mus. F.A.). When a considerable part of the Armory Show was exhibited in Boston in 1913, however, the negative reaction highlighted the conflict between the local allegiance to the academic tradition and the progressive experiments of modernism. Such artists as Benson and Paxton moved in a contracting world of wealth and privilege that lent an increasingly conservative character to the city's art life.

BIBLIOGRAPHY

H. W. Cunningham: *Christian Remick, an Early Boston Artist* (Boston, 1904)
M. A. S. Shannon: *Boston Days of William Morris Hunt* (Boston, 1923)
G. F. Dow: *The Arts and Crafts in New England* (Topsfield, MA, 1927)
C. Lee: *Early American Portrait Painters* (New Haven, 1929)
T. C. Hall: *The Religious Background of American Culture* (Boston, 1930)
S. E. Morison: *Builders of the Bay Colony* (Boston, 1930)
A. Burroughs: *Limners and Likenesses: Three Centuries of American Painting* (Cambridge, MA, 1936)
D. Wecter: *The Saga of American Society: A Record of Social Aspiration, 1607–1937* (New York, 1937)
B. N. Parker and A. B. Wheeler: *John Singleton Copley: American Portraits* (Boston, 1938)
V. Barker: *American Painting: History and Interpretation* (New York, 1950)
C. Bridenbaugh: *Cities in Revolt: Urban Life in America, 1743–1776* (Oxford, 1955)
A. Eliot: *Three Hundred Years of American Painting* (New York, 1957)
O. T. Barck and H. T. Lefler: *Colonial America* (New York, 1958)
J. T. Flexner: *America's Old Masters* (New York, 1967)
M. Baigell: *A History of American Painting* (New York, 1974)
B. Novak: *American Painting of the 19th Century: Realism, Idealism and the American Experience* (New York, 1979)
P. J. Pierce: *Edmund C. Tarbell and the Boston School of Painting, 1889–1980* (Higham, MA, 1980)
The Bostonians: Painters of an Elegant Age, 1870–1930 (exh. cat., ed. T. J. Fairbrother; Boston, MA, Mus. F.A., 1986)
J. H. Chadbourne, K. Gabosh and C. O. Vogel, eds: *Boston Art Club: Exhibition Record, 1873–1909* (Madison, CT, 1991)
A. Harlow: 'Bicoastal Arts of the 1870s', *A. CA*, v/5 (1992), pp. 10–13
M. Pointin, ed.: *Art Apart: Art Institutions and Ideology across England and North America* (Manchester and New York, 1994)
Artists of the Boston Art Club, 1854–1950 (exh. cat., Brockton, MA, A. Mus. and Columbia, SC, Mus. A., 1995); review by W. B. Bodine in *Collct* [Columbia, SC], vii/2 (1995), pp. 12–13

STEPHEN F. THORPE

III. Centre of production.

1. Furniture. 2. Metalwork. 3. Ceramics.

1. FURNITURE. In the 17th century the dominant furniture workshops in Boston were those of Ralph Mason (1599–1678/9) and Henry Messinger (*fl* 1641–81), both London-trained joiners who worked in the Anglo-Dutch Mannerist style using split turnings, bosses, triglyphs and dentils of exotic hardwoods reminiscent of Dutch furniture. The turner Thomas Edsall (1588–1676) arrived in Boston from London *c.* 1735; he made turnings and bosses for joined furniture and chairs with London-style ball-turned stretchers and stiles. By the late 17th century Mannerism in Colonial furniture was superseded by the Baroque style with its sculptural forms and rich, unornamented surfaces (e.g. high chest-of-drawers, prob. Massachusetts, pine, walnut and maple, 1700–25; Boston, MA, Mus. F. A.). In Boston, this fashion manifested itself primarily in such pieces as the high chest-of-drawers with figured walnut veneer on a pine carcass that rests on a frame with turned legs.

In the early 18th century Boston craftsmen provided furnishings for a growing anglophile élite. This first generation of artisans was tightly interconnected through loyalty and an unofficial barter system that prevented many immigrants from establishing their own shops. Nevertheless, many new arrivals trained in London were employed by local cabinetmakers, who utilized their skills and knowledge of up-to-date fashions to produce furniture in the latest styles. Such journeymen were probably responsible for veneered chest-on-chests (e.g. chest-on-chest, Boston, MA, black walnut, burl walnut veneer and eastern white pine, 1715–25; Boston, MA, Mus. F. A.) in the Georgian style with canted corner pilasters and pull-out

folding boards that were originally attributed to English makers.

The typical forms of 18th-century case furniture were high chests, dressing-tables, chest-on-chests and bureau-bookcases. The pad foot was employed in New England, particularly Massachusetts, during the first half of the 18th century on chairs, small tables, case pieces and high chests. It extends from a slender cabriole leg and flares outward in a circular fashion before canting inwards to a smaller round base. Japanning was a Boston speciality, a result of the thriving trade with China and the corresponding popularity of chinoiserie decoration; an example is the high chest (c. 1736; Baltimore, U. MD Mus. A.) by the japanner Robert Davis (fl 1733–9). However, until the mid-18th century most examples were veneered, such as those produced by the Charlestown cabinetmaker Ebenezer Hartsherne or Hartshorn (1690–1781), while others were decorated with a block front, a contouring of the façade with three vertical panels of which the outer two were raised and the central one recessed—an innovation of Boston cabinetmakers that was popular from the 1730s until the 1780s. Other shaped case pieces are *bombé* in form, with the sides of the lower section swelling outwards in serpentine curves that are sometimes echoed by shaped drawers (e.g. desk, Salem, MA, mahogany and white pine, 1760–90; Boston, MA, Mus. F. A.). Although the form was derived from imported English bureau-bookcases, the complicated construction techniques were mastered only by such Boston craftsmen as Benjamin Frothingham sr of Charlestown, George Bright (1726–1805), John Cogswell (1738–1818) and a few others in nearby towns. In the 1770s many case pieces were modified with serpentine or oxbow fronts; some of the finest examples were embellished with carvings and figural sculpture by John (Simeon) Skillin (fl 1791). The demand for Neo-classical furniture was met by John Seymour (c. 1738–1818), who arrived from England c. 1784; he and his son Thomas Seymour (1771–1843) produced elegant tambour desks and semi-circular commodes with mahogany and satinwood veneers (see colour pl. XXXIII, 1).

Boston continued to be an important centre for furniture-making in the 19th century. In the early decades furniture in the bolder Empire style was produced by George Archibald and Thomas Emmons (fl 1813–24) as well as Isaac Vose and Joshua Coates (fl 1805–19). Closely related to French forms, their work incorporated broad expanses of figured mahogany veneer punctuated by cut brass inlay and ormolu. By 1850, the furniture industry produced Rococo and Renaissance Revival furniture for a burgeoning middle-class market. Among the well-known makers were George Croome (fl 1845–c. 1880) and George Ware (fl c. 1860). New forms ranged from pier tables and étagères to large sideboards and included a variety of specialized furniture, some with folding or mechanical parts for invalids, libraries or travel.

Despite the Great Fire of 1872 and the financial panic of the following year, Boston's furniture industry flourished until the end of the century. High productivity was due partly to the influx of unskilled Irish immigrants to man such new steam-powered factories as the A. H. Davenport Co. (1880–1906), which executed commissions for architects H. H. Richardson and McKim, Mead & White among others.

BIBLIOGRAPHY
R. H. Randall jr: *American Furniture in the Museum of Fine Arts, Boston* (Boston, 1965/R 1985)
W. M. Whitehill, B. Jobe and J. L. Fairbanks, eds: *Boston Furniture of the Eighteenth Century* (Boston, 1974)
J. Fairbanks and others: *Paul Revere's Boston, 1810–1835* (Boston, 1975)
P. Talbott: 'Boston Empire Furniture', *Antiques*, cvii (May 1975), pp. 878–86
A. Farnam: 'A. H. Davenport & Co., Boston Furniture Makers', *Antiques*, cix (May 1976)
P. Talbott: 'Boston Empire Furniture', *Antiques*, cix (May 1976), pp. 1004–13
A. Farnam: 'H. H. Richardson and A. H. Davenport: Architecture and Furniture as Big Business in America's Gilded Age', *Tools and Technologies, America's Wooden Age*, ed. P. B. Kebabian and W. C. Lipke (Burlington, VT, 1979), pp. 80–92
E. S. Cooke jr: 'The Boston Furniture Industry in 1880', *Old-time New England*, lxx/257 (1980), pp. 82–98
J. L. Fairbanks and E. Bidwell Bates: *American Furniture, 1620 to the Present* (New York, 1981)
J. Seidler: 'A Century in Transition: The Boston Furniture Industry, 1840–80', *Victorian Furniture*, ed. K. Ames (Philadelphia, 1983), pp. 65–83
New American Furniture: The Second Generation of Studio Furnituremakers (exh. cat. by E. S. Cooke jr, Boston, MA, Mus. F.A., 1989)
Collecting American Decorative Arts and Sculpture, 1971–1991 (exh. cat., intro. J. L. Fairbanks; Boston, MA, Mus. F.A., 1991)
P. Talbott: 'The Furniture Trade in Boston, 1810–1835', *Antiques*, cxli (May 1992), pp. 842–55

2. METALWORK.

(i) Silver. The craft of silversmithing began in Boston in 1652, when John Hull (1624–83) and Robert Sanderson (1608–93) became the first Masters of the Mint for the Massachusetts Bay Colony. Sanderson, who had trained in London, and Hull fashioned the first coins of the colony and much of its earliest plate and were well-respected members of the Puritan oligarchy. Their hollowware followed the latest fashions in silver imported from London and is characterized by a Mannerist style that features strong contrasts in shapes and textures (e.g. caudle cup, 1660–70; Boston, MA, Mus. F.A.).

Hull's and Sanderson's dominance of the craft had faded by 1670, as had the authority of the Puritan founders, and a new group of merchants came to power whose religious, political and commercial interests were orientated towards England. These new arrivals, some of whom were officials of the provincial government, patronized Jeremiah Dummer (1645–1718), JOHN CONEY and Edward Winslow (1669–1753), the first Boston-born silversmiths. During this second period, vessel forms included monteiths, master salts and sugar-boxes in the Baroque style with elaborate repoussé chasing and cast ornament (*see* UNITED STATES OF AMERICA, fig. 40). The need for church plate also grew along with burgeoning congregations. Craftsmen derived their designs primarily from imported English wares, but they also utilized the skills of immigrant craftsmen who brought with them specialized skills, new techniques and the latest fashions. Their lack of family and religious connections prevented most immigrant craftsmen from establishing their own workshops; instead they performed specialized tasks or worked as anonymous journeymen in some of the larger Boston establishments.

Despite the talents of Boston's native-born and immigrant silversmith population, the economic slump of the

5. Three-handled loving-cup designed by H. Langford Warren, made by Arthur J. Stone and enamelled by Laurin Hovey Martin, silver gilt and enamel, h. 146 mm, w. 219 mm, 1906 (Cambridge, MA, Fogg Art Museum)

1730s resulted in the production of silver that was conservative in style, as seen in the work of Thomas Edwards (1701–55), Jacob Hurd (1703–58) and Samuel Edwards (1705–62). The craft as a whole concentrated less on evolving new forms than on creating finely raised and chased vessels, some engraved with coats of arms. Porringers, mugs and domed tankards changed little, while the apple-shaped teapot of the 1730s and 1740s gradually gave way to the more fashionable inverted pear form in the Rococo style by the 1760s (e.g. teapot by Paul Revere, 1760–65; Boston, MA, Mus. F.A.).

With some exceptions, Boston silver from the 1760s to the end of the 18th century is conservative in contrast to the more elaborate decoration found on the silver made in such rapidly growing cities as New York and Philadelphia. Boston patrons generally preferred heraldic engravings to the ciphers chosen by stylish New Yorkers, and they did not embrace the fashionable Rococo style as enthusiastically as did Philadelphians. The careers of PAUL REVERE and Benjamin Burt (1729–1805) spanned the latter half of the 18th century and the early decades of the 19th. Both produced a large quantity of silver for Boston patrons in the Rococo style, and towards the end of the 18th century both also made elliptical fluted vessels in the newly popular Neo-classical vein (e.g. teapot and stand by Benjamin Burt, 1790–1800; Boston, MA, Mus. F.A.). The following generation of silversmiths, which included Lewis Cary (1798–1834) and Obadiah Rich (fl 1830–50), produced more robust forms in the Empire style with mechanically produced naturalistic decoration.

During the second half of the 19th century such Boston firms as Shreve, Stanwood & Co. (1860–69), Crosby & Morse (1848–76) and Goodnow & Jenks (1893–c. 1905) created tea services and coffee services in the newly fashionable Renaissance Revival and Greek Revival styles. But by 1900 few workshops remained in Boston, for such larger concerns as Reed, Barton & Co. (founded 1886) of Taunton, MA, and the silverware firm of GORHAM (founded 1831) of Providence, RI, could produce their wares more competitively. One of the last apprentices to Goodnow & Jenks was George Christian Gebelein (1878–1945), a skilled practitioner of the Colonial Revival style,

a dealer in antique American silver and a member of the Society of Arts and Crafts, Boston. Founded in Boston in 1897, the Society was the first such group to be established in America. The metals department of the Society's Handicraft Shop offered classes in silversmithing in the Arts and Crafts and Colonial Revival styles, and fostered the development of silversmiths Mary Knight (b 1876) and Katherine Pratt (1891–1978). The most prominent and prolific silversmith in the Boston area was Arthur J. Stone (1847–1938). Born and trained in Sheffield, England, Stone moved to Gardner, MA, in 1896 and produced work on commission for many of Boston's prominent families (see fig. 5).

BIBLIOGRAPHY

L. I. Laughlin: *Pewter in America: Its Makers and their Marks*, 3 vols (i–ii, Boston, 1940/*R* Barre, 1969; iii, Barre, 1971; i–iii as 1 vol., 1969–71/*R* New York, 1981)

K. C. Buhler and G. Hood: *American Silver: Garvan and Other Collections in the Yale University Art Gallery*, 2 vols (New Haven, 1970)

M. G. Fales: *Early American Silver* (New York, 1970/*R* 1973)

G. Hood: *American Silver; A History of Style, 1650–1900* (New York, 1971/*R* 1989)

K. C. Buhler: *American Silver, 1665–1825, in the Museum of Fine Arts, Boston*, 2 vols (Boston, 1972)

B. M. Ward and G. W. R. Ward, eds: *Silver in American Life* (New York, 1979)

'*The Art that is Life*': *The Arts and Crafts Movement in America, 1875–1920* (exh. cat. by W. Kaplan and others, Boston, MA, Mus. F.A., 1987)

E. C. Chickering: 'Arthur J. Stone: An Anglo-American Silversmith', *Apollo*, cxxx/330 (August 1989), pp. 95–101

P. Kane and others: *A Dictionary of Colonial Massachusetts Silversmiths Based on the Notes of Francis Hill Bigelow and John Marshall Phillips* (in preparation)

American Silver: The Work of Seventeenth and Eighteenth Century Silversmiths exhibited at the Museum of Fine Arts, June to November, 1906 (*R* Concord, MA, 1990)

E. C. Chickering and S. M. Ross: *Arthur J. Stone, 1847–1938, Designer and Silversmith* (Boston, MA, 1994)

(ii) Pewter, copper, brass and other base metals. The presence of pewterers in Boston was recorded as early as 1635, when a Richard Graves arrived from London on the *Abigail*. By 1640 at least three other pewterers had settled in Boston: Samuel Grame (or Graemes) (fl 1639–45), Henry Shrimpton (fl 1639–66) and Thomas Bumstead (fl 1640–43). Perhaps the most celebrated of this early group are Edmund Dolbeare (1671–1706/11) and his son, John Dolbeare (1670–1740), whose large dishes reveal the 17th-century English method of hammering cast-pewter discs over wooden forms. Robert Bonynge (fl 1731–63) produced the first known examples of pewter beakers made in Boston (see Barquist, no. 205a). By 1800 the number of pewterers in the area had increased ninefold. The success of these craftsmen is remarkable since they were lacking tin, an essential metal in the making of pewter alloy. The British forbade the export of tin to the colonies to protect the British pewterers' guild, yet these entrepreneurs prospered by fashioning new pewter from inexpensive second-hand wares.

The number of pewterers remained stable during the early 18th century, while demand for this base metal and later for Britannia metal remained high. Roswell Gleason (1799–1887) of Dorchester was perhaps the most prominent local maker of pewter and other silverplated wares. South of Boston, in Taunton, MA, Reed & Barton (Henry G. Reed and Charles E. Barton) formed a partnership in

1840 and produced pewter and Britannia, later expanding to silver and silverplate production.

The Arts and Crafts Movement brought with it a revival of pewter as a means of romanticizing Colonial life. During the Colonial and post-Revolutionary era, some pewterers also styled themselves coppersmiths and braziers, because they handled metal through spinning and casting. The earliest of these craftworkers included Henry Shrimpton and Jonathan Jackson (1695–1736). An advertisement from the *Boston News-Letter* of 17 February 1737 indicates the variety of skills with base metals that were practised by these individuals (Dow, p. 126):

> William Coffin, at the Ostrich, near the Draw-Bridge, makes and sells Mill Brasses, Chambers for Pumps, Brass Cocks of all Sizes, Knockers for Doors, Brasses for Chaises and Sadlers, Brass Doggs of all sorts, Candlesticks, Shovels and Tongs, small Bells, and all sorts of Founders ware. Also, all sorts of Braziers and Pewterers ware, small Stills and worms, and all Sorts of Plumbers work; likewise Buys old copper, Brass, Pewter and Lead.

Despite the quantity of objects produced, information on makers for this period is scarce, and it is difficult to determine whether or when specialization in these materials began to occur. Rare, marked works in brass dating to the early 19th century by Boston makers William C. Hunneman and John Molineux suggest that these individuals worked more exclusively in brass than copper, yet it remains likely that brass was only one of the base metals in which they were proficient.

Perhaps the best-known Colonial Boston coppersmith was Shem Drowne (1683–1776), deacon of First Baptist Church. Drowne's most distinctive works included the Indian archer weathervane (1716; Boston, MA Hist. Soc.) that once topped the Province House, and the famous grasshopper weathervane (1742; *in situ*) that he created for Faneuil Hall. Large-scale copper production in the USA was first successfully introduced by the silversmith Paul Revere, who in 1800 established a rolling mill in Canton that produced copper sheathing for sailing vessels. His son Joseph Warren Revere (1777–1868) inherited this business and reorganized it as the Revere Copper Company in an 1828 merger with James Davis of Boston, a maker of brass andirons.

Mid-18th-century copper ventures included the lively weathervane business of Leonard Wareham Cushing (1867–1933) and Stillman White established in Waltham, MA, in 1867, when the business was purchased at auction from the estate of Alvin L. Jewell, who had pioneered cast-iron and brass products in the area. Stillman White sold his interest in the company to Cushing in 1872, and Cushing's sons, Charles and Harry, joined their father to form L. W. Cushing & Sons. The family produced weathervanes until 1933, some of them taken from moulds that dated from the early days of Jewell's ownership.

BIBLIOGRAPHY

G. F. Dow: *Everyday Life in the Massachusetts Bay Colony* (Boston, 1935), p. 126
L. I. Laughlin: *Pewter in America, its Makers and their Marks*, 3 vols (i–ii, Boston, 1940/*R* Barre, 1969; iii, Barre, 1971; i–iii as 1 vol., 1969–71/*R* New York, 1981)
H. J. Kauffman: *American Copper & Brass* (Camden, NJ, 1968)
C. F. Montgomery: *A History of American Pewter* (New York, 1973)
M. Simpson: *All that Glisters: Brass in Early America* (New Haven, 1979)
J. A. Mulholland: *A History of Metals in Colonial America* (Tuscaloosa, 1981)
D. L. Barquist: *American and English Pewter at the Yale University Art Gallery* (New Haven, 1985)
P. M. Leehey and others: *Paul Revere—Artisan, Businessman, and Patriot, the Man behind the Myth* (Boston, 1988)

3. CERAMICS. The earliest mention of earthenware in New England appeared by 1644 in Essex County probate records. Although such documents cannot prove the presence of locally made goods at this early date, the few surviving examples of lead-glazed earthenware from this period have been attributed to Massachusetts or New England as early as 1675. A large supply of red clay along the Mystic River fostered the brickmaking and pottery industries in Boston's nearby towns of Charlestown and Medford and by the 18th century more than 40 potters were known to have worked in Charlestown; in 1750, approximately eight or nine shops were in simultaneous operation. The proliferation of potters in Charlestown explains why so few potters worked in Boston and why references are often found to what was called 'Charlestown ware'.

Although attempts were made from the mid-18th century to make stoneware in Boston, domestic production was not stimulated until after the American Revolution, when charges levied on the weight of imported goods made stoneware an economically attractive commodity. After 1793 a Boston stoneware factory was established by Frederick Carpenter (1771–1827) and Jonathan Fenton (1766–1848). Their goods were made of clay shipped from Perth Amboy, NJ, an arrangement made possible by the financial backing of the Boston merchant William Little. Through Fenton's sons Richard Lucas Fenton (1797–1834) and Christopher Webber Fenton (1806–65) this enterprise eventually led to the establishment in 1849 of the United States Pottery Co. in Bennington, VT. The evidence for the production of such fine ceramics as tortoiseshellware is rather thin compared to that for redware and stoneware. However, at least one advertisement from the period suggests that tortoiseshellware was attempted as early as 1770.

By the mid-19th century one of the major potteries was the East Boston Crockery Manufactory. It was first established in Weston in 1765 by Abraham Hews (1741–1818); by the Civil War it had moved to North Cambridge, where porcelain, yellowware, Rockingham and Parian wares were produced in addition to an expanded line in ornamental ceramics.

HUGH CORNWALL ROBERTSON, who had worked as a manager of the East Boston Crockery Manufactory, established the Chelsea Keramic Art Works in Chelsea, MA (1872–89; see colour pl. XXXIV, 3), and later the Dedham Pottery, Dedham, MA (1896–1943), which were prominent art potteries in the region. Other Arts and Crafts potteries included the Grueby Faience Co. (*see* GRUEBY, WILLIAM HENRY), the Marblehead Pottery, Marblehead, MA (1904–36; see fig. 6), and the Low Tiles, Chelsea, MA (1878–1907). The Paul Revere Pottery (1911–42) of Boston and Brighton was a reform-minded, subsidized pottery that employed young immigrant Italian and Jewish women. One of the few art potteries to flourish until the mid-20th century was the Dorchester Pottery, Dorchester, MA

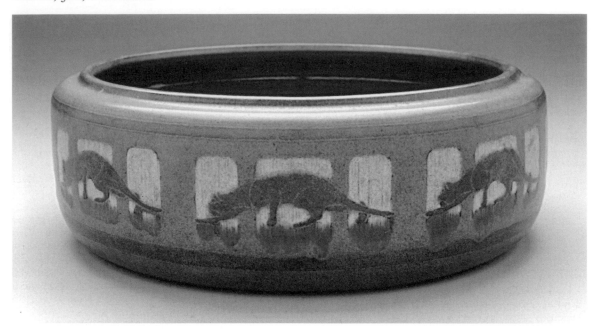

6. Earthenware bowl with incised and glazed decoration, h. 98 mm, diam. 227 mm, from the Marblehead Pottery, *c.* 1910–15 (Boston, MA, Museum of Fine Arts)

(1895–1979), which was best-known for its salt-glazed wares.

BIBLIOGRAPHY
L. W. Watkins: *Early New England Potters and their Wares* (Cambridge, MA, 1950)
J. L. Fairbanks and others: *New England Begins: The Seventeenth Century*, ii (Boston, 1982), pp. 229–30, 303
S. H. Meyers: 'The Business of Potting, 1780–1840', *The Craftsman in Early America*, ed. I. M. G. Quimby (New York, 1984)
P. Evans: *Art Pottery of the United States: An Encyclopedia of Producers and their Marks* (New York, 1974, rev. 1987)
'*The Art that is Life*': *The Arts and Crafts Movement in America, 1875–1920* (exh. cat. by W. Kaplan and others, Boston, MA, Mus. F. A., 1987)
J. Skerry: 'Equal to any Imported from England: The Evidence for American Production of Tortoisewares', *36th Symposium of the American Ceramic Circle: Chicago, 1989*
S. J. Montgomery: *The Ceramics of William H. Grueby: The Spirit of the New Idea in Artistic Handicraft* (Lambertville, NJ, 1993)
Grueby Pottery: A New England Arts and Crafts Venture: The William Curry Collection (exh. cat. by W. P. Curry and S. J. Montgomery, Hanover, NH, Dartmouth Coll., Hood Mus. A., 1994)

JEANNINE FALINO

Boston & Sandwich Glass Co. American glass factory formed by Deming Jarves (1790–1869), who left the New England Glass Co. in 1825. He acquired a site and built a glasshouse in Sandwich, MA. In 1826 the Boston & Sandwich Glass Co. was incorporated, with Jarves gaining financial aid from several partners. In Sandwich, Jarves was agent and general manager and during the following 22 years greatly increased the size and output of the company from 70 to over 500 employees and from $75,000 to $600,000 in value.

Table glass, lighting devices and ornamental wares were produced by using the fashionable techniques of each era. The firm's repertory included free-blown, mould-blown, cut, engraved, colourless and cased products, and various art wares, especially opaline, 'Peachblow' and satin glass.

The company is best known for its lacy pressed glass (*see* UNITED STATES OF AMERICA, fig. 39 and colour pl. XXXV, 3), giving rise to the generic term 'Sandwich Glass' for any American examples of this type. The firm's products were of very good quality but, as with many other New England glasshouses, its fortunes declined after the Civil War (1861–5), and the works closed during the strike of 1888.

BIBLIOGRAPHY
R. W. Lee: *Sandwich Glass* (1939, rev. Northborough, MA, 7/1947)
K. M. Wilson: *New England Glass and Glassmaking* (New York, 1972)
R E. Barlow: *A Guide to Sandwich Glass* (Windham, NH, and Atglen, PA, 1985–99)

ELLEN PAUL DENKER

Bowdoin, James, III (*b* Boston, MA, 22 Sept 1752; *d* Buzzard's Bay, MA, 11 Oct 1811). American diplomat and collector. He was born into a prominent New England mercantile family of broad political and intellectual interests. Using the fortune garnered by his grandfather, a sea captain and merchant, he built on the collection, one of the first in the United States, begun by his father James Bowdoin II (1726–90), eventually bequeathing it to Bowdoin College, Maine, which was named after his father. The collection includes 70 paintings—mainly copies after Old Masters, the first Old Master drawings to arrive in America, and several prints, the latter probably collected by James II. It is likely that James III purchased at least 34 of the paintings in Europe, where he studied, later travelled, and was Minister Plenipotentiary to Spain under President Thomas Jefferson between 1805 and 1808. From the Scottish-born portrait painter John Smibert, he likely acquired additional copies but also, more significantly, two portfolios totalling 141 drawings. Most notable among them are a landscape traditionally attributed to Pieter Bruegel I and a Beccafumi fresco study. The painting

collection is distinguished by portraits of *Thomas Jefferson* and *James Madison* by Gilbert Stuart, as well as by family portraits by Joseph Blackburn, Smibert and Robert Feke, which James III's widow Sarah Bowdoin Dearborn (1761–1826) added to the bequest. According to Wegner, James III may have been influenced in his collecting intentions both by the display of masterpieces he saw in Napoleon's Paris and by Jefferson's own accumulation of portraits of ancient and modern worthies who represented an ethical and cultivated life.

BIBLIOGRAPHY

M. S. Sadik: *Colonial and Federal Portraits at Bowdoin College* (Brunswick, 1966)

Governor Bowdoin and his Family (exh. cat. by R. L. Voltz, Brunswick, ME, Bowdoin Coll. Mus. A., 1969)

D. P. Becker: *Old Master Drawings at Bowdoin College* (Brunswick, 1985)

S. E. Wegner: 'The Collection of James Bowdoin III (1752–1811)', *College Art Association Sessions* [abstracts] (New York, 1991), pp. 192–3

The Legacy of James Bowdoin III (exh. cat. with essays by L. Docherty, R. H. Saunders III, S. E. Wegner *et al.*, Brunswick, ME, Bowdoin Coll. Mus. A., 1993); review by P. Anderson in *A. New England*, xv (1993–4), pp. 52–3

DIANE TEPFER

Bradford, William (*b* Fairhaven, MA, 30 April 1823; *d* New York, 25 April 1892). American painter and photographer. He became a full-time artist about 1853, after spending a few years in the wholesale clothing business. In 1855 he set up a studio in Fairhaven, MA, and made a living by painting ship portraits. At the same time he studied with the slightly more experienced marine painter Albert van Beest (1820–60), and they collaborated on several works. By 1860 Bradford had moved to New York and was starting to gain a reputation for such paintings of the coast of Labrador as *Ice Dwellers Watching the Invaders* (*c.* 1870; New Bedford, MA, Whaling Mus.), which were based on his own photographs and drawings. From 1872 to 1874 he was in London, lecturing on the Arctic and publishing his book *The Arctic Regions* (1873). Queen Victoria commissioned him to paint an Arctic scene that was shown at the Royal Academy in 1875. On his return to the USA, Bradford was elected an associate member of the National Academy of Design. In later years his tight, realistic style went out of favour as French Impressionism became increasingly popular.

WRITINGS

The Arctic Regions (London, 1873)

BIBLIOGRAPHY

William Bradford, 1823–1892 (exh. cat., ed. J. Wilmerding; Lincoln, MA, DeCordova & Dana Mus., 1969)

F. Horch: 'Photographs and Paintings by William Bradford', *Amer. A. J.*, v (1973), pp. 61–70

A.-M. A. Kilkenny: '*Life and Scenery in the Far North*: William Bradford's 1885 Lecture to the American Geographical Society', *Amer. A. J.*, xxvi/12 (1994), pp. 106–8

MARK W. SULLIVAN

Brady, Mathew B. (*b* Warren County, NY, 1823; *d* New York, 15 Jan 1896). American photographer. At the age of 16 he left his home town and moved to nearby Saratoga. There he learnt how to manufacture jewellery cases and met William Page, who taught him the techniques of painting. Impressed by his ability, Page took Brady to New York in 1841 to study with Samuel F. B. Morse at the Academy of Design, and to attend Morse's school of daguerreotypy; there Brady learnt the details of photographic technique. After experimenting with the medium from 1841 to 1843, Brady set up his Daguerrean Miniature Gallery in New York (1844), where he both took and exhibited daguerreotypes. Very soon he established a considerable reputation and in 1845 won first prize in two classes of the daguerreotype competition run by the American Institute. He concentrated on photographic portraits, especially of famous contemporary Americans, such as the statesman *Henry Clay* (1849; Washington, DC, Lib. Congr.). In 1847, with his business flourishing, he opened a second studio, in Washington, DC, and in 1850 published his *Gallery of Illustrious Americans* (New York). These were lithographic portraits of eminent Americans, such as General Winfield Scott and Millard Fillmore, taken from Brady's original daguerreotypes.

In 1851 Brady contributed a number of daguerreotypes to the Great Exhibition in London, which included the largest photographic display so far held. The Americans took all the top awards, Brady himself winning first prize. While in London, he also learnt of the new wet collodion or 'wet plate' process and met one of its leading practitioners, Alexander Gardner. Soon after his return to New York in 1852, the ambrotype (a collodion glass positive with black backing) became his dominant medium. In 1853 he opened a larger gallery in New York and in 1858 added a gallery to his studio in Washington. In 1856, persuaded by Brady, Gardner came to New York, where he was put in charge of the new gallery. He brought with him the details of a process enabling the production of enlargements from wet plate negatives, which allowed Brady to make large 'Imperial' size portraits. In 1860 Brady opened the largest of his galleries in New York, called the National Portrait Gallery, and that year he took his famous photograph of *Abraham Lincoln* (1860; Washington, DC, Lib. Congr.), the first of many, on the occasion of Lincoln's speech to the Cooper Union. Lincoln, who was elected president the following year, attributed his success to a Brady *carte-de-visite*.

In 1861, at the outbreak of the American Civil War, Brady gave up his lucrative career as a portrait photographer and decided to devote himself to documenting the events of the war. During the first few months of the following year, he organized and equipped at his own expense several teams of cameramen to send to the numerous sites of conflict. Among the photographers he employed, apart from himself and Gardner, were Timothy O'Sullivan, William R. Pyell, J. B. Gibson, George Cook, David Knox, D. B. Woodbury, J. Reekie and Stanley Morrow. Though working in extremely difficult conditions, Brady and his team were able to cover virtually all the battles and events of the war (for illustration *see* O'SULLIVAN, TIMOTHY. Those photographs taken by Brady himself included portraits of the protagonists, such as *Robert E. Lee* (1865; Washington, DC, Lib. Congr.), taken after his defeat, and numerous images of its horrors, such as *On the Antietam Battlefield* (1862; Washington, DC, Lib. Congr.). Some of his photographs, such as *Dead Confederate Soldier with Gun* (1863; Washington, DC, Lib. Congr.), were stereoscopic views.

Brady had embarked on this vast enterprise in the belief that both private individuals and, more importantly, the state would be interested in purchasing the photographs

after the war. In fact, the trauma and destruction it caused led to a general desire to forget. Burdened by huge debts, he tried to persuade the government to buy his collection for the archives. It was not until 1875 that it finally did so, after a vote in Congress. The purchase came too late, however: Brady had been forced to sell all his properties except for the one in Washington, which was run by his nephew Levin Handy. Though reduced to poverty, he produced a few further portrait photographs, such as *Chiefs of the Sioux Indian Nations* (1877; Washington, DC, Lib. Congr.). He sold the last of his galleries in 1895.

BIBLIOGRAPHY

R. Meredith: *Mr Lincoln's Cameraman* (New York, 1946)
J. D. Horan: *Mathew Brady: Historian with a Camera* (New York, 1955)
P. Pollack: *The Picture History of Photography* (New York, 1977), pp. 56–9
G. Hobart: *Mathew Brady* (London, 1984)
A. Trachtenberg: *Reading American Photographs: Images as History, Mathew Brady to Walker Evans* (New York, 1989); review by N. Rosenblum in *A. J.* [New York], xlix (1990), pp. 178–81
Photography in Nineteenth-century America (exh. cat., ed. M. A. Sandweiss, Fort Worth, TX, Amon Carter Mus., and Amherst, U. MA, U. Gal., 1991–2)
H. von Amelunxen: 'Von der Vorgeschichte des Abschieds: Bilder zum Zustand des Kriegerischen in der Fotografie', *Fotogeschechte*, xii/43 (1992), pp. 27–38
T. R. Kailbourn, ed.: '"Still Taking Pictures": An Interview with Mathew Brady in April, 1891', *Daguerreian Annu.* (1992), pp. 109–17
G. Gilbert: 'Brady's Four New York City Galleries, Not Three!', *Daguerreian Annu.* (1993), pp. 74–9
Mathew Brady and the Image of History (exh. cat. by M. Panzer, Washington, DC, N.P.G; Cambridge, MA, Fogg; New York, Int. Cent. Phot.; 1997–8)

□

Bremer, Anne M(illy) (*b* San Francisco, CA, 21 May 1868; *d* San Francisco, CA, 26 Oct 1923). American painter and muralist. At the age of 12, she spent a year visiting the important galleries of Europe, which instilled in her aspirations of becoming an artist. Later, in San Francisco, she attended the California School of Design (*c.* 1888) under Emil Carlsen and the San Francisco Art Students League (1889), studying with Arthur F. Mathews. Subsequently, she made two more trips to Europe. In 1901, she studied with André Lhôte (1885–1962) and at La Palette and the Académie Moderne in Paris; in 1910–1911/12, she exhibited at the Paris Salon (1911) and painted and sketched in Brittany and Barbizon. Afterwards she continued to paint, teach and involve herself in women suffrage issues and in the art community of San Francisco.

Best known for her still-lifes, Bremer also painted landscapes (in several northern California counties), marines, figures and portraits. Of her paintings, her cousin and art patron Albert Bender stated: 'She continued to interpret nature, animate and inanimate, through a technique [which is] unmistakably her own and which is distinguished by simplicity, clarity and purity of colors.' Her earlier works were painted in soft, muted tones and in a decorative style, as typified by *Brown and Gold* (untraced), a figure study exhibited at the Paris Salon in 1911. During her last sojourn in Europe, her style changed dramatically, and she opted for the brighter, bolder techniques of Post-Impressionism that reflected the influence

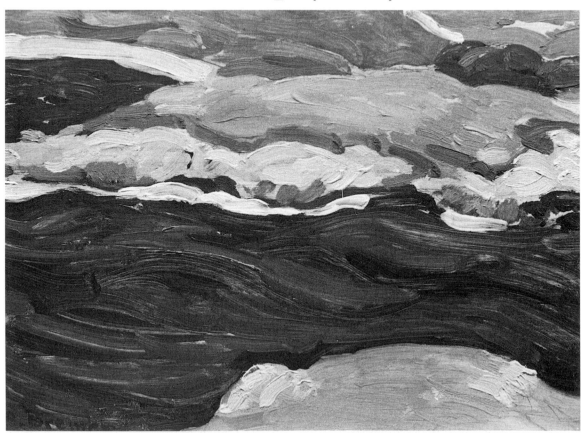

Anne M. Bremer: *Sketch #1—Inlet*, oil on panel, 203×254 mm, [n.d.] (Oakland, CA, Oakland Museum)

of Cubism and Futurism (see fig.), as can be noted in such paintings as the *An Old-Fashion Garden* (Oakland, CA, Mills Coll., A.G.). Commenting on this, a San Francisco art critic stated in 1912 that 'since her return from abroad, her style and ...technique... are more modern than the style and technique of any artist hereabouts'.

Bremer, who was president of the Sketch Club in San Francisco (1905é7) and had solo exhibitions in New York and San Francisco, received a bonze medal at the Panama—Pacific International Exposition in San Francisco (1915). She also executed a number of murals, including *The Years at the Spring* (1914), for the Mount Zion Hospital in San Francisco, and a decorative panel (1916) for the YWCA Building (destr.) in San José.

UNPUBLISHED SOURCES

Oakland, CA, Mills Coll. Lib., Smithsonian Inst., Archvs Amer. A., reels 2293–4 [Albert M. Bender papers]

BIBLIOGRAPHY

Obituary: *San Francisco Examiner* (27 Oct 1923), p. 4
'Anne Bremer (1868–1923)', *California Art Research*, ed. G. Hailey (San Francisco, 1936–7), vii, pp. 88–128
R. L. Westphal, ed.: *Plein-air Painters of California: The North* (Irvine, 1986)
S. Moore, ed.: *Yesterday and Tomorrow: California Women Artists* (New York, 1989)
P. Trenton, ed.: *Independent Spirits: Women Painters of the American West, 1890–1945* (Berkeley, 1995)

MARIAN YOSHIKI-KOVINICK

Brenner, Victor D(avid) (*b* Schavli, Kovno [now Kaunas], 12 June 1871; *d* New York, 5 April 1924). American medallist of Lithuanian origin. He trained as a seal-engraver under his father and worked as a jewellery engraver and type cutter. In 1890 he went to New York, where he worked as a die engraver of badges, and in 1898 to Paris to study at the Académie Julian and later with Oscar Roty (1846–1911). He first exhibited medals in the early years of the 20th century. The influence of Roty is apparent in the low relief and soft-edged naturalism and also in the inclusion of flat expanses of metal in his designs. He occasionally ventured into sculpture, as in the Schenley Memorial Fountain (bronze; Pittsburgh, PA, Schenley Park), but he was best known for his medals and plaquettes, both struck and cast, and his sensitive portraits assured his popularity. The powerful head of President Roosevelt on the Panama Canal medal (bronze, 1908) and the tender *Shepherdess* plaquette (electrotype, 1907) demonstrate his range. He executed coins for the Republic of San Domingo and designed the American cent coin with the head of Abraham Lincoln first used in 1909.

BIBLIOGRAPHY

DAB; Thieme–Becker
L. Forrer: *Biographical Dictionary of Medallists* (London, 1902–30), i, pp. 277–9; vii, pp. 117–22; viii, p. 320
International Exhibition of Contemporary Medals, 1910 (exh. cat., intro. A. Baldwin; New York, Amer. Numi. Soc., 1911), pp. 26–34
Exhibition of American Sculpture (exh. cat., preface H. A. MacNeil; New York, N. Sculp. Soc., 1923), p. 30
D. Taxay: *The US Mint and Coinage: An Illustrated History from 1776 to the Present* (New York, 1966), pp. 330–39
C. Vermeule: *Numismatic Art in America: Aesthetics of the United States Coinage* (Cambridge, MA, 1971)
The Beaux-Arts Medal in America (exh. cat. by B. A. Baxter, New York, Amer. Numi. Soc., 1988)
A. Stahl: 'Victor D. Brenner and the American Numismatic Society', *Italiam fato profugi: Numismatic Studies Dedicated to Vladimir and Elvira

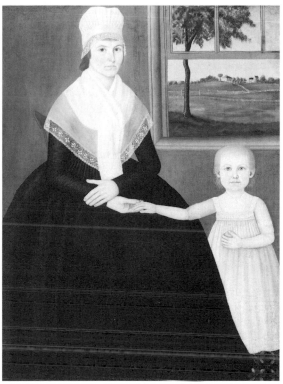

John Brewster jr: *Lucy Knapp Mygatt and her Son George*, oil on canvas, 1.38×1.02 m, 1799 (University Park, PA, Pennsylvania State University, Palmer Museum of Art)

Clain-Stefanelli, ed. T. Hackens and G. Moucharte (Louvain-la-Neuve, 1996), pp. 317 26

PHILIP ATTWOOD

Brewster, John, jr (*b* Hampton, CT, 30 or 31 May 1766; *d* Buxton, ME, 13 Aug 1854). American painter. He was the son of Dr John Brewster, a prominent physician in Hampton, CT, and his first wife, Mary Durkee. Born a deaf mute, Brewster was taught at an early age to communicate through signs and writing. In addition he received instruction in painting from Rev. Joseph Steward (1753–1822), a successful local portrait painter. Essentially self-taught, Steward painted portraits in the manner of Ralph Earl, who inspired a regional portrait style in Connecticut in the 1790s. Brewster began painting full-length likenesses of his family and friends in the mid-1790s, such as the double portrait of his parents (Sturbridge, MA, Old Sturbridge Village), which includes a regional landscape view in the background, a characteristic of Connecticut portraiture of the period.

Brewster began a successful career as an itinerant artist in 1796, when he followed his brother Royal to Buxton, ME. Buxton became Brewster's permanent home between his extensive trips, throughout the north-eastern states, during which he painted portraits and miniatures. His portraits are executed in a flat, decorative style, with realistic likenesses of his subjects, elements related to folk art. Brewster's strong characterizations of his subjects are portrayed with great sensitivity. His finest works are the double portraits of 1799, *Comfort Starr Mygatt and his*

Daughter Lucy (priv. col.) and *Lucy Knapp Mygatt and her Son George* (University Park, PA State U., Palmer Mus. A.; see fig.). After 1805 he often signed and dated his work on the stretcher in pencil.

In 1817, at the age of 51, Brewster enrolled in the first class of the Connecticut Asylum for the Deaf and Dumb in Hartford, where he studied for three years. He returned to Buxton in 1820 and continued painting until his death.

BIBLIOGRAPHY

N. F. Little: 'John Brewster Jr, 1766–1854', *CT Hist. Soc. Bull.*, xxv/4 (1960), pp. 97–129

——: 'John Brewster Jr', *American Folk Painters of Three Centuries*, ed. J. Lipman and T. Armstrong (New York, 1980), pp. 18–26

B. T. Rumford, ed.: *American Folk Portraits* (Boston, 1981), pp. 65–7

J. Hill: 'Miniatures by John Brewster Jr', *The Clarion* (Spring–Summer 1983), pp. 49–50

Ralph Earl: The Face of the Young Republic (exh. cat. by E. M. Kornhauser and others, Hartford, CT, Wadsworth Atheneum, 1991), pp. 242–5

ELIZABETH MANKIN KORNHAUSER

Bricher, Alfred Thompson (*b* Portsmouth, NH, 10 April 1837; *d* New Dorp, Staten Island, NY, 30 Sept 1908). American painter. A landscape painter who primarily painted seascapes, he was the son of an Englishman who had emigrated to the USA in 1820. While working in business, Bricher took art lessons at the Lowell Institute in Boston, MA, and by 1859 was able to set himself up as a painter in Newburyport, MA. His subject-matter derived from sketches made during his summer travels along the Maine and Massachusetts coasts and to the Bay of Fundy; during the winter he worked these into finished paintings. In 1869 Bricher moved to New York, where a lucrative arrangement with the chromolithography firm of Louis Prang & Co. gave his work wide exposure through commercial reproduction.

Bricher exhibited annually at the National Academy of Design in New York. A fine watercolour painter, he was also an active member of the American Society of Painters in Water-Colors. His watercolour *In a Tide Harbour* (untraced) was shown at the Exposition Universelle in Paris in 1878. A steady stream of buyers brought him financial and popular success, enabling him to own homes in Staten Island and Southampton, NY. Bricher's work reflected the Luminist aesthetic of sharply defined panoramic views suffused with crisp, clear light. He was particularly partial to low tide scenes (e.g. *Fog Clearing, Grand Manan, c.* 1898; Hartford, CT, Wadsworth Atheneum; see fig.). His work lacked variety, though it was invariably painted with a high degree of finish.

BIBLIOGRAPHY

J. D. Preston: 'Alfred T. Bricher, 1837–1908', *A. Q.*, xxv (1962), pp. 149–57

Alfred Thompson Bricher, 1837–1908 (exh. cat. by J. R. Brown, Indianapolis, IN, Mus. A., 1973)

Domestic Bliss: Family Life in American Painting, 1840–1910 (exh. cat. by L. M. Edwards, New York, Hudson River Mus., 1986), pp. 92–6

LEE M. EDWARDS

Brite & Bacon. *See under* BACON, HENRY.

Brookes, Samuel Marsden (*b* Newington Green, Middlesex, 8 March 1816; *d* San Francisco, CA, 21 Jan 1892). American painter of English birth. He immigrated with his family to the USA in 1833, settling in Chicago, where in 1841 he received his only art training from two itinerant painters. Essentially self-taught, he spent two years (1845–6) in London copying Old Master paintings; forgoing an anticipated sojourn in Rome, he returned to the USA, at his wife's request, to launch his career in Chicago and Minneapolis. In 1862 he settled permanently in San Francisco, where he built up a highly successful art practice—his income averaging $300 per month and paintings selling for as much as $2000—while establishing a national reputation as perhaps the finest American still-life painter of the 19th century. Thomas Hill and even Albert Bierstadt reportedly acknowledged Brookes's pre-eminent ability to render the iridescence of fish scales, a skill abundantly evident in *Steelhead Salmon* (1885; Oakland, CA, Mus.; see fig.).

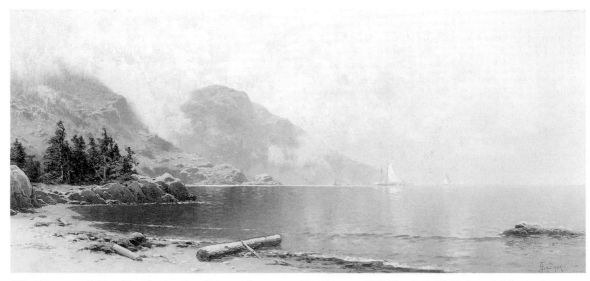

Alfred Thompson Bricher: *Fog Clearing, Grand Manan*, oil on canvas, 460×994 mm, *c.*1898 (Hartford, CT, Wadsworth Atheneum)

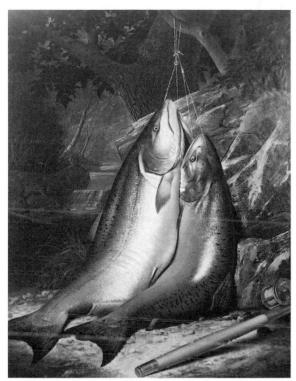

Samuel Marsden Brookes: *Steelhead Salmon*, oil on panel, 1016×762 mm, 1885 (Oakland, CA, Oakland Museum)

When he arrived in San Francisco, Brookes offered art lessons from his studio, and among his students was the young William Keith. His many patrons included Edwin Bryant Crocker and Mrs Mark Hopkins, who commissioned Brookes's *tour-de-force* study of a peacock (1880; Los Angeles, CA, priv. col.) for her Nob Hill mansion. Many of the artist's paintings were lost in the1906 earthquake, when the Mark Hopkins Institute of Art (the mansion had been donated to the California School of Design after Mrs. Hopkins's death) was consumed by fire, but *Peacock* appears to have been among the survivors. A founder of both the Bohemian Club (1872) and San Francisco Art Association (1871), Brookes shared his Clay Street studio during the 1870s with fellow Bohemian Edwin Deakin (1838–1923), who painted several portraits of his colourful friend at work. By the 1880s Brookes had become a well-known San Francisco figure, described as short and stocky with a large head, long hair and flowing beard, always with a cigar clenched between his teeth. His picturesque studio was for years a favourite gathering place for artists, of whom several prominent ones—among them Keith and Norton Bush (1834–94)—served as pallbearers at Brookes's funeral.

Brookes's work was shown at the Mechanics Institute Industrial Exhibitions, San Francisco (1864–90); the San Francisco Art Association (*c.* 1872–86); the Philadelphia Centennial Exposition (1876); the World's Columbian Exposition, Chicago (1893); and the California Midwinter International Exposition, San Francisco (1894). Posthumous exhibitions included a retrospective (1962–3) shown at the California Historical Society, San Francisco, and the Oakland Museum.

BIBLIOGRAPHY

L. A. Marshall: 'Samuel Marsden Brookes', *CA Hist. Soc. Q.*, xxxvi (Sept 1957), pp. 193–203

Samuel Marsden Brookes (1816–1892) (exh. cat. with essay by J. A. Baird jr, San Francisco, CA, Hist. Soc., and Oakland, CA, Mus., 1962–3)

W. H. Gerdts: *Art across America: Two Centuries of Regional Painting, 1720–1920*, iii (New York, 1990)

Beautiful Harvest: Nineteenth-century California Still-life Painting (exh. cat. by J. T. Dreisbach, Sacramento, Crocker A. Mus., 1991)

K. Starr: *The Visual Arts in Bohemia: 125 Years of Artistic Creativity in the Bohemian Club* (San Francisco, 1997)

PAUL J. KARLSTROM

Brooks, Romaine (*b* Rome, 1 May 1874; *d* Nice, 7 Dec 1970). American painter and draughtswoman. She grew up in various European and American cities, including Paris, Rome, Geneva and New York, living in a disturbing family atmosphere. When she was seven, her mother abandoned her in New York, and her Irish laundress, Mrs Hickey, took her into her home, where they lived in severe poverty until Brooks's grandfather's secretary collected her. Brooks was allowed and encouraged to draw by Mrs Hickey. In 1896–7 Brooks went to Rome, studying at the Scuola Nazionale by day and the Circolo Artistico by night. The only woman at the Scuola, she was one of the first to be allowed to draw from a nude male model. In summer 1899 she studied at the Académie Colarossi, Paris. A substantial fortune inherited from her grandfather (1902) markedly altered the quality of her life. Brooks moved to London (1902–4), made her earliest mature portrait paintings of young women, and returned to Paris. Her first one-person exhibition was at the Galerie Durand-Ruel (1910), of 13 portraits, including those of noted members of Parisian society. These and later works for which she is renowned have a characteristic boldness that sets the figures apart from their environments. Her drawings are more imaginary, exploring personal and fanciful themes. Brooks's style suggests an interest in Symbolism and Art Nouveau. Interest in Brooks was reawakened by a major exhibition at the National Collection of Fine Arts, Washington, DC, in 1971.

BIBLIOGRAPHY

A. Breeskin: *Romaine Brooks, Thief of Souls* (Washington, DC, 1971)

M. Secresst: *Between me and my Life: A Biography of Romaine Brooks* (London, 1976)

F. Werner: *Romaine Brooks* (Paris, 1990)

A. Serrano de Haro: 'Mujeres malditas pintadas de gris: El arte de Romaine Brooks', *Espacio, tiempo y forma. Serie 7, Hist. A.*, vii (1994), pp. 313–23

C. M. Chastain: 'Romaine Brooks: A New Look at her Drawings', *Woman's A. J.*, xvii (1996–7), pp. 9–14

Broome, Isaac (*b* Valcartier, Qué., 16 May 1836; *d* Trenton, NJ, 4 May 1922). American sculptor, ceramic modeller and teacher of Canadian birth. He received his artistic training at the Pennsylvania Academy of Fine Arts in Philadelphia, where he was elected an Academician in 1860 and taught (1860–63) in the Life and Antique department. In 1854 he assisted Thomas Crawford with the statues on the pediment of the Senate wing of the US Capitol in Washington, DC, and tried unsuccessfully to establish a firm for architectural terracotta and garden ornaments in Pittsburgh and New York.

From 1875 Broome was employed as a modeller by the firm of Ott & Brewer in Trenton, NJ. The parian porcelain

sculpture he created for their display at the Centennial International Exhibition of 1876 in Philadelphia won him medals for ceramic arts (*see* UNITED STATES OF AMERICA, fig. 35). Following his success at the Exhibition and at the Exposition Universelle of 1878 in Paris, for which he was Special Commissioner from the USA, he was active as a teacher and lecturer and was keenly interested in educational, political and industrial reforms. He also continued as a modeller for potters in Ohio and Trenton, including the Trent Tile Co. and the Providential Tile Co., producing major work as late as 1917.

BIBLIOGRAPHY

Who Was Who in America, i (Chicago, 1943)

ELLEN PAUL DENKER

Brown, Benjamin C(hambers) (*b* Marion, AR, 14 July 1865; *d* Pasadena, CA, 19 Jan 1942). American painter, draughtsman and etcher. He studied at the St Louis School of Fine Arts. In 1886 he travelled to California with his parents, who were considering moving to Pasadena. While in California, he made numerous pencil sketches of landmarks. He returned to St Louis, where he continued his studies and then opened his own art school in Little Rock, AR, while specializing in portrait painting. In 1890 he went to Europe with his friends and fellow artists William A. Griffith (1866–1940) and Edmund H. Wuerpel (1866–1958). In Paris, Brown studied at the Académie Julian for one year. After returning to the USA, he moved to Pasadena in 1896. He continued to do portraiture but, finding few patrons for his works, began also to paint the landscape (see fig.). He was also an etcher and, along with his brother, Howell Brown (1880–1954), founded the Print Makers Society of California. A prolific and well-respected artist, Benjamin Brown received numerous awards, including a bronze medal at the Portland World's Fair in 1905, a silver medal at the Seattle World's Fair in 1909 and a bronze medal for etching from the Panama—Pacific International Exposition in San Francisco in 1915.

BIBLIOGRAPHY

Impressionism: The California View (exh. cat., Oakland, CA, Mus; Laguna Beach, CA, Mus. A., Sacramento, CA, Crocker A. Mus.; 1981)

R. L. Westphal: *Plein-air Painters of California: The Southland* (Irvine, CA, 1982)

JEAN STERN

Brown, George Loring (*b* Boston, MA, 2 Feb 1814; *d* Malden, MA, 25 June 1889). American painter and illustrator. He was apprenticed at about 14 to the Boston wood-engraver Alonzo Hartwell and had produced scores of illustrations by 1832, when he turned to painting and sailed to Europe for further training. After brief stays in Antwerp and London, he settled in Paris, where he was admitted to the atelier of Eugène Isabey (1803–86). Returning to America in 1834, Brown produced illustrations, portraits and landscapes. He travelled throughout the north-eastern USA, sketching in watercolour and in oil. His work was admired by Washington Allston, who assisted him in a second visit to Europe.

Brown and his wife settled in Florence from 1841 to 1846. At first he painted copies from Old Masters for

Benjamin C. Brown: *Joyous Garden*, oil on canvas, 762×1016 mm (Irvine, CA, Irvine Museum)

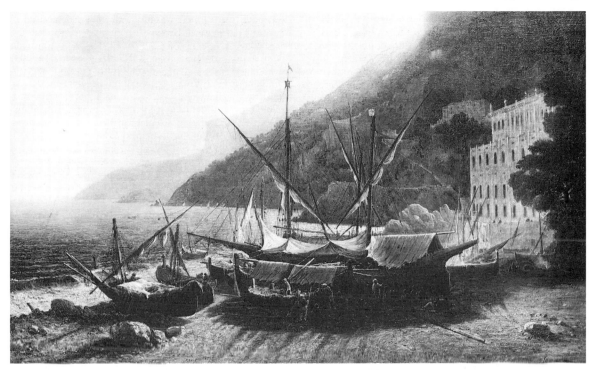

George Loring Brown: *View of Amalfi*, oil on canvas, 845×1365 mm, 1857 (New York, Metropolitan Museum of Art)

American and British tourists, but gradually, as his technique and composition improved, he began to create original Italian landscapes with strong chiaroscuro and impasto. He became closely involved with American expatriates and many artists and writers. He moved to Rome in 1847 and for the next 12 years produced colourful and attractive landscapes such as a *View of Amalfi* (1857; New York, Met.; see fig.).

When American tourism waned during the financial crisis in 1859, Brown returned home. His bold, colourful style shocked American eyes, but he determined to 'fight with my brush' to revitalize American art. At first he succeeded, selling Italian and American scenes, such as a *View of Norwalk Islands* (1864; Andover, MA, Phillips Acad., Addison Gal.), for high prices, but the Civil War intervened and tastes altered to embrace Ruskinian idealism and the Barbizon school. Brown's popularity gradually declined.

BIBLIOGRAPHY

H. T. Tuckerman: *Artist-life, or Sketches of American Painters* (New York, 1847), pp. 229–31

George Loring Brown: Landscapes of Europe and America, 1834–1880 (exh. cat. by W. C. Lipke, Burlington, U. VT, Robert Hull Fleming Mus., 1973)

T. W. Leavitt: 'Let the Dogs Bark: George Loring Brown and the Critics', *Amer. A. Rev.*, i/2 (1974), pp. 87–99

THOMAS W. LEAVITT

Brown, John George (*b* Durham, England, 11 Nov 1831; *d* New York, 8 Feb 1913). American painter. A popular painter of rural and urban genre scenes, he spent his youth in England, where he served an apprenticeship as a glasscutter. By 1853 he was employed in Brooklyn, NY. After serious study he became, in 1860, a fully fledged member of the New York artistic community, with a studio in the Tenth Street Studio Building and participating regularly in National Academy of Design exhibitions.

Brown's first genre scenes focused on rural children out of doors. Often sentimental, these exhibited a clarity of light and drawing attributable to his early interest in the

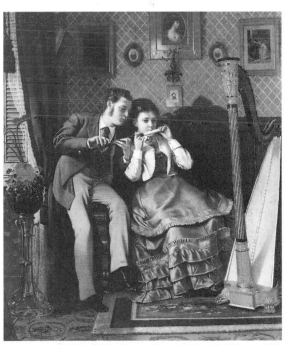

John George Brown: *Music Lesson*, oil on canvas, 610×508 mm, 1870 (New York, Metropolitan Museum of Art)

Pre-Raphaelite painters. The *Music Lesson* (1870; New York, Met.; see fig.), a courtship scene set in a Victorian parlour, reveals his debt to English painting. In 1879 Brown painted the *Longshoreman's Noon* (Washington, DC, Corcoran Gal. A.), an affectionate but sober rendering of the variety of ages and physical types in the urban working class. About 1880 he found a new type for his genre scenes in the urban street-boys in such occupations as newsboy, bootblack and fruit vendor. *Tuckered out—the Shoeshine Boy* (*c.* 1890; Boston, MA, Mus. F. A.) is characteristic; the boy is scrubbed, his clothes patched and ragged but clean, and he appeals to the viewer's sympathy. The motif, which perhaps served as a palliative to the urban poverty and numbers of abandoned children on the streets, was enormously popular, and Brown had many patrons.

BIBLIOGRAPHY

John George Brown, 1831–1913: A Reappraisal (exh. cat., Burlington, U. VT, Robert Hull Fleming Mus., 1976)

N. Spassky, ed.: *American Paintings in the Metropolitan Museum of Art*, ii (Princeton, 1985)

Country Paths and City Sidewalks: The Art of J. G. Brown (exh. cat., Springfield, MA, Smith A. Mus., 1989)

K. S. Placidi: 'Beyond Bootblacks: The Boat Builder and the Art of John George Brown', *Bull. Cleveland Mus. A.*, lxxvii (1990), pp. 366–82

M. J. Hoppin: 'The "Little White Slaves" of New York: Paintings of Child Street Musicians by J. G. Brown', *Amer. A. J.*, xxvi/1/2 (1994), pp. 4–43

ELIZABETH JOHNS

Brown, Joseph (*b* Providence, RI, 3 Dec 1733; *d* Providence, 3 Dec 1785). American architect. He was from one of the leading families of Providence. Primarily a mathematician and astronomer, he became Professor of Experimental Philosophy at Rhode Island College (now Brown University). In 1770 he served, with Robert Smith, on the building committee for the College Edifice (now University Hall), which is modelled on Nassau Hall at Princeton University, NJ (architects Robert Smith and William Shippen, 1754).

Brown was an amateur architect who never developed a personal style. The Providence Market House, built to his design in 1772–7, was of a plainness that makes all the more surprising the Baroque swagger of the curved pediment crowning the façade of his own house in South Main Street, Providence (1774). The design of his biggest building, the First Baptist Meeting House (1774–5), Providence, was assembled from plates in James Gibbs's *Book of Architecture* (1728); its beautiful spire is from one of the alternative designs for the spire of St Martin-in-the-Fields, London, while the underscaled portico comes from the Oxford Chapel (now St Peter's) in Vere Street, London. The substantial house of his brother John in Power Street, Providence, begun in 1786 after Brown's death but nonetheless attributed to him, is in a mid-18th-century style, updated with a projecting porch with columns.

BIBLIOGRAPHY

Macmillan Enc. Archit.

A. F. Downing: *Early Homes of Rhode Island* (Richmond, VA, 1937)

H. R. Hitchcock: *Rhode Island Architecture* (Providence, 1939/*R* New York, 1968)

J. H. Cady: *The Civic and Architectural Development of Providence, 1636–1950* (Providence, 1957)

MARCUS WHIFFEN

Brown, Mather (*b* Boston, 7 Oct 1761; *d* London, 25 May 1831). American painter, active in England. He was descended from four generations of New England religious leaders; John Singleton Copley painted portraits of his mother (New Haven, CT, Yale U., A.G.) and his maternal grandfather (Worcester, MA, Amer. Antiqua. Soc.; Halifax, NS, U. King's Coll.). John Trumbull was his friend and Gilbert Stuart 'learnt me to draw' at age 12. At 16 Brown walked 640 km to Peekskill, NY, and back, selling wine and painting miniature portraits; from these pursuits he earnt enough to pay for three years of study in Europe. In London, on Benjamin Franklin's recommendation, Benjamin West accepted him as a free student. Brown was admitted as a student to the Royal Academy in January 1782 and exhibited four paintings the following year. He showed 80 paintings there in all. In 1785–6 he painted much admired portraits of *Thomas Jefferson* (Charles Francis Adams priv. col., see Meschutt, p. 48) and *John Adams* (untraced; second version, 1788; Boston, MA, Athenaeum) and several of his family. He painted two full-length portraits in 1788 of *Frederick Augustus, Duke of York* (Waddesdon Manor, Bucks, NT; see fig.) and the *Prince of Wales*, later George IV (London, Buckingham Pal., Royal Col.), and in the same year he was appointed historical and portrait painter to the Duke of York.

Brown's portrait style was influenced by that of Gilbert Stuart, under whom he worked in West's studio, with the

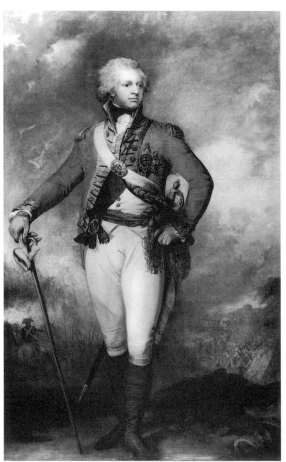

Mather Brown: *Frederick Augustus, Duke of York*, oil on canvas, 2.17×1.31 m, 1788 (Waddesdon Manor, Bucks, National Trust)

result that his unsigned portraits have often been confused with those of Stuart. Evans, however, revealed an impressive body of portraiture in which Brown relied on superior drawing and developed his own freer techniques of high colouring and longer, sweeping brushstrokes. Despite his phenomenal early success, Brown fell on hard times. He was disinherited by his father, and an obsession drove him to concentrate on large unsaleable religious and historical subjects. Typical of these works are *Richard II Resigning his Crown to Bolingbroke* (London, BM), the *Baptism of Henry VIII* (1.83×2.70 m; Bristol, Mus. & A.G.), *Lord Cornwallis Receiving as Hostages the Sons of Tippo Sahib* (2.75×2.14 m; London, Stratford House [Oriental Club]) and *Lord Howe on the Deck of the 'Queen Charlotte'* (London, N. Mar. Mus.). In 1809 Brown left London to live and work in Bath, Bristol and Lancashire. He returned to London in 1824 and died there in poverty, in a room crowded with unsold paintings.

BIBLIOGRAPHY

W. Dunlap: *A History of the Rise and Progress of the Arts of Design in the United States* (New York, 1834/*R* 1969), i, pp. 228–9
F. A. Coburn: 'Mather Brown', *A. Amer.*, xi (1923), pp. 252–60
W. T. Whitley: *Artists and their Friends in England, 1700–1799* (London, 1928), ii, pp. 97–100
D. Evans: 'Twenty-six Drawings Attributed to Mather Brown', *Burl. Mag.*, cxiv (1972), pp. 534–41
——: *Benjamin West and his American Students* (Washington, DC, 1980) : *Mather Brown: Early American Artist in England* (Middletown, CT, 1982); review by R. H. Saunders in *Winterthur Port.*, xix (Winter 1994), pp. 304–6; B. Allen in *Burl. Mag.*, cxxvi (1984), p. 366
D. Meschutt: 'The Adams–Jefferson Portrait Exchange', *Amer. A. J.*, xiv/2 (1982), pp. 47–54

ROBERT C. ALBERTS

Brumidi, Constantino [Costantino] (*b* Rome, 26 July 1805; *d* Washington, DC, 19 Feb 1880). American painter of Italian birth. His father, Stauros Brumidi, was Greek and owned a coffee shop in Rome; his mother, Anna Bianchini, was Italian. Brumidi studied for 14 years, beginning at age 13, at the Accademia di S Luca under sculptors Berthel Thorvaldsen (1768/70–1844) and Antonio Canova (1757–1822) and painters Vincenzo Camuccini (1771–1844) and Filippo Agricola (1776–1857). He was trained in the techniques of true fresco, tempera and oil, and gained a mastery of the human figure and the convincing depiction of three-dimensional forms. He was supervised by his painting teachers in carrying out his first important commissions, decorating the palace of Prince Alessandro Torlonia (beginning in 1838) and restoring with Domenico Tojetti (1840–42) the eleventh bay of the third Loggia of the Vatican Palace. From 1842 to 1844 he created paintings for the Gothic-style family chapel of the Palazzo Torlonia. At the Villa Torlonia, Brumidi is thought to have been in charge of the decoration of the new theatre, where he signed and dated the frescoes in 1844 and 1845.

Although Brumidi was favoured by Pope Pius IX, whose portrait he painted, he became involved in the 1848–50 republican revolution in his role as captain of the civic guard. After the Pope was restored to power, Brumidi was commissioned to decorate the small chapel of the Madonna dell'Archetto. Shortly after he completed the work in early 1851, he was arrested and imprisoned for his part in the revolution. Despite his pleas of innocence and many testimonials written in his support, he was found guilty and sentenced to 18 years in prison. However, after 13 months in prison, he was released on the condition that he leave the country for America. He arrived in New York in September 1852 and immediately applied for citizenship, which he received in 1857.

Brumidi's connections with clergy who had been in Rome led to a number of important commissions over the following years to decorate churches in the New World, including an altarpiece (1854) for the cathedral in Mexico City, extensive murals (1855 and 1871–2) in St Stephen's Church in New York, murals (1856) for St Ignatius Church in Baltimore, the altarpiece (1859) for the church of St Aloysius in Washington, DC, frescoes (dedicated 1864) in the cathedral of SS Peter and Paul in Philadelphia and work (1867) in Havana, Cuba. He also decorated private homes, such as that of Thomas U. Walter in Germantown, PA, painted in 1863 (destr.).

Brumidi, who called himself 'the artist of the Capitol', is known primarily for his murals in the US Capitol, painted over a 25-year period. His work as the Capitol began with his introduction to Captain Montgomery C. Meigs in late 1854. Meigs, who was in charge of the construction and decoration of the new Capitol extensions and dome, agreed to allow Brumidi to paint a sample fresco in his office (now room H-144) in the Capitol, which was to be assigned to the House Agriculture Committee. After it was well received, Brumidi was hired to complete the decoration of the entire room in fresco, and in 1856 he was asked to make designs for other important new rooms. He worked with a team of artists of varied national origins to carry out his designs, although all the difficult true fresco was his work alone. His contributions to the Capitol included designs for the Hall of the House of Representatives, the Senate Library (S-211), the Senate Military Affairs Committee (S-128) and the office of the Senate Sergeant at Arms (S-212). His first room (H-144) and others such as the President's Room (S-216), were strongly influenced by Raphael (1483–1520). The room for the Senate Committee on Naval Affairs (S-127) and the Senate first floor corridors were inspired by the murals of ancient Pompeii and Rome. One of the most lavishly decorated spaces in the Capitol is the Senate Reception Room (S-213), where Brumidi's murals are surrounded with gilded plaster relief. His murals combined Classical and allegorical subjects with portraits and scenes from American history and tributes to American inventions.

Brumidi worked intensively at the Capitol through the early 1860s. He continued with some of the rooms in the 1870s, although a number of them remained incomplete. His major contributions are the monumental canopy and frieze of the new Capitol dome. The canopy over the Rotunda holds the *Apotheosis of George Washington* which he painted in fresco in 1865 (*see* WASHINGTON, fig. 5). Brumidi began painting the frieze in 1878, but died with it less than half finished. His designs were carried out by Filippo Costaggini (*d* 1904) between 1881 and 1889, but the entire frieze was not completed until 1953.

In addition to being respected for his painterly abilities, Brumidi was well liked as a person and known for his love of literature. He enjoyed music and pursued at least some

of his own historical research for his murals. He seems to have worked well with others, and all evidence shows that he was a convivial and generous friend as well as a dedicated artist. He had two children from his two marriages in Rome and an American son, the painter Laurence S. Brumidi.

UNPUBLISHED SOURCES

Washington, DC, Lib. Congress, MS. Div. [journals of Montgomery C. Meigs, transcribed by W. Mohr for the US Senate Bicentennial Commission]
Washington, DC, N. Archvs [correspondence and official transactions]
Washington, DC, Records of the Architect of the Capitol [correspondence and official transactions]

BIBLIOGRAPHY

S. D. Wyeth: *The Federal City* (Washington, DC, 1865)
Obituary, *Washington Post* (20 Feb 1880)
C. Fairman: *Art and Artists of the Capitol of the United States of America* (Washington, DC, 1927)
M. Cheney Murdock: *Constantino Brumidi: Michelangelo of the United States Capitol* (Washington, DC, 1950)
B. A. Wolanin: 'Constantino Brumidi's Frescoes in the United States Capitol', *The Italian Presence in American Art, 1760–1860*, I. B. Jaffe, ed. (New York and Rome, 1989), pp. 150–64
A. Campitelli and B. Steindl: 'Constantino Brumidi da Roma a Washington: Vicende e opere di un artista romano', *Ric. Stor. A.*, xlvi (1992), 49–59
F. V. O'Connor: 'The Murals by Constantino Brumidi for the United States Capitol Rotunda, 1860–80: An Iconographic Interpretation', *Italian Presence in American Art, 1860–1920*: New York, 1992, pp. 81–96
B. A. Wolanin: *Constantino Brumidi: Artist of the Capitol* (Washington, DC, 1998)

BARBARA ANN BOESE WOLANIN

Brunt, Henry van. *See* VAN BRUNT, HENRY.

Brush, George de Forest (*b* Shelbyville, TN, 28 Sept 1855; *d* Hanover, NH, 24 April 1941). American painter.

He began his formal training at the National Academy of Design in New York and in 1873 entered the atelier of Jean-Léon Gérôme (1824–1904) in Paris, studying there and at the Ecole des Beaux-Arts for almost six years. Soon after his return to the USA in 1880, he was elected to the Society of American Artists. Thereafter he spent much time on both sides of the Atlantic, beginning in the American West and including lengthy stays in Paris, Florence, New York and Dublin, NH, where he purchased a farm in 1901.

Brush first attained prominence as a painter of Indian life, which he observed while living in Wyoming and Montana in 1881. His pictures (completed in the studio but frequently based on studies done *in situ*) focus on everyday life and domestic tribal customs, with strict attention paid to documentary detail, a trait adopted from Gérôme and exemplified in the *Moose Chase* (1888; Washington, DC, N. Mus. Amer. A.; see fig.). In the 1890s Brush painted his first family group, the theme for which he is best known. Invariably his own wife and children posed for these works, for example *Mother and Child* (1894; New York, Met.). Brush imbued this and similar works with a feeling of holiness without the use of Christian iconography.

WRITINGS
'An Artist among the Indians', *C. Illus. Mag.*, xxx (May 1885), pp. 54–7

BIBLIOGRAPHY
N. D. Bowditch: *George de Forest Brush: Recollections of a Joyous Painter* (Peterborough, NH, 1970) [by the artist's daughter]
J. B. Morgan: *George de Forest Brush: Painter of the American Renaissance* (New York, 1985)

ROSS C. ANDERSON

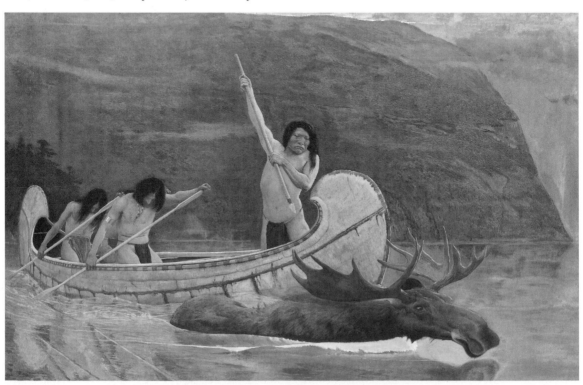

George de Forest Brush: *Moose Chase*, oil on canvas, 956×1457 mm, 1888 (Washington, DC, National Museum of American Art)

Bryant, Gridley J(ames) F(ox) (*b* Boston, MA, 29 Aug 1816; *d* Boston, 8 June 1899). American architect. He was the son of the engineer and railway pioneer Gridley Bryant. He trained in the Boston office of Alexander Parris and Loammi Baldwin in the 1830s and was practising on his own by the autumn of 1837. In the 1840s he designed railway stations and commercial buildings, for example the Long Wharf Bonded Warehouse (1846; destr.) in Boston. During the next decade he also designed schools and court-houses and was involved in no fewer than 30 asylum projects following the design of his influential Charles Street Jail (1848–51), Boston, in conjunction with the prison reformer, the Rev. Louis Dwight. This adaptation of the Auburn System of prison discipline to a cruciform plan became the first executed American project to be published in the British architectural periodical *The Builder* (vii/326, 1849). When the great fire of 1872 devastated Boston's central business district, destroying 152 buildings designed by Bryant, he received commissions to rebuild 111 of them. He was also responsible for 19 state capitol and city hall projects, 95 court-houses, asylums and schools, 16 custom-houses and post offices and eight churches. He worked extensively with ARTHUR DELAVAN GILMAN, who seems to have been responsible for design, while Bryant supervised the construction of such projects as the former Boston City Hall (1862–5), School Street.

Primarily remembered as a great commercial architect and a leading figure in the latter stages of the Boston 'granite school', Bryant was also an innovator in an emerging profession. He was one of the first American practitioners to use labour-saving standardized plans, to specialize in particular building types, to develop a large office and to introduce new styles. In the middle decades of the 19th century he presided over a practice that was regional if not quite national in scope.

BIBLIOGRAPHY

Macmillan Enc. Archit.

H. T. Bailey: 'An Architect of the Old School', *New England Mag.*, xxv (1901), pp. 326–48

W. H. Kilham: *Boston after Bulfinch* (Cambridge, MA, 1946)

B. Bunting: *Houses of Boston's Back Bay* (Cambridge, MA, 1967)

H. R. Hitchcock and W. Seale: *Temples of Democracy: The State Capitols of the USA* (New York, 1976)

R. B. MacKay: *The Charles Street Jail: Hegemony of a Design* (diss., U. Boston, MA, 1980)

ROBERT B. MacKAY

Buckland, William (*b* Oxford, 14 Aug 1734; *d* Annapolis, MD, between 16 Nov and 19 Dec 1774). American architect. In 1748 he was apprenticed to his uncle James Buckland, a London joiner; in 1755, after completing his articles, he became an indentured servant to Thomson Mason, who had been studying law in London and had been asked by his brother George Mason (author of the Virginia Bill of Rights) to find a joiner to finish his house in Virginia. Buckland bound himself to serve 'Thomson Mason, his Executors or Assigns in the Plantation of Virginia beyond the Seas, for the Space of Four Years', and thus came to be responsible for all the woodwork, indoors and out, of Gunston Hall (1755–60), Fairfax County, VA. Gunston Hall served as a showpiece for Buckland. The two porches, one an adaptation of the Palladian motif and the other a half-octagon combining a Doric pilaster order with ogee arches, were the first of their kind in Colonial America, as was the chinoiserie decoration in the dining room. In designing it, he drew on several books from his own library: *The British Architect* (1745, 1750, 1758) and *A Collection of Designs in Architecture* (1757) by Abraham Swan (*fl* 1745–68), *The Gentleman and Cabinet-maker's Director* (1754) by Thomas Chippendale (1718–79) and *The Builder's Companion* (1758) by William Pain.

When Gunston had been completed, Buckland moved to Richmond County, VA, where in 1765 he bought a farm. He moved to Annapolis, MD, in 1771. Buckland's most important work in his Richmond County period was the interior woodwork of Mount Airy (begun 1758, largely destr. 1844), where he was working in 1762. Although documentary evidence is scarce, and it is difficult to be precise about his contribution to the architecture of the period, Buckland is known to have built the county prison and the Lunenburg Parish glebe house. Work in various houses in northern Virginia, including Nanzatico (1767–9), King George County, Menokin (1769–71), Richmond County, and Blandfield (?1769–?72), Essex County, and in Maryland (e.g. Whitehall (begun 1764), Anne Arundel County) has been attributed to him. He was undoubtedly responsible for much of the interior woodwork for the Chase–Lloyd House (1771), Annapolis. The interior has a stately staircase, rising to a half-landing and dividing into two flights with their serpentine underside visible. The dining room has much elaborate carving, mahogany doors with silver handles and panelled window shutters carved with octagonal medallions and rosettes. Buckland was also architect of the Hammond–Harwood House (1773–4), Annapolis, a five-bay house flanked by pavilions with octagonal bays. Although the detail derives from James Gibbs (1682–1754) and Swan, the house is an outstanding example of Colonial domestic architecture. The interior woodwork is intricately carved, notably in the dining room and ballroom above, with beads, acanthus leaves and scrolls.

At his death, Buckland is recorded as leaving a substantial estate, including 15 books on architecture and closely related subjects.

BIBLIOGRAPHY

Macmillan Enc. Archit.

S. F. Limball: 'Gunston Hall', *J. Soc. Archit. Hist.*, xiii (1954), pp. 3–8

R. R. Beirne and J. H. Scarff: *William Buckland, 1734–74: Architect of Virginia and Maryland* (Baltimore, 1958)

W. H. Pierson jr: 'The Hammond–Harwood House: A Colonial Masterpiece', *Antiques*, cxi (1977), pp. 186–93

G. B. Tatum: 'Great Houses from the Golden Age of Annapolis', *Antiques*, cxi (1977), pp. 174–85

C. Lounsbury: 'An Elegant and Commodious Building: William Buckland and the Design of the Prince William County Courthouse, Dumfries, VA', *J. Soc. Archit. Hist.*, xlvi (1987), 228–40

L. Beckerdite: 'Architect-designed Furniture in Eighteenth-century Virginia: The Work of William Buckland and William Bernard Sears', *Amer. Furniture* (1994), pp. 28–42

MARCUS WHIFFEN

Bucklin, James C(hamplin) (*b* Pawtucket, RI, 26 July 1801; *d* Providence, RI, 28 Sept 1890). American architect. His early training in architecture was as apprentice to John Holden Greene. When he was 21 he formed a partnership with William Tallman, a builder and timber merchant, and

they remained associates until the early 1850s. Russell Warren worked with them between 1827 and the early 1830s, as did Thomas Tefft between 1847 and 1851.

Tallman & Bucklin was a prolific firm. It engaged in speculative residential construction and was awarded some choice local commissions between the late 1820s and 1850s. Most of these were Greek Revival, including the Providence Arcade (1828; see colour pl. II, 2), a monumental covered shopping mall; Westminster Street Congregational Church (1829; destr.); Rhode Island Hall, Brown University (1840); the Washington Row (1843–5; destr.); and the Providence High School (1844; destr.), all in Providence. The Tudor-style Butler Hospital (1847), Providence, is probably by Tefft, the architectural prodigy who was working for the firm while a student at Brown University.

After 1851 Bucklin practised alone, but the influence of Tefft remained strong. His Renaissance Revival buildings often imitate Tefft's in both detail and format, as in the Third Howard Building (1859; destr.), Providence, and he adapted Tefft's *Rundbogenstil* brickwork for his mills, such as the Monohasset Mill (1868), Providence. The Thomas Davis House (1869; destr.), Providence, a Gothic Revival villa, recalls some of the designs of Tefft, who left his papers to Bucklin on his death in 1859.

Bucklin's late work demonstrates his desire to keep up to date in his designs. The Néo-Grec Hoppin Homestead Building (1875; destr.) and the high Victorian Gothic Brownell Building (1878; destr.), both in Providence, were conservative interpretations of current styles.

BIBLIOGRAPHY
D.-B. Nelson: *The Greek Revival Architecture of James C. Bucklin* (diss., Newark, U. DE, 1969)
Buildings on Paper: Rhode Island Architectural Drawings, 1825–1945 (exh. cat., ed. W. H. Jordy and C. P. Monkhouse; Providence, RI, Brown U., Bell Gal., 1982)

W. McKENZIE WOODWARD

Buffalo. American city and seat of Erie County in the state of New York. It is situated at the eastern end of Lake Erie, where the lake flows into the Niagara River. Designed as a village for the Holland Land Co. in 1803 by Joseph Ellicott (1760–1826), the settlement grew rapidly after the opening of the Erie Canal in 1825, developing into a major port, rail centre, livestock and grain market and becoming known as the gateway to the Midwest. The city's notable buildings include St Paul's Episcopal Cathedral by Richard Upjohn (spire 1870; church rebuilt after the fire of 1888 by R. W. Gibson (1854–1927); see fig.); the State Hospital (1872–7) by H. H. Richardson; and the Guaranty (1894–6; now Prudential) Building by Dankmar Adler and Louis Sullivan, which is considered to be one of their finest buildings (*see* SULLIVAN, LOUIS, fig. 1). In 1904 Frank Lloyd Wright designed the offices of the Larkin Soap Co. (1903–6; destr. 1950) and the Darwin Martin House (1903–6), an example of his 'Prairie Houses'. Buffalo has two significant art museums. The Albright–Knox Art Gallery (1900–05) was designed by Edward B. Green (1855–1950). The museum is best known for its collection of American and European contemporary art but also contains 18th-century English and 19th-century French and American paintings.

Buffalo, St Paul's Episcopal Cathedral by Richard Upjohn, spire 1870 (rebuilt after the fire of 1888 by R. W. Gibson)

BIBLIOGRAPHY
M. Goldman: *High Hopes: The Rise and Decline of Buffalo, New York* (Albany, 1983)
S. Doubilet: 'In the Empire State', *Prog. Archit.*, xi (1984), pp. 88–94
S. Webster: 'Pattern and Decoration in the Public Eye', *A. America*, lxxv (Feb 1987), pp. 118–25
P. M. Kenny: 'A McKim, Mead and White Stair Hall of 1884', *Antiques*, cxli/2 (1992), pp. 312–19
J. Cigliano and S. B. Landau, eds: *Grand American Avenue, 1850–1920* (Washington, DC, 1994); review by J. E. Draper in *J. Soc. Archit. Hist.*, liv (1995), pp. 478–9
J. Siry: 'Adler and Sullivan's Guaranty Building in Buffalo', *J. Soc. Archit. Hist.*, lv (1996), pp. 6–37

ANN McKEIGHAN LEE

Buffington, LeRoy Sunderland (*b* Cincinnati, OH, 22 Sept 1847; *d* Minneapolis, MN, 6 Feb 1931). American architect. From 1864 to 1871 he was employed by several Cincinnati architectural firms, most notably that of Anderson & Hannaford. Moving to St Paul, MN, in 1871, Buffington first served as the local superintendent of construction for the new US Customs House. In 1872 he formed a partnership with A. H. Radcliffe (1827–86) and two years later established an independent practice in nearby Minneapolis. Within a few years he was known as the best architect in the state and certainly one of the busiest; he produced dozens of residential, commercial, civic and church designs.

Buffington's Queen Anne Revival style designs included the Boston Block (1880–84; destr.), the Pillsbury 'A' Mill (1880–83), the West Hotel (1881–4; destr.), the Tribune Building (1883–4; destr.), the Mechanic Arts Building (1885–6; now Eddy Hall) at the University of Minnesota,

all in Minneapolis, and the North Dakota State Capitol (begun 1880; destr.) in Bismarck. Subsequent designs in the Romanesque Revival style of H. H. Richardson, such as those for Pillsbury Hall (1886–9) at the University of Minnesota, the Charles Pillsbury residence (1887), the Samuel Gale residence (1888), all in Minneapolis, and the Tainter Memorial (1889) in Menomonie, WI, propelled the Buffington office to national fame because of their publication in *American Architect and Building News* and *Inland Architect*. These designs and many other unrealized ones also in the style of Richardson were all done by office employees, most notably Francis W. Fitzpatrick (1864–1931), Harvey Ellis and Edgar Eugene Joralemon (1858–1934).

Buffington claimed that he had invented skyscraper construction, that is a skeletal metal framing system for tall buildings, between the winters of 1880–81 and 1883–4. On 22 May 1888 the US Patent Office granted him patent no. 383170 for his 'cloudscraper', as he called it, although it used an iron construction that was essentially standard. In 1892 he founded the Buffington Iron Building Company to license use of his system. When his practice declined after 1893, Buffington began to gain notoriety because of his repeated legal attempts, unsuccessful except in the instance of the Foshay Tower (1926–9), Minneapolis, by Magney & Tussler, to collect royalties from other architects who were designing tall buildings.

UNPUBLISHED SOURCES

Minneapolis, U. MN, *Memories* [1931, ed. M. B. Christison as MA thesis, 1941]

Minneapolis, U. MN Libs, NW Archit. Archvs [drawings and memorabilia]

BIBLIOGRAPHY

'Buffington, Leroy Sunderland', *The National Cyclopedia of American Biography*, xxii (New York, 1932), p. 364

E. M. Upjohn: 'Buffington and the Skyscraper', *A. Bull.*, xx (1935), pp. 48–70

M. B. Christison: 'How Buffington Staked his Claim', *A. Bull.*, xxvi (1944), pp. 267–76

D. Tselos: 'The Enigma of Buffington's Skyscraper', *A. Bull.*, xxvi (1944), pp. 3–12

E. Manning: *The Architectural Designs of Harvey Ellis* (diss., U. MN, 1953), pp. 19–44

EILEEN MICHELS

Building services. *See under* SKYSCRAPER, §1.

Bulfinch, Charles (*b* Boston, MA, 8 August 1763; *d* Boston, 15 April 1844). American architect. He was a leading architect of the Federal period in America, but had no formal architectural training.

1. BEFORE 1795. Born to an aristocratic Boston family, Bulfinch graduated from Harvard College in 1781. In 1785 he embarked on a two-year tour of Italy, France and England, during which he developed a special enthusiasm for the Neo-classical style of Robert Adam (1728–92). On his return, he married a wealthy cousin and, by his own account, spent the following eight years 'pursuing no business but giving gratuitous advice in architecture'. Bulfinch designed approximately 15 buildings during this early period, including three churches, a theatre, a state house for Connecticut, seven detached houses and a group of row houses. The style derives clearly from Adam, but it is noticeably shallow and linear, owing perhaps to the

American use of wood and brick rather than stone, and to Bulfinch's probable reliance on sketches and engravings of the English models. It is also likely that, at this stage of his career, Bulfinch did not supervise his buildings but merely provided elevations and floor plans to builders who constructed them. Notable among his early works are two churches for Pittsfield and Taunton, MA (both begun in 1790), in which Bulfinch placed a belfry at the join of the principal roof of the building and the lower gable of the entrance porch so as to interlock the three principal masses, an innovation that became a popular standard for New England churches for many decades.

In 1793 Bulfinch designed the Tontine Crescent, a sweeping arc of connected town houses (destr.), which derived its general configuration from the Royal Crescent (1767–*c.* 1775) at Bath by John Wood II (1728–81) and its detailing from the Adelphi Terrace (1768–72) in London by Robert Adam. The failure of this venture, which was Bulfinch's first attempt at large-scale improvement to the Boston townscape, eradicated his fortune, forced him to declare bankruptcy and concluded his amateur status in architecture.

2. 1795–1816. Bulfinch's commission (1795) for the Massachusetts State House in Boston was second only to the US Capitol as the largest and most complex building in America in the 1790s (*see* BOSTON, fig. 2). The elevation of his seven-bay projecting centre is reworked from the design for the centre of the main range to the river of Somerset House (1776–86), London, by Sir William Chambers (1723–96). It has a tall arched arcade at ground-level, a first-floor colonnade with the outer bay to either side emphasized by coupled columns and a five-bay pedimented attic storey with the dome surmounted by a cupola. The building has a slight awkwardness of proportion, characteristic of Bulfinch's large-scale commissions. Documents indicate that he was paid about $600 over a three-year period as supervising architect of the building, a sum that provided only marginal subsistence for the Bulfinch family. In 1799 Bulfinch was made Chairman of the Board of Selectmen and Superintendent of Police of the Town of Boston, a position similar to that of mayor, which he held for nearly 20 years.

With this assurance and a modicum of economic stability (the position paid $600 per year, later raised to $1000), Bulfinch designed approximately 5 churches, 21 houses and 23 civic and commercial buildings between 1799 and 1817, many in Boston. India Wharf (1803), Faneuil Hall (1906) and Boylston Hall and Market (1809), with inadequate decorative elements on a scale more appropriate to domestic buildings, show again his awkward handling of large buildings. He was most confident with domestic architecture, his refined sense of proportion and restrained use of Neo-classical detail culminating in the three houses designed for Harrison Gray Otis between 1795 and 1805. His third house for Otis (1805), on Beacon Street, has a superbly proportioned symmetrical façade, with cast-iron balconies in a handsome fretwork design; behind the façade lies an unexpectedly varied plan. His New South Church, Boston (1814; destr.), was an elegant Neo-classical restatement of one of James Gibbs's alternative designs for St Martin-in-the-Fields, London. His

finest work, the Church of Christ in rural Lancaster, MA (1816; see fig.), is a red brick building with white wooden Neo-classical detail, but its distinction lies in the daringly over-scaled massing of the portico with its three tall arches divided by pilasters, attic block and tall cupola, which nearly hide the main hall with a powerful design of abstract shapes.

Despite his active involvement in architecture and the financial support given by the town of Boston, Bulfinch's financial situation remained tenuous, and in 1811 he was again forced to declare bankruptcy and spent a brief period in jail.

3. 1817–29. Bulfinch finally achieved full professional status as an architect in 1817, when President James Monroe summoned him to Washington, DC, and appointed him Architect of the US Capitol at an annual salary of $2500. Bulfinch was initially daunted by the prospect of carrying out the work begun by Benjamin Henry Latrobe, whose training and abilities were so clearly superior to his own, but he persevered and brought the building to completion in 1829, contributing the old Library of Congress (destr. 1851), the dome (replaced) and the west front. The Capitol building was Bulfinch's crowning achievement in its scale, but it is not his finest work. Under pressure from members of the President's Cabinet, he raised the central dome considerably higher than he wanted, and the west front, which is on a falling site and a full storey taller than the east front, is marred by fussy detail.

Bulfinch returned to Boston in 1829; he lived there in retirement until his death. His last commission, the State House for Augusta, ME, of 1829, follows the general configuration of the Massachusetts State House of 1795, but the details are thickened in response to the developing Greek Revival.

Charles Bulfinch: Church of Christ, Lancaster, Massachusetts, 1816

BIBLIOGRAPHY

C. A. Cummings: 'Architecture in Boston', *The Memorial History of Boston*, ed. J. Winsor, iv (Boston, 1881), pp. 465–88
A. R. Willard: 'Charles Bulfinch, the Architect', *New England Mag.*, iii (1890), pp. 272–99
S. E. Bulfinch: *The Life and Letters of Charles Bulfinch* (Boston, 1896)
A. S. Roe: 'The Massachusetts State House', *New England Mag.*, xix (1899), pp. 659–77
C. A. Place: *Charles Bulfinch: Architect and Citizen* (Boston, 1925)
W. Kilham: *Boston after Bulfinch* (Cambridge, 1946)
A. L. Cummings: 'Charles Bulfinch and Boston's Vanishing West End', *Old-Time New England*, lii (1961), pp. 31–47
——: 'The Beginnings of India Wharf', *Proceedings of the Bostonian Society: Boston, 1962*, pp. 17–24 [annual meeting]
H. and J. Kirker: *Bulfinch's Boston: 1787–1817* (New York, 1964)
H. Kirker: *The Architecture of Charles Bulfinch* (Cambridge, 1969)
B. Pickens: 'Wyatt's Pantheon, the State House in Boston and a New View of Bulfinch', *J. Soc. Archit. Hist.*, xxix (1970), pp. 124–31
W. Pierson: *American Buildings and their Architects: The Colonial and Neo-classical Styles* (New York, 1970), pp. 240–85
R. Nylander: 'First Harrison Gray Otis House', *Antiques*, cvii (1975), pp. 1130
F. C. Detwiller: 'Thomas Dawes's Church in Brattle Square', *Old-Time New England*, lxix (1979), pp. 1–17
J. F. Quinan: 'Asher Benjamin and Charles Bulfinch: An Examination of Baroque Forms in Federal Style Architecture', *New England Meeting House and Church: 1630–1850* (Boston, 1980), pp. 18–29
J. Frew: 'Bulfinch on Gothic', *J. Soc. Archit. Hist.*, xlv (1986), pp. 161–3
R. Nylander: 'The First Harrison Gray Otis House, Boston, Massachusetts', *Antiques*, cxxix (1986), pp. 618–21
On the Boards: Drawings by Nineteenth-century Boston Architects (exh. cat. by J. F. O'Gorman, Wellesley Coll., MA, Mus., 1989)
L. Koenigsberg: 'Life-writing: First American Biographers of Architects and their Works', *Stud. Hist. A.*, xxxv (1990), pp. 41–58
J. F. O'Gorman: 'Bulfinch on Gothic, Again', *J. Soc. Archit. Hist.*, 1/2 (1991), pp. 192–4
Temple of Liberty: Building the Capitol for a New Nation (exh. cat. by P. Scott, Washington, DC, Lib. Congr., 1995); review by D. Stillman in *J. Soc. Archit. Hist.*, liv (1995), pp. 461–4

JACK QUINAN

Bunker, Dennis Miller (*b* New York, 6 Nov 1861; *d* Boston, MA, 28 Dec 1890). American painter. He was a founder-member of the 'Boston school' of painters and was the first artist to bring the Impressionist style to New England. From *c.* 1878 to 1881 he studied with William Merritt Chase, and from 1881 he studied in Paris with Jean-Léon Gérôme (1824–1904), returning to America in the autumn of 1885 to teach at the Cowles Art School in Boston. Although he held this post for only five years, he influenced many Bostonians (among them Isabella Stewart Gardner, founder of the Gardner Museum in Boston) to be more open to European ideas in art. After spending the summer of 1888 at Calcott, Salop, England, painting *plein-air* landscapes with John Singer Sargent, who was working closely with Claude Monet (1840–1926) at the time, he altered his style, his colours becoming brighter and his brushwork looser. However, he always maintained the careful drawing he had learnt from Gérôme. Bunker's best-known works date from the last year or two of his life, such as *Jessica* (1890; Boston, MA, Mus. F.A.; see fig.) and the *Roadside Cottage: Medfield* (1890; Duxbury, MA, A. Complex Mus.). Bunker, whom Sargent once called the most gifted young American, died at 29 of influenza, just a few years after his first solo exhibition.

BIBLIOGRAPHY

R. H. I. Gammell: *Dennis Miller Bunker* (New York, 1953)
Dennis Miller Bunker (1861–1890) Rediscovered (exh. cat., ed. C. Ferguson; New Britain, CT, Mus. Amer. A., 1978)

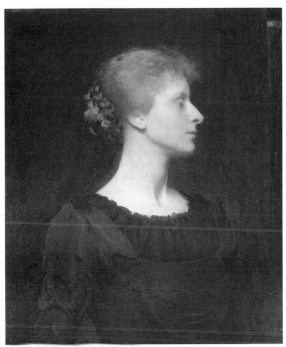

Dennis Miller Bunker: *Jessica*, oil on canvas, 664×610 mm, 1890 (Boston, MA, Boston Museum of Fine Arts)

E. A. Porat: 'Dennis Miller Bunker: A Tribute to an American Impressionist', *Amer. A Rev.*, vii/2 (1995), pp. 104–13, 156–7

Dennis Miller Bunker, American Impressionist (exh. cat. by E. E. Hirshler and D. P. Curry, Boston, MA, Mus. F.A.; Chicago, IL, Terra Mus. Amer. A.; Denver, CO, A. Mus., 1995); review by W. H. Gerdts, *Apollo*, cxli (1995), pp. 61–2

Dennis Miller Bunker and his Circle (exh. cat. by E. E. Hirshler, Boston, MA, Isabella Stewart Gardner Mus., 1995)

MARK W. SULLIVAN

Burnham, Daniel H(udson) (*b* Henderson, NY, 4 Sept 1846; *d* Heidelberg, Germany, 1 June 1912). American architect, urban planner and writer. The most active and successful architect, urban planner and organizer in the years around 1900, Burnham, with his partner JOHN WELLBORN ROOT, created a series of original and distinctive early skyscrapers in Chicago in the 1880s. Burnham's urban plans, particularly those for Washington, DC (1901–2), and Chicago (1906–9), made a crucial contribution to the creation of monumental city centres with a great emphasis on parks.

1. Architectural work, to 1892. 2. Urban plans for the World's Columbian Exposition, 1890–93. 3. Architectural work, 1893 and after. 4. Urban plans, 1901 and after. 5. Critical reception and posthumous reputation.

1. ARCHITECTURAL WORK, TO 1892. In 1854 Burnham's established New England family settled in Chicago. His father, ambitious for his son, sent him for tutoring and to a preparatory school in Waltham, MA (1863). He failed the entrance examinations for both Harvard University, Cambridge, MA, and Yale University, New Haven, CT, before returning in 1867 to Chicago where his father placed him temporarily in the office of the engineer and architect William Le Baron Jenney. After two years of fruitless adventures in the West (1869–70), he worked for other architects in Chicago, and in 1872 he was presented by his father to Peter Bonnett Wight of Carter, Drake & Wight (*fl* 1872–4). There he met Root, who was chief draughtsman, and in 1873 they set up their own firm of Burnham & Root, with Burnham in charge of business and planning and Root of design. Initially they received only house commissions, the first being that in 1874 (destr.) for the businessman and organizer of the Union Stock Yards, John B. Sherman, whose daughter Burnham married in 1876. The firm's domestic commissions for a fashionable clientele were executed in an accurate Ruskinian Gothic Revival style, which Root had learnt from Wight.

From 1880 Burnham & Root emerged as the principal designers of the new ten-storey skyscraper office buildings (*see* SKYSCRAPER, §2), especially with the Montauk Block (1881–2; destr.), Chicago. Here and in some two dozen subsequent structures in the city, the firm perfected 'raft' foundations to support tall buildings on the muddy Chicago soil, iron (and eventually steel) skeletal frames to lighten and expedite their construction, and a frank, unfussy treatment of façades in red brick, terracotta and sandstone to express this new technological creation. The Rookery Building (1885–8; for illustration *see* ROOT, JOHN WELLBORN) was their next prominent work, at the south-east corner of La Salle and Adams Streets, followed by the Rand–McNally Building (1888–90; destr.) with a complete steel frame lightly clad only in terracotta, the Monadnock Building (1889–92) at the south-west corner of Dearborn and Jackson Streets, with a brick exterior ornamented only by the elegant batter of its walls and cavetto cornice, and finally the steel and terracotta Masonic Temple (1890–92; destr.), at 22 storeys then the tallest building in the world.

2. URBAN PLANS FOR THE WORLD'S COLUMBIAN EXPOSITION, 1890–93. In 1890 Burnham & Root were appointed consulting architects to the World's Columbian Exposition, a world fair in commemoration of the discovery of America in 1492. The fair was snatched away from New York by Chicago and held a year late, in 1893, because of construction time. Preliminary plans were worked out in late 1890 by Burnham & Root and the landscape partnership of Frederick Law Olmsted and Henry Sargent Codman (1867–93). In December 1890 it was decided that detailed designs for the pavilions were to be executed by a board of five of the most prestigious architectural firms in the country: Richard Morris Hunt (*see* HUNT, (2)), George Browne Post and McKim, Mead & White, all from New York; Peabody & Stearns of Boston; and Van Brunt & Howe of Kansas City. In the face of local dismay that no Chicago architects were included, an equal number of Chicago practices were added: Adler & Sullivan, Solon S. Beman, Henry Ives Cobb, Jenney & Mundie and Burling & Whitehouse (*fl* 1880s). The board of architects met in Chicago in January 1891 to divide the work. The first five firms and Beman were given the task of designing the pavilions around the monumental Court of Honor, sketched out by Root and Olmsted, and they agreed to adhere to common façade and cornice lines and to adopt a consistent Greco-Roman style, executed in a kind of plaster known as staff. The Chicago firms were mostly assigned structures behind the

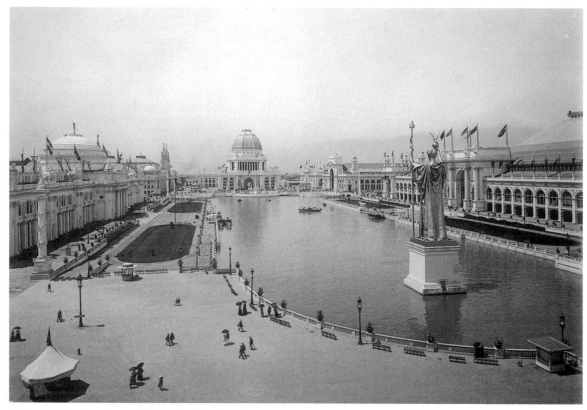

1. Daniel H. Burnham: Court of Honor, World's Columbian Exposition, Chicago, 1891–3 (destr.); from a photograph by C. D. Arnold

Court of Honor, and they produced freer designs, especially Louis Sullivan's Transportation Building and Cobb's Fisheries Building. Root died unexpectedly of pneumonia just after the first meeting of the board of architects, but Burnham carried the project through with legendary assiduousness as Director of Construction, employing CHARLES B. ATWOOD of New York to design structures not envisioned in the initial plans, most notably the celebrated Fine Arts Building. Although Burnham did not design the complex, he was responsible for its execution, deciding such important secondary questions as the painting of the buildings in a uniform ivory white and their illumination at night.

The opening of the Exposition on 1 May 1893 was a triumph for Burnham. The monumental harmony, the classical nostalgia and the white cleanliness of the Court of Honor (see fig. 1) made a tremendous impression on Americans as a vision of what a great orderly city might be.

3. ARCHITECTURAL WORK, 1893 AND AFTER. In the light of all the activity after Root's death, Burnham's day-to-day practice of architecture as the senior partner of one of the largest firms in the country is easily forgotten. He had virtually closed his practice during the erection of the World's Columbian Exposition buildings. When he reopened it in 1893, he organized it around his Exposition staff, with Atwood in charge of design (until 1895) and with a 27% interest in the partnership, and Ernest Graham

controlling the draughting room and Edward Shankland (1854–1924) responsible for engineering, both of them with a 10% interest.

Atwood withdrew in December 1895 and Shankland in January 1900, after which Graham and Burnham split the firm 40:60. In 1900 Peirce Anderson (1870–1924) returned from the Ecole des Beaux-Arts, Paris, to take charge of design and in 1908 he became a partner. In 1910 Burnham's sons Hubert Burnham (1887–1974) and Daniel Hudson Burnham jr (1886–1961) also entered the firm. After Burnham's death in 1912, the firm was reorganized as Graham, Burnham & Co.. (In 1917, when Burnham's sons left the practice, it was to take the name Graham, Anderson, Probst & White.)

It is easy to imagine that Burnham had little impact on the artistic production of the firm, but his contemporaries were vehement in denying this. 'When a man has no time to make large drawings,' wrote Peter Bonnett Wight in *Construction News* on Burnham's death, 'he has to make small ones, and he has to reduce the size of his sheets as the demands upon his time increase. That is what Burnham did. He could lay out the plan for a large office building on sheets six inches square; and he would not only make one plan but would use sheets enough to lay it out according to every arrangement he could conceive of until he found the best one to recommend to his client.'

The production of the firm after 1893 was almost exclusively office buildings and department stores, particularly the large and expensive sort: the Reliance Building

(lower storeys, 1889–91; upper storeys, 1894–5), 32 North State Street, Chicago (for illustration *see* SKYSCRAPER); the Ellicott Square Building (1894), Buffalo, NY; the Frick Building (1901), Pittsburgh, PA; the Flatiron Building (1903), intersection of Broadway and Fifth Avenue, New York; the Railway Exchange (1903) and People's Gas buildings (1910), both Chicago; the department stores Selfridge's (1906), London, and Wanamaker's (1909), Philadelphia. Although widely scattered, these buildings displayed a remarkably consistent vocabulary of a few classical motifs applied over a clearly expressed steel skeleton, small variations in the costliness of materials and extensiveness of ornament responding to the budget and pretences of particular cases. The designs of Burnham & Co. were considered practical and fashionable, the 'latest thing' from Chicago. The firm's few monumental commissions included the Union Station (1907; see fig. 2) in Washington, DC, of which Peirce Anderson was in charge. It is a remarkably spacious and successful composition of characteristic volumes without, however, any individuality or 'punch' in its details.

4. URBAN PLANS, 1901 AND AFTER. The World's Columbian Exposition ultimately inspired a movement that supported monumental municipal planning in New York, Philadelphia and elsewhere. Burnham and his new friend McKim were honoured and consulted, and Burnham was awarded honorary degrees from Yale, Harvard and Northwestern universities. In 1901–2 Senator James McMillan, chairman of the congressional committee administering the national capital, the District of Columbia, commissioned a new plan for the city, based on the 18th-century Baroque scheme of Pierre-Charles L'Enfant (*see* WASHINGTON, DC, §I). Burnham, McKim and Frederick Law Olmsted jr (1870–1957) were appointed to a three-man planning commission and, in collaboration with government authorities, they worked out a scheme of low

Greco–Roman masses set in broad parks along L'Enfant's monumental axes, which was followed in the rebuilding of Washington during the next half century. In 1902–3 Burnham headed a commission to advise on the rebuilding of the centre of Cleveland, a project promoted by the mayor Tom Johnson who supported municipal reform. In 1905 Burnham produced an elaborate plan for San Francisco; the plan was not, however, adopted when the city was rebuilt after the earthquake of 1906, though small fragments of it appeared, as in a portion of Telegraph Hill. In 1904–5 the US government dispatched him to the newly pacified Philippines to redesign Manila and to lay out a summer capital at Baguio. Finally, and most importantly, between 1906 and 1909 Burnham, together with Edward H. Bennett (1874–1954), oversaw a plan for the rebuilding and expansion of Chicago, which they published as *Plan of Chicago* (1909), a magnificent volume with architectural designs by the Frenchman Fernand Janin (1880–1912) and renderings by the American Jules Guérin (1866–1946). The Chicago plan was Burnham's last as well as his greatest work. It provided for streets laid out on a grid with radial and concentric boulevards, monumental civic buildings and efficient transport systems, a greater number of parks and a lakefront park system stretching 20 miles along Lake Michigan. The drawings were displayed around the world, with Burnham himself presenting them at the Town Planning Conference held in London in 1910.

Burnham consolidated his increasing reputation as a planner with a number of professional posts, some of which were created for him. In 1884 he was a founder and officer of the Western Association of Architects. After it amalgamated with the American Institute of Architects (1889), he served as the AIA's President in 1894 and 1895, pushing for application of the Tarsney Act of 1893, which provided for the competitive award of public commissions. In 1894 Burnham and McKim were the prime movers in

2. Burnham & Co.: Union Station, Washington, DC, 1907

the founding of the American School of Architecture in Rome (later the American Academy). In 1910 he was appointed Chairman of the National Council of Fine Arts to oversee all public building and art in Washington, DC.

5. CRITICAL RECEPTION AND POSTHUMOUS REPUTATION. Burnham's critical reputation, both as an architect and as a planner, has fluctuated over time. His contemporaries depicted him as a brilliant planner who conceived initial layouts of buildings in consultation with the clients, and as an omnipresent and incisive critic who controlled his battalion of draughtsmen with great effectiveness. He is often remembered for the words his associate Willis Jefferson Polk attributed to him: 'Make no little plans, they have no magic to stir men's blood Make big plans … remembering that a noble, logical diagram once recorded will never die but long after we are gone will be a living thing asserting itself with ever growing intensity.' His older professional contemporary Wight summarized his accomplishment more succinctly: 'For the practice of the profession of architecture, he did this: he made [his profession] known and respected by millions who had never heard of an architect in all their lives.'

Burnham was tremendously admired at the time of his death, although as a planner rather than as an artist. His initial schemes for Washington and Chicago determined urban development in both cities until the 1950s: the Mall and Federal Triangle projects in Washington and the Lakefront parks and Chicago River quays and bridges in Chicago. In the 1920s advocates of the European International Style praised Burnham's reticent skyscrapers, especially the Reliance Building, while decrying the formality of his urban plans. Today the harmony and expressiveness of his great schemes—the Court of Honor, the Washington Mall, Grant Park in Chicago—have come to seem preferable to the starkness and individuality of postwar Modernism. Yet as early as 1924 concern was expressed by Louis Sullivan in his *Autobiography of an Idea* and later by Thomas Hines in his *Burnham of Chicago* (1974) that Burnham sought a least common denominator and that, for all the efficiency of his execution, his building designs and city plans remain uncommitted either socially or aesthetically.

See also CHICAGO SCHOOL.

UNPUBLISHED SOURCES
Chicago, IL, A. Inst. [Daniel H. Burnham Papers]

WRITINGS
The Final Report of the Director of Works of the World's Columbian Exposition (1894; Chicago, IL, A. Inst., Burnham Lib./R New York and London, 1989); review by C. E. Gregersen, *J. Soc. Archit. Hist.*, l (1991), 219–21
The Improvement of the Park System of the District of Columbia (Washington, DC, 1902)
with J. M. Carrere and A. Brunner: 'The Grouping of Public Buildings at Cleveland', *Inland Architect & News Rec.*, xlii (Sept 1903), pp. 13–15
Report on a Plan for San Francisco, ed. E. F. O'Day (San Francisco, 1905)
with E. H. Bennett: *Plan of Chicago* (Chicago, 1909, R New York, 1970/1993)
'A City of the Future under a Democratic Government', *Trans. of the Town Planning Conference, Royal Institute of British Architects: London, 1910*, pp. 368–78

BIBLIOGRAPHY
H. Monroe: *John Wellborn Root: A Study of his Life and Work* (Boston, 1896)
C. Moore: *Daniel H. Burnham: Architect, Planner of Cities*, 2 vols (Boston, 1921)
L. H. Sullivan: *The Autobiography of an Idea* (New York, 1924)
T. Tallmadge: *Architecture in Old Chicago* (Chicago, 1941)
C. Condit: *The Rise of the Skyscraper* (Chicago, 1952)
D. Hoffmann: *The Architecture of John Wellborn Root* (Baltimore, 1973)
T. Hines: *Burnham of Chicago* (Chicago, 1974)
J. E. Draper: 'Paris by the Lake: Sources of Burnham's Plan of Chicago', *Chicago Architecture, 1872–1922: Birth of a Metropolis*, ed. J. Zakowsky (Munich, 1987)
D. E. Gordon and M. S. Stubbs: 'The Rebirth of a Magnificent Monument: Washington's Union Station Restoration', *Architecture*, lxxvii (1988), pp. 68–75
J. C. Lawrence: 'Steel Frame Architecture versus the London Building Regulations: Selfridges, the Ritz and American Technology', *Constr. Hist.*, vi (1990), pp. 23–46
D. van Zanten: 'Chicago in Architectural History', *Stud. Hist. A.*, xxxv (1990), p. 91–9
T. S. Hines: 'The Imperial Mall: The City Beautiful Movement and the Washington Plan of 1901–1902', *Stud. Hist. A.*, xxx (1991), p. 78–99
D. Dunster: 'The City as Autodidact: The Chicago Plan of 1909', *AA Files*, xxiii (1992), pp. 32–8
G. Ive: 'Urban Classicism and Modern Ideology', *Architecture and the Sites of History: Interpretations of Buildings and Cities*, ed. I. Borden and D. Dunster (Oxford, 1995), pp. 38–52
D. H. Burnham and Mid-American Classicism (exh. cat., Chicago, IL, A. Inst., 1996); review by E. Keegan in *Architecture*, lxxxv (1996), p. 30

DAVID VAN ZANTEN

C

Calder. American family of sculptors. (1) Alexander Milne Calder, of Scottish birth, moved to Philadelphia in his early 20s and produced several important sculptural works for the city. His son (2) Alexander Stirling Calder was also a sculptor. (The family's greatest success was to come in the third generation, however, with Alexander Calder (1898–1976), best known for his kinetic sculptures or mobiles.)

(1) Alexander Milne Calder (*b* Aberdeen, 23 Aug 1846; *d* Philadelphia, PA, 14 June 1923). The son of a stone-cutter, he studied carving at the Royal Institute of Arts in Edinburgh and also in Paris and in London, where he later worked on the carving of the Albert Memorial. In 1868 he went to Philadelphia and studied at the Pennsylvania Academy of the Fine Arts with Thomas Eakins. In 1873 he began a 20-year project to design and execute sculptural decorations for Philadelphia's new City Hall. This is his most significant work, and the elaborate reliefs, statues and panels of statesmen and early settlers form perhaps the most ambitious decorative programme ever executed for a building by a single sculptor in the USA. The bronze statue of *William Penn* (over 11 m high), placed on top of City Hall in 1894, is a well-known landmark in Philadelphia (and was until the 1980s the highest point in the city). Calder exhibited several figures and a carved stone panel (untraced) at the Centennial Exhibition in Philadelphia in 1876. Other notable works include a bronze portrait of *General George Gordon Meade* (Fairmount Park, Philadelphia) and the Hayden Memorial Geological Fund medal for the Academy of Natural Sciences (bronze, 1888).

BIBLIOGRAPHY

W. Craven: *Sculpture in America* (New York, 1968, rev. Newark, New York and London, 1984), pp. 483–6
Sculpture of a City: Philadelphia's Treasures in Bronze and Stone (New York, 1974), pp. 94–109
Philadelphia: Three Centuries of American Art (exh. cat., ed. G. Marcus and D. Sewell; Philadelphia, PA, Mus. A., 1976), pp. 432–3
S. Moore: 'Billy Penn Gets a Scrubbing: Bronze Statue, Philadelphia City Hall', *Hist. Preserv.*, xl (1988), pp. 48–9

(2) Alexander Stirling Calder (*b* Philadelphia, PA, 11 Jan 1870; *d* New York, 6 Jan 1945). Son of (1) Alexander Milne Calder. He studied at the Pennsylvania Academy of the Fine Arts under Thomas Eakins and Thomas Anshutz and later in Paris at the Académie Julian and the Ecole des Beaux-Arts. Returning to Philadelphia in 1892, he won the gold medal of the Philadelphia Art Club and became an assistant instructor in modelling at the Pennsylvania Academy. His first commission, in 1893, was for a portrait statue in marble of the eminent surgeon *Dr Samuel Gross* to go in front of the Army Medical Museum, Washington, DC (now Washington, DC, Armed Forces Inst. Pathology, N. Mus. Health & Medic., on loan to Philadelphia, PA, Thomas Jefferson U., Medic. Coll.). In 1903 he began teaching at the Pennsylvania School of Industrial Art in Philadelphia. His first national recognition came after he won a silver medal for a statue of the explorer *Philippe François Renault* at the World's Fair of 1904 in St Louis, MO. Moving to New York in 1910, he taught at the National Academy of Design and later the Art Students League. Although he was largely trained in the French academic tradition, he transcended its limits in some of his better pieces.

BIBLIOGRAPHY

J. Bowes: 'The Sculpture of Stirling Calder', *Amer. Mag. A.*, xvi (1925), pp. 231, 234–5
W. Craven: *Sculpture in America* (New York, 1968, rev. Newark, New York and London, 1984), pp. 570–73
Sculpture of a City: Philadelphia's Treasures in Bronze and Stone (New York, 1974), pp. 230–39
Philadelphia: Three Centuries of American Art (exh. cat., ed. G. Marcus and D. Sewell; Philadelphia, PA, Mus. A., 1976), pp. 525–6

ABIGAIL SCHADE GARY

California bungalow. *See under* LOS ANGELES, §1; *see also* BUNGALOW.

Cambridge. *See under* BOSTON.

Camp, Joseph Rodefer de. *See* DE CAMP, JOSEPH RODEFER

Carder, Frederick (*b* Brockmoor, Staffs, 18 Sept 1863; *d* 10 Dec 1963). American glass designer and technician of English birth. He trained as an assistant in his father's salt-glazed stoneware factory in Stourbridge, Staffs, and attended evening classes at the Stourbridge School of Art and the Dudley Mechanics Institute, Dudley, W. Midlands, where he came under the tutelage of John Northwood (1836–1902). In 1880, after a recommendation by Northwood, Carder was employed as a designer and draughtsman at the Stourbridge firm of Stevens & Williams. During this period Carder developed his *Mat-su-no-ke* glass (which uses the application of clear or frosted glass in high relief outside the vessel). He also collaborated with Northwood to make coloured art glass and cut and cased glass.

In 1902, after a research trip to the USA for Stevens & Williams, Carder established a factory at Corning, NY, to produce blanks for T. G. HAWKES & Co. In 1903 Carder, who was inspired by the Art Nouveau style, joined with Thomas G. Hawkes (1846–1913) to found the STEUBEN GLASS WORKS, Corning, for the production of ornamental art glass. During his 30 years as Art Director, Carder developed new techniques of enamelling and etching. Some of the types of art glass produced include 'Aurene', 'Calcite' and 'Tyrian' glass. The huge range of ornamental glasswares developed by Carder has resulted in him being generally regarded as the founder of the modern tradition in American art glass.

BIBLIOGRAPHY

P. V. Gardner: *The Glass of Frederick Carder* (New York, 1971)
M. J. Madigan: *Steuben Glass: An American Tradition in Crystal* (New York, 1982)
Steuben Glass: The Carder Years (exh. cat., St Petersburg, FL, Mus. F.A., 1984)

K. SOMERVELL

Carlsen, (Soren) Emil (*b* Copenhagen, Denmark, 19 Oct 1853; *d* New York, NY, 2 Jan 1932). American painter of Danish birth. He immigrated to the USA in 1872 after studying architecture at the Kongelige Danske Kunstakademi in his native Copenhagen. In 1874 he worked under Danish painter Lauritz Holtz in Chicago. After six months study in Paris (1875), he returned to Chicago to teach at the newly founded Academy of Design. Back in Paris (1884–6) for further study of the works of Jean-Siméon Chardin, he produced floral still-lifes for New York dealer Theron J. Blakeslee. America's leading exponent of the Chardin Revival, Carlsen eventually became his adopted country's most famous depicter in paint of fish, game, bottles and related 'kitchen' still-life subjects. A typical fish portrait recently hung in the National Gallery of Art, Washington, DC, near a similar piscean image by one of Carlsen's main competitors in the genre, William Merrit Chase, whose famous fish still-life, *An English Cod* (1904; Washington, DC, Corcoran Gal. A.), also provides a revealing comparison.

Carlsen moved in 1887 to San Francisco, where he had been invited by portraitist Mary Curtis Richardson to succeed Virgil Williams (1830–86) as director of the California School of Design. He later taught at the San Francisco Art Students' League. During his four productive and influential years in California, he shared a Montgomery Street studio with Arthur F. Mathews. Unfortunately, exhibition and sales opportunities proved to be limited, and Carlsen, by then penniless, was forced in 1891 to relocate to New York, where his fortunes improved dramatically. *Still-life* (1891; Oakland, CA, Mus.; see colour pl. XXII, 2) dates from the year of his move east and is typical of the work that established his considerable reputation in New York and launched a long and successful career there. Despite the growing popularity of Impressionism, Carlsen's palette, which tended towards ivory, silver-grey and mauve, remained subdued, in a near monochromatic, realist manner close to that of the Munich-style Chase or Frank Duveneck. However, his massing of broad areas of color and reductive approach lends a modernist quality to many of his paintings. Works such as *Still-life, Pheasant* (1891; San Francisco, CA, private

col.), in which a superbly painted dead pheasant is placed alone on a bare tabletop, reveal Carlsen's interest in formal construction and the abstract opportunities his chosen, traditional subjects provided him.

While in San Francisco, Carlsen exhibited regularly at the Bohemian Club, of which he was and remained a member. Other exhibitions during his lifetime included those at: the National Academy of Design, New York (1885–7, 1894–5, 1903, 1905–21, 1923–32); the Mechanics Institute, San Francisco (1887, 1888); the San Francisco Art Association, *c.* 1890–97; the Louisiana Purchase Exposition, St Louis (1904); Pennsylvania Academy of the Fine Arts, Philadelphia (1912); and the Panama—Pacific International Exposition, San Francisco (1915). The largest exhibition during the artist's lifetime was mounted at the Corcoran Gallery of Art, Washington, DC, in 1923, nine years before his death. At that time, Carlsen was described as 'unquestionably the most accomplished master of still-life painting in America' (Arthur Edwin Bye).

BIBLIOGRAPHY

A. E. Bye: *Pots and Pans: Studies in Still-life Painting* (Princeton, NJ, 1921)
The Art of Emil Carlsen, 1853–1932 (exh. cat., San Francisco, CA, Wortsman-Rowe Gals, 1975)
G. Still: 'Emil Carlsen, Lyrical Impressionist', *A. & Ant.*, iii/2 (1980), pp. 88–95
W. H. Gerdts: *Painters of the Humble Truth* (Columbia, MO, 1981)
H. L. Jones: *Impressionism: The California View* (Oakland, 1981)
W. H. Gerdts: *Art across America: Two Centuries of Regional Painting, 1720–1920*, iii (New York, 1990)

PAUL J. KARLSTROM

Carnegie, Andrew (*b* Dunfermline, Scotland, 25 Nov 1835; *d* Lenox, MA, 11 Aug 1919). American industrialist and patron of Scottish birth. He emigrated to the USA in 1848 and settled in poverty with his family in Allegheny, near Pittsburgh, PA. Entirely self-educated from the age of 11, he acquired by his own efforts and skilful investment an enormous fortune in railways, oil, and the iron and steel industry. During his lifetime he donated more than $350 million to a variety of social, educational and cultural causes, the best-known of which was his support of the free public library movement with grants for buildings, which he believed would provide opportunities for self-improvement without any taint of charity. These ideas, which were set out in his autobiography of 1920, were based on a series of articles he published in 1889 and a book of essays in 1901, the last publication in response to a growing tide of criticism from radical quarters and organized labour to the acceptance of 'tained money'. Carnegie's first library gift went to his native city of Dunfermline in 1881, followed by a library and clubhouse complex (opened 1889) for Braddock, PA, where his principal steel plant was located, and a library and opera house (opened 1890) for Allegheny. His most ambitious cultural creation was the Carnegie Institute at Pittsburgh, where a city library, concert hall, natural history museum, architecture hall and art gallery complex was built in stages by the architects Alden and Harlow between 1891 and 1907. Altogether *c.* 3000 libraries and city branches were constructed throughout the English-speaking world in the main period of his philanthropy, which extended from the late 1890s to 1917, when America's entry into World War I curtailed non-essential building. The USA received half

of these libraries, typically costing between $10,000 and $20,000 and located in the small towns of the Midwest and the West Coast, as well as in the industrial cities. Communities were expected to engage their own architects, and they were required to provide a site and promise annual tax support for the library of not less than 10 per cent of Carnegie's grant. Nationally known architects designing Carnegie's public library buildings included Carrère & Hastings (New York Central Public Library; *see* NEW YORK, fig. 5); McKim, Mead & White (many of the New York City branches); and Cass Gilbert (Detroit and St Louis). However, large numbers of medium- and small-sized libraries were designed by 'specialist' architectural practices, such as Edward L. Tilton in New York, Patton & Miller in Chicago, Claude & Starck in Madison, WI, and Alden & Harlow in Boston and Pittsburgh. Practically every architectural style is represented, the so-called 'Carnegie Classical' predominating simply as the conventional style for public architecture of the period. Carniegie's International Peace Palace in the The Hague opened, inauspiciously, in 1914.

BIBLIOGRAPHY

T. W. Koch: *A Book of Carnegie Libraries* (New York, 1917)
A Manual of the Public Benefactions of Andrew Carnegie, Carnegie Endowment for International Peace (1919)
B. J. Hendrick: *Andrew Carnegie*, 2 vols (New York, 1932)
G. S. Bobinski: *Carnegie Libraries: Their History and Impact on American Public Library Development* (Chicago, 1969)
J. D. Van Trump: *An American Palace of Culture: The Carnegie Institute and Carnegie Library of Pittsburgh* (Pittsburgh, 1970)
J. F. Wall: *Andrew Carnegie* (London and New York, 1970)
M. Beckman, S. Langmead and J. Black: *The Best Gift: A Record of the Carnegie Libraries in Ontario* (1984)
The Taste of Andrew Carnegie (brochure by A. Blaugrund and S. M. Sivard, New York, NY Hist. Soc., 1991)
A. A. van Slyck: 'The Utmost Amount of Effectiv (sic) Accommodation: Andrew Carnegie and the Reform of the American Library', *J. Soc. Archit. Hist.*, l (1991), pp. 359–83
D. Strazdes: 'An Atelier of Drawings: The Collection at the Carnegie Museum of Art', *Drawing*, xiii/2 (1991), pp. 25–8
A. A. van Slyck: *Free to All: Carnegie Libraries and American Culture, 1890–1920* (Chicago, 1995)
K. Neal: *A Wise Extravagance: The Founding of the Carnegie International Exhibitions, 1895–1901* (Pittsburgh, 1996)
T. Jones: *Carnegie Libraries across America: A Public Legacy* (New York, 1997)
H. Schwalb: 'Andy Did It: Criticism of A. Carnegie at the Exhibition Collecting Art in the Gilded Age: Art Patronage in Pittsburgh, 1890–1910 (Frick Art Museum, Pittsburgh)', *ARTnews*, xcvi (1997), p. 33

SIMON PEPPER

Carrère & Hastings. American architectural partnership formed in 1885 by John Merven Carrère (*b* Rio de Janiero, 9 Nov 1858; *d* New York, 1 March 1911) and Thomas Hastings (*b* New York, 11 March 1860; *d* New York, 22 Oct 1929). Carrère studied in Lausanne and at the Ecole des Beaux-Arts, Paris (1877–82), in the atelier of Victor-Marie-Charles Ruprich-Robert (1820–87). On his return to New York, Carrère worked in the office of McKim, Mead & White (1883–5) before setting up practice with his fellow employee Hastings. Hastings had studied more briefly at the Ecole des Beaux-Arts in 1884 in the atelier of Louis-Jules André (1819–90).

The practice was launched with commissions from the developer Henry Morrison Flagler (1830–1913), for whom Carrère & Hastings designed the Ponce de Leon Hotel (1885–8; later Flagler College), the Alcazar Hotel (1888–

9), the Memorial Presbyterian Church (1889–90) and other Spanish–American Renaissance-style buildings in Palm Beach and St Augustine, Florida. For more northerly latitudes Carrère and Hastings developed the Renaissance classicism of McKim, Mead & White with great success, winning the competition for the New York Public Library in 1897 (built 1902–11; *see* NEW YORK, fig. 5). The clear, functional planning and refined use of stylistic ornament distinguished these buildings. Other works include the Russell Senate and Cannon House office buildings (1905–10), and the Carnegie Institution (1909), all in Washington, DC, and the New Theatre (1911–12), New York. Both partners were involved in the movement towards urban planning that accompanied the American Beaux-Arts style. Carrère was architectural director for the Buffalo Exhibition (1901) and drew up plans for Ohio, Baltimore, MD, and Grand Rapids, MI (1909). He originated the Art Commission of the City of New York and was a notable campaigner for architectural education and the improvement of architectural ethics.

After Carrère's death in a motor car accident, Hastings, who had been the principal designer of the two, continued the practice, specializing in tall office buildings adapted to the New York zoning restrictions, for example the Cunard Building (1919–21), the Macmillan Building (1924) and the Standard Oil Building (completed 1926). He was an articulate advocate of American classicism and remained closely in touch with the design work of his office. Other works include the Memorial Amphitheatre at Arlington Cemetery, VA.

WRITINGS

Carrère with A. W. Brunner: *Preliminary Report for a City Plan for Grand Rapids* (1909)
Hastings: 'On the Evolution of Style', *Amer. Architect*, xcvii (1910), p. 71

BIBLIOGRAPHY

'The Work of Messrs Carrère & Hastings', *Archit. Rec.*, xxvii (1910), pp. 1–120
Obituary [Carrère], *RIBA J.*, xviii (1910–11), p. 352; *Amer. Architect*, xci (1911), pp. 131–2
F. S. Swales: 'John Merven Carrère, 1858–1911', *Archit. Rev.* [London], xxix (1911), pp. 283–93
E. Clute: 'Master Draftsmen' [Hastings], *Pencil Points*, vi (1925), pp. 49–60, 88
Obituary [Hastings], *Amer. Architect*, cxxxvi (1929), p. 55; *Archit. Forum* (Dec 1929), p. 35; *Archit. Rec.*, lxvi (1929), p. 596; *RIBA J.*, xxxvi (1929–30), pp. 24–5
D. Gray: *Thomas Hastings, Architect: Collected Writings* (Boston, 1933)
C. Condit: 'The Pioneer Concrete Buildings of St Augustine', *Prog. Archit.* (Sept 1971), pp. 128–33
C. Aslet: 'Nemours, Delaware, USA', *Country Life*, clxxxiii (1989), pp. 92–7
D. Cruickshank: 'New York Public Library, New York, 1911–1998', *RIBA J.*, cv (1998), pp. 58–65

Casilear, John William (*b* New York, 25 June 1811; *d* Saratoga Springs, NY, 17 Aug 1893). American engraver, draughtsman and painter. At 15 he was apprenticed to the engraver Peter Maverick (1780–1871) and then to Asher B. Durand. Casilear and his brother George formed a business partnership that eventually developed into the American Bank Note Co., the principal private bank-note engravers in America. He was perhaps the most fluent and accomplished draughtsman of his generation, and important collections of his landscape drawings are in the

John William Casilear: *Lake George*, oil on canvas, 667×1080 mm, 1860 (Hartford, CT, Wadsworth Atheneum)

Detroit Institute of Arts and the Boston Museum of Fine Arts.

Casilear was an exponent of the HUDSON RIVER SCHOOL of landscape painting. Such works as *Lake George* (1860; Hartford, CT, Wadsworth Atheneum; see fig.) and his views of Genesee Valley, NY, and Niagara Falls manifest the refined colour, restrained brushwork and ordered composition typical of that group. Casilear's compositions are firmly drawn and articulated through a subtle palette that explores the value and saturation of hues.

In 1833 Casilear was elected an Associate at the National Academy of Design, New York, based on his engravings and in 1851 an Academician based on his painting. In 1840 Casilear, Durand, John Frederick Kensett and Thomas Rossiter (1818–71) travelled to Europe to study, visiting London, Paris and Rome. Casilear was a regular exhibitor at the National Academy of Design (1833–90), the Apollo Association (1838–43), the American Art-Union (1847–51), the Pennsylvania Academy of the Fine Arts, Philadelphia (1855–65), and elsewhere.

BIBLIOGRAPHY
D. Stauffer: *American Engravers upon Copper and Steel* (New York, 1907)
American Paradise: The World of the Hudson River School (exh. cat. by J. K. Howat, New York, Met., 1987)

JOHN DRISCOLL

Cassatt, Mary (Stevenson) (*b* Allegheny City [now in Pittsburgh], 25 May 1844; *d* Le Mesnil-Théribus, France, 14 June 1926). American painter and printmaker, active in France. Having settled in Paris, she became a member of the Impressionist circle. The quality of her draughtsmanship is evident in all the media in which she worked,

notably pastel. She is particularly associated with the theme of mother and child.

1. LIFE AND WORK. Daughter of a Pittsburgh banker, Mary Cassatt received a cultured upbringing and spent five years abroad as a child (1851–5). In 1860, at the age of 16, she began classes at the Pennsylvania Academy of the Fine Arts, Philadelphia, and in 1866 sailed again for Europe. During the next four years she studied in Paris with Jean-Léon Gérôme (1824–1904) and Charles Chaplin (1825–91), in Ecouen with Paul Soyer (1823–1903), in Villiers-le-Bel with Thomas Couture (1815–79) and in Rome with Charles Bellay (1826–1900). She concentrated mainly on figure painting, often posing her models in picturesque local costume. When she returned to Europe after 16 months in the USA (1870–71), she painted and copied in the museums of Parma, Madrid, Seville, Antwerp and Rome, finally settling in Paris in 1874. Until 1878 she worked mainly as a portrait and genre painter, specializing in scenes of women in Parisian interiors. She exhibited regularly in the USA, particularly in Philadelphia, and had paintings accepted in the Paris Salons of 1868, 1870 and 1872–6.

Cassatt's study of Velázquez (1599–1660) and Rubens (1577–1640), coupled with her interest in the modern masters Couture, Courbet (1819–77) and Degas (1834–1917), caused her to question the popular Salon masters of the 1870s and to develop her own increasingly innovative style. This led to rejection of some of her Salon entries in 1875 and 1877 but also prompted Degas to invite her to exhibit with the Impressionists. She made her début with them at their fourth annual exhibition (1879), by

which time she had mastered the Impressionist style and was accepted as a fully fledged member by artists and critics alike. She went on to participate in the Impressionist exhibitions of 1880, 1881 and 1886.

In 1877, when her parents and older sister Lydia arrived to settle with her in Paris, she exchanged her youthful lifestyle, living alone in her studio, for a more family-orientated existence. Their more spacious and comfortable accommodation also encouraged Cassatt's two brothers and their families to make frequent visits from Philadelphia. Family members often figure in Cassatt's Impressionist portraits and scenes of daily life during this period (e.g. *Lydia Crocheting in the Garden at Marly*, 1880; New York, Met.; see colour pl. XX, 1).

Cassatt began to revise her Impressionist style in the 1880s, and after the last Impressionist exhibition (1886) she developed a refined draughtsmanship in her pastels, prints and oil paintings. After exhibiting with the new Société des Peintres-Graveurs in 1889 and 1890, she had her first individual exhibition of colour prints and paintings in 1891 at the Galerie Durand-Ruel, Paris. In 1892 she was invited to paint a large tympanum mural, *Modern Woman*, for the Woman's Building at the World's Columbian Exposition (Chicago, 1893). Although the mural itself does not survive, many paintings (e.g. *Nude Baby Reaching for an Apple*, 1893; Richmond, VA, Mus. F.A.), prints (e.g. *Gathering Fruit*, drypoint with aquatint, c. 1895) and pastels (e.g. *Banjo Lesson*, 1894; Richmond, VA Mus. F.A.; see fig.) based on Cassatt's mural designs reflect her concept of modern woman 'plucking the fruits of knowledge or science'. She exhibited these in her first major retrospective exhibition in 1895 at Durand-Ruel's gallery in Paris and again in 1895 at his gallery in New York.

Cassatt's success in Europe and the USA was such that in 1894 she was able to purchase the Château de Beauf-

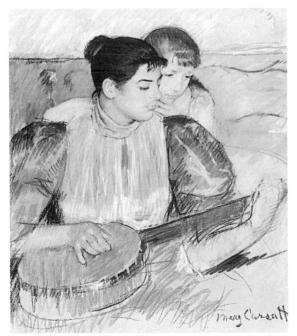

Mary Cassatt: *Banjo Lesson*, pastel on paper, 710×572 mm, 1894 (Richmond, VA, Virginia Museum of Fine Arts)

resne in Le Mesnil-Théribus (c. 90 km north-west of Paris) from the sale of her work. Thereafter she alternated between Paris and the country, with a few months every winter in the south of France. She increasingly concentrated on the mother-and-child theme and on studies of women and young girls, often turning to the Old Masters for inspiration. For this work she was recognized on both continents, and, in addition to receiving a number of awards, including the Légion d'honneur in 1904, she was called 'the most eminent of all living American women painters' (*Current Lit.*, 1909, p. 167). She spent much of her time during these years helping her American friends build collections of avant-garde French art and works by Old Masters. Those she advised included Henry and Louisine Havemeyer, Mrs Montgomery J. Sears, Bertha Honoré Palmer and James Stillman.

Cassatt painted until 1915 and exhibited her latest work that year in the *Suffrage Loan Exhibition of Old Masters and Works by Edgar Degas and Mary Cassatt* at the Knoedler Gallery, New York; but soon afterwards cataracts in both eyes forced her into retirement. She continued to be actively interested in art, however, and until her death she vigorously expressed her own views and opinions to the many young artists who visited her seeking advice.

2. WORKING METHODS, TECHNIQUE AND SUBJECT-MATTER. Cassatt's own experimentation and her openness to new ideas caused her style to change many times during her long career. In her early years (1860–78) she practised a painterly genre style in dark, rich colours as in *A Musical Party* (1874; Paris, Petit Pal.); during her Impressionist period (1879–86) she used a pastel palette and quick brushstrokes in such works as *Cup of Tea* (c. 1880; New York, Met.); in her mature period (1887–1900) she developed a style that was more finished and dependent on abstract linear design, for instance in *The Bath* (1893; Chicago, IL, A. Inst.); and in her late period (1900–26) she often used colour combinations with a sombre cast, as in *The Caress* (1903; Washington, DC, N. Mus. Amer. A.).

As a student and young artist, Cassatt avoided the academic emphasis on drawing and concentrated instead on painting techniques. But as her career progressed, particularly after 1879 when she took up pastels and printmaking, she developed a refined and original drawing style that blended European and oriental effects. Her first efforts in printmaking were in a collaboration with Degas, Pissarro and others to produce a journal combining art criticism and original prints. Although the journal, *Le Jour et la nuit*, never appeared, Cassatt went on to finish several complex prints in etching, aquatint and drypoint, such as *The Visitor* (softground, aquatint and drypoint, c. 1880; Breeskin, 1948, no. 34). In the late 1880s she turned to drypoint for a spare and elegant effect, as in *Baby's Back* (c. 1889; B. 128). Her greatest achievement in printmaking, however, was the group of 18 colour prints she produced during the 1890s. The first ten were completed and exhibited as a set in 1891 and are highly prized for their skilful use of aquatint, etching and drypoint and for Cassatt's hand-inking and wiping of the plates for each print. Prints from this set, such as *The Letter* (drypoint

and aquatint, 1890–91; B. 146), show her successful synthesis of the abstract design of Japanese colour prints and the atmospheric qualities of Western art.

Cassatt's pastels are equally important to her development as an artist. Although she used pastel as a sketching tool from the first, it was not until she joined the Impressionist circle that she began to produce major finished works in this medium. Pastel became increasingly popular in both Europe and the USA in the 1870s and 1880s, and Cassatt was one of the first to exploit the properties of pastel in conveying the vibrancy of 'modern' life. As in oil, she tailored her application of the pastel pigment to fit her changing style: exuberant strokes and rich colours during her Impressionist phase gave way to a calmer, more monumental style (exemplified by *Banjo Lesson*) as she matured. In the 1890s she returned often to the study of pastel techniques of 18th-century masters, particularly Maurice-Quentin de La Tour (1704–88).

In the late 1880s Cassatt began to specialize in the mother-and-child theme (e.g. *The Family*, 1893; Norfolk, VA, Chrysler Mus.). This developed from her interest in the monumental figure and the depiction of modern life and was also in tune with late 19th-century Symbolism. She soon became identified with the theme and continues to be considered one of its greatest interpreters.

BIBLIOGRAPHY

J. K. Huysmans: *L'Art moderne* (Paris, 1883), pp. 6, 110, 231–4 [reviews of Salon of 1879, Impressionist exhibitions of 1880 and 1881]
Exposition Mary Cassatt (exh. cat., preface A. Mellério; Paris, Gal. Durand-Ruel, 1893)
W. Walton: 'Miss Mary Cassatt', *Scribner's Mag.*, xix (1896), pp. 353–61 [review of Cassatt's exhibition in New York, 1895]
'Most Eminent of All Living American Women Painters', *Current Lit.*, xlvi (1909), pp. 167–70
A. Segard: *Mary Cassatt: Une Peintre des enfants et des mères* (Paris, 1913) [first complete study of Cassatt's life and work, based on interviews with her]
A. D. Breeskin: *The Graphic Work of Mary Cassatt: A Catalogue Raisonné* (New York, 1948, rev. Washington, DC, 2/1979) [B.]
L. W. Havemeyer: *Sixteen to Sixty: Memoirs of a Collector* (New York, 1961)
F. A. Sweet: *Miss Mary Cassatt: Impressionist from Pennsylvania* (Norman, OK, 1966)
A. D. Breeskin: *Mary Cassatt: A Catalogue Raisonné of the Oils, Pastels, Watercolours, and Drawings* (Washington, DC, 1970, rev. 2/ in preparation)
Mary Cassatt, 1844–1926 (exh. cat., Washington, DC, N.G.A., 1970)
N. Hale: *Mary Cassatt* (New York, 1975)
Mary Cassatt at Home (exh. cat. by B. S. Shapiro, Boston, MA, Mus. F.A., 1978)
Mary Cassatt and Edgar Degas (exh. cat. by N. M. Mathews, San Jose, CA, Mus. A., 1981)
N. M. Mathews, ed.: *Cassatt and her Circle: Selected Letters* (New York, 1984)
Mary Cassatt and Philadelphia (exh. cat. by S. G. Lindsay, Philadelphia, PA, Mus. A., 1985)
F. Weitzenhoffer: *The Havemeyers: Impressionism Comes to America* (New York, 1986) [explains Cassatt's role as adviser to the Havemeyer collection]
N. M. Mathews: *Mary Cassatt* (New York, 1987)
Mary Cassatt: The Color Prints (exh. cat. by N. Mowll Mathews and B. Stern Shapiro, Washington, DC, N.G.A.; Williamstown, Williams Coll. Mus. A.; Boston, MA, Mus. F.A.; 1989)
S. Craze: *Mary Cassatt* (New York, 1990)
M. R. Witzling: *Mary Cassatt: A Private World: Illustrations from the National Gallery of Art*, Washington, DC, N.G.A. cat (New York, 1991)
C. K. Carr: 'Mary Cassatt and Mary Fairchild MacMonnies: The Search for their 1893 Murals', *Amer. A.*, viii (Winter 1994), pp. 52–69
J. Hutton: 'Picking Fruit: Mary Cassatt's Modern Woman and the Woman's Building of 1893', *Fem. Stud.*, xx/2 (1994), pp. 318–48
N. M. Mathews: *Mary Cassatt: A Life* (New York, 1994)
M. E. Boone: 'Bullfights and Balconies: Flirtation and Majismo in Mary Cassatt's Spanish Paintings of 1872–73, *Amer. A.*, ix (Spring 1995), pp. 54–71
M. Costantino: *Mary Cassatt* (New York, 1995)
B. E. White: *Impressionists Side by Side: Their Friendships, Rivalries and Artistic Exchanges* (New York, 1996)
Mary Cassatt (exh. cat., Chicago, IL, R.S. Johnson F.A., 1997–8); review by G. Holg in *ARTnews*, xcvii (1998), p. 127
Mary Cassatt, Modern Woman (exh. cat. by J. A. Barter, Chicago, IL, A. Inst.; Boston, MA, Mus. F.A.; Washington, DC, N.G.A.; 1998–9)

NANCY MOWLL MATHEWS

Catesby, Mark (*b* Castle Hedingham, Essex, 24 March 1682; *d* London, 23 Dec 1749). English naturalist, painter and graphic artist active in the American colonies. His scientific expeditions to the British colonies in North America and the Caribbean (1712–19 and 1722–6) resulted in the first fully illustrated survey of the flora and fauna of the British Colonies in the Americas. *The Natural History of Carolina, Florida and the Bahama Islands* (1731–47) contains 220 hand-coloured etchings. Catesby received lessons in etching from Joseph Goupy (1686–1770) and executed most of the plates after his own drawings in graphite, gouache and watercolour. He also produced several plates after drawings by John White, Georg Dionysius Ehret (1708–70), Everhard Kick and Claude Aubriet.

Catesby moved against the 18th-century trend in the natural sciences to portray Creation as a neatly ordered hierarchy of clearly definable parts. His pictures helped to promote a revolutionary view of the cosmos as a complex system of interdependent elements and forces. Instead of depicting organisms in the conventional manner as isolated specimens against an empty page, he produced tight compositional arrangements in which animals and plants from similar environments reflect one another's forms. Catesby's radical images of an integrated cosmos influenced eminent English and American naturalists, including George Edwards (1694–1773), William Bartram and John James Audubon.

Important drawings by Catesby are in the British Library and British Museum in London and the Royal Society, London. An almost complete set of preparatory drawings for the *Natural History* is in the Royal Library, Windsor Castle.

WRITINGS

The Natural History of Carolina, Florida and the Bahama Islands, 2 vols (London, 1731–47/*R* Savannah, 1979, rev. 3/1771)
'Of Birds of Passage by Mr. Mark Catesby F.R.S.', *Philos. Trans.*, xliv (1747), pp. 435–44
Hortus Britanno-Americanus (London, 1763, rev. 1767) [new title-page]

BIBLIOGRAPHY

G. Frick and R. Stearns: *Mark Catesby: The Colonial Audubon* (Urbana, 1961)
C. E. Jackson: *Bird Etchings: The Illustrators and their Books, 1655–1855* (Ithaca, NY, 1985)
H. McBurney: 'Painted from Nature', *Country Life*, clxxxix (14 Dec 1995), pp. 44–6
Mark Catesby's Natural History of America: The Watercolors from the Royal Library, Windsor Castle (exh. cat. by H. McBurney, San Marino, CA, Huntington Lib. & A.G. and elsewhere, 1997)
A. Myers and M. Pritchard, eds: *Empire's Nature: Mark Catesby's New World Vision* (Chapel Hill, 1998)

AMY MEYERS

Catlin, George (*b* Wilkes-Barre, PA, 26 July 1796; *d* Jersey City, NJ, 23 Dec 1872). American painter and writer.

Following a brief career as a lawyer, he produced two major collections of paintings of American Indians and published a series of books chronicling his travels among the native peoples of North, Central and South America. Claiming his interest in America's 'vanishing race' was sparked by a visiting American Indian delegation in Philadelphia, he set out to record the appearance and customs of America's native people. He began his journey in 1830 when he accompanied Gen. William Clark on a diplomatic mission up the Mississippi River into Native American territory. Two years later he ascended the Missouri River over 3000 km to Ft Union, where he spent several weeks among indigenous people still relatively untouched by European civilization. There, at the edge of the frontier, he produced the most vivid and penetrating portraits of his career. Later trips along the Arkansas, Red and Mississippi rivers as well as visits to Florida and the Great Lakes resulted in over 500 paintings and a substantial collection of artefacts. In 1837 he mounted the first serious exhibition of his 'Indian Gallery', published his first catalogue and began delivering public lectures, which drew on his personal recollections of life among the American Indians. Soon afterwards he began a lifelong effort to sell his American Indian collection to the US government. When Congress rejected his initial petition, he took the Indian Gallery abroad and in 1840 began a European tour in London.

In 1841 Catlin published *Letters and Notes on the Manners, Customs, and Condition of the North American Indians*, his major literary work, but only the first in a series of books documenting his travels and observations among the indigenous peoples of North and South America. When interest in the Indian Gallery waned in England, he took his collection to Paris, where it was praised by many, including Baudelaire, who found Catlin's colours 'intoxicating'. Confident that Congress would eventually purchase his Indian Gallery, Catlin borrowed heavily against it and in 1852 he suffered financial collapse. Dispersal of the Indian Gallery was avoided only when Joseph Harrison, an American manufacturer, reimbursed the artist's creditors and shipped the entire collection to Philadelphia, where it was stored until donated to the Smithsonian Institution, Washington, DC, six years after Catlin's death (see colour pl. X, 1).

Following his bankruptcy, Catlin lived hand-to-mouth for two years before he secured funds to travel to South America. There he produced paintings of indigenous South Americans that, together with new paintings of American Indians obtained on a trip up the Pacific Coast and copies of works from his original Indian Gallery, made up a second collection of over 500 pictures, which he called the 'Cartoon Collection'. The cartoons were first shown in Brussels in 1870 and in New York the following year, but the accolades of earlier years were not repeated. Discouraged and in ill health, he accepted an invitation to install his cartoons at the Smithsonian Institution in Washington, DC, while waiting for Congress to act on his latest petition. At his death Congress had failed to act and the Cartoon Collection passed to his family. In 1965, the National Gallery of Art, Washington, DC, acquired 351 cartoons. Taken together, the Indian Gallery, the Cartoon Collection and Catlin's supporting publications constitute the most comprehensive record of the life of indigenous people in North and South America during the period 1830–60. Catlin's paintings, long acknowledged as a key ethnographic resource, have only recently been discussed as compelling works of art. Often completed in haste and under adverse conditions, his finest works combine a refreshing immediacy of execution with a pervasive sympathy for the dignity of America's native people.

WRITINGS

Letters and Notes on the Manners, Customs, and Condition of the North American Indians, 2 vols (London, 1841/R New York, 1973)
Catlin's Notes of Eight Years' Travels and Residence in Europe, 2 vols (London, 1848)
Life amongst the Indians (New York, 1857)
Last Rambles amongst the Indians of the Rocky Mountains and the Andes (New York, 1867)
O-Kee-Pa: A Religious Ceremony and Other Customs of the Mandans (London, 1867/R New Haven, 1967)

BIBLIOGRAPHY

T. Donaldson: 'The George Catlin Indian Gallery', *Smithsonian Inst. Annu. Rep.*, v (1886)
L. Haberly: *Pursuit of the Horizon* (New York, 1948)
J. Ewers: 'George Catlin, Painter of Indians and the West', *Smithsonian Inst. Annu. Rep* (1956), pp. 483–528
M. Roehm, ed.: *The Letters of George Catlin and his Family* (Berkeley, 1966)
W. Truettner: *The Natural Man Observed: A Study of Catlin's Indian Gallery* (Washington, DC, 1979)
B. Dippie: *Catlin and his Contemporaries: The Politics of Patronage* (Lincoln, 1990)
W. Rawls: 'Audubon, Bodmer and Catlin: Facsimile Editions from the Editorial Side', *Imprint*, xvi/1 (1991), pp. 2–10
The West as America: Rethinking Western Art (exh. cat. by W. Truettner and others, Washington, DC, N. Mus. Amer. A., 1991); review by S. May in *Southwest A.*, xxi (1991), pp. 100–9
H. Wilderotter: '"Sehet den schnellen Indianer an...": Ideal und Stereotyp in den Indianerbildern George Catlins', *Mus. J.*, vi/3 (1992), pp. 4–8
The North American Indian Portfolios from the Library of Congress, intro. J. Gilreeth (New York, 1993)
First Artist of the West: Paintings and Watercolors by George Catlin from the Collection of Gilcrease Museum (exh. cat. by J. C. Troccoli, Tulsa, OK, Gilcrease Mus., and elsewhere, 1993–6)

NANCY ANDERSON

Ceramic Art Co. *See under* LENOX, WALTER SCOTT.

Chandler, Theophilus Parsons (*b* Boston, MA, 1845; *d* Philadelphia, PA, 16 Aug 1928). American architect and designer. After a year at the Lawrence Scientific School of Harvard University, Cambridge, MA, he is believed to have studied in the Atelier Vaudremer in Paris for a year, following this with European travel, which is documented by drawings (Philadelphia, PA, Athenaeum). Around 1872 Chandler set up practice in Philadelphia. His mother's family had backed the Du Pont industrial empire, and in 1874 Chandler was involved with enlargements to Winterthur, Henry Francis Du Pont's mansion near Wilmington (now Winterthur, DE, Du Pont Winterthur Mus.). Through that connection Chandler married Sophie Madeleine Dupont, which provided him with a position in society and enabled him to practise architecture free from commercial considerations. Unlike his contemporaries in Philadelphia who regularly used brick, Chandler was committed to a stone architecture based rather closely on historical examples, which he adapted to large city and country houses and a significant group of churches. The most successful included the Philadelphia town houses for James Hutchinson (at 1335 22nd Street) and James

Scott (at 2032 Walnut Street; both 1882), the suburban mansions for Edward Benson (1884; destr.) and William Simpson (Ingeborg, Wynnewood, PA, 1885) and the Swedenborgian Church (1882) at Chestnut Street and 22nd Street. These are finely detailed compositions that indicate the influence of Richard Morris Hunt and suggest an almost academic set of values in accord with the taste of the 1890s. He was, therefore, the logical choice to serve as the first Director of the School of Architecture of the University of Pennsylvania in 1890.

BIBLIOGRAPHY

Obituary, *Amer. A. J.*, xxv (1928), p. 369

T. Sande: *Theophilus Parsons Chandler, jr, 1845–1928* (diss., Philadelphia, U. PA, 1971)

S. Tatman and R. Moss: *Biographical Dictionary of Philadelphia Architects, 1700–1930* (Boston, 1985), pp. 139–43

G. Thomas: 'Theophilus Parsons Chandler, jr; FAIA', *Drawing towards Building: Philadelphia Architectural Graphics, 1730–1986* (exh. cat. by J. O'Gorman, J. Cohen, G. Thomas and G. Perkins, Philadelphia, PA Acad. F. A., 1986), pp. 166–8

GEORGE E. THOMAS

Chandler, Winthrop (*b* Woodstock, CT, 6 April 1747; *d* Woodstock, 29 July 1790). American painter. He was one of ten children of William Chandler, a farmer, and Jemima Bradbury Chandler of Woodstock, CT. After the death of his father in 1754 and on reaching the age for apprenticeship, Chandler pursued a career as a portrait and ornamental painter. While there is no proof of his presence in Boston, the *History of Woodstock* (1862) states that he studied portrait painting there. He may also have had the opportunity to view works by the major artist of the city, John Singleton Copley, as well as those of his lesser-known contemporaries, William L. Johnston and Joseph Badger. In the course of his career, Chandler worked in such diverse trades as gilding, carving and illustrating, as well as portraiture, landscape and house painting, suggesting that he received some instruction as an artisan–painter. He is best known for some 50 portraits, all of family and neighbours in the Woodstock area. Chandler adhered to a flat, linear manner of painting and realistic depictions of his subjects throughout his career. His style represented the work of a highly gifted folk painter.

In 1770 he was still in Woodstock, where he completed his first known signed portraits, of *Rev. Ebenezer Devotion* and his wife *Martha Lathrop Devotion* (e.g. in Brookline, MA, Hist. Soc. Mus.) of nearby Windham (now Scotland), CT. These monumental full-length portraits are painted in a highly realistic manner, including faithful likenesses of the subjects and accurate renderings of costumes and furnishings, for example bookshelves filled with worn leather volumes in the background.

In 1772 Chandler married Mary Gleason of Dudley, MA. Although he seems to have taken no part in the Revolutionary War, many members of his family did, fighting on both sides. Two of Chandler's most accomplished portraits are of his brother and sister-in-law, *Captain Samuel Chandler* and *Anna Chandler* (*c.* 1780; both Washington, DC, N.G.A.). The full-length portrait of Samuel (see fig., who commanded a regiment in the Revolutionary War, shows him in uniform with a detailed battle scene visible through the window.

A series of decorative landscapes in the form of overmantel paintings (*c.* 1770–90) for several houses in

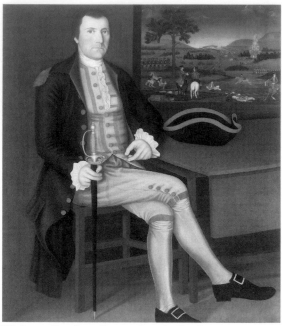

Winthrop Chandler: *Captain Samuel Chandler*, oil on canvas, 1.39×1.22 m, *c.* 1780 (Washington, DC, National Gallery of Art)

the Woodstock area are attributed to Chandler. These combine fanciful compositions that suggest elements taken from English prints with renderings of the New England landscape and its buildings. The *Homestead of General Timothy Ruggles* (*c.* 1770–75; priv. col., see Little, 1980, fig. 29) is a relatively accurate depiction of the Loyalist Ruggles's house and surrounding lands, framed by fanciful trees.

Chandler was often in financial difficulties. In 1785 he moved to Worcester, MA, perhaps in search of new patrons. There he did house painting and in 1788 regilded the weather-vane on the courthouse. A bust-length *Self-portrait* (Worcester, MA, Amer. Antiqua. Soc.) is thought to have been painted at that time. Chandler's obituary in the *Worcester Spy* (29 July 1790) alludes to the difficulties he and other rural painters of the era faced: 'By profession he was a house painter, but many good likenesses on canvas show he could guide the pencil of the limner...The world was not his enemy, but, as is too common, his genius was not matured on the bosom of encouragement. Embarrassment, like strong weeds in a garden of delicate flowers, checked his enthusiasm and disheartened the man.'

BIBLIOGRAPHY

Obituary, *Worcester Spy* (29 July 1790)

N. F. Little: 'Winthrop Chandler', *A. America*, xxxv/2 (1947), pp. 77–168 [special issue]

——: 'Recently Discovered Paintings by Winthrop Chandler', *A. America*, xxxvi/2 (1948), pp. 81–97

——: 'Winthrop Chandler', *American Folk Painters of Three Centuries*, ed. J. Lipman and T. Armstrong (New York, 1980), pp. 26–35

Ralph Earl: The Face of the Young Republic (exh. cat. by E. Mankin Kornhauser and others, Hartford, CT, Wadsworth Atheneum, 1991), pp. 5–10, 102–4

ELIZABETH MANKIN KORNHAUSER

Chapman, John Gadsby (*b* Alexandria, VA, 11 Aug 1808; *d* Staten Island, NY, 28 Nov 1889). American

painter and illustrator. Early encouragement and instruction from George Cooke and Charles Bird King diverted Chapman from a career in law. In 1827 he began painting professionally in Winchester, VA, but quickly sought more training in Philadelphia at the Pennsylvania Academy of the Fine Arts. His desire to learn history painting soon took him to Italy to study the Old Masters. Returning to the USA in 1831, Chapman supported himself by painting portraits and occasional history subjects. Between 1837 and 1840 he executed the most important picture of his career, the *Baptism of Pocahontas*, the fifth painting to decorate the Rotunda of the US Capitol Building in Washington, DC (*in situ*). In the mid-1830s Chapman began to illustrate texts, contributing to numerous magazines and gift-books. His most famous project was *Harper's Illuminated Bible* (New York, 1846), which contains over 1400 wood-engravings in the style of Homer Dodge Martin and the later religious paintings of Benjamin West. Chapman's most lasting achievement was his instruction manual, *The American Drawing-book*, which went into numerous editions.

Constant debt, recurring illness and minimal success as a history painter prompted Chapman in 1848 to return to Italy, where he painted engaging scenes of the Roman Campagna. These panoramas and more portable coloured etchings were very popular among American travellers. In 1884, however, Chapman returned to America physically and financially exhausted; his creative spark was all but extinguished. His sons, John Linton Chapman (1839 or 1840–1905) and Conrad Wise Chapman (1842–1910), were landscape painters of modest distinction.

WRITINGS
The American Drawing-book: A Manual for the Amateur (New York, 1847, rev. 1870)

BIBLIOGRAPHY
G. S. Chamberlain: *Studies on John Gadsby Chapman: American Artist, 1808–1889* (Alexandria, VA, 1962)
John Gadsby Chapman (exh. cat., ed. W. P. Campbell; Washington, DC, N.G.A., 1962)
P. C. Marzio: *The Art Crusade: An Analysis of American Drawing Manuals, 1820–1860*, Smithsonian Studies in History and Technology, 34 (Washington, DC, 1976)
E. B. Davis: 'Fitz Hugh Lane and John Gadsby Chapman's American Drawing Book', *Antiques*, cxliv/5 (1993), pp. 700–07
L. Nelson-Mayson: 'New in the Collection', *Cols* [Columbia, SC], v/3 (Summer, 1993), p. 3

H. NICHOLS B. CLARK

Charleston [formerly Charles Town]. American city in South Carolina. It is a major East Coast port, regional centre and the most important city in the state, although Columbia became state capital in 1786. Sited on a peninsula between the Ashley and Cooper rivers, it overlooks a broad bay opening on the Atlantic Ocean a few miles distant. In pre-Revolutionary times, Charles Town, as it was known until after the British occupation of 1780–82, virtually was the South Carolina colony. On the eve of the Revolution it was a wealthy city, the fourth largest in the British colonies (its 1776 population was 12,800, over half of which was black).

In 1663 Charles II created eight court favourites Lords Proprietors of Carolina, the area south of Virginia. In April 1670 a group sent from England settled on the Ashley River, opposite the peninsula, and in 1672 Anthony Ashley Cooper, 1st Earl of Shaftesbury (1621–83), instructed the Governor, Sir John Yeamans (1610/11–74), to lay out a town on the peninsula. The irregular grid of eight blocks, fronting east on the Cooper River and surrounded by fortifications, was a fragment of the original 'Grand Modell', which was more fully realized in early 18th-century extensions across the peninsula. The plan was a variant of established Colonial planning, important chiefly for the public use of the waterfront (notable today in the promenades of South and East Battery) and in the establishment of a modified grid as the system of planning. King and Meeting streets form a spine through the length of the peninsula, while Broad Street crossing them became the northern boundary of élite Charleston.

The environment of Charleston has been enhanced by architectural and garden development, particularly in the period between the rebuilding after a devastating fire in 1740 and the outbreak of the Civil War in 1861. Its character is set by its fine houses (see fig.). Among these are 'double houses', such as the Miles Brewton House (1765–9; builder, Ezra Waite), which derive from English 18th-century style. They have paired rooms on either side of a central hallway and often a central porch with orders and a pediment. The distinctiveness of the city, however, is due to the 'single house' type (e.g. the Robert Pringle House, 70 Tradd Street, 1774; and the Francis Simmons House, 14 Legare Street, *c*. 1800). A long narrow house with rooms on either side of a central hall, it is raised on a full-storey basement and set with the narrow end to the street; entry is by a door that opens not into the house but into the ground-level of a multi-storey porch known as a 'piazza' running the full length of the house, typically on the south side. This house type, so apt for the narrow lots and the sub-tropical climate of Charleston, may be a local innovation or, as is increasingly argued, may derive from Africa and the Caribbean.

Charles Town was slow to build churches; the first was the original St Philip's (1682); on the site now is Charleston's most revered and oldest intact church, St Michael's (anonymous; 1752–61), a weighty Doric-porticoed and demonstratively sited version of St Martin-in-the-Fields (1720–26), London, by James Gibbs (1682–1754). The Fireproof Building (1821–7), from the early South Carolina career of Robert Mills, is so named as one of the first buildings in the USA conceived to be fireproof. Built as the County Record Building (today the South Carolina Historical Society), it is a tough, double-fronted, four-square Doric building, with masonry vaulted bays at the two lower levels.

BIBLIOGRAPHY
A. R. Huger Smith and D. E. Huger Smith: *The Dwelling Houses of Charleston, South Carolina* (Philadelphia, 1917/*R* New York, n.d.)
B. St J. Ravenel: *Architects of Charleston* (Charleston, 1945)
D. Moltke-Hansen, ed.: *Art in the Lives of South Carolinians: Nineteenth-century Chapters* (Charleston, 1979)
M. Lane: *Architecture of the Old South: South Carolina* (Savannah, 1984)
M. O'Brien and D. Moltke-Hansen, eds: *Intellectual Life in Antebellum Charleston* (Knoxville, 1986)
K. Severens: *Charleston: Antebellum Architecture and Civic Destiny* (Knoxville, 1988)
P. A. Coclanis: *The Shadow of a Dream: Economic Life and Death in the South Carolina Low Country, 1670–1920* (Oxford, 1989)
M. G. Fales: 'Jewelry in Charleston', *Antiques*, cxxxviii/6 (1990), pp. 1216–27

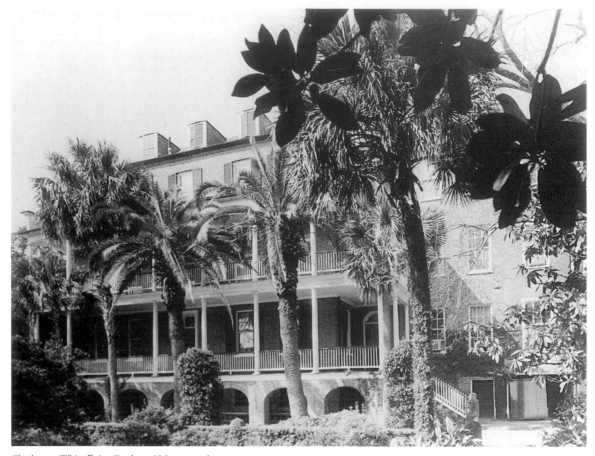

Charleston, White Point Gardens, 18th-century houses

J. B. Gillette: 'American Classic, Drayton Hall: The Oldest Surviving Example of Georgian Palladian Architecture, Charleston, SC', *Hist. Preserv.*, xliii (1991), pp. 22–9
R. A. Leath: 'Jean Berger's Design Book: Huguenot Tradesmen and the Dissemination of French Baroque Style', *Amer. Furniture* (1994), pp. 136–61
S. Scully: *Charleston Style: Past and Present* (New York, 1999)

STANFORD ANDERSON

Chase, William Merritt (*b* Williamsburg, IN, 1 Nov 1849; *d* New York, 25 Oct 1916). American painter and printmaker. He received his early training in Indianapolis from the portrait painter Barton S. Hays (1826–75). In 1869 he went to New York to study at the National Academy of Design where he exhibited in 1871. That year he joined his family in St Louis, where John Mulvaney (1844–1906) encouraged him to study in Munich. With the support of several local patrons, enabling him to live abroad for the next six years, Chase entered the Königliche Akademie in Munich in 1872. Among his teachers were Alexander von Wagner (1838–1919), Karl Theodor von Piloty (1826–86) and Wilhelm von Diez (1839–1907). Chase also admired the work of Wilhelm Leibl (1844–1900). The school emphasized bravura brushwork, a technique that became integral to Chase's style, favoured a dark palette and encouraged the study of Old Master painters, particularly Diego Velázquez (1599–1660) and Frans Hals (1581/5–1666). Among Chase's friends in

Munich were the American artists Walter Shirlaw, J. Frank Currier and Frederick Dielman (1847–1935), as well as Frank Duveneck and John H. Twachtman, who accompanied him on a nine-month visit to Venice in 1877.

In 1878 Chase returned to New York to teach at the Art Students League. Despite his youth and his extended stay in Europe, Chase was not unknown to the American art world, for he had exhibited at the National Academy of Design in 1875, received a medal of honour at the 1876 Centennial Exposition in Philadelphia and won critical attention for his portrait *Ready for the Ride* (1877; New York, Un. League Club), shown at the inaugural exhibition of the Society of American Artists.

The 1880s were for Chase a period of intense activity, as well as artistic growth and maturity. He continued to teach at the Art Students League and to give private lessons in his studio in the Tenth Street Studio Building. In 1881 he won an honourable mention at the Paris Salon for a portrait of Duveneck entitled *The Smoker* (untraced). That year he made the first of many trips to Europe, which brought him into contact with the Belgian painter Alfred Stevens (1823–1906) and the work of the French Impressionists. Their influence is apparent in the lighter palette of the portrait of *Miss Dora Wheeler* (1883; Cleveland, OH, Mus. A.) and *Sunlight and Shadow* (1884; Omaha, NE, Joslyn A. Mus.; see fig.). In 1885 Chase met James McNeill Whistler in London. The two agreed to paint each

other's portrait, although only Chase's of Whistler was completed (1885; New York, Met.). Subsequently Whistler's influence can be seen in a remarkable group of large, full-length female portraits painted between 1886 and 1895: two portraits of Maria Benedict, *Lady in Black* (1888; New York, Met.; see colour pl. XXI, 1) and *Lady in Pink* (1888–9; Providence, RI Sch. Des., Mus. A.), are characterized by a subtly modulated palette accented by shots of brilliant colour, a simple, soft and atmospheric background and brushwork that is lively but not overbearing.

Chase, a member of many art groups, organized with Robert Frederick Blum in 1882 the American Society of Painters in Pastel, which presented four exhibitions between 1884 and 1890. Chase's work in pastel is among the most important in American art. Whether rendering a single figure as in *Back of a Nude* (*c.* 1888; New York, priv. col., see R. G. Pisano, 1979, p. 47) or creating a complex interior with figures as in *Hall at Shinnecock* (1893; Chicago, IL, Terra Mus. Amer. A.), Chase handled pastels with the same skill and panache as he did oils.

In 1883 Chase helped to select American paintings for the Munich Glaspalast exhibition and assisted with the organization of the Bartholdi Pedestal Fund Art Loan Exhibition which, while raising money for the base of the Statue of Liberty, brought important examples of modern European art to America.

In 1891 Chase founded the Shinnecock Summer School of Art on Long Island near the village of Southampton. He conducted classes at this, the first important summer art school in America, until 1902. Chase was known primarily as a Realist, but landscapes that he produced at Shinnecock during the 1890s, such as the *Fairy Tale* (1892; priv. col., see 1983–4 exh. cat., p. 315), capture the essence of American Impressionism. These works are more brilliantly coloured and place greater emphasis on transient atmospheric effects than his earlier park and coastal scenes painted around New York and Brooklyn in the late 1880s. Teaching remained an important part of Chase's life. In addition to his classes at Shinnecock and those at the Art Students League (until 1896, and again 1907–12), Chase taught at the Brooklyn Art Association (1887, 1891–5), at the Chase School of Art (renamed the New York School of Art in 1899) between 1897 and 1907 and at the Pennsylvania Academy of Art (1896–1909). Except in 1906, he took students to Europe every summer from 1903 to 1912. Chase encouraged his pupils to work directly from nature and the model. He stressed technique over subject-matter and advocated drawing directly on the canvas with a fully loaded brush, eschewing a preliminary sketch in pencil or charcoal. His students, who included Charles Demuth (1883–1935), Marsden Hartley (1877–1943), Georgia O'Keeffe (1887–1986), Charles Sheeler (1883–1965) and Joseph Stella (1877–1946), developed very diverse styles, suggesting that Chase provided them with inspiration but did not insist on imitation.

Chase's prominence in the latter part of his life is reflected in the numerous honours he continued to receive. Although by the 1913 Armory Show his style of elegant realism was being superseded by modernist trends, a gallery was devoted to his work at the 1915 Panama-Pacific Exposition in San Francisco.

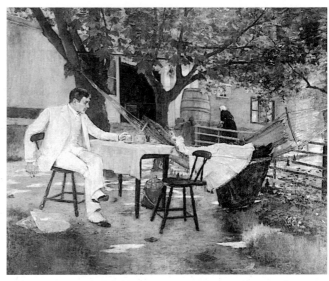

William Merritt Chase: *Sunlight and Shadow*, oil on canvas, 1.62×1.92 m, 1884 (Omaha, NE, Joslyn Art Museum)

BIBLIOGRAPHY

K. M. Roof: *The Life and Art of William Merritt Chase* (New York, 1917/R 1975)
Chase Centennial Exhibition, Commemorating the Birth of William Merritt Chase November 1, 1849 (exh. cat. by W. D. Peat, Indianapolis, IN, Herron Sch. A., 1949)
R. G. Pisano: *William Merritt Chase* (New York, 1979)
C. K. Carr: *William Merritt Chase: Portraits* (Akron, OH, 1982)
R. G. Pisano: *William Merritt Chase 1849–1916: A Leading Spirit in American Art* (Seattle, 1983)
D. C. Atkinson and N. Cikovsky jr: *William Merritt Chase: Summers at Shinnecock 1891–1902* (Washington, DC, N.G.A., 1987)
J. Treiman: *The Artists Series: Monotypes* (New York, 1990)
K. L. Bryant: *William Merritt Chase, A Genteel Bohemian* (Columbia, 1991)
A. Gordon: 'Village Voice', *A. & Ant.*, viii/5 (1991), pp. 90–5
Photographs from the William Merritt Chase Archives at the Parrish Art Museum (exh. cat. by R. G. Pisano and A. G. Longwell, Southampton, NY, Parrish A. Mus., 1992–3)
R. G. Pisano: *Summer Afternoons: Landscape Paintings of William Merritt Chase* (Boston, 1993)
W. H. Gerdts: *Impressionist New York* (New York, London and Paris, 1994)
H. B. Weinberg: 'Impressionists, Realists and the American City', *Mag. Ant.*, cxlv (1994), pp. 542–51
The Artist as Teacher: William Merritt Chase and Irving Wiles (exh. cat by K. Cameron, East Hampton, NY, Guild Hall Mus., 1994)
B. D. Gallati: *William Merritt Chase* (New York, 1995)
L. J. Docherty: 'Model Families: The Domesticated Studio Pictures of William Merritt Chase and Edmund C. Tarbell', *Not at Home: The Suppression of Domesticity in Modern Art and Architecture*, ed. C. Reed (London, 1996), pp. 49–64
H. G. Warkel: 'William Merritt Chase: Works from the Permanent Collection', *Amer. A. Rev.*, viii/1 (1996), pp. 122–7, 160 [works by him in the Indianapolis Museum of Art]

CAROLYN KINDER CARR

Chicago. North American city and seat of Cook County in the state of Illinois. During the late 19th century the city, located at the south-western corner of Lake Michigan, was at the centre of important innovations in the development of modern architecture.

1. History and urban development. 2. Art life and organization.

1. HISTORY AND URBAN DEVELOPMENT. The first European settlement on the site of Chicago was Fort

Dearborn, established in 1803 to protect the portage route between the south branch of the Chicago River and the Des Plaines River, which flows south-west into the Illinois and thence the Mississippi. The fort was abandoned following the massacre of the garrison by American Indians in 1812 but re-established in 1816. The strategic situation of the site stimulated further settlement, and the area at the junction of the north and south branches of the Chicago River was planned in 1830 with a rectangular pattern conforming to the federal Northwest Territories Ordinance of 1787. Following the opening of the Erie Canal (1825), which lowered transportation costs to the eastern seaboard, and with the evacuation of the American Indian population after the Black Hawk War (1832), there was rapid population growth in the settlement and a speculative land boom. Notable early buildings included those in Neo-classical and Greek Revival styles by JOHN MILLS VAN OSDEL, for example the first Chicago City Hall (1844; destr.). In 1848 the Illinois and Michigan Canal connected Chicago with steamboat navigation on the Illinois River and hence the Mississippi, and the first railway to the west was begun. By 1856 Chicago was the most important inland rail centre, a position it maintained. In the next two decades the city's population increased from 30,000 to 300,000; more than half the newcomers were immigrants. Numerous suburban communities became established along the railways radiating from the city. Notable were those along the north lake shore and Riverside, designed by Frederick Law Olmsted and Calvert Vaux in 1869 (see OLMSTED, FREDERICK LAW, §1(iii), and fig. 3). In the same year Olmsted and Vaux laid out South Park (now Washington and Jackson parks)

In October 1871 a fire spread across much of the city, including the central business district and extensive residential areas; an unknown number of lives was lost, property damage was estimated at $200 million, and nearly 100,000 people were made homeless. Rapid suburban development followed, however, and much of the city was rebuilt. During the two decades following the fire the population grew to 1.1 million. This rapid growth and rebuilding programme provided ample opportunity for a large number of architects, many of whom achieved international reputations. In the 1880s the construction and engineering innovations in the development of high-rise buildings (see SKYSCRAPER, §2) came to be associated with the CHICAGO SCHOOL of architecture. Analogous to the introduction of the balloon frame (invented by Chicago carpenters in the 1930s using light milled pine lumber and factory-produced nails in a quick, efficient construction system based on walls as whole units rather than on a separate heavy braced frame), an iron and steel skeleton was first used in 1883–5 by WILLIAM LE BARON JENNEY (with the engineer George B. Whitney) in the Home Insurance Building (destr. 1931; see fig. 1). Jenney's solution to the problem of height, using the skeletal metal frame clad with masonry, became the model for buildings in Chicago. The steel skeleton was used notably in the Reliance Building by D. H. Burnham & Co. (1889–95; for illustration see SKYSCRAPER), designed by John Wellborn Root (1890) and Charles B. Atwood (1894–5). LOUIS SULLIVAN was another a leading designer of high-rise buildings, producing, with Dankmar Adler, the Audito-

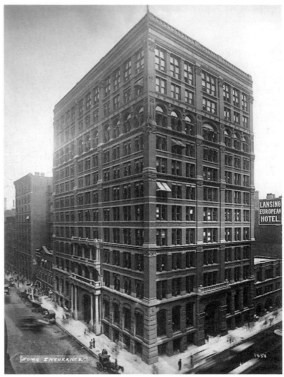

1. Chicago, Home Insurance Building by William Le Baron Jenney, 1883–5 (destr. 1931)

rium Building (1886–9; for illustration see ADLER, DANKMAR), a ten-storey block that at the time was the largest building in Chicago; it is now part of Roosevelt University. Frank Lloyd Wright, then working in Sullivan's practice, also collaborated on this project.

In the late 19th century Chicago's wealth was reflected in the generous contributions to the city's cultural life made by its business leaders and in the construction of many commercial buildings, including the Marshall Field Wholesale Store (1885–7; destr.) by H. H. Richardson (see RICHARDSON, H. H., fig. 5), which was particularly influential; the Montgomery Ward (later Fair) Store (1891–2; destr.) by Jenney; and Sullivan's Schlesinger and Mayer Department Store (1898–1904; now Carson Pirie Scott & Co.; see SULLIVAN, LOUIS, fig. 2), a steel structure noted for its cast-iron ornament. Such works became architectural landmarks. Further technical innovation was introduced in the 1890s by the firm of HOLABIRD & ROCHE, who used portal wind bracing for the first time in the 17-storey Old Colony Building (1893–4; with the engineer Corydon T. Purdy). Around this time FRANK LLOYD WRIGHT was also undertaking commissions of his own in Chicago , including houses for Isidore Heller (1897–8) and Joseph Husser (1899), and, most notably, the Fred Robie House (1908–10; see fig. 2), the last being one of the best-known examples of the style that came to be associated with the PRAIRIE SCHOOL. There were improvements to the city's infrastructure before the end of the 19th century: street railways were electrified after 1885, and elevated railways were built from 1893. The first multiple-unit electric trains operated on the South Side

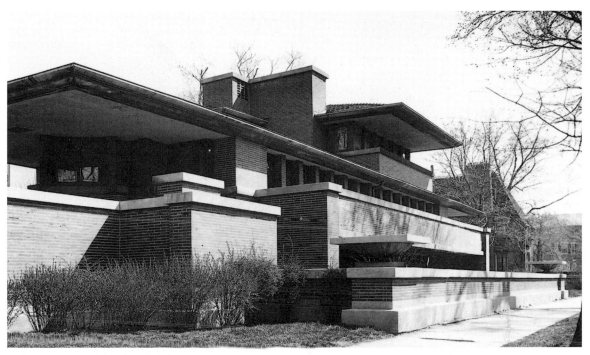

2. Chicago, Fred Robie House by Frank Lloyd Wright, 1908–10

elevated line, and in 1897 the radiating lines were joined in a city-centre loop, which is the source of the name 'the Loop' for the city's commercial district.

To commemorate the 400th anniversary of Christopher Columbus's discovery of America and to celebrate the city's rapid recovery from the fire, the World's Columbian Exposition was held (a year late) in 1893 in Jackson Park. The general site plan was initially drawn up by Burnham (*see* BURNHAM, DANIEL H., §2), later the director of construction, and John Wellborn Root, with Olmsted and Henry Codman (1867–93). Pavilions were designed by, among others, Adler & Sullivan, Jenney & Mundie, RICHARD MORRIS HUNT, SOLON S. BEMAN and HENRY IVES COBB. The fair, which had record attendances, stimulated worldwide interest in comprehensive planning, not only of individual buildings but also of their spatial, functional and aesthetic interrelations, and furthered interest in the ideals of the CITY BEAUTIFUL MOVEMENT for the enhancement of the urban environment. Another effect of the Exposition was, however, its negative impact on developments in skyscraper technology in Chicago, since height limitations were imposed in the city. New York took over as the centre for innovations in high-rises.

As a direct result of the Exposition, Burnham and Edward H. Bennett (1874–1954) were commissioned (1906) by the City Club of Chicago to prepare a comprehensive plan for the city and its environs. Published in 1909, the *Plan of Chicago* was a prototype for comprehensive plans for many other cities, although, as in the plans of the City Beautiful Movement, the absence of skyscrapers, elevated railways and other features of the modern city was in many ways unrealistic. The Chicago Plan Commission, a forerunner of the American Planning Association and a quasi-official organization, was instru-

mental in spreading interest in urban planning. It conducted educational programmes, introduced planning into the American public school curriculum and promoted many of the outstanding infrastructure improvements in Chicago during the following 30 years. These included the almost continuous lake-front parks; the widening of arterial streets; numerous bridges across the Chicago River and its branches; the North Michigan Avenue boulevard development (which a century later would become the axis for a new retail, hotel, office and residential area complementing the older Loop district); a new Union Station (1913–25) by Graham, Burnham & Co. (1913–17) and Graham, Anderson, Probst & White (after 1917); and an outer belt of forest areas, principally along the suburban corridors. In retrospect, the Burnham and Bennett plan had many shortcomings. It treated such social problems as poverty and housing very lightly, implying that physical improvements would stimulate the mitigation of social problems; this proved not to be the case.

BIBLIOGRAPHY

D. H. Burnham and E. H. Bennett: *Plan of Chicago* (Chicago, 1909/R 1960)
H. Hoyt: *One Hundred Years of Land Values in Chicago: The Relationship of the Growth of Chicago to the Rise in its Land Values, 1830–1933* (Chicago, 1933)
B. L. Pierce: *A History of Chicago*, 3 vols (New York, 1937–57)
Residential Land Use: Master Plan of Chicago, Chicago Plan Commission (Chicago, 1943)
C. W. Condit: *The Chicago School of Architecture: A History of Commercial and Public Building in the Chicago Area, 1875–1925* (Chicago, 1964)
H. M. Mayer and R. C. Wade: *Chicago: Growth of a Metropolis* (Chicago, 1969)
I. Cutler: *Chicago: Metropolis of the Mid-continent* (Dubuque, IA, 3/1982)
D. A. Pacyga and E. Skerett: *Chicago: City of Neighborhoods. History & Tours* (Chicago, 1986)
J. Zukowsky, ed.: *Chicago Architecture, 1872–1922: Birth of a Metropolis* (Munich, 1987)

D. van Zanten: 'Chicago in Architectural History', *Architectural Historian in America: A Symposium in Celebration of the Fiftieth Anniversary of the Founding of the Society of Architectural Historians*, ed. E. B. MacDougall (Washington, DC, 1990), pp. 91–9

W. Cronon: *Nature's Metropolis: Chicago and the Great West* (New York and London, 1991)

J. F. Roche: 'Louis Sullivan's Architectural Principles and the Organicist Aesthetic of Friedrich Schelling and S. T. Coleridge', *19th C. Stud.*, vii (1993), pp. 29–55

R. G. Wilson: 'Prairie School Works in the Department of Architecture at the Art Institute of Chicago', *Mus. Stud.*, xxi/2 (1995), pp. 92–111

HAROLD M. MAYER

2. ART LIFE AND ORGANIZATION. The city's first major cultural development was the founding by a group of artists in 1866 of the Chicago Academy of Design, a professional art school. Chicago's cultural needs began to be more broadly addressed, however, after the fire of 1871, when the city was rebuilt and became a centre for modern architecture (*see* §1 above). The great philanthropists Edward E. Ayer, Marshall Field, Charles L. Hutchinson, Potter Palmer, Lambert Tree and MARTIN A. RYERSON, whose wealth was generated through the city's successful commerce and manufacturing, envisaged art as a means of social improvement for the 'brawling masses'. They firmly believed in John Ruskin's notions of the ennobling and purifying effects of art. Their first project was to take over the financially troubled Academy of Design, which they reorganized and renamed the Art Institute of Chicago (AIC) in 1882. The donation of these patrons' collections formed the core of the AIC's renowned Impressionist and Post-Impressionist holdings and established a continuing tradition of high-level collecting by private individuals in the city. The AIC retained its teaching centre as the School of Art Institute, which rapidly became a regional magnet for aspiring artists.

The World's Columbian Exposition, held in Chicago in 1893, provided the second major impetus for cultural growth. The AIC's Beaux-Arts style building located between Lake Michigan and Michigan Avenue was originally an exhibition hall for the Exposition; the central building was later significantly extended. The Fine Arts Building, erected in 1893 on Michigan Avenue, was not primarily an exhibition space, but a commercial studio, recital and office building providing a forum for artists, writers, musicians, craftsmen and other creative people. After the Exposition, an artists' colony grew up, based on 57th Street in housing built for workers employed on construction of the Exposition and then abandoned, and focused on the newly established University of Chicago (founded 1890). Also in the late 19th century, the strong following in Chicago of the Arts and Crafts Movement was indicated by the founding in 1897 of the Chicago Society of Arts and Crafts at Hull House, a settlement house, where immigrants practised such crafts as spinning and weaving. A numer of cultural and artistic organizations sprang up around the turn of the century, most notably and long-lived were the Palette & Chisel Club (founded 1895), the Chicago Society of Artists (founded 1888) and the Chicago Society of Etchers (founded 1910).

By the early 20th century the AIC had amassed a significant collection through donations and purchases. In 1913 the landmark ARMORY SHOW travelled to Chicago from New York, causing great controversy but drawing huge crowds; several important works, including Vasily Kandinsky's *Improvisation with Green Centre (No. 176)* (1913) were bought from the show and eventually donated to the AIC.

BIBLIOGRAPHY

I. Bach and M. L. Gray: *A Guide to Chicago's Public Sculpture* (Chicago and London, 1983)

The Arts Club Of Chicago: Seventy-fifth Anniversary Exhibition (Chicago, 1992)

Master Paintings in the Art Institute of Chicago (exh. cat. by J. Wood, Chicago, IL, A. Inst., 1988)

S. A. Prince: *The Old Guard and the Avant-Garde: Modernism in Chicago, 1910–1940* (London and Chicago, 1990)

LYNNE WARREN

Chicago school. Term applied today to an informal group of architects, active mainly in Chicago in the late 19th century and early 20th. The architects whose names have come to be associated with the term include Dankmar Adler, Daniel H. Burnham, William Holabird, William Le Baron Jenney, Martin Roche and, primarily, LOUIS SULLIVAN. All these architects were linked by their use of the new engineering and construction methods developing in high-rise buildings from the 1880s (sometimes described as 'Chicago construction') and by a new approach to the articulation of façades. In its original use, however, as defined in 1908 by the architect and writer Thomas E. Tallmadge (1876–1940), the term was applied to the work of architects of the next generation (*see* §2 below).

1. FIRST GENERATION. In the more general use of the term 'Chicago school', the first common and uniting element for the architects concerned was their use of the steel skeleton for constructing buildings. In the aftermath of the Great Fire of 1871, which devastated Chicago, rapid expansion took place (*see also* CHICAGO, §1). The high cost and limited availability of sites meant that architects developed the high-rise building and sought new ways to make buildings fireproof; even cast-iron frame buildings had been vulnerable. William Le Baron Jenney pioneered the use of an iron and steel skeleton clad with masonry, which rendered it more heat-resistant, in the Home Insurance Building (1883–5; destr. 1931; *see* CHICAGO, fig. 1). Five years later Burnham and Root built the Rand–McNally Building, for which they employed the steel skeleton.

The second identifying characteristic of 'Chicago construction' is simple exterior decoration, often in red brick or terracotta, and the use of blocky volumes. It was the Bostonian H. H. Richardson who provided the influential model for the stylistic development and the move away from decorative eclecticism, in his massive Marshall Field Wholesale Store (1885–7; destr. 1930; *see* RICHARDSON, H. H., fig. 5), with its plain, rusticated façade and windows grouped under round arches. In 1886–9 Richardson's approach was echoed in the exterior of Sullivan and Adler's Auditorium Building (for illustration *see* ADLER, DANKMAR); it was Sullivan who was responsible for the design and ornament. By contrast, Burnham and Root in their brick Monadnock Building (1889–91), the most celebrated example, avoided ornament.

These two characteristics did not necessarily occur together: the Monadnock Building has no skeleton; the

Home Insurance Building is disappointingly over-decorated. They might, however, coincide, and at that moment the masterpieces of the moment appeared, such as the steel and terracotta Reliance Building (1891–5) by Burnham and Charles Atwood (with John Wellborn Root; for illustration *see* SKYSCRAPER), or the skyscrapers of Adler and Sullivan, beginning with the Wainwright Building (1890–91) in St Louis (*see* UNITED STATES OF AMERICA, fig. 9).

In 1893 the World's Columbian Exposition was held in Chicago, re-establishing the popularity of classicism; in addition, restrictions were placed on the height of buildings in the city. Some critics consider this to be the effective end of the Chicago school, although for others this era is considered as its beginning. □

2. SECOND GENERATION. When Tallmadge first selfconsciously defined the term 'Chicago school' in 1908, he characterized the school's style as the avoidance of historical forms, the invention of original ornament based on real botanical species and acceptance of boxy, geometric massing. He located the formulation of these ideas among the younger Chicago draughtsmen gathering at the Chicago Architectural Club, which organized design competitions and exhibitions, and identified its leaders as George W. Maher, Richard E. Schmidt (1865–1958), Hugh M. G. Garden (1873–1961), George C. Nimmons (1869–1947), Robert C. Spencer, George R. Dean (1864–1919), Dwight H. Perkins (1867–1941), Myron Hunt (1868–1962) and especially Frank Lloyd Wright. Important examples of their work include Maher's Patten House (1901; destr.), Evanston, IL; Schmidt and Garden's Madlener House (1902), Chicago (see fig., and Perkins's work as architect of the Chicago School Board (1905–10), especially his Carl Schurz High School (1908).

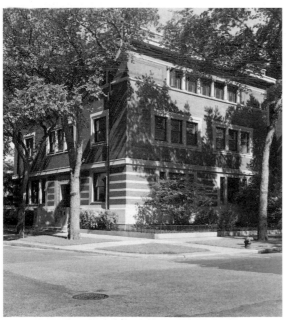

Chicago School, Madlener House by Richard E. Schmidt and Hugh M. G. Garden, Chicago, Illinois, 1902

This selfconscious, second-generation 'Chicago school' was of short duration, having emerged *c.* 1895 when most of the members first set up practice, and was already showing signs of dissolution when Tallmadge wrote in 1908. It was a basically unsuccessful attempt to make a system of the intensely personal contribution of Sullivan, who had been recognized as the creator of a new, antihistorical manner by influential critics Barr Ferree and Montgomery Schuyler early in the 1890s on the basis of his Wainwright Building (1890–91), St Louis, and in Chicago the Schiller Building (1891–3) and the Transportation Building (1891–3) at the World's Columbian Exposition (1893). By 1900, however, Frank Lloyd Wright, in what he called his 'Prairie Houses', was already developing a very different and equally personal style and, like Sullivan, was soon proclaimed the founder of another and equally ephemeral school, christened in the 1960s the PRAIRIE SCHOOL. This included Walter Burley Griffin (1876–1937) and Marion Mahony Griffin (1871–1961), William E. Drummond and John S. Van Burgen (1885–1969).

The flaw in the formulation of these schools would seem to lie in their effort to reduce to systems the manner of two individualists, when what was most fertile was the mentality and technology of the locality. In the 1830s Chicago carpenters had invented the balloon frame. The city had also been at the forefront of the development of fireproof commercial buildings following the Great Fire of 1871 (*see* §1 above). The architects themselves were aware of their accomplishment (Root in particular), and visitors and writers saw these structures as powerful and characteristic expressions of the city's spirit: Henry Blake Fuller in *The Cliff Dwellers* (1893); Achille Hermant in the *Gazette des Beaux-Arts* (1893–4); Paul Bourget in *Outre-Mer* (1895); and Theodore Dreiser in *Sister Carrie* (1900).

When in the 1930s advocates of the European International Style, such as Henry-Russell Hitchcock, Richard Neutra, Nikolaus Pevsner and Sigfried Giedion, evoked Chicago, it was in these terms, and Sullivan and Wright were presented as emanations of a broader Chicago mentality. Between the two World Wars more insular American critics, such as Fiske Kimball (*American Architecture*, 1928) and Tallmadge (*The Story of Architecture in America*, 1927), depicted Sullivan and Wright as romantics attempting (but failing) to create an 'American' style, while Lewis Mumford saw them in the same terms in his *Sticks and Stones* (1924) and *Brown Decades* (1931) but believed that their cause would succeed.

The consequence of seeing Sullivan and Wright as the products of a technological Chicago was to denigrate the aesthetic, humane element in their work: Sullivan's exuberant ornament; Wright's effort to blend his houses with their environment. In his *Space, Time and Architecture* (1941), Giedion argued that Sullivan's skyscrapers should be seen as a particularly frank expression of their innersteel skeletons and that Wright's houses should be appreciated as compositions of geometric forms in space, thus summing up 50 years of critical interpretations of Chicago's contribution beginning with: H.-R. Hitchcock, *The Buildings of Frank Lloyd Wright* (1928) and *Modern Architecture: Romanticism and Reintegration* (1929); R. Neutra, *Amerika* (Vienna, 1930); H. Morrison, *Louis*

Sullivan: Prophet of Modern Architecture (1935); N. Pevsner, *Pioneers of the Modern Movement* (1936). The final result was the doctrine of Carl Condit's *Chicago School of Architecture* (1964), namely that there is a consistent, almost inevitable, Chicago tradition of industrial architecture extending from Jenney to Mies van der Rohe (1886–1969), in which Sullivan and Wright are mere incidents. Other art historians have held that the intentions of Sullivan and Wright should be seen in their immediate historical context, an attitude initiated by Vincent Scully, who treated Sullivan as a humane ornamentalist (*Perspecta*, v, 1959) and Wright as a symbolist (*Frank Lloyd Wright*, New York, 1960). Since then have come Sherman Paul's *Louis Sullivan: An Architect in American Thought* (1962), Narciso Menocal's *Architecture as Nature* (1981) and Lauren Weingarden's essays on Sullivan, as well as Norris Kelly Smith's *Frank Lloyd Wright: A Study in Architectural Content* (1966) and Neil Levine's *The Architecture of Frank Lloyd Wright* (1996). What remains to be addressed, once a more subtle and historically accurate definition of these men's enterprise has been arrived at, is an expansion of the idea of a 'Chicago school' to embrace Daniel H. Burnham with his World's Columbian Exposition work of 1893, as well as his Chicago plan of 1909, and thus to include popular imagery as well as technique in the conception. Chicago's role in the emergence of an unprecedented and revolutionary American visual culture in the late 19th century and early 20th was pervasive and complex; more exploration of this cultural phenomenon is still needed.

BIBLIOGRAPHY

Industrial Chicago, 6 vols (Chicago, 1891–6)
Catalogues of annual exhibitions, Chicago Architectural Club (Chicago, 1894–1923)
T. E. Tallmadge: 'The Chicago School', *Archit. Rev.* [Boston], xv (1908), pp. 69–74
S. Giedion: *Space, Time and Architecture* (Cambridge, MA, 1941)
F. A. Randall: *History of the Development of Building Construction in Chicago* (Urbana, 1949)
C. Condit: *The Rise of the Skyscraper* (Chicago, 1952)
——: *The Chicago School of Architecture* (Chicago, 1964)
M. Peisch: *The Chicago School of Architecture: Early Followers of Sullivan and Wright* (New York, 1965)
H. A. Brooks: *The Prairie School: Frank Lloyd Wright and his Midwest Contemporaries* (Toronto, 1972)
G. Wright: *Moralism and the Model Home* (Chicago, 1980)
C. S. Smith: *Chicago and the American Literary Imagination, 1880–1920* (Chicago, 1984)
K. Sawislak: *Smoldering City* (Chicago, 1995)

DAVID VAN ZANTEN

Church, Frederic Edwin (*b* Hartford, CT, 4 May 1826; *d* New York, 7 April 1900). American painter. He was a leading representative of the second generation of the HUDSON RIVER SCHOOL, who made an important contribution to American landscape painting in the 1850s and 1860s. The son of a wealthy and prominent businessman, he studied briefly in Hartford with two local artists, Alexander Hamilton Emmons (1816–84) and Benjamin Hutchins Coe (1799–1883). Thanks to the influence of the Hartford patron DANIEL WADSWORTH, in 1844 he became the first pupil accepted by Thomas Cole. This was an unusual honour, though Cole probably offered little useful technical instruction—he once observed that Church already had 'the finest eye for drawing in the world'. However, Cole did convey certain deeply held ideas about landscape painting, above all the belief that the artist had a moral duty to address not only the physical reality of the external world but also complex and profound ideas about mankind and the human condition. Church eventually abandoned the overtly allegorical style favoured by his teacher, but he never wavered from his commitment to the creation of meaningful and instructive images.

Church began exhibiting works in New York at the National Academy of Design and American Art-Union while he was still under Cole's instruction. His first success, the *Rev. Thomas Hooker and Company Journeying through the Wilderness from Plymouth to Hartford, in 1636* (1846; Hartford, CT, Wadsworth Atheneum), was a historical landscape that celebrated the founding of his home town. Though the painting was somewhat contrived in composition, and still heavily dependent on Cole, details of foliage, branches and rocks were handled with extraordinary precision, and the radiant, all-encompassing light indicated how carefully the young artist had studied natural phenomena.

After settling in New York in 1847, Church followed a routine of sketching in oil and pencil during summer trips in New York State and New England and painting finished pictures in his studio during the autumn and winter. Most of his works were straightforward American landscapes painted with a crisp realism indicative of his interest in the aesthetics of John Ruskin (1819–1900), but he also exhibited, almost every year until 1851, imaginary or allegorical works reminiscent of Cole with such themes as the *Plague of Darkness* and *The Deluge* (both untraced).

In the summer of 1850 Church made his first visit to Maine, beginning a lifelong association with that state. A number of fine marine and coastal pictures resulted, such as *Beacon, off Mount Desert Island* (1851; priv. col., see 1989–90 exh. cat., p. 26). About this time he started to read the *Cosmos* (1845–62) by the German naturalist Alexander von Humboldt (1769–1859), paying particular attention to the chapter on landscape painting and its relationship to modern science. He began to produce compositions that fused panoramic scope with intricate, scientifically correct detail, such as *New England Scenery* (1851; Springfield, MA, Smith A. Mus.). Although the didactic emphasis of these works recalled Cole's moralizing landscapes, their strongly nationalistic tone and promise of revelation through scientific knowledge made them especially appealing to Church's contemporaries.

Humboldt's description of the tropics of South America as a subject worthy of a great painter inspired Church to travel there in the spring of 1853. He returned to New York with numerous pencil drawings and oil sketches of South American scenery. The first finished pictures based on these studies, such as *La Magdalena* (1854; New York, N. Acad. Des.), appeared in the spring of 1855 at the National Academy, where they caused a sensation. Even more successful was the *Andes of Ecuador* (1855; Winston-Salem, NC, Reynolda House), a sweeping view across miles of mountainous landscape animated by a luminous atmosphere.

In 1857 Church unveiled *Niagara* (1857; Washington, DC, Corcoran Gal. A.; *see* UNITED STATES OF AMERICA, fig. 13), the work that made him the most famous painter in America. This *tour de force* of illusionistic painting

brought the spectator to the very brink of the falls, capturing the effect of North America's greatest natural wonder as had no previous work. Exhibited by itself in America and England between 1857 and 1859, *Niagara* was seen and admired by thousands. In spring 1857 Church returned to South America to gather material for a new series of major tropical landscapes. The first to appear was his masterpiece, the *Heart of the Andes* (1859; New York, Met.; see fig.), which was displayed in the Tenth Street Studio Building in New York in a darkened room with carefully controlled lighting. Surrounded by moulding designed to resemble a window-frame, the painting overwhelmed contemporaries with its intricately painted foreground of tropical plants and its breathtaking vistas along lines leading to several vanishing points in the mountainous distance. Like *Niagara*, the *Heart of the Andes* toured cities in the USA and England, receiving enthusiastic critical and popular acclaim.

During the late 1850s and early 1860s Church was at the height of his powers, painting large-scale exhibition pieces, such as *Twilight in the Wilderness* (1860; Cleveland, OH, Mus. A.; see colour pl. XV,1), *The Icebergs* (1861; Dallas, TX, Mus. A.) and *Cotopaxi* (1862; Detroit, MI, Inst. A.). He continued to paint major works in the years immediately after the Civil War but with an increasing emphasis on visionary atmospheric effects reminiscent of J. M. W. Turner (1775–1851), as in *Rainy Season in the Tropics* (1866; San Francisco, CA, de Young Mem. Mus.), *Niagara Falls, from the American Side* (1867; Edinburgh, N.G.) and the *Vale of St Thomas, Jamaica* (1867; Hartford, CT, Wadsworth Atheneum).

Church continued to travel widely, visiting Jamaica in 1865 and Europe and the Near East in 1867–9. On the journey home, in June 1869, he took advantage of a brief stay in London to study works by Turner. Although a number of important works by Church subsequently appeared in the late 1860s and the 1870s, only a few, such as *Jerusalem* (1870; Kansas City, MO, Nelson–Atkins Mus. A.), approached the power of his earlier works. Similarly, his late South American scenes gradually became less convincing as his memory of the tropics dimmed. Perhaps his last successful full-scale work was *Morning in the Tropics* (1877; Washington, DC, N.G.A.), which has a poetic, introspective quality.

Church spent most of the last years of his life at Olana, the house he built on top of a hill overlooking the Hudson River, just across from Catskill, NY. From there he made numerous trips in the last decades of his life, especially to Maine and Mexico. Although few finished works of note date from these years, Church did paint dozens of superb oil sketches, often of the sky seen from Olana. These sketches, now in Olana and the Cooper-Hewitt Museum of Design in New York, are among his most beautiful creations. Olana survives with many of its original furnishings intact. It contains a collection of Church's works in all media, as well as an important archive of documentary material.

BIBLIOGRAPHY

D. C. Huntington: *Frederic Edwin Church, 1826–1900: Painter of the New World Adamic Myth* (diss., New Haven, Yale U., 1960)
——: *The Landscapes of Frederic Edwin Church: Vision of an American Era* (New York, 1966)
Frederic Edwin Church (exh. cat., Washington, DC, N. Col. F.A., 1966)
Frederic Edwin Church: The Artist at Work (exh. cat. by B. Hanson, West Hartford, U. Hartford, Joselott Gal., 1974)
Close Observation: Selected Oil Sketches by Frederic Edwin Church (exh. cat. by T. E. Stebbins, Washington, DC, Smithsonian Inst. Traveling Exh. Service, 1978)
Frederic Edwin Church: The Icebergs (exh. cat by G. L. Carr, Dallas, Mus. A., 1980)
D. C. Huntington: 'Church and Luminism: Light for America's Elect', *American Light: The Luminist Movement, 1850–75* (exh. cat., Washington, DC, N.G.A., 1980), pp. 155–90

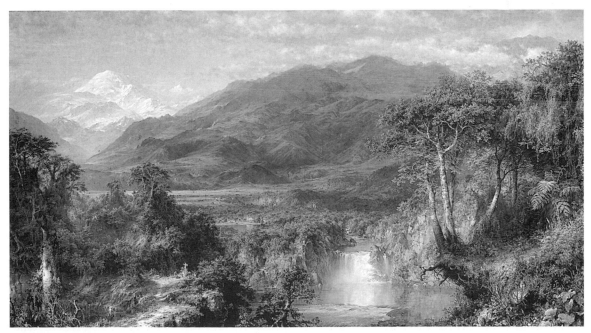

Frederic Edwin Church: *Heart of the Andes*, oil on canvas, 1.68×3.03 m, 1859 (New York, Metropolitan Museum of Art)

To Embrace the Universe: The Drawings of Frederic Edwin Church (exh. cat. by E. Dee, Yonkers, Hudson River Mus., 1984)

Creation and Renewal: Views of Cotopaxi by Frederic Edwin Church (exh. cat. by K. Manthorne, Washington, DC, N. Mus. Amer. A., 1985)

G. L. Carr and F. Kelly: *The Early Landscapes of Frederic Edwin Church, 1845–1854* (Fort Worth, 1987)

F. Kelly: *Frederic Edwin Church and the National Landscape* (Washington, DC, 1989)

Frederic Edwin Church (exh. cat., ed. F. Kelly and others; Washington, DC, N.G.A., 1989–90); review by C. French in *J.A.* [USA], ii/3 (Dec. 1989), p. 14

G. L. Carr: *Frederic Edwin Church: Catalogue Raisonné of Works of Art at Olana State Historic Site* (Cambridge, 1994); review by R. P. Wunder in *Drawing*, xvi/6 (1995), pp. 134–5

FRANKLIN KELLY

Church of Jesus Christ of Latter-day Saints, the. *See* MORMONS.

Cincinnati. American city in Ohio, in the south-west of the state. The metropolitan area of this city, on the banks of the Ohio River, includes parts of Indiana and Kentucky. Known as the 'Queen City of the West', it is one of the largest and most important industrial centres of Ohio. It rises from the river to a valley, known as the 'basin', which is rimmed by a series of steep, wooded hills. Cincinnati evolved from the small frontier settlement (1788) of Losantiville, renamed in 1790 in honour of the Revolu-

tionary War Officers' Society of the Cincinnati. It became a thriving river port in the 1800s, using the Ohio–Mississippi river system. Its narrow streets were lined with sturdy brick and frame buildings, and the city was punctuated by individually significant works such as the businessman Martin Baum's renowned Federal-style mansion (1819, now the Taft Museum) at 316 Pike Street (see fig.; the Greco-Italian hotel Burnet House (1848–50; destr.), designed by Isaiah Rogers, who had settled in Cincinnati in 1848; and John Augustus Roebling's suspension bridge (1856–67) with a span of 322 m, at that time the longest such span in the world. Efforts at rural landscape designs were manifested in Spring Grove Cemetery (1845) by Silesian-born landscape architect Adolph Strauch (1822–83) and at Glendale (1851), one of the nation's earliest planned suburban communities, laid out by the engineer Robert C. Phillips. During the 1870s the city demonstrated its new cultural identity in the Gothic Revival Music Hall (1876–8) by Samuel Hannaford (1835–1910) and Edwin Procter; the nation's second Zoological Gardens (1875), designed with Turkish and oriental-style buildings by James W. McLaughlin (1834–1923); and the city's allegorical bronze centrepiece, the Tyler Davidson Fountain (1871) by Ferdinand von Miller (1842–1929), *in situ* in Fountain Square.

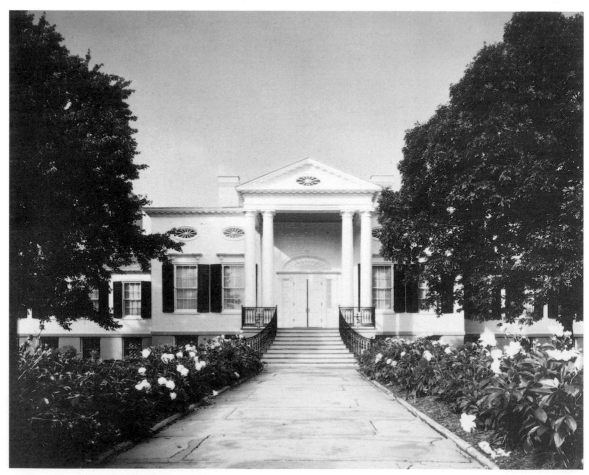

Cincinnati, Martin Baum House (now the Taft Museum), 316 Pike Street, 1819

In the early 20th century a major building boom included the city's first skyscraper (1901), by Daniel H. Burnham, and the world's first reinforced concrete skyscraper, the Ingalls Building (1902–3). Other important works, such as Cass Gilbert's 34-storey Union Central Life Building (1913), then Ohio's tallest structure, helped define the city's emerging skyline. Overcrowding in the 'basin', however, led to the development of the Cincinnati Model Homes (1914), a novel experiment in low-income housing.

The history of Cincinnati's art community began with the founding of the Western Museum by Daniel Drake in 1818 (now the Museum of Natural History). Cincinnati's historically renowned artists included Robert S. Duncanson (who painted murals in the Martin Baum House in 1850), Henry Farny (1847–1916), Frank Duveneck and Hiram Powers. Under the aegis of Benn Pitman (1822–1910), the School of Design became a leader in the design of art furniture, while pioneering efforts in the manufacturing and appreciation of ceramic work helped lead to the formation of the Cincinnati Art Museum Association (1882).

BIBLIOGRAPHY
M. Schuyler: 'The Buildings of Cincinnati', *Archit. Rec.*, xxiii (1908), pp. 337–66
Z. Miller: *Cincinnati's Music Hall* (Virginia Beach, 1978)
The Golden Age: Cincinnati Painters of the 19th Century Represented in the Cincinnati Art Museum (exh. cat., intro. D. Carter; Cincinnati, OH, A. Mus., 1979)
D. Hurley: *Cincinnati: The Queen City* (Cincinnati, 1982)
Architecture and Construction in Cincinnati: A Guide to Buildings, Designers and Builders, Architectural Foundation of Cincinnati (Cincinnati, 1987)
STEPHEN C. GORDON

City Beautiful Movement. American urban planning movement directed towards achieving a cultural parity with the cities of Europe, led by architects, landscape architects and reformers. The movement began in the 1850s with the founding of improvement societies in New England towns, but it gathered momentum and secured a national identity in the 1890s under the stimulus of the World's Columbian Exposition, Chicago (1893), the development of metropolitan park systems and the founding of municipal art societies in major cities. National interest in the movement intensified with the publication of the comprehensive McMillan Plan for Washington, DC (1901–2; see WASHINGTON, DC, fig. 2), designed by the Exposition participants Daniel H. Burnham, Charles F. McKim, Augustus Saint-Gaudens and Frederick Law Olmsted jr.

Charles Mulford Robinson (1869–1917), journalist and author, emerged as the movement's chief spokesperson and advised municipalities to enlist experts. Politicians, art commissions and businessmen's clubs nationwide called on consulting architects, landscape architects and designers. Their objective was not social reform, but municipal reform and beautification, believed to elevate the prestige of cities and thus to attract wealth. The City Beautiful projects, many unrealized, ranged in scale from Cass Gilbert's design for the surroundings of the Minnesota State Capitol in St Paul (1903–6) to the ambitious plan of Daniel H. Burnham and Edward H. Bennett (1874–1954) for San Francisco, CA (1904–5). The movement culminated in Burnham and Bennett's plan for Chicago (1906–9), IL, which encompassed a 95-km radius and proposed a crowning civic centre, radial avenues and ring roads, a rearranged rail network and an extensive system of parks and parkways (see CHICAGO, §1). (By the end of World War I most of the movement's major personalities had completed their careers, but their goals remained an animating force in American urban planning.)

WRITINGS
C. M. Robinson: *Modern Civic Art or the City Made Beautiful* (New York, 1903)
D. H. Burnham and E. H. Bennett: *Plan of Chicago* (Chicago, 1909/R New York, 1970)

BIBLIOGRAPHY
J. Reps: *Monumental Washington: The Planning and Development of the Capital Center* (Princeton, 1967)
M. Scott: *American City Planning since 1890* (Berkeley, 1969)
T. S. Hines: *Burnham of Chicago: Architect and Planner of Cities* (New York, 1974)
J. A. Peterson: 'The City Beautiful Movement: Forgotten Origins and Lost Meanings', *J. Urban Hist.*, ii (1976), pp. 415–34
J. Kahn: *Imperial San Francisco: Politics and Planning in an American City, 1897–1906* (Lincoln, 1979)
A. Sutcliffe: *Towards the Planned City: Germany, Britain, the United States, and France 1870–1914* (New York, 1981)
R. H. Tracy: *John Parkinson and the Beaux-Arts City Beautiful Movement in Downtown Los Angeles, 1894–1935* (diss., Los Angeles, UCLA, 1982)
W. H. Wilson: *The City Beautiful Movement* (Baltimore, 1989)
T. S. Hines: 'The Imperial Mall: The City Beautiful Movement and the Washington Plan of 1901–1902' *Stud. Hist. A.* [Washington, DC], xxx (1991), pp. 78–99
J. A. Peterson: 'The Mall, the McMillan Plan and the Origins of American City Planning', *Stud. Hist. A.* [Washington, DC], xxx (1991), pp. 100–15
K. C. Schlichting: 'Grand Central Terminal and the City Beautiful in New York', *J. Urban Hist.*, xxii/3 (March 1996), pp. 332–49
GAIL FENSKE

Clarke, Thomas B(enedict) (*b* New York, 11 Dec 1848; *d* New York, 18 Jan 1931). American businessman, collector, patron and dealer. He began collecting art in 1869 with paintings by American Hudson River school artists and conventional European works, Chinese porcelain, antique pottery and 17th- and 18th-century English furniture. By 1883 his taste had focused entirely on American works, especially on paintings by George Inness and Winslow Homer. By dealing in such works and by giving frequent exhibitions, Clarke enhanced the popularity of these artists, while also realizing large profits for himself. His founding of Art House, New York, in 1890 confirms the profit motive behind his collecting practices. The most notable sale of his paintings took place in 1899, when he sold at auction 373 contemporary American works at a profit of between 60 and 70%. Four landscapes by Inness—*Grey, Lowery Day* (*c.* 1876–7; untraced), *Delaware Valley* (1865; New York, Met.), *Clouded Sun* (1891; Pittsburgh, Carnegie Mus. A.) and *Wood Gatherers: Autumn Afternoon* (1891; Williamstown, MA, Clark A. Inst.)—received higher prices than any hitherto realized by American paintings. Also sold at this auction were Winslow Homer's *Eight Bells* (1886; Andover, MA, Phillips Acad., Addison Gal.) and Albert Pinkham Ryder's *Temple of the Mind* (*c.* 1885; Buffalo, NY, Albright–Knox A.G.).

Clarke's taste in American art was conventional. He tended to emphasize landscape and genre but also favoured less popular still-life. After the sale of 1899, he collected early American portraits, perhaps partly in response to the

Colonial Revival movement in America and the increased interest in historic American art. Although some of the portraits he collected were misattributed, many of those by John Singleton Copley and Gilbert Stuart, such as *Joseph Coolidge* (1820) in his collection, subsequently given to the National Gallery of Art, Washington, DC, have become national icons. Clarke was admired by his contemporaries for his philanthropy, but a report issued in 1951–2 for the National Gallery of Art in Washington, DC, revealed him as a fraudulent dealer in 18th-century art portraits. Clark's encouragement of art did not extend beyond his lifetime. He did, however, establish a fund at the National Academy of Design, New York, the proceeds of which provide an annual prize of $300 to the best figure painting by a non-academician.

UNPUBLISHED SOURCES
Washington, DC, Smithsonion Inst., Archivs Amer. A.

BIBLIOGRAPHY
DAB
Catalogue of the Private Collection of Thomas B. Clarke (exh. cat., New York, Amer. A. Gals, 1899)
H. B. Weinberg: 'Thomas B. Clarke: Foremost Patron of American Art from 1872 to 1899', *Amer. A. J.*, viii/1 (1976), pp. 52–83
R. H. Saunders: 'The Eighteenth-century Portrait in American Culture of the Nineteenth and Twentieth Centuries', *The Portrait in Eighteenth-century America*, ed. E. G. Miles (Newark, 1993), pp. 138–52

LILLIAN B. MILLER

Claypoole, James (*b* Philadelphia, PA, 22 Jan 1720; *d* Jamaica, *c.* 1784). American painter. He was among the earliest native-born artists in Pennsylvania and painted a number of portraits before 1750 in the Philadelphia area (although none can be identified with certainty). His students, James Claypoole jr (*c.* 1743–1800) and Matthew Pratt, became noted artists at the time of the American Revolution. Claypoole gave up painting for politics later in life, and served for a few years as High Sheriff of Philadelphia before retiring to Jamaica. He is usually remembered, however, for being related to many of the artistic and political leaders of 18th-century Philadelphia. He was the father-in-law of the miniature painter James Peale and of the activist Timothy Matlack. His cousin married Betsy Ross (1752–1836), who is thought to have sewn the first American flag. A portrait of Claypoole by Charles Willson Peale is in the Pennsylvania Academy of Fine Arts in Philadelphia.

BIBLIOGRAPHY
C. Sellers: 'James Claypoole: A Founder of the Art of Painting in Pennsylvania', *PA Hist.*, xvii (1950), pp. 106–9

MARK W. SULLIVAN

Clayton, Nicholas J(oseph) (*b* Ireland, ?1840; *d* Galveston, TX, 9 Dec 1916). American architect of Irish birth. According to family tradition, he was taken to the USA by his recently widowed mother when he was a child. They settled in Cincinnati, OH, where Clayton, after serving in the US Navy, was listed in the city directory as a stone-carver. His architectural apprenticeship may have been with the firm of Jones & Baldwin of Memphis, TN. By 1872 Clayton was in Galveston, TX, as the supervising architect for the First Presbyterian Church, a building thought to have been designed by Jones & Baldwin. In 1875 Clayton was practising in Galveston under his own

name and listed himself in the *Galveston City Directory* as 'the earliest-established professional architect in the state'. He took an active role in the establishment of a professional organization for architects, the forerunner of the present Texas Society of Architects. For his work in promoting the profession, as well as for the quality of his architecture, he was made a Fellow of the American Society of Architects. He enjoyed a successful practice, patronized by leaders in Galveston's business, religious and civic establishments. He worked mainly in the prevailing High Victorian styles, particularly in those of the Gothic and Romanesque revivals, and was admired for his elaborate, inventive and colourful brick detail. Among his most notable works in Galveston are the Gresham House (or Bishop's Palace; 1888), the University of Texas Medical School (or Ashbel Smith Hall; 1889–90) and the Ursuline Convent (1891–4; destr.).

BIBLIOGRAPHY
D. B. Alexander: *Texas Homes of the Nineteenth Century* (Austin, 1966)
H. Barnstone: *The Galveston That Was* (New York, 1966)
W. E. Robinson: *Texas Public Buildings of the Nineteenth Century* (Austin, 1974)

DRURY B. ALEXANDER

Clement, Samuel. *See* FREAKE PAINTER.

Cleveland. North American city and seat of Cuyahoga County in the state of Ohio. Located on the southern shore of Lake Erie, it is an industrial metropolis and a Great Lakes port. The city was founded in 1796 as part of the Western Reserve lands of the old colony of Connecticut. Growth was spurred by the Ohio Canal, the development of the railways, industry and manufacturing, and by 1910 the city was the sixth largest in the USA.

Cleveland's architecture during the first half of the 19th century was typical of a transplanted New England village, with classical and Greek Revival timber houses and churches. In the last quarter of the century the city's most impressive architecture was concentrated on Euclid Avenue, lined with great mansions in every revival style built by the barons of steel, shipping, oil, electricity and the railways (e.g. the Gothic Revival Rufus K. Winslow House by Levi T. Schofield, 1878; destr.). The opportunities for building in a growing and wealthy industrial city attracted many exceptional architects to Cleveland. Several achieved regional, if not national, reputations, including Charles F. SCHWEINFURTH, whose works included the Romanesque Revival Calvary Presbyterian Church (1887–90), and later J. Milton Dyer (1870–1957) and the firm of Walker & Weeks. Cleveland also participated in the commercial architecture revolution that evolved simultaneously in Chicago, New York and other large American cities, which was particularly characterized by the evolution of iron and steel skeletal-frame structures. The most significant example of this development in Cleveland is the Arcade (1890; see fig.) by John Eisenmann (1851–1924) and George H. Smith (1849–1924), a 91-m long, five-storey commercial shopping street connecting two nine-storey office buildings, enclosed in iron and glass with an innovative trussed roof.

In 1903 a commission headed by Daniel H. Burnham produced the 'Group Plan' for Cleveland, in which federal, county and city buildings were built between 1903 and

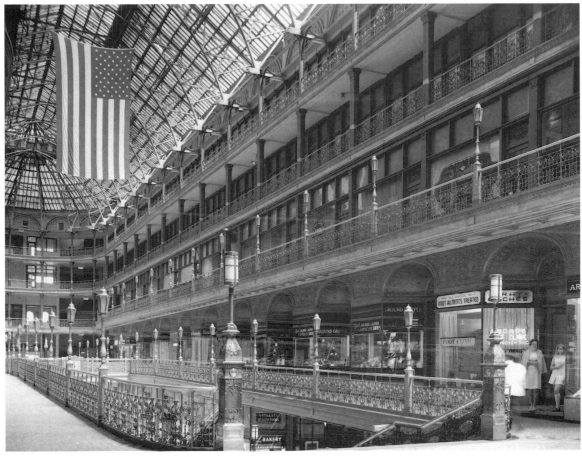

Cleveland, the Arcade by John Eisenmann and George H. Smith, 1890

1936 in a monumental Beaux-Arts ensemble around a mall; it was one of the most fully executed of Burnham's urban plans. Greater Cleveland also developed the first comprehensive modern building code (1904), the first industrial research campus (Nela Park, 1911) by Frank E. Wallis and the most spectacular realization of the garden city suburb, Shaker Heights (1906–30), planned by Oris P. van Sweringen (1879–1936) and Mantis J. van Sweringen (1881–1935).

At University Circle, centred on a lagoon and planned by Frederick Law Olmsted's practice, a unique cluster of cultural institutions was established from the 1880s. The art life of the city became centred on two institutions housed in the Circle, the Cleveland Institute of Art (founded in 1882 as the Cleveland School of Art) and the Cleveland Museum of Art (established 1913).

BIBLIOGRAPHY
E. H. Chapman: *Cleveland: Village to Metropolis* (Cleveland, 1964)
C. F. Wittke: *The First Fifty Years: The Cleveland Museum of Art* (Cleveland, 1966)
The Architecture of Cleveland: Twelve Buildings, 1836–1912 (Cleveland and Washington, DC, 1973)
M. P. Schofield: *Landmark Architecture of Cleveland* (Pittsburgh, 1976)
E. Johannesen: *Cleveland Architecture, 1876–1976* (Cleveland, 1979)
N. C. Wixom: *Cleveland Institute of Art* (Cleveland, 1983)

ERIC JOHANNESEN

Cleveland, Horace William Shaler (*b* Lancaster, MA, 16 Dec 1814; *d* Hinsdale, IL, 5 Dec 1900). American landscape architect and writer. He was a descendant of Moses Cleveland, who came from Ipswich, England, in 1635, and his father, Richard Jaffry Cleveland, was a sea captain. Cleveland gained early agricultural experience in Cuba while his father served as Vice-Consul in Havana. On his return to the USA after 1833, Horace studied civil engineering in Illinois and Maine, settled afterwards on a farm near Burlington, NJ, and became corresponding secretary of the New Jersey Horticultural Society. In 1854 he moved with his family to the vicinity of Boston, spending three years in Salem and ten years in Danvers. During this early phase of his career he formed a partnership with Robert Morris Copeland (1830–74), a landscape architect of Lexington, MA, and designed several rural cemeteries near Boston, including Oak Grove (1854) in Gloucester, MA, and the celebrated Sleepy Hollow (1855) in Concord, MA. In 1856 Cleveland and Copeland entered the competition for the design of the newly acquired Central Park in New York but lost to Frederick Law Olmsted and Calvert Vaux. Cleveland's design bore many of the features of the Olmsted–Vaux design. In a pamphlet accompanying his design Cleveland wrote, 'The tract of land selected for the Central Park comprises such an extensive area and such variety of surface as to afford opportunity for the construction of a work which shall surpass everything of its kind in the world . . .'. Cleveland,

like Olmsted, prescribed broad lawns, undulating surfaces, 'clothed with the rich verdure, dotted here and there with graceful trees and bounded by projecting capes and islands of wood . . .'.

Very little is known of Cleveland's work from 1857 until 1869, when he moved to Chicago. In 1871 he formed a new partnership there with William Merchant French (1843–1914), the architect and civil engineer who later helped to found the Art Institute of Chicago. A professional pamphlet issued by Cleveland and French in 1871 broadly defined landscape architecture as 'the art of arranging land so as to adapt it most conveniently, economically and gracefully, to any of the varied wants of civilization'. In 1873 Cleveland published *Landscape Architecture as Applied to the Wants of the West*, in which he stressed the need for creating broad, tree-lined boulevards to relieve the monotony of the straight lines of Midwestern city grids. In 1876 Cleveland was asked to design Roger Williams Park in PROVIDENCE, RI. He had earlier been associated with the design there of Swan Point Cemetery and of the grounds of the Butler Hospital. His approach to the design of Roger Williams Park was characteristically bold as well as sensitive to the site's topography and natural features. Within ten years he transformed what had been a swampy, unpromising site into one of the finest Picturesque parks in the USA. He created a series of three interconnected lakes, unified by a system of encircling drives and paths. Adjacent lawns were planted with native trees and shrubs, and the whole composition was designed to produce a progression of varying scenes and to give the illusion of naturalness. Cleveland, like Olmsted, with whom he was earlier associated in the design of Prospect Park (1865; *see* OLMSTED, FREDERICK LAW, fig. 2), Brooklyn, New York, and in the design of South Park (now Washington and Jackson Parks) and Drexel Boulevard (1872–6) in Chicago, perceived the park as an instrument of social change and as a work of art. Cleveland moved again in 1886 to Minneapolis, MN. There he made important contributions to civic improvement, fought for the preservation of Minnehaha Falls and designed the regional St Paul–Minneapolis Park system. He contributed a paper on the *Influence of Parks on the Character of Children* to the Chicago Outdoor Art Association in 1898.

WRITINGS
A Few Words on the Central Park (Boston, 1856)
Public Parks, Radial Avenues and Boulevards (24 June 1872) [address given before the Common Council and Chamber of Commerce of St Paul]
Landscape Architecture as Applied to the Wants of the West (Chicago, 1873/ R Pittsburgh, 1965)
Report upon the Improvements of Roger Williams Park (Providence, 1878)
Outline of a Plan of a Park System for the City of St Paul (19 June 1885) [address given before the Common Council and Chamber of Commerce of St Paul]
Park Systems of St Paul and Minneapolis (St Paul, 1887)

BIBLIOGRAPHY
DAB
T. Kimball: 'H. W. S. Cleveland, an American Pioneer in Landscape Architecture and City Planning', *Landscape Archit.*, xx (1929), pp. 99–110
E. M. McPeck: *H. W. S. Cleveland in the East* (paper, Cambridge, MA, Harvard U., Grad. Sch. Des., 1973)
——: *Report to the Roger Williams Park Commission: Historic Factors* (Providence, 1984)
D. J. Nadenicek: 'Civilisation by Design: Emerson and Landscape Architecture', *19th C. Stud.*, x (1996), pp. 33–47

ELEANOR M. McPECK

Clinton & Russell. American architectural partnership formed in 1894 by Charles William Clinton (*b* New York, ?1838–9; *d* New York, 1 Dec 1910) and William Hamilton Russell (*b* New York, ?1854–6; *d* New York, 23 July 1907). Around 1854 Charles Clinton was apprenticed to Richard Upjohn before forming a partnership with Anthony B. McDonald from 1857 to 1862. Clinton then became associated for about ten years with William A. Potter (*see* POTTER, (2)). Thereafter he practised alone for two decades, before forming a partnership with William Russell in 1894. Russell had graduated from the School of Mines at Columbia College in 1878, then joined the office of his great uncle, JAMES RENWICK, becoming a partner in 1883.

Clinton & Russell designed a number of armories, such as the 71st Regiment Armory, New York (1905; destr.), a brick building crowned by an Italianate medieval tower. They also specialized in large commercial buildings of essentially classical design, notably the 19-storey Hudson Terminal (1908) and the Mercantile Building (1901; see fig.), both of which were pioneering efforts in the direct linking of lofty commercial developments with rail transportation. The Mercantile Building, for example, was one of the earliest structures to include a subterranean pedestrian link leading directly to the subway. The firm executed more than a score of mid-rise buildings in lower Manhattan, helping to create the financial district's canyon-like streetscape during the era of New York's emergence as a world financial centre. Clinton & Russell were also responsible for major Beaux-Arts commissions around upper Manhattan, many of which were sponsored by the real

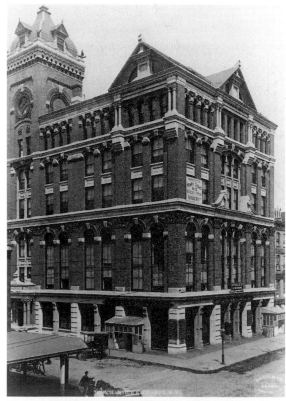

Clinton & Russell: Mercantile Building, New York, 1901

estate magnate William Waldorf Astor. Most notable were the Hotel Astor (1904–9; destr. 1966), a nine-storey French Renaissance style building of brick and limestone noted for its marble and gold lobby arcade and large ballroom; the fashionable Graham Court Apartments (1899–1901); the Astor Apartments (1905); and the sprawling Apthorp Building (1908), said to be, of its time, the largest apartment building in the world.

BIBLIOGRAPHY

Macmillan Enc. Archit.

R. Sturgis: 'A Review of the Work of Clinton and Russell', *Archit. Rec.*, vii (1897), pp. 1–61

R. A. M. Stern: 'With Rhetoric: The New York Apartment House', *Via*, 4 (1980), pp. 78–111

R. A. M. Stern, G. Gilmartin and J. Massengale: *New York, 1900: Metropolitan Architecture and Urbanism, 1890–1915* (New York, 1983)

J. Shockley: 'Graham Court Designation Report', Landmarks Preservation Commission (New York, 1984)

JANET ADAMS

Clonney, James Goodwyn (*b* ?Liverpool, 28 Jan 1812; *d* Binghampton, NY, 7 Oct 1867). American painter. He was one of the first generation of American genre painters. His earliest datable work includes two lithographs of urban views and images of birds and animals published in New York between 1830 and 1835. He studied at the National Academy of Design, New York, and exhibited there periodically between 1834 and 1852. The first genre painting he exhibited at the National Academy was *Militia Training* (1841; Philadelphia, PA Acad. F.A.), although another example, *In the Woodshed* (1838; Boston, MA, Mus. F.A.; see fig.), predates it. He also exhibited at the Pennsylvania Academy of Fine Arts (1845 and 1847) and at the Apollo Association and American Art-Union (1841 50).

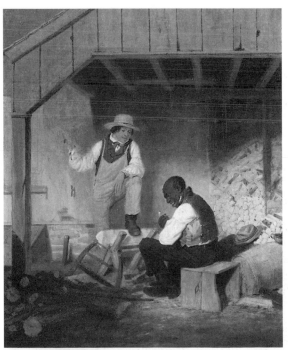

James Goodwyn Clonney: *In the Woodshed*, oil on canvas, 438×356 mm, 1838 (Boston, MA, Boston Museum of Fine Arts)

Clonney worked in watercolours as well as oils and was a prolific draughtsman. Stylistically, his genre paintings indicate an awareness of English precedents and of contemporary American genre painters, especially William Sidney Mount. Clonney's scenes of quiet rural life are typical of the period, but his work is notable for its gentle humour and lack of sentimentality.

BIBLIOGRAPHY

L. H. Giese: 'James Goodwyn Clonney (1812–1867), American Genre Painter', *Amer A. J.*, xi/4 (1979), pp. 4–31

LUCRETIA H. GIESE

Cobb, Henry Ives (*b* Brookline, MA, 19 Aug 1859; *d* New York, 27 March 1931). American architect. He spent one year at the Massachusetts Institute of Technology before enrolling in the Lawrence Scientific School of Harvard University, Cambridge, MA, in 1877. He studied there until 1880 and was awarded a degree in 1881. Cobb worked first for the Boston architectural firm of Peabody & Stearns. Having won the competition of 1881 to design a building for the Union Club in Chicago, Cobb moved to the city in 1882 and began an association with Charles Sumner Frost (1856–1931), who had also worked for Peabody & Stearns. Cobb & Frost's most notable early commission, a castellated Gothic mansion (1882–3; destr. 1950) for Potter Palmer, led to a number of sizeable residential jobs in Chicago. Cobb's popularity rested on his willingness to 'work in styles', as Montgomery Schuyler observed. The Shingle style was used in the Presbyterian Church (1886), Lake Forest, IL, while Romanesque Revival was favoured for the Dearborn Observatory (1888–9), Northwestern University, Evanston, IL, and the Chicago and Alton Railway Station (1885), Dwight, IL. The two major commercial buildings designed by the partnership are the Opera House (1884–5; destr.), which incorporated offices to support the theatre, and the Owings Buildings (1888; destr.), both Chicago.

Working independently after his partnership with Frost ended (1888), Cobb became one of Chicago's most successful architects. In 1891 he proposed the initial campus plan for the University of Chicago. Tudor Gothic in their detailing and arranged in quadrangles, the 17 buildings designed by Cobb's firm between 1892 and 1899 represent an early adoption of the collegiate Gothic in American campus design. In 1891 Cobb joined the National Board of Architects in planning the World's Columbian Exposition in Chicago (1893). Of the seven buildings that his office designed for it, the Fisheries Building received high praise since its design diverged from the classicism and formality of the exposition's principal buildings and used instead Romanesque forms and ornamental details based on marine life.

Cobb had more than 100 office staff in the early 1890s, when he received many of Chicago's most prestigious public and commercial commissions. For the Durand Art Institute (1891), Lake Forest College, Chicago Historical Society (1892) and the Newberry Library (1892; see fig. 1), Chicago, he favoured rugged masonry forms characteristic of H. H. Richardson's Romanesque Revival style. Tall commercial buildings included the Chicago Title & Trust Company Building (1892; destr.), where he had his offices, and the Chicago Athletic Association Club (1893),

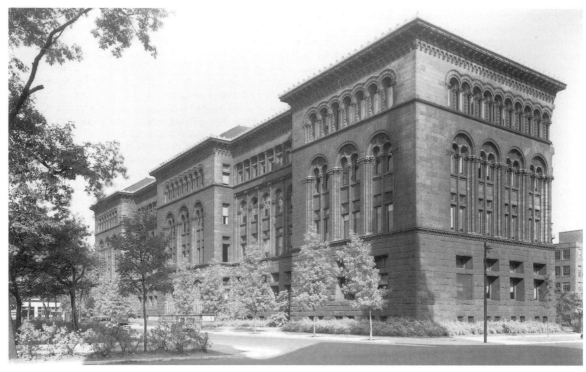

1. Henry Ives Cobb: Newberry Library, Chicago, Illinois, 1892

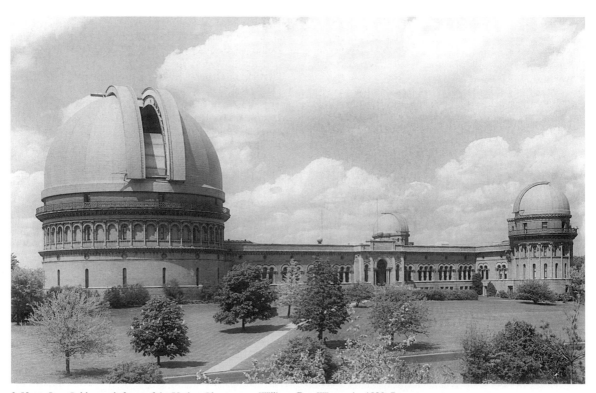

2. Henry Ives Cobb: south front of the Yerkes Observatory, Williams Bay, Wisconsin, 1892–7

with a façade inspired in its colour, texture and forms by Venetian Gothic palaces.

By the turn of the century, Cobb had secured a national reputation. He designed the vast Yerkes Observatory (1892–7; see fig. 2), Williams Bay, WI, with its Romanesque style detailing, the City Hall (1898), Lancaster, PA, and the Capitol Building (1898) at Harrisburg, PA, and he was the architect of the Chicago Federal Building and Post Office (1897–1905). Cobb practised in Washington, DC, from 1898 to 1902, moving there apparently for personal and professional reasons, particularly the prospect of becoming the architect for the American University. He proposed an extensive campus plan for the University in 1898 but only the McKinley-Ohio Hall of Government (1902) was executed. Cobb finally settled in New York in 1902 and practised there until his death. The New York skyscrapers designed by his office include an office building at 42 Broadway (1902–4), the Liberty Tower Building (1909), the Harriman Bank Building (1910).

BIBLIOGRAPHY

'Description of Offices of Henry Ives Cobb, Architect', *Inland Architect & News Rec.*, xxv (May 1895), p. 39

M. Schuyler: Henry Ives Cobb', *Archit. Rec.*, v (1895), pp. 72–110 [Gt. Amer. Architects Ser., no. 2, pt iii]

'The Chicago Post Office and its Architect', *Inland Architect & News Rec.*, xxxi (1898), pp. 25–6

'Henry Ives Cobb, 1859–1931', *Pencil Points*, xii (1931), p. 386

J. Lewis: 'Henry Ives Cobb and the Grand Design', *U. Chicago Mag.*, lxiv (1977), pp. 6–15

K. Alexis: 'Henry Ives Cobb: Forgotten Innovator of the Chicago School', *Athanor*, iv (1985), pp. 43–53

D. Bluestone: *Constructing Chicago* (New Haven and London, 1991)

KATHLEEN ROY CUMMINGS

Coburn, Alvin Langdon (*b* Boston, MA, 11 June 1882; *d* Colwyn Bay, 23 Oct 1966). American photographer, active also in Britain. He was greatly influenced by his mother, a keen amateur photographer, and began taking photographs at the age of eight. He travelled to England in 1899 with his mother and his cousin, F. Holland Day. Coburn developed substantial contacts in the photography world in New York and London, and in 1900 he took part in the *New School of American Pictorial Photography* exhibition (London, Royal Phot. Soc.), which Day organized. In 1902 he was elected a member of the Photo-Secession, founded by Alfred Stieglitz to raise the standards of pictorial photography. A year later he was elected a member of the Brotherhood of the Linked Ring in Britain.

Some of Coburn's most impressive photographs are portraits. He worked for a year in the studio of the leading New York portrait photographer Gertrude Käsebier and became friendly with George Bernard Shaw, who introduced him to a number of the most celebrated literary, artistic and political figures in Britain, many of whom, including Shaw, he photographed (for example see Gernsheim and Gernsheim, p. 13). Shaw also wrote the preface to the catalogue for the exhibition of Coburn's work at the Royal Photographic Society, London, in 1906, and regarded Coburn and Edward Steichen as 'the two greatest photographers in the world'. Coburn produced two books of portraits: *Men of Mark* (1913) and *More Men of Mark* (1922). As a photographer of cities and landscapes (1903–10), he concentrated on mood, striving for broad effects and atmosphere in his photographs rather than clear delineation of tones and sharp rendition of detail. He was influenced by the work of Japanese painters, which he referred to as the 'style of simplification'. He considered simple things to be the most profound. Coburn produced two limited edition portfolios, *London* (1909) and *New York* (1910; see fig.), in photogravure form, which he produced on his own printing press. He claimed that in his hands photogravure produced results that could be considered as original prints, and signed them accordingly. In 1908 he learnt from Steichen the refinements of the Autochrome colour process in New York, though on his return to London he himself claimed to be an innovator and pioneer of colour photography.

Between 1910 and 1911 Coburn spent an extended period in the wilder regions of California, photographing places of great natural beauty, including the Grand Canyon, AZ. Strong design featured in these photographs and in those taken from the top of New York's skyscrapers, such as *House of a Thousand Windows* (1912; see Gernsheim and Gernsheim, p. 109), which was part of the series *New York from its Pinnacles*, exhibited later at Goupil Galleries, London (1913). He defended his right to manipulate photographic perspective to achieve interesting designs, as the Cubists had done in painting. He settled permanently in Britain in 1912 and became involved in Vorticism from its inception in 1914.

PHOTOGRAPHIC PUBLICATIONS

London, text by H. Belloc (London and New York, 1909)

New York, foreword by H. G. Wells (London and New York, 1910)

Men of Mark (London and New York, 1913)

More Men of Mark (London, 1922)

WRITINGS

H. Gernsheim and A. Gernsheim, eds: *Alvin Langdon Coburn: An Autobiography* (London and New York, 1966)

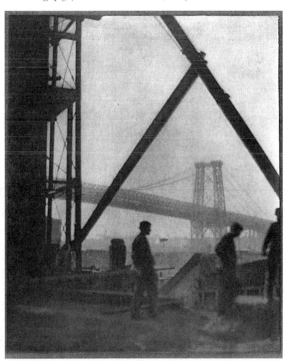

Alvin Langdon Coburn: *Williamsburg Bridge*, photogravure, 1909; from his *New York* (London, 1910), pl. IV (Rochester, NY, International Museum of Photography at George Eastman House)

BIBLIOGRAPHY
Alvin Langdon Coburn: Photographs (exh. cat., preface G. Bernard Shaw; London, Royal Phot. Soc., 1906)
Vortographs and Paintings by Alvin Langdon Coburn (exh. cat. by E. Pound, London, Cam. Club, 1917)
M. F. Harker: *The Linked Ring: The Secession Movement in Photography in Britain, 1892–1910* (London, 1979)
R. F Bogardus: *Pictures and Texts: Henry James, A. L. Coburn and New Ways of Seeing in Literary Culture* (Ann Arbor, 1984)
M. Weaver: *Alvin Langdon Coburn, Symbolist Photographer (1882–1966): Beyond the Craft* (New York, 1986)

MARGARET HARKER

Codman, Ogden, jr (*b* Boston, MA, 19 Jan 1863; *d* Gregy-sur-Yerres, France, 8 June 1951). American architect. His name has been associated primarily with that of the novelist EDITH WHARTON as the co-author of *The Decoration of Houses* published in New York in December 1897. Both as architect and decorator, he is known for his classical interiors adapted from 18th-century models of French, English and American houses, particularly those built on an intimate scale. Born into a distinguished New England family, Codman spent much of his youth in France and returned to Boston to live with his uncle, the architect John Hubbard Sturgis, in 1882. He trained for a year in architecture at the Massachusetts Institute of Technology, Boston, and had several years of practical experience with local architectural firms. An early interest in measured drawing and the study of 18th-century buildings in Boston were important factors in his education.

In 1891 Codman opened an office in Boston, followed by a branch in Newport and a permanent one in New York. During the next 30 years his office specialized in residential commissions, handling approximately 120 projects, 31 of which involved the complete design and remodelling of houses for well-to-do families in the northeast of the USA. These projects included the alteration, interior decoration and landscape design of Edith Wharton's house, Land's End, Newport, RI, in 1893; the decoration (1894–5) of the two upper floors of The Breakers, Newport, RI, for Cornelius Vanderbilt II (1843–99); the interior design (1908) of Kykuit, Pocantico Hills, NY, for John D. Rockefeller; and the building design and interior decoration (1913–15) of 1083 Fifth Avenue (now the National Academy of Design) and 3 East 89th Street, New York, for Archer M. Huntington. Disillusioned by social changes brought about by World War I, Codman later closed his office and moved to France.

Codman was also an antiquarian especially interested in architectural history and genealogy. His most enduring architectural legacy is as an interpreter of the traditional style of interior decoration as popularized by the interior decorator Elsie de Wolfe (1865–1950).

BIBLIOGRAPHY
F. Codman: *The Clever Young Boston Architect* (Augusta, ME, 1970)
P. C. Metcalf: 'The Interiors of Ogden Codman, jr, in Newport', *Antiques*, cviii (1980), pp. 486–97
——: 'Ogden Codman and The Grange', *Old-Time New England*, xvii (1981), pp. 68–83
——: 'Restoring Interiors: The Work of Ogden Codman at The Breakers', *House & Gdn* (September, 1984)
Ogden Codman and the Decoration of Houses (exh. cat., ed. P. C. Metcalf; Boston, MA, Athenaeum, 1988)

PAULINE C. METCALF

Cole, Thomas (*b* Bolton-le-Moor, Lancs, 1 Feb 1801; *d* Catskill, NY, 11 or 12 Feb 1848). American painter and poet of English birth. He was the leading figure in American landscape painting during the first half of the 19th century and had a significant influence on the painters of the HUDSON RIVER SCHOOL, among them Jasper Cropsey, Asher B. Durand and Frederic Church (Cole's only student). In the 1850s these painters revived the moralizing narrative style of landscape in which Cole had worked during the 1830s. From the 1850s the expressive, Romantic landscape manner of Cole was eclipsed by a more direct and objective rendering of nature, yet his position at the beginning of an American landscape tradition remained unchallenged.

1. EARLY CAREER, 1801–29. He spent his first 17 years in Lancashire. Industrialized since the 18th century, Lancashire provided a stark contrast to the wilderness Cole encountered when he followed his family to Steubenville, OH, via Philadelphia, in 1820. To a greater extent than his American contemporaries, therefore, Cole sensed the fragility of the American wilderness, threatened by settlement and industry. Coming of age on a frontier, Cole was largely self-taught as an artist. The somewhat mythologized account of his life set forth by his friend, the minister Louis Noble, describes a youthful romantic in spiritual communion with nature, finding his vocation amid 'the form and countenance, the colours, qualities and circumstances of visible nature' (Noble, p. 12).

Cole's earliest views of the American wilderness were fresh and direct, reinvigorating the worn conventions of the Picturesque and the Sublime that shaped the work of the nation's first landscape painters, Joshua Shaw, Alvan Fisher and Thomas Doughty. He surpassed the topographical tradition represented by British emigrant artists such as William Guy Wall, William James Bennett (1787–1844), William Birch (1755–1834) and his son Thomas Birch. Cole's landscapes, exhibited for the first time in New York in 1825, brought him to the immediate attention of John Trumbull, the patriarch of American history painting, and Asher B. Durand, who succeeded Cole as the most influential spokesman for landscape as a genre. The patronage of men such as Daniel Wadsworth of Hartford, CT, also helped establish Cole as an artist.

Cole's early landscapes, such as *Landscape with Tree Trunks* (1827–8; Providence, RI Sch. Des., Mus. A.) or *The Clove, Catskills* (1827; New Britain, CT, Mus. Amer. A.), were suffused with the drama of weather and seasonal cycles and of natural flux, conditions through which the artist explored his own changing emotional states. Such concerns are evident not only in his painting, but also in the poetry that he wrote throughout his life. His verse and his diaries provide an essential gloss on his art and reveal in his thinking a strong literary and moralizing component that bound nature and imagination together in a complex and unstable unity.

In the late 1820s Cole turned to biblical themes, producing such paintings as *St John the Baptist Preaching in the Wilderness* (1827; Hartford, CT, Wadsworth Atheneum), the *Garden of Eden* (1828; Fort Worth, TX, Amon Carter Mus.), the *Expulsion of Adam and Eve from the Garden of Eden* (1827–8; Boston, MA, Mus. F.A.) and the *Subsiding of the Waters after the Deluge* (1829; Washington, DC, N. Mus. Amer. A.). Among the influences on these

works were the recently published mezzotints of John Martin (1789–1854). Cole's early mode of landscape painting was frequently associated with Salvator Rosa (1615–73), with whose landscapes he was probably familiar. His *Scene from 'Last of the Mohicans'* (1827; Hartford, CT, Wadsworth Atheneum), of which there are several versions (see colour pl. IX, 1), was based on James Fenimore Cooper's novel and was one of the earliest works of art inspired by American literature.

While Cole prepared the way for the *plein-air* naturalism that overtook American landscape painting of the 1850s, his own working methods were grounded in older attitudes. He frequently made precise outline drawings and studies carrying observations about distance and colour from nature and employed these as the sources for his studio compositions, modifying them to produce a synthetic approach to landscape. In certain instances Cole made preparatory oil sketches for such ambitious later series as *The Voyage of Life*. His palette varied from the dark brooding effects of his early Romantic landscapes to the more strident colours of certain works of the 1840s.

2. LATER CAREER, 1829–48. Cole spent the years from 1829 to 1832 in England and Italy. During this period he painted the Roman Campagna in a manner suggestive of the influence of J. M. W. Turner (1755–1851). In Rome, however, while occupying the studio which, according to tradition, had been that of Claude Lorrain (?1604/5–1682), Cole formulated the idea for his most ambitious series, *The Course of Empire* (1833–6; New York, NY Hist. Soc.; see fig.). The generous patronage and friendship of Luman Reed, a newly wealthy New York merchant, made such an extended effort possible for Cole,

and the cycle of five paintings, exhibited in New York in 1836, did much to broaden his reputation.

A dramatic allegory, *The Course of Empire* traced the history of a great nation from its origins in nature and rise to imperial power through its subsequent conquest by invaders and final decline into oblivion. In constructing his series, Cole drew an analogy between ancient and modern republics that had been explored by such works as Edward Gibbon's *Decline and Fall of the Roman Empire* (1776–88) and later by English Romantic works such as Byron's *Childe Harold's Pilgrimage* (1812–18). The implied analogy with ancient Rome reflected Cole's growing disillusionment with America's cultural arrogance and what he felt was its unwitting re-enactment of previous historical cycles. The series also drew on diverse visual sources; for example, on popular panoramas such as *Pandemonium* by Robert Burford (1792–1861) and perhaps on catastrophic themes in the work of Turner, particularly in *The Fifth Plague of Egypt* (exh. RA, 1800; Indianapolis, IN, Mus. A.; engraved 1808).

Such didactic serial allegories consumed a large part of Cole's energies during the remainder of his career, expressing his frustrations with the limits of pure landscape. In works such as *Oxbow on the Connecticut River* (1836; New York, Met.; see colour pl. XI, 1), Cole infused pure landscape with a dynamic sense of historical change. His increasing awareness of the clash between nature and culture is evident not only in his art, but also in his journals, poetry and correspondence. Such landscape views as *Mt Aetna from Taormina* (1843; Hartford, CT, Wadsworth Atheneum) sounded a characteristic note in Cole's later work: culture's impermanence measured by the standards of natural time. Pendant works such as *The Departure* and *The Return* (both 1837; Washington, DC, Corcoran Gal.

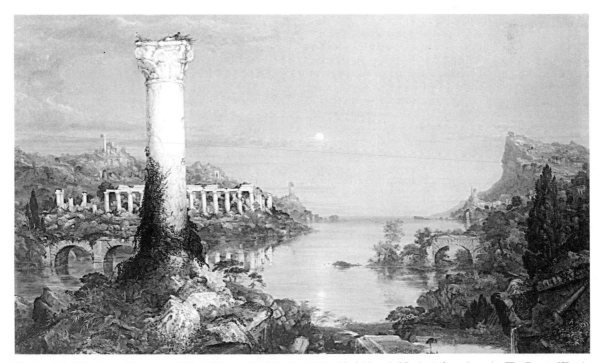

Thomas Cole: *Desolation*, oil on canvas, 975×1587 mm, 1836 (New York, New-York Historical Society); from the series *The Course of Empire*

A.) and *The Past* and *The Present* (both 1838; Amherst Coll., MA, Mead A. Mus.) express a sense of Romantic belatedness, as well as a fascination with the Middle Ages (an interest that linked Cole to the Gothic Revival movement in America during the 1830s and 1840s). These works also furnished the source for later allegorical or literary landscapes, such as Jasper Cropsey's *Spirit of War* (1853; Washington, DC, N.G.A.). Such 'medieval' themes constituted only half of Cole's fascination with the past; equally compelling was the arcadian landscape of the Mediterranean world, evident in such works as *Roman Campagna* (1843; Hartford, CT, Wadsworth Atheneum), *The Dream of Arcadia* (1838; Denver, CO, A. Mus.) and *L'Allegro* (1845; Los Angeles, CA, Co. Mus. A.). In *The Architect's Dream* (1840; Toledo, OH, Mus. A.), commissioned by the architect Ithiel Town, Cole juxtaposed Classical, Gothic and Egyptian styles in a fantastic architectural amalgam recalling the work of the English artist Joseph Michael Gandy (1771–1843).

In 1839, under the patronage of Samuel Ward, a prominent New York banker, Cole undertook another ambitious series, *The Voyage of Life* (1839–40; Utica, NY, Munson–Williams–Proctor Inst.; second version, 1841–2; Washington, DC, N.G.A.). A four-part allegory painted in the period of Cole's conversion to the Episcopal Church, *The Voyage of Life* was a highly accessible series whose Christian theme of resignation appealed to popular sentiments. Engraved by the American Art-Union, it enjoyed a wide national circulation. Cole's tale of youthful imperial visions followed by the sobering setbacks of maturity placed him once again at a philosophical remove from the aggressive expansionism of his contemporaries.

Following a second trip to Europe in 1841–2, Cole was drawn increasingly to Christian subjects; the most ambitious of these works, *The Cross and the World*, remained unrealized at his death. During these years his landscape style shifted towards more domesticated scenes, evident in such works as the *Old Mill at Sunset* (1844) and *The Picnic* (1846; both New York, Brooklyn Mus. A.). During the mid-1840s he also produced a series of paintings on the theme of the home in the woods, which nostalgically evoked the pioneer's earlier more direct association with nature. Although he continued to paint occasional works reminiscent of his wilderness views of the 1820s (e.g *Notch of the White Mountains*, 1839; Washington, DC, N.G.A.; and *Mountain Ford*, 1846; New York, Met.), the pastoralized scenes he executed in the 1840s became the touchstone for American landscape painting over the next decade, as nature came to symbolize communal rather than spiritual and personal values.

Though Cole's work showed no loss of artistic conviction in these years, such stylistic and thematic changes betoken his withdrawal from what he called 'the daily strife' of America in the 1840s into a religiously inspired vision of personal salvation. While he looked to art as an antidote to the rampant materialism of Americans, he nonetheless felt discouraged over the social role of artists and the opportunities for patronage available to them in a democratic culture. Cole remained at root culturally disenchanted, in search of a stability that he found only in private withdrawal and religion. Though he occasionally produced works with a broader cultural significance, such

as his *Prometheus Bound* (1846–7; priv. col.), which symbolizes the subjugation of hubris by a transcendent power, Cole's later career was dominated by a largely personal symbolism. Yet his friendships in the artistic and literary community were strong, and his sudden death in 1848 left a void in the artistic life of the nation.

UNPUBLISHED SOURCES
Albany, NY, New York State Library [Cole papers; also available on microfilm, Archives of American Art]

WRITINGS
M. Tymn, ed.: *Thomas Cole's Poetry* (York, PA, 1972)
——: *The Collected Essays and Prose Sketches of Thomas Cole* (St Paul, MN, 1980)

BIBLIOGRAPHY
L. L. Noble: *The Course of Empire, Voyage of Life and Other Pictures of Thomas Cole, N.A.* (New York, 1853); ed. E. Vesell as *The Life and Works of Thomas Cole* (Cambridge, MA, 1964)
H. Merritt, ed.: 'Studies on Thomas Cole: An American Romanticist', *Baltimore Mus. A. Annu.*, ii (1967) [whole issue]
Thomas Cole (exh. cat. by H. Merritt, U. Rochester, NY, Mem. A.G., 1969)
E. Powell: 'Thomas Cole and the American Landscape Tradition', *A. Mag.*, lii (Feb 1978), pp. 114–23; (March 1978), pp. 110–17; (April 1978), pp. 113–17 [a series of articles with this general title]
A. Wallach: 'Thomas Cole and the Aristocracy', *A. Mag.*, lvi/3 (1981), pp. 94–106
'The Brushes He Painted With That Last Day are There: Jasper F. Cropsey's Letter to his Wife, Describing Thomas Cole's Home and Studio, July 1850', *Amer. A. J.*, xvi (Summer 1984), pp. 78–83
E. C. Parry: *The Art of Thomas Cole: Ambition and Imagination* (Newark, NJ, 1988)
E. A. Powell: *Thomas Cole* (New York, 1990)
Fair Scenes and Glorious Wonders: Thomas Cole in Italy, Switzerland and England (exh. cat., Detroit, MI, Inst. A., 1991)
A. Miller: *The Empire of the Eye: Landscape Representation and American Cultural Politics, 1825–1875* (Ithaca, NY, 1993)
Thomas Cole: Drawn to Nature (exh. cat., ed. C. T. Robinson; Albany, NY, Inst. Hist. & A., 1993)
E. Licata: 'Spirit of the Valley: Landscape into History', *Art & Ant.*, xvii (1994), pp. 44–8
M. P. Sharpe: 'Thomas Cole: Landscape into History', *Amer. A. Rev.*, vi (1994), pp. 122–9
Thomas Cole: Landscape into History (exh. cat., ed. A. Wallach and W. Truettner; Washington, DC, N. Mus. Amer. A.; Hartford, CT, Wadsworth Atheneum; New York, Brooklyn Mus.; 1994–5; review by W. H. Gerdts in *Apollo*, cxli/398 (1995), pp. 56–7, and by A. L. Miller in *Oxford A. J.*, xviii/2 (1995), pp. 93–6
Thomas Cole's Paintings of Eden (exh. cat. by F. Kelly with C. M. Barry, Fort Worth, TX, Amon Carter Mus., 1994–5)
C. Nadelman: 'Thomas Cole: Blending William Wordsworth and James Fenimore Cooper', *ARTNews*, xciv (1995), p. 82
ANGELA L. MILLER

Cole, (Walter Sylvanus) Timothy [Timotheus] (*b* London, 16 April 1852; *d* Poughkeepsie, NY, 17 May 1931). American wood-engraver of English birth. He was one of the most renowned reproductive wood-engravers of his generation. Cole was apprenticed in his early teens to a Chicago firm of commercial wood-engravers and spent several years in New York, working for such periodicals as *Scientific American* and the *Illustrated Christian Weekly*. In 1875 he began an association with *Scribner's Illustrated Monthly Magazine* (later the *Century Magazine*), which continued for the greater part of his career. The magazine was a leader in 'the golden age of American illustration', and its reputation derived in part from the excellence of its engravings, to which Cole made a decisive contribution. He was in the forefront of the 'new school' of wood-engraving, which sought to reproduce more faithfully the textures and tonal values of painting and opposed the prevailing doctrines of such conservative engravers as

William James Linton, who was attempting to retain some artistic licence for the engraver.

In recognition of Cole's extraordinary technical skill and his sensitivity to works of art, the *Century Magazine* commissioned from him a series of engravings after masterpieces owned by leading European museums. Cole spent 27 years on the project, returning to the USA in 1910 to undertake a similar commission in American museums. In addition to appearing regularly in the *Century Magazine*, Cole's engravings were published separately in portfolios and were used to illustrate such books as William James Stillman's *Old Italian Masters* (New York, 1892), J. C. Van Dyke's *Old Dutch and Flemish Masters* (New York, 1895) and Charles H. Caffin's *Old Spanish Masters* (New York, 1902).

WRITINGS
'Some Difficulties of Wood Engraving', *Pr. Colr Q.*, i (1911), pp. 335–43
Considerations on Engraving (New York, 1921)

BIBLIOGRAPHY
R. C. Smith: *The Engraved Work of Timothy Cole* (Washington, DC, 1925)
Timothy Cole Memorial Exhibition (exh. cat., Philadelphia, PA, Prt Club Mus., 1931)
A. P. Cole and M. W. Cole: *Timothy Cole: Wood Engraver* (New York, 1935)

ANNE CANNON PALUMBO

Colman, Samuel (*b* Portland, ME, 4 March 1832; *d* New York, 26 March 1920). American painter, interior designer and writer. He grew up in New York, where his father, Samuel Colman, ran a successful publishing business. The family bookstore on Broadway, a popular meeting place for artists, offered Colman early introductions to such HUDSON RIVER SCHOOL painters as Asher B. Durand, with whom he is said to have studied briefly around 1850. Having won early recognition for his paintings of popular Hudson River school locations, he was elected an Associate of the National Academy of Design in New York in 1854. Most of Colman's landscapes of the 1850s, for example *Meadows and Wildflowers at Conway* (1856; Poughkeepsie, NY, Vassar Coll., Frances Lehman Loeb A. Cent.), reveal the influence of the Hudson River school. An avid traveller, he embarked on his first European tour in 1860, visiting France, Italy, Switzerland and the more exotic locales of southern Spain and Morocco. His reputation was secured in the 1860s by his numerous paintings of romantic Spanish sites, notably the large *Hill of the Alhambra, Granada* (1.2×1.8 m, 1865, New York, Met.).

In 1862 Colman was elected a full member of the Academy. Four years later he was a founder-member of the American Society of Painters in Water Colors, serving as its first President until 1870. He journeyed to California in 1870 and a year later began another extensive European tour, this time to Egypt, Algeria, Morocco, Italy (recorded in the watercolour sketch *On the Tiber, Rome*, 1874; priv. col., see Craven, fig. 18), France, the Netherlands and England. He was a founder-member of the Society of American Artists, established in 1877 as an alternative to the increasingly conservative National Academy of Design. A passionate collector of oriental art and artefacts, Colman expressed his strong interest in the decorative arts through his involvement with the firm of Louis C. Tiffany & Associated Artists, which the two founded with Lockwood de Forest and Candace Wheeler in 1879; they collaborated

on interior design projects, including the redecoration of the White House, Washington, DC, in 1882 (see Faude, figs 6–8). From the mid-1880s Colman made regular sketching trips through the American and Canadian West, producing such vivid and atmospheric watercolours as *Yosemite Valley, California* (*c.* 1888) and *Banff, Canada* (1892; both New York, Kennedy Gals). In the early 1900s he curtailed most of his artistic activities, preferring to devote attention to writing his esoteric theories of art.

WRITINGS
Nature's Harmonic Unity (New York and London, 1912)
Proportional Form (New York and London, 1920)

BIBLIOGRAPHY
'American Painters: Samuel Colman, N.A.', *Appleton's J.* [New York], ii (1876), pp. 264–6
G. W. Sheldon: *American Painters: With Eighty-three Examples of their Work Engraved on Wood* (New York, 1876), pp. 71–6
W. Faude: 'Associated Artists and the American Renaissance in the Decorative Arts', *Winterthur Port.*, x (1975), pp. 101–30
W. Craven: 'Samuel Colman, 1832–1920: Rediscovered Painter of Far-away Places', *Amer. A. J.*, viii/1 (1976), pp. 16–37

MERRILL HALKERSTON

Colonial Revival. Term applied to an architectural and interior design style prevalent in the late 19th century and early 20th in the USA and Australia, countries formerly colonized by Britain. The style, used mostly for domestic architecture, was based on buildings of early colonial periods and had much in common with the contemporary Neo-Georgian tendency in Britain; later developments on the west coast of the USA drew on Spanish styles. It became popular in response to a reaction against the ornate eclecticism of late 19th-century architecture and the search for a new aesthetic: Colonial Revival was promoted as a 'national' style, rooted in the foundations of the nations and suited to their environment and culture.

In the USA scattered praise of Colonial architecture had appeared in architectural publications from the 1840s, and from the 1870s such architects as ROBERT SWAIN PEABODY and ARTHUR LITTLE emphasized the appropriateness and picturesque qualities of Colonial architecture and advocated its revival. Such views were consolidated by the Centennial International Exhibition (1876) in Philadelphia, which crystallized national aspirations towards a simpler way of life, with nostalgia for the values of a pre-industrial society becoming associated with a revival of the building and furnishing styles adopted by the colonists (*see* UNITED STATES OF AMERICA, §§II, 3; V, 5; and VII, 4 and 5). Two buildings at the exhibition attracted particular attention: the Connecticut House by Donald G. Mitchell, which was intended to suggest a Colonial farmstead, and the New England Log House, which had a kitchen with a low-beamed ceiling and Colonial furniture, where traditional boiled dinners—advertised as the kind 'the old Puritans grew strong on'—were served. Two British buildings in a half-timbered style by Thomas Harris were influential in validating the use of a vernacular style. Colonial Revival also drew inspiration from the contemporary resurgence of academic classicism. During the next decades a trend towards greater historical accuracy emerged, with the publication of many illustrated articles and measured drawings of colonial buildings.

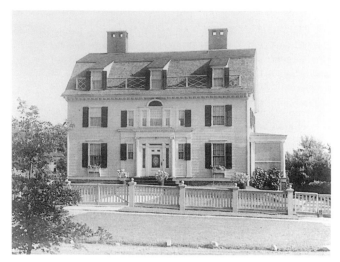

Colonial Revival house by Howells and Stokes, Mary Perkins Quincy House, Litchfield, Connecticut, 1904

The development of resorts in New England provided the opportunity for the Colonial Revival style to be used in settings similar to those experienced by the colonists. Early examples in Newport, RI, include the remodelling (1872) of the Robinson House, Washington Street, by Charles Follen McKim and other buildings by MCKIM, MEAD & WHITE, and Richard Morris Hunt's own house (1870–71); the latter combined elements from Colonial architecture and the SHINGLE STYLE, as did the F. W. Andrew House (1872; destr.) at Middletown, RI, by H. H. RICHARDSON, which had shingles on the upper storey and clapboard below. In Litchfield, CT, the Mary Perkins Quincy House (1904; see fig.) by Howells and Stokes is a clapboard building with green shutters, which harmonizes with its colonial neighbours.

Colonial Revival was adopted for both large and small houses. The simplicity of the New England prototypes and the use of timber as a building material made it a popular, inexpensive choice and led to its widespread use for suburban housing, with several characteristics in common with the late 19th-century QUEEN ANNE REVIVAL style. From the late 1880s, architects in Philadelphia turned to regional models, such as old Pennsylvania farmhouses, and they employed undressed local stone, often whitewashed, as a building material. Among them were WILSON EYRE, Walter Cope (1860–1902) and the practice of Duhring, Okie & Ziegler. Colonial Revival developed later in the southern states, where local models were again adopted; the J. H. Boston House (c. 1913), Marietta, GA, by Joseph Neel Reid, for example, evokes an ante-bellum mansion. The style was also used for other building types. Examples include additions (1870) to Harvard Hall, Harvard University, Cambridge, MA, by Ware & Van Brunt; the Post Office (1902), Annapolis, MD, by James Knox Taylor; and the Unitarian Meeting House (before 1914), Summit, NJ, by John Wheeler Dow, a white clapboard structure with a wooden portico and tower.

A distinctive variant of American Colonial Revival developed on the west coast of the USA. Mission Revival (from the 1890s) drew freely on the old Roman Catholic mission buildings of California and was first popularized after the success of the California Building by A. Page Brown (1859–96) at the World's Columbian Exposition (1893) in Chicago. Typical features included balconies, verandahs and arcades, towers and courtyards. Walls were plastered and roofs pantiled, and there was an almost complete absence of architectural mouldings. Examples of this approach include John Kremple's Otis House (1898), Wilshire Boulevard, Los Angeles, and the Union Pacific Railroad Station (1904), Riverside, CA, by Henry Charles Trost (1860–1933).

BIBLIOGRAPHY

C. F. McKim: *New York Sketch Book of Architecture* (Montrose, NJ, 1874)
R. S. Peabody: 'Georgian Houses of New England', *Amer. Architect*, 2 (1877), pp. 838–9
W. B. Rhoades: *The Colonial Revival*, 2 vols (New York and London, 1977)
K. J. Weitze: *California's Mission Revival* (Santa Monica, 1984)
A. Axelrod: *The Colonial Revival in America* (Winterthur, DE, 1985)
K. A. Marling: 'Parades, Pageantry and the Colonial Revival: The Influence of Popular Culture on the Evolution of Style, 1876–1932', *World Art: Themes of Unity in Diversity*, ed. I. Lavin (University Park, PA, 1989), pp. 686–97
W. B. Rhoads: 'The Discovery of America's Architectural Past, 1874–1914', *Architectural Historian in America: A Symposium in Celebration of the Fiftieth Anniversary of the Founding of the Society of Architectural Historians*, ed. E. B. MacDougall (Washington, DC, 1990), pp. 23–39
M. B. Woods: 'Viewing Colonial America through the Lens of Wallace Nutting', *Amer. A.*, viii/2 (1994), pp. 66–86

BETZY DINESEN

Cone. American family of collectors. Claribel Cone (*b* Jonesboro, TN, 14 Nov 1864; *d* Lausanne, 20 Sept 1929) studied medicine at Johns Hopkins University, Baltimore, MD, and her friendship with fellow student Gertrude Stein led to close contact between the two families from the 1890s. Claribel's sister Etta Cone (*b* Jonesboro, TN, 30 Nov 1870; *d* Blowing Rock, NC, 31 Aug 1949) was the first to travel to Europe in 1901, and she was there again from June 1904 to April 1906, meeting Picasso (1881–1973) through Gertrude Stein in November 1905 and Matisse (1869–1954) in January 1906 through Sarah Stein. After these two studio visits, the Cone sisters began collecting work by both artists and by those artists Matisse and Picasso had led them to admire, including Corot (1796–1875), Cézanne (1839–1906), Renoir (1841–1919), Manet (1832–83), Degas (1834–1917) and Gauguin (1848–1903).

Among the important Picasso works owned by the Cones, some were acquired from the Steins, such as the portrait of *Allan Stein* (1906; Baltimore, MD, Mus. A.). It was Matisse's work, however, that rapidly became the focus of their collection. Their works by Matisse eventually included 42 paintings, 18 sculptures, 36 drawings, 155 prints and 7 illustrated books.

After Claribel's death, Etta continued adding to the collection. She visited Matisse annually to buy key works reserved for her and commissioned him to make a posthumous portrait of her sister. Etta bequeathed the full collection of more than 3000 items—mostly paintings, drawings and sculptures but also fabrics and *objets d'art*—to the Baltimore Museum of Art.

BIBLIOGRAPHY

B. Richardson: *Dr Claribel and Miss Etta: The Cone Collection of the Baltimore Museum of Art* (Baltimore, MD, 1985)

ISABELLE MONOD-FONTAINE

Coney, John (*b* Boston, MA, 5 Jan 1656; *d* Boston, 20 Aug 1722). American silversmith, goldsmith and engraver. The son of a cooper, he probably served his apprenticeship with Jeremiah Dummer (1645–1718) of Boston. Coney may have engraved the plates for the first banknotes printed in the Massachusetts Bay Colony in 1690 and certainly engraved the plates for those issued in 1702. His patrons included important citizens of Boston, churches throughout New England, local societies and Harvard College. Active as a silversmith and goldsmith for 45 years, he produced objects in three distinct styles—that of the late 17th century (characterized by engraved and flat-chased ornament and scrollwork), the Baroque and the Queen Anne—and introduced specialized forms to New England, for example the monteith and chocolatepot. Although derived directly from the English silversmithing tradition and thus not innovative in design, Coney's work exhibits excellent craftsmanship in all technical aspects of gold- and silversmithing. Two lobed sugar-boxes (Boston, MA, Mus. F. A., and Manchester, NH, Currier Gal. A.), a large, gadrooned, two-handled cup (1701; Cambridge, MA, Fogg) made for William Stoughton (*d* 1701), the earliest New England chocolatepot (Boston, MA, Mus. F. A.) and a montcith made *c.* 1705–15 for John Colman (New Haven, CT, Yale U., A.G.; *see* UNITED STATES OF AMERICA, fig. 41) are among the objects he made in the Baroque style. His pear-shaped teapot of *c.* 1710 made for the Mascarene family (New York, Met.) and a two-handled covered cup (1718; Shreveport, LA, Norton A.G.) and a monteith (1719) made for the Livingston family (New York, Franklin D. Roosevelt Lib.) are superb examples of the curvilinear Queen Anne style that was never widely popular in Boston. The more than one hundred surviving objects bearing his mark illustrate the Rev. Thomas Foxcroft's observation that Coney was '*excellently talented* for the Employment assign'd Him, and took a peculiar Delight therein'.

BIBLIOGRAPHY

T. Foxcroft: *A Funeral Sermon Occasion'd by Several Mournful Deaths, and Preach'd on the Decease of Mr. John Coney, Late of Boston, Goldsmith* (Boston, 1722), p. 63

H. F. Clarke: *John Coney, Silversmith, 1655–1722* (Boston and New York, 1932/*R* New York, 1971)

H. N. Flynt and M. Gandy Fales: *The Heritage Foundation Collection of Silver, with Biographical Sketches of New England Silversmiths, 1625–1825* (Old Deerfield, MA, 1968), pp. 188–9

B. McLean Ward: *The Craftsman in a Changing Society: Boston Goldsmiths, 1690–1730* (diss., Boston U., 1983), pp. 169–75, 350

P. E. Kane and others: *Colonial Massachusetts Silversmiths and Jewelers: A Biographical Dictionary* (New Haven, 1998), pp. 315–34

GERALD W. R. WARD

Congdon, Henry Martyn (*b* New Brighton, NY, 10 May 1834; *d* New York, 28 Feb 1922). American architect and designer. His father was a founder of the New York Ecclesiological Society, giving Congdon a propitious beginning to his career as a preferred Episcopal church architect. In 1854 he graduated from Columbia College and was then apprenticed to John W. Priest (1825–59), a leading ecclesiological architect in New York. When Priest died five years later, Congdon inherited the practice. He then moved to Manhattan where he collaborated, from 1859 to 1860, with Emlen T. Littel and later, from around 1870 to 1872, with J. C. Cady (1837–1919). Congdon otherwise practised alone until 1901, when he was joined by his son, Herbert Wheaton Congdon.

Throughout his career Congdon adhered to the ecclesiological tenets he had adopted in his youth. Aside from an occasional deviation, such as his robust Romanesque St James's Episcopal Church, Cambridge, MA (1888), he worked most often in the English Gothic Revival style but treated it in a personal, less archaeologically correct manner. His richly textured churches are often distinguished by prominent towers, compact picturesque massing and a wealth of painstaking detail. His St Andrew's Church, New York (1889–91), is a ruggedly picturesque

Henry Morgan Congdon: St Michael's Episcopal Cathedral, Boise, Idaho, 1899

Gothic Revival building with rock-faced granite walls, a lofty spire off the south transept, a projecting gabled entrance porch on the southwest, a steeply pitched slate roof and deeply set portals, reveals and buttresses. He frequently assumed responsibility for all interior furnishings, including stained glass, pastoral staves and plate.

Most of Congdon's churches are located in the northeast of the USA, particularly in Connecticut and New York. However, he also carried out numerous ecclesiastical commissions in the Midwest, most notably St Michael's Episcopal Cathedral, Boise, ID (1899; see fig.).

UNPUBLISHED SOURCES

H. W. Congdon: 'Autobiography', Eugene, U. Oregon, Special Cols [typescript]

BIBLIOGRAPHY

Macmillan Enc. Archit.

G. W. Shinn: *King's Handbook of Notable Episcopal Churches in the United States* (Boston, 1889)

Obituary, *New York Times* (2 March 1922), p. 21

P. B. Stanton: *The Gothic Revival and American Church Architecture: An Episode in Taste, 1840–56* (Baltimore, 1986), pp. 187, 286, 301

JANET ADAMS

Congregationalists. *See* BAPTISTS AND CONGREGATIONALISTS.

Cook, Walter. *See under* BABB, COOK & WILLARD.

Coolidge, Charles Allerton. *See under* SHEPLEY, RUTAN & COOLIDGE.

Cope & Stewardson. American architectural partnership. It was formed in July 1885 by Walter Cope (*b* Philadelphia, PA, 20 Oct 1860; *d* Philadelphia, 1 Nov 1902) and John Stewardson (*b* Philadelphia, 21 March 1858; *d* Philadelphia, 6 Jan 1896). The firm's early works are typical of the loose eclecticism of the late 1880s; they worked in several modes, from a refined version of the Romanesque Revival of H. H. Richardson in their Young Men's Christian Association (YMCA) building, Richmond, VA (1885; destr.), to the Shingle style of their Edmund Crenshaw House, Germantown, PA (1891), the Netherlandish stepped-gabled fantasy of their Logan Offices, Philadelphia (1888; destr.), and the free broad-eaved Italianate seen in their Harrison Caner House, Philadelphia (1890; destr.), and their Foulke-Long Institute for Orphan Girls, Philadelphia (1890). In each, their invocation of history was blended with the lithe compositional and ornamental goals of their own generation.

Towards the mid-1890s Cope & Stewardson began to garner larger commissions, and their mature work shows a more academic approach to style. Such work also ranged widely, touching on the Spanish Renaissance in their Pennsylvania Institution for the Blind (1897–1900), Overbrook, PA ; on the American Colonial in their James B. Markoe House (1900), 1630 Locust Street, Philadelphia; and on the English Perpendicular Gothic in their Lady Chapel at St Mark's Episcopal Church (1899–1902), 1625 Locust Street, Philadelphia. The firm is most widely remembered, however, for its lively evocations of 17th-century English collegiate buildings at Oxford and Cam-

bridge for American campuses at Bryn Mawr College (begun 1886), PA, the University of Pennsylvania (begun 1895), Philadelphia, Princeton University (begun 1896), NJ, and, further afield at Washington University (begun 1899) in St Louis, MO. In these late works Cope & Stewardson's planning effectively combined order and incident, while their sense of stylistic authenticity revealed the spirit of each place and articulated the intention of the clients. The early deaths of both John Stewardson and Walter Cope left the firm in the hands of Emlyn Lamar Stewardson (1863–1936), brother of John, who continued the firm, changing its name in 1912 to Stewardson & Page.

BIBLIOGRAPHY

R. A. Cram: 'The Work of Cope and Stewardson', *Archit. Rec.*, xv (1904), pp. 407–31

G. B. Tatum: *Penn's Great Town* (Philadelphia, 1961), pp. 118–22

S. Tatman and R. Moss: *Biographical Dictionary of Philadelphia Architects, 1700–1930* (Boston, 1985), pp. 165–70, 759–62

JEFFREY A. COHEN

Copley, John Singleton (*b* ?Boston, 3 July 1738; *d* London, 9 Sept 1815). American painter. He was the greatest American artist of the Colonial period, active as a portrait painter in Boston from 1753 to 1774. After a year of study in Italy and following the outbreak of the American Revolution, in 1775 he settled in London, where he spent the rest of his life, continuing to paint portraits and making his reputation as a history painter.

1. America, 1738–73. 2. Europe, 1774–1815.

1. AMERICA, 1738–73. Copley's parents, Richard and Mary Copley, probably emigrated from Ireland shortly before he was born. Following the death of his father, a tobacconist, Copley's mother in 1748 married Peter Pelham, an engraver of mezzotint portraits. Copley was undoubtedly influenced by Pelham and through him would have had contact with other artists working in Boston, including John Smibert, whose collection of copies of Old Master paintings and casts after antique sculpture constituted the closest thing to an art museum in Colonial America.

Copley began to produce works of art by 1753, when he was only 15. He painted a few early history paintings, largely copied from engravings, but there was no demand for such pictures in Boston. From the beginning he painted primarily portraits. His early style reflects the technical influence of Smibert and the formal influence of a younger artist active in Boston in the late 1740s, Robert Feke. Working in relative isolation, he also relied on English prints for compositional ideas. The portrait of *Mrs Joseph Mann* (1753; Boston, MA, Mus. F.A.), for example, exactly reverses the composition of an English mezzotint of *Princess Anne* by Isaac Beckett after Willem Wissing (*c.* 1683).

The death of Smibert and Pelham in 1751, and the departure of Feke and John Greenwood, left Copley little competition in Boston at the start of his career. In 1755, however, a more polished British painter, Joseph Blackburn, arrived, whose work made Copley's paintings seem pedestrian. Copley quickly absorbed Blackburn's Rococo style of colour, composition and elaborate drapery, but he

retained a strong sense of the physical individuality and presence of his sitters that differs from Blackburn's sweet, sometimes cloying, characterizations.

Whereas Copley's portraits of the 1750s were based on mezzotints after late 17th- and early 18th-century English paintings by Godfrey Kneller (1646–1723) and others, in the early 1760s Copley became indebted via mezzotints to the later English artist Thomas Hudson (?1701–1779). He painted in an English style that was about 15 years out of date, enhanced by characteristics that were fundamental to his developing personal style—simplicity of design, fidelity of likeness, restrained but bold use of colour (Copley was a superb colourist throughout his career), strong tonal contrasts (the mark of an artist trained more through the study of black-and-white prints than of subtly modulated paintings) and a concern more with two-dimensional surface pattern than with the illusionistic representation of masses in space. He painted a few full-length portraits, but most were standard half-lengths (50×40 in.), kit-cats (36×28 in.) or quarter-lengths (30×25 in.). He was an excellent craftsman, preparing his materials with care, and his pictures have stood up well to the passage of time. He was fastidious in the studio and, to the annoyance of some sitters, worked slowly, although he could turn out one half-length or two quarter-length pictures per week. By the mid-1760s Copley was influenced by more recent sources, notably by Joshua Reynolds (1723–92); Copley's portrait of *Mrs Jerathmael Bowers* (1767–70; New York, Met.) was based on the mezzotint of Reynolds's portrait of *Lady Caroline Russell* (1759) by James McArdell (?1728–1765).

Copley prospered by satisfying the taste of his American Colonial sitters for accurate likenesses. But wealth was not sufficient. Aware that he was the best artist in Boston, and perhaps in all of America, Copley yearned to know how good his art was by European standards. In 1765 he painted a portrait of his half-brother Henry Pelham, the *Boy with a Squirrel* (Boston, MA, Mus. F.A.), and sent it to London to be exhibited at the Society of Artists the following year. Reynolds and Benjamin West were favourably impressed, but some criticism was directed at the picture's flatness, and Copley was urged to come to England to perfect his art. He was reluctant, however, to give up a flourishing and profitable business in Boston. During the next few years he painted some of the most brilliant and penetrating portraits of his career. The portrait of *Paul Revere* (1768; Boston, MA, Mus. F.A.; see fig. 1) shows a shirt-sleeved silversmith with his engraver's tools spread on the table before him, contemplating the decorative design he will incise into the surface of a teapot. This portrait is a splendid example of the way in which Copley exercised control of light and colour to achieve a triumph of realistic portraiture.

In 1769 Copley, by then quite prosperous, married Susanna Clarke, the daughter of Richard Clarke, the agent of the British East India Company in Boston. He purchased a 20-acre farm with three houses on it next to John Hancock's house on Beacon Hill. To mark the marriage, Copley painted a pair of pastel portraits of himself and his wife (1769; Winterthur, DE, du Pont Mus.). Although self-taught, Copley was a superb pastellist, one of the best in a century in which the pastel portrait was very popular

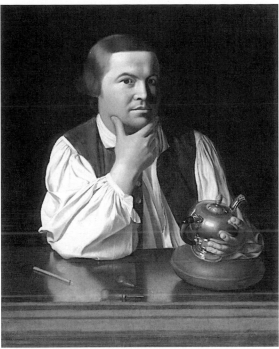

1. John Singleton Copley. *Paul Revere*, oil on canvas, 889×723 mm, 1768 (Boston, MA, Boston Museum of Fine Arts)

in England and on the Continent. Many of Copley's wealthiest sitters, especially those who were young and socially prominent, opted for pastels rather than oils. Copley was also a first rate painter of miniatures, both in watercolour on ivory and oil on copper (e.g. *The Rev. Samuel Fayerweather*, c. 1758; New Haven, CT, Yale U. A.G.).

The political events of the late 1760s and early 1770s split Copley's clientele into opposing camps. Some of his friends and patrons became ardent Whigs, others intractable Tories. Copley was divided in his sympathies. He was a long-time friend of many radicals, including Paul Revere, John Hancock and Sam Adams. On the other hand, he now moved in prominent social circles, and all of his merchant in-laws were Loyalists. Copley also found his business in Boston falling off. In 1771 he took his only extended professional trip in Colonial America, spending over six productive months painting in New York. Copley had by then achieved a powerful, restrained, sophisticated and austere style that had no precise English counterpart; he had, in fact, created an original American style. Sombre in hue and deeply shadowed, his late American portraits, such as that of *Mrs Humphrey Devereux* (1770–71; Wellington, Mus. NZ, Te Papa Tongarewa), are among his most impressive achievements. In the 1770s they directly influenced younger American artists, especially John Trumbull, Gilbert Stuart and Ralph Earl, generating the first definably American style—a development that was unfortunately cut short by the outbreak of the American Revolution and the departure of all these artists for England for the duration of the war.

The political situation in Boston worsened after the Boston Tea Party (1773). The tea had been consigned to

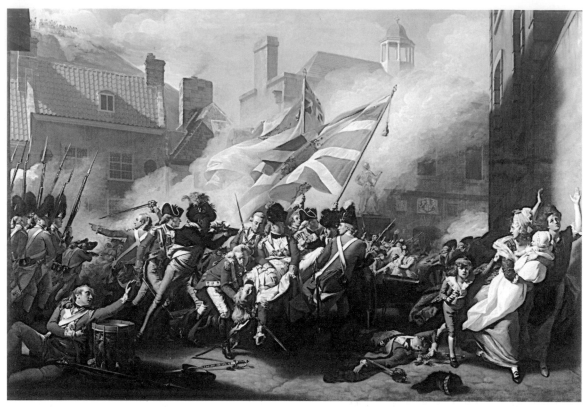

2. John Singleton Copley: *Death of Major Peirson*, oil on canvas, 2.51×3.65 mm, 1782–4 (London, Tate Gallery)

Copley's father-in-law, and Copley unsuccessfully attempted to conciliate both his Tory in-laws and his radical friends. Reluctant to offend either party by taking sides, he decided to go to Europe to improve his art.

2. EUROPE, 1774–1815. Copley left Boston early in 1774. After a brief stay in England, where he finally met and was befriended by Benjamin West, Copley travelled via France to Italy, where he studied for a year. Exposed to works of Classical antiquity and the Old Masters, he overcame earlier apprehensions regarding multi-figure compositions. His new assurance is manifest in the *Ascension* (1775; Boston, MA, Mus. F.A.), inspired by Raphael's *Transfiguration*. By the end of 1775 Copley was back in England and reunited with his family, who had left Boston after the outbreak of hostilities. A large group portrait of *The Copley Family* (1776–7; Washington, DC, N.G.A.) commemorates the reunion.

At the age of 37 Copley launched a second career in England. He hoped that he would be able to concentrate on history painting, fulfilling an early ambition stimulated by reading books on art theory to work in the highest branch of art, although he continued to paint portraits to support his family. His English portrait style, as in *Richard Heber* (1782; New Haven, CT, Yale Cent.) or in the portrait tentatively identified as that of *Mrs Seymour Fort* (*c.* 1778; Hartford, CT, Wadsworth Atheneum), was influenced by West, Reynolds and George Romney (1734–1802) and appears looser than his American manner. Supple brushwork applied the paint fluidly to the canvas,

dissolving detail in favour of more flamboyant visual effects. Strong contrasts of light and dark continued to be important but were used to open up space as well as to enliven the surface.

Watson and the Shark (1778; Washington, DC, N.G.A.; see colour pl. VI, 1), Copley's first English history painting, drew favourable attention when it was exhibited at the Royal Academy in 1779, the year in which he was elected RA. The painting reflected Copley's admiration for what Edgar Wind later called 'the revolution of history painting' (*J. Warb. & Court. Inst.*, ii (1938–9), pp. 116–27), a break with tradition that had been initiated by Benjamin West's *Death of General Wolfe* (1771; Ottawa, N.G.; see WEST, BENJAMIN, fig. 1) through portraying recent events in contemporary rather than classical terms. Copley's next history painting, the *Death of the Earl of Chatham* (1779–81; London, Tate), carried the innovations in history painting a step further, combining history painting and portraiture (genres that had traditionally been separate) and incorporating portraits of 55 of England's most prominent noblemen. Viewing himself as a historian as well as an artist, Copley was trying to record an important event for posterity.

While the *Death of Chatham* was being exhibited, Copley began to work on another large history picture, the *Death of Major Peirson* (1782–4; London, Tate; see fig. 2). On 5–6 January 1781 a detachment of 900 French troops had invaded the island of Jersey, seizing the capital city of St Helier and most of the island. Inspired and led by a 24-year-old major, Francis Peirson, the remaining British

troops and local militia launched a brisk counter-attack that swept back into St Helier and won the day. Peirson was shot and killed at the moment of his triumph. That event, and the revenge exacted by Peirson's black servant, is the primary subject of the picture. The *Death of Major Peirson* is Copley's finest history painting, notable for its vigorous composition, brilliant colour and flickering contrasts of light and dark. Like *Watson and the Shark*, it contains a topographically accurate townscape, the portrait of a black as a central figure and the representation of a dramatic event. Like the *Death of Chatham*, it is centred on a death group and includes actual portraits of key figures. Although Copley had no pupils and founded no school, such paintings influenced John Trumbull's series of American Revolutionary War scenes (New Haven, CT, Yale U. A.G.; for illustration *see* TRUMBULL, JOHN). Thus the large English history paintings that Copley regarded as his major achievement did have some impact, albeit not profound or durable, on the subsequent course of American art. It is also possible that through engravings his history paintings may have had some influence on later French Neo-classicism, particularly such portrait-filled recordings of contemporary history as the *Oath of the Tennis Court* (1790–91; Paris, Louvre) by Jacques-Louis David (1748–1825) with its echoes of the *Death of Chatham*.

In 1783, while at work on the *Death of Major Peirson*, Copley and his family moved from Leicester Square to an elegant house in George Street, where he lived for the rest of his life, as did his son John Singleton Copley jr, later Lord Lyndhurst, three times Lord Chancellor under Queen Victoria. Unfortunately, the quality of his art and indeed of his life deteriorated after the triumph of the *Death of Major Peirson*. In 1783 he won a commission from the Corporation of the City of London to paint the *Siege of Gibraltar* (London, Guildhall A.G.), an enormous canvas (5.5×7.6 m) celebrating a victory over the Spanish (1782). Shortly thereafter he also received his first major royal commission, the *Daughters of George III* (London, Buckingham Pal., Royal Col.). But when this work was exhibited at the Royal Academy in 1785, it was ridiculed by John Hoppner (1758–1810), a rival artist (review repr. in W. T. Whitley, *Artists and their Friends* (Cambridge, 1928), ii, p. 49), and Copley subsequently received little royal or aristocratic patronage. Another blow in 1785 was the sudden illness and death of his two youngest children. The *Siege of Gibraltar*, long delayed in its completion, was not a critical success when it was finally exhibited in 1791.

During the 1790s Copley attempted to apply his realistic history painting techniques to scenes of 17th-century English history, but the results failed to capture the public imagination. He did produce one final impressive modern history picture, the *Victory of Lord Duncan* (1798–9; Dundee, Spalding Golf Mus.), but thereafter his powers declined rapidly. In the early years of the 19th century he became enmeshed in squabbles with patrons and fellow artists, especially during an unfortunate campaign to unseat West as President of the Royal Academy. He sank into debt in attempting to maintain his elegant house and grew increasingly feeble in both mind and body until, following a stroke, he died at the age of 77.

See also UNITED STATES OF AMERICA, fig. 23 and fig. 24.

WRITINGS

G. Jones, ed.: *Letters and Papers of John Singleton Copley and Henry Pelham, 1739–1776*, MA Hist. Soc. col., lxxi (Boston, 1914)

BIBLIOGRAPHY

A. T. Perkins: *A Sketch of the Life and a List of the Works of John Singleton Copley* (Boston, 1873)

Supplementary List of Paintings by John Singleton Copley (Boston, 1875)

M. B. Amory: *The Domestic and Artistic Life of John Singleton Copley, RA* (Boston, 1882/R New York, 1970)

An Exhibition of Paintings by John Singleton Copley (exh. cat. by H. B. Wehle, New York, Met., 1936–7)

B. N. Parker and A. B. Wheeler: *John Singleton Copley: American Portraits in Oil, Pastel and Miniature, with Biographical Sketches* (Boston, 1938)

John Singleton Copley, 1738–1815 (exh. cat., Boston, Mus. F.A., 1938)

J. T. Flexner: *John Singleton Copley* (Boston, 1948)

J. D. Prown: 'An "Anatomy Book" by John Singleton Copley', *A. Q.*, xxvi (1963), pp. 31–46

John Singleton Copley, 1738–1815 (exh. cat. by J. D. Prown, Washington, DC, N.G.A., 1965–6)

J. D. Prown: *John Singleton Copley*, 2 vols (Cambridge, MA, 1966)

A. Frankenstein and others: *The World of Copley, 1738–1815* (New York, 1970)

T. J. Fairbrother: 'John Singleton Copley's Use of British Mezzotints: A Reappraisal Prompted by New Discoveries', *A. Mag.*, lv (1981), pp. 122–30

A. Boime: 'Blacks in Shark-Infested Waters: Visual Encodings of Racism in Copley and Homer', *Smithsonian Stud. Amer. A.*, iii/1 (1989), pp. 19–47

John Copley: 1875–1950 (exh. cat. by G. Cooke and J. R. Taylor, New Haven, CT, Yale Cent. Brit. A., 1990)

C. Rebora: 'Transforming Colonists into Goddesses and Sultans: John Singleton Copley, his Clients and their Studio Collaboration', *Amer. A. J.*, xxvii/1–2 (1995–6), pp. 4–37

C. Troyen: 'John Singleton Copley and the Heroes of the American Revolution', *Mag. Ant.*, cxlviii (1995), pp. 84–93

John Singleton Copley in America (exh. cat. by C. Rebora and others; Boston, MA, Mus. F.A.; New York, Met.; Houston, TX, Mus. F.A.; 1995–6)

John Singleton Copley in England (exh. cat. by E. B. Neff; Houston, TX, Mus. F.A.; Washington, DC, N.G.A.; 1995–6) [entry by W. L. Pressley]; review by J. Wilson in *Burl. Mag.*, cxxxviii (1996), 35–45

E. B. Neff: 'John Singleton Copley's "Native" Realism and his English "Improvement"', *Amer. A. Rev.*, viii/1 (1996), pp. 78–85

S. Rather: 'Carpenter, Tailor, Shoemaker, Artist: Copley and Portrait Painting around 1770', *A. Bull.*, cxxix (1997), pp. 269–90

JULES DAVID PROWN

Corcoran, William Wilson (*b* Washington, DC, 27 Dec 1798; *d* Washington, DC, 24 Feb 1888). American financier, collector and museum founder. The success of the Corcoran & Riggs Bank (now Riggs National Bank) permitted Corcoran to retire in 1854 and devote the remainder of his life to art and philanthropy. His first significant purchase, the *Adoration of the Magi* by Anton Raphael Mengs (1728–1779), was made in 1846. (All works mentioned are in the Corcoran Gallery of Art, Washington, DC.) He began to focus on contemporary American artists from the 1840s with such purchases as the *Greek Slave* by Hiram Powers (1841) and *Mercy's Dream* by Daniel Huntington (1850). Further interests were the artists of the Hudson River school, including Thomas Doughty, Thomas Cole and John Frederick Kensett, in addition to genre painters such as Seth Eastman, William Tylee Ranney and John Mix Stanley. His determination to acquire major works led to costly purchases such as the pair of paintings by Thomas Cole, *The Departure* and *The Return* (both 1837), for which he paid $6000. After trips to Europe in 1849 and 1850, he bought works by contemporary European painters, but they never fully commanded his attention.

In 1848 Corcoran bought the former residence of Daniel Webster and furnished it with his collection. James Renwick renovated the building and designed new wings, while the grounds were landscaped by A. J. Downing. Even at this early date, a public commitment can be discerned; he loaned paintings to exhibitions, provided space for artists' studios and made donations to local arts organizations. In 1851 he opened his home to the public, and around 1855 Renwick began to design and build a gallery in the Second Empire style to house the collection. Construction was interrupted by the Civil War in 1861. Corcoran was accused of Confederate sympathies, his property was partially confiscated and he fled to Europe the same year. On his return in 1865, he sought to redeem his position in Washington by completing the gallery. His plans for the museum, founded in 1869, were threefold: an institution to collect and exhibit American art; a national portrait gallery; and an art school. Between 1874 and 1885 he purchased for the gallery portraits of all the American presidents, including *Andrew Jackson* (1845) by Thomas Sully. He left a bequest of $100,000 to be used by the art school. In 1897 the Corcoran Gallery moved to 17th St, Washington, DC, and is now one of the largest and most extensive collections of 19th-century American painting in the USA.

WRITINGS

A Grandfather's Legacy: Containing a Sketch of his Life and Obituary Notices of some Members of his Family Together with Letters from his Friends (Washington, DC, 1878)

UNPUBLISHED SOURCES

Washington, DC, Lib. Congr. [Papers of William Wilson Corcoran]

BIBLIOGRAPHY

DAB

D. W. Phillips: *A Catalogue of the Collection of American Paintings in the Corcoran Gallery of Art*, 2 vols (Washington, DC, 1966–73)

Corcoran (exh. cat. by D. Spiro, Washington, DC, Corcoran Gal. A., 1976)

R. T. Carr: *32 President's Square*, i of *The Riggs Bank and its Founders* (Washington, DC, 1980)

A. Wallach: 'On the Problem of Forming a National Art Collection in the United States: William Wilson Corcoran's Failed National Gallery', *Stud. Hist. A.*, xlvii (1994), pp. 113–25

LINDA CROCKER SIMMONS

Corning Glass Works. American glass manufactory in Corning, NY. In 1851 Amory Houghton (1813–82), a Boston businessman, became a director of a glass company in Cambridge, MA, and subsequently owner of his own glass factory. Later he sold his Massachusetts glass interests and bought the idle Brooklyn Flint Glass Works in New York. Transportation and labour difficulties caused him to move the equipment and some employees to Corning in 1868. The factory's chief product was blanks for glasscutting, and Houghton persuaded John Hoare (1822–96) to establish a branch of his successful Brooklyn cutting shop in Corning. This was the first of many cutting shops in the region, which became noted for the production of heavily cut glass. By about 1900 more than 500 glasscutters were employed in the Corning area.

In the 1870s Amory Houghton jr (1837–1909) of the renamed Corning Glass Works developed an exceptionally visible and stable red glass for railway signal lanterns, which later became a railway standard, and in 1880 the firm blew the first light bulbs for Thomas Edison (1847–1931). After 1905 Corning phased out the manufacture of blanks for glasscutting, as this type of glass ceased to be fashionable, and developed the heat-resistant glass 'Pyrex' for use in laboratories and kitchens. The works expanded to become the largest speciality glass company in the USA, making all types of products except window glass and containers.

BIBLIOGRAPHY

T. P. Dimitroff and L. S. Janes: *History of the Corning Painted Post Area: Two Hundred Years in Painted Post Country* (Corning, 1977)

E. S. Farrar and J. S. Spillman: *The Complete Cut and Engraved Glass of Corning* (New York, 1979, rev. Syracuse, NY, 1997)

A. Palmer: *Glass in Early America: Selections from the Henry Francis du Pont Winterthur Museum* (Winterthur, DE, 1993)

K. M. Wilson: *American Glass, 1760–1930: The Toledo Museum of Art* (Ann Arbor, 1994)

J. S. Spillman: *The American Cut Glass Industry: T. G. Hawkes and his Competitors* (Woodbridge, 1996)

JANE SHADEL SPILLMAN

Cornish. American town and former artists' colony in the state of New Hampshire. Situated on a line of hills near the eastern bank of the Connecticut River *c.* 160 km northwest of Boston, Cornish looks across to Windsor, Vermont and Mt Ascutney. It was settled in 1763 as an agrarian community, but its population was rapidly reduced during the migration to the cities in the second half of the 19th century. From 1885 until around the time of World War I, Cornish was the summer home of a group of influential sculptors, painters, architects, gardeners and writers. For this coherent group, the Cornish hills symbolized an ideal natural environment that reflected the classical images so important in their work. The sculptor who first spent a summer in Cornish in 1885, AUGUSTUS SAINT-GAUDENS, bought his summer residence there in 1891, and he was soon followed by the painters Henry Oliver Walker (1843–1929), George de Forest Brush, and Thomas Wilmer Dewing and his wife Maria Oakey Dewing (1845–1927). While the Dewings became the most enthusiastic promoters of the colony, Saint-Gaudens, who made Cornish his permanent home from 1900 onwards, clearly established it as a domain for sculptors, attracting Daniel Chester French, who worked there in the summers of 1892 and 1893, and Herbert Adams (1858–1945), who joined the community in 1894.

While the colony in Cornish was not dominated by a major figure, painters formed the largest group of artists. Most of them had trained in New York and in Paris at either the Académie Julian or the Ecole des Beaux-Arts. They shared a common belief in traditional subjects as influenced by the art of antiquity and the Renaissance. The figural tradition was pursued by mural painters, for example Kenyon Cox and John Elliott (1858–1925), and by book and magazine illustrators such as Maxfield Parrish and William Howard Hart (1863–1937). A larger group focused on the local landscape: Willard Leroy Metcalf, Arthur Henry Prellwitz (1865–1940), Stephen Parrish (1846–1938) and CHARLES A. PLATT depicted scenes of the Connecticut River Valley and New Hampshire hills, while Thomas Dewing created a more mythical landscape in haunting canvases populated by ethereal maidens in flowing gowns. Platt also became the resident architect of the Cornish colony after designing nine houses and several gardens for himself and his fellow colonists in the 1890s. While others, including Joseph Wells (1853–90), George

Fletcher Babb (1836–1915), Wilson Eyre and Harrie T. Lindeberg (1880–1959), also designed houses in Cornish, Platt established the model for the urban artist's summer retreat in his combination of the Italian Renaissance villa and local building materials (clapboard, stucco on wooden frame, and brick).

Landscape architects also emerged in the colony: many of the artists were amateur gardeners, but Platt, Ellen Shipman (1870–1950) and Rose Standish Nichols (1872–1960) began their professional careers as landscape designers in their work on Cornish gardens. All three espoused an interest in the formal gardens of the Renaissance, with clear geometry and axial interrelationships providing the basis of their designs. Collaboration was characteristic of the Cornish community, and many artists worked in more than one medium. The architects designed settings for the sculptors, the muralists incorporated gardens modelled on local examples, and the sculptors derived inspiration from the landscape painters. Emblematic of this communal interaction and of the spirit of Cornish at large is the bronze medal (see fig.) cast by Saint-Gaudens in 1905–6 to commemorate the *Masque of the Golden Bowl*, a classically inspired pageant written, acted and staged by the colony to celebrate Saint-Gaudens's 20th summer at Cornish.

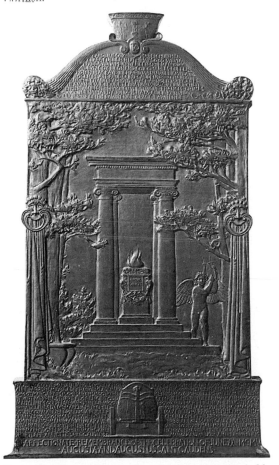

Bronze medal commemorating the Cornish artists' colony's *Masque of the Golden Bowl*, 83×44 mm, cast by Augustus Saint-Gaudens, 1905–6 (Cornish, NH, Saint-Gaudens National Historical Site)

BIBLIOGRAPHY

H. M. Wade: *A Brief History of Cornish, 1763–1974* (Hanover, NH, 1976)

S. Faxon Olney, ed.: *A Circle of Friends: Art Colonies of Cornish and Dublin* (Durham, NH, 1985), intro. and pp. 33–137

K. N. Morgan: *Charles A. Platt: The Artist as Architect* (New York, 1985)

D. van Buren: *The Cornish Colony: Expressions of Attachment to Place, 1885–1915* (diss., Washington, DC, George Washington U., 1987)

K. McCormick: 'A Sculptor's Retreat', *Hist. Preserv.*, xlvi (1994), p. 68

KEITH N. MORGAN

Cox, Kenyon (*b* Warren, OH, 27 Oct 1856; *d* New York, 17 March 1919). American painter, illustrator and writer. He was a member of a prominent Ohio family who fostered in him a strong sense of moral responsibility. From an early age he wished to be a painter and despite severe illnesses studied at the McMicken School in Cincinnati, OH, and at the Pennsylvania Academy of Fine Arts, Philadelphia (1876–7). From 1877 to 1882 he was in Paris, where he worked first with Carolus-Duran (1837–1917), then with Alexandre Cabanel (1823–89) and Jean Léon Gérôme (1824–1904) at the Ecole des Beaux-Arts. He considered Gérôme his master, though he did not adopt his style or subject-matter. In the autumn of 1878 Cox travelled to northern Italy, where he imbibed the spirit of the Italian Renaissance. As a student he gravitated steadily towards the reigning academic ideal of draughtsmanship, especially of the figure, that was to persist throughout his career (e.g. *An Eclogue*, 1890; Washington, DC, N. Col. F.A.). He did paint outdoors, both landscapes and genre, and attained a sense of spontaneity and charm in many such works, but he always insisted on careful composition and interpreted form. He exhibited at the Salon in Paris between 1879 and 1882.

Cox returned to Ohio in the autumn of 1882 and moved to New York a year later. He made a living illustrating magazines and books and writing occasional art criticism. In 1892 he began his career as a mural painter with four mural decorations for the Manufactures and Liberal Arts Building at the World's Columbian Exposition of 1893 in Chicago, IL. He painted a lunette, *Venice* (1894), at Bowdoin College, Brunswick, ME, and in 1896 finished two large lunettes for a gallery in the Library of Congress, Washington, DC. A steady flow of commissions for public buildings followed, providing what he called 'a precarious living'. Among these were a mural for the Public Library, Winona, MN (the *Light of Learning*, 1910; *in situ*), and the sculpture *Greek Science* for the Brooklyn Institute of Arts and Sciences, NY (1907–9).

Cox believed that works of art should speak a universal language based on Classical and Renaissance precedents and promote in the viewer a unified experience of expanded imagination and attachment to tradition. He ardently believed that art is a unifying force in society. Thus in his murals he used idealized, usually female, figures to symbolize abstract ideas such as Truth or Beauty. He was a skilful academic draughtsman and a strong colourist, and he adopted elements of the simplified, decorative style of Pierre Puvis de Chavannes (1824–98) and of the Italian Renaissance masters. However formal, at their best Cox's works are beautifully crafted and impressive. They represent his conception of the artist as a special person with unusual perception who should express ideals in a lofty but comprehensible way.

In his later years, Cox, while not opposed to change, was an outspoken opponent of modernism. Though sceptical of the claims of Impressionism, which dissolved the palpable form and design he thought necessary for artistic expression, he nonetheless approved of the new emphasis on colour and, to a lesser extent, on light in painting. He viewed the most radical aspects of modern art that tended towards abstraction as divisive and particularly disliked the new emphasis on self-conscious individual expression, or 'egotism', because he feared that the artist would ultimately communicate only to a handful of devotees rather than act as a unifying social force. He taught at the Art Students League in New York from 1884 until 1909. In 1892 he married a pupil, Louise King (1865–1945), who also attained some reputation as a painter.

UNPUBLISHED SOURCES
New York, Columbia U., Avery Archit. Mem. Lib. [Cox's pap.]

WRITINGS
Old Masters and New: Essays in Art Criticism (New York, 1905)
Painters and Sculptors (New York, 1907)
The Classic Point of View (New York, 1911)
Artist and Public (New York, 1913)
Concerning Painting: Considerations Theoretical and Historical (New York, 1917)
H. W. Morgan, ed.: *An American Art Student in Paris: The Letters of Kenyon Cox, 1877–1882* (Kent, OH, 1986)
——: *An Artist of the American Renaissance: The Letters of Kenyon Cox, 1883–1919* (Kent, OH, 1995)

BIBLIOGRAPHY
M. C. Smith: 'The Works of Kenyon Cox ', *Int. Studio*, xxxii (1907), pp. i–xiii

H. W. Morgan: *Keepers of Culture: The Art-thought of Kenyon Cox, Royal Cortissoz and Frank Jewett Mather, Jr.* (Kent, OH, 1989)
——: *Kenyon Cox, 1856–1919: A Life in American Art* (Kent, OH, 1994)

H. WAYNE MORGAN

Coxe-DeWilde Pottery. American pottery in Burlington, NJ. It was founded in 1688 by Dr Daniel Coxe (*b* ?Stoke Newington, England, 1640/41; *d* ?London, 19 Jan 1730) and John DeWilde (*b c.* 1665; *d* Doctor's Creek, NJ, 1708). A Cambridge-trained physician, Dr Coxe had extensive interests in the American colonies and was Governor of East and West Jersey from 1688 to 1692. His contract with DeWilde for a pottery 'for white and Chiney ware' was only one of the many ways in which he profited from his colonial holdings. From 1675 DeWilde had trained in London delftware potteries and by the time of his association with Coxe was a master potter and maker of delftware. Documents show that tin-glazed earthenwares were sold in the Delaware River Valley, Barbados and Jamaica, although no pieces from this pottery survive. The pottery was probably disbanded when Coxe sold his Jersey holdings to the West Jersey Society in 1692.

BIBLIOGRAPHY
B. L. Springsted: 'A Delftware Center in Seventeenth-century New Jersey', *Amer. Cer. Circ. Bull.*, iv (1985), pp. 9–46

ELLEN PAUL DENKER

Coxhead, Ernest (Albert) (*b* Eastbourne, Sussex, 1863; *d* Berkeley, CA, 27 March 1933). English architect, active

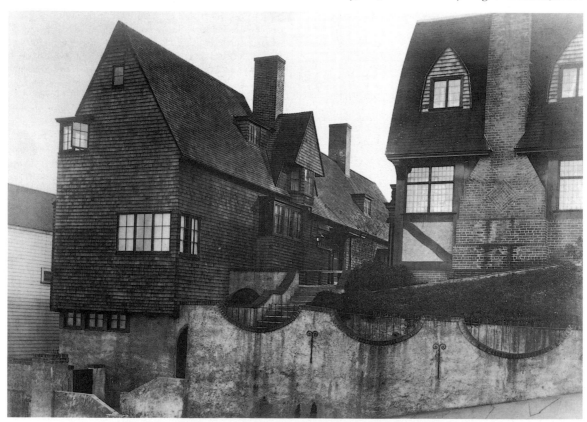

Ernest Coxhead: Coxhead House, San Francisco, California, 1893

in the USA. He was trained in the offices of several English architects and attended the Royal Academy Schools, London. In 1886 he moved with his older brother, Almeric Coxhead (1862–1928), to Los Angeles, CA, where he established an independent practice. The Coxheads moved to San Francisco four years later and soon formed a partnership that lasted until Almeric's death. Ernest Coxhead appears to have retained charge of designing. Until the early 1890s the firm specialized in churches; thereafter, most executed projects were for houses in San Francisco and its suburbs. Coxhead's building schemes of the 1890s were highly inventive, sometimes eccentric, drawing on both the classical tradition in England and contemporary English Arts and Crafts work. He was adept at developing complex, dramatic spatial sequences and creating mannerist plays with form, scale and historical allusions. Like his friend Willis J. Polk, Coxhead excelled in the design both of modest, informal dwellings such as his own house (1893) in San Francisco (see fig.) and of large, elaborate ones such as the Earl House (c. 1895–8; destr. 1957), Los Angeles. Among his most original designs was an unsuccessful entry to the Phoebe Hearst architectural competition for the University of California, Berkeley (1898). Here, grand classical elements are interspersed among others more suggestive of a northern Italian hill town, to form an intricate collage that is a pronounced departure from most planning projects of the period.

After 1900 Coxhead's career declined, the reasons for which are difficult to pinpoint. He continued to practise for another 30 years; however, most of this work fails to match the vital, ingenious spirit that marked earlier efforts.

BIBLIOGRAPHY

A. Coxhead: 'The Telephone Exchange', *Architect & Engin. CA*, xviii/1 (1909), pp. 34–46

'An Echo of the Phoebe Hearst Architectural Competition for the University of California', *Architect & Engin. CA*, xxx/2 (1912), pp. 97–101

J. Beach: 'The Bay Area Tradition, 1890–1918', *Bay Area Houses*, ed. S. Woodbridge (New York, 1976), pp. 23–98

R. Longstreth: *On the Edge of the World: Four Architects in San Francisco at the Turn of the Century* (New York, 1983/R Berkeley, 1998)

RICHARD LONGSTRETH

Cozad, Robert Henry. *See* HENRI, ROBERT.

Cram, Ralph Adams (*b* Hampton Falls, NH, 16 Dec 1863; *d* Boston, 22 Sept 1942). American architect and writer. He was the leading Gothic Revival architect in North America in the first half of the 20th century, at the head of an informal school known as the Boston Gothicists, who transformed American church design.

In 1881 Cram was apprenticed to the firm of Rotch & Tilden in Boston. His letters on artistic subjects to the *Boston Transcript* led to his appointment as the journal's art critic by the mid-1880s. In 1886 he began his first European tour. In 1888 he founded the firm of Cram & Wentworth with Charles Wentworth (1861–97). With the arrival of BERTRAM GOODHUE, the firm became Cram, Wentworth & Goodhue in 1892, and in 1899 Cram, Goodhue & Ferguson, Frank Ferguson (1861–1926) having joined the office as business and engineering partner following the death of Wentworth.

Cram was strongly influenced both by the philosophies of John Ruskin (1819–1900) and William Morris (1834–96)

and by the architectural images of H. H. Richardson, Henry Vaughan (1846–1917) and, behind Vaughan, the English Gothic Revival architects J. L. Pearson (1817–97), G. F. Bodley (1827–1907) and J. D. Sedding (1838–91). Cram became an ardent Anglican, following the precepts of the Oxford Movement. He believed that the development of Gothic had been sundered prematurely at the Renaissance and argued that Gothic Revival should continue the Gothic style. His first work, All Saints (1891), Ashmont, Boston, built of irregular brown granite, is a powerful adaptation of the English Perpendicular style.

Cram's most successful designs were for small village churches and chapels that combined overall strength and simplicity while nonetheless including some rich detail. Examples include Our Saviour's (1897), Middleborough, MA, and the Day Chapel (1902), Norwood, MA. Among his large urban churches is the House of Hope (1912), St Paul, MN. His output was prolific and he undertook commissions for many denominations in a wide variety of styles. For the stained glass and fittings of his churches, he secured exceptionally talented collaborators, including the stained-glass makers Charles Connick, Wilbur Burnham and Reynolds, Francis & Rohnstock and the architectural sculptor and carver Johannes Kirchmayer.

Two of Cram's most outstanding contributions to Gothic Revival are in New York: St Thomas (1905–14), Fifth Avenue, and work on the Cathedral of St John the Divine (1912–41), Amsterdam Avenue. At St Thomas he showed how, even without a tall tower, a Gothic Revival church could still dominate its surroundings, with a majestic and elegant massing of strong forms.

St John the Divine was begun by Heins & La Farge in 1892–1911 in a Romanesque style. Cram took over in 1912 with a new Gothic design. He remodelled the chancel and was responsible for the nave, west front, baptistery and synod house. His intended towers were not built, but the awkward façade is nonetheless imposing. The impressive, spacious nave is tall and narrow (see fig.), with the aisles rising to the height of the nave itself.

Cram was also an important college architect. His educational commissions include the campuses at Wheaton College (1900), Norton, MA, and Sweet Briar College (1902), VA. The magnificent Gothic Revival ranges at the US Military Academy (1903) at West Point, New York, were the result of the winning competition entry that brought the firm national fame. His Graduate College at Princeton University (1910) is an important work in the tradition of the Anglo-American residential college.

Other significant work by Cram includes Richmond Court (1899), Brookline, MA, possibly the first courtyard apartment house in the eastern United States; Harbourcourt, the John Nicholas Brown House (1904, Newport, RI); and the Japanese Garden Court and Temple Room of the Museum of Fine Arts (1910), Boston, MA, which shows his interest in Japanese architecture.

The initial plans for the firm's commissions were prepared by Cram; he outlined the mass, scale and proportions and left the detail to his partners. From 1902 to 1913, when Cram and Goodhue dissolved their partnership, the firm maintained a New York office under Goodhue's charge, Cram remaining in Boston. After 1913 the firm became Cram & Ferguson, Frank Cleveland

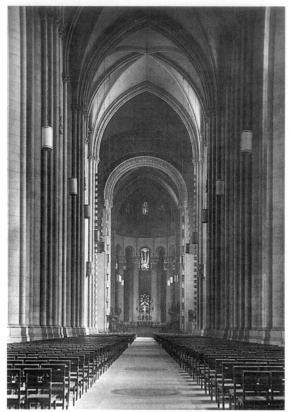

Ralph Adams Cram: Cathedral of St John the Divine, New York, 1912–41; interior looking east

(1878–1950) and Alexander Hoyle (1881–1969) becoming Cram's designing partners.

Cram was the author of nearly two dozen books and many articles on various subjects, including art criticism and Japanese architectural history, on which he was an authority. He was Professor of the Philosophy of Architecture and Head of the School of Architecture at the Massachusetts Institute of Technology. His work was eclectic but his passionate medievalism was the sphere of his greatest influence. He persuaded Henry Adams (1838–1918) to publish privately his *Mont Saint–Michel and Chartres* (1904) and wrote the introduction to it. He also played a leading role in inspiring Kenneth Conant's work on Cluny at Harvard. A founder of the Medieval Academy of America, Cram was also led by his medievalism to an interest in conservative social philosophy, about which he wrote widely. His influence in this field alone has generated considerable scholarship since World War II.

WRITINGS
Church Building (Boston, 1901–2, 2/1914, 3/1924)
Impressions of Japanese Architecture (New York, 1905/R 1966)
Ministry of Art (Boston, 1914/R Freeport, NY, 1967)
Heart of Europe (New York, 1915)
The Substance of Gothic (Boston, 1917)
The Catholic Church and Art (New York, 1930)
The End of Democracy (Boston, 1935)
My Life in Architecture (Boston, 1936/R New York, 1969)

BIBLIOGRAPHY
M. Schuyler: 'The Works of Cram, Goodhue and Ferguson', *Archit. Rec.*, xxix (1911), pp. 1–112
The Work of Cram and Ferguson (New York, 1929)
R. Muccigrosso: *Ralph Adams Cram* (New York, 1931)
D. Shand-Tucci: *Ralph Adams Cram: American Medievalist* (Boston, 1975)
A. M. Daniel: *The Early Architecture of Ralph Adams Cram, 1889–1902* (diss., U. North Carolina, 1978)
R. Muccigrosso: *American Gothic: The Mind and Art of Ralph Adams Cram* (Washington, DC, 1980)
D. Shand-Tucci: *Ralph Adams Cram: Life and Architecture* (Amherst, 1994)

DOUGLASS SHAND-TUCCI

Crawford, Thomas (*b* New York, ?1813; *d* London, 10 Oct 1857). American sculptor. One of the major American Neo-classical sculptors, he learnt wood-carving in his youth. In 1832 he became a carver for New York's leading marble shop, operated by John Frazee (1790–1852) and Robert E. Launitz (1806–70). He cut mantelpieces and busts, and spent his evenings drawing from the cast collection at the National Academy of Design. In 1835 Crawford became the first American sculptor to settle permanently in Rome. Launitz provided Crawford with a letter of introduction to Bertel Thorvaldsen (1768/70–1844), who welcomed Crawford into his studio, gave him a corner in which to work and provided occasional criticism, including the advice to copy antique models and not his [i.e. Thorvaldsen's] own work. It is not known precisely how long Crawford remained under Thorvaldsen's tutelage, but it was probably less than a year. Crawford always esteemed Thorvaldsen's sculpture and continued friendship.

Once in his own studio, Crawford at first eked out a living by producing portraits, such as his bust of *Mrs John James Schermerhorn* (1837; New York, NY Hist. Soc.). By 1839 he had executed a full-scale plaster of his first major ideal work, *Orpheus* (Boston, MA, Mus. F.A.). Charles Sumner, the future US senator and abolitionist, persuaded a group of literati to present an over life-size marble version of *Orpheus* to the Boston Athenaeum, where it was unveiled in 1844 with other sculpture by Crawford: the first one-man exhibition by an American sculptor. With its touching subject, careful nudity and echoes of the *Apollo Belvedere* (Rome, Vatican, Cortile Belvedere)—the statue most revered by Neo-classical artists—*Orpheus* won Crawford a reputation in Roman, British and, most importantly, American art circles. His rise to eminence was steady, and he found ready American patronage for ideal sculptures. Crawford attained particular success with figures of children, such as the *Genius of Mirth* (1842; New York, Met.).

Crawford was singular among the first generation of American Neo-classical sculptors in his success with public statuary. In 1850 he won a competition in Richmond, VA, for his bronze equestrian *George Washington*. Crawford's pediment design of the *Progress of Civilization* was commissioned for the Senate of the US Capitol in 1854. This pediment, composed of figures from America's past and present, dressed in contemporary costume, was thought eminently suitable for public statuary, and Crawford received subsequent Capitol commissions, including *History and Justice* (a pediment); bronze doors for the House of Representatives and Senate; and the colossal bronze *Armed Freedom* for the dome (all begun 1855). Crawford continued to execute ideal figures such as *Flora* (1847; Newark, NJ, Mus.; see fig.) and the *Peri* (1854; versions at

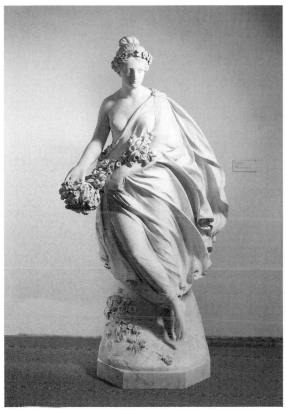

Thomas Crawford: *Flora*, marble, h. 2.18 m, 1853 (Newark, NJ, Newark Museum)

Washington, DC, Corcoran Gal. A., and Philadelphia, PA Acad. F.A.), in which his earlier severe Neo-classicism was sweetened by sentimentality, but his career was cut short by his death from cancer at the age of 44. Many of his projects were completed by colleagues in Rome under the supervision of his widow. His plaster models were presented to the New York Central Park Commissioners and were exhibited until 1881, when a fire destroyed many of them.

BIBLIOGRAPHY
R. J. Gale: *Thomas Crawford, American Sculptor* (Pittsburgh, 1964)
W. Craven: *Sculpture in America* (New York, 1968, rev. Newark, 2/1984), pp. 123–35
L. Dimmick: *The Portrait Busts and Ideal Works of Thomas Crawford (1813?–1857), American Sculptor in Rome* (diss., U. Pittsburgh, 1986)
——: 'Thomas Crawford's *Orpheus*: The American *Apollo Belvedere*', *Amer. A. J.*, xix/4 (1987), pp. 47–79
——: 'Veiled Memories, or, Thomas Crawford in Rome', *The Italian Presence in American Art, 1760–1860*, ed. I. Jaffe (New York 1989), pp. 176–94
——: '"An Altar Erected to Heroic Virtue Itself": Thomas Crawford and his *Virginia Washington Monument*', *Amer. A. J.*, xxiii/2 (1991), pp. 4–73
M. G. Muller: 'Die Obszönität der Freiheit: Politische Ästhetik und Zensur in den USA des 19. Jahrhunderts', *Krit. Ber.*, xxiii/4 (1995), pp. 29–39

LAURETTA DIMMICK

Crolius and Remmey. American pottery established by William Crolius [Johan Willem Crollius] (*b* Neuwied, near Koblenz, *c.* 1700; *d* New York, *c.* 1776) and John Remmey [Remmi] (*d* New York, Nov 1762). Crolius arrived in New York *c.* 1718 and established a stoneware pottery on Pot-Bakers Hill. Bound by intermarriage to the Corselius and Remmey families, who were also in the pottery business, the Crolius family figured prominently in Manhattan pottery history until about 1850. From *c.* 1735 William Crolius and John Remmey were in business together. Although salt-glazed stoneware was the principal product, lead-glazed earthenware was also made in the early years of the Crolius and Remmey potteries. Before the American Revolution, their stoneware closely resembled Rhenish stoneware with incised decoration filled in with a blue cobalt oxide glaze, but subsequent generations usually painted simple blue embellishments (e.g. pitcher, 1798; New York, NY Hist. Soc.). Remmey's grandson Henry Remmey sr (*b c.* 1770; *d c.* 1865) and great-grandson Henry Remmey jr left New York before 1817, when they were working in Baltimore. In 1827 the latter purchased a pottery in Philadelphia and established the Remmey name there.

BIBLIOGRAPHY
W. C. Ketchum jr: *Early Potters and Potteries of New York State* (New York, 1970); rev. as *Potters and Potteries of New York State, 1650–1900* (Syracuse, 1987)

ELLEN PAUL DENKER

Cropsey, Jasper F(rancis) (*b* Rossville, Staten Island, NY, 18 Feb 1823; *d* Hastings on Hudson, NY, 22 June 1900). American painter and architect. He was a practising architect by 1843, but in that year he also exhibited a landscape painting, to favourable reviews, at the National Academy of Design, in New York. He greatly admired Thomas Cole for his dramatic use of the American landscape, but Cropsey brought to his panoramic vistas a more precise recording of nature, as in *View of Greenwood Lake, New Jersey* (1845; San Francisco, CA, de Young Mem. Mus.). Such vastness and detail impressed the viewer with both the grandeur and infinite complexity of nature and indicated a universal order. In 1847 Cropsey made his first trip to Europe, settling in Rome among a circle of American and European painters. His eye for detail in recording nature was encouraged by the Nazarenes, and his American sympathy for historical and literary subjects was sharpened by the antiquities of Italy. In 1848 Cropsey was in Naples, where the work of contemporary painters may have inspired the bold massing, deep space and brilliant lighting in *View of the Isle of Capri* (1848; New York, NY, Alexander Gal.)

After his return to America in 1848, Cropsey painted landscape subjects, including a keenly observed view of a serene and sun-drenched harvest scene, *Bareford Mountains, West Milford, New Jersey* (1850; New York, Brooklyn Mus. A.), and a dramatic thunderstorm and waterfall in *Storm in the Wilderness* (1851; Cleveland, OH, Mus. A.). He also painted canvases after sketches made in Europe, one of the largest being *The Coast of Genoa* (1854; Washington, DC, N. Mus. Amer. A.). The strain of idealism characteristic of America found expression in such allegories as *Spirit of War* (1851; Washington, DC, N.G.A.).

Cropsey spent 1856 to 1863 in England, painting American and Italian subjects as well as the English landscape. He provided 16 scenes of America for lithography by Gambart & Co., drew the rugged coast at

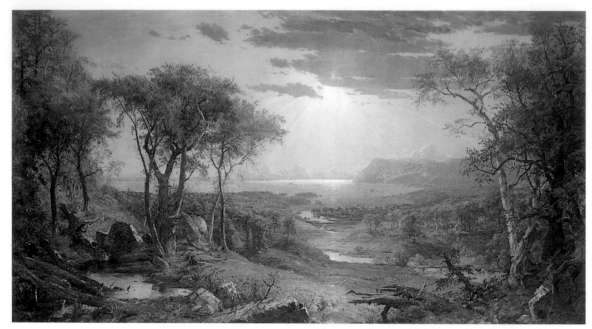

Jasper F. Cropsey: *Autumn—On the Hudson River*, oil on canvas, 1.53×2.75 m, 1860 (Washington, DC, National Gallery of Art)

Lulworth, Dorset, and captured the charm of the Isle of Wight in *Beach at Bonchurch* (1859; Hastings-on-Hudson, NY, Newington Cropsey Found.). The detailed clarity and intense colour of the Pre-Raphaelites impressed Cropsey, and his inclination towards truth to nature was encouraged by his personal acquaintance with John Ruskin (1819–1900). Cropsey portrayed, for an enthusiastic English public, the blazing colours of New England autumn in the vast painting called *Autumn—On the Hudson River* (1860; Washington, DC, N.G.A.; see fig.). Returning to America in 1863, Cropsey repeated his success with such large, crisply drawn and vigorously painted scenes of America as *Indian Summer* (1866; Detroit, MI, Inst. A.). Many of his paintings were modest in size, peopled with boaters or fishermen, sharp in detail but with a serene, burnished, atmosphere, as in *Autumn Greenwood Lake* (1866; Hastings-on-Hudson, NY, Newington Cropsey Found.). During the 1860s and 1870s Cropsey became increasingly concerned with depicting the appearance of landscape strongly modified by sun and atmosphere. Air and light became chief elements in his Luminist pictures, such as *Lake Wawayanda* (1874; Amherst Coll., MA, Mead A. Mus.).

Cropsey revived his architectural practice soon after 1863 and built his own house, Aladdin, Warwick, NY (completed by 1869), in a Gothic Revival style. His scheme (1867) for a five-storey apartment house was one of the first in America without shops on the ground floor. He also designed the 14 stations of New York's Sixth Avenue Elevated Railway (1876; destr. 1939), with much curving ironwork.

In later years Cropsey turned increasingly to watercolour, often with highlights in white gouache and solidly painted darks. An inclination towards the dramatic and imaginative rather than the calm and lyrical is evident in such watercolours as *Under the Palisades* (c. 1891; San Francisco, CA, de Young Mem. Mus.). Despite the growing Tonalist concern for projection of individual temperament and the Impressionist preoccupation with perception of light in the second half of the 19th century, Cropsey's descriptive clarity, spirited handling of paint and expansive vistas brought great vigour to American painting.

BIBLIOGRAPHY

Jasper F. Cropsey, 1823–1900 (exh. cat. by W. S. Talbot, Cleveland, OH, Mus. A.; Utica, NY, Munson–Williams–Proctor Inst.; Washington, DC, N. Col. F.A.; 1970–71)

W. S. Talbot: *Jasper F. Cropsey, 1823–1900* (New York, 1977) [catalogues 245 works]

'The brushes he painted with that last day are there: Jasper F. Cropsey's Letter to his Wife, Describing Thomas Cole's Home and Studio, July 1850', *Amer. A. J.*, xvi (Summer 1984), pp. 78–83

A Man for All Seasons: Jasper Francis Cropsey (exh. cat. by N. Hall-Duncan, Greenwich, CT, Bruce Mus., 1988)

WILLIAM S. TALBOT

Cummings & Sears. American architectural partnership formed in 1857 by Charles A. Cummings (*b* Boston, MA, 26 June 1833; *d* Northeast Harbor, ME, 11 Aug 1905) and Willard T. Sears (*b* New Bedford, MA, 15 Nov 1837; *d* Boston, MA, 21 May 1920). Charles A. Cummings graduated from the Rensselaer Polytechnic Institute, Troy, NY, in 1853. Following a two-year tour of Europe and Egypt, he returned to Boston and began work in the office of Gridley J. F. Bryant. There he met Willard T. Sears, and the two set up in practice together. The partnership lasted until Cummings retired in 1889. Like most Boston architects of the time, Cummings & Sears profited from the destruction caused by the Great Fire of 1872 and from the new land being created by the filling of Boston's Back Bay. They built commercial blocks, apartment hotels and houses throughout the 1870s and 1880s. They also undertook many suburban house commissions. Cummings, who did most of the firm's design work, was strongly influenced

1. Cummings & Sears: New Old South Church, Boston, Massachusetts, 1876

by his travels in Italy. His style can best be seen in the New Old South Church (1876; see fig. 1), Boston, with its pointed arches, polychromatic stonework, fine floral and foliate decoration and tall Italian campanile. This free Italianate Gothic is typical of most of the firm's work.

Cummings was a prominent member of the Boston Society of Architects. He retired from architectural practice in 1889 in order to devote himself full-time to writing, particularly on Greek and Italianate architecture. Sears continued to practise alone after 1889, with the Italian Gothic bent of his practice culminating in Fenway Court (now the Isabella Stewart Gardner Museum), Boston, a mansion built in 1901–3 for Mrs Isabella Stewart Gardner, which housed her important collection consisting largely of Renaissance paintings, sculpture and decorative art. The house, a four-storey stuccoed building with a covered interior courtyard (see fig. 2), utilized European architectural fragments throughout its vast interiors.

WRITINGS
C. A. Cummings and W. P. P. Longfellow: *Cyclopaedia of Works of Architecture in Italy, Greece and the Levant* (New York, 1895)
C. A. Cummings: *A History of Architecture in Italy*, 2 vols (Boston, 1901)
——: contributions to Winsor and Sturgis

BIBLIOGRAPHY
J. Winsor: *The Memorial History of Boston*, 4 vols (Boston, 1881)
R. Sturgis, ed.: *A Dictionary of Architecture and Building* (Boston, 1901)
W. P. P. Longfellow: 'Charles A. Cummings', *Q. Bull. Amer. Inst. Archit.*, vi/10 (1905), pp. 169–73

JEAN A. FOLLETT

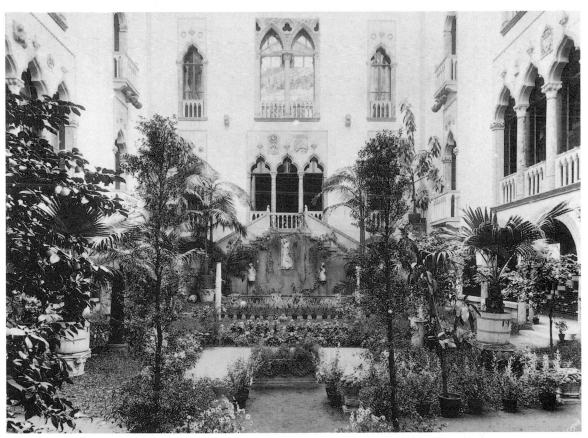

2. Cummings & Sears: courtyard of Fenway Court (now Isabella Stewart Gardner Museum), Boston, Massachusetts, 1901–3

J. Frank Currier: *Head of a Boy*, oil on canvas, 616×500 mm, 1873 (New York, NY, Brooklyn Museum of Art)

Currier, J(oseph) Frank (*b* Boston, MA, 21 Nov 1843; *d* Waverley, MA, 15 Jan 1909). American painter. He first studied art in the late 1860s after working briefly as a stone-cutter (his father's profession) and as a banking apprentice. In 1869, after a short stay in England, he arrived in Antwerp, where he studied at the Koninklijke Academie and benefited especially from the example of Antoine Wiertz (1806–65). Currier visited Paris in the spring of 1870, perhaps intending to undertake a lengthy period of study. With the outbreak of the Franco-Prussian War in August 1870, however, he moved to Munich, where he studied at the Akademie der Bildenden Künste until 1872. He became part of the American contingency of Munich painters, which included Frank Duveneck, Walter Shirlaw and William Merritt Chase. Like them, he became a notable practitioner of Munich realism as taught by Wilhelm Leibl (1844–1900) and others. To this style, based on the chiaroscuro and dramatic brushwork of Frans Hals (1581/5–1666), Currier brought an expressionistic, individual manner, bolder in technique and more emotional and visionary in character. The *Head of a Boy* (1873; New York, Brooklyn Mus. A.; see fig.) and *Peasant Girl* (*c.* 1878; Waterford, CT, Mr & Mrs Henry C. White priv. col., see Neuhaus, p. 126, fig. 93) are representative of his Munich style at its best. In 1877 Currier moved to the Bavarian town of Polling. There, as in Dachau and Schleissheim (located a few kilometres west of Dachau) in the early 1880s, he assumed leadership of the American art colony after the departures of Duveneck and Chase. Currier returned to Boston in 1898 and subsequently gave up painting entirely. In 1909 he took his own life.

BIBLIOGRAPHY
N. C. White: *The Life and Art of J. Frank Currier* (Cambridge, MA, 1936)
M. Quick: 'Munich and American Realism', *Munich and American Realism in the 19th Century* (Sacramento, CA, 1978), pp. 21–36
R. Neuhaus: *Unexpected Genius: The Art and Life of Frank Duveneck* (San Francisco, CA, 1987)
J. Frank Currier, 1843–1909: A Solitary Vision (exh. cat., New York, Babcock Gals, 1994)

JAMES C. COOKE

Currier & Ives. American firm of printmakers. It was founded in New York in 1835 by Nathaniel T. Currier (1813–88), who had been apprenticed as a youth to the Boston lithographic firm of William S. & John Pendleton. Currier & Ives lithographs initially appeared under Currier's imprint (his earlier lithographs had been issued in 1834 under the name of Stodart & Currier), and the name Currier & Ives first appeared in 1857, when James Merritt Ives (1824–95), the company's bookkeeper and Currier's brother-in-law, was made a partner. Currier supervised production while Ives handled the business and financial side. In 1840 the firm began to shift its focus from job printing to independent print publishing, to which it was exclusively devoted from 1852 to 1880.

Currier & Ives prints were decorative and inexpensive, ranging in price from 20¢ to $3.00. Their subject-matter ranged from rural life, ships, trains, animal and sporting scenes to religious images and spectacular news events. The firm produced more than 7000 titles, many in runs of hundreds of thousands, and became the largest and most successful American lithographic publishing company of the 19th century. Vigorous marketing through published catalogues, a sales staff and agents throughout the USA, as well as in London, enabled Currier & Ives to capture approximately three-quarters of the American print market in the peak years of the firm's popularity. Both black-and-white and coloured prints were sold; colour was usually applied by a staff of women working in a production line from a model, although some prints were sent out for hand colouring. Chromolithographs were also published by the firm, but colour-printing was not done on the premises.

Although many of the large number of artists employed by Currier & Ives simply copied the designs of others on to the stone, original works were also commissioned. These occasionally included pictures by well-known artists, such as George Henry Durrie (see colour pl. XVI, 1) Arthur Fitzwilliam Tait's *A Tight Fix: Bear Hunting in Early Winter* (pubd 1861; for illustration of the original painting *see* TAIT, ARTHUR FITZWILLIAM), but more often commissions went to artists closely associated with the firm. Significant among these were FRANCES PALMER; Thomas Worth (1834–1917), whose speciality was comic scenes; Charles Parsons (1821–1910), noted for his sailing ships and steam vessels, for example *A 'Crack' Sloop in a Race to Windward* (pubd 1882); and Louis Maurer (1832–1932), creator of the series *Life of a Fireman* (see fig.) and of a popular group of prints featuring trotting horses.

By the time Currier retired in 1880 in favour of his son Edward West Currier, chromolithography and photography had already begun to challenge the Currier & Ives market. Broader cultural changes also hastened the decline in appeal of the company's products: exuberant self-confidence and belief in the simple values and homely

and builder Josiah Brady (*c.* 1760–1832), gaining practical knowledge in building construction. In the same year he opened his own office and executed high-quality perspective views of existing buildings for New York lithographers. On the strength of these, the National Academy of Design elected him a member in 1827. That year he went to Boston to draw perspectives of buildings, again for lithographic reproduction, and (with help from local patrons) studied at the Boston Athenaeum.

In 1829 Davis returned to New York, where the architect and engineer Ithiel Town made him a full partner; the partnership of Town & Davis lasted until 1835 and was briefly resumed in 1842–3. Town's structural knowledge and connections, combined with Davis's drawing and compositional abilities, quickly made the firm among the most influential in the USA. Although Davis never visited Europe, Town's European travels (1829–30) and library gave the partners an enormous advantage over most American architects. In the 1830s they introduced ideas that, for the first time since Benjamin Henry Latrobe's death in 1820, made American architecture current with European developments. During this period Davis formed the aesthetic theories that he held for the rest of his life. He recorded his reliance on classical works, including those of Palladio (1518–80), Claude Perrault (1613–88), Jacques-François Blondel (1705–74), Étienne-Louis Boullée (1728–99), Claude-Nicolas Ledoux (1736–1806), Jean-Nicolas-Louis Durand (1760–1834) and William Chambers (1723–96); his Picturesque theory was developed from the study of British writers, including Edmund Burke (1729–97), Uvedale Price (1747–1829), Richard Payne Knight (1751–1824) and Humphry Repton (1752–1818). The range of Davis's sources in the 1830s and 1840s is suggested by his diary entries and drawings: he designed theatres after Vitruvius and Palladio; from Pliny the younger's letters he made reconstructions of the Laurentine Villa; and he followed Marc-Antoine Laugier's *Essai sur l'architecture* (1753) to design log-cabins with the appearance of rustic temples.

Town & Davis produced designs for three state capitols: those of Connecticut at New Haven (1827–31; destr.), Indiana at Indianapolis (1831–5; destr.) and North Carolina at Raleigh (1833–42). Davis later submitted a competition entry for the Ohio Statehouse (1839) at Columbus, which influenced its final form. The partners designed the US Customs House (1833–42; now Federal Hall), New York City, and did highly influential drawings for the US Patent Office (1834) in Washington, DC. In many cases, competitions were poorly conducted, and clients and contractors often altered their designs, causing Davis to complain bitterly against government commissions and building committees. Town & Davis's monumental public buildings have a Grecian character but always include creative infusions of Roman structural forms. These Neoclassical public edifices often follow the formula of a Greek, amphi-prostyle temple (having porticos at either end but no columns at the side), occasionally topped by a Roman dome. Along the temple flanks are files of huge square piers or *antae*. Between the piers windows rise through two or three storeys; floor levels are indicated on the exterior only by shallow, wooden panels, flush with the planes of the glass. Davis called these piers 'pilastrades'

and the windows 'Davisean'. Although these designs, which transformed Greek temples into modern, functional, public buildings, resemble the works of Karl Friedrich Schinkel (1781–1841) in Berlin, evidence suggests that neither Davis nor Town knew Schinkel's buildings.

Town & Davis also designed many Grecian suburban and country villas, typically consisting of central temple units often with lower, flanking wings and cruciform plans, possibly modelled on villas by John Nash (1752–1835) and Decimus Burton (1800–81) in Regent's Park, London. Three fine, early villas were the Hillhouse (1828; destr.) and Skinner Villas (1830), New Haven, CT, and the Russell Villa (1829), Middletown, CT. Later Grecian villas by Davis, such as the Stevens Mansion (1845, destr.; see fig. 1), New York, tended to be giant, cubic masses articulated with pilasters and lush, Corinthian porticos.

The partnership took on several pupils and draughtsmen, usually trained by Davis, such as James Gallier (i) and John Stirewalt (1811–71). Davis's most brilliant pupil was James Harrison Dakin, who was a partner in the firm in 1832–4 and assisted in the design of New York University (1833–4 and 1835–8; destr. 1894), the finest collegiate Gothic building of its time in the USA. The central unit of this five-part composition was adapted from King's College Chapel, Cambridge. Dakin also executed designs for the architect Minard Lafever, who published them in his *The Modern Builder's Guide* (1833) and *The Beauties of Modern Architecture* (1835), influential books that caused Town, Davis & Dakin's Grecian domestic formulae to spread throughout the USA.

2. INDEPENDENT WORKS. After the dissolution of the Town & Davis partnership, Davis turned to Italianate and Gothic Revival designs. He did not forsake his earlier Greco-Roman forms entirely but adapted them with Tuscan elements. Responding to the increasing size and complexity of American institutions, Davis abandoned the self-contained units of the Greek temple, substituting for them Etruscan–Roman temples that became the centre-pieces of expanded systems of interconnected wings and pavilions. The three finest of his large institutional complexes are the Lunatic Asylum (begun 1834; one octagon extant) on Blackwell's Island, New York, the North Carolina State Hospital for the Insane (1850–56; partly destr.) at Raleigh, NC, and Davidson College (1856–60), Davidson, NC. Each of these edifices had centre pavilions from which stretched lateral wings lit by vertical, multistorey Davisean windows. Davis planned the wings, some measuring up to 244 m in length, to enclose three or four sides of vast, central courtyards. These flexible schemes were planned for completion in stages as the institutions grew or as public funds became available. Davis also designed numerous Italianate villas ranging from diminutive wooden examples to immense country houses, such as Grace Hill (1854–7), for Edwin C. Litchfield in Brooklyn, New York, which is composed asymmetrically on a cruciform plan with radiating octagonal rooms.

Davis designed a few Gothic Revival churches but remained basically outside the mainstream of ecclesiastical theory and practice of his day. He designed impressive (but unexecuted) Gothic collegiate complexes for Bristol

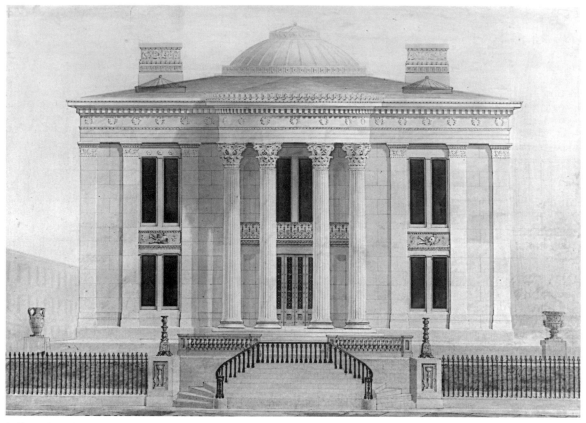

1. Alexander Jackson Davis: Stevens Mansion, New York, 1845 (New York, New-York Historical Society)

College (1835), PA, and for the University of Michigan at Ann Arbor (1838), both similar to the earlier designs for New York University. In 1848 Davis designed the Virginia Military Institute at Lexington, a symmetrical, castellated Gothic composition with bold, octagonal towers and four wings wrapped around a central courtyard.

Davis is best remembered for his large Gothic Revival country houses, for which he sometimes designed furniture as well as interiors. Some 19th-century critics objected to the use of this style in the USA, maintaining that it was inappropriate for republican institutions, and serious Gothic Revival church architects such as Richard Upjohn eschewed it because of the objections raised in England by A. W. N. Pugin (1812–52) and the Ecclesiological Movement. Davis ignored these criticisms and designed over a dozen castellated villas. His clients were mostly wealthy, élitist Episcopalians of British descent. Davis's first castellated villa, and the earliest in the USA, was Glen Ellen (destr.), near Baltimore, MD, designed with Town in 1832. The client, Robert Gilmor, had visited Sir Walter Scott at Abbotsford, near Melrose, Roxburghshire, and had spent time at Horace Walpole's Strawberry Hill, Twickenham, London, which he admired. The design of the American villa owed much to the 18th-century English Gothick castle style. For the Gothic details of his later villas, Davis relied heavily on the beautiful plates published in the books of A. C. Pugin (1769–1832). Davis, surprisingly, developed his Gothic villa ground-plans using the

rational, geometric design processes recommended in Durand's *Précis du leçons d'architecture* (1802–5). Davis's combination of English Picturesque Gothic elevations with French rationalist plans resulted in villas with handsome, asymmetrical exteriors and interpenetrating interior volumes, instead of the static, self-contained spatial units of earlier Neo-classical houses.

The best-preserved of Davis's large Gothic villas is Lyndhurst (originally 'Knoll'; 1838; see fig. 2), at Tarrytown, NY, built for General William Paulding and for which Davis made 50 furniture designs in the Gothic style. The villa was later extended by Davis (1864–7) for George Merritt. At Lyndhurst, Davis deftly fused castellated, monastic and cottage Gothic forms and responded with great sensitivity to the Hudson River site. The plan is an elongated cruciform, its longest axis parallel to the twin lines of the public road in front and the river behind; opposite façades of striking asymmetry face both road and river. Davis effectively connected the villa with its landscape by a one-storey verandah encircling three of the outer walls, thus affording dramatic views of the Hudson River Valley. Davis designed several Gothic 'river villas' from the late 1830s to the early 1850s, mostly for sites along the Hudson River and Long Island Sound but also as far afield as the James River in Virginia, for example the Cocke Villa (1845–8), Belmead. In 1849 Davis read Ruskin's newly published *The Seven Lamps of Architecture* and radically altered his approach to the castellated Gothic

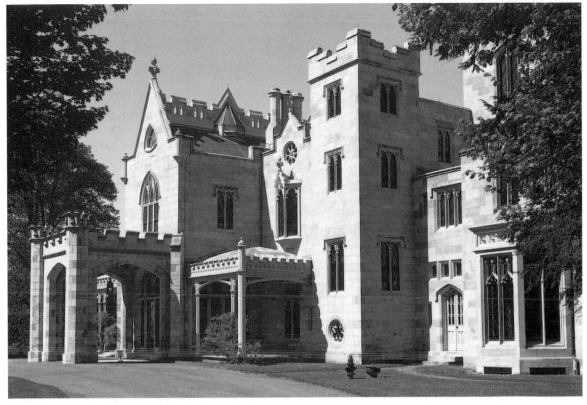

2. Alexander Jackson Davis: Lyndhurst, Tarrytown, New York, 1838 (enlarged 1864–7)

villa. Responding to Ruskin's lamps of Truth and Power, he abandoned the delicate details of his ashlar or stucco-surfaced villas for bold, fortress style castles with heavy, round towers and rock-faced masonry walls. Examples of this style are Ericstan (1855–8; destr.), the Herrick castle at Tarrytown, NY, and Castlewood (1857–60), the Howard villa at Llewellyn Park, NJ.

Davis published a few early villa designs in his book *Rural Residences* (1837–8); further volumes were planned but did not materialize. In the 1840s, however, the landscape gardener A. J. Downing published dozens of Davis's designs for smaller Italianate and Gothic villas, farmhouses and cottages in his influential journal *The Horticulturist* and in his phenomenally popular architectural patternbooks *Cottage Residences* (1842) and *The Architecture of Country Houses* (1850). These books greatly expanded Davis's practice and resulted in his designs influencing the work of local architects and builders throughout the USA.

After the Civil War (1861–5), Davis's creative force in American architecture declined as a result of several factors: the rising numbers of immigrant European architects, the increased training of American architects abroad and the introduction of formal architectural education in American universities. His aesthetic theories of the late 18th century and early 19th and the rural character of his architectural practice hindered his understanding of the synthetic complexities of urban buildings of the 1860s and 1870s, predominantly in the High Victorian Gothic and French Second Empire styles that elicited vitriolic re-sponses from Davis. His last significant project was to collaborate with the developer Llewellyn S. Haskell on the Llewellyn Park project (1853–70) at Orange Mountain, NJ, the finest picturesquely planned residential enclave in the USA, for which Davis designed many of the villas and ornamental structures. In the 1870s Davis retired to Wildmont, his own villa in Llewellyn Park, where, despite losses from a fire, he spent the rest of his life organizing and annotating his immense collection of drawings, letters and diaries.

UNPUBLISHED SOURCES

New York: Columbia U., Avery Archit. Lib.; NY Hist. Soc.; Met.; Pub. Lib. [primary col. of drgs, diaries and doc.]

WRITINGS

Rural Residences, etc., Consisting of Designs, Original and Selected, for Cottages, Farmhouses, Villas and Village Churches (New York, 1837 [1838]/*R* 1980)

BIBLIOGRAPHY

Macmillan Enc. Archit.

W. Dunlap: *History of the Rise and Progress of the Arts of Design in the United States*, iii (New York, 1834), pp. 210–13

Obituary, *Amer. Architect & Bldg News*, xxxv (1892), p. 24

E. Donnell: 'A. J. Davis and the Gothic Revival', *Met. Mus. Stud.*, v (1936), pp. 183–233

R. H. Newton: *Town & Davis, Architects: Pioneers in American Revivalist Architecture, 1812–1870* (New York, 1942)

W. Andrews: 'Alexander Jackson Davis', *Archit. Rev.* [London], cix (1951), pp. 307–12

M. Card: 'A. J. Davis and the Printed Specification', *Coll. A. J.*, xii (1952), pp. 354–9

J. B. Davies: 'The Wadsworth Atheneum's Original Building: Ithiel Town and A. J. Davis Architects', *Wadsworth Atheneum Bull.*, 5th ser. (1959), pp. 7–18

——: 'A. J. Davis' Projects for a Patent Office Building', *J. Soc. Archit. Hist.*, xxiv (1965), pp. 229–51

——: 'Alexander J. Davis: Architect of Lyndhurst', *Hist. Preserv.*, xvii/2 (1965), pp. 54–9

'Alexander Jackson Davis Material in the Metropolitan Museum of Art', *Bull. Met.*, xxv (1967), p. 216

C. M. McClinton: 'Furniture and Interiors Designed by A. J. Davis', *Connoisseur*, clxx (1969), pp. 54–61

C. E. Brownell: *In the American Style of Italian: The E. C. Litchfield Villa* (MA thesis, Newark, U. DE, 1970)

J. B. Davies: 'Blandwood and the Italian Villa Style in America', *19th C.* [New York], i (1975), pp. 11–14

——: 'Llewellyn Park in West Orange, New Jersey', *Antiques*, cvii (1975), pp. 142–58

——: 'Gothic Revival Furniture Designs of Alexander J. Davis', *Antiques*, cxi (1977), pp. 1014–27

J. Donoghue: *Alexander Jackson Davis: Romantic Architect, 1830–1892* (diss., New York U., 1977)

W. H. Pierson jr: 'Alexander Jackson Davis and the Picturesque', *American Buildings and their Architects: Technology and the Picturesque, the Corporate and Early Gothic Styles* (New York, 1978), pp. 270–384

R. G. Wilson: 'Idealism and the Origin of the First American Suburb: Llewellyn Park, New Jersey', *Amer. A. J.*, xi (1979), pp. 79–90

M. Lane: 'A. J. Davis in North Carolina', *Architecture of the Old South: North Carolina* (Savannah, GA, 1985), pp. 234–57

——: 'A. J. Davis in Virginia', *Architecture of the Old South: Virginia* (Savannah, GA, 1987), pp. 230–51

P. A. Snadon: *A. J. Davis and the Gothic Revival Castle in America* (diss., Ithaca, NY, Cornell U., 1988)

J. B. Davies: 'Davis and Downing: Collaborators in the Picturesque', *Prophet with Honor: The Career of Andrew Jackson Downing (1815–1852)*, ed. G. B. Tatum and E. B. MacDougall (Washington, DC, 1989), pp. 81–123

P. A. Snadon: 'Loudoun: Two New York Architects and a Gothic Revival Villa in Ante Bellum, Kentucky', *KY Rev.*, xi/3 (1989), pp. 41–82

Alexander Jackson Davis, American Architect (1803–92) (exh. cat., ed. A. Peck; New York, Met., 1992); review by D. Albrecht in *Architecture*, lxxxi (1992), p. 20

PATRICK A. SNADON

Day, F(red) Holland (*b* Norwood, MA, 8 July 1864; *d* Norwood, 2 Nov 1933). American photographer. He was an eccentric who sought to express his ideas on life and art through Pictorial photography, which he took up in 1887, frequently by interpretations of two opposites—the sacred and the profane. He regarded Classical Greece as the ideal and he pursued an intensive study of the human form, attempting to represent physical perfection in his photographs. These were in medium or large format, with mainly platinum prints.

Day was a cultivated and sensitive man of independent means. As well as studying painting, he was an admirer of Keats, owning a fine collection of the poet's manuscripts, letters and early editions. He published books as a hobby (1893–9), co-founding the Boston publishing house of Copeland and Day and importing the then scandalous works of Aubrey Beardsley (1872–98) and Oscar Wilde (1854–1900).

He became obsessed with photography, and in January 1896 he was elected a member of the Brotherhood of the Linked Ring, a British association that aimed to promote photography as a visual art. In 1899, with Coburn and his mother, he went to England, renting a studio and darkroom in London in an alley north of Mortimer Street, W1. During the summer of 1899 Day worked on a series of photographs devoted to sacred subjects. Some 250 negatives were made, including studies of the *Crucifixion*, the *Descent from the Cross*, the *Entombment* and the *Resurrection* and others showing incidents connected with the Stations of the Cross. He regarded 25 of these as having been fairly successful and a dozen as really successful. He himself posed as Jesus Christ, having fasted until his features and body were emaciated; he grew his hair and beard for over a year in preparation for the photographs. Several of the studies required groups of people, and Day said that the posing of them was a long and arduous task. The models were his friends and professional actors, who wore specially imported antique costumes. Exhibitions of Day's Sacred Art photographs in 1899–1900 brought interesting reactions. Some art critics were prepared to accept photography as a medium for portraying such subjects, while photographers in the main were strongly opposed to it.

In 1900 Day was responsible for arranging and displaying a major exhibition: *The New School of American Photography*. Alfred Stieglitz, who considered Day to be a potential rival, refused to support the exhibition. Both were aiming to establish photography as a pictorial art, and this may explain why Day, although regarded as a distinguished member of the Linked Ring, never joined the PHOTO-SECESSION, founded by Stieglitz in 1902.

Some of Day's most imaginative photographs are in a series illustrating the legend of Orpheus, in which the exotic models included his protégé, Khalil Gibran, one of the immigrant boys he protected. His cousin, the photographer Alvin Langdon Coburn, said: 'To be in the company of this intellectual and artistic man was an education in itself ... In his house, on elegant Beacon Hill (Boston), Day used to exhibit his photographs in an incense-laden atmosphere to the élite of Boston society.' A disastrous fire about 1914 destroyed Day's collection of photographs, with the exception of those that he had given to friends or donated to other collections. (Within three years he was to maintain a self-imposed isolation from society.)

WRITINGS
'The New School of American Photography', *Brit. J. Phot.* (20 Nov 1900)
'Opening Address' [to the Royal Photographic Society], *Phot. J.* (21 Oct 1900)
'Photography as a Fine Art', *Photo-Era* (March 1900)

BIBLIOGRAPHY
R. C. Hazell: 'A Visit to Mr. F. Holland Day', *Amat. Photographer* (27 Oct 1899)
E. F. Clattenburg: *The Photographic Work of F. Holland Day* (Wellesley, 1975)
M. Harker: *The Linked Ring: The Secession in Photography, 1892–1910* (London, 1979)
J. W. Kraus: *Messrs. Copeland and Day* (Philadelphia, 1979)
E. Jussim: *Slave to Beauty* (Boston, 1981)
Hist. Phot., xviii/4 (1994), pp. 299–386 [special issue devoted to F. Holland Day, with contributions by E. Balk, P. G. Berman, J. Crump, V. P. Curtis, B. L. Michaels and J. Van Nimmen]
B. Bradish: 'F. Holland Day', *Hist. Phot.*, xix/3 (1995), p. 272
Symposium and Exhibition on the Life and Work of Fred Holland Day: Stonehill College and Norwood Historical Society, 1997 (Norwood, MA, 1998) [with contributions by V. Curtis, B. L. Michaels, A. Havinga and P. J. Fanning]

MARGARET HARKER

Deas, Charles (*b* Philadelphia, PA, 22 Dec 1818; *d* New York, 23 March 1867). American painter. After an unsuccessful attempt to obtain an appointment at West Point Military Academy, he turned to an artistic career. He quickly earned recognition at the annual exhibitions of the National Academy of Design, New York, to which he was elected an associate member in 1839, with subjects taken from James Fenimore Cooper, such as the *Turkey Shoot* (*c.* 1837; Richmond, VA Mus. F.A.), and from Washington

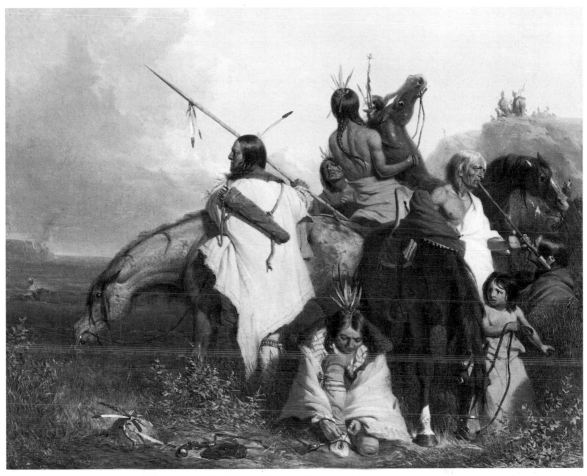

Charles Deas: *A Group of Sioux*, oil on canvas, 359×419 mm, 1845 (Fort Worth, TX, Amon Carter Museum)

Irving, *The Devil and Tom Walker* (1838; Richard P. W. Williams priv. col.).

In 1840, apparently anxious for adventure and perhaps in emulation of George Catlin's travels, Deas journeyed West and there discovered the subjects that established his reputation over the next eight years as a painter of American Indian and trapper life. During his first year in Wisconsin Territory, he observed the trappers, travellers and American Indians who gathered at Ft Crawford and Ft Snelling and persuaded the Indians to sit for their portraits. He also frequently travelled beyond the safety of the forts, especially to observe the Winnebago tribe, who that year were enduring another resettlement further west.

By late 1841 Deas had settled in St Louis, MO, but continued to venture beyond the city to see Indians, notably with Major Clifton Wharton's expedition to the Pawnee in 1844. Typical of his widely exhibited and much praised work are *Winnebagos Playing Checkers* (1842; Madrid, Mus. Thyssen-Bornemisza), *A Group of Sioux* (1845; Fort Worth, TX, Amon Carter Mus.; see fig.) and *Long Jakes* (1844; priv. col.).

Most of Deas's paintings, whether taken from a literary source, from his own experience, or inspired by the compositions of 18th- and 19th-century European precedents, express psychological tension, perceived danger, alarm and flight. The most famous is the *Death Struggle* (1845; Shelburne, VT, Mus.), which depicts a trapper and Indian locked together as they fall to their death from a cliff. Such frenzied subjects may have been symptomatic of his impending illness, for in 1848 the apparently deranged Deas was hospitalized in New York. Although he exhibited a few bizarre pictures in the later 1840s, his career of less than a dozen years had ended.

BIBLIOGRAPHY

H. Tuckerman: *Book of the Artists* (New York, 1867), pp. 424–9

J. McDermott: 'Charles Deas: Painter of the Frontier', *A. Q.* [Detroit], xiii (1950), pp. 293–311

C. Clark: 'Charles Deas', *American Frontier Life* (exh. cat., Fort Worth, TX, Amon Carter Mus., 1987), pp. 51–77

CAROL CLARK

De Camp, Joseph Rodefer (*b* Cincinnati, OH, 5 Nov 1858; *d* Boca Grande, FL, 11 Feb 1923). American painter. He first studied in Cincinnati, at the McMicken School of Design, and in 1875 travelled to Munich, where he attended the Kunstakademie with Frank Duveneck, whom he later accompanied on a trip to Italy. De Camp returned to America in 1883 and settled in Boston, where he

embarked on a highly successful career. He exhibited regularly with many arts organizations in Boston and New York and held several influential teaching posts, including instructor of antique drawing at the Boston Museum School. In 1897, with John H. Twachtman and others, he became a founder-member of the group of American Impressionists known as the TEN AMERICAN PAINTERS.

Like his Boston colleagues Edmund Tarbell and Frank Weston Benson, De Camp is best known for his portraits of elegant, fashionable women, in which he paid great attention to bodily structure and the precise delineation of facial contours. He was less vulnerable than some of his contemporaries to criticisms of studied prettiness and excessive gentility; he often eschewed elaborate interiors and decorative furnishings in favour of flat, dark backdrops, as in the introspective portrait of his daughter *Sally* (1908; Worcester, MA, A. Mus.). When he did paint accompanying domestic objects, their sparseness and deliberate placement within the composition generally contribute to a cooler tone. De Camp's portraits of men are less well known and include a full-length study of *Theodore Roosevelt*, commissioned by the President's former classmates at Harvard (1908; Cambridge, MA, Harvard U., Portrait Col.). His landscapes, painted with a freer hand than his figural work, exhibit the traditional Impressionist concerns with reflected light and the dissolution of form, as seen in the *Little Hotel* (1903; Philadelphia, PA Acad. F.A.).

BIBLIOGRAPHY

W. H. Downes: 'Joseph De Camp and his Work', *A. & Prog.*, i (1913), pp. 918–25

W. H. Gerdts: *American Impressionism* (Seattle, 1980)

The Bostonians: Painters of an Elegant Era, 1870–1930 (exh. cat. by T. J. Fairbrother, Boston, MA, Mus. F.A., 1986)

ROSS C. ANDERSON

Decker, Francis. *See* DUVENECK, FRANK.

Decker, Joseph (*b* Württemberg, 1853; *d* Brooklyn, NY, 1 April 1924). American painter of German birth. He moved with his family to the USA in 1867 and lived most of his life in Brooklyn, NY. While earning his living as a sign-painter, he studied for three years in the evening classes of the National Academy of Design in New York and is first recorded as a portrait and landscape painter in exhibitions in the late 1870s in Brooklyn and New York. In 1879 he returned to Germany, where he studied for a year at the Akademie in Munich with the history painter Wilhelm von Lindenschmidt (1829–95). After his return to the USA, he exhibited regularly throughout the 1880s at the National Academy of Design, the Brooklyn Art Association and the Society of American Artists.

Decker's reputation rests on his still-lifes of the 1880s: sharply focused close-up depictions of pears, apples, nuts and the like, in which cropped compositions suggest the influence of advertisements (e.g. *Russet Apples on a Bough*, probably 1884; Washington, DC, priv. col.). Rendered in firm, visible brushstrokes, these images convey a sense of disquiet and ambiguity, provoked by the contradiction between a three-dimensional object rendered with intense realism and a two-dimensional surface pattern that denies any sense of real space. He also painted landscapes and a small number of genre scenes and portraits.

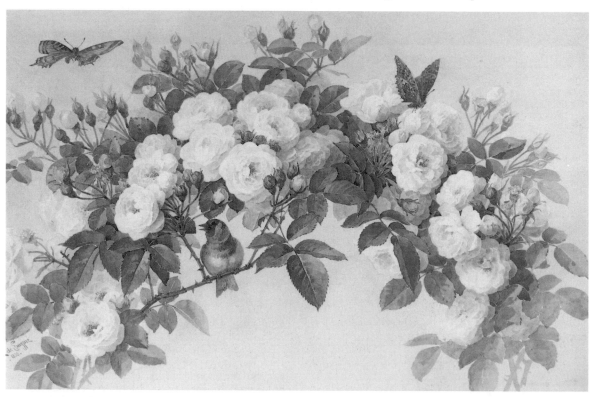

Paul De Longpre: *Wild Roses*, watercolour, 381×610 mm, 1898 (Irvine, CA, Irvine Museum)

About 1886, Decker attracted the attention of the prominent collector of American art, Thomas B. Clarke, who bought eight of his paintings. However, Decker sold few paintings to others and was not able to support himself through his art alone. In the 1890s, perhaps in reaction to negative reviews (critics called his earlier style 'harsh'), he began to paint in a more tonal, painterly style (e.g. *Twelve Plums*, 1896; New Haven, CT, Yale U., A.G.). His still-lifes of this period suggest the influence of Jean-Siméon Chardin (1699–1779), while his landscapes are close to the late style of George Inness, whom he admired. Decker received more favourable notice during the 1890s, but after 1900 his work weakened. He died in obscurity.

BIBLIOGRAPHY

A. Frankenstein: *After the Hunt: William Harnett and Other American Still Life Painters, 1870–1900* (Berkeley, 1953)
H. A. Cooper: 'The Rediscovery of Joseph Decker', *Amer. A. J.*, x/1 (1978), pp. 55–71
W. H. Gerdts: *Painters of the Humble Truth: Masterpieces of American Still Life, 1801–1939* (Columbia, MO, 1981)
Joseph Decker (1853–1924): Still Lifes, Landscapes and Images of Youth (exh. cat., New York, Coe Kerr Gal., 1988)

HELEN A. COOPER

De Forest Brush, George. *See* BRUSH, GEORGE DE FOREST

De Longpre, Paul (*b* Lyon, France, 18 April 1855, *d* Hollywood, CA, 29 June 1911). French painter, active also in the USA. Born to an aristocratic, but poor family of noted artists, he started painting as a young child. At the age of 12, he joined the family business of painting flowers as patterns for the textile mills that proliferated in Lyon, at the time a centre for the European textile industry. He became well known for his renditions of flowers, especially roses. He gained wide popularity in France, before coming to the USA and settling in New York City, around 1890. The lure of California's year round sunshine and blossoms brought De Longpre to Los Angeles in 1898. He held a large exhibition of his flowers paintings and met with immediate success. One of his patrons was the widow of the original developer of Hollywood, and in 1902 De Longpre bought a three-acre parcel off Hollywood Boulevard valued at $3000. The price for the tract was paid in the form of an exchange for three of his paintings. He built a large, Moorish-style mansion and planted a three-acre garden boasting more than 3000 rose bushes. His garden became the first tourist attraction in Hollywood, and De Longpre Avenue was named in his honour. He is most renowned for his beautiful and botanically exact watercolor paintings of roses (see fig.), earning him the sobriquet *Le Roi de Fleurs* ('The King of Flowers').

BIBLIOGRAPHY

N. C. Hall: *The Life and Work of Paul de Longpre* (Irvine, CA, in preparation)

JEAN STERN

Detroit. American city in Michigan, located on the north shore of the Detroit River between lakes St Clair and Erie.

1. Detroit, Jesuit Cathedral of SS Peter and Paul, 1849

One of the oldest cities in the Midwest, it later became known particularly for its motor industry. It was founded as Fort Pontchartrain-du-Détroit (1701) as a fort and fur-trading post by Antoine Laumet de La Mothe Cadillac (1658–1730), on behalf of Louis XIV, King of France (1661–1711). The city was captured in 1760 by the British, who renamed it Detroit; in 1794 it passed to the USA, becoming capital of the state of Michigan in 1805, when it was virtually destroyed by fire. Detroit was rebuilt to a grid-plan, with one- or two-storey clapboard dwellings of simple Colonial type, with low-gabled roof-lines, shallow mouldings, small sash windows and pilaster-framed door-ways. The establishment of a steamboat route between Buffalo and Detroit led to the development of industries. In 1847 Lansing took over as the state capital.

An era of European-influenced architecture began with the adoption of Jeffersonian-type classical structure and details, while the Jesuit cathedral of SS Peter and Paul (1849; see fig. 1) was designed as a triple-aisled basilica. From the 1850s the Gothic Revival style was also popular. In the period of considerable industrial expansion following the Civil War (1861–5), architecture in the city was dominated by Queen Anne Revival and Georgian Revival styles, although public buildings were in French Renaissance and Romanesque Revival or Neo-classical styles.

Among the various immigrant European artists and craftsmen attracted to Detroit were the German sculptor Julius Theodore Melchers (1829–1909), who arrived in 1855 and executed various works in stone, including the statue of *Cadillac* (Detroit, MI, Pub. Lib.; see fig. 2); his workshop thrived between 1870 and 1890. His son Gari Melchers became a successful painter. In 1885 a group of affluent collectors established the Museum of Art (later Institute of Arts), although the city's most important annual exhibition was held at the Hopkin Club, run by Scottish painter Robert Hopkin (1837–1900). The Pewabic Pottery was founded *c.* 1900 by Mary Chase Stratton

(1867–1961) with Horace J. Caulkin; Chase's artistry and unique iridescent glazes brought the pottery wide renown. Detroit was transformed in the early 20th century by the motor industry, with the first precision-engineered, hand-finished Model A Cadillac (named after the city's founder) being made by Martyn Leland (1843–1932) in 1903. A number of skyscrapers dating from the 1900s grace Griswold Street, including the Ford Building (1909) and Dime Building (1910) by Daniel H. Burnham.

BIBLIOGRAPHY

H. D. Brown and others: *Cadillac and the Founding of Detroit* (Detroit, 1976)
W. H. Peck: *The Detroit Institute of Arts: A Brief History* (Detroit, 1991)

□

DeWilde, John. *See under* COXE-DEWILDE POTTERY.

Dewing, Thomas Wilmer (*b* Boston, 4 May 1851; *d* New York, 1938). American painter. Apprenticed at an early age in a lithography shop, he went to Paris in 1876 to study under Jules Lefèbvre (1836–1911) and Gustave Boulanger (1824–88) at the Académie Julian. There he learnt an academic technique; the careful delineation of volumetric form and meticulous but subtle evocation of texture were to be constant features of his work. Paintings done after his return to the USA in 1878, such as *Morning* (1879; Wilmington, DE, A. Mus.), in which two enigmatic figures in Renaissance costume blow delicate, elongated horns before a pair of attentive whippets, have a symbolic quality closer to the work of the Pre-Raphaelites than to contemporary French painting. In addition, they have an aesthetic languor and preciousness reminiscent of James McNeill Whistler. In the considerably more vigorous *The Days* (1887; Hartford, CT, Wadsworth Atheneum), the shallow frieze-like arrangement of robust, rhythmically interacting women in classical drapery strongly recalls the art of Albert Joseph Moore (1841–93) and Lawrence Alma-Tadema (1836–1912).

Dewing's predominant theme emerged in the 1890s with elegant, aristocratic women lost in reverie within sparse but tastefully furnished interiors, or wandering idly in lush but barely indicated landscapes, as can be seen in *After Sunset* (1892; Washington, DC, Freer). Dewing referred to works of this type as 'decorations'; they are usually large in scale and were occasionally applied to folding screens in the Japanese manner. Such works also show the influence of Tonalism in Dewing's use of a single predominating colour and diffuse, gentle lighting.

Dewing's studies of interiors are smaller and more detailed works, although they also exhibit a narrow tonal range and evoke the same understated melancholy. The women are dignified rather than beautiful and often appear with a book or musical instrument, as in *A Reading* (1897; Washington, DC, N. Mus. American A.; see fig.). Devoid of anecdotal drama, yet imbued with an aura of quietude and internal tension, these works recall those of Johannes Vermeer (1632–75), who was much admired at this time. Dewing also became adept with pastel and the demanding medium of silverpoint, producing figure studies and nudes of extraordinary beauty.

2. Detroit, Public Library, *Cadillac* by Julius Theodore Melchers, sandstone, life-size, after 1855

Thomas Wilmer Dewing: *A Reading*, oil on canvas, 514×768 mm, 1897 (Washington, DC, National Museum of American Art)

In 1881 Dewing began teaching at the Art Students League in New York; in the same year he married Maria Oakey (1845–1927), a flower painter, who provided the landscapes in several of Dewing's paintings. In 1898 he was a founder-member of the TEN AMERICAN PAINTERS, after becoming dissatisfied with the aesthetic aims and exhibition policies of the academies.

Dewing enjoyed considerable success in his career. Stanford White was an influential supporter, who designed frames for many of his paintings and introduced him to two influential collectors, John Gellatly and Charles Lang Freer. In his later years Dewing often expressed bewilderment and dismay over the array of modernist styles that gained credibility in American art following the Armory show of 1913. After 1920 he painted very little and spent his last years in relative isolation at his home in Cornish, NH.

BIBLIOGRAPHY

The Color of Mood: American Tonalism, 1880–1910 (exh. cat. by W. M. Corn, San Francisco, CA, de Young Mem. Mus., 1972)

S. Hobbs: 'Thomas Wilmer Dewing: The Early Years, 1851–1885', *Amer. A. J.*, xiii/2 (1981), pp. 4–35

S. Hobbs, U. Cheng and J. S. Olin: 'Thomas Wilmer Dewing: A Look beneath the Surface', *Smithsonian Stud. Amer. A.*, iv/3–4 (1990), pp. 62–85

S. Hobbs and B. D. Gallati: 'Thomas Wilmer Dewing: An Artist against the Grain', *Antiques*, cil (1996), pp. 416–27

The Art of Thomas Wilmer Dewing: Beauty Reconfigured (exh. cat. by S. A. Hobbs with B. D. Gallati, New York, Brooklyn Mus.; Washington, DC, N.G.A.; Detroit, MI, Inst. A.; 1996–7); review by H. Kramer in *New Criterion*, xiv (1996), pp. 48–9

ROSS C. ANDERSON

Dexter, George Minot (*b* Boston, MA, 1802; *d* Brookline, MA, 26 Nov 1872). American architect and engineer. After leaving Harvard University in 1821, he travelled in England, France and Germany during the following decade. He was impressed by the evidence of Romanticism that he saw in England and by the work of Karl Friedrich Schinkel (1781–1841) in Germany, where he studied engineering. In Paris he bought architectural books for the Boston Athenaeum and the library of the architect and civil engineer Alexander Parris. In the 1830s Dexter trained as an engineer in Boston. His engineering studies enabled him to undertake major commissions with advanced engineering requirements, but his technical competence was combined with a romantic sensibility. He designed the houses in Pemberton Square (1836; destr.), Boston, which resembled Charles Bulfinch's Tontine Crescent in plan. He designed two important railway stations in Boston, the Haymarket and the Fitchburg (1844 and 1848 respectively; both destr.), which solved the transport problems of the Boston peninsula. He won the competition of 1844 to design the Boston Athenaeum and provided engineering and design expertise for E. C. Cabot (1818–1901), who was credited in 1847 as architect.

Dexter introduced Picturesque planning and the Gothic style to the Boston area with two stone mansions, namely Oberland (1845), Manchester-by-the-Sea, MA, for F. G. Dexter, and Cottage Farm (1850), Brookline, MA, for Amos Lawrence. Red Cross Cottage (1843), Newport, RI, built for David Sears in the Gothic Revival style, was a modular, prefabricated design, shipped by water to Newport.

UNPUBLISHED SOURCES

Boston, MA, Athenaeum [over 1200 archit. drgs]

BIBLIOGRAPHY

W. Lawrence: *The Life of Amos Lawrence* (Boston, 1888)

'Founding Fathers', *J. Boston Soc. Civil Engineers*, xxiii (1936)

W. Kilham: *Boston after Bulfinch* (Cambridge, MA, 1946)

B. Bunting: *Houses of Boston's Back Bay* (Cambridge, MA, 1967)

A. Wardwell: 'Longwood and Cottage Farm in Brookline', *Victorian Boston Today*, ed. P. C. Harrell and M. S. Smith (Boston, 1975)

'Changing Images of the Boston Athenaeum', *Change and Continuity* (exh. cat. by J. S. Knowles, Boston, MA, Athenaeum, 1976)

M. J. Lamb: *Homes of America* (New York, 1979)

J. N. Pearlman: 'The Red Cross Cottage and Designs for a Villa in Newport', *Buildings on Paper* (exh. cat., ed. W. F. Jordy and C. Monkhouse; Providence, RI, Brown U., Bell Gal., 1982)

MARGARET HENDERSON FLOYD

Dixon, (Lafayette) Maynard (*b* Fresno, CA, 24 Jan 1875; *d* Tucson, AZ, 13 Nov 1946). American painter, muralist and illustrator. Born on a ranch near Fresno in California's Central Valley, he spent his early years immersed in the lore of the Old West. A frail child, he occupied his time drawing Western subjects and at one point sent his sketchbook to his idol, Western painter and sculptor Frederic Remington, who encouraged the boy's efforts. Dixon's family moved in 1893 to the San Francisco Bay Area, and he enrolled briefly at the Mark Hopkins Institute of Art, where he studied with Arthur F. Mathews. Dixon described Mathews's teaching as follows: 'His method was to pounce upon our work, so like a growling dog he scared me out of my boots.' Except for private study with landscapist Raymond Dabb Yelland (1848–1900), Dixon was largely self-taught. After only three months at the MHIA, he went to work as an illustrator for the San Francisco dailies and the *Overland Monthly* until 1907, when a Southern Pacific Railroad mural commission took him to Tucson. During this first California period, Dixon began the regular sketching forays to the Southwest and Northwest that were to provide the inspiration and subjects for the works of his later career.

After several years in New York doing illustrations for *Century* and *Scribner's*, Dixon returned in 1912 to California, settling in Los Angeles, where he shifted his concentration from commercial illustration to easel and mural painting. In his later career Dixon achieved an international reputation for his Western subjects, which he signed with an Indian thunderbird logo. These included representations of desert landscapes, cowboys and Spanish-American subjects, as well as Apache, Hopi and Blackfoot Indians.

BIBLIOGRAPHY

A. Adams: 'Free Man in a Free Country', *Amer. W.*, vi (Nov 1969), pp. 40–47

W. M. Burnside: *Maynard Dixon* (Provo, UT, 1974)

K. Starr: 'Painterly Poet, Poetic Painter: The Dual Art of Maynard Dixon', *CA Hist. Soc. Q.*, lvi (1977–8), pp. 290–309

D. J. Hagerty: *Desert Dreams: The Art and Life of Maynard Dixon* (Layton, UT, 1993)

PAUL J. KARLSTROM

Doolittle, Amos (*b* Cheshire, CT, ?1754; *d* New Haven, CT, 31 Jan 1832). American engraver. Doolittle learnt to engrave in metal through his apprenticeship to a silversmith. His career as an independent craftsman was interrupted by army service during the American Revolution, during which time he met Ralph Earl, whose drawings of battle scenes, including the battles of Lexington and Concord, Doolittle was later to engrave on copper. The success of these historical scenes, for example *A View of the Town of Concord*, published in New Haven in 1775, enabled Doolittle to abandon his trade as a silversmith. Responding to patriotic demand for images of the new American leaders, Doolittle engraved likenesses of successive American presidents, including George Washington, John Adams and Thomas Jefferson. The tribute to Washington he first issued in 1788, *A Display of the United States of America* (1794; New Haven, CT, Yale U. A.G.), was reworked five times. He also engraved book illustrations, scenic views and bookplates. Although not the first engraver in America, as he was later to claim, Doolittle was the only one of his generation to attempt to expand beyond service work to original compositions on a regular basis.

BIBLIOGRAPHY

I. M. G. Quimby: 'The Doolittle Engravings of the Battle of Lexington and Concord', *Winterthur Port.*, iv (1968), pp. 83–108

DAVID M. SOKOL

Dorflinger, Christian (*b* Alsace, 16 March 1828; *d* White Mills, PA, 1915). American glass manufacturer of French birth. He was apprenticed to his uncle at the age of ten to learn glassmaking at the Compagnie des Verreries et Cristalleries de St Louis in eastern France and in 1846 moved to the USA with his family. He first worked in a small glasshouse in Philadelphia. Between 1852 and 1860 Dorflinger built three glasshouses in Brooklyn, NY, each larger than the one before, for the manufacture of lamps, of glass tubes for table lamps and later of blanks for other factories. In his third factory, the Greenpoint Glass Works, he produced blown, cut and engraved tableware of such superior quality that in 1861 it was chosen for use in the White House, Washington, DC, by Mrs Mary Todd Lincoln (1818–82).

In 1863 Dorflinger moved to a farm in White Mills, PA, where in 1865 he built a small glasshouse. Experienced glass workers from Greenpoint taught local farm boys their craft, and French glass artists from St Louis were invited to work there. About 1870 Dorflinger rebuilt an old glassworks in Honesdale, PA. In 1881 his three sons joined him, forming C. Dorflinger & Sons, which included the two Pennsylvania glassworks and the Greenpoint factory, which had been leased to other managers since 1873. By 1903 the White Mills factory alone employed 650 workers. In addition to cutting its own glass, the company sold both colourless and cased blanks to more than 22 decorating shops in the area. Dorflinger's own wares were shipped to the company's warehouses in New York and from there were sold through fine department and jewellery stores across the USA. Dorflinger's works also made services for the presidential administrations of Ulysses S. Grant (1822–85), Benjamin Harrison (1833–1901) and Woodrow Wilson (1856–1924), as well as for dignitaries and royalty around the world. In 1915 Dorflinger's sons closed the White Mills works; potash was in short supply because of World War I, and Prohibition decreased the demand for drinking vessels. Many of the craftsmen went to Corning, NY.

BIBLIOGRAPHY

A. C. Revi: *American Cut and Engraved Glass* (New York, 1965)

J. Q. Feller: *Dorflinger: America's Finest Glass, 1852–1921* (Marietta, 1988)

ELLEN PAUL DENKER

Doughty, Thomas (*b* Philadelphia, PA, 19 July 1793; *d* New York, 24 July 1856). American painter. Doughty belonged to the generation of American landscape painters that included Thomas Cole and Asher B. Durand and was an important precursor of the HUDSON RIVER SCHOOL. Basically self-taught, he worked as a leather currier in Philadelphia, PA, before becoming an artist. In 1816 Doughty exhibited *Landscape—Original* (untraced) at the Pennsylvania Academy of the Fine Arts. Four years later he listed himself in the Philadelphia directory as a landscape painter. Old Master landscapes (or copies) exhibited at the Pennsylvania Academy, together with contemporary European paintings and compositions by fellow Philadelphians Thomas Birch and Joshua Shaw, access to major private collections (such as those of his patron Robert Gilmor jr of Baltimore, MD, and Joseph Bonaparte of Bordentown, NJ), engravings and artists' manuals all contributed to his knowledge of the European landscape tradition. Among Doughty's earliest surviving landscapes are *View of Baltimore from Beech Hill, the Seat of Robert Gilmor jr* (1822; Baltimore, MD, Mus. A.; see fig.) and *Landscape with Pool* (*c.* 1823; Philadelphia, PA Acad. F.A.), which show his mastery of atmospheric effects and command of his medium. They also reveal in their Claudean compositions the artist's familiarity with the then

popular aesthetic of the Picturesque. Although Doughty occasionally depicted cityscapes (e.g. *View of the Waterworks on the Schuylkill*, 1826; priv. col., see 1973 exh. cat., no. 7), he is best known for his romantic interpretations of Sublime American scenery, which were often poetic evocations rather than faithful portraits of specific places (e.g. *On the Beach*, 1827–8; Albany, NY, Inst. Hist. & A.).

A frequent exhibitor at the Pennsylvania Academy, Doughty was elected an Academician in 1824. He also showed regularly in New York and Boston. The works he created during the 1820s are considered to be among his finest. They document his travels along the Eastern seaboard in search of Picturesque and Sublime subjects and include sites in New York, Massachusetts and Connecticut as well as Pennsylvania and Delaware. During the 1830s Doughty lived for periods in Boston, Philadelphia and New York. In 1835 he painted *In Nature's Wonderland* (1835; Detroit, MI, Inst. A.), one of his most affecting compositions and the embodiment of the romantic aesthetic in its depiction of the solitary hunter standing in awe of nature's grandeur. In 1837 Doughty made his first trip to Europe. The so-called *Tintern Abbey* (*c.* 1838; Washington, DC, Corcoran Gal. A.), although similar in composition to *In Nature's Wonderland*, shows the impact of this English sojourn not only in the choice of subject

Thomas Doughty: *View of Baltimore from Beech Hill, the Seat of Robert Gilmor jr*, oil on panel, 327×423 mm, 1822 (Baltimore, MD, Baltimore Museum of Art)

(a Gothic ruin in a moonlit landscape) but also in its painterly style and tonal handling of colour.

Doughty travelled even more frequently in the 1840s, as he tried to make a living from his art at a time when Cole, Durand and other younger artists were in the ascendancy. After a second trip to Britain and the Continent in the mid-1840s, he settled in Manhattan, where he remained until his death, except for brief stays in upstate New York and New Jersey. The final years of Doughty's life were marred by a decline in his health, reputation and income. Although he was still capable of producing an effective work such as *Autumn on the Hudson* (*c.* 1850; Washington, DC, Corcoran Gal. A.), the paintings from late in his career generally show a deterioration in his abilities. Nevertheless, his life-time's contribution to the development of American landscape was substantial.

UNPUBLISHED SOURCES

Washington, DC, N. Mus. Amer. A. [transcript of H. N. Doughty: *Biographical Sketch of Thomas Doughty,* 1969)

BIBLIOGRAPHY

F. H. Goodyear jr: *The Life and Art of Thomas Doughty* (MA thesis, Newark, U. DE, 1969)

Thomas Doughty, 1793–1856 (exh. cat. by F. H. Goodyear jr, Philadelphia, PA Acad. F.A., 1973)

Views and Visions: American Landscape before 1830 (exh. cat. by E. J. Nygren and others, Washington, DC, Corcoran Gal. A., 1986)

'Fra den nye verden: To ukendte vaerker af Thomas Doughty og den amerikanske guldalders landskabsmaleri' [From the new world: Two unknown works by Thomas Doughty and the Golden Age of American landscape painting], *Lyse sale: Festskrift til Bente Skovgaard, 30 oktober 1990,* ed. H. Jonsson, K. Stromstad and H. Westergaard (Copenhagen, 1990), pp. 97–109

EDWARD J. NYGREN

Downing, A(ndrew) J(ackson) (*b* Newburgh, NY, 31 Oct 1815; *d* Hudson River, NY, 28 July 1852). American writer, horticulturist, landscape gardener and architect. From the age of seven he was trained in the family nursery garden by his elder brother Charles Downing (1802–85), an experimental horticulturist. Before he was 15, Downing came under the influence of André Parmentier (1780–1830), a Dutch-trained landscape gardener, and he studied the 700-acre estate that Parmentier had landscaped in the English manner at Hyde Park, NY. Downing was also influenced by the mineralogist Baron Alois von Lederer (1773–1842) and the landscape painter Raphael Hoyle (1804–38). In 1834 Downing's first article, 'Ornamental Trees', appeared in journals in Boston, MA, and France. His article 'The Fitness of Different Styles of Architecture for Country Residences' (1836) was the first important discussion of the topic in America. He expressed enthusiasm for a variety of styles and insisted they must be used in appropriate settings. His *Landscape Gardening* (1841) was the first such work by an American, and *Cottage Residences* (1842) was the first American book on rural architecture. Downing also contributed numerous articles on horticulture, landscape gardening and rural architecture to Hovey's *Magazine of Horticulture,* Boston, from 1835 to 1846, when he founded and edited a monthly journal of rural art, *The Horticulturist.*

Downing's first known landscape design was for a scientifically arranged, four-acre ornamental botanical garden, added to the Downing Nursery in 1836. He also laid out his villa grounds in the natural style; these became known to numerous visitors and to others through published plans. He was subsequently asked to landscape estates from New England to Maryland, for example Matthew Vassar's estate at Poughkeepsie, NY, and a 'National Park' (1851; uncompleted) in Washington, DC. In 1839 Downing designed a villa (destr. 1918) for himself at Newburgh. He designed many of the buildings illustrated in his works, evolving an original American 'Bracketed style', featuring overhanging, bracketed eaves, and a roof pitched higher than 'Italian' and lower than 'Gothic'. In *The Architecture of Country Houses* (1850) Downing included designs not only for cottages, farm houses and villas but also for interiors and furniture; in addition he promoted the latest developments in heating and ventilation. Downing's own design for 'A lake or river villa' may be the first design published in England or America to have been influenced by Ruskin's ideas. In 1850 Downing formed a partnership with Calvert Vaux and opened a practice in Newburgh, which quickly became America's largest architectural firm, the first to specialize in landscape architecture, the combined arts of landscape design, horticulture and architecture. Downing & Vaux's staff included the English architect F. C. Withers, Downing's former pupil F. J. Scott (1826–1919) and an assistant, Clarence Cook (1828–1900).

Downing lived in a time when there was a widespread desire to make real the promise of the Declaration of Independence and to create a new and more perfect civilization. Science and technology were already seen as essential ingredients, but it was Downing's prose style that overcame the nation's puritanical suspicion of art and created the awareness that the useful should be made beautiful. In uniting art with patriotism and 'Yankee ingenuity', Downing became the principal spokesman for a philosophy that replaced Romanticism with Pragmatic Idealism. In his work and writings he established a national agenda for domestic architecture and landscaping, suburban planning and urban parks. His ideas were carried forward by many followers, the most important being Calvert Vaux and F. L. Olmsted.

WRITINGS

'Ornamental Trees', *New England Farmer* (29 Jan 1834), pp. 225–6, and *An. Inst. Hort. Fromont* (June 1834), pp. 74–80

'The Fitness of Different Styles of Architecture for Country Residences', *Amer. Gdnr Mag.,* ii (1836), pp. 281–6 [afterwards *Magazine of Horticulture*]

Landscape Gardening with Remarks on Rural Architecture (New York, 1841, rev. by H. W. Sargent, 6/1859/*R* 1967)

Cottage Residences (New York, 1842, rev. by G. E. Harney, 5/1873/*R* 1981)

Fruits and Fruit Trees of America (New York, 1845, rev. 14/1853–6; new edns by C. Downing to 1900)

The Architecture of Country Houses (New York, 1850/*R* 1969)

Regular contributions to *The Horticulturalist,* 7 vols (1846–52)

BIBLIOGRAPHY

G. W. Curtis, ed.: *Downing's Rural Essays* (New York, 1853/*R* 1974) [incl. Downing's editorials]

G. B. Tatum: 'Andrew Jackson Downing, Arbiter of American Taste' (diss., Princeton U., 1950)

A. C. Downs: 'Downing's Newburgh Villa,' *Bull. Assoc. Preserv. Technol.,* iv (1972), pp. 1–113

J. M. Haley, ed.: *Pleasure Grounds: Andrew Jackson Downing and Montgomery Place* (Tarrytown, NY, 1988)

A. C. Downs: *Downing and the American House* (Newtown Square, PA, 1988)

——: *Preliminary Report III: Brick & Architectural Terra Cotta, Brownstone (Downing & Upjohn): The Colonial Revival* (Newtown Square, PA, 1990)

D. Schuyler: *Apostle of Taste: Andrew Jackson Downing (1815–1852)* (Baltimore, 1996)

A. W. Sweeting: *Reading Houses and Building Books: Andrew Jackson Downing and the Architecture of Popular Antebellum Literature, 1835–1855* (Hanover, NH, 1996)

J. K. Major: *To Live in the New World: A. J. Downing and American Landscape Gardening* (Cambridge, MA and London, 1997)

D. Otis: 'New World Visionary: With Excerpts from A. J. Downing's Books', *Gdn Des.*, xvi (1997), pp. 121–4

ARTHUR CHANNING DOWNS

Drummond, William E(ugene) (*b* Newark, NJ, 28 March 1876; *d* River Forest, IL, 13 Sept 1948). American architect. He studied architecture at the University of Illinois, Urbana (1897–8). By 1899, after several months in the office of Louis Sullivan, he was working as a draughtsman in the studio of Frank Lloyd Wright in Oak Park, IL. Remaining in Wright's employ for ten years, in 1904 Drummond designed his most important work, the First Congregational Church, Austin, IL (built 1908). Although dependent on Wright's Prairie idiom, its interior spaces are boldly expressed through simple, geometric form. In 1910 Drummond moved into a house in River Forest, IL, of his own design, which was a novel variation on Wright's open plans. Among the architects of the PRAIRIE SCHOOL, Drummond established one of the most successful practices. In 1912 he formed a partnership with Louis Guenzel (1860–1956) that lasted until 1915. During this time their firm steadily produced buildings designed in an original manner derived from Wright's work in Oak Park.

WRITINGS
'On Things of Common Concern', *W. Architect*, xxi (1915), pp. 11–15 [with important pls]

BIBLIOGRAPHY
S. Ganschinietz: 'William Drummond', *Prairie Sch. Rev.*, vi/1 (1969), pp. 5–19; no. 2, pp. 5–19

H. A. Brooks: *The Prairie School* (Toronto, 1972)

D. Slaton: 'Burnham and Root and the Rookery', *Midwest in American Architecture*, ed. J. S. Garner (Urbana, IL, 1991), pp. 76–97

PAUL KRUTY

Duché, Andrew (*b* Philadelphia, *c.* 1710, *d* Philadelphia, 1778). American potter and trader. The son of the stoneware potter Anthony Duché (*fl* Philadelphia, 1700–62), he claimed to be the first person in the West to make porcelain, but he produced only a few curiosities in the late 1730s, described by others as being translucent. No pieces have been positively attributed to him. Before 1735 he settled in South Carolina and from 1736 was in Savannah, GA, where he had a small pottery. He tried for several years to obtain financial backing from the Colonial trustees in London but failed to provide enough evidence of his success. Between 1744 and 1769 he was principally occupied in trading with the American Indians in South Carolina and, later, in Virginia. He returned to Philadelphia in 1769.

BIBLIOGRAPHY
G. Hood: 'The Career of Andrew Duché', *A.Q.*, xxxi (1968), pp. 168–84

B. L. Rauschenberg: 'Andrew Duché, a Potter "a little too much addicted to Politicks"', *J. Early S. Dec. A.*, xvii/1 (1991), 1–101

ELLEN PAUL DENKER

Duncanson, Robert S(cott) (*b* Fayette, Seneca County, NY, ?1821; *d* Detroit, MI, 21 Dec 1872). American painter.

A self-taught mulatto artist and a landscape painter of the Hudson River school tradition, Duncanson was the first Afro-American artist to receive international recognition. Born into a family of painters and handymen, Duncanson first worked as a house-painter and glazier in Monroe, MI. By 1841 he was in Cincinnati, OH, where he learnt to paint by executing portraits and copying prints. Throughout the 1840s he travelled as an itinerant artist between Cincinnati, Monroe and Detroit. His early work was crude and primitive, betraying his lack of training.

Around 1850 Duncanson was awarded his largest commission, the landscape murals for the Cincinnati estate Belmont, formerly the Martin Baum House (now Cincinnati, OH, Taft Mus.; for illustration *see* CINCINNATI). These consist of eight landscape panels (2.77×2.21 m each) in *trompe-l'oeil* French Rococo frames on the walls of the entrance halls. The painted decorations were inspired by French and English wallpapers. The panels are among the most accomplished domestic mural paintings of pre-Civil War America.

During the 1850s, influenced by the work of Thomas Cole and William Lewis Sonntag, Duncanson began to specialize in landscape painting. His works were either observations of scenery or imaginary compositions that often illustrated literary subjects. A tour of Europe, made in the summer of 1853 with Sonntag, inspired a series of romantic European scenes in the late 1850s. He also produced realistic views of American scenery, such as *Landscape with Rainbow* (1859; Washington, DC, N. Mus. Amer. A.; see fig.). When it was exhibited, this painting was hailed as 'one of the most beautiful pictures painted on this side of the [Allegheny] mountains' (*Cincinnati Enquirer*, 17 Jan 1860). This success prompted Duncanson to create 'a masterwork'—the largest easel painting of his career, *The Land of the Lotus Eaters* (1.34×2.25 m, 1861; Stockholm, Kun. Husgerådskam.). The subject was suggested by Alfred Tennyson's poem of that title and was also influenced by Frederic Edwin Church's *Heart of the Andes* (1859; New York, Met.; for illustration *see* CHURCH, FREDERICK EDWIN). Duncanson's vast tropical landscape earned him the status of 'the best landscape painter in the West' (*Cincinnati Gazette*, 30 May 1862).

In 1863 Duncanson left for Europe again, to exhibit his work. However, the turmoil of the Civil War forced him to travel first to Montreal, where he quickly became recognized as the city's foremost artist. The stark realism of his Canadian paintings, including *Owl's Head Mountain* (1864; Ottawa, N.G.), stimulated a younger generation of artists to establish the first Canadian school of landscape painting. Duncanson's successful entry as a Canadian in the 1865 International Exposition in Dublin took him to Scotland and England in the summer of that year. In England he was patronized by members of the aristocracy and received critical accolades.

On his return to Cincinnati in 1866, Duncanson began 'working up' his European sketches into finished paintings. Among these was *Ellen's Isle, Loch Katrine* (1870; Detroit, MI, Inst. A.), inspired by Sir Walter Scott's poem 'The Lady of the Lake'. The contrast of serene light and the rugged Scottish Highlands makes this Duncanson's most sensitive synthesis of wilderness scenery, pastoral sentiment and literary subject-matter. However at this time he

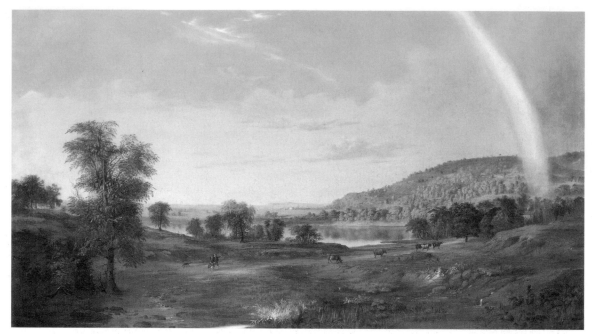

Robert S. Duncanson: *Landscape with Rainbow*, oil on canvas, 763×1327 mm, 1859 (Washington, DC, National Museum of American Art)

began to experience a dementia marked by schizophrenic behaviour, including the belief that he was possessed by spirits. The paintings of this period reflect his mental condition. While many of his landscapes have the serenity of *Ellen's Isle*, he also painted stormy seascapes, such as *Sunset on the New England Coast* (1871; Cincinnati, OH, A. Mus.). He was incarcerated at the Michigan State Retreat in 1872 after experiencing a nervous breakdown while hanging an exhibition of his work in Detroit. He died three months later.

BIBLIOGRAPHY

J. Porter: 'Robert S. Duncanson: Midwestern Romantic-Realist', *AIA J.*, xxxix (1951), pp. 99–154
Robert S. Duncanson (exh. cat., ed. G. McElroy; Cincinnati, OH, A. Mus., 1972)
J. Ketner: 'Robert S. Duncanson: The Late Literary Landscape Paintings', *A.J.* [New York], xv (1983), pp. 35–47
Sharing Traditions: Five Black Artists in Nineteenth Century America (exh. cat., ed. L. Hartigan; Washington, DC, N. Mus. Amer. A., 1985)
J. D. Ketner: *The Emergence of the African-American Artist Robert S. Duncanson, 1821–1872* (Columbia and London, 1993); review by J. Wilson in *Int. Rev. Afr.-Amer. A.*, xii/1 (1995), pp. 45–60
Robert S. Duncanson: Lifting the Veil: The Emergence of the African-American Artist (exh. cat., Cincinnati, OH, Taft Mus. and elsewhere, 1995–6)

JOSEPH D. KETNER II

Dunlap, William (*b* Perth Amboy, NJ, 18 Feb 1766; *d* New York, 28 Sept 1839). American painter, writer and playwright. After working in England with Benjamin West between 1784 and 1787, Dunlap concentrated primarily on the theatre for the next 20 years. His two main interests are documented in his large *Portrait of the Artist Showing his Picture of Hamlet to his Parents* (1788; New York, NY Hist. Soc.; see fig.). He wrote more than 30 plays and was called by some the 'father of American drama'. He was the director and manager of the Park Theatre in New York from 1797 until its bankruptcy in 1805 and again, in

its revived form, from 1806 to 1811. He began to paint miniatures to support his family in 1805 and travelled the East Coast of America as an itinerant artist. By 1817 he had become, in his own words, 'permanently a painter'.

Dunlap always lived on the verge of poverty. To increase his income, he produced a large showpiece *Christ Rejected* (1822; Princeton U., NJ, A. Mus.), which was probably inspired by West's painting of the same subject (1814; Philadelphia, PA Acad. F.A.). Though he exhibited it with considerable success, his later religious and historical canvases were not so well received. Dunlap resigned his membership of the American Academy in New York in 1826 to help Samuel F. B. Morse found the rival National Academy of Design, of which he became treasurer and later vice-president. In 1827 he turned again to the theatre, writing three more plays. Casting about for a profitable venture, he began his *History of the American Theater*, published by subscription in 1832.

Dunlap spent his last years writing reviews for the *New York Mirror* and working on his most important publication, the *History of the Rise and Progress of the Arts of Design in the United States*, a comprehensive compilation of biographies of artists working in America. Arranged chronologically according to the date when each artist began his professional work in the USA, the book includes sculptors, engravers and architects but deals most fully with painters. It comprises 287 lives of artists, varying in length from one line to many pages, and an appendix with brief accounts of 176 more. With little source material available to him, Dunlap based his biographies on material solicited directly from the artists, their friends and relatives. In many cases he used the artists' autobiographical contributions without alteration. In other instances he invented dialogue to establish character, making use of his skills as a playwright to create a convincing narrative. He also drew

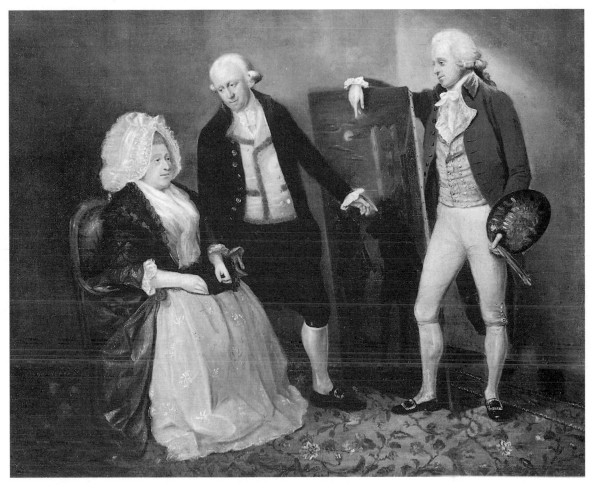

William Dunlap: *Portrait of the Artist Showing his Picture of Hamlet to his Parents*, oil on canvas, 1.07×1.22 m, 1788 (New York, New-York Historical Society)

heavily on his own wide experience, recorded in extensive diaries. His expressed goal was to produce a lively account that would both appeal to the general reader and fulfil an educational function. The biographical form, he wrote, 'admits of anecdote and gossip'.

Dunlap's book is full of exhaustive detail and has its heroes (Benjamin West) and villains (John Trumbull). His approach is factual, anecdotal and opinionated, not theoretical. There is very little critical analysis of art, and his judgements are moral rather than aesthetic. Subject-matter was of greater interest to him than style. The work for this book was accomplished in only two years, yet its overall accuracy remains unchallenged, especially in the material relating to the period of Dunlap's own lifetime. The vivid biographies led one critic to call Dunlap 'the American Vasari'. In spite of some shortcomings, the book is a remarkably complete record of early American artists and is still the single most valuable source of information on many of the artists, containing much primary source material and preserving important facts not recorded elsewhere.

WRITINGS
History of the Rise and Progress of the Arts of Design in the United States, 2 vols (New York, 1834); ed. A. Wyckoff, intro. N. P. Campbell (New York, 1965)

D. C. Barck, ed.: *Diary of William Dunlap (1766–1839)*, 3 vols (New York, 1930)

BIBLIOGRAPHY
O. S. Coad: *William Dunlap: A Study of his Life and Works and of his Place in Contemporary Culture* (New York, 1917/R 1962)

LEAH LIPTON

Durand, Asher B(rown) (*b* Springfield Township, NJ, 21 Aug 1796; *d* Maplewood, NJ, 17 Sept 1886). American painter and engraver. He played a leading role in formulating both the theory and practice of mid-19th-century American landscape painting and was a central member of the HUDSON RIVER SCHOOL. Five years older than Thomas Cole, he matured considerably later as an artist. After an apprenticeship (1812–17) with Peter Maverick, he began his career as an engraver, attaining eminence with plates after John Trumbull's *Declaration of Independence* (1820–23; for the original painting of 1776 *see* TRUMBULL, JOHN) and John Vanderlyn's *Ariadne* (1835), the latter so accomplished that the chronicler William Dunlap claimed it would win Durand immortality as an engraver. As with many contemporary artists, his training was based on drawing, an experience that influenced his insistence on the importance of outline and precise rendering.

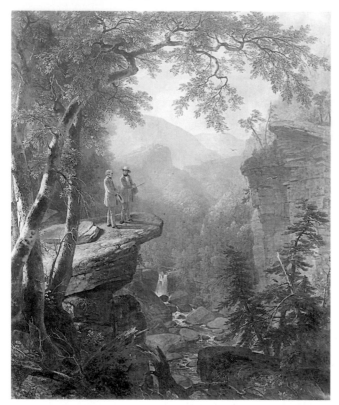

Asher B. Durand: *Kindred Spirits*, oil on canvas, 1168×914 mm, 1849 (New York, New York Public Library)

Durand first took up painting in the 1830s, producing portraits of distinguished Americans and occasional history pieces such as the *Capture of Major André* (1834; Worcester, MA, A. Mus.). Perhaps inspired by the success of Thomas Cole, Durand began exhibiting landscape paintings in 1837; Cole's influence is particularly apparent in allegorical landscapes such as the *Morning of Life* and the *Evening of Life* (both 1840; New York, N. Acad. Des.). This literary or didactic strain was present in Durand's work until the early 1850s; works such as *Thanatopsis* (1850; New York, Met.) embody the 'sister arts' concept that provided American painters with a literary justification for the emergent genre of landscape. At the same time, however, there was a growing interest in precisely observed portraits of American nature.

Durand was credited by his son and biographer, John Durand, with painting the first finished oil landscape studies from nature. *Landscape with a Beech Tree* (1844; New York, NY Hist. Soc.), a highly finished work, is his first such known study; it was followed two years later with *The Beeches* (1846; New York, Met.; see colour pl. XIII, 1). Increasingly thereafter he advocated direct study from nature, finding a more formal expression of his beliefs in the 5-volume *Modern Painters* (1843–60) by John Ruskin (1819–1900). Study from nature, though it carried enormous authority for Hudson River school painters, served for Durand only as the basis for constructing finished compositions that incorporated idealized or composite types distilled out of nature's variety. He distin-

guished between the imitative and representative, or typical, character of art. His 'Letters on Landscape Painting', written in 1855 for *The Crayon* (a Ruskinian art journal published in New York), constitute a key statement of landscape painting theory in mid-19th-century America, namely that nature served as the arbiter of artistic truth. Such Ruskinian ideas, however, were received by Durand within the context of a native idealism and faith in the intuitive apprehension of nature's inherent beauty and goodness.

By the middle of his career Durand had developed a landscape idiom that allowed him to reconcile the naturalism of direct observation with nationalistic themes. In compositions such as the *Advance of Civilization* (1853; Tuscaloosa, AL, Warner Col., Gulf States Paper Corp.), Durand expressed a progressive vision of national destiny through the organization of the landscape scene itself, beginning with the Indians in the foreground wilderness and moving through the stages of national development defined successively by wagon, steamboat and canal, telegraph system and railway.

In works such as the *View of the Hudson Valley* (1857; Ithaca, NY, Cornell U., Johnson Mus. A.), Durand employed established compositional formulae in landscape painting to imbue American wilderness scenes with a stable harmony reminiscent of the 17th-century classical landscapes of Claude Lorrain (?1604/5–1683). His concern with balanced composition, graduated movement into the distance and refined tonal modulation (through subtle gradation of local colour) also points to the influence of Claude. (As he later wrote, Durand 'visited Europe. . .lured above all by the glory of Claude's famous productions'.) Such an approach gave cultural validation to American nature as a subject for art.

By the second quarter of the 19th century Durand's urban patrons, such as Luman Reed and Jonathan Sturges, were developing important collections of American art. It was Sturges who commissioned *Kindred Spirits* (1849; see fig.), which shows the poet William Cullen Bryant admiring a Catskill gorge with Thomas Cole, who had died the previous year. The painting serves as an artistic testament to the importance of wilderness in the formation of national identity. Durand also produced idyllic scenes of domesticated nature, works that breathed an air of reverence and nostalgia for lost origins that was deeply appealing to Americans in a period of rapid economic and social change.

After the death of Cole in 1848, Durand was generally acknowledged as the foremost landscape painter in America, his work embodying many of the principal aesthetic and moral values ascribed to that genre by his contemporaries. Until his retirement in 1878, Durand followed a familiar pattern for many American landscape painters —winter residence in New York, alternating with periodic sketching trips to the Catskills, Adirondacks and other sparsely settled mountainous regions of the north-eastern United States. He travelled to Europe only once, from 1840 to 1841. His example for younger artists, his success with wealthy urban patrons and his term as president of the National Academy of Design from 1845 to 1861 all conferred legitimacy on landscape painting.

WRITINGS

'Letters on Landscape Painting', *Crayon*, i/1 (1855), pp. 1–2; i/3 (1855), pp. 34–5; i/5 (1855), pp. 66–7; i/7 (1855), pp. 97–8; i/10 (1855), pp. 145–6; i/14 (1855), pp. 209–11; i/18 (1855), pp. 273–5; i/23 (1855), pp. 354–5; ii/2 (1855), pp. 16–17; portions repr. in J. W. McCoubrey: *American Art, 1700–1960: Sources and Documents* (Englewood Cliffs, 1965)

BIBLIOGRAPHY

W. Dunlap: *History of the Rise and Progress of the Arts of Design in the United States*, iii (New York, 1834/*R* 1969), pp. 60–65

J. Durand: *The Life and Times of A. B. Durand* (New York, 1894/*R* 1970)

W. Craven: 'Asher B. Durand's Career as an Engraver', *Amer. A. J.*, iii (1971), pp. 39–57

A. B. Durand, 1796–1886 (exh. cat. by D. Lawall, Montclair, NJ, A. Mus., 1971)

D. Lawall: *Asher Brown Durand: His Art and Art Theory in Relation to his Times* (New York, 1977)

——: *Asher B. Durand: A Documentary Catalogue of the Narrative and Landscape Paintings* (New York, 1978)

A. Miller: *The Empire of the Eye: Landscape Representation and American Cultural Politics, 1825–1875* (Ithaca, NY, 1993)

A. U. Abrams: 'Democracy, Regionalism and the Saga of Major André', *Redefining American History Painting*, ed. P. M. Burnham and L. H. Giese (Cambridge, 1995), pp. 54–63

ANGELA L. MILLER

Durand, John (*fl* 1766–82). American painter. A signed portrait (priv. col.) dated 1765 provides the first documentary information on him. He advertised in the *New York Journal* on 26 November 1767 that he had opened a drawing school, and again on 7 April 1768, announcing his availability as a history painter, though no examples of this activity survive. Like other painters in the colonies, he made his living from portrait painting. His most noted work, the *Rapalije Children* (1768; New York, NY Hist. Soc.; see fig.), demonstrates the strong decorative sense, the delicate use of colour and the attempts at sophisticated value and texture application that characterize all his paintings. His skill as a draughtsman is evident in the carefully described details. Here, as in other works, he used a dark outline to define one plane from another, and he imparted a sense of elegance, particularly in the slightly turned heads and animated arms and hands. The existence of a signed and dated portrait of *Sarah Whitehead Hubbard* (Philadelphia, PA, Mus. A.), painted in Connecticut in 1768, suggests that he left New York at around this time, and indeed no paintings of New York citizens of later date survive.

The issue of the *Virginia Gazette*, Williamsburg, dated 21 June 1770, provides the next indication of Durand's whereabouts, in an advertisement he placed announcing his willingness to travel into the country to do portraits. Stylistic characteristics already demonstrated in the *Rapalije Children* appear in two portraits of Virginians from *c.* 1770: *Thomas Newton Jr* and *Martha Tucker Newton* (both Colonial Williamsburg, VA). In these Durand again stressed textural qualities: the sheen of satin and the stiff folds of fabric of the sitters' expensive garments. By 1772 he had returned to Connecticut, perhaps via New York, where he may have come into contact with John Singleton Copley, who was working there in 1771–2. In that year he signed and dated a portrait of *Benjamin Douglas* (New Haven, CT, Colony Hist. Soc. Mus.). The portraits he painted in Connecticut of *Rufus Lathrop* and *Hannah Choate Lathrop* (*c.* 1772; B. R. Little priv. col., see Kelly, figs 11 and 12) suggest a move away from line towards Copley's manner of representing volume. The treatment of the folds and the painterly handling of silver trim on Rufus Lathrop's brown vest further suggest Copley's influence. Durand was again in Virginia in 1775, from the evidence of two signed and dated portraits showing two wealthy citizens of Dinwiddie County, Mr and Mrs Gray Briggs (1775; both priv. col.). A few years later, after the American War of Independence, the 1782 tax list of this county includes his name. Considering the unsettled circumstances that prevailed, paintings by Durand from between these two dates probably do not exist. The landscapes painted by a John Durand that were shown at the Royal Academy in London in 1777 and 1778 are unlikely to be by him, since landscapes do not feature in his work. There is no evidence either for the Huguenot background that many writers ascribe to him.

BIBLIOGRAPHY

T. Thorne: 'America's Earliest Nude?', *William & Mary Q.*, 3rd ser., iv (1949), pp. 565–8

F. W. Kelly: 'The Portraits of John Durand', *Antiques*, cxxii (1982), pp. 1080–86

DARRYL PATRICK

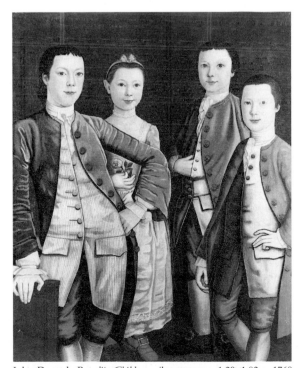

John Durand: *Rapalije Children*, oil on canvas, 1.29×1.02m, 1768 (New York, New-York Historical Society)

Durrie, George Henry (*b* Hartford, CT, 6 June 1820; *d* New Haven, CT, 15 Oct 1863). American painter. Durrie and his older brother John (1818–98) studied sporadically from 1839 to 1841 with the portrait painter Nathaniel Jocelyn. From 1840 to 1842 he was an itinerant painter in Connecticut and New Jersey, finally settling permanently in New Haven. He produced *c.* 300 paintings, of which the earliest were portraits (e.g. *Self-portrait*, 1839; Shelburne, VT, Mus.); by the early 1850s he had begun to paint the rural genre scenes and winter landscapes of New England that are considered his finest achievement. His

landscapes, for example *A Christmas Party* (1852; Tulsa, OK, Gilcrease Inst. Amer. Hist. & A.), are characterized by the use of pale though cheerful colours and by the repeated use of certain motifs: an isolated farmhouse, a road placed diagonally leading the eye into the composition, and a hill (usually the West or East Rocks, New Haven) in the distance. By the late 1850s Durrie's reputation had started to grow, and he was exhibiting at prestigious institutions, such as the National Academy of Design. In 1861 the firm of Currier & Ives helped popularize his work by publishing prints of two of his winter landscapes, *New England Winter Scene* (1858; Mr and Mrs Peter Frelinghuysen Carleton priv. col.) and the *Farmyard in Winter* (untraced). Two more were published in 1863 and a further six after his death (see colour pl. XVI, 1).

BIBLIOGRAPHY
George Henry Durrie, 1820–1863 (exh. cat. by M. B. Cowdrey, Hartford, CT, Wadsworth Atheneum, 1947)
M. Y. Hutson: *George Henry Durrie (1820–1863): American Winter Landscape: Revived through Currier and Ives* (Santa Barbara, 1977)
ANNE R. MORAND

Duveen, Joseph, 1st Baron Duveen of Millbank (*b* Hull, 14 Oct 1869; *d* London, 25 May 1939). English dealer and patron. His father, Sir Joseph Joel Duveen (1843–1909), a Dutch–Jewish immigrant, was a dealer in Delft ceramics who, with his brother Henry Duveen, built a major international art-dealing firm, Duveen Brothers. Duveen left college at 17 to train in and eventually take over his father's company. His personality was charming but shrewd, avuncular yet forceful. With great confidence and an often flamboyant business style, he was supremely successful—through society contacts and spectacular saleroom bidding—in obtaining exceptional paintings and sculpture, particularly of the Italian Renaissance. He also dealt notably in 18th-century French and English works and the paintings of Albrecht Dürer (1471–1528), Hans Holbein the younger (1497/8–1543), Rembrandt (1606–69) and Frans Hals (1581/5–1666). With the aim of suppressing rivals, from 1906 he paid exceptionally high prices for the collections of Oscar Hainauer, Rodolphe Kann and Maurice Kann, R. H. Benson and Gustave Dreyfus.

Duveen channelled major works from an economically pressed European seller's market to an avid buyer's market in America that he created among established American millionaires and the newly rich. His principal clients included Benjamin Altman, Jules S. Bache, Henry Clay Frick, Samuel H. Kress, the Huntington family, Philip Lehman and Robert Lehman, J. Pierpont Morgan, the Rockefeller family, Joseph E. Widener and Andrew W. Mellon. Duveen's virtuosic salesmanship made the acquisition of aesthetically unchallenging and colourful masterpieces into a fashionable pursuit for these often frugal magnates; his advice was followed avidly by powerful but socially insecure buyers. For some 30 years, too, Bernard Berenson (1865–1959) was employed by Duveen as an art expert in a partnership of some notoriety, whereby Duveen was able to sell pictures authenticated by Berenson, who would also discuss them in his books.

Apart from the ultimate enrichment of American art museums through donations from his clients, Duveen envisaged the National Gallery of Art, Washington, DC, founded by Mellon, as a shrine to his own dealing achievements. Duveen donated numerous works to galleries in London, ranging from Correggio's *Christ Taking Leave of his Mother* (before 1514; London, N.G.) to Stanley Spencer's *Resurrection, Cookham* (1923–7; London, Tate). He endowed a chair for art history at the Courtauld Institute, University of London, and donated entire galleries to the National Gallery, the National Portrait Gallery, the Tate Gallery and the British Museum (for the display of the Parthenon marbles), all in London. Among various positions he held, he served as a trustee of the National Gallery, the National Portrait Gallery and the Wallace Collection, London.

BIBLIOGRAPHY
Obituary, *The Times* (26 May 1939)
S. N. Behrman: *Duveen* (London, 1952, rev. 1972)
J. H. Duveen: *The Rise of the House of Duveen* (London, 1957)
HARLEY PRESTON

Duveneck, Frank [Decker, Francis] (*b* Covington, KY, 9 Oct 1848; *d* Cincinnati, OH, 3 Jan 1919). American painter, sculptor, etcher and teacher. The eldest son of German immigrants Bernard and Katherine Decker, Duveneck, who assumed his stepfather's name after his father's death and his mother's remarriage in 1850, received his early art training in Cincinnati as an apprentice to Johann Schmitt (1825–98) and Wilhelm Lamprecht (*b* 1838), decorators of Benedictine churches and monasteries. In 1870 he went to Munich to study at the Königliche Akademie, where he was taught by Wilhelm Diez (1839–1907), among others. The school stressed the study of Old Master painters such as Velázquez (1599–1660) and Frans Hals (1581/5–1666) and emphasized bravura brushwork. Duveneck was an adept pupil. His realistic portraits of the 1870s, such as *Professor Ludwig von Löfftz* (*c.* 1873; Cincinnati, OH, A. Mus.; see fig.), show the sitter placed against a dark background, the face and hands bathed in an intense light and modelled with thick, broad, fleshy brushstrokes.

Duveneck returned to America in 1873 and in 1874 began teaching at the Ohio Mechanics Institute in Cincinnati, where Robert Frederick Blum and John H. Twachtman were among his students. An exhibition at the Boston Arts Club in 1875 brought him his first major critical attention. Henry James, writing in *The Nation* (3 June 1875), called Duveneck 'an unsuspected man of genius'. Accompanied by Twachtman and Henry Farny (1847–1916), he returned that year to Munich, where William Merritt Chase and Walter Shirlaw were among his close associates. In May 1876 he visited Paris; the following March he, Chase and Twachtman went to Venice for nine months.

When he returned to Munich in 1878, Duveneck started his own painting classes, which, in the summer, he conducted in the Bavarian village of Polling. The American artists John White Alexander, Joseph Rodefer De Camp, Julius Rolshoven (1858–1930) and Theodore Wendel (1857–1932) were among his students and companions. In 1879 some of Duveneck's group left for a two-year stay in Florence and Venice. Known as the 'Duveneck Boys', they provided the model for the 'Inglehart Boys' in *Indian Summer* by William Dean Howells. In Venice, Duveneck

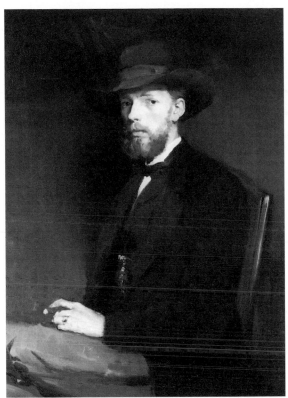

Frank Duveneck: *Professor Ludwig von Löfftz*, oil on canvas, 964×729 mm, *c*.1873 (Cincinnati, OH, Cincinnati Art Museum)

met Whistler and with his assistance and that of Otto Bacher (1856–1909) began to experiment with etching. Although Duveneck's prints are more densely detailed than those by Whistler, when they were first shown at the New Society of Painter-Etchers in London, 1881, they were thought to have been done by Whistler under an assumed name. The resulting furore ended the friendship between the two artists.

During this stay in Italy, Duveneck's work began to change. His subject-matter now included more landscapes and genre scenes. His palette became more colourful and his paint surface less dense. In 1886 Duveneck married his pupil Elizabeth Boott (1846–1888), a Bostonian who resided primarily in Florence. The large, elegant portrait of her (1888; Cincinnati, OH, A. Mus.) typifies the change in his portrait work. The face is more carefully delineated, and the background brushwork, while still lively, reveals a lighter, more delicate touch. After his wife's unexpected death in Paris in 1888, Duveneck returned to Cincinnati to teach. While there he modelled a memorial for his wife. A bronze version of this full-length reclining figure marks her grave in the Allori cemetery in Florence. Duveneck remained in Cincinnati except for trips abroad and summers in Gloucester, MA, where he painted brilliantly coloured landscapes in an impressionistic manner, such as *Dock Sheds at Low Tide* (*c*. 1900; Newport News, VA, Mar. Mus.). He was made a member of the National Academy of Design in 1905. In 1915 a major exhibition of his work was presented at the Panama–Pacific Exposition in San Francisco.

BIBLIOGRAPHY

N. Heerman: *Frank Duveneck* (Boston, 1918)

Exhibition of the Work of Frank Duveneck (exh. cat. by W. H. Siple, Cincinnati, OH, A. Mus., 1936)

E. Poole: 'The Etchings of Frank Duveneck', *Print Colr Q.*, xxv (1938), pp. 312–331, 446–463

J. W. Duveneck: *Frank Duveneck: Painter–Teacher* (San Francisco, 1970)

R. Neuhaus: *Unsuspected Genius: The Art and Life of Frank Duveneck* (San Francisco, 1987)

J. Thompson: *Duveneck: Lost Paintings Found* (Santa Clara, 1987)

An American Painter Abroad: Frank Duveneck's European Years (exh. cat. by M. Quick, Cincinnati, OH, A. Mus., 1987–8)

Explorations in Realism, 1870–1880: Frank Duveneck and his Circle from Bavaria to Venice (exh. cat., Framingham, MA, Danforth Mus. A., 1989)

P. van Gelder: 'Sharing Information, Support and Fun', *Amer. Artist*, liv (1990), pp. 48–51

CAROLYN KINDER CARR

E

Eads, James Buchanan (*b* Lawrenceburg, IN, 23 May 1820; *d* Nassau, Bahamas, 8 March 1887). American engineer. His formal education ended when he was 13, and he was self-taught as an engineer. He acquired an early knowledge of river beds and currents from salvaging sunken vessels, and he launched his engineering career in 1842 with a patent for a diving bell. As an authority on the hydrography of the Mississippi, he went to Washington, DC, in 1861 to advise the Lincoln administration on the use of the river for military purposes during the Civil War. During the Mississippi campaign, 12 iron-clad boats designed by Eads were used by the Union Army.

In 1865 Eads proposed a three-span arch bridge, with two decks, to cross the river at St Louis. The bridge (1867–74) was a pioneer work of unprecedented size: the arches, two spanning 150 m and one 156 m, were of record length for the time; the ribs, bracing and superstructure marked the introduction of chromium steel for structural purposes; and the construction of piers required the deepest pneumatic caissons so far employed, though it was not their first use in the USA, as is widely believed. After the bridge was complete, Eads built a system of jetties along the South Pass of the Mississippi Delta (1875–9), so designed that river currents could sweep sediment out of the pass. In 1880 he proposed a railway to transport ships across the isthmus of Tehuantepec in Mexico to unite the Atlantic and Pacific oceans, but it was never built.

BIBLIOGRAPHY

DAB

C. W. Condit: *American Building Art: The Nineteenth Century* (New York, 1960)

H. S. Miller and Q. Scott: *The Eads Bridge* (Columbia, MO, 1979)

J. A. Kouwenhoven: 'The Designing of Eads Bridge', *Technol. & Cult.*, xxiii (1987), pp. 535–68

CARL W. CONDIT

Eakins, Thomas (Cowperthwaite) (*b* Philadelphia, PA, 25 July 1844; *d* Philadelphia, 25 June 1916). American painter, sculptor and photographer. He was a portrait painter who chose most of his sitters and represented them in powerful but often unflattering physical and psychological terms. Although unsuccessful throughout much of his career, since the 1930s he has been regarded as one of the greatest American painters of his era.

1. Life and work. 2. Working methods and technique.

1. LIFE AND WORK. His father Benjamin Eakins (1818–99), the son of a Scottish–Irish immigrant weaver, was a writing master and amateur artist who encouraged Thomas Eakins's developing talent. Eakins attended the Central High School in Philadelphia, which stressed skills in drawing as well as a democratic respect for disciplined achievement. He developed an interest in human anatomy and began visiting anatomical clinics. After studying from 1862 at the Pennsylvania Academy of the Fine Arts, where instruction was minimal, Eakins went to Paris to enrol at the Ecole des Beaux-Arts, in the studio of Jean-Léon Gérôme (1824–1904). From 1866 to the end of 1869 he worked intensely under Gérôme, supplementing his artistic studies with dissection and also briefly studying under the sculptor Augustin-Alexandre Dumont (1801–84) and the portrait painter Léon Bonnat (1833–1922). He completed his tour of Europe with six months in Spain, the high-point of which was his study of Velázquez (1599–1660) at the Museo del Prado, Madrid. When he returned to settle in Philadelphia in July 1870, he had determined that he would make portrait painting his life's work and that, despite his training in the closely detailed style of Gérôme, he would cultivate the broad brushwork and indirect painting techniques of Velázquez. Assured of his father's financial support, he embarked on a career of painting portraits of eminent men and women, mostly from Philadelphia. Although he ultimately painted just under 300 works, he received commissions for only about 25.

Max Schmitt in a Single Scull (see fig. 1), painted at the start of his career, was the first of a number of paintings and watercolours in which Eakins honoured champion rowers. Rowing had recently become popular, celebrated for its demands on physical and mental discipline, and its experts were widely admired. Eakins portrayed his subject—a friend from boyhood—resting on the oars during an afternoon's sculling on Philadelphia's Schuylkill River. Evidence of Schmitt's triumph in the city's first amateur single sculling race is scattered throughout the painting: specific bridges identifying the race-course, rowers in the middle distance wearing Quaker garb, and the name on Schmitt's racing shell. Eakins himself appears in the scene, sculling in the middle distance. Stylistically, the painting combines exactitude in the boats and bridges with sketchy, generalizing forms in the foliage and sky. During the 1870s Eakins also painted hunting scenes, such as *Will Schuster and Blackman Going Shooting for Rail* (1876; New Haven, CT, Yale U. A.G.), as well as portraits of his sisters (e.g. *Frances Eakins*, 1870; Kansas City, MO, Nelson–Atkins Mus. A.) and other young women at the piano or in other interior pursuits.

In 1875, inspired by the approaching Centennial exhibition for which artists were urged to paint national

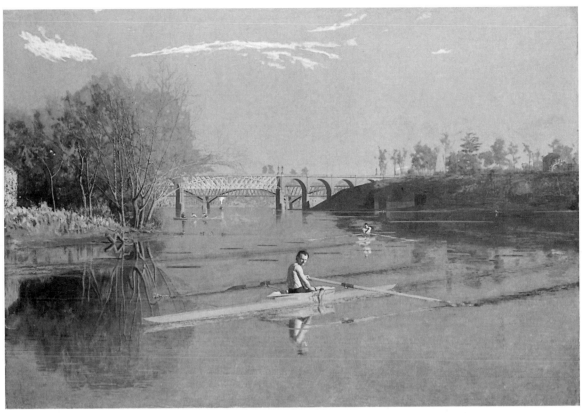

1. Thomas Eakins: *Max Schmitt in a Single Scull*, oil on canvas, 819×1175 mm, 1871 (New York, Metropolitan Museum of Art)

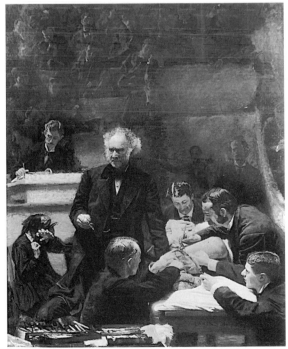

2. Thomas Eakins: *Gross Clinic*, oil on canvas, 2.44×1.99 m, 1875 (Philadelphia, PA, Thomas Jefferson University, Medical Collection)

subjects, Eakins painted the *Gross Clinic* (see fig. 2). It was the largest and most complex figural composition he had undertaken. Calling the work 'Portrait of Professor Gross', Eakins portrayed the internationally renowned Philadelphia surgeon Dr Samuel Gross (who was later portrayed in marble by the sculptor Alexander Stirling Calder), shown presiding over an operation in the surgical amphitheatre at Jefferson Medical College. Several other surgeons assist Gross, medical students look on from the tiers of the amphitheatre, and Eakins himself sketches the scene from front left. Gross lectures, holding in his hand a scalpel covered with blood. Painted in a range of dark tones illuminated by brilliant light on Gross's forehead, hand and on the patient, the work shocked the Centennial jury. While it had obvious precedents in paintings of anatomy lessons by Rembrandt (1606–69) and in 19th-century group portraits of French surgeons preparing for dissection, such as the *Anatomy Lesson of Dr Velpeau* (1864; Tours, Mus. B.-A.) by Auguste Feyen-Perrin (1829–88), Eakins had broken new ground by painting an actual operation in progress, with instruments and blood in full view. With the specific details of his painting, he paid tribute to the advances of American surgery and to the particular role that Gross had played in them. The jury rejected the painting, but Gross sponsored its exhibition in one of the medical exhibits. Eakins was to return to such a powerful theme only once. In 1889 the graduating class of the University of Pennsylvania Medical School asked him to paint a portrait of their retiring professor of surgery, Dr D. Hayes Agnew. Instead, in the *Agnew Clinic*

(1889; Philadelphia, U. PA), Eakins insisted on painting a surgical clinic, presided over by Agnew, in which all the advances of surgery since the portrait of Gross are displayed: the use of antiseptic, white operating clothing, sterilization of instruments and a nurse in an operation for breast cancer.

Despite the critical dismay over the *Gross Clinic*, Eakins gained respect as a teacher at the Pennsylvania Academy of the Fine Arts, becoming its director of instruction in 1882. Drawing on his own experience as a student as well as on his temperament as an artist, he devised a thorough, professional curriculum, at the heart of which was the study of the human figure. Eakins was adamant that the Academy facilities were primarily for professional artists rather than artisans or amateurs. The Board of Directors of the Academy, none of them artists, wanted the programme to be self-sustaining and thus to attract students of all capabilities. In 1886 the Board forced Eakins's resignation, nominally over a dispute about the use of a nude male model in a mixed drawing class: the action deeply hurt him. Although he did teach sporadically at other institutions, he missed the authority the Academy position had given him in Philadelphia's professional community.

The nature of Eakins's portraiture changed after this period. His disappointment at the Academy may have been underlined by the mixed reception that his earlier complex portraits had received and by the personal stress caused by the death of several members of his family. He was sustained emotionally by the artist Susan Hannah Macdowell (1851–1938), a sympathetic companion whom he had married in 1884. After the forced resignation, he travelled to the Dakota Territory in late 1886 for a 'rest cure'. Shortly afterwards he met the poet Walt Whitman (1819–92). They developed a friendship, made more intense by their common experience of having their work misunderstood. Eakins's portrait of *Whitman* (1887; Philadelphia, PA Acad. F.A.)—like many of his later works, a bust-length view—shows him tired and aging. Over the next two decades some of his most sensitive portraits in this format were of women. The subjects seem to be isolated and grieving, yet of great emotional strength. One such picture is *Mrs Edith Mahon* (1904; Northampton, MA, Smith Coll. Mus. A.).

Eakins also painted a number of large, full-length portraits in which accessories and background, if present at all, are set apart from the lone figure. As in earlier works, he continued to choose sitters whose achievements impressed him. Physicians, scientists, anthropologists, members of the Catholic hierarchy and musicians came to his studio at his request to be painted. The *Concert Singer* (1892; Philadelphia, PA, Mus. A.) combines many of the methods he used during these years. The singer stands alone on a stage that is only hinted at, giving herself completely to the performance of her music. Both her posture and the fragile colouring of the work convey a deep-seated melancholy.

In the last working decade of his life, between 1900 and 1910, Eakins enjoyed some critical appreciation. He won several prizes, one in Philadelphia (1904) and others at international expositions in Buffalo (1901) and St Louis (1904), and he served on the art jury of the Carnegie

International in Pittsburgh. The memorial exhibitions in New York and Philadelphia that were to take place in 1917 and 1918 led eventually to the enthusiastic appreciation of his art that continues today. Many of the works in those exhibitions came from Eakins's studio, having been rejected by sitters, and now form the core of the major repository of Eakins's work, the Philadelphia Museum of Art.

In comparison to his contemporaries John Singer Sargent and William Merritt Chase, Eakins was technically conservative, resolutely local and non-aristocratic. He had no direct followers among students. It is not clear whether he realized that, especially in his later work, he subverted the traditional role of the portrait as a conveyor of power and grace. He told an admirer that he considered all his sitters 'beautiful' and yet wrote to a student that the mission of the painter was to 'peer deeply into American life'.

2. WORKING METHODS AND TECHNIQUE. Although Eakins is traditionally called a 'scientific realist', the implications of the term must be tempered in understanding his work. He had an intelligence that demanded precise physical knowledge of his subject, and no other American artist had such a wide range of technical knowledge and skills—several types of perspective, human and equine anatomical dissection, mathematics, the mechanics of stop-motion photography, sculpting and even woodworking. However, he made it clear to his students and to interviewers that these skills were subservient to the goal of art, the creation of beauty.

Early in his career Eakins generally made drawings in preparation for paintings. Extraordinarily detailed studies for one of the boat paintings (the *Pair-Oared Shell*, 1872; Philadelphia, PA, Mus. A.) include precise calculations for the movement of the surface of individual waves of water as well as the fall of light. Yet he apparently abandoned drawing as a preparation as early as the mid-1870s, and, except for works of his youth, no independent drawings are known. His normal preparation for a portrait consisted of a very small oil sketch on cardboard, squared up, and then a larger oil study to set tonal and colour relationships. Increasingly over his career, he relied on layering and glazing in the final work to achieve his delicate psychological effects. Often he used a grey ground; on occasions it was warm brown or even orange. He liked costumes with touches of brilliant reds, pinks, blues or greens. His backgrounds are generalized, his bodies built up from dark to light in surfaces that are often richly tactile. He conveyed a strong sense of space kept in control by darkness. Often a single tightly focused detail, such as Gross's scalpel in the *Gross Clinic*, grounded the emotional superstructure of his paintings in a sharply material universe.

While oil painting was the major focus of Eakins's life—though from 1875 to 1886, teaching may have come first—he also worked in other media. In the 1870s and 1880s he painted a number of works in watercolour, like his contemporaries on both sides of the Atlantic exploring the possibilities of the medium with tight work at first and then a gradual loosening of the forms. The subjects of these watercolours are all lighthearted; they include scenes

of baseball players, sailing, rowing and, with a historical focus unusual in his work, women spinning.

Eakins used sculpture early in his work as a study, most prominently in his extensive preparations for the paintings *William Rush Carving his Allegorical Figure of the Schuylkill River* (1877; Philadelphia, PA, Mus. A.) and *Fairman Rogers Four-in-Hand* (1879; Philadelphia, PA, Mus. A.; see colour pl. XIX, 2), in which he modelled the figures in wax. He made several sculptural reliefs, including *Arcadia* (1883; Philadelphia, PA, Mus. A.) and the horses for two public monuments.

Eakins used the camera from as early as 1875, typically as a vehicle for study, but also to record his family and close friends. He assisted Eadweard Muybridge in his photographic study of men and animals in motion at the University of Pennsylvania in 1884, and later he conducted many photographic motion and anatomical studies, assisted by his students.

For further illustration *see* UNITED STATES OF AMERICA, fig. 14.

UNPUBLISHED SOURCES
Philadelphia, PA, Mus. A., [Eakins archvs]
Philadelphia, PA Acad. F.A. [Eakins archvs]

BIBLIOGRAPHY
L. Goodrich: *Thomas Eakins: His Life and Work* (New York, 1933, rev. 2 vols, Cambridge, MA, 1982)
Thomas Eakins: A Retrospective Exhibition (exh. cat. by L. Goodrich, Washington, DC, N.G.A., 1961)
The Sculpture of Thomas Eakins (exh. cat. by M. M. Domit, Washington, DC, Corcoran Gal. A., 1969)
D. F. Hoopes: *Eakins Watercolours* (New York, 1971)
G. Hendricks: *The Photographs of Thomas Eakins* (New York, 1972)
E. C. Parry and M. Chamberlain-Hellmann: 'Thomas Eakins as an Illustrator', *Amer. A.J.*, v (May 1973), pp. 20–45
G. Hendricks: *The Life and Work of Thomas Eakins* (New York, 1974)
P. Rosenzweig: *The Thomas Eakins Collection of the Hirshhorn Museum and Sculpture Garden* (Washington, 1977)
T. Siegl: *The Thomas Eakins Collection* (Philadelphia, 1978)
Thomas Eakins: Artist of Philadelphia (exh. cat., ed. D. Sewell; Philadelphia, PA, Mus. A., 1982)
E. Johns: *Thomas Eakins: The Heroism of Modern Life* (Princeton, 1983) [with bibliog. essay]
N. Spassky, ed.: *American Painting in the Metropolitan Museum of Art* (Princeton, 1985), ii, pp. 584–619
K. Foster and C. Leibold: *Writing about Eakins: The Manuscripts in Charles Bregler's Thomas Eakins Collection* (Philadelphia, 1989)
K. A. Foster: 'Realism or Impressionism? The Landscapes of Thomas Eakins', *Stud. Hist. A.*, xxxvii (1990), pp. 68–91
J. Tremain: *The Artists Series: Monotypes* (New York, 1990)
Thomas Eakins and the Heart of American Life (exh. cat., ed. J. Wilmerding; London, N.P.G., 1993–4)
S. Danly and C. Leibold: *Eakins and the Photograph: Works by Thomas Eakins and his Circle in the Collection of the Pennsylvania Academy of the Fine Arts* (Washington, DC, 1994)
J. L. Rosenheim: 'Thomas Eakins, Artist–Photographer, in the Metropolitan Museum of Art', *Bull. Met.*, lii (Winter 1994–5), pp. 44–51
R. C. Griffin: 'Thomas Eakins' Construction of the Male Body, or "Men Get to Know Each Other Across the Space of Time"', *Oxford A. J.*, xviii/2 (1995), pp. 70–80
E. Milroy, ed.: *Guide to the Thomas Eakins Research Collection with a Lifetime Exhibition Record and Bibliography* (Philadelphia, 1996)
Thomas Eakins: The Rowing Pictures (exh. cat. by H. A. Cooper, Washington, DC, N.G.A.; New Haven, CT, Yale U. A.G.; Cleveland, OH, Mus. A.; 1996–7)
M. A. Berger: 'Modernity and Gender in Thomas Eakins's *The Swimming Hole*', *Amer. A.*, xi (1997), pp. 32–47
K. A. Foster: *Thomas Eakins Rediscovered: Charles Bregler's Thomas Eakins Collection at the Pennsylvannia Academy of the Fine Arts* (New Haven and Philadelphia, 1997)
C. Masschelein-Currie: 'Thomas Eakins under the Microscope: A Technical Study of the Rowing Paintings', *Amer. Artist*, lxi (1997), pp. 12–15

ELIZABETH JOHNS

Earl [Earle]. American and English family of painters. (1) Ralph Earl and his brother James Earl (1761–96) were born in America, but both fled to England in 1778. Ralph Earl returned to New York in 1785. He established the Connecticut style of portraiture and produced some notable landscape works; his son, (2) Ralph E. W. Earl, continued to paint portraits in the same manner as his father. James Earl's son, Augustus Earle (1793–1838), was born in England, but travelled extensively and is best known as a travel artist who made watercolour sketches during his voyages to the Mediterranean, North and South America, India, Australia and New Zealand.

(1) Ralph Earl (*b* Shrewsbury, MA, 11 May 1751; *d* Bolton, CT, 16 Aug 1801). He was born into a prominent family of farmers and craftsmen. Both he and his brother James chose artistic careers at a young age. Ralph had established himself as a portrait painter in New Haven, CT, by 1774. He returned to Leicester, MA, in the autumn of that year to marry his cousin Sarah Gates, who gave birth to a daughter a few months later. But Earl left his wife and child with her parents and returned to New Haven, where he remained until 1777. There he saw the portraits of John Singleton Copley, which had an enduring impact on him. Works such as Earl's notable full-length portrait of *Roger Sherman* (*c.* 1776–7; New Haven, CT, Yale U. A.G.) were painted in the manner of Copley. During this period Earl also produced four sketches of the sites of the Battle of Lexington and Concord, which were engraved in 1776 by his associate Amos Doolittle.

A Loyalist, in 1778 Earl fled his native country for England, where he first began painting in Norfolk under the patronage of Colonel John Money. Through the studio of Benjamin West, he absorbed some of the mannerisms of English portraiture and exhibited portraits at the Royal Academy, London, in 1783 and 1784. He also acquired an interest in landscape painting, inspired by English country house painting and sporting art. Landscape vignettes first appeared in the background of his numerous English portraits.

In 1785, after the American Revolution, Earl settled in New York with his second wife, Anne Whiteside, an Englishwoman. He was imprisoned for debt from 1786 to 1788, but he eventually obtained his freedom by painting portraits of several prominent New Yorkers, including *Mrs Alexander Hamilton* (New York, Mus. City NY). Most of these patrons belonged to a new benevolent organization, the Society for the Relief of Distressed Debtors, and assisted Earl by sitting for their portraits in prison. On his release, the court appointed a guardian for Earl, Dr Mason Fitch Cogswell (1761–1830), a native of Connecticut who had a medical practice in New York. When Cogswell moved to Hartford in 1789, he assisted Earl in obtaining portrait commissions of prominent Connecticut families.

Earl established the portrait style that has come to be associated with Connecticut, inspiring a school of local followers, including Joseph Steward (1753–1822), John Brewster jr and Captain Simon Fitch (1785–1835). Earl tempered the academic style he had learnt in England to suit the more modest pretentions of his Connecticut patrons, while retaining some of the conventions of

English portraiture in the Grand Manner, including the large scale and the use of red curtains. For the most part, however, Earl's Connecticut portraits departed from these conventions in, for instance, his monumental double portrait of *Chief Justice Oliver Ellsworth and Abigail Wolcott Ellsworth* (1792; Hartford, CT, Wadsworth Atheneum). The subjects were painted in the front parlour of their newly renovated house in Windsor, a view of which appears through the window. In this and his other Connecticut works, Earl tightened his brushwork, painting in a more linear fashion than seen in his earlier portraits. He did not attempt to idealize his subjects but instead created 'true' likenesses of his sitters shown in their own environment. Earl's skill as a landscape painter was encouraged by his later Connecticut patrons, as land ownership had become increasingly important in conveying status in post-Colonial America. In 1796 Earl received three commissions to paint landscapes with the new houses of his patrons in Litchfield County. In 1798 he painted the detailed *View of Old Bennington* (Bennington, VT, Mus.), which includes a self-portrait.

While Earl spent most of his career in Connecticut, he travelled back and forth to Long Island each year from 1791 to 1794, returning to New York City in 1794, where he successfully sought new patrons. That he reverted to a more academic style in these regions to suit his patrons' tastes is demonstrated in such portraits as *Benjamin Judah* (1794; Hartford, CT, Wadsworth Atheneum), a prominent New York City merchant.

From 1799 to 1801, Earl was in Northampton, MA, where he continued to paint portraits and took several students, including his son (2) Ralph E. W. Earl. In 1799 Earl and two business associates from Northampton, one of them the ornamental painter Jacob Wicker, became the first American artists to travel to Niagara Falls. With Wicker's assistance, his sketches of the 'Stupendous Cataract' became the basis for his 'Prospectus' of the Falls, a panorama (4.25×7.30 m) that was exhibited in the Hall of the Tontine Building in Northampton. From there it was sent on a tour to the major cities in America and was last noted on view in London. Earl died of 'intemperance', according to the local minister in Bolton, CT.

(2) Ralph E(leazer) W(hiteside) Earl (*b* 1785–8; *d* 1838). Son of (1) Ralph Earl. After his father's death, he continued to paint portraits in the same manner in the Connecticut River Valley as well as in Troy, NY, where his mother had settled. In 1809 he went to London, where he received encouragement from Benjamin West and John Trumbull. He moved to Norwich in 1810, living with his mother's family and receiving support from Colonel John Money, who had earlier been a patron of his father. Four years later, he travelled to Paris, and he returned to America in December 1815.

Influenced by the history paintings of West and Trumbull, Earl planned to produce a painting of the Battle of New Orleans. He travelled throughout the South in order to take likenesses of the heroes of this battle. While on this trip, he met in Tennessee General Andrew Jackson, who became a lifelong friend and whose niece Earl married in 1818. Earl became the leading artist in Nashville from 1817, and he opened the Museum of Natural and Artificial

Curiosities there. When Jackson became President in 1828, Earl followed him to the White House, where he became Jackson's 'Court Painter'. At the end of Jackson's term of office in 1836, both he and Earl returned to Tennessee, where the artist spent the rest of his life. He is best remembered for his numerous portraits of Jackson.

BIBLIOGRAPHY
W. Dunlap: *A History of the Rise and Progress of the Arts of Design in the United States*, i (New York, 1834/*R* Boston, 1918, rev. New York, 1969)
W. Sawitsky and S. Sawitsky: 'Two Letters from Ralph Earl with Notes on his English Period', *Worcester A. Mus. Annu.*, viii (1960), pp. 8–41
L. B. Goodrich: *Ralph Earl: Recorder of an Era* (Binghampton, NY, 1967)
The American Earls: Ralph Earl, James Earl and R. E. W. Earl (exh. cat. by H. Spencer, Storrs, U. CT, Benton Mus. A., 1972)
E. M. Kornhauser: 'Regional Landscape Views: A Distinctive Element in Connecticut River Valley Portraits, 1790–1810', *Antiques*, cxxvii/5 (1985), pp. 1012–19
E. M. Kornhauser and C. S. Schloss: 'Painting and other Pictorial Arts', *The Great River: Art and Society of the Connecticut River Valley* (exh. cat., Hartford, Wadsworth Atheneum, 1985), pp. 135–85
G. B. Bumgardner: 'Political Portraiture: Two Prints of Andrew Jackson?' *Amer. A. J.*, xviii/4 (1986), pp. 84–95
E. M. Kornhauser: 'Ralph Earl as an Itinerant Artist: Pattern of Patronage', *Itinerancy in New England and New York*, ed. Peter Benes (Boston, 1986), ix of *Annual Proceedings of the Dublin Seminar for New England Folklife*
——: *Ralph Earl, 1751–1801: Artist–Entrepreneur* (diss., Boston U., 1988)
E. M. Kornhauser: 'Ralph Earl: Art for the New Nation', *Mag. Ant.*, cxl/5 (1991), pp. 794–805
Ralph Earl: The Face of the Young Republic (exh. cat. by E. M. Kornhauser and others, Washington, DC, N.P.G.; Hartford, CT, Wadsworth Atheneum; Fort Worth, TX, Amon Carter Mus.; 1991–2)

ELIZABETH MANKIN KORNHAUSER

Eastlake style. Late 19th-century style of American architecture and furniture. It owed its name to the furniture designs of the English writer, designer and museum official Charles Locke Eastlake (1836–1906), which became widely known because of his book *Hints on Household Taste in Furniture, Upholstery and Other Details*, first published in London in 1868 and in Boston, MA, in 1872. The book was an immediate success in the USA, and six more American editions appeared in the next eleven years. In the preface to the fourth English edition (1878), Eastlake wrote of his dismay at finding 'American tradesmen continually advertising what they are pleased to call "Eastlake" furniture . . . for the taste of which I should be very sorry to be considered responsible'. Eastlake-style furniture of the 1870s by such firms as Mason & Hamlin was decorated profusely with heavily carved Gothic ornament, whereas Eastlake's own furniture had decoration that was simpler and more sparingly applied to emphasize function.

The Eastlake style in architecture was a transformation of the Stick style, or more often the Queen Anne Revival, by the use of forms derived from furniture: columns resembled table legs, and there was a profusion of curved brackets, spindles, knobs of various shapes and ornament consisting of circular perforations. It flourished in the USA from the mid-1870s to *c.* 1890, with a large number of examples in California. Eastlake recorded his amazement and regret in the *California Architect and Building News* in 1882. (There was a similar development in England, which has been little noticed.) Most Eastlake-style architecture is anonymous street architecture. Three

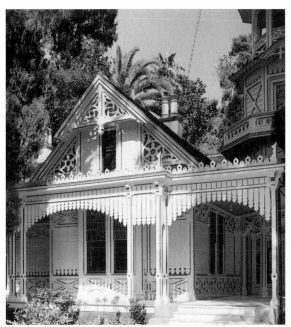

Eastlake style, Baldwin Guest House by Albert A. Bennett, County Arboretum, Los Angeles, California, 1881

houses in California that show something of the variety of the style are the Baldwin Guest House (1881; see fig.) in the County Arboretum, Los Angeles, by Albert A. Bennett (1825–90); the Carson House (1884–6), Eureka, by Samuel Newsom and Joseph Cather Newsom (for illustration *see* NEWSOM); and the Haas-Lilienthal House (1886), San Francisco, by Peter Schmitt.

BIBLIOGRAPHY

C. L. Eastlake: *Hints on Household Taste in Furniture, Upholstery and Other Details* (London, 1868; Boston, MA, 1872/*R* New York, 1969)
H. Kirker: *California's Architectural Frontier: Style and Tradition in the Nineteenth Century* (San Marino, CA, 1960/*R* Salt Lake City, UT, 1986)
Eastlake-influenced American Furniture, 1870–1890 (exh. cat. by W. J. S. Madigan, Yonkers, NY, Hudson River Mus., 1973)

MARCUS WHIFFEN

Eastman, George (*b* Waterville, NY, 12 July 1854; *d* Rochester, NY, 14 March 1932). American inventor and photographer. He took up photography in 1877, and in 1878, dissatisfied with the cumbersome wet collodion process, he started making the new gelatin dry plates. He decided to manufacture them commercially and invented a machine to end the need to hand-coat the glass. In January 1881 he founded the Eastman Dry Plate Company.

Eastman's desire to bring photography to more people, and to satisfy the needs of the growing number of amateur photographers, led him to develop many new products. In 1885 his roll-holder adaptor allowed the heavy and fragile glass plates to be replaced by a roll of sensitive paper; the success of this device inspired him to design a new camera with the roll-holder built in. The result was the Kodak camera (1888), for which Eastman chose the name; it was designed for the general public, who had only to point it in the right direction and release the shutter. When the 100-exposure roll provided with the camera had been exposed, the whole apparatus was returned to Eastman's factory, where the paper rollfilm was developed and printed, the camera reloaded and returned to the customer; 'You press the button, we do the rest' was his slogan.

The introduction of the Kodak camera did much to democratize the practice of photography, taking it out of the hands of the experts. Eastman went on to pioneer other major advances in amateur photography, including in 1889 the first commercial celluloid rollfilm (which made motion picture projection possible), and he brought photography within the economic reach of millions with the introduction of the Brownie camera range in 1900. The company he formed (from 1892 Eastman Kodak) grew to be a giant multinational organization responsible for major technical innovations in photography. After his death, his home became the International Museum of Photography.

BIBLIOGRAPHY

C. Ackerman: *George Eastman* (London, 1930)
B. Coe: *George Eastman and the Early Photographers* (London, 1973)
C. Ford and K. Steinorth, eds: *You Press the Button and We Do the Rest: The Birth of Snapshot Photography* (London, 1988)
E. Brayer: *George Eastman: A Biography* (Baltimore, 1996)
J. K. Brown: '"Seeing and Remembering": George Eastman and the World's Columbian Exposition, Chicago 1893', *Image* [Rochester, NY], xxxix (Spring/Summer 1996), pp. 2–27

BRIAN COE

Eastman, Seth (*b* Brunswick, ME, 24 Jan 1808; *d* Washington, DC, 31 Aug 1875). American painter and draughtsman. He attended the US Military Academy at West Point, NY, and from 1829 to 1831 he was stationed at Ft Crawford, WI, and Ft Snelling, MN, on topographical duty. He returned to West Point from 1833 to 1840 to teach drawing, and under the guidance of Robert Walter Weir he published *Treatise on Topographical Drawing* (West Point, 1837). From 1841 until 1848 Eastman was stationed again at Ft Snelling. He began painting scenes of the local Indians involved in everyday activities, as in *Chippewa Indians Playing Checkers* (1848; priv. col., see Tyler and others, p. 155). Eastman also created several sketchbooks, such as those depicting scenes of the Mississippi River (1846; some in St Louis, MO, A. Mus.) and of Texas (1848–9; San Antonio, TX, McNay A. Inst.).

In the 1850s Eastman was stationed in Washington, DC, to illustrate Henry R. Schoolcraft's *Information Respecting the History, Condition and Prospects of the Indian Tribes of the United States* (Philadelphia, 1851–7). In 1867 he was commissioned by the US Congress to paint a series of Indian scenes and US forts, a project incomplete at his death (26 in Washington, DC, US Capitol). Eastman provided an invaluable record of the scenery of the American West and life of the Native American Indian with journalistic directness. As an artist with little formal training, there is a naive aspect to his work.

BIBLIOGRAPHY

J. F. McDermott: *Seth Eastman: Pictorial Historian of the Indian* (Norman, OK, 1961)
——: *Seth Eastman's Mississippi* (Urbana, IL, 1973)
P. H. Hassrick: 'American Frontier Life', *SWA.*, 17 (June 1987), pp. 52–9
R. Tyler and others: *American Frontier Life: Early Western Painting and Prints* (New York, 1987)

CAREY ROTE

Eckel & Mann. American architectural partnership formed in 1880 in St Joseph, MO, by Edmond Jacques

Eckel (*b* Strasbourg, France, 22 June 1845; *d* St Joseph, 12 Dec 1934) and George R. Mann (*b* IN, 2 July 1856; *d* Little Rock, AR, 20 March 1939). Eckel graduated (1868) from the Ecole des Beaux-Arts in Paris, and Mann studied at Massachusetts Institute of Technology at a time when few architects in the USA were academically trained. St Joseph, the terminus during the 1860s of the Pony Express, was a fast-growing commercial centre. The firm's early work there, such as the Nodaway County Court House (begun 1881), Maryville, MO, often resembled the eclectic red brick Gothic Revival style of Richard Morris Hunt's Tribune Building (1873–6) in New York, but little of it survives. In their later work they often used the Romanesque Revival style of H. H. Richardson, as in the five-storey German–American Bank Building (1889) in St Joseph, built of red brick and stone. The partners employed the talented designer Harvey Ellis from about 1889 until 1893 and opened an office in St Louis, MO. Most important was their City Hall (competition entry 1892; built 1894–5) in St Louis, which resembled the Hôtel de Ville (rebuilt 1876–84 by Théodore Ballu) in Paris, but was of pink granite, buff sandstone and pink-orange Roman brick. The partnership was dissolved in 1892. Eckel remained in St Joseph, where he continued to practise with other partners, and Mann went to St Louis and later to Little Rock, where he was the architect for the Arkansas State Capitol.

UNPUBLISHED SOURCES

Kansas City, U. MO ['Edmond J. Eckel: Architectural Records'; Columbia, MO, State Hist. Soc., MS. 355]

St Joseph, MO, Brunner & Brunner Arch. and Engr. [papers of E. J. Eckel; an extensive col. of drgs and office rec.]

WRITINGS

G. R. Mann: *Sketches from an Architect's Portfolio* (St Louis, 1893)

BIBLIOGRAPHY

'Contemporary Architects and their Works: E. J. Eckel, F. A. I. A.', *W. Architect*, xvii (1911), pp. 79–84

J. A. Bryan, ed.: *Missouri's Contribution to American Architecture* (St Louis, 1928)

[Mann]: Obituary, *Pencil Points*, xx (May 1939), suppl. p. 64

'Edmond Jacques Eckel', *National Cyclopedia of American Biography*, xli (Clifton, NJ, 1956), p. 324

H. R. Hitchcock and W. Seale: *Temples of Democracy* (New York and London, 1976)

L. K. Eaton: *Gateway Cities and Other Essays* (Ames, IA, 1989)

T. M. Prawl: *E. J. Eckel, 1845–1934: A Beaux-Arts Architect at Practice in Missouri* (Columbia, U. MO, 1995)

W. I. Shank: *Iowa's Historic Architects: A Biographical Dictionary* (Iowa City, 1999)

WESLEY I. SHANK

Edbrooke. American family of architects of English birth.

(1) Frank E. Edbrooke (*b* England, 1840; *d* Denver, CO, 1918). Following a brief career as a railway architect, he opened an office in Denver in 1879. Edbrooke brought to the new city his familiarity with the work of H. H. Richardson, Louis Sullivan and other Chicago architects. Working during a period of general prosperity, he was particularly noted for a number of handsome commercial buildings in Second Empire, Romanesque Revival and Renaissance Revival styles. While showing conformity to historic modes, the buildings were nonetheless original and well-proportioned compositions. His crowning achievement is the H. C. Brown Hotel (1890–92), Denver,

a nine-storey building with an atrium, covered by a skylight, that extends from ground-level to the roof. The exterior recalls Dankmar Adler's and Louis Sullivan's Auditorium Building (1886–9) in Chicago (for illustration *see* ADLER, DANKMAR).

BIBLIOGRAPHY

R. R. Brettell: *Historic Denver: The Architects and the Architecture, 1858–1893* (Denver, 1973), pp. 32–63

S. Ries: 'The Brown Palace: Denver's Precedent for the Atrium Hotels', *Interior Des.*, lviii (1987), 268–9

(2) W(illoughby) J. Edbrooke (*b* England, 1843; *d* Chicago, IL, 29 March 1896). Brother of (1) Frank E. Edbrooke. He began practising as an architect in Chicago *c.* 1867. W. J. Edbrooke received the commission for the Main Building (1879) of Notre Dame University in Indiana and used Gothic Revival for this and several other buildings that he designed for the university. From 1887 to 1891 he worked with Franklin P. Burnham (*d* 1909): their work included the Georgia State Capitol in Atlanta (1884–91). In 1891 Benjamin Harrison, the President of the USA, appointed Edbrooke to the post of Supervising Architect of the Treasury, a position he held until 1893. He was responsible for federal architecture throughout the country and designed at least 40 federal court houses and post offices. These buildings were predominantly in the Romanesque Revival style derived from H. H. Richardson and contributed to the spread of the round-arched style. Examples include the Post Office and Customs House (1891–6), Milwaukee, WI, and the Post Office (completed 1899), Washington, DC (now an office building with a gallery of shops). Both are monumental Romanesque Revival buildings. In service with the government, Edbrooke also designed the US Government Pavilion, a huge Renaissance Revival work, for the World's Columbian Exposition (1893) in Chicago.

BIBLIOGRAPHY

Macmillan Enc. Archit.; Withey

D. H. Smith: *The Office of the Supervising Architect of the Treasury* (Baltimore, 1923)

T. J. Schlereth: *The University of Notre Dame: A Portrait of its History and Campus* (Notre Dame, 1976)

WILLARD B. ROBINSON

Edmonds, Francis W(illiam) (*b* Hudson, NY, 22 Nov 1806; *d* Bronxville, NY, 7 Feb 1863). American painter and banker. He achieved recognition both as a painter and as a banker, juggling careers with consummate skill. In 1826 he enrolled at the National Academy of Design while working in a New York bank. Somewhat insecure, he initially exhibited between 1836 and 1838 under the pseudonym E. F. Williams, but favourable reviews subsequently prompted him to use his own name. In 1840–41 Edmonds spent eight months in Europe, where he studied the Old Masters; he particularly admired the 17th-century Dutch painters Pieter de Hooch (1628–84) and Gabriel Metsu (1629–69). The works of these artists were models for Edmonds's meticulous renderings of everyday scenes and anecdotal literary subjects. There is also a similarity between Edmonds's paintings and those of the Scottish painter David Wilkie (1785–1841) who was highly regarded in America at the time.

In his depiction of distinctly American themes, Edmonds paralleled his more famous contemporary, William

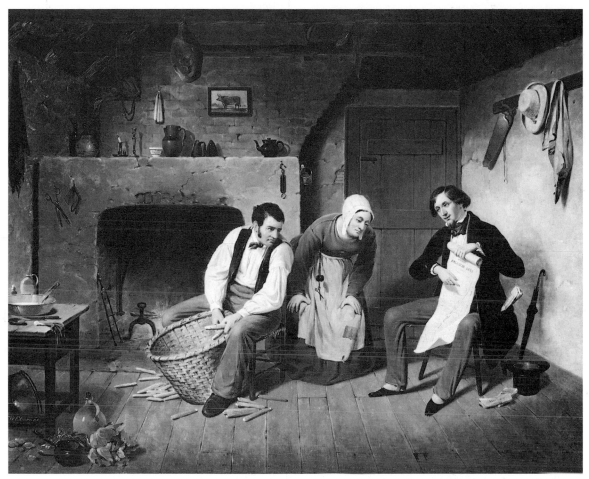

Francis W. Edmonds: *The Speculator*, oil on canvas, 635×762 mm, 1852 (Washington, DC, National Museum of American Art)

Sidney Mount. Both were chroniclers of the sense of opportunity and well-being in the young nation. Edmonds's *The Image Pedlar* (1844; New York, NY Hist. Soc.) mingles the themes of patriotism, family and work ethic, while *The Speculator* (1852; Washington, DC, N. Mus. Amer. A.; see fig.) warns against unscrupulous financial dealing. Edmonds was an accomplished craftsman, and the exquisitely rendered still-life accessories in his pictures often overshadow the sentimentality of the figures. Despite having two occupations, Edmonds was a productive artist and exhibited in New York, Boston and Philadelphia. He was an officer of the National Academy of Design and a founder-member of the Century Association.

BIBLIOGRAPHY

H. N. B. Clark: 'A Fresh Look at the Art of Francis W. Edmonds: Dutch Sources and American Meanings', *Amer. A. J.*, xiv (1982), pp. 73–94

Francis W. Edmonds: American Master in the Dutch Tradition (exh. cat., ed. H. N. B. Clark; Fort Worth, TX, Amon Carter Mus.; New York, NY Hist. Soc.; 1988); review by S. B. Sherrill in *Antiques*, cxxxiii (1988), p. 42

E. Johns: '"This New Man": National Identity in Mid-nineteenth-century Genre Painting of the United States', *World Art: Themes of Unity in Diversity*, ed. I. Lavin (University Park, PA, 1989), pp. 671–8

H. NICHOLS B. CLARK

Ehninger, John W(hetten) (*b* New York, 22 July 1827; *d* Saratoga Springs, NY, 22 Jan 1889). American painter and illustrator. After graduating from Columbia College, New York, in 1847, he immediately departed for Europe to pursue artistic training. He visited Italy and France, but staying in Germany, specifically Düsseldorf, was his main objective. There he studied with Karl Friedrich Lessing (1808–80), Carl Ferdinand Sohn (1805–67) and fellow American Emanuel Leutze, and in Paris he was instructed by Thomas Couture (1815–79). During the early 1850s he travelled between America and Europe but finally settled in New York in 1853 until his move to Saratoga Springs after marrying in 1877. Ehninger exhibited regularly at the National Academy of Design, New York, where he was elected a full member in 1860. His work reveals interests shared by the other Americans in Düsseldorf: these were mainly history and genre painting, with occasional forays in European landscape. But he quickly returned to American subject-matter; *Yankee Peddler* (1853; Newark, NJ, Mus.; see fig.), for example, describes the initiative of an itinerant entrepreneur in the young nation.

Ehninger's work often suffers for being overcrowded with figures, obscuring the effect of the meticulously rendered details. While he was in England, Ehninger designed for the *London Illustrated Times*, and in the USA he illustrated works by Washington Irving, Longfellow and Tennyson. He also introduced *cliché-verre*, a new

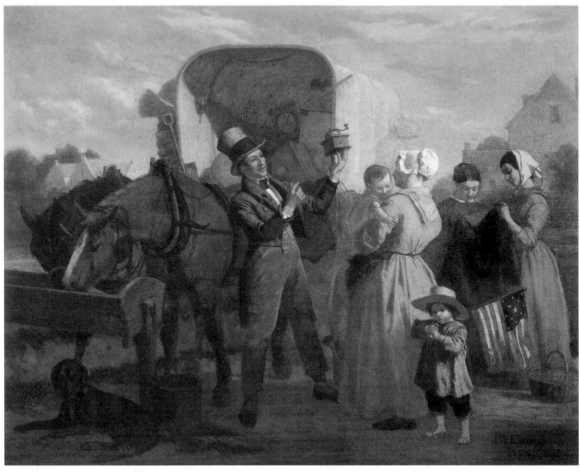

John W. Ehninger: *Yankee Peddler*, oil on canvas, 641×819 mm, 1853 (Newark, NJ, Newark Museum)

technique for photographic etching, to America in a portfolio published in 1859. Ehninger thrived on diversity; as well as being an artist, he was an accomplished linguist, classical scholar and amateur actor.

BIBLIOGRAPHY
H. W. Williams jr: *Mirror to the American Past* (Greenwich, CT, 1973)
American Artists in Düsseldorf, 1840–1865 (exh. cat., ed. A. Harding and others; Framingham, MA, Danforth Mus. A., 1982)

H. NICHOLS B. CLARK

Eichholtz, Jacob (*b* Lancaster, PA, 2 Nov 1776; *d* Lancaster, 11 May 1842). American painter. He trained as a coppersmith and was encouraged to paint by Thomas Sully, who visited Lancaster in 1808 and used his studio. From that point Eichholtz began to paint on canvas instead of panels. Always attempting to improve his work, he visited the portrait painter Gilbert Stuart in Boston about 1811 and soon afterwards turned entirely to painting. He lived in Philadelphia for ten years from 1822, and by the time he moved back to Lancaster he had become one of the leading portrait painters in Philadelphia and Baltimore. His earliest works (*c.* 1808–10) were stiff profile views, but these flat, colourless works gave way to more ornate, even elegant, freshly coloured, three-quarter views. He exhibited almost every year from 1811 to 1833 at the

Pennsylvania Academy of the Fine Arts, Philadelphia, which holds the largest group of his paintings.

BIBLIOGRAPHY
R. Beal: *Jacob Eichholtz, 1776–1842: Portrait Painter of Pennsylvania* (Philadelphia, 1969)
Jacob Eichholtz, 1776–1842, Pennsylvania Painter: A Retrospective Exhibition (exh. cat., intro. E. P. Richardson; Philadelphia, PA Acad. F.A., 1969)

DARRYL PATRICK

Eidlitz. American family of architects of Bohemian origin. (1) Leopold Eidlitz became one of the most influential architects in the USA during the 19th century. Responsible for many New York City churches and for government buildings in the state capital of Albany, he was also a founder of the American Institute of Architects. His son, (2) Cyrus L. W. Eidlitz, is perhaps best known for his New York Times Building in Times Square, New York.

(1) Leopold Eidlitz (*b* Prague, 29 March 1823; *d* New York, 22 March 1908). He studied estate management and construction at the polytechnic in Vienna. In 1843 he settled in New York and entered the architectural office of Richard Upjohn. Among the active projects in Upjohn's office during Eidlitz's brief stay were the Gothic Revival style Trinity Church (*c.* 1839–46), New York, and the

Rundbogenstil-inspired Church of the Pilgrims (1844–6), Brooklyn (*see* UPJOHN, (1), figs 1 and 2). In 1846 Eidlitz and the German-born architect Otto Blesch received a commission from the evangelical congregation of St George's Episcopal Church, Stuyvesant Square, New York. The use of *Rundbogenstil* motifs on St George's reflects the influence of Upjohn's Church of the Pilgrims but, more importantly, indicates both Eidlitz and Blesch's debt to contemporary work in southern Germany, particularly to the *Rundbogenstil* buildings of the Munich architect Friedrich von Gärtner (1792–1847). According to Montgomery Schuyler, Blesch was responsible for the exterior of St George's, while Eidlitz designed the interior. The layout of the interior was unusual for an Episcopal church in that it was an open rectangular space, more akin to a Protestant meeting house. Eidlitz supervised the construction of the entire building and rebuilt the interior after a fire in 1865.

The success of St George's led to Eidlitz receiving several commissions from Episcopal and Protestant congregations. Each of his churches had exposed timber roofs that clearly expressed the building's structure. Among the finest of Eidlitz's churches are the Congregational Church (1856–9), Greenwich, CT, with its German-inspired openwork stone spire, and St Peter's Episcopal Church (1853–5; chapel, 1867–8; restored by Cyrus L. W. Eidlitz following a fire in 1879), Westchester Avenue, Bronx, New York. Eidlitz was also responsible for one of New York's most important 19th-century synagogues, Temple Emanu-El (1866–8; with Henry Fernbach; destr. 1901; see fig.), Fifth Avenue, noted for its distinctive combination of Romanesque and Moorish motifs. Eidlitz's most famous church was Holy Trinity Episcopal Church (1870–75; destr. 1901), Madison Avenue and East 42nd Street, New York: its bold polychromatic brick exterior evoked the appellation 'Church of the Homely Oilcloth'. The plan of Holy Trinity was extremely unusual, with an elliptical auditorium set within rectangular walls.

Eidlitz was also active in the design of commercial and civic buildings. His earliest commercial works, such as the Continental Bank (1856–9; destr. 1901), Nassau Street, New York, and the American Exchange Bank (1857; destr. 1899), Broadway, New York, were stone structures with the rusticated bases, arched windows and rusticated voussoirs found on such German buildings as von Gärtner's Staatsbibliothek (1832–43), Munich. The Produce Exchange (1860–61; destr. 1885), Whitehall Street, New York, and the Academy of Music (1860–61; destr. by fire 1903), Montague Street, Brooklyn, were Eidlitz's most successful efforts at manipulating façade elements to reflect interior spaces. Ornament was kept to a minimum on both buildings, but each had a dramatic street presence.

In the mid-1870s Eidlitz received two major civic commissions. In 1875 he joined H. H. Richardson in the completion of the New York State Capitol, Albany. Eidlitz was responsible for the Assembly Chamber, the Golden Corridor and the Senate Staircase. The Assembly Chamber, described by Schuyler as 'perhaps the noblest monument to the Gothic revival in America' (*Archit. Rec.*, xxiv, p. 369), was a medieval inspired 17 m high room with a stencilled stone-vaulted ceiling supported on granite columns. Ironically, although Eidlitz had a deep concern for structure, both the Assembly Chamber ceiling and the Golden Corridor proved to be structurally unsound and were dismantled in 1888–9. In 1876 Eidlitz was commissioned to complete John Kellum's New York County Court House ('Tweed Courthouse'), begun in 1861. Eidlitz added a Romanesque-inspired wing to Kellum's Italianate building. The stylistic contrast between the wings was widely condemned, although Schuyler noted that Eidlitz was 'puzzled by the commotion' (*Archit. Rec.*, xxiv, p. 374). Eidlitz's last major work was undertaken for his first client. In 1886 he designed a Clergy House for St George's. This rough-hewn brownstone structure (now converted into flats), with its clear exterior delineation of interior spaces, is a perfect complement to the church.

Eidlitz's reputation as one of the most influential architects in the USA between the 1840s and 1890s was also due to his role as a founder of the American Institute of Architects and as an active participant in its affairs. He often delivered papers at the Institute's meetings and his comments, printed in *Crayon*, were some of the first architectural criticism and theory published in the USA. Through his talks and papers, the publication of his lengthy theoretical tract *Nature and the Function of Art, More Especially of Architecture* (1881), and his buildings, Eidlitz had a widespread influence on his contemporaries that began to be understood only later. Because so few of Eidlitz's major buildings survive, it is difficult to comprehend fully his career. He was deeply committed to the view, inspired by medieval architecture, that structure should determine form. He believed that a building's mass should grow directly from its plan and that materials

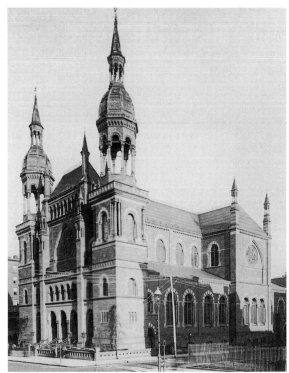

Leopold Eidlitz with Henry Fernbach: Temple of Emanu-El, New York, 1866–8 (destr. 1901)

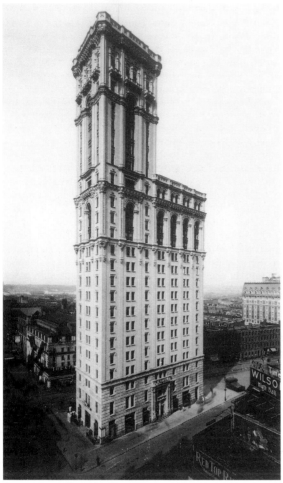

Cyrus L. W. Eidlitz: *New York Times* Building, Times Square, New York, 1903–5 (stripped 1966)

should be used in a clear structural manner, with ornament added only to accent structure, material and function. These concerns are evident in his finest work.

WRITINGS
'Christian Architecture', *Crayon*, v (1858), pp. 53–5
Crayon, v (1858), pp. 109–11 [untitled address at the first annual dinner of the American Institute of Architects]
'On Style', *Crayon*, v (1858), pp. 139–442
'Cast Iron Architecture', *Crayon*, vi (1859), pp. 20–24
'The Architect', *Crayon*, vi (1859), pp. 99–100
'On Aesthetics in Architecture', *Crayon*, viii (1861), pp. 111–13
The Nature and Function of Art, More Especially of Architecture (New York, 1881/R 1977)

BIBLIOGRAPHY
M. Schuyler: 'The Evolution of a Skyscraper', *Archit. Rec.*, xiv (1903), no. 5, pp. 329–43
——: 'A Great American Architect: Leopold Eidlitz, I. Ecclesiastical and Domestic Work', *Archit. Rec.*, xxiv (1908), no. 3, pp. 163–79
——: 'The Work of Leopold Eidlitz: II. Commercial and Public', *Archit. Rec.*, xxiv (1908), no. 4, pp. 277–92
——: 'The Work of Leopold Eidlitz: III. The Capitol at Albany', *Archit. Rec.*, xxiv (1908), no. 5, pp. 364–78
W. Weisman: 'Commercial Palaces of New York: 1845–1875', *A. Bull.*, xxxvi (1954), pp. 285–302
H. Brooks: 'Leopold Eidlitz: 1823–1908' (MA diss., New Haven, CT, Yale U., 1955)
W. Jordy and R. Coe, eds: *American Architecture and Other Writings by Montgomery Schuyler* (Cambridge, MA, 1961/R New York, 1964), pp. 3–53
B. Erdmann: *Leopold Eidlitz's Architectural Theories and American Transcendentalism* (diss., Madison, U. WI, 1977; R Ann Arbor, 1978)
A. Bedell and M. Dierickx: *The Tweed Courthouse Historic Structure Report* (New York, 1980)
Master Plan for the New York State Capitol (Albany, 1982)

(2) Cyrus L(azelle) W(arner) Eidlitz (*b* New York, 27 July 1853; *d* Southampton, NY, 5 Oct 1921). Son of (1) Leopold Eidlitz. He was sent to school in Geneva and at the age of 15 enrolled in the department of architecture at the polytechnic in Stuttgart. In 1871 he entered his father's New York office. He continued to share an office with his father even after he established an independent career. Eidlitz's earliest independent works, such as the Buffalo Library (1884–7; destr.), Buffalo, NY, and Dearborn Station (completed 1885; altered after a fire in 1922), South Dearborn Street, Chicago, were monumental Romanesque Revival style works. In the 1880s he became active in the design of skyscrapers. His earliest have Romanesque details, but by the 1890s he was breaking away from his father's medievalism to make use of Renaissance ornament. Eidlitz's most famous works include the *New York Times* Building (1903–5; stripped 1966; see fig.), Times Square, New York. This trapezoidal tower, with Renaissance- and Gothic-inspired terracotta cladding, had a sophisticated skeletal frame set around a new subway station.

BIBLIOGRAPHY
DAB
M. Schuyler: 'Cyrus L. W. Eidlitz', *Archit. Rec.*, v (1896), no. 4, pp. 411–35
B. Erdmann: *Leopold Eidlitz's Architectural Theories and American Transcendentalism* (diss., Madison, U. WI, 1977)
ANDREW SCOTT DOLKART

Eight, the. Group of eight American painters who joined forces in 1907 to promote stylistic diversity and to liberalize the exclusive exhibition system in the USA. They first exhibited together at Robert Henri's instigation at the Macbeth Galleries, New York, in February 1908, following the rejection of works by George Luks, Everett Shinn, William J. Glackens and others at the National Academy of Design's spring show in 1907, of which Henri was a jury member before resigning in protest. Henri, the driving force behind the group, was joined not only by Luks, Shinn and Glackens but also by John Sloan, Ernest Lawson, Arthur B. Davies and Maurice Prendergast. Henri was a painter of cityscapes and portraits who worked in a dark and painterly, conservative style influenced by Frans Hals (1581/5–1666) and Velázquez (1599–1660); a gifted teacher, he encouraged his students to depict the urban poor with vitality and sensitivity.

Sloan, Luks, Shinn and Glackens had met Henri in Philadelphia in the 1890s while employed as newspaper illustrators. Henri persuaded them to move to New York, where they painted urban realist scenes of prostitutes, street urchins and vaudeville performers, for which they were later called the ASHCAN SCHOOL. Ironically, while these painters were often deemed rebels, all worked in the coarsely brushed academic mode of Henri, and none but Sloan, who espoused Socialism, imposed social criticism. They commonly treated their subjects not as oppressed victims but as colourful and bohemian characters.

Lawson, Davies and Prendergast had little in common with the other members of the Eight; these three were influenced by late 19th-century French painting. Lawson portrayed upper Manhattan and the lower Hudson River with thickly applied impressionist strokes. Davies painted idyllic, symbolist landscapes populated by female nudes. Prendergast used a pointillist technique to depict the middle classes at leisure.

Despite some criticism, the Macbeth exhibition was generally well received and well attended. As a result it travelled to nine major cities, and the National Academy of Design temporarily liberalized its exhibition policies. The historic exhibition of the Eight is considered a milestone in the development of artistic independence, inspiring other independent exhibitions, including the Armory Show (1913; see NEW YORK, fig. 6), which radically transformed American art in the early 20th century.

BIBLIOGRAPHY

The Eight (exh. cat. by E. Shinn, New York, Brooklyn Mus., 1944)
B. B. Perlman: *The Immortal Eight: American Painting from Eakins to the Armory Show, 1870–1913* (New York, 1962); rev. as *The Immortal Eight and its Influence* (1983)
A. Goldin: 'The Eight's Laissez-faire Revolution', *A. America*, lxi/4 (1973), pp. 42–9
M. S. Young: *The Eight: The Realist Revolt in American Painting* (New York, 1973)
F. Goodyear: 'The Eight', *In this Academy: The Pennsylvania Academy of Fine Arts, 1805–1976* (exh. cat., Philadelphia, PA Acad. F A, 1976)
M. Laisson: 'The Eight and 291: Radical Art in the First Two Decades of the Twentieth Century', *Amer. A. Rev.*, ii/4 (1979), pp. 91–106
The American Eight (exh. cat., intro. J. W. Kowelek; Tacoma, A. Mus., 1979)
B. B. Perlman: 'Rebels with a Cause: The Eight', *ARTnews*, lxxxi/18 (1982), pp. 62–7
The Shock of Modernism in America: The Eight and the Artists of the Armory Show (exh. cat. by C. H. Schwartz, Roslyn, Nassau Co. Mus. F.A., 1984)
B. B. Perlman: 'Practicing Preacher', *A. & Ant.*, vii/9 (1990), pp. 84–9
JANET MARSTINE

Eilshemius, Louis M(ichel) (*b* North Arlington, NJ, 4 Feb 1864; *d* New York, 29 Dec 1941). American painter. After early education in Switzerland and Germany (1873–81), he spent a year at Cornell University, Ithaca, NY (1882–3), before studying painting at the Art Students League in New York. He also studied privately with the painter Robert C. Minor (1840–1904), who influenced his early style derived from the Barbizon school. In 1886 he enrolled in life classes at the Académie Julian in Paris. The death of his father in 1892 left him with the means to travel, notably to Europe and North Africa (1892–3) and to the South Pacific and New Zealand. He also made extensive visits to California (1889, 1893–4) and Rome (1903).

One of the most striking features of Eilshemius's artistic development is the dramatic shift from his charming late-19th-century landscapes in the Barbizon manner, for example *Landscape with Woman and Haystack* (1890; Los Angeles, CA, Co. Mus. A.), to the eccentric, frequently disturbing subjects and idiosyncratic style of the later period, seen in *Jealousy* (*c.* 1915; Philadelphia, PA, Mus. A.). Dominated by female nudes, this work is characterized by a colouristic expressionism in which personal fantasy, growing directly from the experience of his life and travels, is more important than the impact of the Armory Show or modernist theory. Like Albert Pinkham Ryder, the painter with whom he has most in common, his work was stamped by a unique and original poetic vision, seen for example in *Flying Dutchman* (1908; see fig.), derived from Ryder's original. His best work was subjective, literary and metaphorical, and related more to late 19th-century Symbolism than to those aspects of modernism that it might superficially resemble. His work was almost entirely ignored during his productive career, and he stopped painting in 1921. He had been, however, discovered by Marcel Duchamp in 1917, and by the early 1930s Eilshemius's name was established.

BIBLIOGRAPHY

D. Phillips: 'The Duality of Eilshemius', *Mag. A.*, xxxii (Dec 1939), pp. 694–7, 724–7
W. Schack: *And he Sat among the Ashes* (New York, 1939)
P. J. Karlstrom: *Louis Michel Eilshemius* (New York, 1978)
——: *Louis M. Eilshemius: Selections from the Hirshhorn Museum and Sculpture Garden* (Washington, DC, 1978)
T. Brumbaugh: 'A Group of Eilshemius Letters', *Bull. Georgia Mus. A.*, xix (1995), pp. 17–23
PAUL J. KARLSTROM

Elevator. *See under* SKYSCRAPER, §1.

Eliot, Charles (*b* Cambridge, MA, 1 Nov 1859; *d* Brookline, MA, 25 March 1897). American landscape architect, regional planner and writer. He was the son of Charles W. Eliot, the influential reforming president of Harvard College (1869–1909). He inherited much of his father's broad vision and organizational talent, and he applied these to his interest in landscape preservation.

After completing his basic studies at Harvard in 1882, Eliot decided to attend courses in botany and horticulture at Harvard's Bussey Institute as preparation for a career in landscape architecture. However, in 1883 he was offered an apprenticeship with Frederick Law Olmsted sr, the foremost landscape architect in the USA; he remained with Olmsted until 1885, during which time the office developed plans for several important projects, notably the Boston municipal park system and the Arnold Arboretum, Boston. He then completed his courses at the Bussey Institute, after which he toured abroad for a year, inspecting parks, gardens and natural landscapes from England to Italy and Russia.

In December 1886 Eliot established his practice as a landscape architect in Boston. He became a frequent contributor to popular and professional journals, explaining both the goals and the history of landscape architecture. In his writings and in his early designs he expressed concern for the disappearance of the New England landscape through rapid urbanization. Projects such as White Park (1888) in Concord, NH, were conceived as opportunities to preserve and make accessible the characteristic local landscape.

Eliot soon saw a need to organize more comprehensive conservation efforts. In an article written for *Garden and Forest* (1890), he argued for 'an incorporated association, composed of citizens of all the Boston towns, and empowered by the State to hold small and well-distributed parcels of land free of taxes, just as the Public Library holds books and the Art Museum pictures'. Eliot proceeded to write the legislation and direct the lobbying campaign for a bill enacted in 1891 to establish the Trustees of Public

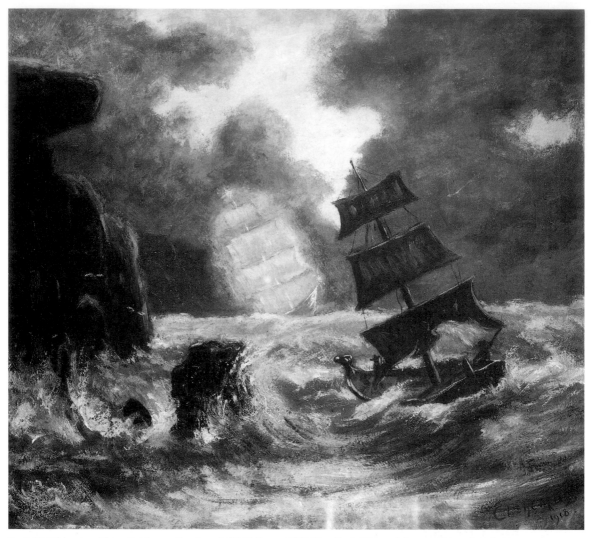

Louis M. Eilshemius: *Flying Dutchman*, oil on board, 600×648 mm, 1908 (New York, Whitney Museum of American Art)

Reservations, a private organization empowered to acquire lands for conservation throughout the state. Using the Trustees as a base, Eliot next conceived of a public metropolitan authority to provide for the recreation and conservation needs of the entire Boston basin. By 1893 he had engineered the creation of the Boston Metropolitan Park Commission and had become the consultant to both the Commission and the Trustees. After an exhaustive survey of the lands within the Commission's jurisdiction, Eliot proposed a landscape preservation philosophy and specific property for acquisition; this report was completed in 1894, and by his death he had overseen the initial development of most of its proposals.

Also in 1893 Eliot accepted an entreaty from Olmsted to establish a new partnership, Olmsted, Olmsted & Eliot; he collaborated on Olmsted projects and accepted major new commissions, such as Keney Park in Hartford, CT. *Vegetation and Scenery in the Metropolitan Reservations of Boston*, a statement of his vision for natural area management (1898), was published posthumously.

UNPUBLISHED SOURCES

Cambridge, MA, Harvard U., Frances Loeb Sch. Des. Lib. [pap.]

WRITINGS

'The Waverley Oaks: A Plan for their Preservation for the People', *Gdn & Forest*, iii (1890), pp. 85–6

Vegetation and Scenery in the Metropolitan Reservations of Boston (Boston, 1898)

BIBLIOGRAPHY

[C. W. Eliot]: *Charles Eliot: Landscape Architect* (Cambridge, MA, 1902) [biog. by his father, incl. substantial quotations from Eliot's rep. and corr.]

N. Newton: 'Charles Eliot and his Metropolitan Park System', *Design on the Land* (Cambridge, MA, 1971), pp. 318–36

KEITH N. MORGAN

Elliott, Charles Loring (*b* Scipio, NY, 12 Oct 1812; *d* Albany, NY, 25 Aug 1868). American painter. Resolved to become an artist, he moved from Syracuse, NY, to New York City around 1830, bearing a letter of introduction to John Trumbull and reportedly receiving some brief instruction from him. Elliott spent six months in the studio of the genre painter John Quidor but returned to upstate

New York, where he worked for several years as an itinerant portrait painter. Back in New York City by 1839, his art steadily improved; Henry Inman met him around 1844–5, whereupon he predicted: 'When I am gone that young man will take my place'. Elliott's portrait of *Capt. John Ericsson* (*c.* 1845; untraced) won praise in 1845 as 'the best American portrait since [Gilbert] Stuart', and from that date he was acknowledged as New York's leading portrait painter. His facility for capturing a vivid, characteristic likeness and his genial personality assured a constant stream of private patrons and public commissions. In 1867 it was reported that he had executed nearly 700 portraits.

Elliott painted with a vibrant palette and a somewhat more fluid brush than his contemporaries, creating direct, unsentimentalized likenesses often relentless in their accuracy. The materiality of his approach is most evident in *Mrs Thomas Goulding* (1858; New York, N. Acad. Des.), a portrait in which forceful character shines through a factual rendering of features and costume. He was intrigued by the new science of photography and based some of his later portraits on daguerreotypes. His best works, such as the full-length *Matthew Vassar* (1861; Poughkeepsie, NY, Vassar Coll., Frances Lehman Loeb A. Cent.), transcend photographic realism through their robust modelling and grand manner style.

BIBLIOGRAPHY

H. Tuckerman: *Book of the Artists* (New York, 1867/R 1966), pp. 302–5
T. Bolton: 'Charles Loring Elliott, an Account of his Life and Work'; 'A Catalogue of Portraits Painted by Charles Loring Elliott', *A. Q.* [Detroit], v (1942), pp. 59–96 [additional bibliography]

SALLY MILLS

Ellis, Harvey (*b* ?Rochester, NY, 17 Oct 1852; *d* Syracuse, NY, 2 Jan 1904). American architect, painter and designer. Between 1879 and 1885 he and a brother, Charles Ellis, maintained an architectural partnership in Rochester that produced commercial buildings and fashionable residences. Simultaneously he exhibited traditional representational drawings and watercolours in the Rochester Art Club. In 1885 Harvey Ellis won first prize and considerable fame with a beautiful perspective for a monument to *General Ulysses Grant* (1822–85), sponsored and published by *American Architect and Building News* (xvii (1885), p. 175). Ellis worked as an architectural draughtsman and designer for a succession of Midwestern firms, including LeRoy Sunderland Buffington in Minneapolis, MN (1887–9); Eckel & Mann in St Joseph, MO (1889–91); and, when the latter partnership was dissolved, until 1893 with George R. Mann in St Louis, MO. During this period a number of his perspectives of various projects were published in *American Architect and Building News* and *Inland Architect*, where they had a considerable influence. They were delightfully imaginative, romantic interpretations of current 19th-century styles, picturesquely interpreted by Ellis's pictorial vision (for illustration *see* MINNEAPOLIS). By late 1893 Ellis had returned to Rochester. He concentrated on painting, in a moderately avant-garde style that stressed abstract two-dimensional pictorial organization (e.g. *The Hourglass*, 1898; Rochester, NY, Strong Mus.; see fig..) rather than the earlier illusionism, graphic designs for posters (e.g. Third National Cycle Exhibition, 1897; Rochester, NY, Strong Mus.), magazine covers and designs for stained glass. Certain of the

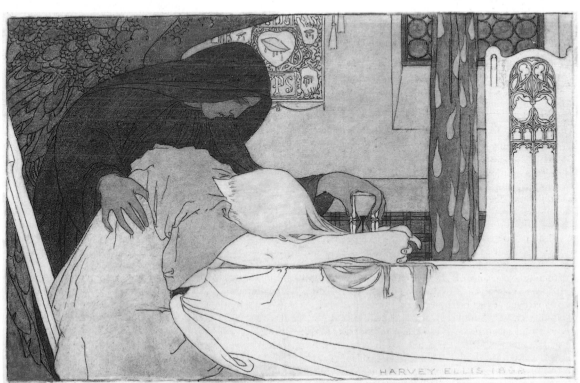

Harvey Ellis: *The Hourglass*, watercolour, 940×1473 mm, 1898 (Rochester, NY, Strong Museum)

furniture designs produced by GUSTAV STICKLEY and his workshop have also been attributed to Ellis, although there is no conclusive documentation to substantiate the claims. Ellis helped to organize the Rochester Arts and Crafts Society in 1897 and, at the invitation of Stickley, publisher of the *Craftsman*, he moved to Syracuse to become a designer for the magazine in 1903, a position he held until his death the following year.

WRITINGS

Regular contributions to *Craftsman* (1903–4) [articles and house designs]

BIBLIOGRAPHY

Macmillan Enc. Archit.

C. Bragdon: 'Harvey Ellis: A Portrait Sketch', *Archit. Rev.* [Boston], xv (1908), pp. 173–86

F. Swales: 'Master Draughtsman III: Harvey Ellis, 1852–1907 [sic]', *Pencil Points*, vii (1912), pp. 49–55, 79

E. Manning: *The Architectural Designs of Harvey Ellis* (diss., Minneapolis, U. MN, 1953)

R. Kennedy: 'The Long Shadow of Harvey Ellis', *MN Hist.*, xl (1966), pp. 97–108

——: 'Long, Dark Corridors: Harvey Ellis', *Prairie Sch. Rev.*, v/1–2 (1968), pp. 5–18

A Rediscovery: Harvey Ellis: Artist, Architect (exh. cat., U. Rochester, NY, Mem. A.G.; Rochester, NY, Strong Mus.; 1972–3)

The Arts & Crafts Movement in New York State, 1890s–1920s (exh. cat. by C. Ludwig, Oswego, SUNY, Tyler A.G., 1983), pp. 75–7

EILEEN MICHELS

Elmslie, George Grant. *See under* PURCELL & ELMSLIE.

Emerson, William Ralph (*b* Alton, IL, 11 March 1833; *d* Milton, MA, 23 Nov 1917). American architect. He trained in the office of Jonathan Preston (1801–88), a little-known architect–builder in Boston. In 1857–61 he was in partnership with Preston, then practised on his own for two years. There followed an association with the Boston architect Carl Fehmer (*b* 1838), which lasted until 1873. A few projects from this early period have been identified, mostly in partnership with Fehmer, which are in the popular historical styles of the period and exhibit little that became characteristic of Emerson's later work.

From 1874 until his retirement in 1909, Emerson practised alone. During this period he became well known with the public and respected among his fellow architects for his suburban and summer residences, mostly in New England. He departed from traditional, symmetrical floor-plans and avoided elaborate exterior ornamentation, which was then popular, by exploiting the potential of the building materials. His most important projects were built on generous plots that allowed picturesque siting of the house. He made frequent use of wood shingles for roofs and walls, often in conjunction with a first storey of rubble, to make his houses harmonious with their suburban or country sites.

Emerson was one of the chief practitioners in the SHINGLE STYLE, and his Redwood (1879), the Charles J. Morrill cottage at Bar Harbor, ME, is considered the first fully developed example of the style; it also displays features of Queen Anne Revival, such as stylized half-timbered gables.

In Bar Harbor, Redwood was quickly followed by several outstanding examples of Emerson's work, all of which have been destroyed: Edgemere (1881), Thirlstane (1881–2), Beau Desert (1881–2) and Mossley Hall (1882–

3). Each of these large cottages had an open plan organized around a large entry hall with windows framing magnificent scenic views. The use of a spacious entry hall or 'living hall' as a focal-point was characteristic of the period and made innovative floor-plans in domestic design possible. In his work at Bar Harbor, Emerson used shingles cut in a variety of patterns and complex roofing plans to achieve striking picturesque effects.

One of Emerson's most important early projects was the Charles G. Loring House (1881) at Pride's Crossing, MA, typical of his best work in its masterful use of a rocky coastal site, in which the house's picturesque asymmetrical exterior responds to the location. Its exterior ornamentation is based on American Colonial architecture, providing an early example of Emerson's interest in the style and an indication of his later development. The gambrel roof derives from Early American architecture and enabled Emerson to treat a large portion of the sweeping roof like a wall, shingling both portions and thereby disguising the transition between two normally sharply delineated sections of a building. His own house (1886) in Milton, MA, is a notable example of this technique.

The last phase of Emerson's career began when his vernacular-inspired designs lost favour among wealthy clients, who came to prefer more palatial country homes based on elaborate historical styles and formal plans. From the 1890s Emerson obtained fewer large-scale commissions offering scope for innovative treatment. With a number of small projects, however, he continued his evolution towards sparsely ornamented shingled buildings. One of his last important projects was Felsted (1896), Deer Isle, ME, a summer cottage for Frederick Law Olmsted. Located at an isolated site on a rocky promontory, it was formed somewhat like the stern of a ship resting on massive granite blocks. Designed in perfect harmony with its site, Felsted is a masterpiece of the Shingle style.

BIBLIOGRAPHY

V. J. Scully jr: *The Shingle Style: Architectural Theory and Design from Richardson to the Origins of Wright* (New Haven, 1955); rev. as *The Shingle Style and the Stick Style* (New Haven, 1971)

C. Zaitzevsky: *The Architecture of William Ralph Emerson, 1833–1917* (Cambridge, MA, 1969)

R. G. Reed: *A Delight to All who Know it: The Maine Summer Architecture of William R. Emerson* (Augusta, ME, 1990/*R* 1995)

ROGER G. REED

Enneking, John Joseph (*b* Minster, OH, 4 Oct 1841; *d* Hyde Park, nr Boston, MA, 17 Nov 1916). American painter. He received his first art instruction in Cincinnati, OH. He moved in 1865 to Boston, MA, where he received further instruction while earning his livelihood in business. In 1873 he determined to make art his full-time profession and spent the following three years in Europe, studying for nine months in Munich and for two years in Paris with Charles-François Daubigny (1817–78) and Léon Bonnat (1833–1922). Settling in Hyde Park, MA, in 1876, he established himself as a landscape painter of picturesque New England scenery and of hazy winter twilight scenes. He occasionally painted genre subjects and was especially noted for his large-scale and sympathetic portrayals of children and the elderly, as can be seen, for example, in *Removing a Splinter* (1894; New York, Arden priv. col.).

Enneking had his first major success when a large exhibition of his pictures was held in Boston in 1878. The sale of these paintings launched him as one of the most popular landscape painters in New England. While his early landscapes reflect the influence of his Barbizon training, his later images of brightly coloured, sunlit scenes reveal the influence of American Impressionist artists such as Theodore Robinson and John H. Twachtman.

BIBLIOGRAPHY

J. Davol: 'The Work of John J. Enneking', *Amer. Mag. A.*, viii (1917), pp. 320–23

John Joseph Enneking: American Impressionist Painter (exh. cat. by P. J. Pierce and R. H. Kristiansen, North Abington, MA, Pierce Gal., 1972)

John J. Enneking: American Impressionist (exh. cat., Brockton, MA, A. Cent., 1974)

Domestic Bliss: Family Life in American Painting, 1840–1910 (exh. cat. by L. M. Edwards, New York, Hudson River Mus., 1986), pp. 122–3

LEE M. EDWARDS

Eugene [Smith], **Frank** (*b* New York, 19 Sept 1865; *d* Munich, 16 Dec 1936). American photographer and teacher, active also in Germany. After attending the Bayerische Akademie der Bildenden Künste, Munich (from 1886), he began exhibiting his photography in New York. Around 1899 he came to the attention of Alfred Stieglitz and was praised by the critic Sadakichi Hartmann for the intelligent combination of painterly and photographic effects in his work. He became a member of the influential transatlantic photographic society, the Linked Ring (1900), and was a founder-member of Stieglitz's PHOTO-SECESSION.

Around 1901 he moved permanently to Germany, where he became a lecturer at the Lehr- und Versuchsanstalt für Photographie und Reproduktionstechnik, Munich. When Stieglitz visited him in 1907, the two made some of the first artistic experiments in colour photography with the newly developed autochrome process. In 1913 Eugene was appointed to the chair in Pictorial photography at the Akademie für Graphische Künste, Leipzig. Two years later, he renounced his American citizenship and became a German citizen.

With the exception of a few landscapes made in Egypt in 1901, Eugene's photographic oeuvre consists almost exclusively of allegorical images, as well as straightforward portraits and female nudes. His finest work, which brought him to the attention of the Stieglitz circle, was done within the decade around 1900. It included *The Horse* (1895; see Hartmann, 1978, p. 176) and a series of nude studies made around 1898, particularly *Adam und Eva* (1898; New York, Met.) and *Dido* (*c.* 1898; see Naef, 1978, p. 163). Here, as earlier, Eugene approached photography like a printmaker, substantially altering his negatives with oils and etched cross-hatching before printing them, which resulted in lively backgrounds to his main figures (see fig..

BIBLIOGRAPHY

S. Hartmann: *The Valiant Knights of Daguerre* (Berkeley, 1978)

W. J. Naef: *The Collection of Alfred Stieglitz* (exh. cat. by W. J. Naef, New York, Met., 1978)

Frank Eugene: The Dream of Beauty (exh. cat. by U. Pohlmann; Munich, Fotomus., and Salzburg, Rupertinum; 1995–7)

TERENCE PITTS

Evans, Allen. *See under* FURNESS, FRANK.

Frank Eugene: *Frank Eugene, Alfred Stieglitz, Heinrich Kühn and Edward Steichen*, platinum print, 110×165 mm, 1907 (Bath, Royal Photographic Society)

Exchange Club [Amateur Photographic Exchange Club]. American photographic society founded in 1861 and open only to amateur photographers. The three founder-members, all from New York, were Henry T. Anthony (1814–84) as President, F. F. Thompson as Secretary and Correspondent, and Charles Wager Hull. Its membership was originally restricted to 20 and, though this rule was later dropped, the members never numbered many more than this. Nevertheless they were from all over the USA and soon included most of the prominent American amateurs of the day. Among them were August Wetmore and Lewis M. Rutherford of New York; Coleman Sellers, Professor Fairman Rogers and Constant Guillou of Philadelphia; Titian R. Peale of Washington; Robert Shirner of Cumberland, Maryland; John Towler of Geneva, New York, author of *The Silver Sunbeam* (New York, 1864), and Professor E. Emerson of Troy, New York. The physician and writer Oliver Wendell Holmes (1809–94) was an honorary member on the strength of his achievements as a photographic pioneer. The Club's existence reflected the enormous popularity of photography in the USA in the 1860s.

One of the main interests of the Exchange Club's members was stereoscopic photography; Wendell Holmes was the inventor of the most widespread version of the stereoscopic viewer, though single plate images were also produced. While the exact activities of the Club are not clear, its rules stated that 'every member shall forward each other member on or before the 15th of January, March, May, July, September and November, at least one stereoscopic print, a copy of which has not been sent before, mounted and finished'. Anyone failing to fulfil this condition would be struck off the membership list. Each member was required to keep an account-book showing all the prints sent and received. On 1 February 1863 Thompson published the first of seven issues of the Club's official journal, *The Amateur Photographic Print*, the last of which appeared on 1 September 1863.

The photographs produced by members of the Exchange Club were of variable interest, often consisting of single and group portraits and landscapes (see Taft, p. 206). As a mark of membership each member designed his own label, which was stuck on to the back of any print sent. The contents of the labels varied from basic descriptions of the subject, as in those of John Towler (see Darrah, fig. 9), to more detailed technical records about how the work was taken, as in those of Coleman Sellers (see Darrah, fig. 10). The Club was active only until late 1863, by which time the American Civil War and the increased availability of commercial prints had virtually brought it to an end. References to the activities of the Club appeared in Wendell Holmes's article 'The Doings of the Sunbeam' in *Atlantic Monthly*, though it was not mentioned by name. In 1888 a more detailed account was published by one of its most energetic members, Sellers, in a series of articles in *Anthony's Photographic Bulletin*.

BIBLIOGRAPHY

O. Wendell Holmes: 'The Doings of the Sunbeam', *Atlantic Mthly*, xii (1863), no. 69, pp. 1–15

C. Sellers: 'An Old Photographic Club', *Anthony's Phot. Bull.*, xix (1888), no. 10, pp. 301–4; no. 11, pp. 338–41; no. 12, pp. 356–61; no. 13, pp. 403–6

R. Taft: *Photography and the American Scene: A Social History, 1839–1889* (New York, 1938, *R*/1964), pp. 213–16, 222

W. Culp Darrah: *Stereo Views: A History of Stereographs and their Collection* (Gettysburg, 1964), p. 4, figs 9–11

☐

Eyre, Wilson (*b* Florence, 31 Oct 1858; *d* Philadelphia, PA, 21 Oct 1944). American architect. He was born to a prominent Philadelphia family and spent his first 11 years in Italy, where his father was serving as a US consular official. Eyre's architectural training came principally through an apprenticeship in Philadelphia under James Peacock Sims (1849–82), whom he joined in partnership just before Sims's sudden death. Sims's last works and Eyre's own early works show the impact of Richard Norman Shaw's Queen Anne and Old English Revival styles, aspects particularly notable in The Anglecot (1883; altered), 401 East Evergreen Avenue, Philadelphia, and in the H. Genet Taylor House (1885) in Camden, NJ. By the late 1880s, however, his designs were moving towards greater stylistic freedom, a departure comparable to that in the works of that decade by McKim, Mead & White, Lamb & Rich and Peabody & Stearns. Some works, particularly suburban houses, were clearly influenced by the Shingle style, such as the Charles L. Freer House (1890), in Detroit, MI. In his town houses Eyre achieved an almost unmatched type of free and flowing design, effortlessly eclectic, without the effect of a 'shotgun marriage' of styles. This is particularly evident in his Rodman Wistar House (1887; altered), 1014 Spruce Street, Philadelphia, and his C. B. Moore House (1891), 1321 Locust Street, Philadelphia. In many ways, such houses represent an urban equivalent to the American achievement in the creation of the Shingle style. They were vaguely anglophile in derivation and selfconsciously artistic but were usually reliant on the horizontal continuity of thin brick courses and the warmth of buff-toned brick in the place of more rustic materials. Often a more formal, cosmopolitan note was introduced by historically allusive stone-carving. In rural settings or for 'bohemian' clubs, Eyre often turned to an engaging Arts and Crafts manner, as in his Mask and Wig Club (1893), 311 South Camac Street, Philadelphia, or his Neilson Brown House (1900) in the Torresdale section of Philadelphia, but only rarely, as in the University of Pennsylvania Museum (begun 1893), Philadelphia, did these qualities feature in his larger urban projects. The Museum was designed in collaboration with his like-minded peers Frank Miles Day (1861–1918), Walter Cope and John Stewardson, but Eyre's hand is the most evident.

By the mid-1890s the selfconsciously artistic stylization of his early work, along with the signs of the Aesthetic Movement generally, began to diminish, and Eyre's subsequent designs embodied such values only more subtly, in more nominally historicist modes. At first his reference to such historicist styles had been remarkably free, as in his quirkily American Colonial Revival Neill and Mauran houses (1891), 315–17 South 22nd Street, Philadelphia, but he later settled into a more plausibly authentic but equally Picturesque manner, evident in such imposing houses as his W. T. Jeffords House (1917) at Glen Riddle, PA. Country houses such as these, often Colonial Revival or 'Jacobethan', were the mainstay of his practice after

1912, when he formed a partnership with J. Gilbert McIlvaine (1880–1939).

Eyre's work had a profound influence on more than one generation, first in the 1880s among the young Philadelphia architects who showed and discussed their designs in the T-Square Club (founded 1883), and later in the less formal but historicizing stone-built suburban houses near Philadelphia that established the reputations of early 20th-century firms such as Mellor, Meigs & Howe (1916–27), Duhring, Okie & Ziegler (1899–1918), and individual architects including Edmund B. Gilchrist (1885–1953) and Robert R. McGoodwin (1886–1967).

BIBLIOGRAPHY

A. M. Githens: 'Wilson Eyre, jr: His Work', *Architectural Annual, 1900*, ed. A. Kelsey (Philadelphia, 1900), pp. 121–84

J. Millard: 'The Work of Wilson Eyre', *Archit. Rec.*, xiv (1903), pp. 279–325

V. J. Scully jr: *The Shingle Style: Architectural Theory and Design from Richardson to the Origins of Wright* (New Haven, 1955); rev. as *The Shingle Style and the Stick Style* (New Haven, 1971)

E. Teitelman: 'Wilson Eyre in Camden: The Henry Genet Taylor House and Office', *Winterthur Port.*, xv (1980), pp. 229–55

B. Fahlman: 'Wilson Eyre in Detroit: The Charles Lang Freer House', *Winterthur Port.*, xv (1980), pp. 257–70

S. Tatman and R. Moss: *Biographical Dictionary of Philadelphia Architects, 1700–1930* (Boston, 1985), pp. 253–61

JEFFREY A. COHEN

F

Farrand [née Jones], **Beatrix Jones** (*b* New York, 19 June 1872; *d* Bar Harbor, ME, 27 Feb 1959). American landscape designer. She was born to a well-connected family, and her cultural mentor was her aunt, Edith Wharton, who introduced her to the great gardens of Europe. Farrand studied horticulture with Charles Sprague Sargent (1841–1927) at the Arnold Arboretum, Boston, MA, and after a period of European travel established a practice in New York (1895). She was a founder-member of the American Society of Landscape Architects (1899).

Farrand received commissions for work throughout the north-eastern USA, creating sophisticated gardens that combined formal elements of Italian villa gardens with the naturalism of the English tradition, but that were appropriate to American conditions. Her approach compared with that of Gertrude Jekyll (1843–1937) because of her understanding and imaginative use of plants. As well as private gardens, she also designed the campuses of a number of colleges, including Yale University, New Haven, CT, and Vassar College, Poughkeepsie, NY. Her most important early extant designs are at Princeton University (*c.* 1913–41), NJ.

WRITINGS
The Plant Book for Dumbarton Oaks (Washington, DC, 1980)

BIBLIOGRAPHY
D. K. McGuire and L. Fern, eds: 'Beatrix Jones Farrand: Fifty Years of American Landscape Architecture', *Dumbarton Oaks Colloquium on the History of Landscape Architecture: Washington, DC, 1980*
D. Balmori, D. K. McGuire and E. M. McPeck: *Beatrix Farrand's American Landscapes* (New York, 1985)

WILLIAM MORGAN

Fassett & Stevens. *See under* STEVENS, JOHN CALVIN.

Federal style. Architectural and decorative arts style that flourished in the USA from shortly after the acknowledgement of independence in the Treaty of Paris (1783) until *c.* 1820. The term is derived from the period surrounding the creation of the federal constitution in 1787 and was in use in a political sense by that year. Essentially it was a form of Neo-classicism, strongly influenced by manifestations of that style in England and, to a lesser extent, in France; but at times certain more conservative qualities inherited from the previous Colonial period are also

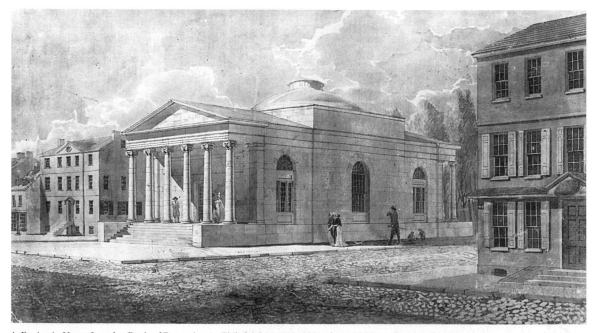

1. Benjamin Henry Latrobe: Bank of Pennsylvania, Philadelphia, 1799–1801 (destr. 1867); preliminary drawing

present. The inspiration of European, and especially English, Neo-classical architecture was to be expected in a society grounded in that of 18th-century England; but an added impetus was the association often cited at the time between the fledgling American republic and the ancient Roman one.

Although a few indications of European Neo-classical influence are found in the American colonies before the Revolution began in 1776, these were almost exclusively restricted to an occasional appearance in such interior decorative details as ceiling patterns, as in the stair-hall ceiling of the Chase-Lloyd House (c. 1771–72) in Annapolis, MD, and in silver. Generally a Palladian style with certain Baroque and Rococo decorative treatments characterized American architecture in the third quarter of the 18th century. After the Revolution, in the second half of the 1780s, a substantial infusion of Neo-classical taste reached the USA, and this began to mix with and in some cases replace the Colonial style.

1. Architecture. 2. Decorative arts.

1. ARCHITECTURE. The importation of newer architectural books, the influence of patrons directly acquainted with European Neo-classicism and the arrival of craftsmen and architects trained in this new manner all helped to establish the Federal style. The earliest examples of the new approach include: John Penn's Solitude (c. 1784–5) and William Hamilton's Woodlands (1786–8), both country houses outside Philadelphia; William Bingham's town house in that city (c. 1785–6; destr.), probably by the English architect John Plaw; and the Virginia State Capitol, Richmond (c. 1785–96; see UNITED STATES OF AMERICA, fig. 7), designed by the statesman and architect Thomas Jefferson with some help from the Frenchman Charles-Louis Clérisseau (1721–1820). Shortly thereafter the style appeared throughout the country, from Salem, MA, to Charleston, SC.

The specific adaptation of Roman buildings (as in the Virginia Capitol, based on the Maison Carrée, Nîmes) is relatively rare. Much more common is the transformation of the Colonial Palladian style by the introduction of attenuated proportions and flatter surfaces, as well as such Neo-classical decorative details as fanlights, chimney-pieces and, occasionally, oval rooms and projections. This type of Neo-classicism is found extensively from Maine to Georgia and as far west as Indiana and Kentucky. Among its leading practitioners were Samuel McIntire in Salem, Charles Bulfinch in Boston, Asher Benjamin in western Massachusetts and later in Boston, John McComb jr in New York and Gabriel Manigault (1758–1809) in Charleston, SC.

Still another form of Neo-classicism, derived not so much from the work of Robert Adam (1728–92) as from the more austere aesthetic popularized in the 1790s by George Dance II (1741–1825) and John Soane (1753–1837) in England and by Claude-Nicolas Ledoux (1736–1806) and Etienne-Louis Boullée (1728–99) in France, reached the USA with the arrival from London in 1796 of Benjamin Henry Latrobe, the first professionally trained architect to practise in the USA. In buildings such as the Bank of Pennsylvania, Philadelphia (1799–1801; destr.

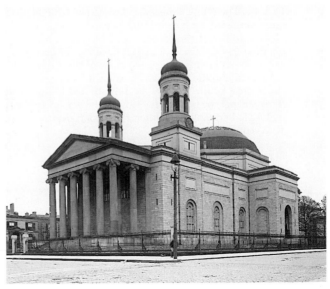

2. Benjamin Henry Latrobe: Roman Catholic Cathedral, Baltimore, Maryland, 1805–20

1867; see fig. 1), and the Roman Catholic Cathedral, Baltimore (1805–20; see fig. 2), Latrobe introduced not only the powerful plain walls, saucer domes and concealed lighting effects of Dance or Soane but also certain more archaeological features, including the Greek Ionic order of the Erechtheion. This brand of Neo-classicism, though derived more from Ledoux and Boullée, was also brought to America by the Frenchman Maximilian Godefroy, as in his Unitarian Church, Baltimore (1817–18). It was practised as well by Latrobe's pupil Robert Mills, for example in his Monumental Church, Richmond (1812–17; see MILLS, ROBERT, fig. 1).

Although he supported Latrobe and his interpretation of Neo-classicism, Jefferson created yet a different facet of the Federal style. Apart from his Virginia Capitol, which was an exercise in Roman Revivalism tempered by the needs of the state government, he also transformed (1796–1809) his own house, Monticello, near Charlottesville, VA (see colour pl. I, 2); built a number of other houses in Virginia for himself and friends, including Poplar Forest (1806–12); and both laid out the plan and designed the buildings for the University of Virginia, Charlottesville (1817–26; for illustration see JEFFERSON, THOMAS). In all of these other works he combined the Palladian influences of his youth with such Neo-classical features as curved and canted projections, saucer domes and an appreciation of certain archaeological details.

Among the other major monuments of the Federal style are the plan of the city of Washington, DC, and its two principal public buildings, the Capitol and the President's House (the White House; see WASHINGTON, DC, figs 1, 5 and 6). The city itself was laid out in 1791 by Pierre-Charles L'Enfant, utilizing grand French Baroque *allées* and *rond-points* overlaid by a grid. The Capitol (1792–1835; wings and dome, 1850–65) was designed by William Thornton, but various changes were made by a series of executing architects, the most important of whom was

Latrobe. The White House was designed by James Hoban and completed by him in 1802 (altered by Latrobe and Hoban, 1807 and 1824).

Although various characteristics of the Federal style, especially its modified simplifications of the Adam style, continued into the 1830s and beyond, it had begun to be supplanted by the GREEK REVIVAL by 1820. Motivated more strongly by both archaeology and Romanticism, this new style became dominant in the second quarter of the 19th century.

BIBLIOGRAPHY

F. Kimball: *Domestic Architecture of the American Colonies and of the Early Republic* (New York, 1922)
——: *Mr. Samuel McIntire, Carver: The Architect of Salem* (Portland, ME, 1940/R Gloucester, MA, 1966)
T. Hamlin: *Greek Revival Architecture in America* (New York, 1944)
S. Boyd: *The Adam Style in America, 1770–1820* (diss., Princeton U., 1967)
——: 'The Adam Style in America, 1770–1820', *Amer. Assoc. Archit. Bibliog.: Pap.*, v (1968), pp. 47–68
W. H. Pierson: *American Buildings and their Architects: The Colonial and Neo-classical Styles* (Garden City, NY, 1970)
J. Quinan: *The Architectural Style of Asher Benjamin* (diss., Providence, RI, Brown U., 1973)
W. H. Adams, ed.: *The Eye of Thomas Jefferson* (Washington, DC, 1976)
L. Craig and others: *The Federal Presence: Architecture, Politics and Symbols in the United States Government Buildings* (Cambridge, MA, 1978)
B. Lowry: *Building a National Image: Architectural Drawings for the American Democracy, 1789–1912* (Washington, DC, 1985)
C. E. Brownell and J. A. Cohen, eds: *The Architectural Drawings of Benjamin Henry Latrobe* (London and New Haven, 1994)
P. Norton: *The Papers and Drawings of Samuel McIntire* (in preparation)
D. Stillman: *Neo-classicism in America: The Architecture of the Young Republic, 1785–1825* (in preparation)

2. DECORATIVE ARTS. Like the architecture in which they were used, the decorative arts of the Federal period reflect the inspiration of Classical antiquity, and even more of Neo-classical England and France, tempered by existing, often conservative traditions. This can be seen most readily in metalwork and furniture, but it is also true of glass, ceramics and textiles. The appeal of antiquity is clearly indicated by the use of such Classical motifs as urns, garland swags and fasciae and such antique shapes as the klismos chair (see colour pl. XXXII, 3) or urn- or helmet-fashioned teapots and sugar bowls. Specific motifs associated with the new American republic are less common than those reflecting antiquity, but they were sometimes employed (eagles, for example, inspired by the Great Seal, were especially popular). Such other patriotic motifs as the liberty cap were used occasionally, and there is even a card-table (Winterthur, DE, Du Pont Winterthur Mus.), made in New York, with a glass decorative panel featuring the names of the Democratic–Republican party candidates for President and Vice-President in 1800, Thomas Jefferson and Aaron Burr. As with architecture, a new lightness and delicacy first appeared, modified towards the end of the period by an increased heaviness and a somewhat more archaeological approach. Again, as with buildings, there is a heightened homogeneity in the decorative arts made in different areas of the new country, but regional differences and the individual characteristics of specific artist-craftsmen can be detected.

Although in general the new style did not appear until after the conclusion of the American Revolution in 1783,

it can be found before then in metalwork, especially silver, as in a presentation tea urn (Philadelphia, PA, Mus. A.; see fig. 3) made in 1774, on the eve of the Revolution, in Philadelphia by Richard Humphreys (1750–1832) and inscribed to Charles Thomson, the secretary to the Continental Congress. Fashioned in the shape of an urn and ornamented with fluted bands and rosettes, as well as having a square base and squared handles and spout, it epitomizes the Neo-classical taste that is synonymous with the Federal style. After the Revolution, a similar taste could be found, for example, in tea services made in Boston by Paul Revere (1735–1818) in 1792 (Minneapolis, MN, Inst. A.) and in Philadelphia by Simon Chaudron (1758–1846) and Anthony Rasch (1778–1857) in 1809–12 (Winterthur, DE, Du Pont Winterthur Mus.), as well as in such objects as a jug shaped like a wineskin, made for Jefferson by Anthony Simmons (*d* 1808) and Samuel

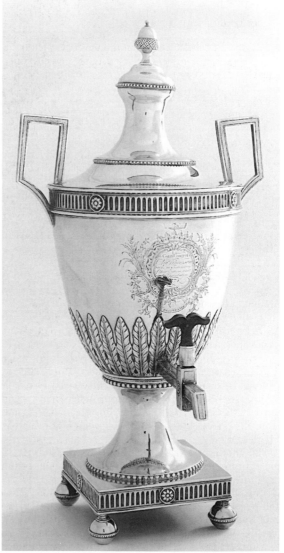

3. Federal style presentation tea urn by Richard Humphreys, silver, h. 546 mm, 1774 (Philadelphia, PA, Museum of Art)

Alexander (d 1847) in Philadelphia in 1801 (Monticello, VA, Jefferson Found.), or a plateau (or tray) executed in New York by John Forbes (1781–1864) and presented to De Witt Clinton in 1825 (priv. col., on loan to New York, Met.).

In furniture the Federal style flourished throughout the country from Salem, MA, to Charleston, SC, and westward into Kentucky and Louisiana. The most direct inspiration was from the pattern books of George Hepplewhite (d 1786) and Thomas Sheraton (1751–1806), but later influences include Thomas Hope (1769–1831), George Smith (fl c. 1786–1828) and Pierre La Mésangère (1761–1831). The presence of French as well as English source books was paralleled by the activity of a number of French-trained cabinetmakers working in Federal America, including Charles-Honoré Lannuier in New York and Michel Bouvier (1792–1874) in Philadelphia, just as Chaudron represents French silversmiths working in the latter city.

Indications of the new style are found in oval- and shield-back chairs, often with delicately tapered or sabre legs; a host of Neo-classical motifs from urns and Classical orders to putti and paterae; and refined inlay and exquisite ormolu mounts (see colour pl. XXXIII, 1). Such mounts were employed especially by French émigrés, but Americans and cabinetmakers from Britain also used them. Representative examples of chairs include those with carved shield-backs made in Salem by Samuel McIntire in the 1790s (e.g. Winterthur, DE, Du Pont Winterthur Mus.); scroll-back and sabre-leg models created by Duncan Phyfe in New York in 1807 (Winterthur, DE, Du Pont Winterthur Mus.; for illustration see PHYFE, DUNCAN); painted oval-backed chairs with Prince of Wales feathers (e.g. New York, Met.) ordered from Philadelphia in 1796 by Salem merchant Elias Haskett Derby (1739–99); and rectangular ones enlivened with scenes of country houses near Baltimore (c. 1800–10; Baltimore, MD, Mus. A.) executed by John Finlay (1777–1840) and Hugh Finlay (1781–1831). Tables range from delicately inlaid Pembroke or breakfast tables made in Salem by Elijah Sanderson (1751–1825) and Jacob Sanderson (1757–1810) in the 1780s or 1790s (Winterthur, DE, Du Pont Winterthur Mus.), to card-tables with gilded winged figures by Lannuier (c. 1815; Baltimore, Mus. & Lib. MD Hist.; New York, Met.). Examples of Federal style cabinets include an inlaid semicircular commode by John Seymour and Thomas Seymour of Boston (c. 1809; Boston, MA, Mus. F.A.); a carved double chest with numerous Neo-classical motifs on top and a more Rococo bombe-shaped lower half, made by William Lemon (fl c. 1796–1827) and carved by McIntire (c. 1796; Boston, MA, Mus. F.A.); or a lady's dressing-table with inlay of fine woods and painting on glass, topped by urns and an eagle (Baltimore, Mus. & Lib. MD Hist.), made in Baltimore in the first decade of the 19th century and attributed to William Camp (1773–1822).

The most noteworthy glass of the period was that made by John Frederick Amelung at his New Bremen Glassmanufactory near Frederick, MD. Established in 1784, this glassworks produced a number of high-quality pieces between c. 1788 and 1792 (for illustration see AMELUNG, JOHN FREDERICK. These are not characterized by Neo-classical motifs but rather by a refined elegance, as in an amethyst-covered sugar bowl (Winterthur, DE, Du Pont Winterthur Mus.) or a clear glass tumbler of 1792 (priv. col., see Cooper, 1980, fig. 175), which sports an engraving of the Great Seal of the USA. Other Federal period glass includes the products of Bakewell & Co., founded in Pittsburgh in 1808; the New England Glass Co., established in Cambridge, MA, in 1818; and a number of glasshouses in southern New Jersey.

Neo-classical ceramics used in the USA during the Federal period were mostly wares imported from England, France and China. Earthenwares were made, some of which, such as a black-glazed coffeepot by Thomas Haig & Co. of Philadelphia (c. 1825; New York, Met.), reflect the influence of English Regency and French Empire silver and porcelain. Only in 1826 did the china manufactory founded by William Tucker in Philadelphia begin to produce similarly inspired porcelain wares. The most fashionable textiles in the Neo-classical taste were also imported from England and France, but both hand-embroidered and machine printed fabrics, notably the printed calicoes of John Hewson (1744–1821) of Philadelphia, were produced in the USA during this era.

BIBLIOGRAPHY

B. Tracy and W. H. Gerdts: Classical America, 1815–1845 (Newark, NJ, 1963)

C. F. Montgomery: American Furniture: The Federal Period (New York, 1966)

19th-Century America: Furniture and Other Decorative Arts (exh. cat., New York, Met., 1970)

W. Cooper: In Praise of America: American Decorative Arts, 1650–1830 (New York, 1980)

B. Garvan: Federal Philadelphia, 1785–1825: The Athens of the Western World (Philadelphia, 1987)

B. Cullity: Arts of the Federal Period (exh. cat., Sandwich, MA, 1989)

S. Feld: Neo-classicism in America: Inspiration and Innovation, 1810–1840 (New York, 1991)

G. Hood: 'Early Neoclassicism in America', Antiques, cxl (1991), pp. 978–85

W. Garrett: Classical America: The Federal Style and Beyond (New York, 1992)

W. Cooper: Classical Taste in America, 1800–1840 (Baltimore, New York and London, 1993)

J. Bell: 'Georgetown's Temple of Liberty', A. & Ant., iv (1996), pp. 81–5

K. L. Ames: 'Surface Charm: Inlay Played a Major Role in Defining American Furniture', A. & Ant., xx (1997), pp. 46–54

DAMIE STILLMAN

Feke, Robert (b Oyster Bay, NY, ?1707; d ?1752). American painter. He was the son of a Baptist preacher. Only one portrait of a small child (Media, PA, R. F. Cox priv. col., see Foote), dated to the 1730s, is associated with his years in the New York area. In 1741 he moved to Boston, MA, where he painted an ambitious group portrait, *Isaac Royall and his Family* (1741; Cambridge, MA, Harvard U., Portrait Col.); the composition relies on John Smibert's *The Bermuda Group* (1729; New Haven, CT, Yale U. A.G.) as a model, which suggests a degree of contact with the elder artist. Although somewhat stiff and rigid in its palette and freshness, the portrait is the most provocative development in Colonial painting since Smibert's arrival 12 years earlier. From 1742 to 1744 Feke may have been in England or Europe, where he would have been exposed to contemporary developments in painting, but this is unsubstantiated.

Approximately 60 portraits by Feke survive, of which 12 are signed and dated. His career reached its zenith in

1748, when he painted numerous impressive three-quarter-length portraits for a number of Boston's leading families. Although their sequence is not known, it is conceivable that they followed his success with a grand portrait of the land speculator and military leader *Brigadier General Samuel Waldo* (*c*. 1748; Brunswick, ME, Bowdoin Coll. Mus. A.). This portrait, which is skilfully drawn and forcefully coloured, is generally accepted as the consummate full-length portrait painted in America during the first half of the 18th century. Other three-quarter-length portraits, painted about the same time, include *James Boutineau* and *Susannah Faneuil Boutineau* (Halifax, NS Mus.) and two Boutineau cousins, the brothers *James Bowdoin* and *William Bowdoin*, and their wives, *Elizabeth Erving Bowdoin* and *Phebe Murdock Bowdoin* (all 1748; Brunswick, ME, Bowdoin Coll. Mus. A.). These last four are all signed and dated. Feke's younger patrons, presumably tired of the sombre-toned palette of artists of John Smibert's generation, found his preference for silver and pastel shades of blue, pink and yellow appealing.

After Feke's success in Boston, he went to Philadelphia, PA, where he painted several documented portraits, the best of which is *Margaret McCall* (1749; Dietrich Corp., on loan to Philadelphia, PA, Mus. A.). The last record of his whereabouts is 26 August 1751. Early biographers said that he made his way to Barbados or Bermuda, where he is thought to have died, although no evidence has been found to substantiate this suggestion. Feke's impact on the development of Colonial painting was substantial, and his pictures set a new standard by which the work of the next generation of aspiring Colonial artists was judged.

BIBLIOGRAPHY
H. W. Foote: *Robert Feke: Colonial Portrait Painter* (Cambridge, MA, 1930)
R. P. Mooz: *The Art of Robert Feke* (diss., Philadelphia, U. PA, 1970)
——: 'Robert Feke: The Philadelphia Story', *American Painting to 1776: A Reappraisal* (Charlottesville, 1971), pp. 181–216
M. Elwood: 'Two Portraits Attributed to Robert Feke', *Antiques*, cxvi (1979), pp. 1150–52
W. Craven: *Colonial American Portraiture* (Cambridge, 1986), pp. 281–95
M. M. Lovell: 'Reading Eighteenth-century American Family Portraits: Social Lives and Self-Images', *Winterthur Port.*, xxii (Winter 1987), pp. 243–64
RICHARD H. SAUNDERS

Field, Erastus Salisbury (*b* Leverett, MA, 19 May 1805; *d* Leverett, 28 June 1900). American painter. He studied with Samuel F. B. Morse in New York during the winter of 1824–5. On his return to the rural isolation of Leverett, MA, he painted his earliest known work, the portrait of his grandmother *Elizabeth Billings Ashley* (Springfield, MA, Mus. F.A.). His career as an itinerant portrait painter began in 1826, most of his commissions coming through a network of family associations in western Massachusetts and Connecticut. The portraits of 1836–40 are considered his best. From 1841 he lived mainly in New York, where he expanded his subject-matter to include landscapes and American history pictures. There he presumably studied photography, for on his return to Massachusetts he advertised himself as a daguerreotypist. His few portraits painted after 1841 are copied from his own photographs and lack the expressive characterization and decorative power of his earlier work. From 1865 to 1885 his paintings were based primarily on biblical and patriotic themes. The

Historical Monument of the American Republic (1867–88; Springfield, MA, Mus. F.A.; see fig. over the page) stands alone in American folk art in size (2.82×3.89 m), scope and imaginative vision. Inspired by plans for a national celebration of the centennial of the USA in 1876, Field painted an architectural fantasy of eight towers linked by railway bridges and trains at the tops, with the history of the USA in low-relief sculpture on the exterior surfaces of the towers. Field added two more towers to the painting in 1888 and thereafter retired.

BIBLIOGRAPHY
Somebody's Ancestors: Paintings of Primitive Artists of the Connecticut Valley (exh. cat. by F. B. Robinson, Springfield, MA, Mus. F.A., 1942)
M. Black: 'Erastus Salisbury Field, 1805–1900', *American Folk Painters of Three Centuries* (exh. cat., ed. T. Armstrong and J. Lipman; New York, Whitney, 1980)
Erastus Salisbury Field, 1805–1900 (exh. cat. by M. Black, Springfield, MA, Mus. F.A., 1984)
P. Staiti: 'Ideology and Rhetoric in Erastus Salisbury Field's *The Historical Monument of the American Republic*', *Winterthur Port.*, xxvii/1 (1992), pp. 29–43
RICHARD C. MÜHLBERGER

Fisher, Alvan [Alvin] (*b* Needham, MA, 9 Aug 1792; *d* Dedham, MA, 13 Feb 1863). American painter. Soon after he left the tutelage of John Ritto Penniman (*c.* 1782–1841), he began to paint genre landscapes such as *Winter in Milton, Massachusetts* (1815; Montclair, NJ, A. Mus.), which depicts a man on a horse-drawn sleigh enjoying the beauty of a fresh New England snowfall. In this work the artist seems more concerned with presenting an image of peacefulness than with the specific identification of the site. Despite its early date, the painting suggests the influence of Claude Lorrain (?1604/5–1682) as well as 17th-century Dutch winter scenes.

Although Fisher regularly accepted portrait commissions, his work demonstrates an appreciation of and continual commitment to the depiction of East Coast scenery. He was one of America's earliest landscape painters and an important member of the HUDSON RIVER SCHOOL. Fisher travelled extensively: by 1820 he had sketched along the Connecticut River Valley and at Niagara Falls. The tiny figures in the foreground of *Niagara Falls* (1820; Washington, DC, N. Mus. Amer. A.; see colour pl. VIII, 1) add anecdotal interest and emphasize the majestic size of the Falls. However, Fisher preferred picturesque sites in New England, to where he often made return trips.

In 1825 Fisher travelled to Europe, visiting England, France, Switzerland and Italy. On his return in 1826, he established a studio in Boston and quickly became a leading figure in the city's artistic community. From 1827 he exhibited landscapes regularly at the Boston Athenaeum. He also exhibited in New York, Philadelphia, PA, Washington, DC, and as far south and west as Natchez, MS.

As early as the mid-1830s Fisher had explored the White Mountains and the coast of Maine, expanding the scenic vocabulary of the Hudson River school; for example, in *The Notch* (1834; Harvard, MA, Fruitlands Mus.) the artist manipulated the lighting and exaggerated the cloud formations to achieve a dramatic composition. The cyclonic sky effects reveal the probable influence of J. M. W. Turner (1775–1851), whose work Fisher had seen in London and

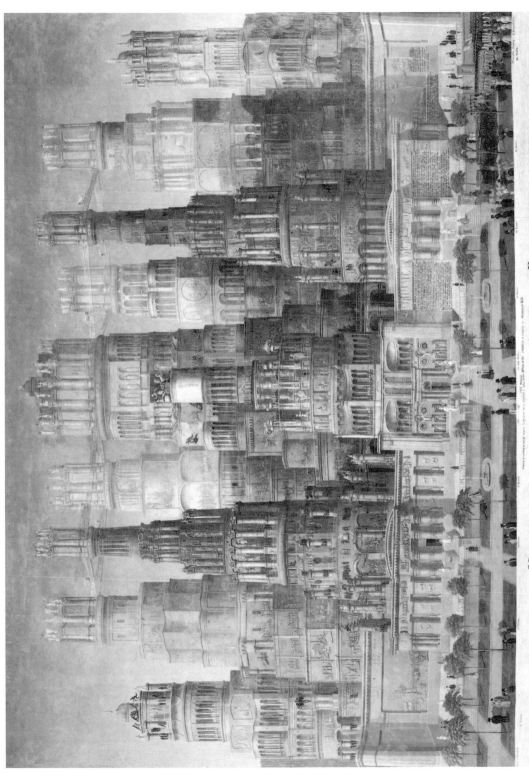

HISTORICAL MONUMENT OF THE AMERICAN REPUBLIC.

Erastus Salisbury Field: *Historical Monument of the American Republic*, oil on canvas, 2.82×3.89 m, 1867–88 (Springfield, MA, Springfield Museum of Fine Arts)

whose landscape prints he collected. Despite his productivity, critical acclaim and financial success, Fisher was quickly forgotten after his death.

BIBLIOGRAPHY

C. B. Johnson: 'The European Tradition and Alvan Fisher', *A. America*, xli/2 (Spring 1953), pp. 79–87

M. M. Swan: 'The Unpublished Notebooks of Alvan Fisher', *Antiques*, lxviii/2 (1955), pp. 126–9

R. C. Vose jr: 'Alvan Fisher, 1792–1863: American Pioneer in Landscape and Genre', *CT Hist. Soc. Bull.*, xxvii/4 (1962), pp. 97–117

F. B. Adelson: *Alvan Fisher (1792–1863): Pioneer in American Landscape Painting* (diss., New York, Columbia U., 1982)

——: 'An American Snowfall: Early Winter Scenes by Alvan Fisher', *A. VA*, xxiv/3 (1983–4), pp. 2–9

——: 'Alvan Fisher in Maine: His Early Coastal Scenes', *Amer. A. J.*, xviii/3 (1986), pp. 63–73

——: 'Home on La Grange: Alvan Fisher's Lithographs of Lafayette's Residence in France', *Antiques*, cxxxiv/1 (1988), pp. 152–7

FRED B. ADELSON

FitzGerald, Desmond (*b* Nassau, 20 May 1846; *d* Brookline, MA, 22 Sept 1926). American engineer, patron and collector. He was educated in Providence, RI, in Paris and at the Phillips Academy in Andover, MA. He studied engineering and in 1873 became superintendent of the western division of the Boston waterworks, where he was instrumental in bringing about the sanitation of the water supply.

FitzGerald had studied sculpture in Paris as a young boy, and his love of art manifested itself in the creation of a collection of contemporary works by American, Dutch, Norwegian, Spanish, and in particular, French artists. He was an early friend of Claude Monet (1840–1926) and owned numerous works by him, including *Mme Monet and Child* (1875), *Fishing Boats at Etretat, Hills of Vétheuil on the Seine* (1880) and *Sunset on the Seine: Winter Effect* (1880). Other Impressionist artists whose works appeared in his collection included Auguste Renoir (1841–1919), Edgar Degas (1834–1917), Camille Pissarro (1830–1903) and Alfred Sisley (1839–99). FitzGerald was an admirer and friend of the American painter W. Dodge Macknight (1860–1950); he owned over 300 works by this artist, built a gallery in his home in Brookline, MA, to house the collection and in 1916 published a study, *Dodge Macknight, Water Color Painter* (privately printed). FitzGerald's gallery also exhibited paintings by such American artists as Julian Alden Weir, Charles Herbert Woodbury (1864–1940), John Singer Sargent, John Joseph Enneking, Childe Hassam, John H. Twachtman, Edmund C. Tarbell, Maurice B. Prendergast and Alexander Robinson (1867–1938). His taste was for landscapes (in watercolour and pastel) of rural beauty or wilderness that responded to his love of the outdoors and the American West. His gallery was open to the public, and during the early decades of the 20th century it was a popular gathering place in Boston for art lovers and tourists. On FitzGerald's death the collection was dispersed at auction.

UNPUBLISHED SOURCES

Washington, DC, Smithsonian Inst., Archvs Amer. A. [Dodge Macknight papers, 1888–1950]

BIBLIOGRAPHY

DAB

Important Paintings by the Impressionists: The FitzGerald Collection (exh. cat., New York, Amer. A. Gals, 1927)

C. Troyen: *The Boston Tradition: American Paintings from the Museum of Fine Arts, Boston* (New York, 1980)

LILLIAN B. MILLER

Flagg, Ernest (*b* Brooklyn, NY, 6 Feb 1857; *d* New York, 10 April 1947). American architect. He had no formal architectural education in the USA and spent his early career in partnership with his father and brother, engaged in land and building speculation in New York. This experience led Flagg's cousin, Cornelius Vanderbilt II, to provide financial support for his education at the Ecole des Beaux-Arts in Paris (1888–90). There he studied in the atelier of Paul Blondel (1847–97) and was joined by Walter B. Chambers (1866–1945), with whom he travelled and later formed a loosely structured partnership.

While studying in Paris, Flagg acquired a broad knowledge of the theory and practice of architecture during the early years of the Third Republic (1871–1900). From the writings of the mid-century theorist Charles Blanc (1813–82), Flagg learnt the concept of *parti* or 'the logical solution of the problem from his [the architect's] dual standpoint as constructor and artist'. This concept reconciled in the 1890s the disparate objectives that had characterized 19th-century architectural theory and design: art and science, aesthetics and technology, intuition and reason. On his return in 1891, Flagg advanced the cause of Beaux-Arts architecture in the USA by helping to found the Society of Beaux-Arts Architects along with Charles Follen McKim, William A. Boring (1858–1937) and Walter Chambers. He also joined with such other Ecole alumni as John M. Carrère and Thomas Hastings in promoting Beaux-Arts theory and practice. An ardent opponent of the World's Columbian Exposition buildings of 1893 in Chicago, he vigorously denied that they reflected genuine Beaux-Arts principles and called on architects to formulate a national style that would be 'architectural' and not 'archaeological'.

Based on the notion of *parti*, Flagg developed in 40 years of architectural practice an approach that stressed academic classicism, idealism and ceremonial planning. He designed each work according to the special needs of its building type. Such institutions as the Corcoran Gallery of Art (1892–7), Washington, DC, St Luke's Hospital (1892–7) in New York and the US Naval Academy (1896–1908) in Annapolis, MD, promoted academic classicism and idealism. His domestic architecture, however, was considerably freer. There he often employed a hybrid of Colonial Revival and 'modern French Renaissance' styles, in the belief that such buildings would advance the 19th-century search for a national style of architecture as a logical evolution from historical precedents. He synthesized these styles in his Alfred Corning Clark House (1898–1900; destr.), Riverside Drive, New York, as well as in his own town house (1905–7; destr.) at 109 East 40th Street, New York, and his country house, Stone Court (1898–9; 1907–9), on Staten Island, NY.

Some of his most inventive works were his commercial and utilitarian buildings, which combined French aestheticism with structural rationalism, conveying a reasoned approach to architecture as decorated structure. The Singer Loft Building (1902–4) in New York is a celebrated example. Its discrete use of metal, terracotta and glass,

according to a method advocated by Eugène-Emmanuel Viollet-le-Duc (1814–79) and his followers, enclosed a skeletal steel frame. Moreover the Scribner Building (1912–13) at 597 Fifth Avenue, New York, with its opulent iron storefront, demonstrated clear affinities with French commercial buildings. Flagg's Singer Tower (building, 1896–8; tower, 1906–8; destr. 1967–8) at 149 Broadway was the first of the needle-like skyscrapers that were to characterize the spectacular New York skyline of the 1920s and 1930s. On its completion, this 47-storey skyscraper became the world's tallest building. It was a pragmatic demonstration of Flagg's solution to zoning reform: a tower, set back and restricted to a quarter of its site, that could rise indefinitely. Yet the design of the Singer Tower was a less successful solution than the Singer Loft Building was to the problem of enclosing a structural steel frame.

Flagg is widely regarded as the 'father of the modern model tenement' in the USA for his light-court plan, published in 1894, which replaced the notorious 'dumb-bell' plan. The plan was first realized in his Alfred Corning Clark Buildings (1896–98; destr.), New York. He was also an ingenious inventor, with 30 registered US patents largely related to house construction techniques.

A rugged individualist generally mistrusted for his personal conduct, Flagg did not achieve professional recognition until 1911 when he was elected to the American Institute of Architects. His importance lies in his advancement of the cause of French classicism in the USA, which challenged a generation of architects to reject archaeological revivalism in favour of a reasoned approach to design through the adoption of Beaux-Arts principles, and in his efforts to achieve height and density reform for skyscrapers and improve housing for the urban poor.

WRITINGS

'The Ecole des Beaux-Arts', *Archit. Rec.*, iii (1894), pp. 302–13, 419–28; iv (1894), pp. 38–43
'Influence of the French School on Architecture in the United States', *Archit. Rec.*, iv (1894), pp. 210–28
'The New York Tenement-house Evil and its Cure', *Scribner's Mag.*, xvi (1894), pp. 108–17
'American Architecture as Opposed to Architecture in America', *Archit. Rec.*, x (1900), pp. 178–90
Small Houses: Their Economic Design and Construction (New York, 1922)

BIBLIOGRAPHY

H. W. Desmond: 'The Works of Ernest Flagg', *Archit. Rec.*, xi (1902), pp. 1–104
O. F. Semsch: *A History of the Singer Building Construction: Its Progress from Foundation to Flag Pole* (New York, 1908)
J. P. Ford: *Slums and Housing*, 2 vols (Cambridge, MA, 1936)
M. Bacon: *Ernest Flagg: Beaux-Arts Architect and Urban Reformer* (New York, 1986)

MARDGES BACON

Forest Brush, George de. *see* BRUSH, GEORGE DE FOREST

Fortune, E(uphemia) Charlton (*b* Sausalito, CA, 15 Jan 1885; *d* Carmel Valley, CA, 15 May 1969). American painter. She began her art studies in 1904 at St John's Wood School of Art in London and then continued her training at the California School of Design/San Francisco Institute of Art (1905–7) with Arthur F. Mathews, and at the Art Students League of New York (1907–10) with Frank V. DuMond (1865–1951), Albert Sterner (1863–1946) and F. Luis Mora (1874–1940). Later, following a stay in Edinburgh, highlighted by an exhibition at the Royal Scottish Academy (1910), she returned to San Francisco, but spent her summers on the Monterey Peninsula (1913–21), during one of which she attended William Merritt Chase's class in Carmel (1914).

Fortune's earlier paintings were primarily portraits and some figures (e.g. *The Secret*; priv. col., see 1990 exh. cat., no. 36), done in a decorative style similar to the works of Mathews. Later, on establishing her summer studio on the Monterey Peninsula (1913), her paintings took on a freer style, with rich colours and hasty brushstrokes that were adaptable to the sunlit landscapes and missions in and around the Monterey Peninsula. Fortune received much acclaim for these Impressionistic paintings of secular subjects, which included *Summer* (1914; San Francisco, CA, F.A. Museums; see fig.). William Merritt Chase acquired one work from this period, *Interior of San Carlos Mission, Carmel* (New York, Estate of William Merritt Chase), following its exhibition at the Panama—Pacific International Exposition in San Francisco in 1915.

BIBLIOGRAPHY

'E. Charlton Fortune, 1885...', *California Art Research*, ed. G. Hailey (San Francisco, 1936–7), xii, pp. 54–76
Obituary: *Monterey Peninsula Herald* (6 May 1969), p. 4
R. L. Westphal, ed.: *Plein-air Painters of California: The North* (Irvine, 1986)
Colors and Impressions: The Early Work of E. Charlton Fortune (exh. cat. by J. F. Hernandez, with essay by M. Schippor, Monterey, CA, Peninsula Mus. A., 1990)
P. Trenton, ed.: *Independent Spirits: Women Painters of the American West, 1890–1945* (Berkeley, 1995)
P. Kovinick and M. Yoshiki-Kovinick: *An Encyclopedia of Women Artists of the American West* (Austin, 1998)
N. D. W. Moure: *California Art: 450 Years of Painting and other Media* (Los Angeles, 1998)

MARIAN YOSHIKI-KOVINICK

Foster, John (*bapt* Dorchester, MA, 10 Dec 1648; *d* Dorchester, 9 Sept 1681). American printer and printmaker. He was the son of early settlers in Massachusetts and graduated from Harvard College in 1667; he then taught in Dorchester (now South Boston) and about 1670 began making the earliest pictorial woodcuts in English-speaking North America. In 1675 he became the first letterpress printer in Boston and the second in New England. Foster's woodcut *Richard Mather* (c. 1670; Cambridge, MA, Harvard U., Houghton Lib.; *see* BOSTON fig. 4) is among the earliest of American portraits and perhaps the first in any medium by an artist born in English-speaking America. His *Map of New-England*, 'White Hills' version (1677; Boston, MA Hist. Soc.), which he adapted from a manuscript source (untraced), was the first map to be cut, printed and published north of Mexico. Despite their primitive quality, Foster's prints are strongly designed and show a keen awareness of Baroque style in the graphic arts. In addition to his work as a printer and printmaker, Foster took an interest in medicine, music, astronomy, meteorology, mathematics and possibly painting.

BIBLIOGRAPHY

R. Holman: 'Seventeenth-century American Prints', *Prints in and of America to 1850*, ed. J. D. Morse (Charlottesville, 1970), pp. 23–52

DAVID TATHAM

Fowler, Orson Squire (*b* Cobocton, NY, 11 Oct 1809; *d* Sharon Station, CT, 1887). American social reformer. His

E. Charlton Fortune: *Summer*, oil on canvas, 559×660 mm, 1914 (San Francisco, CA, Fine Arts Museums of San Francisco)

interest in reform began while he was studying theology at Amherst College, MA. He wrote and lectured on the need to improve the built environment, discussing the question in *A Home for All* (1848), in which he called for economy in construction, better utilization of space and restrained architectural detailing. He justified his demands on the grounds of natural forms, claiming that nature 'appends only what is useful, and even absolutely *necessary*. ... Nature's forms are mostly spherical. . .why not apply her forms to houses?'

During a trip to Milton, WI, in 1850, Fowler visited a six-sided concrete structure built by Joseph Goodrich (1844), which converted him to the use of concrete. Fowler's own home (1848; destr. 1897) in Fishkill, NY, was a starkly detailed concrete octagon that enclosed a greater area per length of wall than any other floor plan. With eight walls instead of four, more sunlight could be admitted; with less exterior wall surface allowing heat loss, it was easier to heat. To cool the house through natural ventilation, the sash window on the windward side could be opened to create a draught in concert with the central stair-hall door and cupola window. Sun or shade, breeze or protection were afforded by encircling porches. With

each side essentially equal, site orientation was simple, allowing multiple views and maximum sunlight. Further, the materials for concrete were available everywhere and hence affordable to the average builder. Critics cited the high labour costs of construction and the difficulty of planning the interior room spaces. While the design was intended for the poor, clients were generally from the upper middle class. Perhaps the grandest of all octagon houses was the Moorish Revival plantation house known as Longwood, designed in 1861 for Dr Haller Nutt of Natchez, MS, by architect Samual Sloan of Philadelphia. Surviving examples of octagon houses include the Armour–Carmer House (1860), Irvington, NY, and a house at Glen Aubrey, NY, built by George W. Smith in 1857.

Fowler's sponsorship of concrete was prophetic, though few used it at first because of the expense of binding cement. *A Home for All*, reprinted every year from 1848 to 1857, exerted an influence on American domestic architecture, as well as small-scale school and church design.

See also IRWIN, HARRIET MORRISON.

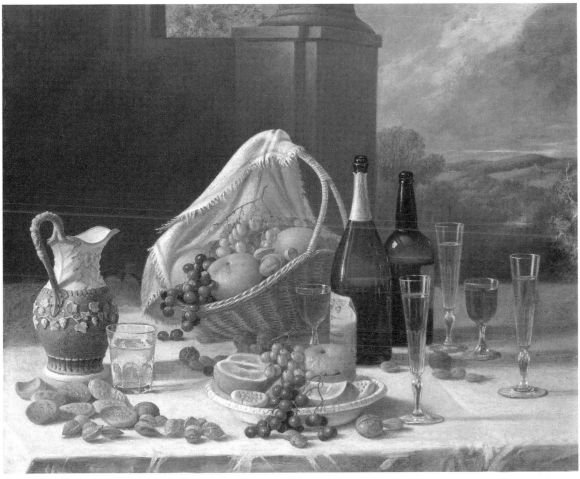

John F. Francis: *Luncheon Piece*, oil on canvas, 635×768 mm, *c.* 1850s (Newark, NJ, Newark Museum)

WRITINGS
A Home for All: or, The Gravel Wall and Octagon Mode of Building (New York, 1848); rev. as *The Octagon House: A Home For All*, with new intro. (New York, 1973)
The Octagon House (1853)

BIBLIOGRAPHY
C. F. Schmidt: *The Octagon Fad* (Scottsville, NY, 1958)
C. F. Schmidt and P. Parr: *More about Octagons* [Caledonia, NY, *c.* 1976]
A. Boulton: 'Age of the Octagon', *Amer. Her.*, xxxiv (Aug/Sept 1983), p. 13

KINGSTON WM. HEATH

Francis, John F. (*b* Philadelphia, PA, 13 Aug 1808; *d* Jeffersonville, PA, 15 Nov 1886). American painter. Beginning as an itinerant portrait painter in rural Pennsylvania, he produced works including flattering, colourful portraits of his sisters in the style of Thomas Sully, often incorporating small still-life details (e.g. *Three Children*, 1840; Boston, MA, Mus. F.A.). He abandoned portraiture after 1850 to concentrate exclusively on still-life subjects in the tradition of the PEALE family.

Francis's still-lifes fall into three main types: luncheon, dessert and fruit-basket. *Luncheon Piece* (Newark, NJ, Mus.; see fig.), a fine example of the first type, shows a porcelain vessel overflowing with grapes, nuts and fruit, which dominates the centre of the well-balanced composition. Ranged horizontally on the linen-draped table are bottles of wine, goblets, a wedge of cheese with biscuits and an elaborate china pitcher, all set against a dark background in the Dutch manner. The dessert pieces, such as *Strawberries and Cake* and *The Dessert* (both 1860; New York, Richard York Gal.), feature fruits, cakes, china, silverware and linen and often include a landscape detail. Basket compositions are simpler, concentrating on fruits, sometimes cut open, and nuts spilling onto a linen cloth (e.g. *Still-life*, 1859; Boston, MA, Mus. F.A.). Francis painted over a hundred variations on these themes. He worked in a broad, painterly style, emphasizing the individuality of the objects, which he rendered in bright colours alternating with subtle tonalities. Francis was one of the most accomplished mid-19th-century American still-life painters, and his work established a link between the tradition of the Peales and the innovations of William Michael Harnett.

BIBLIOGRAPHY
A. Frankenstein: 'J. F. Francis', *Antiques*, lix (1951), pp. 374–7
Catalogue of Paintings by John F. Francis (exh. cat. by G. L. Hersey, Lewisburg, PA, Bucknell U., 1958)
W. H. Gerdts and R. Burke: *American Still-life Painting* (New York, 1971)
A Suitable Likeness: The Paintings of John Francis (1832–1879) (exh. cat. by D. W. Dunn, Lewisburg, PA, Packwood House Mus., 1986)

GERTRUDE GRACE SILL

Fraser, Charles (*b* Charleston, SC, 20 Aug 1782; *d* Charleston, 5 Oct 1860). American lawyer, painter, writer and orator. With the exception of a few trips north, Fraser rarely left Charleston. He showed artistic talent early and began his brief formal training with drawing lessons from the engraver and landscape painter Thomas Coram (1757–1811). He was befriended by the painters Edward Greene Malbone, Washington Allston and Thomas Sully. With his fellow student Sully, he drew lively stage sets and made sketches of comical characters. Fraser's sketchbooks from this period also contain copies after travel-book illustrations and views of historic Charleston and its environs. Despite his artistic inclinations, his family encouraged him to study law, which he practised between 1807 and 1818, while also establishing a reputation as a miniature painter. Several aspects of Fraser's style and working technique remained constant throughout his career. His miniatures were usually signed or initialled and dated on the reverse of the backing card. Between 1818 and 1846 they were documented in a record book (Charleston, SC, Gibbes A.G.). The sitter's eyelid is formed by a dark curved stroke to suggest the crease about the eye. The backdrop to the sitter is generally rendered with dark, blue-grey hatching that is deepest in colour near the shoulders, lightening noticeably towards the side to which the head is turned. Fraser's early miniatures, often small ovals, show the strong influence of Malbone, who worked in Charleston in 1801, 1802 and 1806. In one of Fraser's best and earliest miniatures, *James Reid Pringle* (1803; Charleston, SC, Gibbes Mus. A.; see fig.), the influence of Malbone's light

palette and his modelling technique of hatching and crosshatching is readily apparent. Later, Fraser's brushwork became characterized by a carefully detailed pattern of stippling. Fraser enjoyed a long, active and distinguished career, depicting Charleston's leading citizens and visiting dignitaries. In 1857 he was honoured by his friends and patrons with a major retrospective of his work, including 319 portrait miniatures and 139 landscapes, still-lifes and sketches.

BIBLIOGRAPHY
A. R. Huger Smith and D. E. Huger Smith: *Charles Fraser* (Charleston, 1924/*R* 1967)
A. R. Huger Smith: 'Charles Fraser', *A. America*, xxiii (1935), pp. 22–34
R. P. Tolman: 'The Technique of Charles Fraser, Miniaturist', *Antiques*, xxvii (1935), pp. 19–22, 60–62
M. R. Severns and C. L. Wyrick jr: *Charles Fraser of Charleston: Essays on the Man, his Art and his Times* (Charleston, 1983)
DALE T. JOHNSON

Fraser, Furness & Hewitt. *See under* FURNESS, FRANK.

Freake Painter (*fl* Boston, 1670–*c.* 1680). American painter. He is sometimes incorrectly known as 'The Freake Limner', a term restricted in the 17th century to painters of miniatures, which he is not known to have produced. A group of eight portraits painted in oil on canvas in or near Boston between 1670 and 1678 appear to have been made by the same hand. They represent *John Freake* (n.d.; Worcester, MA, A. Mus.), *Mrs John (Elizabeth) Freake and her Baby, Mary* (1670; Worcester, MA, A. Mus.), *Henry Gibbs* (1670; Charleston, WV, Sunrise Mus.), *Margaret Gibbs* (1670; Boston, MA, Mus. F.A.), *Robert Gibbs* (1670; Boston, MA, Mus. F.A.), the *Mason Children* (1670; San Francisco, CA, de Young Mem. Mus.), *Edward Rawson* (Boston, MA, New England Hist. Geneal. Soc.) and the *Rev. John Davenport* (New Haven, CT, Yale U. A.G.). Six of these paintings bear the date 1670 lettered in a similar manner. All are stylistically and structurally related; they form the largest (and among the most sophisticated) group of portraits made by the same artist or studio/shop in 17th-century New England. All of these paintings, which represent sitters slightly smaller than life, are characterized by precise delineation of features similar to that found in 16th-century English portraiture. The most famous portrait of this group, *Elizabeth Freake and her Baby* (see fig.), is enhanced by a brilliant range of colours. Vermilion and lead–tin yellow are found in the dress, coral beads and ribbons; lead white in the caps, lace and aprons. Mrs Freake is seated on a chair bearing Turkey work upholstery and is holding a six-month-old child. The portrait of the child was added in 1674, four years after the painting was first made. Previously Mrs Freake had been represented with hands in her lap holding a fan; her collar and ribbons were also substantially different. The portrait of the Boston merchant *John Freake* (Elizabeth's husband) is the pendant to this. Carefully wrought details such as the almond-shaped eyes and linear, pursed lips are characteristic of the artist's work. His imagery is spatially flat but not lacking in subtle shading.

Although the identity of the Freake painter is a mystery, Samuel Clement (1635–*c.* 1678), who was known as a painter in Boston, may well have been responsible for the Freake portraits and the other related works. He was the

Charles Fraser: *James Reid Pringle*, watercolour on ivory, 79×65 mm, 1803 (Charleston, SC, Gibbes Museum of Art)

son of Augustine Clement (1600–74) of Reading, Berks, who trained in England (as a painter–stainer) and arrived in New England in 1635. He settled in Dorchester, MA, near the residence of the surgeon Dr John Clark, whose portrait now hangs in the Boston Medical Library in the Francis A. Countway Library of Medicine. Since Clark and the elder Clement were neighbours, it seems possible that the portrait of the surgeon was painted by Augustine. This painting bears the date 1664 and is one of the two earliest dated examples of New England painting. Comparisons between the Clark portrait and the Freake paintings suggest an altogether different artist practising in Boston for a few years following the death of Augustine Clement.

BIBLIOGRAPHY

XVIIth Century Painting in New England (exh. cat. by L. Dresser, Worcester, MA, A. Mus., 1935), pp. 81–3

L. Dresser: 'The Freake Portraits', *Worcester A. Mus. Bull.*, xxix/5 (1964)

——: 'Portraits in Boston, 1630–1720', *Archv Amer. A. J.*, vi (1966), pp. 1–34

S. Gold: 'A Study in Early Boston Portrait Attributions. Augustine Clement, Painter-stainer of Reading, Berkshire, and Massachusetts Bay', *Old-Time New England*, lviii/3 (1968), pp. 61–78

A. L. Cummings: 'Decorative Painting in Early New England', *American Painting to 1776: A Re-appraisal*, ed. I. M. G. Quimby (Charlottesville, 1971), pp. 91–101

S. E. Strickler: 'Recent Findings on the Freake Portraits', *Worcester A. Mus. J.*, v (1981–2), pp. 48–55

J. L. Fairbanks: 'Portrait Painting in Seventeenth-century Boston', *New England Begins: The Seventeenth Century*, iii (exh. cat. by J. L. Fairbanks and R. F. Trent, Boston, MA, Mus. F.A., 1982), pp. 413–53

W. Craven: *Colonial American Portraiture* (Cambridge, 1986), pp. 38–48, 85–8

JONATHAN L. FAIRBANKS

Freer, Charles Lang (*b* Kingston, NY, 25 Feb 1856; *d* New York, 25 Sept 1919). American manufacturer and collector. Born into poverty, he left school at the age of 14 to work, first in a cement factory and then as a clerk in a store. Soon afterwards, Frank J. Hecker, manager of the Kingston & Syracuse Railroad, noticed the young man's business acumen and made him paymaster of the railroad. In 1880 the two men became partners and opened the first railway carriage factory in the Midwest, the Peninsular Car Works. However, by the age of 44, Freer was compelled to retire because of his frail constitution; already a wealthy man, he was on his way to becoming a major collector. He initially collected art to embellish his home in Detroit, MI, built by Wilson Eyre in 1890 and decorated by the American painters Dwight W. Tryon, Thomas Wilmer Dewing and Abbot Handerson Thayer in exchange for advice on investments. Freer valued the moral character of these artists' work and shared their vision of pure and noble womanhood found in such paintings as Thayer's *Virgin Enthroned* (Washington, DC, Freer; for illustration *see* THAYER, ABBOT HANDERSON). Freer soon developed an interest in prints and in 1887 he discovered the etchings of James McNeill Whistler, which he thought the highest expression of his aesthetic. His passion for the artist's work was instant and enduring and, by 1890, when collector and artist met in Paris, Freer owned more than 80 etchings by Whistler. His collection eventually numbered over 1000 prints, pastels and paintings and included *Harmony in Blue and Gold: Peacock Room* (1876–7; Washington, DC, Freer), a dining-room designed for Liverpool shipowner F. R. Leyland by Thomas Jeckyll and radically revised by Whistler.

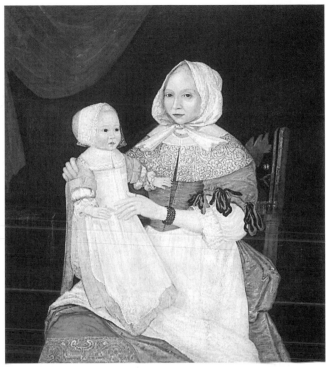

Freake Painter: *Mrs John (Elizabeth) Freake and her Baby, Mary*, oil on canvas, 1080×934 mm, dated 1670, altered 1674 (Worcester, MA, Worcester Art Museum)

Whistler became Freer's close friend and, together with Ernest Francisco Fenollosa, introduced him to the splendours of East Asian art, long before his fellow American collectors became interested in it. As early as 1887 he had purchased a Japanese fan attributed to Ogata Kōrin (1658–1716), and later to a follower. Then, on his friends' advice, he bought Japanese and some Chinese prints and later added fine Korean examples. On four trips to East Asia between 1895 and 1911, he visited the major private and public collections and made important purchases. When he returned from his last Asian trip, Freer owned over 8000 Asian works. These included numerous examples of Chinese ceramics, especially from the early Han, Tang and Song periods. From his Japanese collection he especially cherished some 30 sketches by Katsushika Hokusai (1760–1849) and two Kamakura-period paintings of the *bodhisattva* Jizō.

In December 1904 Freer offered the contents of his collection to the Smithsonian Institution in Washington, DC. This was the first significant bequest of art ever made to the US government by a private citizen, but it was accepted only following the efforts of Theodore Roosevelt. The Freer Gallery of Art finally opened to the public in 1923. Later it was enhanced by the addition of a fine Japanese and Chinese collection belonging to Freer's great friend Agnes Meyer (1887–1970).

WRITINGS

L. Merrill, ed.: *With Kindest Regards: The Correspondence of Charles Lang Freer and James McNeill Whistler, 1890–1903* (Washington, DC, 1995)

BIBLIOGRAPHY

The Freer Gallery of Art, 3 vols (Tokyo, n.d.)

A. E. Meyer: *Charles Lang Freer and his Gallery* (Washington, DC, 1970)

N. Clark: 'Charles Lang Freer: An American Aesthete', *Amer. A. J.*, 11 (Oct 1979), pp. 54–68

Apollo, cxvii/258 (1983) [issue ded. to Freer]

P. Pal, ed.: *American Collectors of Asian Art* (Bombay, 1986)

L. Merrill: *An Ideal country: Paintings by Dwight William Tryon in the Freer Gallery of Art* (Washington, DC and London, 1990)

T. Lawson and L. Merrill: *Freer: A Legacy of Art* (Washington, DC and New York, 1993)

K. A. Pyne: 'Portrait of a Collector as an Agnostic: Charles Lang Freer and Connoisseurship', *A. Bull.*, lxxviii (1998), pp. 75–97

KATHRYN BONOMI

French, Daniel Chester (*b* Exeter, NH, 20 April 1850; *d* Stockbridge, MA, 7 Oct 1931). American sculptor. Essentially self-taught, he studied briefly in the 1870s with John Quincy Adams Ward, William Rimmer, William Morris Hunt and Thomas Ball. In 1873 he was awarded the substantial commission for the life-size *Minute Man* (bronze, 1874) erected in Minute Man National Historical Park, Concord, MA, to commemorate the Battle of Concord. In what became one of his best-known pieces, he adapted the Classical *Apollo Belvedere* (Rome, Vatican, Mus. Pio-Clementino) for his New England farmer to create a sturdy image that forcefully characterizes the determined patriotism of the men who defended their land. After two years in Italy (1874–6), French worked in Washington, DC, and Boston, MA, executing architectural sculpture and a number of portraits, including a distinguished marble bust of *Ralph Waldo Emerson* (1879; Cambridge, MA, Harvard U.), as well as a version in bronze (see colour pl. XXVI, 3).

French's next major commission, the seated statue of *John Harvard* (bronze, 1884; Cambridge, MA, Harvard U.), received creditable reviews; however, he still had not reached artistic maturity. While in Paris in 1886–7, he improved his modelling technique and absorbed current French tendencies. A comparison of *John Harvard* and the Thomas Gallaudet Memorial (bronze, 1888; Washington, DC, Gallaudet Coll.) reveals the enormous benefit that French derived from his stay in France. Not only is the pose of Gallaudet more relaxed than that of Harvard, but French handled his medium with a greater degree of ease and confidence. If the shirt in Harvard has stiff, repetitive folds, in Gallaudet it hangs in a more realistic fashion.

French settled in New York and opened a studio from which he established a reputation—alongside Augustus Saint-Gaudens—as the leader of American sculpture. He was selected to contribute works that were placed prominently in such large collaborative projects as the World's Columbian Exposition of 1893 in Chicago, the bronze doors (1904) at the Boston Public Library and *The Continents* (marble groups, 1907) at the US Custom House in New York. More private in location and content, and superior in composition and sensibility, are the Milmore Memorial ('*Angel of Death and the Sculptor*'; bronze, 1891; Jamaica Plain, MA, Forest Hills Cemetery), a memorial to the sculptor Martin Milmore (1844–83), and the Melvin Brothers Memorial ('*Mourning Victory*'; marble, 1908; Concord, MA, Sleepy Hollow Cemetery), two funerary monuments that are among the sculptor's finest achievements. French's interest in landscape architecture led him to collaborate with the architects to integrate the sculptures with their sites harmoniously. The masterfully conveyed

meaning of these two works makes them especially profound and affecting statements about death.

The over life-size, seated and meditative *Abraham Lincoln* (1914–20) for the Lincoln Memorial (marble, ded. 1922; Washington, DC; see colour pl. XXVIII, 2), French's most famous piece, became a national icon and crowned the artist's long and celebrated career. He continued to sculpt until his death at Chesterwood, his summer home and studio in Stockbridge, MA, which subsequently opened as a museum in his memory.

A chronicler of American heroes and themes, French brought his works from sketch, quarter-size, half-size and occasionally full-size model to completion with the precise, disciplined and measured qualities that were a trademark of his personality. The advent of abstraction cast a shadow over his academic BEAUX-ARTS STYLE; nevertheless, well into the 20th century, he continued in the same mode that had brought him acclaim.

BIBLIOGRAPHY

Mrs D. C. French: *Memories of a Sculptor's Wife* (Boston, 1928)

A. Adams: *Daniel Chester French, Sculptor* (Boston, 1932)

M. Cresson: *Journey into Fame: The Life of Daniel Chester French* (Cambridge, MA, 1947)

W. Craven: *Sculpture in America* (New York, 1968, rev. Newark, 2/1984)

Daniel Chester French (exh. cat. by M. Richman, New York, Met., 1976/R Washington, DC, 1983)

D. Merriam: 'The Allure of Chesterwood, Studio of Daniel Chester French, Stockbridge, Massachusetts', *Sculp. Rev.*, xliv (Spring 1996), pp. 6–13

KATHRYN GREENTHAL

Frick, Henry Clay (*b* West Overton, PA, 18 Dec 1849; *d* New York, 2 Dec 1919). American industrialist and collector. He was born into a well-to-do family of German descent engaged in the distillery business in western Pennsylvania. By clever financing through the Mellon banking interests and by his own business acumen, he developed the coke-mining industry in the environs of Pittsburgh, PA, and by 30 had become a millionaire. Joining forces in 1889 with Andrew Carnegie, he reorganized the steel industry by using railroad connections between coke and steel mills, improving management and exploiting immigrant labour. In 1901, in collaboration with J. Pierpoint Morgan and Elbert Gary, Frick formed the US Steel Corporation, at the time the largest industrial conglomerate in the world. He emerged from this effort a multimillionaire.

While resident in Pittsburgh, Frick began collecting paintings, primarily of the Barbizon school. (All works mentioned are in New York, Frick.) He owned a particularly fine collection of drawings by Jean-François Millet (1814–75), in which he took great pride. By 1901, however, his taste had changed. In that year he bought paintings by J. M. W. Turner (1755–1851) and Vermeer (1632–75) as well as a landscape by Claude Monet (1840–1926). These were followed by works by Hobbema (1638–1709), Aelbert Cuyp (1620–91) and Gerard ter Borch II (1617–81) and the leading 18th-century British portrait painters. When Frick moved to New York in 1904 and rented the Vanderbilt House at the corner of Fifth Avenue and 51st Street, he sold most of his Barbizon works and concentrated instead on Old Masters.

Around 1912 Frick commissioned Thomas Hastings of Carrère & Hastings to design a home on 70th Street at the

corner of Fifth Avenue that would eventually serve as a gallery 'for the use and benefit of all persons whomsoever'. He embarked on an intensive course of collecting, seeking works of the highest quality with no concern for price. Most critics agreed that he had a 'keen sense for really important pictures' and that he was 'a fastidious and cautious' collector. Occasionally, however, he let his acquisitions be guided by intermediaries such as Roger Fry, Knoedler & Co. and Joseph Duveen. Frick's 1916 catalogue of paintings lists 116 works from the Dutch, Flemish, Spanish, German, Italian and British schools, a few Impressionist works (Degas, Manet, Renoir) and a small collection of American art, including four portraits by Whistler and Gilbert Stuart's *George Washington*. Among the most important works included were a *Self-portrait* of 1658 by Rembrandt (1606–69), six portraits by Anthony van Dyck (1599–1641), three by Frans Hals (1581/5–1666), the portrait of *Pietro Aretino* by Titian (*c.* ?1485/90–1576) and that of *Philip IV of Spain at Fraga* by Velázquez (1599–1660) . Frick acquired three of the thirty-two Vermeers then known to exist, and four panels from the *Progress of Love* (1773) series by Fragonard (1732–1806) from the J. P. Morgan Collection, for which he is said to have paid $1,250,000; the latter hang in a room decorated in 18th-century taste. The paintings were augmented by a fine collection of statuary, enamels, bronzes, porcelain and precious furniture.

The Frick House and collection were left to Frick's wife and daughter for their use until 1933, when they were bequeathed to the City of New York. Frick left an endowment of $15,000,000, primarily for the upkeep of the gallery, but also for further acquisitions. Designed to demonstrate that art is not 'a lifeless thing', the Frick Collection evokes the atmosphere of a millionaire's private home in early 20th-century New York; as such, it stands as a monument to its founder. The Frick Art Reference Library, adjacent to it, is one of the major visual reference resources in the USA. It is possible that Frick, sensitive about criticism of his labour policies, hoped that his fabulous gift to the public would improve his image in American history. Whatever his motives, there is no question that the collection is one of the greatest private galleries in the world.

BIBLIOGRAPHY
F. Levy: 'The Frick Art Gallery', *Evening Post Mag.* [NY] (6 Dec 1919)
F. J. Gregg: 'The Frick Collection', *New York Herald* (7 Dec 1919)
G. B. Harvey: *Henry Clay Frick, the Man* (New York, 1928, rev. 1936)
The Frick Collection: An Illustrated Catalogue, 2 vols (Princeton, 1968)
N. Burt: *Palaces for the People: A Social History of the American Art Museum* (Boston, 1977)
Clayton: The Pittsburgh Home of Henry Clay Frick in Pittsburgh: Art and Furnishings (exh. cat. by K. J. Hellerstedt and others, Pittsburgh, PA, Frick A. Mus., 1988); review by A. E. Ledes in *Mag. Ant.*, cxxxiv (1988), pp. 372, 380
B. Gorvy: 'In the Footsteps of Mr. Frick', *Ant. Colr*, lxii/10 (1991), pp. 90–5
M. Brignano: *The Frick Art & Historical Center: The Art and Life of a Pittsburgh Family* (Pittsburgh, 1993)
Legacy of Beauty: The Frick Collection, 1935, intro. by C. Ryskamp (New York, 1995)
M. Frick Symington Sanger: *Henry Clay Frick: A Private Life* (New York, 1998)
LILLIAN B. MILLER

Frontier art. *See* WILD WEST AND FRONTIER ART.

Frost, A(rthur) B(urdett) (*b* Philadelphia, PA, 17 Jan 1851; *d* Pasadena, CA, 22 June 1928). American illustrator and painter. After a short apprenticeship to a wood-engraver and several years in a Philadelphia lithographic shop, he achieved recognition as a comic illustrator with the publication of *Out of the Hurly Burly* (London, 1874) by Max Adeler (the pseudonym of C. H. Clarke). Shortly thereafter he joined the staff of Harper and Brothers, New York, where, along with such artists as Edwin Austin Abbey and Howard Pyle (1853–1911), he contributed pen-and-ink and wash illustrations to the books and journals published by the firm.

During the last quarter of the 19th century, a period often characterized as the 'golden age of American illustration', Frost's humorous, homely subjects and comic caricatures appeared regularly in American magazines such as *The Century Illustrated* and *Collier's* as well as those of the Harper group. Best remembered are his illustrations for Joel Chandler Harris's stories, particularly *Uncle Remus: His Songs and his Sayings* (London, 1895). Frost's use of a sequential format in the presentation of many of his comic drawings, as seen in his books *Stuff and Nonsense* (London, 1884) and *The Bull Calf and Other Tales* (London 1892), was influential in the development of the American comic strip.

Though hampered by colour-blindness, Frost's study of painting, begun in 1882 under Thomas Eakins and resumed in the late 1890s with William Merritt Chase, resulted in a series of sporting and shooting scenes painted in the 1890s, which achieved wide popularity through lithographic reproduction: Scribner's published a portfolio of twelve (1903), and four others were issued posthumously by the Derrydale Press (1933–4). His son, Arthur Burdett Frost jr (1887–1917), was a painter and exponent of Synchromism.

BIBLIOGRAPHY
H. Reed: *The A. B. Frost Book* (Rutland, VT, 1967)
Arthur Burdett Frost: Artist and Humorist, 1851–1928 (exh. cat., Chadds Ford, PA, Brandywine River Mus., 1986)
ANNE CANNON PALUMBO

Frost, Charles Sumner. *See under* COBB, HENRY IVES.

Frothingham, Benjamin (*b* Boston, MA, 6 April 1734; *d* Charlestown, MA, 19 Aug 1809). American cabinet-maker. He was the son of a Boston cabinetmaker of the same name and set up a shop in Charlestown, MA, in 1756. He served as a major in the American army during the American War of Independence (1775–83) and after the war joined the Society of the Cincinnati, a fraternal organization of American officers who had served during the war. In 1789 he was visited by President George Washington, a fellow member and past president of the society. Known for his block-front and serpentine-front case furniture with corkscrew flame finials, Frothingham also worked in other styles: he made a *bombe* secrétaire (1753; Washington, DC) and later in the century a sideboard (sold American Art Association, 2–4 Jan 1930, lot 417) and table (ex-Joseph Kindig III priv. col., York, PA, 1974) in the style of George Hepplewhite (*d* 1786). Most of his known pieces are labelled, the Boston silversmith Nathaniel Hurd (1729–77) engraving his label. Frothing-

ham's eldest son Benjamin Frothingham III (1774–1832) also became a cabinetmaker.

BIBLIOGRAPHY

M. M. Swan: 'Major Benjamin Frothingham, Cabinetmaker', *Antiques*, lxii (1952), pp. 392–5

R. H. Randall, jr: 'Benjamin Frothingham', *Boston Furniture of the Eighteenth Century*, ed W. Whitehill (Boston, 1974), pp. 223–49

JULIA H. M. SMITH

Fuller, George (*b* Deerfield, MA, 17 Jan 1822; *d* Brookline, MA, 21 March 1884). American painter. The son of a farmer, he was partly self-taught. In 1842 he studied drawing in Albany, NY, with the sculptor Henry Kirke Brown (1814–86). Later that year he moved to Boston, where he attended drawing classes at the Boston Artists' Association and admired the dreamy, imaginative paintings of Washington Allston. After 1847 Fuller was based in New York, but he made three extended journeys to the South before 1859 in search of portrait commissions.

As a portrait painter, Fuller attained little distinction in the 1850s; his style was realistic, dark and somewhat dry. He executed several landscape studies and paintings, strongly reminiscent of the dominant Hudson River school manner in their clarity and tight brushwork. His most interesting earlier works are his many acutely observed sketches of black slave life in Montgomery, AL, where he lived in the winter of 1857–8.

When his father died in 1859, Fuller returned to Deerfield, MA, to manage the family farm, but before doing so, he made his only voyage to Europe, a six-month tour of the museums of Britain and the Continent. He continued to paint but had virtually no contact with the art worlds of Boston and New York until 1875, when, close to bankruptcy, he took some of his recent paintings to Boston. Favourable criticism and several sales followed, and he became one of the Boston artistic and literary circle. By 1877 Fuller was exhibiting regularly in both Boston and New York, and his reputation soared.

During his farming years Fuller changed his style from literal realism to reticent mystery. He painted fewer portraits, concentrating instead on quiet, dreamy landscapes and imaginary figures. He drew on memories of Allston, Rembrandt (1606–69) and the Romantic, bucolic paintings of such Barbizon school artists as Jean-François Millet (1814–75) and Camille Corot (1796–1875). The paintings of Fuller's last decade were progressively more nebulous, with blurred outlines and muted atmosphere, using a limited range of dim, muffled tones in amber, green or tan. These evocative compositions were acclaimed by contemporary critics as the quintessence of pictorial poetry.

Fuller was best known for his paintings of young, pensive country women, such as *Winifred Dysart* (1881; Worcester, MA, A. Mus.); critics praised them not as images of the body but as materializations of pure, virginal souls. His paintings of melancholy racial outcasts also have a spiritual quality, as in *The Quadroon* (1880; New York, Met.; see fig.), in which the lovely maiden sits wearily in a cotton field. Fuller's landscapes are similarly nebulous and moody: some are quiet Deerfield farm scenes, but more interesting are Southern scenes based loosely on Fuller's memories and sketches of slave life but in the colours

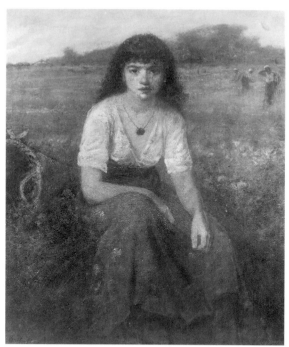

George Fuller: *The Quadroon*, oil on canvas, 1.28×1.03 m, 1880 (New York, Metropolitan Museum of Art)

used by the Barbizon school. *Turkey Pasture in Kentucky* (1878; Norfolk, VA, Chrysler Mus.), with its black turkey herders, its dim, green atmosphere and pervasive bucolic tranquillity, represents an almost perfect fusion of regional idiom and Barbizon sentiment.

Like other American Barbizon followers, Fuller followed William Morris Hunt's lead in rejecting the realism and provincialism of pre-Civil War American painting. His combination of idealism with soft focus and twilight established him as a significant forerunner of TONALISM, the refined, poetic style perfected by late 19th-century aesthetes. Fuller was no aesthete, however, but rather an artist obsessed with the problem of communicating spiritual truths through the crude medium of paint. In this last respect, he was comparable to the *fin-de-siècle* visionaries George Inness and Albert Pinkham Ryder. Fuller's importance was unassailed until the 1920s, but several decades of neglect followed before he was reassessed in the 1980s.

BIBLIOGRAPHY

J. B. Millet, ed.: *George Fuller: His Life and Works* (Boston, 1886)

S. Burns: 'A Study of the Life and Poetic Vision of George Fuller (1822–84)', *Amer. A. J.*, xiii (1981), pp. 11–37

——: 'George Fuller: The Hawthorne of our Art', *Winterthur Port.*, xvii (1983), pp. 125–45

——: 'Images of Slavery: George Fuller's Depictions of the Antebellum South', *Amer. A. J.*, xv (1983), pp. 35–60

George Fuller: At Home (exh. cat., ed. S. L. Flynt; Deerfield, MA, Mem. Hall Mus., 1984)

S. Burns: 'Black, Quadroon, Gypsy: Women in the Art of George Fuller', *MA Rev.*, xxvi (1985), pp. 405–24

SARAH BURNS

Furness, Frank (*b* Philadelphia, PA, 12 Nov 1839; *d* Wallingford, PA, 30 June 1912). American architect. His work celebrated American individualism and represented a commitment to the present while denying the European

past, establishing a peculiarly American sensibility. His buildings, frequently in red brick, are unmistakable in their visceral directness of expression. Severely criticized after the 1880s, they won new appreciation in the second half of the 20th century.

1. LIFE AND WORK.

(i) Early training, until 1870. Furness was strongly influenced by his father, the Rev. William Henry Furness (1802–96), a transplanted Bostonian whose closest friend from childhood was Ralph Waldo Emerson (1801–82). Through Emerson, the family was drawn into the wider circle that shaped American culture, including Henry David Thoreau (1817–62) and Walt Whitman (1819–92). It was an intellectually stimulating environment, in which a copy of *The Seven Lamps of Architecture* by John Ruskin (1819–1900) was in the household by 1849, the year of its publication. Frank's oldest brother, William Henry Furness jr (1827–61), became a talented German-trained portrait painter; his other brother, Horace Furness (1833–1912), became renowned as editor of the *Variorum Shakespeare.* In 1857 Frank travelled to New York to enter the newly formed architectural studio of Richard Morris Hunt. There, with George B. Post, Charles Gambrill (1830–80) and William Robert Ware, Furness was exposed to the foundations of Victorian eclecticism: drawing from nature and design based on the proportions of Classical architecture, flavoured by a pragmatic approach to theory that permitted great flexibility. Guided by Hunt, Furness became a forceful designer and a splendid draughtsman, skilfully emulating Hunt's light pencil, a style that he passed on to Louis Sullivan when he worked briefly in the office of Furness and Hewitt.

Furness's studies were interrupted in 1861 by military service in the cavalry during the Civil War; in 1864 he returned to Hunt's office for more than a year. Then, instead of going to Paris for study, Furness opened a practice in Philadelphia. In 1867 he formed a partnership with John Fraser (1825–1906), who had an established practice, and with George Watson Hewitt (1841–1916), a former member of John Notman's office. At the outset Fraser, Furness & Hewitt were unsuccessful in a number of architectural competitions, but by 1870 they were established as the rising young architects for élite Philadelphia, with several important church and institutional commissions to their credit.

(ii) Professional success, 1871–90. In 1871 while Fraser was in Washington, DC, pursuing government work, Furness and Hewitt, without their senior partner, entered and won the competition for the Pennsylvania Academy of the Fine Arts in Philadelphia (completed 1876). Their scheme overlaid polychromatic Gothic details on a building whose main façade was French with a projecting central pavilion crowned by a mansard roof and flanked by stridently coloured wings. Some elements, notably the triglyph-like blocks on the front, recalled the Greek Revival (Néo-Grec) that Hunt had learnt and taught in the 1850s. The eclectic fusion of classicism and medievalism in Furness's early masterpiece demonstrated his continuing debt to Hunt, but the strikingly asymmetrical composition

of the side elevation in which interior functions were expressed on the exterior denoted an original approach. Equally striking was Furness's use of an exposed, massive iron truss on the side of the building to carry the upper floor galleries over the first floor skylighted studios. Where John Ruskin (1819–1900) had confidently predicted that iron would never become an important building material because it was not commonly used as a metaphor in the Bible, Furness anticipated modern design by giving iron and central architectural role. Furner was equally comfortable creating highly identifiable designs for those businesses that were essentially identical in function, as in the case of banking. The office's violently proportioned and strangely detailed designs reflected the commercial role of the façade. The monochromatic eclectic Northern Savings Fund (1871) at 6th and Spring Garden streets, the polychromed Venetian Gothic Guarantee Trust and Safe Deposit Company offices (1873; destr. 1956) and later the contentiously over-scaled Provident Life and Trust Company offices at Fourth and Chestnut streets (1876; destr. 1959; see fig. 1) demonstrated how far commercial design could be pushed in the Darwinian environment of American commerce. It is those buildings of the 1870s that have fascinated and horrified historians and critics, leading to the reputation of Furness as the most extreme of late 19th-century American architects.

By 1876 the partnership of Furness & Hewitt was dissolved; five years later draughtsman Allen Evans (1849–

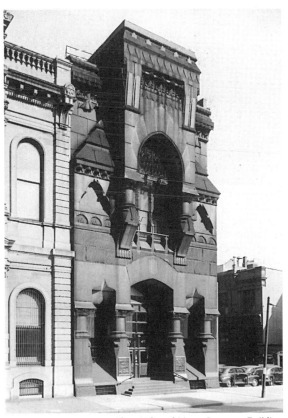

1. Furness & Hewitt: Provident Life and Trust Company Building, Philadelphia, Pennsylvania, 1876; destr. 1959

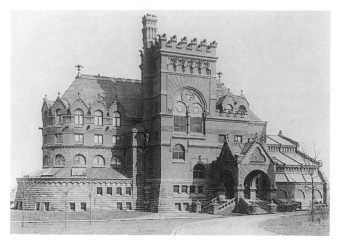

2. Furness, Evans & Co.: Furness Building, formerly the Library of the University of Pennsylvania, Philadelphia, 1888–91

in the 1850s, Philadelphia locomotive engineers had defined a new type of beauty that lay in the relation of forms to their functions—an approach that Furness's family friend Walt Whitman called 'organic'. In the same decade, industrial design that eschewed extraneous ornament for a direct expression of function through form was described as typical of Philadelphia (E. Freedley: *Manufactures in Philadelphia*, 1858):

> The machine work executed in the leading establishments of Philadelphia, ...is distinguished by certain characteristics, which enable a competent judge to...detect a Philadelphia-made machine by the "earmarks". Excellence of material, solidity, an admirable fitting of the joints, a just proportion and arrangement of the parts, and a certain thoroughness and genuineness, are qualities that pervade the machine work executed in Philadelphia, and distinguish it from all other American-made machinery.

Working for clients who were as at home in a factory as in a boardroom, Furness's direct use of brick and iron in forms that expressed function would have seemed unremarkable in Philadelphia and alarming elsewhere. In a city where machine form denoted purpose, it would have been surprising only had Furness not made his architecture of modern materials and in forms that reflected function. This quality animates Furness's best buildings, such as the Baltimore and Ohio (B&O) Station (1886; destr.) and the library for the University of Pennsylvania (1888–91; rest. Venturi, Scott Brown Associates, 1986–91). They have the raw impact of giant machines, even as they transcended their materials to become *summa*s of the industrial age. Directness of expression has defined that most important Philadelphia architecture ever since.

The most remarkable of these commissions was the library for the University of Pennsylvania. There Furness juxtaposed the cultural form of the cathedral for the public spaces with the glass-roofed industrial form of the train shed for the book stack in a red palette of brick, terracotta, sandstone and tile (see fig. 2). The plan was a model of logic. A large entrance porch opens into an immense stair-tower, which provides access to all of the public spaces. The five-storey high, skylighted reading room serves as a giant light well, while the glass-floored and glass-roofed book stack was expandable to meet the needs of the growing collection. In this regard, it was like the self-adjusting machines that were being pioneered in Philadelphia machines shops.

1925) became a partner in Furness & Evans, the name which, with minor modifications reflecting additions to the partnership, remained until the firm's dissolution long after Furness's death. Despite the modest staff of six or eight, which permitted Furness to stamp his personality on most of the designs, the firm was remarkably prolific with more than 600 commissions between 1881 and 1912.

That Furness's vigorous and original architecture was accepted by his clients suggests that it meant more than mere fashion. Furness's and, by extension, Philadelphia's architecture was distinct from that of other American cities because it served a work culture rooted in engineering and industry, in contrast to the more international cultures of finance, commerce and academics that dominated New York and Boston. The leaders of most Philadelphia institutions of the era came from engineering and industry rather than finance. Academy of Fine Arts board member Fairman Rogers trained as a civil engineer and resolved the problem of compass deviation in iron ships for the Navy. William Sellers, head of the University of Pennsylvania's board, was the chief mechanical engineer of his day, designing and manufacturing the great machines that made Philadelphia the world capital of heavy industry. British judges at the American Centennial stated that Sellers machines outshone all that had ever been exhibited in any world's fair for the '...beautiful outlines that are imparted to each structure by the correct proportions that have been worked out in the determining of strength and form and the disposal of material to take full share of the duty' (US Centennial Commission, *International Exhibition 1876: Report and Awards*, vii, ed. Francis A. Walker (Washington, DC, 1880), section 21, 14). A century later, Sellers was still remembered for making the form of the machines 'follow the functions to be performed...'

Furness's ability to make buildings 'out of his head' in pupil Louis Sullivan's phrase, linked his method to the Philadelphia world of work. This approach resonated with the values of Furness's father's close friend Ralph Waldo Emerson, who had preached that American should turn away from Europe to find her own arts in the principles of nature and modern engineering and railroads. Beginning

(iii) Later years, 1891–1912. Furness's style was more successful in small-scale buildings than in the larger scale office towers and institutions permitted by modern construction methods. His architecture remained fundamentally sculptural, only rarely exploring the new spatial possibilities of steel, save for the vast train sheds of his railway buildings. In 1892 Furness recalled the Gothic detail of St Pancras Station (1865) by George Gilbert Scott (1811–78), London, for the massive extension to the Pennsylvania Railroad's Broad Street Station (destr. 1952). Three years earlier, in an extension of the Provident Bank offices, he had demonstrated that Victorian complication, with vari-coloured bands and a multi-storey and dormered roof, were incompatible with the scale of modern build-

ings. As Louis Sullivan would later point out (1924), H. H. Richardson's large, simple buildings better met the requirements of the large building.

By 1905 even Furness was forced to modify his personal style, when he adapted the Roman Pantheon for the offices of the Girard Trust Company on Broad Street just south of City Hall. Although the client had stipulated a scheme in the modern classical style in place of his architect's customary brick, Furness still managed to transform the style into a personal statement contrasting a soaring sail-vaulted interior with the hemispherical and squat exterior. It is a worthy successor to the light-filled stair-hall of the Pennsylvania Academy of the Fine Arts and the great banks of the 1870s. In this building Furness demonstrated most directly that his architecture depended not on the extrinsic issue of style but on the intrinsic factors of proportion, character and scale, qualities that typify great architecture in any age.

2. INFLUENCE. Unlike Richardson in Boston and Hunt in New York, whose work was promoted by the rising national architectural journals, Furness's practice was limited to the zone of the Pennsylvania Railroad and the industrial culture that it served. After 1890 few of his designs were published, and apart from the 'Hints to Designers' (*Lippincott's Magazine*, 1878), he wrote little. By the 1880s, as national taste changed towards a more accurate use of historical styles, his work, rooted in the values of Emerson's demand that architecture respond to the present, was incomprehensible to out-of-town critics.

Though Furness never established a proportion-based theory that could be reduced to academic dogma, those architects who passed through his office and were open to new ideas got the meaning of his practice and carried it into the 20th century. Of these, the best know is Louis Sullivan, who praised Furness's method and recalled his experience in the office as 'a true workshop savoring of the guild where craftsmanship was paramount and per-sonal' (L. H. Sullivan: *Autobiography of an Idea*, New York, 1924). Sullivan communicated these values to Frank Lloyd Wright, who in turn, carried them into the 20th century in the Midwest. Philadelphian William L. Price learnt the Furness method in the 1880s and in the 20th century applied it to large-scale reinforced concrete seashore hotels and railroad stations in the Midwest. Albert Kelsey, who worked in the office in the 1890s and later became a friend of Sullivan, recalled Furness's determination that 'American should create an art of its own making and opposed to copying European styles of ancient or modern design'. After Furness's death in 1912, George Howe (1886–1955) worked for the office and later recalled its 'probity'. The truthfulness lingered in Howe's later masterpiece, the Philadelphia Savings Fund Society (PSFS) Building (1929–33), and, in turn, was communicated to Louis Kahn (1901–74) and Robert Venturi (*b* 1925). It was not a coincidence that Frank Lloyd Wright visited a number of Furness buildings while he was designing Beth Shalom Synagogue (1954), Elkins Park (in the Philadelphia suburbs) and termed Furness's University Library 'the work of an artist'. After World War II, many of Furness's most original buildings were demolished, but their tough brick realism, expressive force, ironic wit and exuberant reflection of the potential of the industrial world stimulated the so-called Philadelphia school, one that could equally be called the Furness school.

BIBLIOGRAPHY

L. Sullivan: *The Autobiography of an Idea* (New York, 1924)

The Architecture of Frank Furness (exh. cat. by J. F. O'Gorman, G. Thomas and H. Myers, Philadelphia, PA, Mus. A., 1973)

Drawing towards Building: Philadelphia Architectural Graphics, 1732–1986 (exh. cat. by J. O'Gorman and others, Philadelphia, PA Acad. F.A., 1986), pp. 128–9, 135–8, 172

G. Thomas and others: *Frank Furness: The Complete Works* (New York, 1991); review by T. A. P. van Leeuwen in *Archis*, x (1992), p. 53; M. Mumford in *J. Soc. Archit. Hist.*, li (1992), pp. 323–5

R. Venturi: 'Learning from Philadelphia: Furness Library, University of Pennsylvania', *Abitare*, cccxii (1992), pp. 146–52

E. R. Bosley: *University of Pennsylvania Library: Frank Furness* (London, 1996)

GEORGE E. THOMAS

G

Gallier. American family of architects of Irish origin. (1) James Gallier (i) was one of the best-known and most successful 19th-century architects working in New Orleans, where he was an exponent particularly of the Gothic and Greek Revival styles. His son (2) James Gallier (ii), less prominent than his father, also worked mainly in New Orleans.

(1) James Gallier (i) (*b* Ravensdale, Ireland, 24 July 1798; *d* at sea, 3 Oct 1866). After a limited basic education, he was apprenticed to his father, Thaddeus Gallier, to learn the building trade. As there was little work, however, he attended the School of Fine Arts, Dublin, and learnt the art of architectural drawing. In 1816 he worked on the building of a cotton mill in Manchester and then worked briefly in Liverpool. He subsequently returned home, but in 1822 he moved to London, where he and his brother John Gallier worked for a building firm and where James spent his spare time studying engineering, architecture and the fine arts. He married in 1823. In 1826 he was engaged as Clerk of Works by William Wilkins (1778–1839) for the Huntingdon County Gaol. On its completion (1828), he returned to London and worked for a time for John Peter Gandy (later Deering; 1787–1850), but deciding that he might find greater success in the USA, Gallier left England (1832) for New York. His first employment there was with the architect James H. Dakin. Gallier soon formed a partnership (1832–4) with Minard Lafever and together they produced numerous drawings for local builders. During this period he published the *American Builder's General Price Book and Estimator* (1833). His association with Wilkins, Dakin and Lafever gave him valuable experience in the Gothic Revival and Greek Revival styles, which he used in most of his subsequent works.

Seeking new opportunities in the South, Gallier and Charles Bingley Dakin (1811–39), James Dakin's brother, left for New Orleans, where they established an architectural office under the name Gallier & Dakin in 1834. They were immediately successful and in their first year designed such distinguished classical buildings as the St Charles Hotel, the Merchants' Exchange, the Arcade Baths, Christ Church and several residences (all 1835–6; destr.). The firm exerted great influence on the architecture of New Orleans, and, as the best-known 19th-century architect there, Gallier was, until recently, credited with the design of almost every Classical columned building in the city.

In 1835 James Dakin arrived in New Orleans to form a new partnership with his brother, and Gallier withdrew shortly afterwards to practise alone. In 1837 Dakin & Dakin began the construction of the great Gothic Revival church of St Patrick, which was completed by Gallier in 1839. The entire interior, including the high altar, is his work, probably his first and finest work in the Gothic Revival style. His most notable surviving building is the former New Orleans City Hall (1845–50; now Gallier Hall; see fig.), with a white marble Ionic portico and a grey granite lower storey. Due to failing eyesight, Gallier retired from active practice in 1850 to travel in America and abroad. He and his second wife were lost at sea in a shipwreck off Cape Hatteras.

WRITINGS
Autobiography of James Gallier (Paris, 1864/*R* New York, 1973)

(2) James Gallier (ii) (*b* Huntingdon, England, 25 Sept 1827; *d* New Orleans, LA, 18 May 1868). Son of (1) James

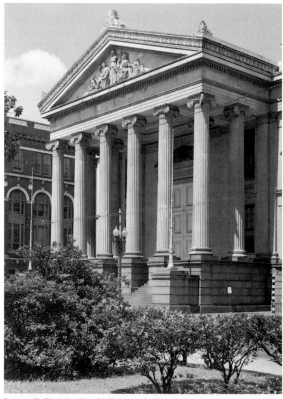

James Gallier (i): City Hall (now Gallier Hall), New Orleans, 1845–50

Gallier (i). He was educated at the University of North Carolina and, after his father retired, was in partnership first with John Turpin and later with Richard Esterbrook. His works include numerous residences and commercial buildings in New Orleans, mostly in the Italianate style, of which many survive. His own house (1857) on Royal Street was restored and opened in 1971 as a historic house museum. His most notable work was the French Opera House (1859; destr. 1919), built by Gallier & Esterbrook. Other surviving works include the Luling Mansion (1865; later the Louisiana Jockey Club) and the Bank of America (1866), a notable commercial building with a cast-iron façade. He is buried in the splendid marble cenotaph in St Louis Cemetery No. 3, which he originally built in memory of his father and stepmother.

BIBLIOGRAPHY

Macmillan Enc. Archit.

T. Hamlin: *Greek Revival Architecture in America* (New York, 1944/R 1964)

L. V. Huber: *New Orleans: A Pictorial History* (New York, 1971)

New Orleans Architecture, i–iii, v–vi (Gretna, LA, 1971–80)

N. Lemann: 'New Orleans Style: The Gallier House Museum', *A. & Ant.* (Summer, 1986), pp. 48–55

J. M. Farnsworth and A. M. Masson, eds: *The Architecture of Colonial Louisiana: Collected Essays* (Lafayette, LA, 1987)

L. Koenigsberg: 'Life-Writing: First American Biographers of Architects and their Works', *Stud. Hist. A.*, xxxv (1990), pp. 41–58

W. N. Banks: 'The Galliers, New Orleans Architects', *Antiques*, cli (1997), pp. 600–11

SAMUEL WILSON JR

Gansevoort Limner (*fl c.* 1730–45). American painter. He was one of several portrait painters, known as the Patroon Painters, active during the first half of the 18th century in the Dutch-settled lands along the Hudson River from New York to Troy. He may have derived his compositions freely from British and Dutch mezzotints, but his style is strongly individualistic. The faces of his sitters are simplified and delicately rendered, while their figures are flat and geometrical, thinly painted in warm colours. His best-known portraits are *Pau de Wandelaer* (*c.* 1730; Albany, NY, Inst. Hist. & A.; see fig.) and *Deborah Glen* (*c.* 1737; Williamsburg, VA, Rockefeller Flk A. Col.).

Black proposed that the Gansevoort Limner was Pieter Vanderlyn, grandfather of the American painter John Vanderlyn, and has since attributed to him around 20 portraits painted between *c.* 1730 and *c.* 1745 in or near Albany and Kingston, NY. Pieter Vanderlyn, born in the Netherlands *c.* 1687, arrived in New York in 1718, probably by way of Curaçao. He resided in or near Albany and Kingston in the years of the Gansevoort Limner's work in those places and died in Shawangunk, NY, in 1778. Black's identification of Vanderlyn as the Gansevoort Limner contradicts Flexner's earlier proposal that Vanderlyn was the De Peyster Limner; Black suggests that the De Peyster Limner was Gerardus Duyckinck (1695–1746).

BIBLIOGRAPHY

J. T. Flexner: 'Pieter Vanderlyn, Come Home', *Antiques*, lxxv (1959), pp. 546–9, 580

M. Black: 'Pieter Vanderlyn and Other Limners of the Upper Hudson', *American Painting to 1776*, ed. I. Quimby (Charlottesville, VA, 1971), pp. 217–49

R. H. Saunders and E. Miles: *American Colonial Portraits* (Washington, DC, 1987), pp. 144–5, 161–2

DAVID TATHAM

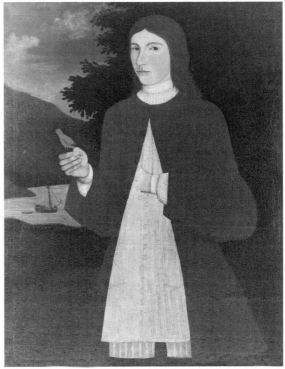

Gansevoort Limner: *Pau de Wandelaer*, oil on canvas, 1137×895 mm, *c.* 1730 (Albany, NY, Albany Institute of History and Art)

Garbisch. American collectors. Edgar William Garbisch (*b* La Porte, IN, 7 April 1899; *d* Cambridge, MD, 13 Dec 1979), president of Grocery Store Products, and his wife, Bernice Chrysler Garbisch (*b* Oelwein, IO, 1908; *d* Cambridge, MD, 14 Dec 1979), daughter of the motor-car magnate Walter P. Chrysler, amassed one of the largest and most comprehensive collections of 18th- and 19th-century American naive painting, purchased to decorate their country home, 'Pokety', on Maryland's eastern shore. Because the Garbisches were among the first to show interest in such art, they were able to assemble rapidly a collection of over 1000 naive paintings of extraordinary quality, including the *Cornell Farm* (1848) by Edward Hicks, the Colonial portraits by Winthrop Chandler of *Capt Samuel Chandler* (for illustration *see* CHANDLER, WINTHROP) and *Mrs Samuel Chandler* (*c.* 1780; all Washington, DC, N.G.A.) and several portraits and Egyptian scenes by Erastus Salisbury Field. Other important artists represented in the collection were Ammi Phillips, William Matthew Prior, Joshua Johnson and Thomas Chambers (1808–after 1866). They also collected outstanding American watercolours, pastels, theorem paintings, examples of *Fraktur*, needlework and furniture, Impressionist, Post-Impressionist and modern paintings, French furniture and European porcelain.

Wishing to foster appreciation of naive art, the Garbisches frequently exhibited their collection. In addition, between their first gifts to the National Gallery, Washington, DC, in 1953, and their bequest in 1979, they donated numerous paintings to museums throughout America. While the National Gallery was the largest recipient of

works from the bequest, 31 other museums benefited from their generosity, notably the Chrysler Museum, Norfolk, VA, the Metropolitan Museum of Art, New York, the Museum of Fine Arts, Boston, and the Philadelphia Museum of Art. The remainder of their collection was auctioned in 1980.

BIBLIOGRAPHY

M. Black: 'Collectors: Edgar and Bernice Chrysler Garbisch', *A. America*, lvii/3 (1969), pp. 48–59
J. E. Patterson: 'The Garbisch Collection: A Major Saleroom Event', *Connoisseur*, cciv/819 (1980), pp. 46–51
American Naive Paintings from the National Gallery of Art (exh. cat., intro. M. Black; Washington, DC, N.G.A., 1985)
D. Chotner: *American Naive Paintings*, Washington, DC, N.G.A. cat. (Washington, DC and Cambridge, 1992); review by A. Berman in *Apollo*, cxxxix/385 (1994), p. 91

LAURIE WEITZENKORN

Garden. When the Spanish arrived in North America in the 16th century, they destroyed the most sophisticated gardening tradition indigenous to the continent, that of the Aztec Indians. The new settlers quickly re-created garden types they had known in Europe, and in Catholic areas these included the utilitarian gardens connected with religious institutions. In the South, fruit trees, kitchen and medicinal gardens were planted in the cloisters and courtyards surrounding the missions; in Quebec, a walled garden at the St Sulpician Seminary in Montreal survives from the building of the monastery in the 1680s. By contrast, the earliest gardens of New Netherland, established as a colony in 1624, were laid out by the Dutch West India Company. At the mansion (*c.* 1685; destr.) built by Peter Stuyvesant, Director-General of the company, on the Battery in Manhattan, the axially arranged garden had symmetrical compartments of parterres and orchards in the Dutch classical manner. Influence was not all in one direction: by the 18th century such nurserymen as John Bartram (1699–1777) of Philadelphia, appointed King's Botanist in 1765, were regular suppliers of plants for gardens in England.

In the English-speaking colonies, English gardening traditions were the most influential. At Williamsburg, the capital of Virginia from 1699 to 1781, the formal Anglo-Dutch combination of parterres and geometric topiary at the Governor's Palace has been restored according to the original plan found in the British Museum. In the upper garden, a central axis divides 16 diamond-shaped parterres of periwinkle and 12 cylindrical topiary yaupons; a series of cross-axes and contiguous gardens culminates in a tunnel of American beech and a maze modelled after the one at Hampton Court, although planted in American holly. The terminal feature, a canal, is Dutch in origin. At Mt Vernon, VA, the 'home farm' along the Potomac River built by George Washington (1732–99) and enlarged by him in 1787, the influence of the English landscape garden is apparent. On the side facing the river, the house is separated from a deer park by a ha-ha (landscape barrier in the form of a hidden trench). Behind the house are a pair of walled gardens, one for flowers and one for vegetables, divided by a serpentine drive planted with 'clever sorts' of flowering trees and shrubs obtained from Bartram's Nurseries or from Washington's daily riding expeditions in the surrounding area.

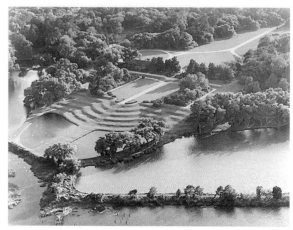

Garden at Middleton Place, near Charleston, South Carolina

In New England there was nothing this grand, although in Newport, RI, the summer colonists competed fiercely to produce the most lavish gardens. Features would include graperies, orangeries, palm, orchid and gardenia greenhouses. It is said the Newporter Fairman Rogers ordered his gardener to create a flowerbed to match exactly in pattern and colour his favourite Persian carpet, while at another garden the Shakespeare quotation from *A Winter's Tale*—'This is an art which doth mend nature, change it, but itself is nature'—was spelled out entirely with flowers of varied hues. The earliest type of Colonial garden has been reconstructed at Whipple House in Ipswich, MA, where paths paved with crushed clamshells surround raised beds, each boarded, pegged and centred with a rose bush. These are filled with pinks, strawberries and marjoram, such medicinal plants as opium poppies and others on which the settlers depended, as described in 17th-century documents. Few gardens in North America have evolved continuously from the Colonial period, although one example can be found at Middleton Place, outside Charleston, SC (see fig. 57), where the first president of the Federal Congress, Henry Middleton, commissioned a formal garden in the French style. A lawn, terraced like an amphitheatre, may have been one of the original features.

BIBLIOGRAPHY

A. Leighton: *American Gardens in the Eighteenth Century: For Use or for Delight* (Boston, 1976)
Voyage de Pehr Kalm au Canada en 1749 (Traduction annotée du journal de route par Jacques Rousseau et Guy Béthune) (Montreal, 1977)
M. H. Ray and R. P. Nicholls: *A Guide to Significant and Historic Gardens of the United States* (Athens, GA, 1982)
E. von Baeyer: *A Preliminary Bibliography for Garden History in Canada* (Ottawa, 1983)
C. E. Beveridge, P. Rocheleau and D. Larkin, eds: *Frederick Law Olmstead, Designing the American Landscape* (New York, 1995)
P. Bowe: 'Pückler-Muskau's Estate and its Influence on American Landscape Architecture', *Gdn Hist.*, xxiii/2 (Winter 1995), pp. 192-200
M. B. Hill: *Grandmother's Garden: The Old Fashioned American Garden, 1865–1915* (New York, 1995)
J. T. Fry: 'An International Catalogue of North American Trees and Shrubs: The Bartram Broadside, 1783', *J. Gdn Hist.*, xvi (1996), pp. 3-21

JUDITH A. NEISWANDER

Garden, Hugh M. G. *See under* SCHMIDT, GARDEN & MARTIN.

Gardner, Alexander (*b* Paisley, Scotland, 17 Oct 1821; *d* Washington, DC, 11 Dec 1882). American photographer of Scottish birth. He was apprenticed to a jeweller (*c.* 1835–43) until his interest in optics, astronomy, chemistry, literature and social welfare led him to move to Glasgow. There he took a position as a reporter for the news journal *Sentinel*, of which he eventually became editor. He is believed to have been a self-taught photographer. Gardner had plans to found a Utopian socialist community in the USA, but when he emigrated in 1856 it was with a fare paid for by the photographer Mathew B. Brady. They had met in England in 1851 at the Great Exhibition. Brady appointed him manager of another branch of his gallery in Washington, DC, in 1858, after first giving him a position in his studio in New York.

When the American Civil War broke out in 1861, Brady appointed Gardner to lead a photographic team to accompany the Union armies. Their aim was to make a potentially commercial record of the war. The photographs produced by this group (for illustration *see* O'SULLIVAN, TIMOTHY) constitute the first comprehensive photographic document of a war in all its aspects and thus a major development in the history of photojournalism. In 1862, however, Gardner argued with Brady over the issue of these photographs being published under Brady's name. Gardner left Brady's employ, taking with him a number of other photographers, as well as his negatives. He established his own studio and gained an appointment as Official Photographer for the Army of the Potomac. The particular privilege he enjoyed in this position enabled him to make documents of some of the most important events and people of the war period. His portraits of *Lincoln* (see W. Welling: *Photography in America: The Formative Years, 1839–1900*, New York, 1978, p. 144) are among the most famous in 19th-century photography, and his series of portraits of the Lincoln assassination conspirators and the views of their subsequent execution are among the masterpieces of photographic reportage. His photographs were direct, informative and unsentimental.

In 1866 Gardner published 100 original photographic prints in two volumes as *Gardner's Photographic Sketch Book of the War*, taken by a team of photographers. Each picture, for example *A Sharpshooter's Last Sleep, Gettysburg, July 1863* (see Gardner, pl. 40), was individually credited and was accompanied by an explanatory text, most probably written by Gardner himself. Unfortunately, this project was not a financial success due to the national desire to forget the horrors of the event. Gardner also sought to sell his negatives to the government but met a similar lack of interest.

In 1867 Gardner became the Official Photographer for the Union Pacific Railroad. He documented scenes along the lines in Kansas, West Mississippi and Missouri, showing American Indian life, railway construction and landscapes. He maintained his portrait studio in Washington, DC, during the 1870s and enjoyed a reputation as one of the most famous photographers of his era.

PHOTOGRAPHIC PUBLICATIONS

Gardner's Photographic Sketch Book of the War, 2 vols (Washington, DC, 1866/*R* New York, 1959)

BIBLIOGRAPHY

R. Taft: *Photography and the American Scene* (New York, 1938)
D. H. Mugridge: *The Civil War in Pictures* (Washington, DC, 1961)
C. Beaton and G. Buckland: *The Magic Image* (London, 1975)
L. Witkin and B. London: *The Photograph Collector's Guide* (London, 1979)
D. M. Katz: *Witness to an Era: The Life and Photographs of Alexander Gardner: The Civil War, Lincoln and the West* (New York, 1991)
An Enduring Interest: The Photographs of Alexander Gardner (exh. cat. by B. Johnson, Norfolk, VA, Chrysler Mus., 1991–2)
S. Danly: 'Photography, Railroads and Natural Resources in the Arid West: Photographs by Alexander Gardner and A. J. Russell', *Perpetual Mirage: Photographic Narratives of the Desert West*, ed. M. Castleberry (New York, 1996), pp. 48–55
J. Charlton: '*Westward, the Course of Empire Takes its Way*': Alexander Gardner's 1867 'Across the Continent on the Union Pacific Railway, Eastern Division' Photographic Series (Topeka, KS, 1997)

GRANT B. ROMER

Gardner [née Stewart], **Isabella Stewart** (*b* New York, 14 April 1840; *d* Boston, MA, 17 July 1924). American patron, collector and museum founder. The daughter of a wealthy New York merchant and wife of the prominent Boston banker, John L. Gardner jr (1837–98), she bought her first important painting in 1873—a small landscape by the Barbizon painter Charles Jacque (1813–94). (All works cited are in Boston, Isabella Stewart Gardner Mus.) In the 1870s she also began to collect rare books, manuscripts, autographs and etchings, under the influence of Charles Eliot Norton. Although she continued to buy such pieces until her death, after the 1880s books took second place to art. During a trip to Europe in 1886, she visited the London studios of James McNeill Whistler and John Singer Sargent, both of whom painted her portrait, and it was at that time that she decided to give serious thought to collecting art.

Mrs Gardner purchased her first Old Master painting in 1888—a *Madonna* by Francisco de Zurbarán (1598–1664), which became her personal altarpiece. A summer visit to Venice that year kindled her interest in Venetian architecture, and subsequent travels provided her with the opportunity to study important paintings in London and Paris, while strengthening her enthusiasm for collecting. She became friendly with Bernard Berenson (1865–1959), whom she had met when he was a young Harvard student in 1886–7. She partly underwrote the postgraduate study trip to Europe in which he began his study of early Renaissance Italian painting, and it was largely through his assistance that she created the collection housed in her Boston mansion, now known as Fenway Court by Cummings & Sears. Begun in 1901 and opened to the public in 1903, Fenway Court incorporated antique and Renaissance architectural fragments imported from Italy to create the appearance of a Venetian palazzo that would serve as both a public museum and private residence (*see* CUMMINGS & SEARS, fig. 2). The collection includes paintings, sculpture, drawings and prints, furniture, textiles, ceramics and glass. Among its treasures are the *Rape of Europa* (*c.* 1560) by Titian (*c.* ?1485/90–1576), *The Concert* (*c.* 1662) by Vermeer (1632–75), the portrait of *Count Tommaso Inghirami* (*c.* 1512) by Raphael (1483–1520), that of *Thomas Howard, Earl of Arundel* (*c.* 1529–30) by Rubens (1577–1640) and two works by Rembrandt (1606–69), *A Lady and Gentleman in Black* (1633) and *Self-portrait* (*c.* 1629). With Berenson's advice, Mrs Gardner bought such important early Italian paintings as the *Presentation in the Temple* (*c.* ?1320s) by Giotto (1267/75–

1337), the *Annunciation* (*c.* 1481) by Antoniazzo Romano (1452–1508/12), *Hercules* (*c.* 1465) by Piero della Francesca (*c.* 1415–1492) and the *Tragedy of Lucretia* (*c.* 1504–10) by Botticelli (1444/5–1510).

Mrs Gardner managed Fenway Court singlehandedly until 1919, when she handed over its direction to Morris Carter, formerly of the Museum of Fine Arts, Boston. Through her friendship with scholars and connoisseurs, she exercised considerable influence on the collecting and exhibition policies of the Museum of Fine Arts and, through that institution, on Boston's cultural life. In her will, Mrs Gardner froze her collection so that it would permanently reflect her personality and taste. Fenway Court was established 'as a Museum for the education and enjoyment of the public forever'. On its seal she inscribed a phoenix, symbol of immortality, and the motto: '*C'est mon plaisir*'—her justification for a life devoted to the enjoyment and encouragement of art.

BIBLIOGRAPHY

M. Carter: *Isabella Stewart Gardner and Fenway Court* (Boston, 1925/*R* 1972)
P. Hendy: *European and American Paintings in the Isabella Stewart Gardner Museum* (Boston, 1931, rev. 1974)
A. B. Saarinen: *The Proud Possessors* (New York, 1958)
L. Hall Tharp: *Mrs. Jack* (Boston, 1965)
R. Hedley, ed.: *Drawings: Isabella Stewart Gardner Museum* (Boston, 1968)
R. van N. Hadley, ed.: *The Letters of Bernard Berenson and Isabella Stewart Gardner, 1887–1924* (Boston, 1987); review by D. Sutton in *Burl. Mag.*, cxxx/1026 (1988), p. 710; D. Garstang in *Apollo*, cxxix/324 (1989), pp. 135–6
C. Giuliano: 'Mrs. Gardner's Mistakes', *ARTnews*, lxxxviii/5 (1989), pp. 47–8
K. Weil-Garris Brandt: 'Mrs. Gardner's Renaissance', *Fenway Court* (1990–91), pp. 10–13 [review of a conference]
R. A. Goldthwaite: 'Finding the Self in a Renaissance Palace', *Fenway Court* (1990–91), pp. 70–76
K. D. McCarthy: *Women's Culture: American Philanthropy and Art, 1830–1930* (Chicago and London, 1991)
L. B. Miller: 'Celebrating Botticelli: The Taste for the Italian Renaissance in the United States, 1870–1920', *The Italian Presence in American Art, 1860–1920*, ed. I. Jaffe (New York, 1992), pp. 1–22

LILLIAN B. MILLER

Gay, Walter (*b* Hingham, MA, 22 Jan 1856; *d* Le Bréau, Dammarie-les-Lys, nr Fontainebleau, 13 July 1937). American painter and collector, active in France. Gay lived all his adult life in and around Paris. He sailed for France in 1876, after a successful exhibition and sale of his still-life paintings at the Williams and Everett Gallery, Boston, which provided funds for his study abroad. Soon after arriving in Paris, Gay entered the atelier of Léon Bonnat (1833–1922), where he remained for about three years. At Bonnat's suggestion, Gay made a trip to Spain in 1879 to study the work of Velázquez (1599–1660). These influences combined to form a style of painterly realism that emphasized fluid brushwork and a high-keyed tonal palette. Gay made his professional début in France in the Salon of 1879 with the *Fencing Lesson* (New York, priv. col.), an 18th-century costume piece in the manner of Mariano Fortuny y Marsal (1838–74). The painting received favourable attention from French and American critics, encouraging Gay to continue this subject-matter for several years. During the late 1880s his summer trips to Brittany and Barbizon inspired a series of paintings of French peasants. One of the most successful of these, *The*

Blessing (Amiens, Mus. Picardie), was shown at the Salon of 1889 and purchased by the French government.

Around 1895 Gay stopped painting large figural compositions and began to paint interiors, inspired by his love of French furniture and interior decoration. In 1907 he purchased Le Bréau, an 18th-century château near Barbizon. Many of his subsequent paintings, for instance *The Medallions* (*c.* 1909; Paris, Pompidou), depict rooms in the château and were exhibited to great acclaim in Europe and America. Gay's memoirs were published in New York in 1930. His collection of Old Master drawings, paintings, bronzes and other works of art was donated to the Louvre by his widow in 1938.

BIBLIOGRAPHY

A. E. Gallatin, ed.: *Walter Gay: Paintings of French Interiors* (New York, 1920)
L. Gillet: 'Walter Gay', *Rev. A. Anc. & Mod.*, xxxix (1921), pp. 32–44
Memorial Exhibition of Paintings by Walter Gay (exh. cat., New York, Met., 1938)
Walter Gay: A Retrospective (exh. cat. by G. Reynolds, New York U., Grey A. G., 1980)
M.-E. Jaffrenou: *Catalogue des dessins de la collection Walter Gay conservés au Cabinet des Dessins du Louvre (Ecoles françaises et anglaises)* (diss., Paris, Ecole du Louvre, 1984)
B. Scott: 'Dancing Sunbeams', *Country Life*, clxxxix/16 (20 April 1995), pp. 82–5

GARY A. REYNOLDS

Gaynor, John P(lant) (*b* Ireland, *c.* 1826; *d* San Francisco, CA, 1889). Irish architect, active in the USA. The first record of Gaynor is a listing in the city directory of 1851 of Brooklyn, New York. Although he worked as an architect in Brooklyn and New York for 12 years, only one building has been firmly attributed to him: the Haughwout Building (1856–7) at the corner of Broadway and Broome Street, New York, erected for E. V. Haughwout & Co., china, glass and silverware manufacturers and importers. Loosely modelled after the Libreria Sansoviniana in Venice, the Haughwout Building is considered to be one of the masterpieces of cast-iron architecture (*see* UNITED STATES OF AMERICA, fig. 8 and NEW YORK, fig. 1). The street façades have large ground-floor windows flanked by tall Corinthian columns. Above are four storeys with virtually identical round arches set on Corinthian colonnettes and separated by projecting Corinthian columns. The exterior was originally painted a stone colour called (in 1859) 'Turkish drab'. The utilitarian interior consists of large open spaces with wooden beams supported by cast-iron columns. The iron for the store was cast by Daniel Badger's Architectural Iron Works. The design relationship between Badger and an architect such as Gaynor remains unclear. In 1863 Gaynor left New York for San Francisco. He was responsible for several prominent buildings in the Bay area, notably two sumptuous works for Gold Rush millionaire W. C. Ralston—the extension of his house in Belmont, CA (1865–75; now Ralston Hall, College of Notre Dame), and the Palace Hotel (1873–5; burnt 1906). The Palace was famous for its enormous glass-enclosed carriage court fully surrounded by six storeys of Renaissance-inspired balconies.

BIBLIOGRAPHY

'The Haughwout Establishment', *Cosmopolitan A. J.*, iii (1859), pp. 141–7

Illustrations of Iron Architecture Made by the Architectural Iron Works of the City of New York (New York, 1865); repr. as *Badger's Illustrated Cast-iron Architecture*, intro. M. Gayle (New York, 1981)

W. Weisman: 'Commercial Palaces of New York: 1845–1875', *A. Bull.*, xxxvi (1954), pp. 285–302

D. Gebhard and others: *A Guide to Architecture in San Francisco and Northern California* (Santa Barbara, 1973)

M. Gayle: *Cast-iron Architecture in New York: A Photographic Survey* (New York, 1974)

R. Bernhardi: *Great Buildings of San Francisco: A Photographic Guide* (New York, 1980)

ANDREW SCOTT DOLKART

Gifford, Sanford Robinson (*b* Greenfield, NY, 10 July 1823; *d* New York, 24 Aug 1880). American painter. He grew up in Hudson, NY, and attended Brown University between 1842 and 1844. He moved to New York in 1845 and studied with the British watercolourist and drawing-master John Rubens Smith (1775–1849), who probably taught him portraiture and topographical rendering. Gifford also enrolled in figure drawing classes at the National Academy of Design and attended anatomy lectures at the Crosby Street Medical College. After a year studying the human figure, he decided to specialize in landscape painting. An admirer of the work of Thomas Cole, he took a sketching trip during the summer of 1846 and visited some of that artist's haunts in the Berkshire and Catskill Mountains. Gifford's earliest works show the combined influence of Cole's style and his own nature studies (e.g. *Summer Afternoon*, 1853; Newark, NJ, Mus.). He first exhibited his work at the National Academy of Design in 1847, the same year the American Art-Union accepted one of his landscapes for distribution through engraving to its members. The next year the Art-Union showed eight of Gifford's canvases. The National Academy elected him an associate in 1851 and an academician in 1854.

Like most American landscape painters of his day, Gifford decided to supplement his training with European travel, and he left for England in 1855. There he studied the work of J. M. W. Turner (1755–1851) and John Constable (1776–1837). That autumn he went to France and spent over a year studying in Paris, Fontainebleau and Barbizon, where he was strongly impressed with the work of Jean-François Millet (1814–75). Before returning home, he toured Germany, Switzerland and Italy, where Albert Bierstadt joined him. Paintings from this trip, such as the *Lake of Nemi* (1856–7; Toledo, OH, Mus. A.), reveal his departure from the dark hued, meticulous compositions of his HUDSON RIVER SCHOOL predecessors, such as Cole, in favour of landscapes painted with barely noticeable brushstrokes and bathed in light that diffuses topographical detail. In the autumn of 1857 Gifford took a studio at the Tenth Street Studio Building in New York, where he painted for the rest of his life. On his annual summer trips, usually with fellow landscape painters, to the Catskills, the Adirondacks and a great variety of scenic locations in Maine, New Hampshire and Vermont, he made pencil sketches that he later developed into oil paintings. He favoured the Catskills and produced numerous paintings of the area. *Kauterskill Clove* (1862; New York, Met.; see fig.) is one of his finest works and shows the successful culmination of his experiments with the dissolution of form in atmospheric light. While serving in the Civil War, he produced such works as *Bivouac of the Seventh Regiment*

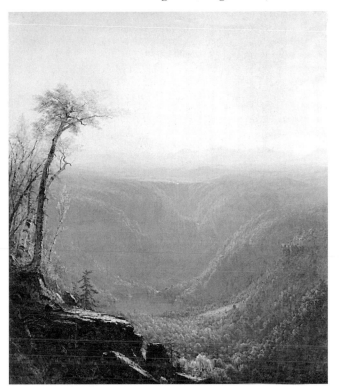

Sanford Robinson Gifford: *Kauterskill Clove*, oil on canvas, 1.22×1.01 m, 1862 (New York, Metropolitan Museum of Art)

at Arlington Heights, VA (1861; New York, Seventh Regiment Armory), in which his fascination with effects of light is equally apparent.

Between summer 1868 and autumn 1869 Gifford visited Italy, Greece, Egypt, Syria, Jerusalem and other countries in the Near East. This trip inspired many of his later paintings, for example the *Ruins of the Parthenon, 1868* (1880; Washington, DC, Corcoran Gal. A.). Shortly after his return, he accompanied Worthington Whittredge and John Frederick Kensett to the Rocky Mountains and continued on to Wyoming with Ferdinand V. Hayden's survey expedition. He travelled in the western USA, British Columbia and Alaska in 1874. He died six years later of pneumonia, after a trip with his wife to Lake Superior. In 1881 the Metropolitan Museum of Art in New York mounted a large memorial exhibition of Gifford's work, accompanied by a catalogue listing 739 of his paintings, which confirmed his position as a major member of the second generation of the Hudson River school. He has subsequently been seen as an important exponent of LUMINISM.

BIBLIOGRAPHY

Sanford Robinson Gifford (1823–1880) (exh. cat. by N. Cikovsky jr, Austin, U. TX, Huntington A.G., 1970)

I. S. Weiss: *Sanford Robinson Gifford, 1823–1880* (New York, 1977)

Sanford R. Gifford, 1823–1880 (exh. cat. by S. Weiss and I. S. Weiss, New York, Alexander Gal., 1986)

I. Weiss: *Poetic Landscape: The Art and Experience of Sanford R. Gifford* (Newark, DE, 1987)

CARRIE REBORA BARRATT

Gignoux, Régis-François (*b* Lyon, 1816; *d* Paris, 6 Aug 1882). French painter, active in the USA. He was educated

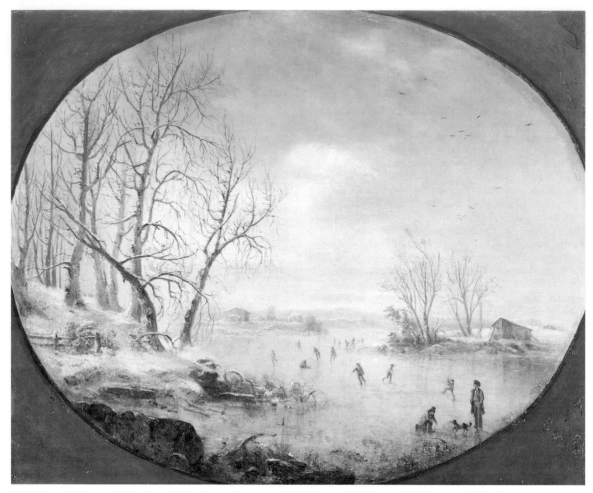

Régis-François Gignoux: *Winter Scene in New Jersey*, oil on canvas, 508×610 mm, 1847 (Boston, MA, Museum of Fine Arts)

at Fribourg, the Académie de St Pierre in Lyon and the Ecole des Beaux-Arts in Paris, where he studied under Paul Delaroche. About 1840 he settled in New York and became a skilled exponent of the HUDSON RIVER SCHOOL. Gignoux's work is distinguished by its delicate touch and velvet colour, recalling that of François Boucher (1703–70), yet he demonstrated an impressive resilience in applying his talents in a thoroughly American idiom. *On the Upper Hudson* (priv. col., see J. K. Howat: *The Hudson River and its Painters*, New York, 1971, p. 93, colour pl. 43), one of Gignoux's finest paintings, shows the subtly modulated palette, diaphanous atmosphere, fine articulation of foreground forms and a cadence of light and shadow that characterize his style. Gignoux's work was widely collected during his lifetime, and he achieved a reputation for his distinctive winter scenes; for example, *Winter Scene in New Jersey* (1847; Boston, MA, Mus. F.A.; see fig.) was purchased by Maxim Karolik. Gignoux exhibited frequently at the National Academy of Design, New York (1842–68), the Boston Athenaeum (1845–62) and the Pennsylvania Academy of the Fine Arts, Philadelphia (1855–68). He was the founding president of the Brooklyn Art Association (serving from 1861 to 1869) and exhibited there between 1860 and 1884. He returned to Paris in 1870.

BIBLIOGRAPHY

H. T. Tuckerman: *Book of the Artists: American Artist Life* (New York, 1867/*R* 1966)
C. Clement and L. Hutton: *Artists of the Nineteenth Century and their Works* (Boston, 1894)

JOHN DRISCOLL

Gilbert, Cass (*b* Zanesville, OH, 24 Nov 1859; *d* Brockenhurst, Hants, 17 May 1934). American architect. He belonged to a group of turn-of-the-century architects who developed an American interpretation of the French Beaux-Arts tradition. He did not rigidly follow Beaux-Arts doctrine, however, choosing instead to support the American Academy in Rome, adopting the point of view of his mentors McKim, Mead & White and Daniel H. Burnham. Gilbert's work following the World's Columbian Exposition (Chicago, 1893) is characterized by its Beaux-Arts monumentality and its reliance on diverse contemporary and historical precedents. He drew on their stylistic associations to forge memorable architectural images for institutional and corporate patrons.

The son of a land surveyor, Gilbert began his architectural career in 1876 as a draughtsman for Abraham Radcliffe in St Paul, MN. In 1878 he enrolled at the Massachusetts Institute of Technology, Cambridge, then

under the direction of William Robert Ware, who had recently modelled its design curriculum on that of the Ecole des Beaux-Arts, Paris. Gilbert toured England, France and Italy the following year and sketched the composition, motifs and ornament of major buildings, an activity that inspired him as a designer and continued throughout his career. In 1880 he entered the office of McKim, Mead & White in New York, working on domestic projects under Stanford White until 1882, when he returned to St Paul.

After acting briefly as McKim, Mead & White's Western representative, Gilbert formed a partnership with James Knox Taylor (1857–1929) in 1884. Gilbert's practice followed the path forged by the McKim, Mead & White office, although he was aware of the CHICAGO SCHOOL. His design for the Charles P Noyes House (1889) in St Paul, for example, resembles that by Charles McKim for the H. A. C. Taylor House, Newport, RI (1883–5; destr. 1952). When Gilbert's partnership with Taylor was dissolved in 1891, he explored the possibility of forming a partnership with Burnham, as a successor to John Wellborn Root, but the association did not materialize.

In 1895 Gilbert won national recognition with his design for the Minnesota State Capitol (completed 1903) in St Paul. Inspired by the Capitol in Washington, DC, and McKim, Mead & White's Rhode Island State House in Providence, it has a dome modelled on that of St Peter's in Rome, a projecting entrance pavilion adapted from Richard Morris Hunt's triple-arched entrance façade for the Metropolitan Museum of Art in New York and wings resembling the extensions to Versailles by Anges-Jacques Gabriel (1698–1782). Gilbert skilfully assembled these elements in an excellently proportioned composition. The Minnesota State Capitol's programme of allegorical decoration illustrates the themes of culture and progress with works such as the mural *The Civilization of the Northwest* by Edward Simmons (1852–1931) and Daniel Chester French's sculpture *The Progress of the State* (both *in situ*).

Gilbert's next major opportunity to define an institutional image with architecture and art arose with his commission for the US Custom House (1899–1906) at the foot of Broadway in Lower Manhattan, New York, which he secured after moving his office to that city. Its façade recalled recent Parisian public buildings in the ornamental detailing of its entablature and window surrounds and the planar rustication of its base. The sculptural decoration, designed to represent the role of the port of New York in the nation's emergence as a commercial power, includes French's *Four Continents* (*in situ*).

Gilbert's plan for Washington, DC (1900), foreshadowed the McMillan Plan (1901–2) and exemplifies his espousal of the ideals of the City Beautiful Movement, although not on so grand a scale as Burnham. For the Minnesota Capitol he designed three monumentally scaled approaches to the building (1903–6, unexecuted). He also proposed a plan for the centre of New Haven, CT (1907–10, unexecuted), as part of a large-scale project prepared with Frederick Law Olmsted, in which two broad avenues would connect the historic green with a new civic centre and a new railway station. Gilbert's campus plans, including the University of Minnesota (1908) in St Paul, the University of Texas (1909–14) in Austin and Oberlin College

(1912), OH, are influenced by City Beautiful aesthetic principles. The campus buildings, however, often allude to local heritage and culture; the composition of the library at the University of Texas (1910) is influenced by the Lonja at Saragossa, Spain, and shows Spanish sources in its detailing.

Although Gilbert believed public buildings should employ Classical precedents, he thought that modern building types, such as the skyscraper, railway station and bridge, could reflect their uses and construction. This assumption was based on his knowledge of the functionalism associated with the Chicago school, which he included in his repertory of available sources and styles. Gilbert's designs for the West Street Building (1905–7) and the Woolworth Building (1910–13; see fig.), both in Manhattan, articulate structure with soaring verticals of ivory-coloured glazed terracotta, set off by darker spandrels, that culminate in efflorescent Gothic ornament.

The Woolworth Building, at 233 Broadway, facing City Hall Park, was conceived by its patron, Frank Woolworth, as a profit-producing skyscraper, as spectacular advertising and as the administrative capital of an empire of five-and-dime stores. Gilbert based the building's composition on the medieval city hall of the Low Countries, a type with both commercial and civic associations, and selected its motifs and ornament from High Gothic, Perpendicular and Flamboyant cathedrals. At the time of its completion the tallest building in the world (241.4 m), it has an interior that rivalled contemporary ecclesiastical interiors, and which is notable for its monumental cross-shaped arcade, Byzantine in inspiration, ornamented with the mural paintings *Labour* and *Commerce* by Carl Paul Jennewein (1890–1978).Gilbert's career after World War I can be interpreted as a conservative reaction to the modernistic tendencies increasingly discernible in American architecture.

WRITINGS
with F. L. Olmsted: *Report of the New Haven Civic Improvement Commission* (New Haven, 1910)

BIBLIOGRAPHY
M. Schuyler: *The Woolworth Building* (New York, 1913)
R. A. Jones: *Cass Gilbert, Midwestern Architect in New York* (diss., Cleveland, OH, Case W. Reserve U., 1976)
P. A. Murphy: *The Early Career of Cass Gilbert, 1878 to 1895* (thesis, Charlottesville, U. VA, 1976)
C. McMichael: *Paul Cret at Texas* (Austin, 1983)
G. Blodgett: 'Cass Gilbert, Architect: Conservative at Bay', *J. Amer. Hist.*, lxxii (1985), pp. 615–36
S. Irish: *Cass Gilbert's Career in New York, 1899–1905* (diss., Evanston, IL, Northwestern U., 1985)
G. Fenske: *The 'Skyscraper Problem' and the City Beautiful: The Woolworth Building* (diss., Cambridge, MA, MIT, 1988)
G. Christen: *Cass Gilbert and the Ideal of the City Beautiful: City and Campus Plans, 1900–1916* (diss., New York, City U., 1997)
GAIL FENSKE

Gilbert, C(harles) P(ierrepont) H(enry) (*b* New York, 29 Aug 1860; *d* Pelham Manor, NY, 25 Oct 1952). American architect. He attended Columbia University, New York, and studied architecture at the Ecole des Beaux-Arts in Paris. In the mid-1880s he established an architectural office in New York after briefly practising in the new mining towns of Arizona and California. Gilbert's early work reflected contemporary Richardsonian Romanesque Revival and Shingle style tendencies, but it soon

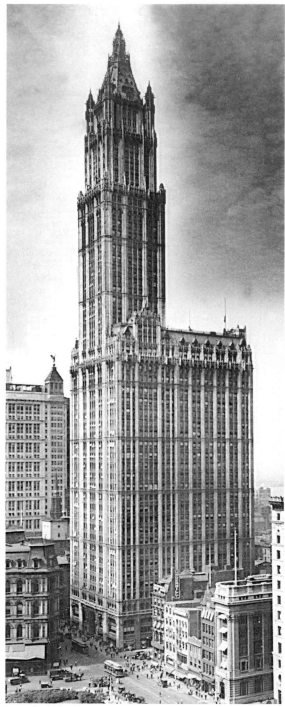

Cass Gilbert: Woolworth Building, New York, 1910–13

exhibited the historical authenticity favoured by leading New York architects, many of whom also trained at the Ecole des Beaux-Arts, such as Richard Morris Hunt, McKim, Mead & White, and Carrère & Hastings. Gilbert's practice consisted predominantly of the luxurious city and country houses he designed for wealthy patrons in New York's Upper East Side. The styles of these houses varied,

but Gilbert was especially known for his 'French Renaissance' city houses, which resembled the châteaux of the Loire Valley. These he designed for the corporate executive Isaac D. Fletcher (1899; 2 East 79th Street, corner of Fifth Avenue), the investment banker Felix M. Warburg (1908; 92nd Street and Fifth Avenue) and the entrepreneur Frank W. Woolworth (1901; 80th Street and Fifth Avenue; destr. 1925). A later design by Gilbert, the investment banker Otto Kahn's mansion (1918; 91st Street and Fifth Avenue), was based on the Palazzo della Cancelleria in Rome. It resembled McKim, Mead & White's earlier Villard Houses (1882–5) but showed an even greater historical accuracy. Gilbert also received commissions for row houses, including the 'French Renaissance' E. C. Converse House (1900; 3 East 78th Street) and the 'Georgian' Harvey Murdock House (1901; 323 Riverside Drive). Although he specialized in houses, Gilbert occasionally designed commercial buildings, including the 13-storey Italian Savings Bank Building (1925) in Manhattan's Lower East Side.

For an illustration of Gilbert's houses in Brooklyn *see* NEW YORK, fig. 3.

BIBLIOGRAPHY
'Some Designs by C. P. H. Gilbert', *Archit. Record*, ix/2 (1899), pp. 165–72
S. B. Landau: 'The Row Houses of New York's West Side', *J. Soc. Archit. Hist.*, xxxiv/1 (1975), pp. 19–36
R. A. M. Stern, G. Gilmartin and J. M. Massengale: *New York 1900* (New York, 1983), pp. 316, 321, 325
J. Tauranac: *Elegant New York* (New York, 1985), pp. 60–63, 181–3, 216–18, 222–5

GAIL FENSKE

Gill, Irving (John) (*b* Tully, NY, 26 April 1870; *d* Carlsbad, CA, 7 Oct 1936). American architect. The son of a building contractor, he was trained in Chicago in the offices of the architects Joseph Lyman Silsbee and Adler & Sullivan. Health considerations prompted his move to San Diego in 1893. Establishing an independent practice there, Gill remained in southern California for the rest of his life. Most of his commissions were for houses, apartment complexes and institutional buildings in residential districts.

Much of Gill's early work follows popularized conventions for American middle-class suburbs; it is commodious, efficient and picturesque but seldom inspired. He produced more distinctive work after 1900 as a result of pursuing the rustic simplicity advocated by proponents of the Arts and Crafts Movement. Sizeable dwellings such as the Marston House, San Diego (1904), possess a clear, purposeful order in their composition and detail. On the other hand, modest dwellings such as the Cossitt House, San Diego (1906), are often imbued with a studied casualness.

By 1910 Gill had developed his own style, which remained constant until the end of his career. His approach was in part reductivist. Decorative details such as eaves and mouldings are pared away, leaving uninterrupted surfaces inside and out. Yet his method relied more on creating a lucid, geometric order, in both form and space, predicated on what he had come to regard as the immutable basics in design: the straight line, circle, cube and arch. The result may be a scheme composed with insistent regularity, as is the Women's Club, La Jolla (1912–14; for

illustration *see* SAN DIEGO), or may appear to have been erected piecemeal, for example the Fulford House, San Diego (1910). Yet neither size nor use determines expression. In this respect a complex such as the Bishop's School, La Jolla (1909–10, 1916), is analogous with substantial residences as well as with Gill's numerous experiments in low-cost housing, for instance Buena Vista Terrace, Sierra Madre (1910). Eschewing a hierarchy based on class or function was seen by Gill as a commitment to democratic values. At a time when the use of reinforced concrete was still a novelty, concrete became Gill's favourite material as it can be easily moulded, is durable and is conducive to attaining simple effects. He also refined tilt-slab construction techniques and developed his own steel door and window casings, bull noses and lath.

Gill sought to revitalize what he regarded as long-standing values. His imagery owes a major debt to Spanish architecture in California and to traditional work in the Mediterranean basin. He intended the plainness of exterior surfaces to be softened by vines and extensive surrounding foliage, and aimed to foster an atmosphere of home life not only in all types of house but also in churches, clubs and schools.

WRITINGS
'The Home of the Future: The New Architecture of the West: Small Homes for a Great Country', *Craftsman*, xxx (1916), pp. 140–51, 220

BIBLIOGRAPHY
'A New Architecture in a New Land', 'The Bishop's School for Girls: A Progressive Departure from Traditional Architecture', *Craftsman*, xxii (1912), pp. 465–73, 653–6
E. Roorbach: 'Celebrating Simplicity in Architecture', *W. Archit.*, xix/4 (1913), pp. 35–8

'Talkative Houses: The Story of a New Architecture in the West', *Craftsman*, xxviii (1915), pp. 448–55
'Garden Apartment-houses of the West', *Architect & Engin. CA*, lviii/1 (1919), pp. 73–7
E. Roorbach: 'A California Home of Distinguished Simplicity', *House Beautiful*, xlix (1921), pp. 94–5, 142
Irving Gill (exh. cat., ed. E. McCoy; La Jolla, Mus. Contemp. A.; Los Angeles, Co. Mus. A.; 1958)
E. McCoy: *Five California Architects* (New York, 1960/R 1975), pp. 58–101
W. H. Jordy: *American Buildings and their Architects: Progressive and Academic Ideals at the Turn of the Twentieth Century* (Garden City, NY, 1972/R New York, 1986), pp. 246–71
B. Kamerling: *Irving J. Gill, Architect* (San Diego, 1993)
K. D. Stein: 'Irving Gill Reconsidered: Museum of Contemporary Art, San Diego', *Archit. Rec.*, clxxxiv (1996), pp. 88–93
T. S. Hines: *Irving Gill and the Architecture of Reform: A Study in Modernist Architectural Culture* (New York, in preparation [?1999])
<div align="right">RICHARD LONGSTRETH</div>

Gilman, Arthur Delavan (*b* Newburyport, MA, 5 Nov 1821; *d* New York, 11 July 1882). American architect, urban planner and writer. He was educated at Trinity College, Hartford, CT, travelled in Europe and practised with Boston architect Edward Clarke Cabot (1818–1901) before establishing his own office in Boston in 1857. With an article of 1844, written apparently before he had been to Europe, he became the first American architect to encourage the use of the Italian Palazzo style espoused by Charles Barry (1795–1860). He later promoted French Second Empire forms, as is evident from the mansard-roofed former Boston City Hall (1862–5; interior altered, 1969–70; now offices and restaurant), School Street, designed in partnership with Gridley J. F. Bryant. While in Boston, Gilman was responsible for the plan of the

Arthur Delavan Gilman: Harbridge House, Arlington Street, Boston, Massachusetts, 1859–60

Back Bay (1856), a residential area focused around Commonwealth Avenue, a French-inspired boulevard. He also designed several houses in this district, most notably the palazzo-like Harbridge House (1859–60; see fig.), Arlington Street, and one of Boston's major mid-19th-century churches, the brownstone Arlington Street Church (1859–61), which fused a classicism reminiscent of the work of James Gibbs (1682–1754) with an Italianate sensibility.

In 1866 Gilman moved to New York, where his most important work, one of the most significant in the history of American architecture, was the Equitable Life Assurance Company Building (1868–70, with Edward Kendall and George B. Post; destr. c. 1912), Broadway. This 35-m high, mansard-roofed Second-Empire structure, which recent research has shown had seven-and-a-half storeys, is often identified as the first skyscraper; although it had load-bearing walls, rather than a steel frame, it was the first building to exploit the elevator's potential for allowing the most prestigious offices to be on the upper floors.

WRITINGS
'Downing on Rural Architecture', *N. Amer. Rev.*, lvi (1843), pp. 1–17
'Architecture in the United States', *N. Amer. Rev.*, lviii (1844), pp. 436–80
'Landscape Gardening', *N. Amer. Rev.*, lix (1844), pp. 302–29
'The Hancock House and its Founder', *Atlantic Mthly*, xi (1863), pp. 692–707

BIBLIOGRAPHY
DAB; *Macmillan Enc. Archit.*
W. Weisman: 'Commercial Palaces of New York: 1845–1875', *A. Bull.*, xxxvi (1954), pp. 285–302
——: 'A New View of Skyscraper History', *The Rise of an American Architecture*, ed. E. Kaufmann jr (New York, 1970), pp. 113–60
S. B. Landau and C. W. Condit: *The New York Skyscraper* (New Haven and London, in preparation)

ANDREW SCOTT DOLKART

Gilmor, Robert, jr (*b* Shadwell, MD, 24 Sept 1774; *d* Baltimore, MD, 30 Nov 1848). American collector and patron. His father was Baltimore's leading merchant and financier. He was one of the first Americans to collect European and American art on a large scale. During his lifetime as many as 500 paintings and 2500 prints and drawings passed through his hands. It is estimated that he owned between three and four hundred paintings at any one time. Dutch and Flemish painting formed the bulk of his collection, but he also accumulated English, French, Spanish and Italian works, though many were of doubtful attribution. A posthumous sale catalogue listed one painting as by Raphael or Leonardo da Vinci. Gilmor began patronizing American artists in the early 1800s. An amateur landscape painter himself, he was attracted to the work of William Groombridge (*fl* 1773–96), Francis Guy, Thomas Doughty and especially Thomas Cole. He also bought from portrait painters (Charles Willson Peale, Gilbert Stuart, Thomas Sully, Henry Inman, John Wesley Jarvis and John Trumbull), as well as genre and history painters (Washington Allston, John Gadsby Chapman, Charles Cromwell Ingham and William Sidney Mount). Hoping to encourage an American school of sculpture as well as painting, he was the first to commission a large-scale work from Horatio Greenough, a recumbent *Medora* (1831–3; Baltimore, MD, Mus. A.). Gilmor was well-read in aesthetics and contemporary art literature, and his letters to Cole form an important chapter in the early history of

American taste. His collection was dispersed at two auctions some time after his death (Baltimore, F.W. Bennett, 10 Nov 1863 and 13 April 1875).

UNPUBLISHED SOURCES
Baltimore, Mus. & Lib. MD Hist. [collection of travel journals, letters, a diary and Gilmor family memorabilia]

BIBLIOGRAPHY
A. W. Rutledge: 'Robert Gilmor, Jr.: Baltimore Collector', *J. Walters A.G.*, xii (1949), pp. 18–39
H. S. Merritt, ed.: 'Correspondence between Thomas Cole and Robert Gilmor, Jr.', *Baltimore Annu.*, ii (1967), pp. 41–102
A. Wallach: '"This is the Reward of Patronising the Arts": A Letter from Robert Gilmor, Jr., to Jonathan Meredith, April 2, 1844', *Amer. A. J.*, xxi/4 (1989), pp. 76–7
E. B. Smith: 'The Earliest Private Collectors: False Dawn Multiplied', *Medieval Art in America: Patterns of Collecting, 1800–1940* (exh. cat., ed. E. B. Smith and others; University Park, PA State U., Palmer Mus. A., 1996), pp. 23–33

ALAN WALLACH

Glackens, William J(ames) (*b* Philadelphia, PA, 13 March 1870; *d* Westport, CT, 22 May 1938). American painter and illustrator. He graduated in 1889 from Central High School, Philadelphia, where he had known Albert C. Barnes (1872–1951), who later became a noted collector of modern art. He became a reporter–illustrator for the *Philadelphia Record* in 1891 and later for the *Philadelphia Press*. In 1892 he began to attend evening classes in drawing at the Pennsylvania Academy of Fine Arts, studying under Thomas Anshutz. In the same year he became a friend and follower of Robert Henri, who persuaded him to take up oil painting in 1894. Henri's other students, some of whom were referred to as the Ashcan school, included George Luks, Everett Shinn and John Sloan, also artist–reporters; together with Henri they formed the nucleus of THE EIGHT (ii).

Glackens and Henri shared a studio in Philadelphia in 1894 and travelled together in Europe in 1895. On returning to the USA in 1896, Glackens followed Henri's lead in moving to New York and supported himself by producing illustrations for the *New York World* and the *New York Herald*, as well as through book illustrations. In 1898 he and Luks went to Cuba to report on the Spanish–American War for *McClure's Magazine*. On his return to New York, Glackens began to concentrate increasingly on painting. For subject-matter he turned to city parks and café scenes. Like Henri, he admired Diego Velázquez (1599–1660) and James McNeill Whistler and adopted the broad brushstrokes of Frans Hals (1581/5–1666) and Edouard Manet (1832–83). He was particularly drawn to the theatrical aspects of urban life, as in *Hammerstein's Roof Garden* (1902; New York, Whitney).

By 1905 Glackens had adopted a style of high-keyed Impressionism, seen in *Chez Mouquin* (1905; Chicago, IL, A. Inst.). This painting, inspired by *A Bar at the Folies-Bergère* by Manet, shows James B. Moore, owner of the Café Francis where the Ashcan painters often met. With him is one of his 'daughters', as he called his numerous young female companions, at Mouquin's, a French restaurant under the Sixth Avenue elevated railway in New York. In the mirror behind the couple can be seen Glackens's wife, Edith, and his future brother-in-law, Charles Fitzgerald, a critic for *The Sun*. The painting is one of several attempts on the part of the Ashcan painters to depict

themselves in bohemian American settings (compare, for example, John Sloan's *Yeats at Petitpas'*, 1910; Washington, DC, Corcoran Gal. A.).

Glackens became increasingly interested in the way in which Auguste Renoir (1841–1919) used colour, seen for the first time in *Nude with Apple* (1910; New York, Brooklyn Mus.), and soon discarded urban themes in favour of studio models, still-lifes, landscapes and seaside subjects, for example *Bathers at Bellport* (1912; Washington, DC, Phillips Col.). In 1910 Glackens was contacted by Barnes. Glackens urged him to consider collecting Impressionist and Post-Impressionist paintings instead of those of the Barbizon school, as he had been doing. Barnes agreed and in 1912 sent Glackens to France with $20,000 to buy art for him as he saw fit. Glackens returned with works by Cézanne (1839–1906), Renoir, Degas (1834–1917), van Gogh (1853–90), Monet (1840–1926), Gauguin (1848–1903), Sisley (1839–99), Camille Pissarro (1830–1903), Seurat (1859–91) and others, forming the nucleus of the Barnes Foundation Collection in Merion Station, PA. In 1913 Glackens served as Chairman for selecting American art for the Armory Show, in which he also exhibited.

WRITINGS

'The American Section: The National Art', *A. & Dec.*, iii (March 1913), pp. 159–64
'The Biggest Exhibition in America', *Touchstone*, i (June 1917), pp. 164–73, 210

BIBLIOGRAPHY

I. Glackens: *William Glackens and the Ashcan Group: The Emergence of Realism in American Art* (New York, 1957)
W. I. Homer: *Robert Henri and his Circle* (Ithaca, 1969)
B. B. Perlman: *The Immortal Eight* (Westport, 1979)
J. Zilczer: 'The Eight on Tour, 1908–1909', *Amer. A. J.*, xvi (Summer 1984), pp. 20–48
R. J. Wattenmaker: 'William Glackens's Beach Scenes at Bellport', *Smithsonian Stud. Amer. A.*, ii/2 (1988), pp. 75–95
William Glackens: The Formative Years (exh. cat., New York, Kraushaar Gals, 1991)
T. Glackens: *William Glackens and the Eight: The Artists who Freed American Art* (New York, 1992)
W. H. Gerdts: *William Glackens* (exh. cat., Fort Lauderdale, FL, Mus. A., 1996)

M. SUE KENDALL

Goddard, John (*b* Dartmouth, MA, 20 Jan 1723; *d* Newport, RI, 9 July 1785). American cabinetmaker. His father, Daniel Goddard, a housewright, shipwright and carpenter, moved his family to Newport, RI, soon after John's birth to join the Quaker community there. At probably age 13 John began an eight-year apprenticeship to Job TOWNSEND. He became a freeman about 1745 and married Hannah Townsend, the daughter of his employer. Three years later he purchased a large house in Newport and opened a cabinetmaking shop adjacent to it. The shop had five work benches, and he apparently employed his sons to help him. At least three of them—Townsend Goddard (1750–90), Stephen Goddard (1764–1804) and Thomas Goddard (1765–1858)—went on to set up their own shops.

By the 1760s Goddard was at the peak of his career and counted among his prominent customers the wealthy Brown family of merchants from Providence and Stephen Hopkins, the Governor of Rhode Island. In the early 1780s Goddard paid taxes at about half the rate of John Townsend, then the most prosperous cabinetmaker in Newport, but more than any of the other members of the Goddard and Townsend families.

Goddard made a wide range of furniture, including three signed, slant-lid desks with blocked fronts and shell carvings (e.g. of 1765–75; Providence, RI Hist. Soc.; see fig.), but it is uncertain whether he made any of the great block and shell bookcase-desks once ascribed to him. Nevertheless, he and John Townsend were the leaders of the distinguished Newport school of cabinetmaking. Goddard came on hard times during the American Revolution, and his will indicates that he became bankrupt. The business was carried on by Stephen and Thomas Goddard until 1804. Stephen's son, John Goddard jr (*d* 1843), also worked as a cabinetmaker.

BIBLIOGRAPHY

M. Swan: 'The Goddard and Townsend Joiners', *Antiques*, xlix (1946), pp. 228–31, 292–5

John Goddard: slant-lid desk, mahogany, 2652×1067×660 mm, *c.* 1760 (Providence, RI, Rhode Island Historical Society)

M. Moses: *Master Craftsmen of Newport: The Townsends and Goddards* (Tenafly, NJ, 1984)

OSCAR P. FITZGERALD

Godefroy, (Jean Maur) Maximilian (*b* Paris, 1765; *d* Paris, 1848). French architect and draughtsman, active in the USA, England and France. All that is known of the first 40 years of Godefroy's life is that he served 18 months in the army, probably practised engineering briefly and spent 19 months in Napoleonic prisons before being exiled to the USA. He arrived in New York on 26 April 1805 and in December took up a post as drawing-master at the college founded by the Sulpicians of St Mary's Seminary in Baltimore. His modest competence in drawing, evident in several works in pencil and pen, bistre and coloured washes, suggests training. A few are landscapes and one, the *Battle of Pultowa* (1804–5; Baltimore, MD Hist. Soc. Mus.), is a historical composition, but most are Neo-classical designs, for example for diplomas, employing allegorical subject-matter. Godefroy's importance lies in his introduction of recent French ideas in the buildings he designed and built in Baltimore. He began to study architecture *c*. 1803, probably by self-instruction from books; the theory concerning expression of purpose by Jacques-François Blondel (1705–74) and the methods of planning and of composing elevations advocated by Jean-Nicolas-Louis Durand (1760–1834) had the greatest influence on him. Godefroy's chapel (1806–8) for St Mary's Seminary, Baltimore, the first ecclesiastical structure in the USA to have Gothic detailing, employs pointed and circular openings to suggest, in Blondel's manner, a character appropriate for this building dedicated to the Virgin. Along with some interior decoration, its planning is indebted to Durand in the grouping of vestibules, sacristy and collegians' chamber around the nave and sanctuary. In the Battle Monument (1815–25), Baltimore, Godefroy used Egyptian elements to commemorate the deaths of the defenders of Baltimore during the War of 1812. Battered walls and doors, cavetto cornices and sun-discs form the base for a large fasces and sculptured personification of the city. A severe Neo-classicism marks his masterpiece, the Unitarian Church (1817–18; altered) in Baltimore, where the entry, auditorium, sanctuary and service rooms fit into a compact geometrical composition. A block topped by a dome, entered through a recessed vestibule behind an Italianate column screen with arches, it resembles work of Claude-Nicolas Ledoux (1736–1806); the publication by Charles Percier (1764–1838) and Pierre-François-Léonard Fontaine (1762–1853) of Renaissance buildings of Rome supplied designs for doors and other details of this house for a modern religion. Both the Seminary chapel and the Unitarian Church had symbolic ornament inside, while column screens and piers, curving surfaces and the play of light and shadow enriched the interior spaces.

In August 1819 Godefroy moved to London, where he exhibited drawings at the Royal Academy (1820–24). He won third premium in the competition of 1821 for Salters' Hall (1823–7; destr. World War II), London, and some elements of his design were probably incorporated into the building by the company's surveyor, Henry Carr (*c*. 1772–1828). He also designed a Catholic Charities School

(1825–6; destr. World War II) in Clarendon Square, London. In January 1827 Godefroy returned to Paris and was soon appointed as municipal architect in Rennes, where he was occupied with minor works and repairs (1827–8). In January 1829 he became architect of the département of Mayenne, residing in Laval. Here he renovated the Palais de Justice (a 16th-century castle) and added a wing (1829–36) consistent with the earlier style. His monumental arched entry, service buildings and enclosure walls (1831–9) at the Préfecture in Laval, and, in nearby Mayenne, the Asile de la Roche-Gandon (1829–36), show his manner after returning to France. In these late works Godefroy employed a spare classical vocabulary and, through string courses and emphatic quoining at corners and openings, achieved the expression of structural strength. The eclectic use of historic styles to express a character reminiscent of Blondel, prominent in his early works, receded before the increased impact of Durand's compositional practices.

BIBLIOGRAPHY

Colvin; *Macmillan Enc. Archit.*

D. M. Quynn: 'Maximilian and Eliza Godefroy', *MD Hist. Mag.*, lii (1957), pp. 1–34 [biography]

R. L. Alexander: 'The Drawings and Allegories of Maximilian Godefroy', *MD Hist. Mag.*, liii (1958), pp. 17–33

——: *The Architecture of Maximilian Godefroy* (Baltimore, 1974)

ROBERT L. ALEXANDER

Goodhue, Bertram (Grosvenor) (*b* Pomfret, CT, 28 April 1869; *d* New York, 23 April 1924). American architect and illustrator. In 1884 Goodhue moved to New York, where he entered the office of Renwick, Aspinwall & Russell as an office boy. In 1891 he won a competition to design a proposed cathedral in Dallas but joined the office of Cram & Wentworth in Boston as chief draughtsman and informal partner. Goodhue worked in partnership with RALPH ADAMS CRAM from 1892 to 1913, designing a remarkable series of Gothic Revival churches.

In 1892 he became a full partner in Cram, Wentworth & Goodhue, which, after the death of Charles Wentworth (1861–97) and his replacement by Frank Ferguson (1861–1926), became in 1898 Cram, Goodhue & Ferguson.

Before Goodhue's arrival, Cram & Wentworth had already begun work on All Saints at Ashmont, Boston, their first major work. The final design clearly derives from their earlier proposal of 1890, but Cram's strong masses were enlivened by Goodhue's eloquent details and their talents clearly complemented each other. In their crusade for good church design, they collaborated on *Church Building* (1901), for which Cram wrote the text and Goodhue prepared the sketches. Cram's books and Goodhue's sketches stimulated an interest in church design and during the 1890s they worked on a series of churches, notably All Saints (1894), Brookline, MA, Our Saviour's (1897), Middleborough, MA, and St Stephen's (1899), Cohasset, MA.

Between 1896 and 1899 Goodhue executed a series of drawings of three imaginary locations. These three drawings, *Traumburg* (1896), *The Villa Fosca and its Garden* (1897) and the town of *Monteventoso* (1899), are highly romantic and embody many of the themes of Goodhue's executed work, such as the integration of buildings and landscape.

Bertram Goodhue: interior of the Chapel of the Intercession, New York, 1910

In 1902 Goodhue designed El Forcidis, Montecito, CA, a house and estate conceived as a Mediterranean villa with Persian gardens. The commission was for James Gillespie, with whom, in preparing for the work, Goodhue travelled on horseback from the Caspian Sea to the Persian Gulf, visiting Samarkand. The trip provided inspiration for much of Goodhue's later work, particularly his garden designs for Sweet Briar College (1902), VA, Rice University (1910), Houston, and the Panama–California Exposition (1911–15).

In 1903 the firm achieved national fame with their winning entry for the competition for extensive work at the US Military Academy at West Point, NY. The buildings were acclaimed, particularly the chapel, designed primarily by Goodhue and picturesquely sited along the Hudson River, and the riding hall, designed primarily by Cram. An office was set up in New York under Goodhue's direction, but the partners' separation, their strong personalities and contentious office staff led to the partnership being dissolved in 1913.

During the decade 1903–13 Goodhue developed his independent ability as a church architect, as the New York office took the lead in the design of a number of church buildings following his West Point Chapel. These include St John's (1907), West Hartford, CT, Christ Church (1908), West Haven, CT, and the First Baptist Church (1909), Pittsburgh, PA. The Chapel of the Intercession (1910), Broadway and 155th Street, New York, is an imaginative Gothic Revival design, with dramatic massing, that exploits its semi-rural location within a cemetery. The interior illustrates Goodhue's command of Gothic detail and

decoration (see fig.), still very much in the style of Cram. Increasingly, however, his best work was secular. The Aldred House (1913), Locust Valley, NY, and the Taft School (1908), Watertown, CT, are both Gothic Revival. In 1911–15 Goodhue was consulting architect for the Panama–California Exposition in San Diego. He designed the overall plan and many individual buildings in a picturesque early Mexican style.

BIBLIOGRAPHY

M. Schuyler: 'The Words of Cram, Goodhue and Ferguson', *Archit. Rec.*, xxix (1911), pp. 1–112
A Book of Architectural and Decorative Drawings by Bertram Grosvenor Goodhue (New York, 1914)
C. H. Whitaker, ed.: *Bertram Grosvenor Goodhue: Architect and Master of Many Arts* (New York, 1925/R 1976)
Book Decorations by Bertram Grosvenor Goodhue (New York, 1931)
R. Oliver: *Bertram Grosvenor Goodhue* (New York and Cambridge, MA, 1983)
C. Bargellini: 'Arquitectura colonial, hispano colonial y neocolonial· Arquitectura americana?', *Arte, historia e identidad en America: Visiones comparativas*, ed. G. Curiel, R. Gonzalez Mello and J. Gutierrez Haces (Mexico City, 1994), pp. 419–29

DOUGLASS SHAND-TUCCI

Gorham. American silverware firm formed in 1831 by Jabez Gorham (*b* Providence, RI, 18 Feb 1792; *d* Providence, 24 March 1869). When he was fourteen Gorham began a seven-year apprenticeship with Nehemiah Dodge (*fl* 1794–1807), a Providence silversmith. He completed his training in 1813 and in the same year opened a jewellery business known as 'The Firm', which lasted until 1818, when economic hardships led to its dissolution. Jabez continued in business in Providence throughout the 1820s, and in 1831 he expanded his production to include the manufacture of coin-silver spoons with Henry Webster (1808–65). In 1837 William G. Price (*d* 1839) also became a partner in what became known as Gorham, Webster & Price, and in 1841 Gorham brought his son, John Gorham (1820–98), into the business under the name J. Gorham & Son. They expanded their line of flatware to include forks, tongs, thimbles, nursing tubes, toiletries and other small articles, sold mainly through the shop and a network of travelling peddlers. By 1847 John Gorham's ambitious plans for the company included the acquisition of larger working space and steam-powered machinery. Jabez Gorham retired in 1848. In 1850 John Gorham made his cousin, Gorham Thurber (1825–88), partner, and the company became known as Gorham & Thurber, producing hollowware and flatware using machines and new technology. In 1865 the firm was incorporated as the Gorham Manufacturing Co., and in the same year electroplating was introduced. In 1868 the English silversmith Thomas Joseph Pairpoint (*fl* 1860–80) joined the company and designed wares in a High Victorian style (e.g. Furber Service, 1873; Providence, RI, Gorham Col.). Gorham went bankrupt in 1877 and was forced to resign, but the company continued to produce wares in revival styles. During the 1890s Art Nouveau wares were produced and the Martelé (hammered) line of silverware and jewellery was introduced.

BIBLIOGRAPHY

D. T. Rainwater: *Encyclopedia of American Silver Manufacturers* (West Chester, 1966, rev. 3/1986)

H. N. Flynt and M. G. Fales: *The Heritage Foundation Collection of Silver, with Biographical Sketches of New England Silversmiths, 1625–1825* (Old Deerfield, 1968), p. 230

C. H. Carpenter jr: *Gorham Silver, 1831–1981* (New York, 1982)

Silver in America, 1840–1940: A Century of Splendor (exh. cat. by C. L. Venable, Dallas, Mus. A., 1994)

GERALD W. R. WARD

Goudy, Frederic William (*b* Bloomington, IL, 8 March 1865; *d* Marlboro-on-Hudson, NY, 11 May 1947). American typographer, printer and graphic designer. He demonstrated his interest in letter forms when a child, cutting out 3000 in paper. While working as a clerk in Boston, he discovered the Kelmscott Press. In 1895 Goudy founded the Booklet Press, a small printing shop, later renamed the Camelot Press. In 1896 he designed his first type, called Camelot, and in 1899 set up as a freelance designer, producing book designs and advertising lettering. His Village Press printed two books before 1904 when he moved to Hingham, MA, where a further nine books were produced over the next two years. The establishment of the press in New York was followed by a fire (January 1908) in which all Goudy's property was lost. From this point he abandoned general printing in favour of type design. A trip to Europe in 1909 enabled him to study inscriptions. His first two types to achieve serious recognition and success were Kennerley and Forum, an inscriptional titling letter. His output was prolific: 122 different types are discussed in his autobiography, many of which were widely used and highly successful in his lifetime. The Grolier Club of New York and the American Institute for Graphic Art devoted exhibitions to his work (1923, 1933).

WRITINGS

The Alphabet (New York, 1918)/*R* with *The Elements of Lettering* (Berkeley and London, 1942)

The Elements of Lettering (New York and London, 1922)

Typologia (Berkeley, 1940)

A Half-century of Type Design and Typography, 1895–1945 (New York, 1946)

BIBLIOGRAPHY

V. Orton: *Goudy, Master of Letters* (Chicago, 1939)

P. Beilenson: *The Story of Frederic W. Goudy* (New York, 1965)

E. H. Emmons: *Goudy in Rhyme* (Pittsburgh, 1967)

LAURA SUFFIELD

Grand Rapids. American city in western Michigan, noted for its furniture production. Its situation at the rapids of the Grand River provided ease of river transportation and proximity to timber from Michigan's great pine and hardwood forests. The furniture industry began in Grand Rapids when the city's first cabinetmaker, William 'Deacon' Haldane (1807–98), established a shop there in 1836. By 1851 E. M. Ball of Powers & Ball was boasting that he could toss 'whole trees into the hopper and grind out chairs ready for use' to fill an order for 10,000 chairs in Chicago (Ransom, p. 5). In the 1870s Grand Rapids became a major factor in the American furniture market. Such companies as Berkey & Gay, Widdicomb, Phoenix and Nelson-Matter built large factories and hired Dutch and other European immigrants to operate them. While most of these manufacturers produced complete lines of bedroom, parlour and dining-room suites, some, like the Grand Rapids Chair Co. (established 1872), became large concerns by concentrating on a single product. To support these firms, smaller enterprises sprang up to produce such speciality items as castors, glue, finishes, veneer, carved ornaments, tools and packing materials.

After the Panic of 1873, almost half the firms in the city went bankrupt; it took several years for expansion to return. Grand Rapids manufacturers gained national recognition for high-quality furniture at the Centennial International Exhibition of 1876 in Philadelphia, where three firms won awards. To showcase new lines, Grand Rapids manufacturers came up with the innovative idea of semi-annual furniture exhibitions. Beginning in the 1870s, these fairs attracted salesmen and exhibitors from all over the country. By 1880 Grand Rapids had developed a nationwide reputation for quality and shipped furniture all over the world. Between 1880 and 1890 the value of furniture produced grew rapidly, and the city moved from seventh to third behind only New York and Chicago.

In the forefront of furniture design, Grand Rapids manufacturers responded quickly to changes in public taste. After the Civil War, high-quality Renaissance Revival styles competed with the Rococo Revival lines popular before the war. By the 1870s factories began making the Eastlake or Modern Gothic line. In the 1890s production of 18th-century style English, French and American Colonial Revival furniture predominated. Before World War I the Stickley Bros Co. produced oak Mission furniture.

BIBLIOGRAPHY

F. E. Ransom: *The City Built on Wood: A History of the Furniture Industry in Grand Rapids, Michigan, 1850–1950* (Ann Arbor, 1955)

K. L. Ames: 'Grand Rapids Furniture at the Time of the Centennial', *Winterthur Port.*, x (1975), pp. 25–50

C. Carron: *Grand Rapids Furniture: The Story of America's Furniture City* (Grand Rapids, 1998)

OSCAR P. FITZGERALD

Greek Revival. Term used to describe a style inspired by the architecture of Classical Greece that was popular throughout Europe and the USA in the early 19th century, especially for the design of public buildings; it was also employed for furniture and interior design. Its gradual spread coincided with and was dependent on the growth of archaeology in Greece in the 18th and 19th centuries. Such archaeologist-architects as James Stuart (1713–88), known as 'Athenian' Stuart in his lifetime, and Nicholas Revett (1720–1804), William Wilkins (1778–1839) and C. R. Cockerell (1788–1863) in England, Jacques-Ignace Hittorff (1792–1867) and Henri Labrouste (1801–75) in France and Leo von Klenze (1784–1864) in Germany were responsible for generating a remarkably selfconscious architectural revival; Cockerell used the term 'Greek revival' at least as early as 1842 in his lectures delivered as Professor of Architecture at the Royal Academy.

The Greek Revival was enthusiastically adopted throughout Europe and the USA by architects who were anxious to express a growing sense of national identity. The forms of Greek architecture, unused from the ancient world to the 18th century, were free of all association with the aristocratically and ecclesiastically organized institutions of Europe before 1789. Nowhere was this freedom more appreciated than in the USA after the signing of the Declaration of Independence in 1776 and the close of the revolutionary war seven years later. The Greek Revival in the USA began in earnest with Benjamin Henry Latrobe's Bank of Pennsylvania (1799–1801; *see* FEDERAL STYLE,

fig. 1) in Philadelphia, the capital of the nation from 1790 to 1800. This austere Greek Ionic temple of commerce was effective as a durable symbol of the wealth and probity of the new democrats. At the Capitol in Washington, DC (*see* WASHINGTON, DC, fig. 5), Latrobe provided further poetic statements of the power of Greek architecture to express the freshness and gravity of the American experiment. As a result, Thomas Jefferson himself wrote to Latrobe in July 1812 (Washington, DC, Lib. Congr.) that the Capitol was 'the first temple dedicated to the sovereignty of the people, embellishing with Athenian taste the course of a nation looking far beyond the range of Athenian destinies'. Jefferson must have had in mind such interiors by Latrobe as the House of Representatives (completed 1811), with 24 columns inspired by those of the choregic monument of Lysikrates, and the Supreme Court Chamber (1809; rebuilt 1815–17; see fig.), where primitive Greek Doric columns support a trio of arches beneath a half umbrella-dome, a haunting disposition recalling the dreams of Ledoux, Soane and Gilly.

Although there were numerous skilled architects ready to follow Latrobe's path, especially his pupils Robert Mills and William Strickland, and Strickland's pupil Gideon Shryock, none had quite his ability. This resulted in the first half of the 19th century in an astonishing number of competent Greek Revival buildings expressing high ideals of civic order, which were supposedly in conformity with those of Athens in the 5th century BC. Mills made his name with the Washington Monument at Baltimore, MD (1813–42; *see* MILLS, ROBERT, fig. 2), an unfluted Greek Doric column of tremendous height. The most characteristic examples of the new style are the government buildings in Washington, DC, which include the Federal Treasury and Patent Office (both begun 1836) and Old Post Office (1839–42) by Mills. Scarcely less imposing was Strickland's contribution to Philadelphia, where his Second Bank of the United States (1818–24; *see* STRICKLAND, WILLIAM, fig. 1), built in marble, echoes the Parthenon, and his Philadelphia (or Merchants') Exchange (1832–4) boasts an elegant semicircular colonnade surmounted by a lantern based on the choregic monument of Lysikrates. A later work, the Tennessee State Capitol (1845–59; *see* STRICKLAND, WILLIAM, fig. 3), Nashville, had isolated Picturesque elements hinting at the subsequent development of Greek Revival forms. Greek Revival was also widely popular for domestic architecture in the USA, as can be seen, for example, in Andalusia, a house near Philadelphia remodelled in 1831 for Nicholas Biddle. Here the architect THOMAS U. WALTER, who designed a wing in the form of the Hephaisteion, provided a worthy parallel to Wilkins's Grange Park for a remarkable patron who believed that 'there are but two truths in the world—the Bible and Greek architecture' (Crook, p. 41). These buildings were designed in what became the international language of architecture, which was widely adopted in the early 19th century not only in America but also by countless European architects for modernizing European cities with public buildings and urban-planning schemes.

BIBLIOGRAPHY

T. Hamlin: *Greek Revival Architecture in America* (New York, 1944/R 1966)

D. Wiebenson: *Sources of Greek Revival Architecture* (London, 1969)

J. M. Crook: *The Greek Revival* (London, 1972)

D. Van Zanten: *The Architectural Polychromy of the 1830s* (New York, 1977)

R. G. Kennedy and M. Bendtsen: *Greek Revival America* (New York, 1989)

Benjamin Henry Latrobe: interior of the Supreme Court Chamber (1809; rebuilt 1815–17), US Capitol Building, Washington, DC

P. McDowell and R. E. Meyer: *The Revival Styles in American Memorial Art* (Bowling Green, OH, 1994)

<div align="right">DAVID WATKIN</div>

Greene, John Holden (*b* Warwick, RI, 2 Sept 1777; *d* Providence, RI, 6 Sept 1850). American architect–builder. He had little formal education and gained his architectural knowledge through apprenticeship, from British and American pattern-books and from contemporary buildings in Boston, MA. In 1794 he went to Providence, RI, where he apprenticed himself to Caleb Ormsbee, then the city's principal architect–builder. He continued to work for Ormsbee after completing his training and was active independently from *c.* 1806 to 1835. His reputation as an innovative designer emerged in two early Providence commissions, St John's Episcopal Church (1809–10) and the Sullivan Dorr House (1810–11). St John's introduced a 'Gothick' vocabulary adapted from mid-18th-century English pattern-books such as those by Batty Langley (1696–1751). Greene blended Gothick details with those probably derived from pattern books by William Pain (*c.* 1730–*c.* 1804), which were in turn reminiscent of the work of Robert Adam (1728–92). This amalgam appeared on the Dorr House, where he sited an L-shaped plan on a terrace on a steep slope. He repeated this striking formula on a number of occasions.

Greene built many three- and five-bay detached houses with hipped roofs between 1810 and 1830. The smaller ones were timber-framed; the larger ones, such as the Truman Beckwith House (1827–8), Providence, RI, were of brick. He apprenticed a considerable number of carpenters and builders during the course of his career. This, and his influential designs, ensured the proliferation of an identifiable local architecture during the first third of the 19th century in Providence. In addition to his work there, Greene was responsible for the Independent Presbyterian Church (1817–19; rebuilt 1891) in Savannah, GA, and he may have designed other buildings during his stay in the South.

<div align="center">BIBLIOGRAPHY</div>

Macmillan Enc. Archit.
F. D. Hurdis: *John Holden Greene: Carpenter–architect of Providence* (Providence, 1972)
——: *The Architecture of John Holden Greene* (diss., Ithaca, NY, Cornell U., 1973)

<div align="right">W. McKENZIE WOODWARD</div>

Greene & Greene. American architectural partnership formed in 1893 by Charles (Sumner) Greene (*b* Brighton, OH, 12 Oct 1868; *d* Carmel, CA, 11 June 1957) and his brother Henry (Mather) Greene (*b* Brighton, OH, 23 Jan 1870; *d* Pasadena, CA, 2 Oct 1954). Both studied at the Manual Training School of George Washington University, Washington, DC, Charles entering in 1883 and Henry in 1884. There they were not only taught woodworking and carpentry but were introduced to the ideals of John Ruskin (1819–1900) and William Morris (1834–96), to which the school strongly adhered. In 1888 they entered the Massachusetts Institute of Technology, Cambridge. On completion of the two-year architectural course, Henry entered the office of Shepley, Rutan & Coolidge in Boston, MA, and Charles became a draughtsman with H. Langford Warren. Later Henry worked in the office of Chamberlin & Austin, and Charles with Winslow & Wetherell.

In the early 1890s the Greenes' parents moved to Pasadena, CA, and suggested that their sons join them in the new and developing city, which they did in 1893; *en route* they visited the World's Columbian Exposition at Chicago, where they saw the Ho-o-den, a traditional Japanese pavilion that later influenced their designs for the California bungalow and its garden. They opened a small architectural office in Pasadena in 1893 and slowly began to build up a clientele. Their work of the first ten years was professionally competent but not distinguished. Their designs ran the full gamut from Colonial Revival to Mission Revival to versions of the Shingle style and to what was referred to locally as the Rustic style. The strongest of these early designs was the Mission-style Hosmer House (1896) and the Colonial Revival Swan House (1895), both in Pasadena.

After 1900 striking changes took place in the Greenes' work. In part the brothers were responding, like a number of other southern Californian architects, to the developing American Arts and Crafts movement, coupled with a fascination with California's Hispanic architecture of the late 18th century and the early 19th. In 1903 they brought together these elements in the Bandini House, Pasadena. The single-storey, U-shaped corridor house was clad in board-and-batten siding covered by a wood shingle roof and visually held to the ground by stout river-boulder fireplaces and chimneys. The concept of the Bandini House was Hispanic, but its rustic character was derived from the Arts and Crafts movement.

The Greenes continued to amalgamate these two sources into an informal Shingle-style dwelling that retained the indoor–outdoor relationship of the Hispanic house. This developed through the White House, the Sandborn House and the Claypole House, all built in Pasadena in 1903, the last in particular epitomizing the emerging bungalow type. The Greenes rapidly perfected their version of the California bungalow: an informal

Greene & Greene: Pratt House, North Foothill Road, Ojai, California, 1909

timber dwelling, in which the rustic was refined through impeccably crafted materials and details. Their interest in refinement led them to the traditional Japanese house with its meticulous wood detailing, and their next houses displayed timber jointing, panelling and cabinetwork, often carried out by one of the brothers, which remain high-points of wood construction. A series of what Randall Makinson called 'ultimate bungalows' followed in quick succession: the Tichenor House (1904), 582 East Ocean Boulevard, Long Beach, CA; the Blacker House, 1177 Hillcrest Avenue, Pasadena; the Gamble House (1908; see colour pl. IV, 2), 4 Westmoreland Place, Pasadena; and the Pratt House (1909; see fig.), Ojai, CA.

After 1910 the Greenes' commissions diminished. Although they continued to design timber bungalows, their strongest designs of this period turned towards Mediterranean and Hispanic traditions. The Culbertson House (1911), 1188 Hillcrest Avenue, Pasadena, not only has stucco walls and a tile roof but is set within a hillside Mediterranean-style garden. Although the Greenes did not invent the California bungalow, they transformed it into an acknowledged high-art product. Like other American adherents of the Arts and Crafts movement, they believed passionately in the ideal of democracy and had reservations about the uneven distribution of wealth within capitalism; they were also sceptical of the impact of the machine. Yet ironically many of the brothers' designs were for wealthy clients. The garden settings of most were made feasible by the automobile, since bungalows with such areas of land were outside the city.

WRITINGS
C. S. Greene: 'Bungalows', *W. Architect*, xiii/1 (1908), pp. 3–5, pls 1–9
——: 'Impressions of Some Bungalows and Gardens', *Homes & Grounds*, 1 (1916), pp. 9–11
——: 'Architecture as a Fine Art', *The Architect*, xiii/4 (1917), pp. 217–22

BIBLIOGRAPHY
A. C. David: 'An Architect of Bungalows in California', *Archit. Rec.*, xx/4 (1906), pp. 306–15
'California's Contribution to a National Architecture: Its Significance and Beauty as Shown in the Work of Greene and Greene', *The Craftsman*, xxii/5 (1912), pp. 532–46
L. M. Yost: 'Greene and Greene of Pasadena', *J. Soc. Archit. Historians*, ix (1950), pp. 11–19
C. Lancaster: 'Some Sources of Greene and Greene', *J. Amer. Inst. Architects*, 34 (1960), pp. 34–46
R. Makinson: 'Greene and Greene', *Five California Architects*, ed. E. McCoy (New York, 1962), pp. 102–47
W. H. Jordy: *American Buildings and their Architects: Progressive and Academic Ideals at the Turn of the Twentieth Century* (New York, 1972), pp. 217–45
W. Current and K. Current: *Greene and Greene, Architects in the Residential Style* (Fort Worth, 1974)
J. Strand: *A Greene and Greene Guide* (Pasadena, 1974)
R. Makinson: *Greene and Greene*, 2 vols (Salt Lake City, 1977–9)
Last of the Ultimate Bungalows: The William R. Thorsen House of Greene and Greene (exh. cat. by E. R. Bosley, R. J. Clark and R. L. Makinson, Berkeley, CA, Thorsen/Sigma Phi House, 1996)

DAVID GEBHARD

Greenough. American family of sculptors.

(1) Horatio Greenough (*b* Boston, MA, 6 Sept 1805; *d* Somerville, MA, 18 Dec 1852). Sculptor and writer. He was brought up in a wealthy, cultured home and was given a classical education. He drew and modelled from engravings and antique plaster casts in the Boston Athenaeum and studied with the French sculptor J. B. Binon (*fl* 1818–20) in Boston. After graduating from Harvard, he was encouraged by Washington Allston, his first mentor and life-long friend, to go to Italy in 1825 to study ancient and Renaissance art. Influenced by the Neo-classical aesthetic of the international art community in Rome and by his studies with Bertel Thorvaldsen (1768/70–1844), he aspired to create a truly American art. In 1826, illness forced him to return home.

Greenough's first extant bust, of the Mayor of Boston, *Josiah Quincy jr* (plaster, 1827; Boston, MA, Hist. Soc.), shows a rigorous application of Neo-classical ideals. The life-size bust of the US President, *John Quincy Adams* (marble, 1828; Boston, MA, Athenaeum), modelled from life in Washington, DC, achieved a stronger realism suited to the young American Republic. His portrait style was fully developed in the expressive life-size bust of *Samuel F. B. Morse* (1831; Washington, DC, N. Mus. Amer A.; see colour pl. XXVI, 2), an artist who shared his devotion to the cause of a national art.

On his return to Italy in 1828, Greenough had workmen at Carrara carve his busts in marble, initiating the subsequent American practice of using the finest materials and inexpensive, highly skilled labour. He settled in Florence, seeking to learn greater naturalism in the studio of Lorenzo Bartolini (1777–1850), exponent of the theory 'all nature is beautiful'. With Hiram Powers and Thomas Crawford he formed a triumvirate who led the first of two generations of American Neo-classical sculptors, most of whom followed Greenough to live in Italy as expatriates. The two putti in his first important commission (from James Fenimore Cooper, 1789–1851), *Chanting Cherubs* (1828; untraced), a theme based on a painting by Raphael (1483–1520) in the Palazzo Pitti, Florence, created a furore for their nudity when exhibited in Boston as the first sculptural group by an American. Two related compositions, *Child and Angel* (1833) and *Love Prisoner to Wisdom* (1834; both Boston, MA, Mus. F.A.), were more acceptable. They are particularly American in their use of children in a moralizing context. The new Romantic sensibility, demanding comprehensible themes and literary evocations, inspired Greenough's choice of the bride from Byron's poem *The Corsair* for the dead *Medora* (1832; Baltimore, MD, Mayor & City Council on loan to Baltimore, MD, Mus. A.). This, his first full-length ideal statue, was commissioned by Robert Gilmor jr. The majestic, striding, under life-size *Angel Abdiel* (1838; New Haven, CT, Yale U. A.G.) was inspired by Milton's *Paradise Lost*. Greenough's life-size homage to his bride, *Venus Victrix* (1839; Boston, MA, Athenaeum; see fig.), popularized representations of the female nude in America.

Greenough's ambitions were fulfilled when he became the first American from whom Congress commissioned a major monumental sculpture: *George Washington* (marble, 3.37 m, 1832–41; Washington, DC, N. Mus. Amer. Hist.; *see* UNITED STATES OF AMERICA, fig. 16), intended for the Rotunda of the US Capitol. Convinced that this challenge would affect all future Americans, and that the form should follow the symbolic function, Greenough faced the dilemma of the American artist in reconciling the real and the ideal. Attempting a synthesis, he took the statue's enthroned, half-draped, god-like image from recent recon-

Horatio Greenough: *Venus Victrix*, marble, h. 1.45m, 1839 (Boston, MA, Athenaeum)

early demise at the height of his career as the first American sculptor of international renown.

During the last decade of his life, Greenough was chiefly occupied in producing influential theoretical writings. In a series of essays he expounded the dictum that 'form follows function', using architecture as his model. He wrote to Ralph Waldo Emerson:

> Here is my theory of structure: a scientific arrangement of spaces and forms to function and to site; an emphasis of features proportioned to their gradated importance in function; color and ornament to be decided and arranged and varied by strictly organic laws having a distinct reason for each decision; the entire and immediate banishment of all make-shift and make-believe.

Greenough was the first to formulate a theory of organic art, and he inspired American Functionalist aesthetics in design and architecture, later developed by Louis Sullivan and Frank Lloyd Wright.

WRITINGS
H. Bender [H. Greenough]: *The Travels, Observations and Experience of a Yankee Stonecutter* (New York, 1852/*R* Gainesville, 1958)
F. B. Greenough, ed.: *Letters of Horatio Greenough to his Brother, Henry Greenough* (Boston, MA, 1887, rev. New York, 1970)
H. A. Small, ed.: *Form and Function* (Berkeley, 1947)
N. Wright, ed.: *Letters of Horatio Greenough, American Sculptor* (Madison, 1972)
——: *Miscellaneous Writings of Horatio Greenough* (Delmar, 1975)

BIBLIOGRAPHY
H. T. Tuckerman: *A Memorial of Horatio Greenough: Memorial Selections from Writings and Tribute* (New York, 1853)
L. Taft: *The History of American Sculpture* (New York, 1930), pp. 37–56
T. B. Brumbaugh: *Horatio and Richard Greenough: A Critical Study with a Catalogue of their Sculpture* (PhD diss., Columbus, OH State U., 1955)
N. Wright: *Horatio Greenough: The First American Sculptor* (Philadelphia, 1963) [biog. and pls]
W. Craven: *Sculpture in America* (New York, 1968), pp. 100–11 [crit. appraisal and pls]
S. Crane: *White Silence: Greenough, Powers and Crawford, American Sculptors in Nineteenth-century Italy* (Coral Gables, 1972)
K. Greenthal, P. M. Kozol and J. S. Ramirez: *American Figurative Sculpture in the Museum of Fine Arts, Boston* (Boston, 1986)
A. Ponente: 'Horatio Greenough: Le origini del funzionalismo architettonico in America e il rapporto con l'Italia', *Ric. Stor. A.*, xlvii (1992), pp. 89–94

(2) Richard Saltonstall Greenough (*b* Jamaica Plain, MA, 27 April 1819; *d* Rome, 4 April 1904). Brother of (1) Horatio Greenough. He studied with Horatio in Florence in 1837. After making portrait busts in Boston (1838–48), he settled in Rome. The marble life-size bust of *Cornelia Van Rensselaer* (1849; New York, NY Hist. Soc.) typifies his tempering of the Neo-classical with a Victorian love of surface patterning and details of dress. The under life-size *Shepherd Boy with an Eagle* (1853; Boston, MA, Athenaeum) amalgamates 'high art' with genre; exhibited at the Salon in 1853, it was one of the earliest bronzes cast in America and heralded the American vogue for bronze statuettes. Boston's first major commission to an American brought the sculptor's career to its climax: *Benjamin Franklin* (bronze, over life-size, 1855; Boston, MA, Old City Hall) won acclaim for its commonsense quality, witty expression and realistic detail. His style, alternating between Victorian fussiness and the new realism, was typical of the decline of Neo-classical ideals in post-Civil War American art. Richard Saltonstall Greenough was one of the first American sculptors to live in Paris (1856–75), he

structions of Pheidias' *Olympian Zeus* and its realistic, fleshy head from the terracotta bust of *Washington* that Jean-Antoine Houdon (1741–1828) had made from life (1785; Mount Vernon, VA, Ladies' Assoc. Un.). The work attracted criticism for showing Washington as a semi-nude Classical deity. Before it was unveiled, Greenough was already at work on a second major over life-size government commission for the east portico of the Capitol. *The Rescue* (marble, 1837; Washington, DC, US Capitol, in storage) is the most complex group attempted by an American at that date and was assembled only after his

was the first to exhibit at the Salon and he was in the vanguard of the expatriates' shift of focus to that city.

BIBLIOGRAPHY

T. B. Brumbaugh: 'The Art of Richard Greenough', *Old-Time New England*, liii/3 (1963), pp. 61–78
W. Craven: *Sculpture in America* (New York, 1968), pp. 269–74
K. Greenthal, P. M. Kozol and J. S. Ramirez: *American Figurative Sculpture in the Museum of Fine Arts, Boston* (Boston, 1986), pp. 102–6

ETHELYN ADINA GORDON

Grueby, William Henry (*b* 1867; *d* 1925). American potter and ceramic manufacturer. He was apprenticed in 1882 to the J. and J. G. Low Art Tile Works, Chelsea, MA, where he remained for ten years. At the World's Columbian Exposition in Chicago in 1893, he was very impressed with the high-temperature flambé glazes of the French art pottery created by Auguste Delaherche and Ernest Chaplet (1835–1909), which encouraged Grueby's own experiments with matt, monochromatic glazes. In 1895 he set up his own factory, the Grueby Faience Co., in Boston, which produced tiles and architectural faience in Greek, medieval and Hispano-Moresque styles, popularized by the Arts and Crafts Movement. From 1897–8 he manufactured a range of vases finished in soft, matt glazes in greens, yellows, ochres and browns, with the 'Grueby Green' predominating. Until 1902 the potter George Prentiss Kendrick was largely responsible for the designs, executed in heavily potted stoneware based on Delaherche's Art Nouveau shapes. Young women were employed to carry out the hand-moulded and incised surface decoration, which consisted mainly of vertical leaf-forms in shallow relief (e.g. stoneware vase, late 19th century; London, V&A). The work was enthusiastically received by the public, and such designers as Tiffany ordered ceramic bases for their lamps. Many American workshops and factories quickly introduced matt glazes, but few could surpass the velvety perfection of Grueby's wares. Between 1900 and 1904 Grueby pottery won awards at a number of important international exhibitions, including a silver and two gold at the 1900 Exposition Universelle in Paris. Despite these successes, the firm was declared bankrupt in 1908. Grueby then opened the Grueby Faience & Tile Co. (though this was taken over in 1919 by the C. Pardee Works of Perth Amboy, NJ, which continued in the production of Grueby-style wares until the late 1920s.)

BIBLIOGRAPHY

E. Cooper: *History of World Pottery* (London, 1972/R 1988), p. 171
G. Clark: *American Ceramics: 1876 to the Present* (New York, c. 1979/R London, 1987)

Guastavino (y Moreno), Rafael (*b* Valencia, 1842; *d* Asheville, NC, 2 Feb 1908). Spanish architect and engineer, active in the USA. After winning a medal for design at the Philadelphia Centennial (1876), he settled in the USA in 1881 to develop his system of vault construction. In 1888 he was awarded the contract for the vaulting of McKim, Mead & White's Boston Public Library (*see* MCKIM, MEAD & WHITE, fig. 2), which proved a great success and launched his business. In 1899 he established the Guastavino Fireproof Construction Company. The Guastavino vault perfected the Catalan system of *bovedas tabicadas* or tile vaults, the kind used extensively by Antoni Gaudí

(1852–1926). These vaults are made of highly fired tiles laid in a herringbone pattern in a tenacious mortar; three or four layers are applied over each other, with the pattern staggered so that no joint lies over another. The strength of the Guastavino vault arises from its curvature of surface and stiffness, not from its mass as in traditional vaulting; high-quality standardized tiles were combined with very strong Portland cement mortar. The rise of Guastavino's company was closely linked with that of McKim, Mead & White, and domes with Guastavino vaults were used in that firm's New York University Library (1897), the restoration (1898–9) of Thomas Jefferson's Rotunda at the University of Virginia, the Brooklyn Museum (1903–4), New York, the Bank of Montreal (1904), New York, and the Madison Square Presbyterian Church (1905–6; destr.), New York. Guastavino's son Rafael Guastavino y Esposito (1872–1950) continued to develop the technique, as in the vast dome for the crossing of the Cathedral of St John the Divine (1908–11), New York, the largest dome ever built without scaffolding. He also worked closely with Wallace Clement Sabine (1868–1919) to develop a patented sound-absorbing masonry tile, 'Akoustolith', which was used in many churches in the 1920s.

WRITINGS

Essay on the Theory and History of Cohesive Construction (Boston, 1893)

BIBLIOGRAPHY

P. B. Wight: 'The Life and Works of Rafael Guastavino', *Brickbuilder*, x (1901), pp. 79–81, 100–02, 184–8, 211–14
G. R. Collins: 'The Transfer of Thin Masonry Vaulting from Spain to America', *J. Soc. Archit. Hist.*, xxvii (1968), pp. 176–201

LELAND M. ROTH

Gullager [Guldager], (Amandus) Christian (*b* Copenhagen, 1 March 1759; *d* Philadelphia, PA, 12 Nov 1826). American painter of Danish birth. Gullager studied at the Royal Academy of Fine Arts in Copenhagen, where he was awarded a silver medal in 1780. His earliest known portrait, of his great aunt or grandmother, *Mrs Bodel Saugaard Acke* (Denmark, priv. col.), is dated 1782. He is next recorded on 9 May 1786, when he married Mary Selman in Newburyport, MA. The portraits he painted in 1787 portray Newburyport residents and, like *Mrs Acke*, are rendered in a Danish provincial style that suggests he rejected the Neo-classical manner current in his homeland. Gullager moved to Boston by 1789, when he advertised his Hanover Street portrait studio, and worked diligently to establish a local reputation.

Gullager's most important early portrait was of *George Washington* (Boston, MA Hist. Soc.), who sat for the artist in Boston in October 1789 and again in Portsmouth, NH, that November. His portraits in the Rococo style from the 1790s suggest the influence of the Swedish painter Carl Gustaf Pilo (1711–93), whose work had been popular in Denmark during Gullager's student days. Gullager opened a studio in New York in the autumn of 1797 but moved the following year to Philadelphia, where he remained until at least 1805. After that he apparently lived in New York and may have tried his hand at scene painting.

BIBLIOGRAPHY

L. Dresser: 'Christian Gullager: An Introduction to his Life and Some Representative Examples of his Work', *A. America*, xxxvii (July 1949), pp. 105–19

Christian Gullager: Portrait Painter to Federal America (exh. cat. by M. Sadik, Washington, DC, N.P.G., 1976)

CARRIE REBORA BARRATT

H

Haberle, John (*b* New Haven, CT, 1856; *d* New Haven, 1 Feb 1933). American painter and lithographer. The son of German immigrants, he displayed an early talent for drawing. At 14 he was apprenticed to a lithographer in New Haven and subsequently earned his living in that field. His only formal training was at the New York National Academy of Design in 1884. Haberle spent most of his life in New Haven, where he was a founder of the New Haven Sketch Club (1884), gave art lessons and was active in art circles until about 1900. In the 1880s he also worked for the Peabody Museum at Yale University as a preparator and designer, occasionally drawing illustrations for its publications.

Haberle began to practise *trompe l'oeil* painting, a popular art form in America after the Civil War. Although often employing the same subject-matter as William Michael Harnett and John F. Peto, Haberle was unique in the precision of his *trompe l'oeil* paintings and in their subtle irony and wit. His humour appears in the *Bachelor's Drawer* (1890–94; New York, Met.; see colour pl. XXII, 1), which contains a conglomeration of brightly coloured playing cards, ticket stubs, photographs, letters, a cigar box top, currency and newspaper clippings, all representing aspects of a bachelor's life. They are set against the front of a bureau drawer, defying gravity, and are rendered to exact scale in realistic colours.

In 1889, when Haberle exhibited *USA* (priv. col.) at the Art Institute of Chicago, an art critic incorrectly accused Haberle, in print, of deception—of gluing objects to the canvas instead of painting them. *USA* was a *trompe l'oeil* composition of coins, frayed currency and stamps, which cleverly included a newspaper clipping referring to another composition by Haberle, *Imitation* (1887; Washington, DC, N.G.A.). The technical expertise that made such illusion possible was perhaps due to Haberle's early career as an engraver; the surface of his work is smooth, without a trace of brushwork. His *Japanese Corner* (1898; Springfield, MA, Mus. F.A.) is one of the largest *trompe l'oeil* paintings in American art (0.91×1.83 m). With dazzling verisimilitude it presents a collection of Japanese furniture, scrolls and bibelots, which were popular at the time. Haberle signed the work with an envelope stuck into the edge of the frame. Written over the typed address is 'Do Not Touch!'

Despite their apparent detachment, Haberle's paintings are highly personal, replete with subtle meanings and visual puns. They are also autobiographical, including a painted tintype photograph as a signature, letters addressed to him and readable newspaper clippings reporting on his artistic importance (e.g. '*Can you break a five?*', *c.* 1888; Fort Worth, TX, Amon Carter Mus.).

Haberle's work attracted considerable attention in the 1880s and 1890s and was exhibited widely in America. He fetched high prices from businessmen and saloon-keepers but was ignored by the artistic establishment who thought his subject-matter too commonplace. Due to failing eyesight, Haberle abandoned his career as a *trompe l'oeil* painter about 1900 and turned to undistinguished impressionistic still-lifes of flowers and animals, clay models and plaster reliefs. He died in obscurity. His work was rediscovered by A. Frankenstein in the 1950s, but in the late 20th century only about half of his known production of about 50 *trompe l'oeil* paintings had been traced; he also left quantities of small pencil sketches, some in the *trompe l'oeil* manner.

BIBLIOGRAPHY
A. Frankenstein: *After the Hunt: William Michael Harnett and other American Still-life Painters, 1870–1900* (Berkeley, 1953, rev. 2/1969)
Haberle Retrospective Exhibition (exh. cat., foreword by A. Frankenstein; New Britain, CT, Mus. Amer. A., 1962)
John Haberle: Master of Illusion (exh. cat. by G. G. Sill, Springfield, MA, Mus. F.A., 1985)
G. G. Sill: *John Haberle: Master of Illusion* (in preparation [?2000])
GERTRUDE GRACE SILL

Hadfield, George (*b* Livorno, Italy, *c.* 1763–4; *d* Washington, DC, 5 Feb 1826). American architect of English origin. After studying architecture with James Wyatt (1746–1813) in London, he received the first travelling scholarship in architecture from the Royal Academy (1790). He was, however, frustrated with his progress professionally. On the recommendation of the painter John Trumbull, then serving as Secretary to the American Minister to Great Britain, Hadfield was appointed superintendent of construction of William Thornton's US Capitol in Washington, DC. In 1795 he emigrated to the USA. While overseeing construction of the Capitol, Hadfield established a practice in Washington, in 1796 designing the first US Treasury building (destr.), the Ionic order of which was based on that of the Erechtheion, Athens. Hadfield thus shares with Benjamin Henry Latrobe the honour of bringing a true Greek Revival to the USA. Hadfield's boldest Greek Revival design was the emphatic portico he added to the Custis-Lee Mansion (1817–20) in Arlington, VA; the six massive unfluted Doric columns are modelled on those at Paestum. His most important extant buildings show his command of the Greek Revival

idiom and include his Ionic Washington City Hall, with its grand Ionic portico (1820–26; now District of Columbia Court House), and his round peripteral mausoleum for John Peter Van Ness (1826) in the Oak Hill Cemetery, Georgetown, Washington, DC.

BIBLIOGRAPHY

DAB; *Macmillan Enc. Archit.*

H. F. Cunningham: 'The Old City Hall, Washington, DC', *Archit. Rec.*, xxxvii (March 1915), pp. 268–73

G. S. Hunsberger: 'The Architectural Career of George Hadfield', *Columbia Hist. Soc. Rec.*, ci–cii (1955), pp. 46–65

D. D. Reiff: *Washington Architecture, 1791–1861: Problems in Development* (Washington, DC, 1971)

J. M. Goode: *Capitol Losses: A Cultural History of Washington's Destroyed Buildings* (Washington, DC, 1979)

LELAND M. ROTH

Hahn, William [Karl Wilhelm] (*b* Ebersbach, Saxony [now Germany], 7 Jan 1829, *d* Dresden 8 June 1887). German painter, active in the USA. He trained at the Kunstakademie in Dresden under Julius Hübner (1806–82) and Ludwig Richter (1803–84), followed by two years at the Düsseldorf Akademie. He received gold and silver medals from the Dresden Gallery in 1851. During the 1860s his paintings were exhibited in Boston, New York and San Francisco, as well as in Europe. He met a number of American artists in Düsseldorf, including William Keith, who was there during most of 1870. When Keith and his wife Elizabeth, also a painter, returned to the USA, they encouraged Hahn to join them. Hahn visited them in Maine in the autumn of 1871, and the three artists set up a studio together in the Lawrence Building in Boston for the 1871–2 season. Hahn then travelled with Keith by train to San Francisco, and by August they had separate studios in the Mercantile Library Building there.

Hahn quickly established himself as a California painter with complex urban genre scenes, such as *Market Scene, Sansome Street, San Francisco* (1872; Sacramento, CA, Crocker A. Mus.) and *Sacramento Railroad Station* (1874; San Francisco, CA, F.A. Museums). He also painted rural scenes around the state, which almost always included animals, especially white horses. Some of his paintings feature children; others draw on California themes, such as grizzly bear hunting and Mexican—American cattle ranching.

When the San Francisco art market took a major downturn in 1878, Hahn moved to New York, where he exhibited at the National Academy of Design and the Brooklyn Art Association. His *Union Square, New York City* (1878; Yonkers, NY, Hudson River Mus.) dates from the year of his move. He returned to San Francisco in late 1879 and exhibited on both coasts in 1880 and 1881. In 1882 he married Adelaide Rising, and they embarked on an extended stay in Europe, settling first in London and relocating to Dresden in 1885. Although they intended to return to California, Hahn became ill and died in Dresden. Despite spending little more than a decade in the USA and splitting his time between the coasts, he had established himself as one of the foremost late 19th-century practitioners of genre painting in America.

BIBLIOGRAPHY

William Hahn: Painter of the American Scene (exh. cat. by H. A. Smith, Yonkers, NY, Hudson River Mus., 1942)

William Hahn: Genre Painter (1829–1887) (exh. cat. by M. D. Arkelian, Oakland, CA, Mus., 1976)

M. D. Arkelian: 'William Hahn: German—American Painter of the California Scene', *Amer. A. Rev.*, iv/2 (Aug 1977), pp. 102–15

ANN HARLOW

Haidt, John Valentine (*b* Danzig [now Gdańsk, Poland], 4 Oct 1700; *d* Bethlehem, PA, 18 Jan 1780). American painter of German birth, active also in England. Born into a family of goldsmiths, he received his first training in that craft from his father. When his father became a court goldsmith in Berlin, Haidt attended his first drawing lessons at the Akademie der Bildenden Künste in that city. After a 10-year journey around Europe (1714–24), he set up his studio in London, where he joined the Moravian Church. From 1724 to 1738 he worked as a preacher in England and Germany; it was probably *c.* 1746 that he began to paint for the Church. In 1747 he exhibited *First Fruits* (version, Bethlehem, PA, Archv Morav. Church), which contained 25 life-size figures of people converted to Christianity by Moravian missionaries.

In 1752 Haidt was sent to assist in the decorating of Lindsey House, London, owned by the Moravians. In 1754 he and his wife settled in Bethlehem, PA, and then in Philadelphia, where he painted portraits of his American associates and religious scenes for various Moravian churches and missions. His religious pictures are frequently crowded with figures and brightly coloured and exhibit an awkwardness of perspective and scale, for example *Christ before Herod* (Nazareth, PA, Whitefield House Mus.). His portraits of women, all dressed in the Moravian dark garb with tight-fitting white caps tied with ribbons, denoting status (e.g. blue for wives, white for widows), are mannered and pleasantly selfconscious. His portraits of men are realistic depictions, the most successful being his perceptive likeness of *David Nitschmann* (Bethlehem, PA, Archv Morav. Church).

BIBLIOGRAPHY

John Valentine Haidt (exh. cat. by V. Nelson, Williamsburg, VA, Rockefeller Flk A. Col., 1966)

American Colonial Portraits, 1700–1776 (exh. cat. by R. H. Saunders and E. G. Miles, Washington, DC, N.P.G., 1987), pp. 248–9

MONROE H. FABIAN

Haight, Charles C(oolidge) (*b* New York, 17 March 1841; *d* Garrison-on-Hudson, NY, 8 Feb 1917). American architect. He was the son of a minister at New York's prestigious Trinity Church. Throughout his career, Haight relied on his connections with Trinity and with New York's Episcopal élite for major commissions. After serving in the Civil War, Haight studied with Emlen T. Littell (1840–91), opening his own office in 1867. In the 1870s he became architect for Trinity Corporation and designed many commercial and institutional buildings for that organization. Haight was an early proponent of the English-inspired collegiate Gothic style, which he used initially for Columbia College's mid-town New York campus (1880–84; destr. *c.* 1900). For the Episcopal Church's General Theological Seminary (1883–1902) at Chelsea Square, New York, he planned a pair of adjoining quadrangles enclosed on three sides by collegiate Gothic buildings of brick with stone trim. The ensemble, dominated by the library (destr. 1958), chapel and refectory,

was to be reminiscent of an English academic complex. Haight made extensive use of the collegiate Gothic at Yale University, New Haven, CT, designing buildings between 1894 and 1914, most notably Vanderbilt Hall (1894) and Phelps Hall (1896) with their Tudor-inspired gatehouses leading to the main campus. Haight was also responsible for the H. O. Havemeyer Residence (1891–3; destr. *c.* 1948), New York, generally considered to have been one of the finest Fifth Avenue mansions. The building exemplified Haight's preference for simple, bold forms rather than the flamboyant ornament favoured by many of his contemporaries. Haight's most unusual work is the New York Cancer Hospital (1884–6; addition, 1889–90; later the Towers Nursing Home), Central Park West, New York, the first hospital in the USA exclusively for cancer patients. The hospital, with its five round towers, was modelled on the French Renaissance château at Le Lude, Sarthe.

BIBLIOGRAPHY

M. Schuyler: 'Great American Architects Series No. 6—The Works of Charles C. Haight', *Archit. Rec.* (1899); repr. in *Great American Architects: Series Nos 1–6, May 1895–July 1899* (New York, 1977)

——: 'Architecture of American Colleges II: Yale', *Archit. Rec.*, xxvi (1909), pp. 393–416

——: 'Architecture of American Colleges IV: New York City Colleges', *Archit. Rec.*, xxvii (1910), pp. 443–69

A. Githens: 'Charles Coolidge Haight', *Archit. Rec.*, xli (1917), pp. 361–9

Towers Nursing Home [New York Cancer Hospital] Designation Report, New York City Landmarks Preservation Commission (New York, 1976)

Buildings and Grounds of Yale University (New Haven, 1979)

B. Bergdoll: *Mastering McKim's Plan: Columbia's First Century on Morningside Heights* (New York, 1997)

ANDREW SCOTT DOLKART

Hall, George Henry (*b* Manchester, NH, 21 Sept 1825; *d* New York, 17 Feb 1913). American painter. Brought up in Boston, he began his career as an artist at the age of 16. In 1849 he travelled with his friend Eastman Johnson to Düsseldorf. Hall studied at the Königliche Akademie for about a year, and after a further two years of study in Paris and Rome he returned in 1852 to New York where he settled. However, he remained an enthusiastic traveller and spent a total of more than 20 years abroad.

One of the best-known still-life painters of the mid-19th century, Hall specialized in painting fruit (raspberries were a particular favourite) and flowers. His work of the 1860s has affinities with the highly detailed, naturalistic imagery of the American Pre-Raphaelites, though by 1868 he was concentrating on figure painting and Spanish and Italian themes. In the early 1880s he returned to still-life subjects (e.g. *California Grapes*, 1893; Worcester, MA, A. Mus.) and remained a popular and successful artist until the turn of the century.

The subject-matter of his figure paintings was often inspired by the Mediterranean locations he favoured. His art was distinguished by a dark colour range and highly polished finish and reflected his love of Venetian painting. After 1870 Hall exhibited regularly at the National Academy of Design, New York.

BIBLIOGRAPHY

W. H. Gerdts: *Painters of the Humble Truth: Masterpieces of American Still-life, 1801–1939* (Columbia, MO, 1981)

Domestic Bliss: Family Life in American Painting, 1840–1910 (exh. cat. by L. M. Edwards, New York, Hudson River Mus., 1986), pp. 66–7

LEE M. EDWARDS

Hamilton, James (*b* Entrien, nr Belfast, 1819; *d* San Francisco, 10 March 1878). American painter of Irish birth. He emigrated to the USA and at the age of 15 arrived in Philadelphia, where he was encouraged to study art by the engraver John Sartain (1808–97). Hamilton had drawing lessons with local teachers and studied from English artists' manuals including that on oil painting by Samuel Prout (1783–1852); he was also influenced by the English watercolour technique of broad transparent washes. With these stylistic interests and his innate sensitivity to nature, Hamilton evolved a style that tended towards Romantic Impressionism, and he became known as 'the American Turner'.

The use of watercolour dominated Hamilton's early career, particularly as the preparatory medium for his designs for book illustration. Most successful were his haunting illustrations of the Arctic, based on the sketches made by the explorer Elisha Kent Kane during his voyages to the Arctic in 1850–51 and 1853–5. Some of the illustrations became the subjects of Hamilton's major oil paintings, notably *The 'Rescue' in her Arctic Ice Dock* (1852; Seneca Falls, NY, Hist. Soc. Mus.) and *Breaking up of an Iceberg in Melville Bay* (1852; Healdsburg, CA, I. McKibbin White priv. col.), and inspired such artists as Frederick Edwin Church and William Bradford to make their expeditions to paint polar regions. Although Hamilton enjoyed popular and critical acclaim as an artist during his lifetime, his work was inconsistent; at his best, for instance in *Foundering* (1863; New York, Brooklyn Mus. A.; see fig.), he followed his natural inclination to spontaneity and suggestiveness, while the influence of his American contemporaries caused him to produce tighter, more precise lines to which he was less well suited. He died on the first

James Hamilton: *Foundering*, oil on canvas, 1.52×1.23 m, 1863 (New York, Brooklyn Museum of Art)

leg of what was to have been a world tour financed by the sale of his paintings in 1875.

BIBLIOGRAPHY

'Arctic Adventure', *Blackwood's Edinburgh Mag.*, lxxxi (1857), pp. 366–79
J. I. H. Baur: 'A Romantic Impressionist: James Hamilton', *Brooklyn Mus. Bull.*, xii/3 (1951), pp. 1–8
E. K. Kane: *US Grinnell Expedition in Search of Sir John Franklin, 1850–51* (New York, 1854)
——: *Arctic Explorations: Second Grinnell Expedition in Search of Franklin, 1853, '54, '55* (Philadelphia, 1956) [illus. Hamilton]; ed. C. Loomis and C. Martin (Chicago, 1996) [with historical introduction]
James Hamilton, 1819–1878: American Marine Painter (exh. cat. by A. Jacobowitz, New York, Brooklyn Mus., 1966)
James Hamilton: Arctic Watercolours (exh. cat. by C. Martin, Calgary, Glenbow–Alta Inst., 1983–4)

CONSTANCE MARTIN

Hamlin, A(lfred) D(wight) F(oster). (*b* Bebek, Turkey, 5 Sept 1855; *d* New York, 21 March 1926). American architect and architectural historian. He was the author of the first American textbook survey of Western architecture and of the only American survey of Western architectural ornament. He studied at the Massachusetts Institute of Technology School of Architecture (1876–8), Boston, and the Ecole des Beaux-Arts in Paris (1878–81), where he was a member of the atelier of Julien Azais Guadet (1834–1908). After working for a year with McKim, Mead & White in New York, in 1882 he joined the staff of the Columbia School of Architecture, where he remained until the year of his death; he became professor there and was executive director from 1903 to 1912.

Hamlin contributed articles to many architectural journals in New York, including *Building*, in which he published a series devoted to architectural composition (1887–8), one of the earliest composition manuals ever published in the USA. His other articles appeared primarily in *Architectural Record*. His address before the International Congress of Arts and Science (St Louis, MO, 1904) is also notable. Hamlin was a pillar of the City Beautiful Movement in New York, serving on many committees concerned with urban growth. In his architectural journalism, he welcomed a broad range of academic historicism; he thought Victorian architecture to be in bad taste, and he disliked Art Nouveau, although he was a champion of Otto Wagner (1841–1918). As an architect, his major work was a set of academic classroom buildings (1889–1913) on the campus of his alma mater, Robert College Preparatory School in Bebek, Turkey. His son Talbot F. Hamlin (1889–1956) was also an architect and architectural historian.

WRITINGS

A Textbook of the History of Architecture, College Histories of Art, ed. J. C. Van Dyke, ii (New York, 1896/*R*1954)
A History of Ornament, 2 vols (New York, 1916–23/*R*1973); vol. i repr. as *A History of Ornament, Ancient and Medieval* (Kennebunkport, ME, 1978)

PETER S. KAUFMAN

Hardenbergh, Henry Janeway (*b* New Brunswick, NJ, 6 Feb 1847; *d* New York, 18 Mar 1918). American architect. He trained (1865–70) in the office of Detlef Lienau in New York. After setting up his own practice, Hardenbergh built (1871–3) a chapel, a library (destr.) and a geology building (destr.) at Rutgers College, New Brunswick, NJ, a commission obtained through family connections. Success came after 1879, when he built the

Henry Janeway Hardenbergh: Dakota Apartments, New York, 1880–84

Vancorlear, an early apartment block, on W. 55th Street, New York. This building brought him to the attention of Edward S. Clark, head of the Singer Sewing Machine Co., who had bought a plot of land between the present W. 72nd and 73rd Streets and Eighth and Ninth Avenues. Clark commissioned Hardenbergh to build a housing development (1880–86) for three different social classes, comprising row houses (some destr.), lower-middle-class apartments and, on the most valuable part of the plot fronting on to Eighth Avenue, a daring foray into the luxury apartment market, now known as the Dakota Apartments (1880–84; see fig.). The façades are in an eclectic style that includes German Renaissance and French château elements. For the Astor Estate in New York, Hardenbergh went on to build the lavish Waldorf Hotel (1893; destr. 1931) and Astoria Hotel (1896; destr. 1931), which established him as a leading architect for luxurious Edwardian hotels. Other such works in New York included the Martinique (1897) and the Plaza (1907; interior altered), and elsewhere the Windsor (1903) in Montreal, Canada, the Willard (1906) in Washington, DC, and the Copley Plaza (1912), in Boston, MA.

BIBLIOGRAPHY

M. Schuyler: 'The Works of Henry Janeway Hardenbergh', *Archit. Rec.*, vi (1897), pp. 335–75
R. F. Bach: 'Henry Janeway Hardenbergh', *Archit. Rec.*, xliv (1918), pp. 91–3
P. Goldberger: *The City Observed: New York: A Guide to the Architecture of Manhattan* (New York, 1979)
——: 'The Dakota, New York City', *Antiques*, cxxvi (1984), pp. 842–51

MOSETTE GLASER BRODERICK

Harding, Chester (*b* Conway, MA, 1 Sept 1792; *d* Boston, MA, 10 April 1866). American painter. This untrained,

itinerant artist from rural New England became one of the most successful American portrait painters in the generation following Gilbert Stuart. A huge man with a hearty, genial personality, he combined a businesslike approach to painting with native talent and hard work. His colourful life epitomized the 19th-century American rags-to-riches success story. He painted the influential men and women of his time: American presidents, congressmen, Supreme Court justices, merchants and sea-captains of Boston and their wives, and members of the British aristocracy. In his memoir, *My Egotistography* (1866), he described his reaction to his first attempt at portraiture, a portrait of his wife, *Caroline Harding* (1816; Washington, DC, priv. col., see 1985 exh. cat., frontispiece): 'The moment I saw the likeness I became frantic with delight: it was like the discovery of a new sense.'

Harding's career began in the prosperous frontier towns of Kentucky, where between 1818 and 1820 he painted nearly 100 portraits at $25 each. After using this money for a brief study trip to Philadelphia, he went to St Louis, MO, where the Governor of the Territory, William Clark, became one of his first sitters. At Clark's request, Harding painted the only portrait from life of the aged pioneer *Daniel Boone* (1818; Boston, MA Hist. Soc.). In 1823 he enjoyed six months of overwhelming popularity in Boston, which he attributed to his being 'a backwoodsman newly caught'. Aware of his technical limitations, however, he left on 1 August for three years in England and Scotland.

Again Harding quickly found enthusiastic patrons, including the brother of George IV, Augustus Frederick, Duke of Sussex. He learnt through observation of other artists. In Kentucky he had absorbed the rudiments of portrait painting from the work of Matthew Jouett, and in Boston, Gilbert Stuart had temporarily influenced his style. Within days of his arrival in London, Harding's admiration for Thomas Lawrence (1769–1830) manifested itself in the broad brushwork and dramatic pose of *Loammi Baldwin* (1823; Washington, DC, N.P.G.), and Lawrence's influence is also evident in such atmospheric Scottish portraits as *Alexander Hamilton Douglas, 10th Duke of Hamilton* (1825; priv. col., see 1985 exh. cat., p. 68) and *Mrs Thomas Graham* (exh. RA 1826; Glasgow, A.G. & Mus.). Once back in America, he quickly reverted to the factual immediacy that was his greatest strength. His deep admiration for the statesman Daniel Webster is manifested in more than 20 portraits (examples at Boston, MA, Athenaeum and Washington, DC, N.P.G.) based on two sittings and two daguerreotypes. At the Constitutional Convention in Richmond, VA (1829), he painted US presidents *James Monroe* (priv. col., see 1985 exh. cat., p. 51) and *James Madison* (e.g. Washington, DC, N.P.G.), along with other establishment figures of Virginian society. In 1830 he was commissioned to paint a portrait of *Chief Justice John Marshall* (Boston, MA, Athenaeum), one of his most polished works. He also painted *President John Quincy Adams* (e.g. Newport, RI, Redwood Lib.) and the ethereally aged *Charles Carroll of Carrollton* (1828; Washington, DC, N.G.A.; see fig.), last living signatory of the Declaration of Independence. Harding made replicas of his well-known sitters' portraits for his own use and for reproduction as engravings. Charles Carroll's portrait was

Chester Harding: *Charles Carroll of Carrollton*, oil on canvas, 902×702 mm, 1828 (Washington, DC, National Gallery of Art)

engraved by both John Sartain (1808–97) and Asher B. Durand.

With his family living in Springfield, MA, Harding maintained a studio and gallery at 22 School Street in Boston, where he rented rooms to other artists and provided exhibition space. In 1841 he was a founder of the Boston Artists' Association, a short-lived attempt to establish an art academy in Boston. After three annual exhibitions at Harding's Gallery, the group exhibited jointly with the Boston Athenaeum each year until disbanding in 1851. Harding continued to travel in search of clients. He made several trips to New Orleans between 1839 and 1849 and a second trip to England in 1847. He finished his last portrait, of *General William Tecumseh Sherman* (1866; New York, Un. League Club), only weeks before his death. Its tighter style reflects the new popularity of photography.

WRITINGS

My Egotistography (Boston, 1866)

BIBLIOGRAPHY

M. E. White, ed.: *A Sketch of Chester Harding, Artist, Drawn by his own Hand* (Boston, 1866/R New York, 1970) [incl. *My Egotistography* and Harding's Brit. diary]

L. Lipton: 'Chester Harding in Great Britain', *Antiques*, cxxvi (1984), pp. 1382–90

——: 'Chester Harding and the Life Portraits of Daniel Boone', *Amer. A. J.*, xvi (1984), pp. 4–19

A Truthful Likeness: Chester Harding and his Portraits (exh. cat. by L. Lipton, Washington, DC, N.P.G., 1985) [illus. checklist of c. 700 ptgs]

LEAH LIPTON

Harnett, William Michael (*b* Clonakilty, Co. Cork, Ireland, 10 Aug 1848; *d* New York, 29 Oct 1892). American

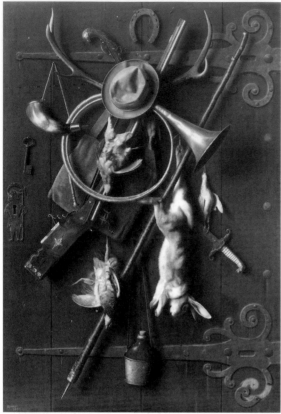

1. William Michael Harnett: *After the Hunt*, oil on canvas, 1.80×1.22 m, 1885 (San Francisco, CA, Palace of the Legion of Honor)

painter. He was brought up in a family of artisans in Philadelphia and was trained as an engraver of silverware. After studying at the Pennsylvania Academy, he moved to New York in 1869 and worked as an engraver while continuing his studies at the Cooper Union. In 1875 he exhibited at the National Academy of Design while supporting himself by painting small, precise still-lifes. He returned to Philadelphia in 1876 and by 1880 had saved enough for a European tour. He settled in Munich, working there and in Paris for six years and returning permanently to New York in 1886.

Although he had no pupils, Harnett was the most influential American still-life painter of the last quarter of the 19th century. Until about 1880 his works were simple table-top still-lifes in the *trompe l'oeil* tradition of Raphaelle Peale. Set against dark, shallow backgrounds, they consisted of mugs, pipes, books, newspapers, currency, letters and writing materials, as in *Writing Table* (1877; Philadelphia, PA, Mus. A.). Carefully composed and balanced with realistic colour, precise detail and smooth brushwork, they reflect his training as an engraver. The *Artist's Letter Rack* (1879; New York, Met.) is a form of bulletin board with various flat objects— tickets, clippings, receipts, visiting-cards, stamps—haphazardly attached to a wooden board by a criss-crossing network of tapes. This format, widely copied in American painting, had its roots in Dutch 17th-century art. In Munich, Harnett's scale became almost miniature. He took as his subject-matter more precious

objects: antique lamps, elaborate tankards and leather-bound books are arranged in pyramidal fashion against dark and undefined backgrounds. Harnett's most famous painting, *After the Hunt* (San Francisco, CA Pal. Legion of Honor; see fig. 1), the last and largest version of four, was painted in Paris and exhibited there to considerable acclaim in the Salon of 1885. The following year he sold it to Theodore Stewart to display in his New York saloon, where it spawned hundreds of imitations. A large and minutely detailed *trompe l'oeil*, it is a trophy-type composition of dead birds, game and hunting accoutrements affixed to a battered wooden door. Harnett's late works include many paintings of single objects set against a green wooden door. The *Faithful Colt* (1890; Hartford, CT, Wadsworth Atheneum) consists of a single revolver hanging against the door, with a newspaper clipping below. *Plucked Clean* (1882; Chicago, IL, A. Inst.) features a scrawny chicken, plucked except for a few tufts of down; a rare glimmer of humour is implied in the title. The *Old Violin* (1886; priv. col., see Frankenstein, 1953, pl. 60), *Music and Good Luck* (1888; New York, Met.; see fig. 2) and *Old Cupboard Door* (1889; Sheffield, Graves A.G.), like most of his work, are infused with a gentle melancholy. Harnett, like his contemporary *trompe l'oeil* painters, received little official attention. The sale of his studio took place at Thomas Birch & Sons, Philadelphia, 23–4 February 1893. After his work was rediscovered by the Downtown Gallery, New York, in 1939, many forgeries of his paintings appeared, among them genuine compositions by John F. Peto to which Harnett's signature had been added. Frankenstein (1949) identified Harnett's genuine oeuvre.

BIBLIOGRAPHY

A. Frankenstein: 'Harnett: True and False', *A. Bull.*, xxxi (1949), pp. 38–56

——: *After the Hunt: William Michael Harnett and Other American Still-life Painters* (Berkeley, 1953, rev. 2/1969)

W. H. Gerdts and R. Burke: *American Still-life Painting* (New York, 1971), pp. 133–43, 248–50

William Michael Harnett (exh. cat., ed. D. Bolger, M. Simpson and J. Wilmerding; New York, Met.; Forth Worth, TX, Amon Carter Mus.; San Francisco, CA, F.A. Museums; 1992–3); review by M. Hutson in *Amer. A. Rev.*, v/1 (1992), pp. 80–3, 152

GERTRUDE GRACE SILL

Harrison, Peter (*b* York, 14 June 1716; *d* New Haven, CT, 30 April 1775). American architect of English birth. Born to Quaker parents, he probably trained in York with William Etty and his son John Etty. On the latter's death in 1739, he followed his seafaring elder brother Joseph and became first a mate and then a captain in the transatlantic trade until captured by a French privateer in 1744. He was imprisoned at Louisburg, Nova Scotia, where he secretly copied plans of the fortress and charts of the coastline. Released in early 1745, he passed the copies to William Shirley (1694–1771), Governor of Massachusetts, who then captured Louisburg in June that year. Harrison settled in Newport, RI, and in 1746 married Elizabeth Pelham (1721–84), a kinswoman of Shirley's wife, which secured his social position. Harrison had two advantages in the colonies: first-hand knowledge of English architecture and a unique library. His library was impressive for the American colonies and included works by Abraham Swan (*fl* 1745–68) and Isaac Ware (1704–66),

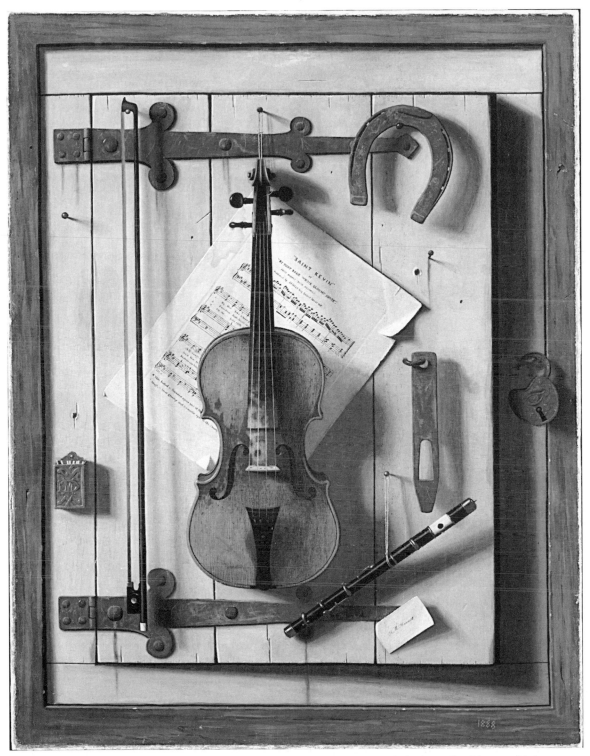

2. William Michael Harnett: *Music and Good Luck*, oil on canvas, 1016×762 mm, 1888 (New York, Metropolitan Museum of Art)

pattern-books by James Gibbs (1682–1754), several treatises on the art of building, and drawings and books by Robert Morris (*c.* 1701–1754), Sébastien Leclerc I (1637–1714), Edward Hoppus and William Salmon (*c.*

1703–1779) covering ancient architecture, ornament, Palladio (1508–80) and contemporary English architecture. These resources, coupled with surveying, cartography, engineering and carpentry skills, established

Peter Harrison: Redwood Library and Athenaeum, Newport, Rhode Island, 1749

Harrison's reputation as a learned architect, an important consideration for Colonial patrons who sought to keep up with their English cultural heritage, and many buildings have been attributed to him.

In 1746 Shirley commissioned Harrison to design his house, Shirley Place, Roxbury, near Boston; for this Harrison invented what George Washington later called 'rusticated boards', a method of making a timber house look as though built of stone. Shirley also provided him with a diplomatic passport that enabled him to visit France and the Veneto in 1748. Harrison's first building in Newport, the Redwood Library and Athenaeum (1749; see fig.), is Palladian in its detailing. He translated the more usual box-like form of Colonial building into an American version of a Roman temple. The interior is essentially one grand hall flanked by two smaller reading rooms. He presented an imposing street façade with a pediment supported by four monumental Doric columns fronting a wooden façade emulating rusticated stone. Raised above a basement platform, the library is replete with a grand entry stair, triglyphs, guttae, brackets and a carved frieze above the massive entrance. The temple analogy is continued by the building's siting on an 'acropolis' overlooking the town, which slopes down to the waterfront. The Redwood Library was one of the few pre-Revolutionary buildings that symbolized the highest aesthetic attitudes of 18th-century America in being based on historical precedent, connected to English culture and erected to celebrate the high esteem placed by the upper classes on the world of knowledge.

Almost immediately after his work on the Redwood Library, Harrison was invited to design a new Anglican church for Boston. King's Chapel (1749–58) was a larger commission, and it gave him the chance to work in stone on a more complex structure. The motif of paired columns that he used in the nave came from the church of Ste Madeleine, Besançon, by Nicolas Nicole (1701–84), which Harrison must have seen under construction in 1748. He designed buildings for Cambridge, MA (Christ Church, 1760–61), and Charlestown, SC (St Michael's, 1751–61), but the bulk of his commissions were for Newport. Along with a number of prominent private houses, such as the elegant brick mansion on the waterfront for Francis Malbone (1760) or the John Banister House (1756) on the outskirts of the town, Harrison created two major public buildings for Newport: Touro Synagogue (1763) and the Brick Market (1761–72). For these, he once again used pattern-books for the general layout and details. The Brick Market, erected to enlarge the storage space of the Long Wharf merchants and to create a new market on the ground-level, was perhaps the most predictable of his designs in that it followed a scheme, popular in England at the time, of a grand order rising through two storeys set over an open arcaded basement. The design may be based either on Etty's Mansion House, York, or on Old Somerset House by Inigo Jones (1573–1652), as published in *Vitruvius Britannicus* (1715) by Colen Campbell (1676–1729), although Harrison used bricks instead of stone and made other changes in dimensions and detailing while maintaining an orderly and monumental appearance. Harrison again showed himself to be sensitive to his given site as he designed the Brick Market facing the Colony House (1739–4), a governmental meeting-hall designed by Richard Munday, Newport's most prolific carpenter–builder of the previous generation; it symbolically balanced governmental and mercantile power across the square. For Touro Synagogue, Harrison blended knowledge of Classical prototypes with the needs of the Sephardic ritual. It remains a testimony to Harrison's sensitivity towards his patrons' needs and his ability to go beyond pattern-books in designing the earliest synagogue building in the USA.

By the mid-1760s, when Harrison had lived in Newport for more than 20 years, several events altered the course of his life. Having pledged himself to such family and community pursuits as running his estate, enlarging Trinity Church and attending scientific lectures, he retreated from active public life after a serious illness in late 1765. His political sympathies as a loyalist supporter of the Crown were established through association with other prominent loyalist Newporters. It was further confirmed when he took the position of tax collector in New Haven, CT, that his brother Joseph had held since 1760 and from which he resigned in 1766 so that his brother might have the security of a government sinecure. By the time the Brick Market, Harrison's final building, was completed in late 1772, he was already in New Haven, and he probably did not see it completed. Harrison was elected to the American Philosophical Society in 1768, and he was consulted about the design of several other buildings (including one for Dartmouth College; unexecuted) but the last decade of his life was one of turmoil. He died during a period of increasing anti-English sentiment throughout the colonies, on the eve of the American Revolution. His library was ransacked, with books and drawings lost in raids by revolutionary groups in late 1775. Harrison received little more than a one-line obituary in the *Newport Mercury*, the newspaper for the town where he had left a most remarkable legacy of Colonial building in America.

BIBLIOGRAPHY

Macmillan Enc. Archit.

C. Bridenbaugh: *Peter Harrison: First American Architect* (Chapel Hill, NC, 1949)

A. F. Downing and V. J. Scully jr: *The Architectural Heritage of Newport, Rhode Island, 1640–1915* (Cambridge, MA, 1952)

P. Metcalf: 'Boston before Bulfinch: Harrison's King's Chapel', *J. Soc. Archit. Hist.*, xiii (1954), pp. 11–14

N. H. Schless: 'Peter Harrison: The Touro Synagogue and the Wren City Church', *J. Soc. Archit. Hist.*, xxx (1971), p. 242

Buildings on Paper: Rhode Island Architectural Drawings, 1825–1945 (exh. cat. by W. H. Jordy and C. P. Monkhouse; Providence, RI, Brown U., Bell Gal.; Providence, RI Hist. Soc.; Providence, RI Sch. Des., Mus. A.; New York, N. Acad. Des.; 1982)

RONALD J. ONORATO

Hart, James McDougal (*b* Kilmarnock, Strathclyde, 10 May 1828; *d* Brooklyn, NY, 24 Oct 1901). American painter of Scottish birth. He moved to America with his family in 1831. He grew up in Albany, NY, where he and his older brother, William Hart (1823–94), also a painter, were apprenticed to a coachmaker as decorators. He produced some amateur portraits during this time and cultivated his natural talent for landscape painting. In 1850 he went to study in Munich and Düsseldorf, where his principal teacher was Johann Wilhelm Schirmer (1807–63); in 1853 he returned to Albany, exhibiting for the first time at the National Academy of Design, New York. By 1857 he had established himself in New York, and he lived there for the rest of his life.

Hart rose to prominence during the 1860s and 1870s, when there was a vogue for his landscapes and pastoral cattle scenes. His landscapes are invariably endowed with tranquillity and a romantically poetic sense of time and place, as in *On the Lake Shore* (1864; Boston, MA, Mus. F.A.) and *Pastoral Scene* (1876; New York, Met.; see fig.). Such pastoral cattle scenes as *Threatening Weather* (1875; Boston, MA, priv. col.) attribute identifiable human emotions to the bovine creatures, frequently hinting at the moralistic themes that were then popular. In 1858 Hart was elected an associate and in 1859 a full member of the National Academy of Design. He subsequently served for three years as its vice-president and, among other places, exhibited there regularly from 1853 to 1900. His sister, Julie Hart Beers Kempson (1835–1913), was a professional landscape painter.

BIBLIOGRAPHY

H. T. Tuckerman: *Book of the Artists: American Artist Life* (New York, 1867/R 1966)

G. W. Sheldon: *American Paintings* (New York, 1879)

JOHN DRISCOLL

Hartford. North American city and capital of the state of Connecticut. It was founded in 1635 at a site on the west shore of the Connecticut River and is *c.* 50 km inland from New Haven. Its broad range of architecture reflects the city's history. The Neo-classical Old State House (1792–6; now a museum) by Charles Bulfinch is in City Hall Square, laid out in 1637. Ithiel Town designed Christ Church Cathedral (1842–4; roof pinnacles, 1902; later additions), a notable Gothic Revival structure. Town also designed the Wadsworth Atheneum (1842–4) with his partner A. J. Davis, which houses the American collection of DANIEL WADSWORTH; the paintings include works by John Trumbull and Thomas Cole. The museum also contains the J. Pierpont Morgan Collection of bronzes, Italian Renaissance objects, 17th century silver and 18th-century porcelain, and the Wallace Nutting Collection of early American furniture, Central and South American art, and European paintings from the 14th to 20th century. Also in Gothic Revival is the Trinity College Group (1873–6) by William Burges. The six-storey Cheney Building (1875–6) by H. H. Richardson is based on the arcaded English commercial style of the 1860s. The State Capitol

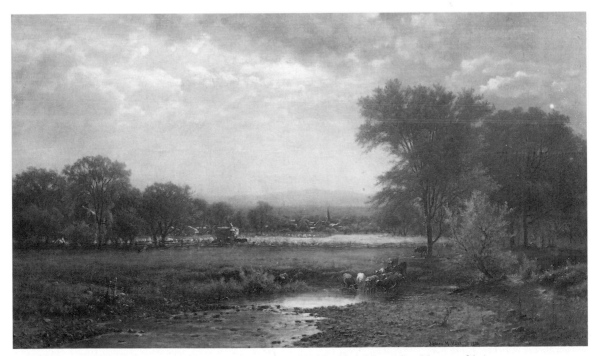

James McDouglas Hart: *Pastoral Scene*, oil on canvas, 508×864 mm, 1876 (New York, Metropolitan Museum of Art)

(1878–82) by Richard Michell Upjohn is a classical model with motifs borrowed from contemporary Gothic Revival ecclesiastical architecture.

BIBLIOGRAPHY

'Hartford's Not-so-steady Habits', *Archit. Rec.*, clxxvi, pp. 100–02
J. Johnson: 'Presence of Stone', *Landscape Archit.*, lxxvi (1986), pp. 64–9
G. E. Andrews and D. F. Ransom: *Structures and Styles: Guided Tours of Hartford Architecture* (Hartford, 1988)
M. J. Crosbie: 'A New Old State House, Hartford, Connecticut', *Hist. Preserv.*, xlviii (1996), pp. 22–3

ANN McKEIGHAN LEE

Hartwell & Richardson. American architectural partnership established in 1881 by Henry Walker Hartwell (*b* Boston, MA, 4 Sept 1833; *d* Waltham, MA, 30 Dec 1919) and William Cummings Richardson (*b* Concord, NH, 12 March 1854; *d* Newton, MA, 17 Oct 1935). Hartwell began his architectural training in 1851 in the Boston office of Joseph E. Billings and Hammatt Billings (1818–75) and established his own practice in Boston in 1856. Working alone until 1869 and then in partnership with other Boston architects, including Albert E. Swasey jr and George Tilden (1845–1919), until 1881, Hartwell produced a series of polychromatic Gothic Revival and Queen Anne style public buildings and churches south of Boston. In 1881 he received a commission to design a town hall for Belmont, MA, and formed a permanent partnership with William Richardson, a younger architect who had trained at the Massachusetts Institute of Technology. This partnership brought a new exuberance to their work and marked the beginning of the most productive period in both men's careers.

Within the firm Hartwell was responsible for construction and management, and Richardson for design. The Queen Anne style brick and terracotta Belmont Town Hall (1881–2) and Odd Fellows Hall (1884) in Cambridge, MA, are among their most original non-residential designs, while in Boston the First Spiritual Temple (1884) shows the increasing influence of H. H. Richardson on their work. Their best residential designs were graceful Shingle style houses near Boston with elaborate interior woodwork, for example 37 Lancaster Street (1887–8), Cambridge. In the 1890s the firm designed some Colonial Revival houses, but specialized increasingly in classical-style public schools, most of which lacked the exuberance of their earlier buildings. In 1895 the English architect James Driver (1859–1923) joined the firm. (After Hartwell's death in 1919 and Driver's departure in 1921, Richardson continued to practice as Hartwell & Richardson until his own death.)

BIBLIOGRAPHY

S. Maycock Vogel: 'Hartwell and Richardson: An Introduction to their Work', *J. Soc. Archit. Historians*, xxxii/2 (1973), pp. 132–46

SUSAN E. MAYCOCK

Haseltine, William Stanley (*b* Philadelphia, PA, 11 June 1835; *d* Rome, 3 Feb 1900). American painter. He was the son of a successful merchant and brother of the sculptor James H. Haseltine (1833–1907) and the art dealer Charles F. Haseltine (1840–1915). In 1850 William Stanley Haseltine enrolled at the University of Pennsylvania in Philadelphia; after two years he transferred to Harvard College, Cambridge, MA, graduating in 1854. He first formally studied painting in that year on his return to Philadelphia, working with Paul Weber (1823–1916). Haseltine went abroad to Düsseldorf in 1855, where he became friends with his compatriots Albert Bierstadt, Emanuel Gottlieb Leutze and Worthington Whittredge. He painted throughout Europe for the next three years, returning from Italy to the USA in late 1858. He was established in the Tenth Street Studio Building in New York by the winter of 1859

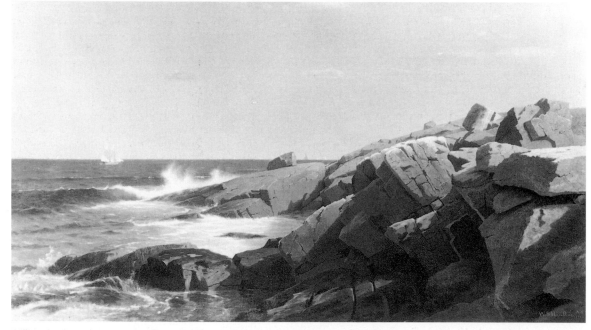

William Stanley Haseltine: *Indian Rock, Narragansett, Rhode Island*, oil on canvas, 559×972 mm, 1863 (San Francisco, CA, M. H de Young Memorial Museum)

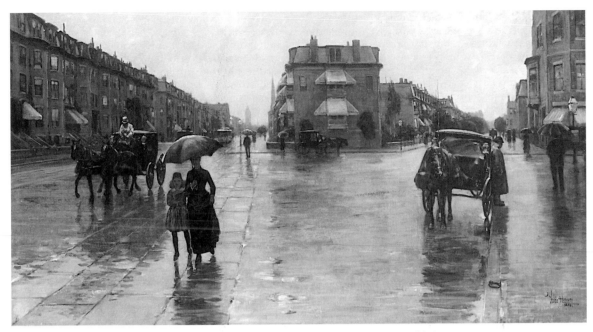

Childe Hassam: *Rainy Day in Boston*, oil on canvas, 663×1220 mm, 1885 (Toledo, OH, Museum of Art)

and played an active role in the city's art world, exhibiting at the Century and Salmagundi clubs and at the National Academy of Design, of which he was an associate by 1860 and an academician in 1861. During the years of the Civil War (from which he was exempt due to a chronic eye ailment), Haseltine journeyed repeatedly to the rocky Atlantic coastline of New England to sketch scenes of sea and shore that form the basis of his strongest work, for example *Indian Rock, Narragansett, Rhode Island* (1863; San Francisco, CA, de Young Mem. Mus.; see fig.).

In 1866, following the death of his first wife and his remarriage, Haseltine and his family moved to Europe. They travelled throughout France, Switzerland and Italy; in 1874, after spending the previous winter in New York, Haseltine settled in the Villa Altieri in Rome. With the exception of extended trips, he lived there for the remainder of his life. He concentrated on picturesque depictions of European scenery that further explore his fascination with shoreline views, such as *Natural Arch at Capri* (1871; Washington, DC, N.G.A.). Haseltine, who was also a gifted draughtsman, worked in a closely detailed manner reflecting his German studies and his admiration of the Pre-Raphaelite Brotherhood. He tempered his concern with fact, however, with an appreciation of illusionistic light effects that added a progressive element to his traditionally plotted landscapes.

BIBLIOGRAPHY

H. Haseltine Plowden: *William Stanley Haseltine* (London, 1947)
William Stanley Haseltine, 1835–1900, Herbert Haseltine, 1877–1962 (exh. cat., New York, Hirschl & Adler Gals, 1992); review by J. C. Skrapits in *Amer. Artist*, lviii (1994), pp. 20–9
Expressions of Place: The Art of William Stanley Haseltine (exh. cat. by M. Simpson, A. Henderson and S. Mills, San Francisco, CA, de Young Mem. Mus.; Chadds Ford, PA, Brandywine River Mus.; 1992–3)

MARC SIMPSON

Hassam, (Frederick) Childe (*b* Dorchester, MA, 17 Oct 1859; *d* East Hampton, NY, 27 Aug 1935). American painter and printmaker. The son of Frederick F. Hassam, a prominent Boston merchant, and his wife, Rosa P. Hathorne, he was initially trained as an apprentice to a wood-engraver. From the late 1870s to the mid-1880s he executed drawings for the illustration of books, particularly children's stories. He had a long affiliation with the Boston firm of Daniel Lothrop & Co., for whom he illustrated E. S. Brooks's *In No-man's Land: A Wonder Story* (1885), Margaret Sidney's *A New Departure for Girls* (1886) and numerous other books.

Hassam's first significant body of non-graphic work was in watercolour. He executed a group of freely washed, light-filled drawings of local landscapes, which provided the basis for his first one-man show in 1882 at the Boston galleries of Williams & Everett. Hassam attended evening classes at the Boston Art Club and by 1883 had a studio on Tremont Street in Boston. His early career was established by his watercolours rather than by his few oils, which were thickly painted landscapes inspired by the Barbizon school. In 1883 he visited Europe for the first time, with fellow artist Edmund C. Garrett (1853–1929). Over 60 bright, illustrative watercolours from this trip were exhibited in Boston in 1884. During the mid-1880s Hassam established himself in Boston as a painter of urban street scenes, employing a tonalist style that emphasized atmospheric conditions, as in *Rainy Day in Boston* (1885; Toledo, OH, Mus. A.; see fig.).

Late in 1886 Hassam and his wife, Kathleen Maud (née Doane), departed for France and spent the next three years abroad. They settled in Paris, and Hassam began lessons in drawing at the Académie Julian with Gustave Boulanger (1824–88) and Jules Lefebvre (1836–1911). His work of these years reflects his growing awareness of the French Impressionists; he consistently used broken brushstrokes, and his palette rapidly became brighter (e.g. *Grand Prix Day*, *c.* 1887–8; New Britain, CT, Mus. Amer. A.).

Hassam's Parisian oils and watercolours depict the more genteel and picturesque aspects of urban life: Montmartre shops, flower vendors, parks and private gardens. Although he adopted an Impressionist brushstroke, he retained a sense of solidity and form in his figures, creating a hybrid style that is characteristic of American Impressionism. Hassam preferred to consider himself a painter of 'light and air' in a general sense rather than be labelled an Impressionist, and he believed that the work of the French Impressionists was derived from earlier sources, particularly English art of the 18th century.

In 1889 Hassam settled in New York. He continued to depict the urban scene, a genre with which he became so closely identified that a monograph entitled *Three Cities* (New York, 1899) was devoted to reproductions of his imagery of Paris, London and New York. In the summer seasons he travelled to artistic resorts throughout New England. Around 1884 he visited Appledore Island, one of the Isles of Shoals off the Maine–New Hampshire coast, and he returned there repeatedly during the early 1890s to produce some of his finest and most sophisticated Impressionist watercolours and oils. His friendship with Mrs Celia Thaxter, a poet and patron of the arts who owned a local hotel, inspired him to execute a series of extremely impressionistic pictures of her opulent flower gardens, including his splendid watercolour the *Island Garden* (1892; Washington, DC, N. Mus. Amer. A.; see colour pl. XXIII, 1).

By 1892 Hassam was exhibiting regularly at the annual exhibitions of most of the major art institutions on the East Coast, including the Boston Art Club, American Water Color Society, National Academy of Design, New York Water Color Club, Pennsylvania Academy of the Fine Arts and the Philadelphia Art Club. He achieved considerable success during this decade and was able to support himself by the sale of his pictures. In 1896–7 he and his wife spent 18 months in Europe, visiting Italy, France and England. His work from this trip indicates his continued adherence to an Impressionist style but reveals also a heightened palette and a new rigid, aggressive brushstroke. In addition to vivid colour, Hassam's pictures of 1897–8 show his awareness of Post-Impressionist and Symbolist art. As well as dazzling urban scenes (e.g. *Pont Royal, Paris*; Cincinnati, OH, A. Mus.), he executed numerous works in Normandy and Brittany, particularly in the village of Pont-Aven.

In 1898 he helped to organize the first exhibition, in New York, of the TEN AMERICAN PAINTERS, with whom he shared a desire to exhibit recent work in an environment both less constrictive and less aesthetically diverse than that of a major academy. Despite Hassam's avowed distrust of modern art, his own 20th-century work reflects his growing interest in the abstract and decorative qualities of paint on a surface. Around 1900 he explored symbolic and anti-naturalistic subject-matter, producing many mythically titled nudes (e.g. *Pomona*, 1900; Washington, DC, N. Mus. Amer. A.). Although Hassam believed many of these pictures to be among his finest, they did not find as receptive an audience as his more naturalistic landscapes.

Between 1900 and 1910 Hassam continued to live and work in New York, during the warmer months visiting the artistic colonies at Cos Cob and Old Lyme, CT; his

brand of Impressionism influenced not only students and amateur artists who gathered there, but also fellow American Impressionists such as Julian Alden Weir and Willard Leroy Metcalf. In the summers of 1904 and 1908 Hassam stayed in Oregon with his friend Colonel Charles E. S. Wood (1852–1944), a lawyer by profession but also an amateur painter, poet and patron of the arts. In addition to executing a mural for Wood's residence, Hassam produced over 40 bright impressionistic landscapes of the stark eastern Oregon desert, which were exhibited at Montross Galleries, New York, in 1909.

In 1910 and 1911 Hassam made his final trips to Europe, where he painted the Bastille Day celebration in Paris, *July Fourteenth, Rue Daunou* (1910; New York, Met.); this work prefigures his renowned series of flag paintings produced in New York between 1916 and 1918 depicting the patriotic parades along Fifth Avenue ('Avenue of the Allies') during World War I (e.g. *Allies Day, May 1917*, 1917; Washington, DC, N.G.A.).

BIBLIOGRAPHY
N. Pousette-Dart, ed.: *Childe Hassam* (New York, 1922)
'Childe Hassam—Painter and Graver', *Index of Twentieth Century Artists*, iii (New York, 1935/*R* 1970), pp. 169–83
A. Adams: *Childe Hassam* (New York, 1938)
Childe Hassam: A Retrospective Exhibition (exh. cat., Washington, DC, Corcoran Gal. A., 1965)
Childe Hassam, 1859–1935 (exh. cat., Tucson, U. AZ, Mus. A.; Santa Barbara, U. CA, A. Mus.; 1972)
D. Hoopes: *Childe Hassam* (New York, 1979)
Childe Hassam, 1859–1935 (exh. cat., East Hampton, NY, Guild Hall Mus., 1981)
Childe Hassam: An Island Garden Revisited (exh. cat. by D. P. Curry, New Haven, CT, Yale U. A.G.; Denver, CO, A. Mus.; Washington, DC, N. Mus. Amer. A.; 1990–91)
Childe Hassam: East Hampton Summers (exh. cat., East Hampton, NY, Guild Hall Mus., 1997)
KATHLEEN M. BURNSIDE

Hastings, T. *See under* CARRÈRE & HASTINGS.

Hatch, Stephen D(ecatur) (*b* Swanton, VT, 1839; *d* Plainfield, NJ, 1894). American architect. He trained in the New York office of the commercial architect John Butler Snook and set up in practice on his own in 1864. Hatch was adept at providing plain buildings, built sturdily and on time. His work was both commercial and domestic, using a free Second-Empire French style during the 1860s and 1870s and a looser late Victorian mode for his later commercial buildings. Much of his work has been destroyed. The commercial work included the iron-fronted Gilsey Hotel (1868), Windsor Hotel (1873; destr.), the Union Dime Savings Bank (1875–7; destr.) and the Murray Hill Hotel (1881; destr.), all in New York. Some of his commissions came from further afield, such as the Jubilee Hall (1876), at Fisk University, Nashville, TN, and the Liverpool and Globe Insurance building (1880; destr.) in London. His domestic work was usually in an Italianate manner and included some grand houses on Fifth Avenue bought by such rich clients as Jay Gould (1868; destr.) and William Rockefeller (1876–7; destr.). Although Hatch was well suited to fulfilling the straightforward requirements of clients following the American Civil War, by the 1880s he was losing ground to more fashionable architects who had trained abroad. When he died during the construction of the headquarters of the New York Life Insurance

Company, he was succeeded by the Beaux-Arts firm of McKim, Mead & White.

BIBLIOGRAPHY
New York's Great Industries (New York, 1885)
Obituary, *Amer. Architect & Bldg News*, xvl (1894), p. 69; *Archit. & Bldg News* (21 Aug 1894)

MOSETTE GLASER BRODERICK

Hathaway, Rufus (*b* Freetown, MA, ?2 Feb 1770; *d* Duxbury, MA, 13 Oct 1822). American painter and physician. He may have been apprenticed to ship-carvers and decorators, but he was not trained in fine art. His earliest known portrait, *Lady with her Pets* (1790; New York, Met.; see fig.), demonstrates his unsophisticated, decorative style. Between 1790 and 1796 he seems to have worked as an itinerant artist; only portraits of relatives and friends survive. During his life he painted at least 25 portraits as well as miniatures, views and decorative overmantels. He also painted a genre subject, the *Welch Curate, c.* 1800 (see Valentine and Little, p. 641), which was freely adapted from an English mezzotint. He carved the frames for some of his paintings. From 1796 he studied medicine and established himself as a physician in Duxbury, MA.

Hathaway communicated a sense of the sitter's individual character in his portraits. His style represented the culmination of the American limner tradition in which a simplified but recognizable facial likeness surmounts a conventionalized figure. He combined this method with an awareness of contemporary academic practice in portraiture, which he may have gained from prints or from works by John Smibert and John Singleton Copley seen in Boston. Since the 1930s his portraits have been admired for exemplifying the strength of design found in the work of many untrained American painters.

BIBLIOGRAPHY
N. F. Little: 'Rufus Hathaway', *American Folk Painters*, ed. J. Lipman and T. Armstrong (New York, 1980), pp. 35–40

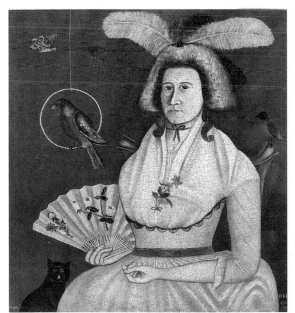

Rufus Hathaway: *Lady with her Pets*, oil on canvas, 870×813 mm, 1790 (New York, Metropolitan Museum of Art)

L. Valentine and N. F. Little: 'Rufus Hathaway, Artist and Physician', *Antiques*, cxxxi (1987), pp. 628–41
American Folk Art in the Metropolitan Museum of Art (exh. cat. by C. Rebora Barratt, New York, Met.,1999–2000)

DAVID TATHAM

Havell, Robert, jr (*b* Reading, 25 Nov 1793; *d* Tarrytown, NY, 11 Nov 1878). English engraver and painter, active in the USA. He learnt the art of aquatint engraving from his father, Robert Havell I (1769–1832). He worked first in the family engraving business and then *c.* 1825–7 with Colnaghi's in London. In 1827 he undertook the execution in aquatint of the plates for John James Audubon's *Birds of America*, published in parts in London between 1827 and 1838. Havell engraved 425 of the plates and reworked the ten that had been engraved by William Home Lizars in Edinburgh. Havell's father printed and coloured some of the double elephant folio sheets in 1827–8 after which Havell took on those tasks himself, establishing himself as a master of aquatint. Among his other important works in the medium are the plates for Mrs E. Bury's *Selection of Hexandrian Plants* (London, 1831–4). In 1839, at Audubon's invitation, Havell moved with his family to New York and embarked on a new career as a landscape painter in the style of the Hudson River school, while also working as an engraver. He settled in the Hudson River villages of Ossining (1841) and Tarrytown (1857) but painted throughout north-eastern America. *View of Deerfield, Massachusetts* (1847; Hist. Deerfield, MA) is characteristic of his quietly romantic idealization of his subjects. *Niagara Falls from the Chinese Pagoda* (1845; New York, Pub. Lib.), engraved by Havell after one of his paintings, is among the best known of his American aquatints. Though his reputation rests largely on his work for Audubon, his original subjects gave him greater opportunities to display the full range of his aquatint technique.

BIBLIOGRAPHY
G. A. Williams: 'Robert Havell, Engraver of Audubon's *The Birds of America*', *Print Colr Q.*, vi (1916), pp. 227–57
H. Comstock: 'Complete Works of Robert Havell, jr', *Connoisseur*, cxxvi (1950), pp. 127–8
W. Fries: *The Double Elephant Folio* (Chicago, 1973)
A. Blaugrund and R. F. Snyder: 'Audubon, Artist and Entrepreneur', *Antiques*, cxliv/5 (Nov 1993), pp. 672–81

DAVID TATHAM

Havemeyer [née Elder], **Louisine** (Waldron) (*b* New York, 28 July 1855; *d* New York, 6 Jan 1929). American collector and patron. At the age of 20, while attending school in Paris, she met Mary Cassatt, who became her cicerone to the arts and introduced her to the pleasures of collecting. Louisine pooled her own and her sisters' funds and in 1875 bought her first modern French painting, the *Ballet Rehearsal* (Kansas City, MO, Nelson–Atkins Mus. A.) by Degas (1834–1917). She went on to purchase works by Monet (1840–1926), Camille Pissarro (1830–1903) and Cassatt. But, on her return to the USA, she discovered that the French artists she admired were either unknown or greeted with hostility.

In 1883 Louisine married Henry [Harry] Osborne Havemeyer (1848–1907), the ex-husband of her aunt. He was a collector in his own right and had assembled outstanding examples of Chinese porcelain, rugs, pottery and Japanese textiles with earnings from his sugar refining

business. He bought in quantity and spared no expense. Although he showed a discerning eye in art objects, his judgement in painting tended towards the prosaic. Louisine persuaded him to buy a few paintings by the Impressionists, a passion he came to share by the late 1880s. In the coming years Louisine was the guiding force behind the accumulation of the finest collection of 19th-century French masters in the USA. It included works by Degas, Manet (1832–83), Courbet (1819–77), Alfred Sisley (1839–99), Corot (1796–1875), Honoré Daumier (1808–79), Jean-François Millet (1814–75), Puvis de Chavannes (1824–98) and Renoir (1841–1919). In 1901 she bought her first Cézanne (1839–1906) and eventually owned 11 of his canvases, including *Still Life, Flowers* (Munich, Franz Heinz col.) and *Flowers in a Glass Vase* (San Diego, CA, Timken A.G.).

The Havemeyer home at 1 East 66th Street, New York (1891–3; destr. *c.* 1948), designed by Charles C. Haight and decorated by the studios of Louis Comfort Tiffany and by Samuel Colman, was built around the expanding collection. Paintings by French artists as well as such Old Masters as El Greco (*c.* 1541–1614), whom the Havemeyers had come to admire on a tour of Europe in 1901, filled a two-storey gallery and an extension off the main hall. The master suite housed Corot's *Bacchante by the Sea* (1865) and *Bacchante in a Landscape* (1865–70; both New York, Met.), Manet's *Ball at the Opéra* (1873; Washington, DC, N.G.A.), and works by Courbet, Degas, Cassatt and Monet. Chinese porcelain and Cypriot glass overflowed the cabinets, while the Rembrandt Room contained numerous portraits by the Dutch master.

From the 1880s to 1907 the collection grew steadily. On 4 December 1907 Harry, whose firm had recently been accused of illegalities, died suddenly of kidney failure, and thereafter Louisine's collecting slowed. On her death, 1972 art objects were bequeathed by Louisine or donated by her children to the Metropolitan Museum of Art in New York. The National Gallery of Art in Washington, DC, received another portion of the collection, and still other items were sold at a private auction (10–19 April 1930) at the Anderson Gallery, New York. Louisine's youngest daughter, Electra Havemeyer Webb (1888–1960), also a collector, founded a museum in Shelburne, VT, in 1947 to exhibit the 125,000 objects she had collected in her lifetime. The bulk of the collection is made up of American folk and decorative arts, including early furniture, quilts and other crafts, pewter and glass.

WRITINGS
Sixteen to Sixty: Memoirs of a Collector ed. S. A. Stein, intro. G. Tinterow (New York, 1993); review by M. Esterow in *ARTnews*, xciv (1995), p. 264

BIBLIOGRAPHY
H. O. Havemeyer Collection: Catalogue of Paintings, Prints, Sculpture and Objects of Art (Portland, ME, 1931) [privately printed]
D. Sutton: 'The Discerning Eye of Louisine Havemeyer', *Apollo*, lxxxii (1965), pp. 231–5
L. B. Gillies: 'European Drawings in the Havemeyer Collection', *Connoisseur*, clxxii (1969), pp. 148–55
A. Faxon: 'Painter and Patron: Collaboration of Mary Cassatt and Louisine Havemeyer', *Woman's A. J.* (1982–3), pp. 15–20
F. Weitzenhoffer: *The Havemeyers: Impressionism comes to America* (New York, 1986)
A. C. Frelinghuysen: 'Louis Comfort Tiffany and the H. O. Havemeyers', *Antiques*, cxliii (1993), pp. 596–607
Splendid Legacy: The Havemeyer Collection (exh. cat. by A. C. Frelinghuysen and others, New York, Met., 1993)
N. M. Mathews: *Mary Cassatt: A Life* (New York, 1994)
H. Bellet: 'Havemeyer: Les impressionistes a Manhattan: La collection Havemeyer, quand l'Amerique decouvrait l'impressionisme', *Beaux-A.*, clxii (1997), pp. 54–63

KATHRYN BONOMI

Haviland, John (*b* Gudenham Manor, near Taunton, Somerset, 12 Dec 1792; *d* Philadelphia, PA, 29 March 1852). English architect and writer, active in the USA. He was apprenticed in 1811 to James Elmes (1782–1862), a successful London architect and writer on art and architecture. In 1815, after the minimal service of four years, Haviland set out for Russia where he hoped to gain an appointment in the Imperial Corps of Engineers. In St Petersburg he met the American ambassador and future president, John Quincy Adams (1735–1826), and his future brother-in-law, George von Sonntag, who encouraged him to emigrate to the USA. In 1816 John Haviland arrived in Philadelphia, where he hoped to set up an architectural practice like Benjamin Henry Latrobe before him. Philadelphia had changed, however, since the national capitol had moved to Washington, DC, and the economic centre had shifted to New York. Where Latrobe had pioneered the role of the professional architect in the USA, Haviland merely succeeded to his position of taste-maker, bringing fashionable English styles to anglophile Philadelphia. Like so many of his contemporaries, Haviland needed to use every opportunity to present his talents, including teaching and publications. Shortly after his arrival, he was conducting classes on architecture; simultaneously he wrote *The Builder's Assistant* (1818–21), a compendium of contemporary architectural practice.

Haviland showed his real abilities as a Greek Revival designer in Philadelphia, as characterized by the primitive Greek façade of the Pennsylvania Institute for the Deaf and Dumb (1823; now the Philadelphia College of Art), the abstract rectangularity of the Franklin Institute (1825; now the Atwater Kent Museum), derived from the rendering of the Choragic Monument of Thrasylus in *Antiquities of Athens* (1787) by James Stuart (1713–88) and Nicholas Revett (1720–1804), and the Nash-like remodelling of the Walnut Street Theater (1827). He also designed churches, including St Andrew's Episcopal Church (now St George's Greek Orthodox Cathedral) at 256 South 8th Street. He was as adventurous in construction as he was in his designs, using iron as an external building skin in the Miners' Bank in Pottsville (1830; destr. 1926) and building on a hitherto unequalled scale in his great prisons. These were Haviland's most memorable commissions; he represented them as castellated Gothic fortresses (e.g. Eastern State Penitentiary, Philadelphia, Cherry Hill; begun 1821, completed 1823–5; see fig.) and as Egyptian pylon temple-prisons as in Trenton, NJ (1832; altered), and in New York (1835; destr.); the latter, the Halls of Justice, entered popular terminology as 'The Tombs'. In Haviland's façades the influence of Newgate Prison, London (1770–85), by George Dance the younger (1741–1825), could be seen, while the radiating plan incorporated features of the panopticon workhouse of Jeremy Bentham (1748–1832), with cells for solitary con-

John Haviland: Eastern State Penitentiary, Cherry Hill, Philadelphia, Pennsylvania, begun 1821, completed 1823–5

finement. Fusing morality with economy, the scheme was widely imitated.

Haviland should have had greater success, for he was the logical successor to Latrobe after the latter's untimely death. However, real estate speculations raised the spectre of financial ruin, which Haviland attempted to resolve by applying funds from government work to his own account, with the result that most Federal work went to William Strickland and Robert Mills. Whereas Latrobe designed with a delicacy reminiscent of John Soane (1753–1837), Haviland introduced brutal proportions and a primitive force of character, which have been a great counterpoint in English design. This strong individuality found a natural home in Philadelphia, and, although Haviland never had any particular following apart from his son, Edward Haviland (1823–72), it remains a regional constant in Philadelphia architecture to this day.

WRITINGS
The Builder's Assistant, 3 vols (Philadelphia, 1818–21); rev. in 4 vols (Baltimore, 1930)
ed.: *Young Carpenter's Assistant* (rev. & enlarged, Philadelphia, 1830) by O. Biddle (1805)

BIBLIOGRAPHY
Obituary, *The Builder*, x/486 (1852), p. 381
N. B. Johnston: 'John Haviland: Jailor to the World', *J. Soc. Archit. Hist.*, xxiii/2 (1964), pp. 101–5
M. E. Baigell: *John Haviland* (diss., Philadelphia, U. PA, 1965)
S. Tatman and R. Moss: *Biographical Dictionary of Philadelphia Architects, 1700–1930* (Boston, 1985), pp. 343–7
J. Cohen: 'John Haviland', *Drawing towards Building: Philadelphia Architectural Graphics, 1732–1986* (exh. cat. by J. O'Gorman and others, Philadelphia, PA Acad. F.A., 1986), pp. 71–5
GEORGE E. THOMAS

Hawes, Josiah Johnson. *See under* SOUTHWORTH & HAWES.

Hawkes, T. G., & Co. American glass-cutting shop formed in 1880 by Thomas Gibbons Hawkes (*b* Surmount, Ireland, 1846; *d* Corning, NY, 1913). Hawkes was born into a glass-cutting family in Surmount. He arrived in the USA in 1863 and first worked at the Brooklyn Flint Glass Works, which moved to Corning, NY, in 1868; in 1871 he became supervisor of the Corning Glass Works. Hawkes's glass-cutting shop was founded in 1880, and he purchased blanks, which are plain, unadorned objects for cutting from the Corning Glass Works. After 1904 his craftsmen used blanks from the newly established Steuben Glass Works, which Hawkes had formed in partnership with members of his family and FREDERICK CARDER. In addition to blanks Carder also provided designs for Hawkes's cutters.

T. G. Hawkes & Co. is perhaps best known for its 'Russian' pattern, a heavy, rich-cut design that decorated a service ordered for the White House, Washington, DC, by President Benjamin Harrison (1833–1901) in 1891 and enlarged by President Grover Cleveland (1837–1908) during his second term and by President Theodore Roosevelt (1858–1919). Along with other designs, the pattern was in continuous use in the White House until 1937. These commissions and others for important American families brought Hawkes's craftsmanship to international attention at the beginning of the 20th century. In 1889 the firm won the grand prize at the Exposition Universelle in Paris for the 'Grecian' and 'Chrysanthemum' patterns, and for many years it was considered to be one of the foremost glass-cutting establishments in the USA.

BIBLIOGRAPHY
A. C. Revi: *American Cut and Engraved Glass* (New York, 1965)
J. S. Spillman: *White House Glassware: Two Centuries of Presidential Entertaining* (Washington, DC, 1989)
ELLEN PAUL DENKER

Hawthorne, Nathaniel (*b* Salem, MA, 4 July 1804; *d* Plymouth, NH, 19 May 1864). American writer. He was born into an eminent Puritan family and educated at Bowdoin College, ME. Although his major novels, *The Scarlet Letter* (1850) and *The House of the Seven Gables* (1851), are on American themes, his term as consul in Liverpool (1853–7) resulted in *Passages from the English Notebooks* (1870), published posthumously and edited by his widow. While his main interest in the *Notebooks* was the literary and historical associations of England, he revealed a growing appreciation of European art and charted his progress from ignorant admiration to a recognition first of defects, then beauties, and finally the 'broader differences of style'. His taste was essentially conventional: he admired the sentiment of Bartolomé Esteban Murillo (1618–82), the attention to detail of David Wilkie (1785–1841) and the Dutch realists' suggestion of the spiritual within the domestic. He objected to the meretriciousness of Thomas Lawrence (1769–1830) and the 'diseased appetite for woman's flesh' of William Etty (1787–1849), but he was impressed by the Pre-Raphaelites' repudiation of visual beauty. He showed a gradual understanding of the landscapes of J. M. W. Turner (1755–1851) but preferred those of Claude Lorrain (?1604/5–1683). His response to English architecture was less obviously subjective but was strongly influenced by

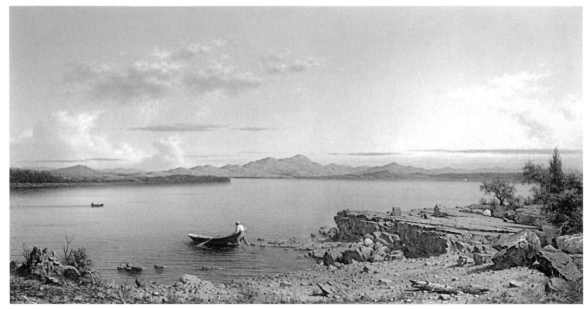

Martin Johnson Heade: *Lake George*, oil on canvas, 661×1264 mm, 1862 (Boston, MA, Museum of Fine Arts)

the ideas of the Romantic revival in that he admired Gothic cathedrals for their 'secrecy' and 'twilight effect'.

Hawthorne's stay in Rome and Florence in 1858–9 resulted in *Passages from the French and Italian Notebooks* (1872). Again, his taste was conventional: he admired Michelangelo (1475–1569), Raphael (1483–1520), Andrea del Sarto (1486–1530), Giambologna (1529–1608), Rubens (1577–1640), Claude and Rosa (1615–73) but confessed that Giotto (1267/75–1337), Cimabue (?*c.* 1240–1302), Fra Angelico (*c.* 1395/1400–1455), Botticelli (1444/5–1510) and Fra Filippo Lippi (*c.* 1406–1469) 'ought to interest me a great deal more than they do'. An element of parochialism is still apparent in his preference for George Loring Brown over Claude and in finding nudity in paintings tolerable if executed in a 'modest' and 'natural' fashion. His aesthetic judgements become gradually more sophisticated through the course of the *Notebooks*, however; he argued that an understanding of realistic art precedes a perception of the grand style and that artistic appreciation has no moral basis. Methods of hanging and mounting pictures in Italian galleries and churches also interested him, techniques that he felt the British had perfected. Hawthorne fictionalized his Italian observations in his novel *The Marble Faun* (1860), attempting to convert artistic judgements into metaphor. His characters' interactions uneasily represent New England moralism coming to terms with Italian aestheticism, the amorality of art and the dangerous lures of the Catholicism that fostered such art.

WRITINGS
The Marble Faun (Boston, MA, 1860)
S. Hawthorne, ed.: *Passages from the English Notebooks* (Boston, MA, 1870); repr. as *The English Notebooks* with additional essays, ed. R. Stewart (New York and London, 1941)
——: *Passages from the French and Italian Notebooks* (Boston, MA, 1872); repr. as *The French and Italian Notebooks* with additional essays, ed. T. Woodson (Columbus, OH, 1980)

BIBLIOGRAPHY
G. Clarke: 'To Transform and Transfigure: The Aesthetic Play of Hawthorne's *The Marble Faun*', *Nathaniel Hawthorne: New Critical Essays*, ed. A. R. Lee (London, 1982), pp. 131–47
T. Martin: *Nathaniel Hawthorne* (Boston, MA, 1983)
A. M. Donohue: *Hawthorne: Calvin's Ironic Stepchild* (Kent, OH, 1985)
L. Ostermark-Johnasen: 'The Decline and Fall of the American Artists: The Fatal Encounter with Rome in Hawthorne, Story and James', *Anlct. Romana Inst. Dan.*, xxi (1993), pp. 273–96
V. M. de Angelis: 'Une città dell'anima: La Roma di Nathaniel Hawthorne', *Veltro*, xxxviii/5–6 (1994), pp. 295–316

EDWINA BURNESS

Heade [Heed], **Martin Johnson** (*b* Lumberville, PA, 11 Aug 1819; *d* St Augustine, FL, 4 Sept 1904). American painter. He began as a portrait painter, working in a primly selfconscious and laboured limner tradition; among his portraits are a small number of real distinction, such as the *Portrait of a Man Holding a Cane* (1851; priv. col.). As with Fitz Hugh Lane, whose career suggests points of contact with Heade, his work was meticulous and restrained in handling and without painterly effects. Only in the early 1860s did Heade turn to a subject well suited to his artistic personality: the salt marshes of Newburyport, RI (e.g. *Sunrise on the Marshes*, 1863; Flint, MI, Inst. F.A.). He worked with a limited range of pictorial elements—haystacks, clouds, sky, water and a flatly receding earth—to create a precise spatial structure within which to explore the fleeting light effects of a coastal environment. Heade did not rely on rapid oil sketches or drawings carrying colour notations of the sort done by his friend Frederic Church; yet he remained responsive to atmospheric variations, transforming a relatively prosaic landscape into a visually heightened field of subtly shifting perceptions. The eerie 'luminist' precision of his landscapes and his independence from conventional composition contribute to the unsettling impression his work makes, as well as to its appeal to modern sensibilities.

Heade's work, in paintings such as *Lake George* (1862; Boston, MA, Mus. F.A.; see fig.), superficially resembles the detailed rendering and crystalline clarity of the American Pre-Raphaelites, such as William Trost Richards, whose practice was based on absolute fidelity to nature. Heade painted not according to a doctrine, but in order to reproduce the disquieting intensity of his own vision, evident in works such as *Coming Storm* (1859; New York, Met.; see colour pl. XIV, 2), *Approaching Storm: Beach near Newport* (*c.* 1865–70; Boston, MA, Mus. F.A.) or *Thunderstorm over Narragansett Bay* (1868; Fort Worth, TX, Amon Carter Mus.). These paintings exude a charged, ominously still atmosphere far removed from the reassuringly pastoral mood of the Hudson River school painters.

Heade worked primarily in a horizontal format, giving a planar organization to many of his landscapes. Such characteristics have earned him a place beside Fitz Hugh Lane and Sanford Gifford in retrospectively defining a luminist mode in American painting (*see* LUMINISM). Heade preferred to paint objects at close range, or rendered familiar through repetition. Such preferences led him to paint a remarkable series of still-lifes of flowers from the 1860s, such as the *Magnolia Grandiflora* (1885–95; Boston, MA, Mus. F.A.). Inspired by a series of trips to South and Central America in 1863–4, 1866 and 1870, Heade began a series of paintings of orchids and humming-birds in a tropical setting that combined his interests in landscape and still-life and that occupied him intermittently until his death (e.g. *Orchids, Passion-flowers and Hummingbird*, 1875–85; New York, Whitney). Though, like Frederic Church, he produced panoramic landscapes of South America, such as the *View from Tree Fern Walk* (*c.* 1870–87; Mr and Mrs Patrick Doheny priv. col.), he drew inspiration not from the exalting scope and breadth of nature, but from its exotic and sensuous forms, which assume a threatening vitality, defamiliarized by dislocations of scale and seductively rendered with characteristic visual intensity. Drawn to the lush profusion and strange mingling of life and death in the tropics, Heade spent the last two decades of his life in Florida. There he also found a patron, Henry Morrison Flagler, who furnished him the nominal security and recognition he had hitherto lacked.

Scholarly interest in Heade has grown steadily since the 1940s, but he remains an elusive and poorly documented figure, known primarily through scattered correspondence, journalistic writings and an extensive oeuvre, much of which is unlocated; the *Roman Newsboys* (*c.* 1848–9; Toledo, OH, Mus. A.), for instance, is a rare identified example of his genre paintings. While his art hints at broader stylistic developments in American landscape painting of the 1850s and 1860s, his genius resisted easy assimilation by popular and critical taste.

In an age of peripatetic artists, Heade was more widely travelled than most. His restless movement hints at a personality rarely at ease with the social environment of the post-Civil War years, in constant search of sympathetic subject-matter and exceptionally reticent. In a period when the growing cultural nationalism of the mid-19th century gave American artists a new legitimacy, Heade's own art retained a sardonic edge, distanced from the idealized, accessible vision of nature afforded by many of his contemporaries of the Hudson River school. Heade's

nickname 'Didymus' may refer to St Thomas, the doubting apostle, a choice that suggests the artist's lifelong scepticism towards the facile pieties and progressive faith of America's 'age of expansion'.

BIBLIOGRAPHY
R. G. McIntyre: *Martin Johnson Heade* (New York, 1948)
B. Novak: *American Painting in the Nineteenth Century* (New York, 1969), pp. 125–37
Martin Johnson Heade (exh. cat. by T. Stebbins, New York, Whitney, 1969)
T. Stebbins: *The Life and Works of Martin Johnson Heade* (New Haven, 1975)
J. G. Sweeney: 'A Very Peculiar Picture: Martin J. Heade's *Thunderstorm over Narragansett Bay*', *Archvs Amer. A. J.*, xxviii/4 (1988), pp. 2–14
D. Miller: *Dark Eden: The Swamp in Nineteenth-century American Culture* (Cambridge, MA, 1989)
K. E. Manthorne: *Tropical Renaissance: North American Artists Exploring Latin America, 1839–1879* (Washington and London, 1989)
Martin Johnson Heade: The Floral and Hummingbird Studies from the St Augustine Historical Society (exh. cat., Boca Raton, FL, Mus. A., 1992)
'Ominous Hush': The Thunderstorm Paintings of Martin Johnson Heade (exh. cat. by S. Cash; Fort Worth, TX, Amon Carter Mus.; Shelburne, VT, Mus.; New York, Met.; 1994–5)
Martin Johnson Heade: A Survey, 1840–1900 (exh. cat. by B. Novak and T. A. Eaton, West Palm Beach, FL, Eaton F.A.,1996)
ANGELA L. MILLER

Healy, George Peter Alexander (*b* Boston, MA, 15 July 1813; *d* Chicago, IL, 24 June 1894). American painter, active also in Europe. At the age of 17 he set up a studio in Boston after receiving encouragement from Thomas Sully, who was painting portraits there. Despite his youth and lack of training, he presented himself to the society figure Mrs Harrison Gray Otis and asked if he might paint her portrait (untraced); she agreed and later sponsored Healy's first trip abroad. In 1834 he entered the studio of Antoine-Jean Gros (1771–1835); the French master's suicide the following year ended Healy's only sustained period of artistic study. In Gros's studio he first encountered Thomas Couture (1815–79), but they did not meet again until the next decade, when Couture's friendship and example became important components of Healy's future success.

Healy opened a studio in Paris in 1835 but soon went to London. Four years later he returned to Paris, where his portrait of the American minister to France, *Gen. Lewis Cass* (1840; Detroit, MI, Hist. Mus.), brought him to the attention of Louis-Philippe (*reg* 1830–48). Winning the King's favour, he travelled back to London under royal patronage to copy portraits in Windsor Castle. Later he returned to America to paint US statesmen and presidents for the King's gallery at Versailles. During these years he created some of his most memorable portraits, including one painted in Paris of *Euphemia White Van Rensselaer* (1842; New York, Met.; see fig.). An exceptionally crisp and colourful portrait for Healy, the beguiling pose and composition were possibly inspired by the portraits of the royal family by Franz-Xavier Winterhalter (1805–73). Yet Healy's portrayal of a wealthy and fashionable American demonstrates the successful balance of modishness and modesty, clarity and flattery that proved so compelling to his clients and sitters.

Healy was in America when Louis-Philippe was forced to abdicate in 1848, but the artist soon returned to France and completed two ambitious history paintings. One of

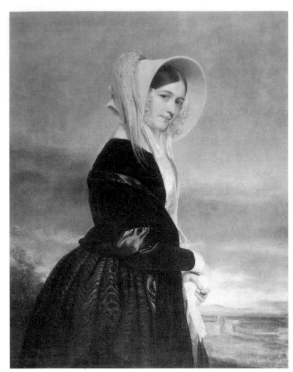

George Peter Alexander Healy: *Euphemia White Van Rensselar*, oil on canvas, 1162×895 mm, 1842 (New York, Metropolitan Museum of Art)

them, *Franklin in the Court of Louis XVI* (*c.* 1855; destr. by fire, 1871; sketch, *c.* 1847–8, see Boime, p. 577), won him a gold medal at the Paris Exposition Universelle of 1855. The same year Healy accepted the invitation of a Chicago businessman to settle in his city. He became the leading artist in the American Midwest, painting hundreds of portraits (e.g. the *Bryan Family*, 1857; Richmond, VA, Mus. F.A.) and helping to organize expositions and artists' organizations. The US Civil War affected his schedule little as he was over-age for military service; between 1860 and 1865 he painted generals, statesmen and presidents. His portrait of a seated, reflective *Abraham Lincoln* (1864; Chicago, IL, Newberry Lib.) is among the most famous images of America's 16th president. He painted several versions and used it as the centrepiece of a historical composition, *The Peacemakers* (1868; Washington, DC, White House Col.).

Healy returned to Europe in 1867, strained by the hectic pace he had kept in America. (By some accounts he was painting nearly 100 portraits a year.) He lived in Rome from 1868 to 1872 and Paris from 1872 to 1892. He travelled ceaselessly, journeying through Italy and Spain and accepting commissions in America, Berlin and Romania. Throughout his career he made more than 30 Atlantic crossings. His last was in 1892, when he announced to his wife that '[Paris] is changing and we are not' and returned to Chicago to spend his final days.

Much of Healy's work was lost in the Chicago fire of 1871, and his remaining portraits include several that command little interest beyond the historical. As his career progressed, his palette darkened to emphasize tonal con-

trasts, his touch became drier and his compositions more rigidly factual (e.g. *Emma Thursby*, 1879; New York, Hist. Soc.). Some of this change can be attributed to the influence of photography, although it also seems that Healy derived formulaic solutions to style and composition from Couture. Yet Healy remained a remarkably successful artist. His international fame was the result of natural facility, exceptional speed and great personal charm. His talents and character appealed to aristocrats, republicans and royalty alike; his sitters included Andrew Jackson, Charles Goodyear, Franz Liszt, Henry Wadsworth Longfellow, King Charles I and Queen Elizabeth of Romania, and Otto von Bismarck. Healy's reputation was unrivalled in his day, and his cosmopolitan career prefigured that of John Singer Sargent in the next generation.

WRITINGS
Reminiscences of a Portrait Painter (Chicago, 1894)

BIBLIOGRAPHY
M. de Mare: *G. P. A. Healy, American Artist: An Intimate Chronicle of the Nineteenth Century* (New York, 1954)
A. Boime: *Thomas Couture and the Eclectic Vision* (New Haven and London, 1980)

SALLY MILLS

Heins & La Farge. American architectural partnership formed in 1886 by George Lewis Heins (*b* Philadelphia, PA, 24 May 1860; *d* Mohegan Lake, NY, 25 Sept 1907) and C(hristopher) Grant La Farge (*b* Newport, RI, 5 Jan 1862; *d* Saunderstown, RI, 11 Oct 1938), son of JOHN LA FARGE. Grant La Farge trained with his father before enrolling at the Massachusetts Institute of Technology, where he met George Heins. La Farge joined the practice of H. H. Richardson, and Heins worked for Leroy S. Buffington in Minneapolis. Later they were both employed as draughtsmen for Cass Gilbert, and in 1884 they became assistants to John La Farge in Manhattan. Their formal partnership began in 1886, La Farge specializing in design, Heins in technical and administrative affairs.

In 1891 Heins & La Farge won the competition for the Episcopal Cathedral of St John the Divine in New York. Aged 31 and 29 respectively, and professionally unproven, they were chosen from over 70 firms to become architects of the grandest ecclesiastical project in America. Their design was a Byzanto-medieval hybrid and reflected the influence of Richardson; however, this style fell from favour as the Gothic Revival style rose in popularity. Burdened by the enormous stylistic and structural problems of the cathedral and by concurrent responsibilities as New York State Architect, Heins died prematurely. When the choir and crossing were consecrated in 1911, Ralph Adams Crams replaced La Farge with the intention of remodelling and completing the cathedral in the Gothic style (it remains unfinished).

The initial success of Heins & La Farge brought them numerous church commissions, most notably the Roman Catholic cathedrals of St Matthew in Washington, DC (1893), and St James in Seattle (1906), both in Renaissance style. They also designed the original buildings for the New York Zoological Park (1899–1911) and the handsomely tiled IRT subway stations in Manhattan, as well as private residences.

BIBLIOGRAPHY
Macmillan Enc. Archit.
J. La Farge: *The Manner is Ordinary* (New York, 1954)

Buildings on Paper: Rhode Island Architectural Drawings, 1825–1945 (exh. cat. by W. H. Jordy and C. P. Monkhouse; Providence, RI, Brown U., Bell Gal.; Providence, RI Hist. Soc.; Providence, RI Sch. Des., Mus. A.; New York, N. Acad. Des.; 1982), p. 221

J. Adams: *The Cathedral of Saint John the Divine in New York: Design Competitions in the Shadow of H. H. Richardson, 1888–1891* (diss., Providence, RI, Brown U., 1989)

L. Stookey: *Subway Ceramics: A History and Iconography of Mosaic and Bas Relief Signs and Plaques in the New York City Subway System with Photographs by the Author* (Brattleboro, VT, 1994)

JANET ADAMS

Henri, Robert [Cozad, Robert Henry] (*b* Cincinnati, OH, 24 June 1865; *d* 12 July 1929). American painter and teacher. He changed his name in 1883 after his father killed someone; in honour of his French ancestry, Henri adopted his own middle name as a surname, taking the French spelling but insisting all his life that it be pronounced in the American vernacular. After living with his family in Denver, CO, and New York, in 1886 he entered the Pennsylvania Academy of Fine Arts, Philadelphia, where he studied with Thomas Anshutz and Thomas Hovenden. In 1888 he attended the Académie Julian in Paris, where he received criticism from the French painters William-Adolphe Bouguereau (1825–1905) and Tony Robert-Fleury (1837–1911). He returned to Philadelphia in 1891 and painted in an Impressionist manner, for example *Girl Seated by the Sea* (1893; Mr and Mrs Raymond J. Horowitz priv. col., see Homer, pl. 1).

In 1895 Henri returned to Europe and adopted a dark-toned, broadly brushed style influenced by Velázquez (1599–1660), Frans Hals (1581/5–1666) and the early paintings of Manet (1832–83). His portrait studies in this style were accepted in the Paris Salons of 1896 and 1897. Through a one-man exhibition in Philadelphia in 1897, he came to the attention of William Merritt Chase, who introduced Henri into the New York art world. In 1900 he established himself in New York and began teaching at the New York School of Art, founded by Chase, until 1908, when he established his own school.

At this early stage Henri was helping younger artists in their struggle for independence against the New York art establishment. By 1906 when he was elected to the National Academy of Design, he had begun to undermine its authority. Angered by the restrictive exhibition policies of the Academy, Henri helped organize an independent exhibition in 1908 at the Macbeth Galleries, New York, of a group of artists who came to be known as THE EIGHT. Henri also helped organize the Exhibition of Independent Artists in 1910. Henri's chief followers were a group of artist newspaper illustrators whom he had encouraged to become painters: John Sloan, William J. Glackens, George Luks and Everett Shinn. They formed the core of the group later dubbed the ASHCAN SCHOOL, who painted with bold, bravura brushwork that imparted a certain spontaneity to their works. For subject-matter they turned to the vitality of everyday urban life in New York, for example *West 57th Street* (1902; New Haven, CT, Yale U. A.G.) by Henri.

Henri painted mainly portraits and landscapes, using impasto brushwork and strong chiaroscuro, as in *Laughing Child* (1907; New York, Whitney) and *The Masquerade Dress: Portrait of Mrs Robert Henri* (1911; New York, Met.). After 1909 his paintings became progressively more colourful as he experimented with the techniques of painter and colour theorist Hardesty Maratta (*b* 1864). Henri's reputation was, however, based on his ability as a teacher and leader of the Ashcan school. His ideas were disseminated further in *The Art Spirit* (1923), a collection of his lectures, precepts and attitudes towards art.

See also ARMORY SHOW and NEW YORK, fig. 7.

WRITINGS

M. Ryerson, ed.: *The Art Spirit* (Philadelphia, 1923, rev. New York, 1960)

B. B. Perlman, ed.: *Revolutionaries of Realism: The Letters of John Sloan and Robert Henri* (Princeton, 1997); review by M. J. Lewis in *New Criterion*, xvi (1997), pp. 65–8

BIBLIOGRAPHY

N. Pousette-Dart: *Robert Henri* (New York, 1922)

G. P. du Bois: 'Robert Henri', *Amer. Mag. A.*, xxii (June 1931), pp. 435–55

J. J. Kwiat: 'Robert Henri and the Emerson-Whitman Tradition', *Pubns Mod. Lang. Assocs*, lxxi/1 (1956), pp. 617–36

M. Sandoz: *Son of the Gamblin' Man: The Youth of an Artist* (New York, 1960)

W. I. Homer: *Robert Henri and his Circle* (Ithaca, 1969, rev. 1988)

John Sloan/Robert Henri: Their Philadelphia Years, 1886–1904 (exh. cat., Philadelphia, PA, Moore Coll. A. & Des., Goldie Paley Gal., 1976)

B. B. Perlman: *Robert Henri: His Life and Art* (New York, 1991)

My People: The Portraits of Robert Henri (exh. cat. by V. A. Leeds, Orlando, FL, Mus. A.; Fort Lauderdale, FL, Mus. A., Columbus, GA, Mus.; 1994–5)

The Allure of the Maine Coast: Robert Henri and his Circle, 1903–1918 (exh. cat. by J. F. Nicoll, Portland, ME, Mus. A., 1995)

V. A. Leeds: 'Robert Henri in Santa Fe', *Southwest A.*, xxviii/5 (1998), pp. 87–91

M. SUE KENDALL

Henry, E(dward) L(amson) (*b* Charleston, SC, 12 Jan 1841; *d* Cragsmoor, NY, 11 May 1919). American painter. He received his first art instruction in New York from Walter M. Oddie (1808–65), followed by two years at the Pennsylvania Academy of the Fine Arts, Philadelphia (1858–60). After this he left for a two-year stay abroad, studying with Paul Weber (1823–1916), Charles Gleyre (1806–74) and Courbet (1819–77). In 1864 he served as a captain's clerk on a boat taking supplies to the Union army. Two notable pictures that emerged from this experience were *City Point, Virginia, Headquarters of General Grant* (1865–72; Andover, MA, Phillips Acad., Addison Gal. A.) and *Westover Mansion* (1869; Washington, DC, Corcoran Gal. A.). He soon won recognition and was elected to the National Academy by 1869. Many of his paintings were sold before exhibition, and he had the reputation of always selling his work on varnishing day.

Henry's earliest paintings were of genre scenes and buildings around Philadelphia and later in New York. He made numerous sketches with details of early buildings and old woodwork, which he was intensely interested in preserving. His paintings of old buildings include the *North Dutch Church* (1869) and *Saint George's Church* (1875; both New York, Met.). In addition to collecting furniture, he kept his own museum of old carriages and costumes, in order to be accurate in his historical paintings.

Henry's interest in all forms of transportation is seen in *Station on the Morris and Essex Railroad* (1864; New York, Chase Manhattan Bank A. Col.) and the *9:45 Accommodation at Stratford, Connecticut* (1867; New York, Met.). The latter was commissioned by John Taylor Johnston, President of the New Jersey Central Railroad and first president of the Metropolitan Museum of Art, New York.

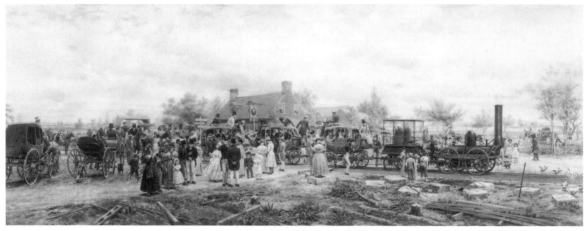

E. L. Henry: *Opening of the Railroad in New York State, August 1831, between Albany and Schenectady*, oil on canvas, 1.09×2.79 m, 1892–3 (Albany, NY, Albany Institute of History and Art)

Henry's widely reproduced watercolour *Before the Days of Rapid Transit* (1890; Albany, NY, Inst. Hist. & A.) portrays a packet-boat on the Erie Canal in the 1830s. The D & H Canal, connecting the Delaware and Hudson rivers, was a popular theme for Henry and other artists.

Henry had a wry but gentle sense of humour. Peter Brown, the town drunk of Ellenville, NY, was one favourite subject, and Henry also sought out other local characters to pose for his genre scenes. One of his most important paintings, the *Opening of the First Railroad in New York State, August 1831, between Albany and Schenectady* (1892–3; Albany, NY, Inst. Hist. & A.; see fig.), won a special prize at the World's Columbian Exposition in Chicago in 1893. His minutely detailed style of painting, so popular when he achieved his early fame, remained unchanged throughout his life.

Henry participated in and helped to develop the artists' colony at Cragsmoor, NY. He was a member of the Century Association, the American Watercolor Society and the Salmagundi Club. By the time of his death, his reputation was waning, but subsequently his work was valued for its warm, accurate and friendly look at the past. Many of Henry's paintings were reproduced and copyrighted by Christian Klackner in platinotypes, etchings and photogravures, while others appeared on calendars and elsewhere.

BIBLIOGRAPHY
E. McCausland: *The Life and Work of Edward Lamson Henry, NA, 1841–1919* (New York, 1945)
E. L. Henry's Country Life: An Exhibition (exh. cat. by M. Radl and J. P. Christman, Cragsmoor, NY, Free Lib., 1981)
M. Mann: *E. L. Henry: A New Look* (in preparation)
 MAYBELLE MANN

Herter, Christian (*b* Stuttgart, 8 Jan 1839; *d* New York, 2 Nov 1883). American cabinetmaker and designer of German birth. He completed his studies in Stuttgart and Paris and arrived in New York in 1859 to join his half-brother, Gustave Herter (1830–98), who ran a decorating business. After becoming an American citizen in 1867, he travelled to Paris and England, returning *c.* 1870, when he bought Herter Bros from Gustave. The firm's luxurious furniture and interiors from the early 1870s show the

influence of the Paris Opéra by Charles Garnier (1825–98), which he had no doubt seen. From the mid-1870s, however, the work of Herter Bros exhibited the more restrained and geometric lines of English design reformers, particularly the architect E. W. Godwin (1833–86), who promoted an enthusiasm for things Japanese. Although Herter's best Eastlake-style furniture reflects many of the reform ideas, he also used earlier Renaissance Revival and Néo-Grec designs. Much of his work shows a strong Japanese flavour, with angular, ebonized cherry cases enlivened with wild flower, insect and bird marquetry. On

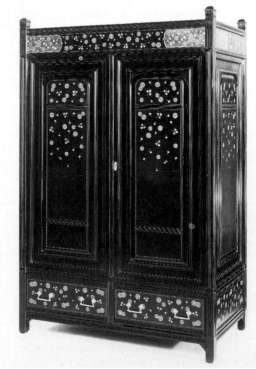

Christian Herter: wardrobe, ebonized cherry, white oak, yellow poplar, brass, 660×1257×1994 mm, 1870s (New York, Metropolitan Museum of Art)

the blonde bedroom furniture (*in situ*) purchased around 1880 for Lyndhurst in Tarrytown, NY, home of the wealthy financier Jay Gould (now owned by the National Trust for Historic Preservation), Herter made use of imported Japanese tiles, and he designed one of the finest Japanese-inspired interiors in the USA for the William H. Vanderbilt House (*c.* 1882; destr. 1927) on Fifth Avenue, New York. Typical of his best furniture is the exquisite ebonized wardrobe (1870s; New York, Met.; see fig.) in his Anglo-Japanese style. The cornice features inlaid, flowering branches from which blossoms shower down the long doors to accumulate on the two drawers below. Although Herter retired in 1879, the firm continued in existence until *c.* 1907 (see also colour pl. XXXIII, 2).

BIBLIOGRAPHY

M. J. Bordes: 'Christian Herter and the Cult of Japan', *Rec. A. Mus., Princeton U.*, xxxiv (1975), pp. 20–27

D. Hanks: *Christian Herter and the Aesthetic Movement in America* (New York, 1980)

Herter Brothers: Furniture and Interiors for a Gilded Age (exh. cat.; Houston, TX, Mus. F. A., New York, Met.; 1994)

A. C. Frelinghuysen: 'Christian Herter's Decoration of the William H. Vanderbilt House in New York City', *Antiques*, cxlvii/3 (1995), pp. 408–17

K. S. Howe: 'New York's German Furniture Makers: Herter Brothers' Furniture', *F.M.R. Mag.*, xci (1998), pp. 103–28

OSCAR P. FITZGERALD

Hesselius. American family of painters, of Swedish origin.

(1) Gustavus Hesselius (*b* Falun, Sweden, 1682; *d* Philadelphia, PA, 23 May 1755). He was trained in Sweden as a wood-engraver, gilder and painter. In 1712 he accompanied his brother, a Lutheran pastor, to America, where he settled in Philadelphia, PA. About 1720 he moved to the Annapolis, MD, area, returning before 1730 to Philadelphia, where he lived until his death. He was one of the first European trained painters to settle permanently in America and introduced a greater technical skill and increased realism into Colonial painting. His painterly, atmospheric style, which derived from European Baroque, contrasted with the more linear technique of American-born painters. During most of his career he was the leading painter of the Middle Colonies. In addition to mythological scenes, altarpieces and portraits of prominent individuals, Hesselius undertook utilitarian work that included painting the country seat at Springettsbury of Thomas Penn (1702–75) and the interior of the Pennsylvania State House, as well as flower-boxes, chairs, gates and altar-rails. He was also paid, probably as contractor and supervisor, for the construction and installation of an organ for the Moravian church in Bethlehem, PA.

Probably dating from quite early in Hesselius's career are two Classical subjects, *Bacchanalian Revel* (Philadelphia, PA Acad. F.A.) and *Bacchus and Ariadne* (Detroit, MI, Inst. A.), perhaps the first examples of mythological themes painted in America. The portrait of *Thomas Bordley* (Baltimore, Mus. & Lib. MD Hist.)—which, before it was cut to bust-length, depicted the prominent jurisprudent standing full-length in legal robes—was painted during his stay in Maryland. Probably his finest extant works are two portraits of chiefs of the Delaware Indians, *Tishcohan* and *Lapowinsa* (Philadelphia, PA, Hist. Soc.; see fig.), painted in 1735 for John and Thomas Penn on the occasion of a

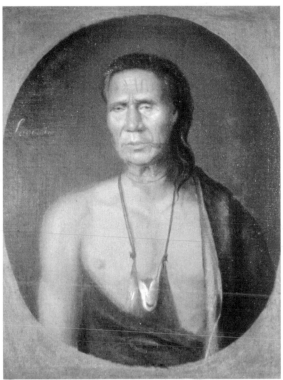

Gustavus Hesselius: *Lapowinsa*, oil on canvas, 838×635 mm, 1735 (Philadelphia, PA, Pennsylvania Historical Society)

meeting between representatives of the Penns and the Indians to settle a land dispute. These sensitive portraits are the first likenesses produced in America that realistically depict the facial characteristics of the Native American Indian. His *Self-portrait* and his portrait of his wife, *Lydia Hesselius* (both *c.* 1740; Philadelphia, PA, Hist. Soc.), reveal his ability to infuse his subjects with a strong sense of character. *Faithful Richardson* (priv. col.) dates from shortly before his death and reflects the growing taste in the Colonies for brighter colours and increased elegance in portraiture during the quarter century before the Revolution. Although Hesselius is known to have produced two altarpieces in the Colonies, neither seems to have survived. Records indicate that James Claypoole was his apprentice.

BIBLIOGRAPHY

Gustavus Hesselius (exh. cat. by C. Brinton, Philadelphia, PA, Mus. A., 1938) [several unsound attributions]

H. E. Keyes: 'Doubts Regarding Hesselius', *Antiques*, xxxiv (1938), pp. 144–5

E. P. Richardson: 'Gustavus Hesselius', *A. Q.* [Detroit], xii (1952), pp. 56–63

R. E. Fleischer: *Gustavus Hesselius* (diss., Baltimore, MD, Johns Hopkins U., 1964)

Philadelphia Painting and Printing to 1776 (exh. cat., ed. S. Whitin; Philadelphia, PA Acad. F.A., 1971), pp. 18–22

R. E. Fleischer: 'Gustavus Hesselius: A Study of his Style', *American Painting to 1776: A Reappraisal: Winterthur Conference Report, 1971*, pp. 127–58

Gustavus Hesselius: Face Painter to the Middle Colonies (exh. cat. by R. E. Fleischer, Trenton, NJ State Mus., 1988)

C. K. Arnborg and R. E. Fleischer: 'With God's Blessings on Both Land and Sea: Gustavus Hesselius Describes the New World to the Old in a Letter from Philadelphia in 1714', *Amer. A. J.*, xxi/3 (1989), pp. 5–17

ROLAND E. FLEISCHER

(2) John Hesselius (*b* ?Philadelphia, PA, 1728; *d* Anne Arundel Co., MD, 9 April 1778). Son of (1) Gustavus Hesselius. Records suggest that he was trained by his father, but there is little evidence of Gustavus's influence in his work. He was one of the leading portrait painters in the Middle Colonies in the third quarter of the 18th century. His lack of European training was possibly responsible for his unaffected attitude towards painting, which allowed him, unlike his contemporaries, to carry his interpretation of the Rococo portrait style to a middle-class, rather than powerful and wealthy, clientele. More eclectic than creative throughout most of his career, Hesselius is important for his reflection and improvement on the imported styles of others. He relied on the European mezzotint prints then popular in the Colonies for the composition and fashion detail in his works; his earliest known works are virtually coloured copies of these prints. He expressed himself primarily through line and colour, but in this too he was often influenced by others.

With his apparent early knowledge of the work of the New England artist Robert Feke, Hesselius developed a use of clear, strong colour that became an identifying feature of his portraits. In the late 1750s he adopted elements of the style of the more prominent itinerant English portrait painter John Wollaston, in particular the puffy, almond-eyed features of most of his American portraits. However, he surpassed Wollaston in such works as *Elizabeth Calvert* (1761; Baltimore, MD, Mus. A.) in his clarity of colour and lightness of line. Although he is generally credited as the first art teacher of Charles Willson Peale *c.* 1764, there is little in Peale's work to suggest a strong influence, but it is noteworthy that the portrait of *John Paca* (*c.* 1765; Peabody Inst., on dep. Baltimore, Mus. & Lib. MD Hist.), long published as by Peale, bears the

signature of John Hesselius. Virtually all traces of the Feke and Wollaston influences disappeared in Hesselius's later works, for example *Mrs Thomas Gough* (1777; Hagerstown, MD, Washington Co. Hist. Soc. Mus.), which shows an increased emphasis on the physical likeness and character of the sitter.

BIBLIOGRAPHY

T. Bolton and G. C. Groce: 'John Hesselius: An Account of his Life and the First Catalogue of his Portraits', *A. Q.* [Detroit], ii/1 (1939), pp. 77–91

R. K. Doud: *John Hesselius: His Life and Work* (diss., Newark, U. DE, 1963)

——: 'The Fitzhugh Portraits by John Hesselius', *VA Mag. Hist. & Biog.*, lxxv/2 (1967), pp. 159–73

——: 'John Hesselius: Maryland Limner', *Winterthur Port.*, v (1969), pp. 129–53

R. E. Fleischer: 'Three Recently Discovered Portraits by John Hesselius', *Antiques*, cix (1981), pp. 666–8

RICHARD K. DOUD

Hicks. American family of painters.

(1) Edward Hicks (*b* Attleborough [now Langhorne], PA, 4 April 1780; *d* Newtown, PA, 23 Aug 1849). He was raised by a devout Quaker family following his mother's death. At thirteen he was apprenticed for seven years to a coachmaker, where he developed the techniques of painting and lettering. By 1801 he had gone into business as a coach-, house- and sign-painter, later expanding his trade to include such items as milk-buckets, clockfaces and elaborate fireboards. Profoundly affected by his Quaker upbringing, he began to disapprove of painting as trifling and insubstantial, and in 1812 he became a Quaker minister. Hicks received no formal artistic training, and it was not until *c.* 1820 that he began to paint creatively. His paintings are infused with his intense religious conviction, and he reconciled his two vocations by keeping the former 'within the bounds of innocence and usefulness' and by creating images of morality. Most of his pictures were variations on Isaiah's biblical prophecy (Isaiah 11:6–9). Hicks's *Peaceable Kingdom* pictures (see colour pl. XXII, 1) were 'painted sermons', executed from about 1820 to the time of his death. Allegorical in nature, they depict the fulfilment of Isaiah's prophecy: benign animals and trusting infants co-exist with equanimity, while, in the background, William Penn can invariably be seen effecting his famous treaty with the Indians. The *Peaceable Kingdom* paintings are imaginative in composition and serene and sincere in mood, although technically unsophisticated. They were generally produced as gifts or commissioned works for relatives and friends. Occasionally Hicks indulged in homily when he lettered rhymed scriptural texts around the border of a picture.

Hicks worked exclusively in oils, and his stylized forms, simple figures, strong sense of design, flat decorative colours and careful lettering were all derived from sign-painting. Indeed, he persisted in seeing himself as a craftsman rather than an artist, continuing throughout his life to paint wagons, signs, farm equipment and other such utilitarian objects. The *Peaceable Kingdom of the Branch* (*c.* 1825–30; New Haven, CT, Yale U. A.G.), painted in oil on a wooden fireboard, neatly combines both Hicks's art and practical craftsmanship. His most accomplished pictures are farm scenes, such as the *Cornell Farm* (1848;

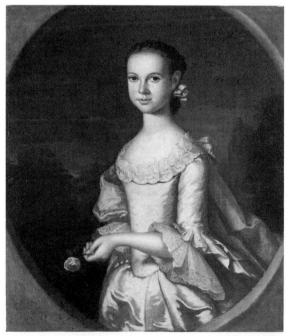

John Hesselius: *Elizabeth Calvert*, oil on canvas, 765×635 mm, 1761 (Baltimore, MD, Baltimore Museum of Art)

Washington, DC, N.G.A.), a large canvas brilliant in colour and full of detail. Most of his compositions were based on popular prints and engravings, often of historical scenes—George Washington at the Delaware; the Declaration of Independence—after the likes of Thomas Sully, John Trumbull and Benjamin West. These were then translated into Hicks's own naive decorative style. His effective use of colour and design provide an intrinsic charm that makes his work appear much more original than it is. Hicks was not widely known outside Pennsylvania until the 1920s and 1930s, when his *Peaceable Kingdom* compositions began to be included in American folk art exhibitions.

UNPUBLISHED SOURCES

New York, Frick ['Miscellaneous Extracts about Edward Hicks, Author of the "Peaceable Kingdom", Compiled by the Newton Library Corporation', 1935]

WRITINGS

Memoirs of the Life and Religious Labours of Edward Hicks (Philadelphia, 1851)

BIBLIOGRAPHY

A. E. Bye: 'Edward Hicks, Painter-preacher', *Antiques*, xxix (1936), pp. 13–16

J. Lipman and A. Winchester, eds: *Primitive Painters in America, 1750–1950: An Anthology* (New York, 1950)

J. Held: 'Edward Hicks and the Tradition', *A. Q.* [Detroit], xiv (1951), pp. 121–36

A. Ford: *Edward Hicks: Painter of the Peaceable Kingdom* (Philadelphia, 1952)

J. T. Flexner: *American Painting: The Light of Distant Skies* (New York, 1954)

E. P. Mather: *Edward Hicks: His Peaceable Kingdoms and other Paintings* (Newark and New York, 1983)

A. Ford: *Edward Hicks: His Life and Work* (New York, 1985)

American Folk Art in the Metropolitan Museum of Art (exh. cat. by C. Rebora Barratt, New York, Met., 1999–2000)

STEPHEN F. THORPE

(2) Thomas Hicks (*b* Newtown, PA, 18 Oct 1823; *d* Trenton Falls, NY, 8 Oct 1890). Cousin of (1) Edward Hicks. After being apprenticed (*c.* 1835–9) in the sign-painting shop of his cousin, he studied at the Pennsylvania Academy of the Fine Arts in Philadelphia (1839–40) and at the National Academy of Design in New York (1840–44). He then sketched and painted in England, Italy and France before becoming a student of Thomas Couture (1815–79) in Paris (1848–9). On his return to the USA in 1849, he established a studio in New York and quickly became a popular portrait painter, although his portrayals only rarely have enough psychological depth to make them of more than documentary interest. *Hamilton Fish* (1852; New York, City Hall) is among his stronger works. Hicks also painted genre subjects, such as *Musicale: Barber Shop, Trenton Falls* (1866; Raleigh, NC Mus. A.), and landscapes, the latter chiefly near Thornwood, his summer residence at Trenton Falls, NY. His early landscape style, which was in the manner of the Hudson River school, gave way to an Impressionist technique in the 1870s.

BIBLIOGRAPHY

G. W. Sheldon: *American Painters* (New York, 1879), pp. 35–9

D. Tatham: 'Thomas Hicks at Trenton Falls', *Amer. A. J.*, xv (1983), pp. 4–20

DAVID TATHAM

Higginson, Augustus Barker (*b* Stockbridge, MA, 1866; *d* Santa Barbara, CA, 17 June 1915). American architect. After graduating from Harvard University, he studied with the Boston firm of Andrews & Jacques (1889–91) and at the Ecole des Beaux-Arts (1892–4), Paris. On returning to the USA, he began his practice in Chicago, where he received various commissions for residential buildings. A representative example is the house (*c.* 1900) of Edwin S. Fechheimer, Winnetka, IL. This wood-shingled house exhibits flowing interior spaces and an interest in the natural colours and textures of building materials. The subtle contrasts of lightly stained pine beams and panels of coarse beige canvas placed between them provide a sophisticated backdrop for the handmade furniture, pottery and brass decorations, the total ensemble being a collaboration between architect and client. The interior and its contents reflect Higginson's involvement in the Arts and Crafts Movement. In 1905 he moved to Montecito, CA, and worked in the Santa Barbara area until his death. He built several houses there in the Arts and Crafts style, including the Higginson House (1905–10) at 1000 Channel Drive, Montecito, and the Coe House (1909), Santa Barbara.

BIBLIOGRAPHY

Macmillan Enc. Archit.; Withey

V. Robie: 'A Bachelor's Cottage in the Country', *House Beautiful*, xvii/5 (1905), pp. 30–31

Hill. American family of artists.

(1) John Hill (*b* London, 9 Sept 1770; *d* Clarksville, NY, 6 Nov 1850). Engraver of English birth. He was one of the most important graphic artists working in America in the first half of the 19th century. He learnt his craft in London and worked for publishers of prints and illustrated books, including Rudolph Ackermann (1764–1834). Hill achieved considerable success as an aquatinter of works by J. M. W. Turner (1755–1851), Thomas Rowlandson (1756/7–1827), Philippe Jacques de Loutherbourg (1740–1812) and others, but concern about his ability to support his growing family in a highly competitive market encouraged him to leave England. Settling in Philadelphia, PA, in 1816, he quickly became the leading printmaker in the area.

Hill was closely associated with two projects important to the history of American printmaking: Joshua Shaw's *Picturesque Views of American Scenery* and William Guy Wall's *Hudson River Portfolio* (issued serially between 1821 and 1825). Begun in 1819, *Picturesque Views* was the first major series of landscape scenes, often of a Romantic nature, to be printed in America. Since the 17th century American views had been published generally in England or on the Continent. With Hill's arrival, quality aquatints were produced in America. Wall's *Hudson River Portfolio* is a cornerstone in the development of American printing and landscape painting. The 20 views trace for 320 km the course of the Hudson River from Luzerne to Governor's Island, near Manhattan. The undertaking required Hill to move to New York in 1822. Throughout the 1830s he worked on further editions of this enormously popular series, an American variation on similar projects dealing with British and European rivers. Hill also engraved numerous single prints and pairs of views, compiled two artists' manuals and contributed plates to Fielding Lucas's *Progressive Drawing Book* (1827–8). Around 1840 Hill

retired to Clarksville, Rockland Co., not far from New York.

BIBLIOGRAPHY

R. J. Koke: 'John Hill, Master of Aquatint', *NY Hist. Soc. Q.*, xliii/1 (1959), pp. 51–117

——: *A Checklist of the American Engravings of John Hill, 1770–1850* (New York, 1961)

EDWARD J. NYGREN

(2) John William Hill (*b* London, 13 Jan 1812; *d* West Nyack, NY, 24 Sept 1879). Painter and illustrator, son of (1) John Hill. At the age of seven he moved to Philadelphia, PA, with his family. In 1822 he moved to New York, where he was apprenticed to his father for seven years. During this time, he worked on the aquatint plates for William Guy Wall's *Hudson River Portfolio* (1821–5), which influenced his early paintings.

By 1828 Hill was submitting his landscapes to the National Academy of Design, New York, and he continued to do so until 1873. He was elected an Associate Academician in 1833, and in the same year he visited London to study Old Master paintings. From 1836 to 1841 Hill served as a topographical artist for the New York State Geological Survey and from 1842 provided illustrations for James E. De Kay's *Natural History of New York, Part 1: Zoology*. After joining the Smith Brothers publishing firm in the late 1840s, he travelled extensively to sketch views of major North American cities. In 1850 he was a founder-member of the short-lived New York Water Color Society, precursor of the American Water Color Society.

About 1855 Hill read the first two volumes of *Modern Painters* (London, 1843–6) by John Ruskin (1819–1900), which significantly changed the direction and style of his art. From then on he devoted himself to painting directly from nature, depicting flowers, plants, fruit and birds in natural backgrounds (e.g. *Bird's Nest and Dogroses*, 1867; New York, NY Hist. Soc.). By adopting the stipple technique—pin-point dabs of pigment applied to a white ground—he was able to achieve brilliant colour and a high degree of exactitude.

In 1863 Hill became President of the American Pre-Raphaelite organization, the Society for the Advancement of Truth in Art. Hill exhibited almost yearly at the Brooklyn Art Association, which held a memorial retrospective of his work soon after his death. Such late landscapes as *View on Catskill Creek* (1867; New York, Met.) focus on the area around his home in West Nyack. One of his sons, John Henry Hill (1839–1922), was a watercolourist; he perpetuated his father's memory by publishing an illustrated biography and by promoting his work at major museums.

BIBLIOGRAPHY

J. H. Hill: *An Artist's Memorial* (New York, 1888)

R. Koke, ed.: *American Landscape and Genre Painting in the New York Historical Society* (Boston, 1982)

ANNETTE BLAUGRUND

Hill, Thomas (*b* Birmingham, England, 11 Sept 1829; *d* Raymond, CA, 30 June 1908). American painter of English birth. Son of a tailor, he emigrated with his family to the USA in 1844. After apprenticing to a carriage painter, Hill joined a Boston firm of interior decorators, but in 1853 moved to Philadelphia to study at the Pennsylvania Academy of Fine Arts. There he began to paint portraits and still-lifes, while continuing to decorate furniture; he returned to Massachusetts two years later. In 1861, seeking a milder climate for his health, he moved to San Francisco. Painting mostly portraits, he also made friends with local artists, two of whom accompanied him on his first visit to the Yosemite Valley in 1862. Hill travelled to Paris in 1866

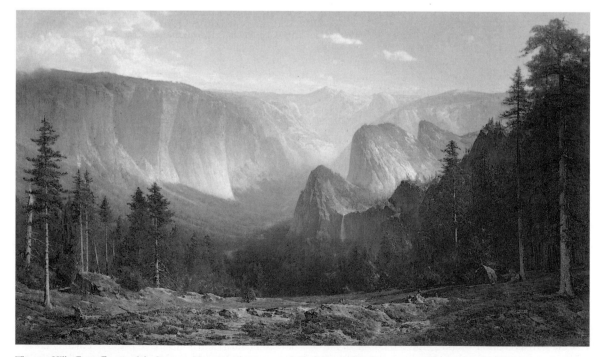

Thomas Hill: *Great Canyon of the Sierras—Yosemite*, oil on canvas, 1.83×3.05 m, 1871 (Sacramento, CA, Crocker Art Museum

for further training; he took sketching trips in the forests around Fontainebleau and studied with the German painter Paul Meyerheim (1842–1915), who encouraged him to specialize in landscape painting. Returning to Boston in the spring of 1867, Hill commenced painting large-scale, panoramic landscapes, including *Great Canyon of the Sierras—Yosemite* (1871; Sacramento, CA, Crocker A. Mus.; see fig.), which exhibits the development in his style towards loosened brushwork and dabs of dry impasto.

In 1871 health concerns induced Hill to return to California, where he quickly regained prominence in San Francisco's burgeoning art circles. During this enormously prosperous decade, Hill travelled and sketched extensively throughout northern California and New England; he exhibited at the Centennial Exhibition in Philadelphia and cultivated the patronage of railroad magnate LELAND STANFORD. A prolific painter renowned for his speed of execution, Hill won admiration from contemporaries for both spectacular vistas and intimate forest scenes. After 1880, however, Hill's career was marred by financial reverses and strained relations with both family and patrons. Like Albert Bierstadt, he found taste and patronage for large-scale landscape painting waning, but continued to work in established modes. Increasingly he focused his travel and painting on Yosemite; he moved permanently to the area in 1887. He continued to paint and exhibit work until the end of his life, although a series of strokes made painting difficult for him after 1897.

BIBLIOGRAPHY

Thomas Hill: The Grand View (exh. cat. by M. D. Arkelian, Oakland, CA, Mus., 1980)
B. Hjalmarson: 'Thomas Hill', *Antiques*, cxxvi/5 (1984), pp. 1200–07

SALLY MILLS

Hine, Lewis W(ickes) (*b* Oshkosh, WI, 26 Sept 1874; *d* Hastings-on-Hudson, NY, 4 Nov 1940). American photographer. Following several years as a factory worker in Oshkosh, and a short period at the University of Chicago, where he studied sociology and pedagogy (1900–01), he went to New York to teach at the Ethical Culture School (1901–8). There he acquired a camera as a teaching tool and soon set up a club and ran classes at the school, while improving his own skills as a self-taught photographer. In 1904 Hine's interest in social issues led him to document newly arrived immigrants at Ellis Island as a way of demonstrating their common humanity, for example *Young Russian Jewess at Ellis Island* (1905; see Rosenblum, Rosenblum and Trachtenberg, p. 43). Thereafter he sought to demonstrate the efficacy of the photograph as a truthful witness, accepting commissions from social-work agencies. Towards the end of the first decade he became official photographer on the Pittsburgh Survey, a seminal investigation of America's archetypal industrial city, producing such images as *Tenement House and Yard* (1907–8; Rosenblum, Rosenblum and Trachtenberg, p. 56).

This experience, coupled with the fact that half-tone process printing had made photographic reproduction more accessible to popular and specialized periodicals, impelled Hine to leave teaching to devote himself entirely to the documentation of social conditions. During almost a decade as staff photographer for the National Child Labor Committee (NCLC), he travelled throughout the USA photographing child workers in mills, mines, on the streets and in fields and canneries. These images, for example *Breaker Boys in Coal Shute, South Pittston, Pennsylvania, January, 1911* (see Rosenblum, Rosenblum and Trachtenberg, p. 59), were used by the NCLC in periodicals, pamphlets, exhibitions (for a time designed by Hine), and as lantern slides for public lectures in an effort to bring about legislation regulating child labour. Hine's photographs, however, transcend basic documentation in that he sought out poses, facial expressions and gestures that not only would be perceived as truthful but would also stir the viewer's sympathy and spur them to action.

PHOTOGRAPHIC PUBLICATIONS

Men at Work (New York, 1932)
Through the Threads of the Shelton Looms (New York, 1933)

BIBLIOGRAPHY

J. M. Gutman: *Lewis W. Hine and the American Social Conscience* (New York, 1967)
N. Rosenblum, W. Rosenblum and A. Trachtenberg: *America and Lewis Hine* (New York, 1977)
D. Kaplan: *Lewis Hine in Europe: The Lost Photographs* (New York, 1988)
——: *Photo Story: Selected Letters and Photographs of Lewis W. Hine* (Washington and London, 1992)

NAOMI ROSENBLUM

Hitchcock, George (*b* Providence, RI, 29 Sept 1850; *d* Marken, 2 Aug 1913). American painter, active in the Netherlands. A descendant of Roger Williams (the founder of Rhode Island), he practised law for several years in New York before deciding in 1879 to become an artist. He studied in Paris with Gustave Boulanger (1824–88) and Jules Lefebvre (1836–1911), in Düsseldorf, and in The Hague with H. W. Mesdag (1831–1915). He settled in Egmond-aan-Zee, near Alkmaar, in 1883, and was soon widely known for his paintings of religious subjects in contemporary settings and of sunlit views of tulip fields. He returned to the USA only occasionally in later years. Hitchcock's style, similar to Impressionism, has been appreciated more in Europe than in the USA. A good example of his style is the *Blessed Mother* (1892; Cleveland, OH, Mus. A.). He received some recognition in the USA, such as election to associate membership in the National Academy of Design, New York, and he was the first American to be made a member of the Akademie der Bildenden Künste, Vienna, and the first to become an officer of the Order of Franz Josef. He was also a chevalier of the Légion d'honneur.

BIBLIOGRAPHY

George Hitchcock (exh. cat., ed. C. Brinton; U. Rochester, NY, Mem. A.G., 1915)
P. Boswell: 'The George Hitchcock Memorial Exhibition to be Held at a New York Gallery', *A. & Dec.*, xiv (1921), p. 297

MARK W. SULLIVAN

Hitchcock, Lambert (*b* Cheshire, CT, 28 May 1795; *d* Unionville, CT, 3 April 1852). American cabinetmaker and furniture manufacturer. He came from a land-owning Connecticut family and in 1826 established a factory near Barkhamsted, CT, in an area renamed Hitchcocksville (now Riverton) after him. His chief product was an American adaptation of a late Sheraton-style, open-backed side chair, painted black with stencilled decoration, known as the 'Hitchcock' chair. In 1832 he entered into a partnership with his brother-in-law Arba Alford (1808–

81), and the firm was called Hitchcock, Alford & Co. Hitchcock's use of stencilled decoration on his painted chairs emulated the gilt and lacquered furniture being imported from Europe. The factory turned out hundreds of these 'fancy' chairs, made from hickory, maple, birch and poplar with rush or cane seats. They have a 'bolster' or flat-fronted top rail, with round, splayed, ring-turned front legs, sometimes tapered with ball feet, and round front, back and side stretchers, also ring-turned. Back uprights and back legs are all-in-one. Decoration consists of large floral and fruit designs, banded patterns or Greek anthemia, mostly in gold or bronze. From c. 1835 chair backs were flat and steam-bent backwards for comfort. The 'Hitchcock' chair was well-made and much copied, but few had the jaunty, inimitable air of the originals. In 1848 Hitchcock severed his relationship with the company, which continued to make furniture until 1853 as the A. & A. Alford Co., and until 1864 as the Phoenix Co. In 1946 the factory, unused since the 1930s, was taken over by the Hitchcock Chair Co., newly formed to restore and expand the premises and produce reproductions of Hitchcock's furniture. The John Tarrant Kenney Hitchcock Museum was established in Riverton in 1972.

BIBLIOGRAPHY

'Lambert Hitchcock of Hitchcock-ville, Connecticut', *Bull. Antiqua. & Landmarks Soc. CT*, xviii (1965)

19th-century America: Furniture and Other Decorative Arts (exh. cat., New York, Met., 1970)

E. Kenney Glennon: 'The John Tarrant Kenney Hitchcock Museum, Riverton, Connecticut', *Antiques*, cxxv (1984), pp. 1140–47

Hoadley, David (*b* Naugatuck, CT, 1774; *d* Waterbury, CT, 1839–40). American builder. He was brought up near Litchfield, CT, where the Scottish builder William Sprats (*c.* 1758–1810) had introduced a rich new ornamental vocabulary into the local vernacular, and he later moved to New Haven, CT, where he also came into contact with the technical innovations and more sophisticated Adam-esque style of the English builder Peter Banner. Hoadley's work is associated with the architectural flowering that came in the wake of Sprats and Banner and distinguishes Federal architecture in central Connecticut. Whether Hoadley was a designer or simply a builder and joiner is unclear. Undocumented attributions have been widely repeated, but with the exception of Yale's Philosophical Building, for which he made a plan in 1819, most are questionable. The most important is the United Church in New Haven (1813–15), which has often been cited as Hoadley's masterpiece but was, in fact, designed by Peter Banner, Ithiel Town and Ebenezer Johnson, although Hoadley was the contractor. The steeple, one of Connecticut's best, may well have been his work.

Hoadley's reputation rests securely on his skill in handling the constructional innovations of his time and his artistry as a joiner. Examples in Connecticut of his restrained ornamental style are Christ Church (1810), Bethany, and the Congregational churches of North Milford [Orange] (1810), Norfolk (1813) and Avon (1818). Other notable works in which he is known to have had a part are the Nathan Smith House (*c.* 1815) and the DeForest House (*c.* 1819), New Haven (both destr. *c.* 1908), the Eli Whitney House (*c.* 1825; destr.) designed by Ithiel Town, New Haven, the Tontine Hotel (1827; destr.) also by Ithiel Town, New Haven, and the Samuel Russell House (1829) by Town and Davis, Middletown, CT.

BIBLIOGRAPHY

Macmillan Enc. Archit.

H. Bronson: *The History of Waterbury, Connecticut* (Waterbury, 1858)

E. E. Atwater, ed.: *History of the City of New Haven* (New York, 1887)

J. F. Kelly: *Early Connecticut Meetinghouses* (New York, 1948)

E. M. Brown: *The United Church on the Green, New Haven, Connecticut: An Architectural History* (New Haven, 1965)

W. H. Watkins: *David Hoadley, Connecticut Builder* (diss., Oneonta, State U. New York Coll., 1974)

ELIZABETH MILLS BROWN

Hoban, James (*b* Kilkenny, Ireland, *c.* 1758; *d* Washington, DC, 8 Dec 1831). American architect of Irish birth. He studied architecture under the guidance of Thomas Ivory (*c.* 1732–1786) at the Royal Dublin Society's School of Architectural Drawing *c.* 1779. Faced with limited professional prospects in Ireland, Hoban emigrated to the USA in 1785, settling first in Philadelphia. Two years later he moved to Charleston, SC, where private residences and public buildings such as the former State House (1789; now a court-house) are attributed to him. In 1787 he met George Washington, who was then on a tour through the southern states; this meeting led to Hoban's participation in the competition of 1792 for the design of the President's House (now the White House; *see also* WASHINGTON, DC, fig. 6). He won with a design for a three-storey rectangular stone building, with a projecting central section of engaged columns above a heavy base. The central section and the floor plan resembled the Neo-classical Leinster House, Dublin, the residence of the Dukes of Leinster, built in 1745–51. After the competition, Washington altered the design to provide additional stone embellishments and an extension of the outer dimensions of the house.

Following his success in the competition, Hoban left Charleston and settled in Washington, DC, where he supervised the construction of the President's House and other public works projects in the city, including the US Capitol building. Among his private commissions was Blodget's Hotel (1793–4; destr.). After the President's House was burnt by the British in 1814, Hoban was invited to design and supervise the rebuilding of the house, a process that was completed in 1818. He also oversaw the rebuilding of the State and War Department structures (1818–20; destr.), which flanked the President's House to the east and the west respectively. Hoban remained in Washington until his death, serving on its city council and designing and building many of its modest Federal-style private buildings.

BIBLIOGRAPHY

DAB

F. D. Owen: 'The First Government Architect: James Hoban of Charleston, SC', *Archit. Rec.*, xi (1901), pp. 581–9

D. D. Reiff: *Washington Architecture, 1791–1861: Problems in Development* (Washington, DC, 1971–7)

W. Seale: *The President's House*, 2 vols (Washington, DC, 1986)

——: *The White House: The History of an American Idea* (Washington, DC, 1992)

ANTOINETTE J. LEE

Hobbs, Brockunier, & Co. American glass manufactory. In 1845 the firm of Barnes, Hobbs & Co. was established in Wheeling, WV, by John L. Hobbs (1804–81) and James B. Barnes (*d* 1849), who had both worked for the New

England Glass Co. In 1863 the firm became Hobbs, Brockunier & Co., and comprised Hobbs, his son John H. Hobbs, company bookkeeper Charles W. Brockunier and a silent partner, William Leighton sr (1808–91), son of Thomas H. Leighton (1786–1849) of the New England Glass Co. William Leighton was a scientist and superintendent of the firm, and his son William Leighton jr (1833–1911) succeeded him on his retirement in 1867.

By 1879 Hobbs, Brockunier & Co. was one of the largest glass factories in the USA and was making fine cut and engraved lead crystal, as well as an extensive range of pressed glass using the soda-lime formula developed by Leighton sr. This formula revolutionized pressed-glass making after 1865. The firm's great success during the Aesthetic period in America can be traced to the expertise of the company's members, whose previous associations had prepared them for producing exquisite art glass in a wide range of colours, patterns and textures. But it was the fancy glass in the Aesthetic taste that secured the firm's reputation. 'Craquelle', a crackled glass, was the first of a long line of these art wares. In addition to types using opal and shaded effects, the firm also made spangled glass with flecks of gold or silver foil in clear glass overlaid with tinted glass. Its most famous line was 'Peachblow', begun in 1886, to imitate a transmutational glaze used on Chinese porcelain known as peach-bloom.

The firm's success was brought to an end by the retirement of Brockunier and Leighton jr in 1887. Although Hobbs continued the works, the poor economic climate of the era adversely affected the business, which was taken over by the United States Glass Co. in 1891.

BIBLIOGRAPHY

D. B. Burke and others: *In Pursuit of Beauty: Americans and the Aesthetic Movement* (New York, 1986), pp. 440–41

ELLEN PAUL DENKER

Hoe, Robert (*b* New York, 10 March 1839; *d* London, 22 Sept 1909). American collector. He was the grandson of Robert Hoe, the manufacturer of printing machines and presses, who had made a fortune after emigrating to America. Hoe entered the family firm in 1856 and became its director in 1886. His thorough understanding of the printing business was allied to a love of books and an expert knowledge of the history of printing, on which he wrote and published various works.

Hoe's collection included illuminated manuscripts, among them a 13th-century Book of Hours, and a large number of early printed books, including a first edition of the *Works* of Ben Jonson (1616) and of the *Comedies and Tragedies of Francis Beaumont* (1647) and a folio first edition of the works of John Donne, which had belonged to Samuel Johnson. He was also a collector of fine bindings and owned a Procopius of 1509 from the library of Thomas Maioli, 11 examples of bindings from the library of Jean Grolier and works from the libraries of Diane de Poitiers and Louis XIII. Other works included examples from the Plantin Press and the Aldine Press, a copy of Albrecht Dürer's *Treatise on Proportion* printed by Formscheyder of Nuremberg (1528) and an edition of the *Cosmographie universelle* (1556) bound for Henry III, King of France.

Hoe's firm was instrumental in the development of high-speed and fine-art colour lithography printing, producing some of the largest and most innovative printing machines then in existence. Hoe himself was also one of the founders of the Metropolitan Museum of Art and a founder-member of the Grolier Club in New York. His collection of almost 21,000 titles was valued at over $1 million and after his death was sold by the Anderson Auction Company in New York on 1 May 1911.

WRITINGS

A Lecture on Book-binding as a Fine Art (New York, 1866)
A Short History of the Printing Press (?New York, 1902)

BIBLIOGRAPHY

DAB
O. A. Bierstadt: *The Library of Robert Hoe* (New York, 1895)
——: *Catalogue of the Library of Robert Hoe*, 8 vols in 4 (New York, 1911–12)

JACQUELINE COLLISS HARVEY

Holabird & Roche. American architectural partnership formed after 1881 by William Holabird (*b* American Union, NY, 11 Sept 1854; *d* Evanston, IL, 19 July 1923) and Martin Roche (*b* Cleveland, OH, 1 Aug 1853; *d* Chicago, IL, 6 June 1927). Holabird was the son of an army general. He became a cadet at the US Military Academy, West Point, but left in 1873 after two years. With this brief introduction to engineering he moved to Chicago and entered the office of architect William Le Baron Jenney. There he met Martin Roche, who had moved as a boy to Chicago, where he attended the Art Institute, which he left in 1867 to begin an apprenticeship as a cabinetmaker. In 1872 Roche entered Jenney's office, where the approach to architectural design was highly functional, with concern for economy of means, the opening up of interior space and the maximum use of natural light. Both Holabird and Roche probably served as draughtsmen on Jenney's First Leiter Building (1879; destr.), Chicago, which exemplified Jenney's Functionalist approach.

In 1880 Holabird left Jenney to form a partnership with Ossian C. Simonds (1857–1931); Roche joined them as a partner in 1881. In 1883 Simonds withdrew to pursue a career as a landscape architect, and the firm became Holabird & Roche. Due to the recession of the mid-1880s, building commissions in those first years were rare, and Roche returned to designing furniture. In 1886, however, Holabird & Roche won the commission for a 12-storey office block, the Tacoma Building (1888–9; with the engineer Carl Seiffert; destr.), which propelled the firm to the forefront of the profession in Chicago and represented their first contribution to the development of the SKYSCRAPER. In collaboration with Seiffert, the architects employed a complete riveted metal frame, using all the available forms of iron, wrought iron and steel. The street elevations were true curtain walls of glass and brick, but the rear walls were load-bearing.

Although the Tacoma Building had rudimentary diagonal bracing to resist lateral wind forces, Holabird & Roche employed extensive portal wind bracing in the 17-storey Old Colony Building (1893–4; with the engineer Corydon T. Purdy), Dearborn and Van Buren Streets, Chicago. In the Marquette Building (1894–5; with Purdy), Dearborn and Adams Streets, Chicago, the firm arrived at

a straightforward expression of the office-building metal frame that they continued to employ with great success for another 30 years. These buildings typically comprised a lower section incorporating entrance, shops and lobby with elevator; above this was a transitional mezzanine and the tall mid-section, where the bulk of the office cells were arranged in a U around an internal light court. In this mid-section the vertical lines were strongly emphasized, with slender, projected piers and recessed spandrel panels, and the wall was opened up with broad windows. At the top was a two- or three-storey crown set off by strong horizontals and a prominent terminating cornice. Other notable examples included the Cable Building (1898–9; destr.); the McClurg Building (1899–1900), 218 S. Wabash Street, Chicago; the Champlain Building (1903), State and Madison Streets, Chicago; and the Republic Building (1904–5; destr.). After 1910 the firm adopted more eclectic and historic forms, particularly in a series of large hotels and most especially in their classical City-County Building (1910–11), Chicago. They also designed a number of well-proportioned Georgian colonial town houses and residences, but virtually all have been demolished.

BIBLIOGRAPHY

DAB; *Macmillan Enc. Archit.*

J. C. Webster: 'The Skyscraper: Logical and Historical Considerations', *J. Soc. Archit. Hist.*, xviii (1959), pp. 126–39

C. W. Condit: *The Chicago School of Architecture: A History of Commercial and Public Building in the Chicago Area, 1875–1925* (Chicago, 1964)

——: *Chicago, 1910–29: Building, Planning and Urban Technology* (Chicago, 1973)

J. Zukowsky, ed.: *Chicago Architecture, 1872–1922: Birth of a Metropolis* (Munich, 1987)

LELAND M. ROTH

Homer, Winslow (*b* Boston, MA, 24 Feb 1836; *d* Prout's Neck, ME, 29 Sept 1910). American painter, illustrator and etcher. He was one of the two most admired American late 19th-century artists (the other being Thomas Eakins) and is considered to be the greatest pictorial poet of outdoor life in the USA and its greatest watercolourist. Nominally a landscape painter, in a sense carrying on Hudson River school attitudes, Homer was an artist of power and individuality whose images are metaphors for the relationship of Man and Nature. A careful observer of visual reality, he was at the same time alive to the purely physical properties of pigment and colour, of line and form, and of the patterns they create. His work is characterized by bold, fluid brushwork, strong draughtsmanship and composition, and particularly by a lack of sentimentality.

1. Early career, to 1872. 2. Middle years, 1873–82. 3. Late works, 1883–1910.

1. EARLY CAREER, TO 1872. Homer was the second of three sons of Charles Savage Homer, a hardware importer, and Henrietta Benson Homer, a gifted amateur watercolourist. Brought up in Cambridge, MA, where he attended school, he had an active outdoor boyhood that left a lifelong liking for the country. An independent, strong-willed young man, he showed an early preference for art and was encouraged in his interest by both parents. Like a number of self-educated American artists, Homer was first known as an illustrator. At 19 he became an apprentice at the lithographic firm of J. H. Bufford in Boston, where he developed a basic feeling for draughtsmanship and for composing in clear patterns of dark and light. When he completed his apprenticeship in 1857, he was determined to support himself as a freelance illustrator. His first illustrations—scenes of life in Boston and rural New England—appeared in *Ballou's Pictorial Drawing-Room Companion*, the noted Boston weekly. In 1859 he moved to New York and became an illustrator for *Harper's Weekly* magazine and for various literary texts, an activity that occupied him intermittently to 1887; among the authors he illustrated were the poets William Cullen Bryant, Henry Wadsworth Longfellow and Alfred, Lord Tennyson. Shortly after arriving in New York, he decided to broaden his artistic training. He attended drawing classes in Brooklyn, went to night school at the National Academy of Design and for a brief time had lessons in oil painting from the French genre and landscape painter Frédéric Rondel (1826–92). During the Civil War he went south with the Union Armies, serving as artist–correspondent for *Harper's*. His illustrations, showing the daily routine of camp life, are marked by realism, firm draughtsmanship and an absence of heroics. They were among the strongest pictorial reporting of the war.

After the war Homer began to concentrate on oil painting. These early oils, inspired by wartime scenes, are sober in colour and reveal the influence of his work as an illustrator in their grasp of the simple, telling gesture and the clarity of tone. They were instrumental in his election to the National Academy at the age of 29. His masterpiece of this period is *Prisoners from the Front* (1866; New York, Met.), which shows a Union officer confronting a group of Confederate prisoners in the midst of a devastated Virginia landscape. Shown at the National Academy of Design in 1866, it created a sensation and was hailed as the most powerful and convincing painting to have come out of the Civil War; it was singled out for praise at the Exposition Universelle in Paris in 1867.

Late in 1866 Homer made his first trip to Europe, spending ten months in France. In Paris he shared a studio in Montmartre with Albert Warren Kelsey, a friend from Massachusetts, and spent time in the countryside. His paintings from this period show the influence of the Barbizon school, especially the work of Jean-François Millet (1814–75). Possibly as a result of seeing the work of such progressive French landscape painters as Eugène Boudin (1824–98), on his return to New York in the autumn of 1867, Homer lightened his palette, and his touch became somewhat freer (e.g. *Long Branch, New Jersey*, 1869; Boston, MA, Mus. F.A.). Although New York was his winter home for over 20 years, he never painted it and seldom illustrated it. The outdoor world furnished the main content of his art for the rest of his life. From late spring into the autumn he worked in the country, mostly in New England but on occasion in New York state and New Jersey. These summer months provided material for almost all his early paintings and illustrations. While in a general sense he was continuing a native genre tradition initiated in the 1830s by William Sidney Mount and still being carried on by such popular painters as John George Brown, Homer's content marked a departure from the sentimentalism of the old school. Within a naturalistic

style he combined authenticity of images and a reserved idyllicism. Rural children at play (e.g. *Snap the Whip*, 1872; Youngstown, OH, Butler Inst. Amer. A.; see colour pl. XVIII, 2) and handsome young people at leisure (e.g. a *Game of Croquet*, 1866; New Haven, CT, Yale U. A.G.) were his subjects, presented within clear, firm outlines and broad planes of colour.

2. MIDDLE YEARS, 1873–82. By 1873 Homer was at a critical point in his career. Although his ability was recognized, he sold few oils, and he derived little sense of achievement from his work as an illustrator, describing it as a form of bondage. Responding perhaps to the growing interest by collectors and critics for watercolours by American artists—undoubtedly stimulated by an immensely successful exhibition of English watercolours shown at the National Academy in 1873—Homer took up the medium. Although he had often used wash drawings in preparation for his wood-engravings and lithographs, it was in the summer of 1873, spent at the fishing port of Gloucester, MA, that he explored the medium seriously for the first time. He exhibited the summer's work at the American Society of Painters in Watercolors in the spring of 1874 and became a member in 1877. Critics praised his originality, while at the same time severely criticizing him for what they called his crude colour and lack of finish. The translucency of watercolour against the white paper made an immediate difference in his colour, which attained a new clarity and luminosity. Thereafter, watercolour became an increasingly important part of his artistic expression. It became the medium in which he experimented with place and subject, and light and colour, the results of which he later embodied in oil. In time it was the medium in which he became America's undisputed master.

During the 1870s Homer's art grew steadily in strength and skill. With a growing command of *plein-air* light and its relation to form and space, his compositions became more complex and subtle. His works of the 1870s were much preoccupied with women, usually shown engaged in genteel activities. There were, however, exceptions: among them a series of paintings of black people in Virginia. Typical is the *Cotton Pickers* (1876; Los Angeles, CA, Co. Mus. A.), in which he imbues the figures with dignity and physical beauty, unlike the condescending images of blacks created by many of his contemporaries.

Unlike other American artists who flocked to Paris during the 1880s, Homer went to England in 1881 and settled in Cullercoats, a fishing village and artists' colony near Tynemouth, Tyne & Wear, an experience that had a profound effect on his art and his life. For the 20 months of his stay he devoted himself almost entirely to watercolour painting, mastering a range of academic techniques and making scores of pictures of the fisherfolk, particularly the women. The first works he produced were narrative and picturesque, closely related to the then-popular fishing subjects of The Hague school artists and to European peasant themes in general. His images gradually became more iconic, revealing a new undertone of seriousness and emotion. With such watercolours as *Inside the Bar* (1883; New York, Met.), Homer arrived at the subject that would concern him for the rest of his life: Man's struggle with Nature.

3. LATE WORKS, 1883–1910. In the autumn of 1882 Homer returned to New York City. A little more than a year later he settled permanently in Prout's Neck, ME, a lonely, rocky promontory on the Atlantic coast. He built a studio on the high shore, near the ocean, where he lived alone. His centre of interest shifted from inhabited to wild

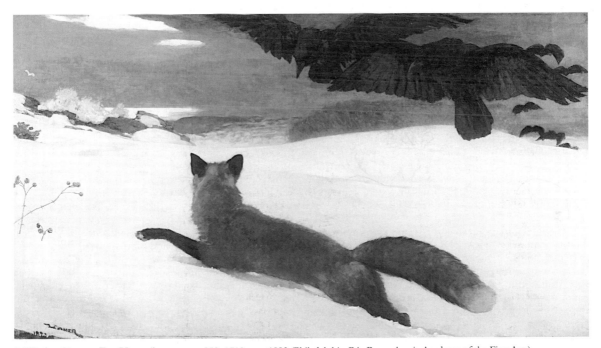

1. Winslow Homer: *Fox Hunt*, oil on canvas, 950×1712 mm, 1893 (Philadelphia, PA, Pennsylvania Academy of the Fine Arts)

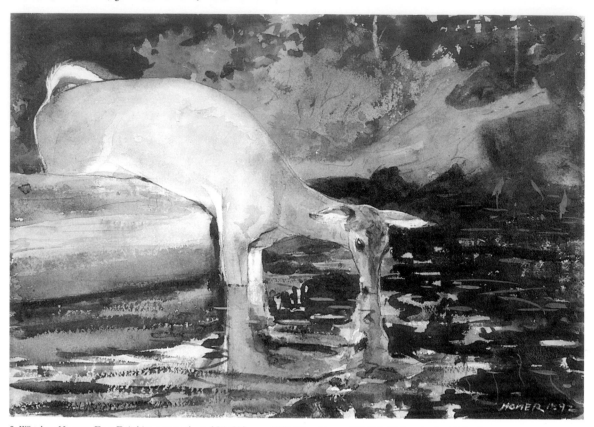

2. Winslow Homer: *Deer Drinking*, watercolour, 357×510 mm, 1892 (New Haven, CT, Yale University Art Gallery)

nature—to the sea and the wilderness, and the men who were part of them. From this time his art changed fundamentally; the idyllic worlds of leisure and of childhood pleasures disappeared, and women appeared less and less. The first product of this change was a series of sea paintings, among them the *Fog Warning* (1885; Boston, MA, Mus. F.A.) and *Eight Bells* (1886; Andover, MA, Phillips Acad., Addison Gal.), in which the recurring theme was the perils of the sea and the drama of Man's battle with it. Neither literary nor sentimental, their power is conveyed in purely pictorial terms. They were immediately successful, commanding high prices, and they established Homer's reputation as one of the foremost American painters. While painting his sea-pieces, Homer embarked on a new medium, etching. He etched eight plates between 1884 and 1889, seven of which were based on his sea paintings and his English watercolours (for illustrations see Goodrich, 1968, pls 90, 92, 94, 96, 98, 100, 102–3).

Although Homer's few recorded remarks on art express a purely naturalistic viewpoint, his images are metaphors of nature, confronting the question of mortality. In one of his greatest paintings, the *Fox Hunt* (1893; Philadelphia, PA Acad. F.A.; see fig. 1), the primitive struggle for survival is played out between a fox, normally the predator, trapped in deep snow, and a flock of birds descending from the sky for the kill.

The sea had been a subject of Homer's from the time he had worked at Gloucester in the early 1870s. In 1890

he began a series of pure seascapes that became his best-known work (e.g. *Sunlight on the Coast*, 1890; Toledo, OH, Mus. A.; *The Northeaster*, 1895; New York, Met.). Critics praised these pictures for their 'virility' and 'Americanness'. Monumental in scale, they were painted with broad brushwork and great plastic strength. The power, the danger, the loneliness and the beauty of the sea are evoked with an immediacy of physical sensation that places them among the most powerful modern expressions of Nature's force (see colour pl. XXIV, 2). The northern wilderness was also a favourite theme, but, unlike the earlier Hudson River school painters whose approach combined spectacular Romanticism and meticulous literalism, Homer expressed the exhilarating experience of this wild and unspoiled world through expressive brushwork and resonant colour, as in his watercolour *On the Trail* (1892; Washington, DC, N.G.A.).

In his later watercolours, however, executed on vacations away from Prout's Neck, Homer attained his purest artistic values. He brought to the medium a basically new style: painterly handling and saturated colour. An outdoorsman all his life, he took a fishing vacation almost every year, to the Adirondack Mountains, NY, and Quebec or to Florida, the Bahamas or Bermuda. The change of scene together with the lighter medium stimulated a more spontaneous expression. In oil, his touch was powerful, exploiting the weight and density of the medium; in watercolour, it was full of sensuous nuance. His watercolours express a private and poetic vision that otherwise

found no place in his art; for example *Adirondack Guide* (1894; Boston, MA, Mus. F.A.) and *Sloop, Nassau* (1899; New York, Met.) contain the pure visual sensation of nature. Painted on the spot, with fluid, audacious brushwork and full-bodied colour, composed with unerring rightness of design and linear beauty (see . 2), Homer's later watercolours have had a wide and liberating influence on much subsequent American watercolour painting by such diverse artists as John La Farge, John Marin and Andrew Wyeth (*b* 1917).

Although he achieved recognition early, Homer never had the financial success of an international favourite such as John Singer Sargent. In old age he was generally regarded as the foremost living American painter, and he received many awards and honours. By the last years of his life, more of his works were in public collections than those of any other living American artist.

UNPUBLISHED SOURCES

Brunswick, ME, Bowdoin Coll. Mus. A. [Homer Archvs]

BIBLIOGRAPHY

L. Goodrich: *Winslow Homer* (New York, 1944)
P. C. Beam: *Winslow Homer at Prout's Neck* (Boston, 1966)
L. Goodrich: *The Graphic Art of Winslow Homer* (Washington, DC, 1968)
P. C. Beam: *Winslow Homer's Magazine Engravings* (New York, 1979)
G. Hendricks: *The Life and Work of Winslow Homer* (New York, 1979)
Winslow Homer: The Croquet Game (exh. cat. by D. P. Curry, New Haven, CT, Yale U., A.G., 1984)
H. Cooper: *Winslow Homer Watercolors* (Washington, DC, 1986)
Winslow Homer's Images of Blacks (exh. cat. by P. H. Wood and K. C. C. Dalton, Houston, TX, Rice U. Inst. A., Rice Mus., Richmond, VA Mus. F.A.; Raleigh, NC Mus. A.; 1988)
Winslow Homer: Paintings of the Civil War (exh. cat. by M. Simpson, San Francisco, F.A. Museums; Portland, OR, A. Mus.; Fort Worth, TX, Amon Carter Mus.; 1988–9)
P. C. Beam: *Winslow Homer in the 1890s. Prout's Neck Observed* (New York, 1990)
N. Cikovsky jr: *Winslow Homer* (New York, 1990)
K. F. Jennings: *Winslow Homer* (New York, 1990)
D. Tatham: 'Trapper, Hunter and Woodman: Winslow Homer's Adirondack Figures', *Amer. A. J.*, xxii/4 (1990), pp. 40–67
J. Treiman: *The Artists Series: Monotypes* (New York, 1990)
M. S. Young: 'The Prophet of Prout's Neck', *Apollo*, cxxxii/346 (1990), p. 425
Winslow Homer: A Symposium: Washington, 1990
Winslow Homer in Gloucester (exh. cat. by D. S. Atkinson and J. Wierich, Chicago, IL, Terra Mus. Amer. A., 1990)
Reckoning with Winslow Homer: His Late Paintings and their Influence (exh. cat by B. Robertson, Cleveland, OH, Mus. A.; Columbus, OH, Mus. A., Washington, DC, Corcoran Gal. A., 1990–91)
D. Tatham: *Winslow Homer and the Illustrated Book* (Syracuse, 1992)
Winslow Homer (exh. cat. by N. Cikovsky and F. Kelly, Washington, DC, N.G.A.; Boston, MA, Mus. F.A.; New York, Met.; 1995–6)
E. B. Davis: 'American Drawing Books and their Impact on Winslow Homer', *Winterthur Port.*, xxxi (Summer/Autumn 1996), pp. 141–63
L. S. Ferber and B. D. Gallati: *Masters of Color and Light: Homer, Sargent and the American Watercolor Movement* (Washington, DC, 1998)
K. Haltman: 'Antipastoralism in Early Winslow Homer', *Art. Bull.*, lxxx/1 (1998), pp. 93–112

HELEN A. COOPER

Homer Laughlin China Co. *See* LAUGHLIN, HOMER.

Hone, Philip (*b* New York, 25 Oct 1780; *d* New York, 5 May 1851). American auctioneer, patron and collector. Hone accumulated a fortune in the auction business, retiring in 1821 to devote himself to Whig politics (he was briefly mayor of New York), fashionable charities, New York's cultural life and his diary. Hone helped to make the collecting of paintings by living American artists fashionable. He was one of the first to patronize Thomas Cole, and in the early 1830s his collection (dispersed at his death) contained works by Thomas Doughty, William Dunlap, Charles Cromwell Ingham, Samuel Morse, Rembrandt Peale, John Vanderlyn and William Guy Wall (1792–after 1864), as well as Charles Robert Leslie and Gilbert Stuart Newton (then considered American painters). When in the early 1830s Hone provided Dunlap with an annotated catalogue of his collection, he wrote with a typical mixture of pride and naivety: 'I do not know of a finer collection of modern pictures [in the United States]'.

UNPUBLISHED SOURCES

New York, NY Hist. Soc. [28-volume diary]

BIBLIOGRAPHY

W. Dunlap: *A History of the Rise and Progress of the Arts of Design in the United States* (New York, 1834/R 1969)
A. Nevins, ed.: *The Diary of Philip Hone, 1828–1851* (New York, 1927/R 1969) [contains only a portion of Hone's diary]

ALAN WALLACH

Hooker, Philip (*b* Rutland, MA, 28 Oct 1766; *d* Albany, NY, 31 Jan 1836). American architect. His earliest training was with his father Samuel Hooker (1746–1832), a carpenter and builder. The family moved in 1772 to Albany, NY, the centre of Hooker's activity throughout his life. The source of his training in drawing and surveying (the latter always a second profession) is unclear: he was possibly a pupil of the French architect Pierre Pharoux (*c.* 1760–95), who spent the winter of 1794–5 in Albany. Hooker's first commission was the North Dutch Church (1796–8; now First Church of Albany). The influence of the Neoclassicism of Charles Bulfinch is strongly evident, particularly the latter's Hollis Street Church, Boston, of 1787–8. Hooker's original design is known from drawings, as the central portico of the church was destroyed during renovations in 1857. His next commission was the first New York State Capitol Building (1804–6; destr. 1883) in Albany. Few of Hooker's buildings survive, although among those that do is the Albany Academy (1814). The unremarkable exterior shows the influence of the New York City Hall (1802) by John McComb jr. The interior details, however, display a concern for impeccable craftsmanship, especially of windows and door frames. Hyde Hall (1817–35), in Otsego County, NY, part of a country estate, is a grandly proportioned structure with elements of the Greek Revival style. Hooker's most outstanding late work was the Albany City Hall (1829–32; destr.), which combines elements of French and English Neoclassicism. While not among the great innovators of his time, Hooker is important as a disseminator of contemporary architectural trends into what was then a frontier area of the USA.

BIBLIOGRAPHY

Macmillan Enc. Archit.
E. Root: *Philip Hooker: A Contribution to the Study of the Renaissance in America* (New York, 1929)
W. R. Wheeler: 'The Architecture of Philip Hooker in New York State', *Antiques*, cxli/3 (1992), pp. 472–9
'A Neat Plain Modern Stile': Philip Hooker and his Contemporaries (exh. cat. by W. R. Wheeler and D. Bucher, Clinton, NY, Hamilton Coll., Emerson Gal., 1992)

□

Hopkins, John Henry (*b* Dublin, 30 Jan 1792; *d* Burlington, VT, 9 June 1868). American architect, designer and

ecclesiastic of Irish birth. He was taken from Ireland to the USA by his parents in 1800 and was successively the superintendent of an ironworks, a lawyer, and an ordained minister (1824) in Pittsburgh, PA. As rector of Trinity Church, he built a new church in 1825 in the Gothic style. The design was based on publications from England of John Britton (1771–1857) and Augustus Charles Pugin (1769–1832). An illustration of Trinity Church was one of 13 lithographs by Hopkins in his *Essay on Gothic Architecture* (1836), published after he became Episcopal Bishop of Vermont. This was the first book in the USA on the Gothic Revival and it preceded the main Gothic Revivalist works of A. W. N. Pugin (1812–52), which in turn influenced Hopkins's later architectural designs. One of Hopkins's first acts as Bishop was to consecrate AMMI B. YOUNG's only Gothic composition, St Paul's, Burlington, for which Hopkins designed the altar (illustrated in the *Essay*). He also designed St Thomas's (1860–63), Brandon, VT, a village church for 200 people, built, following A. W. N. Pugin's precepts, of local blue limestone. The larger Trinity Church (1863–5), Rutland, VT, accommodates 600 people, but uses wooden roof trusses, vaulting and pews similar to those in the Brandon church. Hopkins's *Essay* does not seem to have been widely distributed nor to have been influential. Most architects of the American Gothic took their cues from England, particularly from publications of A. W. N. Pugin and the Oxford Ecclesiologists.

WRITINGS
Essay on Gothic Architecture (Burlington, VT, 1836)

BIBLIOGRAPHY
J. H. Hopkins: *The Life of Bishop Hopkins* (New York, 1873)
L. Wodehouse: 'John Henry Hopkins and the Gothic Revival', *Antiques*, ciii (1973), pp. 76–83

LAWRENCE WODEHOUSE

Hoppin, Francis L(aurens) V(inton) (*b* Providence, RI, 1867; *d* Newport, RI, 10 Sept 1941). American architect and painter. After early training at the Trinity Military Institute, Providence, RI, preparing for a career in the army, he attended Brown University, Providence. From 1884 to 1886 Hoppin studied at the Massachusetts Institute of Technology and after another two years' study in Paris, he briefly joined the architectural firm of his brother Howard (1845–1940) in Providence. This was followed by an apprenticeship with McKim, Mead & White. In 1899, after eight years with this firm, he left and joined Terrence Koen (1858–1923), concentrating on projects in New York City. Luxurious country and city homes became their trademark. The James P. Lanier House (1905–6), 123 East 35th Street and the E. D. Baylies House (1905–9), 10 East 62nd Street, New York, are both in the Louis XVI style favoured by their wealthy patrons. Among his public buildings, the New York City Police Headquarters (1909), 240 Centre Street, reveals the influence of the Ecole des Beaux-Arts in Paris. Most of his fire and police stations in New York were also large and extravagantly ornamented. On retirement he travelled and painted watercolour views in Europe and New England.

BIBLIOGRAPHY
Withey
'Attractive Water-Colors', *New York Times* (26 April 1934), p. 21
Obituary, *New York Times* (11 Sept 1941), p. 23

DARRYL PATRICK

Hosmer, Harriet (*b* Watertown, MA, 9 Oct 1830; *d* Watertown, 21 Feb 1908). American sculptor. Although she was born, educated and died in the USA, Hosmer spent most of her life in Rome. Travelling with the actress Charlotte Cushman (1816–76), who formed a salon in Rome consisting mostly of women artists, Hosmer arrived in Italy in 1852. There she acquired the patronage of Russian and English nobility and became a close friend of Robert and Elizabeth Barrett Browning. She returned to the USA in 1900.

Hosmer's first piece, a bust of *Hesper* carved in the USA (1852; Watertown, MA, Free Pub. Lib.), induced John Gibson (1790–1866) to accept her as a student in Rome. Under his influence, Hosmer produced a variety of idealized marble figures, often with subjects from mythology. Her fame and most of her income were based on the frequently copied conceits of *Puck* (marble, 1856; Washington, DC, N. Mus. Amer. A.; see fig.) and *Will-o'-the-wisp* (marble, Piedmont, NY, priv. col.), but today she is admired for her sensitive and moving portrayals of doomed heroines: *Beatrice Cenci* (1853–5; St Louis, MO, Mercantile Lib.), which reveals her ability to model human form, and *Zenobia, the Queen of Palmyra* (*c.* 1857; Hartford, CT, Wadsworth Atheneum). Her highly polished, detailed and delicately restrained style reached its zenith in the monument to *Judith Falconnet* (*d* 1857), in S Andrea delle Fratte, Rome. Although Hosmer was publicly derided for using studio assistants who transferred the clay model to its marble state, a common practice in the mid-19th century, she was one of the few American sculptors of

Harriet Hosmer: *Puck*, marble, h. 777 mm, 1856 (Washington, DC, National Museum of American Art)

either sex who could, and at times did, carve her own work.

BIBLIOGRAPHY

R. A. Bradford: 'The Life and Works of Harriet Hosmer', *New England Mag.*, n.s., xlv (1911), pp. 265–9

W. H. Gerdts: *American Neoclassic Sculpture* (New York, 1973)

B. Groseclose: 'Hosmer's Tomb to Judith Falconnet: Death and the Maiden', *Amer. A. J.*, xii (1980), pp. 78–89

R. Nickerson: 'A Vanguard of American Women Sculptors', *Sculp. Rev.*, xxxv (Winter 1986–7), pp. 16–24

A. Mariani: 'Sleeping and Waking Fauns: Harriet Goodhue Hosmer's Experience of Italy, 1852–1870', *The Italian Presence in American Art, 1760–1860*, ed. I. B. Jaffe (Rome, 1989), pp. 66–81

D. Sherwood: *Harriet Hosmer, American Sculptor, 1830–1908* (Columbia, SC, 1991)

C. Colbert: 'Harriet Hosmer and Spiritualism', *Amer. A.*, x (1996), pp. 28–49

BARBARA GROSECLOSE

Hovenden, Thomas (*b* Dunmanway, Co. Cork, 28 Dec 1840; *d* nr Trenton, NJ, 14 Aug 1895). American painter of Irish birth. He was orphaned when he was six and was apprenticed to a frame carver and gilder at fourteen. His master encouraged him to enrol at the Cork School of Design. In 1863 Hovenden emigrated to New York and supported himself by colouring photographs and making frames. He attended night classes at the National Academy of Design, but was attracted to Paris in 1874, where he immersed himself in the academic painting of Jules Breton (1827–1906) and Alexandre Cabanel (1823–89) and joined the artists' colony at Pont-Aven. In 1880 he returned to New York with his new wife, the painter Helen Corson (1846–1935), and the following year they settled near Philadelphia. Hovenden's favourite subjects were interiors; he is best remembered for *Breaking Home Ties* (1890; Philadelphia, PA, Mus. A.; see fig.), which was voted the most popular picture at the Chicago World's Columbian Exposition in 1893. It depicts a young man leaving his rural home to make his fame and fortune in the city. The painting conveys a powerful and genuine sentimentality that is saved from excess by the solidity of the compositional structure, derived from his French training.

In general, Hovenden's output is characterized by naturalism of detail and overall clarity. Although he was primarily a genre painter, he also painted some Impressionistic landscapes, with softened forms and a lighter palette. He was elected Academician of the National Academy of Design, New York, in 1882 and succeeded Thomas Eakins as instructor at the Pennsylvania Academy of the Fine Arts in 1886. He was killed by a train while trying to save a child.

BIBLIOGRAPHY

R. Wunderlich: 'Thomas Hovenden and the American Genre Painters', *Kennedy Q.*, iii (1962), pp. 2–11

A. G. Terhune: *Thomas Hovenden (1840–1895) and Late Nineteenth-century American Genre Painting* (diss., New York, City U., 1983)

H. NICHOLS B. CLARK

Howells, John Mead (*b* Cambridge, MA, 14 Aug 1868; *d* New York, 22 Sept 1959). American architect and architectural historian. A son of the novelist William Dean

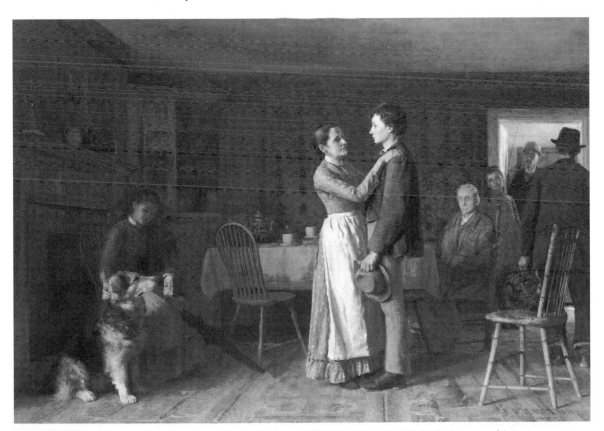

Thomas Hovenden: *Breaking Home Ties*, oil on canvas, 1.33×1.89 m, 1890 (Philadelphia, PA, Philadelphia Museum of Art)

Howells, he studied architecture at Harvard University (1891–4) and the Ecole des Beaux-Arts, Paris (1895–7), where his fellow students included two of his future collaborators: I. N. Phelps Stokes (1867–1944) and Raymond Hood. In 1897 Howells and Stokes formed a partnership in New York. Notable examples of their work include the Neo-classical style St Paul's Chapel (1904–7) at Columbia University, New York, a design proposal (1908) for the New York Municipal Building, and the Paint Hall (1913) music building at Harvard University. Thereafter Howells's interest in commercial skyscraper architecture came to dominate the partnership, while Stokes contributed to low-cost public housing projects in New York.

WRITINGS
The Verticality of the Skyscraper (New York, 1928)
Lost Examples of Colonial Architecture (New York, 1931)
The Architectural Heritage of the Piscataqua (New York, 1937)
Works (New York, 1938) [cat. of bldgs and projects]

BIBLIOGRAPHY
T. E. Tallmadge: *The Story of Architecture in America* (New York, 1927, rev. 1936)
C. W. Condit: *The Rise of the Skyscraper* (Chicago, 1952)
K. Sabbach: *Skyscraper* (New York, 1989)

Hubbard, Elbert (*b* Bloomington, IL, 19 June 1856; *d SS Lusitania*, off Co. Cork, 7 May 1915). American designer. He was initially a successful salesman for the Illinois-based Weller's Practical Soaps. He settled in East Aurora, near Buffalo, NY, and abandoned selling soap in 1893. During a trip to England the following year, he met William Morris (1834–96) and admired the works of his Kelmscott Press. On returning to East Aurora, Hubbard employed his great showmanship to popularize a simplified version of English Arts and Crafts design for a wide audience. With the help of a local press, he began publishing monthly biographies, *Little Journeys to the Homes of the Great* (1895–1909), the first two of which treat the lives of George Eliot (1819–80) and John Ruskin (1819–1900). Soon after, he founded the Roycroft Press with the publication of *The Philistine* (1895–1915), a monthly journal combining popular philosophy, aphorisms and brief preachments with crude Art Nouveau lettering and ornament. *The Song of Songs* (1895), printed on handmade paper with rough and arty bindings, was the first of many Roycroft books. The press became the centre of the Roycrofters, a neo-medieval community of craftsmen that operated on an apprentice system. Furniture production began in 1901; this included simplified Arts and Crafts furniture in oak and adaptations of Gustav Stickley's 'Mission' furniture. Roycroft leather and metal shops produced tooled leather goods, hammered copper and wrought-iron work, and a Roycroft Inn was established at East Aurora in 1903. Hubbard's many critics, such as C. R. Ashbee (1863–1942), maintained that he vulgarized the Arts and Crafts Movement. Commercially successful, the Roycroft shops survived Hubbard's death, existing until 1938.

BIBLIOGRAPHY
F. Champney: *Art and Glory: The Story of Elbert Hubbard* (New York, 1968)
L. Lambourne: *Utopian Craftsmen: The Arts and Crafts Movement from the Cotswolds to Chicago* (London, 1980)
R. Ewald: 'Roycroft Furniture: At the Roots of Arts-and-Crafts', *Fin. Woodworking*, lxxxviii (1991), pp. 90–93
A. Berman: 'AD Travels: Inside the Roycrofters' World: The Arts and Crafts Era Survives in Western New York: East Aurora', *Archit. Dig.*, lii (1995), p. 62
Head, Heart and Hand: Elbert Hubbard and the Roycrofters (exh. cat., Rochester, U. Rochester, NY, Mem. A.G.; Akron, OH, A. Mus.; Allentown, PA, A. Mus. and elsewhere; 1994–6); review by R. Knapp in *A. & Ant.*, xviii (1995), p. 89

E. A. CHRISTENSEN

Hudson, Grace Carpenter (*b* Potter Valley, CA, 21 Feb 1865; *d* Ukiah, CA, 23 March 1937). American painter. She grew up from age four in Ukiah, CA. On completion of her schooling there and in San Francisco, she attended the California School of Design (1880–81), where in her last year she received the Alvord Gold Medal for drawing. After an unsuccessful marriage (1884–5) and a relatively unproductive period in Ukiah, she again took up her art seriously in 1889. The following year she married Dr John Wilz Napier Hudson, a physician and amateur archaeologist and ethnologist, with a deep interest in American Indians, and went on to a successful career as an artist. During the years she continued to reside in Ukiah, though she made trips to Hawaii (1901), Oklahoma (1904), Europe (1905) and other places; from 1912 she lived in 'The Sun House' (now The Sun House and Grace Carpenter Hudson Museum), Ukiah.

Hudson's earliest paintings were largely of portraits, still-lifes and regional landscapes. By 1891, the Pomo became the focus of her interest. In that year, she exhibited

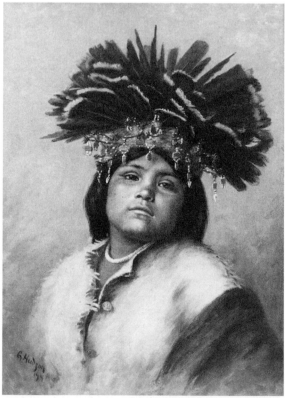

Grace Carpenter Hudson: *To-Tole ('The Star')*, oil on canvas, 356×254 mm, 1894 (Oakland, CA, Oakland Museum)

a study of a papoose at the Minneapolis Art Association show, which brought praise. However, it was *Little Mendocino* (San Francisco, CA Hist. Soc.), her portrait of a crying Pomo baby, that earned her an honourable mention at the World's Columbian Exposition, Chicago (1893) and gained her nationwide recognition. It also led to numerous solo exhibitions and showings at such events as the Carnegie International in Pittsburgh (1896) and the Alaska—Yukon International Exposition in Seattle (1909).

Hudson subsequently completed almost 700 numbered paintings, most of them of American Indian children and young women (see fig.), but some of others, as well. In addition to the Pomo, her oeuvre includes studies of the Pawnee of Oklahoma for the Field Museum of Natural History in Chicago (now Chicago Natural History Museum), for which Dr Hudson acted as Pacific Coast ethnologist in 1904; of the natives of Hawaii and Alaska; and of the Paiute of Nevada.

UNPUBLISHED SOURCES
Ukiah, CA, Sun House & Grace Carpenter Hudson Mus. [Grace Carpenter Hudson papers]

BIBLIOGRAPHY
Obituary: *Mendocino Beacon*, Ukiah, CA (27 March 1937), p. 1
Grace Carpenter Hudson (1863–1937) (exh. cat. by J. A. Baird jr, San Francisco, CA Hist. Soc., 1961)
S. R. Boynton: *The Painter Lady: Grace Carpenter Hudson* (Eureka, CA, 1976)
C. S. Rubinstein: *American Women Artists from Early Indian Times to the Present* (Boston, 1982)
The Pomo: Gifts and Vision (exh. cat. by K. P. Hough, Palm Springs, CA, Desert Mus., 1984)
P. Trenton, ed.: *Independent Spirits: Women Painters of the American West, 1890–1945* (Berkeley, 1995)
P. Kovinick and M. Yoshiki-Kovinick: *An Encyclopedia of Women Artists of the American West* (Austin, 1998)

PHIL KOVINICK

Hudson River school. American group of landscape painters active in the mid-19th century. It was a loosely organized group, based in New York City. The name is somewhat misleading, particularly in its implied geographical limitation; the Hudson River Valley, from New York to the Catskill Mountains and beyond, was the symbolic and actual centre of the school but was not the only area visited and painted by these artists. Neither was this a school in the strictest sense of the word, because it was not centred in a specific academy or studio of an individual artist nor based on consistently espoused principles. The term was in general use from the late 1870s but seems not to have been employed during the 1850s and 1860s, the most important years of the school's activities. It was initially used pejoratively by younger artists and critics who considered the earlier landscape painters hopelessly old-fashioned and insular in training and outlook. Nevertheless, the name gradually gained currency and is accepted by most historians.

Landscape paintings were created in modest numbers in America from the 18th century, but the early decades of the 19th century saw a great rise of interest in the genre. Several painters, notably Thomas Doughty, in Philadelphia, PA, and Alvan Fisher, in Boston, MA, were full-time landscape painters by 1820, but Thomas Cole was the acknowledged founder and key figure in the establishment of the Hudson River school. In 1825 Cole made a sketching trip up the Hudson River, and the resulting paintings brought him immediate fame in New York, where they were seen by John Trumbull, William Dunlap and Asher B. Durand. Cole had a competent understanding of the European landscape tradition, especially the works of Salvator Rosa (1615–73) and Claude Lorrain (?1604/5–1682), and based his interpretation of the American landscape on such 17th-century prototypes. Painting rugged mountain and wilderness scenes, such as *The Clove, Catskills* (c. 1827; New Britain, CT, Mus. Amer. A.), Cole gave the imprint of established art to American nature. At the same time, such writers as William Cullen Bryant (a friend and admirer of Cole) and James Fenimore Cooper were celebrating American scenery in prose and poetry, and this conjunction of artistic and literary interests provided an important impetus to the establishment of the school.

By the late 1820s Cole was the most celebrated artist in America, and he had begun to attract followers. His ambitions led him to investigate subjects other than pure landscape, such as the *Expulsion from the Garden of Eden* (c. 1827–8; Boston, MA, Mus. F.A.), and also to journey to Europe in 1831–2 in search of new subject-matter. For the rest of his career, Cole divided his time between allegorical and moralizing pictures, such as the *Voyage of Life* (1839; Utica, NY, Munson–Williams–Proctor Inst.; version, 1841–2; Washington, DC, N.G.A.), and pure landscapes, such as the *Notch of the White Mountains* (1839; Washington, DC, N.G.A.), establishing a dual focus for the early years of the school (for illustration *see* COLE, THOMAS).

By the early 1840s several artists, including Asher B. Durand, John F. Kensett, Jasper F. Cropsey and FREDERIC EDWIN CHURCH, had been inspired by Cole's example to take up landscape. These men regularly showed their works at the annual exhibitions of the National Academy of Design and the American Art-Union in New York, receiving praise from critics and attracting patronage from important New York businessmen and collectors, such as Philip Hone and Luman Reed.

An increasing number of artists began painting landscapes in the mid-1840s, and after Cole's death in 1848 the school burgeoned under the leadership of Durand, who became its principal spokesman and theorist. Durand's 'Letters on Landscape Painting', published in the New York art magazine *Crayon* in 1855, cogently expressed the aesthetics of the school. Addressed to an imaginary student, Durand's 'Letters' stressed the actual study of nature, the use of meticulous preparatory sketches made on the spot, and the execution of carefully conceived studio works that captured the majestic reality and special character of the American landscape.

Although Durand painted a few imaginary landscapes reminiscent of Cole, and Church and Cropsey often invested their compositions with some of Cole's high drama and intellectual content, the appeal of the allegorical mode gradually diminished in the early 1850s. Durand ultimately concentrated on pure landscape, developing two compositional types that became characteristic of the school: the expansive landscape vista, such as *Dover Plains, Dutchess County, New York* (1848; Washington, DC, N. Mus. Amer. A.), and the vertical forest interior, epitomized by *In the Woods* (1855; New York, Met.). These compo-

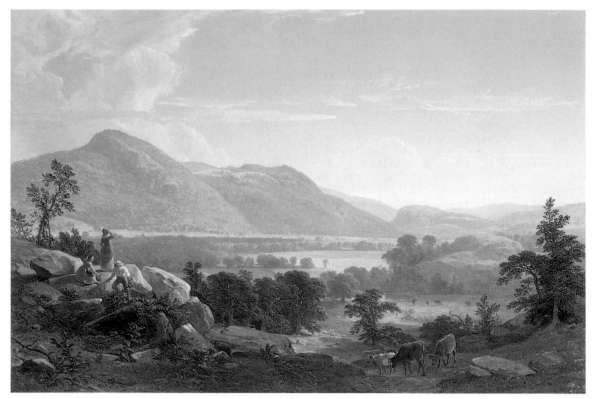

Asher B. Durand: *Dover Plains, Dutchess County, New York*, oil on canvas, 1.08×1.54 mm, 1848 (Washington, DC, National Museum of American Art)

sitions were further developed by other painters, especially Kensett, who, in such paintings as *View on the Hudson* (1865; Baltimore, MD, Mus. A.), combined meticulously rendered foregrounds with expansive, light-filled vistas, achieving perhaps the purest, and most complete, expression of the school's aesthetic.

In the 1850s and 1860s the Hudson River school flourished, and its most important figures, Church, Cropsey, Kensett, Sanford Gifford, Albert Bierstadt, Thomas Moran and Worthington Whittredge, many of whom maintained painting rooms in the Tenth Street Studio Building in New York, created their finest works (for illustration *see* CHURCH, FREDERIC EDWIN and BIERSTADT, ALBERT). These artists travelled widely, painting in remote regions of the northern United States, Canada, the Arctic, the American West and South America. Among others Bierstadt and Whittredge studied in Europe, occasionally painting European scenes once back in America. A number of painters, especially Kensett, Gifford and Martin Johnson Heade, were, by the 1860s, working in a manner that gave light effects predominance, leading some modern historians to isolate their work within a stylistic phenomenon called LUMINISM. Although some artists that were considered Luminist painters, such as Fitz Hugh Lane, had little contact with the Hudson River school, most were part of it, suggesting that Luminism was simply one aspect of the school's approach to landscape.

The school began to wane after the Civil War (1861–5), and by the 1870s it was already considered old-fashioned. American tastes gradually shifted towards more internationally current artists in general and towards Barbizon-inspired painters, such as George Inness, in particular. Although some figures of the movement continued painting into the 20th century, the school's creative energy was largely exhausted by 1880. Interest in the school revived in the 1910s, and exhibitions in the 1930s and 1940s restored it to popular attention and historical importance. By the 1960s the school's place in the history of American art had been solidly established, and by 1980 virtually every major artist had been the subject of a monographic exhibition or published study.

BIBLIOGRAPHY

The Hudson River School and the Early American Landscape Tradition (exh. cat., Chicago, A. Inst., 1945)
J. T. Flexner: *That Wilder Image: The Paintings of America's Native School from Thomas Cole to Winslow Homer* (Boston, 1962)
B. Novak: *American Painting of the Nineteenth Century: Realism, Idealism, and the American Experience* (New York, 1969)
Drawings of the Hudson River School (exh. cat. by J. Miller, New York, Brooklyn Mus., 1969)
J. K. Howat: *The Hudson River and its Painters* (New York, 1972/R 1978)
The Natural Paradise: Painting in America (exh. cat., ed. K. McShine; New York, MOMA, 1976)
B. Novak: *Nature and Culture: American Landscape Painting, 1825–1875* (New York, 1980)
American Light: The Luminist Movement, 1850–1875 (exh. cat., ed. J. Wilmerding; Washington, DC, N.G.A., 1980)
Views and Visions: American Landscape before 1830 (exh. cat., ed. E. J. Nygren; Washington, DC, Corcoran Gal. A., 1986)
R. O. Rodriguez: 'Realism and Idealism in Hudson River School Painting', *Mag. Ant.*, cxxxii (1987), pp. 1096–109
The Catskills: Painters, Writers, and Tourists in the Mountains, 1820–1895 (exh. cat. by K. Myers, Yonkers, NY, Hudson River Mus., 1987)

American Paradise: The World of the Hudson River School (exh. cat. by J. K. Howat, New York, Met., 1987); review by A. Wilton in *Burl. Mag.*, cxxx (1988), pp. 378–9

M. W. Sullivan: *The Hudson River School: An Annotated Bibliography* (Metuchen, NJ, 1991)

A. E. Berman: 'Discovering Values in the Hudson River School', *Archit. Dig.*, l (1993), p. 54

J. Driscoll: *All that is Glorious around us: Paintings from the Hudson River School* (Ithaca, 1997)

FRANKLIN KELLY

Hunt. American family of artists.

(1) William Morris Hunt (*b* Brattleboro, VT, 31 March 1824; *d* Appledore, Isles of Shoals, NH, 8 Sept 1879). Painter, sculptor and teacher. While a student at Harvard College, he exhibited precocious talents in the arts and studied with John Crookshanks King (1806–82), a sculptor working in Boston. In 1843 Hunt went to Europe with his mother and siblings, his father having died of cholera in 1832. They visited Paris and Rome, where he studied briefly under the American Neo-classical sculptor Henry Kirke Brown (1814–86). In 1845 he toured the Near East with his family and Thomas Gold Appleton, a patron and essayist from Boston, visiting Corfu and Athens *en route*. Later that year, he took the advice of Emanuel Leutze and enrolled in the Düsseldorf Academy, but he remained there only nine months. In 1846 Hunt went to Paris with the intention of joining the workshop of the sculptor James Pradier (1790–1852), but he was inspired to become a painter after seeing *The Falconer* (1845; Toledo, OH, Mus. A.) by Thomas Couture (1815–79). Hunt never abandoned his sculptural training, however, and continued to produce work such as the plaster relief of the *Horses of Anahita* (*c.* 1848; New York, Met.). From 1847 to 1852 he worked in Couture's studio, where he rapidly became a favourite pupil. An example of his early figure painting is *La Marguerite* (*c.* 1852; Paris, Louvre), which reflects Couture's influence in its centralized composition, its definition of form through broad masses of light and dark and its rich and elegant textures. Using the same techniques as Couture, Hunt created shaded areas with smooth sepia turpentine washes and contrasted these with dramatic highlights of thick impasto. Couture was a consummate technician, and his pupil assimilated and quickly mastered his doctrine of the primacy of style.

At the Paris Salon Hunt became acquainted with monumental peasant genre paintings of Jean-François Millet (1814–75), such as *The Sower* (1850; Boston, MA, Mus. F.A.). He became a close friend of Millet's and in 1853 moved to Barbizon, where he lived and worked until his return to the USA in the summer of 1855. His subject-matter was deeply influenced by Millet, and his *Belated Kid* (see fig.) shows his Romantic perception of peasant labour. Under the influence of Millet, Hunt abandoned the painterly flourishes he had learnt from Couture and replaced them with firm brushstrokes and thorough colour blending.

Hunt married the heiress Louisa Dumaresq Perkins on his return to the USA and thus secured his position in Boston society. He lived first at his family home in Brattleboro and then in Newport, RI, where he established an informal studio-school that attracted literati and artists, including Henry James and his brother William, as well as

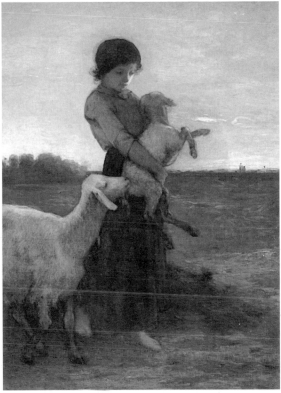

William Morris Hunt: *Belated Kid*, oil on canvas, 1372×978 mm, 1853–7 (Boston, MA, Museum of Fine Arts)

John La Farge. In 1864 Hunt established a studio in Boston, and during the ensuing decades he became a major cultural leader in New England. He was a vigorous spokesman for French modern art, inspiring the American patronage of Millet, Corot (1796–1875) and others. Boston's conservative attitude to art prompted Hunt to found the Allston Club in 1866; it existed only two years, but made important purchases, most notably *La Curée* (1858; Boston, Mus. F.A.) by Courbet (1819–77). During the 1860s Hunt was a highly successful portrait painter. In his portraits he used a variety of techniques ranging from a quasi-academic method based on Couture's work to broader, more expressive treatment with looser brushwork. *Mrs Richard Morris Hunt and Child* (1865–6; Boston, MA, Mus. F.A.) exemplifies the artist's desire to capture the sitter's spirit by the most direct means possible.

In 1866 Hunt made a second trip to France and travelled to Dinan with Elihu Vedder and Charles Coleman (1840–1928). After witnessing Millet's triumph at the Exposition Universelle, Paris (1867), and a brief reunion with the artist at Barbizon, he returned to Boston in 1868 and began teaching a class of women art students. During the 1870s he suffered a number of personal tragedies, beginning with a disastrous studio fire in 1872, followed by separation from his wife in 1873 and the suicide of his brother Jonathan in 1874. Partly as emotional solace, he turned his energies increasingly towards landscape painting (e.g. *Sandbank with Willows, Magnolia*, 1877; New York, Met.), and he spent the summer of 1876 touring rural

Massachusetts in a horse-drawn cart that functioned as a mobile studio.

Hunt received his most important commission in June 1878, for the decoration of two lunettes in the assembly chamber of the Albany State Capitol. He chose the poetic theme of Anahita, the Persian nature goddess, a subject that had attracted him for many years. One panel, the *Flight of Night*, depicted Anahita in a chariot of clouds and the other, *The Discoverer*, portrayed Christopher Columbus accompanied by Fortune, Faith, Hope and Science. Hunt worked in experimental pigments and painted directly on to the wall; this technique, coupled with the excessive damp in the chamber, led to a rapid deterioration of the decoration. The murals were regarded by his contemporaries as the culmination of Hunt's career, yet the demands of the commission left him physically and emotionally debilitated and led to his nervous collapse and subsequent suicide in 1879.

WRITINGS
H. M. Knowlton, ed.: *Talks on Art* (London, 1878/*R* New York, 1975)

BIBLIOGRAPHY
H. Angell: *Records of William Morris Hunt* (Boston, 1881)
E. D. Cheney: *Gleanings in the Field of Art* (Boston, 1881)
H. M. Knowlton: *Art-life of William Morris Hunt* (Boston, 1889, rev. New York, 2/1971)
M. Shannon: *Boston Days of William Morris Hunt* (Boston, 1923)
The Late Landscapes of William Morris Hunt (exh. cat., College Park, U. MD, 1976)
William Morris Hunt: A Memorial Exhibition (exh. cat. by H. Adams and M. J. Hoppin, Boston, Mus. F.A., 1979)
An International Episode: Millet, Monet and their North American Counterparts (exh. cat. by L. L. Meixner, Memphis, TN, Dixon Gal., 1982)
S. Webster: *William Morris Hunt, 1824–1879* (Cambridge, 1991)

LAURA L. MEIXNER

(2) Richard Morris Hunt (*b* Brattleboro, VT, 31 Oct 1827; *d* Newport, RI, 31 July 1895). Architect, brother of (1) William Morris Hunt. He was the most eminent architect of his time in the US, a prolific designer and the most significant figure of the day in the development of architectural professionalism.

Hunt created several nationally important buildings and was a frequent spokesman for his fellow architects; he was also a champion of high standards in building design. He was much honoured in his lifetime and became widely known, even while fairly young, as 'the dean of American architecture'.

1. TRAINING AND EARLY WORK. In 1843 his widowed mother brought the family to Europe. Except for a brief return to the USA in 1848, Richard remained in Europe for 12 years, eventually attending the Ecole des Beaux-Arts in Paris—the first American to be trained there—and from time to time travelling in Europe, Egypt and the Middle East. In 1846 he was admitted to the Ecole and joined the studio of Hector-Martin Lefuel (1810–80). He continued his association with the Ecole until 1854, when Lefuel was put in charge of additions to the Louvre, and Hunt was made inspector of works there. In that capacity he assisted Lefuel in the design of the imposing Pavillon de la Bibliothèque.

Hunt returned to the USA in September 1855 as a trained architect and set up an office in New York City. His first commission, a town house on 38th Street (destr.),

unexpectedly involved him in a lawsuit when the client refused to pay what Hunt considered his rightful commission. The resulting court case helped affirm a set fee schedule for the work of trained architects and identified Hunt as someone striving to protect professional rights. His earliest major commission was for the Tenth Street Studio Building (51 W. Tenth St; destr.) in New York City, the first American structure designed especially for artists. On completion in 1858, it at once became the physical centre of the city's artistic life.

Hunt set up his own training studio there, modelled on those in Paris, and through this studio had considerable impact on subsequent architectural education in the USA. To promote his profession, he also became a founder-member of the American Institute of Architects in 1857, eventually serving as its third national president (1888–91).

In 1861 Hunt married Catharine Clinton Howland; this brought him connections with a wealthy New York merchant family, from whom he later received several commissions. The couple travelled to France, where they remained for over a year. On his return to New York, Hunt prepared designs for formal entrances to the south side of Central Park, but his proposals were widely criticized as inappropriate for the new rustic park and were rejected. He was appointed as a judge and commissioner at the Paris Exposition Universelle in 1867, and he and his family once more travelled to Europe, returning to New York in 1868.

2. MATURE WORK.

(i) *Private commissions.* Hunt was becoming well known for his domestic architecture, having already constructed the J. N. A. Griswold House (1861–3; see fig. 1) in Newport, RI, an early example of his timber-gabled Stick style. It initiated an important series of houses in Newport, including the remodelling of Château-sur-Mer, the Wetmore mansion (1869–79), at that time the largest residence in Newport. Much comment was caused in Boston by Hunt's Brimmer houses (1869–70; destr.), which used French Renaissance details, and in Chicago by the street façade of his mansion for Marshall Field (1871–3), in Second Empire style.

Very large, ornate private houses seemed to give Hunt his greatest satisfaction, and he was given more commissions for these as his career developed. His elegant New York town house for William K. Vanderbilt (1879–82; destr.), 660 Fifth Avenue, designed in a Late Gothic/early French Renaissance style, was widely admired and emulated. The Henry G. Marquand Mansion (1881–4; destr.), the Ogden Mills Mansion (1885–7; destr.), the William V. Lawrence Mansion (1890–91; destr.), the Elbridge T. Gerry Mansion (1891–4; destr.) and the very large double residence (1891–5; destr.) on Fifth Avenue for Mrs William B. Astor and her son, Colonel John Jacob Astor, in various styles, all contributed to the decorative elegance of New York's Upper East Side. In Chicago the William Borden Mansion (1884–9; destr.) echoed the design of the William Vanderbilt House. Large country houses for clients (who were often personal friends) were also important projects. The Levi P. Morton Mansion (1886–7; destr.), near

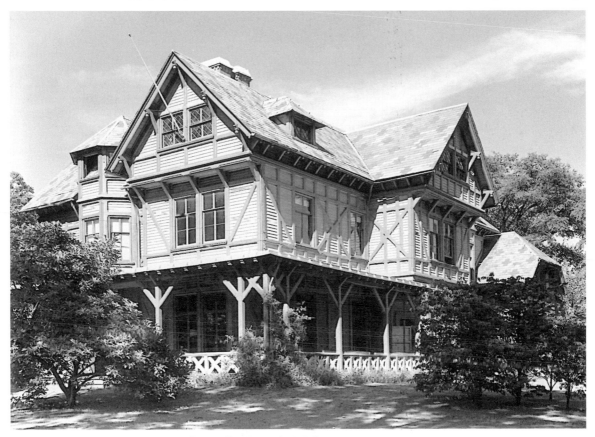

1. Richard Morris Hunt: Griswold House, Newport, Rhode Island, 1861–3

Rhinecliff, NY, was designed as an Elizabethan manor house, and the James W. Pinchot Mansion (1884–6) in Milford, PA, the Archibald Rogers Mansion (1886–9) in Hyde Park, NY, and the Joseph Busk Mansion (1889–91) in Newport were rustic structures in a late medieval French mode.

Hunt is perhaps best remembered today for his huge summer 'cottages' in Newport designed for holiday use and for his great château-style house, Biltmore, in North Carolina; these mansions set the standard for the most opulent way of life in an age of lavish consumption. Ochre Court (1888–92), constructed as a summer home in Newport for Ogden Goelet, who had made a fortune in New York real estate, is in the style of an elegant French château, set on a small town plot. Close by, Marble House (1888–92), erected for William K. and Alva Vanderbilt and modelled in part on the White House in Washington, DC, included the most lavish interiors that Hunt ever designed. Belcourt Castle (1891–4), Newport, commissioned by O. H. P. Belmont and combining French, English and Italian elements, was created as a huge stable and carriage house with living quarters attached. The Breakers (1892–5; for illustration *see* NEWPORT), the grandest of Hunt's Newport houses, commissioned by Cornelius Vanderbilt II, was designed in a 16th-century Genoese style. Biltmore House (1888–95; see fig. 2) was the largest of Hunt's country palaces, erected amid 125,000 acres of farmland and forest preserve close to Asheville,

NC, for George Washington Vanderbilt. Boasting more than 250 rooms, it is the largest American house ever constructed. It was enriched by opulent interiors in a picturesque French Late Gothic and early Renaissance mode and surrounded by elaborate formal gardens.

(ii) Monuments and memorials. Hunt's many monuments and memorials, usually in collaboration with the sculptor John Quincy Adams Ward, who favoured a straightforward realism, also brought him public attention. The Hunt–Ward projects included the *Seventh Regiment* monument (1867–73), Central Park, New York City; the *Matthew C. Perry* statue (1868–72), Newport; the *Yorktown* monument (1880–84), assisted by Henry Van Brunt, in Virginia; the statue of *George Washington* (1883), Wall and Broad Streets, New York City; and the *James Abram Garfield* monument (1884–7), The Mall, Washington, DC. More significant than any of these, however, was Hunt's base and pedestal for Frédéric Auguste Bartholdi's monumental *Statue of Liberty Enlightening the World* (1881–6), the most important American statuary project of the 19th century.

(iii) Commercial and public buildings. Hunt was responsible for several significant commercial structures, at first mainly in New York. He built the Presbyterian Hospital (1868–72; destr.), the most modern hospital in the city, for James Lenox, the wealthy merchant and bibliophile,

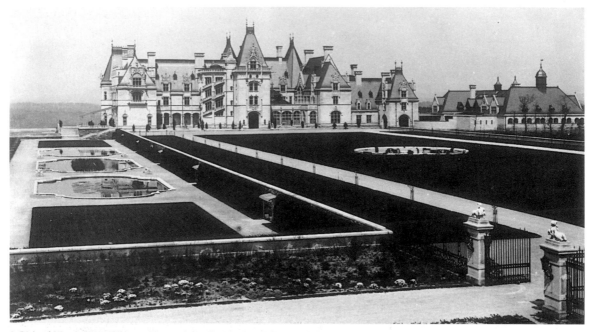

2. Richard Morris Hunt: Biltmore House, Asheville, North Carolina, 1888–95

and for the same client designed the elegant Neo-grèc Lenox Library (1870–77; destr., now the site of the Frick Museum), facing Central Park. In Newport he built the Travers Block (1870–71) of shops and apartments in Bellevue Avenue, and this still stands prominently, not far from the site of Hunt's own summer home. Also in New York were the Stuyvesant Apartments (1869–70) on East 18th Street, based on the Parisian model; this was the first important American apartment house. The large Stevens House (1870–72; destr.), also built as an apartment house, was later turned into a commercial hotel (The Victoria). Two iron-fronted stores—the Van Rensselaer Building (1871–2; destr.) and the Roosevelt Building (1873–4; see NEW YORK, fig. 2), 478–82 Broadway—utilized up-to-date cast-iron technology. The Delaware and Hudson Canal Company Building (1873–6; destr.) was a large and imposing office building. Hunt's Tribune Building (1873–6; destr.), facing City Hall Park, with a clock-tower surmounted by a spire rising from the roof, was for several years the tallest structure in New York.

Following another long visit to Europe in 1874–5, Hunt served as an architectural juror for the Philadelphia Centennial International Exhibition of 1876. His own work became stylistically more varied. Examples are the Scandinavian Stave-style St Mark's Chapel and Rectory (1879–80) at Islip, Long Island; the Association Residence for Respectable Aged Indigent Females (1881–3; now the national headquarters for American Youth Hostels), New York City, combining French Gothic Revival elements; the austere Chemical Laboratory (1885–91) at Princeton College (now University), Princeton, NJ; and the Flemish-gabled Free Circulating Library (1887–8), Jackson Square, New York City.

To his contemporaries, Hunt was probably best known for his Beaux-Arts classical Administration Building, with its gold and white dome (1891–3; destr.), at the World's Columbian Exposition held in Chicago (1893). Hunt was chosen by his peers as chairman of the Board of Architects and awarded the commission for the most prominent building of the Exposition. It rose some 80 m over the site of the fair, and placed as it was at the head of the Court of Honor, it set an elegant and dignified tone.

Three further visits to Europe refreshed Hunt's artistic sensibilities; in his final years, while continuing work on great houses and monuments, he also undertook new academic and church commissions. He designed several small buildings (1887–93) for the US Naval Observatory in Washington, DC; for Adelbert College, later Case Western Reserve University, Cleveland, OH, he designed the eclectic Clark Hall (1889–92); and for the United States Military Academy at West Point, a large Academic Building (1889–95), a gymnasium (1889–93; destr.) and a small guard-house (1894–7; destr.), all in a castellated Gothic Revival style. At Trinity Church on lower Broadway in New York City he devised three sets of elaborate bronze entrance doors (1890–94); on the right-hand panel of the principal entrance door the sculptor Karl Bitter (1867–1915) placed a small portrait head of the architect. At Harvard University Hunt designed the Neo-classical Fogg Museum (1893–5; later Hunt Hall; destr.). Hunt's final major commission was for the large Beaux-Arts-style entrance wing (1894–1902) of the Metropolitan Museum of Art, New York. He planned this wing as part of a general expansion of the museum, but his overall plan was not followed. His eldest son, Richard Howland Hunt (b 14 March 1862; d 12 July 1931), completed the museum entrance wing some years after his father's death.

Hunt designed in many different styles and constructed many building types. Committed to European historicizing styles, he nonetheless attempted to use past ideas for the

needs of his time. More than in his buildings, his significance lies in his endeavours to raise the status and standards of his profession. In 1898 several New York art organizations erected a monument to him on Fifth Avenue near 70th Street.

BIBLIOGRAPHY
M. Schuyler: 'The Works of the Late Richard M. Hunt', *Archit. Rec.*, v (Oct–Dec 1895), pp. 97–180
Paul R. Baker: *Richard Morris Hunt* (Cambridge, MA, 1980)
Susan R. Stein, ed.: *The Architecture of Richard Morris Hunt* (Chicago, 1986)
D. O. Kisluk-Grosheide: 'The Marquand Mansion', *Met. Mus. J.*, xxix (1994), pp. 151–81
P. F. Miller: 'The Gothic Room in Marble House, Newport, Rhode Island', *Antiques*, cxlvi (1994), pp. 176–85
B. Gill: 'Historic Houses: The Breakers: The Newport, Rhode Island Island, Mansion Celebrates its Centennial', *Arch. Dig.*, lii (1995), pp. 134–43

PAUL R. BAKER

Huntington, Daniel (*b* New York, 14 Oct 1816; *d* New York, 18 April 1906). American painter. Born into a distinguished New England family, he studied at Yale College and at Hamilton College, New York, where he met and was encouraged by the painter Charles Loring Elliott. In 1835 Huntington went to New York to study with Samuel F. B. Morse and by 1838 had his first pupil, Henry Peters Gray (1819–77). He was elected an Associate of the National Academy of Design in 1839, an Academician in the following year and twice served as its President (1862–9 and 1877–91). Although based in New York, he exhibited at all the major national art institutions as well as at the Royal Academy, London. In 1847 he was a founder-member of the Century Club, over which he presided in 1879–95. He later helped found the Metropolitan Museum of Art and served as its Vice-President from 1871 until 1903.

Huntington early showed an interest in landscape painting, in which he was an associate and stylistic follower of the Hudson River school, but his academic training and religious convictions inspired an ambition to paint historical, particularly religious, subjects. *A Sibyl* (1840; New York, Hist. Soc.) and *Early Christian Martyrs* (1840; Baton Rouge, LA State U.), both painted in Italy, reflect the spiritual earnestness of the German Nazarenes and the technique of Italian Renaissance masters. On his return to New York, Huntington established his reputation with *Mercy's Dream* (1841; Philadelphia, PA Acad. F.A.). He rendered this unusual subject, taken from Bunyan's *Pilgrim's Progress*, with a delicacy of form, brushstroke and colour reminiscent of Raphael (1483–1520). Its success suggested another subject from Bunyan, *Christiana and her Children Passing through the Valley of the Shadow of Death* (Philadelphia, PA Acad. F.A.), which he finished on his second trip to Europe in 1843–5. There he also painted an ideal portrait entitled *Italy* (1843; Washington, DC, N. Mus. Amer. A.; see fig.) and created illustrations for an engraved edition of Longfellow's poems published by Carey & Hart of Philadelphia. In the late 1840s Huntington chose subjects from English history. *Queen Mary Signs the Death Warrant of Lady Jane Grey* (1848; ex-Douglas Putnam priv. col., Marietta, OH) was engraved for distribution by the American Art-Union in 1848.

In 1850 a major one-man exhibition of Huntington's work demonstrated his popularity with fellow artists and

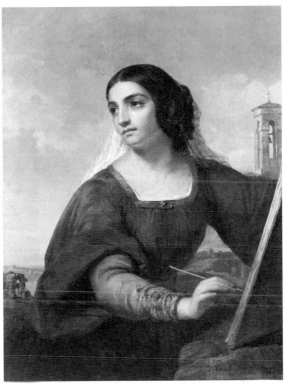

Daniel Huntington: *Italy*, oil on canvas, 981×740 mm, 1843 (Washington, DC, National Museum of American Art)

public alike. At about this time he turned increasingly to portraiture, for which he tapped a network of family, collegiate, social and artistic connections. He painted about a thousand portraits; the earliest show the influence of Henry Inman in their even surfaces and straightforward compositions. By the 1850s his reputation brought commissions for elaborate, full-scale portraits, which he treated with looser brushwork and dramatic lighting inspired by Titian (?1485/90–1576) and Reynolds (1723–92). On a visit to England in 1851, Huntington painted *Sir Charles Lock Eastlake* (1851; New York, Hist. Soc.) and *John Bird Sumner, Archbishop of Canterbury* (1851; New York, Gen. Theol. Semin.). He made four return visits to Europe between 1852 and 1883. His other distinguished sitters include *William Cullen Bryant* (1866; New York, Brooklyn Mus.) and *Ulysses S. Grant* (1875; New York, Donaldson, Lufkin & Jenrette). The group portrait *American Projectors of the Atlantic Cable* (1894; New York, Chamber of Commerce) includes Cyrus W. Field, Samuel F. B. Morse and a self-portrait.

In 1861 Huntington combined history painting with portraiture in the *Republican Court* (or *Mrs Washington's Reception*, 1861, exh. Paris Exposition 1867; New York, Brooklyn Mus.), which anticipated interest in the Colonial period generated by the Centennial celebrations. It was engraved by Alexander Hay Ritchie (1822–95). With religious allegories such as *Sowing the Word* (1868; New York, Hist. Soc.) he reaffirmed his early ideal of art as a moral force and his admiration for the Old Masters. Fundamentally conservative in both technique and prin-

ciples, with an engaging personality and a talent for institutional affairs, he exercised considerable influence in the academic establishment of his day. In this role, as well as in his painting, Huntington resisted the changes sweeping American art in the last quarter of the 19th century and clung to the artistic ideals of his youth.

WRITINGS

Catalogue of Paintings, by Daniel Huntington, N.A., Exhibiting at the Art Union Buildings, 497 Broadway (New York, [1850])

BIBLIOGRAPHY

S. G. W. Benjamin: 'Daniel Huntington, President of the National Academy of Design', *Amer. A. Rev.*, ii/1 (1880), pp. 223–8; ii/2 (1881), pp. 1–6

W. H. Gerdts: 'Daniel Huntington's *Mercy's Dream*: A Pilgrimage through Bunyanesque Imagery', *Winterthur Port.*, xiv (1979), pp. 171–94

American Paintings in the Metropolitan Museum of Art, 3 vols (New York, 1980–86), ii, pp. 56–73

N. Rash: 'History and Family: Daniel Huntington and the Patronage of Thomas Davis Day', *Archvs Amer. A. J.*, xxxiv/3 (1994), pp. 2–15

W. Greenhouse: 'Daniel Huntington and the Ideal of Christian Art', *Winterthur Port.*, xxxi (Summer/Autumn 1996), pp. 103–40

WENDY GREENHOUSE

I

Impressionism. Term generally applied to a movement in art in France in the late 19th century, which gave rise to such ancillaries as American Impressionism. The primary use of the term Impressionist is for a group of French painters who worked between around 1860 and 1900, especially to describe their works of the later 1860s to mid-1880s. These artists include Frédéric Bazille (1841–70), Paul Cézanne (1839–1906), Edgar Degas (1834–1917), Edouard Manet (1832–83), Claude Monet (1840–1926), Berthe Morisot (1841–95), Camille Pissarro (1830–1903), Auguste Renoir (1841–1919) and Alfred Sisley (1839–99), as well as Mary Cassatt, Gustave Caillebotte (1848–94; who was also an important early collector), Eva Gonzalès (1849–83), Armand Guillaumin (1841–1927) and Stanislas Lépine (1835–92). The movement was anti-academic in its formal aspects and involved the establishment of venues other than the official Salon for showing and selling paintings.

The term was first used to characterize the group in response to the first exhibition of independent artists in 1874. Louis Leroy and other hostile critics seized on the title of a painting by Monet, *Impression, Sunrise* (1873; Paris, Mus. Marmottan), as exemplifying the radically unfinished character of the works. The word 'impression' to describe the immediate effect of a perception was in use at the time by writers on both psychology and art. Jules-Antoine Castagnary's review (1874) demonstrates that it was not always used in a negative way: 'They are *Impressionists* in the sense that they render not the landscape but the sensation produced by the landscape.' The name stuck, despite its lack of precision, and came to be used by the artists themselves.

Typical Impressionist paintings are landscapes or scenes of modern life, especially of bourgeois recreation. These non-narrative paintings demonstrate an attention to momentary effects of light, atmosphere or movement. The paintings are often small in scale and executed in a palette of pure, intense colours, with juxtaposed brushstrokes making up a field without conventional perspectival space or hierarchies of forms. Despite stylistic differences, the artists shared a concern for finding a technical means to express individual sensation.

The term is sometimes used to describe freely executed effects in works of other periods in which the artist has presented an impression of the visual appearance of a subject rather than a precise notation. It is also used by analogy in music and literature to describe works that evoke impressions in a subjective way.

Because French Impressionism combined new approaches to formal issues while remaining a naturalist art, it affected a variety of movements in the later 19th century and the early 20th in other European countries and North America as well as France. Although their works were controversial, the French Impressionists were acknowledged as a force in the art of their time, and they contributed to an opening up of the art world. The term 'Impressionist' was used widely and imprecisely as a generic word for vanguard artists or to describe some artists who exhibited in the Salon. A lightened palette, looser brushwork and contemporary subject-matter became features of academic Realism, and Impressionist colour, compositional innovations and subject-matter provided points of departure for several experimental naturalist and Symbolist movements. These Impressionist techniques and approaches were disseminated by several means: through direct contact among artists, through exhibitions and through the adaptations of style and subject by more conservative painters.

American Impressionism was the most unified movement and the one closest in spirit to that of France. In the 1890s and early decades of the 20th century such American artists as Theodore Robinson, Julian Alden Weir, Childe Hassam and John H. Twachtman presented subjects in bright sunlight and used flecked brushwork and intense colour, but frequently retained a more conservative approach to composition and the representation of figures than their French counterparts.

Later artists found Impressionism liberating in its insistence on the artist's sensibility rather than on academic rules as the determining factor in creating a picture. It provided an example for artists who wished to use colour and brushwork, expressively and who wished to find new ways of composing. Its limitation for later artists seemed to be its reliance on nature for inspiration. Gauguin had predicted that the Impressionists would be the 'officials' of tomorrow, and because of its naturalism, its immediacy and its spontaneous and easily imitated brushwork, academic Impressionism became an accepted conservative style in the 20th century.

BIBLIOGRAPHY
D. F. Hoopes: *The American Impressionists* (New York, [1972])
Painters of Light and Color: American Impressionists from the Lyman Allyn Art Museum and Private Collections (exh. cat. by E. G. Gipstein, New London, CT, Lyman Allyn Mus., 1989–90)
J. B. Dominik, P. Trenton and W. H. Gerdts: 'California Light, 1900–1930', *A. CA*, iii/6 (1990), pp. 14–18

Light, Air and Color: American Impressionist Paintings from the Collection of the Pennsylvania Academy of the Fine Arts (exh. cat., Philadelphia, PA, Acad. F.A., 1990)

U. W. Hiesinger: 'Impressionism and Politics: The Founding of The Ten', *Antiques*, cxl/5 (1991), pp. 780–93

Impressionism in America: The Ten American Painters (exh. cat. by U. W. Hiesinger, New York, Jordan-Volpe Gal., 1991)

American Impressionism and Realism: The Painting of Modern Life, 1885–1915 (exh. cat. by H. B. Weinberg, D. Belger and D. P. Curry, Fort Worth, TX, Amon Carter Mus.; New York, Met.; Denver, CO, A. Mus.; Los Angeles, CA, Co. Mus. A.; 1994–5; review by T. Fairbrother, *Archvs Amer. A. J.*, xxxiii/4 (1993), pp. 15–21

W. H. Gerdts: *Impressionist New York* (New York, 1994)

American Impressionism: Boston, New York, Paris (exh. cat., New York, Adelson Gals, 1994)

Triumph of Color and Light: Ohio Impressionists and Post-Impressionists (exh. cat. by J. M. Keny with N. V. Maciejunes, Columbus, OH, Mus. A., 1994)

American Painters in the Age of Impressionism (exh. cat. by E. B. Neff and G. T. M. Shackelford, Houston, TX, Mus. F.A., 1994–5)

American Tradition: The Pennsylvania Impressionists (exh. cat., New York, Beacon Hill F.A., 1995–6)

J. Crawford: 'American Impressionism at the Canajoharie Library & Art Gallery, *Amer. A. Rev.*, viii/3 (June–Aug 1996), pp. 112–15

D. Keyes and J. Simon, eds: *Crosscurrents in American Impressionism at the Turn of the Century* (Athens, GA, 1996)

'Impressions of California: Early Currents in Art, 1850–1930', *Amer. A. Rev.*, viii/4 (Sept–Oct 1996), pp. 150–51

The American Impressionists (exh. cat., New York, Adelson Gals, 1996)

American Impressionism: Paintings of Promise (exh. cat. by D. R. Brigham, Worcester, MA, A. Mus., 1997)

GRACE SEIBERLING

Industrial design. Design process applied to goods produced, usually by machine, by a system of Mass production based on the division of labour. The terms 'industrial design' and 'industrial designer' were first coined in the 1920s in the USA to describe those specialist designers who worked on what became known as product design. The history of industrial design is usually taken to start with the industrialization of Western Europe, in particular with the Industrial Revolution that began in Britain in the second half of the 18th century. The main focus of attention then moved to the USA and Germany when they industrialized and, in the second half of the 19th century, began to challenge Britain's supremacy as 'the workshop of the world'.

The American section of the Great Exhibition of 1851 in England, more properly known as the Great Exhibition of the Industry of All Nations, revealed a new approach to design and manufacture that came to be known as the American System of Manufacture, in which goods using standardized and interchangeable parts were mass-produced by machine. Developments in precision tool-making helped perfect identical components in a society that experienced a shortage of craft skills and high labour costs. Although there had been European precedents for this type of production, they had not been developed, and the British Government recognized that its systematic development in the USA from about 1800 had led to American supremacy in the production of fire-arms (where interchangeable parts meant repairs could take place on the battlefield), locks and machinery. Samuel Colt (1814–62)

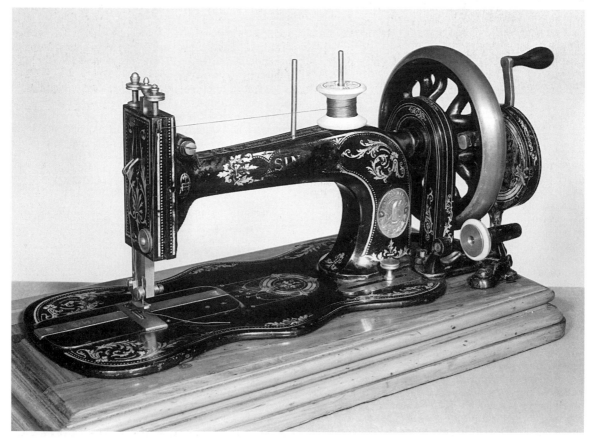

1. 'New Family' sewing-machine, manufactured by I. M. Singer & Co., New York, 1865–85 (London, Science Museum)

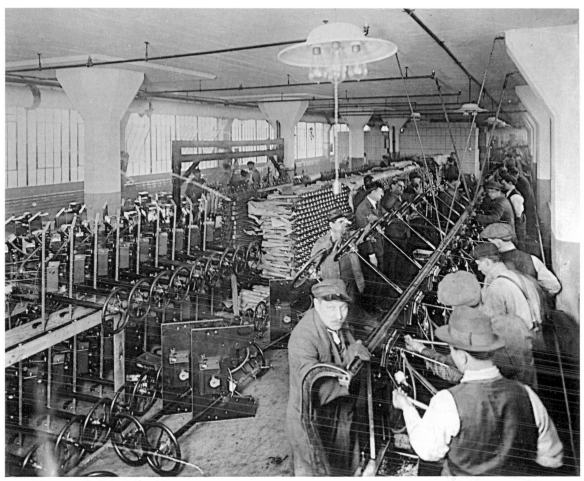

2. Assembly-line manufacture of 'Model T' automobiles, Ford Motor company, Detroit, 1914 (Dearborn, MI, Henry Ford Museum and Greenfield Village)

and Alfred C. Hobbs (1812–91) recognized gaps in the British market and established their own firms in Britain. In 1853 the Enfield Fire-arms Factory was established using American machine tools, and in the same year a commission was sent to America to investigate the new economic threat. The subsequent Report of the Commission on the Machinery of the United States noted the drive towards innovation in the USA—particularly labour-saving machinery—whereas Britain still enjoyed cheap, abundant labour.

In the USA the use of standardized interchangeable parts spread. In 1850 Aaron L. Dennison, founder of the American Horologe Co., Roxbury, MA, expressly visited fire-arms factories to apply their techniques to clock and watch production, and by the end of the century watches were a major American product.

A key feature of American product design in the second half of the 19th century was the proliferation of new products, many of which—for example sewing-machines and typewriters—were mechanical devices for what had previously been hand skills (see fig. 1). Others—the camera, the telephone, the motor- car—were new developments. Many of the companies that became familiar

brand-names—Singer, Kodak (the Eastman Co. was founded by George Eastman in 1881, known as Eastman Kodak from 1892), Ford—developed into major industries with large national and international sales. Such entrepreneurs as Isaac Singer (1811–75), Samuel Colt and Philo Remington (1816–89) all combined an understanding of technical developments with business and marketing acumen. Singer used hire-purchase to sell his goods; during the slump in the fire-arms industry following the Civil War, Remington diversified into typewriters, which the firm's mechanics redesigned for mass production in 1874, by which time the American system formed the basis of more than 20 industries, including precision instruments and tools, machine tools, cutlery and musical instruments.

The success of the motor-car business started in 1903 by Henry Ford (1863–1947), and in particular his Ford 'Model T' (1908), was based on an unvarying standard design, which kept down the cost of what had previously been expensive items. From 1914 it was mass-produced using a moving assembly line and a standardized design with interchangeable parts; as a result costs fell dramatically (see fig. 2). In 1921 Ford still produced half of all the cars made in the USA, but declining sales forced him to

abandon a single design and bring out new models at regular intervals. Manufacturers were confronted with a dilemma: cheapness demanded standardization for long enough to recoup capital-investment costs; demands for novelty meant rapid changes. The solution was to maximize superficial changes related only to appearance, a new mode of operating that came to be known as 'styling' and distinguished American, and later international, design for many years.

BIBLIOGRAPHY

S. Giedion: *Mechanization Takes Command* (New York, 1948)
R. Loewy: *Never Leave Well Enough Alone* (New York, 1951)
C. Singer, E. J. Holmyard and A. R. Hall, eds: *A History of Technology*, 5 vols (Oxford, 1954–8)
C. Harvie, G. Martin and A. Scharf, eds: *Industrialization and Culture, 1830–1914* (London, 1970)
R. Banham: *Theory and Design in the First Machine Age* (London, 1972)
S. Bayley: *In Good Shape: Style in Industrial Products, 1900–1960* (London, 1979)
J. Heskett: *Industrial Design* (London, 1980, 2/1984)
S. Sanders: *Honda: The Man and his Machines* (Tokyo, 1982)
E. Lucie-Smith: *A History of Industrial Design* (Oxford, 1983)
P. Sparke: *Consultant Design: The History and Practice of the Designer in Industry* (London, 1983)
J. M. Woodham: *The Industrial Designer and the Public* (London, 1983)
A. Forty: *Objects of Desire: Design and Society, 1750–1980* (London, 1986)
P. Sparke: *An Introduction to Design and Culture in the Twentieth Century* (London, 1986)
H. Conway, ed.: *Design History: A Student Handbook* (London and Boston, 1987)
D. Miller: *Material Culture and Mass Consumption* (Oxford and New York, 1987)

PAT KIRKHAM

Ingham, Charles Cromwell (*b* Dublin, 1796; *d* New York, 10 Dec 1863). American painter of Irish birth. He was trained in Dublin, and his early work was in the style of Sir Martin Archer Shee (1769–1850). He arrived in New York in 1816 and became a leading figure in its artistic and social circles. Ingham was particularly successful with his flattering portraits of fashionable women and completed over 200 such works between 1826 and 1845. A meticulous draughtsman, Ingham developed a technically advanced style, building up layers of glazes and varnishes to create a glossy surface. Such portraits as *Fidelia Marshall* (Washington, DC, N. Mus. Amer. A.) demonstrate Ingham's careful attention to the rendering of textures and details of dress. Several of his better-known works, including *Flower Girl* (1846; New York, Met.; see fig.), carry allegorical overtones. Although his reputation rested on his portraits of women and children, Ingham painted a considerable number of men as well.

Ingham was a founder-member of and frequent exhibitor at the National Academy of Design, New York, and belonged to the American Academy of Fine Arts. When the National Academy acquired Browere's Stables on Broadway in 1848, Ingham was chairman of the building committee and designed the grand staircase known then as 'Ingham's Stairs'. He is credited with originating the idea for the Sketch Club, established in 1827, and was its first President; when it reorganized and expanded to become the Century Club in 1847, Ingham was among its earliest members.

BIBLIOGRAPHY

DAB
W. Dunlap: *History of the Rise and Progress of the Arts of Design in the United States*, ii (New York, 1834/*R* 1969), pp. 271–4

Charles Cromwell Ingham: *Flower Girl*, oil on canvas, 914×733 mm, 1846 (New York, Metropolitan Museum of Art)

T. S. Cummings: *Historic Annals of the National Academy of Design* (Philadelphia, 1865)
A. T. E. Gardner: 'Ingham in Manhattan', *Bull. Met.*, n.s., x (1952), pp. 245–53

ELEANOR JONES HARVEY

Inman, Henry (*b* Whitestown, nr Utica, NY, 28 Oct 1801; *d* New York, 17 Jan 1846). American painter. The son of an English land agent who had emigrated to America in 1792, he studied under an itinerant drawing-master before moving to New York with his family in 1812. Two years later he obtained an apprenticeship with the city's leading portrait painter, John Wesley Jarvis, drawn to the artist not only for his skill but also for his collection of pictures, which at that time included Adolf Ulric Wertmüller's *Danaë and the Shower of Gold* (1787; Stockholm, Nmus.). Inman worked closely with Jarvis, eventually accompanying him on his travels and serving more as a collaborator than an apprentice. Within this partnership Inman established a speciality in miniature painting. In 1823 he set up his own practice in New York and ceded miniature painting to his student and eventual partner Thomas Seir Cummings (1804–94).

Instrumental in founding the National Academy of Design in New York in 1825, Inman became vice-president of the new organization and found himself at the centre of the so-called 'Knickerbocker society', New York's rapidly developing cultural circle. He began to receive portrait commissions from prominent families and city government but also painted literary, historical and genre subjects, such as *Young Fisherman* (1829–30; New York, Met.). Many of these were engraved for illustration in journals and popular gift books, furthering his renown. He moved to Philadelphia in 1831 and joined the engraver

Henry Inman: *Georgiana Buckham and her Mother*, oil on canvas, 870×692 mm, 1839 (Boston, MA, Museum of Fine Arts)

Cephas G. Childs (1793–1871) as a partner in the lithographic firm Childs & Inman, providing meticulously drafted designs in pencil and watercolour that were reproduced by the firm's talented lithographer, Albert Newsam (1809–64), for example *Mount Vernon* (1832; see 1987 exh. cat., p. 175). He continued to paint portraits despite the presence of Thomas Sully, Philadelphia's reigning artist and an acknowledged master of women's portraits. Inman had greater success with male sitters, such as *John Marshall* (1831; Philadelphia, PA, Bar Assoc.), whom he portrayed with quiet yet forceful dignity, without the suave elegance of Sully's style.

After three years in Philadelphia, Inman returned to New York and from 1834 to 1839 was at the height of his career. For a while he was New York's leading portrait painter, yet he decried the public's 'rage for portraits', which prevented artists from exercising their full powers. Like Sully in Philadelphia, Inman in New York was called 'the American Lawrence', in reference to the English portrait painter Thomas Lawrence (1769–1830). His romantic style is marked by softened contours and a restrained brush, and he often gave his sitters a genial expression or glint of humour. His propensity towards sweetness in depictions of women and children, such as *Georgianna Buckham and her Mother* (1839; Boston, MA, Mus. F.A.; see fig.), rarely slipped into sentimentality, a quality that never coloured his portraits of men, which are painted with vigour if not bravura (e.g. *Richard Channing Moore*, *c.* 1844; priv. col., see 1987 exh. cat., p. 24). His later subjects exhibit a clarified style that anticipated the insistent materiality of mid-19th-century American portraiture and the rise of a photographic standard of naturalism.

Financial reverses and deteriorating health contributed to a decline in Inman's productivity in his later years. Although no longer prosperous, he continued to paint, creating some of his most accomplished and beautiful works, including *Angelica Singleton Van Buren* (1842; Washington, DC, White House Col.), and returning to literary compositions and such genre subjects as *Mumble the Peg* (1842; Philadelphia, PA Acad. F.A.). In 1844 he travelled to England, briefly reviving his spirits and health. After painting several portraits and visiting William Wordsworth at Rydal Mount, Cumbria, Inman considered remaining in London to pursue his career. He returned to New York in 1845, however, and died the following year.

BIBLIOGRAPHY

T. Bolton: 'Henry Inman: An Account of his Life and Work', *A. Q.*, iii (1940), pp. 353–75

The Art of Henry Inman (exh. cat. by W. Gerdts and C. Rebora, Washington, DC, N.P.G., 1987) [additional bibliog.]

SALLY MILLS

Inness, George (*b* Newburgh, NY, 1 May 1825; *d* Bridge of Allan, Central Scotland, 3 Aug 1894). American painter. He grew up in Newark, NJ, and New York City, and received his first artistic training with John Jesse Barker (*fl* 1815–56), an itinerant artist claiming to be a student of Thomas Sully. Between 1841 and 1843 Inness was apprenticed to the engravers Sherman & Smith in New York. More significant was his study in 1843 with Régis-François Gignoux, a student of Paul Delaroche (1797–1856) and a recent immigrant from France, whose landscapes were delicate and sweet. Though Gignoux seems to have had little influence on the development of Inness's style, the Frenchman did provide him with a knowledge of European masters. Inness's early attraction to the Old Masters, especially to Claude Lorrain (?1604/5–1682), is evident in his landscapes of the 1840s, and it prompted him to visit Italy in 1851–2. His *Bit of the Roman Aqueduct* (*c.* 1852; Atlanta, GA, High Mus. A.) is especially derivative of Claude in its classical composition and descriptive details.

In 1853 Inness returned to Europe for two years. In France he was impressed by the Barbizon school of landscape painting which had a decisive influence on his art. The Barbizon style became pronounced in his work after 1860 when he moved from New York, home to the dominant Hudson River school of landscape painting, to Medfield, MA, a village where he could work in isolation. Pictures such as *Clearing up* (1860; Springfield, MA, Smith A. Mus.) have the sketch-like brushwork, loosely structured composition and rustic themes associated with the Barbizon work of Théodore Rousseau.

Inness travelled to Europe a third time in 1870, settling in Rome, where he painted *The Monk* (1873; Andover, MA, Phillips Acad., Addison Gal.). With its ambiguous spaces, enigmatic theme and brooding colours enlivened with chromatic flourishes, it is the most avant-garde American painting of the 1870s. On his return to America in 1875, Inness worked for a while in New Hampshire, where he painted such pictures as *Saco Ford: Conway Meadows* (1876; South Hadley, MA, Mount Holyoke Coll. A. Mus.; see fig.), which shows a heightened confidence in the use of swirling, textured brushwork and a temporary concern for the majesty of open spaces.

George Inness: *Saco Ford: Conway Meadows*, oil on canvas, 965×1650 mm, 1876 (South Hadley, MA, Mount Holyoke College Museum of Art)

Beginning in the late 1870s Inness turned to the thoughtful, personal, non-topographic landscapes that are the trademark of his late style (see colour pl. XIX, 1). In many respects these landscapes were the result of his religious beliefs. As early as the mid-1860s, when he was living at Eagleswood, NJ, the site of the Raritan Bay Union utopian community, Inness began to study spiritualism. Spurred by Marcus Spring, leader of the Eagleswood community, and by the painter William Page, he became a disciple of the teachings of Emanuel Swedenborg (1688–1772). Believing that all material objects were spiritually charged and that the earthly realm was continuous with the heavenly, Inness arrived in the late 1870s and 1880s, after years of effort, at a uniquely spiritual imagery. Though still derived from Barbizon painting, Inness's late work is an effort to convert Swedenborgianism into art. Travelling between Montclair, NJ, his permanent home after 1878, and seasonal retreats in California, Florida and Nantucket, MA, where he went to improve his chronically poor health, he painted highly moving, personal pictures. In *Niagara Falls* (1893; Washington, DC, Hirshhorn) he depicted the Falls dissolved in mists of iridescent colour, in contrast to the highly representational Hudson River style in which it had traditionally been painted, for instance by Frederic Church (1857; Washington, DC, Corcoran Gal. A.). Instead of conveying Church's image of power, Inness's *Niagara Falls* expresses a brooding inner passion through heavy paint surfaces and dematerialized forms. In *Home of the Heron* (1893; Chicago, IL, A. Inst.) Inness constructed a twilight world of hazy forms cast halfway between substance and nothingness. Space and detail were virtually eliminated in favour of a flat and indistinct landscape of softly vibrating colours and gauzy paint surfaces. Though there is nothing in Swedenborg's writings to account for Inness's late imagery in a specifically iconographic way, pictures like this are redolent of the 'correspondence' Swedenborg claimed existed between the material and the spiritual worlds.

Inness's early works received mixed critical reviews. In the 1840s and 1850s he was often criticized for not adhering to the prevailing taste for the Hudson River school. Instead of imitating nature, the critics claimed, Inness was imitating art. Though Hudson River painters such as Asher B. Durand were equally influenced by Claude, in the critics' eyes Inness made the act of imagination unacceptably overt by stressing broad handling of paint, eccentric colours and palpable atmosphere. Nonetheless, Inness's early pictures were promoted by George Ward Nichols (1831–85), a devotee of French art and the owner of the Crayon Gallery in New York. Inness's early patrons included Ogden Haggerty, who financed his first trip to Europe, and the Rev. Henry Ward Beecher (1813–87). The critical response to Inness's art improved greatly during the 1880s and 1890s, though the American Pre-Raphaelites, led by the critic Clarence Cook, condemned his lack of interest in replicating nature. In his later years Inness attracted the attention of Thomas B. Clarke, the leading collector of American art, who purchased works by Inness.

BIBLIOGRAPHY

E. Daingerfield: *George Inness: The Man and his Art* (New York, 1911)
G. Inness jr: *The Life, Art and Letters of George Inness* (New York, 1917)
E. McCausland: *George Inness: An American Landscape Painter, 1825–1894* (New York, 1946)
L. Ireland: *The Works of George Inness: An Illustrated Catalogue Raisonné* (Austin, TX, 1965)

N. Cikovsky jr: *George Inness* (New York, 1971)
A. Werner: *Inness Landscapes* (New York, 1973)
N. Cikovsky jr: *The Life and Work of George Inness* (New York, 1977)
George Inness (exh. cat. by N. Cikovsky jr and M. Quick, Los Angeles, CA, Co. Mus. A., 1985)
N. Cikovsky jr: 'Inness and Italy', *Italian Presence in American Art, 1860–1920*, ed. I. B. Jaffe (Rome, 1992), pp. 43–61
——: *George Inness* (New York, 1993)
S. M. Promey: 'The Ribband of Faith: George Inness, Color Theory and the Swedenborgian Church', *Amer. A. J.*, xxvi/1/2 (1994), pp. 44–65
George Inness, Presence of the Unseen: A Centennial Commemoration (exh. cat., Montclair, NJ, A. Mus.; Southampton, NY, Parrish A. Mus.; South Hadley, MA, Mount Holyoke Coll. Mus. A. and elsewhere; 1994–5); reveiw by J. Arthur in *A. New England*, xvi (1995), p. 64

PAUL J. STAITI

International Exhibition of Modern Art. *See* ARMORY SHOW.

Irwin, Harriet Morrison (*b* Davidson, NC, 18 Sept 1828; *d* Charlotte, NC, 27 Jan 1897). American social reformer and writer. She was educated both in the home of her father, the Rev. Robert Hall Morrison, who was the first president of Davidson College, NC, and later at the Salem Female Academy, NC. In 1869 she was the first American woman to patent an architectural design. Prompted by concerns for health and economy, she presented plans and an exterior elevation for a hexagonal house in Letters Patent, explaining that 'the objects of my invention are the economizing of space and building-materials, the obtaining of economical heating mediums, thorough lighting and ventilation and facilities for inexpensive ornamentation'. With husband and brother-in-law, she promoted hexagonal house designs through advertisements, and at least one house was built, at 912 West Fifth Street (*c.* 1869; destr.) in Charlotte, NC, her home town. Others may also have been built.

Irwin's principal interests seem to have been architecture and literature; in her novel *The Hermit of Petraea* she advanced the idea that architecture affects man's physical well-being and that hexagonal dwellings are preferable to other types. Despite her propaganda, the hexagonal house never had the vogue that the earlier octagonal house design of ORSON SQUIRE FOWLER had enjoyed.

WRITINGS
The Hermit of Petraea (Charlotte, NC, 1871)

BIBLIOGRAPHY
O. S. Fowler: *A Home for All* (New York, 1848/*R* New York, 1973)
D. Cole: *From Tipi to Skyscraper: A History of Women in Architecture* (New York, 1973)
M. B. Stern: *We the Women: Career Firsts of Nineteenth Century America* (New York, 1974)
S. Torre: *Women in American Architecture* (New York, 1977)
B. Heisner: 'Harriet Morrison Irwin's Hexagonal House: An Invention to Improve Domestic Dwellings', *NC Hist. Rev.*, lviii (1981), pp. 105–24

BEVERLY HEISNER

Isham, Samuel (*b* New York, 12 May 1855; *d* Easthampton, NY, 12 June 1914). American writer and painter. After graduating from Yale University in 1875, he travelled to Paris to study art but soon returned to New York to study law at Columbia University. After five years as a practising lawyer (1880–85), he decided definitely to study art and once more went to Paris to work for two years under Louis Boulanger (1806–67) in the Académie Julian. He returned to the USA, where critical acclaim for his landscape and figure paintings eventually attracted the attention of the National Academy of Design, New York, of which he became a full member in 1906. The *Lilac Kimono* (New York, Brooklyn Mus.) displays his broad painterly style. He wrote *The History of American Painting* (1905) with the professed goal of recording the intellectual and cultural growth of the country, although in his widespread coverage 19th-century artists receive most attention. He set each painter within a group, describing individual style and generously giving praise or patiently explaining faults in their work. When the book was reissued in 1927, Royal Cortissoz (1869–1948) updated the original text with a chapter on modern painting. Isham's only other publication was *The Limitations of Verbal Criticism of Works of Art* (1928), which originated as the text of a lecture delivered in 1907 at Columbia University.

WRITINGS
The History of American Painting, iii of *The History of American Art*, ed. J. C. van Dyke (New York, 1905); rev. and suppl. by R. Cortissoz (New York, 1927)
The Limitations of Verbal Criticism of Works of Art (Portland, ME, 1928)

BIBLIOGRAPHY
National Cyclopedia of American Biography, xxxv, p. 343
M. B. Cowdrey: 'A Century of Art History', *A. America*, xlii/3 (1954), p. 225

DARRYL PATRICK

Ives, Chauncey B(radley) (*b* Hamden, CT, 14 Dec 1810; *d* Rome, 2 Aug 1894). American sculptor, active in Italy. He trained as a wood-carver in New Haven, CT, and he may also have studied with the sculptor Hezekiah Augur. In 1838 Ives launched his career as a portraitist. Among the works that contributed to his rising reputation during the next two years were portraits of the professor *Benjamin Silliman* (plaster, *c.* 1840; New York, NY Hist. Soc.) and the architect *Ithiel Town* (marble, *c.* 1840; New Haven, CT, Yale U. A.G.).

Due to illness, Ives sought the milder climate of Italy; he lived in Florence from 1844 to 1851, when he settled permanently in Rome. In the third quarter of the 19th century, he rivalled Hiram Powers as the foremost American sculptor in Italy. Although he continued to produce portraits, Ives developed his reputation as a sculptor of idealized marble figures. He excelled at representations of childhood; for example his *Sans souci* (1863; Washington, DC, Corcoran Gal. A.) was particularly popular, and his workmen generated 22 copies of the dishevelled young girl who abandons her book for a daydream. The work reveals Ives's skill at combining 19th-century naturalism with traditional Neo-classicism; to contemporary audiences the anecdotal quality of the figure epitomized his artistic strength.

Ives catered to the vogue for Old Testament themes with his *Rebecca at the Well* (1854; New York, Met.; see fig.). His Classical subjects also met with extraordinary success. Defying American strictures against nudity, he modelled a *Pandora* in 1851. Using a contrived arrangement of drapery as a concession to modesty, Ives focused on Pandora's hesitant contemplation of the forbidden box. When Ives remodelled his celebrated creation in 1863 (New York, Brooklyn Mus.), the revised version was hailed as his masterpiece. *Undine Receiving her Soul* (1855; New Haven, CT, Yale U. A.G.), an almost life-size standing

Chauncey B. Ives: *Rebecca at the Well*, marble, h. 1.27 m, 1854 (New York, Metropolitan Museum of Art)

female figure, thinly veiled in flowing drapery, further reveals his skill at representing flesh in marble.

BIBLIOGRAPHY

L. Taft: *The History of American Sculpture* (New York, 1903, rev. 1930), pp. 112–13

W. Craven: *Sculpture in America* (Newark, 1968, rev. 1984), pp. 284–8

W. Gerdts: 'Chauncey Bradley Ives, American Sculptor', *Antiques*, xciv (1968), pp. 714–18

American Figurative Sculpture in the Museum of Fine Arts, Boston (Boston, 1986), pp. 44–7

JANET A. HEADLEY

J

Jackson, William Henry (*b* Keesville, NY, 4 April 1843; *d* New York, 30 June 1942). American photographer. Jackson began his career as a colourist and retoucher in photographic studios in New York and Vermont. After enlisting in the infantry and working as a sketcher of camp life, he began to travel. He reached Omaha, NE, in 1867 and set up a photographic studio with his brother Edward Jackson. He began to make expeditions along the Union Pacific Railroad, photographing the Pawnee, Omaha and Winnebago people, and points of interest in and around Omaha. He gained a contract with the E. & H. T. Anthony Company to supply them with 10,000 views of American scenery. In 1870 the government surveyor Ferdinand V. Hayden visited Jackson's studio and invited him to join his US Geological and Geographical Survey of the Territories. Jackson worked with Hayden every year until 1878, using wet collodion negatives to photograph the Oregon trail (1870; see fig.), Yellowstone (1871), the Teton Mountains (1872), the Rocky Mountains (1873), the Southwest (1877) and the Northern territories (1878). The painter Thomas Moran accompanied several of the expeditions, advising Jackson on the composition of his images and using Jackson's photographs to compose his own paintings. Moran appears as the lone figure (a device Jackson often used to heighten the romantic grandeur of the scenery) in the photograph *Hot Springs on the Gardiner River, Upper Basin* (1871; Rochester, NY, Int. Mus. Phot.).

Jackson made a great reputation with the landscapes he produced on these trips. In 1872 sets of *Yellowstone's Scenic Wonders* containing nine images were bound and given to members of the US Congress, with whom they proved influential in the decision to create the national park. In 1873 Jackson photographed the *Mountain of the Holy Cross in the Rockies* (Rochester, NY, Int. Mus. Phot.) with

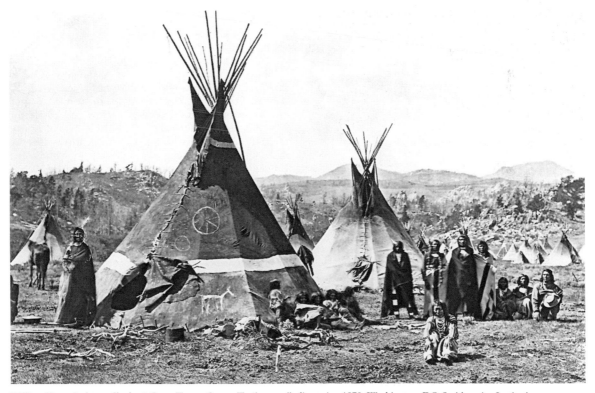

William Henry Jackson: *Shoshoni Camp Tepees, Oregon Trail*, wet collodion print, 1870 (Washington, DC, Smithsonian Institution

its unusual marking and made his first panoramic views; he sold many images of the mountain, some to popular magazines. The US government published two books of his photographs that year, *Photographs of Yellowstone National Park* and *Views in Montana and Wyoming Territories*. In 1874 more photographs were published: *The U.S. Geological Survey Rocky Mountains Natural Surroundings* included Jackson's pictures of the 'lost cities' of Mesa Verde, McElmo Canyon and Hovenweep. In 1875 he added the 20×24 inch mammoth plate camera to his equipment. The resulting images, the largest ever produced in the field, were made much of in the press. He exhibited several of his photographs as painted transparencies in the Centennial Exposition in Philadelphia in 1876 and gained much attention.

In 1879 Jackson discontinued his work for the government and set up the Jackson Photographic Co. in Denver, CO. Railway companies hired him to photograph their routes to stimulate travel; using collodion dry plate materials he produced promotional images for the Denver and Rio Grande Railroad Company, the Colorado Central and the Pacific Railroad. Over a period of about 15 years Jackson made *c*. 30,000 images. During the summers he travelled extensively throughout the USA, Canada and Latin America. In 1893 he exhibited at the Columbia Exposition, Chicago, and was the fair's official photographer. To commemorate the event he produced a special album of 100 views that sold for $1000. In 1894 he published *Wonder Places . . . The Most Perfect Pictures of Magnificent Scenes in the Rocky Mountains . . . Masterworks of the World's Greatest Photographic Artist*. That same year he accompanied the World Transportation Commission on a worldwide study tour of public transportation systems; the magazine *Harper's Weekly* commissioned his pictures of the trip. When the tour ended, Jackson became head cameraman and part owner of the Photochrom Company of Detroit.

WRITINGS

Time Exposure: An Autobiography (New York, 1940/R Albuquerque, 1986)

BIBLIOGRAPHY

C. S. Jackson: *Picture Maker of the Old West, William Henry Jackson* (New York, 1947)
H. Driggs: *The Old West Speaks: Water-color Paintings by William Henry Jackson* (New York, 1956)
L. R. Hafen and A. W. Hafen, eds: *The Diaries of William Henry Jackson, Frontier Photographer* (Glendale, CA, 1959)
H. M. Miller: *Lens on the West: The Story of William Henry Jackson* (Garden City, NY, 1966)
William H. Jackson (exh. cat., ed. B. Newhall and D. E. Edkins; Fort Worth, TX, Amon Carter Mus., 1974) [essay by W. L. Broecker]
P. B. Hales: *William Henry Jackson and the Transformation of the American Landscape* (Philadelphia, 1988)

SHERYL CONKELTON

James, Henry (*b* New York, 15 April 1843; *d* London, 28 Feb 1916). American writer, naturalized British in 1915. Taken to Europe as a child, he visited its museums and on his return to America briefly studied painting under William Morris Hunt. His early fiction shows the effect of further visits to Europe in 1869–70 and 1872–4. During the 1870s he wrote art criticism and short stories for various American periodicals; 30 of his articles on art (1868–97) are reprinted in J. L. Sweeney's *The Painter's Eye* (London, 1956). He was among the first to appreciate

Edward Burne-Jones (1833–98) and wrote with authority on all the traditional schools of European painting but was dismissive of Impressionism, until his *American Scene* (1907), in which he praises Impressionist works he had seen in Farmington, MA (priv. col.). In 1876 he took up permanent residence in London and after 1885 paid annual visits to the American painters Frank Millet (1846–1912), Edwin Austin Abbey and Sargent in Broadway, Worcs. James wrote about Sargent's work in *Picture and Text* (New York, 1893), which also includes an essay on Daumier (1808–79). The theme of his novel *The Tragic Muse* (1890), written during this period, is the seriousness of the painter's vocation. He was commissioned to write *William Wetmore Story and his Friends* (Boston, 1903), although he did not like Story's sculpture. Works of art continue to appear in the late fiction as metaphors. In *The Golden Bowl* (1905) a pagoda, the *Scapegoat* (Port Sunlight, Lady Lever A.G.) by Holman Hunt (1827–1910) and a crystal bowl are central to the plot; the pagoda, a symbol of mystery, stands for the adultery that Maggie Verver senses but has no proof of until the flawed bowl, a symbol of her marriage and an object revealing her husband's adultery, is broken. James anticipated Proust in his appreciation of Vermeer (1632–75) in *The Outcry* (1909). Sargent painted James's portrait on the occasion of the latter's birthday in 1913 (London, N.P.G.).

BIBLIOGRAPHY

V. H. Winner: *Henry James and the Visual Arts* (Charlottesville, 1970)
A. R. Tintner: *The Museum World of Henry James* (Ann Arbor, 1986)
——: *Henry James and the List of the Eyes: Thirteen Artists in his Fiction* (Baton Rouge, 1993); review by B. MacAdam in *ARTnews*, xcii (1993), p. 34

ADELINE TINTNER

Jarvis, John Wesley (*bapt* South Shields, nr Newcastle upon Tyne, 1 July 1781; *d* New York, 12 Jan 1840). American painter of English birth. He grew up in Philadelphia, PA, where he knew many of the city's resident artists and was apprenticed to Edward Savage, whom he remembered as an 'ignorant beast . . . not qualified to teach me any art but that of deception' (Bolton and Groce, pp. 299–300). Jarvis cultivated a formidable natural artistic talent through his own efforts. By 1802 he was established in New York as an engraver and very soon thereafter formed a profitable portrait business with Joseph Wood (*c*. 1778–1830). In 1807 he opened his own studio and from then on was a proficient and celebrated society painter, numbering many statesmen and such writers as Washington Irving among his patrons.

As Jarvis was essentially self-taught, his work lacks a certain grace and finesse, and his style is more vigorous than refined. Yet his finest works are visually lively, and his acutely objective approach reveals much of the sitter's temperament and personality. In his full-length portrait of *Daniel D. Tompkins* (New York, NY Hist. Soc.) the beautifully painted figure and dramatic sky suggest the authority and energy that Tompkins brought to his political career. Many of Jarvis's portraits capture a spirit of national pride and optimism characteristic of this period of American history; that of *Samuel Chester Reid* (1815; Minneapolis, MN, Inst. A.; see fig.) shows a hero of the War of 1812, poised on the deck of his ship engaged in battle, as

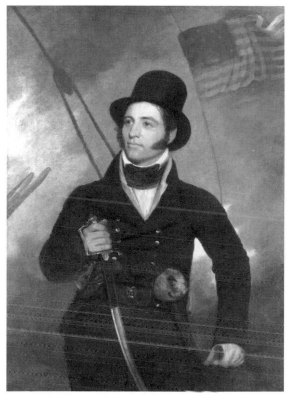

John Wesley Jarvis: *Samuel Chester Reid*, oil on canvas, 1282×924 mm, 1815 (Minneapolis, MN, Minneapolis Institute of Art)

an embodiment of courage and command. Jarvis's only known sculpture, a plaster bust of *Thomas Paine* (New York, NY Hist. Soc.), is naturalistically and dramatically modelled.

Jarvis's considerable artistic and social skills made him the most sought after and wealthiest portrait painter in America during the first quarter of the 19th century. Besides working in his New York studio, where John Quidor and Henry Inman were among his apprentices, he made frequent painting excursions to Boston, MA, Baltimore, MD, Washington, DC, New Orleans, LA, and elsewhere. He exhibited in New York at the National Academy of Design and regularly at the American Academy of Fine Arts (1816–33). Having had an undisciplined lifestyle and having suffered a stroke in 1834, he died in penury.

BIBLIOGRAPHY

T. Bolton and G. C. Groce: 'John Wesley Jarvis: An Account of his Life and the First Catalogue of his Work', *A. Q.* [Detroit], i (1938), pp. 299–321

H. E. Dickson: 'John Wesley Jarvis: Knickerbocker Painter', *NY Hist. Soc. Q.*, xxiv/2 (1940), pp. 47–64

——: *John Wesley Jarvis, American Painter, 1780–1840* (New York, 1949)

JOHN DRISCOLL

Jefferson, Thomas (*b* Shadwell, VA, 13 April 1743; *d* Monticello, VA, 4 July 1826). American statesman and architect. One of the great founding fathers of the American nation, he was a self-taught and influential architect whose work was influenced by his first-hand experience of French architecture and his admiration for Classical architecture. 'Architecture is my delight, and putting up and pulling down one of my favorite amusements', he is reputed to have said. His major works are his own house, MONTICELLO (see colour pl. I, 2), VA, the State Capitol at RICHMOND, VA, and his innovative designs for the University of Virginia, Charlottesville. He also conducted one of the earliest systematic archaeological investigations of a Native North American site, excavating a burial mound on his Virginia farm in 1784.

1. Early architectural interests, before 1784. 2. Paris, 1784–9. 3. Architectural work in America, 1789–1826.

1. EARLY ARCHITECTURAL INTERESTS, BEFORE 1784. Son of a surveyor working in Virginia, he went on his father's death to stay with his cousins at Tuckahoe, an early 18th-century plantation still existing on the lower James River. The H-shaped house had ingenious dome-shaped plaster ceilings in the office and schoolroom, possibly an influence on his later work. While a student at the College of William and Mary, Williamsburg, VA, in 1760–62, he bought his first architectural book, probably *The Architecture of A. Palladio* (London, 1715–20 or the edition of 1742 or both) by James Leoni (*c.* 1686–1746). His next purchase was probably the *Rules for Drawing the Several Parts of Architecture* (London, 1732) by James Gibbs (1682–1754). The buildings of Williamsburg did not appeal to him, and he was highly critical of the college and hospital, even preparing plans to improve the college. He also made drawings for an octagonal chapel, probably for Williamsburg (not executed).

As early as 1767 Jefferson began planning his own house, Monticello, on an isolated hilltop on the family property at Shadwell. For three years he made preliminary studies, inspired by Leoni, Gibbs and Robert Morris's *Select Architecture* (London, 1755). His first design was a centre block with flanking wings, similar to the Semple House (*c.* 1770) in Williamsburg. The two-storey portico, similar to that of the Villa Pisani by Andrea Palladio (1508–80), became a favourite detail in late 18th-century American architecture. In 1770 the family house burned, making the building of his own home a necessity. By November 1770 the first outbuilding with only two rooms, known today as the South Pavilion, was completed, and Jefferson moved in, bringing his wife there after his marriage in 1772. He continued to work on and alter Monticello almost as long as he lived, designing many of the furnishings, which were built in his workshop, known as the Joiner's Shop. In 1776 he made proposals to the House of Delegates in Virginia for a new capitol in Richmond. Separate buildings for the various branches of the government were proposed for the first time. Four years later a decision to erect was accepted, and Jefferson was appointed head of the building committee.

2. PARIS, 1784–9. In 1784 Jefferson went to Paris as American ambassador. There he met Charles-Louis Clérisseau (1721–1820), the French antiquarian and architect, whose *Antiquités de la France: Monumens de Nismes* [Nîmes] (Paris, 1778) had introduced Jefferson to the Maison Carrée, which Jefferson described as 'the most perfect model existing of what may be called Cubic

architecture'. With the help of Clérisseau, Jefferson sent a model, based on the Maison Carrée, to Richmond. The architectural orders on the portico were changed from Corinthian to Ionic because of the scarcity of stone-carvers in America, and Jefferson adapted the interior for the separate legislative, executive and judicial functions. Building of the Virginia State Capitol started in 1785 and was completed in 1799. It marked the first use in America of a Classical temple as a model for a public building and set an influential example for American official architecture (*see* UNITED STATES OF AMERICA, fig. 7).

While in Europe, Jefferson witnessed urban developments in Paris, studying at first-hand the work of Claude-Nicolas Ledoux (1736–1806), Etienne-Louis Boullée (1728–99), Jacques Molinos (1743–1831) and Jacques-Guillaume Legrand (1743–1807), and benefiting from the intellectual and artistic environment. He also added to his collection of books on architecture, notably with *Les Edifices antiques de Rome* (Paris, 1682) by Antoine Desgodets (1653–1728) and *Parallèle de l'architecture antique et la moderne* (Paris, 1650) by Roland Fréart de Chambray (1606–76). From this French experience he became fascinated by octagons, semi-octagons, circles and spheres, later experimenting with the square and the interlocking of ingenious geometrical spaces. Thus when he returned to America in 1789, he possessed a professional breadth of architectural knowledge.

Influenced by European experiments in rehabilitating criminals through solitary confinement, Jefferson prepared designs in 1785 for a semicircular prison with individual cells placed at the periphery, on three storeys. It was based on a design of 1765 by Pierre-Gabriel Bugniet. Jefferson sent his plan to Richmond, VA, where it was later adapted by Benjamin Henry Latrobe for the State Penitentiary (1797–8). Jefferson's residence in Paris was the Hôtel de Langeac, designed from 1768 by Jean-François-Thérèse Chalgrin (1739–1811): Jefferson appreciated the elegance, comfort and privacy of the Hôtel. All the bedrooms had dressing-rooms and water closets as well as their own sitting-rooms. In 1786 Jefferson made a tour of English gardens accompanied by John Adams, the American ambassador to London. He admired the English landscape garden, noting his comments in his copy of *Observations on Modern Gardening* (London, 1770) by Thomas Whately (*d* 1772).

3. ARCHITECTURAL WORK IN AMERICA, 1789–1826.

(*i*) *Plans for Washington, DC, and work on Monticello and other houses.* On his return to America, Jefferson took great interest in the plans for the new capital of the United States of America, which George Washington decided should be located at the settlements of Carrollsburg and Hamburgh in the Territory of Columbia (on the north shore of the Potomac River), in preference to New York or Philadelphia. Jefferson presented the city's architect, PIERRE CHARLES L'ENFANT, with 22 maps of European cities (*see* WASHINGTON, DC, §I, 2). Jefferson's advocacy of Classical architecture and his personal experience of European cities influenced the planning of Washington and had a lasting effect on American architecture. Many

of his ideas were carried out. In 1792 he entered a competition for the President's House under an assumed name, basing his design on Palladio's Villa Rotonda.

Thomas Jefferson was President of the United States from 1801 to 1809, and during this time he continued to add ideas to the plan of Washington, redesigning Pennsylvania Avenue to contain a road separated by rows of trees from the walks on either side. From 1803 Latrobe was employed as Surveyor of the Public Buildings in Washington, where he oversaw further work on the Capitol, the President's House and the Washington Navy Yard.

In 1796 Jefferson started remodelling and enlarging Monticello, a scheme he had been considering during his stay in Paris. His first house derived mainly from Palladio; the alterations were based on designs by Antoine Desgodets, Charles Errard the younger (*c*. 1606/9–1689) and Roland Fréart de Chambray, reflecting the development of his architectural ideas and his reading. These changes resulted in the appearance of a symmetrical one-storey brick house with a prominent wooden balustrade. The west garden façade has a central pedimented portico crowned by a low octagonal drum and shallow dome. Three expert builders from Philadelphia were employed: James Dinsmore from 1798, and James Oldham and John Neilson from 1801. The remodelling was substantially completed by 1809. Numerous ingenious inventions with practical implications were devised.

Jefferson designed several houses for friends, including four in Virginia, Edgemont (*c*. 1797), Edgehill (before 1798, destr. and rebuilt), Barboursville (1817–22) and Bremo (1818–20), the last of which was built by John Neilson, and in Farmington (1809), KY. The houses show a Palladian influence in the treatment of porticos and arcades; most have a single storey, and some have mezzanines, used variously for bedrooms or storage. Bremo is similar to Monticello in its hilltop location, Tuscan orders on the porticos and internal layout. Jefferson's most original small house design was for his own country retreat, Poplar Forest (1806–12), near Lynchburg, VA. The house is an octagon, with octagonal rooms that create a perfectly square dining-room at the centre. The dining-room was lit by an ingenious glass skylight that doubled as a system for gathering water. The garden, and even the privies, are also based on the octagon. Of all the house forms he attempted, the rotunda was Jefferson's favourite. Three different schemes (not executed) were based on Palladio's Villa Rotonda: the Governor's House in Williamsburg (1778–1801), the Governor's House in Richmond (*c*. 1780) and the President's House in Washington (1792). Although his designs for houses often featured domes, the only dome built was at Monticello.

(*ii*) *University of Virginia, Charlottesville.* As early as 1805 Jefferson had realized that a new university was needed in central Virginia, conceiving it as 'an academical village' rather than a single large building. He proposed a long lawn or green, with five pavilions on both sides, each representing a different discipline, with a lecture-room and professor's apartments. The idea may be based on the château of Marly, Louis XIV's favourite retreat near Versailles, a building Jefferson had visited while in France. He consulted William Thornton and Latrobe, welcoming

Latrobe's suggestion for a rotunda as the focal-point and Thornton's idea of pavilions at the corner of the lawn to express the change of direction.

Jefferson designed the Rotunda (see fig.), basing it on the Pantheon in Rome with its proportions reduced by one half. This magnificent and domed building (1823–6), with two tiers of windows behind the six-columned portico and pediment, faces the lawn, with a view of the distant mountains. (This view was subsequently impeded by Stanford White's building of 1897–9.) Jefferson subtly emphasized the view by gradually increasing the spaces between the pavilions, thus falsifying the perspective and increasing the apparent length of the lawn. The interior of the Rotunda was designed with a ground floor for scientific experiments, the main first floor for lectures and the top floor for the library.

The cornerstone of the University was laid in 1817, when Jefferson was already 74 years old. He not only designed and supervised the construction but also raised money to keep the work advancing, successfully defending the idea of separate pavilions against the legislature's wish for a single building. Each pavilion had an architectural order derived from a different Roman temple, giving variety within a unified scheme and intended to serve as an example for teachers of architecture. Jefferson even suggested the first American school for architectural studies, with Francesco Milizia's *Architecture civile* (3 vols, Bassano, 1813; from the Italian *Principi di architettura civile*; Finale, 1791; Bassano, 1785, 1804) to be used as a textbook. The book contains practical information, including a design for cast-iron linings in fireplaces to reflect the heat more efficiently, which Jefferson adapted for fireplaces in the upper floor of the pavilions.

The University of Virginia was opened in 1825, when the Rotunda was almost completed. The University, with its imposing buildings, forms Jefferson's masterpiece,

triumphantly grafting the building tradition of ancient Rome on to the practice of contemporary American architecture. The influence of this fusion has proved to be enduring. During this period Jefferson also designed courthouses for Botetourt and Buckingham counties (1818 and 1821; both destr.), VA, in the Neo-classical style, and Christ Church, Charlottesville (1824–6, destr.), VA, with a portico *in antis*, which derives from St Philippe du Roule in Paris (1764–84) by Jean-François-Thérèse Chalgrin.

WRITINGS

Notes on the State of Virginia (London, 1787); ed. W. Peden (New York, 1954)

T. J. Randolph, ed.: *Autobiography* (1829); ed. D. Malone (New York, 1959)

BIBLIOGRAPHY

H. B. Adams: *Thomas Jefferson and the University of Virginia* (Washington, 1888)

P. L. Ford, ed.: *The Writings of Thomas Jefferson*, 10 vols (New York, 1892–9)

F. Kimball: *Thomas Jefferson, Architect: Original Designs in the Collection of Thomas Jefferson Coolidge, Junior, with an Essay and Notes* (Boston, 1916/R New York, 1968)

E. M. Betts, ed.: *Thomas Jefferson's Garden Book, 1766–1824* (Philadelphia, 1944)

E. D. Berman: *Thomas Jefferson among the Arts* (New York, 1947)

H. C. Rice jr: *L'Hôtel de Langeac: Jefferson's Paris Residence, 1785–1789* (Monticello and Paris, 1947)

D. Malone: *Jefferson*, 6 vols (Boston, 1948–84)

F. Kimball: 'Jefferson and the Public Buildings of Virginia: I. Williamsburg, 1770–1776', *Huntington Lib. Q.*, xii (1949), pp. 115–20

J. P. Boyd, ed.: *The Papers of Thomas Jefferson* (Princeton, 1950)

C. Lancaster: 'Jefferson's Architectural Indebtedness to Robert Morris', *J. Soc. Archit. Historians*, x (1951), p. 4

E. M. Sowerby: *Catalogue of the Library of Thomas Jefferson* (Washington, 1955) [with annotations]

W. B. O'Neal: *Jefferson's Buildings at the University of Virginia: The Rotunda* (Charlottesville, 1960)

F. D. Nichols: *Thomas Jefferson's Architectural Drawings* (Charlottesville, 1961, rev. Boston, 5/1984)

F. D. Nichols and J. A. Bear jr: *Monticello* (Charlottesville, 1967, rev. 1982)

F. J. B. Watson: 'French Eighteenth century Art in Boston', *Apollo*, xc (1969), pp. 474–83

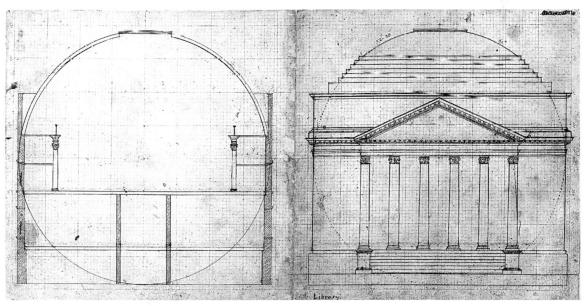

Thomas Jefferson: University of Virginia, section and elevation of the Rotunda, constructed 1823–6; drawing, *c.* 1822 (Charlottesville, VA, University of Virginia Library)

M. D. Peterson: *Thomas Jefferson and the New Nation: A Biography* (New York, 1970)

F. D. Nichols: 'Poplar Forest', *Ironworker*, xxxviii (1974), pp. 2–13

The Eye of Thomas Jefferson (exh. cat., ed. W. H. Adams; Washington, DC, N.G.A., 1976)

W. M. Kelso: 'Mulberry Row: Slave Life at Thomas Jefferson's Monticello', *Archaeol.*, xxxix (1986), pp. 28–35

A. S. Weisser: 'Symposium Examines Jefferson the Architect: University of Virginia, Charlottesville', *Prog. Archit.*, lxxv (1994), p. 20

H. Grandsart: 'Jefferson à Paris: Release of the Historical Film in France', *Conn. A.*, dxviii (1995), pp. 96–103

J. H. Robinson: 'An American Cabinet of Curiosities: Thomas Jefferson's Indian Hall at Monticello, Virginia', *Winterthur Port.*, xxx (Spring 1995), pp. 41–58

J. Kramer: 'Historic Architecture: Edgemont: Virginia Residence', *Archit. Dig.*, liii (1996), p. 70

FREDERICK D. NICHOLS

Jenney, William Le Baron (*b* Fairhaven, MA, 25 Sept 1832; *d* Los Angeles, CA, 15 June 1907). American architect. The son of a prosperous merchant, he studied at Phillips Academy, Andover, MA, and in 1859 entered the Lawrence Scientific School, Harvard College, Cambridge, MA, to study engineering. He took the unusual step of studying at the Ecole Centrale des Arts et Manufactures in Paris (1853–6). In contrast to the course at the Ecole des Beaux-Arts, which stressed the art of design, the course at the Ecole Centrale focused more on expressing function in industrial design and on an empirical and pragmatic approach. Jenney worked for a French railway company for a few years and returned to the USA at the outbreak of the Civil War (1861). He served in the Union Army Corps of Engineers, being discharged in 1866 with the rank of major.

In 1868 Jenney established an architectural practice in Chicago (*see* CHICAGO, §1). Gradually he focused on the design of office and loft buildings, making the structures more efficient and enlarging the windows. Such buildings as his Portland Block (1872; destr.) attracted promising young architects to his office, including Louis Sullivan, William Holabird, Martin Roche, Daniel H. Burnham and Enoch H. Turnock; their work developed the distinctive image of the Chicago skyscraper (*see* SKYSCRAPER).

For the first Leiter Building (1879; destr.) Jenney used an internal skeleton of iron, with slender iron columns embedded in the exterior wall carrying the floor beams; otherwise the exterior masonry wall carried its own weight, which was reduced due to the extremely broad windows. In the Chicago branch of the Home Insurance Company (1883–5; destr. 1931; *see* CHICAGO, fig. 1), working with engineer George B. Whitney, Jenney took the decisive step of using a complete steel frame above the second floor, with metal lintels carrying all exterior masonry cladding and the windows. This was the first building constructed around a steel skeleton. Working with engineer Louis E. Ritter (1864–1934), in 1889–90 he also used an iron-and-steel skeletal frame for the whole of the taller Manhattan Building, 431 S. Dearborn Street, also adding diagonal wind bracing. None of these office blocks as yet had exterior masonry skins commensurate with the daring of their internal frames. In the granite exterior of the huge Sears, Roebuck & Co. Store (1889–91), State and Van Buren Streets in Chicago, he finally clearly expressed the presence of the internal iron and steel skeleton.

After 1891, when Jenney formed a partnership with William B. Mundie (1863–1939), the firm produced the elegantly restrained Ludington Building (1891) and the Montgomery Ward (later Fair) Store (1891–2; destr.). The Morton Building (1896), 538 S. Dearborn Street, and the Chicago Garment Center (1904–5), Franklin and Van Buren Streets, continued this tradition of straightforward structural expression. In 1893 Jenney & Mundie participated in producing designs for the World's Columbian Exposition in Chicago. Jenney then retired and in 1905 moved to Los Angeles. More than any other architect Jenney was instrumental in establishing the character of Chicago office building and contributing to the structural development of the modern metal-framed skyscraper.

WRITINGS
'Construction of a Heavy Fireproof Building on Compressible Soil', *Engin. Rec., Bldg Rec. & Sanitary Engin.*, xiii (1885), pp. 32–3

BIBLIOGRAPHY
DAB; *Macmillan Enc. Architects*

A. Woltersdorf: 'The Father of the Skeleton Frame Building', *W. Architect*, xxxiii (1924), pp. 21–3

J. C. Webster: 'The Skyscraper: Logical and Historical Considerations', *J. Soc. Archit. Hist.*, xviii (1959), pp. 126–39

C. W. Condit: *The Chicago School of Architecture: A History of Commercial and Public Building in the Chicago Area* (Chicago, 1964)

T. Turak: 'Ecole Centrale and Modern Architecture: The Education of William Le Baron Jenney', *J. Soc. Archit. Hist.*, xxix (1970), pp. 40–47

——: *William Le Baron Jenney: A Pioneer of Modern Architecture* (Ann Arbor, 1986)

J. Zukowsky, ed.: *Chicago Architecture, 1872–1922: Birth of a Metropolis* (Munich, 1987)

LELAND M. ROTH

Jennys. American artists. Richard Jennys (*fl* 1766–1801) and William Jennys (*fl* 1793–1808) were successful itinerant portrait, miniature and ornamental painters working mainly in New England; Richard was also an engraver. They both founded art schools and collaborated on several occasions, jointly signing portraits from 1795 to 1801. They were probably related, William possibly being the son and apprentice of Richard. While they were relatively prolific artists, the basic details of their lives, such as dates of birth and death, remain unknown.

The Jennyses worked in an accomplished but highly conservative mid-18th-century portrait style, in which the sitter is represented bust-length within an oval. The continued use of this format may reflect, in part, Richard's work as an engraver while in Boston. About 1766 Richard executed his first known work, a mezzotint of the *Rev. Jonathan Mayhew* (Worcester, MA, Amer. Antiqua. Soc.), pastor of the West Church in Boston. As well as the format, the sharp value contrasts and hard outlines characteristic of line engravings are stylistic elements found in the later oil portraits of the Jennyses.

Richard Jennys is known to have worked in Boston in the 1760s and later in the West Indies. In 1783 he was in South Carolina, where he advertised his intention to pursue portrait painting 'in all its branches'. From 1785 to 1791 he painted both large and miniature portraits in Savannah, GA. He also visited the West Indies during this time. In 1792 he opened his art school in New Haven, CT. From there he travelled to New Milford, CT, where he painted portraits intermittently from 1794 to 1798. William's association with Richard is first documented at this time in the account book of their patron, Jared Lane (ex-CT

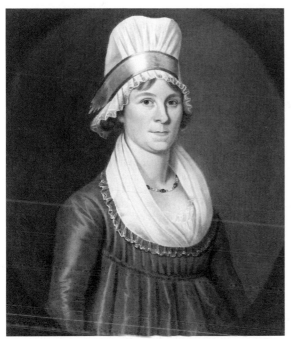

Richard Jennys and William Jennys: *Gifsel Warner Judson*, oil on canvas, 765×638 mm, 1799 (Norfolk, VA, Chrysler Museum)

Hist. Soc., Hartford). Approximately 15 portraits of New Milford subjects have been documented or attributed to Richard and William Jennys, including portraits of Lane's in-laws, *Captain Lazarus Ruggles* and his wife *Hannah Ruggles* (New York, Kennedy Gals). The Jennyses faithfully recorded their subjects' features, often in an unflattering manner, and this intense realism resulted in powerful characterizations. The Jennyses travelled throughout New England in the 1790s, jointly signing such portraits as *Captain David Judson* and *Gifsel Warner Judson* (both 1799; Norfolk, VA, Chrysler Mus.; see fig.) and *Mrs David Longenecker* (1801; Philadelphia, PA, Hist. Soc.). The latter portrait is Richard's last known work. William Jennys is listed in New York City directories for 1797–8, and after 1800 he travelled to central Massachusetts and Vermont and then to Portsmouth, NH, and Newburyport, MA. His last known documented work is the portrait of *James Clarkson* of Newburyport (1807; priv. col., see Warren, 1955, fig. 2).

BIBLIOGRAPHY

W. L. Warren: 'The Jennys Portraits', *CT Soc. Bull.*, xx/4 (1955), pp. 97–128

——: 'A Checklist of Jennys Portraits', *CT Soc. Bull.*, xxi/2 (1956), pp. 33–64

——: 'Captain Simon Fitch of Lebanon', *CT Soc. Bull.*, xxvi/4 (1961), pp. 120–21

E. M. Kornhauser and C. S. Schloss: 'Painting and Other Pictorial Arts', *The Great River: Art and Society of the Connecticut River Valley* (Hartford, 1985), pp. 138, 165–6

Ralph Earl: The Face of the Young Republic (exh. cat. by E. M. Kornhauser and others, New Haven, CT, 1991)

ELIZABETH MANKIN KORNHAUSER

Jocelyn, Nathaniel (*b* New Haven, CT, 31 Jan 1796; *d* New Haven, 13 Jan 1881). American painter, engraver and abolitionist. He learnt the rudiments of engraving while apprenticed to his father, Simeon, a clockmaker. This talent was encouraged by the inventor and manufacturer Eli Whitney, who saw to it that Jocelyn received further training in Hartford, CT. Jocelyn had wanted to study portrait painting in England, but his plan was thwarted by John Trumbull (a distant relative). He concentrated on engraving instead, forming the N. & S. S. Jocelyn Co. with his brother Simeon Smith Jocelyn (1799–1879) in 1818.

Jocelyn continued to paint, however, producing his first miniatures the following year. In June 1820, Samuel F. B. Morse invited Jocelyn to work alongside him in his studio in New Haven. This was the closest to formal instruction that Jocelyn had. In November Jocelyn opened a portrait studio in Savannah, GA, for the winter season, returning again the following year. His success was limited, and he pursued mainly business interests thereafter, though keeping a studio in New Haven until 1849.

In 1829 Jocelyn went to England to study new printing techniques and painting; in November, accompanied by Morse and the architect and inventor Ithiel Town, he toured France and Italy. Later he was a founder of the American Bank Note Co., heading its art department until he retired in 1865. He then had a studio at the new Yale Art School and was Curator of Italian Art there.

Jocelyn was also active in the abolition movement. His most famous portraits are of leading figures in this cause: *Cinqué* (1839; New Haven, CT, Colony Hist. Soc. Mus.), chief of the Amistad blacks who were detained in the New Haven gaol, and *William Lloyd Garrison* (1833; Washington, DC, priv. col., on loan to N.P.G.).

BIBLIOGRAPHY

F. W. Rice: 'Nathaniel Jocelyn 1796–1881', *CT Hist. Soc. Bull.*, xxxi/4 (1966), pp. 97–145

B. Heinz: 'Nathaniel Jocelyn, Puritan, Painter, Inventor', *J. New Haven Colony Hist. Soc.*, xxix/2 (1983), pp. 1–44

R. J. Powell: '*Cinqué*: Antislavery Portraiture and Patronage in Jacksonian America', *Amer. A.*, xi (Autumn 1997), pp. 48–73

BERNARD HEINZ

Johnson, David (*b* New York, 10 May 1827; *d* Walden, NY, 30 Jan 1908). American painter. He was a member of the Hudson River school and was virtually self-taught except for a few lessons from Jasper Francis Cropsey. He was primarily a landscape artist and a Luminist who rendered subtle effects of light and atmosphere with precise realism. His earliest works were copies of prints, for example *West Point from Fort Putnam* after Robert Havell jr (*c.* 1848; Cooperstown, Mus. NY State Hist. Assoc.). His first painting from nature (executed in the company of John William Casilear and John Frederick Kensett) was *Haines Fall, Kauterskill Clove* (1849; untraced, see Baur, fig. 2), and he began exhibiting the same year.

Johnson travelled widely in the north-east states of the USA, finding subjects in the White Mountains of New Hampshire, the Adirondacks and elsewhere in New York State and in Virginia. He made one trip west to the Rocky Mountains in 1864–5, where he painted *Landscape, Mountains and Lake* (New York, David Findlay Gal.). His most striking works are those depicting rock formations, for example *Forest Rocks* (1851; Cleveland, OH, Mus. A.), *Natural Bridge, Virginia* (1860; Winston-Salem, NC, Reynolda House) and *Brook at Warwick* (1876; Utica, NY,

Munson–Williams–Proctor Inst.). He also did many highly finished and detailed drawings of trees and rocks. Occasionally he experimented with a freer, more painterly technique, generally with less success. His few portraits are all copies of photographs or paintings by other artists. He also painted a few still-lifes, such as *Phlox* (1886; Winston-Salem, NC, Reynolda House).

BIBLIOGRAPHY

J. I. H. Baur: '"...The Exact Brushwork of Mr. David Johnson": An American Landscape Painter, 1827–1908', *A. J.* [New York], xii (1980), pp. 32–65

JOHN I. H. BAUR

Johnson, (Jonathan) Eastman (*b* Lovell, ME, 29 July 1824; *d* New York, 5 April 1906). American painter and printmaker. Between 1840 and 1842 he was apprenticed to the Boston lithographer John H. Bufford (1810–70). His mastery of this medium is apparent in his few lithographs, of which the best known is *Marguerite* (*c.* 1865–70; Worcester, MA, Amer. Antiqua. Soc.). In 1845 he moved to Washington, DC, where he drew portraits in chalk, crayon and charcoal of prominent Americans, including *Daniel Webster, John Quincy Adams* and *Dolly Madison* (all 1846; Cambridge, MA, Fogg). In 1846 he settled in Boston and brought his early portrait style to its fullest development. His chiaroscuro charcoal drawings, of exceptional sensitivity, were remarkably sophisticated for an essentially self-trained artist. In 1848 he travelled to Europe to study painting at the Düsseldorf Akademie. During his two-year stay he was closely associated with Emanuel Leutze, and painted his first genre subjects, for example *The Counterfeiters* (*c.* 1851–5; New York, IBM Corp.). He then spent three years in The Hague, studying colour, composition and naturalism in 17th-century Dutch painting. The influence of the Dutch masters on his portrait style was so great that he was called 'the American Rembrandt'. In 1855, after two months in the Paris studio of Thomas Couture (1815–79), he returned to America. He then turned his attention to American subject-matter.

He made studies of Indians in Wisconsin, and painted portraits while in Washington (e.g. *George Shedden Riggs, c.* 1855; Baltimore, Mus. & Lib. MD Hist.) and Cincinnati. He finally settled in New York.

Johnson's painting *Old Kentucky Home—Life in the South* (1859; New York, NY Hist. Soc.) established his reputation and led to his painting a series of sympathetic depictions of American blacks. His *Cornhusking* (1860; Syracuse, NY, Everson Mus. A.), depicting a barn interior, was the culmination of a genre tradition popularized a generation earlier by William Sidney Mount. Between 1861 and 1865 he painted subjects relating to the Civil War, often with a degree of sentimentality or melodrama rarely found in his other works, for example *Ride for Liberty—The Fugitive Slaves* (*c.* 1862; New York, Brooklyn Mus.). His most original works of the 1860s were an extensive series of paintings, oil sketches and drawings made annually in late winter, near Fryeburg, ME, on the subject of life in the maple sugar camps, for example *Sugaring Off* (*c.* 1861–6; Providence, RI Sch. Des., Mus. A.). In contrast to these freely brushed studies of rural life there were several less painterly depictions of the wealthy in rich urban interiors. Among the finest is the *Hatch Family* (1871; New York, Met.; see colour pl. XVII, 2), an elaborate conversation piece set in the Eastlake-style library of the family's Park Avenue, New York, mansion.

Following his marriage in 1869, Johnson spent each summer on Nantucket Island, MA. While there he developed two of his most complex and successful genre subjects, each preceded by numerous oil sketches and studies that show his heightened interest in the naturalistic depiction of outdoor light: *Cornhusking Bee* (1876; Chicago, IL, A. Inst.) and *Cranberry Harvest* (1880; San Diego, CA, Timken A.G.; see fig.). With their studies and variants, these two works represent Johnson's best achievements as a painter of figures in complex relationship to each other and their environment. In the mid-1880s demand for his genre subjects decreased and perhaps a gradual

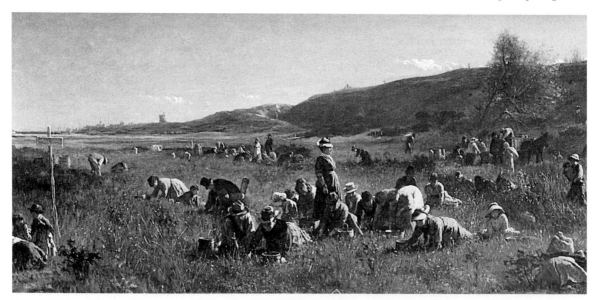

Eastman Johnson: *Cranberry Harvest*, oil on canvas, 695×1388 mm, 1880 (San Diego, CA, Timken Art Gallery, Putnam Foundation)

decline in his powers made him return almost exclusively to portraiture. Earlier in the decade he had painted some successful characterizations, including the artist *Sanford Robinson Gifford* (1880) and the double portrait of Johnson's brother-in-law, Robert Rutherford, and the artist Samuel W. Rowse (1822–91) entitled the *Funding Bill* (1881; both New York, Met.). These vigorously brushed likenesses with their dramatic contrasts of light and shade are in the sombre, Rembrandtesque palette Johnson used for portraits. Some have since darkened further from his use of bitumen in areas of shadow. A good example of his later portraits is his *Self-portrait* (see Hills, 1972, p. 116), which depicts him in 17th-century Dutch costume. He painted little after the early 1890s and his visits to Europe in 1885, 1891 and 1897 had no evident effect on his style, which in composition, colour, light and draughtsmanship, especially in scenes of rural life in Maine and Nantucket, is unsurpassed in American 19th-century painting.

BIBLIOGRAPHY

Eastman Johnson, 1824–1906: American Genre Painter (exh. cat., ed. J. Baur; New York, Brooklyn Mus., 1940/*R* 1969)
Eastman Johnson (exh. cat., ed. P. Hills; New York, Whitney, 1972)
P. Hills: *The Genre Painting of Eastman Johnson: The Sources and Development of his Style and Themes* (New York, 1977)
N. Spassky: *American Paintings in the Metropolitan Museum* (New York, 1985), pp. 220–39
M. Simpson and others: *Eastman Johnson: The Cranberry Harvest* (San Diego, CA, 1990)
J. Davis: 'Children in the Parlour: Eastman Johnson's *Brown Family* and the Post-Civil War Luxury Interior', *Amer. A.*, x (Summer, 1996), pp. 50–77
——: 'Eastman Johnson's Negro Life at the South and Urban Slavery in Washington, DC', *A. Bull.*, lxxx/1 (1998), pp. 67–92

DAVID TATHAM

Johnson, John G(raver) (*b* Chestnut Hill, PA, 4 April 1841; *d* Philadelphia, 14 April 1917). American lawyer and collector. He was the son of a village blacksmith whose life emphasized the middle-class virtues of industriousness and self-reliance. Johnson was admitted to the bar before completing his formal schooling at the University of Pennsylvania. In Philadelphia he built a reputation in the developing area of corporate law; eventually he represented most of the major trusts of America's 'gilded age', in the process accumulating a fortune sufficient to allow him to create a large and historically important collection of paintings. He also represented several other leading US collectors, including J. Pierpont Morgan and Henry Clay Frick.

Johnson's interest in collecting was sparked by the art exhibition at the Philadelphia Centennial Exposition of 1876 and was encouraged by the establishment of the Pennsylvania Museum in Fairmount Park, Philadelphia. His marriage to the socially prominent widow Ida Powel Morrell and biennial trips to Europe beginning in the 1880s strengthened these earlier propensities, as did his appointment as Commissioner of Fairmount Park. By 1892 he could list in a published catalogue of his collection 281 works of art. With the exception of 27 Old Masters, they were almost all 19th-century French paintings, either by Barbizon artists or by those active in Paris during the last quarter of the century. He believed contemporary art was a safer investment than spurious Old Masters, writing in 1892, 'pedigrees are either manufactured, or if genuine usually begin a century too late'.

In 1844 Johnson bought his first Flemish primitive painting—*St Francis Receiving the Stigmata*, the first work by Jan van Eyck (*c.* 1395–1441) in America. After that the collection expanded rapidly, as Johnson became more committed to early Netherlandish and Italian art. By 1913 Johnson had accumulated almost 1200 paintings and had developed a philosophy of collecting, which insisted on constant weeding and trading up of works: 'I have put my foot in it at times', he wrote in 1909, 'but I might have fared far worse in the hands of those beside whom base jackals are Innocents—the Dealers in art.' Johnson believed that the collection itself should be a work of art. 'Art is not of one century only, nor of one country', he wrote, '. . .the best art is nearly on the same plane, and. . .it is possible to hang without jar, side by side, works of the masters of the seventeenth and of the nineteenth centuries.'

On Johnson's crowded walls a few contemporary American and French Impressionist paintings appeared beside Italian Renaissance masterpieces from Florence, Venice and central and northern Italy (including five Botticellis), and a large collection of Flemish primitives (including two monumental panels by Rogier van der Weyden (*c.* 1399–1469)), acquired before such works became popular among collectors following the Dollfus sale in 1912. He also purchased paintings by Hieronymus Bosch (*c.* 1450–1516), Frans Hals (1581/5–1666), Pieter de Hooch (1629–84), Jan Steen (1626–79), Jacob van Ruisdael (1628–82), Aelbert Cuyp (1620–91), Rubens (1577–1640) and David Teniers the younger (1610–90). He bequeathed his collection to the city of Philadelphia; it is housed separately within the Philadelphia Museum of Art.

WRITINGS

Sight-seeing in Berlin and Holland among Pictures (Philadelphia, 1892) [repr. from articles in the *Philadelphia Press*]

BIBLIOGRAPHY

Catalogue of a Collection of Paintings Belonging to John G. Johnson (Philadelphia, 1892)
B. Berenson and W. R. Valentiner: *Catalogue of John G. Johnson Collection*, 3 vols (Philadelphia, 1913–14)
H. M. Allen: 'John G. Johnson: Lawyer and Art Collector', *The Bellman* (12 May 1917), pp. 518–21
M. W. Brockwell: 'The Johnson Collection in Philadelphia', *Connoisseur* (March 1918), pp. 143–53
John G. Johnson Collection: Catalogue of Paintings (Philadelphia, 1941)
B. F. Winkelman: *John G. Johnson, Lawyer and Art Collector* (Philadelphia, 1942)
A. B. Saarinen: *The Proud Possessors* (New York, 1958), pp. 92–117
John G. Johnson Collection: Catalogue of Italian Paintings (Philadelphia, 1966)
John G. Johnson Collection: Catalogue of Flemish and Dutch Paintings (Philadelphia, 1972)
L. B. Miller: 'Celebrating Botticelli: The Taste for the Italian Renaissance in the United States, 1870–1920', *The Italian Presence in American Art*, ed. I. Jaffe (New York, 1992), pp. 1–22

LILLIAN B. MILLER

Johnson [Johnston], Joshua (*fl c.* 1796–1824). American painter, perhaps of West Indian birth. He was probably the first significant Afro-American painter and worked primarily in Baltimore, painting portraits for prosperous, middle-class families. His career and his identity as a 'Free Householder of Colour' are sketchily documented in city records. Circumstantial evidence suggests that he had once been a slave and had arrived from the West Indies before

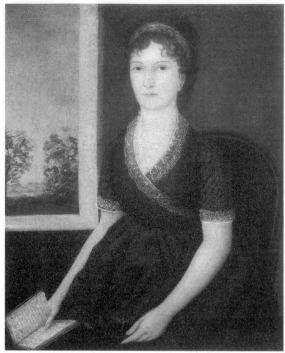

Joshua Johnson: *Sarah Ogden Gustin*, oil on canvas, 832×698 mm, *c*.
1798–1802 (Washington, DC, National Gallery of Art)

1790. More than 80 portraits have been attributed to him.
Sarah Ogden Gustin (*c*. 1798–1802; Washington, DC,
N.G.A.; see fig.) is the only signed work and typifies his
early style. Though the figure is woodenly rendered and
awkwardly seated within a flattened space, the view
through a window reveals a painterly landscape and an
attempt at atmospheric perspective. Johnson's early por-
traits closely resemble compositions by members of
Charles Willson Peale's family, particularly Peale's nephew
Charles Peale Polk, suggesting that he may have studied
under them. His later work is more tightly painted and
includes several large family portraits, such as *Mrs Thomas
Everette and her Children* (1818; Baltimore, Mus. & Lib.
MD Hist.). This is the only painting that can be traced to
Johnson through a patron's family records. The severely
linear, plain style creates a decorative image of middle-
class affluence and virtue. Johnson also painted many
portraits of children in a charming, doll-like fashion.

BIBLIOGRAPHY
Joshua Johnson: Freeman and Early American Portrait Painter (exh. cat.,
 ed. C. J. Weekley and S. T. Colwill; Williamsburg, VA, Rockefeller Flk
 A. Col.; Baltimore, MD Hist. Soc. Mus.; New York, Whitney and
 elsewhere; 1987–8)
J. Bryan and R. Torchia: 'The Mysterious Portraitist: Joshua Johnson',
 Archvs Amer. A. J., xxxvi/2 (1996), pp. 2–7
American Folk Art in the Metropolitan Museum of Art (exh. cat. by C.
 Rebora Barratt, New York, Met.,1999–2000)

DAVID BJELAJAC

Johnston, David Claypoole (*b* Philadelphia, 25 March
1798; *d* Dorchester, MA, 8 Nov 1865). American print-
maker and watercolourist. After training as an engraver
with Francis Kearney (1785–1837) in Philadelphia (1815–
19), he embarked in 1821 on a theatrical career, performing

for five seasons with repertory companies in Philadelphia
and Boston. From this experience came his most important
early work, a series of etched and lithographed character
portraits of notable American and British actors. In 1825
he settled permanently in Boston.

Although Johnston occasionally painted in oils, and
after 1840 conducted classes in many aspects of art, his
reputation was and remains essentially that of a satiric
comic artist who worked mainly as a printmaker and
watercolourist. He was a prolific designer of wood-
engravings, an accomplished etcher and among the earliest
American masters of lithography. His etching style was at
first derived from the work of George Cruikshank (1792–
1878), but grew steadily more individual from the mid-
1830s. This transition is particularly evident in the nine
numbers of Johnston's *Scraps* published between 1828 and
1849, each consisting of four plates of etched comic
vignettes treating a broad range of topical subjects, includ-
ing fashion, art, politics, religion, women's rights and
slavery. His best-known watercolour, *The Militia Muster*
(1828; Worcester, MA, Amer. Antiqua. Soc.; see fig. over
the page), satirizes the American local militia system. He
drew many broadside prints and illustrated dozens of
books and magazines.

Johnston was the most able and original of the many
satiric artists of his time, partly because he was a better
draughtsman than the others and partly because his
interests were much wider than those of his contemporar-
ies. His work abounds in literary allusions, especially to
Shakespeare but also to many contemporary writers. His
knowledge of the history of art was unusual for an
American artist who had never travelled abroad. Though
he aimed his work at a wider, popular audience, it was also
warmly received by cultivated Bostonians, including Wash-
ington Allston and Horatio Greenough. He exhibited
watercolours in many of the annual exhibitions at the
Boston Athenaeum, chiefly genre subjects and landscapes
but also comic subjects. The strong anti-slavery feeling of
his work in the 1850s developed into caustic assaults on
the Confederacy in his work during the Civil War.

BIBLIOGRAPHY
M. Johnson: *David Claypoole Johnston* (Worcester, MA, 1970)
D. Tatham: 'D. C. Johnston's Satiric Views of Art in Boston', *Art and
 Commerce* (Charlottesville, VA, 1978), pp. 9–24
——: 'David Claypoole Johnston's Theatrical Portraits', *American Portrait
 Prints* (Charlottesville, VA, 1984), pp. 162–93

DAVID TATHAM

Johnston, Frances Benjamin (*b* Grafton, WV, 15 Jan
1864; *d* New Orleans, 16 March 1952). American photog-
rapher. She studied art at the Académie Julian in Paris
(1883–5) and at the Art Students League, Washington,
DC. In 1888, in order to write and illustrate articles for
popular magazines, she learnt photography from Thomas
William Smillie (1843–1917), Director of the Smithsonian
Institution's Photography Division, Washington, DC. On
opening a professional portrait studio in 1894, she became
known for images of presidents, government officials and
other notables. Her projects included documentation of
educational facilities at Hampton Institute, VA, and Tus-
kegee Institute, AL. In 1904 Johnston joined the Photo-
Secession. She was a juror for the second Philadelphia

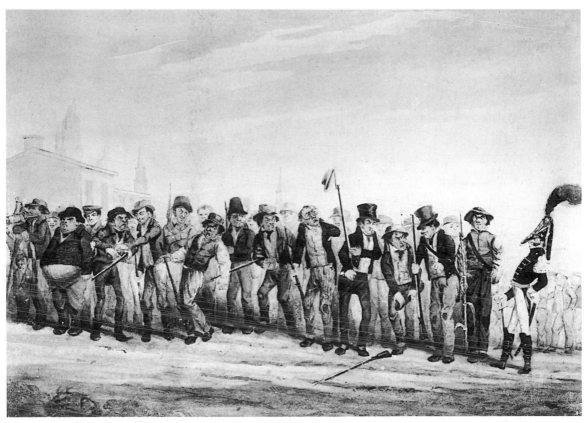

David Claypoole Johnston: *The Militia Muster*, watercolour, 273×381 mm, 1828 (Worcester, MA, American Antiquarian Society)

Salon of Photography, received four consecutive Carnegie Foundation grants to document historic gardens and architecture of the South, and was later made an honorary member of the American Institute of Architects (1945). She donated most of her negatives, prints and correspondence to the Library of Congress, Washington, DC (1948). Johnston is often referred to as America's first female photojournalist.

BIBLIOGRAPHY

The Hampton Album (exh. cat. by L. Kirstein, New York, MOMA, 1966)
P. Daniel and R. Smock: *A Talent for Detail: The Photographs of Miss Frances Benjamin Johnston, 1889–1910* (New York, 1974)
J. A. Watts: 'Frances Benjamin Johnston: The Huntington Library Portrait Collection', *Hist. Phot.*, xix/3 (1995), pp. 252–62
J. M. Przyblyski: 'American Visions at the Paris Exposition, 1900: Another Look at Frances Benjamin Johnston's Hampton Photographs', *A. J.* [New York] , lvii/3 (1998), pp. 60–68

FIONA DEJARDIN

Johnston [Beaulieu], **Henrietta** [de] (*b* ?France, *c.* 1674; *fl* 1705–29). American pastellist. In 1694 she married Robert Dering (*d* between 1698 and 1702), and then on 11 April 1705 she married Gideon Johnston, with whom she emigrated the same year from Ireland to Charleston, SC. Her second husband, an Anglican clergyman, received a position at Charleston, but his salary was poor, and Henrietta eased their financial problems by making and selling modestly priced portraits in pastel, which proved popular. No record exists of any art training, but her early work in Ireland resembles the portraits of Godfrey Kneller (1646–1723), and her pastel technique has much in common with that of Edward Luttrell (*fl c.* 1680–1724), an English painter in Dublin. Her portraits, almost always bust-length and normally 229×305 mm, are dated and signed on the back of the wooden frames that she apparently provided. Among the 40 known portraits, she seldom showed the hands of her sitters and favoured a dark and undefined background that accented her sculptural treatment of the clothing. Strong shadows relieved by bright touches of white suggest the sheen of satin and other fine cloth worn by her subjects. The most characteristic feature of her style, the large liquid dark eyes, have a bright highlight on the left side, suggesting lighting from that direction. She worked only in Charleston, except for some work in New York dated 1725. Most of the pastels are in private collections, with some in the Carolina Art Association (Charleston, SC, Gibbes Mus. A.) and the Museum of Early Southern Decorative Arts, Winston-Salem, NC.

BIBLIOGRAPHY

M. S. Middleton: *Henrietta Johnston of Charles Town, South Carolina: America's First Pastellist* (Columbia, SC, 1966)
A. W. Rutledge: 'Henrietta Johnston', *Notable American Women, 1607–1959: A Biographical Dictionary*, ed. E. T. James (Cambridge, MA, 1971), ii, pp. 281–2
Henrietta Johnston: Who Greatly Helped...by Drawing Pictures (exh. cat., ed. F. Alexander, Winston-Salem, NC, Mus. Early S. Dec. A.; Charleston, SC, Gibbes Mus. A.; 1991–2)
M. R. Severens: 'Who Was Henrietta Johnston?', *Antiques*, cxlviii (1995), pp. 704–9

DARRYL PATRICK

Johnston, William L. (*b c.* 1811; *d c.* 1849). American architect. Details about his early life are obscure. During the mid-1830s he taught drawing at the architectural school run briefly by the Carpenters' Company, Philadelphia. In 1840 and 1842 Johnston exhibited watercolour architectural drawings at the Artists' Fund Society and at about the same time added the 't' to his surname and the middle initial 'L', to avoid confusion with others. Johnston's buildings, all in Philadelphia, were varied in style. His First Methodist Church (1840–41; destr.) incorporated a Greek Ionic order, whereas the Mercantile Library (1844; destr.) and Odd Fellows' Hall (1845–6; destr.) employed Roman elements that approached a Renaissance character. He probably designed a number of residences in Philadelphia and its environs, including an imposing Neo-classical mansion for the chemist George W. Carpenter in Germantown in 1841–4. He was also the designer of Orange Grove (1847–9), the Gothic Revival plantation house of Thomas A. Morgan in Braithwaite, LA; Morgan's wife was from Philadelphia. None of these is extant except for Orange Grove, which is a ruin. Johnston's only surviving major work is the Moorish gate (1849) to Hood Cemetery, Germantown. Johnston is best known as a contributing designer to the seven-storey Granite Building (1848–50; destr. 1957), Philadelphia, also known as the Jayne Building. After Johnston's death from tuberculosis, the owner, Dr Jayne, engaged Thomas U. Walter to complete it. The pronounced verticality of the Venetian Gothic design, with its recessed lintels, may have influenced Louis Sullivan, then working with Frank Furness, whose office on Chestnut Street overlooked the Jayne Building.

BIBLIOGRAPHY

Macmillan Enc. Archit.

C. E. Peterson: 'Ante-bellum Skyscraper', *J. Soc. Archit. Hist.*, ix (1950), pp. 27–8

R. C. Smith: 'The Jayne Building Again', *J. Soc. Archit. Hist.*, x (1951), p. 25

J. C. Massey: 'Carpenters' School, 1833–42', *J. Soc. Archit. Hist.*, xiv (1955), pp. 29–30

W. R. Cullison III: *Orange Grove: The Design and Construction of an Ante-bellum Neo-Gothic Plantation House on the Mississippi River* (diss., New Orleans, Tulane U., 1969)

R. J. Webster: *Philadelphia Preserved: Catalogue of the Historic American Buildings Survey* (Philadelphia, 1976)

LELAND M. ROTH

Jones, Beatrix. *See* FARRAND, BEATRIX JONES.

Jouett, Matthew Harris (*b* nr Harrodsburg, KY, 22 April 1787–8; *d* nr Lexington, KY, 10 Aug 1827). American painter. In 1804 he enrolled in Transylvania College in Lexington, KY, and by 1812 he was practising law in the town. After serving in the War of 1812, he began painting portraits. Around June 1816 he travelled to Philadelphia for instruction but soon moved on to Boston, where he spent about four months in the studio of Gilbert Stuart. Returning to Lexington, Jouett set up a practice painting both portraits and miniatures. In the winters he travelled south, seeking commissions in New Orleans, Natchez, MS, and other towns along the Mississippi River. In 1825 he painted a portrait of *General Marie Joseph du Motier, Marquis de Lafayette* (KY Hist. Soc., on loan to Frankfort, KY, State Capitol) at the request of the Kentucky legislature. In addition to portraits, Jouett also attempted landscape painting and organized art exhibitions to benefit various causes. One of the first artists to emerge from America's then western frontier, he was lauded by his contemporaries and is today remembered for his pioneering accomplishments.

Jouett's straightforward style owes much to the example of Stuart. His portrait of *John Grimes* (*c.* 1824; New York, Met.) is typical in its emphasis on head and features, set against a simple background, while such portraits as that of *Justice Thomas Todd* (*c.* 1825; Frankfort, KY Hist. Soc.) demonstrate his knowledge of the standard vocabulary of state portraiture.

BIBLIOGRAPHY

W. Dunlap: *A History of the Rise and Progress of the Arts of Design in the United States*, 3 vols (New York, 1834, rev. 3/1965), iii, pp. 100–01, 167

W. Floyd: *Matthew Harris Jouett: Portraitist of the Ante-Bellum South* (Lexington, 1980)

SALLY MILLS

K

Kahn, Albert (*b* Rhaunen, nr Mainz, 21 March 1869; *d* Detroit, 8 Dec 1942). American architect. He grew up in Echternach but emigrated to Detroit with his family in 1880, at which time his formal schooling ended. His architectural training was with the Detroit architectural firm of Mason & Rice (1884–95), where he rapidly became chief designer, working in the mode of H. H. Richardson and the Shingle style. His designs of this period may include the Grand Hotel (1888) on Mackinaw Island, MI. He spent 1891 in Europe on a travelling scholarship. During his time with Mason & Rice his admiration began for the work of McKim, Mead & White (which led in the 1920s to his designs for the William L. Clements Library at the University of Michigan, Ann Arbor, and the General Motors Building in Detroit).

In 1903 Kahn became architect for Packard Motor Car Company in Detroit and in 1906 for the George N. Pierce Company of Buffalo, NY, makers of the Pierce-Arrow car. For Pierce he made the first roof-lit factory for heavy industry. This innovation freed interior planning from its prior dependence on wall windows, allowing the plan to spread horizontally to follow whatever configuration the manufacturing process required. In 1908 he was engaged by Henry Ford to design a new factory (now mostly demolished) in Highland Park in Detroit for the Model T. In this factory Ford used assembly-line methods for the first time in heavy industry in 1913, leading Ford and Kahn to consider a vast new industrial complex to build the Model T by assembly-line process.

BIBLIOGRAPHY
G. Nelson: *The Industrial Architecture of Albert Kahn* (New York, 1939)
W. H. Ferry: *The Buildings of Detroit: A History* (Detroit, 1968)
The Legacy of Albert Kahn (exh. cat. by W. H. Ferry, Detroit, MI, Inst. A., 1970)
G. Hildebrand: *Designing for Industry: The Architecture of Albert Kahn* (Cambridge, MA, and London, 1974)

GRANT HILDEBRAND

Kansas City. Name of two American cities in Kansas and Missouri divided by the Kansas River at its confluence with the Missouri River. Although as two cities they are separate politically, together they comprise a single economic unit. Kansas City, MO, is, however, three times the size of Kansas City, KS. Kansas City evolved from a frontier trading post, which functioned as the river landing for nearby Westport, founded in 1835, a town serving the overland trails to the west. Kansas City was formally

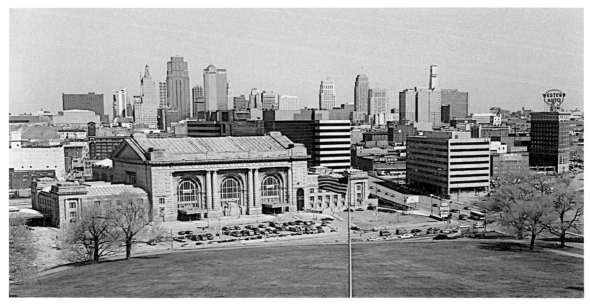

Kansas City, with Union Station in the foreground

267

established in 1850, but its development suffered greatly from partisan conflict over the issue of the extension of slavery into Kansas and then from the effects of the Civil War (1861–5). Recovery and then growth were accelerated when the first bridge over the Missouri River was built in the city (opened 1869). Transformation of the raw frontier town into a city of substance was complicated by the irregular terrain of hills, ravines and steep river-banks, and throughout the 19th century considerable effort was expended to create manageable street gradients and then to adjust building sites accordingly, especially in the area nearest the river.

Major development occurred in the late 1880s, including the New York Life Building (completed 1890) by McKim, Mead & White. A nationally significant park and boulevard plan by George Kessler (1862–1923) was launched in 1893 and was essentially complete by 1915. The first steel-framed skyscrapers in the city were built in 1906–7, and the Boley Building (1909) by Louis Curtiss (1865–1924) is an early example of curtain-wall construction. Systematically planned residential development on a large scale by the J. C. Nichols Company began in 1908, and civic centre planning, influenced by the City Beautiful aesthetic, was given impetus by the building of the enormous Neoclassical Union Station (completed 1914; see fig.) by Jarvis Hunt (1859–91). Among historically recognized artists, George Caleb Bingham and Thomas Hart Benton were residents for extended periods.

BIBLIOGRAPHY

F. Howe: 'The Development of Architecture in Kansas City, Missouri', *Archit. Rec.*, xv/2 (1904), pp. 134–57
G. Mitchell: *There is No Limit: Architecture and Sculpture in Kansas City* (Kansas City, 1934)
W. Wilson: *The City Beautiful Movement in Kansas City* (Columbia, MO, 1964)
A. Brown and L. Dorsett: *K.C.: A History of Kansas City, Missouri* (Boulder, 1978)
G. Ehrlich: *Kansas City, Missouri: An Architectural History, 1826–1976* (Kansas City, 1979); rev. as *Kansas City, Missouri: An Architectural History, 1826–1990* (Columbia, MO, 1992)
S. Piland and E. Uguccioni: *Fountains of Kansas City: A History and Love Affair* (Kansas City, 1985)
W. Worley: *J. C. Nichols and the Shaping of Kansas City: Innovation in Planned Residential Communities* (Columbia, MO, 1990)
J. Mobley and N. Harris: *A City within a Park: One Hundred Years of Parks and Boulevards in Kansas City, Missouri* (Kansas City, 1991)
R. A. Barreneche, 'Greening McKim, Mead and White: New York Life Building Restoration, Kansas City, Missouri', *Archit.*, lxxxvi (1997), pp. 176–81

GEORGE EHRLICH

Käsebier, Gertrude (Stanton) (*b* Fort Des Moines [now Des Moines], IO, 18 May 1852; *d* New York, 13 Oct 1934). American photographer. She studied painting at the Pratt Institute, Brooklyn, NY (1889–93), and in France and Germany (1894–5). She began her professional photographic career *c.* 1894, as a magazine illustrator, and then *c.* 1898 she opened a portrait studio on Fifth Avenue in New York. Her simplified portrait style dispensed with scenic backdrops and fancy furniture and was soon widely

Gertrude Käsebier: *The Picture Book*, photogravure, 1899 or 1902 (Washington, DC, Library of Congress)

emulated. Robert Henri, Auguste Rodin (1840–1917), Stanford White and the chorus girl Evelyn Nesbit were among her subjects. Beginning in 1898, her studies of mothers and children (see fig.) as well as her portraits were acclaimed at major photographic exhibitions such as the Philadelphia Photographic Salons. Käsebier was a founder-member of the Photo-Secession in 1902, and *'Blessed art thou among women'* was among the photographs featured in the first issue of *Camera Work* in 1903. By 1907 she had begun to drift from the Photo-Secession, exhibiting with them for the last time in 1910. She resigned in 1912. A retrospective of her photographs was held at the Brooklyn Institute of Arts and Sciences in 1929.

Käsebier generally printed in platinum or gum bichromate emulsions and frequently altered her photographs by retouching a negative or by rephotographing an altered print. She was the leading woman pictorialist photographer of her day and, as a married woman with children who attained success and fame, she became a model for others, including Imogen Cunningham.

WRITINGS

'Studies in Photography', *Phot. Times* [New York], xxx (June 1898), pp. 269–72; repr. in *A Photographic Vision: Pictorial Photography, 1889–1923*, ed. P. C. Bunnell (Salt Lake City, 1980)

BIBLIOGRAPHY

B. L. Michaels: 'Rediscovering Gertrude Käsebier', *Image*, xix (June 1976), pp. 20–32

A Pictorial Heritage: The Photographs of Gertrude Käsebier (exh. cat., ed. W. I. Homer; Wilmington, DE A. Mus., 1979)

B. L. Michaels: *Gertrude Käsebier: The Photographer and her Photographs* (New York, 1992)

BARBARA L. MICHAELS

Kavanaugh, Marion (Ida). *See* WACHTEL, (2).

Keely, Patrick Charles (*b* Kilkenny, 9 Aug 1816; *d* Brooklyn, NY, 11 Aug 1896). American architect of Irish birth. He was the son of a builder and received no formal training. He emigrated to the USA and settled in Brooklyn, NY, where, in 1847, he designed his first church, the imposing church of SS Peter and Paul in the Gothic Revival style. Over 600 churches are popularly attributed to Keely, and although the total appears exaggerated (only 150 commissions have been documented), it reflects his reputation as the pre-eminent Roman Catholic architect. He earned the sobriquet the 'American Pugin' and won the Roman Catholic Laetare Medal for distinguished service. He was hampered throughout his career by demands for commodious but inexpensive churches, leading him to design large, simple structures, frequently with galleries and plain lath and plaster ceilings. When given greater freedom, he showed skill and refinement in his interpretation of English Gothic, supplemented after 1870 by Romanesque and French Empire designs. Of his few Greek Revival works, the best is the robust domed church of St Francis Xavier in Manhattan (1882).

Keely designed nearly 20 cathedrals during the course of his 50-year career. His most ambitious work, the Immaculate Conception in Brooklyn (destr. 1931), was to have been the largest Gothic Revival cathedral in America. Construction began in 1865, but work progressed slowly and often halted; when Keely died funeral services were held in the unfinished cathedral. J. F. Bentley subsequently prepared plans (unexecuted) for its completion.

BIBLIOGRAPHY

Macmillan Enc. Archit.

W. A. Daley: *Patrick Charles Keely: Architect and Church Builder* (MA thesis, Washington, DC, Catholic U., 1934)

H. L. Wilson: *The Cathedrals of Patrick Charles Keely* (MA thesis, Washington, DC, Catholic U., 1952)

F. W. Kervick: *Patrick Charles Keely, Architect: A Record of his Life and Work* (South Bend, IN, 1953)

William Keith: *Glory of the Heavens*, oil on canvas, 895×1505 mm, 1891 (San Francisco, CA, Fine Arts Museums)

G. Laroche: 'Les Jésuites du Québec et la diffusion de l'art chrétian: L'Église du Gesù de Montréal, une nouvelle perspective', *J. Can. A. Hist.*, xiv/2 (1991), pp. 6–27

JANET ADAMS

Keith, William (*b* Oldmeldrum, Aberdeenshire [now Grampian], 21 Nov 1838; *d* Berkeley, CA, 13 April 1911). American painter of Scottish birth. He arrived in New York as a boy in 1850 and was hired as a wood-engraver by the publishing firm of Harper & Brothers in 1857. In 1859 he established himself as a wood-engraver in San Francisco. Keith soon began to make watercolours of the state's spectacular mountain scenery, and in 1868 he turned to oil painting. After spending two years (1870–72) travelling first to Düsseldorf, where he admired the landscapes of Andreas Achenbach (1815–1910), then to Paris, where he saw the work of the Barbizon painters, and to New York and Boston, he returned to the American West. There he travelled widely during the next decade with the photographer Carleton E. Watkins and the naturalist and conservationist John Muir (1838–1914). From 1883 to 1885 Keith studied informally in Munich; he returned to Europe in 1893 and 1899. In the mid-1880s he was influenced by the philosophical teachings of Emanuel Swedenborg (1688–1772); in response his art moved progressively from the light-filled panoramas of Californian mountains, as in *Headwaters of the San Joaquin* (1878; Oakland, CA, Mus.), to atmospheric renderings of haze-filled meadows and oak groves, as in *Glory of the Heavens* (1891; San Francisco, CA, F.A. Museums; see fig.). Keith's later paintings, constructed with complicated scumbles and glazes, became more suggestive of a mood than descriptive of a particular place. A prolific artist until only months before his death, Keith lost over 2000 paintings when his studio in San Francisco burnt down following the earthquake of 1906.

BIBLIOGRAPHY
E. Neuhaus: *William Keith: The Man and the Artist* (Berkeley, 1938)
Brother Cornelius, FSC: *Keith: Old Master of California*, i (New York, 1942), ii (Fresno, CA, 1956)
A. Harlow and A. C. Harrison jr: *William Keith: The Saint Mary's College Collection*, Moraga, CA, Hearst A.G. cat. (Moraga, CA, 1988/*R* 1994 with supplement)
A. Harlow: 'William Keith, California's Poet-Painter', *Amer. A. Rev.*, vi/6 (1994–5), pp. 140–45

MARC SIMPSON

Kellum, John (*b* Hempstead, NY, 27 Aug 1809; *d* Hempstead, 24 July 1871). American architect. He initially trained as a carpenter, and his architectural career began in the early 1840s when he entered the office of the Brooklyn architect Gamaliel King. Kellum opened his own office in 1859. He worked within the established stylistic currents of the period, designing primarily in the Italianate and Second Empire styles. He received several notable commercial commissions, including the first permanent building for the New York Stock Exchange (1863–5; altered 1880–81; destr. 1901), Wall Street, New York, and one major civic monument, the New York County Courthouse (1861–81; completed by Leopold Eidlitz; main entrance stair removed), City Hall Park, New York, commonly known as the 'Tweed Courthouse'. Kellum was among the first architects to design buildings with cast-iron fronts. His Cary Building (1856–7; with Gamaliel

King), Chambers and Reade streets, New York, with its iron façades cast in imitation of rusticated stone, is among the early masterpieces of the genre. Much of Kellum's work was undertaken for the department store magnate Alexander Turney Stewart. In New York he designed Stewart's cast-iron store on Broadway (1859–68; destr. 1956), his marble mansion on Fifth Avenue (1864–9; destr. 1901) and his Working Women's Hotel (later the Park Avenue Hotel) on Park Avenue (1869–79; destr. 1926), each of which was the largest building of its type yet erected in the USA. Kellum also prepared the master-plan for Stewart's financially unsuccessful suburban community of Garden City, Long Island, NY. Shortly before his death, he laid out the community on a modified grid-plan and designed houses (1871; some destr. or altered), a hotel (1871; destr.) and a railway station (1871; destr.), all in the Second Empire style.

BIBLIOGRAPHY
W. Weisman: 'Commercial Palaces of New York, 1845–1875', *A. Bull.*, xxxvi (1954), pp. 285–302
SoHo Cast-iron Historic District Designation Report, New York City Landmarks Preservation Commission (New York, 1973)
M. Gayle and E. Gillon: *Cast-iron Architecture in New York: A Photographic Survey* (New York, 1974)
J. Cantor: 'A Monument of Trade: A. T. Stewart and the Rise of the Millionaire's Mansion in New York', *Winterthur Port.*, x (1975), pp. 167–97
D. Gardner: *The Architecture of Commercial Capitalism: John Kellum and the Development of New York, 1840–1875* (diss., New York, Columbia U., 1979)
A. Bedell and M. Dierickx: *The Tweed Courthouse Historic Structure Report* (New York, 1980)
A. Robins: *Cary Building Designation Report*, New York City Landmarks Preservation Commission (New York, 1982)

ANDREW SCOTT DOLKART

Kennedy, Edward G(uthrie) (*b* Garvagh, Co. Londonderry, 1849; *d* New York, 8 Oct 1932). American art dealer, collector and writer of Irish birth. In 1867 he arrived in Boston, where he was employed in an art business. In 1877 he moved to New York to work for the print dealer Hermann Wunderlich (1839–91), a job that involved frequent travel to negotiate sales. During his annual visits to Europe, he met and became friends with James McNeill Whistler. Following his purchase in 1901 of a large collection of Whistler prints from B. B. Macgeorge of Glasgow, he compiled a catalogue raisonné, published in 1902 by Wunderlich & Co., which was a notable improvement on earlier authors' attempts. With Whistler's approval, he then gathered together photographs of all his known prints. The resources of the Grolier Club in New York, of which he was president at that time, financed the publication of *The Etched Work of Whistler* (1910) and *The Lithographs by Whistler* (1914). He eventually became the head of Wunderlich & Co., which by the year of his retirement (1916) had become the Kennedy Galleries. (After retirement he continued to travel, and many of the books and prints that he collected on his journeys were donated to the Grolier Club.)

WRITINGS
The Etched Work of Whistler (New York, 1910)
The Lithographs by Whistler: Arranged According to the Catalogue by Thomas R. Way (New York, 1914)

BIBLIOGRAPHY
Obituary, *New York Times* (9 Oct 1932)

DARRYL PATRICK

John F. Kensett: *Sunset on the Sea*, oil on canvas, 711×1044 mm, 1872 (New York, Metropolitan Museum of Art)

Kensett, John F(rederick) (*b* Cheshire, CT, 22 March 1816; *d* New York, 14 Dec 1872). American painter and engraver. Born into a family of skilled engravers, he learnt the craft first from his father, Thomas Kensett (1786–1829), and then from his uncle Alfred Daggett (1799–1872). From this training he acquired the consummate skill that made him an exceptional draughtsman. The engraver's attention to tonal modulation of the grey scale also contributed to Kensett's extraordinary exploration of colour values and saturation in his paintings.

In 1840, in the company of Asher B. Durand, John Casilear and Thomas Rossiter (1818–71), Kensett went to Europe, where he remained for seven years, studying Old Master works and developing his skills as a painter in London, Paris and Rome. On his return to America, he was immediately recognized as one of the most gifted painters of his time. He was soon elected an associate (1848) and then a full member (1849) of the National Academy of Design, New York. Kensett exhibited there in 1838, 1845 and then annually from 1847 until his death.

Kensett's work as a landscape and coastal view painter is endowed with superb draughtsmanship, a suffusive aerial perspective and refined palette. *The White Mountains, from North Conway* (1851; Wellesley Coll., MA, Mus.) demonstrates his total and skilful assimilation of the style and techniques of the HUDSON RIVER SCHOOL. His experimentation with the saturation and values of hues resulted in a warm shimmering effect of light that permeates his finest compositions. The broad vistas across valleys and over wide expanses of water, which typify his work, always create a distinct articulation of hour and mood.

Marine off Big Rock (1864; Jacksonville, FL, Cummer Gal. A.; for illustration *see* LUMINISM) is a mature example of Kensett's departure from Hudson River school imagery and the development of his own unique handling of the style and techniques of landscape painting of the period; the work contains a sense of balanced, geometric precision and a spareness that contrasts with his earlier, more crowded pictures. *Sunset on the Sea* (1872; New York, Met.; see fig.) typifies the final phase of Kensett's career: a distillation of forms, a simplicity of design and a rich evocation of hue. His last paintings explore colour and create a mood of intimate tranquillity, expressing a spirituality that is noteworthy in 19th-century American art.

Kensett's ideas influenced Ogden Rood, whose book, *Modern Chromatics* (New York, 1879), was significant to the development of the colour theory of Georges Seurat (1859–91). Kensett's stature in the art community is reflected in his prominent role in the functions and affairs of the National Academy of Design and the Artists Fund Society. He was a founder-member of the Century Association and in 1870 a founder of the Metropolitan Museum of Art, New York.

BIBLIOGRAPHY
E. Johnson: 'Kensett Revisited', *A. Q.* [Detroit], xx (1957), pp. 71–92
John F. Kensett: Drawings (exh. cat. by J. Driscoll, University Park, PA State U., Mus. A., 1978)
John F. Kensett: An American Master (exh. cat. by J. Driscoll and J. K. Howat, Worcester, MA, A. Mus., 1985)
J. Driscoll: 'Forum: Drawings by John F. Kensett', *Drawing*, xvi (1995), pp. 106–7
JOHN DRISCOLL

Kimball, Francis H(atch) (*b* Kennebunk, ME, 23 Sept 1845; *d* New York, 25 Dec 1919). American architect.

Following service in the Civil War, he began his study in the Boston architectural studio of Louis P. Rogers. Eventually employed by this firm, he did most of their work in Hartford, CT. Encouraged by the English architect William Burges (1827–81), he travelled in 1875 to London to study outstanding Gothic structures. Five months later he returned to Hartford to complete work on Trinity College. In 1879 he opened his own office in New York and began a series of revival designs. For the next 12 years he applied various period styles to churches, clubs and theatres. His eclectic approach is exemplified by the Catholic Apostolic Church (1895), 417 W. 57th Street, which is in a Romanesque Revival style, with a large rose window, and the Montauk Club (1891), 258th Avenue N.E., in Brooklyn, which suggests Venetian Gothic. The theatres he designed (all of which have disappeared or undergone extensive renovation) each reflected a different architectural style. The Casino Theater (1880–82; destr. 1930), on the southeast corner of Broadway and 39th Street, exemplified Moorish architecture, with a prominent minaret-like tower on the corner and lavish mosaic work in the lobby. In 1892 he joined the architect George K. Thompson (1860–1935) and began designing high-rise buildings. Their development of deep concrete caissons as foundations for these buildings revolutionized skyscraper construction. Although most of their tall buildings have been replaced, the Selegman, later called the Lehman, Building (1907), 1 William Street, remains standing. The parts left unchanged strongly suggest Kimball's application of the Italian Renaissance style.

BIBLIOGRAPHY

M. Schuyler: 'The Works of Francis H. Kimball', *Archit. Rec.*, vii (1896), pp. 479–518
Obituary, *New York Times* (29 Dec 1919)
K. Frampton: 'Edificio per uffici, New York: Banca Commerciale Italiana Building Addition', *Domus*, no. 683 (1987), pp. 253–7

DARRYL PATRICK

King, Charles Bird (*b* Newport, RI, 26 Sept 1785; *d* Washington, DC, 18 March 1862). American painter. He was encouraged to paint by his grandfather, Nathaniel Bird (*d* 1796), an amateur painter, and took lessons with Samuel King, a portrait painter. In 1800–05 he was apprenticed in New York to Edward Savage, whose curious studio–museum and period of study abroad with Benjamin West impressed him deeply. King's first *Self-portrait* (*c.* 1805; Oliver, BC, Mrs E. Stanley Dickson priv. col.) and that of his uncle, *David King* (*c.* 1805; Newport, RI, Redwood Lib.), show promise, but limited training.

From 1806 to 1812 King studied with Benjamin West at the Royal Academy in London, where he absorbed the latter's enthusiasm for history painting, something of the skill of Sir Thomas Lawrence (1709–1830) in portraiture and developed a lifelong taste for English and Dutch still-life, and the genre paintings of such artists as Sir David Wilkie (1785–1841). *Still-life, Game* (1806; Armonk, NY, IBM Corp.) reveals his early interest in *trompe l'oeil*.

After his return from England in 1812, King worked for seven years as an itinerant portrait painter in the major cities from Newport to Richmond, VA. The *Poor Artist's Cupboard* (*c.* 1815; Washington, DC, Corcoran Gal. A.) is one of his most technically brilliant and sardonic works and is based on the 17th-century Dutch *vanitas*. He was

the first American to turn the message of the *vanitas* into a metaphor of cultural poverty, lamenting the artist's lowly social status. In 1819 King moved to Washington, DC, where he built a large studio–gallery, which became a centre for artists, students and tourists. He painted portraits of scores of national figures and many still-lifes, genre and 'fancy pieces', as well as landscapes. Best known are his portraits of American Indian delegates to the capital, painted for Thomas L. MacKenney's 'Indian Gallery', which were almost entirely destroyed by fire at the Smithsonian Institution in 1865. His works are highly detailed and compressed towards the picture plane to create an imposing presence. His considerable skill in composition and the use of colour can be seen in the portrait of *Mrs John Quincy Adams* (*c.* 1823; Washington, DC, N. Mus. Amer. Art) and the group of American Indian warriors entitled *Young Omaha, War Eagle, Little Missouri and Pawnees* (1822; Washington, DC, N. Mus. Amer. A.; see colour pl. IX, 2).

His *Catalogue with Landscape* (1828; Newport, RI, Redwood Lib.) shows sporting lovers obscured by an illusionistic catalogue and toys with notions of human mortality and repressed desires in a landscape in the style of Salvator Rosa (1615–73). The *Interior of a Ropewalk* (1845; Charlottesville, U. VA, A. Mus.) was one of the first industrial scenes in American art.

King was a close friend of such leading artists as Thomas Sully, Rembrandt Peale, Samuel F. B. Morse, Charles Robert Leslie and John Gadsby Chapman (one of his students), several of whom used his American Indian and other images in their paintings. He was the first American artist to specialize in portraying the American Indian, and he foreshadowed by 50 years the late Victorian fascination with the iconic power of objects. He was a member of the National Academy of Design and of the Pennsylvania Academy of the Fine Arts, and he served on the first government art commission.

BIBLIOGRAPHY

J. Elliot: *Historical Sketches of the Ten Miles Square Forming the District of Columbia* (Washington, DC, 1830)
W. Dunlap: *History of the Rise and Progress of the Arts of Design in the United States*, 2 vols (New York, 1834, rev. 2/1965, ed. A. Wyckoff, 3 vols)
T. L. MacKenney and J. Hall: *The Indian Tribes of North America*, 3 vols (Philadelphia, 1836–44, rev. Edinburgh, 1933–4, ed. F. W. Hodge, 3 vols)
H. J. Viola: *The Indian Legacy of Charles Bird King* (Washington, DC, 1976)
The Paintings of Charles Bird King (exh. cat., ed. A. J. Cosentino; Washington, DC, N. Col. F. A., 1977)

ANDREW J. COSENTINO

King, Samuel (*b* Newport, RI, 24 Jan 1749; *d* Newport, 20 Dec 1819). American painter, carver and nautical instrument maker. He was the son of Benjamin King, a mathematical and nautical instrument maker of Newport, RI. Samuel King's early portrait of the *Rev. Ezra Stiles* (New Haven, CT, Yale U. A.G.) is undoubtedly his masterpiece and a *tour de force* of symbolism. The portrait was begun in 1770 and completed on 1 August 1771. It shows the interest of the instrument maker in detail and exactitude of delineation. King's other known portraits show no such originality and in the main reflect compositions taken from portraits known to have been hanging

in Newport at the time or from English prints. Since Samuel King and Charles Bird King (unrelated) were neighbours on Clarke Street in Newport, he probably influenced Charles Bird King. Washington Allston and Ann Hall (1792–1863) were both Samuel King's pupils.

In addition to his portraits, in 1783 King made a patriotic transparency (destr.) for display in front of the Rhode Island State House. The transparency was a temporary work probably consisting of over life-size allegorical figures painted on transparent paper illuminated from behind by torches. A bill survives to James Taylor in which King claimed payment for carving three picture frames, painting a signboard and a carriage. He also continued his father's profession, as is testified by his bill of 1797 to William Christopher Champlin for a new compass and for repairing the compass for the ship *Hope*.

BIBLIOGRAPHY

J. Setze: 'Portraits of Ezra Stiles', *Bull. Assoc. F.A. Yale U.*, xxiii/3 (1957), pp. 1–9

W. B. Stevens: 'Samuel King of Newport', *Antiques*, xcvi/5 (1969), pp. 729–33

ROBERT G. STEWART

Knoedler, M., & Co. American art gallery. In 1846 Michel Knoedler emigrated from Paris to manage the New York branch of the French firm Goupil, which opened at 289 Broadway. While continuing the Goupil tradition of selling prints, Knoedler introduced the New York public to French Academic and Barbizon school painting. During the early years the firm also made frames, sold artists' materials and handled restoration work. In 1857, Michael (as he became known) Knoedler, who had become a prominent figure in the New York art world, purchased the gallery, then located at 366 Broadway, which was then called variously Goupil's and Knoedler's but from 1889 known exclusively as Knoedler's. The gallery moved in 1859 to 772 Broadway and again in 1869 to 170 Fifth Avenue.

After Michael Knoedler's death in 1878, the firm continued under the guidance of his son, Roland, who with Charles Carstairs opened galleries in Paris and London in the mid-1890s. In 1895 the New York gallery relocated to 355 Fifth Avenue and again to 556–8 Fifth Avenue in 1912. The firm's business expanded to include Old Master paintings, and M. Knoedler & Co. became one of the world's leading international dealers in European and American art. Among its clients were the American businessmen Jay Gould (1836–92), John D. Rockefeller, Andrew Mellon, Henry Clay Frick, H. O. Havemeyer, John Jacob Astor (1864–1912), Cornelius Vanderbilt and J. Pierpont Morgan.

The work of contemporary American artists has long been championed by Knoedler's. In the 19th century and the early 20th George Caleb Bingham, Frederic E. Church, George Inness, Winslow Homer, Herbert Haseltine (*b* 1877), George de Forest Brush, Frederic Remington, John Singer Sargent, Albert Pinkham Ryder, James McNeill Whistler, William Merritt Chase and Albert Bierstadt were among those whose work was exhibited at the galleries. The firm also granted recognition through its group exhibitions to those who had not yet held national prominence. In its early years the firm also brought art to a wider audience by producing prints of popular paintings

of the day; in the early 20th century the firm expanded this interest to handle Old Master prints.

BIBLIOGRAPHY

ARTnews, xxvi/19 (11 Feb 1928), p. 1

An Exhibition of Paintings and Prints of Every Description on the Occasion of Knoedler, One Hundred Years, 1846–1946 (exh. cat., preface C. Henschel; New York, Knoedler's, 1946)

C. Seligman: *Merchants of Art, 1880–1960: Eighty Years of Professional Collecting* (New York, 1961)

NANCY C. LITTLE, with MELISSA DE MEDEIROS

Knowles, Taylor & Knowles. American ceramics manufacturer. Although a cabinetmaker by trade, Isaac Watts Knowles (1819–1902) founded his first pottery in 1854 with Isaac Harvey in East Liverpool, OH. There they made yellow ware and Rockingham for the West Coast market and were best known for jars used to preserve fruit. Harvey withdrew from the concern in the mid-1860s, and in 1870 Knowles's son Homer S. Knowles (1851–92) and his son-in-law John N. Taylor (1842–1914) joined the firm. Knowles, Taylor & Knowles continued to produce yellow ware until 1873, when the whiteware it had begun making in 1872 became commercially successful. In this medium it produced tea, dinner, toilet and kitchen wares and decorative accessories. Production expanded until, by 1891, the company had become the largest pottery in the USA, with 29 kilns. Fine Belleek porcelain was made only briefly from the late 1880s until 1897, when it was replaced by the range of 'Lotus Ware', a translucent bone china with sprigged filigree ornaments, leaves and flowers. After this product failed, soft porcelain wares were made in the china plant. Hotel china, hospital specialities and porcelain for electrical appliances were also produced.

BIBLIOGRAPHY

W. C. Gates jr and D. Ormerod: 'The East Liverpool Pottery District: Identification of Manufacturers and Marks', *Hist. Archaeol.: Annu. Pubn. Soc. Hist. Archaeol.*, xvi (1982), pp. 1–358 (115–27)

ELLEN PAUL DENKER

Krimmel, John L(ewis) [Johann Ludwig] (*b* Ebingen, Württemberg, 30 May 1786; *d* nr Germantown, PA, 15 July 1821). American painter of German birth. He is considered to have been the first significant genre painter in America. He received his first art training in Germany from Johann Baptist Seele (1774–1814), a military-history painter. When Krimmel moved to Philadelphia in 1809, he at first supported himself as a portrait and miniature painter but quickly developed a penchant for chronicling events in the city and its environs. *Fourth of July in Centre Square, Philadelphia* (c. 1810–12; Philadelphia, PA, Acad. F.A.) is an instance of his formulaic approach, with crowds of well-dressed figures attending a particular event in a carefully depicted location. Krimmel's interiors, such as *Interior of an American Inn* (c. 1813; Toledo, OH, Mus. A.; see fig.), depict typical American activities while revealing the influence of William Hogarth (1697–1764) and David Wilkie (1785–1841), the latter known to Krimmel through prints. Although rigid in composition, Krimmel's scenes, with their energy and sense of well-being, kindled an interest in American life, fostering the quest for a national identity. He returned to Europe in 1817 but was back in Philadelphia in 1819. By the year of his death (by drowning), he had begun to enjoy recognition and was elected

John L. Krimmel: *Interior of an American Inn*, oil on canvas, 429×572 mm, *c.* 1813 (Toledo, OH, Toledo Museum of Art)

president of the Association of American Artists, receiving a major commission for a history painting (not completed) of William Penn's landing at New Castle, PA.

BIBLIOGRAPHY

The Painters' America: Rural and Urban Life, 1810–1910 (exh. cat., ed. P. Hills; New York, Whitney, 1974)

M. M. Naeve: *John Lewis Krimmel: An Artist in Federal America* (Cranbury, 1987)

J. Marstine: 'America's First Painter of Temperance Themes: John Lewis Krimmel', *Rutgers A. Rev.*, ix–x (1988–9), pp. 111–34

A. Harding: *John Lewis Krimmel: Genre Artist of the Early Republic* (Winterthur, DE, 1994)

H. NICHOLS B. CLARK

Kühn, Justus Engelhardt (*b* ?Germany; *d* Anne Arundel County, MD, *bur* 6 Nov 1717). American painter of German origin. He is the earliest documented portrait painter in the American South. In December 1708 he applied to the General Assembly of Maryland for naturalization, describing himself as German and a painter. The naturalization act stated that he was a Protestant. The inventory of his estate listed 'sevl. parcells of paint & all other things belonging to painting', 39 books, 14 'pictures & Landskips', 3 unfinished pictures and an unfinished coat of arms for a Mr Doynes.

Kühn's ten known portraits represent members of three interrelated Catholic families from Maryland, the Digges, the Carrolls and the Darnalls. His major works are three large full-lengths of children (each *c.* 1.37×1.12 m). Of these, *Ignatius Digges* (1710; priv. col., see 1987 exh. cat., no. 9) is Kühn's only signed work. His portraits of *Henry Darnall III* and his sister *Eleanor Darnall* were both painted around the same time (Baltimore, Mus. & Lib. MD Hist.). The boy's portrait contains the first American depiction of a black person, Darnall's servant. The paintings show the children elaborately dressed in equally elaborate architectural settings. The colours consist of warm browns, earth reds, white, pale blue and dark green. The seven portraits of adults attributed to Kühn on the basis of style are mainly bust-lengths, *c.* 800×680 mm. A fourth full-length child's portrait, of *Charles Carroll* (*c.* 1712; Baltimore, Mus. & Lib. MD Hist.), may also be by Kühn.

BIBLIOGRAPHY

J. H. Pleasants: 'Justus Engelhardt Kühn, an Early Eighteenth-century Maryland Portrait Painter', *Proc. Amer. Antiqua. Soc.*, n.s., xlvi (1937), pp. 243–80

A. C. Van Devanter: *'Anywhere so Long as There Be Freedom': Charles Carroll of Carrollton, his Family & his Maryland* (exh. cat., Baltimore, MD, Mus. A., 1975), pp. 121, 123–5, 136–7, 140, 193, 310

Painting in the South, 1564–1980 (exh. cat., Richmond, VA Mus. F.A., 1983), pp. 9–10, 172–3

American Colonial Portraits, 1700–1776 (exh. cat. by R. H. Saunders and E. G. Miles, Washington, DC, N.P.G., 1987), pp. 88–9

ELLEN G. MILES

L

La Farge, C(hristopher) Grant. *See under* HEINS & LA FARGE.

La Farge, John (*b* New York, 31 March 1835; *d* Newport, RI, 14 Nov 1910). American painter, decorative artist and writer. He grew up in New York in a prosperous and cultivated French-speaking household. He received his first artistic training at the age of six from his maternal grandfather, an amateur architect and miniature painter. While at Columbia Grammar School, he learnt English watercolour techniques and afterwards studied briefly with George Inness's teacher, the landscape painter Régis-François Gignoux. In 1856, while touring Europe, he spent a few weeks in the studio of Thomas Couture (1815–79). Returning to New York via England, he was impressed by the Pre-Raphaelite paintings at the Manchester Art Treasures exhibition of 1857 and later said that they had influenced him when he began to paint. In 1859 he decided to devote himself to art and moved to Newport, RI, to study with William Morris Hunt.

Unlike Hunt, who never broke away from the manner of Couture and Jean-François Millet (1814–75), La Farge rapidly evolved a highly original and personal style characterized by free brushwork, unusual colour harmonies and great delicacy of feeling. His landscapes of the 1860s, almost all of which were executed outdoors, have been compared with the work of the Impressionists; one of his best is the monumental canvas, *Paradise Valley* (1869; Boston, MA, priv. col., see R. Cortissoz, 1911, opposite p. 24). His intimate floral still-life paintings recall the work of Henri Fantin-Latour (1836–1904) but are more experimental in approach.

La Farge began to collect Japanese prints in 1856, earlier than Félix Bracquemond (1833–1914), and he also anticipated Whistler in making use of Japanese concepts of colour and composition in his designs. In the 1870s, just as he was beginning to gain recognition for his easel paintings, La Farge shifted his attention to decorative work including encaustic mural painting and stained glass. His first major commission was to decorate the interior of H. H. Richardson's Trinity Church in Boston. Modelled chiefly on medieval and Early Christian precedents, but drawing also on oriental and Renaissance sources, this project was unveiled early in 1877 and was immediately acclaimed. It was the first large-scale decorative scheme in America to be executed by a distinguished painter and it initiated the movement termed the 'American Renaissance'.

By marshalling numerous assistants for this project, including such figures as the sculptor Augustus Saint-Gaudens, in a manner based on the medieval workshop, La Farge was able to integrate architecture and the various decorative and pictorial arts in a unified ensemble. La Farge's example was influential, and he gained further important commissions. These included murals for St Thomas's Church (1878), New York, the Church of the Ascension (1888), New York, the Walker Art Building (1898) at Bowdoin College, Brunswick, ME, the Minnesota State Capitol (1905) and the Baltimore Court-house (1907), as well as decorations for many private residences.

In both his religious and domestic work La Farge sought to give visual form to new impulses in American life. His ecclesiastical work reflected a trend towards High-Church forms of religious observance, and a tendency to approach religion in emotional as well as intellectual terms. His decorative domestic work, such as stained glass, sculpture, mosaic and inlay work, responded to the needs of a new social creature in America, the multi-millionaire. Working for clients (mainly in New York and Newport) such as Cornelius Vanderbilt (1794–1877), William Henry Vanderbilt and William Whitney (1841–1904), La Farge created a decorative splendour that reflected their new wealth and social aspirations.

La Farge's most significant artistic achievement was the development of opalescent stained glass, which he invented in 1879 and for which he received the Légion d'honneur in 1889. It was rapidly imitated by Louis Tiffany, among others, and proved to be America's only original contribution to Art Nouveau. La Farge's invention was inspired by a toothpowder jar on a windowsill. The container was made of the cheapest type of glass, intended to give the effect of marble or porcelain, but it was so poorly manufactured that it looked irregularly streaked and variegated. He reasoned that if such accidental effects could be controlled it would be possible to use the glass itself to create decorative effects. First he concentrated on manufacture, developing new varieties of glass, then he worked on new assembly procedures such as plating (or layering) to modify passages of colour, and the use of copper foil and cloisonné in place of traditional leading. La Farge also enlarged the vocabulary of stained-glass design, in particular by employing Japanese motifs and design. While floral windows were not new, he was the first to create complex and richly pictorial floral windows in stained glass and thus can be credited with originating the 19th-century floral stained-glass window (see fig. and colour pl. XXXVI).

John La Farge: *Three Panels of Morning Glories*, watercolour on paper, 70×255 mm, possibly an early design for a stained-glass window at the William Watts Sherman House, Newport, Rhode Island, before 1878 (Boston, MA, Museum of Fine Arts)

La Farge's later years were occupied chiefly with decorative projects involving murals or stained glass. He also produced some exceptional watercolours, especially during two long journeys with his friend the writer Henry Adams (1838–1918), in 1886 to Japan, and in 1890–91 to the South Seas. Among his wide circle of friends he numbered Henry James and Edmond de Goncourt (1822–96). In the last two decades of his life La Farge wrote eight books and many essays on art. An obituary for his friend Winslow Homer was written on his own deathbed. His son, Christopher Grant La Farge (1862–1938), was an architect and partner in the firm of Heins & La Farge (*see* HEINS & LA FARGE), and another son, Bancel La Farge (1865–1938), was a muralist and stained-glass artist.

WRITINGS

'An Essay on Japanese Art', *Across America and Asia*, ed. R. Pumpelly (New York, 1870), pp. 195–202
Considerations on Painting; Lectures Given in the Year 1893 at the Metropolitan Museum of New York (New York, 1895)
An Artist's Letters from Japan (New York, 1897/R 1975)
Hokusai: A Talk about Hokusai, the Japanese Painter, at the Century Club, March 28 1896 (New York, 1897)
Reminiscences of the South Seas (New York, 1916)

BIBLIOGRAPHY

C. Waern: *John La Farge: Artist and Writer* (London, 1896)
G. Kobbé: 'John La Farge and Winslow Homer', *NY Herald*, 4 Dec 1910, mag. sect., p. 11 [contains obituary of Winslow Homer by La Farge]
R. Cortissoz: *John La Farge: A Memoir and a Study* (Boston, 1911)
R. B. Katz: *John La Farge as Painter and Critic* (diss., Cambridge, MA, Radcliffe Coll., 1951)
H. B. Weinberg: *The Decorative Work of John La Farge* (New York and London, 1977)
K. A. Foster: 'The Flowers of John La Farge', *Amer. A. J.*, xi/3 (1979), pp. 4–37
H. Adams: 'John La Farge's Discovery of Japanese Art', *A. Bull.*, lxvii (1985), pp. 449–85
H. Adams and others: *John La Farge* (New York, 1987)
John La Farge: Watercolours and Drawings (exh. cat. by J. L. Yarnall, New York, Hudson River Mus.; Utica, NY, Munson-Williams-Proctor Inst.; Chicago, IL, Terra Mus. Amer. A.; 1990–91)
J. L. Yarnall: 'Souvenirs of Splendor: John La Farge and the Patronage of Cornelius Vanderbilt House, New York', *Amer. A. J.*, xxvi/1/2 (1994), pp. 66–105
Nature Vivante: The Still Lifes of John La Farge (exh. cat. by J. L. Yarnall, New York, Jordan-Volpe Gal., 1995)

HENRY ADAMS

Lafever, Minard (*b* nr Morristown, NJ, 10 Aug 1798; *d* Williamsburgh [now within Brooklyn], NY, 26 Sept 1854). American writer and architect of French descent. He trained as a carpenter and later became an architect, following a development typical of his generation. By 1828 he had moved to New York City. He is best known for

the manuals he wrote for builders. His first, *The Young Builder's General Instructor* (1829), included plates copied from *Metropolitan Improvements* (1827–9) by the architectural writer and lecturer James Elmes (1782–1862). Dissatisfied with his own work, Lafever withdrew the book, which was succeeded in 1833 by his second and more mature work, *The Modern Builder's Guide*. James Gallier (i), Lafever's partner from 1832 to 1834, did the frontispiece, and James H. Dakin drew six of the 89 plates. By 1855 seven editions had appeared. *The Beauties of Modern Architecture* (1835), with 46 plates by Lafever and one by Charles L. Bell, his partner in 1835, went into six editions. *The Modern Builder's Guide* and *The Beauties of Modern Architecture*, both devoted to the Greek Revival style, were drawn from various British sources: the Scottish architect and writer Peter Nicholson (1765–1844), James Elmes (1782–1862), the *Encyclopedia Britannica* (7th edn) and above all the *Antiquities of Athens* (4 vols, 1762–1816) by James Stuart (1713–88) and Nicholas Revett (1720–1804). Although Lafever drew from known sources, his inventive adaptations of Grecian forms are his own, displaying restraint and elegance. His designs were widely copied, a result both of the popularity of the two books and of the centralized manufacture of architectural ornaments.

The Modern Practice of Staircase and Handrail Construction (1838), based on Nicholson, included two of Lafever's designs for rural villas, one of which was built. Lafever's eclectic pattern-book *The Architectural Instructor* appeared posthumously in 1856 and illustrated his later work, with projects for Gothic and Italianate villas and mansions.

Lafever also designed some 20 churches, of which eight survive. His books profoundly influenced the American Greek Revival, but few of the buildings that can be attributed to him with certainty were Grecian. The Sailors' Snug Harbor (1831–3), Staten Island, NY, a home for retired sailors, and the First Reformed Dutch Church (1834–5, destr. 1886), Brooklyn, NY, had temple fronts, and the Whalers' Church (1843–4, spire destr. 1938), Sag Harbor, NY, has an Egyptian exterior and Grecian interior. The Church of the Saviour (1842–4; now First Unitarian), Brooklyn, is one of Lafever's best buildings, the west front loosely derived from that of King's College Chapel, Cambridge, as is his similar East Church (1844–6), Salem, MA, now a museum.

The Church of the Holy Trinity (1844–7; now St Ann and Holy Trinity), Brooklyn, is built in the Decorated style but has side galleries and a shallow chancel and does not

follow the contemporary doctrines of the British and American ecclesiologists. The lavish interior is further decorated by stained glass with standing figures by William Jay Bolton. Patrick Charles Keely added a spire (1867, destr. 1906). Lafever also used the Renaissance Revival style, returning at the end of his career to the Gothic Revival in the Strong Place Baptist Church (1851–2), Brooklyn, and the Packer Collegiate Institute (1854–6), Brooklyn, both with fine hammerbeam roofs. Minard Lafever was an accomplished architect whose greatest gift was for the creation of exquisite ornament.

WRITINGS
The Young Builder's General Instructor (Newark, 1829)
The Modern Builder's Guide (New York, 1833/*R* 1969, with intro. by J. Landy)
The Beauties of Modern Architecture (New York, 1835/*R* 1968, with intro. by D. P. Myers)
The Modern Practice of Staircase and Handrail Construction (New York, 1838)
The Architectural Instructor (New York, 1856)

BIBLIOGRAPHY
DAB; *Macmillan Enc. Archit.*
T. Hamlin: *Greek Revival Architecture in America* (New York, 1944/*R* 1964)
C. Lancaster: 'Adaptations from Greek Revival Builders' Guides in Kentucky', *A. Bull.*, xxxii (1950), pp. 67–70
J. Landy: 'The Washington Monument Project in New York', *J. Soc. Archit. Hist.*, xxviii (1969), pp 291–7
——: *The Architecture of Minard Lafever* (New York, 1970)
B. Shepherd: 'Sailors' Snug Harbor Reattributed to Minard Latever', *J. Soc. Archit. Hist.*, xxxv (1976), pp 108–23
L. Donnato: *Minard Lafever (1798–1854)* (Monticello, IL, 1988)

DENYS PETER MYERS

Lambdin, George Cochran (*b* Pittsburgh, PA, 6 Jan 1830; *d* Germantown, PA, 28 Jan 1896). American painter. He was a son of the portrait and landscape painter James R. Lambdin (1807–89), who had founded a museum in Pittsburgh in 1828 and directed the Pennsylvania Academy of the Fine Arts in Philadelphia from 1845 to 1864. George Lambdin studied with his father and began exhibiting at the Pennsylvania Academy in 1848 and at the National Academy of Design, New York, in 1856. In the mid-1850s he travelled, probably to Munich, Paris and Rome. His early works were sentimental genre paintings, the best known of which are *Our Sweetest Songs* (1857; New York, N. Acad. Des.) and the *Dead Wife (The Last Sleep)* (exh. 1858; Raleigh, NC Mus. A.). The latter was shown at the Exposition Universelle in Paris in 1867 together with one of his depictions of a Civil War subject, *Consecration, 1861* (1865; Indianapolis, IN, Mus. A.). In 1868–9 he was at the Tenth Street Studio Building, New York, where he continued to exhibit anecdotal genre, especially childhood subjects, as in *The Pruner* (1868; Boston, MA, Mus. F.A.). He was elected an Academician by the Pennsylvania Academy in 1863 and by the National Academy of Design in 1868. In Germantown, after a short trip abroad in 1870, Lambdin turned to floral studies, especially of roses from his own garden. Some of his floral still-life subjects were conventional table-top arrangements in glass or ceramic vases, but most were paintings of blooming plants and shrubs as they grow in nature or in garden pots, their foliage and blossoms silhouetted against blue sky or a neutral wall, as in *Autumn Sunshine* (1880; Washington, DC, N. Mus. Amer. A.; see fig.). Many of Lambdin's flower paintings,

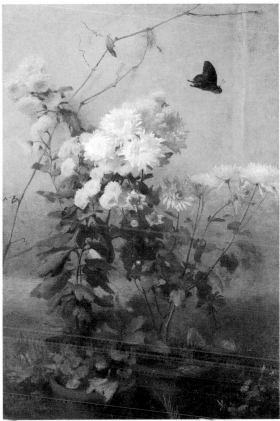

George Cochran Lambdin: *Autumn Sunshine*, oil on canvas, 765×508 mm, 1880 (Washington, DC, National Museum of American Art)

accentuated on solid-coloured, often black-lacquered, backgrounds, were chromolithographed by Louis Prang & Co., of Boston, MA. His studies of women with roses from the 1880s, such as his *Anne S. P. Chew (Alston)* (1881; Philadelphia, PA, Cliveden), elucidate his colour theories, which were influenced by John Ruskin (1819–1900).

BIBLIOGRAPHY
Catalogue of Valuable Paintings: The Collection of George C. Lambdin, Philadelphia, PA, Davis & Harvey Gals cat. (Philadelphia, 1887)
George Cochran Lambdin (exh. cat. by R. I. Weidner, Chadds Ford, PA, Brandywine River Mus., 1986) [with extensive bibliog.]

RUTH IRWIN WEIDNER

Lane, Fitz Hugh (*b* Gloucester, MA, 19 Dec 1804; *d* Gloucester, MA, 14 Aug 1865). American painter and printmaker. He established a strong local reputation among the artists and public of Boston and Gloucester, MA, the harbour town where he was born and spent the majority of his career. Yet Lane's art never enjoyed national standing during his lifetime; not until the term LUMINISM —denoting the fascination with the poetic and transcendental properties of light—gained currency in the historiography of American art was his painting seen to epitomize a broader phenomenon within 19th-century American landscape painting.

Lane began his artistic career as a lithographer for the Boston firm of Pendleton in the early 1830s. By 1844 he

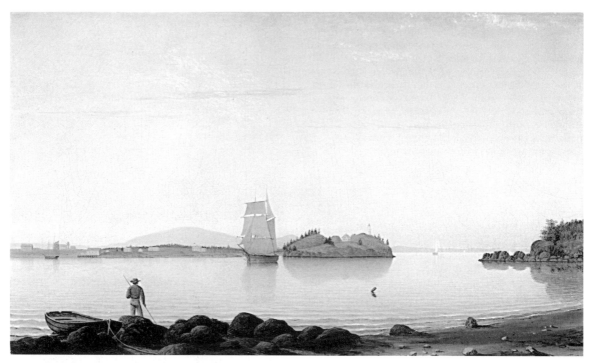

Fitz Hugh Lane: *Owl's Head, Penobscot Bay, Maine*, oil on canvas, 406×660mm, 1862 (Boston, MA, Museum of Fine Arts)

had established his own lithography business but was also painting an increasing number of works for exhibition in Boston and occasionally New York. Lane's style, spare, meticulous and devoid of rhetoric, developed along a consistent course from the time he first took up oil painting in 1840 to the ultimate refinement of his chosen subject-matter, marine and coastal landscapes, in the 1850s and 1860s. From his experience in the graphic arts, he learnt the rudiments not only of perspective but of a careful and precise transcription of a particular scene. During the 1830s paintings by the British marine specialist Robert Salmon, resident in Boston, served as a model for his work. Thereafter Lane's pictures acquired the distinctive qualities that marked his mature style: greater space devoted to the sky within the composition, the reduction and reorganization of elements within the landscape to conform to an abstract geometry, and the elimination of narrative detail as a distraction from the overall mood evoked by atmospheric and light effects. In addition, his Luminist preference for crystalline light allowed, in the words of Henry James, for a 'perfect liberty of self-assertion to each individual object in the landscape'; James's phrase could well apply to Lane's work, in which light paradoxically isolates elements of the scene while unifying the whole.

Despite his meticulous rendering and attention to view, Lane was not a topographical artist. Though he worked from careful pencil sketches with colour notations, his approach to painting remained strongly conceptual, responsive to the inherent geometry of the scene. In works such as *Western Shore with Norman's Woe* (1862; Gloucester, MA, Cape Ann Hist. Assoc.) and *Brace's Rock, Eastern Point* (1864; priv. col.) he reoriented land masses parallel

to the horizon; elsewhere, as in *Owl's Head, Penobscot Bay, Maine* (Boston, MA, Mus. F.A.; see fig.), Lane gave a planar structure to his subject wherein vertical elements —ships' masts and sails, or the distant forms of mountains —were rearranged to create precise visual intervals. Working with a limited number of elements allowed Lane to discipline the formal complexity of nature. He also occasionally turned to photographs, ruled into a perspective grid, as a source for his landscapes. His striving for clarity and balance betokened not only a provincial uneasiness with spatial complexity, but perhaps as well a transcendentalizing belief in the inherent order and harmony of nature. As in 17th-century Dutch marine paintings, which his work occasionally resembles, light, captured through very subtle tonal gradations, suppression of the brushstroke and modifications of local colour, served as the unifying element in his quiescent, austere scenes.

Lane drew his subjects from two main areas: the Gloucester and Boston bays and their surroundings, and the coast of Maine around the Mount Desert (see colour pl. XIII, 2) and Penobscot Bay regions. The bulk of his energy was devoted to painting landscapes made intimate through a lifetime of familiarity. Unlike other painters of his generation, most notably Frederic Church, Albert Bierstadt and Martin Johnson Heade, Lane stayed close to home, partly through physical necessity (a disability dating from his early childhood left him on crutches throughout his life), but more significantly through a temperamental preference for scenes that carried personal resonance. This attachment to locale was central to his sensibility; rather than exploiting the nationalistic overtones of the large-scale exhibition landscape, he preferred to explore his native region of inlets, bays and beaches in intimate and

restrained paintings. Lane's later work is free of picturesque incident, exuding a sense of calm immobility and mysterious power. His fascination with nature's moments of stillness drew him towards scenes of dawn and dusk (e.g. *Lumber Schooners at Evening on Penobscot Bay*, 1860; priv. col.). Lane's status as a minor master of the Luminist mode in American landscape painting derives from his sensitive rendering of a nature that tolerates human presence without being defined or contained by it.

BIBLIOGRAPHY
J. Wilmerding: *Fitz Hugh Lane* (New York, 1971)
Paintings and Drawings by Fitz Hugh Lane at the Cape Ann Historical Association (Gloucester, MA, 1974)
American Light: The Luminist Movement, 1850–1875 (exh. cat. by J. Wilmerding, Washington, DC, N.G.A., 1980)
F. Kelly: 'The Paintings of Fitz Hugh Lane', *Antiques*, cxxxiv (1988), pp. 116–29
Paintings by Fitz Hugh Lane (exh. cat., ed. J. Wilmerding; Washington, DC, N.G.A., 1988)
Training the Eye and the Hand: Fitz Hugh Lane and Nineteenth Century American Drawing Books (Gloucester, MA, 1993)
M. Foley: 'Fitz Hugh Lane, Ralph Waldo Emerson and the Gloucester Lyceum', *Amer. A. J.*, xxvii/1–2 (1995–6), pp. 99–101
ANGELA L. MILLER

Lanman, Charles (*b* Monroe, MI, 14 June 1819; *d* Washington, DC, 4 March 1895). American writer, art critic and painter. He developed his love of nature while growing up in the wilds of Michigan. After attending school in Norwich, CT, he spent ten years (1835–45) in New York, where he made friends with leading members of the Hudson River school, including the poet William Cullen Bryant, the painter Asher B. Durand (with whom he studied painting), Thomas Cole and his biographer Louis Noble, and with William and Shepard Mount (1804–68). He also knew Charles Dickens (1812–70) and Washington Irving (1783–1859); the latter inspired Lanman's literary explorations of nature, calling him 'the picturesque explorer of our country'. His *Letters from a Landscape Painter* (1845) and his article 'Cole and Durand' in the New York *Evening Post* (1847) reflect his synthesizing criticism and contain his best contributions to the nascent field of American aesthetics. In them he conveys the 'holy feeling' experienced by his contemporaries before nature and perceptively contrasts the 'imaginative' landscapes of Cole and the 'actual' views of Durand. His appraisal of such artists as William Mount and Daniel Huntington is equally acute. In 1848 Lanman went to Washington, DC, where he married Adeline Dodge in 1849. Although he held numerous positions—including reporter for the *National Intelligencer*—he continued to explore and paint scenes of nature and to write on nature and, occasionally, on art.

Lanman painted about 1000 pictures, mostly small-scale landscape sketches, many of which are unlocated. Such works as *Frontier Home—Log Cabin in Wilderness* (*c.* 1858; Washington, DC, priv. col.), *Haystacks, New England* (1883; New York, Coe Kerr Gal.) and his Block Island scenes of the 1870s and 1880s (Chatham, NJ, priv. col.) demonstrate his adherence to the Hudson River school traditions of Cole, Martin Johnson Heade and John Frederick Kensett.

UNPUBLISHED SOURCES
Washington, DC, Lib. Congr. [Charles Lanman papers; also available on microfilm, Washington, DC, Smithsonian Inst., Archvs Amer. A.]

WRITINGS
Letters from a Landscape Painter (Boston, 1845)
'Cole and Durand', *Evening Post* [New York] (23 April 1847)
Haw-ho-noo, or, Records of a Tourist (Philadelphia, 1850)
Catalogue of W. W. Corcoran's Gallery (Washington, 1857)
Haphazard Personalities: Chiefly of Noted Americans (Boston, 1886)

BIBLIOGRAPHY
A. J. Cosentino and H. H. Glassie: *The Capital Image: Painters in Washington, 1800–1915* (Washington, 1983)
Charles Lanman: Landscapes and Nature Studies (exh. cat., ed. H. F. Orchard; Morristown, NJ, Morris Mus. A. & Sci., 1983)
ANDREW J. COSENTINO

Lannuier, Charles-Honoré (*b* Chantilly, 27 June 1779; *d* New York, 16 Oct 1819). American cabinetmaker of French birth. He received his training from his brother Nicolas-Louis-Cyrille Lannuier, who was admitted to the Corporation des Menuisiers-Ebénistes in Paris on 23 July 1783. Charles-Honoré arrived in the USA in 1803 and settled in New York. He was a contemporary and rival of Duncan Phyfe and became known as one of the best furnituremakers in the USA working in the Empire style. His craftsmanship was of the highest quality, and his customers included such distinguished New York families as the Morrises, Stuyvesants and Rensselaers. Stylistically his work owes much to the French Directoire, Consulate and Empire styles, but is more delicate and chaste than its French counterpart. He made more extensive use of imported ormolu mounts than other contemporary New York furnituremakers. Of the furniture by Lannuier that has been identified, there is a preponderance of tables, especially pier- and card-tables. Many of Lannuier's card-tables are notable for their sculptural, three-dimensional quality and are particularly successful examples of the integration of form and ornament. Tables by Lannuier are included in the collections of the White House, Washington, DC, the Metropolitan Museum of Art, New York (see fig.), and the H. F. du Pont Winterthur Museum, Winterthur, DE.

BIBLIOGRAPHY
T. H. Ormsbee: 'A Franco-American Cabinetmaker: Charles-Honoré Lannuier', *Antiques*, xxiii (1933), pp. 166–7
——: 'The Furniture of Lannuier and his Successor', *Antiques*, xxiii (1933), pp. 224–6
L. W. Pearce: 'Distinguishing Characteristics of Lannuier's Furniture', *Antiques*, lxxxvi (1964), pp. 712–17
B. B. Tracy: 'For "One of the Most Genteel Residences in the City"', *Bull. Met.*, xxv (1967), pp. 283–74
Honoré Lannuier, Cabinetmaker from Paris: The Life and Work of a French Ebéniste in Federal New York (exh. cat. by P. M. Kenny, F. F. Bretter and U. Leben, New York, Met., 1998)
DONNA CORBIN

Latrobe, Benjamin Henry (*b* Fulneck, W. Yorks, 1 May 1764; *d* New Orleans, LA, 3 Sept 1820). English architect and engineer, active in the USA. His reputation rests on his efforts to introduce into a young USA unfamiliar new standards of professional practice and new advances in design. The standards and advances were those Latrobe absorbed in the 1780s and early 1790s in the offices of engineer John Smeaton (1724–92) and architect S. P. Cockerell (1753–1827), among the most prominent men in Britain in their respective fields. Before Latrobe arrived in Virginia in 1796, European professionals of comparable or greater standing in these fields had come to the USA,

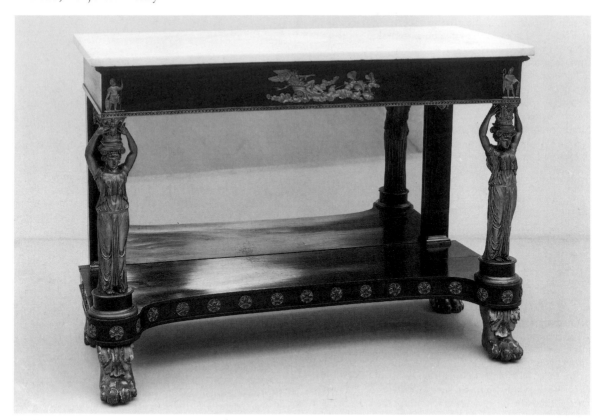

Charles-Honoré Lannuier: console table, rosewood, marble, cast lead, brass, white pine and ash, 914×1257×559mm, *c.* 1815–19 (New York, Metropolitan Museum of Art)

including William Weston (*c.* 1752–1833) in 1792, Etienne-Sulpice Hallet (1755–1825) in the late 1780s and George Hadfield in 1795. It was Latrobe's distinction, however, through his own efforts and through those of his pupils, to establish this professionalism in a lasting way in the USA. Beyond this, his works merit consideration for their artistic quality alongside those of the first rank internationally, while the survival of much of his considered testimony about design, about his professions and about the general temper of his times makes him one of the most articulate informants on these topics.

1. Background and English career. Latrobe was the second son of Benjamin Latrobe, the chief administrator of the Moravian Church in Britain (the Church of the Brethren), and Anna Margaretta Antes who was born in a Moravian community in Pennsylvania but returned to England in 1743. Latrobe was expected to follow his father and elder brother in becoming a minister, and he attended Moravian schools in the north of England and then in Niesky, Silesia, and Barby, Saxony. Other career interests asserted themselves in his late teens, and he left Saxony in 1783, having taken an interest in German military engineering before his departure. At this time, or on a subsequent visit to the Continent, he must have gained a first-hand knowledge of some of the latest developments in European architecture.

On returning to Yorkshire, Latrobe immediately indulged his interest in architecture, as a few surviving drawings in his hand for buildings in Moravian communities there attest. His draughtsmanship in these drawings is immature. His statements that he was in John Smeaton's office in the mid- to late 1780s, in S. P. Cockerell's by the end of the decade and 'conducting' it in 1791–2 are unconfirmed. Some architectural sketches recorded in a small notebook (Washington, DC, Lib. Congr.) probably date from about that time, and shortly thereafter came his first independent architectural commissions. His two best-known English houses are Hammerwood Lodge (begun before 1792; probably a reshaping and expansion of an older house), East Grinstead, W. Sussex and Ashdown House (1793–5), near Forest Row, E. Sussex. These early efforts reveal in a number of ways an architect eager to reflect modern trends. This can be seen in his invocation of a Neo-classical severity of surface, of geometric clarity in massing and disposition of parts, and of ancient Greek detail, and in his active shaping and lively combination of interior spaces. These characteristics continued and evolved in his later work in the USA.

In late 1793 Latrobe's wife died in childbirth. This tragedy, combined with a changed political climate and a decline in patronage, led him to begin a new career in the USA, where, in Pennsylvania, there was also an inheritance of land from his mother. He sailed in November 1795, arriving at Norfolk, VA, in March 1796. Architecturally, he found little satisfaction practising in Virginia. Both his plan for the Virginia State Penitentiary and that for the Harvie-Gamble House in Richmond were altered and, in

Latrobe's eyes, disfigured in execution. Between his arrival and 1799 he did, however, make several surviving drawings for what he called 'castles in the air'. These were impressive designs worked out to varying degrees of finish for various building types, including large houses, villas, a theatre complex, a church and even templar garden structures. In such projects his architectural skills were maturing as he considered and transformed each design. Another valuable legacy of these years of relative underemployment was the series of rich and wide-ranging journals and sketchbooks he kept, which record his reactions to the new land and a new society.

2. ACHIEVING A NATIONAL REPUTATION IN THE USA. In March 1798, while working on the Virginia State Penitentiary, Latrobe went to Philadelphia, PA, the country's cultural and political metropolis, to visit the modest penitentiary built there earlier in the decade. On this trip the groundwork was laid for his landmark design of the Bank of Pennsylvania (built 1799–1801; destr. 1867; *see* FEDERAL STYLE, fig. 1). This monumental bank adopted the form of an ancient temple with pedimental Ionic colonnades at back and front. It was faced in local marble, was vaulted within and was centred on a 13.7 m rotunda. At the same time he successfully employed steam engines to provide the city with a centralized system of water distribution. The system's visual focus was the even more vividly Neo-classical Centre Square engine house (1799–1801; destr. *c.* 1827; see fig. 1). The completed bank and waterworks assured Latrobe's fame nationally as both architect and engineer.

In addition to engineering commissions, particularly for river and canal surveys, Latrobe was soon engaged on two large architectural projects, both outside Philadelphia. In March 1803 he was employed as Surveyor of the Public Buildings in Washington, DC, to oversee further work on the US Capitol, the President's House (the White House) and the Washington Navy Yard. At the Capitol his duty was to continue the work in progress since 1793, which had established a tripartite scheme; block-like north and south wings with identical elevations were to flank a domed centre. The north wing, which was already built by 1803, was intended to contain the Senate, Supreme Court (for illustration *see* GREEK REVIVAL) and Library of Congress, while the south wing was to hold the House of Representatives. These Latrobe thoroughly replanned, but the central section, intended to contain the principal entrance and a large, domed 'Hall of the People', had not been begun when the War of 1812–15 with Great Britain intervened.

The war resulted in the burning of all three of Latrobe's major Washington commissions, but he returned in 1815–17 to rebuild the Capitol's north and south wings, considerably revising their design internally. His work on the Capitol was the most complex he undertook, testing his spatial and decorative ingenuity and his technical skills (involving matters of statics, acoustics, lighting and heating on a scale largely untried in the USA). It also tested his political acumen and his determination in the face of frustratingly dispersed sources of design control and review. As Latrobe confided to his elder brother in March

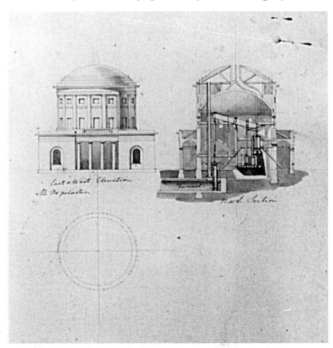

1. Benjamin Henry Latrobe: detail of preliminary design (pen and ink with wash, 1799; Baltimore, MD, Museum and Library of Maryland History) for the Centre Square engine house, Philadelphia, PA, 1799–1801 (destroyed *c.* 1827)

1808, looking back on his first efforts at the Capitol (Jeffrey, ed., 64/A3)

> I have run my race in a sack, and if I have got to the goal it has only been by tumbling on and over all obstacles, and persevering to the end. There are indeed *Bits*, as the artists chuse to say, of which I am not ashamed, such as the entrance to the house in all its parts, and the general effect of the colonnade, but the work is very, very far from being on a level with my first great structure, the Bank of Pennsylvania.

In his other great work begun in the wake of his Philadelphia successes, the Roman Catholic Cathedral at Baltimore, MD (1805–20; see fig. 2; *see also* FEDERAL STYLE, fig. 2), Latrobe was also to persevere despite uncertain funding and what he regarded as interference on the part of his client. He was frustrated by an intrusively assertive on-site clerk of works. As at the Capitol, Latrobe controlled design in the initial phases of the work from Philadelphia and Delaware by post and by occasional visits. He nevertheless managed to produce what many consider his masterpiece. His association with the project began when he submitted both Gothic and classical designs, the latter of which was preferred. In the continuously evolving designs, Latrobe felt bound to adopt the traditional Latin cross plan favoured by the Catholic Church. To this he introduced his own Neo-classical tastes and convictions, investing the cross-fertilized product with his imagination and ability as a designer. The Cathedral surpassed the Bank of Pennsylvania in the depth of its historical resonances, in its spatial unity, in the modulation and integration of its vaulting and in its subtle manipulation of light.

3. LAST YEARS AND LEGACY. Despite Latrobe's prominence nationally, the professions of architect and

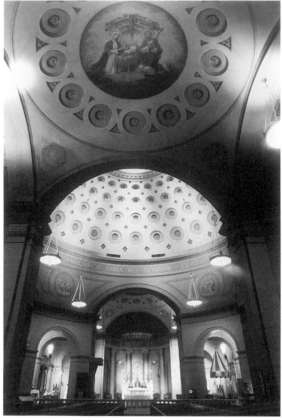

2. Benjamin Henry Latrobe: interior of the Roman Catholic Cathedral, Baltimore, MD, 1805–20

engineer remained essentially itinerant ones in these years, and as prospects evaporated in the Philadelphia area Latrobe moved to Washington, DC, in 1807, and inland from there to Pittsburgh, PA, in 1813 when the war interrupted building activity. He spent two years in Pittsburgh, occupying himself largely with a scheme to build an Ohio River steamboat with Robert Fulton (1765–1815), and all the while placing further financial hopes on the erection of a waterworks in New Orleans, for which his son Henry S. B. Latrobe (1792–1817) acted as his agent and partner. His private architectural commissions were insufficient to provide adequate financial support and his expectations were often disappointed. Such long-term engineering projects as the New Orleans waterworks, in which he took a financial stake, proved disastrous on a much larger scale, and in 1817, after his resignation from the direction of the Capitol because of continuing bureaucratic interference in his control of the work, he sought refuge from his creditors in bankruptcy. Among his losses was his polygraph, a letter-copying apparatus he had used almost constantly since 1803, which retained copies of several thousand letters he wrote during those years (now Baltimore, Mus. & Lib. MD Hist.).

After his resignation, Latrobe moved to Baltimore, working on the large exchange building there that he had begun to design in 1815 in collaboration with Maximilian Godefroy, and also working on the completion of the

Cathedral, the building of which had been interrupted for several years. His son Henry died of yellow fever in New Orleans in late 1817, and soon after Latrobe went to New Orleans to take charge of the great investment they had already placed in the waterworks there. In September 1820 he succumbed to the same disease.

The Bank of Pennsylvania has long been demolished, much of Latrobe's work on the Capitol has been obscured or removed and most of his smaller architectural works in the USA (including a number of important houses) have been destroyed, leaving the Baltimore Cathedral, despite its altered state, as his most important surviving work. Perhaps even greater legacies, however, are found in the early work of his most prominent pupils, Robert Mills, William Strickland, Frederick Graff (1775–1847) and William F. Small (1798–1832), and in the body of his surviving papers, which provide a penetrating and enduring record of his buildings, his intentions and the circumstances faced by architects of his day in the New World.

See also colour pl. XXXII, 3.

UNPUBLISHED SOURCES

Baltimore, Mus. & Lib. MD Hist. [mus. contains large nos of Latrobe's drgs, and lib. letters, etc, many now pubd (see above)]

WRITINGS

T. E. Jeffrey, ed.: *Papers of Benjamin Henry Latrobe* (Clifton, NJ, 1976) [microfiche edn]

E. C. Carter II and others, eds: *Journals of Benjamin Henry Latrobe*, 3 vols (New Haven, 1977–80)

J. C. Van Horne and others, eds: *Correspondence and Miscellaneous Papers of Benjamin Henry Latrobe*, 3 vols (New Haven, 1984–7)

BIBLIOGRAPHY

G. Brown: *History of the United States Capitol* (Washington, DC, 1900–03), i, pp. 32–64

T. Hamlin: *Benjamin Henry Latrobe* (New York, 1955)

P. F. Norton, comp.: 'Benjamin Henry Latrobe', *Amer. Assoc. Archit. Bibliog.: Pap.*, ix (1972), pp. 51–84

D. H. Stapleton, ed.: *Engineering Drawings of Benjamin Henry Latrobe* (New Haven, 1980)

E. C. Carter II, J. C. Van Horne and C. E. Brownell, eds: *Latrobe's View of America, 1795–1820* (New Haven, 1985)

G. Darley: 'The Moravians: Building for a Higher Purpose', *Archit. Rev.*, clxxvii/1058 (1985), pp. 45–9

J. A. Cohen and C. E. Brownell: *The Architectural Drawings of Benjamin Henry Latrobe* (New Haven, 1994)

JEFFREY A. COHEN

Latter-day Saints. *See* MORMONS.

Laughlin, Homer, China Co. American ceramic factory. Homer Laughlin first produced white ironstone in 1873 with his brother Shakespeare, as Laughlin Brothers. The partnership was dissolved in 1877, and Homer Laughlin established the Homer Laughlin China Co. Semi-vitreous dinnerware made for hotels was added as a major product in the 1890s, and in 1896 the firm was formally incorporated. Laughlin retired two years later, but the firm continued to use its new name. By 1905 the company had three potteries in East Liverpool, OH, with a capacity of 36 kilns.

BIBLIOGRAPHY

W. C. Gates jr and D. Ormerod: 'The East Liverpool Pottery District: Identification of Manufacturers and Marks', *Hist. Archaeol.: Annu. Pubn. Soc. Hist. Archaeol.*, xvi (1982), pp. 1–358 (128)

ELLEN PAUL DENKER

Lawson, Ernest (*b* Halifax, NS, 22 March 1873; *d* Miami, FL, 18 Dec 1939). American painter of Canadian birth. He first studied art in 1888 at the Art League School of Kansas City, MO. The following year he attended the Academia de Bellas Artes de S Carlos in Mexico City, while working as an engineering draughtsman. In 1891 he moved to New York and took classes from John H. Twachtman and J. Alden Weir. Under their tutelage at the Art Students League and at Cos Cob, CT, Lawson painted landscapes in a loosely brushed Impressionist style, exploring the transitory effects of light. In 1893 Lawson went to Paris, where he lived with the writer Somerset Maugham (1874–1965); Maugham based the character Frederick Lawson in his novel *Of Human Bondage* (1915) on the artist. Lawson briefly attended the Académie Julian and then studied independently, particularly the works of Cézanne (1839–1906) and Sisley (1839–99).

Lawson returned to New York in 1898. He used thick impasto, strong contour lines and large areas of bold, yet harmonious colour to create highly structured compositions, as in *Winter on the River* (1907; New York, Whitney). His characteristic works were of the semi-industrial landscape of Manhattan and the lower Hudson River, emphasizing its docks, bridges and squatters' huts. Such urban motifs link Lawson to THE EIGHT, with whom he exhibited at the Macbeth Galleries in New York in 1908. Lawson participated in the Independent Artists exhibition (1910) and the Armory Show (1913).

BIBLIOGRAPHY

G. Pène du Bois: *Ernest Lawson* (New York, 1932)

H. Berry-Hill and S. Berry-Hill: *Ernest Lawson: American Impressionist (1873–1939)* (Leigh-on-Sea, 1968)

Ernest Lawson (1873–1939) (exh. cat. by A. L. Karpiscak, Tucson, U. AZ, Mus. A., 1979)

American Impressionism (exh. cat. by W. Gerdts, Seattle, U. WA, Henry A.G., 1980)

For further bibliography *see* EIGHT, THE.

JANET MARSTINE

L'Enfant, Pierre-Charles (*b* Paris, 2 Aug 1754; *d* Green Hill, MD, 14 June 1825). American urban planner and architect of French birth. He was born into an artistic family, members of which served the French court, and grew up in circumstances that imbued him with an appreciation for art, architecture, city planning and garden design (particularly the landscapes of André Le Nôtre (1613–1700) at Versailles and elsewhere). In 1771 L'Enfant studied fine arts at the Académie Royale de Peinture et de Sculpture, Paris. Six years later, as a lieutenant in the French Army, he volunteered his services to the new American republic in its struggle with Great Britain. During the War of Independence (1775–81), he saw action at Valley Forge, PA, Charleston, SC, and Savannah, GA, and produced portraits and other illustrations in such quantity that he was referred to as the 'Artist of the American Revolution'. In 1782, at the request of General George Washington, L'Enfant designed a temporary pavilion (destr.) in Philadelphia for the celebration of the birth of Louis XVI's first son. In recognition of his services to the American nation, he was breveted a major in the Corps of Engineers in 1783. Soon after, L'Enfant designed the insignia and membership diploma for the newly formed Society of the Cincinnati, organized to perpetuate the ideals of the American Revolution. He returned to France in 1783 in order to work with experienced jewellery makers in casting the Society's medals. In 1784 he was in New York, where he practised architecture. Records of his commissions during this period are scarce; one project involved an addition to St Paul's Chapel (1787) to commemorate General Richard Montgomery.

From 1788 to 1789 L'Enfant was engaged on the redesigning of Federal Hall in New York (destr.) to provide a setting for the inauguration of President Washington. In 1789, as Congress took up the task of creating a new national capital city, L'Enfant approached Washington about providing the design. Washington approved of L'Enfant's appointment, and in March 1791 the designer arrived in the port city of Georgetown. By mid-1791 L'Enfant completed the design (for further discussion and illustration *see* WASHINGTON, DC, §I, 2 and fig. 1), which called for a system of radial avenues superimposed over a grid, with the conjunctions of the streets located on strategic topographical features and reinforced by the location of major public buildings and parks on them. The plan provided for a decentralized city, with growth occurring around major nodes spread throughout the city. Despite the brilliance of the plan, disagreements with the District Commissioners led to L'Enfant's dismissal in 1792. He was subsequently invited to prepare a city plan for Paterson, NJ; his design provided for radial avenues running to distant points, but it was never implemented.

From 1794 to 1796 L'Enfant designed and supervised the construction of Robert Morris's residence in Philadelphia, in a French Renaissance style with mansard roof and French windows. A grand building for its day, it was never completed and was demolished about 1800. He later drew designs for the reinforcement of Fort Mifflin, PA, and its Commandant's house. In 1800 he returned to Washington, DC, in an attempt to secure payment for his services in providing the plan for the city but to no avail. After the War of 1812, he designed and superintended the reconstruction of Fort Washington to the south of the capital, along the Potomac River.

L'Enfant was buried in Green Hill, MD, but in 1909 his remains were removed to the US Capitol to lie in state and were reinterred in Arlington National Cemetery. Around this time there was a new appreciation of his plan by the nation's leading architects and designers; when the McMillan Commission produced a new plan for the city in 1902, it cited its debt to the Neo-classical L'Enfant Plan.

BIBLIOGRAPHY

E. D. Kite, ed.: *L'Enfant and Washington, 1791–1792* (Baltimore, 1929)

H. P. Caemmerer: *The Life of Pierre Charles L'Enfant: Planner of the City Beautiful, the City of Washington* (Washington, DC, 1950)

J. Reps: *Monumental Washington: The Planning and Development of the Capital City* (Princeton, 1967)

P. D. Spreiregen, ed.: *On the Art of Designing Cities: Selected Essays of Elbert Peets* (Cambridge, MA, 1968)

ANTOINETTE J. LEE

Lenox, Walter Scott (*b* Trenton, NJ, 29 March 1859; *d* Trenton, 11 Jan 1920). American pottery manufacturer and designer. He aspired to be an artist as a youth, and in 1875 he became interested in applying art to industry, learning to design pottery forms and decoration with

Elijah Tatler (1823–76) at the Trenton Pottery. In 1883 he became art director for Ott & Brewer, Trenton, and was instrumental in developing an American version of Irish Belleek that was highly decorated with coloured glazes and raised gold pastework. In 1887 he developed a similar line for the Willets Manufacturing Co. in Trenton. These two potteries made primarily ironstone dinner and toilet wares, but Lenox was determined to create a company completely devoted to art wares. With several partners he founded in 1889 the small Ceramic Art Co., Trenton, which made a delicate ivory porcelain elaborately decorated in high Victorian taste. About 1902 the firm began to experiment with tableware, making costly services for individual clients. In 1906 the manufacture of exclusively decorated table services was formally inaugurated, and the company's name changed to the Lenox China Co.

BIBLIOGRAPHY

G. S. Holmes: *Lenox China: The Story of Walter Scott Lenox* (Trenton, 1924)

E. P. Denker: *Lenox China: Celebrating a Century of Quality, 1889–1989* (Trenton, 1989)

ELLEN PAUL DENKER

Lester, Charles E(dwards) (*b* Griswold, CT, 15 July 1815; *d* Detroit, MI, 29 Jan 1890). American writer. He qualified as a barrister in Natchez, MS, in 1838 after first studying for the ministry at Auburn Theological Seminary (1835–6). A period as a pastor in Liverpool, NY, was ended by ill health. He left the ministry and travelled to Britain in 1840. In 1842 he became the US Consul in Genoa, Italy (1842–7), and there began translating Italian autobiographies and histories and also wrote his major contribution to American art history, *The Artists of America: A Series of Biographical Sketches of American Artists with Portraits and Designs on Steel* (1846). In this he aimed to persuade the American public of the importance of their art and artists. Lengthy chapters cover the talents of such painters as Benjamin West, John Trumbull and Washington Allston; shorter chapters feature James de Vaux (1812–44), Thomas Crawford and Henry Inman, which Lester included to encourage interest in contemporary art. Two magazine articles on artists comprised the only other published writings by Lester concerning art.

UNPUBLISHED SOURCES

Detroit, Pub. Lib. [letters]

WRITINGS

The Artists of America: A Series of Biographical Sketches of American Artists with Portraits and Designs on Steel (New York, 1846)

BIBLIOGRAPHY

Appletons Cyclo of American Biography; *National Cyclopedia of American Biography*

DARRYL PATRICK

Leutze, Emanuel (Gottlieb) (*b* Schwäbisch Gmünd, Baden-Württemberg, 24 May 1816; *d* Washington, DC, 18 July 1868). American painter of German birth. When he was nine, Leutze's family emigrated to America and settled in Philadelphia. In 1834 he began to study art with the draughtsman John Rubens Smith (1775–1849). Leutze developed his skills as a portrait painter by taking likenesses to be engraved for publication in the *National Portrait Gallery of Distinguished Americans* and then working as an itinerant painter. He also experimented with imaginative

compositions, such as the *Poet's Dream* (Philadelphia, PA Acad. F.A.). Philadelphia patrons sponsored his study in Europe, and in 1841 he enrolled at the Königliche Kunstakademie in Düsseldorf. Although attempts at history painting won approval in Germany and in the USA, Leutze left the academy in 1843. He travelled for two years in Germany and Italy, during which time he became convinced of the importance of freedom and democracy, which he believed to be fundamental institutions of the American political system.

Leutze returned to Düsseldorf, where he married and became one of the city's most prolific painters and active liberals in the period preceding the March 1848 Revolution. As president of the Verein Düsseldorfer Künstler and co-founder of the Malkasten (an artists' club based on democratic principles), Leutze led the independent artists' community and was friend, adviser and financial backer to numerous American painters, such as Eastman Johnson, Worthington Whittredge and Albert Bierstadt, who were studying in Düsseldorf.

Leutze's fame grew steadily as a result of the success of his history paintings, especially those devoted to Christopher Columbus. His most popular painting was *Washington Crossing the Delaware* (1851; New York, Met.; see fig.), and in 1851 Leutze travelled to the USA to exhibit it and to petition Congress to commission another version and a pendant, *Washington Rallying the Troops at Monmouth* (1854; Berkeley, U. CA, A. Mus.). He lived in Düsseldorf until 1859, when he became discouraged by the political situation in Germany and a decline in commissions and so settled once more in the USA. Several important undertakings ensued, including the 1862 mural *Westward the Course of Empire Takes its Way* for the Capitol. After the Civil War he painted portraits of Abraham Lincoln and various Union army officers. Leutze was working on the cartoon for a mural depicting the *Emancipation of the Slaves* when he died.

Leutze was a talented portraitist but is usually regarded as an artist of ambitious, large-scale history pieces, although the quality of his history paintings is inconsistent. He painted figures well but occasionally slipped into melodrama. His announced intention to paint 'a long cycle from the first dawnings of free institutions in the middle ages. . .to the Revolution and Declaration of Independence' resulted in some handsome paintings (e.g. *Hohenstaufen, Württemberg, c.* 1854; New York, Century Assoc.) and culminated in several canvases devoted to George Washington: the 1851 version of *Washington Crossing the Delaware* became an icon of American history and patriotism. There were two other versions of this painting; an earlier one, originally in Bremen, was destroyed by fire during World War II; a third, smaller replica, painted with Eastman Johnson, was the model in 1853 for the engraving by Paul Girardet (1821–93) published by Goupil, Vibert & Co., the distribution of which enhanced the painting's already considerable renown.

BIBLIOGRAPHY

J. Herring and J. Barton: *National Portrait Gallery of Distinguished Americans*, 4 vols (New York, 1834–9)

H. Tuckerman: *Book of the Artists: American Artist Life* (New York, 1867), pp. 333–45

F. von Boetticher: *Malerwerke des neunzehnten Jahrhunderts*, 2 vols (Leipzig, 1891–1901), i, pp. 857–8

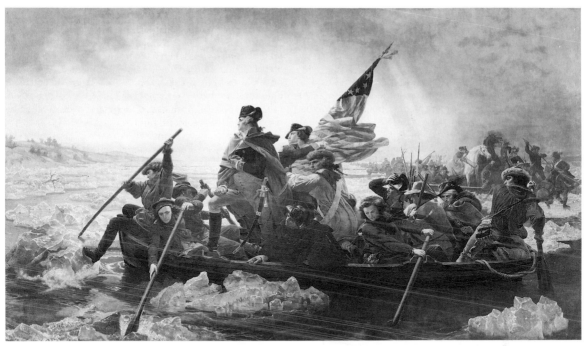

Emanuel Leutze: *Washington Crossing the Delaware*, oil on canvas, 3.78×6.48 m, 1851 (New York, Metropolitan Museum of Art)

Emanuel Leutze, 1816–1868 (exh. cat. by E. Kratz, Schwäbisch Gmünd, Städt. Mus., 1968)
R. L. Stehle: *Life and Works of Emanuel Leutze* (Washington, DC, 1972)
Emanuel Leutze, 1816–1868: Freedom Is the Only King (exh. cat. by B. S. Groseclose, Washington, DC, N. Col. F.A., 1975)
W. H. Trettner: 'Storming the Teocalli - Again, or, Further Thoughts on Reading History Paintings', *Amer. A.*, ix (Autumn 1995), pp. 56–95

BARBARA GROSECLOSE

Lewis, (Mary) Edmonia [Wildfire] (*b* New York, 1845; *d* after 1911). American sculptor. Born to an African-American father and a American Indian mother, she was the first Black American sculptor to achieve national prominence. During her early childhood she travelled with her family in the Chippewa tribe, by whom she was known as Wildfire. At 12 she attended school at Albany, NY (1857–9), then a liberal arts course at Oberlin College, OH (1860–63). Lewis then went to Boston (1863) to study with Edward Brackett (1818–1908) and Anne Whitney. Her medallion of the abolitionist *John Browne* and a bust of the Civil War hero *Col. Robert Shaw* were exhibited at the Soldiers' Relief Fair (1864), Boston; the latter sold over 100 plaster copies, enabling Lewis to travel to Rome (1865). There she was introduced to the White Marmorean Flock, a group of women sculptors, including Harriet Hosmer and Emma Stebbins, who worked in a Neo-classical style. Examples of Lewis's own work include *Forever Free* (1867; Washington, DC, Howard U., Gal. A.), a depiction of a slave breaking his bonds and several sculptures evoking her American Indian heritage, inspired by the *Song of Hiawatha* by Henry Wadsworth Longfellow, such as *Minnehaha* (1867; Detroit, MI, Inst. A.). Notably successful was *Hagar* (1875; Washington, DC, N. Mus. Amer. A.; for illustration *see* AFRICAN AMERICAN ART), portraying the servant of Abraham cast into the wilderness by his wife, Sarah. Many of her works are in the National Museum of American Art, Washington, DC.

BIBLIOGRAPHY
The White Marmorean Flock: 19th-century American Neo-classical Sculpture (exh. cat., ed. W. Gerdts jr; Poughkeepsie, NY, Vassar Coll. A.G., 1972)
Two Centuries of Black American Art (exh. cat. by D. Driskoll, Los Angeles, CA, Co. Mus. A., 1976)
P. Dunford: *A Biographical Dictionary of Women Artists in Europe and America since 1850* (Philadelphia, PA, 1989; 2/Hemel Hempstead, 1990)
C. S. Rubinstein: *American Women Sculptors* (Boston, MA, 1990)
L. Frapiselli: 'Una scultrice afro–indiana dall'America a Roma al tempo di Pio IX', *Strenna Romanisti*, (1994), pp. 213–22
T. A. Bugard: 'Edmonia Lewis & Henry Wadsworth Longfellow: Images & Identities', *Amer. A. Rev.*, vii/1 (1995), pp. 114–7
K. P. Buick: 'The Ideal Works of Edmonia Lewis: Invoking and Inverting Autobiography', *Amer. A.*, ix/2 (1995), pp. 4–19
J. M. Holland: 'Mary Edmonia Lewis's *Minnehaha*: Gender, Race and the "Indian Maid"', *Bull. Detroit Inst. A.*, lxix/1–2 (1995), pp. 26–35
S. May: 'Succeeding against the Odds: Recognition at Last for Edmonia Lewis', *Sculp. Rev.*, xliv/2 (1995), pp. 6–11
M. Richardson: 'Edmonia Lewis's *The Death of Cleopatra*: Myth and Identity', *Int. Rev. Afr. Amer. A.*, xii/2 (1995), pp. 36–52
S. May: 'Cleopatra Lives! Rediscovered Statue at National Museum of American Art, Washington, DC', *ARTnews*, xcv (1996), p. 32

Lewis, Ion. *See under* WHIDDEN & LEWIS.

Libbey Glass Co. American glass factory founded by William L. Libbey (1827–83), who had owned the New England Glass Co. in Cambridge, MA, since 1872. In 1888 his son Edward Drummond Libbey (1854–1925) decided to close the factory during a long strike and to take advantage of the natural gas available in the Midwest. When the firm again made glass in 1888, it was as the W. L. Libbey & Son Co. of Toledo, OH; in 1892 it became

the Libbey Glass Co. The success of the Libbey Glass Co. enabled Edward Drummond Libbey to help found the Toledo Museum of Art, OH, in 1901 and to bequeath to it his collection of European paintings, supplemented by a trust provided by his estate.

Many fashionable cut-glass patterns were produced at Libbey during the so-called 'Brilliant period' between 1880 and 1915, and Libbey produced some magnificent exhibition pieces, including a cut-glass table 813 mm high and a cut-glass floor lamp nearly 1.5 m high. The firm's major product was a more popular line of goods made from blanks; these had previously been pressed in a metal mould in the pattern to be cut, thus avoiding the expense of mould-blowing blanks and marking them for cutting. As one of the most important American cut-glass factories at the time, the firm erected a large crystal palace for the World's Columbian Exposition of 1893 in Chicago. In the exhibition factory glass-blowing and cutting were demonstrated, as were the new methods of spinning and weaving glass fibres for upholstery, drapery and lamp shades.

Libbey became a major force in developing industrial products of glass. The superintendent of the factory, Michael Joseph Owens (1859–1923), developed machinery for producing light bulbs mechanically (c. 1892), for moulding tumblers (1895) and for making bottles automatically (1903), which resulted in the establishment of the Owens Bottle Machine Co.

BIBLIOGRAPHY

A. C. Revi: *American Cut and Engraved Glass* (New York, 1965)
Libbey Glass: A Tradition of 150 Years, 1818–1968 (exh. cat. by J. W. Keefe, Toledo, OH, Mus. A., 1968)

ELLEN PAUL DENKER

Lienau, Detlef (*b* Ütersen, Holstein, 17 Feb 1818; *d* New York, 29 Aug 1887). American architect of Danish origin. He was educated in Stettin and Berlin, where he was trained in carpentry. He pursued further study at the Königliche Baugewerksschule in Munich and by 1842 had moved to Paris, where he spent five years in the atelier of Henri Labrouste (1801–75). Late in 1848 Lienau arrived in New York, and by 1850 he had established an extensive practice, designing both private and public buildings. His first important commission was Grace Church (1850–53), Jersey City, NJ, in a modified Gothic Revival style. Meanwhile Lienau began to receive important commissions from wealthy merchants, beginning with a city residence (1850–52; destr.) for German-born Hart M. Shiff, the first building in the city to incorporate the mansard roof. Lienau used this French Second Empire style, which quickly became highly fashionable in New York, in several subsequent urban residences, most notably the adjoining mansions for the wealthy brothers William Schermerhorn and Edmund H. Schermerhorn (1853–9 and 1867–9 respectively).

After the Civil War, Lienau completed a sumptuous mansion (1864–8) for LeGrand Lockwood at 295 West Avenue, South Norwalk, CT, as well as designing a number of multiple dwelling residences in New York, beginning with the eight attached townhouses (1868–70; destr.) for Rebecca Colford Jones, a long block articulated at roof level by a succession of mansards of differing pitch over the individual house units. In New York Lienau also built a number of apartment hotels, such as the Schermerhorn Apartments (1870–71; destr.), and designed a model tenement block of flats for the poor (1879; destr.) on Elm Street. In the mid-1870s Lienau continued to use his by now old-fashioned French mansard idiom for collegiate buildings, such as Suydam Hall (1871–3) and the Sage Library (1873–5), both at the General Theological Seminary, New Brunswick, NJ.

Although sometimes viewed as a stylist, Lienau was also concerned with rational and functional planning, a practice learnt from Labrouste. This is evident not only in the conveniences he incorporated in his blocks of flats, but even more in the structural solutions and the materials used in his fireproof Hodgson Hall and the Public Library (1873–6), both in Savannah, GA. Even better was his highly functional design for the Matthiessen and Weichers Sugar Refinery complex (1862–70), Jersey City, NJ, whose layout abandoned artificial symmetry and was determined strictly by internal operations based around the new centrifugal separation machines. These buildings served as models for the sugar refining industry for many years. Lienau's extended influence was felt not only through his buildings, which introduced a new urban character to New York, but also through the work of the young men trained in his office, most notably Paul J. Pelz (1841–1918) and Henry Janeway Hardenbergh.

BIBLIOGRAPHY

DAB; *Macmillan Enc. Archit.*
M. Schuyler: 'Works of Henry J. Hardenbergh', *Archit. Rec.*, vi (1897), pp. 335–6
S. Hartmann: 'A Conversation with Henry Janeway Hardenbergh', *Archit. Rec.*, xix (1906), pp. 376–80
E. W. Kramer: 'Detlef Lienau: An Architect of the Brown Decades', *J. Soc. Archit. Hist.*, xiv (1955), pp. 18–25
——: *The Domestic Architecture of Detlef Lienau, a Conservative Victorian* (diss., New York U., 1958)
M. D. Schaak: 'The Lockwood-Mathews Mansion', *Interior Des.*, xxxviii (1967), pp. 155–63

LELAND M. ROTH

Lift. *See under* SKYSCRAPER, §1.

Little, Arthur (*b* Boston, MA, 29 Nov 1852; *d* Wenham, MA, 28 March 1925). American architect. He was an important member of the group of Boston architects who, during the last quarter of the 19th century, were responsible for reviving interest in Colonial buildings (*see* COLONIAL REVIVAL). He trained at the Massachusetts Institute of Technology, Cambridge, MA, in 1871–5. In 1876 he studied architecture there while also apprenticed in the firm of Peabody & Stearns. Robert Swain Peabody, the principal designer of the firm, was an enthusiast of 18th- and early 19th-century architecture and probably encouraged Little to publish *Early New England Interiors* (1878), which reproduces Little's sketches of Colonial buildings in Boston, New Hampshire and Maine. Little established an independent practice in 1878, and one of his first works was Cliffs (1879), Manchester-by-the-Sea, MA, a private house with details such as balustrades and pedimented dormers that derive from Federal-style houses in New England. Between 1880 and 1882 he built a number of summer residences for members of his family at Swampscott, MA, including Shingleside (1880–81) and

Grasshead (1882). Both houses are typical of the Shingle style, responding to their seaside sites with natural materials such as roughly textured wood shingles. The plans of the houses allow living spaces to flow into one another, thus reflecting their use as seasonal retreats by affluent clients. Little formed a partnership with Herbert Browne (1860–1946) around 1890; the two continued to design elaborate residences such as the Larz Anderson House (1902–5), in the north-west part of Washington, DC, which demonstrates Little's interest in Italian Renaissance palaces.

WRITINGS
Early New England Interiors: Sketches in Salem, Marblehead, Portsmouth and Kittery (Boston, 1878)

BIBLIOGRAPHY
V. J. Scully jr: *The Shingle Style: Architectural Theory and Design from Richardson to the Origins of Wright* (New Haven, 1955); rev. as *The Shingle Style and the Stick Style* (New Haven, 1971)
W. K. Sturges: 'Arthur Little and the Colonial Revival', *J. Soc. Archit. Historians*, xxxii (1973), pp. 147–63

KEVIN D. MURPHY

Long, Robert Cary, jr (*b* Baltimore, MD, *c.* 1810; *d* New York, 9 May 1849). American architect and writer. He was the son of the Baltimore architect Robert Cary Long sr (1770–1833), who designed the Baltimore Museum and Gallery of the Fine Arts (1814; now Peale Museum) and other Greek Revival buildings in and around Baltimore. Long jr went to New York in 1826 for further architectural training with Martin E. Thompson (1787–1877). In 1833 he returned to Baltimore and set up his own practice, which he relocated to New York in 1848. A romantic architect influenced by Ithiel Town, Alexander Jackson Davis and William Strickland, Long was eclectic in his choice of style. His State Institution for the Deaf, Dumb and Blind (1839–44), Staunton, VA, is Grecian in style. For the Greenmount Cemetery, Baltimore, he proposed an Egyptian gateway in 1838, later changed to a Gothic Revival design and built in 1840. He specialized in designing churches, some severely Grecian and others Gothic. Among his classical designs the best is perhaps the Roman Catholic Church of St Peter the Apostle (1843–4), Poppleton Street, Baltimore. His most elaborate Gothic Revival design, also Roman Catholic, was St Alphonsus (1842–*c.* 1844), Baltimore. Long was an active writer and lecturer, and on his move to New York contributed regularly to *The Literary World* (1848–9), including a series of articles entitled 'Architectonics'.

WRITINGS
'On the Development of the Semi-Arch with the Future Advancement of Architectural Art', *Civ. Engin. & Architect's J.*, v (1842), pp. 370–72
'On the Alleged Degeneracy of Modern Architecture', *J. Franklin Inst.*, n. s. 2, ii (1843), pp. 346–9
'Gothic Architecture—New Church', *US Cath. Mag.*, ii/5 (1843), pp. 297–304
The Ancient Architecture of America (New York, 1849)

BIBLIOGRAPHY
Macmillan Enc. Archit.
T. B. Ghequiere: 'The Messrs. Long, Architects', *Amer. Architect & Bldg News*, i (1876), p. 207
R. H. Howland and E. Spencer: *The Architecture of Baltimore* (Baltimore, 1953)
W. H. Hunter: 'Robert Cary Long, jr., and the Battle of the Styles', *J. Soc. Archit. Hist.*, xvi (1957), pp. 28–30
P. B. Stanton: *The Gothic Revival and American Church Architecture* (Baltimore, 1968)

LELAND M. ROTH

Longpre, Paul De. *See* DE LONGPRE, PAUL.

Longwood Gardens. Botanical gardens in Kennett Square, *c.* 50 km south-west of Philadelphia, PA. An Englishman, George Pierce, bought the estate in 1700 and in 1720 built a brick house (now a wing of the present house). From 1800 his descendants, the twin brothers Joshua Pierce (1766–1851) and Samuel Pierce (1766–1836), planted the estate with exotic trees, and the collection grew rapidly, including laurels, copper beeches, yews, European and American horse-chestnuts, Norway spruce, several varieties of magnolia, Japanese ginkgos, empress trees and hollies, with evergreens predominating. In 1906 the property, known as Pierce's Park, was bought by Pierre Samuel du Pont (1870–1954) primarily to save the arboretum. Du Pont built the present house and the extensive conservatories and developed the estate, preserving and enhancing the original garden, planting in harmony with the existing scheme. Longwood covers 1000 acres, including woodlands and open spaces, with the formal and informal aspects of the garden carefully harmonized. Among its features are a Fountain Garden, an Italian water garden laid out to the plan of the Villa Gamberaia at Settignano (18th century), a series of garden courts and terraced flowerbeds. The design of the open-air theatre was inspired by the 'green theatre' at the Villa Gori near Siena (1620s), and much of the sculptural ornament was brought from Italy.

BIBLIOGRAPHY
J. T. Faris: *Old Gardens in and about Philadelphia* (Indianapolis, 1932), pp. 215–26

□

Los Angeles. North American city and seat of Los Angeles County, California. It is located on the Pacific coast in the southern part of the state, *c.* 600 km south of San Francisco and just over 200 km north of the Mexican border.

1. History and urban development. 2. Art life and organization.

1. HISTORY AND URBAN DEVELOPMENT. El Pueblo de Nuestra Señora La Reina de Los Angeles was founded on 4 September 1781 by Felipe de Neve, the Spanish governor of the Province of California, on the Los Angeles River *c.* 48 km from the Pacific Ocean. The site for the settlement was selected because of the year-round availability of water and the potential fertility of the area: it was one of the first communities in Spanish Alta California that was not founded as a mission or a military base but was intended to grow food for the province. In October 1781 Neve issued a planning ordinance for Los Angeles that was based on the 'Leyes de Indias' (1573) issued by King Philip II of Spain. As well as providing lots for agriculture and housing and land for common pasturage, Neve noted in this ordinance the settlement's existing grid plan around a central plaza; after a flood in 1815, however, its centre was moved to higher land further south. Throughout its first 40 years the community remained less important than the nearby missions of San Gabriel and San Fernando. After Mexican independence (1821), when California became a province of Mexico, Los Angeles began to assume greater economic and political impor-

tance. San Pedro and its bay to the south emerged as the port, while the town itself became increasingly cosmopolitan, attracting migrants and commercial traders from Mexico, England and elsewhere in North America. By the early 1830s Los Angeles was the largest town in Alta California, with *c.* 1200 inhabitants, and in 1835 it was raised to the status of a city by the Mexican government. Eventually Californian government was divided, with the military governor in Monterey and the civil governor in Los Angeles. By the early 1840s the area around the central plaza had a church (1818) and a number of two-storey 'Monterey style' dwellings. In 1836 a commission was appointed to 'eliminate the extreme irregularity of the streets' that had resulted from haphazard growth. The surrounding area was scattered with one- and two-storey adobe ranch-houses, with some irrigated agriculture.

The acquisition of California by the USA in 1848 did not initially disturb the slow growth of the city. In the early 1850s there was a brief economic boom based on the sale of cattle, followed by an economic decline due to a severe drought of the late 1850s. Land surveys to establish public and private ownership, first carried out in 1846, continued in the following decades, and by the early 1880s almost all the original public land had passed into private hands, the only exception being property with no apparent economic use. Some of this land eventually became public parks: Westlake, Central, Elysian and Echo parks. Problems continually occurred with sewerage, water and transportation, which were frequently the subjects of disputes between public and private interests. The problems became particularly acute in the boom years of the 1880s, when Los Angeles was being promoted as a farming paradise and for its healthy climate: about 50,000 migrants had arrived by the early 1890s. In 1869 the first railway was built to the port at San Pedro, where the development of wharfs and other improvements gradually took place. In 1876 Los Angeles was connected with the rest of the USA by the completion of the Southern Pacific Railroad. In the mid-1880s, as a direct response to land speculation, an electric railway was established; in 1892 this passed into the hands of Henry E. Huntington, who developed it as the Pacific Electric Railroad Co. Private interests also tended to dominate water and sewerage throughout the 1880s and 1890s: only in 1902 did the city finally acquire the Los Angeles Water Co.

By the 1890s the general pattern of Los Angeles was firmly established as a series of independent or semi-independent towns and industrial centres, separated by acres of low-density suburban districts interspersed with orchards and market gardens. The city centre of Los Angeles, which had by then moved south over Bunker and Fort hills, was only the largest of several 'downtown' areas held together by the lines of the Pacific Electric Railroad. Architecturally, by the later 1880s Los Angeles was as vigorous as any other American city. Its commercial and institutional buildings reflected the Romanesque Revival style of H. H. Richardson and the newly emerging classicism of the Beaux-Arts style, while in domestic architecture the Queen Anne Revival and COLONIAL REVIVAL held sway; in the 1890s the Los Angeles region played a major role in the introduction and adaptation of the regional Spanish Mission Revival style. Another pop-

ular form of regional architecture, which was eventually exported outside the state, was the California bungalow, characterized by rustic interiors and exteriors, wide overhanging eaves and extensive porches.

After the World's Columbian Exposition (1893) in Chicago, Los Angeles, in common with other American cities, was strongly influenced by the City Beautiful Movement. In 1904 Los Angeles enacted one of the USA's first zoning ordinances, setting aside an area exclusively for residential use; two more far-reaching zoning ordinances followed in 1908 and 1909. (These measures were upheld by the American Supreme Court in 1915, thus establishing the rights of government to regulate private property for the public good.) The city's population tripled between 1900 and 1910, and in 1909 the city planner Charles Mulford Robinson was engaged to prepare general planning guidelines for its growth; in 1910 an official city planning committee was appointed, supplemented in 1913 by a private city planning association that was ultimately more influential. Los Angeles acquired an ocean port after San Pedro and Wilmington were incorporated into the city in 1909, followed by major improvements (e.g. breakwaters, dredging and docks) in these areas as well as at Long Beach during the next decade. New water supplies were provided by the construction (1907–13) of the Los Angeles Aqueduct, superseded in the late 1930s by the All American Canal. Ordinances limited buildings to no more than 150 ft (45.7 m) in height from the 1910s to the 1950s. This policy, resulting from both aesthetic and seismic considerations, encouraged the city's horizontal growth.

BIBLIOGRAPHY

C. Nordhoff: *California for Health, Pleasure and Residence* (New York, 1873)
J. M. Guinn: 'Los Angeles in the Adobe Age', *Hist. Soc. S. CA Q.*, iv (1897), pp. 49–55
C. M. Robinson: *The City Beautiful: Suggestions for Los Angeles* (Los Angeles, 1909)
G. Wharton James: *California, Romantic and Beautiful* (Boston, 1914)
G. Whitnall: 'Tracing the Development of Planning in Los Angeles', *Annu. Rep. LA Plan. Comm.* (1930)
G. W. Robbins and D. L. Tilton, eds: *Preface to a Master Plan* (Los Angeles, 1941)
Los Angeles: A Guide to the City and its Environs, Works Projects Administration (New York, 1941)
M. Scott: *Metropolitan Los Angeles: One Community* (Los Angeles, 1949)
P. J. Ouellet: *City Planning in Los Angeles* (Los Angeles, 1964)
R. M. Fogelson: *The Fragmented Metropolis: Los Angeles, 1850–1930* (Cambridge, MA, 1967)
D. Streatfield: 'The Evolution of the California Landscape', *Landscape Archit.*, lxvi (1976–7), pp. 39–78, 117–27, 229–39 and 417–27
P. Gleye: *The Architecture of Los Angeles* (San Diego, 1981)
D. Crouch, D. Garr and A. L. Mundigo: *Spanish City Planning in North America* (Cambridge, MA, 1982)
C. W. Moore, P. Becker and R. Campbell: *Los Angeles: The City Observed: A Guide to its Architecture and Landscape* (New York, 1984)
D. Gebhard and R. W. Winter: *Architecture in Los Angeles: A Compleat Guide* (Salt Lake City, 1985)

DAVID GEBHARD

2. ART LIFE AND ORGANIZATION. Although Los Angeles is known primarily as a centre of contemporary art, it had a lengthy early art history. The first 'Los Angeles' artists were the area's Native Americans who excelled at the making of coiled basketry. After *c.* 1550 the area's geography, flora and fauna were delineated by European topographers attached to the many voyages of exploration and commerce mounted by European countries in the

wake of the Renaissance. During Spanish occupation, art was produced at the missions in the form of wall and easel paintings. It was not until the mid-1880s that a sophisticated community of artists, most of whom were trained in Europe or on the East Coast, began to develop in Los Angeles. Between 1887 and 1892 art schools and art clubs were founded, and a room was set aside in the Chamber of Commerce for use as a gallery. Although some artists painted portraits and still-lifes (e.g. *Grapes* (1902; Santa Ana, CA, Bowers Mus.; see fig.) by Alberta McCloskey (1859–1941)), the majority painted landscapes, influenced by the Barbizon school. By *c.* 1914 most artists had adopted Impressionism in one form or another. The most talented landscape painters active in Los Angeles before 1914 were Guy Rose, William Wendt, Marian Wachtel, Elmer Wachtel, Benjamin C. Brown, Alson Clark (1876–1949), Edgar Payne (1882–1947) and Granville Redmond.

From the mid-1880s, when it became the fashion for American municipalities to start museums, Angelenos aspired to have their own art museum. In 1903 Charles Lummis started the Southwest Society, a branch of the Archaeological Institute of America, and four years later this incorporated as the Southwest Museum. Pottery, baskets, blankets and other Native American artefacts were gathered and displayed in temporary sites until the opening of the current museum in 1914.

BIBLIOGRAPHY

California Design 1910 (exh. cat. by T. J. Andersen and others, Pasadena, CA, 1974)

N. D. W. Moure and L. W. Smith: *Dictionary of Art and Artists in Southern California before 1930* (Los Angeles, 1975)

Painting and Sculpture in Los Angeles, 1900–1945 (exh. cat. by N. D. W. Moure, Los Angeles, CA, Co. Mus. A., 1980)

Los Angeles Prints, 1883–1980 (exh. cat. by E. Feinblatt and B. Davis, Los Angeles, CA, Co. Mus. A., 1980–81)

R. L. Westphal: *Plein-air Painters of California: The Southland* (Irvine, CA, 1982)

Drawings and Illustrations by Southern California Artists before 1950 (exh. cat. by N. D. W. Moure, Laguna Beach, CA, Mus. A., 1982)

Early Artists in Laguna Beach: The Impressionists (exh. cat. by J. B. Dominik, Laguna Beach, CA, A. Mus., 1986)

California Light, 1900–1930 (exh. cat. by P. Trenton and W. H. Gerdts, Laguna Beach, CA, A. Mus., 1990)

Loners, Mavericks & Dreamers: Art in Los Angeles before 1900 (exh. cat. by N. D. W. Moure, Laguna Beach, CA, A. Mus., 1993)

N. D. W. Moure: *California Art: 450 Years of Painting and other Media* (Glendale, CA, 1998)

NANCY DUSTIN WALL MOURE

Lowell, Guy (*b* Boston, 6 Aug 1870; *d* Madeira, Spain, 4 Feb 1927). American architect and writer. Born into a prominent New England family, he graduated from Harvard University in 1892, received a degree in architecture from Massachusetts Institute of Technology (MIT) in 1894 and a diploma from the Ecole des Beaux-Arts, Paris, in 1899. On returning to the USA, he opened an architectural office in Boston in 1900. Early commissions include entrances to the Boston Fenway (1902) and a lecture hall (1902) at Harvard University. These works are marked by a restrained Italianate classicism. An authority on the history of landscape architecture, Lowell lectured on this subject at M.I.T. from 1900 to 1913. He also published

Alberta McCloskey: *Grapes*, oil on canvas, 819×1073 mm, 1902 (Santa Ana, CA, Bowers Museum of Cultural Art)

several books on Italian villas and gardens. This interest informs many of Lowell's works, particularly the numerous country houses and estates commissioned by wealthy patrons. The house (1903) for Bryce J. Allan, Prides Crossing, MA, is a particularly grand conception, from the arcades of its façade and classical detailing of the interior, to the layout of the gardens. Lowell made use of the traditional Georgian style in a programme of 25 buildings (1903–23) at the Phillips Academy, Andover, MA, creating a unified scheme with the existing buildings. He returned to classicism again in the Boston Museum of Fine Arts (1907–15), a complex of stolid monumentality. Extraordinarily grandiose in conception was the original plan for the New York County Courthouse (1912–27). The design for a circular building, resembling the Colosseum in Rome, but with receding tiers, was replaced by a modified, octagonal structure with a Pantheon-like temple façade. The building was dedicated shortly after Lowell's unexpected death.

WRITINGS

American Gardens (Boston, 1902)
Smaller Italian Villas and Farmhouses (New York, 1916)
More Small Italian Villas and Farmhouses (New York, 1920)

BIBLIOGRAPHY

DAB; *Macmillan Enc. Archit.*
B. F. W. Russel: 'The Works of Guy Lowell', *Archit. Rev.* [Boston], xiii/2 (1906), pp. 13–40
National Cyclopaedia of American Biography, xxi (New York, 1931), pp. 47–8
W. M. Whitehill: *Museum of Fine Arts, Boston: A Centennial History* (Cambridge, MA, 1970)

☐

Lucas, George A(loysius) (*b* Baltimore, MD, 29 May 1824; *d* Paris, 16 Dec 1909). American agent and collector. The son of a publisher and book illustrator, Fielding Lucas jr (*d* 1854), he worked as an engineer for the New York–New Haven Railroad, the Central Railroad of New Jersey and the Croton Aqueduct Board. In 1856 he inherited a sum sufficient to free him to pursue his interest in the arts. The following year he moved to Paris, never to return to America. In Paris, Lucas gained widespread respect in art circles through his work as agent to several American collectors and art dealers. By the mid-1880s he had expended about half a million francs at the behest of William T. Walters, a prosperous businessman also from Baltimore. Lucas was actively involved in the formation of Walters's collection of 19th-century art, noted for its outstanding works by French Realist, Academic and Barbizon school artists, with works commissioned from such artists as Honoré Daumier (1808–79), Jean-Léon Gérôme (1824–1904) and Camille Corot (1796–1875). The most representative collection in the world of the sculpture of Antoine-Louis Barye (1796–1875) is in the Baltimore–Washington area due to Walters's and Lucas's shared enthusiasm for his work. Lucas alerted Walters to works of potential interest, for example the reduced version of the *Hemicycle* (Baltimore, MD, Walters A.G.) by Paul Delaroche (1797–1856). The largest sum spent by Lucas for Walters was for the *Effect of the Frost* (Baltimore, MD, Walters A.G.) by Théodore Rousseau (1812–67), for which he paid the dealer Albert Goupil 112,000 francs in 1882.

For the New York art dealer Samuel P. Avery, Lucas bought even more extensively from representatives of the same artistic schools. Between the late 1860s and 1885 Lucas shipped over 2,500,000 francs' worth of art to New York on a sale or return basis. Lucas was largely responsible for assembling Avery's collection of 19,000 graphic works (New York, Pub. Lib.), mostly 19th-century French. Lucas acquired for himself a group of about 15,000 prints, including works by Delacroix (1798–1863), Manet (1832–83), Whistler and Mary Cassatt. He bequeathed these and over 400 19th-century French works in various media to the Maryland Institute, College of Art in Baltimore (now in Baltimore, MD, Mus. A.). Through Avery, Lucas served a number of American patrons, including John Taylor Johnston (1820–93), Cyrus J. Lawrence, William Henry Vanderbilt and Henry Field (1841–90). He also received commissions from institutions and oversaw the casting in 1888 and shipping in 1893 of the bust of *St John the Baptist* by Rodin (1840–1917) to the Metropolitan Museum of Art, New York. In the last decade of his life Lucas continued to work for select American collectors, notably Henry Walters, for whom he negotiated purchases of paintings, decorative arts, manuscripts and bookbindings. In accordance with Lucas's instructions, Walters, as his executor, arranged the transfer of his remains and his collection to Baltimore. Lucas's 51-volume diary and 45 ledgers (Baltimore, MD, Walters A.G.) provide a detailed account of his involvement in the Paris art market.

WRITINGS

L. M. C. Randall, ed.: *The Diary of George A. Lucas: An American Art Agent in Paris, 1857–1909*, 2 vols (Princeton, 1979)

BIBLIOGRAPHY

M. Fidell-Beaufort, H. L. Kleinfeld and J. K. Welcher, eds: *The Diaries 1871–1882 of Samuel P. Avery, Art Dealer* (New York, 1979)
W. R. Johnston: *The Nineteenth-century Paintings in the Walters Art Gallery* (Baltimore, 1982)
R. Butler: 'La Sculpture française et les américains au XIXe siècle', *La Sculpture du XIXe siècle: Une Mémoire retrouvée* (Paris, 1986), pp. 39–50

LILIAN M. C. RANDALL

Luce, Clarence Sumner (*b* Newport, RI, 10 June 1852; *d* Staten Island, NY, 1924). American architect. He was born into an established Massachusetts family. He was in practice in Boston by the late 1870s, and by 1885 he had moved to New York. He specialized in residential buildings, although he also designed other building types, for example the Holyoke Opera House (1878–9), MA. His early work chiefly comprised Queen Anne Revival and Shingle-style houses on the East Coast, such as the Lyman Josephs House (1882–3) in Middletown, RI, but he soon graduated from timber resort and suburban houses to urban row (terraced) houses, such as the King Model Houses (1891), Harlem, New York. These were sponsored by a builder, David H. King jr, who commissioned four architects to build them: Luce, Bruce Price, James Brown Lord (1859–1902) and McKim, Mead & White. Having forged a link with King, Luce went on to design for him the Renaissance Hotel (1891; destr.) on Fifth Avenue. He later built other hotels in New York, such as the Hotel Somerset (1901) on W. 47th Street, and on the East Coast, as well as apartment blocks around Fort Washington Avenue in upper Manhattan. Luce also designed exhibition buildings, including the Massachusetts pavilion for the Centennial International Exposition in Philadelphia (1876) and the New York State pavilion for the Lewis and Clark

Centennial and American Pacific Exposition in Portland, OR (1905).

BIBLIOGRAPHY

G. W. Sheldon: *Artistic Country Seats* (New York, 1886)

C. W. Leng and W. T. Davis: *Staten Island and its People*, v (New York, 1933), p. 69

V. J. Scully jr: *The Shingle Style: Architectural Theory and Design from Richardson to the Origins of Wright* (New Haven, 1955); rev. as *The Shingle Style and the Stick Style* (New Haven, 1971)

MOSETTE GLASER BRODERICK

Luks, George (Benjamin) (*b* Williamsport, PA, 13 Aug 1867; *d* New York, 29 Oct 1933). American painter and draughtsman. He lived as a child in the mining town of Shenandoah, PA, but moved to Philadelphia in 1883. The facts of his early career were later confused by the wild stories fabricated by him. After a short stint in vaudeville, he spent a year at the Pennsylvania Academy of Fine Arts, Philadelphia. From 1885 he was in Europe, living most of the next decade in Düsseldorf, Munich, Paris and London, intermittently attending German and French art academies. In 1894 Luks became an artist–reporter for the *Philadelphia Press*, where he befriended Robert Henri, John Sloan, William J. Glackens and Everett Shinn. In late 1895 he went to Cuba as a war correspondent; the following year he moved to New York and joined the staff of the *New York World* as a cartoonist.

In 1897 Luks began to paint. Working with dark, slashing strokes, akin to the style of Henri, he sympathetically portrayed New York's social outcasts, as in the *Spielers* (1905; Andover, MA, Phillips Acad., Addison Gal.). This subject-matter and Luks's treatment of it led critics to characterize him later as part of the Ashcan school. Luks exhibited at the National Arts Club in 1904 (see colour pl. XXV, 1) and four years later, as a member of THE EIGHT, participated in their exhibition at the Macbeth Galleries, New York. In 1913 he exhibited at the Armory Show.

BIBLIOGRAPHY

E. L. Cary: *George Luks* (New York, 1932)

E. Shinn: 'Everett Shinn on George Luks: An Unpublished Memoir', *Archv Amer. A. J.*, vi/2 (1966), pp. 1–12

George Luks (exh. cat. by B. Danenburg, New York, Her. Gal., 1967)

George Luks: An Exhibition of Paintings and Drawings Dating from 1889 to 1931 (exh. cat. by I. Glackens and J. Trovato, Utica, NY, Munson–Williams–Proctor Inst., 1973)

City Life Illustrated, 1890–1940: Sloan, Glackens, Shinn, their Friends and Followers (exh. cat., Wilmington, DE A. Mus., 1980)

S. L. Cuba, N. Kasanof and J. O'Toole: *George Luks: An American Artist* (Wilkes-Barr, 1987)

George Luks, Expressionist Master of Color: The Watercolors Rediscovered (exh. cat., Canton, OH, Mus. A.; Greensburg, PA, Westmoreland Co. Mus. A.; Columbus, OH, Mus. A.; 1994–5); rev. by J. H. O'Toole, *Amer. A. Rev.*, vii/3 (1995), pp. 98–101

For further bibliography *see* ASHCAN SCHOOL and THE EIGHT.

JANET MARSTINE

Luminism. Term coined *c.* 1950 by the art historian John I. H. Baur to define a style in 19th-century American painting characterized by the realistic rendering of light and atmosphere. It was never a unified movement but rather an attempt by several painters working in the USA to understand the mysteries of nature through a precise, detailed rendering of the landscape. Luminism flourished *c.* 1850–75 but examples are found both earlier and later. Its principal practitioners were FITZ HUGH LANE, MARTIN JOHNSON HEADE, ALFRED THOMPSON BRICHER, DAVID JOHNSON and Francis Augustus Silva (1835–86). Several artists of the HUDSON RIVER SCHOOL, among them SANFORD ROBINSON GIFFORD, JOHN F. KENSETT and ALBERT BIERSTADT, painted works that could be considered examples of Luminism, as did such Canadian painters as Lucius R. O'Brien (e.g. *Sunrise on the Saguenay*, 1880; Ottawa, N.G.).

The Luminists concentrated on nuances of light and atmosphere, an approach that may have been suggested by the new, dispassionate medium of photography. The work of slightly earlier 19th-century European artists, such as the German Caspar David Friedrich (1774–1840) and the Dane Christen Købke (1810–48), may also have been influential. Even earlier precedents for Luminist paintings are the works of such 17th-century Dutch masters as Jacob van Ruisdael (1628/9–1682). *Atmospheric Landscapes of North America*, a series of watercolours by George Harvey (1800–78) executed in the mid- and late 1830s, was perhaps the first purely Luminist manifestation in American art. Lane's work recalls the earlier paintings of Thomas Birch and especially those of ROBERT SALMON, an English marine painter active in Boston in the 1830s. However, a more direct influence came from the Transcendentalists, such as Ralph Waldo Emerson (1803–82), who saw nature as the ultimate expression of God's will. In a manner akin to pantheistic communion, Luminist painters strove for this sharpened sense of the awareness of nature's mysteries through concentrated meditation on the landscape.

Luminist paintings have several common characteristics. They show no picturesque details of landscape, have a great sense of interior depth and are usually sparsely composed and peopled with few or no figures, as in Kensett's *Marine off Big Rock* (1864; Jacksonville, FL, Cummer Gal. A.; see fig.) or Lane's *Owl's Head, Penobscot Bay, Maine* (1862; Boston, MA, Mus. F.A.; for illustration *see* LANE, FITZ HUGH). Their dimensions are broad and horizontal, though not encompassing the spectacular panoramic sweep typical of the work of Thomas Cole and Frederic Edwin Church. The main subjects are often sunlight or moonlight, which shines through a cloudless sky revealing crisply outlined forms. The mood tends to be one of magical and eerie stillness, enhanced by the inclusion of calm, glossy surfaces of water. Sometimes, however, impending storms were portrayed, as in Heade's *Coming Storm* (1859; New York, Met.; see colour pl. XIV, 2). In Lane's *Western Shore with Norman's Woe* (1862; Gloucester, MA, Cape Ann Hist. Assoc.) a background haziness characteristically gives way to a pellucid foreground. Brushstrokes are generally invisible, and there is evidence of careful draughtsmanship. Lane, for example, painted his works in the studio using detailed pencil drawings, which he squared for transfer. The preferred locales were New England, New Jersey and Long Island. Among other regions, Heade favoured upstate New York (e.g. *Lake George*, 1862; Boston, MA, Mus. F.A.; for illustration *see* HEADE, MARTIN JOHNSON). By the 1870s Luminist paintings began to be superseded by less detailed views rendered in the looser brushstrokes of the Impressionist technique.

Luminist painting by John F. Kensett: *Marine Off Big Rock*, oil on canvas, 699×1113 mm, 1864 (Jacksonville, FL, Cummer Gallery of Art)

BIBLIOGRAPHY

J. I. H. Baur: 'Early Studies in Light and Air by American Painters', *Brooklyn Mus. Bull.*, ix/2 (1948), pp. 1–9
——: 'Trends in American Painting, 1815–1865', *M. and M. Karolik Collection of American Paintings, 1815 to 1865* (Cambridge, MA, 1949)
——: 'American Luminism, a Neglected Aspect of the Realist Movement in Nineteenth-century American Painting', *Persp. USA*, 9 (1954), pp. 90–98
Luminous Landscape: The American Study of Light, 1860–1875 (exh. cat. by G. Davidson, P. Hattis and T. Stebbins jr, Cambridge, MA, Fogg, 1966)
W. J. Naef and J. N. Wood: *Era of Exploration: The Rise of Landscape Photography in America* (New York, 1974)
The Natural Paradise: Painting in America, 1800–1950 (exh. cat., ed. K. McShine; New York, MOMA, 1976)
B. Novak: *Nature and Culture: American Landscape and Painting, 1825–1875* (New York, 1980)
American Light: The Luminist Movement, 1850–1875: Paintings, Drawings, Photographs (exh. cat., ed. J. Wilmerding; Washington, DC, N.G.A., 1980)
E. G. Garrett: *The British Sources of American Luminism* (diss., Cleveland, OH, Case W. Reserve U., 1982)

JOHN I. H. BAUR

Lungren, Fernand Harvey (*b* Hagerstown, MD, 13 Nov 1857; *d* Santa Barbara, CA, 9 Nov 1932). American painter and illustrator. Of Swedish descent, the family moved to Toledo, OH, when Lungren was four years old. He showed an early talent for drawing but was intended by his father for a professional career and in 1874 entered the University of Michigan, Ann Arbor, to study mining engineering. He left in 1876, however, determined to become an artist. After a protracted dispute with his father, he was allowed briefly to attend the Pennsylvania Academy in Philadelphia, where he studied under Thomas Eakins and had Robert Frederick Blum, Alfred Laurens Brennan (1853–1921) and Joseph Pennell as fellow students. In the winter

of 1877 he moved to New York, where he worked as an illustrator for *Scribner's Monthly* (renamed *Century* in 1881) during the period known as 'the Golden Age of American illustration'. His first illustration appeared in 1879 and he continued to contribute to the magazine until 1903. He was also an illustrator for the children's magazine *St Nicholas* from 1879 to 1904 and later for *Harper's Bazaar*, *McClure's* and *The Outlook*. For all these periodicals he produced landscapes, portraits and social scenes to illustrate articles and stories, being noted for his New York street scenes.

In 1882 Lungren travelled to Europe, visiting Antwerp and then Paris. In Paris he studied briefly at the Académie Julian and saw Impressionist works at first hand. He found the visit largely disappointing, however, and returned to New York late in 1883. Soon after his return, he set up a studio in Cincinnati, OH, and in 1892 made a trip to Santa Fe, NM, where he first encountered American Indian culture and the desert landscape. This was the beginning of a lifelong association with the region and its people, leading to such works as *In the Abyss: Grand Canyon* (*c.* 1895; Santa Barbara, U. CA, A. Mus.) and the huge *Snake Dance* (*c.* 1895; Santa Barbara, U. CA, A. Mus.). He showed a number of these works in 1899 at the American Art Galleries in New York, together with works by Maurice Boutet de Monvel (1851–1913).

After marrying Henrietta Whipple in 1898, Lungren travelled with her in the following year to London, where his desert pictures were given a mixed reception initially. He produced a number of pictures of London street life, particularly using pastels, a medium in which he had become very proficient, as shown by *Where Fog Is King* (1899; Santa Barbara, U. CA, A. Mus.). He also met many

artists, including Whistler, and exhibited at the Royal Academy in London and at the Walker Art Gallery in Liverpool. Late in 1900 he travelled with the medical scientist Henry Solomon Wellcome to Egypt, where he produced such works as the pastel *Pyramids at Ghizeh* (1901; Santa Barbara, U. CA, A. Mus.). In mid-1901 he returned to London, and to New York later that year.

The Lungrens moved in 1903 to California and settled in Santa Barbara in 1906. Lungren made his first trip to Death Valley in 1909, the first of many visits, and produced the painting *Death Valley, Sunrise* (1909; Toledo, OH, Mus. A.). At about this time he began work on a series of paintings designed to show the desert in all its conditions, a project that resulted in such works as *Desert Dawn* (Santa Barbara, U. CA, A. Mus.). He remained based in Santa Barbara and on his death ensured that his paintings were left there. After a legal dispute over his planned foundation of a museum in the town, his collection of some 300 works were donated to Santa Barbara State College, now part of the University of California. Lungren's many depictions of the American desert at their best succeed in recreating its solitary atmosphere and established it as a subject worthy of attention in art.

BIBLIOGRAPHY
J. A. Berger: *Fernand Lungren: A Biography* (Santa Barbara, 1936)

M

McArthur, John, jr (*b* Bladnock, Scotland, 13 May 1823; *d* Philadelphia, PA, 8 Jan 1890). American architect. He came *c.* 1833 to Philadelphia , where he was apprenticed as a carpenter with an uncle but studied architecture at the Carpenters' Company and attended lectures by Thomas U. Walter at the Franklin Institute. By the 1840s McArthur had become an architect and in the 1850s won numerous mercantile commissions for buildings that he usually designed in one of the 19th-century classical styles. Particularly noteworthy were the Italianate hotels La Pierre and Continental (1853 and 1858 respectively; destr.) and the Public Ledger offices (1866; destr.), a handsome Second Empire building crowned by a massive mansard roof, all in Philadelphia.

McArthur is best known as the architect of City Hall (formerly the Public Buildings) in Philadelphia, for which he won two earlier competitions, first in 1860 and again in 1869. The scheme as built was the third design (1871) and consisted of four L-shaped structures at each corner of Centre Square, representing the city, county, judiciary and regulatory branches of government. The corners are joined into a single unit by great archways that frame vistas of avenues and unified by a monumental Second Empire overlay of columns and statues beneath a crowning mansard roof. On the north façade there is an immense tower capped by a statue of Pennsylvania's founder, William Penn (1644–1718), which acts as a landmark for the centre of the city. It is the second tallest masonry structure in the world, exceeded only by Robert Mills's Washington Monument *see* MILLS, ROBERT, fig. 2, Washington, DC, a hierarchy that Philadelphians thought appropriate. When City Hall was finally completed (1901), its architect was long dead and its style was out of fashion. After World War II it was saved from demolition only by its bulk; hemmed in later by austere post-war office slabs, McArthur's masterpiece afforded much needed visual relief in the redeveloped city centre, but it was finally overshadowed in 1986 by taller commercial skyscrapers.

BIBLIOGRAPHY

DAB; *Macmillan Enc. Archit.*

L. Wodehouse: 'John McArthur jr, 1823–1890', *J. Soc. Archit. Hist.*, xxviii (1969), pp. 271–83

S. Tatman and R. Moss: *Biographical Dictionary of Philadelphia Architects, 1700–1930* (Boston, 1985), pp. 510–12

J. Cohen: 'John McArthur jr, AIA, 1823–1890', *Drawing towards Building: Philadelphia Architectural Graphics, 1732–1986* (exh. cat. by J. O'Gordon and others, Philadelphia, PA Acad. F.A., 1986), pp. 111–14

GEORGE E. THOMAS

McComb, John, jr (*b* New York, 17 Oct 1763; *d* New York, 25 May 1853). American architect. The leading architect in New York during the Federal period, he was trained by his father, John McComb sr (1732–1811), a mason and builder–architect. The younger McComb began his career in the 1790s in a style combining Colonial Palladian tendencies with a Neo-classicism inspired by Robert Adam (1728–92), and he retained the latter character in his work to the end. In his unexecuted designs, this quality is especially seen in unusual room shapes, but in his completed buildings it is most revealed in proportions and in decorative detail. His architectural work comprised town and country houses for the leading citizens of New York, a number of churches and a variety of semi-public buildings in that city, two college buildings in New Jersey and a series of lighthouses stretching from Virginia to the eastern end of Long Island.

McComb's best-known work is New York City Hall, the execution of which, based on the competition-winning design submitted jointly by him and Joseph François Mangin, he supervised from 1803 to 1812. That design, in a French Neo-classical vein, was primarily the work of Mangin (for illustration *see* MANGIN, JOSEPH FRANÇOIS), but McComb refined the design and created the interior decoration, introducing significant elements from his English-influenced background. His other major works include Alexander Hamilton's country house, The Grange (1801–02; then outside the city but now in New York); and St John's Chapel (1803–07; destr.) and Washington Hall (1809–14; destr.), both in New York. He largely retired from active practice *c.* 1826.

BIBLIOGRAPHY

D. Stillman: *Artistry and Skill in the Architecture of John McComb jr* (MA thesis, Newark, U. DE, 1956)

——: 'New York City Hall: Competition and Execution', *J. Soc. Archit. Historians*, xxiii (1964), pp. 129–42

A. A. Gilchrist: 'Notes for a Catalogue of the John McComb (1763–1853) Collection of Architectural Drawings at the New-York Historical Society', *J. Soc. Archit. Historians*, xxviii (1969), pp. 201–10

——: 'John McComb, sr and jr, in New York, 1784–1799', *J. Soc. Archit. Historians*, xxxi (1972), pp. 10–21

D. Stillman: 'Architectural Books in New York: From McComb to Lafever', *Architects and their Books in Early America*, ed. J. O'Gorman and K. Hafertepe (in preparation)

DAMIE STILLMAN

McCormick, M(ary) Evelyn (*b* Placerville, CA, 2 Dec 1862; *d* Monterey, CA, 6 May 1948). American painter. After settling in San Francisco in the late 1860s with her family, she attended the Irving Institute. She began her art training at the California School of Design under Virgil Williams (1830–86), Emil Carlsen and Raymond Dabb

Yelland (1848–1900), earning an honourable mention (1886) and the prestigious Avery Gold Medal for oil painting (1888). She continued her studies at the Académie Julian in Paris (1889–91), with Jean-Joseph Benjamin-Constant (1845–1902) and Jules LeFebvre (1836–1911). Travelling the French countryside to paint at Giverny (1890, 1891), she, along with other American Impressionists who frequented the Hotel Baudy, vicariously absorbed the spirit of Givernyés resident Impressionist, Claude Monet (1840–1926). On her return to the Bay Area, McCormick again resided in San Francisco but, as early as 1892, began sojourns to the Monterey Peninsula. By 1899, she had studios in both locations and became a full-time resident of Monterey by 1914.

McCormick painted European scenes during her trips to Europe (1889–91; 1923–5), but her years in Monterey were devoted to painting scenes in and around the Peninsula, all the while remaining a devotee of Impressionism. She exhibited *Un Jardine à Giverny* (Berkeley, U. CA) at the Paris Salon in 1891; *Old Mission of San Luis Rey* (untraced) and *Afternoon at Gin[sic]verny, France* (untraced) at the World's Columbian Exposition in Chicago (1893); another version of the *Mission of San Luis Rey* (untraced) at the National Academy Design (1896); and received a bronze medal for Old Custom House, Monterey (untraced) at the Panama—Pacific International Exposition in San Francisco (1915).

BIBLIOGRAPHY

'A California Girl: Her Pictures Go to the World's Fair', *San Francisco Call* (15 March 1893), p. 7

J. Blanch: 'Evelyn McCormick: Monterey Sunshine Artist', *Game & Gossip* (March 1927)

Obituary: *Monterey Peninsula Herald* (7 May 1948), pp. 1, 7

H. Spangenberg: *Yesterday's Artists on the Monterey Peninsula* (Monterey, 1976)

Six Early Women Artists—A Diversity of Style: Rowena Meeks Abdy, Jeanette Maxfield Lewis, Eunice Cashion MacLennan, Laura Wasson Maxwell, M. Evelyn McCormick, Mary deNeale Morgan (exh. cat., Carmel, CA, A. Assoc., 1992)

W. H. Gerdts and W. South: *California Impressionism* (New York, 1998)

P. Kovinick and M. Yoshiki-Kovinick: *An Encyclopedia of Women Artists of the American West* (Austin, 1998)

MARIAN YOSHIKI-KOVINICK

McEntee, Jervis (*b* Rondout, NY, 14 July 1828; *d* Rondout, 27 Jan 1891). American painter. His only period of professional painting instruction was with Frederic Edwin Church in New York during the winter of 1850–51, after which his family steered him into business. By 1859, however, he had decided to devote himself to painting as a career; he took a studio in the Tenth Street Studio Building in New York and travelled regularly between there and Rondout on the Hudson River. McEntee's speciality was the sober autumnal and winter landscape (e.g. *Autumn Landscape*, 1868; priv. col., see 1987 exh. cat., p. 278); he crafted his imagery from recollections of solitary walks taken in the Rondout area to palliate the effects of his own melancholic temperament. Simple landscape forms, narrow ranges of tone and subdued atmospheric effects distinguish McEntee's work from the dramatic topography and light preferred by many artists associated with the Hudson River school and link his sensibility with those American painters inspired by the Barbizon school. Following his sole trip abroad, to Europe, in 1868–9, he occasionally produced Italian subjects, such as the *Ruins of Caesar's Palace* (*c.* 1869; Philadelphia, PA, Acad. F.A.), and experimented with figural imagery in the 1870s and 1880s. McEntee exhibited landscapes at the National Academy of Design, New York, almost every year between 1850 and 1890. Beginning in 1872 he kept a diary, chronicling two decades of the social life and views of the conservative faction within the National Academy of Design.

UNPUBLISHED SOURCES

Washington, DC, Smithsonian Inst., Archv Amer. A., microfilm, roll no. D180 [McEntee's diaries, 1872–90]

BIBLIOGRAPHY

G. W. Sheldon: *American Painters: With Eighty-three Examples of their Work Engraved on Wood* (New York, 1879), pp. 51–6

'The Jervis McEntee Diary', *J. Archv Amer. A.*, viii (July–Oct 1968), pp. 1–29

American Paradise: The World of the Hudson River School (exh. cat. by J. K. Howat, New York, Met., 1987)

DAVID STEINBERG

McIlworth, Thomas (*fl* New York, 1757–69/70). American painter. An itinerant New York artist, he is first noted as becoming a member of the St Andrews Society in New York in 1757. The following year, on 8 May, he advertised his skills as a portrait painter in the *New York Mercury*. Around 1761, following his marriage, McIlworth moved to nearby Westchester, where he remained briefly before settling for three years in upstate New York. In the Albany—Schenectady region. Apparently he returned to New York but soon afterwards departed for Montreal, where he is last recorded in October 1767.

Presumably born in America and self taught, McIlworth was one of a number of migrant artists who painted in the prevailing provincial Rococo style. Several of his works were formerly attributed to Joseph Blackburn, who was active in America from 1754 to 1763. His portrait style is comparable with that of Copley's early works: distinctive traits in many of McIlworth's portraits include elongated faces, tightly drawn features and flushed skin tones. Among his best-known likenesses are those of the prominent Stuyvesant (e.g. 1760; New York, NY Hist. Soc.), Van Rensselaer (e.g. Albany, NY, Inst. Hist. & A.) and Livingston families of New York. A typical example is his portrait of *Philip Livingston* (New York, Brooklyn Hist. Soc.), a signatory of the Declaration of Independence.

BIBLIOGRAPHY

S. Sawitsky: 'Thomas McIlworth (Active 1758 *c.* 1769)', *NY Hist. Soc. Q.*, xxv (1951), pp. 117–39

S. K. Johnston: *American Paintings, 1750–1900, from the Collection of the Baltimore Museum of Art* (Baltimore, 1983), pp. 101–2

SONA K. JOHNSTON

McIntire, Samuel (*bapt* Salem, MA, 16 Jan 1757; *d* Salem, 6 Feb 1811). American architect, draughtsman and wood-carver. His father was a house carpenter, and with his two brothers he was brought up to the same trade. He went on to become a skilled draughtsman, thus qualifying himself to design buildings in whose construction he was to have no part. His work as a wood-carver included ships' figureheads, the decoration of interiors designed by himself and of furniture designed by others—he was not himself a furniture designer or maker—and a few pieces

of sculpture (mostly symbolic eagles, portrait busts and reliefs). As an architect McIntire won many commissions and was second in importance only to Charles Bulfinch in New England during the early Federal period. As a result of the American War of Independence, Salem became a prosperous seaport, whose merchants were wealthy enough to commission large houses. McIntire was particularly fortunate, at the beginning of his career, in coming to the notice of one of the wealthiest Salem merchants, Elias Hasket Derby, who provided him with almost continuous employment until his death in 1799.

McIntire's architecture divides into two periods. In the first, starting in 1780 with his first house for Derby, he carried on the colonial Georgian tradition. His finest surviving building of this period is the Peirce–Nichols House (*c.* 1782), Salem, a three-storey clapboard building with giant Doric pilasters on the façade. The Doric orders and some interior details came from Batty Langley's *City and Country Builder's and Workman's Treasury of Designs* (1740). Among his other buildings of the period was the Salem Court House (1785; destr. 1839), his first civic building. In 1792 he submitted a design in a public competition for the US Capitol (unexecuted). This design, which is indebted to James Gibbs's *Book of Architecture* (1728), marked the end of McIntire's early period.

In 1793 McIntire made his first contributions to what has since been called the Federal style, with the Nathan Read House (destr. 1857), Salem, and the Lyman House, Waltham, MA. Two features characteristic of the Federal style that appeared for the first time were the semi-circular porch with columns, in the Nathan Read House, and the oval room, in the Lyman House. In 1795 he received a commission for the Elias Hasket Derby Mansion (1795–9; destr. 1815) in Salem. This was Derby's grandest house, for which McIntire designed a façade with Ionic pilasters, balustrade and cupola. Inside, he combined an oval room, with a segmental portico over it, and an oval stair hall. He also supplied much of the carved ornament, which like his other later work derives from William and James Pain's *Practical House Carpenter* (London, 1790; Boston, 1796).

McIntire's elegant South Church (1803–4), Salem, with its graceful steeple, burnt down in 1903. His surviving buildings in Salem include the John Gardner House (1804–5) and Hamilton Hall (1805–7), which housed the Salem assemblies. The John Gardner House is a perfectly proportioned brick mansion, with an imposing yet delicate Corinthian porch. It is undoubtedly McIntire's masterpiece. Inside, on mantelpieces and door surrounds, is some of his finest carved ornament, which typically combines chains of husks and classical frets with naturalistic foliage, vases of flowers, bowls of fruit and wheatsheaves. It shows the same skill and sensitivity as his furniture carving, the few authenticated examples of which have established him as one of the leading craftsmen of the period.

BIBLIOGRAPHY
Macmillan Enc. Archit.
S. F. Kimball: *Mr Samuel McIntire, Carver: The Architect of Salem* (Portland, ME, 1940/*R* Gloucester, MA, 1966)
H. Comstock: 'McIntire in Antiques', *Antiques*, lxxi (1957), pp. 338–41 [summary of articles on McIntire as furniture carver]
B. W. Labaree, ed.: *Samuel McIntire: A Bicentennial Symposium, 1757–1957: Salem, 1957*

MARCUS WHIFFEN

McKim, Mead & White. American architectural partnership formed in September 1879 by Charles Follen McKim (*b* Isabella Furnace, PA, 24 Aug 1847; *d* St James, Long Island, NY, 14 Sept 1909), William Rutherford Mead (*b* Brattleboro, VT, 20 Aug 1846; *d* Paris, 30 June 1928) and Stanford White (*b* New York, 9 Nov 1853; *d* New York, 25 June 1906). This late 19th- and early 20th-century partnership produced over 900 executed designs for prestigious public and private commissions of all types, trained a generation of architects and, perhaps most importantly, created an evocative artistic climate that contemporary architects, artists and patrons believed to be an American Renaissance. Basing its work on a renewal of past forms, it succeeded in establishing an architecture that evoked both the American past of the 17th and 18th centuries and the larger heritage of European classicism from antiquity through the Renaissance to the 18th century. Good craftsmanship was an ideal of the firm and its significant public and other important buildings were decorated by leading artists. Clients were wealthy, frequently from high society, and included prominent financiers and politicians. The firm designed large urban houses, country estates, commercial buildings, clubhouses and university campuses. Because its office was in New York, its work was largely in the north-east, though examples can be found in Virginia, the Midwest, Texas and California; the impact of the firm's work can be felt in nearly every town and city in America.

1. History of the firm. 2. Work. 3. Office organization. 4. Critical reception and posthumous reputation.

1. HISTORY OF THE FIRM. McKim, Mead and White worked as a partnership and sought to have their work thus identified, but contemporary accounts stressed their individual personalities. In these remembrances McKim appears as a calm and deliberate scholar with the office nickname of 'Bramante'; Mead as the quiet office manager known as 'Dummy'; and White as a mercurial redheaded playboy called 'Cellini'. These nicknames reflect their individual architectural preferences: McKim was the leading architectural theorist of the office, the style-setter, and his work tended to be grand and pompous; Mead did little actual design, concentrating on overseeing the working drawings and specifications; and White had a genius for designing ornament. All three partners had similar backgrounds; their families were members of the intellectual élite of the pre-Civil War years. McKim's father was an abolitionist and radical. Mead's father was a lawyer, and his family was connected to the radical religious sect of the Oneida community. Stanford White's father was a prominent music and literary critic. In contrast to their parents, McKim, Mead and White all turned to serving the new wealth, typified by the 'robber barons' who began to emerge in the 1870s and would rule the new industrial America.

Charles McKim was the only member of the firm to be formally schooled as an architect. After a year studying engineering at Harvard University, he attended the Ecole des Beaux-Arts in Paris (1867–70) and returned to New York, where he entered the office of H. H. Richardson for two years. In 1872 he began to work independently,

though he maintained a connection with Richardson's office, and became informally associated with William Mead until 1877 when a formal partnership was created. This partnership included William Bigelow, the brother of Annie Bigelow, whom McKim had married in 1874; when they divorced in 1879, Stanford White took William Bigelow's place in the firm. In 1885 McKim married Julia Appleton, a member of a wealthy Boston family; she died barely a year later. Extremely social, McKim devoted much of his later life to causes such as the World's Columbian Exposition (1893) in Chicago, IL, and the establishment of the American School of Architecture (later the American Academy) in Rome. In 1901–2 he became involved (with Daniel H. Burnham, Frederick Law Olmsted jr and Augustus Saint-Gaudens) in the McMillan Commission for the replanning of Washington, DC, the first large 'City Beautiful' project in America. In 1902–3 he served as president of the American Institute of Architects and helped to transform it from a gentlemen's club into an organization of political power.

William Mead attended Amherst College, MA, and was then apprenticed in the New York office of Russell Sturgis for two years (1867–70). Through his brother Larkin Mead (1835–1910), a sculptor, he studied informally at the Accademia di Belle Arti in Florence in 1871. His architectural work before joining McKim was undistinguished, and his role in the firm was that of office manager. The sculptor Augustus Saint-Gaudens, a close friend of all three partners, once did a cartoon labelled McKim and White, with kites flying in different directions and being held down by Mead. Mead married in 1884, and his personal life was uneventful.

Stanford White had a natural talent for drawing and studied briefly with painter and stained-glass artist John La Farge, but, perceiving the financial penury of an artist's life, he entered the office of H. H. Richardson in 1870. Richardson recognized White's illustrative and ornamental talents and gave him major responsibility for several houses, including the William Watts Sherman House (1874–6), Newport, RI, designed in Richard Norman Shaw's Old English style. In 1878, feeling the lack of foreign training or experience, White left Richardson and travelled for over a year in Europe and England before returning and taking Bigelow's place in the New York office of McKim and Mead. Initially White was a junior member of the firm, specializing in interior decoration ornament and collaborating with artists such as Augustus Saint-Gaudens on pedestals. He also designed picture frames for many leading artists of the day. By the mid-1880s he became a full partner in the firm. He married Bessie Smith of Smithtown, Long Island, NY, in 1884. The high life of New York café society attracted him, and he designed not only buildings but also party and costume decorations. The lure of money and flesh led to a series of liaisons and White's fatal shooting (by Harry K. Thaw in 1906) because of his affair with Evelyn Nesbitt. The murder, ensuing trial and sensational publicity provided fodder for endless books, novels and films and ensured White a posthumous reputation that has little to do with architecture.

2. WORK.

(i) Early period. The work of McKim, Mead & White can be divided into three different periods that overlap

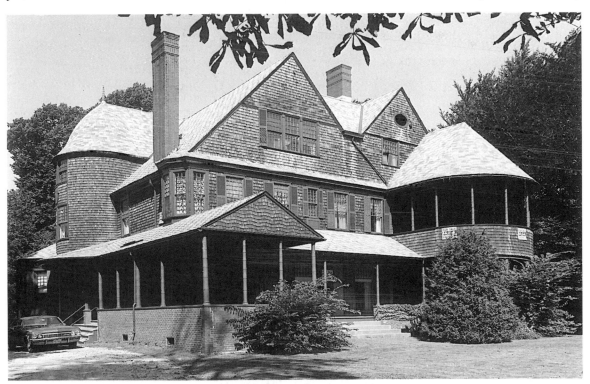

1. McKim, Mead & White: Isaac Bell House, Newport, Rhode Island, 1881–3; south-east view

chronologically but exhibit different characteristics. In the early period, from the mid-1870s to the mid-1880s, buildings have a lightness of form and are frequently asymmetrical in outline. Although McKim had attended the Ecole des Beaux-Arts, much of his and his partner's work of this time reflects the inspiration of the English Aesthetic Movement. The buildings of the early period were eventually christened the SHINGLE STYLE; however, that term was unknown at the time, and they were referred to as either Queen Anne Revival or modernized Colonial Revival. It was the period of the great shingle-covered resorts and country houses clustered along the New Jersey shore, on Long Island and in Newport, RI. Much of the firm's reputation was made in Newport, where it was responsible for the design of the Casino (1879–81) and numerous cottages for wealthy New York clients.

The period is characterized by a picturesque attitude towards form, colour and space; buildings were designed from the inside out, with the plan determining outer form, as can be seen in the Isaac Bell House (1881–3; see fig. 1), Newport. However, both spatially and in massing, the work of McKim and his partners emphasizes the movement of the occupant through grand processional spaces, usually arranged about a central axis. The spaces are clearly arranged in a hierarchical manner, which makes the firm's work stand apart from that of contemporaries. McKim led in the investigation of American 17th-century Colonial buildings, though his partners also had an interest in it. In the Queen Anne Revival, McKim perceived a wholeness of form and the germ of classicism that inspired his later work.

(ii) Consolidation period. McKim, Mead & White's second phase, the consolidation period, from the early 1880s through to the early 1890s, is marked by the increasing use of recognizable historical images and a greater visual weight to the buildings, e.g. the Romanesque Revival Ross Winans House (1882; for illustration *see* BALTIMORE). While buildings of the early period featured replicated Colonial details, such as exaggerated gooseneck pediments, the entire building was now influenced by earlier architecture. Urban buildings dominated the firm's production at this time. The nascent classicism of the early phase became more obvious, as seen in the designs for the Henry G. Villard houses (1882–5), New York City, and the Commodore William Edgar House (1884–6), Newport.

The H. A. C. Taylor House (1883–5; destr. 1952), Newport, was derived from 18th-century New England Georgian houses, while the Edgar House resembled Southern plantation architecture. The buildings are heavier and more regular, and instead of the plan determining the outer form, as Beaux-Arts theory emphasized, the plan and form were conceived as a whole. During this period the partners investigated a number of older styles, such as Colonial Revival and Italian High Renaissance (e.g. the Villard houses), as well as François I (e.g. Mrs Mary Hopkins House, 1884–6, Great Barrington, MA) and Perpendicular Gothic (e.g. St Peter's, 1886–1905, Morristown, NJ).

(iii) High classical period. From the late 1880s into the 1910s the high classical period was based on a reinterpretation of classicism. Monumentality and associations with past civilizations, seen in the Boston Public Library (1887–95; fig. 2) or Pennsylvania Station (1902–11; destr. 1963–5), New York, reflect what McKim and his partners, and the artists with whom they collaborated, saw as an American Renaissance.

In the high classical period the drive towards preestablished order became more evident, along with the

2. McKim, Mead & White: Boston Public Library, Boston, Massachusetts, 1887–95; Copley Square façade

more literal quotation of historical reference especially in ornament. The full range of classical styles, from antiquity to the Italian, French and English Renaissances, along with American architecture of the 18th and 19th centuries were seen as the only suitable choices for the USA. McKim, Mead & White perceived America as a product of the classical Renaissance and the great awakening of the 15th and 16th centuries; America was the heir of the old world. Consequently American architecture and art should be a further development of this classical impulse; they should never strive for uniqueness, as did the work of Louis Sullivan or Frank Lloyd Wright. While the French Beaux-Arts heritage is of importance, McKim, Mead & White's work is different; Harold Van Buren Magonigle (1867–1935), who had been trained at the Beaux-Arts and was also a McKim, Mead & White office member, wrote about the firm: 'The weak point of these men was their plan ... McKim was the only one to enter the Ecole des Beaux Arts, and plan never seems to have touched his consciousness' (Magonigle, p. 224) Magonigle criticized the lack of relationship between plan and elevation at the Boston Public Library, and, while the building does have a great sense of procession through different spaces, connections such as that between the stair hall and main reading room are awkwardly handled. The front elevation indicates a great two-storey palazzo and gives no indication of the tremendous third floor hall. The complexity of the interior spaces can only begin to be grasped on side elevations. Surviving correspondence and plans indicate that the outer impression of a building was always the major concern of the firm; functional considerations were suppressed or sometimes ignored for an evocative effect.

In the high classical period the picturesque effect and colour were toned down. Differences in colour abound, but lighter colours—pinks, whites, creams, tans, yellows——replaced the earlier, deeper and more earthy browns, greens, reds and greys. The Boston Public Library exemplifies this period and is a key building of late 19th-century America, its influence lasting well into the 1930s. For his design McKim was indebted to the Bibliothèque Sainte-Geneviève (1838–50) by Henri Labrouste (1801–75), Paris, though he departed from the French prototype, significantly shortening the length and number of arches of the façade and making the library a free-standing palazzo, unlike its French prototype. The Boston Library, with its calm horizontal classicism, is across from Richardson's Trinity Church (see RICHARDSON, H. H., fig. 1), with its dark colours and vertical organic picturesqueness. Details on the Library are drawn from the Tempio Malatestiano, Rimini by Leon Battista Alberti (1404–72), and Florentine palazzi, and instead of being a narrow rectangular block, as in Paris, McKim's building encloses a courtyard. The arcade of the courtyard is drawn from the Palazzo Cancelleria, Rome. Visualizing the structure as more than simply a building for housing books, McKim persuaded the Board of Trustees to commission leading artists to decorate it; among the many contributors were Pierre Puvis de Chavannes, Augustus Saint-Gaudens, Louis Saint-Gaudens (1854–1913), John Singer Sargent, Edwin Austin Abbey and Rafael Guastavino. Other buildings of this period follow the same general design development: they are classical and frequently replicate details, but as wholes they are new solutions and never imitations of other designs.

3. OFFICE ORGANIZATION. In actual methods of design the two main designing partners had different approaches. McKim was hesitant, as one office man, Henry Bacon, remembered: 'In [McKim's] sketch the idea was evident, but most indefinitely drawn; and in no stage of planning and designing did he make a definite line or contour' (Moore, p. 59). Designs controlled by McKim were constantly under revision, and in many cases substantial alterations were ordered after the building was well into construction. Later in his life he is remembered as 'designing out loud' or sitting at the draughtsman's table and calling out 'cyma recta; cyma reversa; fillet above', expecting these commands to be drawn out. In contrast, White was high-spirited, making instant decisions that frequently had to be corrected in construction, or, as Magonigle remembered, he would 'in five minutes make a dozen sketches of some arrangement of detail or plan, slam his hand down on one of them—or perhaps two or three of them if they were close together—say "Do that", and tear off again' (Magonigle, p. 117).

McKim and White thought of themselves as artists working in architecture, and they tended to run the office as a French atelier, the partners acting as studio masters with draughtsmen assigned to them. During the first decade of the partnership intense collaboration existed, but thereafter each architect tended to handle his own projects and clients, though with design suggestions from the others. Mead ran the office, and—while he made a few design contributions, such as the plan for the Rhode Island State House (1891–1904), Providence, on which McKim was the partner-in-charge—his importance lay in trying to keep the office organized and supervising construction. Inevitably an office hierarchy did exist, and, while designers were clustered around McKim and White, there were also specialists in writing specifications, ink and linen working drawings, presentation drawings and model-making. As the scale of projects grew in the later 1880s, and a shift took place from the smaller resort cottage to large commercial buildings (e.g. the New York Life Insurance Co. buildings in Omaha, NB, and Kansas City, MO; 1887–90) and university campuses (e.g. Columbia University, 1892–1901 and 1903–30, New York; see fig. 3), the role of the partners in each project did diminish, and a particular office style dominated. The size of the office fluctuated; from a handful of men it grew to over a hundred at different periods, depending on the workload. All three of the partners made substantial sums of money, but the office also acted as a studio or training ground for many American architects who went on to important careers across the country. In addition to Bacon and Magonigle, there were John Carrère, Thomas Hastings, Cass Gilbert, John Galen Howard (1864–1931), A. Page Brown (1859–96), Edward P. York (1865–1927), Philip Sawyer (1868–1949) and many others in New York and regional firms across America. After the death of White and McKim, several new partners were added, and Mead gradually withdrew from the business. The firm's name persisted until 1961; however, the last important work done in its classical style dated from the 1910s and 1920s

3. McKim, Mead & White: Low Library (1894–8), Columbia University, New York, 1892–1901 and 1903–30; from a photograph *c.* 1900

(e.g. Minneapolis Institute of Arts, 1912–14, Minneapolis, MN).

4. CRITICAL RECEPTION AND POSTHUMOUS REPUTATION. McKim, Mead & White's work was both widely accepted and understood by the public, in contrast to the general air of incomprehension that greeted the contemporary work of nascent Modernists such as Louis Sullivan or Charles Rennie Mackintosh (1868–1928). As spokesman, McKim made the firm's intentions clear, claiming that classicism was the only one universal language of architecture, and that Americans needed to go to Rome to establish 'standards within reach to stimulate our taste and inspire emulation' (Moore, p. 260). The American Renaissance mentality the firm created was two-sided: to emulate and to be nationalistic. As a belief, it played to American insecurity *vis-à-vis* Europe; America became the heir of all the great art, and indeed McKim, Mead & White inspired their clients to collect European Old Master paintings and other art objects on a grand scale. As McKim was a Bramante, his clients were Medicean princes—for example J. Pierpont Morgan, who commissioned McKim to design his library in New York (1902–6). But another side of the American Renaissance mentality was intensely nationalistic; it coincided with, and helped to celebrate, an American coming of age as a world power. The classical grandeur of the architecture clearly evoked an imperial stance to reflect the overseas colonial possessions that America gained in these years. President Teddy Roosevelt exemplified this new America, and for him McKim remodelled the interior of the White House, Washington, DC, in 1902–3. With McKim's help, the plan of Washington, DC, was redone by the McMillan Commission, and the earlier classical outline laid down by Pierre Charles L'Enfant in the 1790s (but subverted into a picturesque garden in the mid-19th century) was re-established and actually enhanced as a backdrop for great American dramas of ritual. These Classical–Renaissance connections were fully understood at the time; one critical assessment of the firm's work in 1906 asked 'Cannot a very strong case be made in favor of a conscious, persistent attempt to adopt the architecture of the Renaissance to American uses?' (Desmond and Croly, p. 226). The answer was, of course, affirmative, with dissenters such as Louis Sullivan generally ignored.

The esteem in which McKim, Mead and White were held both in their lifetimes and afterwards is remarkable. McKim received two of the highest architectural honours: the gold medal of the Royal Institute of British Architects in 1903, and the gold medal of the American Institute of Architects in 1909. Well into the 1930s McKim, Mead & White, both personally and as a firm, were frequently ranked on a level with Bramante, Wren or Mansart. They were honoured abroad, and the first monograph on the firm came in 1924 from the English architect and educator Charles H. Reilly (1874–1948), who had used their drawings as teaching aids. While their reputations did suffer some diminishment in the 1930s and afterwards, with the onset of Modernism, the quality of their work was always respected. In the 1950s they were admired exclusively for their early shingle-covered buildings, while their classical work was disparaged. By the early 1970s their reputation

began to be rehabilitated and the subsequent outpouring of scholarship by historians and literal quotation of their work by Post-modernist architects indicate a new level of appreciation.

UNPUBLISHED SOURCES

New York, Columbia U., Avery Archit. Mem. Lib. [drgs and major col. of White's pap.]

New York, Mus. City NY [firm's original glass pl. negatives of works in New York City and other bldgs]

New York, NY Hist. Soc. [major repository of firm's rec., drgs and ephemera]

Washington, DC, Lib. Congr. [McKim's personal and office corr.]

[Many individual buildings house collections covering that particular project (e.g. Boston Public Library, Newport Casino). Original materials relating to the firm's work before 1890 are scarce and seem to have been destroyed, at least in part.]

BIBLIOGRAPHY

G. W. Shelton: *Artistic Country-seats, Types of Recent American Villa and Cottage Architecture with Instances of Country Club-houses*, 2 vols (New York, 1886/R 1979)

R. Sturgis: *The Work of McKim, Mead & White*, Architectural Record Great American Architects (New York, 1895)

H. W. Desmond and H. Croly: 'The Work of Messrs. McKim, Mead & White', *Archit. Rec.*, xx (1906), pp. 153–246

A. H. Granger: *Charles Follen McKim: A Study of his Life and Work* (Boston, 1913)

A Monograph of the Works of McKim, Mead & White, 1879–1915, 4 vols (New York, 1915–20/R 1985); abridged student's edn, 2 vols (New York, 1925/R 1981) [illus. only, no text], repr as *The Architecture of McKim, Mead & White*, 1 vol. (New York, 1990)

C. Reilly: *McKim, Mead & White* (London, 1924)

C. Moore: *The Life and Times of Charles Follen McKim* (New York, 1929/R 1970)

C. Baldwin: *Stanford White* (New York, 1931/R 1971)

H. V. B. Magonigle: 'A Half Century of Architecture', *Pencil Points*, xv (1934), pp. 115–18, 223–6

V. J. Scully jr: *The Shingle Style* (New Haven, 1955/R 1971)

L. Roth: *The Architecture of McKim, Mead & White, 1870–1920; A Building List* (New York and London, 1978)

R. G. Wilson, D. Pilgrim and R. Murray: *The American Renaissance, 1876–1917* (New York, 1979)

R. G. Wilson: 'The Early Work of Charles F. McKim: Country House Commissions', *Winterthur Port.*, xiv (1979), pp. 235–67

L. Roth: *McKim, Mead & White, Architects* (New York, 1983)

R. G. Wilson: *McKim, Mead & White, Architects* (New York, 1983)

P. R. Baker: *Stanny: The Gilded Life of Stanford White* (New York, 1989)

D. Garrard Lowe: *Stanford White's New York* (New York, 1992)

S. G. White: *The Houses of McKim, Mead & White* (New York, 1998)

RICHARD GUY WILSON

MacMonnies, Frederick William (*b* Brooklyn, NY, 28 Sept 1863; *d* New York, 22 March 1937). American sculptor and painter. During his apprenticeship in New York (1880–84) with Augustus Saint-Gaudens, who discovered and encouraged his talent, he rose from menial helper to assistant, studying in the evenings at Cooper Union and the National Academy of Design. Through Saint-Gaudens he met two architects who later became invaluable colleagues: Stanford White and Charles F. McKim, who lent him money in 1884 to go to Paris. He studied drawing at Colarossi's then went to Munich, attending drawing and portrait classes at the Akademie (1884–5) and worked for Saint-Gaudens again (1885–6). In Paris he studied sculpture with Alexandre Falguière (1831–1900) at the Ecole des Beaux-Arts, winning the Prix d'atelier in 1887 and 1888, worked in the studio of Antonin Mercié (1845–1916), became Falguière's assistant and won honourable mention at the Salon of 1889 with a life-size *Diana* (plaster; untraced) modelled in Falguière's fluid manner.

Success brought MacMonnies American commissions and the independence to open his own studio. He created his first fanciful life-size fountain figures for country estates, *Pan of Rohallion* (1890; Asadur Azapian priv. col., on loan New York, Met.) and *Young Faun with Heron* (1890; Stockbridge, MA, 'Naumkeag', Trustees of Reservations). These buoyant mythological creatures with vibrant surfaces in the Art Nouveau style introduced fountain sculpture as a new genre in America and inspired a whole generation of sculptors, many of whom were his students. From 1890 MacMonnies had a lucrative bronze production of these and more serious works in bronze statuettes of varying sizes, employing studio assistants and several French and American foundries. In 1891 he was the first American to be awarded a second-class medal at the Paris Salon. Of his two entries, the straightforward naturalism of his over life-size *James S. T. Stranahan* (bronze, 1891; Brooklyn, NY, Prospect Park) won popular approval and the monumental *Nathan Hale* (bronze, 1891; New York, City Hall Park), although criticized for its lack of finish and for being 'too picturesque', achieved lasting success as a new expression of dramatic, uplifting sculpture. The plastic quality animating the Impressionist surface of this imaginary portrait heightens the emotion of the hero's last moment.

MacMonnies had great success at the World's Columbian Exposition of 1893 in Chicago with the 39-figure ensemble, Columbian Fountain, including the central group, *Barge of State* (destr.), a colossal temporary fountain made of staff (plaster and straw). This allegorical set-piece of Beaux-Arts bravura became an icon of the American Renaissance. Equally renowned, his bronze, over life-size *Bacchante and Infant Faun* (1893; New York, Met.; see colour pl. XXVII, 1), unveiled in 1896 at the Boston Public Library (*see* MCKIM, MEAD & WHITE, fig. 2), scandalized Bostonians and had to be removed. When McKim presented it to the Metropolitan Museum of Art, New York, the realistic female nude attracted widespread attention. In the late 1890s MacMonnies returned to painting and subsequently alternated between the two media. Like his close friend James McNeill Whistler and the Impressionists, he admired the work of Diego Velázquez (1599–1660), whose paintings he copied at the Prado in Madrid in 1904. MacMonnies taught drawing with Whistler at the Académie Carmen and for almost two decades was a popular teacher of American artists in Paris and at his Giverny estate. His *Self-portrait with Lilac Boutonnière* (1898–1903; Washington, DC, N.P.G.) owes much to Velázquez, and his full-length portrait of *May Palmer* (1901–2; Bennington, VT, Mus.) displays a skill ranking with major contemporary portrait painters like his friend John Singer Sargent and Giovanni Boldini (1842–1931).

MacMonnies's most ambitious public monuments in the ten years following 1893 were for Prospect Park in Brooklyn, NY. The *Quadriga* and *Army* and *Navy* groups for the Soldiers' and Sailors' Memorial Arch (1898–1901; *in situ*) typify nationalistic outpourings in full-blown Beaux-Arts style. His uniquely eclectic French style merged neo-Baroque with Art Nouveau whiplash curves in the

heroic bronze gatepost groups *Horse Tamers* (1898; *in situ*) for which MacMonnies was awarded a grand prize at the Exposition Universelle of 1900 in Paris. These near-mirror pairs of a mounted rider restraining another rearing horse were intended to represent man's mind pitted against brute force. He modelled them from live prancing horses at his Paris and Giverny studios. He used this technique for the bronze equestrian statues of *General Henry W. Slocum* (1902; Brooklyn, NY, Grand Army Plaza) and *Major George B. McClellan* (1906; Washington, DC, Connecticut Avenue), made for a Congressional commission initiated by Civil War veterans. The historical details of dress and regalia were carefully researched, a hallmark of his sculpture.

MacMonnies's work never reflected modernist currents, despite his shift to direct carving in marble and the later influence of Auguste Rodin. On his return to New York at the end of 1915, he made another controversial work, *Civic Virtue* (1909–22), an over life-size marble male nude with two mermaid 'Vices' writhing at his feet. Public indignation forced its removal from City Hall Park, New York, to a plaza flanking Queens Borough Hall, New York. His last and most colossal monument was the 22 m high Marne Battle Memorial (or *Monument américain*) (1916–32; Meaux), the American nation's gift to France in return for the *Statue of Liberty* (New York Harbor). The output of his years in New York included several dozen portrait busts in bronze, marble and oils. His first wife, Mary Fairchild MacMonnies Low (1858–1946), was a painter.

BIBLIOGRAPHY

L. Taft: *The History of American Sculpture* (New York, 1903, rev. 1923); new edn by A. Adams with suppl. chap. (New York, 1930), pp. 332–55, 545–6, 587

D. M. Lockman: 'Interviews with Frederick MacMonnies, N. A.' (29 Jan and 16 Feb 1927), *DeWitt M. Lockman Collection of Interviews with American Artists* (New York, NY Hist. Soc.; microfilm, Washington, DC, Smithsonian Inst., Archv Amer. A.)

W. Craven: *Sculpture in America* (New York, 1968, rev. 1984), pp. 422–8

R. J. Clark: 'Frederick MacMonnies and the Princeton Battle Monument', *Rec. Mus. Princeton U.*, xliii/2 (1984) [good essays and excellent bibliog. and pls on Monument]

Frederick William MacMonnies and Mary Fairchild MacMonnies: Two American Artists at Giverny (exh. cat. by E. A. Gordon, cat. notes by S. Fourny-Dargère, Vernon, Mus. Mun. Poulain, 1988) [essays in Fr. and Eng. on painting and sculp.]

E. A. Gordon: 'Catalogue Raisonné of Sculpture and Checklist of Paintings', in M. Smart: *A Flight with Fame: The Life and Art of Frederick MacMonnies, 1863–1937* (Madison, CT, 1996) [biog., comprehensive cat. of all works, excellent pls]

—— *The Sculpture of Frederick William MacMonnies: A Critical Catalogue* (diss., New York U., 1998; microfilm, Ann Arbor, 1998) [essential documented resource on all sculp., historical context, crit. assessment of past literature with concordances, relations with Saint-Gaudens, White, Thomas Hastings and others]

ETHELYN ADINA GORDON

Maginnis, Charles D(onagh) (*b* Londonderry, 7 Jan 1867; *d* Boston, MA, 15 Feb 1955). American architect and writer. He moved to the USA from Ireland at the age of 18. After an apprenticeship to Edmund M. Wheelwright in Boston, he established his own office, also in Boston, at about the turn of the century with Timothy Walsh (1868–1934). Among the Boston Gothicists headed by Ralph Adams Cram, Henry Vaughan (1846–1917) and Bertram Grosvenor Goodhue, Maginnis quickly established himself as a leader, best known for the magnificent Gothic Revival buildings of Boston College (begun 1909), for which the firm earned an American Institute of Architects Gold Medal. Like Cram, Maginnis's work was eclectic and included the Spanish-style Carmelite Convent (*c.* 1915), Santa Clara, CA, and the regal Classical Revival chapel of Trinity College (*c.* 1920), Washington, DC, as well as a number of churches in the Lombard style, for which he had a special affinity. The best of these is St Catherine's (1907), Spring Hill, Somerville, near Boston, MA. Important interior work by Maginnis in churches designed by others includes the high altar and baldacchino of St Patrick's Cathedral, New York. (Maginnis, who served as President of the American Institute of Architects, was given the institute's highest award, the Gold Medal, in 1948).

BIBLIOGRAPHY

S. Baxter: 'The Works of Maginnis and Walsh', *Archit. Rec.*, liii (1923), pp. 93–115

R. Walsh and A. Roberts, eds: *Maginnis, Charles Donagh: A Selection of his Essays and Addresses* (New Haven, 1956)

DOUGLASS SHAND-TUCCI

Maher, George W(ashington) (*b* Mill Creek, WV, 25 Dec 1864; *d* Douglas, MI, 12 Sept 1926). American architect. He began his architectural training in 1878 in Chicago with the firm of Bauer & Hill and later joined the office of J. L. Silsbee (1845–1913), where he met George Elmslie and Frank Lloyd Wright. In 1888 he went into private practice with Charles Corwin; the partnership broke up in 1893 when Maher began a year of travel and study in Europe. On his return, he established an independent practice in Chicago. His search for a modern, non-historic style led to the John Farson House in Oak Park, IL (1897). Its monumentality, formal symmetry, broad simple surfaces, rich materials and vaguely classical details are all hallmarks of Maher's personal style, to which he would return throughout his career. Except for the period 1904–8, when he responded to the Austrian and English movements, in particular the work of J. M. Olbrich (1867–1908) and C. F. A. Voysey (1857–1941), Maher's work shows little internal development.

BIBLIOGRAPHY

'Geo. W. Maher, a Democrat in Architecture', *W. Architect*, xx/3 (1914), pp. 25–9

J. W. Rudd: 'George W. Maher', *Prairie Sch. Rev.* i/1 (1964), pp. 5–10

H. A. Brooks: *The Prairie School* (Toronto, 1972)

M. C. Sies: 'George W. Maher's Planning and Architecture in Kenilworth, Illinois: An Inquiry into the Ideology of Arts and Crafts Design', *Substance of Style: Perspectives on the American Arts and Crafts Movement*, ed. B. Denker (Hanover, NH, and London, 1996), pp. 415–45

PAUL KRUTY

Malbone, Edward Greene (*b* Newport, RI, Aug 1777; *d* Savannah, GA, 7 May 1807). American miniature painter. Like his boyhood friend Washington Allston, he was encouraged in his artistic pursuits by Samuel King, who lent him engravings to study. In autumn 1794 Malbone set himself up as a miniature painter in Providence, RI, where he worked for two years, achieving almost immediate success. His earliest miniatures, such as that supposedly of *Nicholas Brown* (1794; New York, NY Hist. Soc.), although somewhat primitive, demonstrate his precosity. The sitters' faces are modelled with a stippling technique and chiselled planes; their outlines are distinct and crisp.

These first compositions all include a conventional portrait background, usually a red curtain pulled back to reveal a blue sky. Despite the laboured technique, they are lively, direct and sensitive. During the second half of the 1790s Malbone travelled the eastern USA in search of commissions. He renewed his friendship with Allston in Boston and later visited New York and Philadelphia. In 1801 he was in Charleston, SC, where he befriended the miniature painter Charles Fraser, on whose work he had a strong influence. He developed a brilliant technique of delicate, barely perceptible crosshatching, using interwoven lines of pale colours to create graceful forms. His brushstroke became freer and more assured, and thin washes of light colour made the image softer and gave his work a luminous quality. In general he focused more closely on the subject.

In May 1801 Malbone and Allston sailed for London, where his portrait of Allston (Boston, MA, Mus. F.A.; see fig.) particularly impressed Benjamin West. Unlike Allston, who preferred the work of earlier masters, Malbone was attracted to the paintings of Sir Thomas Lawrence (1769–1830). He also liked the miniatures of Samuel Shelley (1750–1808) and made a copy of the *Hours* (178 mm×152 mm; Providence, RI, Athenaeum), his largest miniature. Malbone remained in England for about six months. In his subsequent work his delicate brushstrokes became freer and slightly broader, with smoother transitions from one area of paint to another. His backgrounds, in which he now preferred a sky and clouds, were generally lighter. The overall size of the ivory support that Malbone used became larger, measuring up to 85×70 mm, and was generally an oval. Occasionally, towards the end of his

Edward Greene Malbone: *Washington Allston*, watercolour, 98×70 mm, *c.* 1801 (Boston, MA, Museum of Fine Arts)

career, he produced rectangular formats. He usually received $50 for each commission. About one fifth of his works are signed, more frequently his early ones, and in a variety of ways: *Malbone*, *EG Malbone*, EGM or EM, inconspicuously on the ivory. Sometimes he inscribed the backing card. His return to Charleston in December 1801 marked the beginning of his most prolific period. During the next five months his account-book shows that he averaged three miniatures a week. By 1805 he had contracted tuberculosis and by March 1806 had all but ceased painting.

BIBLIOGRAPHY

J. L. Brockway: 'Malbone: American Miniature Painter', *Amer. Mag. A.*, xx (1929), pp. 185–91
Catalogue of Miniatures and Other Works by Edward Greene Malbone, 1777–1807 (exh. cat., Washington, DC, N.G.A., 1929)
R. P. Tolman: *The Life and Works of Edward Greene Malbone, 1777–1807* (New York, 1958) [definitive study]
M. S. Sadik: 'Edward Greene Malbone (1777–1807)', *Colonial and Federal Portraits at Bowdoin College* (Brunswick, ME, 1966), pp. 123–30
J. P. Harding: 'Edward Greene Malbone's Portraits of Colonel William and Catherine Scollay: Two Recently Found Miniatures', *Amer. A. J.*, xxi/1 (1989), pp. 13–17

DALE T. JOHNSON

Mangin, Joseph François (*fl* 1794–1818). French architect, active in the USA. He had already been trained in France when he arrived in 1794 in the USA, where he joined his brother, Charles Mangin, in New York. For several years he served as an engineering adviser for the city fortifications, and in 1796 he became a city surveyor. With his brother he designed the Park Theater (1795–9) and independently the New York State Prison (1797). Mangin collaborated in 1802 with JOHN McCOMB jr in the winning submission for the New York City Hall (see fig., which is his only surviving building in the USA. It is probable that the French Neo-classical character of the winning design was largely Mangin's, although the construction (1803–12) was supervised by McComb, who introduced more English-derived details in the interior. After New York City Hall, Mangin independently designed an early building for St Patrick's Cathedral (1809–15) and the Wall Street Presbyterian Church (1810), both in New York.

BIBLIOGRAPHY

DAB; *Macmillan Enc. Archit.*
'Joseph François Mangin': *National Cyclopedia of American Biography* (New York, 1936), xxv, pp. 289–90
T. F. Hamlin: *Greek Revival Architecture in America* (New York and Oxford, 1944)
D. Stillman: *Artistry and Skill in the Architecture of John McComb, jr* (diss., Newark, U. DE, 1956)
——: 'New York City Hall: Competition and Execution', *J. Soc. Archit. Historians*, xxiii (1964), pp. 129–42

LELAND M. ROTH

Mann, George R. *See under* ECKEL & MANN.

Mare, John (*b* New York, 1739; *d* Edenton, NC, after June 1802–before April 1803). American painter. Little is known of his artistic training, although his portraits have the same terse and stiff qualities associated with the painter Thomas McIlworth. After 1759 Mare is recorded in Albany, NY. His earliest surviving portrait is that of *Henry Livingston* (priv. col.), signed and dated 1760. In 1766 he was commissioned by the Common Council of New York

Joseph François Mangin and John McComb jr: New York City Hall, 1803–12

to execute a portrait of *George III* (destr.). His two most engaging portraits are those of *Jeremiah Platt* (New York, Met.) and *John Keteltas* (New York, NY Hist. Soc.), both painted in 1767. His best work can be distinguished by his devotion to details: the lovingly rendered Chippendale chair in *Jeremiah Platt* or the *trompe l'oeil* house-fly poised on John Keteltas's wristband. Fewer than a dozen portraits by Mare survive. Lack of success may have contributed to his departure for Albany once again in 1772. He painted his last surviving portrait, *Dr Benjamin Youngs Prime* (New York, NY Hist. Soc.), in New York in 1782 and within four years had moved to Edenton, NC, where he abandoned painting for business.

BIBLIOGRAPHY

H. B. Smith: 'John Mare (1739–*c.* 1795), New York Portrait Painter, with Note on the Two William Williams', *NY Hist. Soc. Q.*, xxxv (1951), pp. 355–99
H. B. Smith and E. V. Morris: 'John Mare: A Composite Portrait', *NC Hist. Rev.*, xliv (1967), pp. 18–52
H. B. Smith: 'A Portrait by John Mare Identified: *Uncle Jeremiah*', *Antiques*, ciii (1973), pp. 1185–7

RICHARD H. SAUNDERS

Marin, John (*b* Rutherford, NJ, 23 Dec 1870; *d* Cape Split, ME, 1 Oct 1953). American painter and printmaker. He attended Stevens Institute in Hoboken, NJ, and worked briefly as an architect before studying at the Pennsylvania Academy of the Fine Arts in Philadelphia from 1899 to 1901 under Thomas Pollock Anshutz and Hugh Breckenridge (1870–1937). His education was supplemented by five years of travel in Europe where he was exposed to avant-garde trends. While abroad, he made etchings of notable and picturesque sites, for example *Campanile, S Pietro, Venice* (1907; see Zigrosser, no. 57), which were the first works he sold.

Marin returned permanently to the USA in 1911, settling in New York and devoting the rest of his long career to painting views of the city and country. His art initially reflected the impact of Impressionism and Post-Impressionism. During the next decade he first moved towards a modernist artistic statement, seen in his views of New York and nearby Weehawkin, New Jersey. The *Weehawkin* series (watercolour, 1910; New York, Met.) reveals a Fauvist handling and choice of colour, and an abstract sense of design, while the New York images demonstrate the artist's willingness to fragment and distort a scene for expressive purposes. Marin was one of the first artists to convey the 20th-century city in modern pictorial terms: in works such as *Brooklyn Bridge* (watercolour, *c.* 1912; New York, Met.) the urban landscape seems to erupt; buildings and streets break apart, heaving under the pressure of the frenetic pace and congestion of city life.

Marin was one of the few early American modernists who received substantial attention and critical praise throughout most of his career. Upon his return from abroad, he became a member of the avant-garde circle centred around Alfred Stieglitz, and his work was shown on a regular basis at Stieglitz's galleries from 1909.

PUBLISHED WRITINGS
H. J. Seligman, ed.: *Letters of John Marin* (New York, 1931)
D. Norman, ed.: *The Selected Writings of John Marin* (New York, 1949)
C. Gray, ed.: *John Marin by John Marin* (New York, 1977)

BIBLIOGRAPHY
John Marin (exh. cat., essays by H. McBride, M. Hartley and E. M. Benson, New York, MOMA, 1936/*R* 1966)
M. Helm: *John Marin* (Boston, 1948)
C. Zigrosser: *The Complete Etchings of John Marin: Catalogue Raisonné* (Philadelphia, 1969)
S. Reich: *John Marin: A Stylistic Analysis and Catalogue Raisonné*, 2 vols (Tucson, 1970)

John Marin: 1870–1953 (exh. cat. by L. Curry, Los Angeles, CA, Co. Mus. A., 1971)

ILENE SUSAN FORT

Marquand, Henry G(urdon) (*b* New York, 11 April 1819; *d* New York, 26 Feb 1902). American businessman, philanthropist and collector. Born into a family of silversmiths, he first worked in real estate in New York and then moved into banking and investment. In 1874, together with his brother Frederick and other investors, he purchased the St Louis, Iron Mountain & Southern Railroad; from 1875 to 1881 he served as its vice-president and in 1881 as president, and he continued to serve as director of this railroad and its later parent organization, the Missouri Pacific, until his death.

Marquand was a member of the original group of 50 prominent New Yorkers who met in 1869 to plan the organization of the Metropolitan Museum of Art and to raise an endowment. After he had retired in 1881, he was able to devote his energies to civic activities, primarily to the successful development of the Metropolitan. From 1882 to 1889 he served as its treasurer, and from 1889 until his death as president. In 1886 he gave the Metropolitan $10,000 for the purchase of a collection of sculptural casts and $30,000 for the endowment of a museum art school. He continued his benefactions by enabling the Museum to purchase for $15,000 from Jules Charvet the Charvet Collection of antique glass and by obtaining for the institution reproductions of medieval carvings, Renaissance ironworks, metal reproductions of gold and silver objects in the Imperial Russian Museum, and English and Old Master paintings; these gifts elicited the comment from Russell Sturgis that Marquand 'bought like an Italian Prince of the Renaissance' (Kirby, preface).

The 50 paintings given by Marquand between 1888 and his death contributed to establishing the Metropolitan as one of the most important museums in the world. The collection includes four works by Rembrandt (1606–69), two by Anthony van Dyck (1599–1641), three by Peter Paul Rubens (1577–1640), two by Jan van Eyck (*c.* 1395–1441), four by Frans Hals (1581/5–1666) and the *Young Woman with a Water Jug* by Johannes Vermeer (1632–75), as well as paintings by Diego Velázquez (1599–1660), Gabriel Metsu (1629–69), Gerard ter Borch II (1617–81), Francisco de Zurbarán (1598–1664), Thomas Gainsborough (1727–88) and William Hogarth (1697–1764), among others. Tompkins suggested that Marquand's 'eye for quality may even have influenced the future trend of collecting in America' (p. 74). These works, which represent Marquand's interest in helping the Metropolitan create a historically representative collection, were never hung in Marquand's home, having gone directly from Europe to the museum. Marquand's private collection emphasized contemporary works, including a large number of French Salon paintings, which may have been intended for the museum but were later sold at auction. His richly furnished and artistically decorated home received great public attention, for it boasted a Grecian drawing-room, a Moorish smoking-room and a Japanese morning-room.

UNPUBLISHED SOURCES

Washington, DC, Smithsonian Inst., Archvs Amer. A. [clippings in the Florence N. Levy col.]

BIBLIOGRAPHY
DAB
Twelfth Annual Report of the Trustees of the Association of the Metropolitan Museum (New York, 1882), pp. 215–16
Pictures by Old Masters: The Henry G. Marquand Collection of Old Masters and Pictures of the English School in Gallery No. 6, New York, Met. cat. (New York, 1896)
T. E. Kirby, ed.: *Illustrated Catalogue of the Art and Literary Property Collected by the Late Henry G. Marquand* (New York, 1903)
The Marquand Residence (New York, [?1905])
L. Lerman: *The Museum: One Hundred Years and the Metropolitan Museum of Art* (New York, 1969)
C. Tompkins: *Merchants and Masterpieces: The Story of the Metropolitan Museum of Art* (New York, 1970)
E. McFadden: *The Glitter and the Gold* (New York, 1971)
D. O. Kisluk-Grosheide: 'The Marquand Mansion, New York', *Met. Mus. J.*, xxix (1994), pp. 151–81

LILLIAN B. MILLER

Martin, Edgar. *See under* SCHMIDT, GARDEN & MARTIN.

Martin, Homer Dodge (*b* Albany, NY, 28 Oct 1836; *d* St Paul, MN, 12 Feb 1897). American painter. He was largely self-taught, although he studied briefly with James MacDougal Hart and was encouraged by Erastus Dow Palmer. He specialized in scenes of Lake George, Lake Ontario and the Adirondacks in New York State. These are depictions of the wilderness, exclusive of figures, in the realistic manner of the Hudson River school, for example *Upper Ausable Lake* (1868; Washington, DC, N. Mus. Amer. A.; see fig.). There are preliminary pencil sketches for several early oil paintings.

After 1876, when Martin first visited England and became casually acquainted with Whistler, his painting style became looser and more preoccupied with colour. It was at this time that he started working in watercolour. In the early 1880s he spent four years in France, settling in the Normandy coast near Trouville. In 1886 Martin returned to America, where he painted French, Adirondack and Newport landscapes from memory as his eyesight was failing. His work was exhibited at the Chicago Columbian Exposition of 1893. His best landscapes are the *Harp of the Winds* (1895; New York, Met.) and *Adirondack Scenery* (1895; New York, priv. col., see Mandel, 1973, *Archv Amer. A. J.*, fig. 3).

BIBLIOGRAPHY
E. G. D. Martin: *Homer Martin: A Reminiscence* (New York, 1904)
F. J. Mather jr: *Homer Martin: Poet in Landscape* (New York, 1912)
D. H. Carroll: *Fifty-eight Paintings by Homer D. Martin* (New York, 1913)
P. C. F. Mandel: *Homer Dodge Martin: American Landscape Painter, 1836–1897* (diss., New York U., 1973)
——: 'The Stories behind Three Important Late Homer D. Martin Paintings', *Archv Amer. A. J.*, xiii/3 (1973), pp. 2–8

PATRICIA C. F. MANDEL

Martinez, Xavier [Javier Timoteo Martinez y Orozco] (*b* Guadalajara, Mexico, 7 Feb 1869; *d* Carmel, CA, 13 Jan 1943). American painter and printmaker of Mexican birth. At a young age he began sketching and painting in watercolour and attended art classes at the Liceo de Varones in his native Guadalajara; later he studied pre-Columbian excavations and designs, taking special interest in his own Tarascan Indian heritage. His mother died in 1886, and he was taken under the wing of (and possibly adopted by) the socially prominent Rosalia La Bastida de Coney. After her husband, Alexander K. Coney, became Mexican Consul–General in San Francisco in 1892, Mar-

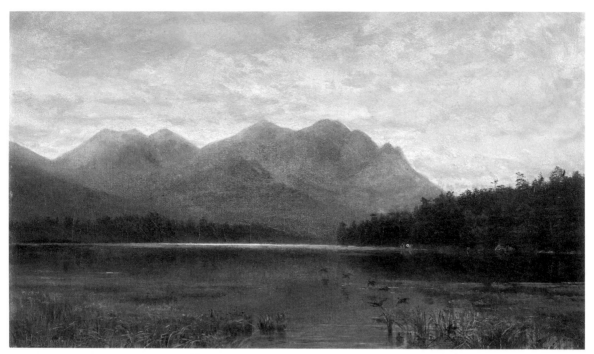

Homer Dodge Martin: *Upper Ausable Lake*, oil on canvas, 470×768 mm, 1868 (Washington, DC, National Museum of American Art)

tinez joined them and in 1893 enrolled at the Mark Hopkins Institute of Art, where he studied under Arthur F. Mathews. Although he was handicapped at first by his limited English, he was a gifted and favoured pupil, who by the time he graduated in 1897 had won the school's highest honours and been appointed assistant to Mathews, by then the school's director.

Martinez travelled to Paris in the autumn of 1897 and spent three years in the atelier of Jean-Léon Gérome (1824–1904) in the Ecole des Beaux-Arts; a shorter period of study (1900–01) under Eugène Carrière (1849–1906) and exposure to the art of James McNeill Whistler seem to have had more impact on Martinez's style, reinforcing the Tonalist tendencies that he had already absorbed under the tutelage of Mathews. For example, *Afternoon in Piedmont* (*c*. 1911; Oakland, CA, Mus.), a later portrait of Martinez's wife, Elsie Whitaker, seated beside a window, echoes Whistler's famous portrait of his mother (1871; Paris, Louvre), while the curtain treatment recalls Carrière's atmospheric veils of pigment. Martinez's stay in Europe also included visits to Spain and Italy, where he especially admired the work of Goya (1746–1828), Velázquez (1599–1660), El Greco (*c*. 1541–1614) and Giotto (1267/75–1337).

In 1901 Martinez returned to San Francisco, where his studio attracted a convivial group of bohemian poets and artists. He was himself a colourful figure, renowned for his rumpled, but dandyish appearance: his typical attire included a velvet or corduroy suit, a flowing red tie and a brightly coloured sash. He changed his middle name to Tizoc to emphasize the Indian part of his ancestry. Following the San Francisco earthquake and fire of 1906, he moved across the Bay to Piedmont, where he married Elsie, built a studio-home and began painting local land-

scapes *en plein air*. His hilltop studio became the site of regular Sunday dinners, famous for their abundant amounts of wine, spaghetti and conversation. He joined the faculty of the newly formed California School (later College) of Arts and Crafts in Oakland in 1909 (a position he held until 1942). Under its auspices, he frequently taught summer classes in Monterey, where he had helped establish the Del Monte Art Gallery. He was also a founder—member of the California Society of Etchers and worked in monotype as well as etching.

Known for his low-keyed landscapes of the Oakland and Piedmont hills, Martinez also painted urban genre scenes and Indian subjects drawn from his travels in Mexico and the American Southwest (e.g. a two-month stay on the Hopi Reservation in 1913). Often he painted twilight or night scenes in broadly brushed strokes of somber greens, ochres, greys and browns. Like Whistler, he signed his works with a monogram, hand-painted or impressed with a Chinese stone stamp. There are also strong traces of French Barbizon influence in his paintings of figures working the land. His academic training is reflected in his mastery of human forms and faces and in his lack of interest in Impressionism.

BIBLIOGRAPHY
'Xavier Martinez . . . Biography and Works', *California Art Research*, ed. G. Hailey (San Francisco, 1936–7), x, pp. 35–60
W. Unna: *The Coppa Murals: A Pageant of Bohemian Life in San Francisco at the Turn of the Century* (San Francisco, 1952)
Xavier Martinez (exh. cat. by G. W. Neubert, Oakland, CA, Mus., 1974)
J.B. Dominik: 'Xavier Martinez (1869–1943)', *Plein-air Painters of California: The North*, ed. R.L. Westphal (Irvine, CA, 1986), pp. 98–103
ANN HARLOW and SALLY MILLS

Mason. American family of architects. George C(hamplin) Mason sr (*b* Newport, RI, 17 July 1820; *d* Philadelphia,

PA, 31 Jan 1894) set up practice in Newport in 1858 and was the city's leading architect in the 1860s and 1870s. His son, George C(hamplin) Mason jr (*b* Newport, 8 Aug 1850; *d* Ardmore, PA, 22 April 1924), became his partner in 1871 after a varied career as a merchant, artist, journalist and estate agent; he was a prolific writer, publishing primarily on Newport topics. The Masons were part of a well-established Newport family, a situation that assisted them in setting up their architectural practice. George C. Mason sr's work was largely residential. The August Belmont Summer House (begun 1860; destr.), Bythesea, RI, was a typical example: a large and unprepossessing, hip-roofed clapboard structure with a cross-gabled pavilion accenting the symmetrical, three-bay entrance front.

With the emergence of the younger Mason as chief designer, the firm's designs became more ambitious. The earliest commission ascribed to him, the Thomas Cushing House (1869–70), Newport, is an elaborate essay in the STICK STYLE. Mason jr studied American Colonial architecture and published many books on the subject. He designed the earliest Colonial Revival house in the USA, the Frederick Sheldon residence (1871–2; destr.), Newport, and he was the first American architect to achieve prominence for his restoration projects. His best-known work was his restoration from 1895 to 1913 of Independence Hall (1731–53), Philadelphia.

WRITINGS

G. C. Mason sr
Newport and its Environs (Newport, 1848)
The Application of Art to Manufactures (New York, 1858)
Newport and its Cottages (Boston, 1875) [contains fine heliotype photographs of many Mason buildings]
The Old House Altered (New York, 1878)

G. C. Mason jr
'An American Country House', *Bldg & Engin. J.*, xxxix/1070 (1875), p. 36
'The Old Stone Mill at Newport', *Mag. Amer. Hist.*, iii/9 (1879), pp. 541–9
Thoughts on Architecture, its Literature and Practice (Newport, 1879)
'Colonial Architecture', *Amer. Archit. & Bldg News*, x/294 (1881), pp. 71–4; x/295 (1881), pp. 83–5
Architects and their Environment (Philadelphia, 1907)

BIBLIOGRAPHY
A. F. Downing and V. J. Scully jr. *Architectural Heritage of Newport, Rhode Island* (Cambridge, MA, 1952, rev. 2/New York, 1967)
D. Chase: 'Mason, George Champlin, Sr.' and 'Mason, George Champlin, Jr.', *Buildings on Paper: Rhode Island Architectural Drawings* (exh. cat., ed. W. Jordy and C. Monkhouse; Providence, RI, Brown U., Bell Gal.; Providence, RI Hist. Soc.; Providence, RI Sch. Des., Mus. A.; New York, Nat. Acad. Des.; 1982), pp. 222–4

DAVID CHASE

Mathews, Arthur F(rancis) (*b* Markesan, WI, 1 Oct 1860; *d* San Francisco, CA, 19 Feb 1945). American painter, designer and teacher. First trained by his architect father, he worked as a freelance illustrator before deciding in 1885 to study painting in Paris. He spent about 15 months at the Académie Julian and exhibited at three Salons before returning to California in 1889. He soon began teaching at the California School of Design (now the San Francisco Art Institute) and in 1896 was promoted to Director. During his 16-year tenure, Mathews reformed the curriculum in line with academic practice in Paris and New York and exerted a powerful influence over hundreds of students. Following the 1906 San Francisco earthquake and fire, Mathews left the school, aligning himself with artists, architects and businessmen eager to rebuild San Francisco. With his wife (and former student), Lucia Kleinhans Mathews (1870–1955), and a partner, John Zeile, he embarked on several ventures: the magazine *Philopolis* (1906–16) emphasized art and city planning; the Philopolis Press (1907–18) published poetry and essays; and the Furniture Shop (?1908–1920) produced decorative furnishings for local businesses and individuals. Their designs for these enterprises included page layouts, furniture (see fig.), decorative objects and picture frames, with motifs drawn from California's landscape, wildflowers and harvest.

While Lucia produced mainly works on paper (e.g. *Portrait of a Red-haired Girl*, 1910; Oakland, CA, Mus.) and designs for *Philopolis* and the Furniture Shop, Arthur also painted easel pictures and mural decorations and wrote articles for the magazine. His early style was coloured strongly by his academic training (e.g. *The Lilies of Midas*, 1888; San Francisco, CA, F.A. Museums), but after 1900 his style shifted to embrace low tonal values and flat decorative patterns (e.g. *Cypress Grove*, 1903; Oakland, CA, Mus.), reflecting his experience as a muralist and admiration of James McNeill Whistler and Pierre Puvis de Chavannes (1824–98). In his paintings, Mathews created idyllic worlds, often pure landscapes, or scenes of women dressed in flowing robes, reading or dancing outdoors. His murals generally envision harmonious progress from nature to civilization. His most elaborate, The *Story of California* (1913-14; Sacramento, CA, State Capitol), ex-

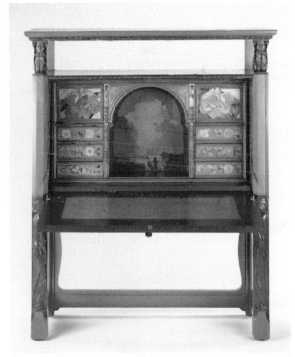

Arthur F. Mathews and Lucia Kleinhans Mathews: desk, carved and painted ?maple, oak, tooled leather and (replaced) hardware, 1499× 1219×508 mm, from the Furniture Shop, San Francisco, California, *c.* 1910–15 (Oakland, CA, Oakland Museum)

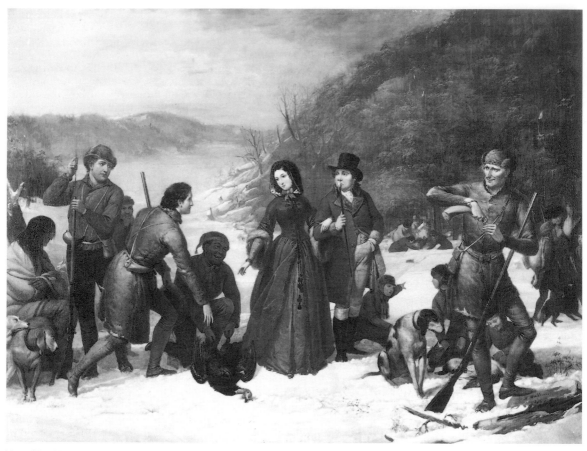

Tompkins Harrison Matteson: *Turkey Shoot*, oil on canvas, 943×1255 mm, 1857 (Cooperstown, NY, Museum of the New York State Historical Association)

presses state history in four triptychs, moving from the landing of the Spanish fleet through the mission and Gold Rush eras, culminating in a classically conceived 'Dream City of Beauty and Justice'.

BIBLIOGRAPHY
'Arthur Mathews . . . Biography and Works', *California Art Research*, ed. G. Hailey (San Francisco, 1936–7), vii, pp. 1–29
Mathews: Masterpieces of the California Decorative Style (exh. cat. by H. L. Jones, Oakland, CA, Mus., 1972/*R* 1980, 1985)
The Arts and Crafts Movement in California: Living the Good Life (exh. cat. by K. R. Trapp and others, Oakland, CA, Mus., 1993), pp. 136–40
S. McCoy: *Brilliance in the Shadows: A Biography of Lucia Kleinhans Mathews* (Berkeley, 1998)

SALLY MILLS

Matteson, Tompkins Harrison (*b* Peterborough, NY, 9 May 1813; *d* Sherburne, NY, 2 Feb 1884). American painter. He lived most of his life in Sherburne, with the exception of the years 1841 to 1850, which he spent in New York, and is known primarily for his genre and historical paintings. A good draughtsman, he painted popular motifs from Colonial and Revolutionary history, and many of his domestic scenes were engraved for women's magazines, especially those with sentimental themes, such as *Taking the Advantage* (a courtship scene) and *The Doctor*. Two of his later works are typical of popular rural genre themes: *Justice's Court in the Backwoods* (1850; Cooperstown, NY, Mus. State Hist. Assoc.), in which the local postmaster–shoemaker is hearing a trial; and the *Turkey Shoot* (1857; Cooperstown, NY, Mus. State Hist. Assoc.; see fig.), taken from James Fenimore Cooper's best-selling novel, *The Pioneers*. Matteson preferred to live in the country at Sherburne, where he brought up a large family and was active in local affairs and politics.

See also colour pl. XIV, 1.

BIBLIOGRAPHY
A. Jones: *Rediscovered Painters of Upstate New York, 1700–1875* (Utica, 1958), pp. 65–7

ELIZABETH JOHNS

Maurer, Alfred H(enry) (*b* New York, 21 April 1868; *d* New York, 4 Aug 1932). American painter. He studied at the National Academy of Design, New York, in 1884 and briefly at the Académie Julian, Paris, during 1897. He received critical success with academic paintings of single female figures in interiors and genre scenes of café society, which reflected the influence of the work of James Abbott McNeill Whistler and William Merritt Chase, for example *At the Café* (*c.* 1905; St Petersburg, Hermitage). His long residence in Paris from 1897, his participation in various independent salons and his association with Leo and Gertrude Stein led to his interest in avant-garde art. He may have been one of a group of Americans who studied briefly with Henri Matisse (1869–1954). By 1907 he was

producing vigorously painted Fauvist landscapes, such as *Landscape with Red Tree* (*c.* 1907–8; New York, Mr and Mrs John C. Marin jr priv. col., see exh. cat., p. 42), which he exhibited in New York at Alfred Stieglitz's gallery, 291, in 1909 and at the Folsom Gallery in 1913.

BIBLIOGRAPHY
'Maurer and Expressionism', *Int. Studio*, xlix/193 (March 1913), p. viii
E. McCausland: *A. H. Maurer* (New York, 1951)
Alfred H. Maurer, 1868–1932 (exh. cat. by S. Reich, Washington, DC, N. Col. F.A., 1973)
N. Madorno: 'The Early Career of Alfred Maurer: Paintings of Popular Entertainment', *Amer. A. J.*, xv/1 (Winter 1983), pp. 4–34
ILENE SUSAN FORT

Maverick, Peter Rushton (*b* Cheshire, CT, 1 April 1755; *d* Newark, NJ, 12 Dec 1811). American silversmith and engraver. After training as a silversmith, he responded to the growing demand for copperplate-engraving by launching his own business in Newark in the 1770s, advertising in the New York and New Jersey newspapers as an engraver of tea sets and as a copperplate printer. Engraving bookplates, broadsides and occasional portraits provided his staple income; in later years, after American Independence, he was also able to meet the demand of nascent banks for individualized, intricately designed banknotes to counter forgery. Although the ephemeral nature of his work makes it difficult to evaluate his talent within the broader context of contemporary engraving, he achieved sufficient status to be elected as the representative of the Engravers' Association to the Federal Procession of 1788. Three of his sons, Samuel Maverick, Andrew Maverick and the best-known, Peter Maverick (1780–1871), also became printmakers. The last established a partnership with Asher B. Durand between 1817 and 1820, producing bookplates, maps, banknotes and book and magazine illustrations. He used lithography as early as 1824, when he designed the plates for the *Annals of the Lyceum of Natural History of New York*.

BIBLIOGRAPHY
S. DeWitt Stephens: *The Mavericks: American Engravers* (New Brunswick, NJ, 1950)
DAVID M. SOKOL

Mayall, John Jabez Edwin [Meal, Jabez] (*b* Manchester, 17 Sept 1813; *d* Southwick, nr Brighton, 6 March 1901). English photographer, active in the USA. He became established as a daguerreotypist in Philadelphia, PA, but returned to England in 1846, rapidly emerging as one of the top daguerreotypists in London. His association with the USA was tenacious; even Queen Victoria, a regular patron, said of him: 'the oddest man I ever saw. . .but an excellent photographer. . .he is an American'. She was not alone in her observation of Mayall's eccentric but charismatic behaviour.

Mayall's forceful monochromatic portrait images were the equal of those of Antoine Claudet (1797–1867) and successful competitors of the hand-coloured daguerreotypes of William Kilburn (*fl* 1846–62). Mayall exhibited portraits of the famous at his Daguerreotype Institution, and many of his sitters, including *Sir John Herschel, Professor Alfred Swain Taylor* (1806–80) and *Sir David Brewster* (1781–1868), were intimately connected with the early history of photography. Mayall also resolutely expanded the scope of the daguerreotype beyond portraiture. His panorama of *Niagara Falls* (1845) excited tremendous interest, including praise from J. M. W. Turner (1755–1851), and he was renowned for his efforts to develop a new branch of photographic fine art by using the daguerreotype in historical allegory. An early series of ten daguerreotypes illustrating the Lord's Prayer was completed while he was in Philadelphia, and in England he compiled a 'Shakespearian Series' (see 1848 exh. cat.).

Mayall remained active as a photographer throughout his life, becoming, among other things, an early specialist in full-length life-size portraits. He moved his main studio to Brighton (where he became the mayor), while maintaining his London operations. His later work is often confused with that of his son, the photographer John Mayall (1842–91).

WRITINGS
Catalogue of Daguerreotype Panoramas, Falls of Niagara, Shakespeare's Birth-place Tomb, Relics, Photographic Pictures, Portraits of Eminent Persons, &c. in the Gallery of the Daguerreotype Institution (London, 1848)

BIBLIOGRAPHY
L. J. Schaaf: 'Mayall's Life-size Portrait of George Peabody', *Hist. Phot.*, ix (1985), pp. 279–88
L. L. Reynolds and A. T. Gill: 'The Mayall Story', *Hist. Phot.*, ix (1985), pp. 89–107
——: 'The Mayall Story—A Postscript', *Hist. Phot.*, xi (1987), pp. 77–80
L. J. SCHAAF

Maybeck, Bernard (Ralph) (*b* New York, 7 Feb 1862; *d* Berkeley, CA, 3 Oct 1957). American architect. He attended the Ecole des Beaux-Arts, Paris (1882–6), and from then on employed academic design principles with spirit and conviction. Concurrently he was influenced by theories as divergent as those of Eugène-Emmanuel Viollet-le-Duc (1814–79) and Gottfried Semper (1803–79), while also pursuing many of the aims of the Arts and Crafts Movement. On his return from Paris, he worked for the firm of Carrère & Hastings, New York (1886–9). He moved to California in 1890, holding a number of minor jobs in the San Francisco region until he opened his own office in 1902. Maybeck continued in active practice until World War II, mostly in partnership with his brother-in-law, Mark White. Their office remained small, with suburban and rural houses comprising the majority of realized commissions.

Maybeck's oeuvre resists categorization. As he drew from many sources for ideas, so he relished diversity in expression. No project was too small or unimportant, too grand or ambitious. Informal, rustic dwellings, such as the Flagg House, Berkeley (1900–01), may be composed with a clear sense of order and unity, or may appear to be a fanciful collage, as did Wyntoon, Phoebe Hearst's great mountain lodge on the McLoud River in northern California (1902–3; destr. 1933). Space may unfold in neat, axial sequences, as in the Roos House, San Francisco (1908–9), or in loose, circuitous paths, as in the Senger House, Berkeley (1906–7). Maybeck sought to emphasize the expressive qualities of structure, sometimes defying rational solutions. But structure could also give lucid coherence to the entire scheme, as with the reinforced concrete Lawson House, Berkeley (1907). Post-medieval vernacular architecture in central Europe provided the

major source for Maybeck's imagery, yet he also drew on the buildings of Imperial Rome.

Many of these dissimilar characteristics are synthesized in the First Church of Christ Scientist, Berkeley (1909–11). Here a simple rectangular plan gains three-dimensional complexity through a tiered cruciform interior space, the lower portion of which is plain, the upper portions richly detailed. Outside, the structure is more or less symmetrical, but divided into small sections—some rendered as fragments—and covered with vines. Its appearance suggests a folk building added to and embellished over time, yet the underlying organization is rigorous and highly sophisticated.

Maybeck long sought commissions for large civic and other institutions. Only a few such projects came his way, however, partly because his approach was so unconventional. The Palace of Fine Arts, San Francisco, built in 1913–15 for the Panama–Pacific International Exposition and reconstructed in the 1960s, is without precedent. The gallery proper, a curving, steel-trussed shed, lies behind a giant Corinthian peristyle and an open rotunda—part Pantheon, part triumphal arch—set amid lush plants and fronted by a lagoon. No scheme better embodies Maybeck's belief that architecture should be principally a purveyor of mood and sentiment; whether tailored to an individual client or to the public, architecture should aim to transcend the value of aesthetic, technical and social ideologies.

WRITINGS

Palace of Fine Arts and Lagoon, Panama–Pacific International Exposition, 1915 (San Francisco, 1915)
'Architecture of the Palace of Fine Arts and the Panama–Pacific International Exposition', *CA Mag.*, i (1916), pp. 161–4

BIBLIOGRAPHY

Contemp. Architects
C. Keeler: *The Simple Home* (San Francisco, 1904, rev. with intro. D. Shipounoff, Santa Barbara, 2/1979)
J. M. Bangs: 'Bernard Ralph Maybeck, Architect, Comes into his Own', *Archit. Rec.*, cii/1 (1948), pp. 72–9
E. McCoy: *Five California Architects* (New York, 1960/R 1975), pp. 1–57
W. H. Jordy: *American Buildings and their Architects: Progressive and Academic Ideals at the Turn of the Twentieth Century* (Garden City, NY, 1972/R New York, 1986), pp. 275–313
J. Beach: 'The Bay Area Tradition 1890–1918', *Bay Area Houses*, ed. S. Woodbridge (New York, 1976), pp. 23–98
K. H. Cardwell: *Bernard Maybeck: Artisan, Architect, Artist* (Santa Barbara, 1977)
J. Maybeck: *Maybeck: The Family View* (Berkeley, CA, 1980)
R. Longstreth: *On the Edge of the World: Four Architects in San Francisco at the Turn of the Century* (New York, 1983/R Berkeley, 1998)
S. Woodbridge: *Bernard Maybeck: Visionary Architect* (New York, 1992)

RICHARD LONGSTRETH

Mead, William Rutherford. *See under* MCKIM, MEAD & WHITE.

Meal, Jabez. *See* MAYALL, JOHN JABEZ EDWIN.

Meigs, Montgomery (Cunningham) (*b* Augusta, GA, 3 May 1816; *d* Washington, DC, 2 Jan 1892). American engineer and architect. He was educated at the University of Pennsylvania and the US Military Academy. He achieved distinction in the construction of government buildings and public works as an officer in the Corps of Engineers, US Army, and as Quartermaster-General of the Union Armies during the American Civil War. He was superin-

tendent of construction for a number of federal projects in Washington, DC, most important of which were the aqueduct of the city water supply system (1852–60) and the wings and dome of the US Capitol (1857–61). The aqueduct included two unusual works of structural engineering: the aqueduct over Cabin John Creek near Washington, an elegant masonry arch bridge with what was then the longest unsupported span in the USA; and the Pennsylvania Avenue Bridge over Rock Creek, a fixed-arch span in which the cast-iron tubular arch ribs functioned also as the water mains of the aqueduct system. For the building of the Capitol, Meigs designed and made extensive use of mechanized construction equipment, of which the most notable examples were the travelling cranes for the wings and the huge radial crane for the dome. Among federal buildings erected in Washington under his authority, the most important were the additions to the General Post Office (1855–9), the War Department (1866–7), the National Museum (1876) and the Hall of Records (1878), all of which are classical in style but structurally innovative.

BIBLIOGRAPHY

DAB
C. W. Condit: *American Building Art: The Nineteenth Century* (New York, 1960)
M. E. Campioli: 'Building the Capitol', *Building Early America*, ed. C. Peterson (Radnor, PA, 1976), pp. 202–31
R. M. Vogel: 'Building in the Age of Steam', *Building Early America*, ed. C. Peterson (Radnor, PA, 1976), pp. 119–34

CARL W. CONDIT

Melchers, (Julius) Gari(baldi) (*b* Detroit, MI, 11 Aug 1860; *d* Falmouth, VA, 30 Nov 1932). American painter. Son of a Westphalian sculptor, Julius Theodore Melchers (1829–1909), he studied at the Königliche Kunstakademie in Düsseldorf with Eduard von Gebhardt (1838–1925) and Peter Janssen (1844–1908) between 1877 and 1881. He then moved to Paris, where he attended the Académie Julian and the Ecole des Beaux-Arts under the instruction of Gustave Boulanger (1824–88) and Jules Lefebvre (1836–1911).

In 1884 Melchers established himself in the small Dutch town of Egmond-aan-den-Hoef and shared a studio in nearby Egmond-aan-Zee with the American painter George Hitchcock. His most important large-scale early works, such as *The Sermon* (1886; Washington, DC, N. Mus. Amer. A.) and *The Communion* (1888; Ithaca, NY, Cornell U., Johnson Mus. A.), depict the peasants of this region at prayer and work. They also show the influence of Max Liebermann and Fritz von Uhde in their use of bright natural light and sympathetic portrayal of the worker.

During the 1890s Melchers began painting murals and works with biblical themes. His *Arts of Peace* and *Arts of War* (both 1893; Ann Arbor, U. MI Mus. A.) are two large-scale lunettes painted for the Manufacturers and Liberal Arts Building at the World's Columbian Exposition, Chicago, in 1893. These works show the influence of his friend Pierre Puvis de Chavannes. Melchers's *Last Supper (Lamplight)* (Richmond, VA Mus. F.A.) is perhaps the finest example of his Symbolist-inspired religious works. The influence of Impressionism is increasingly evident in the artist's domestic interiors of the early 1900s, such as the *Open Door* (Falmouth, VA, Melchers Mem.

Gal.). (In 1915 Melchers returned to America, where he purchased the Belmont estate in Falmouth, VA, which contains an important collection of his work.).

BIBLIOGRAPHY

D. B. Burke: *American Painters in the Metropolitan Museum of Art*, iii (New York, 1980), pp. 378–83 [full bibliog.]

J. G. Dreiss: *Gari Melchers: His Works in the Belmont Collection* (Charlottesville, 1984)

Gari Melchers: A Retrospective Exhibition (exh. cat., ed. D. Lesko and E. Persson; St Petersburg, FL, Mus. A.; 1990–91)

JOSEPH G. DREISS

Metcalf, Willard Leroy (*b* Lowell, MA, 1 July 1858; *d* New York, 9 March 1925). American painter and illustrator. His formal education was limited, and at 17 he was apprenticed to the painter George Loring Brown of Boston. He was one of the first scholarship students admitted to the school of art sponsored by the Museum of Fine Arts, Boston, and took classes there in 1877 and 1878. After spending several years illustrating magazine articles on the Zuni Indians of New Mexico, he decided to study abroad and in 1883 left for Paris. There he studied at the Académie Julian under Jules Lefebvre (1836–1911) and Gustave Boulanger (1824–88). During the five years he spent in France he became intimately acquainted with the countryside around the villages of Grez-sur-Loing and Giverny. He returned to America in 1888 and in the following spring exhibited oil studies executed in France, England and Africa at the St Botolph Club in Boston (e.g. *Street Scene, Tunis*, 1887; Worcester, MA, A. Mus.).

In 1890 Metcalf settled in New York, working as an illustrator for *Harper's*, *Century Magazine* and *Scribner's*. He taught at the Cooper Union and the Art Students League. In 1897 he drafted a declaration of independence from the Society of Academic Artists and was thenceforth identified—along with John H. Twachtman, Childe Hassam and William Merritt Chase—as one of the TEN AMERICAN PAINTERS. He executed two murals in an academic style, *Justice* and the *Banishment of Discord*, for the Appellate Court of New York in 1899. In the early 1900s Metcalf spent the summers working at the artists' colony in Old Lyme, CT. He was strongly influenced by Impressionism, and his works from this period are characterized by loose brushwork and subtle colours. In 1907 *May Night* (1906; Washington, DC, Corcoran Gal. A.; see fig.) won the first gold medal awarded by the Corcoran Gallery of Art. In 1922 he began a series of ambitious large-scale paintings of the New England landscape, including *The Northcountry* (1923; New York, Met.). He was elected a member of the American Academy of Arts and Letters in 1924.

BIBLIOGRAPHY

C. B. Ely: 'Willard L. Metcalf', *A. America*, xiii (1925), pp. 332–6

Willard Leroy Metcalf: A Retrospective (exh. cat. by F. Murphy, Utica, NY, Munson–Williams–Proctor Inst.; Springfield, MA, Mus. F.A.; Manchester, NH, Currier Gal. A.; Chattanooga, TN, Hunter Mus.; 1976–7)

E. de Veer and R. Boyle: *Sunlight and Shadows: The Life and Art of Willard L. Metcalf* (New York, 1988)

FRANCIS MURPHY

Miami. North American city and seat of Dade County, located on Biscayne Bay at the mouth of the Miami River in south-eastern Florida. In the 16th century Spanish

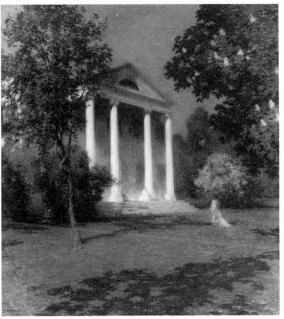

Willard Leroy Metcalf: *May Night*, oil on canvas, 997×921 mm, 1906 (Washington, DC, Corcoran Gallery of Art)

explorers discovered the Tequesta Indian village of Mayaimi on the southern bank of the estuary; in 1567 a Jesuit mission and fort were established on the site, although its fate is unknown. In 1743 the Jesuit mission of S Ignacio was founded on what later became Coconut Grove, and the Spanish crown granted local land to Spanish gentry. In 1821 the US Government purchased the state of Florida from Spain. The landowner Julia D. Tuttle arrived in 1873 and was among the founders of modern Miami, encouraging the oil magnate Henry M. Flagler (1830–1913) to extend his Florida East-Coast Railroad to Miami in return for land. Flagler dredged the harbour and in 1897 opened the six-storey, Colonial-style Royal Palm Hotel. From then on tourists came to enjoy the subtropical climate and miles of beaches, and in 1912–13 Miami Beach, a barrier island of 19 sq. km, was dredged and exploited as a holiday resort.

BIBLIOGRAPHY

J. E. Buchanan: *Miami: A Chronological and Documentary History, 1513–1977* (Dobbs Ferry, 1978)

H. Hatton: *Tropical Splendour: An Architectural History of Florida* (New York, 1987)

N. N. Patricious: *Building Marvellous Miami* (Gainsville, FL, 1994); review by R. G. Wilson in *J. Soc. Archit. Hist.*, liv/3 (1995), p. 358

☐

Military architecture and fortification. Buildings associated with warfare—usually defensive warfare—and political control.

1. INTRODUCTION. Military architecture has existed for millennia, ever since men have needed to compete for territory. It follows and tries to anticipate developments in tactics and weaponry, but historically it has also reflected current political organization and social structures. City walls were a defensive response to siegecraft, while forts and camps were built for tactical advance and to consoli-

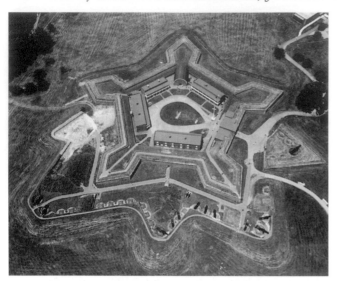

Fort McHenry, Baltimore, Maryland, by Jean Foncin, from 1798

date military achievement. From the deployment of gunpowder artillery until the mid-19th century, the design of fortifications responded to the use of ever more powerful artillery and the limitations imposed on an army dependent on horse transport. With the introduction of rifled artillery and motor-driven armoured vehicles, designs again underwent fundamental changes, until military architecture as such was rendered obsolete by the deployment after World War II of guided missiles that could overfly and destroy the most powerful fortifications. Although military architecture is inherently functional and utilitarian, its aesthetic and symbolic aspects are equally significant.

BIBLIOGRAPHY

C. Bisset: *The Theory and Construction of Fortification* (London, 1751)
J. Boudet: *The Ancient Art of Warfare*, 2 vols (London, 1966)
Q. Hughes: *Military Architecture* (London, 1974)

□

2. 1775–1865. Following the American Revolutionary war, fortification engineers in the USA followed the French school of fortification, which they continued to adopt until the Civil War (1861–5), when Renaissance systems were rendered ineffective by rifled cannons. After that, new designs were heavily influenced by experience on the field of battle.

Following the withdrawal of the British, the newly formed USA undertook the fortification of its extensive coastline. Partially executed by French engineers who had remained after the American Revolution, the first forts were largely temporary structures, consisting of blockhouses and batteries, as at Fort Nelson (1794, by John Jacob Ulrich Rivardi), VA. In several instances, however, including Fort McHenry (from 1798, by Jean Foncin; see fig.), Baltimore, MD, these were bastioned works, laid out according to formal theory. Early in the 19th century the American government hired a French engineer, Simon Bernard (1779–1839), to develop a coordinated system of coastal fortifications to protect vital harbours. Developing unique plans for each fort, Bernard employed massive bastioned fronts revetted with masonry as a defence against land attack, and multiple tiers of artillery to concentrate fire on enemy shipping. Fort Adams, RI, built from 1824, was a fort of this kind, but where sites were well fortified by nature, notably Fort Macon, NC, dating from 1826, Bernard constructed polygonal works with deep ditches and vaulted counterfire rooms.

In the mid-19th century the latest developments in France were adopted in the USA in fronts with detached scarps, designs that were thought to strengthen forts against a *coup de main* by allowing destruction of the scarp without seriously weakening the enceinte (as at Fort Clinch, FL, built in 1851 by Joseph G. Totten, the army's chief engineer from 1838 to 1864). At the same time, the walls, arches and vaults of these structures displayed advanced techniques of masonry construction. During the Civil War, however, all these masonry and earth fortifications were soon found to be ineffective against new, powerful rifled cannons. After an experimental period, massive works of concrete protected by earthworks were built at strategic points along the Atlantic coast, sometimes within or adjacent to earlier works. They contained both large rifled cannons and rapid-firing artillery, and they remained in use until after World War II, when aircraft finally made such fortifications obsolete.

While fortification of the coast was under way in the 19th century, forts were built along the inland frontier as a defence against attacks by the Indians. Although some military establishments had walls or stockades, more often than not the inland frontier fort was simply an open complex of buildings, formally organized as at Fort Leavenworth, KS. These, like the coastal forts, were products of functionalism and a clear sense of geometric order, although occasionally non-essential ornament did appear. Although most American forts have been destroyed, some have survived as museums.

3. AFTER c. 1850/70. In the mid-19th century the most significant technical change to affect the fortress engineer was the development of rifled artillery, which was a far more accurate and destructive form of fire than hitherto, and thus the traditional forms of fortress architecture had to alter. Instead of seeking to terrify the enemy with a show of force in the form of bastions, redans, cavaliers and similar constructions, the engineer now had to conceal his fort against artillery fire and provide it with guns capable of defeating attack. Unfortunately for the engineers, the development of artillery was to outpace the construction of fortification by a considerable ratio.

The American Civil War (1861–5) demonstrated that combined earthen and masonry defence works could withstand artillery fire far better than masonry alone, for a shell bursting against masonry did damage that could not easily be repaired and the shattered stone became a shower of secondary missiles.

An entirely separate aspect of fortification began to rise in the 1860s with the development of the iron-clad ship. An armoured warship with heavy guns was needed to defeat the iron-clad ship, but such guns were also a threat to land fortifications. Powerful defensive works therefore had to be built to protect naval bases and commercial harbours. The first forts of the 1860s were usually granite structures with wrought-iron armour-plate shields protecting the individual guns. As the gun became capable of

greater range, the coastal defence works could be sited further inland, and the 'disappearing carriage' was developed: the gun emplacement was a reinforced concrete pit, blending with the surrounding terrain. With the realization by the turn of the century that naval gunfire, directed from a ship moving on the surface of the sea, was inherently too inaccurate to hit the gun even if it was visible, the disappearing carriage was replaced by fixed 'barbette' mountings, which were quicker to operate and presented a microscopic target when seen from a ship.

BIBLIOGRAPHY

A. F. Lendy: *Treatise on Fortification* (London, 1862)
C. Orde-Browne: *Armour and its Attack by Artillery* (London, 1887)
E. R. Kenyon: *Notes on Land and Coast Fortification* (London, 1894)
G. S. Clarke: *Fortification: Its Past Achievements, Recent Developments and Future Prospects* (London, 1897, 2/1907)
I. V. Hogg: *History of Fortification* (London, 1981)

IAN V. HOGG

Miller, Alfred Jacob (*b* Baltimore, MD, 10 Jan 1810; *d* Baltimore, 1874). American painter. From 1831–2 he studied with the portrait painter Thomas Sully in Philadelphia, PA. In 1832 he went to France, where he studied in Paris at the Ecole des Beaux-Arts. He also visited Rome before returning to Baltimore, to open a portrait studio in 1834. Three years later Miller moved to New Orleans, LA, and was engaged by Captain William Drummond Stewart to accompany an expedition to the Rocky Mountains. The journey brought Miller into close contact with the Ameri-

can Indians, whose hunting and social customs he depicted in 200 watercolour sketches, and with the Far West fur trappers at their annual trading gatherings. He was one of the first artists to leave a detailed visual account of the life of the American mountain men (*see* WILD WEST AND FRONTIER ART). Miller's Rocky Mountain paintings are among the most romantic images of the American West ever created. His works are often panoramic and dramatic, yet he was equally adept at depicting charming, intimate scenes. His free, vigorous painting style brings to life both the American Indian and the rugged pioneer. Such paintings as the *Lost Greenhorn* (1837; Cody, WY, Buffalo Bill Hist. Cent.; see fig.; watercolour version, Baltimore, MD, Walters A.G.; sepia wash version, Omaha, NE, Joslyn A. Mus.) and the *Trapper's Bride* (Omaha, NE, Joslyn A. Mus.) convey the drama, danger and picturesque qualities of the American West of his day.

Following the expedition Miller returned to New Orleans and then to Baltimore, where he resumed his career as a portrait painter. In 1840 he travelled to Scotland to execute a series of paintings based on his Western sketches for Captain Stewart's hunting lodge in Perthshire. By 1842 he had returned to Baltimore and his portrait studio. A collection of 200 of Miller's watercolours (1859–60) is in the Walters Art Gallery, Baltimore.

BIBLIOGRAPHY

W. H. Hunter: *The Paintings of Alfred Jacob Miller* (Baltimore, 1930)
A Descriptive Catalogue of a Collection of Watercolour Drawings by Alfred Jacob Miller in the Public Archives of Canada (Ottawa, 1951)

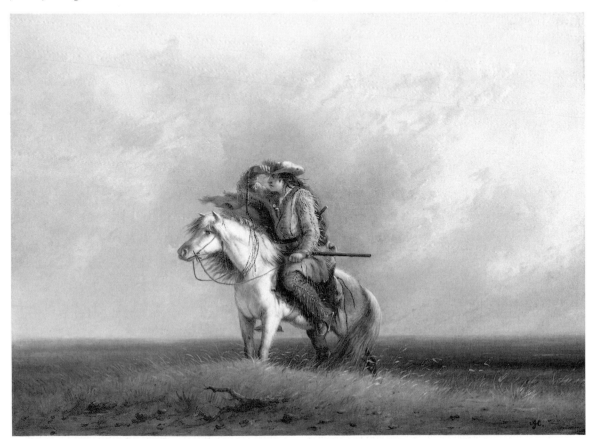

Alfred Jacob Miller: *Lost Greenhorn*, oil on canvas, 448×610 mm, 1837 (Cody, WY, Buffalo Bill Historical Center)

M. C. Ross: *The West of Alfred Jacob Miller* (Norman, OK, 1951/*R* Baltimore, 1968)

M. Bell: *Braves and Buffalo* (Toronto, 1973)

W. R. Johnston: 'Alfred Jacob Miller: Would-be Illustrator', *Walters A.G. Bull.*, xxx/3 (1977), pp. 2–3

Pictures from an Expedition: Early Views of the American West (exh. cat. by M. A. Sandweiss, New Haven, CT, Yale, Cent. Amer. A., 1979)

Alfred Jacob Miller: Artist on the Oregon Trail (exh. cat., ed. R. Tyler; Baltimore, Walters A.G.; Fort Worth, TX, Amon Carter Mus.; 1981–2) [incl. cat. rais. by K. D. Reynolds and W. R. Johnston]

Alfred Jacob Miller: Watercolors of the American West from the Gilcrease Museum (exh. cat. by J. C. Troccoli, Tulsa, OK, Gilcrease Mus. and elsewhere, 1990)

LESLIE HEINER

Mills, Robert (*b* Charleston, SC, 12 Aug 1781; *d* Washington, DC, 3 March 1855). American architect, engineer, cartographer and writer. He claimed to be the first native-born American to have completed 'a regular course of study of Architecture in his own country' and believed this training distinguished him both from 18th-century dilettantes and from contemporary competitors who came to architecture from the building trades. His work is indicative of an informed interest in new building types, materials and techniques and a recognition of the symbolic importance of style. He viewed his profession as a public trust and concentrated on the design of civic buildings and monuments. An influential architect, he promoted both fireproof construction and rational classicism, which later became hallmarks of American Federal architecture. His efforts did much to define the nature of American architectural practice in the 19th century.

1. Training and early work, to 1820. 2. Work in South Carolina and Washington, DC, after 1820.

1. TRAINING AND EARLY WORK, TO 1820. Mills studied English and European pattern-books and learnt the rudiments of draughting and structure. In 1800 he moved to Washington, DC, and entered the office of James Hoban, who was then directing construction of the President's House (designed 1792; *see* WASHINGTON, DC, fig. 6). During his two years with Hoban, he met President Thomas Jefferson, who furthered his education by commissioning drawings, by directing his reading and by prompting a tour (in 1803) of the Eastern seaboard, perhaps the first programmatic architectural tour ever made in the USA. Jefferson then recommended Mills to Benjamin Henry Latrobe, with whom he remained as a pupil and assistant until 1808. Under Latrobe's direction he participated in a broad range of architectural and engineering projects: the Chesapeake and Delaware Canal (1803–5); fireproof offices (1805) for the US Treasury in Washington, DC; a lighthouse (1805–7) intended for the mouth of the Mississippi River; the Roman Catholic Cathedral (1805–6), Baltimore, MD (*see* LATROBE, BENJAMIN HENRY, fig. 2); the Bank of Philadelphia (1807–8; *see* FEDERAL STYLE, fig. 1); and a number of private residences in Philadelphia. This extended apprenticeship shaped Mills's career: his subsequent use of the form of Neo-classicism then practised by John Soane (1753–1837) in England, his penchant for masonry vaulting and hydraulic cement and his interest in acoustics, transportation and public waterworks can all be traced back to Latrobe's influence.

The earliest signed drawings by Mills are those for the South Carolina College competition of 1802. He shared the prize with another competitor, Hugh Smith (1782–1826), but Mills's proposal was not executed. The whole of the principal façade in his drawing is retardataire, a bilaterally symmetrical composition with a projecting, octagonal central block surmounted by a cupola and flanked by wings terminating in projecting pavilions. This elevation reflected the influence of Hoban and of the designs to be found in 18th-century pattern-books. The rear façade was, however, altogether different: the base of its wings consisted of an arcade, which gave access to all public rooms at ground- (or entry) level. Although commonplace in Oxford and Cambridge in England, such an arcade was without precedent in American academic architecture; in 1774 Jefferson had suggested an arcaded quadrangle for the College of William and Mary in Williamsburg, VA, and it is probable that Mills's proposal, which foreshadowed his tendency to look beyond local tradition, was an adaptation of Jefferson's plan. Also through Jefferson's assistance Mills learnt of dome construction, based on laminated wooden ribs, as advocated by Philibert de L'Orme (1514–70). He used this method to fabricate a saucer dome with a diameter of 30 m for the circular Congregational Church (1804; destr.) for Charleston, SC. This was the first of his five round or octagonal churches, which he based on the Pantheon, Rome, on the round churches illustrated in the *Book of Architecture* (1728) by James Gibbs (1682–1754) and on Latrobe's theory of acoustics; as avant-garde auditoria they established his reputation in the USA.

Mills continued to work in Philadelphia for Latrobe until 1808, when his design for the Mount Holly Prison (now Historic Burlington County Prison Museum), NJ, was accepted; this marked the beginning of his independent practice. Its five-bay façade is unified by blind arches, sombre ashlar construction and a strongly projecting string course; except for a heraldic low relief of crossed keys and chains above the central entry, the elevation is wholly without ornament. Public and communal rooms were confined to the rectangular central block; wings containing solitary cells extended from either end to enclose an exercise court. This was Mills's earliest fireproof building; its plan recalls Latrobe's Virginia Penitentiary (1797) in Richmond, and Latrobe, in turn, admitted having drawn on Jefferson's study of the work of Pierre-Gabriel Bugniet in Lyon, France. Mills also cited the writings of John Howard, a prominent English advocate of penal reform. Mount Holly Prison exemplified both the scope of Mills's knowledge and his penchant for institutional planning.

Mills married in 1808 and established himself in Philadelphia. He was active in the Society of Artists, applied unsuccessfully for admission to the American Philosophical Society and obtained commissions for houses: Franklin Row (1809–10; destr.) and Benjamin Chew House (1810); churches: Sansom Street Baptist Church (1811–12) and Octagon Unitarian Church (1812–13; destr.); and public buildings: fireproof office wings (destr.) for the State House (1809–12), Washington Hall (1814; destr.), and a Toll House and exterior finish for the Upper Ferry Bridge (1813; destr.).

During this period Mills largely rejected the forms associated with the Georgian period and Robert Adam (1728–92) in particular and perpetuated by the Carpenters' Company of Philadelphia, adopting instead the spare geometry of John Soane, the robust simplicity of the Doric order and the aesthetic freedom promoted by rational Neo-classicists. The coffered niche with its screen of columns that formed the focal-point of the façade of Washington Hall was without precedent in the USA and was based on the Hôtel Guimard (1772) in Paris. His Upper Ferry Toll House, which took the form of a peripteral temple, was probably derived from a design by Gibbs for a garden pavilion (*Book of Architecture*, pl. LXXII) at Hackwood, Hants, England, for Charles Paulet, 3rd Duke of Bolton. This form of temple, despite its pedigree, had rarely been built in the USA.

The most notably idiosyncratic early building by Mills is the Monumental Church (1812–17; see fig. 1), Richmond, VA. His fifth centrally planned church, it is built on an octagonal plan and supports a saucer dome after de L'Orme and, since it is a memorial to victims of a theatre fire, the principal feature of its façade is a 'Monumental Porch' housing a cinerary urn. For this porch Mills used the primitive Delian Doric order, distyle *in antis*, with fluting restricted to the uppermost and lower drums of the shaft; ornament is restricted to recessed panels, projecting string courses and lachrymatories in the frieze. A lack of funds precluded the execution of acroteria and a steeple. Richmond's Monumental Church, as built, reflected Mills's growing interest in the juxtaposition of unadorned masses. Latrobe had also wanted this commis-

sion, and Mills's victory marked his coming of age as a professional, signifying the beginning of his reputation as a designer of public monuments.

Mills's next major work was the Washington Monument (1813–42), Baltimore, the first large American monument to be built in honour of George Washington. Its Delian Doric column rises 50 m above a cubical base, and it is surmounted by a 5-m statue (by Enrico Causici) that presents Washington as Cincinnatus resigning his commission at Annapolis. The column is hollow and contains a spiral staircase leading to an observation platform on the abacus; despite Mills's disclaimers, it takes its place in a series of commemorative columns, such as those to Trajan and Hadrian in Rome, the monument in London to the Great Fire by Christopher Wren (1632–1723), the columns to Nelson in Edinburgh (1805) and Dublin (1808; destr.) and the Colonne Vendôme (1806; destr.) in Paris. Mills's plans included an elaborate iconographic scheme, but financial constraints prompted modifications that resulted in an unadorned shaft, one often cited as a milestone in the development of the Greek Revival in the USA.

Between 1815 and 1819 Mills lived and worked primarily in Baltimore, directing construction of the Washington Monument. A significant percentage of his time was then focused on engineering projects: he served as President of the Baltimore Water Company (1816–19), proposed flood controls for Jones Falls (Baltimore, 1816–20) and built numerous hot-air furnaces for heating homes, churches and factories. He also drew up proposals for a canal (1816) at Richmond and for powder magazines (1817) at Baltimore. Attempting to supplement his income, he invested

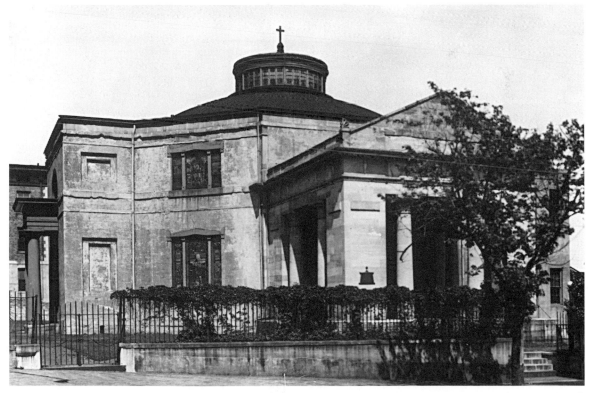

1. Robert Mills: Monumental Church, Richmond, Virginia, 1812–17

in rental housing, a quarry and, disastrously, in the speculative construction of row houses. In Baltimore he built churches, offices and houses, and his first notable Egyptian Revival design, the monument to *Aquilla Randall* (1817), North Point. His elevation for the Randall Monument depicts a truncated obelisk rising from a cubical plinth, crowned by a tripod supporting an orb. The tripod and bas-relief ornament were not executed, but later he used an identical programme for the monument to *Jonathan Maxcy* (1824–7) at the campus of the University of South Carolina, Columbia, which was his first complex Egyptian Revival monument to be executed. The depression of 1819 brought construction to a standstill in Baltimore, and Mills moved to South Carolina to accept the newly created position of Acting Commissioner of the Board of Public Works.

2. Work in South Carolina and Washington, DC, after 1820. During his years in South Carolina (1820–29) Mills participated in an ambitious, state-supported programme of internal improvements. These included the development of canals, the design or supervision of sixteen courthouses, three jails and two hospitals, the fireproof County Record Building (1822–7), Charleston, a complex of powder magazines (1824–6; destr.) in Charleston and various private commissions. These were for churches: Bethesda Presbyterian Church (1821–3), Camden; St Peter's Catholic Church (1824), Columbia; and for homes: Ainsley Hall House (1823), Columbia. In December 1823 the state's legislature became alarmed by mounting construction costs and Mills's position as Superintendent of Public Buildings was abolished. For the next seven years he continued to work for the state on a building-by-building basis, supplementing his income through publications. In 1826, for example, he published his *Atlas of the State of South Carolina, 1825* and a massive companion volume, the *Statistics of South Carolina*. He also published articles and pamphlets on railways and canals and prepared a manuscript concerning his design for a rotary engine. As early as 1822 he had begun to seek work outside South Carolina, for his situation there was always financially precarious.

Mills's buildings in South Carolina are notable as a group for the extensive use made of fireproof masonry vaulting and the frequent appearances of Palladian raised basements, the tripartite window that reflected the influence of Latrobe, and giant Doric columns and elevations articulated by means of massing and planar adjustment. The Insane Asylum (1822–7), Columbia, exemplifies his best work of this period: at 18,000 sq. m, it was the largest building in the state. A five-storey central block contained the asylum's public and communal rooms; this block was flanked by curving dormitory wings, four storeys high, which framed the grounds. The plan reflected English theories of psychiatric care, and its progressive provisions covered heating, ventilation, a roof-garden and the securing of its patients. The cost of construction was more than treble the original estimates and, although this is attributable to Mills's insistence on fireproof construction, it damaged his local reputation.

In 1830, seeking federal employment, Mills moved to Washington, DC, where he remained until his death.

Engaged briefly as a clerk in the Land Office, he soon found more meaningful work, directing alterations and restorations at the White House, the Executive Office buildings and the Capitol. At the Capitol he remodelled the House of Representatives, raising the floor and improving its acoustics, and he also improved the entire water supply and heating system. Through such comparatively mundane tasks he established himself in the city. As a result, his design for a marine hospital was accepted and erected (1831–4) by the federal government in Charleston; it served as a prototype for a series of hospitals, all characterized by galleries for patients and cross-ventilated wards. Four granite, fireproof custom houses were also built to his specifications (Middletown and New London, CT, and New Bedford and Newburyport, MA, 1834–5); each is on a square plan and has a Doric portico, unfluted pilasters at the corners, a plain frieze and decorative detailing restricted to variations in the hammered surface of the stone. They show his response to the Greek Revival and to the Boston Granite style.

In 1836 Mills's design for a fireproof federal treasury in Washington, DC, was adopted. Although never completed as designed, it is arguably the most significant Greek Revival office building in the USA. Its 15th Street façade is screened by a 150-m-long colonnade based on the Ionic of the Erechtheion; its ground-plan consists of barrel-vaulted corridors flanked by groin-vaulted offices, a repetitive module reflecting the work of Jean-Nicolas-Louis Durand (1760–1834). As Architect of the Federal Buildings, Mills also began construction (1836) of the US Patent Office, which had been designed by William Parker Elliot in collaboration with Ithiel Town and Alexander Jackson Davis. The south wing is thought to be largely Mills's own; here Delos-type columns and vaulted corridors and offices recall his earlier work. The same interior plan is repeated in his final notable federal building, the Old Post Office (1839–42), but, unlike anything he had done before, it draws on the Renaissance palazzo for its elevation: a rusticated basement, a *piano nobile* articulated through the use of Corinthian pilasters and an attic storey. The eclecticism that marked his maturity was further demonstrated by a Norman Revival jail (1839–41; destr.) and a proposal in the same revival style for the Smithsonian Institution (1847–9), both Washington, DC. Although Mills did not obtain the latter commission, he did supervise construction of James Renwick's Gothic Revival building for the Smithsonian (see colour pl. II, 3).

In 1845 Mills's plan for the Washington Monument (Washington, DC, designed 1833, executed 1848–84) was adopted. It anticipated an obelisk 200 m high, rising from a circular Doric temple 80 m in diameter (see fig. 2). The temple-base (not executed) was to have served as a Pantheon for founders of the republic; Mills prescribed for it a complex iconography of low relief, paintings and sculpture. The concept was derived from a proposal (1791) for a memorial to the destruction of the Bastille by Jacques Molinos (1743–1831) and Jacques-Guillaume Legrand (1743–1807), to which Mills had access in Jefferson's library. A shortage of funds thwarted full realization of Mills's plan; nonetheless, it is one of the tallest masonry structures in the world (555 feet, or *c.* 170 m) and among the most famous public monuments in the USA.

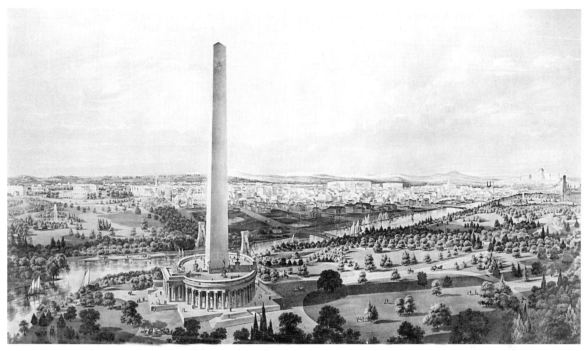

2. Robert Mills: design for the Washington Monument, built 1848–84; from a view of Washington, DC, showing projected improvements, by B. F. Smith jr, 1852 (Washington, DC, Library of Congress)

As a public servant Mills was vulnerable to the vicissitudes of political life, and in 1842 Congress abolished his office. He continued to work on specific commissions, as he had in South Carolina, but in 1851 a controversy arose concerning the vaulting at the Patent Office and plans for the extension of the US Capitol. Thomas U. Walter, Mills's most effective critic, was appointed the Capitol's architect and given responsibility for the Patent Office. Mills was forced from federal service, although his influence was important: the profile of the Capitol dome by Walter is similar to one Mills had proposed; Walter's extension of the building is similar to Mills's earlier plan; and Mills's maligned vaults still stand at the Treasury and Patent Offices. Like his buildings and monuments, Mills's commitments to usefulness, public service and the symbolic import of design were a lasting and constructive influence upon architecture in the USA.

WRITINGS

Atlas of the State of South Carolina, 1825 (Charleston, 1826)
Statistics of South Carolina (Charleston, 1826)
B. Glenn, ed.: *Some Letters of Robert Mills, Engineer and Architect* (Columbia, 1938)
H. Cohen, ed.: 'The Journal of Robert Mills, 1828–1830', *SC Hist. & Geneal. Mag.*, lii (1951), pp. 133–9, 218–24; liii (1952), pp. 31–6, 90–100

BIBLIOGRAPHY

Macmillan Enc. Archit.
H. M. P. Gallagher: *Robert Mills* (New York, 1935)
R. L. Alexander: 'Baltimore Row Houses of the Nineteenth Century', *Amer. Stud.*, xvi (1975), pp. 65–76
J. M. Bryan and J. M. Johnson: 'Robert Mills's Sources for the South Carolina Lunatic Asylum, 1822', *J. S. Carolina Medic. Assoc.*, lxxv/6 (1979), pp. 264–8
G. Waddell: 'Robert Mills's Fireproof Building', *SC Hist. Mag.*, lxxx/2 (1979), pp. 105–35
G. Waddell and R. W. Liscombe: *Robert Mills's Courthouses & Jails* (Easley, SC, 1981)
E. F. Zimmer and P. J. Scott: 'Alexander Parris, Benjamin Henry Latrobe, and the John Wickham House in Richmond, Virginia', *J. Soc. Archit. Hist.*, xli (1982), pp. 202–11
J. M. Bryan: 'Robert Mills, Benjamin Henry Latrobe, Thomas Jefferson and the South Carolina Penitentiary Project, 1806–1808', *J. SC Hist. Soc.*, lxxxv (1984), pp. 1–21
——: *Robert Mills*, Master Builders (Washington, DC, 1985)
R. W. Liscombe: *The Church Architecture of Robert Mills* (Easley, SC, 1985)
J. M. Bryan, ed.: *Robert Mills, Architect* (Washington, DC, 1989)
W. N. Banks: 'The Aiken-Rhett House, Charleston, South Carolina', *Antiques*, cxxxix/1 (1991), pp. 234–45
R. W. Liscombe: *Altogether American: Robert Mills, Architect and Engineer, 1781–1855* (New York, 1993)

JOHN MORRILL BRYAN

Minneapolis. North American city in the state of Minnesota. European settlement dates from the establishment of Fort Snelling (1820–22) at the confluence of the Mississippi and Minnesota rivers. After 1848 growth focused on the Falls of St Anthony, eight miles upstream, which formed the upper barrier to navigation on the Mississippi and provided a cheap, unlimited source of industrial power. Thus assured of effective economic control over the vast forests and agricultural lands of the upper Midwest, Minneapolis grew to become the world's largest timber- and flour-milling centre.

Minneapolis experienced phenomenal growth in the 1880s, and a number of structures were built in the Romanesque Revival style of H. H. Richardson, of which the Masonic Temple (1889; by Louis L. Long and Fred Kees) is the best remaining. The concurrent development of a city-wide system of parks transformed Minneapolis. The Chicago-based landscape architect H. W. S. Cleveland first designed a parks system in 1883 (unexecuted), but a civic committee chaired by William Watts Folwell eventually proposed in 1891 the famed 'Grand Rounds' system,

which overlays a continuous, naturalistic pattern on to the city's street grid, interconnecting six large lakes, Minnehaha Creek and the Mississippi over 55 miles of parkways. After 1900 civic improvement was dominated by the construction of individual buildings, the most significant of which were the residential works of William Gray Purcell and George Grant Elmslie (*see* PURCELL & ELMSLIE), including Purcell's own house (1913) at 2328 Lake Place, in characteristic Prairie school style. Major regional works included the Minnesota State Capitol (1893–1903) in St Paul by CASS GILBERT, with its dome modelled on that of St Peter's in Rome.

The artistic life of the city is dominated by the Walker Art Center (founded 1879) and the Minneapolis Institute of Arts (founded 1883). The comprehensive collection of the Institute is housed in a complex originally designed in a classical style by McKim, Mead & White in 1912–14 (which was extensively enlarged in 1972–4 by Kenzō Tange and remodelled in 1998, with a much-enhanced collection of Asian art). Other important visual arts institutions near by include the Minnesota Museum of Art in St Paul and the Northwest Architectural Archives at the University of Minnesota at Minneapolis; the latter's collection of over 250,000 items includes the papers and drawings of PURCELL & ELMSLIE, Edwin H. Lundie, HARVEY ELLIS and the American Terra Cotta Company.

Two architecturally exceptional structures can be reached within short drives of Minneapolis. The earlier of these is the Mabel Tainter Memorial, designed by Harvey Ellis in 1889. It is located in Menomonie, WI, about 120 km east of the city. The building exterior is rendered in Ellis's characteristically powerful version of the Richardsonian Romanesque Revival. The Memorial's tiny, fully restored interior auditorium is a delicate Moorish fantasy (see fig.), extraordinary even by Ellis's elevated standards. The National Farmer's Bank (now Wells Fargo Bank) is located 105 km south of Minneapolis, in Owatonna. The building was designed in 1907–8 by LOUIS SULLIVAN and George Grant Elmslie (before he established Purcell & Elmslie) and, in David Gebhard's words, is 'one of the points on any serious architectural pilgrimage in the United States'. The bank's exterior is defined by a pristine, cubical mass, two great semicircular windows and rich terracotta detailing. Its single interior space is flooded with light, muted somewhat by coloured glass inserts in the semicircular windows. Elmslie's intricate ornamentation and full wall murals of bucolic farm scenes are visual highpoints of the interior.

BIBLIOGRAPHY

E. Bennett: *Plan of Minneapolis* (Minneapolis, 1917)

T. Wirth: *Minneapolis Park System, 1883–1944* (Minneapolis, 1946)

D. Gebhard: 'Purcell and Elmslie Architects', *Prairie Sch. Rev.*, ii/1 (1965), pp. 5–24

D. Torbert: *Significant Architecture in the History of Minneapolis* (Minneapolis, 1969)

D. Gebhard and T. Martinson: *A Guide to the Architecture of Minnesota* (Minneapolis, 1977), pp. 24–79

TOM MARTINSON

Mission Revival. *See under* COLONIAL REVIVAL.

Monticello. House in Albemarle Co., near Charlottesville, VA, designed and later remodelled by THOMAS JEFFERSON

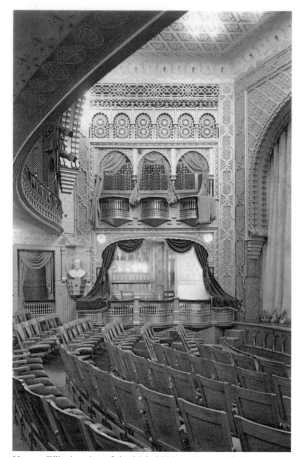

Harvey Ellis: interior of the Mabel Tainter Memorial, Menomonie, near Minneapolis, Minnesota, 1889

for his own use. Although Jefferson continued to work on the house for more than 40 years, there were two main building programmes, in 1770–84 and 1796–1809. Jefferson began designing the house in 1768, mainly using for his guide the 1742 edition of *The Architecture of A. Palladio* (London, 1715–20) by James Leoni (*c.* 1686–1746). This first version of the house superimposed the Ionic and Doric orders for the porticos that fronted the three-bay central block on the entrance and garden façades. Around 1777 the first changes were made, with the addition of octagonal bows to the wings and garden front of the central block. Jefferson used his hilltop site to advantage to conceal the service wings (planned in the 1770s but built during the remodelling in modified form after 1800). He reversed the usual Palladian scheme, where the wings flank an entrance court, by placing the wings behind the house and setting them into the side of the hill. The roofs are transformed into terrace walkways connected to the main floor of the house and serve both as extensions for the house and as landscape elements.

In 1796, as a result of his first-hand experience of French architecture in Paris, Jefferson began remodelling and enlarging the house from eight to twenty-one rooms. He removed the upper storey and constructed a dome, the first on an American house, over the garden front.

The additions reflected French architectural thinking on the division of space. Reception rooms were made the height of the main order on the exterior. Bedrooms were arranged in two tiers, with their windows positioned to suggest a single-storey house. Additional bedrooms on the third storey were concealed under the roof and lighted by skylights. The interior had decorative schemes based on Classical and Palladian examples. The number, variety and placement of windows, as well as the proportions and contrast of red brick and white dressings (see colour pl. I, 2), give the façade a restless quality, unusual in a Neoclassical building. It was also too personal and idiosyncratic to have any significant influence. Jefferson's great interest in horticulture and landscape gardening at Monticello is documented by his many drawings and notes.

BIBLIOGRAPHY

F. Kimball: *Thomas Jefferson, Architect: Original Designs in the Collection of Thomas Jefferson Coolidge, Junior, with an Essay and Notes* (Boston, 1916/R New York, 1968)
E. M. Betts, ed.: *Thomas Jefferson's Garden Book, 1766–1824* (Philadelphia, 1944)
K. Lehman: *Thomas Jefferson, American Humanist* (New York, 1947)
F. D. Nichols: *Thomas Jefferson's Architectural Drawings* (Charlottesville, 1961, rev. Boston, 5/1984)
F. D. Nichols and J. A. Bear: *Monticello* (Charlottesville, 1967, rev. 1982)
W. B. O'Neal: 'A Bibliography of Publications about Thomas Jefferson as an Architect', *American Association of Architectural Bibliographers Papers*, vi (Charlottesville, 1969)
W. H. Pierson: *American Buildings and their Architects: The Colonial and Neoclassical Styles* (Garden City, NY, 1970)
The Eye of Th: Jefferson (exh. cat. by W. H. Adams; Washington, DC, N.G.A., 1976)
W. H. Adams: *Jefferson's Monticello* (New York, 1983)
F. Shuffelton: *Thomas Jefferson: A Comprehensive, Annotated Bibliography of Writings about him, 1822–1980* (New York, 1983)
G. Waddell: 'The First Monticello', *J. Soc. Archit. Hist.*, xlvi/1 (1987), pp. 5–29
J. Bell: 'Jefferson's Real Monticello', *A. & Ant.*, xv/4 (1993), pp. 50–57
J. H. Robinson: 'An American Cabinet of Curiosities: Thomas Jefferson's Indian Hall at Monticello', *Winterthur Port.*, xxx (Spring 1995), pp. 41–58
W. L. Beiswanger: *Monticello in Measured Drawings* (Charlottesville, 1998)

WILLIAM L. BEISWANGER

Moran, Thomas (*b* Bolton, Lancs, 12 Feb 1837; *d* Santa Barbara, CA, 26 Aug 1926). American painter and printmaker of English birth. His brothers Edward (1829–1901), John (1831–1902) and Peter (1841–1914) were also active as artists. His family emigrated from England and in 1844 settled in Philadelphia where Moran began his career as an illustrator. He was guided by his brother Edward, an associate of the marine painter James Hamilton, whose successful career afforded an example for Moran. Between the ages of 16 and 19 Moran was apprenticed to the Philadelphia wood-engraving firm Scattergood & Telfer; he then began to paint more seriously in watercolour and expanded his work as an illustrator. In the 1860s he produced lithographs of the landscapes around the Great Lakes. While in London in 1862 (the first of many trips to England), he was introduced to the work of J. M. W. Turner (1755–1851), which remained a vital influence on him throughout his career. Moran owned a set of the *Liber studiorum* and was particularly impressed by Turner's colour and sublime conception of landscape. With his wife, Mary Nimmo Moran (1842–99), an etcher and landscape painter, he participated in the Etching Revival, scraping fresh and romantic landscapes and reproductive etchings (e.g. *Conway Castle, after J. M. W. Turner*, 1879). During the 1870s and 1880s his designs for wood-engraved illustrations appeared in most of the major magazines and in gift books, which brought him money and recognition.

Between 1871 and 1892 Moran travelled extensively in the western USA, visiting Yosemite, the Teton Mountains,

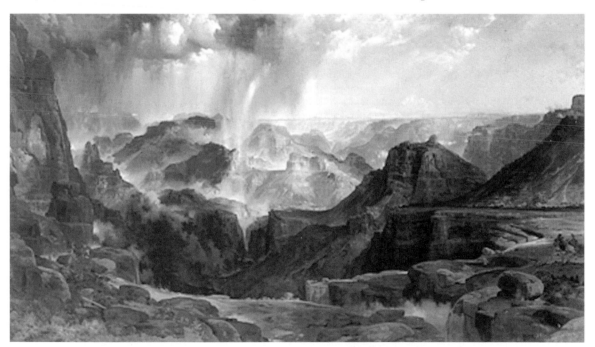

Thomas Moran: *Chasm of the Colorado*, oil on canvas, 2.14×3.68 m, 1873–4 (Washington, DC, US Department of the Interior, on loan to Washington, DC, National Museum of American Art)

New Mexico and Arizona, as well as Mexico. He achieved his first success as a painter in oil and watercolour after he had been commissioned to illustrate a *Scribner's* article on the Yellowstone area. During the summer of 1871 and in the company of the photographer WILLIAM HENRY JACKSON, Moran drew and painted in watercolour hundreds of sketches of the spectacular, and then virtually unknown, regions of Wyoming Territory. Moran kept these sketches (Yellowstone National Park) all his life. He used them as the basis for the many fully realized watercolours commissioned in the 1870s and for a very large painting, *Grand Canyon of the Yellowstone* (1872; Washington, DC, US Dept Interior, on loan to Washington, DC, N. Mus. Amer. A.; see colour pl. XVIII, 1). The reception of this picture as 'the finest historical landscape yet painted in this country' (*New York Tribune*) signalled Moran's emergence as a rival to Albert Bierstadt and assured him recognition in the final years of the popularity of landscape as grand, exotic spectacle. The sketches were used as part of the successful campaign to designate Yellowstone the first national park. His monumental canvas was the first landscape painting to be purchased by the US government (in 1872) and quickly became a symbol of territorial exploration and westward expansion. It was followed two years later by an equally ambitious painting, *Chasm of the Colorado* (1873–4; Washington, DC, US Dept Interior, on loan to Washington, DC, N. Mus. Amer. A.; see fig.), inspired by sketches made in the Grand Canyon region in 1873. Although the government purchased this painting as a pendant to *Grand Canyon of the Yellowstone*, critics greeted it much less enthusiastically and most recoiled at its overpowering and forbidding vista, which for them lacked necessary human reference and, therefore, meaning. Perhaps influenced by such criticism, Moran never again attempted such a daring composition or so large a canvas, and he returned to more acceptable landscapes, such as the *Mountain of the Holy Cross* (1875; priv. col.).

Moran also visited Italy twice (in 1886 and 1890) and began to spend more time in East Hampton, Long Island, NY. His most lyrical paintings explore the relation of architecture to water in Venice and East Hampton. By 1900 Moran's popularity had waned and many of his major canvases went unsold. Although he maintained his appeal with a broad public, he was out of favour with critics and artists. He spent his last years between East Hampton and Santa Barbara, CA, recreating his favourite subjects, especially the varied landscape of the Grand Canyon.

UNPUBLISHED SOURCES
East Hampton, NY, Lib. [MS] Tulsa, OK, Gilcrease Inst. Amer. Hist. & A. [MS]

BIBLIOGRAPHY
'Fine Arts: Mr. Thomas Moran's "Great Canon of the Yellowstone"', *New York Tribune* (4 May 1872), p. 2
T. Wilkins: *Thomas Moran: Artist of the Mountains* (Norman, OK, 1966, rev. 1998)
The Drawings and Watercolors of Thomas Moran (1837–1926) (exh. cat. by T. S. Fern, South Bend, U. Notre Dame, 1976)
C. Clark: *Thomas Moran's Watercolors of the American West* (Austin, TX, 1980)
A. Morand and N. Friese: *The Prints of Thomas Moran in the Thomas Gilcrease Institute of American History and Art, Tulsa, Oklahoma* (Tulsa, 1986)
Splendours of the American West: Thomas Moran's Art of the Grand Canyon and Yellowsone: Paintings, Watercolors, Drawings and Photographs from the Thomas Gilcrease Institute of American History and Art (exh. cat. by A. Morand, Birmingham, AL, Mus. A., 1990)
J. Kinsey: *Thomas Moran and the Surveying of the American West* (Washington, DC, 1992)
A. Morand: *Thomas Moran: The Field Sketches, 1856–1923* (Tulsa, OK, 1996)
Thomas Moran (exh. cat. by N. Anderson, Washington, DC, N.G.A.; Tulsa, OK, Gilcrease Mus.; Seattle, WA, A. Mus.; 1997–8); review by S. May in *Southwest A.*, xxvii (1998), pp. 40–47

CAROL CLARK

Morgan, James (*d* Cheesequake, NJ, 26 Feb 1784). American potter. In 1750 he inherited property near the head of Cheesequake Creek, NJ, from his father and from about that time owned a tavern known as Cheesequake Hotel and Morgan House. From about 1754 he also operated in the same location a stoneware pottery, which may have been started in the early 1740s by members of the Dutch Staats family. Morgan's access to the rich clay resources in this vicinity gave rise to the designation of certain clays as 'Morgan's best'. The wares were not marked, but fragments of pots, jugs, jars, mugs, chamber pots, bowls, plates, cups, colanders and pitchers have been found (e.g. Trenton, NJ State Mus.; see fig.). Grey salt-glazed stoneware in the Rhenish manner with incised and blue-filled decoration is characteristic. The pottery spawned others in the area, which became an important centre for stoneware production in the 19th century. James Morgan jr (1756–1822) operated the pottery from his father's death in 1784 until *c.* 1805, when he founded a pottery in nearby South River Bridge. Thomas Warne (1763–1813) may have been an apprentice or journeyman in Morgan's pottery. In 1786 Warne married Mary Morgan, daughter of James Morgan sr, and shortly thereafter established a pottery near by, which he later ran in

James Morgan: stoneware mug, h. 152mm, 1754–*c.* 1780 (Trenton, NJ, New Jersey State Museum)

association with his son-in-law Joshua Letts until *c.* 1813. It continued to be used by subsequent potters.

BIBLIOGRAPHY

M. L. Branin: *The Early Makers of Handcrafted Earthenware and Stoneware in Central and Southern New Jersey* (Rutherford, 1988)

ELLEN PAUL DENKER

Morgan, J(ohn) Pierpont (*b* Hartford, CT, 17 April 1837; *d* Rome, 31 March 1913). American collector and banker. He was the son of the merchant banker Junius P. Morgan, whose business he continued, and in the late 19th century and the early 20th he was one of the most powerful men in the USA. He did no significant collecting until after his father's death in 1890, when he began to acquire fine manuscripts, incunabula, autographs, first editions and rare books ranging from a copy of the Gutenberg Bible, the Mainz Psalter of 1459 and the Lindau Gospels (9th century) to the original autograph manuscripts of John Keats's *Endymion* and Charles Dickens's *A Christmas Carol.* By 1900 this collection had grown to such proportions that Charles Follen McKim was commissioned to design an Italian Renaissance-style palazzo in New York to hold it (now the Pierpont Morgan Library), and in 1904 Belle da Costa Greene (1883–1950) was appointed curator. He often purchased entire library collections, for example that of Richard Bennett, which included illuminated manuscripts, early books and part of the medieval library of William Morris and 32 items printed by William Caxton.

Morgan began collecting works of art in the early 1900s. By the time of his death his collection was vast and generally considered to be one of the best in the world, with an estimated value of some $160,000,000. His holdings ranged widely and included Byzantine ivories and enamels, Italian maiolica (e.g. plates by Giorgio Andreoli, dated 1525 and 1529), East Asian porcelain, enamel work (e.g. Stavelot Triptych, *c.* 1150), 18th-century snuffboxes, miniatures, French tapestries and furniture and Old Master drawings and paintings, among them Lucas Cranach the elder's portrait of *Martin Luther* (*c.* 1525). Most of the paintings he owned were 18th-century French and English works, including the series of panels painted by Jean Honoré Fragonard (1732–1806) for the pavilion of Marie-Jeanne Bécu, Comtesse Du Barry at Louveciennes in 1772 (now New York, Frick), and the portrait of *Georgiana, Duchess of Devonshire* (1785; Washington, DC, N.G.A.) by Thomas Gainsborough (1727–88), with a small group of 16th- and 17th-century pieces, including a *Portrait of a Moor* (*c.* 1570), from the workshop of Tintoretto (1519–94). The breadth of Morgan's collection resulted from his desire to acquire only the most highly prized works of all types, rather than a comprehensive selection of any one area. To this end he regularly purchased entire collections: among those he acquired were the Gréau collection of ancient glass, the Le Breton collection of faience, the collection of *boiseries* of Georges Hoentschel (1855–1915), and the collection of Old Master drawings assembled by Charles Fairfax Murray (1849–1919). To help him in his search for works, Morgan used a number of experts, such as the German museum curator Wilhelm von Bode (1845–1929) and the English dealers Thos Agnew and Sons.

In keeping with the mood of nascent national pride characteristic of America in the late 19th century, Morgan wished to build up a collection whose quality and range would make travel to Europe superfluous. However, although the Metropolitan Museum in New York (of which Morgan was first a Trustee and then President) was destined to receive his collection, until the early 1910s his holdings, for the most part acquired in Europe, remained housed in his European properties or were placed on loan at the Victoria and Albert Museum in London. This was because until 1910 duty had to be paid on the import of art into the USA. In 1912 Morgan's collection was shipped to New York. In 1913, a small selection of paintings was displayed at the Metropolitan Museum. Following his death in 1913, the bulk of the collection was exhibited there, for what was to be the only time. Although Morgan left his collection to his son, J. P. Morgan (1867–1943), with the proviso that it should be placed in the public domain, it was decided that Morgan's estate was not large enough to provide for the continuation of the family banking business, and about half the collection was sold. Eventually approximately 40% of Morgan's collection went to the Metropolitan Museum, *c.* 4000 works of art ranging from an altarpiece by Raphael (1483–1520), the *Virgin and Child Enthroned with Saints* (1504–5), to 18th-century jewellery. His collection of bronzes, Italian Renaissance objects, 17th-century silver and 18th-century porcelain is now in the Wadsworth Atheneum, Hartford, CT, while the illuminated manuscripts, incunabula, autograph manuscripts, rare books, Old Master drawings and prints remain in the Pierpont Morgan Library, where they are regularly exhibited to the public.

BIBLIOGRAPHY

W. Roberts: *Pictures in the Collection of J. P. Morgan at Prince's Gate* (London, 1907)

Guide to the Loan Exhibition of the J. Pierpont Morgan Collection (exh. cat., New York, Met., 1914)

F. H. Taylor: *Pierpont Morgan as Collector and Patron, 1837–1913* (New York, Pierpont Morgan Lib., 1957)

A. B. Saarinen: *The Proud Possessors* (London, 1959)

D. Sutton: 'Hommage to J. P. Morgan', *Apollo*, cxxiv/297 (1986), pp. 43–79

J. Pierpont Morgan, Collector: European Decorative Arts from the Wadsworth Atheneum (exh. cat., L. H. Roth, ed., Hartford, CT, Wadsworth Atheneum; New York, Pierpont Morgan Lib.; Fort Worth, TX, Kimbell A. Mus.; 1987)

L. Auchincloss: *J. P. Morgan: The Financier as Collector* (New York, 1990)

J. Schaire: 'Mr. Morgan's Nose: A New Look at the Private Treasures Sniffed out by America's All-time Greatest Art Collector', *A. & Ant.*, viii (1991), pp. 50–5

R. A Rottner: *J. P. Morgan and the Middle Ages: Medieval Art in America, Patterns of Collecting, 1800–1940* (University Park, PA, 1996), pp. 115–26

A. DEIRDRE ROBSON

Morgan, Julia (*b* San Francisco, CA, 26 Jan 1872; *d* San Francisco, 2 Feb 1957). American architect. She was probably the first woman to study in the architecture section of the Ecole des Beaux-Arts, having previously graduated in engineering from the University of California at Berkeley. Morgan was also one of the first women to sustain a long-standing and well-known practice in the USA. Working primarily in the suburbs of San Francisco and other northern California communities, she designed hundreds of residences and numerous schools, college buildings, churches and facilities for the Young Women's Christian Association (Y.W.C.A.) between 1904 and 1940.

Women philanthropists and women's organizations comprised a major portion of her clientele.

Morgan designed lavish schemes for newspaper owner William Randolph Hearst, but most of her work is modest in scale and unpretentious in character. Often these buildings possess the simple, rustic qualities associated with the American Arts and Crafts Movement, as seen at St John's Presbyterian Church, Berkeley (1908, 1910; now the Julia Morgan Center for the Performing Arts), or the Drexler House (1913), Woodside, CA. Sometimes inspiration was also drawn from the English Arts and Crafts Movement. Many other examples are more formal in tone, with references to the classical tradition in England and Italy, for example the Chickering House (1912), Piedmont, CA, and the Y.W.C.A. (1913–14), Oakland, CA. In both plan and elevation, her buildings adhere to Beaux-Arts principles and are composed in a straightforward manner, demonstrating a clear, purposeful order in the arrangement of space, form and detail. While unusual in its diversity of expression, Morgan's oeuvre represents the mainstream of 20th-century American academic work at its best.

BIBLIOGRAPHY

W. T. Steilberg: 'Some Examples of the Work of Julia Morgan', *Architect & Engin. CA*, lv/2 (1918), pp. 39–107

R. Longstreth: 'Julia Morgan: Some Introductory Notes', *Perspecta*, 15 (1975), pp. 74–86; repr. as *Julia Morgan, Architect* (Berkeley, 1977, R 1986)

S. Boutelle: 'Women's Networks: Julia Morgan and her Clients', *Heresies*, xi/3 (1981), pp. 91–4

——: *Julia Morgan, Architect* (New York, 1988)

D. Favro: 'Sincere and good: The Architectural Practice of Julia Morgan', *J. Archit. & Planning Res.*, iv/2 (1992), pp. 112–28

RICHARD LONGSTRETH

Mormons [The Church of Jesus Christ of Latter-day Saints]. Religious sect. It was founded in 1830 in a farmhouse near Fayette, NY, by Joseph Smith jr (1805–44), who declared that he had been called by God as a modern prophet to restore Christianity in its purity. The name was taken from the *Book of Mormon*, a companion scripture to the Bible, narrating the religious history of an ancient American people who were visited by the resurrected Christ; this was translated from golden plates and published by Smith in 1830. A central teaching of the Church was that members should gather to the American frontier to build the City of Zion in preparation for Christ's millennial reign. Attempts to build latter-day Zion aroused violent opposition in Ohio, Missouri and Illinois, culminating in the assassination (1844) of Joseph Smith and his brother Hyrum Smith. In 1847 Brigham Young (1801–77), Smith's successor as president and prophet, founded Salt Lake City, UT, as a new headquarters, and over the next 30 years he established hundreds of settlements in the region. Between 1847 and 1900 more than 100,000 converts (mostly American, Canadian, British and Scandinavian) travelled to Utah.

From its early days, the Mormon Church sponsored and inspired architecture, urban planning, painting and sculpture. Mormon urban planning began with Smith's *Plat of the City of Zion* (developed in Kirtland, Ohio in 1833 and proposed to be used as a basis for settling in Independence, MO and other places), which called for cities housing 15,000 to 20,000 believers, laid out in a geometric plan of large square blocks and broad streets surrounding temples and storehouses. In all, *c.* 700 communities modelled on Smith's plan were founded throughout the western USA. The Church's emphasis on community building was particularly important. The first Mormon temple (1834–7) in Kirtland, OH, was an impressive Federal-style structure with Gothic details. In Utah various functions of the early temples were divided among several building types: ward (neighbourhood) meeting-houses for congregational worship, tabernacles for regional conferences and other large gatherings, and temples for sacred ceremonies. The Salt Lake Temple (1853–93; for illustration *see* SALT LAKE CITY), designed by Truman O. Angell (1810–87), became the architectural symbol of the Church, with its buttressed granite walls and six spires.

Early Utah meeting-houses were generally simple rectangular adobe structures with gabled roofs, but as settlements grew they became more elaborate, with entrances and towers in a variety of revival styles (e.g. the Gothic-style Brigham City Tabernacle, 1875–96). Between 1910 and 1925 Frank Lloyd Wright's influence resulted in imposing modern temples (e.g. in Cardston, Alberta, 1912–23).

Although Mormon meeting-houses and tabernacles seldom included paintings and sculpture, the Church offered many commissions for portraits, public sculpture, and symbolic landscape murals in temples. Mormon art in the late 19th century was dominated by European convert immigrants, including the Scandinavian genre painter C. C. A. Christensen (1831–1912). Some, with Church sponsorship, studied in Paris, including the Impressionist painter John Hafen (1857–1910). Folk arts and handicrafts also flourished in Utah, especially furniture-making and quilting. The Museum of Church History and Art (opened in Salt Lake City in 1984) exhibits works of fine and folk arts by Mormons from around the world, and collections of Mormon art are also displayed at the Museum of Fine Arts at the University of Utah, at Utah State Historical Society, both in Salt Lake City, and the Brigham Young University Museum of Art, Provo, Utah.

BIBLIOGRAPHY

G. B. Hinckley and others: *Temples of the Church of Jesus Christ of Latter-day Saints* (Salt Lake City, 1988)

J. Allen and G. Leonard: *The Story of the Latter-day Saints* (Salt Lake City, 1992)

PAUL L. ANDERSON

Morris, George. *See under* BONNIN & MORRIS.

Morrison Irwin, Harriet. *See* IRWIN, HARRIET MORRISON.

Morse, Samuel F(inley) B(reese) (*b* Charlestown, MA, 27 April 1791; *d* New York, 2 April 1872). American painter and inventor. The son of a Calvinist minister, he began amateur sketching while a student at Yale College, New Haven, CT. After graduating in 1810, he returned to Charlestown, MA, to paint family portraits. In Boston in the same year he met Washington Allston, recently returned from Italy, under whose tutelage he executed his first history painting, the *Landing of the Pilgrims at Plymouth* (*c.* 1810–11; Boston, MA, Pub. Lib.). He joined Allston on his trip to London in 1811, enrolled in the Royal Academy

Schools and also studied privately with Allston and Benjamin West. Morse's *Dying Hercules* (1812–13; New Haven, CT, Yale U. A.G.), based on the pose and musculature of the *Laokoon* (Rome, Vatican, Mus. Pio-Clementino) and the theory evident in Allston's *Dead Man Restored to Life by Touching the Bones of the Prophet Elisha* (1811–14; Philadelphia, PA Acad. F.A.), was critically acclaimed when exhibited at the Royal Academy and is indicative of Morse's academic interests. After two trips in 1813 and 1814 to Bristol, where he painted a number of portraits and small subject pieces, Morse ended his period in England with another mythological history painting, the *Judgement of Jupiter* (1814–15; New Haven, CT, Yale U. A.G.).

Morse received critical praise but little financial reward from the exhibition of his London pictures on his return to Boston in 1815, and as a result he turned to portraiture to earn a living. After two difficult years travelling through New England, he made the first of four annual trips early in 1818 to Charleston, SC, where he painted dozens of portraits. That of his wife, *Lucretia Pickering Walker Morse* (c. 1818–19; Amherst Coll., MA, Mead A. Mus.), shows the influence of Gilbert Stuart in its painterly technique and bold colour. Morse's later portraits in Charleston are closer in style to the fluid elegance of Thomas Sully.

Having profited both artistically and financially from his time in Charleston, Morse painted his first mature American history picture, the *House of Representatives* (2.20×3.33 m, 1822–3; Washington, DC, Corcoran Gal. A.). His largest work, it depicts Benjamin Henry Latrobe's newly renovated Hall of Congress and over 80 portraits

of congressmen, Supreme Court justices, journalists, a Pawnee Indian and the artist's father. Morse hoped to demonstrate to a mass audience the rationality, morality and gentility of the American system of government; but because of its emblematic nature and the narrative expectations of the viewing public, the exhibition of the *House* in New Haven, Boston and New York was a popular and financial disaster, forcing Morse to return to portraiture.

In New Haven during the early 1820s Morse painted figures in and around the Yale University community, such as *Eli Whitney, Benjamin Silliman* (both New Haven, CT, Yale U. A.G.) and *Noah Webster* (Amherst Coll., MA, Mead A. Mus.). Moving late in 1824 to New York, which became his permanent home, Morse reached the apex of his career. He painted many of the city's literary and political leaders, including romantic portraits of *William Cullen Bryant* (c. 1826; New York, N. Acad. Des.) and *DeWitt Clinton* (1826; New York, Met.). His most important portrait commission of this period, for the City of New York, was of the *Marquis de Lafayette* (1825–6; New York, City Hall), who was on a triumphant tour of the USA on the occasion of the semi-centennial of the American Revolution. Full-length and life-size, the portrait represents a departure in the grand-style American portrait. Unlike the static classical pose that had dominated American portraiture (e.g. Gilbert Stuart's *'Lansdowne' Washington*, 1796; Philadelphia, PA Acad. F.A.), Morse's *Lafayette* shows the figure in action, a style influenced by the portraits of Sir Thomas Lawrence (1769–1830). During this period Morse also worked for literary publications,

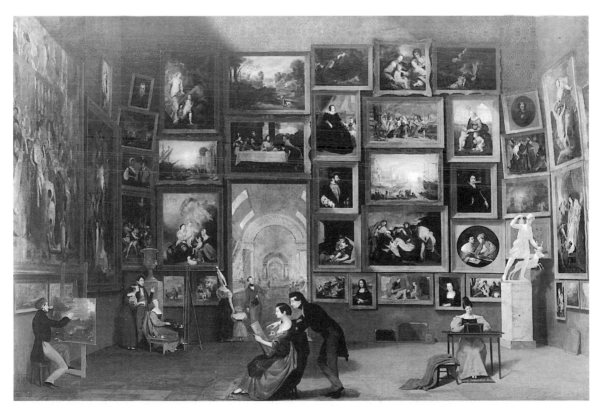

Samuel F. B. Morse: *Gallery of the Louvre*, oil on canvas, 1.87×2.74 m, 1832–3 (Chicago, IL, Terra Museum of American Art)

painted a few landscapes and founded the National Academy of Design, New York, of which he was the first president.

Morse travelled to Europe in 1829, spending a year in Italy, where he studied thousands of Old Master pictures, astutely copied some, including the *Miracle of the Slave* (1548; Venice, Accad.; copy, 1831; Boston, MA, Mus. F.A.) by Tintoretto (1519–94), and sketched and painted landscapes such as his beautiful *Chapel of the Virgin at Subiaco* (1831; Worcester, MA, A. Mus.). In mid-1831 he was in Paris, where he began the *Gallery of the Louvre* (1832–3; Chicago, IL, Terra Mus. Amer. A.; see fig.). A pantheon of the Louvre's masterpieces assembled in Morse's imagination in the Salon Carré, the work, exemplifying his artistic skill, is Morse's attempt to provide Americans with an awareness of their artistic patrimony. However, like the *House of Representatives* before it, the *Louvre* was not a popular success when exhibited in New York in 1833.

The failure of the *Louvre*, coupled with the decision of the US Congress not to commission Morse to paint a mural in the Capitol Rotunda, signalled the waning of his artistic career. He continued as President of the National Academy until 1845, was appointed Professor of the Literature of the Arts of Design at New York University in 1834 and painted a few spectacular pictures in the 1830s, such as the chromatically brilliant portrait of his daughter Susan, *The Muse* (1836–7; New York, Met.; see colour pl. XI, 2). Morse's time was increasingly absorbed by politics, science and technology. In 1839, after meeting Daguerre in Paris, Morse publicized the daguerreotype process in the USA and became one of its earliest practitioners, opening a portrait studio with John William Draper (1811–82) in New York in 1840. In the late 1830s he developed the first practical electromagnetic telegraph and signalling code. After successfully demonstrating the revolutionary instrument before Congress in 1844 and building a telegraphic empire, Morse became the most honoured inventor in 19th-century America, known especially for this Morse Code.

See also colour pl. XXVI, 2.

WRITINGS

E. L. Morse, ed.: *Samuel F. B. Morse: His Letters and Journals*, 2 vols (Boston, 1914)
N. Cikoksky jr, ed.: *Lectures on the Affinity of Painting with the Other Fine Arts, by Samuel F. B. Morse* (Columbia, MO, 1983)

BIBLIOGRAPHY

Samuel F. B. Morse: American Painter (exh. cat. by H. B. Wehle, New York, Met., 1932)
C. Mabee: *The American Leonardo: A Life of Samuel F. B. Morse* (New York, 1943)
O. Larkin: *Samuel F. B. Morse and American Democratic Art* (Boston, 1954)
P. J. Staiti: 'Samuel F. B. Morse's Search for a Personal Style', *Winterthur Port.*, xvi (1981), pp. 253–81
Samuel F. B. Morse (exh. cat. by P. J. Staiti, New York U., Grey A.G., 1982)
Samuel F. B. Morse: Educator and Champion of the Arts in America (exh. cat. by N. Cikovsky jr and P. J. Staiti, New York, N. Acad. Des., 1982)
P. J. Staiti: *Samuel F. B. Morse* (Cambridge, MA, 1989)
G. Batchen: 'Some Experiments of Mine: The Early Photographic Experiments of Samuel Morse', *Hist. Phot.*, xv (Spring, 1991), pp. 37–42

PAUL J. STAITI

Mould, Jacob Wrey (*b* Chislehurst, Kent, 1825; *d* New York, 14 June 1886). English architect and designer, active in the USA. He claimed to have been an assistant to Owen Jones in London. In 1852 he emigrated to New York, where he designed All Souls' Unitarian Church (1853–5; destr.). The banded red brick and white sandstone of the Italian Romanesque design introduced polychromy to American architecture. In subsequent years Mould designed less flamboyant churches, notably West Presbyterian Church (1863; destr.) in New York and First Presbyterian Church (1874) in Bath, NY. His talent as a designer led him to work in the decorative arts. He made designs for stained glass, book bindings, banknotes, textiles and other items. His taste for non-Western design motifs anticipated the American Aesthetic Movement. Unfortunately, little remains as evidence of Mould's inventive manipulation of colour and ornament. His most enduring works as a decorator are the carvings he designed for the Terrace (1858–70) in Central Park, New York, a structure designed by Calvert Vaux. Mould also collaborated with Vaux on the design of the Metropolitan Museum of Art (begun 1874) and the American Museum of Natural History (begun 1874), both in New York. For a brief period in the early 1870s, he served as architect-in-chief of Central Park. In 1874–9 he lived in Lima, Peru, where he planned the municipal park system and designed a polychromatic brick and stone house (*c.* 1879). Mould enjoyed the reputation of a genius among his liberal-minded colleagues. His unconventional way of life, however—he lived openly with a woman who was not his wife—put off many influential clients. Among his more important extant works are Trinity Church Parish School (1860; now the Serbian Eastern Orthodox Cathedral of St Sava), New York; the Sheepfold (1870; now the Tavern-on-the-Green Restaurant) in Central Park; and St Mary's Church (1874), Luzerne, NY.

BIBLIOGRAPHY

Macmillan Enc. Archit.
H.-R. Hitchcock: 'Ruskin and American Architecture, or Regeneration Long Delayed', *Concerning Architecture: Essays on Architectural Writers and Writing Presented to Nikolaus Pevsner*, ed. J. Summerson (London, 1968)
D. Van Zanten: 'Jacob Wrey Mould: Echoes of Owen Jones and the High Victorian Styles in New York, 1853–1865', *J. Soc. Archit. Hist.*, xxviii (1969), pp. 41–57
F. Kowsky: *Country, Park and City: The Architecture and Life of Calvert Vaux* (New York, 1998)

FRANCIS R. KOWSKY

Moulthrop, Reuben (*b* East Haven, CT, 1763; *d* East Haven, 1814). American painter. As proprietor of a waxworks museum and travelling waxworks exhibition, he was interested in modelling in wax in his early years. While moving around his native state, he was exposed to several artistic influences, beginning with Winthrop Chandler. His earliest portraits seem to date from about 1788, when he completed *Mr and Mrs Samuel Hathaway* (1788; New Haven, CT, Colony Hist. Soc. Mus.). Its dark, heavy outlines, its flatness and almost geometric forms derive from Chandler. The quality of Moulthrop's paintings was extremely uneven; many of the best of the surviving body of about 50 works date from around 1800. *The Rev. Thomas Robbins* (1801; Hartford, CT Hist. Soc. Mus.), which depicts the sitter's direct gaze and contains more detail than the earlier portraits, shows the artist at his most

accomplished. In the last years of his brief career he appears to have been influenced by William Jennys and John Durand, but he remained wedded to the flat conservative style seemingly favoured by his subjects.

BIBLIOGRAPHY

S. Sawitzky: 'New Light on the Early Work of Reuben Moulthrop', *A. America*, xliv (1956), pp. 9–11, 55

R. W. Thomas: 'Reuben Moulthrop, 1763–1814', *CT Hist. Soc. Bull.*, xxi (1956), pp. 97–111

S. C. Hollander: 'Reuben Moulthrop: Artist in Painting and Waxworks: Paintings from the Collection of Nina Flekker Little', *Flk A.*, xix (Autumn 1994), pp. 36–41

DAVID M. SOKOL

Mount, William Sidney (*b* Setauket, NY, 26 Nov 1807; *d* Setauket, 18 Nov 1868). American painter. America's first major genre painter and one of the most accomplished of his era (rivalled only by George Caleb Bingham), he spent most of his life on rural Long Island. He was apprenticed as a sign painter in 1825 to his brother, Henry Mount (1802–41), in New York. In 1826, frustrated by the limitations of sign painting, he enrolled for drawing classes at the newly established National Academy of Design, where he aspired to be a painter of historical subjects. His first efforts in painting were portraits; the historical scenes that followed, such as *Saul and the Witch of Endor* (1828; Washington, DC, N. Mus. Amer. A.), were similarly linear, flat and brightly coloured. In 1827 he returned to live on Long Island, and from then onwards he alternated between the city and the country. He began to make the yeomen of Long Island his subject-matter, perhaps inspired by the popularity of engravings after David Wilkie (1785–1841) and 17th-century genre painters.

Mount's first attempt at a genre painting, *Rustic Dance after a Sleigh Ride* (1830, Boston, MA, Mus. F.A.), which he exhibited at the National Academy in New York that year, was a great success. It depicts a farm parlour full of dancing male and female 'rustics', lightly caricatured in their dress and expressions. Amusing as his New York audience found country manners, however, he soon realized that he could probe a deeper vein in this agrarian ideal. On the one hand, Americans considered the landowning and hardworking farmer to be the ideal American; on the other, because political, social and economic decision-makers (and patrons of the arts) tended to be city people, they saw the rural citizen as a shrewd bumpkin. This characterization could also be referred back to the city dwellers. Mount's first painting highlighting this comic discrepancy was so well received that it set the pattern for the rest of his career. His *Bargaining for a Horse* (1835; New York, NY Hist. Soc.; see fig.) shows two farmers in a barnyard whittling to disguise their strategy in working out a deal. The negotiation is overtly for the horse near by, but in the new era of political bargaining and economic speculation that America had entered in the early 1830s, the painting also encouraged the viewer to laugh at many kinds of 'horsetrading' in which American citizens were involved.

Mount followed this huge success—the painting was engraved twice, once for the American Art Union—with a succession of paintings that were rooted in national self-criticism and popular expression. *Farmers Nooning* (1836;

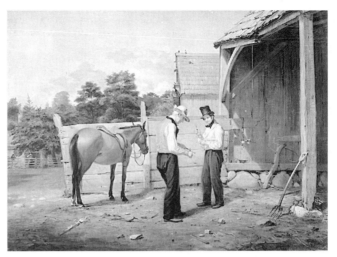

William Sidney Mount: *Bargaining for a Horse*, oil on canvas, 609×762 mm, 1835 (New York, New-York Historical Society)

Stony Brook, NY, Mus.; see colour pl. X, 2) embodied the apprehensions that were held about slavery and emancipation and highlighted the self-indulgent black worker as a major American labour problem. *Cider-making* (1841; New York, Met.) showed farmers directing all the phases of cider-making, a clever allegory for the party machinery of the Whigs, who had used cider (the drink of the 'common man') as one of their major symbols in the 1840 election campaign. *Herald in the Country* (or *The Politics of 1852: Who Let down the Bars?*, 1853; Stony Brook, NY, Mus.) shows a country man and a city man on opposite sides of a partially dismantled rail fence; the city man is reading a newspaper, *The Herald*, a clue that, alongside Mount's alternative title, suggests the painting laughs at the Democratic election victory over the Whigs in 1852, a victory made possible by the huge influx of immigrants who voted Democrat. Although he himself was a Democrat, Mount in his paintings usually rose above party issues to laugh at the political process in general.

In many of his paintings, Mount turned to other themes of rural life. He created several works that celebrated rural music-making. One of his favourite formats was fiddle-playing (Mount was himself a violinist) or the fiddle-accompanied dance inside the country barn, visible from the outside of the barn through a large rectangular open door. In one of his best-known paintings in this format, *The Power of Music* (1847; Cleveland, OH, Mus. A.), a black person leans against the outside wall of the barn, absorbed in the attraction of the music. Mount was unusual in depicting the listener without caricature. Recognizing the attractiveness of this point of view, in the 1850s the art dealer William Schaus commissioned from Mount a number of images of black musicians for distribution in Europe as lithographs.

Mount received commissions from the most influential patrons in New York City, including Luman Reed and Jonathan Sturges (who took *Farmers Nooning*), and many of his works were engraved. He was a favourite of the newspaper and journal critics, who held him up as a model. The wit with which he carried out national self-criticism

was unique among American artists; imitators such as Francis Edmonds and James Clonney failed to capture the spirit of his paintings. His clear draughtsmanship, small, precise brushstrokes, abstemious application of paint and choice of bright colours all contributed greatly to his success. Extraordinarily selfconscious about painting methods, he kept journals in which he recorded experiments with pigments and brushes. He sketched extensively in notebooks and painted *plein-air* oil sketches for several works, devising a studio-wagon in which he travelled over Long Island. In his journals and extensive correspondence he considered a number of ideas for subjects. Although he made a large number of sketches of city characters, he only ever painted rural scenes, as these were what his audience wanted.

Mount never married. Throughout his life he continued to paint portraits; so many of them were posthumous that he once commented that his best patron was death. Although his genre paintings were very much in demand, he went for long stretches without painting—particularly after the Civil War—possibly because of the limited number of popular puns and concerns that he could exploit pictorially.

UNPUBLISHED SOURCES
Stony Brook, NY, Mus. [ntbks, journals, corr.]

BIBLIOGRAPHY
K. Adams: 'The Black Image in the Paintings of William Sidney Mount', *Amer. A. J.*, vii/2 (1975), pp. 42–59
A. Frankenstein: *William Sidney Mount* (New York, 1975)
J. Hudson jr: 'Banks, Politics, Hard Cider and Paint: The Political Origins of William Sidney Mount's *Cider Making*, *Met. Mus. J.*, x (1975), pp. 107–18
D. Cassedy and G. Schrott: *William Sidney Mount: Annotated Bibliography and Listings of Archival Holdings of the Museums at Stony Brook* (Stony Brook, NY, 1983)
——: *William Sidney Mount: Works in the Collection of the Museums at Stony Brook* (Stony Brook, NY, 1983)
J. Armstrong, ed.: *Catching the Tune: Music and William Sidney Mount* (Stony Brook, NY, 1984)
E. Johns: *American Genre Painting: The Politics of Everyday Life* (New Haven, CT, and London, 1991)
William Sidney Mount: Painter of American Life (exh. cat. by D. J. Johnson, New York, Hist. Soc.; Pittsburgh, PA, Frick A. Mus.; Fort Worth, TX, Amon Carter Mus.; 1998–9)

ELIZABETH JOHNS

Mt Washington Glass Works. American glass factory founded in 1837 by Deming Jarves (1790–1869), who was also instrumental in establishing the New England Glass Co. and the Boston & Sandwich Glass Co. Located in South Boston, the Mt Washington Glass Works was operated by Luther Russell until his death. Jarves's son, George D. Jarves, was a partner in the firm with others from 1846 until it was sold in 1861 to William L. Libbey (1827–83) and Timothy Howe (*d* 1866). In 1866 Libbey became sole proprietor, and in 1870 he moved the works to a modern factory in New Bedford, MA. Although the early products were apparently mundane, including lamps, tubes for table lamps, shades and table glass, the art wares produced after 1880 established the firm's reputation. Beginning in 1878 the company patented several types of opal and shaded effects including 'Lava', 'Burmese', 'Peachblow', 'Albertine', 'Royal Flemish' and 'Crown Milano'. Often these wares were fitted with silver-plated covers or holders. In the 1880s the company agent

Frederick Stacey Shirley promoted the firm's place as a leading manufacturer of art glass. In 1894 the firm was purchased by the Pairpoint Manufacturing Co. Established in 1880, Pairpoint had been using Mt Washington glass as inserts and shades for its silver-plated products.

BIBLIOGRAPHY
K. M. Wilson: *New England Glass and Glassmaking* (New York, 1972)
ELLEN PAUL DENKER

Muggeridge, Edward James. *See* MUYBRIDGE, EADWEARD.

Mullett, Alfred B(ult) (*b* Taunton, Somerset, 8 April 1834; *d* Washington, DC, 20 Oct 1890). American architect of English birth. He emigrated to the USA with his family in 1844 and settled in Glendale, OH, located just to the north of Cincinnati. He received training in technical drawing and mathematics from Farmers' College, Hamilton Co., OH, and in 1856 began his architectural career in the office of Isaiah Rogers in Cincinnati. After four years with the firm, Mullett left for a Grand Tour of Europe. In June 1861, soon after the outbreak of the Civil War, he was hired as a clerk by the US Treasury Department. Two years later he was transferred to the Office of the Supervising Architect, then part of the Treasury Department, which was headed by Rogers. Mullett succeeded Rogers as Supervising Architect in 1866. During the eight years that Mullett served in that position, he was in charge of the design and construction of important federal government buildings, including custom houses, court-houses, post offices, branch mints and assay offices, located throughout the country. Several of his earliest federal government buildings were designed in classical styles, such as the Greek Revival San Francisco Mint (1869–74) and the Court House and Post Office in Portland, ME (1869–73; destr. 1965).

Mullett is best remembered for his massive Second Empire style buildings constructed in several of the USA's larger cities. Outstanding examples include the Post Office and Custom House (1872–84) in St Louis, MO, the Post Office and Court House (1869–75; destr. 1939) in New York and the State, War and Navy Building (1871–86; see colour pl. III, 3) on the block immediately to the west of the President's House (now the White House) in Washington, DC (*see* WASHINGTON, DC, fig. 6). Mullett oversaw the design of 40 new federal government buildings. He resigned from his position in 1874, after a change in the administration of the Treasury Department and in the midst of severe criticism voiced by private architects about his authority over federal government buildings. During the remainder of his life, Mullett designed many private buildings in Washington, DC, and elsewhere. Among his most significant private commissions in the capital are the Sun Building (1885–6) and the Central National Bank Building (1887–8; now the Apex Building), both in the Romanesque Revival style.

BIBLIOGRAPHY
D. J. Lehman: *Executive Office Building*, General Services Administration Historical Study, 3 (Washington, DC, 1970)
L. Wodehouse: 'Alfred B. Mullett and his French Style Government Buildings', *J. Soc. Archit. Hist.*, xxxi (1972), pp. 22–37

D. M. Smith: *A. B. Mullett: His Relevance in American Architecture and Historic Preservation* (Washington, DC, 1990)

ANTOINETTE J. LEE

Mullgardt, Louis C(hristian) (*b* Washington, MO, 1866; *d* Stockton, CA, 1942). American architect. His career began at the age of 15 when he became an apprentice with the architectural firm of Wilhelmi & Janssen, followed by work in the office of James Stewart & Co., both offices in St Louis, MO. In 1887 he moved to Brookline, MA, to work for the firm of Shepley, Rutan & Coolidge, successors to the practice of H. H. Richardson. His work in that office included designs for the Stanford University campus, which brought his attention to the idea of developing a uniquely Californian style. In 1889 he entered Harvard College, Cambridge, MA, but left before graduation due to illness.

In 1891 Mullgardt joined the Chicago office of Henry Ives Cobb, where he designed buildings in many styles, including the Newberry Library (1892), Chicago (*see* COBB, HENRY IVES, fig. 1, in the Romanesque Revival style and the Athletic Club (1892), Chicago, in Venetian Revival style. He also worked on buildings in Gothic Revival style for the University of Chicago (1891–3) and was responsible for the decorative detail of Cobb's Fisheries Building (1893) for the World's Columbia Exposition, Chicago. From 1892 to 1894 he was a partner in the firm of Stewart, McClure & Mullgardt in St Louis, designing the American Colonial style Arlington Hotel (1892–4; destr.) of Hot Springs, AR.

After travelling in Europe in 1894 and 1895, Mullgardt returned to a practice in St Louis. From 1903 to 1904 he was in England serving as a consultant on architectural structural design. In 1905 he returned to the USA and opened an office in San Francisco in 1906 where he carried out some of his most influential work. The small Ernest A. Evans House (1907) in Mill Valley, CA, and the vast mansion (1908–10; destr. 1935; see *Macmillan Enc. Archit.*, p. 253) for Henry W. Taylor in Berkeley are examples of Mullgardt's efforts to achieve a California style through the amalgamation of such diverse influences as English Arts and Crafts work, the white walls and tile roofs of the Spanish California missions and the developing bungalow style that became typical of much work in the San Francisco Bay Area.

BIBLIOGRAPHY
Macmillan Enc. Archit.
R. J. Clark: 'Louis Christian Mullgardt and the Court of the Ages', *J. Soc. Archit. Historians*, xxi/4 (1962), pp. 171–8
——: *Louis Christian Mullgardt: 1866–1942* (Santa Barbara, 1966)
JOHN F. PILE

Munday, Richard (*b* ?Newport, RI, *c.* 1685 ; *d* Newport, 1739). American architect. Records show that he was married in Newport in 1713. In 1719 he was listed as an innkeeper and in 1721 as a house carpenter, becoming a freeman in 1722. In the early 1730s he lived at Bristol, RI, but he had returned to Newport by 1738. Munday's high reputation among the craftsmen-architects of New England rests mainly on two buildings in Newport: Trinity Church (1725–6) and the Colony House (1739–41). Trinity Church is a timber structure, resembling St James, Piccadilly, London by Christopher Wren (1632–1723), which was also the model for the Old North Church, Boston, begun in 1723. Old North Church, rather than St James, Piccadilly, was clearly Munday's source. The spire, designed in 1726 but not built until 1741, has much in common with the spire of Old North, which is itself a taller version of the spire of Wren's St Lawrence Jewry, London. A contemporary document shows that Munday was to be paid $25 for 'draughting a plan' for the Colony House. The style and scale of this brick and stone civic building are predominantly domestic, with motifs associated with local domestic architecture. In Godfrey Malbone's House (1727; destr.) in Newport, Munday had employed a broad gambrel roof and a cupola, and the Thomas Hancock House (Joshua Blanchard, builder; 1737–40; destr. 1863), Boston, had a façade with a balcony at first-floor level. To the Colony House, Munday again gave a cupola and front balcony. The civil courtroom occupied the ground floor; on the first floor, the middle room, behind the balcony, was flanked by the Deputies' Room to the west and the Council Room to the east.

BIBLIOGRAPHY
Macmillan Enc. Archit.
H. R. Hitchcock: *Rhode Island Architecture* (Providence, 1939/*R* New York, 1968)
A. F. Downing and V. J. Scully jr: *The Architectural Heritage of Newport, Rhode Island, 1640–1915* (Cambridge, MA, 1952, rev. New York, 1967)
MARCUS WHIFFEN

Murphy, J(ohn) Francis (*b* Oswego, NY, 11 Dec 1853; *d* New York, 10 June 1921). American painter. A self-taught artist, he depicted the coastal flatlands of New York and New Jersey and similar countryside in New England. His early work until *c.* 1885 was based on direct observation of nature and was often small-scale, for example *Summer Afternoon* (1875; Salt Lake City, U. UT, Mus. F.A.). In middle-period works, such as *New England Landscapes* (n.d.; Springville, UT, Mus. A.), Murphy was influenced by A. H. Wyant, George Inness, Homer Dodge Martin and the Barbizon school painters Corot (1796–1875), Rousseau (1812–67) and Daubigny (1817–78). He spent summers at Arkville in the Catskill Mountains from 1887, and Wyant's presence there between 1889 and 1892 had a pronounced influence on Murphy's developing Tonalist style. His work of this time consists of spare expressions of barren wind-blown land painted with a limited palette. Murphy typically prepared his canvases early to give time for the underpaint to dry and then applied brown and gold, which he flattened with a palette-knife as a basis for later stages of rubbing (with pumice), lacquering and glazing. After 1900 Murphy painted some of his finest oils, including *Sprout Lake* (1915; Washington, DC, N. Mus. Amer. A.), in which he achieved an almost pure tonal unity.

BIBLIOGRAPHY
E. Clark: *J. Francis Murphy* (New York, 1926)
American Art in the Barbizon Mood (exh. cat. by P. Bermingham, Washington, DC, Smithsonian Inst., 1975)
M. Muir: *Tonal Painting, Tonalism and Tonal Impressionism* (MA thesis, U. Utah, 1978)
Tonalism: An American Experience (exh. cat., ed. J. Davern; New York, Grand Cent. A. Gals, 1982)
ROBERT S. OLPIN

Muybridge, Eadweard [Muggeridge, Edward James] (*b* Kingston-on-Thames, 9 April 1830; *d* Kingston-on-Thames, 8 May 1904). English photographer, active in the

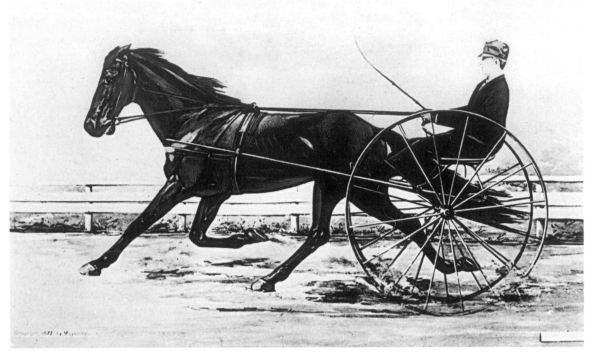

1. Eadweard Muybridge: photograph of a horse ('Occident') trotting, 1877 (London, Science Museum)

USA. He was the first to analyse motion successfully by using a sequence of photographs and resynthesizing them to produce moving pictures on a screen. His work has been described as the inspiration behind the invention of the motion picture.

Born Edward James Muggeridge, he emigrated around 1852 to the USA, where he first worked for a firm of publishers and later became a book dealer. After a stagecoach accident in Texas in 1860, he returned to England, where he took up photography. By 1867 he was back in California, describing himself as 'Eadweard Muybridge, artist–photographer'. During the next five years he took over 2000 photographs, selling many of them under the pseudonym Helios. Muybridge made his name as a photographer with a successful series of views, *Scenery of the Yosemite Valley*, published in 1868. In 1872 he was commissioned by a former governor of California, LELAND STANFORD, to photograph his horse, Occident, trotting at speed. The aim was to test Stanford's theory that at some stage in its trot the horse would have all four feet off the ground. Muybridge's first photographs were inconclusive, but further attempts in 1873 appeared to prove the point, at least to Stanford's satisfaction. Work was interrupted by a dramatic crisis when Muybridge, tried for killing his wife's lover and acquitted, found it prudent to make a photographic expedition to Central America.

In 1877 Muybridge returned to the problem of the trotting horse and began the work which was to make him famous. He designed an improved shutter to work at the astonishing speed of one-thousandth of a second and used all his experience to sensitize his plates for the shortest possible exposure. When the resulting retouched picture of Occident in arrested motion was published in July 1877,

it was so different from the traditional artist's impression that it created a minor sensation (see fig. 1). The next year Muybridge embarked on an even more ambitious series of experiments. In order to secure a sequence of photographs of horses in various stages of trotting, he set up a battery of 12 cameras fitted with electromagnetic shutters. These were activated by strings stretched across the track. Muybridge later repeated his experiments using 24 cameras. The subsequent photographs were widely reproduced in publications throughout America and Europe. The publicity led Muybridge to design a projecting device based on an optical toy by which drawings derived from his photographs could be projected on to a screen as moving pictures. During the early 1880s he toured Europe with this instrument, termed the zoopraxiscope, and a large collection of lantern slides. With the latter he was able to demonstrate that artists throughout the ages had depicted the horse in attitudes that were completely false.

On his return to America, Muybridge quarrelled with Stanford, but in 1884 he was able to begin work at the University of Pennsylvania using elaborate banks of cameras to analyse animal and human motion by means of photographs. He took over 100,000 photographs, 20,000 of which were reproduced in his major publication, *Animal Locomotion* (London, 1887; see fig. 2). This 11-volume work had a tremendous impact, not least on artists, who were forced to reassess completely the manner in which they depicted animal movement.

Muybridge finally returned to England in 1900. He bequeathed numerous relics of his work to Kingston-on-Thames Public Library, a great proportion of which is on loan to the Science Museum, London. Other major repositories of Muybridge's work include the Bancroft

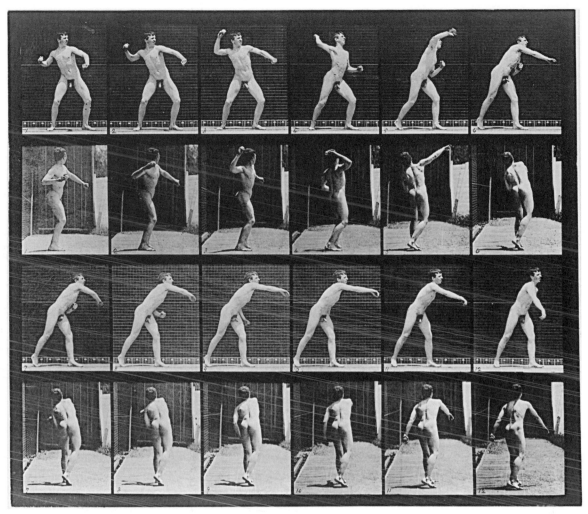

2. Eadweard Muybridge: *Baseball: Throwing*, collotype, 1887; from Eadweard Muybridge: *Animal Locomotion* (London, 1887), pl. 286 (Philadelphia, PA, Museum of Art)

Library at the University of California, Berkeley, the Stanford University Library and the Stanford University Art Gallery and Museum.

BIBLIOGRAPHY

J. M. Eder: *Geschichte der Photographie* (Vienna, 1905, rev. Halle 4/1932; Eng. trans., 1945/*R* 1972)

G. Hendricks: *The Edison Motion Picture Myth* (Berkeley, 1961)

The Painter and the Photograph (exh. cat., ed. Van Deren Coke; Albuquerque, U. NM, A. Mus., 1964)

A. Scharf: *Art and Photography* (London, 1968)

Eadweard Muybridge: The Stanford Years, 1872–1882 (exh. cat., ed. A. V. Mozley, R. B. Haas and F. Forster-Hahn; Stanford U., A.G. & Mus., 1972, rev. 1973)

R. B. Haas: *Muybridge, Man in Motion* (Berkeley, 1975)

G. Hendricks: *Eadweard Muybridge: The Father of the Motion Picture* (London, 1975)

Muybridge's Complete Human and Animal Locomotion, 3 vols (New York, 1979) [reprint of *Animal Locomotion* and *Prospectus and Catalogue of Plates* (London, 1887), with intro. by A. V. Mozley]

B. Coe: *The History of Movie Photography* (London, 1981)

Eadweard Muybridge, Animal Locomotion: Images from the Philadelphia Years (exh. cat. by R. J. Phelan and T. W. Fels, Albany, SUNY, U. A.G., 1985)

Eadweard Muybridge: Extraordinary Motion (exh. cat. by J. Nygren and F. Fralin, Washington, DC, Corcoran Gal. A., 1986)

Motion and Document, Sequence and Time: Eadweard Muybridge and Contemporary American Photography (exh. cat. by J. L. Sheldon and J. Reynolds, Washington, DC, N. Mus. Amer. A.; Andover, MA, Addison Gal. Amer. A.; Hartford, CT, Wadsworth Atheneum; and elsewhere; 1991–3)

D. Harris: *Eadweard Muybridge and the Photographic Panorama of San Francisco* (Cambridge, MA, [1993])

J. P. WARD

Myers, Elijah E. (*b* Philadelphia, 22 Dec 1832; *d* Detroit, 5 March 1909). American architect. Having worked as a carpenter in Philadelphia, he studied architecture in the office of Samuel Sloan and at the Franklin Institute, Philadelphia. His career as an architect began after the Civil War, during which he served as an engineer in the Union Army. He designed a number of churches, hospitals, city halls, court-houses and, most notably, several state capitols. For a short time he had an office in Springfield, IL, where he won the competition for the design of the Michigan State Capitol (1873–9), Lansing; he moved to Detroit to supervise construction of this building, which is in the Renaissance Revival style on a cruciform plan. He went on to win competitions for the Idaho Territorial

Capitol (1885), Boise, and the Colorado State Capitol (1890–96), Denver, also to Renaissance Revival designs. His most important work is the Texas Capitol (1882–8; see fig.), Austin, similarly inspired by the US Capitol (1792–1830, 1855–65), Washington, DC. Built with walls faced on the exterior with pink granite, the Texas Capitol is a monumental work on a cruciform plan, 171 m long and 87 m wide. It is crowned with a colonnaded drum and a hemispherical dome terminated with a lantern. Myers's career was shadowed by accusations of malpractice, but his Renaissance Revival public buildings rank high among 19th-century civic architecture in America.

BIBLIOGRAPHY

The Michigan State Capitol, Michigan Historical Commission (Lansing, 1969)

M. A. K. Koellner: *Elijah E. Myers (1832–1909): Architect* (MA thesis, Macomb, W. IL U., 1972)

W. B. Robinson: *Texas Public Buildings of the Nineteenth Century* (Austin, 1974)

P. Goeldner: 'The Designing Architect: Elijah E. Myers', *SW Hist. Q.*, xcii (1988), pp. 271–87

W. Seale: *Michigan's Capitol: Construction and Restoration* (Ann Arbor, 1995)

WILLARD B. ROBINSON

Elijah E. Myers: Texas Capitol, Austin, Texas, 1882–8

N

Nahl, Charles Christian (*b* Kassel, Germany, 18 Oct 1818; *d* San Francisco, CA, 1 March 1878). American painter and illustrator of German birth. Born to an artistic family, he was an accomplished watercolourist by age 12; he later studied at the Kassel Academy and exhibited work in Berlin and Dresden. In 1846 he moved with his close-knit family to Paris, where he may have worked with the history painter Horace Vernet (1789–1863). In 1849 the Nahls left Europe; settling in Brooklyn, NY, they were soon lured west by the promise of gold. Arriving in California in 1851, the family briefly and unsuccessfully worked a mining claim outside Marysville before moving to Sacramento. There Nahl set up a studio with August Wenderoth (1819–84), producing portraits, lithographs, newspaper illustrations and oil paintings of Gold Rush life (e.g. the jointly signed *Miners in the Sierras*, c. 1851; Washington, DC, N. Mus. Amer. A). Following a disastrous fire in Sacramento in 1852, the family and partnership moved to San Francisco. Wenderoth pursued other interests and eventually moved to Philadelphia. Nahl, by then accepting commissions for portraits, graphic designs and daguerreotypes, turned to his half-brother Arthur Nahl (1833–89) for assistance.

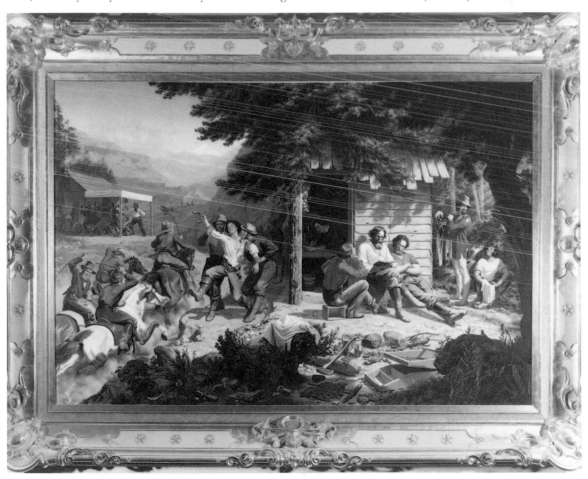

Charles Christian Nahl: *Sunday Morning in the Mines*, oil on canvas, 1.83×2.74 m, 1872 (Sacramento, CA, Crocker Art Museum)

An accomplished draughtsman with both mining experience and professional training, Charles Nahl was easily the foremost illustrator of California's pioneer era. His many illustrations for West Coast journals and books of the 1850s established several visual types now associated with Gold Rush life: the goldmining 'forty-niner', the *vaquero* and the grizzly bear featured on today's California State Flag. Portraiture and commercial work assured his survival, but he preferred to imagine and paint more complex themes. By the late 1860s, Nahl's patronage for such narrative compositions was sufficient to enable him to cede all other work to Arthur. Charles created many of his most ambitious and accomplished paintings for Judge E. B. Crocker of Sacramento, including his most famous work, *Sunday Morning in the Mines* (1872; Sacramento, CA, Crocker A. Mus.; see fig.). Based on Nahl's own illustrations from 1857, this richly anecdotal composition exhibits the vivid colours, theatrical lighting and smooth finish that he derived from his European training.

A prolific, versatile and indefatigable worker, Nahl remained somewhat apart from the dominant art circles in San Francisco, joining none of the various artist associations or social clubs that formed in the city during the early 1870s. His role as a pioneer artist, however, was recognized by his contemporaries and continues to be celebrated today.

BIBLIOGRAPHY

E. Neuhaus: 'Charles Christian Nahl: The Painter of California Pioneer Life', *CA Hist. Soc. Q.*, xv (1936), pp. 295–305

Charles Christian Nahl: Artist of the Gold Rush (exh. cat. by M. L. Stevens, Sacramento, CA, Crocker A. Mus., 1976)

Art of the Gold Rush (exh. cat. by J. T. Driesbach, H. L. Jones and K. C. Holland, Oakland, CA, Mus., 1998), pp. 47–63, 125–6

SALLY MILLS

Nast, Thomas (*b* Landau, Bavaria, 27 Sept 1840; *d* Guayaquil, Ecuador, 7 Dec 1902). American illustrator of German birth. His family emigrated to the USA and settled in New York when he was six. Precocious at drawing, Nast was taught by the German-born history painter Theodore Kaufmann (*b* 1814) and later studied briefly at the National Academy of Design. In 1855, aged 15, he began to work for *Leslie's Illustrated Weekly Magazine*, which continued to publish his political cartoons until 1858.

In 1860 Nast reported the Heenan–Sayers prize-fight in England for the *New York Illustrated News* and spent four months covering Garibaldi's campaign in Sicily and southern Italy for the *News* and the *Illustrated London News*. In 1862 Nast joined the staff of *Harper's Weekly*, where he worked until 1886. During that time he established the power of the American political cartoon. His Civil War drawings for *Harper's* were primarily trenchant propaganda against the South. Abraham Lincoln called Nast 'the Union's best recruiting sergeant'. His drawings mixed patriotism and sentiment, although a few achieved a broader humanistic statement about war.

Nast's style was fully developed by 1870. His drawings concentrated on a single strong image, in contrast to his earlier work, which attempted to combine several incidents. The directness of his mature style may be due to his increased interest in painting and book illustration.

Incisive lines reinforced the pointed wit of his subject-matter, and bold images translated more effectively into wood-engraving. After 1865 he based his portrait caricatures on photographs, as other British and American cartoonists had done. Nast subtly insinuated character traits and personal weaknesses into the expressions of the well-known public figures that were his subject-matter. This combination of truth and exaggeration made provocative concrete imagery out of abstract ideas. The point was reinforced by short satirical captions. The enormous public response to his work gave Nast greater influence than any other cartoonist.

Beginning with Lincoln in 1861, each of the six presidential candidates backed by Nast and *Harper's* was elected, earning Nast the name of 'president maker'. He also originated the Democratic donkey and the Republican elephant as party symbols and helped to shape popular American images of Santa Claus, Uncle Sam and Columbia. While Nast's political cartoons relate to earlier American ephemera, his more direct stylistic influence was the British illustrated press. The caricatures in *Punch* and the line drawings of John Tenniel (1820–1914) were of particular importance to his mature style.

Nast is most famous for his relentless battle from 1869 to 1871 against the 'Tweed Ring', a gang of corrupt politicians who controlled the government of New York. Headed by 'Boss' William Marcy Tweed, the Ring defrauded the city of some $200 million. It was broken as the result of the overwhelming public campaign aroused by Nast's devastating cartoons. 'Boss' Tweed was sentenced to prison but escaped to Spain, where, ironically, he was arrested after being identified from one of Nast's cartoons.

By the mid-1880s interest in Nast's style had declined as popular attention was drawn to the cartoons in Joseph Keppler's *Puck*, a comic weekly illustrated with colour lithographs. In 1886 Nast left *Harper's*; resuming his interest in illustration and painting, he published a book, *Thomas Nast's Christmas Drawings for the Human Race* (New York, 1890, rev. 1978). In 1902 President Theodore Roosevelt, an admirer, appointed Nast American Consul to Guayaquil, Ecuador, where six months later he died of yellow fever.

BIBLIOGRAPHY

A. B. Paine: *Thomas Nast: His Period and Pictures* (New York, 1904/R 1974)

F. Weitenkampf: 'Thomas Nast, Artist in Caricature', *Bull. NY Pub. Lib.*, xxxvii (1933), pp. 770–74

J. C. Vinson: *Thomas Nast: Political Cartoonist* (Athens, GA, 1967)

M. Keller: *The Art and Politics of Thomas Nast* (New York, 1968)

A. Boime: 'Thomas Nast and French Art', *Amer. A.J.*, iv (1972), pp. 43–65

EDWARD BRYANT

Natchez. City in southern Mississippi, USA, built on a 200-ft bluff on the east bank of the Mississippi River. Its associated port is the once semi-independent village of Natchez-under-the-Hill. The area was a centre of late Mississippian culture and of the complex chiefdom of the Natchez Indians, whose Emerald Mound, near Natchez, is the second largest, late prehistoric earthwork in North America. It was then successively a French fort (1716–29), a British settlement (1764–79), under Spanish occupation, and then the extreme south-western outpost of

the USA and capital (1798–1802) of the Mississippi Territory. After 1800 it became the principal centre of American cotton production and an important river port, enjoying an extraordinary prosperity resulting from the fertility of the land and the successive introductions of the cotton gin (1795), hybridized cotton and especially steamboat transportation (1811).

At Natchez, uniquely in the South before the Civil War (1861–5), although the cotton plantations were continuously expanded towards the interior, the planters concentrated their residences in this political, commercial and cultural metropolis. The city therefore possesses, disposed on a grid-plan originally laid out (1780–90) by John Girault (1755–1813) for the Spanish governor, the American South's finest collection of grandiose private buildings erected before the War. The FEDERAL STYLE dominated the city until the early 1830s, as represented by the House on Ellicott Hill (1798–1801) and the brick-built mansion Texada (1798–c. 1802), which introduced the delicate refinements of Federal detailing; while Gloucester (1803, enlarged 1807, porticoes 1830s) is another, and notably larger, early Federal house. Auburn (1812; see colour pl. II, 1) by Levi G. Weeks (1776–1819), pioneered the architectural image of the 'Cotton Kingdom' in first presenting a free-standing, double galleried portico with a colossal columnar order; Rosalie (1823; see fig.) probably by James S. Griffin and named after the French fort on the site of which it stands, established the classic type of a tall cubic block with colonnaded galleries front and back. Among the most interesting refinements of these basic forms were matched dependencies arranged symmetrically around a rear courtyard, creating domestic ensembles of unusual extensiveness, complexity and sophistication.

A contrasting style was provided by the Greek Revival, which dates from the Agricultural Bank (1833) and is particularly accomplished in the mansions D'Evereux (1836) and Melrose (1845–7),—the latter, by Jacob Byers (c. 1800–52), being the nucleus of the Natchez National Historical Park (estab. 1988). The city's architectural magnificence reached its highpoint with Stanton Hall (1857–8), by Thomas Rose (1806–61), the largest and most lavishly decorated of the mansions in Natchez, of which the grillwork and fluted columns of the portico are particularly notable. Longwood (1860–61) by Samuel Sloan is exceptional, being of octagonal plan with an onion-shaped dome and combining a fully developed Italianate villa idiom, which was current from c. 1855, with elements of oriental exoticism. The outbreak of the Civil War, which led to Longwood's abandonment when nearly complete, also marked the end of the prosperity of the Natchez cotton planters and their architectural achievements. In the poverty following the War, even the houses' interiors could not be modernized, so that they continue to display an essentially unrestored domestic architectural and decorative heritage that is unmatched in the USA.

UNPUBLISHED SOURCES

Natchez, Historical Natchez Foundation [MS. of site files for individual bldgs]

BIBLIOGRAPHY

Mississippi: The WPA Guide to the Magnolia State, Federal Writers Project (New York, 1938/R Jackson, MS, and London, 1988)
M. W. Miller and R. W. Miller: *The Great Houses of Natchez* (Jackson, MS, and London, 1986)

Natchez, Rosalie (1823), probably by James S. Griffin

N. Polk, ed.: *Natchez before 1830* (Jackson, MS, and London, 1989)
R. Delehanty, V. J. Martin and others, *Classic Natchez* (New Orleans and Savannah, 1996)
E. Nickens: 'Auntie Bellum: Natchez, Mississippi', *Hist. Preserv.*, xlviii (1996), p. 38
J. D. Elliott jr: 'City and Empire: The Spanish Origins of Natchez', *J. MS Hist.*, lix/4 (Winter 1997), pp. 270–321

DOUGLAS LEWIS

Neagle, John (*b* Boston, MA, 4 Nov 1796; *d* Philadelphia, PA, 17 Sept 1865). American painter. He spent most of his life in Philadelphia, where he received his first art instruction from his schoolfriend Edward F. Peticolas and more formal training from the drawing-master Pietro Ancora. About 1813 Neagle was apprenticed to the sign and coach decorator Thomas Wilson who introduced him to the painters Bass Otis and Thomas Sully, both of whom encouraged the young artist.

In 1818 Neagle set up as a portrait painter in Philadelphia. After brief spells in Lexington, KY (where he was awed by the quality of Matthew Harris Jouett's work), and in New Orleans, he returned to Philadelphia where he remained for the rest of his career. In July 1825 Neagle and the engraver James Barton Longacre (1794–1869) travelled to Boston to visit Gilbert Stuart, who offered criticism of one of Neagle's portraits, also sitting for his likeness (1825; Boston, MA, Athenaeum, on dep. Boston, MA, Mus. F.A.). Stuart's portrait style influenced Neagle throughout his career.

In the autumn of 1825 Neagle received a commission for his most famous painting, *Pat Lyon at the Forge* (1825–6; Boston, MA, Athenaeum; see fig.). It was extraordinary for its time, as it showed the subject at work in his blacksmith's shop, in leather apron with shirt sleeves rolled above the elbows.

Early in 1826 Neagle received a commission for a series of portraits, depicting actors and actresses in costume, which were used as models for engravers. The engravings appeared as frontispieces in a series of stories, based on popular plays, entitled the *Acting American Theatre*. On satisfactory completion of the first eight portraits, Neagle was asked to paint more in New York. On 28 May 1826, in Philadelphia, he married Mary Chester Sully, niece and

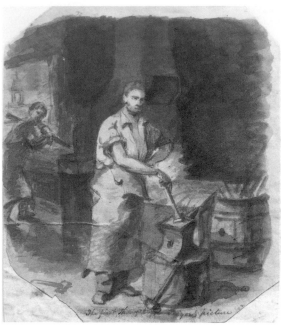

John Neagle: *Pat Lyon at the Forge*, 1825–6 (Boston, MA, Athenaeum)

stepdaughter of Thomas Sully. During their honeymoon in New York, Neagle painted 24 portraits (most of the surviving canvases are at the Players' Club, New York), of which 16 were engraved and issued. Neagle and Sully dominated the art of portraiture in Philadelphia. When Sully increased his prices, he always informed Neagle, who then adjusted his, but never higher than those of his mentor.

Neagle was a founder-member of the Artists' Fund Society of Philadelphia and its president from 1835 to 1843. In 1830–31 he was a director of the Pennsylvania Academy of the Fine Arts. About 1853 Neagle suffered an attack of paralysis, which severely affected his technique. Much of his autograph material, including his daybook, is in the manuscript collection of the Historical Society of Pennsylvania, Philadelphia.

BIBLIOGRAPHY
Exhibition of Portraits by John Neagle (exh. cat., ed. M. Fielding; Philadelphia, PA Acad. F.A., 1925)
M. Lynch: 'John Neagle's Diary', *A. America*, xxxvii (1929), pp. 79–99
John Neagle, Philadelphia Portrait Painter (exh. cat. by R. W. Torchia, Philadelphia, PA, Hist. Soc., 1989)
MONROE H. FABIAN

New Amsterdam. *See* NEW YORK.

New Bremen Glassmanufactory. *See under* AMELUNG, JOHN FREDERICK.

New England Glass Co. American glass factory founded in 1818 in East Cambridge, MA, by Deming Jarves (1790–1869), who developed and managed the company, and his associates. By the early 1820s more than 100 employees produced $150,000 worth of plain, moulded and cut glass using 2 furnaces, 24 glass-cutting mills and a red lead furnace. In 1826 Thomas H. Leighton (1786–1849) became superintendent of the works. During the 1850s the

firm had grown to include 500 employees who operated 5 furnaces of 10 pots each to produce $500,000 worth of ware. Following the Civil War (1861–5), the firm's fortunes declined, although the quality of its products was always held in the highest esteem. In 1878 the works were leased to William L. Libbey (1827–83), who had been agent for the company since 1872. He ran the firm from 1880 until his death in 1883, with his son Edward Drummond Libbey (1854–1925) as partner.

The New England Glass Co. produced wares of the highest quality in all the fashionable types of glass, including free-blown, mould-blown, cut, engraved and art glass. The craftsmen were in the forefront of the industry, being among the first to introduce glass pressing by machine in the USA *c*. 1827 and the first, under Joseph Locke (1846–1936), to introduce shaded art glass, such as 'Amberina' in 1883 (see colour pl. XXXV, 2). All manner of useful and decorative wares were made, including window glass in the earliest years of the firm, although the company was best known for its table glass, lighting devices and lamp shades, paperweights and other ornamental goods, and for their exhibition pieces for the Exhibition of the Industry of All Nations of 1853–4 in New York and the Centennial International Exhibition of 1876 in Philadelphia. During a strike in 1888 Edward Libbey closed the factory, and in 1890 the company dissolved. A number of company officials and workmen moved with Libbey to Toledo, OH, where the Libbey Glass Co. was formed.

BIBLIOGRAPHY
K. M. Wilson: *New England Glass and Glassmaking* (New York, 1972)
ELLEN PAUL DENKER

New Haven. American city in Connecticut, seat of New Haven County. It is in the southern part of the state on Long Island Sound and at the mouth of the Quinnipiac River. From 1701 to 1875 it was the state capital jointly with Hartford. New Haven Colony was founded in 1638 as a separate entity to the west of Connecticut Colony, which had been founded in the Connecticut River Valley in 1634–6. In 1663 New Haven and Connecticut colonies merged under a royal charter. Unlike most other towns in New England founded in the 17th century, New Haven, rather than having an organic and irregular plan, appears to have been conceived from the outset as a 'model' town having a perfectly square grid plan of nine blocks, dominated by a village green in the centre. It has been convincingly argued that not only is New Haven the first regular, formally planned town in the North American English colonies but also that its design was influenced by the famous treatise *On Architecture* by Vitruvius (*fl* later 1st century BC. As the town grew, however, the regularity of the original layout was abandoned. A plan of 1748 (New York, NY Hist. Soc.) shows the village green dominated by the four-square Meeting House (1668), which, well into the 19th century, served not only as a place for public meetings but also for religious services. Other 17th-century buildings include the Eaton House (before 1657; destr. mid-18th century), built for Governor Theophilus Eaton; the house owned by John Davenport, a Puritan clergyman, built before 1643 in the form of a cross and containing 13 fireplaces; and Captain Isaac

Allerton's house (destr.), having four porches and fine gardens.

In 1716 New Haven was selected as the permanent home of Yale College (now Yale University; see below), and by 1790 the town's population was nearly 4500. At this time it was one of the USA's leading manufacturing centres, producing munitions, clocks and hardware. By 1900 its population had risen to almost 100,000 due to industrial growth and an influx of immigrants in the late 19th century. In the very core of the Colonial town, the original village green still stands, flanked by the campus of Yale and three handsome churches: the United Church (1815) by David Hoadley; the First Church of Christ, Congregational (1814), by Asher Benjamin; and Trinity Episcopal Church (1814) by Ithiel Town.

The third oldest institution of higher education in the USA (chartered in 1701) and originally called the Collegiate School of Connecticut, Yale was renamed in 1718 in honour of a major benefactor, Elihu Yale (1648–1721). The college's original building (1717–18; destr. 1787) was designed by Henry Caner (c. 1680–1731), who also drew up the plans for the Rector's House (1722; destr.) and possibly the first State House (1719, destr.). A second, similar college building, Connecticut Hall, was constructed in 1752 according to plans by Francis Letort of Philadelphia and Thomas Bills of New York, with the close involvement of the President of Yale, Thomas Clap.

BIBLIOGRAPHY
E. R. Lambert: *History of the Colony of New Haven* (New Haven, 1838)
J. F. Kelly: *Early Connecticut Meeting Houses* (New York, 1948)
A. N. B. Garvan: *Architecture and Town Planning in Colonial Connecticut* (New Haven, 1951)
R. Osterweis: *Three Centuries of New Haven, 1630–1938* (New Haven, 1953)
J. Reps: *The Making of Urban America* (Princeton, 1965)
——: *Town Planning in Frontier America* (Princeton, 1969)
JAMES D. KORNWOLF

Newman, Robert Loftin (*b* Richmond, VA, 10 Nov 1827; *d* New York, 31 March 1912). American painter and stained-glass designer. He grew up in Clarksville, TN, where his stepfather was a tailor and his mother a milliner. In 1846 his request to be accepted as Asher B. Durand's pupil was turned down, but Newman managed three years later to exhibit in the American Art-Union in New York. In 1850 he studied with Thomas Couture (1815–79) in Paris for five months. On a second trip to Paris in 1854, he visited Jean-François Millet (1814–75) in Barbizon. He worked as a portrait painter and occasional teacher of drawing, before serving briefly as an artillery lieutenant in the Confederate Army. After the Civil War, he apparently remained in New York, apart from a trip to Barbizon in 1882 and to Paris in 1908.

Although in 1872–3 he advertised himself as a portrait painter in Nashville, TN, and in the 1870s worked briefly as a stained-glass designer, Newman was primarily a painter of small compositions with a few figures, usually with a well-known religious, literary or secular theme. One of his favourite subjects was the Virgin and Child (e.g. 1897; New York, Brooklyn Mus.; see fig.). Newman's dark, delicately tinted paintings were frequently compared in colour with those of Delacroix, Millet and Monticelli, and in mood with those of Albert Pinkham Ryder and Millet.

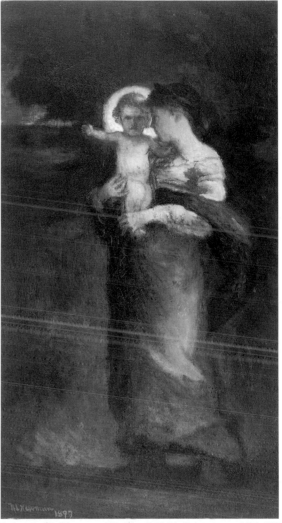

Robert Loftin Newman: *Virgin and Child*, oil on canvas, 1422×787 mm, 1897 (New York, Brooklyn Museum of Art)

He had only one exhibition of his work in his lifetime (1894; New York, Knoedler's), yet he was a favourite of many important collectors in the eastern USA. He was befriended and supported by younger artists such as Ryder, Francis Lathrop (1849–1909) and Wyatt Eaton, by whom he was affectionately known as 'Old Newman'.

BIBLIOGRAPHY
A. Boime: 'Newman, Ryder, Couture, and Hero-worship in Art History', *Amer. A. J.*, iii (1971), pp. 5–22
T. B. Brumbaugh: 'Letters of Robert Loftin Newman: A Tennessee Artist', *TN Hist. Q.*, xxxii (1973), pp. 107–23
Robert Loftin Newman, 1827–1912 (exh. cat. by M. E. Landgren, Washington, DC, N. Col. F.A., 1974)
PETER BERMINGHAM

New Orleans [formerly Nouvelle Orléans]. North American city in the state of Louisiana, situated on a great curve of the Mississippi River, 177 km from its mouth. Although the French laid claim to the Mississippi River and all the territory drained by it and its tributaries in 1682, it was not until 1718 that land was cleared for the city, originally

named Nouvelle Orléans, at the site of an Indian portage to Lake Pontchartrain. In 1721 the French engineer Adrien de Pauger laid out long, narrow plots around a public square facing the river, and this compact urban plan remains the core of modern New Orleans. The oldest surviving building from the French period is the former Ursuline Convent (1745–53), designed by the French engineer Ignace François Broutin (1680/90–1751).

In 1763 the Louisiana Territory was ceded to Spain. A drawing dated 1765 shows that by this time buildings with balconies or narrow galleries on one or more sides and on one or two levels were becoming common. The Spanish favoured inner patios; galleried buildings, adapted to changing tastes, continued to be popular into the 20th century, creating a unity throughout the city. The Cabildo (1795–9) and the Presbytère (1795–1847), two similar buildings flanking St Louis Cathedral (1789–94), were designed by Gilberto Guillemard (1747–1808) during Spanish rule; their arcaded façades dominate Jackson Square (formerly Place d'Armes). The cathedral, built by Guillemard, owes its present appearance to the modifications of 1850 by J. N. B. de Pouilly (1805–75). As a result of disastrous fires in 1788 and 1794, most buildings in the old quarter date from after 1800; the Latin and Catholic character of the city established in this early period survived despite the city's enormous growth.

In 1800 the Territory was returned to France and in 1803 was sold to the USA. In New Orleans, already an important shipping centre for the Mississippi Valley, American ownership and the development of the steamboat produced rapid growth along the riverfront and in particular up-river from the old town. In 1818 Benjamin Henry Latrobe arrived in New Orleans to complete the waterworks and pumping station he had designed for the city. While there, he designed the Louisiana State Bank (1820), with ground-floor vaulting and dome, now an antique shop; he died in New Orleans of yellow fever in September 1820.

The population grew from 8000 (1800) to 100,000 (1840), and the city rivalled Boston as the fourth largest in the USA. The two Pontalba buildings by James Gallier (i) (see fig.) were built on either side of Jackson Square in 1849–50. Shops are on the ground-floor and living-quarters above. Both have the iron balconies and inner patios characteristic of the old quarter. The four most important 19th-century architects active in the city were the father and son James Gallier (i) and James Gallier (ii) (see GALLIER), James Dakin and Henry Howard (1818–84). As the city grew beyond the original plan, adjacent sites were developed to a grid plan along the curving river. The Civil War (1860–65) and the effect of the development of the railway on river transport slowed urban growth, but nevertheless handsome residential areas were built, such as the Garden District, with large mansions on large plots. Smaller vernacular structures throughout the city include those known as 'shotguns' or 'camelbacks' because of their distinctive shapes: either long and narrow, of one storey, or with an added second storey at the back; many have decorative prefabricated millwork. With the introduction of a large drainage and pumping system (completed 1898), areas of the city away from the riverfront could be developed. Tall buildings began to be erected in the central

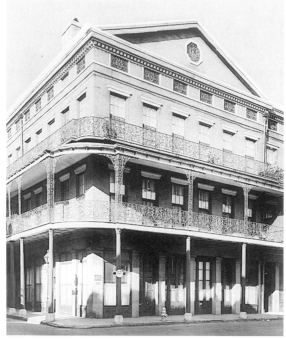

New Orleans, Lower Pontalba Building, Jackson Square, by James Gallier (i) (completed by Henry Howard), 1849–50

business district, adjacent to the old quarter, in the 1910s; these were dependent on the use of technology for creating foundations that would withstand the exceedingly soft soil.

There is little evidence of the presence of artists and craftsmen in New Orleans before c. 1782, when José Salazar y Mendoza (d 1802) arrived from Mexico. From c. 1800 to 1860 a number of artists spent time in the city, including John James Audubon, George Catlin, and the French artists Jean Joseph Vaudechamp (1790–1866) and Jacques Amans (1801–88). Jules Lion (c. 1810–66), a French artist of African descent, who was in New Orleans from 1837 to 1866, was a distinguished lithographer and pioneer daguerreotypist. Early artists' societies and galleries were short-lived. After the Civil War, a local landscape tradition developed, with Richard Clague (1821–73), Marshall J. Smith jr (1854–1923) and others producing calm, serene paintings of the low-lying countryside and its waterways, often depicting fishermen's or trappers' shacks. The Artists' Association of New Orleans (1885–1903) was one of a succession of artists' organizations that existed after 1880, reflecting the increasing number of artists in the city. In 1886 Newcomb College at Tulane University of Louisiana established one of the first art departments in the South; its teachers included Ellsworth Woodward (1861–1931) and Will Henry Stevens (1881–1949). Later, other universities in the city offered similar courses. The Newcomb Pottery was established in 1895 under the aegis of Newcomb College and achieved national recognition. The permanent collection of the New Orleans Museum of Art (formerly Delgado Museum; founded 1911) includes European and American paintings as well as African, Japanese and Latin American art, and an excellent

glass collection. The Louisiana State Museum, the Historic New Orleans Collection and the recently established Ogden Museum of Southern Art hold significant collections of Louisiana and regional art. The latter is in the former Howard Library (1887), designed by Louisiana native H. H. Richardson and built posthumously by Shepley, Rutan & Coolidge.

BIBLIOGRAPHY
L. V. Huber: *New Orleans: A Pictorial History* (New York, 1971)

A Guide to New Orleans Architecture, American Institute of Architects, New Orleans Chapter (New Orleans, 1974)

J. Caldwell: *New Orleans Museum of Art: Handbook of the Collection* (New Orleans, 1980)

J. Poesch: *Newcomb Pottery: An Enterprise for Southern Women, 1895–1940* (Exton, 1984)

J. Bonner: 'Artists' Associations in Nineteenth-century New Orleans, 1842–1860', *Southern Q.*, 24 (Fall–Winter 1985), pp. 119–37

——: *Newcomb Centennial: An Exhibition of Art by the Art Faculty at the New Orleans Museum of Art* (New Orleans, 1986)

J. Mahe and R. McCaffrey, eds: *Encyclopedia of New Orleans Artists, 1718–1918* (New Orleans, 1987)

S. Wilson jr: 'The Architecture of Colonial Louisiana', *Collected Essays*, ed. J. M. Farnsworth and A. M. Masson (Lafayette, LA, 1987)

E. C. Pennington: *Downriver: Currents of Style in Louisiana Painting, 1800–1950* (Gretna, LA, 1991)

R. Delehanty: *Art in the American South: Works from the Ogden Collection* (Baton Rouge, 1996)

B. Bacot and J. Poesch, eds: *Louisiana Buildings, 1720–1940*, The Historic American Buildings Survey (Baton Rouge, 1997)

W. N. Banks: 'The Galliers, New Orleans Architects', *Antiques*, cli (1997), pp. 600–11

M. Heard: *French Quarter Manual: An Architectural Guide to New Orleans' Vieux Carré* (New Orleans, 1997)

JESSIE POESCH

Newport. American city in the state of Rhode Island, situated at the mouth of Narragansett Bay. It was settled in 1639 by Englishmen fleeing religious persecution in Massachusetts, and it soon prospered, particularly in overseas trade. Until the American Revolution (1775–83), more ships entered and departed from Newport than New York. Culture flourished early in the town: Bishop George Berkeley lived in the town from 1729 to 1731, and his entourage included the painter John Smibert. Berkeley's Philosophical Society led to the founding of Redwood Library and Athenaeum in an elegant Palladian, rusticated building designed in 1749 by Peter Harrison (for illustration *see* HARRISON, PETER). The library also houses a collection of over 100 portraits, including some by Gilbert Stuart of Rhode Island. This affluent golden age in Newport allowed such craftsmen as the cabinetmakers TOWNSEND and Goddard (*see* GODDARD, JOHN) to bring to perfection through their many commissions the highly prized block-front and shell furniture.

After the strife of the Revolution, architecture in the mid-19th century was characterized by the Federal style and the Gothic Revival, as in Richard Upjohn's Villa Kingscote (*c.* 1841). The town proceeded to develop along new lines such as tourism. The sobriquet 'The First Resort' refers to Newport's attractiveness: its location at the tip of an island kept the summers cool and salubrious, much sought after by families from the hotter south. Several surges of summer colonists climaxed in the late 19th century and the early 20th, at which point millionaires also began to arrive, most notably the Vanderbilt family, who built the sumptuous villa The Breakers in 1892–5 (see fig.), designed by RICHARD MORRIS HUNT. A stone structure in 16th-century Genoese style, it has an ornate interior; eventually the house came under the auspices of the

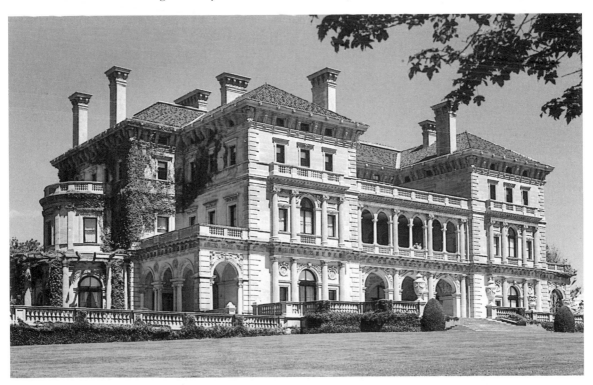

Newport, The Breakers, by Richard Morris Hunt, 1892–5

Preservation Society of Newport County, and it was opened to the public. While Hunt and Horace Trumbauer graced Newport with admittedly derivative architecture, MCKIM, MEAD & WHITE also designed 'cottages' along more classical lines, for example Beacon Rock, with its brick and marble portico, built in 1889 for Edwin D. Morgan on a site overlooking Newport harbour. Entire avenues of mansions used the services of landscape architects, who took advantage of the favourable climate as the summer colonists competed vigorously to produce the most lavish gardens. Among others Frederick Law Olmsted and his brother John C. Olmsted designed estates and parks in Newport. A significant example of their work is at the home of the writer Louis Auchincloss, Hammersmith Farm (later opened to the public). Hints of Newport's affluent history linger in mansions opened to visitors by the Preservation Society. Colonial buildings have been preserved by the Newport Restoration Foundation, founded by Doris Duke, which has restored over 50 Colonial houses for private occupancy. The Newport Historical Society Museum contains a collection of paintings of local scenes as well as items of silverware, glass, china and furniture.

BIBLIOGRAPHY

A. F. Downing and V. J. Scully jr: *The Architectural Heritage of Newport, Rhode Island, 1640–1915* (Cambridge, MA, 1952)

R. L. Champlin: 'Newport Estates and their Flora', *Newport Hist.*, liii (1980), nos 2 and 3; lv (1982), no. 1

D. Guinness and J. T. Sadler jr: *Newport Preserv'd: Architecture of the 18th Century* (New York, 1982)

B. Gill: 'Kingscote: Architectural Heritage of an Original Newport Cottage, Rhode Island', *Archit. Dig.*, xlviii (1991), p. 30

J. K. Ochsner and T. C. Hubka: 'H. H. Richardson: The Design of the William Watts Sherman House, Newport, RI', *J. Soc. Archit. Hist.*, li (1992), pp. 121–45

A. B. Allen: 'A Reverence for the Old World: Newport, Rhode Island', *Antiques*, cxlvii (1995), pp. 584–91

C. J. Burns: 'Newport in the Nineteenth Century', *Antiques*, cxlvii (1995), pp. 564–9

R. E. Carpenter: 'Newport: A Center of Colonial Cabinetmaking', *Antiques*, cxlvii (1995), pp. 550–57

A. C. Frelinghuysen: 'The Aesthetic Movement in Newport, Rhode Island', *Antiques*, cxlvii (1995), pp. 570–77

P. F. Miller: 'Newport in the Gilded Age', *Antiques*, cxlvii (1995), pp. 598–605

RICHARD L. CHAMPLIN

Newsom. American family of architects, active in California from the 1870s. The brothers John J. Newsom (*b* 19 July 1837; *d* 1902) and Thomas D. Newsom (*b* 24 July 1856) established a practice in Oakland, CA, in which their younger brothers Samuel Newsom (*b* nr Montreal, 5 April 1854; *d* San Francisco, CA, 1 Sept 1908) and Joseph Cather Newsom (*b* Montreal, 13 Sept 1858; *d* Oakland, CA, 5 June 1930) were apprenticed. In 1878 Samuel Newsom and Joseph Cather Newsom set up a partnership and opened offices in Oakland and then San Francisco. In 1886, with the economic boom in southern California, Joseph Cather Newsom opened a branch office in Los Angeles. Their formal partnership dissolved in 1888, but Samuel Newsom maintained the San Francisco office and Joseph Cather Newsom that in Los Angeles. In 1893 Samuel Newsom was joined by his son Sidney B. Newsom, and he formed a brief partnership (1898–1900) with Frederick H. Meyer (1875–1917). In 1904 his second son, Noble Newsom, joined him, and the firm soon became Newsom, Newsom & Newsom. Around 1897 Joseph Cather Newsom moved his practice to Philadelphia. After 1900 he was back in the San Francisco area, although by 1903 he was practising in Los Angeles.

The first five years of Samuel Newsom and Joseph Cather Newsom's partnership (*c.* 1878–86) were quite successful in terms of both the number of commissions and the rapidly maturing quality of their designs. Their town houses for the upper-middle class often featured a tall Italianate tower with Eastlake-style details in contrast to the Queen Anne Revival forms of the main house (e.g. Allison House, *c.* 1882, San Francisco). In their best-known work, the Carson House (1884–5; see fig.), Eureka, CA, they drew on many styles, from the late Italianate to Queen Anne Revival. It is an extravagant mansion with a complexity of forms, spaces and surfaces, enriched by an abundance of furniture and decorative arts. In the mid-1880s their designs increasingly used the Queen Anne Revival style, for example the Bradbury House (1887), Los Angeles. The Newsoms also designed a number of hotels in speculative development in southern California in the 1880s, also in the Queen Anne Revival style. The Glendale Hotel (1887), Glendale, is a characteristic example, built as a visual attraction to encourage residential and business development of the area.

The Newsoms were aware of the need to be up-to-date and used a range of fashionable styles: Samuel Newsom's Horticultural Building (1894) for the Midwinter Exhibition in San Francisco was in the style of the Mission churches of California, while *c.* 1900 the Newsoms designed office buildings in the Beaux-Arts style, country houses resembling French 18th-century architecture, suburban houses in the Colonial Revival style and farm houses in a traditional pueblo manner. Later work includes bungalows of clapboard and shingles and houses of stucco with tile roofs in the style of the Spanish Colonial period. It is

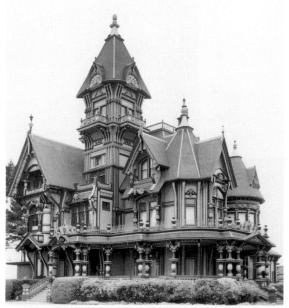

Samuel Newsom and Joseph Cather Newsom, Carson House, Eureka, California, 1884–5

difficult to establish how many buildings built in California and elsewhere were designed by Samuel Newsom or Joseph Cather Newsom, either collaboratively or separately. Because much of their work was in the area of speculative housing for developers, records are scanty. Between 1884 and 1899 they published ten popular pattern-books and established a mail-order plan service where prospective clients could order complete sets of working drawings and specifications. The number of designs derived from these is also unknown.

WRITINGS

J. C. Newsom: *California Low Priced Cottages* (San Francisco, 1880s)
S. Newsom and J. C. Newsom: *Picturesque California Homes*, 2 vols (San Francisco, 1884–7; vol. i *R* Los Angeles, 1978)
J. C. Newsom: *Artistic Buildings and Homes of Los Angeles* (San Francisco, ?1888/*R* Los Angeles, 1981)
——: *Picturesque and Artistic Homes and Buildings of California* (San Francisco, 1890)
S. Newsom: *Some City and Suburban Homes* (San Francisco, 1890)
J. C. Newsom: *Modern Homes of California* (San Francisco, 1893)
—— : *Artistic City Buildings, Flats and Residences* (?San Francisco, 1895)
——: *Artistic Country Homes* (?San Francisco, *c.* 1895)
——: *New Booklet on Churches* (Philadelphia, 1897)
——: *Up-to-date Architecture, an Illustrated Journal of Modern Architecture*, 2 vols (Philadelphia, ?1897–9)

BIBLIOGRAPHY

D. Gebhard, H. Von Dicken and R. W. Winter: *Samuel and Joseph Cather Newsom: Victorian Architectural Imagery in California, 1878–1908* (Santa Barbara, 1979)
B. Sacks: *Carson Mansion and Ingomar Theatre: Cultural Adventures in California* (Fresno, 1979)

DAVID GEBHARD

New York [formerly New Amsterdam]. North American city. It is sited mostly on islands at the mouth of the Hudson River on the east coast of the continent, and its development and rise to prominence have been closely related to its location on one of the world's finest all-weather, deep-water ports. New York City originally comprised only Manhattan, a narrow, 20 km long island bordered by the Hudson River, East River and Harlem River, which remains its commercial, financial and cultural heart. In a series of mergers in 1874 and 1894 the borough of the Bronx became part of New York City, and in 1898 Brooklyn (then the third largest city in the USA), Queens and Staten Island elected to join in the formation of Greater New York, which spreads over *c.* 830 sq. km. Only the Bronx is attached to the mainland, Brooklyn and Queens occupying the western end of Long Island. Often regarded mainly as a great modern metropolis of glass and steel skyscrapers, New York retains a rich architectural heritage from all periods of its development, during which time it was briefly the capital of the USA (1785–90) and the state capital of New York (1784–96).

I. History and urban development. II. Art life and organization.

I. History and urban development.

1. Before *c.* 1790. 2. *c.* 1790–*c.* 1870. 3. *c.* 1870–*c.* 1914.

1. BEFORE *C.* 1790. The site of New York City was originally occupied by a series of American Indian settlements. The first European to record a visit to the harbour (17 July 1524) was Giovanni da Verrazano, an Italian employed by the French. He was followed by Henry Hudson, an Englishman who claimed the area for the

Dutch in 1609. In 1621 the Dutch West India Company was granted a charter with exclusive rights to settle New Netherland, and three years later the first permanent Dutch settlers arrived. The Dutch erected a fort at the southern tip of Manhattan Island (which Governor-General Peter Minuit 'purchased' from the Indians in 1626), and small buildings were erected on surrounding land, establishing New Amsterdam as the capital of New Netherland. Settlement soon followed in what would become the city's other boroughs. In 1653 Governor Peter Stuyvesant enclosed the Manhattan settlement with a wall across the island from the Hudson River to the East River at the latitude of Wall Street in New York's present-day financial centre. Although no buildings remain from this settlement, the original street pattern survives in the area south of Wall Street.

On 12 March 1664 the British sailed into the harbour of New Amsterdam and seized the colony, renaming it New York, although it never became one of the major cities of British North America. Settlement during the British Colonial period expanded both on land and out into the water on several blocks of landfill, and Manhattan was connected to the mainland by the construction of the King's Bridge (1693) across the Harlem River. The British erected Trinity Church (1696; destr. 1776), the city's first Episcopal church, on Broadway and Wall Street and also established the first college, King's College (now Columbia University), in 1754, erecting a building (1756–60; destr. *c.* 1857) on Park Place. The city was occupied by the British during the American Revolution (War of Independence, 1775–83) and suffered from fires set by revolutionaries and, after the war, from serious depopulation. Only one significant building survives from the old British city: St Paul's Chapel (1764–8; tower, 1794, by James C. Lawrence), Broadway and Fulton Street, one of the most important Georgian churches in the USA (see colour pl. I, 1).

2. *C.* 1790–*C.* 1870. As the city recovered from the war and its population again began to increase, development moved northwards up Manhattan Island. During this process, hills were levelled and swamps and watercourses filled in to create the relatively flat landscape of the present city. The lack of a coherent plan for the laying out of the streets led the New York state authorities in 1807 to establish a commission to plan the unsettled parts of Manhattan. The Commissioners' Plan (1811) established the rectangular grid of streets north of about Houston Street that was one of the key determinants of the city's physical form, with avenues running north–south and streets running east–west and numbered east or west of Fifth Avenue. The Dutch street pattern of Lower Manhattan was preserved, as was the layout of the small village of Greenwich on the west side of the island, south of 14th Street. Broadway, originally a part of the Dutch road connecting New Amsterdam with Fort Orange (now Albany), cut diagonally across the island and was intended to survive only as far north as 15th Street in the plan, but it was later preserved, creating small but distinctive open spaces where it crossed the north–south avenues (e.g. at Times Square and Columbus Circle). With the exception of a few open squares, however, no parkland

1. New York, east side of Broadway looking north towards Broome Street, with the Haughwout Building, 1856–7 (background), and two cast-iron buildings, 474–6 and 478–82 Broadway, by Richard Morris Hunt (foreground); from a photograph of 1877 (New York, New York Historical Society)

was provided in this plan. The Commissioners' plan was an indication of the increasing confidence of civic leaders in the early 19th century, as was the construction of a new Neo-classical City Hall by Joseph François Mangin and John McComb jr (1802–12; for illustration *see* MANGIN, JOSEPH FRANÇOIS), Broadway and Murray Street, one of the most beautiful works of the period anywhere in the USA.

New York owed its wealth and dramatic growth in the 19th century to its commercial ascendancy following trade war with Britain (1812–14). Its harbour became the busiest and most prosperous on the continent with the establishment of regularly scheduled trans-Atlantic voyages (1818), the opening of the Erie Canal (1825), which made New York the principal port for goods travelling to and from the West, and close connections with British traders. New York's merchants were responsible for much of the lucrative southern cotton trade, and the convenience of water-borne transport also led to New York becoming the USA's leading manufacturing centre. As a result of this activity, the city's commercial core spread from the waterfront into much of Lower Manhattan. Most early commercial buildings were fairly modest, many serving as both residence and office, but after the great fire of 1835 many architecturally distinguished counting-houses, warehouses, banks and other commercial establishments were erected. Wall Street had begun to evolve into a financial centre as early as 1796, when the city's first bank, the Bank of New York, opened there. By the 1830s its pre-eminence as New York's commercial and financial centre was firmly established with the construction of such imposing, stone Greek Revival buildings as the US Custom House (now Federal Hall; 1833–42; by Town & Davis) and the Merchants' Exchange (1836–41; by Isaiah Rogers; enlarged 1904–10 by McKim, Mead & White for First National City Bank).

New York's commercial success led to a continuing rapid increase in its population, which grew from *c.* 33,000

in 1790 to *c.* 124,000 in 1820; during this period New York overtook Philadelphia as the nation's most populous city, as people moved to the city from the farms of the northeastern USA and as New York became the major port of entry for European immigrants. Residential neighbourhoods began to develop at the northern fringes of the settled area, with the wealthiest quarters almost always along Fifth Avenue and flanking streets. A few architect-designed mansions were commissioned, but the vast majority of New York's early 19th-century residential buildings were terrace houses (row houses) erected by speculative builders. As commerce continued to expand, commercial establishments also began to move north, eventually invading the residential areas and forcing the more affluent to move to new neighbourhoods even further north. This process, which continued until the advent of zoning restrictions (1916) limiting large-scale commercial development to the area south of 59th Street, explains why relatively few early and mid-19th-century residential neighbourhoods in Manhattan survive intact.

In the 1820s Brooklyn also began to evolve as a major middle-class residential centre, growing at an extraordinarily rapid pace: a village of *c.* 7000 inhabitants in 1820, it was incorporated as a city in 1834 and had become the third largest city in the USA by the mid-1850s. This unprecedented growth was stimulated by the advent of safe and reliable ferry services, allowing people to live in Brooklyn and commute to work in Manhattan. Miles of speculative terrace housing were erected in Brooklyn, and, since it had only a small commercial centre of its own, almost all its 19th-century neighbourhoods survive. Small residential communities housing commuters to Manhattan also grew along the Queens and Staten Island shorelines and across the Hudson River in New Jersey.

Architecture in New York before the Civil War (1861–5) tended to be rather conservative in nature. The styles and building types popular during the first half of the 19th century generally appeared first in other American cities and were based on European precedents. Until the mid-1840s all but the most imposing structures were built of brick and ornamented with Federal style or Greek Revival details. Only church steeples rose higher than four or five storeys. In the 1840s, however, brownstone began to supplant brick as the principal building material in New York, where it was used for the new Gothic Revival Trinity Church (1839–46; *see* UPJOHN, (1), fig. 1) and for thousands of residences. A type of sandstone, brownstone became popular because it was quarried in parts of New York, New Jersey and Connecticut, convenient for water transport to the city. Commercial and public buildings were often faced with grey Tuckahoe marble quarried just north of the city. The popularity of both brownstone and marble coincided with the population explosion in New York and Brooklyn and a corresponding boom in residential and commercial construction. Between the 1840s and 1860s large Italianate mansions were erected on and around Fifth Avenue (most destr.), and hundreds of Italianate terrace houses were built on streets in Manhattan and Brooklyn. The marble A. T. Stewart Department Store (1845–6; extended 1850–84; later the Sun Building), 280 Broadway, by Joseph Trench & Co. (1815–79) was the first Italianate-style commercial palace; similar commercial

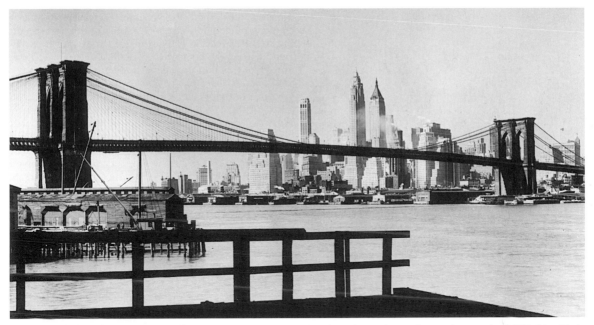

2, New York, view of the Brooklyn Bridge and Lower Manhattan skyline from the south-east; from a photograph of 1932 (New York, Museum of the City of New York)

buildings subsequently rose throughout New York's business districts. Some of the finest, including the Haughwout Building (1856–7; by JOHN P. GAYNOR), 488 Broadway (see fig. 1; see also UNITED STATES OF AMERICA, fig. 8), have cast-iron façades modelled to imitate stone.

During this period New York became the centre of the architectural profession in the USA when the American Institute of Architects (AIA) was founded there in 1857. Most of its members, including Richard Upjohn, James Renwick and Alexander Jackson Davis, were prominent New York professionals. Nevertheless, only a small number of trained architects were active during this period, and they were primarily responsible for the city's most important buildings, for example the Gothic Revival St Patrick's Cathedral (begun 1858), Fifth Avenue and East 50th Street, the largest Roman Catholic cathedral in the USA (see RENWICK, JAMES, fig. 2). The majority of terrace houses continued to be erected by speculative builders without the aid of architects.

The mid-19th century was also marked by the genesis of two of New York's most splendid construction projects: Central Park and the Brooklyn Bridge. Central Park, occupying the centre of Manhattan Island between 59th Street and 110th Street, was planned as a direct response to the need for open space due to increasing population density and the spread of development north into previously open land. Work began in 1858 on the Greensward Plan by Frederick Law Olmsted and Calvert Vaux, which created an almost totally artificial yet naturalistic landscape (see OLMSTED, FREDERICK LAW, fig. 1). Olmsted and Vaux also designed Prospect Park (1865–73), Brooklyn (see OLMSTED, FREDERICK LAW, fig. 2). Brooklyn Bridge (see fig. 2), a suspension bridge across the East River from Lower Manhattan, was designed by John Augustus Roebling (see ROEBLING, (1)) and was finally begun in 1869

after years of planning and debate. Construction was completed in 1883. The bridge created a physical link between New York and Brooklyn that ultimately led to their political union. It also dramatically cut commuting time and led to the conversion of farmland far from the river into new residential neighbourhoods.

3. c. 1870–c. 1914. After the Civil War, which hampered growth in New York as a result of the loss of the cotton trade, the repudiation of Southern debts and contraction of Atlantic trade, there was a short period of prosperity followed by a severe depression beginning in 1873 that brought building to a virtual halt. Recovery late in the 1870s led to a boom lasting until World War I with only short interruptions (notably following a financial panic in 1893). During the final decades of the 19th century New York's population increased at an enormous rate, reaching c. 3.4 million in Greater New York by 1900, stimulated by the arrival of waves of immigrants who generally settled in overcrowded tenement districts; sections of Manhattan's Lower East Side had a population density thought to have been the highest in the world at that time. In contrast, the wealth of New York's more affluent residents reached unprecedented levels, reflected in the scale and grandeur of the residences, clubs, churches and other buildings erected for the social and financial élite.

The economic boom of the 1880s coincided with a change in architectural taste as the restrained brownstone Palazzo style lost favour and was replaced by more dynamic eclectic forms; the houses at 675–9 St Mark's Avenue (1888; by C. P. H. Gilbert; see fig. 3), Brooklyn, for example, typify design inspired by H. H. Richardson's Romanesque Revival style, while other buildings, such as the Century Building (1880–81; by William Schikel), in

3. New York, Romanesque Revival style houses at 675–9 St Mark's Avenue, Brooklyn, by C. P. H. Gilbert, 1888

Union Square, exemplify the English-influenced Queen Anne Revival style. During this period railways brought building stone of various colours from many regions of the country, and brick also returned to popularity. The boldly massed and richly textured buildings of the 1880s and early 1890s were almost all designed by architects, for the profession had by then expanded, and city building codes required that an architect be involved with every project.

By the final decade of the 19th century most of the USA's leading architects had offices in New York, many establishing practices there after studying at the Ecole des Beaux-Arts in Paris. They specialized in the design of buildings inspired by historic European and American Colonial styles as well as contemporary French Beaux-Arts ideals, setting the stage for an academic revival that had a far-reaching influence on American design, particularly in the 1890s and first decades of the 20th century (see UNITED STATES OF AMERICA, §II, 3 and 4). This can be seen particularly in the work of MCKIM, MEAD & WHITE, CARRÈRE & HASTINGS, WARREN & WETMORE, Richard Morris Hunt (see HUNT, (2)) and Delano & Aldrich. This mode of design was introduced at Hunt's William K. Vanderbilt House (1879–82; destr.), 660 Fifth Avenue, and McKim, Mead & White's Villard Houses (1882–5), 451–7 Madison Avenue, modelled respectively on Late Gothic/early Renaissance French châteaux and the Palazzo della Cancelleria in Rome. The construction of such a variety of buildings beside one another, particularly in and around Fifth Avenue north of 59th Street, created what some critics found to be a discordant ensemble; however, it reflected the American desire both for individuality and for buildings comparable in size and grandeur

to those in Europe. Meanwhile speculative terrace housing aimed at the middle classes continued to be built on the Upper West Side, in Harlem and in Brooklyn, where new elevated railway lines opened undeveloped areas. Tenement construction also increased as immigrants continued to pour into the city.

The growing wealth and importance of New York was accentuated at the turn of the century when prominent New Yorkers sponsored a series of monumental public buildings intended to symbolize the city's civic and cultural aspirations. Of a scale and design sophistication rivalling contemporary work in Europe, they included the New York Public Library (1897–1911; by Carrère & Hastings; see fig. 4), Fifth Avenue and 42nd Street; Pennsylvania Station (1902–11; by McKim, Mead & White; destr. 1963–5); and Grand Central Terminal (1903–13; by Warren & Wetmore and Reed & Stem), Park Avenue and 42nd Street. Other educational and cultural complexes included the major additions to the Metropolitan Museum of Art (original building 1874–80, by Calvert Vaux and Jacob Wrey Mould, with additions by Richard Morris Hunt, 1894–5; Richard Howland Hunt and George B. Post, 1895–1902; and McKim, Mead & White, 1904–26), Fifth Avenue and East 82nd Street; the new Columbia University (plan 1893–4; see MCKIM, MEAD & WHITE, fig. 3), Morningside Heights; and the New York University (plan, 1892–4; by McKim, Mead & White; now Bronx Community College) in the Bronx. Private funding also paid for impressive building to serve the social needs of the populace, including such churches as the Cathedral of St John the Divine, Amsterdam Avenue and West 112th Street, begun in 1892 with a Byzantine design by Heins & LaFarge and rebuilt after 1912 as a Gothic Revival building (for illustration see CRAM, RALPH ADAMS); and St Thomas Episcopal Church (1906–12; by Cram, Goodhue & Ferguson), Fifth Avenue at West 53rd Street; the University Club (1896–1900; by McKim, Mead & White), 1 West 54th Street; and the New York Yacht Club (1899–1900; by Warren & Wetmore), 37 West 44th Street (for illustration see WARREN & WETMORE).

During these years of expansion in the final decades of the 19th century the apartment house and skyscraper office building developed as distinct types and major components of New York's urban fabric. Both were stimulated by increasing population growth and rising land values due to the construction of the subway system (inaugurated 1904) and three more East River crossings, the Williamsburg Bridge (1903; engineer Leffert L. Buck) and the Queensboro and Manhattan bridges (both 1909; engineer Gustav Lindenthal). The former is a cantilever bridge given architectural form by Palmer & Hornbostel, while the latter is a suspension bridge designed by Carrère & Hastings, who also designed the Beaux-Arts-inspired bridge approach on Canal Street, with a triumphal arch (1910–15). In addition, several Harlem River spans connected Manhattan and the Bronx. The new bridges provided avenues for new development in Brooklyn, Queens and the Bronx.

Before the 1870s virtually the only New Yorkers who lived in multiple dwellings were the poor. As land values rose, single-family houses became prohibitively expensive, and, under the influence of French residential custom,

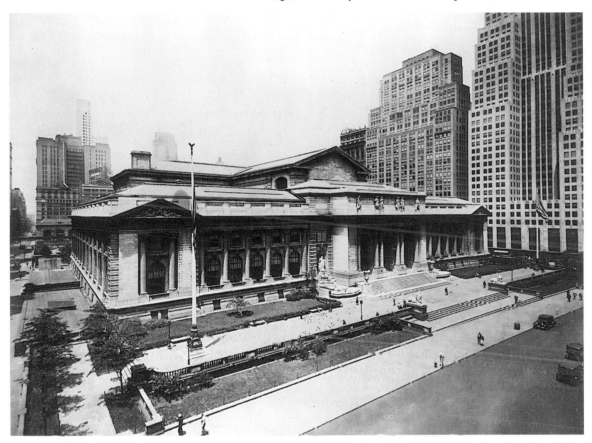

4. New York Public Library, Fifth Avenue and 42nd Street, by Carrère & Hastings, 1897–1911; from a photograph of the 1930s (New York, Public Library)

apartment houses came to be an acceptable alternative to individual home ownership. The earliest building of this type was the French-inspired Stuyvesant Apartments (1869–70; by Richard Morris Hunt; destr.), East 18th Street. It was not until the 1880s, however, that such buildings became popular with the middle classes; thereafter stylish, richly textured buildings were erected, for example the Dakota (1880–84; for illustration *see* HARDENBERGH, HENRY JANEWAY), West 72nd Street, the Gramercy (1882–3; by George da Cunha), Gramercy Park East, and the Chelsea (1883–5; by Hubert, Pirrson & Company; now the Hotel Chelsea), West 23rd Street. At the turn of the century, enormous French Beaux-Arts style apartment buildings with exuberant carved façades were erected, particularly on the Upper West Side, and in the early 20th century luxury apartment houses for the wealthiest proliferated, particularly after the construction of McKim, Mead & White's 998 Fifth Avenue (1910–12), the first luxury apartment house to rise amid the individual residential palaces of Fifth Avenue.

The development of the skyscraper paralleled that of the apartment house, since both were inconceivable without the development of the lift (*see* SKYSCRAPER). The building generally accepted as the first skyscraper was New York's seven-storey Equitable Life Assurance Building (1868–70; by Arthur Delavan Gilman and Edward Kendall, with George B. Post; destr. 1912), Broadway and

Cedar Street; this was the first office building in New York with a passenger lift (elevator) and the first to exploit the lift's potential by placing the finest offices on the upper floors. Throughout the 1870s and 1880s a succession of buildings rose ever higher, but all had masonry load-bearing walls; skeleton construction was introduced to New York with the Tower Building (1887; by Bradford Gilbert; destr.), 50 Broadway. Unlike their counterparts in Chicago, who invented a new design approach for skeleton skyscrapers, architects in New York preferred to adapt traditional architectural styles to the structure: GEORGE B. POST, R. H. ROBERTSON, Francis H. Kimball and Cass Gilbert, for example, were responsible for buildings with Romanesque, Renaissance, Beaux-Arts, Gothic and other historicist cladding. In the 1890s and early 1900s builders began to compete to produce the tallest building, culminating in the 241-m Woolworth Building (1910–13; for illustration *see* GILBERT, CASS), 233 Broadway. The succession of tall buildings, mostly erected in the narrow streets of Lower Manhattan, generated a growing concern for their effect on light and air that peaked with the construction of the 40-storey, 116,000 sq.-m Equitable Life Headquarters (1912–15, by Ernest R. Graham), covering an entire square block along lower Broadway.

BIBLIOGRAPHY

GENERAL

H. R. Stiles: *The History of the County of Kings and the City of Brooklyn, New York*, 2 vols (New York, 1884)

M. King: *King's Handbook of New York City: An Outline History and Description of the American Metropolis* (Boston, 1893/*R* New York, 1972)

——: *King's Photographic Views of New York* (Boston, 1895)

——: *King's New York Views* (Boston, 1896–1915/*R* New York, 1974)

A History of Real Estate, Building and Architecture in New York City during the Last Quarter of a Century (New York, 1898/*R* 1967)

History of Architecture and the Building Trades of Greater New York, 2 vols (New York, 1899)

E. I. Zeisloft: *The New Metropolis* (New York, 1899)

M. King: *King's Views of Brooklyn* (Boston, 1904/*R* New York, 1974)

S. Jenkins: *The Story of the Bronx, 1898–1909* (New York, 1909)

I. N. P. Stokes: *Iconography of Manhattan Island*, 6 vols (New York, 1915–28/*R* 1967)

C. W. Leng and W. T. Davis: *Staten Island and its People* (New York, 1930)

R. G. Albion: *The Rise of New York Port, 1815–1860* (New York, 1939)

The WPA Guide to New York City (New York, 1939/*R* 1982)

J. A. Kouwenhoven: *The Columbia Historical Portrait of New York: An Essay in Graphic History* (New York, 1953)

C. Lancaster: *Old Brooklyn Heights: New York's First Suburb* (Rutland, VT, 1961/*R* New York 1979)

A. Burnham, ed.: *New York Landmarks: A Study and Index of Architecturally Notable Structures in Greater New York* (Middletown, CT, 1963)

A. L. Huxtable: *Classic New York: Georgian Gentility to Greek Elegance* (Garden City, NY, 1964)

N. White and E. Willensky: *AIA Guide to New York City* (New York, 1967, rev. 3/1988)

M. Gayle: *Cast-iron Architecture in New York: A Photographic Survey* (New York, 1974)

J. E. Patterson: *The City of New York: A History Illustrated from the Collection of the Museum of the City of New York* (New York, 1978)

P. Goldberger: *The City Observed: New York, a Guide to the Architecture of Manhattan* (New York, 1979)

J. Tauranac: *Essential New York: A Guide to the History and Architecture of Manhattan's Important Buildings, Parks and Bridges* (New York, 1979)

D. S. Francis: *Architects in Practice: New York City, 1840–1900* (New York, 1980)

R. A. M. Stern, G. Gilmartin and J. M. Massengale: *New York, 1900: Metropolitan Architecture and Urbanism, 1890–1915* (New York, 1983)

C. Boyer: *Manhattan Manners: Architecture and Style, 1850–1900* (New York, 1985)

J. Tauranac: *Elegant New York: The Builders and the Buildings, 1885–1915* (New York, 1985)

R. A. M. Stern, G. Gilmartin and T. Mellins: *New York, 1930: Architecture and Urbanism between the Two World Wars* (New York, 1987)

C. Krinsky: 'Architecture in New York City', *New York Cultural Capital of the World, 1940–1965*, ed. L. Wallock (New York, 1988)

E. K. Spann: 'The Greatest Grid: The New York Plan of 1811', *Two Centuries of American Planning*, ed. D. Schaeffer (Baltimore, 1988)

R. Plunz: *A History of Housing in New York City* (New York, 1990)

A. S. Dolkart: *Guide to New York City Landmarks* (Washington, DC, 1992)

K. T. Jackson, ed.: *The Encyclopedia of New York* (New Haven, 1995)

E. M. Snyder-Grenier: *Brooklyn: An Illustrated History* (Philadelphia, 1996)

K. Bone, ed.: *The New York Waterfront: Evolution and Building Culture of the Port and Harbor* (New York, 1997)

SPECIALIST STUDIES

C. Cook: *A Description of the New York Central Park* (New York, 1869)

H. C. Brown: *Fifth Avenue Old and New, 1824–1924* (New York, 1924)

H. H. Reed: *Central Park: A History and a Guide* (New York, 1967)

E. Barlow: *Frederick Law Olmsted's New York* (New York, 1972)

C. Lockwood: *Bricks and Brownstone: The New York Row House, 1783–1929: An Architectural and Social History* (New York, 1972)

E. F. Rosebrock: *Walking Around in South Street: Discoveries in New York's Old Shipping District* (New York, 1974)

S. B. Landau: 'The Row Houses of New York's West Side', *J. Soc. Archit. Historians*, xxxiv (1975), pp. 19–36

C. Robinson and R. H. Bletter: *Skyscraper Style: Art Deco New York* (New York, 1975)

A. Balfour: *Rockefeller Center: Architecture as Theater* (New York, 1978)

C. H. Krinsky: *Rockefeller Center* (Oxford, 1978)

W. Shopsin and M. G. Broderick: *The Villard Houses: Life Story of a Landmark* (New York, 1980)

P. Goldberger: *The Skyscraper* (New York, 1981)

J. Simpson: *Art of the Olmsted Landscape: His Work in New York City* (New York, 1981)

D. S. Gardner: *Marketplace: A Brief History of the New York Stock Exchange* (New York, 1982)

D. Nevins, ed.: *Grand Central Terminal: City within the City* (New York, 1982)

The Great East River Bridge, 1883–1983 (Brooklyn, 1983)

S. Tunik: 'Architectural Terracotta: Its Impact on New York', *Sites & Mnmts*, xviii (1986), pp. 4–38

A. Robins: *The World Trade Center* (Englewood, FL, 1987)

A. S. Dolkart: *The Texture of Tribeca* (New York, 1989)

E. C. Cromley: *Alone Together: A History of New York's Early Apartments* (Ithaca, 1990)

D. W. Dunlap: *On Broadway: A Journey Uptown over Time* (New York, 1990)

R. Rosenzweig and E. Blackmar: *The Park and the People: A History of Central Park* (Ithaca, 1992)

R. Beard and L. C. Berlowitz, eds: *Greenwich Village: Culture and Counterculture* (New York, 1993)

C. Hood: *722 Miles: The Building of the Subways and How They Transformed New York* (New York, 1993)

A. S. Dolkart: *Touring the Upper East Side: Walks in Five Historic Districts* (New York, 1995)

Bull. Met., liii (Summer, 1995) [issue dedicated to the architectural history of the Metropolitan Museum of Art]

J. Tauranac: *The Empire State Building: The Making of a Landmark* (New York, 1995)

C. Willis: *Form Follows Finance: Skyscrapers and Skylines in New York and Chicago* (New York, 1995)

S. B. Landau and C. W. Condit: *Rise of the New York Skyscraper, 1865–1913* (New Haven, 1996)

B. Bergdoll: *Mastering McKim's Plan: Columbia's First Century on Morningside Heights* (New York, 1997)

A. S. Dolkart and G. Soren: *Touring Historic Harlem: Four Walks in Northern Manhattan* (New York, 1997)

A. S. Dolkart: *Morningside Heights: A History of its Architecture and Development* (New York, 1998)

M. Gayle and C. Gayle: *Cast-Iron Architecture in America: The Significance of James Bogardus* (New York, 1998)

ANDREW SCOTT DOLKART

II. *Art life and organization.*

1. Before *c.* 1778. 2. *c.* 1778–1914.

1. BEFORE *C.* 1778. The Dutch settlers who founded New Amsterdam brought with them a strong tradition of art appreciation and a propensity for collecting fine painting and sculpture. Art ownership was a symbol of wealth and power to this mercantile class, and they freely commissioned portraits of themselves and family members, bolstering their positions in society and, at the same time, preserving a historic record for future generations. Since there were no trained artists in the country at this time, portrait commissions were undertaken by 'limners'—untrained, itinerant artists—who travelled from city to city. Their flat, linear style was modelled on European prints, which freely circulated throughout the colony. The anonymous portrait of *Governor Peter Stuyvesant* (*c.* 1660; New York, NY Hist. Soc.; see fig. 5) is a good example of this early style.

The English settlers who arrived in the new British colony of New York after 1664 were predominantly Puritan, with ascetic tastes and strong strictures against the creation of idolatrous images. Neither religious themes nor displays of personal ostentation were allowed, but portraiture nevertheless continued to be popular in New York and its environs during the Colonial period: the sitter's status and wealth were subtly emphasized by meticulous detailing in clothing and furnishing. The Prot-

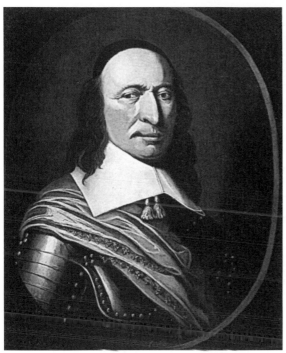

5. *Governor Peter Stuyvesant*, oil on canvas, 572×445 mm, *c.* 1660 (New York, New-York Historical Society)

mostly wealthy Dutch patroon families. Paintings with Classical or religious themes were not generally commissioned, but detailed views of New York harbour were popular in the mid-18th century, of which William Burgis produced many. By the late 18th century many artists were looking to Europe for instruction and experience, and some moved there permanently, seeking a new venue for their art.

2. *c.* 1778–1914. After the Revolution monuments were needed to create a national identity for the new American nation. Since local sculptors were not sufficiently skilled, European sculptors were commissioned in the 1790s to create the first of these heroic monuments. It was not until the early years of the next century that commissions were given to American sculptors, and a new age of sculpture was born in the USA. The 19th century marked a turning-point for American art, as the narrow strictures of previous times were relaxed and academically trained American artists for the first time began to rival their European counterparts. Portraiture, landscape, allegory and history painting became popular. The depiction of landscapes included the 20 aquatints in the *Hudson River Portfolio* (1820–25), published in New York by William Guy Wall and John Hill. John Vanderlyn, who had been in Paris, returned to paint an enormous panorama of the *Palace and Garden of Versailles* (New York, Met.), which he exhibited in a rotunda in City Hall Park in 1815. However, the public was not enthusiastic about a depiction of a European landmark. In contrast, when in 1859 Frederic Edwin Church exhibited his meticulously detailed, epic masterpiece the *Heart of the Andes* (1.68×3.03 m, 1859; New York, Met., for illustration *see* CHURCH, FREDERIC EDWIN), showing a vast South American landscape, the public enthusiastically viewed the painting through binoculars in a dimly lit room, as if actually in the depicted terrain. Church's landscapes typified the work of the HUDSON RIVER SCHOOL, begun by Thomas Cole.

The evolution of art societies and some of the great museums of New York also began in the early 19th century. The New-York Historical Society, founded in 1804, was the first museum in New York and had numerous sites before settling at its permanent address at Central Park West and 77th Street. The basis of the museum's collection was formed by two of the earliest and most important collectors of American art in New York: Thomas Jefferson Bryan and LUMAN REED. Reed, who was one of the most influential art patrons in the USA, opened the first art gallery in the country in 1832 in his mansion in downtown Manhattan. Another institution, the Brooklyn Apprentices Library, started in 1823 in a modest space, but in 1843 it was relocated in the larger Brooklyn Lyceum building and renamed the Brooklyn Institute. A fire in 1890 necessitated a new plan for space for the growing collection, and in 1895 a new building was begun that later became the Brooklyn Museum. Meanwhile, in Manhattan the construction of New York's most distinguished museum, the Metropolitan Museum of Art, began in 1874 (*see* §I above). This formidable landmark structure on upper Fifth Avenue gradually achieved status as one of the great museums of the world.

estant preoccupation with death is recalled in the emblems of mortality that appear in both painted portraits and gravestone carving, the only sculpture produced at this time. Gravestones provided a lively form of stone relief sculpture, incorporating images of mortality in an elaborate iconography that employed skeletons, skulls, hour-glasses marking the passage of time, and animated figures of Father Time. This later changed after the American Revolution (1775–8), when artists were no longer bound to strict Puritan belief systems and began including portrait busts and reliefs of the deceased to mark their graves. During the early Colonial period topographical views of New York were also produced, which remain fine documents of the city's architecture.

At the beginning of the 18th century, New York was a hub of commerce and contained a burgeoning art community. Although the English influence was felt more strongly than ever, the Dutch style was still retained by painters. Gerret Duyckinck was the first portrait painter to emerge in the early part of the century, employing a straightforward realism with sharp angles in the drapery that was characteristic of the New York style. In the early part of the century partially trained painters began migrating to North America, bringing an academic tradition and skill to their portraiture. John Smibert from Scotland was one of the first émigrés: although he settled in Boston, he was patronized by visitors from New York who would also have seen his collection of copies of European works, which had a major influence on American artists in New York. By mid-century English painters such as John Wollaston had arrived. The richest area for portraiture in Colonial America could be charted from New York City to upstate New York around Albany, the clients being

One of the first art organizations in New York in the early 19th century was the American Academy of Fine Arts, founded in 1801 by a group of businessmen and amateur painters. In 1825 the National Academy of Design (NAD) was founded there by a group of professional artists, and, under their exclusive management, the artist-members of the NAD held important exhibitions and produced publications that were the highlights of the art season in New York. Modelled on the Royal Academy of London, the NAD also had a school for academic training for young artists and a professional association, membership of which was considered the mark of excellence for painters and sculptors of the day. The formation of this group helped to establish New York as the art centre of the country in the 19th century. Nevertheless, the stalwart traditions of the NAD came under attack by younger artists returning from study abroad in the 1870s, and a splinter group broke with the academy in 1877 to form the Society of American Artists. This had a more liberal policy of inclusion and promised exhibitions to artists based on merit rather than on political alliances, as in the entrenched academy. Walter Shirlaw and Augustus Saint-Gaudens were among the founders of this group, and in 1878 John La Farge was elected President. Shirlaw was instrumental in organizing classes at the Art Students League (ASL) in 1875 while the NAD school was temporarily closed. When it reopened, the ASL continued to operate, and its student body had swelled to more than 1000 by the late 1890s. Its liberal educational policy led

the way to a decidedly modern school, and the addition of William Merritt Chase to the faculty in 1878 strengthened its power and prestige.

In 1897 the group known as the TEN AMERICAN PAINTERS broke with the Society of American Artists to stage their own exhibition of American Impressionist work at the P. L. Durand-Ruel Gallery, New York; the group, containing artists from both Boston and New York, including Childe Hassam, Edmund C. Tarbell, John H. Twachtman and Julian Alden Weir, continued to exhibit for many years. In the early 20th century Alfred Stieglitz founded the PHOTO-SECESSION group in New York to fight for recognition of photography as a fine art, and the exhibition of photography at the National Arts Club, New York, in 1902 heralded a new era for this art form. Stieglitz also founded (1905) the gallery that became known as 291 (see <TWO-NINE-ONE>) in New York, showing avant-garde artists from the USA and Europe. In 1908 the artists known as THE EIGHT led a revolt against the conservative NAD with their exhibition at the Macbeth Galleries, New York. The Eight included a core group of William J. Glackens, George Luks, Everett Shinn, John Sloan and their leader Robert Henri. Their work had been rejected from the academy's exhibition of 1907, and they decided to organize the 1908 show as a counter-exhibition, to include in addition Arthur B. Davies, Ernest Lawson and Maurice Prendergast. Their loosely rendered impressions of everyday life in New York, characterized by gritty realism in urban scenes, earning them the label of the

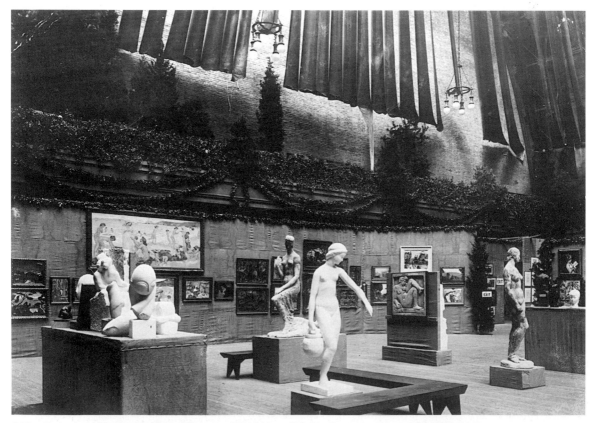

6. New York, view of the Armory Show (International Exhibition of Modern Art) in the Armory of the 69th Regiment, 1913

ASHCAN SCHOOL, decisively broke with academic tradition.

In 1913 the first large-scale show of European and American modern art, the ARMORY SHOW, was held in New York, marking the advent of modernism in the USA and transforming the art market in New York. The show grew out of a desire by members of the Eight to plan an exhibition of artists affiliated with the progressive Association of American Painters and Sculptors to show contemporary trends in American art. Difficulty with funding led them to ask Arthur B. Davies, who had exhibited with the Eight in 1908 and had solid financial connections, to take charge of fundraising. Davies accepted but envisioned a much different show, and with the aid of Walt Kuhn (1877–1949) and Walter Pach, who had been living in Paris, the original idea was expanded and became the International Exhibition of Modern Art, better known as the Armory Show after its location at the Armory of the 69th Regiment in New York (see fig. 6). Some 75,000 people attended the exhibition (17 February–15 March 1913), which received a lively public and critical response.

BIBLIOGRAPHY
GENERAL
A. Burroughs: *Limners and Likenesses; Three Centuries of American Painting* (Cambridge, MA, 1936)
C. E. Lester: *The Artists of America* (New York, 1946)
J. T. Flexner: *First Flowers of Our Wilderness: American Painting* (Boston, MA, 1947)
J. McCoubrey: *American Art, 1700–1960: Sources and Documents* (Englewood Cliffs, NJ, 1965)
C. Caffin: *The Story of American Painting: The Evolution of Painting in America from Colonial Times to the Present* (New York, 1970)
L. Fink: *Academy: The Academic Tradition in American Art* (Washington, DC, 1975)
T. Armstrong: *200 Years of American Sculpture* (Boston, MA, 1976)
S. G. W. Benjamin: *Art in America: A Critical Historical Sketch* (New York, 1980)
M. Baigell: *A Concise History of American Painting and Sculpture* (New York, 1984)

SPECIALIST STUDIES
E. Clark: *History of the National Academy of Design* (New York, 1954)
M. W. Brown: *The Story of the Armory Show* (New York, 1963, rev. 1988)
B. Rose: *American Art since 1900: A Critical History* (New York, 1967)
The 1930s: Painting and Sculpture in America (exh. cat. by W. Agee, New York, Whitney, 1968)
J. D. Prown: *American Painting: From its Beginnings to the Armory Show* (Geneva, 1969)
J. K. Howat and J. Wilmerding: *Nineteenth-century America: Paintings and Sculpture* (Greenwich, CT, 1970)
W. H. Gerdts: *American Neo-Classic Sculpture: The Marble Resurrection* (New York, 1973)
The Golden Door: Artist-Immigrants of America, 1876–1976 (exh. cat. by C. J. McCabe, Washington, DC, Hirshhorn, 1976)
W. I. Homer: *Alfred Stieglitz and the American Avant-Garde* (Boston, MA, 1977)
B. Novak: *American Painting of the Nineteenth Century* (New York, 1979)
W. Craven: *Colonial American Portraiture* (New York, 1986)
W. H. Gerdts: *American Impressionism* (New York, 1989)
NANCY MALLOY

Norton, Charles Eliot (*b* Cambridge, MA, 16 Nov 1827; *d* Cambridge, MA, 21 Oct 1908). American teacher, art historian and writer. He came from a wealthy and scholarly New England family and was educated at Harvard University, Cambridge, MA. He travelled to India and Europe in 1848–50 and later to Europe again (1855–7 and 1868–73). In 1873 he was appointed the first Professor of Fine Arts at Harvard University and in this position exerted a great influence on American scholarship for the next quarter of a century. He opposed the prevalent German cultural influences in American art and education and instead promoted Italian civilization, largely according to the aesthetics of Ruskin (1819–1900) and the Pre-Raphaelites, which linked art to social reform.

Norton's writings, many appearing in the important magazines he founded (*The Nation*, 1865) or edited (*North American Review*, 1863–8), testify to the breadth of his knowledge in art history and such other fields as archaeology and poetry. In *Notes of Study and Travel in Italy* (Boston, 1859) and *Historical Studies of Church Building in the Middle Ages* (New York, 1880), disillusioned by his own times, he developed a moral interpretation of art history, suggesting that lofty spiritual values led to the creation of fine art while materialism poisoned it. A collection of his Harvard lectures, *History of Ancient Art* (1891), shows how he modelled himself on Ruskin at Oxford University, hoping to arouse in his students a concern for beauty. He was the literary executor of both Thomas Carlyle (1795–1881) and Ruskin and had a long and prolific correspondence with such friends as Dickens (1812–70), Matthew Arnold (1822–88), Charles Darwin (1809–82), Arthur Hugh Clough (1819–61), Ralph Waldo Emerson and Mrs Gaskell (1810–65). Although a supporter of democratic ideals (see James), in these letters he discussed his lifelong problem of whether democracy is essentially incompatible with a 'healthy culture'. His rustic retreat in Ashfield, Berkshire, MA, and his home, Shady Hill, in Cambridge, MA, were significant centres of social and intellectual thought in the USA until the end of the 19th century.

WRITINGS
Notes of Study and Travel in Italy (Boston, 1859)
Historical Studies of Church Building in the Middle Ages (New York, 1880)
History of Ancient Art (Boston, 1891)
S. Norton and M. A. DeWolfe, eds: *Letters of Charles Eliot Norton*, 2 vols (Boston, 1913)
Regular contributions to *North American Review* (1851–69) and *The Nation* (1865–1908)

BIBLIOGRAPHY
DAB
H. James: *Notes on Novelists* (London, 1914), pp. 327–35
K. Vanderbilt: *Charles Eliot Norton: Apostle of Culture in a Democracy* (Cambridge, MA, 1959)
[D. Sutton]: 'A Gentleman from New England', *Apollo*, cvii (1978), pp. 356–61
GRETCHEN G. FOX

Notman, John (*b* Edinburgh, 22 July 1810; *d* Philadelphia, 3 March 1865). American architect of Scottish birth. He was prominent among the emigré architects of the first half of the 19th century who introduced into America new styles, a greater professionalism and more sophisticated approaches to design.

According to an anonymous manuscript biography (ex-Hist. Soc., Philadelphia, PA, now lost), Notman served an apprenticeship as a carpenter in Edinburgh. He then worked for the architect William Henry Playfair (1790–1857), whose early essays in the Italianate style Notman later introduced in the USA. In 1831, following a period of economic depression in Edinburgh and the consequent collapse of its construction industry, Notman emigrated to the USA, settling in Philadelphia, where he supported himself as a carpenter. His first major design commission

was for the Laurel Hill Cemetery (1836–9), Philadelphia, PA. Derived from Kensal Green Cemetery, London, Laurel Hill was the earliest architect-designed Picturesque rural cemetery in the USA. Rural cemeteries and other landscape designs continued to be an important aspect of his work. Later cemeteries included Hollywood Cemetery (1848), Richmond, VA, where he also designed Capitol Square (1850–60), the country's first major Picturesque urban park.

Through his work at Laurel Hill, Notman met the patrons for his first important houses, Nathan Dunn's cottage (1837–8; altered early 20th century), Mount Holly, NJ, and Riverside (1839; destr. 1961), Burlington, NJ. Both were published in 1841 in Andrew Jackson Downing's *A Treatise on the Theory and Practice of Landscape Gardening*. Of the two houses, Riverside was more innovative and more influential, introducing the Tuscan villa style into the USA. Notman would have become familiar with the style during his apprenticeship in Playfair's office, when there were at least two major Italianate country houses on the boards: Dumphail House (1828–9; altered 1842, remodelled 1965), Morayshire, and Drumbanagher (1829; destr.), County Armagh. What was significant about Riverside, however, was not so much its style as the approach that Notman took to the organization of space in the building. Notman designed Riverside as a series of irregularly disposed pavilions of differing heights, arranged around a central core rising the full height of the house. This produced an asymmetrical plan and a Picturesque, but controlled, silhouette on the exterior. Notman expanded and refined this theme in his later Italianate villas, notably Prospect (1851–2) and Fieldwood (?1853–5; now Guernsey Hall), both at Princeton, NJ.

The most productive period of Notman's career was the decade from 1845 to 1855. In early 1845 he was working simultaneously on two major commissions: the expansion of the New Jersey State House (largely destr. 1885), Trenton, and The Athenaeum of Philadelphia. At the State House he transformed a vernacular late-18th century building into an example of Picturesque classicism. The Athenaeum (see fig.) was influenced by Sir Charles Barry's Reform and Travellers Clubs, London, and it introduced the Renaissance Palazzo style into the USA.

Notman also established a reputation as a designer of churches, especially Gothic Revival buildings following the tenets of the English ecclesiologists. His first modest

John Notman: The Athenaeum, Philadelphia, Pennsylvania, 1845

essay in the style was the Chapel of the Holy Innocents (1845–7), Burlington, NJ. This was followed by major Episcopal churches, such as St Mark's (1847–52), Philadelphia, St Peter's (1851–2), Pittsburgh, PA, and the Cathedral of St John (1857–8), Wilmington, DE. He also designed the Renaissance Revival façade of the Roman Catholic Cathedral of SS Peter and Paul (1851–7) and the two Romanesque style Episcopal churches Holy Trinity (1856–9) and St Clement's (1855–9), all in Philadelphia.

Notman was quick to use advances in building technology. His earliest houses were equipped with central heating, plumbing and ventilation systems. In rebuilding Nassau Hall, Princeton, NJ, from 1855 to 1859, he used rolled-iron joists, among the first uses of this construction technique in the USA.

BIBLIOGRAPHY

J. Fairbanks: *John Notman: Church Architect* (diss., Newark, U. DE, 1961)

K. Morgan: *The Landscape Gardening of John Notman, 1810–1865* (diss., Newark, U. DE, 1973)

C. M. Greiff: *John Notman, Architect, 1810–1865* (Philadelphia, 1979)

CONSTANCE M. GREIFF

O

Olmsted, Frederick Law (*b* Hartford, CT, 26 April 1822; *d* Waverly, MA, 22 Aug 1903). American landscape designer, urban planner and writer. Influenced by 18th-century English traditions of landscape design and by his own social beliefs in the importance of community and the civilizing role of aesthetic taste, Olmsted undertook a large number of public and private commissions. His commissions ranged from regional plans and scenic reservations to residential communities, academic campuses, and the grounds of private estates. With his partner CALVERT VAUX and later independently, he designed a series of city parks systems between 1858 and 1895 in which landscaped parks were integrated with other public spaces through broad interconnecting thoroughfares, or parkways, which incorporated drives, paths and areas of turf and trees. His major work includes Central Park (1858–77), New York, and the 'Emerald Necklace' series of public spaces in Boston (1880s). He believed in the power of landscaped scenery to exercise a restorative and civilizing influence.

1. Life and work. 2. Working methods and technique. 3. Critical reception and posthumous reputation.

1. LIFE AND WORK.

(i) The years of preparation, 1822–57. (ii) Central Park and other work, 1857–65. (iii) Landscape design and other commissions, 1865–95.

(i) The years of preparation, 1822–57. Olmsted's forebears helped to found Hartford in 1636. The scenery of the Connecticut Valley would significantly affect his landscape design, while the social values of the New England Puritans, passed down through seven generations, were to have a strong influence on his views of society and art. From the age of five to fifteen he studied with ministers in several towns in Connecticut. In 1837 severe sumach poisoning affected his eyes and kept him from entering college, and he spent the next decade nominally studying with farmers and engineers while also dabbling in scientific studies. During this time he was particularly influenced by the writings of Ralph Waldo Emerson, John Ruskin (1819–1900) and Thomas Carlyle (1795–1885). He supported the international cause of republican government and opposed the expansion of slavery in the United States. He looked to the creation of public institutions of education, science and the arts that would enable all classes to acquire 'refinement and taste and the mental and moral capital of gentlemen'.

From 1848 until 1865 Olmsted implemented his programme of social improvement as a farmer, writer, publisher and administrator. On his farm on Staten Island, near New York, he developed a nursery business and promoted agricultural reform among his neighbours. In 1850 he spent six months on a walking tour of Great Britain and the Continent, part of which he chronicled in *Walks and Talks of an American Farmer in England* (1852). The green countryside of England and Wales delighted him, and he was greatly impressed by Birkenhead Park (1843), Liverpool, designed by Sir Joseph Paxton (1803–65).

Shortly afterwards, the *New York Times* commissioned him to write a series of travel accounts on the American South. Between 1852 and 1854 he made two tours through the south, travelling for a total of 12 months and as far as Mexico, and writing 74 letters for the *Times* and the *New York Daily Tribune*. He argued that slavery discouraged the formation of communities, educational institutions and exchange of services, and so perpetuated a 'frontier condition of society', and he developed this theme in his books.

In 1855 Olmsted became a partner in the publishing house of Dix, Edwards & Co., where he was managing editor of *Putnam's Monthly Magazine*, a patron of leading American writers. While travelling in Europe in 1856 on publishing business he visited numerous parks and gardens in France, Italy and Germany. He stayed in London for several months, becoming familiar with the city's parks; later trips in 1859 and 1878 increased his knowledge of the parks of England and Paris. In August 1857 Olmsted's publishing firm failed.

(ii) Central Park and other work, 1857–65. In autumn 1857 Olmsted became Superintendent of Central Park, then still an undeveloped site, in New York. The following spring he and Calvert Vaux, the former collaborator of A. J. Downing, won the public competition to design the 850-acre park. Their plan, Greensward, was the only one that proposed to run the four required transverse roads across the park below the line of sight. It also provided the greatest expanse of meadow of any entry. Appointed Architect-in-Chief of the park in early 1858, Olmsted directed its construction, coordinating the work of engineers, architects and other professionals. By the outbreak of the Civil War in 1861, construction of the park was nearly complete below the reservoir at 79th Street (see fig. 1).

Lameness from a severely broken leg, suffered in 1860, kept Olmsted from military service in the Civil War, and

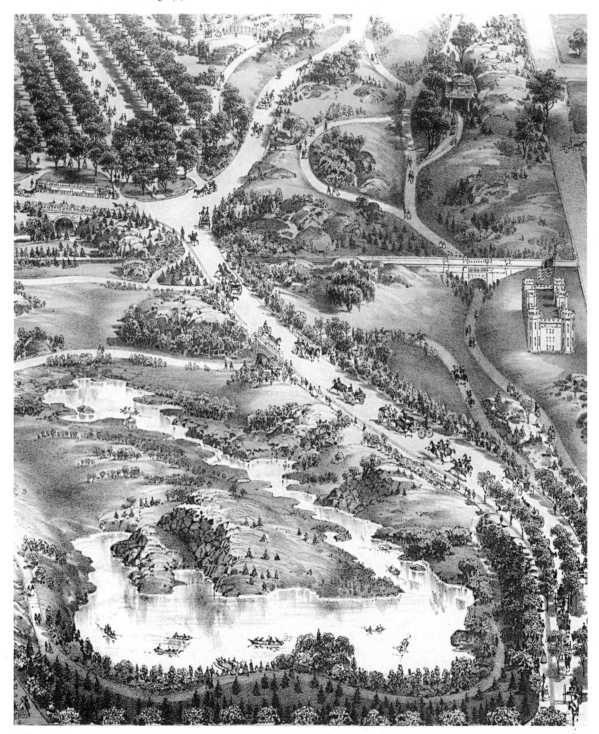

1. Frederick Law Olmsted (Olmsted, Vaux & Co.): Central Park, New York, 1858–63; from a lithograph by John Bachmann, 1863 (New York, New-York Historical Association)

in 1861–3 he served as general secretary of the US Sanitary Commission. In 1863 he accepted a position as manager of the vast Mariposa Estate in California, where he directed the gold mines until 1865. His observation of frontier society clarified for him what constituted the crucial elements of civilized society. He concluded that the mutual exchange of service, which he called 'communitiveness', was the most effective means for overcoming the barbarism of the frontier. He believed in a division of labour whereby each person developed a high level of a particular

skill with which to serve the community at large. Olmsted's basic design principles reflected these social values: landscapes, like communities, required subordination of the individual part to the overall purpose.

While in California, Olmsted secured several landscape design commissions in the San Francisco area, through which he began to develop a water-conserving style of landscape design appropriate for the semi-arid American West, but few of his proposals were implemented. He also served as chairman of the first commission in charge of the Yosemite reservation, created in 1864, setting out a programme for administering the reservation and offering a comprehensive rationale for governmental protection of natural scenery. Olmsted held the traditional view that landscapes could be divided into three categories: the Beautiful (or Pastoral), the Picturesque and the Sublime. These ideas on landscape design originate in 18th-century English theory, popularized by William Shenstone (1714–63), who had designed his own estate at The Leasowes, William Gilpin (1724–1804), Uvedale Price (1747–1829) and Humphry Repton (1752–1818). Themes or types of landscape should not, Olmsted believed, be mixed, or the experience would be diluted. His treatment of the Sublime, as in his plans for Yosemite Valley, was simply to make the experience of it conveniently available to the viewer.

Olmsted returned to New York in 1865 to join Calvert Vaux in designing Prospect Park (1865–73; see fig. 2) in Brooklyn. The Long Meadow at Prospect Park is the best example of Olmsted's use of his Pastoral manner, which was the most important style for him. He had experienced the style in its purest and most powerful form in his tours of the parks of estates in the British Isles. The graceful undulation of the terrain invited movement through it, producing a sense of enlarged freedom. With its seemingly unbounded undulating terrain, pools and groups of trees, Pastoral landscape, Olmsted believed, served as a specific antidote to the congestion, noise and artificiality of the city. Olmsted was convinced that the appeal of Pastoral landscape was not simply a passing fashion: rather, it appealed to the 'common and elementary impulses of all classes of mankind'.

In terrain too steep for Pastoral treatment, Olmsted provided a contrasting experience by employing the Picturesque style. He used a great variety of plant materials, creating a layering of textures. The effect he sought was one of richness and profusion, combined with a sense of mystery produced by dark shadows under scintillating, sunlit foliage. He had experienced this landscape most intensely at the edge of the rainforest in Panama.

(iii) Landscape design and other commissions, 1865–95. Olmsted's partnership with Calvert Vaux lasted until 1872. During that time the firm of Olmsted, Vaux & Co. designed and oversaw construction of major park systems, among them Prospect Park in Brooklyn and the Buffalo Park System, NY (1868). The partners also designed Chicago's South Park (now Washington and Jackson parks), along with smaller parks in Bridgeport and New Britain, CT, and Fall River, MA.

In 1869 Olmsted & Vaux designed the Riverside community, IL (see fig. 3), on the Des Plaines River 14.5 km west of the Chicago Loop. The village was linked to Chicago by a railway and a parkway for carriages. Although Olmsted felt that one-acre plots were the minimum size for a family residence, the Riverside plan included plots ranging in size from three acres to 15×30 m. He reserved the flood plain of the Des Plaines River as park land and set aside space for the Long Common in an upland area.

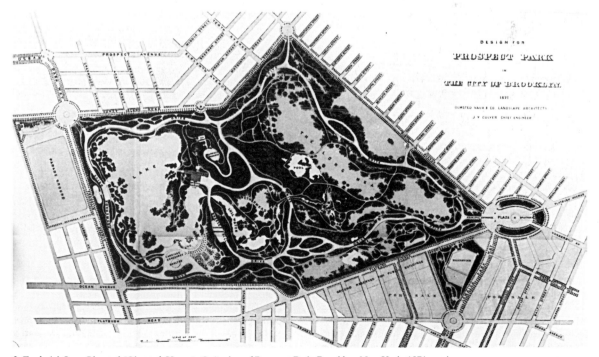

2. Frederick Law Olmsted (Olmsted, Vaux & Co.): plan of Prospect Park, Brooklyn, New York, 1871 version

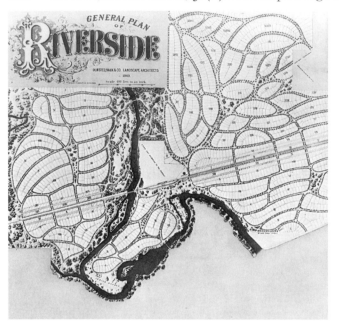

3. Frederick Law Olmsted (Olmsted, Vaux & Co.): general plan for Riverside, Illinois, 1869

He also provided many triangles at the intersection of streets for neighbourhood gatherings and play areas.

The street system was curvilinear, creating a sense of enclosure and intimacy in keeping with the domestic character of the community. It also discouraged cross-town traffic. Pavements flanked the streets, providing convenient access to the town centre and the parks. Olmsted repeated these elements in his later residential designs, notably Druid Hills (designed 1890–93) in Atlanta, GA (see ATLANTA), the area adjacent to Delaware Park (designed 1874–5 and c. 1886) in Buffalo, NY, and at several locations in the Boston region.

The size of Olmsted's designs for the grounds of residences ranged from the backyard of a Manhatten row house to country estates many acres in extent. His primary aim was to provide 'open-air apartments' that would move household activities out of doors, into spaces where a subtle variation of tint, texture and tone of foliage was to be the leading landscape effect. The smaller the space, the less allowance he was willing to make for specimen planting and the placing of objects of individual interest. Flower gardening was to take place in a walled garden enclosure, visually separate from the section of grounds with broader landscape effects. By designing residences in this manner, Olmsted hoped to counteract the decorative gardening so prevalent in his time, and to influence people to reject conspicuous display in favour of tasteful design.

The key element of Olmsted's public park system, both in partnership with Vaux and independently, was the separation of different recreational activities and provision for each activity in its own specially designed space. Each system usually contained only one large park devoted primarily to the enjoyment of scenery, supplemented with public spaces in other sections of the city for competitive sports, gymnastics, concerts, military reviews and large civic gatherings. In Brooklyn the principal park was Prospect Park (1866); in Buffalo, Delaware Park (1870). If there were two parks in a system, each received a distinctive treatment, as with Washington and Jackson parks in Chicago, where Olmsted chose two landscape themes drawn from the natural scenery of the area, prairie and marsh. Some systems also included arboreta and scenic reservations. He intended each element of the park system to attract users from throughout the city, strengthening the sense of community.

The segments of each park system were connected by public ways, known as parkways, 61 m or more wide and containing carriage ways, walks and bridle paths separated by turf and rows of trees. In the centre was the distinctive feature that gave these parkways their name: a hard-surfaced drive designed for the smooth and rapid movement of carriages. This separation of pleasure vehicles from carts and wagons was one of the principal innovations in urban planning that Olmsted and Vaux developed during their partnership.

With such projects as Riverside and the parks systems, Olmsted and Vaux laid the basis for their profession, which they called 'landscape architecture'. The partnership ended at a time when Olmsted was concentrating his attention on Central Park, but he was never able to complete the planting that he felt was necessary to the park as a work of art. Instead, during the 1870s he prepared designs for Morningside and Riverside parks in upper Manhattan, NY (1873 and 1875), and planned the new street system of the recently annexed Bronx. In addition, he wrote much of the report of a committee charged with preparing a regional plan for Staten Island. In 1877 his position with the New York City Department of Parks was abolished. He was becoming increasingly involved in projects outside New York, principally the grounds and terraces of the US Capitol in Washington, DC (1874). The extensive West Front terrace and the paved area at the East Front, relieved only by fountains and panels of grass and shrubs, demonstrate his willingness to use a formal architectural treatment when appropriate. Other work of the period includes Mount Royal in Montreal (1877), the Boston park system (from 1878) and a public park on Belle Isle in Detroit (1881).

In 1883 Olmsted settled in Brookline, MA, a suburb of Boston, which was the base for the Olmsted firm for the next 100 years. During the 1880s planning the parks and suburban residential neighbourhoods of the Boston area became his primary concern. The 'Emerald Necklace', stretching 16 km from the Charles River to Boston harbour, was the most complex linked system of public spaces that he designed (see fig. 4). It contained grounds for gymnastics at Charlesbank and provision for promenading, swimming and boating at Pleasure Bay (now Marine Park), while the botanical collections of the Arnold Arboretum provided contrast to the open fields and rocky 'Wilderness' of Franklin Park, which also contained the Playstead Shelter, a large multi-functional structure of stone and shingle that was Olmsted's most important architectural work. A continuous system of walks and drives connected the various sections. Olmsted planned a series of water features to run inland from the Charles River, beginning with the Back Bay Fens, which he

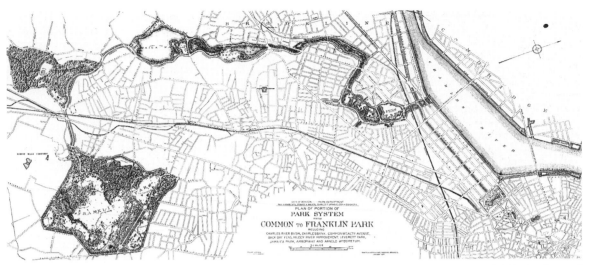

4. Frederick Law Olmsted (Olmsted, Olmsted & Eliot): the Boston 'Emerald Necklace' (detail), section between the Charles River and Franklin Park, 1894

separated from the tidal river with a dam and then planted to resemble the coastal marshland of the region. Beyond the Fens stretched the narrow Riverway section, followed by a series of more open ponds terminating at Jamaica Pond. In this design Olmsted provided his most thorough demonstration of the advantages to be gained by reserving stream valleys for public use instead of filling them in for building land.

Olmsted's work during the 1880s included his collaboration in the Boston area with the architect H. H. RICHARDSON. They were frequent collaborators and neighbours, first on Staten Island and later in Brookline. In Boston they worked together on the Boylston Street Bridge (1880) in the Back Bay Fens, the Robert Treat Paine estate (1885–7) in Waltham, the landscaping of several stations of the Boston and Albany Railroad, and a series of commissions for the Ames family in North Easton, MA. He also worked with other leading architects. The finest example of an Olmsted-designed private estate of moderate extent is Moraine Farm in Beverly, MA, with the house by Peabody & Stearns and its grounds set on a massive terrace overlooking Wenham Lake.

During the 1880s Olmsted designed his two most complete academic campuses, Lawrenceville School, NJ (1883–1901), and Stanford University, CA (1886). His ideas on campus planning derived, once again, from his social beliefs. He planned groups of small residences where the students would experience life in a community that was informally laid out on a human scale. Stanford was his most formal campus at the request of its founder, Leland Stanford.

In 1887 Olmsted collaborated with his former partner Vaux on a plan for the Niagara Falls Reservation: a system of walks, drives and concourses allowed large numbers of people without damaging the scenery. Also in 1887 Olmsted and Vaux collaborated on a new plan for Morningside Park in New York and a design for Downing Memorial Park in Newburgh, NY, created in honour of A. J. Downing.

As his commissions increased, Olmsted employed young men whom he trained in landscape design. The first to become a partner was his adopted stepson, John C. Olmsted (1852–1920), and in 1889 the firm became F. L. Olmsted & Co. with the addition of Henry Sargent Codman (1864–93) as a partner. In 1893 Charles Eliot, who had been apprenticed to the firm, rejoined as a partner, and the practice became Olmsted, Olmsted & Eliot. Olmsted's son Frederick Law Olmsted jr (1870–1957) was a partner of Olmsted Brothers from 1898 until his retirement in 1950.

In 1888 Olmsted was commissioned to design the grounds of George W. Vanderbilt's large estate, Biltmore, near Asheville, NC, which became his main focus of interest: he saw it as his last opportunity to create a major landscape that would be carried to completion. For this commission Olmsted used the Picturesque style for one of his most extensive passages of scenery: the three-mile approach road to the great mansion designed by Richard Morris Hunt. Near the mansion he planned a series of spaces, free of decorative plantings, that gradually progressed from formal terraces near the building to naturalistic scenery in outlying areas. Viewing Biltmore as an opportunity to employ vast private wealth for public ends, he convinced Vanderbilt to devote thousands of acres to an experiment in scientific forestry. He also planned an extensive arboretum through which he intended to promote development of a regional style of landscape design in the American South. Biltmore was also the training ground for Frederick Law Olmsted jr.

During his last years of practice Olmsted remained involved with the development of the Boston park system, and played a leading role in the early design stages of park systems in Rochester, NY (1888), and Louisville, KY (1891). He also oversaw the landscape and transportation planning of the World's Columbian Exposition of 1893 in Chicago, where the shores of the Wooded Isle provide a further example of his use of the Picturesque.

2. WORKING METHODS AND TECHNIQUE. In producing the desired landscape effect Olmsted was willing

to use any plants that could thrive in a given climate and were not obviously exotic. In this way he achieved greater richness and subtlety than could be secured by using only native plant materials. Olmsted valued qualities of complexity and obscurity as contributing to the unconcious power of scenery and civilizing effect of landscape: 'It must contain either considerable complexity of light and shadow near the eye, or obscurity of detail farther away'.

Olmsted eschewed decoration for its own sake and extended the principle of subordination of individual elements to the landscape as a whole to the architectural and engineering features of his parks. The walks and drives that structured the experience of the scenery flowed in a sinuous way through the park, constantly opening up new views. They were wide, smooth surfaced and well drained, and whenever possible the various kinds of traffic were separated by grade elevations. These precautions minimized fear of collision and made it pleasant to use the park in all seasons. Olmsted was convinced that the beneficial effect of scenery resulted from a psychological process that operated below the level of the conscious mind. Only one type of landscape should be present in a given space: an 'incongruous mixture of styles' would dilute the power of the experience. There should be no objects to be viewed for their individual beauty or interest. In this purpose he was inspired by the Swiss physician Johann Georg von Zimmerman (1728–95) whose *Ueber die Einsamkeit* (1784–5) described how park scenery had cured him of deep melancholy. Olmsted applied these design principles more consistently than any other landscape artist of his time.

In the early years of his practice Olmsted spent much of his time in supervising construction, but in his last years he was occupied on the sites of projects, working out design concepts for them. Preliminary planning of designs and writing of reports had been his primary responsibility from the first, and in his 37 years of professional practice he wrote over 6000 letters and reports dealing with over 300 landscape projects. He left preparation of working drawings to others, usually preparing only preliminary sketches. All his plans were in some sense preliminary, giving general indications of what was to occur on the land itself. He ran a busy practice, and, by the time of his retirement in 1895, he and his staff had carried out nearly 500 landscape commissions, including over 100 parks and public recreation grounds, 40 academic campuses, 50 residential subdivisions and 200 private estates.

3. CRITICAL RECEPTION AND POSTHUMOUS REPUTATION. Olmsted's reputation was high in his own time, although his designs ran counter to contemporary American taste for decorative gardening. The best evidence of his continuing effect on the American landscape, however, is the great body of work—some 3000 commissions—accomplished in the half-century after his retirement by the Olmsted firm under John C. Olmsted and Frederick Law Olmsted jr. Olmsted's vision of the role of public spaces in furthering the unity and social progress of the community has been highly regarded in the 20th century. In the belief that place of residence should be separated from place of work, he designed residential communities that served as models for the suburban movement. Despite Olmsted's concern for both the individual and the community, however, his high expectations for the psychological and social benefits of landscape design were not fully shared by his firm and received only partial expression in the work of those who came after him.

WRITINGS

A Journey in the Seaboard Slave States (New York, 1854)
A Journey through Texas (New York, 1856)
A Journey in the Back Country (New York, 1860)
F. L. Olmsted jr and T. Kimball, eds: *Frederick Law Olmsted: Landscape Architect, 1822–1903*, 2 vols (New York, 1922–8), vol. ii repr. as *Forty Years of Landscape Architecture: Central Park* (Cambridge, MA, 1973)
A. Fein, ed.: *Landscape into Cityscape: Frederick Law Olmsted's Plans for a Greater New York City* (Ithaca, 1967)
C. C. McLaughlin, C. E. Beveridge and others, eds: *The Papers of Frederick Law Olmsted* (Baltimore, 1977–)
C. E. Beveridge and D. Schuyler, eds: *The Papers of Frederick Law Olmsted*, iii *Creating Central Park, 1857–1861* (Baltimore, 1983) [contains the Greensward competition design and accompanying studies]

BIBLIOGRAPHY

J. G. Fabos, G. T. Milde and V. M. Weinmyr: *Frederick Law Olmsted, Sr: Founder of Landscape Architecture in America* (Amherst, 1968)
E. Barlow and W. Alex: *Frederick Law Olmsted's New York* (New York, 1972)
A. Fein: *Frederick Law Olmsted and the American Environmental Tradition* (New York, 1972)
L. W. Roper: *FLO: A Biography of Frederick Law Olmsted* (Baltimore, 1973)
C. Zaitzevsky: *Frederick Law Olmsted and the Boston Park System* (Cambridge, MA, 1982)
I. D. Fisher: *Frederick Law Olmsted and the City Planning Movement in the United States* (Ann Arbor, 1986)
D. Schuyler: *The New Urban Landscape: The Redefinition of City Form in Nineteenth-century America* (Baltimore, 1986)
Frederick Law Olmsted: Designs for Buffalos Parks and Parkways, 1868–1898 (exh. cat., ed. F. R. Kowsky; Buffalo, NY, Burchfield A. Cent., 1992)
The Best Planned City: The Olmsted Legacy in Buffalo (exh. cat., ed. F. R. Kowsky; Buffalo, NY, Burchfield A. Cent., 1992)
C. E. Beveridge and P. Rocheleau: *Frederick Law Olmsted: Designing the American Landscape* (New York, 1995)
Viewing Olmsted: Photographs by Robert Burley, Lee Friedlander and Geoffrey James (exh. cat., ed. P. Lambert; Montreal, Cent. Can. A.; New York, Equitable Gal.; Columbus, OH, Wexner Cent. A.; Wellesley Coll., MA, Davis Mus. & Cult. Cent.; 1996–7); review by G. M. Dault in *Can. Architect*, xli (1996), pp. 22–5
K. McCormick: 'Close to Home: Frederick Law Olmsted's Private Garden outside Boston', *Preserv.*, il (1997), pp. 78–84

CHARLES E. BEVERIDGE

Osdel, John Mills Van. *See* VAN OSDEL, JOHN MILLS.

Osma. *See* EIGHT, THE .

O'Sullivan, Timothy (*b* ?Ireland, 1840; *d* Staten Island, NY, 14 Jan 1882). American photographer. He was employed in the studio of Mathew Brady in Washington, DC, when the Civil War (1861–5) broke out. After photographing the early stages of the war in South Carolina, he left Brady's studio to work for ALEXANDER GARDNER, and almost one half of the photographs in *Gardner's Photographic Sketchbook of the War* (?New York, 1866/*R*1959) are by him. O'Sullivan's war photographs, like Gardner's, moved beyond the superficial documentation of battlefields and the mundane activities of armies, and he began to photograph the grim reality of war; he is particularly noted for his photographs of battlefield dead (e.g. *Field where General Reynolds Fell*, 1863; see Snyder, 1981, p. 17; see fig.).

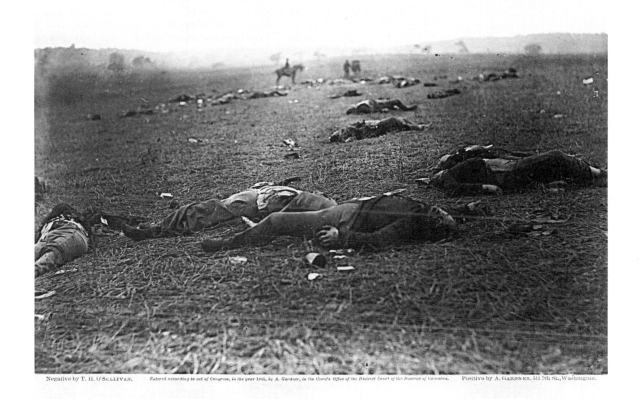

Negative by T. H. O'Sullivan. Entered according to act of Congress, in the year 1865, by A. Gardner, in the Clerk's Office of the District Court of the District of Columbia. Positive by A. Gardner, 511 7th St., Washington.

A Harvest of Death, Gettysburg, Pennsylvania

Timothy O'Sullivan and Alexander Gardner: *A Harvest of Death, Gettysburg*, albumen print, 1863 (New York, Public Library)

In 1867–9 and 1872 O'Sullivan accompanied the geologist Clarence King (1842–1901) on his Fortieth Parallel Survey expeditions, photographing some of the West's more extraordinary geological sites, natural resources and important mining areas. In the landscape of the West, King saw confirmation of his view that geological change came through catastrophic upheaval, and his theories probably influenced O'Sullivan's approach to the landscape. O'Sullivan's work for King depicts immense, arid, unpopulated spaces and freakish remnants of past geological eras. During 1870, O'Sullivan accompanied a US Navy expedition to the Isthmus of Darien in Panama in search of a possible canal route, but the difficult circumstances prevented him from accomplishing much there.

In 1871, 1873 and 1874 O'Sullivan embarked on his final series of photographic explorations of the West, this time with the Geographical Survey West of the One Hundredth Meridian, under Lieutenant George M. Wheeler (1842–1905). During the Wheeler expeditions, he broadened his subject-matter to include images of early pioneer settlements, historic American Indian and Spanish Conquest sites (e.g. *Ancient Ruins in the Cañon de Chelle*, 1873; New York, MOMA, see Snyder, 1981, p. 95), and North American Indian villages and groups. O'Sullivan emerged from these three expeditions with some of his most resonant works: remarkably conceived and emotionally powerful landscapes of the Grand Canyon in Arizona (especially the 1871 series taken in Black Canyon) and of the Shoshone Falls and the Snake River in Idaho.

The years between 1874 and 1880 (when he secured a position as photographer for the US Treasury Department) were difficult and unproductive. Poor health forced O'Sullivan to resign his position only six months after being hired. After his death, he was essentially forgotten for nearly 60 years, until Ansel Adams (1902–84) and others discovered his photographs of the West. Adams proclaimed his work 'extraordinary' and praised him as a 'hardy and direct artist', regarding him as a precursor of Edward Weston (1886–1958), Paul Strand (1890–1976) and their followers. This initiated a revival of interest, and his work was seen to embody the spirit of 19th-century America's national tragedies and aspirations.

PHOTOGRAPHIC PUBLICATIONS

US Geological Surveys West of the 100th Meridian, Photographs . . . of the Western Territory of the United States (Washington, DC, 1874)

BIBLIOGRAPHY

J. D. Horan: *Timothy O'Sullivan: America's Forgotten Photographer* (Garden City, NY, 1966)

B. Newhall and N. Newhall: *T. H. O'Sullivan, Photographer* (Rochester, 1966)

J. Snyder: *American Frontiers: The Photographs of Timothy O'Sullivan, 1867–1874* (Millerton, 1981)

R. Dingus: *The Photographic Artifacts of Timothy O'Sullivan* (Albuquerque, 1982)

J. Snyder: 'Aesthetics and Documentation: Remarks Concerning Critical Approaches to the Photographs of Timothy O'Sullivan', *Perspectives on Photography*, ed. P. Walch and T. F. Barrow (Albuquerque, 1986), pp. 125–50

TERENCE PITTS

Otis, Bass (*b* Bridgewater, MA, 17 July 1784; *d* Philadelphia, PA, 3 Nov 1861). American painter and lithographer. He was apprenticed to a scythe-maker and worked with a coach painter before entering the New York studio of John Wesley Jarvis; Otis's first known work is a portrait of Jarvis (1808; New York, Hist. Soc.). Otis's practice was chiefly devoted to portrait painting; his work was praised for its likeness to life and for characterizing a sitter not only through facial features but also with suitable attributes and surroundings. He painted a series of such notables as *Thomas Jefferson* (1816; Monticello, VA, Jefferson Found.), commissioned by the publisher Joseph Delaplaine for an abortive national biography. The large oil *Interior of a Smithy* (1815; Philadelphia, PA, Acad. F.A.) is a rare subject in American painting of Otis's time.

Otis moved to Philadelphia in 1812 and became a member of the Columbianum, the first academy of art established in the USA. He set up a studio in which Henry Inman, Peter F. Rothermel (1815–95) and John Neagle studied. Although he continued as a portrait painter in Philadelphia until 1845 and later in New York and Boston, it is for a few experiments early in the history of lithography that he is chiefly remembered. His lithographic portrait of the *Rev. Abner Kneeland*, the frontispiece to Kneeland's sermons (Philadelphia, 1818), is believed to be the first lithograph published in the USA, preceding Otis's *House and Trees at Waterside* (*Anlct. Mag.*, July 1819), previously credited with that distinction.

BIBLIOGRAPHY

G. Hendricks: 'A Wish to Please, and a Willingness to Be Pleased', *Amer. A. J.*, ii (1970), pp. 16–29

Bass Otis: Painter, Portraitist & Engraver (exh. cat., Wilmington, DE, Hist. Soc. Mus., 1976)

ANNE CANNON PALUMBO

P

Page, William (*b* Albany, NY, 23 Jan 1811; *d* Staten Island, NY, 1 Oct 1885). American painter. He had little formal education and entered the law office of the secretary of the American Academy in New York in 1825, where his drawings were seen by its President, John Trumbull. After studying the Academy's collection of casts of antique statues, Page became a student of Samuel F. B. Morse, who interested him in historical subjects as well as religion. Page briefly enrolled at Phillips Academy in Andover, MA, to study for the ministry but later returned to an artistic career, working successively in Amherst, Rochester, Albany and New York.

Settling in New York, Page continued to paint miniatures (which had provided him with an income in Andover) while also working on larger literary and historical paintings (all destr.). His portraits, which he exhibited at the American and National academies, portrayed psychologically profound likenesses of such political figures as *Stephen Van Rensselaer* and *John Quincy Adams* (both 1838; Boston, MA, Mus. F.A.; see fig.) and *Governor William L. Marcy* [of New York] (1839; New York, Mus. City NY). In 1832 he was made an associate member of the National Academy and a full academician in 1837; he was made a member of the American Academy in 1834 and elected to the Board of Directors in 1835.

Page's *Cupid and Psyche* (1843; New York, Met.), which caused controversy for the sensual way in which he depicted the warm flesh of the nude, shows his exceptional talent as a colourist. His earlier interest in literature and transcendentalism was reinforced through his friendship with the poet James Russell Lowell. The latter encouraged him to move to Boston, to an excellent reception in 1843. There he was exposed to the art both of Washington Allston and of Ralph Waldo Emerson and his circle, which helped him consolidate his technique. Two basic concerns preoccupied him during this time, both of which he believed were adopted by earlier masters, such as Titian (?1485/90–1576). The first was the application of layers of colour; the second was the concept of the middle tint to create a central hue from which all other colours should spring. The latter was achieved through glazing the ground of the canvas with successive layers of black until a tone halfway between black and white was reached. Page's technical experiments often produced disastrous results, and many of his paintings, once brilliantly luminous, deteriorated visibly during his lifetime.

Page moved to Rome between 1850 and 1860 where, as well as earning the nickname 'the American Titian' for

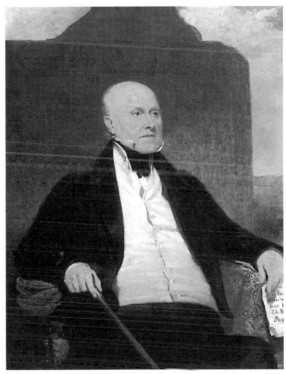

William Page: *John Quincy Adams*, oil on canvas, 1.18×0.90 m, 1838 (Boston, MA, Museum of Fine Arts)

his devotion to the Venetian master, he became the leading painter to the American expatriate community. Despite admiration from such literary friends as Robert and Elizabeth Browning, he achieved little financial success. His third wife, the subject of his best-known late portrait, *Sophie* (1860–61; Detroit, MI, Inst. A.), was compelled to seek portrait commissions on her husband's behalf. Failing to sell many of his paintings, Page was obliged to supplement their income through lecturing and writing. From 1871 to 1875 he served as a reformist president of the National Academy of Design in New York. His later works, including the portrait of *Charles W. Eliot* (1875; Cambridge, MA, Harvard U., Harry Widener Lib.) and *Shakespeare Reading* (1873–4; Washington, DC, Folger Shakespeare Lib.), show none of the colouristic richness of his earlier career, tending to greyness and lifelessness. In spite of the modest size of Page's surviving oeuvre and his unfortunate technical experiments, he was one of the

first American artists to realize the human form in his paintings and brought a genuine intellect and conviction to the study of the art of the past.

WRITINGS

'The Art of the Use of Colour in Imitation in Painting', *Broadway J.* (1845), pp. 86–8, 114–15, 131–3, 150–51, 166–7, 201–2

BIBLIOGRAPHY

J. Taylor: *William Page: The American Titian* (Chicago, 1957)

G. McCoy: 'I am Right and You are Wrong: Charles Briggs' Letters Written in the 1840s to William Page, with Excerpts', *Archvs Amer. A. J.*, xxviii/4 (1988), pp. 15–21

——: 'William Page and Henry Stevens: An Incident of Reluctant Art Patronage', *Archvs Amer. A. J.*, xxx/1–4 (1990), pp. 13–18

DAVID M. SOKOL

Palmer, Bertha Honoré [Mrs Potter Palmer] (*b* Louisville, KY, 22 May 1849; *d* Osprey, FL, 5 May 1918). American collector and exhibition organizer. She was born into a prominent Chicago family and married Potter Palmer, a successful property developer and merchant. In 1882 they commissioned a vast Gothic Revival mansion with an ornate and eclectic interior on the shore of Lake Michigan. In 1890 she was elected president of the Board of Lady Managers of the World's Columbian Exposition (the Chicago World's Fair, held in 1893). This appointment established her in the leading ranks of the national and international art world and marked the beginning of her activities as a collector. She had already participated in discussions on art at meetings of the Chicago Women's Club and in 1889 had purchased in New York from Paul Durand-Ruel *On the Stage* (Chicago, IL, A. Inst.) by Edgar Degas (1834–1917). However, it was during her travels through Europe between 1890 and 1893, enlisting support for the Fair, that she purchased the major part of her collection. In France she began to buy paintings directly from the artists, particularly the French Impressionists—Monet (1840–1926), Renoir (1841–1919), Pissarro (1830–1903), Manet (1832–83) and Sisley (1839–99)—and works by Jean-Charles Cazin (1841–1901), Jean-François Raffaëlli (1850–1924), Albert Besnard (1849–1936), P.-A.-J. Dagnan-Bouveret (1852–1929), Narcisse Diaz (1807–76) and Puvis de Chavannes (1824–98). She also bought paintings by American artists influenced by Impressionism, particularly Mary Cassatt and James McNeill Whistler. Cassatt advised her on her purchases and was invited by her to decorate one of the pavilions at the Columbian Exposition.

As Mrs Palmer grew older, her interest in art waned. She bequeathed most of her collection to the Art Institute of Chicago. She also had a significant influence on other Chicago collectors, notably Martin A. Ryerson; by turning their attention to the French Impressionists, she helped to make the Art Institute the most important museum in the USA for this kind of art.

BIBLIOGRAPHY

A. B. Saarinen: *The Proud Possessors* (New York, 1958)

I. Ross: *Silhouette in Diamonds* (New York, 1960)

Palmer Family Collection: A Selection of Paintings and Drawings Lent by the Family, by the Estate of Pauline K. Palmer, and by the Art Institute of Chicago, Potter Palmer Collection (exh. cat., Chicago, IL, A. Inst., 1963)

LILLIAN B. MILLER

Palmer, Erastus Dow (*b* nr Syracuse, NY, 2 April 1817; *d* Albany, NY, 4 March 1904). American sculptor. He worked first as a journeyman carpenter and then as a carver of models for cast-iron stoves. His interest in sculpture was inspired by an Italianate cameo seen in a shop-window in 1846. For a short time he travelled about the USA, cutting portrait cameos from shell. In 1849 he settled in Albany and began to execute life-size sculpture. Two marble tondo reliefs, *Morning* (1850) and *Evening* (1851; both Albany, NY, Inst. Hist. & A.), show purely idealized figures, whereas his mature works, such as the marble busts *Resignation* (1854) and *Erastus Corning* (1855; both Albany, NY, Inst. Hist. & A.), display a greater realism. In both of these, his characteristic rendering of hair, marked by a soft and flowing effect, is well developed. The exhibition of his work in New York in 1856 established his reputation. Initially he worked only in marble, but later also in bronze. He sometimes carried out the same work in both materials, the results differing only in colour and surface texture.

Palmer's ideas about art were expressed in his essay 'Philosophy of the Ideal' (1856), in which he suggested that art should be directly based on nature without being a literal imitation ('deviation from the actual in form, for truth of effect'). 'Ideal' refers to the distinctive character of an individual, not to an established ideal or to an average. His statements recall the views of Ruskin (1819–1900) in *Modern Painters*; indeed Palmer was at this time in touch with William James Stillman, a disciple of Ruskin and editor of the *Crayon*.

Palmer's best-known works are two marble statues, *Indian Girl* (1856; see fig.) and *White Captive* (1859; both New York, Met.); the latter is a careful life study representing a nude young woman captured by Indians. *Peace in Bondage* (marble relief, 1863; Albany, NY, Inst. Hist. & A.) represents a winged figure bound to a tree, a metaphor of grief for the nation, then divided by civil war. Works such as these found much favour in the USA, and adverse criticism was infrequent.

After the mid-1860s Palmer increasingly chose bronze as his medium. The statue of *Robert R. Livingston* (1874; Washington, DC, Capitol Bldg; 2nd example, Albany, NY, Court of Appeals) was made in Paris, during Palmer's first visit to Europe, and shows sensitive modelling in the face and hands. Later examples of this technical mastery include the bronze relief of *Thomas W. Olcott* (1876) and a bronze bust of *Stillman Witt* (1883; both Albany, NY, Inst. Hist. & A.). The realism of these fine portraits underlines the realism of Palmer's earlier work; always based on a study of nature, his art belongs to the category of 19th-century realism devoted to the character of the subject rather than to surface exactitude. The largest collection of Palmer's work is in the Albany Institute of History and Art. Palmer's son Walter Launt Palmer (1854–1932) was a landscape painter.

See also colour pl. XIV, 1.

UNPUBLISHED SOURCES

Albany, NY, Inst. Hist. & A. [letters and rec. from Palmer's studio] New York, Met. [add. letters]

WRITINGS

'Philosophy of the Ideal', *Crayon*, iii (1856), pp. 18–20

BIBLIOGRAPHY

A. Woltmann: 'Ein amerikanischer Bildhauer', *Recens. & Mitt. Bild. Kst*, iv (1865), pp. 297–9, 313–15

birth. She was one of the principal artists working for the lithographic publishing firm CURRIER & IVES. She learnt to draw at a girls' school in Leicester run by the artist Mary Linwood (1756–1845). With her husband, Edmund S. Palmer, she started a lithography business in 1841 (she was the artist and he the printer). They published a series of picturesque views, *Sketches in Leicestershire* (1842–3).

By 1844 the Palmers had emigrated to New York City and opened the printing firm of F. & S. Palmer. Fanny Palmer created prints of newsworthy subjects such as the *Battle of Palo Alto* (1846), sheet-music covers, flower albums and copies of architectural drawings for her company and other publishers. Nathaniel Currier soon recognized her talent and in 1849 published her two panoramic views of New York, seen from Brooklyn Heights and Weehawken. When the Palmers' business failed (*c.* 1851), Mrs Palmer became a staff artist for Currier (later the partner of James Merritt Ives).

Especially noted for atmospheric landscapes, *F. F. Palmer*, as she signed herself, created many of the company's finest rural and genre scenes (*American Farm Scenes*, 1853), sporting prints (*Woodcock Shooting*, 1852) and still-lifes (*Landscape, Fruit and Flowers*, 1862). Her style and subject-matter later became more dramatic, as in the fiery Civil War steamboat scene *The Mississippi in Time of War* (1865), and *The 'Lightning Express' Trains: 'Leaving the Junction'* (1863), which shows two speeding locomotives belching smoke and cinders against a moonlit sky. In her last years at the firm, Palmer created two romanticized panoramas that capture the scale and drama of the settling of the West: *The Rocky Mountains: Emigrants Crossing the Plains* (1866) and *Across the Continent: 'Westward the Course of Empire Takes its Way'* (with J M Ives, 1868). Although her prints were known to millions (and continue to be reproduced on calendars and greeting cards), Palmer died in obscurity. Prints are in the Museum of the City of New York and the Library of Congress, Washington, DC, drawings and watercolours at the New-York Historical Society, Museum of Fine Arts, Boston, and New York Public Library.

BIBLIOGRAPHY

H. T. Peters: *Currier & Ives. Printmakers to the American People* (New York, 1942), pp. 26–9
M. B. Cowdrey: 'Fanny Palmer, an American Lithographer', *Prints: Thirteen Illustrated Essays on the Art of the Print*, ed. C. Zigrosser (New York, 1962), pp. 217–34
———: 'Palmer, Frances Flora Bond', *Notable American Women, 1607–1950: A Biographical Dictionary*, ed. E. T. James, iii (Cambridge, MA, 1971), pp. 10–11
C. S. Rubinstein: 'The Early Career of Frances Flora Bond Palmer (1812–1876)', *Amer. A. J.*, xvii/4 (1985), pp. 71–85

CHARLOTTE STREIFER RUBINSTEIN

Parris, Alexander (*b* Halifax, MA, 24 Nov 1780; *d* Pembroke, MA, 16 June 1850). American architect and engineer. His career is characteristic of American architects in the early 19th century in that he began as a housewright and trained himself in architecture and engineering through books and experience. He designed houses, churches and public buildings, as well as dry-docks and lighthouses. His influence as an architect was most profound in Boston from 1815 to 1830, but his earlier stints as a builder and designer in Portland, ME, and Richmond, VA, had lasting impact in those areas.

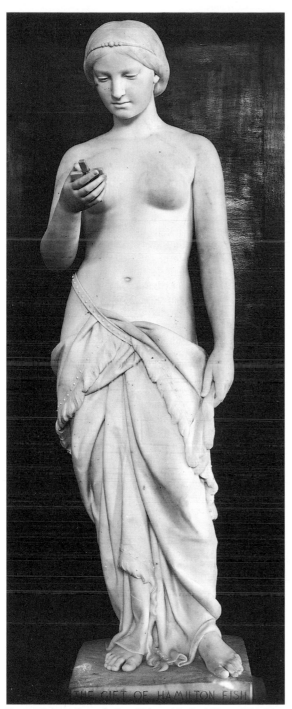

Erastus Palmer Dow: *Indian Girl*, marble, h. 1.51 m, 1856 (New York, Metropolitan Museum of Art)

H. T. Tuckerman: *Book of the Artists: American Artist Life* (New York, 1867/*R* 1966) pp. 355–69 [account of Palmer's studio]
J. C. Webster: *Erastus D. Palmer* (Newark, DE, 1983)

J. CARSON WEBSTER

Palmer [née Bond], **Frances** [Fanny] **(Flora)** (*b* Leicester, England, 26 June 1812; *d* Brooklyn, NY, 20 Aug 1876). American lithographer and draughtswoman of English

1. BACKGROUND AND EARLY WORK, TO C. 1815.
He was brought up in Hebron, ME, and Plymouth County,
MA. At the age of 16 he was apprenticed to a housewright,
and in 1801 he began work in that capacity in Portland,
ME. He quickly established himself as a leading builder,
designing and erecting, mostly in brick, at least six sub-
stantial houses and two major commercial buildings be-
tween 1801 and 1809. His Portland designs show a
familiarity with the latest works of Charles Bulfinch in
Boston, as well as English carpenter's handbooks, such as
Practical House Carpenter (1788) by William Pain (*c*. 1730–
c. 1804) and *Carpenter's New Guide* (1792) by Peter
Nicholson (1765–1844). The Commodore Preble House
(1806; destr. 1923) in Portland was his most sophisticated
early house, involving an asymmetrical plan, perpendicular
orientation of the entrance façade to the street and
decoration from Asher Benjamin's *American Builder's
Companion* (1806). St John's Church (1807) in Portsmouth,
NH, is the most important extant building from Parris's
Portland period. The design reflects Bulfinch's churches
in Boston, such as the Church of the Holy Cross (1800–
03; destr.) and New North Church (1802–4), as well as
the use of Pain's handbook.

The Embargo of 1807 devastated Portland's maritime
economy and ended Parris's commissions. He left Maine
in 1809 to search for work. He later described this period
in a letter of 1838 to the Hon. Levi Lincoln of the US
House of Representatives as one in which he 'spent much
time improving myself in architecture and building'. He
participated in a Boston architectural library and observed
at first hand the latest buildings in New York, Philadelphia,
Richmond, VA, and Washington, DC. Parris settled in
Richmond from 1810 to 1812 and was involved in three
large houses there, including the Virginia Governor's
Residence (1811–13). The John Wickham House (1811–
13) demonstrates the changes wrought by Parris's travels,
studies and especially by the influence of Benjamin La-
trobe. The stuccoed exterior differs from his Portland
houses in its two-storey horizontality and architectonic
correspondence of interior plan and exterior mass. The
interior is organized around a dramatic elliptical central
stairhall. Latrobe played a direct part in this project,
commenting on the preliminary plan at the client's request.
John Wickham (1763–1838) also arranged a meeting
between Latrobe and Parris in Washington, DC, in 1812.
Parris's mature work shows a much greater debt to Latrobe
than to Bulfinch. The War of 1812 ended Parris's stay in
Richmond. For the next three years he served in the US
Army as superintendent of a corps of artisans, acquiring
experience in military engineering and the title of 'Captain'.

2. EMERGENCE AS A PROFESSIONAL ARCHITECT,
c. 1815–*c*. 1827. He settled in Boston after the war in
1815 and from that time was consistently identified as an
architect. He had established the first architectural office
in Boston by 1817, staffed with apprentices and, occasion-
ally, other architects. Parris also developed a professional
approach towards architecture, explaining in a letter to
one client in 1820 that his services consisted of 'planning
drawing and directing the work'. After Bulfinch moved to
Washington, DC, in 1817, Parris dominated the Boston
architectural scene for just over a decade, executing over

24 known projects between 1815 and 1827, including
churches, houses, business blocks and governmental
buildings.

The Parker-Appleton double houses (1817–19), prom-
inently sited overlooking Boston Common, helped estab-
lish his reputation in Boston. The plan demonstrates a
mastery of curved spaces, while the interior decoration is
derived from William Fuller Pocock's *Modern Finishing of
Rooms* (1811). These interiors are the most intact of all his
houses. The David Sears House (1818–21; altered 1830s)
was the last major house of his career and his most
impressive. Located just west of the brick Parker-Appleton
houses, the Sears House was built as a free-standing granite
mansion. The smoothly dressed, light grey stone accentu-
ated the geometry of the building's exterior and its
semicircular bowfront. The highlight of the interior is a
two-storey stairhall, which is nearly square in plan and
topped with a coffered dome 4.6 m in diameter. The dome
was a model, in structure and design, for his later, larger
domes.

Granite remained his preferred building material for the
rest of his career. The body of St Paul's Church (1819–
20) in Boston is of local granite, while the hexastyle Doric
portico and entablature are of softer, more easily carved
Virginia sandstone. St Paul's was Boston's first large,
temple-type Neo-classical church. A tower was considered
but rejected on account of its high cost. The result is his
purest temple, but the handling of Classical detail is less
closely based on ancient examples and the ornament more
restrained than more typical examples of the nascent
Greek Revival style. The interior is especially austere,
incorporating a segmental-vaulted ceiling with shallow
coffers.

Parris's reputation rests to a large degree on two projects
of the 1820s, Faneuil Hall Market (also known as Quincy
Market; 1824–6) in Boston and the Stone Temple (1827–
8), a Unitarian church in Quincy, MA. The very ambitious
market complex consists of three buildings arranged in
parallel, each over 150 m long. The complex presented
substantial technical and design challenges. Although none
of his technical solutions, such as the extensive use of
trabeated forms in granite, abundant application of iron
for fastenings and supports, and laminated wooden ribs
for the double domes, were invented by him, they reflect
the professional architect's familiarity with published
sources, with innovative designs around the country and
his ability to employ the advanced technologies of his day.
His design accomplishments in the market project lie in
unifying three very long, narrow buildings and in establish-
ing the dominance of the central two-storey market-house
over the flanking four-storey buildings. The key to the
latter is the much larger scale of the individual parts of the
smaller, centre building, epitomized by the granite mono-
liths of the two tetrastyle Doric porticos. These stones,
each measuring 6.35 m tall, were among the first large
monoliths quarried in the USA. At the centre of the
market-house Parris employed ashlar granite construction
for the domed pavilion to achieve a weightiness that
underscores its role as the centrepiece of the whole
complex. The outer elliptical, copper-clad dome supports
an inner domed ceiling of the same shape measuring
21×15 m. The strength of the granite was employed to

PLATE I Architecture

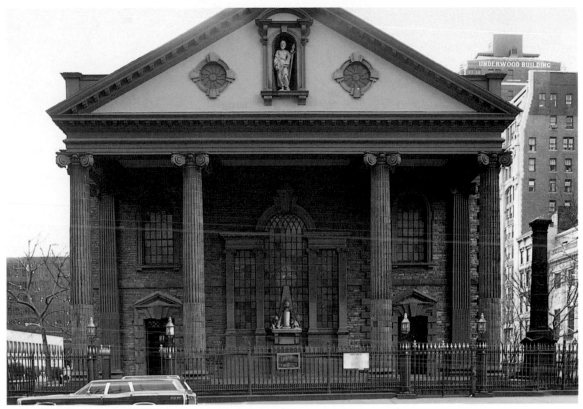

1. St Paul's Chapel, New York, 1764–8

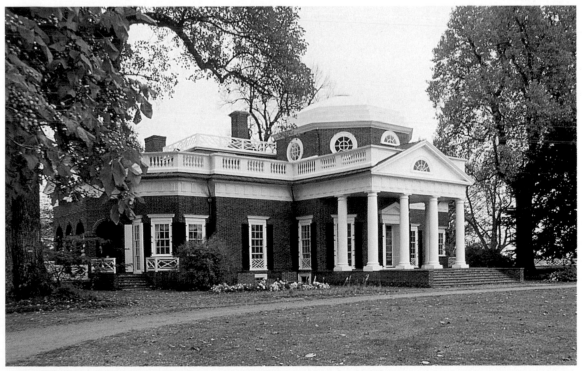

2. Thomas Jefferson: Monticello, Albemarle Co., near Charlottesville, Virginia, 1770–1809

PLATE II

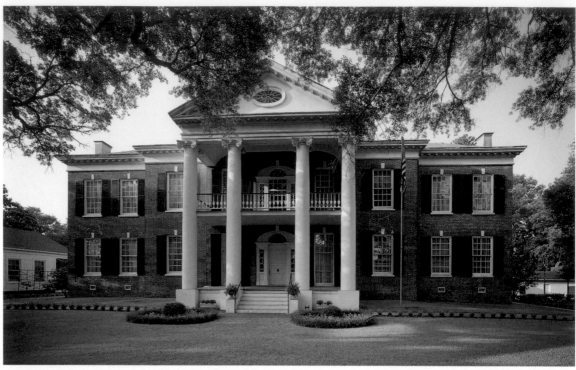

1. Levi G. Weeks: Auburn, Natchez, Mississippi, 1812

2. James C. Bucklin and Russell Warren (for Tallman & Bucklin): Providence Arcade, Providence, Rhode Island, 1828

3. James Renwick: Smithsonian Institution, Washington, DC, 1847–55

PLATE III

Architecture

1. James Hamilton Windrim: Masonic Temple, Penn Square, Philadelphia, Pennsylvannia, 1868–73

2. Frederick Clarke Withers: Jefferson Market Courthouse and Prison (now the Greenwich Village branch of the New York Public Library), Greenwich, Connecticut, 1874

3. Alfred B. Mullett: War and Navy Building, Washington, DC, 1871–86

1. John L. Smithmeyer & Co.: Library of Congress Building, Washington, DC, 1873

2. Greene & Greene: David B. Gamble House, Pasadena, California, 1908

PLATE V Painting

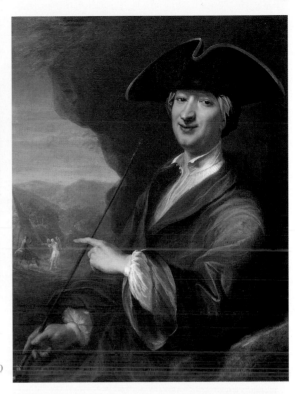

1. Thomas Smith: *Self-portrait*, oil on canvas, 629x604 mm, *c.* 1680 (Worcester, MA, Worcester Art Museum)

2. John Smibert: *Portrait of a Man*, oil on canvas, 975x740 mm, *c.* 1720 (Hartford, CT, Wadsworth Atheneum)

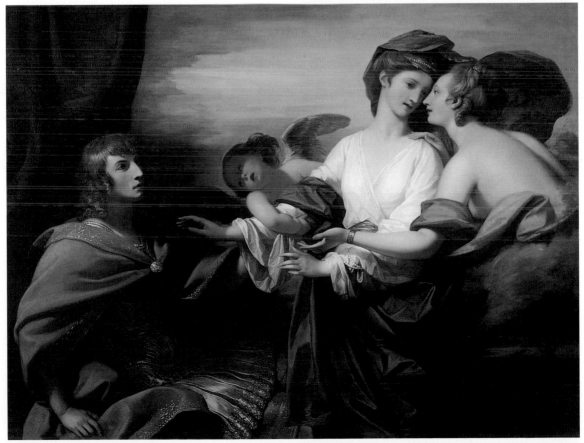

3. Benjamin West: *Helen Brought to Paris*, oil on canvas, 1.43x1.98 m, 1776 (Washington, DC, National Museum of American Art)

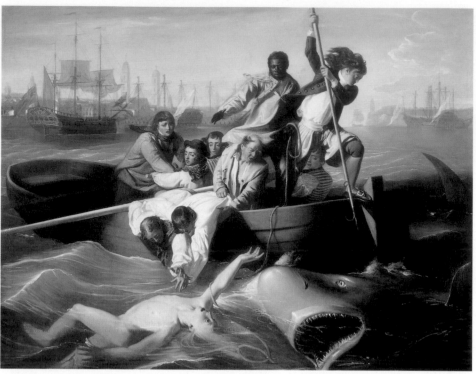

1. John Singleton Copley: *Watson and the Shark*, oil on canvas, 1.83x2.29 m, 1778 (Boston, MA, Museum of Fine Arts)

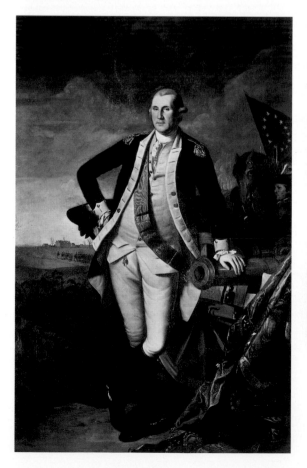

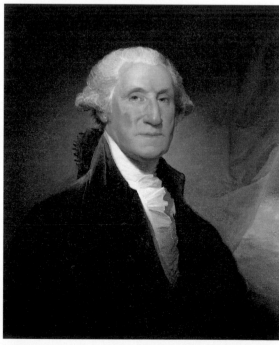

3. Gilbert Stuart: *George Washington*, oil on canvas, 768x641 mm, 1795 (New York, Metropolitan Museum of Art)

2. Charles Willson Peale: *Washington's Victory at Princeton*, oil on canvas, 2.39x1.50 m, 1779 (Philadelphia, PA, Pennsylvannia Academy of Fine Arts)

PLATE VII

Painting

1. Thomas Birch: *Naval Battle between the United States and the Macedonian*, 30 October 1812, oil on canvas, 737x876 mm, 1812 (Philadelphia, PA, Historical Society of Pennsylvannia)

2. Raphaelle Peale: *Melons and Morning Glories,* oil on canvas, 526x654 mm, 1813 (Washington, DC, National Museum of American Art)

PLATE VIII

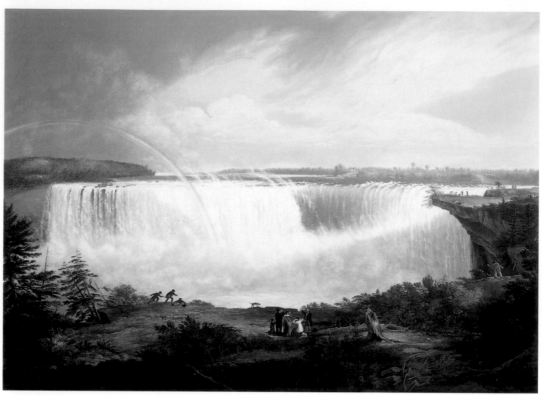

1. Alvan Fisher: *Niagara Falls*, oil on canvas, 872x1220 mm, 1820 (Washington, DC, National Museum of American Art)

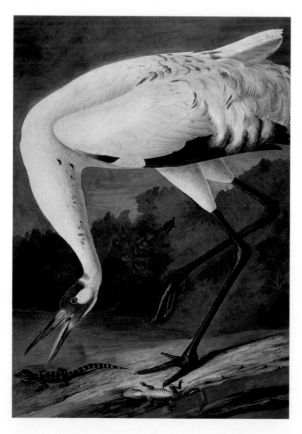

2. John James Audubon: *Whooping Crane*, watercolour and pastel, 947x652 mm, 1821–2 (New York, New-York Historical Society)

PLATE IX

Painting

1. Thomas Cole: *Scene from the 'Last of the Mohicans'*, oil on canvas, 635x787 mm, 1827 (Cooperstown, NY, New York Historical Association)

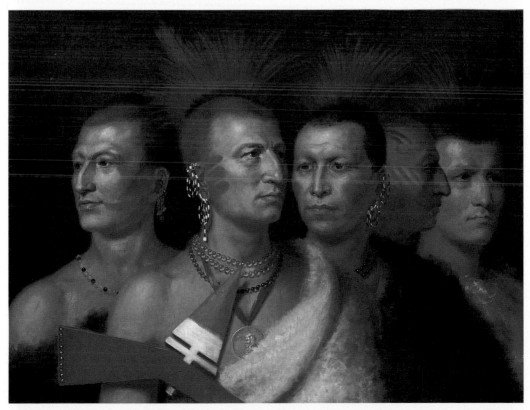

2. Charles Bird King: *Young Omaha, War Eagle, Little Missouri and Pawnees*, oil on canvas, 918x711 mm, 1828 (Washington, DC, National Museum of American Art)

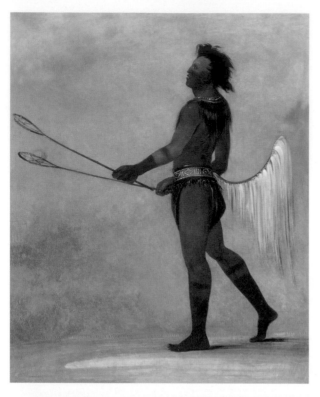

1. George Catlin: *Drinks the Juice on the Stone in Ball-player Dress*, oil on canvas mounted on aluminium, 737x609 mm, 1834 (Washington, DC, National Museum of American Art)

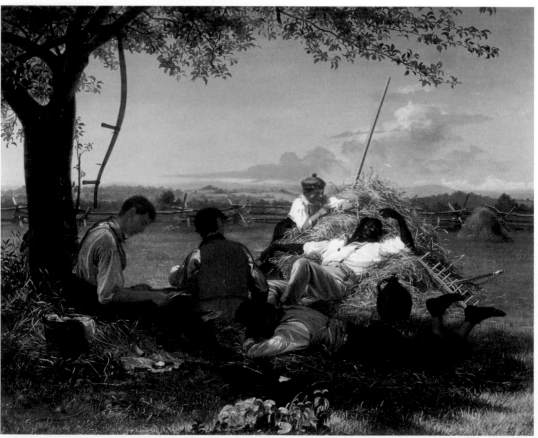

2. William Sidney Mount: *Farmers Nooning*, oil on canvas, 508x610 mm, 1836 (Stony Brook, NY, The Museums of Stony Brook)

PLATE XI Painting

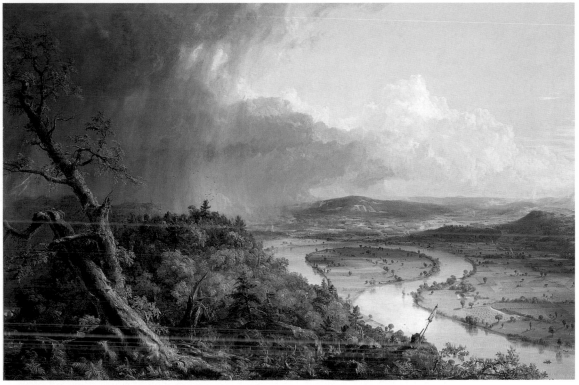

1. Thomas Cole: *Oxbow on the Connecticut River*, oil on canvas, 1.31x1.93 m, 1836 (New York, Metropolitan Museum of Art)

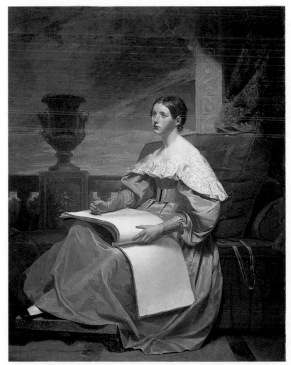

2. Samuel F.B. Morse: *The Muse*, oil on canvas, 1.87x1.47 m, 1836–7
(New York, Metropolitan Museum of Art)

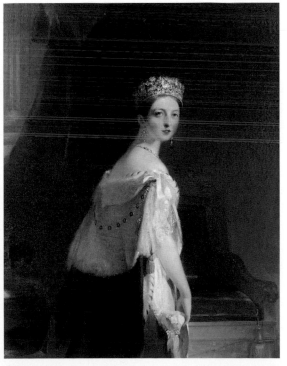

3. Thomas Sully: *Queen Victoria,* oil on canvas, 1.38x1.10 m, 1838
(London, Wallace Collection)

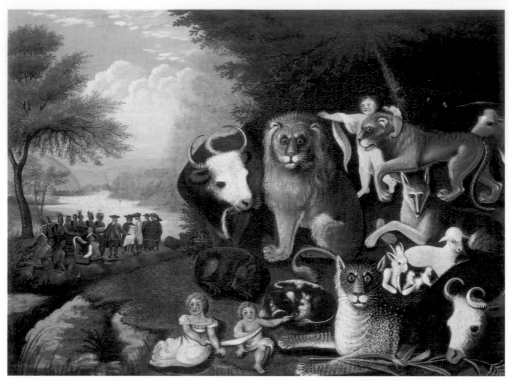

1. Edward Hicks: *Peacable Kingdom of the Branch*, oil on canvas, 457x613 mm, *c.* 1840–45 (New York, Brooklyn Museum of Art)

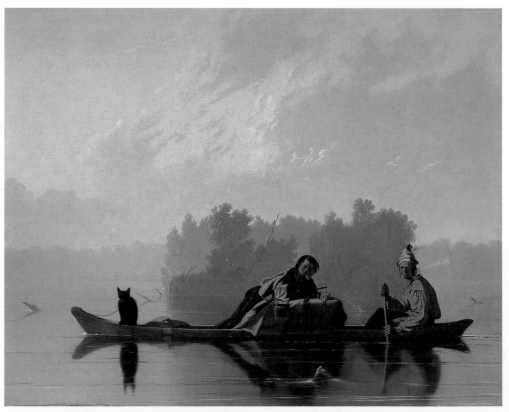

2. George Caleb Bingham: *Fur Traders Descending the Missouri*, oil on canvas, 737x927 mm, 1845 (New York, Metropolitan Museum of Art)

PLATE XIII

Painting

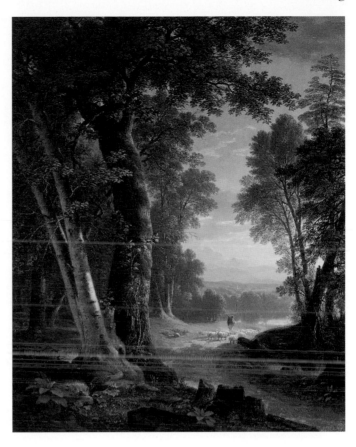

1. Asher B. Durand: *The Beeches*, oil on canvas, 1.53x1.22 m, 1846 (New York, Metropolitan Museum of Art)

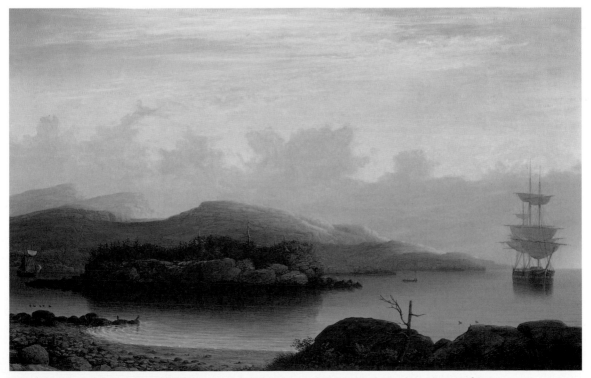

2. Fitz Hugh Lane: *Off Mount Desert Island*, oil on canvas, 614x926 mm, 1856 (New York, Brooklyn Museum of Art)

1. Tompkins Harrison Matteson: *Erastus Dow Palmer in his Studio*, oil on canvas, 743x927 mm, 1857 (Albany, NY, Albany Institute of History and Art)

2. Martin Johnson Heade: *Coming Storm*, oil on canvas, 711x1110 mm, 1859 (New York, Metropolitan Museum of Art)

PLATE XV Painting

1. Frederic Edwin Church: *Twilight in the Wilderness*, oil on canvas, 1.02x1.63 m, 1860 (Cleveland, OH, Cleveland Museum of Art)

2. James McNeill Whistler: *Symphony in White No. 2: The Little White Girl*, oil on canvas, 765x511 mm, 1864 (London, Tate Gallery)

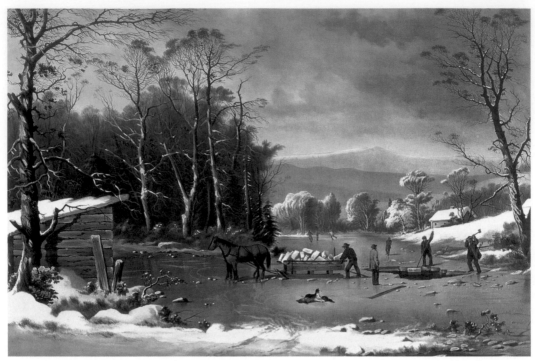

1. Currier & Ives: hand-coloured lithograph of *Winter in the Country: Getting Ice* by George Henry Durrie, 1864 (New York, Museum of the City of New York)

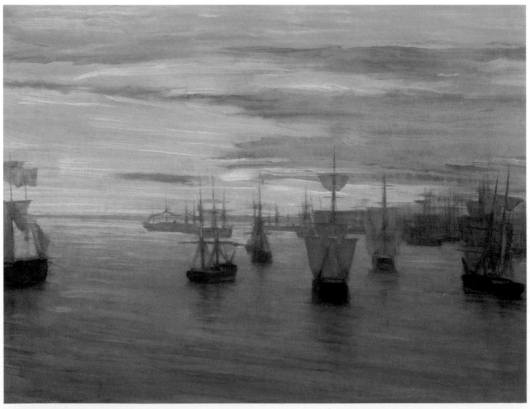

2. James McNeill Whistler: *Crepuscule in Flesh Colour and Green, Valparaìso*, oil on canvas, 584x755 mm, 1866 (London, Tate Gallery)

PLATE XVII Painting

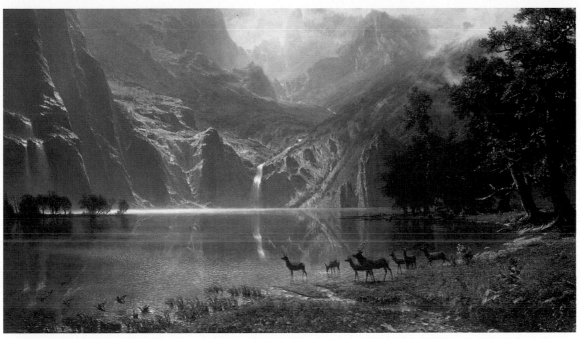

1. Albert Bierstadt: *Among the Sierra Nevada Mountains, California*, oil on canvas, 1.83×3.05 m, 1868 (Washington, DC, National Museum of American Art)

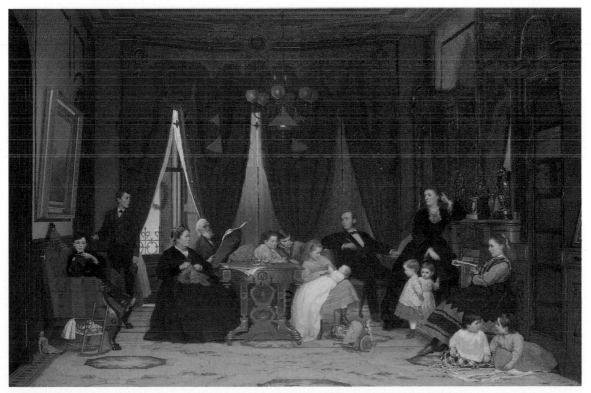

2. Eastman Johnson: *Hatch Family*, oil on canvas, 1.22×1.86 m, 1871 (New York, Metropolitan Museum of Art)

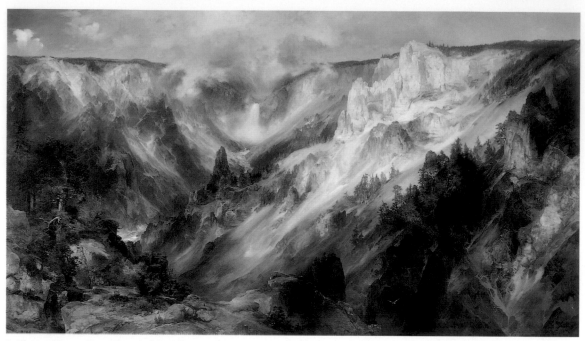

1. Thomas Moran: *Grand Canyon of the Yellowstone*, oil on canvas, 2.13x2.66 m, 1872 (Washington, DC, US Department of the Interior, on loan to the National Museum of American Art)

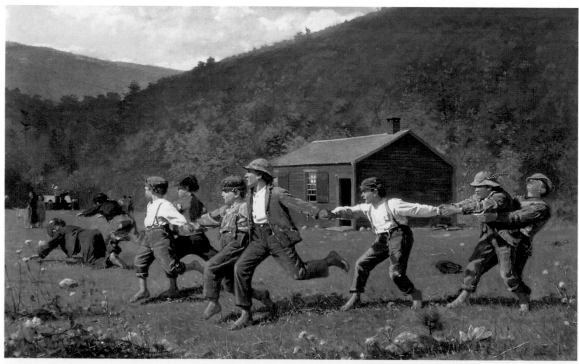

2. Winslow Homer: *Snap the Whip*, oil on canvas, 558x914 mm, 1872 (Youngstown, OH, Butler Institute of American Art)

PLATE XIX Painting

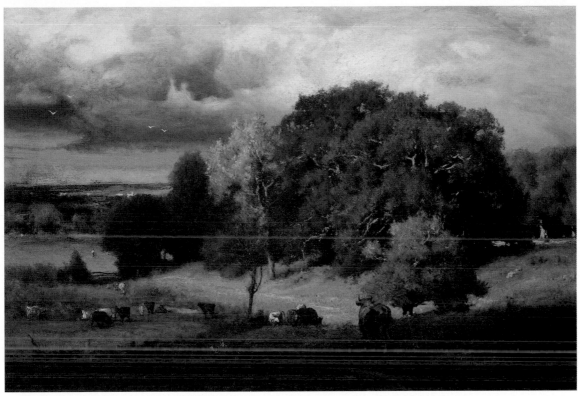

1. George Inness: *Autumn Oaks*, oil on canvas, 543x765 mm, *c.* 1878 (New York, Metropolitan Museum of Art)

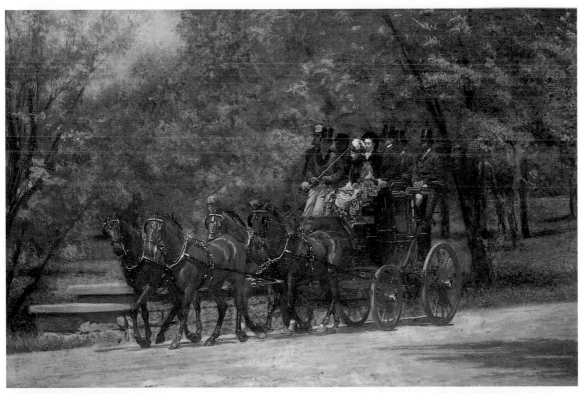

2. Thomas Eakins: *Fairman Rogers Four-in-Hand*, oil on canvas, 603x914 mm, 1879 (Philadelphia, PA, Philadelphia Museum of Art)

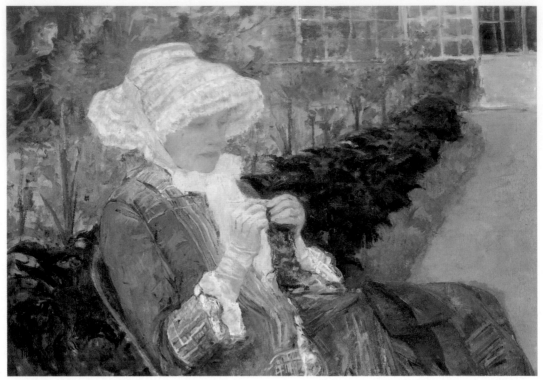

1. Mary Cassatt: *Lydia Crocheting in the Garden at Marly*, oil on canvas, 813x1067 mm, 1880 (New York, Metropolitan Museum of Art)

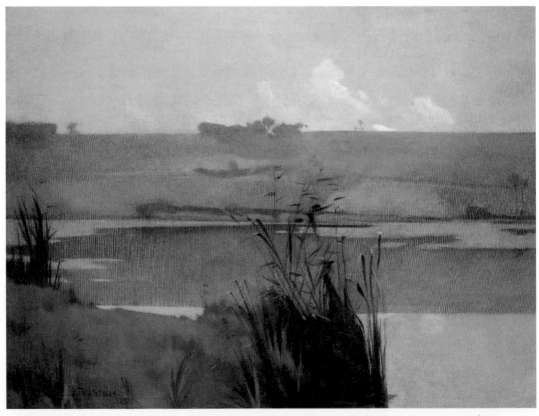

2. John H. Twachtman: *Arques-la-Bataille*, oil on canvas, 1.52x2.00 m, 1885 (New York, Metropolitan Museum of Art)

PLATE XXI Painting

1. William Merritt Chase: *Lady in Black*, oil on canvas, 1880x914 mm, 1888 (New York, Metropolitan Museum of Art)

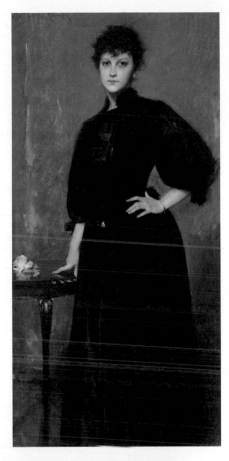

2. Albert Pinkham Ryder: *Jonah*, oil on canvas, 692x873 mm, 1890 (Washington, DC, National Museum of American Art)

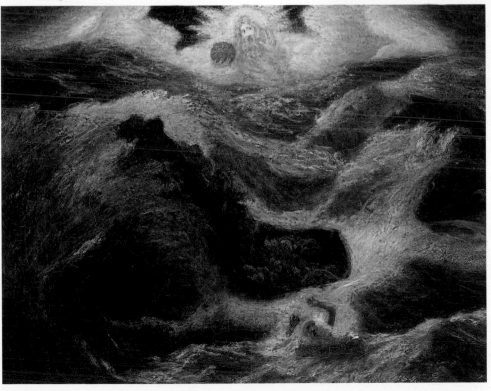

1. John Haberle: *Bachelor's Drawer*, oil on canvas, 508x914 mm, 1890–94 (New York, Metropolitan Museum of Art)

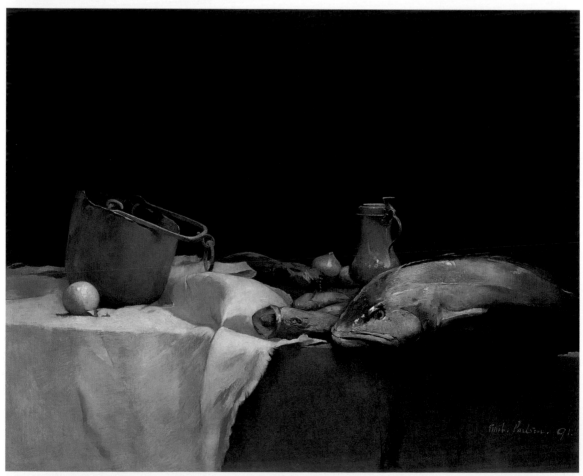

2. Emil Carlsen: *Still-life*, oil on canvas, 889x1092 mm, 1891 (Oakland, CA, Oakland Museum)

PLATE XXIII

1. Childe Hassam: *Island Garden*, watercolour, 565x457 mm, 1892 (Washington, DC, National Museum of American Art)

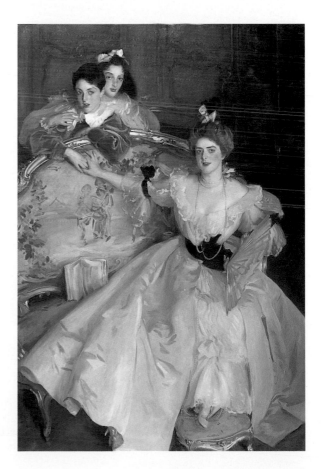

2. John Singer Sargent: *Mrs Carl Meyer and her Children*, oil on canvas, 2.02x1.36 m, 1896 (Sunningdale, Berks, collection of Sir Anthony Meyer)

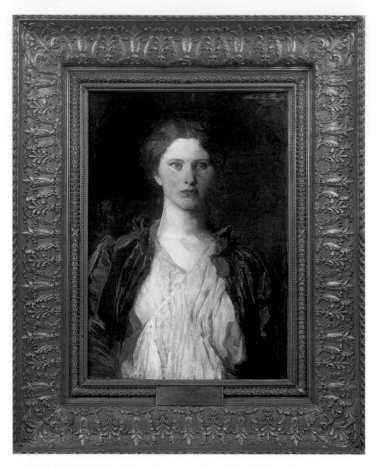

1. Classical Revival style frame designed by Stanford White for Abbott Handerson Thayer: *Portrait of Bessie Price*, oil on canvas, 711x495 mm, 1897 (Hanford, CA, collection of Mr and Mrs W. G. Clark)

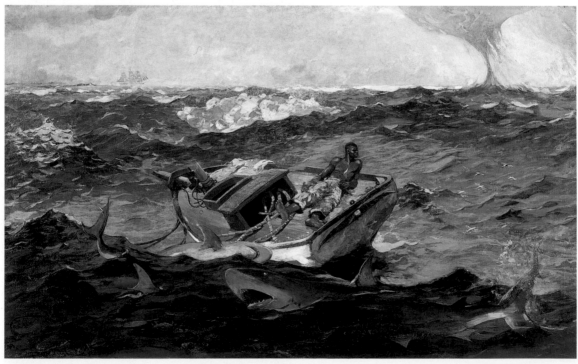

2. Winslow Homer: *Gulf Stream*, oil on canvas, 714x1248 mm, 1899 (New York, Metropolitan Museum of Art)

PLATE XXV

Painting

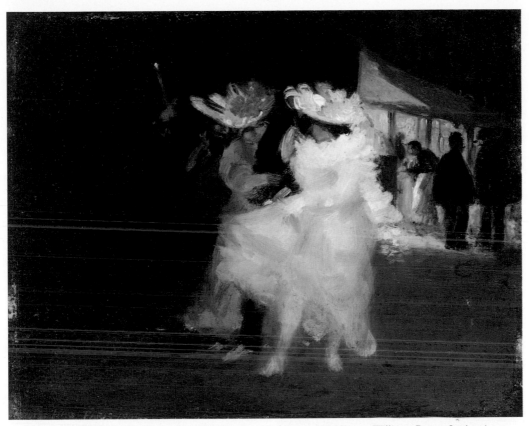

1. George Luks: *Closing the Café*, oil on panel, 216x270 mm, 1904 (Utica, NY, Munson–Williams–Proctor Institute)

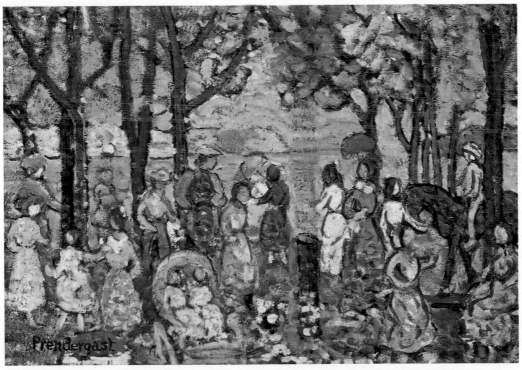

2. Maurice Prendergast: *Summer, New England*, oil on canvas, 489x699 mm, 1912 (Washington, DC, National Museum of American Art)

1. Anonymous: sternboard, polychromed wood, l. 2.96 m, *c.* 1785 (Shelburne, VT, Shelburne Museum)

2. Horatio Greenough: *Samuel F.B. Morse*, marble, h. 546 mm, 1831 (Washington, DC, National Museum of American Art)

3. Daniel Chester French: *Ralph Waldo Emerson*, bronze, h. 572 mm, 1879 (cast 1901) (Washington, DC, National Portrait Gallery)

PLATE XXVII Sculpture

1. Frederick William MacMonnies: *Bacchante and Infant Faun*,
bronze, h. 2.11 m, 1893 (New York, Metropolitan Museum of Art)

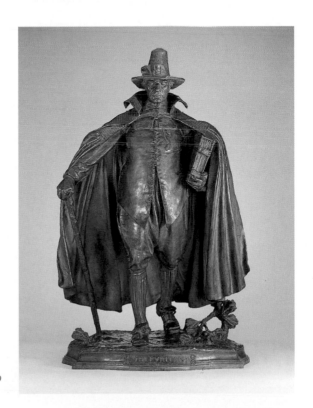

2. Augustus Saint-Gaudens: *The Puritan*, bronze, h. 787 mm, 1899
(New York, Metropolitan Museum of Art)

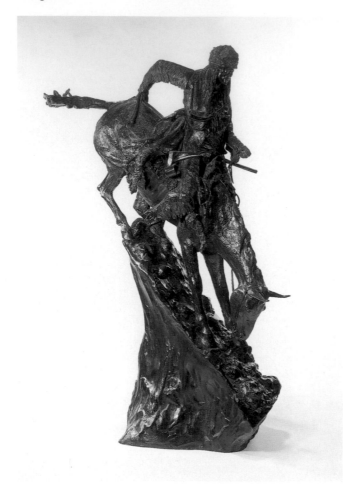

1. Frederic Remington: *Mountain Man*, bronze, h. 3.71 m, 1903 (New York, Metropolitan Museum of Art)

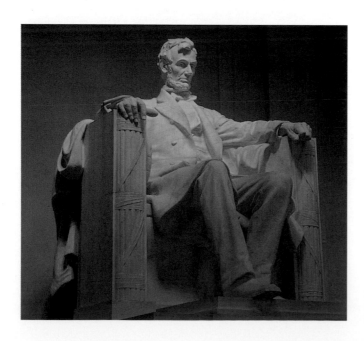

2. Daniel Chester French: *Abraham Lincoln* (1914-20; dedicated 1922), marble, over life-size, Lincoln Memorial, Washington, DC

PLATE XXIX

Interior decoration

1. Thomas Hart Room, from Ipswich, Massachusetts, before 1674 (New York, Metropolitan Museum of Art); reconstruction

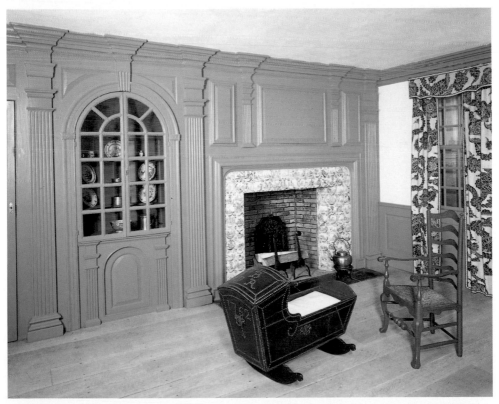

2. Hewlett Room, from Woodbury, Long Island, New York, 1740–60 (New York, Metropolitan Museum of Art); reconstruction

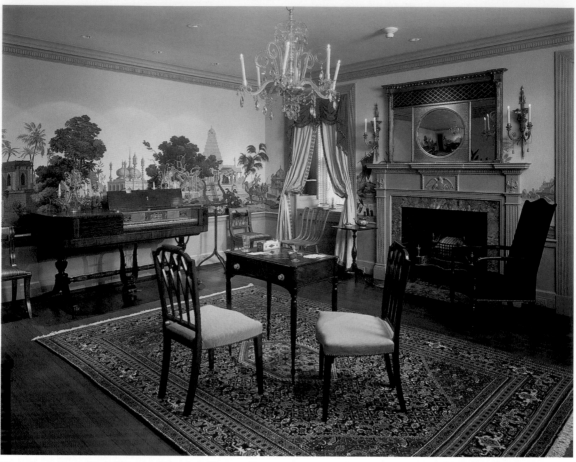

Music Room, Bayou Bend, Museum of Fine Arts, Houston, Texas

PLATE XXXI Interior decoration

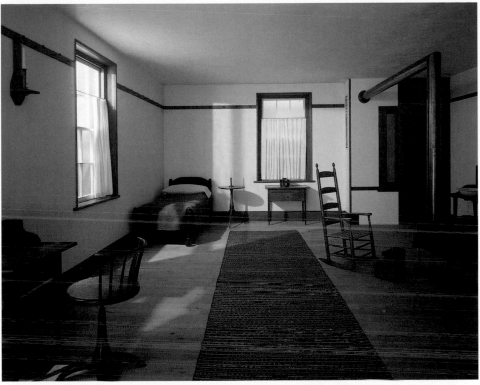

1. Corner of a Shaker retiring room (New York, Metropolitan Museum of Art); reconstruction

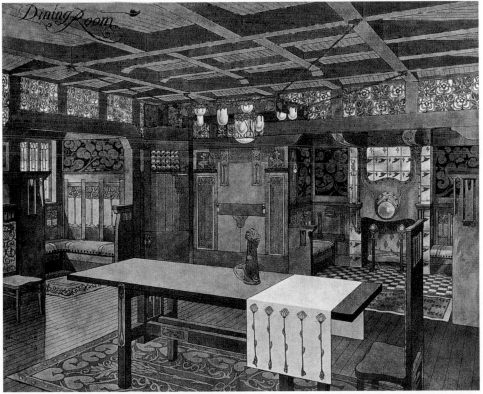

2. Will H. Bradley (1868-1962): design for a dining room, commercial printing process, 254x327 mm, from *The Ladies' Home Journal*, *c.* 1901 (New York, Metropolitan Museum of Art)

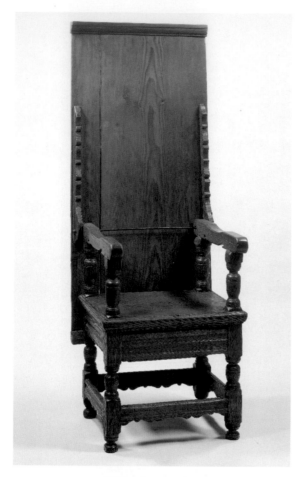

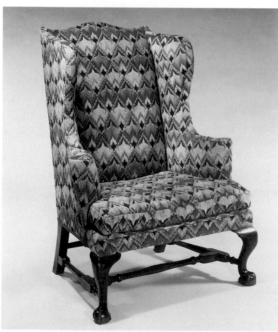

1. Chair-table, oak and pine, h. (of seat) 495 mm, from New England, 1675–1700 (New York, Metropolitan Museum of Art)

2. Easy chair, mahogany and maple, original bargello (or flame stitch) upholstery, h. 1.16 m, c. 1760–90 (Houston, TX, Houston Museum of Fine Arts, Bayou Bend)

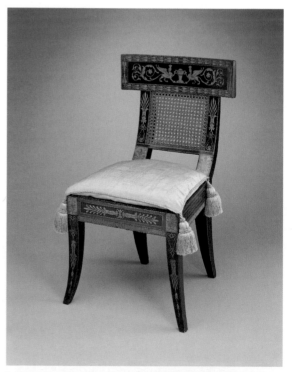

3. Benjamin Henry Latrobe (designer): klismos chair, white oak, yellow poplar, white pine, cane, reproduction silk fabric, h. 876 mm, probably made by Hugh and Robert Finlay, Baltimore, Maryland, c. 1815 (St Louis, MO, St Louis Art Museum)

PLATE XXXIII

Furniture

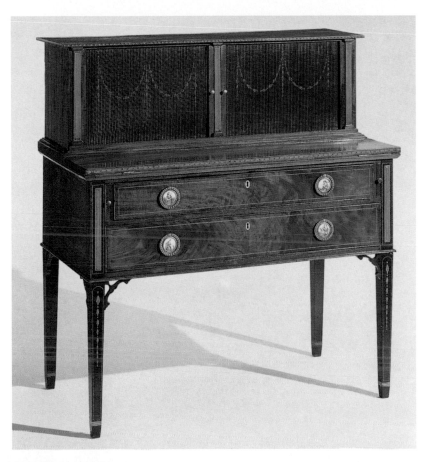

1. John Seymour & Son: mahogany tambour desk, inlaid with light wood, white pine and elm, 1054x959x501 mm, from Boston, Massachusetts, 1794–1804 (Winterthur, DE, H.F. du Pont Winterthur Museum)

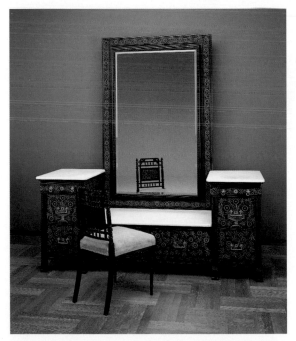

2. Herter Brothers: dresser, mirror and side chair, ebonized cherry, purple heart, white pine, perhaps padouk, holly, marble, brass, h. (dresser with mirror) 2.16 m, c. 1881–4 (St Louis, MO, St Louis Art Museum)

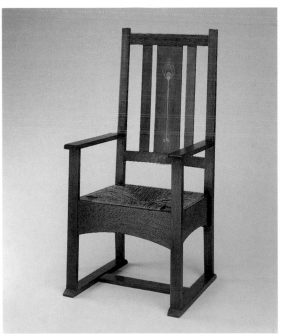

3. Harvey Ellis: arm chair, white oak, copper, pewter, wood, rush, h. 1.17 m, from the workshop of Gustav Stickley, c. 1903 (Pittsburgh, PA, Carnegie Museum of Art)

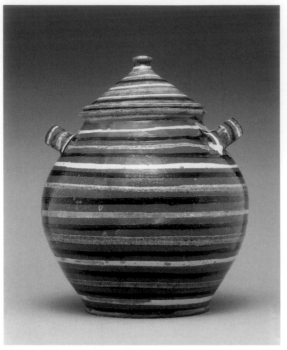

1. Covered jar, red earthenware decorated with bright stripes of slip, h. 324 mm, from North Carolina, 1785–1830 (New York, Metropolitan Museum of Art)

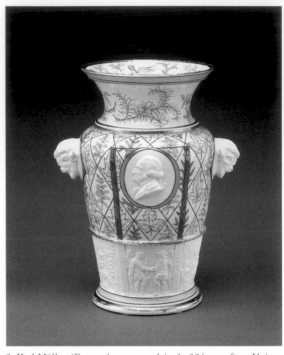

2. Karl Müller: 'Century' vase, porcelain, h. 324 mm, from Union Porcelain Works, Greenpoint (Brooklyn), New York, c. 1876 (New York, Metropolitan Museum of Art)

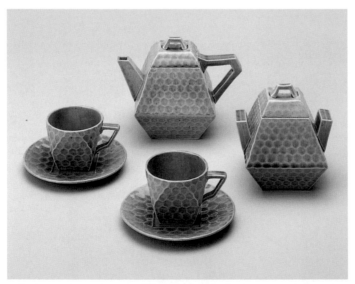

3. Earthenware tea set, h. (teapot) 121 mm, h. (sugarbowl) 108 mm, h. (teacup) 64 mm, from the Chelsea Keramic Art Works, Chelsea, Massachusetts, 1877–80 (New York, Metropolitan Museum of Art)

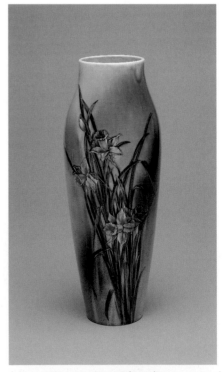

4. Kataro Shirayamadani (1865-1948): vase, painted and glazed earthenware, h. 457 mm, from the Rookwood Pottery, Cincinnati, Ohio, 1890 (Minneapolis, MN, Minneapolis Institute of Arts)

PLATE XXXV

Glass

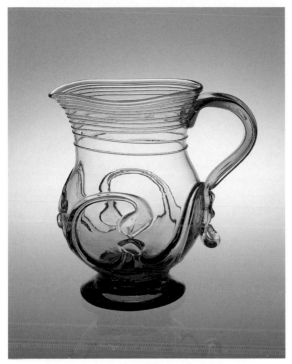

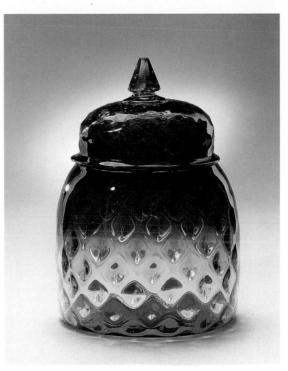

1. Footed pitcher, non-lead glass, blown and tooled with applied decoration, h. 183 mm, probably from New York State, 1835–50 (Toledo, OH, Toledo Museum of Art)

2. 'Amberina' cracker jar, glass shaded from amber at the bottom to ruby at the top, h. 213 mm, from the New England Glass Co., East Cambridge, Massachusetts, 1883 (New York, Metropolitan Museum of Art)

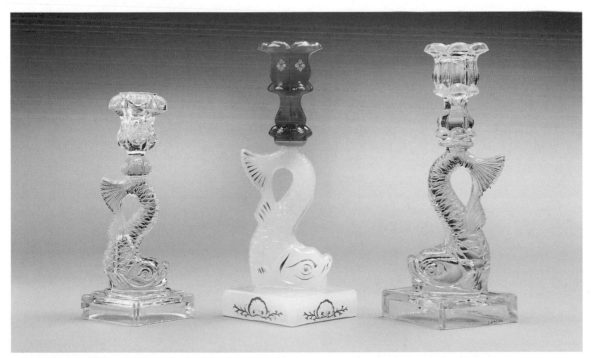

3. Pressed glass dolphin candlesticks, from New England, probably Boston and Sandwich Glass Co., Sandwich, Massachusetts: (left) h. 216 mm, c. 1840; (centre) h. 264 mm, 1845–65; (right) h. 264 mm, c. 1840 (New York, Metropolitan Museum of Art)

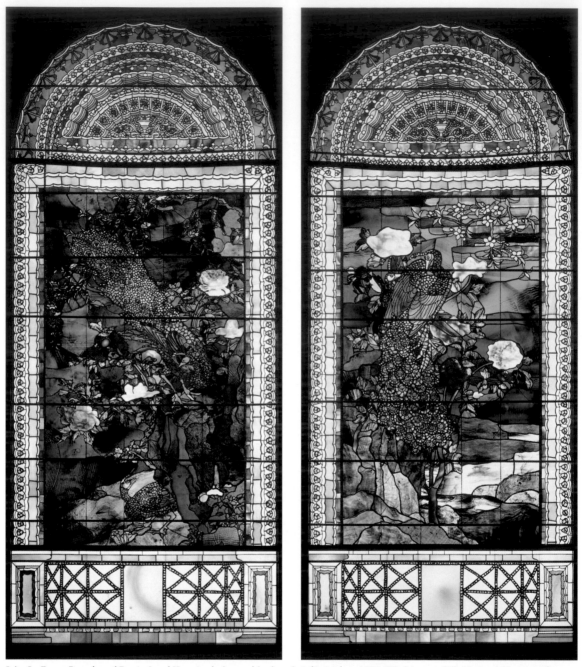

John La Farge: *Peacocks and Peonies I and II*, stained glass and lead, each 2.69x1.14 m, 1882 (Washington, DC, National Museum of American Art)

PLATE XXXVII

Glass and jewellery

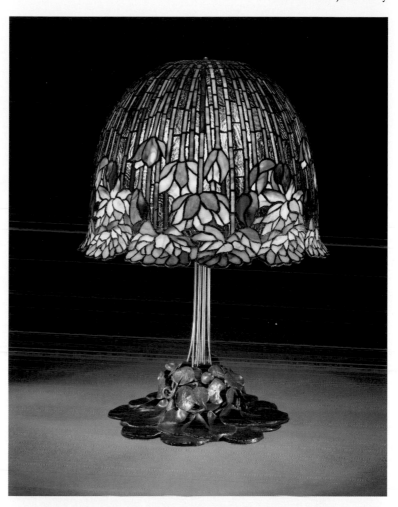

1. Tiffany & Co.: lamp, bronze and leaded glass, h. 673 mm, *c.* 1910 (New York, Metropolitan Museum of Art)

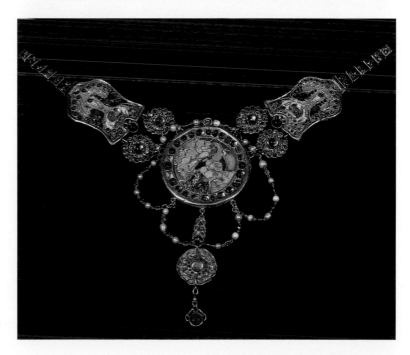

2. Louis Comfort Tiffany: 'Peacock' necklace, gold, enamel, amethysts, sapphires, demantoid garnets, rubies and emeralds, l. 254 mm, *c.* 1905 (Winter Park, FL, Charles Hosmer Museum of American Art)

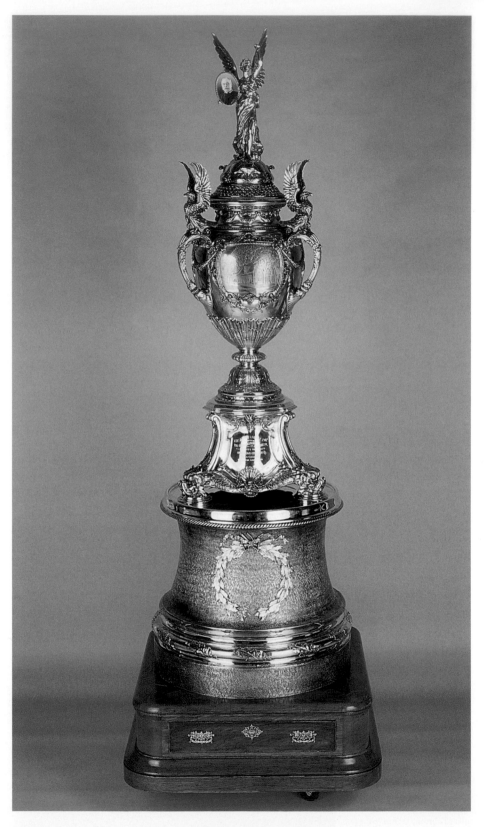

William Christmas Codman (1839–1923): Admiral George Dewey Cup, silver, h. 2.6 m, from the Gorham
Manufacturing Co., Providence, Rhode Island, 1898 (Chicago, IL, Historical Society)

PLATE XXXIX Textiles

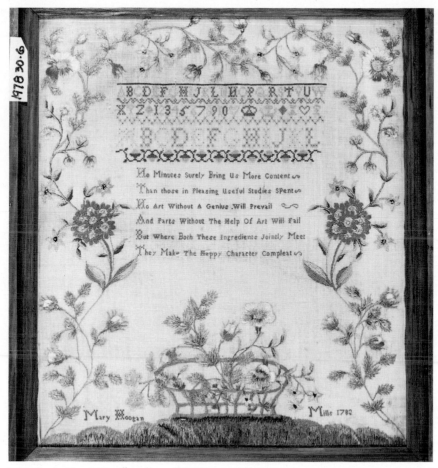

1. Sampler by Mary Mills, silk on linen, 457x343 mm, 1/86 (New York, Museum of American Folk Art)

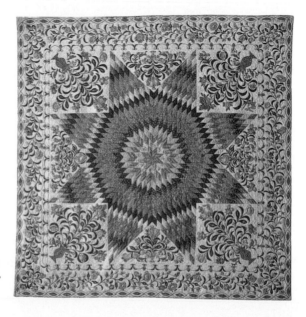

2. Star of Bethlehem or *Rising Sun* quilt, pieced work and appliquè in glazed and unglazed cotton, cotton filling and lining, 2.93x2.43 m, made by Mary (Betsy) Totton, Staten Island, New York, *c.* 1825 (Washington, DC, Smithsonian Institution)

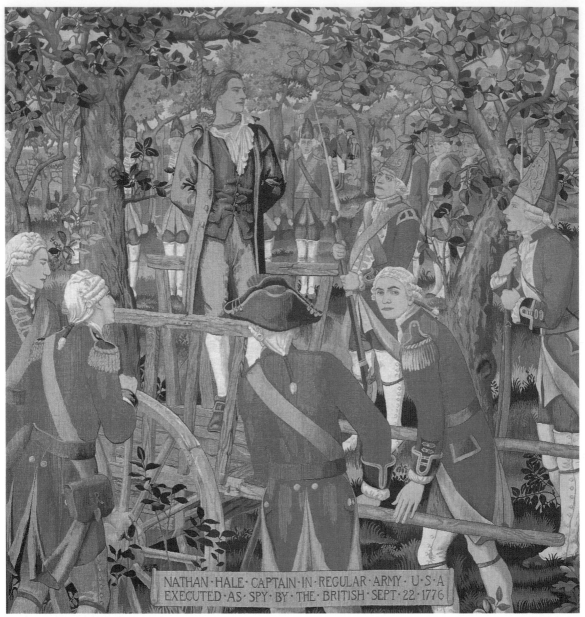

Albert Herter: scene from the *History of New York*, tapestry series of 26, wool, cotton and 'artificial silk', 2.13x1.83 m, from the Herter Looms, New York, 1912 (New York, Metropolitan Museum of Art)

very different effect on the flanking buildings. Light members are used in a four-bay, repetitive, trabeated unit, providing for large windows and reducing the bulky, lengthy appearance of the buildings. The overall effect of the complex is that of a designed urban space of powerful presence.

The Stone Temple in Quincy, MA (see fig.), is another important work. Quincy was a major granite-quarrying town; consequently the congregation insisted on the finest stone and finish, and on massive monoliths, each measuring over 6.7 m tall, for the tetrastyle Doric portico. The granite underscores the bold geometry of the exterior, with sharp differentiation between the portico, the narthex and tower and the nave. In the interior, the nearly square auditorium, measuring approximately 21.5 m on a side, is lit by tall, arched, clear-glazed windows, which imbue the interior with a light and airy quality, and topped by a circular-domed ceiling of even greater size and scale than that at Faneuil Hall Market. The Stone Temple shows Parris at the peak of his powers, working in a local building material that both architect and client knew and appreciated.

3. FINAL DECADES AS AN ENGINEER, *c*. 1827 AND AFTER. Parris was indisputably Boston's leading architect by 1827, designing and superintending major buildings in a personal style firmly rooted in Latrobe's Neo-classicism

Alexander Parris: interior of the Stone Temple, Quincy, Massachusetts, 1827–8

but displaying his own blend of exterior severity, interior grandeur and large scale. In the remaining 25 years of his career he was employed almost exclusively on federal architectural and engineering projects, especially the latter. From 1827 until 1832 he assisted in the construction of large granite dry-docks for the US Navy at Charlestown, MA, and Norfolk, VA, as well as designing several utilitarian granite buildings in the Charlestown navy yard. His most important project there was a nearly 400 m long granite ropewalk (1835–7).

These projects produced a hiatus in his private architectural practice, and it never recovered. A new generation of younger architects, such as Isaiah Rogers and A. B. Young, obtained the major commissions in Boston with Greek Revival designs. Parris never adopted that style. His few late buildings, such as the Naval Hospital (1833–6), Chelsea, MA, and the Massachusetts Bank (1835; destr.), Boston, eschew even pilasters for plain, trabeated façades, relieved only by unadorned fenestration, severe mouldings and blocky parapets. His major projects in the last decade of his life were granite lighthouses, of which he designed at least seven. Through the mid-1840s his Boston office remained an important training ground for another generation of architects and engineers.

UNPUBLISHED SOURCES

Boston, MA, Athenaeum; Worcester, MA, Amer. Antiqua. Soc. [principal collections of Parris architectural drawings]
Boston, MA, New England Hist. Geneal. Soc.; Boston, MA, State Archv.; Pembroke, MA, Hist. Soc. [papers by or about Alexander Parris]

BIBLIOGRAPHY

DAB
C. P. Monkhouse: 'Parris' Perusal', *Old Time New England*, lviii/2 (Autumn 1967), pp. 51–9
E. R. Amadon, A. L. Cummings, C. P. Monkhouse and R. S. Webb: *The Faneuil Hall Market: An Historical Study* (Boston, 1968, rev. 1969)
C. P. Monkhouse: *Faneuil Hall Market: An Account of its Many Likenesses* (Boston, 1969)
M. Dibner, ed.: *Portland* (Portland, 1972) [good pls]
J. Garvin: 'St John's Church in Portsmouth: An Architectural Study', *Hist. NH*, xxviii/4 (Autumn 1973), pp. 153–75
D. P. Myers: *Maine Catalog: Historic American Buildings Survey* (Portland, 1975) [well illus.]
H. W. Davis, E. M. Hatch and D. G. Wright: 'Alexander Parris: Innovator in Naval Facility Architecture', *IA: J. Soc. Indust. Archaeol.*, ii/1 (1976), pp. 3–22
J. D. Dobbs: *A History of the Watertown Arsenal* (Watertown, 1977)
J. F. Quinan jr: 'Some Aspects of the Development of the Architectural Profession in Boston between 1800 and 1830', *Old-Time New England*, lxvii/1–2 (1977), pp. 32–7
P. Fox: 'Nathaniel Appleton's Beacon Street Houses', *Old-Time New England*, lxx (1980), pp. 111–24
E. F. Zimmer: 'Alexander Parris' David Sears House', *Old-Time New England*, lxx (1980), pp. 99–110
B. Norton: 'The Massachusetts Bank Plans of Alexander Parris', *Essex Inst. Hist. Cols*, cxvii/3 (July 1981), pp. 178–91
M. M. Taylor: *Buildings that Last: Parris in Boston* (Wellesley Hills, 1981)
P. J. Scott and E. F. Zimmer: 'Alexander Parris, B. Henry Latrobe, and the John Wickham House', *J. Soc. Archit. Hist.*, lxi/3 (Oct 1982), pp. 201–11
E. F. Zimmer: *The Architectural Career of Alexander Parris, 1780–1852* (diss., Boston U., MA, 1984)

EDWARD F. ZIMMER

Parrish, Maxfield (Frederick) (*b* Philadelphia, PA, 25 July 1870; *d* Plainfield, NH, 30 March 1966). American painter, illustrator and designer. He received early training in painting and etching from his father, the painter and printmaker Stephen Parrish (1846–1938). Parrish studied architecture at Haverford College, PA (1888–91), but

changed to painting at the Pennsylvania Academy of the Fine Arts, Philadelphia; he simultaneously attended classes given by American illustrator Howard Pyle (1853–1911) at the Drexel Institute, Philadelphia (although he was not registered there). Inspired by the graphic style of such artists as Alphonse Mucha (1860–1939), he created posters, cover designs and illustrations for popular American periodicals, including *Harper's Weekly*, *The Century*, *Collier's* and *Scribner's Magazine* (e.g. lithograph, cover for *Scribner's Mag.*, August 1897; New York, Columbia U. Col.). The dominant influence, however, on most American illustrators of the era, including Parrish, was Pre-Raphaelite painting. Parrish's characteristic subject-matter included woodland scenes, populated by fairies, medieval maidens and knights in armour. Working from photographs, he developed a richly coloured palette, becoming noted for his 'Maxfield Parrish blue' and his meticulous attention to detail. He illustrated calendars and books, including *The Golden Age* (London, 1895) and *Dream Days* (London, 1898) by Kenneth Grahame. In 1898 he moved permanently to New Hampshire, where, in Plainfield, he designed and built his home, The Oaks (1898–1906), architectural features of which frequently appeared in his work. He exhibited at the Exposition Universelle in Paris (1900) and at the Pan-American Exposition, Buffalo, NY (1901). He also executed a number of large murals for hotels and clubs in New York, Philadelphia and San Francisco, the most celebrated of which was *Old King Cole* (1.12×3.35 m, 1906; New York, St Regis Hotel). Coloured prints and calendars adapted from his paintings sold in millions during his lifetime.

Haig Patigian: *John M. Keith*, marble, h. 572 mm, 1913 (San Francisco, CA, Fine Arts Museums of San Francisco)

BIBLIOGRAPHY

A Century of American Illustration (exh. cat. by L. S. Ferber, New York, Brooklyn Mus., 1972), pp. 16, 149

C. Ludwig: *Maxfield Parrish* (New York, 1973)

A. Berman: 'Maxfield Parrish: The Importance of Make-believe', *A. & Ant.*, iii/1 (1980), pp. 86–93

L. S. Cutler and J. G. Cutler: *Maxfield Parrish: A Retrospective* (San Francisco, 1995)

J. M. P. Gordon: 'A Granddaughter's Reflections', *Amer. A. Rev.*, vii/6 (1995–6), pp. 135–7 [reminiscence about the artist]

L. S. Cutler: 'Maxfield Parrish: A Retrospective', *Amer. A. Rev.*, vii/6 (1995–6), pp. 130–35

K. Johnson: 'Kitsch Meets the Sublime', *A. Amer.*, lxxxiv/3 (1996), pp. 80–3

□

Patigian, Haig (*b* Van, Armenia, 22 Jan 1876; *d* San Francisco, CA, 19 Sept 1950). American sculptor of Armenian birth. Among the most prominent sculptors in California during the first quarter of the 20th century, he immigrated in 1891 to the USA, where he joined his father who had escaped the Turkish authorities and settled in Fresno, CA. The young Patigian worked as a vineyard labourer and sign painter until he moved in 1899 to San Francisco, enrolled at the Mark Hopkins Institute of Art and worked at the *San Francisco Bulletin*. He spent the years 1906 and 1907 studying in Paris and returned to establish a successful career, greatly admired for his portrait busts (see fig.), monuments and architectural decoration. According to one critic, Patigian loathed the avant-garde, the ideological and the abstract. But he in fact embraced a different ideology, one deployed in traditional (anti-modernist) form. During his study in Paris, Patigian exhibited

at the 1907 Salon his *Ancient History* (San Francisco, CA, priv. col.), a life-size bronze female nude figure with upraised wings instead of arms. This allegorical sculpture, representative of his most interesting work, involves a romantic connection to the past, a mystical and symbolic retrieval of what the artist believed had been lost by the materialism of the modern world. Among related major works are his *Owl Shrine* and *Diana*, both at the Bohemian Grove north of San Francisco.

BIBLIOGRAPHY

D. L. Stover: *American Sculpture: The Collection of the Fine Arts Museums of San Francisco* (San Francisco, 1982)

K. Starr: *The Visual Arts in Bohemia: 125 Years of Artistic Creativity in the Bohemian Club* (San Francisco, 1997)

PAUL J. KARLSTROM

Paul, Jeremiah (*fl* 1795; *d* nr St Louis, MO, 13 July 1820). American painter. He was a minor yet versatile artist whose career began in Philadelphia, PA, in the 1790s. The son of a Quaker schoolmaster, Paul received his early training from Charles Willson Peale and in 1795 participated in the founding of the Columbianum, Peale's ill-fated attempt to establish an art academy in America. Dunlap records that Paul's earliest works were based on engravings after pictures by Benjamin West. (He exhibited a copy (untraced) of West's *Death of Caesar* (untraced) at the Pennsylvania Academy of the Fine Arts, Philadelphia, in 1813.) He later turned to portraiture and in 1796, with several other Philadelphia artists, formed the firm of Pratt, Ritter & Co., whose aim was 'to undertake all manner of commissions, from the painting of portraits, signs and fire buckets to japanning and the execution of coffin plates'. At this time Paul is also known to have engaged in small

tasks for Gilbert Stuart, including the painting of lettering in some of the latter's portraits.

Paul left Philadelphia in the first years of the 19th century and during the winter of 1803 was painting miniatures and tracing profiles at Charleston, SC. A brief sojourn in Baltimore, MD, from 1806 to 1808, preceded his return to Philadelphia, where he exhibited a large *Venus and Cupid* (untraced) in 1811, the same year in which he contributed three works to the first annual exhibition of the Pennsylvania Academy of the Fine Arts. Paul's latter years were spent in Pittsburgh, PA, painting both portraits (e.g. *Mr White* and *Mrs White*; Greensburg, PA, Westmoreland Co. Mus. A.) and signs, and in the region of St Louis, MO, where he is said to have produced theatrical scenery.

BIBLIOGRAPHY

W. Dunlap: *A History of the Rise and Progress of the Arts of Design in the United States*, i (New York, 1834, rev. Boston, 1918), pp. 417–18

H. E. Dickson: 'A Note on Jeremiah Paul, American Artist', *Antiques*, li (June 1947), pp. 392–3

SONA K. JOHNSTON

Peabody, Robert Swain (*b* New Bedford, MA, 1845; *d* Marblehead, MA, 23 Sept 1917). American architect and writer. He attended the Boston Latin School and graduated from Harvard in 1866. He joined the office of Bryant & Gilman, moving to Ware & Van Brunt, where he met his future partner, John Goddard Stearns (1843–1917), an engineer and graduate of Harvard's Lawrence Scientific School. In 1867 he entered the Atelier Daumet at the Ecole des Beaux-Arts in Paris with Charles McKim and Francis Chandler, but the experience served to confirm his affection for English styles and the Picturesque Movement. On his return to Boston in 1870, Peabody formed a partnership with Stearns that lasted until 1917. The practice attracted a creative team, many of them graduates of the Massachusetts Institute of Technology (where Chandler became dean), who spread Peabody's influence nationwide. Peabody controlled the design process by producing the original sketches, delegating executive design responsibility to the younger architects; Stearns supervised the construction.

Peabody's best work is characterized by dramatic siting and by an affinity for the picturesque, even in urban settings, where he designed towers on buildings in all styles. The Park Square Railroad Station (1876; destr.), Boston, had Gothic towers, while the First Parish Church (1887), Weston, MA, built of glacial boulders, was Romanesque, and the tower of Worcester City Hall (1896), MA, accented a baroque staircase. The diagonal corner entrance of the R. H. White Warehouse (1883), Boston, which provided a model for H. H. Richardson's Second Ames Building, and the curved Boston Exchange Building (1887–91) achieved vertical elements without towers. His Custom House (1911–14) in Boston's financial district had an innovative steel frame and was added to Ammi B. Young's monolithic granite building of 1836. It served as the landmark of the port and as Boston's first skyscraper.

The houses of Peabody & Stearns, 80 in the Back Bay of Boston alone, exhibited extraordinary panache with their vitality and movement. Kragsyde (1882; destr.; for illustration *see* QUEEN ANNE REVIVAL), for George Nixon Black, and other houses at Manchester-by-the-Sea and Nahant on Boston's North Shore combined elements of QUEEN ANNE REVIVAL and the SHINGLE STYLE. First Breakers (1878; destr.), for Pierre Lorillard, Vinland (1882), for Catherine Lorillard Wolfe, Rough Point (1889–90), Rockhurst, Bleak House (1892) and numerous other Newport cottages were designed for a wealthy clientele.

Peabody drew not only on Queen Anne Revival but also on the COLONIAL REVIVAL with the Denny House (1878), Brush Hill, Milton, MA. His Massachusetts Building at the World's Columbian Exposition in Chicago in 1893 was an adaptation of Boston's Hancock House (1739), built by Joshua Blanchard, and provided the model for the Colonial Revival home nationwide. At Chicago his Machinery Building with its pair of towers and suggestion of a Spanish theme was also much admired. Peabody's position as the leader of the architectural profession in Boston had been recognized since 1876. He worked on several international exhibitions and made significant contributions to civic activities in Boston.

The output of Peabody's practice was prolific and over 47 years produced more than a thousand buildings nationally in a wide variety of styles. Peabody was influential especially through his writing and speaking; his books, augmented consistently with lectures, set standards for quality. His speech at Harvard and subsequent article 'Architecture and Democracy' (1890) helped to establish the Harvard School of Design. The eloquent expression of his vision of the responsibilities of the architectural profession made him a significant leader of this period.

UNPUBLISHED SOURCES

Boston, MA, Pub. Lib. [drgs and office rec. of Peabody & Stearns]

Boston, MA, Archit. Cent., Lib. [sketchbooks and portions of Peabody's lib.]

Weston, MA, Margaret Henderson Floyd Archives [comprehensive database of works of Peabody & Stearns]

WRITINGS

Note Book Sketches (Boston, 1873)

'A Talk about "Queen Anne"', *Amer. Architect & Bldg News*, ii (1877), pp. 133–4

'Georgian Houses of New England', *Amer. Architect & Bldg News*, ii (1877), pp. 338–9; iii (1878), pp. 54–5

'Architecture and Democracy', *Harper's Mag.*, lxxxi (1890), pp. 219–22

'Architecture as a Profession for College Graduates', *Harvard Mthly*, ix (1890)

with A. Shurtleff: 'A New Civic Center for Boston', *Report of Metropolitan Improvements Commission: Public Improvements for Metropolitan District* (Boston, 1909), pp. 259–65

Notes for Three Lectures on Municipal Improvements (Boston, 1912) [lect. delivered Harvard U., School of Architecture, 1912]

BIBLIOGRAPHY

G. Mason: *Newport and its Cottages* (Boston, 1875)

G. W. Sheldon: *Artistic Country Seats*, 2 vols (New York, 1886–7/R 1979)

M. Schuyler: 'The Romanesque Revival in America', *Archit. Rec.*, i (1891), pp. 151–98

C. Damrell: *A Half Century of Boston's Building* (Boston, 1895)

R. Sturgis: *A Critique of the Work of Peabody and Stearns* (New York, 1896/R 1971)

J. Schweinfurth: 'Robert Swain Peabody: Tower Builder', *Amer. Architect*, cxxx (1926), pp. 181–91

A. Downing and V. Scully jr: *The Architectural Heritage of Newport, Rhode Island* (New York, 1952, rev. 2/1967)

V. J. Scully jr: *The Shingle Style: Architectural Theory and Design from Richardson to the Origins of Wright* (New Haven, 1955); rev. as *The Shingle Style and the Stick Style* (New Haven, 1971)

B. Bunting: *Houses of Boston's Back Bay* (Cambridge, MA, 1967)

E. Hoyt: *The Peabody Influence* (New York, 1968)

W. Holden: 'The Peabody Touch: Peabody and Stearns of Boston, 1870–1917', *J. Soc. Archit. Hist.*, xxxii (1973), pp. 114–31

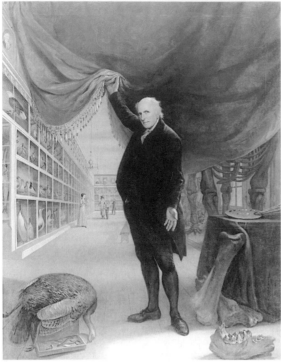

1. Charles Willson Peale: *The Artist in his Museum*, oil on canvas, 1035×800 mm, 1822 (Philadelphia, PA, Pennsylvania Academy of the Fine Arts)

B. Edgerly: 'Sketches of Robert Swain Peabody', *Dichotomy* (Detroit, 1983)

MARGARET HENDERSON FLOYD, WHEATON A. HOLDEN

Peale. American family of artists. They were active from *c.* 1760 to *c.* 1880, and their commitment to art during a period of revolution and nation-building contributed in a large way to the growth of American artistic interests and institutions. The family was established in America by the English post-office clerk Charles Peale (1709–50), a convicted embezzler exiled to the colonies in 1736. In 1740 he married Margaret Triggs (1709–91) and was a schoolteacher in Queen Anne's County and Chestertown, MD. His first son, the portrait painter (1) Charles Willson Peale, exerted a major influence on American painting through his own work and that of his sons, brothers and nieces.

BIBLIOGRAPHY
The Peale Family: Three Generations of American Artists (exh. cat., Detroit, MI, Inst. A., 1967)
Four Generations of Commissions: The Peale Collection (exh. cat., Baltimore, MD Hist. Soc. Mus., 1975)
L. B. Miller, ed.: *The Collected Papers of Charles Willson Peale and his Family* (microfiche edn, Millwood, NY, 1980)
L. B. Miller and others, eds: *Selected Papers of Charles Willson Peale and his Family*, 7 vols (New Haven, 1983–)

For further bibliography on the Peale family and its individual members, see B. Karpel, ed.: *Arts in America: A Bibliography*, 3 vols (Washington, DC, 1979).

(1) Charles Willson Peale (*b* Queen Anne's Co., MD, 15 April 1741; *d* Philadelphia, PA, 22 Feb 1827). Painter and museum founder. After serving as a saddler's appren-

tice in Annapolis, MD, from 1754 to 1761, he worked at various trades, including painting signs and portraits. In 1766 some prominent Marylanders underwrote his studies in London with Benjamin West, from whom he absorbed the fundamentals of the British portrait tradition. Peale probably attended the informal life classes offered at St Martin's Lane Academy, precursor to the Royal Academy Schools, and drew from casts in the Duke of Richmond's collection in Whitehall. He visited the studios of such important British portrait painters as Joshua Reynolds (1723–92), Francis Cotes (1726–70) and Allan Ramsay (1713–84) and studied the techniques of miniature painting, sculpture and engraving. In London he executed his first major commission, a full-length allegorical portrait of *William Pitt, Lord Chatham* (1768; Montross, VA, Westmoreland Co. Mus.), from which he engraved a mezzotint.

In 1769 Peale returned to Annapolis; his portrait of *Mrs Thomas Harwood* (1771; New York, Met.), with its careful drawing, delicate colours and elegance of pose and materials, reveals his debt to both West and Reynolds as well as his mastery of the subtleties of English 18th-century portraiture. He introduced into America the British conversation piece, of which *The Stewart Children* (1770–75; Lugano, Baron Thyssen-Bornemisza priv. col.) is a fine example (*see also* PHILADELPHIA, fig. 4, and the heroic portrait, such as that of *John Beale Bordley* (1770; Barra Found., Washington, DC, N.G.A.), in which he symbolically expressed American opposition to British Colonial control. The first artist to paint *George Washington* (1772; Lexington, VA, Washington & Lee U., Chapel Mus.), between 1779 and 1795 he executed six more life portraits of America's hero; especially important are the great portrait of 1779 celebrating the Princeton victory (Philadelphia, PA Acad. F.A.; see colour pl. VI, 2) and the sitting of 1795 idealizing the civilian leader (New York, NY Hist. Soc.).

In 1776 Peale moved to Philadelphia. During the Revolution he served in the Pennsylvania militia and participated in radical politics. Between 1788 and 1791 he painted a particularly fine group of domestic portraits, for example the complex and elegant *Robert Goldsborough Family* (1789; priv. col., see Richardson, Hindle and Miller, pp. 214–15). From 1791 to 1810 he concentrated on his museum, originally established in 1784 as a portrait gallery, and gave primary attention to inventions, natural history —working with William Bartram on Alexander Wilson's *American Ornithology*—and art institutions: the Columbianum Society (1795) and the Pennsylvania Academy of the Fine Arts (1805). His discovery in 1801 of mastodon bones influenced the scientific debate over the extinction of species and provided the subject for *The Exhumation of the Mastodon* (1805–8; Baltimore, MD, Peale Mus.), a large painting that combined portraits of family members with landscape in order to convey moral significance.

Peale's enthusiasm for painting was rekindled when he retired to his farm, Belfield, in 1810. Experimenting with lighting effects and new colouring methods that he had learnt from his son (4) Rembrandt Peale, he produced some of his most artistically important works: *Hannah Moore (Mrs Charles Willson) Peale* (1816; Boston, MA, Mus. F.A.), *James Peale by Candlelight* (1822; Detroit, MI, Inst. A.) and his famous self-portrait *The Artist in his*

Museum (1822; Philadelphia, PA Acad. F.A.; see fig. 1). Towards the end of his life he painted charming landscapes such as *Belfield* (1815–18; Detroit, MI, Inst. A.).

Peale's best work reveals a command of technique and composition, as in the *Staircase Group* (1795; Philadelphia, PA, Mus. A.), a *trompe l'oeil* vertical double portrait of his sons (3) Raphaelle Peale and Titian Ramsay Peale (i) (1780–98), life-size and depicted on a winding staircase ascending from a doorway, at the base of which an actual step completes the sense of verisimilitude. So faithful is Peale's rendering of both figures and objects in the painting that it is said that President Washington, on visiting Peale's museum, bowed to the boys as he passed.

Group portraits such as *The Peale Family* (*c.*1770–73 and 1808; New York, NY Hist. Soc.; see fig.2) possess a delightful pictorial quality, while his clear colour, naturalistic poses and sensitivity to the relationship between the individual and nature render his paintings lively and frequently beautiful. During his lifetime, he painted over a thousand works, many the only life portraits existing of American military and political leaders.

Peale married three times and had eleven surviving children. Three sons became prominent artists, and two, Titian Ramsay Peale (i) and Titian Ramsay Peale (ii) (1799–1885), were fine naturalist artists.

BIBLIOGRAPHY
C. C. Sellers: *Charles Willson Peale* (Philadelphia, 1947, rev. New York, 2/1969)
——: *Portraits and Miniatures by Charles Willson Peale* (Philadelphia, 1952)
L. B. Miller: 'Charles Willson Peale as History Painter: *The Exhumation of the Mastodon*', *Amer. A. J.*, xiii (1981), pp. 47–68
R. B. Stein: 'Charles Willson Peale's Expressive Design: *The Artist in his Museum*', *Prospects*, vi (1981), pp. 139–85
E. P. Richardson, B. Hindle and L. B. Miller: *Charles Willson Peale and his World* (New York, 1983)
L. B. Miller: 'Father and Son: The Relationship of Charles Willson Peale and Raphaelle Peale', *Amer. A. J.*, xxv/1/2 (1993), pp. 4–61

(2) James Peale (*b* Chestertown, MD, 1749; *d* Philadelphia, PA, 24 May 1831). Painter, brother of (1) Charles Willson Peale. Charles encouraged him to become a painter; James also worked as a frame-maker for his brother until the Revolution, in which he served as a lieutenant. From 1779 James shared Charles's practice, specializing in miniatures. His early work, occasionally confused with Charles's, shows his brother's influence. After 1794, his style became clearly his own: more delicate with subtle colour harmonies, softened outlines and free handling; it may be distinguished by a faint violet tone in the shadows and the inconspicuous signature 'IP'. His miniatures of male subjects are frequently superior to his portraits of women, for example *Benjamin Harwood* (1799; Baltimore, Mus. & Lib. MD Hist.), but his meticulous attention to costume and his success in imparting colour and sparkle to skin and eyes, as in the lovely portrait of *Mrs John McCluney* (1794; Washington, DC, N. Mus. Amer. A.; see fig.), compensate for drawing deficiencies.

A versatile artist, James also painted landscapes (*On the Schuylkill*, 1830; Cincinnati, OH, A. Mus.), historical works (*Ambush of Captain Allan McLane*, 1803; Salt Lake City, U. UT, Mus. F.A.), conversation pieces (*The Artist and his Family*, *c.* 1795–8; Philadelphia, PA Acad. F.A.) and oil portraits (*Maria and Sarah Miriam Peale*, *c.* 1807; Philadelphia, PA Acad. F.A.). He was most fluent with still-life, in which field he was one of the first and highly influential American practitioners. His exuberant fruit pieces reveal a mastery of design, subdued colour and deep shadowing, as in the *Still-life: Fruit* (1820s; San Francisco, CA, de Young Mem. Mus.).

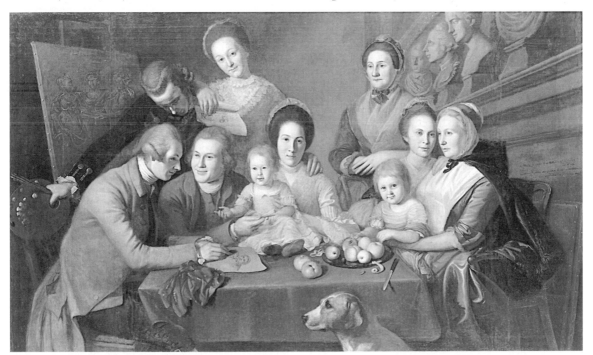

2. Charles Willson Peale: *The Peale Family*, oil on canvas, 1.41×2.24 m, *c.* 1770–73 and 1808 (New York, New-York Historical Society)

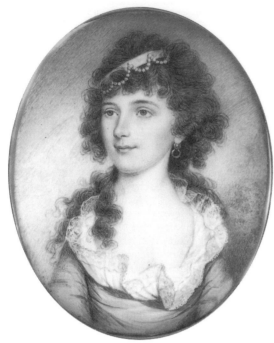

James Peale: *Mrs John McCluney*, watercolour, 63.5×54 mm, 1794 (Washington, DC, National Museum of American Art)

In 1782 James Peale married Mary Claypoole (1753–1829), daughter of the Philadelphia painter James Claypoole. Of their six surviving children, three daughters became professional painters and James Peale jr (1789–1876) an amateur landscape painter.

BIBLIOGRAPHY

E. F. Sherman: 'James Peale's Portrait Miniatures', *A. America*, xix (1931), pp. 208–21
J. L. Brockway: 'The Miniatures of James Peale', *Antiques*, xxii (1932), pp. 130–34
J. I. H. Baur: 'The Peales and the Development of American Still Life', *A. Q.* [Detroit], iii (1940), pp. 81–91

(3) Raphaelle Peale (*b* Annapolis, MD, 17 Feb 1774; *d* Philadelphia, PA, 5 March 1825). Painter, son of (1) Charles Willson Peale. His mother was Rachel Brewer Peale. He studied painting with his father and assisted him in the museum. Raphaelle began to paint portraits professionally in 1794, but poor patronage in Philadelphia forced him to travel in the South and New England, taking silhouettes with the physiognotrace and painting portraits in oil and miniature. From about 1815 onwards, bouts of alcoholism and gout inhibited his progress. He turned to painting still-lifes (see colour pl. VII, 2), but these sold for small amounts. The need to travel weakened an already debilitated constitution and contributed to his early death.

Despite tragedy, failure and physical pain, Raphaelle Peale painted exquisite still-lifes, such as *Blackberries* (*c.* 1813; San Francisco, CA, de Young Mem. Mus.); some fine miniatures, such as the *Unknown Young Man* (1803; Pittsburgh, PA, Carnegie Mus. A.); and a masterpiece of *trompe l'oeil*, *Venus Rising from the Sea* (originally titled *After the Bath*, 1823; Kansas City, MO, Nelson–Atkins Mus. A.). His work, together with that of his uncle (2)

James Peale, encouraged a Philadelphia school of still-life that continued through the 19th century.

BIBLIOGRAPHY

Raphaelle Peale (exh. cat. by C. C. Sellers, Milwaukee, WI, A. Mus.; New York, Knoedler's; 1959)
W. H. Gerdts and R. Burke: *Painters of the Humble Truth* (Columbia, MO, 1981)
D. Evans: 'Raphaelle Peale's *Venus Rising from the Sea*', *Amer. A. J.*, xiv (1982), pp. 63–73
N. Cikovsky jr: *Raphaelle Peale: Still Lifes* (exh. cat., Washington, DC, N.G.A., 1988)
L. B. Miller: 'Father and Son: The Relationship of Charles Willson Peale and Raphaelle Peale', *Amer. A. J.*, xxv (1993), pp. 4–64
D. C. Ward and S. Hart: 'Subversion and Illusion in the Life and Art of Raphaelle Peale', *Amer. A.*, viii (Summer/Autumn 1994), pp. 96–121

(4) Rembrandt Peale (*b* Bucks Co., PA, 22 Feb 1778; *d* Philadelphia, 3 Oct 1860). Painter, museum keeper and writer, brother of (3) Raphaelle Peale. He began to paint at an early age, completing a *Self-portrait* at age 13 (priv. col., see Hevner and Miller, p. 31) and at 17 a portrait of *George Washington* (1795; Philadelphia, PA, Hist. Soc.). Rembrandt's career falls into four periods. The first includes his early portraits, such as the charming *Rubens with a Geranium* (1801; Washington, DC, N.G.A.) and the two impressive renditions of *Thomas Jefferson* (1800, Washington, DC, State Dept; 1805, New York, NY Hist. Soc.), which show the influence of his father and of his studies in England during 1802–3. Paintings from the years following his return from France in 1810 and his discovery of encaustic are more polished and Neo-classical: *Joseph Louis Gay-Lussac* (1810; Philadelphia, PA, Coll. Phys., Mutter Mus.), *Isaac McKim* (*c.* 1815; Baltimore, Mus. & Lib. MD Hist.) and *General Samuel Smith* (1817–

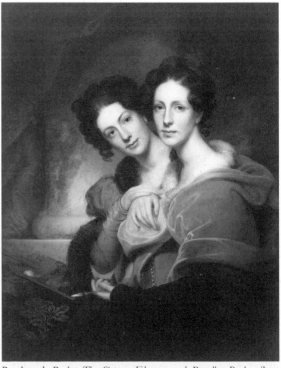

Rembrandt Peale: *The Sisters: Eleanor and Rosalba Peale*, oil on canvas, 1067×832 mm, 1826 (New York, Brooklyn Museum of Art)

18; Baltimore, MD, Peale Mus.). During his middle years Rembrandt sought to establish an artistic reputation with heroic works such as *George Washington, Patriae Pater* (*c.* 1824; Philadelphia, PA Acad. F.A.), *The Court of Death* (1820; Detroit, MI, Inst. A.) and the sumptuous double portrait of his daughters, *The Sisters: Eleanor and Rosalba Peale* (1826; New York, Brooklyn Mus.; see fig.). From the 1840s Rembrandt concentrated on painting copies of his *Washington* and from the Old Masters.

Constantly aspiring to greatness, Rembrandt led a life that was marked by a restless itinerary from Philadelphia to Baltimore, New York and Boston in search of commissions, and to Europe in search of inspiration. From 1812 to 1822 he managed the Baltimore Museum but neglected it when he became interested in developing gas lighting for the city. He wrote poetry, travel accounts (*Notes on Italy*, 1831) and a drawing manual (*Graphics*, 1835). In 1839 he published *The Portfolio of an Artist*, and from 1855 to 1858 his 'Reminiscences' appeared in the *Crayon*.

Despite unevenness and some sentimentality, especially in his later portraits, Rembrandt Peale is an important mid-19th-century American artist. A brilliant colourist and impeccable craftsman, he reveals his exceptional gifts especially in portraits of family members and friends, as in *Rubens Peale* (1834; Hartford, CT, Wadsworth Atheneum) or the very fine *Horatio Greenough* (1829; Washington, DC, N.P.G.). The many replicas of his *Washington* and his monumental *Washington before Yorktown* (1824–5; Washington, DC, Corcoran Gal. A.) have become American icons as well as significant examples of American Neo-classical art.

UNPUBLISHED SOURCES

New York, N. Acad. Des., MS. 1838 [*Lecture on the Fine Arts*]

WRITINGS

'Original Thoughts on Allegorical Painting', *N. Gaz. & Lit. Register*, 28 (1820)
'The Fine Arts', *Philadelphia Museum, or Register of Natural History and the Arts*, i (1824)
Notes on Italy (Philadelphia, 1831)
Graphics: A Manual of Drawing and Writing, for the Use of Schools and Families (Philadelphia, 1834, rev. 1866)
Notes on the Painting Room (MS., 1840s; Philadelphia, PA, Hist. Soc.); intro. and prospectus as *Introduction to 'Notes of the Painting Room'* (n.p., 1852); also in *Crayon*, vii (1860), pp. 333–5; repr. in *Pennsylvania Mag. Hist. & Biog.*, cx (1986), pp. 111–28 [issue devoted to Rembrandt Peale]
'Reminiscences', *Crayon*, i (1855); ii (1855); iii (1856) 'Notes and Queries', *Crayon*, iv (1857)

BIBLIOGRAPHY

W. H. Hunter: *Rendezvous for Taste: An Exhibition Celebrating the 25th Anniversary of the Peale Museum* (Baltimore, 1956)
J. A. Mahey: 'The Studio of Rembrandt Peale', *Amer. A. J.*, i (1969), pp. 20–40
P. C. Marzio: *The Art Crusade* (Washington, DC, 1976)
C. E. Hevner and L. B. Miller: *Rembrandt Peale, 1778–1860: A Life in the Arts* (Philadelphia, 1985)
PA Mag. Hist. & Biog., cx (1986), pp. 2–184 [issue devoted to Peale]
In Pursuit of Fame: Rembrandt Peale, 1778–1860 (exh. cat. by L. B. Miller, Washington, DC, N.P.G., 1992–3)
W. J. Katz: 'A Great Moral Discourse: Rembrandt Peale's *The Court of Death*', *Bull. Detroit Inst. A.*, lxx/1–2 (1996), pp. 14–25

(5) Rubens Peale (*b* Philadelphia, PA, 4 May 1784; *d* Philadelphia, PA, 17 July 1865). Museum keeper and painter, brother of (3) Raphaelle Peale and (4) Rembrandt Peale. He became a painter late in life. Poor eyesight dictated a career in museum management, and from 1810

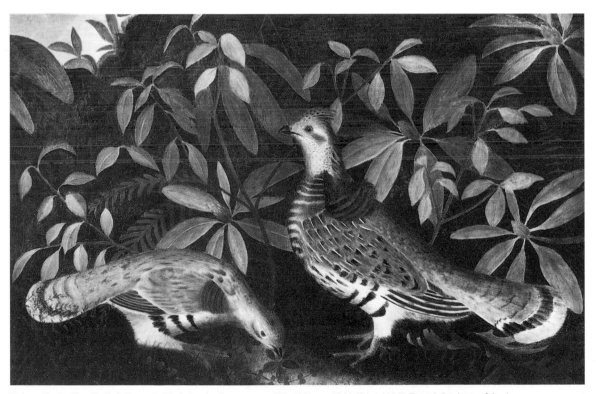

Rubens Peale: *Two Ruffled Grouse in Underbrush*, oil on canvas, 489×692 mm, 1864 (Detroit, MI, Detroit Institute of Arts)

to the 1840s he managed the Philadelphia Museum (1810–22), his brother Rembrandt's Baltimore Museum (1822–5) and the New York Museum (1825–1840s). Following the Panic of 1837, he sold his enterprise to P. T. Barnum and moved to a farm near Schuylkill Haven, PA. In 1855 he began to paint still-lifes, some after James Peale and Raphaelle Peale, some original. In 1864, with his daughter Mary Jane, also a painter, he returned to Philadelphia and studied landscape painting with Edward Moran. Although Mary Jane occasionally finished his landscapes, the still-lifes are clearly his. *Still Life with Grapes, Watermelon and Peaches* (1863; Davenport, IA, Mun. A.G.) and *Fruit on Pewter Plate* (1861; Milwaukee, WI, A. Mus.), with its carefully rendered worm holes, are charming examples of his meticulous attention to detail. Rubens's lifelong interest in birds is expressed in his naive *Two Ruffled Grouse in Underbrush* (1864; Detroit, MI, Inst. A.; see fig.).

BIBLIOGRAPHY
C. C. Sellers: 'Rubens Peale: A Painter's Decade', *A. Q.* [Detroit], xxiii (1960), pp. 139–51

(6) Anna Claypoole Peale (*b* Philadelphia, PA, 6 March 1791; *d* Philadelphia, PA, 25 Dec 1878). Miniature painter, daughter of (2) James Peale. She was instructed by her father. Her first attempt, a fruit piece, was exhibited in 1811 at the Society of Artists in Philadelphia. From 1820 to 1840 she was a popular miniature painter, known for the accuracy of her likenesses and close attention to detail. She worked in the major eastern cities and exhibited regularly at the Pennsylvania Academy of the Fine Arts, to which she was elected a member in 1824. Her lively style, with its emphasis on skin tones, brilliant colours and warm, rich backgrounds, may be seen in *Elizabeth Nicholson Noel (Mrs James) Bosley* (1823) and *Elizabeth Bordley Polk (Mrs Joseph G. B.) Bend* (*c.* 1820; both Baltimore, Mus. & Lib. MD Hist.). Her portrait of *James Peale* (1823; Shreveport, LA, Norton A.G.) reveals the variety of brushstrokes that frequently make her miniatures appear like small oil paintings. Her professional career was interrupted twice by marriage, briefly in 1829 and again in 1841 until 1864; but she resumed her career each time, continuing to paint in Philadelphia until her death.

BIBLIOGRAPHY
C. S. Rubinstein: *American Women Artists* (New York, 1982)
A. S. Hirshorn: 'Legacy of Ivory: Anna Claypoole Peale's Portrait Miniatures', *Bull. Detroit Inst. A.*, lxiv/4 (1989), pp. 16–27

(7) Margaretta Angelica Peale (*b* Philadelphia, PA, 1 Oct 1795; *d* Philadelphia, PA, 17 Jan 1882). Painter, daughter of (2) James Peale. She was taught by her father and painted primarily still-lifes, many of them copies of her father's, such as *Still Life: Pomegranates and Grapes* (*c.* 1820s, Baltimore, Mus. & Lib. MD Hist.). A lovely, simple still-life of *Strawberries and Cherries* is at the Pennsylvania Academy of the Fine Arts, PA. Her work resembles James's in its clear outlines, diagonal lighting and composition.

BIBLIOGRAPHY
C. S. Rubinstein: *American Women Artists* (New York, 1982)

(8) Sarah Miriam Peale (*b* Philadelphia, PA, 19 May 1800; *d* Philadelphia, PA, 4 Feb 1885). Painter, daughter of (2) James Peale. The most notable of James Peale's painting daughters, she also studied with her uncle (1) Charles Willson Peale and her cousin (4) Rembrandt Peale, from whom she developed her talent for colour and precision in details. As studio assistant to her father, she occasionally introduced into his work bright and intricate fabrics. Her career began in 1817 with the exhibition of *Flowers* at the Pennsylvania Academy of the Fine Arts. In the 1820s she painted in Baltimore and Philadelphia; in 1824 she was elected to the Pennsylvania Academy. From 1831 to 1846 she maintained her studio in Baltimore where she was a popular portrait painter, producing unpretentious but intelligent and occasionally romantic portraits characterized by a fine concern for materials, as in *Mrs Perry Eccleston Noel* (*c.* 1822; Baltimore, Mus. & Lib. MD Hist.). Her sitters included such prominent politicians as *Daniel Webster* (1842; St Louis, MO Hist. Soc. Mus.) and *Abel Park Upshur* (1842; Baltimore, Mus. & Lib. MD Hist.). In 1847 Sarah moved to St Louis, MO, where for 32 years she was in great demand. From 1859 her still-lifes won prizes at the St Louis fairs; they were loosely painted works different from the tightly controlled table-top pieces of her father and sister. Sarah's portraiture also changed, from the elegant, precise Neo-classicism learnt from her cousin Rembrandt to a looser, easier handling. In 1878 Sarah returned to Philadelphia to spend her last years with her sisters. She was the first successful woman artist in America and, with her sister (6) Anna Peale, the first to achieve full professional standing.

BIBLIOGRAPHY
W. Born: 'The Female Peales: Their Art and its Tradition', *Amer. Colr*, xv (1946), pp. 12–14
Miss Sarah Miriam Peale (exh. cat. by W. H. Hunter and J. Mahey, Baltimore, MD, Peale Mus., 1967)

LILLIAN B. MILLER

Peck, Sheldon (*b* Cornwall, VT, 26 Aug 1797; *d* Babcock Grove [now Lombard], IL, 19 March 1868). American painter. A self-taught painter, he used his family as subjects in his early works, employing dark colours against flat backgrounds. After moving to Jordan, NY, in 1828 he used brighter colours and included more detail. He continued to paint on panel, almost always making half-length portraits characterized by such features as a broad brow, a wide, intense stare from detailed eyes and the use of a decorative brushstroke—a long stroke with a shorter one on each side, as seen for example on the shawl in *A Miss Dodge Wearing a Tortoiseshell Comb* (*c.* 1840; Pollack priv. col., see Miller, p. 614). About 1845 the family moved to Babcock Grove (now Lombard), IL, a farming community near Chicago. Peck then switched to canvas and introduced full-length figures, occasionally in groups. His colours brightened, and he sometimes added *trompe l'oeil* wood-grained frames to his portraits. Often he included such props as a newspaper or added a still-life or landscape view in the background (e.g. *David Crane and Catherine Stolp Crane*, *c.* 1845; priv. col., see Balazs, p. 279) but continued to portray the figure as immobile, painted in flat, brightly coloured planes. He did not sign his paintings and always advertised himself as a decorative painter who would embellish chairs and furniture.

BIBLIOGRAPHY
M. Balazs: 'Sheldon Peck', *Antiques*, cviii (1975), pp. 273–84
R. Miller: 'Six Illinois Portraits Attributed to Sheldon Peck', *Antiques*, cxxvi (1984), pp. 614–17

DARRYL PATRICK

Pelham, Peter (*b* London, *c.* 1697; *d* Boston, MA, *bur* 14 Dec 1751). American painter and engraver of English birth. He was apprenticed to the mezzotint engraver (John) Simon (1675–1751) in 1713. Between 1720 and 1726 Pelham produced at least 25 mezzotint portraits of prominent London figures. In 1726 or 1727 he left for Boston, MA, which presented him with a new and unchallenged market. His first subject was the popular clergyman Cotton Mather; Pelham painted his portrait (1728; Worcester, MA, Amer. Antiqua. Soc.), from which he engraved the first mezzotint produced in the American colonies. The inscriptions on his portrait engravings reveal that he also painted portraits of *Mather Byles* (Worcester, MA, Amer. Antiqua. Soc.), Charles Brockwell, Timothy Cutler, William Hooper and John Moorhead (all untraced), all Boston clergymen. He engraved 15 mainly bust-length portraits in America, including mezzotints after portraits by John Smibert (1747) and Joseph Highmore (1751).

Pelham also engraved a *Plan of the City and Fortress of Louisbourg*, on a much larger scale (450 × 540 mm). He issued his prints on a subscription basis, but the market for portrait prints in Boston was too weak to support him. He also worked as a dancing master and sponsored dancing assemblies and concerts. In 1738 he opened a school to instruct young men and women in dancing, writing, reading, painting on glass and needlework. In 1748 he married Mary Copley, whose son by a previous marriage, John Singleton Copley, reworked one of Pelham's plates and became acquainted with painting in his stepfather's home.

BIBLIOGRAPHY

J. Chaloner Smith: *British Mezzotinto Portraits*, iii (London, 1883), pp. 964–78

A. Oliver: 'Peter Pelham (*c.* 1697–1751): Sometime Printmaker of Boston', *Boston Prints and Printmakers, 1670–1775* (Boston, 1973), pp. 133–73 [incl. cat. rai.]

American Colonial Portraits, 1700–1776 (exh. cat., ed. R. Saunders and E. Miles; Washington, DC, N.P.G., 1987), pp. 134–43

GEORGIA BRADY BARNHILL

Pelz, Paul Johannes. *See under* SMITHMEYER & PELZ.

Periodicals. Magazines or other publications (not usually including general newspapers) that appear at more or less regular intervals.

1. Before 1900. 2. 1900 and after.

1. Before 1900. Although America's early general magazines offered some coverage of the fine arts and artists, it was not until 1839 that the first American periodical devoted solely to art appeared: the *Transactions of the Apollo Association for the Promotion of the Fine Arts in the United States* (New York, 1839–43). It became the *Transactions of the American Art-Union* (New York, 1844–9), later the *Bulletin of the American Art-Union* (New York, 1850) and the *Supplementary Bulletin of the American Art-Union* (New York, 1851–3). This organization was formed in 1839, two years after its British predecessor, which published the *Art Union* (London, 1839–48). The American Art-Union invited members to take part in an annual lottery for American works of art that it purchased during the year. Members were also favoured with prints of engravings and a regular periodical publication. The *Trans-*

actions of 1839, a pamphlet-length 24 pages, evolved into a fully fledged art periodical with the *Bulletin* for 1850, comprising 192 closely printed pages and illustrated with engravings or etchings. These pioneer issues were instrumental in the Art-Union's mission to cultivate popular taste and appreciation of American art throughout the country, and to champion and support American artists. An urban-based organization, it realized as early as 1849 that its *Bulletin* could reach even into rural areas, where it would compensate for the lack of regular exhibitions. In 1851, as the Art-Union was unsuccessfully defending itself against a legal assault on its lottery activities, it proclaimed among its major good works the monthly publication of a 'large, valuable Art Journal'. The gap left by its demise and that of its regional counterparts was filled by the Cosmopolitan Art Association, founded in 1854 in Sandusky, Ohio. Its handsome periodical, the *Cosmopolitan Art Journal* (New York, 1856–61), published until the onset of the American Civil War, called for art that would stir pride and patriotism in the American people.

There were also art periodicals unattached to formal art associations. The most outstanding title of the pre-Civil War period was the *Crayon: A Journal Devoted to the Graphic Arts* (New York, 1855–61). It is considered as America's first art journal to contain art criticism; its thinking was based on the aesthetic principles of John Ruskin (1819–1900) and the English Pre-Raphaelites, who believed that art should be true to nature. This concept was particularly relevant to the work of American landscape painters as they sought to establish a distinctively American mode of artistic expression. The *Crayon* can also be described as America's first artist's periodical, being founded and edited by two working artists: William James Stillman, the earliest American proponent of Ruskin's ideas, and John Durand, whose father, the painter Asher B. Durand, was president of the National Academy of Design during the years of his son's editorship. Young American painters looked to the *Crayon* for guidance, edification and instruction, such as were provided in the elder Durand's 'Letters on Landscape Painting' that it published. It also served the architectural community by publishing lectures delivered to the membership of the American Institute of Architects, newly founded in 1857 and as yet without its own publication. The *New Path* (New York, 1863–5), published by the Society for the Advancement of Truth in Art, was also under the influence of the Pre-Raphaelites and preached its tenets with passion.

After the end (1865) of the Civil War, American editions of four English art magazines, the *Art Journal* (New York, 1875–87), *Magazine of Art* (New York, 1878–1904), *International Studio: An Illustrated Magazine of Fine and Applied Art* (New York, 1897–1931) and the *Artist* (New York, 1898–1902), served the growing interest in art. Among the new (and still quite short-lived) American art periodicals, the most notable was the *American Art Review* (Boston, 1879–81), edited by Sylvester Rosa Koehler (1837–1900), who aspired to produce a scholarly, critical art journal in the mould of fine European art periodicals such as the *Gazette des beaux-arts* (Paris, 1859–), *The Portfolio* (London, 1870–93) and *L'Art* (Paris and London, 1875–1907). A special feature was the series, written by

the editor, on the work of American etchers, which was accompanied by original etchings.

Two new magazines, *Art Interchange: A Household Journal* (New York, 1878–1904) and *Art Amateur: Devoted to Art in the Household* (New York, 1879–1903), which ostensibly appealed to the amateur in a domestic decorating environment, reflected the impact of the Philadelphia Centennial Exposition of 1876 and the rise of the Aesthetic Movement, which encouraged handicraft as opposed to industrialized products. They enjoyed enormous success, with circulations approaching 10,000, and have served a historical function by recording and documenting the many objects fashioned during this period, as well as the active involvement and accomplishments of women in this field. At this time professional decorators first came on the scene; periodicals designed to serve their needs included the generously illustrated *Beck's Journal of Decorative Art* (New York, 1886–8) and the *Upholsterer*, later (1954) *Interiors* (New York, 1888–).

The first American architectural periodical was the *Architect's and Mechanic's Journal* (New York, 1859–61). It was modelled on *The Builder*, later (1966) *Building* (London, 1842–). Although it was also geared towards the construction industry, it was attentive to the concerns of architects, addressing the issues of their professional status; in 1860 it included the minutes of the American Institute of Architects. Its double orientation presaged the course of events following the Civil War, when purely architectural periodicals did not enjoy the long runs and high circulation of those for the building industry, which prospered because of post-war reconstruction. They included the *American Builder and Journal of Art*, later (1873) *American Builder: A Journal of Industrial Art*, merging (1880) with *Illustrated Woodworker* (New York, 1879) to form *Builder and Woodworker*, from 1893 *Architect, Builder and Woodworker* (Chicago, 1868–73; New York, 1873–95) and *Carpentry and Building* (New York, 1879–1910), later *Building Age* (1910-30); the latter, with a circulation of 20,000 in 1890, led all journals in the architectural and building fields.

However, the architectural community acquired a leading periodical of its own in *American Architect and Building News* (Boston, 1876–1904; New York, 1905–38), which secured the collaboration of the American Institute of Architects as a source of material and illustrations, as well as its promise not to start its own journal. William Robert Ware, the founder and head of the architecture programme at the Massachusetts Institute of Technology, Cambridge, MA, enlisted his nephew William Rotch Ware to edit the journal, which he did for almost 30 years. This editorial cohesiveness gave it the platform from which to promote educational standards and advance professional status, and to assert the distinction between architects and builders that brought about a sharper definition of periodicals serving the two groups. The journal was well illustrated with photolithographs, heliotypes and photographic reproductions. The example it set was followed in regional publications such as the *California Architect and Building Review*, later (1882) *California Architect and Building News* (San Francisco, 1880–1900) and the *Inland Architect and Builder*, later (1887) *Inland Architect and News Record* (Chicago, 1883–1908), which was curiously reluctant to recognize the work of Frank Lloyd Wright. There was now truly nationwide coverage for the architectural profession, correcting a situation where the *American Architect*, although national in intent, was perceived to favour architects in Boston and New York.

The USA can claim the distinction of publishing the world's first periodical devoted solely to photography. The *Daguerreian Journal* (New York, 1850–51), which became *Humphrey's Journal* (New York, 1852–70), was followed closely by the *Photographic Art Journal*, later (1854) the *Photographic and Fine Art Journal* (New York, 1851–60). As the daguerreotype process was superseded, other photographic periodicals appeared, foremost among them the *Philadelphia Photographer* (Philadelphia, 1864–88), the journal of the Photographic Society of Philadelphia. Many similar societies and periodicals appeared after the 1860s for amateur photographers. Alfred Stieglitz was a member of one such group, the Society of Amateur Photographers, and for three years co-edited its journal, the *American Amateur Photographer* (Brunswick, ME, 1889–90; New York, 1891–1906). He used the periodical format to embark soon after on his mission to establish photography as a fine art. *Camera Notes* (New York, 1897–1903), which he founded and edited after a merger between the Society of Amateur Photographers and the New York Camera Club, promoted pictorialism in photography while reporting on the most recent scientific advances in the field. It was the predecessor of the groundbreaking periodical *Camera Work* (New York, 1903–17).

2. 1900 and after. The painter Robert Henri was an early protagonist of artistic change in the USA. He was the leader of the early 20th-century realist group known as the Eight, or the Ashcan school, which defied the academic traditions carried over from the 19th century. The realists were recognized by two very different periodicals: *The Craftsman* (Eastwood, NY, 1901–16), published and edited by the furniture-maker Gustav Stickley, promoted the American Arts and Crafts Movement, while *Arts and Decoration* (New York, 1910–42), edited by Guy Pène du Bois, a pupil of Henri, promoted contemporary artists.

Three periodicals that began in the first 13 years of the 1900s transformed themselves over the years into major publications, still active at the end of the century. *Hyde's Weekly Art News*, later (1969) *ARTnews* (New York, 1902–), appealed to the collector and concentrated on news of exhibitions and sales. *Art in America* (New York, 1913–) made its début one month before the landmark Armory Show, which in February 1913 presented some 1500 works of European and American avant-garde artists to an astonished American public in New York. However, for many years the journal's editorial content, written by European scholars, focused more on traditional European art than on American art or new artistic trends. The *Bulletin of the College Art Association* (Indianapolis, IN, 1913; Providence, RI, 1917–18), which became the *Art Bulletin* (Providence, RI, 1919–24; New York, 1924–), was concerned initially with issues of art education, before concentrating on art history from the early 1920s. The Armory Show aroused less comment in the art magazines than in newspapers and cultural and literary periodicals,

but *Arts and Decoration* and *Camera Work* were supportive, publishing special issues dedicated to the show, while the periodical of the American Federation of Art, *Art and Progress*, later the *American Magazine of Art* and *Magazine of Art* (Washington, DC, 1909–53), belied its title by its strong stand against it.

The three most widely read American architecture periodicals are the *Architectural Record* (New York, 1891–), *Pencil Points*, later (1945) *Progressive Architecture* (East Stroudsburg, PA, 1920–), and the *Journal of the American Institute of Architects*, later (1983) *Architecture: The AIA Journal* (Washington, DC, 1913–); there was formerly a fourth, the *Brickbuilder*, later (1917) the *Architectural Forum* (Boston, 1892–1923; New York, 1923–74). At their inception, these periodicals served limited readerships, such as the brick industry or draughtsmen. As they evolved from their narrow focus and traditional outlook into the broader concerns of the profession and the world around them, they produced material such as the *Architectural Record*'s series on building types.

In terms of periodicals on photography, Stieglitz's *Camera Notes* was followed by the epoch making *Camera Work* (New York, 1903–17), a consummately crafted production presenting the work of the Photo-Secession, a group of Pictorialists formed by Stieglitz in 1902; beginning in 1908, five years before the Armory Show, it started to introduce the work of European and American modernists to American audiences. Although it was read by an élite, rather than the general public, it was a landmark in American art-periodical publishing, presaging the currents of change in the American art world.

BIBLIOGRAPHY

H. E. Roberts: *American Art Periodicals of the Nineteenth Century* (MA thesis, Seattle, U. WA, 1961)
S. T. Lewis: 'Periodicals in the Visual Arts', *Lib. Trends*, x (1962), pp. 330–52
S. Stephens: 'Architectural Journalism Analyzed: Reflections on a Half Century', *Prog. Archit.*, li (1970), pp. 133–9
J. Green: *Camera Work: A Critical Anthology* (New York, 1973)
J. T. Butler: 'Art and Antiquarian Periodicals in the United States', *Connoisseur*, cxci (1976), pp. 210–14
T. Fawcett and C. Phillpot, eds: *The Art Press: Two Centuries of Art Magazines* (London, 1976)
B. Diamonstein, ed.: *The Art World: A Seventy-five-year Treasury of ARTnews* (New York, 1977)
W. J. Dane: 'Serials and Periodicals on the Visual Arts', *Arts in America: A Bibliography*, ed. B. Karpel, iii (Washington, DC, 1979), pp. Si–Sxxxi; S1–S253
B. Newhall: 'Photography: Serials and Periodicals', *Arts in America: A Bibliography*, ed. B. Karpel, iii (Washington, DC, 1979), pp. N296–N348
W. D. Hunt, ed.: *Encyclopedia of American Architecture* (New York, 1980), pp. 328–33
S. R. Gurney: 'A Bibliography of Little Magazines in the Arts in the USA', *A. Libs J.*, vi (1981), pp. 12–49
M. Tomlan: *Popular and Professional American Architectural Literature in the Late Nineteenth Century* (diss., Ithaca, NY, Cornell U., 1983)
R. Prestiano: *The Inland Architect: Chicago's Major Architectural Journal, 1883–1908* (Ann Arbor, MI, 1985)
A. Freeman: 'Architecture: The Autobiography of a Magazine', *Architecture* [USA], lxxvi (1987), pp. 65–71
M. A. Tomlan: 'Architectural Press, US', *Encyclopedia of Architecture, Design, Engineering and Construction*, ed. J. A. Wilkes, i (New York, 1988), pp. 266–94
M. N. Woods: 'The First American Architectural Journals: The Profession's Voice', *J. Soc. Archit. Historians*, xlviii (1989), pp. 117–38
G. W. Kiefer: 'The Leitmotifs of *Camera Notes*, 1897–1902', *Hist. Phot.*, xiv (1990), pp. 349–60
M. N. Woods: 'History in the Early American Architectural Journals', *Stud. Hist. A.*, xxxv (1990), pp. 77–89
W. Marder and E. Marder: 'Nineteenth-century American Photography Journals: A Chronological List', *Hist. Phot.*, xvii (1993), pp. 95–100
Alfred Stieglitz's Camera Notes (exh. cat., ed. C. A. Peterson; Minneapolis, MN, Inst. A., 1993)
M. M. Schmidt, ed.: *Index to 19th-century American Art Journals* (in preparation) [covers about 35 titles]
W. M. Yao, ed.: *International Art Periodicals* (in preparation) [covers about 100 titles]
M. Culbertson, ed.: *American House Designs: An Index to Popular and Trade Periodicals, 1850–1915* (Westport, CT and London, 1994)
E. M. Thomson: 'Early Graphic Design Periodicals in America', *J. Des. Hist.*, vii/2 (1994), pp. 113–26
J. F. Roche: 'Scattered Leaves: Morris's Men in America and the Polemical Magazine', *J. Pre-Raphaelite Stud.*, iv (Autumn 1995), pp. 93–104

WINBERTA M. YAO

Perry [née Cabot], **Lilla Cabot** (*b* Boston, MA, 13 Jan 1848; *d* Hancock, NH, 1933). American painter and writer. She belonged to the East Coast upper middle class, and her paintings reflect her social position and era. She was ahead of her time, however, in admiring and advocating the French Impressionist painters. In 1874 she married Professor Thomas Sargeant Perry, a specialist in 18th-century English literature. Their home became a meeting place for intellectuals. She studied during the 1880s at Cowles School in Boston and later at the Académie Julian and Académie Colarossi in Paris with Alfred Stevens. In 1889 she met Claude Monet (1840–1926), who became a friend and mentor. During the summers of ten years she was a neighbour to Monet in Giverny, coming to know both him and Camille Pissarro well. (Her house was bought in 1987 by American collector Daniel J. Terra to be made into the Musée Américain, to house works primarily by American Impressionists; a new building was, however, opened for this purpose eventually.) Her style of painting reflects their common interest in the depiction of light, the materiality of paint and the dissolution of form. The paintings themselves, however, were not as radical as theirs and showed more attention to detail (e.g. *The Trio (Alice, Edith and Margaret Perry)*, *c.* 1898–1900; Cambridge, MA, Fogg; see fig.). From 1893 she spent eight years in Tokyo, where her husband had taken up a teaching post, and made many paintings of Japanese life and scenery, using the technique she had developed in France. She was an amateur artist but enjoyed a good critical reputation in her time, exhibiting in Boston and New York, as well as in Europe. Perry also wrote poetry, of which she published four volumes between 1886 and 1923.

BIBLIOGRAPHY

Lilla Cabot Perry: A Retrospective Exhibition (exh. cat., Washington, DC, N.G.A., 1969) [entry by S. P. Feld]
A. Sutherland Harris and L. Nochlin: *Women Artists, 1550–1950* (New York, 1976)
C. Streifer Rubinstein: *American Women Artists from Early Indian Times to the Present* (Boston, 1982)
D. Birmingham: '*The Black Hat* by Lilla Cabot Perry', *Currier Gal. A. Bull.*, (autumn 1986), pp. 2–23
M. Martindale with P. Moffat: *Lilla Cabot Perry: An American Impressionist* (Washington, DC, 1990)
Community of Creativity: A Century of MacDowell Colony Artists (exh. cat., Manchester, NH, Currier Gal. A., and New York, Nat. Acad. Des., 1997)

□

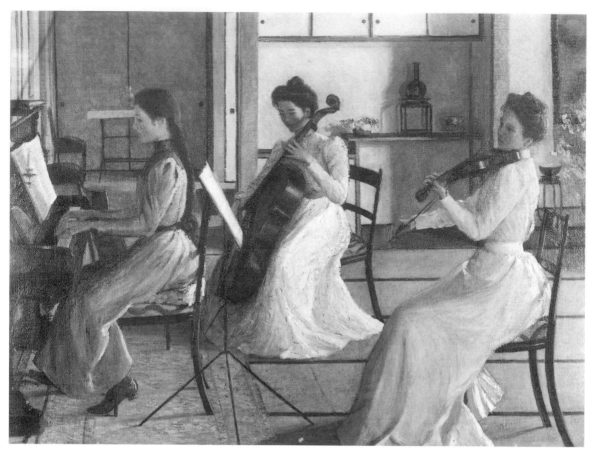

Lilla Cabot Perry: *The Trio (Alice, Edith and Margaret Perry)*, oil on canvas, 730×987 mm, *c.* 1898–1900 (Cambridge, MA, Fogg Art Museum)

Peto, John F(rederick) (*b* Philadelphia, PA, 21 May 1854; *d* New York, Nov 1907). American painter. He trained at the Pennsylvania Academy of Fine Arts (1877–8), Philadelphia, where he became a friend of William Michael Harnett whose work was a dominant influence on his oeuvre. Peto maintained a studio in Philadelphia, exhibiting at the Academy from 1879 to 1887; he earned a living through occasional work as a photographer, sculptor and painter. After moving to Island Heights, NJ, in 1889, he stopped exhibiting at the Academy and sank into obscurity.

Peto's *trompe l'oeil* paintings are composed of humble, discarded, worn objects: old books, fishing-gear, lanterns, scraps of paper, small paintings and photographs. While in Philadelphia, he often painted 'office boards' for businessmen's offices. They consisted of papers secured by a network of tapes nailed to a primitive bulletin board. Some include painted photographs of the men who commissioned them. Two examples are *Old Souvenirs* (1881; New York, Met.; see fig.), which features a photograph of his daughter and includes one of his trademarks—a tan-orange envelope imprinted 'Important Information Inside'—and *Old Time Letter Rack* (1894; Taylor, MI, R. A. Manoogian priv. col., see 1983 exh. cat., p. 218). Both of these paintings bear Harnett's signature. This is the work of an unscrupulous dealer who in 1905 purchased many of Peto's paintings, had the signature forged and sold the

John F. Peto: *Old Souvenirs*, oil on canvas, 679×559 mm, 1881 (New York, Metropolitan Museum of Art)

works as Harnett's. It was not until the 1940s that Frankenstein uncovered these deceptions.

While Peto was indebted to Harnett for some subject-matter and compositional devices, his style and mood are different. His technique is soft-edged, his brushwork broad with a flat, powdery surface, and his colour subdued but true, often enlivened by areas of bright blues, oranges, reds and lavenders. Peto worked slowly and laboriously, often changing elements in a work or painting one composition over another. The battered objects he favoured are bathed in a soft light, as in the pyramid of old books, *Discarded Treasures* (1904; Northampton, MA, Smith Coll. Mus. A.). A dark moodiness pervades *Still-life with Lanterns* (c. 1890; New York, Brooklyn Mus. A.), while a subtle whimsy enlivens *Poor Man's Store* (1885; Boston, MA, Mus. F.A.), in which the two hanging signboards 'Lodging' and 'Good Board $3.00 a week' strike a personal note, since Peto's wife took in summer boarders who sometimes bought his paintings.

BIBLIOGRAPHY
A. Frankenstein: 'Harnett: True and False', *A. Bull.*, xxxi (1949), pp. 38–56
——: *After the Hunt: William Michael Harnett and Other American Still-life Painters* (Berkeley, 1953, rev. 2/1969), pp. 99–111
Important Information Inside: The Art of John F. Peto and the Idea of Still-Life Painting in Nineteenth Century America (exh. cat. by J. Wilmerding, Washington, DC, N.G.A., 1983); review by J. Dreiss in *A. Mag.*, lvii/8 (1983), p. 19
J. Drucker: 'Harnett, Haberle and Peto: Visuality and Artifice among the Proto-Modern Americans', *A. Bull.*, lxxiv (1992), pp. 37–50

GERTRUDE GRACE SILL

Philadelphia. American city in Pennsylvania, located on the west bank of the Delaware River at the point where it is joined by the Schuylkill River, about 160 km inland, north of Delaware Bay. The largest city in the state, Philadelphia was founded in 1682 and was the capital of the federal government between 1790 and 1800. It is an important port and an industrial, commercial and cultural centre.

1. History and urban development. 2. Art life and organization. 3. Centre of furniture production.

1. HISTORY AND URBAN DEVELOPMENT.

(i) William Penn's proprietary commonwealth, 1681–1701. (ii) 18th-century development. (iii) 19th-century decline and revival.

(i) William Penn's proprietary commonwealth, 1681–1701. Philadelphia originated from the utopian values of its Quaker founder, William Penn (1644–1718), who planned it without walls or fortifications and welcomed to it all nationalities and religious groups. Penn's father, Admiral William Penn (d 1670), made loans to King Charles II, which were repaid in 1681 in the land grant that became Pennsylvania. Idealism and English landed class values shaped the Philadelphia of the 17th century and the early 18th, making Penn a key figure in the future of the city.

In 1682 Penn's surveyor, Thomas Holme (1624–95), drew a plan for the 'City of Brotherly Love' located on the narrow waist of a peninsula bounded by the two rivers. It was sited so as to avoid nearby Swedish settlements. The plan recalled Roman military camps, with a central square intersected at right angles by main streets that divided the

urban space into quarters. That 'Centre Square' was to contain the Quaker Meeting, market and public buildings, and secondary squares were laid out near the centre of each quarter.

Because Penn hoped to attract the landed gentry, rather than a mercantile class, sizeable city lots were awarded to those who purchased large plantations in the outlying colony. It was expected that on these city lots would be built manor houses with outbuildings set in gardens to create 'a greene Country Towne'. The so-called 'slate-roofed house' of one of the wealthiest Quakers, Samuel Carpenter, an H-plan, late medieval residence (c. 1692; destr. 1866), probably represented Penn's expectations. However, few such houses were built in the Quaker community, but numerous substantial brick houses had been erected by 1701, when Penn granted the town its city charter and created its government of mayor and aldermen.

(ii) 18th-century development. The plan survived, but the middle-class colonists who came to Pennsylvania rapidly subverted Penn's design, petitioning for the removal of the market, Centre Meeting and Court House from the Centre Square to Second Street near the Delaware River, where a significant port evolved with docks and warehouses and a dense village of two- and three-storey brick row houses. This area then developed its own market shambles and religious buildings at the south end and, later, at the north end of Second Street. Benjamin Franklin (1706–90), who arrived in Philadelphia in 1723, founded many of the city's institutions, including the first subscription library (the Library Company, 1731), its first college (1740; now the University of Pennsylvania), the nation's first scientific institution (the American Philosophical Society, 1743) and the first hospital (Pennsylvania Hospital, begun 1755; Pine Street). With the new churches and government buildings, these formed an urban core that was unified by its material—brick with wood or marble trim—in styles that followed, with some delay, English taste. Relying on amateur architects, such as Dr John Kearsley (1676–1741) at the Episcopalian Christ Church on Second Street (1727), or sophisticated gentlemen, such as Andrew Hamilton (1676–1741) at the State House, Fifth Street (1732), local builders were responsible for most of the work. One of the few architects with a European training was ROBERT SMITH, whose works included the steeple of Christ Church (1753), St Peter's Church (begun 1758) and Carpenters' Hall on Chestnut Street (1768).

Because of Penn's charter, Philadelphia enjoyed a cosmopolitan population drawn from many of the dissenting groups in Europe, a fact that was visible in the city by the remarkabled variety of churches. This drew the attention of Swedish naturalist Pehr Kalm (*Travels in North America*, trans. John Foster, 1770–71) who visited the city in 1748 and noted the many churches and peoples:

> *Freedom.* Everyone who acknowledges God to be the Creator...is at liberty to settle, stay and carry on his trade here, be his religious principles ever so strange. No one here is molested because of misleading principles of doctrine which he may follow...And he is so well secured by the laws, both as to person and property, and enjoys such liberties that a citizen may here, in a manner, be said to live in his house like

a king. It would be difficult to find anyone who could wish for and obtain greater freedom.

It was this religious tolerance that made Philadelphia the setting for the first and second Continental Congresses and later for the Constitutional Convention, as well as the seat of the new national government from 1790 to 1800 (when Washington, DC, was established as capital); all of this resulted in a number of impressive buildings (see fig. 1).

Beyond the city limits were the new Palladian country seats, which were located near the Schuylkill River on the hills above Fairmount. Many of these houses survive because they were later incorporated into Fairmount Park, a vast green that cuts through the centre of the city. An important example is Belmont Mansion, built 1743–51 by lawyer Richard Peters. With a population of nearly 50,000, revolutionary-era Philadelphia was the second largest English-speaking city after London and the principal metropolis of the new nation. By 1800, the city had reached the limits of its first period of growth, hampered by a lack of clean water, the difficulty of crossing the Schuylkill and, with the loss of Federal and State governments, confronted a seemingly bleak future.

(iii) 19th-century decline and revival. An arched wooden bridge crossed the Schuylkill by 1800, and the same year BENJAMIN HENRY LATROBE's steam-powered waterworks

provided clean water across the city through wooden pipes. Pump failures made it unreliable, but within a decade new waterworks guaranteed the future of the city. Latrobe's presence here signified Philadelphia's continuing attraction for immigrants as the nation's creative centre for literature and the arts. In architecture there followed a group of classically inspired public buildings by Latrobe, his pupils and imitators. The marble pump-house of Latrobe's waterworks (1799–1801; destr. *c.* 1827) and the Second Bank of the United States (1819–24; *see* STRICKLAND, WILLIAM, fig. 1), which was inspired by the Athenian Parthenon, the US Mint (1829–33; destr. 1902) and the US Naval Asylum (1826–33), later Biddle Hall on Grays Ferry Avenue, all by Latrobe's pupil William Strickland, stood out in colour and scale in the brick Quaker city. These gave it its new identity as the 'Athens of America', a slogan developed by financier Nicholas Biddle (1786–1844) during his battle with President Jackson to maintain Philadelphia as the national centre of banking. As executor of the will of banker Stephen Girard (1750–1831), Biddle chose Thomas U. Walter to design the Grecian temple for Girard College for Orphans (1835–48; for illustration *see* WALTER, THOMAS U.) on Corinthian and Girard avenues, which dominated the city.

The mature Gothic Revival style was introduced in the 1840s by John Notman, who came from Scotland and who was the designer of the Athenaeum (1845; for

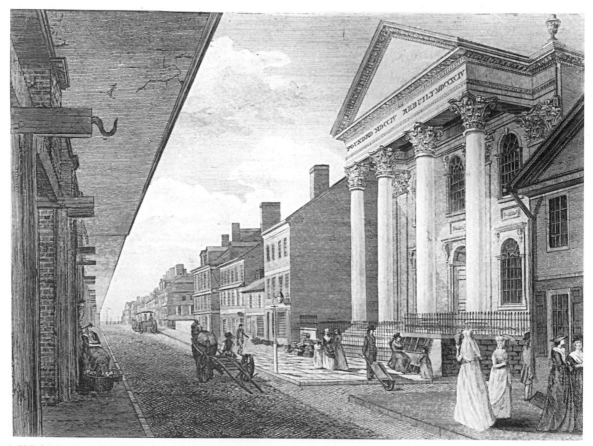

1. Philadelphia, Second and High streets; engraving by William Birch, 1800

illustration *see* NOTMAN, JOHN) and St Mark's Church (1847–52). Terraced rows of brick houses, modelled on those of London, housed the old gentry while new suburban villas and Italianate mansions reflected the growing mercantile and industrially based fortunes. By 1850 the population was nearly 500,000, housed mostly in row houses, made possible by the nation's first savings and loan society. These houses determined Philadelphia's low-scale, anti-monumental character.

By 1857 Philadelphia was the nation's premier manufacturing centre because of its central location, access to raw materials, transport and willing population. The Pennsylvania Railroad, organized in 1847, became the nation's largest rail network and by 1900, with a population of 1.5 million, the city proclaimed itself the 'World's Greatest Workshop', with a diversified economy producing the bulk of the country's textiles, leather goods, machinery and pharmaceuticals. In 1854 the outlying county, independent villages such as Germantown and Holmesburg and the industrial suburb of Manayunk had been incorporated into the city. Congestion near the old State House led to the erection of new government buildings (begun 1871) at Penn's original location, Centre Square (see fig. 2. Gradually the financial and commercial districts also moved to Broad Street, thus creating the modern down-

town and superseding the 18th-century civic core near the Delaware River.

After the Civil War, Philadelphia was one of the wealthiest cities in the world on a per-capita basis. This wealth was made possible because Philadelphia industrialists in the second half of the 19th century had directed the transformation of manufacturing towards modern production practices and then had spread the fruits of that productivity in higher wages. Before the Civil War, in plants such as the Balwin Locomotive Works, piecework rates made it possible for individual workers to attain a high rate of pay based on personal initiative and skill. After the Civil War, Philadelphia industrialists separated production from its craft roots in workshops through industrial standardization, which was led by William Sellers, and fostered through the Franklin Institute of which he was president. The standardization movement ended the isolation of individual workshops by linking them to the goals of their clients, particularly the Pennsylvania Railroad, which made standardization its corporate policy. As the home of the Pennsylvania Railroad and the nation's leading centre of applied research in the Franklin Institute, Philadelphia businesses shaped the national standards, learnt of changes earlier than their competitors and triumphed in head to head competition. A third innovation occurred at

2. Philadelphia, City Hall and Penn Centre, aerial view

the end of the 19th century, when Frederick Winslow Taylor's idea of scientific management radically reshaped every aspect of work practices, producing remarkable increases in productivity. Like the modern technology that underlay the old-fashioned stylistic overlay of City Hall, these achievements signalled the potency of Victorian progressivism that made possible the triumphant turn-of-the-century city awash in industrial wealth. It was this city that the world visited for the 1876 International Exhibition, seeing there innovations in machine design and systemization of manufacturing that were shortly spread worldwide. The perceptive visitor would have also seen the first fruits of the rising consumer culture, characterized by hundreds of thousands of individual rowhouses and a degree of leisure that was unprecedented in the labouring classes. With factories set among row houses, regional commercial districts and institutions, Philadelphia took its mature form of a small financial and government centre surrounded by self-sufficient neighbourhoods connected to the core by rail transport.

By the 1870s, the built-up area of the city covered 130 sq. km. Brick, the material of the Colonial city of industry and the new workers' row houses, was the material of choice for Philadelphia architects, giving it a darkness of tone that soon contrasted with other turn-of-the-century cities. A strident and unconventional regional architecture reflected the progressive values of community whose leaders were engineers and industrialists. Frank Furness's Academy of Fine Arts by (1871–6) and the Library of the University of Pennsylvania (1888–91; *see* FURNESS, FRANK, fig. 2) and the structural innovations of the Wilson Brothers, particularly the remarkable clear span train sheds for Broad Street Station (1892–3; destr. 1956) and Reading Terminal (1893–5) exemplify the daring use of modern construction systems with aesthetic intent.

In the early 20th century, a flood of young artists, including John Sloan, William Glackens and Robert Henri, left Philadelphia, and older creative architects lost out to younger historicist designers. WILLIAM L. PRICE, the most important of Furness's students to remain in the city, was forced to depend on midwestern industrialists and New Jersey seashore hotel operators for commissions. His Arts and Crafts community at Rose Valley, 15 km to the west of the city, represented an attempt to resolve the conflicts of 'Taylorism'. Simultaneously, the gentry regained control of many of the city's institutions, proposing to move the college of the University of Pennsylvania to the suburbs and drastically cutting public school budgets.

BIBLIOGRAPHY

J. Mease: *The Picture of Philadelphia, Giving an Account of its Origins, Increase and Improvements* (Philadelphia, 1811)

R. A. Smith: *Philadelphia as It Is in 1852* (Philadelphia, 1852)

E. T. Freedley: *Philadelphia and its Manufactures in 1857* (Philadelphia, 1858)

J. Scharf and T. Westcott: *History of Philadelphia, 1609–1884*, 3 vols (Philadelphia, 1884)

T. White, ed.: *Philadelphia Architecture in the 19th Century* (Philadelphia, 1953)

E. Baltzell: *Philadelphia Gentlemen: The Making of a National Upper Class* (Glencoe, IL, 1958)

A. Garvan: 'Proprietary Philadelphia as Artifact', *The History and the City*, ed. O. Handlin and J. Burchard (Cambridge, MA, 1963)

S. Warner: *The Private City: Philadelphia in Three Periods of its Growth* (Philadelphia, 1968)

J. O'Gorman, G. Thomas and H. Myers: *The Architecture of Frank Furness* (Philadelphia, 1973)

E. Teitelman and R. Longstreth: *Architecture in Philadelphia: A Guide* (Cambridge, MA, 1974)

T. Hershberg, ed.: *Philadelphia: Work, Space, Family and Group Experience in the 19th Century* (New York, 1981)

R. Weigley, ed.: *Philadelphia: A Three Hundred Year History* (New York, 1982)

W. Ayers, ed.: *A Poor Sort of Heaven, a Good Sort of Earth: The Rose Valley Arts and Crafts Experiment* (Chadds Ford, PA, 1983)

S. Tatman and R. Moss: *Biographical Dictionary of Philadelphia Architects, 1700–1930* (Boston, 1985)

J. O'Gorman, J. Cohen, G. Thomas and G. Perkins: *Drawing towards Building: Philadelphia Architectural Graphics, 1732–1986* (Philadelphia, 1986) [excellent pls and bibliog. on Philadelphia architects]

M. Page: 'From "Miserable Dens" to the "Marble Monster": Historical Memory and the Design of Courthouses in Nineteenth-century Philadelphia', *PA Mag. Hist. & Biog.*, cxix/4 (1995), pp. 299–343

2. ART LIFE AND ORGANIZATION. The arts in Philadelphia can be said to have originated by grafting on to Quaker ideals the values of other English immigrants who sought economic rather than philosophical advantage and who linked the region's artistic interests to the class values of the English society to which they belonged. Quaker encouragement of religious and cultural diversity also shaped the distinctive character of art in Philadelphia, which emphasized individualism and an untheoretical realism that survived well into the 20th century, transcending wider movements in art.

As a result of a substantial community of craftsmen and the number of painters working in the city, during the 18th century Philadelphia became a centre for the training of artists, and considerable sophistication was expected of them. Imported objects, newly arrived artisans from Europe and, after 1750, the use of pattern-books kept the city in touch with innovations of fashion and technique. Unlike craftsmen, painters were not apprenticed and depended on helpful advice from older artists, books of theory and the opportunity to study the work of others. All these approaches are obvious in the work of Benjamin West, who moved to Philadelphia in 1756. There he acquired several important patrons, two of whom, the Allens and the Shippens, made it possible for him to go to Italy in late 1759. From there he went to London, where he produced his great history paintings, including *William Penn's Treaty with the Indians* (1771–2; Philadelphia, PA Acad. F.A.), which celebrated his native state. His studio in London became a centre for fellow Americans who benefited from his influence, including the portrait painters Charles Willson Peale, who moved to Philadelphia in 1776 and remained there until the end of his life, and Gilbert Stuart, who was based in Philadelphia between 1796 and 1800. The disadvantages of the lack of organized training in the arts in North America were obvious to those who had studied in Europe. In 1794 Peale played a leading part in the foundation by a group of artists of the Columbianum in Philadelphia, which was intended to support regular exhibitions and a school, but the organization lasted for only one year. At the same time Peale also constructed a museum adjacent to his home. The contents consisted chiefly of natural curiosities and his portraits of the heroes of the American Revolution (now at Independence National Historical Park).

In 1805 the Pennsylvania Academy of the Fine Arts was founded with Peale, his son Rembrandt Peale and the

sculptor William Rush as the only artist members, for unlike the Columbianum its founders came principally from the legal and business community. Originally no provision was made for exhibitions or a school, and in 1810 the Society of Artists of the United States was organized in protest. In the following year the Academy established an honorary membership of Academicians and a life class, which functioned sporadically through the middle of the 19th century. Nevertheless the Academy served as a focal-point for artists in the city, particularly through its annual exhibitions, which began in 1811. As the century progressed, other forms of training became available, including private study and the curriculum of public schools. There was a considerable variety of art to be seen in Philadelphia, and this, combined with the lack of methodical instruction, produced some naive but sophisticated original work by such painters as Bass Otis and William E. Winner (c. 1815–83). There was no formal instruction for sculpture until late in the century. Even William Rush considered himself a 'carver'. After Peale and his family, Thomas Sully and then John Neagle dominated the art of portraiture in Philadelphia. Neagle also painted landscapes but Sully had a wider repertory, including historical subjects. As a result of the prominence of the city's publishing industry, there was a rapid growth of commercial painting, and this led to the work of a number of professional illustrators, such as Felix Octavius Carr Darley. Publishing reached a highpoint with the appearance of John James Audubon's *Viviparous Quadrupeds of North America* (pl. 13, 1845–8), which was printed by John T. Bowen (1801–56) in Philadelphia.

In 1855 the Academy made an attempt to re-establish its school. In 1868 Christian Schussele (?1824–79) was appointed first Professor of Drawing and Painting, and in its new building, opened in 1876, Frank Furness and George Watson Hewitt (1841–1916) included classrooms. Thomas Eakins, who worked in Philadelphia throughout his life, started to teach at the Academy in 1876. He became Director of Instruction in 1882 but was forced to resign in 1886 in a dispute over his insistence on teaching with the assistance of a nude model in mixed classes of men and women. Eakins's emphasis on the study of the human figure as the basis of art was continued in a more relaxed manner by his former students such as Thomas Anshutz (see fig. 3). Towards the end of the century, under such teachers as William Merritt Chase and Cecilia Beaux, the study of the nude model became less central to the Academy's method.

During the early part of the 19th century artists could see pictures hanging in various public buildings in the city. The annual exhibitions of the Pennsylvania Academy and the Academy's own collection of prints and drawings were also of considerable importance. The influence of the vast Centennial Exposition of 1876 was, however, unparalleled in the history of the city. The Fine Arts section was designed to show American work in relation to that of foreign artists. In this way paintings and sculptures by many well-known artists were introduced to hundreds of thousands of Americans. It was responsible for inspiring John G. Johnson, whose great collection, mainly of European Old Masters, is now in the Philadelphia Museum of Art. The interest thus generated in the work of

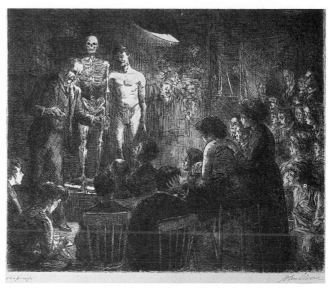

3. John Sloan: *Anshutz on Anatomy*, etching, 185×225 mm, 1912 (Philadelphia, PA, Museum of Art)

craftsmen, artisans and manufacturers led to the creation in 1876 of the Pennsylvania Museum and School of Industrial Art. Modelled on the educational facilities of the South Kensington Museum (now the Victoria and Albert Museum) in London, the classes of the school were organized to provide industry with the technological skills required. Throughout the 19th century the industrial wealth of the city was being used for art patronage, both of contemporary American artists and of European Old Masters. Major collectors at the turn of the century included John G. Johnson and the Widener, Wilstach and Elkins families.

Although teaching methods at the Academy had become more conservative by the end of the 19th century, Philadelphia's role as a centre of industry and progress attracted such students as Robert Henri, William J. Glackens, John Sloan and others. Their determination to reflect the social impact of industrialization won them the name ASHCAN SCHOOL when they regrouped in New York in 1903. Nevertheless the Academy remained receptive to new ideas, and when the sensational exhibition in 1908 by THE EIGHT (which included the work of five ex-Philadelphians) closed in New York, it transferred to the Academy galleries in Philadelphia. Travelling scholarships between 1900 and 1914, the period during which New York became established as the artistic centre for the USA, enabled many Academy students to see avant-garde European art.

BIBLIOGRAPHY

E. S. Strahan, W. Smith and J. M. Wilson: *The Masterpieces of the Centennial International Exhibition* (Philadelphia, 1876–8)
M. Fielding: *Dictionary of American Painters, Sculptors and Engravers* (Philadelphia, 1926)
C. Sellers: *Charles Willson Peale*, 2 vols (Philadelphia, 1947)
A. Rutledge: *Cumulative Record of Exhibition Catalogues: The Pennsylvania Academy of the Fine Arts, 1807–70; the Society of Artists, 1800–14; the Artists Fund Society, 1835–45* (Philadelphia, 1955)
I. Glackens: *William Glackens and the Ashcan Group: The Emergence of Realism in American Art* (New York, 1957)
G. Hendricks: *The Life and Work of Thomas Eakins* (New York, 1974)

D. Sewell, ed.: *Philadelphia: Three Centuries of American Art* (Philadelphia, 1976) [excellent pls and bibliog. on major Philadelphia artists]

GEORGE E. THOMAS

3. CENTRE OF FURNITURE PRODUCTION. Before 1700 Philadelphia patronage supported London-trained cabinetmakers, chairmakers, upholsterers and gilders. Walnut-wood, used only as a veneer in London because it was rare, was so plentiful around Philadelphia that such joiners as Edward Evans (1679–1754) made furniture and panelled ships' cabins with solid, black walnut. Turners used it to make barley-twist chair designs and flaring trumpet-shaped legs for chests-of-drawers and dressing-tables. Early chairmakers were known for the subtlety and strength of their curvaceous, late Baroque designs (*see* UNITED STATES OF AMERICA, fig. 28), and cabinetmakers developed and refined the forms of high chests (tallboys; *see* UNITED STATES OF AMERICA, fig. 30) and dressing-tables embellished with scrolled pediments, cabriole legs and carved aprons in the Rococo style.

In 1763 the Scottish cabinetmaker THOMAS AFFLECK came to Philadelphia with a copy of the *Gentleman and Cabinet Maker's Director* (1754) by Thomas Chippendale (1718–79). He produced conservative, architecturally inspired, mahogany case furniture, sofas and chairs for 30 years for Philadelphia Quakers. Such furnituremakers as Affleck, BENJAMIN RANDOLPH, WILLIAM SAVERY and Plunkett Fleason (1712–91), a prominent upholsterer, were active in the civic life of the city.

In 1765 renewed impetus was given to Philadelphia's furniture industry after the introduction of the Non-Importation Agreement. Patrons challenged craftsmen to produce fine furniture to compete with imports from London. In 1772 John Cadwalader (1742–86), a conspicuous activist in the cause, commissioned Charles Willson Peale to paint the *Cadwalader Family* (Philadelphia, PA, Mus. A.; see fig. 4) and to include in the composition one of the elaborately carved card-tables (Philadelphia, PA, Mus. A.) that he had ordered in 1770 from Benjamin Randolph's shop.

From 1790 to 1800 Philadelphia was the capital and also the social and political centre of the USA. In 1794 the journeymen-cabinetmakers staged a labour strike to force shop owners to adopt regulations regarding hours and wages. Furniture designs from London continued, but French influence became important as a result of the influx of members of the aristocracy seeking refuge from the Reign of Terror and of imports by such francophiles as Robert Morris (1734–1806) and Thomas Jefferson. Benjamin Henry Latrobe, an architect and designer, arrived in 1798, and introduced Philadelphians to Classicism. His house scheme for William Waln in 1805 included wall paintings based on John Flaxman's illustrations for Homer's *Iliad* and a suite of furniture painted and gilded with designs adapted from *Recueil des décorations intérieures* (1801) by Percier and Fontaine.

Furniture made in the mid-19th century by the German-trained cabinetmakers Gottlieb Vollmer (1816–83) and Daniel Pabst (1827–1910) introduced the eclectic styles, as seen in the international exhibitions, into Philadelphia parlours. From 1880, after the Centennial Fair of 1876,

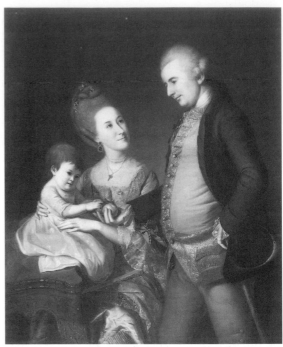

4. Charles Willson Peale: *Cadwalader Family*, oil on canvas, 1.31×1.05 m, 1772 (Philadelphia, PA, Philadelphia Museum of Art)

Philadelphian craftsmen adopted the Colonial Revival style.

BIBLIOGRAPHY
N. B. Wainwright: *Colonial Grandeur in Philadelphia: The House and Furnishings of General John Cadwalader* (Philadelphia, 1964)
J. J. Snyder, ed.: *Philadelphia Furniture and its Matters* (New York, 1975)
Philadelphia: Three Centuries of American Art (exh. cat., Philadelphia, PA, Mus. A., 1976)
B. B. Garvan: *Federal Philadelphia 1785–1825: The Athens of the Western World* (Philadelphia, 1987), pp. 90–93
D. Ducoff-Barone: 'Philadelphia Furniture Makers, 1816–1830', *Antiques*, cxlv/5 (1994), pp. 742–55
J. L. Lindsey: 'The Cadwalader Town House and its Furnishings, Philadelphia', *Bull.: Philadelphia Mus. A.*, xci (Autumn 1996), pp. 10–23

BEATRICE B. GARVAN

Phillips, Ammi (*b* Colebrook, CT, 24 April 1788; *d* Curtisville [now Interlaken], MA, 11 July 1865). American painter. Apparently self-taught, he began his prolific and successful career as a portrait painter *c.* 1811. During his lifetime, he moved several times across the borders of New York, western Connecticut and Massachusetts in search of commissions. Like many of the itinerant artists of the 19th century, he struggled to achieve pictorial solutions and a distinctive style, yet he developed so dramatically that historians originally classified his paintings as the work of two different artists: 'The Border Limner' and 'The Kent Limner'. The earliest works, from his 'Border' period (*c.* 1812–19), are marked by simple forms, shaded outlines and soft, pastel colours. They include ambitious full-length portraits (e.g. *Harriet Leavens*, *c.* 1815; Cambridge, MA, Fogg; see fig.) as well as three-quarter and bust-length examples (*Dr Russell Dorr*, *c.* 1814–15; Williamsburg, VA, Rockefeller Flk A. Col.). In the 1820s he experimented with techniques and formats, developing an attention to detail and naturalism that

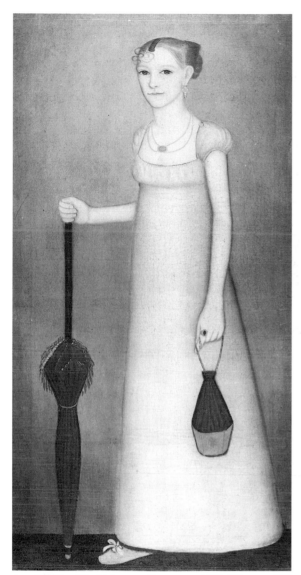

Ammi Phillips: *Harriet Leavens*, oil on canvas, 1448×711 mm, *c.* 1815 (Cambridge, MA, Fogg Art Museum)

BIBLIOGRAPHY
B. Holdridge and L. Holdridge: *Ammi Phillips: Portrait Painter, 1788–1865* (New York, 1968)
J. Lipman and T. Armstrong, eds: *American Folk Painters of Three Centuries* (New York, 1980), pp. 139–44
Revisiting Ammi Phillips: Fifty Years of American Portraiture (exh. cat. by S. C. Hollander and H. P. Fertig, New York, Mus. Amer. Flk A.; San Diego, CA, Mus. A.; Chicago, IL, Terra Mus. Amer. A.; 1994)
American Folk Art in the Metropolitan Museum of Art (exh. cat. by C. Rebora Barratt, New York, Met.,1999–2000)

SALLY MILLS

Photo-Secession. Group of mainly American Pictorialist photographers founded by ALFRED STIEGLITZ in New York in 1902, with the aim of advancing photography as a fine art. Stieglitz, who chose the organization's name partly to reflect the Modernism of European artistic Secession movements, remained its guiding spirit. Other leading members included Alvin Langdon Coburn, Gertrude Käsebier, Edward Steichen and Clarence H. White. The Secession also exhibited and published work by Europeans, for example Robert Demachy (1859–1936), Frederick H. Evans (1853–1943, Heinrich Kühn (1866–1944) and Baron Adolf de Meyer (1868–1949), who shared the Americans' attitude that photography was a valid medium of artistic expression.

All participants placed great emphasis on fine photographic printing. Their gum bichromate or platinum prints often emulated paint, pastel or other media, particularly in their use of soft focus, emphasis on composition and texture, and adoption of traditional academic subject-matter; in addition graphic signatures or monograms were often used. The Secession's shifting aesthetic concerns are well documented in the elegant magazine *Camera Work*, which Stieglitz edited (1903–17). From 1905 exhibitions were held regularly in New York at The Little Galleries of the Photo-Secession, 291 Fifth Avenue, later known as 291 (*see* <TWO NINE ONE>). In order to define photography's position among the arts, it was felt appropriate to exhibit contemporary American and European non-photographic works, and from 1908 there were more exhibitions of paintings than of photographs. After the Secession's last major photographic exhibition in 1910 at the Albright Art Gallery (now Albright–Knox Gallery) in Buffalo, NY, many disaffected Pictorialist photographers left the group, and it disbanded unofficially, although 291 remained open until 1917.

BIBLIOGRAPHY
R. Doty: *Photo-Secession: Photography as a Fine Art* (Rochester, 1960; rev. as *Photo-Secession: Stieglitz and the Fine Art Movement in Photography*, New York, 1978)
J. Green, ed.: *Camera Work: A Critical Anthology* (Millerton, 1973)
W. I. Homer: *Alfred Stieglitz and the American Avant-garde* (Boston, 1977)
——: *Alfred Stieglitz and the Photo-Secession* (Boston, 1983)
J. Munkacsi: *Selections from the Photo-Secession* (New York, 1986)
H. D. Adams: 'The Undiscovered Photo-Secessionist, William B. Dyer', *Hist. Phot.*, xii/4 (Oct–Dec 1988), pp. 281–93
G. W. Kiefer: *Alfred Stieglitz: Scientist, Photographer and Avatar of Modernism, 1880–1913* (New York and London, 1991)
Camera Work: Process and Image (exh. cat. by C. A. Peterson, Minneapolis, MN, Inst. A., 1985)
A. Hammond: 'Introduction: The Autochrome and the Photo-Secession', *Hist. Phot.*, xviii/2 (Summer 1994), p. 110
I. S. Wolins: 'Stieglitz & Modernism: Impresario of the Avant-Garde', *Amer. A. Rev.*, vi/2 (April–May, 1994), pp. 86–7, 168

BARBARA L. MICHAELS

suggests the influence of Albany portrait painter Ezra Ames. By the 1830s, the decade of his 'Kent' portraits, his compositions present his sitters as large, stylized shapes that nearly fill the canvas, while his use of rich, saturated colours creates striking contrasts of light and dark. Typically in this decade, his female sitters are shown leaning forward while male sitters sit upright with one hand draped over a chairback. Among his most appealing and successful works are portraits of children from this period. *Blond Boy with Primer, Peach and Dog* (*c.* 1838; priv. col., see Lipman and Armstrong, p. 143) exemplifies the bold simplicity of his compositions and the dramatic success of his designs. After the 1840s he returned to more conventional poses, and by the late 1850s his work showed the influence of photography. He continued to work at least until 1862, the year of his last dated paintings.

Duncan Phyfe: Phyfe Room, H. F. du Pont Winterthur Museum, Winterthur, Delaware, *c.* 1805

Phyfe, Duncan (*b* Loch Fannich, nr Inverness, 1768; *d* New York, 16 Aug 1854). American cabinetmaker of Scottish birth. He moved to America with his family about 1784 and settled in Albany, NY, where he served his apprenticeship. About 1792 he moved to New York and opened his own shop; his business prospered, and he moved to a new location on Partition Street. As his reputation spread, the most fashionable people in the city, including John Jacob Astor, William Bayard and De Witt Clinton, sought his services. His shop grew to be one of the largest in the city, and he shipped furniture to customers in New Jersey, Philadelphia and the south, particularly Charleston, SC.

Phyfe was an important disseminator of the new English Adam and Regency styles, and his name is synonymous with these neat Neo-classical styles as they developed in New York in the early 19th century. His best furniture is characterized by the use of dark Santo Domingo mahogany, reeding and carved water leaves, lyres, paw feet, swags, tassels, bowknots and cornucopia. In 1808 Phyfe made some of the earliest furniture in America with Empire details for Louisa Throop, including a French-style fall-front secretary with lion's paw feet (priv. col., see McClelland, pl. 284). The chairs have carved paw feet, sabre legs based on Grecian sources, lyre-shaped backs

and scrolled crest rails (priv. col., see McClelland, pl. 287). In 1837 his two sons, Michael Phyfe (*d* 1840) and James Phyfe (*b* 1797), joined him in the business. In that year he made a parlour suite for Samuel Foot in the heavier Empire style, which he later called 'butcher furniture' (New York, Met.). He retired in 1847, having amassed substantial property and a large fortune. His prolific shop and prominent clientele earned him a well-deserved reputation as one of the most influential American cabinetmakers in the early 19th century. Some pieces of furniture made by Phyfe can be seen in the Phyfe Room at the H. F. du Pont Winterthur Museum, Winterthur, DE (see fig.).

BIBLIOGRAPHY
N. McClelland: *Duncan Phyfe and the English Regency, 1795–1830* (New York, 1939/*R* 1980)
R. Reese: 'Duncan Phyfe and Charles-Honoré Lannuier: Cabinetmakers of Old New York', *A. & Ant.*, vii/5 (1982), pp. 56–61
OSCAR P. FITZGERALD

Piazzoni, Gottardo (Fidele Ponziano) (*b* Intragna, Switzerland, 14 April 1872; *d* Carmel Valley, CA, 1 Aug 1945). American painter, muralist, etcher and sculptor of Ticinese birth. He emigrated to California in 1887, following his father to the family ranch established in Carmel Valley, where he painted throughout his life. He studied

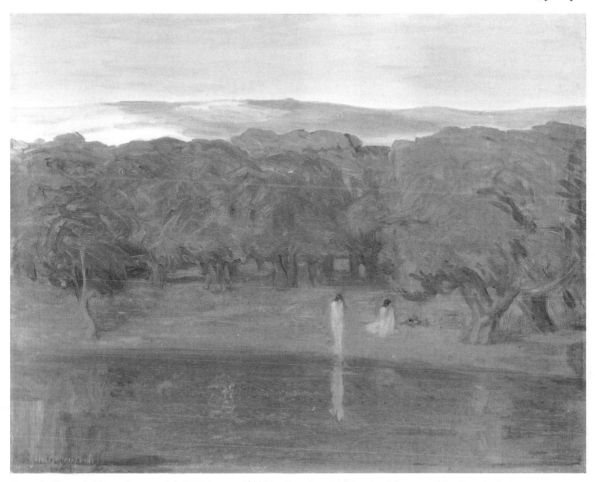

Gottardo Piazzoni: *Silence*, oil on panel, 674×796 mm, *c.* 1912 (San Francisco, CA, Fine Arts Museums of San Francisco)

in San Francisco at the California School of Design with Raymond Dabb Yelland (1848–1900) and Arthur F. Mathews, and subsequently in Paris (1895–8), much of that time with Jean-Léon Gérôme (1824–1904). Back in San Francisco, he established the Piazzoni Atelier d'Art in 1901 and commenced the life-long teaching career that established him as 'spiritual advisor and father confessor' to two generations of local painters. In 1902 he helped found the San Francisco Society of Artists to challenge the dominant Art Association and to expand exhibition opportunities for young artists. In periodic visits abroad, he sought out the most advanced forms of painting and infused his students with the spirit of innovation, while his own art remained rooted in the aestheticism of James McNeill Whistler, the symbolism of Pierre Puvis de Chavannes (1824–98) or of such contemporaries as Ferdinand Hodler (1853–1918), and the quietude of Japanese prints. Nature inspired poetic idylls such as *Silence* (*c.* 1912; see fig.) and *Lux Aeterna* (1914; both San Francisco, CA, F.A. Museums), as well as pure, highly reductive landscape studies in which horizon and colour alone convey the essential look and mood of coastal California.

BIBLIOGRAPHY

G. Hailey, ed.: 'Gottardo Piazzoni', *California Art Research* (San Francisco, 1936–7), vii, pp. 31–87

R. Rosenblum: 'The Primal American Scene', *The Natural Paradise: Painting in America, 1800–1950* (exh. cat., ed. K. McShine, New York, MOMA, 1976), p. 16

American Imagination and Symbolist Painting (exh. cat. by C. C. Eldredge, New York U., Grey A.G., 1979), p. 111

N. Boas and Marc Simpson: 'Pastoral Visions at Continent's End: Painting of the Bay Area, 1890–1930', *Facing Eden: 100 Years of Landscape Art in the Bay Area* (exh. cat., ed. S. A. Nash; San Francisco, CA, F.A. Museums, 1994), pp. 40–43

PATRICIA JUNKER

Pickett, Joseph (*b* New Hope, PA, 1848; *d* New Hope, 12 Dec 1918). American painter. The first 20 years of his working life were spent travelling with carnivals and running a shooting gallery. He may have gained early experience in painting through decorating carnival booths. Later, after settling in New Hope, PA, and opening a general store, he decorated his shop with a large mural and created canvases with house paints and cat hair brushes. He often mixed sand, seashells and other objects into his paint to indicate the three-dimensionality of the objects he portrayed. He later used more conventional materials, but worked slowly, building up his surfaces to the point of almost bas-relief. His perspective was idiosyncratic; objects of importance to the artist appear much larger than those of little concern. He also adopted brilliant colours and avoided shadows. Very few of his works

survive, but *Manchester Valley* (*c*. 1915; New York, MOMA) and *Washington under the Council Tree* (1914–18; Newark, NJ, Mus.) indicate an interest in Pennsylvanian landscape and subjects illustrating local episodes of the American Revolution. Recognition of his work came through its inclusion in the Newark Museum's pioneering exhibition 'American Primitives', in 1930.

BIBLIOGRAPHY

J. Lipman and T. Armstrong, eds: *American Folk Painters of Three Centuries* (New York, 1980)

J. Johnson and W. Ketchum: *American Folk Art of the Twentieth Century* (New York, 1983)

DAVID M. SOKOL

Pierpont Limner (*fl* ?Boston, *c*. 1710–16). English painter, active in the USA. Two of the finest portraits painted in New England during the early 18th century, *The Rev. James Pierpont* and *Mrs James Pierpont* (New Haven, CT, Yale U. A.G.), remain unattributed to a named artist. The Rev. Pierpont, a Congregationalist minister, helped to found the Collegiate School of Connecticut in 1701, which became Yale College in 1718. The pendant portraits of him and his third wife, Mary Hooker, are both dated 1711 and are rendered in the elegant, high style then practised in England by Sir Godfrey Kneller (1646–1723)

and his followers. A portrait of *Caleb Heathcote* (New York, NY Hist. Soc.), a wealthy Colonial leader, executed in a similarly painterly manner, has been attributed to the Pierpont Limner and probably dates from about 1711–13, when Heathcote was mayor of New York. Portraits of *Edward Collins* (*c*. 1716; Albany, NY, Inst. Hist. & A.) and of *Edward Savage* (*c*. 1711–15; priv. col.) are also included in recent discussions of the Pierpont Limner's oeuvre. Pierpont family tradition maintains that the artist was English and painted in Boston between about 1710 and 1716.

BIBLIOGRAPHY

'Caleb Heathcote (1666–1721)', *American Portraits in the New York Historical Society* (New Haven, 1974), i, pp. 344–5

W. Craven: *Colonial American Portraiture* (Cambridge, 1986), pp. 121–3

CARRIE REBORA BARRATT

Pinney, Eunice (*b* Simsbury, CT, 9 Feb 1770; *d* ?Simsbury, 1849). American painter. She was a self-taught artist who, from about 1809 to 1826, devoted part of her time to producing a wide range of subjects in watercolour: landscape, genre, historical, biblical, allegorical and literary. Her distinctive style is solid and robust, with a strong sense of contrast and design. Problems in creating realistic form are apparent: faces are largely expressionless, and

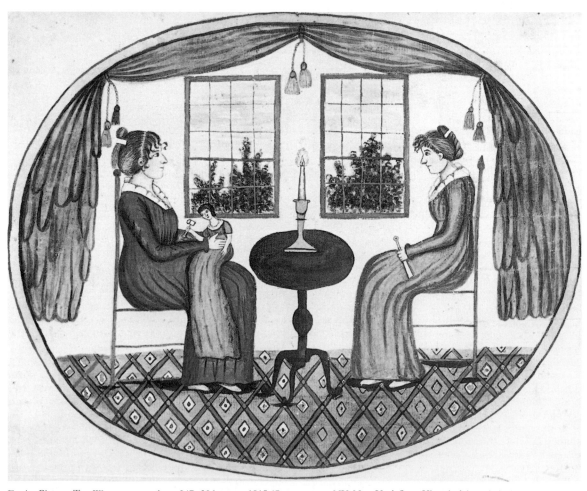

Eunice Pinney: *Two Women*, watercolour, 247×306 mm, *c*. 1815 (Cooperstown, NY, New York State Historical Association)

figures are stocky and two-dimensional. However, these difficulties are compensated for by fresh vigorous colour, bold pattern, artful composition and varied subject-matter. Pinney displayed the primitive artist's tendency to borrow and model from the best sources at hand: *The Cotter's Saturday Night* (*c*. 1820; New York, Edgar William and Bernice Chrysler Garbisch priv. col., see Lipman and Winchester, p. 25), in pastel shades against a soft grey background, was probably inspired by an English aquatint illustrating Robert Burns's poem of the same name, while her most admired watercolour, *Two Women* (*c*. 1815; Cooperstown, Mus. NY State Hist. Assoc.; see fig.), is close in idea and form to a woodcut in an 18th-century children's book. In some compositions rounded forms, drawn in two different scales, suggest that the patterns of English toile fabric were used as inspiration. Her many pencil sketches reveal an assured draughtsmanship and careful organization. There is often a sense of drama inherent in her vigorous scenes of everyday life. She was fond of painting memorials, in which families mourn by the grave, and she occasionally composed verses, which she inscribed in the margins.

BIBLIOGRAPHY

J. Lipman: 'Eunice Pinney: An Early American Watercolourist', *A. Q.* [Detroit], vi (1943), pp. 213–21

J. Lipman and A. Winchester, eds: *Primitive Painters in America, 1750–1950: An Anthology* (New York, 1950), pp. 22–30

M. Black and J. Lipman: *American Folk Painting* (New York, 1987), pp. 97–100

S. Foster: 'Couple and Casualty: The Art of Eunice Pinney Unveiled', *Flk A.*, xxi/2 (1996), pp. 30–37

STEPHEN F. THORPE

Pittsburgh. American city in the state of Pennsylvania, situated at the confluence of the Allegheny and Monongahela rivers, which form the Ohio River. An intensely industrialized city, it has fostered numerous artists, architects and collectors. The area was originally explored by the French in the 17th century, who established a military outpost there in 1754. It was then taken by the British in 1758, who built their largest military establishment in the New World at the substantial Fort Pitt (1759–61), designed by Harry Gordon. The city's distinctive triangular plan was drawn up in 1784 by George Woods (*fl c.* 1750–1820) as a largely pragmatic response to its naturally triangular site, but its geometric elegance also conformed to contemporary Neo-classical urban plans in Europe. The modest but elegant buildings that characterized the city's first period of growth included the Neo-classical Allegheny Arsenal (1814) by Benjamin Henry Latrobe; the Western Penitentiary (1826–35) by William Strickland and John Haviland; the Marine Hospital (1851) by Robert Mills; and a series of finely crafted Greek Revival civic buildings in the 1830s and 1840s by the English-trained architect John Chislett (1800–1869).

In the period of rapid industrialization in the 1850s and 1860s, aided by the arrival of the railway in 1852, Romantic architecture dominated the city. JOHN NOTMAN and FRANK FURNESS produced a number of buildings, and H. H. RICHARDSON captured perfectly the ruggedness of the town in the severe, ahistorical Emmanuel Episcopal Church (1883) and the Beaux-Arts Allegheny County Court House and Jail (1884–8; *see* RICHARDSON, H. H., fig.

4). Inspired by the national admiration for the court-house (one of the USA's most imitated buildings), Pittsburgh subsequently underwent a massive expansion, with the creation of a civic centre in Oakland that gave a whole new face to a city that had become infamous for its industrially related environmental deterioration. The numerous Beaux-Arts buildings erected before 1930 still form the monumental core of the city. Pittsburgh's architecture was also nurtured by a sequence of wealthy patrons, including ANDREW CARNEGIE, HENRY CLAY FRICK and the Mellons.

Although Pittsburgh had no significant painting community in the early Republican period, during the Civil War era the remarkable satirist DAVID GILMOUR BLYTHE was active, and in the late 19th century and early 20th William Archibald Wall (1828–after 1875) and Aaron Gorson (1872–1933) painted both rural and industrial landscapes. A number of notable artists were also born in the city but left later, including Mary Cassatt, John White Alexander and Henry Ossawa Tanner. The patrons of architecture also patronized painting and sculpture. In 1890 Andrew Carnegie founded the Carnegie Institute and Library and six years later created the Carnegie International, the first annual American exhibition of contemporary art (later continued on a triennial basis). Pittsburgh's sculptural tradition was most vigorous in the age of its Beaux-Arts buildings: Giuseppe Moretti (1869–1935) and Frank Vittor (1888–1968) were active locally, while Augustus Saint-Gaudens and Daniel Chester French were among outside sculptors working in Pittsburgh at the time. The Associated Artists of Pittsburgh group was formed in 1910.

BIBLIOGRAPHY

M. Scuyler: 'The Buildings of Pittsburgh', *Archit. Rec.*, xxx (Sept 1911), pp. 205–82

R. Stryker and M. Seidenberg: *A Pittsburgh Album* (Pittsburgh, 1959, rev. 1986)

S. Lorant: *Pittsburgh: An American City* (New York, 1964, rev. 1988)

Art in Nineteenth-century Pittsburgh (exh. cat., ed. J. McCullough; intro. D. Wilkins; Pittsburgh, PA, Carnegie-Mellon U. A.G.; Latrobe, PA, St Vincent Coll., Kennedy Gal.; Slippery Rock U., PA, Gal. Eleven; Washington, PA, Washington and Jefferson Coll.; 1977)

P. Chew, ed.: *Southwestern Pennsylvania Painters, 1800–1945* (Greensburg, PA, 1981)

V. Gay and M. Evert: *Discovering Pittsburgh's Sculpture* (Pittsburgh, 1983)

M. Brignano, ed.: *The Associated Artists of Pittsburgh, 1910–1985: The First Seventy-five Years* (Pittsburgh, 1985)

F. Toker: *Pittsburgh: An Urban Portrait* (University Park, PA, and London, 1986)

FRANKLIN TOKER

Platt, Charles A(dams) (*b* New York, 16 Oct 1861; *d* Cornish, NH, 12 Sept 1933). American architect, garden designer, etcher and painter. He was brought up in New York, where he began his artistic training in 1878 at the National Academy of Design and the Art Students League. The following summer he was introduced to the recently revived art of etching, and he quickly achieved critical recognition for his work in this medium. He continued to etch for most of his life, concentrating on coastal scenes in which he strove to capture the atmospheric interaction of light, air and water. In May 1882 Platt travelled to Paris to continue his training as a painter, working first independently and then after 1883 at the Académie Julian under Jules Lefebvre (1836–1911). Although he exhibited *The*

Etcher (Boston, MA, St Botolph's Club) at the Paris Salon of 1885, Platt eventually rejected his figural training and turned back to his youthful interest in landscape. On his return to New York, he continued to exhibit his paintings and etchings, and in 1894 he was awarded the Webb Prize of the Society of American Artists for his painting *Clouds* (Boston, MA, Mus. F.A.). By this time, however, he had become interested in architecture and landscape design.

In 1889 Platt joined the summer colony of artists at CORNISH, NH, and the following summer he designed and built there a studio house for himself. His fellow colonists thereafter sought his assistance in designing their houses and gardens. He refined his ideas on architecture and landscape design during a tour (1892) of the Renaissance villas of Italy and published his observations in *Italian Gardens* (1894), the first illustrated study in English of the Italian Renaissance garden, illustrated with his own photographs and watercolour drawings. The successful reception of *Italian Gardens* led to further projects for Italian-inspired houses and gardens. By the time of his marriage in July 1893 to Eleanor Hardy Bunker (widow of the painter Dennis Miller Bunker), Platt had begun to consider forsaking his ambitions as a painter for a career in architecture and landscape design. He was encouraged in this by the success of several commissions of the late 1890s, such as his influential gardens (1897–8) for Faulkner Farm, the Charles F. Sprague estate at Brookline, near Boston, MA.

Despite his lack of formal architectural training, between 1900 and 1913 Platt established himself as one of the leading country house architects in the USA. His houses and gardens are well-integrated and characterized by clear spatial order; he derived a personal style from Classical Revival sources and the domestic architecture of Georgian England and Colonial America. The most representative (and best-preserved) example from this period is Gwinn (1907–8), the William Gwinn Mather estate, near Cleveland, OH. In 1913 he published *Monograph of the Work of Charles A. Platt*, an elaborate photographic summary of his works to date.

Although Platt's reputation was largely built on his country house practice, he also designed a distinguished group of city buildings variously derived from the model of the Italian Renaissance palazzo. The finest of these commissions is the Studio Building (1905–6) in New York. Platt designed eight art museums, of which his masterpiece is the Freer Gallery of Art (1913–23), Washington, DC.

UNPUBLISHED SOURCES

New York, Columbia U., Avery Archit. & F.A. Lib., Charles A. Platt Col.

WRITINGS

Italian Gardens (New York, 1894)

PHOTOGRAPHIC PUBLICATION

Monograph of the Work of Charles A. Platt (New York, 1913)

BIBLIOGRAPHY

H. Croly: 'The Architectural Work of Charles A. Platt', *Archit. Rec.*, xv/3 (1904), pp. 181–244
Catalogue of an Exhibition of Etchings and Dry-points by C. A. Platt (exh. cat., New York, F. Keppel, 1907)
K. N. Morgan: *Charles A. Platt: The Artist as Architect* (New York, 1985)
E. E. Hirshler and K. Morgan: 'Charles A. Platt: Shaping an American Landscape', *Amer. A. Rev.*, vii/2 (1995), pp. 114–23
K. N. Morgan, ed.: *Shaping a New American Landscape: The Art and Architecture of Charles A. Platt* (Hanover, NH, 1995)

KEITH N. MORGAN

Polk, Charles Peale (*b* Annapolis, MD, 17 March 1767; *d* Warsaw, VA, 6 May 1822). American painter. Orphaned as a child, he was raised in Philadelphia, PA, by his uncle, Charles Willson Peale, who taught him to paint. In 1791 Polk moved to Baltimore, MD, where he achieved limited success as a portrait painter. Seeking commissions, he moved to Frederick, MD, in 1796. Over the next five years during travels as an itinerant limner through western Maryland and Virginia he reached his mature style. Abandoning his academic training, Polk developed a distinctive but naive artistic vocabulary with a heightened palette, electric highlights and an exaggerated attenuation of the human form. The portraits of *Isaac Hite* and his wife *Eleanor Madison Hite*, as well as *James Madison sr* and *Eleanor Conway Madison* (all Middletown, VA, Belle Grove), were commissioned in 1799 and are accepted as his masterpieces. Isaac Hite also commissioned the quintessentially 'republican' portrait of Thomas Jefferson (New York, Victor Spark priv. col.), executed at Monticello in 1799. In 1801 Polk moved to Washington, DC, working as a clerk in the Treasury. During the next 16 years he painted few portraits in oil but did execute some in *verre églomisé* (a type of reverse painting with gold leaf on glass that first became popular in France at the end of the 18th century). Notable examples include portraits of *James Madison* and *Albert Gallatin* (both *c.* 1802–3; Worcester, MA, Amer. Antiqua. Soc.). Polk spent the last years of his life in Richmond County, VA, presumably as a farmer, although artist's supplies listed in his estate suggest that he may have continued to paint.

BIBLIOGRAPHY

Charles Peale Polk, 1767–1822: A Limner and his Likenesses (exh. cat. by L. C. Simmons, Washington, DC, Corcoran Gal. A., 1981)

LINDA CROCKER SIMMONS

Polk, Willis J(efferson) (*b* Jacksonville, IL, 3 Oct 1867; *d* San Francisco, CA, 10 Sep 1924). American architect. He was the son of an itinerant builder and learnt to design first as an artisan, then in the offices of various architects including Henry van Brunt, Charles Atwood and A. Page Brown. Polk moved to San Francisco in 1889 and maintained a prominent practice there until his death. He was among the region's leading advocates of academic design principles, yet often he interpreted them in idosyncratic ways. During the 1890s most of his realized projects were for houses. Many schemes such as his family's house (1892; 1013–1019 Vallejo Street, Russian Hill, San Francisco) and the Rey House (1893; 428 Golden Gate Avenue, Belvedere, Marin Co., CA) are comparatively modest and informal, drawing from a wide range of vernacular sources. However, Polk proved just as adept at developing elaborate classical designs, such as the Bourn House (1895–6; 2550 Webster Street, Pacific Heights, San Francisco). Throughout, he manipulated form, space and scale in an unorthodox manner, relishing the juxtaposition of dissimilar qualities.

After 1900 Polk began to emulate Daniel H. Burnham, whose West Coast office he established and headed from 1906 to 1910. Much of the firm's work at this time came from the commercial sector. The resulting designs are often elegant and polished, yet adhere to conventional patterns. Polk still excelled as a designer of residences,

most of them quite large by this stage. His adaptations of English Georgian precedent, seen at, for example, Filoli (1914–16; Cañada Road, Woodside, San Mateo Co., CA), or Italian vernacular sources, such as the Hooker House (1913–14), San Francisco, are at once vivacious and restrained, defying convention while providing a sophisticated backdrop for formal living modes. On one occasion Polk made a radical departure to create the Hallidie Building (1917–18), San Francisco, where a curtain wall of glass has a minimal garnish of metal tracery inspired by Venetian examples. Polk's office never reached the size or stature of Burnham's, and long-coveted public commissions always eluded him. Nevertheless, his spirited approach, especially to domestic architecture, has enjoyed a lasting influence on work in the region.

BIBLIOGRAPHY

F. Hamilton: 'The Work of Willis Polk & Company', *Architect & Engin. CA*, xxiv/3 (1911), pp. 34–73
C. M. Price: 'Notes on the Varied Work of Willis Polk', *Archit. Rec.*, xxxiv (1913), pp. 566–83
K. W. Dills: 'The Hallidie Building', *J. Soc. Archit. Hist.*, xxx (1971), pp. 323–9
J. Beach: 'The Bay Area Tradition, 1890–1918', *Bay Area Houses*, ed. S. Woodbridge (New York, 1976), pp. 23–98
R. Longstreth: *A Matter of Taste: Willis Polk's Writings on Architecture in 'The Wave'* (San Francisco, 1979)
——: *On the Edge of the World: Four Architects in San Francisco at the Turn of the Century* (New York, 1983/R Berkeley, 1998)

RICHARD LONGSTRETH

Pope. American family. (1) Alfred Atmore Pope and his wife Ada Pope were important collectors, whose only daughter, (2) Theodate Pope-Riddle became an architect.

(1) Alfred Atmore Pope. (*b* North Vassalboro, ME, 4 July 1842; *d* Farmington, CT, 5 Aug 1913). Industrialist and collector. In 1864 he entered the family wool-manufacturing business but soon extended his interests to iron. By 1877 he was president of the Cleveland Malleable Iron Co., which became the National Malleable Castings Co. in 1891.

Pope began to acquire paintings in the 1880s, and the collection was almost completed by 1901. He had been introduced to the Impressionists by a friend and business colleague, John Howard Whittemore, and his son Harris Whittemore (also a prominent collector), and by Mary Cassatt, who actively directed American collectors to the Impressionists. The Popes were also friendly with James Abbott McNeill Whistler, who, according to Pope, nourished their 'love of the beautiful'. Pope purchased most of his paintings himself from the New York and Paris firms of Paul Durand-Ruel and Boussod & Valadon. The collection, which includes the *Dancers in Pink* by Edgar Degas (1834–1917), *Boats Leaving the Harbour at Le Havre* (1865) by Claude Monet (1840–1926), *Blue and Silver: The Blue Wave, Biarritz* (1862) by James McNeill Whistler (1834–1903), *The Guitar Player* (1867) by Edouard Manet (1832–83) and *Girl with the Cat* by Auguste Renoir (1841–1919) (all Farmington, CT, Hill-Stead Mus.), expresses a bold taste that contrasted with Pope's quiet and rather humble demeanour. The Popes also collected decorative objects, Whistler prints, Persian rugs, bronzes by Antoine-Louis Barye (1796–1875), Chinese porcelain and Japanese prints.

In 1901 Pope moved to Hill-Stead, a sumptuous Colonial Revival farmhouse in Farmington, CT, designed by McKim, Mead & White in concert with (2) Theodate Pope-Riddle, who had discovered Farmington as a student. As a result of Theodate's collaboration, Hill-Stead possesses an unusual design and even more unusual interior colours, selected to enhance the pastel shades of Pope's paintings and his wife's collection of elegant Queen Anne and Victorian furniture. When Henry James visited the house soon after the Popes moved into it, he commented on its artistic mixture of tastes, which brought together 'impressionistic' paintings in an elegant farmhouse (*The American Scene*, New York, 1907, pp. 45–6). The farmhouse was subsequently opened as the Hill-Stead Museum.

BIBLIOGRAPHY

K. Cox and others: 'The Collection of Mr. Alfred Atmore Pope', *Noteworthy Paintings in American Private Collections*, ed. A. F. Jaccacci and J. La Farge, ii (New York, 1907/*R* 1979), pp. 257–370
J. Paine: *Theodate Pope Riddle: Her Life and Work* (New York, 1979)
H. Hall: 'Alfred and Ada Pope as Collectors', *Antiques* (Oct 1988), pp. 862–3
M. A. Hewitt: 'Hill-Stead, Farmington, Connecticut: The Making of a Colonial Revival Country House', *Antiques* (Oct 1988), pp. 848–61

LILLIAN B. MILLER

(2) Theodate Pope-Riddle. (*b* Salem, OR, 1868; *d* Farmington, CT, 30 Aug 1946). Architect, daughter of (1) Alfred Atmore Pope. She was privately tutored in architecture at the College of New Jersey from 1886 and became notable as the first woman architect in the USA. She designed her family home, Hill-Stead (1898–1901), in Farmington, CT, in cooperation with the architect Stanford White. In 1907 she was commissioned by her teacher Mary Hilliard to design the main school building of Westover School for Girls, Middlebury, CT. In this building (completed 1912) she included such innovative facilities as the first all-electric institutional kitchen with a built-in vacuum system.

BIBLIOGRAPHY

Who Was Who in America (1943–50)
H. F. Withey: *Biographical Dictionary of American Architects* (Los Angeles, 1956)
F. Strausser: 'Theodate Pope-Riddle', *Hist. Preserv.*, xxix/2 (1977), pp. 175–87

□

Post, George B(rowne) (*b* New York, 15 Dec 1837; *d* Bernardsville, NJ, 28 Nov 1913). American architect. A major architect of the skyscraper (*see* SKYSCRAPER, §2(i)), he was acknowledged in his lifetime as the 'father of the tall building in New York'. Following his graduation in civil engineering from New York University in 1858, he entered Richard Morris Hunt's studio, where he remained for two years. There he met Charles D. Gambrill (1834–80; later in partnership with H. H. Richardson), with whom he was associated from 1860 to 1867. Afterwards he practised independently until 1904, when his sons William Stone Post (1866–1940) and James Otis Post (1873–1951) became his partners in the firm of George B. Post & Sons.

Post's long, productive career as a New York-based architect and engineering expert began with his work as consulting architect in charge of ironwork and lifts on the Equitable Building (1868–70; enlarged to Post's design, 1886–9; destr. 1912), New York, designed by Arthur

Delevan Gilman and Edward Hale Kendall (1842–1901). As the first office building planned to incorporate a passenger lift (elevator), the Equitable initiated the skyscraper era. Subsequently Post designed one of the earliest skyscrapers, the ten-storey (h. 70.1 m) Western Union Building (1872–5; destr.), New York. The interior metal-framing of his New York Produce Exchange (1881–4; destr. 1957) closely approached the full skeleton framing that within a decade became accepted skyscraper construction. Post was also responsible for many other types of building, ranging from houses to college buildings and a state capitol. Most of his work was in New York and New Jersey, but his firm also designed buildings for sites throughout most of North America.

Post's architecture exhibited the full range of late 19th-century styles, but, doubtless owing to his study with Hunt, French influence predominated. His earliest buildings, such as the domed Williamsburgh Savings Bank (1870–75), Brooklyn, and the Troy Savings Bank–Music Hall (1871–5) in Troy, NY, relate to the Second Empire style. After 1870 aspects of the Néo-Grec inform his work, especially his large, Renaissance-style buildings. Beginning with two such examples, Chickering Concert Hall (1874–5; destr.), New York, and the Long Island Historical Society (1878–80), Brooklyn, Post frequently joined the window ranges of his larger buildings by setting them within inscribed arches or arcades, sometimes superimposed, and often extending through several storeys. The arcade rhythms of his monumental Produce Exchange influenced both H. H. Richardson and Louis Sullivan. Post's Cornelius Vanderbilt II House (1879–82, addn 1892–4; destr. 1927), on Fifth Avenue and West 58th Street, New York, helped introduce a French Renaissance château mode that became popular for mansions. His 20-storey Pulitzer (World) Building (1889–90; destr. 1955), New York, included a five-storey, circular tower crowned by a gilded, ribbed hemispherical dome, enabling it to stand out above the surrounding tall buildings. His arcaded Union Trust Building (1889–90; destr.), New York, was articulated in three parts, a 'base', a 'shaft' and a 'capital'—the so-called column design formula that came to be associated with Louis Sullivan's skyscrapers.

Post's late work conforms to contemporary Beaux-Arts classicism. Superimposed orders articulated his 26-storey St Paul Building (1895–8; destr. 1958), New York, and Roman temple fronts distinguish his New York Stock Exchange (1901–3) and Wisconsin State Capitol (1906–17), Madison. Post conceived his City College campus (1897–1907), New York, as an academic Gothic complex ornamented in glazed terracotta, a material he had been early to use architecturally. His arcaded Manufacturing and Liberal Arts Building (1891–3; destr.) at the World's Columbian Exposition, Chicago, was advertised as enclosing the largest area ever covered by a roof. In the mid-1890s, concerned about the increasing heights of skyscrapers and the durability of their construction, Post advocated the passage of a law restricting their height. By 1900 his practice was one of the largest in the country. Accorded many honours, he was awarded the American Institute of Architects' Gold Medal in 1911.

BIBLIOGRAPHY

R. Sturgis: 'A Review of the Work of George B. Post', *Archit. Rec.*, 4 (1898) [special issue]

W. Weisman: 'New York and the Problem of the First Skyscraper', *J. Soc. Archit. Hist.*, xii (1953), pp. 13–21

——: 'The Commercial Architecture of George B. Post', *J. Soc. Archit. Hist.*, xxxi (1972), pp. 176–203

S. B. Landau: 'The Tall Office Building Artistically Reconsidered: Arcaded Buildings of the New York School, c. 1870–1890', *In Search of Modern Architecture: A Tribute to Henry-Russell Hitchcock* (New York, 1981), pp. 136–64

L. B. Mausolf: *A Catalog of the Work of George B. Post: Architect* (MS. thesis, New York, Columbia U., 1983)

D. Balmori: 'George B. Post: The Process of Design and the New American Architectural Office (1868–1913)', *J. Soc. Archit. Hist.*, xlvi (1987), pp. 342–55

S. B. Landau and C. W. Condit: *Rise of the New York Skyscraper, 1865–1913* (New Haven and London, 1996)

S. B. Landau: *George B. Post, Architect: Picturesque Designer and Determined Realist* (New York, 1998)

SARAH BRADFORD LANDAU

Potter American family of architects. The half-brothers (1) Edward T. Potter and (2) William A. Potter were the sons of Alonzo Potter, who for a time was the Episcopal Bishop of Pennsylvania. Both sons studied at Union College in Schenectady, NY, Edward T. Potter graduating in 1853 and William A. Potter in 1864.

(1) Edward T(uckerman) Potter (*b* Schenectady, NY, 25 Sept 1831; *d* New York, 21 Dec 1904). He played a pre-eminent part in introducing into the USA the High Victorian Gothic style. After his studies he was apprenticed in the office of Richard Upjohn, where he met Charles William Clinton, who became his associate from 1863 to *c.* 1876. For most of Potter's active career, his office was in New York. He designed mainly churches and college buildings. Potter's first important commission came through his grandfather Eliphalet Nott, President of Union College for 62 years. The work began as the realization of the central building proposed in Joseph Jacques Ramée's plan of 1813 for the College, but construction was temporarily stopped in 1859. The building (1858–9, 1872–8), later known as the Nott Memorial, was designed originally to serve as a chapel on the lower storey with a meeting hall above. It was, however, built as an assembly hall encircled by two galleries.

Potter's next noteworthy commission was the First Dutch Reformed Church (1861–3) in Schenectady. There he developed his interpretation of High Victorian Gothic and introduced many of the features that appeared in his mature churches: a subtle polychromy achieved by the combination of several colours of stone; a meeting hall or chapel wing treated as a single transept; abundant and ingeniously programmatic carved ornament, such as the capitals with birds representing the months and seasons of the year in the movable, glazed wooden screen that divided the wing from the nave; and an elaborate interior construction of carved wooden rafters and slender wooden columns. This and other of Potter's churches designed before 1870 combine High Victorian Gothic details, such as the two-colour, banded arch favoured by John Ruskin (1819–1900) and G. E. Street (1824–81), with a formal arrangement derived from Upjohn's churches. After 1867, under the influence of the English and Eugène-Emmanuel Viollet-le-Duc (1814–79), Potter used cast-iron columns in his churches.

The decorative carving of the 'armorer's porch' of Potter's Church of the Good Shepherd (1867–9) in Hartford, CT, unites parts of guns and Christian symbols in a unique symbolic programme to commemorate the arms manufacturer Samuel Colt. A harbinger of the American Colonial Revival, yet Victorian Gothic in form, St John's Church (1871–2; see fig.) in Yonkers, New York, is perhaps Potter's finest work. Surviving segments of the previous 18th-century church were incorporated into the new church and inspired its brick-trimmed, fieldstone walls, round-arched openings and occasional Neo-classical details.

In 1872 Potter resumed work on the Nott Memorial. The resulting domed, 16-sided structure with exposed interior iron framing manifests his characteristic Gothic Revival style. This and the polychrome-brick Mark Twain House (1873–4) in Hartford are his best-known works. Inspired by the French revival of picturesque rustic villas in Normandy, the multi-gabled Twain House was undertaken with the assistance of Alfred H. Thorp (1843–1917), who had trained at the Ecole des Beaux-Arts in Paris. Early retirement (1877), facilitated by his wife Julia Blatchford Potter's inheritance, gave Potter the leisure to design a model tenement that won an award at the World's Columbian Exposition in Chicago (1893). In 1894 he designed the Caldwell Hart Colt Memorial Parish House (1894–6) in memory of Colt's son, who had been a yachtsman. Its shiplike form and maritime decorative programme complement the architect's nearby Church of the Good Shepherd.

WRITINGS
A Statement of the Considerations Influencing the Design of the First Dutch Reformed Church, Schenectady, New York (New York, 1868)

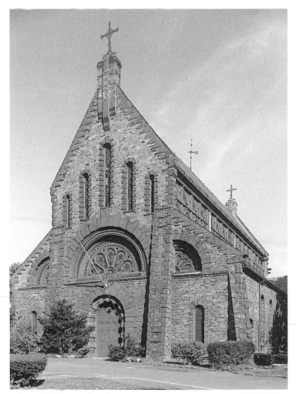

Edward T. Potter: St John's Church, Yonkers, New York, 1871–2

BIBLIOGRAPHY
Mendel, Mesick & Cohen Architects: *The Nott Memorial: A Historic Structure Report* (Albany, 1973)
S. B. Landau: 'The Colt Industrial Empire in Hartford', *Antiques*, cix (1976), pp. 568–79
——: *Edward T. and William A. Potter: American Victorian Architects* (New York, 1979)
——: 'Mark Twain's House in Connecticut', *Archit. Rev.* [London], clxix (1981), pp. 162–6
N. Adams with J. Temos: 'The Speaking Architecture of E. T. Potter at Lehigh University (1866–1869)', *Res*, xxii (Autumn 1992), pp. 152–71

(2) William A(ppleton) Potter (*b* Schenectady, NY, 10 Dec 1842; *d* Rome, 19 Feb 1909). Half-brother of (1) Edward T. Potter. He is noted for his collegiate, church and public buildings in the High Victorian Gothic mode. After his graduation, he worked briefly as a chemistry laboratory instructor in the Columbia University School of Mines. In 1867, following a tour of Europe, he entered his half-brother's office in New York as an apprentice. By 1869 he was accepting work on his own, and in 1871 he designed the Chancellor Green Library (1871–3) at the College of New Jersey (now Princeton University). This enviable commission, which launched his career, resulted in a distinctive octagonal building with brownstone walls, Gothic-arched, stained-glass windows, and decorative interior iron construction. The library was followed by six more Princeton commissions, including Witherspoon (1875–7) and Alexander (1891–4) halls and Pyne Library (1896–7; now East Pyne Building) on the university campus. Potter's boldest design, and one of the finest High Victorian Gothic structures in the USA, is the South Congregational Church (1873–4) in Springfield, MA. Its climactic, wedge-roofed tower, huge rose window and reddish Longmeadow stone walls with bands of yellow Ohio stone introduce a newly monumental interpretation of the High Victorian Gothic that departs from Edward T. Potter's more conservative churches of the late 1860s.

From 1875 to 1881 Potter practised with Robert H. Robertson. Afterwards he continued to practise in New York until 1902 when he retired to Rome. The partnership began around the time that he was appointed to succeed Alfred B. Mullett as Supervising Architect of the US Treasury. During the year and a half that he held the post (1875–6), Potter was responsible for custom-house, court-house and post office buildings built throughout the USA. Several of them, for example the richly polychromatic Custom-house and Post Office (1875–9) in Evansville, IN, and the Custom-house and Post Office (1875–81; destr.) in Fall River, MA, were relatively compact, symmetrical structures with Gothic detailing and ornament subordinated to the overall design. After 1876 Potter & Robertson were responsible for suburban and country houses that contributed to the transformation of the English Queen Anne Revival into the rambling American SHINGLE STYLE. The shingled and clapboarded Adam–Derby House (1878) in Oyster Bay, Long Island, stands out as an early and almost fully developed example of the new style. In his later career Potter's work was on the whole less progressive but nonetheless distinguished. His dramatically composed, round-arched Alexander Hall indicates the strong influence of H. H. Richardson. He designed the nuclear campus of Teachers College (1892–7), now part of Columbia University, New York, as a

conservatively Victorian Gothic complex that recalls the later work of Alfred Waterhouse (1830–1905). The Pyne Library (1896–7) was one of the first collegiate Gothic buildings at Princeton University and is therefore subdued in style in comparison to his earlier Green Library, which adjoins it. Less innovative but more persevering than Edward T. Potter, William A. Potter produced an impressive body of work and achieved a degree of recognition and standing never accorded to his half-brother.

BIBLIOGRAPHY

M. Schuyler: 'The Work of William Appleton Potter', *Archit. Rec.*, xxvi (1909), pp. 176–96
L. Wodehouse: 'William Appleton Potter, Principal *Pasticheur* of Henry Hobson Richardson', *J. Soc. Archit. Hist.*, xxxii (1973), pp. 175–92
S. B. Landau: *Edward T. and William A. Potter: American Victorian Architects* (New York, 1979)
——: 'Potter & Robertson, 1875–1880; William Appleton Potter, 1842–1909; Robert Henderson Robertson, 1849–1919', *Long Island Country Houses and their Architects, 1860–1940*, ed. R. B. MacKay and others (New York, 1997), pp. 365–8, 465

SARAH BRADFORD LANDAU

Potter Palmer, Mrs. *See* PALMER, BERTHA HONORÉ.

Potthast, Edward Henry (*b* Cincinnati, OH, 10 June 1857; *d* New York, ?10 March 1927). American painter. He was apprenticed at an early age to a lithographer and attended night classes at the McMicken School of Design in Cincinnati. He interrupted his studies to travel to Europe in 1882 and 1887, visiting Antwerp, Munich, Paris and Barbizon. His early work features the dark tonalities of the Munich school, evident in *Dutch Interior* (1890; Cincinnati, OH, A. Mus.; see fig.). After his move to New York in 1896, Potthast's palette brightened. There he embarked on what was to become his primary subject: New York beach scenes in which spirited groups of families and children cavort under the strong, even light of the summer sun, as in *Sailing Party* (Cincinnati, OH, A. Mus.; see fig.). Obviously influenced by Impressionism—well established in America by this time—Potthast applied his pigments with a thickly laden brush, obliterating facial expression but conveying gaiety and warmth through his high-keyed colour schemes, energetic brushwork and sharply cropped compositions.

BIBLIOGRAPHY

A. Jacobowitz: 'Edward Henry Potthast', *Brooklyn Mus. Annu.*, xix (1967–8), pp. 113–28
W. H. Gerdts: *American Impressionism* (Seattle, 1980)

ROSS C. ANDERSON

Powers, Hiram (*b* Woodstock, VT, 29 July 1805; *d* Florence, 27 June 1873). American sculptor. He grew up in Cincinnati, OH, and his career as a sculptor began when he created animated wax figures for a tableau of Dante's *Inferno* at Dorfeuille's Western Museum in Cincinnati, where he was supervisor of the mechanical department. He learnt to model clay and make plaster casts from

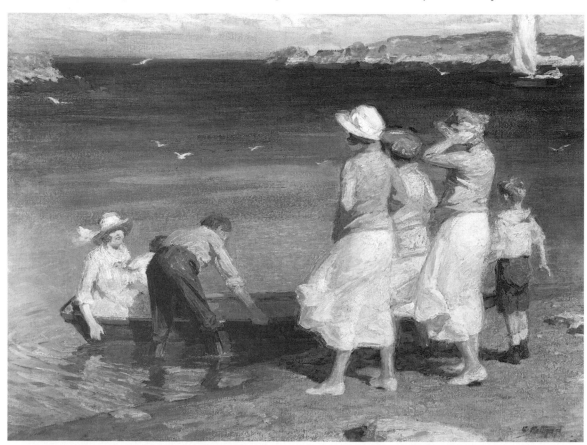

Edward Henry Potthast: *Sailing Party*, oil on canvas, 768×1022 mm, *c.* 1896 (Cincinnati, OH, Cincinnati Art Museum)

Frederick Eckstein (c. 1775–1852). The portrait busts he created of his friends attracted the attention of the wealthy Nicholas Longworth, who financed trips for Powers to New York in 1829 and to Washington, DC, in 1834, when he sculpted President *Andrew Jackson* (marble, c. 1835; New York, Met.). Powers's strikingly lifelike bust, classicized only by the drapery, brought him commissions from other Washington luminaries, including *John Marshall* (marble, 1835; Washington, DC, US Capitol), *Martin van Buren* (marble, 1837; New York, NY Hist. Soc.) and *John Quincy Adams* (marble, 1837; Kinderhook, NY, Columbia Co. Hist. Soc. Mus.).

Powers departed for Italy with his family in 1837, leaving the USA permanently. In Florence he continued to produce portrait busts such as that of *Horatio Greenough* (1805–52) (marble, 1838; Boston, MA, Mus. F.A.), a compatriot sculptor also living in Florence. Powers also began making idealized works imbued with noble sentiment, with subjects taken from religion, history or mythology. He achieved remarkable success with such work: his bust *Proserpina* (marble, c. 1839; Florence, Pitti) was reproduced about 50 times. With only the most rudimentary training in anatomy, Powers began his first life-size figure in 1838, *Eve Tempted* (plaster version, 1841; Washington, DC, N. Mus. Amer. A.). This was followed by other full-length works such as *Fisherboy* (marble, 1841; New York, Met.), which depicts a nude boy, leaning in Praxitelean contrapposto on a tiller as he holds a conch shell to his ear.

Also in 1841, Powers began the work that became the most famous sculpture of the period and that established his reputation. The Greek War of Independence inspired the full-length marble *Greek Slave* (original, Raby Castle, Durham; version, c. 1843, New Haven, CT, Yale U. A.G.; see fig. 1). It depicts a Greek maiden who has been captured by the Turks and forced to stand naked in the slave market. Her pose is reminiscent of Praxiteles' *Aphrodite of Knidos*, a copy or engraving of which Powers may have seen. A locket, evocative of lost loved ones, and a crucifix are conspicuously sculpted on a support to the figure. Powers wrote an explanatory commentary, which was also intended to dispel objections to the statue's nudity, a major issue for the 19th-century public. As an ardent Swedenborgian, he stressed that the slave's faith in God shielded her and kept her from shame. The proclamation of the Rev. Orville Dewey, a noted Unitarian minister, that the girl was not naked but sheltered in a vesture of holiness, was also cited. The *Greek Slave*, which also reflected the growing anti-slavery feeling in America, was exhibited to great critical acclaim in London in 1845, where the original marble was bought by William, 7th Baron Barnard, and appeared again in 1851 at the Great Exhibition at Crystal Palace and in Paris at the Exposition Universelle in 1855. The statue toured American cities in 1847, attracting huge crowds and large revenues, and inspiring articles and poems, including Elizabeth Barrett Browning's 'Hiram Power's *Greek Slave*' (*Poems*, London, 1850). Powers's generation believed that modern sculpture, imbued with Christian sentiment, was superior to Classical statuary, which simply paraded pagan beauty. The success of the *Greek Slave* was thus due more to its literary and philosophical associations than to its artistic

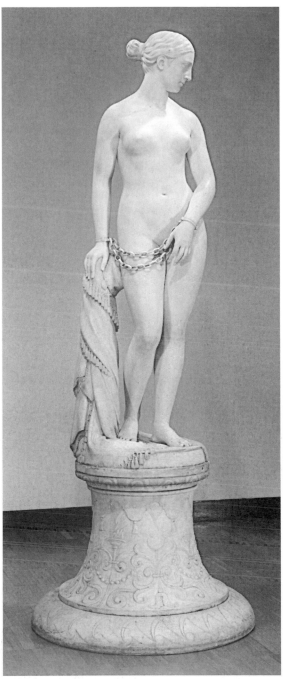

1. Hiram Powers: *Greek Slave*, marble, h. 1.62 m, c. 1843 (New Haven, CT, Yale University Art Gallery)

merit. Powers became the most famous American sculptor and was likened, by his contemporaries, to both Phidias and Michelangelo. Six marble copies of the *Slave* were sold (versions exist in public collections at Newark, NJ, Mus.; Washington, DC, Corcoran Gal. A.; New York, Brooklyn Mus.; New Haven, CT, Yale U. A.G.), as well as smaller versions and busts.

Powers built an improved pointing machine with a movable joint for ease of operation, developed a plaster

the US Government for the Capitol. When it was not, Powers's bitterness led him to reject an offer in 1853 to submit a pedimental sculpture design for the new extension on the Capitol. In 1859 Powers was awarded two federal commissions for over life-size marble statues of *Benjamin Franklin* (1862) and *Thomas Jefferson* (1863) for niches in the Senate and House wings. There was controversy in this period over whether figures should be portrayed in contemporary dress or in a historical costume such as a toga: Powers had executed a statue of *John C. Calhoun* (1844–50; destr.; marble bust, Raleigh, NC Mus. A.) dressed in a toga, and a statue of *Daniel Webster* in contemporary dress (bronze, *c.* 1858), now outside the State House, Boston. The latter had been criticized because the clothes appeared baggy, but in his federal statues Powers succeeded in representing modern attire that did not distract.

Powers continued to create portrait busts and more ideal works, selling many replicas until the end of his life. The Civil War seriously curtailed the demand for white marble statuary in America and when buying resumed, patrons preferred naturalistic bronze pieces and Powers's reputation languished. His final full-length work, *Last of the Tribe* (1872; Washington, DC, N. Mus. Amer. A.; see fig. 2), depicts a semi-nude American Indian girl running and looking backwards over her left shoulder. Powers was America's most famous Neo-classical sculptor and did much to establish American sculpture at home and abroad.

BIBLIOGRAPHY
H. W. Bellows: 'Seven Sittings with Powers, the Sculptor', *Appleton's J.*, i (1869), pp. 342–3, 359–61, 402–4, 470–71, 595–7; ii (1869), pp. 54–5, 106–8
W. H. Gerdts and S. A. Robertson: 'The Greek Slave', *Museum* [New York], xvii (1965), pp. 1–32
W. Craven: *Sculpture in America* (New York, 1968), pp. 111–23
L. Hyman: 'The *Greek Slave* by Hiram Powers: High Art as Popular Culture', *A. J.* [New York], xxxv/3 (1976), pp. 216–23
D. M. Reynolds: *Hiram Powers and his Ideal Sculpture* (New York, 1977)
V. M. Green: 'Hiram Power's *Greek Slave*: Emblem of Freedom', *Amer. A. J.* (1982), pp. 31–9
R. P. Wunder: *Hiram Powers: Vermont Sculptor, 1805–1873*, 2 vols (Newark, NJ, 1991)

LAURETTA DIMMICK

Prairie school. Term given to an American group of architects. Inspired by Louis Sullivan and led by Frank Lloyd Wright, they practised in the American Midwest between 1890 and 1920. Included in the group were Barry Byrne (1892–1967), George Robinson Dean (1864–1919), William E. Drummond, George Elmslie, Hugh Garden (1873–1961), Walter Burley Griffin (1876–1937), Marion Mahony Griffin (1871–1961), Arthur Heun (?1864–1964), Myron Hunt (1868–1962), Birch Burdette Long (1878–1927), George W. Maher, George C. Nimmons (1865–1947), Dwight Perkins (1867–1941), William Purcell, Howard Van Doren Shaw (1869–1926) and Robert C. Spencer jr. Originally these architects were called the Chicago school, but in 1914 Wilhelm Miller, a professor at the University of Illinois, proposed the separate term, because of the visual associations with the broad, level character of the American prairie that he discerned in the residential work of many of these architects. Even so, the term did not come into general use until the 1960s, when

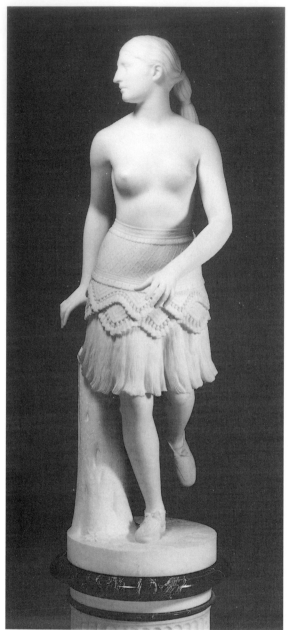

2. Hiram Powers: *Last of the Tribe*, marble, h. 1.68m, 1872 (Washington, DC, National Museum of American Art)

compound which could be modelled as an alternative to clay, and invented files and rasps (which he patented in the USA) to smooth the finish of this compound. He also developed a special finishing process for the fine-grained Serravezza marble from the quarry near Carrara, which, when finished, gave a close approximation to the porosity of human flesh. This became a hallmark of his work and won him wide public and critical acclaim.

While the *Greek Slave* was on tour, Powers modelled *America* (plaster version, 1848; Washington, DC, N. Mus. Amer. A.), which he intended to embody the creed of the United States and which he hoped would be purchased by

The Prairie School Review (1964–76), a journal entirely devoted to the work of these architects, was founded.

These architects were bound by their rejection of revivalist styles and by their goal of evolving new architectural vocabularies for expressing what they believed were the true qualities of life in their region and nation. Although there was no conscious effort to produce a common style, it was inevitable that the group's work should develop similar features, for example the elongated, horizontal massing of their houses. Some, such as Drummond, worked in a manner influenced by Wright, while others, such as Maher, evolved more individual idioms. Interest by clients in the ideas of the architects of the Prairie school began to wane just before World War I as the tide of East Coast historicism swept the Midwest. By the mid-1920s the Prairie school no longer existed.

BIBLIOGRAPHY

T. Tallmadge: 'The Chicago School', *Archit. Rev.*, xv (1908), pp. 69–74; repr. in *Architectural Essays from the Chicago School*, ed. W. Hasbrouck (Park Forest, 1967), pp. 3–8

H. Brooks: 'The Early Work of the Prairie Architects', *J. Soc. Archit. Hist.*, xix (1960), pp. 2–10

——: '"Chicago School": Metamorphosis of a Term', *J. Soc. Archit. Hist.*, xxv (1966), pp. 115–18

T. Karlowicz: 'The Term Chicago School: Hallmark of a Growing Tradition', *Prairie Sch. Rev.*, iv (1967), pp. 26–30

H. Brooks: *The Prairie School: Frank Lloyd Wright and his Midwest Contemporaries* (Toronto, 1972)

B. A. Spencer, ed.: *The Prairie School Tradition* (New York, 1979) [good illus.]

Mus. Stud., xxi/2 (1995) [issue dedicated to the Prairie School]

PAUL E. SPRAGUE

Prang, Louis (*b* Breslau, Silesia [now Wrocław, Poland], 12 March 1824; *d* Glendale, CA, 14 June 1909). American publisher. A leader in the development of chromolithography and its application to fine art printing, he began his lithographic business in 1856 in Boston, where he fled after being banned by the Prussian government for his participation in the uprisings of 1848. Although he did not have particular lithographic training, Prang had considerable knowledge of colour printing and the principles of business management, learnt from his father, a German calico manufacturer. From 1860 until 1897 L. Prang & Co. manufactured a wide range of pictorial products, ranging from maps and fashion plates to advertisements and Christmas cards, and also supplied the plates for several notable publications, including Clement C. Moore's *A Visit from St Nicholas* (New York, 1864) and the ten volumes of W. T. Walters's *Collection of Oriental Ceramic Art* (New York, 1897). He also published drawing books and reproductions of European Old Masters. Black and white was sometimes employed, but Prang's reputation rests on his colour printing, particularly on the large chromolithographic reproductions of oil and watercolour paintings that he published under the name 'Prang's American Chromos' from 1865 to the end of the century. The technical brilliance of these reproductions after works by Winslow Homer (*The North Woods*; *c.* 1894), Eastman Johnson (*Boyhood of Lincoln*; 1868) and Thomas Moran (*Castle Geyser, Yellowstone National Park*; 1874), among others, is generally acknowledged. Prang's proclaimed aim of providing good, affordable art for a mass audience was often applauded, but he was also charged with corrupting public taste by blurring the boundaries between original art and a necessarily inferior substitute.

BIBLIOGRAPHY

M. M. Sittig: *L. Prang & Co., Fine Arts Publishers* (MA thesis, Washington, DC, George Washington U., 1970)

K. M. McClinton: *The Chromolithographs of Louis Prang* (New York, 1973)

P. Marzio: *The Democratic Art* (Boston, 1979)

ANNE CANNON PALUMBO

Pratt, Matthew (*b* Philadelphia, PA, 23 Sept 1734; *d* Philadelphia, 9 Jan 1805). American painter. One of ten children of a goldsmith, he was apprenticed at 15 to his uncle, James Claypoole. He spent almost seven years as an apprentice and eight as a painter of portraits and signs for taverns, shops and counting houses. In 1764 he went to England, where he studied under Benjamin West. Although four years older than West, he became his assistant and the first of his many students.

In 1764–5 Pratt painted portraits of *Betsy West* and *Benjamin West* (Philadelphia, PA Acad. F.A.) and a handsome *Self-portrait* (Washington, DC, N.P.G.) that show some of the fluid handling of contemporary English portraiture. In 1766 he exhibited the *American School* (1765; New York, Met.; see fig.) at the Society of Artists. His most ambitious and successful work (and the only known signed and dated one), the painting is an important document in the history of early American art: it shows five young painters, all full-length and presumably all Americans, working together in West's studio. Their identities are uncertain, although it is known that West and Pratt were among the figures. As an early American conversation piece, it goes beyond the simple compositional conventions of most Colonial portraiture. The careful arrangement and modelling of the figures by a cool light also reveals Pratt's debt to West's Neo-classical style.

Pratt stayed two and a half years with West and then worked for 18 months in Bristol. In 1768 he returned to Philadelphia where he set up a partnership with two other painters. They carried on 'in the most extensive manner the different branches of portrait or other ornamental paintings: such as all kinds of emblematical, masonic, historical, and allegorical devices and designs for pictures,

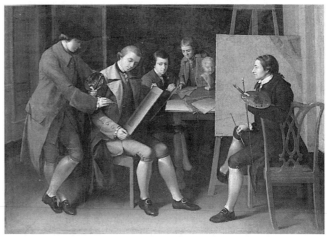

Matthew Pratt: *American School*, oil on canvas, 914×1276 mm, 1765 (New York, Metropolitan Museum of Art)

regimental colors and standards; ships flags, drums, and every other decoration of that kind; ...also fire buckets...coffin plates [and] japanned plates for merchants' counting houses' (Flexner, p. 73). Pratt also taught 'the art of drawing and coloring' and helped Charles Willson Peale with his museum of natural history and portraits. Although active for more than 50 years, Pratt left fewer than 40 securely attributable paintings. Late works, such as *Mrs Peter DeLancey* (New York, Met.), suggest that he reverted to the softer style of his earlier English portraits.

BIBLIOGRAPHY

W. Dunlap: *A History of the Rise and Progress of the Arts of Design in the United States*, 3 vols (New York, 1834/*R* 1969)
C. H. Hart, ed.: 'Autobiographical Notes of Matthew Pratt, Painter', *PA Mag. Hist. & Biog.*, xix (1895), pp. 460–67
W. Sawitzky: *Matthew Pratt: A Study of his Work* (New York, 1942)
J. T. Flexner: *The Light of Distant Skies* (New York, 1954, rev. 1969)

ROBERT C. ALBERTS

Prendergast, Maurice (Brazil) (*b* St John's, Nfld, 10 Oct 1858; *d* New York, 1 Feb 1924). American painter, printmaker, illustrator and designer of Canadian birth. He moved with his family to Boston in 1868 and was working as a commercial artist by 1886, lettering showcards, but his early attempts at watercolour foretold little of the talent that emerged after he travelled to Paris in January 1891. He studied for three years at the Atelier Colarossi under Gustave Courtois (1853–1923), and later at the Académie Julian under Benjamin Constant (1845–1902), Joseph Blanc (1846–1904) and Jean-Paul Laurens (1838–1921). Here the influence of the Nabis and of Whistler was particularly important to his development.

In late 1894 Prendergast returned to Boston as an accomplished watercolourist. Following his work in Paris and along the Breton coast, he began to paint scenes from the life of the urban middle class. During this period (1895–8) he continued to make monotypes, a technique he evidently learnt in Paris, and began to exhibit these and his watercolours with increasing recognition in Boston's commercial galleries. He also worked for a short time as a book illustrator and poster designer. The women depicted by Prendergast, unlike those painted by his Boston contemporaries, were rarely idle, even at leisure, and are never shown in domestic settings. They engage in the life of the city and its recreations, as in the *Stony Pasture* (watercolour, *c.* 1896–7; Manchester, NH, Currier Gal. A.), from whose sure underdrawing and lively surface pattern of fluidly applied watercolour emerge figures of women and children. In this composition one woman rather comically balances herself with a parasol to make her way among the boulders that littered the newly laid out park. Such obvious pleasure in the bustle of a crowd is also evident in scenes at the seashore, such as *Handkerchief Point* (watercolour, *c.* 1896–7; Boston, MA, Mus. F.A.), seen typically from above.

During an extended stay in Italy (1898–9) Prendergast achieved an even greater assurance in watercolour and, under the influence of 15th-century Italian art and architecture, he produced a significant group of works, which focus on life in the streets and piazzas of Venice. Compositionally more daring than the seaside scenes of the mid-1890s were such pieces as *Splash of Sunshine and Rain* (watercolour, 1899; Alice M. Kaplan priv. col.), which display his skill at pencil drawing. He reserved white areas of paper as independent compositional elements and applied washes of colour in rhythmic patterns across a sheet full of light, atmosphere and incident within a grand public setting.

On his return to America, Prendergast held his first one-man show in 1900 at the Macbeth Gallery, New York, and began to spend more time in that city, which provided new themes for his increasingly experimental watercolours. He also became associated with THE EIGHT, whose members recognized Prendergast as stylistically advanced and invited him to exhibit with them at Macbeth's in 1908. Prendergast's contribution included small oils, begun in France in 1907 following his recognition of the art of the Post-Impressionists, particularly Paul Cézanne (1839–1906) and of the Fauves.

In such panels as *In the Luxembourg Gardens* (1907; Margot Newman Stickley priv. col.) Prendergast found release from descriptive narrative. Although he continued to present his favourite seaside and park settings, his true subject was colour, rapidly painted in distinct patches to give a surface pattern to his small oils on panel and canvas. After 1908 his major works were in oil (see colour pl. XXV, 2), on a larger scale than before, and he quickly gained the attention of important collectors of modern European and American art, notably Lillie P. Bliss (1864–1931), Albert C. Barnes (1872–1951), John Quinn (1870–1924) and Edward Root (1884–1956). He participated in the organization of the Armory Show in 1913 and exhibited seven works there, including the exuberant and loosely painted oil *Landscape with Figures* (oil on canvas, *c.* 1910–13; Utica, NY, Munson–Williams–Proctor Inst.), which confirmed his awareness of avant-garde European styles exhibited to the American public for the first time at this show. He also worked closely with his brother Charles Prendergast (1863–1948) on designs for frames and other decorative projects, and some of Maurice's paintings reflect the more fanciful and highly imaginative carved, painted and gilded figurative panels of his brother. During the last decade of his life Prendergast repeatedly painted one subject: figures, usually women, posed along the shore or in a park—Arcadian evocations with vaguely spiritual or mythical overtones.

BIBLIOGRAPHY

Maurice Prendergast, 1859–1924 (exh. cat. by H. Rhys, Boston, MA, Mus. F.A., 1960)
Maurice Prendergast: Art of Impulse and Color (exh. cat. by E. Green, E. Glavin and J. Hayes, College Park, U. MD A.G., 1976)
C. Langdale: *Monotypes by Maurice Prendergast in the Terra Museum of American Art* (Chicago, 1984)
C. Clark, N. Mathews and G. Owens: *Maurice Brazil Prendergast, Charles Prendergast: A Catalogue Raisonné* (Munich, 1990) [incl. illustrations of *Splash of Sunshine and Rain* and *In the Luxembourg Gardens*]
Maurice Prendergast (exh. cat. by N. Mathews, Williamstown, MA, Williams Coll. Mus. A., 1990)
E. Glavin: 'The Early Art Education of Maurice Prendergast', *Archvs Amer. A. J.*, xxxiii/1 (1993), pp. 2–12
R. Wattenmaker: *Maurice Prendergast* (New York, 1994)

CAROL CLARK

Preston, William Gibbons (*b* Boston, MA, 1842; *d* Boston, 1910). American architect, stained glass designer, furniture designer and photographer. He was the son of Jonathan Preston (1801–88), a successful builder in Bos-

ton. William completed a year's study at the Lawrence Scientific School in Cambridge, MA (later incorporated into Harvard University), and then went to Paris where he enrolled briefly in the Atelier Douillard. He returned to Boston in 1861 to work with his father, with whom he remained in partnership until the latter's death. William then practised independently until his own death.

Preston was a prolific architect, designing over 740 buildings in the course of a career spanning 50 years. His early work was in the French Renaissance style, as seen in his Boston Society of Natural History building (1861–4), a tripartite structure with its floor levels arranged to equate with the proportions of the base, shaft and capital of a Classical column. It has monumental Corinthian columns and pilasters, and a central pediment flanked by a balustraded parapet. He worked in a typically eclectic manner during the 1870s, and became an extremely fine designer in the Queen Anne Revival style in the 1880s and early 1890s. The varied massing, stained-glass windows, terracotta, moulded brick and carved-wood detail of the John D. Sturtevant House (1884), Brookline, MA, and the Savannah Cotton Exchange (1886–7; see fig.), Savannah, GA, are good examples of his work in this style. His buildings are to be found in areas as far afield as New Brunswick, Georgia and Ohio. He also designed many stained-glass windows and articles of furniture and was a fine watercolourist and avid photographer, exhibiting regularly at the Boston Camera Club's exhibitions. Preston was a charter-member of the Boston Society of Architects, founded in 1867, and served as its treasurer from 1871 to 1902. He was active on many of its committees, particularly those dealing with construction and technical issues.

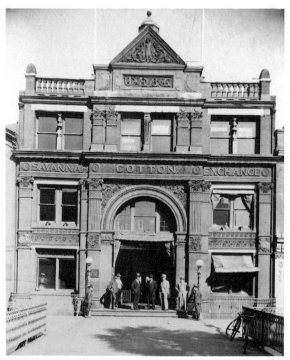

William Gibbons Preston: Savannah Cotton Exchange, Savannah, Georgia, 1886–7

BIBLIOGRAPHY
J. A. Follett-Thompson: *The Business of Architecture* (diss., U. Boston, MA, 1986)

JEAN A. FOLLETT

Price, Bruce (*b* Cumberland, MD, 12 Dec 1845; *d* Paris, 28 May 1903). American architect. An influential and eclectic architect of remarkable vitality and imagination, he contributed significantly to late 19th-century American residential and commercial architecture. He trained in Baltimore and briefly in Europe before practising in Baltimore and then in Wilkes-Barr, PA. In 1877 he moved to New York. In 1884 he was commissioned by Pierre Lorillard to design a hunting lodge near Manhattan, a project that led to his developing the exclusive Tuxedo Park community (1885–9). For this project he used cross-axial planning with richly textured and boldly interlocking volumes to produce some 40 buildings, stylistically diverse but similar in their use of natural materials and their careful integration with their sites. In the process, Price lent maturity to the cottage architecture of the 1880s and exerted a powerful influence on the clean geometry and open plans of Frank Lloyd Wright.

Price designed numerous residences in the USA and Canada, most notably the lavish Georgian Court (1898–1900) at Lakewood, NJ, and the sprawling Château Frontenac (1895) in Quebec. In the 1890s he turned increasingly to commercial architecture. His 20-storey American Surety Building in New York (1895, now the Bank of Tokyo) developed the tripartite column format, a system where the proportions of a building are arranged to equate with the base, shaft and capital of a Classical column. It was articulated on all elevations, as opposed to the usual practice of decorating only the front of a building, and introduced a complete skeletal steel frame, making it among the most celebrated and influential skyscrapers of the decade.

BIBLIOGRAPHY
DAB; *Macmillan Enc. Archit.*
R. Sturgis: 'The Works of Bruce Price', *Archit. Rec.*, Gt Amer. Architect Ser., 5 (June 1899)
V. J. Scully jr. *The Shingle Style: Architectural Theory and Design from Richardson to the Origins of Wright* (New Haven, 1955); rev. as *The Shingle Style and the Stick Style* (New Haven, 1971)
L. Doumato: *Bruce Price, 1845–1903*, Vance Architectural Bibliogs (Monticello, IL, 1984)

JANET ADAMS

Price, William L(ightfoot) (*b* Wallingford, PA, Nov 1861; *d* Rose Valley, PA, 15 Oct 1916). American architect, writer and designer. He was born into a Quaker family and trained in Quaker schools, also studying architecture in the office of Quaker Addison Hutton (1834–1916). By 1900 Price had been influenced by the utopian American economist Henry George (1839–97) and William Morris; Price formed utopian communities, such as a colony at Arden (1896), DE, in which a single tax was levied on land, and an Arts and Crafts commune at Rose Valley (1901), PA, where he lived until his death. There he developed a regional domestic architectural style that incorporated stucco, local stone and tile in gable-roofed houses and that evoked the local agrarian architecture, but with an abstract directness resulting from the merger of modern form with traditional materials. At the same time in 1903 Price formed a partnership with M. Hawley

McLanahan (1865–1929) and designed the great reinforced concrete buildings for which he is remembered. These began with the six-storey, Byzantine Revival Jacob Reed's Sons Store (1903), 1424 Chestnut Street, Philadelphia, and continued with the splendid domed reinforced concrete hotels, the Blenheim (1905) and the Traymore (1906–12; both destr.) in Atlantic City, NJ. With these buildings, Price established a national reputation that brought him commissions from Florida to the Midwest and demonstrated the validity of merging traditional 19th-century expression of function with 20th-century methods of construction. All Price's great hotels and his railway stations, such as the Chicago Freight Terminal (1914–19), were demolished by the last quarter of the 20th century, leaving the Rose Valley community as his principal monument.

BIBLIOGRAPHY
G. Thomas: *William L. Price, 1861–1916; Builder of Men and of Buildings* (diss., Philadelphia, U. PA, 1975) [illus.]
——: 'William L. Price', *Philadelphia: Three Centuries of American Art* (exh. cat., ed. D. Sewell; Philadelphia, PA, Mus. A., 1976), p. 460
——: 'William L. Price, Architect, Prophet without Honor', *Rose Valley: A Poor Sort of Heaven, a Good Sort of Earth* (exh. cat., ed. W. Ayers; Chadds Ford, PA, Brandywine River Mus., 1983), pp. 23–36
GEORGE E. THOMAS

Print clubs. The first American organization with prints in its focus was the Apollo Association, founded in New York in 1839. It published prints copied after paintings by prominent artists and held art lotteries. In 1844 it became the American Art-Union, which distributed thousands of fine prints until the 1850s. Similar groups were active in Philadelphia, Cincinnati, Boston and Newark during the 19th century.

The New York Etchers Club, founded in 1877, was the first organization devoted only to printmakers and it encouraged the attitude that prints should be seen as works of art. Among its early members were Thomas Moran, William Merritt Chase, Frederic Edwin Church, Joseph Pennell and James Smillie. The club, which existed until 1893, held social programmes, published prints, sponsored exhibitions and experimented with new media such as aquatint. Other printmakers' clubs formed in the 19th century, though they lasted only a few years, were the Boston Etching Club and the Philadelphia Society of Etching (both founded 1880), the Brooklyn Scratchers Club (1882), the Society of American Wood Engravers (1881), the Society of American Etchers (1888), the Etchers Club of Cincinnati (1879) and the Brooklyn Etchers Club (1881). The Philadelphia Society of Etching and the Brooklyn Etchers Club commissioned prints and included collector-members. The first association to issue limited edition prints was the Chicago Society of Etchers (1912–44). The California Society of Etchers, organized in 1911, sponsored an exhibit at the Panama Pacific International Exposition, San Francisco, in 1915.

BIBLIOGRAPHY
L. Peters: 'Print Clubs in America', *Prt Colr Newslett.*, xiii (1982), pp. 88–91
J. Watrous: *American Printmaking: A Century of American Printmaking, 1880–1980* (Madison, WI, 1984)
CHARLES J. SEMOWICH

Providence. Capital of and largest city in Rhode Island. It is also the state's commercial centre and a major port,

situated at the head of Narragansett Bay and at the confluence of three rivers about 75 km south of Boston, MA. Providence was settled in 1636 by Roger Williams (*c.* 1603–83) and his followers, religious non-conformists cast out of Massachusetts Bay and Plymouth colonies. The town was organized in linear fashion along its waterfront, unlike traditionally church-focused New England communities, and had no civic focus until well into the 18th century. The small subsistence town, which began to prosper as a port after 1750, remained culturally overshadowed by Newport until the late 1770s, when British occupation during the Revolution shattered Newport's economy.

The wealth brought to the port of Providence in the 18th century through trade financed impressive buildings, including University Hall (1770) of Rhode Island College (now Brown University), the First Baptist Meetinghouse (1774) and several substantial dwellings, including the John Brown House (1786), the Joseph Nightingale House (1792), the Thomas Poynton Ives House (1806) and the Sullivan Dorr House (1810–11), the last designed by JOHN HOLDEN GREENE, Providence's leading architect–builder of the early 19th century. Greene's idiosyncratic interpretation of English and American pattern-books gave Providence its first identifiable local architecture. The houses built on the city's East Side between 1780 and 1830 remain one of the country's most significant and intact groups of early Republican dwellings, epitomized by those that line both sides of Benefit Street.

The wealth accumulated by shipping financed heavy local investment in industry. Providence capital introduced mechanized textile production to America at nearby Pawtucket in 1790. The existing port, abundant availability of fresh water for power and processing, and expanding capital and rail connections after 1835 ensured Providence's growth into the 20th century as a centre for textiles, machines and machine tools, and jewellery.

During the 19th century Providence architecture became less provincial, first under the leadership of architects JAMES C. BUCKLIN (Providence Arcade, 1828; see colour pl. II, 2; Brown University, 1840; Monohasset Mill, 1868), Russell Warren (Athenaeum Row, 1845) and THOMAS TEFFT (Union Passenger Depot, 1848–55, destr.; Tully Bowen House, 1850–53; a landmark from this period is Swan Point Cemetery (begun 1847), an early rural landscaped cemetery notable for its planning and funerary sculpture, with which Horace William Shaler Cleveland was associated. In the second half of the century Stone, Carpenter & Willson (Alfred E. Stone, 1834–1908; Charles E. Carpenter, 1845–1923; Edmund R. Willson, 1856–1906) were the city's major architectural firm, with important buildings in a variety of styles: Arts and Crafts at the Fleur-de-Lys Studios (1885), 7 Thomas Street; Colonial Revival at the Robert W. Taft House (1895), 154 Hope Street; and American Renaissance at the Providence Public Library (1900; see fig.), 225 Washington Street. A key monument of the American Renaissance, McKim, Mead & White's Rhode Island State House was completed in 1904; overlooking the city's downtown area, it led to reorganization of the northernmost section according to the canons of the CITY BEAUTIFUL MOVEMENT. Early examples of landscape architecture appeared in H. W. S.

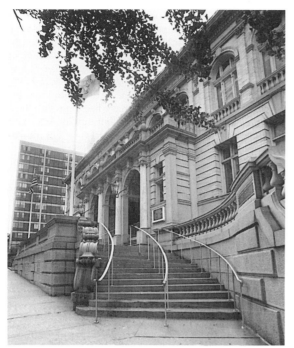

Providence Public Library by Stone, Carpenter & Willson, 1900

Cleveland's designs for Roger Williams Park (1878) and Blackstone Boulevard (1892).

The Rhode Island School of Design (founded 1877) encouraged the growth of several local industries, including textiles and precious metals. Led by Sydney Richmond Burleigh (*b* 1853), painters active here during these years formed the basis of an artistic community that continues to thrive encouraged by the School of Design. Before 1900 historic preservation emerged as a community concern dominated by the architect and scholar Norman Isham (1864–1943). The Museum of Art, Rhode Island School of Design, is a major regional museum, with nationally important collections in 19th-century painting, American decorative arts, prints and drawings and Eastern art.

BIBLIOGRAPHY

N. M. Isham and A. F. Brown: *Early Rhode Island Houses: An Historical and Architectural Survey* (Providence, 1895)

J. H. Cady: *The Civic and Architectural Development of Providence: 1636–1950* (Providence, 1957)

R. Freeman and V. Laskey: *Hidden Treasure: Public Sculpture in Providence* (Providence, 1980)

C. M. Woodward and F. W. Robinson: *A Handbook of the Museum of Art, Rhode Island School of Design* (Providence, 1985)

W. M. Woodward and E. F. Sanderson: *Providence: A Citywide Survey of Historic Resources* (Providence, 1986)

W. McKENZIE WOODWARD

Pullman, George Mortimer (*b* Brocton, NY, 3 March 1831; *d* Chicago, 19 Oct 1897). American industrial designer and philanthropist. His father was a skilled house builder living in Albion, NY, on the Erie Canal. When the canal was widened, Pullman worked with his father, moving houses that were too near the new canal banks. He moved in 1855 to Chicago, then a small, fast-growing city built on mud-flats only slightly above the level of Lake Michigan. There were severe drainage problems and the city authorities undertook to elevate existing buildings and build higher streets. In 1855 this work had just begun and Pullman brought with him the expertise needed to move buildings. Within a year he had established a thriving business.

During the winter, Pullman returned to his family in Albion, experiencing first-hand the rigours involved in long-distance rail travel, and he therefore formed a partnership in 1858 to build railway sleeping-cars. The early models enjoyed modest success and encouraged him to produce a larger, more luxurious version. Built during the winter of 1864, it was named the 'Pioneer' and Pullman benefited greatly from having this coach selected to form part of the funeral train bringing the body of Abraham Lincoln from Washington, DC, to Springfield, IL, which necessitated the modification of all bridges and platforms along the route to accommodate the larger car. Soon successive major railway companies adopted Pullman's sleeping-cars, although increasingly other companies were contracted to produce them.

Pullman and his associates decided to build a centralized factory. From 1869 his agents accordingly began to buy land along Lake Calumet, 12 miles south of Chicago, and work on the factory began in the summer of 1880. Pullman undertook the construction of several allied factories producing all the parts of the carriage and superstructure of his sleeping-cars.

Pullman then resolved to build a town adjacent to the factories and to let houses and office buildings as an additional commercial venture. Believing that good housing would mitigate problems with his workforce, Pullman was a keen observer of tenement housing reform and was familiar with the model tenements built in Brooklyn by Alfred T. White (1846–1921) during the 1870s. He wanted the same quality of design and construction in his brick-built town. The landscape designer Nathan F. Barrett, who had laid out several estates in fashionable suburbs of New York, and who early in 1879 had landscaped Fairlawn, Pullman's summer estate in Long Branch, NJ, was engaged to lay out the workers' town near Chicago. At the same time Pullman appointed Solon S. Beman to design all the factories, housing, markets, schools, a church, and all other major buildings in the town, which was renamed Pullman. By 1887, in addition to the factories and public buildings, Beman had built 1700 dwellings. Meanwhile, in 1883 he designed the Pullman Palace Car Company's national office building in central Chicago. Barrett's public and recreational spaces and Beman's housing were not particularly innovative, but the combination was unique and exceptionally well designed and constructed, resulting in a well-organized, durable and pleasing community. Unfortunately, however, the residents' high rents were expected to pay for the project, leading to labour unrest. Reductions in wages in 1893 resulted in a riot that clouded the architectural achievements made at Pullman, which otherwise constituted a significant contribution to the development of planned industrial communities.

BIBLIOGRAPHY

DAB

D. Doty: *The Town of Pullman: Its Growth, with Brief Accounts of its Industries* (Pullman, 1893/*R* 1974)

'George Mortimer Pullman', *National Cyclopedia of American Biography*, xi (New York, 1901), pp. 279–80

S. Buder: *Pullman: An Experiment in Industrial Order and Community Planning, 1880–1930* (New York, 1967)

H. M. Mayer and R. C. Wade: *Chicago: Growth of a Metropolis* (Chicago, 1969)

LELAND M. ROTH

Purcell & Elmslie. American architectural partnership formed in 1909 by William Gray Purcell (*b* Wilmette, IL, 2 July 1880; *d* Pasadena, CA, 11 April 1965) and George Grant Elmslie (*b* Huntly, Scotland, 20 Feb 1871; *d* Chicago, IL, 23 April 1952). Elmslie settled in Chicago with his family in 1884. After attending high school, he entered the office of Joseph Lyman Silsbee, where Frank Lloyd Wright and George W. Maher were already employed. In 1889 he joined the firm of Adler & Sullivan, becoming chief draughtsman in 1893. He continued in this capacity with Louis Sullivan after the partnership dissolved in 1895. In addition to the usual tasks of preparing contract documents and working drawings, he became increasingly responsible for the ornament that Sullivan lavished on the exterior and interior of his buildings. Elmslie produced many of the drawings for the ornament of the Guaranty Building (1894–6), Buffalo, NY, the Carson Pirie Scott Store (1898–1904), Chicago, IL, and the National Farmers' Bank (1907–8), Owatonna, MN, (*see* SULLIVAN, LOUIS, figs 1–3). In 1909, due to the lack of commissions in the Sullivan office, Elmslie left to join Purcell in Minneapolis.

Purcell was the grandson of the writer and editor William Cunningham Gray. His architectural education was at Cornell University from which he graduated in 1903. He returned to Chicago, where he worked first in the office of Henry Ives Cobb and then in Sullivan's office. In 1904 he went to the West Coast, where he worked as a draughtsman for John Galen Howard (1864–1931) in Berkeley and for a local architects' office in Seattle. Following his office apprenticeships he went to Europe with George Feick jr (1881–1945), a friend from Cornell. In 1907 they returned and founded the firm of Purcell & Feick in Minneapolis, MN. Their most important early works were an unbuilt project for the First National Bank Building (1907; see Gebhard, 1957, p. 105) in Winona, MN, and the Stewart Memorial Church (1909) in Minneapolis. These designs as well as their domestic work showed the influence of both Sullivan and Wright, coupled with ideas that Purcell had developed during his European trip and from his experience on the West Coast.

After Elmslie joined the firm (Purcell, Feick & Elmslie, 1909–13; Purcell & Elmslie, 1913–22), its activities were appreciably expanded, and one of the principal areas of activity was the design of small banks. Like Sullivan, they took the symbolic theme of a jewellery box set down within a small town or city in the American Midwest. The largest of these was the Merchants Bank of Winona (1911–12), MN; one of the smallest was the First State Bank (1914) at LeRoy, MN. Other commercial designs included the four-storey Edison Shop (1912–13) in Chicago, whose façade was composed of vertical piers with delicate recessed spandrels and plate-glass.

Purcell & Elmslie persistently sought out commissions for public buildings, but like other Prairie school architects they often lost these to more traditionalist colleagues. Their largest unrealized design was the projected Capitol Building (1914; see Gebhard, 1957, p. 235) at Canberra, Australia, for a competition that was aborted because of World War I. The principal activities of Purcell & Elmslie were, however, concentrated on suburban domestic architecture. The designs of the Bradley House (1913) at Juniper Point, Woodshole, MA, and the concrete Decker House (1912–13; destr.; see Gebhard, 1965, pp. 29, 80–87), Holdridge, MN, were based on a cruciform scheme terminating in a large curved glass bay. Purcell's own house (1913) at 2328 Lake Place, Minneapolis, MN, with its single connected multi-layered space, is one of the major landmarks of the Prairie school.

WRITINGS

'American Renaissance?', *Craftsman*, 21 (1912), pp. 430–35

G. G. Elmslie: 'The Chicago School: Its Inheritance and Bequest', *J. Amer. Inst. Architects*, 37 (1952), pp. 32–8

BIBLIOGRAPHY

T. R. Hamlin: 'George Grant Elmslie and the Chicago Scene', *Pencil Points*, 22 (1941), pp. 576–86

D. Gebhard: *Purcell and Elmslie, Architects, 1909–1922* (Minneapolis, 1953)

——: *William Gray Purcell and George Grant Elmslie and the Early Progressive Movement in American Architecture from 1900 to 1920* (Minneapolis, 1957)

——: 'Louis Sullivan and George Grant Elmslie', *J. Soc. Archit. Hist.*, xix/2 (1960), pp. 62–8

——: *The Architecture of Purcell and Elmslie* (Chicago, 1965)

H. Allen Brooks: *The Prairie School* (Toronto, 1972), pp. 200–34

DAVID GEBHARD

Putnam, Arthur (*b* Waveland, MS, 6 Sept 1873; *d* Ville d'Avray, near Paris, France, 27 May 1930). American sculptor. Although born in Mississippi, he grew up in the Midwest (Omaha, NE), moving at age 18 to join his widowed mother in San Diego, CA, where his parents had bought a lemon grove. During his late teens, the future sculptor of animals sketched wild horses and buffalo on the plains and later, in southern California, trapped puma for the San Francisco Zoo. The California Midwinter International Exposition attracted him to San Francisco in 1894. While a student there at the Art Students League, he assisted sculptor Rupert Schmid (1864–1932) and supported himself by working in a slaughterhouse, an experience that provided him an intimate knowledge of animal anatomy. In 1895, after only a year in San Francisco, he returned to San Diego to work as a ranch hand and surveyor. (His father, a New Englander, had been a civil engineer in the South after the Civil War.) Other than time spent in the Chicago studio of animal sculptor Edward Kemeys (1843–1907), Putnam remained largely an autodidact. He returned with his bride to San Francisco in 1899 to establish a career as a sculptor. His major work was created there from 1901 to 1905 (see fig.), the period during which he shared studios with fellow Bohemian Club artist members Earl Cummings (1876–1936) and Gottardo Piazzoni. Through the patronage of Mrs William H. Crocker, he was able in 1905 to make a first visit to Europe. In Paris he saw at firsthand the work of Auguste Rodin (1840–1917), whose Impressionist style provided an important influence; Rodin admired Putnam's work, which received praise when exhibited at the salons of Paris and Rome.

Returning to San Francisco late in 1906, Putnam found his home and studio in ruins, the models and plaster casts of his work destroyed by the recent earthquake. The

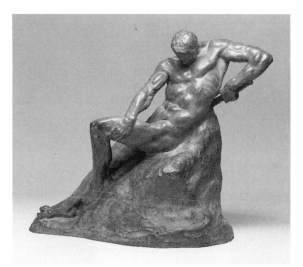

Arthur Putnam: *Il Penseroso*, bronze, h. 553 mm, 1903 (San Francisco, CA, Fine Arts Museums of San Francisco)

Putnams lived temporarily in a tent near the Cliff House while building a new home and studio in the sands of Ocean Beach, where he worked to recreate his lost *oeuvre* and produce numerous architectural commissions for the rebuilding of the city. He provided sculptural ornamentation for the St Francis Hotel, the Masonic Temple, the Pacific Union Club, as well as various banks. By this time, with exhibitions at the Macbeth Gallery (New York) and the acquisition of an animal bronze by the Metropolitan Museum of Art at the suggestion of sculptor Daniel Chester French, Putnam's success seemed assured. But tragically, in 1911, surgery for removal of a brain tumour left him partially paralyzed, effectively ending his career. His work has been included in numerous group exhibitions, and monographic shows have been held at the California Palace of the Legion of Honor (five exhibitions, from 1930 to 1976) and the Oakland Museum (1978).

BIBLIOGRAPHY

J. H. Heyneman: *Arthur Putnam, Sculptor* (San Francisco, 1932)

P. J. Broder: *Bronzes of the American West* (New York, 1974)

D. L. Stover: *American Sculpture: The Collection of the Fine Arts Museums of San Francisco* (San Francisco, 1982)

B. Kamerling: 'Arthur Putnam, Sculptor of the Untamed', *Ant. & F.A.*, vii/5 (1990), pp. 122–9

PAUL J. KARLSTROM

Q

Queen Anne Revival [Free Classic style]. Architectural style popular from the 1870s until the early 20th century in England and the USA. Developing in reaction to the dogma of Gothic Revival, the style borrowed freely from the domestic architecture of the late 17th century and Queen Anne periods in England and the Netherlands. The style is characterized by asymmetrical plans, use of red brick and a combination of medieval and Classical motifs, such as oriel windows and Flemish gables together with pilasters and broken pediments. It was allied to progressive social attitudes and a desire to make good design available to all. The decorative arts were of great importance to the style, and domestic fittings contributed substantially to the desired aesthetic effect. In the USA the style merged into the Shingle style and the vernacular.

In the USA different visual forms evolved for Queen Anne Revival architecture than in England. In 1873 the Scottish designer Daniel Cottier (1838–91) opened a shop in New York selling imported building materials and furniture. A series of articles by Clarence Cook published in *Scribner's Magazine* between 1875 and 1877 (repr. in 1878 as *The House Beautiful*) publicized the Queen Anne Revival movement widely. The depression of the mid-1870s meant that little construction was taking place but opportunity abounded in Boston, MA, following the great fire of 1872 and the filling in of the Back Bay. In Boston and Newport, RI, moreover, architects and clients had knowledge of recent British work from their travels and from imported books, photographs and periodicals.

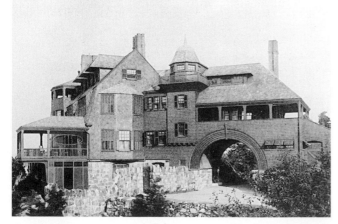

Queen Anne Revival, Kragsyde by Robert Swain Peabody, Manchester-by-the-Sea, Massachusetts, 1882 (destr.)

Already by 1870 John Hubbard Sturgis, an American architect trained in England and half-brother to Voysey's client Julian Sturgis, had designed a building for the new Museum of Fine Arts, Boston. Ornamented with English terracotta like its model, the South Kensington museums in London, Sturgis's museum initiated an educational programme in art and the decorative arts. Robert Swain Peabody's brick and terracotta Hemenway Gymnasium (1878; destr.) at Harvard College, Cambridge, MA, was followed in Back Bay by William Ralph Emerson's Boston Art Club (1882), and many mansions and public buildings, most notably Sturgis's palatial Frederick L. Ames House (1882), 306 Dartmouth Street, Boston .

In the USA, as in England, Queen Anne Revival was used most creatively in domestic architecture. The early 18th century had been the first monumental building period in the English colonies, and traditional American styles of this period were now revived together with English styles. The Bostonian architect Robert Peabody first linked Colonial Revival with Queen Anne Revival in his article 'A Talk about Queen Anne' (1877). Peabody found a romantic inspiration in the wooden architecture of Colonial New England, combining in his John Denny House (1877) in Milton, MA, an 18th-century gambrel roof and Palladian window with an irregular Queen Anne Revival plan.

Queen Anne Revival houses in Boston and Newport constructed in the early 1870s by Sturgis, Richard Morris Hunt and others had broad verandahs and wooden clapboards with stickwork above a masonry ground floor instead of the tile hanging and half-timbering of their English models. Interiors were notable for their free, organic planning, with an emphasis on architectural furniture, and often with an imposing staircase hall.

In 1874 H. H. Richardson used shingles to clad his Queen Anne Revival house in Newport for William Watts Sherman (*see* RICHARDSON, H. H., fig. 2). This house and the Newport Casino (1878–9) by McKim, Mead & White started the SHINGLE STYLE of the 1880s. Wooden shingles or weatherboards were used for the upper storeys, rather than timberwork, tile and pargetting, while the ground floor and foundation were of brick or glacial boulders. The Shingle style immediately became popular and absorbed elements of Queen Anne Revival. In Newport, Peabody's house Breakers (1878) for Pierre Lorillard faithfully translated into wood the gables and swags common in Queen Anne Revival in London; but his Kragsyde (1882, destr., see fig.) at Manchester-by-the-Sea,

MA, evoking Cragside in Northumberland by R. Norman Shaw (1831–1912), brings together the various elements of domestic American architecture of the period. Picturesquely sited on a rocky crag, it has an irregular, organic plan, with an entrance arch placed to one side, and the main portion of the hall reached by a flight of stairs. Many elements are drawn from the English Queen Anne Revival, but its upper walls are clad in smooth shingles in a purely American development of the style.

Queen Anne Revival co-existed and merged freely with COLONIAL REVIVAL and the Shingle style in the 1880s. Urban mansions of brick and stone were built in the style in Boston, Minneapolis, Chicago and New York, documented in Daly's *L'Architecture américaine* (1887) and George Sheldon's *Artistic Houses* (1882) and *Artistic Country Seats* (1882, 1883). After first-hand experience in England, Wilson Eyre produced early designs for houses in Philadelphia in the 1880s that were particularly creative. With completion of the Union Pacific Railroad in 1878, and through pattern books by such firms as Paliser & Paliser of New York (1886), Queen Anne Revival swiftly influenced the American vernacular and continued in a debased form, unprotected by theory or rules. Examples of the style, executed in standard millwork, often with patterned shinglework and bulbous turned posts in a Jacobean style, extended from Boston to San Francisco by 1897, and the style spread to other parts of the English-speaking world.

Although Queen Anne Revival was discussed in both professional and popular periodicals in England and the USA at the time, it plunged from favour in the first half of the 20th century and was derided for its lack of rules and excessive reliance on ornament. From the 1950s, however, growing recognition of its quality and the importance of its legacy led to further research.

Queen Anne Revival flourished during a hopeful and progressive period at the end of the 19th century. Liberated from the doctrinaire rigidity of earlier 19th-century styles, it provided educated and artistic people with many delightful buildings with attractive interiors.

BIBLIOGRAPHY

EARLY SOURCES

B. Talbert: *Gothic Forms* (London, 1876)
R. S. Peabody: 'A Talk about Queen Anne', *Amer. Architect & Bldg News*, ii (1877), pp. 133–4
C. Cook: *The House Beautiful* (New York, 1878)
M. J. Lamb: *Homes of America* (New York, 1878)
J. J. Stevenson: *House Architecture* (London, 1880)
R. W. Edis: *Decoration and Furnishing of Townhouses* (London, 1881)
M. E. Hawes: *Beautiful Houses* (London, 1882)
G. W. Sheldon: *Artistic Houses* (New York, 1882)
M. B. Adams: *Artists' Houses* (London, 1883)
M. Schuyler: 'Recent Architecture in New York', *Harper's Mag.* (Sept 1883); repr. as 'Concerning Queen Anne', in *American Architecture and Other Writings*, ed. W. H. Jordy and Ralph Coe (Cambridge, MA, 1961), pp. 453–68
A. Daly & fils: *L'Architecture américaine* (Paris, 1886)
G. W. Sheldon: *Artistic Country Seats*, 2 vols (New York, 1886–7/R 1979)
J. Moyr Smith: *Ornamental Interiors* (London, 1888)

GENERAL

V. J. Scully, jr: *The Shingle Style: Architectural Theory and Design from Richardson to the Origins of Wright* (New Haven, 1955); rev. as *The Shingle Style and the Stick Style* (New Haven, 1971)
H. R. Hitchcock: *Architecture: Nineteenth and Twentieth Centuries*, Pelican Hist. A. (Harmondsworth, 1958, rev. 1977)
B. Bunting: *Houses of Boston's Back Bay* (Cambridge, MA, 1967)
M. H. Floyd: 'A Terra Cotta Cornerstone for Copley Square: Museum of Fine Arts, Boston by Sturgis and Brigham, 1870–1876', *J. Soc. Archit. Historians*, xxxii (1973), pp. 83–103
W. A. Holden: 'The Peabody Touch: Robert Swain Peabody of Peabody & Stearns of Boston', *J. Soc. Archit. Historians*, xxxii (1973), pp. 114–31
A. Lewis and K. Morgan: *American Victorian Architecture* (New York, 1975)
M. Girouard: *Sweetness and Light: The 'Queen Anne' Movement, 1860–1900* (Oxford, 1977)
R. Longstreth: *On the Edge of the World* (New York, 1983)

MARGARET HENDERSON FLOYD

Quidor, John (*b* Tappan, NY, 26 Jan 1801; *d* Jersey City, NJ, 13 Dec 1881). American painter. As a child Quidor moved with his family to New York, where he studied painting briefly with John Wesley Jarvis. His early work (1823–8) was tentative, judging from the few known examples, and he apparently made his living by painting banners and fire-engine backs, none of which has survived. In 1828 he exhibited at the National Academy of Design a picture that established his mature style, *Ichabod Crane Pursued by the Headless Horseman* (New Haven, CT, Yale U. A.G.). The subject was from Washington Irving's *The Sketch Book*, and Quidor's interpretation, with its fantasy, baroque inventiveness and romantic exaggeration, struck a new note in American genre painting, which until then had been consistently realistic.

During the following decade Quidor scoured the writings of Irving and James Fenimore Cooper for legends and fictional incidents that appealed to his taste for caricature and humour. His masterpiece of this period was the *Return of Rip Van Winkle* (1829; Washington, DC, N.G.A.; see fig.), the first of his pictures in which colour played an important role. Quidor used light and colour even more dramatically in *Money Diggers* (1832; New York, Brooklyn Mus. A.), in which trees emerge threateningly from the darkness and richly painted garments flutter eerily in the firelight. Contemporary critics took Quidor to task for his lack of realism ('his horse is not a horse'), and he seems to have had little financial success. Seeking fortune in another direction, he painted seven huge biblical scenes (3.35×5.18 m; 1843–9), all now lost. He exchanged these for a farm in Illinois, but he was cheated out of it. Except for one smaller biblical scene of *c.* 1845, no picture by Quidor has yet been found from the period 1839 to 1855.

From 1855 to around 1868 (when he apparently stopped painting for good) he returned to the literary subjects of his youth, though he painted in a very different style. Colour almost disappeared, with figures melting into a pervading haze. Shadows were rendered by amber glazes. When faces emerged they were drawn with quick, nervous lines like those that vividly capture Wolfert's conflicting greed and astonishment in *Wolfert's Will* (1856; New York, Brooklyn Mus.). In other late canvases, such as the *Embarkation from Communipaw* (1861; Detroit, MI, Inst. A.), there are no faces but a frieze of capering figures against a fantastic landscape. When Quidor died he had been virtually forgotten, and it was only after a one-man exhibition at the Brooklyn Museum in 1942 that he emerged as one of the most original genre painters of 19th-century American art.

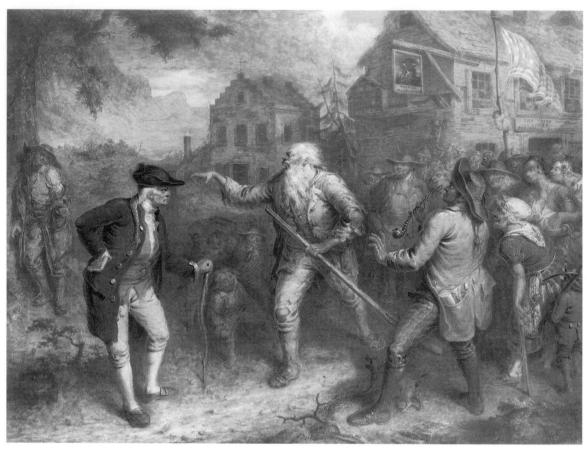

John Quidor: *Return of Rip Van Winkle*, oil on canvas, 1.01×1.26 m, 1829 (Washington, DC, National Gallery of Art)

BIBLIOGRAPHY

John Quidor, 1801–1881 (exh. cat. by J. I. H. Baur, New York, Brooklyn Mus., 1942, rev. Utica, NY, 1965)

E. Rohdenburg: 'The Misrepresented Quidor Court Case', *Amer. A. J.*, ii (1970), pp. 74–80

D. M. Sokol: 'John Quidor, Literary Painter', *Amer. A. J.*, ii (1970), pp. 60–73 [supplemented by 'The Art of John Quidor', *Amer. A. Rev.*, i (1974), pp. 68–73, 128]

John Quidor: Painter of American Legend (exh. cat. by D. M. Sokol, Wichita, A. Mus., 1973)

C. K. Wilson: 'Engraved Sources for Quidor's Early Work', *Amer. A. J.*, viii (1976), pp. 17–25

JOHN I. H. BAUR

R

Randolph, Benjamin (*b* South River, NJ, 30 Jan ?1737; *d* Wading River, NJ, Dec 1791). American joiner and cabinetmaker. By 1762 he was an established craftsman and entrepreneur in Philadelphia. In 1765 he expanded his cabinetmaking business to accommodate increasing Colonial patronage, following the signing of the Non-importation agreements by local craftsmen and patrons. He bought property and built a handsome shop on Chestnut Street, Philadelphia, where he employed several journeymen joiners and two skilled, London-trained carvers, Hercules Courtenay (?1744–84) and John Pollard (1748–87), who were well-equipped to provide customers with furnishings in the current London style. Randolph's accounts ledgers for the years 1768 to 1786 (New York, Pub. Lib.) suggest that his cabinetmaking business was the most prolific in Philadelphia in the mid-18th century, specializing in walnut and mahogany case furniture and elaborately carved sets of chairs in the Chippendale style. In 1775 Thomas Jefferson commissioned him to make the portable writing desk on which the Declaration of Independence was drafted (Washington, DC, N. Mus. Amer. Hist.). After serving in the Revolution (1775–8), he retired and moved to New Jersey.

BIBLIOGRAPHY

Philadelphia: Three Centuries of American Art (exh. cat. by D. Sewell and others, Philadelphia, PA, Mus. A., 1976), pp. 110–16

BEATRICE B. GARVAN

Ranney, William Tylee (*b* Middletown, CT, 9 May 1813; *d* West Hoboken, NJ, 18 Nov 1857). American painter. He spent six formative years in the hill country of North Carolina. By 1834 he was working and studying drawing in New York, but two years later he went to Texas to join in the war for independence. Although he returned to New York a year later, it was not until 1846, with the outbreak of the Mexican War, that Ranney began to use his Western experience as the basis for his painting. With the encouragement of the American Art Union, he executed three types of Western subject: the Western trapper or hunter, pursuing a dangerous life on the prairies, as in *Trapper's Last Shot* (1850; untraced; engraved and lithographed by T. Dwight Booth); the pioneer family, heading across the plains with children, dogs and goods, as in *Advice on the Prairie* (1853; Malvern, PA, Claude J. Ranney priv. col.); and the dangers of emigration, for example *Prairie Fire* (1848; Paoli, PA, J. Maxwell priv. col.). Painting on a fairly large scale, Ranney combined a particularizing, detailed technique in his trappers and pioneers, their costumes and their animals, with broad, freely brushed panoramic backgrounds. His work was praised as completely American, its authenticity vouched for by his West Hoboken studio filled with such Western paraphernalia as saddles, guns and sketches. Ranney also painted Eastern sporting scenes and several historical works about the American Revolution.

BIBLIOGRAPHY

F. S. Grubar: *William Ranney: Painter of the Early West* (New York, 1962)

L. Ayres: 'William Ranney', *American Frontier Life: Early Western Paintings and Prints* (exh. cat., Fort Worth, TX, Amon Carter Mus., 1987), pp. 79–107

William Tynee Ranney, East of the Mississippi (exh. cat., Chadds Ford, PA, Brandywine River Mus.; Youngstown, OH, Butler Inst. Amer. A.; 1991–2)

E. C. Pennington: *Passage and Progress in the Works of William Tylee Ranney* (Augusta, GA, 1993)

ELIZABETH JOHNS

Ransome, Ernest L(eslie) (*b* Ipswich, 1852; *d* 1917). English engineer, active in the USA. His father had developed and manufactured a patented 'concrete stone'. Ransome's early work is all in California, where he went in 1869 to exploit his father's patents, and includes the two first reinforced-concrete bridges (1886–7) in the USA, in Golden Gate Park, San Francisco. Apart from his services as engineer for the museum at Stanford University and the campanile at Mills College, the rest of his California work is entirely for industrial purposes. It is stylistically unremarkable but technically immensely innovative and fully abreast of the work of European pioneers in the material. His reputation spread, and in the later 1890s he began to do more work in the eastern states where, in a final burst of architectural creativity recorded in patents of 1898 to 1902, he produced the 'Ransome System' of standardized industrial building. Two events combined to make him and the system famous at this point; a spectacular fire (1902) at the Pacific Coast Borax Plant at Bayonne, NJ, in which his first factory (1897) on that side of the country survived unscathed, and the construction of a large plant at Beverly, MA, for the United Shoe Manufacturing Co., which was intended from the start as a model demonstration of modern factory construction in concrete. There, and in the second phase of the factory at Bayonne (both begun 1903) he demonstrated the concept of the 'daylight factory', an exposed rectangular reinforced concrete frame with glass replacing solid walling materials almost completely. Because of its advantages in terms of fire-safety, economy of construction and improved working environment, the daylight factory became standard

throughout North America for the next two decades. It also served to illustrate the polemics of Walter Gropius (1883–1969) and Le Corbusier (1887–1965) and thus helped to fix the Modernist imagery of the International Style.

WRITINGS
with A. Saubrey: 'Personal Reminiscence', *Reinforced Concrete Buildings* (New York, 1912)

BIBLIOGRAPHY
Macmillan Enc. Architects
Le Corbusier: *Vers une architecture* (Paris, 1923, rev. 1924; Eng. trans., London, 1927)
A. L. Huxtable: 'Reinforced Concrete Construction: The Work of Ernest L. Ransome', *Prog. Archit.* (Sept 1957)
C. Condit: *American Building Art* (Chicago, 1968)
R. Banham: *A Concrete Atlantis* (Cambridge, MA, 1986)

REYNER BANHAM

Redmond, Granville (Richard Seymour) (*b* Philadelphia, PA, 9 March 1871; *d* Los Angeles, CA, 24 May 1935). American painter. He contracted scarlet fever at the age of two and a half, an illness that left him permanently deaf. In 1874 his family came to California, and in 1879 Redmond enrolled in what was then called the California Institution for the Education and Care of the Indigent Deaf and Dumb, and the Blind at Berkeley (now located in Fremont and called the California School for the Deaf). He studied with deaf photographer and painter Theophilus Hope d'Estrella (1851–1929), who taught him drawing and pantomime. Redmond also received sculpture lessons from the deaf sculptor Douglas Tilden. After graduation in 1890, Redmond enrolled in the California School of Design, San Francisco. In 1893, with a stipend from the Institution for the Deaf, he went to Paris, where he enrolled in the Académie Julian.

After five years in France, Redmond returned to California and opened a studio in Los Angeles. For the next several years he painted throughout the Los Angeles area, including Laguna Beach, Long Beach, Catalina Island and San Pedro. In 1908 he relocated to Parkfield on the Monterey Peninsula, where he resumed his friendships with his former classmates from the California School of Design, Gottardo Piazzoni and Xavier Martinez. He moved to San Marco in 1910 and had a studio in Menlo Park. Hampered by long periods of recurring depression,

Redmond preferred to paint in a moody, introspective style, characterized by the use of dark tones of brown, gold and olive-green, but his patrons favoured cheerful paintings of rolling hills covered with golden poppies and other wildflowers (see fig.).

BIBLIOGRAPHY
Granville Redmond (exh. cat., Oakland, CA, Mus., 1988)

JEAN STERN

Reed, Luman (*b* Green River, NY, 4 June 1785; *d* New York, 6 June 1836). American merchant, collector and patron. The son of a farmer, he accumulated a fortune in New York's wholesale dry-goods trade. Poorly educated and knowing little about art, Reed began collecting Old Master paintings (of dubious authenticity) in the late 1820s, and in 1832, perhaps taking a cue from the fashionable Philip Hone, he began to buy landscape and genre works from contemporary American artists: Thomas Cole, Asher B. Durand, William Sidney Mount, Ernest Flagg, Thomas Doughty, Samuel F. B. Morse, Henry Inman, Charles Robert Leslie and Gilbert Stuart Newton.

Reed had a lavish mansion with a gallery built on Greenwich Street, New York. Probably inspired by the Peale Museum in Philadelphia, the gallery, which Reed opened to the public one day a week, was simultaneously a natural history collection and a gallery of American art. Work on the gallery brought Reed into close contact with Durand and Cole, who devised the gallery's elaborate iconographic programme; Cole's five-painting *Course of Empire* series (New York, NY Hist. Soc.) was planned as its centrepiece, but Reed died before this grand scheme could be carried out. During the 1840s a group of business associates, many of whom had followed his example in collecting contemporary American art, made Reed's collection the nucleus of the New York Gallery of the Fine Arts, the city's first public art museum. The project eventually failed, and Reed's collection was given to the New-York Historical Society in 1857.

BIBLIOGRAPHY
W. Craven: 'Luman Reed, Patron: His Collection and Gallery', *Amer. A. J.*, xii/2 (1980), pp. 40–59
E. M. Foshay: *Mr Luman Reed's Picture Gallery: A Pioneer Collection of American Art* (New York, 1990)

ALAN WALLACH

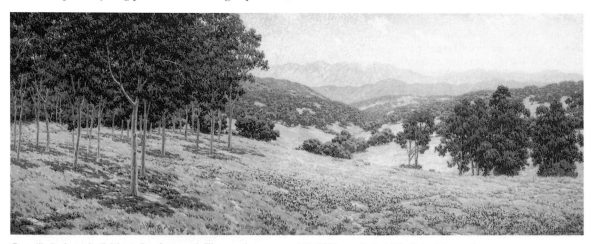

Granville Redmond: *California Landscape with Flowers*, oil on canvas, 813×2032 mm (Irvine, CA, Irvine Museum)

Reid, James W(illiam) (*b* St Johns, NB, 29 Nov 1851; *d* San Francisco, CA, 23 Sept 1943). Canadian architect, active in the USA. He received his architectural training at the Massachusetts Institute of Technology, Cambridge, MA, and at the Ecole des Beaux-Arts in Paris. He first worked as a draughtsman for the Evansville & Terre Haute Railroad in Evansville, IN, but left to go to San Diego, CA, where he built the sprawling and grandiose resort, the Hotel Coronado (1886–8). In 1889 he joined his brother Merritt Reid (*d* 1932) who had already begun an architectural practice in San Francisco (they were later joined by a third brother, Watson E. Reid (*d* 1943)); they soon established one of the most important architectural firms in the city. Their earliest important office buildings in San Francisco included the Call Building (1897; later the Claus Spreckels Building, then Central Tower), a skyscraper that survived the earthquake and fire of 1906. Other important buildings there included the original Fairmont Hotel, the Fitzhugh Building, the Hale Brothers Department Store and Cliff House. They also received commissions for important buildings outside San Francisco, including the Merritt Building in Los Angeles, the Carnegie Library at San Rafael and the Byron Springs Resort Hotel in Contra Costa County. In Portland, OR, they built two office towers, the Yeon Building (1911) and the Journal Building (1912; now Jackson Tower). The practice was dissolved in 1932.

BIBLIOGRAPHY

'Works of Reid Brothers', *Architect & Engin.*, xxiii/1 (1910), pp. 34–91

R. Banham: 'Coronado: Or, Don't Smoke in Bed', *Architects' J.*, cxliii/5 (1966), pp. 317, 319

M. Buckley: *The Crown City's Brightest Gem* (San Diego, 1970)

R. Griebner: 'Hotel del Coronado: A Jewel in the Crown City', *Hist. Preserv.*, xxiv/2 (1972), pp. 4–7

LELAND M. ROTH

Remington, Frederic (Sackrider) (*b* Canton, NY, 4 Oct 1861; *d* Ridgefield, CT, 26 Dec 1909). American painter, sculptor, illustrator and writer. In 1878 he began his studies at the newly formed School of the Fine Arts at Yale University in New Haven, CT, remaining there until 1880. This, along with a few months at the Art Students League in New York in 1886, was his only period of formal art training. In 1881 he roamed through the Dakotas, Montana, the Arizona Territory and Texas to document an era that was fast vanishing. He returned east and in 1882 had his first drawing published (25 Feb) in *Harper's Weekly*. Further commissions for illustrations followed, including that for Theodore Roosevelt's *Ranch Life and the Hunting Trail* (New York, 1888); see fig. 1. He became a business partner for a bar in Kansas City, MO, but its failure, coupled with his continued success as an illustrator, convinced him that he would do better to record the West visually rather than help to develop it financially.

Remington returned to live in New York in 1885 and spent the next few years building a reputation as a renowned professional illustrator for the popular magazines *Harper's Weekly*, *The Century Illustrated* and *Scribner's Magazine*. His only direct contact with his subject-matter was through short periodic trips to the West from his home in Brooklyn in order to make sketches for the black-and-white drawings for these magazines. On his visits he also amassed valuable first-hand experience with the

1. Frederic Remington: pen-and-ink book illustration; from Theodore Roosevelt: *Ranch Life and the Hunting Trail* (New York, 1888)

cavalry, the cowboys and the Indians for the short stories that he was beginning to publish. During the 1880s his style developed and matured, though there is little evidence for this as he destroyed many of his paintings himself, the well-known *Dash for the Timber* (1889; Fort Worth, TX, Amon Carter Mus.) being one of the few surviving works from this period. In the slightly later *Fight for the Waterhole* (*c*. 1895–1900; Houston, TX, Mus. F.A.) features of the landscape are subordinated to the dramatic story line. In 1895 Remington began to exhibit his bronze sculptures of cowboys and horses in motion (e.g. *Mountain Man*, 1903; Cody, WY, Buffalo Bill Hist. Cent.): these became so popular that they were reproduced in multiples (see colour pl. XXVIII, 1).

After 1900 Remington's oils gradually shifted from a tight illustrative style to a somewhat Impressionist one. He became influenced by Monet 1840–1926) as well as by Childe Hassam, John H. Twachtman and Julian Alden Weir, all three of whom he knew personally. Colour, light and composition became more important than details. Some of his late oils combine sharp outlines with sketchier brushstrokes to create a most effective form of impressionistic realism, as in *Pony Herder* (1909; Denver, CO, Mus. W. A.; see fig. 2). In this painting the figures of the Indian and his horse are rendered in a more precise manner, revealing Remington's talents as a draughtsman, while the skies, grass and herd of ponies beyond are executed in loose brushstrokes. He wrote that 'I have always wanted to be able to paint running horses so you could feel the details instead of seeing them'. Another work of his late years, *Downing the Nigh Leader* (1907; Denver, CO, Mus. W. A.), is, with *Dash for the Timber*, his best-known painting: both are valuable documents of the early days of the American West and realistically portray dramatic incidents. Remington was one of the foremost exponents of WILD WEST AND FRONTIER ART. He wrote eight books (e.g. *The Way of an Indian*, New York and London, 1906) and numerous short stories, as well as executing 2500 drawings, 23 sculptures and many paintings in celebration of his chosen subject.

WRITINGS

P. Samuels and H. Samuels, eds: *The Collected Writings of Frederic Remington* (Garden City, 1979)

2. Frederic Remington: *Pony Herder*, oil on canvas, 762×762 mm, 1909 (Denver, CO, Museum of Western Art)

A. P. Splete and M. D. Splete, eds: *Frederic Remington, Selected Letters* (New York, 1988)

BIBLIOGRAPHY
H. McCracken, ed.: *Frederic Remington's Own West* (New York, 1960)
H. McCracken: *The Frederic Remington Book: A Pictorial History of the West* (Garden City, 1966)
Frederic Remington: Paintings, Drawings and Sculpture in the Amon Carter Museum and the Sid W. Richardson Foundation Collections (exh. cat. by P. H. Hassrick, Fort Worth, TX, Amon Carter Mus., 1974)
Frederic Remington: The Late Years (exh. cat. by P. H. Hassrick, Denver, CO, A. Mus., 1981)
P. Samuels and H. Samuels: *Frederic Remington: A Biography* (Garden City, 1982)
M. Atwood and M. Mangum: *Frederic Remington and the North Country* (New York, 1988)
M. E. Shapiro and P. H. Hassrick: *Frederic Remington, the Masterworks* (New York, 1988)
S. Craze: *Frederic Remington* (Leicester, 1989)
Frederic Remington (exh. cat., Santa Fe, NM, Peters Gal., 1991)
Frederic Remington's Southwest (exh. cat. by J. K. Ballinger, Phoenix, AZ, A. Mus.; Memphis, TN, Brooks Mus. A.; Omaha, NE, Joslyn A. Mus.; 1992)
P. H. Hassrick: 'The Frederic Remington Studio: A Reflection', *Antiques*, cxlvi (1994), pp. 666–73
——: *The Frederic Remington Studio* (Cody, WY and London, 1994)
A. Nemerov: *Frederic Remington & Turn-of-the-Century America* (New Haven, 1995)
P. Hassrick and M. Webster: 'Frederic Remington: A Catalogue Raisonné', *Amer. A. Rev.*, viii/3 (1996), pp. 133–7

W. C. FOXLEY

Remmey [Remmi], John. *See under* CROLIUS AND REMMEY.

Rensselaer, Mariana Griswold van. *See* VAN RENSSELAER, MARIANA GRISWOLD.

Renwick, James, jr (*b* New York, 1 Nov 1818; *d* New York, 23 June 1895). American architect. Combining architectural knowledge with his training as an engineer and an artistic sensibility, he became one of the most famous and respected American architects of the 19th century. He worked in a variety of styles in a career that spanned more than 50 years.

1. Training and early work. 2. Smithsonian Institution and other public buildings. 3. St Patrick's Cathedral and late work.

1. TRAINING AND EARLY WORK. Renwick completed the standard curriculum at Columbia College, New York, in 1836 and received his MA in 1839. By that time his father, James Renwick sr (1792–1863), had become a professor of physics and chemistry at Columbia and had earned a formidable reputation as one of the foremost engineers in the USA. Professor Renwick was also a noted astronomer and mineralogist, an art collector and patron, as well as an accomplished painter, a prolific writer on science and history, an architectural historian and an amateur architect of more than average ability. He trained his three sons as engineers and whenever possible assisted them in furthering their careers. James Renwick jr's first job was as an engineer on the Erie Railroad. From 1837 to 1842 he was second assistant engineer for the Croton Aqueduct Commission, in which capacity he worked on the huge Distributing Reservoir that stood on the present site of the main building of the New York Public Library.

Renwick's career as an architect began in 1843, when his design for Grace Episcopal Church (1843–6), a New York landmark on the corner of Broadway and 10th Street, was selected by the vestry over plans submitted by established architects. Situated in Greenwich Village, then an exclusive residential area, it had a reputation as the city's most fashionable church. Grace Church and Richard Upjohn's Trinity Episcopal Church (1841–6) are the earliest American buildings to display a real understanding of the medieval Gothic style and were widely acclaimed. Renwick described the formal design of Grace Church, with its central tower and spire, as 'a small cathedral' in 'the early Flamboyant' style derived from both English and French models. Generally considered an example of the Decorated style of Gothic, it would appear to have been the first use of curvilinear tracery patterns in the USA and also the first time a cruciform plan was employed.

Except for the Romanesque-inspired Church of the Puritans (1846–7; destr.) for the Congregationalists, slightly north of Grace Church in Union Square, Renwick's other urban churches of the 1840s were variations of the Gothic forms of Grace Church. Also in New York, he designed Calvary Episcopal Church (1846–7), on the north-east corner of Fourth Avenue and 21st Street, which has gables across the west front and south entrance and twin towers and triple entrance doors, and the South Dutch Reformed Church (1848–9; destr.), on the south-west corner of Fifth Avenue and 21st Street, which had a single tower on its north-west corner. For the Second Presbyterian Church (?1849–51; destr.), on the north-east corner of Wabash Avenue and Washington Street, Chicago, and for Trinity Episcopal Church (1850–51; destr.), on the north-east corner of 3rd Street and C Street in Washington, DC, Renwick devised similar five-bay entrance façades.

By 1848 Renwick had begun to use Romanesque forms, sometimes in combination with other modes, for many

different types of structure: for civic monuments, Romanesque was combined with classical forms; for commercial buildings, with the Italianate; and in church design, with Gothic. He experimented with an eclectic approach even on major commissions. Two prominent churches, St Stephen's (1853–4), at 128 East 28th Street for the wealthiest Roman Catholic congregation in Manhattan, and the Clinton Avenue Congregational Church (1854–5; destr.), in the exclusive residential neighbourhood of Brooklyn Heights, contain both Romanesque and Gothic motifs, as do the two designs by him in *A Book of Plans for Churches and Parsonages* (New York, 1853), published by the Congregational Churches in the US General Convention. But when he thought it appropriate, Renwick continued to use only the round-arched style. The large row house (1849–51; destr.) he designed for his parents on Fifth Avenue in Greenwich Village appears to have been the first residential use of the Romanesque Revival style in the USA.

2. SMITHSONIAN INSTITUTION AND OTHER PUBLIC BUILDINGS. In 1846 Renwick entered the competition for the Smithsonian Institution (1847–55), Washington, DC; the building was to house a museum, a library,

lecture rooms, chemical laboratories and offices. Despite the fact that the competition regulations limited architects to one entry, Renwick had submitted his symmetrically organized Gothic scheme along with a freer, picturesque design in a round-arched style, the proposal eventually recommended by the influential chairman of the building committee, Robert Dale Owen. (Owen's *Hints on Public Architecture*, New York, 1849, has an elaborate title-page designed by Renwick.) Although the dual submission may have been prompted by Renwick's personal conviction that the Gothic was more appropriate for a major public building, he nevertheless won the competition with his multi-towered, round-arched design, including designs for furniture. (Renwick adapted the central block of his Gothic Revival design for the entrance façade of Trinity Church, Washington, DC.) The Smithsonian's 'Castle' (*see* WASHINGTON, DC, fig. 3 and colour pl. II, 3), as it is commonly called, was the first public building in that style in the USA. Renwick's belief in the Gothic style for important public buildings remained undiminished. In the same year that construction began on the Smithsonian, work was started on another important institutional commission, the Free Academy (1847–9; destr.), on the southeast corner of Lexington Avenue and 23rd Street (later

1. James Renwick: Corcoran Gallery (now the Renwick Gallery), Washington, DC, 1859–61, completed 1870–71

called the College of the City of New York), which was modelled on a northern European medieval town hall.

Renwick was also renowned as the architect of elegant New York hotels, such as the Clarendon (1850–51; destr.), an Italianate building with Elizabethan details, displaying a lively mixture of yellow brick walls, decorative terracotta window heads and brownstone trim; the St Denis (?1851–2), on Broadway and 11th Street, which was commissioned by his mother and designed in a more explicitly Elizabethan manner; and the white marble LaFarge House (1852; burnt 1854, rebuilt 1854–6; destr.) on Broadway, a structure imbued with the more sedate air of an Italian palazzo notwithstanding the presence of cast-iron store fronts at street level. Renwick's design was noteworthy for its extensive use of iron and sophisticated heating, plumbing and ventilation systems. Indeed, he was one of the first architects to use iron for structural purposes, an early example being the Bank of the State of New York (1855–6; destr.) in the financial district of lower Manhattan; it had a complete iron floor system consisting of girders, beams and sheet iron troughs that held sound-deadening and fire-retarding dirt infill. Two municipal hospitals, now neglected ruins, built of stone quarried near the site on Roosevelt Island in the East River, New York, illustrated Renwick's shift from the Gothic to the Second Empire style for public buildings. The Smallpox Hospital (1853–?1856) was designed in the castellated form of the Gothic style. His design for the nearby Island Hospital (1858–61), which has a sprawling, tripartite plan, with mansard roofs of patterned slate and a monumental dome over the central entrance, shows a preference for a simplified version of the Second Empire mode.

The original Corcoran Gallery (1859–61, completed 1870–71; now the Renwick Gallery) at the north-east corner of Pennsylvania Avenue and 17th Street NW, Washington, DC, was the first Second Empire style building in the USA in which the rich spatial and decorative qualities of that elaborate mode were properly used (see fig. 1). Renwick cited the New Louvre, Paris, as the model but emphasized that the details and proportions of his design were 'entirely different'. Also different were the brick exterior with brownstone trim and the use of wrought-iron floor beams. In his design for Vassar College (1861–5; altered), Poughkeepsie, NY, Renwick reflected the constraints placed on him by the client Matthew Vassar, a retired brewer, who chose the Palais des Tuileries, Paris, as the model for the main building of the new college. An indication of Renwick's great skill was his ability to create, in brick, an impressive rendition of that Renaissance palace by focusing on the overall form and massing of the original model rather than on the elaborate details. Despite the reduction in size, the formality and scale of the prototype selected by Vassar was, unfortunately, inappropriate for the building's rural site.

3. ST PATRICK'S CATHEDRAL AND LATE WORK. By the end of the 1850s Renwick's practice had increased to such an extent that he took Richard Tylden Auchmuty (1831–93) and, later, Joseph Sands (*b* 1830/38–1880) into partnership. It was in that decade that he received the most important commission of his career and certainly one of the most important in the history of American architecture, St Patrick's Roman Catholic Cathedral (1853–79; spires 1885–8; see fig. 2), on Fifth Avenue between 50th and 51st Streets in New York. Renwick personally oversaw every detail of the twin-towered Decorated Gothic masterpiece, which is based on ideas taken from the cathedrals of Reims, Amiens, Cologne and Exeter as well as York Minster and Westminster Abbey, from the selection of the marble for the walls to the design for the candelabra in the chancel, and the subsequent design of the archbishop's residence (1880–82) and the rectory (1882–3) at the rear of the site facing Madison Avenue. But St Patrick's was both Renwick's greatest work and his greatest disappointment. A lack of sufficient funds necessitated changes to his plans, the most profound being the substitution of plaster for the masonry specified in his original plan for the vault, after the flying buttresses had been constructed.

Before St Patrick's was completed, Renwick had turned from the Decorated style to the combination of Italian Gothic and Romanesque forms or Ruskinian Gothic for important church commissions. His designs of the 1860s and 1870s were more vigorous, less stylistically selfconscious and more successful in their synthesis of form and fabric than his earlier works. Richly coloured, highly textured materials were used to produce dazzling polychromatic effects.

Among Renwick's finest works designed at that time were the Church of the Covenant (1863–5; destr.), on the north-west corner of Park Avenue and 35th Street, New York; the Irvington Presbyterian Church (?1868–9), in the estate section of Westchester County just north of New York, which has a towering campanile and belfry; and St Bartholomew's Episcopal Church (1871–2; destr.), commonly referred to as 'the Vanderbilt Church', on Madison Avenue near Grand Central Station, a particularly fine building whose campanile was almost twice the height of the nave. An indication of his highly eclectic approach to design was apparent in the difficulty critics had in categorizing the style of St Bartholomew's; one called it 'Byzantine', another 'Lombardo-Gothic' and the most famous American critic of his generation, Montgomery Schuyler, praised it as a superb example of the 'Italian Romanesque'. St Ann's Episcopal Church (1867–9; destr.), at the northeast corner of Clinton and Livingston Streets in Brooklyn Heights, was the first church designed by Renwick in the polychromatic Ruskinian mode. Built of brownstone with sharply contrasting limestone trim, this costly building had an elaborately decorated interior that included iron columns with naturalistic designs for the capitals. However Renwick also worked in other styles at this time and at Booth's Theater (1867–9; destr.), on the south-east corner of Sixth Avenue and 23rd Street, he used the Second Empire mode with considerable success. The innovative structural and mechanical systems Renwick designed for this expensive theatre, which was built for $1,000,000, were also evidence of his exceptional technological skill.

Renwick was devoted to his practice throughout his career and continued to produce buildings ranging from private residences to hospitals during his remaining decades. In keeping with popular taste, commercial work during this period was generally in a classical form, of masonry and, like the LaFarge House, often with iron

2. James Renwick: St Patrick's Cathedral, New York, 1853–79; spires, 1885–8

store fronts. As his office papers were destroyed in a fire, few details of his staff survive. Among his last projects was one in which he collaborated with the amateur architect Franklin Webster Smith (d 1911) to develop a proposal (1890) for an outdoor museum that would consist of reproductions of the world's architecture and culture. The huge Beaux-Arts axial complex was to be constructed entirely of reinforced concrete on a 63–75 acre site in Washington, DC. Although never executed, Renwick's participation in this monumental proposal, a forerunner of the World's Columbian Exposition (Chicago, 1893), was evidence of a mind and talent that constantly sought new challenges.

BIBLIOGRAPHY
DAB; Macmillan Enc. Archit.
R. T. McKenna: A Study of the Architecture of the Main Building and the Landscape of Vassar College, 1860–1970 (diss., Poughkeepsie, NY, Vassar Coll., 1949)
——: 'James Renwick, jr. and the Second Empire Style in the United States', Mag. A., xliv (1951), pp. 97–101
S. Rattner: Renwick's Design for Grace Church: Religious Doctrine and the Gothic Revival (diss., New York, Columbia U., 1969)
J. E. Cantor: The Public Architecture of James Renwick, jr. (diss., Newark, U. DE, 1971)
S. Rattner: 'Renwick's Church for Blacks', Hist. Preserv., xxiv (1972), pp. 32–5
W. H. Pierson jr: American Buildings and their Architects: Technology and the Picturesque, the Corporate and Early Gothic Styles (New York, 1978)
M. Page: Furniture Designed by Architects (New York, 1980)
S. Rattner: 'James Renwick', Master Builders (1985), p. 48
——: 'Landmark Profile: Roosevelt Island's Southern Landmarks', Newslett.: NY Landmarks Conserv. (Autumn 1986)
——: 'James Renwick', Long Island's Country Houses and their Architects, 1860–1940, ed. C. Traynor (in preparation)

SELMA RATTNER

Revere, Paul (b Boston, MA, 1 Jan 1735; d Boston, 10 May 1818). American silversmith, engraver and metalworker. He was trained as a silversmith by his father, Apollos Rivoire (1702–54), who anglicized his name to Paul Revere in 1730. After his father's death, Revere took over the family silver business. He was an active participant in the American Revolution (1775–83). As a member of the Sons of Liberty, he acted as a courier, taking dispatches from Boston to the other colonies, a role described in Henry W. Longfellow's poem The Midnight Ride of Paul Revere (1860). By 1764 Revere had begun working in copper-engraving, creating portraits, cartoons and advertisements. He is best known for his engravings of political events of the American Revolutionary War, for example the Landing of the Troops (1768; see exh. cat., p. 120, pl. 155) and the Boston Massacre (1770; see Brown and others, p. 92, pl. 110). The latter is similar to an engraving by Henry Pelham (1749–1806), who accused Revere of copying his version.

In 1768 Revere made the Sons of Liberty Punch Bowl (Boston, MA, Mus. F.A.; see fig.), which is reputed to be the most famous example of American presentation silver. Commissioned by the Sons of Liberty, the bowl is inscribed with the names of its 15 members and a message in celebration of the Massachusetts House of Representatives' vote against repressive British policies. The shape of the punch bowl is derived from a type of Chinese porcelain bowl exported to the British colonies in the 18th century. Its simple design has been copied repeatedly. Revere also made domestic pieces, particularly pitchers, tankards and tea- and coffeepots in the Rococo and Neo-classical styles (e.g. coffeepot, 1781; Boston, MA, Mus. F.A.). Among his other enterprises, he established a small iron foundry in 1788 for casting cannon and church bells. His first bell (1792) is in the church of St James, North Cambridge, MA. In 1800 he built a mill for rolling sheet-copper and in 1802 coppered the dome of the State House in Boston. The Revere Copper Co. continues to produce sheet-copper. Around 1768–70 John Singleton Copley painted a portrait of Paul Revere (Boston, MA, Mus. F.A.; see COPLEY, JOHN SINGLETON, fig. 1), which emphasizes Revere's trade as a silversmith: he is shown at work, engraving a teapot. Other portraits of Revere include one

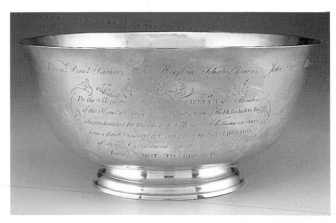

Paul Revere: Sons of Liberty Punch Bowl, silver, diam. 279 mm, 1768 (Boston, MA, Museum of Fine Arts)

in crayon by Charles B. J. F. de Saint-Mémin in 1800 and a later one by Gilbert Stuart (both Boston, MA, Mus. F.A.).

BIBLIOGRAPHY

W. L. Andrews: *Paul Revere and his Engraving* (New York, 1901)

E. Forbes: *America's Paul Revere* (Boston, 1946)

K. C. Buhler: *Paul Revere: Goldsmith, 1735–1818* (Boston, 1956)

C. S. Brigham: *Paul Revere's Engravings* (New York, 1969)

Paul Revere's Boston, 1735–1818 (exh. cat., intro W. M. Whitehill; Boston, MA, Mus. F.A., 1975)

M. W. Brown and others, eds: *American Art* (New York, 1979)

M. K. Brown: 'Paul Revere and the Late Reverend Mr. Prince's Church Cupp: The Study of a Commission', *Amer. A. J.*, xv/1 (1983), pp. 83–90

R. Duthy: 'Paul Revere, Silversmith', *Connoisseur*, ccxv (1985), pp. 160–66

C. Korsmeyer: 'Pictorial Assertion', *J. Aesth. & A. Crit.*, xliii (1985), pp. 257–65

G. Deak: 'Focus on Historical Prints', *Prt Colr Newslett.*, xix/5 (1988), pp. 183–5

A. E. Ledes: 'Paul Revere', *Antiques*, cxxxiii (1988), pp. 776–8

CAREY ROTE

Rhead, Frederick Hurten (*b* Hanley, Staffs, 1880; *d* New York, 2 Nov 1942). American potter and ceramic designer of English birth. Born into a family of potters and designers and trained in the English potteries, he arrived in the USA in 1902. Until 1917 he was associated with several art potteries, notably the Roseville Pottery in Ohio, the Arequipa Pottery in California and the University City Pottery, St Louis, MO. The last was under the aegis of the American Woman's University, for which Rhead created a pottery correspondence course in 1910. His early art pottery used English techniques, including contrasting slip decoration, pictorial low-relief carving and monochromatic low-relief modelling.

BIBLIOGRAPHY

S. Dale: *Frederick Hurten Rhead: An English Potter in America* (Erie, PA, 1986)

A. C. Frelinghuysen: 'Frederick Hurten Rhead (Designer): Vase', *Bull. Met.*, lv/2 (Autumn 1997), p. 65

R. Blaszczyk: *Imagining Consumers: Design and Innovation from Wedgwood to Corning* (Baltimore, 1999)

ELLEN PAUL DENKER

Rhead, Louis John (*b* Etruria, Staffs, 6 Nov 1857; *d* Amityville, NY, 29 July 1926). American painter, illustrator and writer of English birth. He trained at the National Art Training School, South Kensington, London, and in Paris, first making his reputation as a designer of bookbindings. He was invited to New York in 1883 by the Appleton Publishing Company but then stayed on in the USA to work for various publishers. In the late 1880s and early 1890s he designed posters for *Harper's Magazine*, *Century Magazine* and the children's magazine *St Nicholas*. These were praised by an American public hungry for anything similar to the linear style of Walter Crane (1845–1915) and Kate Greenaway (1846–1901).

Rhead's popularity began to wane after 1900, when the vogue for posters also died down; to make a living he began to illustrate children's books with colour lithography, for example producing editions of Jonathan Swift's *Gulliver's Travels* (New York, 1913) and *The Swiss Family Robinson* (New York, 1909) by Jonathan David Wyss. He also wrote a few books for children himself and wrote and illustrated books about fishing, such as the privately printed *How to Fish the Fly Dry* (1921).

BIBLIOGRAPHY

G. White: 'The Posters of Louis Rhead', *The Studio*, viii (1896), no. 41, pp. 156–61

V. Margolin: *American Poster Renaissance* (Secaucus, 1975)

P. Cate: *American Art Posters of the 1890s in the Metropolitan Museum of Art* (New York, 1987)

MARK W. SULLIVAN

Richards, William Trost (*b* Philadelphia, PA, 14 Nov 1833; *d* Newport, RI, 8 Nov 1905). American painter. In 1846–7 he attended the Central High School in Philadelphia, PA, but left before graduating in order to help support his family. He worked full-time as a designer and illustrator of ornamental metalwork from 1850 to 1853 and then part-time until 1858. During this period he studied draughtsmanship and painting with Paul Weber (1823–1916) and probably had some lessons at the Pennsylvania Academy of the Fine Arts, Philadelphia, where he exhibited in 1852. The following year he was elected full Academician there. In 1855–6 he toured Europe with William Stanley Haseltine and Alexander Lawrie (1828–1917), studying for several months in Düsseldorf. Finding contemporary European landscape painting less inspiring than that of America, he returned to Philadelphia.

Richards probably read the first two volumes of *Modern Painters* (London, 1843–6) by John Ruskin (1819–1900) during the 1850s, for soon after he began to show an interest in geological subjects and spent the summers sketching in the Catskills, the Adirondacks and the mountains of Pennsylvania. Striving for the fidelity to nature he had seen in Pre-Raphaelite painting in an exhibition of British art at the Pennsylvania Academy in 1858, Richards began to paint outdoors. In the 1860s he executed several highly detailed landscapes, such as *June Woods* (1864; New York, NY Hist. Soc.), and botanical studies. In March 1863 Richards was unanimously elected to membership of the Society for the Advancement of Truth in Art, an American Pre-Raphaelite organization. In 1862 he was made an honorary member of the National Academy of Design, New York, but he did not become a full Academician until 1871.

From 1868 to 1874 Richards summered annually on the East Coast. This inspired the partiality for coastal topography that persisted throughout his career. Characteristic of his handling of this theme are panoramic views of waves and uninhabited, wet beaches as in *On the Coast of New Jersey* (1883; Washington, DC, Corcoran Gal. A.). A luminist light, painted in harmonious, silvery tones, is reflected on the sand and the water. At first he treated these marine subjects as meticulously as his woodland views, but eventually his technique became broader. In the 1870s he developed his use of watercolour from delicate and transparent washes to opaque layers of gouache. From 1874 he exhibited with the American Water Color Society, and from 1875 to 1884 he sent approximately 185 watercolours to the Philadelphia collector George Whitney.

In 1879–80 Richards was in Europe, for he felt that his style was becoming old-fashioned and that he needed fresh subject-matter. Works from this period, many fea-

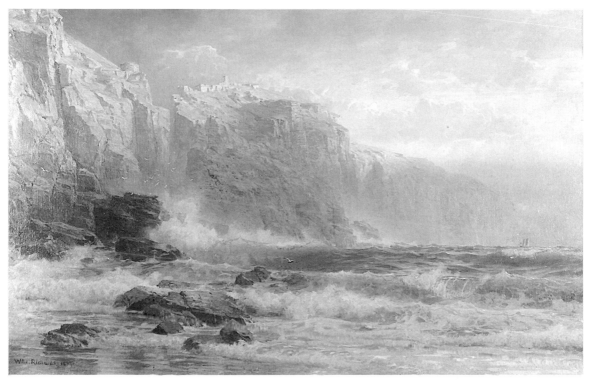

William Trost Richards: *League Long Breakers Thundering on the Reef,* oil on canvas, 715×1120 mm, 1887 (New York, Brooklyn Museum of Art)

turing the English coast (New York, Brooklyn Mus A.; see fig.), are tightly painted and opaque. When he returned to America in 1881, he built a summer-house in Newport, RI, that gave him ready access to the sea and made sketching out of doors in watercolour and oil convenient. Richards's interest in capturing natural light and reflections can be associated with similar concerns of the Impressionists, but his handling was tighter and his palette more tonal; it is only in his oil sketches that an Impressionist freshness and luminosity occur. In 1890 Richards moved permanently to Newport and travelled between there and Europe. He remained active until the end of his life, painting both landscapes and seascapes.

BIBLIOGRAPHY
William Trost Richards (exh. cat. by L. S. Ferber, New York, Brooklyn Mus., 1973)
L. S. Ferber: *William Trost Richards (1835–1905): American Landscape and Marine Painter* (New York, 1980)
ANNETTE BLAUGRUND

Richardson, H(enry) H(obson) (*b* St James Parish, LA, 29 Sept 1838; *d* Brookline, MA, 27 April 1886). American architect. He was the foremost American architect of his generation. His achievement consisted in creating a distinctive personal style that was the first to be both recognizably American and influential beyond the USA.

1. Childhood and education. 2. Early career. 3. Mature career. 4. Last years.

1. CHILDHOOD AND EDUCATION. H. H. Richardson was the eldest of the four children of Catherine Caroline Priestley and Henry Dickenson Richardson, a native of Bermuda who had become a successful Louisiana cotton merchant. He spent his early life on the Priestley Plantation and in New Orleans, and he showed an aptitude for mathematics and was intended for the US Military Academy, West Point, NY, but failed to qualify due to a speech impediment. He spent one year at the University of Louisiana, then entered Harvard College, Cambridge, MA, in February 1856.

While his academic achievement at Harvard was average, Richardson exhibited great personal charm, and a number of close friendships he made during these years were to continue throughout his life. Although he had intended pursuing a career in civil engineering when he entered Harvard, he at some time during these years decided to become an architect instead. After graduating from Harvard in 1859, Richardson spent the summer travelling in Great Britain before going to Paris, where he studied at the Ecole des Beaux-Arts. He failed the examinations that autumn but passed after months of study in November 1860. He entered the atelier of Louis-Jules André (1819–90), but, with the outbreak of the American Civil War in 1861, his family's support was cut off, and he was able to pursue his studies only intermittently thereafter. Although he returned briefly to the USA in 1862, his stay was short as he was torn between opening a practice in Boston and attempting to return to Louisiana. Instead he returned to Paris, where he worked in the offices of Théodore Labrouste (1799–1885) and J. I. Hittorff (1792–1867), while continuing his studies in his spare time. He never completed the course at the Ecole, and he returned to the USA in October 1865.

2. EARLY CAREER.

(i) Initial works. Richardson chose neither to return to New Orleans nor to join his college friends in Boston but settled instead in New York. He worked for a short time for a local builder, but, determined to prove himself, he opened his own office in Manhattan on 1 May 1866. After several months without commissions, he was able to enter a competition for the Unity Church, Springfield, MA, through the intervention of his Harvard classmate and lifelong friend James A. Rumrill. Richardson's project was selected in November 1866. With this success, and his confidence in his own future, Richardson married Julia Gorham Hayden in January 1867. In October 1867, after construction of his first three buildings, Richardson entered into partnership with Charles Dexter Gambrill (1834–80). Gambrill, who had previously been in partnership with George B. Post, functioned largely as the business manager for the new partnership, leaving Richardson free to develop his artistic talent as the primary design partner in the firm.

Richardson's earliest buildings are barely distinguishable from those of his contemporaries. They display the range of stylistic approaches and design influences common to American architects in the later 1860s and early 1870s. For example, his two early churches, Unity Church (completed 1869; destr. 1961), Springfield, and Grace Church (completed 1869), Medford, MA, are based on English parish church conventions, while the Western Railroad Offices (completed 1869; destr. 1926), Springfield, MA,

and the William Dorsheimer House (completed 1871), Buffalo, NY, show the influence of French prototypes. However, even in these early works Richardson displayed some freedom within these conventions. The Grace Church, for example, although it has a typical side-entry English plan, was constructed of local glacial boulders.

In late 1869 Richardson began working on the designs for the Brattle Square Church, Boston, for which Gambrill & Richardson won the commission in July 1870. This structure (completed 1873), in the newly developing Back Bay area of Boston, shows Richardson's first divergence from the styles used by his contemporaries. He employed Romanesque forms executed in Roxbury puddingstone with sandstone trim to enclose a geometrically simple and volumetrically unified interior. The most remarkable feature of the composition is the 54-m-high tower with a frieze by Frédéric-Auguste Bartholdi (1834–1904), sculptor of the *Statue of Liberty*. It has been suggested that the entry into Richardson's office of Charles Follen McKim, soon after the award of the commission, may have helped in crystallizing the design.

Richardson followed this success with a notable design for the New York State Hospital, Buffalo. While not officially commissioned until 1871, work is thought to have begun on the project in 1869. Although Richardson based his plan, a flattened V with a central administration building at the apex and pavilions for men and women to the east and west, on typical 19th-century practice for such structures, he continued his exploration of forms and

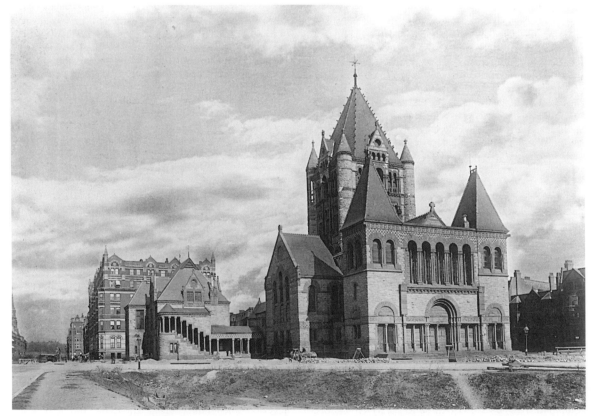

1. H. H. Richardson: Trinity Church, Boston, Massachusetts, west front and parish house, begun 1874

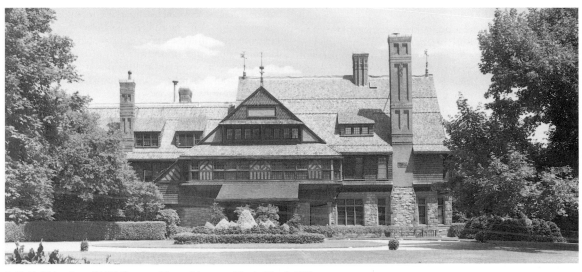

2. H. H. Richardson: W. W. Sherman House, Newport, Rhode Island, 1874

elements such as round arched windows derived from Romanesque architecture. The project was also significant as one of the earliest collaborations between Richardson and his neighbour and close friend, landscape architect FREDERICK LAW OLMSTED.

(ii) Trinity Church. Richardson was one of six architects and firms invited in March 1872 to submit designs for Trinity Church, Boston, to be built in the Back Bay. Richardson's competition scheme, like those of the other competitors, was created to fit a rectangular site, but between 1 May 1872, when designs were received, and 1 June, when Richardson's was selected, the church acquired an additional piece of land to create a trapezoidal site facing Copley Square. Richardson worked over the next two years revising and refining his design. Construction began in April 1874, and the building was not dedicated until February 1877, after JOHN LA FARGE had completed the interior decoration.

The design of Trinity Church is a unified composition including the sanctuary and an attached parish house (see fig. 1). In plan the sanctuary is a Greek cross with a central tower. Three galleries are located in the three square arms of the cross, while the chancel is located in the semi-circular apse in the fourth arm. The square tower rising above the crossing was fully resolved only after construction had begun and the proposed octagonal tower was not feasible. The parish house is diagonally offset to the back of the sanctuary, and the two are attached by an open cloister.

In the revisions he made to the Trinity Church design, Richardson moved towards a fully integrated architecture of mass, gravity and stateliness. The plan and three-dimensional composition reflect his synthesis of the principles of planning and hierarchical order he had learnt in France with the Picturesque forms of contemporary English and American work. The clearly defined nave, tower and parish house present a composition that is volumetrically additive, but these elements are subordinated within a coherent overall pyramidal design.

Trinity Church proved to be a watershed in Richardson's career. His selection as architect, followed by the successful completion of the project, established him as a national figure, one of the leading architects of his time. When construction of Trinity Church began in 1874, Richardson moved his home and personal office to Brookline, a suburb of Boston, to be near the building site, but he continued in partnership with Gambrill for four more years. During that time the office staff remained in New York. Richardson would develop preliminary sketches in a small office in his Brookline house and then send these to New York to be developed into detailed drawings and construction documents.

Richardson's synthesis of Picturesque forms with hierarchical order is also evident in some of his residential projects in this period. While earlier projects for wooden houses generally adopted the principles of the skeletally articulated Stick style, Richardson's 1872 design for the F. W. Andrews House (destr. 1920), Middletown, RI, with its use of shingles as exterior sheathing, shows a new expression of the characteristics of surface texture and treatment of surface as expressive of volumetric enclosure, although the forms remain additive and not well integrated. However, the major innovation of this house is the plan, with a large living-hall as the heart of the house and all other spaces clustered around it.

Richardson further developed this living-hall plan with the W. W. Sherman House (1874; see fig. 2), Newport, RI. The Sherman House also shows the direct influence of the work of the English architect Richard Norman Shaw (1831–1912). Many of Richardson's details closely follow those of Shaw's Old English country houses, such as Leyswood (1868–9; mostly destr. *c.* 1955), near Groombridge, Sussex, although they were executed in the American vernacular materials of shingles and stone in place of Shaw's tiles and brick. Both the Sherman House and the Trinity Church tower featured detailing by Stanford White, who had joined Richardson's office in 1870 and remained with Richardson until 1878.

3. MATURE CAREER.

(i) Expanding practice. During the recession of the mid-1870s, the firm Gambrill & Richardson was supported by the major commissions for the Buffalo Hospital and Trinity Church, as well as a series of residential projects. In 1875 Richardson began work on the Cheney Building, Hartford, CT, a six-storey commercial structure with shops on the ground floor and offices above. Simply designed in brownstone, the street façades are divided into three horizontal zones with windows grouped under arches in a way that prefigures his later masterpiece, the Marshall Field Store (see fig. 5 below). Richardson also began his involvement with the New York State Capitol, Albany, NY, in 1875, when along with Frederick Law Olmsted and Leopold Eidlitz he was selected to review the designs of the original Capitol architect, Thomas Fuller. In 1876 Richardson, Eidlitz and Olmsted replaced Fuller. The project was particularly controversial, both for the way in which Fuller was replaced, and because Richardson and Eidlitz altered Fuller's exterior, adding their Romanesque storeys above Fuller's Renaissance floors. Richardson and Eidlitz divided the interior spaces between them. Richardson's Senate Chamber, with adjoining lobbies and second floor visitors' galleries (completed 1881), is finished in a variety of rich materials, including granite, onyx, marble and oak, and it is generally considered one of the finest late 19th-century architectural interiors in the USA. The western staircase, also by Richardson, a remarkable composition filling a well measuring 21 m by 23 m and rising 36 m to a skylight, earned the sobriquet 'Million Dollar Staircase'. Construction on the Capitol was not completed until 1899, 13 years after Richardson's death.

In 1876 Richardson also received the commission for the first of his series of community libraries. The design developed for the Woburn Public Library, Woburn, MA (a memorial to Jonathan Bowers Winn), clearly articulates the various elements of the design: organized along a longitudinal axis are the stack wing, reading room, picture gallery and museum. The Ames Free Library, North Easton, MA, was begun the following year. In this project, with a simpler design, Richardson achieved a much more tightly woven structure. This project also makes clear Richardson's gradual move away from derivative historical elements in his projects, as the chief features of the Ames Library are its simple, elemental forms, massive stone walls and well-articulated fenestration. The Syrian entry arch is the only feature still showing a strongly archaeological character.

(ii) Home studio. In 1878 Richardson terminated his partnership with Gambrill and moved his office to Brookline. He continued to live in the house he had rented in 1874, but the small room that had served as his design studio was no longer adequate, so he began a series of flat-roofed additions to the back of the house to serve as drafting rooms and office space. By 1885 these serial additions had reached their farthest extent. Nicknamed 'the Coops', these studios provided the setting for Richardson's creation of an environment not unlike that he had experienced in Paris. This arrangement also allowed Richardson to supervise closely the work in the office yet retreat to his bed when required by his continuing poor health.

Richardson's method of working derived from his experiences in Paris and was particularly suited to his uneven health. For each project he would produce small sketches, usually developed in a soft pencil until satisfactory, then gone over in simple outline in ink. These sketches would then be given to his draughtsmen to be developed into simple presentation drawings and from those, once accepted by the client, into construction documents from which the project could be built. Once construction began, the senior draughtsman, who was familiar with all aspects of the project, was prepared to supervise as required. This method allowed Richardson to become involved in an increasing number of projects as his practice expanded yet not be overwhelmed by detail. However, he did not depend on drawings alone, and he did not approve of elaborately worked out presentation drawings that might fix a design in a client's mind. Instead, he visited projects under construction and responded to what he saw with revised drawings and directions: he often withheld detail drawings needed for construction until the last possible moment in order to be able to make last minute changes as he thought necessary. With this approach, Richardson was fortunate in working with a sympathetic and understanding contractor, Norcross Brothers of Worcester, MA, on many of his buildings. O. W. Norcross (1839–1920), the leading partner in the firm, was frequently consulted by Richardson about materials, costs and techniques. In turn, because Norcross Brothers executed over half of Richardson's built projects, the firm could readily ascertain Richardson's intentions from his designs and could anticipate likely changes.

Even more important to Richardson was his continuing friendship with Olmsted. Neighbours first on Staten Island and later in Brookline, Richardson and Olmsted were frequent collaborators on projects throughout Richardson's mature career. Richardson often consulted Olmsted about the siting and landscaping of his buildings, and Olmsted, in turn, brought many architectural problems to Richardson. J. F. O'Gorman has suggested that Olmsted may have contributed to the theoretical consistency of Richardson's work, as Olmsted developed and articulated a broad vision of the place of architecture in the American landscape.

With his move to Brookline, Richardson befriended many of the leading scholars, artists and intellectuals of his time. These included Brookline neighbours such as Charles Sprague Sargent, Francis Parkman and eventually Olmsted and also a circle associated with Harvard, including such figures as Ephraim W. Gurney, Henry Adams, John Fisk and Alexander Agassiz. Richardson's acceptance into the Wintersnight and Saturday dining clubs confirmed his position as a prominent member of the community.

(iii) Achievement. The move of Richardson's office to Brookline and the establishment of his independent practice coincided with the beginning of a particularly productive period of his career. In a series of projects beginning in 1878, Richardson demonstrated his mastery. Sever Hall, Harvard, Cambridge, MA, the first of these projects, is a rectangular three-and-a-half-storey classroom building located on one side of Harvard Yard. Richardson's refined and simply detailed red brick structure shows his response

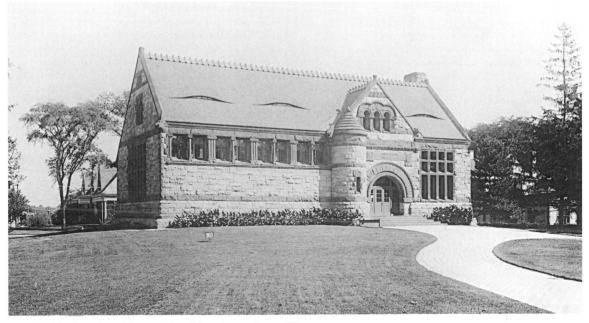

3 H. H. Richardson: Crane Library, Quincy, Massachusetts, begun 1880

to the existing Georgian buildings. Sever's two main façades, divided into three sections by semi-cylindrical towers and marked by windows grouped horizontally, have been acclaimed as among Richardson's finest designs.

Richardson's Ames Monument (begun 1879), Sherman (Buford), WY, is a simple two-step pyramid of granite measuring 18.5 m square at the base and 18.5 m high. Designed to commemorate the builders of the Union Pacific Railroad, Oakes and Oliver Ames, and originally located at the highest point on the Union Pacific tracks, this simple mass, decorated only with a well-designed inscription and two square bronze plaques of the Ames brothers placed near the top on opposite sides, is an abstract outcropping of granite against the background of the Rocky Mountains. Totally without historicist detail, the monument succeeds through its simple but appropriate use of rough-hewn materials in establishing an architecture of gravity and stateliness.

The breadth of Richardson's capabilities at this time is shown by his design for the Ames Gate Lodge (completed 1881), North Easton, MA. One of Richardson's most original designs, this entrance lodge to the estate of Richardson's patron, Frederick Lothrop Ames, was built of glacial boulders, trimmed with brownstone and roofed with bright, red-orange tiles. While the use of boulders gave this a primeval character, the generous and informally composed masses, low spreading roofs and asymmetrical plan established the tone for many of Richardson's later rural and suburban residential designs.

In this period Richardson also produced the best of his libraries. The Crane Library (begun 1880; see fig. 3), Quincy, MA, was the simplest of his library designs, with the elements of stack wing, reading room and hall integrated under a gable roof. Although Romanesque in feeling, the building is nonetheless almost entirely free of any derivative detail. As in Richardson's other mature

work, its essential virtues are its overall coherence and forthright use of materials.

In 1880 Richardson also began work on the Dr John Bryant House, overlooking the harbour in Cohasset, MA. This large, shingled residence is a simple rectangle in plan with an attached service wing projecting at an angle across a bridge over the entrance drive, but the three-dimensional composition presents an irregular profile with projecting bays, an attached porch and steeply pitched roof. Richardson's application of shingles over the entire exterior, with minimal trim and small-paned windows, produced a tautly drawn surface that unifies the whole. This use of plain shingles over the entire exterior surface of this house was a notable innovation that contributed to the continuing development of the Shingle style.

4. LAST YEARS.

(i) Professional success. In the last years of his life, Richardson was besieged with commissions. As demands for his services grew, he expanded the office and continued to add to the Coops at the back of his Brookline home. Because he produced only the initial sketches for his projects, then relied on his staff for the development of the designs under his guidance, Richardson was able to handle the increasing demands of his clients.

After his achievement in the years 1878 to 1882, Richardson's later works are not all of the same high level of creative design. Nevertheless, the works of the last years are remarkable for their generally consistent quality, and among them are several of Richardson's masterpieces. Included in his late works are two additional libraries, one in Malden, MA, and the other at the University of Vermont in Burlington, VT. He was also responsible for another building (begun 1881) at Harvard, Austin Hall (see BOSTON, fig. 3), built to house the law school. During this

period Richardson also produced a series of shingled house designs, of those constructed, the Mrs M. F. Stoughton House (completed 1883; for illustration *see* SHINGLE STYLE) in Cambridge, MA, is the best known.

Richardson's practice also expanded to include new building types: he was responsible for the design of 12 railway passenger stations between 1881 and 1886. Nine of these were for the Boston & Albany Railroad, where Richardson's friends Charles Sprague Sargent and James A. Rumrill were the members of the Board responsible for selecting architects for the railway's expanding station-building programme. The first of these Boston & Albany stations, at Auburndale, MA, was commissioned in 1881. There Richardson set a high standard with his simple rectangle of granite trimmed in brownstone and topped with a slate roof, which extended on one side to form a train shed and on the other to form a *porte-cochère*. The station functioned as a space marker to show where the trains stopped, as a shelter for waiting passengers and as a gateway to the adjoining community. The later stations presented variations on the simple themes established at Auburndale. The stations at Chestnut Hill, MA, for the Boston & Albany and at North Easton, MA, for the Old Colony Railroad are notable for their imaginative use of stone arches. Olmsted provided assistance with the landscaping for the Boston & Albany stations and eventually aided the Railroad in establishing a programme of station landscaping. Although Richardson was not responsible for as many stations as some of his contemporaries, his reputation as a railway architect was established by these designs and reinforced by his collaboration with Olmsted.

During the last years of his life Richardson's practice also expanded geographically. He was responsible for houses in Washington, DC, Buffalo, NY, Chicago and St Louis, MO, as well as other buildings in Cincinnati, OH, Pittsburgh, PA, and Detroit, MI. Of the later urban houses, the pair for John Hay and Henry Adams (1884–6; destr. 1927) in Washington, DC, and the house (1885–7) for J. J. Glessner in Chicago were the most important. Located on a corner site on the then fashionable Prairie Avenue, the Glessner House has an E-shaped plan facing an inner courtyard and presenting a nearly solid wall to the adjoining streets. Richardson told J. J. Glessner, 'I'll plan anything a man wants, from a cathedral to a chicken coop', and throughout his career he was willing to undertake all types of design. Although many of his clients were wealthy, he took projects with very low budgets as well. His Percy Browne House (1881), Marion, MA, was constructed for only $2500. He accepted the commission for the Immanuel Baptist Church, Newton, MA, in 1884, after other architects' designs had been rejected as too expensive, on the basis that he would receive a fee only if he developed an affordable design. In his practice he contributed to designs for passenger cars for the Boston & Albany Railroad and to bridges in Olmsted's park in Boston's Back Bay Fens. He was also responsible for the design for furniture in a number of his projects, including several of the libraries and the New York State Capitol. In 1885 he developed sketches for a lighthouse for Harvard naturalist Alexander Agassiz, and he expressed interest in the design of grain elevators and river boats.

(ii) Masterpieces. Two of the finest works of Richardson's career, and two of the projects that he is known to have been most proud of, were the Allegheny County buildings and the Marshall Field Wholesale Store. Design submissions for the Allegheny County Court-house and Jail (*see* PITTSBURGH) were accepted from five leading architects on 1 January 1884. The selection of Richardson's design was announced on 31 January, and construction by Norcross Brothers began the following July, but the project was not completed until September 1888, over two years after Richardson's death. The Court House and Jail occupy two distinct blocks in downtown Pittsburgh and are connected by a 'Bridge of Sighs'. The Court-house (see fig. 4) is a four-storey rectangular structure around an open central courtyard. Offices and two-storey court-rooms are grouped along the outside of the rectangle facing the surrounding streets and are connected by a corridor that circles the central courtyard on each floor. The chief exterior feature is the tower, which rises an additional five storeys over the main entrance at the front of the Court-house and which originally provided document storage and ventilation. The Jail is an asymmetrical cross within a walled compound. Both buildings are executed in pinkish-grey granite with minimal detail and ornamentation in order not to accumulate grime. Richardson believed that the Court-house and Jail would form a part of the basis for his enduring reputation, and indeed its impact on his contemporaries was dramatic, as its style was echoed across the country in public buildings of all types for the next decade. Many modern architects and historians preferred the Jail to the Court-house because of

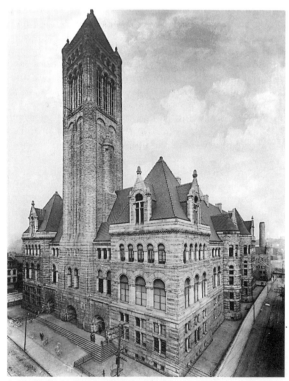

4. H. H. Richardson: Allegheny County Court House, Pittsburgh, Pennsylvania, 1884–8

its plain outline, functional appropriateness and basic application of stone.

The Marshall Field Wholesale Store (1885–7; destr. 1930), Chicago, is thought to be Richardson's greatest design achievement (see fig. 5). This seven-storey U-shaped building in downtown Chicago was constructed in granite and red sandstone. Richardson's personal resolution of the problem of the commercial building was demonstrated by the pattern of fenestration with windows grouped regularly under arches, which doubled and quadrupled on the higher floors. The impact of the building's massiveness (it filled a full Chicago block) and regularity was particularly enhanced by the contrast it presented to the surrounding chaotic development. The building inspired immediate and widespread comment, and its impact on the CHICAGO SCHOOL architects, including Louis Sullivan, was particularly significant. As a result, the Field Store has since been regarded as a critical forerunner to the development of modern architecture.

Less well known, but nearly as fine, was Richardson's design for a store (1886; destr. c. 1950) for F. L. Ames on Harrison Avenue, Boston. For the Ames Store, Richardson created a six-storey structure with narrow piers and wide expanses of glass grouped under arches. Although the exterior masonry was load-bearing, this building appears to presage the development of the design possibilities of the metal skeleton that would be worked out by the Chicago school architects in the 1890s.

(iii) Decline and death. Richardson's health deteriorated rapidly in the last years of his life under the increasing demands of his practice. In the summer of 1882, while he was travelling in Europe, Richardson consulted Sir William Gull about his chronic case of Bright's disease, a renal disorder. Gull cautioned Richardson about his work-load, but he continued to practise at the same pace on his return to Brookline. He died four years later. Richardson's office was maintained by his three chief assistants at the time of his death, George Foster Shepley, Charles Hercules Rutan and Charles Allerton Coolidge, under the name SHEPLEY, RUTAN & COOLIDGE. Nearly all of the works under construction at the time of Richardson's death were completed under their supervision.

UNPUBLISHED SOURCES
Boston, MA Hist. Soc. [H. H. Richardson papers including c. 25 Richardson letters]
Cambridge, MA, Harvard U., Frances Loeb Sch. Des. Lib. [Richardson's own books and photographs]
Cambridge, MA, Longfellow N. Hist. Site, Alexander W. Longfellow papers [include letters and diaries of Alexander W. Longfellow, an apprentice in Richardson's office from 1881 to 1886]
Cambridge, MA, Harvard U., Houghton Lib., Richardson Col. [includes over 15,000 original drawings from Richardson's office, indexed alphabetically, chronologically and geographically]
Washington, DC, Lib. Congr. [F. L. Olmsted papers including letters of Olmsted relating to Richardson–Olmsted collaborations]

BIBLIOGRAPHY
Macmillan Enc. Archit.
GENERAL
L. Mumford: *Sticks and Stones: A Study of American Architecture and Civilization* (New York, 1924), pp. 44–8
B. Bunting: *Houses of Boston's Back Bay: An Architectural History, 1840–1917* (Cambridge, MA, 1967), pp. 212–22, 474
L. K. Eaton: *American Architecture Comes of Age: European Reaction to H. H. Richardson and Louis Sullivan* (Cambridge, MA, 1972)

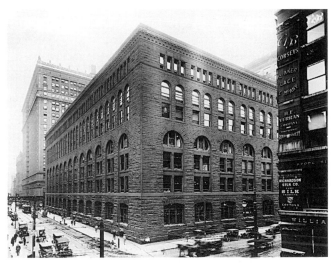

5. H. H. Richardson: Marshall Field Wholesale Store, Chicago, Illinois, 1885–7; destr. 1930

J. D. Van Trump: *Majesty of the Law: The Court Houses of Allegheny County* (Pittsburgh, 1988)
MONOGRAPHS
M. G. Van Rensselaer: *Henry Hobson Richardson and his Works* (Boston, 1888/R 1969)
H.-R. Hitchcock: *The Architecture of H. H. Richardson and his Times* (New York, 1936/R Hamden, CT, 1961, rev. Cambridge, MA, 1966)
——: *Richardson as a Victorian Architect* (Baltimore, 1966)
The Architecture of Henry Hobson Richardson in North Easton, Massachusetts (North Easton, 1969)
J. F. O'Gorman: *H. H. Richardson and his Office: Selected Drawings* (Boston, 1974/R Cambridge, MA, 1982)
J. K. Ochsner: *H. H. Richardson: Complete Architectural Works* (Cambridge, MA, 1982/R 1984)
J. F. O'Gorman: *H. H. Richardson: Architectural Forms for an American Society* (Chicago, 1987)
P. C. Larson and S. M. Brown, eds: *The Spirit of H. H. Richardson on the Midland Prairies: Regional Transformations of an Architectural Style* (Minneapolis, MN, and Ames, IA, 1988)
J. F. O'Gorman: *Three American Architects: Richardson, Sullivan and Wright, 1865–1915* (Chicago and London, 1991)
M. H. Floyd: *Architecture After Richardson: Regionalism Before Modernism: Longfellow, Alden and Harlow in Boston and Pittsburgh* (Chicago and London, 1994)
K. A. Breisch: *Henry Hobson Richardson and the Small Public Library in America: A Study in Typology* (Cambridge, MA and London, 1997)
M. H. Floyd: *Henry Hobson Richardson: A Genius for Architecture* (New York, 1997)
J. F. O'Gorman: *Living Architecture: A Biography of H. H. Richardson* (New York, 1997)
SPECIALIST STUDIES
W. A Langton: 'The Method of H. H. Richardson', *Architect & Contract Rep.*, lxv (1900), pp. 156–8
C. A. Coolidge: 'H. H. Richardson', *The Later Years of the Saturday Club, 1870–1920* (Boston, 1927)
B. L. Pickens: 'H. H. Richardson and Basic Form Concepts in Modern Architecture', *A. Q.* [Detroit], iii (1940), pp. 273–91
H.-R. Hitchcock: 'Richardson's American Express Building: A Note', *J. Soc. Archit. Hist.*, ix (1950), pp. 25–30
J. C. Webster: 'Richardson's American Express Building', *J. Soc. Archit. Hist.*, ix (1950), pp. 21–4
W. Bosworth: 'I Knew H. H. Richardson', *J. Amer. Inst. Architects*, xvi (1951), pp. 115–27
J. D. Van Trump: 'The Romanesque Revival in Pittsburgh', *J. Soc. Archit. Hist.*, xvi (1957), pp. 22–9
W. S. Huff: 'Richardson's Jail', *W. PA Hist. Mag.*, xli (1958), pp. 41–9
D. T. Van Zanten: 'H. H. Richardson's Glessner House, Chicago', *J. Soc. Archit. Hist.*, xxiii (1964), pp. 106–11

C. Price: 'Henry Hobson Richardson: Some Unpublished Drawings', *Perspecta*, ix–x (1965), pp. 199–210

L. J. Homolka: 'Richardson's North Easton', *Archit. Forum*, cxxiv (1966), pp. 72–7

T. E Stebbins jr: 'Richardson and Trinity Church: The Evolution of a Building', *J. Soc. Archit. Hist.*, xxvii (1968), pp. 281–98

M. Friedländer: 'Henry Hobson Richardson, Henry Adams and John Hay', *J. Soc. Archit. Hist.*, xxix (1970), pp. 231–46

D. Tselos: 'Richardson's Influence on European Architecture', *J. Soc. Archit. Hist.*, xxix (1970), pp. 156–62

J. F. O'Gorman: 'O. W. Norcross, Richardson's "Master Builder": A Preliminary Report', *J. Soc. Archit. Hist.*, xxxii (1973), pp. 104–13

M. D. Orth: 'The Influence of the "American Romanesque" in Australia', *J. Soc. Archit. Hist.*, xxxiv (1973), pp. 2–18

C. Zaitzevsky: 'A New Richardson Building', *J. Soc. Archit. Hist.*, xxxii (1973), pp. 164–6

M. Fleming: 'The Saving of Henry Hobson Richardson's Union Station', *Amer. A. Rev.*, ii (1975), pp. 29–40

H.-R. Hitchcock: 'An Inventory of the Architectural Library of H. H. Richardson', *19th C.* [New York], i (1975), pp. 27, 31

A. W. Klukas: 'Henry Hobson Richardson's Designs for the Emmanuel Episcopal Church, Pittsburgh', *Amer. A. Rev.*, ii (1975), pp. 64–76

R. F. Brown: 'The Aesthetic Transformation of an Industrial Community', *Winterthur Port.*, xii (1977), pp. 35–64

R. Chaffee: 'H. H. Richardson's Record at the Ecole des Beaux-Arts', *J. Soc. Archit. Hist.*, xxxvi (1977), pp. 175–88

J. F. O'Gorman: 'H. H. Richardson and the Architecture of the Commuter Railroad Station', *Around the Station: The Town and the Train* (exh. cat., ed. L. Lipton; Framingham, MA, Danforth Mus. A., 1978), pp. 19–34

——: 'The Marshall Field Wholesale Store: Materials toward a Monograph', *J. Soc. Archit. Hist.*, xxxvii (1978), pp. 175–94

A. Farnam: 'H. H. Richardson and A. H. Davenport: Architecture and Furniture as Big Business in America's Gilded Age', *Tools and Technologies: America's Wooden Age*, ed. P. B. Kebabian and W. C. Lipke (Burlington, VT, 1979)

J. F. O'Gorman: 'On Vacation with H. H. Richardson: Ten Letters from Europe, 1882', *Archvs Amer. A. J.*, xix (1979), pp. 2–14

A. J. Adams: 'Birth of a Style: Henry Hobson Richardson and the Competition Drawings for Trinity Church, Boston', *A. Bull.*, lxii (1980), pp. 409–33

H.-R. Hitchcock: 'Henry Hobson Richardson's New York Senate Chamber Restored', *19th C.* [New York], vi (1980), pp. 44–7

F. R. Kowsky: *Buffalo Projects: H. H. Richardson* (Buffalo, NY, 1980)

——: 'The William Dorsheimer House: A Reflection of French Suburban Architecture in the Early Work of H. H. Richardson', *A. Bull.*, lxii (1980), pp. 134–47

J. Coolidge: 'H. H. Richardson's Youth: Some Unpublished Documents', *In Search of Modern Architecture: A Tribute to Henry-Russell Hitchcock*, ed. H. Searing (New York, 1982), pp. 165–71

M. H. Floyd: 'H. H. Richardson, Frederick Law Olmsted, and the House for Robert Treat Paine', *Winterthur Port.*, xviii (1983), pp. 227–48

A. Saint: 'Leviathan of Brookline', *A. Hist.*, lxiii (1983), pp. 376–9

J. K. Ochsner: 'H. H. Richardson's Frank William Andrews House', *J. Soc. Archit. Hist.*, xliii (1984), pp. 20–32

J. F. O'Gorman: 'America and H. H. Richardson', *American Architecture: Innovation and Tradition*, ed. D. G. De Long, H. Searing and R. A. M. Stern (New York, 1986), pp. 93–102

E. Harrington: 'International Influences on Henry Hobson Richardson's Glessner House', *Chicago Architecture, 1872–1922: Birth of a Metropolis*, ed. J. Zukowsky (Munich and Chicago, 1987), pp. 189–207

J. F. O'Gorman: 'Man-made Mountain: "Gathering and Governing" in H. H. Richardson's Design for the Ames Monument in Wyoming', *The Railroad in American Art: Representations of Technological Change*, ed. S. Danly and L. Marx (Cambridge, MA, and London, 1987), pp. 113–26

T. Culvahouse: 'Figuration and Continuity in the Work of H. H. Richardson', *Perspecta*, xxiv (1988), pp. 24–39

J. Garner: 'Architecture and Philanthropy in a Model Company Town', *Places*, v (1988), pp. 22–35

J. K. Ochsner: 'Architecture for the Boston and Albany Railroad, 1881–1894', *J. Soc. Archit. Hist.*, xlvii (1988), pp. 109–31

T. C. Hubka: 'H. H. Richardson's Glessner House: A Garden in the Machine', *Winterthur Port.*, xxiv (1989), pp. 209–29

F. R. Kowsky: 'H. H. Richardson's Ames Gate Lodge and the Romantic Landscape Tradition', *J. Soc. Archit. Hist.*, l (1991), pp. 181–8

J. K. Ochsner and T. C. Hubka: 'H. H. Richardson: The Design of the William Watts Sherman House', *J. Soc. Archit. Hist.*, li (1992), pp. 121–45

E. Harrington: *H. H. Richardson: The J. J. Glessner House, Chicago* (Berlin, 1993)

J. K. Ochsner and T. C. Hubka: 'The East Elevation of the Sherman House, Newport, Rhode Island', *J. Soc. Archit. Hist.*, lii (1993), pp. 88–90

M. H. Floyd: *Architecture after Richardson: Regionalism before Modernism: Longfellow, Alden and Harlow in Boston and Pittsburgh* (Chicago and London, 1994)

M. A. Molloy: 'Richardson's Web: A Client's Assessment of the Architect's Home and Studio', *J. Soc. Archit. Hist.*, liv/1 (1995), pp. 8–23

JEFFREY KARL OCHSNER

Richardson, Mary Curtis (*b* New York, NY, 9 April 1848; *d* San Francisco, CA, 1 Nov 1931). American painter. Descended from pre-Revolutionary War Connecticut stock, she was brought to California at the age of two. Her family early on lived in Sacramento, Vallejo and several other northern California communities. During this time she and her older sister, Leila, learnt to draw and carve from their father, a professional engraver. Exhibiting talent, the girls were sent to Cooper Union in New York City for formal study in the medium (1868–9). On their return, Mary Curtis married (1869) and soon after joined the designing and engraving firm of her sister and Abbie T. Crane. By 1873, Crane left the business, which became known as Leila Curtis & Co. About the same time, Mary began to dabble in painting, encouraged by Benoni Irwin (1840–96), her brother-in-law and first teacher in the medium. In the following year, she enrolled in the newly opened California School of Design, coming under the influence of Virgil Williams (1830–86). More than a decade later, while in New York, at Irwin's urging, she studied with William Sartain (1843–1924), an instructor at the Art Students League (1886–7).

By the early 1880s, Richardson began gaining recognition for her paintings, particularly of children (see fig.) and

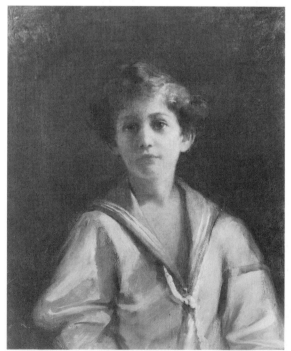

Mary Curtis Richardson: *Joseph M. Bransten as a Child*, oil on canvas, 559×457 mm, [n.d.] (Oakland, CA, Oakland Museum)

Richmond, Virginia State Capitol, central block by Thomas Jefferson and Charles-Louis Clérisseau, 1785–99; adjoining wings, 1904–6

local dignitaries. An 1884 *San Francisco Chronicle* article, commenting on her life-size portrait of *Stephan Leach* (untraced, see Hailey, ed., title-page of Richardson), an actor and composer, stated that the study placed her 'into the front ranks of professional artists on this coast'. Soon after, in 1887, at her third hanging at the annual exhibition of the National Academy of Design (others followed in 1894, 1910 and 1911), she received the Norman Dodge Prize for the best work by a woman artist. Among her other exhibitions were those of the World's Columbian Exposition in Chicago (1893) and the Panama—Pacific International Exposition in San Francisco (1915), where she won a silver medal. Richardson, who came to be known as the 'Mary Cassatt of the West', travelled widely to execute many of her portrait commissions, but her permanent residence remained in the Bay Area—for many years in Oakland and then, from 1888, in a home and studio she and her husband built on Russian Hill in San Francisco, where the élite of the city came to sit for her.

BIBLIOGRAPHY
'Among the Artists', *San Francisco Chronicle* (28 Dec 1884), p. 8
Obituary: *San Francisco Chronicle* (2 Nov 1931), pp. 1, 7
'Mary Curtis Richardson (1848–1931)', *California Art Research*, ed. G. Hailey (San Francisco, 1936–7), v, pp. 16–31
C. Orr-Cahall, ed.: *The Art of California: Selected Works from the Collection of The Oakland Museum* (Oakland, 1974)
P. Trenton, ed.: *Independent Spirits: Women Painters of the American West, 1890–1945* (Berkeley, 1995)

PHIL KOVINICK

Richmond. American city in Virginia, on the James River. It was established in 1742 and designated the capital of Virginia in 1779. It served as the capital of the Confederate States of America from 1861 to 1865. Tobacco processing has been the principal industry since the 18th century, and the source of wealth of many of the city's artistic patrons. Richmond is known for its numerous historic buildings and districts, although the heart of the city was burnt down in 1865 by retreating Confederate forces. The oldest residential district, Church Hill, is centred around one of the city's oldest buildings, St John's Episcopal Church, begun in 1739. Lining Church Hill's grid-plan streets are 19th-century town houses in the Federal, Greek Revival and Italianate styles. The Virginia State Capitol (1785–99, by THOMAS JEFFERSON and Charles-Louis Clérisseau (1721–1820); see fig.; see also UNITED STATES OF AMERICA, fig. 7) dominates Capitol Square, the city's main square. The temple-form structure was inspired by the Maison Carrée, a Roman temple (*c.* AD 4) in Nîmes, France, and marked the beginning of the Classical Revival Movement in the USA. Inside the Capitol is the statue of *George Washington* (commissioned in 1785) by Jean-Antoine Houdon (1741–1828). The city's outstanding example of the Federal style is the Wickham-Valentine House (1811–13) by Alexander Parris, noted for its painted interiors and palette-shaped stair. The domed Monumental Church (begun in 1812) by Robert Mills is one of the earliest American buildings to employ Greek Revival details. The Egyptian Building (1846) at the Medical College of Virginia (now Virginia Commonwealth University), designed by Thomas S. Stewart (1806–89) of Philadelphia, is among the purest expressions of the Egyptian Revival in the USA. Stewart also designed the Greek Revival St Paul's Episcopal Church (completed in 1845), which has a richly decorated plasterwork ceiling and stained-glass windows from the studio of Louis Comfort Tiffany. The grounds of Capitol Square were laid out in the 1850s by the architect John Notman, from Philadelphia, who also designed the Romantic landscape of the Hollywood Cem-

etery (1848), Richmond. The square is also the site of an equestrian statue of *George Washington* (unveiled in 1858), by the sculptor Thomas Crawford (1814–57).

A prodigious example of the High Victorian Gothic style is Old City Hall (1887–94) by Elijah E. Myers. Its elaborate interior court and stair-well are executed in cast iron. Maymont, a late Victorian estate, begun in 1890, features gardens in the Italian, English and Japanese styles and a Romanesque Revival mansion containing a collection of 19th-century furnishings and decorative arts. Monument Avenue, a broad, landscaped boulevard laid out in 1890, is lined with imposing mansions, of which several were designed by the New York architect William Lawrence Bottomley (1883–1951) in the 'Georgian Revival' style. At the avenue's principal intersections are statues of Confederate heroes, including an equestrian statue (1890) of *Robert E. Lee* by the French sculptor Jean-Antonin Mercié (1845–1916). John Russell Pope designed two buildings in Richmond, including the Neoclassical Broad Street Railway Station (begun 1913; now the Science Museum of Virginia), which served as the prototype for several of his later monumental buildings.

The Virginia Museum of Fine Arts is the city's main art museum and contains representative works from ancient times to the present. The Virginia Historical Society has an extensive collection of Virginia portraiture from the Colonial period and 19th century. The Valentine Museum specializes in decorative arts and paintings related to Richmond.

BIBLIOGRAPHY
M. W. Scott: *Old Richmond Neighborhoods* (Richmond, 1950)
C. Loth, ed.: *The Virginia Landmarks Register* (Charlottesville, 1986)
M. Lane: *Architecture of the Old South: Virginia* (Savannah, 1987)
J. Zehmer: *Old Richmond Today* (Richmond, 1988)

CALDER LOTH

Riis, Jacob A(ugust) (*b* Ribe, Denmark, 3 May 1849; *d* Barre, MA, 26 May 1914). American photographer of Danish birth. The son of a school-teacher and editor, he was well-educated when he came to the USA in 1870. He was a self-taught photographer and worked at a variety of jobs before becoming a journalist, and he understood the power of the written and illustrated word. Riis's work in journalism began in 1873 when he was employed by the New York News Association. By 1874 he was editor and then owner of the *South Brooklyn News*. In 1878 he won a coveted job as a police-reporter at the *Tribune* and found the basis of his life's work in his assigned territory, Mulberry Bend (see fig. 1), where the worst slums and tenements were (e.g. *Mulberry Bend as It Was*, see Riis, 1901, p. 265).

Using flash photographs to document articles and lectures, Riis emphasized the dehumanizing conditions of New York's slums with works such as *Tenement House Air-shaft* and *Gotham Court* (see Riis, 1901, pp. 351, 355).

1. Jacob. A. Riis: *Mulberry Bend Looking North*, photograph, 1888 (New York, Museum of the City of New York)

2. Jacob A. Riis: *Home of the Italian Rag Picker*, Jersey Street, photograph, 1889 (New York, Museum of the City of New York)

He photographed only from 1888 to 1898. The photographs, printed as half-tones or used as a basis for engravings, illustrated his newspaper articles and books, chiefly *How the Other Half Lives: Studies among the Tenements* (see fig. 2) and *The Battle with the Slum*. Satisfied that he had sufficient glass plates for illustrations, he gave up photography.

The German invention of magnesium flash was the catalyst in causing Riis to use photography as a reporter's tool. The flash made possible the camera's penetration into tenement interiors, and the grim determination and unfailing vision with which Riis made these exposures is the great source of their continuing vitality and their status as icons of the American reform era. He was the first to realize the power of photographic documentation in the campaign for social reform. The force of Riis's gripping subject-matter and the strength of his composition have drawn later 20th-century photographers, such as Ansel Adams (1902–84) and Rolf Petersen, to print from his glass plate negatives, which are in the Museum of the City of New York.

WRITINGS
The Making of an American (New York, 1901)

PHOTOGRAPHIC PUBLICATIONS
How the Other Half Lives: Studies among the Tenements (New York, 1890)
The Battle with the Slum (New York, 1902)

BIBLIOGRAPHY
L. Ware: *Jacob A. Riis: Police Reporter, Reformer, Useful Citizen* (New York, 1938)
A. Alland sr: *Jacob A. Riis: Photographer and Citizen* (Millerton, 1974)
R. Doherty, ed.: *The Complete Photographic Work of Jacob Riis* (New York, 1981)
L. Fried: *Makers of the City* (Amherst, 1990)

ANNE EHRENKRANZ

Rimmer, William (*b* Liverpool, 20 Feb 1816; *d* South Milford, MA, 20 Aug 1879). American sculptor, painter and writer of English birth. His father Thomas Rimmer, from the time of his youth in France and later in England, believed himself to be the younger son of Louis XVI and rightful heir to the throne of France after the death of his older brother in 1789. Although the validity of Thomas's claims cannot be verified, three generations of the Rimmer family carried this belief.

William Rimmer arrived in America in 1818 and never returned to Europe. Brought up in poverty, he spent most of his life eking out a living for himself and his large family and was virtually unknown as an artist until he was 45. He was essentially self-taught in most of his diverse activities, including painting and composing music. A learned anatomist, Rimmer practised medicine in the Boston area from the late 1840s to the early 1860s, and, through his study of art anatomy, he fashioned a personal grammar of form in which the male nude became a metaphor for themes of heroic struggle. In addition to lecturing on art anatomy in Boston, New York, Providence and other East Coast cities during the 1860s and 1870s, he served as director of the School of Design for Women at Cooper Union in New York from 1866 to 1870. He published two highly illustrated and important books—*Elements of Design* (1864) and *Art Anatomy* (1877)—and taught several of the next generation's major artists, notably John La Farge and Daniel Chester French. Rimmer's art and writings also evince his awareness of contemporary scientific and pseudo-scientific areas of investigation, including photography, physiognomy, phrenology, typology, comparative anatomy and Darwinian thought. His books and teaching earned him many admirers; during the later 20th century, two of the most enthusiastic were the sculptors Gutzon Borglum (1867–1941) and Leonard Baskin (*b* 1922).

Only about two-thirds of Rimmer's approximately 600 known works have been traced, and the quality of most of those that survive is high. Fewer than a quarter of his works were commissioned, and he was not well paid even for such works as his only surviving public monument, the granite statue of *Alexander Hamilton* (1865) on Commonwealth Avenue, Boston, and the 81 drawings for *Art Anatomy* (1876; Boston, MA, Mus. F.A.). His gypsum statuette of a *Seated Youth* ('Despair', 1831; Boston, MA, Mus. F.A.; see fig.) was reputed to be the first nude sculpture in the USA, although it was not generally known until 1882, when it was published by Truman Bartlett in his study of Rimmer. This sculpture looks back to figures in Michelangelo's *Last Judgement*, perhaps known to Rimmer through prints, and anticipates such works as *Count Ugolino and his Sons* (1863) by Jean-Baptiste Carpeaux (1827–75) and *The Thinker* (1880) by Auguste Rodin (1840–1917). With his *Head of a Woman* (*c*. 1859; Washington, DC, Corcoran Gal. A.) and bust of *St Stephen* (1860; Chicago, IL, A. Inst.), Rimmer was probably the first American sculptor to create granite carvings for other than utilitarian purposes.

In Rimmer's finest sculptures—the *Seated Youth, St Stephen*, the *Falling Gladiator* (plaster, 1861; Washington, DC, N. Mus. Amer. A.), the *Dying Centaur* (plaster, 1869; Boston, MA, Mus. F.A.), the *Fighting Lions* (plaster, *c*. 1871; untraced; bronze, 1907; New York, Met.) and the plaster *Torso* (1877; Boston, MA, Mus. F.A.)—the primary emphasis on plastic, non-allusive form as well as the exploration of powerfully expressive anatomy, dynamic composition and animated surfaces foreshadow Rodin's work and fitly embody Rimmer's repeated statement that 'anatomy is the only subject' (Bartlett).

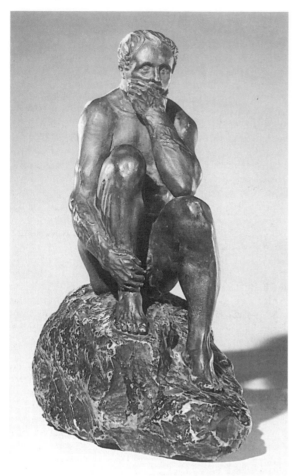

William Rimmer: *Seated Youth* ('*Despair*'), gypsum with bronzed paint, h. 260×197 mm, 1831 (Boston, MA, Museum of Fine Arts)

Rimmer's painted work reflects the influence of English genre painters such as Charles Robert Leslie (1794–1859) and American artists such as William Morris Hunt. His well-known *Flight and Pursuit* (1872; Boston, MA, Mus. F.A.) and *Sunset/Contemplation* (1876; Detroit, MI, Manoogian priv. col.), which shows his brief but significant use of the Luminist mode, rank Rimmer with Washington Allston and Albert Pinkham Ryder. However, far from being derivative, most of his works show a creative assimilation of their divergent thematic and formal sources.

Rimmer generally used a limited number of hues sharing a common tonal range of earth colours, and his paintings are often characterized by delicate colours and subtle atmospheric effects created by a thin application of paint. The occasional absence of a middle ground in his compositions gives them a compressed and ethereal quality. The most adverse result of his technical ignorance has been the darkening of bitumen and concomitant surface deterioration of his paintings. Rimmer's supposed royal heritage provided the source for many of his most powerful and imaginative paintings as well as the recurring themes and motifs of Promethean hubris, exile, thwarted ambition, confrontation, gladiators and soldiers.

Rimmer was once seen predominantly as an enigmatic and isolated artist, but scholars are increasingly placing him within his own times, while recognizing his special achievements. Although an amateur in many respects, he was the most gifted sculptor of his generation in America, a painter of compelling and evocative images and a powerful and imaginative draughtsman.

WRITINGS

Elements of Design (Boston, 1864, rev. and enlarged 2/1879/*R* 1907 as *Elements of Design in Six Parts*) [part vi, 'Form', in 2nd edn reflects material pubd in *Art Anatomy*]
Art Anatomy (Boston, 1877, rev. New York, 1962)

BIBLIOGRAPHY

T. H. Bartlett: *The Art Life of William Rimmer: Sculptor, Painter and Physician* (Boston, 1882/*R* New York, 1970)
L. Kirstein: 'Who was Dr Rimmer?', *Town & Country*, cxviii (1946), pp. 72–3
William Rimmer, 1816–1879 (exh. cat. by L. Kirstein, New York, Whitney, 1946)
J. Weidman: *William Rimmer: Critical Catalogue Raisonné* (diss., Bloomington, IN U., 1982)
——: 'William Rimmer: Creative Imagination and Daemonic Power', *Art Institute of Chicago Centennial Lectures*, Museum Studies, x (Chicago, 1983), pp. 146–63
William Rimmer: A Yankee Michelangelo (exh. cat. by J. Weidman, Brockton, MA, A. Mus., 1985) [incl. essays by N. Harris and P. Cash and a foreword by T. E. Stebbins, jr]
J. Weidman: 'William Rimmer', *American National Biography*, xviii (Oxford, 1999), pp. 521–2
——: *The Life and Art of William Rimmer* (in preparation)
——: *The Poetry and Philosophical Writings of William Rimmer* (in preparation) [incl. transcriptions, annotations and analyses of MS. mat. at the Boston Medical Lib.]

JEFFREY WEIDMAN

Rindisbacher, Peter (*b* Luchsmatt, Switzerland, 12 April 1806; *d* St Louis, MO, 15 Aug 1834). Swiss painter, active in North America. His only training came from a brief sketching trip taken with the Swiss painter Jacob S. Weibel (1771–1846). In the autumn of 1821 his family moved to the Red River Colony in southern Manitoba. On the 79-day journey Rindisbacher sketched the icebergs and views he saw on the trip. During his five-year stay in Manitoba he recorded the Assiniboin, Dakota, Cree and Ojibway tribes. Pencil sketches provided the material for his watercolour paintings of their dress and activities (e.g. *A Party of Indians—Assiniboins, c.* 1820–25; New York, Knoedler's). In 1826 the family moved to southern Wisconsin, where he added miniature portraits to his repertory of Indian and wildlife scenes. The military officers in the region liked his work and were highly supportive. During the late summer of 1829 he moved to St Louis, MO. Newspapers carried praise of his Indian subjects, one journalist mentioning in particular his skill in drawing the human figure and conveying its muscularity, while advertisements placed by Rindisbacher announced his availability to paint miniatures and landscapes. From February 1830 until October 1833 the *American Turf Register and Sporting Magazine* published nine lithographs of Rindisbacher's works.

BIBLIOGRAPHY

A. Josephy jr: *The Artist Was a Young Man: The Life Story of Peter Rindisbacher* (Fort Worth, 1970)
E. Ewers: *Artists of the Old West* (New York, 1982)

DARRYL PATRICK

Rix, Julian W(albridge) (*b* Peacham, VT, 30 Dec 1850; *d* New York, NY, 19 Nov 1903). American painter and

etcher. Primarily self-taught, he studied briefly at the California School of Design under Virgil Williams (1830–86) and in Europe in 1889. He frequently visited his friend Jules Tavernier in Monterey during its early years as an art colony, 1876–9, then shared a studio with Tavernier on Montgomery Street in San Francisco. He made painting trips to Yosemite in 1875 and the Columbia River in Oregon in 1877. At the urging of patron William Ryle, Rix moved to Patterson, NJ, in 1880 and established a studio in New York City, where he soon became quite successful.

Rix stayed in contact with the San Francisco art world and sent 200 paintings there for a solo exhibition in 1883. He returned to California for several months in 1901 or 1902, painting landscapes near Monterey and Santa Barbara.

Rix's typical works, such as *Foggy Morning, San Rafael* (1881; Sacramento, CA, Crocker A. Mus.), capture unpretentious forest scenes in the American Barbizon vein, suffused with the soft light and shadowy forms of early morning or late evening. His landscape etchings were published in *Harper's Magazine* and John Muir's 1888 book, *Picturesque California*.

Artist C. D. Robinson wrote in *Overland Monthly* after Rix's death that 'he was a landscapist of the first ability, was a fine and delicate colorist and was thoroughly in touch with his art. He was making great strides towards a first place in American Art when he was stricken ill and unfortunately died. He would, without a doubt, have occupied one of the greatest places in American landscape art.' Rix's work is in the collections of the Metropolitan Museum of Art (New York), the Corcoran Gallery (Washington, DC) and the Walker Art Gallery (Minneapolis).

BIBLIOGRAPHY
A. Black: 'Rix', *American Art and Artists* (American Art League, 1896)
'Julian Walbridge Rix', *California Art Research*, ed. G. Hailey (San Francisco, 1936-7), iv, pp. 114–37

ANN HARLOW

Robertson, Archibald (*b* Monymusk, Grampian, 8 May 1765; *d* New York, 6 Dec 1835). American painter and drawing-master of Scottish birth. The son of the Scottish architect William Robertson (*fl* Aberdeen, 1752–77), he was brought up in Aberdeen, studying art there and in Edinburgh. In 1786 he was a student at the Royal Academy in London. Several years of practice in Aberdeen followed. In 1791 he arrived in New York to teach art at the invitation of a group of gentlemen. Shortly afterwards he painted miniatures of George and Martha Washington (1791–2; Colonial Williamsburg, VA). With his brother Alexander (1768–1841), who joined him in New York in 1792, he established the Columbian Academy of Painting at 89 William Street, New York, purported to be the first art school in America; most of their students were amateurs, although a few, notably John Vanderlyn, became professional artists. Throughout their lives the Robertsons promoted the exhibition of art and the training of artists in New York, and they were active members of the American Academy of the Fine Arts. Both Archibald and Alexander, as well as their brother Andrew Robertson (1777–1845) who remained in Scotland and England, specialized in painting miniature portraits.

In 1802 Archibald Robertson published his *Elements of the Graphic Arts*, one of the earliest art instructional manuals written and printed in the USA. He championed a generalization of nature and promoted the Picturesque aesthetic as promulgated in the publications of the Rev. William Gilpin (1724–1804). In Robertson's own watercolours and drawings (examples in Newark, NJ, Hist. Soc.; New York, NY Hist. Soc.) he adopted a similar approach, employing formulaic compositions and a highly stylized treatment of landscape elements. Yet, despite these mannerisms, his abstract use of colour remains surprisingly fresh and modern.

WRITINGS
Elements of the Graphic Arts (New York, 1802)

BIBLIOGRAPHY
J. E. Stillwell: 'Archibald Robertson, Miniaturist, 1765–1835', *NY Hist. Soc. Q.*, xiii (1929), pp. 1–33
Views and Visions: American Landscape before 1830 (exh. cat. by E. J. Nygren and others, Washington, DC, Corcoran Gal. A., 1986)

EDWARD J. NYGREN

Robertson, Hugh Cornwall (*b* 1845; *d* 1908). American potter. He came from a family of British potters that settled in Chelsea, MA. The firm Robertson & Sons made Rockingham ware and flower pots. In 1872 the firm was renamed the Chelsea Keramic Art Works and produced redware vases, imitative of ancient Greek pottery, and decorative tiles. Inspired by the ceramic exhibits at the Centennial International Exhibition of 1876 in Philadelphia, Robertson began experimenting to produce wares of a white body with glossy glazes, and in 1877 the works began making vases and plaques with birds and flowers in the Aesthetic style (called Chelsea faience). After 1884 Robertson began to develop certain types of Chinese glazes. During this period he created several coloured glazes, including a crackled apple-green turquoise, mustard yellow and a slightly iridescent variation of oxblood. By 1889 his funds were exhausted, and he was forced to close the pottery. However, Boston collectors of Chinese ceramics, including William Sturgis Bigelow and Denman Ross (1853–1935), were so impressed with his accomplishments that in 1891 they encouraged him to start a new pottery to produce quaint blue-decorated tableware with a crackled glaze that proved to be popular. In 1896 this new operation was moved to Dedham, MA, and was renamed the Dedham Pottery. There Robertson continued to experiment and in this later period produced flowing and volcanic green and blue glazes on heavy porcelaineous bodies. (After Robertson's death, the operation was run by his son William Robertson (*d* 1929) and produced the same type of wares until it closed in 1943.)

BIBLIOGRAPHY
L. C. Hawes: *The Dedham Pottery and the Earlier Robertson's Chelsea Potteries* (Dedham, MA, 1968)

ELLEN PAUL DENKER

Robertson, R(obert) H(enderson) (*b* Philadelphia, PA, 29 April 1849; *d* Nahasane, NY, 3 June 1919). American architect. He trained in Philadelphia with Henry Sims (1832–75) and briefly in New York with George B. Post and Edward T. Potter. From 1875 to 1881 he was the junior partner of William A. Potter. His earliest works were in the Gothic Revival style. In the 1880s and early

R. H. Robertson: Park Row Building, Park Row, New York, 1899–1902

arches and Byzantine ornament, and the Renaissance-inspired Park Row Building (1899–1902; see fig.), Park Row, New York, which was, for a brief period, the world's tallest building.

BIBLIOGRAPHY

M. Schuyler: 'The Romanesque Revival in New York', *Archit. Rec.*, i (1891)
——: 'The Works of R. H. Robertson', *Archit. Rec.*, vi (1896), pp. 184–219
S. Landau: *Edward T. and William A. Potter: American Victorian Architects* (New York, 1979), pp. 70–79
A. Dolkart: *Church of St Paul and St Andrew (Originally St. Paul's Methodist Episcopal Church) Designation Report*, City Landmarks Preservation Commission (New York, 1981)

ANDREW SCOTT DOLKART

Robineau, Adelaide Alsop (*b* Middletown, CT, 9 April 1865; *d* Syracuse, NY, 18 Feb 1929). American potter, teacher and publisher. She first pursued a career in painting but was attracted to decorating ceramics, from which she earned a livelihood as an independent decorator and teacher. In 1899 she married Samuel Edouard Robineau (*b* 1856), and together with George H. Clark they established the monthly journal *Keramic Studio* (later *Design*), which she edited until her death. At the turn of the century she became interested in making art porcelain. Her early work was influenced by the French ceramic artist, Taxile Doat (1851–1938) whose treatise 'Grand Feu Ceramics' she first published in English in *Keramic Studio* as a series of articles in 1904. In 1910–11 she was associated with Doat in the University City Pottery near St Louis, MO. During her tenure there she created some of her most ambitious works, including the 'Scarab' vase (Syracuse, NY, Everson Mus. A.), which required more than 1000 hours to carve and glaze, and the 'Pastoral' vase (Washington, DC, N. Mus. Amer. Hist.; see fig.), covered with an overall pattern of daisies and satyrs' masks. In 1911 she returned to her home in Syracuse, NY, where she worked until her death. She also taught an annual six-week summer arts and crafts school and held a faculty position at Syracuse University. The important Ceramic National Exhibitions were founded in her honour in 1932.

BIBLIOGRAPHY

P. Weiss, ed.: *Adelaide Alsop Robineau: Glory in Porcelain* (Syracuse, 1981)

ELLEN PAUL DENKER

1890s Robertson's buildings, notably institutional and commercial structures, such as the Mott Haven Railway Station, Bronx, New York (1885–6; destr.; for illustration see Schuyler (1891), p. 25), displayed the influence of H. H. Richardson's Romanesque Revival. Following the stylistic trends of the period, Robertson's designs of the 1890s became more eclectic, combining varied historical motifs within a single structure. This is most strikingly apparent at St Paul's Methodist Episcopal Church, West End Avenue, New York (1895–7; now Church of St Paul and St Andrew), with its successful fusion of Italian and Spanish Renaissance, German Romanesque and Early Christian motifs. Robertson was a pioneer in the design of skyscrapers in the historic styles favoured by the commercial architects of New York. Examples include the Romanesque Revival style Lincoln Building (1888–90), Union Square, New York, with its limestone-, brick-, and terracotta-faced façades and its tiers of massive round

Robinson, Theodore (*b* Irasburg, VT, 3 July 1852; *d* New York, 2 April 1896). American painter, active also in France. Brought up in Evansville, WI, he studied art briefly in Chicago at the end of the 1860s, and in New York at the National Academy of Design (1874–6). His early work, for example *Haying* (1882; Cooperstown, NY, Mus. NY State Hist. Assoc.), was in the painterly American genre tradition of Winslow Homer. From 1876 to 1878 he studied in Paris under Carolus-Duran, alongside John Singer Sargent, and under Jean-Léon Gérôme. In 1879 Robinson returned to the USA and lived mainly in New York and Boston; he made a living by teaching and by assisting John La Farge and Prentice Treadwell with mosaic and stained-glass decorations for the Metropolitan Opera House, New York. In 1881 he was elected to the Society of American Artists, a group in revolt against the conservatism of the National Academy. Returning to France in 1884, Robinson worked in Paris and Barbizon and was

Adelaide Alsop Robineau: 'Pastoral' vase, porcelain, h. 235 mm, 1910 (Washington, DC, National Museum of American Art)

strongly influenced for a time by the Barbizon school. A crucial event was his meeting with Monet (1840–1926) at Giverny, near Rouen, in 1887. By 1888 they were close friends and Robinson began to develop his own Impressionist style, which was never as extreme in its use of broken colour as that of Monet. His aim, as he wrote in his journal, was to combine Impressionism's 'brilliancy and light of real outdoors' with 'the austerity, the sobriety, that has always characterized good painting'. Cézanne (1839–1906) seems to have influenced the strong compositional structure of his paintings, and his best work was done mostly in France during the next four years. He also painted in Italy for several months in 1890 and 1891. His favourite subjects were landscapes and intimate vignettes of farm and village life, such as the *Watering Pots* (1890; New York, Brooklyn Mus. A.; see fig.), *In the Grove* (c. 1888; Baltimore, MD, Mus. A.) and *Wedding March* (1892; Chicago, IL, Terra Mus. Amer. A.). Since models were expensive and Robinson was poor, he often took photographs as studies for his figure compositions.

In 1892 Robinson left France for the last time and returned to New York. The Society of American Artists awarded him its Shaw Prize, but he sold few paintings and again was forced to teach for a living, in private classes and at the Pennsylvania Academy of the Fine Arts,

Philadelphia. His first one-man exhibition was held in 1895, at the Macbeth Gallery, New York, only a year before his death. His later career was overshadowed by illness, poverty and aesthetic difficulties with American light, which he found harsher than that of France. But he produced a number of notable paintings at Cos Cob, CT, and along the Delaware and Hudson Canal near Napanoch, NY, for example *Low Tide, Riverside Yacht Club* (1894; New York, Mr & Mrs R. J. Horowitz priv. col.), and he is generally recognized today as a leading figure in the formative years of American Impressionism.

WRITINGS
'Claude Monet', *C. Mag.*, n. s. 22 (1892), pp. 696–707; also in *Modern French Masters*, ed. J. C. van Dyke (New York, 1896/*R*1976)

BIBLIOGRAPHY
Theodore Robinson (exh. cat. by J. I. H. Baur, New York, Brooklyn Mus., 1946)
J. I. H. Baur: 'Photographic Studies by an Impressionist', *Gaz. B.-A.*, n. s. 6, xxx (1946), pp. 319–30
Theodore Robinson (exh. cat., intro. Sona Johnston; Baltimore, MD, Mus. A., 1973)
Theodore Robinson: His Life and Art (exh. cat. by E. C. Clark, Chicago, R. H. Love Gals, 1979)
W. Gerdts: *American Impressionism* (Seattle, 1980), pp. 51–6
The Figural Images of Theodore Robinson (exh. cat. with intro. by W. Kloss, Oshkosh, WI, Paine A. Cent. & Arboretum, 1987)
R. H. Love: *Theodore Robinson: Sketchbook Drawings* (Chicago, 1991)
JOHN I. H. BAUR

Roche, Martin. *See under* HOLABIRD & ROCHE.

Roebling. American family of engineers of German descent.

(1) John Augustus Roebling (*b* Mülhausen in Thüringen, 12 June 1806; *d* New York, 22 July 1869). He was

Theodore Robinson: *Watering Pots*, oil on canvas, 560×460 mm, 1890 (New York, Brooklyn Museum of Art)

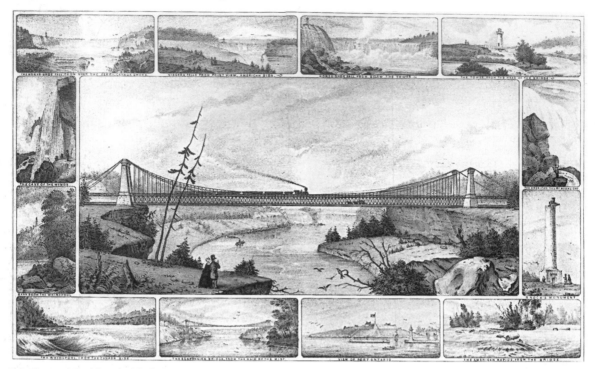

John Augustus Roebling: double-deck suspension bridge over Niagara River, Niagara Falls, New York, 1851–5; litograph by E. B. and E. C. Kellog (New York, New-York Historical Society)

perhaps the single most important figure in the development of the modern suspension bridge. He graduated with a civil engineering degree from the Königliche Technische Hochschule, Berlin, in 1826 and emigrated to the USA in 1831, in part because of political repression in the German states. With a group of other German immigrants, he founded the farming community of Saxonburg in western Pennsylvania, but the poor soil of the region and Roebling's lack of talent or taste for agricultural life meant only marginal success in the enterprise. He soon returned to engineering as a surveyor for various canal and railway companies in the state, an activity that led to the discovery of a market for twisted steel-wire cable to replace the unreliable fibre rope used to haul canal boats up the steep canal railways in the Allegheny Mountains. He founded a small company to manufacture the product on his farm at Saxonburg and greatly expanded the business in Trenton, NJ, in 1849.

As a student Roebling had written a thesis on the suspension bridge, and by the time he began the manufacture of steel-wire cable he was convinced that the flexible wire with its extremely high tensile strength offered the possibility of constructing strong and reliable suspension bridges more efficiently and economically than could be done with the wrought-iron chains that had previously been used as cables. European bridge engineers had independently come to the same conclusion, and they were putting the new theory into practice in the 1830s.

The opportunity to put his own views to the test came when the directors of the Pennsylvania State Canal awarded Roebling the contract to construct the aqueduct (1844–5) to carry the canal over the Allegheny River in

the north-western corner of the state. This launched Roebling's career as an engineer of international importance. The Smithfield Street Bridge (1845–6) over the Monongahela River in Pittsburgh, PA, was his next commission, and the year of its completion brought even greater opportunities. He was commissioned to design and supervise the construction of four aqueducts (1847–9) in north-eastern Pennsylvania to carry the Delaware and Hudson Canal over the Lackawaxen River, Neversink and Rondout creeks and the Delaware River. The 'Roebling system' of suspension bridges consisted essentially of a pair of primary steel cables supported by squat brick or masonry towers rising from the bridge piers. These cables extended beyond the towers to anchorages fixed in the massive abutments at either end of the bridge. Hangers of thinner steel cable were suspended from the primary cables to carry the deck structure on which a framework of iron trusses, beams and girders carried the aqueduct trunk. The basic form could be expanded almost indefinitely by increasing the height of the towers and the size of all supporting elements.

The commission that brought Roebling to the forefront among engineers was the construction of the suspension bridge (1851–5) over the US–Canadian border on the Niagara River near the towns of Niagara Falls, NY, and Ontario (see fig.). It was not only the first bridge to span the formidable Niagara gorge but also the first railway suspension bridge, originally commissioned by the Great Western Railway of Canada. In having two decks, it stood unique among bridges of its type until the increasing weight of rail traffic compelled its replacement by a steel-arch bridge in 1896.

Knowledge gained from experience and the courage to make use of it in unprecedented ways urged Roebling on to extraordinary feats of bridge engineering. A comparatively minor excursion along the way, the Sixth Street Bridge over the Allegheny River in Pittsburgh (1858–60), prepared the path for the grandest of Roebling's works up to that date. After more than ten years of discussion, the citizens of Covington, KY, and Cincinnati, OH, established a company to erect a bridge over the Ohio River between the two cities. Constructed in 1856–67 in the face of numerous delays and difficulties, the bridge embraced what was then the longest clear span in the world, 322 m between the masonry towers.

Roebling broke his own record in little more than a decade with the design for his greatest work, Brooklyn Bridge, spanning the East River between Manhattan and Brooklyn, New York (1869–83; see NEW YORK, fig. 3). It remains a triumph of the structural art: the unprecedented length of span, 486 m between the towers, and the combination of the aerial grace of the steelwork with the mass and strength of the towers immediately gave the bridge the status of a national monument as an expression of American prestige and daring. Its creator, however, was never to see his design realized. In 1869, while conducting the final survey of the site, he suffered a serious injury to his foot. He survived the amputation of several toes but died of the consequent tetanus infection. The directors of the bridge company appointed his son, (2) Washington Augustus Roebling, chief engineer of the project in August of the same year.

(2) Washington Augustus Roebling (*b* Saxonburg, PA, 26 May 1837; *d* Trenton, NJ, 21 July 1926). Son of (1) John Augustus Roebling. He graduated with a degree in civil engineering from Rensselaer Polytechnic Institute, Troy, NY, in 1857 and began his career in the family's steel-wire cable manufactory at Trenton, NJ. In the following year he joined his father as assistant supervisor of construction for the Allegheny River Bridge in Pittsburgh. He served throughout the Civil War (1861–5) as an officer in the Volunteer Corps of the Union Army. At the conclusion of the war in 1865, he rejoined his father to see the Cincinnati Bridge to completion. A year's travel in Europe in 1868 was devoted to studying bridges and conferring with engineers in England, France and Germany. Following his return, he was appointed chief engineer of the Brooklyn Bridge on the death of his father in 1869. He was crippled with caisson disease (the bends) in 1872 after inspecting one of the bridge's underwater chambers and was forced to supervise construction of the bridge by means of a telescope mounted in a room of his Brooklyn home and to rely on his wife, Emily Warren Roebling, to act as secretary and transmitter of messages to the field superintendents. He became President of the John A. Roebling's Sons Co. in 1876, but ill health soon forced him to retire. He moved to Troy, NY, in 1884 and

Severin Roesen: *Still-life: Fruit*, oil on canvas, 914×1270 mm, 1855 (New York, Metropolitan Museum of Art)

in 1888 back to Trenton, where he remained largely inactive except for supervising the company's contract to supply steel-wire cable for the Bear Mountain Bridge over the Hudson River, NY, in 1920.

BIBLIOGRAPHY

DAB

H. Schuyler: *The Roeblings: A Century of Engineers, Bridge-builders and Industrialists* (Princeton, 1931)

C. W. Condit: *American Building Art: The Nineteenth Century* (New York, 1960)

R. M. Vogel: *Roebling's Delaware and Hudson Canal Aqueducts* (Washington, DC, 1971)

D. McCullough: *The Great Bridge* (New York, 1976)

R. M. Vogel: *Building Brooklyn Bridge* (Washington, DC, 1983)

E. L. Kemp: 'Roebling, Ellet and the Wire Suspension Bridge', *A Centennial Celebration of the Brooklyn Bridge*, ed. M. Latimer with B. Hindle and M. Kranzberg (New York, 1984)

CARL W. CONDIT

Roesen, Severin (*b* ?nr Cologne, *fl* 1847–72). American painter of German birth. He exhibited in Cologne in 1847 and may have studied in Düsseldorf. Emigrating to the USA in 1848, he lived, worked and exhibited in New York City until 1852, when he moved to Pennsylvania, settling in Williamsport. He is last listed in the Williamsport directories of 1872.

Roesen was a prolific, if uneven, painter. His complex, lavish still-lifes of fruit and flowers established the tradition for the genre in 19th-century America and the style for large canvases suitable for dining-room decoration. His pendant still-lifes *Flowers* and *Fruit* (both New York, Met.) reveal his training as a painter of enamels and china with their crisp drawing, bright colours and smooth surfaces. The elaborate compositions acknowledge the influence of Dutch 17th-century painting: in *Still-life: Flowers* a large glass bowl is set on a grey marble slab against a dark-toned background and overflows with an extravagant variety of flowers; adjacent is a group of various fruits and a tiny, egg-filled bird's nest; on a second, higher ledge there is a wicker basket of plums. The same bird's nest and basket of plums appear in *Still-life: Fruit* (see fig.), another double-tiered composition overflowing with a succulent array of fruits. Roesen characteristically signed his name in vine tendrils. Other works, of uneven quality, all variations on the theme, include china compotes, wine and water goblets and an occasional glimpse of landscape.

BIBLIOGRAPHY

M. A. Mook: 'Severin Roesen: The Williamsport Painter', *Lycoming Coll. Mag.*, xxv (1972), pp. 33–42

L. G. Marcus: *Severin Roesen: A Chronology* (Williamsport, 1976)

W. H. Gerdts: *Painters of the Humble Truth: Masterpieces of American Still-life Painting, 1801–1939* (St Louis, 1981)

J. H. O'Toole: *Severin Roesen* (Cranbury, 1992)

GERTRUDE GRACE SILL

Rogers, Bruce (*b* Lafayette, IN, 14 May 1870; *d* New Fairfield, CT, 18 May 1957). American typographer and graphic designer. He was taught to draw by his father. At 16 he entered Purdue University, West Lafayette, IN, and studied applied art. He then produced title-pages and decorative elements for college publications. Rogers's first employment was as an illustrator for the *Indianapolis News*. In 1893 he was working as general draughtsman for the Indiana Illustrating Company and was taken on by the periodical *Modern Art*, which moved in 1895 to Boston, where Rogers met George Mifflin of the publishing firm of Houghton, Mifflin and Co., Cambridge, MA. In 1896 he began work at the Houghton's Riverside Press, becoming head of the department responsible for the production of limited-edition books in 1900. The freedom of budget and time allowed him to produce some notable books, including the sonnets of Michelangelo and the love poetry of John Donne (1905).

Rogers's style was eclectic in his choice of type, binding and paper. He selected types suitable to the period and nature of the book. After resigning from the Riverside Press in 1911, he worked in New York, where he received the support of the Museum Press at the Metropolitan Museum of Art, for which he designed labels and posters. Rogers's style has been categorized as clear, unpedantic and totally correct in detail. He has been called 'America's greatest book designer'.

BIBLIOGRAPHY

H. W. Kent: *Bruce Rogers: Marks and Remarks* (New York, 1946)

K. Day: *Book Typography, 1815–1965, in Europe and the USA* (London, 1966)

LAURA SUFFIELD

Rogers, Isaiah (*b* Marshfield, MA, 17 Aug 1800; *d* Cincinnati, OH, 13 April 1869). American architect. He is remembered primarily for having designed some of the earliest modern hotels in America, although he designed noteworthy public and private structures of many types. Almost all have been demolished during subsequent urban development.

The Rogers family had settled in south-eastern Massachusetts by the 1640s and were long engaged in shipbuilding and farming. In 1817 Isaiah was apprenticed to a Boston housewright, Jesse Shaw. After a stay in Mobile, AL, where in 1822 he won a competition to design a theatre, Rogers returned to Boston and worked in Solomon Willard's office from 1822 to 1825, when Willard left to supervise his granite quarrying business in Quincy, MA. Rogers's major Greek Revival works made extensive use of massive granite monoliths.

Rogers's successful design for the Tremont Theatre (1827; destr. 1852), Boston, was termed 'the most perfect ...architecture in Boston ...uncommonly chaste and dignified' by H. R. Cleveland jr in the *North American Review* (1836) and earned him the commission for a large new hotel in the city, the Tremont House (1828–9; destr. 1895; see figs 1 and 2). The hotel's monumental granite front, conveniently planned and elegant interiors and innovative equipment surpassed all earlier hotels, and with the anonymous publication by William Havard Eliot, *A Description of Tremont House* (1830), Rogers achieved national fame. The Tremont House plan had a direct influence on at least two other hotels: Rogers's smaller Bangor House (1833–4; altered to house the elderly, 1979), Bangor, ME, and William Washburn's larger United States Hotel (1840; destr. 1929), Boston.

Several works begun in 1833 still survive: the austere stone Gothic church of St Peter's, Salem, MA; the wooden Gothic First Parish Church (Unitarian; altered 1910), Cambridge, MA; and the wooden Greek Revival house for Captain Robert Bennet Forbes (altered 1872), Milton, MA. Rogers's handsome Suffolk Bank (1833–6; destr. *c.*

1. Isaiah Rogers: ground-plan of Tremont House, Boston, Massachusetts, 1828–9 (New York, Columbia University, Avery Architectural and Fine Arts Library)

1890) in Boston had a granite façade with Ionic tetrastyle *in antis* engaged half-columns above a ground floor.

In 1834 Rogers was commissioned by John Jacob Astor to build a hotel in New York, the Astor House (1834–6; destr. 1913). Larger than any previous hotel, the Greek Revival Astor House, built of granite, had such innovations as running water on every floor. Rogers also designed three banks, the Bank of America (1835; destr. 1889) and the Merchants' Bank (1838–9; destr. 1883), both on Wall Street, New York, and the Exchange Bank (1840–41; destr. 1865) in Richmond, VA; all had distyle *in antis* façades and were built of granite. His Middle Collegiate Dutch Reformed Church (1837–9; destr. 1887), New York, of granite with an Ionic octastyle portico, had a spire supported on a drum surrounded by columns similar to All Souls Church, Langham Place, London by John Nash (1752–1835).

The New York Merchants' Exchange (1836–42) on Wall Street contained a marble-walled rotunda with a diameter of 24.38 m and a coffered dome. This was the largest masonry vaulted space in the USA at the time, but the interior was destroyed in 1907, when four storeys were superposed on Rogers's granite exterior, which had 18 monolithic Ionic columns, each 11.58 m high. The New York Merchants' Exchange was Rogers's structural masterpiece. For the Boston Merchants' Exchange (1840–42; destr. 1889), Rogers used even larger granite monoliths, four engaged piers 17.35 m high, each weighing over 50 metric tonnes. Rogers used his own version of the Corinthian order.

Before moving from New York back to Boston in 1841, Rogers designed the Exchange Hotel (1839–41, destr. 1900) in Richmond, VA. Rogers used designs from the Egyptian Revival with his granite gates for the Old Granary Burying Ground (1839–40) in Boston and the Jews' (or Touro) Cemetery (1841–2) in Newport, RI. Among his other surviving works of the 1840s are the granite Greek Revival Town Hall (1844–5) in Quincy, MA, sometimes incorrectly attributed to Solomon Willard; the Italianate Astronomical Observatory (1844–5) at Harvard University, Cambridge, MA, of which only the central block remains; and the Italianate Horace L. Kent House (1844–5) in Richmond, VA, which was altered in 1900 but retains its Gothic double parlours. Both the Enoch Reddington Mudge House (1843–4; destr. c. 1955) in Swampscott, MA, and the Howard Athenaeum (1846; destr. 1961),

2. Isaiah Rogers: Tremont House, Boston, Massachusetts, 1828–9 (destr. 1895)

Boston, had granite Gothic exteriors. The Howard Athenaeum was a theatre with a sloping parterre instead of an old-fashioned pit. Rogers returned to New York to build the Astor Place Opera House (1847; destr. *c.* 1890).

In 1848 Rogers settled in Cincinnati, OH. He used Gothic for his Tyler Davidson Store (1849–50; destr.) and Romanesque for St John's Episcopal Church (1849–52; destr. 1937), both in Cincinnati, but thereafter he used predominantly either the Italianate or the Neo-classical styles, as he had done in his outstanding Italianate hotel, the Burnet House (1848–50; destr. 1926), Cincinnati, with its central pavilion, crowned by a dome and belvedere. The only surviving Italianate-style hotel from the 1850s is the Oliver House (1858–9), Toledo, OH, which was gutted for use as a warehouse in 1920. His Italianate Longview State Hospital (1856–60; destr. *c.* 1980), Cincinnati, was designed on the plan advocated by Dr Thomas Story Kirkbride, and the Grecian Commercial Bank (1855–6; destr. 1863), Paducah, KY, had an early terracotta façade. One Italianate house, Hillforest (1853–4), Aurora, IN, and examples of his Neo-classical work— the George Hatch Villa, Cincinnati (1850–51), and the Fifth Ward School (1855), Louisville—survive.

In 1862 President Abraham Lincoln appointed Rogers to the Treasury Department, Washington, DC, where he completed the West Wing of the Treasury, resigning in 1865. The Italianate Pike's Opera House (1866; destr. 1903), Cincinnati, was Rogers's last major work. He remained a classicist to the end of his career.

UNPUBLISHED SOURCES

New York, Columbia U., Avery Archit. Mem. Lib. [diaries, 1838–56, 1861, 1867]

BIBLIOGRAPHY

Macmillan Enc. Archit.

[W. Eliot]: *A Description of Tremont House* (Boston, 1830)

W. Whieldon: *Memoir of Solomon Willard* (Boston, 1865)

'Rogers, Isaiah', *Biographical Encyclopedia of Ohio of the Nineteenth Century* (Cincinnati, 1876)

J. Drummond: *John Rogers of Marshfield and Some of his Descendants* (Portland, ME, 1898)

T. Hamlin: *Greek Revival Architecture in America* (New York, 1944/R 1964)

D. Myers: 'The Recently Discovered Diaries of Isaiah Rogers', *Columbia Lib. Columns*, xvi (1966), pp. 25–31

R. Stoddard: 'Isaiah Rogers' Tremont Theatre, Boston', *Antiques*, cv (June 1974), pp. 1314–19

DENYS PETER MYERS

Rogers, James Gamble (*b* Bryants Station, KY, 3 March 1867; *d* New York, 1 Oct 1947). American architect. He graduated from Yale University, New Haven, CT, with a degree in Fine Arts in 1889. He began his architectural career in the office of William Le Baron Jenney in Chicago. In 1893 he enrolled at the Ecole des Beaux-Arts in Paris. He won medals in architecture and construction and graduated with honours in 1899. He returned to Chicago and designed the Winton Building (1904) on Michigan Avenue and 13th Street, an early use of the reinforced concrete frame technology. In 1905 he opened a short-lived practice in New York with Herbert D. Hale (1866–1909). After Hale retired, Rogers rose to national

prominence when he won the competition for the New Haven Post Office and Court-House (1911–19). This, like many of his early projects, combined skilful planning with bold massing and a scholarly use of Roman and Renaissance precedents.

BIBLIOGRAPHY

G. Nichols: 'The New Haven Post Office and Court House', *Archit. Forum*, xxxi/3 (1919), pp. 85–90

S. Ryan: 'The Architecture of James Gamble Rogers at Yale University', *Perspecta*, xviii (1982)

A. Betsky: *James Gamble Rogers and the Architecture of Pragmatism* (Cambridge, 1994)

GAIL FENSKE

Rogers, John (*b* Salem, MA, 30 Oct 1829; *d* New Canaan, CT, 26 July 1904). American sculptor. He had a strong interest in art from an early age and continued to take drawing-lessons after abandoning his school courses at the age of 16. He was also fascinated by inventions and practical machines, and, after briefly working for a surveyor, he trained as a machinist and master mechanic. The financial panic of 1857 threw him back on his drawing and clay working, which he had been practising as time permitted. He went to Paris and Rome for six months but became increasingly disgusted with academic sculpture and instruction. He returned home and, after taking up modelling while working in Chicago, arrived in New York to market his first mature sculptural groups.

After several years in which Rogers alternated between producing inexpensive statuary and experimenting with marble and bronze, he decided to concentrate, in 1863, on the plaster figures and groups (known as the 'Rogers Groups') that were to remain popular for the next 30 years. His first major group, *Checker Players* (1859), was based on his own 1850 clay model, itself based on a design by David Wilkie (1785–1841), and was followed by several Civil War subjects, including *Union Refugees* (1863) and *How the Fort Was Taken* (1863), which appealed to the patriotism of many Americans. Such works as the *Fugitive's Story* (1869; see fig.) reflect Rogers's abolitionist sympathies and illustrate his talent for combining recognizable portraits (of leading abolitionists) and accurate details of contemporary dress and furniture with a more generalized evocation of human compassion in simply composed groupings.

The small figures were mass-produced in moulded plaster, built on metal armatures and painted in a single earth tone to reduce costs. Rogers developed a mail-order business, based in New York, and his groups were widely advertised. Catalogues of his works were issued from 1866 to 1895, latterly by the Rogers Statuary Company. Rogers produced about 100 different groups, with 87 titles and 13 variations, selling in all about 80,000 pieces. His work was also a popular subject for stereoscopic publishers, and at least 40 different groups were made available in that medium. He also produced some larger-scale sculpture. The life-size *Lincoln* (1892; exh. Chicago, World's Columbian Exposition, 1893; Manchester, NH, Cent. High School) is among his finest achievements.

Rogers's inexpensive groups, almost all selling for between $10 and $15, were seen by critics and by sculptors wedded to the dominant ideal tradition as pandering to the uneducated public, but he defended his scenes of

John Rogers: *Fugitive's Story*, moulded plaster, h. 559 mm, 1869 (New York, New-York Historical Society)

everyday life and his groups based on the better-known writings of Washington Irving, Shakespeare, and even Goethe, as a way of developing a broad-based appreciation of sculpture among those who had never purchased it before. By the time of his retirement in 1894, changing tastes had relegated his work to obscurity. Only in 1937 did a representative selection of the 'Rogers Groups' enter a major public collection (New York, NY Hist. Soc.). Rogers was the only active representative in sculpture of the Realist and genre traditions predominant in mid-19th-century American painting, and his strongly anecdotal works remain a unique chapter in American sculptural history.

BIBLIOGRAPHY

C. Smith and M. Smith: *Rogers Groups: Thought and Wrought by John Rogers* (Boston, 1934)

D. H. Wallace: *John Rogers: The People's Sculptor* (Middletown, CT, 1967) [incl. cat. of all known works]

——: 'The Art of John Rogers—So Real and So True', *Amer. A. J.*, iv/2 (1972), pp. 59–70

DAVID M. SOKOL

Rogers, Randolph (*b* Waterloo, NY, 6 July 1825; *d* Rome, 15 Jan 1892). American sculptor. He travelled to New York in 1847 to pursue a career in magazine illustration and ultimately found employment in a dry-goods store. His employers discovered his aptitude for carving and promptly financed his trip to Florence in 1848 for formal training. He studied with Lorenzo Bartolini (1777–1850) until 1850, when he settled in Rome. The poignant gesture and beseeching gaze of the kneeling figure in his first work, *Ruth Gleaning* (marble, 1855; Detroit, MI, Inst. A.),

instantly appealed to popular taste. He sustained this success with his sensational *Nydia, the Blind Girl of Pompeii* (version, 1859; New York, Met.; see fig.). Inspired by Edward Bulwer-Lytton's novel *The Last Days of Pompeii* (1834), Rogers modelled a pathetic blind girl who rushes desperately through the ruined city. Although he capitalized on the sentimental subject, he also created a work that demanded skilful marble carving; he received nearly one hundred requests for duplicates of this masterpiece.

Rogers continued to produce idealized marble statuary throughout his career but shifted his principal creative efforts to the public sphere. Closely following the design of the Florence Baptistery's *Gates of Paradise* (1425–52) by Lorenzo Ghiberti (1378–1455), Rogers represented nine scenes from the *Life of Christopher Columbus* on a pair of bronze doors for the eastern entrance to the Rotunda of the Capitol in Washington, DC (1860). In 1857 Rogers was asked to complete Thomas Crawford's design for the George Washington Monument in Richmond, VA (1861). Although he remained in Rome, he became one of America's foremost monument makers. Later works include military memorials for Detroit, MI (1881), and Providence, RI.

BIBLIOGRAPHY

L. Taft: *The History of American Sculpture* (New York, 1903, rev. 1930), pp. 159–70
W. Craven: *Sculpture in America* (Newark, 1968, rev. 1984), pp. 312–19
M. Rogers jr: *Randolph Rogers: American Sculptor in Rome* (Amherst, 1971)

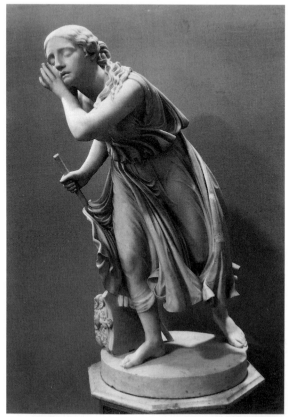

Randolph Rogers: *Nydia, the Blind Girl of Pompeii*, marble, h. 1.40 m, 1859 (New York, Metropolitan Museum of Art)

K. Greenthal, P. M. Kozol and J. S. Ramirez: *American Figurative Sculpture in the Museum of Fine Arts, Boston* (Boston, 1986), pp. 153–8

JANET A. HEADLEY

Rogers, William (*b* England, *c.* 1685; *d* Yorktown, VA, 1739). American pottery manufacturer and merchant of English birth. He arrived in Virginia *c.* 1710, and he was perhaps related to a Lambeth distiller, as his first business in America was a brewery. About 1718–20 he established a pottery at Yorktown, VA. While still operating these two enterprises, he opened a store *c.* 1720 and began a shipping business about 1730. Although described by Governor William Gooch of Virginia as a 'poor potter' whose business was 'inconsequential', Rogers had a large pottery that supplied common lead-glazed earthenware and brown salt-glazed stoneware to markets along the southern coast and probably to Barbados and Jamaica as well. Archaeological investigation of the site of the pottery revealed the existence of two kilns and a complex of adjoining structures, where an impressive range of salt-glazed vessels was made (e.g. mugs, Yorktown, VA, Col. N. Hist. Park; see Barka, Ayres and Sheridan, figs 214–16); these are indistinguishable from wares produced in Fulham, Southwark or Lambeth, London, England, of the same period. Rogers's pottery apparently operated until *c.* 1745 (according to the US Department of the Interior).

BIBLIOGRAPHY

N. F. Barka, E. Ayres and C. Sheridan: *The 'Poor Potter' of Yorktown: A Study of a Colonial Pottery Factory*, Yorktown Res. Ser., no. 5 (Denver, 1984)

ELLEN PAUL DENKER

Rood, Ogden (Nicholas) (*b* Danbury, CT, 3 Feb 1831; *d* New York, 12 Nov 1902). American physicist and theorist. Following his graduation from Princeton University in 1852, he studied in Germany for six years. He taught at Troy University, Troy, AL, from 1858 to 1863 and was Professor of Physics at Columbia University, New York, from 1863 until his death. In 1866 he became one of the first members of the American Water-Color Society. He wrote extensively on physics, but art was the subject of his most important book. Written for artists and general readers, *Modern Chromatics* (1879) explores human perception of colour and explains the laws of simultaneous contrast of colour. In 1881 it was reissued as *Students' Text-book of Color: or, Modern Chromatics, with Applications to Art and Industry*, and in its French translation, *Théorie scientifique des couleurs . . .* (1881), it had a powerful influence on Post-Impressionist painters. Rood advocated using pure colours but also stressed the need to study paintings by proficient colourists and the importance, for the artist, of not slavishly following rules. He particularly admired and recommended the art of J. M. W. Turner (1775–1851), and his long interest in art led to correspondence with John Ruskin (1819–1900).

UNPUBLISHED SOURCES

New York, Columbia U. [Rood's papers]

WRITINGS

Modern Chromatics (New York and London, 1879; Ger. trans., Leipzig, 1879); rev. as *Students' Text-book of Color: or, Modern Chromatics, with Applications to Art and Industry* (New York, 1881; Fr. trans., Paris, 1881)

DAB

BIBLIOGRAPHY

E. L. Nichols: 'Ogden Nicholas Rood', *Biog. Memoirs, N. Acad. Sci.*, vi (1909), pp. 449–72

DARRYL PATRICK

Rookwood Pottery. American pottery manufactory. It was founded in 1880 in Cincinnati, OH, by Maria Longworth Nichols (1849–1932), later Mrs Storer. The Rookwood Pottery originally produced art wares using underglaze painting in coloured slips on greenware. The technique had been adapted in 1878 by M. Louise McLaughlin (1847–1939), who had studied ceramic painting with Nichols in Cincinnati. Rookwood was unprofitable in its early years, but in 1883 William Watts Taylor (1847–1913) was put in charge, and he instituted changes that created a viable art product and established the firm as the USA's foremost art pottery at the end of the 19th century. Using an earth-tone palette, the artists painted popular subjects on moulded or wheel-thrown objects (*see* UNITED STATES OF AMERICA, fig. 37 and colour pl. XXXIV, 4). Each piece was marked with the company cipher, dated and signed by the artist. The early wares used a dark palette of brown earth tones, but after 1890 the colour palette became lighter. After 1900 the firm also produced moulded wares, matt-glazed architectural tiles and porcelain. (Production continued until the 1940s, and the factory closed in 1960.)

BIBLIOGRAPHY

H. Peck: *The Book of Rookwood Pottery* (New York, 1968)

K. R. Trapp: *Ode to Nature; Flowers and Landscapes of the Rookwood Pottery, 1880–1940* (New York, 1980)

A. J. Ellis: *Rookwood Pottery: The Glorious Gamble* (Cincinnati, OH, 1992)

——: *Rookwood Pottery: The Glaze Lines* (Atglen, PA, 1995)

ELLEN PAUL DENKER

Root, John Wellborn (*b* Lumpkin, GA, 10 Jan 1850; *d* Chicago, IL, 15 Jan 1891). American architect and writer. He was educated in Atlanta, GA, then in England at Clare Mount School (1864–6), near Liverpool, and graduated in 1869 from New York University where he trained as a civil engineer. He was apprenticed for a year with the New York architectural firm of Renwick & Sands, then joined John Butler Snook, also in New York, where he acted as superintendent of construction for the immense Grand Central Station for Cornelius Vanderbilt. In January 1872 Root moved to Chicago to serve as head draughtsman (and prospective partner) with Peter Bonnett Wight who had formed a partnership with Asher Carter (1805–77) and William H. Drake (*b* 1837). DANIEL H. BURNHAM entered Wight's office soon afterwards, and in 1873 he and Root set up Burnham & Root, with Root as the designer and Burnham the businessman and organizer. The economic depression of September 1873, triggered by a general financial crisis, made this a difficult moment to commence practice, but good connections, including Burnham's marriage to the daughter of John B. Sherman in 1876, brought the firm a series of important domestic commissions, starting with a house for Sherman, on 21st Street and Prairie Avenue (1874; destr.).

Domestic commissions occupied the practice until 1880 when they received their first commission for a tall office building, from the Boston investors Peter Brooks and Shepherd Brooks, the Grannis Block (1880–81; destr.), Chicago, followed by the Montauk Block (1881–2; destr.), Chicago, a ten-storey building. These were the first of Burnham & Root's skyscraper office buildings, built between 1880 and 1891, a type that developed out of the invention of the elevator and the intense pressure on land values in the booming city of Chicago. It was also made technically and economically possible by the evolution of light steel skeletons on to which a fireproof brick or terracotta cladding might be attached. Stone facings with carved ornament were avoided, and the SKYSCRAPER was consequently inappropriate for conventional architectural treatments based on the horizontal organization of the orders. Root composed with bare red brick or sandstone masses, peppered with windows, shaped like medieval fortifications. The Grannis Block was of warm red brick with exactly matching terracotta. The exterior of the Montauk was devoid of stonework and carving, being one of the first structures of note in Chicago to be built only of brick and terracotta. In this block he invented the 'raft' foundation, a concrete slab laced with steel rails underlying parts of the structure to spread its weight as evenly as possible, which supported a building of unprecedented height on the soft Chicago subsoil.

The Rookery Building (1885–8; see fig.), south-east corner of La Salle and Adams Streets, Chicago, was again built for Peter and Shepherd Brooks and was erected by the general contractors George E. Fuller & Company. In the Rookery, Root supported ten storeys in a block 200 ft square, open on all four sides with an inner courtyard and with a continuous grid of steel columns and beams. Its two principal façades are powerfully composed in stone and brick. The impressive internal court is covered at

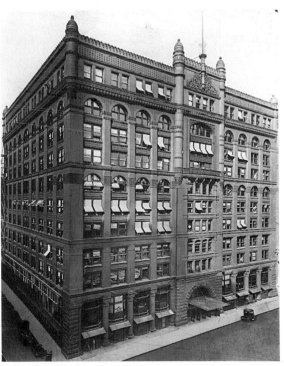

Burnham & Root: Rookery Building, La Salle and Adams Streets, Chicago, 1885–8

second-floor level by glass supported on a filigree of exposed iron beams. In the Rand–McNally Building (1888–90; destr.), Chicago, also built by Fuller, he adopted a complete steel skeleton, clothed only in thin sheets of mass-produced terracotta. In the Monadnock Building (1889–92), south-west corner of Dearborn and Jackson Streets, Chicago, the Brooks commissioned 16 storeys on a narrow site. They were reluctant for the new steel skeletal technology to be used, and so Root erected the structure as a row of tall brick cells, open on the interior. Exterior walls of specially moulded bricks are plain, with a projecting series of window bays from the third to the fifteenth floor. The walls have an elegant batter and flare outwards at the cornice, like an Egyptian cavetto.

The firm was now at the peak of its success and Root was a leader of his profession, appointed Secretary of the American Institute of Architects in 1889. In 1890 planning for the World's Columbian Exposition (1893) to celebrate the discovery of America began in Chicago, and Burnham & Root were placed in charge, Burnham of construction, Root of design. Root had produced imaginative sketches for the exposition buildings as well as for the Art Institute of Chicago, when he died unexpectedly of pneumonia. Between 1880 and 1891 Burnham & Root had erected eighteen office buildings in Chicago as well as eight in other cities. In Chicago they contributed significantly to the urban development of the central business district, known as the Loop, which became almost a private testing ground for their architectural experiments. Critics, such as Root's friend Henry Van Brunt, Sigfried Giedion, Carl Condit and Reyner Banham, have acknowledged Root as the creator of one of the great icons of modern technical building, the tall office building.

See also CHICAGO SCHOOL, §2.

WRITINGS
D. Hoffman, ed.: *The Meaning of Architecture: The Buildings and Writings of John Wellborn Root* (New York, 1967)

BIBLIOGRAPHY
H. Van Brunt: 'John Wellborn Root', *Inland Architect & News Rec.*, xvi (1891), pp. 85–8
P. B. Wight: 'John W. Root as a Draftsman', *Inland Architect & News Rec.*, xvi (1891), p. 88
H. Monroe: *John Wellborn Root: A Study of his Life and Work* (Boston, 1896)
C. Moore: *Daniel Burnham: Architect, Planner of Cities*, 2 vols (Boston and New York, 1921)
S. Giedion: *Space, Time and Architecture* (Cambridge, MA, 1941; rev. 3/1967)
T. Tallmadge: *Architecture in Old Chicago* (Chicago, 1941)
C. W. Condit: *The Chicago School of Architecture* (Chicago, 1964)
D. Hoffman: *The Architecture of John Wellborn Root* (Baltimore and London, 1973)
T. S. Hines: *Burnham of Chicago: Architect and Planner* (Chicago, 1974)

DAVID VAN ZANTEN

Rose, Guy (*b* San Gabriel, CA, 3 March 1867; *d* Pasadena, CA, 17 Nov 1925). American painter. He attended the California School of Design, San Francisco, in 1886 and 1887, studying under Virgil Williams (1830–86) and Emil Carlsen. In 1888 he went to Paris and enrolled in the Académie Julian. While a student, he was accepted for the annual Paris Salon exhibitions. In 1894 Rose experienced a bout of lead poisoning, which forced him to abandon oil painting. He returned to the USA in the winter of 1895

and began a career as an illustrator and taught at the Pratt Institute in Brooklyn, NY. He gradually regained his health and returned to oil painting around 1897. In 1899 he returned to Paris, where he continued to do illustration work for *Harper's Bazaar* and other American magazines. Rose was greatly influenced by Claude Monet (1840–1926), and in 1904 he and his wife, Ethel, settled in Giverny. In 1910 he and Richard Miller (1875–1943), Lawton Parker (1868–1939) and Frederick Frieseke (1874–1939) exhibited in New York as 'The Giverny Group'.

Rose returned permanently to the USA in 1912, settling for a time in New York, then to Pasadena at the end of 1914. Rose painted primarily in the southern part of the state and pursued a serial style of painting, like Monet, in which the same scene would be depicted at different times of day. Among his early awards were a Bronze Medal in the Pan-American Exposition, Buffalo (1901) and a Silver Medal in the Panama—Pacific International Exposition, San Francisco (1915).

BIBLIOGRAPHY
Guy Rose: American Impressionist (exh. cat. by W. South, W. H. Gerdts and J. Stern, Oakland, CA, Mus., and Irvine, CA, Mus., 1995)

JEAN STERN

Roycrofters, the. *See* HUBBARD, ELBERT.

Rug. Floor-mat, especially for the hearth. Floor coverings have been made in societies throughout the world from a variety of woven and non-woven materials, including plaited reeds, felt and bark fibre. The term probably comes from the Norwegian *regga* or *rugga*, meaning a soft, coarse cover used as an alternative to animal fleeces or skins. In Scandinavia long-piled *ryijy* rugs were knotted, but elsewhere in Europe such covers were made of coarse woollen fabric with a raised nap. In the 16th and 17th centuries this yardage fabric was used by the poor for clothing and later for bedding. By the end of the 18th century the term was also applied to small mats and covers produced, mainly domestically, for tables, beds and increasingly floors. These rugs were mostly made by such needlework techniques as canvaswork embroidery, appliqué and patchwork, and by hooking and progging. Early European settlers took these traditions with them to North America.

1. Hooked. 2. Other.

1. HOOKED. This kind of rug is worked from the right side. A long strip of fabric is held under the foundation material, usually burlap or sacking, and a hook rather like a crochet hook is used to pierce the material in order to catch the strip and pull a loop to the top. The strips of fabric can be as wide as 12 mm or as fine as 2 mm.

In the USA rug-hooking was first practised on the eastern seaboard. The earliest rugs were hooked on a linen foundation, but after *c.* 1850 burlap made from jute was used. During the 19th century more hooked rugs were made in the USA than any other kind. The patterns for these early rugs were home-drawn, and the most common designs were made up of a repeat that was easy to follow if more than one person were involved in the making. An American housewife might make two rugs each winter.

After the Civil War, it was possible to buy rug patterns. Edward Sands Frost of Biddeford, ME, became a pedlar

after being invalided out of the army. He added rug patterns, designed by himself, to the usual pedlar's stock and developed a series of stencils, which he used to mark them out. Others copied his ideas, and mail-order firms began to produce patterns commercially, often derived from those of Frost. A distinctive style of rug with a high-sculptured pile was made in Waldoboro, ME, and in time 'Waldoboro' became the name for any rug so made.

In the early 20th century rug-hooking became a cottage industry in parts of New England. One of the earliest, Abnakee, founded in 1902, specialized in rugs with Native American motifs. Many small rug-hooking groups were founded in the Appalachian Mountains of Tennessee, Kentucky, North Carolina and Virginia.

Sometimes more than one technique was used in a rug, for example the centre panel hooked and the border braided (see fig.).

2. OTHER. There are a number of other rug-making techniques used in North America. The first braided rugs were made between 1830 and 1850, and traditionally they were round or oval. Strips of fabric 50 mm wide had both edges turned in to make a 25 mm strand. The strands were grouped in threes, fives or sevens and plaited to make a braid, the end of which was turned in on itself and firmly stitched. The braid was then wound round this core until it was the required shape and size. Stitching with strong carpet thread at regular intervals, keeping the work perfectly flat, held the braids together. More braided rugs were made in North America than in the British Isles.

Shirred rugs, often called 'chenille' rugs after the French word for caterpillar, were popular during the first half of the 19th century. A running stitch was taken lengthwise down the middle of a strip of fabric and the thread pulled up, so that the gathered strip looked rather like a caterpillar. Each 'caterpillar' was then sewn to a foundation fabric. Another method was to stitch strips of woollen fabric across their width to the backing, then to loop and stitch them down again, each loop being very close to the preceding one, forming a series of pleats. On a shirred rug all the cloth is on the top surface, and only the stitches used to attach the strips to the foundation show on the underside.

Tongue rugs were utilitarian and showed another use of thick and heavy material that could not be employed for any other purpose. Pieces of fabric, cut with one end rounded, were sewn to a heavy foundation. Starting at the outside edge, each row of 'tongues' slightly overlapped the previous one, like tiles on a roof, until the centre was reached. Sometimes the 'tongues' were decorated with button-hole stitches. Tongue rugs were usually only door-mat size.

List rugs were woven, with a cotton or linen warp; the weft was list (selvedge) cut from lengths of fabric. Strips cut from worn-out clothing or household textiles were also used.

Knitted and crochet rugs were also made from worn-out textiles. Strips of cloth were wound into balls and used in the same way as yarn. Knitted mats usually consisted of squares that were then joined together. Another method was to knit or crochet a foundation from string or strong

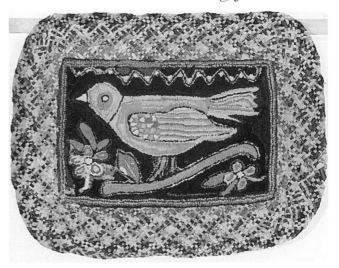

Rug, centre panel hooked with a bird design, braided border, 0.78×1.01 m, New England, 1910–20 (Bath, American Museum in Britain)

yarn and to insert a small piece of cloth into a stitch at intervals, resulting in a shaggy surface.

American bed rugs were made mainly in New England, between c. 1720 and 1830. They were treasured possessions, rarely mentioned in wills or inventories as they were usually passed down in the family from one woman to another. They were the top cover of the bed, and unlike many other rugs they were always made of new materials. The foundation was woollen fabric or a fine blanket, and the embroidery was worked in polychrome wools over a stick or reed to give a looped pile, which was sometimes cut. As many as six strands of wool might be threaded into a large needle for working the embroidery.

Yarn-sewn rugs, also made mainly in New England, used homespun linen or a grain bag for the foundation. Two-ply yarn was sewn with a needle through the base in a continuous running stitch. In the 18th century these rugs were rectangular and were used to cover tables or chests, but c. 1800 they began to be made in a longer shape to cover the hearth stone in the summer months.

American dollar or button rugs were made for use on tables or chests and would not have been put on the floor. Circular patches of three different sizes were cut from felt or discarded clothing, the largest being the size of a silver dollar. These were placed on top of each other, the smallest at the top, to form a 'button', which was then sewn down firmly to a strong foundation fabric. Sometimes the 'buttons' were embellished with embroidery.

BIBLIOGRAPHY

A. Macbeth: *The Countrywoman's Rug Book* (Leicester, 1929)
W. W. Kent: *The Hooked Rug* (New York, 1937)
——: *Rare Hooked Rugs* (Springfield, MA, 1941)
H. H. Feeley: *The Complete Book of Rug Braiding* (New York, 1957)
N. F. Little: *Floor Coverings in New England before 1850* (Sturbridge, MA, 1967)
J. Kopp and K. Kopp: *American Hooked and Sewn Rugs* (New York, 1974)
——: *Hooked Rugs in the Folk Art Tradition* (New York, 1974)
J. Moshimer: *The Complete Rug Hooker* (New York, 1975)
H. von Rosenstiel: *American Rugs and Carpets* (London, 1978)
K. Pyman, ed.: *Rag Rugs* (London, 1980)
S. Betterton: *Rugs from the American Museum in Britain* (Bath, 1981)

D. M. Grayson: *Rugs and Wallhangings* (London, 1984)
E. Tennant: *Rag Rugs of England and America* (London, 1992)

SHIELA BETTERTON

Rush, William (*b* Philadelphia, PA, 4 July 1756; *d* Philadelphia, 17 Jan 1833). American sculptor. The most important sculptor to emerge from the American folk art tradition of figurehead-carving, he learnt to carve from his father, a ship's carpenter. He was apprenticed in 1771 to the figurehead-carver Edward Cutbush, an emigrant from London. Within a few years Rush opened his own shop, before being drawn into the American Revolution (1775–83) as an officer in the Philadelphia militia. He resumed his business after the war; *Indian Trader* (*c.* 1789; untraced), from the ship the *William Penn*, is one of his earliest known works. His superior skill and his lively, animated figureheads (*see* UNITED STATES OF AMERICA, fig. 15) gained him a local reputation, and a number of apprentices assisted him in his busy shop. Rush became increasingly active in the artistic and civic affairs of Philadelphia, joining with Charles Willson Peale in 1804 to found America's first art organization, the Columbianum. This short-lived drawing school disbanded as a result of controversy over the use of live models. Rush was a founder in 1805 of the Pennsylvania Academy of the Fine Arts, where he showed at the annual exhibitions and served as a director. In 1811 Rush became Professor of Sculpture for the newly organized Society of Artists.

Perhaps as a result of the diminishing shipbuilding business, in 1808 Rush turned to 'pure' sculpture, carving the larger than life-size pine figures of *Comedy* and *Tragedy* for second storey niches in the new Chestnut Street Theater designed by Benjamin H. Latrobe (now Philadelphia, PA, Forrest Home for Aged Actors). The following year he executed his most famous sculpture, the *Water Nymph and Bittern*, a wooden fountain figure placed before Latrobe's Neo-classical waterworks building in Centre Square, Philadelphia (cast in bronze in 1854 and placed in Fairmount Park, Philadelphia). In 1814 Rush carved a full-length, life-size statue in pine of *George Washington* (Philadelphia, PA, Indep. N. Hist. Park), which is representative of his best work. He exhibited it at the Pennsylvania Academy of Fine Arts in the hope of receiving orders for replicas.

Nervous contours, deep undercutting and animated expressions characterize Rush's lively wooden sculptures and betray his training and preference for wood-carving. The prevailing European Neo-classical style had not reached America when Rush began his career, but by the early 19th century he was clearly aware of it to some degree, for his work has classicized elements, such as dress and hairstyles and his sculptures were usually painted white to resemble marble. Moreover, they often included superfluous columns in imitation of the supports needed in marble statuary. Rush's fondness for allegorical themes was also Neo-classical in origin. However, he interpreted Neo-classicism in intellectual rather than formal terms, and stylistically his works relate more closely to the decorative 18th-century Rococo tradition, which he may have known from prints.

Rush had learnt to model clay in the late 1780s and about 1811 used this skill to model naturalistic busts of local luminaries. He was perhaps inspired in this by the portrait busts that Jean-Antoine Houdon (1741–1828) had left in Philadelphia on his way to Mount Vernon in 1785 and by the marble portraits Giuseppe Ceracchi (1751–1801) and other immigrant sculptors carved in Philadelphia in the 1790s. Unlike the European exemplars, however, Rush used only plaster or terracotta for his portraits and, by the sculptural standards of the day, this relegated him to the status of artisan. Nevertheless, he produced some remarkable portraits notable for their unpretentious nat-

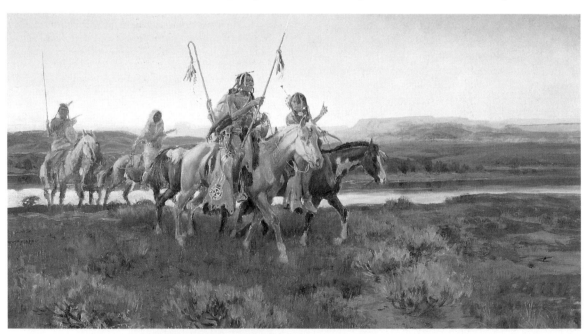

Charles M. Russell: *Piegans*, oil on canvas, 601×914 mm, 1918 (Denver, CO, Museum of Western Art)

uralism. Among his finest is his *Self-portrait* (*c.* 1822; Philadelphia, PA Acad. F.A.), which portrays Rush's head emerging from a pine log; it is one of the most compelling self-portraits produced in America.

BIBLIOGRAPHY
William Rush, 1756–1833: The First Native American Sculptor (exh. cat., intro. W. Rush Denton jr, text H. Marceau; Philadelphia, PA Acad. F.A., 1937)
W. Craven: *Sculpture in America* (New York, 1968, rev. Newark, 2/1984), pp. 20–26
William Rush, American Sculptor (exh. cat. by L. Bantel and others, Philadelphia, PA Acad. F.A., 1982)
M. M. Naeve: 'William Rush's Terracotta and Plaster Busts of General Andrew Jackson', *Amer. A. J.*, xxi (1989), pp. 19–39

LAURETTA DIMMICK

Rushton Maverick, Peter. *See* MAVERICK, PETER RUSHTON.

Russell, Charles M(arion) (*b* St Louis, MO, 19 March 1864; *d* Great Falls, MT, 24 Oct 1926). American painter and sculptor. In 1880 he left his upper-class home in St Louis for Montana Territory. He worked briefly on a sheep ranch, spent two years as a hunter's and trapper's assistant and then became a cowboy. During his considerable spare daytime hours he painted, sketched and modelled small animal figures in clay (e.g. *Antelope*, 1915; Fort Worth, TX, Amon Carter Mus.). Although he painted a few exceptional oils and watercolours prior to 1900, the vast majority of his best work was done in the last two decades of his life. Typically the subject-matter centres around cowboy life (e.g. *Wagon Boss*, 1909; Tulsa, OK, Gilcrease Inst. Amer. Hist. & A.) and the Plains Indians, for whom he had great respect. The luminous *Piegans* (1918; Denver, CO, Mus. W. A.; see fig.), with its depiction of the Plains Indians, is a reminder of the vastness of the American West. Russell's sense of humour and empathy for his subject-matter radiates from his paintings as pleasingly as do the clear colours of the high country. His bronze sculptures (e.g. *Buffalo Hunt*, 1905; Denver, CO, Mus. W. A.) depict the same dramatic and tension-packed themes as his paintings.

See also WILD WEST AND FRONTIER ART.

WRITINGS
N. C. Russell, ed.:*Good Medicine: The Illustrated Letters of Charles M. Russell* (Garden City, NY, 1929)
B. W. Dippie, ed.: *Charles M. Russell, Word Painter: Letters, 1887–1926* (New York, 1993)
BIBLIOGRAPHY
R. F. Adams and H. E. Britzman: *Charles M. Russell: The Cowboy Artist* (Pasadena, 1948)
H. McCracken: *The Charles M. Russell Book: The Life and Work of the Cowboy Artist* (Garden City, NY, 1957)
A. Russell: *Charles M. Russell, Cowboy Artist* (New York, 1959)
F. G. Renner: *Charles Marion Russell: Greatest of all Western Artists*, Great Western Series, ii (Washington, DC, 1968)
R. Stewart: *Charles M. Russell, Sculptor* (New York, 1994)
Charles M. Russell: The Artist in his Heyday, 1903–1926 (exh. cat., Santa Fe, NM, Peters Gal., 1995)
J. Taliaferro: *Charles M. Russell: The Life and Legend of America's Cowboy Artist* (Boston, 1996)

W. C. FOXLEY

Russell, William. *See under* CLINTON & RUSSELL.

Rutan, Charles Hercules. *See under* SHEPLEY, RUTAN & COOLIDGE.

Ryder, Albert Pinkham (*b* New Bedford, MA, 19 March 1847; *d* Elmhurst, NY, 28 March 1917). American painter. He is generally considered to be America's greatest visionary painter. His *c.* 160 canvases, intense in colour and pattern and often with mysterious thematic overtones, are distinctively Romantic.

Raised in the whaling community of New Bedford, MA, Ryder moved to New York with his family *c.* 1870. He had already begun painting landscapes. Independent in mind and inclined to learn from experimentation, he studied at the New York National Academy of Design, but only irregularly. His best instruction was received informally, from the New York portrait painter and engraver William E. Marshall (1837–1906). He adopted the habit of studying engravings and was strongly attracted to the pastoral works of recent painters, particularly those of Camille Corot (1796–1875) and the other Barbizon painters. His own work, for example *Curfew Hour* (1882; New York, Met.), incorporated the earthen tonalities, simplified interlocking patterns of human, animal and landscape forms and the quiet light effects characteristic of the French painters.

Ryder first exhibited at the National Academy in 1873. As a result of this exhibition, he met Daniel Cottier (1838–91), a dealer in paintings and decorative arts, who became his dealer and gave him commissions for decorations on mirrors, cabinets and screens. (A screen of three panels is in Washington, DC, N. Mus. Amer. A.) Cottier encouraged Ryder to travel in Europe, and he made several trips—in 1877, 1882, 1887 and 1896. The trip of 1882 gave Ryder the opportunity to make a detailed study of art collections in England, France, the Netherlands, Italy, Spain and Tangier.

Although his earlier works are fairly naturalistic and directly painted, Ryder moved towards procedures that simplified his design but complicated his technique. He wrote for a magazine interview in 1905 that his early attempts to imitate nature in all her detail were thoroughly frustrating and that his painting did not come alive until he learnt to re-create the large forms of nature only. Increasingly Ryder's technique relied on indirect methods, with heavy glazing and overpainting. He became a tonalist, organizing his pictures around one or two major colours. He also followed this simplicity in his designs, which came to resemble Japanese prints in their careful, planar interlocking. Contemporary critics praised the jewel-like radiance of his surfaces and the pleasing inevitability of the forms.

About 1880, Ryder turned from his concentration on pastoral themes to explore subjects with literary, biblical and Wagnerian themes. His success in these works seems in retrospect to ally him with his contemporaries the Symbolists, although his themes did not suggest the erotic or the decadent. In *Jonah* (1890; Washington, DC, N. Mus. Amer. A.; see colour pl. XXI, 2), painted in golden browns, the heaving sea is locked into place by simplified forms representing a storm-tossed boat and a huge whale; on the horizon the brilliant gold figure of God, globe in hand, implies the satisfying resolution to come. Other works convey a sense of impending doom consonant with late 19th-century pessimism. *Siegfried and the Rhine Maidens* (1891; Washington, DC, N.G.A.), dominated by green

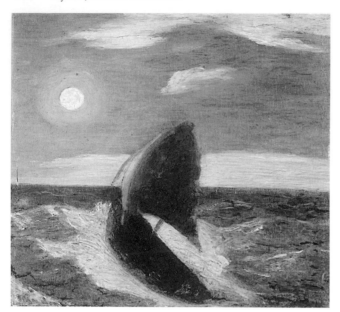

Albert Pinkham Ryder: *Toilers of the Sea*, oil on wood, 292×305 mm, *c.* 1884 (New York, Metropolitan Museum of Art); from a photograph of 1915

and gold and designed in swirling lines, interprets the moment in Wagner's opera when Siegfried first encounters the Rhine maidens and their terrible prophecy. Other works with such ominous overtones include: the *Flying Dutchman* (1887; Washington, DC, N. Mus. Amer. A.), also taken from Wagner; *Temple of the Mind* (1885; Buffalo, NY, Albright–Knox A.G.), inspired by Poe; *Desdemona* (1896; Washington, DC, Phillips Col.), from Shakespeare's tragedy *Othello*; and *Constance* (1896; Boston, MA, Mus. F.A.), from Chaucer's 'Man of Law's Tale' in the *Canterbury Tales*.

Just as forest subjects were popular among the Barbizon painters and dark literary themes among the Symbolists, so Ryder was attracted to a distinguished tradition for his third major subject, the seascape. The marine paintings reflect his childhood experiences in one of the great maritime centres of the world. His *Toilers of the Sea* (*c.* 1884; New York, Met.; see fig.), a work rich in dark tonalities of grey-black and greenish gold, is composed of the stark shapes of boat (with an improbably simple rigging), sea and sky. Ryder exhibited this painting with his own poem, a frequent practice of his. The painting may have had a literary inspiration, the Victor Hugo novel of the same name, published in 1866. Ryder's fondness for marine scenes and his exhibition of his work with fragments of poetry point to the influence of J. M. W. Turner (1775–1851) on his work.

Although Ryder was in some personal ways eccentric, he had several deep friendships with other artists, especially Julian Alden Weir. In 1877 he was one of the 22 founders of the Society of American Artists. His paintings were bought enthusiastically by major patrons such as Thomas B. Clarke, and by the end of his life, although he did not paint consistently after about 1900, his works were so popular that they were widely imitated by forgers. Ryder's reluctance to sign and date his pictures has made verifica-

tion difficult, but because he frequently repainted his canvases, modern methods of technical examination can detect many of these forgeries. Works in museum collections ostensibly by Ryder are now in the process of being reassessed and, in many instances, reattributed. Apart from the problem of forgeries, the major difficulty is that of conservation. Ryder often chose unusual media to carry his pigment and frequently painted over wet layers. Not only have almost all of his paintings needed conservation to prevent further deterioration, but by the 1930s many had already changed beyond remedy. In many instances photographs of the paintings made at the memorial exhibition at the Metropolitan Museum of Art, New York, in 1918 provide the only indication of the early (if not original) appearance of a work.

Several of Ryder's paintings were shown in 1913 at the Armory Show, where they inspired a new generation of artists. The National Museum of American Art in Washington has the most important collection of his works. No known drawings are extant.

BIBLIOGRAPHY

L. Goodrich: *Albert P. Ryder* (New York, 1959)
E. Johns: 'Albert Pinkham Ryder: Some Thoughts on his Subject Matter', *A. Mag.*, liv/3 (1979), pp. 164–71
D. Burke: *American Paintings in the Metropolitan Museum of Art* (Princeton, 1980), iii, pp. 7–34
D. Evans: 'Albert Pinkham Ryder's Use of Visual Sources', *Winterthur Port.*, xxi/1 (1986), pp. 21–40
E. Broun: *Albert Pinkham Ryder* (Washington, DC, and London, 1989) [incl. exh. cat., Washington, DC, N. Mus. Amer. A., 1990; New York, Brooklyn Mus., 1990–91]
W. Homer and L. Goodrich: *Albert Pinkham Ryder: Painter of Dreams* (New York, 1989)

ELIZABETH JOHNS

Ryerson, Martin A(ntoine) (*b* Chicago, IL, 1856; *d* Chicago, 12 Aug 1932). American businessman, collector and philanthropist. Scion of one of Chicago's wealthiest families and educated at Harvard Law School in the 1870s, he was convinced of the importance of culture for community development. He took an active role in most of Chicago's cultural and civic institutions, becoming president of the University of Chicago's board of trustees and vice-president of the Chicago Art Institute.

From the 1890s Ryerson began to create a private art collection, which was considered the greatest in Chicago. His taste ranged widely; he collected works by painters of the early Italian Renaissance (Perugino, Ghirlandaio, Jacopo del Sellaio, Tiepolo and Neroccio de' Landi), Dutch and Flemish masters (Gerard David, Gerard ter Borch, Jan Breughel the younger, Jan van Goyen, Pieter de Hooch, Jacob van Ruisdael, David Teniers the younger, Rogier van der Weyden and Lucas van Leyden), French Impressionists and American 19th-century painters (Winslow Homer watercolours) and Oriental artists. Most of the Ryerson Collection came, by gift or bequest (1933), to the Chicago Art Institute.

Ryerson travelled widely in Europe, Egypt, India and Japan, usually in company with Charles L. Hutchinson, president of the Chicago Art Institute and 'first citizen' of Chicago, whose art collecting Ryerson greatly influenced. With Hutchinson, he was responsible for commissioning John Wellborn Root to design the Art Institute building in a Romanesque Revival style (1886–7). Ryerson and

Hutchinson were also responsible for purchasing for the Art Institute the best of Anatole Demidov's collection of Dutch masters in 1894 for $200,000, including the *Young Girl at an Open Half Door* (1645) by Rembrandt (1606–69) and paintings by Rubens (1577–1640), Frans Hals (1581/5–1666), Holbein (1497–1543) and Jan Steen (1626–97). On his travels in Spain, Ryerson discovered El Greco (*c.* 1541–1614) and in Paris in 1906 bought his *Assumption of the Virgin* at a time when few people in America had heard of the artist. In France he became an early collector of the paintings of Renoir (1841–1919), of which he owned many, including *Child in a White Dress* (1883).

BIBLIOGRAPHY

L. M. McCauley: 'Some Collectors of Paintings', *A. & Archaeol.*, xii/3–4 (Sept–Oct 1921), pp. 155–72

H. Swift: *Martin A. Ryerson, 1856–1932* (Chicago, 1932)

H. Lefkowitz Horowitz: *Culture and the City: Cultural Philanthropy in Chicago from the 1880s to 1917* (Lexington, KY, 1976)

LILLIAN B. MILLER

S

St Augustine. American city and port located on the northern Atlantic coast of Florida. The oldest city in the USA, it was founded by Pedro Menéndez de Avilés (1519–74) as San Agustín de la Florida and was capital of the Spanish colony of Florida for over 250 years. Fortifications soon came to dominate the city, which was attacked regularly by English pirates and military forces, until it passed to the English crown (1763), before reverting to Spain (1783). In 1819 Spain ceded Florida to the USA, who officially occupied it from 1821, renaming it St Augustine. The Colonial area is characterized by a semi-regular plan dating from the 16th century, when the settlement comprised a small cluster of buildings erected on asymmetrical blocks. Although these blocks were never regularized, the network of streets and the main square loosely reflect characteristic 16th-century Spanish urban orthogonal or grid plans. The city was relocated in 1566 and then in 1572 to an elongated peninsular site, where it gained natural protection. Urban growth occurred during the 17th century, the population increasing from 200 to 2000.

Fortifications focused on the Castillo de San Marcos, which was relocated and completely redesigned three times (1572, 1595, 1672); the third structure (the first in stone; see fig.) has been attributed to Juan Síscara (*fl* 1664–91), a Cuban military engineer, and to Ignacio Daza. The star-shaped Castillo was built in 1672–87 (with minor additions still under construction until 1756) and is the oldest masonry fortress in the USA. A surrounding palisade with earthworks and stone bastions (1708–10; destr. 1862) and a masonry-fortified moat defended the city from all sides. These defences were further reinforced by the addition (1790–1800) of a large timber and earth wall and moat connecting with the fortress and palisade in the northern part of the city. By the early 19th century the city was one of the best fortified on the Atlantic coast.

Apart from the fort, nothing survived the burning of St Augustine in 1702. Among the significant surviving build-

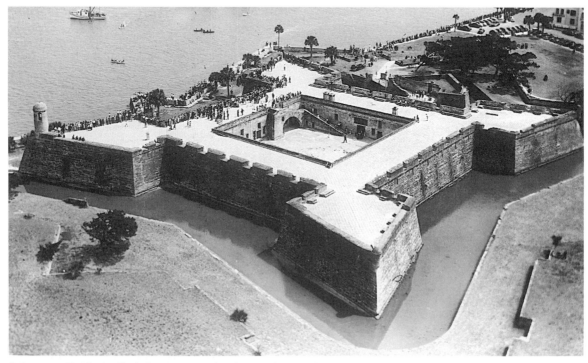

St Augustine, Florida, Castillo de San Marcos, attributed to Juan Síscara and to Ignacio Daza, 1672–87

ings from after this date are the 'Oldest House' (*c.* 1704–1890), purchased by the St Augustine Historical Society in 1918 and restored in the 1960s, and the Catholic Cathedral of St Augustine (1793; partially destr. 1887; rebuilt *c.* 1890; extensively remodelled 1965–6) designed by Mariano de la Rocque (*fl c.* 1775–1810); James Renwick jr redesigned the bell-tower *c.* 1890. Rocque may also have built the monumental city gates (1804–8) in a Neo-classical style. In the 1880s the advent of the railway and construction of luxurious hotels and other civic facilities by the financier Henry Morrison Flagler (1830–1913) made the city a growing tourist resort. The first building realized by CARRÈRE & HASTINGS was the city's Ponce de León Hotel (1885–8; now Flagler College) in Spanish Renaissance style; the firm also designed the Alcázar Hotel opposite (1887–9; now Lightner Museum and City Hall). In 1959 the Historic St Augustine Preservation Board was established, and restoration began of the area of St George Street, near the Castillo; reconstructions range from the Gomez and Gallegos houses of the first Spanish phase to the Arrivas House (18th–19th century).

BIBLIOGRAPHY

A. Manucy: *The Houses of St. Augustine* (St Augustine, 1962)

L. Arana and A. Manucy: *The Building of Castillo de San Marcos* (St Augustine, 1977)

F.-A. de Montéquin: 'El proceso de urbanización en San Agustín de la Florida, 1565–1821: Arquitectura civil y militar', *Anu. Estud. Amer.*, xxxvii (1980), pp. 583–647

K. Deagan: 'The Discovery of 16th-century St. Augustine in an Urban Area', *Amer. Ant.*, 46 (1981), pp. 623–33

J. P. Waterbury, ed.: *The Oldest City: St. Augustine, Saga of Survival* (St Augustine, 1983)

FRANÇOIS-AUGUSTE DE MONTÉQUIN

Saint-Gaudens, Augustus (*b* Dublin, 1 March 1848; *d* Cornish, NH, 3 Aug 1907). American sculptor and painter. His father was a French shoemaker who lived in Dublin for seven years and married an Irish woman. When Augustus was six months old, the family moved to the USA, living briefly in Boston before settling in New York. In 1861 he was apprenticed to the cameo-cutter Louis Avet, who was a good teacher but a harsh employer. After a dispute, Saint-Gaudens left him in 1864 to work for the shell cameo-cutter Jules LeBrethon, producing such works as the *Head of Hercules* (*c.* 1867; Cornish, NH, Saint-Gaudens N. Hist. Site). During these apprenticeships he attended drawing classes at night school, first at the Cooper Union in New York and then at the National Academy of Design, where he studied under Daniel Huntington and Emanuel Gottlieb Leutze. In 1867 he left LeBrethon's employ to travel to Europe, but before departing he modelled a bust of his father, *Bernard Saint-Gaudens* (1867; Cornish, NH, Saint-Gaudens N. Hist. Site). In Paris he again obtained a job as cameo-cutter and studied at the Petite Ecole until he gained admission to the Ecole des Beaux-Arts in 1868, when he enrolled in the studio of François Jouffroy (1806–82). At the Exposition Universelle of 1868, he, like other artists, was greatly impressed and influenced by the gilded bronze *Florentine Singer* (1865; version, Paris, Louvre) by Paul Dubois (1829–1905).

In late 1870, after the outbreak of the Franco–Prussian War, Saint-Gaudens left Paris for Rome, where he associated with those students from Paris who had not enlisted, including the Prix de Rome winner Antonin Mercié (1845–1916). In Rome he worked on the contemplative figure of *Hiawatha* (1872–4; Palm Beach, priv. col., see Dryfhout, pp. 54–5), inspired by the poem by Henry Wadsworth Longfellow, and also experimented with painting, working in the Campagna. Again he supported himself by producing cameos and also by copying Classical sculptures for Senator William Maxwell Evarts. In 1872 he returned to the USA via London, where he modelled a bust of *Evarts* (plaster version, Washington, PA, Co. Hist. Soc. Mus.), which in 1874 was executed in marble. Several other portrait bust commissions followed, such as *Edwards Pierrepont* (1872–4; Washington, DC, N. Mus. Amer. A.). He also received a commission for the figure *Silence* (1874; Utica, NY, Mason. Sailors & Soldiers Hosp.), with which he felt dissatisfied. While in New York in 1873, he taught his brother Louis Saint-Gaudens (1853–1913) the technique of cameo-cutting, and the two brothers went to Rome that year. There Saint-Gaudens executed commissions received in New York and went on a walking tour to Naples. In Rome, too, he met Augusta Homer, a student of painting whom he later married (1877).

Saint-Gaudens returned to New York in 1875 and set himself up in a studio, which he shared with the artist David Maitland Armstrong (1836–1918). He made the acquaintance of the painter John La Farge and the architect Stanford White and began producing decorative work for the Tiffany Studios. He also entered the competition for the Charles Sumner Monument in Boston but, after the committee had accepted the design of a sculptor whose work did not comply with the original specifications, vowed never again to enter a competition. From late 1876 to early 1877 he worked with a group of other artists under the direction of La Farge on the mural paintings for Trinity Church in Boston, painting the figures of *St Paul* and *St James*. Also in 1877, after a sketch submitted to the National Academy of Design was refused, he co-founded the Society of American Artists with the writer and editor Richard Watson Gilder (1844–1909), Helena de Kay Gilder (1846–1916) and others. The same year he joined the Tile Club, whose members included Edwin Austin Abbey, William Gedney Bunce (*b* 1840), George Maynard (1843–1923), Francis Davis Millet (1846–1912) and the sculptor William O'Donovan (1844–1920), all united by their opposition to the conservatism of the National Academy of Design.

Between mid-1877 and 1880 Saint-Gaudens was in Paris and Rome, returning to New York in 1880. During this time he produced several portrait reliefs, such as *Francis Davis Millet* (1879; New York, Met.; see fig.), as well as working on his designs for the Farragut Monument, which had been commissioned in 1876 as a memorial to the naval commander David Glasgow Farragut (1801–70). Produced in collaboration with Stanford White, it was his first large public work and was unveiled in Madison Square Park, New York, in 1881. On the pedestal, beneath the statue of *Farragut*, were carved two figures representing *Loyalty* and *Courage* set in a flowing organic design influenced by the style of Art Nouveau. From 1881 to 1883 he worked on two commissions for interior decorations in New York. One was for the Cornelius Vanderbilt

Augustus Saint-Gaudens: *Francis Davis Millet*, bronze relief, 267×165 mm, 1879 (New York, Metropolitan Museum of Art)

II House (destr.), owned by the philanthropist and financier Cornelius Vanderbilt II (1843–99), for which he provided relief panels and a mantelpiece (latter, New York, Met.); the other was for Villard House (now the Palace Hotel), and was carried out by his brother Louis under Augustus's direction. Both projects used Classical iconography, as in the 'Amor' caryatid of the Vanderbilt mantelpiece, though the pervasive sinuous style again displayed an Art Nouveau aesthetic.

In 1887 two public monuments by Saint-Gaudens were unveiled, the Abraham Lincoln Monument (1884–7; Chicago, IL, Lincoln Park) and *The Puritan* (1883–6; Springfield, MA, Merrick Park). The latter, which was originally located in Stearns Square in Springfield, is a particularly striking work, showing the founder of Springfield, Deacon Samuel Chapin, striding forward, his cape billowing out (for *modello* see colour pl. XXVII, 2). In 1889 Saint-Gaudens visited the Exposition Universelle in Paris, where he was again especially impressed by a work by Dubois: *Joan of Arc* (1889; version, 1896, Reims, Parvis de la Cathédrale). In 1891 he bought the summer residence Aspet in CORNISH, NH, where he spent much of his time thereafter. In the same year two further notable public works were unveiled. The Adams Memorial (1886–91; Washington, DC, Rock Creek Cemetery), commissioned as a memorial for the philosopher and historian Henry Adams's wife, and later for himself, is set in a landscaped

area and consists of a shrouded, seated figure in a contemplative pose, reflecting Adams's interest in Buddhism. The other was the huge *Diana* weathervane (1886–91; see Dryfhout, p. 194), which was originally installed on top of the Madison Square Tower, New York. It was later moved, partly destroyed and finally lost to be replaced by another version (1892–4; Philadelphia, PA, Mus. A.), which was installed in 1894 and removed in 1925.

Despite many public commissions, Saint-Gaudens continued to produce portrait busts and reliefs, such as the relief *Violet Sargent* (1890; Washington, DC, N. Mus. Amer. A.), depicting John Singer Sargent's sister. From 1884 to 1897 he worked on the Shaw Memorial, placed in Boston Common, Boston, as a memorial to the commander Robert Gould Shaw (1837–63) and his African–American troops, nearly all of whom were annihilated in the Civil War (for detail *see* UNITED STATES OF AMERICA, fig. 17). At the end of 1897 Saint-Gaudens moved to Paris and from then until 1901 he travelled in France, England and Spain. Among his last public works were the Sherman Monument (1892–1903; New York, Grand Army Plaza) and *Abraham Lincoln: Head of State* (1897–1906; Chicago, IL, Grant Park). The former is particularly impressive, consisting of an equestrian statue of *General William Tecumseh Sherman* (1820–91) led by a figure of *Victory*. With Henry Bacon jr, in one of several such collaborations, he designed the James McNeill Whistler Memorial (1903) at the US Military Academy, West Point, NY. From 1905 to 1907 he worked on a series of new coin designs for the 1 cent, $10 and $20 pieces. Saint-Gaudens's influence over American sculpture was considerable, both through his work and through his efforts to organize effective training and professional institutions for sculptors. He taught at the Art Students League from 1888 to 1897, founded the National Sculpture Society in 1893 and was instrumental in establishing the American Academy in Rome in 1905.

For an illustration of the bronze medal cast by Saint-Gaudens in 1905–6 *see* CORNISH.

BIBLIOGRAPHY
R. Cortissoz: *Augustus Saint-Gaudens* (Boston and New York, 1907)
C. Lewis Hind: *Augustus Saint-Gaudens* (New York, 1908)
Catalogue of a Memorial Exhibition of the Works of Augustus Saint-Gaudens (exh. cat., New York, Met., 1908)
Catalogue of a Memorial Exhibition of the Works of Augustus Saint-Gaudens (exh. cat. by H. Aspet and J. W. Beatty, Pittsburgh, PA, Carnegie Inst., 1909)
H. Saint-Gaudens, ed.: *The Reminiscences of Augustus Saint-Gaudens*, 2 vols (New York, 1913)
J. H. Dryfhout and B. Cox: *Augustus Saint-Gaudens: The Portrait Reliefs* (Washington, DC, 1969)
J. H. Dryfhout: *The Work of Augustus Saint-Gaudens* (Hannover and London, NH, 1982)
K. Greenthal: *Augustus Saint-Gaudens: Master Sculptor* (New York, 1985)
The Beaux-Arts Medal in America (exh. cat. by B. A. Baxter, New York, Amer. Numi. Soc., 1988)

□

St Louis. American city in Missouri, near the confluence of the Mississippi and Missouri rivers. It was founded by Pierre Laclede (1724–78), who arrived in 1763 holding exclusive trading rights with the Plains Indians along the Missouri and the west bank of the Mississippi. Nothing of the earliest settlement remains. Following President Thomas Jefferson's purchase (1803) of the vast Louisiana Territory from the French, army officers Meriwether Lewis

and William Clark set out from St Louis in 1804 to survey the Missouri and Columbia rivers. By 1812 St Louis had become a prosperous administrative and commercial centre. Two Neo-classical structures survive from the early 19th century: the Courthouse, the second such edifice to be built in St Louis, was built between 1839 and 1862 by Henry Singleton and others and is topped by a cast-iron dome (h. 60.35 m) that predates by two years that of the US Capitol, Washington, DC; near by stands the first cathedral (1831–4), the basilica of St Louis, King of France, a Greek Revival church by George Morton (1790–1865) and Joseph Laveille (d 1842).

Throughout the 19th century, as one of the conduits of westward expansion, the city grew steadily, becoming a stopping-place for wagon trains, riverboats and railways. The Eads Bridge (1867–74), named after its designer and engineer JAMES BUCHANAN EADS, was the first bridge to cross the Mississippi at St Louis and the first in the USA to use steel in its principal sections. It has an upper deck for road and foot traffic and a lower deck for trains, which were previously ferried across. Developments along the Eads Bridge railway line include the Second Empire-style Federal Post Office and Custom House (1872–84), designed by Alfred B. Mullett; Daniel Chester French designed the sculptural group that graces the mansard cupola. In 1890 the brewer and financier Ellis Wainwright com-

missioned Dankmar Adler and Louis Sullivan from Chicago to create a major office building in the city's expanding commercial area. The now-famous ten-storey Wainwright Building (1890–91) was among the first in the USA to demonstrate the potential of steel-framed buildings and was in effect an early skyscraper (see UNITED STATES OF AMERICA, fig. 9). After the sudden death of Wainwright's young wife, Adler and Sullivan were also commissioned to create the first of their famous tombs, the Wainwright Tomb (1892), Bellefontaine Cemetery.

In 1894 the completion of Union Station, St Louis, designed by architect Theodore C. Link (1850–1923), with some decorative designs by Harvey Ellis, married Richardsonian Romanesque Revival architectural forms with the avant-garde technology of a massive train shed below and behind, designed by George H. Pegram. Inside the main doors of the station is a whispering arch inset with a stained-glass window illustrating, by means of three female allegorical figures, the then loci of train travel: New York, St Louis and Los Angeles. (In 1985 the station and shed were renovated and given new functions by Hellmuth, Obata & Kassabaum.)

The World's Fair, or Louisiana Purchase International Exposition, held at Forest Park, St Louis, in 1904 is commemorated by the St Louis Art Museum, the only surviving building built specifically for the event. Cass

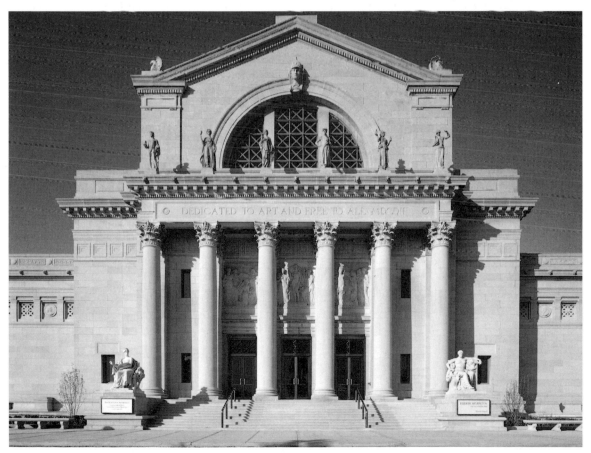

St Louis Art Museum by Cass Gilbert, 1904

Gilbert designed both the permanent building (see fig.), in a rather sparse Renaissance Revival style, and its temporary adjoining sections, the Art Palace. The museum's collection subsequently became famous for its extensive holdings of German Expressionist, Pre-Columbian and Pacific Island art. At the time of the fair, the entrepreneur Edward G. Lewis created University City, a community west of St Louis that later included the celebrated University City Pottery (1910–15). Begun by Lewis as a correspondence school of his People's University, the pottery's staff included Adelaide Alsop Robineau, Taxile Doat (1851–1938), Frederick Hurten Rhead and Kathryn Cherry (d 1931). Between 1907 and 1914 a new cathedral of St Louis was constructed by Barnett, Haynes & Barnett in a Romanesque Revival style with a Greek-cross basilica plan. The Byzantine Revival interior is noted for its magnificent marble and mosaics.

BIBLIOGRAPHY

M. Powell: 'Public Art in St Louis: Sculpture, Architecture, Mural Decorations, Stained Glass', *St Louis Pub. Lib. Mthly Bull.* (July–Aug 1925)

J. A. Bryan: *Missouri's Contribution to American Architecture* (St Louis, 1928)

The Eads Bridge (exh. cat., Princeton U., NJ, A. Mus.; St Louis, MO, A. Mus.; 1974)

The Architectural Heritage of St Louis, 1803–1891: From the Louisiana Purchase to the Wainwright Building (exh. cat. by L. Lowic, St Louis, MO, Washington U., Gal. A., 1982)

C. Loughlin and C. Anderson: *Forest Park* (Columbia, MO, 1986)

C. H. Toft: *St Louis: Landmarks & Historic Districts* (St Louis, 1988)

G. McCue and F. Peters: *A Guide to the Architecture of St Louis* (Columbia, MO, 1989)

JOYCE K. SCHILLER

Saint-Mémin [St-Mesmin]**, Charles B(althazar) J(ulien) F(évret) de** (*b* Dijon, 12 March 1770; *d* Dijon, 23 June 1852). French engraver, painter and museum director, active in the USA. He went to New York in 1793 as a refugee from the French Revolution and by 1796 had taught himself the techniques of engraving. From Thomas Bluget de Valdenuit (1763–1846), his partner in 1796–7, he learnt to take profile portraits in the manner used by Gilles-Louis Chrétien (1754–1811) in Paris in the 1780s and 1790s. Between 1796 and 1810 Saint-Mémin made

about 900 bust-length profile portraits using a pantographic drawing device called a physiognotrace. Each black-and-white chalk portrait was drawn on beige paper (*c.* 540×400 mm) that was first coated with a pink wash. The drawing was then reduced onto a square copperplate about one-tenth its size, engraved in a circular border and printed.

Saint-Mémin worked in New York, Philadelphia, Baltimore, Washington, DC, Richmond, VA, and Charleston, SC. He paid great attention to individualizing his portraits, and his success provoked contemporary artists to imitate his use of a mechanical drawing device. His many portraits include *Thomas Jefferson* (1804; Worcester, MA, A. Mus.) and *Meriwether Lewis* (1803–7; St Louis, MO Hist. Soc.), as well as eight images of American Indian visitors to Washington, DC, in 1804–7 (New York, Hist. Soc.). He also produced some watercolour portraits and landscapes. Saint-Mémin returned to France in 1814, taking a number of examples of his portrait engravings, from which were formed three large collections (Washington, DC, N.P.G. and Corcoran Gal A.; Paris, Bib. N.), as well as several smaller groupings. As Director of the Musée des Beaux-Arts, Dijon (1817–52), he played a major role in the preservation of Burgundian Gothic art.

BIBLIOGRAPHY

P. Guignard: *Notice historique sur la vie et les travaux de M. Févret de Saint-Mémin* (Dijon, 1853)

E. Dexter: *The St-Mémin Collection of Portraits, Consisting of Seven Hundred and Sixty Medallion Portraits, Principally of Distinguished Americans* (New York, 1862) [illustrates Washington, DC, N.P.G. collection and incl. trans. of Guignard]

F. Norfleet: *Saint-Mémin in Virginia: Portraits and Biographies* (Richmond, VA, 1942)

Charles-Balthazar-Julien Févret de Saint-Mémin, artiste, archéologue, conservateur du Musée de Dijon (exh. cat., Dijon, Mus. B.-A., 1965)

E. G. Miles: *Saint-Mémin and the Neoclassical Profile Portrait in America* ([Washington, DC], 1994)

ELLEN G. MILES

Salem. American city and seat of Essex County, Massachusetts, located *c.* 20 km north-east of Boston on a harbour of Massachusetts Bay. Salem was the earliest settlement in the Massachusetts Bay Colony and has some of the USA's most significant historic buildings. Founded in 1626 when a group of colonists moved there from nearby Cape Ann, it was originally called Naumkeag ('fishing place'), but this was soon changed to Salem (Heb.: 'peace'). The settlement was initially concentrated on a narrow peninsula, and Essex Street was (and remains) the principal east–west artery. As land for expansion was scarce, much landfill took place before 1860 and transformed the original shoreline, especially in the harbour area. The city's centre became linked with the north and south districts, and an unsystematically planned grid system of streets evolved.

Many of Salem's buildings from the 'First Period' (1626–1730) are among the best surviving 17th-century timber dwellings in New England, for example the House of Seven Gables (1668), which inspired Nathaniel Hawthorne's novel of the same name; the Jonathan Corwin House ('Witch House'; *c.* 1675), its popular name referring to the investigations held there during the infamous Salem trials of 1692–3; and the John Ward House (after 1684). Notable buildings from the Colonial Georgian period

Salem, south-east side of Chestnut Street, early 19th-century residences

(1730–80) are the Derby House (1761–2) and Crownin-shield-Bentley House (1727–30), which have distinctive gambrel roofs. The Federal era (1780–1830) corresponded with the height of Salem's commercial prosperity, when, following the American War of Independence, it became one of the continent's chief ports for trade with East Asia. This was also the richest period architecturally, producing an impressive array of domestic, public and commercial buildings. One of Salem's most influential architects of the time was Samuel Mcintire, whose works include the clapboard Colonial Georgian Peirce-Nichols House (c. 1782), the brick Federal-style John Gardner House (1804–5), in which McIntire also carved much of the ornament, and Hamilton Hall (1805–7). Other notable Federal-style buildings include the Old Custom House (1805; attributed to Samuel McIntire), the Old Town Hall (1816; by Charles Bulfinch (1763–1844) and Samuel McIntire) and the fine collection of early and mid-19th-century residences lining Chestnut Street (see fig.) representing the work of William Lummus, John Nichols, Perley Putnam, William Roberts, Jabez Smith, Sims Brothers and David Lord.

Salem is less well recognized for its outstanding Victorian architecture of c. 1830–1900. Excellent Greek Revival buildings include Richard Bond's City Hall (1836–7) and the Old Essex County Court House (1839–41; attrib. to Bond), both in granite, while Gothic Revival works include the stone church of St Peter (1833–4; by Isaiah Rogers) and the First Unitarian Church (1835–6; by Gridley J. F. Bryant). A tendency towards late 19th-century revival and eclectic styles is also evident in some buildings. In the early 20th century Salem's architecture was dominated by the Colonial Revival style. A fire levelled over a third of the city in 1914, but substantial rebuilding took place. Artistic institutions in the city include the Peabody Museum of Salem (founded 1799), the USA's oldest continuously operated museum, which has a superb collection of maritime paintings, portraits and oriental artefacts; and the Essex Institute (founded 1848), with fine examples of regional portrait paintings and landscapes. (In 1992 these two institutions were consolidated to form the Peabody Essex Museum.) Notable artists from the city include the portrait artists BENJAMIN BLYTH, James Frothingham (1786–1864) and Charles Osgood (1809–90); FRANK W. BENSON, famous for his impressionistic depictions of women and children and for wildlife scenes, also worked in Salem.

BIBLIOGRAPHY
C. Osgood and H. Batchelder: *Historical Sketch of Salem, 1626–1879* (Salem, 1879)
F. Cousins and P. Riley: *The Colonial Architecture of Salem* (Boston, 1919)
S. Perley: *The History of Salem, Massachusetts*, 3 vols (Salem, 1924–8)
A. Farnam and B. Tolles jr, eds: *Essex Institute Historic House Booklet Series*, 7 vols (Salem, 1976–8)
B. Tolles jr: *Architecture in Salem: An Illustrated Guide* (Salem, 1983)
——: 'The Historic Architecture of Salem', *Cornerstones of Salem* (Beverly, MA, 1999), pp. 55–77

BRYANT F. TOLLES JR

Salmon, Robert (*b* Cumberland [now Cumbria], *c.* 1775; *d?*England, ?1848–51). American painter of English origin. Having trained and painted in England and Scotland, he moved to Boston in 1828, painting in a 'little hut' near the wharves of South Boston. Reportedly an eccentric, he became a successful painter of marine views, adopting a range of different scales, including small wooden panels, larger canvases and theatre backdrops. *Moonlight Coastal*

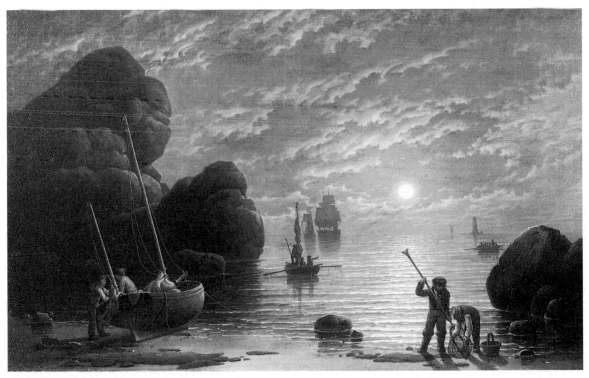

Robert Salmon: *Moonlight Coastal Scene*, oil on canvas, 419×616 mm, 1836 (St Louis, MO, St Louis Art Museum)

Salt Lake City, view from the south-east in 1889, showing Temple Square with the Assembly Hall on the left, Salt Lake Tabernacle in the centre and Salt Lake Temple (then unfinished) on the right

Scene (1836; St Louis, MO, A. Mus.; see fig.) is typical of his works on panel, and it demonstrates his use of light to silhouette form. There are no extant examples of the panoramic views done as backdrops; his canvases such as *Wharves of Boston* (1829; Boston, MA, Old State House) and *View of Charlestown* (1833; Annapolis, MD, US Naval Acad. Mus.) are full of carefully delineated figures, minute and accurate details of the ships and their rigging, and, most importantly, large expanses of sky dominated by strong light. Salmon's portrayal of light-filled water and sky, increasingly luminous in the late 1830s and early 1840s, has caused him to be considered by some as the father of LUMINISM. He used a low viewpoint and contrasted a distant shoreline and small-scale figures in the foreground in a manner that prefigured the work of Fitz Hugh Lane and Martin Johnson Heade, both of whom were influenced by Salmon's manipulation of scale, light and subject-matter. It appears that he returned to England before his death.

BIBLIOGRAPHY
Robert Salmon: Painter of Ship and Shore (exh. cat., ed. J. Wilmerding; Salem, MA, Peabody Mus., 1971)
J. Wilmerding: *American Light: The Luminist Movement, 1850–1875* (exh. cat., Washington, DC, N.G.A., 1980), pp. 104–5
DAVID M. SOKOL

Salt Lake City. American city and state capital of Utah. It was founded in 1847 as the headquarters of the Church of Jesus Christ of Latter-day Saints (also known as the MORMONS) under the leadership of Brigham Young (1801–77), with the intention of creating the kingdom of God on earth, and it was the first in a series of Mormon settlements in the western USA. The plan of the city was based on a Mormon document drawn up by Joseph Smith jr (1805–44), and known as the *Plat of the City of Zion* (Zion, MO, 1833). It is characterized by wide streets running north–south and east–west, separating 10-acre blocks that were originally subdivided into eight tracts for residences and garden plots; farming took place in large fields outside the city. Two central blocks near the northern boundary of the grid were reserved for religious purposes. Temple Square (see fig.), contained by a high wall, housed

Henry Grow's (*d* 1891) domed Salt Lake Tabernacle (1865–7), the Assembly Hall (1883) by Obed Taylor (*d* 1881) and eventually the six-spired Salt Lake Temple (1853–93) built by Truman O. Angell (1810–87) in a Mormon–Gothic style, and with an interior by Joseph Young (1855–1938). The adjacent block to the east housed a tithe yard and Brigham Young's colonnaded and galleried residence, the Beehive House (1855), also by Angell.

Salt Lake City evolved as a city with the completion of the Transcontinental Railroad in 1869 and the development of Utah's mineral wealth. By the 1850s a commercial district had developed along Main Street, with early buildings in brick and stone constructed for Mormon merchants by local architect-builders. Between 1880 and 1910 the city's population quadrupled; many of these new citizens were non-Mormons attracted by mining. In the 1890s they too erected buildings for their businesses, such as the Dooly Building (1892; destr. 1964) by Louis Sullivan. This period of prosperity was also reflected in civic architecture with the Salt Lake City and County Building (1893) by Monheim, Bird & Proudfoot in a Romanesque Revival style influenced by H. H. Richardson. By 1900 the houses of mining magnates began to appear along the tree-lined Brigham Street (or South Temple Street), including the Neo-classical David Keith Mansion (1900) by F. A. Hale (1855–1934). New commercial buildings in the city centre included the Hotel Utah (1909) and the Kearns Building (1910), both clad in decorative terracotta motifs, by Parkinson & Bergstrom of Los Angeles. Henry Ives Cobb designed the twin steel-framed Boston and Newhouse buildings (1911), while the Neo-classical Utah State Capitol (1912–14) by Richard Kletting (1858–1943), a colonnaded structure of granite and marble, was the major architectural commission of the 1910s.

The art life of Salt Lake City was initially centred on a number of painters who were converts to the Mormon Church. In the 1880s George Ottinger (1833–1917) helped establish the art department at the University of Utah. Notable artists include H. L. A. Culmer (1854–1914) who painted secco murals of Utah scenes on the interior walls of his brother's 1890s house, the William Culmer House, Salt Lake City. Mahroni Young (1877–1957) executed sculpture and low-relief panels on the 1911 Technical High School, Salt Lake City, an example of Utah Prairie School design.

BIBLIOGRAPHY
F. Winkler: 'Building Salt Lake City', *Archit. Rec.*, xxii/2 (1907), pp. 15–37
A. Mortensen, ed.: *The Valley of the Great Salt Lake* (Salt Lake City, 1959)
M. Lester: *Brigham Street* (Salt Lake City, 1979)
J. Reps: *Cities of the American West* (Princeton, 1979)
R. Olpin: *Dictionary of Utah Art* (Salt Lake City, 1980)
J. McCormick: *The Westside of Salt Lake City* (Salt Lake City, 1982)
T. Carter and P. Goss: *Utah's Historic Architecture, 1847–1940* (Salt Lake City, 1988)
PETER L. GOSS

San Diego. American city and seat of San Diego County in the state of California. It is situated on a fine natural harbour on the Pacific Coast close to the Mexican border. Attracted primarily by the harbour, it was founded by the Spanish in 1769 as the first colonial outpost in what is now California. The Franciscan Mission San Diego de Alcalá and the Presidio Real, each constructed of adobe

San Diego, La Jolla, the Woman's Club by Irving Gill, 1912–14

in a quadrangular configuration with an open courtyard, were the first permanent structures; the church (1808–13) and Presidio chapel were furnished with religious paintings and sculptures brought from Mexico by the fathers led by Junípero Serra. Adobe remained the primary building material until the settlement's capture by the USA in 1846 and California's achievement of American statehood in 1850.

In the second half of the 19th century many brick and wooden structures were built in revival styles, particularly during the economic boom that followed the arrival of the railway in 1885. Jesse Shepard's residence Villa Montezuma (1887, by Nelson Comstock and Carl Trotsche), an outstanding example of Victorian eclecticism, exhibits the stained-glass windows, gargoyles, ornamental woodwork and decorative shingle patterns popular at the time, and the Hotel del Coronado (1886–8) by JAMES W. REID is one of the largest Shingle-style buildings extant. The arrival in 1893 of IRVING GILL and his development of a severely stripped-down adaptation of the indigenous adobe Mission-style architecture helped bring a more unified look to San Diego through the work of the many architects who trained in his office; his style is exemplified in the Woman's Club (1912–14; see fig.) in the San Diego suburb of La Jolla.

The first professionally trained artists began to arrive in San Diego in the late 1880s, founding the Art Association in 1904. World attention focused on San Diego when the International Theosophical Society chose the city for its headquarters (1897–1942). As well as attracting the art historian Osvald Sirén and the Maya scholar William Gates (1863–1940), a number of artists settled there, particularly from England, creating a school of art, the Point Loma Art School (Part of the Theosophical Society), influenced by the symbolism and occult studies of theosophy. Among the newcomers was Maurice Braun (1877–1941), who became a leading painter of the California landscape and founded the San Diego Academy of Art in 1910.

BIBLIOGRAPHY

E. McCoy: *Five California Architects* (New York, 1960, rev. 2/1975)
J. Nolan: *Discovery of the Lost Art Treasures of California's First Mission* (San Diego, 1978)
B. Kamerling: 'Theosophy and Symbolist Art: The Point Loma Art School', *J. San Diego Hist.*, xxvi (1980), pp. 230–55
R. Westphall: *Plein Air Painters of California: The Southland* (Irvine, CA, 1982)

BRUCE KAMERLING

San Francisco. American city on the coast of California, *c.* 440 km north of Los Angeles. One of the USA's principal ports of entry to the Pacific Ocean, the city is situated on a narrow, steep, hilly peninsula, to the north of which is the Golden Gate Channel giving access to San Francisco Bay—a large natural harbour lying to the east of the peninsula.

1. History and urban development. 2. Art life and organization.

1. HISTORY AND URBAN DEVELOPMENT. The area was first settled by the Spanish in 1776 when the Mission San Francisco de Asís (Mission Dolores) was built on the peninsula; a presidio (not completed) was constructed at its north eastern tip in 1792. In 1834, when California was a province of Mexico, the trading town of Yerba Buena was founded in the south-eastern portion of the peninsula. Jean Vioget, a Swiss inhabitant of the area, laid out a simple grid plan in 1839 that sought to accommodate the few buildings already in existence on the site. Vioget's scheme was 11° in error to the east of its supposed north-south orientation, but it remained intact and was partly extended in various directions as the city grew. It was modified in 1843, when the Irishman Jasper O'Farrell established another grid north of what became Market Street. O'Farrell extended sections of both grids out into the bay, correctly anticipating that this area would eventually be filled in to bring the shoreline out into deep water.

In 1846, during the Mexican–American War, the settlement was captured by the USA; in 1847 its name was

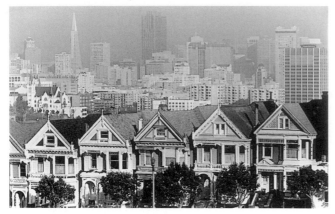

San Francisco, timber houses in Alamo Square, 19th century, with the city centre in the background

changed to San Francisco and after 1848 it was flooded with Europeans and Americans seeking their fortune in the Californian goldfields: between 1847 and 1850, when California became part of the USA, the population grew from a few hundred to an estimated 25,000. By the end of the 1860s the city had acquired several buildings in the latest architectural fashions from Europe, produced by an influx of well-trained European and American architects. The dominant impression, however, was provided by rows of attached timber houses, many of them highly ornamented; by the late 1880s the streets climbing the city's steep hills were lined by such dwellings, and they continued to be built in the 20th century in the latest contemporary styles (see fig.; see also below). The influx of immigrants during the gold rush gave San Francisco a highly cosmopolitan character from its earliest years, with a particularly large Chinese quarter just below Nob Hill. In 1869 the transcontinental railway was completed to the east side of the bay and San Francisco became a principal destination for both immigrants and visitors from the eastern USA, who could find luxurious accommodation in the Grand Hotel (1870) and Palace Hotel (1873–5; destr. 1906), both by JOHN P. GAYNOR.

At this time the city also began to plan public parks. Frederick Law Olmsted was engaged, not only to plan a grand park similar to New York's Central Park but also to replan the hilly sections of the city and to develop an integrated city-wide park system (1865–6). The latter was unexecuted, but Olmsted's idea of a grand park was eventually realized. In 1866 the municipal authorities set aside a long rectangular section of land (c. 800 ha) lying across the peninsula near its tip, which was later laid out by John McLaren (1846–1943) and became Golden Gate Park, one of the USA's most varied and successful public parks. San Francisco's low-rise commercial skyline was first broken in 1887 with the completion of the 10-storey *San Francisco Chronicle* Building by Daniel H. Burnham in the Romanesque Revival style of H. H. Richardson. Other eclectic-style commercial buildings followed, such as A. C. Schweinfurth's *Examiner* Building for William Randolph Hearst (1897–8; for illustration *see* SCHWEINFURTH), and a distinctive version of the East-Coast SHINGLE STYLE was developed for houses in the 1880s and 1890s as the First Bay Area Tradition or Western STICK STYLE; examples are found in the work of such architects as ERNEST COXHEAD, WILLIS JEFFERSON POLK and BERNARD MAYBECK.

In 1904 the Association for the Improvement and Adornment of San Francisco was formed privately and Burnham was engaged to provide a version of how the city might be transformed into the ideal 'City Beautiful' (*see* CITY BEAUTIFUL MOVEMENT). A grand scheme with new boulevards, parks and a civic centre was produced (1905), but it was so grand that it had little likelihood of being carried out. The major earthquake and fire of 1906 destroyed much of San Francisco, but efforts to implement Burnham's scheme for the city's reconstruction were thwarted by the desire of property owners to rebuild as quickly as possible, and the city reverted to the traditional American approach of piecemeal planning.

BIBLIOGRAPHY
D. H. Burnham and E. H. Bennett: *Report on a Plan for San Francisco* (San Francisco, 1905)
A. F. Buchanan: 'Some Early Business Buildings of San Francisco', *Archit. Rec.*, xxl (1906), pp. 15–32
H. Bartholomew: *The San Francisco Bay Region: A Statement Concerning the Nature and Importance of a Plan for Future Growth* (San Francisco, 1925)
San Francisco and the Bay Area (New York, 1939)
M. Scott: *The San Francisco Bay Area: A Metropolis in Perspective* (Berkeley, 1959)
J. A. Baird: *Times Wonderous Changes: San Francisco Architecture, 1776–1915* (San Francisco, 1962)
R. Olmsted, T. H. Watkins and M. Baer: *Here Today: San Francisco's Architectural Heritage* (San Francisco, 1968)
G. Eckbo: *Public Landscape: Six Essays on Government and Environmental Design in the San Francisco Bay Area* (Berkeley, 1978)
R. Clary: *The Making of Golden Gate Park: The Early Years, 1865–1906* (San Francisco, 1980)
D. Crouch, D. Garr and A. L. Mundigo: *Spanish City Planning in North America* (Cambridge, MA, 1982)
J. M. Woodbridge and S. B. Woodbridge: *Architecture, San Francisco: The Guide* (San Francisco, 1982)
R. Longstreth: *On the Edge of the World: Four Architects in San Francisco at the Turn of the Century* (Cambridge, MA, 1984)
D. Gebhard, E. Sandweiss and R. W. Winter: *Architecture in San Francisco and Northern California* (Salt Lake City, 1985)
A. V. Moudon: *Built for Change: Neighborhood Architecture in San Francisco* (Cambridge, MA, 1986)
S. Woodbridge and D. Gebhard: *Bay Area Houses* (Salt Lake City, 1988)
P. Polledri, ed.: *Visionary San Francisco* (Munich, 1990)
DAVID GEBHARD

2. ART LIFE AND ORGANIZATION. San Francisco had an active art association as early as 1873; after several changes, this evolved into two of the city's important art facilities: the San Francisco Art Institute on Russian Hill, and the San Francisco Museum of Modern Art. San Francisco's oldest art museum, however, is the M. H. de Young Memorial Museum, which was opened in 1895 as the Memorial Museum in a building in Golden Gate Park that was used for the California Midwinter International Exposition (1894). The building was offered to the Park Commissioners by the Exposition's executive committee led by M. H. de Young (d 1925), publisher of the *San Francisco Chronicle*, who acquired an eclectic collection of works for the museum.

BIBLIOGRAPHY
Selected Works: M. H. de Young Memorial Museum, California Palace of the Legion of Honor, San Francisco, F.A. Museums cat. (San Francisco, [c. 1987])

T. Albright: *Art in the San Francisco Bay Area, 1945–1980* (Berkeley, 1985)

HENRY T. HOPKINS

Sandwich Glass. *See under* BOSTON & SANDWICH GLASS CO.

Santayana, George [Jorge (Augustín Nicolás Ruiz de)] (*b* Madrid, 16 Dec 1863; *d* Rome, 26 Sept 1952). Spanish philosopher and writer, active in the USA. He grew up in Boston, MA, attended Harvard University, Cambridge, MA, as an undergraduate and taught there from 1889 to 1912. He then retired to Europe, living in England, Paris and finally Rome. His most famous work in aesthetics is an early book, *The Sense of Beauty* (1896), in which he repudiates the Hegelian idealism then current in England and America and gives a psychological analysis of the beautiful, based on 'scientific' neo-empiricist principles. Beauty is defined as 'pleasure objectified' (p. 33). We call objects beautiful when we take pleasure in the experience of them, and this pleasure appears to us to be a quality of the objects themselves. Three sources of beauty are distinguished: beauty of materials (sensuous elements such as colours or sounds), beauty of form (combinations of sensuous elements as in symmetry) and beauty of expression (our associations with an object). Expression occurs when the experienced object suggests to our imagination some other object or event: these two terms 'lie together in the mind, and their union constitutes expression' (p. 121). For expression to be an element of beauty, the association must give pleasure experienced as a quality of the object. Santayana argued that even when what is suggested has negative value, as in tragedy, it is transformed into positive value when united in expression with a beautiful object.

Reason in Art (1905; vol. iv of *The Life of Reason*) gives Santayana's more considered views on art and its role in moral life. The 'life of reason' is the good life in an Aristotelian sense, the rational pursuit of happiness, achieved by the control of reason over experience and the harmonious integration of diverse human interests (science, art, religion etc). Art both contributes to the good life and serves as a model for it, since by its very nature it involves the harmony of spontaneous creativity and practical utility. The term 'art' includes both fine and practical (or 'servile') arts, which are distinguished only in that fine art is supposed to give greater emphasis to aesthetic value (beauty). According to Santayana the distinction is artificial, however, since we cannot separate the aesthetic functions from those that are practical and moral. As he says in his essay 'What is Aesthetics?' (1904), to have an aesthetic interest in things divorced from all other interests would demean the notion of the aesthetic. The Greek temple, which unites beauty with utility, is for Santayana an artistic ideal to which all art should aspire. One implication of this stress on art's moral role is that content becomes as important as form: in training our senses and our emotional sensitivity, the representational arts not only model the harmony of the life of reason but also help us to achieve it.

WRITINGS

The Sense of Beauty (New York, 1896/*R* 1955)
'What is Aesthetics?', *Philos. Rev.*, viii (1904), pp. 320–27

Reason in Art (1905), iv of *The Life of Reason*, 5 vols (New York, 1905–6)
The Realm of Essence (1927), i of *Realms of Being*, 4 vols (London, 1927–40)
Obiter scripta (New York, 1936) [incl. repr. of 'What of Aesthetics?', pp. 23–30]

BIBLIOGRAPHY

The Works of George Santayana: Triton Edition, 15 vols (New York, 1936–40)
P. Schilpp, ed.: *The Philosophy of George Santayana* (Chicago, 1940)
I. Singer: *Santayana's Aesthetics* (Cambridge, MA, 1957)
J. Ashmore: *Santayana, Art, and Aesthetics* (Cleveland, OH, 1966)
T. Sprigge: *Santayana: An Examination of his Philosophy* (London, 1974)
C. Gonzalez-Marin: 'La retórica de la belleza', *Arbor*, 579 (1994), pp. 127–36

JENEFER ROBINSON

Sargent, Henry (*b* Gloucester, MA, 25 Nov 1770; *d* Boston, MA, 21 Feb 1845). American painter. An early work was his small copy (*c.* 1789; Boston, MA, Mus. F.A.) of Valentine Green's mezzotint engraving after John Singleton Copley's *Watson and the Shark* (1778; Washington, DC, N.G.A.; see colour pl. VI, fig. 3). Sargent went to London to study painting in 1793, carrying letters of introduction from John Trumbull to Copley and Benjamin West. Returning to Boston in 1797, he embarked instead on a military career. He then served in the Massachusetts legislature for two years before resuming his artistic career in 1804. His best-known works are a pair of large interior scenes, the *Dinner Party* (*c.* 1821; Boston, MA, Mus. F.A.; see fig.) and the *Tea Party* (*c.* 1821–5; Boston, MA, Mus. F.A.), which depict elegant Federal-period style and taste in the Beacon Hill district of Boston. The *Dinner Party* is said to represent the dining-room of Sargent's own house during a gathering of his supper club. Framed by a brown arched doorway, 18 men sit at a table set with bowls of

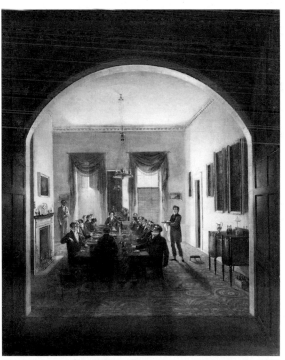

Henry Sargent: *Dinner Party*, oil on canvas, 1.51×1.22 m, *c.* 1821 (Boston, MA, Museum of Fine Arts)

fruit, wine bottles and glasses. The controlled light, the warm tonality of brown paintings in gold frames, the red curtains and brass ornaments all suggest the influence of the Dutch 17th-century genre paintings Sargent is known to have collected. The *Tea Party* is set in a candlelit drawing-room, where fashionably dressed men and women converse amid gilt Empire furniture. The deep illusionistic space and the measured formality of the composition exemplify the growing interest in French Neo-classicism in America during the early 19th century. Sargent was elected an honorary member of the National Academy in 1840 and was president of the Boston Artists' Association from January 1840 until his death.

BIBLIOGRAPHY

W. Dunlap: *History of the Rise and Progress of the Arts of Design in the United States*, ii (New York, 1834, rev. 3/1965), pp. 189–96

J. De Wolf Addison: 'Henry Sargent: A Boston Painter', *A. America*, xvii (1928–9), pp. 279–84

American Paintings in the Museum of Fine Arts, Boston, 2 vols (Boston, 1969), i, pp. 221–3; ii, figs 153, 154

LEAH LIPTON

Sargent, John Singer (*b* Florence, 12 Jan 1856; *d* London, 25 April 1925). American painter and draughtsman, active in England. The most fashionable portrait painter working in England and the USA in the late 19th century, he was brought up by expatriate American parents in an environment of restless travel and insulated family life. He was cosmopolitan in outlook, a linguist, a fine pianist and an avid reader of the classics. The spirit of self-sufficiency and isolation, both physical and emotional, remained with him all his life. He never married, grew wary of emotional entanglements and remained closest to his sisters, especially the eldest, Emily.

1. Training and early career, to 1886. 2. Later career, 1887 and after.

1. TRAINING AND EARLY CAREER, TO 1886. From an early age Sargent was committed to the idea of becoming an artist and threw all his energy into the pursuit of this. The artist's father, Dr Fitzwilliam Sargent, was anxious about the vagaries of an artistic career but did not stand in the way of his son's evident vocation. Together in 1874 they decided that he should enter the Paris studio of the portrait painter Carolus-Duran (1837–1917), which was then becoming popular with American art students. The fashionable Carolus-Duran shared with many of his contemporaries an obsession with tonal values and constantly invoked the example of Velázquez (1599–1660) in his teaching. Sargent studied the work of Velázquez at first hand in Spain in 1879; Frans Hals (1581/5–1666) was also an important influence on his brushwork. Under Carolus-Duran, Sargent was trained to concentrate on painting rather than on a prescribed academic course of drawing, and he soon distinguished himself by his keenness of eye and facility of hand. His first exhibited work, a portrait of *Miss Fanny Watts* (exh. Salon 1877; Philadelphia, PA, Mus. A.), was followed by *Oyster Gatherers of Cancale* (exh. Salon 1878; Washington, DC, Corcoran Gal. A.), an ambitious picture in which he combined formal figure arrangement with the vivid naturalism of his early essays in *plein-air* painting. Inspired by the Barbizon school and by the Impressionists, Sargent spent his summers painting outdoor figure sketches and landscapes in a modernist and experimental vein, as in *Two Boys on a Beach, Naples* (1878; Ormond priv. col., see 1979 exh. cat., p. 21). Summer visits to Brittany were followed by journeys to Capri, Spain and Venice. The studies made during these travels inspired a succession of formal salon pictures. The most significant of these, *El Jaleo* (exh. Salon 1882; Boston, MA, Isabella Stewart Gardner Mus.), depicts a dancer performing in a Madrid café; its exhilarating lighting and theatricality made it instantly popular.

Portraiture, rather than subject painting, however, was to prove Sargent's chosen sphere. His portrait of *Carolus-Duran* (exh. Salon 1879; Williamstown, MA, Clark A. Inst.) is an eloquent testament to the incisive bravura style he had absorbed from his master. On the strength of the portrait's success, he acquired a number of French patrons, chief among them the playwright Edouard Pailleron (1834–99). His portraits of *Edouard Pailleron* (1879; Versailles, Château), *Mme Pailleron* (1879; Washington, DC, Corcoran Gal. A.), posed against an alpine meadow, and their two children, *Edouard and Marie Louise Pailleron* (1881; Des Moines, IA, A. Cent.), combine nervous elegance with qualities of psychological insight and great vigour.

Among his clients, Americans soon outnumbered French. His portrait of the *Four Daughters of Edward D. Boit* (1882; Boston, MA, Mus. F.A.), an amateur artist, with its subtle arrangement and enveloping sense of space, is a landmark in the evolution of his style. It was followed by *Mrs Henry White* (1883; Washington, DC, Corcoran Gal. A.), wife of a diplomat and a prominent socialite, and then by the portrait of the celebrated beauty *Mme Gautreau* (1884; New York, Met.; see fig. 1), exhibited under the title of 'Madame X'. The provocative stance and décolletage of the latter offended French sensibilities, and the portrait was denounced as a decadent example of modern art at the Salon of 1884. It remains Sargent's most famous work, a stylized and original design, perfectly matched to the bizarre beauty of its subject.

The scandal encouraged Sargent to move from Paris to London, for his rising reputation had not been matched by an increase in commissions. After long visits to England in 1884 and 1885, he finally settled in London in 1886, urged to do so by his friend Henry James. For a time his career in Britain was threatened by criticism of his modernist tendencies. He spent his summers in the Cotswolds village of Broadway, Hereford & Worcs, painting in a broad Impressionist manner under the inspiration of Monet (1840–1926), also a friend; he painted *Claude Monet Painting at the Edge of a Wood* (*c.* 1885–6; London, Tate). Sargent's experimental work at Broadway resulted in one large-scale work, an aesthetic study of two young girls lighting Chinese lanterns in a garden at twilight, *Carnation, Lily, Lily, Rose* (1885–6; London, Tate; see fig. 2). It proved popular with the public when exhibited at the Royal Academy in 1887 and was purchased for the Chantrey Bequest.

2. LATER CAREER, 1887 AND AFTER. In 1887 Sargent visited the USA for only the second time to paint *Mrs Henry Marquand* (Princeton U., NJ, A. Mus.). He was greeted as a celebrity and inundated with commissions.

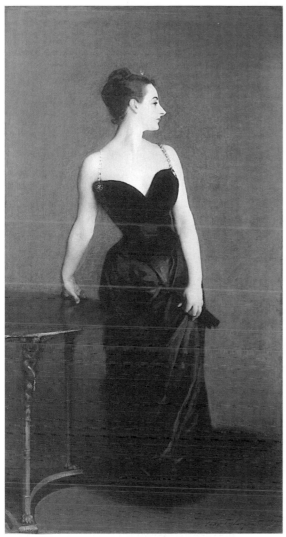

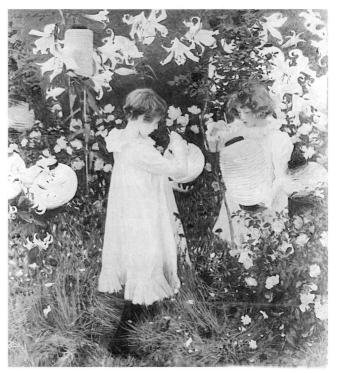

2. John Singer Sargent: *Carnation, Lily, Lily, Rose*, oil on canvas, 1.74×1.54 m, 1885-6 (London, Tate Gallery)

1. John Singer Sargent: *Mme Gautreau* ('*Madame X*'), oil on canvas, 2.1×1.1 m, 1884 (New York, Metropolitan Museum of Art)

During this and a subsequent visit in 1890 he painted more than 50 portraits, establishing a practice in New York and Boston that was to prove nearly as lucrative as that in London. In 1890 he accepted a commission to decorate the Boston Public Library designed by McKim, Mead & White with a series of murals illustrating the development of religious thought. These murals, and a later cycle of Classical and allegorical subjects at the Boston Museum of Fine Arts, were to occupy a large part of Sargent's energies for the rest of his life. He began work on the decoration of the museum in 1916, combining elliptical canvas panels with low-relief mouldings in the rotunda and larger canvasses on the stair-hall walls. The white plaster and gilded framework was also executed by Sargent and blends in with the predominantly blue and golden tones of the scenes, which portray a series of figures painted in a classical style. Sargent's flat, decorative mural style, with its combination of painted and sculpted motifs, has many original features and has been consistently underrated.

In England, Sargent had been aligned with the New English Art Club and other avant-garde groups during the late 1880s and early 1890s. With the success of *Lady Agnew* (exh. RA 1893; Edinburgh, N.G.) and his subsequent election as an ARA, Sargent's career was definitively established. His bravura style, enriched with Impressionist qualities of light and colour, seemed to his supporters to be dazzling by comparison with the dowdy and old-fashioned work of his contemporaries. He presented his sitters with rare immediacy, setting them in real spaces and capturing moments of arrested movement. The artist's ability to set down what he saw with all the force of a first impression was matched to powers of large-scale composition and an intuitive feeling for character and status. In the portrait of *Mrs Carl Meyer and her Children* (1896; priv. col.; see colour pl. XXIII, 2), the family of a wealthy banker, the central figure is dramatically brought forward by means of foreshortened perspective, her enormous peach-coloured dress filling the foreground. The lines of the design incorporate Mrs Meyer's arm and the back of a Louis XV sofa and terminate with the children shyly tucked in at the top of the picture space. This image of *fin-de-siècle* opulence was to be repeated in a series of portraits of the Bond Street dealer Asher Wertheimer and his family, beginning in 1898 with those of himself and his wife and ending in 1908 with the portrait of *Almena, Daughter of Asher Wertheimer* (the majority London, Tate).

By 1900 Sargent was the leading society portrait painter on both sides of the Atlantic, the 'van Dyck of our times' as Auguste Rodin (1840–1917) called him. Over the course of a decade and a half he painted many of the great

political, mercantile and artistic figures of his day in a sequence of powerful images that call to mind the work of his greatest predecessors. Among American sitters, Sargent's successes include portraits of the actress *Ada Rehan* (1895), *Mr and Mrs Phelps Stokes* (1897; both New York, Met.), *Major Henry Higginson* (1903; Cambridge, MA, Harvard U., Portrait Col.) and *Mrs Fiske Warren and her Daughter* (1903; Boston, MA, Mus. F.A.). During the late 1890s and early 1900s, in response to commissions from aristocratic English sitters, Sargent developed a new repertory of poses and settings, inspired in large measure by Reynolds (1723–92) and van Dyck (1599–1641). His languid vision of the *Wyndham Sisters* (1900; New York, Met.), labelled the Three Graces by Edward, Prince of Wales, was matched by the still more imposing *Misses Acheson* (1902; Chatsworth, Derbys) and by his monumental *Marlborough Family* (1905; Blenheim Pal., Oxon), which is one of Sargent's greatest formal portraits. Painted as a pendant to Reynolds's picture of *George Spencer, 4th Duke of Marlborough, and his Family* (1778; Blenheim Pal., Oxon), Sargent's group depicts Charles Richard John, the 9th Duke, his beautiful American wife, Consuelo, and his two sons in van Dyck costume, seen at the base of a great staircase, below flags, trophies and a bust of John Churchill, the 1st Duke.

After 1900 Sargent spent his summers on long sketching holidays in the Alps and southern Europe with his sister Emily and painter friends. His prodigious output of oil paintings and watercolours from this period includes many landscapes, architectural studies, Venetian canal scenes and views of gardens of Italian villas, as well as sketches of his nieces in Alpine meadows and of oxen, of marble quarries and of scenes of rural life. *On his Holidays, Norway* (exh. RA 1902; Port Sunlight, Lady Lever A.G.), an informal portrait of the son of the collector George McCulloch on the banks of a river, concentrates attention on the landscape setting and on the boy's relaxed attitude and dreamy expression. Sargent's ability to record scenes in terms of light and colour gives his landscapes a vivid sense of atmosphere. His paint surfaces have an extraordinary vitality; no brushstroke is wasted. Few of his landscapes were sold or exhibited during his lifetime, although two important blocks of watercolours were sold to the Museum of Fine Arts, Boston, and the Brooklyn Museum in 1911 and 1909. In his watercolours, Sargent often combined highly finished foreground features with an extreme sketchiness in the strokes used to depict background details; in *A Spanish Interior* (c. 1903; priv. col., see 1979 exh. cat., p. 95), for example, the facial features of the foreground figures are vividly portrayed. Contrasts of light and dark are also often extreme. Despite this handling, other watercolours, such as *Miss Sargent Sketching* (c. 1908; Ormond priv. col., see 1979 exh. cat., p. 103), always convey a vivid sense of light and atmosphere.

Preoccupied by his murals and landscape studies, Sargent shocked high-society circles by announcing in 1907 that he was giving up his portrait practice. Exceptions were made only for particular friends or occasional celebrities, among them *Henry James* (1913; London, N.P.G.). For the majority of his sitters Sargent replaced oil paintings by charcoal drawings, which usually required only a single

sitting, and which he referred to as 'mug shots'. Sargent's last years were devoted to the completion of his mural cycles.

On Sargent's death a successful studio sale, held at Christie's, London, on 24 and 27 July 1925, was complemented by large commemorative exhibitions in Boston, London and New York. Thereafter his work, with its traditional themes, fell from critical esteem under the impact of the development of modernist theories, and it was only in the late 1970s that his importance was once more recognized.

BIBLIOGRAPHY

Mrs Meynell: *The Work of John S. Sargent RA* (London, 1903, rev. 2/1927)

Retrospective Exhibition of Important Works by John Singer Sargent (exh. cat., New York, Grand Cent. A. Gals, 1924)

W. H. Downes: *John S. Sargent: His Life and Work* (Boston, 1925)

Memorial Exhibition of the Works of the Late John Singer Sargent (exh. cat., Boston, MA, Mus. F.A., 1925)

Exhibition of Works by the Late John S. Sargent RA (exh. cat., London, RA, 1926)

Memorial Exhibition of the Work of John Singer Sargent (exh. cat., intro. M. Griswold van Rensselaer; New York, Met., 1926)

E. Charteris: *John Sargent* (London, 1927)

M. Birnbaum: *John Singer Sargent* (New York, 1941)

C. M. Mount: *John Singer Sargent: A Biography* (New York, 1955, abridged London, 2/1957, 3/1969)

Sargent's Boston (exh. cat. by D. McKibbin, Boston, MA, Mus. F.A., 1956)

Exhibition of Works by John Singer Sargent RA (exh. cat., Birmingham, Mus. & A.G., 1964)

The Private World of John Singer Sargent (exh. cat., Washington, DC, Corcoran Gal. A., 1964)

R. L. Ormond: *John Singer Sargent* (London, 1970)

John Singer Sargent and the Edwardian Age (exh. cat. by J. Lomax and R. L. Ormond, Lotherton Hall, W. Yorks; London, N.P.G.; Detroit, MI, Inst. A.; 1979)

C. Ratcliffe: *John Singer Sargent* (New York, 1982)

J. T. Fairbrother: *John Singer Sargent and America* (New York, 1986)

S. Olson: *John Singer Sargent: His Portrait* (London, 1986)

R. L. Ormond, W. Adelson and S. Olson: *Sargent at Broadway: The Impressionist Years* (New York, 1986)

John Singer Sargent (exh. cat. by P. Hills, New York, Whitney, 1986)

H. Honour and J. Fleming: *The Venetian Hours of Henry James, Whistler and Sargent* (London, 1991)

K. F. Jennings: *John Singer Sargent* (New York, 1991)

John Singer Sargent's Alpine Sketchbooks: A Young Artist's Perspective (exh. cat. by S. D. Rubin, New York, Met., 1991–2)

John Singer Sargent's El Jaleo (exh. cat. by M. C. Volk, Washington, DC, N.G.A.; Boston, MA, Isabella Stewart Gardner Mus.; 1992)

T. Fairbrother: *John Singer Sargent* (New York, 1994)

H. B. Weinberg: *John Singer Sargent* (New York, 1994)

K. Erickson: 'John Singer Sargent: Reassessing his Boston Murals', *Amer. A. Rev.*, vii/2 (1995), pp. 124–7

S. M. Promey: 'Sargent's Truncated Triumph: Art and Religion at the Boston Public Library, 1890–1925', *A. Bull.*, lxxix (1997), pp. 217–50

Uncanny Spectacle: The Public Career of the Young John Singer Sargent (exh. cat. by M. Simpson with R. Ormond and H. B. Weinberg, Williamstown, MA, Sterling & Francis Clark A. Inst., 1997)

The Portrait of a Lady: Sargent and Lady Agnew (exh. cat. by J. Rayer Rolfe with D. Cannadine, K. McConkey and W. Mellers, Edinburgh, N.G., 1997)

W. Adelson and others: *Sargent Abroad: Figures and Landscapes* (New York, 1997)

R. Ormond and E. Kilmurray: *John Singer Sargent: Complete Paintings, I: The Early Portraits* (London and New Haven, 1998)

——: 'Sargent in Paris', *Apollo*, cxlviii/439 (1998), pp. 13–22

E. Prettejohn: *Interpreting Sargent* (London, 1998)

J. Ridge and J. Townsend: 'John Singer Sargent's Later Portraits: The Artist's Technique and Materials', *Apollo*, cxlviii/439 (1998), pp. 23–30

Masters of Color and Light: Homer, Sargent and the American Watercolor Movement (exh. cat. by L. S. Ferber and B. Gallati, New York, Brooklyn Mus., 1998)

John Singer Sargent (exh. cat. by R. Ormond and E. Kilmurray and others; London, Tate; Washington, DC, N.G.A.; Boston, MA, Mus. F.A.; 1998–9)

For further bibliography see R. H. Getscher and P. G. Marks: *James McNeil Whistler and John Singer Sargent* (New York, 1986).

<div align="right">RICHARD ORMOND</div>

Savage, Edward (*b* Princeton, MA, 26 Nov 1761; *d* Princeton, MA, 6 July 1817). American painter, engraver and museum keeper. Although nothing is known about his artistic training, his earliest dated painting, a copy of John Singleton Copley's portrait of the *Reverend Samuel Cooper* (Lancaster, MA, Town Lib.), signed and dated July 1784, shows he was an accomplished artist. His original portraits also show the influence of Copley. The stiff poses and expressionless faces of his sitters reveal his limited anatomical knowledge. In 1789, Harvard University accepted Savage's offer to paint for it a portrait of *George Washington* (Cambridge, MA, Fogg). This gave him the opportunity to paint his best-known work, *The Washington Family* (Washington, DC, N.G.A.; see fig.), from which his engraving of 10 March 1798 was taken. Contemporary critics regarded this portrait as portraying Washington as serene and venerable, but comparisons with his later portraits show the expression to be wooden and stoic.

Savage worked in Boston (1785–9), New York (1789–91) and London (1791–3). On 22 February 1791 his Columbian Gallery opened in Philadelphia. The emphasis of the museum was on the fine arts, but curiosities of invention and nature were exhibited to attract a less sophisticated audience. His competitor, Charles Willson Peale, on the other hand, had an equal interest in science and natural history and regarded these exhibits as educa-tional tools for the public. Savage operated his museum successfully in New York from 1802 to 1812 and then in Boston until his death.

BIBLIOGRAPHY

L. Dresser: 'Edward Savage, 1761–1817, Some Representative Examples of his Work as a Painter', *A. America*, xl/4 (1952), pp. 157–212

J. M. Mulcahy: 'Congress Voting Independence', *PA Mag. Hist. & Biog.*, lxxx/1 (1956), pp. 74–91

R. S. Gottesman: *The Arts and Crafts in New York, 1800–1804* (New York, 1965), pp. 27–37

R. G. Stewart: *Robert Edge Pine, a British Portrait Painter in America, 1784–1788* (Washington, DC, 1979)

<div align="right">ROBERT G. STEWART</div>

Savannah. North American city in the state of Georgia. Situated on the Savannah River, *c.* 30 km from its mouth on the south-eastern coast of the USA, the city is an important port and regional centre. It was the capital of Georgia from 1754 to 1796 and retained its cultural and economic significance even after the capital was transferred to Atlanta. Savannah was the first and principal town to be founded in the 'charitable colony' of Georgia, initiated (1730) by British politicians to create opportunities for Britain's urban poor; each settler was provided with a period of subsistence in the colony and property comprising a town plot, a nearby garden and a more distant farm plot in order to create a colony of self-sufficient farmers; slavery, the economic basis of the neighbouring colony of Carolina, was forbidden, as was alcohol.

James Oglethorpe, a military officer and one of the most active trustees, led the first group of settlers to

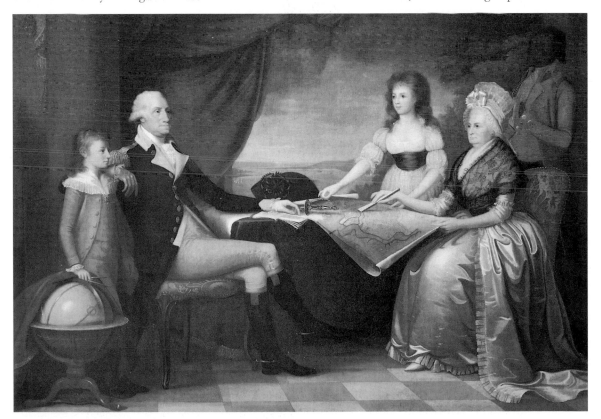

Edward Savage: *The Washington Family*, oil on canvas, 2.14×2.84 m, 1796 (Washington, DC, National Gallery of Art)

Georgia and founded Savannah in 1733, probably drawing up the town's distinctive urban plan, perhaps in association with other trustees. Unlike traditional new towns, Savannah was given no central square, no single hierarchical pattern and no boundary. Instead, it was based on an indefinitely extendable grid of 'wards', each measuring 600 ft sq. (*c.* 183 m sq.), focused on its own square and comprising sectors for public and private buildings and a diversity of street types. Four such wards were set out in 1733, and two more added in the following year. The trustees' paternalism caused discontent among the settlers, however, exacerbated by the existence of traditional property rights and slavery in the neighbouring colony. In 1752 the trustees surrendered their charter to the Crown, their constraints were removed and slavery was introduced.

Savannah nevertheless grew little until after the American Revolution (1775–83), but throughout the early and mid-19th century the region's cotton economy thrived, and the port of Savannah developed as a centre of cotton shipping and naval stores. Urban growth was accommodated through the addition of wards (see fig.); by 1856 there were 24, but still no overall dominating square or centre. Individual squares and certain streets were heavily planted, thus creating an environment of articulated green spaces woven into a continuous urban fabric. The abstract pattern of the city's plan was constantly reinterpreted during its history, and it can be argued that the continuing coherence of Savannah's urban structure, while accommodating change, is partly due to the intrinsic flexibility of the original plan.

During the boom of the first half of the 19th century typical architecture included terraced houses with raised basements at ground-level, their main reception floors reached by a long exterior stairway running across the ground-level façade. Such houses were also built as semi-detached pairs, with side gardens and fenestrated side elevations, often with balconies. Occasionally in the early years and increasingly with the later extension of the urban plan, trustee lots were given over to larger, more architecturally selfconscious houses, including the Alexander Telfair House (1819; now the Telfair Academy of Arts and Sciences) and William Scarborough House (1819), with a revolutionary Doric portico, both by the Englishman William Jay (*c.* 1793–1837); and the Italianate Hugh Mercer House (1860) by John S. Norris. Notable buildings erected in the communal areas of wards include the Greek Revival Christ Episcopal Church (1838) by James H. Couper and the Richardsonian Romanesque Revivial Chatham County Court House (1889) by the Boston architect William Gibbons Preston. The Independent Presbyterian Church (1817–19; rebuilt 1891) by John Holden Greene faces the ceremonial Bull Street. The stone and brick commercial

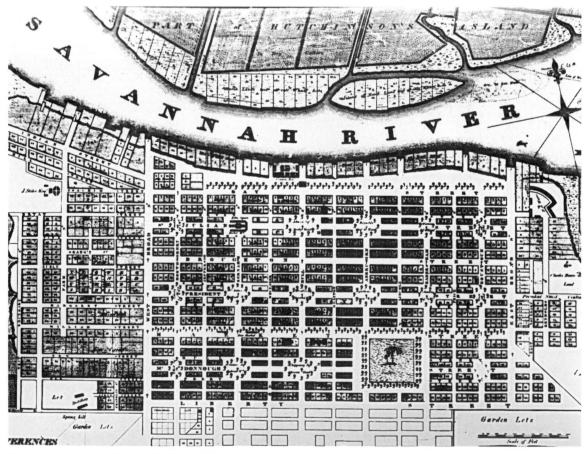

Savannah, plan of the city by John McKinnon, 1820

buildings of Factors' Row, including Preston's Queen Anne Revival Savannah Cotton Exchange (1886–7; for illustration *see* PRESTON, WILLIAM GIBBONS), were built over a series of free-standing arched warehouses along the riverside, inventively negotiating the change of level from the river to the city, to which they are connected by cast-iron bridges.

BIBLIOGRAPHY

T. C. Bannister: 'Oglethorpe's Sources for the Savannah Plan', *J. Soc. Archit. Hist.*, xx (1961), pp. 47–62

J. Reps: *The Making of Urban America* (Princeton, 1965), chap. 7

Historic Savannah (Savannah, 1968, rev. 2/1979)

M. Lane and others: *Savannah Revisited: A Pictorial History* (Savannah, 1969, rev. 3/1977)

P. S. Taylor: *Georgia Plan, 1732–1752* (Berkeley, CA, 1972)

S. Anderson: 'Savannah and the Issue of Precedent: City Plan as Resource', *Settlements in the Americas: Cross-Cultural Perspectives*, ed. R. Bennett (Newark, DE, 1993)

STANFORD ANDERSON

Savery, William (*b* Philadelphia, 1721/2; *d* Philadelphia, 1787). American cabinetmaker. From 1735 to 1741 he was apprenticed to Solomon Fussell (*d* 1762), a chairmaker in Philadelphia and a fellow Quaker. By 1750 he owned a house on Second Street, Philadelphia, with a small, active furniture shop attached. He was primarily a cabinetmaker and chairmaker; no carving tools were listed in his inventory when he died, and it seems likely that he employed the common practice of subcontracting to specialists the carving of such details as claw-and-ball feet and shells on chair backs. His case furniture is distinguished by its fine proportions and plain, polished surfaces (e.g. mahogany high chest of drawers, *c.* 1770; priv. col., on loan to Philadelphia, PA, Mus. A.) He used mahogany and curled maple for the furniture that he produced for well-known local Quaker families. Like most Quakers, he played an active part in the civic life of Philadelphia and was a member of many philanthropic groups as well as a supporter of the Friendly Association for Regaining and Preserving Peace with the Indians.

BIBLIOGRAPHY

Philadelphia: Three Centuries of American Art (exh. cat. by D. Sewell and others, Philadelphia, PA, Mus. A., 1976), pp. 50–51, 94–5

BEATRICE B. GARVAN

Schmidt, Garden & Martin. American architectural partnership formed in 1906 by Richard F.(rnst) Schmidt (*b* Ebern, W. Germany, 14 Nov 1865; *d* Winnetka, IL, 17 Oct 1959), Hugh M(ackie) G(ordon) Garden (*b* Toronto, 9 July 1873; *d* Chicago, IL, 6 Oct 1961) and Edgar Martin (*b* Burlington, IO, 26 Feb 1871; *d* Chicago, IL, 17 Sept 1951). Richard E. Schmidt studied (1883–5) at the Massachusetts Institute of Technology, Cambridge, before opening a practice in Chicago in 1886. After a brief partnership with T. O. Fraenkel from 1891 to 1895, Schmidt practised alone until 1906.

The early designs in Schmidt's office continued the restrained, commercial style that Louis Sullivan had introduced in the 1880s and 1890s. The Schoenhofen Brewing Company Building (1902) and the Albert Madlener House (1902; for illustration *see* CHICAGO SCHOOL), Chicago, especially, were recognized by critics for their geometric massing, careful proportions and skilful effects of brickwork. Perhaps from as early as 1899 Schmidt employed

Hugh M. G. Garden, a graduate of the Bishop College School, Lennoxville, Quebec, Canada, who had trained in Minneapolis and practised in Chicago from 1892; in 1899 Schmidt and Garden shared the same office address in city directories of Chicago. Many of the innovative buildings designed in the office of Richard E. Schmidt in the years following Garden's employment are generally attributed to Garden. The Montgomery Ward Warehouse (1906–8) is distinguished for a pronounced horizontality that clearly expresses its reinforced concrete frame.

Hugh Garden's work in parks in Chicago, particularly the refectory and boat landing (completed 1907) in Humboldt Park, is significant. The firm's design of the Michael Reese Hospital (1905–6), Chicago, was among the first in a long series of hospital commissions that the firm and their successors secured. An expert on hospital design, Schmidt wrote several publications on the subject. (Schmidt, Garden & Martin formally practised together until 1925 when Martin, a structural engineer, left to form the firm Pond, Pond, Martin & Lloyd; in 1926 the firm's name changed to Schmidt, Garden & Erickson.)

WRITINGS

H. M. G. Garden: 'Modern Garden Architecture in Germany', *Archit. Rev.* [Boston], xv (1908), pp. 81–6

J. Hornsby and R. E. Schmidt: *The Modern Hospital* (Philadelphia, 1914)

R. E. Schmidt: 'The Rise and Growth of Hospitals', *Living Architecture*, ed. A. Woltersdorf (Chicago, 1930)

H. M. G. Garden: 'The Chicago School', *IL Soc. Archit. Mthly Bull*, xxiv/4–5 (1939), pp. 6–7

BIBLIOGRAPHY

R. Sturgis: 'The Schoenhoten Brewery', *Archit. Rec.*, xvii (1905), pp. 201–7

———: 'The Madlener House in Chicago', *Archit. Rec.*, xvii (1905), pp. 491–8

C. Condit: *The Chicago School of Architecture* (Chicago, 1964)

B. Greengard: 'Hugh M. G. Garden', *Prairie Sch. Rev.*, iii/1 (1966), pp. 5–18

H. Brooks: *The Prairie School* (Toronto, 1972)

C. Westfall: 'Manners Matter', *Inland Architect & News Rec.*, xxiv (1980), pp. 19–23

R. Geraniotis: 'An Early German Contribution to Chicago's Modernism', *Chicago Architecture, 1872–1922: Birth of a Metropolis*, ed. J. Zukowsky (Chicago and Munich, 1987)

Madlener House: Tradition and Innovation in Architecture (Chicago, 1988)

KATHLEEN ROY CUMMINGS

Schuyler, Montgomery [Winkler, Franz K.] (*b* Ithaca, NY, 19 Aug 1843; *d* New Rochelle, NY, 16 July 1914). American architectural writer. He began his career as a literary critic. Without training in architecture or a university degree, he acquired his knowledge and developed his point of view through wide reading and, from 1865, by immersing himself in the literary and artistic milieu of New York. His subjects included historical styles, issues in the architectural profession, the architecture of individual towns and cities (from New York to Salt Lake City) and building types (from houses and churches to a long series on the architecture of American colleges). He also wrote monographs on such architects as Louis Sullivan and Frank Lloyd Wright. A prolific writer using his own name, Schuyler also published anonymously and under the pseudonym Winkler.

Schuyler's critical approach can be seen as a distillation of the progressive ideas of the mid-19th century, increasingly informed by changes that occurred later in the century. At the core of his conception of architecture,

inherited from John Ruskin (1819–1900) and Eugène-Emmanuel Viollet-le-Duc (1814–79) through Leopold Eidlitz (Schuyler's primary mentor in architectural matters), were structural expression, modelling of mass and ornamentation of structure, with minimal concern for the manipulation of space and the intricacies of planning. For Schuyler, architecture was the medium through which a society expressed itself. He saw its development as the refinement of an established body of thought: a gradual stylistic development based on the evolution of technological, cultural and historical conditions aspiring over generations to express truth with beauty.

Looking to France as a potential model for the American profession, Schuyler found an exemplary standard of practice and supportive popular appreciation of architecture. But he also felt innovation was stifled by formalism and the rigidity of the establishment. Although French architecture offered order and beauty, the USA addressed the new and approached truth free of the burden of a native architectural tradition. The most ambitious of Schuyler's writings tried to reconcile this conflict between resolved perfection and innovative excellence.

If Schuyler did not fully grasp the implications of the work of the major innovators whom he praised selectively (H. H. Richardson, Louis Sullivan, Frank Lloyd Wright), and if, even after the turn of the century, his attitudes were still those of the late 19th century, he displayed, along with Russell Sturgis, the greatest insight into American architecture of the time. He was the first American writer to look seriously at the bridge as expressive architecture, and he grappled extensively with the issue of the skyscraper. His work has lasting value as a vivid contemporaneous view of late 19th-century American architecture and its struggle to find significant expression.

Most of his essays were published in *Architectural Record*, of which he was one of the founders in 1891. From the late 1870s until his death, Schuyler also wrote for other journals (including *American Architect and Building News*, *Scribner's*, *Harper's Weekly* and *Harper's Monthly*), as well as for newspapers on which he was a staff writer (*New York World Magazine*, 1868–83) or editor and literary critic (*New York Times*, 1883–1907).

WRITINGS
W. H. Jordy and R. Coe, eds: *American Architecture and Other Writings by Montgomery Schuyler* (Cambridge, MA, 1961, rev. New York, 1964)

BIBLIOGRAPHY
H. Lipstadt: *In the Cause of Criticism: Montgomery Schuyler and the 'Architectural Aberrations'* (New York, 1988)
SAMUEL BERKMAN FRANK

Schweinfurth. American family of architects, of German origin. Charles Julius Schweinfurth (*b* Reutlingen, Germany, 1827; *d* Cleveland, OH, 12 Oct 1909) trained as an engineer in Germany and moved to the USA, settling in Auburn, NY, in 1852. He was active there as a designer and manufacturer of architectural ornament, and he had four sons who all became architects. Charles F(rederick) Schweinfurth (*b* Auburn, 3 Sept 1856; *d* Cleveland, OH, 8 Nov 1919), the eldest son, worked in New York and Washington, DC, before setting up a successful practice in Cleveland in 1883. There he designed numerous residences, churches, college buildings and bridges. Most of

his earlier buildings in Cleveland, for example the Calvary Presbyterian Church (1887–90), were in the Romanesque Revival style of H. H. Richardson, which Schweinfurth was chiefly responsible for introducing to Cleveland. His later works there (e.g. Trinity Episcopal Cathedral, 1901–7) tended to be Gothic Revival compositions. Julius A(dolph) Schweinfurth (*b* Auburn, 20 Sept 1858; *d* Wellesley Farms, MA, 29 Sept 1931) went to work as a draughtsman in 1879 for Peabody & Stearns in Boston and was promoted to chief designer in 1887. He practised independently after 1896, becoming something of a specialist in college and school architecture. He also worked as an architectural journalist. A(lbert) C(icero) Schweinfurth (*b* Auburn, 7 Jan 1864; *d* Dryden, NY, 27 Sept 1900) also worked for Peabody & Stearns from 1882 to 1885 and then in New York for A. Page Brown (1885–6). In the period 1886–90 he practised briefly with his eldest brother in Cleveland, worked alone and again with Brown in New York and then with the firm of Andrews and Jacques and independently in Denver, CO; he rejoined Brown in San Francisco (1890–95) before establishing his own firm there (1895–8). Together with Brown he was ranked among the architects most instrumental in developing a regional Californian style based on a broad interpretation of Spanish and Spanish Colonial precedents. His masterpieces in this style were the Hacienda del Pozo de Verona (1895–6) in Pleasanton, CA, and the *Examiner* Building (1897–8; see fig.), San Francisco, both commissioned by William Randolph Hearst. His last major design, the First

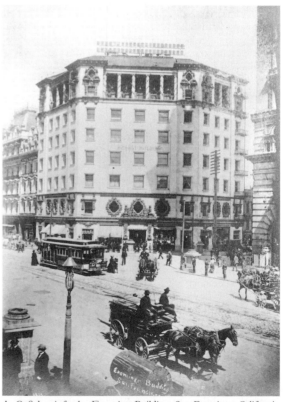

A. C. Schweinfurth: *Examiner* Building, San Francisco, California, 1897–8

Unitarian Church (1898), Berkeley, CA, was an important structure in the newer, more abstract San Francisco Bay Area Tradition or Western Stick style, of which Bernard Maybeck became one of the chief exponents. The fourth son, Henry Green Bronson Schweinfurth (*b* ?1864), also practised as an architect but never attained the professional distinction of his brothers. He worked in his eldest brother's office from 1887 to 1889.

BIBLIOGRAPHY
R. A. Perry: *The Life and Work of Charles Frederick Schweinfurth: Cleveland Architect, 1856–1919* (diss., Cleveland, OH, Case Western Reserve U., 1967)
L. M. Freudenheim and E. S. Sussman: *Building with Nature: Roots of the San Francisco Bay Area Tradition* (Santa Barbara and Salt Lake City, 1974), pp. 55–6, 59–60
S. Neitz and W. Holden, eds: *Julius A. Schweinfurth: Master Designer, 1858–1931* (Boston, 1975)
R. Longstreth: *On the Edge of the World: Four Architects in San Francisco at the Turn of the Century* (New York, 1983), pp. 56–9, 265–89, *passim*
J. Cigliano: *Showplace of America: Cleveland's Euclid Avenue, 1850–1910* (Kent, OH, 1991)
F. Armstrong and others: *A Guide to Cleveland's Sacred Landmarks* (Kent, OH, 1992)
ALFRED WILLIS

Sears, Willard T. *See under* CUMMINGS & SEARS.

Seattle. North American city and seat of King County in the state of Washington. It is located on an isthmus between Puget Sound and Lake Washington, on the north west coast of the continent. The area's natural resources, timber and fisheries first attracted settlers to Seattle in 1851. They developed a town on the harbour's east shore, initially creating a loose cluster of timber buildings, including a sawmill, docks, shops and housing. A fire in 1889, which almost entirely destroyed the town's core, provided an opportunity for a fresh start, and new buildings were required by ordinance to be of brick or stone. Largely dominated by the work of the architect Elmer H. Fisher (*c.* 1840–1905), reconstruction was in picturesque interpretations of the Romanesque Revival style (e.g. Fisher's Pioneer Building, 1890).

The town's steep site, although scenically beautiful, made a standard layout of streets and blocks difficult. However, an ambitious programme beginning in the 1890s levelled the topography and opened it up for the city's northward expansion. This factor, coupled with demands for commercial space, led to the erection of several tall skeletal-frame structures, beginning with the 14-storey Alaska Building (1904; by Eames & Young; see fig.) and culminating in the handsome 42-storey Smith Tower (1914; by Gaggin & Gaggin), which was then the tallest building (h. 158 m) in the world outside New York City.

To improve the city's amenities, the Olmsted Brothers, John C. Olmsted (1852–1920) and Frederick Law Olmsted jr (1870–1957), were hired to design a park plan for Seattle. Their park and boulevard system outlined in 1903 was substantially realized and was augmented in subsequent years. Included in the plan, but on a site acquired in 1893, was the new campus (designed by Carl F. Gould and Charles H. Bebb but significantly influenced by the Olmsted Brothers' plan for the Alaska–Yukon–Pacific Exposition) for the University of Washington, originally located in the city centre after its founding (1861). The university, in splendidly planned and landscaped surroundings, plays

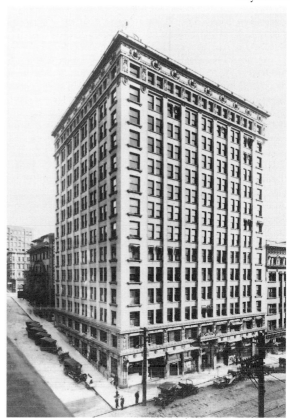

Seattle, Alaska Building by Eames & Young, 1904

a key role in the state's creative arts; the architecture, visual and performing arts of Seattle have been significantly shaped by its influence and the careers of its graduates. As a result of the modern city's commitment to preservation, two historical districts were designated by popular vote for restoration and revitalization: Pioneer Square, dating back to the city's early years and containing, in addition to the Pioneer Building, the Pergola (1909), a cast-iron and glass pavilion influenced by European Art Nouveau designs; and Pike Place Market, one of Seattle's best-known retail areas comprising building from the early 20th century.

BIBLIOGRAPHY
M. Morgan: *Skid Road* (New York, 1951)
R. Sale: *Seattle, Past to Present* (Seattle, 1976)
S. B. Woodbridge and R. Montgomery: *A Guide to Architecture in Washington State* (Seattle, 1980), pp. 99–232
Downtown Seattle Walking Tours (Seattle, 1985)
NORMAN J. JOHNSTON

Services, building. *See under* SKYSCRAPER, §1.

Seymour. American family of cabinetmakers of English origin. John Seymour (1738–1819) emigrated with his wife and eight children from Axminster, Devon, to Portland, ME, in 1785. In 1794 he moved to Boston where, soon after, he opened a shop with his son Thomas Seymour (1771–1848) in Creek Square in the North End, an area popular with other cabinetmakers. His selection to the Massachusetts Charitable Mechanics Association—an or-

ganization that counted among its members the most successful craftsmen in the city—was a measure of the stature he had attained. A tambour desk (1794–1804; Winterthur, DE, Du Pont Winterthur Mus.; see colour pl. XXXIII, 1) with a Seymour & Son label indicates the high quality of work produced by the firm. Although other cabinetmakers used some of the same characteristics, the Seymours favoured blue-painted interiors, flat mahogany strips or bell-flower inlay on tambour doors, inlaid ivory escutcheons, lunette inlay banding on case edges and satinwood veneers.

John continued to work until 1813. Thomas opened the Boston Furniture Warehouse between 1804 and 1808. He had a brief partnership with James Cogswell before going independent again in 1812. Like many other cabinetmakers, he sold a variety of items in addition to his own work, including used furniture, carriages, carpets and pieces made by such other cabinetmakers as Stephen Badlam and Isaac Vose. His reputation rests largely on the magnificent semicircular commode that he made for Elizabeth Derby of Salem, MA, in 1809 (Boston, MA, Mus. F.A.). The pilasters were probably carved by Thomas Whitman, and the shells at the centre of radiating mahogany and satinwood veneers were painted by John Ritto Penniman (1783–c. 1837). Although Thomas continued in business until 1842, no documented examples of his work surpass this piece.

BIBLIOGRAPHY

M. Swan: 'John Seymour & Son Cabinetmakers', *Antiques*, lxxxii (1937), pp. 176–80
V. C. Stoneman: *John and Thomas Seymour: Cabinetmakers in Boston, 1794–1816* (Boston, 1959)

OSCAR P. FITZGERALD

Shakers [The United Society of Believers in Christ's Second Appearing]. American religious order founded on the personality and teachings of Ann Lee (1736–84). In 1774 she moved from England to America in search of religious freedom, and by the early 1780s began to attract converts. From 1788 subsequent leaders gathered her followers into a disciplined religious order. Shakers believed in a male and a female godhead and in Ann Lee as the second manifestation of the Christ spirit, and they insisted on celibacy and the confession of sins. The name Shaker derives from their charismatic form of worship, in which they sang, danced and shook with emotion. They were widely respected for their acts of benevolence and for the success of their communitarian experiment, founded on equality of the sexes, joint ownership of all property and the consecration of labour. At its peak in the 1840s, the Shakers had a membership estimated at 6000 in 19 communities scattered from Maine to Kentucky.

In the decades between 1820 and 1860 every aspect of Shaker life was rigidly dictated by the Millennial Laws of the sect, which provided the basis of all design. Shaker workmanship is characterized by its purity of line and lack of ornamentation, which grew from the Believers' respect for simplicity and usefulness and their dislike of all display asserting self, privilege and status. This painstaking austerity, running counter to all accepted popular taste and commercial demands in the 19th century, is manifest in all Shaker work. Design in any form was seldom worked out consciously in a formal, diagrammatic way, but evolved

from the craftsman's 'inner eye', as he drew on examples of earlier work. The Shaker way of life and means of production were not geared to the rapid industrialization of the latter part of the 19th century, and the decline of the celibate sect was hastened by legislation limiting the adoption of children.

BIBLIOGRAPHY

E. D. Andrews: *The Community Industries of the Shakers* (Albany, 1933)
The People Called Shakers: A Search for the Perfect Society (New York, 1953, rev., enlarged 1963)
M. L. Richmond: *Shaker Literature: A Bibliography*, 2 vols (Hanover, NH, 1977)
The Gift of Inspiration: Shaker and American Folk Art (exh. cat., ed. J. Sprigg; New York, Hirschl & Adler Gals, 1979)
M. Freeman: *Shaker: Life, Work, Art* (London, 1989)
S. J. Stein: *The Shaker Experience in America: A History of the United Society of Believers* (New Haven, 1992)
S. T. Swank: *Shaker Life, Art and Architecture* (New York, 1999)

MALCOLM JONES

1. Architecture. 2. Painting. 3. Decorative arts.

1. ARCHITECTURE. The Millennial Laws ordered that 'odd or fanciful styles of architecture may not be used . . . beadings, mouldings and cornices may not be made'. The majority of buildings were constructed of brick, wood or limestone, and their design sprang initially from local vernacular styles. None of those responsible for the principal planning and construction had any formal architectural training. Plans as such did not exist, and few written records of particular buildings survive. Moses Johnson (1752–1842), a young carpenter at Enfield, NH, may have been the greatest influence on Shaker building design. His first major construction was the First Church (1785; replaced 1824) at New Lebanon (now Mount Lebanon), NY, and he was responsible for many of the Meeting Houses with mansard (gambrel) roofs in New England. In addition to Johnson, the foremost Believer engaged in construction was Micajah Burnett (1791–1879) of Pleasant Hill, KY, who designed and constructed the graceful interior staircases there and did the overall planning of that community.

The Meeting House was the most important building in any Shaker community. One of the largest is at Mount Lebanon, built in 1824 to replace the original church. Its measurements are 24.38×19.81 m, excluding the porch (10.36×8.22 m). An outstanding feature of the rectangular Meeting House is the absence of any obvious interior support; the essential element in Shaker worship, the 'round dance', dictated the need for a spacious, uncluttered floor area. Consequently, an arched truss, the so-called 'rainbow', was used to support the roof. Separate entrances for male and female Believers were set into the longer walls, and a stepped observation gallery was provided at one end for visitors.

Light, space and cleanliness were vital characteristics of Shaker life, and perhaps the most outstanding feature of their building design is the large number of windows, even set into interior walls. To the Shakers, light and cleanliness were synonymous with good and the driving out of evil, and, while they sang of 'Mansions of Light', this preoccupation led directly to the simple, spartan style of both their architecture and interior design. Their dwelling houses were remarkably efficient places for feeding, sheltering

and maintaining the health and privacy of large numbers of people. These houses were dormitory structures, some of five storeys, consisting of simple, well-proportioned rooms (see colour pl. XXXI, 1) and, having regard to the basic Shaker tenet of celibacy, dividing halls and staircases, with dual exterior doors. The Family House was constructed for between 30 and 90 adults; that at Canterbury, NH, has 56 rooms. Interior floors were usually of bare, polished wood, with interior wall colours specified by strict rules (Ministry Green, Meetinghouse Blue and Trustee Brown). The exterior finish of the Meeting House only was white, with other buildings of 'a darker hue'. Around the dwelling house were workshops, machine-shops, laundry, saw-mill and stables. Most communities had a separate infirmary building.

Ventilation was of paramount importance, and ingenious wooden transoms were fitted to doors and sliding panes to windows. In the school-house at Canterbury, whole windows, held in place by several screwed wooden strips, could be quickly removed for cleaning or repair. In the two-storey structure, an adjustable trap-door in the lower ceiling was used for summer cooling, and all the buildings at Canterbury were insulated with moss and bark inserted between the roof shingles and interior plaster.

Agriculture was an important facet of non-spiritual Shaker life, and the community barns, often extremely large structures, were vital elements in village planning. The most remarkable extant Shaker building is the massive, stone-built Round Barn at Hancock, MA (1826; see fig. 1), designed, according to oral tradition, by Daniel Goodrich. The top level is a haystore, enabling the feed to be pitched down to the stalls in the centre level. The lower level forms a waste pit. The highly imaginative and progressive circular plan facilitated the rapid feeding of a large herd from the central point with a minimum use of manpower and allowed for the easy entry and exit of hay carts. The barn is about 27.5 m in diameter at its base, where the supporting wall is approximately 9 m thick. The original wooden framing was replaced after a fire in 1870. The rectangular wooden barn at Canterbury (1858; destr. 1975) was 60.96 m long by 13.71 m wide. End ramps increased the length by a further 12.19 m. A raised, wagon-wide 'central bridge' ran along its whole length, again enabling hay to be forked down from the wagons rather than up. Below the hay floor were stalls for 100 cattle, each with its own trap-door over the waste pit beneath. Provision was also made for warming the animals' drinking water in winter.

In spite of their solidity and high degree of maintenance, many Shaker buildings do not survive. As the numbers of Believers declined, unused structures were simply dismantled rather than being allowed to fall into neglect and become a blemish on the community.

BIBLIOGRAPHY
W. L. Lassiter: *Shaker Architecture* (New York, 1966)
J. Poppeliers, ed.: *Shaker Built: A Catalog of Shaker Architectural Records from the Historic American Buildings Survey* (Washington, DC, 1974)
 MALCOLM JONES

2. PAINTING. As codified in the Millennial Laws, the Shaker ethos virtually precluded the graphic arts: 'No maps, Charts, and no pictures or paintings, shall ever be hung up in your dwelling-rooms, shops, or Office. And no pictures or paintings set in frames, with glass before them shall ever be among you.' Nevertheless, graphic arts did develop within the Shaker communities, particularly in the forms of 'village views' and 'gift drawings'.

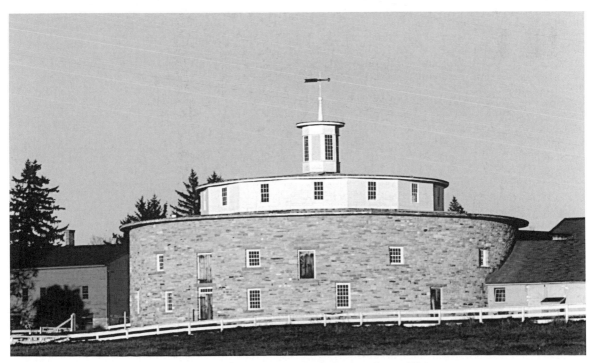

1. Shaker architecture, the Round Barn, attributed to Daniel Goodrich, Hancock, Massachusetts, 1826

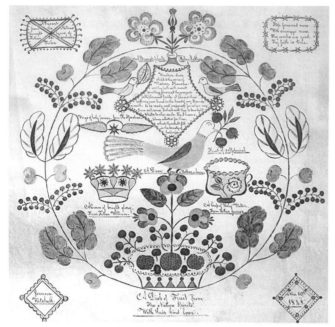

2. Shaker gift drawing attributed to Polly Jane Reed: *A Dish of Fruit from the Native Spirits with their Kind Love* [to Joanna Kitchell], ink and watercolour, 225×225 mm, 1848 (Cleveland, OH, Western Reserve Historical Society)

(i) *Village views.* The village views—sketches that Shakers most commonly called 'plans', executed in pencil, ink and watercolour on paper—were a product of the communitarian side of Shaker life. Shaker men made these works as an extension of their practical activities to document land use and buildings in their communities. Forty-one village views made between 1806 and 1880 have been found (Emlen); these are valuable chiefly as historic records of the Shaker communities. Others mentioned in early documents are untraced. A few of the works are approximately 200×250 mm, but most are on much larger sheets of paper, or even several sheets pasted together to form a scroll.

Related to surveyors' maps, the plans show coloured, isometric sketches of all buildings within the boundaries of the community. These are precise, literal and carefully labelled. Typically, the Shaker artist showed three-dimensional structures standing on the two-dimensional plane, producing a naive effect. The drawings have no unity of orientation; the artist chose his vantage-point in the middle of the village and rotated the map as he turned to sketch different buildings. The most skilled and prolific of the artists were Henry Clay Blinn (1824–1905), David Austin Buckingham (1803–85), Joshua H. Bussell (1816–1900), George Kendall (*b* 1813) and Isaac Newton Youngs (1793–1865).

From most of these hands fewer than five village views survive, executed in the 1830s or 1840s, but Joshua Bussell executed seventeen, many in the 1850s and the rest in the 1880s. Elder Joshua lived in Alfred, ME, and was a cobbler by trade. He was unusual in including people and animals in his drawings and in absorbing popular influences. After encountering several lithographs and a wood-engraving of the Shaker village at Canterbury in the *American Magazine*

of Useful and Entertaining Knowledge (Nov 1835), he shifted from isometric sketches to landscape views of the Maine communities, drawing in perspective and sometimes using a bird's-eye view or an inset (e.g. *Plan of Poland Hill Shaker Village: In the State of Maine, c.* 1854; Sabbathday Lake, ME, Shaker Mus.).

(ii) *Gift drawings.* Shaker women produced delicate drawings originating in a gift of spiritual inspiration. Like the men, they used pencil, ink and watercolour, but they generally worked on a smaller scale and were more prolific. Some 190 examples survive, possibly only one fifth of those produced (see Patterson, 1983).

The sisters' gift drawings (also called 'spirit drawings' and 'inspirational drawings') date from the 1840s and 1850s. They must be understood as products of a powerful revival known as the 'Era of Spirit Manifestations' or 'Mother's Work', which arose as a response to stresses within the communities. In the 1830s the Shakers had begun accepting orphans as wards and hoped that they would become members. Instead, many of these young people quickly became restive. The anxiety their disaffection roused among the Believers prepared the way for Mother's Work. Beginning unexpectedly among young girls at Watervliet, NY, in 1837, Mother's Work quickly swept all Shaker villages and lasted for more than a decade. It produced intense spiritualist phenomena: trances, visions, possession states and a rich profusion of spirit-inspired songs and rituals. These hastened the departure of many of the disaffected but won the credence and strengthened the faith of others. Shaker records of the manifestations rarely distinguish between gift drawings, written or oral messages and songs. When they refer to the drawings at all, the language denotes their function ('token of love'), format ('scroll', 'roll') or symbolic mode ('emblem', 'type'). Each artist was an 'instrument' for but one of the kinds of gifts successively produced by Mother's Work.

Most of the first gift drawings (from *c.* 1843) are mysterious 'signs and figures'. For six of these, the instruments appear to have been Semantha Fairbanks (1804–52) and Mary Wicks (*b* 1819; apostatized 1846). Through them a 'Holy Angel of Many Signs' delivered designs that are a visual equivalent of speaking in tongues. These had a preparatory purpose: to disarm carnal reason by showing that 'God is able to confound the Wisdom of the wise'.

Another form of gift drawing seems more nearly equivalent to oral testimony recounting a vision. The clearest examples are several bold paintings by Hannah Cohoon (1788–1864), in particular a *Bower of Mulberry Trees* (Hancock, MA, Shaker Village). Her inscription on the painting clearly indicates that she was attempting to record the setting of a vision in which she beheld two spirits supping from a table and drinking from a spring.

By far the most common gift drawings are ones labelled as a 'token of love', a 'gift', a 'present', a 'reward' or a 'word of notice' sent from the spirit world through the artist to a worthy member of the Society. Some of these tokens are verbal messages of love and encouragement illuminated with drawings of angels, doves, lamps, roses and stars. Other drawings (see fig. 2) mix words of

encouragement with labelled groups of emblematic objects from the spirit world: 'Fruit of Self Denial', 'A Crown of Glory', 'Roses of Holy Wisdom's Approbation' etc. Although lacking visual models within the Shaker tradition, the artists clearly drew on memories of objects seen before they entered Shakerism—gravestones, painted tinware and especially quilts, samplers and embroidery—but imbued them with a powerful devotional impulse. The most talented artists executing the tokens were Miranda Barber (1819–71), Sarah Bates (1792–1881), Polly Collins (1808–84) and the skilled and prolific Polly Jane Reed (1818–81). Eleven Shaker sisters in two villages, Hancock and New Lebanon, executed most of the gift drawings. They had no models to emulate, few occasions to practise and little recognition for their work. Their drawings served communal needs, but did so less well than song.

BIBLIOGRAPHY

D. Sellin: 'Shaker Inspirational Drawings', *Bull. Philadelphia Mus. A.*, xvii (1962), pp. 93–100
E. D. Andrews and F. Andrews: *Visions of the Heavenly Sphere: A Study in Shaker Religious Art* (Charlottesville, 1969)
D. Patterson: *The Shaker Spiritual* (Princeton, 1979)
R. Wolfe: 'Hannah Cohoon, 1788–1864', *American Folk Painters of Three Centuries*, ed. J. Lipman and T. Armstrong (New York, 1980), pp. 58–65
D. Patterson: *Gift Drawing and Gift Song: A Study of Two Forms of Shaker Inspiration* (Sabbathday Lake, 1983)
R. P. Emlen: *Shaker Village Views: Illustrated Maps and Landscape Drawings by Shaker Artists of the Nineteenth Century* (Hanover, NH, 1987)
S. Kitch: '"As a Sign that All May Understand": Shaker Gift Drawings and Female Spiritual Power', *Winterthur Port.*, xxiv (1989), pp. 1–28
D. Patterson: 'Shaker Visionary Art', *Antiques*, cxxxvii (1990), pp. 460–73
S. Promey: *Spiritual Spectacles: Vision and Image in Mid-nineteenth-century Shakerism* (Bloomington, 1993)
G. C. Wertkin: '"Given by Inspiration": Shaker Drawings and Manuscripts in the American Society for Psychical Research', *Folk A.*, xx (1995), pp. 56–62
W. D. Garrett: 'Shaker Gift Drawings', *Important Americana*, sale, New York, Sotheby's, 1995, lots 1560–61

DANIEL W. PATTERSON

3. DECORATIVE ARTS. To the Shakers, ornament of any kind was associated with ostentation and vanity: 'The beautiful, as you call it, is absurd and abnormal. It has no business with us. The divine man has no right to waste money upon what you would call beauty, in his house or his daily life, while there are people living in misery' (Shaker Elder Frederick Evans, quoted in Nordhoff, pp. 164-5). Paradoxically, while denying beauty, the Shakers apparently could not help producing it, particularly in their graceful, austere furniture, in which form always followed function. In Shaker furniture, the form itself, devoid of surface decoration or ornament, is paramount, and its first and most important principle is simplicity. To the Shaker, waste of any kind was abhorrent, and this concern for economy, when applied to free-standing furniture, resulted in an extraordinary lightness and elegance. Regularity of line, harmony and fitness for purpose produced their own beauty, as did the nature of the wood itself. Veneers were frowned on as 'sinful deception', and even identification of particular craftsmen was discouraged by the Elders. In consequence, precise authorship of specific pieces is, in the majority of cases, impossible to establish, though at least 27 craftsmen, including Orren Haskins (1816–92), did leave their marks on at least some of their cabinets,

clocks and tools (see Grant and Allen). Should a man begin to exhibit too obvious a pride in his work, he would be moved to another area of construction.

The sect's earliest chair factory was established at New Lebanon in 1789. Pieces dating from that time were painted, unlike the delicate staining and varnishing of later years. Woods most frequently used were maple, pine and cherry; bird's-eye and curly maple were specially favoured. All were carefully seasoned for many months, and, wherever possible, wooden pegs rather than nails were used.

In early chairs the mushroom-topped front post, turned in one piece, was extensively used before being superseded by the more elegant vase shape, with its separate top. The Shakers invented 'tilting buttons' on back chair legs, which, together with 'swivel' feet, cut down wear on both chair and floor. As the 19th century progressed, chairs generally became even more delicate in construction, with arms and slats often slimmed to between 63 and 127 mm. The Shakers probably produced the first rocking chair in America on a systematic scale (see fig. 3). Low arm rests and narrow, four-slatted backs held by wooden pegs and topped by elongated finials emphasized the chair's height and gave it a natural grace. 'Shawl-bar' rockers from New Lebanon incorporated a bar across the back top, from which a shawl or cushion could be hung to minimize

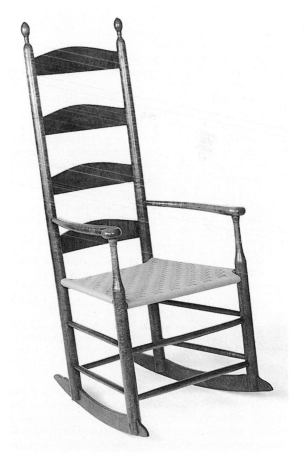

3. Shaker rocking chair, bird's-eye maple, replacement canvas-tape seat, h. 1.12 m, c. 1850 (Hancock, MA, Hancock Shaker Village)

draughts. Chairs with short runners, favoured by the space-conscious Shakers, were termed 'suicide rockers'. Shaker chairs are numbered in size from the largest (7) to the smallest (0), and it was boasted that the number 7 weighed no more than 10 lbs.

Much furniture was used on a cooperative basis, and this led naturally to some unique features of design. Sewing desks and stands, for example, were often fitted with double sets of drawers at front and sides, with concealed sliding cutting boards, and space-saving vertical drawers for spool storage. At Canterbury, NH, there are in one room 88 built-in drawers of incredibly smooth, glowing pine, dovetailed front and back, and 'walk-in' clothes cupboards, dating from 1795. Buildings and rooms were numbered, as were all such movables as drawers and tools, for, to the Shaker, order was an act of worship.

Concerning the use of colour in interiors and textiles, the Millennial Laws dictated that: 'Bedsteads should be painted green: "comfortables" should be of a modest colour. Blankets for outside spreads should be blue and white, but not checked or striped ... window curtains should be white, or of a blue or green shade ... and not red, checked, striped or flowered ...'. A vital element of the Shaker interior was the beautifully hand-turned and finely proportioned wooden peg, the mushroom cap being the most characteristic shape. Each community would have many thousands of these, not only for the hanging of clothes but to enable cupboards, utensils and chairs to be hung on the walls, leaving an uncluttered, highly flexible and easily cleaned floor area.

Nests of delicate oval boxes were used for storage. Each box was jointed by interwoven wooden 'fingers' that could 'breathe' without warping and non-rusting copper nails, which were unique to the Shakers. The 'flat' broom—infinitely more efficient than its round predecessor—was a Shaker innovation in 1798. Exquisite satin 'strawberries', with hanging ribbons and filled with powdered emery, were produced for sharpening sewing needles. The Shaker communities of Kentucky were among the earliest silk producers (c. 1832) in the USA.

BIBLIOGRAPHY
C. Nordhoff: *The Communistic Societies of the United States* (London, 1875)
E. D. Andrews: *Shaker Furniture: The Craftsmanship of an American Communal Sect* (New York, 1950)
E. D. Andrews and F. Andrews: *Religion in Wood: A Book of Shaker Furniture* (Bloomington, 1966)
J. G. Shea: *The American Shakers and their Furniture* (New York, 1971)
R. F. W. Meader: *Illustrated Guide to Shaker Furniture* (New York, 1972)
J. V. Grant and D. R. Allen: *Shaker Furniture Makers* (Middlefield, CT, 1989)
J. M. Burks: 'The Evolution of Design in Shaker Furniture', *Antiques*, cxlv (May 1994), pp. 732–41
Making his Mark: The Work of Shaker Craftsman Orren Haskins (exh. cat. by E. M. Budis, Old Chatham, NY, Shaker Mus. & Lib., 1997)
Shaker: The Art of Craftsmanship (exh. cat., London, Barbican Cent., 1998)
MALCOLM JONES

Sharples, James. (*b* 1751–2; *d* New York, 26 Feb 1811). English painter and pastellist, active in the USA. He worked in Bristol, Liverpool and Bath before he went to the USA with his family, which consisted of his third wife, Ellen, née Wallace (1769–1849), and children, Felix Thomas Sharples (*c.* 1786–after 1823), son of his second wife, James Sharples jr (*c.* 1788–1839) and Rolinda Sharples

(1793 or 1794–1838). From 1796 to 1801 he worked mainly in Philadelphia and New York, making profile and three-quarter bust-size pastel portraits, which measured about 230×180 mm. He may have used a mechanical drawing aid. His pastels were drawn with a delicate, precise touch, using predominantly black, white, grey and flesh tones with blue backgrounds. He produced vivid images of many American and English sitters, including George Washington, John Adams, James and Dolley Madison, and Joseph Priestley. Other members of the family duplicated his portraits, making it difficult to distinguish the originals. The family returned to Bath in 1801, but soon went back to the USA, Felix and James jr in 1806, and their parents and sister Rolinda in 1809. After James Sharples's death, all but Felix returned to England. Felix's later portraits are notable for his preference for full-face and three-quarter views and a broader technique than his father's.

Collections of work by the Sharples family are in the City of Bristol Museum and Art Gallery and the Independence National Historical Park, Philadelphia.

BIBLIOGRAPHY
K. Knox: *The Sharples* (New Haven, 1930/*R* New York, 1972)
A. Wilson: 'The Sharples Family of Painters', *Antiques*, c/5 (1971), pp. 740–43
W. B. Floyd: 'The Portraits and Paintings at Mount Vernon from 1754 to 1799, part II', *Antiques*, c/6 (1971), pp. 894–9 (897–8)
D. Meschutt: 'Portraits of Anthony Wayne: Re-identifications and Re-attributions', *Amer. A.J.*, xv/2 (1983), pp. 32–42
ELLEN G. MILES

Shattuck, Aaron Draper (*b* Francestown, NH, 9 March 1832; *d* Granby, CT, 30 July 1928). American painter. He began his career as a portrait painter in Boston, MA, but moved to New York in 1852 to enrol in antique and life classes at the National Academy of Design; he first exhibited there in 1855. During his studies he turned to landscape painting, becoming a successful member of the second generation of the HUDSON RIVER SCHOOL. Such wilderness and marine paintings as *Autumnal Snow on Mt Washington* (1856; Poughkeepsie, NY, Vassar Coll., Frances Lehman Loeb A. Cent.) combine precise foreground detail with a more painterly realism in the middle- and background, following the Hudson River tradition. Inspired by the American Pre-Raphaelite movement, Shattuck produced a number of carefully observed nature studies including *Leaf Study with Yellow Swallowtail* (*c.* 1859; Santa Barbara, CA, Jo Ann and Julian Ganz jr priv. col.). Many of his works also reveal a knowledge of the Luminist aesthetic, with its concentration on soft lyrical light and colour and a quiet, poetic evocation of nature. During the 1870s Shattuck's subject-matter shifted from wilderness to pastoral themes, reflecting the growing taste in America for the mood of Barbizon school pictures. Because of his discontent with the art world and a dissatisfaction with his own work, complicated by a serious illness, Shattuck stopped painting in 1888. Thereafter he experimented in horticulture and animal breeding and invented a patented metal key for stretching canvases.

BIBLIOGRAPHY
Aaron Draper Shattuck, N.A., 1832–1928: A Retrospective Exhibition (exh. cat. by C. B. Ferguson, New Britain, CT, Mus. Amer. A., 1970)

J. W. Myers: *Aaron Draper Shattuck, 1832–1928: Painter of Landscape and Student of Nature's Charms* (diss., Newark U. DE, 1981; microfilm, Ann Arbor, 1981)

An American Perspective: Nineteenth-century Art from the Collection of Jo Ann and Julian Ganz jr (exh. cat. by J. Wilmerding, L. Ayres and E. A. Powell, Washington, DC, N.G.A., 1981)

JOHN WALKER MYERS

Shaw, Joshua (*b* Bellingborough, Lincs, *c.* 1777; *d* Burlington, NJ, 8 Sept 1860). American painter of English birth. He is a pivotal figure in the history of American landscape painting. Despite his modest origins as a sign-painter in Manchester, he achieved recognition in Bath and London before moving to America in 1817. He exhibited at the Royal Academy and the British Institution. One of the most important paintings from this period, *The Deluge* (1813; New York, Met.), was favourably compared with the treatment of a similar subject by J. M. W. Turner (1775–1851), when shown at the British Institution.

Shaw accompanied Benjamin West's *Christ Healing the Sick in the Temple* (1816; Philadelphia, PA Hosp.) to Philadelphia, when he moved to America. Shortly after his arrival, he travelled along the East Coast making sketches that eventually resulted in *Picturesque Views of American Scenery*; engraved by John Hill and published between 1820 and 1821, this group of scenes, which are Romantic in their handling of light and setting, is a landmark in the development of American landscape art. Shaw, who considered himself a historical landscape painter, created pastoral visions of England and America as well as fanciful scenes. His compositions at times recall the work of Richard Wilson (1713 or 1714–1782) and Thomas Barker of Bath (1813–82). Many of his paintings were exhibited at the Pennsylvania Academy of the Fine Arts and the Artists' Fund Society in Philadelphia. He also showed frequently in New York and Boston. His subjects ranged from imaginary landscapes with castle ruins (*Stormy Landscape*, 1818; priv. col., see 1986 exh. cat., p. 48) to depictions of specific British sites (*Landscape with Cattle*, 1818; Youngstown, OH, Butler Inst. Amer. A.) and renderings of American scenes (*View of Kiskeminitas*, 1838; Washington, DC, State Dept). His late works frequently depict Italianate landscapes reminiscent of compositions by Claude Lorrain (*Early Morning: A Dream of Carthage*, 1840s; Utica, NY, Munson–Williams–Proctor Inst.). A prominent figure in the artistic life of Philadelphia for several decades, Shaw was an irascible person who alienated many of his colleagues. About 1843 he moved to New Jersey.

BIBLIOGRAPHY
M. C. Woods: *Joshua Shaw: A Study of the Artist and his Paintings* (MA thesis, Los Angeles, U. CA, 1971)

Views and Visions: American Landscape before 1830 (exh. cat. by E. J. Nygren and others, Washington, DC, Corcoran Gal. A., 1986)

EDWARD J. NYGREN

Shaw, Quincy Adams (*b* Boston, MA, 8 Feb 1825; *d* Jamaica Plains, MA, 11 June 1908). American businessman and collector. He added to inherited wealth by successful copper mining operations in Michigan in the 1860s. On his honeymoon in Paris in 1860, Shaw met the French artist Jean-François Millet (1814–75). By 1872 Millet had promised to make Shaw a painting from a drawing that he

admired, and in 1874 Shaw purchased five oil paintings by Millet from William Morris Hunt (*see* HUNT, (1)). This was the start of a concentrated collecting effort that resulted in the largest gathering of Millet's art in one place, the range of which often amazed visitors to the Shaw home. Shaw also bought some Italian Renaissance sculpture, including works by Donatello (1386 or 1387–1466), Bartolomeo Bellano (1437/8–1496/7) and the members of the della Robbia family. The Boston Museum of Fine Arts received several items from his Renaissance collection, including an altarpiece by Bartolomeo Vivarini (*fl c.* 1440–after 1500), an *Annunciation* by Palma Giovane (*c.* 1548–1628) and a relief by Luca della Robbia (1933/ 1400–1482), and in 1917 Shaw's children donated all 56 pieces of his Millet collection to the Museum.

BIBLIOGRAPHY
W. Whitehill: *Museum of Fine Arts of Boston: A Centennial History* (Cambridge, MA, 1970), pp. 328–31

The Great Boston Collectors: Paintings from the Museum of Fine Arts (exh. cat. by C. Troyen and P. Tabbaa, Boston, MA, Mus. F.A., 1984), p. 19

DARRYL PATRICK

Shepley, Rutan & Coolidge. American architectural partnership formed in 1886 by George Foster Shepley (*b* St Louis, MO, 1860; *d* Promontonio, Switzerland, 17 July 1903), Charles Hercules Rutan (*b* Newark, NJ, 1851; *d* Brookline, MA, 17 Dec 1914) and Charles Allerton Coolidge (*b* Boston, MA, 1858; *d* Locust Valley, Long Island, NY, 1 April 1936). Shepley was trained at Washington University, St Louis, and continued his architectural training at the Massachusetts Institute of Technology (MIT) from 1882, when he joined the office of H. H. Richardson as a draughtsman. Rutan was trained by the architectural firm in Boston of H. H. Richardson and Charles D. Gambrill (1834–80) and was the former's chief engineer from 1880. Coolidge graduated from Harvard in 1881 and attended MIT from 1881 to 1883, when he joined Richardson, also as a draughtsman.

Shepley, Rutan and Coolidge established their partnership at Richardson's death (1886), their initial goal being to complete various projects that he had started. These included the Lionberger Warehouse (1887), St Louis, the Public Library (1887), New Orleans, and a series of railway stations for the Boston & Albany Railroad. Their first major independent project was the campus of Stanford University (1892), Palo Alto, CA. Here Richardson's Romanesque Revival style is still evident, particularly in the Memorial Church, an adaptation of his Trinity Church (commissioned 1872) in Boston. The arcades enclosing the campus quadrangles also incorporate the Romanesque Revival style, with Byzantine references in the short columns and deeply cut decoration.

The partnership did not, however, continue to develop Richardson's style. From the 1890s it embraced the current trend for classical styles as well as accommodating the needs and requirements of its patrons. This remarkable adaptability is seen in all its subsequent work. The Ames Building (1889), 1 Court Street, Boston, a 14-storey office building and the city's first skyscraper, was the partnership's first essay in the Renaissance Revival style being promoted by McKim, Mead & White, although it retained some elements of the Richardsonian Romanesque. More

complete embodiments of Renaissance Revival appear in major commissions from Chicago: the Public Library (1893), 78 East Washington Street, and the Art Institute of Chicago (1897), Michigan Avenue and Adams Street. The former is very close in conception to McKim, Mead & White's Boston Public Library (1887–95; *see* McKIM, MEAD & WHITE, fig. 2), particularly in its use of glazed arcades. Other works of this period are in a completely different style. Conant Hall and Perkins Hall (1894) at Harvard University, Cambridge, MA, for example, are in the Georgian Revival style because the authorities wanted the new buildings on the campus to be visually homogeneous with earlier ones. A later complex of buildings in the Renaissance style is the Harvard Medical School group (1907), Longwood Avenue, Boston. These five buildings are organized in a U-shaped plan reminiscent of the layout of Thomas Jefferson's University of Virginia, Charlottesville. Buildings designed by Shepley, Rutan & Coolidge for the University of Chicago are in yet another style—the collegiate Gothic, largely inspired by the colleges at Oxford and Cambridge universities in England and dictated by the trustees of the University of Chicago. The earliest structures built there by the partnership included Hutchinson Commons and the Reynolds Club (both 1903).

Although Shepley died in 1903, the partnership retained its original name until 1914, the year of Rutan's death. Between these years, Coolidge lived mainly in Chicago as overseer of the branch office there. He was primarily responsible for buildings at the University of Chicago, such as the Bartlett Gymnasium (1904) and the Harper Memorial Library (1912). In 1914 Coolidge formed the practice of Coolidge, Shepley, Bulfinch & Abbott, which subsequently became Shepley, Bulfinch, Richardson & Abbott.

BIBLIOGRAPHY

Macmillan Enc. Archit.

R. Sturgis: 'The Work of Shepley, Rutan and Coolidge', *Archit. Rec.*, iii (1895–6) [special issue]

J. D. Forbes: 'Shepley, Bulfinch, Richardson & Abbott, Architects: An Introduction', *J. Soc. Archit. Hist.*, xvii/3 (1958), pp. 19–31

J. F. O'Gorman: *H. H. Richardson and his Office* (Boston, 1974/R Cambridge, MA, 1982)

P. V. Turner: *The Founders and the Architects: The Design of Stanford University* (Stanford, 1976)

J. F. Block: *The Uses of Gothic: Planning and Building the Campus of the University of Chicago, 1892–32* (Chicago, 1983)

J. K. Ochsner: 'Architecture for the Boston & Albany Railroad, 1881–94', *J. Soc. Archit. Hist.*, xlvii/2 (1988), pp. 109–31

L. S. Phipps: 'The 1893 Art Institute Building and the Paris of America: Aspirations of Patrons and Architects in late Nineteenth Century Chicago', *Mus. Stud.*, xiv/l (1988), pp. 28–45

WALTER SMITH

Shingle style. Late 19th-century architectural style in the USA. The style, identified by V. J. Scully in 1952, originated in New England *c.* 1880 and became popular across the whole of the USA by the beginning of the next decade. Broadly, it was a return to traditionalism and discipline after the licence of the High Victorian architecture of the 1860s and 1870s. More precisely, it was a reaction against the American Queen Anne Revival: it avoided the more extreme picturesque effects and varied wall surfaces and textures of Queen Anne in favour of the uniform wall covering of shingles that give the style its name. This use of shingles was also felt to make the style American, which

the Queen Anne Revival, originating in England, could never really be; it was, as H.-R. Hitchcock wrote, 'to its protagonists already a sort of Colonial Revival'.

In Shingle-style houses the walls were perceived as thin, light membranes shaped by the space they enclosed, an effect heightened by segmental bays or round turrets swelling out from the body of the house. Sometimes the shingled walls seem all the thinner and lighter for being contrasted with a basement of rubble masonry or fieldstone. Roofs were usually of gentle pitch with broad gables; in two-storey houses the roofs often continued down and out to ground-floor level in a manner reminiscent of the lean-to of 17th-century New England 'saltbox' houses. The gambrel roof was more common than the hipped. The tall, panelled brick chimneys that were a feature of the Queen Anne Revival were used by William Ralph Emerson for the Charles J. Morrill Cottage (now Redwoods), Bar Harbor, ME, in the first completely shingled house (1879), but generally chimneys were less obtrusive, conforming to the prevailing horizontality of the style.

The plan of the Shingle-style house was characterized by freedom and openness. Typically, the nucleus was a living-hall complete with fireplace, a feature inherited from the English Queen Anne houses of R. Norman Shaw (1831–1912). The main stairs often rose from the living-hall, around which were disposed other ground-floor reception rooms. These rooms were often entered through wide openings with sliding doors, so that the whole area could be made into a single, if subdivided, space. Verandahs or piazzas, instead of being attachments as they were in earlier 19th-century styles, were integral parts of the plan.

A comparison of the Isaac Bell jr House (1881–3), Newport, RI (*see* McKIM, MEAD & WHITE, fig. 1), and the

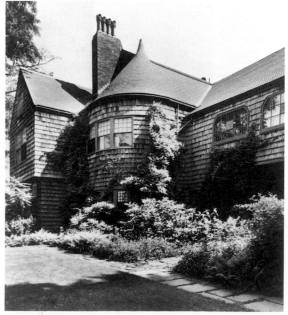

Shingle style, Mrs M. F. Stoughton House by H. H. Richardson, Cambridge, Massachusetts, completed 1883

Mrs. M. F. Stoughton House (completed 1883), Cambridge, MA, by H. H. Richardson (see fig.), reveals a variety typical of the Shingle style. Although they share almost all of the style's general characteristics, they are vastly different in spirit and overall effect. The Bell House, although quite compact, is picturesque in its massing: round-ended shingles add to the texture of the walls, and posts imitating bamboo (there are other oriental features in the interior) support the verandah roof. Everything is delicate and decorative in the Stanford White manner. The Stoughton House, in contrast, has long, level roof lines and is clad in uniform rectangular shingles. In its simplicity of form and lack of ornament, it is entirely characteristic of Richardson.

Among the other architects who did notable work in the style were Robert Swain Peabody, John G. Sterns (1843–1917), Arthur Little and John Calvin Stevens in New England, Hugo Lamb (1848–1903), Charles A. Rich (1855–1943) and Bruce Price in New York, Wilson Eyre in Pennsylvania, and John Wellborn Root and Joseph Lyman Silsbee in Chicago. In California, A. Page Brown (1859–96), Ernest Coxhead and Willis Jefferson Polk worked in the style in the 1890s. Although it was primarily a domestic style, it was employed for at least two outstanding churches: the Lake View Presbyterian Church (1887), Chicago, by Root, and St John's Episcopal Church (1891), Monterey, CA, by Coxhead. Owing to the influence of Scully's book of 1955, which established the currency of the term, the style acquired a following among Postmodern architects.

BIBLIOGRAPHY
A. F. Downing and V. J. Scully jr: *The Architectural Heritage of Newport, Rhode Island, 1640–1915* (Cambridge, MA, 1952, rev. New York, 2/1967)
V. J. Scully jr: *The Shingle Style: Architectural Theory and Design from Richardson to the Origins of Wright* (New Haven, 1955); rev. as *The Shingle Style and the Stick Style* (New Haven, 1971)
H.-R. Hitchcock: *Architecture: Nineteenth and Twentieth Centuries*, Pelican Hist. A. (Harmondsworth, 1958, rev. 4/1977)
V. J. Scully jr: *The Shingle Style Today: Or, The Historian's Revenge* (New York, 1974)
S. B. Woodbridge, ed.: *Bay Area Houses* (New York, 1976)

MARCUS WHIFFEN

Shinn, Everett (*b* Woodstown, NJ, 6 Nov 1876; *d* New York, 1 May 1953). American painter, illustrator, designer, playwright and film director. He studied industrial design at the Spring Garden School in Philadelphia from 1888 to 1890. In 1893 he became an illustrator at the *Philadelphia Press*. Simultaneously he attended the Pennsylvania Academy of Fine Arts, Philadelphia, where he met Robert Henri, John Sloan, William J. Glackens and George Luks. Their style of urban realism prompted him to depict the bleak aspects of city life. In 1897 Shinn moved to New York and produced illustrations for several newspapers and magazines, for example *Mark Twain* (March 1900; see Perlman, p. 80), a frontispiece for *The Critic*. He also drew sketches for a novel by William Dean Howells on New York; although the novel was not published, Shinn's drawings brought him national recognition.

Shinn's work changed radically when, on a trip to Paris in 1901, he was inspired by the theatre scenes of Manet (1832–83), Degas (1834–1917) and Jean-Louis Forain (1852–1931). He began to paint performers in action,

from unusual vantage points, as in *London Hippodrome* (1902; Chicago, IL, A. Inst.). Shinn was also influenced by Rococo painting in his choice of motifs for the decorations of the Belasco Theatre, New York (1907), and for private homes.

In the first decade of the century, Shinn held several one-man shows; he also participated in the exhibition by THE EIGHT at the Macbeth Galleries, New York (1908), and the exhibition of Independent Artists in New York (1910). In 1911 he painted murals for Trenton City Hall, NJ, which were unusual in their depiction of labourers at work, rather than the allegorical or historical figures typical of other contemporary cycles. Despite his success, in 1913 Shinn abandoned painting to become a playwright, film director and interior designer. Most of his literary projects failed, however, and eventually Shinn resorted to commercial art, which occupied him until his death.

BIBLIOGRAPHY
E. De Shazo: *Everett Shinn, 1876–1953: A Figure in his Time* (New York, 1974)
B. B. Perlman: *The Immortal Eight: American Painting from Eakins to the Armory Show, 1870–1913* (New York, 1962); rev. as *The Immortal Eight and its Influence* (1983)
City Life Illustrated, 1890–1940: Sloan, Glackens, Luks, Shinn, their Friends and Followers (exh. cat., Wilmington, DE A. Mus., 1980)
T. Folk: 'Everett Shinn: The Trenton Murals', *A. Mag.*, lvi/2 (1981), pp. 136–8
L. S. Ferber, 'Stagestruck: The Theater Subjects of Everett Shinn', *Stud. Hist. A.* [Washington, DC], xxxvii (1990), pp. 50–67
S. L. Yount: 'Consuming Drama: Everett Shinn and the Spectacular City', *Amer. A.*, vi/4 (Fall 1992), pp. 86–109

For further bibliography see EIGHT, THE.

JANET MARSTINE

Shirlaw, Walter (*b* Paisley, Strathclyde, 6 Aug 1838; *d* Madrid, 26 Dec 1909). American painter, illustrator and teacher of Scottish birth. He moved to America with his parents in 1841. At the age of 14 he was apprenticed to a banknote engraving firm in New York. He exhibited his first painting at the National Academy of Design, New York, in 1861, although at this point he was largely self-taught. In Chicago (1865–70) he again worked as an engraver and was active in founding the Chicago Academy of Design. In 1870 Shirlaw went abroad. Unable to study painting in Paris because of the Franco-Prussian War, he went, instead, to Munich, where in 1871 he enrolled at the Akademie der Bildenden Künste. During the next six years he studied with several important Munich teachers and mastered the dark, painterly realism adopted also by Frank Duveneck and William Merritt Chase, compatriots Shirlaw became associated with as leaders of the Munich school. *Toning the Bell* (1874; Chicago, IL, A. Inst.; see fig.) is representative of the Munich style he helped to introduce in America. Returning to New York in 1877, he was a founder-member and first president of the Society of American Artists, as well as an influential teacher at the Art Students League. Elected to the National Academy in 1888, Shirlaw was also an early popularizer of mural painting in late 19th-century America, contributing decorations to the World's Columbian Exposition in Chicago in 1893 and the allegorical *Sciences* (1895; *in situ*) for the Library of Congress, Washington, DC. His last years were devoted primarily to travel in Europe and to private teaching.

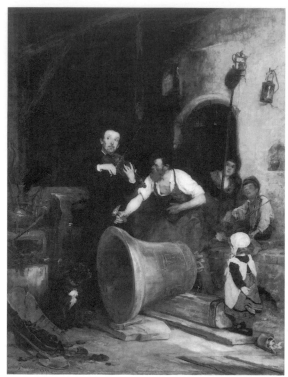

Walter Shirlaw: *Toning the Bell*, oil on canvas, 1016×762 mm, 1874 (Chicago, IL, Art Institute of Chicago)

BIBLIOGRAPHY
T. H. Bartlett: 'Walter Shirlaw', *Amer. A. Rev.*, ii (1881), pp. 97–102, 145–9
D. A. Dreier: 'Walter Shirlaw', *A. America*, vii (1919), pp. 206–16
JAMES C. COOKE

Shryock, Gideon (*b* Lexington, KY, 15 Nov 1802; *d* Louisville, KY, 19 June 1880). American architect. After attending the Lancastrian Academy in Lexington, KY, he learnt about procedures of construction from his father who was a builder. He also gained an appreciation for architectural refinement from books in his father's library, which included at least one volume of Asher Benjamin's works. In 1823 he went to Philadelphia to study architecture under William Strickland, a leading proponent of the Greek Revival; Strickland was then working on the Second Bank of the United States (1818–24; see STRICKLAND, WILLIAM, fig. 1), a building that took the Athenian Parthenon as its model.

After spending about a year in Philadelphia, Shryock returned to Lexington, where he became one of the most notable designers in the Greek Revival style. His best buildings were generally distinguished by rational planning, handsome proportions and archaeologically accurate detail. In 1826 he won the competition for the design of the third State House (1827–30) of Kentucky in Frankfort. This monumental work with a hexastyle portico was based, according to Shryock, on the Temple of Athena Polias at Priene in Ionia. In plan it had a central entrance hall, which allowed access to a rotunda containing a stairway leading to the House of Representatives and Senate Chamber on the first floor. Equally impressive are Morrison College

(1830–34), Transylvania University, Lexington, and the Jefferson County Court House (1838–9; altered), Louisville, the latter commissioned after Shryock had moved to that city. Morrison College is a dignified three-storey building containing hall, chapel, library and recitation rooms, with a hexastyle Doric portico. The main entrance is located on the first storey, approached by a wide flight of steps. Although not executed entirely according to Shryock's plans, the Jefferson Court House is an impressive building with tetrastyle Ionic porticos. A cupola modelled after the Choragic Monument of Lysikrates was never built. Shryock was deeply committed to Hellenistic architecture and also designed several noteworthy houses with Greek features. Generally the form of these conformed to Neo-classical Federal-style practices, but the porches and other decorative features incorporated Greek details. All these works by Shryock were important in the westward spread of the Greek Revival style in North America.

BIBLIOGRAPHY
R. Newcomb: 'Transylvania College and her Century-old Greek Revival Building', *A. & Archeol.*, xxix (1930), pp. 251–5
C. Lancaster: 'Gideon Shryock and John McMurtry: Architect and Builder of Kentucky', *A. Q.* [Detroit], vi (1943), pp. 257–75
C. Price: *The Louisville Buildings of Gideon Shryock* (diss., U. Kentucky, 1943)
R. Newcomb: *Architecture in Old Kentucky* (Urbana, 1953), pp. 107–19
WILLARD B. ROBINSON

Silsbee, Joseph Lyman (*b* Salem, MA, 25 Nov 1848; *d* Chicago, 31 Jan 1913). American architect. He was trained at Harvard University and at the Massachusetts Institute of Technology (1869) and worked briefly in Boston (1870–71). He settled in Syracuse, NY, where he was Professor of Architecture (1873–8) at Syracuse University, and designed both the Syracuse Savings Bank (1875) and the White Memorial Building (1876) in a Gothic Revival style.

Silsbee moved to Chicago in 1882 but maintained offices in Syracuse, NY until 1884 and Buffalo, NY until 1887. He soon established a reputation for his domestic work, which Frank Lloyd Wright described as a 'picturesque combination of gable, turret and hip with broad porches, quietly domestic and gracefully picturesque'. Initially using Queen Anne elements as in the J. M. Bemis House, Buffalo, 1885, Silsbee later favoured the Shingle style, as in All Souls' Church (1885; destr.), Chicago, for Wright's uncle Jenkin Lloyd Jones, which was underway when Wright entered Silsbee's office in 1887. George Grant Elmslie and George Maher also served as draughtsmen in Silsbee's office in the 1880s and Irving J. Gill worked there in 1890.

Silsbee designed some 30 villa residences in the Chicago suburb of Edgewater (1886–9). With the Chicago Telephone Company Building (1887), he adopted the Romanesque Revival style popularized by H. H. Richardson, which Silsbee used later in Chicago houses for H. B. Stone (1888) and Horatio N. May (1891). For the World's Columbian Exposition (World's Fair), Chicago (1893), he invented the moving sidewalk and executed state buildings for West Virginia and South Dakota, and the Hagenbeck Zoological Arena Building. Several structures in the Chicago parks survive: in Lincoln Park, a public toilet (1888) and the conservatory (1890), and in Garfield Park, the

bandstand (1897). Silsbee maintained an office in Chicago until 1912. His later work includes the Memorial Arch (1903) and the Men's Building (1910) at Oberlin College, Oberlin, Ohio; the William Bartlett Estate at Vermejo Park, New Mexico (1908–10); and buildings for the Gary Land Company Gary, Indiana (1906–08)

BIBLIOGRAPHY

F. Wright: *An Autobiography* (London, 1932, rev. 1977)

S. Sorrell: 'A Catalog of Work by J. L. Silsbee', *Prairie Sch. Rev.*, vii/4 (1970), pp. 17–21

——: 'Silsbee: The Evolution of a Personal Architectural Style', *Prairie Sch. Rev.*, v/4 (1970), pp. 5–13

T. McCormick: 'The Early Work of Joseph Lyman Silsbee', *In Search of Modern Architecture: A Tribute to Henry-Russell Hitchcock*, ed. H. Searing (New York, 1982), pp. 172–84

G. Blodgett: *Oberlin Architecture, College and Town* (Oberlin, 1985/R 1990)

A. Lufkin Reeve: *From Hacienda to Bungalow: Northern New Mexico Houses, 1850–1912* (Albuquerque, 1988)

B. A. Kamerling: *Irving J. Gill, Architect* (San Diego, 1993)

KATHLEEN ROY CUMMINGS

Singleton Copley, John. *See* COPLEY, JOHN SINGLETON.

Skillin. American family of wood-carvers. Trained in wood-carving by their father, Simeon Skillin sr (1716–78), who was a prominent New England ship-carver, John Skillin (1745–1800) and Simeon Skillin jr (1756–1806) established by 1780 their own carver's shop in the north end of Boston, MA. During this partnership their brother, Samuel Skillin (1742–93), also took part in the family business. Together they worked extensively in the early 1790s for the Salem shipping magnate Elias Hasket Derby (1739–99), completing a relief and three figures, *Peace*, *Virtue* and *Plenty*, for a chest-on-chest (1791; New Haven, CT, Yale U. A.G.) by Stephen Badlam (1751–1815), as well as four garden statues for Derby's summer residence, Oak Hill, in Danvers, CT. Of these figures, only *Plenty*, with its elaborately carved cornucopia, survives (1793; Salem, MA, Peabody Mus.). Although a number of works have been attributed to the workshop of John and Simeon jr, only one other wood-carving has been documented—a statuette of *Mercury* (Boston, MA, Old State House), which once stood above the doorway of the Boston Post Office.

BIBLIOGRAPHY

L. L. Thwing: 'The Four Carving Skillins', *Antiques*, xxxiii (1938), pp. 326–8

P. A. Pinckney: *American Figureheads and their Carvers* (New York, 1940), pp. 32–3, 45–54, 79, 81

M. Munson Swan: 'Simeon Skillin, sr.: The First American Sculptor', *Antiques*, xlvi (1944), p. 21

E. O. Christensen: *Early American Wood Carving* (Cleveland, 1952), pp. 18, 34, 72–5

W. Craven: *Sculpture in America* (Newark, NJ, 1968, rev. New York, 1984), pp. 10–16

DONNA J. HASSLER

Skyscraper. Colloquial term referring to a multi-storey building designed for human occupancy (usually for office use), the height of which greatly exceeds one or both of its horizontal dimensions. The term, which can be defined only from an empirical and historical viewpoint rather than a formal and ontological one, was coined in the late 18th century in a non-architectural context, and its use subsequently spread to include other designations before being applied to tall buildings; the first building to be termed a skyscraper was Queen Anne's Mansions, an apartment building erected in London *c.* 1880. The evolution of the skyscraper took place in the USA; the first application of the term to American high-rise commercial buildings appeared in 1889 ('Chicago's Skyscrapers', *Chicago Tribune*, 13 Jan 1889), but it was in New York that the economic imperatives for the development of sky-scrapers first became decisive (*see* §1 below). The sky-scraper subsequently became the most representative building type of the 20th century in cities all over the world, the possibilities of the form inspiring architects and allowing the fulfilment of corporate aims for prestigious, landmark buildings; many utopian skyscraper projects are milestones of 20th-century architecture.

1. Technical characteristics. 2. History and development.

1. TECHNICAL CHARACTERISTICS. The skyscraper is so intimately bound up with the urban economy and its industrial base that it could not come into existence until a broad range of technological innovations had been perfected and drawn together into an integrated working complex. These innovations relate to structure and foun-dation, which determine the height, form and appearance of the building; internal vertical transportation, essential in any building more than about five storeys in height; fireproofing, the chief factor (other than the strength and durability of materials) guaranteeing the safety of occu-pants; and building services, which ensure the health and comfort of occupants.

In structural terms the evolution of the skyscraper initially depended on the development of iron- and steel-framing techniques in place of traditional masonry con-struction, the mass of which restricts the height achievable. Iron framing was a product of the Industrial Revolution and was first used in structures at the end of the 18th century. In the early years of their development, however, tall buildings were typically constructed with masonry load-bearing walls or piers, with a partial internal frame-work of iron columns, girders and beams. Soon after 1880, New York builders introduced cage construction in the Produce Exchange (1881–4; by George B. Post; destr.), where the loads were carried almost entirely on an internal iron skeleton. Steel was introduced in the upper part of the frame of the 10-storey Home Insurance Building (1884–5; by William Le Baron Jenney; destr.), Chicago, but a small proportion of the load was still carried on granite piers and brick party walls. Fully load-bearing skeletal frames for tall buildings were adopted in New York and Chicago almost simultaneously in the 11-storey, iron-framed Tower Building (1887; by Bradford Gilbert; destr.), New York, and the 9-storey, steel-framed Rand–McNally Building (1888–90; by Daniel H. Burnham and John Wellborn Root; destr.), Chicago. The Tower Building incorporated diagonal wind bracing, the first example for which drawings survive. The concept of wind bracing was well known to the medieval builders of timber-framed structures and such wind-resistant masonry buildings as Gothic cathedrals. Braced iron frames for tall buildings were introduced around 1870, yet bracing was not generally regarded as essential to the stability of tall framed structures until the 1890s.

Foundations for tall buildings posed a difficult problem in cities where water-saturated soil lay above bearing strata or bedrock, as in Chicago. In such circumstances neither traditional piling nor raft foundations—developed in Chicago in 1881–2 to spread the load and reduce unit pressures—could reliably sustain the extreme loads imposed by tall iron- and steel-framed structures. Caissons had to be used to allow excavation down to bearing strata or bedrock, and open or well-type caissons suitable for buildings appear to have been introduced in the USA in the City Hall (1888–90), Kansas City, MO. Pneumatic caissons, based on the principle of the air-lock invented by the British admiral Thomas Cochrane in 1830, provide a sealed chamber at the bottom filled with compressed air to keep soil and ground-water out; they permit deep excavations, and they were first used in high-rise building construction for the Manhattan Life Insurance Co. Building (1892–4; by Napoleon Le Brun), New York.

A crucial factor for the evolution of the skyscraper was the introduction of the passenger elevator (lift). The first mechanized lifts were used in English cotton mills in the 1830s and were hoisted by ropes and sheaves connected to the belted shafting of the mill's steam engine. The earliest steam-driven passenger elevator with a safety brake was that invented by Elisha Graves Otis in 1852 and first installed in the Haughwout Building (1856–7; by John P. Gaynor), New York. Steam-driven elevators were superseded by hydraulic elevators, invented by Cyrus Baldwin in 1870 and introduced in a practical form by William Hale in 1873. Electrically powered elevators were invented in 1887, while the introduction of the electric gearless traction elevators in 1903 enabled the top of any structure, regardless of its height, to be reached.

The danger of fire in tall buildings was a matter of highly emotional concern until the end of the 19th century. It was widely believed that masonry and iron construction provided the best protection against fire, although it subsequently became apparent that combustible contents could transform even a fireproof structure into a furnace. The first scientific investigation into the problem resulted in a paper on fireproof construction, read before the New York Chapter of the American Institute of Architects in 1869 by the architect Peter B. Wight. He was the first to emphasize that iron and steel suffer rapid loss of strength when heated, and he urged the covering of iron members with hollow tiles or other fire-resistant materials. Practical results soon followed: George H. Jonson and Balthasar Kreischer were awarded patents in 1869 and 1871 for a hollow-tile cladding for iron structural members, which was first used for a multi-storey structure in the Kendall Building (1872–3; by John Mills Van Osdel), Chicago, and subsequently widely adopted. Spray-on asbestos for interior members became common c. 1900.

The provision of building services—central heating, plumbing, artificial lighting and ventilation—was also essential to the evolution of the skyscraper: without adequate services such large buildings are uninhabitable. Steam heating had been introduced in buildings by James Watt (1736–1819) and Matthew Boulton (1728–1809) in the late 18th century, and warm-air central heating was pioneered by William Strutt (1756–1830) in Derby at the Belper Mill and Derbyshire General Infirmary in the first decade of the 19th century. Important inventions of the 19th century included a closed-circuit hot-water system (1831; by Jacob Perkins in England) and a similar system for steam (1860; by Joseph Nason in the USA). Plumbing followed a more complex history because of the diversity of elements and its dependence on a city-wide pressurized water supply. Although a pressurized water supply sustained by steam-driven pumps appeared in England as early as 1712, the first municipal water-supply system of a scale adequate for the modern city was provided with the construction of the Croton Reservoir and aqueduct (1839–42) for New York. The modern flush toilet was largely the creation of Joseph Bramah in England from 1775 to 1790, with improvements made in the 19th century.

Adequate artificial lighting was introduced with the multiple-burner gas system designed by William Murdock and installed in 1806 at the Philips and Lee Mill (by James Watt and Matthew Boulton), Salford, Lancs. Practical incandescent electric lamps were perfected in 1878 by Joseph Swan in England and in 1879 by Thomas Edison in the USA; Edison installed the first large central power station in New York in 1882. The multiple-burner gas installation needed only to have the burners replaced with electric lamps and the gas piping with an electrical circuit to transform it into the modern multiple-unit lighting system for large commercial buildings. The evolution of forced-draught ventilation systems arose almost entirely from the patent granted to the American inventor Benjamin Franklin Sturtevant in 1870 for a steam-driven fan blowing air into ducts over steam- or hot-water-heated coils. Air conditioning, an essential service for most modern skyscrapers, was introduced in buildings in the 19th century in various primitive forms, mostly using the evaporation of ice-blocks to cool the air. The first practical mechanical air-conditioning system was invented only in the first years of the 20th century by Willis Carrier. By 1900 the increasing complexity and multiplicity of services and protective devices meant that they represented half the cost of construction.

2. HISTORY AND DEVELOPMENT. The first building in which many of these technological developments converged at a sufficient level of maturity, and one that was consciously planned to be conspicuously higher than existing commercial structures, was New York's Equitable Life Assurance Company Building (1868–70; by ARTHUR DELEVAN GILMAN and Edward Kendall, with George B. Post; destr. 1912), which had only five working storeys but was the first office building in the city to have an elevator from the time of its completion. It was constructed with granite piers, brick partitions and wrought-iron beams, but the ironwork was left exposed, a fact that contributed to its destruction by fire. Its counterpart in Chicago, the Equitable Life Assurance Society Building (1872–3; by Van Osdel) was the first building with hollow-tile floor arches.

The New York Equitable clearly proclaimed the forces and motives underlying the creation of the skyscraper. Foremost was intensive land use and the consequent rise in the value of land, particularly in the dense street pattern of downtown Manhattan, which followed economic expansion and the increasingly financial and institutional

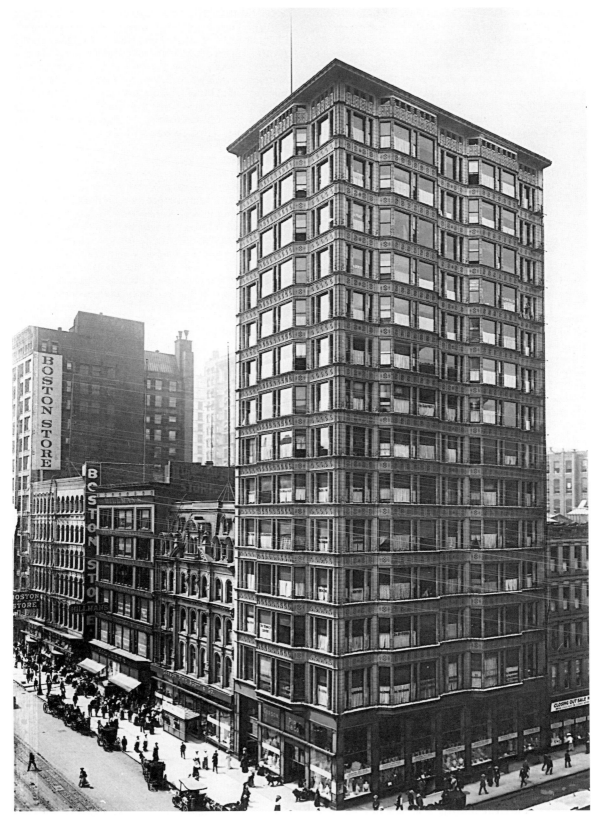

Skyscraper by Daniel H. Burnham & Co.: Reliance Building, Chicago, 1889–95

nature of business. The need to earn a maximum return on the investment in land and buildings and to centralize all services necessary to public occupancy were the chief economic factors in erecting ever higher buildings. Personal and corporate aims were satisfied by the combination of the sensational advertising value of great height, the prestige conferred by elegant design, and the image— especially important to insurance and banking companies —of integrity, respectable wealth, civic idealism and community service. A feature that achieved major importance was the elevator: it not only allowed construction to the available height limits but gave the top-floor space the highest status in the business hierarchy, commanding the highest rents.

The progressive increase in the height of skyscrapers and more assured architectural control resulted in tall buildings of great visual power and technical audacity. The most decisive step for architectural form after the Equitable was the *New York Tribune* Building (1873–6; by Richard Morris Hunt; destr.) in New York. Hunt sought an entirely new form, something that proclaimed the idea of 'skyscraper', at least in youthful but promising form. The masonry building had eight storeys and a two-storey mansard-roofed attic and dormers, with a vertical emphasis provided by prominent piers and a tower capped by a spire. The technological innovations of the 1880s that culminated in Gilbert's Tower Building (1887) were adopted in a series of elegant towers in various classical modes erected in New York in the 1890s; notable examples include the Gillender Building (by Berg & Clark), the Central Bank Building (by William H. Birkmire) and the 20-storey American Surety Building (1894–5; by BRUCE PRICE; now the Bank of Tokyo); the latter established the braced and riveted steel skeleton frame in New York, enabling heights to be increased further.

Technological innovation developed rapidly in Chicago, where reconstruction was taking place after the fire of 1871, and it was accompanied by a more functional architectural expression to suit the technology. The Home Insurance Building (1883–5; destr. 1931; see CHICAGO, fig. 1) by WILLIAM LE BARON JENNEY, which introduced the use of steel, had a classicizing masonry skin, but it was quickly followed by three distinguished works that demonstrated the city's pre-eminence in skyscraper design: the 16-storey Monadnock Building (1889–91; by DANIEL H. BURNHAM and JOHN WELLBORN ROOT), a narrow slablike form that depended on great simplicity and sculptural mass in brick for its powerful expression; and the 22-storey steel-framed, terracotta-clad Masonic Temple (1890–92; by Burnham and Root) and the Schiller Theater Building (1891–3; by Louis Sullivan and Dankmar Adler; destr.), which were lighter and more open, marked by a pronounced vertical emphasis, particularly dynamic in the Schiller. The aesthetic and philosophical aspects of the skyscraper were explored by Sullivan in an influential essay (1896), in which he wrote that the tall building should be 'every inch a proud and soaring thing' and evolved his famous maxim 'form ever follows function'. His rationalized, but ornamented designs of this period (*see also* SULLIVAN, LOUIS, fig. 1, and UNITED STATES OF AMERICA, fig. 9) contrasted with the structural expression of the 15-storey Reliance Building (1889–95; see fig.) by Burnham

& Co., which marked the culmination of the CHICAGO SCHOOL. Further technical innovations appeared in the 17-storey Old Colony Building (1893–4; by HOLABIRD & ROCHE), Chicago, which introduced an exceptionally rigid form of wind bracing known as portal-arch bracing. Another innovation at the turn of the century had revolutionary implications: the 16-storey Ingalls Building (1902–3; by Elzner & Anderson) in Cincinnati was the first skyscraper supported by a reinforced-concrete frame, and although it was modest in height, it held immense promise for the future.

A strict height-limitation ordinance arrested further progress in Chicago until after World War I, but unparalleled increase in height, progress in braced steel framing and imaginative formal expression produced three sensational triumphs in New York in the early years of the 20th century. The 47-storey Singer Building (1896–8; tower, 1906–8; by ERNEST FLAGG; destr.), a slender tower in the Beaux-Arts mode, established a new height record. This was quickly exceeded by the Metropolitan Life Building (1907–9; by Napoleon Le Brun), an adaptation of the campanile form to the skyscraper. Both gave place to the 55-storey Woolworth Building (1910–13; for illustration *see* GILBERT, CASS), an acknowledged masterwork of skyscraper design.

<div align="right">CARL W. CONDIT</div>

BIBLIOGRAPHY
L. Sullivan: 'The Tall Office Building Artistically Considered', *Lippincott's Mthly Mag.*, lvii (1896), pp. 403–9; also in *Kindergarten Chats and Other Writings* (New York, 1947/*R* 1976)
W. H. Birkmire: *The Planning and Construction of High Office Buildings* (New York, 1905)
W. A. Starrett: *Skyscrapers and the Men who Build them* (New York, 1928)
F. Mujica: *History of the Skyscraper* (Paris, 1929)
E. Schultz and W. Simmons: *Offices in the Sky* (Indianapolis, 1959)
C. W. Condit: 'The First Reinforced Concrete Skyscraper', *Technol. & Cult.*, ix/1 (1968), pp. 1–33
——: 'The Wind Bracing of Buildings', *Sci. American*, ccxxx/2 (1974), pp. 82–105
P. Goldberger: *The Skyscraper* (New York, 1981)
——: *American Building: Materials and Techniques* (Chicago, 1982)
A. L. Huxtable: *The Tall Building Artistically Reconsidered: The Search for a Skyscraper Style* (New York, 1984)
C. Robinson and R. Haag Bletter: *Skyscraper Style* (New York, 1985)
G. R. Larson: 'The Iron Skeleton Frame: Interactions between Europe and the United States', *Chicago Architecture, 1872–1922: Birth of a Metropolis*, ed. J. Zukowsky (Munich, 1987), pp. 38–55
C. W. Condit: 'The Two Centuries of Technical Evolution Underlying the Skyscraper', *The Second Century of the Skyscraper*, ed. L. S. Beedle (New York, 1988), pp. 11–24
T. A. P. van Leeuwen: *The Skyward Trend of Thought: The Metaphysics of the American Skyscraper* (Cambridge, MA, 1988)
Der Schrei nach dem Turmhaus (exh. cat., ed. F. Zimmermann; W. Berlin, Bauhaus-Archv, 1988)
D. Neumann: *Die Wolkenkratzer kommen! Deutsche Hochhäuser der Zwanziger Jahre–Debatten Projekte Bauten* (Wiesbaden, 1995)
C. Willis: *Form Follows Finance: Skyscrapers and Skylines in New York and Chicago* (New York, 1995)
S. B. Landau and C. W. Condit: *Rise of the New York Skyscraper, 1865–1913* (New Haven, 1996)

<div align="right">CARL W. CONDIT</div>

Sloan, John (*b* Lock Haven, PA, 2 Aug 1871; *d* Hanover, NH, 7 Sept 1951). American painter, printmaker and draughtsman. He studied at the Pennsylvania Academy of Fine Arts with Thomas Pollock Anshutz from 1892 to 1894 and worked as a commercial artist, first with the newspaper the *Philadelphia Inquirer* (1892–5) and then the *Philadelphia Press* (1895–1903). He first gained national

recognition for his illustrations in the turn-of-the-century poster style, for example *Atlantic City Beach* (*Philadelphia Inquirer*, 19 Aug 1894). He earned his living through magazine illustrations until 1916.

Through his association with Robert Henri and the group of young Philadelphia artists around him, Sloan began *c*. 1897 to paint in oil and became interested in depicting city life. In 1904, he followed Henri to New York, where he stayed for the rest of his life. In 1908, he participated with seven other artists in an exhibition at the Macbeth Gallery to protest the conservative taste of the National Academy of Design. The group was dubbed THE EIGHT, and several of the artists became known as Ashcan painters (*see* ASHCAN SCHOOL) because of their fondness for depicting the seamier side of urban life. At this time Sloan's paintings were archetypal Ashcan images: genre scenes of lower-class neighbourhoods in New York, painted thickly in a dark or at least strong palette, as in the *Hairdresser's Window* (1907; Hartford, CT, Wadsworth Atheneum; for illustration *see* ASHCAN SCHOOL). Sloan avoided all sentimentality in his 'slices of life', often infusing a light humour into vignettes of crowds, people entering bars (e.g. *Haymarket*, 1907; New York, Brooklyn Mus.) and playing in parks, or young women at their toilet. His paintings were never intended as social criticism although he was a socialist. Sloan's only use of art for critical purposes was during his short period as art editor of the radical journal the *Masses* (1912–16) and can be seen in *Ludlow, Colorado* (cover, June 1914).

After the Armory Show (1913), Sloan began to focus on formal issues rather than subject-matter. Fascinated by colour theories, Sloan began applying the colour system created by Hardesty Maratta (1864–1924) in the landscapes and town views that he created from 1914. Sloan is also renowned as a printmaker and was a master draughtsman. His etchings (*see* PHILADELPHIA, fig. 3), for example, the earliest of which dates from 1888 (e.g. the *New York City Life* series, 1904), relate thematically to his paintings and influenced his late, linear painting style.

WRITINGS
New York Scene: From the Diaries, Notes, and Correspondence, 1906–1913, ed. B. St John, intro. H. F. Sloan (New York, 1965)

BIBLIOGRAPHY
John Sloan Retrospective Exhibition (exh. cat., Andover, MA, Phillips Acad., Addison Gal., 1938)
V. Brooks: *John Sloan: A Painter's Life* (New York, 1955)
J. E. Bullard III: *John Sloan and the Philadelphia Realists and Illustrators, 1890–1920* (MA thesis, Los Angeles, UCLA, 1968)
P. Morse: *John Sloan's Prints: A Catalogue Raisonné of the Etchings, Lithographs and Posters* (New Haven, CT, 1969)
D. Scott: *John Sloan* (New York, 1975)
P. Hills: 'John Sloan's Images of Working-class Women: A Case Study of Poles and Interrelationships of Politics, Personality and Patrons in the Development of Sloan's Art', *Prospects*, v (1980), pp. 157–96
John Sloan: Spectator of Life (exh. cat. by R. Elzea and E. Hawkes; New York, IBM Gal. Sci. & A.; Wilmington, DE, A. Mus.; 1988)
R. Elzea: *John Sloan's Oil Paintings: A Catalogue Raisonné*, 2 vols (Newark and London, 1991)
The Gist of Drawing: Works on Paper by John Sloan (exh. cat., ed. W. I. Homer; Wilmington, DE, A. Mus., 1997)

ILENE SUSAN FORT

Sloan, Samuel (*b* Beaver Dam, nr Honeybrook, PA, 7 March 1815; *d* Raleigh, NC, 19 July 1884). American architect and writer. He was born into a family of builders and was apprenticed in 1821 to a cabinetmaker and carpenter in Lancaster. His thorough training enabled him to find immediate employment in Philadelphia. Sloan's first jobs as a carpenter were on a prison and two hospitals; at the second hospital, the new Department for the Insane of the Pennsylvania Hospital, he rose to the position of superintendent of work, and when the building's architect, Isaac Holden (*d* 1884), returned to England before work was completed, Sloan became, effectively, the supervising architect. While the Department was in construction, Sloan was befriended by Dr Thomas S. Kirkbride, who became the leading alienist in the USA. Through the support and patronage of Dr Kirkbride, Sloan turned himself from a craftsman into an architect and became the agent who transformed Kirkbride's theories of treatment into architectural fact. In the period that the two men worked together (1852–82), they produced 32 hospitals for the mentally ill designed on the Kirkbride System. Sloan gained national fame for his hospitals of all types designed for particular methods of treatment; at his death there was at least one in every state of the USA.

Sloan's first independent work in Philadelphia was Bartram Hall (1850), a large suburban villa for the industrial millionaire Andrew M. Eastwick. It was an immediate success with the city's commercial aristocracy, its speculative builders and its politicians. By spring 1851 he had commissions for 40 residences, a commercial block, a church and seven public schools, and in 1852 the pressure of work led him to form a partnership with John S. Stewart. The firm of Sloan & Stewart was among the most active in Philadelphia until the Panic of 1857, when it was dissolved. In 1852–3 Sloan issued *The Model Architect*, a remarkable pattern book, which ran to five editions and was the first of five such works that Sloan wrote or edited. His chief assistant in the production of the later books was Addison Hutton (1843–1916), a young Quaker who became Sloan's draughtsman in 1857 and his partner from 1864 to 1868.

Sloan had hundreds of commissions in the 1850s; he introduced or championed several important new concepts in the design of schools, churches, public and civic buildings and speculative housing. These included flexible classroom space, improved circulation, ventilation and heating in residences, and extensive use of glass. However, he could not adjust to the economic and social changes that took place in the USA between the Panic of 1857 and the end of the Civil War. He was involved in scandals and was estranged from the architects of Philadelphia, even from the reorganized American Institute of Architects, of which he was made a Fellow in 1868 for the joint editorship of the nation's first architectural periodical, *Sloan's Architectural Review and Builders' Journal: An Illustrated Monthly* (1868–9). After a disappointing second prize in the competition for the Centennial Exposition of 1876 in Philadelphia, Sloan moved his office to Raleigh, NC, and he practised in North and South Carolina until his death. His contribution to architecture in the USA was largely forgotten within a few years of his death; however, his ability to adapt building types to particular functional needs was a critical force in its evolution and development, and from 1849 to 1859 he was among the most productive and original practitioners in the USA.

WRITINGS

The Model Architect: A Series of Original Designs for Cottages, Villas, Suburban Residences, etc, 2 vols (Philadelphia, 1852–3, 5/1873)

City and Suburban Architecture: Containing Numerous Designs and Details for Public Edifices, Private Residences and Mercantile Buildings (Philadelphia, 1859, 2/1968)

Sloan's Constructive Architecture: A Guide to the Practical Builder and Mechanic, in which Is Contained a Series of Designs for Domes, Roofs and Spires (Philadelphia, 1859, 2/1873)

Sloan's Homestead Architecture, Containing Forty Designs for Villas, Cottages and Farm Houses, with Essays on Style, Construction, Landscape Gardening, Furniture etc. (Philadelphia, 1861, 3/1870)

American Houses, a Variety of Designs for Rural Buildings (Philadelphia, 1862, 2/1868)

ed. with C. J. Lukens: *Sloan's Architectural Review and Builders' Journal: An Illustrated Monthly*, i (1868–9)

Description of Design and Drawings for the Proposed Centennial Buildings, to Be Erected on Fairmount Park (Philadelphia, 1873)

BIBLIOGRAPHY

F. Gleason, ed.: 'The Eastwick Villa', *Gleason's Drawing Room Companion*, v (Boston, 1854)

T. S. Kirkbride: *On the Construction, Organization and General Arrangements of Hospitals for the Insane* (Philadelphia, 1854, 2/1880)

——: *The Presbyterian Church in Philadelphia* (Philadelphia, 1895)

F. D. Edmunds: *The Public School Buildings of the City of Philadelphia*, 7 vols (Philadelphia, 1913–33) [privately printed]

W. L. Whitwell: *The Heritage of Longwood* (Jackson, MS, 1975)

H. N. Cooledge jr: *Samuel Sloan, Architect of Philadelphia, 1815–1884* (Philadelphia, 1986)

HAROLD N. COOLEDGE JR

Smibert, John (*b* Edinburgh, 24 March 1688; *d* Boston, 2 April 1751). American painter of Scottish birth. From 1702 to 1709 he was apprenticed to a house painter and plasterer in Edinburgh. He set out for London at the end of his apprenticeship, about which time he began recording in a *Notebook* the events of his life and in succeeding years the details of his travels and records of his painting activities.

In 1713 Smibert joined the Great Queen Street's Academy, London, governed by Godfrey Kneller (1646–1723), who greatly influenced his style. Smibert spent two years there, drawing from casts of antique sculpture and from live models. Thereafter he returned to Edinburgh and within a few months found a patron in the Scottish judge Francis Grant, Lord Cullen of Monymusk (1658–1726). Smibert's half-length portrait of *Sir Francis Grant* (*c.* 1720–26; Edinburgh, N.P.G.) and the ambitious 11-figure conversation piece *Sir Francis Grant and his Family* (Monymusk, Grampian, Grant family priv. col.) are among his earliest surviving works.

In 1719 Smibert went to Italy, where he remained until 1722. During his stay (partially documented in his *Notebook*), he looked at and acquired works of art, as well as painting portraits from life and copies after Raphael (1483–1520), Titian (*c.* 1485/90–1576), Rubens (1577–1640) and van Dyck (1599–1641). The first and best-known of those that survive is his half-length copy (Cambridge, MA, Fogg) of van Dyck's striking full-length portrait of *Cardinal Guido Bentivoglio* (*c.* 1623; Florence, Pitti). Also surviving from this trip are Smibert's earliest signed portrait, of an unidentified man (Hartford, CT, Wadsworth Atheneum; see colour pl. V, 2), and a portrait of *Dean George Berkeley* (Glos, Mrs Maurice Berkeley priv. col.), who was to become his life-long friend.

In 1722 Smibert returned to London, where he opened a studio. His clientele consisted primarily of tradesmen, merchants and professional people, along with a handful of noblemen of modest wealth and power. His circle included artists and connoisseurs, among them the noted engraver and biographer George Vertue (1684–1756). He was an active member of the Rose and Crown Club (a bawdy assembly of younger artists and cognoscenti, which met weekly), and *c.* 1725 he joined the Society of Antiquaries, one of few artists to do so. His most notable portraits from these years are his full-length *Benjamin Morland* (1724; New Haven, CT, Yale Cent. Brit. A.) and a three-quarter-length *Colonel James Otway* (1724; Chichester, Royal Sussex Regiment).

By 1728 Berkeley convinced the painter to accompany him on his unsuccessful mission to establish a college in Bermuda, where Smibert was to teach painting. As Smibert was occasionally in poor health, an improved climate was to his advantage. Smibert's masterpiece, the *Bermuda Group* (New Haven, CT, Yale U. A.G.; see fig.), commemorates those instrumental in the endeavour. The painting was commissioned in 1728, just prior to the group's departure, by John Wainwright, an Irish baronet, who considered accompanying the entourage and who is depicted prominently in the foreground. Smibert boldly signed and dated the portrait 1729, after the arrival of the entourage in Rhode Island in 1729 (they never went to Bermuda), but, as the painting was not completed until the following year, the date is commemorative of the event depicted. Here Smibert melded the Renaissance tradition of grand allegory and the contemporary need for a recognizable group portrait. It was the most sophisticated group portrait painted in the colonies during the first half of the 18th century and a source of inspiration to numerous Colonial artists, such as Robert Feke, during the succeeding 80 years.

Smibert settled in Boston, where many of the leading citizens patronized him, as did visitors from Rhode Island, Connecticut and New York. Smibert's American portraits closely follow the repertory of poses he developed in London, but his tight brushwork gradually loosened, his colour contrasts became less pronounced and he ceased to experiment. Notable works from these years include portraits of merchants, such as *Richard Bill* (Chicago, IL, A. Inst.), as well as several portraits of ministers, such as *Reverend Joseph Sewall* (New Haven, CT, Yale U. A.G.), reproduced in mezzotint by Peter Pelham. Aside from a lucrative painting trip in 1740 to Philadelphia, New York and Burlington, NJ, Smibert remained in Boston, where he painted 250 portraits.

In 1734, to supplement his income, Smibert opened a 'color shop' in which he sold artists' colours, brushes, canvas and prints. In his studio, above the shop, Smibert displayed many of the copies after Old Masters that he had brought to America, as well as plaster casts of ancient and modern sculpture. This collection, certainly unmatched in New England, if not in all the colonies, constituted America's first art gallery. As such, it exercised considerable influence over Colonial artists, among them John Singleton Copley, Charles Willson Peale and John Trumbull. Many of Smibert's copies, as well as two portfolios with 141 Old Master drawings, were sold to James Bowdoin III (now Brunswick, ME, Bowdoin Coll. Mus. A.)

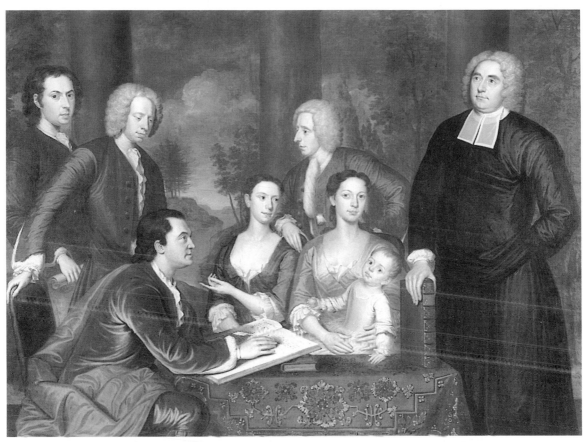

John Smibert: *Bermuda Group*, oil on canvas, 1.76×2.36 m, *c.* 1729–31 (New Haven, CT, Yale University Art Gallery)

Smibert painted landscapes for his own amusement, the only surviving example of which is his *View of Boston* (Boston, MA, Childs Gal.), and completed the design for Faneuil Hall, Boston's first public market. During the 1740s his health became increasingly frail, and he ceased painting in 1746. His son, Nathaniel Smibert (1735–56), briefly continued his father's profession.

WRITINGS

The Notebook of John Smibert (London, PRO, pubd, intro. D. Evans, J. Kerslake and A. Oliver, Boston, 1969)

BIBLIOGRAPHY

'The Note-books of George Vertue', *Walpole Soc.*, xxii (1934), pp. 14, 24, 28–9, 36, 42–3, 161 [first biog. of Smibert]
H. W. Foote: *John Smibert, Painter* (Cambridge, MA, 1950) [with cat. of portraits attrib. Nathaniel Smibert]
R. H. Saunders: *John Smibert (1688–1751): Anglo-American Portrait Painter* (diss., New Haven, CT, Yale U., 1979)
M. Chappell: 'A Note on John Smibert's Italian Sojurn', *A. Bull.*, lxiv (1982), pp. 132–8
R. H. Saunders: 'John Smibert's Italian Sojurn—Once Again', *A. Bull.*, lxvi (1984), pp. 312–18
W. Craven: *Colonial American Portraiture* (Cambridge, 1986), pp. 152–77
R. H. Saunders: *John Smibert, Colonial America's First Portrait Painter* (New Haven and London, 1995)

RICHARD H. SAUNDERS

Smith, Frank Eugene. *See* EUGENE, FRANK.

Smith, Robert (*b* Dalkeith, Lothian, 1722; *d* Philadelphia, PA, 11 Feb 1777). American architect of Scottish birth.

Arriving in Philadelphia *c.* 1749, with a house carpenter's training possibly acquired under William Adam (1689–1748) at Dalkeith Park, he soon became the leading craftsman–architect in the city, where in 1752–4, as principal carpenter, his first major work was the construction of the spire of Christ Church, freely modelled on the spire of St Martin-in-the-Fields, London by James Gibbs (1682–1754). From 1758 to 1761 he was in charge, as 'City house carpenter', of the construction of St Peter's, Philadelphia, and in 1766 of the construction of the Zion Lutheran Church there (destr. 1869), apparently one of the largest churches in North America at the time. Smith's secular works included Nassau Hall (1754–6), Princeton, which was designed in collaboration with Dr William Shippen; Carpenters' Hall (designed 1768, executed 1770–73), Philadelphia; the Public Hospital for the Insane (1770–73; destr.), Williamsburg, VA, which he designed but did not build; and the Walnut Street Prison (1773–6; destr. 1836), Philadelphia, which was his biggest commission and which he both designed and built. In 1764 Benjamin Franklin was his client for a house (destr. 1812) off Market Street, Philadelphia. In 1776, working as a military engineer, he designed *chevaux-de-frise* for obstructing the navigation of the Delaware River. With his sound Scottish training, supplemented by the 'Sundrey Books of Architecture' that he is recorded as owning at his death, Smith represented the late Colonial craftsman–architect at his scarcely original, but extremely competent best.

BIBLIOGRAPHY

C. E. Peterson: 'Carpenters' Hall', *Trans. Amer. Philos. Soc.*, xliii/1 (1953), pp. 96–128 [with appendix, 'Notes on Robert Smith']

T. Sellin: 'Philadelphia Prisons of the Eighteenth Century', *Trans. Amer. Philos. Soc.*, xliii/1 (1953), pp. 326–30

M. Whiffen: *The Public Buildings of Williamsburg, Colonial Capital of Virginia* (Williamsburg, 1958) [for the Public Hospital, Williamsburg]

MARCUS WHIFFEN

Smith, Thomas (*b* ?England; *d* ?Boston, MA, before 25 April 1691). American painter. He is the earliest identifiable painter in English-speaking North America, and the sophistication of his style suggests he had a professional training. He may have arrived in Boston *c.* 1650; his surviving works, which amount to five signed or attributed portraits, suggest that he painted in Boston between 1670 and 1691. His only dated work is *Major Thomas Savage* (1679; Boston, MA, Mus. F.A.).

Smith's portraits followed by about a decade the work of the Freake Painter and the Mason Limner in Boston. Unlike the limners, who practised a provincial version of the Tudor style, Smith painted in mid-17th-century Baroque style. His *Self-portrait* (*c.* 1670–91; Worcester, MA, A. Mus.; see colour pl. V, 1) includes depictions of ships and a skull and poem, references to his occupation as a mariner, and his Puritan faith. The quality of Smith's work was not matched in New England until the arrival of John Smibert in 1729.

BIBLIOGRAPHY

L. Dresser: *Seventeenth-century Painting in New England* (Worcester, MA, 1935), pp. 133–40

J. Fairbanks, ed.: *New England Begins*, iii (Boston, 1982), pp. 419–74

R. B. Stein: 'Thomas Smith's Self-portrait: Image/Text as Artifact', *A. J.* [New York], xliv (Winter, 1984), pp. 316–27

W. Craven: *Colonial American Portraiture* (Cambridge, 1986), pp. 65–8, 116–17

DAVID TATHAM

Smithmeyer & Pelz. American architectural partnership formed in 1873 by John L. Smithmeyer (*b* Vienna, 1832; *d* Washington, DC, 13 March 1908) and Paul Johannes Pelz (*b* Seitendorf, Waldenburg, Silesia [now Poland], 18 Nov 1841; *d* Washington, DC, 30 March 1918). Smithmeyer moved to the USA and worked for architectural firms in Chicago, IL, and Indianapolis, IN, before taking up a position with the Office of the Supervising Architect under Alfred B. Mullett from 1869 to 1871. As the business manager of the firm, his commissions as an independent architect were meagre. Pelz left Germany in 1858 and settled in New York. He worked for private firms there before taking a position with the US Lighthouse Board in Washington, DC, in 1872. The principal designer of the firm, he also enjoyed an active career as an independent practitioner.

Under the name of John L. Smithmeyer & Co., Smithmeyer and Pelz won the national competition for the new Library of Congress building, Washington, DC, in 1873. The firm prepared many alternative designs between 1873 and 1886, when Congress authorized funds for the construction of the building. The Italian Renaissance style structure (completed in 1897; see colour pl. IV, 1) was admired and acclaimed by both critics and the public. A fusion of function, symbolism and architectural decoration, the three-storey building occupies an entire city block and is constructed of grey granite. Its rectangular floor-plan is composed of a succession of pavilions and galleries and includes four large inner courts (two of which were later filled in with bookstacks) and a great rotunda (Main Reading Room) that extends above the main part of the building. A ribbed-copper dome with a finial symbolizing the Flame of Knowledge crowns the rotunda. The west front is notable for its great double staircase that leads down around an elaborate fountain; below the central landing of the staircase is a grotto that forms a background to the Court of Neptune Fountain by the sculptor Roland Hinton Perry (1870–1941). The interior of the building is especially sumptuous, second only to that of the US Capitol building. The central stairhall is decorated with mural paintings, mosaics and marble sculpture. Octagonal in plan, the Main Reading Room incorporates Edwin Howland Blashfield's allegorical paintings of the *Evolution of Civilization* (1895–6) in the lantern of the dome.

The Library of Congress commission gained notoriety when Smithmeyer was dismissed in 1888 and Pelz in 1892; General Thomas L. Casey of the Army Corps of Engineers was placed in charge of construction in 1888, and his son, Edward Pearce Casey, took over from Pelz. The dismissal of Smithmeyer and Pelz caused a furore among professional architects and resulted in an unsuccessful attempt by the firm's principals to gain compensation and recognition for their accomplishments.

Aside from the Library of Congress project, the firm undertook the design of the Gothic-style Healy Building at Georgetown University in Washington, DC (1877–1909), the wood-frame US Army and Navy Hospital at Hot Springs, AR (1884; destr. 1930–31) and the Romanesque Revival Carnegie Library and Music Hall at Allegheny, PA (1889), designed in the manner of H. H. Richardson.

BIBLIOGRAPHY

DAB

J. Y. Cole: 'Smithmeyer and Pelz: Embattled Architects of the Library of Congress', *Q. J. Lib. Congr.*, xxix (1972), pp. 282–307

ANTOINETTE J. LEE

Snook, John Butler (*b* London, 16 July 1815; *d* New York, 1 Nov 1901). American architect of English birth. He emigrated with his family to the USA in 1817 and trained initially in his father's carpentry shop in New York. After 1830 he was apprenticed to Thomas Gospil, a builder, in New Jersey. In 1835 Snook practised independently in Manhattan, and he later collaborated with William Beer (1836–40), before joining Joseph Trench (1815–79) in 1842. He became a junior partner two years later, and from 1845 to 1846 Trench & Snook executed their greatest commission, the Renaissance Revival A. T. Stewart Department Store (now the Sun Building; enlarged 1850, 1872, 1884). Originally consisting of a ground floor of plate-glass and three storeys of white marble, it was the first department store in New York and established the Renaissance Revival style and the palazzo formula as models for large mercantile buildings in New York.

From 1850 Snook practised alone. He gradually accepted three sons and a son-in-law into the firm and in 1887 changed its name to John B. Snook & Sons. The firm executed numerous cast-iron buildings in New York, such as the luxurious Metropolitan Hotel (1850–52; destr.),

the St Nicholas Hotel and the St John's Park Freight Depot (1867; destr.). Snook designed his most important commission, the original Grand Central Station, in 1869–71 (destr.). It was a sprawling three-storey building of French Renaissance design with a mansard roof and cast-iron decoration. He enjoyed a long, stylistically diverse and extraordinarily prolific career, designing over 500 commercial buildings as well as private residences, apartment buildings, hotels, schools and churches.

BIBLIOGRAPHY

Macmillan Enc. Architects
So-Ho Cast-iron Historic District Designation Report, Landmarks Preservation Commission (New York, 1973)
M. A. C. Smith: *The Commercial Architecture of John Butler Snook* (diss., University Park, PA, State U., 1974)
J. T. Dillon: *The Sun Building Designation Report*, Landmarks Preservation Commission (New York, 1986)

JANET ADAMS

Sonntag [Sontag], William Louis (*b* East Liberty, PA, 2 March 1822; *d* New York, 22 Jan 1900). American painter. Born the son of a merchant in a suburb of Pittsburgh, he moved to Cincinnati at an early age. Despite his father's opposition, he began a career as an itinerant landscape painter in the mid-1840s, selling paintings and sketches throughout the Ohio Valley. An exhibition of his work, held in a store, won him a commission in 1846 from the Baltimore & Ohio Railroad to paint a series of views along its route. In 1855 Sonntag travelled to Italy to study in Florence for a year, a journey that resulted in *Classic Italian Landscape with Temple of Venus* (*c*. 1860; Washington, DC, Corcoran Gal. A.). He lived permanently in New York after 1860, and by 1862 he was a full academician at the National Academy of Design there.

Sonntag was always a wanderer in the lesser-known, picturesque areas of Ohio, Kentucky, West Virginia, along the Kanauba, Potomac and Ohio rivers, which often featured in his paintings, for example *Mountain Scene on the Ohio River* (1852; Robert P. Coggins priv. col., see 1977 exh. cat.). His artistic model was Thomas Cole: both artists were raised in the Midwest, a generation apart, and travelled many of the same routes in search of landscape subjects; both shared a Romantic spirit, devoted especially to wilderness with little or no evidence of man's intrusion. Sonntag's obvious affection for uncultivated nature was exceptional among his peers because he sustained it for nearly 50 years, long after the sentiment seemed quaint in industrial America. In later life his painting style changed considerably in response to the influence of the Barbizon school.

BIBLIOGRAPHY

'William Louis Sontag', *Cosmopolitan A. J.* (Dec 1858), pp. 2–4
Selection from the Robert P. Coggins Collection of American Painting (exh. cat. by B. Chambers, U. Rochester, NY, Mem. A.G., 1977)
William Sontag: Artist of the Ideal (exh. cat. by N. Moure, Los Angeles, CA, Goldfield Gals, 1980)

PETER BERMINGHAM

Southworth & Hawes. American photographic partnership formed in 1843 by Albert Sands Southworth (*b* West Fairlee, VT, 12 March 1811; *d* Charlestown, MA, 3 March 1894) and Josiah Johnson Hawes (*b* East Sudbury [now Wayland], MA, 20 Feb 1808; *d* Crawford's Notch, NH, 7 Aug 1901). In the late 1830s Southworth was a pharmacist and Hawes was an itinerant portrait painter who also lectured on electricity. In the first months after the publication of the daguerreotype process in France, they learned the procedure, independently of each other, from François Gouraud (*fl* 1839–42), the agent licensed by Daguerre (1787–1851) to teach the process in the USA. Southworth opened a studio with Joseph Pennell in 1840; in 1843 Pennell retired and Hawes joined the firm. Southworth and Hawes worked together in Boston until 1861, when Southworth moved to California to seek a fortune in gold, and Hawes continued alone as a successful portrait photographer.

Southworth & Hawes's production includes some of the most unusual portrait daguerreotypes on either side of the Atlantic. They excelled in portraiture at a time when other daguerreotype photographers were simply mastering the technical fundamentals. Like other successful portrait photographers, Southworth & Hawes are distinguished for their ability to assess quickly and astutely the nuances of their sitter's expressions and gestures, as in *Lola Montez* (*c*. 1852; see fig.), a notorious courtesan posed with a cigarette. While other portrait photographers braced their subjects in lifeless poses to endure the long exposures, Southworth & Hawes perfected methods that reduced exposure times and let chiaroscuro create a dramatic psychological ambience; *Lemuel Shaw, Chief Justice of the Massachusetts Supreme Court* (1851; see Newhall, pl. 96) was photographed under a shaft of natural light, enhancing his strong features. Southworth's sister, Nancy, who married Hawes, also worked for the studio; her delicate hand-colouring of portraits resulted in what have become

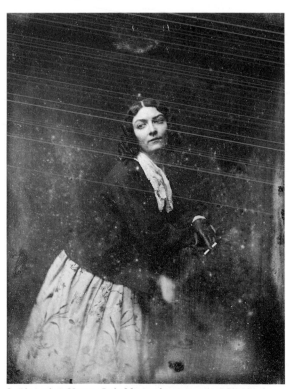

Southworth & Hawes: *Lola Montez*, daguerreotype, 133×102 mm, *c*. 1852 (New York, Metropolitan Museum of Art)

highly prized images. In addition to their portraits, Southworth & Hawes photographed many views of Boston as well as Niagara Falls. They patented many photographic inventions, including a large full-plate viewer for stereoscopic daguerreotypes. It is thought that while Southworth was most responsible for technical inventions, Hawes's background as a portrait painter was responsible for the very high artistic quality of their photographs, a presumption supported by Hawes's excellent later independent work.

WRITINGS

J. J. Hawes: *Twenty-three Years under a Skylight, or Life and Experiences of a Photographer* (Hartford, 1872)

BIBLIOGRAPHY

I. N. Phelps Stokes: *The Hawes-Stokes Collection of American Daguerreotypes* (New York, 1939)

B. Newhall: *The Daguerreotype in America* (New York, 1961, rev. 3/1968)

R. Rudisill: *Mirror Image: The Influence of the Daguerreotype on American Society* (Albuquerque, 1971)

R. J. Homer: *The Legacy of Josiah Johnson Hawes: Nineteenth-century Portraits of Boston* (Barre, 1972)

The Spirit of Fact: The Daguerreotypes of Southworth and Hawes, 1843–1862 (exh. cat., ed. R. Sobieszec; Rochester, NY, Int. Mus. Phot., 1976)

F. Rinhart and M. Rinhart: *The American Daguerreotype* (Athens, GA, 1981)

MARY CHRISTIAN

Spanish Colonial Revival. *See under* COLONIAL REVIVAL.

Spencer, Lilly Martin (*b* Exeter, 26 Nov 1822; *d* New York, 22 May 1902). American painter of English birth. At the age of eight, she and her family emigrated to America, and after three years in New York they moved to Marietta, OH. In 1841 her father took her to Cincinnati, where she exhibited and received help from artists such as the animal painter James Henry Beard (1812–93). However, she refused the offer of the city's most important art patron, Nicholas Longworth, to assist in her art studies in Boston and Europe. Instead she stayed in Cincinnati and married an Englishman, Benjamin Spencer, by whom she had thirteen children, seven living to maturity. In 1848 they moved to New York to take advantage of the greater professional opportunities.

By the 1840s art patronage was in the hands of the middle class, who preferred scenes of everyday life and decorative anecdotal paintings. In response to this, Spencer used her family, her cook and even her pets as subjects and models. She is most noted for her colourful, carefully delineated, detailed scenes from her daily life: the cook, pausing amid her kitchen chores, a child playing with the cat or dressing up in adult clothes. The life she portrayed is cheerful and devoid of tragedy; the mischief is harmless and endearing (e.g. *Reading the Legend*, 1852; Northampton, MA, Smith Coll. Mus. A.; see fig.). Her keenly observed, highly finished, brightly coloured still-lifes were popular. She also painted portraits.

To gain public attention, Spencer made good use of the art unions and art lottery schemes, first in Cincinnati's Western Art Union, then in New York's American Art-Union (until its demise in 1851), followed by the Cosmopolitan Art Union in the late 1850s. Many of her paintings were purchased by William Schaus, the New York agent for the French publishing firm of Goupil, Vibert & Co., which brought out and sold large lithographs after her work.

Lilly Martin Spencer: *Reading the Legend*, oil on canvas, 1280×965 mm, 1852 (Northampton, MA, Smith College Museum of Art)

In the 1860s a new class of art patron made rich by the Civil War began to shift public taste from scenes of everyday life to more serious subject-matter influenced by imported European paintings. In 1869, to accommodate this change, Spencer completed a large allegorical work, *Truth Unveiling Falsehood* (untraced), which she exhibited in New York, Boston, Portland, ME, and at the Centennial Exposition in Philadelphia in 1876. But she soon abandoned this type of painting and returned to her usual subject-matter.

From 1858 the Spencers lived outside New York City, but Lilly Martin kept a studio in the city, and, following her husband's death in 1900, she returned to live there and continued to paint until her death.

UNPUBLISHED SOURCES

Marietta, OH, Campus Martius Mus., also on microfilm at the Archv Amer. A., Washington, DC [letters and archival mat. on the Martin fam.]

Washington, DC, Archv Amer. A. [Lilly Martin Spencer Papers]

BIBLIOGRAPHY

Robin Bolton-Smith and W. H. Truettner: *Lilly Martin Spencer: The Joys of Sentiment* (Washington, DC, 1973) [incl. extensive bibliog.]

H. S. Langa: 'Lilly Martin Spencer: Genre, Aesthetics and Gender in the Work of a Mid-Nineteenth Century American Woman Artist', *Athanor*, ix (1990), pp. 37–45

ROBIN BOLTON-SMITH

Spencer, Robert C(lossen), jr (*b* Milwaukee, WI, 13 April 1864; *d* Tucson, AZ, 9 Sept 1953). American architect and writer. He received his architectural education at the Massachusetts Institute of Technology, Cambridge, MA (1886–8), and worked for Wheelright & Haven and for

Shepley, Rutan & Coolidge, both in Boston. After visiting Europe as recipient of the Rotch Traveling Fellowship, he returned to work at Shepley, Rutan & Coolidge in 1893 and was sent to their office in Chicago, where he went into private practice in 1894. In 1905 he formed a partnership with Horace S. Powers (1872–1928) that lasted until 1923.

Early in his career Spencer came under the influence of Louis Sullivan and joined three other young radicals, Frank Lloyd Wright, Dwight H. Perkins (1867–1941) and Myron Hunt (1868–1962), in a common pursuit of a new architecture. Spencer's style, strongly influenced by the English Arts and Crafts Movement, emerged with the Orendorff House (Canton, IL) in 1902. Spencer softened the simple geometric forms and rectilinear detailing of his stucco houses by the use of elegant stained-glass windows with motifs based on native Midwestern flora. He closely followed the foreign press and became an important disseminator to American popular journals of the English and German domestic revivals. In 1900 he wrote one of the first important articles on his friend Frank Lloyd Wright, which was published with illustrations in the Boston-based periodical *Architectural Review*, and the following year he began producing articles published during the next 15 years in *House Beautiful*, *Architectural Record*, *Brickbuilder*, *Suburban Life* and *American Homes and Gardens* that explained in simple terms the goals of the PRAIRIE SCHOOL.

WRITINGS

'The Work of Frank Lloyd Wright', *Archit. Rev.* [Boston], vii (June 1900), pp. 61–72

BIBLIOGRAPHY

W. G. Purcell: 'Spencer & Powers, Architects', *W. Architect*, xx/4 (April 1914), pp. 35–9
J. W. Rudd: 'The Edward J. McReady House, Spencer & Powers, Architects', *Prairie Sch. Rev.*, iv/1 (1967), pp. 18–19
H. A. Brooks: *The Prairie School* (Toronto, 1972)
P. Kruty: 'Wright, Spencer and the Casement Window', *Winterthur Port.*, xxx/2–3 (Summer/Autumn 1995), pp. 103–27

PAUL KRUTY

Stanford, Leland (*b* Watervliet, NY, 9 March 1824; *d* San Francisco, CA, 21 June 1893). American businessman, politician and patron. An innkeeper's son schooled as a lawyer, he moved in 1852 to California and in 1861 became governor of that state. He was one of the 'Big Four' who that year began the western link of the first continental railway, and it was as president of the Central Pacific Railroad that he made his fortune. He and his wife Jane (née Lathrop; 1828–1905) were the principal patrons of artists working in northern California during the 1870s; they built a grand house in San Francisco with an art gallery for the display of western landscapes by Albert Bierstadt, Thomas Hill, William Keith and others. The trotting horses Stanford bred on his farm at Palo Alto, CA, were depicted in paintings, published as Currier & Ives lithographs, and photographed by Eadweard Muybridge in an experimental series of animals in motion (*see* MUYBRIDGE, EADWEARD, fig. 1).

During trips abroad the Stanfords bought Old Master and French Salon paintings and were portrayed by Ernest Meissonier (1815–91), Carolus-Duran (1837–1917) and Léon Bonnat (1833–1922), who painted *Jane Lathrop Stanford* (1881; Stanford, CA, U. A.G. & Mus.). Their only child, Leland Stanford jr (1869–84), an enthusiastic collector of Egyptian, Greek and Roman objects, was taken to Athens to meet Heinrich Schliemann (1822–90). The boy's death at 15 from typhoid fever was deeply felt by his parents, and in his name they established Leland Stanford Junior University and its museum in Palo Alto. Both founders played substantial roles in the design of the campus, and they employed Frederick Law Olmsted and Charles Coolidge (*b* 1858), an associate of H. H. Richardson, as landscape designer and architect. The couple added to the museum 15,000 items—bought up as collections—of ancient Egyptian, Greek, Cypriot, Native American, Chinese, Japanese and Korean art. Stanford served as US senator from 1885 to 1893.

BIBLIOGRAPHY

A. V. Mozley and others: *Eadweard Muybridge: The Stanford Years, 1872–1882* (exh. cat., Stanford, CA, U. A.G. & Mus., 1972)
P. V. Turner and others: *The Founders & the Architects: The Design of Stanford University* (Stanford, 1976)
C. M. Osborne: 'Stanford Family Portraits by Bonnat, Carolus-Duran, Meissonier, and other French Artists of the 1880s', *Stanford Mus.*, x–xi (1980–81), pp. 2–12
C. M. Osborne and others: *Museum Builders in the West: The Stanfords as Collectors and Patrons of Art, 1870–1906* (Stanford, 1986)
P. J. Maveety: *The Ikeda Collection of Japanese and Chinese Art at Stanford* (Stanford, 1987)

C. M. OSBORNE

Stanley, John Mix (*b* Canandaigua, nr Rochester, NY, 14 Jan 1814; *d* Detroit, MI, 10 April 1872). American painter and photographer. He spent his youth in New York State, where, aged 14, he was apprenticed to a coach maker. In 1834 he moved to Detroit, MI, where he gained his first artistic experience, working as a sign painter. One year later he began to study art more seriously, enrolling as a pupil of the Philadelphia portrait painter James Bowman (1793–1842), with whom he opened a studio in Chicago in 1838. From 1839 he was an itinerant portrait painter, travelling from New York to Minnesota and working mostly in Wisconsin and Illinois. His first Indian portraits date from these years.

Throughout the 1840s Stanley accompanied many military expeditions as a documentary artist and photographer, travelling throughout the West, to the Dakotas, New Mexico, California and even Hawaii. In 1853 he visited Oregon and Washington, particularly the Columbus River area. It was at this time that he amassed the sketches and daguerreotypes that he later turned into his 'Indian Portrait Gallery', which successfully toured America during the 1850s and was eventually donated to the Smithsonian Institution in Washington, DC, in 1852 (mostly destr., 1865). Stanley returned to Detroit in 1864.

Stanley's paintings are characterized by great naturalism and vigour, partly facilitated by his use of photographs. His scenes of Indians, such as *Prairie Indian Encampment* (*c.* 1870; Detroit, MI, Inst. A.; see fig.), are full of intimacy and lack the selfconsciously dramatic quality often found in such renderings. He also painted panoramic landscape scenes, often with Indians in the foreground, for example *Mountain Landscape with Indians* (Detroit, MI, Inst. A.).

BIBLIOGRAPHY

W. V. Kinietz: *John Mix Stanley and his Indian Paintings* (Ann Arbor, 1942)
John Mix Stanley: A Traveler in the West (exh. cat., Ann Arbor, U. MI, Mus. A., 1969)

John Mix Stanley: *Prairie Indian Encampment*, oil on canvas, 1222×914 mm, *c.* 1870 (Detroit, MI, Detroit Institute of Arts)

J. Schimmel: *John Mix Stanley and Imagery of the West in Nineteenth-century American Art* (diss., New York U., 1983)

LESLIE HEINER

Stearns, Junius Brutus (*b* Arlington, VT, 2 July 1810; *d* Brooklyn, NY, 17 Sept 1885). American painter. He spent a long career as a portrait, genre and historical painter in New York. He studied at the National Academy of Design in New York, becoming an Associate in 1848 and an Academician the next year. From 1838 he exhibited at the Academy, as well as at the Apollo Association (later the American Art Union). In 1849 he went to Paris and London to study; on his return, he served as Recording Secretary of the Academy from 1851 to 1865.

Although Stearns made his living primarily through portraits, he painted a number of rural fishing scenes, some of children that were anecdotal and sentimental, others that were group portraits of male fishing parties, for example *Elliott and his Friends* (1857; C. O. von Kienbusch priv. col.). Stearns was best known for his contribution to the iconography of George Washington during the mid-century political renewal of the ideals of the founding fathers. Among his series of paintings commemorating the roles of George Washington as citizen, farmer, soldier, statesman and Christian are *Washington as Farmer, at Mt Vernon* (1851; Richmond, VA Mus. F.A.; see fig.), a relaxed genre scene filled with domestic detail of children, slaves and work animals, and *Washington as Statesman, at the Constitutional Convention* (1856; Richmond, VA Mus. F.A.), a formal Neo-classical composition with portraits of all the delegates. Some works in the series were lithographed and/or engraved.

BIBLIOGRAPHY
'A Life of George Washington Series', *Old Prt Shop Port.*, v (1946), pp. 123–5
M. Rogers: 'Fishing Subjects by Junius Brutus Stearns', *Antiques*, xcviii/2 (1970), pp. 246–50
In this Academy (exh. cat., Philadelphia, PA Acad. F.A., 1976) [repr. ptgs of Washington]

ELIZABETH JOHNS

Stebbins, Emma (*b* New York, 1815; *d* New York, 1882). American sculptor. Her parents encouraged her early artistic interest. She first studied in the studio of the leading portrait painter Henry Inman. In 1843 Stebbins was elected an associate of the National Academy of Design, New York. In 1847 she exhibited at the Pennsylvania Academy of Fine Arts, Philadelphia. From 1857 to 1870 she lived in Rome, where she studied for a period with Benjamin Paul Akers (1825–61), an American sculptor from Maine, and met the renowned sculptor Harriet Hosmer. Hosmer's sponsor in Rome, the actress Charlotte Cushman, became Stebbins's lifelong companion, and in 1860, largely through Cushman's efforts, Stebbins was commissioned to execute a statue of the leading educator Horace Mann. This was cast in 1867 and installed in the Old State House, Boston. At this time she also completed the low-relief sculpture the *Treaty of Henry Hudson with the Indians* (1860), for the collection in New York of Marshall O. Roberts; he also commissioned a monument to *Christopher Columbus* (1867), which was first sited at Central Park and 102nd Street (now New York, Brooklyn Civ. Cent.). Stebbins's most celebrated work is the *Angel of the Waters* (1862; cast 1870), made for the Bethesda Fountain in Central Park, New York, where the angel infuses miraculous powers into the Bethesda Waters. Stebbins's artistic production

was limited by the incidence of Cushman's ill-health. She nursed her companion to her death in 1876.

BIBLIOGRAPHY

The White Marmorean Flock: Nineteenth-century American Neo-classical Sculpture (exh. cat. by Nicolas Cikovsky jr and others, Poughkeepsie, NY, Vassar Coll. A.G., 1972)
P. Dunford: *A Biographical Dictionary of Women Artists in Europe and America since 1850* (Philadelphia, 1989, 2/Hemel Hempstead, 1990)
C. Streifer Rubinstein: *American Women Sculptors* (Boston, MA, 1990)

Steichen, Edward J(ean) [Eduard-Jean] (*b* Luxembourg, 27 March 1879; *d* West Redding, CT, 25 March 1973). American photographer, painter, designer and curator of Luxembourgeois birth. Steichen emigrated to the USA in 1881 and grew up in Hancock, MI, and Milwaukee, WI. His formal schooling ended when he was 15, but he developed an interest in art and photography. He used his self-taught photographic skills in design projects undertaken as an apprentice at a Milwaukee lithography firm. *The Pool-evening* (1899; New York, MOMA, see 1978 exh. cat., no. 4) reflects his early awareness of the Impressionists, especially Claude Monet (1840–1926), and American Symbolist photographers such as Clarence H. White. While still in Milwaukee, his work came to the attention of White, who provided an introduction to Alfred Stieglitz; Stieglitz was impressed by Steichen's work and bought three of his photographs.

Steichen studied briefly in Paris at the Académie Julian and participated in the *New School of American Photography* exhibition in London and Paris (1900). He was elected a member of the Linked Ring society of British Pictorialist photographers. His homage to Auguste Rodin, *Rodin—le penseur* (1902; priv. col., see 1978 exh. cat., no. 11), a platinum and gum-bichromate print made from two negatives, is a masterpiece of ethereal form and light, which remains one of his most familiar images. Returning to New York, he became a founder, with Stieglitz, of the PHOTO-SECESSION group and, in 1903, designed the cover of Stieglitz's new magazine *Camera Work* (1903–17). A special edition of his work, *The Steichen Book* (New York, 1906), was published as a supplement to *Camera Work*. When he moved from his small studio at 291 Fifth Avenue, he encouraged Stieglitz to use the space as a gallery for new art and photography, and in 1905 it became the Little Galleries of the Photo-Secession, later known as 291 (*see* ⟨TWO NINETY-ONE⟩).

Steichen was still involved in painting as well as photography and abandoned a successful photographic portrait studio to return to Paris in 1906. Through Gertrude and Michael Stein he became acquainted with the most important artists of the École de Paris and arranged, with Stieglitz, for their work to be seen for the first time in the USA at 291. In 1907 he created a series of remarkably delicate colour images within a week of the introduction of the autochrome process by the Lumière brothers, Auguste and Louis, including *Houseboat on the Thames* (1907; New York, MOMA, see Steichen, 1963, no. 55). On the eve of World War 1 Steichen returned to New

Junius Brutus Stearns: *Washington as Farmer, at Mt Vernon*, oil on canvas, 952×1371 mm, 1851 (Richmond, VA, Virginia Museum of Fine Arts)

York. Differing views on the war, the future of 291 and Steichen's expressed desire to become a photojournalist in the tradition of Mathew Brady severed the close ties that he had preivously enjoyed with Stieglitz.

WRITINGS

A Life in Photography (New York, 1963) [many excellent plates]

BIBLIOGRAPHY

The Family of Man (exh. cat., prologue C. Sandburg, intro. E. Steichen; New York, MOMA, 1955)

Steichen the Photographer (exh. cat. by A. Liberman, C. Sandburg and E. Steichen, New York, MOMA, 1961) [biog. outline, bibliog.]

D. Longwell: *Steichen: The Master Prints, 1895–1914: The Symbolist Period* (New York, 1978) [pubd on the occasion of the MOMA exhibition of the same title]

Edward Steichen (exh. cat., Rochester, NY, Int. Mus. Photog., 1986)

From Tonalism to Modernism: The Paintings of Edward J. Steichen (exh. cat., Washington, DC, Fed. Reserve Board, 1988)

Edward Steichen: La collezione della Royal Photographic Society (exh. cat. by P. Costantini and P. Roberts, Mestre, Ist. Cult., 1993)

R. J. Gedrim, ed.: *Edward Steichen: Selected Texts and Bibliography* (Oxford, 1996)

P. Niven: *Steichen: A Biography* (New York, 1997)

CONSTANCE W. GLENN

Stein. American family of patrons, collectors and writers, active in France. Upon the death of Daniel Stein in 1891, (2) Leo Stein and (3) Gertrude Stein were entrusted to the care of their elder brother (1) Michael Stein, who managed the family's finances without asking them to justify their expenditure. Their financial independence allowed them to pursue their artistic interests freely and individually, and to become some of the most influential patrons of European avant-garde art during the first quarter of the 20th century.

(1) Michael Stein (*b* Pittsburgh, PA, 26 March 1865; *d* San Francisco, CA, 1938). He married Sarah Stein [née Samuels] (*b* 1870; *d* 1953) in 1893, the same year that he became Vice-President of the San Francisco Tramway Company. In 1903 they moved to Paris. At their refurbished studio at 58 Rue Madame, close to Rue de Fleurus where Leo and Gertrude were living, they quickly formed a collection of paintings by Cézanne (1839–1906), Renoir (1841–1919), Picasso (1881–1973) and Matisse (1869–1954), and instituted regular soirées. Matisse, with whom Sarah was especially close, gradually came to dominate the collection, and the Steins assembled an excellent representation of his development from 1896 to 1917. In 1908, with Hans Purrmann, Sarah Stein helped to fund the Académie Matisse in Paris (which existed until 1911). She registered as a student at the academy of painting opened by Matisse and regularly took notes, which give a fascinating insight into his teaching activities (see A. Barr: *Matisse, his Art and his Public*, New York, 1951, pp. 550–52).

Part of Michael and Sarah Stein's collection was sold after World War I, having first been confiscated by the Germans as American property while it was on loan to the Galerie Gurlitt in Berlin. After Michael's death, Sarah progressively disposed of what remained of the collection, but continued to keep up a faithful correspondence with Matisse.

(2) Leo Stein (*b* Pittsburgh, PA, 1872; *d* Settignano, 29 July 1947). Brother of (1) Michael Stein. After abandoning his studies in biology at Johns Hopkins University, Baltimore, for history of art, in 1900–01 he spent a year in Florence, where he befriended Bernard Berenson (1865–1959). He considered writing a monograph on Mantegna (1430/1–1506) but could not settle on a topic. In 1902 he went to London, where he was briefly joined by (3) Gertrude Stein. Together they bought Japanese prints, antique furniture and curios. Travelling through Paris in 1903 on his way to the USA, he responded to his artistic vocation by taking a studio in the Latin Quarter at 27 Rue de Fleurus. Through Berenson he met Ambroise Vollard (*c.* 1867–1939), and in spring 1904 bought his first painting by Cézanne, *The Conduit* (*c.* 1879; Merion Station, PA, Barnes Found.). The following summer in Florence, accompanied by his sister, he saw further works by Cézanne in the collection of Charles Alexander Loeser (1864–1928).

An intelligent and learned man, Leo Stein was invaluable to his sister as an intellectual and aesthetic guide. He was the first in the family to buy works by Félix Vallotton (1865–1925), Henri Manguin (1874–1949), Renoir (1841–1919) and Gauguin (1848–1903). Among his other purchases were Cézanne's portrait of *Mme Cézanne* (*c.* 1881; Zurich, Stift. Samml. Bührle), bought in spring 1905, and Matisse's *Woman with a Hat* (1905; San Francisco, Mus. Mod. A.), the painting derided at the Salon d'Automne of 1905 not only by members of the public but also by many of Stein's friends. Some weeks later he bought Picasso's *Acrobat's Family with Monkey* (1905; Göteborg, Kstmus.) from the dealer Clovis Sagot; he later visited Picasso in his studio and bought another of his paintings, *Young Girl with a Basket of Flowers* (1905; New York, priv. col., see *Pablo Picasso: A Retrospective*, exh. cat., New York, MOMA, 1980, p. 67). This marked the start of a period of great vitality, both in his acquisition of new works and in lively social evenings in which he feverishly defended the new art, often in the presence of the painters. Nevertheless he stopped buying Matisse in 1908, and Picasso in 1910, refusing to accept Cubism as a serious form of art and becoming something of an outsider in his own salon. In 1913 Leo moved to Settignano, Italy, taking with him two Cézannes, one or two Matisses and sixteen Renoirs.

(3) Gertrude Stein (*b* Allegheny, PA, 3 Feb 1874; *d* Paris, 27 July 1946). Sister of (1) Michael Stein. She moved to Paris in 1902 after studying psychology at Radcliffe College, Cambridge, MA, and later anatomy of the brain at Johns Hopkins University, Baltimore. Living with her brother (2) Leo Stein at 27 Rue de Fleurus, she discovered affinities between the work of contemporary avant-garde artists and her own objectives as a writer. She was attracted to the work of Cézanne and especially Picasso, with whom she developed a close friendship. Between 1906, when her iconic portrait was painted by Picasso (New York, Met.; see fig.), and 1911, she completed her great novel *The Making of Americans* (1925) in which she made direct use of her psychological insights into artists' personalities. Just as Picasso had elaborated a complex system of grids and signs in the analytical phase of Cubism, so Gertrude designed a comparable network of psychological relationships, rather like diagrams, which interested her more than the actual characters. Unlike Leo, Gertrude Stein remained intensely concerned with Picasso's development and continued to buy papiers collés and important canvases, such

Gertrude Stein by Pablo Picasso, oil on canvas, 1000×813 mm, 1906 (New York, Metropolitan Museum of Art)

as *Man with a Guitar* (1913; Philadelphia, PA, Mus. A.). She also recognized and respected Matisse's work but was reserved with him personally, judging him to be slow, stubborn and almost monstrously egocentric. She ceased to appreciate the development of his work after 1912–14, finding it over-decorative. In 1910 or 1911 Gertrude Stein met Juan Gris (1887–1927), with whom she was later to develop a close friendship; she made her first purchases of his work in 1914. On Stein's death, her collection was entrusted to her companion Alice B. Toklas until her own death in 1967. The works were then sold to a consortium of great American collectors (including John Hay Whitney and the Rockefellers), who in turn placed some of them in museums, notably MOMA, New York.

BIBLIOGRAPHY
Four Americans in Paris: The Collections of Gertrude Stein and her Family (exh. cat., New York, Met., 1970)
J. R. Mellow: *Charmed Circle: Gertrude Stein and Company* (New York, Washington and Oxford, 1974)
J. Rewald: *Cézanne, the Steins and their Circle* (London, 1986)
ISABELLE MONOD-FONTAINE

Steuben Glass Works. American glass manufactory in Corning, NY, named after the county in which it is located. In 1903 the Steuben Glass Works were incorporated by T. G. Hawkes (1846–1913), his son Samuel Hawkes (*d* 1959), a cousin Townsend Hawkes and Frederick Carder, who in 1903 accepted Hawkes's offer to join the firm. The works originally supplied blanks for cutting to T. G. Hawkes & Co., but later a great variety of decorative effects were produced at Steuben under Carder. 'Aurene', trademarked in 1904, was the most popular effect; this lustred surface was made by spraying the glass at-the-fire in blue, gold or in combination, with coloured bases on

which a feathered effect was sometimes drawn. Jade glass, which has the appearance of jade stone, was produced in rose, white, blue, green, amethyst and two shades of yellow. Many different colours of transparent glass were made in a single hue or with shaded effects. (In 1918 Steuben became a subsidiary of the Corning Glass Works, where Carder continued to be art director until he retired in 1933.)

BIBLIOGRAPHY
P. V. Gardner: *The Glass of Frederick Carder* (New York, 1971)
P. N. Perrot, P. V. Gardner and J. S. Plaut: *Steuben: Seventy Years of American Glassmaking* (New York, 1974)
M. J. Madigan: *Steuben Glass: An American Tradition in Crystal* (New York, 1982)
J. L. Block: 'Steuben Glass', *Amer. Craft*, xlv (Feb–March 1985), pp. 10–15
Steuben Crystal in Private Collections (New York, *c.*1985)
Masterpieces of American Glass: The Corning Museum of Glass, the Toledo Museum of Art, Lillian Nassau Ltd. (exh. cat. by J. S. Spillman and S. K. Frantz, Corning, NY, Steuben Glass, 1990)
ELLEN PAUL DENKER

Stevens, John Calvin (*b* Boston, MA, 8 Oct 1855; *d* Portland, ME, 25 Jan 1940). American architect. From 1873 he trained as an architect in the office of Francis H. Fassett (1823–1908). In 1880 he became Fassett's partner. The work of Fassett & Stevens consisted of a general range of building types and included some of the finest examples of the Queen Anne Revival style in Maine. As the firm's principal designer, he began to produce original work in the Shingle style for which he is best known. He established his own firm in Portland in 1884. His own residence, built in the same year, initiated a design motif that he frequently adopted during his career: the ordering of the volume of a house through the use of an all-encompassing mansard (gambrel) roof. The James Hopkins Smith House (1884–5) in Falmouth Foreside, ME, carried the mansard roof to its strongest resolution; in it the proportions of the roof are broadened to encompass a mortared-rubble first storey and an open floor plan organized around a living hall.

In a sketch for *A House by the Sea* (1885; priv. col., see Stevens and Cobb, pl. xxxviii), Stevens produced an emphatic horizontal quality by the broad sweep of the gable roof, which is shingled and encompasses a porch and first storey. The cottage designed for Sidney W. Thaxter (1884–5) on Cushing's Island, ME, has a fully shingled exterior and a distinctive double side-gable roof. The latter feature became an important motif in the architect's work.

A brief partnership of Stevens and Albert Winslow Cobb (1858–1941) lasted from 1888 to 1891; their work included a series of outstanding Shingle-style churches and the publication of a book of Stevens's work, *Examples of American Domestic Architecture* (1889). Stevens practised alone from 1891 until his son, John Howard Stevens (1879–1958), became a partner in 1904. While John Calvin Stevens continued to work in the Shingle style until well into the 20th century, more formal interpretations of the Colonial Revival came to dominate his work after 1890. By that time he had acquired a national reputation and was the leading architect in Maine. Although residential work had secured his reputation, he also designed other types of building throughout the country. His practice

continued until his death. His best-known buildings are the Sweat Memorial Museum (1911–12) and City Hall (1909–12), Portland; the latter was done with Carrère & Hastings and is more representative of that firm's work.

WRITINGS

with A. W. Cobb: *Examples of American Domestic Architecture* (New York, 1889/*R* 1978)

BIBLIOGRAPHY

Macmillan Enc. Archit.
V. J. Scully jr: *The Shingle Style: Architectural Theory and Design from Richardson to the Origins of Wright* (New Haven, 1955); rev. as *The Shingle Style and the Stick Style* (New Haven, 1971)
J. C. Stevens II and E. G. Shettleworth jr: *John Calvin Stevens: Domestic Architecture, 1890–1930* (Scarborough, 1990)

EARLE G. SHETTLEWORTH JR

Stewardson, John. *See under* COPE & STEWARDSON.

Stewart, Alexander Turney (*b* Lisburn, Co. Antrim, 12 Oct 1803; *d* New York, 10 April 1876). American businessman and collector of Irish birth. He emigrated to New York at the age of 20 and in 1823 opened a small dry goods store selling Irish lace and linen. He developed the business and by 1862 had opened the largest retail store in the world at that time, a five-storey building covering an entire city block. Designed by John Kellum, A. T. Stewart & Co.'s 'Great Iron Store' (1859–68; destr. 1956) was one of the first commercial buildings to be constructed with an internal iron framework and to have cast-iron walls on all four façades. In 1869 Stewart moved into his new residence on Fifth Avenue (1864–9; destr. 1901), a mansion in the Italian Renaissance style designed by Kellum and known as the 'Marble Palace'. In the picture gallery were displayed about 200 paintings collected in Europe, as well as large sculptures, bronzes, glass and ceramics. The Stewart collection was dispersed at a three-day auction in 1887. The picture *1807, Friedland* (1875) by Ernest Meissonier (1815–91), which Stewart is said to have bought by telegraph, sight unseen, and *Horse Fair* (1853) by Rosa Bonheur (1822–99) were bought and presented to the Metropolitan Museum of Art, New York. Other items included *Niagara* (1857; Washington, DC, Corcoran Gal. A.) by Frederic Edwin Church, *Chariot Race* (1876; Chicago, IL, A. Inst.) by Jean-Léon Gérôme (1824–1904) and a replica of Hiram Powers's *Greek Slave* (*c.* 1843; New Haven, CT, Yale; original, Raby Castle, Durham; for illustration *see* POWERS, HIRAM) on a green and rose marble pedestal with a revolving top. In 1869 Stewart, with Kellum, started to plan the suburban community of Garden City, Long Island, NY.

BIBLIOGRAPHY

O. W. Larkin: *Art and Life in America* (New York, 1949, rev. 1966), p. 295
R. Lynes: *The Tastemakers* (New York and London, 1954), p. 291
M. H. Smith: *Garden City, Long Island in Early Photographs, 1869–1919* (New York, 1987)

M. SUE KENDALL

Stickley, Gustav (*b* Osceola, WI, 9 March 1858; *d* Syracuse, NY, 21 April 1942). American designer and publisher. During most of the period 1875–99, he worked in various family-owned furniture-manufacturing businesses around Binghamton, NY. He travelled to Europe in the 1890s, seeing work by Arts and Crafts designers. In 1899 he established the Gustav Stickley Company in Eastwood, a suburb of Syracuse, NY. The following year he introduced his unornamented, rectilinear Craftsman furniture inspired by the writings of John Ruskin (1819–1900) and William Morris (1834–96). He adopted a William Morris motto, '*Als ik kan*' ('If I can'), as his own and used the symbol of a medieval joiner's compass as his trademark.

Stickley published *The Craftsman* (1901–16), a periodical devoted to the Arts and Crafts Movement. The first issue was dedicated to Morris, the second to Ruskin. Most issues contained articles and illustrations of Craftsman furniture by Stickley. The periodical contained information on American and foreign designers, Japanese and Native American crafts, manual arts education, socialism and gardens. The architect Harvey Ellis wrote articles and produced house designs for *The Craftsman* and may have designed furniture for Stickley in 1903–4. There were *Craftsman* articles on American architects, including Wilson Eyre (1902, 1909, 1912), Charles and Henry Greene (1907, 1912) and Louis Sullivan (1906), and a series of 26 articles (1909–12) by the English architects Barry Parker (1867–1947) and Charles Unwin. Stickley's interest in garden cities led to articles on Letchworth, Herts, Hampstead Garden Suburb, London (1909), and Forest Hills Gardens, NY (1911).

Stickley's interest in furniture design extended to a wider interest in house design. He established the Craftsman Home Builders' Club in 1904 through his magazine. Readers could order complete plans of houses published monthly in *The Craftsman*. Although these houses varied in size and building materials, their ground floors were usually open, and they typically included such details as small-paned casement windows, exposed ceiling beams, built-in furniture, prominent fireplaces and flat, naturally finished board panelling. The W. T. Johnson House (designed 1909) in Lyons, NY, is a typical small Craftsman house. It is one and a half storeys in height with a broad porch across the front. The exterior is shingled. The 11.3 m long living-room has an inglenook with a fieldstone fireplace and built-in settee. Hammered metal Craftsman light-fittings were used throughout the house. Dumblane, the S. Hazen Bond house in Washington, DC, is one of the larger Craftsman designs. It was built in 1912 from a modified 1904 Craftsman plan. Two storeys high with dormers, Dumblane was built of large bricks with oiled cypress exterior woodwork and a pergola on three sides of the house. The open ground floor has a 19.8 m axis from the dining-room through the entrance hall to the living-room fireplace. Stickley liked log-houses, which he considered to be especially American in character. He built a log-house (1909–10) at his Craftsman Farms in Morris Plains, NJ. It was planned to be the clubhouse for an ideal crafts community with a boys' school and workers' cottages. Although the community never materialized, he lived in the house until 1915. The logs are exposed on the exterior and interior of the one and half-storey house. At each end of the house there is a large fieldstone chimney.

Stickley expanded his business activities constantly. For a short period in 1909, his Craftsman House Building Company constructed houses in New York and New Jersey. In 1913 he opened a 12-storey Craftsman Building in New York to house his publishing and design offices,

crafts exhibitions, furniture showrooms and a restaurant. (He declared bankruptcy in 1915 as a result of taking on too many ventures.) At the peak of his career, Stickley was one of the most important leaders of the Arts and Crafts Movement in the USA. His furniture (see colour pl. XXXIII, 3) was sold throughout the country, and Craftsman houses were built in many areas. *The Craftsman* magazine was widely read. After his bankruptcy, Stickley was largely forgotten until the 1970s when his importance as a designer and spokesman for the movement was rediscovered.

BIBLIOGRAPHY

J. C. Freeman: *The Forgotten Rebel: Gustav Stickley and his Craftsman Mission Furniture* (Watkins Glen, 1966)

R. J. Clark, ed.: *The Arts and Crafts Movement in America 1876–1916* (Princeton, 1972)

B. Sanders, ed.: *'The Craftsman': An Anthology* (Santa Barbara, 1978)

D. M. Cathers: *Furniture of the American Arts and Crafts Movement* (New York, 1981)

M. A. Smith: *Gustav Stickley: The Craftsman* (Syracuse, 1983/R New York, 1993)

M. A. Hewitt: 'Words, Deeds and Artifice: Gustav Stickley's Club House at Craftsman Farms', *Winterthur Port.*, xxxi (1996), pp. 23–51

B. Sanders: *A Complex Fate: Gustav Stickley and the Craftsman Movement* (New York, 1996)

MARY ANN SMITH

Stick style. Architectural term coined in 1949 by Vincent J. Scully jr to describe a style of mid-19th-century American timber-frame domestic architecture. Scully posited a common theoretical link: the desire to express structure with an externally visible wooden frame. 'This new aesthetic sensitivity to the expression of light wood structure', wrote Scully in 1953, 'in a sense stripped the skin off the Greek Revival and brought the frame to light as the skeleton of a new and organically wooden style.' While acknowledging European sources, Scully concluded that the Stick style was, like the other style he identified, the Shingle style, essentially American. He cited as noteworthy examples A. J. Downing's board-and-batten cottage designs of the 1840s and 1850s, Richard Morris Hunt's J. N. A. Griswold House (1861–3), Newport, RI (see HUNT, (2), fig. 1), and Dudley Newton's Cram House (1875–6), Middletown, RI. Despite its wide acceptance, a few critics have questioned the validity of Scully's term. Rarely is there a direct correlation between external woodwork and actual structure; Hunt's Griswold House drawings bear this out; and there is little evidence that American designers sought structural expression. Their goals had more to do with the Picturesque, historicism, eclecticism and a wish to follow the latest fashion from abroad. These houses recall a variety of wooden building types, from the half-timbered Late Gothic domestic architecture of England, France and Germany to the Swiss chalet and Scandinavian, Tyrolean and Slavic vernacular building. They reflect the contemporary European taste for houses that invoked these traditions.

BIBLIOGRAPHY

V. J. Scully jr: *The Cottage Style: An Organic Development in Later 19th-century Wooden Domestic Architecture in the Eastern United States* (diss., New Haven, CT, Yale U., 1949)

——: 'Romantic Rationalism and the Expression of Structure in Wood: Downing, Wheeler, Gardner and the "Stick Style"', *A. Bull.*, xxxv (1953), pp. 121–42

——: *The Shingle Style and the Stick Style* (New Haven, 1955, rev. 1971)

——: *The Shingle Style Today: Or the Historian's Revenge* (New York, 1974), pp. 6–19

S. B. Landau: 'Richard Morris Hunt, the Continental Picturesque and the Stick Style', *J. Soc. Archit. Hist.*, xlii (1983), pp. 272–89

DAVID CHASE

Stiegel, Henry William [Heinrich Wilhelm] (*b* Cologne, 13 May 1729; *d* Charming Forge, PA, 10 Jan 1785). American manufacturer of German birth. He moved to Pennsylvania in 1750 and became associated with iron manufacturing through his marriage in 1752 to Elizabeth Huber, whose father owned an iron furnace in Lancaster Co., PA. At Elizabeth Furnace, near Brickerville, PA, Stiegel built in 1763 his first glasshouse, where window glass and bottles were made. Several of the craftsmen employed there had probably come from Caspar Wistar's operation in southern New Jersey. Beginning in 1762 Stiegel was involved with other investors in the creation of Manheim, PA, a village for his workers. In 1764–5 he built there on his own account a glasshouse, where he produced in addition some tableware.

In anticipation of the demand following the levying in 1767 of a tax on imported glass, and despite generally poor economic conditions, Stiegel opened in 1769 a second glasshouse at Manheim, the American Flint Glass Manufactory, for the production of fine tablewares in lead glass and coloured glass. The work of Stiegel's English and German craftsmen is documented almost exclusively by written record, which claims many different blown tablewares, including wine-glasses, tumblers, cans, decanters, cruets, servers, syllabubs, jellies in several patterns, flowerpots, candlesticks, sugar dishes and cream jugs. Engraving, cutting and enamelling were offered as decorative techniques, in addition to moulding by which were produced, among other objects, distinctive diamond-daisy-pattern pocket flasks. A piece that survives is a wheel-engraved, lead-glass goblet made to commemorate the wedding of Stiegel's daughter (1773; Corning, NY, Mus. Glass; see UNITED STATES OF AMERICA, fig. 38).

Stiegel's Manheim warehouse continued to fill up, and in 1774 the glasshouse was closed. Stiegel was so heavily in debt on account of his third factory that he was imprisoned for a short time and he died in poverty.

BIBLIOGRAPHY

F. W. Hunter: *Stiegel Glass* (Cambridge, MA, 1914)

A. Palmer: ' "To the Good of the Province and Country": Henry William Stiegel and American Flint Glass', *The American Craftsman and the European Tradition, 1620–1820*, ed. F. Puig and M. Conforti (Hanover, NH, 1989), pp. 202–39

ELLEN PAUL DENKER

Stieglitz, Alfred (*b* Hoboken, NJ, 1 Jan 1864; *d* New York, 13 July 1946). American photographer, editor, publisher, patron and dealer. Internationally acclaimed as a pioneer of modern photography, he produced a rich and significant body of work between 1883 and 1937. He championed photography as a graphic medium equal in stature to high art and fostered the growth of the cultural vanguard in New York in the early 20th century.

1. Life and works. 2. Working methods and technique.

1. LIFE AND WORKS.

(i) *Formative period in Germany, 1881–90.* The first of six children born to an upper-middle-class couple of German–Jewish heritage, Stieglitz discovered the pleasure

of amateur photography after 1881, when his family left New York to settle temporarily in Germany. His father, Edward Stieglitz, had retired from a successful business in the wool trade with a fortune that enabled him to educate his children abroad. In 1882 Alfred enrolled in the mechanical engineering programme of the Technische Hochschule in Berlin, but he spent his spare time experimenting with photography in a darkroom improvised in his student quarters. His self-directed experiments led him to study photochemistry with an eminent scientist, Hermann Wilhelm Vogel (1834–98), who taught him the scientific bases and technical principles of photography. Building on this scientific knowledge, Stieglitz decided to pursue serious photography. He absorbed artistic influences from 19th-century painters working in the style of the Barbizon school and, more significantly, from English photographers, notably P. H. Emerson (1856–1936). Emerson had rejected the sentimental subjects and manipulated prints of Victorian and pictorial photography, instead advocating 'truth to nature' in straight photography that captured the appearance and atmosphere of the visible world by respecting the integrity of the photographic medium. Stieglitz owed many of his ideas, as well as his early use of platinum paper for printing and photogravure for reproduction, to Emerson's example. In 1887 Emerson awarded Stieglitz first prize for *A Good Joke* (Washington, DC, N.G.A.), one of a group of Italian photographs submitted to a competition sponsored by the English journal *Amateur Photographer*. Stieglitz's *Sun Rays—Paula* (1889; Chicago, IL, A. Inst.), an early silver print of a young woman writing in an interior illuminated by slatted blinds, revealed his technical mastery of composition and tonal range.

(ii) New York, 1890–1901. Although he would have preferred to remain in Germany, Stieglitz returned to New York in 1890. Complying with his parents' wishes, he entered a photo-engraving business in partnership with the friends with whom he had lived in Berlin, and in 1893 he married Emmeline Obermeyer (1873–1953), the sister of one of them. During the 1890s Stieglitz used his hand-held camera to capture candid scenes of New York life. *The Terminal* (1893; Washington, DC, N.G.A.; see fig. 1), a photogravure of a street-car driver watering down his horses, and *Winter on Fifth Avenue* (1893; Rochester, NY,

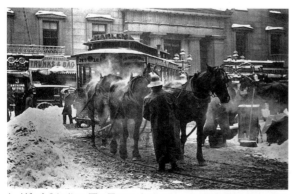

1. Alfred Stieglitz: *The Terminal*, photograph, 196×300 mm, 1893 (Washington, DC, National Gallery of Art)

Int. Mus. Phot.), the first pictorial photograph of a snowstorm, anticipated the frank treatment of working-class urban subject-matter by such Ashcan school painters as John Sloan in the following decade. Working outside at night, Stieglitz photographed the Savoy Hotel after a rainstorm in *Reflections—Night, New York* (1896; Boston, MA, Mus. F.A.). During his honeymoon abroad in 1893–4 he produced prize-winning photographs of Venice and the Netherlands. Throughout the 1890s his photographs won prizes in British and European competitions and earned him an international reputation.

In 1895 Stieglitz left the photo-engraving business to pursue photography full-time. For years thereafter, his father paid him an annual allowance. Serving from 1892 to 1895 as editor of the *American Amateur Photographer*, Stieglitz determined to crusade for the improvement of American photography. In 1896 he helped merge the Society of Amateur Photographers with the New York Camera Club to form the Camera Club of New York. As its vice-president and editor of its quarterly publication, *Camera Notes*, from 1897 to 1901, he tried to bring American photography into the international arena.

(iii) Photo-Secession, 1902–17. In February 1902, after the growing progressive movement in American photography provoked conservative opposition within the Camera Club, Stieglitz founded an alternative group concerned with PICTORIAL PHOTOGRAPHY, the PHOTO-SECESSION, loosely modelled on the English Linked Ring and European Secessionist groups. In March he organized an exhibition, *American Pictorial Photography*, at the National Arts Club in New York to introduce the new group. EDWARD J. STEICHEN, a friend and also a prominent photographer, helped formulate their goals: to promote photography as 'applied pictorial expression', to unite progressive American photographers and to sponsor exhibitions of members' works. In 1903 Stieglitz published the inaugural issue of *Camera Work*, the journal that served for the next 14 years as the organ of the Photo-Secession and as the platform for his aesthetic programme. Its contents ranged from technical articles on photography to essays on aesthetics, literature, criticism (particularly Symbolist and modernist theories) and modern art. Lavishly illustrated with superb photographic reproductions, *Camera Work* included essays by such photographers as Steichen and Alvin Langdon Coburn, such writers as Gertrude Stein (1874–1946), such critics as Charles Caffin (1854–1918) and Sidney Allen (pseud. of Sadakichi Hartmann), and artists such as Max Weber and the Mexican illustrator Marius de Zayas (1880–1961). In quality of printing, reproduction, typography and design, *Camera Work* embodied Stieglitz's rigorous aesthetic standards.

Between 1902 and 1904 Stieglitz arranged Photo-Secession exhibitions throughout Europe and across North America. In November 1905, with Steichen's assistance, he opened the Little Galleries of the Photo-Secession on the top floor of 291 Fifth Avenue in Manhattan. Later known simply as 291 (*see* ⟨TWO NINETY-ONE⟩) the gallery displayed selections of Pictorial photography and became the headquarters of the Photo-Secession. With Steichen's help, Stieglitz began to show contemporary art at 291 in 1907 and was the first in

the USA to present works by such European modernists as Matisse (1908 and 1912), Cézanne (1911), Picasso (1911) and Constantin Brancusi (1914), as well as African sculpture as art (1914–15). The gallery also actively supported art by the American pioneers of modernism, notably Oscar Bluemner (1867–1938), Arthur Dove (1880–1946), Marsden Hartley (1877–1943), John Marin, Elie Nadelman (1882–1946), Georgia O'Keeffe (1887–1986) and Max Weber. Under Stieglitz's direction, 291 became a meeting-place and focal-point for the New York avant-garde.

The scope of Stieglitz's activities as publisher, patron and gallery owner necessarily diminished the quantity, though not the quality, of his own photographic output during this period. He continued to record New York and repeatedly photographed the view of buildings from the back window of 291. He also produced a remarkable series of character studies: portraits of the artists, critics and friends of the 291 group. During this period he created one of his most enduring images, *The Steerage* (photogravure, 320×257 mm, 1907; Washington, DC, N.G.A.), a masterfully composed picture of a ship filled with prospective immigrants to America returning to Europe. Exhausted by his manifold efforts on behalf of modern art and photography, Stieglitz closed 291 and ceased publication of *Camera Work* in 1917.

2. WORKING METHODS AND TECHNIQUE. Stieglitz's methods reflected his commitment to 'straight' photography. Opposed to 'dodging' and retouching, he carefully selected and framed his subjects, thereby composing his images directly through the camera lens on to the glass plate negative. He preferred to use a sharp focus and generally refrained from editing or manipulating his prints. Homer (1983) discovered variant states of well-known early photographs among the key set in the National Gallery of Art. While these variations revealed that Stieglitz occasionally cropped images to achieve a desired composition, such departures from 'straight' photography were not part of his usual practice. Around 1898, together with another American photographer, Joseph T. Keiley (1869–1914), Stieglitz devised a method to control development by coating the exposed platinum print with glycerine to produce the effect of a wash drawing. Stieglitz experimented briefly with this more pictorial technique. As the leader of the Photo-Secession, he exhibited and supported the work of photographers who used a soft focus or other pictorial methods, but for his own work he restricted the range of control as much as possible to the camera rather than to the printing process.

A perfectionist more than a technical innovator, Stieglitz extended the expressive limits and power of existing photographic techniques. He was a meticulous craftsman who insisted on the best equipment and materials for his photographic work. For printing, he preferred to use a high-quality platinum paper imported from England, until its prohibitive cost ended its commercial manufacture in 1916. During the 1890s he demonstrated the artistic potential of lantern slides when he produced high-quality reproductions of his photographs by this method. Between 1917 and 1932, he periodically reprinted earlier negatives from the 1880s and 1890s. By the late 1990s a full-scale

technical analysis of Stieglitz's photography had yet to be undertaken.

UNPUBLISHED SOURCES

New Haven, CT, Yale U., Beinecke Lib. [Alfred Stieglitz Archive: personal pap., corr., writings and gal. rec.]

WRITINGS

'A Plea for Art Photography in America', *Phot. Mosaics*, xxviii (1892), pp. 135–7
ed.: *Amer. Amat. Photographer*, v/7 (1893)–viii/1 (1896)
'The Hand Camera: Its Present Importance', *Amer. Annu. Phot.* (1897), pp. 19–27
ed.: *Cam. Notes*, i/1 (1897)–vi/1 (1902)
'Night Photography with the Introduction of Life', *Amer. Annu. Phot.* (1898), pp. 204–7
'The Progress of Pictorial Photography in the United States', *Amer. Annu. Phot.* (1899), pp. 153–9
ed.: *Cam. Work*, i (1903)–xvix/1 (1917)
Photo-Secession and its Opponents: Five Letters (New York, 1910)
Photo-Secession and its Opponents: Another Letter—the Sixth (New York, 1910)

BIBLIOGRAPHY

W. Frank, ed.: *America and Alfred Stieglitz: A Collective Portrait* (New York, 1934)
D. Norman: 'From the Writings and Conversations of Alfred Stieglitz', *Twice a Year*, i (1938), pp. 77–110
D. Norman, ed.: *Stieglitz Memorial Portfolio, 1864–1946* (New York, 1947)
Catalogue of the Alfred Stieglitz Collection for Fisk University (Nashville, 1949)
D. Norman: *Alfred Stieglitz: Introduction to an American Seer* (New York, 1960)
Alfred Stieglitz: Photographer (exh. cat. by D. Bry, Boston, MA, Mus. F. A., 1965)
H. J. Seligmann: *Alfred Stieglitz Talking: Notes on Some of his Conversations, 1925–1931* (New Haven, 1966)
B. Dijkstra: *The Hieroglyphics of a New Speech: Cubism, Stieglitz, and the Early Poetry of William Carlos Williams* (Princeton, 1969)
J. Zilczer: 'The Aesthetic Struggle in America': Abstract Art and Theory in the Stieglitz Circle (diss., Newark, U. DE, 1975)
W. Homer: *Alfred Stieglitz and the American Avant-garde* (Boston, 1977) [definitive account of Stieglitz's role in early modernism; excellent bibliog.]
The Collection of Alfred Stieglitz: Fifty Pioneers of Modern Photography (exh. cat. by W. J. Naef, New York, Met., 1978)
Alfred Stieglitz: Photography and Writings (exh. cat. by S. Greenough and J. Hamilton, Washington, DC, N.G.A., 1983) [major retro. incl. annotated selection of letters and superb reproductions]
W. Homer: *Alfred Stieglitz and the Photo-Secession* (Boston, 1983)
S. D. Lowe: *Stieglitz: A Memoir/Biography* (New York, 1983) [first full scale, well-documented biography, written by Stieglitz's grand-niece]
S. Greenough: *Alfred Stieglitz's Photographs of Clouds* (diss., Albuquerque, U. NM, 1984)
E. Abrahams: *The Lyrical Left: Randolph Bourne, Alfred Stieglitz and the Origins of Cultural Radicalism in America* (Charlottesville, 1986)
E. Turner, B. Rathbone and R. Shattuck, eds: *Two Lives: Georgia O'Keeffe and Alfred Stieglitz* (New York, 1992) [a conversation in ptgs and photographs]
S. Philippi and U. Kieseyer: *Alfred Stieglitz, 'Camera Work': The Complete Illustrations, 1903–1917* (Cologne and new York, [1997])

For further bibliography *see* PHOTO-SECESSION and 〉TWO NINE ONE〉

JUDITH ZILCZER

Stillman, William James (*b* Schenectady, NY, 1 June 1828; *d* Surrey, 6 July 1901). American painter, photographer and art critic. Stillman studied landscape painting with Frederick Church after graduating from Union College, Schenectady, in 1848. He met other painters of the Hudson River school in Church's studio and read *Modern Painters* (1843–60) by John Ruskin (1819–1900), which had a great influence on him. He studied art in England in 1850 and formed friendships with Ruskin and Dante Gabriel Rossetti (1828–82). In New York he exhibited

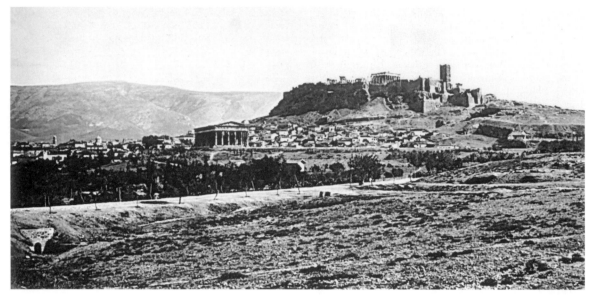

William James Stillman: *View of the Acropolis, Athens, from the North-west*, carbon print photograph from wet-collodion plate, 1869; from *The Acropolis of Athens* (London, 1870)

paintings at the National Academy of Design and was called the 'American Pre-Raphaelite'. Two of his paintings are in public collections: *Saranac Lake* (Boston, MA, Mus. F.A.) and the *Philosopher's Camp* (Concord, MA, Free Lib.). In 1855 he founded a weekly art journal, the *Crayon*, to which he contributed important reviews until 1861.

Stillman learnt photography in 1859 and made his first photographs, from wet-collodion plates, while guiding Ralph Waldo Emerson, Louis Agassiz and others through the Adirondack wilderness. The photographs are nature studies and show Stillman's concern with composition and detail. While serving as consul in Rome and Crete, he photographed landscape and architectural views (now in Schenectady, NY, Un. Coll.). Stillman's major work, a volume of carbon prints made from wet-collodion plates entitled *The Acropolis of Athens* (see fig.), was dedicated to his wife, the painter Marie Spartali (1844–1927). The photographs combine technical mastery with a formal, planar structure. *Poetic Localities of Cambridge* is an expression of imaginative vision and atmospheric effect. Stillman considered himself a journalist and a painter, but he produced a body of photographic work of exceptional merit.

PHOTOGRAPHIC PUBLICATIONS
The Acropolis of Athens (London, 1870)
Poetic Localities of Cambridge (Boston, MA, 1876)
The Old Rome and the New (London, 1897)

BIBLIOGRAPHY
R. D. Bullock: *William James Stillman: The Early Years* (diss., Minneapolis, U. of MN, 1976)
F. Miller: *Catalogue of the William James Stillman Collection* (Schenectady, NY, 1974) [cat. of Un. Coll. Lib. col., with complete bibliog. of pubns]
A. B. Ehrenkrantz: *Poetic Localities* (New York, 1988)
ANNE EHRENKRANZ

Stock, Joseph Whiting (*b* Springfield, MA, 30 Jan 1815; *d* Springfield, MA, 28 June 1855). American painter. He was physically handicapped and confined to his house until his doctor advised a wheelchair, which, when placed on a railway carriage, allowed him to travel. He took painting lessons as therapy from Franklin White, a pupil of Chester Harding, and became proficient as an artist. This enabled him to make a living painting portraits, landscapes and miniatures throughout New England and part of New York State. He kept a journal that lists 912 examples of his work executed between 1832 and 1846, with the names of his sitters, canvas sizes, the prices charged and where the pictures were painted. No examples of his landscapes have survived and only a few of his 80 miniatures have been located. The earliest miniatures date from 1836, but most were executed in 1842 and 1845 when he lived in New Bedford, MA. Few American primitive artists of the 19th century were as productive as Stock.

Though his technique is not as finished as some of his contemporaries, he achieved a distinctively decorative style, often using photographs. He specialized in full-length portraits of children (e.g. *William Howard Smith* and his sister *Mary Jane Smith* (1838; both Williamsburg, VA, Rockefeller Flk A. Col.; see fig.) and was fond of including details of his sitters' possessions such as draperies, books, hats, pets and furniture, which provide a vivid insight into life in 19th-century America. Small landscapes were sometimes included in the background of his paintings.

BIBLIOGRAPHY
J. L. Clarke jr: 'Joseph Whiting Stock: American Primitive Painter (1815–1855)', *Antiques*, xxiv/2 (1938), pp. 82–4
J. Tomlinson: *The Paintings and Journal of Joseph Whiting Stock* (Middletown, CT, 1976)
Joseph Whiting Stock, 1815–1855 (exh. cat. by B. B. Jones, Northampton, MA, Smith Coll. Mus. A., 1977)
JULIETTE TOMLINSON

Story, William Wetmore (*b* Salem, MA, 12 Feb 1819; *d* Vallombrosa, Italy, 5 Oct 1895). American sculptor and writer. Son of a justice of the US Supreme Court, he was

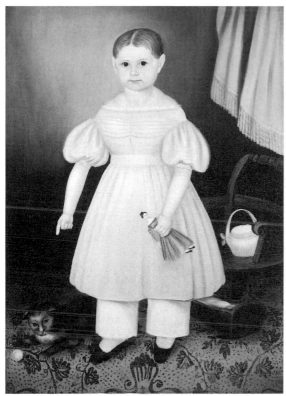

Joseph Whiting Stock: *Mary Jane Smith*, oil on canvas, 953×1372 mm, 1838 (Williamsburg, VA, Rockefeller Folk Art Collection)

educated at Harvard and practised law in Boston, where he also earned recognition as an art critic, poet and literary editor. He was part of an élite circle that included Ralph Waldo Emerson, Washington Allston and James Russell Lowell.

When his father died in 1845, a memorial statue was planned in his honour. Somewhat unexpectedly, Story was commissioned to design it, with the proviso that he first be permitted several years study abroad to acquire technical proficiency in sculptural modelling, a hobby in which he had already displayed natural ability. The resulting marble portrait of *Joseph Story* (1854; Cambridge, MA, Harvard U., Portrait Col.) was enthusiastically received when it was installed in Mount Auburn Cemetery, encouraging both Story's artistic ambitions and his desire for further European adventure. He settled in Rome in 1856 and worked assiduously at his new profession, drawing around him an urbane, affluent group of international friends who proved an invaluable source of commissions.

Story's work in the ideal mode, which he preferred to portraiture, first attracted critical notice at the London International Exhibition of 1862, at which his meditative figures of the *Libyan Sibyl* (1861; New York, Met.) and *Cleopatra* (1858; Los Angeles, CA, Co. Mus. A.) excited the public's imagination. Thereafter his studio produced a series of acclaimed compositions, most depicting mythological or biblical characters in melancholic attitudes, arrayed with archaeologically correct props. Characteristic of these over life-size works in marble are his studies of

Medea Contemplating the Murder of her Children (1864; version, 1868; New York, Met.), *Saul, When the Evil Spirits Were upon him* (version, 1882; San Francisco, CA, de Young Mem. Mus.) and *Sappho* (1863; Boston, MA, Mus. F.A.). Story's choice of dramatic themes and the probing psychological approach he employed in his mature oeuvre were strongly influenced by the theories of his friend Robert Browning.

Although Story's artistic reputation plummeted after his death, he secured some posthumous celebrity through the two-volume biography that Henry James produced at the request of the sculptor's family. Story had three children who pursued artistic careers: Waldo (1855–1915), sculptor of the *Fountain of Love* (1894–6; Cliveden, Bucks, NT); Julian Russell (1857–1919), a painter; and Edith Marion (1844–1907), the Marchesa Peruzzi de' Medici, a writer.

WRITINGS
Conversations in a Studio (Boston, 1890)
Excursions in Art and Letters (Boston, 1891)

BIBLIOGRAPHY
M. Phillips: *Reminiscences of William Wetmore Story, the American Sculptor and Author* (Chicago, 1897)
H. James: *William Wetmore Story and his Friends*, 2 vols (London, 1903)
W. Gerdts: 'William Wetmore Story', *Amer. A. J.*, iv/2 (1972), pp. 16–33
F. DiFederico and J. Markus: 'The Influence of Robert Browning on the Art of William Wetmore Story', *Browning Inst. Stud.*, i (1973), pp. 63–85
J. Seidler [Ramirez]: 'The Lovelorn Lady: A New Look at William Wetmore Story's *Sappho*', *Amer. A. J.*, xv/3 (1983), pp. 80–90
——: *A Critical Reappraisal of the Career of William Wetmore Story, American Sculptor and Man of Letters* (diss., Boston U., MA, 1985)
J. L. Fairbanks: 'William Wetmore Story's Marble *Sappho*', *Antiques*, cli (1997), pp. 240–43

JAN SEIDLER RAMIREZ

Strickland, William (*b* Philadelphia, PA, 1788; *d* Nashville, TN, 6 April 1854). American architect, engineer and painter. Among the first generation of native-born architects, he was an influential designer in the GREEK REVIVAL style. Over a period of almost 50 years he executed more than 70 commissions, many of them in Philadelphia. His last major building was the Tennessee State Capitol in Nashville, built from 1845.

1. TRAINING AND EARLY WORK, 1803–25. Through his father, a master carpenter who had worked on Latrobe's Bank of Pennsylvania, Strickland was apprenticed to Benjamin Henry Latrobe in 1803, remaining in his office for about four years. During his apprenticeship he studied Latrobe's folios of Greek antiquities, including James Stuart's and Nicholas Revett's *Antiquities of Athens*, 4 vols (1762–1816), as well as publications by the Society of Dilettanti. By 1807 he was in New York with his father, working as a painter of stage scenery. The following year he returned to Philadelphia, where he received his first major commission: a design for the city's Masonic Hall (1809–11; destr. 1853; see *Macmillan Enc. Archit.*, iv, p. 140). The Masonic Hall was a two-storey building in brick and marble, surmounted by a 60-m wooden steeple. This picturesque medley of pinnacles, buttresses, crenellations and niches, somewhat after the manner of Batty Langley's Gothick, was an early example of American Gothic.

Despite the impressive design of the Masonic Hall and its technically innovative interior gas lighting, Strickland

had no further architectural commissions after its completion. During the War of 1812 he worked on Philadelphia's fortifications as a surveyor and engineer, and he also gained some success with his engravings and aquatints, providing plates for *Port Folio* and *Analectic Magazine*. Books illustrated by him included David Porter's *Journal of a Cruise Made to the Pacific Ocean* and *The Art of Colouring and Painting in Water Colours* (both 1815). He also worked as a landscape painter and exhibited at the annual exhibitions of the Pennsylvania Academy of the Fine Arts between 1811 and 1843. Among the pictures he exhibited was his view of *Christ Church, Philadelphia* (1811; Philadelphia, PA, Hist. Soc.).

In 1816 Philadelphia's Swedenborgian community commissioned Strickland to design their Temple of the New Jerusalem (1816–17; destr.). The Temple supported a low dome with a lantern, and its elevations were decorated with pointed Gothic arches, but its plan followed the current fashion for centralized chapels and churches. Two years later Strickland won a competition to design the Second Bank of the United States in Philadelphia (see fig. 1), ahead of Latrobe and other distinguished rivals. The bank's directors required that the building be 'a chaste imitation of Grecian Architecture, in its simplest and least expensive form', and Strickland based his octastyle Doric porticoes at the north and south fronts on the Parthenon's, as depicted in the *Antiquities of Athens*. For reasons of light and space, the Parthenon's flanking colonnades were not copied in Strickland's design, and the Second Bank's interior featured a basilican hall of Ionic colonnades after that by Richard Boyle (1694–1753), 3rd Earl of Burlington, at his Assembly Rooms, York, England (1731–2). However, by preserving the templar block, and through its scale, proportion, siting and use of authentic detail, Strickland's Second Bank was the purest Greek Doric building then to be seen in North America, and it was to play an influential part in subsequent American Neo-classicism.

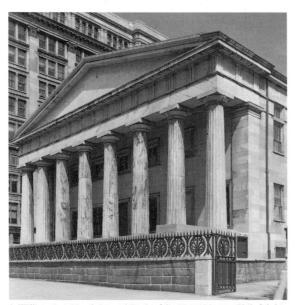

1. William Strickland: Second Bank of the United States, Philadelphia, Pennsylvania, c. 1818

The Second Bank resulted in a flood of commissions for Strickland over the next 20 years. He was also elected to various intellectual and cultural societies, including the Franklin Institute and the Musical Fund Society, and he designed the latter's Hall (1824; altered) in Philadelphia. Elected to the American Philosophical Society in 1820, he also became a shareholder that year in the Athenaeum of Philadelphia. His work during this period already showed a strong vein of eclecticism. In 1820 he began rebuilding Philadelphia's Chestnut Street Theatre (destr. 1850s), a building in the Federal Style (*see* FEDERAL STYLE, §1) with details in the manner of John Soane (1753–1837). Its ground-floor entrance arcade supported a Corinthian colonnade, echoing the design of numerous 18th-century town halls and theatres in England. In 1821 he made his first (six-month) trip to Britain, ostensibly to study prison architecture, although he was undoubtedly more interested in and influenced by his first-hand experience of English Palladianism and of Greek and Gothic Revival architecture. The Gothic influence can be seen in his St Stephen's Episcopal Church (1822–3), Philadelphia, with its twin octagonal towers, while the effects of his study of Greek Revival architecture in England can be traced in his chaste Doric design (1824; unexecuted; see 1986–7 exh. cat., p. 68, fig. 19) for a Masonic Hall at Germantown, Philadelphia.

2. MATURE WORK IN PHILADELPHIA AND ELSEWHERE, 1826–44. Strickland's abilities as an engineer, demonstrated by his land survey (1821–3) for the Chesapeake and Delaware Canal, for example, brought him to the attention of the Pennsylvania Society for the Promotion of Internal Improvement who sent him on a nine-month study tour of British transportation systems in 1825. The following year he published his *Reports on Canals, Railways, Roads, and Other Subjects*. Its 72 engraved plates further enhanced his reputation, but the *Reports* also helped spread the influence of advanced British technology through the USA. Supplemented by his correspondence, the *Reports* make it possible to document this second British trip and assess the impact on him of the cities he visited. His exquisitely graceful, yet broadly monumental designs of the 1820s and 1830s were often to reflect British Neo-classical architecture. After 1826 his series of commissions for Neo-classical buildings in Philadelphia transformed the city. One outstanding example is his US Naval Asylum (1826–33). Its broad, octastyle Ionic portico (from the Temple of the Ilissos as depicted by Stuart and Revett) serves as a foil for the broadly extended wings with their balconies on three storeys supported by cast-iron columns. These allowed fresh air to circulate more freely and were modelled after hospitals for service pensioners in London. His innovative use of structural cast-iron columns followed progressive British constructional practice.

Strickland pursued this successful blend of antique elements and modern construction and design. Over the next few years in Philadelphia he built the US Mint (1829–33; destr. 1902), the First Congregational Unitarian Church (1828; destr. 1885), the Mechanics' Bank (1837; altered) and, in Rhode Island, the Athenaeum (1836) at Providence (see fig. 2). He also continued with engineering projects,

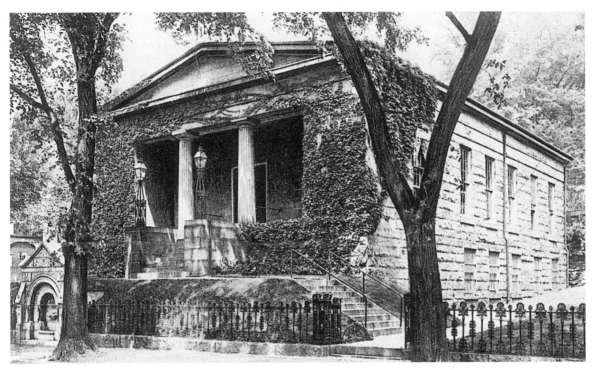

2. William Strickland: Athenaeum, Providence, Rhode Island, 1836

and between 1828 and 1840 he built the Delaware Breakwater that still protects Philadelphia's harbour. He also made one of the first attempts in the USA at historic restoration when in 1828 he designed a wooden replica of Independence Hall's original steeple, which had been removed in 1781.

Strickland's effort to make Greek Revival architecture ever more acceptable as the national style is expressed at its best in his design for the Philadelphia (or Merchants') Exchange (1832–4). Exploiting its triangular site, the building comprised both block and cylinder, for at its apex he added a dramatically curved Corinthian colonnade, ranging through the second and third storeys. This motif was derived from the Literary and Philosophical Institution (1821–3), Bristol, by Charles Robert Cockerell (1788–1863), studied by Strickland on his visit of 1825. Rising from this cylinder was a lantern copied by Strickland from the Choragic Monument of Lysikrates, again via the *Antiquities of Athens*, but further authorized by a paraphrase of the same structure used for the Burns Monument, near Alloway in Scotland, and extolled for its beauty by Strickland in his letters of 1825. The Merchants' Exchange stands as a monument to Strickland's sensitivity to nuances of shape and form. Never rigidly doctrinaire, he used his understanding of the character of the Classical orders to create controlled grace.

The financial panic of 1837 resulted in a depression in the USA. With few commissions on offer, Strickland chose to travel to Europe with his family in 1838, visiting Britain, France and Italy, and documenting his travels with notes and watercolour sketches. On his return, his career for the next six years was desultory: engineer and urban planner (1838–9) for Cairo, IL, and minor Government commissions in Philadelphia and Washington, DC.

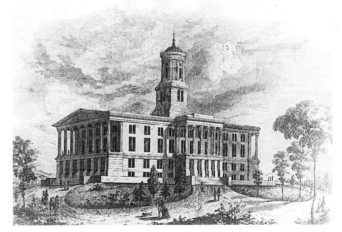

3. William Strickland: Tennessee State Capitol, Nashville, 1845–59; from an engraving by H. Bosse, 1855 (Nashville, TN, Tennessee State Library and Archives)

3. THE LAST YEARS: NASHVILLE, 1845 AND AFTER. Strickland was thus delighted in 1845 to be offered the appointment of architect for the Tennessee State Capitol in Nashville (see fig. 3). This, his last major commission, was the culmination of his career. Begun in 1845 it was not completed until 1859. Dramatically sited on an urban hillside, it is composed of forceful, interlocking forms defined by an Ionic portico at each of the building's four sides. These were derived from the Erechtheion in Athens, and a variant of the Choragic Monument of Lysikrates crowns the building. The State Capitol hints at the impending devaluation of Classical forms into isolated

picturesque parts that was to characterize architectural design in the second half of the 19th century. A similar tendency is revealed in his other major project of this period, the Egyptian Revival First Presbyterian Church (1848–51), Nashville. Strickland had earlier experimented with the style in Philadelphia (e.g. his unexecuted proposal of 1836 for a gate at Laurel Hill Cemetery), but at Nashville's First Presbyterian, motifs of great scale and height created an effect of precarious rigidity. Both this church and the State Capitol are symbols of style in transition. Strickland's body was buried in a crypt beneath the State Capitol's north portico. His son and assistant, Francis William Strickland, continued work on the unfinished building for two years until he was replaced in 1857.

UNPUBLISHED SOURCES
Nashville, TN State Lib. & Archv ['Sketches of Roman Architecture': notebook and watercolour sketchbook of tour of 1838]
Philadelphia, PA, Amer. Philos. Soc. Lib., J. K. Kane papers [autobiographical fragments, c. 1825]

WRITINGS
Reports on Canals, Railways, Roads, and Other Subjects Made to the Pennsylvania Society for the Promotion of Internal Improvement (Philadelphia, 1826)
Reports, Specifications, and Estimates of the Public Works in the United States of America (London, 1841)

BIBLIOGRAPHY
Macmillan Enc. Archit.
T. F. Hamlin: Greek Revival Architecture in America (New York, 1944)
N. S. Mahoney: 'William Strickland and the Building of the Tennessee Capitol', TN Hist. Q., iv/2 (1945), pp. 99–153
A. A. Gilchrist: William Strickland: Architect and Engineer, 1788–1854 (Philadelphia, 1950/R New York, 1969)
Two Centuries of Philadelphia Architectural Drawings (exh. cat., ed. James C. Massey; Philadelphia, PA, Mus. A., 1964), pp. 21–7
C. B. Dekle: 'The Tennessee State Capitol', TN Hist. Q., xxv/3 (1966), pp. 3–28
P. B. Stanton: The Gothic Revival and American Church Architecture: An Episode in Taste, 1840–1856 (Baltimore, 1968)
N. H. Schless: 'William Strickland', Master Builders, ed. Diane Maddex (Washington, DC, 1985), pp. 32–5
Mendel, Mesick, Cohen, Waite, Hall, Architects: Tennessee State Capitol: Historic Structure Report (Albany, NY, 1985–6) [invalubale for its extensive footnotes]
Drawing toward Building: Philadelphia Architectural Graphics, 1732–1986 (exh. cat., ed. J. F. O'Gorman and others; Philadelphia, PA, Acad. F.A., 1986), pp. 62–5, 68–9, 89–91
N. H. Schless: 'William Strickland', American National Biography, xxi (Oxford and New York, 1999), pp. 26–8

NANCY HALVERSON SCHLESS

Stuart [Stewart], Gilbert (b North Kingston, RI, 3 Dec 1755; d Boston, MA, 9 July 1828). American painter, active also in England and Ireland. The son of a snuff grinder, he grew up in Newport, RI. His innate talent for drawing was such that in his early teens he was engaged to paint Dr William Hunter's Spaniels (c. 1765; Hunter House, Newport, RI, Preservation Soc.).

During the summer of 1769 young Stuart travelled with the Scottish artist Cosmo Alexander (b c. 1724) on his tour of the South and ultimately to Edinburgh. In August 1772, Alexander died and a friendless Stuart had to work his way home. Back in Newport, he won a number of commissions. These included portraits of John Bannister, Mrs John Bannister and their son John, Abraham Redwood and Jacob Rodriguez Rivera (all 1773–5; Newport, RI, Redwood Lib.), in a hard-edged style very different from the fluid style of his maturity.

From September 1775 until 1787 Stuart was in London; early in 1775 he entered the studio of Benjamin West, for whom he painted drapery and finished portraits in return for half a guinea a week. John Trumbull, who came to West's studio while Stuart was there, commented that West commenced a course of drawing, but that Stuart 'never could exercise the patience necessary to correct drawing'. Stuart exhibited for the first time at the Royal Academy in the spring of 1787. His first full-length portrait was of William Grant, the Portrait of a Gentleman Skating (1782; Washington, DC, N.G.A.), shown in 1782. Its fluent brushwork and unconventional pose, indebted to English artists such as Romney, brought him recognition in the press and belied the prevailing opinion that Stuart 'made a tolerable likeness of a face, but as to the figure, he could not get below the fifth button'.

Stuart maintained an expensive London establishment and had considerable success as a fashionable portrayer of the English and various Americans who found themselves in London. However, in 1787 Stuart fled to Dublin perhaps to escape his creditors. Stuart remained in Ireland for five years, where he painted several majestic full-length portraits, including one of John Fitzgibbon, 1st Earl of Clare, who was then Lord Chancellor of Ireland (1789; Cleveland, OH, Mus. A.), and numerous bust portraits, in three-quarter frontal pose. In the spring of 1793, after 18 years abroad, Stuart returned to America, leaving behind scores of unfinished canvases.

On his arrival at New York, one lady noted in her diary that Stuart was 'an extraordinary limner, said to excel by far any other in America'. Over the next 18 months Stuart executed some of his most meticulous portraits. Although he proclaimed 'I copy the works of God, and leave clothes to tailors and mantua-makers', his portraits of the mod-

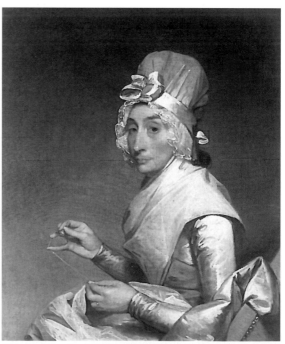

Gilbert Stuart: Mrs Richard Yates (Catherine Brass), oil on canvas, 768×635 mm, 1793–4 (Washington, DC, National Gallery of Art)

estly-dressed *Mrs Richard Yates (Catherine Brass)* (1793–4; Washington, DC, N.G.A.; see fig.) and of the elaborately attired *Matilda Stoughton de Jaudenes y Nebot* (1794; New York, Met.), wife of the Spanish *chargé d'affaires*, were rendered in fine detail.

Late in 1794 or early the next year, Stuart travelled to Philadelphia, where, during 1795, George Washington posed for him; the resulting portrait, showing the right side of the President's face, has been dubbed the 'Vaughan-type' after Samuel Vaughan, one of the many who ordered copies; only a few of these were ever executed. Washington sat again for Stuart, facing left, on 12 April 1796; the head (unfinished) was purchased by the Boston Athenaeum shortly after the impoverished artist's death (Washington, DC, N.P.G.; Boston, MA, Mus. F.A.). This portrait Stuart used for all his subsequent likenesses of Washington. He replicated it over and over again as a bust portrait (see colour pl. VI, 3) and in full lengths known as the 'Lansdowne-type', after Lord Lansdowne, for whom a full-length portrait was commissioned by William Bingham (Lord Rosebery priv. col., on loan to Washington, DC, N.P.G.). There were also variations on the portrait, as well as *Washington at Dorchester Heights* (1806; Boston, MA, Mus. F.A.).

In December 1803, Stuart moved to the new capital at Washington. 'Stuart is all the rage', it was reported in May 1804. 'He is almost worked to death, and everybody is afraid that they will be the last to be finished'. President Thomas Jefferson, who first sat for Stuart in Philadelphia in 1800, posed again, at the artist's request, in 1805, but Stuart delivered his portrait only in 1821 (Monticello, VA, Jefferson Found.; Washington, DC, N.P.G.). It took 18 years for him to complete his portrait of *Abigail Adams* (*c.* 1800–18; Washington, DC, N.G.A.). She wrote: 'There is no knowing how to take hold of this man, nor by what means to prevail upon him to fulfill his engagements.'

Stuart visited Boston in 1805. There he remained for the rest of his life, both delighting and exasperating his clients. Many artists sought his advice; these included John Trumbull, William Dunlap, Thomas Sully, Washington Allston, John Vanderlyn and Samuel F. B. Morse; after his death they drew up a resolution naming him the father of American portraiture. Stuart told Matthew Harris Joucett, 'Never be sparing of colour, load your pictures, but keep your colours as separate as you can. No blending, tis destruction to clear & bea[u]tiful effect.' Stuart advised, 'Short and chopping strokes are preferable to swashing handling. The last order of style is apt to toughen the skin, and render it wormy.'

BIBLIOGRAPHY

W. Dunlap: *A History of the Rise and Progress of the Arts of Design in the United States*, 2 vols (New York, 1834); rev. 3, ed. R. Weiss, 3 vols (New York, 1969), pp. 161–222
G. C. Mason: *The Life and Works of Gilbert Stuart* (New York, 1879)
L. Park: *Gilbert Stuart: An Illustrated Descriptive List of his Work*, 4 vols (New York, 1926)
W. T. Whitley: *Gilbert Stuart* (Cambridge, MA, 1932)
J. H. Morgan: *Gilbert Stuart and his Pupils* (New York, 1939)
C. M. Mount: *Gilbert Stuart: A Biography* (New York, 1964)
Gilbert Stuart, Portraitist of the Young Republic (exh. cat., ed. E. P. Richardson; Providence, RI Sch. Des., Mus. A., 1967)
R. McLanathan: *Gilbert Stuart* (New York, 1986)

MARGARET C. S. CHRISTMAN

Sturges, Jonathan (*b* Southport, CT, 24 March 1802; *d* New York, 28 Nov 1874). American merchant, patron and collector. In 1821 he joined the grocers R. & L. Reed, married the daughter of the owner, Luman Reed, and by 1828 was a partner in the firm. He was an influential figure in New York business circles and the director of several East Coast railroad companies.

Sturges was an important patron and collector of mid-19th-century American art. He inherited from his father-in-law (an enthusiastic patron of Thomas Cole) a fondness for Hudson River school painting. He financed Asher B. Durand's trip abroad in 1840–41 and commissioned Durand's *Kindred Spirits* (1849; New York, Pub. Lib.; for illustration *see* DURAND, ASHER B.) in memory of Cole. Among many other works by Durand in his collection were *In the Woods* (New York, Met.). Sturges also owned works by Cole and Frederic Edwin Church. He was an equally keen collector of genre painting, particularly by William Sidney Mount. He commissioned *Farmers Nooning* (1836; Stony Brook, NY, Mus.; see colour pl. X, 2) and helped to establish Mount's national reputation by arranging for the picture to be engraved in 1843. He was a founder-member of the Sketch Club (later the Century Club), active in the American Art-Union and the President and one of the main contributors to the New York Gallery of Fine Arts (1844–50). Sturges's collection was sold by his family.

BIBLIOGRAPHY

J. T. Callow: *Kindred Spirits* (Chapel Hill, 1967)
T. S. Cummings: *Historic Annals of the National Academy of Design* (New York, 1969)
M. Mann: 'The New York Gallery of Fine Arts: "A Source of Refinement"', *Amer. A. J.*, xi (1979), pp. 76–86

MAYBELLE MANN

Sturgis, John Hubbard (*b* Macao, 5 Aug 1834; *d* St Leonards-on-Sea, Sussex, 4 Feb 1888). American architect. His father, Russell Sturgis, was the director in Macao of Far Eastern operations for Russell & Co. of Boston, MA. He attended the Boston Latin School. When the First Opium War of 1839–42 closed China, his father returned to Boston, moving to London and accepting a partnership in Barings Bank in 1848. Russell Sturgis founded a circle of American expatriates in London, described in the fiction of Henry James.

In 1850 John Hubbard Sturgis joined his father in London, and saw the Great Exhibition of 1851. He studied in Munich and Belgium in 1853 and then toured North Africa, the Nile and the Near East. In 1855–7, under the influence of John Ruskin (1819–1900), he studied architecture in South Kensington, London, and with James Kellaway Colling (1816–1905), master draughtsman and author of *Art Foliage* (1865). From Colling, who also instructed W. E. Nesfield (1835–88), Sturgis learnt the techniques of measured drawing, later making a record of the Hancock House (1737) on Beacon Hill, Boston, in 1863 before it was demolished, the first American record of its kind. He practised with Colling in 1857–61, primarily on commissions for Richard Naylor (1814–99) of Liverpool.

Sturgis returned to America in 1861. He worked independently at first and then in partnership with Gridley J. F. Bryant and Arthur Delevan Gilman. In 1866 he set up a transatlantic architectural practice with Charles Brigham (1841–1925). As a result of Sturgis's education and expe-

rience in England, the practice was familiar with English aesthetic ideas and had the means through Barings Bank and family shipping resources to import building materials; it attracted an aristocratic clientele. Sturgis made annual trips abroad, while Brigham ran the Boston office.

In his domestic commissions, Sturgis designed innovative cottages, irregular in plan, with deep verandahs, cascading roofs and walls, articulated with imported tile and terracotta. His earlier houses include Sunnywaters (1863), Manchester-by-the-Sea, MA, for Russell Sturgis jr; Lowlands (1866; destr.), for George Abbott James, and Cottage (1868; destr.), for Henry Cabot Lodge, both at Nahant, MA; Greenvale Farm (1864), Portsmouth, RI, for John Barstow; and Land's End (1864), for Samuel Ward, and the Rocks (1866; destr.), for Edward Darley Boit, both at Newport, RI. Sturgis was conversant with the QUEEN ANNE REVIVAL that was taking place in England, borrowing elements of the style and demonstrating an encyclopedic knowledge of ornament. He also utilized COLONIAL REVIVAL and details from his Hancock House drawings in the Grange (1862), Lincoln, MA, for Ogden Codman, Homestead (1875), Groton, MA, for James Lawrence, Homestead (1874), Geneseo, NY, for Austin Wadsorth, and the Boylston House (1878), Brookline, MA, which were all spectacular enlargements of 18th-century houses for the Boston aristocracy.

In 1881, in his house for Isabella Stewart Gardner in Boston, he incorporated objects from her art collection into the interiors. These architectural concepts were adopted in a later mansion, Fenway Court (1901–3; now the Isabella Stewart Gardner Museum), designed for Mrs Gardner by Cummings & Sears (*see* CUMMINGS & SEARS, fig. 2). Sturgis confirmed his position as master of the artistic interior with the Frederick L. Ames House (1882), 306 Dartmouth Street, Boston. The palatial building had a top-lit, carved staircase, mosaics by Antonio Salviati (1816–90), stained glass by John La Farge and mural paintings.

Most of Sturgis's work was domestic, where his innovative ideas were essential to the development of the SHINGLE STYLE. He also designed the Museum of Fine Arts (1870–76), Boston, introducing to Boston English terracotta for the Gothic ornament. The Church of the Advent (1874–8), Boston, was reminiscent of church designs in London by James Brooks (1825–1901), J. L. Pearson (1817–97) and G. E. Street (1824–81).

UNPUBLISHED SOURCES
Boston, MA, Athenaeum [letters and papers]
Weston, MA, Margaret Henderson Floyd archives [draft MS. of 'John Hubbard Sturgis of Boston: American Architecture in the English Image', which may yet be completed by a colleague following Prof. Floyd's death]

WRITINGS
'Terra Cotta and its Uses', *Proc. Amer. Inst. Architects*, v (1871), pp. 39–43
From the Books and Papers of Russell Sturgis (Oxford, 1893)

BIBLIOGRAPHY
M. King, ed.: *King's Handbook of Boston* (Boston, 1878, rev. Cambridge, MA, 2/1889)
M. J. Lamb, ed.: *The Homes of America* (New York, 1879)
'The Museum of Fine Arts, Boston', *Amer. Architect & Bldg News*, viii (1880), pp. 205–15
B. Bunting: *Houses of Boston's Back Bay* (Cambridge, MA, 1967)

W. M. Whitehill: *Museum of Fine Arts, Boston: A Centennial History*, 2 vols (Cambridge, MA, 1970)
M. H. Floyd: 'A Terra Cotta Cornerstone for Copley Square: Museum of Fine Arts, Boston, 1870–1876, by Sturgis and Brigham', *J. Soc. Archit. Hist.*, xxxii (1973), pp. 83–103
——: 'Measured Drawings of the Hancock House by John Hubbard Sturgis: A Legacy to the Colonial Revival', *Architecture in Colonial Massachusetts* (Boston, 1979), pp. 87–111
——: 'John Hubbard Sturgis and the Redesign of The Grange for Ogden Codman', *Old Time New England*, lxxiv (1981), pp. 41–65

MARGARET HENDERSON FLOYD

Sturgis, Russell (*b* Baltimore, 16 Oct 1836; *d* New York, 11 Feb 1909). American architect, art historian, writer and critic. Drawn to architecture by observing, as a student in New York, construction influenced by John Ruskin 1819–1900), Sturgis was trained (1856–7) in the office of Leopold Eidlitz. This was followed by a period of study (1859–61) at the Academy of Fine Arts and Sciences, Munich. He was the most active of the founders of the Society for the Advancement of Truth in Art, which published *The New Path* (1863–5), devoted to the improvement of the arts in America; in 1869 he was a founder of the Metropolitan Museum of Art, New York, and he was later instrumental in the establishment and guidance of the Avery Architectural Memorial Library at Columbia University, New York. Sturgis practised architecture through the 1870s, meticulously producing a small number of buildings, the most significant of which is the Queen Anne Revival-style Farnam Hall (1869–70), Yale University, New Haven; three adjacent buildings are also by Sturgis. By 1880 he had retired from architectural practice, devoting his last 30 years to scholarship and writing. Sturgis wrote a score of books on architectural history and the fine arts, including reference works and introductions to various arts. He served as fine arts editor for a number of dictionaries and encyclopedias, and was a prolific contributor to both professional and popular journals from the 1860s to 1909, most notably *Architectural Record* and *Scribner's Magazine*.

Conservative in tastes and values, Sturgis moved gradually from Ruskinian Gothic to an early appreciation of the utilitarian architecture of the factory, the formal austerity of Chicago commercial architecture, reflected in his own Austin Building (1876), New York, and the work of Louis Sullivan. While less inspired than the best of his contemporaries (H. H. Richardson or Frank Furness in architecture; Montgomery Schuyler in criticism), he produced a few significant buildings, some solid scholarship, and a vast amount of lucid prose that introduced issues of architecture and the decorative arts to the American public.

WRITINGS
The Works of McKim, Mead & White, Gt Amer. Architect Ser., i (New York, 1895)
ed.: *Dictionary of Architecture and Building*, 3 vols (New York, 1901–2)
How to Judge Architecture (New York, 1903)
The Interdependence of the Arts of Design (Chicago, 1905)
History of Architecture, 4 vols (New York, 1906) [vols i & ii by Sturgis]

BIBLIOGRAPHY
D. H. Dickason: *The Daring Young Men: The Story of the American Pre-Raphaelites* (Bloomington, IN, 1953)

SAMUEL BERKMAN FRANK

Sullivan, Louis (Henri) [Henry] (*b* Boston, MA, 3 Sept 1856; *d* Chicago, IL, 14 April 1924). American architect and writer. He was the leading progressive architect in

Chicago at its most revolutionary period in the 1890s, and a designer of amazing virtuosity. His executed buildings include tall office buildings, theatres, department stores and banks, some of them in partnership with DANKMAR ADLER. Sullivan accepted frankly the new creation of industrialized architecture, the steel-framed skyscraper building, but covered it with the most delicate ornament, also designed by him and executed in mass-produced terracotta slabs. He also wrote poetically of the position of the sensitive individual in the mechanized world.

1. Life and work. 2. Critical reception and posthumous reputation.

1. LIFE AND WORK.

(i) Before 1890. (ii) 1890–c. 1908. (iii) After c. 1908.

(i) Before 1890. Sullivan himself told the story of his youth and education in his *Autobiography of an Idea*. His father was an Irish dancing master, his mother Swiss. He grew up in Boston and, after his parents moved to Chicago in 1868, on his maternal grandfather's farm in South Reading, MA. From 1870 to 1872 he attended the Boston English High School. In 1872 he entered the Massachusetts Institute of Technology, Cambridge, MA, as a non-degree student, following the first architectural course in the USA. This was directed by William Robert Ware, a student of the French-trained Richard Morris Hunt in New York. Design was taught by Eugène Letang , who had recently arrived from Emile Vaudremer's atelier at the Ecole des Beaux Arts, Paris. Sullivan was a brilliant, but impatient student and left after only a year, but Ware and Letang influenced the course of his later architectural training. In the summer of 1873 he visited Hunt in New York, then continued to Philadelphia, where he lodged at the home of his cousin and found a job with Hunt's student Frank Furness. After being made redundant during the depression of September 1873, Sullivan followed his parents to Chicago, which was still being rebuilt after the fire of 1871, and joined the office of the engineer and architect William Le Baron Jenney, who had studied at the Ecole Centrale des Arts et Manufactures in Paris. In the summer of 1874 Sullivan went to France and entered the atelier of Vaudremer (1829–1914) at the Ecole des Beaux-Arts, Paris. Again he proved to be an impatient student, and after only a year he returned to the USA in May 1875, although in his *Autobiography* he claims to have stayed two years in France.

Sullivan's career during the eight years that followed his return from Europe appears to have been strangely nebulous, but it is known that he decorated the interiors of the Sinai Synagogue (1876; destr.), Indiana Avenue, Chicago, and a tabernacle (1876; destr.), also in Chicago, for the evangelist Dwight L. Moody, in partnership with Jenney's former chief draughtsman, John Edelmann (1852–1900). Surviving drawings and descriptions of both interiors indicate that Sullivan had already by this time evolved a powerful, idiosyncratic style of ornamental decoration, which he admitted to having learnt from Furness. It seems also derived in part from the French *Néo-Grec* style (especially as displayed in Victor-Marie-Charles Ruprich-Robert (1820–87) in his *Flore ornementale*, Paris, 1866–76) and in part from the publications of Christopher Dresser (1834–1904).

Sullivan probably did occasional work for other architects, and by 1880 he was working in the office of Dankmar Adler. In 1883 he became a full partner, and the firm was renamed Adler & Sullivan, with Sullivan in charge of design and Adler of business and engineering.

Between 1880 and 1886 Sullivan designed a series of houses and commercial buildings, the exteriors of which were notable for their strange floral decoration, again influenced by Furness's over-scaled, flat decorative touch. This first appeared in the Borden Block (1880; destr. 1916), and culminated in the Ryerson and Troescher Buildings (1884; both destr.), all in Chicago. The firm was not yet receiving commissions for the eight- or ten-storey 'skyscraper' office buildings of the sort that Jenney or the new firm of Burnham & Root were then perfecting, but in 1886 Adler & Sullivan obtained the commission for the Auditorium Building, an opera house enclosed in a ten-storey block of hotel rooms and offices and the largest building yet projected in Chicago (for illustration *see* ADLER, DANKMAR). It was a difficult job, both technically and aesthetically, and both partners carried off their departments magisterially. For the exterior design, Sullivan abstained from ornamental experiments, adopting a severe round-arched treatment derived from H. H. Richardson; but inside the hotel and especially in the auditorium itself he perfected his characteristic style of ornament, which was integrated with the surfaces it covered, the latter being shaped and articulated to express their function. Making the auditorium ceiling an elaborately shaped sounding board, Adler & Sullivan created a steep ascending series of spaces, more complex and geometrically powerful than conventional theatre interiors. They had evolved this configuration in a series of theatre designs, notably in the Chicago Opera Festival Theatre (1885; destr.) and the Pueblo Opera House in Colorado (1888–90; destr.); later they carried it to perfection in the Schiller Theatre (1891–3; destr.), Chicago, regrettably the last of the firm's theatre commissions.

(ii) 1890–c. 1908. The inauguration of the Auditorium Theatre on 9 December 1889 marked an epoch in Sullivan's work. In his *Autobiography* the architect himself writes of a long vacation, followed by his return to Chicago and his conception of his first steel-framed 'skyscraper', the Wainwright Building in St Louis, MO, built in 1890–91 (*see* UNITED STATES OF AMERICA, fig. 9). Here he used the licence of *Néo-Grec* proportioning to treat the whole façade as a single order of attenuated piers, with the bottom storeys forming a solid sandstone plinth and the top (service) storey an entablature. In his essay 'The Tall Office Building Artistically Considered' (1896), Sullivan explained this articulation as the expression of interior function, the base containing the public commercial spaces, the entablature the mechanical plant and water tanks, and the intervening grill of piers and windows a honeycomb of offices 'all look[ing] alike because they all are alike'. This functional analysis of the Wainwright Building, which has been extended by some critics to interpret the whole structure as a minimal cage of masonry lightly veiling a steel skeleton, obscures its essentially classical origins and the resemblances to the contemporaneous skyscrapers of McKim, Mead & White.

The ambitions kindled by the success of the Auditorium Theatre were in fact not focused so much on the Wainwright Building as on another project of the period, the design of the World's Columbian Exposition of 1893. Indeed it was the frustration of his ambitions here that diverted Sullivan's attention to skyscraper design and later to writing and proselytizing. In the autumn of 1890 the plans for the World's Columbian Exposition were formulated by Burnham & Root (*see* BURNHAM, DANIEL H.), who invited five firms from the East Coast to provide detailed plans of the pavilions; five Chicago practices, including Adler & Sullivan, were invited in addition shortly thereafter. The Board met as a whole in January 1891, with Richard Morris Hunt in the chair and Sullivan as secretary. The designs were completed and published by April. The buildings designed by the original five firms were clustered around the breath-taking Court of Honor and produced a harmonious ensemble of colonnaded classical façades, all painted a soothing ivory white. Just behind these Sullivan erected his Transportation Building, a boxy composition in his new ahistorical style, relying on passages of his ornament and stencils for its articulation, painted crimson and gold with touches of green and blue. The boldness of the building, and the striking contrast it gave to the comradely historicism of the Court of Honor, provided an exciting decorative display that was far more public and insistent than the contemporaneous Wainwright Building. Sullivan later described the objective of the design as 'an architectural exhibit': the building was an abstract demonstration of the elaboration of colour and form and was 'a natural, not historical, exhibit'.

The Transportation Building attracted a great deal of attention and was awarded the gold, silver and bronze medals by the Union Centrale des Arts Décoratifs, Paris, but after it was demolished, the public remembered the Court of Honor more vividly. However, some critics contrasted the confectionary quality of the latter with the frank and elegant design of the skyscrapers that from the late 1880s had come to mark the centre of Chicago. For the remainder of the 1890s Sullivan concentrated on producing a series of brilliant 'skyscraper' designs. Of the nineteen such designs conceived between 1890 and 1901, nine were executed. All follow the basic type of the Wainwright Building—base, colonnade, entablature—but with refinements and variations. The Schiller Building (1891–3) in Chicago was powerfully shaped, stepping back from the party walls at the ninth storey to become a free-standing tower. The Guaranty Building (1894–6; see fig. 1) in Buffalo, NY, was the most sophisticated, with an unbroken surface of decorative terracotta and an interwoven, curving solution at the cornice. The Carson Pirie Scott Store (1898–1904; see fig. 2) in Chicago is the most minimal, with the broad grid of its steel structure frankly exposed.

Curiously, Sullivan's perfection of the 'skyscraper' type was little appreciated. The depression of 1893 had curtailed his firm's practice, and then in 1895 he had parted with Adler. Only a few opportunities came after that; the Carson Pirie Scott Store was his last large urban structure. In 1896 he published his celebrated article, 'The Tall Office Building Artistically Considered', and as his practice contracted after the completion of the Carson Pirie Scott Store, he began writing in earnest, particularly in his 'Kindergarten Chats', published weekly in the Cleveland *Interstate Architect and Builder* in 1902–3.

Other manuscripts followed, including the massive *Democracy: A Man Search* of 1904–8 (published posthumously in 1961). Sullivan was probably encouraged to write seriously by the group of younger architects who gathered around him in the closing years of the 19th century. They constituted what in 1908 one of them, Thomas Tallmadge (1876–1940), named the CHICAGO SCHOOL. Frank Lloyd Wright (once Sullivan's chief draughtsman) was a leading member, together with such contemporaries as George Elmslie, Dwight Perkins (1867–1941), George R. Dean, Richard E. Schmidt and his partner Hugh M. G. Garden, Myron Hunt (1868–1952) and Tallmadge himself, as well as Wright's own assistants Walter Burley Griffin (1876–1937), Marion Mahony Griffin (1871–1961) and William E. Drummond.

During the late 1890s this group dominated the Chicago Architectural Club. It was very active with exhibitions and design competitions, where Sullivan's characteristic style was expanded and adapted into an elastic vocabulary applicable to any design problem. In 1899–1901, during Emil Lorch's period as Assistant Director at the Art Institute of Chicago, this was taught in that institution's architectural syllabus under the name 'pure design'. In 1899 this group from the Chicago Architectural Club, led by Wright and Lorch, helped found the Architectural League of America. Its motto was 'Progress before Precedent', and its aim was to oppose the conservative inclinations of the American Institute of Architects, invoking Sullivan's name and principles. In 1908, however, Tallmadge wrote the movement's obituary in the Boston *Architectural Review*, saying that ultimately no-one really understood what 'pure design' was, and the group had gradually dispersed.

(iii) After c. *1908.* The last phase in Sullivan's career was largely devoted to designing banks in small towns in the Midwest. Midwestern agriculture thrived in the early 20th century, leading to a revolution in rural banking and the proliferation of small institutions sympathetic to local needs. Sullivan's first commission in this field was the magnificent National Farmers' Bank (1907–8; see fig. 3) in Owatonna, MN, which was followed by the People's Savings Bank (1911), Cedar Rapids, IA, the Merchants' Bank (1914), Grinnell, IA, the Home Building Association Bank (1914), Newark, OH, the Purdue State Bank (1914), West Lafayette, IN, and later two others. These buildings posed no problems in the expression of structure, as they were all low, load-bearing brick constructions; they did, however, raise important questions of institutional expression. Sullivan's solution was to make them monumental, as befitted banks, but 'modern' and unrelated to historical precedent in order to communicate their transformed character. They are the final and most richly impressive demonstrations of his ornamental skill, with their rich use of polychromy in brick and terracotta. Furthermore, the design of each was sensitively adapted to its setting, usually at the end of the main street facing the town square (as at Owatonna, Grinnell and Newark). At Owatonna the mass of the structure rises above the surrounding shops and

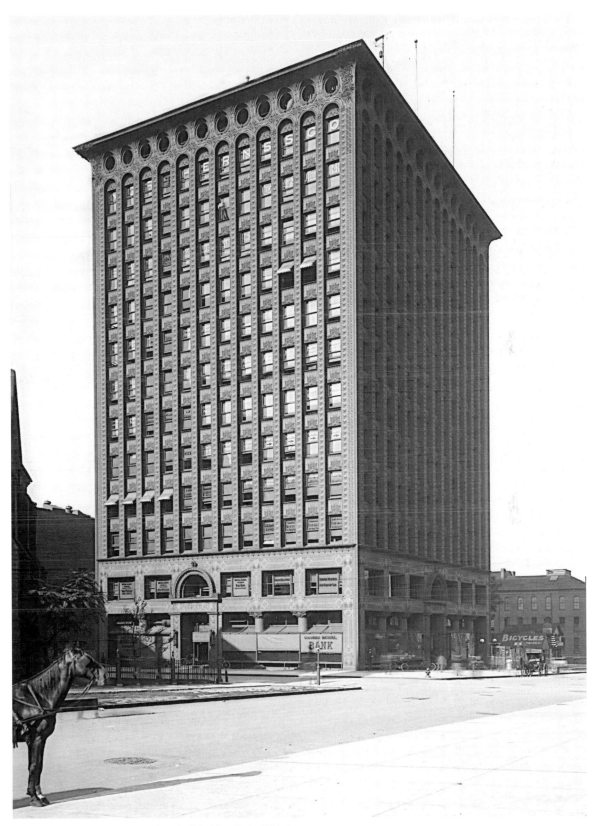

1. Adler & Sullivan: Guaranty Building, Buffalo, New York, 1894–6

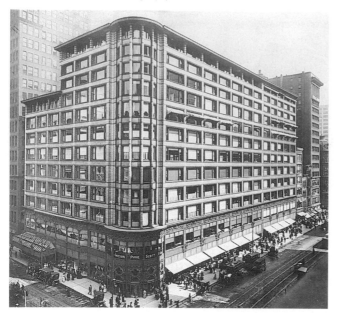

2. Louis Sullivan: Carson Pirie Scott Store, Chicago, Illinois, 1898–1904

balances the mass of the court-house facing it across the square. Although these buildings were in remote areas, the care bestowed on them by Sullivan suggests that here he had finally found appreciative recipients for his exquisite talents.

During this period Sullivan also designed the Van Allen Department Store (1913–15), Clinton, IA, and two large houses, the Babson House (1907; destr.), Riverside, IL, and the Bradley House (1909), Madison, WI. He continued to be beset by financial difficulties, and became destitute and dependent on the charity of friends.

2. CRITICAL RECEPTION AND POSTHUMOUS REPUTATION. Critical evaluation of Sullivan's work has been inconsistent. European or European-inspired modernists have praised the frankness of the articulation of his steel-framed skyscrapers and overlooked (or denigrated) the Transportation Building, the late banks and his new vocabulary of ornament. This interpretation is evident, for example, in the assessments offered by Hugh Morrison (1935), Sigfried Giedion (1941) and Carl Condit (1952 and 1964). More recently, American scholars, led by Vincent Scully, have reversed this emphasis and depicted Sullivan as a humanist who shunned historical imitation to create a vivid sense of shape and surface through his ornament. To these writers the surfaces of his skyscrapers, clad in terracotta, communicate the elastic stresses within the steel membering, and the shape of his office buildings and banks give form to their settings, while the obscure poeticizing of his later theoretical works express a belief in spontaneous expression. This interpretation informs the assessments given by Sherman Paul (1962), Narciso Menocal (1981), Robert Twombly (1986), Lauren Weingarden (1986) and others.

WRITINGS
'Essay on Inspiration', *Inland Architect & News Rec.*, vi (1886), pp. 61–4
A System of Architectural Ornament According with a Philosophy of Man's Powers (New York, 1924); ed. L. S. Weingarden (New York, 1989)

The Autobiography of an Idea (New York, 1924)
C. Bragdon, ed.: *Kindergarten Chats* (Lawrence, KS, 1934)
I. Athey, ed.: *Kindergarten Chats (revised 1918) and Other Writings* (New York, 1947) [contains Sullivan's essay 'The Tall Building Artistically Considered']

BIBLIOGRAPHY
B. Ferree: 'The High Building and its Art', *Scribner's Mag.*, xv (1894), pp. 297–318
T. Tallmadge: 'The "Chicago School"', *Archit. Rev.* [Boston], xv (1908), pp. 69–74
L. Mumford: *The Brown Decades* (New York, 1931)
F. Lloyd Wright: *An Autobiography* (New York, 1932)
H. Morrison: *Louis Sullivan: Prophet of Modern Architecture* (New York, 1935)
S. Giedion: *Space, Time and Architecture* (Cambridge, MA, 1941)
F. Lloyd Wright: *Genius and the Mobocracy* (New York, 1949)
C. Condit: *The Rise of the Skyscraper* (Chicago, 1952)
V. Scully: 'Louis Sullivan's Architectural Ornament', *Perspecta*, v (1959)
A. Bush-Brown, *Louis Sullivan* (New York, 1960)
W. Connely: *Louis Sullivan: The Shaping of American Architecture* (New York, 1960)
M. Schuyler: *American Architecture and Other Writings*, 2 vols, ed. W. Jordy and R. Coe (Cambridge, MA, 1961)
S. Paul: *Louis Sullivan: An Architect in American Thought* (Engelwood Cliffs, 1962)
C. Condit: *The Chicago School of Architecture* (Chicago, 1964)
H. Duncan: *Culture and Democracy* (Totawa, NJ, 1965)
W. Jordy: *American Buildings and their Architects*, iii and iv (New York, 1972)
P. Sprague: *The Drawings of Louis Henry Sullivan* (Princeton, 1979)
N. Menocal: *Architecture as Nature: The Transcendentalist Idea of Louis Sullivan* (Madison, 1981)
D. Andrew: *Louis Sullivan and the Polemics of Modern Architecture* (Urbana, 1985)
L. Millett: *The Curve of the Arch: The Story of Louis Sullivan's Owatonna Bank* (St Paul, 1985)
R. Twombly: *Louis Sullivan: His Life and Work* (New York, 1986)
L. Weingarden: 'Naturalized Technology: Louis H. Sullivan's Whitmanesque Skyscrapers', *Centen. Rev.*, xxx (1986), pp. 480–95
Louis Sullivan: The Function of Ornament (exh. cat. by D. Van Zanten; Chicago, IL, Hist. Soc.; New York, Cooper–Hewitt Mus.; St Louis, MO, A. Mus.; 1986–7)
J. Siry: *Carson Pirie Scott: Louis Sullivan and the Chicago Department Store* (Chicago, 1987)
L. S. Weingarden: *Louis H. Sullivan: The Banks* (Cambridge, MA [1987])

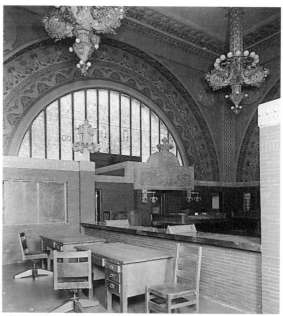

3. Louis Sullivan: interior of the National Farmers' Bank, Owatonna, Minnesota, 1907–8

R. Twombly, ed.: *Louis Sullivan: The Public Papers* (Chicago, 1988)
S. C. Mollman, ed,: *Louis Sullivan in the Art Institute of Chicago: The Illustrated Catalogue of Collections* (New York, 1989)
M. M. Elia: *Louis Henry Sullivan* (Milan, 1995)
J.-C. Garcias: *Sullivan* (Paris, [1997])
D. van Zanten: *Sullivan's City: The Meaning of Ornament for Louis Sullivan* (New York, 1999)

DAVID VAN ZANTEN

Sully, Thomas (*b* Horncastle, Lincs, 19 June 1783; *d* Philadelphia, PA, 5 Nov 1872). American painter of English birth. Sully went to America in 1792 with his family, who were theatre and circus performers. He made at least one appearance on stage as an acrobat in 1794 and was then apprenticed with an insurance broker, after which he was placed with his brother-in-law, Jean Belzons, a miniature painter. After an argument with Belzons, Sully fled and in September 1799 joined his older brother Lawrence (1769–1804), also a miniature painter, in Richmond, VA. In 1801 the Sully family moved to Norfolk, VA, where Thomas painted his first miniature, a likeness of his brother Chester. In January 1803 Lawrence and his family returned to Richmond. Thomas remained in Norfolk for another six months but in July 1803 returned to Richmond, where he opened his own studio.

By 1804 Sully was planning to go to England to study but postponed his plans due to the sudden death of his brother Lawrence. In the spring of 1806 Thomas married his sister-in-law, Sarah Annis Sully, assuming responsibility for her three children. The couple went to New York, where Sully set up a studio in the lobby of the Park Theatre. In July 1807 Sully moved his family to Hartford, CT, and then went to Boston to visit Gilbert Stuart, from whom he received helpful criticism. In December 1807 Sully moved his family to Philadelphia, where he resided for the rest of his life. By the end of 1808 he was established there as a successful and popular portrait painter.

After being made a citizen of the USA in 1809, Sully placed his family in the care of fellow painter Benjamin Trott (1770–1841) and left for England. He was in London from July 1809 until March 1810. While there he had the benefit of criticism from Benjamin West, the great champion of young American painters. At West's suggestion, Sully studied anatomy and borrowed paintings for copying from West's collection. He also drew from the collection of plaster casts of Classical sculpture in the Antique Room of the Royal Academy.

Early in his career, Sully painted two of his finest works, which did much to enhance his growing reputation. His portrait of *George Frederick Cooke in the Role of Richard III* (1812; Philadelphia, PA Acad. F.A.) shows the famous British actor life-size and full-length. The other noteworthy full-length painting was a portrait of *Samuel Coates* (1813; Philadelphia, PA Hospital), President of the Pennsylvania Hospital. Sully's likeness of *General Andrew Jackson* (1819; Clermont, NY, Taconic State Park) and portrait of *Mrs Robert Gilmor (Sarah Reeve Ladson)* (1823; Charleston, SC, Gibbes Mus. A.; see fig.) are outstanding examples of the work of this period. By 1828, following the death of Gilbert Stuart, Sully was considered by some American observers as 'the Prince of American portrait painters'.

In October 1837 Sully made a second trip to England. On the request of the Society of the Sons of Saint George

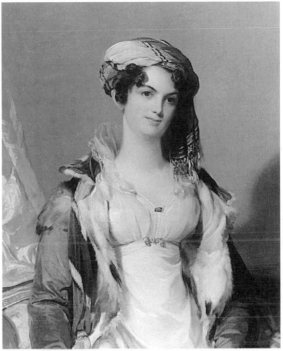

Thomas Sully: *Mrs Robert Gilmor (Sarah Reeve Ladson)*, oil on canvas, 918×713 mm, 1823 (Charleston, South Carolina, Gibbes Museum of Art)

of Philadelphia, Sully obtained a series of sittings from the new, and as yet uncrowned, Queen Victoria. From the study (New York, Met.) Sully painted a three-quarter length portrait of her for the publishers Hodgson & Graves (1838; London, Wallace; see colour pl. XI, 3) and on returning to Philadelphia a full-length portrait for the Society (on loan to Washington, DC, N.G.A.).

In the 1840s Sully's painting began to show signs of unevenness. He was still capable of producing handsome masterpieces, such as his portrait of *Eliza Leslie* (1844; Philadelphia, PA Acad. F.A.) and his superlative full-length portrait of *Sarah Sully with her Dog, Ponto* (1848; San Antonio, TX, A. League Col.), but many of his later portraits are lacklustre. From 1855 both Sully's health and the number of commissions for portraits declined, as did his prices. Increasingly he painted subject or fancy pictures. His portraits were frequently fuzzy copies of other artists' work or were from photographs, but occasionally he was able to paint a creditable likeness. His painting of the Liberian politician, *Edward James Roye* (1864; Philadelphia, PA, Hist. Soc.), although based on a photograph, is a handsome work.

UNPUBLISHED SOURCES
Philadelphia, Soc. PA [Sully's MS. register or 'Account of pictures']
New Haven, CT, Yale U. Lib.
New York, Hist. Soc.

WRITINGS
Hints to Young Painters (Philadelphia, 1873)

BIBLIOGRAPHY
E. Biddle and M. Fielding: *The Life and Works of Thomas Sully (1783–1842)* (Philadelphia, 1921)
Mr Sully, Portrait Painter (exh. cat., ed. M. Fabian; Washington, DC, N.P.G., 1983)

MONROE H. FABIAN

T

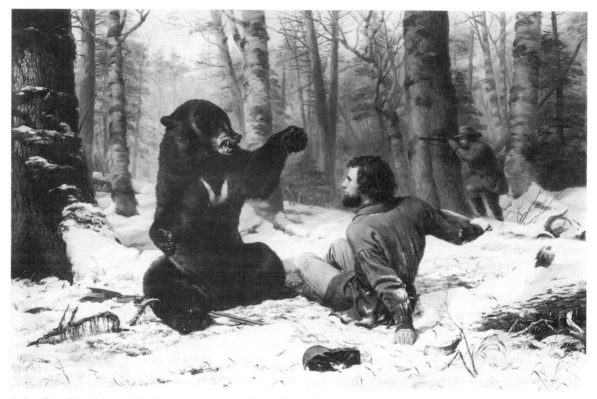

Arthur Fitzwilliam Tait: *A Tight Fix: Bear Huntiong in Early Winter*, oil on canvas, 1.02×1.52 m, 1856 (Detroit, MI, Manoogian private collection)

Tait, Arthur Fitzwilliam (*b* Livesey Hall, nr Liverpool, 5 Aug 1819; *d* Yonkers, NY, 28 April 1905). American painter and lithographer of English birth. He spent the first three decades of his life in England and arrived in New York in 1850. Steeped in admiration for the subjects of Edwin Landseer (1802–73) and the style of the Pre-Raphaelites, he established himself as a realistic painter of animals and sporting scenes. For his images of Western hunters and trappers, he used as sources the works of George Catlin and William Ranney, artists who, unlike himself, had travelled extensively. He established a summer studio at a camp in the Adirondack Mountains, where he painted sporting scenes. These wilderness scenes, often composed around an anecdote, appealed to a wide popular audience, and from 1852 Currier & Ives as well as Louis Prang published a number of lithographs and chromolith-

ographs of his work. Tait also composed still-lifes of game birds and, in his later career, barnyard scenes of sheep and chickens. His painting *A Tight Fix: Bear Hunting in Early Winter* (1856; Detroit, MI, Manoogian priv. col.; see fig.) shows a characteristic drama: a wounded hunter has lost his gun in a deadly-looking encounter with a bear, from which a companion, attempting to shoot the bear from behind a tree, may or may not be able to rescue him.

BIBLIOGRAPHY

A New World: Masterpieces of American Painting, 1760–1910 (exh. cat., ed. T. E. Stebbins jr; Boston, MA, Mus. F.A.; Washington, DC, Corcoran Gal. A.; Paris, Grand Pal., 1983–4), pp. 274–5

W. Cadbury: *Arthur Fitzwilliam Tait: Artist in the Adirondacks* (Newark, 1986)

ELIZABETH JOHNS

Tanner, Henry Ossawa (*b* Pittsburgh, 21 June 1859; *d* Paris, 25 May 1937). American painter. He was one of the

foremost African American artists, achieving an international reputation in the early years of the 20th century for his religious paintings. The son of an African Methodist Episcopal bishop, he studied art with Thomas Eakins from 1880 to 1882 at the Pennsylvania Academy of the Fine Arts in Philadelphia. He then worked in Philadelphia and Atlanta, GA, where he ran a photography studio and taught at Clark College. He also exhibited in New York and Philadelphia and attracted several patrons who sponsored him to study abroad.

In 1891 Tanner travelled to Paris, enrolling at the Académie Julian where he received instruction from Benjamin Constant (1845–1902) and Jean-Paul Laurens (1838–1921). He first exhibited his figure paintings at the Paris Salon of 1894 and by 1897 received a medal for the *Raising of Lazarus* (1897; ex-Pal. Luxembourg, Paris), which was bought by the French government. With *Daniel in the Lions' Den* (lost; second version, Los Angeles, CA, Co. Mus. A.), shown in the Salon of 1896, he established his specialization. To assure the accuracy of his biblical scenes, Tanner travelled to Palestine in 1897 and 1898, studying the terrain, people, costumes and customs. As a result of a later visit to Morocco, he painted several city views of Tangiers.

Inspired by Symbolism and the art of Whistler, Tanner later moved increasingly from his realistic, academic style to an evocative and painterly approach. He limited his palette to monochromatic hues, cast the scenes in soft, shadowy lighting and used layers of glazes and scumbling. Tanner retained dual allegiance, living in France and exhibiting in America. He served as the President of the Société Artistique de Picardie in 1913. There is an important collection of his work in the National Museum of African Art in Washington, DC.

WRITINGS
'The Story of an Artist', *World's Work*, xviii (1909), pp. 11661–6, 11769–75

BIBLIOGRAPHY
M. M. Mathews: *Henry Ossawa Tanner: American Artist* (Chicago, 1969)
The Art of Henry O. Tanner (1859–1937) (exh. cat., Washington, DC, N. Mus. Afr. A., 1969–70)
Sharing Traditions: Five Black Artists in Nineteenth Century America (exh. cat. by L. R. Hartigan, Washington, DC, N. Mus. Amer. A., 1985)
Henry Ossawa Tanner (exh. cat. by D. F. Mosby with D. Sewell and R. Alexander-Minter, Philadelphia, PA, Mus. A.; Atlanta, GA, High Mus. A.; Detroit, MI, Inst. A.; San Francisco, CA, de Young Mem. Mus.; 1991–2)
Across Continents and Cultures: The Art and Life of Henry Ossawa Tanner (exh. cat. by D. F. Mosby, Kansas City, MO, Nelson-Atkins Mus. A.; Dallas, TX, Mus. A.; Chicago, IL, Terra Mus. Amer. A.; 1995–6)

ILENE SUSAN FORT

Tarbell, Edmund C(harles) (*b* West Groton, MA, 26 April 1862; *d* New Castle, NH, 1 Aug 1938). American painter, illustrator and teacher. He attended drawing lessons at the Normal Art School, Boston, MA, and art classes with W. A. G. Claus. From 1877 to 1880 he was apprenticed to a lithographic company in Boston. In 1879 Tarbell entered the School of the Boston Museum of Fine Arts, where he was a pupil of Otto Grundmann (1844–90), a former student of Baron Hendrik Leys in Antwerp. In 1883 Tarbell left for Paris with his fellow student Frank W. Benson. Both Tarbell and Benson attended the Académie Julian, where they studied with Gustave Boulanger (1824–88) and Jules Lefebvre (1836–1911). They travelled to Italy in 1884 and to Italy, Belgium, Germany and Brittany the following year. Tarbell returned to Boston in 1886. Initially after his return, Tarbell made a living from magazine illustration, teaching privately and painting portraits. In 1889 Tarbell and Benson took Grundmann's place at the Museum School. Tarbell was a popular teacher, whose prominence was so marked that his students were called 'Tarbellites'. His teaching methods were traditional and academic: he required his pupils to render casts before they were allowed to paint. His motto was 'Why not make it like?', a query that shows his dedication to the model.

In the early 1890s Tarbell painted *plein-air* canvases such as *In the Orchard* (priv. col., see 1986 exh. cat., p. 136) in an Impressionist technique reminiscent of Renoir (1841–1919), although tempered by his academic background. In 1899, with *Across the Room* (New York, Met.), he began a series of paintings of figures in sunlit interiors, whose tilted perspectives and vast empty spaces were more directly influenced by Degas (1834–1917). From around 1905 Tarbell was especially drawn to Vermeer (1632–75), and in numerous works such as *Girl Crocheting* (1904; Canajoharie, NY, Lib. & A.G.) he painted young women in interiors quietly engaged in solitary activities such as sewing or reading. They are less stylistically advanced than his earlier works and include props—yellowed old paintings, flower arrangements, dishes of fruit and antiques—that reinforce their identification with Old Master paintings. In general, his paintings project a comfortable and genteel atmosphere, often populated by his children, as in *My Family* (1914; priv. col., see 1986 exh. cat., p. 162), an informal portrait of young people arrayed in summer cottons in a bright interior.

Tarbell was a leader of the 'Boston School' and also a member of the TEN AMERICAN PAINTERS, formed in 1898 so that its members, mostly American Impressionists, might exhibit in a congenial and stylistically harmonious atmosphere. He was elected an Academician at the National Academy of Design in 1906. Tarbell was also the first president of the Guild of Boston Artists, which was founded in 1914 to exhibit and sell works of living American artists. Tarbell resigned his position at the Museum School in 1913 in protest at school policies.

BIBLIOGRAPHY
Two American Impressionists: Frank W. Benson and Edmund C. Tarbell (exh. cat., ed. S. F. Olney; Durham, U. NH, A. Gals, 1979)
P. J. Pierce: *Edmund C. Tarbell and the Boston School of Painting, 1889–1980* (Hingham, MA, 1980) [contains errors]
The Bostonians: Painters of an Elegant Age, 1870–1930 (exh. cat., ed. T. J. Fairbrother; Boston, MA, Mus. F.A., 1986)
L. J. Docherty: 'Model Families: The Domesticated Studio Pictures of William Merritt Chase and Edmund C. Tarbell', *Not at Home: The Suppression of Domesticity in Modern Art and Architecture*, ed. C. Reed (London, 1996), pp. 49–64

BAILEY VAN HOOK

Tavernier, Jules (*b* Paris, France, April 1844; *d* Honolulu, HI, 18 May 1889). American painter and illustrator of Anglo—French origin. Born to British parents of French Huguenot descent, he studied in Paris at the Ecole des Beaux-Arts under Felix Barrias (1822–1907) and from 1864 to 1870 exhibited at the Salon. After fighting in the Franco—Prussian War, Tavernier moved to London,

working briefly as a newspaper illustrator before moving to New York in late 1871. He became a contributing artist to several journals, including *Harper's Weekly*, which in 1873 sent him and fellow Frenchman Paul Frenzeny (1840—?1902) to remote US territories and Indian lands; the two created a rich pictorial record of the changing landscape and peoples of the West. Reaching San Francisco in 1874, Tavernier decided to stay. He cultivated a bohemian lifestyle, socializing, travelling, entertaining and occasionally working in his lavish, exotically decorated studio. Primarily he painted landscapes and subjects drawn from his Western travels: *Dreams at Twilight (The Artist's Reverie)* (1876; San Francisco, CA., priv. col.) exemplifies Tavernier's Romantic imagination and bold use of colour, while *Indian Village at Acoma* (1879; Denver, CO, Anschutz priv. col.) abounds in both description and atmosphere. Active in social clubs and artists' groups, Tavernier challenged the complacency of the San Francisco Art Association in 1884 by creating an insurgent 'Palette Club', whose two exhibitions encouraged younger talents and convinced the older organization to change its methods of selecting and installing exhibitions.

An impractical *bon vivant*, Tavernier was threatened frequently by debt or arrest; his friends raised funds to send him to Honolulu in December 1884. There he became nearly obsessed with the dramatic colour and spectacle of volcanoes. His night views of smoldering mountains and fiery lava, such as *Kilauea at Night* (c. 1887; Hilo, HI, priv. col., see Forbes, p. 190) excited the Hawaiian royalty, populace and tourists alike; his presence catalyzed an artistic community, later termed the Volcano school or Little Hawaiian Renaissance. Tavernier planned a career revival based on volcano and Western pictures, but died early from acute alcoholism.

BIBLIOGRAPHY

'Jules Tavernier, 1844–1889: Life and Works', *California Art Research*, ed. G. Hailey (San Francisco, 1936–7), iv, pp. 1–26a

R. Taft: *Artists and Illustrators of the Old West, 1850–1900* (Princeton, 1953), pp. 94–115

Encounters with Paradise: Views of Hawaii and its People, 1778–1941 (exh. cat. by D. W. Forbes, Honolulu, HI, Acad. A., 1992), pp. 178–82, 190–98

SALLY MILLS

Tefft, Thomas (Alexander) (*b* Richmond, RI, 3 Aug 1826; *d* Florence, 12 Dec 1859). American architect. He was a schoolteacher when Henry Barnard, State Commissioner of Education, induced him to continue his education at Brown University, Providence, RI. In 1845 he moved to Providence, enrolled and entered the firm of Tallman & Bucklin. After graduating in 1851, he opened his own office and became a part of the cosmopolitan intellectual circle gathering seasonally in Newport in the 1850s. His first major work, the Union Passenger Depot (1848–55; destr. 1898), Providence, was his masterpiece. It was a large, eight-building complex, built of brick in the *Rundbogenstil* (German rounded arch style). The centrepiece of this complex was the passenger depot, a curving 230-m long structure with a steep hipped roof and a central entrance flanked by slender towers. One-storey arcades extended back from this section at an angle and culminated in octagonal pavilions. The complex included extensive freight depots, engine-houses and repair sheds. This early

and sophisticated essay in the Lombard Romanesque Revival was perhaps the most technologically advanced railway station on the west side of the Atlantic Ocean. In 1885 the *American Architect and Building News* included it as one of the 20 best buildings in the country.

Tefft's association with Tallman & Bucklin introduced him to industrial architecture. Only one of his mills is extant: the Cannelton Cotton Mill (1849), Cannelton, IN, but the designs he produced, such as the Atlantic-Delaine Co. Mill (1851; destr.), incorporate brick construction and *Rundbogenstil* machicolations. Many of the mid-19th-century textile mills in Rhode Island and nearby Massachusetts incorporate these features. The Romanesque proved adaptable for ecclesiastical architecture: his Central Congregational Church (*c*. 1850) in Providence uses the same stylistic vocabulary as Union Station, but, being a more traditional building type, is closer in its general aspect to its Romanesque precedents and has twin towers flanking the west front. However, for St Thomas's Episcopal Church (1851) in rural Smithfield, RI, he deftly used the English Gothic of the small country church, then becoming popular in the USA.

The commercial buildings that Tefft designed include several sober, Renaissance Revival buildings, whose style recalls that of Charles Barry (1795–1860) such as the Bank of North America (1856), Providence. His daring is revealed in his design for the Merchants' Exchange (1856), a circular, five-storey structure with a central glass-domed atrium; dissension among the financial backers meant that this imaginative scheme was never built. Domestic architecture constituted a large part of Tefft's work. He was an early American practitioner of the Italianate mode: his Tully D. Bowen House (*c*. 1852), 389 Benefit Street and Robert Lippitt House (1852–4), 193 Hope Street, both in Providence, are symmetrical cubes of brick with severe, simple detail. His country houses are rambling, asymmetrical designs, done either in the Italian villa mode, as in the Charles Bradley House (*c*. 1855), 235 Eaton Street, Providence, or in the rural Gothic style, as in the William Grosvenor House (*c*. 1855; destr. 1967, see 1988 exh. cat., pp. 234–5), Providence.

Tefft was an early advocate of historic building conservation. He lectured and wrote on American Colonial architecture, and his addition of 1853 to the Rhode Island State House (1762), Providence, follows the forms and details of the original. In 1856 he left for a tour of Europe, where he studied buildings and was introduced to British and European architects. In his absence he was a foundermember of the American Institute of Architects. Before completing his trip, he died of a fever and was thus unable to fulfil his pledge that the introduction of brick architecture in the USA would be his life's work. Despite his youth and provincial situation, Tefft was conversant with international trends and designed buildings of exceptionally high quality, many being new types necessitated by changing society and technology.

UNPUBLISHED SOURCES

Architecture: Ancient and Modern [Paper read before the Newport Historical Society, 22 Nov. 1853]

BIBLIOGRAPHY

Macmillan Enc. Architects

E. M. Stone: *A Brief Memoir of Thomas Alexander Tefft: The Architect and Monetarian* (Providence, 1869)

'Thomas A. Tefft and Brick Architecture in America', *Amer. Architect. & Bldg News*, xix/546 (1886), pp. 282–3

B. Wriston: 'The Architecture of Thomas Tefft', *Bull. Mus. A., RI Sch. Des.*, xxviii/2 (1940), pp. 37–45

——: *Thomas Alexander Tefft: Architect and Economist* (MA thesis, Providence, RI Sch. of Des., 1942)

M. R. Little: *The Architecture of a Late, Lamented Genius: Thomas Alexander Tefft* (MA thesis, Providence, RI, Brown U., 1972)

Buildings on Paper: Rhode Island Architectural Drawings, 1825–1945 (exh. cat., ed. W. H. Jordy and C. P. Monkhouse; Providence, RI, Brown U., Bell Gal.; Providence, RI Sch. Des., Mus. A.; Providence, RI Hist. Soc.; New York, N. Acad. Des.; 1982)

Thomas Alexander Tefft: American Architecture in Transition, 1845–1860 (exh. cat., Providence, RI, Brown U., 1988)

W. McKENZIE WOODWARD

Ten American Painters [The Ten]. Group of American painters who exhibited together from 1898 to 1918. In 1897 ten New York- and Boston-based artists withdrew from the Society of American Artists, the most progressive art organization of the period. Their common interest was not the promotion of a new art, but rather the improvement of the quality of their exhibitions. The Ten—a shortened version of the name given to them by the press—was organized by John H. Twachtman, Julian Alden Weir and Childe Hassam. The other members were Frank Weston Benson, Joseph Rodefer De Camp, Thomas Dewing (1851–1938), Willard Leroy Metcalf, Robert Reid (1862–1929), Edward E. Simmons (1852–1931) and Edmund C. Tarbell. There was in fact a total of 11 members, for William Merritt Chase was asked to join when Twachtman died.

The group was usually identified with Impressionism, since its organizers ranked as America's leading Impressionists, and most of its other members painted in an Impressionist style. Dewing, however, was not a true Impressionist, and Simmons and Reid were major muralists of the period. All the members were well established and some highly successful.

The Ten decried the overcrowded walls of the established annual exhibitions, feeling that their paintings would be better seen in smaller shows where all the exhibits were of a similar, harmonious character. Their desire for an installation that would inspire an air of quiet contemplation derived from ideas initiated by Whistler and artists of the Aesthetic Movement, who believed that principles of good taste should be applied to the display of paintings. In the Ten's exhibitions each artist was allocated ample wall space, and all paintings were hung so that they could be easily seen; even the colour of the walls was chosen to be compatible with the exhibits. The group exhibited annually in New York and occasionally in other American cities. All exhibitions were selected by the members themselves, and no prizes were awarded.

BIBLIOGRAPHY

A. Hoeber: 'The Ten Americans', *Int. Studio*, xxxv/137 (1908), pp. xxiv–xxix

K. Haley: *The Ten American Painters: Definition and Reassessment* (diss., Binghamton, SUNY, 1975)

W. A. Gerdts: *American Impressionism* (New York, 1984), pp. 171–86

ILENE SUSAN FORT

Thayer, Abbott Handerson (*b* Boston, MA, 12 Aug 1849; *d* Dublin, NH, 29 May 1921). American painter and naturalist. He spent his youth in rural New England, where his earliest paintings were wildlife subjects, reflecting his interest in hunting and fishing. While in his teens Thayer achieved some success doing portraits of family pets, which he continued after a move to New York. He attended classes at the Brooklyn Art School and National Academy of Design, but in 1875 he settled in Paris, studying under Henri Lehmann (1814–82) and Jean-Léon Gérôme (1824–1904) at the Ecole des Beaux-Arts. While abroad he produced landscapes in the Barbizon style and genre scenes, but on his return to New York in 1879 he established himself as a portrait painter.

Thayer's earliest portraits were black-and-white illustrations of literary figures to accompany articles in *Scribner's Magazine*. However, Thayer's reputation was to be established primarily in his paintings of women. His fashionably dressed *Mrs William F. Milton* (1881; New York, Met.), with its subdued palette, careful modelling and elegant feminine accoutrements, demonstrates his mastery of the Parisian society portrait. Thayer was soon to reject such worldly images in favour of a more subdued, unadorned approach, as in *The Sisters* (1884; New York, Brooklyn Mus. A.), which reflects his oft-stated belief that serene, handsome women were sacred embodiments of moral virtue. Such concerns became more pronounced in later years, when Thayer portrayed his female subjects in Classical robes or supplied them with wings to emphasize their timeless and symbolic qualities, as in *Seated Angel* (1899; Chicago, IL, A. Inst.).

Thayer sketched and painted his children frequently. Following the mental deterioration and death of his wife in 1891, these portraits evolved into large allegorical tableaux, such as *Virgin Enthroned* (1891; Washington, DC, N. Mus. Amer. A.; see fig.), in which his eldest daughter Mary poses as the Virgin, with his son Gerald and youngest child Gladys on either side as John the Baptist and Jesus. Such a work is evidence of Thayer's interest in the Italian Renaissance, though his loose handling of paint and lack of specific Christian iconography are firmly contemporary.

In 1901 Thayer and his family settled in Dublin, NH. From his house Thayer had a magnificent view of Mount Monadnock, which he often painted. Much influenced by the writings of Emerson, who wrote a poem about the peak, Thayer regarded Monadnock as both a visual synecdoche of earthly experience and an emblem of earthly transcendence. Always painted in winter, these works feature the summary effects and calligraphic swathes of pigment reminiscent of Japanese painting and link the artist to Impressionist trends in America at the time.

Through his lifelong interest in natural history, Thayer developed a theory of natural camouflage in animals, which appears in its most complete form in the book *Concealing Coloration in the Animal Kingdom* (1909), nominally written by his son Gerald. Interspersed in the text are illustrations of various animals, which demonstrate their invisibility under certain environmental conditions. Thayer's precepts were challenged by some scientists and by Theodore Roosevelt, but his research brought the issue of camouflage before the public (and some of his theories were later put to military use during World War II). A large collection of manuscript material relating to Thayer is in the Archives of American Art, Washington, DC.

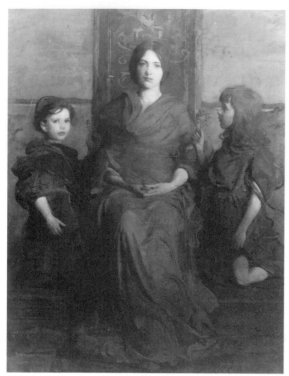

Abbott Handerson Thayer: *Virgin Enthroned*, oil on canvas, 1.80×1.30 m, 1891 (Washington, DC, National Museum of American Art)

BIBLIOGRAPHY
N. C. White: *Abbott H. Thayer: Painter and Naturalist* (Hartford, CT, 1951)
R. C. Anderson: *Abbott Handerson Thayer* (Syracuse, NY, 1982)
A. Nemerov: 'Vanishing Americans: Abbott Thayer, Theodore Roosevelt and the Attraction of Camouflage', *Amer. A.*, xi (1997), pp. 50–81
ROSS C. ANDERSON

Theus, Jeremiah (*b* Chur, Switzerland, 1719; *d* Charleston, SC, 18 May 1774). American painter of Swiss birth. He moved with his family to South Carolina *c.* 1735 at a time when accounts of the rich farmlands available in that area encouraged many Swiss immigrants to settle there. In 1740 he advertised in the *South Carolina Gazette* as a painter of portraits, landscapes, crests and coats of arms, stating his willingness to travel 'to wait on [his clients] at their respective plantations'. The appearance of this announcement indicates Theus's degree of satisfaction with his painting skills. Because there was no contemporary painter of comparable standard in the colony, it is doubtful his training continued after leaving Switzerland. A further advertisement in the *Gazette* (22 Oct 1744) announced the opening of his drawing school: an evening school for 'all young Gentlemen and Ladies' to whom the art of drawing would 'be taught with the greatest exactness by Jeremiah Theus, Limner'.

Theus is best known for his half-length portraits of the wealthy of Charleston. Throughout his career he demonstrated a delicate sense of colour, particularly in the treatment of costume, although the use of fold pattern is repeated in nearly all of his portraits. The close similarity of elegant and refined dress in his paintings suggests that he used imported engravings as models. His treatment of faces—all with close-set eyes, long noses and full, upturned lips, in a pouting pose—is a characteristic feature of his work. Perhaps, like the fashionable dress, these characteristics indicated status. Two excellent examples of his work, both in oval format, are *Elizabeth Rothmahler* (1757; New York, Brooklyn Mus. A.) and *Polly Ouldfield of Winyah* (*c.* 1761; Washington, DC, N. Mus. Amer. A.; see fig.). The *Rothmahler* portrait is signed, as usual with Jeremiah Theus, in the lower left corner; the *Ouldfield* portrait includes the suggestion of a row of trees on the left, an example of the glimpses of landscape he sometimes set behind his aristocratically posed figures. As in most of his portraits, the light source is above the subject, giving the characteristic fold pattern in their dresses, which, except for a difference in colour and for the lacy sleeves of Polly Ouldfield, are identical. Theus often used pearls as a decorative feature on bodices: a single loop hangs beneath a bright silver bow on Rothmahler's mustard-yellow bodice and a three-loop arrangement is found at the collar of Ouldfield's white dress. The faces possess an attractive alertness that contrasts with the women's stiff poses. Theus had a successful career, becoming a respected member of various civic, social and religious institutions and amassing land, slaves and wealth.

BIBLIOGRAPHY
M. S. Middleton: *Colonial Artist in Charles Town* (Columbia, SC, 1953)
W. Craven: *Colonial American Portraiture* (Cambridge, 1986)
DARRYL PATRICK

Thomas. English family of architects, active in the USA. Thomas Thomas (*b* Isle of Wight, ?1787–8; *d* New York, 1871) studied architecture in London (possibly with Peter Nicholson) before moving to New York in 1833. He had

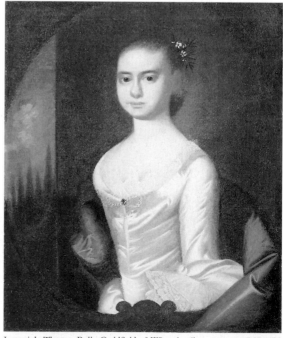

Jeremiah Theus: *Polly Ouldfield of Winyah*, oil on canvas, 765×638 mm, *c.* 1761 (Washington, DC, National Museum of American Art)

a successful career that included the design of classically inspired buildings such as the imposing granite Greek Revival St Peter's Roman Catholic Church (1836–40; with John Haggerty), Barclay Street, New York. His son, Griffith Thomas (*b* ?Isle of Wight, 1820; *d* New York, 11 Jan 1879), arrived in New York in 1838 and joined his father in the firm of Thomas & Son. Griffith Thomas was one of the first architects in the USA to popularize the Italian palazzo mode, particularly for hotels (e.g. Fifth Avenue Hotel, 1856–8, New York; with William Washburn, 1808–90; destr. 1908) and commercial buildings, notably the marble-faced Arnold Constable Store (1856–60), Canal Street, New York. Griffith Thomas designed many marble palazzi in New York and was an early proponent of the use of cast iron for building façades. He was also one of the first American architects to adopt the French Second Empire style. The second Arnold Constable building, commissioned by the department store as it followed the northward movement of New York's commercial centre, sums up Griffith Thomas's career. The original building (1868–9) on Broadway and East 19th Street is an Italianate palazzo faced with marble. In 1872–3 he extended the store along 19th Street and added a splendid two-storey mansard roof to the original building. A final wing on Fifth Avenue (1876–7) has a cast-iron façade and mansard roof that virtually repeats the earlier Broadway elevation.

BIBLIOGRAPHY

'The Death of Mr. Griffith Thomas', *Amer. Architect & Bldg News*, v (1879), p. 29

W. Weisman: 'Commercial Palaces of New York: 1845–1875', *A. Bull.*, xxxvi (1954), pp. 285–302

SoHo-Cast Iron Historic District Designation Report, New York City Landmarks Preservation Commission (New York, 1973)

M. Gayle and E. Gillon: *Cast-iron Architecture in New York: A Photographic Survey* (New York, 1974)

Ladies Mile Historic District Designation Report, New York City Landmarks Preservation Commission (New York, 1999)

ANDREW SCOTT DOLKART

Thompson, Jerome (*b* Middleborough, MA, 30 Jan 1814; *d* Glen Gardner, NJ, 1 May 1886). American painter. He was the son of the portrait painter Cephas Thompson (1775–1856) and the brother of the artist Cephas Giovanni Thompson (1809–88). At the age of 17 he opened a portrait studio in Barnstable, MA, and moved to New York in 1835. In 1850 he began to exhibit genre subjects, although he never entirely abandoned portraiture, and after studying in England from 1852 to 1854, he returned to New York where he achieved success with his rustic genre scenes. These include *Apple Gathering* (1857; New York, Brooklyn Mus. A.; see fig.) and the *Belated Party on Mansfield Mountain* (1858; New York, Met.). His works were particularly praised for the equal emphasis given to landscape and genre elements within the same picture.

Through the sale of chromolithographs of his paintings commissioned by such important print publishers as Louis

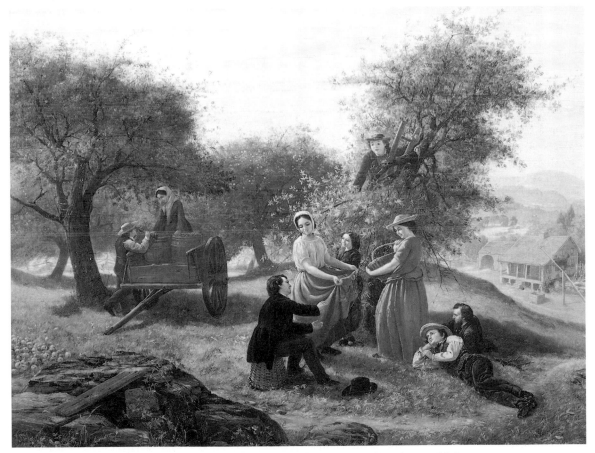

Jerome Thompson: *Apple Gathering*, oil on canvas, 1.00×1.26 m, 1857 (New York, Brooklyn Museum of Art)

Prang, Thompson achieved national fame and personal wealth. Thompson also painted scenes of the American West and Indian subjects later in his career. His style changed from the linear detail of his earlier work to a broader, more painterly touch. Late examples include the *Voice of the Great Spirit* (1877; Boston, MA, Athenaeum), one of several paintings based on Longfellow's poem the *Song of Hiawatha* (1855), and the *Falls of Minnehaha* (1870; Minneapolis, U. MN, A. Mus.). Though he is often cited in the literature as Jerome 'B.' Thompson, the 'B.' is a misnomer, the artist having never signed his paintings in this way.

BIBLIOGRAPHY

L. M. Edwards: 'The Life and Career of Jerome Thompson', *Amer. A. J.*, xiv/4 (1982), pp. 4–30

LEE M. EDWARDS

Thornton, William (*b* Tortola, British Virgin Islands, 20 May 1759; *d* Washington, DC, 28 March 1828). American architect, naturalist and civil servant of British birth. Born on a West Indian sugar plantation, to which he became an heir on the death of his father in 1760, he spent his youth among his English Quaker relatives in Lancaster. He was apprenticed to a 'practical physician' and apothecary in Ulverston, Lancs (now Cumbria), then studied medicine at the University of Edinburgh (1781–3), receiving the MD degree from the University of Aberdeen in 1784. He continued his medical studies and pursued his other interests of drawing and painting in London and Paris, and travelled on the continent and in Scotland, before returning to Tortola in May 1785. In the autumn of the following year he emigrated to the USA.

Thornton practised medicine briefly in Philadelphia but found the fees low and the nature of physicians' work there 'laborious' and 'disgusting'. His scientific accomplishments, however, gained him election to the American Philosophical Society, and his visionary turn of mind attracted him to causes as varied as the anti-slavery campaign and John Fitch's experimental steamboats, to which he contributed designs as well as capital. His inclination for design led him to enter the competition for the hall of the Library Company of Philadelphia, and his designs were accepted with slight alterations in 1789.

This success and his desire to win fame in the service of the new Republic explain Thornton's decision to enter the competition for the proposed 'capitol' that was to house the national Congress in the new Federal City on the Potomac River. The central element in his design, selected in January 1793, was a rotunda covered by a saucer dome, modelled after the Pantheon. This element dominated the central block of a 107-m (initially a 152-m) front, the façade of which was inspired by the colonnaded east front of the Louvre, Paris, and its 18th-century architectural heritage. While it was *retardataire* from the perspective of European Neo-classicism, Thornton's Capitol expressed with clarity the republican aesthetics and aspirations of the new nation. President George Washington and Secretary of State Thomas Jefferson differed about components of the plan, but they remained in agreement about 'The Grandeur, Simplicity, and Beauty of the exterior'.

Thornton served on the three-member Board of Commissioners of the Federal District from 1794 to 1802 and in that capacity influenced the first public works in Washington; from 1802 until his death he superintended the first US Patent Office. Although generally receptive to modifications to the Capitol (most often dictated by economy), he campaigned vigorously against two ambitious superintendents, George Hadfield and Benjamin Henry Latrobe, when they sought to depart substantially from the accepted design. Latrobe prevailed in the interiors when the building was reconstructed after the War of 1812, and Charles Bulfinch completed work on the modified central block (ineptly, in Thornton's opinion) in 1827. The US Capitol was later altered considerably.

Among Thornton's other architectural designs, the most notable were schemes for two Washington residences: a townhouse for John Tayloe III (1799–1802; known as the Octagon), and the Georgetown villa Tudor Place (*c.* 1808–16) for Thomas Peter (both now historic house museums). One of the two elevation drawings he prepared for the University of Virginia (Charlottesville) influenced Thomas Jefferson's design for Pavilion VII and his decision to employ rounded columns rather than square pilasters in the colonnade that unites the principal university buildings. Many of Thornton's architectural drawings must be presumed lost, and few of his other compositions have survived or been located; however, the observations and critical commentary found in his correspondence constitute a valuable resource for the history of American art and architecture in the early national period.

WRITINGS

C. M. Harris, ed.: *Papers of William Thornton*, 2 vols (Charlottesville, 1995–)

BIBLIOGRAPHY

G. Brown: *History of the United States Capitol*, 2 vols (Washington, DC, 1900, *R* 1970)

S. F. Kimball and W. Bennett: 'William Thornton and the Design of the United States Capitol', *A. Stud.*, i (1923), pp. 76–92

C. Peterson: 'Library Hall: Home of the Library Company of Philadelphia, 1790–1880', *Trans. Amer. Philos. Soc.*, n. s., xliii/1 (1953), pp. 129–47

D. D. Reiff: *Washington Architecture, 1791–1861: Problems in Development* (Washington, 1971, 2/1977)

William Thornton: A Renaissance Man in the Federal City (exh. cat., eds E. Stearns and D. N. Yerkes; Washington, DC, Amer. Inst. Architects Found., 1976)

Building the Octagon (exh. cat. by O. V. Ridout, Washington, DC, Octagon Mus., 1989)

C. M. Harris: 'Specimens of Genius and Nicknacks: The Early Patent Office and its Museum', *Prologue*, 23 (1991), pp. 406–17; 24 (1992), p. 94

Temple of Liberty: Building the Capitol for a New Nation (exh. cat. by P. Scott, Washington, DC, Lib. Congress, 1995)

C. M. Harris: articles in *Washingtoniana: 200 Years of Architectural, Design and Engineering Drawings in the Prints and Photographs Division of the Library of Congress* (Washington, DC, in preparation)

——: 'Washington Gamble, L'Enfant's Dream: Politics, Design and the Founding of the National Capital', *William and Mary Q.*, 3rd ser., lvi (in preparation)

C. M. HARRIS

Tiebout, Cornelius (*b* New York, *c.* 1773; *d* New Harmony, IN, 1832). American engraver. He was significant for his role in introducing the English method of stippled portraiture to America. Stauffer called him the 'first American-born professional engraver to produce really meritorious work'. Tiebout learnt to engrave while apprenticed to New York silversmith John Burger (*fl* 1786–1807). In 1789 and the early 1790s Tiebout's engravings appeared regularly in books and periodicals such

as the *New York Magazine*. In 1793 he went to London, where he studied with the printmaker James Heath and issued his much acclaimed stipple engraving of the American statesman and diplomat *John Jay* (1795).

Returning to New York in 1796, Tiebout published handsome stipple portraits of the politician and soldier *George Clinton* (1796), the soldier *Horatio Gates* (1798), the naval officer *Thomas Truxtun* (1799) and others. Although most American engravers had combined stippling with line work, Tiebout's portraits were produced from an almost entirely stippled plate in the English manner. With the English-born engraver David Edwin (1776–1841), Tiebout established stipple as the favourite technique for printed portraiture for the next quarter of a century. In 1799 Tiebout moved to Philadelphia, where he produced impressive portraits of Washington and Jefferson, as well as numerous illustrations. After joining Benjamin Tanner (1775–1848) and Francis Kearny (1785–1837) in a banknote company from 1817 to 1824, he went to live in New Harmony, IN, where he worked as an engraver and teacher until his death.

BIBLIOGRAPHY

DAB
W. Dunlap: *A History of the Rise and Progress of the Arts of Design in the United States* (New York, 1834)
American Engravers upon Copper and Steel, 3 vols (i–ii, New York, 1907; iii, Philadelphia, 1917), i, pp. 271–2; ii, pp. 520–33; iii, pp. 271-84 [vols i–ii by D. M. Stauffer, vol. iii by M. Fielding]
N. E. Cunningham jr: *The Image of Thomas Jefferson in the Public Eye: Portraits for the People, 1800–1809* (Charlottesville, VA, 1981) [disc. of Tiebout's Jefferson prts, incl. newspaper advertisements and publishers' corr.]
W. C. Wick: *George Washington, an American Icon: The Eighteenth-century Graphic Portraits* (Washington, DC, 1982)
G. W. R. Ward, ed.: *The American Illustrated Book in the Nineteenth Century* (Winterthur, DE, 1987)

WENDY WICK REAVES

Tiffany. American family of jewellers, merchants and designers. Charles Louis Tiffany (*b* Killingly, CT, 15 Feb 1812; *d* Yonkers, NY, 18 Feb 1902) was the founder of the prestigious New York jewellery firm Tiffany & Co. (*see* §1 below). His son, the designer and painter Louis Comfort Tiffany (*see* §2 below), is renowned for his Art Nouveau glass and jewellery.

1. TIFFANY & Co. The firm Tiffany & Young was founded in New York on 21 September 1837 by Charles Louis Tiffany and his partner John B. Young (1802–52) as a small fancy goods and stationery store. Tiffany proved to be a gifted entrepreneur with an impeccable sense of style; he catered to newly rich clients unsure of their tastes by offering rare and exotic imported goods, and the business thrived. In 1841, with a third partner, John L. Ellis, the company added fine European silver, porcelain, crystal glassware, personal and desk-top accessories and later jewellery, Swiss watches and bronze statuary to its stock. As a champion of American craftsmanship and materials, Tiffany established his own jewellery-making workshop in 1848 and subsequently became one of the greatest merchant-jewellers in the USA; the firm produced such pieces of individually crafted jewellery as the 'Chrysanthemum' brooch (*see* UNITED STATES OF AMERICA, fig. 46).

In 1851 Tiffany brought the silver manufacturer John C. Moore into the firm, and under Moore's direction the company rose to dominate the domestic silver market. By 1853 the firm was known as Tiffany & Co. In 1850 Tiffany opened a branch in Paris; at the Expositions Universelles of 1867 and 1878 in Paris the firm was awarded medals, the first to be given to an American silver-maker. Moore's son, the silver designer Edward Chandler Moore (1827–91), also joined the company; in 1871 he created the celebrated 'Audubon' flatware, with its modelled and cast design of birds, which continued to be produced during the 1990s, and later such pieces as the opulent enamelled silver and inlaid 'Magnolia' vase (*c*. 1892–3; New York, Met.).

By 1900 Tiffany & Co. included among its clients 23 royal families, including that of Queen Victoria, as well as celebrities, millionaires and successive US presidents. A notable presentation item was the Adams Vase, designed by Paulding Farnham (1893–5; *see* UNITED STATES OF AMERICA, §IX, 1(v) and fig. 43). Louis Comfort Tiffany inherited the business on the death of his father in 1902. Tiffany's also produced some of the most important trophies in the USA.

BIBLIOGRAPHY
J. Loring: *Tiffany's 150 Years* (New York, 1987)
N. Potter and D. Jackson: *Tiffany Glassware* (New York, 1988)
G. Mirabella: *Tiffany & Co.* (London, 1997)

□

2. LOUIS COMFORT TIFFANY. American designer and painter. He was the son of Charles Louis Tiffany, from whom he inherited the business of Tiffany & Co. (*see* §1 above) in 1902. As a youth he showed an interest in art, and he received his early training (1866) in the studios of the landscape painter George Inness, from whom he gained an appreciation of nature that was to provide the subject-matter for many of his future designs. In 1868 he trained in Paris under Léon Bailly (*b* 1826) and then travelled extensively in North Africa and Spain. In the same year he met Samuel Colman, with whom he shared an interest in the forms, ornament and patterns of Islamic and Romanesque art. Tiffany returned to the USA in the early 1870s and began to paint travel scenes and landscapes in the fashionable Orientalist style (e.g. *Harbour Scene in the Far East*, 1872; Winter Park, FL, Morse Gal. A.), as well as experimenting with such novel subject-matter as New York slums. From the mid-1870s he began to form a collection of East Asian (particularly Japanese) and Islamic ceramics, glass, furniture and metalwork that reflected his taste for the exotic and mystical. As early as 1867 Tiffany had won recognition for his paintings from the National Academy of Design, but he later rebelled against the institution's conservative attitudes. In 1877, together with John La Farge, Augustus Saint-Gaudens and other American avant-garde figures, he formed the American Art Association (from 1878 the Society of American Artists), which advocated modern European painting styles. Although Tiffany's interest in painting continued, by the late 1870s he had turned his attention primarily to the design and manufacture of the decorative arts.

From 1875 Tiffany experimented with stained-glass techniques, working first at the Thill Glasshouse in Brook-

lyn, New York, and in 1880 at the Heidt Glasshouse, also in Brooklyn. Disappointed by the poor quality of American glass, he set out to develop a technique to imitate and surpass the brilliant colour effects achieved by medieval stained-glass artists. At first he was influenced by La Farge, who was also experimenting with various glass techniques; when Tiffany became more commercially successful, however, their friendship ended. Tiffany's earliest glass was made exclusively for windows, which were incorporated into interior-design schemes. In these windows, which were either geometric patterns or depictions of landscapes, Tiffany used metallic oxides to develop numerous colour gradations, while experimenting with various effects to create the appearance of wrinkled and folded surfaces; this was particularly effective to convey the rippled effect of water or clouds. In 1879 he established, in conjunction with Colman, Lockwood de Forest (1850–1932) and Candace Wheeler, the interior decorating firm of Louis C. Tiffany & Associated Artists. The company designed a number of interiors, such as the Veterans' Room of the Seventh Regiment Armory, New York, and the house of Samuel L. Clemens (Mark Twain) in Hartford, CT, and redecorated (1883) the White House in Washington, DC. The firm's decorative schemes were eclectic and heavily influenced by the contemporary English Arts and Crafts Movement and the Aesthetic Movement; they were also noted for their daring combinations of Japanese-style gilt wallpaper, medieval-style stained glass, mosque-style hanging lamps and Islamic-style textiles.

Despite its great success, the firm was dissolved in 1883, and thereafter Tiffany operated alone under various names. In 1885 he established the Tiffany Glass Co. in Brooklyn, which continued to design interiors; its principal concern, however, was the production of windows, mosaics and blown, decorative glass. From 1889 Tiffany Studios (integrated into Tiffany & Co. in 1902) in New York produced such items of jewellery as the 'Peacock' necklace (c. 1902; Winter Park, FL, Morse Gal. A.; see colour pl. XXXVII, 2), made of gold, amethysts, opals, sapphires and rubies. In 1892 Tiffany established the Tiffany Glass and Decorating Co. in Corona, Long Island, NY. Although Tiffany was not responsible for all the designs made for the company and did not actually make the glass produced in his workshops and studios, he closely supervised production. It was his overall approach to design—using sensuous and organic forms from nature in the Art Nouveau style—that dominated production. His most important assistant was Arthur J. Nash (1849–1934), who had managed the White House Glassworks in Stourbridge, England, and was brought to the USA in 1892 to manage a separate division at Corona called Tiffany Furnaces. Nash's technical skills, combined with Tiffany's chemical discoveries, accounted for much of the company's success. Nash played a very important role in the development of 'Favrile' glass, the company's famous range of iridescent glass (registered trademark name, 1894); the production process involved treating the hot glass with metallic oxides that were absorbed into the glass to produce a luxurious, nacreous surface. 'Favrile' glass was used for a variety of objects, including vases (e.g. vase with peacock feather decoration, 1900; Manchester, C.A.G.) and hanging- and table-lamps in delicate shapes. Later developments of

iridescent glass included 'Lava' glass, which has a roughened surface, and Nash's 'Cypriote' glass, which is an opaque, pitted glass inspired by ancient Roman glass. Tiffany table-lamps made use of stained-glass techniques and were constructed on a simple production-line basis. The leaded shades incorporate small, multicoloured pieces of glass above a moulded, bronze base (see colour pl. XXXVII, 1). The completed lamp often imitated natural or floral forms, as in the 'Dragonfly' electric lamp (c. 1900; Norfolk, VA, Chrysler Mus.; see fig.), and the 'Lily' lamp (1902), with individual flower heads of gold iridescent glass suspended from bronze branches.

Tiffany gained an international reputation through such exhibitions as the World's Colombian Exposition of 1893 in Chicago, for which he designed a Romanesque-style chapel with glass mosaics (destr.). His work was admired by the Parisian critic and dealer S. Bing (1838–1905), who exhibited it in his Paris shop L'Art Nouveau. In 1894–5 Bing commissioned Tiffany to make 11 glass windows (Paris, Mus. d'Orsay) for the shop, based on designs by such artists as Bonnard (1867–1947), Maurice Denis (1870–1943) and Toulouse-Lautrec (1864–1901). Tiffany also designed a number of houses and apartments for himself and his family, including a studio (late 1880s) in New York with a chimney-piece that anticipated the work of Gaudí (1852–1926). Between 1902 and 1904 he designed his large country residence, Laurelton Hall (destr. 1957), Oyster Bay, NY. This was an expression of Tiffany's eclectic interests: it combined various exotic styles in a colourful assemblage and incorporated some of his best

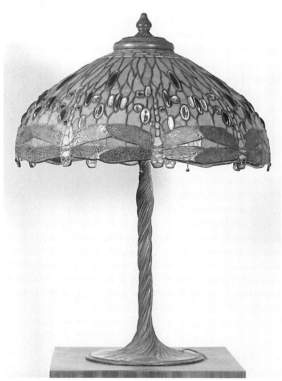

Tiffany 'Dragonfly' electric lamp on twisted waterlily base, leaded glass and bronze, h. 686 mm, c. 1900 (Norfolk, VA, Chrysler Museum)

windows, such as the *Four Seasons* (exh. 1892) and *Wisteria* (both Winter Park, FL, Morse Gal. A.). Other major accomplishments of the early 20th century include a glass curtain (1911; *in situ*) for the Palacio de Bellas Artes of Mexico City. In later years Tiffany's interest in the daily running of the glassworks decreased. Despite his alignment with the Art Nouveau style, he had little sympathy with such later modern movements as Cubism and found himself increasingly at odds with American modernism. The most important collections of Tiffany glass are in the Morse Gallery of Art, Winter Park, FL, and the Chrysler Museum, Norfolk, VA.

WRITINGS
'American Art Supreme in Colored Glass', *The Forum*, xv (1893), pp. 621–8

BIBLIOGRAPHY
S. Bing: *La Culture artistique en Amérique* (Paris, 1895); Eng. trans. as *Artistic America: Tiffany Glass and Art Nouveau* (Cambridge, MA, 1970)
C. Waern: 'The Industrial Arts of America: The Tiffany Glass and Decorating Co.', *Int. Studio*, 2 (1897), pp. 156–65; 5 (1898), pp. 16–21
C. DeKay: *The Art Work of Louis C. Tiffany* (Garden City, NY, 1914)
R. Koch: *Louis C. Tiffany: Rebel in Glass* (New York, 1964, rev. 2/1966)
M. Amaya: *Tiffany Glass* (New York, 1967)
R. Koch: *Louis C. Tiffany Glass, Bronzes, Lamps: A Complete Collector's Guide* (New York, 1971)
W. Faude: 'Associated Artists and the American Renaissance in the Decorative Arts', *Winterthur Port.*, x (1975), pp. 101–30
H. McKean: *Laurelton Hall: Tiffany's Art Nouveau Mansion* (Winter Park, FL, 1977)
P. Doros: *The Tiffany Collection of the Chrysler Museum at Norfolk* (Norfolk, VA, 1978)
H. McKean: *The Lost Treasures of Louis Comfort Tiffany* (New York, 1980)
D. Stover: *The Art of Louis Comfort Tiffany* (San Francisco, 1981)
G. Weisburg: *Art Nouveau Bing: Paris Style, 1900* (New York, 1986)
Masterworks of Louis Comfort Tiffany (exh. cat. by A. Duncan, M. Eidelberg and N. Harris, Washington, DC, Renwick Gal.; New York, N. Acad. Des.; 1989–90)
A. Duncan: *Louis Comfort Tiffany* (New York, 1992)
J. Zapata: *The Jewelry and Enamels of Louis Comfort Tiffany* (New York, 1993)
The Lamps of Tiffany: Highlights of the Egon and Hildegard Neustadt Collection (exh. cat., Coral Gables, FL, U. Miami, Lowe A. Mus.; Memphis, TN, Dixon Gal.; 1993–4)
J. E. Price: *Louis Comfort Tiffany: The Painting Career of a Colorist* (New York, 1996)
J. Loring: *Tiffany's 20th Century: A Portrait of American Style* (New York, 1997)
A. C. Frelinghuysen: 'Louis Comfort Tiffany at the Metropolitan Museum of Art', *Bull. Met.*, lvi/1 (1998), pp. 4–100; repr. as book (New York, 1998)

RICHARD GUY WILSON

Tilden, Douglas (*b* Chico, CA, 1 May 1860; *d* Berkeley, CA, *c.* 4 Aug 1935). American sculptor. Speech and hearing impaired from shortly before his 4th birthday, he nonetheless enjoyed a productive and successful career as a sculptor. With works such as *Baseball Player* (1889; San Francisco, CA, Golden Gate Park), *Bear Hunt* (1892; Fremont, CA, CA Sch. Deaf) and *(California) Admission Day Monument* (1897; San Francisco, CA, Market, Post and Montgomery Streets), he established himself as a designer of major monuments now regarded as comprising the greatest single legacy of public art in the San Francisco Bay area. Described in his day as the Father of Sculpture on the Pacific Coast, he was the first California-born sculptor to receive international recognition. His reputation was such that in 1900, despite his disabilities, he was appointed Professor of Sculpture at the Mark Hopkins

Institute of Art by the Regents of the University of California (the school was at the time part of UC). Six years earlier, he had founded the first department of modelling at MHIA, introducing live nude models into the classroom.

Tilden lost his hearing and speech as the result of a scarlet fever epidemic in Stockton, CA, where his physician father had moved his family the boy was a year old. In 1866 he entered the California Institution for the Education and Care of the Indigent Deaf and Dumb, and the Blind, in San Francisco (now the California School for the Deaf, located in Fremont). Demonstrating an early talent for art and encouraged by his author/sculptor mother Catherine Hecox (Tilden Brown, 1841–1934), Tilden studied briefly in 1882 with Virgil Williams (1830–86) at the California School of Design and the following year with Francis Marion Wells (1848–1903), at the time San Francisco's leading sculptor. In 1887 he left Berkeley for New York, where he studied at the National Academy of Design with John Quincy Adams Ward and, in the evenings, at the Gotham Students' League. From 1888 to 1894 he was in Paris, studying with deaf sculptor Paul-François Choppin (1856–after 1909) for five months (1888) and in 1890 with animal sculptor Emmanuel Frémiet (1824–1910). Tilden began exhibiting at the Paris Salon in 1889 with *Baseball Player*, winning an Honourable Mention the following year for *Tired Boxer* (plaster destr at Chicago A. Inst., 1923; bronze table model, cast 1892,

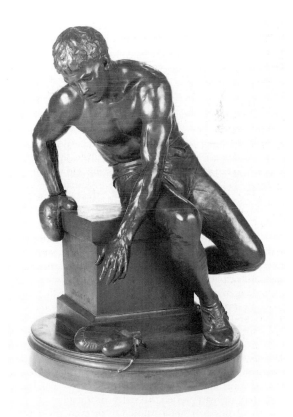

Douglas Tilden: *Tired Boxer*, bronze, h. 743 mm, 1892 (San Francisco, CA, Fine Arts Museums of San Francisco)

San Francisco, CA, F.A. Museums; see fig.). In 1894 he was joined in Paris by fellow Californian Granville Seymour Redmond, a painter who was also deaf and with whom he remained close friends of their lives.

Tilden's most famous work, regarded by many as his masterpiece, is the Donahue Memorial Fountain, now simply called *The Mechanics* (1901; San Francisco, CA, Market, Bush and Battery Streets). A spectacular photograph shows the controversial (for its semi-nude male workers) monument proudly standing in the midst of the gutted buildings and debris left by the devastating earthquake and fire of 18 April 1906. Among his more eccentric sculptures is *Golden Gate* (plaster model 1907, cast in bronze 1969; Oakland, CA, Mus.), an erotic pairing of a mermaid and merman that he gave to Charmian London, widow of author Jack London, shortly after her husband's death in 1916. Jack London had been among Tilden's Bohemian Club friends, as was Granville Redmond.

After about 1914 Tilden's career as a sculptor began to decline, and he turned his attention to writing, unsuccessful attempts to find teaching positions and various activities on behalf of the deaf, an interest he had from at least 1889, when he helped inaugurate the International Congress of the Deaf (Paris, July 1889).

Among the many exhibitions in which Tilden participated were the World's Columbian Exposition, Chicago (1893); the Pan-American Exposition, Buffalo, NY (1901); the Louisiana Purchase Exposition, St Louis, MO (1904); and the San Francisco Museum of Art's *Thirty Years of Sculpture in CA* (1935). A solo exhibition was organized in San Francisco at the M. H. de Young Memorial Museum in 1980.

BIBLIOGRAPHY
M. Albronda: *Douglas Tilden: Portrait of a Deaf Sculptor* (Silver Spring, MD, 1980)
——: *Douglas Tilden: The Man and His Legacy* (Seattle, 1994)

PAUL J. KARLSTROM

Tiles. English transfer-printed decorative tiles were in use in North America as fireplace facings as early as the 18th century. Before 1850, however, tile production in the USA was limited to plain, undecorated paving and roofing tiles made by Colonial Redware potters. Production of decorative tiles began in earnest in the 1870s, inspired by the English imports shown in 1876 at the Centennial International Exhibition in Philadelphia. Over the next 25 years many immigrant tilemakers brought English ceramic technology and design to the USA, where native clays and motifs were used to produce distinctly American tiles. By 1900 at least 40 potteries produced decorative tiles.

American decorative tiles fall into two stylistic groups: machine-made art tiles of the late Victorian period (1870–1900); and handcrafted Arts and Crafts Movement tiles after 1900, first made in the east from *c.* 1897 (to the late 1920s) and then in California from 1911 (until the late 1940s). Victorian art tiles, machine-pressed from dry clay dust, successfully competed with imports. Tiles for fireplaces, walls and other vertical surfaces have realistic or idealized imagery, often in relief or intaglio but also transfer-printed or hand-painted. Ornamental floor-tiles are sometimes encaustic. Clay bodies are often white earthenware, and glazes are frequently glossy and transparent. The most important art-tile producers before 1900 include Hyzer & Lewellyn (founded in Philadelphia in 1872), the Chelsea Keramic Art Works (Chelsea, near Boston, MA, 1872), the American Encaustic Tiling Co. (Zanesville, OH, 1875) and the J. & J. G. Low Art Tile Works (Chelsea, near Boston, MA, 1877), among others. The most influential designers and modellers were HUGH CORNWALL ROBERTSON, ISAAC BROOME, Herman Carl Mueller (1854–1941), John Gardner Low (1835–1907) and Arthur Osborne (*c.* 1877–*c.* 1911), most of whom worked for more than one pottery.

Exceptions to factory manufacture in the 1870s include hand-decorated tiles by such artists as John Bennett (*fl* 1876–82) and Charles Volkmar (1841–1914). From 1877 to 1887 a group of 30 painters, including Winslow Homer, formed the Tile Club in New York and decorated tiles at their meetings.

From 1895 to 1914 the Arts and Crafts Movement transformed decorative tile design in the USA. Tile firms led by inspired artists adopted a handcrafted style, in appearance if not always in fabrication. These tiles were pressed from plastic clay and decorated with stylized, conventionalized designs, often of medieval, romantic and American vernacular subjects, with matt glazes on flat or counter-relief surfaces. Several key figures making handcrafted tiles during this period in the east included Henry Chapman Mercer (1856–1930), an archaeologist, who established the Moravian Pottery and Tile Works in Doylestown, PA, in 1898; WILLIAM HENRY GRUEBY and Addison Le Boutillier (1872–1951), who worked at Grueby Faience, Boston; Mary Chase Perry (1868–1961), who established the Pewabic, Detroit; and Arthur Eugene Baggs (1886–1947). Such art potteries as the ROOKWOOD POTTERY opened faience divisions (1902), and university art courses such as that at Newcomb College, New Orleans, produced Arts and Crafts tiles in addition to other wares. Many commercial tile factories also set up divisions to meet the market for handcrafted tiles.

By 1904 a population shift to the west and a consequent building boom opened a new market for tiles, which led to the development of the California tile industry. Some California tilemakers developed regional expressions of the Arts and Crafts Movement, designed for use on fireplaces. Other Californian tilemakers were influenced by Hispano-Moresque traditions and created light-hearted designs glazed with bright colours. Important California tilemakers, many of whom began their careers in the east, include Fred Wilde (1857–1943), Rufus Keeler (1885–1934), Ernest Batchelder (1875–1957), Albert Solon (1887–1949) and Fred H. Robertson (1869–1952).

BIBLIOGRAPHY
J. Barnard: *Victorian Ceramic Tiles* (London, 1972)
R. Kovel and T. Kovel: *The Kovels' Collector's Guide to American Art Pottery* (New York, 1974)
American Decorative Tiles (exh. cat. by T. Bruhn, Storrs, U. CT, Benton Mus. A., 1979)
S. Strong: *History of American Ceramics: An Annotated Bibliography* (Metuchen, NJ, 1983)
C. Reed: *Henry Chapman Mercer and the Moravian Pottery and Tile Works* (Philadelphia, 1987)
R. L. Rindge and others: *Ceramic Art of the Malibu Potteries, 1926–1932* (Malibu, 1988)
Flash Point, i–vii (1988–95)
L. Rosenthal: *Catalina Tile* (Sausalito, CA, 1992)

J. Taylor: 'Creating Beauty from the Earth: The Tiles of California', *The Arts and Crafts Movement in California: Living the Good Life*, ed. K. Trapp (New York, 1993)

S. Tunick: 'The New World', *Tiles in Architecture*, ed. H. van Lemmen (London, 1993)

Tile Heritage, i–ii (1994–5)

T. Herbert and K. Higgins: *Decorative Tile in Architecture and Interiors* (London, 1995)

D. B. Driscoll: 'Henry Chapman Mercer: Technology, Aestheticsd and Arts and Crafts Ideals', *Substance of Style: Perspective on the American Arts and Crafts Movement*, ed. B. Denker (Hanover, NH, 1996), pp. 243–62

A. E. Ledes: 'Arts and Crafts Tiles', *Antiques*, cliv/3 (1998), p. 366

N. Karlson: *American Art Tile, 1876–1941* (New York, 1998)

CLEOTA REED

Tonalism. Style of American painting that appeared between *c.* 1880 and 1920. Though not clearly defined, its main exponents were George Inness, James McNeill Whistler, Thomas Wilmer Dewing, Dwight W. Tryon, Alexander Helwig Wyant and such artists of the Photo-Secession as Edward J. Steichen. The term was used by Isham in 1905 and by Brinton in an essay in a catalogue for an exhibition of American painters held in Berlin in 1910. Brinton named the now virtually forgotten artists J. Francis Murphy, Bruce Crane (1857–1937), Ben Foster (1852–1926) and Henry Ward Ranger (1858–1916) as exponents of the style and as leaders of contemporary art in the USA. The style is characterized by soft, diffused light, muted tones and hazily outlined objects, all of which imbue the works with a strong sense of mood. The term was applied especially to landscape painting in which nature is presented as serene or mysterious, never disquieting or dramatic.

Tonalism grew up alongside American Impressionism yet is distinguished from that (and from French Impressionism) by its restrained palette and strongly subjective aesthetic. Somewhat in the tradition of George Fuller and of the earlier HUDSON RIVER SCHOOL in America, the Tonalists approached nature in a contemplative, Romantic manner, the intention being to capture not so much the appearance of a landscape as its mood as perceived by the artist. This idealistic attitude linked Tonalism to the contemporary Symbolist aesthetic, particularly evident in such paintings as Steichen's *Across the Salt Marshes, Huntington* (*c.* 1905, Toledo, OH, Mus. A.). The outlines of the trees are scarcely visible in the dim, misty atmosphere, lending the scene a strong sense of mystery. Whistler's earlier *Nocturnes*, which date from the 1870s onwards, have similar qualities, as shown by *Nocturne in Blue and Silver: The Lagoon, Venice* (*c.* 1880; Boston, MA, Mus. F.A.; see fig.). Closer to Impressionism in its lighting and in the brushwork, though still characteristic of Tonalism, is Tryon's *Morning in May* (1911; Oshkosh, WI, Paine A. Cent.) depicting a serene area of tree-lined

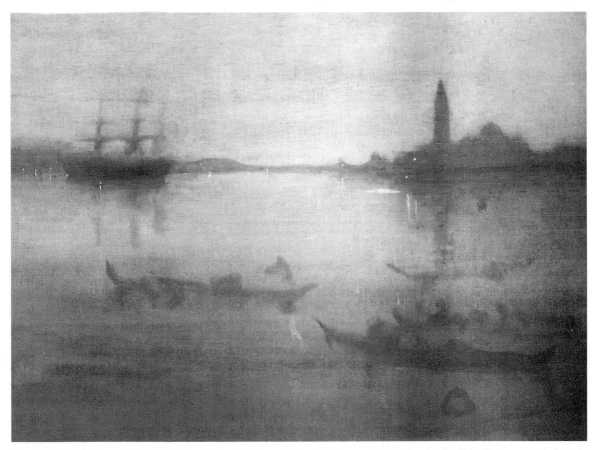

Tonalist painting by James McNeill Whistler: *Nocturne in Blue and Silver: The Lagoon, Venice*, oil on canvas, 508×654 mm, *c.* 1880 (Boston, MA, Museum of Fine Arts)

landscape. Occasionally the Tonalist style was applied to figure and interior subjects, as in Dewing's *The Spinet* (1902; Washington, DC, Smithsonian Inst., Archvs Amer. A.), in which the prominent soft brown hues fuse the foreground with the background, blending the central figure into her surroundings.

BIBLIOGRAPHY

S. Isham: *The History of American Painting* (New York, 1905)

C. Brinton: 'Die Entwicklung der amerikanischen Malerei', *Ausstellung amerikanischer Kunst* (exh. cat., ed. K. Francke; Berlin, Akad. Kst., 1910), pp. 9–42

E. P. Richardson: *Painting in America from 1502 to the Present* (New York, 1956, rev. 1969), pp. 304–7, 368

The Color of Mood: American Tonalism, 1880–1910 (exh. cat. by W. Corn, San Francisco, CA, de Young Mem. Mus., 1972)

R. J. Boyle: *American Impressionism* (Boston, 1974), pp. 76–8

The Paintings of Edward Steichen (exh. cat. by M. Steichen Calderone and A. C. De Pietro, Huntington, NY, Heckscher Mus., 1985)

A. J. Ellis: 'American Tonalism and Rookwood Pottery', *Substance of Style: Perspectives on the American Arts and Crafts Movement*, ed. B. Denker (Hanover, NH, 1996), pp. 301–15

American Tonalism: Paintings, Drawings, Prints and Photographs (exh. cat. by K. Avery, New York, Met., 1997)

Town, Ithiel (*b* Thompson, CT, 3 Oct 1784; *d* New Haven, CT, 13 June 1844). American architect and writer. He was born in the years when architecture was just beginning to become a profession in America. His father, a gentleman farmer in north-east Connecticut, died in 1792. His mother soon remarried, and Town was sent to live with an uncle in Cambridge, MA. He later recalled being fascinated at the age of eight by the engraved diagrams in *The Young Man's Best Companion*. The passion for books never left him.

The nature of Town's schooling and training is not known. His biographer, Roger Hale Newton, suggested that he attended Asher Benjamin's architectural school in Boston between 1804 and 1810, but there is no proof that such a school ever existed. He was probably apprenticed as a housewright. In 1810 Town, Solomon Willard and several housewrights founded the Boston Architectural Library. By 1813 Town had moved to New Haven, CT, where he seems to have functioned as superintendent of Asher Benjamin's Center Church, a Federal-style interpretation of St Martin-in-the-Fields, London (1722–6) by James Gibbs (1682–1754). In 1814 Town designed and built the 'Gothick' Trinity Church on the New Haven green. Trinity is derived, like the nearby Center Church, from plates in James Gibbs's *A Book of Architecture* (London, 1728). Town's early Romantic eclecticism seems to have been inspired by his enthusiasm for architectural books.

In 1816 Town became involved in bridge construction with Isaac Damon, the builder of Center Church. They created a wooden span over the Connecticut River at Springfield, MA; others followed at Northampton, MA, and at Fayetteville, NC. Based on these experiences Town patented in 1820 a new bridge truss, based on the lattice principle, that was both simpler and more efficient than its predecessors. The Town truss was employed for at least 33 major bridges in eastern North America during Town's lifetime. The royalties from these works enabled Town to indulge increasingly his passion for collecting architectural books, prints and paintings. Town travelled

to Europe with Samuel F. B. Morse and Nathaniel Jocelyn in 1829, and made a second journey in 1843; in each case he bought books and artefacts copiously. By the end of his life Town's collection is said to have included over 11,000 books, 20,000 to 25,000 separate engravings, 117 portfolios and 170 paintings. In 1834 William Dunlap described the library as 'magnificent and unrivalled by anything of the kind in America'.

Despite his precocious interest in the Gothic style at Trinity Church, New Haven, Town's work during the 1820s in New Haven, New York, and elsewhere remained resolutely in the Greek Revival manner, with details informed by the books of Stuart and Revett and their followers. Town's villas for Henry G. Bowers at Northampton, MA (1825–6), James Abram Hillhouse at New Haven (1828) and for himself at New Haven (1833–7) each have a two-storey central mass flanked by symmetrically placed one-storey wings, a configuration that can be traced to English Regency architecture, probably known to Town through the writings of James Elmes.

In 1825 Town established an additional office in New York, which broadened his practice and enabled him to become involved in the city's flourishing artistic community. He was an original member of the New York Drawing Association and a member of the National Academy of Design. Between 1826 and 1829 he designed a variety of Greek Revival buildings, including, most notably, the pseudo-peripteral Doric Connecticut State Capitol building in New Haven (1828), which stood between and slightly behind Center and Trinity churches. The demands of his growing practice may have led him to become associated with Martin Thompson (1786–1877), a conservative architect, for several New York area commissions during this period.

Town's celebrated partnership with ALEXANDER JACKSON DAVIS, a highly accomplished draughtsman 19 years his junior, began in 1828 and lasted six years. Together, and with the occasional involvement of James Dakin and James Gallier sr, they created some of the finest Greek Revival buildings in America, including the Indiana State Capitol, Indianapolis (see fig.), the North Carolina State Capitol (1833–40), Raleigh, the New York Custom House (1833–42), the French Church du Saint Esprit (New York, 1831–4) and many distinguished town houses, villas and commercial buildings.

Ithiel Town's involvement with the Gothic Revival was limited but significant. With Robert Gilmor, a client who had visited and admired Sir Walter Scott's Abbotsford House in the Scottish Borders, Town planned Glen Ellen, Baltimore, America's first Gothic villa (1833–4); details were designed by Davis. Town, Davis and Dakin also designed the New York University Building (1833–7) in the Gothic style.

The Town and Davis firm was dissolved in 1835, perhaps because Town was awarded a second bridge patent that year that would re-involve him in engineering projects, and perhaps because Davis was emerging as a major Gothic Revivalist while Town preferred to adhere to the Grecian mode. In 1835 Town began a fireproof Greek Revival house in New Haven featuring a vast second-storey space for his collection of books and art

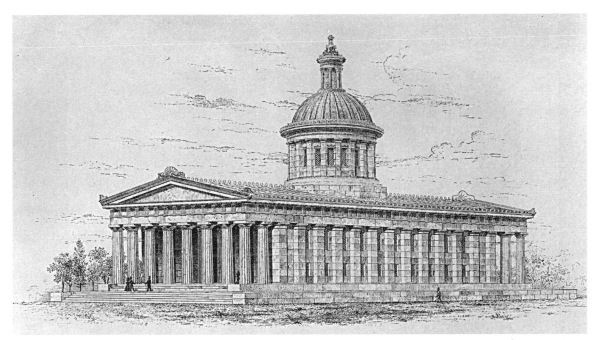

Ithiel Town: Indiana State Capitol, Indianapolis, 1831–5 (destr.); lithograph (New York, Metropolitan Museum of Art)

works. He moved there from New York in 1836, although the house was not complete.

Town's architectural output diminished after 1836, although he competed for the Illinois State Capitol commission with Davis in 1837 and they had an important coordinating role in the design of the Ohio State Capitol, Columbus (1839–61). A nationwide financial panic in 1837 interfered with some of Town's bridge construction projects. In 1842 he returned to New York and briefly resumed his partnership with Davis. In 1843 he travelled to England and France for the second time, but on his return he began selling his collections. He died the following year.

Ithiel Town's role in the development of architecture and the fine arts in America is underappreciated, and it is unfortunate that so few of his fine Greek Revival buildings have survived to bear witness to his taste and ability as an architect.

WRITINGS
Improvement in the Construction of Wood and Iron Bridges (New Haven, 1821)
The Outlines of a Plan for Establishing in New York an Academy and Institution of the Fine Arts (New York, 1835)
Important Notice to All Colleges, State and Other Public Libraries, Athenaeums & Other Institutions (New York, 1842)

BIBLIOGRAPHY
W. Dunlap: *History of the Rise and Progress of the Arts of Design in the United States*, 3 vols (New York, 1834/*R* 1965), iii, p. 77
L. H. Sigourney: 'The Library of Ithiel Town, esq.', *Ladies Companion*, x (1839), pp. 123–6
G. D. Seymour: 'Ithiel Town: Architect', *A. & Prog.*, iii (1911–12), pp. 714–16
——: *The Residence and Library of Ithiel Town* (1930)
H. W. Congdon: *The Covered Bridge: An Old American Landmark* (Middlebury, VT, 1941)
J. F. Kelly: 'A Forgotten Incident in the Life of Ithiel Town', *Old-Time New England*, xxxi (1941), pp. 62–9
R. H. Newton: *Town and Davis, Architects: Pioneers in American Revivalist Architecture* (New York, 1942)
T. Hamlin: *Greek Revival Architecture in America* (New York, 1944)
H. A. Brooks: 'The Home of Ithiel Town: Its Date of Construction and Original Appearance', *J. Soc. Archit. Historians*, xxiv (1954), pp. 27–8
C. Condit: *American Building Art: The Nineteenth Century* (New York, 1960), pp. 89–92
W. Pierson: *American Buildings and their Architects: The Colonial and Neoclassical Styles* (New York, 1970)
H.-R. Hitchcock and W. Seale: *Temples of Democracy: The State Capitols of the USA* (New York, 1976)
W. Pierson: *American Buildings and their Architects: Technology and the Picturesque: The Corporate and Early Gothic Styles* (New York, 1978)
JACK QUINAN

Townsend. American family of cabinetmakers. This talented Quaker family, at least 11 of whom worked as cabinetmakers in Newport, RI, left a rich legacy of some of the most extraordinary furniture produced in America during the 18th century. Although they did not invent the block and shell form, in their hands it reached its highest level of development.

Job Townsend (1699–1765) and his brother Christopher Townsend (1701–73) were both prominent cabinetmakers in Newport. Probably at the age 13 JOHN GODDARD became Job's apprentice. Goddard married Job's daughter, Hannah Townsend, about 1745, opened his own shop and, together with John Townsend, became one of the leading cabinetmakers of the famous Newport school.

John Townsend (1732–1809) was born in Newport and, after serving an apprenticeship with his father Christopher, opened his own shop at the age of 21. By the 1760s he was prospering and owned major tracts of land in the city. The best of more than 30 labelled John Townsend pieces (e.g. long-case clock, h. 2.53m, 1789; New York, Met.; see fig.) were executed in rich, highly figured, Santo Domingo mahogany. His cousin Edmund Townsend (1736–1811) also opened his own shop after an apprenticeship with his father, Job Townsend. Job died

John Townsend: long-case clock, Santo Domingo, mahogany, cherry, chestnut and oak, h. 2.53 m, 1789 (New York, Metropolitan Museum of Art)

before the Revolution, but both John and Edmund suffered during the British occupation of Newport between 1776 and 1779. Despite his Loyalist sympathies, John was even taken prisoner for a short while in 1777. They reopened their shops by 1781, turning out furniture in the traditional Chippendale style and, by the 1790s, in the Federal style as well.

The fame of the Townsend family rests on their carved block-front and shell furniture, including chests, kneehole desks, slant-front desks, clockcases and high chests-of-drawers. Their customers included many distinguished citizens of Newport, including Aaron Lopez (1731–82),

William Channing (1780–1842) and Governor Joseph Wanton (1705–80).

BIBLIOGRAPHY
W. Garrett: 'The Goddard and Townsend Joiners of Newport', *Antiques*, cxxi (1982), pp. 1153–5
M. Heckscher: 'John Townsend's Block and Shell Furniture', *Antiques*, cxxi (1982), pp. 1144–52

OSCAR P. FITZGERALD

Troye, Edward (*b* Lausanne, 12 July 1808; *d* Georgetown, KY, 25 July 1874). American painter of Swiss birth. Before 1822, his father, Jean-Baptiste de Troy, a sculptor of minor fame, moved his family to England, where Edward was instructed in drawing and perhaps painting. The animal painter Jacques-Laurent Agasse (1767–1849) knew the family well. Troye wrote in 1857 that he was trained in London by the best masters and stated that he followed the style of George Stubbs (1724–1806) and John N. Sartorius (1759–1828). In 1831 Troye arrived in Philadelphia, where he was employed as a magazine illustrator. The following year he exhibited animal subjects at the annual Pennsylvania Academy of Fine Arts exhibition and rapidly found patrons among racehorse owners. His typical works show motionless, unsaddled and riderless animals against a low horizon (e.g. *Undefeated Asteroid*, 1864; Richmond, VA, Mus. F.A.; see fig.). Light glistens across the body surface, detailing muscle and bone structure with a skill that received critical acclaim. Many of his works were engraved for publication in the media. From 1849 he taught French and drawing at Spring Hill College, Mobile, AL. In 1855 he left to spend 18 months travelling in Europe and the Near East. His large landscape views of Syria and the Holy Land went on exhibition and were well received. Thereafter he spent 19 years travelling between the major horse breeding centres in Kentucky, Virginia, Ohio and New York.

BIBLIOGRAPHY
J. W. Coleman jr: *Edward Troye: Animal and Portrait Painter* (Lexington, 1958)
K. Barron: 'Edward Troye, Sporting Artist', *Antiques*, cv (1974), pp. 799–807
A. Mackay-Smith: *The Race Horses of America, 1832–1872: Portraits and Other Paintings by Edward Troye* (Saratoga Springs, 1981)

DARRYL PATRICK

Trumbull, John (*b* Lebanon, CT, 6 June 1756; *d* New York, 10 Nov 1843). American painter, architect and diplomat. His importance lies in his historical paintings memorializing events in the American War of Independence. Applying Benjamin West's and John Singleton Copley's realistic innovations in history painting to American subjects, he created a series of images, reproduced in countless illustrations, that have become icons of American nationalism. They are also symbolic of his lifelong political and artistic identity.

Born into a well-to-do and politically prominent Connecticut family, Trumbull was the youngest child of Jonathan Trumbull, later Governor of Connecticut, and his wife Faith, a descendant of the Pilgrim leader John Robinson. Despite blindness in one eye (the result of a childhood accident), Trumbull was inclined from early boyhood towards art. His father intended that he prepare for one of the learned professions, either the ministry or the law, and in 1771 sent him to Harvard College. On his

Edward Troye: *Undefeated Asteroid*, oil on canvas, 718×975 mm, 1864 (Richmond, VA, Virginia Museum of Fine Arts)

way to Cambridge, MA, Trumbull met Copley in Boston and was impressed by the artist's personal elegance as well as by his paintings. At Harvard, Trumbull tutored himself in the fine arts both by studying the Copley portraits that hung there (he copied at least one, *Rev. Edward Holyoke*; untraced) and by reading extensively on the history, theory and practice of art. He graduated in 1773 (the first American artist to be college-educated) and returned home to Lebanon, CT, to take up painting. His early efforts were based on engravings, generally scenes of ancient Roman heroism (e.g. the *Death of Paulus Aemilius at the Battle of Cannae*, 1773; New Haven, CT, Yale U. A.G.). Trumbull's father strongly opposed his artistic ambitions, considering a manual craft beneath the family's station. When war with Britain broke out at Lexington, MA, on 19 April 1775, his father, by now governor, arranged for him to become an aide to General Joseph Spencer. In this capacity, Trumbull saw, from a distance, the Battle of Bunker Hill; it was the closest he came to any of the events he later depicted.

Following the British evacuation of Boston in March 1776, Trumbull moved to New York. His skill at drawing maps brought him to the attention of General George Washington and General Horatio Gates for whom he served briefly as aide-de-camp and adjutant-general respectively, attaining the rank of colonel. Always hypersensitive, he resigned from military service in 1777 when his expected commission did not arrive on time. He returned to Lebanon and resumed painting, mainly executing family portraits in the style of Copley (e.g. *Governor and Mrs Jonathan Trumbull, Sr*, 1778; Hartford, CT Hist. Soc.). Trumbull moved to Boston in June 1778, renting the former studio of the Scottish-born artist John Smibert. Since he could not study with Copley, who had gone to England, he taught himself by studying Smibert's copies of Old Master paintings by Anthony van Dyck (1599–1641), Poussin (1594–1665) and Raphael (1483–1520), which had remained in the studio.

In 1780 Trumbull went to France on a speculative commercial venture for his family. The enterprise was unsuccessful and he continued on to England, where he sought out Benjamin West, who had become Painter of Historical Pictures to George III. West agreed to accept him as a pupil. Perhaps in retaliation for the execution in New York of Major John André as a British spy, or because he may have had a clandestine diplomatic mission, Trumbull was soon arrested as a spy and charged with treason. Thanks to West's influence with the King, Trumbull's life was spared but he was imprisoned for almost eight months and then deported. After hostilities ceased, he returned to London in January 1784 to resume his studies with West and to attend classes at the Royal Academy.

At West's suggestion, and further encouraged by Thomas Jefferson, then American Minister in Paris, Trumbull began in 1785 what was to become his life's great work—a series of paintings depicting events from the American War of Independence. (His original plan called for fourteen subjects, eight of which were completed.) By 1786 he had

finished the first two, the *Death of General Warren at the Battle of Bunker's Hill* (which West called the best picture of a modern battle that had been painted) and the *Death of General Montgomery in the Attack on Quebec* (both New Haven, CT, Yale U. A.G.), and shortly afterwards he started three other Revolutionary War battle scenes. West's paintings served as theoretical and pictorial sources, while the active compositions, animated brushwork, rich colours and dramatic lighting were derived from Copley's *Death of Major Peirson* (1782–4; London, Tate; *see* COPLEY, JOHN SINGLETON, fig. 2). A high moral tone pervades the series: officers on opposing sides are shown to display courage, dignity and kindness; and American history is raised to the level of timeless example. The best-known picture in the series is the *Declaration of Independence* (New Haven, CT, Yale U. A.G.; see fig.), which Trumbull began in July 1786 in Paris, Jefferson having provided a first-hand account of the event. Jefferson, Benjamin Franklin and John Adams were painted from life directly on to the canvas in 1787, but the majority of the likenesses in this and in the other history paintings were added from small pencil studies or miniature oil on mahogany panels made several years later (the largest number of studies is in the Yale University Art Gallery, New Haven, CT). These miniature portraits show Trumbull's talent at its best, the fluid brushstrokes and subtle glazes, spontaneity and sensitive renderings of personality, a mark of his work during the 1790s.

In 1789 Trumbull returned to America, where he hoped to make his fortune from the sale of engravings after his history paintings, but he was able to sell few subscriptions.

Discouraged, he ceased painting and in 1794 returned to Europe, where he remained for almost seven years, serving the new American government in various diplomatic and administrative posts. After his marriage to the English-woman Sarah Hope Harvey in 1800, Trumbull once again determined to paint for a living. In 1804 the Trumbulls moved to New York, where he soon became the city's pre-eminent portrait painter. Despite his dislike of the 'mere copying of faces', portraits ultimately constituted the largest part of his oeuvre, the sitters being among the foremost political and cultural figures of New York society (e.g. *Robert Lenox* and *Mrs Robert Lenox*, both 1805; New York, Pub. Lib.). For the most part, these later works are uninspired. Trumbull had a short-lived interest in land-scape, which led him to create a number of compositions whose structure anticipates the wilderness landscapes of the later Hudson River school (e.g. *Falls of the Yantic at Norwich*, c. 1806; Norwich, CT, Slater Mem. Mus.). Throughout his career he painted religious and literary subjects. During a stay in England (1808–16), prolonged because of the War of 1812, he produced a series of monumental subjects (e.g. *Woman Taken in Adultery*, 2.39×1.71 m, 1811; New Haven, CT, Yale U. A.G.), which show the influence of West's late paintings.

On returning to New York, he was elected a director of the new American Academy of Fine Arts, and from 1817 to 1835 he served as its president, an important position that he used largely for his own advancement. He considered the commission of 1817 from Congress to paint four life-size Revolutionary War scenes for the

John Trumbull: *Declaration of Independence*, oil on canvas, 536×791 mm, begun 1786 (New Haven, CT, Yale University Art Gallery)

Rotunda of the US Capitol in Washington, DC, to be his crowning achievement. He chose as subjects replicas of his original versions of the *Declaration of Independence* and the *Surrender of Lord Cornwallis at Yorktown, October 19, 1781* (New Haven, Yale U. A.G.) and added the *Resignation of General Washington, December 23, 1783*, and the *Surrender of General Burgoyne at Saratoga, October 16, 1777*. The paintings were installed in the Rotunda in November 1826.

Trumbull's art had a relatively limited impact on other artists. Despite his desire to be a mentor to younger artists, his increasingly intransigent ideas about artistic training alienated most younger members of the New York art world and resulted in the founding in 1826 of the National Academy of Design. By 1830 Trumbull received few commissions, and he was in poor health and difficult financial circumstances. Feeling unappreciated for his artistic contributions and concerned that the complete history series should find a permanent exhibition space, in 1831 he sold most of the works he possessed, including the Revolutionary War series, to Yale College in return for an annuity and the establishment there of a Trumbull Gallery, designed by himself with the help of architects Ithiel Town and A. J. Davis. Of his architecture, which included unexecuted plans for the expansion of Yale College, only the Meeting House in Lebanon, CT (1804–6), in an unadorned Neo-classical idiom, survives. At his death he was buried, as he had requested, beneath his life-size portrait of *George Washington at the Battle of Trenton* (1792; New Haven, CT, Yale U. A.G.) in the Trumbull Gallery.

WRITINGS

Autobiography: Reminiscences and Letters by John Trumbull from 1756 to 1841 (New York, 1841)

BIBLIOGRAPHY

T. Sizer: *The Works of Colonel John Trumbull* (New Haven, 1950, rev. 1967)

I. B. Jaffe: *John Trumbull: Patriot-artist of the American Revolution* (Boston, 1975)

John Trumbull: The Hand and Spirit of a Painter (exh. cat. by H. A. Cooper, New Haven, Yale U. A.G., 1982)

P. M. Burnham: 'John Trumbull, Historian: The Case of the Battle of Bunker's Hill', *Redefining American History Painting*, ed. P. M. Burnham and L. H. Giese (Cambridge, 1995), pp. 37–53

HELEN A. COOPER

Tryon, Dwight W(illiam) (*b* Hartford, CT, 13 Aug 1849; *d* South Dartmouth, MA, 1 July 1925). American painter. From 1876 to 1879 he studied in Paris with Jacquesson de La Chevreuse (1839–1903), a pupil of Ingres (1780–1867). Tryon also knew and was influenced by the Barbizon painters Henri-Joseph Harpignies (1819–1916) and Daubigny (1817–78). Study of their work as well as that of Whistler resulted in the poetic and darkly tonal orientation of many of Tryon's earlier landscapes, for example *Moonlight* (1887; New York, Met.). The lighter palette and broken brushstroke of the Impressionist painters led Tryon to develop a subtle style, now known as Tonal Impressionism, which by the late 1890s concentrated on transient atmospheric effects as in *Early Spring, New England (Springtime)* (1897; Washington, DC, Freer; see fig.). It is a pastoral scene of a brook in a pasture, with a plough team and hills in the distance and leafless trees across an open sky, which warms to the horizon. 'People

Dwight W. Tryon: *Early Spring, New England (Springtime)*, oil on canvas, 1.83×1.48 m, 1897 (Washington, DC, Freer Gallery of Art)

think of atmosphere as somehow less real than the other facts of Nature,' Tryon commented, 'but to the painter it is simply a more subtle truth, which he can no more disregard than the rocks in his foreground' (quoted in J. Pearce: *American Painting, 1560–1913*, New York, 1964, p. 47).

In 1879 Tryon donated a gallery to Smith College, Northampton, MA, to house a collection of his own work and that of his contemporaries. His work is also well represented in the Freer Gallery, Washington, DC, since Charles Lang Freer had been an important patron of the artist.

WRITINGS

'Charles François Daubigny', *Modern French Masters*, ed. J. C. van Dyck (New York, 1896/*R* New York, 1976), pp. 153–66

BIBLIOGRAPHY

C. H. Caffin: *The Art of Dwight W. Tryon: An Appreciation* (New York, 1909)

H. C. White: *The Life and Art of Dwight William Tryon* (Boston, 1930)

Dwight W. Tryon: A Retrospective Exhibition (exh. cat., ed. P. F. Rovetti; Storrs, U. CT, Benton Mus. A., 1971)

D. F. Hoopes: *The American Impressionists* (New York, 1972)

M. E. Yehia: *Dwight W. Tryon* (diss., U. Boston, 1977)

Tonalism: An American Experience (exh. cat., ed. J. Davern; New York, Grand Cent. A. Gals, 1982)

L. Merrill: *An Ideal Country: Paintings by Dwight William Tryon in the Freer Gallery of Art*, cat. (Washington, DC, 1990)

ROBERT S. OLPIN

Tucker China Factory [American China Manufactory]. American porcelain manufactory. William Ellis Tucker (*b* Philadelphia, 11 June 1800; *d* Philadelphia, 22 Aug 1832) made an enormous contribution to the history of American ceramics as the founder of this major porcelain factory in Philadelphia. His interest in ceramics probably stemmed from working with the material in his father's china store,

where he occasionally painted European blanks and fired them in a small kiln. Experiments to make porcelain began in 1825. Funding the experiments and later the production of porcelain was so expensive that partners were acquired to help alleviate the financial problems. The factory was known under various titles, chiefly Tucker & Hulme (1828) and Tucker & Hemphill (1831–8). After Tucker's death, production continued with his brother Thomas Tucker (1812–90) as manager. Tableware and decorative pieces in the fashionable French Empire style were the main products of the firm. Although the company stayed in business until 1838, financial stability was always elusive, as European porcelain was cheaper than Tucker's.

BIBLIOGRAPHY

P. H. Curtis: 'The Production of Tucker Porcelain, 1826–1828', *Ceramics in America*, ed. I. Quimby (Charlottesville, 1973), pp. 339–74

A. Frelinghuysen: *American Porcelain, 1770–1920* (New York, 1989)

ELLEN PAUL DENKER

Tuckerman, Henry T(heodore) (*b* Boston, MA, 20 April 1813; *d* New York, 17 Dec 1871). American writer. Born into a prosperous and intellectually minded merchant family, he attended Harvard College for two years before frail health prevented him from continuing. On advice from a physician, in 1833 he travelled to Italy, where he developed a devotion to literature and art. Returning to Boston in 1834, over the next decade he distinguished himself as a travel essayist, poet and magazine editor. He moved to New York in 1845, finding ready acceptance in the city's social, intellectual and cultural circles. Tuckerman's writings emphasize the aesthetics of the Picturesque, the value of travel and the enrichments afforded by the historical and literary associations of Europe. He balanced his yearning for the refinement of the 'Old World' with an enthusiasm for the budding native school of American artists. As a critic, he was both sympathetic and analytical. His most important volume of art criticism, *Book of the Artists: American Artist Life* (1867), written in New York's Tenth Street Studio Building, was based on years of personal association with artists and scores of critical assessments written for such journals as *The Knickerbocker* and *Godey's Magazine and Lady's Book*. It chronicles the achievements and ambitions of American artists by combining contemporary estimation with historical overview.

WRITINGS

Book of the Artists: American Artist Life (New York, 1867/*R* 1966)

BIBLIOGRAPHY

Obituary, *New York Tribune* (18 Dec 1871)

J. Flexner: 'Tuckerman's *Book of the Artists*', *Amer. A.J.*, i/2 (1969), pp. 53–7

SALLY MILLS

Turner, C(laude) A(llen) P(orter) (*b* Lincoln, RI, 1869; *d* 1955). American engineer and writer. He completed a civil engineering degree at Lehigh University, Bethlehem, PA, in 1890 and for the next 12 years he worked for various railway and bridge companies, including the New York and New England Railway, the Edgmore Bridge Company of Wilmington, DE, and the Pittsburg Bridge Company where he supervised a group of draughtsmen. In 1901 he opened his own office in Minneapolis as a consulting bridge engineer and a specialist in reinforced-concrete design. During the first decade of the 20th century there was enormous interest in the structural potential of reinforced concrete, both in the USA and Europe. Turner made a major contribution to the field with the development of the mushroom slab system, a method of constructing flat reinforced concrete slabs without using supporting beams. This system was based on Turner's insight that the actions of a slab are different from those of a beam, and that the structural theories evolved by François Hennebique (1842–1921) and Ernest L. Ransome (1852–1917) were inadequate to describe the behaviour of a slab. Reworking the theory, he found that a reinforced concrete slab could be supported simply on columns with broad 'mushroom' capitals. He originally conceived of his system as a means of simplifying construction and reducing its cost, finding that the heavier the load to be carried, the more economical the system became; but he also realized that it had several other advantages: for example it is easier to install services such as automatic sprinkler systems in buildings that do not have beams running across the ceilings; lighting is more effective and vibration can be minimized. The system could be adapted for almost any type of building, but it was particularly useful for warehouses and factories.

Turner first demonstrated his system in the Lindake-Warner Building, St Paul, MN, in 1908–9, and for the next ten years his business boomed; by 1916 he had opened offices in New York, Chicago, Houston and Danville, VA, as well as Vancouver and Winnipeg in Canada. His firm was responsible for the engineering design of thousands of buildings, while he personally designed many others. His mushroom or flat-slab system was also adopted by many other architects including Kees & Colburn of Minneapolis who used it for the Northern Implement Building (1910) and its Deere-Webber addition (1912), Minneapolis, and Schmidt, Garden & Martin who used it for the Dwight Building (1910), Chicago.

Following the usual practice among the pioneers of structural design in the USA, Turner attempted to patent his slab design; however, a patent for a flat arch resembling the Turner slab had already been purchased and, after prolonged litigation, Turner's claim was disallowed. The financial returns from his invention were thus limited, but he continued working on structural theory and its applications.

Turner was also a bridge designer of considerable ability; among several works are the three-hinged arch of the railway bridge (1910–11) over the St Croix River, near New Richmond, WI, and, perhaps his best-known work in this field, the swing bridge at Duluth, which he both promoted and designed. His flat slab system was also adapted for bridge construction by other engineers. He eventually abandoned the construction industry and ended his days running a condiments factory in Southern Illinois, but he had made a substantial contribution to the development of the reinforced-concrete flat slab in the USA. Historians of engineering now hold that Turner and Robert Maillart (1872–1940) in Switzerland invented their systems of flat-slab design almost simultaneously and quite independently; Maillart's understanding of reinforced-concrete behaviour was perhaps more profound and his expression more elegant.

WRITINGS

with H. T. Eddy: *Concrete Steel Construction* (Minneapolis, 1919)
Elasticity and Strength, 5 vols (Minneapolis, 1922, rev. 1934)

BIBLIOGRAPHY

H. A. Castle: *Minnesota: Its Story and Biography*, ii (New York and Chicago, 1915)
C. W. Condit: *American Building: Materials and Techniques from the First Colonial Settlements to the Present* (Chicago and London, 1968; 2/1982)
H. Newlon, ed.: *A Selection of Historic American Papers on Concrete* (Detroit, 1976)
D. Billington: *Robert Maillart: The Art of Engineering* (Princeton, NJ, 1980)

LEONARD K. EATON

Twachtman, John H(enry) (*b* Cincinnati, OH, 4 Aug 1853; *d* Gloucester, MA, 8 Aug 1902). American painter and printmaker. He began as a painter of window-shades but developed one of the most personal and poetic visions in American landscape painting, portraying nature on canvases that were, in the words of Childe Hassam, 'strong, and at the same time delicate even to evasiveness'. His first artistic training was under Frank Duveneck, with whom he studied first in Cincinnati and then in Munich (1875–7). His absorption of the Munich style, characterized by bravura brushwork and dextrous manipulation of pigment, with the lights painted as directly as possible into warm, dark grounds derived from Frans Hals (1581/5–1666) and Courbet (1819–77), is reflected in such paintings as *Venice Landscape* (1878; Boston, MA, Mus. F.A.) and *Landscape* (*c.* 1882; Utica, NY, Munson Williams Proctor Inst.).

Twachtman became increasingly dissatisfied with the Munich style's lack of draughtsmanship, so he went to Paris in 1883 to study at the Académie Julian. In the winter he concentrated on drawing, and in the summer he painted in the Normandy countryside and at Arques la Bataille, near Dieppe. *Springtime* (*c.* 1885; Cincinnati, OH, A. Mus.) and *Arques-la-Bataille* (1885; New York, Met.; see colour pl. XX, 2) mirror not only his training at the Académie Julian but also the influence of the draughtsmanship and tonal values of Jules Bastien-Lepage (1848–84). In its emphasis on pattern and economy of form, *Arques-la-Bataille* may also suggest an awareness of Whistler and oriental art. This period of Twachtman's work was his most popular, and in 1888, three years after his return to the USA, he won the Webb Prize of the Society of American Artists.

Soon after his return from France, Twachtman changed his style, painting with a lightened palette and a modified Impressionist technique, which derived less from Monet (1840–1926) and French art than from his friend Theodore Robinson, whom Twachtman first met in Paris. By 1890 Twachtman was developing a mature and personal vision, which can be seen in pastels and etchings and in the subtle poetry of *Winter Harmony* (see fig.) and *Old Holly House, Cos Cob* (Cincinnati, OH, A. Mus.), both painted *c.* 1890–1900. Twachtman's work is complex, although his myriad brushstrokes and wide range of colours combine to give the impression of great simplicity.

Although he was essentially a private man, Twachtman founded an informal art school at the Holly House, a boarding house for artists at Cos Cob near Greenwich, NY, and he taught at the Art Students League and the Cooper Union in New York. In 1897, along with Childe

John H. Twachtman: *Winter Harmony*, oil on canvas, 654×813 mm, *c.* 1890–1900 (Washington, DC, National Gallery of Art)

Hassam and J. Alden Weir, he was one of the principal founders of the TEN AMERICAN PAINTERS, who were considered to be a kind of Academy of American Impressionism and who left the more conservative Society of American Artists to exhibit on their own. About three years later, Twachtman and his colleagues began painting in Gloucester, MA, where his style changed once again. His painting became more direct, his colour more defined and, as in *Fishing Boats at Gloucester* (1901; Washington, DC, N. Mus. Amer. A.), his brushwork bolder. His overall approach began to be more openly expressive, pointing in the direction later taken by his most famous pupil, Ernest Lawson (1873–1939).

Twachtman's few figure pieces were not very successful. He was more comfortable with nature, and his attitude towards it was basically romantic and contemplative. He had a small, but impressive output of etchings. In a manner similar to that of Whistler, he used just a few lines to suggest an entire scene, as in *Boats on the Maas* (*c.* 1881–3; Philadelphia, PA, Mus. A., see 1966 cxh. cat., p. 38).

BIBLIOGRAPHY

T. Dewing and others: 'John Twachtman: An Estimation', *N. Amer. Rev.,* clxxvi/1 (1903), pp. 555–7
C. G. Mase: 'John H. Twachtman', *Studio Int.,* lxxii/286 (1921), pp. lxxi–lxxv
R. J. Wickenden: *The Art and Etching of John Henry Twachtman* (New York, 1921)
E. Clark: *John H. Twachtman* (New York, 1924)
A. Tucker: *John H. Twachtman* (New York, 1931)
J. D. Hale: *The Life and Creative Development of John H. Twachtman*, 2 vols (diss., OH State U., 1957)
A Retrospective Exhibition: John Henry Twachtman (exh. cat., Cincinnati, A. Mus., 1966)
R. J. Boyle: 'John H. Twachtman: An Appreciation', *Amer. A. & Ant.,* i/3 (1978), pp. 71–7
——: *John Twachtman* (New York, 1979)
Twachtman in Gloucester: His Last Years, 1900–1902 (exh. cat., New York, Spanierman Gal., 1987) [essays by J. D. Hale, R. J. Boyle and W. H. Gerdts]
In the Sunlight: The Floral and Figurative Art of J. H. Twachtman (exh. cat., New York, Spanierman Gal., 1989)
John Twachtman: Connecticut Landscapes (exh. cat. by D. Chotner, L. Peters and K. Pyne, Washington, DC, N.G.A.; Hartford, CT, Wadsworth Atheneum; 1989–90)

L. N. Peters: *John Henry Twachtman: An American Impressionist* (New York, 1999)

RICHARD J. BOYLE

291. American art gallery founded in New York in 1905 by ALFRED STIEGLITZ and Edward J. Steichen (1879–1973). It was located at 291 Fifth Avenue and soon came to be known simply as 291 ('Two ninety-one').The gallery at 291 was an important early centre for modern art in the USA. Originally called the Little Galleries of the Photo-Secession, it was founded to promote photography as an independent art form. In their first exhibition, Stieglitz and Steichen featured the work of the PHOTO-SECESSION group. However, their concentration on photography was brief, and they soon broadened the scope of the gallery to include exhibitions of avant-garde painting, sculpture and graphic arts.

Aptly described by Marsden Hartley (1877–1943) as 'the largest small room of its kind in the world', the gallery became a pioneering force in bringing European modern art to American attention, even before the Armory Show of 1913. Following the first American exhibition of Auguste Rodin watercolours (1908), similar début exhibitions were held for Henri Matisse (1908), Toulouse-Lautrec (1909), Henri Rousseau (1910), Paul Cézanne (1911), Pablo Picasso (1911), Francis Picabia (1913) and Constantin Brancusi (1914). Equally important was Stieglitz's promotion, through the gallery, of contemporary American artists. He staged the first exhibitions for Pamela Coleman Smith (1877–1925; exhibition in 1907), John Marin (1909), Alfred H. Maurer (1909), Arthur B. Carles (1882–1952), Arthur G. Dove (1880–1946), Marsden Hartley (1877–1943) and Max Weber (a group show of 1910) and Abraham Walkowitz (1880–1965; exhibition in 1912) among others. Stieglitz also organized at the gallery what were possibly the first exhibitions of children's art in 1912 and, in 1914, of African sculpture as art rather than anthropological material. (In 1915–16 the gallery gave its name to the short-lived Dadaist magazine *291*, edited by Stieglitz and emulated later in the title of Picabia's magazine, *391*.) Over 70 exhibitions had been held at 291 by 1917, when the building's scheduled demolition forced Stieglitz to close it down.

BIBLIOGRAPHY
R. Doty: *Photo-Secession: Photography as Fine Art* (Rochester, 1960; rev. as *Photo-Secession: Stieglitz and the Fine Art Movement in Photography*, New York, 1978)
D. Norman: *Alfred Stieglitz: An American Seer* (New York, 1973)
W. Homer: *Alfred Stieglitz and the American Avant-garde* (Boston, 1977)
The Eye of Stieglitz (exh. cat., New York, Hirschl & Adler Gals, 1978)
R. L. Harley: 'Edward Steichen's Modernist Art-Space', *Hist. Phot.*, xiv/1 (Jan–March 1990), pp. 1–22
W. Rozaitis: 'The Joke at the Heart of Things: Francis Picabia's Machine Drawings and the Little Magazine 291', *Amer. A.*, viii, 3–4 (Summer–Fall 1994), p. 42–59
C. McCabe and L. D. Glinsman: 'Understanding Alfred Stieglitz' Platinum and Palladium Prints: Examination by X-ray Flourescence Spectrometry', *Stud. Hist. A.*, li (1995), pp. 70–85
M. B. Parsons: 'Pamela Colman Smith and Alfred Stieglitz: Modernism at 291', *Hist. Phot.*, xx (Winter 1996), pp. 285–92
M. de Zayas and F. M. Naumann, ed.: *How, When and Why Modern Art Came to New York* (Cambridge, MA, and London, 1996)

ROGER J. CRUM

U

Union Porcelain Works. American porcelain factory. Originally founded in Greenpoint, NY, as William Boch & Bros in 1850 to make porcelain hardware trimmings, it was bought by Thomas Carll Smith (1815–1901) *c.* 1861. The wares were first made of bone china, but in 1864 Smith began to experiment with a hard-paste formula, and his firm is considered the first in America to have used this material. In 1875 Smith hired Karl Müller (1820–87), a German sculptor, to create models for the Centennial International Exhibition of 1876 in Philadelphia, and his work includes the 'Century' vase (New York, Met.; see colour pl. XXXIV, 2), 'Liberty' cup and 'Keramos' vase. In addition to artwares, the firm also made porcelain tiles for fireplaces and decorative wainscoting, hardware trimmings and tableware. (The factory closed *c.* 1922.)

BIBLIOGRAPHY

E. A. Barber: *The Pottery and Porcelain of the United States* (New York, 1893, rev. 3/1909/*R* 1976), pp. 252–8

A. Frelinghuysen: *American Porcelain, 1770–1920* (New York, 1989)

ELLEN PAUL DENKER

United Society of Believers in Christ's Second Appearing. *See* SHAKERS.

United States of America. Country composed of 50 states, 48 of them contiguous and stretching between the Atlantic and Pacific Oceans and between the borders of Canada to the north and Mexico to the south (see fig. 1). Of the other two (granted statehood only in 1959), Alaska, which was purchased from Russia in 1867, is on the northwestern tip of the North American land mass, while Hawaii comprises a group of islands in the Pacific Ocean, *c.* 3800 km off the western American coast, which were annexed by the USA in 1898. The total land mass of the USA is *c.* 9,370,000 sq. km. Its rich and varied array of natural resources, including minerals, oils, forests and fertile soil, led to its rapid development and prosperity, especially in the 19th and 20th centuries. The country became the United States of America in 1781 during the American Revolution. The first inhabitants of North America, however, came *c.* 15,000 BC from Asia in a series of migrations across the Bering Strait and established distinct Native American cultural and linguistic units. Although Vikings explored North America in the 10th and 11th centuries AD, it was Christopher Columbus's voyage of 1492 that signalled the beginning of intensive exploration and settlement by numerous European countries, most notably Spain, Great Britain, France and the Netherlands, which created an enduring diversity of cultures. The importation of slaves from Africa in the 17th and 18th centuries added to this cultural diversity (*see* AFRICAN AMERICAN ART).

I. Introduction. II. Architecture. III. Painting and graphic arts. IV. Sculpture. V. Interior decoration. VI. Frames. VII. Furniture. VIII. Ceramics. IX. Glass. X. Metalwork. XI. Jewellery. XII. Textiles. XIII. Patronage. XIV. Collecting and dealing. XV. Museums. XVI. Art education. XVII. Art libraries and photographic collections. XVIII. Historiography.

I. Introduction.

The history of the visual arts in the USA is intimately tied to the political, social and cultural histories of the European nations that initially explored and colonized North America. This close relationship with Europe was crucial not only to the stylistic development of all the arts (*see* §§II–XII below) but also to the establishment of public cultural institutions and the character of patronage (*see* §§XIII–XVII below). The first Europeans were Spanish settlers and explorers who arrived in Florida and New Mexico during the early 16th century. By the early 17th century several other European countries, including France, the Netherlands and Great Britain, had settlements in the New World. The earliest British settlements were Jamestown, VA (1607), and Plymouth, MA (1620). The British were by far the most successful of the colonists and built up a distinctly British provincial culture. By the late 18th century, however, dissatisfaction with British rule and taxation led to the American Revolution and the War of Independence (1776–83), after which the USA set out on a path of aggressive expansionism.

The Louisiana Purchase (of land from France), secured by Thomas Jefferson in 1803, nearly doubled the size of American territory, and westward expansion to the Pacific coast became America's goal. Conflicts with the French, British and Spanish continued throughout early 19th-century American history, and in 1845 Texas, which had declared its independence from Mexico in 1835–6, was annexed, leading to the Mexican War (1846–8). The displacement of native American Indians also continued, while huge waves of European immigrants, mostly German and Irish, arrived between 1830 and 1850. Throughout this period the northern states were becoming increasingly industrial, while the southern ones remained agricultural. The South's continued use of African slaves amid growing calls for abolition led to the Civil War (1860–65). The South's defeat resulted in the preservation of the Union and the emancipation of slaves (although segregation continued to be officially sanctioned in some parts of the South until the 1960s). The second half of the 19th century was marked by increased industrialization, westward expansion and immigration from Europe and Asia. This growth and prosperity resulted, however, in greater injustices to American Indians: their numbers dwindled through armed conflict, their lands were confiscated and the peoples themselves were, for the most part, relegated to 'reservations' in underdeveloped areas of the country.

Despite the remarkable growth and prosperity of the 19th century, however, in the early 20th century the USA remained culturally insular and provincial. The shock, disbelief and ridicule that met the European works in the Armory Show (1913), an exhibition of contemporary European and American art (*see* §III, 3 below), testified to America's cultural backwardness, which would change dramatically in the 1940s, when the USA, and specifically New York, would become the new centre of Western culture, at least in regard to the visual arts (*see* §III, 4 below).

BIBLIOGRAPHY

D. M. Mendelowitz: *A History of American Art* (New York, 1960, rev. 1970)

J. Wilmerding: *American Art*, Pelican Hist. A. (Harmondsworth, 1976)

M. Brown and others: *American Art* (New York, 1979)

M. Baigell: *Dictionary of American Art* (London, 1980)

R. B. Morris, ed.: *Encyclopedia of American History* (New York, 1982)

M. Baigell: *A Concise History of American Painting and Sculpture* (New York, 1984)

A Proud Heritage: Two Centuries of American Art (exh. cat., ed. T. A. Neff; Chicago, IL, Terra Mus. Amer. A., 1987)

W. H. Gerdts: *Art across America: Two Centuries of Regional Painting, 1720–1920*, 3 vols (New York, 1990)

II. Architecture.

1. The Colonial period, before 1776. 2. The Federalist period and eclectic revivalism. 3. The Civil War and late 19th-century eclecticism. 4. The Chicago school, the Prairie school and academic eclecticism in the early 20th century.

1. THE COLONIAL PERIOD, BEFORE 1776. The architecture of the Colonial era in the USA reflects the wide variety of influences brought by the European settlers, adapted to the needs imposed and the resources afforded by the local environment. The oldest surviving building of the period is the Governor's Palace at Santa

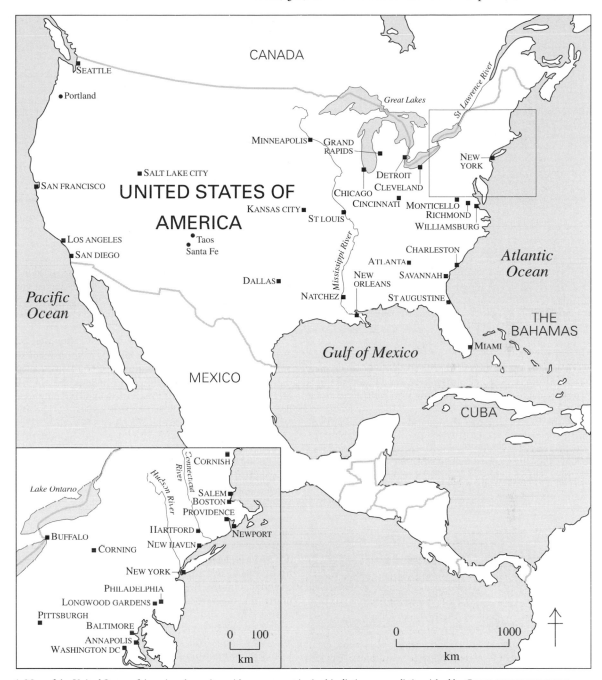

1. Map of the United States of America; those sites with separate entries in this dictionary are distinguished by CROSS-REFERENCE TYPE

Fe, NM. Begun in 1610, it formed the south range of the *presidio*. The walls are built of adobe, which had been used by the Pueblo Indians for centuries. The Spanish, however, introduced the technique of making adobe into bricks (see fig. 2), which greatly facilitated the church-building programme undertaken by the Franciscan friars who began the conversion of the Pueblos in the early 17th century. In many of their churches a transverse clerestory window was placed between the roof of the sanctuary and the lower roof of the nave, a feature apparently unique to

New Mexico; these Franciscan buildings constitute a most remarkable regional development. In Florida, although the town of St Augustine was founded 44 years before Santa Fe, its major Spanish monument, the Castillo de San Marcos (for illustration *see* ST AUGUSTINE), the last of a succession of three structures bearing the same name, was not begun until 1672, as the northernmost of a chain of fortresses built to protect the Spanish fleet against the British. Its design has been attributed to the Cubans Juan Síscara (*fl* 1664–91) and Ignacio Daza. Of the bastioned

2. Church and convent of S Estevan, Acoma, New Mexico, 1629–42; view from the south-east before restoration

type invented in the early 16th century in Italy and perfected in the 17th by Sébastien Leprestre de Vauban (1633–1707), it was built of a local shell-limestone, the special qualities of which enabled it to withstand three British sieges.

In the British Colonies the vast majority of buildings in the 17th century were of wood, the ready availability of which attracted settlers from a land where its price had been rising disproportionately since the 13th century. In Puritan New England the central building of each com-munity was the meeting-house, which served both religious and secular functions. The earlier meeting-houses were indistinguishable externally from dwellings, but in the second half of the century a distinctive new building type, derived from the English market hall, appeared. The Old Ship Meeting-house (1681; enlarged 1729 and 1755), Hingham, MA, with its square plan and hipped roof, contrasts tellingly with the most important survival of 17th-century Anglican church architecture in the South, the Old Brick Church (c. 1660), Isle of Wight County, VA, whose antiquated Gothic features can also be seen in English churches of the time. Most Anglican churches in the South were simple wood-frame structures; none has survived.

In domestic architecture too there were marked regional differences. In New England the typical middle-class house was of two storeys, with two rooms to a floor and a central chimney. It was never more than one room deep under the main roof, although extra rooms might be provided in a lean-to at the rear. Its equivalent in the South was of one or one-and-a-half storeys, with end chimneys and two rooms (hall and parlour) on the ground floor; from c. 1700 the rooms were divided by a central passage containing the stairs to the rooms in the roof. Each type was suited to the climate of the region in which it was built, but while the New England type had first appeared in England in the 16th century, the Southern type had no English antecedents. The grander Southern houses, how-ever, such as Bacon's Castle, Surry County, VA, designed by Arthur Allen in 1664–5 (see fig. 3), remained purely English. Another innovative type of house was built in southern New York (including Long Island) and northern New Jersey, both of which from 1626 to 1664 were parts of New Netherland, in which the Dutch influence was prominent. This was a single-storey or one-and-a-half-storey house with end chimneys and a gently sloping roof

3. Arthur Allen: Bacon's Castle, Surry County, Virginia, 1664–5

with flared eaves of unusual projection; early in the 18th century a distinctive form of mansard or gambrel roof came to be substituted for the two-slope roof of the 17th century (see fig. 4), and towards its end a raised platform (*stoep*) along the front of the house, sheltered by the eaves, became a frequent feature. In New Amsterdam (now New York City) and Albany, the Dutch built narrow-fronted houses with stepped gables facing the street, continuing to do so under British rule. The Swedes also made an invaluable contribution to the settling of the continent in bringing to the USA the log cabin, built with horizontal logs notched at the corners; however, Sweden profited less than its European rivals from its American venture. Another log-building technique, of disputed origin, was employed by the French in the Mississippi Valley, with vertical logs trimmed flat on two sides and either set in the earth (*poteaux en terre*) or on a sill (*poteaux sur sole*).

In the 18th century, outside New Mexico, where the indigenous 17th-century style continued unchanged, Spanish Colonial architecture followed Mexican precedents. Thus the unfinished façade of S Antonio de Valero (1744– after 1777; now Church of the Alamo), San Antonio, TX, is a naive imitation of the north transept façade of Durango Cathedral; that of S José y S Miguel de Aguayo (1768–77), near San Antonio, by Pedro Huizar belongs to the final phase of the Mexican Baroque; and that of S Xavier del Bac (1775–97), near Tucson, AZ, is a belated example of the *estípite* style. There are no surviving mission churches in California from before 1776. In Louisiana the French developed a type of house well suited to the climate, with a hipped roof spreading out to shelter a *galerie* surrounding the principal rooms on the first floor; Parlange (1750), Pointe Coupée Parish, is a fine early example. The British, on the other hand, showed little concern for climate: in their colonies porches of any kind were conspicuous by their absence. In the early 18th century the influence of Christopher Wren (1632–1723) became evident for the first time in the church of St Philip (1711–23; destr. 1835), Charleston, SC, and the double pile was generally adopted for grander houses (see fig. 5). The Governor's Palace, Williamsburg, VA, probably designed by Henry Cary and Alexander Spotswood in 1706–20 (destr. 1781; reconstructed 1931–4; see fig. 6), was the grandest early 18th-century double pile. It was as English as Bacon's Castle,

5. North front of Westover, Charles City County, Virginia, *c.* 1730–35

as was the typical Virginian plantation house of *c.* 1720–*c.* 1760, five bays wide, of two or two-and-a-half storeys with a hipped roof, whose antecedents are to be found in the brick vernacular of south-eastern England. Exceptional houses of the second quarter of the century include Stratford Hall (1725–30), Westmoreland County, VA, which has been seen both as an imitation of the first Capitol (1701–5; destr. 1747; reconstructed 1931–4) at Williamsburg, VA, because of its E-plan, and as a product of the English Baroque school of John Vanbrugh (1664– 1726) and Hawksmoor (1661/2–1736) because of its grouped chimneys linked by arches. Another example is Drayton Hall (1738–42), Charleston, SC, whose two-storey portico makes it the first unequivocally Palladian house in British America.

By mid-century architectural books from England were beginning to make an impact, and there was an American building—the Redwood Library (1749–50; for illustration *see* HARRISON, PETER), Newport, RI—of which the most doctrinaire Palladian could have approved. Its architect, Peter Harrison, followed it with other buildings, of which the King's Chapel (1749–58), Boston, MA, influenced by James Gibbs (1682–1754), was the finest, showing Harrison to be adept in the intelligent use of printed sources. As a rich merchant with a gift for design, he was an exceptional figure in the Colonial scene. Most of those who are named as architects of Colonial buildings, such as ROBERT SMITH in Philadelphia and WILLIAM BUCKLAND in Virginia and Maryland, had a craft training. Thanks to them, and the books they used, British Colonial architecture of the quarter of a century before Independence, although very rarely original, attained a high level of competence in craftsmanship and design.

BIBLIOGRAPHY
S. F. Kimball: *Domestic Architecture of the American Colonies and of the Early Republic* (New York, 1922/*R* 1966)

4. Ackerman House, Hackensack, New Jersey, 1704

6. Henry Cary and Alexander Spotswood: Governor's Palace, Colonial Williamsburg, Virginia, 1706–20

G. Kubler: *The Religious Architecture of New Mexico in the Colonial Period and since the American Occupation* (Colorado Springs, 1940/*R* Albuquerque, 1972)

T. T. Waterman: *The Dwellings of Colonial America* (Chapel Hill, NC, 1950)

H. S. Morrison: *Early American Architecture from the First Colonial Settlements to the National Period* (New York, 1952)

H. W. Rose: *The Colonial Houses of Worship in America* (New York, 1963)

M. C. Donnelly: *The New England Meeting House of the Seventeenth Century* (Middletown, 1968)

W. H. Pierson jr: *The Colonial and Neo-classical Styles*, i of *American Buildings and their Architects* (Garden City, NY, 1970)

A. L. Cummings: *The Framed Houses of Massachusetts Bay, 1625–1725* (Cambridge, MA, 1979)

M. Whiffen and F. Koeper: *American Architecture, 1607–1976* (Cambridge, MA, 1981)

D. D. Reiff: *Small Georgian Houses in England and Virginia: Origins and Development through the 1750s* (London, 1986)

A. H. Ameri: 'Housing Ideologies in the New England and Chesapeake Bay Colonies, *c.* 1650–1700: Expression of Puritan and Anglican Communities', *J. Soc. Archit. Hist.*, lvi (1997), pp. 6–15

R. B. St-George: 'Afterthoughts on Material Life in America, 1600–1860: Household Space in Boston, 1670–1730, *Winterthur Port.*, xxxii (Spring 1997), pp. 1–38

MARCUS WHIFFEN

2. THE FEDERALIST PERIOD AND ECLECTIC REVIVALISM. American architecture began a new phase at the time of the Revolution with a general desire to establish identifiable American models following political independence. After the signing of the Treaty of Paris, the writing of the Constitution and the creation of the federal form of government, the first requirement was for a seat for the new government. In 1791 the site for a new capital was selected on the Potomac River, roughly midway between the northern and southern states. A ten-mile (16-km) square was set aside as the District of Columbia for a federal city, named Washington in honour of the first US President (*see* WASHINGTON, DC). PIERRE-CHARLES L'ENFANT was appointed to plan the new city. He employed a series of radiating diagonals (inspired by Versailles, where he had spent his childhood) and a grid-plan to encourage land sale and development. The two principal government buildings, for the legislature and the president, were designed by WILLIAM THORNTON, a gifted self-trained amateur, and an Irish emigrant, JAMES HOBAN. Thornton's US Capitol (begun 1793; *see* WASHINGTON, DC, fig. 4) incorporated a Classical Roman rotunda on the centre axis. Hoban's presidential residence, later known as the White House (1792–1803; *see* WASHINGTON, DC, fig. 6), was modelled on 18th-century Irish country houses.

After 1795 New England architecture began to develop its own identity, although it was still strongly indebted to such contemporary English practitioners as William Chambers (1723–96). Samuel McIntire of Salem, MA, was typical of the self-taught architects who had begun as craftsmen and who were still common in the early 19th century. Trained as a wood-carver and cabinetmaker, he designed such residences as the John Gardner House

7. Thomas Jefferson: Virginia State Capitol, Richmond, 1785–99; from a photograph c. 1900, before the addition of the wings and front steps in 1906

(1804–5), Salem, which have a tautness and linearity of ornament characteristic of Federalist work in New England.

In Boston CHARLES BULFINCH was even more influential. He pursued architecture as a gentlemanly avocation until investment losses forced him to make his living by designing buildings. His best work included elegant brick houses for prominent Boston merchants as well as rows of brick town houses built speculatively, the most notable being the Tontine Crescent (1793; destr.). Bulfinch is perhaps best known for his domed, brick-built Massachusetts State House (1795–8), Boston. Although designed to house the legislature of the newly independent state, the building was based on William Chambers's Somerset House (1776–1801), London.

In the more southerly states, architects and designers attempted to develop an architecture appropriate to the character of the new nation. THOMAS JEFFERSON, the last and perhaps the most skilled of the gentlemen amateur architects, was well known among Virginians for his architectural accomplishments, most notably his hill top home, Monticello (begun 1770; see colour pl. I, 2). In 1785 Jefferson was asked to provide a design for a new Virginia State Capitol at Richmond. His solution (see fig. 7), developed in collaboration with Charles-Louis Clérisseau and based on the ancient Roman Maison Carrée, Nîmes, was the earliest Neo-classical building in the USA and a characteristic example of the emerging Federal style (see FEDERAL STYLE, §1). Jefferson also used a Roman model, the Pantheon, for his Library Rotunda of the University of Virginia (1823–6; for illustration see JEFFERSON, THOMAS), Charlottesville.

Jefferson exerted a marked influence on the development of early American architecture, but he was even more influential through his sponsorship of one of the first professional architects to arrive in the USA, BENJAMIN HENRY LATROBE. Jefferson obtained for him the commission for the Virginia State Penitentiary (1797–8). Also trained as an engineer, Latrobe designed the waterworks system (1798–1801; destr.) for Philadelphia. Like Jefferson, Latrobe advocated Neo-classicism as the style for the

new nation, best represented in his Greco-Roman Bank of Pennsylvania (1798–1800; destr.; see FEDERAL STYLE, fig. 1), Philadelphia. Latrobe's most acclaimed design, Baltimore Cathedral (1804–18), MD, has solid ashlar masonry vaulting, with precise Greek detailing in the Ionic porch (see FEDERAL STYLE, fig. 2). Like the architecture of John Soane, Latrobe's used the stark geometries of ancient Greece and Rome as a point of departure for the creation of an original and consciously modern idiom.

Unlike Great Britain, the USA had only a few trained professionals throughout the country trying to meet the needs of a burgeoning westward-moving population. Inexpensive architectural manuals aimed not at educated amateurs but at builders were published to meet the challenge. ASHER BENJAMIN was most successful in this enterprise, publishing a series of books from 1797. His most popular include *The American Builder's Companion* (1806), presenting designs for houses and for a county court-house, a building-type invented for the American frontier.

American architecture entered a new and increasingly nationalist phase c. 1815 with the beginnings of revivalism. Latrobe's inventive variations on Greco-Roman classicism were replaced with increasingly accurate recreations not only of ancient Greek and Roman buildings but also of a broad range of styles, from ancient Egyptian through medieval to Italian Renaissance. One aspect of this historicism that soon acquired nationalistic connotations was the GREEK REVIVAL. Many Americans saw a parallel between their recent struggle for freedom and the struggle of the Greeks to free themselves from Turkish domination. Ancient Greek temples were reproduced almost exactly, as in the Second Bank of the United States (1818–24) in Philadelphia, designed by William Strickland (see STRICKLAND, WILLIAM, fig. 1). The white marble exterior was inspired by the recently published restoration drawings of the Parthenon by James Stuart (1713–88) and Nicholas Revett (1720–1804). The Greek Revival soon established itself as the style for public and government buildings, for example Alexander Parris's Quincy Market (1825–6; for illustration see PARRIS, ALEXANDER) in Boston, MA, and Robert Mills's US Treasury Building (1836–42), Washington, DC.

The adaptation of the Greek temple for white-painted wood-frame houses was uniquely American. Many were built in upper New York state and throughout the developing Northwest Territory. Unlike the earlier Federal-style house, the Greek Revival house was more nearly square in plan, with a low pitched roof, and the entrance through a portico on one of the gable ends. One example is the Boody House, called Rose Hill (c. 1835), outside Geneva, NY. One reason for the widespread popularity of such houses was the availability of engravings of the Classical orders, especially in the new pattern-books produced by MINARD LAFEVER. His most influential book, *The Modern Builder's Guide* (1833), contains detailed plates of the orders, elaborate house plans, and even a design for a simpler Grecian house that could be built with plain wooden boards, eliminating costly carved ornament. Thus popularized, the Greek Revival spread throughout the USA, especially in the ante-bellum South.

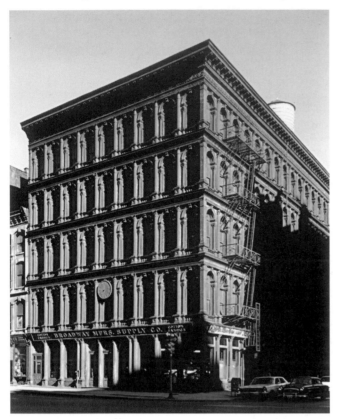

8. Daniel D. Badger and John P. Gaynor: Haughwout Building, New York, 1856–7

During the late 1830s, however, a broadly interpreted medieval idiom began to be used for country houses. This style was popularized by A. J. DOWNING in his two books, *Cottage Residences* (1842) and *The Architecture of Country Houses* (1850). A horticulturist, Downing advocated the fusion of the building and its landscape. For him the most appropriate setting was one in which plants and topography asserted their own character rather than having a geometric shape imposed. The architecture complementing such a landscape was to have similar irregularity and roughness; thus Downing preferred medieval vernacular and Gothic forms. The houses illustrated in his books, designed by such prominent architects as Alexander Jackson Davis, often had irregular, L-shaped plans, elaborate medieval details, steeply gabled roofs and dormers, and broad porches from which to survey the surrounding landscape. A characteristic example is the Nicholls–McKim House (1858–9), Llewellyn Park, West Orange, NJ. This is doubly significant for being built in a utopian suburb outside New York. Llewellyn Park, begun by manufacturer Llewellyn Haskell in 1852, was an ideal retreat from the city made possible by the rapidly expanding railway. The site for Llewellyn Park was a steeply rolling hillside in which the streets were laid out to follow the topography, leaving a strip of public park along a stream, and realizing Downing's recommended reciprocal relationship between buildings and landscape.

The various historical styles became invested with associational meanings, so that Roman or Greek classicism was deemed appropriate for public and commercial buildings, and Downing's medievalism was viewed as suitable for country residences. A more 'correct' Gothic idiom became established for churches (especially Episcopalian) through the efforts of Richard Upjohn. Although he employed a variety of stylistic idioms, he became best known as an advocate of 14th- and 15th-century English Gothic for churches. His best-known application is Trinity Church (1839–46; *see* UPJOHN, (1), fig. 1), New York, which is reminiscent of the work of A. W. N. Pugin (1812–52).

A more generic medievalism was established for prisons and was promoted by John Haviland in his Eastern State Penitentiary (1821–5; for illustration *see* HAVILAND, JOHN), Philadelphia, PA. If the heavy medievalism of the outer walls was retardataire compared to European historicism, the arrangement of individual cells in radiating arms for easier central control was radically new and established a system of prison design named after Haviland, which was closely studied by European penal experts. Haviland also used Egyptian motifs for some of his prisons, such as the Halls of Justice (1835; destr.) in New York, popularly known as The Tombs, but Egyptian motifs were more commonly used for cemeteries, for example Henry Austin's massive pylon gate (1845–8) for the Grove Street Cemetery, New Haven, CT.

Other stylistic idioms employed in the early 19th century included the round-arched Romanesque Revival used in THOMAS TEFFT's expansive Union Passenger Railroad Station (1848–55; destr. 1896), Providence, RI, and JAMES RENWICK's Smithsonian Institution (1847–55; see colour pl. II, 3) in Washington, DC. It is significant that these were new building types that had appeared in the early part of the century. Romanesque details were used for such buildings, as this style had less firmly established associational links than did Greek or Gothic. However, in the USA at this time the connections between historic detail and function were far less fixed than in Europe.

Industrialization had a major influence on American architecture. As in Britain, manufacturers quickly turned to making parts of buildings in cast iron. One example is the Haughwout Building (1856–7), New York, designed by JOHN P. GAYNOR but better known as the work of its manufacturer, DANIEL D. BADGER (see fig. 8; *see also* NEW YORK, fig. 1). Entire façades of such buildings were assembled from identical prefabricated pieces of cast iron bolted together, with wide glazed window-openings. The Haughwout Building was also notable for containing the first steam-operated passenger elevator (lift), which made feasible the construction of higher commercial buildings. Mechanization made an even more dramatic impact on house construction. Standardized, machine-cut pieces of timber were assembled rapidly into a complete house-frame held together by cheap, machine-made wire nails. A carpenter could hammer together such a balloon frame in the space of one day, needing none of the skills of a traditional joiner in cutting mortice-and-tenon joints.

3. THE CIVIL WAR AND LATE 19TH-CENTURY ECLECTICISM. The limits of literal replication gradually became apparent, and architects needed to use historical references more inventively for new building types. In the USA this shift coincided with the outbreak of the Civil

War, although little civil building took place between 1860 and 1866. Just before the war Americans had become aware of the new French mode of classical design exemplified by the additions (1852–7) of Louis-Tullius-Joachim Visconti (1791–1853) and Hector-Martin Lefuel (1810–80) to the Musée du Louvre in Paris, just as they also read avidly the views of John Ruskin (1819–1900). The result was that almost immediately after the war, fully developed versions of both the French Second Empire style and the English High Victorian Gothic appeared in the USA.

The Second Empire style was employed for similar building types to those previously designed in the Greek Revival style—commercial buildings, banks, office blocks and especially governmental buildings. The Second Empire style was characterized by pavilions with mansard (gambrel) roofs, connected by lower wings also with mansard roofs. Such a composition allowed these buildings to be built on large irregular sites, for example Alfred B. Mullett's triangular Post Office (1869–75; destr. 1939), New York. Other examples include Mullett's Executive Office Building (1871–86; originally the War and Navy Building; see colour pl. III, 3) next to the White House in Washington, DC, and the Philadelphia City Hall (1871–1901) by John McArthur jr. The tall mansard-capped tower also became identified with the houses of the growing upper middle class in the 1870s and 1880s.

High Victorian Gothic developed from the writings of John Ruskin, who advocated the development of a new Gothic idiom suited to modern needs but inspired by the commercial Gothic of Venice. This was to be a boldly irregular and colourful Gothic architecture, freed of archaeological dependence in its massing and details. Like the Gothic Revival of the 1840s and 1850s, however, this idiosyncratic High Victorian Gothic was used for churches, collegiate buildings and some houses. Two examples illustrating the use of variously coloured materials are the Old South Church (1876; see CUMMINGS & SEARS, fig. 1), Copley Square, Boston, by Cummings & Sears and the Memorial Hall (1870–78; for illustration see WARE, (1)) at Harvard University, Cambridge, MA, by William Robert Ware and Henry Van Brunt. This style allowed the architect an almost unprecedented margin for invention, and FRANK FURNESS was perhaps the most successful in exploiting this. Several of his extant buildings have been restored, most notably his Pennsylvania Academy of the Fine Arts (1871–6), Philadelphia, a combined public gallery and art school. Furness was one of a new group of architects who began to redirect the course of American architecture in the 1870s and 1880s. Their extensive formal training was strongly influenced by the academic programme of the Ecole des Beaux-Arts in Paris. In Furness's case, this influence was indirect, through his teacher Richard Morris Hunt (see HUNT, (2)), who had been a student at the Ecole des Beaux-Arts for nine years, and who had supervised construction of the additions to the Louvre under Lefuel. Hunt returned to the USA in 1855 and established in New York a studio where he trained some of the most important architects active at the end of the century, including Furness and George Browne Post. The French influence is most apparent in Hunt's command of historical detail, unparalleled at the time. This was demonstrated in his French Renaissance-style residence for William Kissam

Vanderbilt (1879–82; destr.), Fifth Avenue, New York, which established Hunt as the architect for the very wealthy.

After the Civil War, domestic architecture became the focus of stylistic experimentation. The New Jersey coast and Newport, RI, became the settings for the creation of two new informal residential styles. The STICK STYLE (c. 1870–80) developed out of High Victorian Gothic and employed multiple, intersecting steep roofs with prominent gables and exposed timbers. Such houses were usually completely surrounded by verandahs. The basic elements of this style are evident in the Jacob Cram House (1872) of Middletown, RI, believed to be by Dudley Newton. The spiky appearance of the Stick style soon gave way to the greater integration and stylistic unity of the SHINGLE STYLE (c. 1880 to 1895), which exploited long sweeping roofs and wall surfaces covered with wooden shingles. Windows and porches were grouped more harmoniously than in the Stick style. Shingle style houses had large rooms grouped around a spacious central hall dominated by a hearth and a staircase, ascending by means of various landings. A particularly good example is the Isaac Bell House (1881–3; see McKIM, MEAD & WHITE, fig. 1), Newport, RI, by McKim, Mead & White, who were leading practitioners of this idiom. Although these styles were at first used in houses for the very wealthy, they soon appeared in such popular pattern-books as those of Paliser & Paliser and thus spread across the USA.

Commercial architecture after the Civil War was usually either Second Empire style or High Victorian Gothic, but increasingly in the major commercial centres the emphasis was on size and height. In New York new records were quickly set in building height, with the Equitable Life Assurance Company Building (1868–70; destr.) by Gilman, Kendall & Post, which rose to 39 m, then superseded by Richard Morris Hunt's *New York Tribune* Building (1873–6; destr.), which rose to an astonishing 78 m. Boisterous assertiveness in these commercial blocks was characteristic in the post-Civil War period, but a measure of authoritative calm was introduced by the most influential architect of this period, H. H. Richardson. By 1872 he had developed a highly individual style that employed great masses of solid masonry with stylized Romanesque ornament. His architecture was not a Romanesque revival, but rather the result of careful analysis of functional requirements in dense building masses. Richardson's buildings had a monumental quality, an early example being his massive pyramidal Trinity Church (1875–7; see RICHARDSON, H. H., fig. 1), Boston, MA, but his best work was done towards the time of his early death, for example the Marshall Field Wholesale Store (1885–7; destr. 1930; see RICHARDSON, H. H., fig. 5), Chicago, and the Allegheny County Courthouse and Jail (1885–7; see RICHARDSON, H. H., fig. 4), Pittsburgh, PA.

A detailed knowledge of history, honed by training in Paris studios, marked the last phase of eclecticism in the 19th century. After new schools of architecture were established in the USA (see §XVI below), architects increasingly began to consider their designs as integrated wholes rather than a collection of historic details, the result of their intensive educational programme. They also began to devise new structural elements to enclose the spaces

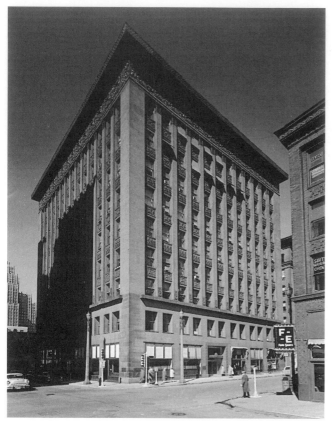

9. Louis Sullivan and Dankmar Adler: Wainwright Building, St Louis, Missouri, 1890–91

founded in 1883. Another significant development in American building in this period was the long-span suspension bridge using twisted cables of steel wire, a method perfected by John Augustus Roebling and Washington Augustus Roebling (*see* ROEBLING) in their Brooklyn Bridge (1869–83; *see* NEW YORK, fig. 2). Bridge construction also influenced the technique and materials of metal-frame skyscraper design.

In the face of industrial expansion and social disruption during the 1870s, American architects and clients sought a sense of cultural continuity, admiring the balance and repose of Colonial and Federal style architecture. The result, beginning *c.* 1880 and widespread by the early 1890s, was a resurgence of academic classicism, in the form of a COLONIAL REVIVAL in domestic architecture. The leading advocate of this classicism was the firm of McKim, Mead & White, who introduced the Colonial Revival in their 18th-century style house (1883–5; destr. 1952) at Newport, RI, for H. A. C. Taylor. They also developed a more generic Italian Renaissance classicism for urban buildings in their six-house complex (1882–6; altered, 1975–6) for Henry G. Villard in New York and in the magisterial Boston Public Library (1887–95; *see* McKIM, MEAD & WHITE, fig. 2).

By the mid-1890s academic classicism had become the preferred idiom for urban buildings across the country, and the most influential event in popularizing this civic classicism was the World's Columbian Exposition (1893), Chicago. The team of architects who designed its buildings decided in favour of a unified ensemble of buildings in a Renaissance style (the only style all of them knew equally well; *see* BURNHAM, DANIEL H., fig. 1). The white plaster buildings of the Columbian Exposition spurred the CITY BEAUTIFUL MOVEMENT, which swept the USA at the turn of the century and led to the creation of scores of neo-classical civic centres. It also led Daniel H. Burnham to devote his energies to urban planning, then in its infancy.

they desired, including metal and concrete frames and Guastavino tile vaults.

Perhaps the most important creation of American architects during this period, exceeding even the balloon frame in its social impact, was the metal-framed commercial SKYSCRAPER. Richard Morris Hunt had provided the conceptual model in his soaring tower for the *New York Tribune*, but the traditional load-bearing wall construction of such early skyscrapers limited their height. In Chicago WILLIAM LE BARON JENNEY was the first to substitute an internal metal skeleton to support all the wall and floor loads of a commercial office block in his Home Insurance Building (1883–5; destr. 1931; *see* CHICAGO, fig. 1). The technology of these first hybrid skeletons of cast- and wrought-iron and steel members was quickly perfected, resulting in frames made entirely of steel in such towers as DANIEL H. BURNHAM and JOHN WELLBORN ROOT's Reliance Building (1889–95; for illustration *see* SKYSCRAPER). The architect who did most to determine the form of these metal-framed skyscrapers was LOUIS SULLIVAN, briefly a student at the Ecole, working with his partner, DANKMAR ADLER. Their trend-setting office towers included the Wainwright Building (1890–91; see fig. 9), St Louis, MO, and the Prudential (now Guaranty) Building, Buffalo, NY, in which continuous vertical lines stress the height of these skyscrapers (*see* SULLIVAN, LOUIS, fig. 1). Among important contributors to the developing Chicago school was the firm of HOLABIRD & ROCHE,

4. THE CHICAGO SCHOOL, THE PRAIRIE SCHOOL AND ACADEMIC ECLECTICISM IN THE EARLY 20TH CENTURY. Among the most potent agents shaping American architecture in the early 20th century were the progressive architects now labelled the CHICAGO SCHOOL. Although the movement had reached maturity by the turn of the century, its most incisive thinker, Louis Sullivan, had by then separated from Dankmar Adler, and had begun a slow decline into virtual obscurity. During his enforced leisure, however, he wrote his theoretical study *A System of Ornament According with a Philosophy of Man's Powers* (1922–4) and his *Autobiography of an Idea* (New York, 1924) among other essays. The further development of the Chicago skyscraper was carried on by Burnham & Root, particularly by the younger partners. Burnham's planning projects included a master plan for Chicago, finished in 1909. The firm of Holabird & Roche was especially active, developing a standardized form for their office towers, as characterized by their white terracotta-clad Republic Building (1905–9; destr. 1961).

The other principal focus of the progressive Chicago architects was the suburban family house. The most revolutionary changes in its design were made by FRANK LLOYD WRIGHT. For his own house (and later studio) in

the Chicago suburb of Oak Park (1889), Wright drew on the Shingle style favoured by J. L. Silsbee, then popular along the eastern seaboard. Wright's goals of ridding the house of applied ornament and of opening up and connecting its spaces were realized in a series of houses built around the turn of the century, particularly in the expansive Willits House (1902–6) in the suburb of Highland Park (see fig. 10; for plan *see* WRIGHT, FRANK LLOYD, fig. 1). Scores of houses followed, all with these characteristics, relating the house to the flat Midwestern prairie by emphasizing the horizontal line. The culmination of the Prairie house type was his own house, Taliesin, built in 1911 at Spring Green, WI. In his few non-residential buildings—most notably the Larkin Building (1903–6; destr. 1950), Buffalo, NY, and the Unity Temple (1905–8), Oak Park (*see* WRIGHT, FRANK LLOYD, figs 2 and 3)—Wright turned the cubic masses in on themselves, creating inwardly focused spaces.

Wright attracted to his studio a number of associates (most of whom soon left to set up their own practices), including Marion Mahony (later Mahony Griffin; 1871–1961) and Walter Burley Griffin (1876–1937). These disciples, together with Wright, established a PRAIRIE SCHOOL, which existed until World War I. Their work should also be considered part of the Arts and Crafts Movement, whose chief American proponent was GUSTAV STICKLEY. Also related to this Arts and Crafts aesthetic is the work of the brothers Charles Sumner Greene and Henry Mather Greene (*see* GREENE & GREENE) of Pasadena, CA. Their masterwork, the David B. Gamble House (1908; see colour pl. IV, 2), Pasadena, synthesizes elements of the Stick style, the Shingle style, Japanese architecture and construction methods, with Arts and Crafts interiors and furnishings (for illustration *see* ARTS AND CRAFTS MOVEMENT).

The Chicago skeletal metal frame for commercial skyscrapers was quickly adopted in New York. By 1900 office towers in New York were being built higher than those in Chicago. Because of greater height and smaller building sites, New York skyscrapers took on the form of a slender spire rising from a lower block. This profile was used by ERNEST FLAGG in his soaring Singer Building tower (1906–8; destr. 1967–8), whose 47 storeys rose 612 ft (186.54 m), and by Cass Gilbert in his even higher Woolworth Building (1910–13; for illustration *see* GILBERT, CASS), whose 55 storeys rose 761 ft (231.95 m) and held the record for height until 1930.

The inspiration for the period of academic eclecticism that was to flourish after World War I, paralleling America's political isolationism, lay in the work of such architects as McKIM, MEAD & WHITE. Their major building of the early years of the 20th century was Pennsylvania Station (1902–11; destr. 1963–5), New York, which formed a node of majestic order at the end of the railway line into the city. Academic eclecticism also prevailed in church design. The Gothic Revival was vigorously championed by Ralph Adams Cram together with BERTRAM GOODHUE and was taken up by other architects. Cram & Goodhue's work is well represented in St Thomas's (1905–14), Fifth Avenue, New York. Cram later developed an immense Gothic scheme for St John the Divine, Amsterdam Avenue, New York (for illustration *see* CRAM, RALPH

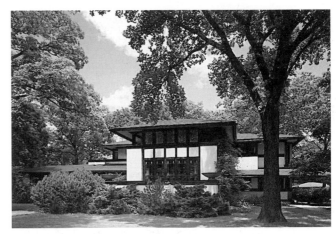

10. Frank Lloyd Wright: Ward Willits House, Highland Park, Illinois, 1902

ADAMS, on which he worked from 1912 until 1941, and which was still under construction in 1998. In city centres the continuing City Beautiful Movement inspired classical city halls, court-houses and public libraries until the mid-1930s, but as before the spirit of American inventiveness would increasingly come to focus on the creation of a new generation of office skyscrapers.

BIBLIOGRAPHY
G. H. Edgell: *The American Architecture of Today* (New York, 1928)
F. Lloyd Wright: *An Autobiography* (New York, 1932, rev. 4/1977)
T. Hamlin: *Greek Revival Architecture in America* (New York, 1944/R 1966)
J. M. Fitch: *American Building: The Historical Forces that Shaped it* (Boston, MA, 1948, 2/1966)
H. Morrison: *Early American Architecture, from the First Colonial Settlements to the National Period* (New York, 1952)
W. Andrews: *Architecture, Ambition and Americans* (New York, 1955, 2/1964)
V. J. Scully jr: *The Shingle Style: Architectural Theory and Design from Richardson to the Origins of Wright* (New Haven, 1955), rev. as *The Shingle Style and the Stick Style* (New Haven, 1971)
H.-R. Hitchcock: *Architecture, Nineteenth and Twentieth Centuries* (Harmondsworth, 1958, 4/1977)
V. J. Scully jr: *Frank Lloyd Wright* (New York, 1960)
J. Burchard and A. Bush-Brown: *The Architecture of America: A Social and Cultural History* (Boston, 1961, 2/1967)
P. Heyer, ed.: *Architects on Architecture: New Directions in Architecture* (New York, 1966)
C. W. Condit: *American Building* (Chicago, 1968, 2/1982)
P. B. Stanton: *The Gothic Revival and American Church Architecture: An Episode in Taste, 1840–1856* (Baltimore, 1968)
V. J. Scully jr: *American Architecture and Urbanism* (New York, 1969)
W. H. Pierson jr: *The Colonial and Neo-Classical Styles*, i of *American Buildings and their Architects* (Garden City, NY, 1970)
W. H. Jordy: : *Progressive and Academic Ideals at the Turn of the Century*, iii of *American Buildings and their Architects* (Garden City, NY, 1972)
L. Cummings: *The Framed Houses of Massachusetts Bay, 1625–1725* (Cambridge, MA, 1974)
W. H. Pierson jr: *Technology and the Picturesque, the Corporate and Early Gothic Styles*, ii of *American Buildings and their Architects* (Garden City, NY, 1978)
G. Ciucci, F. Dalco, M. Manieri-Elia and M. Tafuri: *The American City: From the Civil War to the Deal* (Cambridge, MA, 1979, 2/London, 1980)
L. M. Roth: *A Concise History of American Architecture* (New York and London, 1979, 2/1988)
M. Whiffen and F. Koeper: *American Architecture, 1607–1976* (Cambridge, MA, 1981)
L. M. Roth: *America Builds: Source Documents in American Architecture and Planning* (New York, 1983)
D. P. Handlin: *American Architecture* (London and New York, 1985)

LELAND M. ROTH

III. Painting and graphic arts.

1. The Colonial period, to 1820. 2. 19th-century developments. 3. Early 20th-century developments.

1. THE COLONIAL PERIOD, TO 1820. The opportunistic nature of early explorations and the impermanence of ill-fated settlements that characterized the period between 1492 and 1600 did not encourage elaborate artistic production among European colonists. It was not until the mid-17th century, after permanent civilian communities had begun to thrive in Philadelphia, New York, Boston and elsewhere, that notable paintings and prints were produced by artists resident in the colonies. However, the constant importation of paintings and reproductive prints, and the regular presence of artists trained in Europe—who emigrated, worked itinerantly throughout the colonies or made art in some official capacity such as that of military draughtsman—meant that in the 17th and 18th centuries Americans were accustomed to western European traditions and continued to be aware of the contemporary artistic developments in such centres as London, Paris and Rome.

Political patterns of colonization, concentrated along the Atlantic seaboard, affected the visual arts in that they determined settlers' immediate sources of cultural training and conventions. As Britain secured control of North America in the 18th century, and as cities with strong economic and political ties to London—such as Boston, New York, Philadelphia and Charleston—simultaneously grew and prospered, British art and aesthetic sensibilities dominated American cultural development throughout the North American colonies. Consequently, French influence along the Mississippi and the St Lawrence rivers and the Spanish presence in Florida and the far Southwest had little lasting impact on the development of the fine arts.

Most works produced during the Colonial period were commissioned or purchased for domestic situations, and this dictated the predominance of modestly sized easel paintings and of such subjects as portraits, still-lifes and landscapes, rather than grandiose religious or historical images. Indeed, when attempted soon after independence, history painting met with little enthusiasm. Prints designed and produced in the USA were published in books or general digest-type magazines, individually on speculation to be sold in art-supply and stationery shops, or in portfolios by subscription from private individuals. Portraits and landscape scenery were the most common subjects. While American printmakers most frequently employed simple line engraving, they also worked with aquatint and mezzotint.

The painters responsible for most extant 17th-century New England portraits remain anonymous, although scholars have identified individual artists at work in discrete groups of images. The finest of these was the painter of *Mrs John (Elizabeth) Freake and her Baby Mary* (1670; Worcester, MA, A. Mus.; for illustration *see* FREAKE PAINTER). This image of a prosperous Boston matron and her child exemplifies the transatlantic migration of late Elizabethan style and form in its flat, straightforward presentation, dark background punctuated by rudimentary drapery and close attention to intricate decorative patterns. The only contemporary painter whose name is known is THOMAS SMITH, to whom a number of Boston portraits

have been attributed, including a *Self-portrait* (1670–91; Worcester, MA, A. Mus.; see colour pl. V, 1) with *memento mori* objects. Smith's more robust tone and occasional insertion of narrative scenery behind his sitters anticipated the relative sophistication and complexity introduced to American portraiture by the Scottish-born John Smibert. Smibert settled in Boston in the early 1730s, bringing with him the portrait style of Godfrey Kneller and Peter Lely then current in London. His large conversation piece *Bermuda Group* (1729–31; New Haven, CT, Yale U. A.G.) demonstrates an easy competence in handling full figures and natural scenery unprecedented in the colonies (for illustration *see* SMIBERT, JOHN). Smibert's London training, his collection of Old Master paintings, prints and drawings gathered in Italy and London, and his richly coloured portraits for prosperous mercantile families provided models for several generations of American painters. His most immediate heir was ROBERT FEKE, a native of Long Island who was active in Rhode Island and Boston, and whose facility for opulent textures and imitation of English portrait compositions and poses (e.g. *James Bowdoin*, 1748; Brunswick, ME, Bowdoin Coll. Mus. A.) rivalled Smibert's own.

Smibert was the first and best of a number of painters who left Europe and spread simplified and sometimes awkward versions of their native late Baroque styles throughout the colonies in the early 1700s. English and Dutch portrait painters active in Manhattan Island and the Hudson River Valley remain anonymous. Simplicity and realism characterize the work of GUSTAVUS HESSELIUS, a Swedish artist active in the Middle Atlantic region, while the work of the German immigrant JUSTUS ENGELHARDT KÜHN, active in Maryland, is marked by intricate, elaborate backgrounds and an emphasis on ornate costume. Portraits by JEREMIAH THEUS, a Swiss who settled in Charleston, show an incipient Rococo lightness in colour and form. This form of pretty elegance found its fullest expression in the colonies at mid-century in the work of the itinerant, wide-ranging Englishmen JOHN WOLLASTON, JOSEPH BLACKBURN and WILLIAM WILLIAMS.

The careers of the native-born colonials JOHN SINGLETON COPLEY and BENJAMIN WEST mark the beginning of an efflorescence of American art. Although both men, natives of Boston and Pennsylvania respectively, spent most of their careers in London, their work was certainly strongly flavoured by their Colonial origins and had an immense impact on the young Americans who went abroad to study with them. Copley, who educated himself with imported prints and closely studied the work of Smibert and such travellers as Blackburn, had by the 1760s and early 1770s attained a personal style in portraiture, distinguished by a crisp light full of subtle colour, sumptuous textures and a penetrating appraisal of his sitters, a style exemplified in his portrait of *Mrs Ezekiel Goldthwait (Elisabeth Lewis*; 1771; see fig. 11). Although his work became grander after he moved to London with his Loyalist in-laws in the 1770s, Copley never surpassed the individualistic boldness of his late Boston portraits. West, influenced by the itinerant Williams and sent to Italy and England for study by a group of Philadelphia educators and philanthropists in 1760, became history painter to the court of George III and in 1792 second President of the Royal Academy of Arts, London. West's early work is

marked by a smooth, almost Neo-classical manner (see colour pl. V, 3), but as his career progressed his hand became increasingly loose and almost romantic in its emotional drama. Although much of his work depicts standard mythological and scriptural subjects, West made a major innovation in history painting with the *Death of General Wolfe* (1770; Ottawa, N.G.), in which contemporary clothing and a realistic setting rather than timeless classical accessories commemorate the British victory at Quebec (*see* WEST, BENJAMIN, fig. 1).

Painters who came to maturity during the Revolution sought to blend the European sophistication of their models—Smibert, Copley and West—with fresh, distinctly American subjects and approaches. Charles Willson Peale, a Philadelphia portrait painter with an astonishing range of interests from natural history to progressive agriculture, infused his likenesses with both tender familial sentiment and adamant political commentary, as did other members of his family (*see* PEALE). A student also of landscape and still-life, he often included these as personally symbolic elements in portraits, as in *William Smith and Grandson* (1788; Richmond, VA, Mus. F.A.). GILBERT STUART, a contemporary whose informal, loose style, imitative of Gainsborough and his followers, is very different from Peale's simplicity, returned in the early 1790s from a lengthy period in England and Ireland to become the most popular portrait painter of the nation's emerging Federalist élite (see colour pl. VI, 3). Persuaded by West that the new nation should glorify and preserve the pivotal episodes of its birth, Connecticut native John Trumbull sought to launch an indigenous tradition of history painting. Deviating from his master's dignified reserve towards a more personally felt, earnest interpretation of events that his generation had experienced closely, Trumbull planned a series of Revolutionary images commemorating key battles and political debates, such as the *Declaration of Independence* (1786; New Haven, CT, Yale U. A.G.; for illustration *see* TRUMBULL, JOHN). History painting was likewise the principal occupation of John Vanderlyn, who trained in Paris and brought the cool sharpness of French Neo-classicism to peculiarly American subjects. In such works as the *Murder of Jane McCrea* (1804; Hartford, CT, Wadsworth Atheneum), Vanderlyn sought to marry the drama of frontier settlement to ennobling, classically inspired figures and monumental composition (for illustration *see* VANDERLYN, JOHN). America's pioneer Romantic painter was WASHINGTON ALLSTON, also a student of West. Concentrating on the realm of the imagination, the emotions and the soul, as in *Hermia and Helena* (c. 1818; see fig. 12), Allston's work is distinguished by lush colours, complex glazes and loose brushwork. He was particularly interested in literary subjects that broached the intricate connection between vision and the spoken word.

Although landscape did not become a major theme in American art until the 1830s, the subject had been pursued and appreciated for decades. Immigrant painters and printmakers trained in England brought with them the soft, graceful Picturesque modes then current. Peale, Trumbull and Allston all experimented with native landscape subjects, but American-born painters THOMAS DOUGHTY and ALVAN FISHER (see colour pl. VIII, 1) were the first to specialize in the genre. Their work,

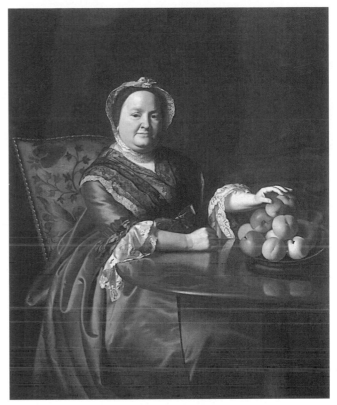

11. John Singleton Copley: *Mrs Ezekiel Goldthwait (Elizabeth Lewis)*, oil on canvas, 1.27×1.01 m, 1771 (Boston, MA, Museum of Fine Arts)

sometimes marred by an inarticulate haziness or a cloying charm, at least recognized American scenery as a legitimate subject and at best introduced the identification of nationalism with place, which became a central inspiration of subsequent landscape painters.

The work of native-born printmakers, generally trained as artisans (such as the silversmith and printmaker PAUL REVERE), is generally coarse and awkward. Subjects included original themes, as in Revere's engraving *Boston Massacre* (1770; New York, Pub. Lib.), copies after American painters and the quasi-industrial decoration of banknotes and business documents. As in painting, immigrant artists contributed considerably to the overall quality of American printmaking. The elegant cityscapes and views of country houses of William Russell Birch (1755–1834), for example, were notable examples for Americans to emulate. Magazines published in Philadelphia and New York provided such fledgling American printmakers as James Trenchard (*b* 1747) and CORNELIUS TIEBOUT with an outlet for original, if rather crudely executed, compositions. ASHER B. DURAND, the most accomplished native-born and trained engraver of the early 1800s, later turned to painting.

While scholars seeking to identify the distinguishing features of American art in this period have noted a fascination with tangible reality and a resultant focus on realistic texture and form (as in Copley's Boston portraits) or a willingness to challenge tradition (as in West's contemporary heroes), American art was to establish a distinctive

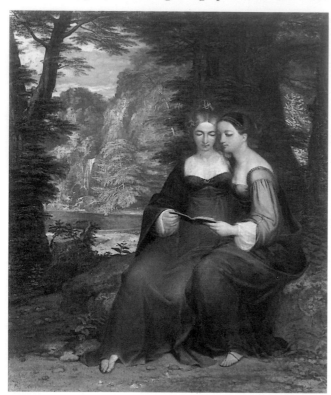

12. Washington Allston: *Hermia and Helena*, oil on canvas, 737×635 mm, *c.* 1818 (Washington, DC, National Museum of American Art)

and independent character. This process had only just begun by 1820, and the art of the USA before that time is often marked by a distinct simplicity or literalness in its interpretation of contemporary styles. Although Peale and Trumbull certainly attempted to address specifically national concerns in their work, it was not until the generation of Allston and Vanderlyn that Americans began confidently to innovate in aesthetic terms.

BIBLIOGRAPHY
W. Dunlap: *History of the Rise and Progress of the Arts of Design in the United States*, 3 vols (New York, 1834)
D. M. Stauffer and M. Fiedling: *American Engravers upon Copper and Steel* (New York, 1907/*R* Philadelphia, 1917)
F. Weitenkampf: *American Graphic Art* (New York, 1912)
——: 'Early American Landscape Prints', *A. Q.* [Detroit], viii (1945), pp. 40–67
G. C. Groce and D. H. Wallace: *The New York Historical Society's Dictionary of Artists in America, 1564–1860* (New York, 1957)
J. Dolmetsch: 'Prints in Colonial America: Supply and Demand in the Mid-18th Century', *Prints in and of America to 1850*, ed. J. D. Morse (Charlottesville, 1970), pp. 53–74
The Flowering of American Folk Art, 1776–1876 (exh. cat. by J. Lipman and A. Winchester, New York, Whitney, 1974)
H. Honour: *The European Vision of America* (Cleveland, 1975)
J. Dolmetsch, ed.: *Eighteenth Century Prints in Colonial America: To Educate and Decorate* (Charlottesville, 1979)
J. L. Fairbanks and R. F. Trent, eds: *New England Begins*, 3 vols (Boston, 1982)
N. Harris: *The Artist in American Society: The Formative Years, 1790–1860* (Chicago, 1982)
J. Poesch: *The Art of the Old South: Painting, Sculpture, Architecture and the Products of Craftsmen, 1550–1860* (New York, 1983)
E. J. Nygren, ed.: *Views and Visions: American Landscape before 1830* (Washington, DC, 1986)
J. Yarnall and W. H. Gerdts: *The National Museum of American Art's Index to American Art Exhibition Catalogues from the Beginning through the 1876 Centennial Year*, 6 vols (Boston, 1986)
R. H. Saunders and E. Miles: *American Colonial Portraits, 1770–1776* (Washington, DC, 1987)

KAROL ANN PEARD LAWSON

2. 19TH-CENTURY DEVELOPMENTS. As the USA expanded in the first half of the 19th century, artists shared in this process of nation building by developing an American style and mythology. Although portraiture and history painting were vehicles for nationalistic sentiments, landscape and genre played a particularly active role in defining the country and its people. From 1821 to 1825 the *Hudson River Portfolio* was published in New York by the watercolourist William Guy Wall and the engraver John Hill. Charting the river from its source to New York harbour, this series of 20 aquatints is one of the early masterpieces of American graphic art. The prints reveal a debt to British practice and theory, particularly the aesthetic concepts of the Sublime, the Beautiful and the Picturesque.

With the rise to prominence of THOMAS COLE in 1825, landscape painting began to glorify the wilder aspects of American scenery. Among his first works was *Falls of Kaaterskill* (1826; Tuscaloosa, AL, Warner Col. Gulf States Paper Corp.), in which an American Indian overlooks a cascade in the Hudson River Valley, vibrant with autumnal colours. Like many of Cole's compositions, this painting depicts a primeval America untouched by civilization and alludes to the changing of the wilderness, a theme treated in the novels of James Fenimore Cooper. Such works as *Oxbow on the Connecticut River* (1836; New York, Met.; see colour pl. XI, 1) present a transcendental view of nature. In the composition the artist serves as an intermediary between nature and the divine, a concept later embodied in Asher B. Durand's *Kindred Spirits* (1849; New York, Pub. Lib.; for illustration *see* DURAND, ASHER B.). Painted a year after Cole's death, this homage to the deceased artist portrays him on a precipice in the wilderness with the poet William Cullen Bryant. Cole fostered the HUDSON RIVER SCHOOL, which included Albert Bierstadt, Frederic Edwin Church, Jasper Francis Cropsey, Sanford Robinson Gifford and John Frederick Kensett, among many others. Their works often treated awe-inspiring scenery and emphasized the country's manifest destiny. This is particularly evident in such monumental canvases as Church's *Niagara* (1857; Washington, DC, Corcoran Gal. A.; see fig. 13) with the river and falls under a protective rainbow, symbolizing the potential and power of the New World (see also colour pl. VIII, 1). These artists also recorded the USA's pastoral character, presenting the country as an earthly paradise. Such painters as Martin Johnson Heade and Fitz Hugh Lane, meanwhile, focused on scenes in which light and atmosphere are the subjects (see colour pls XIV, 2 and XIII, 2). This development became known as LUMINISM.

While landscape painting extolled the potential of the American land, genre painting glorified working people and the ideals of democracy. Paintings of people engaged in everyday activities, which had their roots in 17th-century Dutch art and were treated in Britain by David Wilkie (1785–1841) and his contemporaries, inspired such

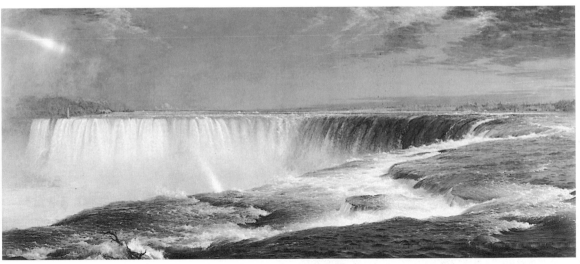

13. Frederic Edwin Church: *Niagara*, oil on canvas, 1.08×2.30 m, 1857 (Washington, DC, Corcoran Gallery of Art)

artists as John Lewis Krimmel of Philadelphia. It was, however, in the work of WILLIAM SIDNEY MOUNT of New York and GEORGE CALEB BINGHAM of Missouri (see colour pl. XII, 2) that genre painting found its finest expression in the decades before the Civil War. Some of their paintings were translated into popular prints by Currier & Ives and others.

Genre scenes tended to idealize life in America even as they underscored regional differences. Many also embodied racial and social attitudes characteristic of the time but offensive today. For example, Mount's *Farmers Nooning* (1836; Stony Brook, NY, Mus.; see colour pl. X, 2) can be seen as a visual essay on the carefree nature of rural America, but the portrayal of the sleeping African American, undoubtedly a slave, is ambivalent. Although sympathetically presented in a classical pose, he is nonetheless to some extent the butt of the white man's joke. Compositions by FREDERIC REMINGTON, William Ranney, John Mix Stanley, Arthur Fitzwilliam Tait and others often give stereotypical views of American Indians as blood-thirsty savages or noble primitives (see WILD WEST AND FRONTIER ART). Bingham's exuberant series depicting grass-roots politics in Missouri, while critical of the democratic process in the depiction of drunken voters in, for example, his two versions of the *County Election* (1851 and 1852; version in St Louis, MO, A. Mus.), still expresses the vitality of the USA's political system in the years following the collapse of republican movements in Europe.

The Civil War allowed such photographers as Mathew Brady and Timothy O'Sullivan to establish themselves through their documentary work (for illustration *see* O'SULLIVAN, TIMOTHY). It also brought with it rapid industrialization, which eventually led to the urbanization of the USA and the internationalization of its economy. The arts also underwent a transformation. Although landscape and figure painting remained dominant, with black artists such as Robert S. Duncanson, Edward Mitchell Bannister and Grafton Tyler Brown (1841–1918) becoming prominent for the first time through their

treatment of landscape, the tone of many compositions became intimate and reflective. Styles also changed from contact with Europe as well as through exhibitions of European works in the USA. While academies had been established in New York, Philadelphia and elsewhere in the early 19th century (*see* §XVI below), these were small institutions, and many artists went abroad for study. In the second part of the century, as travel increased, American art responded to European developments. Pre-Raphaelitism, Realism, Impressionism and Symbolism all had American phases. Hundreds of American artists settled abroad, and their choice of subjects frequently reflected their new surroundings: Thomas Hovenden and Daniel Ridgway Knight (1840–1924), for example, painted European peasants, while Frederick A. Bridgman (1847–1927) and Edwin Lord Weeks (1849–1903) depicted exotic scenes in the Near East and North Africa.

American painters, once they had adopted European styles and themes, saw themselves as part of an international community wherever they lived. Many, such as JAMES McNEILL WHISTLER and MARY CASSATT, stayed in Europe, while others, such as JOHN SINGER SARGENT and HENRY OSSAWA TANNER, lived there for extended periods. Their reputations and influence transcended national boundaries. For example, Whistler's Art-for-Art's-Sake aesthetic was embraced by artists on both sides of the Atlantic, and his etchings and lithographs were widely imitated. Cassatt was aligned with the most progressive forces in Paris, and, like the work of some of the Impressionists, her compositions show the influence of Japanese prints in motif, design and patterning. Sargent, a fashionable portrait painter (see colour pl. XXIII, 2), was in great demand in both Europe and the USA, while Tanner gained an international reputation for his religious paintings.

In the last quarter of the century, still-life painting emerged as an important art form in the USA. Following the example of the Peale family at the beginning of the century (see colour pl. VII, 2) and of the American Pre-Raphaelites, who had treated related subjects, especially in

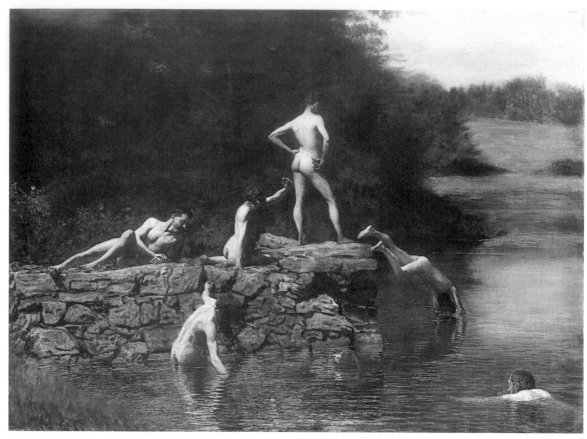

14. Thomas Eakins: *Swimming Hole*, oil on canvas, 685×915 mm, 1883 (Fort Worth, TX, Amon Carter Museum of Western Art)

watercolour, a number of artists, using a heightened realism, created *trompe l'oeil* paintings of extraordinary verisimilitude in the final decades of the century (e.g. *Music and Good Luck*, 1888; New York, Met.; *see* HARNET, WILLIAM MICHAEL, fig. 2). Most notable were William Michael Harnett, whose trophy pieces frequently contain references to the past, John F. Peto, whose imagery includes personal allusions, and John Haberle, whose works often jokingly refer to his own paintings. One peculiarly American subject was the representation of paper money, as in Haberle's *Bachelor's Drawer* (1890–94; New York, Met.; see colour pl. XXII, 1). Such images commented on the materialism of the society as well as on monetary issues also treated in contemporary literature.

Figurative art during this period often alluded to social and demographic changes. Rural subjects tinged with nostalgia continued to attract such artists as Eastman Johnson and Winslow Homer, but urban themes became commonplace. Such realists as Thomas Anshutz, John George Brown and Charles Ulrich (1858–1908) depicted the working classes and portrayed their country as a melting-pot society. Middle- and upper-class women engaged in genteel pastimes often appear in compositions by such American Impressionists as William Merritt Chase (see colour pl. XXI, 1), Childe Hassam and Edmund Tarbell. Although generally not appreciated at the time, Thomas Eakins's portraits of doctors, sportsmen and

musicians actively engaged in their pursuits offer psychological insights into human activity. Painted in 1875 and intended for the Centennial International Exhibition of 1876 in Philadelphia, *The Gross Clinic* (Philadelphia, PA, Thomas Jefferson U., Medic. Col.) is a powerful, if brutally realistic, homage to modern science and affirms the artist's commitment to anatomical training (*see* EAKINS, THOMAS, fig. 2). Eakins's interest in science was further manifested in his photographs, which he used to study motion and to develop such compositions as the *Swimming Hole* (1883; Fort Worth, TX, Amon Carter Mus.; see fig. 14).

While Church, Thomas Moran, Thomas Hill and Albert Bierstadt continued to produce monumental views of Sublime scenery (for illustration *see* BIERSTADT, ALBERT; see also colour pl. XVII, 1), landscape painting after the Civil War generally became more modest in scale and subject. It also underwent stylistic shifts, for example in the work of GEORGE INNESS, who rejected the meticulous manner of the Hudson River school for painterly handling in the style of the Barbizon school (see colour pl. XIX, 1). His late paintings are reflections on a spiritual landscape rather than depictions of specific places. Internalization of nature is even more apparent in the darkly poetic compositions of Albert Pinkham Ryder (see colour pl. XXI, 2) and Ralph Albert Blakelock. On the other hand, the contemporary light-filled landscapes of Willard Leroy Metcalf, Theodore Robinson, John H. Twachtman (see

colour pl. XX, 2) and Julian Alden Weir, as well as those of Chase and Hassam, are buoyantly optimistic; their impressionistic style survived well into the 20th century.

The shift from objective observation to subjective interpretation of nature is particularly noticeable in the work of Winslow Homer (see colour pl. XXIV, 2). His depictions of the Civil War, growing out of his work as a journalist illustrator, gave way, by the end of the century, to such intensely symbolic compositions as the *Fox Hunt* (1893; Philadelphia, PA Acad. F.A.) in which natural enemies engaged in a life-and-death struggle become metaphors for human existence (*see* HOMER, WINSLOW, fig. 1). Homer also emerged in the closing decades of the century as a gifted watercolourist. Earlier, such artists as William Guy Wall had practised a variation on British topographical art, and such painters as John William Hill had produced brilliant Pre-Raphaelite watercolours. However, it was not until Homer that the full potential of the medium was realized in the USA. His loose and quick application of washes, particularly after 1880, created expressive works of crystalline colour unequalled by any other American until Charles Prendergast (1863–1948) and Sargent at the turn of the century.

By 1900 the expansion of the USA and the growth of its population from just over five million in 1800 to almost seventy-six million, together with increased wealth and improved transportation, all encouraged internationalization in the arts as well as in commerce. Major collections were formed by American millionaires, and American art began to outgrow its provincialism.

BIBLIOGRAPHY

A. Frankenstein: *After the Hunt: William Harnett and other Still-life Painters, 1870–1900* (Berkeley and Los Angeles, 1953, rev. 1969)

J. Flexner: *That Wilder Image: The Painting of America's Native School from Thomas Cole to Winslow Homer* (Boston, 1962)

B. Novak: *American Painting of the Nineteenth Century: Realism, Idealism and the American Experience* (New York, 1969, rev. 1979)

W. Gerdts and R. Burke: *American Still-life Painting* (New York, 1971)

H. Williams jr: *Mirror of the American Past: A Survey of American Genre Painting, 1750–1900* (Greenwich, CT, 1973)

The Flowering of American Folk Art, 1776–1876 (exh. cat. by J. Lipman and A. Winchester, New York, Whitney, 1974)

American Art in the Barbizon Mood (exh. cat., ed. P. Bermingham; Washington, DC, N. Mus. Amer. A., 1975)

American Expatriate Painters of the Late Nineteenth Century (exh. cat., ed. M. Quick; Dayton, OH, A. Inst., 1976)

American Master Drawings and Watercolors (exh. cat., ed. T. Stebbins jr; New York, Whitney, 1976)

P. Marzio: *The Democratic Art: Pictures of a 19th Century America* (Boston, 1979)

B. Novak: *Nature and Culture: American Landscape and Painting, 1825–1875* (New York and Toronto, 1980)

American Light: The Luminist Movement, 1850–1875 (exh. cat., ed. J. Wilmerding; Washington, DC, N.G.A., 1980)

A New World: Masterpieces of American Painting, 1760–1910 (exh. cat., ed. J. Silver; Boston, MA, Mus. F.A.; Washington, DC, Corcoran Gal. A.; Paris, Grand Pal.; 1983–4)

The New Path: Ruskin and the American Pre-Raphaelites (exh. cat., ed. L. Ferber; New York, Brooklyn Mus., 1985)

American Paradise: The World of the Hudson River School (exh. cat., ed. J. Howat; New York, Met., 1988)

W. Gerdts: *American Impressionism* (New York, 1989)

M. Lovell: *A Visitable Past: Views of Venice by American Artists, 1860–1915* (Chicago, [1989])

H. B. Weinberg: *The Lure of Paris: Nineteenth-century American Painters and their French Teachers* (New York, 1991)

The West as America: Reinterpreting Images of the Frontier, 1820–1920 (exh. cat., ed. W. Truettner; Washington, DC, N. Mus. Amer. A., 1991)

EDWARD J. NYGREN

3. EARLY 20TH-CENTURY DEVELOPMENTS. Despite the exemplary technical and aesthetic qualities of the work of such artists as Homer, Eakins and Albert Pinkham Ryder, in the early 20th century many American artists sought to go beyond the depiction of landscape, portrait and genre scenes and looked to Europe for inspiration, not so much in deference to their European roots as from a sense that American art was still parochial and backward in comparison with contemporary European work. While a similar sentiment had already drawn such artists as Whistler, Cassatt and Sargent to Europe (*see* §2 above), a more influential figure in stimulating the growth of an indigenous modernist movement in the USA was ROBERT HENRI. When he returned to Philadelphia in 1891 from an extended European study journey, Henri found a group of young artists anxious to learn what he had absorbed of European painting movements. John Sloan, William J. Glackens, George Luks and Everett Shinn had studied art at the Pennsylvania Academy of Fine Arts and were earning their livings as political cartoonists for various newspapers in Philadelphia. They were inspired by Henri to use their journalistic instincts to record the exciting and colourful spectacle of the noisy, crowded city. With Henri they gravitated to New York, where they were joined by Arthur B. Davies, Ernest Lawson and Maurice Prendergast. Although they called themselves THE EIGHT, the group became known as the ASHCAN SCHOOL, because of their defiance of existing academic principles in ignoring classical themes and high moral messages in their work and their depiction instead of backstreets, popular entertainments and humble events in the lives of ordinary working people, as in Luks's *Closing the Café* (1904; Utica, NY, Munson–Williams–Proctor Inst.; see colour pl. XXV, 1).

With Walt Kuhn (1877–1949), who painted acrobats and circus performers in a rich realist manner, the group also instigated and organized an exhibition that radically changed the face of American art. Officially entitled the International Exhibition of Modern Art, the ARMORY SHOW was staged from 17 February to 15 March 1913 in the 69th Regiment Armory in New York. Comprising more than 1600 works of art by contemporary European and American artists, the exhibition had two purposes: the first was to stimulate an interest in new American painting and to create a market for it, while the second was to introduce American audiences to European modernism. It was for its pursuit of this second aim that the exhibition was most memorable, as the introduction of the work of the Impressionists, Post-Impressionists, Fauves and Cubists to unprepared American audiences almost caused riots, and conservative critics ridiculed in particular the works of Matisse (1869–1954) and *Nude Descending a Staircase No. 2* (1912; Philadelphia, PA, Mus. A.) by Marcel Duchamp (1887–1968). Selections from the exhibition moved on to Chicago and Boston, where the criticism was even more strident.

After the Armory Show ALFRED STIEGLITZ, who had earlier opened his 291 (*see* ⟨TWO NINETY-ONE⟩) or PHOTO-SECESSION gallery in New York to fight conservatism in American photography, assumed the mantle of defender of all that was new and exciting in the visual arts. He exhibited work by the Americans John Marin and Max Weber, who had studied abroad and absorbed Cubist,

Futurist and primitivist methods, and he also showed work by such Europeans as Brancusi (1876–1957), Matisse, Cézanne (1839–1906) and Picasso (1881–1973). The gallery became a meeting-place for artists sympathetic to the modernist ideal, who were venerated by Stieglitz. His magazine *Camera Work* defended all new artistic currents and began to educate a small but sympathetic audience. Although his difficult manner sometimes led to arguments, even with artists whose work he exhibited, Stieglitz was undoubtedly the single most important influence on the advent of modernism in American art, and he helped establish the careers of Arthur Dove (1880–1946), Charles Demuth (1883–1935) and Marsden Hartley (1877–1943), and Georgia O'Keeffe (1887–1986), whom he later married.

BIBLIOGRAPHY

D. Tashjian: *Skyscraper Primitives: Dada and the American Avant-garde, 1910–1925* (Middletown, CT, 1975)
B. Rose: *American Painting* (London, 1980)
A. A. Davidson: *Early American Modernist Painting, 1910–35* (New York, 1981)
The Advent of Modernism: Post-Impressionism and North American Art, 1900–1918 (exh. cat. by P. Morrin, J. Zilczer and W. Agee, Atlanta, GA, High Mus. A., 1986)

HENRY T. HOPKINS

IV. Sculpture.

1. The Colonial period to *c.* 1850. 2. *c.* 1850 to 1914.

1. THE COLONIAL PERIOD TO *C.* 1850. During the 17th and 18th centuries American sculpture was predominantly produced by craftsmen: indigenous stonecutters satisfied the steady demand for burial markers, and local wood-carvers decorated everyday objects (see colour pl. XXVI, 1). The earliest gravestones, made principally from slate, were low in relief and modest in design, with a mere inscription forming the overall composition. Later, intricate geometric and floral motifs were superseded by a variety of symbols of death, such as crossed bones, skeletons, hour-glasses and winged souls' heads, but the most significant innovation was the portrayal of the deceased. As stonecutters experimented with a wider selection of materials and developed a facility in carving them, they were able to gratify the increasing worldliness of the colonists and the consequent desire for more elaborate and less grim imagery. Nevertheless, it was not until the beginning of the 19th century that the quality of the tombstones was elevated to a fine art by American sculptors whose awareness of sophisticated European works helped foster the transformation.

For wood-carvers, too, the social, religious and economic character of the first 100 years in the colonies offered little opportunity for ornamentation of a high style and on a grand scale. They confined their efforts to incising shallow geometric and floral patterns on utilitarian boxes and other items of furniture that they made. In time figurative sculpture found expression in shop signs, ships, bureau bookcases and chest-on-chests. The most versatile of these craftsmen were Simeon Skillin sr and his sons John Skillin and Simeon Skillin jr. Samuel McIntire was equally talented, especially in architectural and furniture decoration, but he had less command of figuration. Of all the wood-carvers of the late 18th century and the early 19th, it was William Rush who best exemplified the

transition from artisan carving ship figureheads (see fig. 15) to sculptor. His experience of clay modelling was the key to his achieving a confident air in his portraiture in plaster and terracotta, a medium rarely chosen by American

15. William Rush (attrib. to): carved figurehead of *Pocahontas*, polychromed pine, over life-size, *c.* 1800–20 (Sharon, MA, Kendall Whaling Museum)

sculptors. Further, the natural ease of his rendering surpassed the typically stiff handling of his fellow carvers. His life-size, pine *George Washington* (1815; Philadelphia, PA, Indep. N. Hist. Park) demonstrates this mastery of wood and reflects his knowledge and assimilation of English late Rococo statuary.

While many aspiring sculptors at the turn of the 19th century had access to books, engravings and plaster casts of Greek and Roman sculpture, it was the War of Independence that served as perhaps the single most important stimulus for these artists by creating an immediate need to commemorate the new national heroes with portrait busts and statues. The paucity of native sculptors qualified to supply marmoreal tributes was exposed, and orders were awarded to foreigners. The enormous publicity surrounding the marble statue of *George Washington* (1788; Richmond, VA, Capitol Bldg) by Jean-Antoine Houdon (1741–1828), who actually travelled to the USA to sketch the General, and those (also in marble; unveiled in Raleigh, NC, in 1821; destr. 1830) by Antonio Canova (1757–1822) and that (1826; Boston, MA, Capitol Bldg) by Francis Chantrey (1781–1841) had a telling effect on young Americans who dreamt of major commissions.

It became clear to Horatio Greenough, Hiram Powers and Thomas Crawford, the leading figures of the first generation to adopt Neo-classicism, that extensive travel was essential to compete with the finest sculptors of the era and to escape from provincialism. The prevailing attitude in Europe that a period of study in Italy was fundamental to a sculptor's education had a massive impact in the USA. Between 1825, when Greenough left Boston, and c. 1875, if a sculptor did not stay at home—as did John Frazee (1790–1852), Erastus Dow Palmer (though the latter did have a sojourn in Europe in the mid-1870s), Clark Mills (1815–83) and William Rimmer—Rome or Florence was the destination necessary for the training, practice and cultural enrichment of countless American artists, many of whom remained abroad permanently.

In Italy they found a conducive artistic milieu, in which studios were readily available, marble was plentiful and skilled marblecutters were indispensable assistants. Like most 19th-century sculptors, Greenough relied on portrait busts to support himself (see colour pl. XXVI, 2), but he and others preferred literary, mythological, religious or historical themes. His masterpiece, installed in the US Capitol Rotunda in 1841, was the monumental seated marble *George Washington* (1832–41; see fig. 16), the bare chest, robe and sandals revealing how thoroughly steeped in classicism Greenough had become. The American public, however, received it poorly, being ill-prepared for so Olympian a reference and preferring their heroes to be shown less grandly.

The delicate balance between satisfying typical middle-class taste and illustrating narratives that reflected the sculptor's lofty ideals was achieved by Hiram Powers in his internationally acclaimed life-size standing marble figure, the *Greek Slave* (c. 1843; see POWERS, HIRAM, fig. 1). Although a few condemned the figure's nudity, Powers succeeded in ensuring that the rendering of the pathetic story of the slave being held captive by the Turks militated against a prurient response. For the rest of the century,

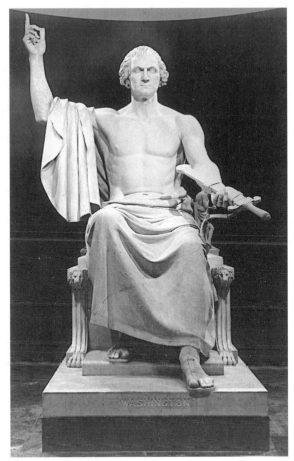

16. Horatio Greenough: *George Washington*, marble, 3.45×2.59×2.09 m, 1832–41 (Washington, DC, National Museum of American History)

similar judgements were delivered by a puritanical society: nudity was acceptable if justified by the context.

2. c. 1850 TO 1914. A second generation of Neo-classical sculptors settled in Italy between c. 1850 and 1875 and was far more numerous, including Richard Greenough, William Wetmore Story, Harriet Hosmer, Emma Stebbins, William Rinehart (1825–74), Randolph Rogers and Larkin Mead (1835–1910). Frequently Victorian in spirit and mood, the work of these artists bore little relation to the urgent political and social issues of slavery, the preservation of the Union and the Civil War. The sentimental content of much of the sculpture lacked the force of its antecedents and was matched in its decline by the Neo-classical style itself, which was being emasculated and replaced by a vigorous naturalism.

By the second half of the 19th century, patrons wanted greater realism in their sculpture, in the form of either portrait busts or monuments in public parks and squares. For outdoor statuary bronze was more suitable than stone, as it easily survived the harsh North American climate, was lighter and reflected contemporary stylistic changes. Henry Kirke Brown (1814–86), Clark Mills, Thomas Ball, Anne Whitney (1821–1915), Launt Thompson (1833–94),

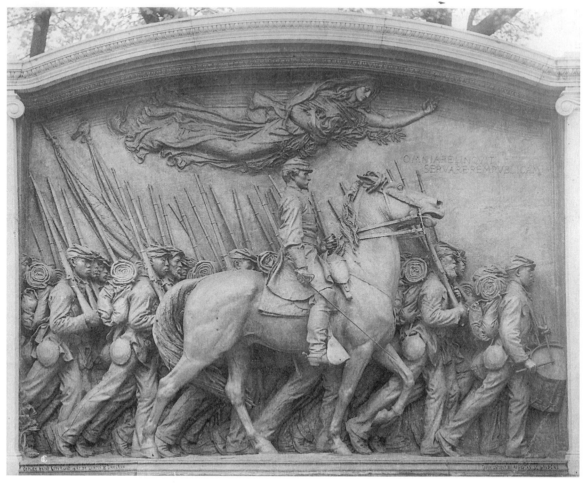

17. Augustus Saint-Gaudens: *Colonel Robert Gould Shaw* (1884–97), bronze relief, 3.35×4.27 m, Boston Common, Boston, Massachusetts

George Bissell (1839–1920) and Martin Millmore (1844–83) were transitional figures using bronze; they presented their subjects with a straightforward and accurate, if not always exciting or even memorable, execution. JOHN QUINCY ADAMS WARD belongs in this period of objective naturalism, although his later works in particular are more animated and endowed with a keener psychological insight than those of his contemporaries.

Plaster was explored for its inexpensiveness rather than for its inherent properties by John Rogers, who was acclaimed for his statuette groups depicting genre scenes of American life (for illustration *see* ROGERS, JOHN). These were so popular that Rogers sold thousands of plaster copies by mail order. The Civil War was a source for many of his pieces, and after 1861 it provided a powerful inspiration for innumerable artists. In fact AUGUSTUS SAINT-GAUDENS and DANIEL CHESTER FRENCH, his Yankee compatriot, are remembered not least for their monuments and memorials celebrating Civil War heroes. Saint-Gaudens's portrayals of *Admiral David Glasgow Farragut* (1876–81, New York, Madison Square Park), *Abraham Lincoln* (1884–7, Chicago, IL, Lincoln Park; 1897–1906, Chicago, IL, Grant Park), *General William Tecumseh Sherman* (1892–1903, New York, Grand Army

Plaza) and *Colonel Robert Gould Shaw* (see fig. 17), and French's versions of *Abraham Lincoln* (e.g. seated marble figure for the Lincoln Memorial, 1914–20, ded. 1922; Washington, DC; see colour pl. XXVIII, 2) are unmistakably American in content despite bearing the stylistic imprint of mid- to late 19th-century French sculpture. During the late 1860s several American sculptors, including Saint-Gaudens and Olin Levi Warner, understood that Paris had replaced Rome and Florence as the city where the most rigorous artistic instruction could be obtained. The prestige attached to residing in Paris, enrolling in the Ecole des Beaux-Arts and exhibiting in the annual Salons was so pronounced that it gave enterprising sculptors a distinct advantage on their return home in gaining commissions over those lacking in Parisian experience.

The flickering and lively surfaces that Saint-Gaudens and Warner learnt to use in their bronze portrait reliefs (for illustration *see* SAINT-GAUDENS, AUGUSTUS and WARNER, OLIN LEVI), or that Frederick William MacMonnies lavished on his picturesque, decorative and highly expressive bronze groups, such as *Bacchante and Infant Faun* (1893; New York, Met.; see colour pl. XXVII, 1), were not the only elements adapted from the French for American consumption. These three and such other

sculptors as Frederic Ruckstull (1853–1942), Francis Edwin Elwell (1858–1922), Herbert Adams (1858–1945), Charles Grafly (1862–1929), George Grey Barnard, Paul Wayland Bartlett (1865–1925) and Karl Bitter (1867–1915), all of whom worked in the richly modelled, spontaneous and seemingly unlaboured manner that came to be known as the Beaux-Arts style, also imported ideas on the teaching of sculpture, implementation of studio systems, expansion of foundries and the establishment of organizations, exhibitions and collaborative projects for the display of their art.

Figurative French-derived sculpture was the dominant strain for the last quarter of the 19th century and was carried over into the early 20th century with offshoots as dissimilar as works reminiscent of Auguste Rodin (1840–1917) and a virtual school of 'cowboy and Indian' themes, executed with a French-influenced technique. Frederic Remington (see colour pl. XXVIII, 1), Cyrus Dallin (1861–1944), Charles M. Russell and Hermon Atkins MacNeil (1866–1947) captured a nostalgia for the American frontier in their bronzes and implied that a unique facet of the nation's life had been lost forever (*see* WILD WEST AND FRONTIER ART). The genteel Beaux-Arts mode survived but was sent a death knell by the convulsions of World War I and its aftermath, which quickly made artists of a traditional vein seem antiquated. In its place, a modern art was being born that reflected the dynamism of the by this time firmly industrialized, internationalized and urban-centred USA.

BIBLIOGRAPHY

L. Taft: *The History of American Sculpture* (New York, 1903, rev. 1924)
W. Craven: *Sculpture in America* (New York, 1968, rev. Newark, DE, 1984)
200 Years of American Sculpture (exh. cat. New York, Whitney, 1976)
G. B. Opitz: *Dictionary of American Sculptors* (Poughkeepsie, 1984)
C. Rubinstein: *American Women Sculptors* (Boston, MA, 1990)

KATHRYN GREENTHAL

V. Interior decoration.

The surviving examples of American interiors are to be found mostly in museum re-creations that use rooms salvaged from historic houses, which are then furnished in the appropriate manner. For early interiors these re-creations are based on information gleaned from inventories and literary records or adapted from European sources. In the USA, unlike France and England, few early interiors survive with their original setting and contents, and there is little other visual evidence for interior decoration in the early years of the colonies. Museums where room re-creations can be seen include the Metropolitan Museum of Art and the Brooklyn Museum of Art, both in New York, the H. F. Du Pont Winterthur Museum in Delaware and the American Museum in Britain at Claverton Manor, Bath.

1. Before 1730. 2. 1730–90. 3. 1791–1830. 4. 1831–1914.

1. BEFORE 1730. In the 17th century American houses were usually relatively simple structures. Few grand houses were built, and these were probably furnished in the manner of their English models, but little survives of their interiors. More typical were clapboard, brick or stone houses divided into a few rooms by panelling made of simple vertical boards, very much like 15th-century northern European dwellings. The exterior walls of these rooms were finished with whitewashed plaster and punctuated by small windows with diamond-shaped panes set in lead frames. The structural beams that formed the framework of the house were visible in each room, and the ceiling was usually made up of the floorboards of the upper storey, as seen in the Thomas Hart Room, Ipswich, MA (before 1674; reconstruction, New York, Met.; see colour pl. XXIX, 1). The overall appearance of these rooms was not very different from the simple, functional interiors of medieval European houses.

The amount of furniture in early rooms has been disputed and obviously varied, though some inventories suggest that there was very little. As in Europe in this period, rooms were multipurpose, with beds a feature of almost every one. The other furniture, generally made of oak and embellished with motifs of Classical or Renaissance derivation, consisted of blanket chests, cabinets, cupboards for display as well as storage, small and large tables, chairs and stools. The furniture made by Colonial craftsmen was based on English provincial models rather than on the more fashionable Baroque styles that had been introduced in London by 1650. Candles were a common source of light and were preferred by those who could afford them to the oil lamps (now known as Betty lamps), which were easily supplied with fuel from fish oils. In the simple home, ceramics included basic, functional earthenware along with decorative tin-glazed wares from England, the Netherlands, Italy and Spain. Archaeological excavation has also uncovered stoneware of German origin and even a few pieces of Chinese porcelain. Metalware included pewter, brass and silver, some of which was produced locally. The silver that was produced in Boston and New York in the 17th century is conservative in design, mostly following English examples. Early room descriptions suggest that the simple furnishings and panelling were occasionally enlivened with japanning, which first became popular in the 1670s and was particularly favoured in Boston and New York.

A few textiles would have been found in these interiors, including plain curtains attached to poles by rings sewn on tapes, cupboard cloths, and cushions of plain woollen fabric, needlework or imported turkeywork. The most conspicuous, and often the most valuable items listed in inventories, would have been bed-hangings and coverlets. Most of these textiles would have been home produced from wool, linen or a mixture of the two known as linsey-woolsey, but costly silks, chintzes and embroideries were occasionally imported. Bedrugs were popular throughout the 17th and 18th centuries; they were made of heavy canvas through which strands of wool were pulled to form loops or cut pile.

Carpets were used on tables and cupboards but not on floors, which were generally bare. Where Dutch influence was strong, the floor was sanded and the sand swept into patterns. The existence of Colonial portrait painters and the availability of prints based on paintings suggest that, at least in some interiors, pictures were to be found on the walls.

A change in fashion is discernible at the end of the 17th century, when such interiors as the Wentworth Room (*c.*

1690; reconstruction, New York, Met.; see fig. 18) in Portsmouth, NH, began to reflect the William and Mary style. More emphasis was placed on elaborate ornament and fine craftsmanship. The profusion of design books, illustrating objects and interiors, that appeared in Europe at the end of the 17th century left its mark on American rooms. An interest in Classical design was demonstrated in room panelling that was made of wood but modelled on Classical stonework. One likely source of inspiration for the panelling and the bold mouldings around chimney-pieces was the work of the Huguenot designer Daniel Marot the younger (1695–1769). In more elegant interiors the panelling was stained, painted in stone colours or, in rare instances, marbled. Ceilings were usually plastered; when the beams showed they were often cased in panels cut in the same patterns as the wall panelling. Larger houses were built on a central plan, with a central hall and an elegant staircase, and the use of rooms became more specialized: the kitchen, for example, was separated from the living quarters. Many different activities—eating, entertaining and sleeping—still took place in the same room, and special forms of furniture, such as trestle tables, gate-legged tables and chair-tables, were devised to save space and to fulfil several functions.

Greater elegance was a factor in every aspect of room decoration. Comfort was provided by upholstered day-beds and wing-chairs, and, to complement the classicism of the panelling, furniture design became more refined and ornate, often emulating London fashions rather than the provincial models that had been used earlier. If not japanned, surfaces could be painted to look like japanning, veneer or grained wood. Curtain styles became more elaborate and included festoons similar to those illustrated by Marot. Carpets continued to be used on tables not floors. Prints, portraits and, occasionally, townscapes or landscapes were hung on the walls. Interiors were lit by candles in holders that were shaped as balusters or as richly detailed classical columns.

2. 1730–90. The sixty years between 1730 and 1790 were marked by increasing affluence and ease. This, and the growing demand for intimacy, comfort and convenience, led to more elegant interiors. Few, if any, Colonial houses rivalled the English country house in size; they compared instead with English merchant homes of the same period. Many of the interiors, however, were just as well appointed as those in Europe—inventories of the grander American houses testify to that. They contained a great profusion of objects for eating, drinking and writing, and at the same time rooms came to be used for more specific purposes. Another trend was towards regionalization: Boston, New York, Philadelphia and Newport, RI, developed their own tastes, while in Connecticut, which was more conservative, the Queen Anne style in furniture persisted until the 19th century. In rural areas many householders retained the customs of their Dutch, German and Scandinavian ancestors, preferring simple, heavy furniture with painted decoration to more fashionable styles. (see colour pl. XXIX, 2)

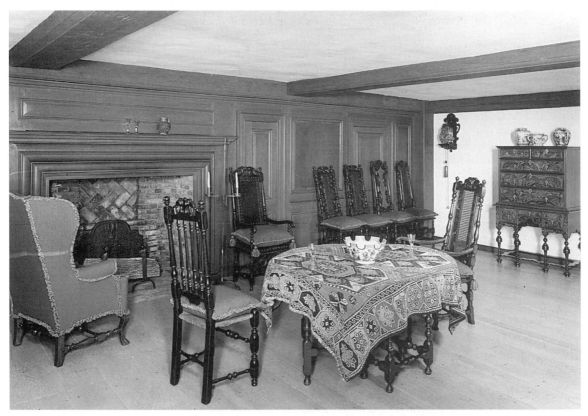

18. Wentworth Room, from Portsmouth, New Hampshire, c. 1690 (New York, Metropolitan Museum of Art); reconstruction

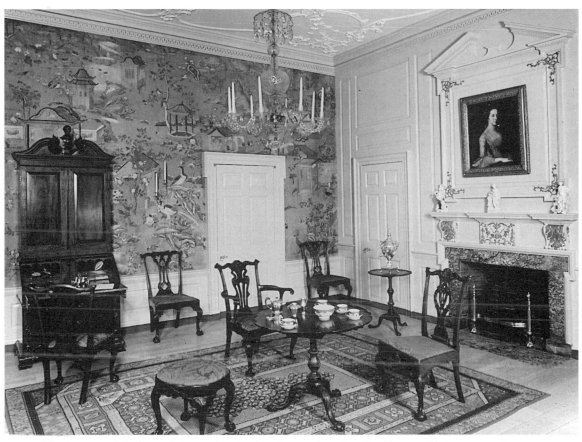

19. Powel Room, from Philadelphia, 1765–6, remodelled 1769–71 (New York, Metropolitan Museum of Art); reconstruction

In sophisticated homes new influences became apparent. The Palladian style, which was introduced in England in the 1720s, reached America through architectural handbooks, including that of William Kent (1685–1748); these provided suggestions for the treatment of windows, doors and chimney-pieces. The European taste for Rococo and chinoiserie also extended to America. Chinese goods, including wallpaper, porcelain and lacquer panels, were imported via England from the mid-18th century, and Chinese influence can be seen in locally made furniture and porcelain.

Panelling design continued to be based on Classical stonework, but mouldings became smaller in proportion, and colours that were not associated with stone or wood, such as pink, tan, green and blue, were introduced to paint the woodwork. Some clients and builders preferred simple surrounds and delftware tiles for fireplaces, while others chose designs from handbooks. Wallpapers were introduced, in floral patterns inspired by painted cottons or with chinoiserie scenes. Many were simply painted or printed, but flock was not unknown; some were locally made, others imported.

An ever-increasing number of furniture forms appeared: the tea-table became popular as tea-drinking became a social ritual, and a number of tables, desks and chests for varied purposes were introduced. Mirrors and longcase clocks were elegant embellishments to an affluent interior.

Upholstery became more widely used on chairs and settees, but the finer fabrics were still imported and therefore expensive. Plain, strong colours—reds, blues, greens and yellows—were preferred, and the curtains would often be in a matching fabric. Printed cottons became fashionable in the mid-18th century, and chintz reproductions of Indian calicoes were imported from England. Crewelwork and flamestitch embroidery was popular for beds. Candles continued to be the favoured source of lighting; although metal was more common, ceramic holders were to be found.

In the 1760s greater flamboyance in design was introduced as the Rococo entered its second phase. Essentially the change was not radical since it involved the same combination of Classical and chinoiserie elements, but more relief ornament was employed on furniture, wall decoration and decorative objects. This taste, which can be seen in the Powel Room (built in Philadelphia, 1765–6; remodelled 1769–71; reconstruction, New York, Met.; see fig. 19), became fashionable at the same time that Thomas Chippendale's *Gentleman and Cabinet Maker's Director* (London, 1754) brought new furniture designs to the American colonies. Other architectural handbooks published in London in the mid-18th century, for example those by Batty Langley (1696–1751) and Abraham Swan (*fl* 1745–68), provided ideas for architectural details, mainly chimney-pieces and doors. Although American craftsmen

were able to do the elaborate carving, records show that mouldings were sometimes ordered from London.

Americans did not follow Chippendale's book as closely as Londoners, but they did enjoy its suggestions for greater and more obvious elegance, and they achieved the desired effects in rooms by adding the appropriate embellishments. In furniture design, however, Americans were conservative. While chair forms, at least in part, were inspired by engravings in the *Director*, such pieces as the tallboy, which was not included in the *Director* because it had gone out of fashion in England, continued to be popular in the colonies. In fact, 'Chippendale' is simply the popular name for the style that is the American equivalent of the Rococo and a version of what is known as Georgian in England. Even the colours are related, featuring the same pastel palette, slightly greyed, that was used in England between 1760 and 1790. Wallpaper patterns reflected this more elaborate Rococo style by including complex designs in which architectural elements were used in surprising juxtapositions. Also, with the greater demand for chinoiserie, Chinese landscapes became an increasingly popular subject for papers.

3. 1791–1830. In design, the Federal era was marked by a preference for classicism that was characterized at first by its delicacy and later by a grander, heavier look (*see* FEDERAL STYLE). In the early work the influence of English designers, led by Robert Adam (1728–92), is discernible. Later it was French designers, particularly Charles Percier (1764–1838) and Pierre-François Fontaine (1762–1853), whose influence was important. Other fashionable stylistic elements of the period derived from Napoleon's Egyptian campaign of 1798–1802, which inspired the Egyptian designs popularized in England by Thomas Hope (1769–1831), and from the opening of direct trade between the USA and East Asia in the 1790s, which stimulated a renewed craze for chinoiserie.

Neo-classicism came into fashion in the USA several decades after its advent in England and France, its arrival coinciding with the publication in London of the popular furniture design books of George Hepplewhite (1788) and Thomas Sheraton (1791). The new style was characterized by a Classical Revival in which the ornament was directly inspired by Greek and Roman decoration, but the forms were adapted to 18th-century taste. This decoration was delicate and flat or in low relief, and it was in the decoration rather than the plan that the American house of the Federal era differed from what had been popular earlier. However, there were more big houses and more rooms segregated for such specific purposes as dining, sewing, reading, or music (see colour pl. XXX). Bedrooms now received special attention, with elaborately dressed toilet-tables and beds.

The introduction of mass-production techniques transformed interior design. Bands of ready-made decoration were available for furniture and silver; classical architectural trim could be bought by the yard, moulded rather than carved; wallpaper became cheaper due to technical advances and therefore more widespread; and the introduction of the Jacquard loom brought down the price of textiles and allowed windows to be extravagantly draped.

Furniture of the period before about 1815 was made with the same delicacy as before, but the decoration was flatter. Veneers and inlays were used to emphasize surfaces, and carving, if present at all, was generally in lower relief. For the newly fashionable dining-room, cabinetmakers designed tables to stay open in the centre of the room. They were supported by either a pedestal or by straight legs; in the case of the latter, the tables were made up of separate units that could be added when needed or used independently as side tables. The sideboard with ample storage space was a new form introduced by English furniture design books. All around the house there was an increasing number of small tables with a single drawer or a set of drawers. For furnishing textiles cotton became more popular, as did horsehair. The small sprigs and stripes of the late 18th century were gradually replaced by bolder versions of these patterns and by medallion designs. Similarly, light colours were followed by strident reds, yellows, greens and blues.

Decorative objects reflected the same taste for delicate, classical design. Lighting was brighter as chandeliers were used more widely, and a variety of oil lamps offering brighter light than candles was introduced. An oil lamp with special construction to provide a draught and so increase the light was patented by the French inventor Louis Argand. Silver design tended to be restrained, with elegance achieved not in decoration but through form, inspired, at least in part, by ancient models. Carpets became more popular in the Federal era, but oriental patterns were less fashionable than classical ones. Contemporary paintings of interiors often show boldly patterned carpets or painted floor cloths covering the entire floor or, more simply, floors stencilled or painted in overall patterns.

Around 1815 interior decoration shifted from delicacy to monumentality. The second phase of the Federal style, which is commonly called the Empire style, was clearly the result of French influence, but this could have come through London as well as directly through Paris. In architecture the equivalent of the Empire style was the Greek Revival: both styles had political implications for the newly independent nation, and it was no accident that the main source of influence became France rather than England. The Greek Revival was most important between 1825 and 1860, when houses were built on a grander scale, with high-ceilinged rooms finished with elegant but heavy and simple classical trim. It appears, however, that the new fashion was introduced first in objects. The pattern-books and magazines that were influential in the USA showed people in the latest Empire clothing sitting on chairs in the same taste, but architects and builders did not respond to this trend for a while. The first furniture-makers to follow the more monumental style were such French emigrants as Charles-Honoré Lannuier who embellished their work with handsome gilt swans, caryatids and eagles (for illustration *see* LANNUIER, CHARLES-HONORÉ). Silver design was influenced further by the publications of collections of ancient Greek and Roman works as well as by designs made for the court of Napoleon. This second phase of classicism was characterized by heavy forms and very prominent, large-scale decoration, as evident in ceramics as it was in metalwork. The first interiors in the new style were strikingly simple

in detail, with several of the most notable examples reflecting the influence of English Regency architects. Large rooms with bold classical detailing were characteristic. Doors might be crowned with pediments, and in the ceilings there were elaborate plaster rosettes from which were suspended chandeliers. The ideal mantelpiece was white or black marble, either very simple or with carved caryatids supporting the shelf. Scenic wallpapers were popular because they were considered to be in the spirit of ancient Roman mural decoration.

4. 1831–1914. The commonly held view that 19th-century design was eclectic and unimaginative is unfortunate. There was indeed a tendency all through the period to exploit tradition and seek inspiration in historic styles, but there were also changes in approach. The manner in which early design was used varied, as did the eras or areas that provided inspiration: it is possible to see a succession of revivals in which ancient, medieval, Renaissance and Rococo models were adapted to 19th-century use. This was encouraged by the growing number of interior decorating firms. By the last quarter of the century designers had divided into two camps. There were those dedicated to reform, architect-designers whose work lay at the foundations of the Modern Movement, and those whose work in historic styles, until closely inspected, bears at first sight a convincing resemblance to its models. It is possible therefore to trace historicism and reform as parallel trends. This was a period of great social advancement, which naturally had an impact on interior design. The growth of an affluent middle-class market was accompanied by increasing demands for comfort and style in the home. Mass production encouraged a proliferation of ornate furniture and decorative knickknacks; the development of interior springing transformed the role of upholstery; the invention of aniline dyes introduced brighter, harsher tones to vie with the prevailing dull greens, reds and browns; and by the 1870s such modern conveniences as gas lighting and central heating were widespread. It must not be forgotten, however, that away from the affluent urban centres there was a very different approach to home life. The SHAKERS were the most extreme proponents of rural simplicity (see colour pl. XXXI, 1), but until the 1860s many country interiors were sparsely decorated with locally made textiles and boldly painted furniture and ceramics. At the end of the century this folk art and other vestiges of Colonial life, including Spanish influence in the Southwest, provided inspiration for designers who sought alternatives to European historicism.

Although Greek Revival was considered particularly appropriate to public buildings, it was also used freely for domestic architecture. The leading practitioner of the style was Alexander Jackson Davis, who frequently took overall control of interiors and furnishings as well as exteriors. Grand, temple-like porticos gave access to a central hall off which the main rooms were symmetrically arranged. Double parlours on one side and a dining-room and library on the other constituted a particularly popular ground-floor plan. The rooms were high-ceilinged with heavy classical detailing in the form of cornices, pilasters and architraves. The furniture was equally imposing and char-acterized by bold shapes, particularly large-scale pillar and scroll motifs.

A reaction against the Greek Revival inspired more romantic designs in the 1840s. The Italianate villa, based on 16th-century Tuscan prototypes, was introduced, though it was rarely Italian on the inside, and the picturesque Gothic villa was popularized by A. J. Downing's books *Cottage Residences* (1842) and *Architecture of Country Houses* (1850). Both these styles allowed for more freedom in internal planning than the Greek Revival. The pointed arch and tracery of Gothic architecture were used as motifs to embellish furniture, and in some instances walls and ceilings were decorated with similar Gothic elements. The most extreme reaction against classicism can be seen in the extravagantly curved and ornamented Rococo Revival furnishings of the 1840s to 1860s (e.g. the Richard and Gloria Manney Rococo Revival Parlour by JOHN HENRY BELTER, *c.* 1852; reconstruction, New York, Met.; see fig. 20). These historical styles were sometimes associated with certain rooms: the Gothic with the library, for example, and the Rococo with entertaining. The severe and classical lines of a Greek Revival room could be modified to a Gothic or Rococo concept by the addition of the appropriate wallpaper, mantelpieces and furniture. Ingrain carpeting, made to cover the entire floor, was available in detailed Rococo or classical patterns; but 'Brussels' pile carpeting with scroll patterns and floral motifs was also favoured for Rococo interiors.

In the 1860s a renewed burst of French influence in the USA brought flatter ornament in incised linear patterns to replace the relief decoration on chimney-pieces and door surrounds; sometimes the woodwork was stained rather than painted. The straight lines of this Renaissance Revival are to be found on furniture as well, but a close look at objects reveals a fascinating juxtaposition of Neo-classical and Renaissance motifs. The larger furniture manufacturers provided sets of furniture in a particular style, but in the grander homes there tended to be a mixture of styles. This can be seen in the portrait of the *Brown Family* (priv. col.) by Eastman Johnson, where the furniture is in several styles to suggest wealth over a long period.

The publication in London in 1868 of *Hints on Household Taste* by Charles Locke Eastlake (1836–1906) introduced a new approach to design that was soon adopted in the USA (*see* EASTLAKE STYLE). After 1875, rather than reviving historic styles, designers began to use historic motifs in distinctively different designs, embellishing rich, elegant interiors with exotic decoration. Although Eastlake had followed William Morris (1834–96) in advocating reform and a return to the functionalism of medieval design, designers who seemed to base their work on his suggestions for new forms embellished them in ways he detested, resulting in a rich eclecticism. In New York several cabinetmaking establishments expanded their businesses to include decorating and took on the responsibility of providing everything necessary for the interior. In 1879 Louis Comfort Tiffany (*see* TIFFANY, §2) and CANDACE WHEELER were two of the founder-members of the Louis C. Tiffany & Associated Artists, a decorating firm that created Aesthetic Movement interiors. Christian Herter and Potier & Stymus were two of the most prominent firms to offer furnishings carefully selected from a variety

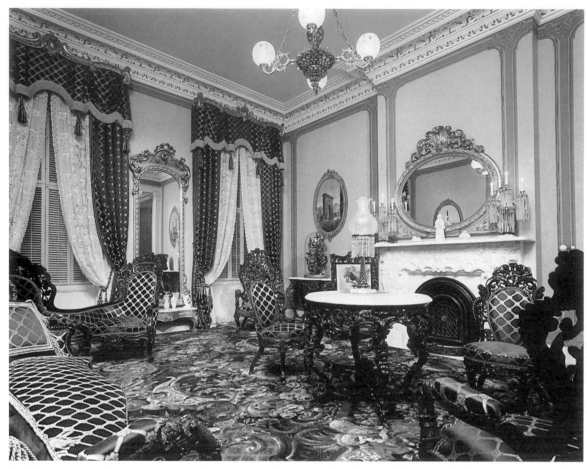

20. Richard and Gloria Manney Rococo Revival Parlour by John Henry Belter, New York, *c.* 1852 (New York, Metropolitan Museum of Art); reconstruction

of sources, and in parlours designed by them old and new were tastefully combined. While the lines of furniture were restrained, inlays, painting and gilding were popular. By the 1880s the use of elegant antiques or finely made furniture in 17th- and 18th-century styles began. The interiors of elegant homes were embellished with exotic patterns on the walls as well as in the designs of the objects that filled the rooms (see fig. 21). Tapestries for period interiors were supplied by such studios as that of William Baumgarten (*see* §XII, 3 below).

At the turn of the 20th century, when the Arts and Crafts Movement flourished, such designers as Gustav Stickley began to produce simple oak furniture. Amateur cabinetmakers were encouraged to imitate the style with the aid of such publications as Stickley's *The Craftsman*, a magazine that was published monthly from 1901 to 1916. The magazine, which had great appeal among the reform-minded, reported on adventurous European designs and reviewed Art Nouveau exhibitions, although Americans did not use that style to any great degree. It was the ARTS AND CRAFTS MOVEMENT that inspired the foundation of a few magazines specifically focusing on home decoration (see colour pl. XXXI, 2): *House Beautiful* (est. 1896) and *House and Garden* (est. 1903) were started as publications

advocating reform in design and continued to reflect popular taste in the late 20th century.

Also at the beginning of the 20th century traditionalists became somewhat more aware of authentic historical design, and they introduced furnishings that combined original period work with their own designs in the spirit of the 16th century to the early 19th. In such houses as the Breakers, built for Cornelius Vanderbilt in Newport, RI, by Richard Morris Hunt, the mixture of old and new works so well that there is sometimes confusion in distinguishing what was designed specifically for the house. The grander town houses of *c.* 1900 were designed in the Georgian style, but country or suburban houses were more frequently made classical by exploiting American antecedents, a style generally called Colonial Revival, even when the model was a late Federal style house. In each variation equal attention was devoted to the decorative and functional aspects, and houses were equipped with the latest conveniences to make living comfortable. Servants' quarters were done simply but efficiently, whereas reception rooms and those reserved for the family were decorated in the appropriate styles. Such architects as H. H. Richardson, Louis Sullivan and Frank Lloyd Wright led the reform trend in interiors (see fig. 22), which would have such as

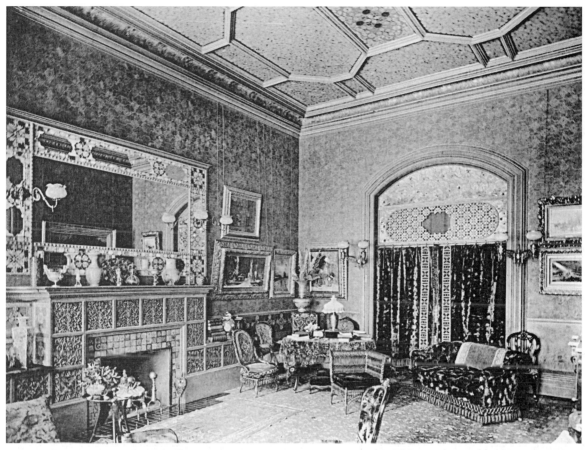

21. Mr J. Taylor Johnston's parlour, New York, early 1880s; from *Artistic Houses* (New York, 1884)

impact on the rest of 20th-century design, while Richard Morris Hunt and McKim, Mead & White head the list of traditionalists.

BIBLIOGRAPHY

A. J. Downing: *Cottage Residences* (New York, 1842)
——. *Architecture of Country Houses* (New York, 1850/R 1969)
H. H. Holly: *Dwellings in Town and Country* (New York, 1878)
E. Wharton and O. Codman: *The Decoration of Houses* (New York, 1897)
R. R. Meyric: *American Interior Design: The Traditions and Development of Domestic Design from Colonial Times to the Present* (New York, 1947)
M. D. Schwartz: *American Interiors, 1675–1885: A Guide to the American Period Rooms in the Brooklyn Museum* (New York, 1968)
H. L. Peterson: *Americans at Home: From the Colonists to the Late Victorians: A Pictorial Sourcebook* (New York, 1971)
W. Seale: *The Tasteful Interlude: American Interiors through the Camera's Eye, 1860–1917* (New York, 1975)
E. De Noilles Mayhew with M. Myers jr: *A Documentary History of the American Interior* (New York, 1980)
R. Bishop and P. Coblenz: *American Decorative Arts: 360 Years of Creative Design* (New York, 1982)
M. B. Davidson and E. Stillinger: *The American Wing in the Metropolitan Museum of Art* (New York, 1985)
C. Gere: *Nineteenth-century Decoration: The Art of the Interior* (London, 1989)

MARVIN D. SCHWARTZ

VI. Frames.

A distinguishing attribute of American picture frames is the extreme diversity of styles. Primarily influenced by European designs (like other American decorative arts),

American frames are a curious hybrid of many English, French, Dutch, Spanish, Italian and German styles. In spite of this cross-cultural barrage of influences from a variety of immigrant craftsmen, there has gradually emerged a basic characteristic of simplicity and strength of design. The reduction of complex ornamentation has been a common theme throughout the constantly changing styles of American frames. This process of simplification also appears in the altering of the profiles or shapes of the mouldings. Such an approach was possibly due to the American craftsman's desire to design a new order. It could also have been caused by the lack of strict trade guilds, which allowed for a greater latitude in patternmaking and a freedom that may have encouraged creativity. Shortage of traditional moulding profiles and gilding materials may also have furthered this tendency towards rustic approaches to framing. In rural areas, frames were often finished with common house paint. In some cases frames were marbled or grained to create a more refined appearance. The Decorative Arts Photographic Library at Winterthur, DE, the Museum of Early Southern Decorative Arts, in Winston-Salem, NC, and the International Institute for Frame Study (founded in the 1990s) in Washington, DC, are three major repositories of information on American framemakers and dealers of picture frames.

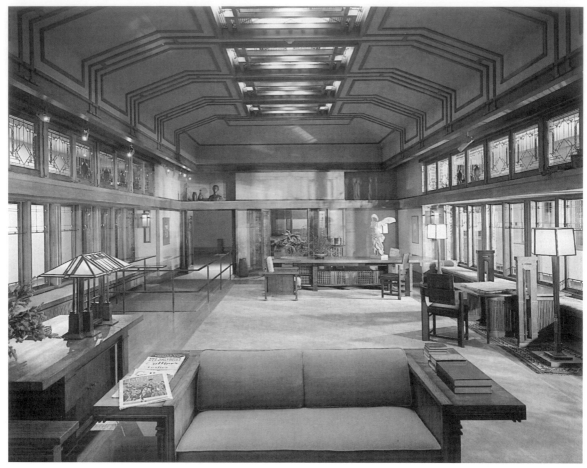

22. Living-room of the Francis W. Little House by Frank Lloyd Wright, Wayzata, Minnesota, 1912–14 (New York, Metropolitan Museum of Art)

1. Before 1776. 2. 1776–1914.

1. BEFORE 1776. Although frames created by 18th-century craftsmen in such metropolitan areas as Boston, New York and Philadelphia echo more closely the sentiments of English taste, those produced in rural areas were more idiosyncratic and naive. Many framemakers in Colonial America had been apprenticed in England or else used English patternbooks for inspiration. Thomas Chippendale's *Gentleman and Cabinet-maker's Director* (London, 1754) was an influential and widely distributed manual of the decorative arts. Although in the major cities there were a few framemakers, picture frames were usually imported or made by a local craftsman out of window or door trim. The usual method of fabrication for these early frames was to hand-gouge the wood with a variety of curved, shaped, moulding planes. Methods of joinery are often an important clue in establishing a provenance for a frame. For example, the lap-joint or mortise-and-tenon construction method usually indicates a sophisticated European training. On the other hand, the simple 45% miter cut, joined with glue and nails, is more typically found in American-made frames. The splined corner, an elaborate technique often employed on large, highly embellished, carved European frames, made use of a com-

pression joint. A piece of hardwood, tapered and chamfered, is inlaid into the back of the frame perpendicular to the mitered corner.

American framemakers in mid-18th-century Boston were considered to be inferior to and more expensive than their English counterparts. For example, the Boston selectmen were considering the purchase of a frame for a portrait of *Peter Faneuil* (Boston, MA, Mus. F.A.) by John Smibert. They stated that 'it could be got in London cheaper and better than with us'. In comparing the Rococo frames on two portraits by John Singleton Copley there is a marked difference between the frame on the painting of *Mrs John Scollay* (1763; New York, Kennedy Gals; see fig. 23) and the frame on *Mr Isaac Smith* (1769; New Haven, CT, Yale U. A.G.; see fig. 24). The profile on the earlier portrait is quite simple and consists of two flat boards that have been joined at an angle and later carved with typical foliate designs and piercing. The profile on the later portrait is an elaborately shaped deep scoop with a gadrooned sight edge. In addition to the dynamic carving of foliage and floral patterns, there is a separately carved and pierced shell at the top center indicating a more sophisticated approach than the earlier, more rustic frame. Although there is no conclusive evidence as to who made either of

23. Rococo frame on John Singleton Copley's *Mrs John Scollay*, 889×686 mm, 1763 (New York, Kennedy Galleries Inc.)

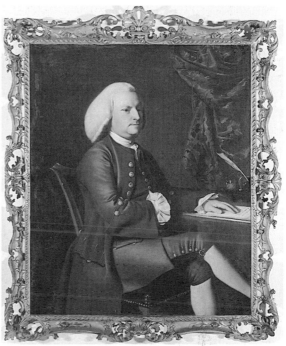

24. Rococo frame on John Singleton Copley's *Mr Isaac Smith*, 1.27×1.02 mm, 1769 (New Haven, CT, Yale University Art Gallery)

these frames, it might be surmised that the simpler, more provincial frame on *Mrs Scollay* was made by a local craftsman influenced by Chippendale's *Director* rather than a highly trained London framemaker who was bound by a strict adherence to style and form. The analysis of wood type does not yield absolute proof, however, as north-east American white pine was exported to London during the 18th century.

2. 1776–1914. After the Revolution, Americans were inclined to produce frames on a large scale in their own manufacturing facilities rather than to import them. Taste in frame styles leant towards the Neo-classical patterns that were adopted via French influence. The simple restrained elegance of the Louis XVI style profile was easily adapted to the austere Yankee mentality. Charles Willson Peale's painting of *Henrietta Margaret Hill* (1790; Winston-Salem, NC, Mus. Early S. Dec. A.) illustrates the use of the Classical ornamentation of egg-and-dart, lamb's tongue and twisted ribbonwork carved into a flat shallow profile. Peale, the first museologist in America, was adamant about frame styles chosen for clients, as evidenced by a letter he wrote in 1807 stating, 'A good picture deserves a good frame and a bad picture may sometimes preserve its place longer by having a handsome frame.' The Neo-classical taste continued into the first quarter of the 19th century, later evolving into the French Empire style of wide, deep-scooped mouldings ornamented with anthemion motifs in the corners. These were fabricated with low-relief composition or gesso putty.

Again, as in the previous century, the American penchant for design was one of simplification and reduction. In the 1830s, through the elimination of ornamentation,

mouldings that were strong and simple, yet elegant were created. In rural areas, frames were made using raised cornerblocks, and sometimes floral and foliate designs were stencilled on to the painted surface (see fig. 25). The most typical finish was to paint the frame black, although there were many regional variations that have yet to be catalogued and documented. During the 1850s, as mass

25. Raised cornerblock frame, 502×444 mm, 1830 (Washington, DC, Gold Leaf Studios)

production increased, individual expression and innovative frame designs were not typically pursued. Factories were producing larger amounts of heavily ornamented moulding, previously unavailable to the average consumer. Important centres of manufacturing fluctuated between such larger cities as Boston, New York, Philadelphia and as far south as Baltimore. Although Baltimore was by then considered to be one of the largest furniture manufacturing centres, in 1850 there were over 130 framemaking concerns in New York alone. Accelerated production created a stagnation in original designs, and the repetition of composition patterns was standard in the industry. Hand-carved frames were rare. Once a pattern was created, extrusion machines, embossing wheels and similar mass-production techniques were employed to make moulding by the length for national distribution.

Some innovations in design appeared in the 1870s. For example, a stencilling technique using glue and sand to create a textured effect similar to the patterning on a giraffe was used until the 1880s. Orientalist, Moorish, Gothic Revival and finally Renaissance Revival styles were popular during the last quarter of the 19th century. Most of these frames were constructed with composition, which allowed for a greater number to be produced. James McNeill Whistler, active mainly in England, was among the first Americans to react to the Victorian penchant for superfluous ornamentation; his frame designs were to prove particularly influential. As a popular reaction to such ornamentation, frames were often made from a simple gilded plank of oak made from quarter-sawn wood. This style of frame became popular during the last quarter of the 19th century. Thomas Eakins often used this format to frame his work (e.g. *Prof. Henry A. Rowland*; Andover, MA, Phillips Acad., Addison Gal.). For some of his portraits, he carved into the wood a design that related to the subject. On small works, he used a simple pine plank with no gilding. His use of this style of frame was caused by the ever-increasing influence of the Arts and Crafts Movement, which took hold in the USA at the end of the 19th century. Although the austerity of this approach was contrary to the opulence of the preceding generation, the simplicity appealed to the American sentiment.

Not all artists, however, used this simple type of frame. Many were inspired by the Renaissance Revival that was adopted by the architect Stanford White of McKim, Mead & White. His sphere of influence was widespread. He received many important commissions and was involved in the selection of paintings and frames for several of his clients. He was friendly with many of the leading artists of the day and often designed frames for them. Abbott Handerson Thayer, for example, used White's designs for his paintings, as they were particularly well suited to his style of idealistic realism (see colour pl. XXIV, 1). Thayer painted women as angels to complement White's tabernacle frames. These frames were sometimes made by a leading framemaking company, Newcomb-Macklin Co., which had a showroom in New York and a factory in Chicago. Their patternbooks show the wide diversity of styles available to artists and collectors alike (see fig. 26).

Arthur F. Mathews, a Californian artist and designer, made hand-carved, polychromed frames for his paintings. Many of the floral patterns carved into the frames were

26. Early modernist frame from Newcomb–Maclin Co. catalogue, 1913

inspired from such indigenous flora as orange blossoms and leaves. These images were also painted into the background of the painting, creating a harmonious and integrated combination of painting and frame. The tabernacle-style frames that he made were also polychromed and accented with an embellishment of gold leaf. These frames, often including such symbolic images as the swan, encompassed allegorical paintings and in some cases helped to convey subtle messages about the meaning of the painting. For his paintings in the Tonalist style, he created frames with subtler variations to accent the muted, somber tones.

In Boston, another Tonalist painter, Herman Dudley Murphy (1867–1945), started a framemaking concern called the Carrig-Rohane Shop, which had a wider sphere of influence than Mathews's work. Charles Prendergast (1869–1948) and Walfred Thulin (1878–1949) collaborated with Murphy to revolutionize framemaking in America. They made frames that were interpretations of European designs: hand-carved, carefully gilded and toned to harmonize with the paintings. Each frame was signed and dated on the verso. In New Hope, PA, during the first quarter of the 20th century, Frederick Harer (1880–1948) designed and carved frames in the Carrig-Rohane manner. His apprentice, Bernard Badura (1896–1986), carried on the tradition of hand-carving and gilding, with each frame carefully wrought and chromatically keyed into the painting. The designs were distinctive and innovative, often made from hand-shaped wood. They reflected the new influences of Art Deco and other Modernist architecture.

Many artists were involved with the creation of frames for their paintings. The most inventive, John Marin, handcrafted his frames with simple carving and painted the surfaces with varied colours to match the sentiment of his paintings. Marin used the frame as a device to integrate the flat surfaces of his abstract canvases with the frame, causing the viewer to see the frame and painting as one complete entity. Marin was exhibited and promoted by American photographer and art dealer Alfred Steiglitz in his 291 Gallery, along with other Modernist artists such as Georgia O'Keeffe (1887–1986), Arthur B. Davies and Lyonel Feininger (1871–1956). All of these artists were obsessed with the simplified presentation of their art work. Most of their streamlined patterns were made by framer/artist George F. Of. This second generation New York framemaker was responsible for making and designing many of the frames used by this circle of influential artists. With the advent of the Armory Show of 1914, a new era of design developed that was more restrained and austere, with the reduction of frames to a single strip of wood. The formal elements of the frames were carefully considered in relation to the paintings. Proportion, scale, texture, colour and tone were all evaluated in context with the new Modernist aesthetic.

BIBLIOGRAPHY
H. Heydenryk, *The Art and History of Frames* (New York, 1963)
——: *The Right Frame* (New York, 1964)
The Art of Charles Prendergast (exh. cat. by R. Wattenmaker, New Brunswick, NJ, Rutgers U. A. Mus.; Boston, MA, Mus. F.A.; 1968)
R. Maryanski: *Antique Picture Frame Guide* (Niles, IL, 1973)
H. Jones: *Mathews: Masterpieces of the California Decorative Style* (Santa Barbara and Salt Lake City, 1980)
Herman Dudley Murphy (exh. cat. by W. Coles, New York, Graham Gal., 1982)
W. Adair: *The Frame in America, 1700–1900: A Survey of Fabrication Techniques and Styles* (Washington, DC, 1983)
A. Katlan: *American Artist's Materials Suppliers Directory* (Madison, CT, 1987)
The Art of the Frame: An Exhibition Focusing on American Frames of the Arts and Crafts Movement, 1870–1920 (exh. cat. by S. Smeaton, New York, Eli Wilner Gal., 1988)
W. Adair: 'Picture Framing, ii: Two Exhibitions of American Picture Frames', *Int. J. Mus. Mgmt & Cur.*, ix (1990), pp. 318–22
S. Mills: 'The Framemaker's Art in Early San Francisco', *A. CA* (Nov 1990), pp. 54–9
S. Burns: *Forgotten Marriage: The Painted Tin Type and the Decorative Frame* (New York, 1991)
'Stanford White's Frames', *Antiques*, cli/3 (March 1997), pp. 448–57
S. McCoy: *Brilliance in the Shadows: A Biography of Lucia Kleinhans Mathews* (Berkeley, 1998)

WILLIAM B. ADAIR

VII. Furniture.

1. Before 1725. 2. 1725–90. 3. 1791–1840. 4. 1841–1914.

1. BEFORE 1725. During this period American furniture changed markedly both in style and construction. Colonial furniture of the mid-17th century, like its English models, was characterized by simple, heavy forms with architectural, geometric and floral decoration derived from northern European Mannerism. By the end of the century American furniture reflected the Baroque style that was then fashionable in Europe. This furniture, with its exuberant carving, turnings and elaborately veneered surfaces, is known as William and Mary style, after the English monarchs whose reign (1685–1702) brought about an influx of new ideas from the Continent.

In the early Colonial period furniture was made by local joiners who often also applied their skills to the building of houses. In the 1690s, however, with the arrival in New England of such London-trained cabinetmakers as John Brocas (d 1740), joinery gave way to cabinetmaking. Where joiners used framed panels for the sides of their case pieces, cabinetmakers fastened the solid sides to the top and bottom with dovetails. Where joiners ornamented the surfaces of their work with carving and applied geometric mouldings and half-spindles, or in New Haven with inlay, cabinetmakers applied rich veneers.

Until the mid-17th century the colonists had very few chairs with backs; instead they sat on stools or long benches called forms. By mid-century, however, three types of 'back-stools' were common: turned, wainscot and 'Cromwell'. Turned chairs were produced on a lathe and had a rush or splint seat. Instead of vertical spindles some had slats across the back, a design that originated in Germany and the Netherlands. Wainscot chairs were made by joiners. They had plank seats and solid, carved backs and were fitted with a cushion. The large oak boards from which they were made were also used for wainscoting, hence the name of the chairs. By the end of the 17th century sets of upholstered side chairs (later called Cromwell chairs after Oliver Cromwell, the Protector of England from 1649 to 1658) were found in the homes of prosperous merchants. They were usually made of maple and oak with ball-turned legs and stretchers and upholstered backs and seats. Occasionally spiral turning was substituted, particularly on chairs made in New York and New Jersey. They were upholstered in leather or brightly coloured Turkey work. Fringe or brass nails at the edges of the upholstery heightened the appearance of these chairs.

The impact of East Asian culture in England in the mid-17th century substantially altered the appearance of chairs in the William and Mary style. The elaborate carving and turning were predominantly Baroque, but the frequent use of caning and the curved backs that replaced the stiff, straight backs of 17th-century chairs were all derived from Chinese prototypes. Banister-back chairs, which were less expensive than caned ones, repeated the shape of turned back posts in half-balusters across the back. Another variation with leather backs and seats, turned legs and stretchers, Spanish feet and moulded top rails (crest rails) developed in Boston. These were imitated in other major cabinetmaking centres, notably New York and Philadelphia. Also by 1700 a new type of chair, the easy chair, with turned legs, an arched cresting and upholstered wings, became common. Associated with invalids and the elderly, these chairs were used for sleeping in an upright position. Also, day-beds or couches, fitted with a long cushion or squab, appeared for the first time.

Tables were rare in the 17th century, and only a few trestle- and chair-tables in the medieval tradition survive (see colour pl. XXXII, 1). By the end of the century gate-leg tables began to appear. By the early 18th century these tables were made of walnut instead of oak, and their turnings had become lighter and more complex. Some had gates in the shape of a butterfly supported from a single point on the stretcher. Another innovation was the toilet or dressing table (lowboy).

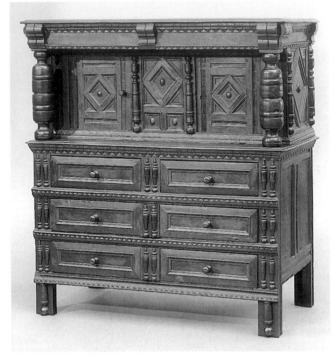

27. Cupboard, oak with pine and maple, 1.42×1.27×0.58 m, from Massachusetts, c. 1675–90 (New York, Metropolitan Museum of Art)

more serviceable drawers. When closed, the slanting lid provided a convenient lectern; when open and supported by slides or small drawers, it formed a writing surface. As merchants expanded their accounts the need for handy storage of ledgers was filled by the addition of a bookcase on top of the desk.

The splendid cupboards that graced the best rooms of many colonists' homes by the mid-17th century were used to display expensive silver, glass and tin-glazed earthenware, and so to impress visitors with the wealth of the household. The enclosed upper sections, on which a length of brightly coloured cloth was often laid, were framed by massive turned pillars; the panels were elaborately carved or, later, fielded, and further decoration was applied in the form of bosses and half-balusters. The lower sections often contained drawers (e.g. a cupboard from Massachusetts, c. 1675–90; New York, Met.; see fig. 27). By the end of the 17th century these cupboards went out of fashion and were replaced by the tallboy (highboy) as the best piece of furniture in the house. This, along with the corner cupboard, assumed the role of the cupboard as a place to display finery.

Even more valuable than the tallboy was the fourposter bed with its canopy, expensive hangings and mattresses stuffed with as much as 30 kilos of feathers. Cots, hammocks and simple, low-post frames were even more common. By the beginning of the 18th century bed rails were fastened with screws in a departure from the 17th-century practice of using mortice and tenon joints, making them easy to dismantle.

Only clocks rivalled fine beds as the greatest luxury a gentleman could own. Most clocks were imported from London. The earliest had only an hour hand: minute hands were unnecessary since clocks were not accurate to the minute. By the beginning of the 18th century longer pendulums were added to clocks that had formerly hung on the wall, and a tall wooden case was required to protect the pendulum. Although by the early 18th century American clockmakers were turning out brass works and faces in such major cities as Philadelphia and Boston, most works continued to be imported from England. Few colonists could afford looking-glasses before 1700. Virtually all the glass was imported, as were most of the frames. William and Mary style looking-glasses were usually square or rectangular with an angular cresting and ogee curves often pierced with hearts and geometric designs. The appearance of such luxury items as expensive looking-glasses and longcase clocks attested to the growing wealth of the colonists and to their desire to display that wealth through the most fashionable furniture.

Chests were also used as tables in the 17th century. They sometimes had drawers that ran on side runners and were fitted with wooden handles. The most popular form of decoration was shallow relief carving highlighted with red, blue, white, black, brown or green paint. Panelled chests were made by joiners and fall into three major categories, depending on the type of carved decoration. The most elaborately carved chests with tulips, first discovered in the Hadley area of Massachusetts, were made in the Connecticut River Valley. Another group, from the Wethersfield area of southern Connecticut, has stylized Tudor roses and tulips. Chests from Guilford and Saybrook, CT, feature painted tulips, thistles, urns and roses based on stylized Dutch and English designs.

The chest-of-drawers gradually replaced the chest by 1700. Originating in London and evolving from the chest-of-drawers with doors, these were found in Boston by the 1640s. They usually had turned feet, ball- or turnip-shaped, or feet formed by extending the sides or corner stiles below the bottom drawer. By 1700 they were often adorned with japanning, veneer or inlay. Single- or double-arched mouldings typically outlined each drawer. By 1700 drawers ran on the bottom edge of the drawer side instead of on grooves cut into the drawer sides. The earliest drawer handles were usually of wood, but by the end of the 17th century brass pear-shaped drops hung in front of rosette-shaped back plates, and matching cartouche-shaped brass escutcheons protected the wood around the keyholes. Such variations as brass knobs or ring pulls were also found. Related to chests-of-drawers were bureaux, which developed when the so-called bible box of the 17th century was placed on a frame. Later the frame was replaced with

BIBLIOGRAPHY

I. Lyon: *The Colonial Furniture of New England* (Boston and New York, 1891/*R* 1977)

P. Kane: *Furniture of the New Haven Colony: The Seventeenth Century*, (New Haven, 1973)

V. Chinnery: *Oak Furniture: The British Tradition* (Woodbridge, 1979)

R. St George: *The Wrought Covenant* (Massachusetts, 1979)

R. H. Randall: 'Boston Chairs', *Old-Time New England*, liv (May 1980), pp. 12–20

New England Begins: The Seventeenth Century (exh. cat. by J. Fairbanks and R. Trent, Boston, MA, Mus. F.A., 1982)

B. Forman: *American Seating Furniture, 1630–1730: An Interpretive Catalogue*, Winterthur, DE, Du Pont Winterthur Mus. cat. (New York and London, 1988)

OSCAR P. FITZGERALD

2. 1725–90. With increasing prosperity colonists built grand houses and decorated them with luxurious furnishings in the latest fashion, which by the 1730s was the Queen Anne style. This had been popular in England for more than a decade before it appeared c. 1725 in Boston, the largest Colonial city in the first half of the 18th century, and in other major American cities. The best pieces were executed in walnut and later in mahogany, replacing the coarser oak used in the 17th century.

The new style combined Classical and oriental elements. The Classical proportions, architectural details and carved motifs, such as scallop shells and acanthus leaves, reflected European late Baroque traditions. The cabriole leg, called a 'hoursebone' or 'crook'd foot' in the 18th century, the hallmark of the new style, was a universal form found in Classical, European and East Asian cultures. The claw-and-ball foot, which appeared for the first time on Queen Anne furniture and became even more popular in America in the Chippendale period, had clear oriental antecedents. Japanning, a decorative technique that imitated oriental lacquerwork, was most popular in Boston but was known in all the colonies. Queen Anne brass drawer handles on case furniture imitated the simple batwing handles found on oriental furniture.

Although Queen Anne curves continued to grace some furniture until after the Revolution (and remained popular in rural areas until the 19th century), the more angular Chippendale style gradually gained ascendancy between 1755 and 1790. The elements of the new style were set out in Thomas Chippendale's *Gentleman and Cabinet Maker's Director*, first published in London in 1754. Chippendale (1718–79) understood the importance of Classical proportions and admonished his readers to study the Classical columns that he displayed in the front of his book. His designs show three major influences, Chinese, Gothic and Rococo, grafted on to furniture with Classical proportions. The most obvious influence in Chippendale was the Rococo style with such asymmetrical motifs as rocks, shells, vines, leaves and flowers. The rounded top rail of the Queen Anne chair was replaced by an angular one with projecting ears similar to those on Chinese chairs. The pierced baluster splat had occasionally appeared on Queen Anne chairs, but in the Chippendale period carvers turned the splat into a panoply of ribbons, cusps, arches and scrolls (e.g. an armchair from Philadelphia, c. 1756; New York, Met.; see fig. 28). Densely grained and richly figured imported mahogany was the perfect wood for the beautiful carving of the Chippendale period. It was first imported from the West Indies soon after 1700 but was not widely used until the mid-18th century, for example in the shop of BENJAMIN RANDOLPH, when carving became so important. Veneer and inlay, which were occasionally found on American Queen Anne furniture particularly from Boston, were rarely used in the Chippendale period.

In the 18th century strong regional variation, arising from disparate cabinetmaking traditions learnt in various parts of England or the Continent, could be seen in furniture, particularly chairs. The persistence of the apprentice system and such closely knit communities of cabinetmakers, many of them Quakers (*see* SAVERY, WILLIAM), helped perpetuate these differences. One par-

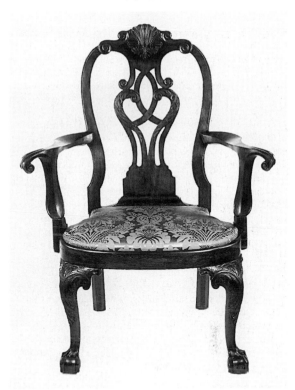

28. Walnut armchair, h. 1.12 m, from Philadelphia, Pennsylvania, c. 1756 (New York, Metropolitan Museum of Art)

ticularly good index of this was the shaped or carved foot characteristic of each major cabinetmaking centre (*see* BOSTON, §III, 1 and PHILADELPHIA, §3). This work was often done by a few specialist craftsmen. The pad foot was associated with Massachusetts, the slipper foot with Newport, RI, and the trifid foot with Philadelphia. The elongated ball and finely sculpted talon of Newport work contrasted with the squashed ball and webbed talon of Philadelphia examples. The retracted or raked talon of Boston differed from the square, blockish balls and talons of New York. Brightly upholstered easy chairs in the Queen Anne style (see colour pl. XXXII, 2) but now with smoothly curving cresting and cabriole legs, also showed distinctive regional variation. Arms on New England chairs rested on vertical cones, whereas in Philadelphia they were supported by C-scrolled blocks. By the mid-18th century carved acanthus leaves and claw-and-ball feet were often grafted on to the Queen Anne form. By the 1770s straight Marlboro' legs replaced cabriole legs on both easy chairs and sofas. As large parlours became more common early in the 18th century, sofas and settees proliferated and daybeds declined in popularity.

Windsor chairs also exhibited regional variation, though they did not follow the stylistic progression characteristic of other furniture in the 18th and 19th centuries. American Windsors were made in Philadelphia by the 1740s but did not surpass the cheaper rush-seated chairs in popularity until after the Revolution. The low-backed chair, precursor of the type known in 19th-century America as a Captain's chair, was the earliest. Soon a horizontal top rail evolved,

supported on spindles rising from the seat through a rail following the curvature of the seat. The double bow back (sack back), particularly popular in New England, was similar but had a rounded top rail. Such makers as Ebenezer Tracey (1744–1803) of Lisbon, CT, made Windsor settees, stools, cradles, high chairs and tablet chairs (writing armchairs) using several different woods in their construction.

Some of the most distinctive American furniture was produced outside the major centres of Boston, Newport, New York and Philadelphia. While city cabinetmakers made fashionable furniture, often as close to London styles as possible, craftsmen in rural areas, where the majority of the population lived, followed traditional designs that survived long after they had been abandoned in the cities. Notable work was produced by relatively isolated craftsmen, such as Eliphalet Chapin (1741–1807) in the Connecticut River Valley, the brothers John Dunlap (1746–92) and Samuel Dunlap (1752–1830) of southern New Hampshire and the Dominy family, Nathaniel Dominy (iv) (1737–1812), Nathaniel Dominy (v) (1770–1852) and Felix Dominy (1800–68), on Long Island. In Pennsylvania, German craftsmen perpetuated their peasant folk traditions, particularly in the construction of highly painted chests.

Among the most impressive pieces of furniture produced in the urban areas were the high chest-of-drawers or tallboy (highboy) and the matching dressing table (lowboy). The flat tops of Queen Anne tallboys, with their heavy cornice mouldings often derived from architectural design books, gave way to ogee or cove mouldings and frets, which were popular until the end of the century. Triple-arched aprons (skirts) were fitted with drop finials, vestiges of the multiple front legs on earlier pieces. By the 1740s tallboys were fitted with broken arches over central drawers with carved fans or scallop shells copied from architectural designs. As the century progressed, the gentle arches of the Queen Anne pediment (bonnet) often with a closed top, gave way to the more abrupt thrust of the Chippendale pediment, carved and ornamented with elaborate finials and a central cartouche. The Queen Anne chest-on-stand tallboy had been replaced in England by the chest-on-chest form by about 1740 but continued to be popular in America where the best examples carried elaborately carved Rococo and Classical motifs. Only in Charleston, SC, was the chest-on-chest form widely popular. On bureau bookcases (desk and bookcase) the pediments followed the same progression. Glass panes or sparkling looking-glass added elegance, but wooden panel doors, usually with rounded arches, were more common in the Queen Anne period. Chippendale pieces had square-hinged doors, the frames of which had ogee mouldings around wood or glass panels.

Newport and Boston favoured block-front furniture that depended on three panels alternately concave and convex in a Baroque fashion for their pretensions to elegance (e.g. a bureau bookcase from Newport, c. 1760–90; New York, Met.; see fig. 29). The earliest documented block front, a walnut bureau bookcase (Winterthur, DE, Du Pont Winterthur Mus.), was made by Job Coit (1692–1742) and his son Job Coit the younger (1717–45) in Boston in 1738. Later the idea was executed with paramount success by a talented group of craftsmen working

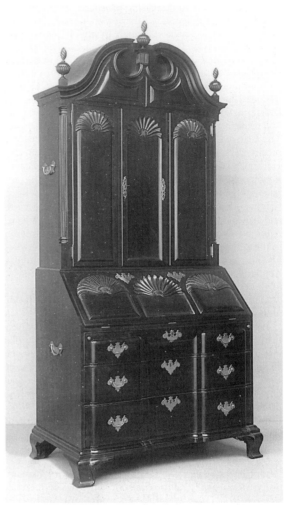

29. Bureau bookcase, mahogany with chestnut, pine and cedar, h. 2.52 m, from Newport, Rhode Island, c. 1760–90 (New York, Metropolitan Museum of Art)

in Newport, principally the TOWNSEND and Goddard families, who produced more than twenty cabinetmakers, including JOHN GODDARD, in that city before the Revolution. In addition to block fronts, customers in Boston, Newport and adjoining areas enjoyed serpentine or reverse serpentine fronts on case furniture. However, the height of elegance in Boston was the bombé chest or bureau bookcase. BENJAMIN FROTHINGHAM made the earliest dated bombé form in 1753, a bureau bookcase (Washington, DC, State Dept) possibly copied from an imported English example.

Whereas Boston and Newport excelled in making outdated Baroque forms, Philadelphia carried the Rococo aesthetic of the second half of the 18th century to its highest pitch. Tallboys with flat tops continued to be made, but such Philadelphia craftsmen as William Savery (1721–88) and THOMAS AFFLECK added pediments for their best customers. These were most often designed as scrolls or pitched in a triangular shape. Fluted columns on the corners of the case and richly carved pediments and

aprons enhanced the finest pieces (e.g. a tallboy, c. 1762–90; New York, Met.; see fig. 30). Sculptural finials and cartouches in the form of urns and flames, carved busts or baskets of fruit and flowers added unexcelled richness. The pieces were finished off with imported English brass handles, the best with Rococo detailing.

A variety of tables proliferated. In the Queen Anne period serving tables were fitted with tile, slate or marble. Cabriole legs and pad feet gave way in the Chippendale period to straight legs. Tea-tables became more common as the price of tea dropped to a level where it was no longer a luxury. Card-tables and games-tables with fold-over tops were common even in Philadelphia, where the Quakers frowned on gambling. By the mid-18th century a characteristic five-legged table with a serpentine apron and square corners for candles developed in New York. Plainer card-tables with four straight legs were made in all the colonies. As the century progressed, wealthy merchants filled their houses with an ever-increasing array of forms, such as fire screens, slab, dining- and corner-tables, and candle, basin and kettle stands.

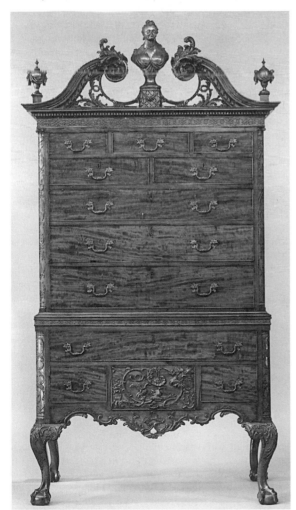

30. Tallboy, mahogany with yellow pine, tulip and cedar, h. 2.33 m, from Philadelphia, Pennsylvania, c. 1762–90 (New York, Metropolitan Museum of Art)

Looking-glasses in the Queen Anne style often had solid walnut, veneered or japanned frames surmounted by hoods with carved and gilded shells or feathers. Vertical pier glasses were designed to hang between two windows and horizontal looking-glasses for use over a fireplace. Chippendale's *Director* illustrated a new type with a tabernacle frame, so-called because of its relationship to architectural niches in Gothic and Renaissance buildings (*see also* §VI above). These frames were gilded and surmounted with triangular or scrolled pediments topped by a central eagle or phoenix. Carved vines and flowers and later acanthus leaves and C-scrolls streamed down each side of the frame. By 1775 oval looking-glasses with Rococo ornament were particularly popular. Throughout the 18th century most looking-glasses and frames were imported from England.

The most expensive piece of furniture continued to be the elaborately hung beds, which became more common in the early 18th century as houses were built with bedrooms. Low posted beds were frequently surrounded by hangings strung from hooks. Field beds with arched canopies became common by the end of the century, but fourposter beds were the most desirable. Press beds were used until the middle of the century when houses became larger and the need for fold-up furniture lessened. Octagonal posts indicate an earlier date, whereas round posts were used throughout the century.

The American Revolution drastically curtailed the production of fine furniture as the war affected both cabinet-makers and their patrons. Many of the best customers were wealthy Tories who fled to Britain or Canada. Supporters of the Revolution found that extra money that might have been spent on furniture was taxed away to finance the war effort, and many cabinetmakers turned their talents to supporting the war. By the 1760s Neo-classicism was developing in England, but in America, on of the war, the Chippendale style lingered well into the 19th century. However, the Neo-classical taste had found its way into the more stylish homes by the 1790s.

BIBLIOGRAPHY
W. Hornor: *Blue Book, Philadelphia Furniture: William Penn to George Washington* (Philadelphia, 1935/*R* Washington, DC, 1977)
R. Randall: *American Furniture in the Museum of Fine Arts, Boston* (Boston, 1965)
C. Hummel: *With Hammer in Hand: The Dominy Craftsmen of East Hampton, New York* (Charlottesville, 1968) [cat. rais.]
The Dunlaps & their Furniture (exh. cat by C. Parsons, Manchester, NH, Currier Gal. A., 1970)
J. Kirk: *American Chairs: Queen Anne and Chippendale* (New York, 1972)
B. Greenlaw: *New England Furniture of Colonial Williamsburg* (Williamsburg, 1974)
W. Whitehill: *Boston Furniture of the Eighteenth Century* (Boston, 1974)
D. Warren: *Bayou Bend: American Furniture, Paintings and Silver from the Bayou Bend Collection* (Houston, 1975)
D. Fales: *The Furniture of Historic Deerfield* (New York, 1976)
R. Trent: *Hearts & Crowns* (New Haven, 1977)
B. Jobe and M. Kaye: *New England Furniture: The Colonial Era* (Boston, 1984)
M. Herckscher: *American Furniture in the Metropolitan Museum of Art: Late Colonial Period: Queen Anne and Chippendale Styles* (New York, 1985)
G. Ward: *American Case Furniture*, New Haven, CT, Yale U. A.G. cat. (New Haven, 1988)
C. Venable: *American Furniture in the Bybee Collection*, Dallas, TX, Mus. A. cat. (Dallas, 1989)
G. W. R. Ward, ed.: *American Furniture and Related Decorative Arts, 1660–1830* (New York, 1992)

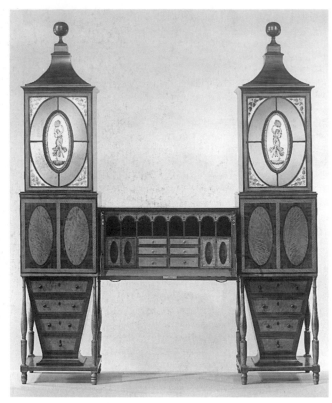

31. Bureau bookcase, mahogany and satin-wood, h. 2.31 m, from Baltimore or Philadelphia, *c.* 1811 (New York, Metropolitan Museum of Art)

N. Evans: *American Windsor Chairs* (New York, 1996)
L. Keno, J. Freund and A. Miller: *The Very Pink of the Mode: Boston Georgian Chairs, their Export and their Influence in American Furniture* (Hanover and London, 1996)
N. Richards and N. Evans: *New England Furniture at Winterthur: Queen Anne and Chippendale Periods* (Wintherthur, 1997)

OSCAR P. FITZGERALD

3. 1791–1840. Between the 1790s and 1840s furniture-makers in the USA, as in Europe, interpreted and reinterpreted the designs found on Classical artefacts and architectural remains. The initial phase of Neo-classicism, the FEDERAL STYLE, was followed about 1815 by a new interpretation called the *Style antique* or American Empire style. The subtle geometrical and classical inlay of the largely two-dimensional Federal style (e.g. a bureau bookcase from Baltimore or Philadelphia, *c.* 1811; New York, Met.; see fig. 31) was supplanted by the three-dimensional sculptural carving of the Empire style.

American Federal furniture was derived largely from English sources, which in turn were inspired by Robert Adam's reinterpretation of Classical design. English books containing Neo-classical furniture designs by George Hepplewhite (*d* 1786), Thomas Sheraton (*d* 1806) and Thomas Shearer (*fl* 1788) were available in the USA and helped to popularize the Adam designs. Immigrant cabinetmakers, such as John and Thomas SEYMOUR, who had been trained in the new style also brought the new ideas to the USA (see colour pl. XXXIII, 1), while imported furniture served as models for local cabinetmakers. The Empire style that followed originated in France, but came to the

USA by way of both England and France. Thomas Hope's *Household Furniture and Interior Decoration*, first published in London in 1807, was particularly important in spreading the new style.

Specialization in the woodworking trade was known even in the 17th century, but the trend accelerated at the end of the 18th century as shops, such as that of STEPHEN BADLAM, grew larger. Rarely did a single craftsman working in a large urban cabinetmaking shop both design and construct a single piece of furniture. The efficiency of specialization allowed the cabinetmaker to meet the demands of a rapidly expanding population and a growing export trade. Various workshops of carvers, inlay makers, upholsterers and turners contributed to the final product, which was then warranted by the seller who might not have done any of the work on the furniture himself.

After the Revolution, many of the cabinetmakers settled in New York, which by 1815 was the centre of furniture manufacturing in the new nation. Foremost among the city's cabinetmakers was DUNCAN PHYFE, who dominated the trade from 1792 until his retirement in 1847. Other important makers included the French-born CHARLES-HONORÉ LANNUIER and the New York firm of Joseph Meeks & Sons (active 1797–1868). Boston and Philadelphia continued to be important into the 19th century (*see* BOSTON, §III, 1 and PHILADELPHIA, §3), but Newport declined. Neighbouring Salem, MA, even though it was less than half the size of Boston, produced some of the finest Federal furniture, which was then shipped to major East Coast ports and to many foreign countries. Salem work is particularly known for the fine carving of eagles, fruit baskets, cornucopias and wheat sheaves. These have often been attributed to Samuel McINTIRE. After the Revolution, Baltimore became the fastest growing city in the USA. Its cabinetmakers (*see* BALTIMORE, §2) produced some of the most elegant Federal furniture, often with distinctive bellflower inlay and inset *verre églomisé* panels. Although the art of painted furniture was popular everywhere in the early 19th century, the technique was used to spectacular effect by Baltimore painters.

Neo-classical dining chairs had either a square, tapered leg and an oval- or shield-shaped back, or a round, tapered leg, usually reeded, and a square back with small columns. Easy chairs, now with tapered or turned legs, continued to be popular along with upholstered barrel-back chairs and lolling or Martha Washington chairs. The latter evolved from the mid-18th-century upholstered armchair but had a higher back and tapered or turned and reeded legs reflecting the new Federal styling. By 1815 chairs based on actual Classical examples, such as the sabre-legged klismos, were popular (see colour pl. XXXII, 3). A horizontal rail, often painted or carved with cornucopias, anthemia, eagles and lyres, replaced the vertical splat common in the 18th century. An innovation in chair design in the 1830s was the gondole chair, in which the rear stiles curved down and forward. Cheaper chairs had rush seats, turned legs and stiles and stencilled decoration instead of expensive upholstery, carving and brass mounts. The best-known maker of these 'fancy chairs' was LAMBERT HITCHCOCK, who opened his Connecticut factory in 1818.

Before 1800 sofas were seen only in the richest homes. Cabinetmakers in the Federal period softened the bold lines of the Chippendale sofa, tapered the legs and accented the top rail and legs with delicate carving, veneer or inlay. Also popular were the square-backed sofa and the cabriole sofa with a delicately curved back. By the Empire period, the sofa had become more widespread. It was heavier in style, and the Grecian couch with lion's paw feet and double scrolls on the cresting was among the most popular.

In addition to sofas, the parlour contained an assortment of tables. The Pembroke table, now with tapered legs and delicate inlay, continued in use, as did the fire screen, lighter now with classical and patriotic embellishments. The centre table first became popular in the Empire period and served much like the coffee-table of the 20th century. Card-tables were ubiquitous. Work tables both for writing and sewing grew in number. Pier tables, used as serving or hall tables, rested on supports carved in the form of caryatids, dolphins, swans, lion-footed scrolls, eagle monopodia and simple Doric and Ionic columns. In the dining-room large banquet tables seated up to 20 guests. 'Pillar-and-claw' pedestal tables with curved legs and brass feet were found in the finest houses. These, along with tables with tapered or turned legs, were made in sections and set against the wall when not in use. The most impressive piece in the dining-room was the sideboard: Federal examples stood on delicate turned or tapered legs, while Empire ones rested on carved feet and had doors extending almost to the floor.

Other luxury items included pianofortes, mirrors and clocks. Longcase clocks continued to be among the most expensive pieces of furniture. The so-called Roxbury type, made in the Roxbury suburb of Boston, had spaghetti-like scrolls on the rounded hood (bonnet), brass finials, fluted corner columns and an inlaid case. Longcase clocks were gradually replaced by less expensive mass produced wall or shelf clocks by the second quarter of the century. Pillar-and-scroll shelf clocks made by Eli Terry (1772–1852) and so-called banjo or wall clocks patented by Simon Willard (1753–1848) were particularly sought after and were widely imitated. Mirrors, rectangular with painted top sections, had ball-hung cornices or lightly scrolled pediments with Neo-classical motifs or were made with round frames often topped by a carved gilt eagle and fitted with a convex glass. Horizontal chimney glasses framed by heavy, turned balusters exhibited standard Empire motifs.

Desks and bureau bookcases changed radically in the Federal period. The slant-front type of the 18th century, updated with Neo-classical carving or inlay, continued to be made into the first quarter of the 19th century, but the fashionable desk was now fitted with an escritoire or secretary drawer. This pulled out and its front folded down to form the writing surface. Another design had hinged flaps that folded down and rested on sliding supports to make the writing surface. Bookcase sections on these were often fitted with tambour doors made by gluing thin strips of wood on to a canvas backing. By the Empire period the French-inspired *secrétaire à abattant* had become popular. This had a flat-topped case flanked by classical columns and a large door in the upper section that folded down to form the writing surface.

Beds continued to carry a high value. Like other Federal furniture, the bedstead featured delicately turned, reeded or carved posts and occasionally carved or inlaid cornices. Empire ones had massive carved or turned posts and tall, carved headboards. The French bed, today called a sleigh bed, with headboard and footboard the same height, became popular about 1815. The typical chest-of-drawers had flaring French feet with a scrolled apron and a straight, bowed or serpentine front. Oval brass handles, often embossed with patriotic images, enlivened drawer fronts. By the early 19th century the looking-glasses that hung above the chest in most bedrooms were supplanted by chests with the looking-glass attached, similar to modern dressing-tables. Other bedroom furniture included large wardrobes.

By the 1830s Neo-classicism in furniture design entered a third and final stage dominated by massive pillars and scrolls. Imported ormolu mounts were replaced by wooden knobs, and gilding and stencilling no longer enlivened the broad expanses of mahogany veneer. This style developed in France after the restoration of the monarchy in 1815, and the advertising broadside of Joseph Meeks & Sons published in 1833 illustrates a number of such pillar-and-scroll pieces. Shortly before he retired in 1847, Duncan Phyfe referred to the current style as 'butcher furniture'. Its popularity, however, was so great that it continued to appear throughout the 19th century, alongside the Victorian revivalist styles.

BIBLIOGRAPHY

N. McClelland: *Duncan Phyfe and the English Regency, 1795–1830* (New York, 1939/*R* 1980)
Classical America, 1815–1845 (exh. cat. by B. Tracy, Newark, NJ, Mus., 1963)
C. Montgomery: *American Furniture: The Federal Period*, Winterthur, DE, Du Pont Winterthur Mus. cat. (London, 1966)
D. Fales: *American Painted Furniture, 1660–1880* (New York, 1972)
M. Clunie: 'Joseph True and the Piecework System in Salem', *Antiques*, cxi (May 1977), pp. 1006–13
B. Hewitt: *The Work of Many Hands: Card Tables in Federal America, 1790–1820* (New Haven, 1982)
G. Weidman: *Furniture in Maryland, 1740–1940* (Baltimore, 1984)
G. W. R. Ward, ed.: *American Furniture and Related Decorative Arts, 1660–1830* (New York, 1992)
W. Cooper: *Classical Taste in America, 1800–1840* (New York, 1993)
Portsmouth Furniture: Master Works from the New Hampshire Coast (exh. cat. by B. Jobe, Manchester, NH, Currier Gal. A., 1993)
P. Kenny: *Honoré Lannuier: Cabinetmaker from Paris* (New York, 1998)

OSCAR P. FITZGERALD

4. 1841–1914. From the end of the 1840s American furniture was characterized by a succession of revivalist styles, notably Gothic, Rococo, Renaissance and Eastlake. These were popularized by the great world fairs, beginning in 1851 with the Great Exhibition in London and followed in 1853 by a similar exhibition in New York. Their dissemination was made possible by the Industrial Revolution, which by the mid-19th century was well established in the USA. Throughout the century the shift accelerated from small cabinetmaking shops selling to a local market to large-scale factories that distributed their products nationally from their bases in Chicago, GRAND RAPIDS, MI, and other Midwestern centres. Using steam-driven band saws and new manufacturing techniques, these factories could produce furniture by the train load in every

conceivable revivalist style to satisfy the demands of a booming consumer market.

Another innovation was the use of new and exotic materials. Wicker was exhibited at the Great Exhibition and steadily grew in popularity. Like animal horn, it was used for chairs, tables and sofas, and it appealed because of its novelty and its association with frontier life. Rustic furniture made of roots and branches had a similar novelty value and was used in gardens and rural retreats. Other innovative materials included papier mâché, cast iron and wire.

The first revivalist style to be used in the USA was Gothic, complete with crockets, quatrefoils, cusps, pointed arches, cluster columns and rose-window forms. This was particularly popular in the 1840s but continued throughout the century. Even though the USA had no medieval heritage, American manufacturers, drawing on the work of such English designers as Augustus Charles Pugin (1769–1832) and his son A. W. N. Pugin (1812–52) produced a wide variety of Gothic furniture for use in halls and libraries. The Gothic style, however, was never as popular as the Rococo, or Louis XIV as it was inaccurately called in the 19th century. This style was first revived in France during the reign of Louis-Philippe (reg 1830–45). Furniture designers of the period looked back to the 18th century as the great age of French design, and such French cabinetmakers as Alexander Roux (fl 1837–81) and CHARLES A. BAUDOUINE brought the style to the USA in the 1850s. Numerous French publications available in the USA reinforced its popularity. Its best-known exponent was JOHN HENRY BELTER, who used lamination and steam-moulding to make strong, heavy, curved boards

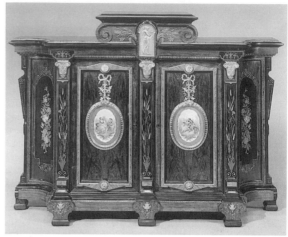

33. Rose-wood cabinet by Alexander Roux, h. 1.36 m, c. 1860–70 (New York, Metropolitan Museum of Art)

that could sustain deep and intricate carving (e.g. sofa, c. 1850–60; New York, Met.; see fig. 32).

Several design sources were plundered for Renaissance Revival furniture, which was particularly favoured for dining-rooms. Sixteenth-century French models inspired the Baroque cartouches, animal and human figures, flattened arches and roundels, while 18th-century Louis XVI prototypes gave rise to straight, turned legs, straight backs and gilt and ebonized surfaces. Many of these motifs can be seen in a cabinet (c. 1860–70; New York, Met.; see fig. 33)

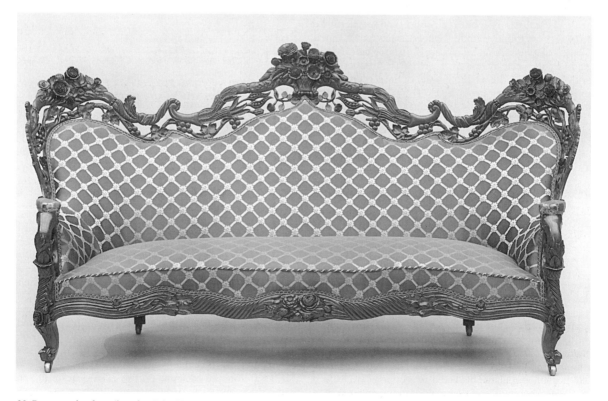

32. Rose-wood sofa attributed to John Henry Belter, l. 2.28 m, c. 1850–60 (New York, Metropolitan Museum of Art)

by Alexander Roux. This style had been originally promoted in France by Empress Eugénie, wife of Napoleon III. Another group of furniture known as *Néo-Grec* features such Greek, Roman and Egyptian motifs as columns, paterae, acroteria, sphynxes, anthemia and lions' paws.

By the 1870s there was a reaction against the complex and extravagant Rococo and Renaissance revival styles. Drawing on the ideas of such English reformers as John Ruskin (1819–1900), William Morris (1834–96) and Charles Locke Eastlake (1836–1906), American furniture manufacturers produced lines featuring turnings and plain oak surfaces, sometimes enlivened by reeding and incised decoration (*see* EASTLAKE STYLE). Reflecting its medieval inspiration, the style was sometimes called 'Modern Gothic'. Another strain, contributed by such English designers as E. W. Godwin (1833–86), arose from a fascination with East Asia, particularly Japan. Oriental elements, such as ebonized surfaces and exotic inlay, characterized exclusive custom-made furniture produced by such cabinetmakers as CHRISTIAN HERTER in New York (see colour pl. XXXIII, 2). Just as Eastlake's followers drew on medieval England for inspiration, some American designers referred back to the American Colonial style, which loosely included the Federal and Empire styles as well. Colonial Revival furniture manufactured after the Centennial International Exhibition of 1876 in Philadelphia thrived on the need for Americans to express their cultural nationalism.

New forms of furniture proliferated in the Victorian period. By mid-century every household required a seven-piece matching suite, consisting of an armchair, a lady's chair, a sofa and four armless parlour chairs. Some of the best Rococo Revival suites were produced by Belter (see fig. 20 above). Rococo Revival chairs had cabriole legs and balloon backs. Naturalistic carving of flowers, vines, birds and animals evoked French culture and aristocratic pretensions. In addition to carving, the elegance of these Rococo suites depended on rich upholstery of satin, silk and plush, tufted, pleated and finished by tassels and fringes. Renaissance Revival suites had square-backed chairs and sofas, bulging U-shaped seats, incised designs and triangular pendants on the seat rails, applied roundels and turned legs. Eastlake chairs were less ornate and even more angular. Turned spindles, echoing turned legs, often supported the top rails. Shallow carving, reeding, geometric or floral marquetry and incised decoration enlivened the seat rails and other exposed wooden parts. By the 1880s elaborate fretwork inspired by Japanese design offered an acceptable alternative for top rails and the area beneath the arms. The Morris chair, based on a reclining chair produced by William Morris, was widely copied in the USA. The Eastlake sofa was a pale reflection of bold Empire models. A few squiggles were incised into bracket feet, and carving on angular, stepped-down crests flanked by wheel-like crowns and simple scrolls repeated the shallow work on the feet. In the 1870s and 1880s Turkish corners were set up, with overstuffed chairs and sofas trimmed with fringe and tassels, to achieve an exotic effect. Simple chairs sold by the Shakers (*see* SHAKERS, fig. 3) offered a sharp contrast to such ornate parlour furniture.

Many creative designers patented unique furniture in the 19th century. The first patent for folding chairs was issued in 1855. Those of George Hunzinger (1835–98), with their vertical stretchers and pipe-like frames, looked as if they should fold but often did not. By the 1870s the distinctive American form, the rocking chair (rocker), was redesigned as a stationary platform that rocked quietly on coil springs.

Chairs were often grouped around a centre table in the parlour. Rococo Revival tables, often topped with white marble, were circular, oval or oblong and rested on cabriole legs. Renaissance Revival examples took on a characteristic angular and jagged outline; their roundels, panels of veneer and incising related to similar embellishments on chairs. Oval tops continued to be made, but rectangular shapes with rounded ends gradually became more stylish. Giant cup-like finials were sometimes placed beneath the tables to add interest. A new type of table, the étagère or whatnot, emerged. Made in Rococo and Renaissance styles, it usually consisted of four or five shelves either free-standing or surmounting a table or cabinet. It held the personal knicknacks through which Victorians expressed their individuality in an age of increasingly standardized factory production. Other parlour furniture included easels for the display of art, sewing tables, music racks and library or writing tables.

Among the most impressive pieces of furniture were Renaissance Revival sideboards and cabinets. They consisted of two or three drawers above two doors resting on a raised plinth that sat directly on the floor. Above the top of the cabinet rose a wooden back that supported shelves and was topped with a Renaissance pediment. Cheaper versions had incised gilded lines and burl veneer, a highly figured veneer cut from a growth on the trunk of a tree, instead of costly carving or abundant applied ornament. The more expensive Eastlake cabinets had ebonized and painted geometrical or floral decoration, but even the cheapest ones were often crowned with the familiar gallery of spindles.

In the 1870s many prominent industrialists owned desks of an ingenious design patented by William S. Wooton (1835–1907). They consisted of a case of pigeonholes with a drop-front writing top. Large doors, also with pigeonholes and shelves, were hinged to the central section so that the owner could close up the entire cabinet when not in use. Eastlake-style desks and secrétaires of the cylinder or slant-front varieties were decorated like the Eastlake cabinets. Convertible furniture, such as chest-beds, proliferated in this period as apartment living became increasingly common.

Ornate, richly carved beds continued to be among the most expensive pieces of furniture. In the 1840s massive fourposter ones with Gothic details contrasted with less expensive spool-turned beds later named after Jenny Lind, the Swedish opera star who toured the USA in the 1850s. The naturalistic carving of the best Rococo Revival beds was replaced in Renaissance Revival versions by more angular carving dominated by cartouches. Eastlake beds, often made of maple, were less massive and were ornamented with restrained reeding, incising and ebonizing.

By the turn of the 20th century, many Americans were breaking away from the revival styles of the 19th century and were purchasing the new Mission furniture. The principal purveyor of this style was GUSTAV STICKLEY and

his Craftsman Workshops near Syracuse, NY. Heavily influenced by John Ruskin, William Morris and the Arts and Crafts Movement in England, the best of his furniture depended on rich grained oak, good proportion and avoidance of ornament (see colour pl. XXXIII, 3). Stickley had many imitators, including his own brothers, Leopold Stickley (1869–1957) and J. George Stickley (1871–1921). Others, including the Roycroft Shops of ELBERT HUBBARD and Charles P. Limbert's Grand Rapids factory (1894–1944), offered their own interpretations of Mission furniture. Charles Rohlfs (1853–1936), an actor turned cabinetmaker, enjoyed international fame with his idiosyncratic designs. Such avant-garde architects as Frank Lloyd Wright and other Prairie school members in Chicago and Charles Sumner Greene and Henry Mather Greene in California commissioned custom-made Mission furniture for their clients (for illustration see ARTS AND CRAFTS MOVEMENT). By 1915 Stickley was bankrupt, a victim of overexpansion and shifting public taste. Even at the height of Mission's popularity, revivals of 18th- and early 19th-century styles, both American and European, commanded the lion's share of the furniture market.

BIBLIOGRAPHY

C. Otto: *American Furniture of the Nineteenth Century* (New York, 1965)
Eastlake-influenced American Furniture, 1870–1890 (exh. cat. by M. J. Madigan, Yonkers, Hudson River Mus., 1974)
W. Seale: *The Tasteful Interlude: American Interiors through the Camera's Eye, 1860–1917* (New York, 1975)
The Gothic Revival Style in America, 1830–1870 (exh. cat. by K. Howe and D. Warren, Houston, TX, Mus. F.A., 1976)
E. Denker and B. Denker: *The Rocking Chair Book* (New York, 1979)
D. Hanks: *Christian Herter and the Aesthetic Movement in America* (New York, 1980)
D. Cathers: *Furniture of the American Arts and Crafts Movement* (New York, 1981)
M. Schwartz, E. Stanek and D. True: *The Furniture of John Henry Belter and the Rococo Revival in America* (New York, 1981)
A. Axelrod, ed.: *The Colonial Revival in America* (New York, 1985)
Herter Brothers: Furniture and Interiors for a Gilded Age (exh. cat., Houston, TX, Mus. F.A.; Atlanta, GA, High Mus. A.; New York, Met.; 1994–5)
C. D. Edwards: 'British Imports of American Furniture in the Later Nineteenth Century', *Furn. Hist.*, xxxi (1995), pp. 210–16

OSCAR P. FITZGERALD

VIII. Ceramics.

1. Before 1800. 2. 1800–c. 1900. 3. c. 1900–1914.

1. BEFORE 1800. Although native American Indians had a long-established pottery tradition, Europeans brought their own techniques when they began to colonize North America after 1600. Small potteries in most Dutch, English, French and Spanish settlements successfully made bricks, roof tiles and utilitarian earthenware for kitchen, dairy and tavern use. In the 17th century, Colonial earthenware followed English and Continental models so closely that identification is difficult, and only in the late 20th century have archaeologists begun to develop laboratory techniques for separating indigenous from imported wares found in early Colonial sites. Among the 17th-century potteries known from documentation or archaeological evidence are two identified with the making of tin-glazed earthenware. Wasters of chargers and a single tin-glazed cup (Yorktown, VA, Colon. N. Hist. Park) excavated from Governor William Berkeley's Green Spring Plantation, VA, suggest that a London-trained maiolica potter was working there after 1660. In 1688 Dr Daniel Coxe and others contracted John DeWilde of London and William Gill (*fl* 1688–93) of Lambeth to establish a pottery making tin-glazed earthenware in Burlington, NJ (see COXE-DEWILDE POTTERY). Their products were reportedly sold locally and in Barbados and Jamaica. The pottery operated until *c.* 1692.

As the population of the colonies increased, potteries became more numerous, and the wares made were more elaborate. These potteries were generally scattered throughout the countryside wherever there was sufficient demand, and certain urban areas, such as Boston (see BOSTON, §III, 3), became important pottery centres from which large quantities of ware were traded inland and along the coast. In the mid-18th century the village of Charlestown, MA, boasted nearly forty potters, who shipped their wares along the New England coast. Production declined when the town was badly damaged during the American Revolution, and its pottery business was undermined by general overproduction in eastern Massachusetts.

From 1730 Danvers in Essex Co., MA, had a large pottery community active for two centuries. Large potteries around New York Bay from Norwalk, CT, to Rahway, NJ, supplied a burgeoning population well into the 19th century. Philadelphia was the major centre farther south. Philadelphia earthenware was traded widely along the coast from New England to Virginia and became a standard to which other potters referred and aspired. In 1773, for example, the potter Jonathan Durrell advertised in a New York newspaper that he could provide 'Philadelphia Earthen-Ware . . . equal to the best of any imported from Philadelphia'. At his pottery on the outskirts of New York, he made such typical Colonial products of this period as oyster and chamber pots, milk pans and porringers.

Decoration of 18th-century American earthenware was usually minimal. Plain lead-glazed and black-glazed redwares were the most common, but simple slip decoration was also used, and some potters, particularly those in the mid-Atlantic region from Connecticut to Philadelphia, used copper-oxide to heighten white slip decoration with 'clouds' of green. In contrast to these common and usually rather plain slip-decorated wares were the special commemorative pieces made with elaborate slip or sgraffito decoration by potters working in the German settlements of south-eastern Pennsylvania and the colourful slipwares made in the Moravian settlements of Bethlehem, PA, and Salem, NC. The inscriptions on many of the pieces are in German dialects, and motifs used include symbolic birds, such as double-headed eagles and pelicans, flowers, horses and figures of men and women. Many of the artists have been identified, including Georg Huebner (1757–1828), John Jacob Stoudt (1710–79) and John Leidy (1764–1846). GOTTFRIED AUST, the master potter of the Moravian communities in North Carolina, used the forms and colourful, elaborate slip decoration with which his brethren had been familiar in Moravia (see colour pl. XXXIV, 1).

Minimal evidence exists to prove the making of fine earthenware in America before 1800. Cream-coloured earthenware in the English manner is mentioned in a Boston newspaper in 1769, although actual examples have

not been certainly identified. In Salem, NC, William Ellis introduced the manufacture of creamware in 1773 alongside the flamboyant, traditional redwares of Aust, which remained the principal product. Archaeological evidence from Philadelphia suggests attempts to make refined earthenware at this time, but the relatively inexpensive importation of European finer ceramics hampered the founding of successful enterprises for large-scale production in America.

Stoneware production began during the first half of the 18th century. William Crolius and John Remmey (see CROLIUS AND REMMEY) were probably in the pottery business together shortly after their arrivals in New York, making lead-glazed earthenwares and salt-glazed stonewares. Similarly, Anthony Duché (fl Philadelphia, 1700–62) was already making stoneware in Philadelphia in 1730 when he applied to the provincial legislature for a monopoly and subsidy that were eventually denied. The stoneware potters in Manhattan exploited part of the Raritan Formation, NJ, a major bed of blue-stoneware clays; the same resource prompted a large group of stoneware potteries to be established near by, beginning about 1754 with that of JAMES MORGAN and continuing through the 19th century. Clay from this resource supplied many potters from New England to upstate New York via clay-mining operations in New Jersey. In contrast to these northern stonewares in the Rhenish style, as early as the 1730s WILLIAM ROGERS of Yorktown, VA, was making large quantities of salt-glazed stoneware for home and tavern use indistinguishable from English stoneware of the period. In New England, however, there was a lack of proper clays for stoneware production, which did not begin until after the American Revolution; instead stoneware was imported from England or from other American colonies.

In spite of the difficult conditions in the colonies during the 17th and 18th centuries, there was some interest in making porcelain. ANDREW DUCHÉ attempted to produce porcelain with indigenous materials in Savannah, GA, during the 1730s, but it was the porcelain factory of BONNIN & MORRIS that turned out an identifiable body of work between 1770 and 1772 at Southwark in Philadelphia. The bone china body was decorated in underglaze cobalt blue in the style of such English factories as Bow, and ambitious forms were produced, including tiered shell-shaped sweetmeat stands (see fig. 34) and pierced fruit baskets. Despite the high quality of the porcelain, high labour costs and competition from abroad proved to be too extensive to overcome, and the factory closed in 1772.

2. 1800–*c.* 1900. The American ceramics industry developed dramatically during the 19th century as the population grew and spread to the West and the demand for finer products increased. The centres of ceramic production also moved west to accommodate the growing population, and after 1840 modest cities served by major transportation networks were more likely to become pottery centres than the urban areas of the previous century. By 1885 a variety of wares was produced, including industrial stoneware, decorative tiles, earthenware for kitchen, table and sanitary uses, art pottery and porcelain.

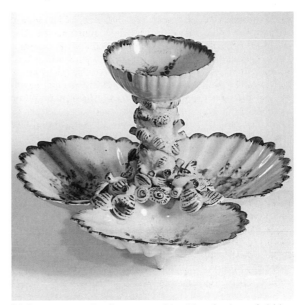

34. Sweetmeat stand, soft-paste porcelain with underglaze cobalt blue decoration, h. 133 mm, made by Bonnin & Morris, Philadelphia, 1770–72 (New York, Brooklyn Museum)

(i) Earthenware and stoneware. (ii) Art wares.

(i) *Earthenware and stoneware.* After 1800 red earthenware continued to be made, while an increasing number of potteries adopted salt-glazed stoneware as a viable product. For both wares greater competition engendered more decoration, and regional characteristics can thus be more readily identified in wares made after 1800. New England redware, for example, displays colourful effects obtained by firing the wares in a reducing atmosphere that forced the lead glazes to 'bloom' in contrasting colours around trace imperfections in the body or glaze. The region around New York Bay from coastal Connecticut to north-eastern New Jersey produced wares with a distinctively bold use of trailed white slip on a bright red body. Decorations included geometric ornament, spirals, birds, names, mottoes and aphorisms. The same aesthetic was translated into brilliant cobalt blue slip trailed on to grey, salt-glazed stoneware made during the mid-19th century inland from the bay area in New Jersey, but especially north along the Hudson River and Erie Canal in New York state. A menagerie of animals, whimsical birds and human figures engaged in humorous activities were used on the pots and jugs from this region. Outside Philadelphia, in south-eastern Pennsylvania, the use of highly stylized sgraffito and slip decoration of the previous century continued unabated in the German settlements until at least 1840, especially on presentation pieces.

The consumer interest in redwares, however, began to fade during the early 1800s. Three factors effectively eliminated redware as a popular ceramic product by 1850: the danger of the lead in the glaze was known, the affordability of English white earthenwares increased, and Rockingham-glazed yellow wares emerged as the most popular kitchen crockery. Press-moulding and Rockingham (wares with a brown mottled glaze) were introduced to American potteries by English potters coming from the

over-competitive industry in Staffordshire. The transition to press-moulding had already begun on a small scale during the 1810s and early 1820s when some potters in the mid-Atlantic region used moulds to make black-glazed teapots. In 1828 D. & J. Henderson purchased a pottery in Jersey City, NJ, and began making high-quality brown-glazed, and later Rockingham, in moulds for the first time in the USA. This operation, renamed the AMERICAN POTTERY MANUFACTURING CO. in 1833, is thought to have been the first true pottery factory in the USA in which a large number of skilled potters, semi-skilled workers and labourers were organized to mass produce good-quality tableware. Their modeller between 1839 and 1850 was the Englishman Daniel Greatbach, who introduced the classic Hound-handle pitcher (e.g. Newark, NJ, Mus.; Trenton, NJ State Mus.) to the American potter's repertory, a form that was popular for the rest of the century. While in Jersey City, he also made large, fine Toby jugs, vine-covered tea sets and an 'Apostle' jug. By 1852 he was employed by the United States Pottery Co. in Bennington, VT, to produce exhibition pieces for the Crystal Palace Exhibition of 1853 in New York. In Bennington, Greatbach used the 'flint enamel' glaze developed by Christopher Webber Fenton (1806–65), as in the 'Apostle' pattern water cooler (1849; New York, Brooklyn Mus. A.; see fig. 35) attributed to him and made at Lyman, Fenton & Co.

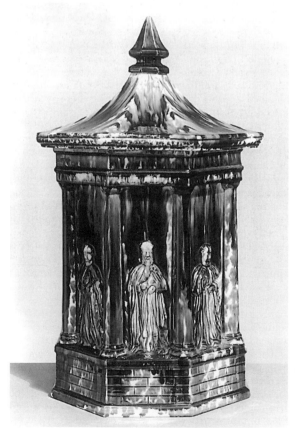

35. Stoneware water cooler attributed to Daniel Greatbach, earthenware with flint enamel glaze, h. 597 mm, made by Lyman, Fenton & Co., Bennington, Vermont, 1849 (New York, Brooklyn Museum)

Like Rockingham, white earthenwares were press-moulded, but were not made in the USA until the late 1850s. In the second half of the 19th century Rockingham and yellow wares were used primarily in kitchens, while whiteware was considered suitable for dinnerware because of its colour. Both were generally embellished with motifs popular on similar wares in England: hunt scenes, dead game, anchors, putti, scrolls and such simple border patterns as wheat for white dinnerware. Transfer-printed whiteware, sometimes filled with colours, was popular by about 1880, and coloured lithographic decoration began to appear *c.* 1890. Until 1880 most of these wares were not marked or were marked with pseudo-English makers' devices to confuse buyers who preferred English goods.

The manufacture of press-moulded wares provided the cornerstones for the development of America's two most important ceramic centres in the 19th century and the early 20th: East Liverpool, OH, and Trenton, NJ. Manufacturers in each city were able to take advantage of water and rail transportation networks to serve highly populated areas. In addition, the early success of the first English potters to arrive in these cities during the second quarter of the 19th century attracted more potters and more investment capital from local businessmen. Between 1850 and 1920 most of the American crockery used in the USA was produced in these two cities, and although many of the potteries lasted for fewer than 20 years, the wares of such manufacturers as the Homer Laughlin China Co. (*see* LAUGHLIN, HOMER) in East Liverpool and the Ceramic Art Co. (later the Lenox China Co.; *see* LENOX, WALTER SCOTT) in Trenton were consistently popular with American consumers.

Utilitarian stoneware was used throughout the later 19th century, although more for industrial use than for homes, where such lighter materials as tin and glass were used for storage. After 1850 many of the stoneware potteries switched to industrial products (e.g. drainage tiles) as their mainstays.

Some of the most imaginative stoneware was made in utilitarian potteries during the second half of the 19th century in Ohio and Illinois, at a time when the Renaissance and Rococo revival styles coincided with a decline in handcraft. This dénouement generated some extravagant sculptural work; Wallace Kirkpatrick (1828–96) and Cornwall Kirkpatrick (1814–90) of Anna, IL, for example, made stoneware temperance jugs covered with writhing lifelike snakes. Their pig-shaped whisky flasks with railroad maps inscribed on the side were metaphors for corn production and consumption in the Midwest. A distinctly different tradition in stoneware developed in the southern states, where potters preferred alkaline to salt glaze. Wood ash was a commonly used flux in the mixtures with sand and clay that produced glassy green glazes ranging from clear pale celadon to dripping dark effects later called 'tobacco spit'.

The manufacture of decorative tiles flourished in the USA between 1870 and 1930 (*see* TILES). Inspired by the public interest in the exhibits of English tilemakers at the Centennial Exhibition of 1876 in Philadelphia, a number of tile companies were established in the late 1870s in Ohio, Pennsylvania, Massachusetts and New Jersey to make fashionable high-glazed, relief-moulded tiles. During

the 1890s the fashion in tile decoration shifted to matt glazes in flat stylized patterns.

(ii) Art wares. The making of decorative ceramics in the USA received little encouragement until the 1880s: before 1800 Americans depended on English merchants to supply fine ceramics, and after the American Revolution, when trade conditions were more favourable to manufacturers, consumers already preferred wares from England, Europe and China. Porcelain was rarely produced with much commercial success until after the Civil War. In the early 19th century Dr Henry Mead (1774/5–1843), a New York physician, Abraham Miller (?1799–1858), a Philadelphia potter, and William Ellis Tucker (*see* TUCKER CHINA FACTORY), also of Philadelphia, all made table and decorative porcelains in the fashionable Empire style, but only Tucker was successful for any period.

In 1849 Christopher Webber Fenton established the firm that would become the United States Pottery Co. in Bennington, VT, which made parian figures, pitchers and vases. Charles Cartlidge & Co. in Greenpoint, NY (1848–56), made soft-paste porcelain doorknobs and buttons, but is best known for the parian portrait busts and porcelain pitchers in his display in the New York Crystal Palace Exhibition of 1853. In 1863 William Boch and Bros' Union Porcelain factory became Thomas C. Smith's (1815–1901) UNION PORCELAIN WORKS, where the first hard-paste porcelain was made c. 1865.

In Trenton, porcelain was produced at least as early as 1854 by William Young (1801–71), who had worked for Cartlidge, but his stock-in-trade remained hardware trimmings. In the 1860s William Bloor (1821–77) introduced parian manufacture to East Liverpool. Although this venture was a false start, his partnership in the late 1860s with Joseph Ott and John Hart Brewer in Trenton bore fruit. Ott & Brewer (1863–93) continued to make parian portrait busts after Bloor's departure, and in 1875 they hired the sculptor ISAAC BROOME to prepare models for exhibition pieces to be shown at the Centennial International Exhibition of 1876.

In a similar move, Thomas Smith hired German sculptor Karl Müller (1820–87) for the Union Porcelain Works. Each sculptor produced several models for exhibition and sale, but for size and complexity Müller's 'Century' vase (e.g. Atlanta, GA, High Mus. A.; New York, Brooklyn Mus. A.; New York, Met., see colour pl. XXXIV, 2; Trenton, NJ State Mus.) and Broome's 'Baseball' vase (1875; Trenton, NJ State Mus.; see fig. 36) were their principal contributions and rank as the USA's first major ceramic exhibition sculpture. Müller's vase is historical in terms of the modelled decoration, which celebrates the virgin land and early republic. In Broome's large covered vase, which honours contemporary sport, throwing, catching and batting are depicted by three figures arranged around a cone-shaped faggot of bats topped by a baseball on which an American eagle sits. Ott & Brewer persisted in the development of American art porcelain by producing a version of Belleek beginning in 1883. This was decorated in the Aesthetic taste with gold encrustations, delicate flowers and flying cranes. In 1887, after his success as art director at Ott & Brewer, Walter Scott Lenox took the same concept for art porcelain to the Willets Manufac-

36. Parian porcelain 'Baseball' vase by Isaac Broome, h. 864 mm, made at Ott & Brewer, Trenton, New Jersey, 1875 (Trenton, New Jersey State Museum)

turing Co., a rival Trenton firm, where his famous nautilus-shell ewer was first produced. In 1889 Lenox founded the Ceramic Art Co., which specialized exclusively in porcelain art wares, a radical idea in the American ceramics industry. In East Liverpool, KNOWLES, TAYLOR & KNOWLES produced a version of Belleek during the late 1880s, and they also introduced 'Lotus Ware', a bone china that was slip cast in lacy shapes, in 1890.

During the 1870s Maria Longworth Nichols, later Mrs Storer (1849–1932), and Mary Louise McLaughlin (1847–1939), both from Cincinnati, OH, were learning to deco-

rate china and were impressed with the painterly style of the slip-decorated pottery exhibited by Haviland & Co. of Limoges at the Centennial Exhibition of 1876, as well as with the art wares sent by Japan to the same exhibition. In 1878 McLaughlin successfully imitated the slip-decorated effect, though not the process, and in 1880 Nichols established the ROOKWOOD POTTERY in Cincinnati to produce the wares (see fig. 37). Nichols later hired Japanese designers, such as Kataro Shirayamadani (1865–1948), to work at Rookwood (see colour pl. XXXIV, 4). Although lesser-known firms were doing similar slip-decorated work, Rookwood survived and was often copied by such later Ohio companies as the Weller Pottery (1888–1948) and the Roseville Pottery (1898–1954). The painterly slip decoration of Rookwood contrasted with the Chinese-style wares with monochromatic glazes that were produced by HUGH CORNWALL ROBERTSON in his family's Chelsea Keramic Art Works (1872–89) in Chelsea, MA (see colour pl. XXXIV, 3). In 1895 a new pottery was established in Dedham, MA, using Robertson's distinctive crackled glaze for dinnerware, decorated in cobalt blue with stylized flowers and animals.

Other important American art wares of the late 19th century included those made by WILLIAM HENRY GRUEBY

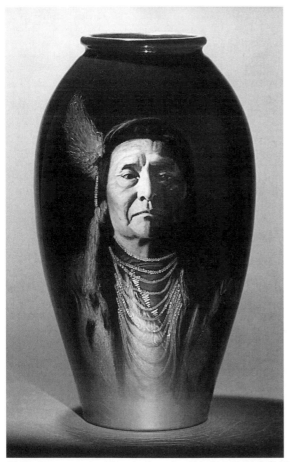

37. Earthenware vase with underglaze slip-painted portrait of *Chief Joseph of the Nez Percés* painted by William P. McDonald, h. 356 mm, made by the Rookwood Pottery, Cincinnati, Ohio, 1895 (New York, Metropolitan Museum of Art)

between 1894 and 1913. Inspired by the work of the French art potter Auguste Delaherche, Grueby's art wares combined monochromatic flowing matt glazes with organic low-relief decoration. The Newcomb Pottery in New Orleans, LA, developed a distinctive regional style by rendering local flora in stylized patterns in a limited colour palette. The pottery employed art graduates from the Newcomb College for Women, to which it was connected, from 1895 to 1940. Master potter George E. Ohr (1857–1918), of Biloxi, MS, produced artistic redwares of unusual character between 1890 and 1910. His work was wheel-thrown to exquisite thinness and then adeptly altered with twists and frills.

3. c. 1900–1914. American ceramics matured as both industry and art during the 20th century, and much of this development came from the institutionalization of ceramics education. Industrial art education in the USA began in the late 19th century; although initially based on the English system, which for potteries had begun much earlier, it focused instead on education within a university setting, segregated from the workplace. Important ceramics and clayworking courses were established in the late 19th century and the early 20th at such universities as Ohio State University, Columbus; Alfred University, Alfred, NY; Rutgers University, New Brunswick, NJ; and the University of Illinois, Urbana–Champaign. Such courses trained engineers, chemists and industrial designers to develop original forms and to improve the quality of the product for commercial potteries. Independent potters began to think of themselves as artists in the same way as painters and sculptors; they were associated primarily with small, hand-production potteries, serving a giftware market created by the American Arts and Crafts Movement, and later operated their own studios.

The American Ceramic Society, founded in 1899, also contributed greatly to the development of commercial ceramics. Unlike its predecessor, the American Potters' Association, which consisted of pottery owners and focused primarily on management and labour issues, the American Ceramic Society was open to anyone associated with the pottery industry. Meetings provided forums for sharing technical research and design concerns that addressed common problems in the potteries.

(i) Production ceramics. (ii) Art wares.

(i) *Production ceramics.* By the end of the 19th century the composition of domestic whitewares was so refined that it was closer to stoneware or proto-porcelain than to earthenware. By 1920 this low-cost, high-quality product dominated the American market, but modernization of factory technology was necessary to meet increased demand profitably.

(ii) *Art wares.* By contrast, in the early 20th century art ceramics were still made largely by the small art potteries that were founded under the Arts and Crafts Movement. Such pioneering firms as the ROOKWOOD POTTERY, the Newcomb Pottery (1895–1931) and the Dedham Pottery (1896–1943) survived until at least the middle of the 20th century. A host of other small art potteries were established

and capitalized for a short time on the distinctive artistic inventions of their founders: Clewell Metal Art (1906–c. 1920), Canton, OH, produced earthenwares covered in a patinated metal, a process developed by Charles Walter Clewell (c. 1876–1965); the Tiffany Pottery (1904–c. 1919), Corona, NY, of Louis Comfort Tiffany (see TIFFANY, §2), made wares with matt, crystalline and iridescent glazes; the Clifton Art Pottery (1905–11), Newark, NJ, specialized in shapes and decorations modelled after early American Indian pottery; the Markham Pottery of Ann Arbor, MI (1905–13), and National City, CA (1913–21), produced redware vases with applied finishes that made them resemble archaeological relics; in 1909 the Fulper Pottery (1860–1935), Flemington, NJ, began using its 19th-century utilitarian stoneware body to make 'Vasekraft' wares, created by the German designer J. Martin Stangl (d 1972), which were covered with colourful crystalline, flambé and monochromatic glazes.

Several art potteries founded during the early 20th century operated for many years because their products filled particular market niches. The work of the Van Briggle Pottery (1901–) in Colorado Springs, CO, is based on the artistic concepts of Artus Van Briggle (1869–1904), who modelled Art Nouveau vases with designs based on American flora. Many of his original designs continued to be used after his death. The Pewabic Pottery (1903–61) was founded by Mary Chase Perry (1868–1961) in Detroit, MI, and specialized in the development of iridescent glazes on flat tiles or simply shaped vases. The firm's broad, flat, pictorial designs for tile installations were particularly popular with ecclesiastical customers.

BIBLIOGRAPHY

E. A. Barber: The Pottery and Porcelain of the United States: An Historical Review of American Art from the Earliest Times to the Present Day (New York, 1893, rev. 3/1909/R New York, 1976)
——: Tulip Ware of the Pennsylvania Germans: An Historical Sketch of the Art of Slip-decoration in the United States (Philadelphia, 1903)
——: Marks of American Potters (Philadelphia, 1904)
L. W. Watkins: Early New England Potters and their Wares (Cambridge, MA, 1950)
R. C. Barret: Bennington Pottery and Porcelain (New York, 1958)
D. B. Webster: Decorated Stoneware Pottery of North America (Rutland, 1971)
P. Evans: Art Pottery of the United States: An Encyclopedia of Producers and their Marks (New York, 1974, rev. 1987)
R. Kovel and T. Kovel: The Kovels' Collector's Guide to American Art Pottery (New York, 1974)
G. Clark: A Century of Ceramics in the United States, 1878–1978: A Study of its Development (New York, 1979)
S. S. Darling: Chicago Ceramics and Glass: An Illustrated History from 1871 to 1933 (Chicago, 1979)
H. V. Bray: The Potter's Art in California, 1885 to 1955 (Oakland, 1980)
L. Lehner: Complete Book of American Kitchen and Dinner Wares (Des Moines, 1980)
S. H. Myers: Handcraft to Industry: Philadelphia Ceramics in the First Half of the Nineteenth Century (Washington, DC, 1980)
G. H. Greer: American Stonewares: The Art and Craft of Utilitarian Potters (Exton, 1981)
A. K. Winton and K. B. Winton: Norwalk Potteries (Norwalk, 1981)
W. C. Gates jr and D. Ormerod: 'The East Liverpool Pottery District: Identification of Manufacturers and Marks', Hist. Archaeol., xvi (1982), pp. 1–358
R. I. Weidner: American Ceramics before 1930: A Bibliography (Westport, 1982)
J. D. Burrison: Brothers in Clay: The Story of Georgia Folk Pottery (Athens, GA, 1983)
S. R. Strong: History of American Ceramics: An Annotated Bibliography (Metuchen, 1983)
W. C. Gates jr: The City of Hills and Kilns: Life and Work in East Liverpool, Ohio (East Liverpool, 1984)
J. Poesch: Newcomb Pottery: An Enterprise for Southern Women, 1895–1940 (Exton, 1984)
E. Denker and B. Denker: The Main Street Pocket Guide to North American Pottery and Porcelain (Pittstown, 1985)
J. Liebowitz: Yellow Ware: The Transitional Ceramic (Exton, 1985)
C. G. Zug III: Turners and Burners: The Folk Potters of North Carolina (Chapel Hill, 1986)
M. L. Branin: The Early Makers of Handcrafted Earthenware and Stoneware in Central and Southern New Jersey (Rutherford, 1988)
A. C. Frelinghuysen: American Porcelain, 1770–1920 (New York, 1989)
S. J. Montgomery: The Ceramics of William H. Grueby: The Spirit of the New Idea in Artistic Handicraft (Lambertville, 1993)
N. Karlson: American Art Tile, 1876–1941 (New York, 1998)
M. Brown Klapthor: Official Whitehouse China: 1789 to the Present (New York, 1999)

ELLEN PAUL DENKER

IX. Glass.

1. Before 1800. 2. 1800–80. 3. 1880–1914.

1. BEFORE 1800. The first permanent English settlement in North America, at Jamestown in the colony of Virginia, was founded in 1607 principally to furnish the English market with raw materials for industry, but the merchant investors who made up the Virginia Company of London were also alert to profitable manufactures that could be carried on there. One obvious choice was glassmaking: as the land was heavily wooded, fuel for the furnaces—in short supply in England—was abundant, and it was assumed that the raw materials necessary for glassmaking could be found near by. Although two different attempts at glassmaking were tried during the first quarter of the 17th century, the primitive conditions and the distance from the customers in England meant failure for this first effort to found an industry in America. Glassmaking, unlike cabinetmaking, silversmithing and other Colonial crafts that supplied the populace with goods, required a few skilled workmen—at least one person with experience in mixing the raw materials and with knowledge of furnace construction—and a considerable amount of raw material and fuel before any saleable products could be made. These requirements made a substantial capital outlay a necessity for any potential glassmaker, and they explain why other crafts flourished in the colonies well before glassmaking did.

There was considerable demand for both window and bottle glass, and the immense tracts of forest, which were a hindrance to agriculture, encouraged glassmaking. Between 1732 and 1780 nearly 20 glasshouses were started. The three most ambitious and commercially successful factories were founded by German entrepreneurs, and most of the workers were German as well. Investors found it easier to induce German rather than English glassblowers to come to America, because the Germany economy was less stable than that of England.

In 1738 CASPAR WISTAR brought over four German glassblowers and financed the building of a glasshouse in what came to be known as Wistarburgh, near Alloway in Salem Co., NJ. By 1739 it was in production, using wood from nearby forests for fuel and local sand and wood ashes as the principal raw materials. The glass produced was typical Waldglas, an impure greenish glass common throughout northern Europe from the Middle Ages.

Wistar's advertisements indicate that he produced mainly window glass and bottles, the glass commodities most needed by the colonists. Tablewares were still largely supplied from abroad; however, some sugar bowls, cream baskets, mugs and candlesticks in green, blue and colourless glass were probably made at the factory for sale in Wistar's store and for the use of his family. The manufacture of glass and similar goods was officially discouraged by the British authorities, who viewed the colonies solely as producers of raw materials for British manufacturers. By the mid-18th century, however, there was considerable interest in the domestic manufacture of glass in several colonies, particularly in Massachusetts, New York and Pennsylvania.

Among Colonial glass factories, the most famous is that of HENRY WILLIAM STIEGEL. In 1764 he opened his first glasshouse at Manheim, PA, a village he had founded for his workers. Although he manufactured principally bottles and window glass there, Stiegel was determined to produce fine lead-glass tableware in the English tradition. By 1769 he was advertising an extensive assortment of 'white and blue flint' glass tablewares, including tumblers and decanters in several sizes, water bottles, wine and water glasses, serving glasses for salt and cream, cruets for vinegar and mustard, and vials for chemists and apothecaries, all produced at his American Flint Glass Manufactory. Some of Stiegel's tableware was decorated with wheel engraving (see fig. 38). His factory prospered for several years, but his continued expansion led to increasing debt and by 1774 he was forced to close.

In 1784 John Frederick Amelung moved from Germany to Maryland with equipment and workmen for three furnaces. Within a few months he advertised that window glass and green and white hollowware were for sale at his New Bremen Glassmanufactory in Frederick, MD. In one of the first planned industrial villages in the USA, he built homes for his workmen near the factory and a school for their children. By 1789 Amelung claimed to manufacture 'all kinds of Flint-Glass, such as Decanters, and Wine Glasses, Tumblers of all Sizes, and any other Sort of Table Glass. He also cuts Devices, Cyphers, Coats of Arms, or any other Fancy Figure on Glass.' Probably as a means of attracting public notice, Amelung presented a pair of elaborately engraved goblets (untraced) to President George Washington, a goblet (New York, Met.; for illustration *see* AMELUNG, JOHN FREDERICK) to Governor Thomas Mifflin of Pennsylvania and other pieces to some influential citizens. Many of these glasses are dated and signed, which aids in the identification of similar, unsigned pieces. Although a little old-fashioned by contemporary European standards, Amelung's presentation pieces are the most ambitious and elegant tableware produced in the USA in the 18th century.

With the end of the Revolutionary War in 1783, official restraints on manufacturing were removed, thus encouraging the development and growth of new industries. Manufacturers still had to compete with imported goods, and the British were especially eager to preserve their markets and to discourage American manufacturing. Except for Amelung's ambitious venture and a short-lived factory in Philadelphia, the managers of glasshouses started in the 1780s and 1790s were content to manufacture

38. Lead-glass goblet, h. 172 mm, made by Henry William Stiegel's American Flint Glass Manufactory, Manheim, Pennsylvania, 1773; wheel-engraved by Lazarus Isaacs in commemoration of the marriage of Stiegel's daughter Elizabeth to William Old (Corning, NY, Museum of Glass)

windows and bottles, leaving the tableware market to importers.

2. 1800–80. After the American Revolution, settlers flowed west, lured by the promise of free land. The price of the commonest household goods sold in the western communities was greatly increased by freight charges, thus providing an irresistible impetus for manufacturers in the West to compete with goods shipped in from coastal cities. Window glass was especially prone to breakage during shipment, and it was thus one of the products made in the first glasshouses west of the Allegheny Mountains in Pennsylvania. While window and bottle glasshouses continued to be concentrated in the heavily forested areas of New England, upstate New York and southern New Jersey, the factories that produced fine tablewares were in cities, closer to the centres of population.

American manufacturers were not freed from foreign competition until the Acts of Embargo (1807) and the

Napoleonic Wars (1803–15) cut off the supply of imported British goods. This was only a temporary respite; the glass industry did not really flourish until it was protected by the Tariff Act of 1824. The first successful manufactory of lead-glass tablewares in the USA was located in Pittsburgh, PA. The distance from foreign competition, as well as the availability of customers and of coal for fuel, may have prompted Benjamin Bakewell, a Pittsburgh merchant, to start a glasshouse, BAKEWELL & CO., in 1808. Anxious to show off his cut glass, Bakewell presented a pair of decanters (Washington, DC, White House Col.; priv. col., on loan to Corning, NY, Mus. Glass) to President James Madison and another pair (untraced) to President James Monroe when they visited Pittsburgh in 1816 and 1817. President Monroe then ordered a set of English-style cut glass (untraced) for the White House, Washington, DC, from the Bakewell glasshouse in 1818. These early products of the American glass industry are astonishingly well cut and are difficult to distinguish from English cut glass of the same period: English glass was the standard by which American glass was judged, most of the glasscutters had learnt their trade in England, and such motifs as strawberry diamonds, fine diamonds, arches, fans, circular facets and flutes were fashionable in both places.

By the 1820s Bakewell had competitors in Pittsburgh and western Virginia, as well as in Boston, New York and Philadelphia. In 1818 a group of investors opened the NEW ENGLAND GLASS CO. in East Cambridge, MA. It eventually became one of the largest and most successful glass factories in the USA, making all types of tableware and lighting devices. In 1825 Deming Jarves (1790–1869) started the BOSTON & SANDWICH GLASS CO. in Sandwich, MA, which made similar products. These two factories dominated the market in New England. By 1830 three glasshouses in the New York area were producing fine tablewares, two of which had been started by workmen from the New England Glass Co. There were several independent cutting shops, which used glass blanks made in the New York factories or abroad. In Philadelphia the Union Flint Glass Co. was started in 1826 by a group of workmen from the New England Glass Co. It is difficult to make any stylistic distinctions among the products of the various factories making wares for the luxury market, as all the factories were producing blown and cut wares in the English style.

Although the largest factories often made tableware and containers, it was during the early 19th century that factories began to specialize. The raw materials and skills necessary to make refined, colourless tableware differed from those for commercial green-glass containers and flat glass. The blowers in the window- and bottle-glass factories were allowed to use their free time to make whatever they wished from the unrefined glass left in the pots at the end of the shift. Most of these were utilitarian household wares, such as milk pans, sugar bowls, creamers and large jugs. Although composed of many shades of green, amber and aquamarine, they are often attractive and skilfully made. They are usually simple in shape and often decorated with applied threading and extra gathers of glass tooled into leaflike decorations called lily pads (see colour pl. XXXV, 1). The making of these wares flourished throughout the first half of the 19th century.

By the mid-19th century the growth in population meant a greater demand for glassware, and because the manufacture and decoration of hand-blown glassware was slow and costly manufacturers sought ways to speed production and to decorate their glass more cheaply. In the early 19th century the technique of mould-blowing glass, which produced the shape and surface pattern in one operation, was introduced in the manufacture of European and American tablewares. The first patterns used were copies of the cut glass then in vogue, but later manufacturers made use of other decorative elements. Although this was an efficient method of mass production, a number of American glassmakers experimented further in the 1820s with new methods to reduce costs and speed production. The result was the pressing or casting of glass into moulds. This was not a new technique: its origin can be traced back to ancient Rome. The principle of forcing rather than blowing glass into a shape had also been practised in Europe since the early 18th century. The process, however, of pressing molten glass into metal moulds by machine was perfected first in the USA by a series of improvements between 1820 and 1825, and within a few years many companies were using the new technique. Large quantities of American pressed-glass tableware were exported to Europe, the Caribbean and South America. By 1840 the patterned, mould-blown tableware was completely outmoded by pressed glass (see colour pl. XXXV, 3).

Some of the earliest pressed patterns were probably copied from cut glass, still the most fashionable tableware. Designs of Gothic arches, acanthus leaves, scrolls and other elements fashionable to interior decoration were copied from architectural pattern-books, and stylized floral designs may have been copied from English transfer-printed ceramics. Identifying the manufacturers of many of the earliest pressed patterns is difficult because so few pieces are marked, and many firms copied one another's popular patterns, thereby making absolute identification of early pressed glass nearly impossible; the examples in fig. 39 are all from New England. The development of the mechanical press and improved technology also gave rise to a greater variety of new shapes; this was accompanied by a shift in taste to simpler panelled and fluted decorative patterns that emphasized the purity of the glass and related to the new fashion in cut glass. Copies of every shape of the more expensive cut glass were suddenly available to people of lesser means, and the popularity of pressed-glass table sets was a tremendous boost for glass factories. By the mid-19th century machine pressing had become so efficient that a team of five men could make one hundred tumblers in an hour. This was much faster than producing blown wares in similar shapes. For the first time the American glass industry was stable and prosperous, able to fill the demands of an expanding market with quality products. Mass production was thus the most important American contribution to the glass industry.

The development of a cheaper, non-lead formula for glass pressing, combined with the availability of coal and natural gas for fuel in the Midwest, gave the western factories an economic edge that gradually shifted the centre of the American glass industry westwards. Most of the eastern companies, such as the New England Glass

39. Pressed glass (from left to right): covered sugar bowl, h. 152 mm, probably from Providence Flint Glass Works, Providence, Rhode Island, *c.* 1830–33; bowl (on stand), h. 47 mm, 1830–45; cup plate, diam. 88 mm, *c.* 1835; salt dish, h. 50 mm, probably from Boston & Sandwich Glass Co., 1830–40; plate, h. 40 mm, 1835–50 (Corning, NY, Museum of Glass)

Co., stopped making pressed glass in the 1870s and concentrated on the market for luxury wares, where the higher manufacturing costs could be more easily passed on to the buyer.

In the 1860s, after two decades of heavy pieces cut in simple patterns, tableware became lighter and thinner, and the cutting finer. This style did not remain popular for long as the glass was more fragile, and heavier, thicker glass, more deeply cut in intricate patterns, regained popularity in the 1870s. This change was heralded at the Centennial International Exhibition of 1876 in Philadelphia, where the East Coast glass companies exhibited cut and engraved glasses in both the new, heavier style and the older lightweight one. Gillinder & Co. of Philadelphia operated a complete glass factory on the exhibition grounds, making and selling popular pressed souvenir pieces as well as cut and engraved glass. The attention that Gillinder's displays of cut glass attracted, combined with the growing middle-class prosperity in the USA, led to a boom in the cut-glass industry. A new class of millionaires whose fortunes were made in railways, steamships, oil, steel and other industries created a large market for luxury goods. The entire surface of an object was decorated with intricate cutting—a style that went well with the heavy furniture, patterned fabrics and rich colours popular at that time.

Copper-wheel engraving was used increasingly to embellish glassware, especially presentation pieces. Many of the engravers were Germans or Bohemians who had been trained in highly organized apprenticeship systems, although by the end of the 19th century the demand for skilled cutters and engravers was so high that a number of Americans were able to find both training and employment in the indigenous glass industry. Although monograms and inscriptions of various sorts were popular on glass throughout the 1800s, mid-19th-century engravers added elaborate floral patterns, views of American scenery and buildings and naturalistic motifs of plants and animals.

3. 1880–1914. Several firms in New England and the Midwest in the 1880s and 1890s sought new methods and styles of decoration for their products. Some of the varicoloured art glass of this period imitates such substances as mercury glass, which resembles silver, and tortoiseshell glass. Other glassmakers created new and dramatic colour effects; the addition of special ingredients to the raw materials meant that the finished product could be shaded or particoloured, and reheating portions of the glass caused them to strike or change colour. This became a popular method of decoration when in 1883 the New England Glass Co. introduced 'Amberina' (see colour pl. XXXV, 2). It inspired a host of imitators, the most famous of which is 'Peachblow', an 'Amberina' glass lined with opaque white to give it a porcelain-like appearance. The name was adopted after the sale in 1886 of a Chinese porcelain peach-bloom vase for $18,000. The sale made national headlines, and such glass factories as HOBBS, BROCKUNIER & CO., the LIBBEY GLASS CO. and the Mount Washington Glass Co. (*see* MT WASHINGTON GLASS WORKS), as well as pottery manufacturers, rushed to

capitalize on the publicity by making objects in the same shape with vaguely related colours. These pieces of art glass came in a variety of shapes and colours, some with elaborate applied decoration and crimped edges, others with silver or silver-plated stands. Because most of the decoration was done at the furnace, while the glass was hot, it cost less to make and sold for half the price of heavy, cut glass. It is likely that cut glass appealed to more conservative buyers, and that art glass was favoured by buyers interested in something new and more stylish. Both styles, however, suited cluttered, over-decorated Victorian interiors, and they remained widely popular throughout the last two decades of the 19th century.

As the Art Nouveau style gradually made the popular Victorian strongly coloured art glass and the complex, prickly cut glass look fussy, people of discriminating taste began to prefer the work of Louis Comfort Tiffany (see TIFFANY, §2) and his competitors. Tiffany was the leading exponent of the Art Nouveau style in the USA, although it was his chief rival, the painter JOHN LA FARGE, who, in 1879, first perfected a striated, opalescent glass, which was immediately copied by artists in the USA and abroad. Tiffany was fascinated by the possibilities of stained glass and began using it extensively for decorative glass windows and in domestic interiors in the 1880s. Tiffany had his designs made for him in several factories until 1893, when he set up his own plant at Corona, Long Island, NY. From windows Tiffany turned to iridescent glass vessels and was influenced by both the French glass designer Emile Gallé (1846–1904), who was the acknowledged leader of this style, and the English exponents of the Aesthetic Movement. With the introduction of electricity in domestic lighting, Tiffany's firm began to make lamps with mosaic and stained-glass shades, which were immensely popular (see colour pl. XXXVII, 1). In the USA Tiffany's competition in the field of Art Nouveau glass included Victor Durand jr (1870–1931) of the Vineland Flint Glass Works and FREDERICK CARDER, who founded the Steuben Glass Works with Thomas G. Hawkes (see HAWKES, T. G., & Co.). Carder's 'Aurene' glass is nearly indistinguishable from Tiffany's in some shapes and colours. Other glass companies in New England, New York and the Midwest began to copy ornamental glass in the style of Tiffany, and soon a flood of cheaper wares, including pressed glass with an iridescent surface, was available. By World War I both art glass and the brilliant cut glass had been eclipsed in popularity by simpler, lighter styles, which were less expensive and suited modern taste.

BIBLIOGRAPHY

G. S. McKearin and H. McKearin: *American Glass* (New York, 1941/R 1989)

——: *Two Hundred Years of American Blown Glass* (New York, 1950)

A. C. Revi: *Nineteenth-century Art Glass: Its Genesis and Development* (New York, 1963, rev. 1967)

R. Koch: *Louis C. Tiffany: Rebel in Glass* (New York, 1964)

A. C. Revi: *American Pressed Glass and Figure Bottles* (New York, 1964)

——: *American Cut and Engraved Glass* (New York, 1965)

——: *American Art Nouveau Glass* (Camden, NJ, 1968)

P. V. Gardner: *The Glass of Frederick Carder* (New York, 1971)

K. M. Wilson: *New England Glass and Glassmaking* (New York, 1972)

L. Innes: *Pittsburgh Glass, 1797–1891: A History and a Guide for Collectors* (Boston, 1976)

D. P. Lanmon and A. M. Palmer: 'John Frederick Amelung and the New Bremen Glassmanufactory', *J. Glass Soc.*, xviii (1976), pp. 14–137

A. M. Palmer: *The Wistarburgh Glassworks: The Beginning of Jersey Glassmaking* (Alloway, NJ, 1976)

H. McKearin and K. M. Wilson: *American Bottles and Flasks and their Ancestry* (New York, 1978)

C. U. Fauster: *Libbey Glass since 1818: Pictorial History and Collector's Guide* (Toledo, OH, 1979)

A. Duncan: *Tiffany Windows* (New York, 1980)

J. S. Spillman: *American and European Pressed Glass in the Corning Museum of Glass* (Corning, 1981)

M. J. Madigan: *Steuben Glass: An American Tradition in Crystal* (New York, 1982)

A. Duncan: *American Art Deco* (New York, 1986)

A. Palmer: "To the Good of the Province and Country": Henry William Stiegel and American Flint Glass', *The American Craftsman and the European Tradition*, ed. F. J. Puig and M. Conforti (Minneapolis, 1989), pp. 202–39

J. S. Spillman and S. K. Frantz: *Masterpieces of American Glass* (New York, 1990)

A. Palmer: *Glass in Early America: Selections from the Henry Francis duPont Winterthur Museum* (Winterthur, 1993)

K. M. Wilson: *American Glass, 1760–1930: The Toledo Museum of Art* (New York, 1994)

J. S. Spillman: *The American Cut Glass Industry: T. G. Hawkes and his Competitors* (Suffolk, 1996)

E. S. Farrar and J. S. Spillman: *The Complete Cut and Engraved Glass of Corning* (Syracuse, 1997)

JANE SHADEL SPILLMAN

X. Metalwork.

1. Silver. 2. Base metals.

1. SILVER. The search for silver and gold was a driving force behind the settlement of the American continent, and silver coins and objects have been an integral part of American art ever since. In Colonial America the silversmith was a leader in introducing the newest and most fashionable styles from abroad, especially from England. His craft was perceived as one of the fine arts in the New World and it received greater attention from patrons in the 17th and 18th centuries than the sister arts of painting, sculpture or architecture. American silver remained responsive to the major artistic movements abroad and it rivals English silver in its skill and elaboration. Americans also introduced their own innovations, particularly in the continuing development of such traditional forms as porringers and tankards long after they ceased to be popular in Europe. In the 19th century American firms and designers became leaders in the development of new designs.

(i) Before 1700. (ii) 1700–50. (iii) 1751–75. (iv) 1776–1820. (v) 1821–1900. (vi) 1900–1914.

(i) Before 1700. Colonial silversmiths were not regulated by the guild system long present in England, and thus American objects lack hallmarks. The craftsman's touch-mark was his guarantee that the work leaving his shop was of sufficient quality. Most silversmiths ran small-scale operations, employing only one or two apprentices and journeymen. Sons often followed their fathers in the trade; notable examples include the Edwards family of Boston, the Richardson family of Philadelphia, and, on a lesser scale, the Lang and Northey families of Salem, MA. Journeymen specializing in such branches of the craft as engraving, chasing and casting often contributed to the definition of regional characteristics, for example the banding and pierced galleries that were used on the products issued by different shops in the Philadelphia–

Baltimore area, or by engraving the products of more than one silversmith. Scholars continue to focus attention on the importance of these skilled journeymen, whose contribution to the transfer of styles from England and Europe and to the development of new artistic expressions were significant as early as the 17th century. Colonial silversmiths drew on a wide variety of design sources in their work. Imported English objects provided first-hand knowledge of the latest fashions, and ceramic forms were another frequent source of inspiration. Immigrant craftsmen brought new ideas and fashions with them when they came to America. Dutch and French influence can be seen primarily in the work of silversmiths from New York, northern New Jersey and Albany.

Much of the silversmith's day-to-day work consisted of repairing worn pieces, replacing lost parts and making jewellery or small objects. Raw material was derived from melting down clipped and worn coins and damaged or unfashionable objects. In the early years of Spanish exploration of Central and South America, silver was mined in large quantities at the mines at Potosi in the Andes, and bullion and roughly minted coins were transported to Europe. However, silver in bullion form was rare in the British Colonies of North America, coming only from the occasional Spanish ships captured during periods of war. Most American silversmiths worked in gold as well as silver, and the terms goldsmith and silversmith were used interchangeably in early documents. Gold, rare in the colonies, was used only to fashion such small pieces of jewellery as buttons, lockets and buckles. Many silversmiths practised related crafts, including engraving, making coins and engraving paper currency, cutting seals and medals, making clocks, watches, mathematical, nautical and medical instruments, firearms, swords and other military equipment, and working in other metals.

American silver of the 17th century is notable for its broad proportions, fine engraved detail and flat-chased ornament. Stylish objects, such as cups with cast scroll and caryatid handles by Jeremiah Dummer (1645–1718) and JOHN CONEY of Boston and Bartholomew Le Roux (c. 1663–1713) of New York reveal the influence of the Mannerist style, also seen in the engraved strapwork designs on beakers. The rectilinear and architectural nature of much work in this period is evidenced by Dummer's monumental cluster-column candlesticks (New Haven, CT, Yale U. A.G.). English influence was predominant, as would be true of New England silver throughout the Colonial period. Occasionally, Continental sources seem to have provided prototypes for American work, as with Dummer's Portuguese-inspired two-handled bowl (New Haven, CT, Yale U. A.G.).

Silversmithing in 17th-century America was almost exclusively practised in the major seaports of Boston and New York; only towards the very end of the century did craftsmen practising this luxury trade work in Philadelphia, Charleston, SC, and elsewhere. Boston was the centre of the craft and the source of supply for all of New England (*see* BOSTON, §III, 2). The partnership of John Hull (1624–83) and Robert Sanderson (1608–93) in Boston began in the 1650s; they are the first silversmiths active in America by whom any work survives (e.g. dram cup, c. 1650–60; New Haven, CT, Yale U. A.G.). Both Hull and Sanderson

were born in England and came to the Massachusetts Bay Colony in the 1630s. Dummer, one of their apprentices, was the first American-born silversmith to produce a substantial body of work. John Coney was the outstanding Boston craftsman; Timothy Dwight (1654–92) and William Rouse (1639–1705) were other important Boston artisans of this early period.

A rich body of Dutch-related silver was produced in New York, which came under English rule in 1674 but retained a distinctly Dutch air well into the 18th century. Beakers, such as the large example of 1685 (New Haven, CT, Yale U. A.G.; see fig. 40) by Cornelius van der Burch (c. 1653–99), were a distinctive, Dutch-inspired form popular with New York craftsmen. The van der Burch beaker is engraved with designs derived from the engravings of Adriaen van de Venne (1589–1662) used as illustrations in a popular Dutch emblem-book by Jacob Cats (1577–1660). Tankards made by such prominent New York silversmiths as Jacobus van der Spiegel (1668–1708) and Jurian Blanck jr (c. 1645–1714) represent an important hybrid object. Generally English in form, although lower and broader than most New England examples, the New York tankard is often embellished with applied meander wire at the base, a corkscrew-spiralled

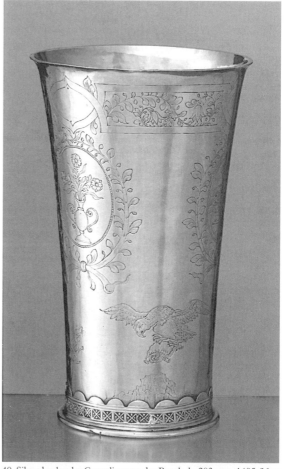

40. Silver beaker by Cornelius van der Burch, h. 203 mm, 1685 (New Haven, CT, Yale University Art Gallery)

thumbpiece, ornamental engraving featuring pendent fruit, cast and applied decoration on the handle and, occasionally, with a coin or medal inset in the lid. Late in the century such immigrant Huguenot craftsmen as Bartholomew Le Roux had an impact on New York styles. Members of the Ten Eyck family of Albany and others carried the Dutch tradition into the 18th century.

American silversmiths produced many forms, but spoons, porringers, beakers, dram cups, standing wine cups, two-handled cups, bowls, plates, salts and tankards were among the most common in this period. Silver objects were extremely expensive and were owned only by wealthy members of society or institutions, particularly churches. In the South most large planters traded directly with London merchants and therefore had credit there that could be used to acquire and import English silver.

(ii) 1700–50. The Baroque style, with its undulating lines and contrasting surfaces, is perhaps the most striking of all styles in early American silver. The forms produced were similar to those fashioned in the 17th century, but they were embellished with new ornament. Bold gadrooned bands and distinct mouldings were often used by the silversmith as an artistic foil for the plain shimmering silver surfaces in the creation of such elaborately three-dimensional masterpieces as John Coney's monteith (*c.* 1705–15; New Haven, CT, Yale U. A.G.; see fig. 41), used for rinsing and cooling wine glasses, and sugar boxes by Coney and Edward Winslow (1669–1753). Coney's monteith, made for the Colman family of Boston, is stylish by London standards and is testimony to Coney's skill in all areas of the craft. Even the simplest objects were often distinguished by elaborate piercings and exquisite ornamental engraving.

The Baroque style was brought to New England by an influx of immigrant craftsmen who came to Boston to fill the needs of the newly appointed British officials after the Massachusetts Old Charter was replaced by a royal charter in 1692. Boston and New York grew and developed in this period, and Philadelphia began to emerge as a significant port during this era of peace. This new affluence led to the production of such new forms as teapots, chocolate-pots, sugar-boxes, casters for condiments, chafing dishes, inkstands, large covered cups and punch-bowls.

In Boston the craft was dominated, among others, by Coney, Dummer, Winslow and John Edwards (1671–1746). Samuel Vernon (1683–1737) practised the trade in nearby Newport, RI. Craftsmen of Dutch and French descent, including Gerrit Onckelbag (*c.* 1670–1732), van der Speigel, Cornelius Kierstede (1675–1757), Le Roux and Peter Van Dyck (1684–1751), dominated the trade in New York. Cornelius Kierstede's work, including a pair of monumental candlesticks and a snuffers stand *en suite*, a tea kettle and a brandywine bowl (all New York, Met.) and numerous tankards, represents perhaps the finest work done in New York at this time. Three two-handled covered cups by Onckelbag (New Haven, CT, Yale U. A.G.; Hist. Deerfield, MA; Winterthur, DE, Du Pont Winterthur Mus.) and an example by Kierstede (Chicago, IL, A. Inst.) are evidence, however, that these Continental makers could also fashion objects in the English tradition. In Philadelphia, Cesar Ghiselin (*c.* 1663–1733), Johannis

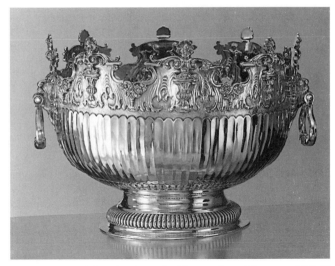

41. Silver monteith by John Coney, h. 219 mm, diam. 273 mm, *c.* 1705–15 (New Haven, CT, Yale University Art Gallery)

Nys (1671–1734), Francis Richardson (1681–1729) and Philip Syng sr (1676–1739) were major silver producers whose work is in the English style.

Characterized by balanced, symmetrical forms that rely on line and form rather than ornament for their visual impact, the Queen Anne style was popular in the colonies from about 1715 to 1750. Such geometric forms as the circle and octagon, smooth surfaces, superb proportions and the subtle interplay of reverse curves, particularly the S-curve, distinguish objects in this style, noted for its simplicity and restraint. The plain surfaces of the Queen Anne style allowed the engraver to display his abilities to great advantage (e.g. a salver by Jacob Hurd (1703–58); New Haven, CT, Yale U. A.G.).

In Boston, Hurd was the leader of his generation, noted especially for his large two-handled presentation cups (e.g. of 1744; New Haven, CT, Yale U. A.G.) and the high quality of engraving on his objects. He received many commissions for church silver, tutorial plate and civic objects. In New York, Charles Le Roux (1689–1745) and Simeon Soumaine (1685–1750) were accomplished masters. Soumaine's sugar bowl (New Haven, CT, Yale U. A.G.), based on East Asian ceramic prototypes, is a sophisticated statement of harmonious proportions and the interplay of circles on various planes, while a two-handled cup by Le Roux (New Haven, CT, Yale U. A.G.) is decorated with the harp-shaped handles and cut-card work characteristic of French Huguenot work produced in London. Philip Syng jr (1703–89) of Philadelphia produced a marvellous capacious tankard (New Haven, CT, Yale U. A.G.) that embodies the best of the Queen Anne style.

More specialized forms of tea equipment began to be made, as tea-drinking became a widespread form of domestic entertainment, and every fashionable hostess sought to acquire her own silver service. Large numbers of teapots, sugar bowls, cream jugs, tea caddies, sugar scissors and teaspoons were produced to fill the demand. The so-called keyhole-handled porringer (a small bowl

with one handle for multipurpose domestic use and frequently given to infants and children) was developed in this period and remained a standard design for the rest of the century.

(iii) 1751–75. Silver in the Rococo style is more elaborately embellished and more asymmetrical than its Queen Anne style predecessors. The repoussé ornament popular during this period was expensive, because it required great skill and much time for the maker to produce. Therefore, much American silver of this period is Rococo in form but lacks ornamentation other than engraving. Sugar bowls, teapots and coffeepots share the inverted pear (or 'double-bellied') shape and high centre of gravity characteristic of this style. The full vocabulary of Rococo ornament, including shells, scrolls and flowers, can be seen on a tea kettle with stand (New Haven, CT, Yale U. A.G.; see fig. 42) by Joseph Richardson (1711–84) of Philadelphia, probably based on an English example by Paul de Lamerie (1688–1751) owned in Philadelphia. Cast ornament, repoussé decoration and gadrooning were popular techniques used to place emphasis on ornament and small details in this period. Echoing furniture styles, silver objects were sometimes supported on short cabriole legs terminating on claw-and-ball, pad or, as with the Richardson kettle, shell feet. The highest achievements of American Rococo were made in Philadelphia, which by 1775 had become the largest city in America. Imported English silver played an increasingly important role, as silversmiths attempted to satisfy the demands of an increasingly large and affluent population by becoming importers and retailers as well as producers.

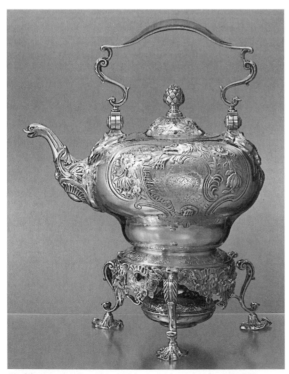

42. Silver tea kettle with stand by Joseph Richardson, h. 389 mm, *c.* 1745–55 (New Haven, CT, Yale University Art Gallery)

Rococo silver from New York is noted for its pierced decoration, as seen on a cake basket and dish ring (New Haven, CT, Yale U. A.G.) by Myer Myers (1723–95), who also produced important examples of Jewish ritual silver for synagogues in New York and Philadelphia. John Heath (*fl c.* 1760–70) and the Swiss immigrant Daniel Christian Feuter (1720–85) were other New York makers of prominence. Feuter's sophisticated Rococo work includes a cake basket (Boston, MA, Mus. F.A.), a gold coral and bells (New Haven, CT, Yale U. A.G.) and a beaker elaborately engraved with anti-papist propaganda (Winterthur, DE, Du Pont Winterthur Mus.). During the latter part of his years in New York (1754–69), Feuter employed John Anthony Beau (*fl c.* 1769), a specialist chaser who also emigrated from Switzerland and whose work is representative of the importance of such immigrant craftsmen.

In Boston, where the growth in population had slowed, a more restrained type of Rococo was practised, in which engraved ornament often appeared, for example on more traditional forms. The finest wares were produced by Benjamin Burt (1729–1805) and PAUL REVERE, who produced an impressive variety of objects, well documented in his surviving account-books and represented by objects in most major collections. His colleague Nathaniel Hurd (1730–77) is more noted for the high quality of his engraving in the Rococo style on both silver objects and bookplates. They relied on such English sources as Sympson's *New Book of Cyphers* (1726) and John Guillim's *Display of Heraldry* (6th edn, 1724) for their coats of arms and heraldic devices; Hurd, in fact, was painted by John Singleton Copley with these books at his side (*c.* 1765; Cleveland, OH, Mus. A.).

The first production of silver hollow-ware in substantial amounts by southern makers came in the Rococo period. By mid-century Thomas You (*fl* 1753–86) and Alexander Petrie (*d* 1768) were producing fine wares in Charleston, SC, and a teapot (New Haven, CT, Yale U. A.G.) by Gabriel Lewyn (*fl c.* 1768–80) of Baltimore is one of the most sophisticated American expressions of the Rococo.

Tea equipment grew to include large-footed trays or salvers and cream pots, and candlesticks, cruet-stands and large pierced baskets joined the repertory of forms in this period.

(iv) 1776–1820. The Neo-classical style marked a return to elegant simplicity. After a lull during the Revolution, silversmiths emphasized such forms as the urn and the oval and ornament inspired by the art and architecture of ancient Egypt, Greece and Rome. The influence of Classical antiquity came to America through the filter of Robert Adam (1728–92) of England. The style was introduced as early as 1774 in the form of an urn (Philadelphia, PA, Mus. A.; *see* FEDERAL STYLE, fig. 3) fashioned by Richard Humphreys (1750–1832) and engraved by James Smither (1741–97) of Philadelphia, and gained currency in the 1790s, remaining fashionable into the 1820s. Ornament, including pierced galleries, strips of beading and reeding, tended to be used with restraint. Despite the Revolution, English taste continued to be profoundly influential. In the 19th century the making of sterling silver

objects evolved from a craft into an industry. Such labour-saving techniques as drop-stamping, rolling, spinning and machine-engraving augmented traditional methods of handcraftsmanship. Sheet silver, used by Revere and others for teapots, made it possible to create objects of thinner-gauge material, with the result that more objects could be made from the same amount of raw material. This factor and the rise of fortunes made in international commerce, particularly with East Asia, that emerged after independence resulted in the production of more extensive tea services, often including coffeepots, two teapots, hot milk and cold cream pitchers and slop or waste bowls, and the first matched sets of silver flatware. The first silver substitute, fused or Sheffield plate, was imported in large quantities from England, and craftsmen from Philadelphia and elsewhere attempted to manufacture their own variety of this less expensive metal. Silver forms became broader and heavier in the 19th century as Neo-classicism developed into the Empire style.

Bright-cutting, a technique in which the silver is gouged or notched to form facets, was an important decorative technique in this period. Matching tea services became fashionable, as represented by a tea set (New Haven, CT, Yale U. A.G.) by Abraham Dubois (*fl c.* 1777–1807) of Philadelphia in which all the vessels are fashioned with urn-shaped bodies. The hot-water urn, used to heat water for diluting tea or coffee, was a characteristic form of the period. Coffeepots, too, became much more common.

Production in Philadelphia and New York eclipsed that of Boston in this period, and silversmiths began to find more work in such smaller cities as Baltimore, MD, Salem, MA, Hartford, CT, Alexandria, VA, and in many small towns on the expanding western frontier.

(v) 1821–1900. Design in the 19th century was characterized by an eclectic medley of successive yet overlapping styles borrowed from the past. The most successful designers avoided imitation and were able to assimilate and transform historical styles into a synthesis that was truly original. As the century progressed, objects were influenced by the French Rococo, Gothic, Greek, Renaissance and many other revival styles. The more exotic flavour of Egyptian, Japanese, Moorish and East Indian taste is also evident. Manufacturers competed for the buyer's attention by creating increasingly fanciful designs, many of which were now being patented at the US Patent Office, founded in 1791. At the end of the century a few manufacturers produced silver in the Art Nouveau style, led by the GORHAM Manufacturing Co. of Providence, RI, and popularized by such firms as Unger Bros of Newark, NJ. Gorham indicated in 1912 that with its Martelé ('hammered') line of silverware and jewellery, 'The form is the important thing, and the decoration, far from being conventional, partakes almost wholly of naturalistic forms: waves of the sea, natural flowers, mermaids, fishes, cloud effects—almost anything can be used provided it is treated in a naturalistic manner.' (Holbrook, pp. 113–14)

Early in the century there was a huge increase in small-shop production, but by mid-century these firms began to consolidate to form large manufacturing companies. New York played an increasingly important role, but as huge fortunes were made in the gold and silver rushes, silver-smiths began to move west to provide objects for the new clientele. Small firms opened throughout the country, but these increasingly served as retailers of objects made by the major firms that began in this period, including Gorham (1831), Tiffany & Co. of New York (1837), Reed & Barton of Taunton, MA (1824), Samuel Kirk of Baltimore (1815) and others. Such significant designers as William Christmas Codman (1839–1923) at Gorham, and Edward C. Moore (1827–91) and Paulding Farnham (*fl* 1889–*c.* 1904) at Tiffany played important roles in shaping taste. The exhibits by Tiffany, Gorham and other American firms at international exhibitions and fairs, including the Exposition Universelle of 1889 in Paris, the World Columbian Exposition of 1893 in Chicago, the Esposizione Internazionale d'Arte Decorativa Moderna of 1902 in Turin, the World's Fair of 1904 in St Louis, MO, and others, established American firms as leaders in international design and provided an opportunity for American companies to publicize their technical and design expertise through exceptional showpieces in a variety of styles.

While large quantities of domestic silver were produced in this period, presentation occasions provided silvermakers with some of their most lucrative commissions. Vases, pitchers and other presentation pieces made for heroes of the War of 1812 by such firms as that of Thomas Fletcher (*fl* 1809–50) and Sidney Gardiner (*fl c.* 1812–38) of Philadelphia were among the first major examples of a tradition that would last the century. Silver objects were used to commemorate a wide variety of accomplishments, from swords presented to war heroes, to monumental prizes for yachting and other sports, and full dinner services for use on US Navy battleships. Perhaps the most opulent of all American presentation pieces is the vase (New York, Met.; see fig. 43) for Edward Dean Adams (1846–1931); designed by Farnham and produced by Tiffany in 1893–5, it is made of gold and decorated with quartz, rock crystal, pearls, spessartites, tourmalines, amethysts and enamel. Another particularly impressive example of presentation silver is the 2.6 m high cup (Chicago, IL, Hist. Soc.) made in 1898 by Gorham to honour Admiral George Dewey. Designed by Codman, the enormous cup (see colour pl. XXXVIII) was fashioned from more than 70,000 dimes donated by men and women throughout the country in grateful appreciation for Dewey's victory at Manila in the Spanish–American War.

With the opening of the great silver mines in the American West in the 1850s and the introduction of electroplating techniques at about the same time, the ownership of silver and silverplate became much more commonplace. Suddenly silver was no longer the province of the few but was made accessible to the many. Silver-plated objects were made in a variety of revival styles, closely following forms in silver, and could be cheaply produced and widely marketed. Large factories and increased automation became the rule. Major manufacturers of silverplated wares were located in Connecticut, including Rogers Bros, the Meriden Britannia Co. and others. In 1898 more than 20 companies joined to form the International Silver Co. in Meriden, CT. In the 19th century nearly any article might be fashioned in sterling or silver-plate; elaborate dining customs called for many specialized forms of flatware (such as terrapin spoons, fish forks and

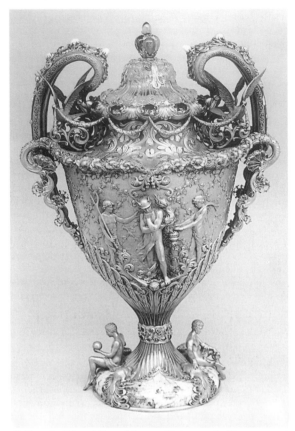

43. Vase for Edward Dean Adams, gold decorated with quartz, rock crystal, pearls, spessartites, tourmalines, amethysts and enamel, designed by Paulding Farnham for Tiffany & Co., New York, h. 495 mm, 1893–5 (New York, Metropolitan Museum of Art)

asparagus tongs) and table services consisted of tureens, trays, dinner plates, serving dishes, candlesticks and large decorative centrepieces, many to hold flowers or fruit. The service made by Tiffany in the 1870s for Mr and Mrs John W. Mackey consisted of about 1250 pieces (dispersed, see Carpenter and Carpenter, figs. 55–64) made from silver taken from Mackey's Comstock Lode mines in Virginia City, NV.

(vi) 1900–1914. At the beginning of the 20th century opulent naturalistic designs existed alongside the fluid functionalism of the Arts and Crafts aesthetic. Noted practitioners of the Arts and Crafts manner included Karl F. Leinonen (1866–1957) of Boston, Clara Welles (1868–1965), founder of the Kalo Shop in Chicago, Robert Jarvie (1865–1941) of Chicago, and Porter Blanchard (1886–1973) and Clemens Friedell (1872–1963) in southern California. Leinonen's hot chocolate set (1906; New Haven, CT, Yale U. A.G.; see fig. 44), commissioned as a gift for Louise G. Dietrick by the principal patron of the Boston Society of Arts and Crafts Handicraft Shop, Arthur Astor Carey, represents the restraint, sobriety and clean look of much Arts and Crafts work.

The same purity of line carried over into items manufactured by such firms as Tiffany & Co. but did not totally overshadow the prevailing taste for more traditional forms.

Some firms, such as those of Arthur J. Stone (1847–1938) of Gardner, MA, and George C. Gebelein (1878–1945) of Boston, turned to 18th-century American and English forms for inspiration (e.g. loving-cup by Arthur J. Stone; Cambridge, MA, Fogg; *see* BOSTON, fig. 5).

BIBLIOGRAPHY
J. S. Holbrook: *Silver for the Dining Room: Selected Periods* (Cambridge, MA, 1912), pp. 112–19
Colonial Silversmiths: Masters and Apprentices (exh. cat. by K. C. Buhler, Boston, MA, Mus. F. A., 1956)
K. Morrison McClinton: *Collecting American 19th-century Silver* (New York, 1968)
D. T. Rainwater and H. I. Rainwater: *American Silverplate* (Nashville and Hanover, PA, 1968)
K. C. Buhler and G. Hood: *American Silver: Garvan and other Collections in the Yale University Art Gallery*, 2 vols (New Haven, 1970)
G. Hood: *American Silver: A History of Style, 1650–1900* (New York, 1971)
N. D. Turner: *American Silver Flatware, 1837–1910* (New York, 1972)
M. Gandy Fales: *Early American Silver* (New York, 1973)
C. H. Carpenter jr and M. G. Carpenter: *Tiffany Silver* (New York, 1978)
Silver in American Life (exh. cat., ed. B. McLean Ward and G. W. R. Ward; New York, Amer. Fed., 1979–82)
B. McLean Ward: *The Craftsman in a Changing Society: Boston Goldsmiths, 1690–1730* (diss., Boston U., 1983)
Marks of Achievement: Four Centuries of American Presentation Silver (exh. cat. by D. B. Warren, K. S. Howe and M. K. Brown, Houston, TX, Mus. F.A., 1987)
American Rococo, 1750–1775: Elegance in Ornament (exh. cat. by M. H. Heckscher and L. G. Bowman, New York, Met.; Los Angeles, CA, Co. Mus. A., 1992)
C. L. Venable: *Silver in America, 1840–1940: A Century of Splendor*, Dallas, TX, Mus. A. cat. (Dallas, 1994)
P. M. Johnston, H. H. Hawley and B. Christman: *Catalogue of American Silver*, Cleveland, OH, Mus. A. cat. (Cleveland OH, 1994)
I. M. G. Quimby with D. Johnson: *American Silver at Winterthur*, Winterthur, DE, Du Pont Winterthur Mus. cat., (Winterthur, DE, 1995)
GERALD W. R. WARD

2. BASE METALS.

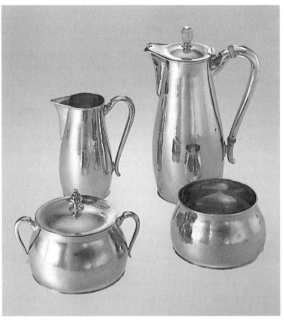

44. Silver hot chocolate set by Karl F. Leinonen, h. 205 mm (pot), 1906 (New Haven, CT, Yale University Art Gallery)

(i) Pewter. (ii) Iron and tinware. (iii) Copper, brass and bronze.

(i) Pewter. American pewter was based on English forms. The first known American pewterer was Richard Graves, who is recorded as working in Salem, MA, in 1635. By 1700 there were six pewterers working in the colonies, although few examples of their work survive: fragments of a pewter spoon (Jamestown, VA, N. Hist. Site) made by Joseph Copeland (1675–95) were excavated at Jamestown, VA, and the second oldest documented piece is a bowl (Winterthur, DE, Du Pont Winterthur Mus.) made by Edmund Dolbeare (1671–1711) of Massachusetts. After 1700 the number of pewterers increased, with production strongest in the Boston area, supplemented by work in New York, Middleton, CT, Rhode Island and Philadelphia. By the 1760s over 300 tonnes of pewter were shipped annually to America from England. Throughout the Colonial period, England placed strict restrictions on the importation of raw materials in order to discourage local production and to increase the market for English pewter and other goods. The major pewterers in the 18th century were: in Massachusetts, John Skinner (1733–1813) and Nathaniel Austin (1741–1816); in Rhode Island, Lawrence Langworthy (*fl* 1735) and David Melville (*fl* 1755–93); in the Connecticut Valley, Thomas Danforth (*fl* 1733–86) and Thomas Danforth II (*b* 1756); in New York, William Diggs (*fl* 1702), William Horsewell (*fl* 1705), Joseph Liddell (*d* 1754), Francis Basset (1690–1758) and his family, John Will (1696–1770) and William Bradford (1688–1759); and in Philadelphia, William Will (1742–98). Individual makers can sometimes be identified by certain characteristics: Peter Young (1749–95) of Albany, NY, is known for baluster stem chalices, and the work of Johann Christoph Heyne (1715–81) of Philadelphia shows German influence, seen for example in a flagon with angel head feet (Winterthur, DE, Du Pont Winterthur Mus.).

The pewter made in Colonial America reflected the styles and tastes of the makers' and customers' ethnic origins, usually England, although immigrants from Germany and Sweden exerted some stylistic influence. Pewter forms usually followed silver forms, though often lasted longer. There were regional differences; in New York, for example, tankards usually had a crenated lip, whereas in the Lancaster area of Pennsylvania, German influence was strong. Porringers were made with solid handles in Rhode Island and floral-design handles in the rest of New England. Multi-reeded edged plates were made prior to 1700, followed by single-reeded ones. From 1750 to 1775 hammered booges (the section between the bottom of the plate and the rim) appeared on some plates, while plates made in Boston were thinner.

After the Revolution, there was a significant increase in the amount of pewter made in the USA as the English control of commerce ended. Some of the major pewterers active until the first half of the 19th century were: in the Massachusetts Bay area, the Green family (*fl* 1710s–1790s) and George Richardson (*fl* 1818–28); in Rhode Island, Samuel Hamlin (*fl* 1840s) and William Calder (1792–1856); in New York, William Elsworth (*fl* late 1750s–1780s) and Henry Will (*fl* 1750s–1780s); in Albany, Spencer Stafford (*fl* 1794) and Timothy Brigden (*fl* 1770–1818); and in Philadelphia, Blakeslee Barnes (1781–1823).

The largest pewter business in the USA was that of the Boardman and Danforth families of Connecticut (about 14 members; *fl* until the 1850s).

From about 1825 Britannia metal was produced in the USA; it was cheaper to make than pewter and allowed for more complicated forms because it could be spun. Britannia was used to make, among other objects, pitchers, coffeepots, whale-oil lamps and caster sets. The major makers of Britannia metal were: William Calder; Roswell Gleason (Dorchester, MA, 1799–1865); Reed & Barton (Taunton, MA, 1824–); Babbit Crossman (Taunton, MA, *fl* 1826–8); Eben Smith (Beverly, MA, *fl* 1814–56); Philip Lee (Beverly, MA, *fl* 1807–12); Israel Trask (Beverly, MA, 1786–1867), known for his bright-cut engraving; Capen & Molineaux (New York, *fl* 1848–53), makers of whale-oil lamps; Crossman, West & Leonard and the Taunton Britannia Manufacturing Co. (Taunton, MA, *fl* 1828–35); Ashbil Griswold (Meriden, CT, *fl* 1784–1853); Rufus Dunham (Westbrooke, ME, *fl* 1815–82); and the Boardman and Danforth families.

The further decline of pewter began in the 1850s when electroplate silver replaced Britannia as a favoured domestic metal, and production essentially ceased by 1875. In 1898 W. F. Cowleshow of Boston made pewter reproductions.

Touchmarks contained a lion or rose and crown prior to 1776, after which an eagle was used; an 'X' meant high-quality pewter. Touchmarks on Britannia metals were usually a manufacturer's name in intaglio.

(ii) Iron and tinware. During the Colonial period large amounts of iron goods were imported. The earliest known blacksmith was James Read (*fl* 1607–?1624) of Jamestown, VA, in 1607. A large number of craftsmen were making guns, locks, hinges, farm equipment, andirons and other fireplace equipment, cooking utensils, candlesticks and lamps. The first attempt to establish an iron-producing furnace was in 1622 at Falling Creek, VA, but it never went into production because of an Indian attack. The first successful furnace was constructed in 1644 at Saugus, MA, and operated until 1663 (the site has been excavated and restored). Weathervanes were often made of iron; the earliest American one (in the shape of a flag), dated 1673, is at the Meeting House, Concord, MA.

A furnace was opened in Connecticut in the 17th century, and by the 18th century numerous foundries were operating. Among them were the Principio Furnace in Maryland (1728), a furnace at Ancram, NY (1740), and in New Jersey the Sterling Furnace (1740s) and the Basto Furnace (1766–1876). The Basto Furnace sold work to George Washington and made the fence for Independence Hall in Philadelphia. The Colebrookdale and Hopewell Furnaces (1770s–1930s) were among the large number operating in Pennsylvania.

In 1742 Benjamin Franklin (1706–90) invented a fireplace insert stove made from cast-iron plates. The glassmaker Henry William Stiegel of Pennsylvania made stoves in 1756. In the 18th century they were decorated with Rococo motifs similar to those found on furniture of the period, and in the early 19th century elaborate, tall columnar stoves were made.

Several regional differences in ironwork exist; for example, staghorn hinges were used in Pennsylvania, and L-shaped hinges were used in New England. Samuel Wheeler (1742–1820) made the gate (1785) at Old Church, and an iron railing for Congress Hall, both in Philadelphia. There exists a railing with 13 arrows (1789) made for Federal Hall, New York, and there is an important 18th-century wrought-iron chandelier in the collection of Old Sturbridge Village, Sturbridge, MA.

Tinsmiths created objects by using tin-coated rolled iron. They made weathervanes, lanterns and a range of domestic goods, chiefly cooking utensils. In the 17th and 18th centuries a great deal of tin-faced ironware was shipped from England. Shem Drowne (1683–?1750) of Boston was the first known maker of tinware, producing lanterns, trays and candlesticks. Other early tinsmiths were Edward Pattison (or Paterson) & Sons (1730–?1787) of Berlin, CT; the Oliver Filley family (*fl* 1784) of Simsbury, CT; Henry Degenhardt (*fl*1765) of Reading, PA; Passmore & Williams (est. 1796) of Philadelphia; and the Zachariah Stevens family of Maine.

Pierced tin objects were popular in New England, while punched tin and wriggleware were preferred in Pennsylvania. Tin mirror-frames were popular in the Southwest. By the early 19th century machines increased productivity. Tinsmiths made coffeepots, food warmers, cookie cutters, sconces, trays and boxes among other domestic wares. Prior to 1800 American tinware was usually undecorated. By 1800 Edward Pattison of Berlin, CT, began to paint tin (called 'Japan' ware). Some pieces were stencilled or hand decorated with folk designs of fruit and flowers. Some of the major decorators were the Filleys of Connecticut and New York, the Stevens of Maine, the Butler family (*fl* 1824–60) of Greenville, NY, and the North family (*fl* 1806–41) of Fly Creek, NY.

The city of Charleston, SC, is known for its fine ironware, including the gates at St John's Church by Jacob P. Roh and the gates (1848) by A. W. Iusti (*fl*1840s) at St Michael's. Such whitesmiths as John Long (*fl* 1832–5) of Pennsylvania made small, fine iron articles. Excellent locks were made by the Rohrer family (*fl* 1808–22) of Pennsylvania.

Iron and tin weathervanes were popular throughout the 19th century. Some major makers were L. W. Cushing Sons (1867–1933) of Waltham, MA; J. W. Fiske (1858–) of New York; W. A. Snow & Co. (1885–1940) of Boston; and E. G. Washburne (1853–) of New York. Designs in weathervanes progressed from animals, flags, angels and Indians to such elaborate items as copies of the *Statue of Liberty* and steam engines. (Production of many of these designs was revived in the late 20th century, using old moulds and forms.)

By the mid-19th century large iron manufacturers were making goods based on English forms. During the second half of the 19th century cast iron was used for garden furniture and cemetery fixtures. A major maker of such forms in the ornate Victorian style was Robert Wood (1839–81) of Philadelphia. Fine hand-wrought ironware, gates, railings and candlesticks were made by Samuel Yellin (1885–1940) of Philadelphia.

(iii) Copper, brass and bronze. The earliest European coppersmiths and braziers to move to America settled in New England and Pennsylvania. The first copper mine opened in Simsbury, CT, in 1705, and other early mines were operating in New Jersey and Maryland. Brassworkers, including the earliest recorded one, Joseph Jenks (*fl*1647–79) of Lynn, MA, melted old brass for reuse, because brass manufacturing was severely restricted by England in order to control the market for English brass in the colonies. Some significant brassmakers working in the 18th century were: William Bailey (*fl* 1720; *d* 1797) of Lancaster, PA, Caspar Wistar (also a glassmaker), John Sarrett (*fl* 1760), Richard Collier (*fl*1763–79), George Plumly (*fl*1760), the silversmith Phillip Syng jr (1703–89), Daniel King (1731–1806) and William Wittingham (*fl*1791; *d*1821). A notable early copper piece is the weathervane in the shape of a grasshopper made in 1749 by Shem Drowne for Faneuil Hall in Boston (*in situ*; see fig. 45).

While large amounts of copper and brass articles were imported from England, pieces made in the USA have traits that identify them as American, for example straight body copper teapots without spout covers. Brass andirons evolved from those with bold, simple turnings and pad

45. Copper weathervane (1749) by Shem Drowne, Faneuil Hall, Boston, Massachusetts

feet of the late 17th century to ones with complicated turnings and ball-and-claw feet of the period from 1740 to 1770. Neo-classical andirons employed columns and urns, while Empire style andirons had bold turnings and ball feet. Richard Collier created andirons with scenic or Neo-classical engravings. Richard Lee (*fl c.* 1800) of Springfield, VT, made brass skimmers and ladles. Philadelphia was a centre for brass production; Baltimore became a centre for copper production after 1800. In the early 19th century Benjamin Harbeson & Son of Philadelphia was a prominent company. The silversmith Paul Revere and his sons in Boston made brass bells and copper articles. Heddeley & Riland of Philadelphia made pewter moulds in 1819, and William C. Hunneman of Boston (*fl* 1798–1845) made andirons. Mass-produced objects were made in the 19th century. Sleigh bells were first made by William Barton (*fl* 1808–32) of Connecticut and New York. In the 19th century many companies made copper weathervanes, while others produced only utilitarian ware.

Copper, brass and bronze were used extensively in the Arts and Crafts Movement. Hand hammered pieces with a dark patina (with hammer marks remaining) were made by the Roycroft Shops (1895–1938) of Elbert Hubbard; Leopold and J. George Stickley and Gustav Stickley's Craftsman Workshops; and the workshop (1908–1930s) of Karl Kipp. Bronze lamps and desk sets were made by Tiffany & Co. Dirk Van Erp of Chicago (*fl* 1908–25) made copper lamps and bowls. Bradley & Hubbard of Boston made a large number of brass lamps, desk sets and accessories. After the period of the Arts and Crafts Movement, interest in copper and brass declined.

BIBLIOGRAPHY

A. Sonn: *Early American Wrought Iron* (New York, 1923)
Bull. Pewter Colrs' Club America (1934–)
L. Laughlin: *Pewter in America: Its Makers and their Marks*, i–ii (Boston and Barre, MA, 1940, rev. 1969), iii (1971) [the most complete book on the subject]
M. Gould: *Antique Tin and Tole Ware* (Rutland, 1958)
J. Lindsay: *Iron and Brass Implements of the English and American House* (Bass River, MA, 1964)
N. Goyne: 'Britannia in America: The Introduction of a New Alloy and a New Industry', *Winterthur Port.*, ii (1965)
J. R. Mitchell: *Marked American Andirons before 1840* (MA thesis, Winterthur, Du Pont Winterthur Mus., 1965)
H. Kauffman: *Early American Ironware* (New York, 1966)
M. Coffin: *The History and Folklore of American Country Tinware, 1700–1900* (Camden, NJ, 1968)
S. DeVoe: *The Tinsmiths of Connecticut* (Middletown, 1968)
H. Kauffman: *American Copper and Brass* (Toronto, 1968)
——: *The American Pewterer: His Techniques and his Products* (Camden, NJ, 1970)
J. Thomas, ed.: *American and British Pewter: A Historical Survey* (New York, 1971)
K. Ebert: *Collecting American Pewter* (New York, 1973)
C. Klamkin: *Weather Vanes: The History, Design and Manufacture of an American Folk Art* (New York, 1973)
C. Montgomery: *A History of American Pewter* (New York, 1973, rev. 1978)
A. C. Revi: *Collectible Iron, Tin, Copper and Brass* (Hanover, NH, 1973)
American Metalsmiths (exh. cat., Lincoln, MA, DeCordova & Dana Mus., 1974)
American Pewter in the Museum of Fine Arts (exh. cat., Boston, MA, Mus. F.A., 1974)
Forms in Metal: 275 Years of Metalsmiths in America (exh. cat. by P. Luck and P. Smith, New York, Mus. Contemp. Crafts, 1975)
J. Thomas: *Connecticut Pewter and Pewterers* (Hartford, 1976)
P. Schiffer: *The Brass Book* (Exton, 1978)
P. H. Schiffer and N. Schiffer: *Antique Iron: A Survey of American and English Forms* (Exton, 1979)
S. DeVoe: *The Art of the Tinsmith* (Exton, 1981)
J. Mulholland: *A History of Metals in Colonial America* (Tuscaloosa, AL, 1981)
C. Goodman: *Copper Artifacts in Late Eastern Woodland Prehistory* (Kampsville, IL, 1984)
T. Groft: *Cast with Style: Nineteenth-century Cast-iron Stoves from the Albany Area* (Albany, 1984)
Pewter in American Life (exh. cat., Lexington, MA, Scot. Rite Mason. Mus. N. Her., 1984)
D. Lamoureaux: *The Arts and Crafts Studio of Dirk Van Erp* (San Francisco, 1989)
B. Sven and G. Hassell: *The Geddy Foundry* (Williamsburg, 1992)
J. B. Whisker: *Pennsylvanian Silversmiths, Goldsmiths and Pewterers, 1684–1900* (Lewiston, NY, 1993)
J. Lovell: 'American Mixed Metalware', *Ant. Collct.*, xxx/6 (1995), pp. 8–10
Metalwork in Early America: Copper and its Alloys from the Winterthur Collection (Winterthur, DE, 1996)

CHARLES J. SEMOWICH

XI. Jewellery.

Although some Colonial silversmiths made and repaired jewellery, its design and manufacture was not properly established in the USA until the mid-19th century. This was prompted by the government's imposition in 1850 of heavy import duties on fashionable, but often inferior-quality European jewellery, much of which came from London and Birmingham. The wealthy, nevertheless, continued to shop in Paris and London for their important jewels. Early American-made jewellery emulated European styles with perhaps a more vigorous approach to form and an extravagant use of materials. A taste for cameos and parures of matching jewellery, set with turquoises, garnets, coral, seed pearls, *millefiori* or dark blue or black enamel, was influenced by European examples. Chased, pierced or engraved gold with stones pavé set or surrounded by rich gold scrolls was popular.

From the mid-19th century the luxury jewellery trade was dominated by Charles Louis Tiffany (1812–1902) of New York. Established as Tiffany & Young in 1837 as a stationer and importer, in 1848 Tiffany set up a goldsmithing workshop on the company premises, which was among the first serious attempts to make high-quality jewellery in the USA. The fashion for archaeological jewellery in Etruscan, Greek and Roman styles that swept Europe and the USA in the 1860s suited such early manufacturers as Tiffany, with its emphasis on gold and sculptural forms rather than on gemstones. In 1861 Abraham Lincoln celebrated his inauguration with the purchase of a Tiffany-made parure of gold and seed pearls for his wife, Mary Todd Lincoln (Washington, DC, Lib. Congr.). Other well-known silversmiths and jewellers included the Gorham Manufacturing Co. (founded 1831) of Providence, RI, which introduced factory methods for casting and stamping out silverware and silver jewellery *c.* 1841 (*see* GORHAM).

From the late 1860s, after the opening of South Africa's diamond mines, diamond jewellery was in demand for formal wear, with diamond-studded flower-and-leaf shapes giving way after 1900 to elaborate linear and scrolled patterns set in platinum, a material known since the 16th century but little used before this period. Tiffany & Co., with the New York jeweller Harry Winston (1896–1978), became the country's most prominent dealers in gems, followed by the Linz Bros, established in Dallas,

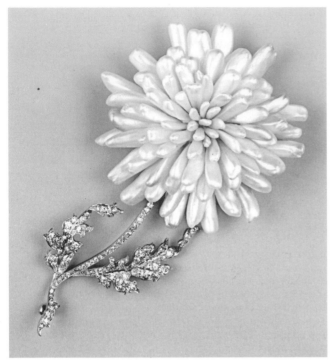

46. 'Chrysanthemum' brooch, dogtooth Mississippi River pearls, gold, platinum and diamonds, made by Tiffany & Co., New York, 1904 (London, Wartski Jewellers)

Arts and Crafts jewellery was largely influenced by the English movement and gave rise to cooperatives and guilds in Boston, Chicago and Minneapolis, MN. Most notable was the work of Florence Koehler (1861–1944) of Chicago. The Gorham Co. inaugurated their studio-designed Martelé ('hammered') line of Art Nouveau and Crafts Revival mixed-metal jewellery (e.g. brooch, c. 1900; priv. col., see Gere, 1975, p. 188). Silver and enamel floral jewellery, buckles and buttons were mass-produced; a typical example is the 'Gibson Girl' silver brooch (c. 1903; untraced) sold by Averbeck & Averbeck of New York (fl early 1900s).

BIBLIOGRAPHY
G. Hughes: *Modern Jewelry: An International Survey, 1890–1963* (London, 1963)
D. J. Willcox: *Body Jewellery* (London, 1974)
C. Gere: *European and American Jewellery, 1830–1914* (London, 1975)
V. Becker: *Antique and Twentieth Century Jewellery: A Guide for Collectors* (Colchester, 1980)
K. Harlow: 'A Pioneer Master of Art Nouveau: The Handwrought Jewellery of Louis C. Tiffany', *Apollo*, cxvi (1982), pp. 46–50
V. Becker: *Art Nouveau Jewelry* (London, 1985)
J. Loring: *Tiffany's 150 Years* (Garden City, NY, 1987)
C. Gere and G. C. Munn: *Artists' Jewellery: Pre–Raphaelite to Arts and Crafts* (Woodbridge, 1989)

XII. Textiles.

1. Woven and printed fabrics. 2. Needlework. 3. Tapestry. 4. Lace.

1. WOVEN AND PRINTED FABRICS. The first European settlers depended on imported fabrics for clothing themselves and furnishing their homes. The European imperial powers were not interested in promoting textile manufacture in North America, and England, ultimately the dominant European power, actively deterred textile production in the colonies, preferring instead to supply the market with her own textiles. This policy was generally successful, but as early as 1640 Colonial governments began to promote the production of linen, wool and cotton textiles. These efforts were important but they did not result in a highly organized or comprehensive manufacturing system. Instead, American textile production developed around individuals and small groups of hand-weavers, who primarily produced staple textiles for local and regional markets. Throughout the Colonial period and into the 19th century the American consumer chose from a mixture of imported and domestically produced textiles, with imports providing the greater volume and a broader range of fabrics. American interest in ending the dependence on imports rose and fell, and textile production increased during periods of political or economic estrangement from Europe.

Textile manufacture in America operated in several different ways, providing domestic versions of some imported fabrics and also supplying speciality items. Although self-sufficient household production of textiles in the pre-industrial period is a myth, many households did participate in the creation of textiles. Household weavers usually made such relatively simple fabrics as tow cloth (coarse linen or hemp), household linens, blankets and, occasionally, decorative furnishing textiles. However, looms were never a common feature of all homes, and families were more likely to do only parts of the textile process. They might spin yarn and use it to knit stockings

TX, in 1891. An American version of the brilliant-cut for diamonds was developed, allowing more facets and sparkle; the solitaire diamond ring was also an American invention. The popularity of Japonisme in the 1870s and 1880s influenced American jewellers to mix metals or use coloured gold in pieces delicately engraved, appliquéd or enamelled with such motifs as dragonflies, herons and women in kimonos (e.g. Fringe necklace, New York, Tiffany's, c. 1880; London, BM). The Centennial Exhibition of 1876 in Philadelphia marked a watershed for American jewellery-makers, who exhibited in strength for the first time and excited international recognition for their distinctive designs, highlighted with native gemstones.

About 1889 Louis Comfort Tiffany (*see* TIFFANY, §2) established the Tiffany Studios for the production of handmade artistic jewellery, inspired by Art Nouveau and using innovative combinations of gold, enamels, gems and hardstones. He delighted in the use of fantastic animal and plant forms (e.g. orchid brooches, 1889; New York, Ruth Sataloff and Joseph Sataloff priv. col., see Loring, p. 88) and later embraced Celtic, medieval and Renaissance Revival designs (e.g. 'Peacock' necklace, c. 1905; Winter Park, FL, Morse Gal. A.; see colour pl. XXXVII, 2). About 1900 a keen interest in the natural world encouraged the production of jewelled insect brooches and pins, as well as hair and dress ornaments of horn and tortoiseshell. Such American stones as river pearls, sapphires, garnets and topazes enriched many pieces (e.g. 'Chrysanthemum' brooch, 1904; priv. col.; see fig. 46), and turquoises and fire opals obtained from Mexico were also used. American

or send it to someone else for dyeing, weaving into fabric and finishing. Outworkers were used but they were never as important in the USA as in Europe. The mills distributed prepared warps to hand-weavers, including stripes, checks and plaids.

From the 17th century well into the 19th, professional weavers (almost exclusively men) produced a variety of domestic textiles, from simple utilitarian fabrics to decorative dress and furnishing fabrics. Weavers' account-books include entries for gingham, shirting, jean, fustian, stripe, diaper, swan-skin, coverlets, carpets and bed tick, among many other fabrics. Opportunities for these craftsmen began to diminish in the industrial period, but many urban weavers continued to find work producing such textiles as carpets and silks even after those fabrics could be woven on powered machinery.

Other hand-weavers found a niche for themselves producing decorative bedcovers. These were made in a range of designs, from simple alternating blocks of colour to portraits and elaborate scenes, each design determined by the weave structure and patterning mechanism. The most common materials were undyed cotton and blue wool, but coverlets were also made of linen and wool, all-wool and all-cotton in such colours as red, black, brown, green, gold and lavender. Weave structures included overshot, summer-and-winter, twill, double-weave and tied double-weaves. Harness-controlled structures produced geometric designs imaginatively described as 'roses', 'tables' and 'chariot wheels', but the introduction of the Jacquard loom in the 1820s made it easier for weavers to produce curved lines, flowers, buildings and even faces by mechanizing the creation of hundreds of warp combinations (see fig. 47). Hand-weavers, primarily in the mid Atlantic and Midwestern states, produced Jacquard coverlets until about the time of the Civil War. The Centennial celebration in 1876 sparked a revival of coverlet production, but these textiles, which were made in factories of poor-quality materials, quickly disappeared from the market. Hand-weaving was on the wane and survived, barely, in a few areas such as Appalachia and the Midwest.

As increasing industrialization transformed the English textile-production system, so it radically altered the organization, output and importance of American production. Samuel Slater's success in 1790 in spinning cotton yarn on water-powered machinery patterned after the Arkwright system and Eli Whitney's invention of the cotton gin, patented in 1794, had an important effect on the availability of cotton and of cotton yarn. However, it was not until the introduction of the power loom at Waltham, MA, in 1813–14 that mass production of textiles began. In northern New England cotton manufacture quickly developed in large, fully integrated mills. At Waltham and later at Lowell, MA, the Boston Associates, a group of wealthy merchants who invested heavily in the textile and other industries, used the limited capabilities of their early machinery to produce large quantities of heavy cotton sheeting and drill. This practice of manufacturing long runs of coarse fabrics came to be seen as the standard American approach, but other mills, for example those in Rhode Island and Philadelphia, became very successful in producing a broad range of textiles.

Throughout most of the 19th century, woollen mills were typically smaller and more specialized. In the early years they manufactured broadcloths, as well as jeans and relatively coarse woollens. Of particular importance was satinet, a medium-grade fabric used for outer wear, which looked like wool but was woven on a cotton warp. Flannels, delaines and cassimeres gradually accounted for more of the production, but imported woollen and worsted fabrics maintained their importance in the American market. It was not until the last quarter of the 19th century that American production of worsted fabrics came into prominence.

As early as the Colonial period, Americans were fascinated by the prospect of developing a domestic silk industry. Although the cultivation of mulberry trees and breeding of silkworms was never successful, the manufacture of silk products increased throughout the 19th century. The industry, which developed dramatically from 1870 to 1890, concentrated initially on the manufacture of sewing silk and machine twist (silk thread for sewing machines), then on ribbons, trimmings and handkerchiefs, and finally on broad silks, velvets and plushes. The products of Connecticut, New Jersey and Pennsylvania, the primary American centres of production, never displaced the finest European luxury silks, but they amply supplied the market for good-quality, medium-grade fabrics.

Block- and plate-printing never became well established in the USA, but copper-roller printing grew steadily from its introduction on a large scale in the 1820s to become the dominant, though not exclusive, supplier of the American market. Printed textiles continued to be imported, and the design of American prints drew heavily on European models. Among the thousands of new patterns that appeared each year were two- and three-colour geometrics and a limited repertory of florals used as shirting fabrics. Variety in both design and colour became important in dress prints, which changed more frequently and completely according to fashion. Furnishing

47. Cotton and wool coverlet by P. Warner, 2.35×2.03 m, from Carroll County, Maryland, 1848 (North Andover, MA, Museum of American Textile History)

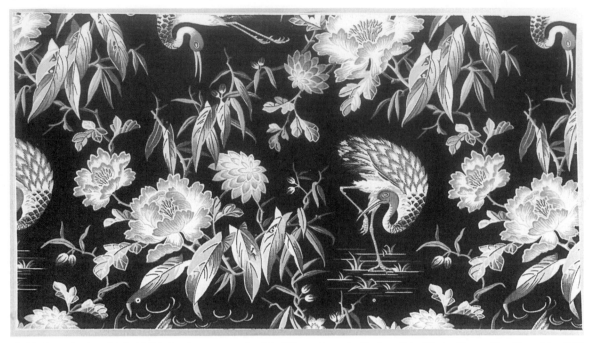

48. 'Cocheco Furniture Twills XX', printed cotton sample, 263×454 mm, from the Cocheco Print Works, Dover, New Hampshire, 1888 (North Andover, MA, Museum of American Textile History)

prints (see fig. 48) were usually larger in scale and more complicated in design than shirting or dress prints. During the 20th century the variety of designs produced in any one season decreased.

Woven and printed textiles in the USA have followed a stylistic course parallel to that of Western decorative arts. The Arts and Crafts Movement was of particular importance in its direct effect on style and motif, but even more in its impact on Americans' attitudes to their own decorative arts history. It advanced the development of American textile designers in general and inspired the work of high-style, art-conscious individuals such as CANDACE WHEELER. The Arts and Crafts Movement, along with the retrospection that accompanied the 1876 Centennial were factors in the growth of the Colonial Revival..

2. NEEDLEWORK. Until the 20th century plain sewing was the most widely known and practised form of needlework in the USA. Nearly every American female learnt basic sewing and knitting, which she used in the construction of clothing and the finishing of household textiles. Sheets and other large textiles were usually created by joining two or three widths of fabric with a whip stitch. Hems were generally rolled or very narrow. Household textiles of all types were marked with cross-stitched initials and numbers to differentiate one piece from another; in the 19th century names and numbers inscribed in ink appeared more frequently. With the invention of the sewing-machine in the middle of the 19th century and the development of the ready-to-wear trade, extensive hand-production of clothing and household textiles began to disappear.

Fancy needlework was, by definition, non-utilitarian, but it was sometimes used to decorate useful textiles.

During the 17th and 18th centuries fancy work was a prerogative of the rich, but in the 19th and 20th centuries more middle-class needleworkers took an interest in the art. In the 1720s distinctive groups of needlework began to emerge as a result of the influence of particular schools and individual teachers, whose styles are clearly recognizable in surviving needlework. Silk-on-silk embroideries, especially mourning pictures, became very popular in the late 18th century and the early 19th.

The sampler was common. From the 17th century to the end of the 18th, samplers were most often stitched in silk threads on linen or linen/wool grounds. Embroiderers sometimes used the woven structure of the ground fabric as a grid on which to work their letters and designs, but, especially in later years, design motifs were also created by free-hand 'drawing' with embroidery floss. In their most basic form, samplers were used to teach a young girl the basic stitches necessary to mark textiles; later work might include more intricate and decorative stitches, which could be used to embellish clothing or household textiles. In the 17th century American samplers echoed contemporary English work: they were typically long, narrow pieces of fabric with horizontal bands of stitching intended to serve as catalogues of stitches and designs. From the first, however, American samplers included verses, a trait not found this early in English samplers. During the 18th century American samplers became shorter and wider and often included borders. They were used less as reference and more to display the embroiderer's abilities. Simple alphabets began to be combined with more decorative designs, and eventually a completely decorative picture developed as the showpiece of a young woman's accomplishments (see colour pl. XXXIX, 1).

Canvaswork, executed in woollen yarns on a linen ground, always used the ground fabric as the geometric

grid on which the design was placed. Colourful geometric shapes or fanciful landscapes decorated pocket-books and upholstery, or were used in a needlework picture. Wool embroidery on a fabric other than canvas and stitched in a more free-hand style is known as crewelwork. Although crewelwork petticoat borders and pockets are known, much of the finest crewel embroidery of the late 17th century and the 18th survives in the form of bed-hangings. In the 19th century, wool embroidery was done on linen canvas in the same style as samplers; because Germany had become a major source of wool yarns, canvas and printed patterns, this type of embroidery came to be called Berlin woolwork. By the middle of the century, embroidery using woollen yarns on perforated paper or board became popular. In the late 19th century there was a proliferation of different styles of needlework, followed by a period of selfconscious examination of needlework arts sparked by the American Arts and Crafts Movement. The Deerfield Blue and White Society, a group of embroiderers directed by Margaret C. Whiting and Ellen Miller, was foremost among those who deplored late 19th-century embroidery and looked to Colonial styles and materials for inspiration.

Quilting, in a variety of forms including quilted petticoats, was brought to America by European immigrants. In the 18th century bed quilts were generally one-piece quilts; that is, the top was made from a single, solid colour fabric. This fabric, often a dark glazed wool, was quilted with fine stitches in an elaborate design, for example flowers, fruits and feather-like leaves. Patchwork and appliqué combined printed and dyed fabrics of many different colours and styles (see colour pl. XXXIX, 2). Sometimes used together in the same quilt, the two techniques differ in that patchwork (or piecing) is the joining of small pieces to create a flat textile, while appliqué is the stitching of fabric pieces on top of an already existing flat textile. One important type of quilt made in the late 18th century often used a central image of an appliqué flower or tree surrounded by pieced borders. Quilts made entirely by piecing sometimes utilized bits of fabric from textiles that were too worn to use any other way. This was not always the case, however, and very often pieced quilts were made with fabrics acquired specifically for the project. Appliqué allowed greater freedom in creating designs on quilts, lending itself to more pictorial images. In the late 20th century some traditional pieces, notably the bold patchwork produced by the Amish communities, became collectors' items.

See also RUG.

BIBLIOGRAPHY
L. R. Brockett: *The Silk Industry in America: A History Prepared for the Centennial Exposition* (New York, 1876)
W. R. Bagnall: *The Textile Industries of the United States, Including Sketches and Notices of Cotton, Woollen, Silk and Linen Manufactures in the Colonial Period*, i (Cambridge, MA, 1893)
J. H. Brown, E. M. Norris and E. E. Foster, eds: *Lamb's Textile Industries of the United States, Embracing Biographical Sketches of Prominent Men and a Historical Résumé of the Progress of Textile Manufacture from the Earliest Records to the Present Time*, 2 vols (Boston, 1911–16)
R. M. Tryon: *Household Manufactures in the United States, 1640–1860* (Chicago, 1917)
A. H. Cole: *The American Wool Manufacture*, 2 vols (Cambridge, MA, 1926)
C. F. Ware: *The Early New England Cotton Manufacture: A Study in Industrial Beginnings* (Boston, 1931)
G. B. Harbeson: *American Needlework* (New York, 1938)
F. M. Montgomery: *Printed Textiles: English and American Cottons and Linens, 1700–1850* (New York, 1970)
P. Orlofsky and M. Orlofsky: *Quilts in America* (New York, 1974)
A. N. Landreau: *America Underfoot: A History of Floor Coverings from Colonial Times to the Present* (Washington, DC, 1976)
S. B. Swan: *Plain & Fancy: American Women and their Needlework, 1700–1850* (New York, 1977)
G. F. Krueger: *New England Samplers to 1840* (Sturbridge, MA, 1978)
C. L. Safford and R. Bishop: *America's Quilts and Coverlets* (New York, 1980)
D. J. Jeremy: *Transatlantic Industrial Revolution: The Diffusion of Textile Technologies between Britain and America, 1790–1830s* (Cambridge, MA, 1981)
P. Scranton: *Proprietary Capitalism: The Textile Manufacture at Philadelphia, 1800–1885* (Cambridge, MA, 1983)
C. Anderson: 'Coverlet Bibliography', *A. Textrina*, ii (1984), pp. 203–15
F. M. Montgomery: *Textiles in America, 1650–1870* (New York, 1984)
B. Ring: *American Needlework Treasures: Samplers and Silk Embroideries from the Collection of Betty Ring* (New York, 1987)
C. M. Sheridan, ed.: 'Textile Manufacturing in American History: A Bibliography', *Textile Hist.*, xviii (1987), pp. 59–86
DIANE L. FAGAN AFFLECK

3. TAPESTRY. The first large-scale tapestry studio in the USA was that founded by William Baumgarten (1845–1906), the owner of a firm specializing in interior decoration. The studio opened in New York City in 1893, staffed by the Foussadier family, who had originated from and trained in Aubusson, France, and had subsequently been employed at the Royal Windsor Tapestry Factory, England. The tapestries, designed primarily for period rooms in the city homes of the rich, were woven to commission and reflected the prevailing conservative taste. Although Renaissance and Baroque styles were popular, the 18th-century tapestries designed by François Boucher (1703–70) were by far the favourite models. Wall hangings were supplied for state buildings (e.g. Rhode Island State House, Providence; *in situ*), hotels (e.g. Manhattan Hotel, New York; untraced, see Baumgarten, p. 16) and private businesses (e.g. New York Life Insurance Co.; untraced, see Baumgarten, p. 40). Tapestries more contemporary in style and individualized in subject-matter were also made. The tapestries were designed in the New York office but woven on low-warp looms by the French weavers (and later by American apprentices) at the firm's studio in Williamsbridge, the Bronx. The warp was wool or cotton, with wool, silk and metal thread for the weft. Natural dyes were employed. Many of the tapestries bear the initials B (or WB), NY and the year of production. The tapestries were of varying quality, but the best were so fine that two won the grand prize at the World's Fair of 1904 in St Louis, MO. (After Baumgarten's death, the studio continued until the 1920s.)

The second major American tapestry studio was founded in New York City in 1908 as Aubusson Looms, but changed its name the following year to Herter Looms, after its creator and chief designer, Albert Herter (1871–1950). He had been a student in Paris of Jean-Paul Laurens (1838–1921), a mural painter who designed tapestries for the Gobelins. The workshop initially produced copies and adaptations of old tapestries, as well as new designs for wall hangings and furniture coverings. The hallmark of the company was its innovative subject-matter, interpreted in a style reflecting that of the Middle Ages. Its first major commission, for Arden House (1909; *in situ*), the New

York home of E. H. Harriman, included Louis XVI style wall panels, a modern-medieval *millefleurs* panel entitled the *Spirit of Arden House*, and more contemporary pieces showing the surrounding countryside and the building of the house. Herter's most ambitious project is a set of 26 tapestries, the *History of New York* (1912; 21 tapestries, New York, Met., see colour pl. XL; 1 tapestry, priv. col., see De Kay, p. 202; 4 tapestries, untraced, see De Kay, pp. 202, 204, and *Good Furn. Mag.*, vi (1916), p. 315) for the Hotel McAlpin, New York. The company also produced transparent tapestries (in which the dyed wool warp was left partially exposed and the piece was finished on both sides), primarily for *portières*. Herter's designs were developed by other studio artists into detailed cartoons for the weavers to follow, as can be seen in the *Great Crusade* cartoon and tapestry (Bloomfield Hills, MI, Cranbrook Acad. A. Mus.). Materials included wool, silk, cotton, mercerized cotton and silver and gold thread. Charles E. Pellew, Viscount Exmouth (1863–1945), was employed as a dye chemist to develop a range of synthetic dyes for the Herter palette. Each tapestry bears the logo HL, a cherry blossom and the date of the design. (Herter disassociated himself from the company in 1922, but it remained in business until 1934.)

The Edgewater Tapestry Looms, of Edgewater, NJ, was founded by Lorentz Kleiser (1879–1963) in 1913. After training as a painter in Europe, he returned to the USA to work for Baumgarten & Co., where his interest in tapestry was intensified. For his own company he designed tapestries in styles from medieval to Louis XVI, as well as developing a conservative but contemporary manner for depicting themes drawn from American history, literature and everyday life. His most inventive works were fantastic florals and landscapes. In addition to commissions for private clients, tapestries were made for churches (e.g. the Blessed Sacrament, New York; *in situ*), state houses (e.g. Missouri and Nebraska; both *in situ*) and for the Newark Museum in Newark, NJ (*in situ*). Although Kleiser made the initial sketches, the cartoons were developed by others. In addition to the weavers, who were both French and American, there was also a group of assistants or protégés, who could both design and weave, and a dye studio. The tapestries were woven on low-warp looms using cotton, mercerized cotton, wool, silk and silver and gold thread. The company logo changed over the years: until 1915 it was L.K. above U.S.A.. The Edgewater Tapestry Looms was particularly interested in the relationship between art and industry. The company participated in numerous exhibitions, and Kleiser did much to popularize tapestry through lectures and articles.

BIBLIOGRAPHY
W. Baumgarten: *Tapestry* (New York, 1897)
G. L. Hunter: 'Tapestries in America', *Int. Studio*, xlvii (1912), pp. xxviii–xxxvi
C. De Kay: 'Tapestries for Schools and Hotels', *A. & Dec.*, iii (1913)
A. D. Fleetwood: 'The New Home of the Herter Looms', *House Beautiful*, xxxv (1913), pp. 4–9
A. Lee: 'Tapestries Made in America', *Int. Studio*, lxxxi (1925), pp. 297–301
L. Kleiser: 'Arras', *Good Furn. Mag.*, xxxiv (1930), pp. 21–30
A. Zrebiec: *The American Tapestry Manufactures: Origins and Development, 1893 to 1933* (diss., New York U., Inst. F.A., 1980)

A. M. ZREBIEC

4. LACE. America's only documented pre-19th-century lace industry of any size was a cottage industry in Ipswich, MA. From the 17th century to the 1820s Ipswich produced white and black silk and thread laces in bobbin techniques characteristic of laces produced in the English Midlands, homeland of the original settlers. By 1790 the industry claimed to produce 38,000 m annually. Thirty years later Ipswich laceworkers were embroidering lacelike designs on mesh fabric. The first machines to manufacture mesh fabric in the USA were apparently constructed from memory by English immigrants in 1818. From these a machine-made lace industry grew, relying heavily on (often illegally) imported European textile technology and machines.

Handmade lace industries reappeared in the late 19th century when American philanthropists, imitating European self-help industries, established schools to teach marketable lacemaking skills to indigent women. In 1890 an Episcopalian missionary, Sibyl Carter, began classes among Minnesota's Ojibwa Indians. By 1908 Indians of ten tribes from New York State to the West Coast were producing bobbin, tape and needlepoint laces, which, except for occasional Indian figures with bow, papoose or canoe, are indistinguishable from European laces. In 1905 an Italian lacemaker from a self-help lacemaking school in Burano, Italy, was imported to teach Italian immigrant women and girls in New York City's Scuola d'Industrie Italiane to copy needle-made antique laces and contemporary European fashion laces. (These and similar industries died in the 1930s when fashion interest in lace declined.) America's first identifiable 'lace artist' was an English immigrant, Marian Powys (1882–1972), whose Honiton technique design won a gold medal in the 1915 Pan American Exposition.

The amateur lacemaker has always been part of American domestic life. Early 19th-century ladies' academies routinely offered lace instruction, and later in the century instruction books for a wide range of openwork techniques were readily available. Lacemaking became a late 19th- and early 20th-century fad.

BIBLIOGRAPHY
E. N. Vanderpoel: *American Lace & Lace-makers* (New Haven, 1924)
F. Morris and M. Hague: *Antique Laces of the American Collectors* (New York, 1926)
V. Bath: *Lace* (Chicago, 1974) [Amer. lace artists]
K. Duncan: 'American Indian Lace Making', *Amer. Ind. A.*, v/3 (1980), pp. 28–35, 80
P. P. Grey: 'In these Delicate Constructions', *Amer. Craft*, xxxxi/4 (Aug/Sept 1981), pp. 51ff [on Marian Powys]
M. Sonday: *Lace*, New York, Cooper-Hewitt Mus. cat. (New York, 1982)
S. M. Levy: *Lace: A History* (London, 1983)

J. HEINRITZ BIDNER

XIII. Patronage.

Private patronage, both individual and corporate, has played a substantial role in the evolution of American art, while the relatively modest and sporadic levels of public funding for the arts throughout much of American history reflects national wariness of the élitism and constraints inherent in the European examples of ecclesiastical and royal patronage. After the Revolution, patriotism and civic pride prompted members of the educated, professional class to form voluntary societies and academies such as

the Columbianum in Philadelphia (founded 1794) and the Boston Athenaeum (founded 1807), which sought to promote the study of the arts. Direct public patronage began meanwhile with Pierre Charles L'Enfant's design for the seat of government and the subsequent construction of federal buildings in the capital city, Washington, DC (see §II, 2 above). The variety of classicizing styles adopted by James Hoban for the President's House (the White House; 1792–1830; see WASHINGTON, DC, fig. 6), by Robert Mills for the Treasury Department and the Patent Office (now the National Museum of American Art and National Portrait Gallery building; both begun 1836), and by William Thornton for the US Capitol (completed 1830) were intended to symbolize the nation's democratic ideals. Funded by Congressional appropriations, the construction, redesign and expansion of the Capitol continued periodically from 1793 until after the Civil War. The building originally entailed commissions to foreign artists for murals and architectural sculpture. By the 1820s, however, merchants such as Luman Reed and Thomas J. Bryan of New York, and Nicholas Longworth of Cincinnati were beginning to form collections and to play a role in the art community. Wealthier, but less educated than the professional class of patrons, these merchants supported and befriended artists, occasionally opened their collections to the public and fostered the growth of a 'native school' of landscape painters (i.e. those who had not studied in Europe, as had hitherto been considered obligatory for aspiring artists). By the 1830s Congress directed that commissions for the decoration of the Capitol be awarded to American artists, such as John Trumbull, Horatio Greenough and Thomas Crawford.

In the period before the Civil War, subscription organizations broadened the democratic base of support for the arts. The most successful of these, the American Art-Union (1844–51), based in New York, sponsored exhibitions, commissioned engravings, published two art journals documenting its transactions and acquired works of art to be sold by lottery to its members. Before its demise, the union boasted over 16,000 members throughout the nation and had distributed over 150,000 engravings and 2400 paintings by 250 American artists. After the war, concentration of industrial wealth produced a new group of entrepreneurial patrons. Less concerned with American art and more enamoured of European culture, the new industrialists not only formed large and sometimes eclectic collections (see §XIV below) but also commissioned the building of palatial residences and founded art museums in the cities of the Northeast and Midwest. A few collectors, however, such as Thomas B. Clarke and Charles Lang Freer, continued to collect American art during the late 19th century.

State governments continued to fund construction of Neo-classical, domed legislatures that echoed Thomas U. Walter's monumental dome for the US Capitol until the 1880s, when Italian Renaissance, ornamented architecture became the dominant style for federal, state and municipal buildings, exemplified by City Hall in Philadelphia and the Library of Congress and the Department of Agriculture buildings in Washington, DC. The US Commission of Fine Arts, established by Congress in 1910, and Secretary of the Treasury Andrew W. Mellon carried out the mandate of the 1926 Public Buildings Act by perpetuating the Italian Renaissance tradition in federal monuments and in the complex of government buildings known as Federal Triangle (1926–37) in Washington, DC.

The accelerated pace of industrialization in the late 19th century, however, was meanwhile transforming American architecture more radically and altering patterns of architectural patronage. Newly powerful industrial and corporate clients were responsible for the proliferation of a new commercial building type, the SKYSCRAPER, examples of which were erected in such cities as Chicago and New York, soon becoming emblems of corporate enterprise. Corporations not only commissioned prominent architects to design their headquarters but also occasionally gave direct commissions to American artists.

BIBLIOGRAPHY
R. Brimo: L'Evolution du goût aux Etats-Unis (diss., Paris, Inst. A. & Archéol., 1938)
N. Harris: The Artist in American Society: The Formative Years, 1790–1860 (New York, 1966)
L. B. Miller: Patrons and Patriotism: The Encouragement of the Fine Arts in the United States, 1790–1860 (Chicago and London, 1966)
JUDITH ZILCZER

XIV. Collecting and dealing.

Apart from isolated collections of prints, drawings and copies, such as that of John Smibert (see §XV, 1 below), in Colonial times the furnishings of the houses of the wealthy constituted the only significant artistic collections. The only paintings commonly owned were family portraits, which functioned as likenesses rather than works of art. Even after the Revolution, a concern for the sciences was at first more apparent than any interest in the fine arts, and collections of art were extremely rare, despite the efforts of such artists as Charles Willson Peale and Rembrandt Peale. It was not until the early 19th century that there were the first signs of collecting activity by such figures as JAMES BOWDOIN III, who acquired much of Smibert's collection. Collections formed at this time generally included either Dutch and Flemish art and/or works by contemporary local artists, a pattern similar to that in England in the same period. Because opportunities to buy European work in the USA were generally restricted to rather questionable auction sales, such art was generally acquired in Europe by the collectors concerned, or by artists acting as agents, while American art was acquired directly from the artists responsible.

Despite the occasional notable collection, such as those of grocer LUMAN REED and Thomas Jefferson Bryan (1802–70) in New York, the ownership of art works was still regarded as eccentric in the mid-19th century. A landmark in efforts to counter this prejudice, particularly with regard to local artists, was the American Art-Union (1844–51), based in New York. This organization, by holding regular exhibitions of works by American artists and distributing over 150,000 engravings and paintings to its members by means of a lottery, introduced original art into many districts and made ownership of art works more widespread. Other organizations such as the Dusseldorf Art Union attempted to stimulate interest in foreign artists in a similar manner. Art collecting in the USA continued, however, to be circumscribed by the dearth of outlets

where potential collectors could obtain works until after the 1850s, when a number of knowledgeable dealers, the most notable of whom were connected with galleries in Paris (e.g. Michel Knoedler), began to appear in New York and a few other East Coast cities. The success of John Rogers in selling plaster copies of his statuette groups by mail order (*see* §IV, 1 above) is indicative of the expanding market in the second half of the 19th century, but it was not until just after the Civil War that there was significant collecting and dealing in the USA, partly stimulated by the emergence of a new class of wealthy industrialists.

In the third quarter of the 19th century the standard of American collecting underwent a qualitative change as the first American collections to contain works of real art-historical significance began to appear. The new collectors of the time did not share their predecessors' reservations about buying art; instead they wished to advertise their wealth and status by living in opulent surroundings, accompanied by large, dramatic works of art. The works they collected were also very different from those previously sought after, as the dubious Old Masters (mainly of the Italian and northern European Renaissance) or contemporary American works of earlier collections were replaced by contemporary French painting, particularly by such established French Salon favourites as Rosa Bonheur, William-Adolphe Bouguereau, whose work was promoted by SAMUEL P. AVERY, or, from the 1870s, the Barbizon painters, whose work was introduced to the New York public largely by Michel Knoedler (*see* KNOEDLER, M., & Co.). This shift was stimulated partly by a number of European-minded American artists who acted as advisers to collectors, and despite the introduction in 1883 of a heavy import duty on works of art, contemporary American art declined in relative popularity with collectors in the late 19th century. (Duty on works more than 20 years old was only repealed in 1909; in 1913 works less than 20 years old were exempted.) It was not until 1892 that the first gallery specializing in American art opened in New York.

In the mid-1880s Impressionism was introduced to the USA by such dealers as Paul Durand-Ruel (1831–1922), and, with the added encouragement of Mary Cassatt, a number of collectors such as BERTHA HONORÉ PALMER and Henry and LOUISINE HAVEMEYER acquired notable groups of Impressionist paintings. However, although these collectors acquired substantial amounts of contemporary art, their collections still also included art of the past. By the 1890s the taste of such tycoons as Andrew W. Mellon (1855–1937), J. PIERPONT MORGAN and Samuel H. Kress (1863–1955), on the other hand, had become synonymous with accredited Old Masters and 18th-century works. Typically these collections were large and historical, including works from the early Renaissance to the 18th century; some were almost encyclopedic, or even acquired in bulk. The USA's new economic and cultural strength was the stimulus behind such collections, which were characterized by an enthusiasm for the most prestigious works and by the remarkably high prices paid for their masterpieces. Another important element was the intention of collectors such as Isabella Stewart Gardner, William T. Walters and others to leave their collections to the public as memorials to their achievements (*see* §XV, 2 below). The shift in emphasis from contemporary to past

art was made possible by improvements in art scholarship and the appearance of the first expert advisers. A number of prestigious European dealers, including JOSEPH DUVEEN and Nathan Wildenstein (1851–1934), established themselves in New York and played a crucial part in building these collections. (The era of such collections lasted until the late 1920s, when it was curtailed by the Stock Market Crash and the subsequent Depression.)

On the whole, American collectors ignored subsequent developments in European art such as Post-Impressionism. Before World War I the only American collectors who showed any enthusiasm for modern art from Post-Impressionism onwards were distinguished by their strong ties to Europe, such as the STEIN family and the CONE sisters, who bought works from European dealers or from the artists themselves. In the early 20th century the Madison Gallery and the 291 Gallery of ALFRED STIEGLITZ were among the first few galleries handling modern European art and contemporary American artists in New York. It was the Armory Show of 1913, which introduced the American public to European avant-garde art, that was most effective in stimulating American collectors in this direction.

BIBLIOGRAPHY

R. Brimo: *L'Evolution du goût aux Etats-Unis* (diss., Paris, Inst. A. & Archéol., 1938)
A. B. Saarinen: *The Proud Possessors* (London, 1959)
W. G. Constable: *Art Collecting in the United States* (London, 1964)
J. Lipman, ed.: *The Collector in America* (New York, 1970)
W. Towner: *The Elegant Auctioneers* (New York, 1970)
L. Skalet: *The Market for American Painting in New York, 1870–1915* (diss., Baltimore, MD, Johns Hopkins U., 1980)
T. A. Carbone: 'At Home with Art: Paintings in American Interiors, 1789–1920', *Amer. A. Rev.*, vii/6 (1995–6), pp. 86–93

XV. Museums.

In the USA the development of the art museum has led to the existence of a museum in almost every major town. It has also grown from being a repository of an eclectic collection of curiosities to a specifically designed building, its commission often offering a prestigious opportunity for national and international architects. The general organizational patterns of museums in the USA were laid down in the 19th century and changed little over time. There are two basic kinds of museums, both effectively created by the wish of prominent citizens to commemorate civic and personal pride. The first is the institution initially organized by a committee of prominent and wealthy citizens and/or collectors and run by a board of trustees. A variant on this is the museum that was founded by an art association, which might have been stimulated by a local art exhibition, for example the Detroit Museum of Art, founded in 1885. The second clearly defined strand within the museum sector is that of the museum derived from the collecting activity of a single individual.

1. Early developments: mid-18th century to the mid-19th. 2. Period of expansion and the roles of individual collectors: mid-19th century to the early 20th century.

1. EARLY DEVELOPMENTS: MID-18TH CENTURY TO THE MID-19TH. During the Colonial period there was little development in the museum sphere as the priorities of settlers lay more towards solving the imme-

diate difficulties of living and working in a new and often hostile land. Only in the middle of the 18th century could Benjamin Franklin suggest that at last 'circumstances that . . . afford leisure to cultivate the finer Arts, and improve the common Stock of Knowledge' had been attained (cited in Pach). Unlike Europe, where art institutions generally relied on royal or noble collections, in the New World local associations organized by private citizens to promote learning and culture were responsible for the birth of the first museums. In Boston in the early 18th century John Smibert provided the forerunner of the art gallery in the USA, when he displayed copies after Old Masters and plaster casts of ancient and modern sculpture in the space above his 'color shop', selling artists' materials.

In the 1750s Harvard College attempted to build a 'repository of curiosities' (destr.) along the lines of the Ashmolean Museum, founded at Oxford University in England in 1683. In 1705 the Library Society of Charleston, SC, began to collect materials for a record of the natural history of the state. In 1791 the Massachusetts Historical Society, the model for many subsequent societies, was founded in Boston and opened a small gallery and library. Other developments included the opening by the Society of St Tammany of a museum on Wall Street, in fact a room in the City Hall (destr.), with a collection consisting primarily of American Indian relics, while the New-York Historical Society opened its doors in 1804 and ran what was for many years the only museum in New York.

Attempts to ameliorate the scientific and historical emphases of most early American collections were made from the 1770s. The first of these was arranged by Charles Willson Peale (see PEALE, (1)), who in 1784 began to exhibit his paintings in his own museum in Philadephia, PA, with the addition of objects such as minerals, whale bones and stuffed animals. The collection was displayed in various venues until 1820. In 1814 his son Rembrandt Peale (see PEALE, (4)) opened the Baltimore Museum and Gallery of the Fine Arts (now the Peale Museum, Baltimore, MD) with a similar collection ranging from paintings to ethnographic specimens. The building, designed by Robert Cary Long sr (1770–1833), was the first in the USA and only the third in the world to be constructed as a museum, preceded by the Ashmolean Museum in Oxford and the Museo del Prado in Madrid. Peale charged an admission fee, and there were lecture programmes and nightly 'Philosophical demonstrations'. Such collections tended to present art as a curiosity: it was not until the foundation of the Pennsylvania Academy of the Fine Arts, Philadelphia, in 1805, intended to be the American counterpart of the Royal Academy in London, that there was any attempt to bring together works of art in a display with the intention of elevating public taste. The academy was organized at the suggestion of Charles Willson Peale, but the 71 founders were mainly from the business and legal community, keen to cultivate the arts as part of a nationalistic consciousness. In 1846 the Smithsonian Institution was founded in Washington, DC, from the bequest of James Smithson, a chemist and mineralogist, for a scientific institution.

By the end of the first quarter of the 19th century the society-organized gallery, with its somewhat heterogeneous collection of natural and historical specimens, was one of only two significant types of museum in the USA. The second was the 'dime' museum or emporium of curiosities operated for profit and entertainment, for example Barnum's American Museum in New York. Despite the paucity of public collections, however, college museums expanded in the early 19th century. These contained mainly zoological and geological specimens that were used for teaching purposes, but a number were open to the general public. By 1852 c. 20 colleges had started their own 'cabinets' along these lines; in the next decade another 25 were founded. Although in 1811 JAMES BOWDOIN III endowed the college in Brunswick, ME, named after him with a collection of Old Master paintings and drawings, the first college museum devoted specifically to art was not opened until 1832, when Yale University, New Haven, CT, opened its Trumbull Gallery to stage temporary exhibitions; it was named after JOHN TRUMBULL, who had sold most of his collection to the college in 1831. In the 1850s Harvard University, Cambridge, MA, acquired its first art collection when it accepted the gift of a group of prints, and the University of Michigan began collecting sculpture casts, while Yale began a permanent collection when in 1871 it purchased the collection of Italian Primitive paintings formed by the writer James Jackson Jarves (1818–88).

The main developments of public art museums during the first half of the 19th century were within the context of libraries that added art galleries: the Boston Athenaeum, founded in 1807 as a library, began to stage art exhibitions in one of its rooms in 1826, while the Wadsworth Atheneum added a picture gallery to its building in 1842 and began to build a collection of paintings. In the 1850s, however, the Brooklyn Museum in New York opened, and, aided by a bequest of $5000, instituted a gallery of fine art. During this period the main alternative to the rare public galleries were a few public displays of private collections, such as those of both LUMAN REED, which could be viewed at his home during the 1830s, and the lawyer Thomas Jefferson Bryan (1802–70), whose collection was shown as the Bryan Collection of Christian Art in the 1850s.

2. PERIOD OF EXPANSION AND THE ROLES OF INDIVIDUAL COLLECTORS: MID-19TH CENTURY TO THE EARLY 20TH. The first public museums to open in the USA were the Metropolitan Museum of Art, New York (1870), and the Boston Museum of Fine Arts (1875), followed by the Philadelphia Museum of Art (1876) and the Chicago Academy of Fine Arts (1879; Art Institute of Chicago from 1882). The establishment of these and other institutions marked an important period of growth of museums in the USA. In the 50 years after 1876 the national total of museums of all types rose from 233 to nearly 2500. In earlier decades museums had been dominated by historical and scientific collections, but during this later period it was art museums that demonstrated the greatest expansion; from only 11 such museums in 1870, half a century later there were 224 public art museums and 115 college or university art museums. Moreover, the period signalled a change in the nature of museum formation and organization: the societies, academies and lyceums that had played the central role in establishing

'cabinets' and collections in previous decades gave way to formally chartered institutions. These museums were characterized by a new emphasis on their role as a public service that could help to raise the standards of American taste, especially in the context of manufacturing design. The Chicago Academy of Fine Arts, for example, aimed to promote design, holding both exhibitions and classes for this purpose.

An important influence on the establishment of public institutions was the new civic and national pride stimulated by the centennial of the War of Independence, and the urge to rebuild after the bitter divisions of the Civil War. These forces, coupled with the post-war period of prosperity, which created a considerable number of private fortunes, encouraged persons of private wealth to involve themselves in philanthropy and the foundation of institutions that could serve as monuments to civic pride and personal munificence. For example, the M. de Young Memorial Museum, San Francisco, CA, grew out of the newspaper publisher's role in organizing the California Midwinter International Exposition in 1894, and the decision to create a permanent museum as a memorial to the International Exposition.

The appearance of art museums in the late 19th century was due largely to a change in attitudes towards art; it was no longer regarded merely as a curiosity but was seen as a cultural product with a moral and aesthetic value. This shift, concomitant with improvements in art-historical scholarship, both in Europe and the USA, and the growth in the art market in such cities as New York, helped to lead to an improvement in the standards of private collections in the USA (*see* §XIV above). It is unlikely that American museums and their collections could have been started without a body of individuals willing and able to acquire their own private collections. A factor discernible from the 1870s was that these were built up with a view to being presented to an institution.

A characteristic of all American museums founded by boards was the dominant role of the private individual collector since, in the absence of public funding for the purpose, an institution's collection generally grew from works provided or promised by the founding trustees. Moreover, although a museum's direction might be established by its founder, the development of its collection was likely to be shaped significantly by later donations. Museum collections were therefore often a barometer of contemporary taste. On occasion, where civic pride demanded a municipal institution but the question of local private patronage was neglected, the ridiculous situation arose of a museum with empty galleries. For example, the Toledo Museum of Art, OH, founded in 1901 by a group of citizens led by the industrialist Edward Drummond Libbey, had no collections when it opened, and it was thus dependent on loans. Libbey, whose successful LIBBEY GLASS CO. provided the basis of the economy in Toledo, formed a collection of European paintings, however, which he bequeathed to the museum in 1925 and which was supplemented by a trust provided by his estate.

Art collections in American museums were augmented either by complete collections or by individual works. For instance, the Metropolitan Museum of Art, New York, founded by 50 New Yorkers, including Henry G. Mar-

quand, who grouped together to raise an endowment for the museum, was given several collections in the 1880s. Many gifts followed, including parts of the J. Pierpont Morgan collection and the Havemeyer collection; by the 1920s it was the largest and wealthiest art museum in the country.

Institutions dependent on private patronage were varied with respect both to scale and to the kind of work they contained. The collections formed at smaller art museums, effectively in many cases by an individual, are sometimes eccentric in scope and taste. The first such institution open to the public was the Corcoran Gallery of Art in Washington, DC, which opened in 1869 displaying the collection built up by its founder, WILLIAM WILSON CORCORAN, in the mid-century. In the 1870s and 1880s a number of American collectors began to amass collections with the aim of eventually presenting them to the public. Among these was that of ISABELLA STEWART GARDNER at Fenway Court in Boston, MA (now Isabella Stewart Gardner Museum, made public in the 1920s), and the WALTERS collection (now Walters Art Gallery) in Baltimore, MD, formed by William T. Walters and his son Henry Walters and bequeathed in 1931. There are some discernible strands within the category of museum derived from the individual collector. Some of the museums based on a single collection, such as the Gardner Museum and the Frick Collection in New York, founded by HENRY CLAY FRICK, have remained frozen in time, explicit memorials to the taste of their founders, perpetually presented in much the same settings as in the patron's lifetime. In other cases a collection amassed by one person has been memorialized in a more conventional institutional setting, with new acquisitions generally orientated toward the original collector's taste.

BIBLIOGRAPHY

L. V. Coleman: *The Museum in America: A Critical Study*, 3 vols (Washington, DC, 1939)
W. Pach: *The Art Museum in America* (New York, 1948)
G. Bazin: *The Museum Age* (New York, 1967)
D. Ripley: *The Sacred Grove: Essays on Museums* (New York, 1969)
E. Spaeth: *American Art Museums* (New York, 1969)
S. Lee, ed.: *On Understanding Art Museums* (Englewood Cliffs, 1975)
Museums USA: A Survey Report, National Endowment for the Arts (Washington, DC, 1975)
N. Burt: *Palaces for the People* (Boston, 1977)
K. E. Meyer: *The Art Museum: Power, Money, Ethics* (New York, 1979)

A. DEIRDRE ROBSON

XVI. Art education.

1. To 1914.

(i) Higher education. The first institutions to foster training in the visual arts in the USA were academies such as the Pennsylvania Academy of Fine Arts in Philadelphia (founded 1805), the National Academy of Design in New York (founded 1825), the Cincinnati Academy of Fine Arts (founded 1838) and, to a lesser extent, the Art Students League (founded 1875). These were modelled on European academies and were initially dedicated to the display and promotion of the fine arts rather than to education. Until then, most aspiring artists were trained in other artists' studios or were self-taught; many still looked to Europe for examples and for guidance; for sculptors in particular a period of study in Italy was considered almost

essential during much of the 19th century (*see* §IV, 1 above). Architects usually had a formal university education followed by a period at the Ecole des Beaux-Arts in Paris, before working in the office of a Beaux-Arts trained architect.

As industrialization spread in the second half of the 19th century, some art academies evolved into professional art schools seeking to promote emergent industries by training designers. This includes the Rhode Island School of Design (founded 1877) in Providence, RI, which offered training in textile design, while the New York State College of Ceramics (founded 1900), administered by Alfred University, was founded to promote the ceramics industry. Yale University's art school (founded 1863) was predicated on the notion that the study of fine arts fell within the province of the university, an idea at variance with European practices. Still other art schoools were affiliated with museums, such as the Chicago Academy of Design (founded 1863), later to become the Art Institute of Chicago in 1882. The School of Drawing and Painting was attached in 1877 to the Museum of Fine Arts, Boston, and became the School of the Museum of Fine Arts in 1901. The School of Drawing and Painting was attached in 1877 to the Museum of Fine Arts, Boston, and became the School of the Museum of Fine Arts in 1901. Art appreciation courses were introduced at Harvard University in 1874 by Charles Eliot Norton. In 1901, a survey by F. F. Frederick found that one in every three undergraduate college students came into contact with a professor of fine arts. Formal study in art history in the USA began in 1882 at Princeton University, NJ, with the creation of a department of fine arts directed by Allan Marquand. This fledgling deprartment had begun to detach art-historical study from the study of archeology or the classics. By the end of the 19th century, Harvard, Yale and Princeton were among some 47 colleges and universities in the USA offering courses in art as a form of liberal study.

(ii) Drawing in the common schools. The establishment of state-supported common schools was under way in the 1830s and 1840s, made necessary by emerging industries where reading and writing were practical necessities, and this embraced aspects of the visual arts. Drawing had become an essential skill, yet its acceptance as a requisite part of schooling was slow in coming. Horace Mann (1796–1859), one of the early advocates for drawing, used three arguments to convince his contemporaries of its merits: (1) it would improve handwriting, (2) it was an essential industrial skill, and (3) it was a moral force. He advocated methods of instruction that he attributed to Pestalozzi in the *Common School Journal* and in his annual reports to the state-board of education in Massachusetts. Most systems of elementary drawing used in schools were based on the drawing of simple geometric figures. Texts in drawing were prepared by John G. Chapman, William Bentley Fowle, William Minife and others (Marzio, 1976). By the 1870s publicly funded schools were assuming preliminary responsibility for the teaching of drawing, a skill that assumed greater importance as the pace of industrialization increased, especially in the education of working-class pupils. The first state-wide system of art education was established in Massachusetts in 1871 by

Walter Smith, who had trained in South Kensington, London, and emigrated to Boston to establish a graded programme, which began in the primary and grammar school grades, culminating in a normal art school for training teachers of drawing. Evening drawing school classes for workers were also offered.

(iii) Art as cultural refinement. In a number of private schools, especially those for women, art was regarded as a source of cultural refinement. Girls were taught fancy drawing as a female accomplishment along with elocution, literature and French (Sigourney, 1837). By the 1870s art began to be studied through printed reproductions, copies of plaster casts, as well as through practical instruction in drawing and painting. Abbot's Academy for girls in Andover, MA, introduced courses in the history of art in 1873 antedating its introduction at Harvard. By the 1880s and 1890s industrial drawing was opposed by a rising middle class who regarded it as training for working-class vocations. Public schools began offering some of the same cultural subjects found in private schools to attract middle-class pupils. Study of art as objects of refinement and beauty by 'picture study' and by 'schoolroom decoration' was urged by American disciples of John Ruskin (1819–1900). Picture study using small reproductions was also introduced as a regular art activity by the turn of the century. The *Perry Magazine* made its appearance in 1899, containing articles on the use of art reproductions in the classroom. Though ceasing publication in 1906, Perry prints were available for study up to and including World War II. The ARTS AND CRAFTS MOVEMENT was concurrent with the picture study and schoolroom decoration initiatives. This movement first arose in England, winning many adherents in the USA. In England the movement was an attempt to remedy the social costs of the industrial revolution and to improve the quality of life of working men and women. Its proponents, including William Morris (1834–96) and Walter Crane (1845–1915), advocated a view of socialism based on the practices of the medieval guilds. However, in the USA the movement promoted the revival of handmade crafts to overcome the ugliness of products made by machine. It fostered a return to the ideals of good craftsmanship and design but lacked the social vision of the movement in England. Craftsman style artefacts were regularly featured in courses for manual training, and in such publications as the *School Arts Book* and the *Manual Training Magazine*. These journals featured art lessons in the primary and secondary levels that were strongly influenced by the Arts and Crafts styles. Art and manual training teachers were frequently members of the same professional associations.

(iv) Elements and principles of design. At the turn of the 20th century the study of design was promoted by Arthur W. Dow (1857–1922), although interest in discerning universal principles of artistic design had begun to appear in 1856 in Owen Jones's *Grammar of Ornament*. Dow's *Composition*, first published in 1899, was organized around 'synthetic exercises' based on the element of line, 'notan' (light–dark) and colour. Dow also identified five principles of composition, namely opposition, transition, subordination, repetition and symmetry. His system was called

'synthetic', because these elements and principles were taken as the foundation for all art forms, past, present and future. Dow's *Composition* anticipated by a generation the type of educational practices developed at the Bauhaus that were widely disseminated throughout the 20th century.

(v) Art in progressive education. By the turn of the 20th century two educational pioneers of the progressive education movement deserve mention because their ideas presaged the teaching of art in public schools in the USA in later generations. Frances W. Parker and John Dewey were both active in Chicago, as heads of experimental schools that included teaching in the arts and crafts. Parker headed the Cook County Normal School, while in 1897 Dewey founded a laboratory school under the auspices of the University of Chicago. Parker recognized the importance of imagination in the art activities of children, while Dewey's early efforts focused on learning by doing where art and craft were integrated into the daily activities of the school

BIBLIOGRAPHY

Thirty-fourth Annual Report of the Secretary, Massachusetts Board of Education (Boston, 1871)
P. McKeen and P. A. McKeen: *History of Abbot's Academy* (Andover, MA, 1880)
I. E. Clarke: *Art and Industry: Education in the Industrial and Fine Arts in the United States*, i (Washington, DC, 1885)
A. W. Dow: *Composition* (New York, 1899)
F. F. Frederick: 'The Study of Fine Art in American Colleges and Universities: Its Relation to the Study in Public Schools', *National Education Association Journal of Proceedings and Addresses of the 40th Annual Meeting: Chicago, 1901*, pp. 695–704
H. T. Bailey: *The Flush of the Dawn: Notes on Art Education* (New York, 1910)
K. Vanderbilt: *Charles Eliot Norton: Apostle of Culture in a Democracy* (Cambridge, MA, 1959)
L. Cremin: *Transformation of the School* (New York, 1964)
N. Pevsner: *Academies of Art Past and Present* (New York, 1973)
P. C. Marzio: *The Art Crusade: An Analysis of American Drawing Manuals* (Washington, DC, 1976)
Art in Transition: A Century of the Museum School (exh. cat. by B. Hayes, Boston, MA, Mus. F.A., 1977)
M. Stankiewicz: 'The Eye is a Nobler Organ: Ruskin and American Art Education', *J. Aesth. Educ.*, xviii/2 (1984), pp. 51–64
A. Efland: 'Art and Education for Women in Nineteenth-century Boston', *Stud. A. Educ.*, xxvi/3 (1985), pp. 133–40
A. Efland: *A History of Art Education: Intellectual and Social Currents in Teaching the Visual Arts* (New York, 1990)

ARTHUR D. EFLAND

XVII. Art libraries and photographic collections.

The development of art libraries in the USA is closely related to the formation of the great art collections and the growth of art history as an academic discipline, with many libraries being established to support the educational programmes of art schools and academies. Another related factor was the extension of services in public libraries, to which responsibility for cultural education and enrichment increasingly devolved. The first small art libraries were established in the 19th century with the foundation of major museums such as the Boston Museum of Fine Arts (1875) and the Metropolitan Museum in New York (1880). At the same time libraries were also necessarily gradually fostered by art schools and academies: the great collection of the Ryerson and Burnham Libraries of the Art Institute of Chicago began as a shelf of books in the director's office. Meanwhile, in the case of those universities or colleges with their own museums, libraries arose to serve the dual purpose of supporting the museum's collecting activities and of promoting the educational mission of the parent institutions, as with the Fine Arts Library at Harvard University, Cambridge, MA. The changing nature of the contents of the art library during the 19th century and the early 20th reflects the development of the literature of art, which originally comprised primarily biographies, guide-books, handbooks for collectors and auction sale catalogues, but which was soon augmented by the growth of PERIODICALS, systematic inventories of the great museums and monumental corpora and catalogues raisonnés.

BIBLIOGRAPHY

W. Freitag: 'Art Libraries and Collections', *Encyclopedia of Library and Information Science*, i (New York, 1968), pp. 571–621
P. Pacey: *Art Library Manual: A Guide to Resources and Practice* (London, 1977)
A. B. Lemke: 'Education for Art Librarianship: The First Decade', *A. Libs J.*, vii (1982), pp. 36–41
S. S. Gibson: 'The Past as Prologue: The Evolution of Art Librarianship', *Drexel Lib. Q.*, xix (1983), pp. 3–17
J. Larsen, ed.: *Museum Librarianship* (Hamden, 1985)

SARAH SCOTT GIBSON

XVIII. Historiography.

Throughout much of the 19th century, interest in the arts in the USA was primarily aesthetic rather than historical, and appreciation of art was considered a morally uplifting ingredient of a well-rounded humanist education; it was not until late in the century that this moral aspect was seen as a focus for formal art education (*see* §XVI above). Historical texts on art and design, such as William Dunlap's *History of the Rise and Progress of the Arts of Design in the United States* (New York, 1834), James Jackson Jarves's history of Italian art (1861) and *A Glimpse of the Art of Japan* (1876), and William C. Prime's *The Pottery and Porcelain of All Times and Nations* (1878), were published only occasionally. Charles E. Lester made a major contribution when he published *The Artists of America: A Series of Biographical Sketches of American Artists with Portraits and Designs on Steel* (1846). In the second half of the century the history of art was introduced into American colleges and universities. For the pioneers of art history in the USA, original scholarship was not an issue of great importance, and, as Charles Eliot Norton recognized, American art history students and scholars were reliant on European texts.

Two individuals of note, however, did explore new areas and methodologies in art history. The Leipzig-trained scholar Charles C. Perkins (1823–86), who helped found the Boston Museum of Fine Arts, wrote five academic books on Italian art. Because he never held a university position, however, Perkins's historical rigour found few disciples. The example of Bernard Berenson (1865–1959), on the other hand, was widely followed. Having earnt his degree at Harvard, Berenson settled in Italy, where he adopted the methodology of the connoisseur Giovanni Morelli (1819–91), who had sought to establish a scientific method to determine the authorship, date and provenance of works of art. Although Berenson's application of Morelli's method of connoisseurship sometimes led him to questionable historical conclusions, his *Drawings of the*

Florentine Painters (3 vols, 1903) is an enduring example of his scholarship.

Connoisseurship has had a lasting legacy in American art history. Meanwhile, from the early 20th century a number of new approaches evolved, without necessarily preventing existing and very different approaches from continuing to develop. During the first few decades of the century, as leading humanists attempted to model their disciplines on the natural sciences, the positivist compilation and examination of data displaced what was seen by some as an outmoded predilection for aesthetics and interpretation.

BIBLIOGRAPHY
P. Hiss and R. Fansler: *Research in Fine Arts in the Colleges and Universities of the United States* (New York, 1934)
A. Neumeyer: 'Victory without Trumpet', *Frontiers of Knowledge*, ed. L. White jr (New York, 1956), pp. 178–93
R. Wittkower: 'Art History as a Discipline', *Winterthur Seminar on Museum Operation and Connoisseurship: Winterthur, 1959*
J. S. Ackerman and R. Carpenter: *Art and Archaeology* (Englewood Cliffs, NJ, 1963)
J. G. Schimmelman: 'A Checklist of European Treatises on Art and Essays on Aesthetics available in America through 1815', *Proc. Amer. Antiqua. Soc.*, xciii (1983), pp. 93–195
J. G. Schimmelman: *American Imprints on Art through 1865: An Annotated Bibliography of Books and Pamphlets on Drawing, Painting, Sculpture, Aesthetics, Art Criticism and Instruction* (New York, 1990)
SHANA GALLAGHER

Updike, Daniel Berkeley (*b* Providence, RI, 1860; *d* Boston, MA, 1941). American typographer, printer and graphic designer. He was advertising manager and layout artist at the publishing house of Houghton, Mifflin & Co. before transferring to the firm's printing works at the Riverside Press, where he worked until 1892. Updike's first freelance commission, the design of a *Book of Common Prayer* (1892), was well received, and in 1893 he set up his own studio, initially with the idea of designing types but then as a printing press, the Merrymount Press. He commissioned a new type called Merrymount from Bertram Goodhue for use on a new *Episcopalian Altar Book* (Boston, 1896). Between 1893 and 1896 Updike produced *c.* 18 books before turning to printing them himself, assisted by John Bianchi (*fl* 1893–1947), his first typesetter and later his partner. The Merrymount Press undertook a wide range of work for publishers, book clubs, libraries, churches and institutions. In 1896 Updike purchased the Caslon face for use at the press; in 1904 Herbert Horne designed Montallegro for him; other types employed included Scotch Roman, Janson, Mountjoye and Oxford; Updike was the first American to use Times New Roman. In 1899 the Merrymount was firmly established by a commission to print Edith Wharton's novels for the publisher Charles Scribner & Sons; however, much of Updike's work was for the private collectors' market and limited-editions clubs. His finest work is thought to be the *Book of Common Prayer* (Boston, 1930), financed by J. Pierpont Morgan and begun in 1928, for which he employed Janson type. His *Printing Types* was first published by Harvard University Press in 1922 and was based on lectures that he had given at the University (1911–16). At his own estimate Updike produced *c.* 14,000 pieces of printing.

WRITINGS
Printing Types: Their History, Forms and Use, 2 vols (Cambridge, MA, 1922)

BIBLIOGRAPHY
The Work of the Merrymount Press and its Founder, Daniel Berkeley Updike (1860–1941) (exh. cat., San Marino, CA, Huntingdon Lib. & A.G., 1942)
K. Day, ed.: *Book Typography, 1815–1965, in Europe and the USA* (London, 1966)
J. Blumenthal: *The Printed Book in America* (Dartmouth, NH, 1989)
LAURA SUFFIELD

Upjohn. American family of architects of English birth. The principal and best-known member of an architectural dynasty comparable to the Scotts in England, (1) Richard Upjohn, was born in Shaftesbury, Dorset, but enjoyed a successful career in the USA. His most important contribution was Trinity Church, Wall Street, New York (1839–46), which introduced to the USA the phase of the Gothic Revival represented in the work of A. W. N. Pugin (1812–52) and the Ecclesiologists. The most obvious result was the creation of an architecture for the Protestant Episcopal Church in America. The ultimate effect, however, was to dramatize ideas that had played a vital role in American architectural thought since Thomas Jefferson: that the arts have a role in a democracy; that architecture should suit its purpose; that architecture can have a particular psychological impact on the viewer and thus can affect, in a positive way, the morality of the individual and of society.

Richard Upjohn's son (2) Richard Michell Upjohn was also an architect, who perpetuated the Gothic Revival style championed by his father. Richard Michell Upjohn's youngest son, Hobart Upjohn (1876–1949), took up the cause of church architecture, designing Colonial Revival churches, especially in the South in the early 20th century. Several other family members of Richard Michell's and Hobart's generations either became Episcopalian priests or had artistic interests in a way that makes the family an embodiment of the 19th-century belief in the moral power of the arts. A member of the fourth generation, Everard Upjohn (1903–78), was trained as an architect at Harvard University but devoted his life to teaching art history.

(1) Richard Upjohn (*b* Shaftesbury, Dorset, 22 Jan 1802; *d* Garrison, NY, 17 Aug 1878). His father was a builder and estate agent, who also taught at Christ's Hospital, London. The daughter of a clergyman, Upjohn's mother also came from an educated family. Despite his family's objections, Upjohn secured an apprenticeship to a cabinetmaker in 1819. In 1829, following his marriage and the birth of his first son, (2) Richard Michell Upjohn, Richard Upjohn and his family emigrated to the USA. By 1830 he was working in New Bedford, MA.

1. Life and work. 2. Office organization. 3. Influence.

1. LIFE AND WORK.

(i) Early years, before 1837. One of his earliest works was the William Rotch House (1834) in New Bedford, which shows Upjohn's English experience as a cabinetmaker in the Regency details of the interior and his American experience of drawing houses for building speculation in such details of the New England vernacular as clapboarding, the gabled roof and the exterior proportions. Of Upjohn's other early works, those in Boston, MA, where he settled in 1834, proved important because it was through his acquaintance with prominent Bostonians

that he acquired a reputation and national contacts that led to the work at Trinity Church, New York. The major work of this period was the country house Oaklands (1835–42) for Robert Hallowell Gardiner and his family in Gardiner, ME. A Tudor-style manor house, it is of additional significance as one of the few houses by Upjohn that remains in original condition. Upjohn's work in Boston also established his place in the continuum of American architecture. Many of his Boston clients were members of Trinity Church, Boston. It was there that Upjohn, after a lapse, reaffirmed his ties with the Episcopal Church, as others did at this time. He also made alterations to the 1829 Trinity Church and designed a new organ-case. The building later burnt down and was replaced by H. H. Richardson's famous Copley Square structure (1872–9; *see* RICHARDSON, H. H., fig. 1).

Both the Reformation and Puritanism had affected the design of English and American ecclesiastical architecture, especially in restraining the use of colour and ornament and in the emphasis in the plan on the congregation and on preaching. Even in the 1830s, the Puritan legacy still contributed to the suspicion with which Americans regarded art in general and their preference for the written word over visual representations as the means for communicating religious truth; this was particularly true in

Boston. It may not, therefore, be a coincidence, given the traditions of Boston and New York, that while four people important to the Gothic Revival in the USA (Upjohn, the Rev. John Henry Hopkins, the Rev. George Washington Doane and the Rev. Jonathan Mayhew Wainwright) were at Trinity Church, Boston, in the 1830s, it was in New York, always a more secular city with a more lavish lifestyle, that the English medieval parish church was revived.

(ii) Mature work, 1837 and after.
(a) Trinity Church. In October 1837 the Rev. Wainwright became assistant minister at Trinity Church, Wall Street, New York. When the Building Committee authorized inspection of the 18th-century building in February 1839, it hired Upjohn, who soon moved to New York. After inspecting the roof, he recommended extensive renovations, and on 9 September 1839 he submitted plans for a new church (see fig. 1). Several innovations appeared in Upjohn's early longitudinal section. The balconies, as well as the plaster and lath vaults found in the 18th-century church, were gone, to be replaced by an open timber ceiling. Furthermore, the chancel was differentiated from the nave by size, shape and an arch, and thus formed a separate compartment. As opposed to broad naves to

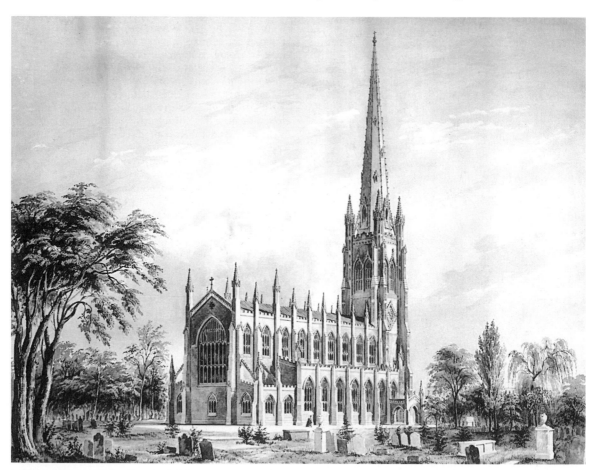

1. Richard Upjohn: Trinity Church, Wall Street, New York, 1839–46; from a watercolour by Richard Upjohn, 526×670 mm (New York, Columbia University, Avery Architectural Memorial Library)

emphasize the congregation characteristic of the 18th century, the nave in Upjohn's design is long, accentuating the chancel and the rite of communion. This represents a shift in theological tenets and liturgical practices, which had been the subject of debate in England since the 1830s, a debate that the Ecclesiologists, the group that had codified precise guidelines for church design, carried on with great vigour in the 1840s and 1850s.

A. W. N. Pugin's *True Principles of Pointed or Christian Architecture* (1841) recommended changes in church design, predicated on the belief that the Middle Ages were morally superior to the 19th century and that the use of medieval forms would morally improve modern society. Like Pugin, Upjohn believed that use and circumstances, not arbitrary laws, should dictate the form buildings should take. Their concept of fitness, which emphasized truth in materials, structure and purpose, regarded the deliberate use of past forms as necessary. Upjohn's alterations for Trinity Church, Boston, incorporated these views, and his 1839 section for Trinity Church, New York, is the first representation of these ideas in the USA.

Deemed 'the puny cathedral of Broadway' by Horatio Greenough and praised by others, Trinity Church as built was different from Upjohn's initial plan. It did revive 14th-century English Gothic in its elevations, but the roof timbers were concealed behind imitation plaster vaulting (the antithesis of Pugin's *True Principles*) and the chancel was made more continuous with the nave. Although Upjohn did not carry out as elaborate a decorative scheme on the interior as Pugin and the Ecclesiologists thought ideal, the stained-glass windows over the altar were among the first examples in the USA and represented the collaboration of Upjohn with the painter and stained-glass artist Thomas Hoppin (1816–72). Upjohn designed the church furniture and supervised its carving, along with all other aspects of the building, in a churchyard shed in the tradition of the medieval mason's lodge. Even in its simplified state, Trinity Church allowed the wealthy parishioners to indulge their desire for art in a manner sanctified by the church, in which materialism and morality were effectively blended.

(b) Later churches. Upjohn's success at Trinity and his contact with Episcopal clergymen who supported the reformed liturgy were the basis of future patronage. He first achieved complete expression of Ecclesiological ideals at St Mary's (begun 1846), Burlington, NJ, commissioned by Bishop George Washington Doane. This church has a cruciform plan with a spire over the crossing, and it has the exposed roof timbers that Trinity Church lacks. It was not as lavish in its interior decoration as Pugin might have wished, but Upjohn and Doane carefully worked out a suitable interior scheme. The church of the Holy Communion (1844–6), New York, exhibited all of the attributes advocated by the church reformers.

The parish church was regarded as vital for spreading the Christian word. Its importance in Upjohn's career is evident in the number of parish churches designed by him and his office, as well as in his only book, *Upjohn's Rural Architecture* (1852). In it Upjohn presented a set of drawings for a small church, comprising the first stage of a commission: a perspective, elevations, plans, sections and diagrams of the structural timbers, as well as drawings for a school and a parsonage. *Upjohn's Rural Architecture* made standardized designs available throughout the USA and spread current architectural idioms to many parts of the country. Churches built according to this book may be found in upstate New York (for illustration *see* BUFFALO), northern New England, the South and as far west as Wisconsin. Although Upjohn's motivation was religious, the effect was to popularize church architecture.

(c) Domestic architecture and public buildings. Upjohn clearly regarded domestic architecture as the staple of his practice and it accounted for a substantial amount of the office's work. The Edward King House (1845–7), Newport, RI, in the Italianate style, has stood for many years as the main example of Upjohn's domestic architecture and his ability to design in a style other than the Gothic. Like all of Upjohn's house plans, this one is a variation of a plan, with rooms distributed around a central hall, with which he must have become familiar during his New Bedford days. Somewhat earlier and smaller than the King House but close in design was Highlawn (1844–5), Lenox, MA, built for the minor Transcendentalist writer and patron of the arts Samuel Gray Ward. Although Upjohn used the Italianate style in varied ways throughout the 1840s and 1850s, he soon began to exploit the stylistic possibilities of timber construction. The George Atwater House (1854–5), Springfield, MA, is one of the earliest examples of a conscious revival of American Colonial architecture and one that preceded by 15 years Upjohn's important address to the American Institute of Architects, 'The Colonial Architecture of New York and the New England States'.

Upjohn's exclusive use of the Gothic for Episcopal churches and rectories may have been an article of religious faith: he is remembered for refusing to build for the Unitarians because they denied the Trinity. However, the architectural corollary of this doctrinaire refusal is the strength of his conviction that style and purpose should be in accord. Thus for Congregational institutions, such as Bowdoin College (1845–55), Brunswick, ME, Upjohn used the *Rundbogenstil* (German rounded arch style). His Church of the Pilgrims (1844–6; see fig. 2), Brooklyn, NY, is the first example of that style in the USA and may have been designed in collaboration with the Austrian immigrant Leopold Eidlitz.

2. OFFICE ORGANIZATION. Richard Upjohn's office, one of the largest of its day, was organized as a family practice. In addition to his eldest son, (2) Richard Michell Upjohn, who worked with his father from a very early age, Upjohn had as many as five draughtsmen and assistants, depending on the amount of work in the office. Between 1843 and 1846 Leopold Eidlitz worked there. Upjohn's collaboration with the younger men in his office was first recognized in 1851 when the first partnership between father and son, Upjohn & Co., was created. Charles Babcock (1829–1913) joined the office in 1850 and three years later was made a junior partner. He married Upjohn's daughter several months after becoming his partner.

3. INFLUENCE. Upjohn gained a strong reputation as the defender of professional ethics at a time when the

2. Richard Upjohn: Church of the Pilgrims, Brooklyn, New York, 1844–6; engraving (New York, New-York Historical Society)

architect and builder were still closely identified in fact and in the public mind. By insisting that the architect be a man of honour, whom the public could trust to uphold high standards of design and construction, Upjohn sought to distinguish the professional architect from the builder. He led the movement for the founding of the American Institute of Architects (A.I.A.) in 1857 and was made its first president. It is indicative of Upjohn's impact on the evolving profession that a high percentage of the original members of the A.I.A. had either worked in his office or been closely associated with him in some way. As part of the campaign to increase the status of the architect, Upjohn sought to establish a library and a collection of architectural and engineering models in the A.I.A. offices, where young architects could study them. Yet Upjohn does not appear to have been particularly interested in breaking away from the tradition of training the young in an architect's office. His commitment to the office apprenticeship may be reflected in Babcock's departure from the office in 1858, as a year earlier Babcock had argued strenuously for professional training institutes, criticizing contemporary office training of the sort that he had received from his father-in-law. Babcock subsequently took up this cause at Cornell University, where he became the first professor of architecture.

Despite the size and success of his practice and his careful attention to all aspects of a commission, Upjohn's architecture often appears more successful in elevation than in perspective, as a result of his approach to design and reliance on architectural illustrations. Often austere at its best, his architecture is restrained and carefully, even delicately, detailed, with finely proportioned interior spaces. Nonetheless, Upjohn was instrumental in developing for his clients an American architecture based on the traditions of Europe.

Although he saw himself as crusading for the cause of the architectural profession and the Episcopal Church in America, his achievements had other dimensions. Many of his clients, such as Robert Hallowell Gardiner, Theodore Lyman, Samuel Gray Ward and the Rev. George Washington Doane, had ambitions for the establishment of American culture in a broad sense. But in the period before the Civil War, with industrialism still growing, they lacked the material resources and institutional organization to achieve all their goals. By supporting their ideals, by introducing new styles, by insisting on truth and by advancing the profession, Upjohn furthered the cause of the arts in general. He thereby created the foundations for the achievements of such architects as McKim, Mead & White, H. H. Richardson and Frank Lloyd Wright.

(2) Richard Michell Upjohn (*b* Shaftesbury, Dorset, 7 March 1828; *d* Brooklyn, New York, 3 March 1903). Son of (1) Richard Upjohn. He succeeded his father as head of the firm Upjohn & Co. in 1872. He had been very active in the office since the mid-1850s and his work is particularly evident after Babcock's departure. Known as the architect of the Connecticut State Capitol (1872–88), Hartford, in a Gothic Revival style, he also designed many houses, small churches and innumerable grave-markers while working for his father and seems to have introduced Ruskinian motifs to the office's repertory. His later career remains unstudied, except for the Connecticut State Capitol; he did carry on the tradition of designing for the Episcopal Church but was a very difficult personality, who, having been overshadowed by his father as a young man, never achieved equal success in his own right.

UNPUBLISHED SOURCES
New York, Columbia U., Avery Archit. Mem. Lib., Richard and Richard Michell Upjohn Collection [incl. typescript of E. M. Upjohn: 'A Brief Note on Richard Michell Upjohn', *c.* 1971]
New York, Pub. Lib., Manuscripts Division, Richard and Richard Michell Upjohn Papers
Washington, Amer. Inst. Architects, Archvs [MS. of R. Upjohn: *Addresses to the A.I.A.; 1857–1878*]

WRITINGS
Richard Upjohn: *Upjohn's Rural Architecture* (New York, 1852)
Richard Upjohn and others: *Rural Church Architecture* (New York, 1860s/ *R* 1876)
Richard Upjohn: 'Colonial Architecture of New York and the New England States', *Proc. Amer. Inst. Architects*, ii (1869–70), pp. 177–9

BIBLIOGRAPHY
T. U. Walter: 'Richard Upjohn, F.A.I.A., 1802–1878', *J. Amer. Inst. Architects*, viii (1878), pp. 272–6
E. M. Upjohn: *Richard Upjohn: Architect and Churchman* (New York, 1939/*R* 1969)
W. H. Pierson: *American Buildings and their Architects: Technology and the Picturesque, the Corporate and the Early Gothic Styles* (Garden City, NY, 1978), pp. 159–205
D. P. Curry and P. D. Pierce, eds: *Monument: The Connecticut State Capitol* (Hartford, 1979)
J. S. Hull: *Richard Upjohn: Professional Practice and Domestic Architecture* (diss., New York, Columbia U., 1987)
——: 'The "School of Upjohn": Richard Upjohn's Office', *J. Soc. Archit. Educ.*, lii (1993), pp. 281–306

JUDITH S. HULL

V

Van Brunt, Henry (*b* Boston, MA, 5 Sept 1832; *d* Milton, MA, 8 April 1903). American architect and writer. Educated at Harvard University (1850–54), Cambridge, MA, and trained in the studio of Richard Morris Hunt, New York, he formed a partnership in Boston (1863) with fellow trainee William Robert Ware. In 1865 Ware and Van Brunt were awarded their best-known commission, Memorial Hall at Harvard University, in a limited competition (for illustration *see* WARE, (1)). The building incorporated in an ecclesiastical plan two functional components—a dining-hall (nave) and a theatre (chancel)—as well as a Civil War memorial (transept). Influenced by John Ruskin (1819–1900), Viollet-le-Duc (1814–79), and Hunt's teaching of Beaux-Arts composition, the design was derived from a number of English precedents, both medieval and contemporary Gothic Revival.

Following the lead of Hunt's professionalism, Van Brunt served as Secretary (1860) and as President (1899) of the American Institute of Architects (AIA), and was a founder of the Boston Society of Architects. Ware and Van Brunt set up a studio to pass on Hunt's teachings from the lessons delivered at the Ecole des Beaux-Arts. Ware became increasingly engaged in education, and when he left for New York in 1881, Van Brunt formed a new partnership, Van Brunt and Howe, with Frank Howe (1849–1909), who had joined the previous partnership in 1868.

Despite his exceptional training, Van Brunt never developed into an innovative designer. He adapted to the changing styles of his era while gaining a reputation for attention to the needs and preferences of clients, and for the design of libraries. As his importance in Boston architecture began to diminish, he found new opportunities in the West, moving to Kansas City, MO, in 1887, where again his training placed him to the fore. There he adopted the style of H. H. Richardson, as the mainstay of his practice (other than residential work) shifted from churches and libraries to railway stations and commercial buildings. On joining the group of architects of the World's Columbian Exposition in Chicago in 1893 (he designed the Electricity Building), he converted somewhat awkwardly to the new régime of Beaux-Arts classicism. He retired from active practice in 1900 and took his only trip to Europe to see the architecture he knew from photographs and drawings.

Of more lasting importance than his buildings are Van Brunt's prolific writings, which reflect the changing conditions, ideals and controversies that affected his practice.

His first published essay, 'Cast Iron in Decorative Architecture' (1859), challenged the basis of Ruskin's utopian vision on philosophical, pragmatic and theoretical grounds, arguing for control over the forces of modernity rather than avoidance of them in handcraft. In 'Greek Lines' (1861) Van Brunt advocated a romantic individualistic idealism inspired by Henri Labrouste (1801–75), to balance the regimentation of the Ecole des Beaux-Arts, thus introducing the juxtaposition that was to occupy much of his later writing. 'Architectural Reform' (1866), a review of the first volume of Viollet-le-Duc's *Entretiens sur l'architecture*, proclaimed in Viollet a new hero-antagonist within the French system. Van Brunt began a translation in the hope that Viollet could provide a critical standard lacking in the USA, but by the time the first volume was published (Boston, 1875), Van Brunt's faith in individual innovation had waned markedly. His emphasis had shifted to institutions, the training and professionalism of the schools and the AIA. To undisciplined American architecture, the Ecole des Beaux-Arts offered a system of rules and precedents that could serve as a model for education and practice. By the time Van Brunt's translation of the second volume was published (Boston, 1881), he had turned away from theory entirely in favour of accepting architecture as a cultural index. Thus his participation in the Court of Honour buildings at the World's Columbian Exposition (*see* BURNHAM, DANIEL H.) marked a shift of emphasis in what he believed. He now thought architects should provide a collective reaction to the public's requirements rather than imposing their individual innovations.

WRITINGS
'Cast Iron in Decorative Architecture', *The Crayon*, vi (1859), pp. 15–20
Greek Lines, and Other Architectural Essays (Boston, MA, 1893)
W. Coles, ed.: *Architecture and Society: Selected Essays of Henry Van Brunt* (Cambridge, MA, 1969) [incl. 'Architectural Reform']

BIBLIOGRAPHY
W. J. Hennessey: *The Architectural Works of Henry Van Brunt* (diss., New York, Columbia U., 1979)

SAMUEL BERKMAN FRANK

Vanderbilt, William Henry (*b* New Brunswick, NJ, 8 May 1821; *d* New York, 8 Dec 1885). American financier, patron and collector. He was the eldest surviving son of Cornelius Vanderbilt (1798–1877) and inherited $100 million (made from steam navigation and transport), which he doubled by the time of his death. He was educated at Columbia College Grammar School and began to work for a banking firm at the age of 18. His first paintings were

purchased in Italy in 1853. Once back in New York, he bought works by such American artists as James Mac-Dougal Hart, Arthur Fitzwilliam Tait, William Holbrook Beard (1823–1900), Jasper Francis Cropsey, John George Brown and Samuel Colman. Eastman Johnson painted Vanderbilt's portrait (Nashville, TN, Vanderbilt U.) and Seymour Joseph Guy (1824–1910) depicted him surrounded by his family at his home on the corner of Fifth Avenue at 40th Street (1873; Asheville, NC, Biltmore Estate).

In 1879 Vanderbilt decided to build homes for himself and his daughters. John Butler Snook designed the twin brownstone mansions that were built on the west side of Fifth Avenue between 51st and 52nd Street (destr. 1927). Christian Herter supervised the interiors, which were described in a book by Earl Shinn and functioned as a showcase for works of the Aesthetic Movement. John La Farge designed two major stained-glass windows for the main staircase depicting allegories of *Commerce* and *Hospitality* and an elaborate glass décor for the Japanese parlour.

Along with an outstanding display of oriental porcelain, Vanderbilt's mansion had a picture gallery filled with paintings bought with the advice of Samuel P. Avery. It contained works by such celebrated contemporary European artists as William-Adolphe Bouguereau (1825–1905), Jules Breton (1827–1906), Thomas Couture (1815–79), Jean-Léon Gérôme (1824–1904), Ludwig Knaus (1829–1910), Ernest Meissonier (1815–91) and Jean-François Millet (1814–75), including Millet's *The Sower* (1850; Boston, MA, Mus. F.A.). On occasion Vanderbilt invited large groups of friends to view his collection.

Liberal in his charities, in 1881 he underwrote the cost of transporting to Central Park, New York, a 22-m high granite obelisk, known as Cleopatra's Needle, which had been given to the city by the Khedive of Egypt. In 1884 he commissioned Richard Morris Hunt to design a family mausoleum on a one-acre plot in the Moravian cemetery at New Dorp, Staten Island. Completed in 1889, its details were inspired by the Romanesque church of St Gilles-du-Gard, near Arles. Shortly before his death, Vanderbilt sat for a portrait bust by John Quincy Adams Ward (New York, Columbia U.). Among other bequests Vanderbilt left $100,000 to the Metropolitan Museum of Art, New York.

BIBLIOGRAPHY
E. Strahan [E. Shinn]: *Mr. Vanderbilt's House and Collection*, 2 vols (Boston and New York, 1883–4)
W. A. Croffut: *The Vanderbilts and the Story of their Fortune* (New York, 1886)
W. Andrews: *The Vanderbilt Legend: The Story of the Vanderbilt Family* (New York, 1941)

MADELEINE FIDELL-BEAUFORT

Vanderlyn, John (*b* Kingston, NY, 15 Oct 1775; *d* Kingston, 24 Sept 1852). American painter. The grandson of Pieter Vanderlyn (1687–1778), a portrait painter active in the Hudson River Valley (*see* GANSERVOORT LIMNER), he manifested an early talent for penmanship and drawing. During his late youth he moved to New York, where he worked in a frame shop and studied in Archibald Robertson's drawing academy. His copy of a portrait by Gilbert Stuart brought him to the attention of that artist, with whom he then worked in Philadelphia.

Under the patronage of the politician Aaron Burr (1756–1836), Vanderlyn went to France in 1796, becoming the first American painter to study in Paris. He gained a reliable Neo-classical technique and aspirations after 'the Grand Manner' from his teacher François-André Vincent. Exhibits at the Paris Salons over several years—beginning with the notable *Self-portrait* of 1800 (New York, Met.)—reflected his growing ambitions. In 1804 he produced a history painting with an American subject, the *Murder of Jane McCrea* (Hartford, CT, Wadsworth Atheneum; see fig.), taken from a poem describing an incident in the Revolutionary War. *Caius Marius on the Ruins of Carthage* (1808; San Francisco, CA, de Young Mem. Mus.) won him a *médaille d'encouragement* from Napoleon. *Ariadne Asleep and Abandoned by Theseus on the Island of Naxos* (1812; Philadelphia, PA Acad. F.A.) was the first monumental female recumbent nude painted by an American-born artist. Painted within the traditions of 19th-century Salon art, the solidly modelled figure of Ariadne, reclining in a lush American landscape, did not arouse the immediate acclaim or controversy for which Vanderlyn had hoped. Asher B. Durand made an engraving of the painting in 1835.

Vanderlyn had ambitions as an entrepreneur but was not always successful. On a return visit to America in 1801, he painted several views of the Niagara Falls, intending to capitalize on the Falls' vast appeal by having his oils engraved in order to reach the general public. In 1815, returning from Europe more permanently, he displayed a panorama made of enlarged sketches of the palace and gardens of Versailles (New York, Met.). Later he sent exhibitions to such places as Charleston, New Orleans and Havana.

The popularity of these ventures waned, so Vanderlyn had to earn a living by painting portraits. The quality of

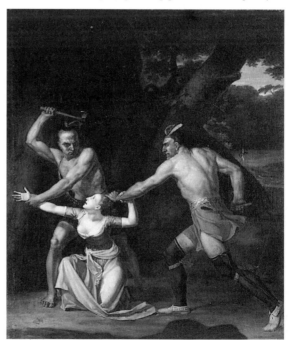

John Vanderlyn: *Murder of Jane McCrea*, oil on canvas, 813×673 mm, 1804 (Hartford, CT, Wadsworth Atheneum)

these works reflected the status of the subject: he treated ordinary citizens casually, especially during the 1830s, while state portraits of presidents and the powerful stimulated a certain inventiveness. When the Congress commissioned a portrait of George Washington, to be based on Gilbert Stuart's *Atheneum Washington* (1796; jointly owned by Washington, DC, N.G.A. and Boston, MA, Mus. F.A.), for the House of Representatives, Vanderlyn was awarded the task because of his ability as a copyist and because Congressmen from his home state lobbied effectively for him.

The *Landing of Columbus* for the Rotunda of the US Capitol in Washington was his last and largest (3.60×5.49 m) public commission. It was painted in Paris between 1839 and 1846. He built up the painting step by step in the Neo-classical manner, using vegetation studies he had made in San Salvador, and exercising care in the accuracy of the costumes. This characteristically bold achievement did not match contemporary taste; Vanderlyn ended his career embittered and neglected.

BIBLIOGRAPHY

L. Hunt Averill: *John Vanderlyn, American Painter* (diss., Yale U., 1949) [incl. unfinished biography by R. Gosman, much of which was written during the artist's lifetime]

M. Schoonmaker: *John Vanderlyn, Artist* (Kingston, NY, 1950)

S. Edgerton: 'The Murder of Jane McCrea: The Tragedy of an American Tableau d'Histoire', *A. Bull.*, xlvii (1965), pp. 481–92

K. C. Lindsay: *The Works of John Vanderlyn: From Tammany to the Capitol* (exh. cat., Binghamton, SUNY, 1970)

——: 'John Vanderlyn in Retrospect', *Amer. A. J.*, vii (1975), pp. 79–90

W. T. Oedel: *John Vanderlyn: French Classicism and the Search for an American Art* (diss., U. Delaware, 1981) [incl. documentary data relating to the artist's activities in France]

K. J. Avery and P. L. Fodera: *John Vanderlyn's Panoramic View of the Palace and Gardens of Versailles* (New York, 1988)

KENNETH C. LINDSAY

Van Osdel, John Mills (*b* Baltimore, MD, 31 July 1811; *d* Chicago, IL, 21 Dec 1891). American architect. About 1840 he moved to New York, where he studied architecture by reading at the Apprentice Library. In 1836 William B. Ogden, a prosperous merchant from Chicago, commissioned him to design an elaborate Neo-classical residence in Chicago, then a town of only several hundred inhabitants with no other architects. His designs included residences and blocks of houses, the Rush Medical College (1844), the first Chicago City Hall (1844; destr.) and the second Cook County Court House (1853; destr.), all in a variant of the Greek Revival style. Chicago grew rapidly in the 1860s and 1870s. After 1865 Van Osdel's stylistic range broadened; his Second Presbyterian Church (1869; destr.) was Gothic Revival in style. He designed a number of hotels, including the third Tremont House (1850; destr.) and the large Palmer House (1869–70; destr.) in the popular Second Empire Style. His Kendall Building (1872–3) had fireproofing applied by George H. Johnson (*b* 1830) to the internal iron structure. One of his last buildings was the imposing third Palmer House (1873–5; destr.). Although few of Van Osdel's buildings are extant, he was an inspiration to the architects who created the Chicago school in the late 19th century.

WRITINGS

The Carpenter's Own Book (Baltimore, 1834)

BIBLIOGRAPHY

DAB; *Macmillan Enc. Architects*

J. Van Osdel: *A Quarter Century of Chicago Architecture* (Chicago, 1898)

T. E. Tallmadge: *Architecture in Old Chicago* (Chicago, 1941)

F. A. Randall: *History of the Development of Building Construction in Chicago* (Urbana, 1949)

C. W. Condit: *The Chicago School of Architecture: A History of Commercial and Public Building in the Chicago Area* (Chicago, 1964)

D. Lowe: *Lost Chicago* (Boston, 1975)

LELAND M. ROTH

Van Rensselaer, Mariana Griswold [Mrs Schuyler] (*b* New York, 21 Feb 1851; *d* New York, 20 Jan 1934). American writer. She was educated at home by tutors and travelled in Europe, chiefly in Germany. In 1873 she married Schuyler Van Rensselaer, an engineer. They lived in New Brunswick, NJ, until her husband's death in 1884. Mrs Van Rensselaer then lived with her mother in New York while pursuing the writing career she had begun shortly before her husband's death. Some of her essays had already appeared in *American Architect* and the popular *Century Magazine*. From May 1884 to July 1886 *Century Magazine* published six extended illustrated essays in which she examined the current state of American architecture. A writer on all the visual arts, she published numerous books on painting, architecture, photography and landscape architecture, as well as two of her own poetry. In her writing she addressed a broad popular audience, particularly potential patrons of architecture. She published a small book on this topic, *Client and Architect*. A keen admirer of the work of H. H. Richardson, she wrote *Henry Hobson Richardson and his Works*, which was the first monograph on a modern American architect. For her efforts in cultivating the public awareness of architecture, she was made an honorary member of the American Institute of Architects and the American Society of Landscape Architects.

WRITINGS

American Etchers (New York, 1886)

Book of American Figure Painters (New York, 1886)

Henry Hobson Richardson and his Works (Boston, MA, 1888)

Client and Architect (Chicago, 1891)

English Cathedrals (New York, 1892, 6/1914)

Art out of Doors (New York, 1893, 2/1914)

Jean-François Millet: Painter-etcher (New York, 1901)

Art of Gardening (Amherst, MA, 1907)

History of the City of New York in the Seventeenth Century, 2 vols (New York, 1909)

BIBLIOGRAPHY

L. M. Roth: *America Builds: Source Documents in American Architecture and Planning* (New York, 1983), pp. 242–3

LELAND M. ROTH

Vaux, Calvert (*b* London, 20 Dec 1824; *d* Bensonhurst, NY, 19 Nov 1895). American architect and landscape designer of English birth. He was apprenticed (?1840–45) to the architect Lewis Nockalls Cottingham (1787–1847) in London. In 1846 he and George Truefitt (1824–1902) toured Europe and afterwards helped found the Architectural Association in London.

In 1850 Vaux accepted the offer of A. J. DOWNING to work in Newburgh, NY, and in 1851 the two formed a partnership. Vaux became involved in an expanding architectural and landscape design business extending from New England to Washington, DC. After Downing's death (1852), Vaux collected the partnership's house plans and

his own designs done alone or with FREDERICK CLARKE WITHERS and published them as *Villas and Cottages* (1857). This became the principal vehicle for transmitting Downing's distinctly American planning idioms to builders and the architectural profession. Opposed to Revivalism, Vaux was probably the era's first architectural author to abandon style-based design titles. Believing that all styles have the 'self-same geometry', he urged that they all be studied, but only for the appropriate ideas, not 'authority'. Having been naturalized in 1856, in 1857 he helped found the American Institute of Architects.

Vaux wished to use architecture and landscape design as a means to implement social improvement, and his work included hospitals (the first being Sheppard Asylum, Baltimore, planned in 1861), museums (the original parts of the Metropolitan Museum of Art, New York, 1874–80, with JACOB WREY MOULD, and the Museum of Natural History, New York, 1874–7; see fig.), planned suburban residential communities (Riverside, IL, 1868–70, *see* OLMSTED, FREDERICK LAW, fig. 3), charitable institutions (11 buildings for New York City's Children's Aid Society) and numerous public parks. For Central Park (begun 1858), the result of a competition instigated by the board of Park Commissioners, Vaux collaborated with Olmsted (*see* OLMSTED, FREDERICK LAW, fig. 1). Their plan, Greensward, became the model for urban American parks and established the profession of landscape architect (Vaux's term). Vaux was eventually appointed Landscape Architect to the Department of Parks in New York City.

Vaux was technically as well as aesthetically progressive, creating many significant innovations. With the ventilation expert Lewis W. Leeds (?1829–96), he obtained several patents for heating devices. In 1857 he became the first architect to advocate apartment houses for New York City. The 'parkway' concept of urban planning was developed from Vaux's plan for Prospect Park (from 1865), Brooklyn (*see* OLMSTED, FREDERICK LAW, fig. 2). Vaux's polychromatic stonework was considered equal to that of Mould by the contemporary critic Schuyler.

Vaux wrote the entry on 'Landscape Gardening' for the *Encyclopedia Britannica* (1866). The London *Builder* featured his designs from 1856 (Bank of New York) to 1873 (proposed Philadelphia Centennial Building). His New York town house (1881–4) for Governor Samuel J. Tilden was illustrated in both the Parisian *L'Architecture américaine* (1886) and the *American Architect and Building News* (5 Sept 1891). Vaux worked in partnership, at various times, with Withers, Leeds, Olmsted, George K. Radford (*b* 1826; *fl* 1900) and Samuel Parsons jr (1844–1923). His English-born assistant Thomas Wisedell (1846–84) went on to become New York's 'leading theatrical architect' (*NY Times*, 1884). His pupils included Parsons, his son Downing Vaux (1856–1926), Robert W. Gardner (1866–1937) and Charles Francis Osborne (1855–1913), later a professor of architecture at Cornell University and the University of Pennsylvania. He also influenced H. H. Richardson in his bold use of stone in the landscape architecture of Central Park.

WRITINGS
Villas and Cottages (New York, 1857/*R* 1968, rev. 2/1864/*R* 1970)
Regular contributions to the London *Builder* (1856–73)

BIBLIOGRAPHY
Macmillan Enc. Archit.
[M. Schuyler]: 'Recent Building in New York', *Harper's Mthly*, lxvii (1883), p. 573
S. Giedion: *Space, Time and Architecture* (Cambridge, MA, 1941, rev. 5/ 1982), p. 360, figs 217–18
J. D. Single: 'Bibliography of the Life and Works of Calvert Vaux', *Amer. Assoc. Archit. Bibliog.: Pap.*, v (1968), pp. 71–93

Calvert Vaux: Museum of Natural History, New York, 1874–7

W. Alex: *Calvert Vaux: Architect and Planner* (New York, 1994)
F. R. Kowksy: *Country, Park and City: The Architecture and Life of Calvert Vaux* (New York and Oxford, 1998)

ARTHUR CHANNING DOWNS

Vedder, Elihu (*b* New York, 26 Feb 1836; *d* Rome, 29 Jan 1923). American painter, illustrator, sculptor and writer. He studied under Tompkins Harrison Matteson in Shelbourne, NY, and went to Paris in March 1856. After eight months in the studio of François-Edouard Picot (1786–1868), he settled in Florence until the end of 1860. There he learnt drawing from Raffaello Bonaiuti, became interested in the Florentine Renaissance and attended the free Accademia Galli. A more significant artistic inspiration came from the Italian artists at the Caffè Michelangiolo: Telemaco Signorini (1835–1901), Vincenzo Cabianca (1827–1902) and especially Nino Costa (1827–1902). This group sought new and untraditional pictorial solutions for their compositions and *plein-air* landscapes and were particularly interested in the experiences of Gustave Courbet (1819–77) and the Barbizon painters. They became known as Macchiaioli for their use of splashes (*macchia*) of light and shadows and for their revolutionary (*maquis*) attitude to prevailing styles. Among Vedder's most notable Florentine landscapes are *Mugnone Torrent near Fiesole* (Detroit, MI, Inst. A.) and *Le Balze, Volterra* (Washington, DC, N. Mus. Amer. A.); he also made many sketches, drawings and pastels of the Tyrrhenian coast, Lake Trasimene, the Roman Campagna, Egypt and Capri, which exemplify the realistic approach to landscape practised by the artists of the Macchiaioli.

Vedder returned to New York and supported himself during the American Civil War (1861–5) as an illustrator for *Vanity Fair* and *Leslie's Illustrated News*. He also began painting such works as the *Questioner of the Sphinx* (1863; Boston, MA, Mus. F.A.), the *Lair of the Sea Serpent* (1864; Boston, MA, Mus. F.A.) and the *Lost Mind* (1864–5; New York, Met.), which evoke a melancholy atmosphere that presages European Symbolism. In 1865 he returned to Paris and joined William Morris Hunt and Charles Caryl Coleman (1840–1928) for painting in Brittany in the summer. After another visit to Rome in 1866, Vedder returned to New York in 1868, where he sold his landscape and genre paintings to Boston patrons and married Caroline Rosekrans who settled with him in Rome in October 1869. His works of this period include the tiny drawings of the *Soul of the Sunflower* (1868; priv. col., see exh. cat., fig. 142) and the *Sea Princess* (1868; priv. col., see exh. cat., fig. 143). A visit to London in 1870 resulted in contact with the Pre-Raphaelites and other English artists. Works such as the *Cumaean Sibyl* (1876; Detroit, MI, Inst. A.), *Greek Girls Bathing* (1877; New York, Met.) and *Head of Medusa* (1878; San Diego, CA, Mus. A.; see fig.) reveal the Classical subject-matter and stylistic linearity more commonly associated with Edward Burne-Jones (1833–98), Frederic Leighton (1830–96) and Lawrence Alma-Tadema (1836–1912).

During the 1880s Vedder returned almost every year to America, where he was active in the decorative arts, designing stained-glass windows for Louis Comfort Tif-

Elihu Vedder: *Head of Medusa*, oil on paper attached to canvas, 282×304 mm, 1878 (San Diego, CA, San Diego Museum of Art)

fany and illustrating five covers for *The Century Illustrated* (1881). His 56 drawings for Edward FitzGerald's translation of *The Rubáiyát of Omar Khayyám* (Washington, DC, N. Mus. Amer. A.) are some of the earliest examples of Art Nouveau in America, and this edition (pubd 1884) opened an era in American art publishing; these drawings also inspired Vedder to paint such works as the *Cup of Death* (1881; Washington, DC, N. Mus. Amer. A.) and *The Pleiads* (1885; New York, Met.). At the turn of the century he received many important commissions for mural painting, including those for the Walker Art Building (1892) at Bowdoin College, Brunswick, ME, Collis P. Huntington's dining-room (1893; New York) and the five panels *Government* (1896–7; Washington, DC, Lib. Congr.). He also produced designs for small sculptural objects, including bell-pulls and door-knockers. His only large scale work was *The Boy* (1900–02; Chicago, IL, A. Inst.), a fountain cast in bronze by Charles Keck.

After 1900 Vedder painted little, spending many months at his villa in Capri and writing his humorous, whimsical autobiography, *The Digressions of 'V'* (Boston, 1910), as well as two volumes of verse. Edgar P. Richardson compared Vedder's art to a visit to the Etruscan museum in the Villa Giulia, Rome, where bursting through the cold order of Roman art is a weird and haunting imagination, a fantastic invention that disconcerts and fascinates (see Soria, 1970, p. 6).

BIBLIOGRAPHY
R. Soria: *Elihu Vedder: American Visionary Artist in Rome (1836–1923)*, intro. E. P. Richardson (Cranbury, NJ, 1970)
Perceptions and Evocations: The Art of Elihu Vedder (exh. cat., Washington, N. Mus. Amer. A., 1979)
R. Soria: *Dictionary of Nineteenth-century American Artists in Italy, 1760–1914* (Cranbury, NJ, 1982)

REGINA SORIA

W

Wachtel American painters. In 1903 the San Francisco painter William Keith sent the young artist (2) Marion Kavanaugh to see (1) Elmer Wachtel in Los Angeles. A whirlwind courtship ensued, and the couple was married the following year near Chicago. They spent the next 25 years as inseparable painting companions, he working in oils and she in watercolour. They travelled throughout California, the deserts of Arizona and New Mexico, and in Mexico.

(1) Elmer Wachtel (*b* Baltimore, MD, 21 Jan 1864; *d* Guadalajara, Mexico, 31 Aug 1929). He came to southern California in 1882, to live with his older brother John Wachtel, who was married to the sister of artist Guy Rose and managing the Rose family ranch, Sunny Slope. An aspiring violinist, Wachtel was first violin of the Philharmonic Orchestra in Los Angeles, while he pursued his painting. With artists Gutzon Borglum and J. Bond Francisco (1863–1931), he founded the Los Angeles Art Association in the late 1880s. In 1895 Wachtel went to New York and enrolled in the Art Students League but, unhappy with the teaching methods, left after only two weeks. He remained in New York and received criticism from William Merritt Chase. Working in watercolor, he exhibited with the New York Water Color Society.

After returning to California in 1896, Wachtel spent a brief period in San Francisco, where he exhibited with the San Francisco Art Association. He then returned permanently to Los Angeles, where he worked as an illustrator for *Land of Sunshine* and *Californian* magazines. Around 1900 he went to Europe, studying at the Lambeth Art School in London and visiting and painting with his friend Borglum, who was living there. Wachtel returned to Los Angeles and, within a few years, enjoyed a reputation as an accomplished landscape artist (see fig.).

BIBLIOGRAPHY
Loners, Mavericks and Dreamers: Art in Los Angeles before 1900 (exh. cat. by N. D. W. Moure, Laguna Beach, CA, A. Mus., 1994)
J. Stern and others: *Impressions of California: Early Currents in Art, 1850–1930* (Irvine, CA, 1996) [companion volume to KOCE-TV (PBS) video series]
JEAN STERN

(2) Marion (Ida) Kavanaugh [Kavanagh] **Wachtel** (*b* Milwaukee, WI, 10 June 1870; *d* Pasadena, CA, 22 May 1954). Painter, wife of (1) Elmer Wachtel. She grew up in Milwaukee of a family steeped in art and followed in the tradition. Her first teacher was her mother, Jean Kavanaugh (*d* 1894), a leading Milwaukee watercolourist and teacher. Marion also studied there with Richard Lorenz (1858–1915); in Chicago with Henry Spread (1844–90) until his death and at the School of the Art Institute of Chicago, under John H. Vanderpoel (1857–1911) and Frederick Freer (1849–1908); and in New York City with William M. Chase.

Wachtel began as a teacher in Chicago, while pursuing a career as a portrait painter. She also made landscape sketches. One of the latter fortunately caught the eye of a Santa Fe Railway executive, who offered her free passage to California in exchange for future paintings. Unhappy in the classroom, she quickly accepted the proposition. Although Wachtel had visited California earlier, the trip made in 1903 proved to be significant to her future life. She spent several months sketching coastal scenes in the environs of Santa Barbara, which she exhibited at the home of an art patron in San Francisco. It was at this time that she may have visited William Keith's studio before going to Los Angeles, where she met her future husband, (1) Elmer Wachtel, a painter and gifted violinist.

The Los Angeles area remained Marion's home, but much of the West and Mexico became her studio. Influenced by the scenery, she was primarily a painter of landscapes, although she also featured figures and structures in many of her renderings. Her works, mostly watercolours during her marriage, done in an Impressionist style, included such paintings as *The Sierra Madre*, which appeared as the frontispiece of the 1911 catalogue of the American Watercolor Society's annual exhibition in New York City, and *Sunset Clouds #5, 1904* (priv. col., see Trenton, ed., p. 63); these evoked such comments from art critics as 'She is one of the strongest exponents of the water color tradition we have in this country'.

BIBLIOGRAPHY
A. Anderson: 'Editor's Own Page', *Touring Topics* (June 1929), p. 9
Obituary: *Los Angeles Times* (25 May 1954), ii, p. 12
R. L. Westphal: *Plein-air Painters of California: The Southland* (Irvine, CA, 1982)
Early Artists of Laguna Beach: The Impressionists (exh. cat. by J. B. Dominik, Laguna Beach, CA, A. Mus., 1986)
P. Trenton, ed.: *Independent Spirits: Women Painters of the American West, 1890–1945* (Berkeley, 1995)
P. Kovinick and M. Yoshiki-Kovinick: *An Encyclopedia of Women Artists of the American West* (Austin, 1998)
MARIAN YOSHIKI-KOVINICK

Wadsworth, Daniel (*b* Middletown, CT, 8 Aug 1771; *d* Hartford, CT, 28 July 1848). American patron and collector. The son of Hartford's wealthiest merchant and

Elmer Wachtel: *Convict Lake*, oil on canvas, 406×508 mm (Irvine, CA, Irvine Museum)

financier, Wadsworth led the retired and somewhat eccentric life of a *rentier*. He dabbled in architecture and achieved a moderate competence in landscape drawing. Wadsworth collected art in a desultory manner, buying original paintings and copies from John Trumbull (his wife's uncle) and commissioning works from Thomas Sully, Alvan Fisher, Chauncey B. Ives and Robert Ball Hughes (1806–68). His preference was for landscape painting, his interest no doubt stimulated by his purchase in 1805 of a spectacular country estate, Monte Video, overlooking Hartford. He was an early and fervent supporter of Thomas Cole, commissioning seven paintings from the artist between 1826 and 1828, including *White Mountain Scenery, St John the Baptist in the Wilderness, Last of the Mohicans* and *View of Monte Video* (all Hartford, CT, Wadsworth Atheneum).

Wadsworth is remembered primarily as the founder of the first public art museum in the USA. Conceived in 1841, the Wadsworth Atheneum opened in 1844 in a Gothic Revival building designed by Ithiel Town and Alexander Jackson Davis. Wadsworth commissioned works from Cole and Frederic Edwin Church for the fledgling institution and bequeathed to it his own collection.

BIBLIOGRAPHY
Daniel Wadsworth, Patron of the Arts (exh. cat. by R. Saunders and H. Raye, Hartford, CT, Wadsworth Atheneum, 1981)
B. J. McNulty, ed.: *The Correspondence of Thomas Cole and Daniel Wadsworth* (Hartford, 1983)
ALAN WALLACH

Waldo, Samuel Lovett (*b* Windham, CT, 6 April 1783; *d* New York, 16 Feb 1861). American painter. After attending a country school and working on his father's farm, he decided at the age of 16 to become an artist. He took lessons from Joseph Steward (1753–1822), a retired minister who operated a portrait studio in Hartford, CT. Waldo opened his own studio in Hartford in 1803, before moving on to paint portraits in Litchfield, CT, and Charleston, SC. In 1806, bearing letters of introduction to Benjamin West and John Singleton Copley, Waldo travelled to London, where he studied at the Royal Academy. His portrait of *Mr M'Dougle* (untraced) was shown at the Royal Academy in 1808.

In January 1809 Waldo returned to America and settled in New York. By 1812 he was exhibiting frequently there and in Philadelphia. Waldo's education and period of study in Europe prepared him for a leading role in the emerging cultural life of New York. He became a director of the American Academy of the Fine Arts in 1817 and remained active in that institution even while supporting the development of its rival, the National Academy of Design. He encouraged the aspirations and efforts of younger artists,

such as Charles Loring Elliott and Asher B. Durand, and he initiated a subscription to commission Thomas Lawrence (1769–1830) to paint a full-length portrait of *Benjamin West* (*c*. 1819; Hartford, CT, Wadsworth Athenaeum). His own work from this time demonstrates a vigorous style and considerable ambition, as seen in a romantically conceived *Self-portrait* (*c*. 1817; New York, Met.) and the forceful, but empathetic *Old Pat, the Independent Beggar* (1819; Boston, MA, Athenaeum; see fig.).

In 1812 Waldo accepted an apprentice, William Jewett (?1789–90/92–1874), who had purchased a release from his apprenticeship to a coachmaker. After Jewett had completed his apprenticeship, Waldo offered him a salary and then a partnership. The team was active in New York from about 1818 to 1854 (when Jewett retired to a farm in New Jersey), painting some of the most solid and characteristic portraits of the period. Although they produced portraits in such number as to become formulaic and monotonous, their best paintings, such as the portrait of *George Griffin* (1827; New York, NY Hist. Soc.), stand as vivid likenesses and lively characterizations. Their typical waist-length portraits combine strong modelling, broad paint handling and robust colour, and their sitters wear comfortable, genial expressions. Such later works as *Stephen Allen* (1846; New York, NY Hist. Soc.) demonstrate more ambitious compositions, elaborate settings and richer colours, although the appealing portrait of *The Knapp Children* (*c*. 1849–50; New York, Met.) betrays in its awkward composition the team's unfamiliarity with group portraiture.

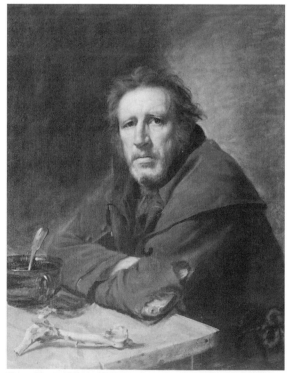

Samuel Lovett Waldo: *Old Pat, the Independent Beggar*, oil on canvas, 832×648 mm, 1819 (Boston, MA, Boston Athenaeum)

In practice, it seems that Waldo determined the composition and executed the heads of portraits before turning them over to Jewett, who painted the costume and background (see, for example, the unfinished portrait of *Deliverance Mapes Waldo*, *c*. 1826; New York, Met.). Yet so closely bound are the two artists' styles that even their contemporaries admitted it was impossible to distinguish the work of one from the other. Waldo occasionally exhibited independent work after 1820 (e.g. *Mrs C. F. Lindsley*, 1844; San Francisco, F.A. Museums), although Jewett did not. (Contemporary sources indicate that Jewett was often inactive for long periods due to illness.) Waldo's successful collaboration with Jewett appears to have overshadowed and eventually consumed his individual talents and contributions; by 1820 he had settled into the predictable rewards of his portrait practice, and his later career is marked by prosperous, if uneventful, success.

BIBLIOGRAPHY

W. Dunlap: *A History of the Rise and Progress of the Arts of Design in the United States* (New York, 1834, rev. 3/1965), ii, pp. 295, 354–8; iii, p. 61.

'Artist Biography: Samuel L. Waldo', *Crayon*, viii (1861), pp. 98–100

F. F. Sherman: 'Samuel L. Waldo and William Jewett, Portrait Painters', *A. America*, xviii (1930), pp. 81–6

Benjamin West and his American Students (exh. cat. by D. Evans, Washington, DC, N.P.G., 1980)

SALLY MILLS

Walker, C(harles) Howard (*b* Boston, MA, 9 Jan 1857; *d* Boston, MA, 17 April 1936). American architect, teacher and writer. He trained (1874–9) in the office of the Boston firm Sturgis & Brigham before moving to New York City, where he organized a sketch club where he and other young men could draw in congenial surroundings. The membership included Thomas Hastings (1860–1929; later a partner in Carrère & Hastings) and Cass Gilbert, both of whom worked in the office of McKim, Mead & White. Influenced by such European-trained architects as Charles F. McKim, Walker travelled in Europe and Asia Minor (1882–3) before returning to Boston to practise. In 1883 he began lecturing on the philosophy of fine arts at the Massachusetts Institute of Technology, where he taught for the next 47 years. His buildings were comparatively few, and he was best known as a teacher and writer and also, for a period, as editor of the *Architectural Review*. As a designer, however, he cooperated with the sculptor Daniel Chester French in making bases for public sculpture and built the Charles Rollins House (1897) at 497 Commonwealth Avenue, Boston, and the Carnegie Public Library (1914), Sharon, MA. Walker took an active role in the celebrations following the World's Columbian Exhibition (1893) in Chicago and was architect-in-chief of the Great Exposition (1898) in Omaha, NE. He also designed the layout of the Louisiana Purchase International Exposition (1904) in St Louis, MO. In his last years he devoted himself to automotive design.

WRITINGS

'The Great Exposition at Omaha', *C. Illus.*, lv (1898), pp. 518–21

'Louisiana Purchase Exposition at St Louis, Missouri', *Archit. Rev.* [Boston], xi (1904), pp. 197–220

An Architectural Monograph on Some Old Houses on the Southern Coast of Maine (St Paul, MN, 1918)

The Theory of Mouldings (Cleveland, 1926)

BIBLIOGRAPHY
Macmillan Enc. Archit.
G. Sheldon: *American Country Seats* (New York, 1886)
W. Emerson: Obituary, *Amer. Architect*, cxlviii (1936), p. 109
MOSETTE GLASER BRODERICK

Walker, William Aiken (*b* Charleston, SC, 23 March 1838; *d* Charleston, 3 Jan 1921). American painter. Together with Richard Clague (1821–73) and Joseph Rusling Meeker (1827–89), he is considered to be one of the leading painters of the American South in the late 19th century. Brought up in Baltimore and Charleston, he quickly showed a talent for painting and was given his first one-man exhibition at the age of 20. In 1861 he enlisted in the Confederate army, was wounded and returned to Charleston, working as a topographical artist mapping the defence works. Walker remained in Charleston until 1868, when he returned to Baltimore. After a trip to Cuba in 1869 and some European travel in 1870, he worked in the South, primarily in New Orleans, but making an annual circuit of the tourist areas of the Carolinas and Florida. His paintings are of landscapes and still-lifes, and his most typical scenes depict the unchanging ways of the 'old South', often showing blacks working at domestic chores or out in the cotton fields as in *Cotton Plantation in the Mississippi* (1881; Mobile, AL, J. Altmayer priv. col.). His work is usually small-scale with carefully delineated forms statically arrayed across the picture plane under bright, even daylight.

BIBLIOGRAPHY
A. P. Travaioli and R. B. Toledano: *William Aiken Walker: Southern Genre Painter* (Baton Rouge, LA, 1972)
Painting in the South, 1564–1980 (exh. cat., Richmond, VA Mus. F.A., 1983), pp. 96–7, 252
Art and Artists of the South: The Robert P. Coggins Collection (exh. cat. by B. W. Chambers, Nashville, TN Botan. Gdns & F.A. Cent., 1984), pp. 44, 46–7
DRUCE W. CHAMBERS

Wall, William Guy (*b* Dublin, 1792, *d* Ireland, *c.* 1864). American painter of Irish birth. He arrived in New York in 1812, already well-trained as an artist and soon became famous for his sensitive watercolour views of the Hudson River Valley and environs. Some of these watercolours were published as engravings by John Hill and his son John William Hill in the *Hudson River Portfolio* (New York, 1821–5), the first book to make Americans aware of the beauty and sublimity of their own scenery. Wall is often seen as a forerunner or early member of the HUDSON RIVER SCHOOL. Good examples of his work are the *Covered Bridge across the Sacandaga River, Hadley, New York* (1820; New York, NY Hist. Soc.; see fig.) and the *View near Hudson* (1822; Yonkers, NY, Hudson River Mus.). Wall was a founder-member of the National Academy of Design, New York, and exhibited frequently at such institutions as the Pennsylvania Academy of Fine Arts, Philadelphia, and the Apollo Association, New York. He lived in America from 1812 to 1835 and again from 1856 to 1860; little is known of the years after his final return to Ireland. His son, William Archibald Wall (1820×686 mm, 1820 (New York, New-York Historical Society)–1875), was also a landscape painter.

BIBLIOGRAPHY
D. Shelley: 'William Guy Wall and his Watercolours for the Historic *Hudson River Portfolio*', *New York Hist. Soc. Q.*, xxxi (1947), pp. 24–45

William Guy Wall: *Covered Bridge across the Sacandaga River, Hadley, New York*, watercolour, 486×686 mm, 1820 (New York, New-York Historical Society)

J. Howat: 'A Picturesque Site in the Catskills: Katerskill Falls as Painted by William Guy Wall', *Honolulu Acad. A. J.*, 1 (1974), pp. 16–29, 63–5
MARK W. SULLIVAN

Walter, Thomas U(stick) (*b* Philadelphia, PA, 4 Sept 1804; *d* Philadelphia, 30 Oct 1887). American architect. In 1818 he was apprenticed as a bricklayer to his father, the builder Joseph Walter (1782–1855), who was contracted that year to build William Strickland's Second Bank of the United States (1819–24; *see* STRICKLAND, WILLIAM, fig. 1) in Philadelphia, one of the earliest examples of Greek Revival architecture in the USA. Although no formal architectural curriculum had been established at this time, Walter's professional education followed a pattern that later became standard practice. During a six-year apprenticeship he acquainted himself with the operations of Strickland's office and learnt Euclidian geometry. After becoming a master mason in 1824, he joined his father's business, took membership in the Bricklayers' Company and enrolled in the 'Drawing School' at the Franklin Institute, Philadelphia, under the direction of John Haviland. After four years studying mathematics, physics, draughtsmanship and other subjects related to building, as well as landscape painting in watercolour, he entered Strickland's office as a draughtsman in 1828. In 1831, Walter set up his own practice, which was immediately successful. Through connections in city government he won the commission for the Philadelphia County Prison and Debtors Apartment (destr. 1967).

In 1833 Walter's design for the Girard College for Orphans in Philadelphia won the premium award in what was then the most prestigious architectural competition to have been held in the USA. To honour the French origin of the banker Stephen Girard (1750–1831), who had bequeathed $2,000,000 to build the college, Walter originally presented an impressive but naive reworking of the two massive blocks on the north side of the Place de la Concorde, Paris by Anges-Jacques Gabriel (1698–1782), framing a third, central block. The importance of the commission and the shortcomings of Walter's design induced Nicholas Biddle (1786–1844), a financier and the principal arbiter of American taste at the time, to take on the chairmanship of the college's building committee, in which capacity he influenced Walter's final design. Having

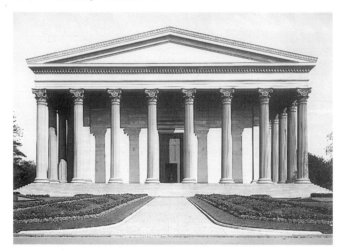

Thomas U. Walter: Founder's Hall, Girard College for Orphans, Philadelphia, Pennsylvania, 1833–48

travelled in Greece, Biddle had become the leading advocate of Greek Revival architecture as an expression of the American spirit. The college remains one of the finest examples of Greek Revival architecture in the USA. It consists of a central block and associated flanking blocks. The centrepiece, known as Founder's Hall (see fig.), has three storeys, with two vestibules and four large vaulted classrooms on each floor. Under Biddle's influence, Walter radically simplified the flanking buildings and dressed Founder's Hall with a peristylar screen of giant marble Corinthian columns reminiscent of La Madeleine, Paris, by Alexandre-Pierre Vignon (1763–1828), but with the Corinthian order closely based on the choregic monument of Lysikrates in Athens. Few of the interior details were Greek; indeed the functional nature of the building led Walter to visit Europe in 1838 to study educational facilities in England and buildings in Paris and Rome. The economic depression of 1841 interrupted work on the college, during which time Walter worked on the design and construction of the breakwater at La Guaira, Venezuela, and the college was eventually finished in 1848.

Walter established a reputation for immaculate taste, partly through his association with Biddle, to whose country house called Andalusia, near Philadelphia, he added a wing in 1831, surrounded with a Doric peristyle in the form of the Temple of Hephaestos in Athens. By 1851 he had produced hundreds of designs for simple and monumental buildings from Maine to South Carolina and as distant as Shanghai. It is not known how many of these were built, but the largest concentrations of his surviving work are in West Chester, PA (e.g. Presbyterian Church, 1831–5; County Court House, 1847; and Chester County Bank), and in Virginia (e.g. First Baptist Church, Richmond, 1839; Freemason Street Baptist Church and Norfolk Academy, Norfolk; and Presbyterian churches in Petersburg and Lexington). Most follow the external form of Greek temples, with or without a columned porch and without the academic emphasis that characterizes most Greek Revival buildings in Europe. Walter's principal aim was to emulate Greek thought, and he consistently relied on simplicity, regularity and restraint, even when he embraced other styles. None of his Egyptian pieces survive, however, and what remains of his work in the Picturesque taste, such as the Italianate Glenelg (1851), Ellicott City, MD, has been severely altered. His finest work in a Renaissance style is the small, but monumental front added in 1851 to the Spruce Street Baptist Church in Philadelphia, which is based on Trinità dei Monti in Rome. His Gothic Revival buildings were always basic Classical volumes in schematic medieval dress.

In 1851 US President Millard Fillmore chose Walter as the architect of the extensions of the US Capitol in Washington, DC. The new building is on a huge scale (214×107 m) and accommodates two congressional chambers and their associated offices. It is covered externally in white marble and decorated in the Greek Revival style, resulting in a stylistic marriage between a severe Neoclassicism and the late Palladianism of the original Capitol building, which was retained. The altered proportions of the building required a new dome, which was designed in 1855 and constructed during the following decade, during which the Civil War was waged, before becoming a symbol of national unity (see WASHINGTON, DC, fig. 5). It was frequently imitated in new state capitol buildings, for example at Sacramento, CA. The dome was executed entirely in cast iron, with the assistance of Montgomery C. Meigs (1816–1892), and served as a stimulus to the iron industry and the development of architectural applications of metal in America. Walter executed numerous other government and private commissions while in Washington, before retiring to Philadelphia in 1865. In 1873 he undertook to supervise the construction of John McArthur's Second Empire design for the Philadelphia City Hall (completed 1900). At the time of his death, Walter was president of the American Institute of Architects, which he helped found in 1857, after a previous unsuccessful attempt to establish such an institute in 1835. Through his lectures on the history and philosophy of architecture he was among the first to raise public taste in architectural matters in the USA.

UNPUBLISHED SOURCES
Philadelphia, PA, Athenaeum [Walter's pap. and drgs]

BIBLIOGRAPHY
W. S. Rusk: 'Thomas U. Walter and his Works', *Americana*, xxxiii (1939), pp. 151–79
T. Hamlin: *Greek Revival Architecture in America* (New York, 1944/R 1964)
T. C. Banister: 'The Genealogy of the Dome of the United States Capitol', *J. Soc. Archit. Hist.*, vii/1–2 (1948), pp. 1–31
A. A. Gilchrist: 'Girard College: An Example of the Layman's Influence on Architecture', *J. Soc. Archit. Hist.*, xvi/2 (1957), pp. 22–5
R. B. Ennis: 'Thomas U. Walter', *19th C. [New York]*, v (1979), pp. 59–60
R. W. Liscombe: 'T. U. Walter's Gifts of Drawings to the Institute of British Architects', *J. Soc. Archit. Hist.*, xxxix (1980), pp. 307–11
J. M. Goode: *Architecture, Politics and Conflict: Thomas Ustick Walter and the Enlargement of the United States Capitol, 1850–1865* (diss., Washington, DC, George Washington U.,1995; microfilm, Ann Arbor, 1995)
ROBERT B. ENNIS

Walters. American family of businessmen, collectors and patrons.

(1) William T(hompson) Walters (*b* Liverpool, PA, 23 May 1819; *d* Baltimore, MD, 21 Nov 1894). By 1850

he headed his own liquor importing business in Baltimore. He maintained that with the first five dollars he earned he bought a painting, the *Retreat from Moscow*, by E. A. Odier (1800–87). By the late 1850s he had become an influential patron, not only of such regional talents as the sculptor W. H. Rinehart (1825–74) and the painter of the Far West Alfred Jacob Miller but also of such leading American artists as Asher B. Durand, Frederic Edwin Church and John Frederick Kensett. Following his purchase in 1859 of the *Duel after the Masquerade* (after 1857; Baltimore, MD, Walters A.G.) by Jean-Léon Gérôme (1824–1904), he turned increasingly to contemporary European painting, eventually disposing of much of his earlier, American holdings. During the American Civil War (1861–5) he made a sojourn in Paris, where he met many leading French artists, with his friend and adviser GEORGE A. LUCAS serving as intermediary. Back in Baltimore after the war, he increased his fortunes through investment in banking and railways, which enabled him to continue to buy art by both academic and Barbizon artists; he had a particular passion for the *animalier* sculpture of Antoine-Louis Barye. After 1873 he began to assemble one of the first extensive collections in the USA of Chinese and Japanese ceramics and other decorative arts. Walters opened his collections to the public on a regular basis, printed handbooks and financed several major publications, including *Notes: Critical and Biographical: Collection of W. T. Walters* (Indianapolis, 1895). He also served as chairman of the acquisitions committee of the Corcoran Gallery of Art in Washington, DC, and as US Commissioner at the Weltausstellung of 1873 in Vienna.

(2) **Henry Walters** (*b* Baltimore, MD, 20 Sept 1848; *d* New York, 30 Nov 1931). Son of (1) William T. Walters. He succeeded his father in business. Though a resident of New York, he retained his ties with Baltimore and continued his father's practice of making the collections accessible to the public. Initially he augmented the 19th-century works with paintings by Romantic artists and the Impressionists. His aims, however, were more ambitious, and with the purchase in 1893 of some Ancient Near Eastern cylinder seals he began to widen the collection so that it would include works from all periods. In 1902 he bought the collection of Marcello Massarenti, Assistant Almoner to the Holy See under Leo XIII and Pius X, which comprised more than 1540 works, including 500 late medieval, Renaissance and Baroque paintings, numerous examples of Renaissance decorative arts and sculpture and an array of antiquities. To house these works Walters commissioned Delano & Aldrich to design a Renaissance-style building (1903–5) in Baltimore, with its interior modelled after the Palazzo dell'Università in Genoa by Bartolomeo Bianco (1579–1640). Although the gallery was quickly filled, Walters's collecting continued at an unabated pace, extending into such diverse fields as incunabula and medieval manuscripts, Sasanian silver, Coptic ivories and textiles, Asiatic migration arts, Limoges enamels, maiolica and jewellery of all periods. He served as vice-president of the Metropolitan Museum of Art and as a trustee of the New York Public Library. He was also one of the ten founders of the American Academy in Rome. He bequeathed his gallery and collections (now the Walters Art Gallery) and a portion of the income from his estate to the City of Baltimore. (His New York holdings were sold at auction by his widow in 1941 and 1943.)

BIBLIOGRAPHY

E. Strahan [E. Shinn]: *The Art Treasures of America, Being the Choicest Works of Art in the Public and Private Collections of America* (Philadelphia, [1886]), pp. 91–4

D. Sutton: 'Connoisseur's Haven', *Apollo*, lxxxv (1966), pp. 422–33

W. R. Johnston: *The Nineteenth Century Paintings in the Walters Art Gallery* (Baltimore, 1982)

A. Partner: 'Loyal Citizens of Baltimore', *A. & Ant.*, vi (1995), pp. 64–9

WILLIAM R. JOHNSTON

Ward, John Quincy Adams (*b* nr Urbana, OH, 29 June 1830; *d* New York, 1 May 1910). American sculptor. He was apprenticed to the sculptor Henry Kirke Brown in Brooklyn from 1849 to 1856 and learnt to work in clay, plaster, marble and bronze. In 1861 Ward opened his own studio in New York. His first life-size sculpture, the *Indian Hunter* (1866; New York, Cent. Park); see fig., was based on numerous studies and first-hand observation of the Dakota Indians and convincingly depicts a sinewy Indian youth holding back his snarling dog. The sculpture's success brought Ward numerous commissions for outdoor portrait busts and statues. Among his most celebrated monuments are the equestrian statue of *Major-Gen. George H. Thomas* (1878; Washington, DC, Thomas Circle) and the grandiose monument to *James Abram Garfield* (1887; Washington, DC, The Mall).

Ward believed that American sculptors should depict American subjects, and he fostered a native school of sculpture. In works such as *George Washington* (1883; New York, Wall and Broad Streets) and his masterful *Henry Ward Beecher* (bronze, 1891; Brooklyn, NY, Cadman

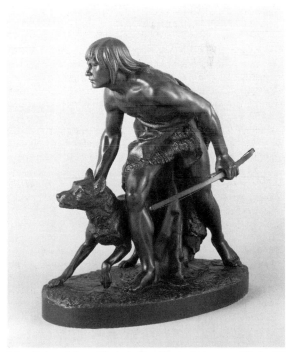

John Quincy Adams Ward: *Indian Hunter*, bronze *modello*, h. 406 mm, 1866 (New York, Metropolitan Museum of Art)

Plaza), he combined the grace of Classical sculpture with a straightforward naturalism and psychological intensity. His mature bronzes are also attuned to the influence of Beaux-Arts sculpture (although not so closely as the work of Daniel Chester French and Augustus Saint-Gaudens), evidenced by their heightened realism, animated surfaces and multi-figure compositions.

Ward was the first sculptor to become president of the National Academy of Design (1874) and was the National Sculpture Society's first president (1893).

BIBLIOGRAPHY
W. Walton: 'The Work of John Quincy Adams Ward, 1830–1910', *Int. Studio*, xl (1910), pp. lxxxi–lxxxviii
A. Adams: *John Quincy Adams Ward: An Appreciation* (New York, 1912)
W. Craven: *Sculpture in America* (New York, 1968, rev. Newark, 2/1984), pp. 245–57
L. I. Sharp: *John Quincy Adams Ward: Dean of American Sculpture* (Newark, 1985) [definitive monograph, excellent plates]
MICHELE COHEN

Ware. American family of architects, writers and teachers.

(1) William Robert Ware (*b* Boston, MA, 1832; *d* Boston, 1915). He belonged to a Boston family that played a crucial part in the development of the architectural profession in the USA. Graduating from Harvard University (1852), Cambridge, MA, he subsequently studied civil engineering at Harvard's Lawrence Scientific School and architecture in the Boston office of Edward Clarke Cabot (1818–1901). By 1859 he was in Richard Morris Hunt's New York studio, where he was introduced to the ideas of the Ecole des Beaux-Arts, Paris, where Hunt had studied. In 1863 Ware formed a professional practice with HENRY VAN BRUNT, a companion in Hunt's studio, and the firm of Ware & Van Brunt became active in the Boston area. The partnership's most notable work, the result of a limited competition held in 1865, is the Memorial Hall (1868–80; see fig.), Cambridge, MA, a High Victorian Gothic Revival monument to Harvard men who died in the Civil War (1861–5). The partnership was dissolved in 1881 when Ware moved to New York, and his only substantial commission thereafter was the American School of Classical Studies (1886–8) in Athens.

In 1865 Ware was appointed the first professor and head of the new architecture programme at the Massachusetts Institute of Technology, Cambridge. His approach to architectural education was based on the design principles of the Ecole des Beaux-Arts, which he modified to suit conditions of practice in the USA. In 1881 he was asked to found a department of architecture in the School of Mines, Columbia University, New York, providing further evidence of the debt that 19th-century American architecture owed to building and engineering. A writer

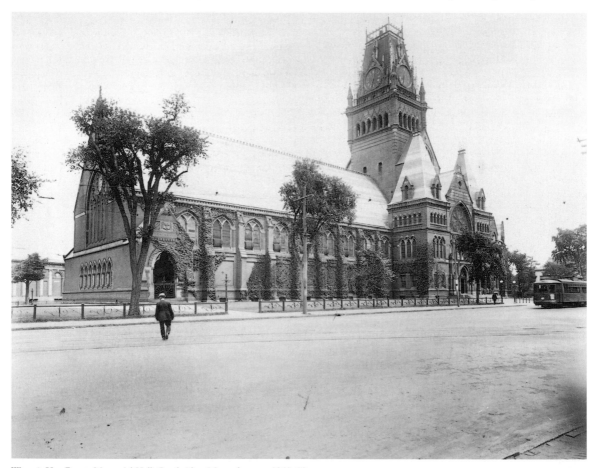

Ware & Van Brunt: Memorial Hall, Cambridge, Massachusetts, 1868–80

and lecturer on architecture, Ware lent his sense of professionalism to *The American Vignola* (1901), a presentation of the Classical orders, written to assist those who were unable to go to architectural school and which has remained a standard text. He was also active in professional affairs, and, as a member of the American Institute of Architects, he drew up the official rules for architectural competitions adopted by the institute. He also served on many competition juries. Ware retired in 1903.

WRITINGS
An Outline of a Course of Architectural Instruction (Boston, 1866)
'On the Condition of Architecture and of Architectural Education in the United States', *Pap. RIBA* (1866–7), pp. 81–90
Greek Ornament (Boston, 1878)
'Architecture at Columbia University', *Architect & Bldg News*, x (1881), pp. 61–2
Modern Perspective (New York, 1882, rev. 1900)
'Instruction in Architecture at the School of Mines', *Sch. Mines Q.*, x (1888), pp. 28–43
The American Vignola (New York, 1901/R 1977)

BIBLIOGRAPHY
Macmillan Enc. Archit.
J. A. Chewning: 'William Robert Ware at MIT and Columbia', *J. Archit. Educ.*, xxxiii (1979), pp. 25–9

<div style="text-align:right">JUDITH S. HULL</div>

(2) William Rotch Ware (*b* Boston, MA, 1848; *d* Boston, 1917). Nephew of (1) William Robert Ware. He was encouraged in the study of architecture and the promotion of the architectural profession by his uncle. After studying architecture at the Massachusetts Institute of Technology, Cambridge, MA, he worked in his uncle's firm of Ware & Van Brunt before going to Paris, where, at the Ecole des Beaux-Arts, he was a member of the studio of Joseph Auguste Emile Vaudremer (1829–1914). On his return to the USA, he became first assistant editor and then editor (from 1880) of the *American Architect and Building News*, the first American architectural journal. The publication was as important in establishing the professional status of the architect as were architectural schools and the American Institute of Architects (founded 1857), because it spread ideas about the professional practice of architecture to those beyond academia and the AIA meetings. Ware championed the work of such architects as H. H. Richardson, Robert Swain Peabody and McKim, Mead & White, and his influence through his journal's editorials and the works he edited was considerable.

BIBLIOGRAPHY
Obituary, *Amer. Architect*, cxi (1917), pp. 273–6
C. H. Walker: Obituary, *J. Amer. Inst. Architects*, v (1917), p. 242

<div style="text-align:right">JUDITH S. HULL</div>

Warner, Olin Levi (*b* West Suffield, CT, 9 April 1844; *d* New York, 14 Aug 1896). American sculptor. Between 1869 and 1872 he studied at the Ecole des Beaux-Arts in Paris under François Jouffroy (1806–82) and worked as an assistant to Jean-Baptiste Carpeaux (1827–75). Warner returned to New York in 1872 with a sound technical training and an intimate knowledge of the current French Beaux-Arts style but initially struggled to make a living. Portrait busts and medallions, such as his characteristically boldly modelled relief *Chief Joseph* (1889; Washington, DC, N. Mus. Amer. A.; see fig.), accounted for the majority

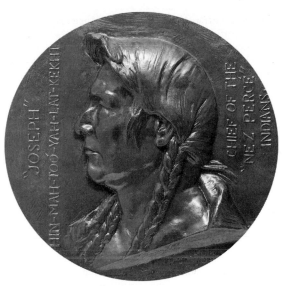

Olin Levi Warner: *Chief Joseph*, bronze, diam. 444 mm, 1889 (Washington, DC, National Museum of American Art)

of his production; he did much to establish low-relief sculpture in America. Critical recognition came with busts of his two friends, *Daniel Cottier* (1878; New York, N. Acad. Des.) and *J. Alden Weir* (bronze, 1880; New York, Amer. Acad. A. & Lett.), and with the seated, ideal nude *Diana* (1887; New York, Met.). These works reveal his development of a personal brand of the Beaux-Arts style that combined his innate strength as a modeller with a restrained and classical sensibility.

Few in number, Warner's public monuments and architectural decorations, such as the superb *William Lloyd Garrison* (bronze, 1885; Boston, MA, Commonwealth Avenue) and the impressive bronze doors for the Library of Congress (1896; Washington, DC), which depict in elaborate allegory the *Transmission of Human Knowledge*, attest the range of his abilities. Warner was a founder-member of the Society of American Artists and the National Sculpture Society. At the time of his accidental death, he was considered one of the leading American sculptors.

BIBLIOGRAPHY
W. Craven: *Sculpture in America* (Newark, 1968, rev. 1984), pp. 406–9, 419
G. Gurney: *Olin Levi Warner (1844–1896): A Catalogue Raisonné of his Sculpture and Graphic Works*, 3 vols (diss., Newark, U. DE, 1978)
P. M. Kozol: *American Figurative Sculpture in the Museum of Fine Arts, Boston* (Boston, 1986), pp. 201–3
The Beaux-Arts Medal in America (exh. cat. by B. A. Baxter, New York, Amer. Numi. Soc., 1987–8); pp. 4–5, 12, 26–7, 32–4, 47
A. Boime: 'Olin Levi Warner's Defence of the Paris Commune', *Archvs Amer. A. J.*, xxviiii (1993), nos 3/4, pp. 2–22

<div style="text-align:right">GEORGE GURNEY</div>

Warren, Russell (*b* Tiverton, RI, 5 Aug 1783; *d* Providence, 16 Nov 1860). American architect. Born into a family of builders, he was the first individual in Rhode Island to make the transition from architect–builder to architect. His move in 1800 to Bristol, RI, where he worked as a carpenter with his brothers, was timely: under the mercantile leadership of the De Wolf family, Bristol experienced an economic boom based on shipping and

the illegal slave trade. Warren designed four large, elaborate houses for that family between 1808 and 1840; the two early ones, Hey Bonnie Hall (1808; destr.) and Linden Place (1810), gave the talented young designer an early opportunity to deal with ambitious commissions for sophisticated patrons.

By 1827, after a few years in Charleston, SC, Warren was in Providence, RI, where he was associated with Tallman & Bucklin. Warren and James C. Bucklin introduced the Greek Revival to Rhode Island with their monumental Providence Arcade (1828; see colour pl. II, 2). By the summer of 1835 Warren was in New York and was associated with Alexander Jackson Davis. His work with Davis provided him with a variety of projects in north-east USA and led to his involvement with the short-lived American Institution of Architects, founded in 1837.

Warren returned to Providence in the late 1830s. His stature as an architect helped him to obtain important commissions in Bristol and the nearby cities of Fall River and New Bedford, MA. Many of these were sober, monumental Greek Revival structures, such as the Dr Nathan Durfee House (1840; destr.) in Fall River. He remained active into the late 1850s. His last designs, such as the Henry Lippitt House (1856) in Providence, were stylish Italianate buildings, but they lack the vigour of the many buildings he designed in the Greek Revival style.

BIBLIOGRAPHY

R. L. Alexander: *The Architecture of Russell Warren* (diss., New York U., 1952)

Buildings on Paper: Rhode Island Architectural Drawings, 1825–1945 (exh. cat., ed. W. M. Jordy and C. P. Monkhouse; Providence, RI, Brown U., Bell Gal.; Providence, RI Sch. Des., Mus. A.; Providence, RI Hist. Soc.; New York, Met.; New York, N. Acad. Des.; Washington, DC, Amer. Inst. Architects Found.; 1982)

W. McKENZIE WOODWARD

Warren & Wetmore. American architectural partnership founded in 1898 by Whitney Warren (*b* New York, 29 Jan 1864; *d* New York, 24 Jan 1943) and Charles D. Wetmore (*b* Elmira, NY, 10 June 1866; *d* New York, 8 May 1941). The partnership was formed when Wetmore, a successful

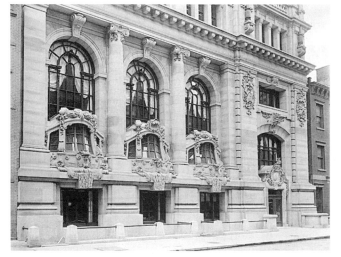

Warren & Wetmore: Yacht Club, New York, 1899; exterior view showing carved waves and dolphins

lawyer, contracted Warren to design a country house. So impressed was Warren with Wetmore's contribution to the design that he persuaded him to enter into an architectural partnership. Warren entered Columbia University, New York, in 1882, but continued his studies in Paris (1885–94) at the Ecole des Beaux-Arts. On his return to New York, he was employed by McKIM, MEAD & WHITE. Wetmore graduated from Harvard University in 1889, receiving his law degree there in 1892. Before beginning law practice he designed three dormitories (*c.* 1890) for Harvard: Claverly Hall and Westmorly Hall and Apley Court.

The new firm's first major recognition was winning the competition for a new club house for the New York Yacht Club (see fig.), built in 1899. This building is in the rather flamboyant Beaux-Arts style that was to become the trademark of all the firm's work. Between 1899 and 1913 they designed a number of railway stations, for the New York Central, the Michigan Central, the Canadian Northern and the Erie railways. Warren & Wetmore's best-known work is the Grand Central Terminal (completed 1913) at 42nd Street and Park Avenue, New York, initially designed by Charles Reed (1858–1911) and Allen Stem (1856–1931); Warren & Wetmore were commissioned to modify the design in 1903. The major modifications were the incorporation of a French Beaux-Arts façade, and designs for the monumental, flowingly spacious interiors, which were similar in concept to those of the Opéra in Paris by Charles Garnier (1825–98). Indeed, Warren & Wetmore's main contribution is 'the general *parti*, or character and form of the building, as well as … its imagery and finesse' (Nevins, p. 16). The project was not free from controversy, however. When Reed died in 1911, Warren & Wetmore arranged with the New York Central Railroad, without consulting Stem, to take on sole responsibility for the project. Stem subsequently sued, and in 1920 he and Reed's estate were awarded $500,000.

Warren & Wetmore also designed a number of hotels, apartment houses and office buildings conceived as part of the 'Terminal City' being developed around Grand Central Station. The Biltmore Hotel (1914) at Madison Avenue and 43rd Street has a façade characterized by its overall restraint, although certain passages, such as the Beaux-Arts arcade facing the top three storeys, display extraordinarily elaborate detailing. Among the projects for which Wetmore was primarily responsible was the Ritz–Carlton Hotel (1911), Montreal.

BIBLIOGRAPHY

Macmillan Enc. Archit.

G. H. Edgell: *The American Architecture of Today* (New York, 1928)

National Cyclopaedia of American Biography (New York, 1948–58), xxxiv, pp. 173–4, xlii, pp. 213–14

D. Nevins, ed.: *Grand Central Terminal: City within the City* (New York, 1982)

I. Gournay: 'Architecture at the Fontainebleau School of Fine Arts', *J. Soc. Archit. Historians*, xlv/3 (1986), pp. 270–85

K. Powell: *Grand Central Terminal: Warren and Wetmore* (London, 1996)

□

Washington, DC. Capital city of the USA. Founded as the permanent seat of Federal government in 1790, it is located in and around a Federal enclave, the District of Columbia (DC), at the confluence of the Potomac and

Anacostia rivers, and bordered by the states of Maryland and Virginia.

I. History and urban development. II. Art life and organization. III. Buildings.

I. History and urban development.

1. Introduction. 2. The L'Enfant Plan. 3. 19th century. 4. Early 20th century.

1. INTRODUCTION. The city was established following years of uncertainty regarding its appropriate location. Between 1774 and 1789 the Federal government met in eight established East Coast cities, giving a distinctly itinerant character to the fledgling institution. The Constitution of the USA in 1787 provided for the permanent national capital city to consist of a Federal district not exceeding 25.9 sq km. The subsequent Residence Act of 1790 established a broad 80-km area along the Potomac River between the Eastern Branch (now the Anacostia River) and the Pennsylvania line where the President of the US might locate the new city. In the 1790 Act, the Federal government agreed to meet for the next ten years in Philadelphia, before moving to the new capital. In the interim, three District Commissioners were to oversee the planning of the city and the construction of the necessary buildings.

The site President Washington selected in 1791 was located on land belonging to the states of Maryland and Virginia, with the President's House approximately at midpoint and the corners of the square due north, east, south and west. The selection of the site incorporated several strategic considerations. It straddled the Piedmont Plateau and the Coastal Plain and reflected a compromise between the sectional and cultural differences of the Northern and the Southern states. The site lay just south of the point where the rivers began to fall and thus stood poised to benefit from this limitation on river traffic. The presence of the thriving port cities of Georgetown, established in 1751 in Maryland, and Alexandria, established in 1749 in Virginia, gave credence to the urban aspirations of the city's founders. President Washington's home at Mount Vernon, VA, south of Alexandria, was also a factor in the location of the Federal city. The settlements of Hamburg, now Foggy Bottom, and Carrollsburg, now the Southwest Quadrant, were plotted but remained largely undeveloped.

At the time the Federal government took up residence in the new city in 1800, the population stood at 8000. By the mid-19th century the growth of the government brought the population to 52,000. After the Civil War (1861–5) the population burgeoned to 132,000 by 1870. By 1900 suburban development began to extend beyond the District's boundaries into Maryland and Virginia, a pattern continued into the 20th century.

2. THE L'ENFANT PLAN. The city was designed by PIERRE-CHARLES L'ENFANT in 1791 and covered only the triangular flat basin closest to the junction of the two rivers. Its northernmost boundary was Boundary Street, now Florida Avenue. Rings of terraces, escarpments, slopes and ridges cut through by creeks and stream valleys surrounded this flat area.

The plan created by L'Enfant (see fig. 1) consisted essentially of a right-angled triangle formed by the President's House (now the White House; see §III, 2 and fig. 6 below) on a small rise to the west of the ceremonial core. The short leg of the triangle ran south from the President's House through the President's Park (now the Ellipse) to an equestrian statue of George Washington (later the Washington Monument; see below). The long leg of the triangle linked the statue with the Capitol through a 'Grand Avenue' (later the Mall) 122 m wide, lined with carriage drives and gardens and bordered by embassies. The Capitol (see §III, 1 and fig. 4 below) was located on Jenkins' Hill, described by L'Enfant as a pedestal waiting for a monument. The hypotenuse, a road 1.6 km long, which connected the President's House and the Capitol, became Pennsylvania Avenue; it was envisaged as the commercial and social heart of the city, and lined with shops, boarding houses, hotels and playhouses. Pennsylvania Avenue did, in fact, serve as a major commercial thoroughfare for more than a century and a half.

From this central core, streets that were criss-crossed by a grid of irregularly placed roads radiated out to Boundary Street and the river frontages. This pattern allowed for the aggrandizement of certain axes, such as 8th Street, which was to be highlighted by a proposed non-sectarian National Church placed due east of the President's House. 8th Street continued south to end on the banks of the Potomac River where the site for a naval column was provided, although this was never erected. The site intended for the National Church was used for the Patent Office building (1836; now the National Portrait Gallery). The points in the L'Enfant Plan where the grid and radial streets met were located on strategic topographical features and were reinforced by the siting of major public buildings and parks. The points of conjunction were also visualized as development nodes, which would generate growth throughout a decentralized city.

A canal fashioned from the Tiber Creek was initially intended to transport building materials to the public building sites and, later, to generate the commercial life of the city. The canal was also envisaged as a picturesque and tranquil element in the landscape. It ran from the mouth of the Tiber, at its confluence with the Potomac River, east through a turning basin on the 8th Street axis (the site of the Central Market) to the foot of the Capitol in a Grand Cascade. From the Capitol, the canal flowed diagonally to a Civic Center containing five 'grand fountains intended with a constant spout of water', and then divided into two legs, each running into the Eastern Branch. The canal was filled in the early 1870s and renamed Constitution Avenue on its east–west axis. The major triangle evolved as planned, although the location of the Washington Monument was off-centre owing to the instability of the land for the necessary foundations. Rather than a residential Grand Avenue, the Mall gradually became the sites of the Smithsonian museums, the National Gallery of Art and the Department of Agriculture building.

The essentials of the L'Enfant street system endured, although several radial avenues were straightened or eliminated soon after the plan's publication in 1792. In the District of Columbia, beyond the area covered by the

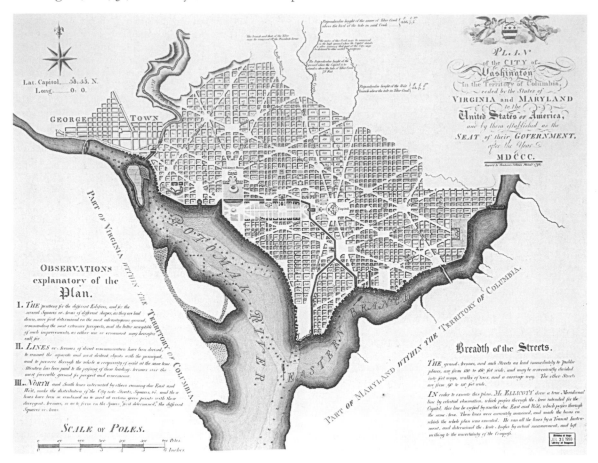

1. Washington, DC, official city plan by Andrew Ellicott, 1792, reproducing much of the plan of 1791 by Pierre-Charles L'Enfant (Washington, DC, Library of Congress)

L'Enfant Plan, many of the radial streets were extended, for example Massachusetts and Pennsylvania Avenues, which run to the District boundary line.

3. 19TH CENTURY. In 1800 the unfinished President's House and the Capitol figured prominently on the landscape. In between these major buildings, houses were scattered over what seemed interminable distances. The Washington Canal was built of inferior materials and was in constant need of repair. Few streets were paved and few municipal services were available.

Over the first half century, the city developed closest to the river frontages and between the President's House and the Capitol. Several major Classical Revival structures were constructed with light-coloured materials, such as marble and sandstone. The first was City Hall, designed by GEORGE HADFIELD with an Ionic order and begun in 1820; it became the focal-point of the area known today as Municipal Center. The Greek Revival sandstone Treasury building of Robert Mills, designed with Ionic columns, was begun in 1836 on 15th Street, one block east of the President's House. The 8th Street axis was emphasized by the location in 1836 of the Doric order Patent Office Building (now the National Portrait Gallery) constructed of marble and designed by Mills. Also by Mills were the

Post Office Department Building (begun 1839; now the Tariff Commission), located just to the south of the Patent Office, and the great marble obelisk, the Washington Monument (1848–84; *see* MILLS, ROBERT, fig. 2).

In 1850 A. J. Downing was commissioned to prepare the first comprehensive plan for the area, which L'Enfant called the 'Grand Avenue' and is now known as the Mall. It had become a patchwork of lands, each under the jurisdiction of a separate government agency, and Downing's plan provided for a sequence of distinctive pleasure grounds linked by carriage drives and walkways. Owing to Downing's untimely death and the lack of Federal government commitment, however, only the grounds surrounding the Romanesque style Smithsonian Institution building of 1847–55 (see fig. 3 below and colour pl. II, 3) by JAMES RENWICK were redesigned to conform to the plan.

At the outbreak of the Civil War in 1861, Washington's settlement pattern strongly evoked L'Enfant's intentions. Much of the settlement clustered close to the White House and the Capitol and along the stretch in between, as well as along the river frontages and around the Navy Yard, which faced on to the Eastern Branch. The neat, compact pattern was changed with the introduction in the 1850s of an expanded water system originating at Great Falls, and the development of rail and streetcar lines, which led to

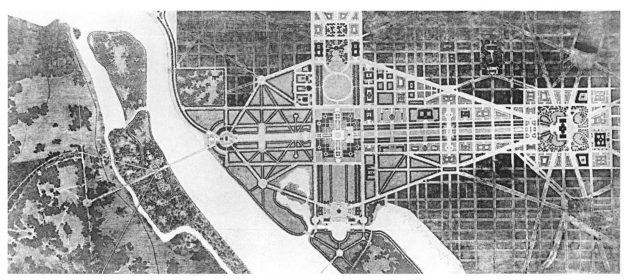

2. Washington, DC, McMillan Commission plan for the Mall, 1902 (Washington, DC, National Archives)

growth beyond the city planned by L'Enfant and eventually beyond the District boundaries.

During the Civil War, the capital, especially vulnerable to attack by Confederate forces owing to its proximity to Virginia, became an armed camp. Forts were sited on the circle of heights that ringed the city and new military roads were cut through from the city to the hinterland, thereby reinforcing the role of the capital as the centre of communication.

The city's brief experiment with the territorial form of government between 1871 and 1874 resulted in a vigorous programme to pave streets, construct sewers and plant trees, in the process of which Constitution Avenue was formed from the original city canal. After 1874 the Army Corps of Engineers assumed responsibility for the Federal government's public works, buildings and parks, and municipal public works fell under the jurisdiction of the Engineer Commissioner. The Corps of Engineers supervised the reclamation of the swampy Potomac Flats, which created East and West Potomac Parks, thus enlarging the monumental core south and west of the Washington Monument, the completion of which was overseen by the Corps.

Important buildings of this period include the grey granite State, War and Navy Building (1871–86; see colour pl. III, 3) west of the President's House, designed in the Second Empire style by Alfred B. Mullett, and the Library of Congress (1886–97; see colour pl. IV, 1) at the other end of Pennsylvania Avenue. Also of grey granite, the latter was designed by SMITHMEYER & PELZ in Italian Renaissance style and crowned by a copper dome. Beyond the monumental core, dense residential areas developed, such as Capitol Hill and Foggy Bottom and other areas around Logan, Scott and Dupont Circles, with whole blocks of red-brick town houses, elaborated with turrets and bay windows, and decorated with terracotta, pressed brick and cast iron.

4. EARLY 20TH CENTURY. In the 1890s proposals were developed to commemorate the centennial of the 'removal of government'. Sweeping all the proposals under a single study, the Senate Park Commission, commonly referred to as the McMillan Commission, provided a plan in 1902 (see fig. 2) that was the most comprehensive since the L'Enfant Plan. Chaired by Senator James McMillan of Michigan, the Commission included as members DANIEL H. BURNHAM, FREDERICK LAW OLMSTED, Charles McKim of McKIM, MEAD & WHITE and AUGUSTUS SAINT-GAUDENS. The Commission proposed a kite-shaped configuration that lengthened the White House cross axis southwards to the head of the Washington Channel. Here, on a reclaimed site, the Commission proposed a Pantheon, which later became the Jefferson Memorial, and the Washington Common. The plan called for a westward extension of the Washington Monument–Capitol axis to what became the site for the Lincoln Memorial, joined to the Washington Monument by the Reflecting Pool.

Portions of the L'Enfant Plan were transformed into City Beautiful set pieces made up of groupings of monumental public buildings with adjoining plazas and formal parks. Around the White House and the Capitol, the Commission proposed the Executive Group and Legislative Group of new public buildings and the triangle formed by the Mall, Pennsylvania Avenue and 15th Street (later known as the Federal Triangle) as the location for future public buildings.

The McMillan Commission Plan formed a comprehensive system of regional parks, reminiscent of the metropolitan one in Boston, MA (see BOSTON, §I), which linked the formal open spaces of the Mall and those around major public building groupings with parkland adjoining the shores of the Potomac and the Anacostia rivers and along the stream valleys of Rock Creek, and extended as far as Mount Vernon to the south and Great Falls to the north-west. The park plan provided for a variety of functional and formal needs for open space and formed the basis of a long-term programme to acquire land. The McMillan Plan, which was institutionalized in 1910 by the Commission of Fine Arts, was implemented gradually, but its power was such that, for decades afterwards, private

organizations commissioned new structures to conform to it in location and architectural style. Private individuals donated lands for parks and open spaces according to the comprehensive park proposal.

BIBLIOGRAPHY

Washington: City and Capital, US Works Progress Administration (Washington, DC, 1937)
F. Gutheim: *The Potomac*, Rivers of America (New York, 1949, rev. 1974)
H. Caemmerer: *The Life of Pierre Charles L'Enfant, Planner of the City Beautiful, the City of Washington* (Washington, DC, 1950)
M. Green: *Washington, Village and Capital, 1800–1878* (Princeton, 1962)
——: *Washington, Capital City, 1879–1950* (Princeton, 1963)
J. Reps: *Monumental Washington: The Planning and Development of the Capital Center* (Princeton, 1967)
Toward a Comprehensive Landscape Plan for Washington, D.C., US National Capital Planning Commission (Washington, DC, 1967)
M. Scott: *American City Planning since 1890* (Berkeley, 1969)
F. Gutheim: *Worthy of the Nation: The History of Planning for the National Capital*, US National Capital Planning Commission (Washington, DC, 1977)

ANTOINETTE J. LEE

II. Art life and organization.

Since the designation of Washington as the permanent seat of the Federal government in 1790, the local art community has struggled to establish and maintain a sense of regional identity in a city devoted to national issues. Although generations of talented artists have lived and worked there, the District of Columbia is best known for its museums and monuments.

Early in the life of the city, artists came to the District of Columbia to paint portraits and views of the new capital and to seek government patronage, which was generous. From the first Federal building boom in the mid-19th century, European and American artists created or installed architectural sculpture and ornament, murals and other public works of art in and around the new Federal buildings. The building campaigns that involved the greatest number of artists were the US Capitol (*see* §III, 1 below), the Library of Congress and the buildings of the Federal Triangle bounded by Pennsylvania and Constitution avenues and by 6th and 15th streets.

Throughout the 19th and 20th centuries, art schools and other organizations in the city fostered a sense of community among local artists. Such accomplished painters as Charles Bird King, Joseph Wood (1778–1832) and Pietro Bonanni (1792–1825), who came to Washington in the early 19th century, offered the first private art instruction. The Washington Art Club, established in 1877, sponsored one of the earliest schools, which was active between 1879 and 1885. The oldest and most important professional art school in the District is now the Corcoran School of Art, established in 1890 as an integral part of the Corcoran Gallery of Art, which was itself founded in 1869. Other local organizations followed the establishment of the Washington Art Club, the most important of which were: the Art Students' League of Washington (1884); the Society of Washington Artists (1891); the Washington Watercolor Club (1896); the Fine Arts Union (*c.* 1899); the Washington Society of Fine Arts (1905); and the Landscape Club of Washington, DC (1913).

The Smithsonian Institution, the world's largest museum complex comprising 15 museums and the National Zoo, both overshadows and enriches the local art community. Established in 1846 with funds bequeathed to the United States by the English James Smithson (1765–1829), the Smithsonian holds some 137 million artefacts and specimens in trust 'for the increase and diffusion of knowledge'. It is partially funded by the Federal Government and is dedicated to public education, national service and scholarship in the arts, science and history (see fig. 3).

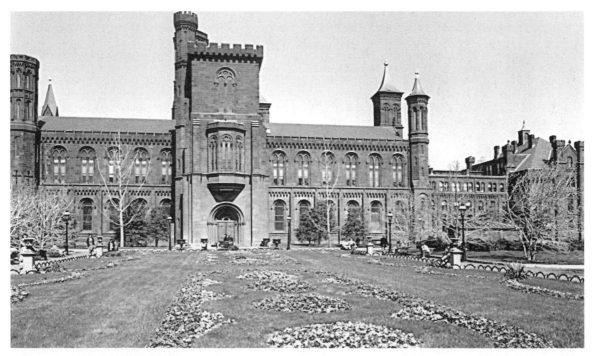

3. Washington, DC, original Smithsonian Institution building by James Renwick, 1847–55, with the Haupt Green garden in the foreground

Among the Smithsonian's art museums are: the National Museum of American Art, which includes 34,000 paintings, sculptures and examples of the graphic arts, photography and folk art by American artists housed in a restored landmark, the old Patent Office building (*see* §I, 2 above), which it shares with the National Portrait Gallery and the Archives of American Art; the Renwick Gallery, a department of the National Museum of American Art featuring 20th-century American crafts and decorative arts; and the National Portrait Gallery, where visitors can trace US history through representations of men and women who contributed to its political, military, scientific and cultural development.

Washington possesses an unparalleled wealth of libraries, special collections and research facilities for the study of art, including the Smithsonian's Archives of American Art, the world's largest collection of primary source material documenting the visual arts of the United States and such national databases as the Inventory of American Sculpture and the Inventory of American Paintings at the National Museum of American Art and the Catalog of American Portraits at the National Portrait Gallery. The Sculpture Source of the International Sculpture Center has an international database and slide registry for sculptors.

BIBLIOGRAPHY
J. Goode: *Outdoor Sculpture of Washington, DC: A Comprehensive Historical Guide* (Washington, DC, 1974)

V. McMahan: *Washington, DC: Artists Born before 1900: A Biographical Dictionary* (Washington, DC, 1976)
A. Consentino and H. Glassie: *The Capital Image: Painters in Washington, 1800–1915* (Washington, DC, 1983)
G. Gurney: *Sculpture and the Federal Triangle* (Washington, DC, 1985)
L. KIRWIN

III. Buildings.

1. Capitol. 2. White House.

1. CAPITOL. Located on Jenkins' Hill and linked by the Mall to the White House, the distance between the two buildings reflects the separation of the Legislative and Executive Branches of federal government. The three distinct sections of the Capitol itself, the centre balanced by equal wings (see fig. 4), express the structure of the US Congress, with the Senate and the House of Representatives. The dome over the centre symbolizes the enduring unity of the nation. The interior of the Capitol is arranged in interlocking rooms and corridors, a product of several enlargements and rebuildings, and is decorated with architectural ornament and works of art.

The Capitol's location was fixed in the L'Enfant Plan of 1791 (*see* §I, 2 above). In 1792 the District Commissioners responsible for the implementation of the plan announced a competition for the design of the building, offering $500 and a city lot. The competition yielded at least 16 entries, but no suitable design. A few months

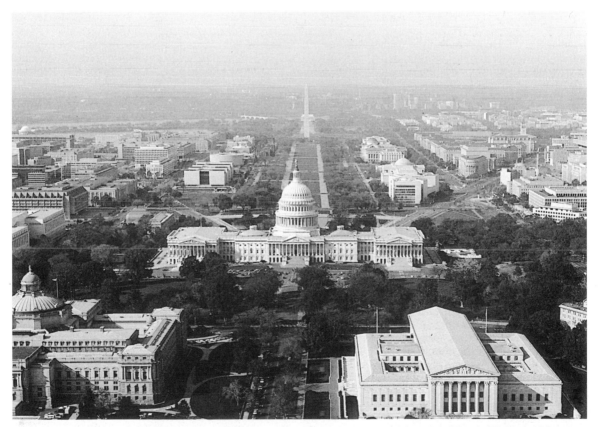

4. Washington, DC, aerial view from the east in 1987, showing the main vista from the Capitol along the Mall to the Washington Monument with the Lincoln Memorial behind

later, the Commissioners accepted a submission by WILLIAM THORNTON and in 1793 awarded him the premium. Thornton's design called for a central section, modelled on the Panthéon in Paris, and comprising a shallow dome placed behind a seven-bay portico and above a one-storey arcade. Flanking the central section were balanced wings with elevations of Corinthian pilasters supported by rusticated piers. Above the pilasters was a full entablature with balustrade. The overall composition was based on English Palladian architecture.

Construction on all sections of the building began in 1793. By 1796, however, difficulties associated with the transportation of the Aquia sandstone, labour shortages and the scarcity of funds limited work to the north wing. During this period three architects, Stephen Hallet (?1760–1825), George Hadfield and James Hoban, took turns superintending the construction. By 1800 the north wing was complete enough to incorporate both houses of Congress, the Supreme Court and other legislative and judicial functions.

During much of the first decade of the 19th century BENJAMIN HENRY LATROBE served as architect of the Capitol. He altered Thornton's design for the interior of the south wing by elevating the House Chamber over a floor of offices. He also built the wing's interior of brick vaults and embellished the Hall of the House with decorations inspired by Classical Greece. Once the south wing was underway, Latrobe redesigned and rebuilt the eastern half of the north wing with brick vaults and columns with capitals sculpted into the shape of corncobs and leaves.

On 24 August 1814 British forces burnt the major buildings in the city, including the Capitol. Latrobe returned to Washington to redesign and supervise the restoration of the two wings. The House Chamber was rebuilt as a semicircle. Columns in the House and Senate Chambers were modelled on the Greek orders. The Supreme Court Chamber, directly below the Senate Chamber in the north wing, was also rebuilt, with a semi-dome ceiling and archway supported by Doric columns. Demands for greater speed and economy forced Latrobe to give up the work on the Capitol in 1817 and to leave the city altogether.

Charles Bulfinch was appointed in 1818 to complete the restoration of the wings. He also oversaw the construction of the centre section and a copper-covered wooden dome. On the East Front, at the base of the dome, Luigi Persico (1791–1860) designed the sandstone pediment sculpture depicting the *Genius of America*, with America pointing to Justice and Hope. It was executed from 1825 to 1828 and was later reproduced in white Georgia marble when the East Front was extended from 1958 to 1962. The Capitol building with its grounds was completed by 1829, 36 years after it was begun.

By 1850 the entry of new states into the Union and an increase in Congressional work led to severe overcrowding. The Senate Committee on Public Buildings held a competition for the Capitol extension and, after a second informal competition, selected a design by Thomas U. Walter. Over the next 14 years Walter provided large wings on either end of the building connected by narrow corridors. The resulting floor plan was an amalgamation of the original section with subsequent additions. The wings were designed to harmonize with the existing building; but Walter used marble from Massachusetts and Maryland instead of the sandstone used in the original building.

In 1853 Captain MONTGOMERY MEIGS of the Corps of Engineers was placed in charge of the work and proceeded to make changes to Walter's plans for the location of the House and Senate Chambers in the new wings. Despite disagreements between Meigs and Walter, the House wing was completed in 1857 and the Senate wing in 1859. The former Senate Chamber was assigned to the Supreme Court (which occupied it until 1935, when it acquired its own building). The old House Chamber was converted into Statuary Hall to contain statues contributed by each state, representing notable citizens. The collection includes over 90 statues, mostly of politicians, religious leaders, educators and scientists.

As part of the Capitol extension the pediment on the Senate side of the East Front, *Progress of Civilization*, was designed from 1855 to 1859 by THOMAS CRAWFORD and erected in 1863. (The House pediment, *Apotheosis of Democracy* by Paul Wayland Bartlett, was unveiled much later, in 1916.) The enlarged Capitol building was by the late 1850s more than double its original length and required a new dome. Designed by Walter in 1855 and fabricated of cast iron with the assistance of Meigs, the Capitol dome was modelled on those of St Paul's Cathedral, London, and St Peter's, Rome. It was completed in 1863, and a bronze statue of *Freedom* (1855–62) by Crawford was placed on top. CONSTANTINO BRUMIDI completed the fresco *Apotheosis of George Washington* on its inner canopy, and in 1878 he began painting the Rotunda frieze, which depicted American history from the landing of Columbus to the Gold Rush (see fig. 5). The frieze was eventually completed by 1953, with the historical panorama being updated to include the Wright Brothers' flight of 1903.

In 1874 Frederick Law Olmsted designed a comprehensive landscape plan for the Capitol grounds, leading to the creation of a great marble terrace around the north, west and south elevations of the building, as well as broad open lawns, low stone walls and picturesque landscape features (see fig. 4 above). By the early 20th century the Capitol was again overcrowded, and new office buildings, including the Beaux-Arts Cannon House office building and the Russell Senate office building (both 1905–8) by Carrère & Hastings of New York, were constructed around the perimeter of the grounds, following the McMillan Plan's recommendation of a legislative group of public buildings.

BIBLIOGRAPHY

G. Brown: *History of the United States Capitol*, 2 vols (Washington, DC, 1900–03)

C. Fairman: *Art and Artists of the Capitol of the United States of America* (Washington, DC, 1927)

M. E. Campioli: 'Building the Capitol', *Building Early America*, ed. C. Peterson (Radnor, PA, 1976), pp. 202–31

P. Scott and A. J. Lee: *Buildings of the District of Columbia* (New York, 1993)

ANTOINETTE J. LEE

2. WHITE HOUSE. Although it is best known as the residence of the US president, the White House is a complex of residential, ceremonial and office spaces, which serves as the centre of the Executive Branch. By European

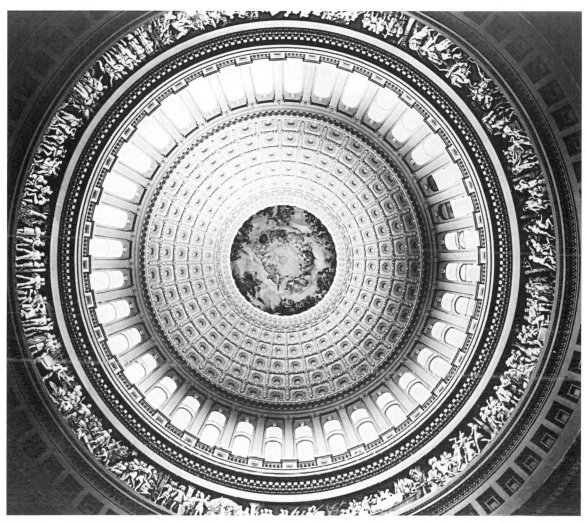

5. Washington, DC, the Capitol, interior view of the dome designed in 1855 in cast iron by Thomas U. Walter, showing the central fresco of the *Apotheosis of George Washington* (1865) by Constantino Brumidi and the Rotunda frieze (begun 1878; completed 1953) illustrating American history

standards, the White House is small, but the building above ground represents only a fraction of the complete structure, which is spread over several subterranean levels and two wings.

The White House originated as the President's House in the L'Enfant Plan. It is located on a rise in the western portion of the Federal city, providing for a view of the river, and six avenues radiate from the site, reinforcing the building's central position in the city. In 1792 the City Commissioners held a competition for the design of the President's House. JAMES HOBAN won the competition with a design for a three-storey rectangular building with a projecting central section of engaged columns over a heavy base. Hoban's source was Leinster House, the Dublin residence of the Duke of Leinster. President Washington later made several changes to Hoban's design: he extended the outer dimensions by one fifth, added the pediment ornament and called for more stone embellishments. The building was constructed of Aquia sandstone

and the planned third storey was omitted. The elaborate swag above the entrance door was carved in the 1790s.

Completed in 1803, the building was the largest house in the United States. It was rebuilt under Hoban's supervision (completed 1818) after it was burnt by British forces in 1814. In 1824 the semicircular south portico was added, consisting of Ionic columns two storeys in height carved of Seneca sandstone. From 1829 to 1830, the north portico (see fig. 6) was built, an addition that served as a *porte-cochère* and lightened the stern façade. The restoration of 1902 and the addition of the west and east wings, carried out according to designs prepared by Charles McKim, improved the interior layout of the rooms in the main building but left the exterior undisturbed. The building's role as a national monument was underscored during the reconstruction of the interior (1949–52) with a free-standing steel frame, undertaken during the presidency of Harry S. Truman. The Truman-era rebuilding took pains to avoid disturbing the exterior. Thus, while none of the

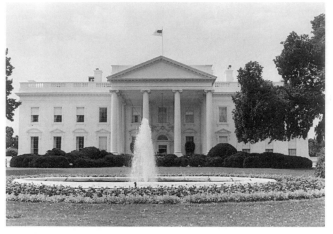

6. Washington, the White House, by James Hoban, 1792–1803 (rebuilt after 1814, completed 1818); view of the north elevation with the north portico addition of 1829–30

public rooms of the house dates from the building's early years, they are finished in Federal and classical style and adorned with fine works of statuary, porcelain, paintings and period furniture.

BIBLIOGRAPHY
The White House: An Historic Guide, White House Historical Association (Washington, DC, 1962, rev. 1982)
W. Ryan and D. Guinness: *The White House: An Architectural History* (New York, 1980)
W. Seale: *The President's House*, 2 vols (Washington, DC, 1986)
——: *The White House: The History of an American Idea* (Washington, DC, 1992)

ANTOINETTE J. LEE

Watkins, Carleton E(mmons) (*b* Oneonta, NY, 11 Nov 1829; *d* Imola, CA, 23 June 1916). American photographer. He migrated to San Francisco in the early 1850s in the wake of the gold rush. In 1854 Watkins met the daguerreotypist Robert Vance (1825–76), who hired him as a camera operator. Watkins opened his own studio in 1858 and began travelling to photograph the American West. Using a mammoth-plate camera (some views measuring as much as 560×710 mm), he photographed in Yosemite Valley from 1861 (e.g. *Panoramic View of the Yosemite Valley*, *c*. 1865; Washington, DC, Lib. Congr.).

These transcendental views were praised in the early photographic journals by many writers, including Oliver Wendell Holmes (1809–94), and influenced the US Congress to make the Valley a national park. By making purposefully artistic images, Watkins became one of the best-known landscape photographers, with an international reputation.

For three decades Watkins was a very successful commercial photographer, working for government-sponsored geological surveys and for industrial clients including, Las Mariposas Mines and the Central and Southern Pacific Railroads. Watkins used the commissions to travel and to produce views of landscapes in Oregon (1868), Utah (1873), Nevada (1876), Southern California and Arizona (1880), the Pacific Northwest (1882–3) and Idaho and Montana (1884–5). All of these trips yielded series of photographs sold through Watkins's San Fran-

cisco studio. He sent the best examples to exhibitions across the USA and Europe, winning prizes and maintaining a strong reputation until his eyesight began to fail in 1892. In 1906 all his negatives were lost in the San Francisco earthquake fire.

BIBLIOGRAPHY
Carleton E. Watkins: Photographer of the American West (exh. cat. by P. Palmquist, Fort Worth, TX, Amon Carter Mus.; Boston, MA, Mus. F. A.; St Louis, MO, A. Mus.; Oakland, CA, Mus.; 1983)
P. E. Palmquist: 'Carleton E. Watkins: A Biography', *Phot. Hist.*, viii/4 (Winter 1987–8), pp. 7–26 [chapters 1 & 2]
——: *Carleton E. Watkins: Photographs, 1861–1874* (San Francisco, 1989)
——: 'Carleton E. Watkins: A Biography', *Daguerreian Annu.* (1990), pp. 165–86 [chapter 3]
A. Rule, ed.: *Carleton Watkins: Selected Texts and Bibliography* (Oxford, 1993)
Carleton Watkins: Photographs from the J. Paul Getty Museum (Los Angeles, 1997)

SHERYL CONKELTON

Weber, Max (*b* Belostok, Russia [now Białystok, Poland], 18 April 1881; *d* Great Neck, NY, 4 Oct 1961). American painter, printmaker, sculptor and writer of Russian birth. He was born of Orthodox Jewish parents and in 1891 emigrated with his family to America. After settling in Brooklyn, NY, Weber attended the Pratt Institute (1898–1900), where he studied art theory and design under Arthur Wesley Dow (1857–1922). Dow's extensive knowledge of European and Far Eastern art history, together with his theories of composition, made a lasting impression on Weber. Weber was in Paris from 1905 to 1908 and studied briefly at the Académie Julian. He developed a close friendship with Henri Rousseau (1844–1910) and helped to organize a class with Henri Matisse (1869–1954) as its instructor. Visits to the ethnographic collections in the Trocadéro and other Parisian museums extended his sensitivity to non-Western art, while travels through Spain, Italy and the Netherlands broadened his knowledge of the Old Masters.

For several years following his return to America in January 1909, Weber's art consisted largely of still-lifes and nudes in the landscape, which gave strong evidence of his assimilation of Matisse's theories of decorative harmony and the primitivism evident in the work of Pablo Picasso (1881–1973). By 1910 Weber was contributing articles on art and colour theory to Alfred Stieglitz's pioneering journal, *Camera Work*, and in that year arranged the first one-man show of the work of Henri Rousseau in the USA at Stieglitz's 291 Gallery. Stieglitz was one of the first to recognize Weber's talent and in 1911 gave him his second one-man exhibition.

In 1914 Weber published his first volume of poetry, *Cubist Poems*, which confirmed his interest in Picasso and primitive art.

WRITINGS
'Chinese Dolls and Modern Colorists', *Cam. Work*, 31 (1910), p. 51
'The Fourth Dimension from a Plastic Point of View', *Cam. Work*, 31 (1910), p. 25
'To Xochimilli, Lord of Flowers', *Cam. Work*, 33 (1911), p. 34
Cubist Poems (London, 1914)
Essays on Art (New York, 1916)
Primitives: Poems and Woodcuts (New York, 1926)

BIBLIOGRAPHY
Max Weber Retrospective Exhibition, 1907–1930 (exh. cat., ed. A. H. Barr jr; New York, MOMA, 1930)

Max Weber (exh. cat., ed. L. Goodrich; New York, Whitney, 1949)
S. Leonard: *Henri Rousseau and Max Weber* (New York, 1970)
P. B. North: *Max Weber: The Early Paintings (1905–1920)* (diss., Wilmington, U. DE, 1974)
A. Werner: *Max Weber* (New York, 1975)
D. R. Rubenstein: *Max Weber: A Catalogue Raisonné of his Graphic Work* (Chicago, 1980)
Max Weber: American Modern (exh. cat., ed. P. North; New York, Jew. Mus., 1982)

<div align="right">RUTH L. BOHAN</div>

Weinman, Adolph Alexander (*b* Karlsruhe, 1870; *d* New York, 1952). American sculptor and medallist of German birth. He was brought up in New York from the age of ten. He was apprenticed as a carver of wood and ivory under F. R. Kaldenberg, also studying at the Cooper Union School and later for five years at the studio of the sculptor Philip Martiny (1858–1927). From 1895 he served as assistant to Olin L. Warner and from Warner's death in 1896 until 1898 he worked under Augustus Saint-Gaudens. There then followed five years in the studio of Charles H. Niehaus (1855–1935) and two years under Daniel C. French, with whom he worked on the figures of *The Continents* (1907) for the New York Customs House. In 1906 he set up his own studio.

Saint-Gaudens was without doubt the major influence on his work, and most of Weinman's work was, like that of Saint-Gaudens, modelled to be cast in bronze. He belonged to the generation of sculptors working in the USA who continued the French tradition of naturalistic, Romantic bronzes well into the 20th century. His statue of *Major General Alexander Macomb* (1906–8; Detroit, MI, Public Square) is a fine example. Besides free-standing works, he produced sculpture as architectural decoration (e.g. Pennsylvania Station, New York) and like Saint-Gaudens worked in relief.

Weinman's interest in medals stemmed from his visit to the World's Columbian Exposition in Chicago (1893), at which a room was devoted to the work of European medallists. In 1896 he modelled a portrait medal of his mother, which was followed by two portraits of children. One of his earliest commissions for a struck medal came with the Louisiana Purchase Exposition of 1904, and in the following year he collaborated with Saint-Gaudens on Theodore Roosevelt's inauguration medal. For over 40 years he was one of America's foremost medallists.

BIBLIOGRAPHY
Forrer: vi, pp. 427–8, viii, pp. 266–70; Thieme–Becker
Catalogue of the International Exhibition of Contemporary Medals, 1910 (New York, 1911), p. 357
H. Saint Gaudens, ed.: *The Reminiscences of Augustus Saint Gaudens*, 2 vols (New York, 1913)
S. P. Noe: *The Medallic Work of A. A. Weinman* (New York, 1921)
Exhibition of American Sculpture (exh. cat., New York, 1923), pp. 246–7
D. Taxay: *The U.S. Mint and Coinage: An Illustrated History from 1776 to the Present* (New York, 1966)
C. Vermeule: *Numismatic Art in America: Aesthetics of the United States Coinage* (Cambridge, MA, 1971)
J. H. Dryfhout: *The Work of Augustus Saint Gaudens* (Hanover and London, 1982)
B. Wilkinson: *The Life and Works of Augustus Saint Gaudens* (New York, 1985)
The Beaux-Arts Medal in America (exh. cat. by B. A. Baxter, New York, Amer. Numi. Soc., 1988)
J. Connor and J. Rosenkranz: *Rediscoveries in American Sculpture: Studio Works, 1893–1939* (Austin, 1989)

<div align="right">PHILIP ATTWOOD</div>

Weir. American family of artists and teachers.

(1) Robert Walter Weir (*b* New York, 18 June 1803; *d* New York, 1 May 1889). Painter and teacher. By his own account he was self-taught, with the exception of a few lessons from an unknown heraldic painter named Robert Cooke. However, after exhibiting a few works that were praised by the local press, he was sent to Italy by a group of New York and Philadelphia businessmen for further studies. There he trained with Florentine history painter Pietro Benvenuti (1769–1844). After three years in Europe (1824–7), he returned to New York, where he quickly became a mainstay of the artistic community. In 1831 he was elected to membership in the National Academy of Design in New York, and three years later he was made instructor of drawing at the US Military Academy in West Point, New York, a post he held for the next 42 years. Most scholars agree that he was more important as a teacher than as a painter. His best-known work is the *Embarkation of the Pilgrims* (1837–43), which hangs in the Rotunda of the US Capitol Building in Washington, DC.

BIBLIOGRAPHY
K. Ahrens: *Robert Walter Weir* (diss., Newark, U. DE, 1972)
Robert Weir: Artist and Teacher of West Point (exh. cat., ed. W. Gerdts and J. Callow; West Point, US Mil. Acad., 1976)

<div align="right">MARK W. SULLIVAN</div>

(2) John Ferguson Weir (*b* West Point, NY, 28 Aug 1841; *d* Providence, RI, 8 April 1926). Painter, teacher and sculptor, son of (1) Robert Walter Weir. He grew up at the US Military Academy at West Point, where he was taught by his father. His earliest paintings record the handsome landscape of the surrounding countryside, including *View of the Highlands from West Point* (1862; New York, NY Hist. Soc.). By November 1862 Weir had settled in New York, occupying quarters in the Studio Building on West Tenth Street, where he became friendly with many of the well-known artists residing there. He also made important contacts through the Century Club and the Athenaeum Club and the Artists' Fund Society. He made his début at the National Academy of Design with an *Artist's Studio* (1864; Los Angeles, CA, Co. Mus. A.), a detailed view of his father's painting room at West Point. The picture's favourable reception led to his election as an Associate of the National Academy of Design. However, it was the *Gun Foundry* (1866; Cold Spring, NY, Putnam County Hist. Soc.), set in the West Point Iron and Cannon Foundry, that established Weir as one of the most important 19th-century American painters of industrial themes. The foundry also inspired his *Forging the Shaft* (1867–8, destr. 1869; replica 1877; New York, Met.). Other themes undertaken by Weir included several variants of *Christmas Eve* (1864; New York, C. Assoc.).

From December 1868 until August 1869 Weir made his first trip to Europe; then he moved to New Haven, CT, as the first Director of the recently founded Yale School of the Fine Arts, the first professional art school to be established on a American campus. During his 44-year tenure there, Weir organized an ambitious programme of artistic training, modelled on that of the Ecole des Beaux-Arts in Paris. During this period he lectured widely at institutions along the East Coast and wrote extensively on

art topics for such periodicals as the *New Englander, Princeton Review, Harper's New Monthly Magazine, North American Review* and *Scribner's Magazine*. He also acted as commissioner for the art section of the 1876 Centennial Exposition in Philadelphia. His duties at Yale made it difficult for him to maintain his national reputation as a painter, but Yale provided him with regular portrait commissions, which included several sculptures, the most important being those of *Benjamin Silliman* (1884; Sterling Chemistry Laboratory) and *Theodore Dwight Woolsey* (1895–6; opposite the College Street entrance to the Old Campus). During his years in New Haven, his palette gradually lightened, in part due to the influence of his half-brother, (3) Julian Alden Weir. Still-life themes began to interest him, and paintings inspired by the local landscape also became more prominent in his work, for example *East Rock* (*c.* 1900; New Haven, CT, Colony Hist. Soc. Mus.).

UNPUBLISHED SOURCES

New Haven, CT, Yale U. Lib. [John Ferguson Weir papers, mss and archvs]
Washington, DC, Smithsonian Inst., Archvs Amer. A. [John Ferguson Weir papers]

BIBLIOGRAPHY

T. Sizer, ed.: *The Recollections of John Ferguson Weir* (New York, 1957)
——: 'Memories of a Yale Professor', *Yale U. Lib. Gaz.*, xxxii (1958), pp. 93–8
L. Dinnerstein: 'The Iron Worker and King Solomon: Some Images of Labor in American Art', *A. Mag.*, liii (1979), p. 112–17
B. Fahlman: 'John Ferguson Weir: Painter of Romantic and Industrial Icons', *Archvs Amer. A. J.*, xx (1980), pp. 2–9
D. B. Burke: 'John Ferguson Weir (1841–1926)', *American Paintings in the Metropolitan Museum of Art*, ii (New York, 1985), pp. 566–74
B. Fahlman: *John Ferguson Weir: The Labor of Art* (Newark, DE, 1997)

BETSY FAHLMAN

(3) Julian Alden Weir (*b* West Point, NY, 30 Aug 1852; *d* New York, 8 Dec 1919). Painter, printmaker and teacher, son of (1) Robert Walter Weir. His art education began in the studio of his father. There he and his half-brother (2) John Ferguson Weir acquired an appreciation for the Old Masters, particularly of the Italian Renaissance and of the 17th-century Dutch schools. While Weir pursued in his art a course very different from that of his father and half-brother, his personality as well as his artistic attitudes were shaped by them. In the winters of 1870–71 and 1871–2, he continued his studies at the National Academy of Design in New York, where his instructor was Lemuel Wilmarth (1835–1918).

Weir arrived in Paris in the autumn of 1873 and remained there for almost four years. He enrolled in the studio of Jean-Léon Gérôme (1824–1904) and on 27 October 1874 became a matriculant at the Ecole des Beaux-Arts, where he drew such studies as *Male Nude Leaning on a Staff* (1876; New Haven, CT, Yale U. A.G.). He also studied at the Ecole Gratuite de Dessin, often called the Petite Ecole, and in independent classes taught by Gustave Boulanger (1824–88) and Louis-Marie-François Jacquesson de la Chevreuse (1839–1903). He also travelled to Belgium, the Netherlands and Spain. During the summers he worked in the French villages of Portrieux and Pont-Aven, where he painted landscapes and peasant subjects including *Interior—House in Brittany* (1875; priv. col., see Burke, 1983, p. 53) and the *Oldest Inhabitant* (1875–6; Youngstown, OH, Butler Inst. Amer. A.). He

first exhibited at the Paris Salon in 1876. Weir developed close friendships with Jules Bastien-Lepage (1848–84) and Pascal-Adolphe-Jean Dagnan-Bouveret (1852–1929), who drew him into an international circle of naturalists, under whose influence he painted *Children Burying a Dead Bird* (1878; Washington, DC, N. Mus. Amer. A.).

When Weir returned to New York in 1877, he was quickly established in the vanguard of an internationally trained generation of painters that transformed American art around 1880. He joined many organizations founded or supported by these young painters, including the Tile Club, the Art Club, the American Watercolor Society, the Society of Painters in Pastel and the Society of American Artists. He began a long and active career as a teacher at the Cooper Union and the Art Students League. He had first exhibited at the National Academy in 1875 and was elected an Associate in 1885 and an Academician the following year.

From the early 1880s Weir chose a wide variety of subjects and worked in styles that reveal his continuing contact with European art and artists. His still-life paintings range from ambitious arrangements of flowers and elaborate decorative objects, such as *Roses* (1883–4; Washington, DC, Phillips Col.), to smaller, more intimate compositions of kitchen items and a few flowers or pieces of fruit. Some of his figure paintings, among them *In the Park* (*c.* 1879; later cut into three separate canvases, see Burke, 1983, pp. 92, 99), a scene of modern urban life, reveal the influence of Edouard Manet (1832–83), whom Weir met in 1881, but others, such as *Idle Hours* (1888; New York, Met.), show the enduring effect of his academic training. He also acted as an agent for Erwin Davis in purchasing works by Manet (e.g. *Woman with a Parrot*, 1866; New York, Met.).

During the 1880s and 1890s Weir began to experiment with pastel and watercolour and achieved daring effects that do not appear in his oil paintings until a later date. Many of his small and informal pastels seem to have been done for his own satisfaction. He often combined watercolour and pastel, achieving richly textured surfaces with high-keyed colours, applied with free, broad strokes. From about 1887 to 1893 he also made prints, mainly etchings and drypoints, characterized by the seemingly fragmentary nature of their compositions and the artist's use of broken lines to suggest the qualities of light and air.

For the final three decades of his life Weir was most strongly affected by Impressionism. Around 1890, influenced by the work of his friends Theodore Robinson and John H. Twachtman, he turned more often to landscape subjects, producing small, freshly brushed views of the Connecticut countryside, for example the *Farmer's Lawn* (*c.* 1890; priv. col., see Burke, 1983, p. 192), and informal figure studies, mainly of his wife and children posed out-of-doors. He worked on mural decorations for the Columbian Exposition in Chicago (1893). Among his most important Impressionist works are those inspired by Japanese prints, of which he was an avid collector. These include such landscapes as the *Red Bridge* (*c.* 1895; New York, Met.; see fig.) and a series of life-size figure studies (e.g. *Baby Cora*, 1894; priv. col., see Burke, 1983, pl. 25), in which he used oriental devices, most notably asymmetrical compositions brought close to the picture plane and

Julian Alden Weir: *Red Bridge*, oil on canvas, 616×857 mm, 1895 (New York, Metropolitan Museum of Art)

unconventionally cropped. By about 1897 the academic character of Weir's earlier work reasserted itself in more representational views of Connecticut, as in two versions of the *Factory Village* (1897; New York, Met., and Wilton, CT, The Weir Farm Her. Trust), and in less adventurous figure studies. From 1902 until his death, he painted idealized, somewhat sentimental portraits of women and pleasant landscapes, typically with soft, regularized brush-strokes and a silvery palette of pale blue and green.

Weir achieved tremendous recognition during his life-time: he exhibited widely in one-man shows, annuals and international expositions; he won awards and medals; and he was among the founder-members of the popular TEN AMERICAN PAINTERS in 1897. An important collection of his work can be found at Brigham Young University, Provo, UT.

WRITINGS

'Jules Bastien-Lepage', *Modern French Masters: A Series of Biographical and Critical Reviews*, ed. J. C. Van Dyke (New York, 1896/R 1976), pp. 227–35
'What Is Art?', *A. & Dec.*, vii (1917), pp. 316–17, 324, 327

BIBLIOGRAPHY

J. B. Millet, ed.: *Julian Alden Weir: An Appreciation of his Life and Works* (New York, 1921)
A. Zimmerman: 'An Essay towards a Catalogue Raisonné of the Etchings, Dry-points and Lithographs of Julian Alden Weir', *Met. Papers*, i/2 (New York, 1923), pp. 1–50
D. W. Young: *The Life and Letters of J. Alden Weir* (New Haven, 1960) [incl. extensive quotations from the artist's corr.]
J. Alden Weir: American Impressionist, 1852–1919 (exh. cat. by J. A. Flint, Washington, DC, N. Mus. Amer. A., 1972)
J. Alden Weir and the National Academy of Design (exh. cat. by D. B. Burke, New York, N. Acad. Des., 1981)
D. B. Burke: *J. Alden Weir: An American Impressionist* (Newark, DE, 1983) [extensive bibliog.]
J. Alden Weir: A Place of his Own (exh. cat. by H. Cummings, H. K. Fusscas and S. G. Larkin, Storrs, U. CT, Benton Mus. A.; Greenwich, CT, Bruce Mus.; 1991)

DOREEN BOLGER

Wendt, William (*b* Bentzen, Germany, 20 Feb 1865; *d* Laguna Beach, 29 Dec 1946). American painter of German birth. He came to the USA in 1880, settling in Chicago, where he worked in a commercial art firm. Essentially self-taught, he attended evening classes at the Art Institute of Chicago for only a brief period. Dissatisfied with figure studies, he preferred painting landscapes and quickly became an active exhibitor in various Chicago art shows, winning the Second Yerkes Prize at the Chicago Society of Artists exhibition in 1893. Wendt and Gardner Symons (1862–1930) made a number of trips to California between 1896 and 1904 and, in 1898, to the art colony at St Ives in Cornwall, England. In 1906 Wendt settled in Los Angeles with his wife, sculptor Julia Bracken. He became a leading member in the art community and was a founder—member of the California Art Club in 1909. In 1912 he moved his home and studio to the art colony at Laguna Beach, the same year that he was elected to the National Academy of Design. Although somewhat shy and reclusive, he was Laguna's most important resident artist—teacher. To Wendt, nature was a manifestation of God, and he viewed

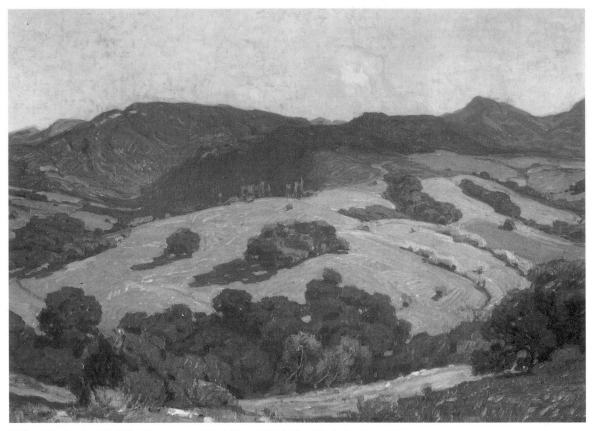

William Wendt: *Arcadian Hills*, oil on canvas, 1.02×1.40 m , 1910 (Irvine, CA, Irvine Museum)

himself as nature's faithful interpreter (see fig.). In his later works, after about 1912, he employed a distinctive block-like brushwork, giving solidity to his renditions of natural forms. A prolific painter, he was known as the 'dean' of Southern California's landscape painters. Wendt received numerous awards for his works, among these were a Bronze Medal at the Pan-American Exposition, Buffalo (1901); a Silver Medal at the Louisiana Purchase Exposition, St Louis (1904); and a Silver Medal at the Panama—Pacific International Exposition, San Francisco (1915).

BIBLIOGRAPHY

Early Artists in Laguna Beach: The Impressionists (exh. cat. by J. B. Dominik, Laguna Beach, CA, A. Mus., 1986)

W. H. Gerdts: *Art across America: Two Centuries of Regional Painting, 1720–1920* (New York, 1990)

JEAN STERN

Wertmüller, Adolf Ulric [Ulrik] (*b* Stockholm, 19 Feb 1751; *d* Chester, DE, 5 Oct 1811). Swedish painter, active also in France, Spain and the USA. He was trained in sculpture and painting at the Stockholm Academy and was a student of Joseph-Marie Vien in Paris (1772–5) and Rome (1775–9). In 1781 he settled in Paris, painting *Ariadne on the Shore of Naxos* (1783; Stockholm, Nmus.), a meticulously executed Neo-classical work. He became a member of the French Academy in 1784 and First Painter to Gustavus III of Sweden (*reg* 1771–92). The latter commissioned him in 1784 to paint the massive *Marie*

Antoinette and her two Children Walking in the Trianon Gardens (Stockholm, Nmus.). Wertmüller's most interesting work, *Danaë and the Shower of Gold* (1787; Stockholm, Nmus.), a masterpiece of mythological portrayal, is the foremost example of Swedish Neo-classical painting.

A lack of portrait commissions in Paris prompted Wertmüller in 1788 to go and work for wealthy merchants in Bordeaux, Madrid and Cadiz. His career as a portrait painter proceeded successfully; his portraits display an unsentimental and cool, smooth style. In 1794 he went to Philadelphia, where he painted *George Washington* in an intimate, realistic manner (1794; New York, Met.). During the following two years he produced portraits in Philadelphia, Annapolis and New York. Wertmüller went back to Sweden from 1797 to 1799, mostly painting family and friends. In 1800 he returned to the USA. His *Danaë*, which was shown to the public in Philadelphia in 1806, led to some commissions in 1806–8, but from 1802, due to failing sight, Wertmüller almost wholly abandoned painting for farming in Delaware.

BIBLIOGRAPHY

SKVL

M. N. Benisovich: 'Wertmüller et son livre de raison intitulé la Notte', *Gaz. B.-A.*, xlviii (1956), p. 51

——: 'Further Notes on A. U. Wertmüller in the United States and France', *A. Q.* [Detroit], xxvi (1963), pp. 7–30

F. D. Scott: *Wertmüller: Artist and Immigrant Farmer* (Chicago, 1963)

G. W. Lundberg: *Le Peintre suédois de Marie-Antoinette: Adolf Ulrik Wertmüller à Bordeaux, 1788–1790* (Bordeaux, 1970)

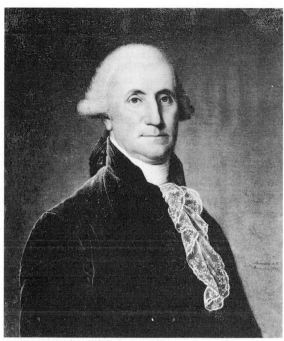

Adolf Ulric Wertmüller: *George Washington*, oil on canvas, 764×537 mm, 1794 (New York, Metropolitan Museum of Art)

——: *Le Peintre suédois: Adolf Ulrik Wertmüller à Lyon, 1779–1781* (Lyon, 1973)

MARIANNE UGGLA

West, Benjamin (*b* Springfield [now Swarthmore], PA, 10 Oct 1738; *d* London, 11 March 1820). American painter and draughtsman, active in England. He was the first American artist to achieve an international reputation and to influence artistic trends in Europe. He taught three generations of his aspiring countrymen. His son Raphael Lamar West (1769–1850) was a history painter.

1. Life and work. 2. Reputation.

1. LIFE AND WORK.

(i) Early career, 1738–60. (ii) Italy and early years in England, 1760–92. (iii) President of the Royal Academy, 1792–1805. (iv) Later career, after 1805.

(i) Early career, 1738–60. He was one of ten children of a rural innkeeper whose Quaker family had moved to the USA in 1699 from Long Crendon, Bucks. In romantic legends perpetuated by the artist himself, he is pictured as an untutored *Wunderkind*. However, it has become clear that West received considerable support from talented and generous benefactors. West's earliest known portraits, *Robert Morris* and *Jane Morris* (both West Chester, PA, Chester Co. Hist. Soc. Mus.), date from about 1752. He spent a year (probably 1755–6) painting portraits in Lancaster, PA, where one of his subjects, William Henry (Philadelphia, PA, Hist. Soc.), a master gunsmith, told him of a nobler art than painting faces—that of depicting morally uplifting historical and biblical episodes. West obliged him by painting the *Death of Socrates* (*c.* 1756; priv. col., see von Erffa and Staley, no. 4), which, notwithstanding its crude style and frieze-like composition, anticipated

European Neo-classical painting by several decades. Rev. William Smith (1727–1803), principal of the College of Philadelphia, was so impressed by the work that he gave West informal instruction in Classical art, literature and history.

In 1756, West moved to Philadelphia, PA, where he was taught by, among others, William Williams and John Valentine Heidt (*c.* 1700–1780), a Moravian lay preacher who had been trained as a painter and metal-engraver. Williams lent West his landscapes to copy, as well as editions of Charles Alphonse Du Fresnoy's *De arte graphica* and Jonathan Richardson's *An Essay on the Theory of Painting*. West spent almost a year painting portraits in New York, hoping to earn enough to study in Italy. In 1760 two leading Philadelphia families, the Allens and the Shippens, gave him free passage to Italy and later advanced him $300 as payment for copies of Old Master paintings he was to make for them.

(ii) Italy and early years in England, 1760–92. West embarked for Livorno in April 1760. E. P. Richardson described his journey as an act of profound importance to American art; West was the first American painter to transcend the boundaries of the Colonial portrait tradition, to enlarge the field of subjects that painting could deal with and eventually to take part in the great movements of Neo-classical and Romantic idealism that were to dominate European culture for the next 75 years.

West arrived in Rome in July. Personal charm, good looks, excellent letters of introduction and his unique position as an American (and a presumed Quaker) studying art in Italy endeared him at once 'in a constant state of high excitement' to artistic society. Anton Raphael Mengs (1728–79) taught him at the Capitoline Academy and sent him to study art collections in northern Italy. He was made a member of the academies at Bologna, Florence and Parma. Gavin Hamilton (1723–98), who in the early 1760s was painting the first works in the Neo-classical style, spent time with West, no doubt conveying to him his enthusiasm for antiquity.

West arrived in England in August 1763, intending to make a short visit before he returned to America. He showed two Neo-classical works that he had painted in Rome, the *Continence of Scipio* (*c.* 1766; Cambridge, Fitzwilliam) and *Pylades and Orestes* (1766; London, Tate), at the Society of Arts exhibition of 1766, where they caused an artistic furore. 'He is really a wonder of a man', his patron, William Allen, wrote to Philadelphia, 'and has so far outstripped all the painters of his time [in getting] into high esteem at once.... If he keeps his health he will make money very fast' (see Kimball and Quin). On the advice of his American patrons, he decided to stay in England. He married Elizabeth Shewell, the daughter of a Philadelphia merchant, in London in 1764. One of West's admirers, Dr Robert Hay Drummond, Archbishop of York, asked him to paint an episode famous in Roman history, *Agrippina Landing at Brundisium with the Ashes of Germanicus* (1768; New Haven, CT, Yale U. A.G.). West drew on his sketches and drawings of Classical dress, sculpture and architecture to depict a moment frozen in history with a haunting sense of time, place and actuality. He combined a cool palette with a severe composition and calculated

gestures. The work created a sensation when it was exhibited in 1768. With this picture of Roman courage, grief and conjugal virtue, West became at once the foremost history painter in England and the most advanced proponent of the Neo-classical style in Europe (see colour pl. V, 3).

George III (*reg* 1760–1820), who admired the picture, asked West to paint for him another episode from Roman history, the *Departure of Regulus from Rome* (1769; Brit. Royal Col.), and thereafter made him historical painter to the King with an annual stipend of £1000, which freed West from the need to support himself by painting portraits. The King commissioned West to paint 36 scenes depicting the *History of Revealed Religion* for the Royal Chapel at Windsor Castle. Although saints and the Virgin were excluded as subjects, they broke the Protestant barrier in English churches against 'Popish pictures'. West completed 18 large canvases, including the *Last Supper* (1784; London, Tate). However, they were never installed, and remained in the artist's studio until after his death. Between 1787 and 1789 he also painted for the King's Audience Room at Windsor a series of vast canvases celebrating British victories during the Hundred Years' War and the Foundation of the Order of the Garter (Brit. Royal Col.). West's concern for accurate detail reflects the antiquarian research of Joseph Strutt (1749–1802) and marks a considerable advance on earlier 18th-century history painting in England.

In 1771 West exhibited the *Death of General Wolfe* (see fig. 1), the painting for which he is best known. Despite the advice of his peers and of the King, he painted Wolfe and his men as they were dressed at Quebec in 1759 rather than in Greek or Roman attire, although by including an Indian guide in the foreground he was able to display a more conventional talent for painting the nude. The work was an immediate popular and critical success; four replicas were commissioned, including one for the King. West's achievement in bringing a new realism to history painting by his care in recording the exact details of the participants and their costume was widely recognized. Reynolds predicted that it would 'occasion a revolution in the art'. At the same time the composition made a ready appeal to the emotions of the spectator by recalling the long tradition of the Christian Pietà. He followed a year later with another historical painting, *William Penn's Treaty with the Indians* (1771–2; Philadelphia, PA, Acad. F.A.). West was one of the first artists to realize the commercial and publicity value of mechanical reproduction of his works: engravings of these paintings (by John Hall, 1775, and William Woollet, 1776) were sold by the tens of thousands in Europe and America.

(iii) President of the Royal Academy, 1792–1805. In 1768 West and three other dissident officers of the Society of Artists, at the King's suggestion and with his financial support, had drawn up an 'Instrument of Foundation' for a new association of 40 artists to be called the Royal Academy of Arts. Joshua Reynolds was the first president, and when he died in 1792, West was elected to succeed

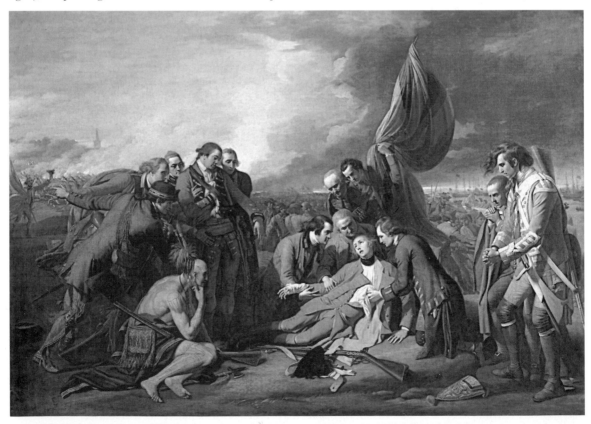

1. Benjamin West: *Death of General Wolfe*, oil on canvas, 1.52×2.14 m, 1770 (Ottawa, National Gallery of Canada)

him. As President of the Royal Academy, the major recipient of the King's patronage and the leading artist in Neo-classical and realistic history painting, West held a position of commanding authority in English art. His influence was further extended by what came to be known as 'the American school'. Almost from the time of his arrival in London, West's home and studio became a haven for American artists seeking advice, employment or instruction. Matthew Pratt, who stayed for two and a half years, was followed by a succession of other students remarkable both for their number and their talent. The first generation included Gilbert Stuart (his paid assistant for some four years), Charles Willson Peale, Ralph Earl, Joseph Wright, William Dunlap, John Trumbull, Robert Fulton (1765–1815), Henry Benbridge and Abraham Delanoy (1742–95). Even West's severest critics have allowed that he was an unfailingly kind and generous mentor, not only to Americans but also to English pupils. He made known his admiration for the early work of William Blake (1757–1827) and Turner (1775–1851), and he gave Constable (1776–1837) encouragement that was gratefully acknowledged. John Singleton Copley, though never his student, sought West's advice on taking up a career in London.

West's influence was extended as a discreet seller, trader and collector of works of art. He was known to be the King's buyer at auctions, was often consulted on appraisals, attributions and prices of paintings and testified in some notable lawsuits involving artists' fees and the quality of engravings. In 1779 he and a colleague were commissioned to place a valuation on 174 Old Master paintings in the collection of Robert Walpole at Houghton Hall in Norfolk (Walpole had urged Parliament to buy his entire collection, but Catherine II (reg 1762–96), Empress of Russia, acquired it at West's price of £40,555). West engaged in a costly and unsuccessful speculative venture with his pupil John Trumbull in attempting to import Old Master works from France. His great triumph came in 1785, when he bought for 20 guineas at auction, amid general laughter, a dirty, wax-encrusted landscape, having identified it as the *Death of Actaeon* (London, N.G.) by Titian (c. ? 1485/90–1576).

West was able to keep George III's favour throughout the American War of Independence (1775–83), despite his unconcealed sympathy for his rebellious countrymen. He was, indeed, almost a member of the royal household, with working rooms in Buckingham House and Windsor Castle. In the 1790s, however, he was criticized at the court for holding 'French principles' and for praising Napoleon Bonaparte (reg 1804–14). He incurred the dislike of Queen Charlotte, and George, intermittently ill after 1788, wavered in his friendship and support. In 1802, during the lull in the war with France, West made a five-week visit to Paris, where Napoleon met with him, and French artists, including Jacques-Louis David (1748–1825), paid him homage. Thereafter West's stipend as history painter to the King and his *History of Revealed Religion* commission were cancelled. His troubles were further compounded by two improvident sons, the death of his ailing wife in 1814, heavy debts, a bad investment in American land, a decline in public favour and a group of hostile Royal Academicians, including Copley, who in 1805 forced him to resign as President.

(iv) Later career, after 1805. At 66 West accomplished a remarkable recovery. He found a new wealthy patron in William Beckford (1760–1844) of Fonthill Abbey, Wilts. He scored a stunning popular success with the *Death of Lord Nelson* (1806; Liverpool, Walker A.G.). He surpassed that triumph with two huge religious paintings: *Christ

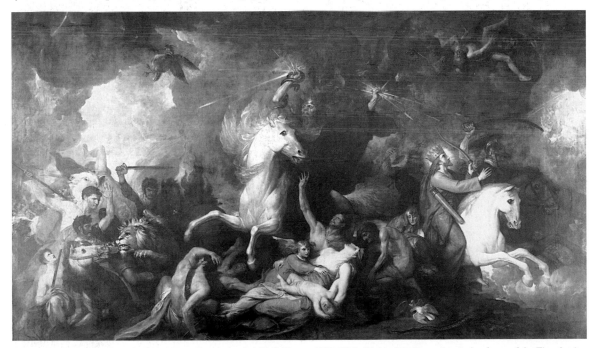

2. Benjamin West: *Death on the Pale Horse*, oil on canvas, 4.47×7.65 mm, 1817 (Philadelphia, PA, Pennsylvania Academy of the Fine Arts)

Healing the Sick in the Temple (2.74×4.27 m, 1811; London, Tate), which he painted over a ten-year period for the Pennsylvania Hospital in Philadelphia, was sold to the British Institution for the unheard-of price of 3000 guineas (four years later an 'improved version' was sent to the hospital; *in situ*); *Our Saviour Brought from the Judgement Hall by Pilate to Caiaphas the High Priest*, commonly known as *Christ Rejected* (5.08×6.60 m, 1814; Philadelphia, PA, Acad. F.A.), is still more ambitious in scale than *Christ Healing the Sick* (it includes more than 60 faces) and was greeted with great popular and critical acclaim. West introduced still another new direction in painting with his huge *Death on the Pale Horse* (see fig. 2). Drawing on contemporary conceptions of the Sublime, it combines Christian imagery of the Apocalypse with pagan myth in a frenzy of movement that foreshadows Delacroix (1798–1863) and the Romantic movement in European art. West introduced the Romantic style into portrait painting with his small *General Kosciuszko in London* (1797; Oberlin Coll., OH, Allen Mem. A. Mus.) and *Robert Fulton* (1806; Cooperstown, NY, Mus. State Hist. Assoc.). In 1806 he accepted the pleas of the Royal Academicians to resume the presidency and to restore harmony to the Academy.

West's last years were productive and relatively peaceful. He testified before a government commission on the value of 'those sublime sculptures', the Parthenon Marbles (London, BM). He played a role in the founding of the British Academy, which became the National Gallery. He continued pioneering work he had undertaken in the new medium of lithography, having contributed to *Specimens of Polyantography* (1803). He achieved a new celebrity in 1816 with the publication of the first volume of his biography by John Galt. He welcomed, taught and sometimes housed members of another generation of talented young American students, among them Washington Allston, Rembrandt Peale, Samuel F. B. Morse, Charles Bird King, Charles Robert Leslie and Thomas Sully.

2. REPUTATION. West's reputation as an artist and teacher began to decline with his death. For more than a century, because of the weakness of his technique and lack of imagination in much of his work, his paintings were ignored or were cited as examples of all that was meretricious in art. Critical opinion began to change with a bicentennial exhibition of his work at the Philadelphia Museum of Art in 1938. He is generally recognized as 'a stylistic innovator of immense influence' and as the artist who first attempted to bring American art into contiguity with European art.

BIBLIOGRAPHY
J. Galt: *The Life, Studies, and Works of Benjamin West. Composed from Materials Furnished by Himself*, 2 vols (London, 1816–20)
W. Dunlap: *A History of the Rise and Progress of the Arts of Design in the United States*, 3 vols (New York, 1834/*R* 1969)
W. Sawitzky: 'The American Work of Benjamin West', *PA Mag. Hist. & Biog.*, lxii (1938), pp. 433–62
J. T. Flexner: *America's Old Masters: First Artists of the New World* (New York, 1939, rev. 2/1967), pp. 19–97
——: 'The American School in London', *Bull. Met. Mus. A.*, n. s., vii (1948), pp. 64–72
E. P. Richardson: *Painting in America: The Story of 450 Years* (New York, 1956)
D.A. Kimball and M. Quinn: 'William Allen–Benjamin Chew Correspondence, 1763–1764', *PA Mag. Hist. & Biog.*, xc (1966)
G. Evans: *Benjamin West and the Taste of his Times* (Carbondale, 1959)
Drawings by Benjamin West and his Son Raphael Lamar West (exh. cat. by R. S. Kraemer, New York, Pierpont Morgan Lib., 1975)
J. Dillenberger: *Benjamin West: The Context of his Life's Work, with Particular Attention to Paintings with Religious Subject Matter* (San Antonio, 1977)
R. C. Alberts: *Benjamin West: A Biography* (Boston, 1978)
K. Garlick, A. Macintyre and K. Cave, eds: *The Diary of Joseph Farington, 1793–1821*, 16 vols (New Haven, 1978)
E. P. Richardson: 'West's Voyage to Italy, 1760, and William Allen', *PA Mag. Hist. & Biog.*, cii (1978), pp. 3–26
D. Evans: *Benjamin West and his American Students* (Washington, DC, 1980)
A. U. Abrams: *The Valiant Hero: Benjamin West and Grand-style Historical Painting* (Washington, DC, 1985)
W. Greenhouse: 'Benjamin West and Edward III: A Neoclassical Painter and Medieval History', *A. Hist.*, viii (1985), pp. 178–91
H. von Erffa and A. Staley: *The Paintings of Benjamin West* (New Haven, 1986)
Benjamin West Drawings from the Historical Society of Pennsylvania (exh. cat. by S. Weintraub and R. Ploog, University Park, PA State U., Mus. A., 1987)
Benjamin West: American Painter at the English Court (exh. cat. by A. Staley, Baltimore, MD, Mus. A., 1989)
Benjamin West: Romanticism in Religious Drawings (exh. cat., Wilmington, DE, A. Mus., 1989)
M. H. Duffy: 'West's *Agrippina*, *Wolfe* and the Expression of Restraint', *Z. Kstgesch.*, lviii/2 (1995), pp. 207–25
A. S. Marks: 'Benjamin West's *Jonah*: A Previously Overlooked Illustration for the First Oratorio Composed in the New World', *Amer. A. J.*, xxviii, 1/2 (1997), pp. 122–37
A. Einhorn and T. S. Abler: 'Tattooed Bodies and Severed Auricles: Images of Native American Body Modification in the Art of Benjamin West', *Amer. Ind. A. Mag.*, xxiii/4 (Autumn 1998), pp. 42–53

ROBERT C. ALBERTS

Wharton [née Newbold Jones], **Edith** (*b* New York, 24 Jan 1862; *d* Pavillon Colombe, nr Paris, 11 Aug 1937). American writer. She was born into a wealthy New York family and was educated privately; she travelled widely, settling in France in 1907. Her first book was *The Decoration of Houses* (1898), written in collaboration with the Boston architect Ogden Codman (who had remodelled her home at Newport, RI, in 1893). Their aim was to raise the standard of decoration in modern houses to that of the past through a return to 'architectural proportion' and an avoidance of the 'superficial application of ornament'. Each room should be furnished for comfort and according to its use and should be organically related to the rest of the house and the quality of life to be expressed. The work was successful and influential among both the public and such decorators as Elsie De Wolfe and William Odom. Wharton's house in Lenox, MA, the Mount, built to her design from 1901 by Francis L. V. Hoppin (after Codman's early dismissal), displayed many of the classical features of symmetry, decorum and restraint found in her book.

Wharton's second art-historical work, *Italian Villas and their Gardens* (1904), provides a competent survey of Renaissance garden planning and villa architecture, with a reading list (as in *The Decoration of Houses*) in four languages and short biographies of the designers cited. She draws a modern lesson from the 'harmony of design' of the Italian garden, its logical divisions and the relation of its architectural lines to those of the villa and the landscape. The accompanying illustrations from original watercolours by Maxfield Parrish are fanciful and vague, inappropriate to the rigorous accuracy of the text, as reviewers (and Wharton herself) were quick to note. Her most serious travel book, *Italian Backgrounds* (1905), with

more suitable line drawings by E. C. Peixotto (1869–1940), contends that a study of Italy is like the paintings of Vittore Carpaccio (? 1460/6–1525/6) or Carlo Crivelli (?1430/5–1495), the formal foreground being the property of the guidebook that must be known before the background, which is the province of the 'dreamer' and the 'student'. Descriptions of Italian towns and buildings are thus interspersed with speculations about the dating and provenance of obscure works of art. Although Wharton produced no other art-historical writings, her fiction shows a continuing interest in the effect of taste, setting and décor as a gauge for character and situation.

WRITINGS

with O. Codman: *The Decoration of Houses* (New York, 1898); repr. with critical essays by J. B. Bayley and W. A. Coles (New York, 1978)
Italian Villas and their Gardens (New York, 1904/R 1976)
Italian Backgrounds (New York, 1905)
A Backward Glance (New York, 1934) [autobiography]

BIBLIOGRAPHY

'Pen and Pencil in Italy' [review of *Italian Villas and their Gardens*], *The Critic*, xlvi/2 (1905), pp. 167–8
R. W. B. Lewis: *Edith Wharton: A Biography* (London, 1975)
J. Fryer: *Felicitous Spaces* (Chapel Hill and London, 1986), pp. 53–199
T. Craig: *Edith Wharton: A House Full of Rooms, Architecture, Interiors and Gardens* (New York, 1996)

EDWINA BURNESS

Wheeler, Candace (Thurber) (*b* Delhi, Delaware Co., New York, 1827; *d* 5 Aug 1923). American designer. She came from a prosperous and artistic background. She saw the Royal School of Needlework's exhibition at the Centennial International Exhibition of 1876 in Philadelphia, which inspired her to found, in 1877, the Society of Decorative Arts of New York City, the aim of which was to restore the status of crafts traditionally associated with women and provide them with the opportunity to produce high-quality, handmade work which could be profit-making. The Society, which generated sister branches in major American cities, taught many design and craft techniques, but art needlework remained the focus. In 1879 Wheeler entered into partnership with Louis Comfort Tiffany (*see* TIFFANY, §2) to form Louis C. Tiffany & Associated Artists, which, by the early 1880s, was the most successful decorating firm in New York. She designed embroideries, textiles and wallpaper for the company, but in 1883 the partnership was dissolved. Wheeler retained the Associated Artists name and continued to practise (e.g. portière, *c.* 1884; New York, Met.; see fig.). While still handling private commissions, she was asked by textile manufacturers to produce designs for such mass-produced fabrics as printed cotton. In addition to working in the Japanese idiom, she was instrumental in initiating designs inspired by traditional American patchwork, indigenous flora and fauna and events from American history and literature. In 1893 she was appointed Director for the Women's Building at the World's Columbian Exposition in Chicago. At the end of 1899 she retired from Associated Artists but continued to contribute to Arts and Crafts literature.

WRITINGS

The Development of Embroidery in America (New York and London, 1921)

BIBLIOGRAPHY

A. I. Prather-Moses: *Women Workers in the Decorative Arts* (Metuchen, NJ, 1981)
J. Dunbar: 'One House at a Time', *Preserv.*, l/5 (1998), pp. 60–67

JOHN MAWER

Candace Wheeler: portière, embroidered basket-weave silk and plush, 2.36×1.49 m, *c.* 1884 (New York, Metropolitan Museum of Art)

Wheeler, Gervase (*b* ?London, *c.* 1815; *d* London, *c.* 1872). English architect and writer, active in the USA. He was the son of a jeweller and trained under R. C. Carpenter. In the 1840s he emigrated to the USA and established a practice first in Hartford, CT, later moving to Philadelphia. From 1851 to 1860 he worked in New York. In 1860 his address was listed as the Brooklyn Post Office (destr.), a building that he had designed. Apparently Wheeler returned to London in the same year, for his name no longer appeared in New York city directories after that date. In London he continued to practise architecture and in 1867 became a FRIBA.

Most of Wheeler's known commissions were for houses. His designs, which appeared in architectural periodicals and in his own books, contributed to the growing body of literature in the USA that concentrated on the detached middle-class dwelling as a building type. A champion of affordable housing, Wheeler attracted the attention of A. J. Downing, who published designs for houses by Wheeler in his book *The Architecture of Country Houses* (New York, 1850), as well as in *The Horticulturist*, the journal that he edited. The large house that Wheeler built in 1849 for Henry Boody in Brunswick, ME, was praised by Downing for its well-conceived plan and its economical construction. He also admired its board-and-batten exterior as it expressed the internal frame. The house was one of the early and best examples of this form of construction that, largely because of Downing's prose-

lytizing, became a popular feature of American Gothic Revival houses. The brick Patrick Barry House (1855) in Rochester, NY, was built in an Italianate style, which Wheeler regarded as particularly suited to suburban residences. Sited on grounds laid out by the nurseryman who commissioned the building, the Barry house is a splendid example of the mid-Victorian ideal of the union of Picturesque architecture with cultivated nature.

Downing's endorsement of Wheeler's work must have encouraged Wheeler to think that a successful career lay before him in the USA, but with the publication of Wheeler's *Rural Homes* in 1851, Downing abruptly withdrew his support. In a review of the book—which, with Downing's works, was one of the earliest American pattern-books of house design—Downing called Wheeler a 'pseudo-architect from abroad' who 'borrowed from the works of native authors who have trodden the same ground more earnestly and truthfully before him'. Downing was particularly incensed over Wheeler's inadequate verandahs. Wheeler's Henry Olmsted House (1849; destr.) in East Hartford, CT, was criticized by Downing for its excessively tall roof, which would make the bedrooms hot in summer.

Downing's rejection must have hurt Wheeler's chances of attracting clients. The number of works Wheeler is known to have designed is small, although he managed to secure commissions from Bowdoin College, Brunswick, ME, and Williams College, Williamstown, MA, and for New York University. Rockwood (begun 1849; destr.), the estate near Tarrytown, NY, which he designed for Edwin Bartlett, was one of the finest country seats in the USA. In 1855 Wheeler published another book on domestic architecture, *Homes for the People*, which illustrated a number of wooden houses with decorative external framing reflecting the influence of medieval half-timbering as well as contemporary continental picturesque architecture. When he returned to England, he published a third volume on house architecture, *The Choice of a Dwelling* (1871). In it he discussed certain American practices and suggested that they might be adapted for British usage. He also praised American houses for the way reception rooms could be thrown together by means of sliding doors to form larger spaces to accommodate the 'party-giving spirit of the Americans', and illustrated plans of houses he had designed during his time in the USA.

WRITINGS
Rural Homes: Or Sketches of Houses Suited to American Country Life (New York, 1851)
Homes for the People, in Suburb and Country (New York, 1855/R 1972)
The Choice of a Dwelling (London, 1871)

BIBLIOGRAPHY
Macmillan Enc. Archit
V. J. Scully jr: 'Romantic Rationalism and the Expression of Structure in Wood: Downing, Wheeler, Gardner and the "Stick Style", 1840–1876', *The Shingle Style and the Stick Style* (New Haven, CT, rev. 1971), pp. xxiii–lix [this introductory essay is not in first edn of 1955]
M. Tomlin: 'The Domestic Architectural Styles of Henry Hudson Holly', *Country Seats and Modern Dwellings* (Watkins Glen, NY, 1977), pp. 3–12

FRANCIS R. KOWSKY

Wheelwright, Edmund M(arch) (*b* Roxbury, MA, 14 Sept 1854; *d* Thompsonville, CT, 14 Aug 1912). American architect and writer. He studied architecture at Massachu-

setts Institute of Technology, Cambridge, MA, and worked for Peabody & Stearns in Boston, McKim, Mead & Bigelow in New York and E. P. Treadwell in Albany, NY, before establishing his own practice in 1883. He took Parkman B. Haven (1858–1943) as his partner in 1888, the firm becoming Wheelwright & Haven, and added Edward H. Hoyt (1868–1936) to the firm in 1912 (Wheelwright, Haven & Hoyt). He was strongly influenced by developments in England and the Continent, as a result of an extended sketching tour abroad in 1881–2.

As City Architect of Boston (1891–5), Wheelwright designed about a hundred municipal buildings—hospitals, fire and police stations, park facilities and especially schools—as well as reforming his own department. He also had a large and varied independent practice and served as consulting architect for several major museums, including the Boston Museum of Fine Arts.

Combining historical precedents with his rich imagination, Wheelwright used a broad range of styles, as in the stone and shingle Picturesque summer seaside cottage (1883, destr.) for E. C. Stedman at Newcastle, NH; the sedate half-timbered, multi-gabled Islesboro Inn (1890, destr.), Islesboro, ME; the redbrick Choate Burnham School (1894), South Boston, with features derived from the northern Italian Renaissance; the Georgian Revival façade, in red brick with limestone dressings, of the Horticultural Hall (1900), Boston, which has a sequence of pilasters to an ornamental entablature; and the Lampoon Building (1909; see fig.), Harvard University, Cambridge,

Edmund M. Wheelwright: Lampoon Building, Harvard University, Cambridge, Massachusetts, 1909

MA, with its Gothic-inspired treatment of the red brick. Wheelwright was noted for his practice of freely combining diverse stylistic elements within a single design. He was the author of many scholarly articles as well as a book, *School Architecture*, and his municipal designs were also published.

UNPUBLISHED SOURCES
Boston, MA, Hist. Soc. [Wheelwright family papers]
Boston, MA, Pub. Lib. [Haven & Hoyt Col.]

WRITINGS
F. W. Chandler, ed.: *Municipal Architecture in Boston from Designs by Edmund M. Wheelwright, City Architect, 1891 to 1895*, 2 vols (Boston, 1898)
School Architecture (Boston, 1901)

BIBLIOGRAPHY
G. W. Sheldon, ed.: *Artistic Country-seats: Types of Recent American Villa and Cottage Architecture with Instances of Country Club-houses*, 2 vols (New York, 1886)
'Annual Reports of the Architect Department', *Documents of the City of Boston* (Boston, 1891–4)

CAROLE A. JENSEN

Whidden & Lewis. American architectural partnership formed in 1889 in Portland, OR, by William M(arcy) Whidden (*b* Boston, MA, 10 Feb 1857; *d* Portland, OR, 27 July 1929) and Ion Lewis (*b* Lynn, MA, 26 March 1858; *d* Portland, OR, 27 Aug 1933) and active until Lewis's death. Both Whidden and Lewis attended the Massachusetts Institute of Technology (MIT), Cambridge, during the mid-1870s. After MIT, Whidden spent four years at the Ecole des Beaux-Arts in Paris. He returned to New York in 1882 and joined McKim, Mead & White. Under McKim, Whidden worked on the Portland Hotel design and supervised construction until work was halted late that year. Whidden returned east to work in Boston. In 1888 he was commissioned to oversee completion of the hotel.

After graduation from MIT, Lewis was employed by Peabody & Stearns in Boston. He left the firm in 1882 and formed a partnership with Henry Paston Clark. A few years later he moved west, working for a time in Chicago before his arrival in Portland in 1889, when he visited Whidden and stayed to join him in partnership. The arrival of Whidden & Lewis marked the coming-of-age of architecture in Portland. They introduced the latest East Coast styles, particularly the Colonial Revival in residential designs, and the neo-classic revivals in commercial and institutional projects. Whidden & Lewis was Portland's pre-eminent architectural firm for two decades. Notable examples of their work include Portland Public Library (1891; destr. 1914), inspired by McKim, Mead & White's Boston Library, the Hamilton Building (1893), the Renaissance Revival Portland City Hall (1895), the Arlington Club (1909) and Multnomah County Courthouse (1909).

BIBLIOGRAPHY
T. Vaughan and G. McMath: *A Century of Portland Architecture* (Portland, 1967)
T. Vaughan and V. Ferriday, eds: *Space, Style and Structure: Building in Northwest America*, 2 vols (Portland, 1974)
R. Marlitt: *Matters of Proportion: The Portland Residential Architecture of Whidden & Lewis* (Portland, 1989)

GEORGE A. McMATH

Whistler, James (Abbott) McNeill (*b* Lowell, MA, 11 July 1834; *d* London, 17 July 1903). American painter, printmaker, designer and collector, active in England and France. He developed from the Realism of Courbet (1819–77) and Manet (1832–83) to become, in the 1860s, one of the leading members of the Aesthetic Movement and an important exponent of Japonisme. From the 1860s he increasingly adopted non-specific and often musical titles for his work, which emphasized his interest in the manipulation of colour and mood for their own sake rather than for the conventional depiction of subject. He acted as an important link between the avant-garde artistic worlds of Europe, Britain and the USA and has always been acknowledged as one of the masters of etching.

From his monogram JW, Whistler evolved a butterfly signature, which he used after 1869. After his mother's death in 1881, he added her maiden name, McNeill, and signed letters *J. A. McN. Whistler*. Finally he dropped 'Abbott' entirely.

1. Life and work. 2. Working methods and technique. 3. Personality and influence.

1. LIFE AND WORK.

(i) Early life, 1834–59. (ii) 1859–66. (iii) 1866–77. (iv) 1877–94. (v) Later life, 1894–1903.

(i) Early life, 1834–59. The son of Major George Washington Whistler, a railway engineer, and his second wife, Anna Matilda McNeill, James moved with his family in 1843 from the USA to St Petersburg in Russia, where he had art lessons from a student, Alexander O. Karitzky, and at the Imperial Academy of Science. In 1847 he was given a volume of engravings by William Hogarth (1697–1764), which made a great impact on him. In 1848 he settled in England, attending school near Bristol and spending holidays with his step-sister Deborah and her husband, the collector Seymour Haden (1818–1910), who sent Whistler to lectures by Charles Robert Leslie (1794–1859) at the Royal Academy, London, and showed him his etchings by Rembrandt (1606–69). William Boxall (1800–79) painted Whistler's portrait (exh. RA 1849; U. Glasgow, Hunterian A.G.), showed him the cartoons at Hampton Court Palace by Raphael (1483–1520) and gave him a copy of Mrs Jameson's *Italian Painters* (1845).

After Major Whistler's death in 1849, James returned to America and entered the US Military Academy, West Point, NY, in 1851. At Robert W. Weir's classes he copied European prints. He also produced caricatures and illustrations to Walter Scott and Dickens, influenced by Paul Gavarni (1804–66) and George Cruikshank (1792–1878). Whistler's first published work was the title-page of a song sheet, *Song of the Graduates* (1852; MacDonald, no. 108). Although he received top marks for art and French, he had to leave West Point in 1854 for failing chemistry. He joined the drawing division of the US Coast and Geodetic Survey in Washington, DC, where he learnt to etch (e.g. the *Coast Survey Plate*, 1855; Kennedy, no. 1). In 1855 he left, took a studio in Washington and painted a portrait of his first patron, *Thomas Winans* (untraced; see Young and others, no. 3). He made his first lithograph, the *Standard Bearer* (Chicago, no. 2), with the help of Frank B. Mayer (1827–99) in Baltimore.

At 21 Whistler sailed for Europe, determined to make a career as an artist. He joined the Ecole Impériale et

Spéciale de Dessin in Paris, where Degas (1834–1917) was also a student, and in 1856 entered the studio of Charles Gleyre (1806–74). His copies in the Louvre included *Roger Freeing Angelica* (copy; U. Glasgow, Hunterian A.G.; Young, MacDonald, Spencer and Miles, no. 11) by Ingres (1780–1867). With Henri Martin (1860–1943) he saw Dutch etchings and paintings by Velázquez (1599–1660) at the Manchester Art Treasures Exhibition in 1857. In Paris he met the English painters Edward Poynter (1836–1919), T. R. Lamont (1826–98), George Du Maurier (1834–96) and Thomas Armstrong (1832–1911), and in 1857 he asked them to etch illustrations to accompany his studio scene *Au sixième* (K 3) in an ultimately abortive joint venture known as 'PLAWD'. Whistler was encouraged to etch from nature by Haden. In 1858, while touring the Rhineland with an artist–friend Ernest Delannoy, he etched five or six plates and traced others from sketches. *Douze eaux-fortes d'après nature* (known as the 'French Set') has seven Rhineland plates, dramatic compositions with finely modelled figures drawn with confident and varied line. Dedicated to Haden, 20 sets were printed in 1858 at the shop of Auguste Delâtre (1822–1907), and a further 50 sets were later printed in London. Also in 1858 Whistler met Henri Fantin-Latour (1836–1904) and Alphonse Legros (1837–1911), who shared his interest in printmaking and respect for Courbet and Dutch 17th-century and Spanish art. Together they formed the informal Société des Trois. Whistler went with Fantin-Latour to the Café Molière and showed the 'French Set' to Courbet and Félix Bracquemond (1833–1914).

In November 1858 Whistler painted his first major oil, *At the Piano* (Cincinnati, OH, Taft Mus.; YMSM 24), which features Deborah Haden and her daughter. The predominantly sombre tonality and broad brushwork reflect his study of Courbet and Velázquez. The figures have a convincing solidity set against the rectangles formed by the dado and pictures on the wall behind—a formula Whistler often applied in later works. Rejected at the Salon in 1859, it hung with works by Legros and Fantin-Latour (with which it had obvious affinities) at the studio of François Bonvin (1817–87), where Courbet admired it.

(ii) 1859–66. The failure of *At the Piano* in Paris and the favourable reception given the 'French Set' in Britain encouraged Whistler to move in 1859 to London, where he remained for most of his life. That same year he took rooms in Wapping on the River Thames and began the series of etchings known as the 'Thames Set' (*Sixteen Etchings of the Thames*). He completed most of the etchings that year, taking just three weeks to capture the fine detail of rickety warehouses and barges in *Black Lion Wharf* (K 42). The success of this series established Whistler's reputation as an etcher.

In 1860 *At the Piano* was accepted by the Royal Academy and bought by John Phillip (1817–67). *The Times* critic wrote 'it reminds me irresistibly of Velasquez' (17 May 1860). The same year Whistler began to paint *Wapping* (Washington, DC, N.G.A.; Y 35) from the balcony of The Angel, an inn at Cherry Gardens, Rotherhithe. He reworked the picture completely over four years: at first Joanna Heffernan, the coppery red-haired Irish model who became his mistress, was posed looking out over the

Thames; later she was seated with two men at a table, a sailor from the Greaves boatyard and an old man, for whom Legros was later substituted. This colourful and atmospheric picture was bought by Winans and shown in New York in 1866 and at the Exposition Universelle in Paris in 1867.

Joanna posed in Paris in December 1861 for *Symphony in White, No. 1: The White Girl* (Washington, DC, N.G.A.; Y 38), the first of Whistler's four *Symphonies in White* (*see also* colour pl. XV, 2). It was rejected by the Royal Academy and hung at a small London gallery. Whistler claimed that the subject was not the heroine of Wilkie Collins's novel *The Woman in White*, first published serially in 1859–60, 'it simply represents a girl dressed in white standing in front of a white curtain' (*The Athenaeum*, 5 July 1862). In 1863 it shared a *succès de scandale* with Edouard Manet's *Déjeuner sur l'herbe* at the Salon des Refusés. It was Paul Mantz, in the *Gazette des Beaux Arts*, who called it a 'Symphonie du blanc'; he was the first to associate Whistler's paintings with music. Later Whistler blamed Courbet for the painting's realism, and between 1867 and 1872 he reworked it to make it more spiritual.

Whistler's first contact with the Pre-Raphaelites was in 1862, when he met Dante Gabriel Rossetti (1828–82) and Algernon Swinburne (1837–1909). In 1863 he moved to Chelsea, near Rossetti's home and the boatyard of the Greaves family, two of whose members, Walter ((1846–1930) and Henry (*b* 1843), became his followers. In 1863 he met the architect E. W. Godwin (1833–86) and went to Amsterdam with Haden to see Rembrandt's prints. Neither Paris nor London suited Whistler's health and he had to convalesce by the sea, where he painted his first great seascape, the *Coast of Brittany* (1861; Hartford, CT, Wadsworth Atheneum; YMSM 37), and the powerful *Blue and Silver: Blue Wave, Biarritz* (1862; Farmington, CT, Hill-Stead Mus.; YMSM 41). In 1865 he painted Courbet in *Harmony in Blue and Silver: Trouville* (Boston, MA, Isabella Stewart Gardner Mus.; YMSM 64). The two artists found much in common, including Jo, and Courbet painted her as *La Belle Irlandaise* (1865; New York, Met.; versions, Kansas City, MO, Nelson–Atkins Mus. A., priv. cols).

From 1863 Whistler began to introduce oriental blue-and-white porcelain, fans and other *objets d'art* from his own extensive collection into his paintings, signalling his increasing interest in Japonisme. Initially, these objects formed little more than props to what remained in both composition and finish essentially traditional Western genre subjects. Important examples include *Purple and Rose: The Lange Leizen of the Six Marks* (1863–4; Philadelphia, PA, Mus. A.; YMSM 47), which was given a specially designed frame with related oriental motifs, and *La Princesse du pays de la porcelaine* (1863–4; Washington, DC, Freer; YMSM 50; see fig. 1). However, in February 1864 Whistler painted an oriental group, *Variations in Flesh Colour and Green: The Balcony* (Washington, DC, Freer; YMSM 56), which also incorporates compositional elements from the Japanese woodcuts of Suzuki Harunobu (?1725–1770) and *Autumn Moon on the Sumida* by Torii Kiyonaga (1752–1815). Although signed in 1865, it was reworked, even after exhibition at the Royal Academy in 1870. Whistler planned to enlarge it, but in his preliminary sketch, possibly started in 1867 (U. Glasgow, Hunterian

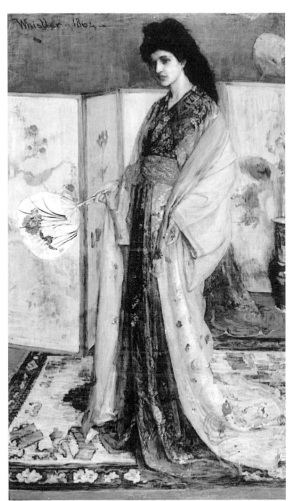

1. James McNeill Whistler: *La Princesse du pays de la porcelaine*, oil on canvas, 2.00×1.16 m, 1863–4 (Washington, DC, Freer Gallery of Art)

A.G.; YMSM 57), the figures became more Greek than oriental, as his interests began to shift. He liked the collection of Tanagra statuettes owned by his Greek patrons, the Ionides family. In 1865 he had met Albert Moore (1841–93) and both artists painted women in semi-Classical robes. By 1868 Whistler was at work on the 'Six Projects' (YMSM 82–7), decorative paintings of women with flowers, but, fearing that one of his studies, *Symphony in Blue and Pink* (Washington, DC, Freer; YMSM 86), was too similar to Moore's work, he abandoned the project. He blamed Courbet for his failures and felt he lacked the basic draughtsmanship of an artist such as Ingres (1780–1867).

(iii) 1866–77. During the mid-1860s Whistler went through a time of artistic and emotional crisis. He fell out with Legros, who was replaced by Moore in the Société des Trois, and he quarrelled finally with Haden in 1867. When his mother had moved in with him in late 1863, Jo had had to move out. To escape from family pressures, Whistler left for Valparaíso in 1866 to help the Chileans

in a confrontation with Spain. He saw little fighting but painted his first night scenes, including *Nocturne in Blue and Gold: Valparaíso Bay* (Washington, DC, Freer; YMSM 76) and *Crepuscule in Flesh Colour and Green, Valparaíso* (1866; London, Tate; see colour pl. XVI, 2). On his return to London he left Jo, but she looked after his illegitimate son, Charles, born to the parlour-maid, Louisa Hanson, in 1870.

Without Jo, Whistler lacked a regular model, and in 1871, when another model fell ill, he asked his mother to pose. He struggled to perfect a simple composition with her sitting in profile before rectangular areas of dado, wall, curtain and picture, using thin broad brushstrokes for the wall, narrow expressive strokes for hands, flesh and curtain. The finished painting was exhibited at the Royal Academy in 1872 as *Arrangement in Grey and Black No. 1: Portrait of the Artist's Mother* (Paris, Mus. d'Orsay; YMSM 101). Whistler wrote in *The World* on 22 May 1878, 'To me it is interesting as a picture of my mother; but

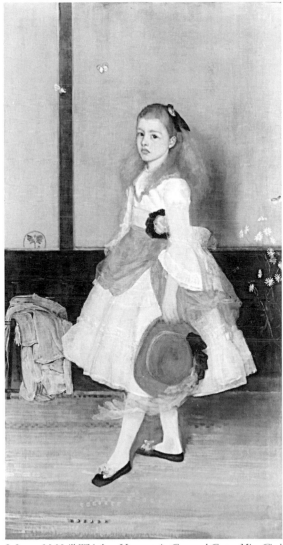

2. James McNeill Whistler: *Harmony in Grey and Green: Miss Cicely Alexander*, oil on canvas, 1.90×0.98 m, 1872 (London, Tate Gallery)

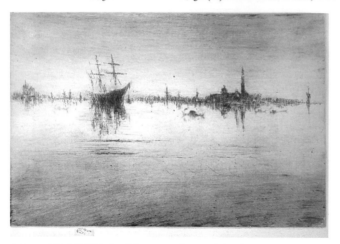

3. James McNeill Whistler: *Nocturne*, etching and drypoint, 202×298 mm, *c.* 1879–80 (Glasgow, University of Glasgow, Hunterian Art Gallery)

what can or ought the public to care about the identity of the portrait?' He went on to explain, 'As music is the poetry of sound, so is painting the poetry of sight, and subject matter has nothing to do with harmony of sound or colour.'

In 1869 Whistler started to paint the Liverpool ship-owner F. R. Leyland (1831–92) at Speke Hall, near Liverpool. The *Arrangement in Black: Portrait of F. R. Leyland* (1870–73; Washington, DC, Freer; YMSM 97) hung in Whistler's first one-man exhibition at the Flemish Gallery, London, in 1874, which Rossetti, who introduced them, claimed had been financed by Leyland. A superb portrait of Leyland's wife, *Symphony in Flesh Colour and Pink* (1871–3; New York, Frick; YMSM 106), was shown in the same exhibition. Whistler also made lovely drypoints (Kennedy, nos 109–10) and drawings of the Leyland daughters, Elinor and Florence (1873; U. Glasgow, Hunterian A.G.; see M 509–31), but did not finish their portraits. Pennell believed that the '*Six Projects*' were intended for Leyland's house at 49 Prince's Gate, London. Leyland let Whistler paint the dining-room (designed by Thomas Jeckyll) to harmonize with *La Princesse du pays de la porcelaine* (see fig. 1 above), which he had bought in 1872. *Harmony in Blue and Gold: The Peacock Room* (Washington, DC, Freer; YMSM 178) became a major decorative scheme and one of the finest achievements of the Aesthetic Movement, but it so exceeded the original commission that artist and patron eventually fell out over the cost (*see* §2(v) below).

It was Leyland who in 1872 suggested that Whistler call his night pictures 'Nocturnes'. At the Dudley Gallery *Harmony in Blue-Green—Moonlight* was bought in 1871 by the banker W. C. Alexander, but it was renamed *Nocturne: Blue and Silver—Chelsea* (London, Tate; YMSM 103). Alexander so liked the portrait of Whistler's mother that in 1872 he ordered portraits of his daughters. Cicely suffered 70 sittings for *Harmony in Grey and Green: Miss Cicely Alexander* (YMSM 129; see fig. 2). Thomas Carlyle (1795–1881) was the subject of *Arrangement in Grey and Black, No. 2* (1872–3; Glasgow, City Mus. & A.G.; YMSM 137), which shares the severely restricted and sombre

palette, solemn mood and economical composition of Whistler's portrait of his mother. It was the first of Whistler's oils to enter a British public collection, in 1891.

A red-headed English girl, Maud Franklin, took Jo's place as Whistler's mistress and principal model. Although she looks lovely in *Arrangement in White and Black* (*c.* 1876; Washington, DC, Freer; YMSM 185) and subtle in *Arrangement in Black and Brown: The Fur Jacket* (1876; Worcester, MA, A. Mus.; YMSM 181), she is depicted as a sombre figure in *Arrangement in Yellow and Grey: Effie Deans* (1876; Amsterdam, Rijksmus.; YMSM 183). Effie Deans, the heroine of Scott's *Heart of Midlothian*, was an odd subject for Whistler, but perhaps appropriate because Maud, like Effie, bore an illegitimate child (by Whistler in 1878).

(iv) 1877–94. By the late 1870s the artistic uncertainties of the 1860s had been resolved, but Whistler was in severe financial difficulties. In 1877 he sent *Nocturne in Black and Gold: The Falling Rocket* (1875; Detroit, MI, Inst. A.; YMSM 170), one of a series on Cremorne Gardens, to the first Grosvenor Gallery exhibition. John Ruskin (1819–1900) wrote that he 'never expected to hear a coxcomb ask 200 guineas for flinging a pot of paint in the public's face' (*Fors Clavigera*, 2 July 1877). Whistler sued him for libel. At the Old Bailey in November 1878, asked if he charged 200 guineas for two days' work, Whistler said, 'No, I ask it for the knowledge which I have gained in the work of a lifetime.' He won damages of a farthing and faced huge costs. His account of the trial, *Art and Art Critics*, was published in December the same year.

On 8 May 1879 Whistler was declared bankrupt. He destroyed work to keep it from creditors, and the White House in Chelsea (destr.), which had been designed for him by E. W. Godwin and completed only the previous year, had to be auctioned. In 1880 he left for Venice with a commission from the Fine Art Society for a set of 12 etchings. In fact he made 50 etchings, including *Nocturnes* (e.g. K 184, see fig. 3; K 202, 213) and *Doorways* (K 188, 193, 196), of unsurpassed delicacy. He drew 100 pastels, including the glowing *Venice: Sunset* and *Bead Stringers*, with the figures set in a close hung with washing, brought alive by touches of colour (both Washington, DC, Freer; M 812, 788). His work made considerable impact on Frank Duveneck and his students, particularly Otto Bacher, who met him in Venice. The Fine Art Society showed the first 12 *Etchings of Venice* in December 1880. Whistler had to print 25 sets, but he kept trying to perfect them, and Frederick Goulding (1842–1909) completed the editions after Whistler's death. A second set, *Twenty-six Etchings of Venice*, exhibited in 1883 and published by Dowdeswell's in 1887 in an edition of 30, was printed by Whistler with rare efficiency within a year.

The brewer Sir Henry Meux commissioned Whistler to paint two portraits of his wife: a luscious *Arrangement in Black* (1881–2; Honolulu, HI, Acad. A.; YMSM 228), delighted Degas at the Salon of 1882, while *Harmony in Pink and Grey* (1881–2; New York, Frick; YMSM 229) was exhibited at the Grosvenor Gallery the same year. In 1883 Théodore Duret (1838–1927) discussed with Whistler the problem of painting men in evening dress and posed, a domino over his arm to add a note of colour, for

Arrangement en couleur chair et noir (New York, Met.; YMSM 252; see fig. 4). To keep a unified surface, the whole canvas was repainted ten times before the Salon of 1885. Whistler sent work to the Impressionist exhibitions at the Galerie Georges Petit in 1883 and 1887 and to Les XX in Brussels in 1884. His own exhibition *'Notes'—'Harmonies'—'Nocturnes'*, including the painting *The Angry Sea* (Washington, DC, Freer; YMSM 282) and the watercolour *Amsterdam in Winter* (Washington, DC, Freer; M 877), hung at Dowdeswell's in 1884. A second show in 1886 had pastels of models in iridescent robes and such watercolours as *Gold and Grey—The Sunny Shower, Dordrecht* (U. Glasgow, Hunterian A.G.; M 973).

On 20 February 1885 Whistler gave his 'Ten o'clock lecture'. 'Nature', he said, 'contains the elements, in colour

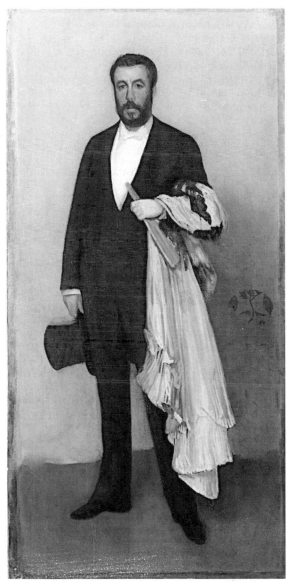

4. James McNeill Whistler: *Arrangement en couleur chair et noir: Portrait of Théodore Duret*, oil on canvas, 1.93×0.91 m, 1883 (New York, Metropolitan Museum of Art)

and form, of all pictures, as the keyboard contains the notes of all music. But the artist is born to pick, and choose, and group with science, these elements, that the result may be beautiful.' Whistler believed that art could not be made nor understood by the masses; a Rembrandt or a Velázquez was born, not made, and if no more masters arose, 'the story of the beautiful is already complete—hewn in the marbles of the Parthenon—and broidered, with the birds, upon the fan of Hokusai—at the foot of Fusiyama.'

Whistler's followers included Walter Sickert (1860–1942) and Mortimer Menpes (1855–1938), who helped him print the Venice etchings, and in January 1884 they joined him at St Ives in Cornwall. In 1885 Whistler joined Sickert in Dieppe and went with William Merritt Chase to Antwerp, Haarlem and Amsterdam. In the same year he showed a portrait of the violinist *Pablo de Sarasate* (Pittsburgh, PA, Carnegie; YMSM 315) at the Society of British Artists, to which he had been elected the previous year. In 1886 he became President of the Society. He reorganized the exhibitions and brought in such young artists as Menpes, William Stott of Oldham (1857–1900), Waldo Story (1855–1915) as well as the Belgian Alfred Stevens (1817–75) as members and invited Monet (1840–1926) to exhibit. When he was forced to resign in 1888 after objections to his exhibiting policy, his friends left too: 'the "Artists" have come out, and the "British" remain', he told the *Pall Mall Gazette* (11 June 1888).

Whistler started to paint Beatrice Godwin (1857–96), the wife of E. W. Godwin and daughter of the sculptor John Birnie Philip (1824–75), in 1884: her portrait, *Harmony in Red: Lamplight* (U. Glasgow, Hunterian A.G.; YMSM 253), hung at the Society of British Artists exhibition of 1886–7. Beatrice and Maud Franklin both exhibited as Whistler's pupils at the Society. They fought over Whistler and Maud lost. Beatrice's husband died in 1886, and Whistler married her in August 1888. They had a working honeymoon in France, where he taught her to etch. In his *'Renaissance Set'* he isolated architectural details, little figures and hens, in such etchings as *Hôtel Lallement, Bruges* (K 399), and painted such elegant watercolours as *Green and Blue: The Fields, Loches* (Ithaca, NY, Cornell U., Johnson Mus. A.; M 1183).

A set of six lithographs, *Notes*, was published by Boussod, Valadon & Cie. in 1887. With Beatrice's encouragement, Whistler made lithographs, including stylish portraits of her sister Ethel. The *Winged Hat* and *Gants de suède* (C 34–5) appeared in the *Whirlwind* and *Studio* in 1890. Whistler hoped to popularize the medium but found the clientele limited. Experiments in Paris with colour lithography, as in *Draped Figure, Reclining* (C 56), were halted by problems with printers.

In 1889 Whistler made a set of ambitious etchings, including the *Embroidered Curtain* (K 410), in Amsterdam, which he felt combined 'a minuteness of detail, always referred to with sadness by the critics who hark back to the Thames etchings, . . .with greater freedom and more beauty of execution than even the Venice set or the last Renaissance lot can pretend to'. Among the eager American purchasers of these etchings was Charles Lang Freer, who met Whistler in 1890 and amassed a huge collection of his work (now in the Freer Gallery of Art, Washington,

DC). In 1891 Mallarmé (1842–98) led a successful campaign for the French State to acquire Whistler's portrait of his mother. The following year Whistler drew for *Vers et prose* a sympathetic portrait of Mallarmé (C 60), who became one of his closest friends, and Whistler was himself drawn into the Symbolist circle. In 1892 the Whistlers moved to Paris.

Whistler remained a combative public figure. In June 1890 William Heinemann had published Whistler's *Gentle Art of Making Enemies*—letters and pamphlets on art, designed by Whistler to the last jubilant butterfly. A second edition included the catalogue of his Goupil Gallery retrospective in 1892, *Nocturnes, Marines & Chevalet Pieces*, incorporating early reviews of his work. In 1894 George Du Maurier's *Trilby* appeared in *Harper's* with the character of 'the Idle Apprentice' based on the student Whistler, but he forced Du Maurier to make it less explicit. Sir William Eden commissioned a small full-length portrait of his wife in 1894 (U. Glasgow, Hunterian A.G.; YMSM 408). No price was set, and the amount and manner of payment upset Whistler. He kept the panel and changed the figure. Eden sued him, but Whistler won on appeal. Whistler later published his own account in *Eden v. Whistler: The Baronet and the Butterfly* (1899).

(v) Later life, 1894–1903. In December 1894 Whistler's wife became ill with cancer. They visited doctors in Paris and London and went in September 1895 to Lyme Regis in Dorset. Beatrice returned to London, but Whistler stayed to confront an artistic crisis, which echoed his emotional one. Samuel Govier posed for lithographs (e.g. *The Blacksmith*; C 127) and the masterly oil, the *Master Smith of Lyme Regis* (Boston, MA, Mus. F.A.; YMSM 450). Whistler felt he had fulfilled his *Proposition No. 2*: 'A picture is finished when all trace of the means used to bring about the end has disappeared.' Back in London, he held an exhibition of lithographs at the Fine Art Society. In 1896 he drew poignant portraits of his dying wife, *By the Balcony* and *The Siesta* (C 160, 159), and made his last nocturne, a superb lithotint, *The Thames* (C 161). Beatrice died on 10 May 1896.

The same year Whistler took a studio at 8 Fitzroy Street and in 1897 set up the Company of the Butterfly to sell his work, but it was not effective. In Paris his favourite model was Carmen Rossi (YMSM 505–7, C 71–4). Whistler helped her set up an art school (the Académie Carmen) in 1898, where he and the sculptor Frederick MacMonnies taught. Carl Frieseke (1874–1942) and Gwen John (1876–1939) were among the pupils, the most dutiful of whom, Inez Bate and Clifford Addams (1876–1932), became Whistler's apprentices. The school closed in 1901.

In April 1898 Whistler was elected President of the International Society of Sculptors, Painters and Gravers. Aided by Albert Ludovici jr (1852–1932), John Lavery (1856–1941) and Joseph Pennell (1857–1926), he supervised exhibitors and exhibitions, designing a monogram and catalogues. His friends Rodin (1840–1917) and Monet sent work; other contributors included such Frenchmen as Toulouse-Lautrec (1864–1901), Bonnard (1867–1947), Vuillard (1868–1940) and (under protest from Whistler) Cézanne (1839–1906); northern Europeans Gustav Klimt (1862–1918), Max Klinger (1857–1920), Max Liebermann

(1847–1935), Jacob Maris (1837–99), Franz von Stuck (1863–1928), Hans Thoma (1839–1924) and Fritz Thaulow (1847–1906); and many Scots, led by George Henry (1858–1943), James Guthrie (1859–1930) and E. A. Walton (1860–1922). The Society's exhibitions were outstanding for their quality and unity.

In 1899 Whistler went to Italy and visited the Uffizi in Florence and the Vatican, where he liked Raphael's *Loggie* but little else. He spent summers by the sea: at Pourville-sur-Mer in 1899 he painted panels of the sea (e.g. *Green and Silver: The Great Sea*), whose strength belies their size, and of shops, simple and geometrical (e.g. *La Blanchisseuse, Dieppe*; both U. Glasgow, Hunterian A.G.; YMSM 517, 527). In poor health, he spent the winter of 1900–01 in Algiers and Ajaccio, Corsica, painting, etching and filling sketchbooks with drawings of robed Arabs, donkeys and busy streets (U. Glasgow, Hunterian A.G.; M 1643). In October 1901 he sold his Paris house and studio and moved to Cheyne Walk, London. Freer took him on holiday in July 1902, but he fell ill at the Hôtel des Indes in The Hague. The *Morning Post* published an obituary, which revived him, and he went on to visit Scheveningen, the Mauritshuis and the galleries in Haarlem (see *Morning Post*, 6 Aug 1902).

Whistler was cared for after the death of his wife by her young sister, Rosalind Philip, who became his ward and executrix. After Whistler's death in 1903, she bequeathed a large collection of his work to the University of Glasgow, including two introspective self-portraits (c. 1896; YMSM 460–61).

2. WORKING METHODS AND TECHNIQUE. Whistler's oeuvre is considerable and of particular technical interest: about 550 oils, 1700 watercolours, pastels and drawings, over 450 etchings and 170 lithographs are known.

(i) Paintings. Whistler's early oil paintings vary in technique as he bowed to conflicting influences, Dutch art above all. Usually he painted thickly and broadly with brush and palette knife. His first over-emphatic use of colour soon modified, and he became sensitive to small variations in colour and tone. In the 1860s he used longer strokes, varying their shape and direction to describe details, with creamy ribbon-like strokes for draperies or water. In the 1870s his brushwork became bold, sweeping and expressive. He liked the texture of coarse canvas. The paint was thin and allowed to drip freely. Some of his *Nocturnes*, painted on a grey ground, have darkened badly. In the 1880s he began to work direct from nature, on panels only 125×200 mm. He painted freely, with creamy paint, making few alterations, whereas his later works were painted thinly, the brushwork softer and often showing signs of repeated reworking. His taste was refined and brushwork and colour schemes elegant. Not easily satisfied, he left many works incomplete and destroyed others.

Whistler perfected his use of watercolour when illustrating the catalogue of Sir Henry Thompson's collection of Nanjing china in 1878 (see M 592–651). In the 1880s he worked on white paper laid down on card of the same size as his small panels of the period. In the late 1880s he tried linen and in the late 1890s used brown paper. He

painted thinly, leaving areas blank to suggest light or texture. He outlined a subject in pencil or brush, then added washes quickly with small brushes, altering, but rarely rubbing out.

(ii) Etchings and drypoints. Whistler usually worked on the plate directly from nature, and he proofed and printed most plates himself. He brushed acid on the plate with a feather to get the strength of line required. He used various colours of ink, mainly black at first and brown later. In 1886 his first *Proposition* stated that etchings should be small because the needle was small; and no margin should be left outside the plate-mark. After 1880 he trimmed etchings to the plate-mark, leaving a tab for his butterfly signature. He liked Dutch paper, torn from old ledgers, and fine Japanese paper. Apart from published sets, most were printed in small editions.

In Whistler's earliest etchings, influenced by Dutch art, intricately cross-hatched shadows blur outlines. The Thames etchings were drawn with a fine needle in fine detail, the foreground bolder, with lines scrawled across the plate. The plates were then bitten and altered little. The drypoints of the 1870s were drawn more freely, with longer lines and looser shading, giving silky, misty effects. They went through several states, because the lines wore down or because Whistler changed his mind, and were printed with a lustrous burr. The '*Venice Sets*' were more elaborate. The design was drawn with short, delicate lines, etched quite deeply. Mistakes were burnished out and re-etched, and areas touched up with drypoint. In printing, a thin film of ink was smoothed across the plate to provide surface colour. Some plates went through a dozen states. The plates of the 1880s often had only a single state. They were smaller and simpler, with less surface tone, subjects vignetted and drawn with a minimum of short, expressive lines. Usually only one area was drawn in detail, shaded like velvet. The Dutch etchings of 1889 were larger and had many states. In the first he outlined the design, enriching it later with a variety of shading and cross-hatching softened with rubbing down, drypoint and some surface tone. His last etchings achieved amazing richness and variety in a single state, showing Whistler in total command of the medium.

(iii) Lithographs. Whistler's earliest lithographs and lithotints were drawn on stone and printed by Thomas Way & Son. Most later ones were drawn on transfer paper and transferred to stone and printed by Way's firm. The transfer paper obtained from Way was mechanically grained, but later Whistler used a smooth paper, which he preferred. He sometimes worked on textured board or paper to add to the variety of line. The grain affected the appearance of the drawing and the success of the transfer. Whistler used the whole range of chalks in his first lithographs (e.g. *The Toilet*; C 10), hard and medium chalk, and some so soft it was applied with a stump of paper, and dark areas scraped down again. In the 1890s he usually drew with a hard crayon and used stumping for soft, velvety effects. For lithotints, Way mixed a wash to his own prescription, prepared stones for the artist and proofed and printed the result. Whistler made alterations in Way's printing office. He experimented, but destroyed

his failures. His first colour lithograph in 1890 (W 99) was to have had five colours, but two sheets did not transfer. Later experiments were more successful (W 100–01).

Whistler's lithographs were published in small editions, of six plus two or three proofs in 1878, up to twenty-five by 1895. There were exceptions: *Old Battersea Bridge* (C 18), for instance, had over 100 pulled by 1896. Some drawings were transferred to several stones and printed in large numbers for journals, such as 3000 of *The Doctor* (C 110) for *The Pageant* in 1894. Whistler's style was similar to that in chalk drawings of the same period, with firm, expressive lines, broken outlines and simple diagonal shading. He usually vignetted his subject and built up the details with flickering, curving lines, with cross-hatching enriching the shadows.

(iv) Pastels and other drawings. Most of Whistler's pastels were small (125×200 mm) and drawn on brown paper. The earliest, in black and white, were indecisive, a maze of circling lines. Around 1870 his line became more angular and economical. In Venice he gained confidence, outlining a view with lively and expressive strokes of black chalk and illuminating it with rich colours, shading or scumbling large areas for variety in texture. His later pastels were mostly of models, draped or nude, in his studio. Delicate and rainbow-coloured, his pastels became freer, more loosely drawn and increasingly expressive in his last years.

The early St Petersburg Sketchbook (U. Glasgow, Hunterian A.G.; see M 7) includes careful drawings of figures, immature and weak in line. Whistler's juvenile drawings were small vignettes, drawn jerkily with repeated angular, broken outlines, neatly cross-hatched and accented so that faces look like masks. His teenage drawings are a scrawl of zig-zag cross-hatching, with vague outlines. In his sketchbooks of 1858 (Washington, DC, Freer; see M 229–84), pencil studies from nature combine angular outlines and stylized shapes with softer, more varied shading. The few sketches surviving from the 1860s have simple shapes and curving outlines. Working drawings from the 1870s, mostly in pen, were straightforward. Shading replaced cross-hatchings. Caricatures were stylized, with jagged, pot-hooked lines. His sketchbooks were small (100×150 mm) and in constant use through the 1880s and 1890s (U. Glasgow, Hunterian A.G.; M 1001, 1144–5, 1333, 1363, 1475, 1580, 1634, 1643). Lively, broken lines, punctuated with dots, were used expressively. About 1900 his work became tentative, with silvery shading and very free, loose outlines.

(v) Designs and interior decoration. Whistler designed floor-matting (Cambridge, MA, Fogg; Cambridge, Fitzwilliam; M 493–4), dresses for his sitters, such as Mrs Leyland (Washington, DC, Freer; see M 429–37), book covers for Elizabeth Robins and Charles Whibley (Washington, DC, Lib. Congr.; M 1479–81) and his own pamphlets and books (e.g. M 1238–70, 1547–79)). He also designed furniture and painted *Harmony in Yellow and Gold: The Butterfly Cabinet* (U. Glasgow, Hunterian A.G.; YMSM 195), originally for a fireplace designed by E. W. Godwin for William Watts's stand at the Exposition Universelle, Paris, in 1878. Whistler paid considerable attention to the framing of his own pictures, in the 1860s

choosing chequered, basket-weave or bamboo patterns, and in the 1870s painting fish-scale patterns on the frame itself to accord with the tone or subject of his painting. In the 1880s he used a flat, beaded frame, in shades of gold to complement the picture. In the 1890s he developed a standard gilt frame with deep moulding and decorated with narrow beading for his paintings and pastels.

Whistler made gouache studies of colour schemes for interiors for W. C. Alexander (U. Glasgow, Hunterian A.G.; M 490), Ernest Brown of the Fine Art Society (Glasgow, U. Lib.; M 909), ships for the walls of his Lindsey Row houses (U. Glasgow, Hunterian A.G.; M 659) and others, but the schemes themselves have not survived. His major decorative projects were carried out for F. R. Leyland: besides the 'Peacock Room', he decorated the staircase at 49 Prince's Gate (Washington, DC, Freer; YMSM 175). Although Whistler claimed he painted the 'Peacock Room' without a preliminary sketch, a large cartoon, pricked for transfer, for the panel of rich and poor peacocks at the south end of the room survives (U. Glasgow, Hunterian A.G.; M 584). Whistler, aided by the Greaves brothers, did the designs in gold leaf and painted in cream and verdigris blue over the ceiling, leather-covered walls, wood panelling and window shutters.

3. PERSONALITY AND INFLUENCE. Whistler's personality was central to his art and career. While in Paris, he read Henri Murger's *Scènes de la vie de bohème* (1848) and was captivated by the bohemian world it portrayed, in which artists lived slightly apart from the rest of society and by a more relaxed moral code. In dress and manner Whistler presented the image of the immaculate dandy. In his work this attitude was reflected in a relentless perfectionism. He combined wit with a truculent aggressiveness towards critics and criticism. He shared with the other great dandy of the period, Oscar Wilde (1854–1900), a certain recklessness about the demands of money and social decorum. He survived bankruptcy in 1879 with dignity and became widely accepted in his later years as a great artist, but he remained by choice an outsider.

The ideas Whistler expounded so fluently have perhaps been as influential in the long term as his own work. He encouraged artists to recognize the pictorial possibilities of the urban landscape, notably the Thameside area of London, both in daylight and darkness. In this respect Sickert (his most important pupil) was his direct heir. Whistler's emphasis on evocative colour and mood helped to undermine the position that literal naturalism had occupied as the dominant style in Victorian painting in Britain and the USA. In the USA Whistler was an important influence on such exponents of Tonalism as Thomas Wilmer Dewing and Dwight W. Tryon.

Through his own work and the exhibitions he organized, Whistler helped to introduce avant-garde artistic ideas from the Continent to Britain, where they were particularly well-received in Scotland. His technical mastery and imaginative exploration of etching did much to inspire the Etching Revival in Britain and France in the late 19th century and the early 20th, and his decorative work anticipated the achievements of Art Nouveau.

UNPUBLISHED SOURCES

Centre for Whistler Studies, Glasgow, U. Lib. [incl. correspondence, ledgers, photographs and press-cuttings bequeathed by his sister-in-law]

Washington, DC, Lib. Congr. [correspondence, photographs, press-cuttings and contemporary letters about him accumulated by his biographers E. R. Pennell and J. Pennell]

WRITINGS

The Gentle Art of Making Enemies (London, 1890, rev. 2/1892)
Eden v. Whistler: The Baronet and the Butterfly, a Valentine with a Verdict (Paris and New York, 1899)
C. Barbier: *Correspondance Mallarmé—Whistler* (Paris, 1964)
J. A. Mahey: 'The Letters of James McNeill Whistler to George A. Lucas', *A. Bull.*, xlix (1967), pp. 247–57
N. Thorp, ed.: *Whistler—MacColl—Wright: Art History Papers* (Glasgow, 1979)
J. Newton: 'La Chauve-souris et la papillon: Correspondance Montesquiou—Whistler', *Nottingham Fr. Stud.*, xx/1 (May 1981), pp. 30–41; xxi/1 (May 1982), pp. 9–25
M. F. MacDonald and J. Newton: 'Letters from the Whistler Collection (University of Glasgow): Correspondence with French Painters', *Gaz. B.-A.*, n. s. 6, cviii (1986), pp. 201–14
M. F. MacDonald and J. Newton: 'Correspondence Duret—Whistler', *Gaz. B.-A.* (Nov 1987), pp. 150–64
N. Thorp, ed.: *Whistler on Art: Selected Letters and Writings, 1849–1903* (Manchester, 1994)
L. Merrill, ed.: *With Kindest Regards: The Correspondence of Charles Lang Freer and James McNeill Whistler, 1890–1903* (Washington, DC, 1995)

BIBLIOGRAPHY

CATALOGUES RAISONNÉS

E. G. Kennedy: *The Etched Work of Whistler* (New York, 1910) [K]
——: *The Lithographs by Whistler: Arranged According to the Catalogue by Thomas R. Way* (New York, 1914)
M. Levy: *Whistler Lithographs: A Catalogue Raisonné* (London, 1975) [L]
A. M. Young, M. F. MacDonald, R. Spencer and H. Miles: *The Paintings of James McNeill Whistler*, 2 vols (New Haven, 1980) [YMSM]
M. F. MacDonald: *James McNeill Whistler: Drawings, Pastels and Watercolours* (London and New Haven, 1995) [M]
H. K. Stratis and M. Tedeschi, eds: *A Catalogue Raisonné*, i of *The Lithographs of James McNeill Whistler*, Chicago, A. Inst. cat. (Chicago, 1998) [with cat. entries by N. R. Spink, H. K. Stratis and M. Tedeschi and essays by K. Lochnan] [C]
M. Tedeschi, ed.: *Correspondence and Technical Studies*, ii of *The Lithographs of James McNeill Whistler*, Chicago, A. Inst. cat. (Chicago, 1998) [with essays by N. Smale and H. K. Stratis and contributions by D. Kiehl and K. Sharp]

MONOGRAPHS AND EXHIBITION CATALOGUES

T. Duret: *Histoire de J. McN. Whistler et de son oeuvre* (Paris, 1904, rev. 2/1914); Eng. trans. as *Whistler* (London, 1917)
M. Menpes: *Whistler as I Knew him* (London, 1904)
O. H. Bacher: *With Whistler in Venice* (New York, 1908)
E. R. Pennell and J. Pennell: *The Life of James McNeill Whistler*, 2 vols (London and Philadelphia, 1908, rev. 6/1920)
T. R. Way: *Memories of James McNeill Whistler* (London, 1912)
E. R. Pennell and J. Pennell: *The Whistler Journal* (Philadelphia, 1921)
James McNeill Whistler (exh. cat., ed. A. M. Young; London, ACGB, 1960)
D. Sutton: *James McNeill Whistler: Paintings, Etchings, Pastels and Watercolours* (London, 1966)
D. Holden: *Whistler Landscapes and Seascapes* (New York, 1969)
From Realism to Symbolism: Whistler and his World (exh. cat., New York, Wildenstein's; Philadelphia, Mus. A.; 1971)
G. Fleming: *The Young Whistler, 1834–66* (London, 1978)
H. Taylor: *James McNeill Whistler* (New York, 1978)
Whistler: Themes and Variations (exh. cat., ed. B. Fryberger; Palo Alto, Stanford U., Mus. & A.G.; Claremont Colls, CA, Gals; 1978)
Whistlers and Further Family (exh. cat., ed. N. Thorp and K. Donnelly; Glasgow, U. Lib., 1980)
James McNeill Whistler at the Freer Gallery (exh. cat., ed. D. P. Curry; Washington, DC, Freer, 1984)
Notes, Harmonies and Nocturnes (exh. cat., ed. M. F. MacDonald; New York, Knoedler's, 1984)
Whistler Pastels (exh. cat., ed. M. F. MacDonald; U. Glasgow, Hunterian A.G., 1984)
James McNeill Whistler (exh. cat., ed. D. Sutton; text M. Hopkinson; essay N. Senzoku; Tokyo, Isetan Mus. A; Sapporo, Hokkaido Mus. Mod. A.; Shizuoka, Prefect. Mus.; Osaka, Daimaru Mus.; 1987–8)
Whistler in Europe (exh. cat., intro. by M. J. Hopkinson, Glasgow, U. Lib., Hunterian Mus., 1990–1)

R. Getscher: *James Abbott McNeill Whistler Pastels* (London, 1991)

H. Honour and J. Fleming: *The Venetian Hours of Henry James, Whistler and Sargent* (London, 1991)

L. Merrill: *A Pot of Paint: Aesthetics on Trial in Whistler v. Ruskin* (Washington, 1992)

A. Berman: *First Impressions: James McNeill Whistler* (New York, 1993)

R. Anderson and A. Koval: *James McNeill Whistler: Beyond the Myth* (London, 1994)

A. Koval: *Whistler in his Time* (London, 1994)

James McNeill Whistler (exh. cat., London, Tate; Paris, Mus. d'Orsay; Washington, DC, N.G.A.; 1994–5) [with essays by N. Cikovsky and C. Brock, R. Dorment, G.Lacambré and M. F. MacDonald]

In Pursuit of the Butterfly: Portraits of James McNeill Whistler (exh. cat. by E. Denker, Washington, DC, N.P.G., 1995)

J. F. Heijbroek and M. F. MacDonald: *Whistler and Holland* (Amsterdam, 1997)

L. Merrill: *The Peacock Room: A Cultural Biography* (Washington, DC, 1998)

Whistler and Sickert (exh. cat., Madrid, Fund. 'La Caixa'; Bilbao, Mus. B.A.; 1998)

The Society of Three (exh. cat., Cambridge, Fitzwilliam Mus., 1999) [with essays by J. Munro and P. Stirton]

PRINTMAKING

J. Pennell: 'Whistler as Etcher and Lithographer', *Burl. Mag.* (Nov 1903), pp. 160–8

E. G. Kennedy: *The Etched Work of Whistler* (New York, 1910/R San Francisco, 1978)

R. H. Getscher: *Whistler and Venice* (diss., Cleveland, Case W. Reserve U., 1970)

Whistler, the Graphic Work: Amsterdam, Liverpool, London, Venice (exh. cat., ed. M. F. MacDonald; London, Agnew's; Liverpool, Walker A.G.; Glasgow, A.G. & Mus.; 1976)

The Stamp of Whistler (exh. cat., ed. R. H. Getscher; Oberlin Coll., OH, Allen Mem. A. Mus.; Boston, Mus. F.A.; Philadelphia, Mus. A.; 1977–8)

Lithographs of James McNeill Whistler: From the Collection of Steven Louis Block (exh. cat., ed. N. Spink; Washington, DC, Int. Exh. Found., 1982–5)

K. Lochnan: *The Etchings of James McNeill Whistler* (New Haven, 1984)

N. Smale: 'Whistler and Transfer Lithography', *Tamarind Pap.*, vii (Fall 1984), pp. 72–83

Drawing near: Whistler Etchings from the Zelman Collection (exh. cat., ed. R. Day; Los Angeles, Co. Mus. A., 1984–5)

K. J. Lochnan: *Whistler's Etchings and the Sources of his Etching Style, 1855–1880* (New York, 1988)

M. F. MacDonald: 'Whistler's Lithographs', *Prt Q.*, v (1988), pp 20–58

M. Hopkinson: 'Whistler's Recipe for Cleaning Etching Plates', *Prt Q.*, xi/4 (1994), pp. 420–1

K. A. Lochnan: 'The Gentle Art of Marketing Whistler Prints', *Prt Q.*, xiv (1997), pp. 3–15

M. Tedeschi: 'Whistler and the English Print Market', *Prt Q.*, xiv (1997), pp. 15–41

M. Hopkinson: 'Whistler's Mezzotints', *Prt Q.*, xv (1998), pp. 396–401

Mus. Stud., xxiv/1 (1998) [issue dedicated to Whistler's lithography]

SPECIALIST STUDIES

P. Ferriday: 'Peacock Room', *Archit. Rev.* [London], cxxv (1959), pp. 407–14

M. F. MacDonald: 'Whistler's Last Years: Spring 1901—Algiers and Corsica', *Gaz. B.-A.*, n. s. 6, lxxiii (1969), pp. 323–42

A. Grieve: 'Whistler and the Pre-Raphaelites', *A. Q.*, xxxiv (1971), pp. 219–28

N. Pressley: 'Whistler in America: An Album of Early Drawings', *Met. Mus. J.*, v (1972), pp. 125–54

M. F. MacDonald: 'Whistler's Designs for a Catalogue of Blue and White Nankin Porcelain', *Connoisseur*, cxcviii (1975), pp. 290–91

——: 'Whistler: The Painting of the *Mother*', *Gaz. B.-A.*, n. s. 6, lxxxv (1975), pp. 73–88

J. Newton and M. F. MacDonald: 'Whistler: Search for a European Reputation', *Z. Kstgesch.*, xli (1978), pp. 148–59

M. F. MacDonald and J. Newton: 'The Selling of Whistler's "Mother"', *Amer. Soc. Legion Honor Mag.*, xlix/2 (1978), pp. 97–120

I. M. Horowitz: 'Whistler's Frames', *A. J.* [New York], xxxix (Winter 1979–80), pp. 124–31

R. Spencer: 'Whistler's Subject Matter: *Wapping*, 1860–64', *Gaz. B.-A.*, n. s. 6, c (1982), pp. 131–41

D. P. Curry: 'Whistler and Decoration', *Antiques*, cxxvi (1984), pp. 1186–99

M. F. MacDonald and J. Newton: 'Rodin, Whistler, and the International', *Gaz. B.-A.*, n. s. 6, ciii (1984), pp. 115–23

R. Spencer: 'Whistler and James Clarke Hook', *Gaz. B.-A.*, n. s. 6, civ (1984), pp. 45–8

Venice: The American View (exh. cat. by M. M. Lovell, San Francisco, CA, F. A. Museums; 1984–5), pp. 134–67

R. Anderson: 'Whistler in Dublin, 1884' *Irish A. Rev.*, iii/3 (1985), pp. 45–51

J. Winter and E. W. Fitzhugh: 'Some Technical Notes on Whistler's Peacock Room', *Stud. Conserv.*, xxx (1985), pp. 149–53

T. Watanabe: 'Eishi Prints in Whistler's Studio? Eighteenth-century Japanese Prints in the West before 1870', *Burl. Mag.*, cxviii (1986), pp. 874–81

R. E. Fine, ed.: *James McNeil Whistler: A Re-examination* (Washington, DC, 1987) [with essays by M. F. MacDonald, K. A. Lochnan, R. Spencer, D. P. Curry and N. Thorp]

R. Spencer: 'Whistler's First One-man Exhibition Reconstructed', *The Documented Image*, ed. G. P. Weisberg and L. S. Dixon (Syracuse, NY, 1987), pp. 27–50

J. F. Heijbroek: 'Holland vanaf het water: De bezoeken van James Abbott McNeill Whistler aan Nederland', *Bull. Rijksmus.*, xxxvi/3 (1988), pp. 225–56

R. Spencer: *Whistler: A Retrospective* (New York, 1989)

S. Bliss: 'Conservators Use New Approach to Restore Freer Gallery Icon', *Smithsonian Inst. Research Reports*, lx (Spring 1990), pp. 3, 6

H. Honour and J. Fleming: *The Venetian Hours of Henry James, Whistler and Sargent* (London, 1991)

S. Hackney: 'Colour and Tone in Whistler's "Nocturnes" and "Harmonies", 1871–2, *Burl. Mag.*, cxxxvi/1099 (1994), pp. 695–9

K. Pyne: 'Whistler and the Politics of the Urban Picturesque', *Amer. A.*, viii/3–4 (1994), pp. 60–77

R. Spencer: 'Whistler's Early Relations with Britain and the Significance of Industry and Commerce for his Art, pt 1', *Burl. Mag.*, cxxxvi/1093 (1994), pp. 212–24

J. H. Townsend: 'Whistler's Oil Painting Materials', *Burl. Mag.*, cxxxvi/1099 (1994), pp. 690–5

S. Hackney: 'Art for Art's Sake: The Materials and Techniques of James McNeill Whistler, 1834–1903', *Historical Painting Techniques, Materials and Studio Practice: Leiden, 1995*, pp. 186–90

J. H. Stoner: 'Whistler's Views on the Restoration and Display of his Paintings', *Stud. Conserv.*, xlii/2 (1997), pp. 107–14

L. Batis: 'Whistler: Impressions of an American Abroad', *Amer. A. Rev.*, x (1998), pp. 102–9

R. Spencer: 'Whistler's *The White Girl*: Painting, Poetry and Meaning', *Burl. Mag.*, cxl/1142 (1998), pp. 300–11

For further bibliography see R. H. Getscher and P. G. Marks: *James McNeill Whistler and John Singer Sargent* (New York, 1986).

MARGARET F. MacDONALD

White, Clarence H(udson) (*b* West Carlisle, OH, 8 April 1871; *d* Mexico City, 8 July 1925). American photographer and teacher. A self-taught photographer, he began taking photographs in 1893 and soon developed a style that showed the influence of Whistler, Sargent and Japanese prints. He was elected to the Linked Ring group of Pictorial photographers in 1900 and was a leading member of the PHOTO-SECESSION from 1902. His evocative photographs of rural landscapes and of his family celebrate the joys and virtues of the simple, middle-class way of life that existed in the USA before World War I (e.g. *Ring Toss*, 1899; Washington, DC, Lib. Congr.).

By 1906 White was already a major figure in American photography and moved to New York, where he began a close professional and artistic relationship with Alfred Stieglitz that lasted until 1912. His work was published in *Camera Work* in July 1903, Jan 1905, July 1908, July 1909 and Oct 1910. In 1908 he began teaching photography, founding in 1910 his own Summer School of Photography in Seguineland, ME, with F. Holland Day, Max Weber

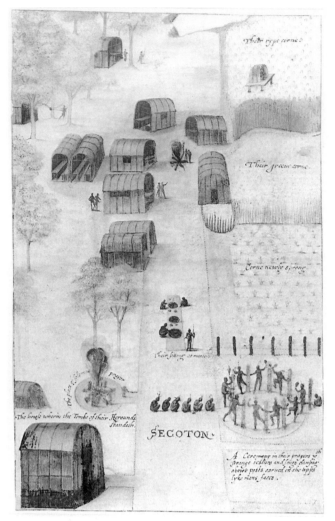

John White: *Native American Village of Secoton* (detail), watercolour, 324×199 mm, 1585 (London, British Museum)

and Gertrude Käsebier, and the highly successful and influential Clarence White School of Photography in New York in 1914. Although his own photography went into decline during the last decade of his life, his students included Laura Gilpin (1891–1979), Karl Struss (*b* 1886), Dorothea Lange (1895–1965), Paul Outerbridge (1896–1958), Ralph Steiner (*b* 1899) and Anton Bruehl (1900–83).

BIBLIOGRAPHY
Symbolism of Light: The Photographs of Clarence H. White (exh. cat., Wilmington, DE, A. Mus., 1977)
W. Naef: *The Collection of Alfred Stieglitz* (New York, 1978)
The Art of Pictorial Photography, 1890–1925 (exh. cat., Princeton U., NJ, A. Mus., 1992)
M. Fulton, ed.: *Pictorialism into Modernism: The Clarence H. White School of Photography* (New York, 1996)

TERENCE PITTS

White, John (*fl* 1585–93). English watercolourist, active in North America. His drawings are among the earliest known images of the North American continent by an English artist. He is thought to have accompanied an exploratory expedition to the New World led by Sir Martin Frobisher (?1535–94) in 1577 and another sponsored by Sir Walter Ralegh (1552–1618) in 1584. In 1585 White served as official artist on a venture sponsored by Ralegh to establish the first English settlement in North America, on the Island of Roanoke, Virginia. Although this venture failed, Ralegh sponsored a second settlement expedition in 1587, naming White governor of the colony.

On the 1585 expedition, White collaborated with the scientist Thomas Harriot (1560–1621) in charting the North American coastline and recording the New World's native inhabitants, flora and fauna. In producing his finished watercolours, White consulted works by the Huguenot artist Jacques Le Moyne de Morgues (*c.* 1533–1585), who had visited Florida from 1563 to 1565. Many of White's images were issued as engravings by Theodor de Bry (1528–98) in Harriot's *A Briefe and True Report of the New Found Land of Virginia*, published in 1590 by de Bry as the first part of his series *America*. White also produced copies of his watercolours for the naturalists John Gerard (1545–1612) and Thomas Penny (*c.* 1530–88). His surviving drawings are in the British Museum and the British Library, London.

White's images rendered the unfamiliar landscape and native flora and fauna of the New World accessible to English viewers. His diagrammatic pictures of larger scenes, particularly Indian settlements (see fig.), portray the New World as a fruitful, well-ordered environment in which settlers might thrive. He represented individual animals and plants in the conventional terms of the specimen drawing, allowing previously unknown organisms to be named and ordered according to traditional systems of classification.

BIBLIOGRAPHY
L. Binyon: 'The Drawings of John White', *Walpole Soc.*, xiii (1924–5), pp. 19–24
T. P. Harrison, ed.: *J. White and E. Topsell: The First Watercolors of North American Birds* (Austin, 1964)
P. Hulton and D. Beers Quinn, eds: *The American Drawings of John White, 1577–1590*, 2 vols (London, 1964)
The Watercolor Drawings of John White from the British Museum (exh. cat., Washington, DC, N.G.A.; New York, Pierpont Morgan Lib.; 1965)
M. R. Novelli: *American Wildlife Painting* (New York, 1975)
W. Sturtevant: 'First Visual Images of Native America', *First Images of America*, ed. F. Chiappelli (Berkeley, 1976), pp. 417–54
P. Hulton: 'Jacques Le Moyne de Morgues and John White', *The Westward Enterprise*, ed. K. Andrews, N. Canny and P. Hair (Liverpool, 1978), pp. 195–214
——: *America, 1585: The Complete Drawings of John White* (London, 1984)

AMY MEYERS

White, Stanford. *See under* McKIM, MEAD & WHITE.

Whitney, Anne (*b* Watertown, MA, 2 Sept 1821; *d* Boston, MA, 23 Jan 1915). American sculptor and writer. She achieved eminence not only as a sculptor but also as a campaigner for social justice, pressing for the abolition of slavery and equality for women. From 1846 to 1848 she ran a small school in Salem, MA. She also wrote and became well known in New England literary circles. In 1855 Whitney turned to sculpture, studying at the Pennsylvania Academy of Fine Arts (1860) and in Boston (1862–4) with William Rimmer. Her sculptures often carried social messages: *Africa* (1864) depicts a woman

awakening from the sleep of slavery. Between 1867 and 1876 she visited Munich, Paris and Rome. The most celebrated work of this period, *Roma* (1869), a seated figure of a decrepit beggar-woman, wearing medallions of monuments, symbolizes the decay of the city. Scandalized, the authorities prevented its public display, but several versions were later exhibited in Rome, in London, and at the World Columbian Exposition (1893), Chicago. In 1876 Whitney moved to Boston. Her subjects included such women as *Harriet Beecher Stowe* (1892; Hartford, CT, Stowe House). In 1902 she cast a statue of the abolitionist *Charles Sumner*, but it was set up publicly in Harvard Square, Cambridge, MA, only in 1929, after its initial rejection by the Boston Arts Committee on the grounds of Whitney's gender.

BIBLIOGRAPHY
The White Marmorean Flock: 19th-century American Neo-classical Sculpture (exh. cat., ed. W. H. Gerdts jr; Poughkeepsie, NY, Vassar Coll. A.G., 1972)
P. Dunfold: *A Biographical Dictionary of Women Artists in Europe and America since 1850* (Philadelphia, 1989, rev. Hemel Hempstead, 2/1990)
C. S. Rubinstein: *American Women Sculptors* (Boston, MA, 1990)
L. B. Reitzes: 'The Political Voice of the Artist: Anne Whitney's *Roma* and *Harriet Martineau*', *Amer. A.*, viii/2 (1994), pp. 44–65

□

Whittredge, (Thomas) Worthington (*b* nr Springfield, OH, 22 May 1820; *d* Summit, NJ, 25 Feb 1910). American painter. With little education but with a longing to be an artist, he went at the age of 17 to Cincinnati, OH, where he served an apprenticeship as a sign painter to his brother-in-law Almon Baldwin (1800–70). In the summer of 1842 Whittredge opened a daguerreotype studio in Indianapolis, IN, but left the following summer when it proved an unsuccessful venture. He then joined B. Jenks to work as a portrait painter in Charleston, WV, but dissolved the arrangement because of his partner's alcoholism. There after Whittredge decided to concentrate on landscapes, though he is documented as having painted some earlier. His first surviving landscape, *Scene near Hawk's Nest* (1845; Cincinnati, OH, A. Mus.), is in the picturesque manner of the Hudson River school painter Thomas Doughty. A year later he adopted the style of Thomas Cole, as did William Lewis Sonntag, with whom he defined a distinctive regional style. Around the same time Whittredge began painting directly from nature. *Rolling Hills* (Atlanta, GA, High Mus. A.) has a light-filled palette that suggests contact with the Philadelphia artist Russell Smith (1812–96).

Despite his growing success, Whittredge decided to go to Europe for further training. After securing sufficient commissions from Cincinnati patrons, he left in May 1849, accompanied by Benjamin McConkey. They settled in Düsseldorf, and, like other American painters, Whittredge enjoyed the benefits of the Düsseldorf Akademie without formally enrolling in it, thanks to the protection of Emanuel Gottlieb Leutze (1816–68). He lived for a year in the attic of the landscape painter Andreas Achenbach (1815–1910), then became a member of the circle around Carl Friedrich Lessing (1808–80), whom he accompanied on a tour of the Harz Mountains in 1852. From 1853 his paintings, such as *Summer Pastorale* (Indianapolis, IN, Mus. A.), follow the naturalistic vein of Lessing's follower

Johann Wilhelm Schirmer (1807–63). Whittredge spent the summer of 1856 sketching in Switzerland with Albert Bierstadt; in September they moved to Rome, where they were joined later by Sanford Robinson Gifford and William Stanley Haseltine. Whittredge remained in Italy for three years painting scenic landscapes as souvenirs for tourists; like *Landscape near Rome* (1858; Youngstown, OH, Butler Inst. Amer. A.), these are in the prevailing Düsseldorf style.

Whittredge seems to have returned to America in 1859. After visiting Newport, RI, and Cincinnati, he moved to New York, where he rented quarters in the recently completed Tenth Street Studio Building and gained almost immediate recognition. In 1860 he was elected an associate of the National Academy of Design, New York, becoming a full member two years later. *View of West Point* (Boston, MA, Mus. F.A.), the first work he painted after returning from Europe, shows that initially he experienced great difficulty adjusting to the differences in topography and style between American and European landscapes. However, his membership of the Century Club put him in contact with the mainstream of American art and thought. Through his friendships with the painter Asher B. Durand and the poet William Cullen Bryant, Whittredge developed a mature style that is seen in his great forest landscape, *Old Hunting Ground* (1864; Winston-Salem, NC, Reynolda House; see fig.).

In summer 1866 Whittredge joined General John Pope's inspection tour of the Missouri Territory, which consolidated his vision of the United States. He travelled to

Worthington Whittredge: *Old Hunting Ground*, oil on canvas, 914×656 mm, 1864 (Winston-Salem, NC, Reynolda House)

Colorado in 1870 with John Frederick Kensett and Gifford, and again in 1871 with John Smillie. Such Western scenes as *Crossing the Ford* (1867–70; New York, C. Assoc.) are unusual in treating the frontier not as mountainous vistas but as a pastoral Eden. The height of his career came in the mid-1870s: he served two terms as President of the National Academy of Design (1874–7) and was a prominent member of the paintings committees for the Centennial Exhibition in Philadelphia, responsibilities that kept him from painting.

By the late 1870s there was an evident change in Whittredge's style, inspired by the Barbizon school. Such scenes of Newport of the early 1880s as *Second Beach* (Minneapolis, MN, Walker A. Cent.) show the heightened *plein-air* style of Charles-François Daubigny (1817–78). In 1880 Whittredge moved to Summit, NJ, and his work from the mid-1880s, notably *Dry Brook, Arkville* (Manchester, NH, Currier Gal. A.), is marked by a new introspection under the influence of George Inness, who lived near by. By 1890 Whittredge had reverted to his earlier Hudson River school style, but he continued to experiment with the latest tendencies, including a modified Impressionism in *Artist at his Easel* (New York, Kennedy Gals). In 1893 he visited Mexico with Frederic Edwin Church, and he continued to paint with some regularity to the age of 83.

UNPUBLISHED SOURCES
Washington, DC, Smithsonian Inst., Archvs Amer. A. [account bk; sketchbooks]

WRITINGS
The Autobiography of Worthington Whittredge (MS; *c.* 1905; Washington, DC, Smithsonian Inst., Archvs Amer. A.); ed. J. I. H. Baur (Brooklyn, 1942/*R* 1972)

BIBLIOGRAPHY
S. Omoto: 'Berkeley and Whittredge at Newport', *A. Q.* [Detroit], xxvii/1 (1964), pp. 43–56
Worthington Whittredge Retrospective (exh. cat. by E. H. Dwight, Utica, NY, Munson–Williams–Proctor Inst., 1969)
A. F. Janson: 'Worthington Whittredge: Two Early Landscapes', *Detroit Inst. A. Bull.*, lv/4 (1977), pp. 199–208
——: 'Worthington Whittredge: The Development of a Hudson River Painter, 1860–1868', *Amer. A. J.*, xi/2 (1979), pp. 71–84
A. F. Janson: *Worthington Whittredge* (Cambridge and New York, 1989)
Worthington Whittredge (exh. cat., Sarasota, FL, Ringling Mus. A., 1989–90)
R. S. Favis: 'Home Again: Worthington Whittredge's Domestic Interiors', *Amer. A.*, ix/1 (1995), pp. 14–35

ANTHONY F. JANSON

Wight, Peter B(onnett) (*b* New York, 1 Aug 1838; *d* Pasadena, CA, 8 Sept 1925). American architect and writer. In 1855 he graduated from the Free Academy in New York, and from 1859 to 1871 he practised in New York. He is best known for his National Academy of Design (1863–5; mostly destr. 1901), which was on Fourth Avenue and 23rd Street, New York, and which he won in competition (1861), with a design heavily influenced by the theories of John Ruskin (1819–1900) and reminiscent of the Doge's Palace in Venice. With Russell Sturgis, his partner during 1863–8, he helped found a society dedicated to the ideals of Ruskin and the Pre-Raphaelites, the Association for the Advancement of Truth in Art. Wight's articles in the society's journal *The New Path* (1863–5) advocated honest construction and the Gothic style. Wight's Yale School of Fine Arts Building (1864–6, now Street Hall), New Haven, housed the first college art school in America. The decoration and furnishings he designed for his Brooklyn Mercantile Library (1865, 1867–9; destr.) and his furniture and wallpaper produced in the 1870s anticipated the American Arts and Crafts Movement.

Following the great Chicago fire of 1871, Wight moved to Chicago where, in partnership with Asher Carter (1805–77) and William H. Drake (*b* 1837), he designed commercial buildings and houses. Daniel H. Burnham and John Wellborn Root were draughtsmen in the office. In 1874 Drake and Wight patented a fireproof iron column that was subsequently much used. From 1881 to 1891 Wight operated his own fireproofing company. He was responsible for the innovative fireproof construction of many important Chicago buildings, for example, William Le Baron Jenney's Home Insurance Building (1883–5). He also wrote widely on architecture and fireproofing technology and frequently reviewed Chicago school work.

WRITINGS
National Academy of Design: Photographs of the New Building with an Introductory Essay and Description (New York, 1866)
'Remarks on Fireproof Construction', *Archit. Rev. & Amer. Builders' J.*, ii (1869), pp. 99–108
'The Origin and History of Hollow Tile Fire-proof Floor Construction', *Brickbuilder*, vi (1897), pp. 53–5, 73–5, 98–9, 149–50
'Reminiscences of Russell Sturgis', *Archit. Rec.*, xxvi (1909), pp. 123–31

BIBLIOGRAPHY
S. B. Landau: *P. B. Wight: Architect, Contractor, and Critic, 1838–1925* (Chicago, 1981)

SARAH BRADFORD LANDAU

Wild West and frontier art. Genre of art inspired by the land and the peoples of the American West, particularly in the period during and shortly after white settlement of the area. It was practised first by explorer-artists and later by permanent settlers of the area. Incorporating the media of painting, drawing and sculpture, such art records the dramatic topography west of the Mississippi River extending to the Pacific Ocean and often deals with the frequently violent events that helped to shape its settlement. The first major depictions of the area occurred in the years prior to the American Civil War (1861–5), but the heyday of Wild West and frontier art was between 1880 and 1910, when such artists as CHARLES M. RUSSELL and FREDERIC REMINGTON lived and worked there, depicting the cowboys and Native Americans of the region. It was this type of art that gave rise to the romantic notion of the West as an area of danger, excitement and dramatic confrontation, stirring the imagination of many easterners. Aspects of the life and culture of the West continued to be treated into the first half of the 20th century. However, by this time both white settlers and their culture had long been dominant, and consequently the fascination that the region had formerly exercised over white artists dwindled.

In 1819–20 the topographer Stephen Long (1784–1864) followed the Platte River to the present site of Denver and then south-east to the present Fort Smith, AR. On his return east, he prepared a map, which did much to draw attention to the existence of the desert regions in the USA. In the 1830s and 1840s a few early artist-explorers journeyed to the West to depict scenes of aboriginal cultures and wilderness, displaying their results to those in search of vicarious adventure. The most accomplished of

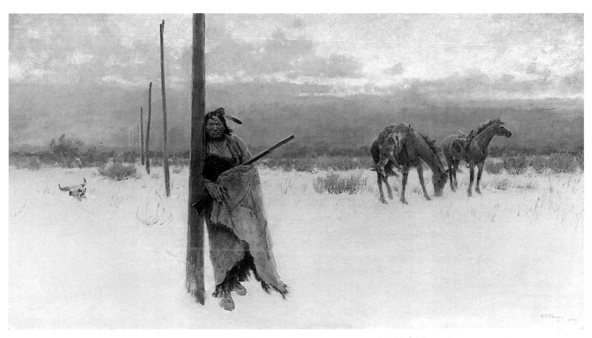

Henry F. Farny: *Song of the Talking Wire*, oil on canvas, 562×1012 mm, 1904 (Cincinnati, OH, Taft Museum)

the artists prior to the Civil War was the Swiss painter Karl Bodmer. He travelled up the Missouri River with Prince Maximilian of Wied–Neuwied in 1833–4, a journey that provided the source for such exquisite watercolours as '*Two Ravens*' (1834; Omaha, NE, Joslyn A. Mus.; for illustration *see* BODMER, KARL). In 1837 ALFRED JACOB MILLER journeyed to the Rocky Mountains and recorded the American West in a series of watercolours (e.g. the *Trapper's Bride*, Omaha, NE, Joslyn A. Mus.) depicting the life of the Indians and fur traders. At this time such Indian tribes as the Assiniboine, the Arapahoe and the Comanche moved relatively freely across the plains on horses, while major westward migration by white settlers did not really begin until the birth of a viable cattle industry after the Civil War. Russell was one of the first eastern artists to settle in the West, and from 1880 he lived as a trapper and cowboy. His illustrations, often for *Harper's Weekly*, and his paintings (e.g. *Wagon Boss*, 1909; Tulsa, OK, Gilcrease Inst. Amer. Hist. & A.) depict the exciting and dangerous aspects of frontier life. Remington, although living in New York, made frequent visits to the West to document the displacement of the Indians and buffalo by white men and longhorn cattle. The handling of paint in his later works (e.g. *Pony Herder*, 1909; for illustration *see* REMINGTON, FREDERIC) often approaches Impressionism. Both Russell and Remington had an intimate knowledge and love of the West that is often revealed in their works. These two artists also produced bronze sculptures of cowboys, Indians and horses (e.g. Russell's *Smoking Up*, *c.* 1903; St Petersburg, FL, Mus. F.A., and Remington's *Mountain Man*, 1903 (see colour pl. XXVIII, 1); Cody, WY, Buffalo Bill Hist. Cent.). Other sculptors who continued these themes were Cyrus Dallin (1861–1944), who often worked on a large scale (e.g. *Appeal of the Great Spirit*, 1908; Boston, MA. Mus. F.A.),

and Hermon Atkins MacNeil (1866–1947), who produced such works as *Chief of the Multnomah Tribe* (bronze, 1907; Tulsa, OK, Gilcrease Inst. Amer. Hist. & A.).

Henry F. Farny (1847–1916) was also an easterner who was lured by the subject-matter of the West. Before moving to New York in 1867, he worked in Cincinnati for engravers and lithographers and was an illustrator for *Harper's Weekly*. He painted in the tight, precise manner of the Düsseldorf school and studied in Munich in 1875–6. He first visited Sioux Indian Territory in 1881 and by 1890 had turned exclusively to painting, recording the quieter aspects of Indian life and their vanishing culture. He is best known for *Song of the Talking Wire* (see fig.), a painting that shows the Indians' attempts to come to terms with the white man's technology. Such artists as Joseph Henry Sharp (1859–1953), WILLIAM TYLEE RANNEY and Arthur Fitzwilliam Tait depicted the hardships encountered by those who settled in rugged and unexplored terrain. Sharp rendered many Indian portraits (e.g. *Yellow Tail, Crow Indian Chief, Montana*, *c.* 1901–16; St Petersburg, FL, Mus. F.A.), while Ranney painted large-scale genre pictures of pioneer families, hunters and trappers (e.g. *Advice on the Prairie*, 1853; Malvern, PA, Claude J. Ranney priv. col.). Tait, although working mostly in the Adirondack Mountains, dramatically captured the dangers of mountain life in such paintings as *A Tight Fix: Bear Hunting in Early Winter* (1856; Detroit, Manoogian priv. col.; for illustration *see* TAIT, ARTHUR FITZWILLIAM). He was also skilled at painting scenes of hunters, trappers and dead game. John Mix Stanley was another artist who emphasized the romantic melodrama of pioneer and Indian life, though in a quieter, less dramatic, if no less stereotypical, way, as in *Prairie Indian Encampment* (*c.* 1870—troit, MI, Inst. A.; for illustration *see* STANLEY, JOHN MIX). He used his daguerreotypes, taken on expedi-

tions to New Mexico, California and the Oregon Territory, as aidsfor his painting. The works of these men were widely disseminated through illustrations in various weekly and monthly magazines.

Many of the artists who painted the western landscape were trained in Europe. Albert Bierstadt and WORTHINGTON WHITTREDGE both studied in Düsseldorf and THOMAS MORAN in England. Bierstadt first went to the West with the explorer and soldier Frederick W. Lander (1821–62) in 1859, and in the 1860s he produced his most celebratedworks, a series of large paintings of the majestic Rocky Mountains (e.g. *The Rocky Mountains, Lander's Peak*, 1863; New York, Met.; for illustration *see* BIERSTADT, ALBERT; see also colour pl. XVII, 1). Whittredge's scenes of the West, such as *Crossing the Ford* (1867–70; New York, C. Assoc.), are unusual in treating the frontier not as a series of mountainous vistas but as a pastoral Eden. Moran's vivid watercolours (e.g. *Mammoth Hot Springs*, 1872; Washington, DC, N. Mus. Amer. A.), reminiscent of Turner's work, interpret the beauty of the Yellowstone area of Wyoming and are said to have convinced Congress to make the area the first national park in the world. His oils depict the same subject-matter: the canyons, cliffs, buttes and geysers of the American West (e.g. *Grand Canyon of the Yellowstone*, 1872; Washington, DC, US Dept Inter., on loan to Washington, DC, N. Mus. Amer. A.; see colour pl. XXVIII, 1). Both of these artists painted their canvases to be shown primarily in eastern galleries and to be seen by the eastern public. The Taos Ten, a colony of artists that included Joseph Henry Sharp, Bert Greer Philips (1868–1956) and Oscar Edmund Berninghaus (1874–1952), was organized in 1897 in the Taos region of northern New Mexico and was one of the last groups to make almost exclusive use of the subject-matter of the West. Nevertheless, the styles of group members were influenced by Manet (1832–83) and his followers and by the works of Duchamp (1887–1968), Picasso (1881–1973), Matisse (1869–1954) and Braque (1882–1963) exhibited in the Armory Show in New York in 1913.

BIBLIOGRAPHY

Joseph Henry Sharp and the Lure of the West (exh. cat. by C. S. Dentzel, Great Falls, MT, C. M. Russell Mus., n.d.)
H. Inman: *The Old Santa Fe Trail* (New York, 1897)
R. F. Adams and H. E. Britzman: *Charles M. Russell: The Cowboy Artist* (Pasadena, 1948)
R. Taft: *Artists and Illustrators of the Old West, 1850–1900* (New York, 1953)
L. M. Bickerstaff: *Pioneer Artists of Taos* (Denver, 1955)
M. H. Brown and W. R. Felton: *Before Barbed Wire* (New York, 1956)
Albert Bierstadt: Painter of the American West (exh. cat. by G. Hendricks, Fort Worth, TX, Amon Carter Mus., 1973)
R. B. Hassrick: *Cowboys and Indians: An Illustrated History* (New York, 1976)
P. H. Hassrick: *The Way West: Art of Frontier America* (New York, 1977)
Henry Farny (exh. cat. by D. Carter, Cincinnati, OH, A. Mus., 1978)
Thomas Moran: Watercolours of the American West (exh. cat. by C. Clark, Fort Worth, TX, Amon Carter Mus.; Cleveland, OH, Mus. A.; New Haven, CT, Yale U.A.G.; 1980–1)
A New World: Masterpieces of American Painting, 1760–1910 (exh. cat., ed. T. E. Stebbins jr; Boston, MA, Mus. F.A.; Washington, DC, Gal. A.; Paris, Grand Pal.; 1983–4)
J. L. Bara: 'Cody's Wild West Show in Canada', *Hist. Phot.*, xx/2 (1996), pp. 153–5
D. Pierce: 'From New Spain to New Mexico: Art and Culture on theNorthern Frontier', *Converging Cultures: Art & Identity in Spanish*

America (exh. cat., ed. D. Fane; New York, Brooklyn Mus.; Phoenix, AZ, A. Mus.; Los Angeles, CA, Co. Mus. A.; 1996–7)

W. C. FOXLEY

Willard, Daniel Wheelock. *See under* BABB, COOK & WILLARD.

Willard, Solomon (*b* Petersham, MA, 26 June 1783; *d* Quincy, MA, 27 Feb 1861). American architect. He trained in Petersham, MA, and moved in 1804 to Boston, where he distinguished himself as a carpenter and wood-carver working for the architects Charles Bulfinch, Asher Benjamin, Alexander Parris and Peter Banner (*fl* 1795–1828). Between 1810 and 1818 Willard made trips to the mid-Atlantic states, where he worked with the artists and architects Benjamin Rush, Maximilian Godefroy, Robert Mills and Benjamin Latrobe. Bulfinch commissioned a wooden model of the US Capitol from Willard in 1817 and installed versions of Willard's hot air furnace in the Capitol and the President's House. Willard assisted Alexander Parris in the design of Boston's first Greek Revival buildings, the Sears Mansion (1816) and St Paul's Cathedral (1820). As an independent architect, Willard worked in Grecian, Gothic and Egyptian styles, but his buildings are uniformly heavy in appearance owing to his preference for local Quincy granite. Willard designed less than ten major buildings in his career; most of his energy between 1825 and 1843 went into the design and supervision of the Bunker Hill Monument (see fig.), a 68 m-high granite

Solomon Willard: Bunker Hill Monument, Charlestown, Massachusetts, 1825–43

obelisk in Charlestown, MA. He moved to Quincy to supervise the extraction of granite from quarries for this monument and for buildings by other architects, such as the Merchant's Exchange (1836) in New York by Isaiah Rogers.

WRITINGS
Plans and Sections of the Obelisk on Bunker's Hill (Boston, 1843)

BIBLIOGRAPHY
W. Wheildon: *Memoir of Solomon Willard* (Boston, 1865)
J. Winsor: *The Memorial History of Boston*, iv (Boston, 1880–81)
T. Hamlin: *Greek Revival Architecture in America* (New York, 1944/R 1964)
W. Edwards: *Historic Quincy, Massachusetts* (Quincy, MA, 1946, rev. 1954)
JACK QUINAN

Williams, William (*b* Bristol, *bapt* 14 June 1727; *d* Bristol, 1791). American painter of English birth. An unwilling apprenticed seaman, he jumped ship in North America (1747) and for 30 years in Philadelphia, PA, and New York pursued a variety of occupations: painter of stage scenery, ship decoration, portraits and landscapes, and teacher of drawing, lettering and gilding. He is most famous for having given the young Benjamin West his first training in painting in the late 1740s in Philadelphia. In 1776 he returned penniless to England, where West made him welcome in his home and studio, occasionally using him as a model.

Despite confusion with works by several other American artists of the same name, up to 12 paintings have been identified as American works by Williams. These include a *Self-portrait* that shows the artist, in a dark green dressing-gown and a puce-coloured velvet cap, looking out from working at his easel (see fig.), and a full-length portrait of a *Gentleman and his Wife* (1775), which shows Mr and Mrs

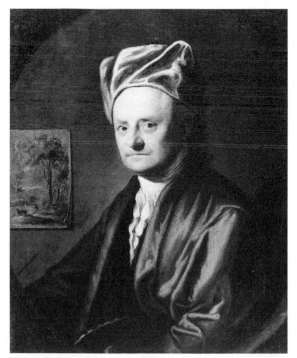

William Williams: *Self-portrait*, oil on canvas, 857×716 mm, *c.* 1750s (Winterthur, DE, H. F. du Pont Winterthur Museum)

William Denning standing against a fanciful romantic landscape containing a thatched mill, a ruined castle and a Norman church tower (both Winterthur, DE, du Pont Mus.). Uneven in execution and primitive in style, his group portraits were among the first 'conversation pieces' painted in North America.

BIBLIOGRAPHY
W. Sawitzky: 'William Williams: The First Instructor of Benjamin West', *Antiques*, xxxi (1937), pp. 240–42
J. T. Flexner: 'The Amazing William Williams: Painter, Author, Musician, Stage Designer, Castaway', *Mag. A.*, xxxvii (1944), pp. 243–6, 276–8
——: *American Painting: First Flowers of our Wilderness* (Boston, 1947), pp. 179–85
W. H. Gerdts: 'William Williams: New American Discoveries', *Winterthur Port.*, 4 (1968), pp. 159–68
D. H. Dickason: 'Benjamin West on William Williams: A Previously Unpublished Letter', *Winterthur Port.*, 6 (1970), pp. 128–33
——: *William Williams: Novelist and Painter of Colonial America* (Bloomington, 1970)
E. P. Richardson: 'William Williams: A Dissenting Opinion', *Amer. A. J.*, iv/1 (1972), pp. 3, 23
ROBERT C. ALBERTS

Williamsburg. North American town in the state of Virginia, USA. It is notable for its 18th-century buildings, many of which were restored (from 1927) or reconstructed through the patronage of John D. Rockefeller jr. It was formally founded and laid out in 1699 as Virginia's new capital, superseding the settlement of Middle Plantation (founded 1633), which had served as temporary capital during the rebuilding of Jamestown (1698), following a fire. Williamsburg was the first American city to embody effectively the full range of Classical and Baroque principles of design; the interiors of its early 18th-century buildings were typically decorated in the William and Mary style.

Williamsburg was probably designed by the state's governor, Francis Nicholson, who supported the Bishop of London's Commissary in Virginia, Rev. James Blair, in his successful effort to obtain a Royal Charter for the College of William and Mary (built 1693–1700) as the temporary seat of Virginia's government. The College was probably designed by the Office of the King's Works, headed by Sir Christopher Wren (1632–1723), as a three-storey quadrangular building; unfinished when it burnt down, it was rebuilt in 1705–15 as a two-storey block facing east, with projecting hall and chapel (1732) to the west. The siting of the College strongly influenced the layout of the rest of the city.

The original survey of the site exists, but other plans have been lost; of those made in the early 1780s during the Yorktown campaign of the American Revolution (1775–83), the most detailed is the so-called Frenchman's Map (*c.* 1782). Similarly, the only 18th-century print of the city's buildings is a single engraving (*c.* 1740) called the Bodleian Plate (see fig.). The survey shows a town of 200 acres, with an additional 63 reserved for access roads to the York and James rivers to north and south, major routes of arrival and departure. The town is bisected by Duke of Gloucester Street, which, at 30 m, was of a width unprecedented in the colonies; it provided the axial link between the College and the Capitol (1699–1705). The spacious Market Square is at the centre, crossed east–west by Duke of Gloucester Street and north–south by England

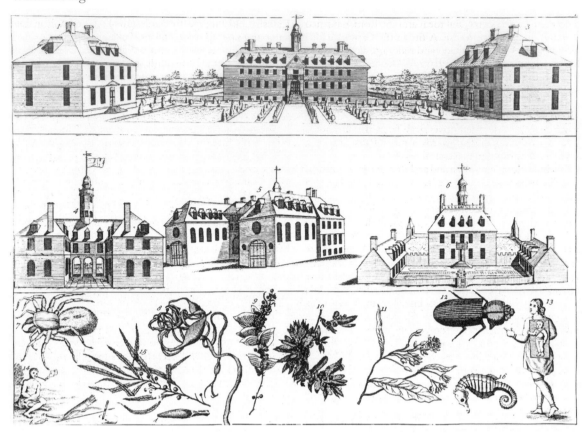

Williamsburg, engraving known as the Bodleian Plate, *c.* 1740 (Colonial Williamsburg, VA)

Street. There is evidence that 'W' and 'M' ciphers honouring William III and Queen Mary (possibly conceived by Nicholson) were originally incorporated to give diagonal access and emphasis to buildings planned for Market Square and the area around the Capitol; the octagonal, brick Powder Magazine (1714–15) may have been located at the centre of the angle of the Market Square cipher; the Courthouse of 1771, however, was not aligned with the Magazine but with the centre of the Square, which had probably been altered by that date.

The unusual, but peculiarly American, feature of the arrangement of buildings on the main street is that a college and legislative structure terminate vistas that in Europe would usually by occupied by a palace and church. The Capitol was the first legislative building in North America to be so called. Its nominative allusion to the Roman civil basilica is enhanced by its form, with two-storey rectangular piles with semicircular apses on the south façade, linked by an open loggia supporting a conference room above. Its lofty, Dutch-inspired cupola probably responds to that on the first college building. In 1701 Nicholson was authorized to purchase 63 acres, on which the Governor's house would be built (1705–20). The house's novel style, excessive cost and sumptuousness—previously unknown in the colony—caused it to be called derisively the Governor's Palace. Its site, surrounded on three sides by ravines, adjoined Williamsburg's northern boundary; topography and the existence of the first Bruton

parish church (1683; rebuilt 1711–15 by James Morris to a plan by Governor Alexander Spotswood) were probably factors in the site's selection. The creation of Palace Green to the south, an allée of 65×330 m, provided a vista to the Palace from Duke of Gloucester Street, linking the church and Palace visually. The Palace (*see* UNITED STATES OF AMERICA, fig. 6) was indebted stylistically to Dutch architecture, with flanking symmetrical forecourt dependencies, and proved influential (if controversial) with lavish formal gardens, vistas to north and south and descending terraces, which led to what Governor Spotswood called his 'fish-pond', a dammed creek that made a 'fine canal' by 1720. An early response to the arrangement of buildings at the Palace came when the College built Brafferton Hall (1723) and the President's House (1732) as forecourt dependencies of the main building. A departure from the English medieval tradition of quadrangular buildings, this domestic model was the precedent for many American campuses, where a single dominant building is flanked by a series of less imposing structures.

Spotswood also designed the Magazine and Bruton Parish Church. While the dimensions of the church are determined by a play of proportions derived from the equilateral triangle, symbolic of the Holy Trinity, those of the Magazine follow a Classical ratio of one to two, first seen in Virginia with the original design of the College in 1693. The location of the Magazine and Courthouse in the square also provides an allusion to the Roman forum,

as do the former's octagonal form and the Roman portico intended for the Courthouse. A fire in the Capitol (1747) necessitated its reconstruction and redesign, also motivating construction of the Secretary's Office near by. By 1772, when the Courthouse and Public Hospital (1769–72) were complete, Williamsburg possessed a full array of carefully arranged public buildings unmatched by any other North American city by that date; these last two structures also show the move away from the Wren-like style of earlier buildings towards a more Palladian style, anticipating forthcoming classical revivals.

The important new urban and architectural relationships of Williamsburg seem to have had a marked influence on THOMAS JEFFERSON during his years as a student, legislator and governor in the city, despite his criticism of the workmanship of construction. When he wrote much later that the success of the republic hung on 'two hooks' (strong education and local government), Williamsburg's plan stood to exemplify this view. The city is also the clearest American precedent for Pierre-Charles L'Enfant's plan for Washington, DC (1791; see WASHINGTON, DC, §I, 2 and fig. 1), with the Capitol linked to the President's House (now White House) by Pennsylvania Avenue. Williamsburg's initial status soon declined, however, when it ceased to function as Virginia's capital; RICHMOND, with its more central location, was chosen instead in 1779.

BIBLIOGRAPHY
M. Whiffen: *The Public Buildings of Williamsburg* (Williamsburg, 1958)
——: *The Eighteenth-century Houses of Williamsburg* (Williamsburg, 1960, rev. 1984)
N. H. Schless: 'Dutch Influence on the Governor's Palace, Williamsburg', *J. Soc. Archit. Historians*, xxviii (Dec 1969), pp. 254–70
G. Patton: 'The College of William and Mary, Williamsburg, and the Enlightenment', *J. Soc. Archit. Historians*, xxix (March 1970), pp. 24–32
Colon. Williamsburg (1977–)
C. Hosmer: *Preservation Comes of Age*, 2 vols (Charlottesville, 1981)
Official Guide to Colonial Williamsburg, Colonial Williamsburg Foundation (Williamsburg, 1985)
P. Kopper: *Colonial Williamsburg* (New York, 1986)
J. D. Kornwolf: *'So Good a Design': Anglo-Dutch Sources for the Architecture of the College of William and Mary and Williamsburg, 1693–1732* (Williamsburg, 1989)
J. C. Austin and R. Hunter: *British Delft at Williamsburg* (Williamsburg, VA, 1994)
J. A. Hyman: *Silver at Williamsburg: Drinking Vessels* (Williamsburg, VA, 1994)
M. R. Wenger: 'Jefferson's Design for Remodeling the Governor's Palace', *Winterthur Port.*, xxxii (Winter 1997), pp. 223–42
JAMES D. KORNWOLF

Wilson, Alexander (*b* Paisley, Strathclyde, 6 July 1766; *d* Philadelphia, PA, 23 Aug 1813). American draughtsman of Scottish birth. After an unsuccessful attempt to establish himself in the Paisley weaving trade and a failed start as a poet, he moved in 1794 to the USA. For about ten years he was a school teacher in New Jersey and eastern Pennsylvania, finally, in 1802, taking a post at a school at Gray's Ferry, PA, where he came to know William Bartram. Bartram encouraged Wilson's nascent interest in ornithology, which soon developed into an ambition to create a comprehensive illustrated book on North American birds, resulting in the *American Ornithology* (1808–14). Bartram also helped Wilson to learn to draw birds, offering him the use of his library so he could study illustrations of American birds by such 18th-century naturalists as Mark

Catesby and George Edwards (1694–1773). Wilson also came to know Charles Willson Peale, in whose museum, an important research centre for Philadelphia naturalists, he drew many of the birds included in the *American Ornithology* from mounted specimens. He travelled extensively in search of new birds, encountering other naturalist-artists, including John Abbot (1751–*c*. 1840) and JOHN JAMES AUDUBON, along the way.

Wilson's drawings for the *American Ornithology* are remarkably fine for an artist who learnt to draw so late in life, but they are far simpler in composition than Audubon's works; indeed, they are even less complex than the 18th-century prototypes that he had studied in Bartram's library. His images remain essentially specimen drawings, stressing anatomical features over behaviour or habitat as the defining characteristics of a species. Alexander Lawson (1772–1846), the primary engraver of the plates for *American Ornithology*, composed larger, more integrated scenes from Wilson's material by creating collages with the individual drawings and filling in background details before engraving the plates. The engravings become particularly elaborate in the final volume of the *Ornithology*, which was completed the year after Wilson's death. This suggests that while Wilson was able to oversee the publication of his work, he preferred to adhere to the straightforward anatomical clarity that suited the needs of systematic science, rather than attempting to explore the complicated network of physical and behavioural relationships that had become the focus of more revolutionary scientific research.

WRITINGS
Poems (Paisley, 1816)
Memoir of Alexander Wilson at Paisley (Philadelphia, 1831)

PRINTS
American Ornithology, 9 vols (Philadelphia, 1808–14, rev. 1824–5); suppl. by C. L. Bonaparte, 4 vols (Philadelphia, 1825–33)

BIBLIOGRAPHY
C. L. Bonaparte: *Observations on the Nomenclature of Wilson's Ornithology* (Philadelphia, 1826)
G. Ord: *Sketch of the Life of Alexander Wilson* (Philadelphia, 1828)
R. Cantwell: *Alexander Wilson: Naturalist and Pioneer* (Philadelphia, 1961)
M. R. Novelli: *American Wildlife Painting* (New York, 1975)
C. Hunter, ed.: *The Life and Letters of Alexander Wilson* (Philadelphia, 1983)
C. Jackson: *Bird Etchings: The Illustrators and their Books, 1655–1855* (Ithaca and London, 1985)
A. S. Blum: *Picturing Nature: American Nineteenth-century Zoological Illustration* (Princeton, 1993), pp. 24–48
L. Rigal: *The American Manufactory: Art, Labor and the World of Things in the Early Republic* (Princeton, 1998), pp. 145–78
AMY R. W. MEYERS

Wimar, Charles [Carl; Karl] **(Ferdinand)** (*b* Siegburg, nr Bonn, 19 Feb 1828; *d* St Louis, MO, 28 Nov 1862). American painter and photographer of German birth. He arrived in St Louis in 1843. From 1846 to 1850 he studied painting under the St Louis artist Leon de Pomarede (1807–92). In 1852 he continued his studies at the Kunstakademie in Düsseldorf, where he worked with Josef Fay (1813–75) and Emanuel Gottlieb Leutze (1816–68) until about 1856. In 1858, having once more based himself in St Louis, he travelled up the Mississippi in order to draw and photograph Indians. Wimar joined a party of the American Fur Trading Company and made several journeys between 1858 and 1860 up the Mississippi,

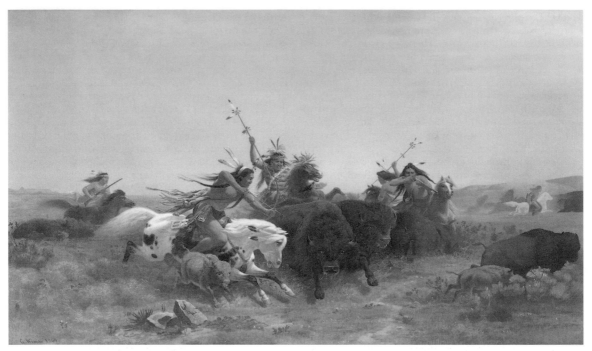

Charles Wimar: *Buffalo Hunt*, oil on canvas, 895×1524 mm, 1860 (St Louis, MO, Washington University Gallery of Art)

Missouri and Yellowstone rivers in search of Indian subjects. His painting, the *Buffalo Hunt* (1860; St Louis, MO, Washington U., Gal. A.; see fig.), became one of the original works in the collection of the Western Academy of Art. In 1861 Wimar was commissioned to decorate the rotunda of the St Louis Court-house with scenes of the settlement of the West (mostly destr.).

Among Wimar's favourite subjects, even while working in Germany, were scenes of Indians at war and hunting buffalo. He depicted them with vigour and energy, adapting the linear Düsseldorf figural style to active poses (e.g. *Indians Pursued by American Dragoons*, 1853; St Louis, MO, Mon. Club). In later works he softened his technique yet continued his scrupulous concern for accurate details of costume and gesture (e.g. *Indians Approaching Ft Benton*, 1859; St Louis, MO, Washington U., Gal. A.).

BIBLIOGRAPHY
Charles Wimar: Painter of the Indian Frontier, 1828–1862 (exh. cat. by P. T. Rathbone, St Louis, MO, A. Mus., 1946)
A. Englaender: 'Karl Friedrich Wimar, der Indianermaler aus Siegburg', *Heimatbl. Siegkreises*, xxi/67 (1953), pp. 62–4
——: 'Der Indianermaler Wimar in Heidelberg', *Heidelberg. Fremdenbl.* (1960–61), pp. 2–4
America through the Eyes of German Immigrant Painters (exh. cat., ed. A. Harding; Boston, MA, Goethe Inst., 1975)
The Hudson and the Rhine: Die amerikanische Malerkolonie in Düsseldorf im 19. Jahrhundert (exh. cat. by W. von Kalnein, R. Andree and U. Ricke-Immel, Düsseldorf, Kstmus.; Bielefeld, Städt. Ksthalle; 1976)
LESLIE HEINER

Windrim, James Hamilton (*b* Philadelphia, PA, 4 Jan 1840; *d* Philadelphia, 26 April 1919). American architect. He was in the first class to graduate from Girard College, Philadelphia, in 1856 and trained as a draughtsman with Archibald Catanach, the mason who built John Notman's Holy Trinity Episcopal Church (1856–9) in Philadelphia.

Early in the 1860s Windrim was sent to Pittsburgh to supervise construction of the Union Depot that was being built by the Pennsylvania Railroad. When he returned to Philadelphia (1867), he won the competition for the Masonic Temple (1868–73; see colour pl. III, 1), built on the north side of Penn Square. An extravaganza of Romanesque ornamentation, it has equally rich interiors by George Herzog (1845–1913). His other major works in Philadelphia included the Academy of Natural Sciences (1872), the US Centennial Agricultural Hall (1876) in Fairmount Park, and the Italianate Kemble House (mid-1880s), which resembles McKim, Mead & White's Villard House complex (1882–6) in New York City. He served (1889–91) as Supervising Architect of the United States in Washington but returned to Philadelphia to take up the post of Director of Public Works, in which capacity he built the classical Richard Smith Memorial Gateway (1897) in Fairmount Park. After 1909 he practised in conjunction with his son John T. Windrim; one of their most important works was a planned residential complex of 800 houses and service buildings designed for the Girard Estate adjacent to the original Stephen Girard House of 1798.

BIBLIOGRAPHY
Macmillan Enc. Archit.
'James H. Windrim', *National Cyclopedia of American Biography*, iii (New York, 1893), p. 422
'James H. Windrim', *Steel and Garnet*, i (1911), pp. 7–8
G. B. Tatum: *Penn's Great Town: 250 Years of Philadelphia Architecture Illustrated in Prints and Drawings* (Philadelphia, 1961)
J. Poppliers: *James Hamilton Windrim* (M.A. thesis, U. PA, 1962)
——: 'The 1867 Philadelphia Masonic Temple Competition', *J. Soc. Archit. Historians*, xxvi (1967), pp. 278–84
E. Teitelman and R. W. Longstreth: *Architecture in Philadelphia: A Guide* (Cambridge, MA, 1974)
LELAND M. ROTH

Winkler, Franz K. *See* SCHUYLER, MONTGOMERY.

Wistar, Caspar (*b* Hilspach [now Hilsbach], Germany, Feb 1696; *d* Philadelphia, PA, ?April 1752). American glass manufacturer of German birth. He moved to Philadelphia in 1717 and learnt to make brass buttons, for which he quickly became famous and from which he earned an ample income. Wistar was the first person to make glass profitably in America. He bought 2000 acres of land on Alloways Creek in Salem Co., NJ, and brought four German glass blowers to his 'Wistarburgh' factory, which opened in 1739.

The major products of the factory were window glass, a wide variety of bottles and vials, and such scientific equipment as electrical tubes and globes used to generate static electricity in experiments in the 1740s and 1750s. Table wares in colourless, bottle-green and pale blue glass were produced regularly, though sparingly. Free-blown covered bowls, small buckets or baskets, tapersticks, candlesticks, mugs and tumblers, some made with part-size moulds, have been attributed to Wistar through historical association and through laboratory analysis. Decoration, using certain *Waldglas* motifs, was generally restrained.

The operation grew and prospered under Wistar. In addition to the glasshouse, his business included button-making, real estate and the importation of English window and table glass for stores in Philadelphia and Alloway. After his death, his son Richard Wistar (1727–81) ran the operation until the hostilities and volatile markets during the American Revolution made production impossible. When Wistarburgh closed in 1780, the village included two furnaces with annealing ovens, two separate houses with flatting ovens for making window glass by the cylinder method, a pottery, a cutting house, stamping mills, a rolling mill for clay, ten dwelling houses, a mansion house and a store, with 250 acres cleared, 1500 acres of woodland, stables for sixty cattle, a barn, a granary and a wagon house. Both before and after Wistarburgh closed, glass craftsmen from the factory founded their own furnaces or worked for other glass manufacturers.

BIBLIOGRAPHY

A. Palmer: 'Glass Production in Eighteenth-century America: The Wistarburgh Enterprise', *Winterthur Port.*, xi (1976), pp. 75–101

The Wistars and their Glass, 1739–1777 (exh. cat. by A. Palmer, Millville, NJ, Wheaton Village, Amer. Glass Mus., 1989)

ELLEN PAUL DENKER

Withers, Frederick Clarke (*b* Shepton Mallet, Somerset, 4 Feb 1828; *d* New York, 1 Jan 1901). English architect, active in the USA. Following architectural training in Dorchester and London (where he worked with Thomas Henry Wyatt and David Brandon), he emigrated to the USA in 1852 at the invitation of the landscape architect A. J. Downing. At Downing's office in Newburgh, NY, Withers worked with Calvert Vaux, another English immigrant architect. Downing died soon after, but Withers stayed in Newburgh, first in partnership with Vaux and then working on his own. There he designed a number of Gothic Revival houses and churches, including the David Clarkson House (1856), the Frederick Deming House (1859; gutted; library installed New York, Met.) and First Presbyterian Church (1859; now Calvary Presbyterian Church). A number of houses on which Withers had assisted Downing and Vaux appeared in Vaux's book *Villas and Cottages* (New York, 1857).

After brief service as an engineer in the Union army during the Civil War, Withers moved to New York in 1863. There he joined Vaux in a partnership that lasted until 1872. During this period, Withers enlarged his reputation as a designer of churches, typical of which are St Paul's Episcopal Church (1864; unfinished) in Newburgh and St Luke's Episcopal Church (1869) in Beacon, NY. These buildings conformed to rules for church design laid down by the Ecclesiologists, unlike Withers's more adventurous, polychromatic brick Dutch Reformed Church (1859) in Beacon, which was an early instance of the influence of the teachings of John Ruskin (1819–1900) among a small group of progressive American architects. The publication in 1873 of his book *Church Architecture*, a collection of many of his church plans, confirmed Withers as a designer of archaeologically correct Gothic churches. Notable among his later ecclesiastical commissions are the Astor Memorial Reredos (1876) in Trinity Episcopal Church, New York, and his largest church, the Chapel of the Good Shepherd (1888), Roosevelt Island, New York.

In the years immediately following the Civil War, Withers became one of the leading practitioners of the High Victorian Gothic style in the USA. He reserved this modern expression of Gothic for secular structures, to create such buildings as the Jefferson Market Courthouse and Prison (1874; possibly with the assistance of Vaux), now the Greenwich Village branch of the New York Public Library (see colour pl. III, 2), a design strongly reminiscent of William Burges's entry for the Law Courts competition of 1866. The Hudson River State Hospital, Poughkeepsie, NY (1866), and College Hall (1875) at Gallaudet College, Washington, DC, are two of several collaborative ventures of the 1860s and 1870s with Vaux and Frederick Law Olmsted who, as the nation's leading landscape architects, designed the grounds around the buildings.

Although architectural thought in America changed greatly in the 1880s and 1890s, Withers remained committed to Gothic Revival principles of design. He maintained an active practice until the time of his death, albeit with diminishing success: his last building, the New York City Prison (begun 1896; destr.), designed jointly with Walter Dickson (1834–1903), was unfinished when he died. He enjoyed a career that spanned the entire second half of the 19th century and is best remembered for his association with the mid-century revolution in domestic architecture fostered by Downing.

WRITINGS

Church Architecture (New York, 1873)

BIBLIOGRAPHY

F. R. Kowsky: 'The Architecture of Frederick Clarke Withers (1828–1901)', *J. Soc. Archit. Hist.*, xxxv (1976), pp. 83–109

——: *The Architecture of Frederick Clarke Withers and the Progress of the Gothic Revival in America after 1850* (Middletown, CT, 1980)

FRANCIS R. KOWSKY

Wollaston, John (*b* ?London; *fl* 1734–67). English painter, active in the USA. Horace Walpole (1717–97) mentioned in his *Anecdotes of Painting in England* (1765) that a

London portrait painter, John Woolston, had a son who also became a portrait painter. From works that this son painted in London in 1744, it appears that he changed the spelling of his last name to Wollaston. The American painter Charles Willson Peale in a letter of 1812 to his son referred to Wollaston's training with a London drapery painter, but the portraits he was producing by the time he reached New York reflect abilities beyond those of a drapery painter. They are three-quarter-lengths showing little else than the subject, sombrely dressed. This style continued throughout his stay in New York (1749–51), with a growing concentration on fine apparel. The elegant dress of the females and subdued refinements of male attire advertise wealth and status. Despite a heavy reliance on engravings for pose and composition, his best portraits possess an animation about the mouth and eyes. His peculiar treatments of the eyes, slanted almond shapes, and rich fabrics in a range of colours that were touched with subtle highlights, identify even his unsigned portraits, for example *John Dies* (c. 1750; Amherst Coll., MA, Mead A. Mus.; see fig.). Appearing in some late New York portraits is the suggestion of landscape. Judging from the number of such works that survive, at least 75, he was eagerly sought after.

In the spring of 1753 Wollaston moved to Annapolis, MD. Recorded as living there from around March 1753 until August 1754, he completed at least 55 individual portraits. Such prolific activity and the larger size of the paintings might suggest that these clients enjoyed greater wealth than their New York neighbours. Theirs now commonly included objects in the hands of his sitters, such as books for the men and flowers for the women. There are also *c.* 100 paintings of similar size featuring

colonists in Virginia, where Wollaston seems to have painted from *c.* 1755 until October 1757. It appears from records that in late 1757 he accepted a position with the British East India Company and moved to Philadelphia, perhaps in search of transportation. While there he completed at least a dozen portraits before March 1759. Indications are that Wollaston's work in India, primarily legal in nature, made him wealthy. He reappeared in America briefly in late 1766 or very early 1767, painting portraits in Charleston, SC. In these, the expressionless stare that confronts the viewer is of much less importance than how closely the sitters' costumes imitates those of their wealthy English cousins. The *South Carolina Gazette* announced Wollaston's departure for England in late May 1767. His popularity in the colonies led to many copies of his work and imitation by several artists. Among his admirers were Benjamin West, who was impressed with Wollaston's New York portraits, and John Hesselius, who for a period borrowed elements of his style. Even Charles Willson Peale, while working in Annapolis as a saddler's apprentice (1754–61), found inspiration in his paintings.

BIBLIOGRAPHY
G. Groce: 'John Wollaston: A Cosmopolitan Painter in the British Colonies', *A. Q.* [Detroit], xv (1952), pp. 133–48
W. Craven: 'John Wollaston in England and New York', *Amer. A. J.*, viii/2 (1975), pp. 19–31
C. J. Weekley: *John Wollaston, Portrait Painter: His Career in Virginia, 1754–1758* (MA thesis, Newark, U. DE, 1976)

DARRYL PATRICK

Wood, Thomas Waterman (*b* Montpelier, VT, 12 Nov 1823; *d* New York, 14 April 1903). American painter. His art career dates from 1846, when he visited Boston, MA, and was either inspired or taught by the noted portrait painter Chester Harding. For the next 20 years he was an itinerant and little-known portrait painter. Then in 1867 he exhibited a set of three paintings collectively entitled a *Bit of War History* (1866; New York, Met.) at the National Academy of Design in New York. These genre paintings celebrated those freed slaves who had fought for the Union cause in the Civil War, and they touched a strong chord in the public feeling of the day. On the strength of these oils, Wood was made a member of the National Academy in 1871, and in 1873 he painted what may be his best work, the *Village Post Office* (New York, NY Hist. Soc.). He eventually served as president of the Academy (1891–9) and was instrumental in the founding of a museum and several artists' organizations. He has been largely forgotten, because he tended toward sentimentalism later in his career, but his works contain a wealth of information on 19th-century life.

BIBLIOGRAPHY
Catalog of the Pictures in the Art Gallery in Montpelier, Montpelier, VT, Wood A.G. cat. (Montpelier, 1913)
Thomas Waterman Wood, PNA, 1823–1903 (exh. cat., ed. W. Lipke; Montpelier, VT, Wood A.G., 1972)

MARK W. SULLIVAN

Woodville. Family of artists of American descent.

(1) Richard Caton Woodville (*b* Baltimore, 30 April 1825; *d* London, 13 Aug 1855). Painter. Although he grew up in Baltimore and is known for his American genre

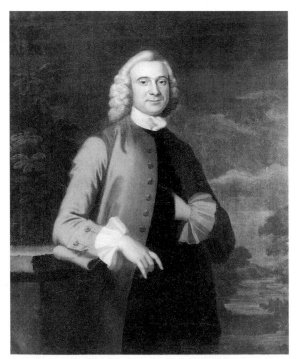

John Wollaston: *John Dies*, oil on canvas, 1160×929 mm, *c.* 1750 (Amherst, MA, Amherst College, Mead Art Museum)

paintings, he created most of his work abroad. He relied during his schooling on engravings and art books, possibly studying with the Baltimore artist Alfred Jacob Miller and copying works in the Baltimore collection of Robert Gilmor, which was strong in Dutch and Flemish paintings, and had at least two genre works by William Sidney Mount. By 1842, when Woodville enrolled briefly at medical school, he was working as a portrait painter, although he soon turned his efforts to genre scenes. He exhibited *Scene in a Bar-room* (untraced) at the National Academy of Design, New York, in 1845 and the same year went to Düsseldorf, where he studied with Carl Ferdinand Sohn (1805–67). Absorbing to stunning advantage the careful draughtsmanship, use of local colour, complex figural groupings and precise finish of the Düsseldorf school, Woodville produced a small but accomplished group of genre paintings that comprise his life work.

Some of these paintings transposed traditional genre motifs into American settings. For instance, in 1851 he created the painting *Sailor's Wedding* (Baltimore, MD, Walters A.G.), in which a colourful wedding party crowds the chambers of a magistrate. In addition to the careful attention given to the furnishings, he included such character types as the cocksure sailor and demure bride, tipsy-looking father and commandeering mother of the bride. Two paintings incorporate card-playing in an American tavern setting: the *Card Players* (1846; Detroit, MI, A. Inst.) and *Waiting for the Stage* (1851; Washington, DC, Corcoran Gal. A.). However, he also painted period costume pieces such as the *Cavalier's Return* (1847; New York, NY Hist. Soc.).

Several of Woodville's paintings focus on American politics, a topic that interested the artist during at least two visits home. The best-known of these works, during his lifetime as well as today, is *News of the Mexican War* (1848; New York, N. Acad. Des.), which was exhibited at the American Art Union in 1849 and distributed as a folio engraving by Alfred Jones (1819–1900) in 1851 to 14,000 subscribers. One reason for the painting's popularity is that it captures the unpopularity of the war and the cynical assessment that it was fought primarily for the fortunes to be made in land speculation and slavery. Another work on a political theme is *Politics in the Oyster House* (1848; Baltimore, MD, Walters A.G.), in which two American men, one considerably older than the other, discuss politics. The younger man leans forward, newspaper in hand, arguing with conviction, but his companion looks out of the space with a bored expression.

Woodville's works, which he submitted regularly to the American Art Union from 1847, were received in America with high enthusiasm. His sensitivity to American self-definition, his solid grasp of anecdote, and his clear light and colour earned him wide praise. The Baltimore collector William T. Walters bought a number of his paintings after his death, and the Walters Art Gallery is today the major repository. Woodville died accidentally of an overdose of morphine, taken medicinally, in London.

BIBLIOGRAPHY
Richard Caton Woodville, an Early American Genre Painter (exh. cat. by F. Grubar, Washington, DC, Corcoran A.G., 1967)
B. Groseclose: 'Politics and American Genre Painting of the Nineteenth Century', *Antiques*, cxx (Nov 1981), pp. 1210–17

ELIZABETH JOHNS

(2) R(ichard) Caton Woodville (*b* London, 7 Jan 1856; *d* London, 17 Aug 1927). Painter and illustrator, posthumous son of (1) Richard Caton Woodville. Like his father, he studied in Düsseldorf. He arrived in London in 1876 at the time of the Russo-Turkish War, when battle painting was enjoying a temporary vogue in England; he therefore chose to make battle scenes his speciality. He exhibited regularly at the Royal Academy from 1879. The drama and violence of his pictures found particular favour with the army and the Crown, and he received several commissions to commemorate British military exploits in Egypt and the Sudan (e.g. *H.R.H. The Duke of Connaught with the Guards at Tel-el-Kebir*, 1884; British Royal Col., on loan to Camberley, Army Staff Coll.). He rarely witnessed battle himself and as an illustrator it was his practice to work up sketches by other artists sent from the site of a campaign. His best-known drawn work was for the *Illustrated London News* (his depictions of the Irish poor in 1880 in this journal were particularly admired by van Gogh), and *Boy's Own Paper*.

WRITINGS
Random Recollections (London, 1914)

BIBLIOGRAPHY
F. Villiers: *Peaceful Personalities and Warriors* (London, 1907), pp. 24–5
Obituary, *The Times* (18 Aug 1927)

PAUL USHERWOOD

Wores, Theodore (*b* San Francisco, CA, 1 Aug 1859 [or possibly 1858 or 1860]; *d* San Francisco, CA, 11 Sept 1939). American painter. He started his art training at age 12 in the studio of Joseph Harrington and was one of the first pupils enrolled in the San Francisco School of Design when it opened in 1874. After a year there, he was encouraged by San Francisco artist Toby Rosenthal (1848–1917), whose father knew Wores, to study art in Munich. In the fall of 1875, following some lessons with Rosenthal, Wores was admitted to the Akademie der Bildenden Künste. He was taught there by Ludwig von Löfftz (1845–1910) and Alexander Wagner (1826–94), and he won several awards. He took some additional art instruction from William Merritt Chase and Frank Duveneck.

Wores became even more widely travelled than some of his fellow expatriate American artists. James McNeill Whistler, whom Wores met in Venice in 1881, helped him with letters of introduction that led to a three-year stay in Japan (1885–8). First, however, Wores returned to San Francisco, where he opened a studio in the Mercantile Library Building, painted genre scenes of Chinatown and society portraits, and did some teaching. He was chosen by fellow Bohemian Club members to paint a portrait of Oscar Wilde during the famous Englishman's visit.

After painting many scenes of traditional Japanese life and developing an increasingly Impressionist style, Wores went on to New York, where he had a studio in the Tenth Street Building in 1888, and London, where Whistler and Wilde helped him gain recognition for his work. After a second trip to Japan (1892–4), he returned to San Francisco, but within a few years he was on the road again, painting in Hawaii, Samoa and Spain. He served as director of the California School of Design from 1907 to 1913, then spent more time in Hawaii and in Calgary, Canada (1913). During his lifetime he exhibited in Paris, London,

Tokyo, New York, Boston, Philadelphia, Chicago, Washington, DC, and San Francisco; his works are held in many museums, including the National Museum of American Art.

BIBLIOGRAPHY

L. Ferbraché: *Theodore Wores: Artist in Search of the Picturesque* (San Francisco, 1968)
G. A. Reynolds: 'A San Francisco Painter, Theodore Wores', *Amer. A. Rev.*, iii (Sept–Oct 1976) pp. 107–8
Theodore Wores: The Japanese Years (exh. cat., Oakland, CA, Mus., 1976)
J. A. Baird jr, ed.: *Theodore Wores and the Beginnings of Internationalism in Northern California Painting, 1874–1915* (Davis, CA, 1978)
Theodore Wores (1859–1939): A Retrospective Exhibition (exh. cat., Huntsville, AL, Mus. A., 1980)
C. Mandeles: 'Theodore Wores's *Chinese Fishmonger* in a Cosmopolitan Context', *Amer. A. J.*, xvi/1 (Winter 1984), pp. 65–75
J. Thompson: 'Theodore Wores', *A. CA*, iii/3 (May 1990), pp. 16–24
Theodore Wores: An American Artist in Meiji Japan (exh. cat. by W. H. Gerdts and J. N. Thompson, Pasadena, CA, Pacific Asia Mus., 1993)

ANN HARLOW

Wright, Frank Lloyd (Lincoln) (*b* Richland Center, WI, 8 June 1867; *d* Phoenix, AZ, 9 April 1959). American architect and designer. He is one of the most universally acclaimed and admired of all American architects, and his name is known worldwide, to laymen as well as to architects and historians. Yet, unlike other important architects whose reputations rest at least in part on the influence of their work in shaping the architecture of their time, Wright's buildings and theories seem to have had only a slight impact on the evolution of 20th-century architecture. While the example of his buildings may have nurtured the early development of Walter Gropius (1883–1969), Le Corbusier (1887–1965) and Ludwig Mies van der Rohe (1886–1969), the mature work of these architects seems largely unaffected by Wright. Instead, his work came to be appreciated primarily for its intrinsic artistic qualities, especially those dealing with spatial definition and surface articulation. That his architecture should be so highly regarded for its inherent values is remarkable testimony to the magnitude of his genius.

1. Training, early influences and work, before 1901. 2. Prairie houses and mature work, 1901–14.

1. TRAINING, EARLY INFLUENCES AND WORK, BEFORE 1901. His father, William Russell Cary Wright, was a lawyer with qualifications in music and the ministry. A widower with young children, he was Superintendent of Schools in Richland County, WI, when he married Anna Lloyd Jones, a young teacher from a local Welsh Unitarian pioneer farming family. The marriage was not happy, ending in divorce in 1885. Frank Lloyd Wright was the first child and only son of Anna's family of three children. He became the special object of his mother's devotion, acquiring from her the tenacious determination of her pioneering background; to his father he owed his artistic gifts and lifelong love of music.

After leaving school, Wright went to work for the engineer Allan D. Conover in Madison; he also studied engineering at the University of Wisconsin, Madison, for two quarters until 1887, when he went to Chicago to seek his fortune in architecture. There he worked first for Joseph Lyman Silsbee, an architect who had designed religious buildings for the Lloyd Jones family. From early 1888 to mid-1893 he served as chief draughtsman for Adler & Sullivan, whose designing partner, Louis Sullivan, was then gaining recognition for the unique style of architecture he was forging. In 1891 Wright began to design houses in his spare time and, as this practice was not authorized by his contract, his employment was terminated in June 1893. In 1889 Wright married Catherine Tobin and later that year they moved into a house Wright designed for them in Oak Park, a suburb of Chicago. During this ensuing decade of marital stability, during which Catherine bore him six children, Wright worked to perfect his own architectural expression. Wright absorbed the essentials of picturesque design from Silsbee, whose houses consisted of asymmetrically organized rooms of contrasting shapes opening into each other through wide doorways, the spatial flow accentuated by long diagonal views that often continued outside on to wide porches. The complex exterior massing of these houses echoed the irregularity of their interior plans and volumes. If Wright derived his fascination for complex interior spaces from Silsbee, however, his mastery of plane and mass came from Louis Sullivan. In early 1888 he joined Adler & Sullivan, acting as their chief draughtsman from 1889 to mid-1893; during the years 1887 to 1889, Louis Sullivan designed buildings of a stark, abstract character, almost devoid of ornament. Although Wright believed that his interest in plain surfaces and simple masses resulted from play with the geometric Froebel kindergarten blocks his mother gave him when he was nine years old, it is more likely that he came to appreciate the rugged beauty of abstract masses through the influence of Sullivan.

It was Wright's destiny to integrate Sullivan's formal abstraction with Silsbee's involved spatial effects, and in working towards that end Wright evolved the system of design for which he is famous. He termed it 'organic'. Wright was also inspired by Japanese architecture, from which he derived his method of using solid and transparent rectangular planes to define space. These originated in the fixed and sliding screens and their framing members which make up the walls and interior partitions of traditional Japanese wooden houses. Another significant attribute of Wright's design process may be traced to the same source: the planning module, a rectangular grid laid over drawings to regulate the placement of walls, windows and doors, thus giving a consistent scale to a building. These reflected the simple planning grids of Japanese timber buildings—such as the Phoenix Villa that Wright saw in 1893 at the World's Columbian Exposition, Chicago—that were derived from the use of the 2×3 m *tatami* mat, which regulated room sizes. Wright also found inspiration in the abstract aesthetics of Japanese prints, which he later collected, exhibited and wrote about. From the English Victorian Gothic Revival, Wright borrowed the casement window, which he arranged most often in horizontal bands that served both to open up and to echo the rectangular shape of the wall planes from which he constructed his houses and, at the same time, illuminated their interiors with nearly continuous horizontal bands of light.

The development of Wright's mature architecture may be traced in a series of house designs of the 1890s, beginning with the brick house for James Charnley, which he designed in 1891 while with Adler & Sullivan. Its

abstract massing and formal composition was based on Sullivan's experiments with pure geometry in the late 1880s. The same theme reappeared in the William Winslow House (1894), River Forest, IL, also of brick. Not until 1900 was Wright able to design an equally abstract house of wood frame. He accomplished this by replacing traditional weather boarding with plaster in the house he built that year for B. Harley Bradley, Kankakee, IL. In doing so, he was influenced by the modern plaster houses of English architects such as C. F. A. Voysey (1857–1941).

2. PRAIRIE HOUSES AND MATURE WORK, 1901–14. In 1901 Wright published a project for 'A Home in a Prairie Town' (*Ladies' Home J.*, xviii/3, Feb 1901, p. 17); it was characterized by continuous hip roofs of low pitch extended to cover the carriage entrance, a continuous screen or frieze of casement windows, and a wall and base course below them. Together these gave the design a horizontal character, which Wright likened to the level character of the Midwestern prairie. It was a type of house that decades later would be called by historians 'the Prairie house', though the actual relationship between these houses and the prairie should not be taken too literally since Wright built many of them for sites distant from the Midwestern prairie. This approach culminated in 1902 in the house he designed for Ward Willits, Highland Park, IL (*see* UNITED STATES OF AMERICA, fig. 10). In that year Wright finally achieved the kind of pure design he had been seeking in the Willits House (1902–6; see fig. 1) and the Larkin Building (destr. 1950), Buffalo, NY. In each of them the two fundamental attributes that would continue to characterize Wright's architecture for the rest of his career may be discerned. One is the way his buildings are organized around interlocking spatial units defined by solid and transparent planes. The other is the simplicity of expression accorded each surface, which serves to convert the planes and masses into abstract geometric shapes and masses.

Between 1903 and 1914 Wright designed many brilliant variations on the theme of the Willits House. They included houses for Darwin Martin (1903–6), Buffalo, NY; Thomas Hardy (1905), Racine, WI; Steven Hunt (1907), La Grange, IL; Avery Coonley (1907–10), Riverside, IL; Isabel Roberts (1908), River Forest, IL; Fred Robie (1908–10), Chicago; Mrs Thomas Gale (1909), Oak Park; and Francis Little (1913–14; destr.), Lake Minnetonka, MN. The houses are usually of two storeys, set on projecting masonry platforms or podiums and built of brick, stone or wood frame, the latter clad either with horizontal board-and-batten or smooth-finished stucco. A few were designed for execution in reinforced concrete and even concrete block, although none of these were built. In general they are characterized by horizontal wall planes, grouped casement windows and widely overhanging hipped or flat roofs. Outside walls rise from a podium to the lower edge of the first-floor (second storey) windows, which form a horizontal frieze around the house just below the eaves. The podium and lower walls connect the houses directly to the earth, thus visually eliminating the basement; in some cases, as in the Robie House (*see* CHICAGO, fig. 2), Wright was able to build the house over an above-ground basement. Living areas consist of interconnected spaces defined by wall and window screens and by ceilings of contrasting heights, most focused on a massive wood-burning fireplace, the symbolic centre of family life. Bedrooms often have ceilings that slope up to

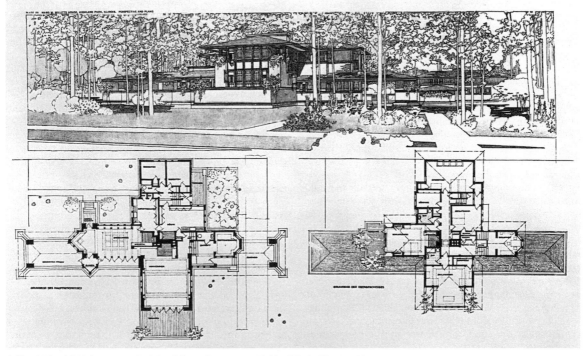

1. Frank Lloyd Wright: view and plans of the Willits House, Highland Park, Illinois, 1902

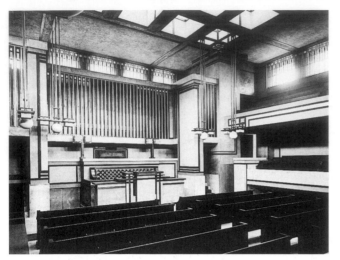

2. Frank Lloyd Wright: auditorium of Unity Temple, Oak Park, Illinois, 1905–8

time the central space is transfused with a mellow light filtering down through the translucent art glass rooflights overhead. Another element of the composition is provided by corner staircases, derived from the Larkin Building, each housed in its own vertical block. The exterior (see fig. 3) consists of planes, rectangular masses, ornamental piers and projecting roof overhangs that express the interconnected spatial units of the interior. The exterior concrete surfaces, although lightly textured with an exposed pebble aggregate, are largely unadorned, except for the ornamental piers and flower boxes.

Wright recognized that his method of composing buildings—in which the traditional self-contained 'box' punctured by doors and windows was broken down into opaque planes and transparent screens merging inside and outside—was revolutionary, and he began to write about it in 1908. He asserted that he designed from the inside outwards, meaning that he did not begin with a preconceived idea of the exterior form or its details, as he supposed most other architects did, but with the building's requirements, both material and subjective, from which he developed a suitable plan and spatial configuration. Only then did he define interior spaces with rectangular screens, both solid and transparent, and raise the elevations that gave physical reality to the spaces enclosed. That Wright actually worked in this manner is certain from the testimony of his employees between 1902 and 1910 (as well as after 1931). Architecture conceived of in this way, growing like a plant 'from the ground up into the light by gradual growth' he called 'organic' (*see* ORGANIC ARCHITECTURE and Wright's essay (1910) of the same name (Kaufman and Raeburn)).

In Wright's mature architecture there is virtually no hint of historic styles, and he realized that to achieve integrated artistic compositions he would also have to design the furniture and furnishings for his buildings. For those residential clients who could afford both house and custom-designed fittings, Wright provided interiors of the highest quality, for example in the two houses for Francis Little (*see* UNITED STATES OF AMERICA, fig. 29); the Martin House, where he designed such items as complex rectilinear oak bookcases and tables, upholstered settles, and armchairs with circular seats, and coloured, geometrically patterned art glass windows (examples in Buffalo, NY, Albright-Knox A.G.); and the Robie House, where he designed settles and chairs, lamps, rugs, and a massive dining-table with lamps and flower vases at the corners and tall, rigidly rectangular slat-backed dining-chairs (U. Chicago, IL, Smart Mus. A.). For these and many of his early houses, he also designed coloured, geometrically patterned art glass windows. Wright also designed the metal office furniture and filing cabinets for the Larkin Building as well as other fittings (New York, MOMA).

In 1905 Wright made his first visit to Japan, where he studied Japanese architecture and collected *ukiyoe* prints. At this time, however, his personal life changed dramatically as a result of his liaison with Mrs Mamah Cheney, the wife of a client for whom he built a house in Oak Park in 1904. In 1909, accompanied by Mrs Cheney, he went to Europe to arrange for the first extensive publication (1911) of drawings and photographs of his architecture by Ernst Wasmuth of Berlin; much of the preparatory work

a central ridge in the manner of a tent, for example in the Robie House, then continue over the window heads to become the light-coloured plaster underside of overhanging eaves, symbolizing the protective character of the roof and also serving to reflect a soft, mellow light into the bedrooms. The interiors were integrated with the surrounding landscape by terraces, courts and wall planes extended into the gardens.

In the early years Wright had relatively few commissions for non-residential buildings. The largest and most significant executed examples were the Larkin Building, Buffalo, NY, and Unity Temple (1905–8), Oak Park. Both were similar in the way their interior volumes were expressed on the exterior. Both had a vertically orientated rectilinear space at the centre, with subsidiary volumes opening into it at various levels, and they were both originally designed to have brick walls trimmed in stone. In the Larkin Building the central work space rose through five office floors treated as galleries, which looked into this central space over solid balustrades slightly set back from the faces of full-height, internal brick piers with deep, ornate capitals. The work space was naturally lit by roof lights and the galleries by continuous windows above built-in filing cabinets. The walls, floors and roof of the Larkin Building were supported by a cage of steel beams, a system also planned for Unity Temple, but in 1906 Wright decided to build the church of reinforced concrete, and it became the first of his many buildings in this material. Another project of this period, the 25-storey San Francisco Call Building (1912; unexecuted), San Francisco, would have been his first tall building in reinforced concrete, conceived as a rectangular slab skyscraper with concrete load-bearing walls.

The auditorium of Unity Temple (see fig. 2) is conceived as a cube of space surrounded on three sides by two levels of balconies and on the fourth by the chancel. The central space expands horizontally into the subsidiary spaces and at the top of the auditorium it follows the underside of the ceiling through stained-glass windows, continuing outside as the soffit of the overhanging roof. At the same

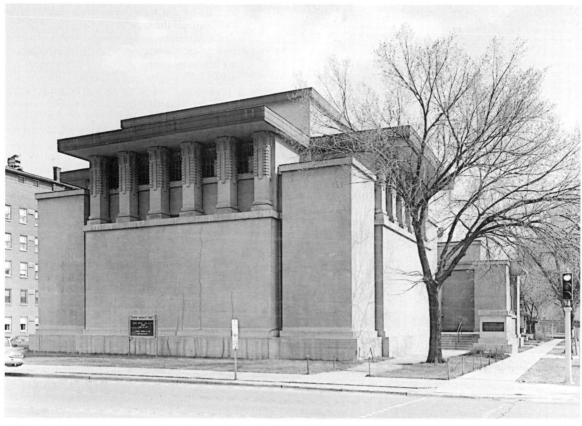

3 Frank Lloyd Wright: north front of Unity Temple, Oak Park, Illinois, 1905–8

was carried out with the help of his eldest son, Lloyd Wright (1890–1978), who also practised as an architect. The Wasmuth portfolio may have influenced a number of early Modern Movement architects in Europe, including Mies van der Rohe, Le Corbusier and Walter Gropius. On his return to the USA in 1911, Wright built Taliesin, a country home for himself and Mrs Cheney in the Lloyd Jones Valley near Spring Green. In August 1914, when Midway Gardens was nearly complete, Wright's affair with Mrs Cheney ended in tragedy when a deranged servant murdered her, her children and four others at Taliesin after setting fire to the living-quarters.

Although Wright rebuilt Taliesin, for the next decade he was a wandering architect, living variously at Taliesin, as well as Los Angeles, Arizona and Tokyo, where in 1913 he had made preliminary drawings for the Imperial Hotel. The same year he had also designed Midway Gardens (destr. 1929), Chicago, a place for outdoor dining while listening to a symphony orchestra. It was his version of a continental outdoor pleasure garden, for which he also designed murals, decorative sculpture, interiors, furniture and other objects such as ceramics and table-lamps. While retaining the spatial complexity of his earlier work, the design of Midway Gardens marked an aesthetic turning-point in the direction of greater interest in decorative and ornamental surface treatment, an emphasis that would characterize the designs of the next phase of Wright's long career.

UNPUBLISHED SOURCES

Los Angeles, CA, Getty Research Inst.
Scottsdale, AZ, Frank Lloyd Wright Found.

WRITINGS

'The Art and Craft of the Machine', *Catalogue of the Fourteenth Annual Exhibition of the Chicago Architectural Club* (exh. cat., Chicago, IL, Archit. Club, 1901) [no pagination]
'In the Cause of Architecture', *Archit. Rec.*, xxiii (1908), pp. 155–221
The Japanese Print: An Interpretation (Chicago, 1912, rev. 2/New York, 1967)
'In the Cause of Architecture: Second Paper', *Archit. Rec.*, xxxv (1914), pp. 405–13
'Non-competitive Plan', *City Residential Land Development: Studies in Planning; Competitive Plans for Subdividing a Typical Quarter Section of Land in the Outskirts of Chicago*, ed. A. Yeomans (Chicago, 1916), pp. 95–102
An Autobiography (New York, 1932, rev. 4/1977)
The Disappearing City (New York, 1932); rev. 2 as *When Democracy Builds* (Chicago, 1945); rev. 3 as *The Industrial Revolution Runs Away* (New York, 1969)
'Frank Lloyd Wright', *Archit. Forum*, lxviii (1938) [whole issue devoted to Wright's buildings, mainly 1920–38]
F. Gutheim, ed.: *Frank Lloyd Wright on Architecture: Selected Writings, 1894–1940* (New York, 1941) [contains unpubd writing, but mostly abridged]
'Frank Lloyd Wright', *Archit. Forum*, lxxxviii (1948) [whole issue devoted to Wright's buildings, mainly 1938–48]
The Future of Architecture (New York, 1953) [reprints of previous writings]
The Natural House (New York, 1954) [four chaps reprint earlier writings; five new chaps]
A Testament (New York, 1957)
E. Kaufmann and B. Raeburn: *Frank Lloyd Wright: Writings and Buildings* (New York, 1960) [selections from Wright's writings]
O. Wright: *Frank Lloyd Wright: His Life, his Work, his Words* (New York, 1966) [incl. prev. unpubd writings, illus. of work by Taliesin Associated Architects and other mat.]

A. Crawford: 'Ten Letters from Frank Lloyd Wright to Charles Robert Ashbee', *Archit. Hist.*, xiii (1970), pp. 64–73

N. Smith, ed.: 'Letters (1903–1906) by Charles E. White, Jr., From the Studio of Frank Lloyd Wright', *J. Archit. Educ.*, xxv (1971), pp. 104–12

In the Cause of Architecture (New York, 1975) [reprinted articles from *Archit. Rev.* [New York], 1927–8]

B. Pfeiffer, ed.: *Frank Lloyd Wright: Letters to Apprentices* (Fresno, 1982)

——: *Frank Lloyd Wright: Letters to Architects* (Fresno, 1984)

P. Meehan, ed.: *The Master Architect: Conversations with Frank Lloyd Wright* (New York, 1984)

B. Pfeiffer, ed.: *Frank Lloyd Wright: Letters to Clients* (Fresno, 1986)

——: *Frank Lloyd Wright: The Guggenheim Correspondence* (Fresno, 1986)

——: *Frank Lloyd Wright: Collected Writings*, 6 vols (New York, 1992–)

PHOTOGRAPHIC PUBLICATIONS

Frank Lloyd Wright: Ausgeführte Bauten und Entwürfe (Berlin, 1911); *R* as *Studies and Executed Buildings by Frank Lloyd Wright* (Palos Park, 1975); *R* as *Drawings and Plans of Frank Lloyd Wright: The Early Period, 1893–1909* (New York), 1983

Frank Lloyd Wright: Ausgeführte Bauten (Berlin, 1911; *R* as *Frank Lloyd Wright: The Early Work* (New York, 1968); *R* as *The Early Work of Frank Lloyd Wright: The 'Ausgeführte Bauten' of 1911* (New York, 1982)

'Frank Lloyd Wright', *Wendingen*, vii (1925) [whole issue]

'Frank Lloyd Wright', *Archit. Forum*, lxviii (1938), pp. 1–102 [whole issue devoted to Wright's buildings, mainly 1920–38]

'Frank Lloyd Wright: A Selection of Current Work', *Archit. Rec.*, cxxiii/5 (1958), pp. 167–90

Drawings for a Living Architecture (New York, 1959)

A. Drexler: *The Drawings of Frank Lloyd Wright* (New York, 1962)

Y. Futagawa, ed.: 'Frank Lloyd Wright: Houses in Oak Park and River Forest, Illinois (1889–1913)', *Global Archit.*, xxv (Tokyo, 1973) [whole issue]

——: 'Houses by Frank Lloyd Wright: 1', *Global Interiors*, ix (1975) [whole issue]

Y. Futagawa, ed.: 'Houses by Frank Lloyd Wright: 2', *Global Interiors*, x (1976) [whole issue]

A. Izzo: *Frank Lloyd Wright: Three-quarters of a Century of Drawings* (Florence, 1976, rev. New York, 1981)

D. Hanks: *The Decorative Designs of Frank Lloyd Wright* (New York, 1979)

'Frank Lloyd Wright', *A + U* (1981) [whole issue contains photographs of Wright's archit.]

Y. Futagawa, ed.: *Frank Lloyd Wright* (Tokyo, 1984–8), 12 vols [drgs from col. at Scottsdale, AZ, Frank Lloyd Wright Found.]

P. Guerrero: *Frank Lloyd Wright: An Album from Frank Lloyd Wright's Photographer* (New York, 1994)

BIBLIOGRAPHY

GENERAL

T. Tallmadge: 'The Chicago School', *Archit. Rev.* [Boston], xv (1908), pp. 69–74; also in *Architectural Essays from the Chicago School*, ed. W. Hasbrouck (Park Forest, 1967), pp. 3–8

H. Berlage: 'Neuere amerikanische Architektur', *Schweiz. Bauztg*, lx (1912), pp. 148–50, 165–7; Eng. trans. by D. Gifford, ed. in *The Literature of Architecture* (New York, 1966), pp. 607–16

V. J. Scully, jr: *The Shingle Style: Architectural Theory and Design from Richardson to the Origins of Wright* (New Haven, 1955); rev. as *The Shingle Style and the Stick Style* (New Haven, 1971)

R. Adams: 'Architecture and the Romantic Tradition: Coleridge to Wright', *Amer. Q.*, ix (1957), pp. 46–62

P. Blake: *The Master Builders: Le Corbusier, Mies van der Rohe, Frank Lloyd Wright* (New York, 1960, rev. 1976)

M. Peisch: *The Chicago School of Architecture: Early Followers of Sullivan and Wright* (New York, 1964)

L. Eaton: *Two Chicago Architects and their Clients: Frank Lloyd Wright and Howard Van Doren Shaw* (Cambridge, 1969)

S. Sorell: 'Silsbee: The Evolution of a Personal Architectural Style', *Prairie Sch. Rev.*, vii (1970), pp. 5–21

H. Brooks: *The Prairie School: Frank Lloyd Wright and his Midwest Contemporaries* (Toronto, 1972)

MONOGRAPHS, EXHIBITION CATALOGUES AND COLLECTIONS OF ESSAYS

The Work of Frank Lloyd Wright (exh. cat., Chicago, IL, Archit. Club, 1902)

The Work of Frank Lloyd Wright (exh. cat., Chicago, IL, Archit. Club, 1914) [work between 1911 and 1914]

H. Wijdeveld, ed.: *The Life-work of the American Architect Frank Lloyd Wright* (Santpoort, 1925, rev. New York, 1965)

H. de Fries, ed.: *Frank Lloyd Wright: Aus dem Lebenswerke eines Architekten* (Berlin, 1926)

J. Badovici: *Frank Lloyd Wright: Architecte américain* (Paris, 1932) [compilation of mat. prev. pubd in *Archit. Viv.*]

H. Hitchcock: *In the Nature of Materials: 1887–1941, The Buildings of Frank Lloyd Wright* (New York, 1942)

J. Wright: *My Father Who Is on Earth* (New York, 1946)

G. Manson: *Frank Lloyd Wright to 1910: The First Golden Age* (New York, 1958)

V. Scully jr: *Frank Lloyd Wright*, Masters of World Architecture (New York, 1960)

N. K. Smith: *Frank Lloyd Wright: A Study in Architectural Content* (Englewood Cliffs, 1966)

R. Twombly: *Frank Lloyd Wright: An Interpretive Biography* (New York, 1973); rev. as *Frank Lloyd Wright: His Life and his Work* (New York, 1979)

W. Storrer: *The Architecture of Frank Lloyd Wright: A Complete Catalogue* (Cambridge, 1974) [guide to Wright's buildings]

H. Jacobs: *Building with Frank Lloyd Wright: An Illustrated Memoir* (San Francisco, 1978)

R. Sweeney: *Frank Lloyd Wright: An Annotated Bibliography* (Los Angeles, 1978)

D. Hanks: *The Decorative Designs of Frank Lloyd Wright* (New York, 1979)

E. Tafel: *Years with Frank Lloyd Wright: Apprentice to Genius* (New York, 1979)

H. Brooks, ed.: *Writings on Wright: Selected Comment on Frank Lloyd Wright* (Cambridge, 1981)

O. Graf: *Frank Lloyd Wright und Europa: Architekturelemente, Naturverhältnis, Publikationen, Einflüsse* (Stuttgart, 1983)

P. Meehan: *Frank Lloyd Wright: A Research Guide to Archival Sources* (New York, 1983)

B. Gill: *Many Masks: A Life of Frank Lloyd Wright* (New York, 1987)

C. Bolon and others, eds: *The Nature of Frank Lloyd Wright* (Chicago, 1988)

B. Pfeiffer, ed.: *Frank Lloyd Wright: In the Realm of Ideas* (Carbondale, 1988)

E. Kaufmann jr: *Nine Commentaries on Frank Lloyd Wright* (New York, 1989)

G. Hildebrand: *The Wright Space: Pattern and Meaning in Frank Lloyd Wright's Houses* (Seattle, 1991)

S. Kohmoto: *The Frank Lloyd Wright Retrospective* (exh. cat., Tokyo, Sezon Mus. A., 1991)

R. McCarter: *Frank Lloyd Wright: A Primer on Architectural Principles* (New York, 1991)

T. Marvel, ed.: *The Wright State: Frank Lloyd Wright in Wisconsin* (exh. cat., Milwaukee, WI, A. Mus., 1992)

N. Menocal, ed.: *Wright Studies: Taliesin, 1911–1914* (Carbondale, IL, 1992)

M. Secrest: *Frank Lloyd Wright* (New York, 1992)

The Wright State: Frank Lloyd Wright in Wisconsin (exh. cat. by J. Lipman and N. Levine, Milwaukee, WI, A. Mus., 1992)

A. Alofsin: *Frank Lloyd Wright—The Lost Years, 1910–22: A Study of Influence* (Chicago, 1993)

W. Storrer: *The Frank Lloyd Wright Companion* (Chicago, 1993)

Frank Lloyd Wright, Architect (exh. cat., ed. T. Riley; New York, MOMA, 1994)

N. Levine: *The Architecture of Frank Lloyd Wright* (Princeton, [1996])

SPECIALIST STUDIES

R. Spencer jr: 'The Work of Frank Lloyd Wright', *Archit. Rev.* [Boston], vii (1900), pp. 61–72 (*R* Park Forest, 1964)

H. Hitchcock: 'Frank Lloyd Wright and the "Academic Tradition" of the Early 1890s', *J. Warb. & Court. Inst.*, vii (1944), pp. 46–63

'Frank Lloyd Wright and Architecture around 1900', *Acts of the Twentieth International Congress of the History of Art: Princeton, 1963*, iv, pp. 3–87

H. Brooks: 'Frank Lloyd Wright and the Wasmuth Drawings', *A. Bull.*, xlviii (1966), pp. 193–202

D. Hoffmann: 'Frank Lloyd Wright and Viollet-le-Duc', *J. Soc. Archit. Historians*, xxviii (1969), pp. 173–83

J. O'Gorman: 'Henry Hobson Richardson and Frank Lloyd Wright', *A.Q.* [Detroit], xxxii (1969), pp. 292–315

E. Michels: 'The Early Drawings of Frank Lloyd Wright Reconsidered', *J. Soc. Archit. Historians*, xxx (1971), pp. 294–303

C. Besinger: 'Comment on "The Early Drawings of Frank Lloyd Wright Reconsidered"', *J. Soc. Archit. Historians*, xxxi/3 (1972), pp. 217–20

R. Twombly: 'Saving the Family: Middle-class Attraction to Wright's Prairie House (1901–1909)', *Amer. Q.*, xxvii (1975), pp. 7–71

H. Brooks: 'Frank Lloyd Wright and the Destruction of the Box', *J. Soc. Archit. Historians*, xxxviii (1979), pp. 7–14

E. Kaufmann jr: 'Frank Lloyd Wright's Mementos of Childhood', *J. Soc. Archit. Historians*, xli (1982), pp. 232–7

——: 'Frank Lloyd Wright at the Metropolitan Museum of Art', *Bull. Met.*, xl (1982), pp. 5–47

N. Levine: 'Frank Lloyd Wright's Diagonal Planning', *In Search of Modern Architecture: A Tribute to Henry-Russell Hitchcock*, ed. H. Searing (Cambridge, 1982), pp. 245–77

J. Meech-Pekarik: 'Frank Lloyd Wright and Japanese Prints', *Bull. Met.*, xl (1982), pp. 48–56

J. Quinan: 'Frank Lloyd Wright's Reply to Russell Sturgis', *J. Soc. Archit. Historians*, xli (1982), pp. 238–44

P. Turner: 'Frank Lloyd Wright and the Young Le Corbusier', *J. Soc. Archit. Historians*, xlii (1983), pp. 350–59

D. Hoffmann: *Frank Lloyd Wright's Robie House* (New York, 1984)

J. Quinan: *Frank Lloyd Wright's Larkin Building* (Cambridge, 1987)

N. Menocal: 'Frank Lloyd Wright as the Anti-Victor Hugo', *American Public Architecture*, ed. C. Zabel and others (University Park, PA, 1989)

S. Robinson: 'Frank Lloyd Wright and Victor Hugo', *Modern Architecture in America: Visions and Revisions*, ed. R. Wilson (Ames, IA, 1991), pp. 106–11

J. Siry: 'Frank Lloyd Wright's Unity Temple and Architecture for Liberal Religion in Chicago, 1885–1909', *A. Bull.*, lxxiii/2 (June 1991), pp. 257–82

T. Turak: 'Mr Wright and Mrs Coonley', *Modern Architecture in America: Visions and Revisions*, ed. R. Wilson (Ames, IA, 1991), pp. 144–63

K. Nute: *Frank Lloyd Wright and Japan* (New York, 1993)

P. Kruty: 'Wright, Spencer and the Casement Window', *Winterthur Port.*, xxx/2–3 (Summer–Autumn 1995), pp. 103–27

J. Siry: *Unity Temple: Frank Lloyd Wright and Architecture for Liberal Religion* (Cambridge and New York, 1996)

P. S. Kruty: *Frank Lloyd Wright and Midway Gardens* (Urbana, IL, 1998)

PAUL E. SPRAGUE

Wright, Joseph (*b* Bordentown, NJ, 16 July 1756; *d* Philadelphia, PA, 13 Sept 1793). American painter, sculptor and engraver. He probably received his first art training from his mother, the modeller in wax Patience Lovell Wright (1725–86). After the death of his father in 1769, he was placed in the Academy in Philadelphia, while Patience opened a waxworks in New York. In 1772 she moved to London to open a studio and waxworks there; by the spring of 1775 Joseph joined her and was the first American-born student admitted to the Royal Academy Schools, where he won a silver medal for 'the best model of an Academy figure' in December 1778. In 1780 he exhibited publicly for the first time with *Portrait of a Man* in the annual exhibition of the Society of Artists of Great Britain. In that year he caused a scandal at the Royal Academy by exhibiting a portrait of his mother modelling a head of King Charles II, while busts of King George III and Queen Charlotte looked on (ex-artist's col.). He went to Paris in December 1781 and, while there, painted several portraits of *Benjamin Franklin* (version, *c.* 1782; London, Royal Soc. A.) from observation and from the 1778 pastel by Joseph Siffred Duplessis (1725–1802).

He sailed from Nantes in early autumn 1782; his ship was wrecked on the coast of Maine ten weeks later. He returned to Philadelphia, where he painted his first known American portrait in June 1783, *Anne Shippen Livingston and her Daughter* (ex-Livingston priv. col.). Late in the summer of 1783, at the request of the federal government,

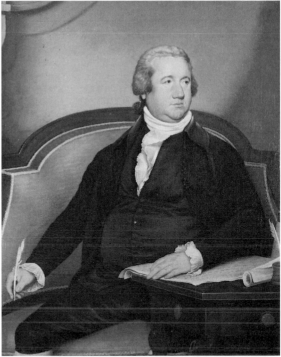

Joseph Wright: *Frederick Augustus Muhlenberg*, oil on canvas, 1193×940 mm, *c.* 1786–90 (Washington, DC, National Portrait Gallery)

Wright went to Rocky Hill, NJ, where he made a plaster cast of the face of George Washington, from which he modelled the first known sculpture of the president. He executed several other versions in different media (e.g. wax) and also painted a small oil-on-panel portrait from life (1783; Philadelphia, PA, Hist. Soc.). In 1786 Wright moved to New York, where he painted some of his most stylish and finished portraits, such as *Frederick Augustus Muhlenberg*, first Speaker of the US House of Representatives (*c.* 1786–90; Washington, DC, N.P.G.; see fig.). He returned to Philadelphia, probably in the autumn of 1790.

Wright worked as an engraver for the newly founded US Mint. He is known to have cut dies for a medal honouring the Revolutionary War general Henry Lee and for an unissued quarter-dollar coin. Among the works he left unfinished is a well-known self-portrait with his wife and three children (Philadelphia, PA Acad. F.A.).

BIBLIOGRAPHY
Joseph Wright: American Artist, 1756–1793 (exh. cat. by M. H. Fabian, Washington, DC, N.P.G., 1985)

MONROE H. FABIAN

Wyant, Alexander Helwig (*b* Evans Creek, nr Port Washington, OH, 11 Jan 1836; *d* New York, 11 Nov 1892). American painter. He began as an itinerant painter of topographical landscapes along the banks of the Ohio River *c.* 1854, influenced by such landscape artists as Worthington Whittredge and George Inness. In 1863–4 Wyant moved to New York, where he was impressed by the paintings of the Norwegian artist Hans Gude (1825–1903) in the Düsseldorf Gallery. This led him to work

with Gude in Karlsruhe, Germany, in 1865. On his way both there and back, he studied paintings by Constable (1776–1837) and used a more painterly technique especially for views of Ireland, for example *Irish Landscape* (1865; Cleveland, OH, Mus. A.). Gude's influence in Germany was very strong, when Wyant painted hard-edged, but broad and expansive landscapes such as *Tennessee (formerly The Mohawk Valley)* (1866; New York, Met.).

In 1873 Wyant permanently lost the use of his right arm due to a stroke and started to paint with his left hand. *The Flume, Opalescent River, Adirondacks* (c. 1881; Washington, DC, N. Mus. Amer. A.; see fig.) is typical of his later style, in which looser brushstrokes are used to paint mountain scenery. His subjects came from sketches made during summer holidays at Keene Valley, NY, in the Adirondack Mountains (1880–89) and Arkville, NY, in the Catskill Mountains (1889–92). Influenced by Constable, George Inness and the Barbizon artists, Wyant developed an introspective form of Tonalism and Tonal Impressionism. His oil and watercolour works such as

Moonlight and Frost (1890–92; New York, Brooklyn Mus.) and *Afternoon* (1891–2; Worcester, MA, A. Mus.) influenced most of the younger Tonalists, especially Bruce Crane (1857–1934) and J. Francis Murphy.

BIBLIOGRAPHY

Alexander Helwig Wyant, 1836–1892 (exh. cat., ed. E. F. Sanguinetti; Salt Lake City, U. UT, Mus. F.A., 1968)
R. S. Olpin: *Alexander Helwig Wyant: American Landscape Painter: An Investigation of his Life and Fame and a Critical Analysis of his Work with a Catalogue Raisonné of Wyant's Paintings* (diss., Boston U., 1971)
P. Bermingham: 'Alexander H. Wyant: Some Letters from Abroad', *Archv Amer. A. J.*, xii (1972), pp. 1–8
D. O. Dawdy: 'The Wyant Diary', *Arizona & W.*, xxii (1980), pp. 255–78

ROBERT S. OLPIN

Wyman, George Herbert (*b* Dayton, OH, 1860; *d* Los Angeles, CA, *c.* 1900). American architect. He received little formal architectural training, having had a brief apprenticeship in Dayton in the architectural office of his uncle Luthor Peters (*d* 1921), followed by a period as a draughtsman in the office of Sumner P. Hunt (1865–1938) in Los Angeles, where he moved in 1891 for health reasons. In 1893 his first and only major work was constructed. The Bradbury Building, on Third Avenue and Broadway, invokes 19th-century traditions of industrial and commercial architecture, particularly those of the early Chicago school, with its steel-frame construction and Romanesque details. Drab and undistinguished on its exterior, the interior of the five-storey building opens into a light-flooded court, surrounded by series of iron balconies, galleries, and exposed lifts and stairs, framed in masonry. The expressive potential of this open, light-filled construction is seen even in the glass letter-chutes that run parallel to the lifts. Wyman's visionary concept was probably inspired by the imagery in Edward Bellamy's utopian novel *Looking Backward* (Boston, 1888), which describes a futuristic architecture, with one building referred to as 'a vast hall of light' surrounded by windows and capped by a glass dome. The Bradbury Building stands as a precursor of the utopian tradition of later architecture in Los Angeles. After receiving several commissions in the wake of the successful reception of the Bradbury Building, Wyman enrolled in a correspondence course in architecture, after which he lost interest in the use of light as a formal element. His later office buildings, most of which have been destroyed, were characterized by their weighty solidity, as were his frame buildings, for example the National Soldiers' Home (destr.) at Sawtell, CA.

BIBLIOGRAPHY

E. McCoy: 'The Bradbury Building', *A. & Archit.*, lxx/4 (1953), pp. 20, 42–3
'Blending the Past with the Present: A Hall of Light and Life', *AIA J.*, xlviii/5 (1967), pp. 66–9
W. Jordy: *American Buildings and Their Architects* (New York, 1972)
T. Hines: 'Origins and Innovations', *Archit. Rev.* [Boston], clxxxii/1090 (1987), pp. 73–9

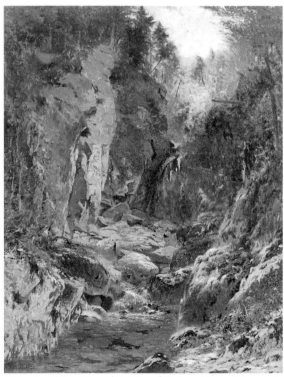

Alexander Helwig Wyant: *The Flume, Opalescent River, Adirondacks*, oil on canvas, 612×917 mm, *c.* 1881 (Washington, DC, National Museum of American Art)

Y

Young, Ammi B(urnham) (*b* Lebanon, NH, 19 June 1798; *d* Washington, DC, 13 March 1874). American architect. Trained by his father as a builder, he designed houses, churches and collegiate buildings in New Hampshire and Vermont, including three utilitarian dormitories (1828–9, 1839–40) and an observatory (1852) for Dartmouth College. Although he lacked a formal architectural education, he obtained the commission for the Vermont State Capitol (1833–6), a Neo-classical building with a Doric portico, capped for exterior effect by a hemispherical dome as there was no internal domed space. (A new drum and dome were added after a fire in 1857.) In 1837 Young won a competition for the Boston Custom House; this was his largest commission, completed in 1847 at a cost of over one million dollars. In 1911–14 it became the base for a skyscraper for the federal government. The only surviving competition drawing (pencil, watercolour and gouache; Washington, DC, N. Archvs) illustrates the building's magnificent internal domed space; monolithic granite columns surround the exterior of the building, which has pedimented ends and Doric porticos on the long sides.

This design for a federal building led to Young's appointment in 1852 as Supervising Architect of the Treasury Department. Here he worked with Alexander H. Bowman, Captain of the Corps of Engineers, on *c.* 80 fireproof iron-framed post offices, custom houses, court facilities and marine hospitals. The Roman temple form was the basis for several designs, including the Custom House (1852–9) in Norfolk, VA, but Young also used the Italian palazzo style, as in the Post Office (1856–8) at Windsor, VT, which has quoins and other Italianate decorative features in cast iron. Complaints about overspending on federal buildings led to his dismissal as Supervising Architect in 1862. Little is known of Young after this time, but he is described by Alfred B. Mullett in his diary of 1865 as working with a former draughtsman from the Treasury Department.

BIBLIOGRAPHY

L. Wodehouse: 'Ammi Burnham Young, 1798–1874', *J. Soc. Archit. Hist.*, xxv (1966), pp. 268–80

——: 'Architectural Projects in the Greek Revival Style by Ammi Burnham Young', *Old Time New England*, lv (1970), pp. 73–85

L. Craig: *The Federal Presence* (Cambridge, MA, 1978)

B. Lowry: *Building a National Image* (Washington, DC, 1985)

LAWRENCE WODEHOUSE

Black and White Illustration Acknowledgements

We are grateful to those listed below for permission to reproduce copyright illustrative material and to those contributors who supplied photographs or helped us to obtain them. The word 'Photo:' precedes the names of large commercial or archival sources who have provided us with photographs, as well as the names of individual photographers (where known). It has generally not been used before the names of owners of work of art, such as museums and civic bodies. Every effort has been made to contact copyright holders and to credit them appropriately; we apologize to anyone who may have been omitted from the acknowledgements or cited incorrectly. Any error brought to our attention will be corrected in subsequent editions. Where illustrations have been taken from books, publication details are provided in the acknowledgements below.

Abbey, Edwin Austin Trustees of the Boston Public Library, Boston, MA

Adler, Dankmar Photo: Rochelle Berger Elstein

Affleck, Thomas Metropolitan Museum of Art, New York (Purchase, 1959, Robert G. Guelet gift; Sulmaris Collection, gift of George Coe Graves, gift of Mrs Russell Sage; no. 59.154)

African American art National Museum of American Art, Washington, DC (Gift of Delta Sigma Theta Sorority, Inc.)/Photo: Art Resource, New York

Alexander, Francis Hood Museum of Art, Dartmouth College, Hanover, NH (Gift of Dr George C. Shattuck, Class of 1803)

Alexander, Henry Oakland Museum, Oakland, CA

Allston, Washington Harvard University Art Museums, Cambridge, MA

Amelung, John Frederick Metropolitan Museum of Art, New York (Rogers Fund, 1937; no. 37.101)

Ames, Ezra Albany Institute of History and Art, Albany, NY

Annapolis Maryland Historical Society, Baltimore, MD

Anshutz, Thomas Fine Arts Museum of San Francisco, San Francisco, CA (Gift of Mr and Mrs John D. Rockefeller 3rd; no. 1979.7.4)

Arts and Crafts Movement Board of Trustees of the Victoria and Albert Museum, London

Ashcan school Wadsworth Atheneum, Hartford, CT

Atlanta Georgia Historical Society, Savannah, GA

Audubon, John James (Laforest) New-York Historical Society, New York

Austin, Henry Photo: © Wayne Andrews/Esto

Baltimore © *The Catholic Review*, Baltimore, MD/Photo: Denise Walker

Bannister, Edward Mitchell National Museum of American Art, Washington DC/Photo: Art Resource, New York

Barnard, George N. George Eastman House, Rochester, NY

Baudouine, Charles A. Munson–Williams–Proctor Institute Museum of Art, Utica, NY (Proctor Collection; no. PC. 423.5)

Benbridge, Henry National Portrait Gallery, Smithsonian Institution, Washington, DC/Photo: Art Resource, New York

Bierstadt, Albert Metropolitan Museum of Art, New York (Rogers Fund, 1907; no. 07.123)

Bingham, George Caleb National Gallery of Art, Washington, DC

Birch, Thomas Pennsylvania Academy of the Fine Arts, Philadelphia, PA (Bequest of Charles Graff)

Bischoff, Franz A. Irvine Museum, Irvine, CA

Blackburn, Joseph Museum of Fine Arts, Boston, MA (Abraham Shuman Collection)

Blakelock, Ralph Albert Corcoran Gallery of Art, Washington, DC (William A. Clark Collection)

Blum, Robert Frederick Metropolitan Museum of Art, New York (Gift of the Estate of Alfred Corning Clark, 1904; no. 04.31)

Blythe, David Gilmour Memorial Art Gallery of the University of Rochester, Rochester, NY (Purchased from M. Knoedler & Co., New York, R.T. Miller Fund, transferred to Marion Stratton Gould Fund)

Bodmer, Karl Joslyn Art Museum, Omaha, NE (Gift of Enron Art Foundation)

Bogardus, James Photo: Phyllis Hoffzimer

Boston *1* Bostonian Society/Old State House, Boston, MA; *2* Boston Picture File, Fine Arts Department, Boston Public Library/Trustees of the Boston Public Library, Boston, MA; *3* Harvard Law School Art Collection, Cambridge, MA; *4* Houghton Library, Harvard University, Cambridge, MA; *5* Harvard University Art Museums, Cambridge, MA; *6* Museum of Fine Arts, Boston, MA (Gift of John P. Axelrod and Mary Baggs Tweet)

Bremer, Anne Oakland Museum, Oakland, CA

Brewster, John Palmer Museum of Art, Pennsylvania State University, University Park, PA (Gift of Mrs Nancy Adams McCord)

Bricher, Alfred Thompson Wadsworth Atheneum, Hartford, CT (The Ella Gallup Sumner and Mary Catlin Sumner Collection Fund)

Brookes, Samuel Marsden Oakland Museum, Oakland, CA

Brown, Benjamin C. Irvine Museum, Irvine, CA

Brown, George Loring Metropolitan Museum of Art, New York (Gift of William Church Osborn, 1903; no. 03.34)

Brown, John George Metropolitan Museum of Art, New York (Gift of Colonel Charles A. Fowler, 1921; no. 21.115.3)

Brown, Mather The National Trust Waddesdon Manor/Cortauld Institute of Art, London

Brush, George de Forest National Museum of American Art, Washington, DC/Photo: Art Resource, New York

Buffalo Buffalo and Erie County Historical Society, Buffalo, NY

Bulfinch, Charles Library of Congress, Washington, DC

Bunker, Dennis Miller Museum of Fine Arts, Boston, MA (Gift by contribution)

Burnham, Daniel H(udson) *1* Chicago Historical Society, Chicago, IL/Photo: C.D. Arnold; *2* Architectural Association, London/Photo: Karin Hay

Casilear, John William Wadsworth Atheneum, Hartford, CT (The Ella Gallup Sumner and Mary Catlin Sumner Collection Fund)

Cassatt, Mary (Stevenson) Virginia Museum of Fine Arts, Richmond, VA

Chandler, Winthrop National Gallery of Art, Washington, DC (Gift of Edgar William and Bernice Chrysler Garbisch)/© Board of Trustees, 1999

Charleston South Carolina Historical Society, Charleston, SC

Chase, William Merritt Joslyn Art Museum, Omaha, NE (Friends of Art Collection, 1932)

Chicago *1* Chicago Historical Society, Chicago, IL (no. ICHi-00990); *2* Balthazar Korab, Troy, MI

Chicago School © Wayne Andrews/Esto, Mamaroneck, NY

Church, Frederic Edwin Metropolitan Museum of Art, New York (Bequest of Mrs David Dows, 1909; no. 09.95)

Cincinnati Taft Museum, Cincinnati, OH

Cleveland © Wayne Andrews/Esto, Mamaroneck, NY

Clinton & Russell New-York Historical Society, New York

Clonney, James Goodwyn Museum of Fine Arts, Boston, MA (Gift of Mrs Maxim Karolik for the M. and M. Karolik Collection of American Paintings, 1815-1865)

Cobb, Henry Ives *1* Chicago Historical Society, Chicago, IL; *2* Yerkes Observatory Photographs, Williams Bay, WI

Coburn, Alvin Langdon International Museum of Photography at George Eastman House, Rochester, NY

Cole, Thomas New-York Historical Society, New York

651

Colonial Revival Historical Society, Litchfield, CT

Congdon, Henry Martyn Idaho State Historical Society, Boise, ID

Copley, John Singleton *1* Museum of Fine Arts, Boston, MA (Gift of Joseph W. Revere, William B. Revere and Edward H. R. Revere); *2* Tate Gallery, London

Cornish US Department of Interior, National Park Service, Saint–Gaudens National Historic Site, Cornish, NH/Photo: Gordon Sweet

Coxhead, Ernest Photo: Richard Longstreth

Cram, Ralph Adams Cathedral Church of St John the Divine, New York

Crawford, Thomas Newark Museum, Newark, NJ (Gift of Franklin Murphy, Jr, 1926)/Photo: Art Resource, New York

Cropsey, Jasper F(rancis) National Gallery of Art, Washington, DC

Cummings & Sears *1* © Wayne Andrews/Esto, Mamaroneck, NY; *2* Boston Public Library, Print Department, Boston, MA

Currier, Frank Brooklyn Museum of Art, Brooklyn, NY (Gift of Mrs. John W. Alexander; no. 30.1083)

Currier & Ives Library of Congress, Washington, DC

Davis, Alexander Jackson *1* New-York Historical Society, New York; *2* Lyndhurst (property of the National Trust for Historic Preservation)

Deas, Charles Amon Carter Museum, Fort Worth, TX

De Longpre, Paul Irvine Museum, Irvine, CA

Detroit *1–2* Burton Historical Collection, Detroit Public Library, Detroit, MI

Dewing, Thomas Wilmer National Museum of American Art, Washington, DC/Photo: Art Resource, New York (Bequest of Henry Ward Ranger through the National Academy of Design)

Doughty, Thomas Baltimore Museum of Art, Baltimore, MD (Gift of Dr and Mrs Michael A. Abrams; no. BMA 1955.183)

Duncanson, Robert National Museum of American Art, Washington, DC/Photo: Art Resource, NY

Dunlap, William New-York Historical Society, New York

Durand, Asher B(rown) New York Public Library (Astor, Lenox and Tilden Foundations)

Durand, John New-York Historical Society, New York

Duveneck, Frank Cincinnati Museum of Art, Cincinnati, OH (John J. Emery Endowment; no. 1917.8)

Eakins, Thomas (Cowperthwaite) *1* Metropolitan Museum of Art, New York (Alfred N. Punnett Endowment Fund and George D. Pratt gift, 1934; no. 34.92); *2* Jefferson Medical College of Thomas Jefferson University, Philadelphia, PA

Eastlake Style © Wayne Andrews/Esto, Mamaroneck, NY

Edmonds, Francis W. National Museum of American Art, Washington, DC/Photo: Art Resource, New York

Ehninger, John W. Newark Museum, Newark, NJ/Photo: Art Resource, New York

Eidlitz, Leopold New-York Historical Society, New York

Eidlitz, Cyrus L.W. New-York Historical Society, New York

Eilshemius, Louis M(ichel) Whitney Museum of American Art, New York

Ellis, Harvey Strong Museum, Rochester, NY

Eugene, Frank Royal Photographic Society, Bath, England

Federal Style *1* Maryland Historical Society, Baltimore, MD; *2* Library of Congress, Washington, DC; *3* Philadelphia Museum of Art, Philadelphia, PA

Field, Erastus Salisbury Museum of Fine Arts, Springfield, MA (The Morgan Wesson Memorial Collection)

Fortune, E. Charlton Fine Arts Museum of San Francisco, San Francisco, CA

Francis, John F. National Museum of American Art, Washington, DC/Photo: Art Resource, New York

Fraser, Charles Gibbes Museum of Art, Charleston, SC

Freake Painter Worcester Art Museum, Worcester, MA (Gift of Mr and Mrs Albert W. Rice)

Fuller, George Metropolitan Museum of Art, New York (Gift of George A. Hearn, 1910; no. 10.64.3)

Furness, Frank *1* Yale University Press, London/Photo: J.L. Dillon and Co.; *2* Photo: Dr George E. Thomas

Gallier, James © Wayne Andrews/Esto, Mamaroneck, NY

Gansevoort Limner Albany Institute of History and Art, Albany, NY

Garden South Carolina Historical Society, Charleston, SC

Gifford, Sanford Robinson Metropolitan Museum of Art, New York (Bequest of Maria De Witt Jesup, 1915; no. 15.30.62)

Gignoux, Regis-Francois Museum of Fine Arts, Boston, MA (Bequest of Martha C. Karolik for the M. and M. Karolik Collection of American Paintings, 1815-1865)

Gilbert, Cass Library of Congress, Washington, DC

Gilman, Arthur Delavan Boston Public Library, Print Department, Boston, MA

Goddard, John Rhode Island Historical Society, Providence, RI (no. 1944.5.1)

Goodhue, Bertram (Grosvenor) British Architectural Library, RIBA, London

Greek Revival Library of Congress, Washington, DC

Greene & Greene Photo: Prof. David Gebhard

Greenough, Horatio Boston Athenæum, Boston, MA

Hamilton, James Brooklyn Museum of Art, Brooklyn, NY (Dick S. Ramsay Fund; no. 55.139)

Hardenbergh, Henry Janeaway © Peter Mauss/Esto, Mamaroneck, NY

Harding, Chester National Gallery of Art, Washington, DC (Gift of Mr and Mrs Alexander Dallas Thayer)/© 1999 Board of Trustees

Harnett, William Michael *1* Fine Arts Museum of San Francisco, San Francisco, CA (Mildred Anna Williams Collection; no. 1940.93); *2* Metropolitan Museum, New York

Harrison, Peter Library of Congress, Washington, DC

Hart, James McDougal Metropolitan Museum of Art, New York (Gift of Colonel Charles A. Fowler, 1992; no. 21.115.2)

Haseltine, William Stanley Fine Arts Museums of San Francisco, San Francisco, CA (Museum purchase, Roscoe and Margaret Oakes Income Fund; no. 1985.28)

Hassam, (Frederick) Childe Toledo Museum of Art, Toledo, OH (Purchased with funds from the Florence Scott Libbey Bequest in Memory of her Father, Maurice A. Scott)

Hathaway, Rufus Metropolitan Museum of Art, New York (Gift of Edgar William and Bernice Chrysler Garbisch, 1963; no. 63.201.1)

Haviland, John © Wayne Andrews/Esto, Mamaroneck, NY

Heade, Martin Johnson Museum of Fine Arts, Boston, MA (Bequest of Maxim Karolik)

Healy, George Peter Alexander Metropolitan Museum of Art, New York (Bequest of Cornelia Cruger, 1923; no. 23.102)

Henry, E.L. Albany Institute of History and Art, Albany, NY

Herter, Christian Metropolitan Museum of Art, New York (Gift of Kenneth O. Smith, 1969; no.69.140)

Hesselius, Gustavas Historical Society of Pennsylvania, Philadelphia, PA

Hesselius, John Baltimore Museum of Art, Baltimore, MD (Gift of Alfred R. and Henry G. Riggs, in Memory of General Lawrason Riggs; no. BMa 1941.10)

Hill, Thomas Crocker Art Museum, Sacramento, CA (Crocker Collection)

Homer, Winslow *1* Pennsylvania Academy of the Fine Arts, Philadelphia, PA (Joseph E. Temple Fund); *2* Yale University Art Gallery, New Haven, CT

Hosmer, Harriet National Museum of American Art, Washington, DC/Photo: Art Resource, New York (Gift of Mrs George Merrill)

Hovenden, Thomas Philadelphia Museum of Art, Philadelphia, PA (Given by Ellen Harrison McMichael in memory of C. Emory McMichael)

Hudson River School National Museum of American Art, Washington, DC/Photo: Art Reource, New York

Hudson, Grace Carpenter Oakland Museum, Oakland, CA

Hunt, William Morris Museum of Fine Arts, Boston, MA (Bequest of Elizabeth Howes)

Hunt, Richard Morris *1* Preservation Society of Newport County, Newport, RI/Photo: John W. Corbett; *2* North Carolina Division of Archives and History, Raleigh, NC

Huntington, Daniel National Museum of American Art, Washington, DC/Photo: Art Resource, New York

Industrial design *1* Trustees of the Science Museum, London/Photo: Science and Society Picture Library; *2* Henry Ford Museum and Greenfield Village, Dearborn, MI

Ingham, Charles Cromwell Metropolitan Museum of Art, New York (Gift of William Church Osborn, 1902; no. 02.7.1)

Inman, Henry Museum of Fine Arts, Boston, MA (Bequest of Georgiana Buckham Wright)

Inness, George Art Museum Mount Holyoke College, South Hadley, MA (Gift of Miss Ellen W. Ayer)

Ives, Chauncey B. Metropolitan Museum of Art, New York (Gift of Anne C. McCreery, 1899; no. 99.8)

Jackson, William Henry National Anthropological Archives, Smithsonian Institution, Washington, DC

Jarvis, John Wesley Minneapolis Institute of Arts, Minneapolis, MN

Colour Acknowledgements

PLATE I. **Architecture**

1. St Paul's Chapel, New York, 1764–8 (Photo: Robert M. Craig)

2. Thomas Jefferson: Monticello, Albemarle Co., near Charlottesville, Virginia, 1770–1809 (Photo: Ezra Stoller/© Esto, Mamaroneck, NY)

PLATE II. **Architecture**

1. Levi G. Weeks: Auburn, Natchez, Mississippi, 1812 (Photo: Van Jones Martin, Savannah, GA)

2. James C. Bucklin and Russell Warren (for Tallman & Bucklin): Providence Arcade, Providence, Rhode Island, 1828 (Photo: Robert M. Craig)

3. James Renwick: Smithsonian Institution, Washington, DC, 1847–55 (Photo: Robert M. Craig)

PLATE III. **Architecture**

1. James Hamilton Windrim: Masonic Temple, Penn Square, Philadelphia, Pennsylvania, 1868–73 (Photo: Robert M. Craig)

2. Frederick Clarke Withers: Jefferson Market Courthouse and Prison (now the Greenwich Village branch of the New York Public Library), Greenwich, Connecticut, 1874 (Photo: © Susan Oristaglio/Esto, Mamaroneck, NY)

3. Alfred B. Mullett: War and Navy Building, Washington, DC, 1871–86 (Photo: Robert M. Craig)

PLATE IV. **Architecture**

1. John L. Smithmeyer & Co.: Library of Congress Building, Washington, DC, 1873 (Photo: Robert M. Craig)

2. Greene & Greene: David B. Gamble House, Pasadena, California, 1908 (Photo: © Peter Aaron/Esto, Mamaroneck, NY)

PLATE V. **Painting**

1. Thomas Smith: *Self-portrait*, oil on canvas, 629x604 mm, *c.* 1680 (Worcester, MA, Worcester Art Museum/Photo: David Tatham)

2. John Smibert: *Portrait of a Man*, oil on canvas, 975x740 mm, *c.* 1720 (Hartford, CT, Wadsworth Atheneum/Photo: Wadsworth Atheneum, The Ella Gallup Sumner and Mary Catlin Sumner Collection Fund)

3. Benjamin West: *Helen Brought to Paris*, oil on canvas, 1.43x1.98 m, 1776 (Washington, DC, National Museum of American Art / Photo: Art Resource, New York)

PLATE VI. **Painting**

1. John Singleton Copley: *Watson and the Shark*, oil on canvas, 1.83x2.29 m, 1778 (Boston, MA, Museum of Fine Arts/Photo: Boston Museum of Fine Arts, Gift of Mrs George von Lengerke Meyer)

2. Charles Willson Peale: *Washington's Victory at Princeton*, oil on canvas, 2.39x1.50 m, 1779 (Philadelphia, PA, Pennsylvania Academy of Fine Arts /Photo: Bridgeman Art Library, London/New York)

3. Gilbert Stuart: *George Washington*, oil on canvas, 768x641 mm, 1795 (New York, Metropolitan Museum of Art/Photo: Metropolitan Museum of Art, Rogers Fund, 1907; no. 07.160)

PLATE VII. **Painting**

1. Thomas Birch: *Naval Battle between the United States and the Macedonian, 30 October 1812*, oil on canvas, 737x876 mm, 1812 (Philadelphia, PA, Historical Society of Pennsylvania/Photo: Historical Society of Pennsylvania)

2. Raphaelle Peale: *Melons and Morning Glories*, oil on canvas, 526x654 mm, 1813 (Washington, DC, National Museum of American Art/Photo: Art Resource, New York)

PLATE VIII. **Painting**

1. Alvan Fisher: *Niagara Falls*, oil on canvas, 872x1220 mm, 1820 (Washington, DC, National Museum of American Art/Photo: Art Resource, New York)

2. John James Audubon: *Whooping Crane*, watercolour and pastel, 947x652 mm, 1821–2 (New York, New-York Historical Society/Photo: New-York Historical Society)

PLATE IX. **Painting**

1. Thomas Cole: *Scene from the 'Last of the Mohicans'*, oil on canvas, 635x787 mm, 1827 (Cooperstown, NY, New York Historical Association/Photo: New York State Historical Association; photographer: Richard Walker)

2. Charles Bird King: *Young Omaha, War Eagle, Little Missouri and Pawnees*, oil on canvas, 918x711 mm, 1828 (Washington, DC, National Museum of American Art/Photo: Art Resource, New York)

PLATE X. **Painting**

1. George Catlin: *Drinks the Juice on the Stone in Ball-player Dress*, oil on canvas mounted on aluminium, 737x609 mm, 1834 (Washington, DC, National Museum of American Art /Photo: Art Resource, New York)

2. William Sydney Mount: *Farmers Nooning*, oil on canvas, 508x610 mm, 1836 (Stony Brook, NY, The Museums of Stony Brook/Photo: Museums at Stony Brook Collection; no. 836)

PLATE XI. **Painting**

1. Thomas Cole: *Oxbow on the Connecticut River*, oil on canvas, 1.31x1.93 m, 1836 (New York, Metropolitan Museum of Art/Photo: Metropolitan Museum of Art, Gift of Mrs Russell Sage, 1908; no. 08.228)

2. Samuel F.B. Morse: *The Muse*, oil on canvas, 1.87x1.47 m, 1836–7 (New York, Metropolitan Museum of Art/Photo: Metropolitan Museum of Art, Bequest of Herbert L. Pratt, 1945; no. 45.62.1)

3. Thomas Sully: *Queen Victoria*, oil on canvas, 1.38x1.10 m, 1838 (London, Wallace Collection/Photo: Trustees of the Wallace Collection)

PLATE XII. **Painting**

1. Edward Hicks: *Peaceable Kingdom of the Branch*, oil on canvas, 457x613 mm, *c.* 1825–30 (Brooklyn, NY, Brooklyn Museum of Art /Photo: Bridgeman Art Library, London/New York)

2. George Caleb Bingham: *Fur Traders Descending the Missouri*, oil on canvas, 737x927 mm, 1845 (New York, Metropolitan Museum of Art/Photo: Metropolitan Museum of Art, Morris K. Jesup Fund, 1933; no. 33.61)

PLATE XIII. **Painting**

1. Asher B. Durand: *The Beeches*, oil on canvas, 1.53x1.22 m, 1846 (New York, Metropolitan Museum of Art/Photo: Metropolitan Museum of Art, Bequest of Maria DeWitt Jesup, from the collection of her husband, Morris K. Jesup, 1914; no. 15.30.59)

2. Fitz Hugh Lane: *Off Mount Desert Island*, oil on canvas, 614x926 mm, 1856 (New York, Brooklyn Museum of /Photo: Bridgeman Art Library, London/New York)

PLATE XIV. **Painting**

1. Tompkins Harrison Matteson: *Erastus Dow Palmer in his Studio*, oil on canvas, 743x927 mm, 1857 (Albany, NY, Albany Institute of History and Art/Photo: Albany Institute of History and Art)

2. Martin Johnson Heade: *Coming Storm*, oil on canvas, 711x1110 mm, 1859 (New York, Metropolitan Museum of Art/Photo: Metropolitan Museum of Art, Gift of Erving Wolf Foundation and Mr and Mrs Erving Wolf, 1975; no. 1975.160)

PLATE XV. **Painting**

1. Frederic Edwin Church: *Twilight in the Wilderness*, oil on canvas, 1.02x1.63 m, 1860 (Cleveland, OH, Cleveland Museum of Art/Photo: Cleveland Museum of Art, Mr and Mrs William H. Marlatt Fund; no. 1965.233)

2. James McNeill Whistler: *Symphony in White No. 2: The Little White Girl*, oil on canvas, 765x511 mm, 1864 (London, Tate Gallery/Photo: © Tate Gallery, London, 1998)

PLATE XVI. **Painting and printmaking**

1. Currier & Ives: hand-coloured lithograph of *Winter in the Country: Getting Ice* by George Henry Durrie, 1864 (New York, Museum of the City of New York/Photo: Bridgeman Art Library, London/New York)

2. James McNeill Whistler: *Crepuscule in Flesh Colour and Green, Valparaiso*, oil on canvas, 584x755 mm, 1866 (London, Tate Gallery/Photo: © Tate Gallery, London, 1998)

PLATE XVII. **Painting**

1. Albert Bierstadt: *Among the Sierra Nevada Mountains, California*, oil on canvas, 1.83x3.05 m, 1868 (Washington, DC, National Museum of American Art/Photo: Bridgeman Art Library, London/New York)

2. Eastman Johnson: *Hatch Family*, oil on canvas, 1.22x1.86 m, 1871 (New York, Metropolitan Museum of Art/Photo: Metropolitan Museum of Art, Gift of Frederic H. Hatch, 1926; no. 26.97)

PLATE XVIII. **Painting**

1. Thomas Moran: *Grand Canyon of the Yellowstone*, oil on canvas, 2.13x2.66 m, 1872 (Washington, DC, US Department of the Interior, on loan to the National Museum of American Art /Photo: Art Resource, New York)

2. Winslow Homer: *Snap the Whip*, oil on canvas, 558x914 mm, 1872 (Youngstown, OH, Butler Institute of American Art /Photo: Bridgeman Art Library, London/New York)

PLATE XIX. **Painting**

1. George Inness: *Autumn Oaks*, oil on canvas, 543x765 mm, *c.* 1878 (New York, Metropolitan Museum of Art/Photo: Metropolitan Museum of Art, Gift of George I. Seney, 1887; no. 87.8.8)

2. Thomas Eakins: *Fairman Rogers Four-in-Hand*, oil on canvas, 603x914 mm, 1879 (Philadelphia, PA, Philadelphia Museum of Art/ Photo: Philadelphia Museum of Art, Given by Mr William Alexander Dick)

PLATE XX. **Painting**

1. Mary Cassatt: *Lydia Crocheting in her Garden at Marly*, oil on canvas, 813x1067 mm, 1880 (New York, Metropolitan Museum of Art/Photo: Metropolitan Museum of Art, Gift of Mrs Gardner Cassatt, 1965; no. 65.184)

2. John H. Twatchman: *Arques-la-Bataille*, oil on canvas, 1.52x2.00 m, 1885 (New York, Metropolitan Museum of Art/Photo: Metropolitan Museum of Art, Morris K. Jesup Fund, 1968; no. 68.52)

PLATE XXI. **Painting**

1. William Merritt Chase: *Lady in Black*, oil on canvas, 1880x914 mm, 1888 (New York, Metropolitan Museum of Art/Photo: Metropolitan Museum of Art, Gift of William Merritt Chase, 1891; no. 91.11)

2. Albert Pinkham Ryder: *Jonah*, oil on canvas, 692x873 mm, 1890 (Washington, DC, National Museum of American Art /Photo: Art Resource, New York)

PLATE XXII. **Painting**

1. John Haberle: *Bachelor's Drawer*, oil on canvas, 508x914 mm, 1890–94 (New York, Metropolitan Museum of Art/Photo: Metropolitan Museum of Art, Purchase, 1970, Henry R. Luce gift; no. 1970.1)

2. Emil Carlsen: *Still-life*, oil on canvas, 889x1092 mm, 1891 (Oakland, CA, Oakland Museum/Photo: Oakland Museum)

PLATE XXIII. **Painting**

1. Childe Hassam: *Island Garden*, watercolour, 565x457 mm, 1892 (Washington, DC, National Museum of American Art /Photo: Art Resource, New York)

2. John Singer Sargent: *Mrs Carl Meyer and her Children*, oil on canvas, 2.02x1.36 m, 1896 (Sunningdale, Berks, collection of Sir Anthony Meyer/Photo: Bridgeman Art Library, London/New York)

PLATE XXIV. **Painting**

1. Classical Revival style frame designed by Stanford White for Abbott Handerson Thayer: *Portrait of Bessie Price*, oil on canvas, 711x495 mm, 1897 (Hanford, CA, collection of Mr and Mrs W.G. Clark/Photo: collection of Mr and Mrs W.G. Clark)

2. Winslow Homer: *Gulf Stream*, oil on canvas, 714x1248 mm, 1899 (New York, Metropolitan Museum of Art/Photo: Metropolitan Museum of Art, Catharine Lorillard Wolfe Collection, Wolfe Fund, 1906; no. 06.1234)

PLATE XXV. **Painting**

1. George Luks: *Closing the Café*, oil on panel, 216x270 mm, 1904 (Utica, NY, Munson–Williams–Proctor Institute/Photo: Munson–Williams–Proctor Institute Museum of Art, Edward W. Root Bequest; no. 57.175)

2. Maurice Prendergast: *Summer, New England*, oil on canvas, 489x699 mm, 1912 (Washington, DC, National Museum of American Art/Photo: Art Resource, New York)

PLATE XXVI. **Sculpture**

1. Anonymous: sternboard, polychromed wood, l. 2.96 m, *c.* 1785 (Shelburne, VT, Shelburne Museum/Photo: Shelburne Museum)

2. Horatio Greenough: *Samuel F.B. Morse*, marble, h. 546 mm, 1831 (Washington, DC, National Museum of American Art, Gift of Edward L. Morse/Photo: Art Resource, New York)

3. Daniel Chester French: *Ralph Waldo Emerson*, bronze, h. 572 mm, 1879 (cast 1901) (Washington, DC, National Portrait Gallery/ Photo: Art Resource, New York)

PLATE XXVII. **Sculpture**

1. Frederick William MacMonnies: *Bacchante and Infant Faun*, bronze, h. 2.11 m, 1893 (New York, Metropolitan Museum of Art/ Photo: Metropolitan Museum of Art, Gift of Charles F. McKim, 1897; no. 97.19)

2. Augustus Saint-Gaudens: *The Puritan*, bronze, h. 787 mm, 1899 (New York, Metropolitan Museum of Art/Photo: Metropolitan Museum of Art, New York, Bequest of Jacob Ruppert, 1939; no. 39.65.53)

PLATE XXVIII. **Sculpture**

1. Frederic Remington: *Mountain Man*, bronze, h. 3.71 m, 1903 (New York, Metropolitan Museum of Art/Photo: Metropolitan Museum of Art, Rogers Fund, 1907; no. 07.79)

2. Daniel Chester French: *Abraham Lincoln* (1914-20; dedicated 1922), marble, over life-size, Lincoln Memorial, Washington, DC (Photo: Robert M. Craig)

PLATE XXIX. **Interior decoration**

1. Thomas Hart Room, from Ipswich, Massachusetts, before 1674 (New York, Metropolitan Museum of Art; reconstruction/Photo: Metropolitan Museum of Art, Munsey Fund, 1936; no. 36.127)

2. Hewlett Room, from Woodbury, Long Island, New York, 1740–60 (New York, Metropolitan Museum of Art; reconstruction/Photo: Metropolitan Museum of Art, Gift of Mrs Robert W. de Forest, 1910; no. 10.183; photographer: Richard Cheek)

PLATE XXX. **Interior decoration**

Music Room, Bayou Bend, Museum of Fine Arts, Houston, Texas (Photo: The Museum of Fine Arts, Houston, The Bayou Bend Collection, gift of Miss Ima Hogg)

PLATE XXXI. **Interior decoration**

1. Corner of a Shaking retiring room (New York, Metropolitan Museum of Art; reconstruction/Photo: Metropolitan Museum of Art, Purchase, Emily C. Chadbourne Bequest, 1972; no. 1972.187.1-.3)

2. Will H. Bradley (1868-1962): design for a dining room, commercial printing process, 254x327 mm, from *'The Ladies' Home Journal*, *c.* 1901 (New York, Metropolitan Museum of Art/Photo: Metropolitan Museum of Art, Gift of Fern Bradley Dufner, 1952; no. 52.625.88(6))

PLATE XXXII. **Furniture**

1. Chair-table, oak and pine, h. (of seat) 495 mm, from New England, 1675–1700 (New York, Metropolitan Museum of Art/Photo: Metropolitan Museum of Art, Gift of Mrs Russell Sage, 1909; no. 10.125.697)

2. Easy chair, mahogany and maple, original bargello (or flame-stitch) upholstery, h. 1.16 m, *c.* 1760–90 (Houston, TX, Houston Museum of Fine Arts, Bayou Bend/Photo: The Museum of Fine Arts, Houston, The Bayou Bend Collection, gift of Miss Ima Hogg)

3. Benjamin Henry Latrobe (designer): klismos chair, white oak, yellow poplar, white pine, cane, reproduction silk fabric, h. 876 mm, probably made by Hugh and Robert Finlay, Baltimore, Maryland, *c.* 1815 (St Louis, MO, St Louis Art Museum/Photo: St Louis Art Museum, Funds given by the Decorative Arts Society in honour of Charles E. Buckley)

PLATE XXXIII. **Furniture**

1. John Seymour & Son: mahogany tambour desk, inlaid with light wood, white pine and elm, 1054x959x501 mm, from Boston, Massachusetts, 1794-1804 (Winterthur, DE, H.F. du Pont Winterthur Museum/Photo: H.F. du Pont Winterthur Museum)

2. Herter Brothers: dresser, mirror and side chair, ebonized cherry, purple heart, white pine, perhaps padouk, holly, marble, brass, h. (dresser with mirror) 2.16 m, *c.* 1881-4 (St Louis, MO, St Louis Art Museum/Photo: St Louis Art Museum, Funds given by Mrs Harold Baer; Mrs Ernest Eddy, in memory of William P. Williams; the Weiss Foundation in memory of Edith N. Weiss, Mr and Mrs I. K. Ayers and the Decorative Arts Society)

3. Harvey Ellis: arm chair, white oak, copper, pewter, wood, rush, h. 1.17 m, from the workshop of Gustav Stickley, *c.* 1903 (Pittsburgh,

PA, Carnegie Museum of Art/Photo: Carnegie Musuem of Art, Decorative Arts Purchase Fund: gift of Mr and Mrs Aleon Deitch, by exchange)

PLATE XXXIV. **Ceramics**

1. Covered jar, red earthenware decorated with bright stripes of slip, h. 324 mm, from North Carolina, 1785–1830 (New York, Metropolitan Museum of Art/Photo: Metropolitan Museum of Art, Rogers Fund, 1918; no. 8.95.16)

2. Karl Müller: 'Century' vase, porcelain, h. 324 mm, from Union Porcelain Works, Greenpoint (Brooklyn), New York, *c.* 1876 (New York, Metropolitan Museum of Art/Photo: Metropolitan Museum of Art, Gift of Mr and Mrs Franklin M. Chace, 1969; no. 69.194.1)

3. Earthenware tea set, h. (teapot) 121 mm, h. (sugarbowl) 108 mm, h. (teacup) 64 mm, from the Chelsea Keramic Art Works, Chelsea, Massachusetts, 1877–80 (New York, Metropolitan Museum of Art/ Photo: Metropolitan Museum of Art, Gift of Mr and Mrs I. Wistar Morris III, 1982; no. 1882.4401-.4)

4. Kataro Shirayamadani (1865-1948): vase, painted and glazed earthenware, h. 457 mm, from the Rookwood Pottery, Cincinnati, Ohio, 1890 (Minneapolis, MN, Minneapolis Institute of Arts/Photo: Minneapolis Institute of Art)

PLATE XXXV. **Glass**

1. Footed pitcher, non lead glass, blown and tooled with applied decoration, h. 183 mm, probably from New York State, 1835–50 (Toledo, OH, Toledo Museum of Art/Photo: Toledo Museum of Art, Purchased with funds from from the Libbey Endowment, Gift of Edward Drummond Libbey; no. 1959.73)

2. 'Amberina' cracker jar, glass shaded from amber at the bottom to ruby at the top, h. 213 mm, from the New England Glass Co., East Cambridge, Massachusetts, 1883 (New York, Metropolitan Museum of Art/Photo: Metropolitan Museum of Art, Gift of Mrs Emily Winthrop Miles, 1946; no. 46.140.483; photographer: Paul Warchol)

3. Pressed glass dolphin candlesticks, from New England, probably Boston and Sandwich Glass Co., Sandwich, Massachusetts: (left) h. 216 mm, *c.* 1840; (centre) h. 264 mm, 1845–65; (right) h. 264 mm, *c.* 1840 (New York, Metropolitan Museum of Art/Photo: Metropolitan Museum of Art, Rogers Fund, 1936; gift of Mrs Emily Winthrop Miles, 1946; and bequest of Anna G. W. Green, in memory of her

husband, Dr Charles W. Green, 1957; no. 36.148.1, 46.140.360, 57.131.3)

PLATE XXXVI. **Glass**

John La Farge: *Peacocks and Peonies I and II*, stained glass and lead, each 2.69x1.14 m, 1882 (Washington, DC, National Museum of American/Photo: Art Resource, New York)

PLATE XXXVII. **Glass and jewellery**

1. Tiffany & Co.: lamp, bronze and leaded glass, h. 673 mm, *c.* 1910 (New York, Metropolitan Museum of Art/Photo: Metropolitan Museum of Art, Gift of Hugh J. Grant, 1974; no. 1974.214.15ab)

2. Louis Comfort Tiffany: 'Peacock' necklace, gold, enamel, amethysts, sapphires, demantoid garnets, rubies and emeralds, l. 254 mm, *c.*1905 (Winter Park, FL, Charles Hosmer Morse Museum of American Art/Photo: Charles Hosmer Morse Museum of American Art)

PLATE XXXVIII. **Silver**

William Christmas Codman (1839–1923): Admiral George Dewey Cup, silver, h. 2.6 m, from the Gorham Manufacturing Co., Providence, Rhode Island, 1898 (Chicago, IL, Historical Society/ Photo: Chicago Historical Society; no. DIA-1934.77)

PLATE XXXIX. **Textiles**

1. Sampler by Mary Mills, silk on linen, 457x343 mm, 1786 (New York, Museum of American Folk Art/Photo: Museum of American Folk Art, Gift of Alfred Rosenthal; no. 1978.30.6)

2. *Star of Bethlehem* or *Rising Sun* quilt, pieced work and applique in glazed and unglazed cotton, cotton filling and lining, 2.93x2.43 m, made by Mary (Betsy) Totton, Staten Island, New York, *c.* 1825 (Washington, DC, Smithsonian Institution/Photo: Smithsonian Institution; no. 78-12461)

PLATE XL. **Textiles**

Albert Herter: scene from the *History of New York*, tapestry series of 26, wool, cotton and 'artificial silk', 2.13x1.83 m, from the Herter Looms, New York, 1912 (New York, Metropolitan Museum of Art/ Photo: Metropolitan Museum of Art, Gift of "A Bicentennial Gift to America from a Grateful Armenian People", 1978; no. 1978.15.14)

Appendix A

LIST OF LOCATIONS

Every attempt has been made in compiling this encyclopedia to supply the correct current location of each work of art mentioned, and in general this information appears in abbreviated form in parentheses after the first mention of the work. The following list contains the abbreviations and full forms of the museums, galleries and other institutions that own or display art works or archival material cited in this encyclopedia; the same abbreviations have been used in bibliographies to refer to the venues of exhibitions.

Institutions are listed under their town or city names, which are given in alphabetical order. Under each place name, the abbreviated names of institutions are also listed alphabetically, ignoring spaces, punctuation and accents. The list includes internal cross-references to guide the reader to the correct or most common form of place or institution name. Square brackets following an entry contain additional information about that institution, for example its previous name or the fact that it was subsequently closed. Such location names are included even if they are no longer used, as they might be cited in the encyclopedia as the venue of an exhibition held before the change of name or date of closure. The information on this list is the most up-to-date available at the time of publication.

Akron, OH, A. Mus.
 Akron, OH, Akron Art Museum
Albany, NY, Court of Appeals
Albany, NY, Inst. Hist. & A.
 Albany, NY, Institute of History and Art
Albany, NY, State Capitol
Albany, SUNY, U. A.G.
 Albany, NY, State University of New York, University Art Gallery
Albuquerque, U. NM, A. Mus.
 Albuquerque, NM, University of New Mexico, Art Museum
Allentown, PA, A. Mus.
 Allentown, PA, Art Museum
Amherst, U. MA, U. Gal.
 Amherst, MA, University of Massachusetts at Amherst, University Gallery [Fine Arts Center]
Amiens, Mus. Picardie
 Amiens, Musée de Picardie
Amsterdam, Rijksmus.
 Amsterdam, Rijksmuseum [includes Afdeeling Aziatische Kunst; Afdeeling Beeldhouwkunst; Afdeeling Nederlandse Geschiedenis; Afdeeling Schilderijen; Museum von Asiatische Kunst; Rijksmuseum Bibliothek; Rijksprentenkabinet]
Andover, MA, Phillips Acad., Addison Gal.
 Andover, MA, Phillips Academy, Addison Gallery of American Art
Annapolis, MD, US Naval Acad. Mus.
 Annapolis, MD, US Naval Academy Museum
Ann Arbor, U. MI, Mus. A.
 Ann Arbor, MI, University of Michigan, Museum of Art
Atlanta, GA, High Mus. A.
 Atlanta, GA, High Museum of Art
Atlanta, GA, Hist. Soc. Mus.
 Atlanta, GA, Atlanta Historical Society Museum
Austin, U. TX, Huntington A.G.
 Austin, TX, University of Texas at Austin, Archer Museum Huntington Art Gallery [until 1980 called U. TX, A. Mus.]

Baltimore, MD Hist. Soc.
 Baltimore, MD, Maryland Historical Society
Baltimore, MD, Mus. A.
 Baltimore, MD, Baltimore Museum of Art
Baltimore, MD, Peale Mus.
 Baltimore, MD, Peale Museum
Baltimore, MD, Walters A.G.
 Baltimore, MD, Walters Art Gallery
Baltimore, Mus. & Lib. MD Hist.
 Baltimore, MD, Museum and Library of Maryland History
Baton Rouge, LA State U.
 Baton Rouge, LA, Louisiana State University
Bennington, VT, Mus.
 Bennington, VT, Bennington Museum
Berkeley, CA, Thorsen/Signa Phi House
Berkeley, U. CA, A. Mus.
 Berkeley, CA, University of California, University Art Museum
Berlin, Akad. Kst.
 Berlin, Akademie der Künste [formed by unification of former Preussische Akademie der Künste & Deutsche Akademie der Künste der DDR]
Berlin, Bauhaus-Archv
 Berlin, Bauhaus-Archiv
Bielefeld, Städt. Ksthalle
 Bielefeld, Städtische Kunsthalle
Bilbao, Mus. B.A.
 Bilbao, Museo de Bellas Artes
Birmingham, Mus. & A.G.
 Birmingham, City of Birmingham Museum and Art Gallery
Birmingham, AL, Mus. A.
 Birmingham, AL, Museum of Art
Bloomfield Hills, MI, Cranbrook Acad. A. Mus.
 Bloomfield Hills, MI, Cranbrook Academy of Art Museum
Bloomington, IN U.
 Bloomington, IN, Indiana University
Boca Raton, FL, Mus. A.
 Boca Raton, FL, Boca Raton Museum of Art

Boston, MA, Archit. Cent.
 Boston, MA, Boston Architectural Center
Boston, MA, Athenaeum
 Boston, MA, Boston Athenaeum
Boston, MA, Capitol Bldg
 Boston, MA, Capitol Building
Boston, MA, Childs Gal.
 Boston, MA, Childs Gallery
Boston, MA, Goethe Inst.
 Boston, MA, Goethe Institute
Boston, MA Hist. Soc.
 Boston, MA, Massachusetts Historical Society
Boston, MA, Isabella Stewart Gardner Mus.
 Boston, MA, Isabella Stewart Gardner Museum
Boston, MA, Mus. F.A.
 Boston, MA, Museum of Fine Arts
Boston, MA, New England Hist. Geneal. Soc.
 Boston, MA, New England Historical Genealogical Society
Boston, MA, Old City Hall
Boston, MA, Old State House
Boston, MA, Photo. Res. Cent.
 Boston, MA, Photographic Resource Center
Boston, MA, Pub. Gdn
 Boston, MA, Boston Public Garden
Boston, MA, Pub. Lib.
 Boston, MA, Public Library
Boston, MA, St Botolph's Club
Bristol, Mus. & A.G.
 Bristol, City of Bristol Museum and Art Gallery
Brit. Royal Col.
 British Royal Collection
Brockton, MA, A. Mus.
 Brockton, MA, Brockton Art Museum [Fuller Memorial]
Brookline, MA, Hist. Soc. Mus.
 Brookline, MA, Brookline Historical Society Museum

660

Brunswick, ME, Bowdoin Coll. Mus. A.
Brunswick, ME, Bowdoin College Museum of Art

Buffalo, NY, Albright–Knox A.G.
Buffalo, NY, Albright–Knox Art Gallery [formerly Albright A.G.]

Buffalo, NY, Burchfield A. Cent.
Buffalo, NY, Burchfield Art Center

Burlington, U. VT, Robert Hull Fleming Mus.
Burlington, VT, University of Vermont, Robert Hull Fleming Museum

Calgary, Glenbow–Alta Inst.
Calgary, Glenbow–Alberta Institute

Cambridge, Fitzwilliam
Cambridge, Fitzwilliam Museum

Cambridge, MA, Fogg
Cambridge, MA, Fogg Art Museum

Cambridge, MA, Harvard U., Frances Loeb Sch. Des. Lib.
Cambridge, MA, Harvard University, Frances Loeb School of Design Library

Cambridge, MA, Harvard U., Grad. Sch. Des.
Cambridge, MA, Harvard University, Graduate School of Design

Cambridge, MA, Harvard U., Houghton Lib.
Cambridge, MA, Harvard University, Houghton Library

Cambridge, MA, Harvard U. Law Sch.
Cambridge, MA, Harvard University Law School

Cambridge, MA, Harvard U., Portrait Col.
Cambridge, MA, Harvard University, Portrait Collection

Cambridge, MA, Longfellow N. Hist. Site
Cambridge, MA, Longfellow National Historic Site

Cambridge, MA, MIT
Cambridge, MA, Massachusetts Institute of Technology

Canajoharie, NY, Lib. & A.G.
Canajoharie, NY, Canajoharie Library and Art Gallery

Canton, OH, Mus. A.
Canton, OH, Canton Museum of Art

Carmel, CA, A. Assoc.
Carmel, CA, Carmel Art Association

Casper, WY, Nicolaysen A. Mus.
Casper, WY, Nicolaysen Art Museum

Chadds Ford, PA, Brandywine River Mus.
Chadds Ford, PA, Brandywine River Museum

Charleston, SC, Gibbes Mus. A.
Charleston, SC, Gibbes Museum of Art

Charleston, WV, Sunrise Mus.

Charlottesville, U. VA
Charlottesville, VA, University of Virginia

Chattanooga, TN, Hunter Mus. A.
Chattanooga, TN, Hunter Museum of Art

Chicago, IL, A. Inst.
Chicago, IL, Art Institute of Chicago

Chicago, IL, Archit. Club
Chicago, IL, Chicago Architectural Club

Chicago, IL, Hist. Soc.
Chicago, IL, Chicago Historical Society

Chicago, IL, Newberry Lib.
Chicago, IL, Newberry Library

Chicago, IL, Richard Nickel Cttee
Chicago, IL, Richard Nickel Committee

Chicago, IL, R. S. Johnson F.A.
Chicago, IL, R. S. Johnson Fine Art

Chicago, IL, Terra Mus. Amer. A.
Chicago, IL, Terra Museum of American Art [moved from Evanston in April 1987]

Chichester, Royal Sussex Regiment

Cincinnati, OH, A. Mus.
Cincinnati, OH, Cincinnati Art Museum

Cincinnati, OH, Taft Mus.
Cincinnati, OH, Taft Museum

Claremont Colls, CA, Gals
Claremont, CA, Galleries of the Claremont Colleges

Clermont, NY, Taconic State Park

Cleveland, OH, Case W. Reserve U.
Cleveland, OH, Case Western Reserve University

Cleveland, OH, Mus. A.
Cleveland, OH, Cleveland Museum of Art

Clinton, NY, Hamilton Coll., Emerson Gal.
Clinton, NY, Hamilton College, Emerson Gallery

Cody, WY, Buffalo Bill Hist. Cent.
Cody, WY, Buffalo Bill Historical Center

College Park, U. MD A.G.
College Park, MD, University of Maryland Art Gallery

Colonial Williamsburg, VA

Columbia, MO, State Hist. Soc.
Columbia, MO, State Historical Society of Missouri

Columbia, SC, Mus. A.
Columbia, SC, Museum of Art

Columbus, GA, Mus.
Columbus, GA, Columbus Museum

Columbus, OH, Mus. A.
Columbus, OH, Museum of Art [formerly Gal. F.A.]

Columbus, OH State U.
Columbus, OH, Ohio State University

Cooperstown, Mus. NY State Hist. Assoc.
Cooperstown, NY, Museum of New York State Historical Association

Coral Gables, FL, U. Miami, Lowe A. Mus.
Coral Gables, FL, University of Miami, Lowe Art Museum

Corning, NY, Mus. Glass
Corning, NY, Museum of Glass

Corning, NY, Steuben Glass

Cornish, NH, Saint Gaudens N. Hist. Site
Cornish, NH, Saint-Gaudens National Historical Site

Cragsmoor, NY, Free Lib.
Cragsmoor, NY, Free Library

Dallas, TX, Mus. A.
Dallas, TX, Dallas Museum of Art

Davenport, IA, Mun. A.G.
Davenport, IA, Davenport Municipal Art Gallery

Dayton, OH, A. Inst.
Dayton, OH, Dayton Art Institute

Deerfield, MA, Mem. Hall Mus.
Deerfield, MA, Memorial Hall Museum

Denver, CO, A. Mus.
Denver, CO, Denver Art Museum [Museum of Fine Arts]

Denver, CO, Mus. W. A.
Denver, CO, Museum of Western Art

Des Moines, IA, A. Cent.
Des Moines, IA, Art Center

Detroit, MI, Hist. Mus.
Detroit, MI, Historical Museum

Detroit, MI, Inst. A.
Detroit, MI, Detroit Institute of Arts

Dijon, Mus. B.-A.
Dijon, Musée des Beaux-Arts

Dundee, Spalding Golf Mus.
Dundee, Spalding Golf Museum [Camperdown House; now closed]

Durham, U. NH, A. Gals
Durham, NH, University of New Hampshire, University Art Galleries, Paul Creative Arts Center

Düsseldorf, Kstmus.
Düsseldorf, Kunstmuseum im Ehrenhof

Duxbury, MA, A. Complex Mus.
Duxbury, MA, Art Complex Museum

East Hampton, NY, Guild Hall Mus.
East Hampton, NY, Guild Hall Museum

East Hampton, NY, Lib.
East Hampton, NY, Library

Edinburgh, N.G.
Edinburgh, National Gallery of Scotland

Edinburgh, N.P.G.
Edinburgh, National Portrait Gallery

Evanston, IL, Northwestern U.
Evanston, IL, Northwestern University

Falmouth, VA, Melchers Mem. Gal.
Falmouth, VA, Gari Melchers Memorial Gallery, Belmont

Farmington, CT, Hill-Stead Mus.
Farmington, CT, Hill-Stead Museum

Florence, Pitti
Florence, Palazzo Pitti [houses Appartamenti Monumentali; Collezione Contini-Bonacossi; Galleria d'Arte Moderna; Galleria del Costume; Galleria Palatina; Museo degli Argenti; Museo delle Carrozze; Museo delle Porcellane]

Fort Lauderdale, FL, Mus. A.
Fort Lauderdale, FL, Museum of Art

Fort Worth, TX, Amon Carter Mus.
Fort Worth, TX, Amon Carter Museum of Western Art

Fort Worth, TX, Kimbell A. Mus.
Fort Worth, TX, Kimbell Art Museum

Framingham, MA, Danforth Mus. A.
Framingham, MA, Danforth Museum of Art

Frankfort, KY, State Capitol

Glasgow, A.G. & Mus.
Glasgow, Art Gallery and Museum [Kelvingrove]

Glasgow, U. Glasgow, Hunterian Mus.
Glasgow, University of Glasgow, Hunterian Museum

Glasgow, U. Lib.
Glasgow, University of Glasgow, University Library

Glendale, CA, Forest Lawn Mem. Park
Glendale, CA, Forest Lawn Memorial Park

Gloucester, MA, Cape Ann Hist. Assoc.
Gloucester, MA, Cape Ann Historical Association

Göteborg, Kstmus.
Göteborg, Göteborgs Konstmuseum

Greensburg, PA, Westmoreland Co. Mus. A.
Greensburg, PA, Westmoreland County Museum of Art

Greenwich, CT, Bruce Mus.
Greenwich, CT, Bruce Museum

Hagerstown, MD, Washington Co. Hist. Soc.
Mus.
 Hagerstown, MD, Washington County
 Historical Society Museum
Halifax, NS Mus.
 Halifax, NS, Nova Scotia Museum
Halifax, NS, U. King's Coll.
 Halifax, NS, University of King's College
Hancock, MA, Shaker Village
 Hancock, MA, Hancock Shaker Village
Hanover, NH, Dartmouth Coll., Hood Mus. A.
 Hanover, NH, Dartmouth College, Hood
 Museum of Art [name changed from Hopkins
 Cent. A.G. in 1985]
Hartford, CT Hist. Soc. Mus.
 Hartford, CT, Connecticut Historical Society
 Museum
Hartford, CT, Wadsworth Atheneum
Harvard, MA, Fruitlands Mus.
 Harvard, MA, Fruitlands Museum
Hastings-on-Hudson, NY, Newington Cropsey
Found.
 Hastings-on-Hudson, NY, Newington
 Cropsey Foundation
Honolulu, HI, Acad. A.
 Honolulu, HI, Honolulu Academy of Arts
Houston, TX, Mus. F.A.
 Houston, TX, Museum of Fine Arts
Houston, TX, Rice U. Inst. A., Rice Mus.
 Houston, TX, Rice University Institute for the
 Arts, Rice Museum
Huntington, NY, Heckscher Mus.
 Huntington, NY, Heckscher Museum [Long
 Island]
Huntsville, AL, Mus. A.
 Huntsville, AL, Museum of Art
Indianapolis, IN, Herron Sch. A.
 Indianapolis, IN, John Herron School of Art
Indianapolis, IN, Mus. A.
 Indianapolis, IN, Museum of Art [incl.
 Clowes Fund Collection of Old Master
 Paintings]
Irvine, CA, Mus.
 Irvine, CA, Irvine Museum
Ithaca, NY, Cornell U., Johnson Mus. A.
 Ithaca, NY, Cornell University, Herbert F.
 Johnson Museum of Art
Jacksonville, FL, Cummer Gal. A.
 Jacksonville, FL, Cummer Gallery of Art
Jamestown, VA, N. Hist. Site
 Jamestown, VA, National Historic Site
Kansas City, MO, Nelson–Atkins Mus. A.
 Kansas City, MO, Nelson–Atkins Museum of
 Art [name changed from W. Rockhill Nelson
 Gal. c. 1980]
Kerrville, TX, Cowboy Artists Amer. Mus.
 Kerrville, TX, Cowboy Artists of America
 Museum
Kinderhook, NY, Columbia Co. Hist. Soc. Mus.
 Kinderhook, NY, Columbia County
 Historical Society Museum
Laguna Beach, CA, A. Mus.
 Laguna Beach, CA, Laguna Art Museum
 [formerly Laguna Beach Mus. A.]
Laguna Beach, CA, Mus. A.
 Laguna Beach, CA, Laguna Beach Museum of
 Art [name changed to Laguna A. Mus. in
 1986]
La Jolla, CA, A. Cent.
 La Jolla, CA, Art Center [name changed to
 Mus. Contemp. A. in 1971]

Lancaster, MA, Town Lib.
 Lancaster, MA, Town Library
Latrobe, PA, St Vincent Coll., Kennedy Gal.
 Latrobe, PA, St Vincent College, Kennedy
 Gallery
Lewisburg, PA, Bucknell U.
 Lewisburg, PA, Bucknell University
Lewisburg, PA, Packwood House Mus.
 Lewisburg, PA, Packwood House Museum
Lexington, MA, Scot. Rite Mason. Mus. N. Her.
 Lexington, MA, Scottish Rite Masonic
 Museum of Our National Heritage
Lexington, VA, Washington & Lee U., Chapel
Mus.
 Lexington, VA, Washington and Lee
 University, Lee Chapel Museum
Lincoln, MA, DeCordova & Dana Mus.
 Lincoln, MA, DeCordova and Dana Museum
 and Park
Lincoln, U. NE, Sheldon Mem. A.G.
 Lincoln, NE, University of Nebraska, Sheldon
 Memorial Art Gallery
Liverpool, Walker A.G.
 Liverpool, Walker Art Gallery
London, ACGB
 London, Arts Council of Great Britain
London, Agnew's
 London, Thomas Agnew and Sons Ltd
London, Barbican Cent.
 London, Barbican Centre
London, BM
 London, British Museum
London, Christie's
 London, Christie, Manson & Woods Ltd
London, Guildhall
London, Guildhall A.G.
 London, Guildhall Art Gallery
London, Hamilton Gals
 London, Hamilton Galleries
London, N.G.
 London, National Gallery
London, N. Mar. Mus.
 London, National Maritime Museum
 [Greenwich]
London, N.P.G.
 London, National Portrait Gallery
London, PRO
 London, Public Record Office and Museum
London, RA
 London, Royal Academy of Arts [Burlington
 House; houses RA Archives & Library]
London, Royal Phot. Soc.
 London, Royal Photographic Society [now
 Bath, Royal Phot. Soc.]
London, Royal Soc.
 London, Royal Society
London, Royal Soc. A.
 London, Royal Society of Arts
London, Tate
 London, Tate Gallery
London, V&A
 London, Victoria and Albert Museum [houses
 National Art Library]
London, Wallace
 London, Wallace Collection
London, Westminster Abbey
Los Angeles, CA, Co. Mus. A.
 Los Angeles, CA, County Museum of Art
 [incl. Robert Gore Rifkind Center for German
 Expressionist Studies]

Los Angeles, CA, Goldfield Gals
 Los Angeles, CA, Goldfield Galleries
Los Angeles, UCLA
 Los Angeles, CA, University of California
Macomb, W. IL U.
 Macomb, IL, Western Illinois University
Madison, U. WI
 Madison, WI, University of Wisconsin
Madrid, Fund. 'La Caixa'
 Madrid, Fundación 'La Caixa'
Madrid, Mus. Thyssen-Bornemisza
 Madrid, Museo Thyssen-Bornemisza [in Pal.
 Villahermosa]
Manchester, C.A.G.
 Manchester, City Art Gallery
Manchester, NH, Currier Gal. A.
 Manchester, NH, Currier Gallery of Art
Marietta, OH, Campus Martius Mus.
 Marietta, OH, Campus Martius Museum and
 River Museum
Memphis, TN, Brooks Mus. A.
 Memphis, TN, Memphis Brooks Museum of
 Art [Brooks Memorial Art Gallery]
Memphis, TN, Dixon Gal.
 Memphis, TN, Dixon Gallery and Gardens
Merion Station, PA, Barnes Found.
 Merion Station, PA, Barnes Foundation
Miami, FL, Lowe A. Mus.
 Miami, FL, Lowe Art Museum
Millville, NJ, Wheaton Village, Amer. Glass Mus.
 Millville, NJ, Wheaton Village, American
 Glass Museum
Milwaukee, WI, A. Mus.
 Milwaukee, WI, Milwaukee Art Museum
 [formerly A. Cent.]
Minneapolis, MN, Inst. A.
 Minneapolis, MN, Minneapolis Institute of
 Arts
Minneapolis, MN, Walker A. Cent.
 Minneapolis, MN, Walker Art Center
Minneapolis, U. MN, A. Mus.
 Minneapolis, MN, University of Minnesota,
 University Art Museum
Minneapolis, U. MN Libs, NW Archit. Archvs
 Minneapolis, MN, University of Minnesota
 Libraries, Northwest Architectural Archives
Montclair, NJ, A. Mus.
 Montclair, NJ, Montclair Art Museum
Monterey, CA, Peninsula Mus. A.
 Monterey, CA, Monterey Peninsula Museum
 of Art
Monticello, VA, Jefferson Found.
 Monticello, VA, Thomas Jefferson
 Foundation
Montpelier, VT, Wood A.G.
 Montpelier, VT, Thomas W. Wood Art
 Gallery [Vermont College Arts Center]
Montross, VA, Westmoreland Co. Mus.
 Montross, VA, Westmoreland County
 Museum
Morristown, NJ, Morris Mus. A. & Sci.
 Morristown, Morris Museum of Arts and
 Sciences
Mount Vernon, VA, Ladies' Assoc. Un.
 Mount Vernon, VA, Ladies' Association of
 the Union
Munich, Fotomus.
 Munich, Fotomuseum

Nashville, TN Botan. Gdns & F.A. Cent.
 Nashville, TN, Tennessee Botanical Gardens
 and Fine Arts Center

Nashville, TN, Vanderbilt U.
 Nashville, TN, Vanderbilt University

Nazareth, PA, Whitefield House Mus.
 Nazareth, PA, Whitefield House Museum

Newark, NJ, Hist. Soc.
 Newark, NJ, Historical Society

Newark, NJ, Mus.
 Newark, NJ, Newark Museum

Newark, U. DE
 Newark, DE, University of Delaware

New Bedford, MA, Whaling Mus.
 New Bedford, New Bedford Whaling
 Museum

New Britain, CT, Mus. Amer. A.
 New Britain, CT, New Britain Museum of
 American Art

New Haven, CT, Colony Hist. Soc. Mus.
 New Haven, CT, Colony Historical Society
 Museum

New Haven, CT, Yale Cent. Brit. A.
 New Haven, CT, Yale Center for British Art

New Haven, CT, Yale U.
 New Haven, CT, Yale University

New Haven, CT, Yale U. A.G.
 New Haven, CT, Yale University Art Gallery

New Haven, CT, Yale U., Beinecke Lib.
 New Haven, CT, Yale University, Beinecke
 Library

New Haven, CT, Yale U. Lib.
 New Haven, CT, Yale University Library

New London, CT, Lyman Allyn Mus.
 New London, CT, Lyman Allyn Museum

New Orleans, LA State Mus.
 New Orleans, LA, Louisiana State Museum

Newport, RI, Redwood Lib.
 Newport, RI, Redwood Library

Newport News, VA, Mar. Mus.
 Newport News, VA, Mariners Museum

New York, Adelson Gals
 New York, Adelson Galleries

New York, Alexander Gal.
 New York, Alexander Gallery

New York, Amer. Acad. A. & Lett.
 New York, American Academy of Arts and
 Letters

New York, Amer. A. Gals
 New York, American Art Galleries

New York, Amer. Fed. A.
 New York, American Federation of Arts

New York, Amer. Numi. Soc.
 New York, American Numismatic Society

New York, Babcock Gals
 New York, Babcock Galleries

New York, Beacon Hill F.A.
 New York, Beacon Hill Fine Art

New York, Berry-Hill Gals
 New York, Berry-Hill Galleries

New York, Betty Parsons Gal.
 New York, Betty Parsons Gallery

New York, Brooklyn Civ. Cent.
 New York, Brooklyn Civic Centre

New York, Brooklyn Hist. Soc.
 New York, Brooklyn Historical Society

New York, Brooklyn Mus. A.
 New York, Brooklyn Museum of Art

New York, C. Assoc.
 New York, Century Association

New York, Chamber of Commerce
 New York, Chamber of Commerce of the
 State of New York

New York, Chase Manhattan Bank A. Col.
 New York, Chase Manhattan Bank Art
 Collection

New York, City Coll. City U.
 New York, City College of the City University
 of New York

New York, City Hall

New York, City U.
 New York, City University of New York

New York, Coe Kerr Gal.
 New York, Coe Kerr Gallery, Inc.

New York, Columbia U.
 New York, Columbia University

New York, Columbia U., Avery Archit. & F.A.
Lib.
 New York, Columbia University, Avery
 Architectural and Fine Arts Library

New York, Columbia U. Col.
 New York, Columbia University Collection

New York, Cooper-Hewitt Mus.
 New York, Cooper-Hewitt Museum,
 Smithsonian Institution; National Museum of
 Design

New York, Cult. Cent.
 New York, Cultural Center

New York, David Findlay Gal.
 New York, David Findlay Gallery

New York, Donaldson, Lufkin & Jenrette
 New York, Donaldson, Lufkin and Jenrette,
 Inc.

New York, F. Keppel
 New York, F. Keppel and Co.

New York, Franklin D. Roosevelt Lib.
 New York, Franklin D. Roosevelt Library

New York, Frick
 New York, Frick Collection

New York, Gen. Theol. Semin.
 New York, General Theological Seminary

New York, Graham Gal.
 New York, Graham Gallery

New York, Grand Cent. A. Gals
 New York, Grand Central Art Galleries, Inc.
 [Painters & Sculptors Assoc.]

New York, Hirschl & Adler Gals
 New York, Hirschl and Adler Galleries, Inc.

New York, Hudson River Mus.
 New York, Hudson River Museum at
 Yonkers

New York, IBM Corp.
 New York, IBM Corporation

New York, IBM Gal. Sci. & A.
 New York, IBM Gallery of Science and Art

New York, Int. Cent. Phot.
 New York, International Center of
 Photography

New York, Jew. Mus.
 New York, The Jewish Museum

New York, Jordan-Volpe Gal.
 New York, Jordan-Volpe Gallery

New York, Kennedy Gals
 New York, Kennedy Galleries, Inc.

New York, Knoedler's
 New York, M. Knoedler and Co. [Knoedler
 Contemporary Art]

New York, Kraushaar Gals
 New York, Kraushaar Galleries

New York, Met.
 New York, Metropolitan Museum of Art

New York, MOMA
 New York, Museum of Modern Art

New York, Mus. Amer. Flk A.
 New York, Museum of American Folk Art

New York, Mus. City NY
 New York, Museum of the City of New York

New York, Mus. Contemp. Crafts
 New York, Museum of Contemporary Crafts

New York, N. Acad. Des.
 New York, National Academy of Design

New York, N. Sculp. Soc.
 New York, National Sculpture Society

New York, NY Hist. Soc.
 New York, New-York Historical Society

New York, Pierpont Morgan Lib.
 New York, Pierpont Morgan Library

New York, Pub. Lib.
 New York, Public Library [formed 1895 by
 amalgamation of Aster & Lenox libraries]

New York, Richard York Gal.
 New York, Richard York Gallery

New York, Salander O'Reilly Gals
 New York, Salander-O'Reilly Galleries, Inc.

New York, Seventh Regiment Armory

New York, Sotheby's
 New York, Sotheby's [until 17 July 1984
 called Sotheby Parke Bernet & Co.]

New York, Spanierman Gal.
 New York, Spanierman Gallery

New York U., Grey A.G.
 New York, New York University, Grey Art
 Gallery and Study Center

New York U., Inst. F.A.
 New York, New York University, Institute of
 Fine Arts

New York, Un. League Club
 New York, Union League Club

New York, Whitney
 New York, Whitney Museum of American
 Art

New York, Wildenstein's
 New York, Wildenstein and Co., Inc.

Norfolk, VA, Chrysler Mus.
 Norfolk, VA, Chrysler Museum

North Abington, MA, Pierce Gal.
 North Abington, MA, Pierce Gallery

Northampton, MA, Smith Coll. Mus. A.
 Northampton, MA, Smith College Museum
 of Art

Norwich, CT, Slater Mem. Mus.
 Norwich, CT, Slater Memorial Museum [and
 Converse Art Gallery]

Oakland, CA, Mills Coll.
 Oakland, CA, Mills College

Oakland, CA, Mills Coll. Lib., Smithsonian Inst.,
Archvs Amer. A.
 Oakland, CA, Mills College Library,
 Smithsonian Institution, Archives of
 American Art

Oakland, CA, Mus.
 Oakland, CA, Oakland Museum

Oberlin Coll., OH, Allen Mem. A. Mus.
 Oberlin, OH, Oberlin College, Allen
 Memorial Art Museum

Omaha, NE, Joslyn A. Mus.
 Omaha, NE, Joslyn Art Museum

Santa Ana, CA, Bowers Mus.
 Santa Ana, CA, Bowers Museum

Santa Barbara, CA, Mus. A.
 Santa Barbara, CA, Museum of Art

Santa Barbara, U. CA, A. Mus.
 Santa Barbara, CA, University of California,
 University Art Museum [formerly U. CA, A.
 Gals]

Santa Fe, NM, Peters Gal.
 Santa Fe, NM, Gerald G. Peters Gallery

Sapporo, Hokkaidō Mus. Mod. A.
 Sapporo, Hokkaidō Museum of Modern Art
 (Hokkaido-ritsu Kindu Bijutsukan)

Sarasota, FL, Ringling Mus. A.
 Sarasota, FL, John and Mable Ringling
 Museum of Art

Schenectady, NY, Un. Coll.
 Schenectady, NY, Union College

Schwäbisch Gmünd, Städt. Mus.
 Schwäbisch Gmünd, Städtisches Museum

Scottsdale, AZ, Frank Lloyd Wright Found.
 Scottsdale, AZ, Frank Lloyd Wright
 Foundation

Seattle, WA, A. Mus.
 Seattle, WA, Seattle Art Museum

Seattle, U. WA
 Seattle, WA, University of Washington

Seattle, U. WA, Henry A.G.
 Seattle, WA, University of Washington, Henry
 Art Gallery

Seneca Falls, NY, Hist. Soc. Mus.
 Seneca Falls, NY, Historical Society Museum

Sheffield, Graves A.G.
 Sheffield, Graves Art Gallery

Shelburne, VT, Mus.
 Shelburne, VT, Shelburne Museum

Shizuoka, Prefect. Mus.
 Shizuoka, Shizuoka Prefectural Museum

Shreveport, LA, Norton A.G.
 Shreveport, LA, R. W. Norton Art Gallery

Southampton, NY, Parrish A. Mus.
 Southampton, NY, Parrish Art Museum

South Hadley, MA, Mount Holyoke Coll. A. Mus.
 South Hadley, MA, Mount Holyoke College
 Art Museum

Springfield, MA, Mus. F.A.
 Springfield, MA, Museum of Fine Arts

Springfield, MA, Smith A. Mus.
 Springfield, MA, George Walter Vincent
 Smith Art Museum

Springville, UT, Mus. A.
 Springville, UT, Springville Museum of Art

Stanford, CA, U. A.G. & Mus.
 Stanford, CA, Stanford University Art Gallery
 and Museum

Stockholm, Kun. Husgerådskam.
 Stockholm, Kungliga Husgerådskammar med
 Skattkammar och Bernadotte-Bibliotek [Royal
 collections]

Stockholm, Nmus.
 Stockholm, Nationalmuseum

Stony Brook, NY, Mus.
 Stony Brook, NY, Museum at Stony Brook

Storrs, U. CT, Benton Mus. A.
 Storrs, CT, University of Connecticut, William
 Benton Museum of Art

Sturbridge, MA, Old Sturbridge Village

Syracuse, NY, Everson Mus. A.
 Syracuse, NY, Everson Museum of Art

Tokyo, Sezon Mus. A.
 Tokyo, Sezon Museum of Art

Toledo, OH, Mus. A.
 Toledo, OH, Museum of Art

Tours, Mus. B.-A.
 Tours, Musée des Beaux-Arts

Trenton, NJ State Mus.
 Trenton, NJ, New Jersey State Museum

Tulsa, OK, Gilcrease Inst. Amer. Hist. & A.
 Tulsa, OK, Thomas Gilcrease Institute of
 American History and Art

Tulsa, OK, Gilcrease Mus.
 Tulsa, OK, Gilcrease Museum

Tuscaloosa, AL, Warner Col., Gulf States Paper
Corp.
 Tuscaloosa, AL, Warner Collection, Gulf
 States Paper Corporation

Ukiah, CA, Sun House & Grace Carpenter
Hudson Mus.
 Ukiah, CA, Sun House and Grace Carpenter
 Hudson Museum

University Park, PA State U., Mus. A.
 University Park, PA, Pennsylvania State
 University, Museum of Art [name changed to
 Palmer Mus. A. in 1989]

University Park, PA State U., Palmer Mus. A.
 University Park, PA, Pennsylvania State
 University, Palmer Museum of Art [formerly
 PA State U., Mus. A.]

Utica, NY, Mason. Sailors & Soldiers Hosp.
 Utica, NY, Masonic Sailors and Soldiers
 Hospital

Utica, NY, Munson–Williams–Proctor Inst.
 Utica, NY, Munson–Williams–Proctor
 Institute

Venice, Accad.
 Venice, Galleria dell'Accademia

Vernon, Mus. Mun. Poulain
 Vernon, Musée Municipal A. G. Poulain

Washington, DC, Amer. Inst. Architects Found.
 Washington, DC, American Institute of
 Architects Foundation [name changed to
 Amer. Archit. Found. Octagon in Dec 1987]

Washington, DC, Armed Forces Inst. Pathology,
N. Mus. Health & Medic.
 Washington, DC, Armed Forces Institute of
 Pathology, National Museum of Health and
 Medicine

Washington, DC, Capitol Bldg
 Washington, DC, Capitol Building [incl.
 Statuary Hall]

Washington, DC, Corcoran Gal. A.
 Washington, DC, Corcoran Gallery of Art

Washington, DC, Folger Shakespeare Lib.
 Washington, DC, Folger Shakespeare Library

Washington, DC, Freer
 Washington, DC, Freer Gallery of Art
 [Smithsonian Inst.]

Washington, DC, Gallaudet Coll.
 Washington, DC, Gallaudet College

Washington, DC, George Washington U.
 Washington, DC, George Washington
 University

Washington, DC, Hirshhorn
 Washington, DC, Hirshhorn Museum and
 Sculpture Garden [Smithsonian Inst.]

Washington, DC, Howard U., Gal. A.
 Washington, DC, Howard University, Gallery
 of Art

Washington, DC, Int. Exh. Found.
 Washington, DC, International Exhibition
 Foundation

Washington, DC, Lib. Congr.
 Washington, DC, Library of Congress

Washington, DC, N. Archvs
 Washington, DC, National Archives

Washington, DC, N. Col. F.A.
 Washington, DC, National Collection of Fine
 Arts [closed 1980]

Washington, DC, N.G.A.
 Washington, DC, National Gallery of Art

Washington, DC, N. Mus. Afr. A.
 Washington, DC, National Museum of
 African Art [Smithsonian Inst.; name changed
 from Mus. Afr. A. in 1987]

Washington, DC, N. Mus. Amer. A.
 Washington, DC, National Museum of
 American Art [Smithsonian Inst.]

Washington, DC, N. Mus. Amer. Hist.
 Washington, DC, National Museum of
 American History [Smithsonian Inst.;
 formerly N. Mus. Hist. & Technol.]

Washington, DC, N.P.G.
 Washington, DC, National Portrait Gallery
 [Smithsonian Inst.]

Washington, DC, Octagon Mus.
 Washington, DC, Octagon Museum

Washington, DC, Renwick Gal.
 Washington, DC, Renwick Gallery
 [Smithsonian Inst.]

Washington, DC, Smithsonian Inst.
 Washington, DC, Smithsonian Institution
 [admins Anacostia Neighborhood Mus.;
 Freer; Hirshhorn; N. Air & Space Mus.; N.
 Mus. Afr. A.; N. Mus. Amer. A., N. Mus. Nat.
 Hist.; N.P.G.; N. Zool. Park; Renwick Gal.;
 Cooper-Hewit Mus.]

Washington, DC, Smithsonian Inst., Archvs
Amer. A.
 Washington, DC, Smithsonian Institution,
 Archives of American Art

Washington, DC, State Dept
 Washington, DC, State Department

Washington, DC, US Capitol

Washington, DC, US Dept Inter.
 Washington, DC, US Department of the
 Interior

Washington, DC, White House Col.
 Washington, DC, White House Collection

Washington, PA, Co. Hist. Soc. Mus.
 Washington, PA, Washington County
 Historical Society Museum [Le Moyne House]

Watertown, MA, Free Pub. Lib.
 Watertown, MA, Free Public Library

Wellesley Coll., MA, Mus.
 Wellesley, MA, Wellesley College Museum [in
 Jewett A. Cent.]

Wellington, Mus. NZ, Te Papa Tongarewa
 Wellington, Museum of New Zealand, Te
 Papa Tongarewa

West Chester, PA, Chester Co. Hist. Soc. Mus.
 West Chester, PA, Chester County Historical
 Society Museum

West Palm Beach, FL, Eaton F.A.
 West Palm Beach, FL, Eaton Fine Art

Williamsburg, VA, Rockefeller Flk A. Col.
 Williamsburg, VA, Abby Aldrich Rockefeller
 Folk Art Collection

Williamstown, MA, Clark A. Inst.
 Williamstown, MA, Sterling and Francine
 Clark Art Institute

Williamstown, MA, Williams Coll. Mus. A.
 Williamstown, MA, Williams College Museum
 of Art

Wilmington, DE A. Mus.
 Wilmington, DE, Delaware Art Museum

Wilmington, DE, Hist. Soc. Mus.
 Wilmington, DE, Historical Society Museum
 of Delaware

Winston-Salem, NC, Mus. Early S. Dec. A.
 Winston-Salem, NC, Museum of Early
 Southern Decorative Arts

Winston-Salem, NC, Old Salem

Winston-Salem, NC, Reynolda House

Winter Park, FL, Morse Gal. A.
 Winter Park, FL, Morse Gallery of Art

Winterthur, DE, Du Pont Winterthur Mus.
 Winterthur, DE, H.F. Du Pont Winterthur
 Museum

Worcester, MA, Amer. Antiqua. Soc.
 Worcester, MA, American Antiquarian
 Society

Worcester, MA, A. Mus.
 Worcester, MA, Worcester Art Museum

Yorktown, VA, Colon. N. Hist. Park
 Yorktown, VA, Colonial National Historical
 Park [incl. Yorktown Visitor Center]

Youngstown, OH, Butler Inst. Amer. A.
 Youngstown, OH, Butler Institute of
 American Art

Zurich, Stift. Samml. Bührle
 Zurich, Stiftung Sammlung E.G. Bührle

Appendix B

LIST OF PERIODICAL TITLES

This list contains all of the periodical titles that have been cited in an abbreviated form in italics in the bibliographies of this encyclopedia. For the sake of comprehensiveness, it also includes entries of periodicals that have not been abbreviated, for example where the title consists of only one word or where the title has been transliterated. Abbreviated titles are alphabetized letter by letter, including definite and indefinite articles but ignoring punctuation, bracketed information and the use of ampersands. Roman and arabic numerals are alphabetized as if spelt out (in the appropriate language), as symbols (e.g. A + 'á A plus ñ'). Additional information is given in square brackets to distinguish two or more identical titles or to cite a periodical's previous name (where such publishing information was known to the editors).

AA Files
 AA [Architectural Association] Files

A. America
 Art in America [cont. as *A. America & Elsewhere*; *A. America*]

A. & Ant.
 Art and Antiques

A. & Archaeol.
 Art and Archaeology

A. & Archit.
 Arts and Architecture

Abitare

A. Bull.
 Art Bulletin

A. CA
 Art of California

A. Crit.
 Art Criticism

A. & Dec.
 Arts and Decoration

A. & Déc.
 Art et décoration [prev. pubd as *A. Déc.*]

A. Doc.
 Art Documentation

Afr. A.
 African Arts

Africa
 Africa: Journal of the International Institute of African Languages and Cultures

A. Hist.
 Art History

AIA J.
 AIA [American Institute for Architects] Journal [cont. as *Architecture* [USA]]

A. Libs J.
 Art Libraries Journal [prev. pubd as *ARLIS Newslett.*]

A. Mag.
 Arts Magazine [prev. pubd as *Arts* [New York]; *A. Dig.*]

Amat. Photographer
 Amateur Photographer

Amer. A.
 American Art

Amer. A. Annu.
 American Art Annual [cont. as *Amer. A. Dir.*]

Amer. A. & Ant.
 American Art and Antiques

Amer. A. J.
 American Art Journal

Amer. Amat. Photographer
 American Amateur Photographer

Amer. Architect
 American Architect [prev. pubd as *Amer. Architect & Bldg News*; cont. as *Amer. Archtect & Archit. Rev.*; *Amer. Architect*; *Amer. Architect & Archit.*]

Amer. Architect & Bldg News
 American Architect and Building News [see *Amer. Architect*]

Amer. A. Rev.
 American Art Review

Amer. Artist
 American Artist

Amer. Assoc. Archit. Bibliog.: Pap.
 American Association of Architectural Bibliographers. Papers

Amer. Cer.
 American Ceramics

Amer. Cer. Circ. Bull.
 American Ceramic Circle Bulletin

Amer. Colr
 American Collector

Amer. Craft
 American Craft

Amer. Furn.
 American Furniture

Amer. Gdnr Mag.
 American Gardener Magazine

Amer. Her.
 American Heritage

América

Américas

Amer. Ind. A.
 American Indian Art

Amer. Ant.
 American Antiquity: Quarterly Review of American Archaeology [incorp. *Mem. Soc. Amer. Archaeol.*]

Amer. Antiqua. Soc. Proc.
 American Antiquarian Society Proceedings

Amer. Mag. A.
 American Magazine of Art

Amer. Q.
 American Quarterly

Amer. Stud.
 American Studies

Amer. W.
 American West

A. New Eng.
 Art New England

An. Inst. Hort. Fromont
 Annales de l'Institut horticole de Fromont

Anlct. Mag.
 Analectic Magazine

Anlct. Romana Inst. Dan.
 Analecta Romana Instituti Danici

Annu. Rep. LA Plan. Comm.
 Annual Report of the Los Angeles Planning Commission

Ant. Collct.
 Antique Collecting

Ant. Colr
 Antique Collector

Anthony's Phot. Bull.
 Anthony's Photographic Bulletin

Antiquaria

Antiques
 Magazine Antiques

Anu. Estud. Amer.
 Anuario de estudios americanos

A + U
 A plus U [Architecture and urbanism]

Apollo

Appleton's J.
 Appleton's Journal

A. & Prog.
 Art and Progress

Arbor

Archis

Archit. Dig.
 Architectural Digest

Architect & Bldg News
 Architect and Building News

Architecte

Architect & Engin.
 Architect and Engineer

Architect & Engin. CA
 Architect and Engineer of California

Architects' J.
 Architects' Journal

Archit. Forum
 Architectural Forum

Archit. Hist.
 Architectural History [Society of Architectural Historians of Great Britain]

Archit. Rec.
 Architectural Record

Archit. Viv.
 L'Architecture vivante

Archvs Amer. A. J.
 Archives of American Art Journal

Arizona & W.
 Arizona and the West

ARTnews

A. Stud.
 Art Studies

A. Textrina
 Ars textrina

Athanor

Atlantic Mthly
 Atlantic Monthly: Devoted to Literature, Art and Politics

A. VA
 Arts in Virginia

Artweek

Baltimore Annu.
 Baltimore Annual

Bldg & Engin. J.
 Building and Engineering Journal

Brickbuilder

Brit. J. Phot.
 British Journal of Photography

Broadway J.
 Broadway Journal

Brooklyn Mus. Annu.
 Brooklyn Museum Annual

Browning Inst. Stud.
Browning Institute Studies
Brush & Pencil
Brush and Pencil
Bull. Assoc. F.A. Yale U.
Bulletin of the Associates in Fine Arts at Yale University
Bull. Assoc. Preserv. Technol.
Bulletin of the Association for Preservation Technology
Bull. Cleveland Mus. A.
Bulletin of the Cleveland Museum of Art
Bull. D
Bulletin D
Bull. Detroit Inst. A.
Bulletin of the Detroit Institute of Arts
Bull. GA Mus. A.
Bulletin of the Georgia Museum of Art
Bull. Met.
Bulletin of the Metropolitan Museum of Art
Bull. Mus. A., RI Sch. Des.
Bulletin of the Museum of Art, Rhode Island School of Design
Bull. NY Pub. Lib.
Bulletin of the New York Public Library
Bull. Pewter Colrs' Club America
Bulletin of the Pewter Collectors' Club of America
Bull.: Philadelphia Mus. A.
Bulletin: Philadelphia Museum of Art [prev. pubd as *Philadelphia Mus. A.: Bull.*; *PA Mus. Bull.*]
Bull. Rijksmus.
Bulletin van het Rijksmuseum
Burl. Mag.
Burlington Magazine
CA Hist. Soc. Q.
California Historical Society Quarterly
CA Mag.
California's Magazine
Camera
Cam. Notes
Camera Notes: Official Organ of the Camera Club of New York
Cam. Work
Camera Work
Can. A.
Canadian Art [cont. as *A. Canada*]
Cathedra
Centen. Rev.
Centennial Review
Center
C. Illus.
Century Illustrated [prev. pubd as *Scribner's Monthly*; cont. as *C. Monthly Mag.*]
Civ. Engin. & Architect's J.
Civil Engineer and Architect's Journal
C. Mag.
Century Magazine [prev. pubd as *C. Monthly Mag.*]
Coll. A. J.
College Art Journal [prev. pubd as *Parnassus*; cont. as *A.J.* [New York]]

Collier's
Colon. Soc. MA
Colonial Society of Massachusetts
Colon. Williamsburg
Colonial Williamsburg: The Journal of the Colonial Williamsburg Foundation
Cols [Columbia, SC]
Collections [Columbia, SC]
Columbia Hist. Soc. Rec.
Columbia Historical Society Records
Comm.
Community
Commentari
Commentary
Confrontation
Conn. A.
Connaissance des arts
Connoisseur
Constr. Hist.
Construction History
Copé
Cosmopolitan A. J.
Cosmopolitan Art Journal
Cosmos
Country Life
Cras
Crayon
CT Hist. Soc. Bull.
Connecticut Historical Society Bulletin
Currier Gal. A. Bull.
Currier Gallery of Art Bulletin
Daguerreian Annu.
Daguerreian Annual
Design
Domus
Drawing
Drexel Lib. Q.
Drexel Library Quarterly
Du
Embroidery
Engin. Rec., Bldg Rec. & Sanitary Engin.
Engineering Record, Building Record and Sanitary Engineer
Fem. Stud.
Feminist Studies
Fenway Court
Fine Woodworking
Flash Point
Flash Point: Journal of the Tile Heritage Foundation
Flk A.
Folk Art
Furn. Hist.
Furniture History
G
Gaz. B.-A.
Gazette des beaux-arts [suppl. is *Chron. A.*]
Gdn Des.
Garden Design
Gdn & Forest
Garden and Forest
Gdn Hist.
Garden History
Global Archit.
GA [Global Architecture]

Global Interiors
Good Furn. Mag.
Good Furniture Magazine
Harper's Bazaar
Harper's Mag.
Harper's Magazine [prev. pubd as *Harper's New Mthly Mag.*; cont. as *Harper's Mthly*]
Harper's Mthly
Harper's Monthly [see *Harper's Mag.*]
Harper's Weekly
Harvard Mthly
Harvard Monthly
Heimatbl. Siegkreises
Heimatblätter des Siegkreises
Heresies
Hist. Archaeol.
Historical Archaeology: The Annual Publication of the Society for Historical Archaeology
Hist. NH
Historical New Hampshire
Hist. Phot.
History of Photography
Hist. Preserv.
Historic Preservation [cont. as *Hist. Preserv. Q. Rep.*; reverts to *Hist. Preserv.*]
Homes & Grounds
Homes and Grounds
Horticulturalist
House Beautiful
House & Gdn
House and Garden
Huntington Lib. Q.
Huntington Library Quarterly
IA: J. Soc. Indust. Archaeol.
IA: Journal of the Society for Industrial Archaeology
IL Soc. Archit. Mthly Bull.
Illinois Society of Architects Monthly Bulletin
Imprint
Infinity
Inland Architect & News Rec.
Inland Architect and News Record
Interior Des.
Interior Design
Interiors
Int. Rev. Afr. Amer. A.
International Review of African American Art
Int. Studio
International Studio
Irish A. Rev.
Irish Arts Review
Ironworker
J. Aesth. & A. Crit.
Journal of Aesthetics and Art Criticism
J. Aesth. Educ.
Journal of Aesthetic Education
J. Amer. Hist.
Journal of American History
J. Amer. Inst. Architects
Journal of the American Institute of Architects
J. Amer. Inst. Conserv.
Journal of the American Institute for Conservation [prev. pubd as

Bull. Amer. Inst. Conserv. Hist. & A. Works]
J. Archit. Educ.
Journal of Architectural Education
J. Archit. & Planning Res.
Journal of Architectural and Planning Research
J. Can. A. Hist.
Journal of Canadian Art History
J. Early S. Dec. A.
Journal of Early Southern Decorative Arts
J. Franklin Inst.
Journal of the Franklin Institute
J. Gdn Hist.
Journal of Garden History
J. Mus. F.A., Boston
Journal of the Museum of Fine Arts, Boston
J. Pre-Raphaelite Stud.
Journal of Pre-Raphaelite Studies [prev. pubd as *Pre-Raphaelite Rev.*]
J. San Diego Hist.
Journal of San Diego History
J. SC Hist. Soc.
Journal of the South Carolina History Society
J. Soc. Archit. Hist.
Journal of the Society of Architectural Historians [prev. pubd as *J. Amer. Soc. Archit. Hist.*]
J. Urban Hist.
Journal of Urban History
J. Walters A.G.
Journal of the Walters Art Gallery
J. Warb. & Court. Inst.
Journal of the Warburg and Courtauld Institutes [prev. pubd as *J. Warb. Inst.*]
Kennedy Q.
Kennedy Quarterly
Krit. Ber.
Kritische Berichte
KY Rev.
Kentucky Review
Ladies Companion
Landscape
Landscape Archit.
Landscape Architecture
L'Art
L'Art: Revue hebdomadaire illustrée
Lib. Trends
Library Trends
Life
Lippincott's Mthly Mag.
Lippincott's Monthly Magazine
Mag. A.
Magazine of Art [incorp. suppl. *RA Illus.* until 1904]
Mag. Amer. Hist.
Magazine of American History
MA Rev.
Massachusetts Review
Master Builders
MD Hist. Mag.
Maryland Historical Magazine
Met. Mus. J.
Metropolitan Museum Journal
Met. Mus. Stud.
Metropolitan Museum Studies

Met. Papers
Metropolitan Papers
MN Hist.
Minnesota History
MO Hist. Rev.
Missouri Historical Review
Monumentum
Mus. J.
Museum Journal
Mus. Stud.
Museum Studies [Art Institute of Chicago]
N. Amer. Rev.
North American Review
NC Hist. Rev.
North Carolina Historical Review
NC Mus. A. Bull.
North Carolina Museum of Art Bulletin
New Criterion
The New Criterion
New England Farmer
New England Mag.
New England Magazine
Newport Hist.
Newport History
Newslett.: NY Landmarks Conserv.
Newsletter: New York Landmarks Conservancy
N. Gaz. & Lit. Register
National Gazette and Literary Register
19th C [New York]
Nineteenth Century [Victorian Society of America, NY]
19th C. Stud.
Nineteenth Century Studies
Nottingham Fr. Stud.
Nottingham French Studies
NY Herald
New York Herald
NY Hist. Soc. Q.
New York Historical Society Quarterly
NY Times
New York Times
Old Prt Shop Port.
Old Print Shop Portfolio
Oxford A. J.
Oxford Art Journal
PA Hist.
Pennsylvania History
PA Mag. Hist. & Biog.
Pennsylvania Magazine of History and Biography
Pencil Points
Perspecta
Persp. USA
Perspectives USA
Philos. Rev.
Philosophical Review
Phot. Hist.
Photographic Historian
Phot. J.
Photographic Journal

Phot. Mosaics
Photographic Mosaics
Photo-Era
Places
Porticus
Porticus: The Journal of the Memorial Art Gallery of the University of Rochester
Prairie Sch. Rev.
Prairie School Review
Preserv.
Preservation
Princeton U. Lib. Chron.
Princeton University Library Chronicle
Priv. Lib.
Private Library
Proc. Amer. Antiqua. Soc.
Proceedings of the American Antiquarian Society
Proc. Amer. Inst. Architects
Proceedings of the American Institute of Architects
Proc. MA Hist. Soc.
Proceedings of the Massachusetts Historical Society
Prog. Archit.
Progressive Architecture
Prologue
Prospects
Prt Colr Newslett.
Print Collector's Newsletter
Prt Q.
Print Quarterly
Puck
Puck: A Journalette of Fun
Pué
Punch
Q. J. Lib. Congr.
Quarterly Journal of the Library of Congress
Rec. A. Mus., Princeton U.
Record of the Art Museum, Princeton University
Recens. & Mitt. Bild. Kst
Recensionen und Mitteilungen über bildende Kunst
Register Spencer Mus. A.
Register of the Spencer Museum of Art
Res
Res: Anthropology and Aesthetics
Rev. & Expositor
Review and Expositor
Rhythms
RIBA J.
Royal Institute of British Architects Journal [cont. as J. RIBA; reverts to RIBA J.]
Ric. Stor. A.
Ricerche di storia dell'arte
Roma
Rutgers A. Rev.
Rutgers Art Review

SC Hist. & Geneal. Mag.
South Carolina Historical and Genealogical Magazine [cont. as SC Hist. Mag.]
SC Hist. Mag.
South Carolina Historical Magazine [prev. pubd as SC Hist. & Geneal. Mag.]
Sch. Mines Q.
School of Mines Quarterly
Schweiz. Bauztg
Schweizerische Bauzeitung
Sciences
Scribner's Mag.
Scribner's Magazine [cont. as The Commentator]
Sculp. Rev.
Sculpture Review
Sites & Mnmts
Sites et monuments: Bulletin de la Société pour la protection des paysages et de l'esthétique générale de la France [prev. pubd as Bull. Soc. Prot. Pays. Esthét. Gén. France]
Smithsonian
Smithsonian Stud. Amer. A.
Smithsonian Studies in American Art
Soc. Hist.
Social History
Southern Q.
Southern Quarterly
Southwest A.
Southwest Art
St Louis Pub. Lib. Mthly Bull.
St Louis Public Library Monthly Bulletin
St Nicholas
Strenna Romanisti
Strenna dei romanisti
Stud. A. Educ.
Studies in Art Education
Stud. Conserv.
Studies in Conservation: The Journal of the International Institute for Conservation of Historic and Artistic Works
Stud. Hist.
Studime historike
Stud. Hist. A.
Studies in the History of Art
Studio Int.
Studio International
SW A.
Southwest Art
SW Hist. Q.
Southwestern Historical Quarterly
Tamarind Pap.
Tamarind Papers
Technol. & Cult.
Technology and Culture
Textile Hist.
Textile History

The Architect
The Bellman
The Clarion
The Craftsman
The Critic
The Forum
The Herald
The Outlook
The Studio
The Sun
Times
TN Hist. Q.
Tennessee Historical Quarterly
Touchstone
Town & Country
Town and Country
Trans. Amer. Philos. Soc.
Transactions of the American Philosophical Society
Twice a Year
U. Chicago Mag.
University of Chicago Magazine
US Cath. Mag.
United States Catholic Magazine
Vanity Fair
Wadsworth Atheneum Bull.
Wadsworth Atheneum Bulletin [prev. pubd as Wadsworth Atheneum News Bull.; Wadsworth Atheneum & Morgan Mem. Bull.]
W. Architect
Western Architect
Washington Post
Wendingen
Werk: Schweizer Monatschrift für Architektur, Kunst und künstlerische Gewerbe [merged with Archithese to form Werk-Archithese]
Wesleyan U. Alumnus
Wesleyan University Alumnus
William & Mary Q.
William and Mary Quarterly
Winterthur Port.
Winterthur Portfolio
Woman's A. J.
Woman's Art Journal
Women's Stud.
Women's Studies
Worcester A. Mus. Bull.
Worcester Art Museum Bulletin
Worcester A. Mus. J.
Worcester Art Museum Journal
Word & Image
World's Work
Yale U. Lib. Gaz.
Yale University Library Gazette
Z
Z. Kstgesch.
Zeitschrift für Kunstgeschichte [merger of Z. Bild. Kst with Repert. Kstwiss. & with Jb. Kstwiss.]

Appendix C

LISTS OF STANDARD REFERENCE BOOKS AND SERIES

LIST A

This list contains, in alphabetical order, the abbreviations used in bibliographies for alphabetically arranged dictionaries and encyclopedias. Some dictionaries and general works, especially dictionaries of national biography, are reduced to the initial letters of the italicized title (e.g. DAB) and others to the author/editor's name (e.g. Thieme-Becker) or an abbreviated form of the title (e.g. Macmillan Enc. Archit.). Abbreviations from List A are cited at the beginning of bibliographies or bibliographical subsections, in alphabetical order, separated by semi-colons; the title of the article in such reference books is cited only if the spelling or form of the name differs from that used in this dictionary or if the reader is being referred to a different subject.

Contemp. Architects
 M. Emanuel, ed.: *Contemporary Architects* (London, 1980, rev. 1986)
DAB
 Dictionary of American Biography (New York, 1928–)
Forrer
 L. Forrer: *Biographical Dictionary of Medallists*, 8 vols (London, 1902–30)

LK
 Lexikon der Kunst: Architektur, bildende Kunst, angewandte Kunst, Industrieformgestaltung, Kunsttheorie (Leipzig, 1968–)
Macmillan Enc. Archit.
 A. K. Placzek, ed.: *Macmillan Encyclopedia of Architects*, 4 vols (New York, 1982)

Thieme–Becker
 U. Thieme and F. Becker, eds: *Allgemeines Lexikon der bildenden Künstler von der Antike bis zur Gegenwart*, 37 vols (Leipzig, 1907–50) [see also Meissner above]
Withey
 H. F. Withey and E. R. Withey: *Biographical Dictionary of American Architects* (Los Angeles, 1956/R 1970)

Series List

This list comprises the abbreviations used in this encyclopedia for publisher's series; they are arranged in alphabetical order by title. Series titles appear in bibliographical citations in roman, immediately before the publication details.

LIST B

Global Archit.
 Global Architecture
Gt Amer. Architect Ser.
 Great American Architect series

Pelican Hist. A.
 Pelican History of Art
Stud. Hist. A.
 Studies in the History of Art

Appendix D

Early America Contributor List

Adair, William B.
Adams, Henry
Adams, Janet
Adelson, Fred B.
Affleck, Diane L. Fagan
Alberts, Robert C.
Alexander, Drury B.
Alexander, Robert L.
Anderson, Nancy
Anderson, Paul L.
Anderson, Ross C.
Anderson, Stanford
Attwood, Philip
Bacon, Mardges
Baker, Paul R.
Banham, Reyner
Barnhill, Georgia Brady
Barratt, Carrie Rebora
Baur, John I. H.
Beiswanger, William L.
Bermingham, Peter
Betterton, Shiela
Beveridge, Charles E.
Bidner, J. Heinritz
Bjelajac, David
Blaugrund, Annette
Bohan, Ruth L.
Bolger, Doreen
Bolton Smith, Robin
Bonomi, Kathryn
Boyle, Richard J.
Broderick, Mosette Glaser
Brown, Elizabeth Mills
Bryan, John Morrill
Bryant, Edward
Burness, Edwina
Burns, Sarah
Burnside, Kathleen M.
Carr, Carolyn Kinder
Chambers, Bruce W.
Champlin, Richard L.
Chase, David
Christensen, E. A.
Christian, Mary
Christman, Margaret C. S.
Clark, Carol
Clark, H. Nichols B.
Coe, Brian
Cohen, Jeffrey A.
Cohen, Michele
Condit, Carl W.
Conkelton, Sheryl
Cooke, James C.
Cooledge jr, Harold N.
Cooper, Helen A.
Corbin, Donna
Cosentino, Andrew J.
Craig, Robert M.
Crawford, Alan
Crum, Roger J.
Cummings, Kathleen Roy
Dejardin, Fiona

De Medeiros, Melissa
Denker, Ellen Paul
Dimmick, Lauretta
Dinesen, Betzy
Dolkart, Andrew Scott
Doud, Richard K.
Downs, Arthur Channing
Dreiss, Joseph G.
Driscoll, John
Eaton, Leonard K.
Eccleshall, Julian A.
Edwards, Lee M.
Efland, Arthur D.
Ehrenkranz, Anne
Ehrlich, George
Elstein, Rochelle Berger
Ennis, Robert B.
Fabian, Monroe H.
Fahlman, Betsy
Fairbanks, Jonathan L.
Falino, Jeannine
Fenske, Gail
Fidell-Beaufort, Madeleine
Fitzgerald, Oscar P.
Fleischer, Roland E.
Floyd, Margaret Henderson
Follett, Jean A.
Fort, Ilene Susan
Fox, Gretchen G.
Foxley, W. C.
Frank, Samuel Berkman
Gallaghe, Shana
Garvan, Beatrice B.
Gary, Abigail Schade
Gayle, Carol
Gayle, Margot
Gebhard, David
Giese, Lucretia H.
Glenn, Constance W.
Gordon, Ethelyn Adina
Gordon, Stephen C.
Goss, Peter L.
Gournay, Isabelle
Greenhous, Wendy
Greenthal, Kathryn
Greiff, Constance M.
Groseclose, Barbara
Gurney, George
Halkerston, Merrill
Harker, Margaret
Harley jr, R. L.
Harlow, Ann
Harris, C. M.
Harvey, Eleanor Jones
Harvey, Jacqueline Colliss
Hassler, Donna J.
Headley, Janet A.
Heath, Kingston Wm.
Heiner, Leslie
Heinz, Bernard
Heisner, Beverly
Hendricks, William L.

Henry, Jay C.
Hildebrand, Grant
Hogg, Ian V.
Holden, Wheaton A.
Hopkins, Henry T.
Hull, Judith S.
Jaffe, Irma B.
Janson, Anthony F.
Jensen, Carole A.
Jervis, Simon
Johannesen, Eric
Johns, Elizabeth
Johnson, Dale T.
Johnston, Norman J.
Johnston, Sona K.
Johnston, William R
Jones, Malcolm
Junker, Patricia
Kamerling, Bruce
Karlstrom, Paul J.
Kaufman, Peter S.
Kelly, Franklin
Kendall, M. Sue
Ketner II, Joseph D.
Kirkham, Pat
Kirwin, L.
Kornhauser, Elizabeth
Mankin
Kornwolf, James D.
Kovinick, Phil
Kruty, Paul
Landau, Sarah Bradford
Lawson, Karol Ann Peard
Leavitt, Thomas W.
Lee, Ann McKeighan
Lee, Antoinette J.
Lewis, Douglas
Lindsay, Kenneth C.
Lipton, Leah
Little, Nancy C.
Llewellyn, Briony
Longstreth, Richard
Loth, Calder
Macdonald, Margaret F.
Mackay, Robert B.
Malloy, Nancy
Mandel, Patricia C. F.
Mann, Maybelle
Marstine, Janet
Martin, Constance
Martinson, Tom
Mathews, Nancy Mowll
Mawer, John
Maycock, Susan E.
Mayer, Harold M.
McMath, George A.
McPeck, Eleanor M.
Meixner, Laura L.
Metcalf, Pauline C.
Meyers, Amy
Meyers, Amy R. W.
Michaels, Barbara L. Garvan

Michels, Eileen
Miles, Ellen G.
Miller, Angela L.
Miller, Lillian B.
Mills, Sally
Monod-Fontaine, Isabelle
Montêquin, François-Auguste de
Morand, Anne R.
Morgan, H. Wayne
Morgan, Keith N.
Morgan, William
Moser, Charlotte
Moure, Nancy Dustin Wall
Mühlberger, Richard C.
Murphy, Francis
Murphy, Kevin D.
Myers, Denys Peter
Myers, John Walker
Neiswander, Judith A.
Nichols, Frederick D.
Nygren, Edward J.
Nylander, Richard C.
Ochsner, Jeffrey Karl
Olpin, Robert S.
Onorato, Ronald J.
Ormond, Richard
Osborne, C. M.
Palumbo, Anne Cannon
Patrick, Darryl
Patterson, Daniel W.
Pepper, Simon
Perry, Regenia A.
Pile, John F.
Pitts, Terence
Poesch, Jessie
Preston, Harley
Prown, Jules David
Quinan, Jack
Ramirez, Jan Seidler
Randall, Lilian M. C.
Rattner, Selma
Reaves, Wendy Wick
Reed, Cleota
Reed, Roger G.
Reynolds, Gary A.
Robinson, Jenefer
Robinson, Willard B.
Robson, A. Deirdre
Romer, Grant B.
Rosenblum, Naomi
Rote, Carey
Roth, Leland M.
Rubinstein, Charlotte Streifer
Saunders, Richard H.
Schaaf, L. J.
Schiller, Joyce K.
Schlereth, Thomas J.
Schless, Nancy Halverson
Schwartz, Marvin D.
Scott, Gibson Sarah
Seiberling, Grace

Semowich, Charles J.
Shand-Tucci, Douglass
Shank, Wesley I.
Shettleworth jr, Earle G.
Sill, Gertrude Grace
Simmons, Linda Crocker
Simpson, Marc
Smith, Julia H. M.
Smith, Mary Ann
Smith, Walter
Snadon, Patrick A.
Sokol, David M.
Somervell, K.
Soria, Regina
Spillman, Jane Shadel
Sprague, Paul E.
Staiti, Paul J.
Steinberg, David
Stern, Jean
Stewart, Robert G.
Stillman, Damie
Suffield, Laura
Sullivan, Mark W.
Talbot, William S.
Tappert, Tara L.
Tatham, David
Tepter, Diane
Thomas, Christopher A.
Thomas, George E.
Thorpe, Stephen F.
Tintner, Adeline
Toker, Franklin
Tolles jr, Bryant F.
Tomlinson, Juliette
Uggla, Marianne
Usherwood, Paul
Van Hook, Bailey
Van Zanten, David
Wallach, Alan
Ward, Gerald W. R.
Ward, J. P.
Warren, Lynne
Watkin, David
Webster, J. Carson
Weidman, Jeffrey
Weidner, Ruth Irwin
Weitzenkorn, Laurie
Whiffen, Marcus
Willis, Alfred
Wilson, Richard Guy
Wilson, Samuel jr
Wodehouse, Lawrence
Wolanin, Barbara Ann Boese
Woodward, W. Mckenzie
Yao, Winberta M.
Yoshiki-Kovinick, Marian
Zilczer, Judith
Zimmer, Edward F.
Zrebiec, A. M.

Index

This index comprises a selective listing of references in the *Encyclopedia of American Art before 1914*. It has been compiled to be useful and accessible, enabling readers to locate both general and highly specific information quickly and easily. Colour plate references appear as large roman numerals. The index contains cross-references to direct the reader from various spellings of a word or from similar terms; an arrow (→) indicates that the term is to be found under a sub-heading following the main entry; for example, for the cross-reference.